International Dictionary of Art and Artists

ARTISTS

International Dictionary of Art and Artists

ART
ARTISTS

International Dictionary of Art and Artists

ARTISTS

With a foreword by
Cecil Gould

Editor
James Vinson

ST. JAMES PRESS

AN IMPRINT OF GALE

Detroit • New York • Toronto • London

ST. JAMES PRESS
645 Griswold, Suite 835
Detroit, MI 48226

British Library Cataloguing in Publication Data
International dictionary of Art and Artists.
 1. Visual Arts
 I. Vinson, James
 700

ISBN 1-55862-000-1

10 9 8 7 6 5 4 3 2

CONTENTS

FOREWORD

I have been asked to write a short foreword to this new *International Dictionary of Art and Artists*, to explain its novelties in its arrangement and presentation.

It is arranged in two volumes. The first, *Artists*, lists in alphabetical order the most important artists from the 13th to the 20th centuries (from Cimabue to Hockney). But in place of a "life and works" article in the style of other art encyclopedias, the *International Dictionary of Art and Artists* presents the work in four parts.

The first records the essential facts in the artist's career. The second lists the most important public and private collections of his work. Third is a bibliography, titles and dates of publication of books and articles – sometimes amounting to more than 50 items – on the subject of the artist; as well, where applicable, his own writings are listed. Lastly, there is a critical essay of up to 2,000 words which discusses historical and critical aspects of his art.

The other volume, *Art*, discusses some 500 individual works of art, arranged in roughly chronological order. In some cases the work is the artist's acknowledged masterpiece, in others a representative production. In some ways, this volume functions as an extended catalogue of the ideal art gallery.

Since the writer of each critical essay is given a free hand to express his views, there are variations in the approach and style of the results.

It is hoped that the arrangements of the material and the freedom given the essayists will make for an avoidance of monotony and will help to throw new light on the artists and their work.

CECIL GOULD

EDITOR'S NOTE

The selection of artists and art works in the two volumes of the *International Dictionary of Art and Artists* is based on comments by the contributors, listed on page xi. In addition, valuable advice has been given by a number of other critics and scholars, including Brian Allen, Alexandra Comini, Creighton Gilbert, Ronald Lightbown, Linda Murray, Colin Naylor, and Peter Selz. Special thanks are due to Henry Adams, Reidar Dittmann, Laurinda Dixon, Cecil Gould, Annie-Paule Quinsac, Guilhem Scherf, Ruth Wilkins Sullivan, and Christopher Wright.

The entry for each artist consists of a short biography, a list of collections/locations where works can be seen, a list of books and articles on the artist (as well as books and articles *by* the artist, where applicable), and a signed critical essay.

Collections are listed alphabetically by city (though the Royal Collection is generally listed last). Abbreviations are avoided, but one exception is the abbreviation "cat", indicating an exhibition catalogue. Revised or expanded editions of books are indicated by the addition of a second date at the end of the entry.

We would like to thank the contributors for their cooperation and patience in helping us compile the *Dictionary*.

CONTRIBUTORS

Ackerman, Gerald M.
Acres, Alfred J.
Adams, Henry
Ahl, Diane Cole
Azuela, Alicia
Balakier, Ann Stewart
Barrett, Elizabeth
Bazarov, Konstantin
Benge, Glenn F.
Bergstein, Mary
Bird, Alan
Bisanz, Rudolf M.
Bock, Catherine C.
Boström, Antonia
Bourdon, David
Bradley, Simon
Bremser, Sarah H.
Brown, M.R.
Burnham, Patricia M.
Campbell, Malcolm
Caplow, Harriet McNeal
Cavaliere, Barbara
Caygill, Caroline
Chappell, Miles L.
Cheney, Liana
Chevalier, Tracy
Clegg, Elizabeth
Cohen, David
Collins, Howard
Cossa, Frank
Crellin, David
Crelly, William R.
Croydon, Abigail
Davidson, Abraham A.
Davidson, Jane P.
Dittmann, Reidar
Dixon, Annette
Dixon, Laurinda S.
Dodge, Barbara
Downs, Linda
Edmond, Mary
Eustace, Katharine
Evans, Magdalen
Evelyn, Peta
Faxon, Alicia
Florence, Penny
Foskett, Daphne
Gale, Matthew
Galis, Diana
Garlick, Kenneth
Gash, John
Gauk-Roger, Nigel
Gibson, Jennifer
Glenn, Constance W.
Goldfarb, Hilliard T.
Gould, Cecil
Green, Caroline V.
Greene, David B.
Griffin, Randall C.

Grunenberg, Christoph
Gully, Anthony Lacy
Habel, Dorothy Metzner
Hancock, Simon
Harper, Paula
Heath, Samuel K.
Heffner, David
Hirsh, Sharon
Holloway, John H.
Howard, Seymour
Hulsker, Jan
Hults, Linda C.
Hutchison, Jane Campbell
Jachec, Nancy
Jacobs, Fredrika H.
Jeffett, William
Jenkins, Susan
Kahr, Madlyn Millner
Kaplan, Julius D.
Kapos, Martha
Kaufman, Susan Harrison
Kenworthy-Browne, John
Kidson, Alex
Kind, Joshua
Kowal, David Martin
Lago, Mary
Landers, L.A.
Larsson, Lars Olof
Lawrence, Cynthia
Lesko, Diane
Levin, Gail
Levy, Mark
Liedtke, Walter A.
Lister, Raymond
Lothrop, Patricia Dooley
Mack, Charles R.
Mackie, David
Mainzer, Claudette R.
Maller, Jane Nash
Manca, Joseph
Massi, Norberto
Matteson, Lynn R.
Mattison, Robert Saltonstall
McCullagh, Janice
McGreevy, Linda F.
McKenzie, A. Dean
Milkovich, Micheal
Miller, Lillian B.
Miller, Naomi
Mills, Roger
Milner, Frank
Minor, Vernon Hyde
Minott, Charles I.
Mitchell, Timothy F.
Moffitt, John F.
Morris, Susan
Moskowitz, Anita F.
Murdoch, Tessa
Nelson, Kristi

North, Percy
Nuttall, Paula
Olson, Roberta J.M.
Oppler, Ellen C.
Overy, Paul
Palmer, Deborah
Parker, Stephen Jan
Parry, Ellwood C. III
Parshall, Peter W.
Partridge, Loren
Pelzel, Thomas
Peters, Carol T.
Piperger, Justin
Pomeroy, Ralph
Powell, Cecilia
Powell, Kirsten H.
Pressly, William L.
Quinsac, Annie-Paule
Radke, Gary M.
Rajnai, Miklos
Rand, Olan A., Jr
Reynolds, Lauretta
Riede, David G.
Robinson, Susan Barnes
Roworth, Wendy Wassyng
Ruda, Jeffrey
Russo, Kathleen
Scherf, Guilhem
Schneider, Laurie
Scott, David
Scribner, Charles III
Shaw, Lindsey Bridget

Shesgreen, Sean
Shikes, Ralph E.
Slayman, James H.
Smith, David R.
Sobré, Judith Berg
Spike, John T.
Stallabrass, Julian
Standring, Timothy J.
Stevenson, Lesley
Stratton, Suzanne L.
Sullivan, Ruth Wilkins
Sullivan, Scott A.
Surtees, Virginia
Teviotdale, E.C.
Thompson, Elspeth
Tomlinson, Janis A.
Tufts, Eleanor
Verdon, Timothy
Walder, Rupert
Walsh, George
Wanklyn, George A.
Wechsler, Judith
Weil, John A.
Weiland, Jeanne E.
Wells, William
West, Shearer
Whittet, G.S.
Wolk-Simon, Linda
Woods-Marsden, Joanna
Wright, Christopher
Zilczer, Judith

International Dictionary of Art and Artists

ARTISTS

Niccolò dell'Abbate
Pieter Aertsen
Alessandro Algardi
Albrecht Altdorfer
Bartolommeo Ammanati
Andrea del Castagno
Andrea del Sarto
Fra Angelico
Antonella da Messina
Karel Appel
Alexander Archipenko
Hans Arp

Francis Bacon
Hans Baldung
Giacomo Balla
Ernst Barlach
James Barry
Fra Bartolommeo
Antoine-Louis Barye
Evaristo Baschenis
Jacopo Bassano
Pompeo Batoni
Domenico Beccafumi
Max Beckmann
Gentile Bellini
Giovanni Bellini
Jacopo Bellini
George Bellows
Benedetto da Maiano
Thomas Hart Benton
Nicolaes Berchem
Gerrit Berckheyde
Bartolomé Bermejo
Gian Lorenzo Bernini
Alonso Berruguete
Pedro Berruguete
Master Bertram
Albert Bierstadt
George Calab Bingham
William Blake
Umberto Boccioni
Arnold Böcklin
Rosa Bonheur
Richard Parkes Bonington
Pierre Bonnard
Hieronymous Bosch
Ambrosius Bosschaert
Botticelli
Edmé Bouchardon
François Boucher
Eugène Boudin
Dirk Bouts
Constantin Brancusi
Georges Braque
Melchior Broderlam
Agnolo Bronzino
Adriaen Brouwer
Ford Madox Brown
Jan Bruegel
Pieter Bruegel

Hans Burgkmair
Edward Burne-Jones
Alexander Calder
Jacques Callot
Robert Campin
Antonio Canaletto
Alonso Cano
Antonio Canova
Caravaggio
Vittore Carpaccio
Carlo Carrà
Annibale Carracci
Rosalba Carriera
Mary Cassatt
Giovanni Benedetto Castiglione
Pietro Cavallini
Benvenuto Cellini
Giacomo Ceruti
Paul Cézanne
Marc Chagall
Philippe de Champaigne
Jean Baptiste Chardin
Petrus Christus
Cima da Conegliano
Cimabue
Claude Lorrain
Clodion
François Clouet
Jean Clouet
Claudio Coello
Thomas Cole
John Constable
Samuel Cooper
John Singleton Copley
Lovis Corinth
Jean Baptiste Camille Corot
Correggio
Francesco del Cossa
John Sell Cotman
Gustave Courbet
Jean Cousin
Antoine Coysevox
John Robert Cozens
Lucas Cranach
Giuseppe Maria Crespi
Carlo Crivelli
John Crome
Aelbert Cuyp

Bernardo Daddi
Johan Christian Dahl
Salvador Dalí
Honoré Daumier
Gerard David
Jacques Louis David
Stuart Davis
Giorgio de Chirico
Edgar Degas
Willem de Kooning
Eugène Delacroix
Robert Delaunay

Paul Delvaux
Charles Demuth
André Derain
Desiderio da Settignano
Nicolas de Staël
Otto Dix
William Dobson
Domenichino
Domenico Veneziano
Donatello
Gustave Doré
Dosso Dossi
Jean Dubuffet
Duccio
Marcel Duchamp
Raymond Duchamp-Villon
Raoul Dufy
Albrecht Dürer

Thomas Eakins
Adam Elsheimer
James Ensor
Jacob Epstein
Max Ernst

Carel Fabritius
Etienne Maurice Falconet
Giovanni Fattori
Lyonel Feininger
Domenico Fetti
John Flaxman
Frans Floris
Jean Fouquet
Jean Honoré Fragonard
Francesco di Giorgio
Master Francke
Caspar David Friedrich
William Powell Frith
Henry Fuseli

Naum Gabo
Agnolo Gaddi
Taddeo Gaddi
Thomas Gainsborough
Paul Gauguin
Giovanni Battista Gaulli
Geertgen tot Sint Jans
Gentile da Fabriano
Artemisia Gentileschi
Orazio Gentileschi
Théodore Géricault
Jean Léon Gérôme
Lorenzo Ghiberti
Ghirlandaio
Alberto Giacometti
Giambologna
Luca Giordano
Giorgione
Giotto
Giovanni da Milano
François Girandon

Thomas Girtin
Giulio Romano
Hendrick Goltzius
Julio Gonzalez
Arshile Gorky
Jan Gossaert
Jean Goujon
Francisco Goya
Jan van Goyen
Benozzo Gozzoli
El Greco
Jean Baptiste Greuze
Juan Gris
George Grosz
Mathis Grünewald
Francesco Guardi
Guercino

Frans Hals
Willem Claesz. Heda
Jan Davidsz. de Heem
Maerten van Heemskerck
Barbara Hepworth
Nicholas Hilliard
Meindert Hobbema
David Hockney
Ferdinand Hodler
Hans Hofmann
William Hogarth
Hans Holbein
Winslow Homer
Gerrit van Honthorst
Pieter de Hooch
Edward Hopper
John Hoppner
John Hoskins
Jean Antoine Houdon
Wolf Huber
Jaume Huguet
William Holman Hunt

Jean Auguste Ingres

Augustus John
Jasper Johns
Johan Barthold Jongkind
Joos van Ghent
Jacob Jordaens
Asger Jorn

Willem Kalf
Wassily Kandinsky
Angelica Kauffmann
Edward Kienholz
Ernst Ludwig Kirchner
Paul Klee
Gustav Klimt
Franz Kline
Max Klinger
Godfrey Kneller

Oskar Kokoschka
Käthe Kollwitz

Giovanni Lanfranco
Georges de La Tour
Thomas Lawrence
Charles Le Brun
Fernand Léger
Wilhelm Leibl
Frederic Leighton
Peter Lely
Louis Le Nain
Leonardo da Vinci
Roy Lichtenstein
Limbourg Brothers
Jacques Lipchitz
Filippino Lippi
Fra Filippo Lippi
Stefan Lochner
Pietro Longhi
Ambrogio Lorenzetti
Pietro Lorenzetti
Lorenzo Monaco
Lorenzo Lotto
Morris Louis
Luca della Robbia
Lucas van Leyden

August Macke
Alessandro Magnasco
René Magritte
Aristide Maillol
Juan Bautista Maino
Lorenzo Maitani
Kasimir Malevich
Edouard Manet
Andrea Mantegna
Franz Marc
Hans von Marées
Marino Marini
Simone Martini
Masaccio
Maso di Banco
Masolino da Panicale
André Masson
Quentin Massys
Master of the Housebook
Henri Matisse
Guido Mazzoni
Luis Meléndez
Melozzo da Forli
Hans Memling
Anton Raphael Mengs
Adolph von Menzel
Gabriel Metsu
Michelangelo
Michelozzo
John Everett Millais
Jean-François Millet
Joan Miró
Paula Modersohn-Becker

Amedeo Modigliani
Piet Mondrian
Claude Monet
Henry Moore
Anthonis Mor
Giorgio Morandi
Gustave Moreau
Berthe Morisot
Lukas Moser
Robert Motherwell
Hans Multscher
Edvard Munch
Bartolomé Estebán Murillo

Nanni di Banco
Barnett Newman
Niccolò dell'Arca
Ben Nicholson
Emil Nolde
Joseph Nollekens

Georgia O'Keeffe
Claes Oldenburg
Isaac Oliver
Orcagna
José Clemente Orozco
Friedrich Overbeck

Michael Pacher
Palma Vecchio
Samuel Palmer
Gian Paolo Pannini
Parmigianino
Victor Pasmore
Joachim Patinir
Charles Willson Peale
Perino del Vaga
Jean Perréal
Perugino
Antoine Pevsner
Giovanni Battista Piazzetta
Francis Picabia
Pablo Picasso
Piero della Francesca
Piero di Cosimo
Pietro da Cortona
Jean-Baptiste Pigalle
Germain Pilon
Pintoricchio
Giovanni Battista Piranesi
Antonio Pisanello
Andrea Pisano
Giovanni Pisano
Nicola Pisano
Camille Pissarro
Antonio Pollaiuolo
Jackson Pollock
Jacopo Pontormo
Pordenone
Nicolas Poussin
Andrea Pozzo

Maurice Prendergast
Mattia Preti
Francesco Primaticcio
Pierre Paul Prud'hon
Pierre Puget
Pierre Puvis de Chavannes

Jacopo della Quercia

Henry Raeburn
Allan Ramsay
Raphael
Robert Rauschenberg
Man Ray
Odilon Redon
Rembrandt
Guido Reni
Pierre Auguste Renoir
Ilya Repin
Joshua Reynolds
Francisco Ribalta
Jusepe de Ribera
Sebastiano Ricci
Tilman Riemanschneider
Diego Rivera
Larry Rivers
Ercole de'Roberti
Auguste Rodin
George Romney
Salvator Rosa
Antonio Rossellino
Bernardo Rossellino
Dante Gabriel Rossetti
Medardo Rosso
Rosso Fiorentino
Mark Rothko
Georges Rouault
Louis François Roubiliac
Henri Rousseau
Théodore Rousseau
Thomas Rowlandson
Peter Paul Rubens
Andrei Rublev
Jacob van Ruisdael
Philipp Otto Runge
Rachel Ruysch
Albert Pinkham Ryder
Michael Rysbrack

Andrea Sacchi
Pieter Saenredam
Francesco Salviati
Juan Sánchez-Cotán
Andrea Sansovino
Jacopo Sansovino
John Singer Sargent
Sassetta
Egon Schiele
Oskar Schlemmer
Martin Schongauer
Kurt Schwitters

Sebastiano del Piombo
Giovanni Segantini
Hercules Seghers
Georges Seurat
Gino Severini
Ben Shahn
Walter Sickert
Luca Signorelli
David Alfaro Siqueiros
Alfred Sisley
John Sloan
Claus Sluter
John Smibert
David Smith
Frans Snyders
Sodoma
Francesco Solimena
Chaim Soutine
Stanley Spencer
Jan Steen
Wilson Steer
Joseph Stella
Viet Stoss
Bernardo Strozzi
Gilbert Stuart
George Stubbs
Graham Sutherland

Rufino Tamayo
Yves Tanguy
Vladimir Tatlin
David Teniers
Gerard ter Borch
Hendrick Terbrugghen
James Thornhill
Bertel Thorvaldsen
Giovanni Battista Tiepolo
Tintoretto
Titian
Mark Tobey
Henri Toulouse-Lautrec
Francesco Traini
John Trumbull
Cosmè Tura
J.M.W. Turner

Paolo Uccello

Juan de Valdés Leal
Willem van de Velde
Hugo van der Goes
Rogier van der Weyden
Anthony Van Dyck
Jan Van Eyck
Vincent Van Gogh
Victor Vasarely
Giorgio Vasari
Diego Velázquez
Jan Vermeer
Paolo Veronese
Andrea del Verrocchio

Elisabeth Vigée-Lebrun
Alessandro Vittoria
Maurice de Vlaminck
Simon Vouet
Adriaen de Vries
Edouard Vuillard

Ferdinand Georg Waldmüller
Andy Warhol
Antoine Watteau
Jan Weenix
Benjamin West

James McNeill Whistler
David Wilkie
Richard Wilson
Emanuel de Witte
Konrad Witz
Michael Wolgemut
Joseph Wright

Ossip Zadkine
Johann Zoffany
Taddeo Zuccaro
Francisco de Zurbarán

ABBATE, Niccolò dell'.

Born in Modena, 1509 or 1512. Died in Fontainebleau or Paris, 1571?. Early career is undocumented; painted frescoes based on the Aeneid for castle at San Scandiano, and in Modena, 1546, and Bologna, 1547; assistant to Primaticcio at Fontainebleau from 1552, and then settled in France.

Major Collection: Florence.
Other Collections: Bologna: Palazzo Torganini and Palazza Poggi (university); Detroit; Dresden; Fontainebleau: Salle de Bal; London; Modena: Museum, Palazzo Publicco; Oxford: Christ Church; Paris; Rome: Borghese; Vienna.

Publications

On ABBATE: books—

Béguin, Sylvie M., *Abbate* (cat), Bologna, 1969.
Mezzetti, Amalia, *Per Abbate: Affreschi restaurati* (cat), Modena, 1970.
Bellochi, Ugo, *Il Mauriziano: Gli affreschi di Abbate nel nido di Ludovico Ariosti,* Modena, 1974.
Godi, Giovanni, *Abbate e la presunta attività del Parmigianino a Soragna,* Parma, 1976.

articles—

Langmuir, Erika, "Abbate at Bologna," in *Burlington Magazine* (London), October 1969.
Langmuir, Erika, "Arma virumque. . . : Abbate's Aeneid Gabinetto for Scandiano," in *Journal of the Warburg and Courtauld Institutes* (London), 39, 1976.
Langmuir, Erika, "Triumvirate of Brutus and Cassius: Abbate's Appian Cycle in the Palazzo Communale Modena," in *Art Bulletin* (New York), June 1977.
Heinz, Günther, "Gedanken zu Bildern der 'Donne Famose' in der Galerie der Erzherzogs Leopold Wilhelm," in *Jahrbuch der Kunsthistorischen Sammlungen in Wien,* 41, 1981.

*

Niccolò dell'Abbate's transformation from a humbly derivative practitioner in an Italian backwater into one of the sophisticated arch-Mannerists of the School of Fontainebleau was as gradual as it was superficially complete; and yet from almost his earliest works his ability to achieve a charming novelty in congenial subjects is evident.

He was first recorded in 1537, contributing to the decoration of a public building in Modena known as the Beccherie. His fresco of *St. Geminianus,* patron of the city (Modena, Galleria Estense) is signed "Abati Nic." (thus disposing of the old theory that his name derived from his later collaboration with Primaticcio, who became an abbé in France); the style of the fresco is a simplistic interpretation of the softness and fluidity of Correggio combined with breadth and unusual lighting of Dosso Dossi. Niccolò also seems to have collaborated with the obscure painter Alberto Fontana on decorative friezes in the Beccherie: the remaining fragments again show the amplitude and eccentric charm of Dosso, charged in the *Musical Party* with Venetian romance and in the *Bacchanal of Putti* with Roman liveliness.

Niccolò's most important early commission was to fresco a room in the castle of the Boiardo family at Scandiano, near Modena (fragments in Modena, Galleria Estense). His scheme included battle scenes in the dado, and large main panels of *Scenes from the Aeneid* set in vast fantastic landscapes of Flemish inspiration, peopled with crowds of small figures and painted in clear bright colours; above were lunettes with more naturalistic landscapes containing allegorical and poetic scenes, while in the vault a crowded ring of members of the Boiardo family peered down, many playing musical instruments. This delightful and festive decoration was certainly naive and not without clumsiness, but its lack of accomplishment was compensated by an equal freshness.

More considered, and more conventional, was his frieze with the *History of the Triumvirate* (1546; Modena, Palazzo Comunale), with Correggesque figures in delicate but prosaic landscapes, between bands of fruit- and flower-garlands.

In 1547 Niccolò obtained the commission for a large altarpiece for the church of SS. Pietro e Paolo, Modena, the *Martyrdom of St. Paul with St. Peter.* This, probably his only major religious work, showed in the lower half a dramatic group of Paul and his executioner imitated from Correggio's *Martyrdom of SS. Placidus and Flavia* (Parma). Peter, kneeling to one side between his guards, gazed at the arched upper half filled with a glory of angel *putti* supporting the Virgin and Child, where the Correggesque elements were overlaid with the elegance of Parmigianino.

The success of his altarpiece led Niccolò to try his luck in Bologna, where he soon received two important commissions for decorative frescoes. In Palazzo Poggi (now the University)

he painted friezes in two rooms which specifically revised the motifs of his and Fontana's work in the Beccherie. One depicted scenes of *Bacchanalian Putti*, both designed and executed with great liveliness and freedom, flanked by fictive scrolls and herms and with elaborate pendant garlands; the other showed groups of *Card-players* and *Musicians,* conceived naturalistically and presented illusionistically, but imbued with a precious grace derived from Parmigianino, distilled through Niccolò's own intimate and playful charm. In Palazzo Torfanini similar figures act out *Scenes from Orlando Furioso* in courtly fashion, in front of delicately fantastic landscapes, surrounded by Michelangelesque nudes and inflated garlands which suggest a knowledge of central Italian Mannerism. Equally clear are the echoes in two imaginary landscapes painted for the Castello Estense in Ferrara (possibly during Niccolò's Modenese period), the *Deer Hunt* and *Landscape with Monsters* (Rome, Borghese), of northern landscape artists like Patinir, Altdorfer, and Bosch, in the dizzyingly high viewpoints and vast distances, the minute and sometimes fantastic details seen with unnatural clarity, and the artificially light tonalities.

These were Niccolò's achievements and influences when he was summoned to France to assist Primaticcio on the decoration of the royal chateau at Fontainebleau in 1552. Most of his work there has been destroyed, but enough evidence remains in drawings and engravings to reconstruct it. His first task was to assist in the execution of Primaticcio's designs for the frescoes of the enormous Salle de Bal, or Galerie Henri II (1552–56; heavily restored and repainted), where he may have contributed to Primaticcio's already growing predilection for the elegantly elongated forms of Parmigianino. Niccolò may also have encouraged the development in the later stages of the ceiling decoration of the immensely long Galerie d'Ulysse (destroyed) towards specifically illusionistic scenes; but these do not seem to have depended on the Correggesque type of effects Niccolò had used at the Rocca di Scandiano more than on those derived from Mantegna and Giulio Romano which Primaticcio had known first-hand in Mantua. It was Primaticcio, too, who certainly knew the Vatican works of Raphael and Perino del Vaga which clearly inspired other aspects of the scheme. Further evidence of Niccolò's dependence on his compatriot is shown by the easel painting of the *Continence of Scipio* (Paris), in which the frigid academic composition controls the grace and originality of the figures.

Niccolò's most characteristic works in France were landscapes. In 1557 he provided four large paintings for the king; two of these have been tentatively identified with his superb landscapes of the *Rape of Persephone* (Paris) and the *Death of Eurydice* (London). They are entirely decorative, and share a silvery tonality which lends to their restricted colour range of pale blue, green, and brown a delicately unreal air. This is compounded by the frankly invented distances in which fantastic cities, mountains, and seas shimmer like mirages. Their theatrical effect is emphasised by the balletic posturing of the elegant figures: mythologies are realised as masques at the French court. Niccolò's naivety is still an underlying force in these inventions; it imposes a sense of dislocation which perversely heightens the poetic artificiality of the result. His Modenese provinciality provides a piquancy which sharpens his acquired sophistication.

—Nigel Gauk-Roger

AERTSEN, Pieter; also called Lange Pier.

Born in Amsterdam, 1509. Died in Amsterdam, 3 June 1575. Married. Studied with Allaert Claesz. in Amsterdam, then with Jan Mandijn, the Flemish painter, at Bossau Castle, Hennegau; lived in Antwerp, 1535–56 (citizen, 1542), then settled in Amsterdam; specialized in kitchen scenes with a Biblical scene in the background: often assisted by his pupil Joachim Beuckelaer.

Collections: Amsterdam; Antwerp; Brussels; Copenhagen; Frankfurt; The Hague; Rotterdam; Stockholm; Uppsala: University Museum; Vienna; Warsaw.

Publications

On AERTSEN: books—

Sievers, Johannes, *Aertsen,* Leipzig, 1908.
Moxey, Keith P. F., *Aertsen, Joachim Beucklaer, and the Rise of Secular Painting in the Context of the Reformation,* New York, 1977.

articles—

Genaille, Robert, "L'Oeuvre de Aertsen," in *Gazette des Beaux-Arts* (Paris), 44, 1954.
Bruyn, J., "Some Drawings of Aertsen," in *Master Drawings* (New York), 3, 1965.
Havekamp-Begemann, Egbert, "Aertsen, not Beccafumi," in *Master Drawings,* (New York), 4, 1966.
Genaille, Robert, "D'Aertsen à Snyders: Manierisme et baroque," in *Bulletine des Musées Royaux des Beaux-Arts de Belgique* (Brussels), 6, 1967.
Kreidl, Detlev, "Die religiöse Malerei Aertsen als Grundlage seiner künstlerischen Entwicklung," in *Jahrbuch des Kunsthistorische Sammlungen in Wien,* 67, 1972.
Grosjean, A., "Toward an Interpretation of Aertsen's Profane Iconography," in *Konsthistorisk Tidskrift* (Stockholm), 43, 1974.
Genaille, Robert, "Aertsen, Précurseur de l'art Rubénien," in *Jaarboek van het Kininklijk Museum voor Schone Kunsten Antwerpen,* 17, 1977.
Irmscher, Giinter, "Ministrae voluptatum: Stoicizing Ethics in the Market and Kitchen Scenes of Aertsen and Beuckelaer," in *Simiolus* (Utrecht), 16, 1986.

*

Pieter Aertsen is now seen as the only contemporary of Pieter Bruegel the Elder able to be compared with his universality and invention. Although both were among the first to work with native and peasant themes, Aertsen moved his figures to the frontal plane, unlike Bruegel's smaller figures and panoramic landscape settings; and unlike the thinly brushed paint and even archaic look, deliberately contrived, in Bruegel's work, Aertsen's freer, self-conscious brushwork carries almost a Venetian look which might even anticipate Rubens's mature facture. As well, Aertsen's modelling on robust and massive figures has come to be labelled "Romanist," that is, derivable

ultimately from a tradition established in the Netherlands during the 1520-40 period—the predilection for Italiante, essentially sculptural models.

Such formal bruvura was then the basis of his exploration of older Netherlandish treatment of genre images featuring peopled kitchens, with peasants, and markets in which still-life elements such as foodstuff, fowl, fish, and meat, come to occupy more and more importance and interest. The Flemish 17th-century Baroque still life, dynamic and even dramatic, as in Snyders and Fyt, found only infrequently in Holland, developed from Aertsen's pictures such as *Market Stallholder*, 1567 (Berlin). Through the import of such work into Italy, where it was reflected and developed in paintings by Bartolomeo Passarotti and Vincenzo Campi, and then further exported to Spain at the end of 16th century to become the source of the *bodegone*, Aertsen's larger part in the diffusion of a still-life, genre-based art in Europe is very compelling. As well, his approach was adopted, both in technique and narrative intent, by his pupil and nephew Joachim Beuckelaer during a short but influential career.

Aertsen is also associated with the beginnings of a non-traditional religious image, at times called "secular/religious," in which the accessory still-life elements, traditionally accompanying religious narrative scenes, are placed in the forward plane and the religious narrative appears, proportionally small and at times painted in grisaille, at the rear of the pictorial stage. The earliest known is from 1551, the vivid *Butcher's Stall* (Uppsala, University College), where the *Flight into Egypt* is seen through the hanging meat display of the foreground. These images have also come to be labelled "inverted still life," partially to account simply for the reversal of a traditional arrangement; but the term is also an attempt to categorize the Mannerist atmosphere of the moment, with its turn towards seeming ambiguity and its resultant heightened tension, perhaps as a means to cope with and even tacitly represent the epoch's psychic turmoil. Such pictures still survive in fair number and apparently were popular in the time of their creation. Explanation of these images would link them with the long Netherlandish tradition of hidden or "disguised" symbolism: the foreground display of material goods, whether food and drink, or luxurious materiality, can be taken as more than a simple foil for the spiritual force emmanating, fragile and transient, from the rear space. For instance, in *The Butcher's Stall*, a sign in the upper right corner offers a farmland for sale, with the specific indication that portions "at one's needs" are available; thus gluttony and the world's lust, seen in the foreground meats, as well in banquets at the rear where the aphrodisiac mussel is in evidence, are contradicted by the offering of the "spiritual food" of Salvation and Christ, also symbolized by such Eucharist emblems as the wine and pretzels displayed nearby.

Although a serious artist, Aertsen is non-critical and so outward moralization is rare in his work. Only, for example, in *The Still Life with Christ in the House of Mary and Martha*, 1552 (Vienna), does a literal inscription (in Dutch) occur— "Mary hath chosen the better part"—to point out the event's significance and its possible pairing with the still life of the foreground. Still another version of this theme, in Rotterdam, 1553, presents a grand summation of this secular/religious theme. With the scene of Christ in the house of Mary and Martha in the background, an acknowledgement of 16th-century humanist culture in the Netherlands is given by a Serlio-derived classical facade just behind the figures. In the foreground, along with an elaborate and symbolic still life with flowers and comestibles, one group of figures presents, on the right, the Apostles who accompanied Christ and have fallen under the spell of gluttony, drunkenness, and lust as they dally with servant women; at the left are shown the dispensers of the foodstuff.

Unlike the presentation of peasants, there had been no tradition in the visual arts for such singular display of still life, especially foodstuff. Partially fueled by a contemporary Dutch writer's description of Aertsen as a second Piraikos, an ancient still-life painter mentioned by Pliny the Elder, critics have searched for an antique literary source for Aertsen's use of such food dispensers or sellers. Even such genre-seeming situations as found in the foreground of an "inverted still life" such as *The Christ in the House of Mary and Martha* become an aspect of Christian moralization. Records speak of Aertsen's major altarpieces, such as *The Crucifixion Tryptych*, 1546, (Antwerp), now mostly lost, victim to the Iconoclasm of 1566 and other Reformation violence. Although only one document refers to the artist's religious outlook—it is his burial in the Catholic Oudekerk in Amsterdam—seemingly much of his production was traditional devotional material, and poignant contemporary accounts relay to us Aertsen's great distress at its destruction.

—Joshua Kind

ALBERS, Josef.

Born in Bottrop, Germany, 19 March 1888; naturalized United States citizen, 1939. Died in Orange, Connecticut, 24 March 1976. Married Anni Fleischmann, 1925. Attended Teachers College, Buren, 1905-08; Königliche Kunstschule, Berlin, 1913-15, qualified as art teacher, 1915; Kunstgewerbeschule, Essen, 1916-19; Kunstakademie, Munich, 1919-20; Bauhaus, Weimar, 1920-23; taught in public schools, Bottrop, 1908-19; developed glass paintings, and organized stained glass workshop at the Bauhaus, 1922, then became lecturer at the Bauhaus, in Weimar, then in Dessau and Berlin, 1923-33; emigrated to the United States, 1933, and taught at Black Mountain College, North Carolina, 1933-49, and Yale University, New Haven, 1950-60.

Collections/Locations: Amsterdam: Stedelijk; Basel; Cambridge, Massachusetts; Darmstadt: Bauhaus Archiv; New York: Guggenheim, Metropolitan, Moma, Time-Life Building; Paris: Beaubourg; Stockholm: Moderna Museet; Vienna: Museum des 20. Jahrhunderts; Zurich.

PUBLICATIONS

By ALBERS: books—

Interaction of Color. New Haven, 1963.
Poems and Drawings, New Haven, 1958; New York, 1961.

Despite Straight Lines, New Haven, 1961, 1977.
Search Versus Re-Search: Three Lectures, New Haven, 1969.
Formulation, Articulation, New York, 1972.

On ALBERS: books—

Bayer, Herbert, and Ilse Gropius, *Bauhaus 1919–28,* New York, 1938.
Hamilton, G. H., *Albers: Paintings, Prints, Projects* (cat), New Haven, 1956.
Schreyer, Lothar, *Erinnerungen an Sturm und Bauhaus,* Munich, 1956.
Bucher, François, *Albers: Despite Straight Lines: An Analysis of His Graphic Constructions,* New Haven, 1961, 1977.
McShine, K., *Albers: Homage to the Square* (cat), New York, 1964.
Albers: The American Years (cat), Washington, 1965.
Gomringer, Eugen, *Albers: Das Werk des Malers und Bauhausmeisters als Beitrag zur visuallen Gestaltung im 20. Jahrhunderts,* Starnberg, 1968, 1971; as *Albers: His Work as Contribution to Visual Articulation in the Twentieth Century,* New York, 1968.
Wissmann, Jürgen, ed., *Albers* (cat), Münster, 1968.
Wingler, Hans Maria, *The Bauhaus: Weimar, Dessau, Berlin, Chicago,* Cambridge, Massachusetts, 1969.
Borovicka, Jaroslav, *Albers* (cat), Dusseldorf, 1970.
Spies, Werner, *Albers,* Stuttgart and New York, 1970; London, 1971.
Wissmann, Jürgen, *Albers in Landesmuseum Münster,* Munster, 1971.
Wissmann, Jürgen, *Albers: Murals in New York,* Stuttgart, 1971.
Wissmann, Jürgen, *Albers,* Recklinghausen, 1971.
Albers In the Metropolitan Museum of Art (cat), New York, 1971.
Miller, Jo, *Albers: Prints 1915–1970* (cat), New York, 1973.
Wissmann, Jürgen, et al., *Albers* (cat), New Haven, 1978.
Weber, Nicholas Fox, *The Drawings of Albers,* New Haven, 1984.
Benezra, Neal D., *The Murals and Sculpture of Albers,* New York, 1985.
Bucher, François, *Albers* (cat), Cologne, 1986.
Feeney, Kelly, *Albers* (cat), New York, 1986.
Weber, Nicholas Fox, *Albers: A Retrospective* (cat), New York, 1988.

*

The works of Josef Albers span much of the 20th century and, although seminal in generating considerable similar output by others, bear unmistakably the stamp of his strong individuality. They are part of his evolving quest for simplicity and understanding. His practical background as the son of a Westphalian furniture manufacturer gave him experience with wood, glass and other construction materials. Indeed, among his numerous interests during his early Bauhaus years was furniture design, where woodgrain and natural whorled patterns were (frustratingly?) bounded and constrained by simple rectangular shapes. His pieces feature studies in contrast (light vs. dark oak, flat-back painted vs. natural wood surfaces), as well as economy of design and rationing of decoration. Per-

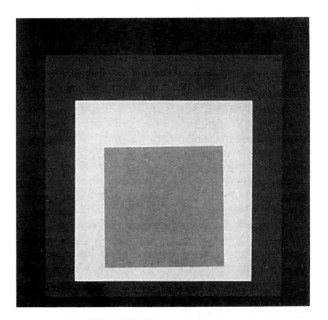

Day and Night VIII, 1963; lithograph

haps an early portent of his colored squares to come are to be found on an Albers-designed set of four hand-painted glass-topped stacking tables.

His graphics from the period 1930–50 exhibit preoccupation with the contrast between, and the not obviously reconcilable superposition of, grain patterns and geometric designs. Also evident is a struggle between and attempts at fusion of curved boundaries and straight-edged objects. With the eventual rejection of the former, which implies also a disposal of most of the demands for emotional analysis of his productions, Albers's works came to feature primarily the seemingly simple rectangle and square. The realization that even these exhibit intriguing and non-trivial complexities led to a search for simplification, to separation into studies of the effects of geometry and those of color and shading.

Albers's studies of simple lined black and white planar objects led to numerous examples of interactions of lines and of the trickery encountered when the eye views 2-dimensional information and the brain attempts a 3-dimensional interpretation of it. Here, for example, he produced a massive output of interwoven box-figures, each interpretable in multi-variate readings.

Simultaneously his quest for successful analysis and understanding and his long career in teaching led him to study interaction of colors, whereupon he produced a monumental and still much-discussed book on the topic, *Interaction of Color* (1963). A primary idea was the use of squares of colors to minimize as much as possible the intrusion of shape and of associative, descriptive, or emotional context. His celebrated series of hundreds of paintings, *Homage to the Square,* yields clear examples of what the physical scientist has also come to realize, that scientific method to focus on the simplest possible system is rewarding but has ultimate limitations, in that the surroundings and the presence of the observer can never be completely eliminated. Albers's squares, and their more elaborate cousins, entitled *Variants,* amply demonstrate that identi-

cal colors in different settings are perceived to be different by different observers, in different lighting, at different times.

Whatever his final place in art history, Josef Albers was a charming and exciting man, a teacher who felt that "good teaching is more a giving of right questions than a giving of right answers," a lifelong student whose "main concern [was] to remain a student looking for further problems to be solved and working for [his] own development," and an artist who produced superficially impersonal images but images which echoed the pithy quality of his written statements. His aims were simple—"My painting is meditative, is restful. . . . I seek no quick effects. . . . You see, this is what I want to create: meditation pictures of the 20th century."

—John A. Weil and John H. Holloway

ALGARDI, Alessandro.

Born in Bologna, 31 July 1598. Died in Rome, 10 June 1654. Pupil of G. C. Conventi and of Ludovico Carracci, and worked in Carracci Academy in Bologna; went to Rome, 1625; sometimes considered leader of the classical opposition to Bernini: Principe of Guild, 1639, and successful under Pope Innocent X (1644–55); also worked for the Spada family. Knighted 1648.

Collections: Berlin; Bologna; Cleveland; Hamburg; Leningrad; Manchester; Minneapolis; New Haven; New York; Paris; Ravenna; Rome: Biblioteca Vallicelliana, St. Peter's, S. Maria in Vallicella, S. Maria in Popolo, S. Marcello; Sao Paolo.

Publications

On ALGARDI: books—

Vitzthum, Walter, *Algardi,* Milan, 1966.
Heimbürger-Ravalli, Minna, *Algardi, scultore,* Rome, 1973.
Strazzullo, Franco, *Una replica di Algardi nel Duomo di Napoli,* Naples, 1974.
Montagu, Jennifer, *Algardi,* New Haven, 2 vols., 1985.

articles—

Munoz, Antonio, "Algardi ritrattista," in *Dedalo* (Milan), 1, 1920.
Labo, Mario, "La Cappella dell'Algardi nei Santi Vittore e Carlo a Genova," in *Dedalo* (Milan), 11, 1930–31.
Raggio, Olga, "A Rediscovered Portrait: Algardi's Bust of Cardinal Scipione Borghese," in *Connoisseur* (London), 138, 1956.
Antonia Nava Cellini, "Per un busto dell'Algardi a Spoletto," 87, 1957, "Per Algardi e Domenico Guidi," 121, 1960, "Il Borromini, l'Algardi, e il Grimaldi per Villa Pamphilj," 161, 1963, "Per l'integrazione e lo svolgimento della ritrattistica di Algardi," 177, 1964, and "Note per l'Algardi, il Bernini, e il Reni," 207, 1967—all in *Paragone* (Florence).

Gennari, Gualberto, "Sculture di Algardi a Bologna . . .," in *Strenna Storica Bolognesi,* 8, 1958.
Arfelli, Adriana, "Tre note intorno ad Algardi," in *Arte Antica e Moderna,* 8, 1959.
Mezzetti, Amalia, "Algardi," in *L'ideale classico del seicento in Italia e la pittura di paesaggio* (cat), Bologna, 1962.
Eglinski, Edmund, "A Flagellation Group by Algardi," in *University of Kansas Register of the Museum of Art* (Lawrence), December 1963.
Vitzthum, Walter, "Disegni di Algardi," in *Bolletino d'Arte* (Rome), 48, 1963.
Colonni, Gabriella Gallo, "Note su Algardi," in *Arte Lombarda* (Milan), 10, 1965.
Heimbürger, Minna, "Un disegno certo dell'Algardi e alcuni probabili di Gregori Spada," in *Paragone* (Florence), 237, 1969.
Heimbürger, Minna, "Un disegno di Algardi per la pala di S. Agnese in Agone," in *Studi Romani,* 18, 1970.
Heimbürger, Minna, " Algardi architetto?," in *Analecta Romana Instituti Danici,* 4, 1971.
Raggio, Olga, "Algardi e gli stucchi di Villa Pamphili," in *Paragone* (Florence), 251, 1971.
Pope-Hennessy, John, "Some Newly Acquired Italian Sculptures: A Portrait Sketch by Algardi," in *Victoria and Albert Museum Yearbook* (London), 4, 1974.
Senie, Harriet F., "The Tomb of Leo XI by Algardi," in *Art Bulletin* (New York), 60, 1978.
Androsov, Sergej O., "Some Works of Algardi from the Farsetti Collection in the Hermitage," in *Burlington Magazine* (London), February 1983.
Hughes, Anthony, "The Real Algardi," in *Art History* (Oxford), March 1986.

*

Algardi has always been regarded as the greatest exponent of the classical trend in 17th-century Roman sculpture, as distinct from the Baroque one exemplified by his great rival, Bernini. If by classicism we mean an idealized naturalism of the figure, which deploys restrained rather than expansive gestures and is rooted in admiration not simply for antique sculpture but also for the tradition of Raphael and Annibale Carracci in painting, then Algardi was assuredly a classicist. He is, further, a classicist by association: singled out for memorialization by the intellectual high priest of classic idealism, Giovanni Pietro Bellori, in his *Lives of the Modern Painters, Sculptors and Architects,* 1672, (a polemical tract which pointedly excluded the greatest sculptor of the age, Bernini), he was also reputedly a friend of another sculptor (Du Quesnoy) and painters (Sacchi and Poussin) whom Bellori praised and whom we too tend to regard as practitioners of a calculatedly reticent, antique-inspired language.

While inevitably oversimplified, and subject to some important qualifications, there is much to commend this "classic" interpretation of Algardi. His sober, Carracci-inspired selective naturalism was very different from Bernini's galvanic rhetoric—so much so that it can, on occasions, appear stodgy and unexpressive. Yet the equally classic counterpart of these negative tendencies is an at times eloquent generalization of pose, facial expression, and drapery. Algardi was familiar with the idioms of antique sculpture, both through his early training

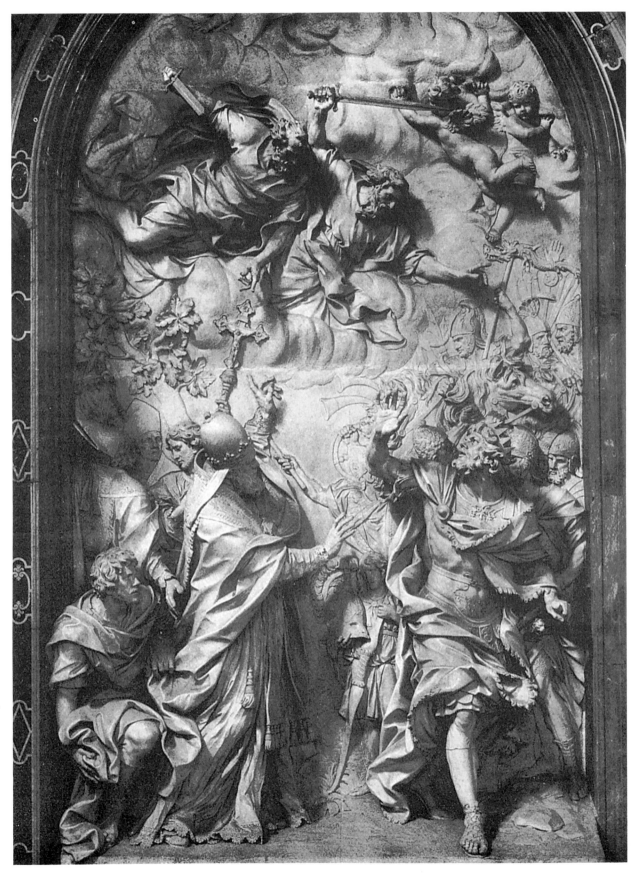

Meeting of Pope Leo I and Attila; marble; Rome, St. Peter's

in the Bolognese Academy of the painter Ludovico Carracci and through his subsequent work as a restorer of ancient sculpture in Mantua and Rome. His own sculptures show him to have been clearly appreciative of antique conventions and techniques—from relaxed standing poses with one weight-bearing leg and the other flexed, through draperies which follow and indicate the underlying contours of the body, to a taste for the blank, pupil-less eyes favoured by the Greeks. Indeed he could, when subject-matter suggested, engineer some decidedly antique-seeming statues (e.g., the three Ancient Roman Martyr Saints in the church of SS. Martina e Luca, Rome).

But Algardi's art was fed, and his classicism circumscribed, by other currents. His strong, intuitive naturalism tended to override other considerations, so that a characteristically 17th-century realism (of faces, hands, and feet) is always there to remind us of the contingent and, for Algardi, peripheral nature of style. This is what made him such a convincing portrait sculptor. To such directness of vision was added a fascination with decorative drapery detail and graceful poses which may have been inculcated in the studio of Ludovico Carracci, who was as fond of some of the refinements of Mannerism as he was, also, of the naturalistic classicism with which his cousin, Annibale, is more completely identified. The affiliation with Ludovico is underlined by Algardi's declared admiration for one of Ludovico's most gifted and "mannered" pupils, the painter Guido Reni, whose figures often possess a timeless spiritual grace occasionally echoed in Algardi's statues. Furthermore, Algardi was a critic of Reni's chief rival and Annibale's favourite pupil among the Bolognese classicists, Domenichino, disliking (ironically, given his own propensity in that direction) what he regarded as his stiff and forced manner. In the 1630's in Rome he was friendly too with another of Domenichino's rivals, Pietro da Cortona, the painter who has come to typify the Italian High Baroque. Indeed Cortona seems to have had a considerable influence on Algardi's figure and costume style, his full-bodied, curvacious forms, rhythmic draperies and dulcet facial expressions setting the tone for many an Algardi statue (e.g., the figure of Liberality on the tomb of Pope Leo XI, 1634–44, and those of St. Paul and the kneeling page in *The Meeting of Pope Leo the Great and Attila,* 1646–53, both in St. Peter's). Such a framework of influence was not so much counter-classical (Ludovico and Cortona, after all, were keen admirers of antique statuary) as romantically classical.

The other main factor affecting Algardi's style was his strong preference for modelling over carving. His stuccoes and terracottas (and bronze cast from the latter) have about them an animation of surface which is usually absent from his full-length marble figures. It was with two statues in stucco of *St. Mary Magdalen* and *St. John the Evangelist* (1620's, San Silvestro al Quirinale) that Algardi established his Roman reputation, the former ranking alongside Bernini's contemporary *S. Bibiana* as a prototype for the religious Baroque—pose, drapery, and expression combining to project a spiritual aura.

For all the spontaneous grace, however, there is an emotional and physical restraint about even these fondly realized pieces of modelling, so that it is hardly surprising that we should choose to emphasize the latter qualities in the more awkwardly executed marbles, viewing them as the antithesis of Bernini's bolder poetry. The all-white, marble figures of Al-

gardi's tomb of Pope Leo XI seem hesitant and palsied, though not without a faltering eloquence, compared with Bernini's analogous mixed media group in the nearby tomb of Pope Urban VIII. In the portrayal of mystical union, too, Algardi opts, in his group of *S. Filippo Neri with an Angel* (1636–38, Rome, Chiesa Nuova) for a Reni-inspired icon of quiet spiritual with sexual energy in *The Ecstasy of St. Teresa.* While two other major commissions, *The Beheading of St. Paul* (1634–44, Bologna, S. Paolo Maggiore) and the huge marble relief of *The Meeting of Pope Leo the Great and Attila* are, in their controlled, mimetic drama, consistent with the narrowly Bellorian classical ideal. And although occasional discrepancies between more lively preparatory drawings or models and finished marble sculptures might suggest that Algardi was held in check by conservative patrons, it is probably more accurate to see the variegated strands of classicizing decorum throughout his *oeuvre* as a deeply engrained consequence of his Bolognese training.

—John Gash

ALTDORFER, Albrecht.

Born probably in Regensburg, c. 1480; son of the artist Ulrich Altdorfer; brother of the artist Erhard Altdorfer. Died in Regensburg, 12 February 1538. Possibly trained in calligraphy and miniature painting by his father; first signed work, 1506; worked in Regensburg: citizen, 1505, city architect, 1526, and councillor; in Vienna, 1511 (probably), and 1535 (certainly); commissions from Emperor Maximilian and Duke Wilhelm IV of Bavaria; frescoes for Regensburg episcopal bath. Assistant: Wolf Huber?

Major Collection: Berlin.
Other Collections: Bremen, Budapest; Cleveland; Florence; Frankfurt; Kassel; Munich; Nuremberg; Regensburg; S. Florian bei Linz: Augustiner Chorherrenstift; Washington.

Publications

On ALTDORFER: books—

Friedländer, Max J., *Altdorfer,* Leipzig, 1891.
Moore, Thomas Sturge, *Altdorfer,* London, 1900.
Friedländer, Max J., *Altdorfers Landschaftsradierungen,* Berlin, 1906.
Hildebrandt, Hans, *Die Architektur bei Altdorfer,* Strasbourg, 1908.
Voss, Hermann, *Altdorfer und Wolf Huber,* Leipzig, 1910.
Bredt, Ernst W., *Altdorfer,* Munich, 1919.
Friedländer, Max J., *Altdorfer,* Berlin, 1923.
Waldmann, Emil, *Altdorfer,* London and Boston, 1923.
Tietze, Hans, *Altdorfer,* Leipzig, 1923.
Baldass, Ludwig von, *Altdorfer,* Vienna, 1923.
Wolf, Georg J., *Altdorfer,* Bielefeld, 1925.
Friedländer, Max J., *Altdorfer: Ausgewählte Handzeichnungen,* Berlin, 1926.

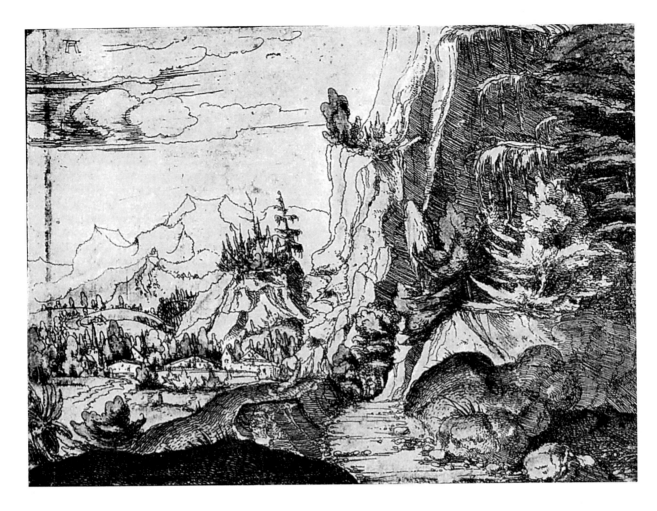

Landscape with Dark Cliff-Wall, c. 1517–19; etching

Becker, Hanna L., *Die Handzeichnungen Altdorfers,* Munich, 1938.

Buchner, Ernst, editor, *Altdorfer und sein Kreis* (cat), Munich, 1938.

Benesch, Otto, *Der Maler Altdorfer,* Vienna, 1939.

Baldass, Ludwig von, *Altdorfer,* Zurich, 1941.

Strohmer, Erich V., *Der Altdorferaltar in St. Florian,* Vienna, 1946.

Winzinger, Franz, *Altdorfer: Zeichnungen,* Munich, 1952.

Buchner, Ernst, *Altdorfer: Die Alexanderschlacht,* Stuttgart, 1956.

Oettinger, Karl, *Altdorfer-Studien,* Nuremberg, 1959.

Winzinger, Franz, *Altdorfer: Graphik, Holzschnitte, Kupferstiche, Radierungen,* Munich 1963.

Ruhmer, Eberhard, *Altdorfer,* Munich, 1965.

Martin, Kurt, *Die Alexanderschlacht von Altdorfer,* Munich, 1968.

Burkhard, Arthur, *The St. Florian Altar,* Cambridge, Massachusetts, 1972.

Winzinger, Franz, *Altdorfer: Gemälde,* Munich, 1975.

Brucher, Günter, *Farbe und Licht in Altdorfers Sebastiansaltar in St. Florian,* Graz, 1978.

Schulz, Georg Friedrich, *Altdorfer,* Herrrsching am Ammersee, 1978.

Janzen, Reinhild, editor, *Altdorfer: Four Centuries of Criticism,* Ann Arbor, 1980.

Henrich, Dieter, editor, *Altdorfer und seine Zeit,* Regensburg, 1981.

Landau, Edwin Maris, *Altdorfer: Leidensweg, Heilsweg: Der Passionsaltar van St. Florian,* Stuttgart, 1983.

Smith, Alistair, *Altdorfer, Christ Taking Leave of His Mother,* London, 1983.

Guillaud, Jacqueline and Maurice, editors, *Altdorfer and Fantastic Realism in German Art* (cat), Paris, 1984.

*

The German painter and printmaker Albrecht Altdorfer was born about 1480 and from as early as 1505 until his death in 1538 was a citizen of Regensburg in Bavaria. Altdorfer lived a prosperous life, serving on Regensburg's town council from 1519. He was appointed city architect in 1526 and is credited with several projects including the rebuilding and fortification of the city walls. In 1528 Altdorfer was offered the office of Burgomeister of Regensberg but turned it down in order to execute the commission for his most famous painting, *The Battle of Alexander.* He is known to have travelled at least once to

Vienna and it is speculated that he may have journeyed in Italy as well. Albrecht's brother, Erhard Altdorfer, was also a painter and printmaker. Erhard lived in Regensburg until about 1512, when he moved to Schwerin, in North Germany.

Albrecht Altdorfer is remembered as the leading artist of the so-called "Danube School." More a characteristic than a school, it is represented by a number of German artists of the early 16th century who at various periods of their lives used landscape features derived from the regions of the Danube's course through Germany and Austria in their paintings and prints. One sees snowy Alpine mountains, deep valleys, conifers and other trees draped with trailing mosses. At times, Hans Burgkmair, Lucas Cranach the elder, Hans Baldung Grien, Wolf Huber, and a number of minor artists were associated with the style.

Altdorfer was an inventive and prolific artist. A rich variety of his paintings survives, from great altarpieces to portraits and small prints. His little painting (11″ x 8⅝″) of a *Danube Landscape* in the Alte Pinakothek in Munich, made about 1520, is possibly the first finished painting of pure landscape since antiquity. Albrecht Dürer had made watercolors of landscape earlier, but these were private, preparatory studies. These watercolor landscapes often appear in the backgrounds of Dürer's finished works. Others of Altdorfer's painting are so dominated by the representation of mountains, trees, and skies that the subject matter is reduced to a secondary role. His art shows the influence of Dürer and Cranach and a knowledge of North Italian masters, yet it developed individually with great power and imagination. Altdorfer stands at the beginning of a mighty tradition of landscape art that leads to Bruegel and Rembrandt.

In 1518 Albrecht Altdorfer was at the monastery of St. Florian near Linz in Austria. He produced a series of panel painting of the Passion of Christ and another of the life of St. Sebastian for a great altarpiece. The altarpiece, which combined the paintings with sculptures in a fashion traditional in Germany at the time (see Michael Pacher and the *St. Wolfgang Altarpiece*), does not remain intact, but most of Altdorfer's paintings survive. The works for the *St. Florian Altarpiece* and the *Battle of Alexander* represent the great masterpieces of Albrecht Altdorfer's career.

In printmaking as in painting, Altdorfer was an active and inventive artist. Here, too, he made the first images of pure landscape. Nine of his prints in the new medium of etching depict landscapes in the Danube School style. Augustin Hirschvogel and Hanns Lautensack are among the artists most immediately influenced by these landscape prints. They begin a tradition that also continues to Bruegel and Rembrandt.

Two other etchings by Altdorfer are of the Regensburg synagogue, made before it was torn down in 1519 when the Jews were expelled from the city on orders of the Town Council. Altdorfer was a new member of the council at the time. While we have no record of his feelings on the subject, lengthy inscriptions on the etchings document the action with wrenching clarity.

Altdorfer also executed a variety of engravings. These give evidence of the influence of Italian artists including Mantegna and Jacopo de' Barbari. The dark backgrounds of Altdorfer's engravings also suggest the influence of Italian niello works. Their small scale links him to the German "little masters," artists such as the Beham brothers and George Pencz, who specialized in small prints made for connoisseurs and collectors.

Altdorfer made a large number of woodcuts. Among them are 38 designs for part of the great *Triumphal Procession of the Emperor Maximilian I,* which was commissioned in 1512. Hans Burgkmair designed 63 of the *Procession's* total of 138 woodcuts. Leonhard Beck, Hans Schäufflein, and Hans Springinklee designed the remainder. Another series, *The Fall and Redemption of Man,* including 40 small woodcuts, was made about 1513. These works are closely related to the *St. Florian Altarpiece* paintings and also linked to Dürer's *Small Woodcut Passion.* He made one color woodcut, *The Beautiful Madonna of Regensburg,* with five colors added to the linear design. It copied the painting he had made based on an Italo-Byzantine icon of the 13th century.

In sum, Albrecht Altdorfer was an inventive and expressive artist. Very much a part of his own times, he was highly influential on his contemporaries as they served to inspire him. With Albrecht Dürer, Lucas Cranach, and Matthis Grünewald, he belongs to the great age of German Renaissance art.

—Charles I. Minott

AMIGONI, Jacopo.

Born in Naples, 1675?. Died in Madrid, 1752. Possible studied under Bellucci in Dusseldorf; influenced by Sebastiano del Ricci and Francesco Solimena; first documented in Venice, 1711; then worked as portrait painter and decorator all over Europe, including a period for the Elector of Bavaria in Munich, c. 1717–29; England, 1729–39 (altarpiece for Emmanuel College, Cambridge, 1730, and ceiling for Moor Park, c. 1732); Venice, 1739–47 (encouraged Canaletto to go to England); and Spain, 1747–52 (Court Painter in Madrid); also did tapestry cartoons.

Collections: Barcelona; Cambridge: Emmanuel College; Darmstadt; London: Tate; Madrid; Melbourne Hall; Moor Park; Schleissheim Castle; Sheffield; Venice; York; Royal Collection.

Publications

On AMIGONI: book—

Holler, Wolfgang, *Amigonis Frühwerk in Süddeutschland,* Hildesheim, 1986.

articles—

Voss, H., "Amigoni und die Anfänge Malerei des Rokoko in Venedig," in *Jahrbuch der Königlich-preussischen Kunstsammlungen,* 39, 1918.
Fiocco, G., "G. B. Pittoni e Amigoni ad Alessandria," in *Rivista di Venezia,* 14, 1935.
Arslan, E., "Dipinti di Amigoni," in *Belle Arti* (Pisa), 1, 1947.

Woodward, John, "Amigoni as Portrait Painter in England," in *Burlington Magazine* (London), 99, 1957.

Pilo, G. M., "Studiando L'Amigoni," in *Arte Veneta* (Venice), 12, 1958.

Griseri, A., "L'ultimo tempo dell'Amigoni e il Nogari," in *Paragone* (Florence), 11, 1960.

Fiocco, G., "I fiori di Amigoni," in *Pantheon* (Munich), 28, 1970.

Claye, E., "A Group of Portrait Drawings by Amigoni," in *Master Drawings* (New York), 2, 1974.

Garas, K., "Appunti per Amigoni e Jacopo Guarana," in *Arte Veneta* (Venice), 32, 1978.

Griffin-Hennessy, L., "Amigoni and the Myth of Andromeda: Four New Paintings," in *Arte Veneta* (Venice), 37, 1982.

*

A painter who had successful careers in Venice, Bavaria, England, and Spain, Jacopo Amigoni was a key figure in the spread of the Venetian Rococo style in northern and southern Europe. Little is known of his earliest period, though he is recorded painting, by 1711, an altarpiece at S. Stae in Venice which already displays his characteristic boneless, soft figures whose edges seem to dissolve into space and who reveal a minimum of emotion to the circumstances.

Venice provided few opportunities for the great decorative schemes needed to keep large numbers of painters employed. Amigoni, along with many other artists, left Venice for other European countries where large-scale building projects were available for decoration. Sedlmayr and Bauer credit Amigoni with introducing illusionistic painting (scenes which appear to be beyond the actual surface on which they are painted) to Germany on the domed ceiling of a cloister chapel at Ottobeuren (1725). He also spent an extended period in Munich painting for the Elector of Bavaria, Maximillian Emmanuel, whose court was strongly French in character. Here, in response to the French influence, he painted with a greater clarity of color and profile. Amigoni worked on ceilings in Munich for almost twelve years (1717–29), including ones at Schleissheim Castle and the Nymphenburg Palace.

By the time of his arrival in England in 1729, Amigoni's mature style had developed. In treating mythological subject matter he continued to paint boneless, soft-edged figures who seem to evaporate into thin air. These English paintings are characterized by the same lack of chiaroscuro and use of clear color of his earlier period, but he now emphasizes rose, blue-green, and gold all with a high intensity that suggests porcelain. Critics comment on the theatrical arrangement of figures in these paintings, close to the front of the picture plane like actors on a stage. Amigoni had close ties with the theater world in London, and was hired to decorate, for example, the newly built Covent Garden Theater in 1732, and to paint sets for Handel's opera *Atalanta* in 1736. It is assumed that such associations with the theatrical world strengthened his already existing interest in Baroque stage-like presentation.

Though Amigoni decorated parts of many great houses in England, few examples still exist. The best-known extant commission was Moor Park, Hertfordshire (1732), where he painted the story of Jupiter and Io for the entrance hall in four narrative scenes on large canvases, rather than in fresco directly onto the plaster. This alternative method of displaying paintings was pioneered in Venice as a practical measure against the humid climate. Amigoni is credited with popularizing this practice.

For the most part Amigoni spent his life painting decorative schemes. But he also did a few altarpieces in Venice and at Emmanuel College Chapel, Cambridge, as well as a number of genre scenes and portraits. Among the portraits he painted while in England are those of the Royal Family. His portraits were not entirely a success, his faces being judged "not very like." The figures are also somewhat wooden, though he sometimes attempted to alleviate the problem by enlivening the surrounding space with flying putti. Finally, Amigoni even decorated a famous musical clock now at Kensington Palace.

English taste was really not in tune with the lightness and gaiety of the Venetian Rococo. The fashion was changing from an emphasis on decorative painting to a display of ornate interior architecture. When the sober, more classicizing style of the Augustan Age became dominant, Amigoni left England permanently for Venice (1739–47). At this point his style underwent some, though not radical, change. Paradoxically, it lost some of its gaiety and lightness of form and color but gained in expressiveness. The *Venus and Adonis* (Accademia, Venice), which dates from the 1740's, illustrates change. The colors are more subdued and there is subtler tonal gradation than in the paintings of the earlier period.

At the Royal Court of Ferdinand IV in Madrid, Amigoni found again the new building schemes which called for the talents of decorative painters. From 1747 to his death in 1752, he continued working in his established style. Recorded decorative works include a ceiling and overdoors at Aranjuez, and paintings of the Four Seasons for the Royal Box in the theater at Buen Retiro Palace—neither of which have survived. Amigoni also left portraits and cartoons for tapestries which date from this period.

—Ann Stewart Balakier

AMMANATI, Bartolommeo.

Born in Settignano, 18 June 1511. Died in Florence, 22 April 1592. Married the poet Laura Battiferri, 1550. Trained with Baccio Bandinelli; then worked with Jacopo Sansovino in Venice; worked in Florence as sculptor and architect: designed extension of the Pitti Palace, churches, etc., as well as the tomb for the jurist Benavides, in Padua, 1546, and, with Vignola and Vasari, on the Villa Giulia, 1552, and the Del Monte tombs in S. Pietro in Montorio, 1553, both in Rome; sculpture of Neptune in Piazza della Signoria, 1575; also worked for Archduke Cosimo I of Tuscany, and in Lucca; author of a letter on mannerist art theory.

Collections/Locations: Florence: Piazza della Signoria, Pitti; Padua: church of the Eremitani; Rome: Villa Giulia, Palazzina of Pius IV, S. Pietro in Montorio.

Publications

On AMMANATI: books—

Fossi, Mazzino, *Ammanati, architetto*, Naples, 1966.
Kinney, Peter, *The Early Sculpture of Ammanati*, New York, 1976.

articles—

Davis, C., "The Tomb of Mario Nari for the SS. Annunziata in Florence: The Sculptor Ammanati until 1544," in *Mitteilungen des Kunsthistorischen Instituts in Florenz*, 21, 1977.
Heikamp, D., "Ammanati's Fountain for the Sala Grande of the Palazzo Vecchio in Florence," in *Dumbarton Oaks Colloquium on the History of Landscape Architecture*, 5, 1978.
Puppi, L., "Il Colosso del Mantova," in *Essays Presented to Myron P. Gilmore*, Florence, 1978.

*

Although Ammanati lived to a considerable age his artistic output was comparatively small. Perhaps for this reason his works were not particularly influential at the time, and have not been sufficiently appreciated since. But they were characteristic products of a typically versatile Florentine Mannerist, who both created and contributed to some of the most famous and evocative sights of the period.

Ammanati's training under the mediocre sculptor Baccio Bandinelli can have given him little more than a knowledge of the techniques of stone-cutting, an understanding of carving in relief (Bandinelli's greatest strength) and a fascination with his master's hated rival, Michelangelo. Ammanati's own absorption into Michelangelo's orbit came in 1536, when he was allocated the carving of three of the figures for the monumental tomb of Jacopo Sannazaro designed by Michelangelo's assistant Gian Angelo Montorsoli. Probably at about the same time Ammanati drew copies of Michelangelo's cartoon of *Leda and the Swan* (lost), of which he subsequently produced a marble version (Florence, Bargello) reflecting on a small scale—as had Michelangelo's original painting—the elegiac self-containment of the nudes in Michelangelo's Medici Chapel.

The same source informs Ammanati's first major work, the sculptures intended for the tomb of Mario Nari (1540; dispersed), especially the recumbent effigy; but the elegant group of *Victory* (Florence, Bargello) intended to stand above it, although apparently based on one of Michelangelo's designs for the tomb of Julius II, also reveals a different influence, the classicising one of Andrea and Jacopo Sansovino, as is evident in the clear outline, noble physical type, and fine drapery of the main figure. Owing to Bandinelli's jealous machinations Ammanati's tomb was never set up. Probably for this reason Ammanati followed Jacopo Sansovino to Venice, though none of Ammanati's few works in Venice survive. His most important undertaking of this period was in Padua: the tomb of the humanist scholar Marco Benavides (1546; church of the Eremitani). In this Ammanati affirmed his allegiance to Michelangelo and to Sansovino, especially in the easy grace of the allegorical figures and their harmonious relationship with

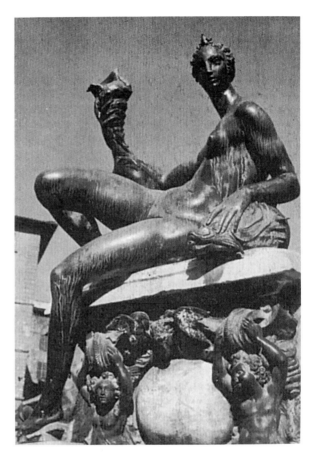

Neptune Fountain—detail; Florence, Piazza della Signoria

the surrounding architectural elements—Ammanati's first essay in architecture.

The success of the Benavides tomb probably led directly to Ammanati's commission to provide the sculptures for Vasari's chapel for Pope Julius III in S. Pietro in Montorio, Rome (1550–53). The noble simplicity of the architecture was due to the influence of Michelangelo, who had criticised Vasari's plans; the appointment of Ammanati may also have been at his instigation. The interaction between the architecture and sculpture recalls Ammanati's plans for both the Nari and the Benavides tombs; but the figures themselves show a grace and their draperies a decorative delicacy which enliven their Michelangelesque gravity and Classical poise. Vasari, again (supposedly) with Michelangelo's advice, was also supervising the lay-out of the Villa Giulia outside Rome (1551–55; now the Etruscan Museum). Ammanati was responsible for various fountain sculptures, and it seems reasonably certain that he also designed the charming water-garden, or *nymphaeum*, which, with its river gods, caryatid herms, and Roman mosaic floor, epitomises his increasing interest in the Antique.

On the death of Julius III in 1555 both Vasari and Ammanati returned to Florence. Ammanati was entrusted by Duke Cosimo I de' Medici with the enlargement of the rugged 15th-century Palazzo Pitti into a lavish suburban villa for the Duchess, Eleanora de Toledo. Cosimo I's most regal chamber was the *Sala dei Cinquecento* in the Palazzo Vecchio. The decision to enliven the southern end of the room with an inter-

nal emblematic fountain must surely have originated with an idea by Ammanati. He certainly created his most beautiful marbles in order to realise it. The scenographic ensemble was to encompass a central figure of Ceres, from whose breasts spouted water, surrounded by other figures. Most of these figures survive, but the masterpieces are the exquisite *Ceres,* a meditation on the Medici Venus with a more luscious sway and Grecian profile, and the splendid *Juno,* her vigorous limbs encased in airily striated folds of drapery (both 1556–63; Florence, Bargello). Sadly the ensemble was never realized.

Ironically, the Ceres debacle probably ensured Ammanati's success in the competition for a fountain of Neptune in the Piazza della Signoria, which Cosimo I had commissioned from Bandinelli before the latter's death in 1560. Bandinelli had already chosen and begun to carve a huge block of white marble for the central figure, and had probably also planned the insufficiently large pedestal and basin below it; he may therefore be partly to blame for the fountain's disappointing effect. However, Ammanati failed to instill any life or conviction into the vast *Neptune* (erected in 1565)—although it has impressive lateral views—or to relate its bulk to the modest sea horses in front and the comparatively small bronzes (completed by 1575) around the rim. These bronzes, in fact lifesize, represent lesser marine deities, and are memorably graceful and lively, and the most successful part of the scheme. Their mannered elegance was reflected in an actually small bronze, a figure of *Ops,* which Ammanati contributed in 1572–73 to the rich decoration of the Studiolo (study) of Cosimo I's son Francesco in the Palazzo Vecchio; though clearly based on his marble *Ceres,* the *Ops* is more elongated and attenuated, and has an exquisite air of sophisticated and courtly grace.

Ammanati may have contributed, along with Tribolo and Giambologna, to the statues and fountains of the pleasure-gardens at Pratolino and Castello, then being laid out by Bernardo Buontalenti. He certainly provided statues for Buontalenti's decoration of the Florence Baptistery for the christening of Francesco de' Medici's son in 1576. These were probably his last sculptures. He had become concerned, under the influence of Counter-Reformation ideas, over the morality of sculpture, and bitterly regretted his earlier nudes. His final works were architectural and ecclesiastical: in 1579 he began the rebuilding of the small church of S. Giovanni degli Scolopi in Florence (completed only in 1661), and in 1582–84 he assisted the Jesuit architect Giovanni Tristano on the design of the Collegio Romano in Rome. The facade of the latter shows some of subtlety of proportion and interest in surface texture that had so elegantly informed both Ammanati's architecture and his sculpture.

—Nigel Gauk-Roger

ANDREA del Castagno.

Born in Castagno, c. 1419. Died of the plague in Florence: buried 19 August 1457. Married. Studied in Florence under the patronage of Bernardetto de' Medici, then worked in Florence until c. 1440: in Venice, c. 1442; then entered Florentine painters guild, 1444: worked on the Cathedral, for the Guild of Judges and Notaries, for the convent of Sant'Apollonia, Villa Carducci, and in various churches; worked for Pope Nicholas V in Rome, 1454.

Collections: Berlin; Edinburgh; Florence: Cathedral, S. Apollonia [this is now the Castagno Museum], S. Maria degli Angeli, SS. Annunziati, S. Egidio; London; New York: Metropolitan, Frick; Venice: S. Mario, S. Zaccaria; Washington.

Publications

On ANDREA: books—

Salmi, Mario, *Andrea del Castagno, Domenico Veneziano,* Milan, 1936.
Richter, George M., *Andrea del Castagno,* Chicago, 1943.
Fortuna, Alberto M., *Andrea del Castagno,* Florence, 1957.
Russoli, Franco, *Andrea del Castagno,* Milan, 1957.
Salmi, Mario, *Andrea del Castagno,* (cat), Florence, 1957.
Salmi, Mario, *Andrea del Castagno,* Novara, 1961.
Zanoli, Anna, *Andrea del Castagno,* Milan, 1965.
Berti, Luciano, *Andrea del Castagno,* Florence, 1966.
Horster, Marita, *Andrea del Castagno: Complete Edition with a Critical Catalogue,* Oxford, 1980.

articles—

Horster, Marita, "Castagno's Fresken in Venedig und seine Werke der vierziger Jahre in Florenz," in *Wallraf-Richartz Jahrbuch* (Cologne), 15, 1953.
Horster, Marita, "Castagno's Florentiner Fresken 1450–57," in *Wallraf-Richartz Jahrbuch* (Cologne), 17, 1955.
Fortuna, Alberto M., "Alcuni note su Andrea del Castagno," in *L'Arte,* (Milan), 57, 1958.
Hartt, Frederick, "The Earliest Works of Andrea del Castagno," in *Art Bulletin* (New York), 41, 1959.
Hartt, Frederick, and Gino Corti, "Andrea del Castagno: Three Disputed Dates," in *Art Bulletin* (New York), 48, 1966.
Bellosi, Luciano, "Intorno ad Andrea del Castagno," in *Paragone* (Florence), 18, 1967.
Mode, Robert L., "Re-creating Adam at Villa Carducci," in *Zeitschrift für Kunstgeschichte* (Munich), 47, 1984.

*

Andrea del Castagno's art may well be the result of his legendary irascible temperament and the inescapable Florentine sculptural evolution of the earlier 15th century, most especially the intensity of Donatello. Castagno also absorbed those paintings clearly inspired by that sculpture—works by Masaccio, Fra Angelico, and Filippo Lippi. Castagno is close to Piero della Francesca and to Domenico Veneziano (a long-persisting and only recently refuted story, from Vasari's *Lives,* had it that he was Domenico's murderer). Even Castagno's earliest works, such as the *God the Father with Six Saints* (Venice, S. Zaccaria), done apparently in his early 20's, display his monumental bodies and enraptured demeanor, with vivid precise

edges and deep pockets of light and dark in the drapery patterning. Beyond such idiomatic motifs lies his intense desire to effect an awe-inspiring force and monumentalism.

In the second decade of his creative life, Castagno's figural style became somewhat lither. In such works as *The Last Supper* (S. Apollonia), 1447, where inner psychic sensation is not shown through outward bodily gesture, later works show his interest in displaying force as movement. Perhaps it was inevitable that an artist so imbued with the need to display emotional content would evolve "the first great action figures in the Renaissance." Foremost among these is the *David* (Washington) on a parade shield, a trapezoidal leather surface where, above the emblematic severed head of Goliath, David is shown running and about to dispatch his stone-loaded sling. The four angels who guide the fiery cloud on which the Madonna ascends to heaven in *The Assumption of the Virgin* (Berlin) are also filled with dynamic motion. Castagno's use of extreme foreshortening, as in *The Crucified Christ Held Aloft by God the Father* (in *The Trinity Appearing to SS. Jerome, Paula, and Eustochium*, Florence, SS. Annunziata) results in a sense of swift motion. While the motif may derive from Masaccio's *Trinity* fresco (Florence, S. Maria Novella), Castagno has made it into a dynamic variant on such flying figures in Ghiberti as the angel in the *Sacrifice of Isaac* (Florence, Bargello) and God the Father in the Panel of *The Annunciation* (Florence, Baptistery).

Two large-scale secular frescoes survive. The series of life-size standing figures (the first secular wall-painting of the Florentine Renaissance), *Famous Men and Women*, was made in the year following *The Last Supper*. Originally placed in the garden loggia of the Villa Carducci, the forms are more decorative, thinner, with handsome physiognomies compared to the massive and coarser figures in the earlier religious works. The nine figures—three Florentine military leaders, three great women of antiquity, and three Florentine poets—were once part of a far larger and complex illusionistic architectural setting. The illusionism is further emphasized by arms and feet which protrude beyond their rectangular niches. Only the format of ancient Roman triumphal arches has been offered as a precedent for such an ensemble.

The other non-religious work, his last dated image, is also a tribute to Florentine history: the huge equestrian fresco—"in the manner of a tomb," reads the original commission—honoring Niccolo da Tolentino, the military commander in the victory over the Sienese at the Battle of San Romano in 1432. More than 30 feet tall, the work is on the north wall of the Cathedral of Florence; the height, as well as the need to emphasize military might, may account for what is Castagno's signature-like metallic linear precision. The emphatic turn of the enormous and carefully modelled horse's head may be a lost iconographic conceit; with its open mouth, teeth revealed, it is a contract to the profile equine head of the adjacent fresco by Uccello, *Sir John Hawkwood*, and also clearly recalls the open-mouthed horses in Uccello's *Battle of San Romano* (London). If this is humor, it is apparently without precedent in Castagno's work. "Expressionism," in fact, is a modern term that might be applied to Castagno. His use of color is highly personal. There is also an extraordinary explosion of marble veining in the panel behind Christ, Judas, and Peter in *The Last Supper*. Equally forceful are the pervasive blood-redness in *The Trinity Appearing to SS. Jerome, Paula, and Eusto-*

chium and the fiery red-orange cloud in *The Assumption of the Virgin.*

Such emotional insistence is also found in Castagno's seeming passion for a low view-point, as in the Tolentino fresco, which places the spectator looking upward and then seemingly below "stage level," as in The Last Supper. This spatial device—no doubt garnered from actual sculpture in niches, and also from such painted works as Masaccio's *Trinity*—is coercive, as it forces the viewer into a subservient position; consequently the painted figures appear to tower over the onlookers. Such controlled positioning is Castagno's own variant on the one-point perspective system with a single vanishing point which the Florentine perspective scheme imposed upon a hypothetical viewer. Yet in the crystalline volume of *The Last Supper*, there is no single vanishing point, and several of the orthogonals run parallel to one another. Castagno's space is more significantly created by the plastic force and three-dimensionality of the figures within it. And so his works uphold and carry into the mid-century the moral dignity, albeit with a dark intensity akin to that of Donatello, of the Florentine monumental tradition.

—Joshua Kind

ANDREA del Sarto.

Born Andrea d'Agnolo di Francesco, in Florence, 14 July 1486. Died of the plague in Florence, 28 or 29 September 1530. Married Lucrezia del Fade, 1517-17; one stepdaughter. Apprenticed to a goldsmith, then studied with the painters Gian Barile and Piero di Cosimo, 1498-1508; set up his own shop, 1508, for the first 2 or 3 years with Francesco Franciabigio; then many fresco commissions, especially for SS. Annunziata and the Confraternity of the Scalzo; worked for Francis I in France, 1518-19; captain of the painters guild, 1525. Pupils: Pontormo, Rosso, Bandinelli, and Vasari worked in his studio.

Major Collection: Florence: Pitti.
Other Collections: Berlin; Cleveland; Dresden; Florence: Uffizi, SS. Annunziata, Cloister of the Scalzo, S. Salvi; London: National Gallery, Wallace; Madrid, New York; Paris; Philadelphia; Vienna; Washington.

Publications

On ANDREA DEL SARTO: books—

Guinness, H., *Andrea del Sarto*, London, 1899.
Schaeffer, E., *Andrea del Sarto*, Berlin, 1903.
Knapp, Fritz, *Andrea del Sarto und die Zeichnung des cinquecento*, Halle, 1905.
Knapp, Fritz, *Andrea del Sarto*, Bielefeld, 1907, 1928.
Pietro, F. di, *I disegni di Andrea del Sarto negli Uffizi*, Siena, 1911.
Pfeiffer, Ch., *Les Madones d'Andrea del Sarto*, Paris, 1913.

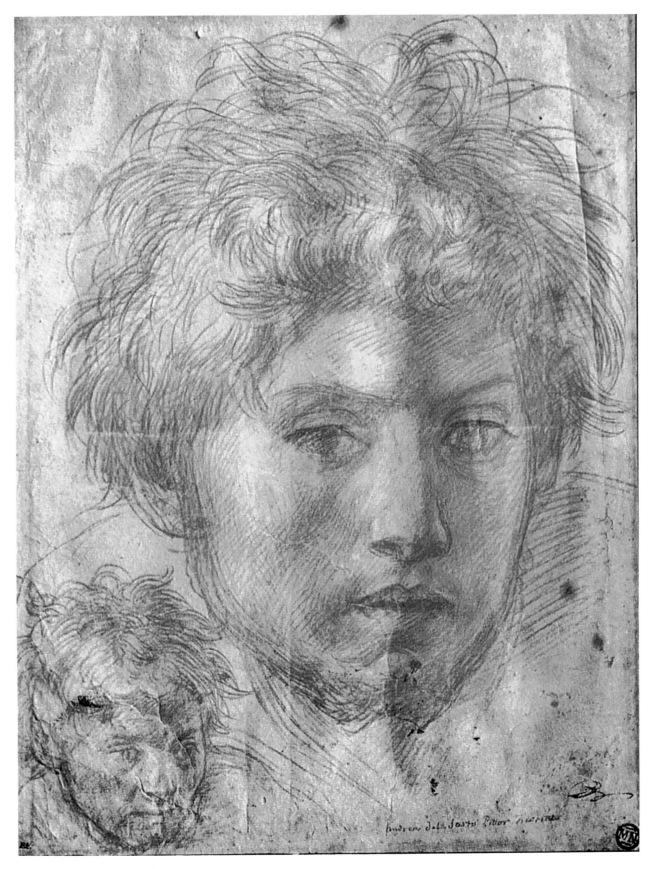

Man with Dishevelled Hair; drawing; Paris, Louvre

Fraenkel, Ingeborg, *Andrea del Sarto: Gemälde und Zeichnungen,* Strasbourg, 1935.

Rouches, Gabriel, *Andrea del Sarto: Quatorze dessins,* Paris, 1939.

Wagner, Hugo, *Andrea del Sarto: Seine Stellung zu Renaissance und Manierismus,* Basel, 1950.

Commande, Giovanni B., *Introduzione allo studio dell'arte di Andrea del Sarto,* Palermo, 1952.

Commande, Giovanni B., *L'opera di Andrea del Sarto,* Palermo, 1952.

Becherucci, Luisa, *Andrea del Sarto,* Milan, 1955.

Freedberg, Sydney J., *Andrea del Sarto,* Cambridge, Massachusetts, 2 vols., 1963.

Sricchia Santoro, Fiorella, *Andrea del Sarto,* Milan, 1964.

Monti, Raffaele, *Andrea del Sarto,* Milan, 1965, 1981.

Shearman, John, *Andrea del Sarto,* Oxford and New York, 2 vols., 1965.

Petrioli Tofani, Annamaria, *Andrea del Sarto: Disegni,* Florence, 1985.

Cordellier, Dominique, *Hommage à Andrea del Sarto* (cat), Paris, 1986.

Petrioli Tofani, Annamaria, et al., *Andrea del Sarto: Dipinti e disegni a Firenze* (cat), Florence, 1986.

*

A native Florentine, Andrea del Sarto was trained as a painter in the workshops of Piero di Cosimo and, perhaps, Raffaellino del Garbo—artists with whom his earliest works bear affinities. A debt to the former is particularly evident in the craggy landscapes of Sarto's first frescoes, the scenes from the life of S. Filippo Benizzi in the atrium of SS. Annunziata (1509–10), and one of the panels from a series executed for Pierfrancesco Borgherini depicting the story of Joseph (1515–16). His formation as an artist did not take place strictly in the late quattrocento milieu to which these artists belonged, however, and Andrea was equally responsive to the progressive currents of Florentine art in the early 16th century represented by Fra Bartolommeo and his collaborator Mariotto Albertinelli, who had established a workshop at the convent of San Marco, and especially Leonardo da Vinci, whose evocative *chiaroscuro* profoundly influenced the younger artist. Raphael, who has worked in Florence from 1504 to 1507, was also an important model for Andrea del Sarto; the latter painted many versions of the Madonna and Child and the Holy Family for his Florentine patrons—subjects with which Raphael had earned fame during his Florentine period. Raphael's removal to Rome, which followed the earlier departures from Florence of Michelangelo and Leonardo, cleared the field, leaving Sarto and Fra Bartolommeo as the pre-eminent painters of the city. Following the Frate's death in 1517, Andrea del Sarto was the undisputed Florentine *caposcuola,* and save for a brief sojourn in France in 1518–19 in the service of King Francis I, he was active for his entire career in his native city.

By 1508 Andrea del Sarto was an independent master in Florence and the head of his own workshop. His partner in this enterprise was the less gifted painter Franciabigio, with whom Sarto collaborated until the year 1517. The sculptor Jacopo Sansovino was closely associated with this *bottega* and with Sarto in particular, for whom he occasionally furnished models for figures. By the beginning of the second decade of the 16th century, Andrea del Sarto had become the major mural painter in Florence, engaged to carry out important fresco cycles in the atrium of the Annunziata (S. Filippo Benizzi, 2 frescoes, 1509–10; the Life of the Virgin, 2 frescoes: *The Journey of the Magi,* 1511; *The Birth of the Virgin,* 1514), the Chiostro dello Scalzo (scenes from the life of John the Baptist, 1513–1526), and the Medici villa of Poggio a Caiano (the *Tribute to Caesar,* 1521). Franciabigio had a hand in all three of these undertakings, although he was soon eclipsed by Sarto, whose talents were increasingly sought. Partly in response to the demands posed by his many commissions, Andrea occasionally adopted the practice of "sub-contracting" work to younger artists in his circle. This is notably the case with Pontormo and Rosso Fiorentino, seminal figures in the development of the style known as Mannerism: both these artists were entrusted with one of the frescoes of the Marian cycle in the atrium of the Annunziata which was carried out under Sarto's auspisces. The influence of Andrea del Sarto is readily apparent in the early works of both artists, particularly in the rich, glowing colors, shadowed physiognomies, exquisite emotional intensity, and vaguely enigmatic character of both Rosso's and Pontormo's paintings of the teens. The graphic style of both artists also derives from Sarto's consummate demonstrations as a draftsman, and like their master, Rosso and Pontormo produced some of the most beautiful red chalk drawings of the 16th century.

In addition to his work in fresco, Andrea del Sarto was also active as a painter of altarpieces and private devotional images. Perhaps his most beautiful, and certainly his most well-known, painting is the haunting *Madonna of the Harpies,* executed for the convent of S. Francesco de'Macci in 1517 (Uffizi). In this work, as in the contemporary *Dispute on the Trinity* (Pitti), the later *Luco Lamentation* (Pitti; 1524) and the *Pala Vallombrosana* (Uffizi, 1528), Sarto's brilliance as a colorist is fully revealed, the artist favoring a broad range of rich, slightly acidic hues and *cangiante* draperies. This gift was not lost on Sarto's early admirers: the later 16th-century writer Borghini described the Borgherini Joseph panels as "truly like precious gems," referring no doubt to their rich color. Stimulated in part by the example of Fra Bartolommeo, who had traveled to Venice and transmitted something of the glowing, limpid Venetian palette to Florence, Sarto's coloristic innovations, and his smooth, metallic draperies, exercised a profound influence on later generations of central Italian painters. To his refined sensibility for color and composition, Andrea del Sarto added a particular facility for profoundly moving, if understated, drama. The convergence of these different strands of his artistic genius produced such poignant images as the *Pietà* in Vienna and the *Last Supper* at S. Salvi (1526–27)—"one of the most beautiful paintings of the universe," according to the mid-16th-century writer Benedetto Varchi—in which one of the central mysteries of Christianity is articulated in a timeless and universal language.

A link between the late quattrocento tradition represented by Filippino Lippi and Piero di Cosimo, the High Renaissance classicism of Leonardo, Michelangelo, and Raphael, and the artificial, precious, and emotionally high-pitched intensity of early Mannerism, Andrea del Sarto occupies a unique position in the history of Florentine art. His formative experience tied him to the High Renaissance, and it is in this stylistic category that he is most comfortably accomodated, but without his ex-

ample, the Mannerism of Pontormo and Rosso would not have been born. The shadow of Andrea del Sarto in fact extends across the entire 16th century, and artists like Santi di Tito at the end of the cinquecento effected a "Sarto revival," returning to his example as an antidote to the stylistic excesses and exaggerations of the later *maniera*. If he never earned the epithet "Divine," Andrea del Sarto ranks on a tier just immediately below that of his great compatriots Leonardo, Michelangelo, and Raphael in the history of Italian Renaissance art.

—Linda Wolk-Simon

ANGELICO, Fra.

Born in Vicchio di Mugello, c. 1400; also called Guido di Pietro and Guido da Mugello. Died in Rome, 18 February 1455. Domenican friar: took habit, c. 1418-20, and ordained, c. 1423-25; in convent in Fiesole (Prior of Fiesole, 1449-52); worked as painter from c. 1418, and did work in Orvieto, and much work for the church and monastery of S. Marco, Florence; worked in the Vatican, 1446-49 and 1452-55.

Major Collections: Florence: S. Marco Museum; Paris.
Other Collections: Berlin; Boston: Museum of Art, Gardner; Cambridge, Massachusetts; Cortona; Detroit; Dublin; Fiesole: S. Domenico; Florence: Uffizi; Frankfurt; Houston; Leningrad; Madrid; Munich; Perugia; Rome: Palazzo Barberini; Vatican; Washington.

Publications

On FRA ANGELICO: books—

Douglas, R. Langton, *Fra Angelico,* London, 1900.

Williamson, George C., *Fra Angelico,* London, 1901.

Beissel, Stephan, *Fra Angelico: Sein Leben und seine Werk,* Freiburg, 1905.

Wingenroth, Max, *Angelico da Fiesole,* Bielefeld, 1906.

Wurm, Alois, *Meister- und Schülerarbeit in Fra Angelicos Werk,* Strasbourg, 1907.

Schottmüller, Frida, *Fra Angelico da Fiesole,* Stuttgart, 1911, 1924.

Papini, Roberto, *Fra Angelico,* Bologna, 1925.

Hausenstein, Wilhelm, *Fra Angelico,* London, 1928.

Muratoff, Paul, *Fra Angelico,* London, 1930.

Bazin, Germain, *Fra Angelico,* Paris, 1941, London, 1949.

Gengaro, Maria Luisa, *Il Beato Angelico a San Marco,* Bergamo, 1944.

Hulftegger, Adeline, *Fra Angelico: The Coronation of the Virgin,* London, 1948.

Ciaranfi, Maria Francini, *Beato Angelico: Gli affreschi di San Marco a Firenze,* Milan, 1949.

Pope-Hennessy, John, *Fra Angelico,* London, 1952; as *The Paintings of Fra Angelico,* London, 1974.

Argan, Giulio Carlo, *Fra Angelico,* Geneva and Cleveland, 1955.

Becherucci, Luisa, *Le celle di San Marco,* Florence, 2 vols., 1955.

Beato Angelico (cat), Vatican and Florence. 1955.

Procacci, Ugo, *Mostra dei documenti sulla vita e le opere dell'Angelico e delle fonte storiche fino al Vasari,* Florence, 1956.

Urbani, G., *Beato Angelico,* Milan, 1957.

Salmi, Mario, *Il Beato Angelico,* Florence, 1958.

Berti, Luciano, *Beato Angelico,* Milan, 1964; as *Fra Angelico,* London, 1968.

Orlandi, Stefano, *Beato Angelico: Monografia storica della vita e delle opere,* Florence, 1964.

Berti, Luciano, *L'Angelico a San Marco,* Florence, 1965.

Baldini, Umberto, *L'opera completa dell'Angelico,* Milan, 1970.

Fremantle, Richard, *Massaccio e l'Angelico: Estratto da "Antichità viva,"* Florence, 1970.

Procacci, Ugo, *Beato Angelico al Museo di San Marco di Firenze,* Milan, 1972.

Boskovits, Miklos, *Un "Adorazione dei Magi" e gli inizi dell'Angelico,* Berne, 1976.

Lloyd, Christopher, *Fra Angelico,* Oxford, 1979.

*

Fra Angelico was a major Florentine painter active in the first half of the 15th century. A monk whose training as an artist preceded his religious profession, Angelico was among the greatest interpreters of sacred iconography. At the same time as his work was inspired by the tradition of Dominican spirituality, it was highly advanced. For generations, an erroneous chronology and the romantic notion of him as a "mystic" artist confined to the cloister blinded critics to his true role in the development of Renaissance painting. Archival research has revised our knowledge of his oeuvre, and a greater understanding of his role as both innovator and heir to a rich theological tradition greatly has enriched our conception of Angelico's role.

While his true juvenilia are lost, his earliest works seem to reveal training by Lorenzo Monaco in the second decade of the 15th century. The luminous pastels, sinuous line, and spiritual reticence of Angelico's *San Domenico di Fiesole Altarpiece* (c. 1425; in situ), done for the monastery in which he took his vows, bespeak his early formation. No less apparent is the incipient influence of Gentile da Fabriano, Masolino, and Masaccio, demonstrating the monk's precocious understanding of their innovations. His works of the 1420's and early 1430's display a concerted emulation of their paintings and an understanding of the principles that underlay Gentile's and Masaccio's discoveries.

With the death of Lorenzo Monaco and of the luminaries of the 1420's, Angelico became the most prominent Florentine artist. The 1430's began a decade of unprecedented innovation. His documented collaboration with Ghiberti on the *Linaiuoli Tabernacle* (1433; Florence, Museo di San Marco), signalled an allegiance to the principles of monumental sculpture that henceforth was to characterize his oeuvre. The *Descent from the Cross* (before 1434; Museo di San Marco), works for San Domenico di Cortona (c. 1434-39; Cortona,

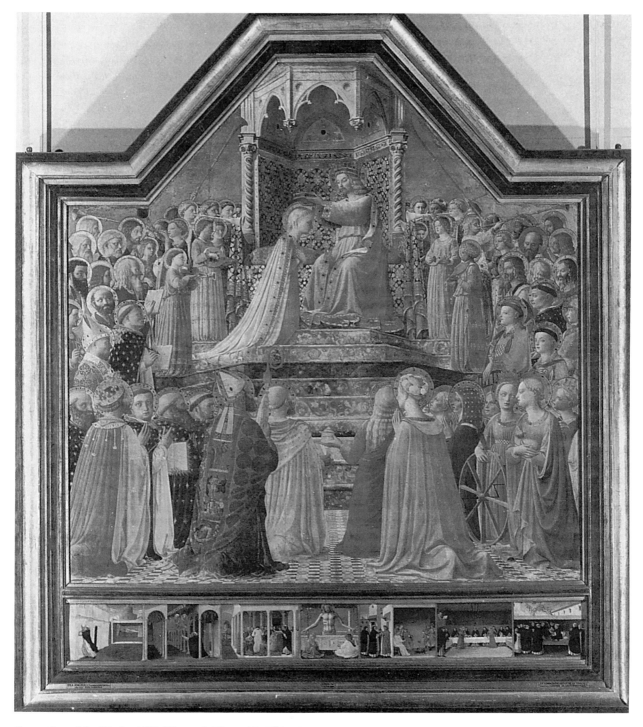

Coronation of the Virgin, 1430–35; panel, 7 ft × 6 ft 10$\frac{7}{8}$ in (213 × 211 cm); Paris, Louvre

Museo Diocesano), and *Perugia Altarpiece* (1437; Perugia), with their strongly illuminated figures, slender proportions, elegant drapery, and intensely characterized gestures and expressions attest Ghiberti's influence, also found in Angelico's multi-episodic predellas.

Angelico's genius is most elequently expressed in the works that he executed for the monastery of San Marco, Florence, whose extensive renovation and decoration were subsidized by Cosimo de'Medici. The *San Marco Altarpiece* (1438–40/42; Museo di San Marco) seems to have introduced the single-panel "sacred conversation" type and a lucid, one-point perspective system to the altarpiece. Eliminating the traditional gold background, Angelico portrayed the forecourt of heaven, the garden of paradise, identifiable as such by the inscriptions on the Virgin's drapery, Saint Mark's open book, and the flowering cedars and palms. In this work, a uniquely Dominican sensibility is extolled. The frescoes of the more private space of the monastery are conceived in a different spirit. The 43 cells, the cloister, corridor, and chapter house (c. 1440–50) are adorned with images that exhort and exalt meditation and imitation of Christ. Painted by Angelico and students, they are luminous, visionary evocations, sparing in detail, where Dominican saints witness, and are inspired to emulation of, the Christological scenes before them. Recent studies have demonstrated that the varied gestures and postures of the saintly exemplars correspond to the modes of prayer commended in *De modo orandi*, a Dominican devotional text.

No less than five fresco cycles seem to have been executed by Angelico in Rome from the mid-1440's on, though only one survives. Painted with the assistance of Benozzo Gozzoli, the Chapel of Nicholas V in the Vatican (c. 1446–47) speaks a different language from that of the San Marco cell frescoes. In these episodes from the lives of Saints Lawrence and Stephen, the spaces are vast and populous, their architecture evocative of the antique world of these martyrs. As if to display the spiritual kinship between the saints, whose remains were interred in a common tomb and whose lives were in many ways parallel, Angelico repeated some of their postures and gestures from scene to scene. The elevated, solemn pictorial language translates the sacred and intellectual ideals of the humanist pope Nicholas V who commissioned the chapel.

The only work universally ascribed to Angelico's last years is the Santissima Annunziata silver chest (c. 1450; Museo di San Marco). While the master's mind is evident in the monumentally conceived yet minutely detailed compositions of its panels as well as in its theological sophistication, his hand is found with difficulty. He died on 18 February 1455, in the mother church of the Dominicans in Rome, Santa Maria sopra Minerva. Venerated even in his own lifetime, nominated to the position of archbishop of Florence, a role he declined, Angelico was beatified formally in 1982 by Pope John Paul II.

Since the quincentennial of Angelico's death, several new documents and studies have expanded our knowledge of the artist's development, oeuvre, and his importance as an innovator and influence in Florentine painting. At the same time, as more is learned about Dominican spirituality and the ambitions of his patrons, the character of his works, at once utterly unique and yet universally apprehended, is better understood. Aptly described as "painted prayers," his art reveals a rare, transcendent beauty.

—Diane Cole Ahl

ANTONELLO da Messina.

Born in Messina, c. 1430. Died in Messina, between 14 and 25 February 1479. Married Giovanna; children. Probably apprenticed to Colantonio in Naples, c. 1450; set up as painter in Messina by 1456; possibly worked in Rome, 1465–73; in Venice, c. 1475–76. Apprentice: Paolo di Ciacio.

Collections: Antwerp; Baltimore: Walters; Berlin; Bucharest; Cefalu: Museo Mandralisca; Dresden; London; Munich; New York; Paris; Piacenza; Reggio di Calabria; Philadelphia; Rome: Borghese; Siracusa; Turin: Sabauda; Venice: Correr; Vienna; Washington.

Publications

On ANTONELLO DA MESSINA: books—

Lauts, Jan, *Antonello da Messina*, Vienna, 1933.
Bottari, Stefano, *Antonello*, Milan, 1939, 1953; Greenwich, Connecticut, 1956.
Brandi, Cesare, *Restauro dei dipinti di Antonello da Messina*, Rome, 1942.
Vigni, Giorgio, and Giovanni Carandente, *Antonello da Messina e la pittura del '400 in Sicilia* (cat), Messina, 1953.
Bernardi, M., *Antonello in Sicilia*, Turin, 1957.
Vigni, Giorgio, *Tutta la pittura de Antonello da Messina*, Milan, 1957; as *All the Pictures of Antonello da Messina*, New York and London, 1963.
Rossi, G. F., *Antonello da Messina*, Picaenza, 1960.
Causa, R., *Antonella da Messina*, Milan, 1966.
Mandel, Gabriele, *L'opera completa dell' Antonello da Messina*, Milan, 1967.
Marabottini, Alessandro, et al., *Antonello da Messina* (cat), Messina, 1981.
Tramontana, Salvatore, *Antonello e la sua città*, Palermo, 1981.
Sricchia Santoro, Fiorella, *Antonella e l'Europa*, Milan, 1986.

articles—

Robertson, G., "The Architectural Setting of Antonello da Messina's San Cassiano Altarpiece," in *Studies in Late Medieval and Renaissance Painting in Honour of Millard Meiss*, Oxford, 1977.
Paolini, M. G., "Antonello e la sua scuola," in *Storia della Sicilia*, 5, Naples, 1979.
Wright, Joanne, "Antonello da Messina: The Origins of His Style and Technique," in *Art History* (Oxford), 3, 1980.
Jolly, P. H., "Antonello da Messina's *Saint Jerome in His Study:* An Iconographic Analysis," in *Art Bulletin* (New York), June 1983.

*

Antonello was the only major Italian artist of the 15th century to have been born south of Rome. His career is inextricably linked to his masterful control of the oil paint medium. Logically then, it is assumed that his acquaintance with stylistic mannerisms of Flemish technique came about through contact with one or several avenues of northern art in the Italian south: Colantonio, often cited as "his teacher," in Naples; or Flemish-

influenced Spanish artists in his native Sicily; or, equally possible, contact with the little-understood southern French Master of the Annunciation of Aix. Northern paintings—including those of Jan van Eyck and Rogier van der Weyden—were available, in fact, in Naples. For instance, Antonello's *St. Jerome in His Study* (London) has been shown to reflect, both in technique and even iconography, the now-lost van Eyck Lomellini Triptych, at that time in the collections of King Alphonso of Naples. Nonetheless, Antonello's art continued to evince a Mediterranean passion for abstract clarity; it has even been suggested that he may have studied archaic Greek sculpture while a youth in Sicily. With more certainty, the influence of both Piero della Francesca and Andrea Mantegna can be felt in the static grandeur and web of geometry in his few-surviving altarpiece fragments.

Whatever its sources, Antonello had developed a confident understanding of the objective signification of figures and objects brought forth by the mystic force of light in an oil-based medium. In the *St. Jerome,* recently with some security dated to c. 1458, the profundity of this grasp is apparent in the varied and virtuosic textures and light-dark filled spaces of the nave-like scene; if he repeated such an Eyckian performance—also available in the complexity of the disguised symbolism—it has been lost. Yet Flemish art of that time continued to inspire him, and he produced, in Flemish fashion, a series of heads in three-quarter profile against a dark rearground. Attempts to label two of them as self-portraits, through an intensity of psychic exploration seemingly impossible beyond the self alone, have not been successful (*Portrait of a Man,* London, and the so-called *Trivulzio Portrait,* Turin). In these, and others works such as the *Condottiere* (Louvre) and the *Portrait of a Man* (Philadelphia), the figure is shown just below the shoulders, all the more forcibly establishing bodily presence—a southern trait—along with the insubstantiality of psychic enigma. Similarly presented, religious themes such as the *Virgin Annunciate,* (Palermo) and the *Salvator Mundi* (London) are re-examined with no focus on religious emblem, instead operative only by their physiognomic gesture and immediate presence behind some forward, again Eyckian, parapet-like device. Pentimenti, visible as here in important passages of an image, reveal his continuing perfectionism.

Antonello's greatest influence has for long been said to be in the northern corner of Italy furthest from his southern home. In under two years spent in Venice (1475–76)—some argue that Antonello was strongly influenced by the progressive work of Giovanni Bellini—he produced, with other now lost work, the *San Cassiano Altarpiece* (Vienna) and the *St. Sebastian* (Dresden). Both these works survive now only as fragments of far larger assemblages. The former has been reconstructed (Wilde) so as to appear inspired by the sacra conversazione before a barrel-vaulted apse found in Piero della Francesca's *Madonna and Child with Saints,* (Milan); while the haunting surreality of the *St. Sebastian,* with facial features like the *Virgin Annunciate,* seems indebted to patterns established in works by Mantegna, although his nude does not show any sculptural harshness. Along with the insistent Paduan perspective devices and architectural environment, Antonello laid down the poetic and luminescent harmony to be found in the work of Giovanni Bellini to follow and flourish into the incredible Venetian cinquecento.

—Joshua Kind

APPEL, Karel.

Born in Amsterdam, 25 April 1921. Attended Royal Academy of Fine Arts, Amsterdam, 1940–43; friend of Corneille, Louis Van Lint, and Marc Mendeksin, 1946, and co-founder of the Cobra group, 1948–50; first visit to the United States, 1957, and now lives and works in New York. Address: c/o Marisa del Re Gallery, 41 West 57th Street, New York, New York 10022, U.S.A.

Collections: Amsterdam: Stedelijk; Boston; Brussels; Copenhagen; Eindhoven; Hamilton, Ontario; London: Tate; Los Angeles; Montreal; New York: Moma, Guggenheim; Paris: Beaubourg; Toronto.

Publications

By APPEL: books—

Appel over Appel, edited by Albert Rikmans, Amsterdam, 1971.

illustrator: *De blijde en onvoorziene week,* by Hugo Claus, 1950; *A Beast-Drawn Man,* by Bert Schierbeek, 1962; *Encres à deux pinceaux et leurs poèmes,* by Hugo Claus and Pierre Alechinsky, 1978; *De ronde Kant van de aarde,* by Hans Andreus, 1979; *Le Noir de l'azur,* by Jean-Clarence Lambert, 1980; *Nocturne de San Ildefonso,* by Octavio Paz, 1987.

On APPEL: books—

Claus, Hugo, *Appel,* Amsterdam and New York, 1962.
Schierbeek, Bert, *Appel: Nudes* (cat), New York, 1964.
Alvard, Julien, *Appel: Reliefs 1964–1968* (cat), Paris, 1968.
Bellew, Peter, *Appel,* Milan, 1968.
Choisez, Anne, *Het Tijdschrift Cobra,* Brussels, 1970.
Rombout, Luke, *Appel's Appels* (cat), Toronto, 1972.
Nocentini, Armondo, *Opere di Appel,* Florence, 1973.
Sandberg, Willem, *Cobra + Contrasts* (cat), Detroit, 1974.
Read, Herbert, *Appel* (cat), London, 1975.
Berger, Peter, *Appel,* Venlo, 1977.
Koster, Nico, and Edward Wingen, *Het Gezicht van Appel / The Face of Appel,* Venlo, 1977.
Rodriquez, Antonio, *Appel, pintor de insolita expresividad* (cat), Mexico City, 1977.
Wingen, Edward, *30 Years of Painting by Appel,* Venlo, 1977.
Claus, Hugo, *Ontmoetingen met Corneille en Appel,* Antwerp, 1980.
Frankenstein, Alfred, *Appel,* New York, 1980.
Lambert, Jean-Clarence, *Appel: Works on Paper,* New York, 1980.
Appel: Werk op papier (cat), The Hague, 1982.
Lambert, Jean-Clarence, *Cobra,* Paris, London, and Totowa, New Jersey. 1983.
Restany, Pierre, et al., *Appel,* New York, 1985.
Hunter, Sam, *Appel: Recent Paintings* (cat), New York, 1986.
Kuspit, Donald, *Appel: Recent Paintings and Sculpture* (cat), New York, 1987.
Appel: 40 Years of Paintings, Sculpture, and Drawings, Paris, 1987.

Appel is a Dutch artist, one of the trio who formed in 1948 the Amsterdam wing of the European revolutionary movement in abstract painting, called COBRA (So-called because the letters formed an abbreviation of Copenhagen, Brussells and Amsterdam—the three cities from which the contributing artists came). Cobra itself only lasted three years, but Appel's influence, originated within the movement, was sustained long after the demise of the group.

The Dutch, as a nationality, held such an important place in the work of Appel because of the Netherland's singular position in Europe after World War II. The effects of the conflict were particularly hard-felt in Amsterdam, and especially brutal towards those, including the artists, who had been so confused by the duplicitous behaviour of the Nazis. The occupying government had been seductively liberal at first, but as the results had proved so disappointing, it had then resorted to terror of an extreme nature. There was never even a collaborationist government in the Netherlands, and it was there that the Nazis claimed more victims, proportionately, than in any other place in Europe. Cobra's foundation was almost entirely political, though the artists themselves did not necessarily subscribe to every condition, and would often retain an a-political perspective.

Appel had studied at the Royal Academy of Fine Arts in Amsterdam between 1940 and 1943; after the end of the war he travelled to Belgium, France, Scandinavia, and Germany: he joined up with a fellow student and friend, Cornelle, another painter, Constant, and painters from Denmark and Belgium, to initiate the Cobra movement. All the contributing artists had Surrealist origins, and their aim was to form a cohesive organisation whose *artistic* aim was to combat the existing hegemony of geometric and decorative painting.

The cobra itself was symbolic of the group's identity: the snake is one of the most important archetypes of the human soul. The unity of the group was supposed to be a reflection of their youth: reflexive and rebellious. One of Appel's famous remarks is "I paint like a barbarian in a barbarous age." Christian Dotrement, a communist, was the member responsible for the publication of the magazine dedicated to the promotion of their ideas. While adopting a whole-hearted contempt for the classical tradition, they instead admired the spontaneity of folk art. They liked creative activity for its own sake and did not attempt to be either realistic or abstract.

One of the most interesting features of Cobra, uniting them with the American Abstract Expressionists, was their dislike of the French supremacy in painting, hitherto taken for granted in all circles of the art world. Dotrement read out controversial statements at one of their meetings, "Paris is no longer the centre of art. It is the centre of difficulties." Their lack of regard for a so-called cultural heritage, plus the faith that the Cobra artists had in children's art, formed the greatest antipathy to the "isms" of the time.

Appel frequently applied his paint straight from the tube, building up an interlacing and multi-layered network of colour. His techniques extend into the medium of sculpture itself. Inevitably, some of the techniques have lead to criticism—"My child could have done that"—but they have forced a crucial debate about the limitations of technical and formal analysis.

—Magdalen Evans

ARCHIPENKO, Alexander.

Born in Kiev, Ukraine, 30 May 1880; naturalized United States citizen, 1928. Died in New York, 25 February 1964. Married 1) Angelica Bruno-Schnitz, 1921 (died, 1957); 2) the artist Frances Grey, 1960. Studied painting and sculpture at Kiev School of Art, 1902–05, and Ecole des Beaux-Arts, Paris, 1908; lived and taught in Paris, 1908–14, Cimiez, 1914–18, and Berlin, 1921–23; then settled in the United States, 1923: lived and taught in New York, 1923–35, Los Angeles, 1935–37, Chicago, 1937–39, and New York from 1939: taught in his own art schools, and at Mills College, Oakland, 1933, Chouinard Art School, Los Angeles, 1933, University of Washington, Seattle, 1935–36, 1951, New Bauhaus, Chicago, 1937, Dalton School, New York, 1944, Institute of Design, Chicago, 1946, University of Kansas City, 1950, University of Oregon, Eugene, 1951, University of Delaware, Newark, 1952, and University of British Columbia, Vancouver, 1956.

Collections: Berlin: Nationalgalerie; Chicago; Cleveland; Darmstadt; Hagen; New York: Guggenheim, Moma, Whitney; Paris: Beaubourg; Tel Aviv.

Publications

On ARCHIPENKO: books—

Däubler, Theodor, and Ivan Goll, *Archipenko-Album,* Potsdam, 1921.
Reynal, Maurice, *Archipenko,* Rome, 1923.
Hildebrandt, Hans, *Archipenko: Son oeuvre,* Berlin, 1923.
Weise, Erich, *Archipenko,* Leipzig, 1923.
Archipenko: 50 Creative Years 1908–1958, New York, 1960.
Sangiorgi, Giovanni, and Gino Severini, *Archipenko,* Rome, 1963.
Karshan, Donald, *Archipenko: Content and Continuity 1908–1963,* Chicago, 1968.
Karshan, Donald, editor, *Archipenko, International Visionary,* Washington, 1969.
Archipenko (cat), Brussels, 1969.
Archipenko: The American Years 1923–1963 (cat), New York, 1970.
Karshan, Donald, *Archipenko: The Sculpture and Graphic Art, Including a Print Catalogue Raisonné,* Tubingen, 1974.
Michaelsen, Katherine Janszky, *Archipenko: A Study of His Early Works 1908–1920,* New York, 1977.

*

Alexander Archipenko's career has been marked by successive periods of innovation and the reworking of his previous approaches. He is best remembered for the works he made in France from 1908 to 1921, his most innovative period. His early work, from 1908, show a deep interest in archaic art of diverse origin, including Near Eastern, Greek, Chinese, and Egyptian art. He was also influenced by the Post-Impressionist Gauguin's Polynesian works. His sculpture at this point is

Two Nudes, 1921; lithograph

characterized by a stripping down of detail and the use of broader, more volumetric forms, and the incision of details. These features can be seen in his *Woman with Cat* of 1910.

In the years 1911 to 1913 Archipenko began to experiment with the problems posed by contemporary sculpture, notably that of the relationship of space to the solid surface. During this time he devised a system of counter-volumes, where concave surfaces are used to suggest the presence of a convex volume. He also enclosed areas of space with sculptural elements, leaving the void to represent the object defined by the material. Both these principles are clearly visible in *Geometric Figure* (1914). The head of the figure is a void defined by two thin planes which add no dimension to it from any perspective. The figure is concave from the waist to the knee, the thighs in particular are scooped out, leaving the spectator to construct the intended appearance with the implied convex shape. Implicit in this activity are the elements of time and motion, a concern which Archipenko returned to several times throughout his career. This development of space creating form has been credited to Archipenko, yet it seems that he was informed by Cubist painting. Archipenko was associated with the Cubists early on, showing in the Brussels exhibition in 1911 and with the *Section d'Or* in 1912. By 1909–10 Braque was already using concave and convex forms in his work, and by 1912 Léger, whom Archipenko knew, was exploring the dynamics of form. Léger's *Les Fumeurs* of 1912, with its receding angular forms and protruding curved ones, resembles Archipenko's *Madonna of the Rocks* of the same year. Archipenko also at this time painted some of his works a single color to assert their identity as art objects and not representations of reality.

The war years were a mixture of innovation and the reworking of previous discoveries. Archipenko experimented with construction and polychromy and also developed his sculpto-paintings. The latter, which he made between 1915 and 1920 and further developed by Laurens and Lipchitz in subsequent years, were a synthesis of his interests in color, form, abstraction, and motion, and show both a continuation of and a moving away from the Cubist principles in his past work. As in his previous work, he used concave and convex forms to create optical movement, and there is a certain geometricism in the forms, yet his attitude towards color is markedly different: through the use of polychrome, he tried to revitalize the sculpture surface. This, he thought, would bring an element of change through the nuance of light and shadow on a multi-colored surface. This interest in motion is more clearly expressed in *Archipentura* of 1924, a machine which caused the illusion of movement in a painted subject by means of moving canvas strips within a frame, thereby altering the image. Archipenko said of this piece: "*Archipentura* paints time."

There are certain themes that Archipenko always returned to throughout his career. While making Cubist sculpture, he was also producing more archaic works like those of his earliest pieces. In the postwar years he made these repetitions more often. Using upright female figures as his main subject matter, he relied on his discoveries of space-forms, albeit used in a more conventional manner. His work also became more decorative, often characterized by highly polished surfaces. His *Silver Torso* of 1934 is somewhat representative of his postwar style.

—Nancy C. Jachec

ARP, Hans [Jean].

Born in Strasbourg, 16 September 1887. Died in Basel, 7 June 1966. Married 1) Sophie Taeuber (i.e., the artist Sophie Taeuber-Arp), 1921 (died, 1943); 2) Marguerite Hagenbach, 1959. Studied at the Ecole des Arts et Metiers, Strasbourg, 1904–05; privately with George Ritleng; under Ludwig von Hofmann at Weimer School of Art, 1905–07; briefly at Julian Academy, Paris, 1908; lived in Switzerland, and associated with members of the Moderne Bund and Blaue Reiter groups, early association with Dada and Surrealist groups; lived in Meudon, 1928–40, and after the war.

Collections: Basel: Kunstmuseum, Galerie d'Art Moderne; Berne; Detroit; Edinburgh; Grenoble; Hamburg; London: Tate; New York, Guggenheim, Moma; Otterlo; Paris: Beaubourg; Strasbourg.

Publications

By ARP: books—

Der Vogel selbdritt (verse and woodcuts), Berlin, 1920.
Die Wolkenpumpe (verse), Hanover, 1920.
Der Pyramidenrock (verse), Zurich and Munich, 1924.
Die Kunstismer—Les Ismes de l'art—The Isms of Art, with El Lissitzky, Zurich and Munich, 1925.
Weisst du Schwarzt du (verse), illustrated by Max Ernst, Zurich, 1930.
Konfiguration (verse), Paris, 1930.
Tres immensas novelas (fiction), with Vicente Huidobro, Santiago, 1935.
Des taches dans le vide (verse), Paris, 1937.
Sciure de gamme (verse), Paris, 1938.
Muscheln und Schirme (verse), Meudon, 1939.
Poèmes sans prénoms (verse), Grasse, 1941.
Rire de coquille (verse), Amsterdam, 1944.
1924-1925-1926-1943 (verse), Berne, 1944.
Le Blanc aux pieds de nègre (prose poetry), Paris, 1945.
Le Siège de l'air: Poèmes 1915-1946 (with drawings), Paris, 1946.
Monuments à lécher. Paris, 1946.
On my Way: Poetry and Essays 1912-1947, edited by Robert Motherwell, New York, 1948.
Onze peintres vus par Arp, Zurich, 1949.
Souffle (verse), Alès, 1950.
Auch das ist nur eine Wolke: Aus den Jahren 1920-1950 (prose poetry), Basel, 1951.
Wegweiser—Jalons, Meudon, 1951.
Die Engelsschrift (verse), Tubingen, 1952.
Dreams and Projects, New York, 1952.
Wortträume und schwarze Sterne: Auswahl aus den Gedichten der Jahre 1911 bis 1952, Wiesbaden, 1953.
Behaarte Herzen 1923-1926, Könige vor der Sintflut 1952-1953 (verse), Frankfurt, 1953.
Un Jour—des années—une vie, Alès, 1955.
Auf einem Bein (verse), Wiesbaden, 1955.
Unsern täglichen Traum. . . : Erinnerungen, Dichtungen, und Betrachtungen aus den Jahren 1914-1954, Zurich, 1955.
Le Voilier dans la forêt (verse), Paris, 1957.

Kore, 1958; bronze; 34½ in (87.7 cm); Courtesy Sidney Janis Gallery, New York

Worte mit und ohne Anker (verse), Wiesbaden, 1957.
Nôtre petit continent, Alès, 1958.
Monsand (verse and illustrations), Pfullingen, 1959.
Vers le blanc infini (verse and illustrations), Lausanne, 1960.
Zweiklang, with Sophie Taeuber-Arp, edited by Ernst Sheidegger, Zurich, 1960.
Sinnende Flammen: Neue Gedichte, Zurich, 1961.
Gesammelte Gedichte, edited by Marguerite Arp-Pagenbach, Peter Schifferli, and Aimée Bleikasten, Wiesbaden, 3 vols., 1963–84.
Logbuch des Traumkapitäns (verse), Zurich, 1965.
L'Ange et la rose (verse and designs), Forcalquier, 1965.
Le Soleil recerclé (verse), Paris, 1966.
Jours éffeuillés: Poèmes, essais, souvenirs 1920–1965, edited by Marcel Jean, Paris, 1966; as *Arp on Arp: Poems, Essays, Memories,* New York, 1971; as *Collected French Writings,* London, 1974.
Ich bin in der Natur geboren: Ausgewählte Gedichte, edited by Hans Bolliger, Guido Magnaguagno, and Harriett Watts, Zurich, 1986.

Illustrator: *Phantastische Gebete: Verse,* by Richard Huelsenbeck, 1916.

On ARP: books—

Giedion-Welcker, Carola, *Arp,* Stuttgart, London, and New York, 1957.
Seuphor, Michel, *Arcadie d'Arp,* Paris, 1957.
Soby, James Thrall, *Arp* (cat), New York, 1958.
Marchiori, Giuseppe, *Arp: Cinquante ans d'activité,* Milan, 1964.
Seuphor, Michel, *Arp: Sculptures,* Paris, 1964.
Seuphor, Michel, *Arp,* Paris, 1964.
Beyer, Victor, editor, *Hommage à Arp* (cat), Strasbourg, 1967.
Read, Herbert, *Arp,* London, 1968; as *The Art of Arp,* New York, 1968.
Trier, Eduard, *Arp Skulpturen 1957–1966,* Stuttgart, 1968.
Last, H. W., *Arp, Poet of Dadaism,* London, 1969.
Seuphor, Michel *Les Sources littéraires chez Arp et Mondrian,* Geneva, 1974.
Watts, H., editor, *Arp, Schwitters, Klee: 3 Painter Poets,* London, 1974.
Poley, Stefanie, *Arp in der Hamburger Kunsthalle,* Hamburg, 1976.
Poley, Stefanie, *Arp: Die Formensprache im plastischen Werk,* Stuttgart, 1978.
Arntz, Wilhelm F., *Arp: Das graphischen Werk/The Graphic Work 1912–1966,* The Hague, 1980.
Arp: Sculpture (cat), Lugano, 1980.
Bleikasten, Aimée, *Arp: Bibliographie,* London, 2 vols., 1981–83.
Rau, Bernd, *Arp: Die Reliefs: Oeuvre-Katalog,* Stuttgart, 1981; as *Arp: The Reliefs: Catalogue of Complete Works,* New York, 1981.
Usinger, Fritz, *Huldigung für Arp,* Merzhausen, 1981.
Arp (cat), Basel, 1982.
Trier, Eduard, *Arp,* Bonn, 1985.
Hancock, Jane, and Stefanie Poley, editors, *Arp* (cat), Stuttgart, Minneapolis, and Cambridge, 1986.
Fauchereau, Serge, *Arp,* New York, 1988.

*

Along with Kandinsky and Mondrian, Arp was one of the main founders of pure abstraction in 20th-century art. His contribution consisted of biomorphic abstractions by which he attempted to imitate natural processes rather than natural forms. He did not restrict himself to this style or to the visual arts, however; he was also an accomplished poet in both French and German.

Arp's sculpture, the principal medium in which he worked, does not receive much attention today from artists and critics. One reason is that biomorphism is not a viable style for most contemporary artists. Another is that his sculpture seems monotonous; it tends to repeat similar shapes in similar configurations and utilize a uniformly high finish.

On the whole, despite elements of black humour, Arp's oeuvre is informed by a conscious naivety, purity, and fantasy. He was a dreamer, a spinner of fairy tales in both his poetry and visual work. Although his oeuvre is often associated with Dada and Surrealism, his attitudes were much more in keeping with the zeitgeist of early 19th-century Romanticism than with the angst-ridden movements of 20th-century art.

Arp's work can be divided into the following periods: chunky nude drawing from the early period before World War I, wood reliefs, drawings and automatic collages of the Dadaist period, and the later three-dimensional sculpture. The later period contains the biomorphic abstractions and disembodied fragments of human anatomy of the 1920's, the concretions from the 1930's that embody natural processes, and the geometric/biomorphic abstractions and quasi-figurative work that Arp produced from the 1940's until his death in 1967. It is important to recognize, however, that Arp worked in several sculptural styles simultaneously.

In 1916, dissatisfied with a drawing, Arp tore it up, let the pieces fall to the floor and noticed the aesthetic quality of the patterns so he labeled his work *According to the Laws of Chance.* Chance allowed Arp and the other Dadaists to circumvent the rational mind and become vehicles for higher creative forces. For Arp and the Dadaists, it was the rigid patriarchy of middle-class conventions and values, especially the so-called "reason" that led millions of men to absurd deaths over worthless portions of European real estate in World War I. Chance also broke down the hierarchy between simple objects and objects d' art. "In nature," wrote Arp, "a broken twig is as beautiful and important as the stars and it is mankind who decides on beauty and ugliness. Who has shown the beauty of twigs, splinters, fragments, rubbish on the ground . . . all are transformed into a temple for dreamer's alone." Although Arp used chance procedures for only a brief period of time, these procedures were picked up by the Surrealists and by later artists such as John Cage who wished to break down hierarchies in music.

Another important work from the late Dadaist period is the *Eggboard* (1922). Arp describes this wooden relief as follows: "The Eggboard, a game for the upper ten thousand [of the bourgeois] in which the participants leave the arena covered with egg yolk." Here Arp has arranged 11 multi-colored plywood cutouts of figures in uneven diagonal rows against a blue background. The torsos/heads are abruptly cut off by the frame so that the illusion of an endless multiplication of figures is created—perhaps an indirect reference to "the ten thousand." Most of the figures contain egg-shaped objects as the region of their navels and are partially covered with green, brown, orange, and blue paint, possibly the "egg yoke" of Arp's description. The bright colors, the movement created by the uneven rows of figures, as well as the elliptical and humorous relationship between description, title, and object, give this sculpture a complexity that goes beyond most of Arp's later sculptures.

In *Human Concretion* (1934), a sculpture that purports to express the complex process of concretion (the coalescence of natural forms), it is easy to recognize the work as a woman's torso bent over the pedestal by two enormous breasts. Even the arms strongly resemble breasts. This multiplication of breasts is particularly noticeable in the *Crown of Buds* (1936) where five bud/breasts encircle a womblike core of empty space. Although Arp strongly renounced representational sculpture at various intervals in his career, he seems to have had a fixation on the archetype of the Great Mother which appears fairly often in his work in several guises.

The lack of complexity in Arp's sculpture becomes increasingly evident in his later work. In *Geometric/Ageometric* (1940) for example, the sculpture merely consists of a simple branch-and bud-like shape inserted into a geometrical pyramid that acts as a base. Its highly finished bronze surface is of no particular textural interest. From this sculpture and many of the other ones, it becomes evident that Arp was not a master of materials. Nor did he want to be. For him the idea was more important than the execution. For the most part, Arp executed his work in plaster and then had the models duplicated in bronze at the foundry or in marble. Unlike Brancusi, who let a wide variety of materials influence the shapes and materials of his sculpture, Arp's materials relate only peripherally to the formal language of the piece. Furthermore, the highly polished surfaces reveal a utopian desire for perfection which is at odds with his other desire to mirror natural processes or suggest natural forms. His earlier experiments with torn papers that produced rougher, more imperfect works were largely abandoned in the later decades of his life.

Arp once said, "If to suppose the impossible, I had to choose between visual arts and the poetry of words, if I had to abandon sculpture or poems, I would choose to write poems." Having read Arp's poetry and seen his sculpture, I am drawn to the same conclusion. As Herman Hesse once remarked about the poetry: "And the mad poems of Arp are distinguished by an innate melody and a melancholy beauty which can be heard through madness. Whoever composes this music may be mad but he is a born musician." If more of the melancholy, melody, and madness of Arp's poetry had found its way into his sculpture, it would be more interesting for artists and critics today.

—Mark Levy

BACON, Francis.

Born in Dublin, 28 October 1909. Lived in Berlin and Paris, 1920–29, then settled in London: furniture and interior designer in 1930's; then concentrated on painting, lived in Monte Carlo, 1946–50. Address: c/o Marlborough Fine Art, 6 Albemarle Street, London W1X 4BY, England.

Collections: Belfast; Berlin: Nationalgalerie; Birmingham; Brussels; Buffalo; Canberra; Chicago; Detroit; London: Tate; New Haven; New York: Guggenheim, Moma; Ottawa; Paris: Beaubourg.

Publications

By BACON: book—

Interviews with Bacon by David Sylvester, London and New York, 1975, 1980; as *The Brutality of Fact: Interviews with Bacon,* London, 1987.

On BACON: books—

Clarac-Serou, M., *Bacon* (cat), London, 1955.
Lessore, Helen, *Bacon* (cat), Nottingham, 1961.
Carluccio, Luigi, *Bacon* (cat), Turin, 1962.
Rothenstein, John, and Ronald Alley, *Bacon* (cat), London, 1962.
Alloway, Lawrence, *Bacon* (cat), New York, 1963.
Rothenstein, John, *Bacon,* London, 1963.
Alley, Ronald, *Bacon,* London and New York, 1964.
Russell, John, *Bacon,* London, 1964.
Alley, Ronald, *Bacon* (cat), Hamburg, 1965.
Dückers, Alexander, *Bacon: Painting 1946,* Stuttgart, 1971.
Leiris, Michel, *Bacon* (cat), Paris, 1971.
Russell, John, *Bacon,* Greenwich, Connecticut, and London, 1971, New York and London, 1979.
Leiris, Michel, *Bacon, ou la vérité criante,* Montpellier, 1974.
Geldzehler, Henry, *Bacon: Recent Paintings 1968–1974* (cat), New York, 1975.
Trucchi, Lorenza, *Bacon,* Milan, 1975, 1986, New York and London, 1976.
Bacon (cat), Marseilles, 1976.
Correa, Antonio Bonet, *Bacon* (cat), Madrid, 1978.
Davies, Hugh M., *Bacon: The Early and Middle Years 1928–1958,* New York, 1978.
Bacon, Aix-en-Provence, 1978.
Van Wladegg, Joachim Heusiger, *Bacon: Schreiender Papst 1951,* Mannheim, 1980.
Deleuze, Gilles, *Bacon: Logique de la sensation,* Paris, 2 vols., 1981–84.
Gowing, Lawrence, *Bacon: Paintings 1945–1982* (cat), Tokyo, 1983.
Leiris, Michel, *Bacon: Face et profil/Full Face and in Profile,* Paris and New York, 1983.
Ades, Dawn, and Andrew Forge, *Bacon* (cat), London, 1985.
Schmied, Wieland, *Bacon: Vier Studien zu einem Portrait,* Berlin, 1985.
Davies, Hugh M., and Sally Yard, *Bacon,* New York, 1986.
Zimmerman, Jorg, *Bacon: Kreuzigung,* Frankfurt, 1986.
Bacon: Paintings of the Eighties (cat), New York, 1987.
Leiris, Michel, *Bacon,* London and New York, 1988.

articles—

Kuspit, Donald, "Bacon: The Authority of Flesh," in *Artforum* (New York), Summer 1975.
Peppiatt, Michael, "Bacon: The Anatomy of Enigma," in *Art International* (Lugano), September-November 1984.

*

Few viewers can fail to be shocked by the violence in Francis Bacon's paintings, the gruesomely distorted half-animal half-human figures with distended necks and bandaged wounds, the Popes screaming in threateningly ambiguous cage-structures, the bloodied contorted male nudes splayed on beds or vomiting in toilets, portraits of faces not so much abstracted as maliciously gorged by the painters brush. Early advocates identified his vision as "existentialist," linking his imagery to Hiroshima, the liberated concentration camps, the Cold War. Bacon himself has never encouraged such a political view of his art. Instead he insists on the "reality" and "truth" of his painting, and mundanity does indeed coexist in an eerie fashion with his scenes of defecation, onanism, torture, and suicide. The familiar props in his urban interior settings are rollerblinds, cords, mirrors, iron-frame beds, modern chairs, light-bulbs, switches, locks, keys, doors, umbrellas. One critic, Norbert Lynton, has said that his angst-ridden pictures "belong to the tradition of genre painting . . . Vermeers for an age of Kafka and Beckett."

Two Figures with a Monkey, 1973; 6 ft 6 in × 4 ft 10 in (198.1 × 147.3 cm)

Bacon's work, however, has always aroused indignation among critics, from the start of his career in 1945 when he exhibited, alongside consoling images by artists like Henry Moore and Graham Sutherland, his ghoulish triptych *Three Studies for Figures at the Base of a Crucifixion.* Since then, popular journalism has related his violent imagination and disturbing imagery with the "personality of the artist." It has even been suggested that his reliance on chance effects in his painting relates to his compulsive gambling. As the artist has only ever encouraged the legends about himself, it is important to remember that his context is the London Bohemia of the post-war years.

Bacon's interviews with the critic David Sylvester are a major document in the literature of modern art, and are revealing about the artist's sources, practise, and intentions. Bacon likes to quote the French poet Valéry, saying "What modern man wants is the grin without the cat, the sensation without the boredom of its conveyance." A vital component of Bacon's aesthetic is a dislike of narrative painting, of a story-line. He draws a distinction between intelligence and sensation, striving in his art for the latter, but he has never been lured by "pure sensation," that is abstraction. His career is marked by an obstinate working from the human body, but not from any humanist desire to derive from it a source of proportion or harmony. Instead, figures are the vehicle for his obsessive misanthropic themes of violence, sacrifice, and degradation. In the 1930's Bacon was influenced by the French writer Georges Bataille, collecting his journal, "Documents," where he studied André Masson's automatic drawings of rape and sexual release, and Eli Lotar's photographs of abbatoirs. The poet Michel Leiris, associated with this group, has championed Bacon's work. Bacon's fascination with the literature of violence and terror reaches a climax with the *Triptych Inspired by the Orestia of Aeschylus,* 1981.

The visual sources of Bacon's imagery are both art historical and contemporary. His study of Velázquez's portrait of Pope Innocent X led to a whole series of screaming prelates in menacing tubular constructions. Van Gogh inspired paintings of deceptively optimistic colour and a rare foray beyond the city. Rembrandt's *Slaughtered Ox,* 1655, suggested a recurrent Bacon metaphor, his racks of meat, a subject which also motivated Soutine. Indeed, Bacon belongs to a modern tradition of low-life painting which includes Degas, Soutine, and Rouault as depictors of charnel houses and brothels, while in the same vein he shares with de Kooning and Picasso an identification of subject matter with painterly process. Bacon is not concerned with illustrating violence, but with a violence inherent within the image.

Bacon's use of photography, a major source for his material, is a unique and fascinating aspect of his practise. Eadweard Muybridge's experimental sequential photographs of the 1880's, which immediately influenced Eakins and Rodin, assume a new significance with Bacon's treatment. The photographs of men wrestling, originally intended to demonstrate motion, are transformed in *Two Figures,* 1953, a potent image of homosexual intercourse. Muybridge's serial frames are perhaps the source of the triptych format so dear to Bacon, which it has also been suggested derives from police records, but a cinematic metaphor is unyielding in this case. It is never possible to "read" a Bacon triptych from left to right, the artist avoiding any degree of narrative. This is not to say that cinema has not been an influence: the poignant moment in the Odessa steps scene from Eisenstein's *Battleship Potemkin,* in which a bullet hits a bespectacled nurse in the eye, appealed directly to Bacon, who has used the image repeatedly. In line with his mentor Bataille, Bacon has a macabre fascination with the orifices, and with eyes; he has drawn many ideas from a medical textbook on diseases of the mouth purchased in Paris in 1936. In many of his twisted, abused figures, attention is focused on an ambiguous spot which reads like a cross between the oral and anal orifice.

Besides drawing inspiration from photographs, Bacon makes practical use of them, preferring to work from celluloid, for instance, in portraits of friends, and even in self-portraits. There is a dialectical tension in Bacon's painting between meticulously worked, analytical passages, and an impulsive, risky use of chance effects. Over carefully studied structures appear splatters of paint, smears, drips. He does not do preparatory sketches, preferring to "draw with the brush." A vital formal element is the dramatic contrast between the figures, worked and over-worked in oil paint, and the ground, added last in fields of monochrome, the acrylics or house paints rubbed with determined vigour into the unprimed canvas.

Francis Bacon enjoys an international following, which was even extended in 1988 with a retrospective in Moscow. He is also a pivotal figure in the celebrated School of London, whose members include Hockney, Kitaj, Freud, Auerbach, and Kossoff. These artists are clearly indebted to Bacon's remarkably homogeneous oeuvre, continuing his particular and obstinate reliance on the human body, his sense of urban alienation, and his passionate concern with the mastery of technique.

—David Cohen

BALDUNG, Hans.

Also called Hans Baldung Grien. Born in Gmünd, Swabia, 1484 or 1485. Died in Strasbourg, September 1545. Married Margarethe Herlin. Possibly trained in Dürer's workshop, in early 1500's; in Halle, 1507, and in Strasbourg (citizen in 1509): painter, and designer of woodcuts and stained glass; also worked on Freiburg Cathedral, 1512–16.

Collections: Bamberg; Basel; Berlin; Breslau; Budapest; Cleveland; Dessau; Dresden; Frankfurt; Freiburg: Cathedral, Museum; The Hague; Innsbruck; Karlsruhe; Kassel; Leipzig; Liverpool; Madrid; Munich; Nuremberg; Ottawa; Otterlo; Paris; Schwabach: S. Johannes; Strasbourg; Vienna; Washington; Weimar.

Publications

On BALDUNG: books—

Terey, Gabriel von, *Die Handzeichnungen [and Gemälde] des Baldung,* Strasbourg, 5 vols., 1894–1900.
Escherich, Mela, *Baldung Bibliographie 1509–1915,* Strasbourg, 1916.

Fighting Stallions; woodcut

Schmitz, Hermann, *Baldung,* Bielefeld, 1922.

Curjel, Hans, *Baldung,* Munich, 1923.

Curjel, Hans, *Holzschnitte des Baldung,* Munich, 1924.

Hagen, Oskar, *Baldungs Rosenkranz, Seelengärtlein, Zehn Begote, Zwölf Apostel,* Munich, 1928.

Fischer, Otto, *Baldung,* Munich, 1939.

Koch, Carl, *Die Zeichnungen Baldungs,* Berlin, 1941.

Perseke, Helmut, *Baldungs Schaffen in Freiburg,* Freiburg, 1941.

Winkler, Friedrich, *Baldung, ein unbekanntner Meister deutscher Zeichnung,* Burg, 1941.

Weihrauch, H. R., *Baldung,* Mainz, 1948.

Martin, Kurt, *Skizzenbuch des Baldung: Karlsruher Skizzenbuch,* Basel, 2 vols. 1950.

Lauts, Jan, and Carl Koch, *Baldung* (cat), Karlsruhe, 1959.

Hartlaub, C. F., *Baldung,* Stuttgart, 1960.

Hartlaub, C. F., *Baldung: Hexenbilder,* Stuttgart, 1961.

Oldenbourg, M. Consuelo, *Die Buchholzschnitte des Baldung: Ein bibliographisches Verzeichnis ihrer Verwendungen,* Baden-Baden, 1962.

Oettinger, Karl, and Karl-Adolf Knappe, *Baldung und Albrecht Dürer in Nürnberg,* Nuremberg, 1963.

Bussman, Georg, *Manierismus im Spätwerk Baldungs: Die Gemälde der zweiten Strassburger Zeit,* Heidelberg, 1966.

Burkhard, Arthur, *The Freiburg Altar of Baldung,* Cambridge, Massachusetts, 1970.

Koch, Robert A., *Baldung: Eve, The Serpent, and Death,* Ottawa, 1974.

Bernhard, Marianne, editor, *Baldung: Handzeichnungen, Druckgraphik,* Munich, 1978.

Boerlin, Paul H., et al., *Baldung im Kunstmuseum Basel,* Basel, 1978.

Mende, Matthias, *Baldung: Das graphische Werk: Vollständiger Bildkatalog der Einzelholzschnitte, Buchillustrationen, und Kupferstiche,* Unterschneidheim, 1978.

Marrow, James H., and Alan Shestack, editors, *Baldung: Prints and Drawings* (cat), Washington, 1981.

Osten, Gert von der, *Baldung: Gemälde und Dokumente,* Berlin, 1983.

articles—

Lanckoronska, Maria Gräfin, "Scherz, Satire, Ironie, und tiefere Bedeutung in Baldungs Bacchus-Bilder," in *Gutenberg Jahrbuch 35,* 1960.

Neubauer, Edith, "Zum Problem 'Künstler und Gesellschaft': Dargestellt am Beispiel von Baldung," in *Lucas Cranach,* edited by Peter Feist et al., Berlin, 1973.

Olbrich, Harald, "Baldung in der Krise seiner Zeit," in *Lucas Cranach,* edited by Peter Feist et al., Berlin, 1973.

Brady, Thomas A., Jr., "The Social Place of a German Renaissance Artist: Baldung at Strasbourg," in *Central European History,* 8, 1975.

Pariset, Francois-Georges, "Grunewald und Baldung," in *Cahiers Alsaciens,* 19, 1975–76.

Brady, Thomas A., Jr., "Der gmünder Kunstler Baldung in Strassburg: Seine gesellschaftliche Stellung und seine Haltung zur Reformation," in *Gmünder Studien,* 1, 1976.

Hugelshofer, Walter, "Uberlegungen zu Baldung," in *Zeitschrift für Schweizerische Archäologie und Kunstgeschichte* (Zurich), 35, 1978.

Mesenzeva, Charmian, "*Der Behexte Stallknecht* des Griens," in *Zeitschrift für Kunstgeschichte* (Munich), 44, 1981.

Hults, Linda C., "Baldung's *Weather Witches* in Frankfurt," in *Pantheon* (Munich), April, May, June 1982.

Hults, Linda C., "Baldung's *Bewitched Groom* Revisited: Artistic Temperament, Fantasy, and the 'Dream of Reason,' " in *Sixteenth Century Journal*, 15, 1984.

Hoak, Dale, "Art, Culture, and Mentality in Renaissance Society: The Meaning of Grien's *Bewitched Groom*," in *Renaissance Quarterly* (New York), 38, 1985.

Hults, Linda C., "Baldung and the Witches of Freiburg: The Evidence of Images," in *Journal of Interdisciplinary History*, Autumn 1987.

<center>*</center>

Hans Baldung Grien was the most talented pupil to emerge out of Dürer's workshop, in which he served as apprentice from ca. 1503 to 1507. He probably underwent earlier training in an Alsatian or Swabian workshop. The choice of art as a profession within Baldung's upper-class family of physicians and lawyers was unusual. Perhaps his social status and his family's connection to learned Strasbourg circles made him especially welcome in Dürer's shop. He quickly began to absorb what Dürer had to offer, while establishing his own distinctive style: flatter, more flamboyant, linear, and ornamental, and less tied to nature. This style expressed a world-view that differed dramatically from Dürer's in its emphasis on the demonic and sensual aspects of the human condition. Whereas Dürer's art is grounded in a deep piety and intellectual humanism, Baldung's art posits a vital, sensual drive conflicting with Christianity and death. Given the differences between Baldung and his teacher, their lifelong friendship is remarkable. References to Dürer's works abound in Baldung's, although motifs, figures, or compositions are altered, much as Italian Mannerist artists would modify the examples of Michelangelo and Raphael.

After completing two early altarpieces in Halle and his first, brief stay in Strasbourg, Baldung undertook his most ambitious work, the High Altar of the Freiburg Munster. This large altarpiece necessitated many assistants whose less skillful hands are visible in varying degrees throughout. The main panel is a Coronation of the Virgin, revealing a dependence on Dürer's woodcut versions of this subject, but reinterpreted by Baldung. The most striking and idiosyncratic aspect of this composition is the horde of musical angels, ostensibly celebrating Mary's triumph but giving the impression of uncontrolled rowdiness.

During the completion of the Freiburg Altar—a work primarily venerating the Virgin—Baldung took up the diametrically opposite, relatively new theme of witchcraft in erotic and scatological chiaroscuro drawings which apparently circulated privately to his friends (one was used as a New Year's greeting). While he was in Strasbourg, he had produced his famous chiaroscuro woodcut of witches preparing to fly to their "sabbath" orgy. The reality of witches' flight was a controversial and topical issue; it is not surprising that Baldung focused on their magical levitation. His images are important documents of the developing stereotype of witchcraft, which would fuel the mass persecutions after 1560. Baldung used the witch for his vehement satire of women, whose lust and gullibility, especially about being able to fly, were supposed to lead them to the devil.

Another theme which captivated Baldung was Death and the Maiden. During his early Strasbourg period, he had produced an awkward composition showing Death and the Three Ages of Woman (Vienna), but about the time of his permanent move to the Alsatian capital, he painted two dramatically concentrated confrontations between the female nude, as Luxuria or Sensuality, and animated skeletons symbolizing Death (Basel, Offentliches Kunstsammlung). Baldung prospered in Protestant Strasbourg, producing portraits, religious works including numerous Madonnas (the patroness of the city), book illustrations and single-sheet prints, and works with allegorical or historical themes. He even served as part of the city government toward the end of his life. Although the Reformation shrunk his repertory of religious themes, it allowed him to explore secular themes and his private interests further.

Outstanding among Baldung's works produced in Strasbourg are the female nudes of the 1520's, which combine plasticity and powerful contours and express the sensuality of woman. The coloristically spectacular *Weather Witches* (Frankfurt) reveals his continued interest in demonic themes and projects a refined, Mannerist ideal of the nude. A gem of a picture dating from late in this decade is *Eve, the Serpent, and Death* in the National Gallery of Canada, Ottawa, in which Baldung combined the Death and Maiden theme with his longstanding interest in the Fall of Man. The Ottawa painting elucidates Baldung's sense of the human being coerced by the sexual drive (embodied in the phallic serpent and the wonderful, leering Eve) into original sin and mortality—expressed by Baldung's imaginative conflation of the rotting corpse and Adam.

In the 1530's Baldung ventured into history painting with a cycle depicting virtuous deeds of antiquity. Another remarkable product of this decade is the series of woodcuts of wild horses, which describes their mating habits, and depicts the frustration of an excited stallion, who ejaculates on the ground. Such a powerful horse appears again in Baldung's enigmatic woodcut, *The Bewitched Groom* of 1544. Here, the horse (based on Dürer's engraving *The Large Horse*) is apparently inspired by a torch-bearing witch to harm or kill a reclining groom, probably meant to suggest the artist himself. Scholars have related this print to Franconian and Alsatian folk tales, or interpreted it as an expression of the artist's fear of bewitchment, his "flight" to the sabbath, or an allegory of his artistic creativity. The witch and the demonic horse both embodied the sensual drive which is a central focus of Baldung's art.

Whatever its meaning (and multiple meanings are possible), the *Bewitched Groom* expresses the artist's fear of his own mortality and for the salvation of his soul. Two strange, attenuated allegorical paintings of the Ages of Life theme (one in the Prado, Madrid, and one known by its left half in Leipzig, and a copy of its right half in Rennes) also express his late meditation on these themes.

Although attempts to place Baldung in libertine circles remain unconvincing, he is surely one of the most unusual artists of the northern Renaissance, and the most brilliant and idio-

syncratic interpreter of Dürer's legacy. The anti-feminism and morbidness of his art are redeemed by his irrepressible vitality and the appealing, flamboyant vigor of his style.

—Linda C. Hults

BALLA, Giacomo.

Born in Turin, 18 July 1871. Died in Rome, 1 March 1958. Married Elisa Marcucci, 1904; two children. Attended the Albertina Academy, Turin, 1886–89; also studied photography; settled in Rome: worked as illustrator, 1895–1900, and as private teacher to Umberto Boccioni, Gino Severini, and others: associated with the Italian Futurists, and co-signed Futurist manifestos, 1910–31; painted in Futurist style until 1931, then more conventionally.

Collections: Buffalo; London: Tate; Milan: Arte Moderna; New York: Moma; Paris: Beaubourg; Rome: Arte Moderna, Istituto Svizzero, Accademia di San Luca; Stockholm: Moderna Museet; Turin: Arte Moderna; Venice: Guggenheim.

Publications

On BALLA: books—

Gambillo, Maria Drudi, and Teresa Fiori, *Archivi del futurismo*, Rome, 2 vols., 1958–62.

Falqui, Enrico, *Bibliografiae iconografia del futurismo*, Florence, 1959.

Gambillo, Maria Drudi, and Claudio Bruni, *After Boccioni: Futurist Paintings and Documents from 1915 to 1919*, Rome, 1961.

Taylor, Joshua C., *Futurism*, New York, 1961.

Carrieri, Raffaele, *Futurismo*, Milan, 1961; as *Futurism*, Milan, 1963.

Crispolti, Enrico, and Maria Drudi Gambillo, editors, *Balla* (cat), Turin, 1963.

Barricelli, Anna, *Balla*, Rome, 1967.

Fagiolo dell'Arco, Maurizio, *Omaggio a Balla*, Rome, 1967.

Martin, Marianne W., *Futurist Art and Theory 1909–1915*, Oxford, 1968.

Dortch-Dorazio, Virginia, *Balla: An Album of His Life and Work*, New York, 1970.

Fagiolo dell'Arco, Maurizio, *Futur Balla*, Rome, 1970.

Apollonio, Umbro, editor, *Futurismo*, Milan, 1970; as *Futurist Manifestos*, London, 1973, and New York, 1973.

De Marchis, *Balla* (cat), Rome, 1971.

Kirby, Michael, *Futurist Performance*, New York, 1971.

Passani, Franco, *Balla* (cat), Milan, 1973.

Marcucci, Luigi, editor, *Balla* (cat), Verona, 1976.

Marchis, Giorgio de, *Balla: L'aura futurista*, Turin, 1977.

Poggianella, Sergio, editor, *Balla: Opere dal 1912 al 1930* (cat), Modena, 1980.

Robinson, Susan Barnes, *Balla: Divisionism and Futurism 1871–1912*, Ann Arbor, 1981.

Lista, Giovanni, *Balla*, Modena, 1982.

Hanson, Anne Coffin, *The Futurist Imagination* (cat), New Haven, 1983.

Crispolti, Enrico, *Il futurismo e la moda: Balla e gli altri*, Venice, 1986.

Fagiolo dell'Arco, Maurizio, *Balla the Futurist* (cat), Milan, London, and New York, 1988.

*

One year after he launched Futurism in Paris in 1909, the Italian poet Filippo Tommaso Marinetti welcomed five artists to his literary movement. Led by Umberto Boccioni, the painters Giacomo Balla, Carlo Carrà, Luigi Russolo, and Gino Severini, joined Marinetti in declaring their rejection of the dead weight of past culture and their desire to celebrate the dynamism of a new age. In two painting manifestos which quickly followed each other in 1910, they outlined a program and then preceded to create their first works in the new idiom.

Although Balla is known today chiefly for his contribution to Futurism, when he joined the movement he was already a mature and established artist, a full decade older than the other painters of the group. Stylistically and thematically, the paintings of his pre-Futurist period were allied to Divisionism, the style of the Italian avant-garde at the turn of the century. Divisionism appealed to Balla both for its pictorial energy of color and light and for its socialist orientation. Developing his own highly personal version of Divisionism, he communicated its premises to Boccioni and Severini, his pupils in Rome in the early years of the century. With the advent of Futurism in 1910, Divisionism became the initial vehicle for the artists' renewed vision of painting.

Much of Balla's early work foreshadowed in its preoccupations the art of his Futurist years. In the austerely beautiful *Work* (c. 1902–03; New York, Winston Malbin Collection), Balla's realism, his social concerns, his study of natural and artificial light, and his interest in photography all come together. Divisionist dots and streaks of color—charged particles of artificial light glowing from the gas lamp signalling a factory—illuminate this tightly cropped silent corner of the nighttime city where some must labor as others sleep.

In *Street Light* (c. 1910–11; New York, Moma), Balla pursues the logic of his Divisionism a step further. Where earlier he had depicted the impact of light as it illuminated areas of color, in *Street Light* Balla found pictorial equivalents for light itself—brittle vectors of electricity anticipating Futurist lines of force. While the starting point of the painting—a street lamp in Rome's Piazza Termini—is consistent with Balla's practice of working from direct observation, the artist nonetheless moves in this canvas a step away from the precise study of reality, achieving a degree of abstraction heretofore absent in his work. This change in his stylistic vocabulary, representing an adjustment and partial rejection of his realist training, was surely precipitated by his interest in realizing a new content, theoretical and literary in its source. The energy of electric light, an image fully in the spirit of early Futurism, was a recurrent theme in Marinetti's writings. Balla's painting recreates the central image of Marinetti's second Futurist manifesto, *Let's Kill the Moonlight* (April 1909), where modern electric light obliterates romantic moonlight.

While Balla was part of the Futurist group by the spring of 1910 he did not immediately take part in its events, nor con-

Boccioni's Fist—Lines of Force, 1915; metal; $31\frac{1}{2}$ in (80 cm); private collection

tribute to its exhibitions. Isolated from the frenetic activities of the Milan-based group by his residence in Rome, Balla's highly independent Futurist vision does not fully emerge until 1912. In three canvases of that year, *Dynamism of a Dog on a Leash* (Buffalo), *Girl Running on the Balcony* (Milan, Civica Galleria d'Arte Moderna), and *Rhythms of the Bow* (London, Estorick Collection), he effectively converted his Divisionist style into a fully modern idiom under the influence of Futurist theory, to express his new concern with the visualization of consecutive phases of movement in space.

Then, late in 1912, Balla pushed the fundamental tenets of Divisionism—the analysis of light and color—into abstraction with the first of the *Iridescent Interpenetration* studies. Beginning with a series of watercolor studies in which prismatic colors are arranged in patterns made up of variously shaped triangles or segmented circles and then moving to oil versions of this theme (*Iridescent Interpenetration,* New York, Winston Malbin Collection), Balla transformed the canvas, in the parlance of Futurism, into the "dynamic sensation itself," creating the first totally abstract works of the Futurist movement.

By the beginning of 1913, Divisionism ceased to be the primary mode of Balla's art. Now fully a part of the Futurist group, Balla's work became more synthetic in style, and his subject matter too, came more into line with Futurist imagery of aggressive modern movement than the earlier personal and whimsical subjects of his daughter running on the balcony or a dachshund scampering along. The imagery of the automobile, one of the primary Futurist symbols of modernity, occupied Balla through a series of paintings. Nearly obliterating the car's form, he analyzed its shape into a network of quasi-abstract lines, expressive of Futurist principles of velocity, dynamism and simultaneity, in paintings such as *Abstract Speed—the Car Has Passed* (1913; London, Tate) and *Abstract Speed + Sound* (1913–14; Venice, Guggenheim).

By late 1916, with Futurism disrupted by World War I, by Boccioni's death, and by the move away from its tenets on the part of Carrà and Severini, Balla alone of the original artists carried on, with Marinetti, the aims of the movement, now centered in Rome. Already he had moved into sculpture with his "plastic complexes" announced in a manifesto issued in 1915, *The Futurist Reconstruction of the Universe,* co-authored with the newcomer Fortunato Depero. In the following years he broadened the base of his art still further to include experiments in theater, cinema, and the decorative arts. Finally, in 1931, Balla too, left Futurism for a more conservative figurative style.

—Susan Barnes Robinson

BARLACH, Ernst.
Born in Wedel, 2 January 1870. Died in Rostock, 24 October 1938. One illegitimate son. Attended Hamburg School of Arts and Crafts, 1888–91; Dresden Academy, 1891–95; also studied at the Academie Julian, Paris, 1895–96; often collaborated with Carl Garbers, 1898–c.1901; Editor, *Jugend,* 1898–1902; designed ceramics for the Mutz factory in Wedel, 1901–05; taught at Hör School of Ceramics, Westerwald, 1904; illustrator for *Simplicissimus,* 1907–08; settled in Güstrow, 1910;

worked on plays from 1912, and illustrated published versions with his own lithographs; banned by the Nazis, and 381 sculptors removed from German museums, 1938.

Major Collections: Hamburg: Barlach-Haus; Lüneburg: Barlach Museum.

Other Collections: Berlin: Charlottenburg; Berlin (East); Bremen; Cologne: Antoniter-Kirche; Essen; Lubeck: St. Catherine's; Magdeburg: Cathedral; Mannheim; Minneapolis; Munich: Bavarian Museum; New York: Moma; Zurich.

Publications

By BARLACH: books—

Der tote Tag (play), Berlin, 1912.
Der arme Vetter (play), Berlin, 1918.
Die echten Sedemunds (play), Berlin, 1920.
Der Findling (play), Berlin, 1922.
Die Sündflut (play), Berlin, 1924.
Der blaue Boll (play), Berlin, 1926.
Ein Selbsterzähltes Leben, Berlin, 1928.
Die gute Zeit (play), Berlin, 1929.
Aus seinen Briefen, edited by Friedrich Dross, Munich, 1937.
Fragmente, Berlin, 1939.
Barlach im Gespräch, edited by Friedrich Schult, Wiesbaden, 1948.
Seespeck (novel), Berlin, 1948.
Der gestohlene Mond (novel), Berlin, 1948.
Güstrow Fragmente, Bremen, 1951.
Leben und Werk in seinen Briefen, edited by Friedrich Dross, Munich, 1952.
Pariser Fragmente, Hamburg, 1952.
Die dichterische Werk, edited by Klaus Lazarowicz and Friedrich Dross, Munich, 3 vols., 1956–59.
Die Prosa, edited by Friedrich Dross, Munich, 1958.
Spiegel des Unendlichen: Auswahl aus dem dichterischen Gesamtwerk, Munich, 1960.
Der Graf von Ratzeburg (play), Hamburg, 1961.
Frühe und späte Briefe, edited by Paul Schurek and Hugo Sieker, Hamburg, 1962.
Three Plays (The Flood, The Genuine Sedemunds, The Blue Doll), Minneapolis, 1964.
Die Briefe 1888–1938, edited by Friedrich Dross, Munich, 2 vols., 1968–69.
Berichte, Gespräche, Erinnerungen, edited by Elmar Jansen, Frankfurt, 1972.

illustrator: *Der Kopf: Ein Gedicht,* by Reinhold von Walter, 1919.

On BARLACH: books—

Walter, Reinhold von, *Barlach,* Berlin, 1929.
Carls, Carl D., *Barlach,* Berlin, 1931, 1968, New York and London, 1969.
Barlach (cat), Berlin, 1951.

The Murderess, from The Dead Day, 1912; lithograph

Lantz-Oppermann, Gisela, *Barlach der Illustrator,* Wolfshagen-Scharbentz, 1952.

Schurek, Paul, *Begegnungen mit Barlach,* Gütersloh, 1954.

Fechter, Paul, *Barlach,* Gütersloh, 1957.

Flemming, Willi, *Barlach: Wesen und Werk,* Berne, 1958.

Schuldt, Friedrich, *Barlach: Das plastische Werk, Das graphische Werk, Die Zeichnungen,* Hamburg, 3 vols., 1958–71.

Schweitzer, Heinz, *Barlachs Roman "Der gestohlenen Mond,"* Berne, 1959.

Stubbe, Wolf, *Barlach: Plastik, Zeichnungen,* Munich, 2 vols., 1959–61.

Barlach, Karl, *Mein Vetter Ernst Barlach,* Bremen, 1960.

Franck, Hans, *Barlach: Leben und Werk,* Stuttgart, 1961.

Schurek, Paul, *Barlach: Eine Bildbiographie,* Munich, 1961.

Fühmann, Franz, *Barlach: Das schlimme Jahr: Grafik, Zeichnungen, Plastik, Dokumente,* Rostock, 1963.

Meier, Herbert, *Der verborgene Gott: Studien zu den Dramen Barlachs,* Nuremberg, 1963.

Bevilacqua, Giuseppe, *Barlach: Letteratura e critica,* Urbino, 1963.

Starczewski, Hanns Joachim, *Barlach: Interpretationen,* Munich, 1964.

Werner, Alfred, *Barlach: His Life and Work,* New York, 1966.

Gloede, Günter, *Barlach: Gestalt und Gleichnis,* Hamburg, 1966.

Chick, Edsom M., *Barlach: His Life and Work,* New York, 1967.

Gross, Helmut, *Zur Seinserfahrung bei Barlach,* Freiburg, 1967.

Barlach: Das druckgraphische Werk (cat), Bremen, 1968.

Groves, Naomi Jackson, *Barlach: Leben im Werk: Plastiken, Zeichnungen, und Graphiken, Dramen, Prosawerk, und Briefe/His Life in Work: Sculpture, Drawings, and Graphics, Dramas, Prose Works, and Letters in Translation,* Königstein i.T., 1972.

Schneckenburger, Manfred et al., *Barlach* (cat), Cologne, 1974.

Beckmann, Heinz, *Ich habe keinen Gott: Barlachs religiöse Provokation,* Munich, 1974.

Fühmann, Franz, *Barlach in Güstrow,* Frankfurt, 1977.

Falkenstein, Henning, *Barlach,* Berlin, 1978.

Fischer, Willi Ferdinand, *Zwei Aussenseiter: Barlach und Arnold Krieger,* Lorrach, 1981.

Jansen, Elmar, editor, *Barlach* (cat), East Berlin, 3 vols., 1981, 1983.

Piper, Ernst, *Barlach und die nationalsozialistische Kunstpolitik,* Munich, 1983.

Jansen, Elmar, *Barlach,* Berlin, 1984.

Kleberger, Ilse, *Der Wanderer im Wind: Barlach,* Berlin, 1984.

*

Ernst Barlach's career can be sharply divided into two parts, the conventional and the individualistic. His earlier work is both competent and derivative, its style dictated largely by the contemporary taste for Art Nouveau. Meticulously executed but rather formulaic pieces such as the languid female figure of the *Moeller-Jarke Tomb* (1901) characterize the type of commission work that he executed as an apprentice as well as an independent sculptor and ceramic designer. During this period, however, there was a developing interest in a more expressive means of representation, as certain of his works on paper demonstrate. His design for the title-page of *Jugend* (1899) with its cobwebs and monsters, the frankly naturalistic rendering of the woman in the foreground, and the nail-biting gesture of the male figure are the antithesis of Art-Nouveau. As Barlach became more financially independent his work left behind its Art Nouveau origins, moving toward greater simplicity and variation of mood.

This new approach coincided with an event which Barlach himself acknowledged as the turning point in his art, a trip in 1910 taken with his brothers through Poland and across the Russian steppes. The great number of sketches he made during this trip show a paring down of the human figure to essentialising geometric forms. Many of these figures are detached from any sort of landscape; the human subject and its expression alone make up the picture. Barlach said that he saw the Russian peasants as ideal vehicles for his new artistic goals because they mediated between the divine and the mundane, and because of their primitive relationship with the forces of nature. He described *Russian Beggar Woman with Cup* (1906) as "comic, vile . . . divine."

Although his work was stylistically unlike that of his contemporaries, Barlach's growing interest in the spiritual in art is part of a broader movement in Germany at that time. Worringer's influential publications *Abstraction and Empathy* (1908) and *Problems of Form in Gothic* (1911) were known to him, as well as *Der Blaue Reiter* group, which in its *Munich Almanach* (1912) attempted to reconcile primitivism and modern life. The primitive subject matter of Barlach's sculpture, however, was not matched by an idiom considered primitive because of its finish and naturalistic detailing, even in wood. When one compares his wooden sculptures with Heckel's or Kirchner's, which are rough hewn and have mask-like features, Barlach's distance from German primitivism is clear. The spiritual aspect of Barlach's work derived, as the artist saw it, from the "human condition," and the titles of his work, which often name the single emotion or action of his subjects, bear this out. His graphic and literary work reinforces the themes that occupy his sculpture.

Most of his work was not overtly political, except for a few notable lithographs contributed to *Bildermann,* a socialist publication from World War I which featured the works of Kokoschka, Kollwitz, and Liebermann, among others. By 1933, though, Barlach was seen by the Nazi state as subversive, his memorial at Magdeburg, which emphasized the nightmare rather than the glory of war, was removed, his publications were banned, his studio destroyed, and his rights to exhibit suppressed. His work was included in the Nazi "Degenerate Art" exhibition of 1937, and it was not until after World War II that his works were reinstated and his plays performed.

—Nancy Jachec

BARRY, James.

Born in Cork, 11 October 1741. Died in London, 22 February 1806. Studied under John Butts in Cork, and under Jacob Ennis at the Dublin Society for Encouragement of Arts drawing school, 1763–64; befriended by William and Edmund Burke; in London, 1764: worked for James "Athenian" Stuart; trip to Europe financed by the Burkes: in Paris, 1765–66, and Rome 1766–70; then worked in London: exhibited at the Royal Academy, 1771; elected a member, Royal Academy, 1773 (expelled, 1799: the only artist ever expelled); Professor of Paintings, RA, 1782; decorated the Great Room of the Society of Arts with murals, 1777–84; did 2 pictures for Boydell's Shakespeare Gallery, from 1786.

Collections: Bath; Belfast; Bologna; Cork; Dublin; London: College of Physicians, Portrait Gallery, Royal Society of Arts, Tate, Victoria and Albert; New Brunswick, Nova Scotia; New Haven; Sheffield.

Publications

By BARRY: books—

An Inquiry into the Real and Imaginary Obstructions to the Acquisition of the Arts in England, London, 1775.

An Account of a Series of Pictures in the Great Room of the Society of Arts . . . , London, 1783.

A Letter to . . . the Society of Arts, London, 1793.

A Letter to the Dilettanti Society, London, 1798.

Works, edited by Edward Fryer, London, 2 vols., 1809.

On BARRY: books—

Pressly, William L., *The Life and Art of Barry,* New Haven, 1981.

Pressly, William L., *Barry: The Artist as Hero* (cat), London, 1983.

Barrell, John, *The Political Theory of Painting from Reynolds to Hazlitt,* New Haven, 1986.

articles—

Barrell, John, "The Functions of Art in a Commercial Society: The Writings of Barry," in *Eighteenth Century: Theory and Interpretation,* 1984.

Pressly, William L., "A Chapel of Natural and Revealed Religion: Barry's Series for the Society's Great Room Reinter-

Eastern Patriarch, 1803; lithograph

preted," in *Journal of the Royal Society of Arts* (London), July-September 1984.

Pressly, William L., "Portrait of a Cork Family: The Two James Barrys," in *Journal of the Cork Historical and Archaeological Society,* 1985.

Brown, David Blayney, "Testaments of Friendship: Two New Portraits by Barry of Francis Douce and Joseph Nollekens," in *Burlington Magazine* (London), 1986.

*

Born in Cork, Ireland, in 1741, Barry early determined to become a history painter. As a young man of 22, he left for Dublin, where he met the writer and statesman Edmund Burke. Burke arranged employment for the artist in London and soon supported him for over five years of study on the Continent, primarily in Rome. On his return to London in 1771, Barry began to exhibit at the Royal Academy and by 1773 had been appointed a full academician.

In Italy he studied the Grand Style, aspiring to compete with the Renaissance Old Masters. The first painting he exhibited at the Royal Academy was *The Temptation of Adam,* a subject that gave him an opportunity to depict the male and female nude in accordance with the heroic figurative tradition of academic art. Even in this apprentice piece he showed his originality: the subject matter was drawn from Milton's *Paradise Lost* rather than the Bible, while stylistically the painting's reliance on fluid, abstracted contours broke new ground.

Throughout his career, Barry employed an abstract linear style characterized by bold rhythmic contours and the suppression of anatomical detail. He often compressed his images into a constricted space, establishing a close-up focus that added to their sense of heroic monumentality. Distortions in anatomy and in scale, the cutting of figures by the picture frame, discomforting juxtapositions, and the portrayal of intense emotions were elements that often disconcerted his audience, yet many were aware of the imaginative power of his achievement. As George Cumberland wrote in 1781, "whatever his defects may be, they are defects arising from very uncommon attempts, and, like the errors of philosophers, are respectable."

In 1777 Barry embarked on six large murals for the [Royal] Society of Arts, a series that has been called the greatest achievement in the Grand Style by any British painter of the 18th century. These large canvases offer a complex depiction of the advancement of classical Greek and contemporary English culture. However, a pointed allegory lies hidden beneath the surface meaning, as what at first appears to be an Enlightenment program on the advancement of civilization is in fact a testament to Revealed Religion as embodied in the teachings of the Roman Catholic Church.

Barry was one of the most passionate artists of his generation, his closest counterpart in England being his friend Wil-

liam Blake and in France Jacques-Louis David. There is a sense of mission to his art. His paintings and prints were intended to reform corrupt standards by recasting the modern citizen in the image of antique virtue and self-sacrifice. Religious reform must also accompany this transformation, as the fragmented modern world, consisting of numerous sects, must find again a common purpose as embodied in the early church. Barry's art and critical writings were directed toward the reinstatement of his vision of republicanism and Roman Catholicism. Yet, as with Christ, who spoke in parables, he was not always explicit, forcing the viewer to work to uncover his meaning.

Barry's more assertive statements often offended, and remarks he made as professor of painting to the Royal Academy and in one of his books led to his expulsion from the Academy in 1799. Discouraged by an unresponsive public, suffering from severe depression and persecution mania, he increasingly withdrew into a defiant isolation. In the last 23 years of his life, he completed only four history paintings, his most ambitious being *The Birth of Pandora,* a last testament that only a select few were permitted to see.

—William L. Pressly

BARTOLOMMEO, Fra.

Born Baccio della Porta in Soffignano, 28 March 1475. Died in Florence, 6 October 1517. Apprenticed to Cosimo Roselli, 1484 (fellow pupil was Piero di Cosimo; another fellow pupil, Mariotto Albertinelli, was a later collaborator); became a novitiate monk, S. Marco, Florence, 1500 (took vows, 1501, head of the monastery workshop, 1504); also worked in Venice, 1508, and Rome, 1514 or 1515.

Major Collection: Florence: Accademia; Paris: Louvre.
Other Collections: Besançon: Cathedral; Cambridge, Massachusetts; Florence: Pitti, S. Marco, Museo di S. Marco, Uffizi; Leningrad; London; Los Angeles; Lucca: Cathedral, Museum; Philadelphia; Pian di Mugnone: S. Maria Maddalena; New York; Rome; Vatican; Vienna; Volterra: Cathedral; Washington.

Publications

On BARTOLOMMEO: books—

Gruyer, G., *Fra Bartolommeo et Mariotto Albertinelli,* Paris, 1886.
Knapp, Fritz, *Fra Bartolommeo und die Schule von San Marco,* Halle, 1903.
Gabelentz, Hans von der, *Fra Bartolommeo und die Florentinische Renaissance,* Leipzig, 2 vols., 1922.
Gronau, Georg, *Catalogue of Drawings of Landscapes and Trees by Fra Bartolommeo,* London, 1957.
Borgo, Ludovico, *The Works of Mariotto Albertinelli* [and Fra Bartolommeo], New York, 1976.

Fischer, Chris, *Disegni di Fra Bartolommeo* (cat), Florence, 1986.

article—

Fisher, Chris, "Remarques sur *Le Mariage mystique de Sainte Catherine de Sienne* par Fra Bartolommeo," in *Revue du Louvre* (Paris), 32, 1982.

*

Baccio della Porta, called Fra Bartolommeo, was trained in the workshop of the late quattrocento painter Cosimo Roselli in the company of Piero di Cosimo and Mariotto Albertinelli. A major protagonist of the High Renaissance and the preeminent artist in Florence following the departures of Michelangelo, Raphael, and Leonardo from the city by the year 1508, he is best known for his monumental altarpieces, in which the "Sacra Conversazione" type achieves a heightened formal and dramatic unity. These were commissioned for a number of Florentine churches, where they were avidly studied by such artists of the next generation as Pontormo and Rosso Fiorentino. The artist also produced small-scale, private devotional images of the Madonna and Child; the new intimacy that characterizes his treatment of the theme profoundly influenced Raphael during his Florentine period of 1504–07, as witnessed in such works as the *Tempi Madonna* (Munich).

Around the year 1490, Baccio and Albertinelli left Cosimo Roselli's atelier and formed their own "compania"—a loose collaborative enterprise rather than a formal workshop. A decade later, however, in 1500, Baccio abruptly ceased painting, having earlier fallen under the sway of the fiery, ascetic Dominican preacher and *de facto* ruler of Florence, Fra Girolamo Savonarola. Few securely identified works from this early period of Fra Bartolommeo's career are known—like Botticelli, the artist was persuaded by Savonarola to burn his paintings of mythological subjects in the famous "bonfire of vanities" which were staged in the Piazza della Signoria of Florence in 1496 and 1497, and so a number of works from this period were destroyed by Baccio's own hand. A document of the artist's association with Savonarola in these years is his portrait of the monk, painted around 1497 and now in the convent of S. Marco in Florence. The *Last Judgment* fresco, commissioned for a funerary chapel in S. Maria Nuova (Florence, S. Marco Museum), was in progress at the moment when the artist decided to cease his activity as a painter; it was continued by Albertinelli, but was never completed. Despite its unfinished state, the work was very influential. The two-tiered composition, particularly the seated saints in the celestial zone flanking the powerful figure of Christ, provided the inspiration for Raphael's first monumental frescoes, the *Trinity with Saints* in S. Severo, Perugia (1506), and the *Disputà* in the Stanza della Segnatura in the Vatican (1508).

In 1501, Baccio took monastic vows, assuming the name of Fra Bartolommeo and entering the Dominican convent of S. Marco in Florence. At the urging of the prior, he resumed painting in 1504, producing one of his masterpieces—the *Vision of Saint Bernard* (Florence, Accademia). In this work, the celestial apparition of the Virgin and Child is described in human terms, his vision as real and palpable as St. Bernard. That the monumental, spiralling Virgin cloaked in swirling

Virgin and Child with Kneeling Angels; drawing; Royal Collection

draperies is indeed a celestial apparition is communicated by her floating posture, while the diagonal break in the center of the composition serves to distinguish the two realms of vision and visionary. The fluid movement of the figures, and particularly the serpentine torsion of the Virgin, imparts a sense of dynamic if restrained action to the scene, the artist here responding to Leonardo's recent demonstrations such as the *Madonna and Child with Saint Anne* cartoon (lost). In the background, a distant, atmospheric landscape is glimpsed, suffused in the soft, limpid light characteristic of Fra Bartolommeo.

Fra Bartolommeo responded with keen interest to Leonardo's experiments with light and shadow—his evocative, delicate chiaroscuro, concern for tonal unity, and representation of forms articulated in a consistent, optically correct light. His figures are endowed with a sense of relief through their forceful modeling and delicately shadowed contours, an aspect of his style particularly noted by Vasari and inspired by Leonardo's example. Light and shadow came to play an increasingly prominent role in his art, since he was concerned with the subtle modulation of forms unified by an atmospheric haze. This concern is evident in such works as the *Mystical Marriage of St. Catherine* (Florence, Accademia) and the *Salvator Mundi* (Florence, Palazzo Pitti), where a delicate veil of shadow envelopes the figures, emphasizing their relief-like aspect and subsuming even color in its smoky tonality. This all-

embracing chiaroscuro is characteristic of the "School of San Marco," as the artist's atelier was known, and the stylistic current in Florentine High Renaissance painting represented by Fra Bartolommeo exists as a counterpoint or alternative to the chromatic brilliance of the art of his contemporary Andrea del Sarto and his followers. Fra Bartolommeo was far from impervious to the effects of color, but he favored glowing, resonant tones suffused in shadow. His particular sensibility as a colorist was shaped in part as a result of the artist's trip to Venice, where he traveled in 1508, and his exposure to the art of Giorgione and Giovanni Bellini.

Following his return from Venice, Fra Bartolommeo reunited with Albertinelli to form a workshop at S. Marco. This bottega existed from 1509 until 1512, when Albertinelli abandoned painting. Many of Fra Bartolommeo's most important works date from this period, among then the *Mystical Marriage of St. Catherine of Siena* (Paris, Louvre, 1511) and the *Madonna in Glory with Saints* (Besançon, Cathedral), both of which were executed in collaboration with Albertinelli. In these works the "sacra conversazione" format favored by Florentine painters for over a century is invested with a new drama and energy, as an enlarged cast of figures twists and postures in space, responding to each other and to the divine presence of the Madonna and Child whose company they share. The animated winged angels in the upper zone of both altarpieces impart a sense of energy to what is a fundamentally

iconic, non-narrative subject, while the curtained baldacchino of the Louvre painting and the later Accademia *Mystical Marriage of St. Catherine,* the "Pala Pitti," adds a theatrical element to the sacred drama. Fra Bartolommeo's example underlies such later inventions as Rosso Fiorentino's *Pala Dei* (Pitti).

A major commission awarded to the artist in this period was the *St. Anne Altarpiece,* intended for the Sala del Consiglio of the Palazzo Vecchio where Leonardo and Michelangelo were to have painted the Battle of Anghiari and the Battle of Cascina. Like these frescoes, Fra Bartolommeo's painting, which was begun in 1510, was never completed, worked up only to the stage of the monochrome underdrawing in which state it survives (Florence, Museum of S. Marco). The work is essentially an enormous drawing which reveals the artist's pre-eminent concern with the modelling of forms in space. Its formal and dramatic unity, the monumentality of the figures, and the ordered, basilica-like architectural space they occupy render this the consummate High Renaissance invention.

In 1514, Fra Bartolommeo travelled to Rome to see the Sistine ceiling and Raphael's frescoes in the Vatican. Michelangelo's heroic figures in particular had a profound, even overwhelming, impact on the artist, whose response to the grandeur of the modern Roman manner is apparent in such works as the *Prophets Isaiah and Job* (Florence, Accademia). A new, inflated monumentality characterizes these figures, but their posturings seem somewhat rhetorical when compared with the psychologically motivated gestures of Michelangelo's ponderous prophets and sibyls. A more sober and restrained, if equally moving, drama was more sympathetic to Fra Bartolommeo's temperament. This is testified in one of the his last paintings, the recently restored *Lamentation* (Florence, Pitti), on which the artist was at work at the time of his death in 1517. In this straightforward, simplified, and even austere treatment of one of the central mysteries of the Catholic faith, the artist's own piety finds visual expression.

—Linda Wolk-Simon

BARYE, Antoine-Louis.
Born in Paris, 24 September 1795. Died in Paris, 25 June 1875. Apprenticed at the metal crafter Fourrier at age 14, and studied briefly with the sculptor Bosio, 1816, and the painter Gros, 1817; worked for the goldsmith Fauconnier, 1823–31, in Jardin des Plantes; served as his own dealer, 1839–48 (bankrupt): patronized by the House of Orleans; curator of the Gallery of Plaster Replicas, Louvre, 1848–50; taught zoological draftmanship, Museum of Natural History, 1854–75; also a painter: spent summers at Barbizon from 1830's.

Major Collections: Baltimore: Walters; Paris; Washington: Corcoran.
Other Collections: Bayonne; Cambridge, Massachusetts; London; Montpellier; New York; Paris: Ecole National des Beaux-Arts, Petit-Palais; Rouen; Washington.

Publications

On BARYE: books—

Catalogue des oeuvres de Barye, Paris, 1875.
De Kay, Charles, *Barye,* New York, 1889.
Ballu, Roger, *L'Oeuvre de Barye,* Paris, 1890.
Alexandre, Arsène, *Barye,* Paris, 1889.
Walters, W. T., *Barye,* New York, 1902.
Saunier, Charles, *Barye,* Paris, 1925.
Zieseniss, Charles Otto, *Les Aquarelles de Barye: Etude critique et catalogue raisonné,* Paris, 1955.
Hubert, Gerard, et al., *Barye* (cat), Paris, 1956.
Lengyel, Alfonz, *Life and Art of Barye,* Dubuque, Iowa, 1963.
Pivar, Stuart, *The Barye Bronzes,* Woodbridge, Suffolk, 1974.
Wasserman, Jeanne L., *Sculpture by Barye in the Collection of the Fogg Art Museum,* Cambridge, Massachusetts, 1982.
Benge, Glenn F., *Barye, Sculptor of Romantic Realism,* University Park, Pennsylvania, 1984.
Robinson, L., et al., *Barye: The Corcoran Collection,* Washington, 1988.

articles—

Hamilton, G. H., "The Origins of Barye's Tiger Hunt," in *Art Bulletin* (New York), 18, 1936.
Johnson, Lee, "Delacroix, Barye, and the Tower Menagerie . . .," in *Burlington Magazine* (London), 106, 1964.
Benge, Glenn F., "Barye's Uses of Some Géricault Drawings," in *Walters Art Gallery Journal* (Baltimore), 31–32, 1968–69.
Johnston, William R., "The Barye Collection," in *Apollo* (London), 100, 1974.
Kliman, Eve Twose, "Delacroix's *Jeune tigre jouant avec sa mère,*" in *Gazette des Beaux-Art* (Paris), September 1984.
Benge, Glenn F., "Barye, Flaxman, and Phidias," in *La scultura nel XIX secolo* (colloquium), edited by H. W. Janson, Bologna, 1984.

*

Antoine-Louis Barye was without doubt the most innovatory and daring *animalier* of the early 19th century in Paris. His personal nature-romanticism was the projection of human feeling onto images of animals, the latter created in an exquisitely precise realism.

Barye's art of sculpture evolved through several distinct phases: the artistic and scientific investigations of the 1820's, the exciting romantic-realist pinnacles of the 1830's, the academic-classical imagery created from the 1840's to the 1860's, the marketing of his serially produced small bronzes through his firm Barye and Company, 1845–57, and the very late reiterations of his earliest romantic conceptions, a reaffirmation of their fundamental significance for him and for French art of the period.

As the son of a goldsmith, Barye learned his father's craft, and worked for the neoclassical goldsmith to Napoleon, Guillaume-Martin Biennais—a formative apprenticeship that stamped the whole of his artistic oeuvre with certain of its values: a sensitivity of art in miniature format, a style reflect-

Theseus and the Minotaur, 1849–52; bronze; 17 in (43 cm)

ing a close scrutiny of nature, and a commitment to the highest standards of craftsmanship. Monumental forms Barye studied in the atelier of Baron François-Joseph Bosio, who embellished his large works with the detail and precision of a goldsmith. Barye also studied with the great romantic colorist and battle-painter Baron Antoine-Jean Gros, creator of the unforgettable *Napoleon in the Pesthouse at Jaffa,* whose emotive power and compositional concepts he greatly admired.

Animal anatomy Barye studied intensively from the late 1820's in the *ménagerie* of the Jardin des plantes, and in the Baron Cuvier's world-famous cabinet. His drawings of dissected animals encompass the range of reptiles, felines, deer, elephants, and bears which he treated in his small bronze sculpture. Barye sketchbooks are in the Louvre and the Walters Art Gallery in Baltimore.

Works of the 1820's vary in style and concept from the delicate painter-liness of the medallion *Milo of Crotona Devoured by a Lion* (Walters), to the neoclassical types derived from Flaxman's engravings in *Hector Reproaching Paris,* 1823 (Paris, Ecole des Beaux-Arts), to the literal naturalism of *Stag, Doe and Nursing Fawn* (Philadelphia), to the heraldic formality of the *Eagle and Serpent* relief (Walters). Themes include single animals, the hunt, the struggle of predator and prey, mythological combats, and heroic figures.

Toward 1830 the size and subtlety of his words increase, as in the romantically pathetic, exhausted *Poised Stag* (1829, Walters). Large combats of predator and prey assume allegorical significance as symbols of the July Revolution: *Tiger Devouring a Gavial Crocodile,* bronze, and *Lion Crushing a Serpent,* bronze, (both in Louvre)—the former imaging revolutionary violence in keeping with such usage of the tiger figure as that of the verse of the "Marseillaise," 1792, and of William Blake's poem, "The Tiger," as Ronald Paulson has shown. The *Lion Crushing a Serpent* flatters the newly elevated king: the royal lion triumphant over evil. It is also a reference to the celestial aegis of the July Revolution, couched in astrological terms, as the constellation Leo beside Hydra. These stunning works provoked the admiration and vilification of critics of the day, establishing both Barye's excellence and his notoriety in the Parisian art world. One critic saw in the *Tiger and Gavial* "the strongest work of the entire Salon," while another found in the *Lion and Serpent* a mere "odor of the *ménagerie.*"

Barye created many small sculptures during the 1830's, including an ensemble of nine groups comprising a banquet-table decoration for the young Duc d'Orléans. Five large hunting scenes set in various lands are framed within four further scenes of predators seizing prey, such as *Python Killing a Gnu* (Walters). Models for this ensemble were rejected from the Salon of 1837, leading Barye not to exhibit there again, a jury of artists rather than academicians was established. Barye's choices of animal rather than human protagonists, and of miniature rather than monumental scale, ran counter to the long academic tradition of a hierarchy in artistic subject matter, and to the entrenched notion that monumental forms are inherently superior to the miniature.

A symphonic variety of style and character marks his small sculpture of the 1830's, ranging from the jeweler's intricacy of the hunts, to the starkly classical planarity of the relief plaques *Walking Leopard* and *Walking Panther* (Walters). Mood varies from the dreaminess of *Bear in Its Trough,* to the vicious tension of *Elk Attacked by a Lynx,* to the agony of *Wounded Boar* (Walters). Predators and prey, such as *Panther Seizing a Stag* (Walters) and *Tiger Devouring a Gavial Crocodile* (Washington, Corcoran), rival the power and nuance of, say, Goya's *Disasters of War* etchings, for Barye's animal protagonists are suffused with a palpably human emotion that is elegantly focused for a romantic delectation.

Lion of the Zodiac, bronze, 1835–40 (Paris, Place de la Bastille), a monumental relief for the July Column monument to the fallen heroes of 1830, comprises a second version of the *Lion and Serpent* of 1832, one given a more accessible iconography in the motif of the band of the Houses of the Zodiac, which replaces the rather arcane serpent of Hydra of the earlier design. One of Barye's artistic sources was an engraving by Bartoli of an ancient Roman *Walking Lion* relief (Rome, Palazzo Barberini), an image in an anthology of antiquities of the sort he often consulted.

Barye and Company, a legal partnership with the entrepreneur Emile Martin, he established in 1845 to produce and sell the sculptor's small bronze designs. Barye's limited mass-production of his proofs was a democratic gesture, aimed at the patronage of the new middle class. His operation raised fundamental questions of connoisseurship and value never before entertained in Europe, such as the presence (or absence) of the artist's autograph touch in the multiple casts of a particular design, and the early practice of numbering successive casts taken from a specific model. Such numbering was soon dropped as irrelevant, for Barye used a type of model made of plaster covered with wax, the outer surface of which he would retouch before each mold was taken, thus refreshing completely and even subtly altering the autograph surface detail. Examples of such models are in the Louvre, the Walters, and the Fogg. An original account book (Walters) documents Barye's payments to some 16 founders and 32 artisans for various tasks in the production and finishing of his small bronzes between 1850 and 1858.

Several major trends appear in the late monumental works of Barye. A public academic style marks the *Saint Clotilde,* marble, 1840 (Paris, Church of the Madeleine), a figure reminiscent of the Roman marble *Julia, Daughter of Augustus* (Louvre). Barye's four personification groups for facades of the New Louvre—*Strength, Order, War* and *Peace,* (Cour du carrousel)—were based upon the *Torso Belvedere* and the Hellenistic *Seated Boxer* type, for their classically pensive, seated figures, though a romantically heightened emotion charges the animal attribute of each group in a personal if skewed emphasis. A simplified monumental style is seen in bronzes such as *Jaguar Devouring a Hare* (Corcoran) and the four animal combats for a stairway of the Palais du Longchamp (Marseilles). The virtuoso sequence of 97 *Decorative Masks,* 1851, for the cornice of the Pont Neuf (Paris), embraces a very great range of mood and type, from the demonic to the lyrical, masks conceived as vigorously plastic arabesques of a notable richness and invention.

Barye influenced Christophe Fratin, Pierre-Jules Mêne, and Jules Moignez. Their art, however, cultivated extremes of pictorialism, melodrama, and structural fragility completely unlike the dignified works of Barye. Emmanuel Frémiet also stood in Barye's debt, as his famous *Joan of Arc, Equestrienne,* 1872–89 (Paris, Place des pyramides), attests: it is as though Barye's miniature *Charles VII, Victorious* (Walters)

were simply magnified to heroic scale. Even the giant of the late 19th century, Auguste Rodin, studied under Barye in 1863, and carried the scientifically accurate anatomy and freely developed surfaces of the art of his mentor to unprecedented heights of romantic expressiveness. Alfred Gilbert, the lyrical British sculptor and goldsmith, arrived in Paris at the time of the vast posthumous exhibition of Barye's sculpture, and was deeply impressed—as his art of small sculpture well demonstrates.

—Glenn F. Benge

BASCHENIS, Evaristo.

Born in Bergamo, 7 December 1617. Died in Bergamo, 16 March 1677. From a long line of painter: studied with his father; ordained a priest in Bergamo, c. 1643; most famous for still lifes with musical instruments, but also did kitchen scenes and some religious works. Pupil: Bartolomeo Bettera.

Major Collection: Bergamo.
Other Collections: Brussels; Milan; Venice.

Publications

On BASCHENIS: books—

Angelini, Luigi, *I Baschenis,* Bergamo, 1946.
Geddo, Angelo, *Baschenis,* Bergamo, 1965.
Baschenis (cat), Bergamo, 1965.
Rosci, Marco, *Baschenis, Bettara, and Co.: Produzione e mercato della natura morta del seicento in Italia,* Milan, 1971.
Rosci, Marco, *I pittori Bergamaschi: Il seicento,* Bergamo, 1985.

Article—

Longhi, Roberto, "Un momento importante nella storia della 'natura morta,' " in *Paragone* (Florence), 1, 1950.

*

The life of Evaristo Baschenis appears to have been passed in an ambient of quietude and contemplation much like that which we find in his art. He was born and died in the same parish in Bergamo. He is not known to have resided elsewhere in his life, although he probably visited Venice. Baschenis was ordained a priest in about 1643; he was often called *Prevarisco* for "Prete Guarisco" (his baptismal name). The leading Bergamasque painters of the pre-Baroque generation were Enea Salmeggia, Giovan Paolo Cavagna, or Francesco Zucco, and it is only likely to assume, as did his biographer, Francesco Maria Tassi (1793), that the young Baschenis apprenticed with one or other of these artists.

By 1647, Baschenis was well embarked on an entirely independent direction, however, as a specialist in still-life painting.

His Lombard antecedent, Caravaggio, was evidently a source; another was the emblematic tendencies of Dutch still lifes. He evidently organized a productive workshop that included at least one competent replicator of his designs, the monogramist *B.B.* (who was perhaps his brother, Bartolomeo). In the words of Tassi, "That in which Baschenis truly succeeded was a most unusual manner that he himself invented, which was his alone and never used again by others: he painted every sort of instrument of sound with incredible naturalness and truth, and he succeeded in this with a perfection that I know has never been equaled."

In recent years, in addition to his established reputation as one of the protagonists of Italian still-life painting, Baschenis has been recognized as a painter of greater than parrochial interest. The critic Roberto Longhi wrote that Baschenis belonged to a restricted category of painters (e.g., Caravaggio, Chardin, Goya, Courbet), whose still lifes contained dimensions of philosophic expression that went far beyond the traditionally modest—and essentially decorative—scope of still-life painting.

Baschenis's images of superbly crafted instruments arranged in forgetful disarray are basically *vanitas* images, yet they evoke a conflicting range of associations, including repose, melancholy, optimism, and *memento mori*. It is evident that Baschenis was convinced that his chosen motifs were suitable vehicles for humanistic expression. A very personal cycle of paintings must have been the triptych of canvases that he painted containing portraits of himself and members of the noble Agliardi family playing various instruments. The portraits are placed in the two outside canvases, while the central picture, which should be the resolution of the whole work, is reserved to a pure still life of disused musical instruments.

In one respect, Tassi was not strictly accurate: Baschenis's still lifes were never equalled in quality, but they were massively imitated in kind. Marco Rosci has concluded that the master himself oversaw the production of his atelier of repetitions and variants of his prototypes. His manner was closely followed by his pupil Bartolomeo Bettera (not to be confused with the anonymous *B.B.*) and by the latter's son, Bonaventura Bettera, and countless other painters.

A poem written in his honor during his lifetime (1675) reveals that works by Baschenis had already entered princely collections in Rome, Florence, Venice, and Turin. Eight still lifes by Baschenis once comprised a highly noted, but now dispersed, decoration in the library of the convent of San Giorgio Maggiore, Venice. The paintings were donated to the convent by Francesco Soperchi, who was abbot between 1667 and 1671. A single picture, now in the Accademia Gallery, Venice, is all that is traceable today of this important chapter in the patronage of still-life paintings.

—John T. Spike

BASSANO, Jacopo.

Born Jacopo (or Girolamo) da Ponte in Bassano, c. 1510; son of the painter Francesco da Ponte. Died in Bassano, 1592. Married; sons include the painters Francesco (the younger), Leandro, and Girolamo. Possibly studied under the painter

Portrait of a Man; drawing

Bonifazio de' Pitati in Venice, c. 1535; then worked in Bassano: did work for the Sala dell' Udienza and the Sala del Consiglio in late 1530's (now the Museo Civico); also frescoes on the facade of the Palazzo dal Corno; well-known in his own day, and active until his death.

Major Collection: Bassano: Museo Civico.
Other Collections Angarano: SS. Trinità; Borso del Grappa: parish church; Budapest; Cittadella: parish church; Cleveland; Copenhagen; Detroit; Edinburgh; Florence; Hampton Court; Havana; London; Memphis; Milan: Brera, Ambrosiana; Modena; Munich; New York: Metropolitan, Frick; Nimes; Oxford; Padua: S. Maria in Vanzo; Pasadena; Philadelphia; Rome: Borghese; Stockholm; Treviso; Venice: S. Giorgio Maggiore; Vienna.

Publications

On BASSANO: books—

Zottmann, Ludwig, *Zur Kunst der Bassani*, Strasbourg, 1908.
Bettini, Sergio, *L'arte di Bassano*, Bologna, 1933.
Magagnato, L., *Dipinti dei Bassano* (cat), Venice, 1952.
Zampetti, Pietro, *Bassano* (cat), Venice, 1957.
Zampetti, Pietro, *Bassano*, Rome 1958.
Arslan, Wart, *I Bassano*, Milan, 2 vols., 1960.
Zampetti, Pietro, *Bassano*, Milan, 1964.
Da Tiziano a El Greco (cat), Venice, 1981.
Pallucchini, Rodolfo, *Bassano*, Milan, 1982.
The Genius of Venice 1500–1600 (cat), London, 1983.

articles—

Longhi, R., "Suggerimenti per Bassano," in *Arte Veneta* (Venice), 2, 1948.
Godfrey, F. M., "Bassano in English and Scottish Collections," in *Connoisseur Year Book*, (London), 1955.
Pallucchini, Rodolfo, "Bassano e il manierismo," in *Studies in the History of Art Dedicated to William E. Suida*, London, 1959.
Ballarin, A., "L'orto del Bassano (a proposito di alcuni quadri e disegni inediti singolari)," in *Arte Veneta* (Venice), 18, 1964.
Ballarin, A., "Bassano e lo studio de Raffaello e dei Salviati," in *Arte Veneta* (Venice), 21, 1967.
Ballarin, A., "Introduzione a un catalogo dei disegni di Bassano III," in *Arte Veneta* (Venice), 27, 1973.

*

Jacopo da Ponte, better known as Jacopo Bassano, takes his name from the town of Bassano del Grappa where he was born in about 1510, the son of an undistinguised painter, Francesco. His own distinct artistic personality had emerged by his mid-twenties, founded on what he had learned from his father and Bonifazio de' Pitati with whom he is thought to have worked for a short time in Venice. Through the medium of prints he was influenced by Northern European artists such as Dürer and fellow Italians such as Parmigianino and Raphael and he also shows constant awarness of the work of Titian, Tintoretto, and other Venetian painters.

Although Jacopo Bassano spent his entire career in his native town, he cannot be called a provincial painter as his artistic qualities far surpass that level of achievement. In the Veneto, the region of the mainland dominated by Venice, he was one of the most outstanding figures of his day and had a powerful influence on other, lesser, painters. He is unquestionably of a lower rank than an artist such as Titian, but he is the more approachable as a result.

Parmigianino had an impact on the painter from the later 1540's onwards and his influence is often spoken of as paramount. But within the one painting a range of borrowings can be observed, drawn from Jacopo's diverse anthology of sources which are then woven by him into a style that is instantly recognisable and completely his own. The *Adoration of the Magi* at Edinburgh of the early 1540's, for example, is in part influenced by the work of Pordenone and owes its compositional structure to an altarpiece by Raphael known as *Lo Spasimo di Sicilia* now at Madrid. Within this structure are disposed a series of quotations from Dürer and other artists which underlie the depiction of features such as the stable and some of the animals. In the Edinburgh painting there is as yet no reference to Parmigianino. However, the Milan *Rest on the Flight into Egypt* shows Jacopo making similar discreet connections with other works but now with considerable indebtedness to that artist. During the 1550's the search for refinement and elegance led Bassano to depict the human form in a highly distorted, elongated manner as seen in the *Adoration of the Magi* at Vienna. This heightened physical grace, for this seems to be the aim of the artist, is termed Mannerism.

The figures in the early paintings are sharp edged in their delineation, but this definition of form gives way in later works to softer modelling as if the image is less crisply focused. The later paintings become more subdued in tone and eventually the light of day yields to visions of twilight. In these nocturnes, for example, the *Susanna and the Elder* at Nimes, the forms, no longer defined by line, gently melt into one another and the surrounding atmosphere.

Bassano's work is always suffused with a sense of compassion and human warmth. The rustic settings and pastoral qualities in his work seem to have been popular with townsmen eager to take pleasure in depictions of country life, and they still have this appeal for us today. Jacopo painted well into his old age and the highly productive studio he founded was continued by his children after his death in 1592.

—David Mackie

BATONI, Pompeo (Girolami).
Born in Lucca, 25 January 1708; son of a goldsmith. Died in Rome, 4 February 1787. Moved to Rome, 1727, and member of the Rome guild from 1741; established as a history painter, but also did religious works; his most famous works, however, are his portraits of princes and tourists (especially English) in Rome: he also painted three popes, and many princes, often against a classical background.

Collections: Berlin (East); Brescia: S. Maria della Pace; Cardiff; Cracow; Dresden; Dublin; Florence; Hartford, Connecticut; Leeds; Leningrad; London: Portrait Gallery, National Gallery, Victoria and Albert; Lucca; Madrid; Milan; New York; Oxford; Paris; Potsdam: Sans Souci; Rome: Barberini, Pallavicini, Caetani, Il Gesu, S. Maria degli Angeli; St. Louis; Stuttgart; Turin: Sabauda; Vienna.

Publications

On BATONI: books—

Barsali, Isa Belli, *Batoni* (cat), Lucca, 1967.
Bowron, Edgar Paters, *Batoni and His British Patrons* (cat), London, 1982.

articles—

Battisti, E., "Una vita inedita del Batoni," in *Commentari* (Rome), 3, 1952.
Cochetti, L., "Batoni e il neoclassicismo a Roma," in *Commentari* (Rome), 3, 1952.
Macandrew, Hugh, "A Group of Batoni Drawings at Eton College," in *Master Drawings* (New York), 16, 1978.
Clark, Anthony M., "Batoni's Professional Career and Style," in *Studies in Roman Eighteenth-Century Painting,* edited by Edgar Peters Bowron, 1982.
Bowron, Edgar Peters, "Le Portrait de Charles John Crowle par Batoni: Les Dilettanti et le Grand Tour," in *Revue du Louvre* (Paris), 35, 1985.

*

Trained as a goldsmith by his father in his native Lucca, Pompeo Batoni settled in Rome in 1727 to pursue (over his father's vehement objections) his own career as a painter. By the 1740's he had established there a considerable reputation. His religious pieces, much influenced by his admiration for Guido Reni, were admired for their rich color, energetic composition and rhetorical drama. His classical history-pieces of the same period (e.g., *Antiochus and Stratonice,* 1746) are distinctive in their marked deviation from the then-prevailing Roman style of Imperiale and Antonio Masucci in favor of the more academic tradition of Raphael and Annibale Carracci, with the result that Batoni emerged as the most important precursor of the incipient neo-classical movement in Roman painting prior to the advent of Anton Raphael Mengs in 1752. For the next quarter-century, he and Mengs were locked in an intense, though apparently amiable and mutually respectful rivalry for recognition as the foremost painter in Rome. In their shared admiration of Raphael and classical antiquity they held much in common and at times, especially in their portraits, their styles are almost indistinguishable. Batoni, however, never immersed himself in the theoretical speculations as to the definition of a universal standard of taste which so influenced the style of Mengs, with the result that Batoni emerged as the more prolific and flexible painter.

Batoni's most ambitious undertaking of the 1740's and 1750's was a gigantic altarpiece for St. Peter's (since placed in S. Maria degli Angeli) depicting *The Fall of Simon Magus,* by which he hoped to crown his reputation as a history-painter. Upon the hostile reception of *Simon Magus,* however, Batoni increasingly devoted himself over the next several decades to portraiture, a genre in which he had already achieved some degree of success. Due to the relative indifference to portraiture among 18th-century Italians, Batoni's patrons were almost exclusively transalpine visitors on the Grand Tour to Rome. Batoni's name became (and still remains) virtually synonymous with the Grand Tour portrait, in which the sitter is depicted before a background of antique ruins or statuary as evidence of his educated taste and as a perpetual memento of the Roman pilgrimage.

No other artist of his time painted so comprehensive a roster of the nobility and the cultured classes of the 18th century. Of his 265 surviving portraits, 200 depict British or Irish sitters. Batoni owed much of his success to the good offices of Alessandro Cardinal Albani who, through his friendship with the British Envoy in Florence, Sir Horace Mann, provided a convenient contact for British visitors in search of art works in Rome.

While both popular and prolific, Batoni had a reputation as a dilatory painter. He painted the facial features of the sitter directly upon the canvas, a process usually requiring three visits to his studio. But by the time the meticulous Batoni was satisfied with the last detail of a portrait, the sitter often had to wait months (or even up to three years) for the finished canvas. This was due not only to the artist's perfectionism, but also to the fact that, in his eagerness to attract commissions, he was prone to abandon a half-finished portrait to accomodate a new patron.

Batoni's contemporaries have left us two diametrically opposite accounts of his character. On the one hand, he was described as pious, charitable, congenitally good-natured, and indifferent in his dress to the point of shabbiness. On the other hand, he was reported to have been vain and pretentious far beyond his social rank, devious and avaricious in dealing with his clients, constantly inflating his fees, demanding a large deposit in advance, and not surrendering a canvas until the last scudo had been paid.

Despite the substantial fortune he undoubtedly earned in his active career of 60 years, at his death in 1787 Batoni died virtually destitute. The decline of his fortunes was soon followed by a parallel collapse of his reputation. In 1788, little more than a year after his death, in his Fourteenth Discourse for the Royal Academy (dedicated in homage to the recently deceased Thomas Gainsborough), Sir Joshua Reynolds dismissed Batoni as a painter who, whatever his success during his lifetime, was destined to fall into total oblivion.

Reynolds's prediction was in part accurate. For a century and a half, Batoni and the whole school of 18th-century Roman painting suffered relative neglect among historians and critics. Only in the past few decades, in large measure thanks to the writings of Anthony Clark, has Batoni reclaimed proper recognition, not only for the invaluable visual record he has left us of many of the most familiar names of the 18th century, but also a painter of striking verve and felicity.

—Thomas Pelzel

Studies of Male Nude and Drapery; drawing; Royal Collection

BECCAFUMI.

Born Domenico di Giacomo di Pace, in Arbia, near Siena, c. 1486, or later. Died in Siena, c. 1551. Educated by his peasant father's employer; worked in Siena, and eventually opened his own studio; visited Rome, 1510–12, and also Florence, Pisa, and Genoa, for short periods.

Major Collections: Pisa: Cathedral; Siena: Museum.
Other Collections: Baltimore; Birmingham; Boston; Cambridge; Detroit; Dresden; Dublin; Florence: Uffizi; London: National Gallery, Wallace; New Haven; Rome: Galleria Nazionale, Borghese, S. Maria Maggiore; Sarasota, Florida, Siena: Museo dell'Opera, Oratorio di S. Bernardino; Washington.

Publications

On BECCAFUMI: books—

Nuti, G. Palmieri, *Discorso sulla vita e sulle opere di Beccafumi . . .*, Siena, 1882.
Trotta-Tieyden, H., *Das Leben und die Werke des sienesischen Malers Beccafumi,* Berlin, 1913.
Gibellino-Krasceninnicowa, Maria, *Il Beccafumi,* Siena, 1933.
Ciaranfi, Anna Maria Francini, *Beccafumi,* Florence, 1966.
Dupre, M. G. Ciardi, *Beccafumi,* Milan, 1966.
Sanminiatelli, Donato, *Beccafumi,* Milan, 1967.
Baccheschi, Edi, *L'opera completa del Beccafumi,* Milan, 1977.

article—

Guerrini, R., "Valerio Massimo e l'iconografia umanistica: Perugino, Beccafumi, Pordenone," in *Studi su Valerio Massimo,* Pisa, 1981.
Srichia Santoro, Fiorella, "Ricerche senesi 5: Agli inizi di Beccafumi," in *Prospettiva* (Florence), 30, 1982.

*

Domenico Beccafumi was the greatest native Sienese painter of the 16th century. With the exception of brief trips to Genoa, Pisa, and Rome, the artist's career was spent entirely in Siena, where he executed numerous frescoes, altarpieces, and private devotional images. In addition to his work as a painter, Beccafumi is well known for his splendid designs for the pavement of the Siena cathedral. He was also active as a designer of prints and, late in his life, as a sculptor: one of Beccafumi's last undertakings was a series of large bronze angels which ornaments the choir of the Duomo.

Beccafumi's artistic beginnings are mysterious, and Vasari is the only source of information concerning his training as a painter. According to the biographer, this took place under the auspices of an unremarkable, anonymous local artist. Many suggestions concerning the identity of Beccafumi's first master have been advanced, but none has as yet proved entirely persuasive. Nonetheless, the formative influences on the young painter can be adduced: the sweet, Umbrian style of Perugino,

who was represented in Siena with two altarpieces and whom Vasari indicated was the source of the refinement of Beccafumi's early style, the shadowy chiaroscuro of Leonardo, which was transmitted to Siena by the painter Sodoma, and the High Renaissance classicism of the contemporary Florentine painters, Fra Bartolommeo and Albertinelli. The artist was also responsive to the works of his compatriot Peruzzi, whom he encountered on a trip to Rome around the year 1510, and to the grand Roman manner of Raphael and Michelangelo. And a reciprocal influence with Beccafumi's contemporary and adopted Sienese, Sodoma, persisted throughout much of the artist's career.

In the company of the Florentines Rosso and Pontormo, Beccafumi is often considered a key protagonist in the development of the so-called anti-classical style, an early phase of Mannerism which is characterized by a rejection of many of the tenets and norms of the High Renaissance manner represented by Leonardo and Raphael. While this stylistic construct has been largely abandoned, scholars instead emphasizing the continuity with earlier traditions rather than a supposed rupture, it is true that Beccafumi shares with Rosso a certain tendency toward elongated figures, exaggerated gestures, heightened emotion, and hot, acidic colors. This is evident in his earliest extant fresco, the *Meeting of Joachim and Anna at the Golden Gate* from the Capella della Madonna del Manto of the Hospital of S. Maria della Scala, Siena's main charitable organization, a work executed around the year 1513. (The chapel was deconsecrated in the 17th century, but Beccafumi's frescoed lunette remains in situ in the hospital.) But the precisely contemporary *Saint Catherine of Siena Receiving the Stigmata* (Siena, c. 1513–1515) reveals a different sensibility, Beccafumi allied in this work to the restrained, sober manner of Fra Bartolommeo and his associate Albertinelli. The balance and order of the composition and the serene, monumental figures recall such works as Albertinelli's *Visitation* (Uffizi), with which Beccafumi's altarpiece shares a similar vaulted, open arcade as its setting, and the Frate's *God the Father with Saints Mary Magdalene and Catherine of Siena* (Lucca). And the luminous, airy landscape of Beccafumi's painting is analagous to the same detail in Fra Bartolommeo's work. The *Holy Family with Saint John the Baptist* (Munich), a private devotional image, and particularly the figure of Saint Joseph, is also clearly inspired by the manner of the "School of S. Marco," as Fra Bartolommeo and Albertinelli's workshop is known.

Beccafumi's altarpieces reveal the artist's keen interest in the effects of light. In the *Nativity* (Siena, S. Martino, c. 1523–1524), the natural light of the new dawn, with its pink and golden sky, is contrasted with the brilliant, glowing, supernatural light of the celestial zone above, where animated angels form a ring around the dove of the Holy Ghost. An expressive contrast between natural and symbolic light also characterizes the artist's *Birth of the Virgin* (Siena). In the *Mystical Marriage of Saint Catherine* (Siena, Palazzo Chigi Saraceni), a murky shadow envelopes the enthroned Virgin and Child and the figures immediately flanking them, while a bright light falls on the seated Saints Peter and Paul at the base of the steps leading to the Virgin's throne, highlighting the rich, glowing colors of their robes. And nowhere has the demonic, incendiary light of hell been rendered more dramatically than in Beccafumi's *Saint Michael Vanquishing the Rebel Angels* (Siena,

S. Nicolò al Carmine) where glowing sparks and hot flames silhouette the writhing, tortured figures of the damned in the artist's vision of the Inferno. Beccafumi's richly expressive light in all these works is combined with the glowing, liquid colors that are a hallmark of his style.

Beccafumi executed four major mural cycles in Siena: the Oratory of S. Bernardino, carried out in the company of Sodoma (Beccafumi was responsible for two frescoes, the *Sposalizio* and the *Death of the Virgin*, between 1518 and 1520); the decorations of the Palazzo Bindi Sergardi representing scenes from classical antiquity (1520's); the Sala del Gran Concistoro in the Palazzo Pubblico (1529–35); and the apse of the Siena Cathedral (1535–44; repainted). In these works, the artist's talents as a narrative painter were put to the test. The S. Bernardino frescoes hark back to Florentine High Renaissance models, but the Palazzo Pubblico Frescoes seem instead fully Mannerist inventions, with their extravagently posturing figures and dense compositions, which were in part dictated by the didactic content and function of the imagery. In the celebrated designs for the Siena cathedral pavement, a new heroic grandeur has entered in Beccafumi's artistic idiom. These too are Mannerist inventions, but style and grace have been fused with dramatic energy to create some of the most powerful narrative images of the 16th century.

Although he was a somewhat provincial painter by training and practice, choosing to remain in his native city rather than removing to an artistic capital such as Rome or Florence, Beccafumi is one of the creative geniuses of the later Renaissance. The lilting grace of his figures ties him to the venerable Sienese tradition of Simone Martini and Sassetta, of whom he was the 16th-century heir, while his fanciful imagination and willful exaggerations reveal him attuned to the most progressive currents of Italian painting of his day.

—Linda Wolk-Simon

BECKMANN, Max.

Born in Leipzig, 12 February 1884. Died in New York, 27 December 1950. Married 1) Minna Tube, 1906 (divorced, 1925), one son; 2) Mathilde von Kaulbach, 1925. Attended schools in Brunswick, Gandersheim, and Falkenburg, Pomerania; studied under Carl Frithjof, Art Academy, Weimar, 1899–1903, and under Julius Meier-Graefe, Paris, 1903; worked in Berlin, 1904–15 (Member of the Berlin Secession Committee, 1910–11), Frankfurt, 1915–33, Berlin, 1933–37, Amsterdam, 1937–47; moved to the United States, 1948: taught at Washington University, St. Louis, 1947, University of Colorado, Boulder, 1949, and Brooklyn Museum Art School, 1949–50.

Major Collection: St. Louis.
Other Collections: Amsterdam: Stedelijk; Basel; Belfast; Berlin: Nationalgalerie; Birmingham; Bristol; Brussels; Cardiff; Dallas; Dublin; Edinburgh; Essen; Frankfurt; The Hague: Gemeentemuseum; Hartford, Connecticut; Karlsruhe; London: National Gallery, Tate, Victoria and Albert; Los An-geles; Manchester; Minneapolis; New York: Guggenheim, Moma, Whitney; Otterlo; Rome: Arte Moderna; Rotterdam; Stockholm: Moderna Museet; Stuttgart; Tel Aviv; Turin: Arte Moderna; Wuppertal.

Publications

By BECKMANN: books—

Briefe im Kriege, edited by Minna Tube, Berlin, 1916.
Ebbi: Komödie, Vienna, 1924.
On My Painting, New York, 1941.
Tagebücher 1940–50, edited by Mathilde Beckmann, Munich, 1955; edited by Erhard Göpel, Munich, 1979.
Sichtbares und Unsichtbares, edited by Peter Beckmann, Stuttgart, 1965.
Leben in Berlin: Tagebuch 1908–1909, edited by Hans Kinkel, Munich, 1966, 1983.
Apokalypse, Frankfurt, 1974.

illustrator: *Eurydikes Wiederkehr*, by Johannes Gunthmann, 1909; *Die Fürstin*, by Kasimir Edschmid, 1918; *Stadtnacht*, by Lili von Braunbehrens, 1921; *Der Mensch ist kein Haustier*, by Stephan Lackner, 1937.

On BECKMANN: books—

Kaiser, Hans, *Beckmann*, Berlin, 1913.
Glaser, Curt, et al., *Beckmann*, Munich, 1924.
Simon, Heinrich, *Beckmann*, Berlin, 1930.
Schone, W., *Beckmann*, Berlin, 1947.
Rathbone, P., *Beckmann* (cat), St. Louis, 1948.
Reifenberg, Benno, and Wilhelm Hausenstein, *Beckmann*, Munich, 1949.
Göpel, Erhard, *Beckmann der Zeichner*, Munich, 1954, 1958.
Beckmann, Peter, *Beckmann*, Nuremberg, 1955.
Göpel, Erhard, *Beckmann in seinen späten Jahren*, Munich, 1955.
Göpel, Erhard, *Beckmann: Die Argonauten: Ein Triptychon*, Stuttgart, 1957.
Göpel, Erhard, *Beckmann der Maler*, Munich, 1957.
Buchheim, Lothar-Günther, *Beckmann*, Feldafing, 1959.
Busch, Günter, *Beckmann: Eine Einführung*, Munich, 1960.
Wichmann, Hans, *Beckmann*, Berlin, 1961.
Martin, Hans von Erffa, and Erhard Göpel, editors, *Blick auf Beckmann: Dokumente und Vorträge*, Munich, 1962.
Gallwitz, Klaus, *Beckmann: Die Druckgraphik* (cat), Karlsruhe, 1962.
Kaiser, Stephan, *Beckmann*, Stuttgart, 1962.
Lackner, Stephan, *Beckmann*, Berlin, 1962.
Selz, Peter, *Beckmann* (cat), New York, 1964.
Lackner, Stephan, *Beckmann: Die neun Triptychen*, Berlin, 1965.
Lackner, Stephan, *Beckmann: Memories of a Friendship*, Coral Gables, Florida, 1969.
Fischer, Friedhelm W., *Der Maler Beckmann*, Cologne, 1972; as *Beckmann*, New York, 1973.
Fischer, Friedhelm W., *Beckmann: Symbol und Weltbild*, Munich, 1972.
Beckmann (cat), Bielefeld, 2 vols., 1975.

Self-Portrait, 1917; drypoint

Göpel, Erhard, and Barbara Göpel, *Beckmann: Katalog der Gemälde,* Berne, 2 vols., 1976.

Lenz, Christian, *Beckmann und Italien,* Frankfurt, 1976.

Perucchi-Petri, Ursula, editor, *Beckmann: Das druckgraphische Werk* (cat), Zurich, 1976.

Beckmann, Peter, *Die Versuchung: Eine interpretation des Triptychons von Beckmann,* Heroldsberg, 1977.

Güse, Ernst-Gerhard, *Das Frühwerk Beckmanns: Zur Thematik seiner Bilder aus den Jahren 1904–1914,* Frankfurt, 1977.

Lackner, Stephan, *Peter Beckmann im Bild seines Vaters,* Murnau, 1978.

Wiese, Stephan von, *Beckmanns zeichnerisches Werk 1903–1925,* Dusseldorf, 1978.

Wachtmann, Hans G., *Beckmann: Von der Heydt-Museum Wuppertal,* Wuppertal, 1979.

Dube, Wolf-Dieter, *Beckmann: Das Triptychon "Versuchung,"* Munich, 1981.

Erpel, Fritz, *Beckmann,* Berlin, 1981.

Selz, Peter, et al., *Beckmann: Die Triptychen im Städel* (cat), Frankfurt, 1981.

Beckmann, Peter, *Beckmann: Leben und Werk,* Stuttgart, 1982.

Beckmann, Mathilde Q., *Mein Leben mit Beckmann,* Munich, 1983.

Dückers, Alexander, *Beckmann: Die Holle, 1919* (cat), Berlin, 1983.

Gohr, Siegfried, *Beckmann* (cat), Cologne, 1984.

Belting, Hans, *Beckmann: Die Tradition als Problem in der Kunst der Moderne,* Berlin, 1984.

Lenz, Christian, *Beckmann: Ewig wechselndes Welttheater,* Esslingen, 1984.

Piper, Reinhard, *Beckmann in seinen Selbstbildnissen,* Esslingen, 1984.

Schulz-Hoffman, Carla, and Judith C. Weiss, editors, *Beckmann Retrospective* (cat), Munich and St. Louis, 1984.

Twohig, Sarah O'Brien, *Beckmann: Carnival,* London, 1984.

*

Max Beckmann's decidedly academic early paintings, completed in the first decades of the century but reflecting the perserverance of 19th-century traditions, would probably have relegated him to the ranks of the obscure had it not been for his increasing sensitivity to his milieux. Precisely because he was in sympathy with Daumier's prescient modernist adage, "il faut être de son temps," he inevitably adopted reflexive contemporary styles (utilizing a personal amalgam of Cubism, Futurism, and Expressionism after 1915) as well as an attitude commonly found in the confrontational Critical Realist wing of an international postwar Realist revival. But because he maintained his initial interest in allegory, his brand of metaphorical Realism transcended and tempered—with mythic and metaphysical themes—the commonplace depiction of contemporary society, and stamped the artist as an original whose stylistic and thematic appropriations merged smoothly into enigmatically familiar works.

Beckmann emerged from academicism slowly (which reflects Germany's stubborn traditionalism), ultimately shocked into modernity by his grisly experiences as a medical orderly in the First World War, undoubtedly the cause of his nervous breakdown in 1915. Prior to this the artist, though troubled by the avant-gardists in the Brücke and the Blaue Reiter, had pursued a career as a history painter, following Gericault's epic Romanticism and choosing tragic events—or mythic struggles—as his subjects. In his *Scene from the Destruction of Messina* (1909), devastated by post-quake pillage, and *The Sinking of the Titanic* (1912), both of which share the Rubenesque chaos of his *Battle of the Amazons* (1911), Beckmann failed to create convincing images of victimization, evoking the turgid brushwork, odd spatial recession, and clumsy posturing of Slevogt and Corith's lesser efforts.

The war functioned in anticipated apocalyptic fashion for this widespread form of academicism which flourished and died with the Belle Epoque. After his release from the war, Beckmann's style altered radically, substituting the claustrophobic spaces and skewed perspectival collisions of Cubo-Futurism for his prewar "window on the world," now shattered into confusing fragments. The artist merged perceptibly with the Critical Realists in the immediate postwar years, encapsulating the shock of a new world where violence, deprivation, and depravity confronted a fragile bourgeois tradition.

Beckmann's Olympian desire, stated in a prewar exchange with Franz Marc, to create a mythology for the 20th century, one that would offer a range of heroes, ideals, and gods, was irretrievably altered, lost to circumstance. This mythos mutated out of a series of realistically squalid images of banal terrorism and soulless anomie, exemplified in *The Night* of 1918–19 and the lithographic cycle *Hell* of 1919, into the great triptychs of the 1930's, like *Departure* and *The Temptation of St. Anthony,* which offer a modicum of redemption in the form of physical and spiritual odysseys.

In 1918, with a new sense of dark purpose, he stated that he wanted, above all, to "give people an image of their fate," and in subsequent works abandoned grandiose vistas for confrontational tableaux fraught with psycho-social tensions in airless urban spaces. His avowed—if brief—affinity for the *Neue Sachlichkeit*, by 1924 a widely acknowledged albeit ill-codified style, focussed entirely on the linguistic connotations of the word "objectivity," implications which infuse his work with bleak aggression, cooled by a blonde-grey tonality.

For Beckmann, *Sachlichkeit* conflated the dual concepts of *Gegendstandlichkeit* and *Genauigkeit*—opposition and accuracy—which clearly define the approach taken by the Critical Realist wing. Like Otto Dix and George Grosz, he pursued this oppositional accuracy in topical subjects in his postwar graphics, preferring in his paintings (unlike his more vitriolic colleagues) to set stages for modern secularized versions of medieval passion plays, scenes of obscurely motivated tortures, mutilations, and terrifying incursions in such canvases as *The Night* and *The Dream* or for the series featuring masked performers whose entertainments, in luminous hues outlined by tarry blacks à la Rouault, remain disconnected actions.

Beckmann, who revered the moral force of predecessors like Bruegel, Goya, and Hogarth, was loath to relinquish his paradoxical intentions of achieving a specifically "*metaphysical* objectivity," which he implied by use of the medieval device of the triptych whose panels may be read inter-referentially in traditional sequences. Yet, even when these are specifically religious in content, their brooding surrealistic intensity and alienation render them utterly modern. It is in these cryptic images that he transcends the manifesto-laden movements of his era and joins the rarified ranks of mystics.

While Beckmann's *oeuvre* included a wide range of topics—from still lifes, streetscapes, nudes, seascapes, and portraits to the politicized works of the Critical Realist years—beyond mythic or mystic images, his enduring attraction resides in those examples of "metaphysical objectivity" which touch upon deeper, less descriptive content, whether spiritual or philosophical.

Beckmann's formal approach, a harsh, almost clumsy figuration with startling changes of space and proportion, planar areas of localized—but not necessarily realistic—color overlaid by an increasingly agitated and dense outline that threatens the canvases of the late 1930's with tenebrist murk, developed from the Cubo-Futurist style of the postwar years. The eclectic content of the mythic works heightens the enigmatic—and unique—character of the artist's modern metaphysics.

A mix of references from Schopenhauer to the Kabbala, from Gnostic dogma, classical mythology, Nietzsche, and alchemical lore to Indian mysticism and Jungian archetypal theories, makes Beckmann one of the most erudite and mysterious of modern artists. The combination of brutal form and elegant, arcane content can be daunting. His allegorical painting *Death,* completed in 1938 in Amsterdam after his exile from a Nazified Germany, attempts to convey theosophical theories surrounding the soul's final odyssey to the next world, a project more nightmarish than redemptive to the uniniated. Nonetheless, Max Beckmann's most powerful works remain those which transcend description, those doubled assaults on the viscera and the intellect, difficult expressions of a recognizable and human search for mythic connections.

—Linda McGreevy

BELLINI, Gentile.

Born in Venice, 1429; son of the painter Jacopo Bellini; brother of the painter Giovanni Bellini. Died in Venice, buried 23 February 1507. Married 1) Caterina Baresina; 2) Maria di Antonio da Gabona. Probably worked in the family shop until the death of Jacopo, 1470-71; in Constantinople on official appointment, 1479-81; later had many civic commissions; like his father and brother, associated with Scuola Grande di S. Marco; also did works for Sculoa di S. Giovanni Evangelista; collaborated with his assistant Mansueti. Pupils: Carpaccio, Cima da Conegliano.

Major Collection: Venice: Accademia.
Other Collections: Bergamo; Berlin; Birmingham; Boston: Gardner; Budapest; Chicago; London; Milan; New York: Frick; San Francisco; Venice: Museo di S. Marco, Doge's Palace, Correr.

Publications

On BELLINI: books—

Gronau, Georg, *Die Kunstlerfamilie Bellini*, Bielefeld, 1909.

articles—

Collins, Howard F., "Time, Space, and Bellini's *The Miracle of the Cross at the Ponte San Lorenzo,*" in *Gazette des Beaux-Arts* (Paris), December 1982.
Meyer zur Capellen, Jürg, "Das Bild Sultan Mehmets des Eroberers," in *Pantheon* (Munich), July-December 1983.

*

Probably the eldest son of Jacopo Bellini, Gentile learned the rudiments and technique of painting from his father. Although his extant production is limited, Gentile certainly deserves a place in the history of Venetian painting, at a time when the Byzantine and Gothic traditions were gradually supplanted by the artistic rules of the Renaissance. The examples given by Mantegna in nearby Mantua, or by Donatello in Padua, never slavishly copied by Gentile, did however help him to bridge the passage from the archaic, over-decorated style then reigning in Venice to a more sober, monumental, convincing way to depict the tangible world.

His first works, in which, in a probably minor role, he collaborated with his father are lost or dismembered; they are the altarpiece for the funeral chapel of Erasmo da Narni in the basilica of S. Antonio of Padua, and the 18 canvases completed in 1465, with the participation of his brother Giovanni, for the Scuola Grande di San Giovanni Evangelista. In this year he signed his first original work, the portrait of the first Patriarch of Venice, the Blessed Lorenzo Giustiniani (Venice) a monochrome tempera in which the hieratic figure of the prelate, seen in profile, filled with intense spirituality and raising his hand in a blessing gesture, is accompanied by two *angioletti* and two kneeling canons, whose prosaic faces strongly contrast with the ascetic ardor of the Blessed. Probably also by his hand is the portrait of Francesco Foscari (Ven-

ice, Correr) in which the old Doge, represented again in profile, has the spontaneity of a snapshot: the sagacity, the wisdom, the cunning of the old man, whose heavy lined face, painted in a light hue, receives as much attention as the folds and arabesques of his official robe, is an early example of his later art. Although documentation is lacking, Gentile's fame as portrait painter must have been established quite early and steadily increased. In 1469 the Emperor Frederick III, on an official visit to Venice, made him a Knight and Palatine Count. From around 1472 date the lost portrait of Cardinal Bessarion and a cover for a relic (Vienna), painted for the same Cardinal, in which we see the kneeling portrait of Bessarion and those, more vigourously painted, of Guardians of the Scuola della Carità.

Much less satisfying than his portraits are the huge organ-shutters commissioned by the *Provveditori* of San Marco (Venice, Museo di San Marco): the four colossal figures show the direct influence and the undigested lesson of Mantegna's harsh style; they are strongly painted, but less than pleasing. This commission, however, opened the doors of official recognition for Gentile, and in 1474 he was nominated State Painter of the Republic, his first assignment being the restoration of fresco cycles painted for the Hall of the Gran Consiglio in the Ducal Palace by Gentile da Fabriano and Pisanello.

His best-known portrait, and deservedly so, is that of Sultan Mohammed II, painted by Gentile during his stay in Costantinople. The fact that the Republic sent him (the Sultan had asked for a painter and a master-founder) speaks well of his fame within the city and its political elite. Of the many works done for Mohammed II, only his portrait (London) survives. Seen behind a balaustrade covered with a rich carpet encrusted with precious stones, and framed by a simplified triumphal arch covered with intricate patterns, the Sultan is depicted half-bust and in three-quarter view. Memories of the precise, crystalline clarity of Antonello da Messina, from whom the spatial structure also derives, Gentile seems to take an extraordinary delight in the perfect rendition of architectural and decorative details, contrasting them with the pale, refined, emaciated traits of the sitter. It is truly a masterpiece of keen psychological penetration in which sensuality, cruelty, intelligence, nobility, even greatness, are combined and painted with cool colors, subtle light effects, and, above all, an incisive, sharp line.

Once back in Venice he began to paint, with his brother Giovanni, a series of canvases to replace the decrepit frescos for the Hall of the Gran Consiglio in the Ducal Palace. Unfortunately the cycle was destroyed by fire in 1577. All that remains is a fragmentary description of one canvas, in which, faithful to his artistic nature, he had painted gorgeously dressed personages and many portraits. What today is left to give us a taste of what the lost cycle must have been are the later works done for two *Scuole*, of San Giovanni Evangelista and San Marco.

In the *Procession of the Cross in St. Mark's Square* and the *Miracle of the True Cross*, Gentile has reached the highest point of his art, in which with dry realism and dispassionate accuracy he depicts the stately rhythm of a procession and the astounded surprise aroused by a miracle. In both works the mass of participants is broken into a multitude of individuals and characters faithfully portrayed; with a penetrating eye Gentile registers, with affection and gusto, the changing expressions of the human face or minute architectural details, finding beauty in the life and spectacle around him. Works of art, yet at the same time important, unique documents of the time, the two compositions are the conclusion of a life-long search, a hymn to the beauty of Venice and the quality of its people.

The last work of Gentile, left unfinished after his death and completed by his brother Giovanni, the *Preaching of St. Mark in Alexandria* (Milan), seems a coagulation on canvas of stirred memories: eastern architectures, minarets, obelisks, exotic animals, crowds dressed in Oriental fashion, fill the huge space, whose compositional structure recalls the earlier *Procession of the Cross*. Obviously a derivation from the Venetian basilica is the pseudo-mosque that closes the background, in this work; however, the photographic realism of the latter has been replaced by faded memories of Constantinople. Light also acquires a new value; it fills the canvas with a soft luminosity, striking the buildings and underlining their simple volumes that stand out as metaphysical, mysterious presences, or shaping the tall, round, veiled hats of the women sitting in the foreground, whose closed mass creates volumes of almost Cubist purity. Although the figure of St. Mark and those standing behind him were painted by Giovanni Bellini (Gentile never painted with such a fluid brush), the canvas in the Brera is a fitting conclusion of a very long career, a lasting legacy to the power of the observing eye sustained by memory, a fascinating combination of Renaissance pictorial rules and the exotic appeal of the East. It well summarizes not only the artistic personality of the painter but also of his native milieu, ready to adopt what was being elaborated by artists in other regions yet unable to turn its gaze from the Byzantine heritage and the brilliant culture of Islam.

—Norberto Massi

BELLINI, Giovanni.

Born in Venice, c. 1430; son of the painter Jacopo Bellini; brother of the painter Gentile Bellini. Died in Venice, 29 November 1516. Worked in the family shop until 1459, and probably until the death of Jacopo, 1470–71; strongly influenced by Mantegna, who married Bellini's sister Nicolasia; chief painter to the state: many official commissions; also worked at the Scuola Grande di S. Marco (replaced some of Gentile's works destroyed by fire). Pupils: Giorgione, Titian, Palma Vecchio; Sebastiano del Piombo.

Major Collection: Venice: Accademia.
Other Collections: Atlanta; Bergamo; Berlin; Detroit; Florence; Hampton Court; London; Milan: Brera, Castello Sforesco; Murano: S. Pietro Martire; Naples; New York: Frick, Metropolitan; Paris; Pasadena; Pesaro; Rome: Borghese, Capitolina; Sao Paulo; Venice: Correr, Museo di S. Marco, SS. Giovanni e Paolo, S. Maria dei Frari, S. Zaccaria; Washington.

Publications

On BELLINI: books—

Fry, Roger, *Bellini*, London, 1899.
Gronau, Georg, *Die Kunstlerfamilie Bellini*, Bielefeld, 1909.
Gronau, Georg, *Die Spätwerk des Bellini*, Strasbourg, 1928.
Gronau, Georg, *Bellini*, Stuttgart, and New York, 1930.
Düssler, Luitpold, *Bellini*, Frankfurt, 1935.
Gamba, Carlo, *Bellini*, Milan, 1937.
Moschini, Vittorio, *Giambellino*, Bergamo, 1943.
Hendy, Philip, and Ludwig Goldscheider, *Bellini*, Oxford and New York, 1945.
Wind, Edgar, *Bellini's Feast of the Gods*, Cambridge, Massachusetts, 1948.
Düssler, Luitpold, *Bellini*, Vienna, 1949.
Pallucchini, Rodolfo, *Bellini* (cat), Venice, 1949.
Walker, John, *Bellini and Titian at Ferrara*, London, 1956.
Pallucchini, Rodolfo, *Bellini*, Milan, 1959, London, 1962.
Heinemann, Fritz, *Bellini e i Bellianiani*, Venice, 2 vols., 1962.
Bottari, Stefano, *Tutta la pittura de Bellini*, Milan, 2 vols., 1963.
Meiss, Millard, *Bellini's St. Francis in the Frick Collection*, Princeton, 1964.
Robertson, Giles, *Bellini*, Oxford, 1968.
Hubala, Erich, *Bellini: Madonna mit Kind, Die Pala di San Giobbe*, Stuttgart, 1969.
Pignatti, Terisio, *L'opera completa di Bellini*, Milan, 1969.
Huse, Norbert, *Studien zu Bellini*, Berlin, 1972.
Cannon-Brookes, Peter, *The Cornbury Park Bellini*, Birmingham, 1977.
Fleming, John V., *From Bonaventure to Bellini: An Essay in Franciscan Exegesis* [on *San Francesco nel deserto*], Princeton, 1982.
Goffen, Rona, *Piety and Patronage in Renaissance Venice: Bellini, Titian, and the Franciscans*, New Haven, 1986.

articles—

Meyer zur Capellen, Jürg, "Bellini in der Scuola Grande di S. Marco," in *München Jahrbuch der Bildenden Kunst*, 22, 1971.
Delaney, Susan J., "The Iconography of Bellini's *Sacred Allegory*," in *Art Bulletin* (New York), 59, 1977.
Humfrey, Peter, "The Bellinesque Life of St. Mark Cycle for the Scuola Grande di San Marco in Venice in Its Original Arrangement," in *Zeitschrift für Kunstgeschichte* (Munich), 48, 1985.

*

Venetian painting reaches the high level long enjoyed by Tuscan art only with Giovanni Bellini. His long career spans the second half of the 15th century and the beginning of the following one. No artist before him was so captivated by the beauty of nature, seen and interpreted poetically, even, at times, pantheistically. The formation of his early style shows the influence of his father Jacopo, of Antonio Vivarini, the most progressive painter in Venice toward 1450, and, above all, of Andrea Mantegna. Indeed Bellini's production, from about 1460 up to 1475, is heavily indebted to Mantegna, although the humanistic, archeological approach to painting of this master quickly gave place to a style which had its sources not in intellectualizing idealizations of Roman art but in the emotions, filtered through Christian beliefs, stirred and aroused by the created world. With the discovery of Piero della Francesca (probably seen in Ferrara or Rimini) and the arrival in Venice of Antonello da Messina in 1475, Bellini's compositions become softer and less angular, line and color sustain and complete each other in a poetic synthesis of simple magnificence. Bellini was endowed with a surprising capacity for assimilation; in his work the Gothic tradition learned from his father, the timid advances proposed by Vivarini, the firm, sharp drawing of Mantegna, the precise, perfect space of Piero della Francesca, and the cool but exquisite color of Antonello are blended and become the foundation for his later manner. In Bellini's art, color, often redolent of melancholy, warm and rich in tonality, never strident or vulgar, plays a key role and seems to anticipate the romanticism of Giorgione.

Outstanding early paintings are the *Blood of the Redeemer* (London) and the *Agony in the Garden* (London), both from about 1465. If in the first work the foreground reflects the elegance of late Gothic joined to the dry contours of Vivarini, the landscape already reveals Bellini's peculiar sensibility, and in the second the influence of Mantegna's harsh style is strong. In his two versions of the theme (Tours and London) Mantegna concentrates on anatomy and perspective, an incisive line, and vivid, contrasting colors to create an idealized version steeped in Roman archeology. Bellini, instead, closely follows the Gospel story: it is early morning and light, still contrasting with darkness, reveals and shapes figures whose softened volumes have lost the hard plasticity of Mantegna. The wide, open landscape, more than a composite, abstract amalgam of separate elements forced together by the artist's inspiration, is truly a portion of nature breathing with intense life. Light and color, more than form, are the unifying elements of the scene, and their dramatic intensity are means to describe a psychological mood. The melancholy of the story and of the hour, of desolate contemplation, are reflected in the red glowing of the clouds, in the quiet luminosity of the horizon, and the cool, bluish air surrounding the ethereal form of the angel. Man and nature seem here parts of a unified whole.

The *Pietà* (Milan), datable around 1470, is the last work of Bellini's early style in which color and line are not yet harmoniously blended: each strikes a different note and the pictorial result is not totally satisfying. The three solitary figures stand out against a pale sky; the motions of the hands and the expressions of their heads tell with contained grief the tragedy of the scene, centered on the lifeless, beautiful body of Christ. The painting is certainly remarkable but shows the effort, the strain, of the artist to strike out in new directions.

We do not know when or how Bellini came into contact with works by Piero della Francesca; it seems, however, that the impact prompted a loosening of the plastic effect and a greater reliance on color: as such the *Coronation of the Virgin* (Pesaro), from about 1475, represents a turning point in Bellini's career. Freed from the restraining sculptural form of Mantegna, Bellini adopts the perspectival conception of Piero, in which color and light are means to emphasize the underlying geometrical structure. The statuary relief of Mantegna is substituted by a precise perspectival grid and within it Bellini's

Man with a Turban; drawing; Florence, Uffizi

coloristic abilities are given free rein. The conception of the altarpiece has a grandiose monumentality. Flanked by four saints that, like the marble tiles of the pavement and the architecture of throne, mark the spatial recession, the Virgin and Christ are seen against a hilly landscape, whose towers and embattlements pull the eye inside the painting, toward the most distant horizon. Like a picture within a picture, the central group is framed by an elaborate, carved frame that adds a note of stately magnificence to the scene. Volumes are sober and realistically drawn, diagonally illuminated by a soft light that gently planes over faces, carves deep shadows in the garments' folds, and brightens the landscape and the sky with a joyous radiance.

The arrival in Venice of Antonello da Messina in 1475, and his chromatic lesson allied to a minute, precise rendition of space, are the last influencing factors in the full development of Bellini's style. The northern realism of Antonello and his compositional schemes were enthusiastically adopted by Bellini; his portraits, *sacre conversazioni,* practically every painting executed between c. 1475–85, reveal this. To this period (c. 1480) belong the *St. Francis* (New York, Frick) and the *Transfiguration* (Naples). In both paintings the landscape, brightly illuminated by a pure, morning light, plays the major role, while personages seem ancillary, or a pious pretext to depict not just nature but the world of man: flocks and shepherds, birds, animals, hamlets and cities, herbs, trees and flowers, as finely depicted as in a Medieval *herbarium,* are all parts of a single religious experience, in which holiness is present in every leaf, every stone, every person. The solemn majesty of the human figures is underlined by the grandiose vastness around them, spaces bathed in a warm light that seem to exalt colors.

Fame and official recognition were Bellini's rewards for his work: on 26 February 1483, he was appointed painter of the Venetian Republic. The *Pala di San Giobbe,* datable c. 1487–89 (Venice), and the *Triptych of the Frari,* dated 1488 (Venice, S. Maria Gloriosa dei Frari), are among his best mature works. If in the *Pala* Antonello's conception is of paramount importance, in the *Triptych* the old-fashioned format becomes the occasion for an illusionistic tour-de-force (as it had for Mantegna before him in San Zeno.) Behind the architectural frame, in a unified space that echoes the frame itself and lets the landscape intrude into the composition, the saints and the Virgin are rendered in solid, dense volumes, color is strong and intense, light ethereal, golden, and soft. The central section is so graceful and sweet that it seems indeed a vision of Paradise. Even more paradisiacal, and one of the highest expressions of spirituality, is the panel representing the *Virgin and Child Between Saints Catherine and Mary Magdalene,* from about 1488 (Venice). Following Antonello's dictates the composition is harmoniously symmetrical, the central group gently balanced by the two saints who, turning toward the Virgin, make her the focus of the composition in which a soft penumbra caresses forms, modelling them in a sweet relief of utter sensibility. Deep and touching is the serenity, the spiritual sublimity, that pervades the whole atmosphere, a testimony to Bellini's conception of Christian piety.

Perhaps the greatest poet of his time, Bellini imbued his later paintings with an identical, immense peace. The mastery of the brush and the originality of the mind kept creating religious works in which the spirit of the personages comes to the surface and fills the canvases with calm certainty. The last of his great altarpieces, the *San Zaccaria Altarpiece,* completed in 1505, for appears at first a variation of the earlier *pala* for San Giobbe. But though they are fundamentally alike, everything is different: the tiled floor leads the viewer toward, and at the same time separates him from, the *sacra conversazione;* the angels are reduced to a single one; two saints squarely face us and, like human pillars, enclose the core of the composition in which the physical, serene beauty of the female saints contrast with the gravity of Peter and Jerome. Again light strikes obliquely, revealing profiles, folds, architecture, gently shaping heads and bodies with a tender *sfumato.* Grandiosity of conception and forms heavy with colors of warm tonality are coupled to an unreal silence, a perfect harmony.

Well advanced in years Bellini was not yet overshadowed by the rising stars of Giorgione and Titian. On the contrary, his last years witness the final flowering of his genius. As in the past he was ready to assimilate from others, and his *Assumption of the Virgin,* from about 1507 (Murano, San Pietro Martire), or the altarpiece for San Giovanni Crisostomo, dated 1513, show how ready he was to learn from the two younger leaders of Venetian painting. Never totally at ease with secular subjects, his last unfinished masterpiece, the *Feast of the Gods,* from 1514 (Washington), later completed by Titian, filled with warmth and sympathy, proves how young Bellini's mind was even in his last days.

—Norberto Massi

BELLINI, Jacopo.

Born in Venice, c. 1400. Died in Venice between 7 January 1470 and 25 November 1471. Married Anna; two sons, the painters Gentile and Giovanni, and a daughter, Nicolasia. Probably a pupil or assistant of Gentile da Fabriano in Florence, 1420's; in Venice by 1424; partner of Donato Bragadin for sale of works, 1440; various commissions, including work in S. Antonio, Padua, the Scuola di S. Giovanni Evangelista, and the Scuola Grande di S. Marco; 2 volumes of his drawings survive; pupils include, beside his sons, Leonardo di Ser Paolo.

Collections: Florence; Milan; New York: Brooklyn Museum; Padua; Paris; San Diego; Venice: Accademia, Correr, Museo di S. Marco; Verona.

Publications

On BELLINI: books—

Goloubew, Victor, *Les Dessins de Bellini au Louvre et au British Museum,* Brussels, 2 vols., 1908-12.
Ricci, Corrado, *Bellini e i suoi libri di disegni,* Florence, 2 vols., 1908.
Gronau, Georg, *Die Kunstlerfamilie Bellini,* Bielefeld, 1909.
Simon, H., *Die Chronologie der Architektur- und Landschaft-

Funeral of the Virgin; drawing; Paris, Louvre

zeichnungen in den Skizzenbüchern des Bellini, Berlin, 1936.

Moschini, Vittorio, Disengni di Bellini, Bergamo, 1943.

Joost-Gaugier, Christiane L., Bellini: Selected Drawings, New York, 1980.

Meyer zur Capellen, Jürg, La "figura" del San Lorenzo Giustinian di Bellini, Venice, 1981.

Degenhart, Bernhard, and Annegrit Schmitt, Bellini: The Louvre Album of Drawings, New York, 1984.

Eisler, Colin, Bellini, New York, 1988.

articles—

Collins, Howard, "Major Narrative Paintings by Jacopo Bellini," in Art Bulletin (New York), September 1982.

Collins, Howard, "The Cyclopean Vision of Jacopo Bellini," in Pantheon (Munich), October 1982.

*

The art of Jacopo Bellini, together with that of his two sons, Gentile and Giovanni, virtually defines the boundaries of painting in 15th-century Venice. Indeed, as patriarch of this renowned family of painters, Jacopo is generally acknowledged as one of the principal conduits through which the stylistically advanced concepts of Florentine art were introduced into the still gothic lagoon city. His youngest son, Giovanni, used this legacy to develop, in the early years of the High Renaissance, that particularly Venetian quality of depicting forms by means of light and color.

As might be expected of a painter born at the beginning of the 15th century, Jacopo's early works strongly reflect the then fashionable International Gothic Style which was characterized by richly decorative surfaces and rythmic linear patterns of an elegant nature and had its origins in the late 14th-century court of Burgundy at Dijon. In fact, Jacopo may have been in Florence in 1423 as assistant to Gentile da Fabriano, one of the most celebrated International Gothic painters in Italy. Although this is uncertain, he did sign his fresco of the Crucifixion in the Cathedral at Verona, as "Jacopo of Venice, disciple of Gentile da Fabriano." This work, which helped establish his early fame, was painted in 1436 and, unfortunately, destroyed in the 18th century. Attempts to reconstruct the career of Jacopo have been made especially difficult by the fact that so few of his important works have survived. Two monumental wall cycles commissioned by the Venetian religious lay confraternities called *scuole* (schools) have not survived, and there is little evidence of the altarpiece he painted in 1460—with the aid of his sons—for the Gattamelata Chapel in the Basilica of San Antonio in Padua. However, a number of his surviving half-length Madonnas are portentous in that they show a feeling for space and volume that begins to move decisively beyond the International Gothic—e.g., *The Madonna and Child with Angels* in the Accademia in Venice.

It would be difficult to form an artistic profile of Jacopo Bellini based on his few surviving paintings. Fortunately, however, he left a unique legacy in the form of two books of drawings. They are unusual for the time in that they were apparently intended as exercises or works of art in their own right and not primarily as source material for paintings as in the case of medieval pattern books. Together they comprise two hundred and twenty nine pages and are generally viewed as marking a transition from Gothic archaisms to a Renaissance portrayal of rational space. In addition to the influence of the great Florentine sculptor Donatello, whose bronze high altar for the church of the Santo at Padua was completed in 1450, Jacopo's art was deeply affected by the ideas and writings of the Renaissance humanist Leon Battista Alberti whose treatise on painting, *De Pictura,* was written in 1435. Alberti's influence is apparent throughout the books, particularly in Jacopo's use of the new mathematics of perspective in place of the more traditional, intuitive depiction of pictorial space. Strangely enough, Jacopo's rigid application of Alberti's perspective (central point projection) may appear somewhat distorted to the eye of the modern viewer who is more accustomed to a perspective that has been "corrected" to more closely simulate human perception.

One of the books, now in the British Museum, was drawn in lead point on prepared paper. The other, in the Louvre, is largely in ink on parchment. Although both volumes reflect a wide variety of sources, often classical—reflecting Jacopo's surprising sophistication as an antiquary—they are particularly characterized by a profusion of imaginary architectural settings which virtually obscure the narratives presented within. In fact, Jacopo's frequent use of antique monuments and studies of domestic and exotic animals often lends a secular spirit to many of the ostensibly religious scenes. The dating of the books is conjectural, ranging from as early as the 1430's to the last decade of his life. The pen work in the Paris volume would appear to be restorative in nature since three different hands can be distinguished, and it is generally assumed that it was so prepared by Jacopo and his two sons, Gentile and Giovanni sometime before 1479 when it is believed that Gentile took the volume to Constantinople as a gift to the Sultan Mehmet II. In some instances the effect is anachronistic, as the severity of Jacopo's early Renaissance space is softened by Giovanni's fluid, more modern penwork.

Recent studies offer hope that knowledge of Jacopo will expand as lost works begin to emerge from obscurity. An image of San Barnardino in a private collection in New York, for example, supports Jacopo's proclaimed skill as the portrait painter who, in 1441, won a competition to paint a portrait of Lionello d'Este at the court of Ferrara. Another painting newly emerged from obscurity—*Saints Anthony Abbott and Barnardino of Siena*—has been convincingly proposed as a unit of the *Gattamelata Altarpiece.* Equally exciting is the suggestion that two paintings from a private collection in New York—*The Epiphany* and *The Marriage of the Virgin,* together with two canvasses in the Sabauda Gallery in Turin—*The Annunciation,* and *The Birth of the Virgin*—are part of the Jacopo's lost cycle of eighteen canvasses depicting the lives of Christ and of the Virgin painted for the Scuola Grande di San Giovanni Evangelista and possibly one of the oldest wall cycles painted of canvas.

—Howard Collins

BELLOWS, George (Wesley).

Born in Columbus, Ohio, 12 August 1882. Died in New York City, 8 January 1925. Married Emma Story, 1910; two daughters. Attended Ohio State University, Columbus, 1901–04; pupil, with Edward Hopper and Rockwell Kent, of Robert Henri at New York School of Art, 1904–06; exhibited from 1907; taught at the University of Virginia, 1908, and at the Art Students League, New York, from 1910; one of the organizers of the Armory Show, 1913; Lithographer and illustrator.

Collections: Boston: Public Library; Buffalo; Chicago; Cleveland; Columbus; Fort Worth: Amon Carter; Minneapolis; New York: Whitney; Washington: Corcoran, Hirshhorn, National Gallery.

Publications

By BELLOWS: articles—

"Relation of Painting to Architecture," in *American Architect* (New York), 20 December 1920.
"What Dynamic Symmetry Means to Me," in *American Art Student* (New York), June 1921.
"The Relation of Art to Everyday Things," interview with E. H. Ries, in *Arts and Decoration* (New York), July 1921.

illustrator: *The Wind Bloweth* by Donn Byrne, 1922.

On BELLOWS: books—

Bellows, Emma, and Thomas Beer, *Bellows: His Lithographs,* New York, 1927, 1928.
Bellows, Emma, *The Paintings of Bellows,* New York, 1929
Eggers, George, *Bellows,* New York, 1931.
Boswell, Peyton, Jr., *Bellows,* New York, 1942.
Bellows (cat), Chicago, 1946.
Bellows (cat), Columbus, Ohio, 1957.
Bellows: A Retrospective Exhibition (cat), Washington, 1957.
Nugent, Frances Roberto, *Bellows, American Painter,* Chicago, 1963.
Morgan, Charles H., *Bellows, Painter of America,* New York, 1965.
Braider, Donald, *Bellows and the Ashcan School of Painting,* New York, 1971.
Morgan, Charles H., *The Drawings of Bellows,* Alhambra, California, 1973.
Young, Mahonri Sharp, *The Paintings of Bellows,* New York, 1973.
Mason, Laurie, and Joan Ludman, *The Lithographs of Bellows: A Catalogue Raisonné,* Millwood, New York, 1977.
Bellows (cat), Columbus, Ohio, 1979.
Christman, Margaret, *Portraits by Bellows* (cat), Washington, 1981.
Carmean, E. A., Jr., et al., *Bellows: The Boxing Pictures* (cat), Washington, 1982.
Myers, Jane, and Linda Ayers, *Bellows: The Artist and His Lithographs 1916–24,* Fort Worth, 1988.

Business-Men's Bath, 1923; lithograph

articles—

Young, Mahonri Sharp, "Bellows, Master of the Prize Fight," in *Apollo* (London), February 1969.

Tufts, Eleanor, "Realism Revisited: Goya's Impact on Bellows . . . ," in *Arts Magazine* (New York), February 1983.

Zurier, Rebecca, "Hey Kids: Children in the Comics and the Art of Bellows," in *Print Collector's Newsletter* (New York), January-February 1988.

Haywood, Robert, "Bellows's *Stag at Sharkey's*," in *Smithsonian Studies in American Art* (Washington), Spring 1988.

*

In his own time, George Bellows was frequently characterized as the quintessential American painter: American in his realist subject matter, his midwestern origins, his extroverted personality, his masculine athleticism, his devotion to family life, and, perhaps above all, his success. His reputation was made before he was 30 with election in 1909 to the National Academy of Design, as one of the youngest members in its history. Bellows's early boxing pictures secured this reputation and remain his symbol in the public mind; with three later boxing pictures, they bracket his career. But for many critics his urban landscapes and scenes of street kids at play, his portraits of family and friends and his work in lithography, are equally representative of Bellows's achievement as an artist.

The formative influence on Bellows's art was Robert Henri whom Bellows met in 1904 when, fresh from Ohio, he enrolled at the New York School of Art where Henri taught. A charismatic and gifted teacher and painter, Henri inspired an entire generation of American artists including The Eight, later known as the Ashcan School—John Sloan, George Luks, and William Glackens, among them—with whom Bellows would come to be associated (although he was not one of the original members). Henri's innovation was the introduction of a new subject to American genre painting—urban life in its less genteel aspects: back streets populated by the poor and by immigrants, lower-class gathering places, the masses at work and play. But while Henri's 20th-century social content was new to American art, it was expressed in a 19th-century technique with its origins in Munich and Dusseldorf.

Bellows responded to the basic premises of realism as set forth by Henri: that art must be an expression of its time and the artist actively contemporary in his choice of subject matter. He absorbed Henri's advice to observe directly and paint directly in order to capture the essence of the moment, along with Henri's dark colors and painterly brushwork. Henri and his group also provided Bellows with a sense of community that had been all too often denied to artists living in America.

Bellows's selection of subjects played a critical role in his early success. In his boxing pictures of 1909, *Stag at Sharkey's* (Cleveland) and *Both Members of This Club* (Wash-

ington), he brashly coupled his interest in sports to the contemporary urban milieu. The paintings attracted a lot of attention; critics noted that while the subject matter was neither pleasing nor edifying, the poses and gestures were "positively exciting." To create such excitement, Bellows used stylistic devices that were to become an established part of his repertoire: a packed shallow space, dramatic contrasts of light, and dark and highly charged brushstrokes.

Bellows explored the leisure moments of his fellow New Yorkers in other boldly original paintings of these years. A favorite theme was the camaraderie of young boys swimming in the East River and lounging on its banks: *River Rats* (1906; Columbus, Ohio, Reese Collection), *Forty-two Kids* (1907; Washington, Corcoran), *Riverfront No. 1* (1915; Columbus, Ohio) all depict swarms of nude or partially clothed youths. Again, as in the boxing pictures, Bellows successfully unites the physical and emotional exuberance of the scene through animated brushwork and strong tonal contrasts. Similarly, in *Cliff Dwellers* (1913; Los Angeles), where the occupants of grimy tenements on New York's Lower East Side take to the streets to escape the oppressive heat of summer, Bellows creates visual drama through his energetic painterly treatment while retaining a sense of positive human interaction.

With his reputation as a painter firmly established, Bellows began to explore lithography in 1916. In the United States, lithography had previously been the province of the commercial artist while etching was the medium for the fine art print. Bellows's lithographs spawned a new interest in the potential of this previously neglected branch of printmaking as an artistic medium. The directness and flexibility of the lithographic process were particularly attractive to Bellows; he exploited its possibilities, drawing in broad, movemented strokes and creating dense tonal areas to render some of the same lively subjects that had intrigued him in his paintings: the boxing ring, city streets, and other views of everyday life ranging from gentle satires on efforts at physical fitness (*Business-Men's Class,* 1916), to sharp-edged commentaries on religious hypocrisy (*Benediction in Georgia,* 1916; *Billy Sunday,* 1923).

Bellows did not return to the boxing theme in his paintings until 1923, two years before his early death from a ruptured appendix. By then, his style had changed dramatically. Although critics disagree on this point, the Armory Show, held in New York in 1913, and the awareness he acquired there of international avant-garde art, seems to have been pivotal to his subsequent changes. Bellows, one of the organizers of the Armory Show, said after it was over: "I expect to change my methods entirely when I learn what I can in a new direction." That new direction took years to evolve, but was speeded along by his exposure, beginning in 1917, to the theories of Jay Hambridge and a system of compositional organization which he called "dynamic symmetry." Rather than making his paintings more dynamic, this system resulted in greater rigidity of composition, suppression of brushwork, and a formalization of gesture that saps the vigor of late boxing pictures such as *Ringside Seats* (1924; Washington, Hirshhorn). However, in his lithographs and in his more intimate paintings of family and friends (*Katherine Rosen,* 1921; *Lady Jean,* 1924, both in New Haven), Bellows retained the directness and vitality of subject and handling that are the hallmarks of his best work.

—Susan Barnes Robinson

BENEDETTO da Maiano.

Born in 1442; son of the stonemason Leonardo d'Antonio da Maiano; younger brother of the architect Giuliano da Maiano. Died 24 September 1497. Earliest attributed work is S. Savino shrine, Faenza Cathedral, 1468–71; major work is the pulpit decorated with scenes from the life of S. Francis, S. Croce, Florence; other works in San Gimignano, S. Domenico, Siena, marble doorway in the Sala dei Gigli, Palazzo Vecchio, Florence, Basilica of the Holy House, Loreto; he completed the tomb of Mary of Aragon begun by Antonio Rossellino, S. Anna dei Lombardi, Naples, and helped design the Palazzo Strozzi, Florence; also sculpted portrait busts; several terracotta models of his works survive; also active as an intarsiast and architect.

Collections/Locations: Boston: Gardner; Faenza: Cathedral; Florence: Cathedral, Palazzo Vecchio, Palazzo Strozzi, S. Maria Novella; London: Victoria and Albert; Loreto: Basilica of the Holy House; Naples: S. Anna dei Lombardi, Capodimonte; Prato: Cathedral; San Gimignano: Collegiate; Siena: S. Domenico; Washington.

Publications

On BENEDETTO: books—

Dussler, Luitpold, *Benedetto da Maiano,* Munich, 1924.
Cendali, L., *Giuliano e Benedetto da Maiano,* San Casciano Val di Pesa, 1926.

articles—

Hersey, G. L., "Alfonso II, Benedetto e Giovanni da Maiano, e la Porte Reale," in *Napoli Nobilissima,* 4, 1964.
Friedman, D., "The Burial Chapel of Filippo Strozzi in Santa Maria Novella in Florence," in *L'Arte* (Florence), 3, 1970.
Borsook, Eve, "Documents for Filippo Strozzi's Chapel in Santa Maria Novella and Other Related Matters," in *Burlington Magazine* (London), 112, 1970.
Tessari, A. S., "Benedetto da Maiano tra il 1490 e il 1497," in *Critica d'Arte* (Florence), 143 and 145, 1975 and 1976.
Radke, Gary M., "The Sources and Composition of Benedetto da Maiano's San Savino Monument in Faenza," in *Studies in the History of Art* (Hanover, New Hampshire), 18, 1986.

*

Benedetto da Maiano was the leading marble sculptor of late 15th-century Florence. Trained in the intarsia and woodworking shop of his brother Giuliano, Benedetto also produced numerous pieces of domestic and liturgical furniture. The rather ornate quality of his mature works in marble and the illusionism evident in many of his reliefs may owe something to his early training in intarsia. The example of his brother must also have been important for some of the architectural commissions he received.

Benedetto's figural style, on the other hand, is closely associated with the workshop of Antonio Rossellino. Indeed, Benedetto's earliest independent work, the S. Savino shrine in

St. John the Baptist, c. 1480–81; marble; 57⅛ in (145 cm); Florence, Palazzo Vecchio

Faenza, has sometimes been confused with the work of Rossellino. Already at Faenza, however, Benedetto demonstrated a singular interest in pictorial illusionism and spatial complexity that are foreign to the Rossellino workshop. His rather rambunctious early works gave way in the 1470's to more harmonious compositions like the S. Fina monument, culminating in the 1480's in the reliefs of the S. Croce pulpit and the altarpiece-sized Annunciation relief for the Terranuova Chapel in Naples. In them Benedetto combined detailed reliefs, freestanding statues or statuettes, and complex architectural framing to form impressive sculptural complexes. Only rarely did he receive a commission for a single, isolated work of sculpture, though his workshop did carry on a thriving business in the production of small devotional plaques and figures in wood, stucco, and terracotta.

In the late 1480's and 1490's Benedetto retreated from the somewhat extravagant detailing of his earlier work, preferring simpler compositions, bulkier, more serious figures, and bolder architectural forms. In so doing, his work pointed towards the grand style of the High Renaissance. At least one author has suggested that the young Michelangelo worked in Benedetto's shop, and the broad musculature of Benedetto's unfinished St. Sebastian or the sober gravity of his similarly unfinished Madonna and Child may have interested the younger artist.

At the same time, Benedetto's sculpture is distinctly representative of main currents in the early, not the High, Renaissance. His consummate skill at veristic portraiture, his deft handling of narrative, his sincere depiction of the Madonna and saints, his mastery of the technical difficulties of his craft, and the business-like way he handled his affairs make him the sculptural counterpart of the painter Domenico Ghirlandaio, who also ran a highly efficient and popular workshop.

Benedetto's work is rarely overtly inventive, but neither is it ever dull or repetitive. It is always charming and accessible, well wrought and attractively presented, an art with broad appeal that both confirmed and celebrated the social order of merchant Florence. Benedetto and his contemporaries portrayed an eminently comfortable universe. They were rewarded with regular commissions that in Benedetto's case brought him profits substantial enough to support a secure middle-class life and the purchase of property outside Florence. Highly talented and extremely hardworking, Benedetto made no claims to be a genius. What his works do attest, however, is his devotion to visible truth, to honest and straightforward depiction, to a basically benign view of his world. His work gives an alluring portrait of the Quattrocento as it wished to be remembered: at once pious, confident, and proud.

—Gary M. Radke

BENTON, Thomas Hart.
Born in Neosho, Missouri, 15 April 1889. Died in Kansas City, Missouri, 19 January 1975. Attended schools in Washington, D.C., and Neosho; Art Institute, Chicago, 1906–07; Julian Academy, Paris, 1908–11; set up studio in Fort Lee, New Jersey, 1912; joined the Synchronist movement, 1915,

but rejected modernist technique, 1919; taught at the Art Students League, New York, 1927; settled in Missouri, 1935; muralist from 1928; also a book illustrator. Pupil: Jackson Pollock.

Collections: Bloomington: Indiana University; Jefferson City, Missouri: State House; New York: Metropolitan, Moma, Whitney.

Publications

By BENTON: books—

An Artist in American, New York, 1937; 4th ed., Columbia, Missouri, 1983.
An American in Art: A Professional and Technical Autobiography, Lawrence, Kansas, 1969.
A Benton Miscellany: Selections from His Published Opinions 1916-1960, edited by Matthew Baigell, Lawrence, Kansas, 1971.

illustrator: *Europe after 8:15,* 1914; *We, The People,* 1932; *Schoolhouse in the Foothills,* 1935; *The Adventures of Tom Sawyer,* 1939, *Adventures of Huckleberry Finn,* 1942, and *Life on the Mississippi,* 1944, all by Mark Twain; *The Grapes of Wrath,* by John Steinbeck, 1940; *Taps for Private Tussie,* by Jesse Stuart, 1943; *The Autobiograph of Benjamin Franklin,* 1944; *The Oregon Trail,* by Francis Parkman, 1946.

On BENTON: books—

The Arts of Life in America: A Series of Murals by Benton (cat), New York, 1932.
A Descriptive Catalogue of the Works of Benton . . . , by Thomas Craven, New York, 1939.
The Years of Peril: A Series of War Paintings by Benton, Chicago, 1942.
La Farge, Henry A., *Benton* (cat), New York, 1968.
Benton Drawings: A Collection of Drawings, Columbia, Missouri, 1968.
Fath, Creekmore, *The Lithographs of Benton,* Austin, 1969, 1979.
Warten, Mary Curtis, *Benton: A Personal Commemorative,* Joplin, Missouri, 1973.
Baigell, Matthew, *Benton,* New York, 1974.
Benton: An Artist's Selection 1908-1974, Kansas City, 1974.
Broun, Elizabeth, et al., *Benton's Bentons* (cat), Lawrence, Kansas, 1980.
Burroughs, Polly, *Benton: An Island Portrait,* New York, 1981.
Guedon, Mary Scholz, *Regionalist Art: Benton, John Stewart Curry, and Grant Wood: A Guide to the Literature,* Metuchen, New Jersey, 1982.
Weintraub, Linda, *Benton* (cat), Annandale-on-Hudson, New York, 1984.
Marling, Karal Ann, *Tom Benton and His Drawings,* Columbia, Missouri, 1985.

*

Thomas Hart Benton stirred up heated controversy in his lifetime and even now, more than a decade after his death, continues to stimulate vehement differences of opinion. In the 1930's, after being featured on the cover of *Time* magazine, he became the most famous artist in America—a public celebrity on a par with movie stars and politicians. During the same period, however, he was vigorously denounced both by the New York leftists, and by conservatives offended by his satire of American life. Similarly, a recent retrospective of his work attracted enormous crowds and national media attention, but was vigorously denounced by many art critics. One writer declared that the exhibition was the worst he had seen in 40 years, while another likened Benton to the anti-Christ.

Benton's pugnacious temperament, which seems to lie at the heart of these varied responses, was to some extent a family inheritance. Born in Neosho, Missouri, on the edge of the Ozarks, he was descended from a long line of frontier politicians. His great-uncle and namesake, Senator Thomas Hart Benton, once nearly killed President Andrew Jackson in a street brawl, and his father, U.S. Congressman Maecenas E. Benton, was an outspoken populist. Benton's combativeness thus closely followed the model of his famous ancestors, but he diverged from them in his choice of a profession. Rather than opting for politics or law, the approved course of action in his family, he determined at an early age to become a painter— a choice that occasioned many heated battles with his father.

At the age of 17, Benton left home for good, first to work as a newspaper cartoonist in the rough mining boomtown of Joplin, Missouri, and then to pursue artistic studies in Chicago and Paris. His study in Paris was cut short, however, when family funding ran low and his mother discovered that he was keeping a French mistress. In 1911 Benton returned to the United States and settled in New York, where he lived a hand-to-mouth existence for more than a decade. Until the mid-1920's he was generally viewed as a modernist and concentrated on mastering the abstract organization of color and form. During this period much of his work was influenced by that of the Synchronist painter Stanton MacDonald-Wright, whom he had befriended in Paris.

In 1924, however, when his father lay dying of throat cancer, Benton was called back to Missouri, and the visit rekindled vivid memories of his childhood. Shortly afterwards he began to embark on long wanderings around the United States, during which he created thousands of sketches of the American people at work and play—particularly those of the south. In 1928 he combined these notations into a huge mural of *America Today* in the New School for Social Research in New York—and the painting created a sensation. Benton was the first to present the daily activities of American life in mural form, and he combined the bold forms and arbitrary handling of space in Modernist painting with a caustic social commentary heavily influenced by Marxist theory. His work had a gritty immediacy and relevance to actual events that were lacking from the abstract exercises of most Modernists. In addition, Benton's career was energetically pushed forward by his former roommate, Thomas Craven, who wrote numerous books and articles in praise of Benton's work, while attacking the creations of his artistic rivals. In short order, Benton became famous.

Benton's fame and unblushing self-promotion, however, stirred up bitter enmities, and by 1935 New York City had

Frankie and Johnny—detail, 1936; lithograph

grown uncomfortable for him. In that year he returned to his native state of Missouri to paint a large mural for the State Capitol. On the eve of his departure he penned a notorious letter, "Farewell to New York," which condemned the city as a hotbed of decadence, dominated by communists and homosexuals. For a decade his career thrived in the midwest, but in 1941 he was fired from the Kansas City Art Institute because of some untactful and widely publicized remarks that he made about the sexual preferences of museum curators. By that time the attention of most art critics had begun to shift from regionalist and realistic painting towards modernist and abstract experiments. Benton's work came to seem passé, and no longer worthy of much notice. While Benton continued to paint until his death in 1975, he never regained his position as a national celebrity.

—Henry Adams

BERCHEM, Claes.

Born Claes or Nicolaes Berchem in Haarlem, baptized 1 October 1620; son of the still-life painter Pieter Claesz. Died in Amsterdam, 18 February 1683. Studied with his father and others, but his style was most influenced by Italy: possibly visited Italy with Jan Weenix in 1642–45, and/or possibly 1653–56; entered the Haarlem guild, 1642; recorded in Amsterdam in 1660, and probably settled there in 1677; he painted the decorations for Visscher's maps; also painted figures for landscapes by Hobbema and Jacob van Ruisdael, etc. Pupils: de Hooch, du Jardin.

Major Collections: Amsterdam; Dresden; Leningrad; London.
Other Collections: Bristol; Budapest; London: Buckingham Palace, Dulwich; Munich; Paris; Schleissheim: Castle; Stockholm; Toledo, Ohio; York.

Publications:

On BERCHEM: books—

Schaar, E., *Studien zu Berchem,* Cologne, 1958.
Blankert, Albert, *Italienisernde Landschapschilders* (cat), Utrecht, 1965.

articles—

Schatborn, P., "Figuurstudies van Berchem," in *Bulletin van het Rijksmuseum* (Amsterdam), 22, 1974.
Schapelhouman, Marijn, "Berchems Landschap met Diana en haar nimfen in het Rijksprentenkabinet," in *Bulletin van het Rijksmuseum* (Amsterdam), 32, 1984.

*

Although he spent only a brief period in Italy in the early 1640's, Berchem is rightly considered to be one of the leading Dutch Italianate landscape painters. A few of his pictures are dated but his stylistic development was not coherent. Many of his compositions dominated by trees show an obvious debt to Jan Both's interpretation of the Italian landscape, and indeed most of his Italianate landscape show little originality in either their composition or lighting. The reverse is true of his other pictures. He painted a few subject pictures such as the memorable *Annunciation to the Shepherds* (Bristol), as well as some more naturalistic landscapes which owe much more to the local Haarlem tradition of realistic landscape painting.

Alone of Haarlem landscape painters, Berchem was a brilliant painter of figures and animals. He added the figures to the landscapes of both Jacob van Ruisdael and Hobbema, adding his own wry sense of humour to their treatment.

An Italian Landscape with Figures and Animals, 1655; panel; 13 × 17⅜ in (33 × 44.1 cm); Royal Collection

Berchem was immensely successful in his lifetime, painting a great variety of subjects including winter scenes and battle pieces. His work was much sought after in the 18th and 19th centuries, and it is only in modern times that his reputation has suffered. This is probably caused by the fact that he was so very versatile that the modern habit of studying Dutch pictures by subject category has caused him to be somewhat neglected.

—Christopher Wright

BERCKHEYDE, Gerrit (Adriaensz.).

Born in Haarlem, baptized 6 June 1638; brother of the painter Job Berckheyde. Died in Haarlem, 10 June 1698. Pupil of his brother in Haarlem; influenced by Saenredam; visited Germany with his brother in the 1650's: painted views in Cologne and Heidelberg for the Elector of the Palatinate Karl-Ludwig; also painted views of Haarlem, Amsterdam, and the Hague; entered the Haarlem guild, 1660; also painted church interiors.

Major Collections: Amsterdam: Rijksmuseum, Historisch Museum, Six Collection.
Other Collections: Antwerp: Smidt van Gelder; Brussels; Cambridge; Cologne; Douai; Haarlem; The Hague: Mauritshuis, Gemeentemuseum; Hanover; Leipzig; London; Raleigh, North Carolina; Philadelphia; Schwerin; Springfield, Massachusetts.

Publications

On BERCKHEYDE: books—

Brown, Christopher, *Dutch Townscape Painting*, London, 1972.
Wattenmaker, *The Dutch Cityscape in the Seventeenth Century and Its Sources*, Amsterdam and Toronto, 1977.
Lawrence, Cynthia, *Berckheyde, Haarlem Cityscape Painter*, Utrecht, forthcoming.

articles—

Liedtke, Walter, "Pride in Perspective: The Dutch Townscape," in *Connoisseur* (New York), April 1979.
Biesboer, Pieter, "De Bavo in de beeldende kunst van de 17de eeuw," in *De Bavo te Boek bij het gereedkomen van de restauratis van de Grote of St.-Bavo kerk te Haarlem*, Haarlem, 1985.

*

The Dutch cityscape painter Gerrit Adriaensz. Berckheyde was baptized in Haarlem on June 6, 1638. According to Arnold Houbraken, his first biographer, he was the student of his older brother Job (1630–93) who specialized in architectural subjects (especially church interiors) and genre scenes. Gerrit became a member of the painters guild in July 1660. Both brothers were elected commissioners of the group during the 1680's and 1690's, and they were also members (and sometimes officers) of the *rederijkerskamer* (amateur drama society) called "De Wijngaardranken" (the Vineyard Tendrils). Although of different generations, and of markedly different temperaments (Houbraken describes Gerrit as more attentive, as well as more modest and retiring), the bachelor brothers remained close, sharing a house (with their sister) in Haarlem, and perhaps a studio as well, until Job's death.

During his career of nearly forty years, Berckheyde produced a vast number of views of the major sites and monuments of Haarlem, Amsterdam, The Hague, and Cologne, as well as some Dutch and Italianate landscapes. He frequently collaborated with Dutch staffage specialists (including Johannes van Huchtenberg, Nicholas Guerard, Dirck Maas, and Johannes Lingelbach) who were responsible for placing the figures in his town views. While the tradition that Job *routinely* executed the staffage in his brother's pictures, a claim which first appears in 18th-century sale catalogues, is undoubtably false, it is likely that Job was involved in some of his brother's works. Gerrit's swift appropriation of new subjects and new markets, his great skill and productivity, and his legendary frugality (praised by Houbraken) evidently made him a wealthy man. On the night of 10 June 1698, after spending a festive evening in a tavern, Berckheyde fell into a canal (while taking a shortcut home), and drowned. He was buried on June 14 in the nave of the Janskerk. He left no students, and, in fact, the popularity of the genre of the Dutch town view, which was just emerging at the beginning of his career, was already in eclipse at the time of his death.

At some point during the 1650's, Gerrit and Job set off on a trip along the Rhine into Germany. After an apparently lengthy sojourn in Cologne, where Job supported them by painting portraits, they moved on to Heidelberg where they were named artists at the court of Karl-Ludwig, Elector of the Palatinate. The brothers' portraits of the Elector and his entourage departing for the hunt may be the basis for Gerrit's later views of mounted hunters accompanied by servants, bird carriers, and dogs. However, the brothers were not happy in Heidelberg (Houbraken notes their apparent inability to deal with court intrigues), and after numerous petitions they were permitted to return to Haarlem (by 1660).

Although his early career is poorly defined (he may have been painting genre scenes and landscapes inspired by his recent travels), by the middle of the decade Berckheyde was producing views of Haarlem's central square (the Grote Markt), with either the Town Hall or the church of St. Bavo, and the markets and shops that line its perimeter. These pictures were initially based on etched views (c. 1627–28) by Jan van de Velde II which were included as illustrations in Samuel Ampzing's *Beschrijvinge ende Lof der Stad Haerlem* (1628). This monumental history and description of Haarlem extolled the city's magnificent public buildings as well as her virtue and glory: its presentation of the buildings on the Grote Markt as symbolizing Haarlem's political, religious and commercial institutions, and as embodying the city's identity, power, and pride, is important for interpreting the iconographic component of Berckheyde's Dutch cityscapes more generally.

Van de Velde's etchings are based on drawings by Pieter Saenredam whose influence on Berckheyde's conception of the town view is profound: Saenredam's "building portraits" are

the most important source for Berckheyde's tendency to establish a structure as a work's dominant motif, as well as his accurate depiction of architecture and topography, his interest in period styles, his impeccable delineation and his restrained use of color. However, Berckheyde's chiaroscuro, which he employs both to establish volume and spatial relationships and to evoke a sense of mood or atmosphere, appears to depend on the church interiors of Emanuel de Witte.

During the mid-1670's, Berckheyde executed several views of the Haarlem Grote Markt, as well as the Dam in Amsterdam, that include dramatic oblique angles and emphatic recession: these paintings suggest that at least momentarily he was influenced by architectural specialists from Delft who were interested in problems of perspective. However, Berckheyde's abandonment of this approach by the end of the decade, and his subsequent return to less complicated views of the square, in which the Town Hall or St. Bavo's is nobly presented in a refined setting with few temporal intrusions indicates a classicistic mode not unlike the contemporary canvases of Johannes Vermeer, or the French landscape specialist Claude Lorrain. Berckheyde's other Haarlem subjects include the river Spaarne with the weigh-house, the city's medieval walls and gates, and country houses and castles in the vicinity.

In the mid-1660's, Berckheyde also began executing views of Amsterdam: this initiative reflects contemporary demand for histories and descriptions of the city, as well as pictures of its major monuments, which was generated by its emergence as the nation's trading capital. Just as his Haarlem scenes, the majority of these depict Amsterdam's central square, the Dam, and the buildings located on it (the Town Hall, the Nieuwekerk, and the weigh-house): they too allude, respectively, to their city's political, religious, and commercial institutions. In most of these pictures the square is dominated by the new Town Hall which was completed in 1665, and which was the proud symbol of Amsterdam.

At the same time, Berckheyde was also responding to the market for pictures of sites in the new neighborhoods created by the extension of the city's concentric canals (1657–63). One of his views of the Herengracht, lined on either side with sumptuous double houses built by members of the city's prosperous merchant class, was praised by the poet Joost van den Vondel in a short verse. Such scenes indicate Berckheyde's interest in contemporary architecture; however, whenever possible, he tends to contrast modern with medieval structures for a nostalgic or symbolic effect.

The appearance of views of The Hague in the mid-1680's, rather late in Berckheyde's career, once more demonstrates his avid entry into yet another new market. The demand for these scenes can be traced to the contemporary popularity of the Stadhouder, Willem III, and the House of Orange. Without exception, Berckheyde's pictures record views of their ancestral home, the castle of the counts of Holland: they depict either the Hofvijver, the lake created from the moat and the buildings facing on it, or the interior court of the castle complex (the Binnenhof) with the Ridderzaal (Knight's Hall). Although there are sometimes echoes in these works of his rather robust style of the 1670's, Berckheyde's views of The Hague are particularly refined: while on one hand they appear to anticipate the emergence of the rococo, on the other they may simply reflect the courtly tastes of that city's aristocratic patrons and collectors.

In addition to his views of Dutch cities, in the early 1670's Berckheyde began to paint scenes of German towns, the majority of which are pictures of the romanesque parish churches of Cologne. Which it is tempting to think that they somehow reflect his own earlier sojourn in that city, and may even be based on sketches that he made on the spot, there is no evidence that this is the case. In contrast to his Dutch subjects, Berckheyde's Cologne scenes occasionally reflect significant compositional liberties since they sometimes bring together monuments actually distant from one another in capricious composite views. Although there is no obvious explanation for this aberration, it is perhaps a clue to the identity of the patrons, or the market, for which they were produced.

—Cynthia Lawrence

BERMEJO, Bartolomé.

Born Bartolomé de Cárdenas in Córdoba, c. 1450. Died in Catalonia after 1498. Married Gracia de Palaciano. Possibly trained in Roger van der Weyden's shop in Brussels; active in Valencia by 1468, then in Daroca, 1470's, Zaragoza, 1477–81, Valencia, early 1480's, and in Catalonia after c. 1485.

Collections: Barcelona: Cathedral Museum, Museum of Catalan Art, Amatiler Collection; Berlin; Boston: Gardner; Chicago; Daroca: S. María, Museo Colegial; Granada: Royal Chapel; Lisbon; Luton Hoo; Madrid; Seville; Valencia.

Publications

On BERMEJO: book—

Young, Eric, *Bermejo, The Great Hispano-Flemish Master,* London, 1975.
Rebora, G. Rovera, and G. Bocchiotti, and Laboratorio Restauro Nicola di Aramengo, *Bermejo e il trittico di Acqui,* Acqui Terme, 1987.

articles—

Tormo, Elías, "Bermejo, el mas recio de los primitivos espanoles," in *Archivo Español de Arte y Arquelogia* (Madrid), 2, 1926.
Mayer, A. L., "En torno al Maestro Alfonso y a Bermejo," in *Revista Española de Arte* (Madrid), 3, 1934.
Angulo Iñiguez, Diego, "The Flagellation of St. Engracia by Bermejo," in *Art in America* (Marion, Ohio), 27, 1939.
Sterling, Harry G., "Another Panel from the Altar of St. Engracia by Bermejo," in *Art in America* (Marion, Ohio), 29, 1941.
Brown, Jonathan M., "Dos obras tempranas de Bermejo y su relación con Flandes," in *Archivo Español de Arte* (Madrid), 26, 1963.
Sobré, Judith Berg, "Bermejo in Valencia: A Reevaluation," in *23rd Congress of the History of Art,* Granada, 1973.

Sobré, Judith Berg, "Bermejo, the *Piedat* of Johan de Lape-ruelo, and Painting at Daroca (Aragon)," in *Art Bulletin* (New York), December 1976.

Sobré, Judith Berg, "S. Engracia Revisited," in *Fenway Court* (Boston), 1980.

*

There is little doubt that Bermejo received at least part of his training in Flanders, though no agreement has been reached as to where. Petrus Christus or Dirk Bouts has been suggested as his teacher, but the most likely candidate seems to have been Roger van der Weyden in his shop at Brussels, for two of his early works, a *Nursing Madonna* (Valencia, Museo de Bellas Artes) and the center panel of the *Retable of Saint Michael* (Wernher Collection, Luton Hoo), appear to depend on Roger-ian prototypes.

Certainly, by the time that Bermejo appears in Valencia in 1468, both technical aspects of his painting and some style elements reveal an intimate knowledge of Flemish technique and conventions. However, it is Bermejo's particular genius that he adapted these conventions, such as crumpled drapery, illusion of texture, minute detail, and the deep glinting surfaces of oil technique perfectly to the local aesthetic. The *Saint Michael*, with its glittering simulated metallic armor of the angel saint, contrasts but never clashes with the traditional Valencian gold ground, stamped with a design at its borders, creating a perfect tension of three-dimensional illusion and two-dimensional surface.

These illusionistic details, blended with a sense of surface in a very Spanish way, constitute one of Bermejo's great strengths. His other great strength is very un-Spanish indeed: an interest in landscape. Like Bouts in Flanders and Bellini in Venice, Bermejo, early in his career, began to explore atmospheric landscape settings, with depictions of sunrise or sunsets in low raking light. We see this, for example in his *Resurrection* (Barcelona, Museu d'art de Catalunya), which along with the *Ascension* and two scenes dealing with *Christ and the Patriarchs in Limbo* constituted side panels of a Valencian retable.

These same panels show one of Bermejo's weaknesses: he painted what are probably the ugliest nudes in art history; they are pot-bellied, round-shouldered individuals with a lack of anatomical correctness.

When Bermejo moved on to Aragon in the early 1470's, he continued to show the same stylistic characteristics. Similar sensitive landscapes appear in the *banco* of the *Retable of Saint Engracia* (Daroca, Museo Colegial), and similar brilliantly painted formal effigies against gold grounds can be seen in the center panel of the same retable (Boston, Gardner Museum), and in the central panel of the *Retable of Santo Domingo de Silos* (Madrid, Prado) of 1474.

On the other hand, interior scenes or those outdoor scenes that require architectural vistas demonstrate a total unconcern for perspective in either the mathematical or empirical sense. The floor of the *Flagellation of Saint Engracia* from the same retable mentioned above (Bilbao, Museo de bellas artes) tilts at a peculiar angle, as do the buildings in *The Imprisonment of Saint Engracia* (Daroca, Museo Colegial).

Bermejo's greatest paintings are either retable centers, such as the *Santo Domingo de Silos*, or large panels featuring land-scapes that depart from the traditional retable format. The best is probably the product of a second, albeit brief, time in Valencia in the early 1480's, the center of a triptych depicting the *Virgin of Montserrat,* commissioned by an Italian merchant, Francesco della Chiesa, for his home church, the Cathedral of Acqui Terme. In it, the Virgin, the Child, and the donor are placed in a beautiful setting that includes a monastery, a house on a cliff, and an extensive marine scene in the background replete with accurately depicted contemporary sailing vessels, all bathed in a glowing red-gold sunrise. An even more elaborate landscape is found in one of his last works, painted after he moved to Catalonia around 1485, the *Pietà* executed for canon Lluis Desplà's private chapel, in which, along with the four large figures of Virgin, Christ, Saint Jerome, and the donor, there are a myriad of wildlife, a sunset, a rainbow, and a rain squall.

Unfortunately, Bermejo's limitations also persist to the end of his career, for the Christ in the *Pietà* is anatomically incorrect and awkwardly posed, and in an *Epiphany* (Granada, Capilla Real) probably painted for Queen Isabel of Castile, the stable space is cramped, and the figure placement is ambiguous.

Bartolomé Bermejo, then, remains a painter of both astonishing talent, yet limitations. He put Flemish oil technique superbly at the service of Spanish needs, and was one of the premier landscapists of his generation, yet he never appeared interested in mastering either human anatomy or interior space.

—Judith Berg Sobré

BERNINI, Gian Lorenzo.

Born in Naples, 7 December 1598; son of the sculptor Pietro Bernini. Married Caterino Tezio, 1639 (died, 1673); 11 children. Died in Rome, 28, November 1680. Trained in his father's workshop in Rome; patronized by Cardinal Scipione Borghese as a youth, and later patronized by Popes, beginning with Urban VIII, 1623; knighted, and elected President of the Academy of St. Luke by 1621; Master of the Royal Foundry, 1623, and Architect to St. Peter's, 1629; prepared designs for Louis XIV's rebuilding of the Louvre, Paris, 1665 (his only extensive trip outside Rome); also wrote plays, designed costumes and stage machinery, monuments, temporary displays, etc.

Major Collection: Rome: Borghese.
Other Collections: Birmingham; Bologna; Bordeaux: S. Bruno; Cambridge, Massachusetts; Florence: Bargello, Uffizi; London: Victoria and Albert; Madrid; Montpellier; New York; Oxford; Paris: Louvre, Jacquemart-Andre; Rome: Barberini, S. Maria della Vittoria; Vatican: St. Peter's; Versailles: Chateau.

Louis XIV, 1665; marble; 31½ in (80 cm); Versailles

Publications

By BERNINI: book—

Fontana di Trevi: Commedia inedita, edited by Cesare D'Onofrio, Rome, 1963.

On BERNINI: books—

Baldinucci, Filippo, *Vita del Cavaliere Bernini,* Rome, 1682; as *The Life of Bernini,* University Park, Pennsylvania, 1966.

Chantelou, Paul F., *Journal du voyage du Cav. Bernini en France,* edited by L. Lalanne, Paris, 1885; as *Diary of the Cavaliere Bernini's Visit to France,* edited by Anthony Blunt, Princeton, 1985.

Reymond, Marcel, *Le Bernin,* Paris, 1911.

Boehn, Max von, *Bernini: Seine Zeit, sein Leben, sein Werk,* Bielefeld, 1912.

Munoz, Antonio, *Bernini archetetto e decoratore,* Rome, 1925.

Benkard, Ernst, *Bernini,* Frankfurt, 1926.

Brauer, Heinrich, and Rudolf Wittkower, *Die Zeichnungen des Bernini,* Berlin, 2 vols., 1931.

Battaglia, R., *Crocifissi del Bernini in S. Pietro,* Rome, 1942.

Schiavo, A., *La donna nelle sculture del Bernini,* Milan, 1942.

Battaglia, R., *La cattedra berniniana di San Pietro,* Rome, 1943.

Grassi, Luigi, *Disegni del Bernini,* Bergamo, 1944.

Grassi, Luigi, *Bernini pittore,* Rome, 1945.

Wittkower, Rudolf, *Bernini's Bust of Louis XIV,* Lonson, 1951.

Martinelli, Valentino, *Bernini,* Milan, 1953.

Pane, Roberto, *Bernini architetto,* Venice, 1953.

Wittkower, Rudolf, *Bernini, The Sculptor of the Roman Baroque,* London, 1955; as *The Sculpture of Bernini,* 1966; revised by Margot Wittkower, Howard Hibbard, and Thomas Martin, Oxford, 1981.

Martinelli, Valentino, *I ritratti di pontefici di Bernini,* Rome, 1956.

Reidl, P. A., *Bernini: Apollo und Daphne,* Stuttgart, 1960.

Grassi, Luigi, *Bernini,* Rome, 1962.

Hibbard, Howard, *Bernini,* London, 1965.

Fagiolo dell'Arco, Maurizio, and Marcello, *Bernini: Una introduzione al gran teatro del barocco,* Rome, 1967.

Kitao, T. K., *Circle and Oval in the Square of St. Peter's,* New York, 1968.

Lavin, Irving, *Bernini and the Crossing of St. Peter's,* New York, 1968.

Petersson, R. T., *The Art of Ecstasy: Teresa, Bernini, and Crashaw,* New York, 1970.

Kauffmann, Hans, *Bernini: Die figürlichen Kompositionen,* Berlin, 1970.

Mariani, Valerio, *Bernini,* Naples, 1974.

Weil, Mark, *The History and Decoration of the Ponte S. Angelo,* University Park, Pennsylvania, 1974.

Bauer, George C., editor, *Bernini in Perspective,* Englewood Cliffs, New Jersey, 1976.

Hibbard, Howard, *Bernini,* London, 1976.

Harris, Ann Sutherland, *Selected Drawings of Bernini,* New York and London, 1977.

Birindelli, Massimo, *La machina heroica: Il disegno di Bernini per Piazza San Pietro,* Rome, 1980.

Borsi, Franco, *Bernini architetto,* Milan, 1980.

Lavin, Irving, *Bernini and the Unity of the Visual Arts,* New York, 2 vols., 1980.

Paoletti, Laura, *Il Bernini in Roma,* Poggibonsi, 1980.

Fagiolo dell'Arco, Maurizio, and Angela Cipriani, *Bernini,* Rome, 1981.

Gould, Cecil, *Bernini in France,* London, 1981, Princeton, 1982.

Grammatica, A., *Bernini in Vaticano* (cat), Rome, 1981.

Lavin, Irving, *Drawings by Bernini from the Museum der Bildenden Künste Leipzig,* Princeton, 1981.

D'Onofrio, Cesare, *Bernini e gli angeli di Ponte d. Angelo,* Rome, 1981.

Bialostocki, J., *Bernini,* Berlin, 1981.

Mehuert, K. H., *Bernini: Zeichnungen,* Leipzig, 1981.

Martinelli, V., *Bernini: Disegni,* Florence, 1981.

Fagiolo dell'Arco, Maurizio, and G. Spagnesi, editors, *Immagini del barocco: Bernini e la cultura del seicento,* Rome, 1982.

Lavin, Irving, *Drawings by Bernini* (cat), Princeton, 1984.

*

Gian Lorenzo Bernini, the pre-eminent personality of Roman baroque sculpture, architecture, and festival arts, was born in Naples in 1598. His father, Pietro Bernini, was a Florentine sculptor of considerable merit who moved to Rome c. 1605 in order to enter the service of Pope Paul V Borghese. The young Gian Lorenzo was a recognized prodigy. Baldinucci tells the story that Bernini was only 10 was he was first ushered into the presence of Paul V. The pontiff was as impressed by child's self-assurance as by the ease with which he improvised a drawing of Saint Paul.

Before his 20th birthday, Gian Lorenzo was already a full-fledged sculptor who had confidently assimilated a wide range of sources. The funerary bust of Giovanni Vigevano (c. 1616) betrays Pietro Bernini's influence in its formulaic treatment of hair; on the other hand, the intensity of expression and the informality of the pose are derived from ancient Roman portraiture. Bernini's full-length marble of *Saint Sebastian* (Lugano) quotes both from Michelangelo and from the "Barberini Faun" of antiquity; the ponderous limbs and torso strike a proto-Baroque effect that is closely analogous to the figure styles that Annibale Carracci and Peter Paul Rubens had pioneered in Roman painting exactly ten years before.

For the noble Strozzi family, the 18-year-old Bernini sculpted the martyrdom of his name saint, *Saint Lawrence on the Gridiron* (Florence, Contini Bonacorsi Collection), an early work that presages many lifelong qualities. The effort expended to achieve unprecedented and seemingly impossible effects in carved marble—flames—is characteristic of Bernini. The handsome saint is portrayed in the throes of a spiritual ecstasy that overwhelms his dreadful suffering. Domenico Bernini (1713) tells the story that the young Bernini deliberately burned his thigh as part of his preparations to represent the saint's agony as vividly as possible.

For Cardinal Scipione Borghese, the pope's nephew and the greatest collector of the day, Bernini executed his first major figurative group, the *Aeneus, Anchises, and Ascanius* of 1618–19. The treatment of details is so close to Pietro Bernini's manner that some authorities have doubted the assignation

to the son, but documents published by Italo Faldi (1955) apparently confirm the younger Bernini's authorship. Indeed, the various ages and emotional states of the three Trojan fugitives are distinguished with a subtle wit and warmth of human sympathy that are never encountered in Pietro Bernini's documented works.

The *Aeneus, Anchises, and Ascanius* inaugurates an extraordinary series of sculptural groups that Bernini carved for Scipione Borghese over the next five years. As he progressed from the *Pluto and Proserpina* to the *Apollo and Daphne* and finally to the *David* (the only single figure of the series), Bernini made his way to the very pinnacle of European sculptural achievement. The young man had evidently challenged himself to force the fragile medium of marble beyond the traditional limits of illusionism and technical skill. In his later years, Bernini is reported to have said during a visit to the Villa Borghese that he himself could hardly believe the energy with which he had carved marble in his youth.

The *Apollo and Daphne* (1622-23 and 1624-25) is perhaps Bernini's most famous sculpture, apart from the *Ecstasy of St. Teresa*. Bernini's "pictorial" approach to sculpture is nowhere so striking as in his astonishing representation of the metamorphosis of Daphne, a beautiful, but unfortunate nymph, into a laurel tree. Apollo's reaching hand grasps scrubby bark not pearly flesh, as twigs and leaves sprout instantaneously from the nymph's luxurious locks. The *Apollo and Daphne* was Bernini's overt attempt at a technical tour-de-force, and it succeeded resoundingly.

The *David* (1623-24), which must have stood adjacent to the *Apollo and Daphne* in the sculptor's studio during these very years, breaks new ground in an entirely different dimension. The quality of carving is for once unremarkable in the *David,* but the concept is bolder. Bernini's hero strains with effort as he prepares to hurl his sling: Goliath's immediate presence is compellingly evoked. Bernini created his *David* as a sculptural analogue to one of the fundamental principles of the new baroque style in painting, i.e., the space implied in the work of art is completely unified with the real world of the spectator. The election of the Barberini pope Urban VIII resulted in the promotion of Bernini's status from prodigy to *caposcuola* of Roman art. The new pope summoned Bernini to the Vatican to inform him: "It is your great fortune, Cavalier, to see Cardinal Maffeo Barberini made pope, but much greater is our own that the Cavalier Bernini lives during our pontificate." Amongst Urban VIII's immediate requirements of Bernini were that he train himself in the arts of painting and architecture.

The refurbishment of the early Christian church of S. Bibiana (1624), with high altarpiece from his own chisel, was Bernini's inaugural effort as architect. It is notable that Bernini's architecture, though distinguished, was never so bold or unconventional as his sculptures or monuments. With the notable exception of the lavish decorations in Sant'Andrea al Quirinale (1658), Bernini was attracted to lucid and symmetrical designs, which seem, in comparison to his rival Borromini, almost neo-Renaissance. His greatest achievement as an architect, indeed his greatest legacy to Rome, consists of the totality of sculptures and monuments that he executed in the course of his lifetime inside and in front of the basilica of St. Peter's.

Urban VIII was the first pope to direct Bernini's talents toward St. Peter's, beginning with the baldacchino (1629-33) over the high altar and under the dome designed by Michelangelo. The monumental canopy (95 feet in height) of the baldacchino was an early but supreme expression of baroque style and an extraordinary feat of bronze-casting. (Borromini was called upon for technical assistance, and resented afterwards that Bernini had received by far the greater share of money and acclaim.) Urban's high-handed appropriation of ancient Roman bronze from the portico of the Pantheon was the brunt of a contemporary pasquinade, "What the barbarians couldn't accomplish, Barberini did."

Bernini was simultaneously responsible for the design and construction of the four reliquary loggias, consisting of sculpture niches and balconies for ceremonial presentations, in the pillars under the dome of St. Peter's. He personally carved the *St. Longinus* (about 14½ feet high) for one of the niches. Urban VIII also charged Bernini with designing, supervising, and carving marbles for the pope's own tomb: this project was frequently put aside for other matters and only finished posthumously.

During the Barberini papacy (1623-44), Bernini's duties as architect of St. Peter's, artistic advisor, and theatrical designer and impresario left him little time for sculptures other than portraits. Urban VIII employed him repeatedly for portrait busts in marble and in bronze, as did subsequent popes. Bernini's papal busts restored portrait sculpture to a position of achievement and prestige that the form had not enjoyed since the early Renaissance in Florence. In 1632 he sculpted a "speaking likeness" of his first patron, Cardinal Scipione Borghese, which seems to capture its subject in motion. His unpretentious portrait of his mistress, Constanza Bonarelli (Florence, Bargello), is one of the most revealing expositions of romantic passion ever left us by an artist.

At the death of Urban VIII in 1644, Bernini's fortunes suffered the only serious setback of his career: the self-indulgent policies of the Barberini regime were severely condemned by both the new pope, Innocent X Pamphili, and by the Roman public, as well. The papal theatre was closed.

The hiatus of the 1640's allowed Bernini to accept a commission from the Cornaro family of Venice to design and carve sculptures for their chapel in the Roman church of S. Maria della Vittoria. The Cornaro Chapel with Bernini's marble altarpiece, *The Ecstasy of St. Theresa,* is perhaps the quintessential monument of the Roman Baroque. In flanking boxes, left and right, Bernini's portraits of Cornaro noblemen and ecclesiastics are present at the mystic Teresa's rapturous vision of her heart being pierced by a flaming arrow. The lustrous marbles and colored stones, gilt bronze, and a hidden source of light are some of the elements of this extraordinary fusion of art, architecture, and scenographic effects.

Even the obstinate Innocent X was won over, eventually, as a result of Bernini's plan for the *Fountain of the Four Rivers* (1648-51) in the Piazza Navona, directly opposite the Pamphili-commissioned church of S. Agnese. Innocent X himself is quoted as saying, "He who does not wish to use the designs of Bernini, must not see them." Bernini's studio sculpted four giant figures in travertine, with palm trees, dolphins, and other exotic attributes, as personifications of the Danube, Rio della Plata, Nile, and Ganges rivers.

Bernini regained all his former influence upon the election in 1655 of Alexander VII Chigi. The learned and intelligent

pope admired Bernini unreservedly and met with him almost daily. Much of Bernini's efforts were directed towards Chigi family properties: he designed and carved sculptures for family chapels in S. Maria del Popolo, Rome, and the Duomo, Siena. In Ariccia, a Chigi feudality, Bernini constructed a circular church based on the Pantheon.

Under Alexander VII, with Bernini as principal agent, architect, and advisor, Rome shed its medieval skin and was metamorphosed into a showplace for monuments. Alexander supported Bernini in one of the masterstrokes of the latter's career: the giant colonnades which curve like arms to encircle the elliptical piazza in front of St. Peter's. The expense of this undertaking caused a scandal. In the tribune of the Vatican basilica, Bernini designed his towering *Cathedra* (throne) of St. Peter, a resplendent symbol of papal authority.

In 1665 Bernini made a triumphant, albeit reluctant, progress from Rome to Paris, the result of astute political maneuvering by Louis XIV. Bernini was charged to design a new wing for the Louvre, but French chauvinism and Bernini's characteristic frankness doomed the project in short order. The sole success of this abortive visit was the portrait bust of Louis XIV, a marble embodiment of absolutistism, which played a central rôle in the development of the Louis XIV style. In addition, posterity owes to Bernini's Parisian sojourn the diary kept by the Sieur de Chantelou, a collector and courtier, who diligently recorded many pages of the artist's comments and opinions.

Alexander VII was succeeded by Clement IX Rospigliosi (1667–69), a literary pope whose plays Bernini had directed and staged years before. The short-lived Clement IX granted the assignment to refurbish the Ponte S. Angelo, the principal approach to St. Peter's, with ten larger than life-size statues of angels holding the Instruments of the Passion. Bernini selected the sculptors and carved two of the marbles himself (but these were deemed too valuable and were replaced by copies on the bridge).

Despite uneasy relations with the Altieri pope, Clement X (1670–76), Bernini's old age was as productive as ever, nor did he abandon the sculptor's chisel. His *Blessed Lodovica Albertoni* in the Altieri chapel, S. Francesco a Ripa, Rome, is a masterly reprise of the Counter-Reformational spirituality that had informed the Cornaro Chapel. His half-century of labors in St. Peter's was worthily concluded with his elegant design for the Chapel of the Sacrament.

At the end of life, Bernini was little used by the pious, austere, and resolute pope Innocent XI, who justifiably turned the Church's attentions from building to ministry. Bernini's influence continued unabated, however, notably in his contribution of drawings and other assistance to G. B. Gaulli's decorations in Il Gesù. Personally devout, Bernini died in 1680 after careful preparations. One of his supporters, the convert Queen Christina of Sweden sponsored an authoritative biography by the Florentine historian Baldinucci. Bernini left his family well off, although Queen Christina commented, when his estate was made known: "I would be ashamed if Bernini worked for me all his life and left so small a fortune." Endlessly creative and effortlessly inventive, Bernini decisively influenced the architecture and sculpture of his time and shaped Rome forever, no doubt because he possessed in equal measure the qualities of ambition, confidence, and practicality.

—John T. Spike

BERRUGUETE, Alonso (González).

Born in Paredes de Nava (Palencia), c. 1487; son of the painter Pedro Berruguete. Died in Toledo, September 1561. Married Juana de Pereda, 1525; sons Alonso and Juan. Painter, sculptor of statues and reliefs in marble, alabaster, and wood, designer of retables, and architect; in Rome and Florence, c. 1507–17; named painter to King Charles V by 1518; active principally in Valladolid, 1523–61, and Toledo, 1539–47, 1559–61, and also in Zaragoza, Oviedo, Granada, and Medina del Campo. Pupils/assistants: Francisco Giralte, Isidro de Villoldo, Pedro Martinez de Castaneda, Manuel Alvarez, Innocencio Berruguete (his nephew), and Cornelis de Holanda.

Major Collections/Locations: Toledo: Cathedral; Valladolid.
Other Collections/Locations: Caceres: Church of Santiago; Salamanca: Colegio Mayor de Fonseca; Toledo: Santa Ursula Convent and Tavera Hospital; Ubeda: Church of El Salvador; Valladolid: Church of Santiago.

Publications

On BERRUGUETE: books—

Orueta, Ricardo de, *Berruguete y su obra,* Madrid, 1917.
Agapito y Revilla, Juan, *La obra de los maestros de la escultura vallisoletana . . .: Berruguete,* Valladolid, 1929.
Gomez Moreno, Manuel, *Las aguilas del renacimiento español: Bartolomé Ordonez, Diego Silóe, Pedro Machuca, Berruguete,* Madrid, 1941.
Gaya Nuño, Juan Antonio, *Berruguete en Toledo,* Barcelona, 1944.
Cossio y Martinez, Francisco de, *Berruguete,* Valladolid, 1949.
Ascárate, José María de, *Berruguete: Cuatro ensayos,* Valladolid, 1963.
Camón Aznar, José, *Berruguete,* Madrid, 1980.

articles—

Martin González, Juan José, "Consideraciones sobre la vida y la obra de Berruguete," in *Boletin del Seminario de Arte y Arqueologia* (Valladolid), 27, 1961.
Mazariegoes Pajares, Jesus, "Berruguete, pintor," in *Publicaciones Tello Tellez de Meneses* (Palencia), 42 1979.

*

Alonso Berruguete is considered by his countrymen as Spain's greatest sculptor, although he is little know outside the country. Under the patronage of an educated elite associated with the royal court, Berruguete created great ensembles of painting, sculpture, and architecture in churches throughout Spain. He eschewed traditional ideas of craftsmanship and design to experiment with novel ideas of form, technique, and expression. The result was an idiosyncratic and highly expressive body of work which, while it has been variously labeled "gothicizing," "mannerist," and "proto-baroque," is the quintessence of Renaissance sculpture in Spain.

Berruguete was trained as a painter, probably in the studio of his father, but his real artistic formation took place in central Italy during a time of extraordinary artistic ferment. Although little is actually known of his decade in Italy (c. 1507–17), scholars have attributed a variety of Italian paintings to the artist and invented a place for him as the original mannerist in Italy. Recollections of High Renaissance and early Mannerist art echo throughout Berruguete's later *oeuvre:* he synthesized Italian traits and attitudes with Spanish traditions and iconographic requirements to create an original style.

Despite his prestigious title "painter to the king," Berruguete was unsuccessful in finding major painting commissions after his return to Spain in 1518. Spanish patrons preferred the more tangible arts of sculpture and architecture, and both of Berruguete's major works of the decade after his return were collaborations with sculptors: Felipe Vigarny (retable and tomb in Zaragoza, Sta. Engracia; destroyed) and Vasco de la Zarza (retable from Olmedo, now Valladolid Museum). Berruguete's role was surely that of a painter in both projects, but Vasco's death forced Berruguete to take up the chisel himself on the Olmedo retable. The delirious energy and arbitrary distortions characteristic of Berruguete's later works are already evident in these crude, uncompromising reliefs, and for the rest of his career the artist explored the expressive possibilities of sculpture with a freedom unparalleled on the peninsula.

Berruguete's art is about instability and flux. In the retablos from his Valladolid period (1523–39) which culminate in the controversial high altar of San Benito (now dismantled, in Valladolid Museum), the muscular, attenuated figures pirouette on tiny bases or lean precariously out of niches too small to contain them. Gesticulating limbs, great swags of drapery, and wild beards and locks of hair accentuate the internal tensions of the bodies' rampant contraposto. The multi-figured scenes are composed with arbitrary changes in depth and scale that challenge the concept of narrative relief itself. In the final work of the period, a small retable for a private chapel (Valladolid, Church of Santiago), the Adoration of the Magi becomes a drama of uncontrolled centripetal forces, and the three groups of figures are carved from enormous, irregular slabs of walnut set unconnected within a low niche. These are dizzying, experimental works, and it is no wonder that conservative patrons and artists like the monks of San Benito and the sculptor Vigarny took offense.

The choir stalls at Toledo Cathedral (1539–42) reveal Berruguete's arrival of full maturity. Working in the new media of unpainted walnut and white alabaster and spurred on by competition with his rival Vigarny, Berruguete abandoned the overt bravado of his earlier works for a sculpture of increasing sophistication and more profound meaning. Berruguete and his excellent team of sculptors produced over 70 individual figures in relief within a sumptuous architectural setting. The carving is superb, a far cry from the conscious crudities and often clumsy shop work at San Benito. Berruguete's technical mastery can be seen in gouged, fractured surfaces that translate brilliantly into flesh, bone, and sinew or varying textures of cloth and hair.

The Toledo figures are more intense and introverted than the apostles and prophets from San Benito and they have a heightened spiritual power. The unbridled forces of the earlier figures are here subjected to a precarious control, released only

St. John the Baptist, 1539–42; walnut; Toledo, Cathedral

in rare moments like the figure of Job toppling backwards through the relief ground or the right arm of the Baptist thrusting from the topography of the relief into sudden, surprising three dimensions. A quarter century after his return from Italy, the artist achieved a dynamic, expressive, and highly personal definition of the classical style.

Berruguete pursued the possibilities and ramifications of this new style in a variety of ambitious later works, beginning with the alabaster Transfiguration group over the Toledo choir. It is a triumphant work of unprecedented scale and a tour-de-force of relief carving which brilliantly translates its visionary subject into a metaphoric sculptural language. Below it, hidden inside the vaults of the Archbishop's throne, three tiny reliefs filled with writing, naked figures reveal a disturbing, personal vision of good and evil. Another side of the artist is evident in the figure of Christ in polychrome wood which survives from a later Transfiguration group (Ubeda, El Salvador): the ethereal yet vividly human figure exudes a haunting beauty.

In Berruguete's final work, a funerary monument for his great patron Cardinal Tavera, the contradictions inherent in his style achieve equilibrium. The violence is there in the unyielding portrait of the dead cleric, and Berruguete's nervous modeling is evident in fluctuating surfaces and distorted anatomies. Yet the design of the floor tomb has an elegant geometry and the figures and reliefs an idealizing beauty that mark a final, reflective stage of Berruguete's extraordinary career.

—Samuel K. Heath

BERRUGUETE, Pedro.

Born in Paredes de Nava, c. 1450 or c. 1440. Died in Paredes de Nava, 6 February 1503. Married Elvira Gonzales; sons the sculptor Alonso and Pedro, and other children. Possibly court painter to Archduke Philip of Austria, King of Spain, and for Ferdinand and Isabella; series of paintings for Convent of Santo Tomé, Avila, probably commissioned by the Inquisitor-General Torquemada; lived some time in Italy: helped decorate the Duke of Urbino's palace as assistant and successor to Josse van Gent, 1477–82; worked at Toledo Cathedral from 1483.

Collections: Avila: Museum, S. Tomé, Cathedral; Madrid; Paredes de Nava: Museum, S. Eulalia; Paris; Segovia: Cathedral; Urbino: Ducal Palace.

Publications

On BERRUGUETE: books—

Lavalleye, J., *Juste de Gand ou Berruguete*, 1933.

Loo, G. H. de, *Berruguete et les portraits d'Urbin*, 1942.

Lainez Alcalá, R., *Berruguete, pintor de Castilla*, Madrid 1943.

Angulo Iñiguez, Diego, *Berruguete en Paredes de Nava*, Barcelona, 1946.

One of the most prominent painters of 15th-century Castile, Berruguete was of Basque descent from minor nobility, and was born in Paredes de Nava, near Palencia. Though the dominant style of painting in Castile during the late 15th-century was heavily influenced by Flemish prototypes (Queen Isabel's court painter Juan de Flandes painted the *retablo mayor* of Palencia Cathedral, among other works in the area), Berruguete is unique in having had first-hand knowledge of contemporary Italian painting. He is identified with the "Pietro Spagnuolo" active at the court of Duke Federigo da Montefeltro at Urbino, probably residing there from around 1477 until the death of his patron in 1482.

Berruguete was one of the painters who worked on the paintings for the duke's small study in Urbino's Palazzo Ducale, but contrary to what Spanish scholars have long maintained, recent technical analyses of these works indicate that his role in these decorations was no more than an assisting collaborator to Josse van Gent, who had been at the court of Urbino at least since 1474 (even though the text on the book of *Saint Albert the Great* is in Spanish).

However, Berruguete's stay at Urbino was to bear fruit in his manner of painting when he returned to his native soil. It can be seen, for example, in the prophet figures that constitute the *banco* of the great *Retablo mayor* from Santa Eulalia, in his home town of Paredes de Nava, in which the half-length figures are posed behind parapets inscribed with their names. But if we compare Berruguete's *King Solomon* from this retable with the same king as painted by Josse van Gent at Urbino, we can see that though there are resemblances in pose and physical types, Berruguete's forms are more solid and less ethereal than Josse van Gent's, with a brighter color range. There are Hispanic traits in these prophets, too: half-length *banco* figures are very much in the Castilian 15th-century tradition, and Berruguete has reinforced this with Castilian brocaded gold grounds with Mudéjar borders.

The impact of Berruguete's Italian experience was not limited to contact with a Flemish collaborator. Panels such as the *Beheading of John the Baptist* from Santa Maria del Campo and an *Annaunciation* in the Cartuja de Miraflores show an awareness of Italian Renaissance perspective—imperfect in the *Beheading* with its slightly sloped floor, but beautifully carried out in the tiled perspective of the *Annaunciation,* which follows the Italian custom of dividing the Virgin and the Angel Gabriel by means of a perspective vista, in this case a view through an arched doorway into another room.

It is, however, in the great retables that Berruguete executed for Avila that his style reaches its greatest maturity as an amalgam of Flemish techniques, Italian space, and Hispanic realization of the potentials of the retable form. This can be seen in the three retables done for the Dominican church of Santo Tomás, the *Retablo Mayor* dedicated to Saint Thomas Aquinas which is still in place, and the two side altarpieces dedicated to Saints Dominic and Peter Martyr, now dismantled, which are in the Prado Museum.

The narrative scenes in these retables are depicted in logical depth, the textures shimmer, and gold brocades, so dear to Spanish painters and patrons of the period, are used lavishly, but never intrude into the three dimensionality of the individual scenes. In the *Retablo Mayor,* we can see these narratives skilfully blended with the hieratic images of angels placed against brocade panels and the elaborate gilded frames to

make the altarpiece an organic, formal whole.

In Berruguete's last work, the *Retablo Mayor* of Avila Cathedral, which he had begun painting around 1499, only the *Banco* figures of Evangelists and Church Fathers, plus two narratives of the *Agony in the Garden* and the *Flagellation* were complete at his death. The rest of the altarpiece was executed first by Diego de la Cruz, then completed by Juan de Borgoña. Although it is easy to distinguish Berruguete's contributions from his successors, the three painters' contributions blend so well that the retable forms an harmonious whole. Thus Berruguete's style, while firmly rooted in the 15th-century, looks forward to the 16th.

—Judith Berg Sobré

BERTRAM, Master. [Bertram of Minden.]

Born in or near Minden, Westphalia, c. 1340. Died in Hamburg between February 1414 and May 1415. Married Grete; one daughter. Worked in Hamburg: first recorded in 1367, and recorded as "Master" in 1372; official trip to Lübeck, 1375; the only painter to have official commissions in Hamburg between 1367 and 1387; painted (and probably sculpted) the Grabow Altar for Sts. Peter and Paul in Hamburg, 1379–83; had a workshop with apprentices.

Collections: Hamburg; Hanover; London: Victoria and Albert.

Grabow Altar—detail; Hamburg, Kunsthalle

Publications

On BERTRAM: books—

Lichtwark, Alfred, *Bertram*, Hamburg, 1905.
Pauli, Gustav, *Bertram*, Hamburg, 1920.
Martens, Friedrich A., *Bertram: Herkunft, Werk, und Wirken*, Berlin, 1936.
Dorner, Alexander, *Bertram*, Berlin, 1937.
Platte, Hans, *Bertram in der Hamburger Kunsthalle*, Hamburg, 1960, 1973.
Möller, Ingrid, *Bertram*, Dresden, 1983.
Beutler, Christian, *Bertram: Der Hochaltar von Sankt Petri: Christliche Allegorie als protestantisches Ärgernis*, Frankfurt, 1984.

articles—

Jensen, Jens Christian, "Bertram: Quellen und Untersuchungen," in *Zeitschrift des Deutschen Vereins für Hamburgischen Geschichte*, 44, 1958.
Kaufmann, Georg, "Bertrams Engelsturz," in *Festschrift for Millard Meiss*, New York, 1977.
Schwartz, Sheila, "St. Joseph in Bertram's Petri-Altar," in *Gesta* (New York), 24, 1985.

*

Master Bertram of Minden dominated Hamburg painting during the latter half of the 14th century, and his masterpiece, the so-called Grabow Altar, is the largest and most important 14th-century altarpiece in northern Europe. He was first mentioned in 1367 in the Hamburg city archives, when he was paid for painting an image of the Madonna for the Milderntor (one of the city gates), an angel for the City Hall, and for decorating a mail bag. Other minor commissions are mentioned in the records, but his most famous work, the Grabow Altar, was probably executed in the period 1379–83 for the high altar of the parish church of Sts. Peter and Paul in Hamburg. (It is given its current name because it was donated to a church in the small village of Grabow in Mecklenburg when it was replaced by a baroque altarpiece in 1731.) The altar consists of two pairs of wings covering a sculptured shrine (which Bertram probably also executed). The sculptured section of the altarpiece has been modified, but the painted wings which remain intact are splendid examples of an altarpiece with a full cycle of panels representing a narrative order of Old Testament history (and not merely comparative material for subjects from the New Testament). The large scale of the work is also impressive. Bertram painted other works, but they are overshadowed by his masterpiece.

BIERSTADT, Albert.

Born in Solingen, Germany, 7 January 1830; emigrated with family to Massachusetts, 1832. Died in New York City, 18 February 1902. Married 1) Rosalie Osborne Ludlow, 1866 (died, 1893); 2) Mary Hicks Stewart, 1894. Set up as painter and teacher in Boston, 1850; studied in Dusseldorf, 1853–56, and toured Italy, 1856–57; worked in Boston, 1857–59; traveled with Lander Wagon Road Expedition to Colorado and the Wyoming territories, then settled in New York, 1859; toured the White Mountains, 1860, and again in the far west, 1863; lived in Irvington-on-Hudson after 1865; visited Europe, 1867–69, California, 1871–73, and later; declared bankruptcy, 1895.

Collections Athens: University of Georgia; Boston; Buffalo; Hartford, Connecticut; Ithaca: Cornell University; New York: Metropolitan, Brooklyn Museum, Historical Society; Northampton, Massachusetts: Smith College; St. Louis; Seattle; Washington: Corcoran, National Gallery; Youngstown, Ohio: Butler Institute.

Publications

By BIERSTADT: book—

illustrator: *The Heart of the Continent* by Fitz Hugh Ludlow, 1870; *Wanderings in the Western Land . . .*, by Arthur P. Vivian, 1879.

On BIERSTADT: books—

Trump, Richard S., *A Selection of Paintings by Albert Pinkham Ryder and Bierstadt*, New Bedford, Massachusetts, 1960.
Hendricks, Gordon, *Bierstadt* (cat), New York, 1972.
Hendricks, Gordon, *Bierstadt* (cat), Fort Worth, 1972.
Hendricks, Gordon, *Bierstadt, Painter of the American West*, New York, 1973.
Baigell, Matthew, *Bierstadt*, New York, 1981.

articles—

Draper, B. P., "Bierstadt," in *Art in America* (Marion, Ohio), 28, 1940.
Snell, Joseph, "Some Rare Western Photographs of Bierstadt Now in the Historical Society Collections," in *Kansas Historical Quarterly* (Topeka), September 1958.
Hendricks, Gordon, "The First Three Western Journeys of Bierstadt," in *Art Bulletin* (New York), September 1964.
Lindquist-Cock, Elizabeth, "Stereoscopic Photography and the Western Paintings of Bierstadt," in *Art Quarterly* (Detroit), Winter 1970.
Bendix, Howard E., "The Stereographs of Bierstadt," in *Photographia*, September–November 1974.
Campbell, Catherine H., "Bierstadt and the White Mountains," in *Archives of American Art Journal* (Washington, D.C.), 21, 1981.
Pringle, Allan, "Bierstadt in Canada," in *American Art Journal* (New York), Winter 1985.
Witthoft, Brucia, "The History of James Smillie's Engraving after Bierstadt's *The Rocky Mountains*," in *American Art Journal* (New York), 19, 1987.

Carr, Gerald, L., "Bierstadt, Big Trees, and the British: A Log of Many Anglo-American Ties," in *Arts Magazine* (New York), June 1986.

*

Albert Bierstadt's career offers a classic example of how, in a middle-class, capitalistic society where the marketplace, rather than aristocratic or institutional patronage, sets the agenda, an artist's reputation may enjoy a meteoric rise, followed by an equally sudden collapse in a remarkably short span of time. In the decade between his first western journey, accompanying the Lander Wagon Road Expedition as far west as the Wind River Mountains of Wyoming in 1859, and the historic driving of the golden spike at Promontory Point, Utah, in 1869, an event which linked the east and west coasts by railroad, Bierstadt became the pre-eminent painter of the American west. In fact, his gigantic canvases from this period, often measuring seven, ten, or even fifteen feet wide, can easily be read as direct expressions of Manifest Destiny, that nationalistic and quasi-religious belief in western expansion as an inalienable right that God had somehow pre-ordained for the United States of America.

Where steamboats and canals had had an important impact on earlier American landscapists like Thomas Cole and Asher B. Durand, Bierstadt was a direct beneficiary of the great expansion in railroad building before and after the Civil War. It was wealthy railroad magnates, either Americans or visiting Englishmen like James McHenry or Thomas William Kennard, who had the ready cash to pay the artist twenty or twenty-five thousand dollars per canvas for works that pleased their eyes with minute realistic details, stirred their emotions with breath-taking romanticized vistas, and reinforced their self-images as men of prominence and power able to tame entire continents.

After 1870, however, the number of critical voices beginning to find fault with Bierstadt's theatricality and occasionally uneven production started to multiply mercilessly. In addition, Barbizon influence on American landscape painting in the form of *paysages intimes,* small-scale works with more familiar backyard or farmyard subject matter, began to make both Church and Bierstadt's pictures look old-fashioned and overblown. And a serious revival of figure painting, especially in terms of rural and urban genre scenes, was dramatically evident in the art galleries at the Centennial Exposition in Philadelphia in 1876, whereas Bierstadt's major entry on that occasion, a vertical composition portraying the Grisly Giant, a heroic redwood tree in the Mariposa Grove near Yosemite Valley, California, was generally ignored by reviewers who turned their attention elsewhere.

The rapid decline of Bierstadt's reputation was accelerated after 1880 by a series of personal misfortunes: the mansion he had built and christened Malkasten, overlooking the river at Irvington-on-Hudson, New York, was destroyed by fire in 1882; his first wife, Rosalie Ludlow, died in 1893; and the artist was forced to declare bankruptcy in 1895, allowing a sheriff to seize 150 of his paintings to satisfy a $10,000 debt, despite the fact that he had recently married a wealthy widow, Mary Hicks Stewart.

By the turn of the 20th century, the grandiose pretensions and stagy compositional effects of Bierstadt's western landscapes were completely out of synchronization with the impressionist or symbolist tendencies of the time. Harsh criticism of Bierstadt's output has begun to abate only recently as scholars have found things to admire in his best, epoch-defining pictures, in his devotion to various charities, in his decidedly international outlook, and in his life-long devotion to his art which never wavered despite the increasing hostility of the critics after his first decade of spectacular popularity.

—Ellwood C. Parry

BINGHAM, George Caleb.

Born in Charlottesville, Virginia, 20 March 1811. Died in Kansas City, Missouri, 7 July 1879. Apprenticed to a cabinet-maker, late 1820's; attended Pennsylvania Academy of Fine Arts, Philadelphia, for 3 months, early 1830's; worked in Washington, D.C., and then in Missouri; lived in Germany (Dusseldorf and other cities), 1856–59; much of his later life was devoted to politics: served as Adjutant General of Missouri, 1875–77; Professor of Art, University of Missouri, Columbia, 1877–79.

Collections: Detroit; Kansas City; New York: Metropolitan, Brooklyn Museum; St. Louis: Museum, Washington University, Boatman's National Bank.

Publications

On BINGHAM: books—

Rusk, F. H., *Bingham,* Jefferson City, Missouri, 1917.
Bingham (cat), New York, 1935.
Christ-Janer, Albert, *Bingham of Missouri,* New York, 1940.
Larkin, Lew, *Bingham, Fighting Artist: The Story of Missouri's Immortal Painter, Patriot, Soldier, and Statesman,* Kansas City, 1954.
McDermott, John Francis, *Bingham, River Portraitist,* Norman, Oklahoma, 1959.
Bingham (cat), Kansas City, 1961.
Bloch, E. Maurice, *Bingham* (cat), Washington, 1967.
Bloch, E. Maurice, *Bingham: The Evolution of an Artist,* Berkeley, 2 vols., 1967.
Constant, Alberta Wilson, *Paintbox on the Frontier: The Life and Times of Bingham,* New York, 1974.
Bloch, E. Maurice, *The Drawings of Bingham, with a Catalogue Raisonné,* Columbia, Missouri, 1975.
Christ-Janer, Albert, *Bingham, Frontier Painter of Missouri,* New York, 1975.
Bloch, E. Maurice, *The Paintings of Bingham: A Catalogue Raisonné,* Columbia, Missouri, 1976.

articles—

Rusk, F. H., "Bingham's Jolly Flatboatmen," in *Art Quarterly,* Winter 1954.

Taggart, Ross E., "Canvassing for a Vote and Some Unpublished Portraits by Bingham," in *Art Quarterly*, Autumn 1955.

Adams, Henry, "A New Interpretation of Bingham's Fur Traders Descending the Missouri, in *Art Bulletin* (New York), December 1983.

*

George Caleb Bingham moved to Missouri from Virginia in 1819, at the age of eight, and his career is closely associated with that of his adopted state. Most of his genre paintings depict the rough politics and colorful characters of rural Missouri—such as mountain men, riverboatmen, town drunks, and country politicians. Moreover, he did most of his work while living in the hamlets that had sprung up along the Missouri stretch of the Santa Fe trail—places such as St. Louis, Kansas City, Jefferson City, Arrow Rock, and Booneville. Bingham, in fact, was the first significant American painter to live west of the Mississippi and to devote himself to the documentation of the western frontier.

Despite the rustic character of his subject matter, Bingham was more than a mere provincial. His career was remarkably itinerant—from the age of 20 he seldom resided for more than six months in one place. Along with his travels through Missouri he made many journeys to the cities of the east coast, such as New York, Washington, and Philadelphia, as well as one long sojourn in the German art center of Dusseldorf. He not only acquired much new knowledge about artistic technique during these eastern visits, but also established a major source of patronage. Most of the genre paintings on which his reputation now rests were sold not in his native state but through eastern institutions, to an audience eager for knowledge of the western life.

Bingham's artistic career can be roughly divided into three phases. During the first of these he worked as a wandering portraitist in Missouri, producing likenesses of farmers and small businessmen in an unsophisticated style, with a tendency toward unmodulated shapes and flattened space, as is typical of untrained artists. Indeed, at this time he had received no artistic instruction other than the opportunity, as a child, to watch the visiting east coast portraitist Chester Harding create a likeness of the pioneer Daniel Boone.

Between 1838 and 1845, however, Bingham made several trips to the east coast, during which he vastly improved his technical ability. During his subsequent residence in Missouri, however, his career entered a second phase: he began producing the remarkable genre scenes of western subjects on which his reputation rests today. Many of these paintings were sold through the American Art Union, a lottery organization in New York City which provided high prices for paintings of American scenes.

Unfortunately, after the Art Union was disbanded by court order in 1852, Bingham lost his major source of patronage. In addition, he devoted much energy in his later years to political affairs, for Missouri was at the heart of the controversies concerning the rights of slaveholders which led to the Civil War. Bingham's political involvement included terms in several important positions, including treasurer of the State of Missouri and Police Commissioner of Kansas City. The third phase of Bingham's career, however, was one of artistic decline. Nearly all of Bingham's later paintings are either replicas of his earlier compositions, or rather uninteresting likenesses of local notables.

—Henry Adams

BLAKE, William.

Born in London, 28 November 1757. Died in London, 12 August 1827. Married Catharine Boucher (Butcher), 1782. Pupil from age 10 at Henry Pars's school; apprenticed to engraver James Basire, London, 1772–79; studied at the R.A. schools while earning his living as illustrator and engraver: friend of Flaxman and Fuseli; first book of verse, 1783, then began series of illuminated books combining printing with engraving and painting (first and most famous was Songs of Innocence, 1789); patronized by Thomas Butts, William Hayley (who encouraged him to move to Felpham, 1800–03), and John Linnell; after unsuccessful one-man show of his works in 1809, retreated into obscurity, though in the 1820's a group of young painters became his admirers.

Major Collections: London: Tate.
Other Collections: Birmingham; Boston; Cambridge; Cambridge, Massachusetts; London: British Museum, Victoria and Albert; Manchester: City Art Gallery, Whitworth; New Haven; New York: Metropolitan, Brooklyn Museum, Morgan Library; Petworth House; San Marino, California.

Publications

By BLAKE: books—

Poetical Sketches, London, 1783.
The Book of Thel, London, 1789; edited by Nancy Bogen, Providence, Rhode Island, 1971.
Songs of Innocence, London, 1789; expanded edition, as *Songs of Innocence and of Experience*, London, 1794; edited by Geoffrey Keynes, London, 1967.
The Marriage of Heaven and Hell, London, 1790–93(?); edited by Geoffrey Keynes, London, 1975.
For Children: The Gates of Paradise, London, 1793; revised ed., as *For the Sexes*, London, 1818 (?).
Visions of the Daughters of Albion, London, 1793.
America: A Prophecy, London, 1793.
Europe: A Prophecy, London, 1794.
The First Book of Urizen, London, 1794; as *The Book of Urizen*, edited by Kay P. and Roger R. Easson, New York and London, 1978.
The Book of Ahania, London, 1795.
The Book of Los, London, 1795.
The Song of Los, London, 1795.
Milton, London, 1804–08 (?); edited by Kay P. and Roger R. Easson, New York and London, 1979.
Jerusalem, London, 1804–20 (?).
The Ghost of Abel, London, 1822.
Tiriel, London, 1874; edited by G. E. Bentley, Jr., London, 1967.

Writings, edited by Geoffrey Keynes, London, 3 vols., 1925; 5th ed., as *Complete Writings,* Oxford, 1966.

Notebook, edited by Geoffrey Keynes, London, 1935; edited by David Erdman, London, 1973, 1977.

Vala, edited by H. M. Margoliouth, London, 1956; as *The Four Zoas,* edited by G. E. Bentley, London, 1963; edited by Bettina Tramontano Magno and David Erdman, Lewisburg, Pennsylvania, 1988.

Letters, edited by Geoffrey Keynes, London, 1956, 3rd ed., 1980.

Writings, edited by G. E. Bentley, Jr., Oxford, 2 vols., 1978.

On BLAKE: books—

Gilchrist, Alexander, *Life of Blake,* London, 2 vols., 1863, edited by Ruthven Todd, London, 1942.

Wilson, Mona, *The Life of Blake,* London, 1927, revised by Geoffrey Keynes, 1971.

Baker, C. H. Collins, *Catalogue of Blake's Drawings and Paintings in the Huntington Library,* San Marino, 1938, revised ed. with Robert P. Wark, 1957.

Keynes, Geoffrey, *Blake Studies,* London, 1949, Oxford, 1971.

Roe, Albert S., *Blake's Illustrations to the Divine Comedy,* Princeton, 1953.

Keynes, Geoffrey, and Edwin Wolf, 2nd, *Blake's Illuminated Books,* New York, 1953.

Keynes, Geoffrey, *Engravings by Blake: The Separate Plates: A Catalogue Raisonné,* Dublin, 1956.

Keynes, Geoffrey, *Blake's Illustrations to the Bible,* London, 1957.

Butlin, Martin, *A Catalogue of the Works of Blake in the Tate Gallery,* London, 1957.

Willard, Helen D., *Blake: Water-Color Drawings* (cat), Boston, 1957.

Blunt, Anthony, *The Art of Blake,* London and New York, 1959.

Bentley, G. E., Jr., and Martin K. Nurmi, *A Blake Bibliography,* Minneapolis, 1964; as *Blake Books,* by Bentley, Oxford, 1977.

Keynes, Geoffrey, *Blake, Poet, Printer, Prophet,* London, 1964.

Damon, S. Foster, *A Blake Dictionary,* Providence, Rhode Island, 1965, 1988.

Lister, Raymond, *Blake,* New York and London, 1968.

Bentley, G. E., Jr., *Blake Records,* Oxford, 1969, supplement, 1988.

Raine, Kathleen, *Blake and Tradition,* London, 2 vols., 1969.

Bindman, David, *Blake: Catalogue of the Collection in the Fitzwilliam Museum,* Cambridge, 1970.

Bentley, G. E., Jr., *The Blake Collection of Mrs. Landon K. Thorne,* New York, 1971.

Taylor, Irene, *Blake's Illustrations to the Poems of Gray,* Princeton, 1971.

Todd, Ruthven, *Blake the Artist,* London, 1971.

Easson, Roger R., and Robert N. Essick, *Blake, Book Illustrator,* 2 vols., 1972–79.

Lindberg, Bo, *Blake's Illustrations of the Book of Job,* Abo, 1973.

Erdman, David V., *The Illuminated Blake,* New York, 1974, London, 1975.

Bindman, David, *Blake* (cat), Hamburg, 1975.

Lister, Raymond, *Infernal Methods: A Study of Blake's Art Techniques,* London, 1975.

Bentley, G. E., Jr., editor, *Blake: The Critical Heritage,* London, 1976.

Bindman, David, *Blake as an Artist,* Oxford and New York, 1977.

Butlin, Martin, *Blake* (cat), London, 1978.

Bindman, David, *The Complete Graphic Works of Blake,* London, 1978.

Mitchell, W. J. T., *Blake's Composite Art: A Study of the Illuminated Poetry,* Princeton, 1978.

Johnson, Mary L., and John E. Grant, *Blake's Poetry and Designs,* New York and London, 1979.

Erdman, David V., *Blake's Designs for Edward Young's Night Thoughts,* Oxford, 1980.

Essick, Robert N., *Blake, Printmaker,* Princeton, 1980.

Dunbar, Pamela, *Blake's Illustrations to the Poetry of Milton,* 1980.

Butlin, Martin, *The Paintings and Drawings of Blake,* New Haven, 2 vols., 1981.

Essick, Robert N., and Morton D. Paley, *Robert Blair's "The Grave," Illustrated by Blake,* London, 1982.

Raine, Kathleen, *The Human Face of God: Blake and the Book of Job,* London, 1982.

Bindman, David, *Blake: His Art and Times* (cat), New Haven, 1982.

Essick, Robert N., *The Separate Plates of Blake: A Catalogue,* Princeton, 1983.

Essick, Robert N., *The Works of William Blake in the Huntington Collection* (cat), San Marino, California, 1985.

Lister, Raymond, *The Paintings of Blake,* Cambridge, 1986.

*

William Blake was a many-sided genius. By trade an engraver, he was apprenticed to James Basire (1730–1802). Throughout his life he supported himself as an engraver of such things as book illustrations from designs of other artists. Yet he expressed himself in many other ways: he drew and painted (he studied at the Royal Academy Schools), made relief etchings in a method devised by himself, and engraved in various techniques, including wood-engraving and lithography. He was also, despite the lack of a formal education, one of the greatest English poets.

Blake's most original works include books of his own poetry, illustrated, printed, and decorated by himself in relief-etching, a method unlike the usual technique, the blank areas being etched away, leaving the design in relief like a modern photo-line block. It has never been finally proved how he did this; one current hypothesis is that the design was painted on to the metal plate in reverse in acid-resistant ink and then etched; another view is that the design was drawn on thin paper in acid-resistant ink and transferred to the plate, perhaps in a press before being bitten. It is possible that he combined both methods. Blake claimed that the technique was revealed to him in a dream by his dead brother Robert.

Blake's relief-etched books include *Songs of Innocence* (1789), *America: A Prophecy* (1793), *Jerusalem: The Emanation of the Giant Albion* (1804–20), and others. Designs and text were printed in monochrome and usually coloured by

Newton, 1795; print

hand, sometimes simply and sometimes elaborately, in water-colour or, more rarely, by colour transferred under pressure from a metal plate or millboard sheet. The designs are often highly dramatic *terribilità* recalling passages in Michelange-lo's frescoes in the Sistine Chapel.

In colouring these books, Blake was frequently assisted by his wife Catherine, whom he married in 1782. Catherine was then illiterate, and Blake taught her to read and write, to pre-pare his colours, to draw, and to print from his engraved plates.

Blake's paintings and drawings were realized in various techniques. He claimed to have rediscovered the "lost" art of fresco, but his method was really a form of tempera, with carpenter's glue replacing the usual egg yolk. Although much of their beauty remains, Blake's temperas have not lasted well and have become badly cracked and discoloured. Among the best preserved are *The Ghost of a Flea* (c. 1819–20; Tate Gal-lery, London) and the magnificent *Virgin and Child* (1825?, Collection of Paul Mellon).

Blake also used watercolour, often combined with pen and ink, as in his series of illustrations to the poems of Thomas Gray (c. 1797–98; Collection of Paul Mellon). Some late wa-tercolours, like his illustrations to Milton's *Paradise Regained* (c. 1816–20; Fitzwilliam Museum, Cambridge) are finely stippled, like miniatures. Blake's drawing is highly idiosyn-cratic, and although much of it was dominated by classical precepts (knowledge of which he derived from prints of classi-cal sculpture), it contains considerable distortion, which, how-ever, he used consciously, being perfectly capable when he wished, of making "correctly" proportioned studies, as in his drawing *Old Par When Young* (1820; Huntingdon Library and Art Gallery, San Marino, California). For one thing he consid-ered beauty of line and spiritual intensity of greater impor-tance than conventional verisimilitude; his distortions usually add a dreamlike, almost surrealistic dimension and intensity to his work. This is evident in the dramatic watercolour *The An-gel Rolling the Stone from the Sepulchre* (c. 1805; Victoria and Albert Museum, London), in which the Angel is depicted as if he were simultaneously both inside and outside the tomb, and the figure of Christ is unnaturally elongated, being thus dis-tanced from the mundane world.

Another of Blake's original techniques was colour-printed drawing, examples of which are in the Tate Gallery, and in-clude *Elohim Creating Adam* and *Nebuchadnezzar* (both 1795). These were realized in a combination of drawing, painting, and printing, the outlines and some details being drawn on a sheet of millboard and transferred to paper in a press, after which they were worked up in watercolour. It was

a laborious process, and it was impossible to take more than one or two impressions without losing the details on the millboard, but the result is both luxuriant and pellucid.

In 1800 Blake met the minor poet and dilettante William Hayley (1745–1820), friend and biographer of the painter George Romney and of the poet William Cowper. Hayley commissioned Blake to engrave three illustrations for his book *An Essay on Sculpture* (1800), and soon after suggested that he should move to the coastal village of Felpham, where he lived, and where he would try to obtain further commissions for him. For a time this worked, but Hayley, though kind, would not leave Blake to develop his work as he wished, and tried to persuade him to undertake unsuitable work, such as miniature painting and the decoration of firescreens. Blake decided in 1803 to return to London, but before doing so, became involved in a quarrel with a soldier, who falsely accused him of uttering treasonable opinions. For this, Blake stood trial at Chichester Guildhall in January 1804, but was acquitted.

In 1818 he met the painter, John Linnell (1792–1882), who commissioned from him what many believe to be his greatest engraved work, *Illustrations of the Book of Job* (1826). He also commissioned a series of watercolours and engravings to Dante which remained uncompleted when Blake died. He probably also recommended that Blake should make the wood-engravings, illustrating the First Eclogue in R. J. Thorton's school edition of *The Pastorals of Virgil* (1821). Linnell introduced a circle of young artists to Blake, included among whom were Samuel Palmer (1805–81), Edward Calvert (1799–1883), and George Richmond (1809–96). These young men called themselves "The Ancients" and idolized Blake, being influenced especially by his Virgil wood-engravings. They were foremost among those who ensured that Blake's reputation and art, of limited renown in his lifetime, were not lost to posterity.

—Raymond Lister

BOCCIONI, Umberto.

Born in Reggio Calabria, 19 October 1882. Died in Verona, 16 August 1916. Attended schools in Padua and Catania; studied at the Academy of Fine Arts, Rome, 1901, in the studio of Giacomo Balla in Rome, 1901–04, and at the Academy of Fine Arts, Venice, 1906–07; associated with the Futurists Marinetti, Balla, Carrà, and Severini from 1909; served in the Battalion of Voluntary Cyclists, 1914–16: wounded, 1915, and sent to Verona to recuperate.

Collections: Basel; Milan: Brera, Arte Moderna; New York: Moma; Rome: Arte Moderna; Sao Paulo: Arte Moderna; Venice: Guggenheim, Arte Moderna.

Publications

By BOCCIONI: books—

Pittura, scultura futuriste, Milan, 1914.

Estetica e arte futuriste, Milan, 1946.
Gli scritti editi e inediti, edited by Zeno Birolli, Milan, 1971.
Altri inediti e apparati critici, edited by Zeno Birolli, Milan, 1972.

On BOCCIONI: books—

Marinetti, F. T., *Boccioni,* Milan, 1924.
Marinetti, F. T., *Boccioni: Opera completa,* Foligno, 1927.
Argan, Giulio Carlo, *Boccioni,* Rome, 1953.
Gambillo, Maria Drudi, and Teresa Fiori, *Archivi del futurismo,* Rome, 2 vols., 1958–62.
Falqui, Enrico, *Bibliografia e iconografia del futurismo,* Florence, 1959.
Gambillo, Maria Drudi, and Claudio Bruni, *After Boccioni: Futurist Paintings and Documents from 1915 to 1919,* Rome, 1961.
Taylor, Joshua C., *Futurism,* New York, 1961.
Carrieri, Raffaele, *Futurismo,* Milan, 1961; as *Futurism,* Milan, 1963.
Taylor, Joshua C., *The Graphic Work of Boccioni* (cat), New York, 1961.
Grada, Raffaele de, *Boccioni: Il mito del moderno,* Milan, 1962.
Ballo, Guido, *Boccioni: La vita e L'opera,* Milan, 1964.
Banham, Reyner, *Boccioni* (cat), London, 1964.
Martin, Marianne W., *Futurist Art and Theory 1909–1915,* Oxford, 1968.
Cucchetti, Gino, *Marinetti e il futurismo,* 1968.
Bruno, Gianfranco, *L'opera completa di Boccioni,* Milan, 1969.
Apollonio, Umbro, editor, *Futurismo,* Milan, 1970; as *Futurist Manifestos,* London and New York, 1973.
Bellini, Paulo, *Catalogo completo dell'opera grafica di Boccioni,* Milan, 1972.
Golding, John, *Boccioni: Unique Forms of Continuity in Space,* Newcastle upon Tyne, 1972.
Fezzi, E., *Boccioni,* Milan, 1973.
Calvesi, Maurizio, *Boccioni: Incisioni e disegni,* Florence, 1973.
Cordioli, Rosanna, *Boccioni e il suo tempo* (cat), Milan, 1973.
Fagiolo dell'Arco, Maurizio, and Ester Coen, editors, *"C'e solo l'arte": Boccioni Luglio 1915—agosto 1916* (cat), Rome, 1978.
Ballo, G., *Boccioni a Milano* (cat), Milan, 1982.
Tallarico, Luigi, editor, *Boccioni cento anni,* Rome, 1982.
Calvesi, Maurizio, and Ester Coen, *Boccioni,* Milan, 1983.
Calvesi, Maurizio, *Boccioni prefuturista* (cat), Milan, 1983.
Hanson, Anne Coffin, *The Futurist Imagination* (cat), New Haven, 1983.
Tallarico, Luigi, *Boccioni,* Reggio Calabria, 1985.
Coen, Ester, *Boccioni* (cat), New York, 1988.

*

Umberto Boccioni was the leader and principal spokesman of the Futurist artists. Boccioni's restless spirit had responded to the dramatic vision of a new culture for a new age coupled to a strident rejection of the art of the past propounded in 1909 by Filippo Tommaso Marinetti, the poet-founder of Italian Futur-

ism. Marinetti, who conceived Futurism as a literary movement, was nonetheless eager to see his ideas extended to all creative endeavors, including the visual arts. In 1910 Boccioni brought the painter's wing together enlisting Giacomo Balla, Carlo Carrà, Luigi Russolo, and Gino Severini in the issuance of two manifestos of Futurist painting.

Boccioni was ripe for Futurism. His pre-Futurist years had been spent searching for a personal style and approach. His quest led him from his native Reggio Calabria to Rome where he met Gino Severini; both soon became pupils of Giacomo Balla, the older artist who would later become their colleague in Futurism. Balla introduced Boccioni to his own realist variant of Divisionism, then the style of the Italian avant-garde. To the broken line and color of Divisionism, Boccioni joined the loaded symbolism of Gaetano Previati (1852–1920) which enabled him to move Balla's fundamentally realist vision to a more expressionist plane. After Rome, the peripatetic Boccioni moved around in Italy and travelled abroad—Paris, St. Petersburg, and Munich—before settling in Milan late in 1907. Three years later his search for a modern Italian artistic identity led him to the Futurist movement.

While Futurism did not at once suggest a new style to Boccioni, it nonetheless encouraged in him a new boldness of execution visible in his first major Futurist canvas, *The City Rises,* 1910–11 (New York, Moma). Restating a theme he had previously addressed—the building of the modern city—the artist attempted, as he wrote, "a great synthesis of labor, light and movement." While the treatment of light and color in *The City Rises* is still Divisionist in origin, Boccioni pushes his style to new aggressiveness, catalyzing this image of modern labor into an environment of relentless activity, where, in the words of the *Technical Manifesto of Futurist Painting,* "Everything moves, everything runs, everything rapidly evolves." Already in this canvas, however, something of the contradictory nature of Boccioni's Futurism emerges: for despite the Futurist embrace of technology, it is a horse that occupies the center of *The City Rises,* not a machine; Boccioni makes this animal his symbol of the dynamism of modern life.

The next step was to be a major stylistic revision, the outgrowth of a quick trip to Paris in the fall of 1911 with Carrà, made at the urging of Severini (resident in Paris since 1906), as preparation for the Futurists' Paris debut at Bernheim-Jeune the following February. Boccioni's encounter with Cubism emboldened him to develop a new visual vocabulary and to a certain extent to break with his Divisionist past, but did not change the fundamental aims of his art. Before he left for Paris, Boccioni had already begun work on a triptych, *The States of Mind* (New York, Moma), set in the dynamic modern environment of the railroad station and intended by Boccioni as the centerpiece of the coming Paris exhibition. Returning to Milan he reworked the three paintings synthesizing the newly acquired formal, analytical approach of the Cubists with his own emotionally expressive style. In *The States of Mind,* the key to his union of Cubism and Futurism are "lines of force." Contributing to Boccioni's visualization of the interrelatedness of phenomena, lines of force are directional lines that represent emotion as well as motion, both expressive of the Futurist sense of universal dynamism.

Boccioni's move into sculpture in 1912 was perhaps inevitable given the Futurist emphasis on the intermingling of the arts. Characteristically reflection on his artistic goals, in the

form of a manifesto—the *Technical Manifesto of Futurist Sculpture*—preceded his first works. The possibilities Boccioni envisioned for sculpture were astounding, even within the context of the avant-garde. The new sculpture was to combine multiple media into a sculpture of environment; traditional materials—marble and bronze—were to be cast aside as was traditional subject matter. However, in his greatest sculpture, *Unique Forms of Continuity in Space* (1913; London, Tate), Boccioni, in another one of the many paradoxes of Futurism, tackles the familiar problem of the human form in motion in dynamic silhouette and in a single material (plaster, later cast in bronze). Although his involvement with sculpture was to be brief, it was nonetheless intense.

In 1914 Boccioni's work began to change once again. While he continued to be preoccupied with Futurist themes—speed, modernity—exploring them through a series of works in mixed media including collage and assemblage influenced by Synthetic Cubism, there is a new tendency in his art toward order and control. By 1916 Boccioni seems to have left Futurism behind for a new interest in the monumentality of Cézanne; this direction is particularly apparent in one of his last paintings, his portrait of his friend, the composer Ferruccio Busoni (1916; Rome, Galleria Nazionale d'Arte Moderna).

When Italy entered the first World War in May 1915, Boccioni, with Marinetti, Russolo, and other Futurists, eagerly joined the volunteer cyclist brigade. The following year Boccioni lost his life in a fall from a horse, far from the scene of battle. Boccioni's untimely death in 1916 at 34 brought to a close the first phase of Futurism. In the end, Boccioni's search for a definable Italian artistic identity in the modern period had produced both radical proposals and remarkable works.

—Susan Barnes Robinson

BÖCKLIN, Arnold.

Born in Basel, 16 October 1827. Died in S. Domenico, near Fiesole, 16 January 1910. Married Angela Pascucci, 1853; six surviving children, including the painter Arnold Böcklin the younger. Trained under Johann Wilhelm Schirmer at the Dusseldorf Academy, and in Flanders, Paris, and Rome, 1850–57; taught at the Academy of Art, Weimar, 1860–62; lived in Rome, 1862–66, Basel, 1866–71, and Munich, 1871–74; then mainly in Italy: in Florence, 1874–85; there are several version of his most famous picture, *Island of the Dead.*

Major Collections: Basel; Munich: Neue Pinakothek, Schack-Galerie.
Other Collections: Berlin: Nationalgalerie, Berlin (East); New York; Posnam; Washington; Zurich.

Publications

By BÖCKLIN: book—

Neben meiner Kunst: Flugstudien, Briefe, und Persönliches,

edited by Ferdinand Runkel and Carlo Böcklin, Berlin, 1909.

On BÖCKLIN: books—

Schmid, H. A., *Böcklin*, Munich, 4 vols., 1892–1901.

Floerke, Gustav, *Zehn Jahre mit Böcklin*, Munich, 1901, 1902, 3rd ed., edited by Hanns Floerke, as *Böcklin und seine Kunst*, 1921.

Mendelsohn, H., *Böcklin*, Munich, 1901.

Frey, Adolf, *Böcklin*, Stuttgart, 1902, 1912.

Seidel, P., *Die Werke Böcklins in der Schackgalerie in München*, Munich, 1902.

Meier-Graefe, Julius, *Der Fall Böcklin und die Lehre von den Einheiten*, Stuttgart, 1905.

Thode, Henry, *Böcklin*, Heidelberg, 1905.

Graborsky, Adolf, *Der Kampf um Böcklin*, Berlin, 1906.

Back, F., *Handzeichnungen Böcklins*, Darmstadt, 1907.

Fleiner, Albert, *Mit Böcklin*, Frauenfeld, 1915.

Schmid, H. A. *Böcklin*, Munich, 1919, 1922.

Schmid, H. A. *Böcklin: Handzeichnungen*, Munich, 1921.

Justi, Ludwig, *Die Landschaften von Böcklin*, Berlin, 1925.

Floerke, Gustav, *Böcklin und das Wesen der Kunst*, Munich, 1927.

Justi, Ludwig, *Böcklin* (cat), Berlin, 1927.

Barth, Wilhelm, *Böcklin*, Frauenfeld, 1928.

Fischer, O., *Böcklin*, Burg bei Magdeburg, 1940.

Schneider, Max F., *Böcklin, ein Maler aus dem Geiste der Musik*, Basel, 1943.

Pfister-Burkhalter, Margarete, *Böcklin: Die Basler Museumsfresken*, Basel, 1951.

Schmidt, Georg, *Böcklin Heute*, Basel, 1951.

Schmidt, Georg, *Böcklin*, Stuttgart, 1963.

Rathke, Ewald, and Sylvia Rathke-Köhl, *Böcklin* (cat), Frankfurt, 1964.

Andree, Rolf, *Böcklin* (cat), London, 1971.

Kalnein, Wend von, editor, *Böcklin* (cat), Dusseldorf, 1974.

Dollinger, Hans, *Böcklin* (in German and English), Munich, 1975.

Andree, Rolf, *Böcklin: Die Gemälde*, Basel, 1977.

Burger, Susanne, et al., *Böcklin* (cat), Basel, 1977.

Christ, Dorothea, *Böcklin: Gemälde, Zeichnungen, Plastiken*, Basel, 1977.

Krimmel, Bernd, *Böcklin* (cat), Darmstadt, 2 vols., 1977.

Böcklin e la cultura artistica in Toscana (cat), Fiesole, 1980.

Volpi, Marisa, *Böcklin: Disegni*, Florence, 1982.

Zelger, Franz, *Böcklin*, Olattbrugg, 1982.

*

The work of Arnold Böcklin has been increasingly appreciated as re-evaluation of 19th-century European art continues. Neither a radically progressive artist nor an absolutely acceptable society painter, Böcklin remained throughout his life an individualist whose work represented a melange of influences and, in many ways, a duality of technical approaches and artistic goals. He was a truly international artist: born in Switzerland, trained in Germany, and nurtured in Italy, he moved rather regularly between the three countries, with additional trips to Paris and Vienna, throughout his life. He was an important link between the various artistic movements represented in each of these areas, and his work served as a strong continuation of German Romanticism in the 19th century. His work, particularly that after 1870, has been cited as either precursor to, or actually "Symbolist," although his sensual scenes remain more neo-Romantically enticing than Symbolistically evocative. His efforts to create "dream-world" imagery were a direct inspiration to Giorgio de Chirico and later Surrealistists, while the sensual abandonment and violent themes of his late works provided important precedents for the German Expressionists.

Böcklin's earliest painting of the 1840's reveal his Dusseldorf Academy background; here, especially in the landscape class taken under Johann Wilhelm Schirmer, he was trained in the recording of exact details. Böcklin always combined this approach, however, with Romantic compositional and iconographic devices in order to establish a "mood" rather than a view. Compositions are consistently dramatic, with shortened, often darkened foregrounds set before infinite skies. Already in these early works—overwhelmingly landscapes, such as *Moonlit Landscape with Ruin* (1849; private collection)—can be found the duality between naturalism and romanticism, between the real and ideal, that characterizes most of his mature works.

Having traveled in the 1840's to Switzerland, Brussels, Antwerp, and Paris, Böcklin was most influenced by the Swiss landscapist Alexandre Calame and by two French painters, Thomas Couture and Camille Corot. He then went, on the advice of his mentor Jacob Burckhardt, to Rome. He stayed there for the next seven years, discovering Renaissance art and the Roman countryside. These influences resulted in immediate changes in his painting; while his subject matter became more varied, he introduced to his landscapes more natural lighting, less overtly dramatic composition, and larger figures, often mythological characters. Centaurs, nymphs, and fauns began to populate Böcklin's idyllic Italian landscapes, culminating in *Pan in the Rushes* of 1859 (Munich, Bavarian Museum). This work proved to be a turning point for Böcklin: it was his first real success in Munich, and foretold future developments with detailed figural compositions.

In 1860 Böcklin accepted a professorship in Weimar, and enjoyed for the first time in years some measure of health and financial stability for his family. Lured once again by Italy, however, he returned to Rome in 1862, and spent four years there followed by five years in Basel. Throughout, he turned to portraiture, primarily of his family and friends, including several of the painter Lenbach. At the same time he created a series of canvases entitled *Villa on the Sea*, the first of his well-known compositions combining a solitary, meditative figure, classical Roman architecture, with outlined trees and sea.

Upon his return to Basel, at the instigation of Burckhardt, Böcklin turned to the mural format and traditional subjects popular at that time. Iconography included not only mythological but also religious themes, beginning with *Grief of Mary Magdalen over the Dead Christ* (Basel) of 1868. In the same year he painted religious subjects in his frescoes for the Sarasin summer-house in Basel; these were epic history landscapes reminiscent of the Baroque compositions of Claude Lorrain. The success of these murals gained for Böcklin the prized commission to execute three paintings for the Basel Museum, completed in 1870. In these works, today so seemingly trite in both subjects (*Flora, Magna Mater,* and *Apollo*) and high Ba-

roque style (Burckhardt compared it to Rubens), can be found the bold qualities that also characterized the murals of Puvis de Chavannes. Böcklin's figures overtly announce their Renaissance/Baroque heritage—suitably for 19th-century historicism—yet also convey a modern sensibility in their flat space and simple composition.

Böcklin's conventional subjects were also infused with a very individual, often personal sensibility. In 1872, Böcklin portrayed himself caught, in the act of painting, by a skeletal specter of death who plays on a single violin string. Entitled *Self Portrait with Fiddling Death* (Berlin, Nationalgalerie), this canvas characteristically combines conventional imagery (the *Totentanz* which in his native Basel usually ended with scenes of the artist and death), and in idiosyncratic revelation of death as his own muse. It also summarized Böcklin's fascination with death, personalized by the deaths of eight of his fourteen children and, according to some, by suicidal inclinations. In *Island of the Dead* Böcklin later expressed this death fascination by means of a neo-Romantic landscape.

Island of the Dead typifies Böcklin's mature works in its meshing of seeming dualities into one composition. Combining figures and landscape, these paintings contrast specific images of the real world with idealized evocations of feelings and concepts. Despite his seeming versimilitude, many of the exact sources for Böcklin's landscapes remain after rigorous research unidentified, leading to the assumption that they were invented. Böcklin admitted that his reliance on human models was "the tragedy of my life," since he believed it almost impossible to work without one, yet understood that his wife was opposed to it. Still, Böcklin cursed his "confounded studies," claiming that "painting pictures out of one's head or from one's soul is good, but wasting one's time with studying is not." Yet he continued to do them nonetheless; as Heinrich Wölfflin wrote in 1897, "One of the peculiarities which astonished everyone on studying Böcklin is his habit of contemplating things, firmly rooted to the spot, for hours on end."

Ultimately, Böcklin sought a compromise between two sources, nature and imagination. In doing so, he produced an art that summarized 19th-century art, from Romanticism through Realism, without straining those approaches into totally new styles or modern content as did so many of the Post-Impressionists. Compared to their work, Böcklin's seems hopelessly recalcitrant, maintaining a late Romantic world of myth and metaphor rather than venturing into the more personal realms of ideas to which, for example, the Symbolists referred. Even in mystical paintings, such as *The Sacred Grove* (1886, Hamburg), the mystery suggested by the white-robed figures is nevertheless rendered in the crisp air of a believable and attainable woodland setting. Compared to the radical stylistic "distortions" introduced by the Post-Impressionists, Böcklin's style was comfortingly conventional. It was, however, the boldness with which Böcklin presented his vision that resulted in early rejection. It was only in the mid-1880's— precisely when the Post-Impressionists were first exhibiting— that Böcklin was "accepted." Notably, it was also when his painting took on a new epic grandeur, with strong themes and brutally forceful compositions, visual acknowledgment of the painter's own maturity. It was this striking clarity with which Böcklin embodied an imaginary world that most appealed to the 20th-century artists who followed him.

—Sharon Hirsh

BONHEUR, Rosa.

Born Rosalie Bonheur in Bordeaux, 16 March 1822; daughter of the painter Raimond Oscar Marie Bonheur; her sister and two brothers were also artists; lived in Paris from 1829. Died in By, 25 May 1899. Taught by her father; exhibited from 1841, especially animal pictures; exhibition of the Horse Fair at the Salon made her reputation; took over her father's art school on his death in 1849; lived with her childhood friend Nathalie Micas from 1853, first in Paris, then in Chateau de By, near Fontainebleau (Nathalie died, 1894), then lived with the American painter Anna Klumpke from 1897; made animal studies in markets and fairs dressed as a man (given official permission to cross-dress); popular in England: first visit, 1856. Made a member of the Legion of Honor (first woman to be given this honor), 1865.

Major Collection: Fontainebleau: Palace.
Other Collections: Florence; London: National Gallery, Wallace; New York; Paris: d'Orsay; Sarasota, Florida.

Publications

On BONHEUR: books—

Roger-Milès, Léon, *Bonheur: Sa vie, son oeuvre,* Paris, 1900.
Roger-Milès, Léon, *Atelier Bonheur* (cat), Paris, 2 vols., 1900.
Klumpke, Anna, *Bonheur: Sa vie, son oeuvre,* Paris, 1908.
Stanton, Theodore, *Reminiscences of Bonheur,* London and New York, 1910.
Digne, Danielle, *Bonheur, ou l'insolence: L'Histoire d'une vie,* Paris, 1980.
Ashton, Dore, *Bonheur: A Life and a Legend,* New York and London, 1981.
Shriver, Rosalia, *Bonheur, with a Checklist of Works in American Collections,* Philadelphia, 1982.

*

Rosa Bonheur is one of those artists toward whom the critical choices of the 20th century have been particularly cruel. Virtually ignored today by mainstream art historians and often belittled even by those who have dealt with French Second Empire painting, her work has been condemned to an unfair limbo which seems to avenge the enormous popularity which she enjoyed during her lifetime.

From 1848 when, as a young woman of 26, she obtained the Gold Medal at the Salon for the totality of her exhibited works (seven paintings and one bronze sculpture), her success never stopped growing. In Anglo-Saxon countries, where her dealer, the London-based Gambard, manufactured her image, she became literally idolized by certain types of collector—the gentry, or those industrialists who were nostalgically looking at the nature their spirit of initiative was slowly destroying. After Empress Eugénie discovered her, her name became a symbol of artistic success. If one adds to this the competition between her dealers (Gambard, the Tedesco brothers in The Hague, Petit and Knoedler in Paris), it becomes easier to understand

why record prices were paid for her works during her life time.

Crucial in setting that trend was the sale history of *The Horse Fair*. Exhibited at the Salon in 1853, the huge canvas had been commissioned by the politically influential Duke of Morny. It was bought a year later by Gambard for 40,000 francs, and then bought in 1881 by Cornelius Vanderbilt for the Metropolitan for 258,000 francs (roughly $5,000,000 in today's terms). The market value of her work influenced her popularity, and vice-versa, and, among the external circumstances that augmented it was the prurient interest of a male-oriented society in the fact that the artist was a woman, and an eccentric one at that. After her death, a decline in popularity began, followed by the critics' desertion and a crash in market values. Today she is snubbed equally by scholar and art market. Though in recent years the feminists have begun to look at her (though not seriously at her work), the recent monographs have not been sufficiently centered on the real issues to create a revival of interest.

In today's perspective, however, a re-evaluation is seriously needed. Her masterpiece, *The Horse Fair* (still at the Metropolitan) is one of the greatest achievements of 19th-century realism. Devoid of sentimentalism, her rendition of the animals she loved conveys an intensity and strength not present in the other "animaliers." Her best works transcend the limitations of the genre to reveal the rich nature of her pictorial temperament. Unfortunately, because she worked for such a long time, often under the pressures of exhibitions and commissions, her oeuvres is enormous—some 6000 pieces (including drawings, paintings, and a few sculptures). This mammoth production does not allow for evenness in quality: though she remained a superb draftsman all her life, her paintings at times are not as consistently masterful.

After 1870, most of her renditions of atmosphere are marred by the use of a diluted purple color, systematically opposed to deep greens. It is also fundamental to realize that in the absence of a catalogue raisonné (I am currently at work preparing one), works by her brother August or her sister Juliette Peyrolle, as well as copies commissioned by Rosa for other animaliers, have been reproduced in auction catalogues and sold as works by Rosa. Such misattributions have contributed to further confusion on the issue of the quality of her work.

Rosa Bonheur's realism owes very little to Courbet's. It is linked, on the contrary, to a romantic vision of the world, rooted in the egalitarian socialist utopia of the Saint-Simonians, which she had absorbed as a child from her father, a disciple of the "Père Enfantin," who had deserted his family to live the communal existence prescribed by his master. From that rather ambiguous father figure, she derived a contempt for men, as well as an emotional identification with women and a surprisingly unconventional theogony: the creator of the universe was a female power whose divine order presided over human and animal fate equally. She also held staunch Republican convictions.

Animals to her were noble beings, gifted with a soul. Her representation of them is the result of tireless studies from nature, in all possible conditions. Sketches and drawings form the basis from which to create studio compositions in which the harmony of nature will be translated and an atmosphere similar to that which permeates George Sand's novels expressed. Literary works, in fact, inspired her until her death.

The unfinished masterpiece, *La Foulaison*, painted for the Exposition Universelle of 1900, took form in her mind after reading *Mireille* by the Provencal writer Frédéric Mistral.

Landscapes, still lifes, and portraits are rare in her oeuvre. In the large compositions in which she depicted the lives of hard-working animals in harmony with the peasants they work for, such as *Le Labourage nivernais*, *La Fenaison en Auvergne*, or *Contrebandiers traversant les Pyrénées*, Rosa Bonheur was able to give her total measure, producing works of towering power that are unique in the context of French 19th-century art.

—Annie-Paule Quinsac

BONINGTON, Richard Parkes.

Born in Arnold by Nottingham, 25 October 1802; lived in Calais with his family from 1817. Died in London, 23 September 1828. Pupil of Louis Francis in Calais; entered studio of Baron Gros in the Ecole des Beaux-Arts, Paris, 1820–22; friend of Delacroix; exhibited in Paris from 1822, and in London at the Royal Academy, 1827–28; in failing health from tuberculosis from 1827.

Major Collection: London: Wallace
Other Collections: Cambridge, Massachusetts; London: British Museum, Courtauld, Tate, Victoria and Albert; Muncie, Indiana; New Haven; New York; Nottingham; Ottawa; Paris.

Publications

On BONINGTON: books—

Harding, J. D., *A Series of Subjects from the Works of the Late R. P. Bonington Drawn on Stone*, London, 1829–30.
Stokes, Hugh, *Girtin and Bonington*, London, 1922.
Dubuisson, A., *Bonington: His Life and Work*, London, 1924.
Curtis, Atherton, *Catalogue de l'oeuvre lithographie et gravé de Bonington*, Paris, 1939.
Shirley, Andrew, *Bonington*, London, 1940.
Race, Sydney, *Notes on the Boningtons*, Nottingham, 1950.
Cain, Julien, *Bonington* (cat), Paris, 1966.
Lepoittevin, Lucien, and Pierre Miquel, *Bonington* (cat), Cherbourg, 1966.
Spencer, Marion, *Bonington* (cat), Nottingham, 1966.
Bonington, Thomas Shotter Boys (cat), Stanford, California, 1975.
Ingamells, John, *Bonington*, London, 1979.
Peacock, Carlos, *Bonington*, London, 1979.
Pointon, Marcia, *The Bonington Circle: English Watercolour and Anglo-French Landscape 1790–1855*, Brighton, 1985.
Pointon, Marcis, *Bonington, Francia, and Wyld*, London, 1985.
Cormack, Malcolm, *Bonington*, Oxford, 1989.

*

Rue du Gros Horloge, Rouen, 1824; lithograph

Bonington has often been characterized as the major link between English and French painting in the opening years of the 19th century. As an Englishman living in France and educated in Paris he had access to the work of traditional academics and the burgeoning group of romantic artists gathered around Théodore Géricault. His modest-sized watercolors, oils, and lithographs were equally popular in London and Paris. His work along with that of Constable and Lawrence was well received at the Paris Salon of 1824. Though his technique was neither as radical as Constable's nor his sensibilities inclined towards the allegorical like Turner, his work had a profound impact on practioners of landscape and marine painting on both sides of the Channel.

His early training in the port city of Calais (he arrived in France at the age of 16) may have contributed to his sensitivity towards light and atmospheric effects. His contrived pictur-

esque views are memorable because of his technical virtuosity with reserved accents of bright opaque color. His sense of composition owes a great deal to the Venetian school of veduta painters, especially Canaletto.

His work falls into distinct genres. In the many cityscapes the favorite subjects are venerable buildings. He was attracted to the gothic architecture of Venice and Bologna, and the cathedral cities of France, especially Rouen. The drawings are remarkable for the delicate delineation of the complicated surfaces of the buildings set against open, active skies. Transparent washes applied with broad gestural strokes strongly evoke a sense of light and atmosphere. His marine views, like those of Constable, are highly effective in suggesting the movement of air and the play of light on the shifting surfaces of the water. His scenes of shipping owe something to Dutch 17th century work which he knew well from his travels and study at the

Louvre. A third group of works are of the open countryside, small pastoral scenes where the sky plays a dominant role. He executed a small number of competent portraits. He anticipated Delacroix's fascination with Middle Eastern subjects in a series of works dating from the mid-1820's in which he explored the exotic costumes and settings of the forbidden world of the harem and a romantically charged vision of Turkish life.

But the genre to which he happily devoted his energies were his romantic historical scenes. He accepted commissions for many landscapes because they afforded him the funds to create his historical paintings for which there was not much market. Bonington had a penchant for 16th and 17th century costume dramas. The two earlier artists who most profoundly affected his notion of figural compositions were Rubens and Watteau. The latter is particularly important. Bonington imitated the same sense of grace, elegant costuming, and precision of gesture he saw in Watteau's work. It is reputed that he once offered the entire contents of his studio in exchange for a Watteau drawing on the market about to be purchased by a man Bonington did not feel truly appreciated the genius of Watteau. It was his intrigue with costume and accessories that led him in 1825 to travel in company with Delacroix to London to see the collection of armour owned by a Mr. Meyrick, to visit the London stage, especially productions of Shakespeare, and to see the works of Turner and other contemporaries.

His small landscapes and coastal scenes appealed to the French, and it has often been suggested that his works created a vogue for the intimate landscape paintings of the type later created by Corot and members of the so-called Barbizon school.

He died tragically young at the age of 25 from complications of tuberculosis, and though the body of his work is relatively small his influence on subsequent landscape art is perhaps more widespread than expected. This is largely the result of the many lithographs he produced of his own designs and others based on the work of other artists. His distinctive method of stippling is effective in suggesting a wide range of values from powerfully lit surfaces to those cast in dank shadows. He was highly regarded by his contemporaries, especially Delacroix, with whom he shared a studio in 1825. His academic mentor in Paris, Baron Antoine Gros, with whom Bonington studied until around 1820, greatly admired his small truthful sketches. His work is similar to that of his contemporaries Thomas Girtin and John Sell Cotman; all three produced modest works, keen in their sense of observation, truth to texture and atmospheric reality and derived ultimately from the picturesque tradition of the 18th century.

—Anthony Lacy Gully

BONNARD, Pierre

Born in Fontenay-aux-Roses, 13 October 1867. Died in Le Cannet, 23 January 1947. Married Maria (Marthe) Boursin, 1925 (died, 1942). Attended Lycée Louis-Le-Grand, Paris, to 1885; studied law (and received a law degree, 1888), and also studied at the Académie Julian and the Ecole des Beaux-Arts; military service, 1889–90; shared a studio with Vuillard and Denis, and associated with the Nabis group to 1899; first one-man show, 1896; stage designs for Lugné-Poë's experimental theatre (e.g., *Ubu Roi* by Jarry, 1896); also designed the ballet *Jeux*, 1920; occasional teacher at Académie Ransom after 1909; lived in Le Cannet from 1925.

Major Collections: Paris: Art Moderna; Washington: Phillips.
Other Collections: Assy: Parish Church; Chicago; Hamburg; London: Tate; New York: Moma, Guggenheim; Paris: Petit Palais; Washington: Hirshhorn; Zurich.

Publications

By BONNARD: books—

illustrator: *Parallèlement,* by Verlaine; *Daphnis et Chloe; Histoires naturelles,* by Jules Renard, 1904.

On BONNARD: books—

Werth, Léon, *Bonnard,* Paris, 1923.
Gutman, Walter, *Bonnard,* New York, 1928.
Laprade, J. de, *Bonnard,* Lyons, 1944.
Courthion, Pierre, *Bonnard, peintre du merveilleux,* Lausanne, 1945.
Beer, F. J., *Bonnard,* Marseilles, 1947.
Rewald, John, *Bonnard* (cat), New York, 1948.
Jedlicka, Gotthard, *Bonnard: Ein Besuch,* Zurich, 1949.
Natanson, Thadée, *Le Bonnard que je propose,* Geneva, 1951.
Roger-Marx, Claude, *Bonnard Lithographe,* Monte Carlo, 1952; as *Bonnard the Lithographer,* Monte Carlo, 1952.
Rumpel, Heinrich, *Bonnard,* Berne, 1952.
Bonnard (cat), Basel, 1955.
Sutton, Denys, *Bonnard,* London, 1957.
Soby, James Thrall, James Elliott, and Monroe Wheeler, *Bonnard and His Environment* (cat), New York, 1964.
Terrasse, Antoine, *Bonnard,* Geneva and Cleveland, 1964.
Dauberville, Jean and Henry, *Bonnard: Catalogue raisonné de l'oeuvre peint,* Paris, 4 vols., 1965-74.
Sutton, Denys, *Bonnard* (cat), London, 1966.
Terrasse, Antoine, *Bonnard* (cat), Munich, 1966.
Vaillant, Annette, *Bonnard, ou le bonheur de voir,* Neuchatel, 1966.
Bouret, Jean, *Bonnard: Séductions,* Paris, 1967; as *Bonnard: The Magic Ring,* New York, 1967.
Russoli, Franco, *Bonnard,* Paris, 1967.
Terrasse, Antoine, *Bonnard,* Paris, 1967.
Cogniat, Raymond, *Bonnard,* Paris, 1968.
Fermigier, André, *Bonnard,* Paris, New York, and London, 1969; concise edition, 1984.
Perucchi-Petri, Ursula, *Bonnard und Vuillard im Kunsthaus Zurich,* Zurich, 1972.
Negri, Renata, *Bonnard und die Nabis* (cat), Munich, 1974.
Clair, Jean, *Bonnard,* Paris, 1975.
Perucchi-Petri, Ursula, *Die Nabis und Japan: Das Frühwerk von Bonnard, Vuillard, und Denis,* Munich, 1976.
Arland, Marcel, and Jean Leymarie, *Bonnard dans sa lumière,* Paris, 1978.

The Little Laundress, 1896; lithograph

Bouvet, Francis, *Bonnard: L'Oeuvre gravé,* Paris, 1981; as *Bonnard: The Complete Graphic Work,* New York, 1981.

Bozo, Dominique, et al., *Bonnard* (cat), Paris, 1984; as *Bonnard,* edited by Sasha M. Newman, New York and London, 1984.

Harrison, Michael, and Judith Kimmelman, *Drawings by Bonnard,* London, 1984.

Amoureux, Guy, *L'Univers de Bonnard,* Paris, 1985.

Heilbrun, Françoise, and Philippe Néagu, *Bonnard photographe* (cat), Paris, 1987; as *Bonnard, Photographer and Painter,* New York, 1988.

Terrasse, Antoine, *Bonnard at Le Cannet,* London, 1988.

Ives, Colta, Helen Giambruni, and Sasha M. Newman, *Bonnard: The Graphic Art,* New York, 1989.

*

Pierre Bonnard was no great theorist or politician. Unlike so many of his contemporaries he was not concerned with the aesthetic debates of the day, nor did he feel that his work had any particularly didactic qualities. As a founding member of the Nabis group, he took a consciously anti-intellectual approach to the role of the artist in society. As a young man he preferred to describe himself as a decorator rather than a painter. This early preoccupation with the decorative can be seen in the artist's choice of mediums and subjects. Lithographs, decorative panels, poster and even furniture designs were executed as a testimony to Bonnard's desire to decorate

and design. The first piece that he sold was a poster design for French champagne (apparently much admired by Lautrec).

The studio that Bonnard shared with Eduard Vuillard and Maurice Denis in 1890 was to become a focal point for the Nabis. Taking their lead from Gauguin, the Nabis saw the primary objective of the artist to cover plain surfaces with colour and form. The group was much influenced by an exhibition of Japanese art and artefacts at the Ecole des Beaux Arts in 1890. Bonnard's *Croquet Match* and *Four Panels for a Screen,* both painted in 1892, seem ample evidence for the suitability of the artist being nicknamed the "Nabis très Japoniste." The strong flowing outline, apparent disinterest in modelling or studying of the human features, and an overall emphasis on surface pattern and strong planes of colour show the influence of the Japanese upon the young artist. Bonnard's use of a somewhat subdued and murky palette in his work before the turn of the century has often been read as a conscious move away from the work of such Impressionists as Degas and Manet.

Having exhibited at the Salon des Indépendants in 1891, Bonnard was to move away from the decorative and primitive Nabis style towards a style that is known as Intimisme. This style, also taken up by Vuillard under the guidance of Bonnard, showed a predilection for the depiction of the everyday and the domestic. Emphasis was not on the chic and fashionable Paris so adored by the Impressionists, but on a dimly lit interior or a back street, never disturbed or tidied up by the artist. A rare formal portrait of 1900, by the Intimiste Bonnard, shows the artist's apparent disinterest in the high life of Paris. Claude Anet's wife is shown in an almost ridiculously posed position, her dress filling the whole of the front of the painting. Only when looking at a painting like *Young Woman in Lamplight,* painted in the same year, can the viewer see the real charm of the world of Intimisme. The figure, almost certainly Bonnard's wife, sits in a dark undefined room, apparently sewing a simple dark cloth. All emphasis is on ambience and overall design rather than specific character and careful rendering of the room's objects.

After 1908, with the strength of a one man show at Benheim-Jeunes, and no doubt influenced by the Fauves exhibition at the Salon d'Automne, Bonnard seems to have had the conviction and confidence to concentrate on what must now be seen as his most important contribution to painting: the use and abuse of colour. Besides a lapse between 1912 and 1913 when the critics seem to have intimidated the artist into inactivity, shortly after Picasso had dismissed his work as "piddling," Bonnard spent the rest of his long life exploring the expressive and decorative possibilities in colour. Spending most of his life in the country at Vernet, Bonnard developed and created a style that, in its apparent disinterest in structure and emphasis on fields of colour, opened the way for the abstract and non-figurative painters of the following decades.

It is only in recent years that Bonnard has been recognised as a major figure in 20th-century art. His inability to take part in the Cubist movement, his disinterest in being known as a great artist, and the very simple choice of subjects have often led critics to dismiss him as a rather sad and undeveloped child of Impressionism. Yet in the work done between 1908 and the end of his life Bonnard created a style that today seems vibrant, modern, and, of course, prophetic.

There is nothing grand or classical in Bonnard's choice of

subject matter. More often than not he was content to paint his wife in a simple domestic setting, or a table covered in pans and dishes. Although he did paint landscapes in the later part of his life, the land shown is not vast and overpowering but sketchy and undetailed (*Seascape of the Mediterranean,* 1941). Paintings such as *Dining Room in the Country,* 1913, show a quality beyond the large statement so often sought by painters. These paintings show an ability to design, though not necessarily structure, a scene so that the viewer can enjoy the "purer" values of painting, mood, texture, and colouration. It is this very straightforward view of painting, as an exercise in the use of paint rather than an academic or intellectual exercise, that made Bonnard such a touchstone to modern painters.

There are many characteristic features of the work of Bonnard, e.g., an air of unreality created by the artist's odd choice of perspective and his ability to allow a simple object such as a jug or a tablecloth to dominate a entire scene. *The Tub* of 1915 requires careful study before the apparently abstract shapes can be read as real objects, as do many of his paintings. Yet it is the artist's use of colour that differentiates him from other artists. To be a colourist in the 1920's in France was not to be mainstream. Bonnard was an anachronism in the development of French art. He was not a rebellious or antagonistic figure. He prided himself in his disinterest in politics. He was an artist's artist in that he was preoccupied with painting to the extent that he was able, in some way, to develop a personal style, decorative, colourful, and enormously evocative.

—Rupert Walder

BOSCH, Hieronymus.
Born c. 1450, in 's-Hertogenbosch; son of the painter Anthonis van Aken; brother of the painter Goossen Bosch. Buried in 's-Hertogenbosch, 9 August 1516. Married Aleyt Goyaerts van der Meervenne, 1479–81. One of a long line of painters: worked in 's-Hertogenbosch: mentioned in records from 1474 to 1516; enrolled in Brotherhood of Our Lady by 1486–87, and had commissions from the Brotherhood (altarpieces, church furniture, stained glass—now lost); commissioned to do *Last Judgment* triptych for Philip the Fair, 1504.

Major Collections: Madrid: Prado.
Other Collections: Berlin; Cologne; Escorial; Frankfurt; Ghent; Lisbon; London; Munich; New Haven; New York; Paris; Philadelphia; Rotterdam; Venice: Doge's Palace; Vienna; Washington.

Publications

On BOSCH: books—

Friedländer, Max F., *Die Altniederländische Malerei 5:*

Geertgen van Haarlem und Bosch, Berlin, 1928; as *Geertgen tot Sint Jans and Jerome Bosch* (notes by G. Lemmens), New York, 1969.
Tolnay, Charles de, *Bosch,* Basel, 1937, Baden-Baden, 1965; as *Bosch,* New York and London, 1966.
Baldass, Ludwig von, *Bosch,* Vienna, 1943, New York, 1960.
Combe, Jacques, *Bosch,* Paris, 1946, London, 1947.
Boschere, Jean de, *Bosch et le fantastique,* Paris, 1962.
Delevoy, Robert L., *Bosch,* Geneva, 1960.
Wertheim Aymes, C. A., *Die Bildersprache des Bosch . . . ,* The Hague, 1961; as *The Pictorial Language of Bosch,* Horsham, 1975.
Puyvelde, Léo van, *Die Welt von Bosch und Bruegel,* Munich, 1963.
Gauffeteau-Levy, Marcelle, *Bosch,* Paris, 1965.
Bussagli, Mario, *Bosch,* Florence, 1966, London, 1967.
Cinotti, Mia, *L'opera completa di Bosch,* Milan, 1966; as *The Complete Paintings of Bosch,* New York, 1969.
Linfert, Carl, *Bosch,* Cologne, 1970, New York, 1972.
Reuterswürd, Patrick, *Bosch,* Uppsala, 1970.
Marijnissen, R. H., *Bosch,* Brussels, 1972.
Gibson, Walter S., *Bosch,* New York, 1973.
Snyder, James, editor, *Bosch in Perspective,* Englewood Cliffs, New Jersey, 1973.
Einem, Herbert von, *Zur Deutung des Heuwagentriptychons von Bosch,* Gottingen, 1975.
Fraenger, Wilhelm, *Bosch,* Dresden, 1975, New York, 1983.
Höllander, Hans, *Bosch: Weltbilder und Traumwerk,* Cologne, 1975.
Schuder, Rosemarie, *Bosch,* Vienna, 1975.
Solier, Rene de, and Sandra Orienti, *Bosch,* New York, 1976.
Goertz, Heinrich, *Bosch in Selbstzeugnissen und Bilddokumenten,* Reinbek, 1977.
Jouffrey, Jean-Pierre, *Le Jardin des Délices de Bosch,* Paris, 1977; as *The Garden of Earthly Delights,* Oxford and New York, 1979.
Chailley, Jacques, *Bosch et ses symboles: Essai de décryptage,* Brussels, 1978.
Martin, Gregory, *Bosch,* London, 1978.
Bax, Dirk, *Bosch: His Picture-Writing Deciphered,* Rotterdam, 1979.
Bergman, Madeleine, *Bosch and Alchemy: A Study of the St. Anthony Triptych,* Stockholm, 1979.
Francis, Anne F., *Bosch: The Temptation of St. Anthony,* New York, 1980.
Mulazzani, Germano, *Bosch: Tutti i dipinti,* Milan, 1980; as *Bosch: Every Painting,* New York, 1980; as *Bosch: The Complete Paintings,* London, 1980.
Snyder, James, *Bosch,* New York and London, 1980.
Unverfehrt, G., *Bosch: Die Rezeption seiner Kunst im frühers 16. Jahrhundert,* Berlin, 1980.
Dixon, Laurinda S., *Alchemical Imagery in Bosch's Garden of Delights,* Ann Arbor, 1981.
Hammer-Tugendhat, Daniela, *Bosch: Eine historische Interpretation seiner Gestaltungsprinzipien,* Munich, 1981.
Bax, Dirk, *Bosch und Lucas Cranach: Two Last Judgement Triptychs . . . ,* Amsterdam and Oxford, 1983.
Gibson, Walter S., *Bosch: An Annotated Bibliography,* Boston, 1983.
Myers, Marshall Neal, and Wayne Dynes, *Bosch and the Certitude of Isaiah,* New York, 1987.

articles—

Frankfurter, A. M., "Interpreting Masterpieces: Bosch, Death, and the Miser, ca. 1500," in *Art News Annual, 21*, 1952.

Cuttler, C. D., "Bosch: The Lisbon Temptation of St. Anthony," In *Art Bulletin* (New York), 39, 1957.

Philip, Lotte Brand, "The Peddler by Bosch: A Study in Detection," in *Nederlands Kunsthistorisch Jaarboek* (Amsterdam), 9, 1958.

Rosenberg, J., "On the Meaning of a Bosch Drawing," in *Essays in Honor of Erwin Panofsky*, New York, 1961.

Lennenberg, H. H., "Bosch's Garden of Earthly Delights: Some Musicological Considerations and Criticisms," in *Gazette des Beaux-Arts* (Paris), 58, 1961.

Gerlach, P., "Les Sources pour l'etude de la vie de Bosch," in *Gazette des Beaux-Arts* (Paris), 71, 1968.

Calas, E., "D for Deus and Diabolus: The Iconography of Bosch," in *Journal of Aesthetics and Art Criticism, 27,* 1969.

Cuttler, C. D., "Bosch and the Narrenschiff: A Problem in Relationships," in *Art Bulletin* (New York), 51, 1969.

Gombrich, Ernst, "Bosch's *Garden of Earthly Delights*: A Progress Report," in *Journal of the Warburg and Courtauld Institutes* (London), 32, 1969.

Traeger, J., "Der *Heuwagen* des Bosch und der eschatologische Adventus des Papstes," in *Zeitschrift für Kunstgeschichte* (Munich), 1970.

Boczkowska, A., "The Lunar Symbolism of the *Ship of Fools* by Bosch," in *Oud Holland* (The Hague), 86, 1971.

Libdberg, B., "The Fire Next Time," in *Journal of the Warburg and Courtauld Institutes* (London), 35, 1972.

Filedt Kok, J. P., "Underdrawing and Drawing in the Work of Bosch . . . ," in *Simoilus* (Utrecht), 6, 1972–73.

Gibson, Walter S., "Bosch and the Mirror of Man . . . ," in *Oud Holland* (The Hague), 87, 1973.

Slatkes, Leonard J., "Bosch and Italy," in *Art Bulletin* (New York), 57, 1975.

Gibson, Walter S., "Bosch's Boy with a Whirligig: Some Iconographical Speculations," in *Simiolus* (Utrecht), 8, 1975–76.

Glum, P., "Divine Judgment in Bosch's Garden of Earthly Delights," in *Art Bulletin* (New York), 58, 1976.

Boczkowska, A., "The Crab, the Sun, the Moon and Venus: Studies in the Iconology of The Garden of Earthly Delights," in *Oud Holland* (The Hague), 91, 1977.

Tuttle, V., "Bosch's Image of Poverty," in *Art Bulletin* (New York), 63, 1981.

Dixon, Laurinda S., "Water, Wine, and Blood—Science and Liturgy in the *Marriage at Cana* by Bosch," in *Oud Holland* (The Hague), 96, 1982.

Dixon, Laurinda S., "Bosch's St. Anthony Triptych—An Apothecary's Apotheosis," in *Art Journal* (New York), 44, 1984.

*

Surprisingly little is known about the life of Hieronymus Bosch, one of the most popular painters in the history of art. His date of birth is shrouded in obscurity, and can only be estimated on the basis of a copy of a posthumous portrait in the *Arras Sketchbook* (c. 1550), presumably done shortly before Bosch's death in 1516. It shows a thin, wrinkled man of advanced years whose age in 1516 might conceivably have been 65 or older. On the basis of this evidence, the date of Bosch's birth is assumed to have been c. 1450. Albeit flimsy, the documentation of Bosch's birth date is strong compared to most historical data concerning the painter. Unlike his famous contemporary Albrecht Dürer, Bosch left no letters or writings that might provide clues to the events of his life or the inspiration behind his fantastic imagery. The few biographical facts that exist come from the municipal records of Bosch's home town and the rolls and account books of the Brotherhood Of Our Lady, a confraternity to which he belonged. These tell us that Bosch took his name from his home town of 's-Hertogenbosch, a city known in the 15th century for its cloth industry, organ builders, and bell foundries. His family name, however, was Van Aken, assumed to derive from the German town of Aachen. Bosch's ancestors are traceable beginning in the late 14th century in 's-Hertogenbosch, where they established themselves as a family of painters generations before the birth of Hieronymus. Indeed, Bosch's father Anthonius, at least four uncles, and a brother named Goossen were also artists, though no works from their hands exist today. Scholars assume, therefore, that Hieronymus Bosch (van Aken) must have been trained to carry on the family profession by either his father or one of his uncles.

Hieronymus Bosch first appears in the municipal record of 's-Hertogenbosch in 1474, where he is named with his brothers and sister. The next notice, in 1481, concerns a lawsuit between the painter and his brother-in-law over family property. From this, we learn of Bosch's marriage to Aleyt Goyaerts van den Meervenne, a woman of some financial means. In 1486 Bosch appears for the first time in the membership rolls of the Brotherhood of Notre Dame, an organization whose religious devotions centered around a miracle-working image of the Virgin in the local Church of St. John. The Brotherhood was a large, venerable institution, and was responsible, among other things, for engaging musicians and composers for the church. Records also show that Bosch, his assistants and members of his family were employed in creating works of art for the Brotherhood's chapel. The first recorded date for Bosch's participation on behalf of the confraternity is 1480–81, when he bought the side panels of an old altarpiece owned by the confraternity. Thereafter, he received commissions from the Brotherhood to design a stained glass window (1493–94) and some pieces of church furniture (a crucifix in 1511–12 and a chandelier in 1512–13). Bosch was also consulted in 1508–09 on the polychromy of an altarpiece depicting the Virgin Mary, and he may have done some of the work himself. The last entry concerning Hieronymus Bosch is August 9, 1516, when a funeral mass was said in his honor.

Ironically, all of the projects that Bosch completed for the Brotherhood of Our Lady are now lost, as is the only other documented work by his hand, a "Last Judgement" commissioned by Duke Philip the Handsome in 1504. Doubtless these and many other paintings fell victim to the wave of iconociastic vandalism that swept much of Northern Europe in the 16th century. There exist today only 30 or so works thought to be by Bosch himself, though copies of lost works exist as well as many paintings "in the style of" the master. As the Spaniard

The Human Tree; drawing; Vienna, Albertina

Felipe de Guevara wrote in 1560, most people saw Bosch as an "inventor of monsters and chimeras." Some viewed his fantastic images as vehicles for sinful amusement and titillation. Modern scholars have shown that, in reality, the works of Hieronymus Bosch were intended for an audience schooled in a set of visual and philosophical conventions entirely different from our own. His paintings are full of profound meaning and religious sentiment drawn from the popular wisdom of the 15th and early 16th centuries. Bosch was neither a heretic nor a superficial jokester, a fact confirmed by the esteem that Philip II of Spain, inventor of the inquisition and an arch-conservative Catholic, held for Bosch's works. If Philip had not purloined many of Bosch's paintings from Holland during the Spanish occupation of that country, the remaining works of the master would be far fewer. To this day, Bosch's most important paintings can be seen in Spain, where they are held primarily by museums in the city of Madrid.

The few facts known about Bosch's life are of little use in decoding the complicated messages of his paintings. As a result, some of the modern interpretations of Bosch's iconography are as fantastic as the paintings themselves. Evidently, Bosch's unique imagination produced visual incongruities that cannot be comfortably rationalized within the context of 20th-century experience. As a result, Bosch has been described variously as a worshipper of Satan, a devout Catholic, a naive humorist, and a multi-lingual sage. Scholars have labeled him a psychotic madman, a religious fanatic, a drug addict, a debauched sex fiend, and a Biblical scholar. Netherlandish folklore, witchcraft, astrology, alchemy, Biblical commentaries, and even Freudian psychology have all fueled the controversy surrounding this enigmatic painter. Art historians have found visual models for some of Bosch's images among 15th-century prints, manuscript illuminations, church furniture, and Cathedral sculpture. Scientists have joined the controversy, examining the painting with X-rays and ultra-violet light in an effort to attribute works to the master and chart the development of his style. Many of these methods are yielding fascinating truths about the painter, his patrons, and his method of working. Our current ideas about who Bosch was and what he meant to communicate in his art will certainly change as the work of responsible scholars proceeds.

It is sensible to presume that, like all artists, Bosch was influenced by the concerns of his fellow human beings. Working from this practical assumption, scholars have found keys to much of Bosch's symbolism in the literature of his time. Hundreds of books, for example, were published on the subjects of astrology and alchemy, philosophies now relegated to the realm of the "occult," but which were once practical disciplines essential to late medieval science. The validity of these beliefs was never questioned, for to do so would risk the wrath of God and the Church. In Bosch's time, alchemy was the early science of chemistry, the method by which healing substances were distilled into medicines. The fact that Bosch's wife's family included apothecaries adds further credence to the theory that he could have been more familiar than most with the apparatus and procedures of alchemy. Thus, the medieval alchemical imagery so obvious in Bosch's paintings (i.e., the *Garden of Earthly Delights* in Madrid, and the *St. Anthony* triptych in Lisbon) does not suggest that the painter was a heretic, but that he was a man of his time, aware of current intellectual developments.

Allusions to witchcraft and demonology in Bosch's paintings also reflect the common wisdom of his day, when belief in the devil was essential to proper religious devotion (see the *St. Anthony* triptych, and *The Conjurer,* a copy of a lost work in St.-Germain-en-Laye). Books like the *Malleus Maleficarum* (*Hammer of Witches,* Jacob Sprenger and Heinrich Kramer, Nuremberg, 1494) were practical manuals that told how witches could be identified, brought to trial, and destroyed. Also understandable in the context of the time is the sense of evil and impending doom that permeates many of Bosch's paintings. People were convinced that the destruction of the world was foretold in *Revelations* was immanent. Plague stalked the land and struck the human race at random, giving rise to even greater fear of God's wrath. Thus, Bosch's tortured saints and Passion scenes were intended as Biblical models for emulation, urging viewers, in the manner of Thomas à Kempis, to rise above their worldly pain and imitate Christ in their lives (see the *Saint Jerome* and *Christ Carrying the Cross,* both in Ghent). The harowing hell scenes for which Bosch is best known today must have instilled a deep dread of the consequences of sin in 15th-century viewers (see especially the "Hell" wing of the *Garden of Earthly Delights* triptych).

Bosch drew heavily upon popular folklore and moralizing literature to illustrate the folly of the human race, painting worldly sinners as negative examples of how not to conduct a proper Christian life (see, for example the *Tabletop of the Seven Deadly Sins,* Madrid, Prado; the *Death of the Miser,* Washington; and *Haywain* Triptych and *Stone Operation,* both in the Prado). Bosch was especially unsparing in his depiction of the foibles of monks and nuns under the protection of the Catholic Church. His harsh treatment of the clergy may seem heretical by modern standards, but it does indeed reflect the critical atmosphere of his time. The years preceding Luther's posting of his reforms in 1517 produced many moralistic tirades against the abuses of organized religion, from the learned tomes of Erasmus (*In Praise of Folly,* 1509) to the vernacular rhymes of Sebastian Brant (*The Ship of Fools,* 1494). We know that many convents and monasteries surrounded the town of 's-Hertogenbosch in the 15th century, and that the antics of monks and nuns were a source of irritation to the townspeople. Furthermore, 's-Hertogenbosch was also a center for the lay organization Brothers and Sisters of the Common Life, who practiced the so-called "Modern Devotion." Their aim was to purify and simplify the practice of religion through the imitation of Christ in their daily lives. Thus, Bosch was presented with two opposing forms of religious life in the very town where he lived and worked. Clearly, he sympathized with the Modern Devotion, as the moralizing tone of many of his works demonstrates (see especially *The Ship of Fools,* Paris, and the *Haywain* triptych).

The brief historical record does not indicate if Bosch ever traveled beyond his home town of 's-Hertogenbosch, though a trip to Italy is suggested from the subject matter and details of some of his paintings and the fact that a few of his works are housed in venerable Italian collections (for example, the *Hermit Saints* triptych and the so-called *Altarpiece of St. Julia,* both in Venice, Doge's Palace). Though these works could just as easily have been produced for Italians living in northern Europe, it is not beyond the realm of possibility that Bosch, who attained some measure of fame during his life, traveled

beyond the narrow boundaries of the Duchy of Brabant in connection with the business of painting. The fact remains that we do not know for whom Bosch painted his fascinating pictures. It is highly unlikely, however, that they illustrate any secret heretical or moral purposes beyond those recognized by any literate, devout Christian of the 15th century. Bosch was a man of his time, deeply involved with the religious and moral concerns of his fellow human beings. His works, however, are timeless, and seem to speak in a special way to the troubled 20th century. The inventive imagination of Hieronymus Bosch continues to intrigue all who view his paintings, and is a continuing source of inspiration for modern artists, authors, and composers.

—Laurinda S. Dixon

BOSSCHAERT, Ambrosius.

Born in Antwerp, 1573. Died in the Hague, 1621. Married Maria van der Ast, 1604; three sons, the painters Ambrosius the Younger, Johannes, and Abraham. Trained in Antwerp; recorded in Middleburg, c. 1593-1613; also worked in Bergen op Zoom, Utrecht, and Breda; one of the first flower painters (with Osias Beert and Clara Peeters); also an art dealer (dealt in paintings by the German still-life painter Georg Flegel). Pupil: his brother-in-law Balthasar van der Ast.

Major Collection: The Hague: Mauritshuis.
Other Collections: Amsterdam; Copenhagen; Cleveland; Detroit; Oxford; Pasadena; Stockholm: Hallwylska; Tours; Vienna; Paris.

Publications

On BOSSCHAERT: book—

Bol, L. J., *The Bosschaert Dynasty: Painters of Flowers and Fruit,* Leigh-on-Sea, 1960.

*

The career of Ambrosius Bosschaert was essentially peripatetic, ranging from his obscure origins in Antwerp to his fruitful stay in Middelburg, his transfer to Utrecht, and finally The Hague. Records of these movements are of little help to the historian because the artist did not change his style as he moved and grew older. He evolved his very personal form of still-life painting under the obvious influence of the Bruegel dynasty in Antwerp but gave it a new character. Bosschaert's contribution to the development of Dutch flower painting was a crystalline clarity which was never equalled. This approach he applied both to his flowerpieces and to his much rarer studies of shells. (He also sometimes includes a shell or two on a niche near a vase of flowers.)

Not all of Bosschaert's pictures were directly observed from nature; they were worked up from elaborate studies which meant that flowers which bloom at different seasons are usu-ally included in the same composition. (Nor was each one drawn afresh for each picture—which goes some way to explain the fact that his style hardly changed.) So restricted was the artist's approach that his flowerpieces fall into two clearly defined categories. The first follows the Bruegel tradition by placing the brilliantly coloured flowers against a plain dark background. The second, more adventurous and innovative, shows the flowers set against a pale blue sky usually seen through a dark niche. This treatment has the effect of intensifying the brilliance of the flowers to a nearly hallucinatory degree. The artist also liked to include such creatures as grasshoppers and beetles almost as if they were deliberate displays of technical skill.

In spite of his brilliance, the influence of Ambrosius Bosschaert was relatively limited. His sons never came up to his standard, and only the Delft painter Balthasar van Ast was able to assimilate Bosschaert's special approach to each individual flower.

Bosschaert's surviving output is remarkably limited, and the handful in public collections is paralleled by equally restricted holdings in the private sector.

—Christopher Wright

BOTTICELLI.

Born Alessandro di Mariano Filipepi in Flornece, 1445. Died in Florence, 17 May 1510. Probably a pupil of Fra Filippo Lippi, 1465-67, and influenced by the Pollaiuoli brothers and Verrocchio; set up his own shop in Florence by 1470: many commissions for the church and for Lorenzo di Pierfrancesco de Medici and Lorenzo the Magnificent; worked on Sistine Chapel in Vatican, 1481-82. Pupil: Filippino Lippi.

Major Collections: Florence: Uffizi.
Other Collections: Bergamo; Berlin; Boston: Museum of Art, Gardner; Cambridge, Massachusetts; Carrara; Chicago; Florence; Pitti, S. Martino; London; Milan: Ambrosiana, Poldi Pezzoli; Munich; New York; Paris: Louvre, Jacquemart-André; Philadelphia; Vatican: Sistine Chapel; Washington.

Publications

On BOTTICELLI: books—

Warburg, Aby, *Botticellis "Geburt der Venus" und "Frühling,"* Leipzig, 2 vols., 1892-93.
Ulmann, Hermann, *Botticelli,* Munich, 1893.
Streeter, A., *Botticelli,* London, 1905.
Horne, Herbert P., *Botticelli, Painter of Florence,* London, 1908.
Supino, I. B., *Botticelli,* 1908.
Binyon, Laurence, *The Art of Botticelli,* London, 1913.
Bode, Wilhelm von, *Botticelli,* Berlin, 1921, London, 1925.
Venturi, Aldolfo, *Il Botticelli interprete di Dante,* Milan, 1921.

Bode, Wilhelm von, *Botticelli: Des Meisters Werke*, Stuttgart, 1926.

Venturi, Aldolfo, *Botticelli*, Rome, 1926, London, 1927.

Gamba, Carlo, *Botticelli*, Milan, 1936.

Venturi, Lionello, *Botticelli*, New York, 1937, Vienna, 1949, New York, 1961.

Mesnil, Jacques, *Botticelli*, Paris, 1938.

Bettini, Sergio, *Botticelli*, Bergamo, 1942, 1947.

Bardi, P. M., *La Primavera*, 1953.

Bertini, Aldo, *Botticelli*, Milan, 1953.

Hartt, Frederick, *Botticelli*, New York, 1953.

Pucci, Eugenio, *Botticelli nelle opere e nella vita del suo tempo*, Milan, 1955.

Argan, Giulio Carlo, *Botticelli*, Geneva and New York, 1957.

Chastel, André, *Botticelli*, Milan and Greenwich, Connecticut, 1958.

Lauts, Jan, *Botticelli: Die Geburt der Venus*, 1958.

Salvini, Roberto, *Tutta la pittura del Botticelli*, Milan, 2 vols., 1958; as *All the Paintings of Botticelli*, New York, 4 vols., 1965.

Becherucci, Luisa, *Botticelli: La Primavera*, Florence, 1965.

Mandel, Gabriele, *L'opera completa di Botticelli*, Milan, 1967; as *The Complete Paintings of Botticelli*, New York 1969, London, 1970, 1985.

Clark, Kenneth, *The Drawings of Botticelli for Dante's Divine Comedy . . .* , New York and London, 1976.

Ettlinger, Leopold D., and Helen S., *Botticelli*, London, 1976, New York, 1977.

Santi, Bruno, *Botticelli*, Florence, 1976, London, 1979.

Hatfield, Rab, *Botticelli's Uffizi "Adoration": A Study in Pictorial Content*, Princeton, 1976.

Legouix, Susan, *Botticelli*, New York and London, 1977.

Stella, Maria Carmela, *Le adorazioni dei magi e la natività mistica di Botticelli*, Lanciano, 1977.

Lightbown, Ronald, *Botticelli*, Berkeley and London, 2 vols., 1978.

Angelis, Rita de, *Botticelli*, Milan, 1979; as *Botticelli: The Complete Paintings*, London, 1980.

d'Ancona, Mirella Levi, *Botticelli's Primavera: A Botanical Interpretation Including Astrology, Alchemy, and the Medici*, Florence, 1983.

Baldini, Umberto, *La Primavera del Botticelli: Storia di una quadro e di un restauro*, Milan, 1984; as *Primavera: The Restoration of Botticelli's Masterpiece*, New York, 1986.

Cheney, Liana, *Quattrocento Neoplatonism and Medici Humanism in Botticelli's Mythological Paintings*, Lanham, Maryland, 1985.

Meltzoff, Stanley, *Botticelli, Signorelli, and Savonarola: "Theologia Poetica" and Painting from Boccaccio to Poliziano*, Florence, 1987.

articles—

Gombrich, E. M., "Botticelli's Mythologies," in *Journal of the Warburg and Courtauld Institutes* (London), 8, 1945.

Dempsey, Charles, "Botticelli's Three Graces," in *Journal of the Warburg and Courtauld Institutes* (London), 34, 1971.

Shearman, John, "The Collections of the Younger Branch of the Medici," in *Burlington Magazine* (London), 117, 1975.

*

In his lifetime, Botticelli was considered one of the greatest painters of Florence, a second Apelles, according to the humanists of the day. Even in 1502 he was held as one of the premier painters of Italy by Isabella d'Este, engaged in a search for the best artists to decorate her famed *studiolo*. With the High Renaissance, Botticelli's reputation soon fell into eclipse, and he was thought to be old-fashioned even before his death in 1510. It is ironic that Vasari in both editions of his *Lives* continued this assessment of Botticelli, especially since his paintings contain many characteristic that anticipate mannerist developments in the later sixteenth century. Until the last years of the eighteenth century, when English buyers began purchasing his paintings, Botticelli's reputation lay fallow. Under the influence of a general antiquarianism, the Italian "primitives" became fashionable. The interest blossomed during the nineteenth century, when A. F. Rio, the exponent of neo-Catholicism and the person who first showed the Sistine frescoes to Ruskin, became the catalyst for a Botticelli revival. The Pre-Raphaelites and later *fin-de-siècle* critics and artists, like Pater, also gravitated to the bittersweet, suggestive world of Botticelli's melancholic grace. In 1893, H. Ulmann's first art historical monograph on the artist, following close on the heels of A. Warburg's seminal studies, initiated the flood of literature on the artist.

Little is documented about Botticelli's private life. Born around 1444 or 1445 to Mariano di Filipepi, he probably acquired his surname from his endest brother Giovanni, nicknamed "Il Botticello" on account of his rotund physique, who appears to have become head of the family. Another family document of about 1457/8 significantly states that Alessandro was sickly and studying, unlike other boys destined for an art career, who usually began their apprenticeships at 10 or 11 years of age. Thus, Botticelli was better educated than most artists of his time and even may have read Latin. This knowledge is important in order to understand both the intellectual, abstract nature of his paintings and the patrons and commissions he attracted. Botticelli's first artistic training was with a goldsmith, perhaps his brother Antonio. The goldsmith shop, the crucible of good Florentine design and the frequent background for sculptors and painters in Florence, predisposed his art toward a strong linearity and a decorative orientation.

His official painting master was Fra Filippo Lippi, from whom he absorbed a lyrical approach to themes of the Virgin and Child and who reinforced the decorative tendencies in his art that were so much in demand in Florence during the last third of the century. He was with Lippi from the early sixties, so that the first traces of Botticelli's hand are to be found in the Prato Cathedral frescoes. When Lippi left for a commission in Spoleto in 1467, Botticelli began his more or less independent existence. After Lippi's departure, he has been associated traditionally with Andrea del Verrocchio and Antonio del Pollaiuolo, links borne out in certain aspects of his paintings, although no documentary evidence exists for any formal liaison. When Lippi died in 1469, his son Filippino went into Botticelli's workshop where he was to stay until as late as 1481.

Perhaps Botticelli's earliest extant independent painting is the horizontal *Adoration of the Magi* (London, National Gallery). It, like the *Judith* and *Holofernes* panels (Florence, Uffizi), reveals his skill in delicate, small scale works, which betray his indebtedness to the goldsmith tradition. By 1470,

Nativity; drawing; Florence, Uffizi

Botticelli had established a studio of some repute and perhaps even Medici support, because the Mercanzia commission for seven Virtues, originally given to Piero Pollaiuolo, was bestowed upon Botticelli, who only executed one of the two remaining panels, the *Fortitude* (Florence, Uffizi). In this large scale figure Botticelli's poetry and vivacity, as opposed to Pollaiuolo's prose is clearly established, as are his exquisite draughtsmanship and rhythmic contour lines. From the early period, when he was most tied to the naturalistic goals of the fifteenth century, date the greatest number of his few extant portraits. A distinctive example is the *Man with a Medal* (Florence, Uffizi) with its gessoed medal of Cosimo de'Medici *Pater Patriae*. It already intimates Botticelli's tendency to exaggerate proportions and linear contours.

During this early phase, Botticelli seems to have captured the patronage of both branches of the influential Medici family as well as their associates. The first definite record dates from 1475, when he fashioned the no longer extant standard with Pallas for the joust of Giuliano, the brother of Lorenzo the Magnificent. Guiliano was killed in the Pazzi conspiracy of 26 April 1478, and subsequently Botticelli was commissioned to paint the effigies of eight of the conspirators for public ridicule on the facade of the Dogana. Later, he painted the Lami *Adoration of the Magi* (Florence, Uffizi) which contains at the right of the composition portraits of the patron, Guaspare Lami, Lorenzo de'Medici, and his own self-portrait, as well as portraits of three deceased Medici as the Magi and thus the three ages of man at the center (Cosimo, Lorenzo's grandfather, his son Piero, and Guiliano). Botticelli's early period is

capped off by his large fresco *St. Augustine* for the Ognissanti Church. It depicts the Bishop of Hippo experiencing a vision, revealing the ecstatic potential of Botticelli's art. In this year he is also responsible for designing 19 illustrations for the Neoplatonist Cristoforo Landino's commentary on the *Divine Comedy* of Dante. This is the first evidence of the artist's life-long connection with Dante, whose imagery and thought was to permeate his oeuvre, and with Neoplatonism, whose ephemeral doctrines are difficult to connect specifically with works of art. It also marks Botticelli's first contact with his most significant patron, Lorenzo di Pierfrancesco de'Medici, cousin of Lorenzo the Magnificent, who paid for the cost of printing and publishing Landino's commentary.

Between 1481 and 1482 Botticelli made his only lengthy sojourn from Florence, travelling to Rome to paint three fresco scenes from the life of Moses and a series of popes on the walls of the Sistine Chapel for Pope Sixtus IV. While painting this prestigious commission in the Eternal City, Botticelli became enamoured of ancient works of art, so much so in fact, that he embedded a reference to at least one in all the paintings he executed there. For example, in the *Temptation of Moses* the figure examining his foot is based on the Roman bronze sculpture of the thorn puller (*Spinario*), while in the *Punishment of Korah* one notices two important ancient Rome buildings as they appeared in the fifteenth century—not only the no longer extant Septizonium but also a magnificent, archaeologically correct rendition of the Arch of Constantine. In his *Adoration of the Magi* (Washington, D.C., National Gallery of Art), the groom restraining a rearing horse is based on Botti-

celli's study of the famous Dioscuri. Moreover, during the artist's Roman stay his compositions began to display a new breadth and compositional solidity.

Upon returning to Florence, Botticelli's career flourished. He continued to produce devotional works and altarpieces as well as images to please the increasingly courtly society of Florence with their growing secular tastes for paintings based on the maturing and humanist learning. His *Primavera* (Florence, Uffizi)—probably painted just before his Roman trip for Lorenzo di Pierfrancesco's marriage—is a visual essay on love and Spring based on ancient ideas. He continued this type of allegory in the so-called *"Pallas and the Centaur"* (Florence, Uffizi), c. 1484, documented in the same room of Lorenzo di Pierfrancesco as the *Primavera*. It too illustrates a secular theme with Medicean symbolism that is not so far removed from heraldry. The *Birth of Venus* (Florence, Uffizi), which dates slightly later in the 1480's, is a significant watershed not only in Botticelli's career, but in the Renaissance. Unusual for Botticelli because it is painted on canvas, the work may be an actual recreation of a lost painting from antiquity by Appelles, whose general description was preserved in classical texts and also was mentioned by Alberti in his treatise *On Painting*. A passage in Poliziano's poem *Stanze per la Giostra* has also been suggested as its literary source. Like the less broadly painted *Primavera*, it contains a number of literary and visual quotations from ancient works of art—e.g., the *venus pudica* covering her genitals and the intertwined Zephyr and Chloris from the so-called "Tazza Farnese" cameo. Botticelli's *Mars and Venus* (London, National Gallery) was also most likely a decorative commission to celebrate a marriage. Its subject is a Neoplatonic allegory of Love (Venus) conquering Strife (Mars), appropriately suggestive for a bedchamber. Its frolicking satyrs are taken directly from Lucan's description of an ancient painting. Botticelli seems to have specialized in these conceits, because even later, c. 1492–94, in his over-burdened allegory the *Calumny of Appelles,* another recreation of a lost painting from antiquity (from Lucian's *De calumnia*), he embedded yet another reconstruction of a lost Greek painting of a satyr family by Zeuxis. During these years Botticelli is also recorded as participating in the unfortunately lost frescoes for Spedaletto, one of the villas of Lorenzo the Magnificent.

Botticelli also executed some of his most important religious paintings during this decade. He painted a number of large scale altarpieces like the now destroyed *Bardi Altarpiece,* c. 1485, for Santo Spirito, filled with intricate plant symbolism that one scholar has allied to the current theological debate regarding the Immaculate Conception of the Virgin. Later, he painted the main altarpiece for the church of San Barnaba, founded by the Florentine republic and then administered by Botticelli's own guild, the Arte dei Medici e Speziali, with its inscription from Dante's *Paradiso* on the base of the Virgin's throne: *VERGINE.MADRE./FIGLIA.DELTVO./FIGLIO.* With the *Annunciation* for Cestello (S. M. Maddelena dei Pazzi), 1489–90, Botticelli's forms start to become more abstract, and his figures bend and sway in a rhythmical excitement that suggests a kind of internal frenzy. A parallel development occurs in his *tondi,* paintings in round formats. Of all the painters who executed *tondi,* perhaps Botticelli was the most prolific, if one includes the *tondi* produced by his shop. Not only was he predisposed to the form because of his lyrical, decorative inclinations, but also he produced the most integrated composi-

tions within the difficult constraints of the shape, for example his *Madonna of the Pomegranate* (Florence, Uffizi). In addition, the abstract content of his works complemented the geometrical format of the *tondo,* best seen in his *Madonna of the Magnificat* (Florence, Uffizi), and the *Madonna of the Baldacchino* (Milan, Ambrosiana).

The 1490's were troubled times for Florence. Even before the 1492 death of Lorenzo the Magnificent there were religious, economic, and political rumblings. At the same time, the Dominican preacher Savonarola was thundering about religious reform from the pulpit. When Lorenzo died, succeeded by his weak son Piero, the controlling influence that held the delicate equilibrium in check was lost. Soon after, in 1494, Charles VII of Florence invaded Florence, actually occupying the Medici Palace; it was no wonder that he was viewed as the Antichrist incarnate. Subsequently, the Medici branch of Lorenzo the Magnificent went into exile, while that of Lorenzo di Pierfrancesco, Botticelli's major patron, supported the republican cause and continued to patronize the artist. There is evidence to believe that Botticelli's political sympathies were in the same direction. It was during the 1490's that Botticelli began, among other commissions, his large illustrations for Dante's *Commedia* for Lorenzo di Pierfrancesco that he probably worked on with a personal commitment until his death in 1510, long after his patron's passing in 1503. Later in the decade, first Louis XII of France and then Cesare Borgia threatened Florence, seeming to fulfill Savonarola's prophecies.

During the middle 1490's, when commissions in Florence were no doubt more difficult to come by, Botticelli produced a number of small works that seem to reflect the tenor of the times. One secular subject, the *Calumny of Appelles* (Florence, Uffizi), contains a moral fervor and agitated mood that dominates the complicated humanist program cast in an antiquarian vein. His small panels depicting *St. Augustine in His Cell* (Florence, Uffizi), the *Last Communion of St. Jerome* (New York, Metropolitan Museum of Art), and the *Agony in the Garden* (Granada, Capilla de los Reyes) reveal the deep religiosity of the Florentine environment.

Vasari first suggested that the changes apparent in Botticelli's art was due to the fact that he was a follower of Savonarola. Nineteenth-century writers naturally inflated the association. Certainly, Savonarola exerted a strong impact on Florence during the tumultuous, unstable late Quattrocento that extended even beyond his excommunication and burning at the stake in 1498. However, while one of Botticelli's brothers, Simone, was an ardent and renowned *piagnone* (a follower of Savonarola meaning weeper), there is no direct evidence that Botticelli too was affiliated directly with Savonarola. In fact, the extant evidence suggests that he was not a follower. In addition, from what is known about his personality, Botticelli was neither a joiner of groups nor the kind of person to keep quiet about his beliefs. It has even been suggested that Vasari confused the artist with his *piagnone* brother, who was a collector of books including a commentary on Dante and with whom Botticelli was in close association during his later life. But the ascendency of millenarian ideas with its hopes for the renewal of the Church expressed by the Dominican and other individuals did not fail to influence Botticelli and his art. Probably nothing and no one alive in Florence during the decade of the nineties escaped the influence of Savonarola, bound up closely

with the cause of republicanism. This tendency is seen most noticeably in the *Mystic Crucifixion* (Cambridge, Fogg Art Museum) and the *Mystic Nativity* (London, National Gallery). Although he might have been sympathetic to ideas of Savonarola, it is possible, however, to state that Botticelli was definitely not an overt *piagnone* like his brother Simone and never was connected publicly to the cause. There are a number of documents that argue the case strongly. For example, Botticelli's name is not among the 363 signatures on a petition to pardon Savonarola that are also recorded in Simone's chronicle of 1503. Moreover, it is telling that Simone, writing when it had become fashionable again to demonstrate an association with Savonarola, did not mention his brother, a respected citizen of the city, as a supporter of Savonarola. There is also a conversation recorded between Botticelli and Doffo Spini, one of the men who condemned the Dominican preacher to death, which reveals that while Botticelli was interested in the issue of Savonarola's innocence he was not a dogmatic follower and even entertained one of Savonarola's persecutors in his studio.

Botticelli's later works include several secular paintings which are directly associated with overt republican statements and are appropriate for the epoch after the Medici expulsion and the re-establishment of the republic. Two panels, once perhaps part of a larger series to decorate a room, illustrating the *Story of Virginia* (Bergamo, Accademia Carrara) and the *Story of Lucretia* (Boston, Gardner Museum) each contain a republic theme about a virtuous female role model based on Livy's account of republican Rome. Their associations with contemporary Florence are quite graphically shown in the Lucretia panel with a statue of David, a relief of Judith, and perhaps a view of Florence and the Arno in the background. The acidic colors, frenzied motion, and grainy texture of the pigment in the two words are characteristic of Botticelli's late style about 1505, perhaps assisted in these panels. In his late period, Botticelli, one of the supreme decorative artists in the history of art, often went beyond the confines of a conventional theme, infusing it with new poetic meaning. His paintings, while not longer filled with lyrical power, reach a novel intense, expressive dimension.

—Roberta J. M. Olson

BOUCHARDON, Edmé.

Born in Chaumont en Bassigny, 29 May 1698; son of the sculptor and architect Jean-Baptiste Bouchardon; brother of the sculptor Jacques-Philippe Bouchardon. Died in Paris, 27 July 1762. Trained as a sculptor under Guillaume Coustou the Elder, 1721–23; received the Prix de Rome, and lived and worked in Rome, 1723–32: copied antiques, and also had important commissions; returned to France and had rooms at the Louvre; then worked at Versailles; best known for the Four Seasons Fountain, Paris, 1739–45; his equestrian statue of Louis XV in the Place de la Concorde, 1763, was destroyed in 1792; member and professor, Royal Academy; his drawings and designs were highly admired, and prints were made of them (large collection in the Louvre).

Collections: Bayonne; Berlin; Besançon; Dijon; Florence: Galleria Corsini; Leningrad; London: British Museum; Paris; Troyes; Valenciennes; Versailles.

Publications

On BOUCHARDON: books—

Roserot, Alphonse, *Bouchardon,* Paris, 1910.
Colin, Odile, editor, *Bouchardon* (cat), Chaumont, 1962.

articles—

Parker, K. T., "Bouchardon's Cries of Paris," in *Old Master Drawings* (London), December 1930.
Duclaux, Lise, "La Statue équestre de Louis XV: Dessins de Bouchardon, Sculpteur du Roi," in *Revue du Louvre* (Paris), 22, 1972.
Ames, Winslow, "Bouchardon and Company," in *Master Drawings* (New York), Winter 1975.
Campbell, Richard J., "The Sculptor as Draftsman: Three French Neoclassical Drawings," in *Minneapolis Institute of Arts Bulletin,* 65, 1981–82.
Jordan, Marc, "Bouchardon: A Sculptor, A Draughtsman, and His Reputation in Eighteenth-Century France," in *Apollo* (London), June 1985.

*

Edmé Bouchardon was born into a family of artists at Chaumont, near Troyes, trained in the family workshop, and completed his training in Paris under Guillaume Coustou the Elder, the most important sculptor of the time, heir to the tradition established by his uncle Coysevox. In 1723, Bouchardon won the Academy's Grand Prix with a bas-relief, *Gideon Choosing His Soldiers According to Their Way of Drinking.* The prize included a time for study in Rome, and Bouchardon left for Italy with his fierce rival, Lambert-Sigisbert Adam.

Rome proved a revelation. Bouchardon won the esteem of the Directors of the French Academy, the Corsini family, and important art lovers, and enjoyed a real career in Rome. The starting point of his success there was his copy of a classical *Sleeping Faun* (Louvre) for the king. He also did two superb marble miniatures of the *Faun with Kid* and the *Faun with Flute* (Potsdam, Neues Palais).

In the course of frequenting antique art collectors, Bouchardon came to meet the most famous among them, Baron Philip von Stosch, and produced a marble bust of him in 1727 (Berlin-Dahlem). Stosch is given a heroic Roman look: he has short hair, a bare torso, and a garment draped over his left shoulder. The sculptor repeated this design for the marble bust of *John Lord Hervey* (1729, Melbury House). These two portraits are among the first known neo-classical works, contemporaries of those executed in England by Rysbrack and Roubiliac. Bouchardon's project for a portrait of the *Prince de Waldeck,* which is known from two drawings in the Louvre, is an astonishing prefiguration of the aesthetic which involved the transformation of illustrious personages into classical heroes which developed in France during the last third of the 18th century, and continued up until the time of David d'Angers.

The sculptor was finally lured back to France in 1732 by insistent offers of patronage from the Duke of Antin, and he was immediately given rooms in the Louvre. In 1733, he received his first royal commission: a statue of Louis XIV for the choir of the cathedral of Notre-Dame, to replace Coysevox's, which was no longer in favour. Bouchardon completed the terracotta and plaster models, but, feeling little inspired by the subject, never made the marble version. In 1734, Bouchardon received a long-term commission: the execution in Tonnerre stone of 24 monumental statues to be installed on corbels in the nave and choir of Saint-Sulpice. In fact, only ten statues were completed—*Christ at the Pillar,* a *Dolorous Virgin,* whose head alone emerges out of a shroud of cloth, and eight splendidly draped apostles, executed by Bouchardon's pupils. In style, the group is reminiscent of Italian baroque pieces at St. John Lateran and in Siena cathedral.

Bouchardon shared his second royal commission with Adam. They had to provide the Minister of Justice, Chauvelin, with two stone groups (now disappeared) for his residence at Grosbois. Bouchardon produced an *Athlete Taming a Bear,* Adam a *Hunter Fighting a Lion.* Bouchardon denigrated the work of his rival and in 1737 exhibited at the Salon two terracotta models representing the two subjects (Leningrad), soon to be turned into popular engravings.

Monumental simplicity is evident in a work of impeccable single-mindedness, the bas-relief *Procession of St. Charles Borromeo* (1737–47; bronze, Versailles, Chapel), but it is most apparent in his masterpiece, the fountain in the Rue de Grenelle. Commissioned in Paris in 1739 by the town magistrates (completed in 1745), this is the key work of Bouchardon's classicism. He was responsible for the architecture of the fountain—a monumental pediment of vast proportions, extended by curvilinear wings—and for its decorative sculpture: the *City of Paris,* accompanied by the *Seine* and the *Marne* (all in marble), stands at the centre of the composition, flanked by four adolescent *Génies* and four narrative reliefs (*Children's Games*) in Tonnerre stone, representing the *Seasons.* The fountain's winged genies reflected the current preoccupations of the artist, who was due to execute for the king a particularly ambitious work, *Love Using Mars's Weapons to Make Himself a Bow from Hercules's Club.* Bouchardon executed a great number of preparatory drawings from his living model, made several plaster versions, and also made casts from living human bodies in an attempt to study nature more closely. The marble version (1747–50; Louvre) attracted the scorn of the Court, disturbed as by a vision of a young adolescent with an unformed body and features lacking all trace of idealism, a *Love as a Street Urchin.*

The work to which Bouchardon devoted the last years of his life was a major project: an equestrian statue of Louis XV commissioned by the magistrates of Paris. The king offered the city the plot of land (the current Place de la Concorde) on the condition that the statue be placed on the axis of the main walkway of the Tuileries and the Champs-Elysées. Bouchardon executed a number of studies from nature in order to familiarize himself with the anatomy of the horse. After producing a wax sketch (miraculously still in existence: Besançon), he made a clay model of medium height, then a plaster model the size of the eventual statue. Louis XV was represented in classical dress, seated on a walking horse, in conformity with the classical *Marcus Aurelius* in Rome. The statue was successfully cast in one piece in May 1758, thanks to the skill of the founder Pierre Gor. Bouchardon died before the statue was erected (1763), but before he died he designed the pedestal on which four caryatids (*Strength, Love of Peace, Prudence,* and *Justice*) were to frame two narrative bas-reliefs illustrating the king's conquests and his love of peace. Three days before his death, he requested that Pigalle complete his monument, a fine example of the mutual regard that existed between them. The monument was destroyed in 1792 by hordes of revolutionaries. A few fragments (Louvre) and some fine miniatures by Vassé and Pigalle (Louvre, Versailles, and Windsor Castle, in particular) are all that remain to remind us of it.

—Guilhem Scherf

BOUCHER, François.

Born in Paris, 29 September 1703; son of the decoration and embroidery draftsman Nicolas Boucher. Died in Paris, 30 May 1770. Married Marie Anne Buseau, 1733; one son, Juste, an architect and decorator, and two daughers. Worked in the studio of the decorator François Lemoyne and of the engraver Jean François Cars; in Rome with Charles van Loo, 1727–31; friend and protégé of Mme. de Pompadour: succeeded Oudry as director of the Gobelins tapestry works; member of the Academy, 1734 (director, 1765); appointed Premier Peintre du Roi, and lived in Louvre after 1752; very productive: variety of designs for tapestries and porcelain, as well as paintings. Pupils: Fragonard, Jean Baptiste Deshays, Pierre Antoine Baudouin (the latter two married his daughters).

Major Collections: London: Wallace; Paris.
Other Collections: Amiens; Boston; Cambridge; Fontainebleau: Château; Fort Worth; London: National Gallery, Kenwood; Manchester; Munich; New York; Orleans; Paris: Banque de France; San Marino, California; Stockholm; Waddesdon Manor.

Publications

On BOUCHER: books—

Goncourt, Edmond and Jules, *Boucher,* Paris, 1862; revised version in *L'Art du XVIIIe siècle,* 1880.

Michel, André, *Boucher,* 1889; revised edition, with catalogue raisonné by L. Soulier and Ch. Masson, 1906.

Kahn, Gustave, *Boucher,* Paris, 1904.

Pollard, Eliza F., *Greuze and Boucher,* London, 1904.

Nolhac, Pierre de, *Boucher,* Paris, 1907, 1925.

Macfall, Haldane, *Boucher: The Man, His Times, and His Significance,* London, 1908.

Hind, Arthur M., *Watteau, Boucher, and the French Engravers and Etchers of the Earlier Eighteenth Century,* New York, 1911.

Bearne, C. M., *A Court Painter and His Circle: Boucher,* London, 1913.

Landscape Near Beauvais; drawing; Amsterdam, Rijksprentenkabinett

Fenaille, Maurice, *Boucher,* Paris, 1925.

Reau, Louis, *Dessins de Boucher,* Paris, 1928.

Bloch, Maurice, *Boucher and the Beauvais Tapestries,* Boston, 1933.

Hullenbroek, A., *Boucher,* Paris, 1937.

Mac Innes, Ian, *Painter, King, and Pompadour: Boucher at the Court of Louis XV,* London, 1965.

Ananoff, Alexandre, *L'Oeuvre dessiné de Boucher,* vol. 1, Paris, 1966.

Jean-Richard, Pierette, *Boucher: Gravures et dessins* (cat), Paris, 1971.

Slatkin, Regina Schoolman, *Boucher in North American Collections,* Washington, 1973.

Ananoff, Alexandre, and Daniel Wildenstein, *Boucher,* Lausanne, 2 vols., 1976.

L'Oeuvre gravé de Boucher dans la collection Edouard de Rothschild, Paris, 1978.

Ananoff, Alexandre, and Daniel Wildenstein, *L'opera completa di Boucher,* Milan, 1980.

Brunel, Georges, *Boucher* (cat), Paris, 1986; English-language version by Alastair Laing et al., New York and London, 1987.

articles—

Slatkin, Regina Schoolman, "Portraits of Boucher," in *Apollo* (London), October 1971.

Slatkin, Regina Schoolman, "Some Boucher Drawings and Related Prints," in *Master Drawings* (New York), 10, 1972.

Bordeaux, Jean-Luc, "The Epitome of the Pastoral Genre in Boucher's Oeuvre: *The Fountain of Love* and *The Bird Catcher* from *The Noble Pastorale,*" in *Getty Museum Journal* (Malibu), 3, 1976.

Hiesinger, Kathryn B., "The Sources of Boucher's *Psyche* Tapestries," in *Bulletin of the Philadelphia Museum of Art,* November 1976.

Slatkin, Regina Schoolman, "The Fêtes Italiennes: Their Place in Boucher's Oeuvre," in *Metropolitan Museum Journal* (New York), 12, 1977.

Standen, Edith A., "Fêtes Italiennes: Beauvais Tapestries after Boucher in the Metropolitan Museum of Art," in *Metropolitan Museum Journal* (New York), 12, 1977.

Standen, Edith A., "The *Amours des Dieux:* A Series of Beauvais Tapestries after Boucher," in *Metropolitan Museum Journal* (New York), 19-20, 1986.

Goodman-Soellner, Elise, "Boucher's *Madame de Pompadour at Her Toilette,*" in *Simiolus* (Utrecht), 1987.

*

The middle years of the century rightly belong to Boucher as the focal French Rococo artist. Creator of a regal realm—whether mythic, genre, landscape at times religious—seemingly untouched by mundane concern, he created images which are often surprisingly resonant with a fragile immediacy. That this was due to his well-known genial and unprepossessing humanity is clear; also, through his surpassing facility, Boucher came young, by age 19, to the graphic workshop of

Laurent Cars, where he actively worked as engraver on the publication of the graphic work of Watteau. These four volumes, which preserved the major pictures and drawings of the master, were the other substratum upon which Boucher's artistic outlook was founded. Even as late as 1734, when he had returned from three years in Italy and his public career had begun, Boucher still preserved—in the face of his absorbed Italianate grand manner—his understanding of Watteau's evanescent world in the compositions which he made for the 6-volume edition of Molière's works, engraved by Cars. His genre scenes at this time, such as the characteristic *Le Dejeuner,* 1739 (Paris, Louvre), show his strong feel for Dutch art, yet his apparent desire was for a career close to the Crown which his ability easily sustained in the fantasies of decoration based upon a mix of a Rubens-Venetian idiom, such as *Venus Requesting Vulcan for Arms for Aeneas,* 1732 (Louvre). Boucher's father, a minor painter, had instilled such ambition and took the teen-age boy to François Lemoyne for apprenticeship. Boucher remained with him only a short while, but Lemoyne's work in the 1720's is strangely proto-Boucher in its ease and naturalness before the landscape and nude, and in its brilliant, decorative coloration. Boucher's own energy and sheer skill in this realm were early recognized so that he was chosen in 1734 by Jean-Baptiste Oudry as designer for the tapestry manufactory at Beauvais. The cartoons with their often astonishing virtuosity—a surmise based upon small sketches and the existing tapestries since the weaving process at Beauvais destroyed the model—were used by the craftsmen for their woven images; and for the following 35 years, the looms, centering about six major series including *The Fêtes Italiennes* and the famous Chinese set, seldom produced work designed by anyone else. Boucher became the Tiepolo of French art—the grand decorator. Later, in the 1750's, among his accumulating honors even as his idiom fell out of step with the increasingly classicizing moment, Boucher became the director of the Gobelins manufactory.

Already having worked at Versailles, in the Queen's apartments, Boucher began to work for Madame de Pompadour, the Mistress to Louis XV, only in 1750. Even with such engrossing yet indulgently luxurious works associated with her patronage such as *The Toilet* and *The Bath of Venus,* both 1751 (New York and Washington), two were considered masterpieces from the moment of their completion, *The Rising* and *The Setting of the Sun,* 1752 (London, Wallace Collection). Like many of the large-scale extravagant mythic works of the previous two decades, they are nonetheless marked by warmth and this-worldly details—the tying of Apollo's sandals and the charming bodies of the naiads; and amidst the virtuosic sweep of the natural forces of water and light, there is the poignance of the reference to the romance, already then past, the Pompadour and Louis XV. In these two works, and others such mythic-peopled images where earth, air, and water meet—such as the *Birth of Venus,* 1740 (Stockholm), Boucher presents his sincere empathy with the natural landscape scene. Perhaps as a relief from his decorative stages filled with figures, his sustained production of landscapes, often without known commission, allowed him to indulge himself in pictures where his keenly felt perception of light and space was the foremost goal of representation.

Similarly, despite Boucher's continual use of the nude in his large allegorical work, it is his ability to respond to the actualities of the female body which not only saved inherently monotonous work, but also led to the hypnotic and sensual innocence in such images as *The Blond Odalisque,* 1752 (Munich), or the evocation of Rococo feminine elegance within the world of vividly depicted natural elements, *Diana at the Bath,* 1742 (Louvre). Surely there is high irony, in the face of these impassioned works, in Boucher's long-sustained reputation as a sensualist; it was naturally drawn from his professional association with the nobility and the environment in which he moved—which included the passing presence of Casanova—and his use of female nudity. Yet no hint of scandal ever attached itself to him or his impossibly pretty wife, and their two daughters happily married two of his better students.

—Joshua Kind

BOUDIN, (Louis) Eugène.

Born in Honfleur, 13 July 1824. Died in Deauville, 8 August 1898. Married Marie-Anne Guédès, 1863 (died, 1889). Clerk for publisher Joseph Morlant, then for stationer Alphonse Lamaste, Le Havre, 1836–44; operated stationer's shop with Jean Acher, Le Havre, 1844–46; encouraged by Millet, set up studio, and exhibited in Le Havre, 1850; municipality of Le Havre gave him grant to spend 3 years in Paris, 1851–54; exhibited in Paris from 1857, and settled there, 1863; exhibited at first impressionist exhibition, 1874.

Major Collection: Honfleur: Boudin Museum.
Other Collections: Boston; Chicago; Dijon; Glasgow; Hartford, Connecticut; Le Havre; London; New York; Oxford; Paris: Louvre, Marmottan, d'Orsay; St.-Lô.

Publications

On BOUDIN: books—

Cahen, Gustave, *Boudin: Sa vie et son oeuvre,* Paris, 1900.
Jean-Aubry, Georges, *Boudin: La Vie et l'oeuvre d'après ses lettres et documents inédits,* Paris, 1922; edited by Robert Schmit, Neuchâtel, 1968; as *Boudin,* Greenwich, Connecticut, 1968, London, 1969.
Roger-Marx, Claude, *Boudin,* Paris, 1927.
Cario, Louis, *Boudin,* Paris, 1928.
Benjamin, L. Ruth, *Boudin,* New York, 1937.
Arnould, Raymond, *L'Oeuvre de Boudin au Musée des Beaux-Arts du Havre,* Le Havre, 1955.
Les Boudin du Musée Municipal de Honfleur (cat), Honfleur, 1956.
Boudin (cat), London, 1958.
Schmit, Robert, *Boudin en Bretagne* (cat), Rennes, 1964.
Duclaux, Lise, and Geneviève Monnier, *Boudin: Aquarelles et pastels* (cat), Paris, 1965.
Schmit, Robert, *Boudin: Catalogue raisonné de l'oeuvre peint,* Paris, 3 vols., 1973.
Knyff, Gilbert de, *Boudin raconté par lui-même,* Paris, 1976.

Young, Mahonri Sharp, and Katherine Wallace Paris, *Boudin, Precursor of Impressionism* (cat), Santa Barbara, California, 1976.

Lemoine, Pascale, *Boudin, roi des ciels,* Lausanne, 1981.

Selz, Jean, *Boudin,* Naefels and New York, 1982.

*

"To steep oneself in the sky. To capture the tenderness of the clouds. To let the cloud masses float in the background, far off in the grey mist, and then make the blue blaze forth." Boudin and his Dutch contemporary Jongkind are sometimes labelled the Channel Coast painters, and constitute—with the independent Barbizon group—the forerunners of Impressionism. While a painter of some integrity in his own right, Boudin is nevertheless often best remembered for his key role in shaping the artistic destiny of the young Monet: acquainted with, but at first unsympathetic to Boudin's style, Monet reluctantly abandoned caricature to experiment with painting "en plein air" at Boudin's request—and never looked back. Boudin may best be described as a painter's painter; for while his success with public and critics may have been uneven, he was much respected by the likes of Courbet, Daubigny, and Corot as well as the group of acolytes that came to be called the Impressionists.

Urged to paint, and subsequently influenced by Troyon and Millet who were frequent visitors to his stationery and picture-framing shop, Boudin produced his first paintings around 1850. Few works remain from this period, with the exception of copies of Old Masters from the Louvre, some landscapes, and a portrait of the artist's father, all executed in an academic, slightly laboured style that betrayed the artist's inexperience and lack of direction. Portraiture was never again practiced, as Boudin shunned detail and physiognomic precision in favour of painting landscapes in a swift, sketchy manner. The mature style reveals in fact the way the artist triumphed over what he considered in his early training to be a serious flaw. Depressed by his inability to paint in close detail, Boudin collaborated with the painter Cassinelli in the early 1850's, creating seascapes to which the latter contributed the occasional finely executed sailing ship. Fortunately Boudin was later able to make a feature of his free, spontaneous style and award it the appropriate subject matter.

Very much a provincial personality, Boudin was at his happiest living and painting on the Normandy coast, the place of his birth. He tolerated Paris for the winter months, obtaining the requisite injection of culture; then in the spring, in the best bourgeois manner, Boudin retreated from the city to the sea. His oeuvre was later to include a number of city-scapes, particularly of Venice and Antwerp, but the artist was neither a town-dweller nor a great traveller. The seascapes of the 1860's form the bulk of Boudin's work, earning him at the time the title of "the painter of beaches." Following in the tradition of Dutch landscape painters like Ruisdael and Van Goyen, Boudin invariably divided his canvas unequally into sea and sky, devoting the greater part to the latter. Thus the compositions exude space and airiness, the vast expanses of sea and sky articulated by wind-whipped clouds and waves. Reducing his subject matter to these two basic components meant that Boudin could concentrate on perfecting them, which he achieved in the form of many preparatory sketches in pencil or pastel. Baudelaire, who became acquainted with Boudin and his art in 1859, thought very highly of the latter's seascapes and expressed his enthusiasm in lyrical terms:

> In the end all those clouds with their fantastic and luminous shapes, the chaotic darkness, the floating and intermingling masses of green and pink, the yawning furnaces, the firmaments of crushed, curled or torn black or purple satin, the horizons draped with mourning or streaming with molten metal, all those depths and splendors went to my head like an intoxicating drink or the eloquence of opium.

Boudin's greatest stylistic claims to fame are his painterly technique and sensitivity to colour. With the possible exception of Daubigny and the Florence-based Macchiaioli painters, Boudin is regarded as the first artist of his generation to advocate working in oils in the open air, capturing with speed and dexterity the temporary effects of light and atmosphere. With little spare time to mix paints in the studio manner, pure colours were instead applied directly to the canvas in swift, summarizing strokes, grey being Boudin's only concession to an otherwise unblended palette. The artist believed "everything that is painted directly on the spot always has a force, a power, a vivacity of touch that cannot be re-created in the studio." In 1874 Boudin showed three paintings with the Paris-based Co-operative Company of Painters, Sculptors, Engravers, etc., later to be remembered as the first Impressionist exhibition. The 30 participants were by no means unified by a common style; indeed, Boudin's work became more truly "Impressionist" years later, in the 1880's and 1890's when, independent of the Impressionist group and assured of public patronage, he felt he could pursue his own artistic course.

—Carolyn Caygill

BOUTS, Dirk.

Born in Haarlem, c. 1415. Died in Louvain after 17 April 1475. Married 1) Katharina van der Brugghen (nicknamed Metten Gelde—"with the money"), 1447 or 1448; sons, the painters Dirk II and Aelbrecht; 2) Elizabeth van Voshem, 1472 or 1473. Possibly studied with Ouwater, and then in Flanders; influenced by Rogier van der Weyden; worked in Louvain from 1448 or 1457: official painter of Louvain from 1468; dated works from 1464–75.

Collections: Bruges: S. Salvador; Brussels; Granada: Cathedral; Lille; London; Louvain: S. Peter; Madrid; Malibu; Munich; New York; Paris; Pasadena; Philadelphia; Washington.

Publications

On BOUTS: books—

Friedländer, Max J., *Die Altniederlandische Malerei, vol. 3, Dieric Bouts und Joos van Gent,* Berlin, 1925; as *Bouts and Joos van Gent* (notes by Nicole Veronee-Verhaegen), New York, 1967.

The Last Supper—detail; Louvain, St. Peter

Schöne, Wolfgang, *Bouts und seine Schule,* Berlin, 1938.
Baudouin, Frans, *Bouts* (cat), Brussels, 1957.
Denis, Valentin, *Thierry Bouts,* Brussels, 1957.
Bouts en zijn tijd (cat), Louvain, 1975.
Silver, Larry, *Bouts,* New York, 1983.
Lane, Barbara G., *The Altar and the Altarpiece: Sacramental Themes in Early Netherlandish Paintings,* New York, 1984.

*

Dirk (or Dieric, or Thierry) Bouts's early life is not documented, but from the evidence of his work it is assumed that he was associated with Albert van Ouwater (who later taught Geertgen tot Sint Jans), since they were the only recorded painters from Haarlem in the mid-15th century, and their works are similar. In fact, four panels in the Prado have been attributed to both painters at different times.

After Bouts's move to Louvain in the southern, Flemish section of the Netherlands, his life is more documented, though the exact date of his move (probably in the 1440's or 1450's) is not known. The influence of Rogier van der Weyden is strong, though Bouts always retained a northern, naive air, allied with dignity and restraint.

A work like the *Infancy Altarpiece* (c. 1445; Prado) shows the influence of Rogier, and also motifs from Petrus Christus and Jan van Eyck, but the sense of spatial continuity is personal with Bouts. This is probably his earliest work. The *Descent from the Cross* (Granada, Cathedral) also shows Rogier's influence in the use of the motif of a decorated arch to frame the action, a device also used by Petrus Christus. The main scene is set slightly back from the arch, and there is a landscape background, suggesting Bouts's interest in showing depth. A more emphatic influence from Rogier is the elongated figures and their exaggerated emotions.

Generally, though, Bouts is restrained in his handling of potentially emotional scenes. The *Adoration of the Magi* (Munich, Staatsgemäldesammlungen) is placid and still, the two kneeling Magi functioning to halt the implied movement in the road that leads to the open-sided porch where the Virgin and Christ sit calmly. The *Martyrdom of St. Erasmus* (Louvain, St. Peter), despite its horrendous subject (Erasmus's entrails are being wound onto a rod), also shows great emotional restraint. The two workmen handling the winding mechanism are light-footed and unconcerned, and a couple of figures seem to be portraits. A series of shallow curves shows Bouts's care in the composition.

An indication of Bouts's interest in theological niceties is displayed in a surviving panel from a *Last Judgment Altarpiece* (now in Lille). A group of men and women, clothed in robes that only partly conceal their nakedness, are approaching a fountain, directed by an elaborately robed angel standing on a carpet of flowers. The concept of the earthly paradise is based on a theme in St. Augustine's *City of God.*

Even more theologically complicated is his commissioned work for the Brotherhood of the Holy Sacrament in Louvain in the 1460's, *The Last Supper* (Louvain, St. Peter). The theological theme was dictated by two University of Louvain professors, and the central panel is meant to represent the *Institution of the Eucharist,* and not the more familiar prophesy of Judas's betrayal often emphasized in such pictures. The central panel is almost completely formalized, with Christ, at the absolute

center, facing forward with his right hand raised in blessing. The 12 disciples sit round a rectangular table, each of them characterized, and each of their faces clearly seen. (Judas *is* noticeable: he is one of the two disciples sitting with their backs to the viewer, but his stance is a bit convoluted and his hand is held behind his back.) Four extraneous figures (two attendants, and two men seen through a hatch) are probably portraits. The theological complexity is emphasized in the less formal side panels showing Old Testament pre-figurations of the Eucharist: the *Meeting of Abraham and Melchizedek,* the *Sacrifice of the Paschal Lamb,* the *Gathering of Manna,* and *Elijah in the Wilderness.*

The picture evidently pleased the authorities, since in 1468 Bouts was made official painter of Louvain. One of the resulting "official" commissions, no doubt, is the *Justice of Otto* (Brussels). There are two panels, though it is generally accepted that Bouts himself painted only one of them. They are meant to tell a familiar local story of infidelity and justice loosely related to the story of Joseph and Potiphar's wife: a man falsely accused of adultery, and his wife's successful attempt to clear his name by undergoing the ordeal of fire. Bouts's panel is the one showing the wife's ordeal: she is holding a cherry-red iron bar without flinching, to the astonishment of Otto and his court. Though the work is not overly dramatic, it is very moving, especially the face of the wife. The panels—an appropriate civic and moralizing work—were painted to decorate the Town Hall.

Two paintings, both in the National Gallery in London, are worth mentioning. The *Portrait of a Man* follows a Petrus Christus tradition (begun in his portrait of *Edward Grimston,* 1446) of placing the subject in the angle of a room. Bouts complicates this by adding an open window, with a sliver of landscape seen through it. (This formula of a portrait in a corner angle of a room with an open window giving onto a view of a landscape was used by others in Bouts's circle, and was transplanted to Italy where Ghirlandaio was using it by 1480; Dürer also used the formula in several works, including his 1498 *Self-Portrait* in the Prado). In the London portrait, the window provides the single light source, and the fall of light on the man's face and hair is exquisitely done. The *Virgin and Child* centers on the child itself, resting on a cushion on a stone window sill. A strip of brocade hanging on the wall behind the Virgin picks up the both the decoration and the color of the cushion. This picture also has a landscape seen through a window, this time with a church tower.

—George Walsh

BRANCUSI, Constantin.
Born in Hobitza, Gorj, Romania, 21 February 1876; naturalized French citizen, 1956. Died in Paris, 16 March 1957. Attended School of Arts and Crafts, Craiova, 1894–98, and School of Fine Arts, Bucharest, 1898–1902; studied under Antonin Mercie, Ecole des Beaux-Arts, Paris, 1905–07; worked in Paris from 1904, briefly under Rodin; exhibited at the Armory Show in New York, 1913; involved in notorious case when United States customs refused to admit one of his pieces as a work of art; erected large group of monumental sculptures at Tirgu Jiu, Romania (near his birthplace), 1937–38.

Collections: Boston; Bucharest; Chicago; London: Tate; New York: Moma; Paris: Beaubourg; Pasadena; Philadelphia; Venice: Guggenheim; Washington.

Publications

By BRANCUSI: book—

Histoire de brigands, Paris, 1969.

On BRANCUSI: books—

Paleolog, V. G., *Brancusi,* Bucharest, 1947.
Zervos, Christian, *Brancusi: Sculptures, peintures, fresques, dessins,* Paris, 1957.
Giedion-Welcker, Carola, *Brancusi,* Basel, 1958, New York, 1959.
Jianou, Ionel, *Brancusi,* Paris and London, 1963.
Geist, Sidney, *Brancusi: A Study of the Sculpture: An Oeuvre Catalogue,* New York and London, 1968, 1983.
Geist, Sidney, *Brancusi: A Retrospective Exhibition* (cat), New York, 1969.
Spear, A. T., *Brancusi's Birds,* New York, 1969.
Salzman, Gregory, *Brancusi's Woods,* London, 1972.
Brezianu, Barbu, *Opera Luí Brancusi in Romania,* Bucharest, 1974; as *Brancusi in Romania,* Bucharest, 1976.
Geist, Sidney, *Brancusi: The Sculpture and the Drawings,* New York, 1975.
Uscatescu, Jorge, *Brancusi y el arte del siglo,* Madrid, 1976.
Geist, Sidney, *Brancusi: The Kiss,* New York, 1978.
Tabart, Marielle, and Isabelle Monod-Fontaine, *Brancusi: Photographe* (cat), Paris, 1979; as *Brancusi, Photographer,* New York, 1979; as *Brancusi's Photographs,* London, 1981.
Grigorescu, Dan, *Brancusi: Ses Racines roumaines,* Bucharest, 1984.
Istrati, Alexandre, and Natalia Dumitresco, *Brancusi,* Paris, 1987, London, 1988.
Varia, Radu, *Brancusi,* New York, 1987.

*

Working almost exclusively in the medium of sculpture, Brancusi sought, through natural materials and biomorphic form, to create an art that would appeal to as many senses—and sensibilities—as possible. The visual and also tactile senses (Brancusi actually entitled one very touchable ovoid form *Sculpture for the Blind*) are celebrated and stimulated by the artist's treatment of his media. A sense of purity and dignity pervades the sculptor's work, hinting at his wish to express the essence of natural media, subject matter, and ultimately life itself.

By 1920 Brancusi had conceived and incubated the basic forms and media of his oeuvre. The preceding years since the Romanian peasant's arrival in Paris, 1904, were a period of exploration and assessment. In 1907, after much experimentation with busts and bas-reliefs of a classical nature, Brancusi abandoned the technique of modelling in clay, preferring to chisel stone like the original carvers of the primitive masks and statues fashionable at the time. His first two significant

Torso of a Young Man, 1922; maple wood; 19 in (48 cm);
Philadelphia, Museum of Art

commissions, both funerary monuments, formed the basis for subsequent work. *The Prayer* at Dumbrava Cemetery, Bouzau, Romania, 1907, and *The Kiss,* Montparnasse Cemetery, Paris, 1909, reflect Brancusi's new sense of purpose and the influence of contemporary Parisian "primitives" such as Picasso and Gauguin. The sculptor began to lose interest in the surface appearance of things, instead reducing form to the bare minimum and eliminating superfluous detail. He gradually developed a repertoire of free-standing natural forms—birds, small animals, and the human body—which he rendered in highly polished bronze and stone or wood, placing the finished sculpture on its own unique pedestal. Bases, Brancusi maintained, form an integral part of the work of art, relating it to its environment and binding it to the earth yet simultaneously carrying it aloft towards sky and spirit. Keenly interested in eastern

religion and mysticism Brancusi wished to express via his sculpture the dual nature—the body and the soul—of living things. The materials and textures of the pedestals usually differ radically from the sculpture-proper: the *Maiastra,* a magic solar bird from Romanian folklore is reborn by Brancusi in several versions, its bright, bronze or polished marble form complemented by the rough wood or stone block upon which it rests.

Brancusi's sculptures bridge the gap between old and new: he embraces the natural world with egg- or head-shaped objects (e.g., *Sleeping Muse, 1917, Beginning of the World,* 1920) and applauds pagan art and people (e.g., *Plato,* 1919), yet with these forms he echoes very contemporary concerns. The streamlined forms of birds and fish reflect a contemporary obsession with technological advancement, akin to Futurist depictions of speed and energy. The sculptor also reacted, like his fellow artists, against the academic painters and sculptors of the last century by rejecting tasteful realism or fancy embellishment. He introduced certain innovations to the art of sculpture, relating individual pieces to one another—the "group mobiles"—and to their environment. Denied the opportunity of working on architectural projects with the exception of the Tirgu Jiu monument, Brancusi instead created a total environment in his studio, in the manner of Schwitters's *Merzbau,* placing his sculptures so that they would interact harmoniously with the space, home-made furniture, and, Brancusi's only concession to Surrealism, his prized "objet-trouvé" *The Crocodile,* 1925.

In 1937 Brancusi was commissioned by the National Women's League of Gorj to erect a funerary monument in honour of the Romanian troops who fought in the First World War. This was to be a "group mobile" of three sculptures at Tirgu Jiu in Romania. Brancusi gladly took the opportunity to embark on a project in his homeland which would enable him to create on a grand scale at a specific location. The Tirgu Jiu complex can be seen as the climax of the sculptor's career, a consolidation of the motifs and meanings of his work to date. The *Gate of the Kiss,* a triumphal arch decorated with a stylized frieze based on *The Kiss,* and the *Table of Silence,* a round table surrounded by twelve stone stools evoking the famous tables of Christian and Arthurian legend, complement the *Endless Column,* a looming cast iron erection based on smaller wooden prototypes from the 1920's. The *Endless Column* is constructed from fifteen modules which are stacked, then capped and shod by two half-modules, the latter lending an incomplete, infinite quality to the monument. Here pedestal and sculpture are incorporated and reconciled; earth and sky are linked by this organic, cellular form.

—Caroline Caygill

BRAQUE, Georges.
Born in Argenteuil-sur-Seine, 13 May 1882. Died in Paris, 31 August 1963. Married Marcelle Laprés, 1912. Attended Ecole des Beaux-Arts, Le Havre, under M. Courchet, 1897–1900; apprentice to commercial decorator Roney, Le Havre, 1899–1900, and to Laberthe, Paris, 1900–01; attended evening art classes, Les Batignolles, Paris, 1900–01; military service,

Teapot with Lemons, 1949; lithograph

1901–02; studied at the Académie Humbert, Paris, 1902–04, and under Léon Bonnat at the Ecole des Beaux-Arts, Paris, 1903; established studio in Paris, 1904 (spent summers in Varengeville, 1931–63); associated with the Fauves, 1905–07, and friendship with Picasso from 1907; designed ballets *Salade*, 1924, *Les Facheux*, 1924, 1927, and *Zéphyre et Flore*, 1925; designed stained glass and jewelry.

Collections: Amsterdam: Stedelijk; Basel; Buffalo; Chicago; Cleveland; Cologne; Copenhagen; Detroit; Eindhoven; Le Havre; New York: Guggenheim, Moma; Ottawa; Paris: Beaubourg, Petit Palais; San Francisco; Stockholm: Moderna Museet; Washington: Phillips; Zurich.

Publications

By BRAQUE: books—

Cahier 1917–47, Paris, 1947; as *Le Jour et la nuit, 1917–52*, 1952; as *Illustrated Notebooks, 1917–1955*, edited by Stanley Applebaum, New York, 1971.

Conversations and Thoughts, edited by Dora Vallier, Geneva, 1973.

illustrator: *Theogony*, by Hesiod, 1931.

On BRAQUE: books—

Bissiere, R., *Braque*, Paris, 1920.
Einstein, Carl, *Braque*, Paris and New York, 1934.
Gallatin, A. E., *Braque: Essay and Bibliography*, New York, 1943.
Paulhan, Jean, *Braque le patron*, Geneva, 1946.
Ponge, Francis, *Braque le réconsiliateur*, Geneva, 1946.
Cooper, Douglas, *Braque: Paintings 1909–47*, London, 1948.
Grenier, J., *Braque*, Paris, 1948.
Hope, Henry R., *Braque*, New York, 1949.
Reverdy, Pierre, *Braque: Une Aventure méthodique*, Paris, 1949.
Ponge, Francis, *Braque: Dessins*, Paris, 1950.
Fumet, Stanislaw, *Sculptures de Braque*, Paris, 1951.
Buchheim, L. G., *Braque: Das graphische Werk*, Feldafing, 1952.
Laufer, F., *Braque*, Berne, 1954.

Gieure, Maurice, *Braque: Dessins,* Paris, 1955.

Gieure, Maurice, *Braque,* Paris, 1956.

Verdet, A., *Braque,* Geneva, 1956.

Engelberts, Edwin, *Braque: Oeuvre graphique original,* Geneva, 1958.

Mangin, Nicole S., *Catalogue de l'oeuvre de Braque: Peintures,* Paris, 6 vols., 1959–73.

Richardson, John, *Braque,* London, 1959, New York, 1961.

Russell, John, *Braque,* London, 1959.

Hofmann, Werner, *Braque: Das graphische Werk,* Stuttgart, 1961; as *Braque: His Lithographic Work,* New York, 1961; London, 1962.

Leymarie, Jean, *Braque,* Geneva and New York, 1961.

Mourlot, Fernand, *Braque Lithographe,* Monte Carlo, 1963.

Mullins, Edwin, *Braque,* London, 1968.

Craven, John, *Les Bijoux de Braque,* Paris, 1969.

Masini, Lara Vinci, *Braque,* Florence, 1969.

Cogniat, Raymond, *Braque,* Lugano, 1970.

Brunet, Christian, *Braque et l'espace,* Paris, 1971.

Carrà, Massimo, *L'opera completa di Braque 1908–1929,* Milan, 1971.

Ponge, Francis, et al., *Braque de Draeyer,* Montrouge, 1971; as *Braque,* New York, 1971.

Cooper, Douglas, *Braque: The Great Years,* 1973.

Richet, Michele, and Nadine Pouillon, *Braque* (cat), Paris, 1973.

Fortunescu, Irina, *Braque,* London, 1974.

Judkins, Winthrop, *Fluctuant Representation in Synthetic Cubism: Picasso, Braque, Gris 1910–1920,* London and New York, 1976.

Fortunescu, Irina, editor, *Braque,* Bucharest and London, 1977.

Cogniat, Raymond, *Braque,* New York, 1980.

Braque (cat), Saint-Paul-de-Vence, 1980.

Bozo, Dominique, editor, *Braque: Les Papiers collés* (cat), Paris, 1982; edited by Monod-Fontaine, Isabelle, Washington, 1982.

Worms de Romilly, Nicole, and Jean Laude, *Braque: Le Cubisme fin 1907–1914,* Paris, 1982.

Chipp, Herschel B., *Braque: The Late Paintings 1940–1963* (cat), Washington, 1982.

Pouillon, Nadine, *Braque* (cat), Paris, 1982.

Vallier, Dora, *Braque: L'Oeuvre gravé: Catalogue raisonné,* Paris, 1982.

Fauchereau, Serge, *Braque,* Paris and New York, 1987.

Leymarie, Jean, editor, *Braque,* Munich and New York, 1988.

Zurcher, Bernard, *Braque: Life and Work,* New York, 1988.

Rubin, William, *Picasso and Braque: Pioneering Cubism* (cat), New York, 1989.

*

"I love the rule that corrects the emotion," wrote Georges Braque in 1947. With the exception of an early experiment with Fauvism, this statement is the key to understanding his work. It separates him from his friend and co-founder of Cubism, Picasso, who was forever flamboyant, experimental, and outspoken. Yet for a time during their great alliance their paintings became almost indistinguishable.

Braque first moved to Paris in 1905. He was immediately struck by the fervour with which Fauvism attacked Impressionism, and for a while he painted bright, expressive landscapes from his trips to Antwerp and L'Estaque. It was while in Provence that the quiet, meditative, and logical artist began to emerge, with the influence of the recently discovered Cézanne. Colourful, loose paint strokes changed to methodical stripes of sombre yellows and greens.

He returned to Paris and was introduced to Picasso, who had recently completed *Demoiselles d'Avignon* (1907). The obvious similarities in the artists' aims led to the foundation of Cubism. For Braque it represented a need to interpret the world in a different way. No longer wishing simply to imitate with the conventions of perspective, he used the still life as a basis from which to create his own language. Continually attempting to paint the present instead of the past and future, he used tonality to give objects volume in a vague, undefined space.

During the second, "Analytical" period of Cubism, Braque showed a growing interest in composition, juggling with shapes in order to find tight-fitting relationships. The introduction of an oval canvas (*Still Life with Violin,* 1910), further enhanced a need to break away from traditional perspective, and towards an introspective form.

The overall effect of this reconstruction of dislocated space was to create in the canvas the rhythm of the artist as opposed to the rhythm of nature: "The object dissolves, the form disintegrates, the only thing that is still identifiable is the sign . . . a sign that is a moment of space, something as abstract and real as a musical score."

Equipped with a language of signs, Braque entered a synthetic period, adding materials such as sand, rope, and tobacco to canvas giving the pictures tangibility. He also introduced letters, numbers, and newspaper-cuttings that mystify and question the difference between objects and words. The completed canvas had become a thing, independent of both nature and artist, an autonomy. "A picture is finished when it has cancelled the idea."

Braque's Cubist progress was cut short by World War I. During active service he suffered a head injury, and did not paint again until 1917. In 1920 he returned to Paris. Picasso had moved on to new beginnings, and only Juan Gris seemed to be continuing the Cubist ways. Braque's work had changed. Henceforth, suppleness prevailed over stiffness as Braque began to search for a languid rhythm. During this time he often adopted elongated pictures, influenced by a reassessment of Matisse, allowing still life objects to "swim" into each other. According to Jean Paulhan, these works are "Fluid (without needing water); radiant (without the slightest source of light); dramatic (without pretence)."

Braque also returned to the nude. Instantly personal with their massive forms and small apple breasts, these "canephorae" have a sensual nervous touch, indicating a light-hearted period away from investigation and experiment.

During the German occupation of Paris, Braque mainly produced still lifes in his studio. A recent time spent making sculpture influenced him to concentrate on painting the weight and volume of objects. Compositions became much simplified; a lowering of the horizon line allowed Braque to include the light source of a window, (*Blue Wash-Basin,* 1942) and the resulting flickering light travelling over the studio. These lead on to the "Atelier" series, large "chaotic" paintings which contain rigid structure, pattern, flowing rhythm, and the beau-

tiful theatricality of the artist's studio. They seem to represent the culmination of all Braque had worked towards, and, buried within the composition, growing ever clearer as the series progresses, the image of a bird in flight foretells Braque's preoccupation in his final years. With thick impasto and deep, rich colours, his last paintings of birds in flight, ploughs becoming birds, bicycles, and boats have a religious quality for the love of these things as well as compounding what had always been Braque's main desire, to paint the continual present. "We shall never rest, the present is perpetual."

—Justin Piperger

BROEDERLAM, Melchior.

Born in Ypres, in the 14th century. Died after 1409. Flemish painter, he first worked for Philip the Bold, Duke of Burgundy, 1378; also worked for Louis de Mâle, Count of Flanders, 1981; appointed valet to Philip the Bold, 1385, and "peintre monseigneur" to Philip the Bold, 1391.

Collection: Dijon.

Publications

On BROEDERLAM: books—

Panofsky, Erwin, *Early Netherlandish Painting*, Cambridge, Massachusetts, 1964.
Meiss, Millard, *French Painting in the Time of Jean de Berry*, London, 1967.
Cuttler, C. D., *Northern Painting from Pucelle to Bruegel*, New York, 1968.

article—

Martindale, Andrew, "The Changing Status of the Craftsman," in *The Flowering of the Middle Ages*, New York, 1966.

*

Little is known about Melchior Broederlam and his artistic career. Few documents record his name. He is mentioned as "varlet de chambre" in 1387 and "peintre monseigneur" in 1391 with reference to Philip the Bold, Duke of Burgundy. We know that he worked at the ducal castle of Hesdin and at Ypres, the city where he was born and educated. He spent practically his entire life in Ypres with only a few trips to France. We also know that in his earlier artistic career he painted banners in oils, chairs, and wooden galleries and made drawings for tiled floor decorations. It is recorded that he painted not only the hearse of the Duchess in 1386, but also the drapery and pavilions on the Duke's boat as well. His versatility is also reflected in the fact that he decorated two sets of jousting harness for his major patron, Duke Philip, in

1390–91. Needless to say, none of these works has survived. In fact, only one work, albeit a major one, has survived from the hand of Melchior Broederlam. That is the marvelously painted altar wings commissioned by Duke Philip in 1394 and presently in the Musée des Beaux-Arts in Dijon.

During the later 14th century the works of the major artists in northern Europe, especially in France and the Netherlands, reflected an increasing influence from progressive elements in Italian art. Developing from a miniaturist art, since manuscript painting had been the major outlet for French and Flemish artists, those who worked on panels were bound to show the emphasis on detail and elegant court life that permeates the earlier manuscript paintings by Master Honoré, Jean Pucelle, and their followers. Broederlam's tempera paintings on the Dijon altar wings show some of this earlier courtly style but at the same time a strong emphasis on sculptural form and bold color to suggest spatial depth. His landscape elements show a careful and sensitive understanding of the natural form existing within a three-dimensional setting. Yet these landscape elements are never allowed to obstruct our view of the holy figures that inhabit the space. Homely details are juxtaposed with courtly figures. He has been called a realist with a naturalism that can also be found in the work of other, contemporary Flemish artists. Broederlam also incorporated disguised symbolism, a feature that became increasingly in vogue in the works of the great Flemish masters of the 15th century, such as Jan Van Eyck or Roger van der Weyden.

Although Broederlam never established a school of painting, his influence can be seen at the beginning of the 15th century, particularly in four panels now divided between the Walters Art Gallery in Baltimore and the Musée Mayer van den Bergh in Antwerp. Broederlam's experimentation with space, sculptural form, atmospheric color, disguised symbolism, realism, and naturalism sets him apart as a great master who was able to absorb and integrate the progressive artistic developments not only from Flanders and France, but also from Italy. His importance in the history of northern painting has yet to be disputed.

—A. Dean McKenzie

BRONZINO, Agnolo.

Born Angelo di Cosimo di Mariano in Monticelli, near Florence, 17 November 1503. Died in Florence, 23 November 1572. Entered Raffaellino's studio for 1 year, c. 1514, then pupil (and later friend) of Pontormo from c. 1515; worked with Pontormo at Certosa del Galluzzo during plague years of 1523–25; assistant on Girolamo Genga's decoration projects for Villa Imperiale, Pesaro, 1530–32; court painter to Cosimo I de' Medici from late 1530's to 1550's: many portraits, theatrical and other temporary decorations, tapestries for *Story of Joseph* cycle, 1545–53; also in Rome, 1546–47; co-founder, with Vasari and others, Accademia del Disegno, 1563; also wrote verse. Pupil: Alessandro Allori.

Major Collection: Florence.

Joseph Recounting His Dream; drawing; Oxford, Ashmolean

Other Collections: Berlin; Boston: Gardner; Florence: Pitti, Museo dell'Opera di S. Croce, Palazzo Vecchio, SS. Annunziata, S. Felicita, S. Lorenzo, S. Maria Novella; Galluzzo: Certosa; London; Milan; New York: Frick, Metropolitan; Ottawa; Pisa: S. Stefano; Rome: Barberini, Borghese, Doria Pamphili, Galleria Nazionale; Turin: Sabauda; Worcester, Massachusetts.

Publications

On BRONZINO: books—

Furno, Albertina, *La vita e le rime di Bronzino*, Pistoia, 1902.
Goldschmidt, Fritz, *Pontormo, Rosso, und Bronzino*, Leipzig, 1911.
Schulze, Hanns, *Die Werke Bronzinos*, Strasbourg, 1911.
Tinti, Mario, *Bronzino*, Florence, 1927.
McComb, Arthur, *Bronzino: His Life and Works*, Cambridge, Massachusetts, 1928.
Becherucci, Luisa, *Bronzino*, Florence, 1949.
Smyth, Craig Hugh, *Bronzino Studies*, Princeton, 1955.
Emiliani, Andrea, *Il Bronzino*, Busto Arsizio, 1960.
Emiliani, Andrea, *Bronzino*, Milan, 1966.
Levey, Michael, *Bronzino*, London, 1967.
Smyth, Craig Hugh, *Bronzino as Draughtsman*, Locust Valley, New York, 1971.
Baccheschi, Edi, *L'opera completa del Bronzino*, Milan, 1973.
Smith, G., *Cosimo I and the Joseph Tapestries for Palazzo Vecchio*, Ann Arbor, 1978.
McCorquodale, Charles, *Bronzino*, London, 1981.
Cox-Rearick, Janet, *Dynasty and Destiny in Medici Art: Pontormo, Leo X, and the Two Cosimos*, Princeton, 1984.

articles—

Levey, Michael, "Sacred and Profane Significance in Two Paintings by Bronzino," in *Studies . . . Presented to Anthony Blunt*, London, 1967.
Matteoli, Anna, "La ritrattistica del Bronzino nel *Limbo*," in *Commentari* (Rome), 20, 1969.
Simon, R. B., "Bronzino's Portrait of Cosimo I in Armour," in *Burlington Magazine* (London), 125, 1983.
Simon, R. B., "Bronzino's Cosimo I de' Medici as Orpheus," in *Bulletin of the Philadelphia Museum of Art*, Fall 1985.
Tucker, Mark S., "Discoveries Made During the Treatment of Bronzino's Cosimo I de' Medici as Orpheus," in *Bulletin of the Philadelphia Museum of Art*, Fall, 1985.
Cox-Rearick, Janet, "Bronzino's *Crossing of the Red Sea and Moses Appointing Joshua*: Prolegomena to the Chapel of Eleonora di Toledo," in *Art Bulletin* (New York), March 1987.

*

The art of Agnolo Bronzino (Agnolo di Cosimo di Mariano) represents a natural progression from the union of real with ideal achieved during the High Renaissance. Bronzino's place in the history of art is as a portraitist as well as an allegorical painter. In his early years, Bronzino was a student of Raffaellino del Garbo and learned the art of color. Vasari relates how in 1514 Bronzino passed to the studio of Pontormo, where he developed the concept of clarity of form rendered with a polished finish. In 1523, to escape the plague in Florence, Bronzino followed Pontormo, who treated him like a son, to the Certosa del Galluzzo, where he painted two lunettes in the Chiostro Grande, *Dead Christ Supported by Angels* and *The Martyrdom of St. Lawrence*. Between 1525 and 1528 Bronzino assisted Pontormo in the painting of the vault fresco (destroyed) and the pendentive tondi of the Capella of Ludovico Capponi in Santa Felicità (Florence). The tondi depicted the four Evangelists. Bronzino painted *St. Mark* (Besançon) and *St. Luke*. In 1530–32 Bronzino worked at Pesaro as an assistant to Girolamo Genga, decorating the Villa Imperiale. Guided by Pontormo's Mannerist style, Bronzino clarifies and crystallizes his subject matter with formal ideas. This distinction of Bronzino's art is in the representation of aristocratic portraiture. The combination of social and intellectual status of his sitters is portrayed with a psychological sense of inner life and a rigorous formal process of abstraction, creating a Manieroso portrait. Bronzino's religious paintings demonstrate his theories about art that painting, as the finest of the arts, is capable of evoking plasticity of sculpture and recreates all nature. The paradigm of Bronzino's Maniera style with its command of *disegno* is *The Allegory of Love* (London).

After the siege of Florence by Imperial troops, Bronzino sought refuge in the court of Duke of Urbino at Pesaro. In 1533 he was back in Florence, creating theatrical design with the assistance of Vasari. Between 1536 and 1543 Bronzino worked with Pontormo on frescoes at the Medici Villa of Careggi and loggia frescoes at the Medici Villa of Castello (all destroyed). For the nuptials of Cosimo I, Duke of Tuscany, and Eleanor of Toledo, Bronzino did several decorative projects and, between 1541 and 1545 he frescoed the Chapel of Eleanor of Toledo in the Palazzo Vecchio in Florence. The newly founded Medici tapestry manufactory stimulated Bronzino to design cartoons illustrating the story of Joseph.

Before being expelled from the Florentine Academy by Francis I of France in 1547 Bronzino wrote a letter to Benedetto Varchi on the supremacy of painting over sculpture, expounding his theories about art. Upon his return to Rome, Bronzino signed a contract for *The Resurrection of St. Annunziata*. Two years later he was summoned by Eleanora to paint her son, Giovanni, and herself in Pisa. And in 1552 Bronzino painted *The Descent of Christ in Limbo*.

Inspired by Cellini's *Perseus*, Bronzino composed a sonnet as well as the Joseph tapestries in 1553. He collaborated with Pontormo on the San Lorenzo frescoes (1546–58; now destroyed), as well as on Pontormo's diary. Bronzino's literary interests continued and were recognized by contemporary poets—Laura Battiferri published his sonnets with commentaries. Vasari's foundation of the Academy of the Arts of Drawing included Bronzino as a participating member in 1563. Two years later Bronzino painted three paintings for the nuptials of Francesco de Medici and Joanna of Austria, as well as *The Nativity* for San Stefano in Pisa. *The Martyrdom of St. Lawrence* was unveiled in 1569. Shortly after, on 23 November 1572, Bronzino died in the house of Allori and was buried in San Cristoforo.

—Liana Cheney

BROUWER, Adriaen.

Born in Oudenaarde, Flanders, c. 1605; son of a tapestry designer. Died in Antwerp, January 1638. Possibly a pupil of Frans Hals in Haarlem, c. 1623–24; worked in Amsterdam, 1625; then in Haarlem until 1631; joined Antwerp guild, 1631, and worked there until his death (briefly imprisoned for political reasons, 1633); themes are drawn from peasant life, a Flemish theme Brouwer introduced to Haarlem. Pupil: Joos van Craesbeck.

Major Collection: Munich.
Other Collections: Amsterdam; Antwerp; Berlin; Brussels; Dresden; Frankfurt; Haarlem; The Hague; Leipzig; London: National Gallery, Wellington, Wallace, Dulwich; New York; Paris: Louvre, Petit Palais; Philadelphia; Rotterdam; Schwerin; Zurich.

Publications

On BROUWER: books—

Schmidt-Degener, Frederik, *Brouwer et son évolution artistique*, Brussels, 1908.
Bode, Wilhelm von, *Brouwer: Sein Leben und seine Werke*, Berlin, 1924.
Drost, Willi, *Motivübernahme bei Jacob Jordaens und Brouwer*, Konigsberg, 1928.
Reynolds, E. J., *Some Brouwer Problems*, Lausanne, 1931.
Böhmer, Günter, *Der Landschafter Brouwer*, Munich, 1940.
Höhne, Erich, *Brouwer*, Leipzig, 1960.
Knuttel, Gerard, *Brouwer: The Master and His Work*, The Hague, 1962.
Brouwer, Teniers the Younger (cat), New York, 1982.
Scholz, Horst, *Brouwer invenit: Druckgraphische Reproduktionen des 17.–19. Jahrhunderts nach Gemälden und Zeichnungen Brouwers*, Marburg, 1985.
Renger, Konrad, *Brouwer und das niederländische Bauerngenre*, Munich, 1986.

*

Adriaen Brouwer was born about 1605 at Audenaerde. Records indicate that he was working in Haarlem and Amsterdam in 1625–26. Brouwer is traditionally believed to have been a student of Frans Hals, although his landscapes also contain some influence from Pieter Brueghel the Elder. In 1631, Brouwer moved to Antwerp where he was listed in the Guild of St. Luke records, the *Liggeren*, for 1631–32. About 1633, he was arrested and held in the Antwerp city prison, the Steen, supposedly for trying to cross the border between the United Provinces and the Spanish Netherlands without proper credentials. Again, as is the case with much of his history, there is dispute about this. Some authorities believe that he was actually imprisoned for debts. Brouwer died in Antwerp in 1638.

Brouwer's paintings were chiefly of genre subjects, although there is also a small corpus of landscapes, and at least one lost *Temptations of St. Anthony*. Brouwer's life seems to have been filled with controversies, many of which were recorded by the Dutch 18th-century writer Arnold Houbraken. It appears that he spent no little amount of time in the taverns which he frequently painted. Despite his brief life, Brouwer had a considerable impact on the number of Flemish and Dutch artists, especially among his fellow genre painters. His works were sought after by fellow artists of the stature of Rubens. He had a large impact on the early works of David Teniers II. Others influenced by Brouwer were Joos van Craesbeck and David Ryckaert III. Teniers the Younger and van Craesbeck produced paintings which were quite close at times to those of Brouwer. This is especially the case with Teniers, in whose work one sees paintings, such as the *Smoker* in the Los Angeles County Museum of Art and the *Smoker* in Madrid, which contain close copies of a figure in Brouwer's *The Smokers* (Metropolitan Museum of Art, New York). Brouwer's works are characterized by their small size and incredible technical skill.

—Jane P. Davidson

BROWN, Ford Madox.

Born in Calais, 16 April 1821. Died in London, 6 October 1893. Married 1) Elizabeth Bromley, 1840 (died, 1845); 2) Emma Hill, 1848 (died, 1890); two daughters, one son (one daughter married Dante Gabriel Rossetti's son, the other was the mother of the writer Ford Madox Hueffer). Trained under Professor Gregorius in Bruges, under Van Hanselaer in Ghent, and under Baron Wappers at Antwerp Academy for three years; in Paris, 1840–44; exhibited frescoes in England, 1845; in Rome, 1845–46, where he met Overbeck and other Nazarene artists; worked in London from 1846, though refused to exhibit at the Royal Academy after 1851; in the orbit of the Pre-Raphaelite Brotherhood through Rossetti, who studied with Brown from 1848; taught at the Working Men College from 1854, and did design work for Morris and Co., 1861–74; did 12 large panels for the Manchester Town Hall, 1878.

Collections: Birmingham; Bradford; Liverpool; London: Tate, Victoria and Albert; Manchester: Town Hall, City Art Gallery, Whitworth; Melbourne; New Haven; Sydney.

Publications

By BROWN: books—

The Slade Professorship (lecture), London, 1872.
Diary, in *Praeraphaelite Diaries and Letters*, edited by William Michael Rossetti, London, 1900; edited by Virginia Surtees, New Haven, 1981.

article—

"On Mural Painting," in *Arts and Crafts Essays*, London, 1903.

On BROWN: books—

Hueffer, Ford Madox, *Brown: A Record of His Life and Work*, London, 1896.

Brouwer: The Wound Being Treated; By Permission of the Trustees of the Will of the 8th Earl of Berkeley; Berkeley Castle

Rossetti, Helen M. Madox, *Brown,* London, 1902.
Bennett, Mary, *Brown* (cat), Liverpool, 1964.
Hilton, Timothy, *The Pre-Raphaelites,* London, 1970.
Rabin, Lucy, *Brown and the Pre-Raphaelite History-Picture,* New York, 1978.

articles—

Paden, W. D., "The Ancestry and Families of Brown," in *Bulletin of the John Rylands Library* (Manchester), 50, 1967.
Bennett, Mary, "The Price of Work: The Background to Its First Exhibition, 1865," in *Pre-Raphaelite Papers,* edited by Leslie Parris, London, 1984.

*

Ford Madox Brown is often thought to be the most important of the Victorian painters, or at least the creator of two of the most famous of Victorian paintings—*Work* and *The Last of England.* Though he was not a member of the Pre-Raphaelite Brotherhood, his friendship with Rossetti and his status as an older, more experienced painter influenced the movement. Brown's own early study was in Europe: he studied with two former pupils of Jacques-Louis David, and later with Gustave Wappers (later Baron Wappers), who also taught Lawrence Alma-Tadema. His early historical subjects also reflect his admiration for Hogarth, whom he thought of as the founder of English painting. Though he was later to expand his thematic awareness, throughout his career he tended to work Chaucer, Wycliffe, Cromwell, and other English worthies into his historical pictures. His time in Rome (1845–46) brought him under the influence of Cornelius, Overbeck, and other Nazarene painters. By the time he met Rossetti in England in 1848, a combination of interests and antipathies made him susceptible to the mood of the young Pre-Raphaelite: an interest in early renaissance art, including frescoes, a concern for the exact look of things, a fear of becoming too dominated by the Academy, a strong civic interest, and a great concern in moral issues as they affect modern life.

A painting like *The Last of England* (Birmingham) fits into the overall pattern of his works: a specific modern problem (emigration) affecting specific individuals (friends of his had recently emigrated to Australia—and he actually painted himself and his wife as the two parents on the emigrant ship), the exactness of the paraphernalia of the ship and its occupants. There is also an artfulness about the painting that might escape someone interested only in the social and historical values: the oval composition, and the couple and their child separated from the rest of the ship by the opened umbrella suggest a rigorous image-making. Perhaps this is what tempted David Hockney to make a parody of the work (called *The Last of England?,* with an added question mark), substituting two young men (himself and Cliff Richard) for the young couple, and smearing the rest of the details of the picture out.

Work (Manchester), a vivid, highly colored, and exactly located painting, lends itself to specific interpretation (analysis of the variety of workers and non-workers as well as social and moral implications of each detail of the picture—as one might interpret a Hogarth painting). But it is also a bright, beautiful narrative picture, pungent with the breath of real life, almost like a novel instead of a fable. Contemporary critics *did* make a link between Brown's work and that of Hogarth, but interestingly enough for *The Last of England.*

Brown also delighted in pure landscape. *An English Autumn Afternoon* (Birmingham) was painted from the back window of his Hampstead lodging in 1852–54 on an oval canvas. A couple with their backs to the viewer are sitting on the roof of the building in the extreme foreground looking out over the heath and away into the far distance; the result is dizzying. He also painted more conventional landscapes, e.g., *Walton-on-the-Naze* (Birmingham) and *Carrying Corn* (London, Tate). "*Take Your Son, Sir!*" (London, Tate) shows his strong views on social injustice. It depicts an unmarried mother handing over her child, held forward in womb-like swaddling to her seducer (he can be glimpsed in a circular mirror halo-ing her head)— and incidentally to the viewer.

Though Brown's historical works are less satisfying to the modern viewer, they form a substantial part of his corpus, and include works like *St. Ives, A.D. 1630: Cromwell on His Farm* (Port Sunlight), *Chaucer at the Court of Edward III* (London, Tate), and *Wycliffe Reading His Translation of the Bible to John of Gaunt* (Bradford). Brown was never popular or financially successful, and possibly for these reasons he spent the last 15 years of his life laboring on a series of 12 historical panels for the Great Hall of Manchester Town Hall.

—George Walsh

BRUEGEL, Jan.

Born in Brussels, 1568; son of Pieter Bruegel. Died in Antwerp of cholera, 1 January 1625. Married 1) Isabella de Jode, 1599 (died, 1603), son, the painter Jan Bruegel the Younger, one daughter; 2) Catharine van Marienberghe, 1605, 8 children, including the painter Ambrosius Bruegel; his daughter Anna married the painter David Teniers II. Attended school in Antwerp; pupil of Pieter Goetkind, and probably of Gillis van Coninxloo, 1578–84; also studied watercolor painting with his grandmother, Mayken Verhulst; in Italy, c. 1589: entered the service of Cardinal Borromeo (1595 in Rome, and 1596 in Milan); settled in Antwerp, and member of painters guild, 1597 (Dean of the guild, 1601–02), citizen of the city, 1601; appointed Court Painter to Archduke Albert, 1609; traveled in Germany and Bohemia, 1610–20.

Major Collection: Munich.
Other Collections: Amsterdam; Antwerp; Brussels; The Hague; London: National Gallery, Wellington; Madrid; Milan: Ambrosiana; New York; Oxford; Paris; Rome: Doria Pamphili; Vienna.

Publications

On BRUEGEL: books—

Crivelli, G., *Bruegel,* Milan, 1898.
Denuce, Jean, *Brieven en documenten betreffen de Bruegel I en II,* Antwerp, 1934.

Arch of Severus; drawing; Chatsworth House

Combe, Jacques, *Bruegel de Velours,* Paris, 1942.

Clerici, F., *Allegorie dei sensi di Bruegel,* Florence, 1946.

Eemans, M., *Bruegel de Velours,* Brussels, 1964.

Winkelmann-Rhein, Gertraude, *Blumen-Brueghel,* Cologne, 1968; as *The Paintings and Drawings of "Flower" Bruegel,* New York, 1969.

Baumgart, Fritz Erwin, *Blumen-Brueghel: Leben und Werk,* Cologne, 1978.

Ertz, Klaus, *Bruegel der Altere: Die Gemälde mit kritischem Oeuvrekatalog,* Cologne, 1979.

Ertz, Klaus, *Bruegel der Altere,* Cologne, 1981.

articles—

Winner, Matthias, "Zeichnungen des älteren Bruegel," in *Jahrbuch der Berliner Museen,* 3, 1961.

Podles, Mary Smith, "Virtue and Vice: Paintings and Sculpture in Two Pictures from the Walters Collection," in *Journal of the Walters Art Gallery* (Baltimore), 41, 1983.

*

Jan Bruegel has been given several nicknames, which might suggest that over the centuries his critics have not known quite how to evaluate him. He has been called "Velvet," "Flower," and "Paradise" Bruegel, but we should perhaps remember that his father, Pieter Bruegel, was often called "Peasant" Bruegel. The nicknames are to some extent an effort to distinguish between members of the same family (Jan's brother, Pieter II, has been called "Hell" Bruegel). If Jan's having three nicknames might suggest a lack of solidity in his reputation (as if he had a "knack" for a certain kind of painting), all three names (velvet, flower, and paradise) might be applied to the same picture. In fact, Jan Bruegel's position in society and among his fellow artists was assured during his lifetime, and as Klaus Ertz has noted, he solidified the family reputation established by his famous father, and his works were very influential.

His flower paintings are perhaps his most well known, though he began painting flowers only toward the end of his career (his earliest seems to be 1608). He had been taught the art of watercolor by his grandmother, Mayken Verhulst (or Bessemers), and many of his paintings are on a small scale. Though flower paintings as a genre had a short history at the time of Bruegel's taking it up (the earliest known picture of a vase of flowers is possibly by Ludger tom Ring the Younger in 1562), the use of flowers as an iconographical symbol went back to gothic times, and is found in most of the northern painters, associated with strength or essence, and came to be seen as a memento mori. By the time Bruegel was painting, "Turkish" flowers such as tulips and hyacinths had appeared in Europe, as well as American plants such as marigolds, nasturtiums, and sunflowers. Bruegel's reputation as a master at painting flowers is notable because of the newness of the

genre, and he was proud of his mastery of minute detail.

Most of his flower paintings date from c. 1610–21, and his bouquets all have a sure touch in terms of composition. His juxtaposition of flowers of all seasons in the same picture is less a botanical curiosity than a suggestion of the "paradise" or "Eden" quality added to the very idea of such beauty and fullness of nature. There is perhaps also a childlike sense of wonder as well—often the flowers do not touch each other, and appear to be in the same plane in relation to each other—yet there is much refinement in terms of juxtaposition of open and closed blossoms, different angles of similar flowers, and the variety of insects. He was able to study rare flowers in his patron Archduke Albert's Brussels garden.

His landscapes, which he painted all his life, and which show the influences he encountered on his trip to Italy, also take on certain characteristics of his father's work, which he obviously studied. His use of motley, rough figures, often providing the focus of the composition of the work, his delicate coloring of the background, and his simple structuring of space all owe something to Pieter Bruegel. (The *Adoration of the Kings,* in the National Gallery in London, also owes much in subject matter.) Yet one characteristic of his landscapes in his own: a refined, gentle color, often glazed over with a hazy gloss that shows many tints of red, blue, green, and brown, easily leading into the background. Often, too, the distant background is marked off by a completely different quality of light. His sketches show nothing of the complicated and sophisticated structural elements found in the finished works, and much of this effect can be attributed to his use of watercolor mixed with gouache he learned from his grandmother. He is most praised for his small works (and some of his landscapes are veritable miniatures), and his larger works have been criticized as lacking in definition, though this is a matter of taste.

He collaborated with many of his contemporaries—most famously with Rubens (who wrote his epitaph). Two of his most famous works, in fact, are Rubens collaborations: *Madonna in a Wreath of Flowers* (Munich; Bruegel painted the wreath), and *Paradise* (also called *Adam and Eve in the Garden;* The Hague), but he also worked with Paul Bril, Sebastian Vrancz, Hans Rottenhammer, Pieter van Avont, Hendrick van Balen, Henri de Clerck, Joos de Momper, Frans Francken II, and Pieter Needs the Younger. The *Paradise,* with a rather obvious moral view, also points to his allegorical *Five Senses*—examples of a late-medieval concept popular in the baroque period, and of interest to Bruegel for the chance it gave him to paint flowers, animals, and still-life objects.

—George Walsh

BRUEGEL, Pieter.

Born in Breda, c. 1525–30; gave up earlier spelling of name—Brueghel—c. 1559. Died in Brussels, 9 September 1569. Married c. 1563; sons, the painters Jan and Pieter II. Member of the Antwerp guild, 1551; moved to Brussels, c. 1563; traveled to France and Italy, 1552, Rome, 1553; did engravings for the publisher Cock, in Antwerp; patronized by the Emperor's representative, Cardinal Granvelle.

Major Collection: Vienna.
Other Collections: Antwerp: Mayer van der Bergh; Berlin; Boston; Brussels; Darmstadt; Detroit; London; Madrid; Munich; Naples; New York: Frick, Metropolitan; Paris; Prague; Rome: Doria Pamphili; Rotterdam; Royal Collection; San Diego; Washington.

Publications

On BRUEGEL: books-

Bastelaer, René van, and G. H. de Loo, *Bruegel,* Brussels, 2 vols., 1907.

Friedländer, Max J., *Bruegel,* Berlin, 1921.

Dvorak, Max, *Bruegel,* Vienna, 1921.

Fraenger, Wilhelm, *Der Bauern-Bruegel und das deutsch Sprichwort,* Erlenbach-Zurich, 1923.

Tolnay, Charles de, *Die Zeichnungen Bruegels,* Munich, 1925; Zurich, 1952; as *The Drawings of Bruegel,* New York, 1952.

Barker, Virgil, *Bruegel: A Study of His Paintings,* New York, 1926.

Glück, Gustav, *Bruegels Gemälde,* Vienna, 1932; as *Bruegel,* London, 1936.

Tolnay, Charles de, *Bruegel l'ancien,* Brussels, 2 vols., 1935.

Friedländer, Max J., *Die Altniederländische Malerei, vol. 14: Bruegel,* Leiden, 1937.

Jedlicka, Gotthard, *Bruegel der Maler in seiner Zeit,* Erlenbach, 1938.

Bruhns, Leo, *Das Bruegel Buch,* Vienna, 1941.

Puyvelde, Leo van, *Bruegel: The Dulle Griet in the Mayer van der Bergh Museum, Brussels,* London, 1946.

Barnouw, A. J., *The Fantasy of Bruegel,* New York, 1947.

Fierens, Paul, *Bruegel: Sa vie, son oeuvre, son temps,* Paris, 1949.

Faggin, Giuseppe, *Bruegel,* Milan, 1953.

Grossman, Fritz, *Bruegel: Die Gemälde,* Cologne, 1955; as *Bruegel: The Paintings,* London, and New York, 1955, 1966, 1973.

Stridbeck, Carl G., *Bruegelstudien,* Stockholm, 1956.

Münz, Ludwig, *Bruegel: The Drawings,* London and New York, 1961.

Klein, H. A., *Graphic Worlds of Bruegel,* New York, 1963.

Puyvelde, Leo van, *Die Welt von Bosch und Bruegel,* Munich, 1963.

Portmann, Paul, *Children's Games by Bruegel,* Berne, 1964.

Lavalleye, Jacques, *Lucas van Leyden, Bruegel: Gravures: Oeuvre complet,* Paris, 1966.

Bruegel: The Painter and His World (cat), Brussels, 1969.

Bianconi, Piero, *L'opera completa di Bruegel,* Milan, 1967; as *The Complete Paintings of Bruegel,* London, 1969.

Lebeer, Louis, *Catalogue raisonné des estampes de Bruegel* (cat), Brussels, 1969.

Rousseau, Jeanne, and Bob Claessens, *Notre Bruegel/Our Bruegel,* Antwerp, 1969.

Seidel, M., and R. H. Marijnissen, *Bruegel,* Stuttgart, 1969, New York, 1971.

Roberts, Keith, *Bruegel,* London, 1971, Oxford, 1982.

Hare Hunt, 1566; etching

Stechow, Wolfgang, *Bruegel,* New York, 1972.

Brown, Christopher, *Bruegel: Paintings, Drawings, Prints,* London, 1975.

Genaille, Robert, *Bruegel,* Brussels, 1976.

Lebeer, Louis, *Les Estampes de Bruegel,* Antwerp, 1976.

Mettra, Claude, *Bruegel,* Paris, 1976, New York, 1980.

Gibson, Walter S., *Bruegel,* London, 1977.

Martin, Gregory, *Bruegel,* New York and London, 1978.

Bianconi, Piero, *Bruegel,* Bologna, and Woodbury, New York, 1979.

Frati, Tiziani, *Bruegel,* Milan, 1979, New York and London, 1980.

Simson, Otto von, and Matthias Winner, editors, *Bruegel und seine Welt,* Berlin, 1979.

Bruegel: Une Dynastie de peintres (cat), Brussels, 1980.

*

Pieter Bruegel stands out as a rather unique artist among Flemish painters of the 16th century, many of whom were intent upon importing the High Renaissance style of Michelangelo to the north. Despite his trip to Italy in 1552–53, Bruegel rejected the self-consciously Italianate manner of the Romanists, choosing instead to develop a personal style that was based largely on Netherlandish precedents and concerned primarily with contemporary Flemish subjects. The seemingly earthy quality of his art and his frequent selection of subjects from rural life led early scholars to regard him as a country painter, and he was long referred to as "Peasant Bruegel." It is now known, however, that Bruegel was an educated and cultured urban artists, who counted among his friends in Antwerp such leading intellectuals as Ortelius, Coornhert, Goltzius, and Plantin. His earthy style was simply a device he chose to comment upon the political and social turmoil of his day.

His day indeed had much cause for comment. Peasant uprisings afflicted Northern Europe throughout the 16th century. In addition, the Netherlands were engaged in a long and bloody struggle for independence from Spain, a cause which Bruegel commented upon in several paintings. Closely connected with this fight were the religious controversies which had spread throughout Europe as a result of the Reformation, and which figured particularly strongly in the Netherlands. Is it any wonder, then, that Bruegel, rather than merely imitating the Italian Renaissance artists as did so many of his contemporaries, decided instead to question their humanist philosophy and show people dominated by, rather than dominant over, their surroundings, their fellow humans, and their own sinful natures?

Bruegel may have had his early training, as Van Mander

stated, with Pieter Coecke van Aelst, a learned painter whose daughter he subsequently married. His work shows little evidence of that master's influence, however, a fact that has led to recent suggestions that he may have trained with an Antwerp landscape painter, Matthijs Cock, instead. In any case, Bruegel soon turned to other painters for inspiration as well. His early collaboration with Pieter Baltens, a follower of Hieronymus Bosch, may have sparked his interest in that painter. His early work for the engraver Hieronymus Cock shows the influence of Bosch, whose nightmarish visions may have seemed like appropriate expressions of the turmoil of his own time. Yet unlike Bosch, Bruegel was not a fantastic painter. Rather, he gave natural form to abstract concepts thereby forcing the viewer to confront them: in the *Netherlandish Proverbs* of 1559 (Berlin-Dahlem, Staatliche Museen), for instance, he clothes almost one hundred sayings about subjects such as human greed, lust, and deceit in the recognizable look of one's neighbors; and in *Children's Games* of 1560 (Vienna, Kunsthistorisches Museum), he presents a myriad of childhood pastimes as metaphors for adult activities.

The style which Bruegel developed to present these subjects was quite unique and altogether different from that of the Romanists of the time. His compositions, rather than being centralized and monumental, are intentionally diffuse so the viewer spreads his attention across a vast plane of activities. The rich colors, tilted space, and attention to detail which characterize his early works at first seem old-fashioned, as they were based on 15th-century techniques. There is a major distinction between the work of Bruegel and that of his predecessors, however; whereas the earlier painters used their technique of rich colors, textures, and detail to express spiritual wealth, Bruegel adopted and in a way fragmented them to express the diversity and disunity of human existence.

As Bruegel grew older, the tone of his work became more overtly serious. In the mid-1560's he created a number of religious paintings, such as the *Tower of Babel* (1563, Vienna, Kunsthistorisches Museum), the *Road to Calvary* (1564, Vienna, Kunsthistorisches Museum), the *Numbering in Bethlehem*, (1566, Brussels, Musées Royaux des Beaux-Arts), and the *Massacre of the Innocents* (c. 1566, Vienna, Kunsthistorisches Museum). Despite their religious subjects, these works were probably not intended to hang in churches, but rather in the homes of free-thinking intellectuals who would appreciate Bruegel's rather unorthodox approach to his biblical sources. He used his religious subjects less as ends in themselves than as vehicles through which he could depict human folly and suggest the troubles of his time: in the *Road to Calvary,* for instance, Christ is carrying His cross, but He does so in a Flemish landscape. Moreover, He is almost lost in the swarm of activity around Him. Many people go about their daily routines, unaware of the significance of the event that is taking place before them. One senses that they have seen so many executions that they are no longer appalled or even interested by them. Indeed, the large wheel on a stake that parallels the right edge of the panel reminds the viewer of the religious executions that took place frequently in Flanders under the terror of Spanish rule.

In the *Numbering in Bethlehem* Bruegel similarly submerges the Holy Couple in a swarm of oblivious townspeople who go about their business in a snowy Flemish village. The significance of the use of a Netherlandish setting is even more

pointed in the *Massacre of the Innocents*. There the brutal killing of the infants takes place in a Flemish town, but Herod's soldier executioners wear the uniforms of 16th-centruy Spanish troops.

In the mid-1560's Bruegel also began to paint the peasant scenes for which he became so famous. The *Wedding Dance, Peasant Dance* and *Wedding Feast* all date from about 1566–67. According to the early biographer Van Mander, Bruegel frequently disguised himself as a peasant in order to observe peasant manners. Whether or not this is true, it is clear that Bruegel's images are more than mere descriptions of rural life; they are an urbanite's comments—at times envious of the peasant's freedom and communal identity, at others disdainful of their rough manners—on the raucous earthiness of country life of his time.

Dating also from the mid-1560's are some of Bruegel's most stunning—and, for his time, unusual—works, the series of landscapes depicting the months of the year. Painted for the wealthy Flemish art collector, Nicolas Jongeling, in 1565, the series probably originally consisted of six panels, each of which illustrated two months. Five of the works remain: the *Hunters in the Snow, Gloomy Day,* and the *Return of the Herd,* are now in the Kunsthistorisches Museum in Vienna; the *Haymaking* is in Prague today, whereas the *Harvest* is in the Metropolitan Museum in New York. Though based on the calendar pages found in earlier Flemish manuscripts, Bruegel's works are anything but miniaturist in tone. Rather, their sweeping vistas, stately trees and hills, and their subdued coloring give these landscapes a grandeur which was new to that genre. In so elevating landscape, however, Bruegel demoted the figures peopling the scenes to small, trudging, impotent souls who are enslaved to the chores and conditions of nature. These beautiful paintings are finally among the most unhumanistic works ever created.

In some of his late pieces, such as the *Conversion of Saul* (1567, Vienna, Kunsthistorisches Museum), Bruegel returned to his earlier style of vast landscapes peopled with small figures. More often, however, he painted simplified compositions dominated by a few large figures. Proverbs and parables again provide frequent subjects for his art, but his approach to them is marked by a new cynicism so the viewer is hit hard by the bitterness of his themes. Christ's parable of the *Blind Leading the Blind,* painted by Bruegel in 1568 (Naples, Museo Nazionale), is set in a Flemish landscape. The men's eye diseases are depicted with such meticulous observation that opthalmologists have been able to identify them. The anonymous moon-like faces that marked many of his earlier works, such as *Children's Games* have been replaced by wrenching portraits of these unfortunates, who seem all too recognizable as one's suffering countrymen.

The *Misanthrope* of 1567 is similarly bitter in tone. One may be inclined to criticize the sullen old man's misanthropy, but as the man behind him, dressed in a transparent globe symbolizing a treacherous world, cuts his pursestrings, we are forced to admit some justification for his dark view of his fellow humanity. Bruegel himself seems to take the side of misanthropy, for he has inscribed the scene, "Because the world is so untrue, I go in mourning." By the time he died two years later, Bruegel seems to have seen more in the world to mourn than applaud.

—Jane Nash Maller

BURGKMAIR, Hans.

Born in Augsburg, 1473; son of the painter Thomas
Burgkmair. Died in Augsburg, before October 1531. Married
in 1498; son, the artist Hans Burgkmair the Younger. Trained
under Martin Schongauer in Colmar; patronized by the Em-
peror Maximilian I, Frederick the Wise, Elector of Saxony,
and Duke Wilhelm IV of Bavaria; painter and designer of
woodcuts: illustrated the New Testament, The Triumphs of
Maximilian. Students included Hans Weiditz.

Major Collections: Augsburg; Munich.
Other Collections: Berlin; Cologne; Hanover; Nuremberg;
Stuttgart; Vienna.

Publications

On BURGKMAIR: books—

Burgkmair: Altarbild des Christus am Olberg, Hamburg,
1921.
Feuchtmayr, Karl, *Das Malerwerk Burgkmairs von Augsburg:
Kritisches Verzeichnis der Gemälde des Meisters,* Augsburg,
1931.
Burkhard, Arthur, *Burgkmair,* Leipzig, 1934.
Haug, Hans, *Martin Schongauer et Burgkmair: Etude sur une
vierge inconnue,* Strasbourg, 1938.
Appelbaum, Stanley, *The Triumph of Maximilian I: 137 Wood-
cuts by Burgkmair and Others,* New York, 1964.
Falk, Tilman, *Burgkmair: Studien zum Leben und Werk des
Augsburger Malers,* Munich, 1968.
Burgkmair: Das graphische Werk (cat), Augsburg, 1973.
Wuttke, Dieter, *Humanismus als integrative Kunst: Die Philo-
sophia des deutschen ''Erzhumanisten'' Conrad Celtis: Eine
ikonologische Studie zu programmatischer Graphik Dürers
und Burgkmairs,* Nuremberg, 1985.

articles—

Ivens, W. M., Jr., "Burgkmair's Prints in the Museum" in
Metropolitan Museum Bulletin (New York), November
1937.
Buchner, F., "Der Meister des Seyfriedsberger Altars und
Burgkmair," in *Zeitschrift für Kunstwissenschaft,* 10, 1956.
Oertel, R., "Ein Bildnis von Burgkmair aus dem Jahre 1506."
in *Festschrift für Friedrich Winkler,* Berlin, 1959.
Halm, Peter, "Burgkmair als Zeichner," in *Münchner Jahr-
buch,* 13, 1962.
Koreny, Fritz, "Burgkmair—unbekannte Zeichnungen: Uberle-
gungen zu einem verlorenen Werk altniederländische Male-
rei," in *Jahrbuch der Kunsthistorischen Sammlungen in Wien,*
42, 1982.
Silver, Larry, "Shining Armor: Maximilian I as Holy Roman
Emperor," in *Museum Studies* (Chicago), Fall 1985.

*

As the most important artist in Augsburg in the early 16th
century, Hans Burgkmair enjoyed a fine reputation during his
lifetime. The restrained stability of his work epitomizes for us
the spirit of Burger society in Renaissance Germany. His
friendship with humanists, particularly Konrad Peutinger, led
to some important commissions, and also gave him access to
new ideas through the humanists' collections of books, prints,
coins, etc. Burgkmair was an important disseminator of Italian
Renaissance motifs in Germany. Yet his interest in Italy was
different from that of his Nuremberg contemporary Albrecht
Dürer. Burgkmair showed little interest in theories of propor-
tion or perspective or in ancient art. He looked to contempo-
rary Italian Renaissance art for decorative motifs and rich
color. Burgkmair was a prolific designer of woodcuts. As a
major contributor of images for Maximilian I's projects,
Burgkmair did much to further Maximilian's imperial dream
through visual propaganda.

Burgkmair trained under Martin Schongauer in Colmar. The
evidence of this apprenticeship is twofold. A portrait of Schon-
gauer in Munich, ascribed to Burgkmair, bears an inscription,
the ending of which reads in translation: "I, his pupil, Hans
Burgkmair in the year 1488." Burgkmair's *Virgin and Child* of
c. 1498–1500 (private coll.) relies heavily on Schongauer's
Virgin and Child in a Rosebower (Colmar). Burgkmair no
doubt trained under his father, Thoman Burgkmair, as well.
But there is little of the father's mediocre abilities to be seen in
the son's work. Burgkmair probably made two brief trips: to
the lower Rhine region in 1503, and to northern Italy around
1507.

Burgkmair's early works are easily distinguished from those
of his maturity. His portrait of the preacher Gailer von Kayser-
berg of 1490 (Augsburg) is clearly hesitant juvenilia. His
woodcuts of the 1490's are typical of Augsburg book illustra-
tion at that time. Rather than try to fit Burgkmair's work into a
traditional tripartite developmental scheme, perhaps it is more
rewarding to see his entire oeuvre after 1500 as varying re-
sponses to the demands of different commissions and tasks,
that is, as visual problem solving.

Between 1501 and 1504 Burgkmair painted three panels in a
series of six for the St. Katherine's Cloister in Augsburg (now
in the Staatsgalerie). The series focuses on the major pilgrim-
age churches of Rome, and Burgkmair's contributions were
Basilica San Pietro (1501), *Basilica San Giovanni in Laterano*
(1502), and *Basilica Santa Croce* (1504). In these works
Burgkmair subjugates individual style to the overall uniformity
of the series. He successfully combines narrative and iconic
elements in an awkward format—pointed arch panels. The San
Pietro panel is often singled out as the most successful due to
the relationship of figures to the setting and the Italianisms of
the Passion scene landscape in the upper register, but in the
Santa Croce panel Burgkmair gives full reign to the pageantry
of exotic figures and the decorative aspects of gold and cos-
tume.

The blond tonalities of the *All Saints' Altar* of 1507 (Augs-
burg) are rare in Burgkmair's work, but effective for this ren-
dering of the heavenly court as a vision of the hereafter. The
separating devices of clouds, color of clothing, and mock trac-
ery effectively distinguish groups of saints, and at the same
time unify the altarpiece as a whole. The presentation of the
scene as a vision through the open tracery of a window clearly
distinguishes the realm of the viewer from that of the saints—
the present from the future.

The *Virgin and Child* of 1509 (Nuremberg) shows the frui-
tion of Burgkmair's Virgin type as developed in numerous

Venus and Mercury, c. 1520; etching

woodcuts from 1507–09. Burgkmair's interest in Italian decorative motifs is evident, and the pose of the figures is reminiscent of Michelangelo's Bruges *Madonna,* but it is clearly Burgkmair's own adaptation.

The *St. John Altarpiece* of 1518 and the *Crucifixion Altarpiece* of 1521 (both in Munich; exterior wings in Augsburg) show Burgkmair's adoption of the deep, saturated color of Venetian painting. Both altarpieces have a continuous landscape across three panels. Burgkmair's interest in the unity of figures within an atmospheric space is realized here, and the overall effect of both works is one of visual harmony tinged by a mild psychic disturbance.

Burgkmair's last paintings, the *Story of Esther* of 1528 and the *Battle of Cannae* of 1529 (both in Munich) are again works in series. Duke Wilhelm IV of Bavaria commissioned two cycles of history paintings from various artists, the subjects being the heroic deeds of men, exemplified by grandiose battle scenes, and the virtuous acts of women, portrayed as individual acts of heroism. It appears that within a few basic parameters of the series the individual artists' varying interpretations and styles were sought after. In both paintings Burgkmair shows a knack for closely following his texts yet creating individual visual narratives. The *Story of Esther* is a scintilating rendering of court opulence, here given an exotic Venetian flavor. In the *Battle of Cannae,* the viewer's position in regard to the scene is ambiguous, unlike the other battle scenes in the cycle where a high aerial vantage point organizes space. The tripartite battle rendering is presented as a series of stacked tiers, reminiscent of Roman battle reliefs.

Burgkmair's graphic production was large and the nature of different projects necessitated various approaches to subject matter, yet throughout this work, as in his paintings, one can discern an interest in overall harmony, visual splendor, and decorative effect. Burgkmair's line is always heavy, and forms are clearly outlined. While recension into space is believable, this is always balanced by the two-dimensional decorative effect of the whole. The technical quality of Burgkmair's graphic work (entirely woodcut, save for one etching) rarely falters—the result of his collaboration with a superb cutter for his blocks, Jost de Negker.

Burgkmair was a master of the portrait woodcut. *Konrad Celtis Epitaph* (1507), *Hans Baumgartner* (1512), and *Julius II* (1512) show the successful adoption of various Italian portrait conventions, respectively: the classically inspired funeral image, the three-quarter view with perspectival architecture behind, and the medallic profile view. As an early experimenter in chiaroscuro woodcuts, Burgkmair created a number of rich images, notably the *St. George* and *Maximilian I* woodcuts of 1508, and *Death Overtakes Two Lovers* of 1510. In the various series of c. 1510 (Virtues, Vices, Planets) the decorative nature of Italian ornament reigns supreme. The *Crucified Christ in a Landscape* (c. 1510) is a quiet, contemplative image of suffering, and unique in its iconography. Christ is shown bound by ropes, without saint intercessors flanking the cross, and crucified with the antiquated formula of four nails rather than three. Though rare for Burgkmair, the *Monstrous Child of Tettnang* (1516) shows that this artist could also create images in a more popular, broad-sheet tradition.

Again collaborating with other artists, Burgkmair was occupied for the better part of the decade after 1510 designing woodcuts for Maximilian I's grandiose projects. Burgkmair's contributions included a great number of woodcuts for the *Genealogy, Theuerdank, Weisskunig,* and *Triumphal Procession,* as well as drawings for the *Prayerbook.* Pageantry and decorative effect are stunning in these images, and the rendering of visual narrative, is superb. The *Weisskunig* illustrations are perhaps the most successful. Here, the drawing is completely relaxed and bolder than in the *Theuerdank* illustrations.

Burgkmair's mature work from 1500 on never mimics others. He adapts elements from various traditions into his own organized, restrained style. Burgkmair rarely shows frantic energy or unrestrained emotion; he always strikes a balance and presents a middle path. There is little in his work to show partisan sentiment for any cause. Notably, he did not take part in the Lutheran propaganda campaign via printed images. This restrained, stable harmony that characterizes his work is clearly the result of an upstanding Burger creating images for a like-minded audience.

—David Heffner

BURNE-JONES, (Sir) Edward.

Born Edward Coley Burne Jones in Birmingham, 28 August 1833. Died in London, 17 June 1898. Married Georgina MacDonald, 1860; one son and one daughter. Attended Kind Edward's School, Birmingham; Exeter College, Oxford; pupil of D. G. Rossetti at Working Men's College, and with him, Morris, and others decorated the Oxford Union Debating Society Library, 1857; in Italy, 1859 and 1862 (copied works by Tintoretto for Ruskin), and later trips; designed tapestries and stained glass for Morris's firm; exhibition at the Grosvenor Gallery in 1877 made him famous (the "Burne-Jones Look"); several painting series, including Briar Rose. Knighted, 1894.

Major Collections: London: Tate; Birmingham: City Art Gallery.
Other Collections: Cambridge; Cambridge, Massachusetts; Cardiff; Lisbon: Gulbenkian; Liverpool; London: Victoria and Albert; Melbourne; New Haven; Newcastle upon Tyne; Ponce, Puerto Rico; Port Sunlight; Stuttgart.

Publications

By BURNE-JONES: books—

Letters to Katie, London, 1925; edited by John Christian, London, 1988.
The Little Holland House Album, edited by John Christian, North Berwick, 1981.
Burne-Jones Talking: His Conversations 1895–1898 Preserved by His Studio Assistant Thomas Rooke, edited by Mary Lago, Columbia, Missouri, 1981.

On BURNE-JONES: books—

Bell, Malcolm, *Burne-Jones: A Record and a Review,* London, 1892.

Schleinitz, O. von, *Burne-Jones,* Bielefeld, 1901.

Burne-Jones, Georgiana, *Memorials of Burne-Jones,* London, 2 vols., 1904.

Lisle, Fortunée de, *Burne-Jones,* London, 1904.

Arsène, Alexandre, *Burne-Jones,* London, 1907.

Wood, T. Martin, *Drawings of Burne-Jones,* London, 1907.

Ironside, Robin, and John Gere, *Pre-Raphaelite Painters,* London, 1948.

Grossman, Fritz, *Burne-Jones: Paintings,* London, 1956.

Cecil, David, *Visionary and Dreamer: Two Poetic Painters, Samuel Palmer and Burne-Jones,* Princeton, 1969, London, 1977.

Hilton, Timothy, *The Pre-Raphaelites,* London, 1970.

Harrison, Martin, and Bill Waters, *Burne-Jones,* New York and London, 1973, 1989.

Löcher, Kurt, *Der Perseus-Zyklus von Burne-Jones,* Stuttgart, 1973.

Fitzgerald, Penelope, *Burne-Jones: A Biography,* London, 1975.

Marcus, Penelope, editor, *Burne-Jones* (cat), London, 1975.

Spalding, Francis, *Magnificent Dreams: Burne-Jones and the Late Victorians,* Oxford, 1978.

Johnson, May, *Burne-Jones,* London, 1979.

Pre-Raphaelite Drawings by Burne-Jones, New York, 1981.

Wood, Christopher, *The Pre-Raphaelites,* New York and London, 1981.

Bell, Quentin, *A New and Noble School: The Pre-Raphaelites,* London, 1982.

articles—

"Burne-Jones Issue" of *Apollo* (London), 102, 1975.

Christian, John, " 'A Serious Talk': Ruskin's Place in Burne-Jones's Artistic Development," in *Pre-Raphaelite Papers,* edited by Leslie Parris, London, 1984.

*

Edward Burne-Jones's mentors were the Pre-Raphaelite painter Dante Gabriel Rossetti, five years his senior, and John Ruskin, who by his notice and encouragement became the legitimator of the Pre-Raphaelite movement, launched in 1848. Rossetti's brother, William Michael, stated its principles as follows: "1 To have genuine ideas to express; 2 to study Nature attentively, so as to know how to express them; 3 to sympathise with what is direct and serious and heartfelt in previous art, to the exclusion of what is conventional and self-parading and learned by rote; and 4 and most indispensable of all, to produce thoroughly good pictures and statues." For Rossetti and his colleagues—in particular William Holman Hunt, Ford Madox Ford, and John Everett Millais—such a high standard offered an antidote to the stagnation into which Victorian art had fallen by mid-century. For Burne-Jones, intensely aware that industrial Birmingham had starved his early years of beauty and of the chance to learn art's history, Pre-Raphaelite philosophy and example were to be nourishment and incentive.

As young men at Oxford in the 1850's, Burne-Jones and William Morris together fell under the spell of the ancient Grail stories, among which Malory's *Morte d'Arthur* became their book of books. They did not at first intend to become artists. Morris began a career in architecture; Burne-Jones in-

A Female Head, 1896; drawing; Royal Collection

tended to take Holy Orders. But the Mystique of the Grail and the influence of Rossetti were too strong. They vowed to dedicate themselves to "a life of art" as painters. They would take their "genuine ideas" from the past and would be faithful to Ruskin's principle of Nature as the supreme model. After 1861 Morris, through his firm, would concentrate upon design and crafts production. Burne-Jones's collaboration on the firm's stained glass, in particular, would become the steady work to provide the wherewithal by which he could continue as a painter.

He had no academic qualifications. He learned by trial and error, by watching Rossetti at work and by using Rossetti's drawings as guide. To those were added Ruskin's personal encouragement, and admission to "that heavenly company," as Burne-Jones called it, the senior Pre-Raphaelites, their disciples, and their friends. The style that evolved, first in watercolours, later in gouache and oils, was intense and unorthodox. He experimented with deep, rich colors, and light seems to strike his surfaces from some indirect source, reflections from within the painted scene. A roughened surface and underpainting with Chinese white, a favorite Pre-Raphaelite technique, contributed to that effect. His subject matter was literary or fanciful. He borrowed directly and indirectly from Tennyson, Malory, English folklore, classical mythology, and his own imagination, from medieval tapestries and illuminations, from early Italian Masters and imagined classical settings: elements

of a composite idiom all his own. He combined them according to an unconventional inner vision. This individualism was consonant with his lifelong distrust of artists' organisations and their inevitable pressures to conform. It was certainly connected to his unhappiness in the Royal [Old] Watercolour Society, with whom he exhibited in 1864 and as a result had his first direct confrontation with the critics, who could not stomach his stylised and eccentric picture *The Merciful Knight*. The influential *Art Journal* could not even imagine "what spectacles he can have put on to gain a vision so astonishing."

On the other hand, just as Rossetti had become his inspiration, that exhibition did much to make him an inspiration for younger painters. Walter Crane wrote that it was Burne-Jones's glimpses of "a twilight world of dark mysterious woodlands, haunted streams, meadows of dark green starred with burning flowers, veiled in a dim and mystic light, and stained with low-toned crimson and gold" that fired younger painters with "such visions" and made them "desire to explore further for themselves."

Burne-Jones continued to go his own way. From 1877, when the Grosvenor Gallery opened, until it closed 11 years later, it was his regular place of exhibition. It did not mind eccentricity, and it became the center of the aesthetic movement, with its no less intense dedication to personal principles of beauty and, like Pre-Raphaelitism, a reaction to the ugliness and materialism of Victorian England. Burne-Jones was fortunate, even in his early years, in finding wealthy, faithful patrons. Among them were T. E. Plint, a wealthy Leeds businessman; the Liberal M.P. for Glasgow, William Graham; Whistler's patron, Frederick Leyland; Constantine Ionides, of the London clan of Greek merchant families; and George Howard, later the Earl of Carlisle, who became a close friend. But by the 1890's Burne-Jones began to be oppressed by the sense of an ending. Rossetti had died in 1882. Since 1878 Ruskin had had repeated breakdowns of health. The age of patronage was giving way to the age of the commercial dealer. Some of the great Victorian collections were being dispersed, to pay debts or because no one cared enough to keep important art works in the country. Burne-Jones drew even closer to Morris, who had turned away, disillusioned, from organised Socialism, which Burne-Jones dismissed as a "parenthesis" in Morris's life, a digression from their dedication to "the life of art." Their continuing collaboration included not only the firm's stained glass, but the publications of Morris's Kelmscott Press, founded in 1891; the most notable of these was the famous Kelmscott *Chaucer*, for which Burne-Jones designed illustrations.

In his last years he gained perspective on his past loyalties and enthusiasms. The best understanding of these is found in the studio conversations recorded in the notes of Thomas Rooke, his assistant for 30 years. Rossetti, Burne-Jones knew, had failed to fulfill his great promise through carelessness and lack of staying power. Everlasting gratitude for Ruskin's encouragement and generosity was balanced by realisation that although his gospel of art endured, in his social gospel he had preached principally to the converted: "Only Ruskin that was ever worth listening to," he told Rooke, "and he was far from always right." But in Burne-Jones's memory he was always "dear Ruskin," "that dear Ruskin." The death of William Morris in 1896 left Burne-Jones desolate, not only for the loss of a friend, but for the close of the tradition that they had inherited and now saw no heirs to whom to bequeath it. He said to Rooke, "I'm sorry for the world and the years of splendid work it has lost—he could well do without it, but the world's the loser. And now I must go on with my work; things must be done and the living have to live." He carried on for only two years.

An impression has persisted of Burne-Jones as unworldly dreamer, stranded in a romanticised Middle Ages and ineffective in coping with the new age that had overtaken him there. Undoubtedly, his archaic subject matter helped to create this impression; the women in his pictures so often seem just about to float from the solid ground, and their surroundings are suffused with that unearthly, exceptional quality of light. But in fact he was well aware of the world outside the studio. His scorn for imperialism, for the vanity and futility of rampant nationalism, was devastating and forthright. He admired Gladstone for his stand on Irish Home Rule. He thought that England's superior attitude toward the United States would eventually prove self-defeating. He abominated snobbery and prudishness and refused to join in the ostracism of Oscar Wilde. And if he deprecated Morris's Socialist phase, it was not because he lacked a social conscience, but because he felt that Morris's unique talents should be dedicated to art.

In his own art, Burne-Jones contributed to 19th century art a new sense of color as an emotional medium, and a reminder that the past had a message of continuity for the present. In the 1890's he became a decided influence on the French Symbolists. His stained-glass designs for Morris helped to revitalise that art. His stylisations no longer seem eccentric but have a place in the stream of influences pointing to the art of the 20th century.

—Mary Lago

CALDER, Alexander.

Born in Philadelphia, Pennsylvania, 22 July 1898; son of the sculptor Alexander Stirling Calder. Died in New York, 11 November 1976. Married Louisa James, 1931; two daughters. Attended school in Berkeley, California; studied mechanical engineering Stevens Institute of Technology, Hoboken, New Jersey, 1915–18, M.E. 1918; draftsman and engineer, logging camps, 1919–23; studied drawing and painting, Art Students League, New York, with Boardman Robinson, 1923–25, and at the Académie de la Grande Chaumière, Paris, 1926–27; contributed sketches to *National Police Gazette*, New York, 1925–26; worked on wood sculpture, and produced miniature circus, Paris, 1926–27; member, Abstraction-Création group, Paris, 1930–31; first mobiles, 1931; lived in Roxbury, Connecticut, after 1933, and spent much time in Saché, near Tours, France, after 1960; set designer for Martha Graham ballets, and for *Socrate* by Satie, 1935, *Provocation* by Pierre Halet, 1963, *Metaboles*, 1969, and *Eppur si muove* by Francis Miroglio, 1971; his own ballet *Work in Progress* produced in Rome, 1968.

Collections: Amsterdam; Andover, Massachusetts; Berlin: Neue Nationalgalerie; Humlebaek, Denmark; New York: Moma, Whitney, Guggenheim; Paris: Art Moderne; Philadelphia; Stockholm.

Publications

By CALDER: books—

Calder's Circus, New York, 1964.
An Autobiography with Pictures, New York, 1966.
Calder at the Zoo, Washington, D.C., 1974.

illustrator: *Animal* Sketching, by Charles Liedl, 1926; *Fables of Aesop,* 1931; *3 Young Rats and Other Rhymes,* edited by James Johnson Sweeney, 1944; *The Rime of the Ancient Mariner,* by Coleridge, 1946; *Selected Fables,* by La Fontaine, 1948; *A Bestiary,* edited by Richard Wilbur, 1955; *Fêtes,* by Jacques Prévert, 1955; *La Proue de la table,* by Yves Elleouet, 1967; *Santa Claus* by D. Jon Grossman, 1974.

On CALDER: books—

Sweeney, James Johnson, *Calder* (cat), New York, 1951.

Messer, Thomas, *Calder* (cat), New York, 1964.
Arnason, H. H., *Calder: A Study of the Works,* Princeton, 1966.
Ragon, Michel, *Calder: Mobiles and Stabiles,* Paris and New York, 1967.
Caradente, Giovanni, *Calder,* London, 1968.
Bellow, Peter, *Calder,* Dusseldorf, 1969.
Rose, Bernice, *A Salute to Calder* (cat), New York, 1969.
Calder (cat), Saint-Paul-de-Vence, 1969.
Arnason, H. H., *Calder,* New York, 1971.
Sweeney, James Johnson, *Calder,* Paris, 1971.
San Lazzaro, G., editor, "Calder Issue" of *20th Siècle* (Paris), 1972.
Lipman, Jean, *Calder's Universe,* New York, 1976, London, 1977.
Hayes, Margaret Calder, *The Calders: A Family Memoir,* Middlebury, Vermont, 1977.
Bruzeau, Maurice, *Calder,* New York, 1979.
Bourdon, David, *Calder: Mobilist, Ringmaster, Innovator,* New York, 1980.
Wattenmaker, Richard J., and Christopher R. Young, *Calder,* Flint, Michigan, 1983.
Marter, Joan, *Calder,* New York, 1984.
Lipman, Jean, *Calder's Creatures—Great and Small,* New York, 1985.
Lipman, Jean, and Margaret Aspinall, *Calder and His Magic Mobiles,* London, 1987.

*

Alexander Calder invented the mobile, and thereby established himself as one of the great innovators of kinetic art. By equipping his constructions with movable parts, he injected considerable liveliness to sculpture and literally added another dimension to it—that of time. Unlike traditional sculptures, which typically assume a closed, solid, and freestanding form, Calder's mobiles are linear, open-worked configurations, often suspended from the ceiling. His mobiles typically consist of several flat pieces of sheet metal, cut into rounded or angular shapes and fastened to lengths of wire, which are looped to one another so that each is capable of whirling independently. Like sails, the pieces of metal are set in motion by passing air currents, rotating around their individual axes and endlessly rearranging themselves in an ever-changing pattern. Later in his prolific career, Calder also created looming, standing constructions of intersecting planes of steel plate that he called stabiles; these works, many of which are more than 50 feet

Untitled, 1972; aluminum stabile; Courtesy Waddington Galleries

high, sometimes suggest giant, geometrized dinosaurs, at once imposing, wry, majestic, and slightly preposterous.

Calder was born into a dynasty of artists. His mother, Nanette, was an accomplished painter; his father, Alexander Stirling Calder, was a prominent sculptor of allegorical and historical figures who carved a notable statue of George Washington for the monumental arch in Manhattan's Washington Square. His grandfather, Alexander Milne Calder, born in Aberdeen, Scotland, in 1846, created the 37-foot-high bronze effigy of William Penn that stands on top of Philadelphia's City Hall. As a young man, Calder displayed a talent for caricature, which he put to good use by sketching sporting events for *The National Police Gazette,* a popular weekly published in New York. In the mid-1920's, he studied art in Paris, where he fell in with a group of avant-garde painters and sculptors. There, he initiated his international reputation by making clever wire sculptures of figurative subjects; he could deftly manipulate continuous lengths of wire—as if he were creating three-dimensional line drawings—into concise representations of circus acrobats, Josephine Baker, and droll animals, as well as startlingly accurate portraits of his friends.

Calder became an abstractionist largely as a result of a visit to Piet Mondrian's Paris studio in 1930. The Dutch painter's austere, non-referential pictures, restricted to straight black lines and white or primary-colored rectangles, gave the young American a jolt from which he never recovered. He subsequently adopted Mondrian's minimalist palette, limiting himself mainly to black, red, white, and sometimes blue. But unlike Mondrian, Calder generally avoided straight lines and rectilinear configurations, preferring to compose with organic, free-form shapes that allude to the flora and fauna of the natural world. In this respect, he was inspired by the "biomorphic" or lifelike forms that appear in the art of his good friend Joan Miró and Jean Arp, both key figures in the Dada and Surrealist movements.

Calder's first abstract constructions were extremely spare in form: by joining two wire circles, one horizontal and one vertical, he suggested a sphere with a minimum of mass. He titled several of his early mobiles *Universe,* and he later maintained that he was inspired by "the system of the universe." Detached bodies of different sizes, floating in space, struck him as the "ideal source of form." His mobiles are in effect lyrical, entirely imaginative counterparts to orreries—scientists' scale models of the solar system with orbiting spheres representing the planets and their satellites. Although he initially motorized some of his mobiles, he generally found motors bothersome, preferring the greater freedom of movement provided by air.

Calder's ebullient humor, simplicity, and distaste for aes-

thetic pretensions prompted many of his fans to seek connections between his art and folkloric whirligigs, weather vanes, and toys. In the 1960's and 1970's, he consolidated his reputation as one of the most popular and beloved artists in American history by accepting many governmental and corporate commissions for large mobiles and stabiles.

—David Bourdon

A Peasant Holding a Basket, 1617; etching

CALLOT, Jacques.

Born in Nancy, 1592. Died in Nancy, 25 March 1635. Married Catherine Kuttinger, 1623. Pupil of Claude Henriet, 1606; apprenticed to the silversmith and engraver Domenge Croq, 1607; in Rome in 1608 or 1609 (in Thomassin's studio, 1610); and lived and worked in Florence, 1612-21: in service of the Medici for 1614; developed hard ground on plate from etching; then settled in Nancy, 1621—recorded life at court, and made battle scenes for the Spanish Regent and for Louis XIII; produced about 1500 etchings and 2000 drawings.

Collections: Chantilly; Chatsworth; Darnstadt; Florence; Leningrad; London: British Museum; Paris; St. Louis; Weimar.

Publications

On CALLOT: books—

Bouchot, Henri, *Callot: Sa vie, son oeuvre, et ses continuateurs,* Paris, 1889.
Plan, Pierre Paul, *Callot, maître gravure,* Paris, 1911.
Bruwaert, Edmond, *Vie de Callot, graveur lorrain,* Paris, 1912.
Nasse, Hermann, *Callot,* Leipzig, 1919.
Zahn, Leopold, *Die Handzeichnungen des Callot,* Munich, 1923.
Lieure, Jules, *Callot: Catalogue de l'oeuvre gravé,* Paris, 8 vols., 1924-29.
Meaume, Edouard, *Recherches sur la vie et les ouvrages de Callot,* Wurzburg, 2 vols., 1924.
Cain, J., R. A. Weigert, and P. A. Lemoigne, *Callot: Etudes de son oeuvre gravé,* Paris, 1935.
Levertin, Oscar, *Callot: Vision du microcosme,* Paris, 1935.
Marot, Pierre, et al., *Callot et les peintres et gravures du XVIIe siècle* (cat), Nancy, 1936.
Marot, Pierre, *Callot d'après des documents inédits,* Nancy, 1939.
Daniel, Howard, *The World of Callot,* New York, 1948.
Bechtel, Edwin de T., *Callot,* London and New York, 1955.
Feinblatt, Ebria, *Callot* (cat), Los Angeles, 1957.
Löffler, Peter, *Callot: Versuch einer Deutung,* Winterthur, 1958.
Mayor, A. Hyatt, *Callot and Daumier,* New York, 1959.

Ternois, Daniel, *Callot: Catalogue complet de son oeuvre dessiné,* Paris, 1962.
Ternois, Daniel, *L'Art de Callot,* Paris, 1962.
Mongan, Elizabeth, *Callot: A Selection of Prints from the Collections of Rudolf L. Baumfeld and Lessing J. Rosenwald* (cat), Washington, 1963.
Daniel, Howard, *The Commedia dell'Arte and Callot,* Sydney, 1965.
Knab, Eckhart, *Callot und sein Kreis* (cat), Vienna, 1968.
Rossier, E., *Callot: L'Oeuvre gravé* (cat), Geneva, 1968.
Averill, Esther, *Eyes on the World: The Story and World of Callot,* New York, 1969.
Sadoul, Georges, *Callot: Miroir de son temps,* Paris, 1969.
Callot (cat), Providence, 1970.
Schroeder, Thomas, *Callot: Das gesamte Werk,* Munich, 2 vols., 1971.
Daniel, Howard, *Callot's Etchings: 388 Prints,* New York, 1974.
Russell, H. Diane, *Callot: Prints and Related Drawings* (cat), Washington, 1975.
Ballerini, Paolo, et al., editors, *Callot, Stefano Della Bella* (cat), Florence, 1976.
Kahan, Gerald, *Callot, Artist of the Theatre,* Athens, Georgia, 1976.
Caffier, Michel, *L'Arbre aux pendus: Vie et misères de Callot,* Nancy, 1985.

articles—

Klingender, Francis, "Les Misères et les Malheurs de la Guerre," in *Burlington Magazine* (London), 81, 1942.
Posner, Donald, "Callot and the Dances Called Sfessania," in *Art Bulletin* (New York), 59, 1977.

Wolfthal, Diane, "Callot's Miseries of War," in *Art Bulletin* (New York), 59, 1977.

*

Jacques Callot's primary technical accomplishment was his reform of etching. Developed in the early 16th century from the use of acid to achieve designs on armour, etching had been a faster second-cousin to the more polished medium of engraving. At first, the etched line could approximate neither the fineness of the engraved line nor its capacity to describe textures and model volumes.

Callot's technical innovations included the replacement of the usual soft, waxy ground with a hard varnish, and the invention—or perhaps only the first effective use of—the *échoppe*. The varnish had been developed by Florentine stringed instrument makers and allowed for a more precise line and better control over multiple biting, which increased etching's tonal range. The *échoppe,* a large needle with a slanted, oval-shaped end, could be rotated in the fingers to produce a swelling and tapering line as it scratched through the varnish. When etched, this line approximated the modelling capacity of the engraved line, which swelled and tapered because of the muscular action of the artist as he pushed the burin through the copper.

Callot's etchings frankly imitated engravings. His approach differed from that of Rembrandt and other 17th-century printmakers who exploited, during this great century of etching, its spontaneous, experimental qualities.

Callot's oeuvre is marked by virtuoso technical achievements and by many scholarly problems. He derived much of his subject-matter from Florentine festivals and the Italian theater. Yet juxtaposed to these lighter themes are controversial images of beggars, dwarves, war, and punishment. There is an elegant neutrality in Callot's style that complicates the interpretation of many of his prints. We must be careful not to impose 20th-century ideas about justice, war, the indigent, and the deformed onto Callot, who was above all an artist immersed in 17th-century attitudes. His fascination with theater and pageantry on the one hand and deformity and horror on the other are characteristic of his century.

Certainly his most spectacular print is *The Fair at Impruneta* (1620), depicting the Feast of St. Luke near Florence and dedicated to the Medici Grand Duke, Cosimo II. Incredibly, Callot etched another plate of this image after his return to Nancy. There are 1300 perfectly realized figures, spread out in a panoramic landscape in the tradition of Bruegel. The crowd is ostensibly there to honor St. Luke and his painting of the Virgin, but the religious goal is lost in the carnival atmosphere, which includes an execution and snake charmer among many other activities. In the center of the print, Callot emphasizes his satirical point with two copulating dogs.

Callot's oeuvre includes controversial series, *Varie Figure di Gobbi* (Various Figures of Dwarves), *Les Gueux* (The Beggars), the *Balli di Sfessania* (Sfessanian Dances), and the small and large *Misères et les Malheurs de la Guerre* (Miseries and Misfortunes of War). The "Gobbi" were an Italian troupe of comedic dwarves whose physical characteristics were greatly exaggerated by Callot. His series, like the performers themselves, mocked human pretensions by couching them in grotesque terms. Rather than being a plea for social reform, *The Beggars* is better understood in light of a fearful and satirical attitude toward the homeless, reinforced in the 17th century by the almost constant warfare which forced peasants off their land and threatened social order. The *Balli di Sfessania* have been associated with the Commedia dell'arte. But Donald Posner has argued that, although the *Balli* include Commedia dell'arte characters, they really represent a Neapolitan version of the medieval morris dance which merged with another local, erotic dance. In Posner's interpretation, Callot's series, despite its surface elegance, has to do with the ludicrous and brutal aspects of human behavior.

None of Callot's series is more problematic than the large *Miseries and Misfortunes of War* (1633). A smaller set, published posthumously, may have served as preliminary studies for the large. The large *Miseries* builds on Dutch and Flemish military genre prints and his own etchings, such as *The Siege of Breda* (1628) and *The Punishments* (c. 1630), a gruesome panorama of 17th-century justice. The large *Miseries* has been variously interpreted as an objective account of the siege of Lorraine by Louis XIII, an outcry against this invasion, a call for social justice in the form of a peasant revolt, or a statement of the religious meaning of war as a means of disciplining humanity and as a punishment for original sin. Perhaps the most convincing view of the series is that of Diane Wolfthal, who has analysed it in the light of 17th-century concerns about good and bad military behavior. A significant addition to the large *Miseries,* distinguishing it from the small, were the six plates depicting the capture and punishment of marauding soldiers.

Despite Wolfthal's analysis, it is hard to deny the possibility of a greater irony in Callot's juxtaposition of images like *Enrolling the Troops* and *Awarding the Honors of War* with horrifying scenes of rape and pillage, and of lines of maimed soldiers filing into hospitals. True to its time, Callot's series combines brutality and pageantry, glory and horror. Whether we can truly see it as a spiritual ancestor to Goya's more overtly passionate *Disasters of War* remains unanswered. In fact, the content of Callot's art as a whole is still open to question. That he is a fascinating and technically superlative artist who made an important contribution to etching is certain. It is significant for the history of printmaking that an artist of Callot's magnitude restricted himself to graphic media.

—Linda C. Hults

CAMPIN, Robert [Master of Flémalle; also called Master of Mérode].
Born in Tournai or Valenciennes, c. 1378. Died in Tournai, 26 April 1444. Worked in Tournai: a "free master," 1406, and dean of painters guild, 1423; burgess, 1410, and member of Communal Council, 1425–27. Pupils: Jacques (Jacquelotte) Daret and Rogier (Rogelet) de la Pasture (usually identified with Rogier van der Weyden).

Collections: Aix-en-Provence; Berlin; Cleveland; Dijon; Frankfurt; Leningrad; London: National Gallery, Courtauld; Madrid; New York: The Cloisters; Philadelphia.

Publications

On CAMPIN: books—

Friedländer, Max J., *Die altniederländische Malerei, vol. 2: Rogier van der Weyden und der Meister van Flémalle*, Berlin, 1924; as *Rogier van der Weyden and the Master of Flémalle* (notes by Nicole Veronee-Verhaegen), New York, 1967.

Beyaert-Carlier, Louis, *Le Problème van der Weyden, Flémalle, Campin*, Brussels, 1937.

Tolnay, Charles de, *Le Maître de Flémalle et les frères van Eyck*, Brussels, 1938.

Panofsky, Erwin, *Early Netherlandish Painting*, Cambridge, Massachusetts, 2 vols., 1953.

Frinta, Mojmir S., *The Genius of Robert Campin*, The Hague, 1966.

Davies, Martin, *Rogier van der Weyden: An Essay, with a Critical Catalogue of Paintings Assigned to Him and to Robert Campin*, New York, 1972.

Lane, Barbara G., *The Altar and the Altarpiece: Sacramental Themes in Early Netherlandish Painting*, New York, 1984.

articles—

Schapiro, Meyer, " '*Muscipula Diaboli*': The Symbolism of the Mérode Altarpiece," in *Art Bulletin* (New York), 27, 1945.

Rousseau, T., Jr., "The Mérode Altarpiece," in *Bulletin of the Metropolitan Museum* (New York), 16, 1957.

Freeman, M. B., "The Iconography of the Mérode Altarpiece," in *Bulletin of the Metropolitan Museum* (New York), 16, 1957.

Van Gelder, J. G., "An Early Work by Campin," in *Oud Holland* (The Hague), 82, 1967.

Heckscher, William, "The Annunciation of the Mérode Altarpiece: An Iconographic Study," in *Miscellanea Josef Duverger*, Ghent, 1968.

Minott, Charles Ilsley, "The Theme of the Mérode Altarpiece," in *Art Bulletin* (New York), 51, 1969.

Gottlieb, Carla, "*Respiciens per Fenestras*: The Symbolism of the Mérode Altarpiece," in *Oud Holland* (The Hague), 85, 1970.

Schabacker, Peter H., "Notes on the Biography of Campin," in *Mededelingen van de Koninklijke Academie voor Wetenschappen, Letteren, en Schone Kunsten van Belgie*, 41, 1980.

De Coo, Joseph, "A Medieval Look at the Mérode Altarpiece," in *Zeitschrift für Kunstgeschichte* (Munich), 44, 1981.

Hahn, Cynthia, " 'Joseph Will Perfect, Mary Enlighten, and Jesus Save Thee': The Holy Family as Marriage Model in the Mélrode Altarpiece," in *Art Bulletin* (New York), 68, 1986.

Pitts, Frances, "Iconographic Mode in Campin's London Madonna," in *Konsthistorisk Tidskrift* (Stockholm), 55, 1986.

*

Robert Campin was a painter on record in the Flemish city of Tournai from 1406, when he is first listed as a master there, until his death. There are no records of his birth or training. In 1423 Campin became dean of the Tournai painters guild.

The works presently attributed to Robert Campin emerged, with the development of scholarly awareness of the style of Flemish art, as a body of paintings that had been attributed or related to the style of Roger van der Weyden. These works were subsequently deemed to be the work of a pupil of Roger, an artist provisionally called the "Master of Flémalle." The name came from a group of three panels now in Frankfurt that originally were said to have come from a monastery near the village of Flémalle.

Eventually, it became clear that this artist's style was earlier than that of Roger. Since it was also evident that the painter, Robert Campin, was Roger's master for a period, the theory that the works were Campin's was proposed and has now gained nearly universal acceptance.

Robert Campin's paintings have an appealing and direct style. It relates to that of the painters, miniaturists, and sculptors of the so-called International Gothic style around the end of the 14th century. Surpassing their achievement, Campin worked with more naturalistic forms. His works are less regal, utlizing homely and more simple subjects. Figures and landscapes, textures and colors are all presented convincingly in the new medium of oil paint on panel. The medium itself has a great luminosity that Campin uses to great advantage.

Additionally, Robert Campin is especially known for the enhancement of his paintings with symbolic meaning expressed through ordinary objects in the environs of the persons and places depicted. It is a means to meditative contemplation for the artist's patrons and contemporaries. Now frequently the focus of controversy about the interpretation and significance of such usage, these symbolic elements are, nonetheless, essential aspects of the art of the period. Their popularity at the time is most easily explained as a substitute for the accompanying texts to the manuscript illustrations that were the works of the best artists of the generation before Campin.

In addition to his most famous painting, the *Mérode Triptych* of about 1426, there are several important surviving paintings by this master. An *Entombment of Christ* is the main panel of a small triptych now in the collection of the Courtauld Institute of the University of London. It may date from as early as 1415 and appears to be the earliest of the panel paintings to survive. His *Nativity* in the Dijon Musée des Beaux-Arts is often dated around 1420 and is close in style to a *Betrothal of the Virgin* panel in the Prado Museum in Madrid (this writer feels that the Prado panel is an excellent copy of a lost Campin original). Later in style is the *Madonna of the Firescreen*, in London's National Gallery and a trio of panels, the *Madonna and Child, St. Veronia* and *Holy Trinity* in the Städelsches Kunstinstitut in Frankfurt, Germany. These works may date around 1430.

Also in Frankfurt's Städelsches Kunstinstitut, probably dated to the 1430's, is a fragment of a panel, the upper part of the right wing of a lost triptych showing one of the two thieves on his cross. The lost altarpiece is known to have been a *Deposition of Christ*. A copy of the whole work is in the Museum in Liverpool. Possibly the latest of the survivng works by Robert Campin are a pair of wings from a triptych commissioned by Heinrich van Werl, dated 1438. The wings are in the Prado Museum. They show the donor, van Werl, in the left wing, introduced to the main panel by St. John the Baptist. On the

right wing is an image of St. Barbara, seated on a bench in a household room, reading as a fire crackles in the fireplace behind her. The central panel, surely of the Madonna and Child, is missing and unrecorded.

A small panel with the *Head of St. John the Baptist* is in the Cleveland Museum of Art. Another with the *Heads of Christ and the Virgin Mary* is in the Philadelphia Museum of Art. Copies of several works by Campin, whose originals are lost, exist in many versions in various museums. They help to demonstrate the enormous influence exerted by Robert Campin on his times.

—Charles I. Minott

CANALETTO, Antonio.

Born Giovanni Antonio Canal in Venice, 28 October 1697; son of the scene-painter Bernardo Canal. Died in Venice, 20 April 1768. Worked as a scene-painter with his father in Rome, c. 1719; influenced by Panini; in Venice guild, 1720–67 (and in Venetian Academy, 1763); in earliest works, figures were painted in by collaborators Piazzetta, Pittoni, and Cimaroli: specialized in city views ("vedute"), possibly using camera oscura; arrangements for marketing his pictures for English buyers was made through Joseph Smith, the British consul; lived in England, 1746-c. 1755. Pupil: probably his nephew Bellotto; many assistants.

Major Collections: London: National Gallery; Royal Collection.
Other Collections: Berlin; Boston; Cambridge, Massachusetts; Dresden; London: Dulwich; Malibu; New York; Ottawa; Oxford; St. Louis, Venice; Washington.

Publications

Uzanne, Octave, *Les Deux Canaletto*, Paris, 1906.
Ferrari, Giulio, *Les Deux Canaletto*, Turin, 1914.
Finberg, Hilda F., *Canaletto in England*, London, 2 vols., 1920–21.
Uzanne, Octave, *Les Canaletto*, Paris, 1925.
Hadeln, Detlev von, *Die Zeichnungen von Canaletto*, Vienna, 1930; as *The Drawings of Canaletto*, London, 1930.
Pallucchini, Rodolfo, *Le acqueforti del Canaletto*, Venice, 1945.
Parker, Karl T., *The Drawings of Canaletto . . . at Windsor Castle*, London, 1948.
Watson, F. J. B., *Canaletto*, London, 1950, 1954.
Moschini, Vittorio, *Canaletto*, Milan, 1954, London, 1956.
Pignatti, Terisio, *Il quaderno di disegni del Canaletto alle gallerie di Venezia*, Milan, 2 vols., 1958.
Brandi, Cesari, *Canaletto*, Milan, 1960.
Constable, William G., *Canaletto*, London, 1960.
Gioseffi, Decio, *Canaletto and His Contemporaries*, New York, 1960.
Parker, Karl T., and I. Byam Shaw, *Canaletto e Guardi*, Venice, 1962.

Pilo, Giuseppe Maria, *Canaletto*, New York, 1962.
Constable, William G., *Canaletto*, Oxford, 2 vols., 1962; revised edition, with J. G. Links, 1976.
Levey, Michael, *Canaletto Paintings in the Collection of Her Majesty the Queen*, London, 1964.
Kainen, Jacob, *The Etchings of Canaletto*, Washington, 1967.
Martin, Gregory, *Canaletto: Paintings, Drawings, and Etchings*, London, 1967.
Puppi, Lionello, *L'opera completa di Canaletto*, Milan, 1968; as *The Complete Paintings of Canaletto*, London, 1970.
Pignatti, Terisio, *Canaletto disegni*, Florence, 1969; as *Canaletto: Selected Drawings*, University Park, Pennsylvania, 1970.
Links, J. G., *Views of Venice by Canaletto*, New York, 1971.
Salamon, Harry, *Catalogo completo delle incisioni di Canaletto*, Milan, 1971.
Bromberg, Ruth, *Canaletto's Etchings*, London, 1974.
Pignatti, Terisio, *Canaletto*, Milan, 1976.
Barcham, William L., *The Imaginary View: Scenes of Canaletto*, New York, 1977.
Links, J. G., *Canaletto and His Patrons*, London and New York, 1977.
Potterton, Homan, *Pageant and Panorama: The Elegant World of Canaletto*, New York and Oxford, 1978.
Links, J. G., *Canaletto*, Milan, 1979; as *Canaletto: The Complete Paintings*, London, and New York, 1981.
Pignatti, Terisio, *Canaletto*, Bologna and Woodbury, New York, 1979.
Canaletto: Paintings and Drawings (cat), London, 1980.
Links, J. G., *Canaletto*, Ithaca, New York, and Oxford, 1982.
Bettagno, Alessandro, editor, *Canaletto: Disegni, dipinti, incisioni* (cat), Venice, 1982.

*

Canaletto first studied with his father, the scene-painter Bernardo Canal, and worked on scene-painting for the operas *Tito Sempronico Gracco* and *Turno Aricino*, both by Scarlatti, during the Rome carnival season of 1719–20. By 1720, however, he was recorded in Venice again, and his works from the 1720's in Venice are influenced by the leading view painter of Venice, Luca Carlevaris; they also had a firm grounding in perspective, often with elaborate architectural details, as in the stage sets of the Galli-Bibiena family. Though Carlevaris's paintings lack the sparkle and sense of life we associate with those of Canaletto, Carlevaris was a competent painter, and to some extent established the format followed by later view painters. His urge to depict life in a town or city was merely the culmination of a long tradition, going back to Pompeii murals, through Ambrogio Lorenzetti, Robert Campin, Van Eyck, Van der Weyden, and even the earlier Venetians Carpaccio and Gentile Bellini: in fact Bellini's *Procession of the Holy Cross* is sophisticated enough to use multiple viewpoints in his rendition of the Piazza San Marco. The scale of Canaletto's early works, and his frequent use of large posed foreground figures (often in scarlet or purple robes), owe something to Carlevaris.

Canaletto was soon successful, and mentioned as the leading view painter by 1725. In his very earliest works (*not* Venetian views) he was responsible for architectural elements, the figures being painted by his collaborators Piazzetta, Pittoni, and

The Campanile Damaged by Lightning, 1745; drawing; Royal Collection

Cimaroli, but his own works are documented from 1725–26, and possibly date from 1723. English patrons accounted for much of his early success (accounting for the current location of much of his output). The main characteristic of his work of the 1720's is one of free, rather impressionistic brushwork, with strong contrasts of light and dark. From c. 1730, his works tend to have a more linear, simpler style, with an overall luminosity and very sensitive awareness of light (as in the panoramic *Bacino of S. Marco,* in Boston). This linear style was possibly the result of having to produce more works to accommodate increased popularity, and his use of rulers, compasses, and even the camera oscura possibly date from this time. It is assumed that his studio employed many assistants, but it is difficult to confirm this sort of detail; in fact, it is not even certain that his nephew Bellotto was in his studio. Joseph Smith an English merchant and collector, and later the British Consul in Venice, became his agent, and commissions increased; Smith also encouraged the publication of a set of 12 engravings based on Canaletto's works in 1735 (a further 26 plates were added in 1742). Some English clients bought large numbers of his works, and the Duke of Bedford commissioned 24 in the 1730's; 54 paintings by Canaletto from Smith's own collection were sold to George III in 1763.

Yet if Canaletto had a large output and used mechanical aids, his works are by no means mechanical themselves. Even the large *Venice: The Feastday of St. Roch* (London, National Gallery) whose recent cleaning revealed ruled lines and compass points, is a "rearranged" work: though the buildings are recorded accurately, the viewpoint is false, suggesting that Canaletto's visual sense went beyond mere accuracy. The perspective is also slightly askew in the *View of Piazza San Marco and the Piazzetta Looking Toward San Giorgio Maggiore* (Cleveland), since to include all the buildings shown in the painting, the artist would have had to move 30–35 feet. If he is famous for the views which feature a grand occasion (an Ascension Day Wedding of the Sea Ceremony or a Regatta) or a grand space (the Piazza San Marco), one remembers as well the variety of buildings in their size, texture, and color, the range of occupations and activities of the figures, and the small details of life in a thronged and lively city. The St. Roch picture, with the magnificent procession of the Doge visiting the church to commemorate the end of the 1576 plague, includes minor details of the nosegays (reminders of the plague) and paintings hanging on the outside of buildings; a rooftop garden on a small building near the church is an informal note. In most of the paintings, the details—limp ragged sails, peeling walls, beggars and workers alongside elegant merchants, unfocused, uncentered small-scale buildings contrasting with the ordered lines of the massive architectural sequences—heighten the drama of the city itself, confirming the buyer's satisfaction in wanting a souvenir of the city in the first place.

—George Walsh

CANO, Alonso.
Born in Granada, 19 March 1601; son of the sculptor Miguel Cano. Died in Granada, 5 October, 1667. Married twice. Apprenticed to the painter Pacheco; influenced by Velázquez and Zurbarán; possibly apprenticed with the wood sculptor Juan Martínez Montañes, 1620–25; master painter, 1626; eventually took over his father's sculpture workshop in Seville; large sculpted altarpiece, S. María Lebrija, 1629–31; left Seville for court in Madrid, possibly at behest of Velázquez, 1638; sojourn in Valencia, 1644–45, after murder of his wife; returned to Madrid, and then moved to Granada where became a prebendary of Granada Cathedral, 1652 and finally ordained, 1658; sojourn in Malaga, 1665–66; designed the facade of the cathedral, 1666–67.

Major Collections: Granada; Madrid.
Other Collections: Avila: Carmilite Church; Budapest; Dresden; Granada: Cathedral; Leningrad; London: Wallace; Los Angeles; Malaga: Cathedral; Munich; New York: Hispanic Society; Seville; Stockholm; Worcester, Massachusetts.

Publicaions

On CANO: books—

Diaz Jiménez y Molleda, Eloy, *El escultor Cano,* Madrid, 1943.
Martinez Chumillas, Manuel, *Cano: Estudio monografico de la obra del insegne racionero que fue de la Catedral de Granada,* Madrid, 1948.
Moreno, Elena Gomez, *Cano* (cat), Madrid, 1954.
Wethey, Harold E., *Cano, Painter, Sculptor, and Architect,* Princeton, 1955.
Wethey, Harold E., *Cano, pintor,* Madrid, 1958.
Cano (cat), Granada, 1967.
Colloquios sobre Cano y el barrocco español, Granada, 1968.
Centenario de Cano en Granada (cat), Granada, 2 vols., 1970.
Bernales Ballestros, Jorge, *Cano en Sevilla,* Seville, 1976.
Wethey, Harold E., *Cano, pintor, esculptor, arquitecto,* Madrid, 1983.

*

Alonso Cano is unique among Spanish 17th-century artists for the amazing versatility of his talents and the exceptional skill with which he exercised them all. A universal genius, Cano engaged in the major arts of painting, sculpture, and architecture, as well as the minor arts. Likewise, Cano was an indefatigable sketcher and a notable collector of prints, which he sometimes used as sources for his works. The multi-talented artist, however, thought of himself first as a painter, and the number of surviving canvases from his hand outnumber all else. Notwithstanding, Cano exercised all his many talents in varying degrees over a tumultuous lifetime spent in the three major artistic centers of Spain—Seville, Madrid, and Granada—where he was exposed to the major currents of past and contemporary art and where he likewise left his example for others to follow.

Born into an artistic family from Granada, Cano received his first training from his father, a designer of altarpieces. Upon the family's move to Seville, Cano was apprenticed to the prominent painter Francisco Pacheco, and spent time in

The Virgin of Belén, 1664; cedarwood; 18$\frac{7}{8}$ in (46 cm); Granada, Cathedral Museum

the master's shop together with fellow pupil, Diego Velázquez, with whom Cano continued to maintain a friendship and whose style exercised influence upon Cano's own early pictorial vocabulary. Cano's earliest paintings from Seville—among them his first work of 1624, *San Francisco Borja*—display large convincing figures modeled by a sharp tenebristic light, similar to that used by contemporaries Velázquez and Zurbarán. But already evident—and best seen in such works as *St. John the Evangelist's Vision of Jerusalem* (London, Wallace) or the striking *St. Agnes* (Berlin, destroyed in 1945)—is the artist's penchant for endowing his figures with a degree of idealization and grace, and the composition as a whole with a sense of decorative beauty achieved through fluid manipulation of line and soft color.

The major activities of Cano's Seville years were, however, in sculpture and altarpiece design. Although undocumented, Cano must have studied sculpture under Seville's pre-eminent image-maker, Juan Martínez Montañes, for the elder master's figure types and style are reflected in Cano's earliest sculpted works. Among the statues for the high altar of Sta. Maria, Lebreja (1629–31), Cano produced his first masterpiece, an image of the Madonna and Child technically and stylistically more advanced than other Spanish sculpture of the epoch. The figure is of true heroic dignity, defined within a broadly sweeping robe unified by flowing contours. Reticent in expression, the Virgin holds a nude Christ Child, unusual for decorum-conscious Spain. This feature, and the guise of the retable's accompanying saints, indicate Cano's acquaintance with Roman sculpture from the remains of neighboring Italica.

In 1638 Cano departed Seville for Madrid where he was called to serve as painter to the Count Duke of Olivares, Phillip IV's chief minister. Cano is known to have worked for the king and, in the company of Velázquez, then Phillip's court painter, to have journeyed through Castile seeking paintings to replace those destroyed by fire in the king's Madrid palace. Much of Cano's subsequent time was spent on restoration of damaged works and study of surviving paintings in the royal collections. He was particularly attracted to Venetian painting, and this acquaintance, together with the impact of Velázquez's developing style, led Cano to reorient his painting style away from the tight compositions, firm sculptural modeling, and sharp lighting of Seville toward more activated spatial compositions and a soft, illusionistic modeling technique of Venetian origin. His most famous painting, *St. Isidore's Miracle of the Well* (1646–48), is characterized by its warm colors, broken contours, fluid pigment, and transparent glazing technique. Also standing out among the many painted works of this period is the now destroyed *Immaculate Conception* (1642–43) painted for the church of San Isidro, Madrid, with its delicate but lively Virgin and sky ballet of enchanting putti, anticipating Murillo's better-known compositions by years. The exquisite draughtsmanship, soft modeling, and color—characteristic of most of his painted works from this time on—create a mood of sensuality balanced by a decorous sense of the beautiful, linking Cano more closely than other Spanish masters of the 17th century back to the measured, classical equilibrium of the 16th-century High Renaissance.

The proficiency of Cano's work and his prestigious reputation give little indication of the series of personal misfortunes that first befell him in Seville and continued to plague Cano throughout his life. An event of major emotional impact oc-

curred in 1644 when the artist's wife was stabbed to death in her bed. Although it was later determined that a youth studying in Cano's shop was responsible, Cano himself was accused of conspiracy and tortured before being declared innocent and released. The pain of this tragic experience led him to seek solace in Valencia, where he resided for a short time in the Carthusian monastery of Porta Coeli and contemplated entrance into the cloister. Within a year, however, he returned to Madrid—where his painting was in great demand—and continued productively at work until his departure for Granada in 1652.

The Granada years (broken by a trip to Madrid and a sojourn in Malaga from 1665–67) mark the final phase of Cano's career, amazingly prolific in the production of painting, sculpture, and architectural designs. Cano received a position as prebend at the Cathedral in his native Granada, granting him the right to ordination within a year in exchange for employing his artistic talents in the service of the church. While fulfilling his obligations, the artist came into virulent conflict with fellow canons who ultimately refused to ordain him. After a trip to Madrid to seek the support of the king (which he received), Cano was ordained and eventually reinstated in his post, although tensions continued.

From these years come some of Cano's most accomplished paintings, such as the seven canvases illustrating the life of the Virgin executed on a grand scale for the upper sanctuary of Granada Cathedral (1652–64). In an amazing burst of activity, he produced 14 paintings for the Franciscan convent of the Guardian Angel, of which the stunning *Holy Family*, activated by baroque diagonals and rich color, survives. Many of his late paintings, particularly those for monastic orders, take on a deeper profundity of religious expression, as in the inwardly contemplative depiction of *Sts. Bernadino and Juan Capistrano* for another Franciscan establishment. Also there are a number of stunning images of the Virgin Mary, including several variations of the Immaculate Conception (that for the Oratory of Granada Cathedral being the finest), all serenely colored and exquisitely drawn, the Virgin possessing a tapering silhouette that anticipates the decorative delicacy of the 18th-century rococo.

In Granada Cano returned to the sculptural medium which had provided him fame in his youth but which he had virtually abandoned in Madrid, where his paintings were in greater demand. In theme, composition, and figure type, Cano's Granadine polychromed sculptures often mirror his painted work. Best known are the tiny *Immaculate Conception* and the *Virgin of Bethlehem,* produced for the sacristy of Granada Cathedral, both three-dimensional counterparts to paintings, delicately designed with tapering silhouettes and a rippling flow of decoratively conceived drapery. Comparable in depth of expression to paintings like the *Sts. Bernard and Juan Capistrano* are the over life-size statues—*S. Diego de Alcala, S. Anthony of Padua,* and *St. Joseph with the Christ Child*—designed by Cano (and faithfully executed by Pedro de Mena) for the Convento del Angel. These subtley refined yet profoundly moving figures, lost in their mystical thoughts, capture the inward religious spirit of the cloister.

Significantly, Cano was also responsible for the plans of the now destroyed Guardian Angel church as well as the design for the facade of Granada Cathedral, his only surviving large-scale architectural work. Based on an Albertian triumphal arch

and a geometrical concentration upon circular motifs, the facade is an imposing statement of classical-baroque architectural principles. Cano, however, did not live to see its realization, for soon after his appointment as the Cathedral's chief architect, this fascinating and ill-fated genius died, leaving his legacy of refined beauty coupled with naturalistic strength and technical perfection for others to emulate.

—David Martin Kowal

CANOVA, Antonio.

Born in Possagno, 1 November 1757. Died in Venice, 13 October 1822. Trained as a mason in Venice under Giuseppe Bernardi; prodigy: set up his own studio at age 18, in 1774; worked in Rome from 1781; worked in Vienna, 1797; in Paris to work for Napoleon, 1802 (did several busts of him); helped to get works looted by Napoleon returned to Italy: Pope made him Marchese d'Ischia; director of painters guild, Rome, 1810 (permanent director, 1814).

Collections: Bassano, Bergamo; Berlin; Florence: Pitti, S. Croce; Genoa: Bianco; Liverpool; London: Victoria and Albert; New York; Ottawa; Paris: Philadelphia; Rome: Borghese, Capitolino, S. Antonio dei Portoghesi, S. Marco, SS. Luca e Martini; Venice: Accademia, Correr, Arsenale; Vienna.

Publications

By CANOVA: books—

Pensieri su le belle arti, Milan, 1824.
Lettere inedite, edited by Melchiorre Missirini, Padua, 2 vols., 1833–37.
Diario, edited by Antonio Munoz, Rome, 1949.

On CANOVA: books—

Malamani, Vittorio, *Canova,* Milan, 1911.
Foratti, Aldo, *Canova,* Milan, 1922.
Bassi, Elena, *Canova,* Bergamo, 1943.
Fallani, Giovanni, *Canova,* Brescia, 1949.
Pantaleoni, Massimo, *Disegni anatomici di Canova,* Rome, 1949.
Della Pergola, P., *Paolina Borghese Bonaparte di Canova,* Rome, 1953.
Lavagnino, Emilio, *Canova e le sue "invenzioni,"* Rome, 1954.
Bassi, Elena, *La Gipsoteca di Possagno: Sculture e dipinti di Canova* (cat), Venice, 1957.
Clark, Anthony M., *The Age of Canova* (cat), Providence, 1957.
Coletti, Luigi, *Mostra Canoviana* (cat), Treviso, 1957.
Munoz, Antonio, *Canova: Le opere,* Rome, 1957.
Bassi, Elena, *Canova: I quaderni di viaggio 1779–1780,* Venice, 1959.

Bassi, Elena, *Il Museo Civico di Bassano: I disegni di Canova,* Venice, 1959.
Gonzales-Palacios, Alvar, *Canova,* Milan, 1966.
Scarpellini, Pietro, *Canova e l'ottocento,* Milan, 1968.
Argan, G. C., *Canova,* edited by Elisa Debenedetti, Rome, 1969.
Ost, Hans, *Ein Skizzenbuch Canovas 1796–1799,* Tubingen, 1970.
Bassi, Elena, *Canova a Possagno,* Treviso, 1972.
Pavanello, Giuseppe, *L'opera completa del Canova,* Milan, 1976.
Bassi, Elena, *Venezia dell'età di Canova 1780–1830* (cat), Venice, 1978.
Stefani, Ottorini, *La poetica e l'arte del Canova,* Treviso, 1980.
Disegni di Canova del Museo di Bassano (cat), Milan, 1982.
Licht, Fred, *Canova,* New York, 1983.
Brusatin, Manlio, *La Gipsoteca di Canova,* Possagno, 1987.

*

Although it is fairly accepted that the abstract lines and planes of the Neoclassical style are the basis of the modern style, Canova—probably the best-known artist of the movement in his own time—is not honored today. This is ironic in an age that cherishes abstract values in art, for Canova is an artist whose abstract refinement of human anatomy has not been equaled since ancient times. Canova's colleague and fellow developer of the style, Jacques-Louis David, has recouped his popularity through the propaganda of critics and art historians. Although not moved by David's work, people still sense or see his greatness; not so with Canova. He is the victim of the ridicule of art historians who have blinded the public to the singular qualities of his work by misinterpreting his intellectuality as coldness and his technical perfection as sterility; and they have made current the notion that his small preparatory models in terra cotta are superior to his finished marbles, that the vitality of the *bozzetti* was ruined during the interpretation into marble. As C. G. Argan pointed out, this prejudice is based on an arbitrary premise that the creation of vivacious pictorial effects is artistically valid but not the solution of formal problems.

Canova has produced a large number of true masterpieces in marble. Only one seems to have enough immediate éclat to make an impression during the short attention span of modern gallery visitors, the famous *Paolina Bonaparte as Venus* (1804–08; Rome, Borghese). Perhaps it is the originality of the invention as well as the novelty of the format that catches the attention long enough for the eye to enjoy the authority of the lyrical outlines that frame refined modulations of anatomical forms. The polish of the surface immediately reflects the courtliness of the subject instead of offending the modern love of texture. And certainly the contrast between the chaste but nude front view and the erotic but draped rear view makes the modern viewer forget the bizarre contrast between the realistic cushions upon which Maria reclines and the svelte abstractions of her body.

As a young man Canova had left his native province of Veneto (he had been trained in Venice) to visit Rome. When he arrived in 1799, Rome was the Mecca of all young artists of Europe and even of America. Although they came to Rome to

Briseis Surrendered to the Heralds of Agamemnon; marble; Possagno, Gipsoteca Canoviana

learn the secrets of tradition, the city was a hotbed of the radical aesthetic theories of Mengs and Wincklemann, ideas which were forcing the creation of a new figurative style. The discussion of these ideals and the effort to put them into practice were mainly among foreigners. And the young Canova—a foreigner too, with his strong Venetian accent—stayed in Rome and joined them in their discussions. He beccame allied with Gavin Hamilton, a pioneer painter in the new style and an exporter of Roman antiquities to British town and country houses. Hamiton tutored Canova's taste in antiquities, heightened his ambition, and procured him his first important commission: for the tomb of Clement the XIV in SS Apostoli in Rome (1783–87). Finished, the staid, geometrically simplified, and revolutionary monument was at once recognized as both a continuation of the great series of tombs started by Bernini in St. Peter's, and as a brilliant criticism of their tradition. By diligent thought and effort, the young Canova had refined away all frivolous decoration and conspicuous drama; the tomb was a model of geometrical clarity and compositional integrity, and, hence, of eternal values. It made Canova famous.

The complicated rhythms of the *Cupid and Psyche* (three versions, the earliest in Paris, 1787–1803) may win back some popularity. The elegance of the gestures overwhelms the simplification of outline. The tightness and logic of the composition compel a correct reading of the forms.

With the aid of a large and organized workshop Canova's production became enormous; supervising every part of the execution from plaster to marble, he still joined his staff every morning for a drawing session after nature. It is often claimed—to show his distance from "hands-on creation"—that "he didn't even do his own carving, assistants did it," a criti-

cism that should mean nothing to anyone who knows the historical practice of sculptors, and in any case belies the evidence of the autopsy: Canova's lungs were filled with marble dust, and his rib cage deformed by the use of marble drills.

It is hard to imagine anyone viewing the *Hercules and Lichas,* (1795–1815; Rome Galleria Nazionale d'Arte Moderna) without being moved, first by the terrible event—the enraged Hercules is about to dash the young boy against the ground—then by the successive rhythms of the clearly defined yet anatomically convincing masses whose rhythmic movement contest Lessing's theory that sculpture cannot represent movement in time.

Two famous "imitations" after the antique show how Canova distanced himself from the imitation of reality. The *Venus italica* (1804–12; Florence, Pitti) was patterned after the *Medici Venus,* a famous marble of the 1st century A.D. Surprised while drying herself after a bath, Venus shivers with chilled apprehension as she turns to identify the intruder. The movement of the statue—revealed to the intelligent observer of the multiple views it offers—arouses more interest that the monumental placement of limbs in the Hellenistic model. The *Perseus* (Vatican, 1795–1801, and New York, 1804–06) reinterprets the pose and the forward movement of the *Belvedere Apollo.* Apollo's gesture of relaxation becomes one of triumph, and the vitality of the reinterpreted gesture evades the sentimental softness of the *Apollo.* Canova even does Roman sculpture one better, for where the Romans suppress anatomical difficulties, he simplifies them.

The refinements of Canova's work are so intellectual, and we might even say "professional," that the misled public of today cannot fasten onto it except in a few instances. His virtues are even hidden from artists who should—if their life-

drawing classes had been strict enough—see and understand the miracles of simplification that he pulls off. Canova may have to wait for a more intellectual age before his name is accorded its proper place in the very short list of great sculptors in Western Art: Donatello, Michelangelo, Bernini, Canova, and Rodin.

—Gerald M. Ackerman

CARAVAGGIO.

Born Michelangelo Merisi (or Merighi, or Amerighi) in Caravaggio or Milan, probably between September and December 1571. Died in Port'Ercole, near Civitavecchia, 18 July 1610. Apprentice to painter Simone Peterzano, Milan, for a 4-year term, 1584; went to Rome, c. 1592-93: probably worked for the painter Giuseppe Cesari (the "Cavaliere d'Arpino") in the 1590's, worked for Cardinal del Monte, and did pictures for the Contarelli Chapel, S. Luigi dei Francesci, 1599-1600 and 1602-03, and Cerasi Chapel, S. Maria del Popolo, 1601; imprisoned briefly for libel, 1603, and for violence, 1604; left Rome in 1606 after a stabbing, then in Naples, 1606-07, and Malta, 1607; made a Knight of St. John; imprisoned in Malta, 1608; in Syracuse, Messina and Palermo, Sicily, 1608-09, Naples, 1609-10; died while returning to Rome where a pardon had been arranged for the stabbing.

Collections: Berlin; Cleveland; Cremona; Detroit; Escorial; Florence: Pitti, Uffizi; Hartford, Connecticut; Leningrad; London; Lugano; Madrid; Messina; Milan: Brera, Ambrosiana; Naples: Capodimonte, Banca Commerciale Italiana, Pio Monte della Misericordia; Paris; Rome: Borghese, Doria Pamphili, S. Agostino, Galleria Nazionale, S. Luigi dei Francesi, S. Maria del Popolo; Valletta: Cathedral, Cathedral Museum; Vatican; Vienna.

Publications

On CARAVAGGIO: books—

Marangoni, Matteo, *Il Caravaggio*, Florence, 1922.
Zahn, Leopold, and Georg Kirsta, *Caravaggio*, Berlin, 1928.
Berenson, Bernard, *Delle Caravaggio, delle sue incongruenze, e della sua fama*, Florence, 1951; as *Caravaggio: His Incongruity and His Fame*, London, 1953.
Longhi, Roberto, *Mostra del Caravaggio e dei Caravaggheschi* (cat), Milan, 1951.
Venturi, Lionello, *Caravaggio*, Novara, 1951.
Longhi, Roberto, *Il Caravaggio*, Milan, 1952.
Hinks, Roger P., *Caravaggio: His Life, His Legend, His Works*, London, 1953.
Baumgart, Fritz, *Caravaggio: Kunst und Wirklichkeit*, Berlin, 1955.
Friedländer, Walter F., *Caravaggio Studies*, Princeton, 1955.
Ludovici, Sergio Samek, *Vita del Caravaggio dalle testimonianze del suo tempo*, Milan, 1956.
Wagner, H., *Caravaggio*, Berne, 1958.

Joffroy, A. B., *Le Dossier Caravage*, Paris, 1959.
Jullian, René, *Caravage*, Lyons, 1961.
DeLogu, G., *Caravaggio*, Milan and New York, 1962.
Ottino della Chiesa, Angela, *Caravaggio*, Bergamo, 1962.
Scavizzi, Giuseppe, *Caravaggio e i caravaggheschi* (cat), Naples, 1963.
Bottari, Stefano, *Caravaggio*, Florence, 1966.
Causa, R., *Caravaggio*, Milan, 1966.
Causa, R., *I seguaci del Caravaggio a Napoli*, Milan, 1966.
Moir, Alfred K., *The Italian Followers of Caravaggio*, Cambridge, Massachusetts, 2 vols., 1967.
Ottino della Chiesa, Angela, *L'opera completa del Caravaggio*, Milan, 1967; as *The Complete Paintings of Caravaggio*, New York and London, 1969; edited by Michael Kitson, London, 1985.
Schneider, Arthur von, *Caravaggio und die Niederländer*, Amsterdam, 1967.
Longhi, Roberto, *Il Caravaggio*, Rome, 1968, 1982.
Borea, Evelina, editor, *Caravaggio e caravaggheschi nelle gallerie di Firenze* (cat), Florence, 1970.
Dell'Acqua, G. A., *Il Caravaggio e le sue grandi opere di San Luigi dei Francesi*, Milan, 1971.
Spear, Richard S., *Caravaggio and His Followers* (cat), Cleveland, 1971, New York, 1975.
Cinotti, Mia, et al., *Immagine del Caravaggio* (cat), Milan, 1973.
Marini, Maurizio, *Io Caravaggio*, Rome, 1973, 1974.
Perez Sanchez, Alfonso, *Caravaggio y el naturalismo espanol* (cat), Seville, 1973.
Mariani, Valerio, *Caravaggio*, Rome, 1973.
Röttgen, Herwarth, *Il Caravaggio: Ricerche e interpretazioni*, Rome, 1974.
Moir, Alfred K., *Caravaggio and His Copyists*, New York, 1976.
Bardon, Francoise, *Caravage, ou l'experience de la matière*, Paris, 1978.
Marini, Maurizio, *Michael Angelus Caravaggio Romanus*, Rome, 1978.
Nicolson, Benedict, *The International Caravaggesque Movement*, Oxford, 1979.
Gash, John, *Caravaggio*, London, 1980.
Moir, Alfred K., *Caravaggio*, New York, 1982.
Cinotti, Mia, and G. A. Dell'Acqua, *Il Caravaggio*, Bergamo, 1983.
Hibbard, Howard, *Caravaggio*, New York and London, 1983.
Freedberg, Sidney J., *Circa 1600: A Revolution in Style in Italian Painting*, Cambridge, Massachusetts, 1983.
Pacelli, Vincenzo, *Caravaggio: Le sette opere di misericordia*, Salerno, 1984.
Spear, Richard S., and Mina Gregori, *The Age of Caravaggio* (cat), New York, 1985.
Marini, Maurizio, *Caravaggio*, Rome, 1987.

*

Many artists are credited with being revolutionary but Caravaggio's claim is better than most. At a time when Roman and Florentine painting was evolving slowly towards a greater degree of naturalism, Caravaggio insisted on a bolder and more dramatic break. The circumstances, both public and individual, were propitious. The Counter-Reformation Church,

Peter's Denial of Christ, 1603; etching

eager to reassert its doctrinal authority after the Protestant secession, took the lead in harnessing art to this end. The decrees on visual art promulgated by the Council of Trent in 1563 were a restatement of the Church's traditional position: paintings and sculptures were books for the illiterate poor and, as such, should convey their religious message clearly and directly—in contrast to the confusing decorative complexities of some Mannerist images.

Caravaggio's north Italian background and his character aided him in accommodating the Church's platform. He was trained in the naturalistic modes of Lombardy and also inspired by the more imaginative naturalism of Venice. His teacher in Milan, Simone Peterzano, was a pupil of Titian and, despite his deployment of some of the Manneristic conventions of his day, was, at heart, a painter of observable rather than imagined reality. His precise handling of paint (tighter than that of the Venetians), which reflects a keen interest in the tonal register, and his fascination with the varied, sometimes unbeautiful, detail of nature, are typical Lombard concerns to which Caravaggio was heir. This Lombardic perspective was deepened by study of the works of other 16th-century artists in Milan and its hinterland: the strong, form-enhancing contrasts of light and shade in the paintings of Leonardo and his Milanese followers; the wide, almost Netherlandish, range of natural effects, including light, of the great Brescian painters of the early and mid 16th-century—Moretto, Savoldo and Romanino; and the cruder realism and, at times, dramatic night lighting of Peterzano's Cremonese contemporaries, the Campi brothers.

A provincial with a very different artistic heritage from that of metropolitan Rome, Caravaggio was strengthened in his radical artistic resolve by a forceful idiosyncracy of character that was often remarked. His leading Roman patron, Cardinal Francesco del Monte, referred to him as "un cervello stravagantissimo" (extremely capricious), while Giampietro Bellori, the high priest of classic idealist art theory, claimed, disapprovingly, in 1672 that he scorned all artistic mentors and boasted of his indebtedness to nature alone. The need to view the world in terms of polarities and struggle, which may lie at the root of the intense conflicts of emotion and contrasts of light and shade (chiaroscuro) in his mature art, extended to his

personal life. The police records in Rome show him to have been constantly embroiled in fights and litigation. As Howard Hibbard remarked, "Caravaggio's greatness is rooted in perversity." And whatever the undiscoverable personal origin of this perversity, we might legitimately see in it, too, a Lombard dimension. For the Lombards, and especially the denizens of Bergamo, near his reputed birthplace of Caravaggio, were renowned for their down-to-earth country manners and unconventionality. The wily servant figure, Zanni, who appears as one of the stock characters in the Commedia dell'Arte, was thought to typify the breed: rude and opinionated, an accomplished cheat, he displays a crude sense of humour and is always bearing grudges.

Caravaggio's extreme individualism is nowhere more apparent than in his earliest surviving work—a small group of enigmatic half-lengths of scantily clad boys with still-life accessories of fruits and flowers, done during his first years in Rome (c. 1592–98). They are not iconographically of a type, ranging from possibly symbolic "genre" subjects such as The Boy with a Basket of Fruit (Rome, Borghese) through the mythological figure of Bacchus (Borghese, and Florence, Uffizi) to more sophisticated and elusive allegories linking music with love (The Luteplayer, Leningrad, and Concert of Youths, New York). The formula seems to have been Caravaggio's own but the Concert and a version of The Luteplayer were owned by Caravaggio's friend and patron, the late Renaissance polymath Cardinal del Monte, and it is probable that he contributed something to their ethos. What unites them all is an unmistakable aura of homosexual suggestiveness and an equally exhibitionistic display of Caravaggio's realist credentials. In demonstration of the latter he pays due attention to minute details (maggots in an apple, drops of water on a leaf), the play of light (reflections in a decanter), and objects displayed, or proffered, to the viewer (sheet music, a violin, a glass of wine). Like another such picture, of uncertain, though possibly del Montean, patronage, the camp Boy Bitten by a Lizard (versions in Florence, Longhi Foundation, and London), in which Caravaggio displays his sense of humour in a literary-style conceit about the dangers of sensual indulgence, they hint at the vanity of the senses while simultaneously giving them full rein. Ambiguities and unresolved elements of one kind or another are never far away in Caravaggio's art. They are the inevitable corollary of his overriding devotion to representation, pithily expressed in his only known aesthetic pronouncement—that "a good painter is one who knows how to paint well and imitate natural objects well."

Caravaggio also executed for del Monte two examples of a more anecdotal type of half-length, picturesque genre painting, of Netherlandish pedigree, The Fortune Teller (Rome, Capitoline Gallery) and The Cardsharps (Fort Worth, Kimbell), both c. 1594–96—subsequently producing a second version of the former (Paris, c. 1598). They were to be especially influential on Caravaggio's many followers, prompting the likes of Manfredi, Honthorst, Valentin, and Tournier to develop a whole new category of bohemian genre scenes. In the Louvre version of The Fortuneteller, as in other pictures of these years, Caravaggio deploys a device which was to become a hallmark of his style: a broad beam of sunlight, emanating from a high window outside the picture space and slanting diagonally across a shadowed back wall. In this "cellar lighting," as it came to be known, Caravaggio was once again asserting the

primacy of appearance (what he saw in his studio) but equally sensing its emphatic, dramatic potential.

Caravaggio's efforts to apply this studio realism to religious subjects in the second half of the 1590's produced some beautiful but expressively limited images which made only slight or forced attempts to reformulate the observed in terms of the imagined (e.g., *The Penitent Magdalen*, which Bellori likened to a girl drying her hair, and *The Rest on the Flight into Egypt*, both Rome, Doria Pamphili). It was not until his first public commission, in 1599, to paint two large, multi-figure oils of *The Calling* and *Martyrdom of St. Matthew* for the French church of San Luigi in Rome that Caravaggio discovered the extent of his ability as a painter of significant human action. Together with two smaller pictures of *The Crucifixion of St. Peter* and *The Conversion of St. Paul*, done in 1601 for the Cerasi Chapel of Santa Maria del Popolo, they cemented his reputation and led to an uninterrupted flow of religious commissions, both from churchmen and lay patrons, such as the Marchese Vincenzo Giustiniani. Indeed he hardly painted any more secular subjects after this date.

The secret of his success was his creation of a new and emotive combination: realistic figure types (complete with tattered clothes and dirty feet) allied to bold *chiaroscuro*. The former flattered the aspirations of the Counter-Reformation Church by emphasizing the ordinary humanity of the apostles and martyrs (and sometimes, as in *The Madonna of the Pilgrims*, Rome, S. Agostino, c. 1603–05, and *The Madonna of the Rosary*, Vienna, c. 1605–06, actually including humble peasant worshippers kneeling at the feet of the saints whom they adore), while the latter aided the process by providing dramatic emphasis and evoking the mystery of the faith. The new-found role for *chiaroscuro* also inaugurates a permanent shift in Caravaggio's attitude to color—away from the more delicate contrasts and fuller, Lombard range of colors of his earlier pictures to a much more restricted and puritanical palette. Caravaggio must have been familiar, through the writings of Leonardo and Lomazzo and his study both of some of Leonardo's darker paintings and of the phenomenon of "cellar lighting," with the fact that light directed from above into a dark space accentuates the three dimensionality of forms. It is certainly one of the most striking and effective features of his mature *chiaroscuro* that it sculpts the figures out of shadow and thrusts them insistently on our attention. But it becomes far more in his hands than a further weapon in the armoury of representation. In some instances, such as his first version of *The Supper at Emmaus* (c. 1602–03; London), the *chiaroscuro* seems to be essentially that of natural "cellar lighting," but in others the shadows are so darkened and the origin of the light is so obscure as to dispel all certainty of time or location. *Chiaroscuro*, in fact, assumes an increasingly metaphoric role. The bright beams or scatterings of light with which Caravaggio conveys the presence of the divine, irrupting into the fumbling desolation of human affairs, speak a symbolic language as old as that of the Gospel of St. John. In addition, the fall of light on faces or limbs often has the specific function of creating emphasis in the articulation of action, while it not infrequently also provokes secondary reflections on the human condition.

This impressive array of techniques, purposefully directed towards a powerful evocation of presence, understandably inspired a major following. The Caravaggist movement which flourished in Italy during the first 30 years of the 17th century was a truly international affair—attracting Italians (Orazio and Artemisia Gentileschi; Saraceni; Manfredi), Frenchmen (Valentin; Vouet; Tournier), Dutchmen (Terbrugghen; Honthorst; Baburen; Bijlert), and Spaniards (Maino). And many of the foreigners transported the style back to their homelands. Yet Caravaggio's revolution did not go unchallenged—especially by the pupils and apologists of his only serious rival in Rome, Annibale Carracci. From the standpoint of Annibale's vigorous but idealized naturalism, with its roots in Raphael and the antique, Caravaggio's approach had two fundamental flaws: his purported devotion to copying the posed model with a minimum of modification produced inappropriate characterizations; and his deployment of deep shadow was a means of concealing both his ungainly studio poses and his inability to effectively link figures together, either in space or action.

Such criticism is partly correct in point of detail but ignores the expressive humanity of Caravaggio's unorthodox zeal. Certainly, some of the great religious works of his early maturity (e.g., *The Conversion of St. Paul* and the National Gallery *Supper at Emmaus*) tend towards the stiffly histrionic in their quest for an illusionistic realism, allowing an obsession with foreshortened gestures of surprise or alarm to dominate disproportionately. But such excesses of enthusiasm were often enough modified over time into a much more integrated vision. For instance, in his second version of *The Supper at Emmaus* (c. 1606; Milan), expansive gestures have been replaced by restrained ones and interaction is geared more to eye-contact than limb movements. Furthermore, the virtuoso color effects and sensuous surface detail of the National Gallery picture, realized with long, firm brushstrokes, have been rejected in favour of a much darker palette through which only essential objects and actions are revealed.

Prompted perhaps by the increasing urgency and insecurity of his life as a fugitive after 1606, the majority of Caravaggio's pictures in his last years, including the Brera *Supper*, also undergo a change of technique. They are executed with rapid and free brushstrokes which are highly expressive of mood and atmosphere while enhancing pictorial unity. In some cases Caravaggio allows the reddish-brown ground to show through in certain places and serve as a unifying middle tone.

Caravaggio was as experimental with composition as he was with technique in his last four *wanderjahre* in southern Italy, Malta, and Sicily, especially in the larger alterpieces. Thus, for example, the crowded *Seven Works of Mercy*, done in Naples in 1606–07 (Church of the Pio Monte della Misericordia), is, in its complex, dynamic illusionism, perhaps the first fully Baroque altarpiece. Yet, as such, it also stands in counterpoint to a more persistent tendency of these years, towards a kind of classicism. It has been claimed that Caravaggio had sometimes been attracted in Rome to the poses of certain antique statues, but he now experimented with a compositional and emotional distancing which are more essentially classical. In visual terms this meant the placing of figures further back from the picture plane, sometimes in a classicizing frieze and usually with a substantial empty space above them. The shift in the ratio and relationship of figure to space, evident in such works as the great *Beheading of St. John the Baptist* (Valletta, Oratory of the co-Cathedral of St. John, 1608), *The Burial of St. Lucy* (1608; Syracuse, Santa Lucia), and *The Raising of Lazarus* and *Adoration of the Shepherds* done in Messina in 1609 (Mu-

seo Nazionale), encourages in the viewer a detached and contemplative "reading" of the pictures which contrasts with the proto-Baroque insistence of many of his previous efforts. Because these works were in very peripheral locations they had less influence on the development of Baroque art than Caravaggio's more illusionistic essays in Rome and Naples. But it is arguable that this late-flowering and idiosyncratic classicism, rooted in instinct and mature judgment rather than ideology, is one of the more evocative manifestations of the classical sense of order—pictorial arrangement hinting at an elusive underlying pattern in human affairs.

—John Gash

CARPACCIO, Vittore.

Born in Venice, c. 1465. Died in Venice before 26 June 1526. Married Laura; son, the painter Pietro Carpaccio. Probably a pupil of Gentile Bellini; assistant to Giovanni Bellini, 1507, in work on Doge's Palace: other Venetian commissions include S. Pietro in Castello and Patriarch's Palace, both single works and narrative cycles; possibly made an early visit to Rome, but otherwise worked only in Venice.

Major Collections: Venice: Accademia, Scuola di S. Giorgio degli Schiavoni.
Other Collections: Berlin; London; Milan; New York; Paris: Louvre, Jacquemart-André; Philadelphia; Rome: Borghese; Stuttgart; Udine; Venice: Correr, Doge's Palace; Washington.

Publications

On CARPACCIO: books—

Ludwig, Gustav, and Pompeo Molmenti, *Carpaccio: La vita e le opere*, Milan, 1906; as *The Life and Works of Carpaccio*, London, 1907.
Hausenstein, Wilhelm, *Das Werk des Carpaccio*, Stuttgart, 1925.
Fiocco, Giuseppe, *Carpaccio*, Rome, 1931.
Moschini, Vittorio, *Carpaccio: La legenda di Sant'Orsola*, Milan, 1948.
Vertova, L., *Carpaccio*, Milan, 1952.
Pignatti, Terisio, *Carpaccio*, Milan, 1955; New York, 1958.
Muraro, Michelangelo, *Carpaccio alla Scuola di San Giorgio degli Schiavoni in Venezia*, Milan, 1956.
Fiocco, Giuseppe, *Carpaccio*, Novara, 1958.
Pallucchini, Rodolfo, *Carpaccio: Le storie di Sant'Orsola*, Milan, 1958.
Perocco, Guido, *Tutta la pittura del Carpaccio*, Milan, 1960; as *L'opera completa di Carpaccio*, 1967.
Pallucchini, Rodolfo, *I teleri del Carpaccio in San Giorgio degli Schiavoni*, Milan, 1961.
Lauts, Jan, *Carpaccio: Paintings and Drawings: Complete Edition*, London and Greenwich, Connecticut, 1962.
Pallucchini, Anna, *Carpaccio*, Milan, 1963.
Valcanover, Francesco, *Carpaccio: La legenda di S. Orsola*, Milan, 1963.
Zampetti, Pietro, *Carpaccio*, Venice, 1963.
Pignatti, Terisio, *Carpaccio: San Giorgio degli Schiavoni*, Milan, 1965.
Muraro, Michelangelo, *Carpaccio*, Florence, 1966.
Zampetti, Pietro, *Carpaccio*, Venice, 1966.
Perocco, Guido, *Carpaccio: Le pitture all Scuola di S. Giorgio degli Schiavoni* (in Italian and English), Treviso, 1975.
Serres, Michel, *Esthétiques sur Carpaccio*, Paris, 1975.
Muraro, Michelangelo, *I disegni di Carpaccio*, Florence, 1977.
Sgarbi, Vittorio, *Carpaccio*, Bologna, 1979.
Bardon, Francoise, *La Peinture narrative de Carpaccio dans le cycle de Ste. Ursule*, Venice, 1985.
Brown, Patricia Fortini, *Venetian Narrative Paintings in the Age of Carpaccio*, New Haven, 1988.

articles—

Magagnato, Licisco, "A proposito delle architetture del Carpaccio," in *Communita*, 17, 1963.
Zampetti, Pietro, "L'Oriente del Carpaccio," in *Venezia e l'Oriente, fra tardo mediovo e rinascimento*, edited by A. Pertusi, Venice, 1966.
Jacobs, Fredrika H., "Carpaccio's Vision of Saint Augustine and Saint Augustine's Theories of Music," in *Studies in Iconography*, 6, 1980.
Marshall, David R., "Carpaccio, Saint Stephen, and the Topography of Jerusalem," in *Art Bulletin* (New York), 46, 1984.

*

Despite a scarcity of documents concerning his life, Carpaccio left a corpus of works large enough to trace his artistic development across four decades, a development that is characteristically Venetian yet distinctly personal. Like that of other Venetian painters, Carpaccio's handling of light and color had little to do with the rigorous clarity typically seen in contemporaneous central Italian painting. Works such as the *Dream of St. Ursula* and *St. Augustine's Vision of St. Jerome* illustrate respectively his ability to use luminescent light and tonal patterning as unifying elements. Although Carpaccio's manipulation of chromatic effects demonstrates his awareness of Giovanni Bellini's rich color and chiaroscuro, the narratival compositions to which it was applied are not to be found in Giovanni's works. Similarly, the apparent affinity between Carpaccio's crowded vistas and those of Gentile Bellini is but an impression. While Carpaccio shared the older Bellini's insistent emphasis on realistic detail, his concern with *colorito* tempered the graphic description of his visions.

Although Carpaccio's style is, in the final analysis, wholly his own, his earliest paintings, c. 1480–85, demonstrate a dependence on the works of already established masters. Both his formal language as well as specific figure types indicate a youthful attempt to emulate the clarity of form visible in the works of Antonello de Messina, while efforts to enhance the plasticity of form by synthesizing it within a carefully defined space evince his struggle to grasp Giovanni Bellini's subtle nuances of modelling and rich chromaticism.

St. George Showing the Slain Dragon to the People; drawing; Florence, Uffizi

Not surprisingly, Carpaccio's concentrated attempts to emulate the more accomplished style of others imparted to his early works a persistent sense of stagnation, a lack of centralized focus, a stiffness of form, and a flatness of applied drapery. These deficiencies were, however, short-lived. The lack of unity evident in the *Salvator Mundi and the Four Evangelists* (Florence, Conte Contini Bonacossi Collection), considered to be his earliest work, was replaced by a synthesis of form and content in the slightly later *Meditation on the Passion,* 1485–90 (New York). Despite a sharp division in the background of the *Meditation,* a rocky, almost desolate landscape on the left juxtaposed with a rich agrarian vista on the right, Carpaccio unified the work by enveloping the sleeping Christ and meditating Saints Job and Jerome in a glowing light that reverberates with a mysterious restraint approaching mysticism. Like Giovanni Bellini's contemporaneous paintings of the Redeemer, Carpaccio's *Meditation on the Passion* captures the symbiotic relationship between man and the divine.

A master of the principles of narrative, Carpaccio repeatedly displayed his penchant for anecdote and an ability successfully to continue a story from one canvas to another without disrupting the spatial integrity within individual paintings. Combined, these two qualities established him as a favored painter with the many *scuole* of Venice; indeed, he spent most of his career painting narrative cycles. Few commissions for altarpieces and Madonnas were awarded to him. Carpaccio's appeal was his style. Like Gentile Bellini, he populated his scenes with numerous recognizable figures and countless familiar details. But unlike Bellini's, Carpaccio's reality remained allusive, more implicit than explicit, more subjective than objective. Adopting the light and color of Giovanni Bellini, he rendered his images more poetic than prosaic.

Perhaps the greatest indicator of Carpaccio's progress as an artist is seen in his cycle of nine paintings for the Scuola di Sant'Orsola. Commissioned to execute the series in 1488, Carpaccio completed the first canvas, *The Arrival of Saint Ursula at Cologne,* in 1490. When this early scene is juxtaposed with either of the later works in the cycle, *Return of the English Ambassadors to the King of England* or *Arrival and Reception of the English Ambassadors,* c. 1496–98, the artist's acquired confidence with large-scale narrative is obvious. Regardless of a marked increase in the complexity of the composition, the later paintings are not marred by an awkward and disquieting recession of space that in the earlier works had resulted in violent foreshortenings of distant architectural detail. Similarly, the contrived division of the painting of the Saint's arrival in Cologne was replaced with an ordered spatial progression that is, in essence, classical.

Belonging roughly to the same period, c. 1500, and revealing another side of Carpaccio's imagination is a *Sacra Conversazione* (Caen). Set against a walled town at the base of a mountain and beneath a fantastic rock-arch, the holy gathering has been removed from its more traditional setting within a church. Although he later repeated the central group from the Caen painting, Carpaccio never pursued the possibilities of this composition, instead he adopted a mode of presentation similar to that of Giovanni Bellini's half-length Madonnas. Nonetheless, as noted by Jan Lauts, the "inherent possibilities of formal development [in the *Sacra Conversazione*] were later fully realized by Palma Vecchio, Bonfazio Veronese and Titian."

During the first decade of the 16th century Carpaccio developed further the principles of decorative narrative he had articulated in the cycle for the Scuola di Sant'Orsola. Begun in 1502 and completed c. 1507–08, the series of seven paintings commissioned by the Dalmatian Scuola di San Giorgio

Schiavoni, evinces a conscious attempt on Carpaccio's part to simplify his compositions by directing the viewer's eye to a specific point within each canvas. Unlike the main figures in the Ursula paintings, those in this cycle are placed in the immediate foreground, which, in some cases, is distinguished from the background by a stage-like strip of ground (*The Obsequies of St. Jerome*) or dais (*St. George Baptising the Heathen King and Queen*). Despite the stressed dichotomy of space, Carpaccio integrated the distant background with the foreground through a careful repetition of complimentary colors. Thus, in *St. Augustine's Vision of St. Jerome*, the saturated green of the dais is carried back along the left wall and repeated in the cupboard in the left background, while the deep red of the distant centrally placed niche is repeated midway on the right and in the left forefront. Here, as in the rest of the series, a golden light bathes the scene, thereby keeping the colors from becoming too strident an imparting a soft luminescense to the whole.

Although Carpaccio continued to paint into the 1520's, he never surpassed the luminosity and atmospheric quietude seen his works executed prior to 1510. Unable, or unwilling, to grasp the new principles of the High Renaissance, his works show a gradual and predictable evolution of style rather than any fundamental change in response to the new style of Giorgione and Titian. Color and form continued to function as surface pattern and emotive actions continued to be calmed by a poetic lyricism rather than intensified through an immediacy of drama. Lacking the prized and popular qualities of the High Renaissance, Carpaccio was unable to secure major commissions in Venice.

—Fredrika H. Jacobs

CARRÀ, Carlo (Dalmazzo).

Born in Quargnento, 11 February 1881. Died in Milan, 13 April 1966. One of the original Futurists, and associated with Boccioni, Balla, Severini, and others from 1910; served in the Italian army during World War I; met de Chirico in 1917, and they evolved Pittura Metafisica; then associated with Morandi, and linked with the term "heightened realism."

Collections: New York: Moma; Milan: Arte Moderna; Paris: Art Moderne; Rome: Arte Moderna.

Publications

By CARRÀ: books—

Pittura metafisica, Florence, 1919, 1945.
Soffici, Rome, 1922.
Giotto, Rome, 1924, London, 1925.
Pittori romantici Lombardi, Rome, 1932.
La mia vita, Rome, 1943; edited by Vittorio Fagone, Milan, 1981.
Il rinnovamento delle arti in Italia, Milan, 1945.

Giotto: La cappella degli Scrovegni, Milan, 1945, New York, 1950.
Documenti per Cézanne, Milan, 1946.
Giotto, Verona, 1951.
Segreto professionale, edited by Massimo Carrà, Florence, 1962.
Tutti gli scritti, edited by Massimo Carrà, Milan, 1978.

On CARRÀ: books—

Raimondi, Giuseppi, *Carrà*, Bologna, 1916.
Torriano, Piero, *Carrà*, Milan, 1928.
Longhi, Roberto, *Carrà*, Milan, 1937, 1945.
Cardazzo, Carlo, *Carrà*, Venice, 1940, 1952.
Raimondi, Giuseppi, *Disegni di Carrà*, Milan, 1942.
Pacchioni, Guglielmo, *Carrà, pittore*, Milan, 1945, 1959.
Gambillo, Maria Drudi, and Teresa Fiori, editors, *Archivi del Futurismo*, Rome, 2 vols., 1958–62.
Falqui, Enrico, *Bibliografia e iconografia del Futurismo*, Florence, 1959.
Gambillo, Maria Drudi, and Claudio Bruni, *After Boccioni: Futurist Paintings and Documents from 1915 to 1919*, Rome, 1961.
Valsecchi, Marco, *Carrà*, Milan, 1962.
Carriere, Raffaele, *Futurismo*, Milan, 1961; as *Futurism*, Milan, 1963.
Fantuzzi, Gabriele, *Carrà*, Milan, 1964.
Carrà, Massimo, *Carrà: Tutta l'opera pittorica*, Milan, 3 vols., 1967–68.
Martin, Marianne W., *Futurist Art and Theory 1909–1925*, Oxford, 1968.
Cucchetti, Gino, *Marinetti e il futurismo*, 1968.
Bigongiari, Piero, and Massimo Carrà, *L'opera completa di Carrà dal Futurismo alla Metafisica e al Realismo Mitico 1910–1930*, Milan, 1970.
Apollonio, Umbro, editor, *Futurismo*, Milan, 1970; as *Futurist Manifestos*, London, 1973.
Carrà, Massimo, *Carrà: Opera grafica (1922–1966)*, Vicenza, 1976.
Russoli, Franco, and Massimo Carrà, *Carrà: Disegni*, Bologna, 1977.
Haenlein, Carl, *Carrà: Zeichnungen* (cat), Hanover, 1981.
Il magico realismo di Carrà (cat), Sasso Marconi, 1981.
Fagiolo dell'Arco, Maurizio, *Carrà: The Primitive Period*, Milan, 1987.
Carrà: Mostra antologica (cat), Milan, 1987.

*

The career of Carlo Carrà can be clearly divided into three broad stages: youth and Futurism (1900–15), Metaphysical Art (1916–21), and maturity (1922–66). The works produced during these states are quite different and mark Carrà's long passage from stylistic fragmentation to solidity. Along the way he shared a number of close collaborations which drove him to produce some of his most striking works; in Futurism he was close to Umberto Boccioni, and in the Metaphysical phase he collaborated with Giorgio de Chirico. The least troubled association was with the Florentine painter and writer Ardengo Soffici, who, from 1914, provided an artistic and theoretical foil for Carrà's researches. It was only after reassessing the

Portrait of Marinetti, 1910–11; 38¼ × 31¾ in (97 × 81 cm); private collection

achievements of these early stages that he settled into the extended formal investigations of his mature years.

Carrà had come to prominence in 1910 as one of the signatories of the *Manifesto of Futurist Painters,* along with Boccioni, Luigi Russolo, Gino Severini and Giacomo Balla, a prominence confirmed by a group exhibition which travelled through Europe in 1912. Despite this internationalism, Futurist concerns were rooted in Italy. Their leader, the poet Filippo Tommaso Marinetti, had proposed, in his 1909 *Founding Manifesto of Futurism,* a social and artistic revolution which would sweep aside the decayed structures of the 19th century. This included replacing the artistic subservience to the past with an art appropriate to the new machine age.

Adherence to Futurism combined Carrà's early anarchist sympathies with a desire to overthrow academic art. Employed for some years as a painter decorator, he had worked through evening classes in order to enter the Brera Academy in 1906. This training contrasted with his participation in the *Famiglia Artistica,* an exhibiting co-operative for which he organized shows of contemporary Divisionist painting, and where he met Boccioni and Russolo. Their *Technical Manifesto of Futurist Painting* (1910) was more detailed than their earlier declaration. It proclaimed that their paintings would capture the dynamic effects of the new urban experiences (people seen on a moving tram, electric street lighting), and that the sensations of speed and light would determine the multiplication and disintegation of pictorial forms. A Symbolist interest in the persistence of remembered images, influenced by the philosophy of Bergson, was later termed "simultaneity."

Initially the stylistic solutions to these propositions relied upon Divisionism: Carrà's *Leaving the Theatre* (1910–11; Estorick Collection) remained indebted to Gaetano Previati. Only in 1911, when Severini advised Carrà and Boccioni to visit Paris, did they find a formal vocabulary—based on Cubism—which suited the radical message of the manifestos. The style was immediately integrated into the works, such as Carrà's *Funeral of the Anarchist Galli* (1910–11; New York, Moma), which were to be shown at their 1912 Parisian exhibition.

The expansion of the movement brought Carrà into contact with the Florentine group. In 1914, he moved closer to their more Francophile ideas when his stay in Paris with Soffici and the writer Giovanni Papini coincided with his break with Boccioni (over the latter's book *Futurist Painting and Sculpture*). Soffici, whose work was orientated towards Cubism, encouraged Carrà to investigate their constructive use of form; this pursuit marked the beginning of his period of revision. During 1916, in concert with Soffici's theories, Carrà turned from the Futurist programme to an experimentation with "concrete forms." These were simplified figures and objects painted in a primitivizing style (which he called "antigrazioso") inspired by the Douanier Rousseau, Giotto, and Uccello. This approach, far from the iconoclasm of early Futurism, was strengthened by the example of the enigmatic squares and interiors of the Metaphysical painter Giorgio de Chirico. His paintings provided an appropriately clear but contemporary style, which Carrà adapted for his own investigations into pictorial solidity during their close collaboration in Ferrara in 1917. Through this new style of precise figures and mannequins in empty rooms, Carrà hoped to re-capture a lost mystery and spirituality. De Chirico and Carrà's style was

perceived by Soffici and Papini and representing the post-war renewal of contemporary art; Metaphysical art was to be the constructive phase that benefitted from the cleansing destruction of Futurism. Both Carrà's position as a senior defector from Futurism and the formal qualities of his new art made his Metaphysical phase extremely influential in Italy and abroad. His ideas, published in the periodical *Valori Plastici* (1918–21) and elsewhere, emphasized the relationship with the Italian tradition while attempting to avoid simple revivalism. They share the post-war concerns with reconstruction and the renewed interest in realism, the so-called "return to order," experienced in other countries. While these attitudes would be pursued by the artists of the Novecento group, Carrà's work took on a greater lyricism, from 1921 onwards blending observation and mystery together with the lessons of the past in a style christened "magic realism." It was this personal realism that Carrà continued to refine throughout the rest of his life.

—Matthew Gale

CARRACCI, Annibale.

Baptized in Bologna, 3 November 1560; cousin of Ludovico, and brother of Agostino Carracci. Died in Rome, 15 July 1609. Pupil of his cousin Ludovico; participated with his brother and cousin in the Academy of painting in Bologna, set up about 1585–86, and in decoration of two Bologna palaces, Fava, 1584, and Magnani, 1588–91; pupils of the Academy include Domenichino, Reni, and Guercino; worked in Rome after 1594, principally involved in decorative work in Farnese Palace, including the massive Gallery ceiling, 1595–1604; debilitating illness from 1605.

Major Collection: Rome: Farnese Palace.
Other Collections: Atlanta; Berlin; Bologna: Fava and Magnani palaces, S. Niccolo; Dresden; Florence; Hampton Court; London; Milan: Brera, Ambrosiana; Marseilles; Naples; New York; Oxford: Christ Church; Paris; Parma; Rome: Colonna, Doria Pamphili; Venice; Vienna; Washington.

Publications

On CARRACCI: books—

Foratti, Aldo, *I Carracci nella teoria e nella pratica,* Città di Castello, 1913

Rouchès, Gabriel, *Le Peinture bolognaise à la fin du XVI siècle: Les Carrache,* Paris, 1913.

Peyre, Roger, *Les Carraches,* Paris, 1925.

Pergola, P. della, *I Carracci,* Rome, 1932.

Bodmer, Heinrich, *Ludovico Carracci,* Burg bei Magdeburg, 1939.

Wittkower, Rudolf, *The Drawings of the Carracci . . . at Windsor Castle,* London, 1952.

Gnudi, Cesare, et al., *Mostra dei Carracci* (cat), Bologna, 1956, 1963.

Mahon, Derek, *Disegni dei Carracci* (cat), Bologna, 1956.

Holland, R., *The Carracci: Drawings and Paintings*, Newcastle upon Tyne, 1961.

Martin, John Rupert, *The Farnese Gallery*, Princeton, 1965.

Calvesi, Maurizio, and Vittorio Casale, *Le incisioni dei Carracci*, Rome, 1965.

Calvina, Anna Ottani, *Gli affreschi dei Carracci in Palazzo Fava*, Bologna, 1966.

Bellori, Giovanni Pietro, *The Lives of Annibale and Agostino Carracci*, edited by Robert Enggass, University Park, Pennsylvania, 1968.

Posner, Donald, *Carracci: A Study in the Reform of Italian Painting Around 1590*, London, 2 vols., 1971.

Boschloo, A. W. A., *Carracci in Bologna: Visible Reality in Art after the Council of Trent*, The Hague, 2 vols., 1974.

Malafarina, Gianfranco, *L'opera completa di Carracci*, Milan, 1976.

Dempsey, Charles, *Carracci and the Beginnings of the Baroque Style*, Gluckstadt, 1977.

Bohlin, Diana DeGrazia, *Prints and Related Drawings by the Carracci Family: A Catalogue Raisonné* (cat), Washington, 1979.

Marabottini, Alessandro, editor, *Le arte di Bologna di Carracci*, Rome, 1979.

Briganti, Giuliano, et al., *The Age of Correggio and the Carracci* (cat), Washington and Cambridge, 1986.

Goldstein, Carl, *Visual Fact over Verbal Fiction: A Study of Caracci and the Criticism, Theory, and Practice of Art in Renaissance and Baroque Italy*, Cambridge, 1988.

articles—

Howard, Seymour, "Carracci-School Drawings in Sacramento," in *Zeitschrift für Kunstgeschichte* (Munich), 47, 1984.

Wetenhall, John, "Self-Portrait on an Easel: Carracci and the Artist in Self-Portraiture," in *Art International* (Lugano), August 1984.

Hughes, Anthony, "What's the Trouble with the Farnese Gallery? An Experiment in Reading Pictures," in *Art History* (Oxford), September 1988.

*

The founding of the Carracci Academy was the most significant single event in Bolognese artistic history, transforming the city briefly into the most progressive centre in Europe and, more enduringly, creating a school which produced most of the important painters of the Early Baroque, inspired the lastingly influential mode of Baroque Classicism, and over the next two centuries both trained one of the most consistently accomplished groups of Italian artists and influenced the development of academies throughout Europe.

Annibale was undoubtedly the great creative genius of the Carracci family. It was probably his cousin Ludovico who pioneered their escape, through the study of Correggio and the Venetians, from both the empty decorative formulae of Late Mannerism and the stultifying oversimplifications of Counter-Reformation art; he developed a truly original style of asymmetrical compositions, dramatic shadows, and vivid colour. Annibale's brother Agostino was the inspiring teacher of the three, and his sensitive draughtsmanship and superb engraving technique were also influential. But it was Annibale who carried their revolutionary artistic attitudes to logical conclusions, anticipating before the end of the 16th century the development of the characteristic 17th-century combination of compositional vigour, formal clarity, emotional drama, and sensuous realism.

The major vehicles for the Carracci reform of artistic values were religious works. Annibale's revolutionary attitude was clear almost from his first examples. The *Crucifixion with Saints* (1583; Bologna, S. Maria della Carità), for instance, recalls in its direct frontality the great masters of the High Renaissance, eschewing Mannerist formal and compositional complexity in favour of the narrative clarity demanded by Counter-Reformation decrees, but enlivening it with rich natural colours and textures, emotionally dramatic light effects, and physically weighty figures. However, there is a schematic quality in the central image which precludes convincing naturalism, and Annibale did not attempt such simplicity again for many years. More typical of his early works was the *Baptism* (1585; Bologna, S. Gregorio), decoratively elaborate and specifically dependent on the tender gracefulness of Correggio, and with some touches of Mannerist elegance in the figures and artificiality in the colouring, reminiscent in part of Correggio's follower Federigo Barocci.

The Classical tendencies which formed the basis of Annibale's mature style were formed through the influence, chiefly, of Venice. This was already evident in Annibale's 1587 *Assumption of the Virgin* (Dresden), in which the clearer groupings and larger, more solid figures clearly reflect Titian's great Frari *Assumption* (1518). Another Dresden painting, the *Madonna of St. Matthew* of 1588, shows Annibale assimilating the measured opulence of Veronese. More prophetic was the *S. Ludovico Altarpiece* (c. 1590; Bologna) which combines Titian's monumental naturalism and Correggio's lively richness with a measure of Raphael's classic beauty, all infused with a new feeling for optical realism.

In the following few years Annibale retreated from this high point of eclecticism to follow Ludovico's contemporary exploration of pictorial drama through asymmetry, colour, and chiaroscuro. By 1593 Annibale had already achieved a further level of synthesis in the *Virgin and Child with SS. John the Baptist and Catherine of Alexandria* (Bologna), indebted to the balanced harmonies of Raphael and Fra Bartolommeo; Correggesque lessons of warmth and opulence have been intensified by the immediacy of the surface texture and the dominating bulk of the figures. The development separating this richly compelling image from the superficially similar scheme of the 1583 *Crucifixion* is impressively mature and original. Equally so is the contrastingly elaborate composition of *St. Roch Distributing Alms* (1594; Dresden) which vies with the poised complexity of Raphael's mature Vatican works.

This was the highly developed manner Annibale took with him when he settled permanently in Rome in 1595. There he was, ironically, concerned chiefly with secular commissions. The religious works he did paint, however, show him returning, under the influence of prolonged exposure to Antique sculpture and the Roman masterpieces of Raphael and Michelangelo, to the classicising bent of his youth. But his mature power invested his hieratic images, such as the Michelangelesque *Pietà* (1599; Naples) and the bulkily inflated forms of another *Assumption* (1601; Rome, S. Maria del Popolo), with

Self-Portrait; drawing; Royal Collection

a force no longer dependent on realistic visual effects, but imbued with an emotional dimension as much philosophical as religious. This is especially evident in the small *Quo Vadis?* of 1602–03 (London, National Gallery).

Annibale was one of the first Italian history painters outside Venice to take a serious interest in landscape. This was due not only to his influential re-evaluation of Titian, but also to his appreciation of northern European landscape painters. But he transformed both types of model, wedding the artificial compositional divisions and naturalistic detail of the latter with the rich atmospheric effects and harmonious dispositions of the former, as in the *Fishing Scene* (1590's; Paris), where the loose construction and genre subject create a decorative impression. More formal is the *Flight into Egypt,* a lunette painted for the chapel of the Palazzo Aldobrandini (now Doria Pamphili; 1604); its rigorously balanced parts, geometric structure, and air of stasis, combined both with genuinely natural observation and with generalised idealisations, formed the foundation of the development of 17th-century ideal landscape. Annibale also used landscape backgrounds to create moods, not only of moral drama as in the *Quo Vadis?,* but of sensual pleasure as in the *Olympus and Marsyas* (c. 1599; London). This last panel (originally part of a keyboard instrument), of typically Venetian influence in its rich colouring and gently erotic atmosphere, is one of Annibale's most romantically evocative recreations of the pagan world.

It was just such a recreation, but on the grandest scale, which occupied most of Annibale's Roman activity in his decorations in Palazzo Farnese. In Bologna Annibale had been involved in decorative friezes on themes from mythology and Roman history, of a frequently bucolic and humorous charm, in Palazzo Fava (1583–84) and Palazzo Magnani (1588). In Rome his undertaking was more serious in intent and more concentrated in application. His first work in Palazzo Farnese was the painted ceiling of the Camerino (1595–97), with frescoed *Stories of Ulysses and Hercules* and a central canvas of the *Choice of Hercules* (original in Naples). The latter displays almost didactically Annibale's Classical reorientation in Rome, with its symmetrical arrangement, references to Michelangelo's Sistine Chapel and Raphael's Vatican *Stanze,* and adherence to the canons of Hellenistic sculpture. The decoration of the neighbouring Galleria (1597–1608) was both freer and more considered, and far more complex; it was Annibale's single most influential work. The subject of the frescoed ceiling was the *Loves of the Gods,* and it was symptomatic of the post-Counter-Reformation atmosphere of contemporary Rome that such a theme, presented without overt philosophical or literary overtones, could be considered suitable for the residence of a newly created young Cardinal, Odoardo Farnese.

Annibale's great and original achievement in the Galleria was to depict a convincing and unified illusionistic system in which all the elements share the same space, are closely related in scale and mood, and occupy precisely defined levels of apparent reality. It is this above all which marks the decoration as Baroque, as opposed to such Mannerist precedents as Pellegrino Tibaldi's Sala d'Ulisse in Palazzo Poggi, Bologna. Even more impressive to contemporaries was the confidence with which Annibale challenged the High Renaissance masterpieces in the Vatican, outdoing in the rich complexity of his scheme (and freely borrowing details from) Michelangelo's Sistine ceiling and Raphael's *Logge.* Moreover, to Michelangelo's moral grandeur and Raphael's Classical seriousness—both, of course, dealing with Biblical themes—Annibale presented a world of happy sensuality and humorous warmth, which clearly heralded a new age.

The visual realism which is such an important part of the total effect of the Farnese decoration was achieved in the traditional Renaissance manner of making careful preparatory drawings of every part of the design, down to the smallest detail. Many hundreds of these survive, and they and other drawings attest to the pleasure as well as the care which evidently went into their production. Two of the most delightful are the self-portrait sketches of Annibale and Agostino as young men (Royal Collection). Annibale was, indeed, a portraitist of distinctive skill, although his busy schedule allowed him little time to indulge it. Agostino's interest in physiognomy led him to apply the lessons of Leonardo da Vinci's comically grotesque inventions to real faces, and thus originate the modern art of caricature. The brothers were clearly as fascinated by the minutiae of ordinary life as any north European genre painters. In fact Annibale had produced a painting of this kind by the early 1580's, the remarkable *Butcher's Shop* (Oxford, Christ Church), far more naturalistic than earlier Bolognese examples. Even more original was the slightly later *Bean Eater* (Rome, Palazzo Colonna), which combines competent still life with an effective moment of arrested movement. Other studies, such as the *Boy Drinking* (Oxford, Christ

Church) and the *Man with a Monkey* (Florence), are even simpler and more direct, and constitute an intriguing realist undercurrent to the ever increasingly grand and formal public works Annibale was producing.

But it was the latter which formed his most influential corpus, constituting the true school of Guido Reni and Domenichino, the Baroque elements crucial to the development of Rubens, Cortona, and Bernini, the Classical to that of Sacchi and Poussin, both reverberating throughout Europe well into the 19th century.

—Nigel Gauk-Roger

CARRIERA, Rosalba (Giovanna).

Born in Venice, 7 October 1675. Died in Venice, 15 April 1757. Studied oil painting with Giuseppe Diamantini and Antonio Balestra; introduced to miniature painting by the Frenchman Jean Steve; member of the Rome painters guild, 1705; began working with pastels, 1708, and became famous for her pastels; worked in Paris, 1720–21, and probably influenced the pastelist Maurice Quentin de la Tour, and in Vienna; highly prized and collected by Elector Augustus of Saxony in Dresden; blind from 1747.

Major Collection: Dresden.
Other Collections: Boston; Cleveland; Copenhagen; Dijon; Florence; London: Victoria and Albert; Venice; Vienna; Washington.

Publications

By CARRIERA: books—

Journal . . . pendant son séjour à Paris en 1720 et 1721, edited by Alfred Sensier, Paris, 1865; as *Rosalba's Journal,* London, 1915.
Lettere, diari, frammenti, edited by Barnardina Sani, Florence, 2 vols., 1985.

On CARRIERA: books—

Hoerschlemann, Emilie von, *Carriera,* Leipzig, 1908.
Malamani, Vittorio, *Carriera,* Bergamo, 1910.
Cessi, F., *Carriera,* Milan, 1967.
Sani, Bernardina, *Carriera,* Turin, 1987.

article—

Gatto, Gabrielle, "Per la cronologia di Carriera," in *Arte Veneta* (Venice), 25, 1971.

*

Rosalba Carriera was an 18th-century portrait painter, best known for popularizing the use of pastels for finished works rather than for the customary sketches or copies of works in oil. She was first introduced to this medium by a fellow Venetian artist, Gian Antonio Lazzari. Carriera, however, developed an expressive, light, and elegant style not formerly attained.

The Venetian studio of Carriera was visited by aristocrats from all over Europe, seeking the type of fashionable and flattering portraits for which she became renowned. Among this group were Frederick IV, King of Norway and Denmark, and Maxmilian II of Bavaria. The monarch who proved to be her most loyal patron was Augustus III. She painted many works for his collection, of which *Augustus III, King of Poland* (Vienna) is a fine example. Typical of Rosalba's portraits, the focus of the work is on the face and the elaborate and very freely rendered powdered wig. There is no background setting indicated, and little detailing of the King's attire. Due to the enthusiasm of Augustus, the Dresden Museum now houses a sizable collection of Carriera's work.

Another important visitor to her studio was the wealthy French art collector Pierre Crozat. Crozat was responsible for Rosalba's celebrated trip to Paris (1720–21), accompanied by her mother, two sisters, and brother-in-law, the painter Pellegrini. During her successful stay there she received many major commissions, including those for portraits of both the King, Louis XV, and the Regent, Philip of Orleans. Many French painters were encouraged by Rosalba to use pastels, most notably Maurice Quentin de la Tour.

One of Rosalba's best-known paintings is her *Self-Portrait Holding Portrait of her Sister* (1715, Florence). Although she was known for flattering her sitters, she portrays herself as quite plain and unassuming. In this work, she holds a portrait of her sister Giovanna. It was this painting that she sent to Cosimo III de'Medici, Grand Duke of Tuscany, when he requested a portrait of her for his gallery.

Giovanna Carriera often assisted Rosalba in her works. She was employed in this task when she accompanied her sister on a trip to Vienna in 1730. There Rosalba was again deluged with requests from patrons.

It is not surprising that Carriera's works were so much in demand. They not only accommodated the rococo desire for elegance and charm, but were rendered in a deft, spontaneous, almost impressionistic style that appealed to early 18th-century patrons. Her sitters were usually posed in a three-quarter view, looking directly at the viewer. They possess an air of confidence and sociability that was highly admired, as is obvious in her *Portrait of a Man in Grey* (London).

Carriera's paintings were still in demand when she went blind in 1747, but by the time of her death ten years later the rococo style had waned. Her productivity enabled her, however, to amass a sizable fortune, which she left to her surviving sister, Angela.

Although Carriera was very famous during her lifetime, very little serious attention has been devoted to her work.

—Kathleen Russo

CASSATT, Mary.

Born in Allegheny, Pennsylvania, 22 May 1844; lived with her family in Paris, 1851–53, and Germany, 1853–55. Died in Mesnil-Théribus, 14 June 1926. Studied at the Pennsylvania Academy, Philadelphia, 1861–65, and under Chaplin in Paris,

Carriera: Portrait of a Man; $22\frac{3}{4} \times 18\frac{1}{2}$ **in (67.7 × 47 cm); London, National Gallery**

The Bonnet, 1891; drypoint

1866; settled in Paris, 1868; studied graphics under Carlo Raimondi in Parma, 1872; exhibited regularly from 1872, and with the Impressionists, 1879-81; partly blind by 1912, and totally blind at her death.

Major Collections: Chicago; Philadelphia; Washington.
Other Collections: Baltimore; Birmingham; Boston; Cincinnati; Cleveland; Flint, Michigan; Glasgow; Kansas City; Paris: Louvre, Petit Palais; Pasadena; St. Louis; Seattle; Wichita.

Publications

On CASSATT: books—

Segard, Achille, *Cassatt, un peintre des enfants et des mères,* Paris, 1913.
Valerio, Edith, *Cassatt,* Paris, 1930.
Forbes, Watson, *Cassatt,* New York, 1932.
Cassatt, Haverford, Pennsylvania, 1939.
Breuning, Margaret, *Cassatt,* New York, 1944.
Sweet, Frederick A., *Sargent, Whistler, and Cassatt* (cat), Chicago, 1954.
Carson, Julia, *Cassatt,* New York, 1966.
Sweet, Frederick A., *Miss Mary Cassatt, Impressionist from Pennsylvania,* Norman, Oklahoma, 1966.
Cassatt among the Impressionists (cat), Omaha, Nebraska, 1969.
Breeskin, Adelyn D., *Cassatt* (cat), Washington, 1970.
Breeskin, Adelyn D., *Cassatt: A Catalogue Raisonné of the Oils, Pastels, Watercolors, and Drawings,* Washington, 1970.
Bullard, E. John, *Cassatt: Oils and Pastels,* New York, 1972.
Hale, Nancy, *Cassatt* (biography), New York, 1975.
Bullard, E. John, *Cassatt: Pastels and Color Prints* (cat), Washington, 1978.
Breeskin, Adelyn D., *The Graphic Work of Cassatt: A Catalogue Raisonné,* New York, 1948; as *A Catalogue Raisonné of the Graphic Work,* Washington, 1979.
Roudebush, Jay, *Cassatt,* Naefels and New York, 1979.
Getlein, Frank, *Cassatt: Paintings and Prints,* New York, 1980.
Love, Richard, *Cassatt, the Independent,* Chicago, 1980.
Pollock, Griselda, *Cassatt,* London, 1980.
Mathews, Nancy Mowll, editor, *Cassatt and Her Circle: Selected Letters,* New York, 1984, London, 1988.
Lindsay, Suzanne G., *Cassatt and Philadelphia,* Philadelphia, 1985.
Mathews, Nancy Mowll, *Cassatt,* New York, 1987.
Getlein, Frank, *Cassatt: Prints and Drawings,* New York and London, 1988.

articles—

Duncan, C., "Happy Mothers and Other New Ideas in French Art," in *Art Bulletin* (New York), December 1973.
Yeh, S. F., "Cassatt's Images of Women," in *Art Journal* (New York), 1976.

*

Though American by nationality Mary Cassatt established herself, after academic training, as a painter and graphic artist in Paris during the 1880's, exhibiting her work in several Impressionist shows and mingling with such notables as Degas, Morisot, and the writer Zola. Her vision is essentially French, inspired by the realist painters Courbet, Manet, and Degas, tempered with Correggio's madonnas and Rubens's voluptuous style. Her debt to Degas is great: impressed by Cassatt's evident talent Degas motivated her to look to her contemporaries and to current cultural trends and further artistic media. Thus in the late 1870's Cassatt abandoned her previous study and faithful imitation of Old Masters and concentrated on painting and etching contemporary themes of everyday life, influenced by Monet and the Impressionists, photography, and Japanese prints. For subject matter she followed the example of Renoir and Degas and painted elegant portrayals of female family members in domestic settings and at the opera. *Lydia Seated in a Loge Wearing a Pearl Necklace,* 1879, is inspired by Degas's interest in things operatic and echoes something of the latter's style, with its use of mirrors to create ambiguity of viewpoint, asymmetrical composition, flatness and foreground focus reminiscent of a snapshot photograph.

Without a doubt Cassatt owed the greatest debt to Japanese art, for much of the work produced in the years between 1880 and 1900 is a testimony to her assimilation of the oriental style. After visiting the exhibition of Japanese woodcuts at the Paris Ecole des Beaux-Arts in 1890 and returning home with several purchases of portraits of ladies by Utamaro and Yeishi, Cassatt began work on an ambitious series of ten color prints in an effort to imitate the style of the Japanese woodcut. The prints have since been hailed as masterpieces of their medium, as well as successfully incorporating the desired characteristics of Japanese figure composition: vertically emphasized depictions of compositionally dominant women occupied with various gentle activities (bathing, adjusting their hair), executed with a minimum of props, line, and modelling, and color applied in large, flat areas. Patterns, so sumptuously exploited in Japanese art, feature too in Cassatt's oeuvre, relieving an otherwise austere composition; clothing, upholstery, the occasional jug, modestly display their decoration while structuring the composition. The oil painting *Girl Arranging Her Hair,* 1886, comprises a female dressed in a pale, voluminous gown, supported by the horizontal and vertical lines of chair, cupboard and mirror. The wall is daubed with vague foliage in the style of the Japanese; the chair and mirror are made of bamboo!

Those portrayed in Cassatt's compositions, invariably women, seem seriously occupied with their alloted tasks, quite unaffected by painter or audience. The elongated and asymmetrical "keyhole" format contributes to the intimacy of the image and excludes us from it. We are so accustomed to the patriarchal notion of possession that often colors images of women, of meeting the subject's gaze, that this exclusion proves most disconcerting. Perhaps Cassatt herself felt excluded from the scenes she depicted. It has been suggested that the artist's passion for painting mothers and babies indicates a feeling of personal inadequacy: although the number of these compositions amount to less than one third of her output, Cassatt is nevertheless sometimes dismissed as a childless, frustrated spinster who relieved her creative urges by painting envious portraits. Undoubtedly, at a time when motherhood was con-

sidered a woman's destiny Cassatt may have felt herself unfulfilled; but in terms of painting she, like Degas and others, believed that justice could not be done to a subject unless it was examined repeatedly with ruthless dedication. Many male artists of the time, Degas, Bonnard, Vuillard, turned to painting domestic interiors, a genre that had been somewhat neglected since the endeavors of the Dutch painters of the 17th century.

Cassatt's painting and graphic work enjoyed a twenty-year period of fruitfulness, from the Degas-inspired opera scenes and figure compositions of the 1880's to the Japanese-oriented interiors of the 1890's. However, with the waning of the 19th century so too waned Cassatt's talent. Much time was spent travelling instead of painting: the artist went back to the USA in 1898 to promote her own work and to assist with the Havemeyer collection of European art. Her work rejected, she returned to Paris dispirited. Unfortunately Cassatt could not accept the new trends in Parisian art, the innovations of Cézanne, late Monet, and Matisse; consequently her own work began to seem rigid and old-fashioned by comparison. The elderly painter was also experiencing difficulties with her eyesight: diminishing vision meant that the muted colors and fine draughtsmanship of the earlier work gave way to lurid oil and pastel compositions of affected and sentimental matriarchs, executed in large, coarse brushstrokes.

—Caroline Caygill

CASTIGLIONE, Giovanni Benedetto [Il Grechetto].

Born in Genoa, 1609. Died in Mantua, 1663 or 1665. Pupil of G. B. Paggi and others, perhaps Van Dyck, in Genoa, 1621–27; worked in Rome, 1632–35 (member of the guild by 1634); then worked in Naples, perhaps early 1635, Genoa, 1639–45, Rome, 1647–51, Genoa, 1652–55, and Mantua (under the patronage of Carlo II Gonzaga Nevers, IX Duke of Rethel), 1655? to 1663; early practitioner of the monotype.

Collections: Bergamo; Berlin: Bodemuseum; Birmingham; Cambridge; Cleveland; Dresden; Dublin; Genoa: Oratorio di S. Giacomo, S. Luca, S. Maria di Castello, Palazzo Doria, Palazzo Spinola, Accademia Ligustica; Hartford, Connecticut; Kansas City; Los Angeles; Lyons; Madrid; Manchester; Milan; Minneapolis; Munich; Naples: Museo di San Martino; Ottawa; Paris; Ponce, Puerto Rico; Rome: Doria Pamphili; Rouen; St. Quentin; Sampierdarena: S. Maria della Cella, S. Martino; Turin; Vienna.

Publications

On CASTIGLIONE: books—

DeLogu, Giuseppe, *Castiglione*, Bologna, 1928.
Blunt, Anthony, *The Drawings of Castiglione and Stefano della Bella . . . at Windsor Castle*, London, 1954.
Percy, Ann, *Castiglione: Master Draughtsman of the Italian Baroque* (cat), Philadelphia, 1971.

Bellini, Paolo, editor, *L'opera incisa di Castiglione* (cat), Milan, 1982.

articles—

Percy, Ann, "Castiglione's Chronology: Some Documentary Notes," in *Burlington Magazine* (London), 109, 1967.
Waterhouse, Ellis, "An Immaculate Conception by Castiglione" in *Minneapolis Institute of Arts Bulletin*, 56, 1967.
Richards, Louise S., "A Painting and Two Drawings by Castiglione," in *Cleveland Museum of Art Bulletin*, 57, 1970.
Newcomb, Mary, "A Castiglione-Leone Problem" in *Master Drawings* (New York), 1978.
Brigstocke, Hugh, "Castiglione: Two Newly Discovered Paintings and New Thoughts on His Development," in *Burlington Magazine* (London), 122, 1980.
Standring, Timothy J., "A Signed Penitence of St. Peter of Castiglione," in *Burlington Magazine* (London), March 1985.
Standring, Timothy J., "Castiglione," in *La pittura a Genova e in Liguria dal seicento al primo novecento*, revised edition, Genoa, 1987.

*

Giovanni Benedetto Castiglione, called Il Grechetto, emerged as one of the most famous Genoese 17th-century painters primarily because connoisseurs and collectors recognized that he was more than just an animal specialist or a painter of patriarchial journeys, but a painter of major pictures, including altarpieces, a clever printmaker who invented the monotype, and an astonishing draughtsman. His wide variety of subjects proves this point: we find ourselves captivated by his half-prosaic, half-poetic patriarchial journeys inspired by the book of *Genesis,* his phantasmagorical images of disease and death—most likely conjured up by the many plagues he witnessed during his life lifetime—and his images of a rustic past predating Antiquity itself, drawn from the poetry of ancient and contemporary writers as well as from the evocative ruins in and around Rome. We are also struck by his interest in such profound philosophical questions as the frailty of human life, the inevitability and consequences of death, and the search for honesty among human beings.

But it is really Castiglione's uncategorizable style that draws our immediate attention. Surely the wide range of stylistic and iconographic sources he assimilated during his lifetime has made it virtually impossible to define his art with the present classifications of trends for Italian *Seicento* painting. While the stylistic sources and motifs he grafted to his own art from such diverse *cinquecento* artists as Michelangelo, Correggio, Parmigianino, the Bassani, and Titian—as well as from contemporaries such as Poussin, Rembrandt, Lanfranco, and Bernini—would lead us to think that he worked throughout his career within the conventions of making images, he very much followed his own path by conforming to or by disregarding traditions to suit his own artistic intentions. In fact, since Castiglione's art really did not find theoretical justification until the late 1660's, when Roger de Piles proclaimed that the primacy of painting resides predominantly in its visual effectiveness, we may conclude that his contemporaries, who obvious admired his works during his lifetime, may have found his

Sacrificial Offering; etching

genius difficult to define as well. They may have considered his style too capricious to correspond to any of the rational/idealist-orientated theories of their day.

Indications of Castiglione's fame appear perhaps as early as 1634 when the poet Ottavio Transarelli, a poet associated with the Barberini circle, described one of his paintings—most likely the *St. Peter Crying in the Wilderness* (private collection)—in his book of verse entitled *L'Apollo* of 1634. Sebastian Bourdon and particularly Andrea de Leone began as early as the late 1630's to produce their own version of *Patriarchial Journey* compositions which had undoubtedly already emerged as Castiglione's specialty. He soon found imitators of other aspects of his art, particularly in Genoa, where many artists—and Anton Maria Vassallo in particular—managed to produce a style close enough to Castiglione's to continue to confuse connoisseurs. Domenico Piola, for example, began to distinguish between copies and originals of Castiglione's paintings as early as 1666 in an inventory he took of the effects left by Giovanni Howart, a Flemish artist active in Genoa. Piola himself assumed a particularly strong Castiglionesque mode during his formative years throughout the 1640's, while Salvatore Castiglione, Grechetto's brother, and Antonio Travi developed a habit of imitating Castiglione's prints. Perhaps the greatest testimony to Castiglione's fame during his lifetime and shortly after, however, is to be found in the numerous works Castiglione's son Francesco (1641–1710) made in imitation of his paintings.

Evidence of Castiglione's fame north of the Alps emerges as early as 1638 when a picture described as *Depart de tobie et de sa famille* was listed among the pictures owned by the Marechal Charles I de Crequy, a work that was later apparently owned by Cardinal Richelieu in 1643; yet another work was recorded in the French Royal collection as early as 1665. Since Castiglione's prints were known as early as 1666 when de Marolles described 47 prints by the artist in his *Catalogue de Livres d'estampes . . .*, it is natural to think that they helped encouraged Watteau and Boucher to follow their own stylistic inclinations towards the Rococo. Castiglione's art in general also led critics such as Antoine de La Roque, who wrote for the important *Mercure de France* and who owned a *Rape of Europa* attributed to the artist, to refer to him with as much familiarity as we would today to Raphael or to Michelangelo. Numerous artists such as Domenichino, Carlo Maratta, Joshua Reynolds, Ignazio Hugford, and Benjamin West and influential connoisseurs such as the Bailly de Breteuil, Mariette, Crozat, Algarotti, Sir Robert Walpole, and Consul Smith—all of whom owned works by the artist—also helped establish his fame and popularity.

Why Castiglione's critical fortune fell to its nadir sometime during the mid-18th century may have been due to the limited examples of his works in public collections rather than to the change in artistic taste. In the end, Castiglione benefited greatly from the general re-evaluation of Italian *seicento* painting by historians during this century, many of whom have taught us that works of art might best be appreciated and understood through the eyes and comments of the artist's contemporaries. Indeed, it is to Castiglione's earliest biographers such as Soprani, Ratti, Baldinucci, and Pio that we owe a great deal of understanding about the artist and his works. They were among the first to recognize the true merits of his art by praising his technical brilliance and by noting his attempts to imitate a wide variety of styles during his formative years, a practice not uncommon for Castiglione's time, but one which was influenced strongly by theoretical discussions initiated by G. B. Paggi in Genoa which may explain—in part at least—the numerous stylistic mutations Castiglione exhibited throughout his career.

Shortly after leaving Genoa for Rome, perhaps as early as 1631, Castiglione gradually began to adjust the major stylistic characteristics of his formative years—on the one hand, a Flemish inspired naturalism learned by looking closely at the works of Jan Roos and Sinibaldo Scorza, and on the other, a latent Tuscan-Genoese *maniera* coming from any number of local Genoese artists—to the rigors of a rational academic classicism inspired by Poussin's and Sacchi's examples. Seemingly unsatisfied, he began throughout the 1640's to incorporate rhetorical devices learned from Rembrandt's prints, Bernini's sculpture, and Lanfranco's altarpieces, and for the remainder of his career, he achieved a curious stylistic synthesis consisting of all of these influences, including some from Parmigianino. In fact, because he borrowed from such a wide variety of images both stylistically as well as iconographically, his works remain even more compelling because of their resultant sense of equivocation about artistic intentionality.

Attempts to assemble a *catalogue raisonné* of his paintings from a corpus of over 300 related pictures have been hampered by the scant documentation on the artist. Although he was recorded as having resided in his native Genoa in addition to Rome, Venice and Mantua, many of his early biographers report that he spent time in Florence, Bologna, and Parma as well. Information about collectors and patrons of Castiglione's works is not particularly abundant either—at least during the early part of his career, perhaps because one has the impression that he sold most of his canvases as ready-for-sale pictures in Rome to relatively modest collectors on the open market. It was not until the mid-1640's that Castiglione began to receive major commissions, such as the *Nativity* altarpiece, San Luca, Genoa, signed and dated 1645, for the Spinola family. Members of the Balbi, Lomellini, Doria, Invrea, and Raggi families, among others, also managed to acquire his works, as did the Chigi in Rome; and the Segredo and Nani in Venice. We know that he also received financial support from picture dealers and print publishers in Rome.

Despite the numerous studies that have emerged on Castiglione in recent times—Ann Percy's catalogue of Castiglione's prints and drawings, Mary Newcome's many publications on the artist's drawings—research on various aspects of his art still remain, such as examining the theoretical underpinnings which constitute the intricate relationship between his drawings, etchings, monotypes, and paintings, and determining the significance of some of his more enigmatic images. Moreover, much could be learned by examining his relationships with various members of literary circles, such as Gian Vincenzo Imperiale, Agostino Mascardi, and Ottavio Transarelli.

While our current fascination with Castiglione's works may be due to our modernist sensitivity to his virtuoso handling, to his proto-romantic bohemian spirit that emerges in the early biographies on him, and to his compelling images on a wide variety of themes, his fame, regardless of the reason, is quite assured, as he himself so proudly proclaims in his print of 1648 entitled *Genium IO: Gio Benedetto Castiglione*.

—Timothy J. Standring

CAVALLINI, Pietro.

Born Pietro Cerroni in Rome, c. late 1240's. Died in Rome in 1330's or 1340's. One son, Giovanni (who claimed his father lived 100 years). Documented from the period 1273 to 1308: did frescoes and mosaics in Rome (S. Maria in Trastevere, S. Cecilia, S. Paolo-fuori-le-mura); worked in Naples as a member of the entourage of the King of Naples, 1308: worked on S. Maria Connaregina, 1316–20.

Collections/Locations: Rome: S. Cecilia, S. Maria in Trastevere, S. Giorgio in Velabro, S. Maria d'Aracoeli; Naples: S. Maria Connaregina.

Publications

On CAVALLINI: books—

Emilio Lavagnino, *Cavallini,* Rome, 1953.
Sindona, Enio, *Cavallini,* Milan, 1958.
Toesca, Pietro, *Cavallini,* London and New York, 1960.
Matthiae, Guglielmo, *Cavallini,* Rome, 1972.
Hetherington, Paul, *Cavallini: A Study in the Art of Late Medieval Rome,* London, 1979.

articles—

White, J., "Cavallini and the Lost Frescoes in S. Paolo," in *Journal of the Warburg and Courtauld Institutes* (London), 19, 1956.
Sindona, Enio, "Il *Giudizio universale* di Cavallini: Necessita di un restauro e altri problemi," in *L'Arte* (Milan), 6, 1969.
Paeseler, W., "Cavallini e Giotto: Aspetti cronologici," in *Giotto e il suo tempo,* Rome, 1971.
Gardner, John, "S. Paolo fuori le mura, Nicholas III, and Cavallini," in *Zeitschrift für Kunstgeschichte* (Munich), 34, 1971.
Gardner, John, "Pope Nicholas IV and the Decoration of Santa Maria Maggiore," in *Zeitschrift für Kunstgeschichte* (Munich), 36, 1973.
Hetherington, Paul, "Cavallinesque Panel Painting in Grenoble," in *Gazette des Beaux-Arts* (Paris), March 1984.

*

Although only a few works remain of the many listed by Ghiberti and Vasari, these extant works serve to place Cavallini among the bold innovators of his period. Ignored for a long time, his activity has been seriously investigated by scholars only since the discovery, in 1899, of a large fragment from his *Last Judgment,* painted around 1293 for the Roman Church of Santa Cecilia (*in situ*). Roman by birth, working for Popes and prelates, Cavallini's artistic formation is steeped in the legacy of the Byzantine tradition, yet, like his contemporary and collegue Arnolfo di Cambio, in his maturity his attention was increasingly drawn toward the ideals of classical sculpture and his works acquired such a monumentality and convincing plas-

ticity that today it is not totally improper to consider him Giotto's forerunner.

Of the huge decoration once covering the interior of San Paolo Fuori le Mura (burnt in 1823) nothing remains; we have only watercolor copies from the 17th century. It is hard to gauge the quality of the originals, and all one can discern is that Cavallini's figures moved and acted in spaces, be they landscapes or buildings, that were not just backdrops to the stories, but were blended and integrated with the figures themselves. Cavallini's figures, eschewing the rigid Byzantine formalism, play their role in a spontaneous, convincing way.

His first work to have reached us is the mosaic cycle, signed in 1291, in Santa Maria in Trastevere. Here the well-established iconography of the six episodes from the life of the Virgin Mary becomes less stiff and conventional than in earlier Mediterranean mosaic cycles. Often inhabiting simplified, classicizing architecture, the figures stand out as if in relief, quietly gesturing; characters are majestically draped in soft garments of full, rich colors. Sharp outlines are practically nonexistent; color itself, bright with light or darkened by deep shadows, builds forms and volumes in a harmonious and lively manner. Although bound by the peculiarity of the mosaic technique, Cavallini already proves himself a superb colorist of classical force and an outstanding "stage director," and his figures, far from being hieratic, inert, and bloodless, seem to breathe and pulsate with a subdued, majestic vitality.

That which remains of his *Last Judgment* fresco at Santa Cecilia (about one third of the original composition) shows Cavallini's fully matured style. Freed from the inherent restrictions of the mosaic technique the painter displays here all the capabilities of his talent. Severe yet serene, draped in heavy garments modelled by deep shadows, the row of seated Apostles have the solidity and the gravity of classical statuary. Each figure portrays a particular character and all of them together form a profound choral comment on the last act of human history. The transcendental central figure of Christ, firmly modelled, shows the serene, inscrutable, but ultimately just countenance of a deity. Color alone, used with unsurpassed dexterity and virtuosity, seems to shape the bodies: glowing like burning coals in the angels' wings, softening with its light shading the ovals of the faces, imparting weight and mass to the dignified row of figures.

More than 20 years later, in 1308, we find Cavallini in Naples, working with other artists on the choir decoration of Santa Maria Donna Regina. It is practically impossible to ascertain which portions of the cycle belong to him, or to what degree his sober realism and his loose, fluent narrative style influenced the artists working side by side with him. All one can say is that the moral intensity of the figures, their lack of traditional stylization, their keen individuality, have their source in Cavallini; no one but he (or the young Giotto) could have been capable of such a classical synthesis. (Apropos of Giotto: the possibility of a stylistic exchange between the younger and the older master can only be posed as an educated guess.) Severe and thoughtful, Cavallini strove to enliven the moribund Byzantine tradition by allying its traditional schemes with the concepts and values of local, Roman classical art filtered through the tenets of his Christian culture. As such Cavallini planted the seeds that two hundred years later brought forth the flowering of the Italian Renaissance.

—Norberto Massi

CELLINI, Benvenuto.
Born in Florence, 3 November 1500. Died in Florence, 13 February 1571. Married; two legitimate children. Trained as a goldsmith in Florence; refused invitation to accompany Torrigiano to England, 1519; worked in Rome, 1519–40, with short stays in Pisa, Bologna, and Venice: served Popes Clement VII and Paul III, 1532–40; worked in France, 1537, 1540–45: served Francis I at Fontainebleau (famous salt-cellar, made first large-scale sculpture); then worked in Florence from 1545: imprisoned, 1556, took priestly vows, 1558 (released, 1560); designed coins, medals, seals.

Collections/Locations: Boston: Gardner; Cleveland; Escorial; Florence: Bargello, Loggia dei Lanzi; New York; Oxford; Paris; Raleigh, North Carolina; San Francisco; Vienna; Washington.

Publications

By CELLINI: books—

Vita, edited by A. Cocchi, Cologne, 1728; as *Autobiography,* edited by Charles Hope and Alessandro Nova, Oxford, 1983.
Due trattati dell'oreficeria e della scultura, Florence, 1568; as *The Treatises on Goldsmithing and Sculpture,* London, 1888.
Opere, edited by Bruno Maier, Milan, 1962.
Scritti e inediti Cellianiani by Piero Calamandrei, edited by Carlo Cordié, Florence, 1971.

On CELLINI: books—

Plon, Eugène, *Cellini, orfevre, médailleur, sculpteur,* Paris, 2 vols., 1883–84.
Cust, Robert H. H., *Life of Cellini,* London, 2 vols., 1900.
Supino, Igino B., *L'arte di Cellini,* Florence, 1901.
Focillon, Henri, *Cellini,* Paris, 1911.
Schlosser, *Das Salzfass des Cellini,* Vienna, 1921.
Allendoli, E., *Cellini,* Florence, 1930.
Klapsia, H., *Cellini,* Berlin, 1943.
Maier, B., *Svolgimento storico della critica su Cellini scrittore,* Trieste, 2 vols., 1950–51.
Maier, B., *Umanità e stile di Cellini scrittore,* Milan, 1952.
Camasasca, Ettore, *Tutta l'opera del Cellini,* Milan, 1955.
Braunfels, W., *Cellinis Perseus und Medusa,* Stuttgart, 1961.
Heikamp, D., *Cellini,* Milan, 1966.
Dussarat, J., *Cellini, héros de la renaissance: Etude de son autobiographie,* Grenoble, 1967.
Winner, M., *The Marble Portrait of Cosimo I de' Medici by Cellini in San Francisco,* San Francisco, 1968.
Porcella, A., *Cellini,* Rome, 1971.
Cellini artista e scrittore (colloquium), Rome, 1972.
Perrig, Alexander, *Die "Michelangelo": Zeichnungen Cellinis,* Frankfurt, 1977.
Cervigni, D. S., *The "Vita" of Cellini: Literary Tradition and Genre,* Ravenna, 1979.
Barbaglia, Susanna, *L'opera completa di Cellini,* Milan, 1981.

Cosimo I de' Medici, 1545–47; bronze; 43¼ in (110 cm)
Florence, Museo Nazionale

Trento, D., *Cellini: opere non esposte e documenti notarili,* Florence, 1984.
Pope-Hennessy, John, *Cellini,* New York, 1985.

*

The son of an architect and musician, but trained as a metal-worker and designer in the workshop of Antonio di Sandro (called Marcone), Cellini developed great skill and originality in artistic techniques and received numerous commissions for his sculptures from princely and papal patrons. Cellini's account of his dramatic and colorful life is recorded in his *Autobiography,* left unfinished in 1558 and finally published in 1728. The autobiography was translated by numerous writers, including Goethe, and served as the basis for the Berlioz opera *Benvenute Cellini* (1837). The autobiography stops in 1558, when he decided to take religious vows, but he never followed through in the priestly calling. Instead he married, and left two legitimate children. In his later years, as his productivity as an artist diminished, Cellini concentrated his efforts on writing a treatise on sculpture (*Trattato della scultura*) and the gold-smith's art (completed in 1568).

Cellini worked with Francesco Castoro in Siena and had short stays in Pisa, Bologna, and Venice and longer sojourns in Rome (1533–40), as well as Paris (1540–45). From 1519 to 1527, while in Rome, Cellini worked on a silver casket and elaborate vase for the bishop of Salamanca and a medallion of *Leda and the Swan* (Vienna). In 1527, while residing in Florence, he executed *Hercules and the Nemean Lion* in gold repoussé, and *Atlas Supporting the Sphere* in chased gold. Back in Rome, Cellini served Pope Clement VII (Medici) and Pope

Paul III (Farnese), working on minor objects and portrait medallions, coins, and jewels. His tense relations with Pope Paul III and several violent incidents led to Cellini's imprisonment in Castel San Angelo. After his famous flight, he sought protection in the Fontainebleau court under the patronage of Francis I of France.

For Francis I Cellini executed an elaborate salt cellar of Neptune and Ceres (1543; Vienna) from a model prepared earlier (1539) for the cardinal of Ferrara; and *The Nymph of Fontainebleau,* a bas relief (1545; Paris). These works are precious examples of the Mannerist style. After five years, Cellini returned to Florence to work for Cosimo I de Medici, Duke of Tuscany, where he was able to display his unmatched skills in bronze casting. Cellini executed portrait busts of Duke Cosimo I (Florence, Museo Nazionale) and Bindo Altoviti (Boston, Gardner) and some figures of classical themes (wax and bronze nudes, *Narcissus,* 1545–54; Florence, Museo Nazionale). Cellini's bronze Mannerist masterpiece is *Perseus with the Head of Medusa* (1564; Florence, Loggia della Signoria). The artist gives an eloquent account in his autobiography of the virtuoso casting of the serpentine movement of the bronze figure, tensely poised body contrasting with the decapitated head of the Medusa. His *Crucified Christ* (1556–72; Escorial), however, shows his limitations in marble.

While in Florence, Cellini was involved in quarrels and rivalries with other artists, especially Ammanati, Bandinelli, and Vasari. Personality conflicts intensified also in his relations with Duke Cosimo I and other patrons.

Cellini's sculptural Mannerist style reflects not only his personal strifes and tensions but also the religious, political, and social environment of his time (Charles V of Germany and Francis I of France causing the sack of Rome in 1527). Cellini's Mannerist style is elaborate, elegant, and precious. His subject matters are filled with allegorical allusions designed with skillful effects and virtuosity of execution. His fame and success made an impact in his time as Gianbologna; and his art was an influential force in the style of the French sculptor Goujon. Cellini is viewed as the prototype figure of the tragic, romantic artist.

—Liana Cheney

CERUTI, Giacomo (Antonio Melchiorre) [Il Pitochetto].
Born in Milan, 13 October 1698. Died in Milan, 28 August 1767. Married Angiola Caterina Carozza, 1717; two sons and two daughters; one daughter by Mathilde de Angelis. Worked in Brescia, Gandino, and Venice, 1734–39, Padua, 1739, Venice (Palazzo Grass, c. 1740), Piacenza, 1744–47; then in Milan by 1757; though famous for lace-makers and vagabonds, also painted straight portraits and religious works.

Major Collection: Milan.
Other Collections: Artogne: S. Maria ad Elisabetta; Belfast; Bergamo: Credito Bergamasco; Bione: Parrocchiale dei Santi Gaustino e Giovita; Brescia: Museum, Badia Nuova; Carrara; Gandino: S. Maria Assunta; Goteborg; Hartford, Connecticut; Kassel; London; Los Angeles; Lugano; Milan: Poldi Pezzoli,

Ospedale Maggiore, Castello Sforesco; Padua: S. Antonio, S. Lucia; Piacenza: S. Teresa; Raleigh, North Carolina; Rome: Galleria Nazionale; Turin: Museo Civico, Sabauda; Venice: Ca' Rezzonica; Vienna.

Publications

On CERUTI: books—

Ferro, F., *Ceruti,* Milan, 1966.
Testori, G., *Ceruti* (cat), Milan, 1966.
Malle, L., and G. Testori, *Ceruti e la ritrattistica del suo tempo* (cat), Turin, 1967.
Gregori, Mina, editor, *Ceruti,* Milan, 1982.
Ceruti (cat), Brescia, 1987.

articles—

Testori, G., "Il Ghislandi, il Ceruti, e i veneti," in *Paragone* (Florence), 57, 1954.
Morassi, A., "Ceruti pittore verista," in *Pantheon* (Munich), 25, 1967.
Fiocco, G., "Ceruti a Padova," in *Saggi e Memorie di Storia dell'Arte,* 6, 1968.

*

Giacomo Ceruti led a restless and unstable life, the details of which have only recently been rediscovered by scholars. The critical reputation of Ceruti's art has coincidentally been the subject of one of the most remarkable re-appraisals in recent years. More or less forgotten prior to the landmark '600 and '700 exhibition in Florence in 1922, Ceruti's cause was subsequently championed in many writings by Roberto Longhi, most effectively in the exhibition catalogue *I pittori della realtà in Lombardia* (1953). In the last decade, Mina Gregori's catalogue raisonné of the paintings (1982) and a full-scale monographic exhibition at Brescia (1987) have decisively established Ceruti as a major figure who bravely pursued an independent path between Caravaggesque naturalism and the Age of Enlightenment.

Born in Milan in 1698, Ceruti passed a peripatetic career in northern Italy. Details of his training are wanting: he was already working independently in Brescia in 1721. His earliest dated work is a portrait of 1724 (he evidently specialized in portraits from the outset), which closely resembles the Lombard realism of Carlo Ceresa of Bergamo. Ceruti's early activity in Brescia teems with question marks, of which the most pressing regards the extent and nature of his genre paintings, specifically his portraits of beggars, for which he earned the sobriquet "il Pitochetto."

In 1734, Ceruti signed and dated an altarpiece in Artogne, near Brescia, and in March of the same year he travelled to Gandino, northeast of Bergamo, to begin work on an extensive series of canvases for the local basilica of Santa Maria Assunta. These paintings of only marginal competence are strongly impressed with the manner of Antonio Cifrondi, who had worked in Brescia throughout the previous decade.

Cifrondi was doubtless important for Ceruti, since he specialized in single-figure canvases of grimacing beggars and

hoary apostles. But Cifrondi typically spiced his subjects with heavy doses of broad humor verging on caricature; G. F. Cipper, called Todeschini, another prolific painter of beggars and low life, did the same. Ceruti's great achievement was to paint porters, peasants, and mendicants without the mocking, superficial, or caricatured attitudes of his predecessors; he limned the portraits of these humble souls with neither "sympathy nor disgust," as E. K. Waterhouse (1962) said so aptly. Ceruti's *Beggars* were collected by a small circle of patrons; their motives and interest in exhibiting such subjects, as Ceruti's in painting them, are issues that remain to be resolved.

The archival discoveries published by Vittorio Caprara and Mina Gregori (1982) have revealed, in addition to particulars of the artist's birth and death, that from 1736 onwards Ceruti struggled to maintain and to keep apart two separate families in different cities. He was married in Milan in 1717 to Angiola Carozza; however, his willingness to accept commissions outside Brescia after 1734 must have been motivated to some extent by his efforts to share his household with Mathilde de Angelis, who bore him a daughter in Padua in February 1738.

Between 1734 and 1736, Ceruti made an astonishing career change when he abandoned (incomplete) the provincial patronage of Gandino in favor of cosmopolitan Venice, where he worked for the renowned collector Marshal Johann Matthias von der Schulenberg. From February to July 1736, Ceruti received payments from Schulenberg for paintings of *pitocchi*, portraits, and still lifes. The artist's exposure to Venice must have inspired the development of the monumental compositions that are the hallmark of his maturity. He probably came into contact with Giambattista Piazzetta, who advised Schulenberg on art.

Ceruti's itinerary during the early 1740's has not as yet been ascertained. In 1744, he began a sojourn of several years' duration in Piacenza, painting an altarpiece and innumerable portraits. His whereabouts are undocumented between 1746 and 1757: perhaps he returned to Brescia. He reappears in the records of his native Milan, still plying his trade as a portraitist, although without much recognition. He died poor in 1767.

—John T. Spike

CÉZANNE, Paul.

Born in Aix en Provence, 19 January 1839. Died in Aix en Provence, 22 October 1906. Married Hortense Fiquet, 1886; one son. Attended College Bourbon, Aix; studied law at University of Aix, 1858–61; also studied drawing with Joseph-Marc Gibert at Ecole des Beaux-Arts, Aix, from 1856; lived in Paris, 1861, 1862–70, then in L'Estaque, and in 1872 at Pontoise: close associate of Pissarro; exhibited at first Impressionist exhibition, 1874; after the death of his father (a rich man), lived in Provence, mainly at Jas de Bouffan, near Aix.

Major Collection: Paris.
Other Collections: Amsterdam: Stedelijk; Basel; Berlin; Boston; Budapest; Cambridge; Cambridge, Massachusetts: Chicago; Copenhagen; Cleveland; Copenhagen; Detroit; Edinburgh; Essen; Leningrad; Liverpool; London: Tate, National Gallery, Courtauld; Los Angeles; Merion, Pennsylvania; Minneapolis; Moscow: Museum of Modern Western Art; Munich: Neue Pinakothek; New York: Guggenheim, Brooklyn Museum, Moma; Paris: Petit Palais; Philadelphia; St. Louis; Sao Paulo; Washington: National Gallery, Phillips.

Publications

By CÉZANNE: books—

Correspondance, edited by John Rewald, Paris, 1937; as *Letters,* London, 1941, 4th edition, Oxford, 1976, New York, 1984.
Conversations avec Cézanne, edited by P. M. Doran, Paris, 1978.
Cézanne by Himself, edited by Richard Kendall, London, 1988.

On CÉZANNE: books—

Meier-Graefe, Julius, *Cézanne und seine Ahnen,* Munich, 1910.
Burger, Fritz, *Cézanne und Hodler,* Munich, 1913.
Vollard, Ambroise, *Cézanne,* Paris, 1914; as *Cézanne: His Life and Art,* Boston, 1923.
Meier-Graefe, Julius, *Cézanne und sein Kreis,* Munich, 1919.
Meier-Graefe, Julius, *Cézannes Aquarelle,* Munich, 1920.
Bernard, Emile, *Souvenirs sur Cézanne,* Paris, 1921.
Gasquet, Joachim, *Cézanne,* Paris, 1921.
Rivière, Georges, *Le Maître Cézanne,* Paris, 1923.
Larguier, Leo, *Le Dimanche avec Cézanne,* Paris, 1925.
Faure, Elie, *Cézanne,* Paris, 1926.
Fry, Roger, *Cézanne: A Study of His Development,* London, 1927.
Pfister, Kurt, *Cézanne: Gestalt, Werk, Mythos,* Potsdam, 1927.
Meier-Graefe, Julius, *Cézanne,* London, 1927.
d'Ors, E., *Cézanne,* Paris, 1930, London, 1936.
Mack, Gerstle, *Cézanne,* London and New York, 1935.
Huyghe, René, *Cézanne,* Paris, 1936.
Larguier, Leo, *Cézanne, ou le drame de la peinture,* Paris, 1936.
Rewald, John, *Cézanne et la Provence,* Paris, 1936.
Rewald, John, *Cézanne et Zola,* Paris, 1936; as *Cézanne: Sa vie, son oeuvre, son amitié pour Zola,* 1939; as *Cézanne,* New York, 1948; London, 1986.
Venturi, Lionello, *Cézanne: Son art, son oeuvre,* Paris, 2 vols., 1936.
Novotny, Fritz, *Cézanne,* New York, 1937.
Novotny, Fritz, *Cézanne und das Ende der wissenschaftlichen Perspektive,* Vienna, 1938.
Barnes, Albert C., and Violette De Mazia, *The Art of Cézanne,* New York, 1939.
Venturi, Lionello, *Cézanne: Water-Colours,* London, 1943.
Loran, Erle, *Cézanne's Composition,* Berkeley, 1943, 1970.
Rilke, Rainer Maria, *Lettres sur Cézanne,* Paris, 1944.
Larguier, Leo, *Cézanne, ou la lutte avec l'ange de la peinture,* Paris, 1947.
Dorival, Bernard, *Cézanne,* Paris and New York, 1948.
Jedlicka, Gotthard, *Cézanne,* Berne, 1948.

Bathers (Large Plate); lithograph

Rewald, John, *Cézanne: Carnets de dessins,* Paris, 2 vols., 1951.

Schniewind, C. O., editor, *Cézanne Sketchbook,* New York, 2 vols., 1951.

Gachet, P. *Cézanne à Anvers: Cézanne gravure,* Paris, 1952.

Schmidt, G., *Aquarelle von Cézanne,* Basel, 1952.

Sherman, H. L., *Cézanne and Visual Form,* Columbus, Ohio, 1952.

Gowing, Laurence, *Cézanne: Painting* (cat), Edinburgh, 1954.

Raynal, Maurice, *Cézanne,* Geneva and Cleveland, 1954.

Beucken, J. de, *Un Portrait de Cézanne,* Paris, 1955.

Badt, Kurt, *Die Kunst Cézannes,* Munich, 1956; as *The Art of Cézanne,* Berkeley, 1956.

Perruchot, Henri, *La Vie de Cézanne,* Paris, 1956.

Chappuis, Adrien, *Les Dessins de Cézanne,* Lausanne, 2 vols., 1957.

Berthold, Gertrude, *Cézanne und die alten Meister,* Stuttgart, 1958.

Neumeyer, Alfred, *Cézanne: Drawings,* New York, 1958.

Neumeyer, Alfred, *Cézanne: Die Badenden,* Stuttgart, 1959.

Rewald, John, *Cézanne, Geffory, et Gasquet,* Paris, 1959.

Novotny, Fritz, *Cézanne,* London, 1961.

Chappuis, Adrien, *Die Zeichnungen von Cézanne,* Basel, 1962.

Les Dessins de Cézanne au Cabinet des Estamps du Musée des Beaux-Arts de Bale, Olten, 2 vols., 1962.

Feist, P. H., *Cézanne,* Leipzig, 1963.

Schapiro, Meyer, *Cézanne,* New York, 1952, 3rd edition, 1965.

Guerry, Liliane, *Cézanne et l'expression de l'espace,* Paris, 1966.

Chappuis, Adrien, *Album de Cézanne,* Paris, 1967.

Neiss, Robert, *Zola, Cézanne, and Manet: A Study of L'Oeuvre,* Ann Arbor, 1968.

Lindsay, Jack, *Cézanne: His Life and Art,* London, 1969.

Anderson, Wayne V., *Cézanne's Portrait Drawings,* Cambridge, Massachusetts, 1970.

Orienti, Sandra, *L'opera completa di Cézanne,* Milan, 1970; as *The Complete Paintings of Cézanne,* London, 1972, 1985.

Badt, Kurt, *Das Spätwerk Cézannes,* Constance, 1971.

Hoog, M., *L'Univers de Cézanne,* Paris, 1971.

Cherpin, Jean, *L'Oeuvre gravé de Cézanne,* Marseilles, 1972.

Radcliffe, Robert, *Water Color and Pencil Drawings by Cézanne,* London, 1973.

Chappuis, Adrien, *The Drawings of Cézanne: A Catalogue Raisonné,* Greenwich, Connecticut, and London, 2 vols., 1973.

Wadley, Nicholas, *Cézanne and His Art,* London, 1975.

Wechsler, Judith, editor, *Cézanne in Perspective,* Englewood Cliffs, New Jersey, 1975.

Rubin, William, editor, *Cézanne: The Late Work,* New York, 1977, London, 1978.

Wechsler, Judith, *The Interpretation of Cézanne,* Ann Arbor, 1981.

Adriani, Götz, *Cézanne: Aquarelle,* Tubingen, 1982; as *Cezanne Watercolors,* New York, 1983.

Richel, Joseph, *Cézanne in Philadelphia Collections,* Philadelphia, 1983.

Rewald, John, *Cézanne: The Watercolors: A Catalogue Raisonné,* Boston and London, 1983.

Shiff, Richard, *Cézanne and the End of Impressionism,* Chicago, 1984.

Jean, Raymond, *Cézanne: La Vie, l'espace,* Paris, 1986.

Rewald, John, *Cézanne, The Steins, and Their Circle,* London, 1987.

Gowing, Laurence, *Cézanne: The Basel Sketchbook,* New York and London, 1988

Rewald, John, *Cézanne and America: Dealers, Collectors, Artists, and Critics,* London, 1988.

Gowing, Laurence, *Cézanne: The Early Years 1859–1872* (cat), London, 1988; Washington, 1989.

Brion, M., *Cézanne,* London, 1988.

*

Cézanne exhibited twice with the Impressionists (in 1874 and 1877) and worked closely with Pissarro (in 1872–74, 1877, and 1881), from whom he absorbed the lessons of Impressionist color theory and brushstroke. Yet Cézanne seems definitively to have departed from Impressionism—in a manner that was wholly different from that of Seurat, Van Gogh, or Gauguin—in order to seek a new pictorial structure composed of a non-instantaneous notion of glowing color and what Reff has termed a "constructive" brushstroke. According to the painter Maurice Denis, Cézanne wanted to re-do Poussin after nature.

From the hindsight of 20th-century modernism, Cézanne has often been interpreted as a founder of abstract tendencies and specifically Cubism. Following the memorial retrospective of his work in Paris in 1907, this interpretation sprang from formalist readings of his work by Denis and by the Cubists Gleizes, Metzinger, and Lhote and was amplified by the critics Roger Fry and Clive Bell of the Bloomsbury circle, who saw Cézanne as distorting and manipulating three-dimensional subject matter for the sake of the "pure form" of the two-dimensional picture plane. Yet other critics and historians see this as a reductivist, overly simplistic reading of the art of a complex and problematic artist.

Schiff in particular argues that Cézanne should be understood more from a 19th-century point of view, that is, in rela-

tion to Impressionism and the goal of truth to nature. Examining contemporary critical responses which found odd qualities in Cézanne's paintings, including primitivism, awkwardness, and distortion, Shiff claims that these qualities were by-products of an essentially Impressionistic attitude on the part of Cézanne—especially his interest in atmospheric effects filtered through a temperament. Shiff suggests that it was the component of temperament that resulted in Cézanne's apparent distortions, but that this was permitted by the dialectic of objectivity and subjectivity that had been central to Impressionism from the outset. Shiff believes that Cézanne's distortion had its origin in impressionist "sensation" rather than Symbolist "idea." But he asserts that the importance of Cézanne's art is that it broke down the barrier between sensation as seeing and sensation as feeling, so as to restore the wholeness of conscious experience.

Perhaps Cézanne's art can be best understood as a transition between the concerns of the late 19th and early 20th centuries, between objectivity and subjectivity, seeing and knowing, representation and abstraction. In seeking to understand and explain the complexity of Cézanne's achievement, several different critical and historical approaches to his work have emerged (many are discussed in a book by Wechsler). In the convergence of these various interpretations, all of which have strong and weak points, seem to lie the contradictions of Cézanne's art. The major approaches have been formalist, psychoanalytical, cultural, perceptual, and phenomenological. Catalogues of Cézanne's paintings and drawings by Venturi and Chappuis, as well as biographies by Rewald, have provided foundations for other kinds of investigations.

Analyzing Cézanne's renunciation of traditional illusory space, Novotny saw his art as leading towards a predominance of formal and chromatic combinations. Perhaps the most sustained formalist interpretation of Cézanne's art was that of Loran. Providing extensive diagrams of what he saw as the formal structure of individual works, including still-lifes, landscapes, portraits, and genre scenes, Loran claimed that Cézanne's great contributions to the history of painting were the mastery of structural planes, the synthesis of the abstract and the real, and the emphasis of surface. As Wechsler points out, Loran underplayed the role of color and relied on black and white photographs which artificially flattened the images. Aside from Loran, Brion-Guerry suggested that all of Cézanne's work constituted a search for a compositional equilibrium which eventually necessitated formal distortion. Gray argued that in his landscapes Cézanne engaged in distortion permitted by contemporary perspective manuals in the interest of better composition. Rubin has emphasized the formal significance of Cézannisme for the beginnings of Cubism, especially the influence of the various *Bathers* and landscapes on Picasso and Braque. Formalist interpreters have often sought corroboration for what they see as abstract reductivism in Cézanne's famous statement written in 1904 to Emile Bernard about treating nature in terms of the cylinder, the sphere, and the cone (a dictum he probably picked up from Charles Blanc's *Grammaire des arts de dessin*). Yet later the same year he likewise wrote to Bernard "I do not want to be right in theory but in nature"—just one example of the contradictions abounding in Cézanne's verbal statements about art.

In an effort to understand the paradoxical sensuality and impersonality of Cézanne's art (largely unexplained by formal-

ist interpretations), a more psychoanalytical approach was adopted by Schapiro and subsequently by, among others, Badt and Reff. These accounts often highlight Cézanne's solitary life in the south of France, his cantankerous personality, and his difficulties keeping friendships—most notably the break with his childhood friend Zola after the publication in 1886 of Zola's novel *L'Oeuvre,* whose unsuccessful and suicidal artist-protagonist Cézanne evidently took as a personal slight. Also recounted are the difficulties of Cézanne's relationships with women, including Hortense Fiquet, whom he married after the end of another tumultuous affair in 1886 (the same year as the break with Zola), when his son by Fiquet was already fourteen. Freud's theory that art sublimates sexual desires and complexes is applied accordingly in various ways to Cézanne's art. According to Schapiro, Cézanne treated the subject of fruit as sublimated female form, so that by the 1870's, formally balanced still-life paintings began to offer him a means of distancing himself from, controlling, and repressing the irrational, aggressive, erotic desires expressed in his earlier crudely painted fantasy scenes of orgies, temptations, and sexual conflict. (Compare, for example, *The Temptation of Saint Anthony,* 1869, Bührle Collection, Zurich, or *La Lutte d'amour,* 1875–76, National Gallery, Washington, to *Still-Life with Plaster Cast of Cupid,* 1895, Courtauld Institute, London.)

According to Badt, Cézanne became converted to solitude after the break with Zola and thus could study "objectively" the structural interrelationships of objects from which he himself felt separate. People, too, were treated as objects in an aesthetic sublimation of Cézanne's inability to communicate on a human level. Reff interpreted the increasingly "dematerialized" late genre, still-life, portrait, and landscape paintings (of the Bibemus quarry, the Château Noir, and Mont Sainte-Victoire) as conveying a somber and introspective mood of solitude and meditation. Following in the steps of Schapiro, Reff also interpreted the late *Bathers,* in which males and females are separated, as another artistic means of attaining a kind of sexual control—a reading echoed by Ballas. (Compare, for example, the male *Bathers,* 1898–1900, Baltimore Museum of Art, to the female *Large Bathers,* ca. 1906, Philadelphia Museum of Art.) Krumrine has purposed this line of thought into a more tenuous iconographical interpretation of the various *Bathers* as a meditation on the duality of the sacred and the profane. In any event, Cézanne's various anxieties can be read as translating formally into his seeming hesitation and reluctance to finish works, especially the late ones. Although this kind of interpretation makes assumptions about Cézanne's personality which are of necessity based largely on anecdote, biographical hearsay, and iconographical readings, it gains support from a distinctively non-formalist assessment by Picasso in 1935: "It's not what the artist *does* that counts, but what he *is.* . . . What forces our interest is Cézanne's anxiety."

The cultural approach seeks to situate Cézanne's formal distortions and psychological disquiet in the context of changing scientific and philosophical theories of his day. Lindsay draws connections between Cézanne's art and new physical theories of cosmic change, movement, instability, and asymmetry espoused by scientists like Spencer, Fechner, Petzolt, Mayer, Mach, Mallard, and Pierre Curie. Lindsay suggests that Cézanne's system of interacting planes of color be understood as a field of force in which physical tensions of symmetry and asymmetry operate. A drawback is the lack of documentable correlation between such scientific theories and Cézanne's artistic practice and product.

The same holds true for Hamilton's account of analogies between Cézanne's formal innovations and the contemporary philosophy of Bergson, specifically the Bergsonian notion of time and space as comprehended intuitively through the process of change in duration rather than in the instantaneous moment. Cézanne is interpreted as having attempted to record eye movement and multiple points of view which imply the duration of time—a pictorial equivalent of Bergson's theories. But it is impossible to prove whether or not Cézanne was familiar with Bergson's ideas: the artist's letters seem to indicate that, on the whole, he disliked speculative theory; and Reff's research on books owned by Cézanne at the time of his death seems to indicate a complete indifference to contemporary philosophical speculation. Moreover, Bergson's first major treatise on such topics, the *Essai sur les données immédiates de la conscience,* was not published until 1889, by which time Cézanne was already involved in the relevant spatial experiments.

As Druick argued in an unpublished thesis, it is perhaps more feasible to draw connections with contemporary optical theory, especially the ideas of Helmholtz, which were evidently known to Pissarro, with whom Cézanne worked closely in the 1870's. Helmholtz's *Physiological Optics* was translated into French by 1867 and translations of his *Popular Lectures on Scientific Subjects,* which included optics, appeared in the 1870's. His ideas on eye movement, binocular vision, peripheral distortion, and on the distinction between immediate sensation and synthesized perception, between apparent and actual shape, seem especially pertinent to Cézanne. Even though Cézanne probably did not read Helmholtz and other contemporary optical scientists who wrote of comparable topics, such visual ideas were perhaps more likely to have been discussed in the artistic community than physical theories of cosmic instability of philosophical notions about time.

The issue of optics leads from cultural approaches to the interpretation which seeks to understand Cézanne's art in terms of perceptual physiology. Proponents of this view believe that much of Cézanne's so-called distortion of form results from his acceptance that such deformation can develop out of strict adherence to visual sensation rather than to the static, monocular conventions inherited from Renaissance perspective and reinforced by photography. Corroboration is found in the artist's numerous verbal statements about submission to "sensation" and his goal of the "realization" of nature. Psychologists, critics, and historians including Blanshard, Ehrenzweig, Friedenwald, Berkman, Machotka, and Rauschenbach have located Cézanne's departure from visual convention in such optical phenomena as binocular perspective, successive or shifting points of view, peripheral distortion, and size constancy, and in the conceptual synthesis and reorganization of raw visual data. Cézanne himself stated to Bernard: "I conceive of [art] as a personal apperception. I situate this apperception in sensation, and I ask that the intelligence organize it into a work."

The perceptual interpretation (albeit not Rauschenbach's systematized analysis of Cézanne's landscape perspective) for the most part gained backing from French phenomenologist Merleau-Ponty, who suggested affinities between his own phi-

losophy and what he saw as Cézanne's aim of "truth to phenomena." This involved an intuitive process of seeing and composing in which Cézanne's "perspectival distortions are no longer visible in their own right but rather contribute, as they do in natural vision, to the impression of an emerging order, of an object in the act of appearing, organizing itself before our eyes." Given the apparent difficulties of separating and resynthesizing the variables of perception and cognition, of getting between and reorganizing the activities of eye and brain, Cézanne's "doubt" and "anxiety" may well have been grounded as much in his evident sensitivity to optical phenomena as in his reputed psychoanalytical problems and strategies of formal control.

It seems that formalist, psychoanalytical, cultural, perceptual, and phenomenological approaches to Cézanne's complex art all have light to shed. As Schapiro put it: "We cannot say how much in Cézanne's distortions arises from odd perceptions, influenced by feeling, and how much depends on calculations for harmony or balance of forms." The very relativity of issues and readings would seem to indicate that a single, static world view was no longer possible for Cézanne and that a monolithic critical or historical position would prove ineffectual in interpreting his work today.

—M. R. Brown

Self-Portrait with Goat, 1922–23; lithograph

CHAGALL, Marc

Born in Vitebsk, Russia, 7 July 1887; naturalized French citizen, 1937. Died in Saint-Paul-de-Vence, 28 March 1985. Married Bella Rosenfeld, 1915 (died, 1944), one daughter; lived with Virginia Leirens, 1945–52, one son; married Vava Brodsky, 1952. Studied with the painter Jehuda Pen, Vitebsk, 1906; Imperial School for the Protection of Arts, St. Petersburg, 1907–08, and privately with Saidenberg and Leon Bakst, 1908–09; lived in Paris, 1910–13; lived in St. Petersburg, 1915–17, and Vitebsk, 1917–20: Commissar for Art in Vitebsk, 1918, and founder of the Vitebsk Academy (El Lissitzky and Malevich were staff members), 1919–20; in Moscow, 1920–22: first stage designs for Kameray State Jewish Theatre (later designs for ballets *Aleko*, 1942, *The Firebird*, 1949, and *Daphnis et Chloé*, 1958, and the opera *The Magic Flute*, 1967); lived in Berlin, 1922–23, then settled in Paris, 1923–41; lived in the United States, 1941–48, then in Saint-Paul-de-Vence after 1950; first sculptures, 1951, and stained glass designs, 1957; established Musée National Message Biblique, Nice, 1972.

Major Collection: Nice: Musée National Message Biblique.
Other Collections: Basel; Berlin: Nationalgalerie; Cologne; Grenoble; Jerusalem: Hadassah Medical Center synagogue; Leningrad: Russian Museum; Los Angeles; Mainz: S. Stephan; Metz: Cathedral; New York: Moma, Guggenheim, Metropolitan Opera House; Paris: Beaubourg, Opéra; Tel Aviv.

Publications

By CHAGALL: books—

Sturm-Bilderbuch, Berlin, 1923.
Ma vie, Paris, 1931; as *My LIfe*, New York, 1960.
The Work of My Mind (lecture), Chicago, 1947.
Le Cirque, Paris, 1967.
Propos de Chagall, with Pierre Schneider, Paris, 1967.
Poèmes 1909–1972, Geneva, 1975.
Chagall by Chagall, edited by Charles Sorlier, New York, 1979.

illustrator: *Dead Souls*, by Gogol, 1925; *Fables of La Fontaine*, 1931; *Arabian Nights*, 1948; *Daphnis and Chloe*, 1961, etc.

On CHAGALL: books—

Efros, Abram, and J. Tugendkhold, *The Art of Chagall* (in Russian), Moscow, 1918.
Däubler, Theodor, *Chagall*, Rome, 1922.
Aronson, Boris, *Chagall* (in Russian), Berlin, 1923.
With, Karl, *Chagall*, Leipzig, 1923.
Salmon, Andre, *Chagall*, Paris, 1928.
George, Waldemar, *Chagall*, Paris, 1928.
Fierens, P., *Chagall*, Paris, 1929.
Schwab, R., *Chagall et l'ame juive*, Paris, 1930.
Vollard, Ambroise, *La Fontaine par Chagall* (cat), Paris, 1930.

Maritain, Raissa, *Chagall*, New York, 1943.

Apollonio, Umbro, *Chagall*, Venice, 1944.

Venturi, Lionello, *Chagall*, New York, 1945.

Sweeney, James Johnson, *Chagall*, New York, 1946.

Degand, Leon, and Paul Eluard, *Chagall: Paintings*, London, 1947.

Ayrton, Michael, *Chagall*, London, 1948.

Maritain, Raissa, *Chagall, ou l'orage enchanté*, Geneva, 1948.

Kloomok, I., *Chagall: His Life and Work*, New York, 1951.

Lassaigne, Jacques, *Chagall*, Geneva, 1952.

Schmalenbach, Werner, *Chagall*, Milan, 1954.

Shapiro, Meyer, and Jean Wahl, *Chagall: La Bible*, Paris, 1956.

Venturi, Lionello, *Chagall*, Geneva and New York, 1956.

Lassaigne, Jacques, *Chagall*, Paris, 1957.

Meyer, Franz, *L'opera grafica di Chagall*, Milan, 1957; as *Chagall: His Graphic Work*, New York, 1957.

Erben, Walter, *Chagall*, Munich and New York, 1957, 1966.

Cain, Julian, Fernand Mourlot, and Charles Sorlier, *Chagall lithographe 1927-1973*, Monte Carlo, 4 vols., 1957-73; as *The Lithographs of Chagall 1962-68*, Boston, 1969.

Mathey, François, *Chagall*, Paris, 2 vols., 1959.

Mathey, François, *Chagall* (cat), Paris, 1959.

Bachelard, Gaston, *Chagall: Dessins pour la Bible*, Paris, 1960.

Meyer, Franz, *Chagall: Leben und Werk*, Cologne, 1961; as *Chagall: Life and Work*, New York, 1963.

Brion, M. *Chagall*, London, 1961.

Debenedetti, Elisa, *I miti di Chagall*, Milan, 1962.

Damase, Jacques, *Chagall*, Paris, 1963.

Cassou, Jean, *Chagall*, Paris, London, and New York, 1965.

Cogniat, Raymond, *Chagall*, New York, 1965.

Lassaigne, Jacques, *Le Plafond de l'Opéra de Paris*, Monte Carlo, 1965; as *The Ceiling of the Paris Opera*, New York, 1966.

Foster, Joseph S., *Chagall: Posters and Personality*, New York, 1966.

Leymarie, Jean, *Chagall: Monotypes 1961-1975*, Geneva, 2 vols., 1966-76.

Parinaud, André, *Chagall*, Paris, 1966.

Leymarie, Jean, *Chagall: Vitraux pour Jerusalem*, Monte Carlo, 1967; as *The Jerusalem Windows*, New York, 1967.

Leymarie, Jean, *Chagall: Dessins inédits*, Paris, 1968; as *Chagall: Unpublished Drawings*, Geneva, 1968.

Bidermanas, Iziz, and Roy McMullen, *The World of Chagall*, New York, 1968.

Lassaigne, Jacques, *Chagall: Dessins et aquarelles pour le ballet*, Paris, 1969; as *Chagall: Drawings and Water Colors for the Ballet*, Paris, 1969.

Crespelle, Jean-Paul, *Chagall: L'Amour, le rêve, et la vie*, Paris, 1969.

Leymarie, Jean, *Hommage à Chagall* (cat), Paris, 1969.

Kornfeld, E. W., *Verzeichnis der Kupferstiche, Radierungen, und Holzschnitte von Chagall, vol. l, 1922-1966*, Berne, 1970.

Bucci, Mario, *Chagall*, Florence, 1970.

Voimant, Françoise, *Chagall: L'Oeuvre gravé*, Paris, 1970.

Werner, Alfred, *Chagall: Watercolors and Gouaches*, New York, 1970.

Genauer, Emily, *Chagall at the "Met,"* New York, 1971.

Bachelard, Gaston, et al., *Chagall: Le Message Biblique*, Paris, 1972.

Haftmann, Werner, *Chagall*, Cologne and New York, 1972.

Marq, Charles, and Robert Marteau, *Les Vitraux de Chagall 1957-1970*, Paris, 1972.

Sorlier, Charles, *Les Céramiques et sculptures de Chagall: Catalogue raisonne*, Monaco, 1972; as *The Ceramics and Sculptures of Chagall*, Monaco, 1972.

Amisha-Maisels, Ziva, and Israel Yeshayahu, *Chagall at the Knesset*, New York, 1973.

Laymarie, Jean, *Catalogue du Musée National Message Biblique Chagall*, Paris, 1973.

Marq, Charles, and Pierre Provoyeur, *Chagall: Catalogue de l'oeuvre monumental*, Paris, 1974.

Pieyre de Mandiargues, André, *Chagall*, Paris, 1974.

Sorlier, Charles, *Les Affiches de Chagall*, Paris, 1975.

Souverbie, Marie-Therese, *Chagall*, Paris and London, 1975.

Alexander, Sidney, *Chagall: A Biography*, New York, 1978.

Goldmann, Christoph, *Kinder entdecken Gott mit Chagall: Bilder und Gespräche*, Gottingen, 1978.

Keller, Horst, *Chagall: Life and Work*, New York, 1978.

Mayer, Klaus, *Der Gott der Väter: Das Chagall-Fenster zu St. Stephan in Mainz*, Wurzburg, 1978.

Schmalenbach, Werner, and Charles Sorlier, *Chagall*, Paris, 1979.

Trotabas, Louis, *Chagall: Le Message d'Ulysse*, Paris, 1980.

Raboff, Ernest, *Chagall*, London, 1980.

Sorlier, Charles, *Chagall et Ambroise Vollard: Catalogue complet des gravures executés par Chagall à la demande de Vollard.* Paris, 1981.

Granath, Olle, et al., *Chagall* (cat), Stockholm, 1982.

Verdet, André, *Chagall méditerranéen: Gouaches et dessins inédits de Chagall*, Paris, 1983.

Haftmann, Werner, *Chagall*, Paris, 1983.

Provoyeur, Pierre, *Chagall: Le Message biblique*, Paris, 1983; as *Chagall: Biblical Interpretations*, Jerusalem, 1983.

Lescault, Gilbert, *Chagall* (cat), St. Paul, Minnesota, 1984.

Compton, Susan P., *Chagall* (cat), Philadelphia and London, 1985.

Targat, Francois le, *Chagall*, Barcelona, 1985, London, 1987.

Forestier, Sylvie, and Laurence Sigalas, *Chagall: L'Oeuvre gravé* (cat), Paris, 1987.

Rosensaft, Jean Bloch, *Chagall and the Bible*, New York, 1987.

*

Marc Chagall was one of a number of immigrant artists who came to Paris in the early 20th century in search of the artistic centre of Europe. By the time of his arrival there in 1910 he had a distinctive body of work behind him drawn from Jewish folk-lore, childhood memories of Vitebsk, and personal fantasy. He now had to come to terms for the first time with the mainstream of modern European art and particularly with Cubism, which placed its emphasis on an aesthetic apparently poles apart from Chagall's Russian-Jewish subjects and imagination. However, in his writings Chagall has indicated that what interested him in Cubism was not the realism of objects literally perceived from different angles, but a "realism of the psyche." He wanted to dissociate himself from the academic interpreters of Picasso and Braque and to locate his painting

within that "other movement" to which he had been introduced by the poets Apollinaire and Blaise Cendrars. This "other movement" was concerned with the invention of a new language in painting and poetry for transforming conventional ways of thinking about the world and conventional means of representing it.

Chagall was attracted to the most radical capacities of Cubism, and in the period immediately after his arrival in Paris developed its flattened space, fragmented and transparent objects, and startling juxtapositions into a means of psychological and imaginative exploration. This new approach to structure was to expand enormously the earlier work which had the basic life events, love, death, birth, marriage, as its subject matter. In the early St. Petersberg paintings, for example, *The Dead Man,* 1908, separate images tend to focus on particular aspects of experience. A distinct cluster of associations and thoughts is concentrated on, for example, the self-abandoned violin player on the rooftops, the screaming woman, the nonchalant street sweeper. These contrasts in form and meaning give the images an intensified, mutually heightened effect that is not able to be contained within any overall narrative unity. In these early paintings, images seem to be bursting at the seams. After 1910 Cubism confers a radical mobility on the relationships between these enlarged concentrated clusters of meaning.

In the paintings from the period 1910–14, the physical restrictions of the seen world give way to the demands of imagination. Cubism provides the means for breaking up the given unities of objects and space. Distinctions between up and down, in front, behind, figure and ground are no longer binding. This enables Chagall to merge images together so that opposites can share the same meaning. In *I and the Village,* 1911, for example, an animal with a human eye is also a woman. Memories of Vitebsk strung partly upside down along the top edge of the picture have their visual conterpart in the blossoming branch held in the foreground. The Cubist circle within which the main motifs of the painting intersect brings its contrasting ideas, memories, and symbols together into a new fusion.

The major themes of Chagall's poetic mythology, pairs of lovers, artist and muse, acrobats, animals, and flowers, together with images invoking Paris, Russia, and Judaism, remain constant throughout his career. But the hard edges and geometry of Cubism give way increasing to structures based on color. From the late 1940's, Chagall often described the process of painting in terms of "chemistry," suggesting, like the *solve et coagula* of the alchemists, a process through which elements combine to produce new forms by first being broken down and dissolved. The increasing "abstractness" of form in Chagall's later paintings where brushstrokes become more separate and discrete, and where color is only very loosely identified with images and spaces, takes his painting toward such a state of dissolution. In these paintings images seem to be formed out of color rather than being filled in by it. The drawing follows the demands of color relationships. In major paintings such as *All Around Her,* 1945, brushstrokes have an increasing presence and images seem to rise to the surface through transparent layers of color. In the paintings produced in the years before his death zones of color are independent of images or depicted space. In *Rest,* 1975, within large areas of red, blue, or green, details of a reclining woman, a landscape, and a figure with an animal are defined by drawing. But although the drawing belongs to the color, it neither limits it nor defines it. The figure of the woman appears to be crystallised out of the red in such a way that the making of images seems to be about the associations, thoughts, and feelings that are generated by the colors themselves.

—Martha Kapos

CHAMPAIGNE, Philippe de.

Born in Brussels, baptized 26 May 1602; naturalized French citizen, 1629. Died in Paris, 12 August 1674. Married Charlotte Duchesne, 1628; three children. Studied in Brussels with Jean Bouillon, Michel de Bourdeaux, and Jacques Fouquières; settled in Paris, 1621; worked with Poussin in decorating Luxembourg Palace gallery for Marie de Medici (director of the project from 1628); also worked for Louix XIII, Anne of Austria, Richelieu, and Louis XIV; set up studio, 1629; associated with the Jansenists of Port-Royal from 1643; founding member of Academy of Painting and Sculpture, 1648 (later Professor, Rector); numerous religious paintings, mural decorations, and portraits.

Major Collection: Paris.
Other Collections: Amsterdam; Angers; Barnard Castle; Boston; Brussels; Caen; Chantilly; Detroit; Dijon; Ghent; Greenville, South Carolina; Grenoble; Greoux-les-Bains: Chapelle de Rousset; Houston; Libourne: parish church; London: British Museum, National Gallery, Wallace; Lyons; Montigny-Lemcoup: parish church; Montpellier; New York; Paris: Petit Palais; Rome: Galleria Nazionale; Rouen: Cathedral; Toledo, Ohio; Toulouse; Versailles; Vienna; Washington.

Publications

On CHAMPAIGNE: books—

Gazier, Augustin, *Phillippe et Jean Baptiste de Champaigne,* Paris, 1893.
Aubouin, E., *Le Peintre des Jansenistes, Champaigne,* Laval, 1911.
Meunier, Mme. Stanislas, *Champaigne,* Paris, 1924.
Mabille de Poncheville, André, *Champaigne,* Paris, 1938.
Dorival, Bernard, *Champaigne* (cat), Paris, 1952.
Dorival, Bernard, *Champaigne* (cat), Paris, 1957.
Dorival, Bernard, *Champaigne: La Vie, l'oeuvre, et le catalogue raisonné de l'oeuvre,* Paris, 2 vols., 1976.

articles—

Rand, Olan A., "Champaigne and the *Ex-Voto of 1662:* The Historical Perspective," in *Art Bulletin* (New York), March 1983.
Eeckhout, Paul, "Un Tableau de Champaigne retrouvé: *La Translation des Reliques de Saint Arnould,*" in *Revue Belge d'Archéologie et d'Histoire de l'Art* (Brussels), 54, 1985.

Allden, Mary, and Richard Beresford, "Two Altar-Pieces by Champaigne: Their History and Technique," in *Burlington Magazine* (London), June 1989.

*

Unquestionably the best source for the life of Philippe is Félibien's *Entrétiens* of 1688. Considerable information has been gathered by modern archival research, but very little contradicts his biography. From him we learn Philippe came from Brussels, from a family we would describe as middle class. His artistic inclination emerged early; while at school he drew figures rather than letters. He often visited a relative who fostered his interests by showing him works by her father, Bernard van Orley. When Philippe was twelve his father overcame his objections to a career in which so few succeeded and sent him to study with a local painter, Jean Bouillon, of whom little else is known. Four years later he went to a miniaturist, Michel de Bourdeaux, where he drew and painted both figures from nature and landscapes. During this period he met Fouquières, a landscapist of some reputation, who offered further instruction. When he was 19, his father suggested study with Rubens, but Philippe thought this too expensive, preferring instead to go to Rome, a destination he never reached. He arrived in Paris in 1621 where he worked for Lallement and where he met young Poussin with whom he painted for Marie de Medici at the Luxembourg under Nicholas Duchesne, whose daughter he married. At 26 he was well on his way to success; he was *peitre ordinaire de la reine* and *valet de chambre* of the king with wages of 1,200 pounds and lodging in the Luxembourg. His connections served him well; he was in effect court painter to the queen mother, the king, and Richelieu, a situation lasting into the regency of Anne of Austria. In the 1640's his clientele gradually changed, owing perhaps to newer and different tastes and definitely to his association with Jansenists.

His quick ascent and continued reputation were based on undeniably great talent aided initially by the lack of any real rival in Paris. In addition to his mastery of Flemish formal elements and techniques of verisimilitude, his work also reveals an absorption of Italian Renaissance and early 17th-century elements. These were provided in part by prints from which specific borrowings are obvious such as Plato and Aristotle from the *School of Athens* in the Dijon *Presentation* and the *Gaston de Foix* portrait from Giorgione's St. Liberale in the *Castelfranco Madonna*. Decidedly Italian formal and compositional influences ranging from the Bolognese to Caravaggio are present in any number of works that are never at the same time really Baroque in the Italian sense. One has only to compare his *Ex-Voto of 1662* with Bernini's *St. Teresa* to see the difference.

Two practices of his are particularly revealing. In accord with the Tridentine call for truth in art he utilized publications of an archaeological nature for correct detail, clearly seen in *The Feast in the House of Levi*. The other was his practice of close examination and copying of Italian paintings. Titian is a case in point, for the drapery behind Richelieu in the Louvre portrait is very close to the Venetian's superimposed glazes. His reliance on "correct" sources is especially obvious in his earlier decades, but techniques and forms absorbed from the study of Italian painting continue along with Flemish influ-

ences throughout his career. Another, less fortunate practice, common at the time, was his use of assistants on certain large works. Some of these contain disturbing passages; when they do not they, like his own work, are superb.

As a member of the *Académie Royal* he delivered a series of addresses aimed primarily at the students in attendance. Unlike many others, his stick to the point and are truly instructive. They do indicate, however, that as much as he loved great painting and encouraged students to find their own style, he abhorred Mannerism and was closer in his theory to the Renaissance than to the Baroque. Nature, he contended, must never be contravened and the literal truth must be shown. His most famous address, then as now, on Poussin's *Eliezar and Rebecca,* owes its prominence to his censuring Poussin for omitting the camels. What is overlooked, however, is his telling criticism of Poussin's rendering of a specific figure that was, as he pointed out, pillaged from antique sculpture and not, as Raphael would have done, drawn from nature. In that comment is revealed both the great importance he attached to nature and his willingness to criticize the idol of the *Académie* to insure that those he was instructing would not fall into the same easily avoided error.

As a person he was greatly admired by patrons, friends, and family for his rectitude, his quiet, unassuming life, and the remarkable generosity his financial success permitted. Because of his Jansenism, it has been assumed he represents a Jansenist esthetic. That this is not the case is evidenced by several factors. The taste for simplicity of the nuns of Port-Royal is based not on their present theological inclinations, but on their Cistercian origins. The taste of other Jansenists in general, as shown by their portraits—notably that Omar Talon—did not differ from that of other Frenchman of their time and class. Moreover, Philippe's nephew and assistant, Jean-Baptiste de Champaigne, also a Jansenist, had a personal style that clearly reveals the effects of 18 months in Baroque Italy. Philippe's style is his own, drawn from many sources, like bees gathering pollen to make honey, as he said, and formed, as he would have the students form theirs, by the force of their genius.

—Olan A. Rand, Jr.

CHARDIN, Jean Baptiste (Siméon).

Born in Paris, 2 November 1699. Died in Paris, 6 December 1779. Married 1) Marguerite Saintard, 1731 (died, 1735), son, the painter Pierre Jean Chardin, one daughter; 2) Françoise Marguerite Pouget, 1744, one daughter. Studied under the painters Pierre Jacques Cazes and Noel Nicolas Coypel; worked on restoration at Fontainebleau, 1728; member of the Academy, 1728 (later treasurer, and hung its exhibitions for 20 years from 1755); lived in the Louvre from 1757. Pupil: Fragonard.

Major Collection: Paris.
Other Collections: Berlin: Charlottenburg, Dahlem; Boston; Dublin; Edinburgh; Glasgow; Leningrad; London; Minneapolis; Munich; New York: Metropolitan, Frick; Princeton; St.

Louis; Stockholm; Toronto; Washington: National Gallery, Phillips; Williamstown, Massachusetts.

Publications

By CHARDIN: book—

Chardin et M. d'Anguiviller: Correspondance inédite, edited by M. Furcy-Raynaud, Paris, 1900.

On CHARDIN: books—

Schefer, Gaston, *Chardin,* Paris, 1904.
Dayot, Armand, *Chardin, avec un catalogue complet by Jean Guiffrey,* Paris, 1907; catalogue published separately, 1908.
Dayot, Armand, and L. Vaillet, *L'Oeuvre de Chardin et du J. H. Fragonard,* Paris, 1908.
Furst, H., *Chardin,* London, 1911.
Klingsor, F., *Chardin,* Paris, 1924.
Leclere, Tristan, *Chardin,* Paris, 1924.
Pascal, Andre, and Roger Gaucheron, editors, *Documents sur la vie et l'oeuvre de Chardin by H. J. N. C. de Rothschild,* Paris, 1931.
Ridder, Andre de, *Chardin,* Paris, 1932.
Wildenstein, Georges, *Chardin,* Paris, 1933; revised by Daniel Wildenstein, Zurich, 1963, Oxford, 1969.
Florisoone, Michel, *Chardin,* Geneva, 1938.
de la Mare, Walter, *Chardin,* New York, 1948.
Jourdain, Francis, *Chardin,* Paris, 1949.
Denvir, Bernard, *Chardin,* Paris, and New York, 1950.
Hommage à Chardin (cat), Paris, 1959.
Rosenberg, Pierre, *Chardin,* Geneva and Cleveland, 1963.
Chardin: His Paintings and His Engravers (cat), Columbus, Ohio, 1965.
Valcanover, F., *Chardin,* Milan, 1966.
Cotte, Sabine, *Chardin,* Paris, 1978.
Rosenberg, Pierre, *Chardin* (cat), Paris, 1979.
Weisberg, Gabriel P., *Chardin and the Still-Life Tradition in France* (cat), Cleveland, 1979.
Rosenberg, Pierre, *Chardin: New Thoughts,* Lawrence, Kansas, 1983.
Rosenberg, Pierre, *Tout l'oeuvre peint de Chardin,* Paris, 1983.
Conisbee, Philip, *Chardin,* Oxford, 1986.
Breitmoser, Angelika, *Tradition als Problem in der Stillebenmalerei Chardins,* Munich, 1987.

articles—

McCourbrey, J. W., "The Revival of Chardin in French Still-Life Painting 1850–1870," in *Art Bulletin* (New York), 46, 1964.
Snoep-Reitsma, Ella, "Chardin and the Bourgeois Ideals of His Time," in *Nederlands Kunsthistorisch Jaarboek* (Amsterdam), 24, 1973.
McCullagh, Suzanne Folds, and Pierre Rosenberg, "The Supreme Triumph of the Old Painter: Chardin's Final Work in Pastel," in *Museum Studies* (Chicago), Fall 1985.

*

The picture of Jean-Baptiste-Siméon Chardin that has come down to us is his picture of himself, that of the frumpy little man who stares out at us through his spectacles in the pastel *Self-Portrait with an Eyeshade* (1775; Paris), the modest crafter of small still lifes and moralising genre scenes who never ventured beyond the environs of Paris. While there is some truth in this image it would be a costly error not to recognize that he was also a prudent and sagacious professional, and a man of considerable fame and substance. He rose from the artisan class—his father was a carpenter—to be an official of the Royal Academy who was responsible for hanging many of its exhibitions. He married well—twice—and lived quite comfortably, eventually being granted quarters in the Palace of the Louvre.

Chardin prepared for the highest echelon of academic tradition and acceptance when placed by his father in the studio of Pierre-Jacques Cares, a respected history painter. He then worked with Noel-Nicolas Coypel of the illustrious dynasty of painters. Legend has it that it was with Coypel that Chardin learned the value of close observation of detail. In any case he realized, early on, that he was not cut out for the elevated rhetoric of history painting; he never seriously attempted to paint in the Grand Manner.

Around 1722, his sojourn with Coypel over, Chardin painted a signboard for a barber-surgeon showing a street scene with a wounded man. The painting does not survive (an etching after it by J. de Goncourt does) but clearly Watteau's legendary *Shopsign for Gersaint* of 1720 (Berlin) had exerted an influence. Chardin saw a more naturalistic alternative to the imaginative, literary painting in vogue in the academy. By 1728 he had established himself as a still-life painter, and gained acceptance into the academy as a painter of "animals and fruits."

Writing about Chardin's still-life paintings—following in the enormous foosteps of Diderot and Proust—is a daunting prospect, particularly in that their great appeal lies not in their subject, composition, draughtsmanship, originality, or place in the history of art, but rather in the artist's handling of paint, treatment of color, and chiaroscuro. These, to be sure, are subjective qualities but, from his time to ours, they have inspired the highest admiration. Such an early work as *Carafe, Goblets, and Fruit* (c. 1727–28, St. Louis) announces an artist in full possession of his powers and vision. This spare, luminous picture shows the artist's slow, rigorously selective method. Each fruit, nut, and vessel has a full-bodied identity, yet each mark of the brush is an event of itself. As Diderot observed: "Approach the painting, and everything comes together in a jumble, flattens out, and vanishes; move away, and everything creates itself and reappears." Light passes across a narrow shelf in a dusky interior, illuminating, penetrating, and reflecting off a few objects. The coloristic harmonies are reminiscent of 16th-century Venetian painting while the gradations of light and shadow calls to mind the Netherlands still-life specialists of the 17th century. The extraordinarily personal and ambiguous treatment of space in these works, however, is singularly Chardin.

Chardin worked only from the model; he selected and arranged objects he owned, some of which are mentioned in inventories. The same objects appear repeatedly, like characters in Watteau's *fête galante* pictures. In *The Smoker's Case* (c. 1734; Paris) the same silver goblet appears as in *Carafe,*

Goblets, and Fruit, reflecting light in a prismatic array of colors. The rosewood case—which he owned—the faience jug, the glowing pipe with its wisp of smoke are each lovingly observed for every nuance of light, color, and texture that can be wrung from them. Yet these disparate objects are so cunningly composed as to create a kind of inanimate conversation piece, each part relating easily to each other and to the whole.

Predictably, Chardin's still lifes were praised in his day for their realism; Pliny's story about birds trying to eat Zeuxis's grapes was involved yet again—prompting Diderot to remark that birds were no great judges of painting. The great critic tried repeatedly to understand Chardin's technique, which the artist took pains to keep a secret. He was aware of "thick layers of colour applied one on top of the other and beneath which an effect breathes out." He used such terms as "vapor" and "foam" but in the end could only conclude that it was "magic."

In the early 1730's Chardin decided to return to figure painting. He was now an Academician, a husband, and parent. Mariette, writing in 1749, suggested that he might have feared that people would tire of his homely still lifes, and that if he painted live animals he would have to compete with the glossier academic styles of his more established contemporaries Oudry and Desportes. An early figurative work, *A Lady Sealing a Letter* (1733; Beriin, Charlottenburg) shows a certain and not surprising debt to Dutch 17th-century genre painting, particularly that of Gerard TerBorch who treated this very subject. But whereas TerBorch's composition is cool and detached, emphasizing verticals and horizontals, Chardin's is more fluid and fraught with an expectancy and tension reminiscent of Watteau.

His scenes dealing with the bourgeoisie most frequently focus on the theme of familial instruction, and are a major component of the moralising tone of French genre painting in the middle third of the century. In *The Young Schoolmistress* (1736-37; London) the sharply rendered older child intructs the pudgy, unfocussed younger one to read. *The Governess* (1738; Ottawa) scolds the master of the house for leaving his playthings strewn about. A mother teaches her young daughter to pray in *Grace* (c. 1740; Paris) and in *The Morning Toilet* (1741; Stockholm) a young girl is shown, by her mother, how to dress properly for church, although she demonstrates a bit of vanity in stealing a glance at the mirror. As in the still lifes, the figures in these works are vibrant, elegant forms set in a vague, subdued space.

The sincerity of the theme of virtuous family life in Chardin's genre subjects has never been doubted. They never become histrionic or sentimental as do those of Jean-Baptiste Greuze, who became the hero of Diderot and whose star—as a genre painter—was to rise above that of Chardin. Chardin's figures concentrate on what they are doing, and never flirt with the viewer.

There are those who would insist that Chardin's true place is in the kitchen, and that his finest genre scenes are of scullery maids going about their chores below stairs. Whether they scrape turnips, wash the laundry, or draw water from a familiar cistern—it belonged to Chardin and appears in a number of paintings—they perform these tasks with utter commitment. There are none of Lancret's coy maids searching themselves for fleas here, none of Greuze's nubile and bogus peasantesses with symbolically broken eggs or mirrors. This is not to say

that they lack style. *The Kitchen Maid* (1739; Paris) sets down her burden of loaves with a sideways bend and a wistful look worthy of the ballet. Her small head and long proportions belong in a Watteau *fête galante,* demonstrating that Chardin was perhaps a Rococo painter after all.

Chardin's still lifes as well as his genre paintings show the virtues of hard work, frugality, and prudence in family life. By all contemporary accounts Chardin was a man who practiced what he painted, and painted as he lived, with sustained, methodical effort. His success, however, was not at all modest as his works were acquired by such illustrious collectors as Frederick II of Prussia, Catherine the Great of Russia, the Prince of Liechtenstein, and Count Tessin of Sweden.

—Frank Cossa

CHRISTUS, Petrus.

Born in Baerle, Brabant, c. 1410-20. Died in Bruges, 1473?. Married; had one illegitimate son. Sometimes said to have been Jan van Eyck's pupil; possibly pupil of Ouwater, Haarlem; first recorded as a citizen of Bruges, 1444; his signed and dated works (six) are from the 1440's and 1450's.

Collections: Berlin; Brussels; Copenhagen; Dessau, Detroit; Frankfurt; Kansas City; London; Los Angeles; Madrid; New York: Metropolitan, Frick; San Diego; Washington.

Publications

On CHRISTUS: books—

Friedländer, Max J., *Die Altniederländische Malerei, vol. 1: Die Van Eyck, Petrus Christus,* Berlin, 1924; as *The Van Eycks—Petrus Christus* (notes by Nicole Veronee-Verhaegen), New York, 1967.
Schabacker, Peter H., *Petrus Christus,* Utrecht, 1974.
Panhans-Bühler, Ursula, *Eklektizismus und Originalität in Werk des Petrus Christus,* Vienna, 1978.

articles—

Lane, Barbara G., "Petrus Christus: A Reconstructed Triptych with an Italian Motif," in *Art Bulletin* (New York), 52, 1970.
Schabacker, Peter H., "Peter Christus' Saint Eloy: Problems of Provenance, Sources, and Meaning," in *Art Quarterly* (Detroit), Summer 1972.
Upton, Joel M., "Devotional Imagery and Style in the Washington Nativity by Petrus Christus," in *Studies in the History of Art* (Hanover, New Hampshire), 7, 1975.
Pieper, Paul, "Petrus Christus: Verkündigung und Anbeutung des Kindes," in *Pantheon* (Munich), April–June 1984.

*

The rediscovery and critical evaluation of Petrus Christus has

taken place largely within this century. Though there exist six signed and dated paintings by his hand, Petrus Christus is notably absent among the luminaries of northern renaissance art mentioned in Van Mander's *Het Schilder-boek* (*Book of Painters*) of 1604. This situation contrasts ironically with the case of Rogier van der Weyden, for example, whom Van Mander showered with hyperbole, but whose painterly output is not represented by a single signed or dated work. Nonetheless, the works of Petrus Christus are all that is left of painting in Bruges from the death of Jan van Eyck in 1441 to the appearance of Hans Memling in 1465. Though over 70 painters were registered in Bruges during that time, the violent history of the Netherlands, which suffered both peasant iconoclastic riots in 1566 and a destructive Spanish looting in 1572–73, has obliterated much of the material evidence of the city's celebrated artistic excellence under the Valois Dukes. Thus, the solid, unremarkable works of Petrus Christus are appreciated more today as representatives of a "missing link" between artistic traditions than for their exceptional artistic merits.

Nothing is known of the circumstances of Petrus Christus's life or artistic training. Thus, any critical discussion of his style must begin with the paintings themselves, which display unmistakable affinities with works produced in the third quarter of the 15th century by Dirk Bouts and other painters trained in the northern Dutch town of Haarlem. This city experienced a flourishing of artistic activity in the 15th century under the influence of the cultured Jacoba of Bavaria, whose castle was 30 miles north of the Hague. Van Mander, himself a Haarlemer, declared it a place "for good artists—if not for the best painters of the entire North." It is logical to assume, then, that Petrus Christus probably received his early training in a workshop dominated by the Haarlem tradition before moving on to Bruges, where he came under the influence of the recently deceased Jan van Eyck.

Scholars are not united in this explanation of the genesis of Petrus Christus's style. Panofsky and Friedlander disregarded any Haarlem influence, preferring the romantic notion that Petrus Christus inherited Van Eyck's workshop in Bruges after the latter's death in 1441. They explained the absence of Petrus Christus's name in the city guild archives of that time by positing a court appointment for the painter, which would have obviated the necessity of guild membership. Though this theory would explain Petrus Christus's strong dependence upon Eyckian models, several salient facts argue against it. For one, Petrus Christus is not mentioned among the many artists participating in the elaborate preparations for the marriage of Charles the Bold and Margarite of York in 1468, a civic occasion that involved all artists and craftsmen connected even tangentially with the Burgundian Court. In addition, the first mention of Petrus Christus in Bruges occurs in the *Poorterboeken* (visitors' register) in 1444, when he applied for citizenship "in order to be a painter." According to civic law, Petrus would have automatically become a citizen after a year and one day's residence in Bruges. Since he evidently applied for citizenship before a year had elapsed in 1444, the idea that Petrus Christus took over Van Eyck's shop in 1441 under the patronage of the Burgundian court must be denied. It is far more logical to assume that Petrus Christus absorbed the distinctive Haarlem tradition during his early training and took on the forms and compositions of Van Eyck and van der Weyden later after moving to Bruges.

Petrus Christus's painterly style amalgamates the emerging northern Dutch tradition with technique and models inherited from earlier masters. His earliest dated works, two portraits from the year 1446 (*Portrait of Edward Grymestone*, National Gallery, London, and *Portrait of a Carthusian*, Metropolitan, New York), enlarge upon the Eyckian three-quarter portrait formula by placing the subject within a believable space. The result is an increased naturalism characteristic of the emerging Dutch school. Likewise, Petrus's *Lamentation* (Musées Royaux des Beaux-Arts, Brussels), dated 1445–50, draws obviously from Rogier's famous *Deposition* (Madrid, Prado), but expands upon it by placing the figures within a unified background vista. In these works, and others that depend upon earlier models, Petrus Christus simplifies, clarifies, and organizes his derivative compositions, purging them of excess detail and iconographic clutter, and monumentalizing and abridging the familiar forms of his famous predecessors. His basic Dutch temperament reveals itself in a new clarity of space, achieved in some cases by the use of a single-perspective vanishing point. With one foot firmly anchored in tradition and the other stepping forward to the future, Petrus Christus is an important figure in the emergence of a distinctive "Dutch" style of painting. The soft, modulated light, rational space, and geometric forms of his painting prefigure the art of Vermeer two centuries later.

—Laurinda S. Dixon

CIMA da Conegliano, Giovanni Battista.

Born in Conegliano, 1459–60. Died in Conegliano, 1517–18. Married twice; three daughters and five sons. Influenced by, or possibly a puil of, Giovanni Bellini and Antonella da Messina; in Venice by 1492 (and probably earlier): first documented work is Vicenza altarpiece, 1489; patronized particularly by Franciscan groups in Venice and on the nearby mainland; produced many Bellini-type madonnas, but later influenced by Giorgione; also did a few secular works.

Collections: Baltimore: Walters; Berlin; Boston: Museum of Fine Art, Gardner; Cambridge; Conegliano: Cathedral; Edinburgh; Leningrad; Lisbon: Gulbenkian; London: National Gallery, Courtauld, Wallace; Milan; Modena; Padua; Paris; Parma; Philadelphia; Venice: Accademia, S. Giovanni in Bragora, S. Maria del Carmine; Vicenza; Vienna; Washington.

Publications

On CIMA: books—

Botteon, Vincenzo, *Ricerche intorno alla vita e alle opere di Cima*, Conegliano, 1893.
Gardin, A., *La pala del Cima netta chiesa di San Fior*, Oderzo, 1894.
Burckhardt, Rudolf F., *Cima*, Leipzig, 1905.
Coletti, Luigi, *Cima*, Venice, 1959.

Menegazzi, L., *Cima* (cat), Venice, 1962.
Kemp, M., *Cima,* London, 1967.
Menegazzi, Luigi, *Cima,* Treviso, 1981
Humfrey, Peter, *Cima,* Cambridge, 1983.

*

Cima was a native of Conegliano, a town about forty miles north of Venice, which he depicted in the background of a painting of *St. Helen* (c. 1495, National Gallery of Art, Washington). But for almost his entire artistic career, which spanned about four decades bridging the 15th and 16th centuries, he was a resident of Venice. His prolific workshop—we have knowledge of over two hundred works—mainly specialized in large altarpieces of the *sacra conversazione* type, and smaller half-length madonnas, often with accompanying saints, for private devotion. His clients, so far as they are known, were largely from the clergy with a smaller portion from the lay middle class, who in turn were mostly associated with confraternities or parish churches. He seems to have very little contact with the nobility or the government of Venice. Almost unique among Venetian artists he did not come from a family of painters, nor did his family or any disciple continue his practice after his death, even though he was twice married and survived by five sons and three daughters. The circumstances of his artistic training are not known, but from the visual evidence it is clear that he modelled his style, and often even his compositions, primarily on the works of Giovanni Bellini.

In no way an innovator like Bellini and even less like the next generation of artists which included Giorgione and Titian, Cima, nevertheless, was a significant figure in the history of Venetian painting, especially with regard to the painted altarpiece. Following the example of Bellini, Cima in most of his altarpieces created a strong sense of spatial continuity between the viewer's world and the world of the painting, often by use of an architectural setting that seemed to be constructed from the same elements used in the frame or even with those employed in the actual architecture of the chapel in which the painting was placed. Backgrounds were often bright and sunny landscapes exquisitely rendered with scrupulous and loving attention to naturalistic detail, details that were more often than not symbolic. These natural and architectonic painted spaces were suffused with a warm golden light and populated by a gorgeously dressed, monumental race of mostly quietly contemplative and gravely dignified saints of the utmost moral rectitude. At their best these altarpieces were not only spiritually uplifting but visually exciting as well.

For example, the altarpiece of 1496–98 for SS. Annunziata in Parma (now in the Galleria Nazionale, Parma) showing the *Virgin and Child with SS. Michael and Andrew* instructed the faithful that God's grace and justice (St. Michael) must be combined with sacrifice and penance (St. Andrew) to achieve salvation through the Church (the Virgin). At the same time the massive, obliquely arranged classical architecture (emblematic of the triumph of Christianity over paganism) not only added visual emphaisis to the Virgin and Child, but also acted as a foil for the Virgin's movement as she turned sharply on her makeshift throne to support the blessing Christ Child. This dynamic composition which counterbalanced along a diagonal a closed form on one side and an open landscape on the other was an important precedent for the later highly influential obliquely arranged compositions of Titian, such as the Pesaro altar in the church of the Frari. The altarpiece of *St. Peter Martyr with SS. Nicholas and Benedict and a Music Making Angel* for the Venetian Church of Corpus Domini (Brera, Milan, c. 1505–06) with its massive Bellinesque architectural setting and vast idyllic landscape background is another of many pacesetting works. Particularly notable are the height and solidity of the octagonal pedestal on which St. Peter stands, the luminosity of the sky which silhouettes and projects the blessing saint, the bold grandeur of the barrel and groin vaults that rise over his head, and the columnar bulk and solemn dignity of his flanking companions. All of these elements were to become important devices in the High Renaissance style at the turn of the century which strove to add a monumentality and majesty to the earlier 15th-century tradition of Venetial realism.

It is probably true that Cima did not alter the course of Venetian painting history. But his large output of extremely intelligent variations upon, and extensions of, Bellini's art have made that history infinitely richer.

—Loren Partridge

CIMABUE.

Born Cenni de Pepo in Florence, c. 1240 or c. 1250. Died February or March 1302. In Rome by 1272; worked in Assisi; sole documented work is the mosaic St. John in Pisa Cathedral, 1302.

Collections/Locations: Assisi: S. Francesco; Arezzo: S. Domenico; Bologna: S. Maria dei Servi; Florence: Uffizi, S. Croce, S. Maria Nevlla, Baptistery; Paris; Pisa: Cathedral; Siena: Cathedral Museum.

Publications

On CIMABUE: books—

Nicholson, Alfred, *Cimabue,* Princeton, 1932.
Salvini, Roberto, *Cimabue,* Rome, 1946.
Coletti, L., *Gli affreschi della Basillica de Assisi,* Bergamo, 1949.
Ludovici, S. Samek, *Cimabue,* Milan, 1956.
Battisti, Eugenio, *Cimabue,* Milan, 1963; revised edition, as *Cimabue,* University Park, Pennsylvania, 1967.
Bologna, Ferdinando, *Cimabue,* Milan, 1965.
Battisti, Eugenio, *Il Crocifisso de Cimabue in Santa Croce,* Milan, 1967.
Sindonia, Enio, *L'opera complete di Cimabue e il momento figurativo pregiottesco,* Milan, 1975.
Borsook, Eve, *The Mural Painters of Tuscany: From Cimabue to Andrea del Sarto,* London, 1980.
Baldini, Umberto, *Cimabue: Le crucifix de Santa Croce* (cat), Milan, 1982.

articles—

Stubblebine, James H., "Cimabue and Duccio in Santa Maria Novella," in *Pantheon* (Munich), 31, 1973.

Hueck, Irene, "Cimabue und das Bildprogramm der Oberkirche von San Francesco in Assisi," in *Mitteilungen des Kunsthistorischen Institutes in Florenz,* 25, 1981.

Bologna, Ferdinando, "Crowning Disc of a Duecento Crucifixion and Other Points Relevant to Duccio's Relationship to Cimabue," in *Burlington Magazine* (London), June 1983.

*

Cimabue's enduring fame as the founder of early Italian Renaissance painting rests largely on the authority of the biographer Giorgio Vasari in his *Lives of the Most Eminent Painters, Sculptors, and Architects,* first published in 1550 and revised in 1568. Inevitably, by that time, the biographical facts of Cimabue's life had long since become lost in legend. Vasari prefaces his *Lives* with an account of the decadence into which art had fallen. "Then, by the grace of God, there was born in the year 1240 in the city of Florence, Giovanni, surnamed Cimabue, of the noble family of the Cimabui, to give the first light to the art of painting." According to Vasari, the young Cimabue learned his art by watching the "Greek" painters at work in the Gondi Chapel at Santa Maria Novella. In fact, he undoubtedly learned his art from the mosaicists of the Florence Baptistery, where he probably did his earliest work. In his hyperbole, Vasari attributed to Cimabue a vast number of paintings by other artists, including Duccio's Rucellai *Madonna.* Vasari further popularized the notion that Cimabue was the teacher of Giotto, relating how the older artist had discovered the boy tending sheep and drawing them from nature. Vasari conceded, however, that by the end of Cimabue's life, his fame had been obscured, citing Dante's famous lines, "Cimabue thought to hold the field in painting, and now Giotto has the cry" (*Purgatorio,* canto XI, 94–95).

But Vasari exaggerated on this score also, for Cimabue's place in history as precursor appears to have remained secure. In a famous conversation, reputedly held at San Miniato al Monte around 1350 and recorded in Franco Sacchetti's *Trecento novelle* (c. 1390), Cimabue is mentioned first as the greatest master of painting "other than Giotto," in answer to the question posed by Orcagna. In the same vein, more than half a century after his death, Cimabue's portrait appears in Andrea da Firenza's fresco, the *Triumph of the Church* (1366–68), in the Spanish Chapel, where he stands as one of the illustrious faithful, among such notables as Giotto, Boccaccio, Petrarch, and Dante. Even in the late quattrocento, Piero de' Medici is reported to have acquired a small, doublesided panel attributed to Cimabue, even though the artist's style had long since been superseded.

It was Vasari's heroic and often inaccurate view of Cimabue that was handed down to later generations. In the mid-19th century, *Cimabue Finding Giotto in the Fields of Florence* was a popular subject of the fashionable Victorian artist Frederic Leighton. When Leighton wanted to pay further homage to early Renaissance artistic genius, he painted *Cimabue's Celebrated Madonna Carried in Procession Through the Streets of Florence* (Royal Collection), portraying Cimabue at the center as a noble, elegant figure in pure white, with wreathed head,

holding the hand of the pensive young Giotto. This highly acclaimed painting perpetuated innumerable Vasarian misconceptions, for the truth was that Duccio, not Cimabue, had painted the celebrated Rucellai *Madonna* pictured in the canvas; the famous procession from the artist's studio to the church had taken place in Siena, not Florence; and had related to Duccio's masterpiece, the *Maestà.* Nor was Cimabue a member of the nobility, as claimed by Vasari, and implied by Leighton's portrayal of him in the guise of an English knight of the Garter.

Because so much that has come down to us about Cimabue is thus apocryphal, and documentary evidence concerning his life and art is so scarce, the works themselves must provide the answers. Although there is a small nucleus of universally accepted works, their chronology is disputed. This is further complicated by their ties to the larger problem of dating his various fresco cycles at Assisi, on which there is no agreement. The earliest document, dated 8 June 1272, records "Cimabove pictore de Florentia," in Rome, serving as a witness in the presence of high church dignitaries, thus establishing him as an independent painter of some stature by that time.

Cimabue's *Crucifix* for San Domenico in Arezzo, probably his earliest surviving work, reveals his mixed Italo-Byzantine origins. Here, Cimabue follows a general type and system of proportions established by Giunta Pisano, in which Christ's sagging body arches in a wide curve to the viewer's left. But Coppo di Marcovaldo's harsher influence can be seen in Cimabue's insistence on human physical suffering, particularly in the treatment of the facial features and the slumped head. Although Cimabue retains the Byzantine use of striations on Christ's loincloth and the mantles of the Virgin and Saint John, in the overall he achieves a more plastic, dynamic image than his predecessors. There is no way of telling whether this work was painted before or after his trip to Rome.

It was in the Church of San Francesco at Assisi, however, in the face of complex new challenges posed by decorating the walls of this vast Gothic structure, that Cimabue surpassed his dugento contemporaries. In the Upper Church, as part of an overall Franciscan program, he treated a variety of subjects including the Four Evangelists, Apocalyptic and Marian cycles, and scenes from a Petrine cycle. In the Lower Church, he painted an enthroned *Madonna with Angels and Saint Francis.* To meet the resultant diversity of needs and functions, Cimabue invented new formal, stylistic, and iconographic solutions. His acknowledged masterpiece is his great *Crucifixion* in the left transept of the Upper Church, where he freed himself from the formulas of the past, achieving a new emotional and psychological intensity. Here, all the elements work together to express the tragedy of the sacred drama on a cosmic scale. His innovations include the positioning and gesticulations of the immediate foreground figures. Mary Magdalen and the Centurian, with their outstretched arms, are given new prominence in their stations on either side of the Cross. These new motifs also include the repetition of wrinkled foreheads and wrathful, menacing facial expressions on the massed crowd of onlookers; the writhing agony of Christ expressed in the swerving S-curve of his body and the fluttering drapery of his loincloth; and the reiteration of this impassioned mood in the agitated gestures and wildly fluttering draperies of the distraught angels circling above.

Cimabue's most important surviving altarpiece, the Santa

Trinita *Madonna,* retains the traditional hieratic frontality of
the throne and the Byzantine use of gold striations to suggest
drapery folds. At first glance, it appears conservative and
static when compared with the heroic, highly emotive imagery
of the Assisi *Crucifixion.* But it, too, was innovative in its use
of the four bust-length Prophet figures in the arches beneath
the woodcarved throne, forming a kind of proto-predella (or
base), which was a new feature evolving at this time. The
device of the proto-predella serves an important function in
elevating the image of the Virgin, thus further exalting her.

Perhaps Cimabue's most renowned work is his *Crucifix* for
the Franciscan church of Santa Croce, Florence, which was so
extensively damaged in the 4 November 1966 flood. Here the
promise of the artist's early Arezzo *Crucifix,* whose scheme it
faithfully repeats, is brought to fruition. Eschewing the old
fashioned anatomical formulas and Byzantine striations, Ci-
mabue here models in light and shade with rapid, direct brush-
strokes to achieve a convincing plasticity. His creation of a
near-transparent loincloth, which reveals the contours of the
body beneath, is an astonishing advance in illusionistic paint-
ing. Although some critics hail this work as a sublime achieve-
ment, others fault Cimabue for clinging to the traditional
format that he had used years earlier.

From the very end of his life comes the figure of *Saint John
the Evangelist* in the apse mosaic in the Cathedral at Pisa
(1302), his only surviving work that is both documented and
dated. Overlooking its classical beauty and serenity, critics
frequently berate the *Saint John* for its inertia and lack of
expressive vitality. In the end, Cimabue's role is not easy to
assess. It is difficult to speak of him as a colorist, since his
frescoes have faded, or become distorted, primarily through
the chemical inversion of the white lead pigment to black. His
innovations at Assisi are universally rated as his highest
achievement, with some critics considering everything else as
a regression, including his much revered Santa Croce *Crucifix.*
Even though Cimabue continued to innovate within his own
idiom, his style became outmoded by the end of his life. In
spite of his advanced art at Assisi, Cimabue is generally re-
garded today as the end of the old Byzantine tradition, rather
than the start of the new Renaissance art.

—Ruth Wilkins Sullivan

CLAUDE LORRAIN.
Born Claude Gellée in Champagne, 1600. Died in Rome, 23
November 1682. Lived in Rome, possibly as early as 1613,
certainly by 1620: probably worked in Naples with Goffredo
Wals, but main master was Agostino Tassi in Rome; assistant
to Claude Deruet in Nancy, 1625–26; settled permanently in
Rome, 1626–27: member of painters guild, 1633 (later held
offices in the guild); frescoes for palazzos Crescenzi and Muti
in 1630's; also landscapes; compiled record of his paintings
(*Liber Veritatis*) from 1635. Assistant: Giovanni Desiderii.

Major Collections: Paris
Other Collections: Chicago; Cincinnati; Cleveland; Dresden;
Florence; Hartford, Connecticut; Leningrad; London: Na-
tional Gallery, British Museum; Madrid; Moscow; Naples;
Pasadena; Rome: Doria Pamphili, Pallavicina; San Diego;
Stockholm.

Publications

On Claude: books—

Pattison, Mme. Mark, *Claude: Sa vie, ses oeuvres d'après des
documents inédits suivi d'un catalogue des oeuvres . . .,*
Paris, 1884.
Friendländer, Walter, *Claude,* Berlin, 1921.
Blum, Andre, *Les Eaux-fortes de Claude,* Paris, 1923.
Demonts, Louis, *Les Dessins de Claude/Drawings by Claude*
(cat), Paris, 1923.
Hind, Arthur M., *Catalogue of the British Museum: The
Drawings of Claude,* London, 1925.
Courthion, Pierre, *Claude,* Paris, 1932.
Christoffel, Ulrich, *Poussin und Claude,* Munich, 1942.
Hetzer, Theodor, *Claude,* Frankfurt, 1947.
Gerstenberg, K., *Claude: Landschaftzeichnungen,* Baden-
Baden, 1952.
Animal Studies from Nature by Claude (cat), New York, 1961.
Roethlisberger, Marcel, *Claude: The Paintings: Critical Cata-
logue,* New Haven, 2 vols., 1961.
*Claude und die Meister der römischen Landschaft im XVIII
Jahrhundert* (cat), Vienna, 1964.
Kitson, Michael, *Claude: Landscape with the Nymph Egeria,*
Newcastle upon Tyne, 1966.
Roethlisberger, Marcel, *Claude: The Drawings,* Berkeley, 2
vols., 1968.
Kitson, Michael, *The Art of Claude* (cat), London, 1969.
Cotté, Sabine, *L'Univers de Claude,* Paris, 1970; as *Claude,*
New York, 1971.
Roethlisberger, Marcel, *The Claude Album in the Norton Si-
mon Museum of Art,* Los Angeles, 1971.
Cecchi, Doretta, *L'opera completa di Claude,* Milan, 1975.
Bacou, Roseline, *Claude: Dessins du British Museum* (cat),
Paris, 1978.
Kitson, Michael, *Claude: Liber Veritatis,* London, 1978.
Wilson, Michael, *Claude: The Enchanted Castle,* London,
1982.
Russell, H. Diane, *Claude* (cat), Washington, 1982.
Thuillier, Jacques, et al., *Claude* (cat), Rome, 1982.
Claude e i pittori lorenesi in Italia nel XVII secolo (cat),
Rome, 1982.
Roethlisberger, Marcel, *Im Licht von Claude* (cat), Munich,
1983.
Askew, Pamela, editor, *Claude: A Symposium,* Washington,
1984.
Bjurström, Per, *Claude Sketchbook Owned by Nationalmu-
seum, Stockholm,* Stockholm, 1984.
Mannocci, Lino, *The Etchings of Claude,* New Haven, 1988

*

Claude Gellée, usually known as Claude Lorrain, is today
considered one of the greatest of all landscape painters and,
with his contemporary and acquaintance Poussin, the most im-
portant of French 17th-century painters.

Landscape with a Dance; drawing; Royal Collection

He is also an example of that 17th-century type, the "successful artist," the international prestige of his clientele being rivalled only by that of Rubens and Van Dyck, and unrivalled by any other landscapist. The fame and value of his work is seen in the *Liber Veritatis,* the record he made of nearly all his paintings, unique among artists of his calibre, and whose principal function would seem to have been to prevent the forgeries of his work rife in contemporary art markets.

Nevertheless, this position enjoyed by him since his successes in 1630's Rome has not been, as his grand and apparently simple art itself is not, without its ambiguities and idiosyncracies. First, in his lifetime he was not regarded as a French painter, until the 19th century being placed in the Roman school. Lorraine was then still a formally independent duchy, and Claude lived nearly all his life in Rome, only leaving once between his return from Nancy in 1627 and his death. While his patrons included Pope Urban VIII and Philip IV of Spain, it is perhaps significant that Louis XIV did not own any of his works until, after the painter's death, the king was presented with some examples by Le Nôtre.

Roman stylistic and generic influences can be seen in his early work. He began to paint in the milieu of northern landscape artists then resident there, and according to Sandrart, his first biographer, the roots of his later work could be found in the late Mannerist "vedute" of artists like his master Tassi or others such as Brill or Elsheimer—that is, picturesque views of real or imaginary monuments seen in sharp perspective. An early example of Claude making use of such a device is the *View of Rome* (1632; London), which characteristically combines a view of S. Trinita de Monti with an imaginary architectural "caprice" and may be compared to the impossibly grand palaces, only partly based on Roman examples, in the "Seaports" of the artist's maturity (*The Embarkation of St. Paula,* 1639–40, Madrid, or *The Embarkation of St. Ursula,* 1641, London).

This combination of the real and the imaginary is one way in which Claude's art tends towards a blurring of traditional boundaries and distinctions. Although his work clearly establishes him as the originator of the "ideal" or "classical" landscape, the precise interpretations to be placed on many of his works have been the source of critical disagreement in the centuries since his death, and his art has often been made to mirror and anticipate the preoccupations of each generation.

In England, the place where he was most admired and where the majority of his main works is still to be found, he was valued above all as a "pure landscapist." While Reynolds found in him "general and intellectual beauty" and in his *Thirteenth Discourse* compared his landscapes to the most presti-

gious genre of History Painting, he was also able, in the following discourse, to decry Claude's practice of "meddling" with mythological subjects. In claiming that, above all, Claude "conducts us to the tranquillity of Arcadian scenes and fairy land," Reynolds introduces a subjectivizing Romantic element into the appreciation of Claude which formed the basis of his appeal to figures as diverse as Richard Wilson, Keats, Turner, and Corot.

It has been the mistake of such an approach to see his works as beautiful but largely meaningless pastoral fantasies. Even the original titles of many works, as recorded in the *Liber Veritatis,* were forgotten, to be replaced by vaguer but more immediately suggestive names: so, the National Gallery's *Psyche Outside the Palace of Cupid* (1664) was known by Keats under the title of *The Enchanted Castle,* which is still popular today.

However, despite the fact there is only one documented example of a patron setting the subject for the painter, and that Claude may occasionally have planned formal variants on finished works before being commissioned, the context of general art practice in the 17th century points to a direct mythological or biblical subject for at least most of his oeuvre, particularly once he had emerged from his picturesque early period. The importance given to his work by his patrons, given the hierarchized theory of the genres, means that it should be seen as occupying a space intermediate between narrative history techniques and the unhistorical idea of "pure" landscape.

Another tendency of Claude criticism has been to see his style and techniques as unchanging throughout his long career. In fact, his art is as varied as its commentaries. It is true, as all agree, that if he made an abiding contribution to the formal development of painting it was in his masterful handling of light—and in particular of the device of a resplendent sun, either in the early morning or evening, shining over, filling, and unifying both an imaginary landscape and the picture-space used to represent them (*The Embarkation of the Queen of Sheba,* 1648; London). But even this is characteristic mainly of works of his middle period, and even then is confined largely to the "Seaports," of which the above is a magnificent example.

There is, too, a discernible development which distinguishes early, middle, and late works. From the 1630's onwards his paintings tended towards grandeur and ever greater size, and it is from this period that the "Seaports" date. In his later works, by contrast, grand effects are achieved by simpler means, as in the *Coast View with Ezekiel Mourning over the Destruction of Tyre* (1667; Lord Ellesmere Collection) where the "scenery" consists merely of an open portico with masts of ships behind to the left, balanced by a group of trees to the right. Although in the mature works there is a greater emphasis on subject matter, in his last pieces on themes taken from Ovid and Virgil the figures seem to be so insubstantial as to allow the landscape to reclaim its position as chief protagonist. What is actually happening in these works, however, is a new perfection of the unifying continuum between humanity and nature glimpsed throughout Claude's art. In *Ascanius Shooting the Stag of Silvia* (1682; Oxford), his last painting the fragile, intentionally elongated figures of the huntsmen (they are not elongated in the Chatsworth drawing) seem as vulnerable as the animal about to be killed, whose death will bring about the war presaged by the wind-torn trees and the menacingly huge

ruins.

Above all, the metaphysical preoccupations of the age should not be ignored. The Bible is the source of the greatest number of subjects in Claude's work; and even pagan topoi could be reconciled with Catholic doctrine according to the Neoplatonist exegeses of the time with which he was most probably conversant. In his work the totalizing vision of the artist corresponds to a divine unity behind the variety of nature. In this sense, Reynolds was right to say that Claude despised the particular, despite the felicities of spontaneous observation displayed in his preparatory sketches from nature. Nevertheless, that Claude was the supreme exponent of "classical" landscape does not mean that that terrain is void of human or historical meaning.

—David Crellin

CLODION.

Born Claude Michel in Nancy, 20 December 1738. Died in Paris, 28 March 1814. Won the Rome Price, 1759 and was in Rome, 1762–77: had important patrons while still in Rome (including Catherine II of Russia); never a full academician (associate, 1793), and received only one royal commission, but was able to continue in fashion after the revolution: worked on Colonne de la Grande Armée, 1806–10, and Arc de Triomphe du Carrousel, 1806–09.

Collections: London: Wallace, Victoria and Albert; Paris: Louvre, Institut; Versailles.

Publications

On CLODION: book—

Thirion, Henry, *Les Adam et Clodion,* Paris, 1885.

article—

Guiffrey, Jules Joseph, "Le Sculpteur Clodion," in *Gazette des Beaux-Arts* (Paris), 1892–93.

*

Clodion was born into a family sculptor dynasty, at least three generations old, through his mother, a sister of Lambert Sigisbert Adam and their brothers. Even his grandfather, Jacob Sigisbert Adam, a court sculptor in their native Nancy, was known for his terracotta work. The young Clodion is held the first artist in history to take this material—fired clay, formerly used for its economy and easy manipulation as a small-scale modelling material—and make it his major material. As early as the 1760's when he was still a virtual student in Rome, Clodion was besieged by collectors desiring that small-scale, warm-toned evocation of pagan sensuality. Clodion was also

fortunate enough to be in Rome when excavation was bringing antique terracotta to view; and surely some vital part of his genius was his translation of such ancient frankness into the *douceur vie* of the French Rococo. In a work such as *The Nymph and Satyr* (*The Intoxication of Wine*, c. 1770–80, New York), this vivid animality that must have been exhilarating in his time—it still is—can be felt; the musicality of the two celebrants in motion is the haunting force of this and other Bacchic works of the artist. But although securely linked to his almost miniature world of fauns, nymphs, bacchants, and cherubs, Clodion is not sentimental. His lilting sensuality may be an inheritance from the Baroque; additionally his work being sculpture, and thus tactile and immediately three-dimensional, moved it away from the more abstract Rococo in paint of his fellow French artists.

Clodion was surely led to an understanding of the transition of style by the works of his uncle Lambert Sigisbert Adam, and his other uncles in the family studio. Clodion worked there for a few years in his late teens. Common understanding of his evolution was that there was little available there to form his mature style since the studio was best identified with large-scale, and outdoor, decorative work which preserved the grandeur of the older Baroque style. If there was elegance in their work, it did not seem at all relevant for the young Clodion. But more recently, his qualities of compositional understanding—especially in the breathtakingly dynamic, yet gentle Bacchic flights of Clodion's celebrants—and his elegance as a modeller, and as well his grasp of psychology so as to place a living emotion in the gestures of his mythic figures, have all found a fuller understanding. Not only was Clodion's grandfather skilled in terracotta, but his uncles also used it. Little known, because rarely preserved, these elegant clay works such as the *Bust of Amphitrite*, c. 1725 (Chicago), and other Bacchic celebrations by L. S. Adam, have now produced a picture of a young Clodion very well prepared, both technically and ideationally, by the time he arrived in Rome in 1762. Aside from hard-headed business practice and modelling skills, Clodion also learned to work in stone, and life-size; and throughout his career, he produced several public works, from the 1783 *Montesquieu* (Paris, Institut) to Neo-Classical post-1800 Empire works such as reliefs for the Column of the Grand Army. With the onset of the Revolutionary period, he adopted that cooler idiom to enable him to compete for public commission—which he had rarely sought in his maturity—while his Rococo suavity and charm continued to fascinate collectors, now underground, who wished his great signature works throughout the century. His works survive that century to remind us of a seemingly impossible moment when man and nature might have been conceived in such harmony.

—Joshua Kind

CLOUET, François (called Janet).
Born probably in Tours, c. 1515–20; son of the painter Jean Clouet. Died in Paris, 22 September 1572. Married; two surviving illegitimate daughters. First appeared in royal accounts, 1540, succeeding his father as royal painter and valet of the king's bedchamber; given estate of Jean Clouet by Francis I in 1541, and confirmed as royal painter; continued as royal painter under Henry II, 1547–59, with annual wage, living in Paris; was given office of commissioner of the Châtelet of Paris by the king in 1551; after that worked intermittently for the royal court until 1572; presided over a large workshop.

Collections: Chantilly; Florence: Uffizi, Pitti; Leningrad; Lugano; Paris: Louvre, Bibliothèque Nationale; Rouen; Versailles; Vienna; Washington; Windsor; Worcester, Massachusetts.

Publications

On CLOUET: books—

Bouchot, Henri, *Les Clouet et Corneille de Lyon*, Paris, 1892.
Germain, Alphonse, *Les Clouets: Biographie critique*, Paris, 1906.
Moreau-Nélaton, Etienne, *Les Clouet, peintres officiels des rois de France*, Paris, 1908.
Moreau-Nélaton, Etienne, *Les Clouet et leurs émules*, Paris, 3 vols., 1924.
Fourreau, Armand, *Les Clouet*, Paris, 1929.
Malo, Henri, *Les Clouet de Chantilly*, Paris, 1932.
Adhémar, Jean, *Les Clouet et la cour de rois de France* (cat), Paris, 1970.

articles—

Ede, H. S., "Authenticated Information Concerning Jehannet and François Clouet," in *Burlington Magazine* (London), March 1923.
de Broglie, Raoul, "Les Clouets de Chantilly," in *Gazette des Beaux-Arts* (Paris), May-June 1971.
Admehar, Jean, "Documents and Hypotheses Concerning François Clouet," in *Master Drawings* (New York), 18, 1980.
Bradshaw, Jillian Anne, and Dorothy Margaret Jone, "Luxury, Love, and Charity: Four Paintings from the School of Fontainebleau," in *Australian Journal of Art*, 3, 1985.

*

To attempt an understanding of the artistic achievement of François Clouet, one must first look closely at the figure of his father, the royal painter Jean Clouet. For the son, as for the father, one is hampered by gaps in vital documentation, by a general ignorance of French 16th-century art, and by some uncertainty as to the attribution of works. The younger Clouet began in the shadow of his father, whose nickname "Janet" he also took. He was surely trained by Jean Clouet, but his art does evolve into something broader than the virtually exclusive exercise of portrait painting and drawing of the father.

There is no record of the date and place of François Clouet's birth, but it seems probable that he was born in Tours, where his father was recorded as living in 1521, and had probably resided for some time previous to that. The Loire valley was

the preferred place of residence of the kings of France at this time, and the members of the enormous royal entourage were also settled in the region. Different interpretations of the wording of an important document of 1541 confirming the transfer of the father's estate to the son have given rise to different suppositions as to the birthdate of François Clouet. It seems most reasonable to place this in the last half of the second decade of the century.

The last years of the life of Jean Clouet give indications of a curtailing of his activity, and in 1540, his name was replaced in the accounts of the royal household by that of his son. François Clouet was there identified in just the same way as his father had been, as "peintre et valet de chambre," and was paid the same handsome annual wage of 240 livres as Jean Clouet had been receiving since 1526. In November 1541, King Francis I ordered that the estate of Jean Clouet, to which the king was legally entitled, be settled upon the late painter's son. The language of the document praises the art of the father, "auquel il estoit très expert et en quoy son dict fils l'a jà très bien imyté, et espérons qu'il fera et continuera encores de bien en mieulx cy-après." This royal appreciation seems definitely to be addressed to an artist who is seen as being both notably gifted and notably young.

Even though the proof of François Clouet's professional establishment dates from 1540, one has to go more than two decades later to find his first precisely dated work, the 1562 Louvre portrait of *Pierre Quthe*. One may suppose that the work of the younger Clouet for Francis I—who retained him until the sovereign's death in 1547—was indeed essentially an "imitation" of what Jean Clouet had been doing earlier, producing portrait drawings and paintings of members of the royal family and of the court. The enormous popularity of this portraiture persisted, both at home and in courts abroad, and François Clouet came to preside over a large atelier, where younger artists received instruction while helping the master meet the artistic demands placed upon him.

François Clouet did not, however, enjoy the constant royal respect and admiration for his art that his father had apparently enjoyed, as Jean Adhémar has shown. He did have a powerful backer in Catherine de' Medici, wife of King Henry II and mother of three successive French kings. Portraits of all of these family members, as well as others, are to be found in the Bibliothèque Nationale, Paris. Catherine's appetite for drawn and painted portraits was positively gargantuan, and it is thanks to her collecting so many works, and annotating many of them, that one has so many surviving original drawings, and some knowledge of who is depicted.

Clouet retained his position as royal painter through the reign of Henry II (1547-59), but after that he seems to have been called to the court on something of a piecework basis, to produce effigies for various purposes. There might be a portrait of a prince destined for a prospective bride abroad, such as the drawing of the future *Henry III* (Paris, Bibliothèque Nationale), or a profile likeness of his brother Charles IX, designed for a coin. In the last year of his life, Clouet worked on the festival decorations for the marriage of the young King of Navarre, the future Henry IV of France, and Marguerite de Valois, daughter of Henry II and Catherine de' Medici. The chalk portraits of the couple, among the very last of his works, are also in the Bibliothèque Nationale.

Various influences evidently came to play upon François

Clouet's style. Not surprisingly, the style of his portrait drawings is based upon the art of his father. There are a clarity of observation and engagement and a solidity of form that may be related to the Netherlandish tradition. But in their actual elaboration, the chalk drawings of Jean Clouet present soft contours and gently curved forms. The drawn portraits of the son show a much harder outline, and a certain slickness in the finish. There is more attention to surface effects, and to details of jewelry and costume, than one finds in the drawings of the elder Janet. The result is a more chilly or brittle type of drawing, generally speaking, with rather less communication of the personal substance of the sitter. A definition of social station, or public appearance, is conveyed, in the place of a penetration of the individual.

The greater sense of elegance that is to be noted in the art of François Clouet has been attributed to his absorbing lessons of Italian Mannerist portraiture, from painters such as the Florentines Bronzino and Salviati. A voyage of study to Italy has been posited, but Clouet would also have been able to keep abreast with artistic developments in Florence through his great patron Catherine de' Medici, herself from that city. At least one great painting by Bronzino, the *Allegory of Venus and Cupid* (now in the National Gallery, London), was in the collection of Henry II for Clouet to see. As Adhémar has pointed out, the Venetian Mannerist painter Paris Bordone also visited the French court, at least once, and the hard and chilly finish Clouet can impart to areas of fabric in his paintings, rendering them rather like frosted colored metal, can be compared to Bordone's technique.

The younger Janet painted works that depart from conventional portraiture, even if such paintings continue to aim at conveying the likeness of a real figure. They are portraits, but idealized ones, fitted out with copious allegorical trappings. A good example is the signed panel in Washington, which is believed to represent a French royal mistress in her bath. There is disagreement over the identity of the sitter—the idealization of the figure hindering normal identification—with some authorities seeing Diane de Poitiers, mistress of Henry II, and others opting for Marie Touchet, mistress of Charles IX. In its type, its pictorial construction, and its imagery, the painting recalls antecedents in 16th-century Venetian painting, especially Titian. But the hard finish and density of form send one to Netherlandish works for the best comparisons. Clouet here produces a kind of chilly and impassive eroticism that is like Canova, *avant le lettre*.

A painting like *Le Billet Doux* (Lugano) is a pure genre scene, deriving from the Commedia dell'Arte. Three abbreviated figures are shown in a frieze-like composition, a beguiling nude female in the center, flanked by her dandyish suitor, and an aged procuress who makes the assignation. The panel painting can be related to brothel scenes in 16th-century Netherlandish art, by artists such as Jan Sanders van Hemessen. Clouet's utilization of the theater as a source of subjects, and inspiration for the presentation of a scene, is also revealed in an engraving after one of his drawings, *La Farce des Grecx descendue*. It is also presented like a *tableau vivant*. The impatient female figure at the right of the print could be a daughter of the procuress in the Lugano painting, and a sister of the nursing servant who appears in the Washington *Lady at Her Bath*.

—George A. Wanklyn

François or Jean Clouet: Portrait of Francis I; panel; 37¾ × 29⅛ in (95.8 × 74 cm); Paris, Louvre

CLOUET, Jean (called Janet).

Born probably in Flanders, c. 1485–90; possibly the son of
the painter Jean Clouet of Brussels. Died in Paris, 1540–41.
Married; son, the painter François Clouet. Probably on royal
payroll prior to advent of Francis I in 1515, but first men-
tioned only in 1516, then drew wages as royal painter and valet
of the king's bedchamber through 1537; lived in Tours, 1521–
25, then in Paris, though never became a French citizen; few
attributed paintings, but many drawings.

Collections: Antwerp; Bergamo; Chantilly (drawings); Edin-
burgh; Florence: Uffizi (drawings), Pitti; London: British
Museum; Lyons; Minneapolis; New York; Paris: Louvre, Bib-
liothèque Nationale; St. Louis; Windsor.

Publications

On CLOUET: books—

Bouchot, Henri, *Les Clouet et Corneille de Lyon,* Paris, 1892.
Germain, Alphonse, *Les Clouets: Biographie critique,* Paris,
 1906.
Moreau-Nélaton, Etienne, *Les Clouet, peintres officiels des
 rois de France,* Paris, 1908.
Moreau-Nélaton, Etienne, *Les Clouet et leurs émules,* Paris, 3
 vols., 1924.
Fourreau, Armand, *Les Clouet,* Paris, 1929.
Malo, Henri, *Les Clouet de Chantilly,* Paris, 1932.
Jolly, Alphonse, *Les Crayons de Jean Clouet,* Paris, 1952.
Adhémar, Jean, *Les Clouet et la cour de rois de France* (cat),
 Paris, 1970.
Mellen, Peter, *Jean Clouet: Complete Edition of the Draw-
 ings, Miniatures, and Paintings,* New York and London,
 1971.

articles—

Ede, H. S., "Authenticated Information Concerning Jehannet
 and François Clouet," in *Burlington Magazine* (London),
 March 1923.
de Broglie, Raoul, "Les Clouets de Chantilly," in *Gazette des
 Beaux-Arts* (Paris), May–June 1971.
Bradshaw, Jillian Anne, and Dorothy Margaret Jone, "Lux-
 ury, Love, and Charity: Four Paintings from the School of
 Fontainebleau," in *Australian Journal of Art,* 3, 1985.

*

The life of Jean Clouet is sporadically documented, and igno-
rance of vital facts concerning the place and date of his birth,
and his training as a painter, has worked against a clear appre-
ciation of his artistic quality and importance. No signed work
by Jean Clouet is known to exist, and only one painting sur-
vives to which reasonably clear reference is made during the
artist's lifetime (*Guillaume Budé,* New York). Furthermore,
there is disagreement concerning the attribution of a number
of works to him, which are held by some scholars to be cop-
ies, or works by his son François Clouet. Such disputed works
include the celebrated *Francis I* portrait (Paris), which has

been variously given to one or the other of the two painters, or
described as a collaborative exercise, or said to be by another
hand altogether, perhaps Italian, or German, or Swiss! In con-
temporary documents, both father and son are confusingly re-
ferred to by the same nickname "Jehannet" or "Janet."

Various hypotheses have been advanced giving the birth-
place of Jean Clouet as France, as Flanders, and as Italy—
these suppositions being based on French, Flemish, and Italian
influences discerned in his portraits. It is now known from a
posthumous document that he was born outside France, and,
furthermore, that he never became a French citizen. It is gen-
erally believed that he was born in Flanders into a family of
artists, and that he was established as a royal painter in France
some time prior to his being cited in a document of 1516, at
the outset of the reign of Francis I.

All surviving works which are attributed to the elder Clouet
are portraits. These are divided between chalk drawings of
individuals, panel paintings, and miniatures on parchment.
The catalog in Peter Mellen's monograph on the artist runs to
125 drawings, 14 paintings, and 10 miniatures. Among the
works known today only through documentary reference were
a painting contracted for in 1522, representing *Saint Jerome,*
at the same time as tapestry designs, the only specified works
of Clouet's that are not portraits.

French 16th-century art has been insufficiently studied, and
is still inadequately appreciated. Jean Clouet and his son Fran-
çois came to be completely forgotten until the middle of the
19th century. When French art historians began defining a
corpus of portraits by the father, attributions had to be prized
away from such better-known figures as Hans Holbein the
Younger. There are indeed cogent reasons for relating the art
of Clouet to that of Holbein, and for positing a transmission of
artistic influence and technical knowledge, but it was the
Augsburg painter, probably a decade or so younger than
Clouet, who seems to have been on the receiving end of this
process. The young Holbein sojourned in France in 1524–25.

The style of Jean Clouet, as noted above, can be related to
Netherlandish and Italian art, and can also be connected to the
portraits of such older French artists as Jean Fouquet and Jean
Perréal. By its very geographical position, France was almost
inevitably swept by the strong artistic currents flowing at the
time from neighboring Flanders and Italy. One might say that
the art of Jean Clouet, and also that of François, is located in
an "international style," as one observes strong affinities in
different works with notable examples of portraiture produced
both north and south of the Alps. It does, after all, seem clear
that Clouet was born into the grand Netherlandish artistic tra-
dition, one of the chief glories of which was the portrait, as
defined by such great masters as Jan van Eyck and Rogier van
der Weyden, and spread by their pupils and followers.

Working at the French royal court in the early decades of the
16th century, Clouet came into contact not only with splendid
examples of Italian Renaissance art, but also with important
Italian artists. Francis I had succeeded in luring the great Leo-
nardo da Vinci to France, acquiring him rather like a living
masterpiece. Leonardo spent the last three years of his life in
France (1516–19), and Clouet was a young artist at the court
when the grand old Florentine arrived, accompanied by the
contents of his studio. A specific influence of Leonardo on
Clouet may be observed in the hatching technique found in the
younger artist's drawings (e.g., *King Henry of Navarre* or *Leo-*

nora de Sapata, both in the Musée Condé, Chantilly), where diagonal lines of different length and strength define areas of light and shade, and build up volumes in the head and neck.

The superb hoard in Chantilly—the repository of almost all the elder Clouet's drawings, done in mixed black and red chalk—offers examples of the artist's work extending over something like a quarter of a century, from about 1515 until Clouet's death. There are portraits of the king and of several members of his family, of lords and ladies of the court, of ecclesiastics and of the king's mistresses, along with others. Their names are often inscribed, sometimes erroneously. The size of the Chantilly Clouet collection, and the existence of many copies done from these and other originals, testifies to the very great importance of the portrait in French court art during the years of the Valois dynasty. This appreciation of portrait drawings in court circles continued strongly, in fact, into the next century.

Interestingly, all of the Clouet portrait drawings but one adopt a three- quarter pose for the sitter, who is shown usually in bust length, but sometimes in half length. The portrait likenesses are drawn with varying degrees of rapidity and finish, but it is always the head and neck only which are fully defined, with the torso merely summarily suggested. The smaller number of meticulously painted gouache miniatures portray a selection of male sitters, also in a three-quarter pose, all in bust length. The panel paintings, in oil and tempera, also employ a three-quarter pose, but all define the torso at sufficient length to include the hands, which may hold something, or which merely rest along the lower edge of the painting. For most of the panel paintings, a corresponding drawing can be found.

Clouet convinces the viewer of the individuality of the sitter. He finds the appropriate means to convey the dash of a soldier (drawing of René de Montjean, Chantilly,), the grave acuity of an old scholar (*Guillaume Budé,* New York, and drawing, Chantilly), the soft allure of a royal mistress (*Madame de Canaples,* Edinburgh), or the soulful remove of a reader of poetry (*Man with a Petrarch,* Windsor). His success in isolating and defining this individuality becomes all the more apparent as one considers the formal uniformity with which he creates his "effigies au vif," and his avoidance of very pronounced emotional states. Jean Clouet has been admired for his attentive documentation of the appearance of the members of a large troupe of characters, major and minor, in orbit around the splendid King Francis I. He has perhaps not been justly appreciated for the finesse of his psychological penetration and definition.

—George A Wanklyn

COELLO, Claudio.

Born in Madrid, of Portuguese descent, 2 March 1642; son of a painter. Died in Madrid, 20 April 1696. Studied with his father, and with Francisco Rizi (Ricci); influenced by the Royal Collection in Spain, but also visited Italy in the 1656–64 period and experienced Italian art first-hand; painted portraits, decorated churches in the Madrid area; began doing frescoes in the early 1670's with José Jiménez Donoso, partnership which survived into the 1690's; made Painter to the King, 1683, and promoted to Pintor de Cámara, 1686. Pupil: Antonio Palomino.

Major Collection: Madrid.
Other Collections: Budapest; Castres; Escorial; Frankfurt; London: Wellington; Madrid: Academy, S. Cruz, S. Jeronimo, Convent of S. Placido; Munich; Norfolk, Virginia; Salamanca: S. Esteban; Toledo: Cathedral; Toledo, Ohio; Torrejón de Ardoz: parish church.

Publications

On COELLO: books—

Estaban, E., *La Sagrada Forma de El Escorial,* El Escorial, 1911.
Gaya Nuño, J. A., *Coello,* Madrid, 1957.
Sullivan, Edward J., *Baroque Painting in Madrid: The Contribution of Coello, with a Catalogue Raisonné of His Works,* Columbia, Missouri, 1986.

articles—

Sullivan, Edward J., "Politics and Propaganda in the *Sagrada Forma* by Coello," in *Art Bulletin* (New York), June 1985.
Lopez Torrijos, Rosa, "Grabados y dibujos para la entrada en Madrid de Maria Luisa de Orleans," in *Archivo Español de Arte* (Madrid), July-September 1985.

*

Claudio Coello was born in Madrid in 1642 of Portuguese parents. His father, a bronze craftsman, apprenticed him to Francisco Rizi in c. 1654–55, hoping that he would train to practice the family craft. Coello's talent, however, showed that he could make a living through his painting, aided by Rizi who appears to have helped him secure his early commissions. There are certain indications that during part of this training period of c. 1656–64 Coello may have undertaken a study trip to Italy, although the documentary evidence is not conclusive on this point.

Stylistically, however, Coello proved himself very open to the influence of Italian, Flemish, and Spanish masters. Indeed, his master Francisco Rizi was a particularly useful and experienced artist to learn from. His prestigious court post of "painter to the king" proved him to be popular at court and gave him the opportunity to undertake a variety of different commissions. This must have served as useful training to Coello, who was himself painter to the king from 1683. Rizi was to introduce Coello to fresco painting, which had not flourished in Spain until the 1650's when Velazquez brought back Colonna and Mitelli with him from Italy. In addition, Rizi's large-scale religious paintings served as models for Coello, for instance, the *Virgin and Child Adored by St. Francis and St. Philip* of 1650 for the high altar of the Capuchin church of El Pardo. Indeed, Rizi's direct influence helps explain Coello's use of bright colours and his free technique. Another Spanish master with whom Coello was on good terms

was Juan Carreño de Miranda who allowed Coello access to the Royal collection where he copied the Titians, Rubens, and Van Dycks.

Coello's formative period thus provided him with an unusually good all-round training. He was able to study Flemish and Italian art closely and was proficient in a number of different mediums. Although his style did experience a subtle evolution, even his early works show him to have an excellent grasp of composition and a technical proficiency and attention to fine detail which remained fundamental to his work. One of the earliest works to demonstrate Coello's controlled composition and sense of drama is his *Jesus at the Door of the Temple* of 1660 (now in the Prado). Jesus stands at the left of the picture gesturing up to heaven with his right hand, as Mary bends towards him. Both the architectural setting and the sensitive detail of the faces and hands were to become favourite themes for Coello. The unusual flatness of the drapery, however, confirms that this is an early work. By the mid-1660's, this slight austerity and stiffness had disappeared, as can be seen in the *Vision of St. Anthony of Padua* of 1663 (now in the Chrysler Museum, Virginia) and the *Triumph of St. Augustine* of 1664, painted for the convent of Strict Augustinians at Alcala de Henares (now in the Prado). The *Vision of St. Anthony* uses the same compositional division as the *Jesus at the Door of the Temple* but is a much more complex picture. There is considerable movement and interaction between the figures—flying putti carry flowers over St. Anthony's head, the Christ child moves to speak to the saint, and the architectural background is more elaborate. The *Triumph of St. Augustine,* painted the following year, is a fully mature work. It demonstrates a mastery of anatomy and an ability to paint twisting bodies using quick brushstrokes (ideas which had been treated less successfully, for instance, in the *Christ Served by Angels* of 1661—now in a private collection in Barcelona). Coello paints St. Augustine in a billowing red cape in a landscape and architectural setting, surrounded by angels. One of the sources for this composition may be the *Triumph of St. Hermengild* by Francisco Herrera the Younger in 1654 (now in the Prado). Coello, however, has demonstrated his mastery of composition by simplifying the original and using a subtler colour scheme.

Among the most spectacular of Coello's works were large-scale multi-figure compositions. In 1668, for instance, he designed 23 canvasses for three altarpieces in the Church of the Benedictine nuns of San Placido, Madrid. The centrepiece of the high altar was a painting of the *Annunciation* with, on the altar to the right, the *Vision of St. Gertrude* and, on the left, *St. Benedict and St. Scholastica* beneath a vision of the Holy Trinity. The *Annunciation* is a complex composition, involving over 50 figures and probably based on a design by Rubens. Two sketches in private collections show how Coello creates space and depth through his use of repoussoir figures in the bottom left and right hand corners and by isolating the Virgin on a podium in the middle ground.

Another large multi-figure composition is the *Virgin and Child Adored by Saints and Theological Virtues* of 1669 (now in the Prado). Once again the Virgin is placed in a prominent position at the top of some carpeted steps, and set in an elaborate architectural setting with draped curtains and writhing putti. Perhaps the most successful and unified of these large compositions, however, is the *Torment of St. John the Evangelist* of 1674-75. It is the only surviving canvas in a commission

for six paintings for the Church of St. John the Evangelist in Torrejón de Ardoz, near Madrid, and shows St. John being tortured in a vat of oil. Its rich colours and strongly modelled figures with an upward corkscrew motion make it a dramatic and powerful picture.

Coello was also involved in large-scale fresco projects with his collaborator José Jiménez Donoso. Most important was his work in the Casa de la Panadería, Plaza Mayor, of c.1672, in the Vestry of Toledo Cathedral (c.1674), and in the Augustinian College of Santo Tomás de Villanueva, Zaragoza (now the Church of San Roque) of c.1683, which incorporate illusionistic architecture, allegorical figures, and grisaille medallions and herms.

Coello's attention to detail and fine painting of faces and hands facilitated his success as a painter of single features and portraits. Particularly notable are the *St. Catherine of Alexandria* (now in the Wellington Museum, London) of 1683 and the pendant pictures of *St. Rose of Lima* and *St. Dominic Guzmán* of 1684-85 (now in the Prado). Similarly, Coello painted Charles II and Queen Mariana in c.1675-80 and c.1690 respectively.

Claudio Coello, therefore, was a master of composition, movement, and detail. He was influenced both by the Madrid school of painting and by the Italian and Flemish masters. But he evolved his own individual style to become the last great Madrid painter of the 17th century.

—Susan Jenkins

COLE, Thomas.

Born in Bolton-le-Moors, Lancashire, 1 February 1801. Died near Catskill, New York, 8 February 1848. Married Maria Bartow, 1836. Attended school in Chester; apprenticed to an engraver, then an engraver's assistant in Liverpool; emigrated to the United States, 1818; worked with his father in wallpaper business, Steubenville, Ohio, 1819; learned painting from the itinerant painter Stein, and worked as a painter from 1821; worked in Philadelphia, 1823-25: exhibited at Pennsylvania Academy of Fine Arts, 1824; settled in New York, 1825: one of the founders of the National Academy of Design, 1826; principal member of the Hudson River school; visited Europe, 1829-32, 1841-42; lived in Catskill, New York, after 1836. Pupils: Frederic Church. Benjamin McConkey.

Collections: Albany: Institute of History and Art; Boston; Cleveland; Detroit; Fort Worth: Amon Carter; Hartford, Connecticut; Los Angeles; Minneapolis; New London, Connecticut; New York: Metropolitan, New York Historical Society; Providence; Toledo, Ohio; Utica, New York; Washington: National Gallery, Corcoran, American Art.

Publications

By COLE: books—

Poetry, edited by Marshall B. Tymn, York, Pennsylvania, 1972.

The Correspondence of Cole and Daniel Wadsworth, edited by J. Bard McNulty, Hartford, Connecticut, 1983.

articles—

"Lecture on American Scenery," in *Northern Light,* May 1841.
"Sicilian Scenery and Antiquities," in *Knickerbocker Magazine,* February 1844.
"Essay on American Scenery," in *American Art 1700–1960: Sources and Documents,* edited by John W. McCoubrey, Englewood Cliffs, New Jersey, 1965.

On COLE: books—

Noble, L. L. *The Course of the Enpire, Voyage of Life, and Other Pictures of Cole,* New York, 1853; as *The Life and Works of Cole,* edited by Elliot S. Vessel, Cambridge, Massachusetts, 1964.
Sweet, Frederick A., *The Hudson River School* (cat), New York, 1945.
Seaver, Esther I., *Cole: One Hundred Years Later* (cat), Hartford, Connecticut, 1948.
Cole (cat), New York, 1964.
Merritt, Howard, and William H. Gerdts, *Studies on Cole, an American Romanticist,* Baltimore, 1968.
Merritt, Howard S., *Cole* (cat), Rochester, New York, 1969.
Baigell, Matthew, *Cole,* New York, 1981.
Wolf, Bryan Jay, *Romantic Re-Vision: Nineteenth-Century American Painting and Literature,* Chicago, 1982.
Schweizer, Paul D., and Dan Kushel, *Cole's Voyage of Life,* Utica, New York, 1985.
Parry, Ellwood C., III, *The Art of Cole: Ambition and Imagination,* Newark, Delaware, 1988.

articles—

Sanford, Charles L,, "The Concept of the Sublime in the Works of Cole and William Cullen Bryant," in *American Literature,* 28, 1956–57.
Ringe, Donald A., "Painting as Poem in the Hudson River Aesthetic," in *American Quarterly,* 12, 1960.
Moore, James C., "Cole's *The Cross and the World:* Recent Findings," in *American Art Journal* (New York), November 1973.
Parry, Ellwood C., III, "Gothic Elegies for an American Audience: Cole's Repackaging of Imported Ideas," in *American Art Journal* (New York), November 1976.
Powell, Earl A., "Cole and the American Landscape Tradition" (3 parts), in *Arts Magazine* (New York), February, March, and April 1978.
Rodriguez Roque, Oswaldo, "*The Oxbow* by Cole: Iconography of an American Landscape Painting," in *Metropolitan Museum Journal* (New York), 17, 1982.

*

Thomas Cole's mature career spanned the second quarter of the nineteenth century—from the opening of the Erie Canal across upstate New York to the first discovery of gold in California. Although he was born and raised in England, it is with good reason that Cole has always been described as founder of the Hudson River School of American landscape painting. His compositions of real or imaginary scenery, produced between the fall of 1825 and his untimely death early in 1848, helped to establish landscape as a viable alternative to portraiture or figure painting for professional artists in the United States.

Despite his late entrance into the realm of Romanticism and despite his lack of early training in Lancashire, Pennsylvania, and Ohio, once Cole was discovered by fellow artists, John Trumbull, William Dunlap, and Asher B. Durand, in the fall of 1825, his career skyrocketed almost immediately. Though far from the first foreign-born painter to tackle American scenery, Cole succeeded because his pictures, based on a sequence of summer sketching trips to the Catskill Mountains and Kaaterskill Falls (1825), to Lake George and Fort Ticonderoga (1826), and to New Hampshire's White Mountains and Lake Winnepesaukee (1827 and 1828), seemed to invent the wilderness just in time to complement the great popularity of James Fenimore Cooper's Leather-stocking novels. In retrospect, while following Cole's shifting enthusiasm for different aspects of undeveloped land in North America, it is easy to trace his pictorial outlook to eighteenth-century British theories of the Beautiful versus the Sublime, contrasting the jutting rocks and blasted tree trunks of Salvator Rosa with the gentler terrain and golden sunshine of Claude Lorrain.

This basic aesthetic contrast surfaced as an operating principle early in 1828, when Cole sent two large historical landscapes to the third annual exhibition of the National Academy of Design in New York. *Garden of Eden* (unlocated) and *Expulsion from the Garden of Eden* (Museum of Fine Arts, Boston) were based in part on John Martin's mezzotint illustrations to Milton's *Paradise Lost* of 1825–1827; and Cole was even accused of plagarism by one hostile critic in the New York press. But the majority of his audience recognized this attempt to elevate landscape to the height of history painting as a noble and worthy cause, requiring the soul of a poet.

During his first long study trip to Europe from June 1829 until November 1832, Cole absorbed enormous quantities of ideas about the history of art and western civilization which he transformed, on return to America, into an ambitious set of five large canvases called *The Course of Empire* (New York Historical Society). This series was intended to cover the fireplace wall in the front room of a third-floor gallery in the new house owned by Luman Reed, a wealthy retired grocery wholesaler, at 13 Greenwich Street, near the Bowling Green at the tip of Manhattan Island. In the same gallery Reed had a set of copies of life-portraits of the first seven Presidents of the United States, Audubon's *The Birds of America* in elephant folios, wooden cabinets with elaborately labeled collections of shells and minerals, plus the rest of his art collection, including portfolios of engravings, and an extensive library—all open to persons properly introduced one afternoon per week. In the context of such an American *kunstkammer* and *wunderkammer,* displaying the accumulated treasures or art and science, it is no wonder that Cole's synthesis of myriad pictorial sources in *The Course of Empire* should also seem so enthusiastically didactic.

In spite of a steep economic decline after the financial panic of 1837, the success of *The Course of Empire* brought Cole a continuing series of commissions culminating in *The Voyage of Life,* painted first in 1839–1840 for the banker and philanthro-

pist, Samuel Ward, whose art gallery was intended to be a source of moral and religious edification for his children. The four scenes Cole produced (Utica), exemplifying the pleasures of Childhood, the worldly ambitions of Youth, the trials and temptations of Manhood, and the ultimate hope and promise of salvation in Old Age, must have matched the patron's religious outlook. But Samuel Ward's sudden death and the plummeting value of his real estate holdings led to difficulties between the artist and the executor of the Ward estate. Knowing that his finished paintings were left resting on the floor of Ward's gallery, collecting dust and liable to injury, Cole was doubly motivated to replicate the series while in Rome in 1841–1842 before making an arduous sketching trip to Sicily where he even climbed Mount Etna.

On return to the United States, Cole kept the second set of *The Voyage of Life* (National Gallery, Washington, D.C) on almost constant exhibition, while continuing to produce both American and European views for private patrons as well as the new Art Unions that were promoting American Art in the 1840's. His last series, *The Cross and the World*, an elaborate synthesis again of several iconographic traditions including Hercules at the Crossroads, Pilgrim's Progress, and the Separation of the Blessed and the Damned at the Last Judgment, was left unfinished when he died at his home in Catskill just a week after his forty-seventh birthday. Thereafter, his widow kept his house and studio as a kind of shrine to what a Romantic landscape painter, deeply imbued with a love of nature and a passionate desire to teach grand moral lessons, could achieve despite many obstacles in an abbreviated lifetime.

—Ellwood C. Parry III

CONSTABLE, John.

Born in East Bergholt, Suffolk, 11 June 1776. Died in London, 31 March 1837. Married Maria Bickell, 1816 (died, 1829); two sons and one daughter. Studied at Royal Academy school from 1799; first exhibited in 1802; elected R.A., 1829; worked in Suffolk, London, Salisbury, and Dorset coast.

Major Collections: London: National Gallery, Victoria and Albert, Tate.
Other Collections: Boston; Cambridge; Cambridge, Massachusetts; Chicago; Edinburgh; Hartford, Connecticut; London: British Museum, Guildhall, Royal Academy; New Haven; New York: Frick; Oxford; Philadelphia; St. Louis; San Marino, California; Washington: Corcoran, National Gallery, Phillips.

Publications

By CONSTABLE: books—

Letters to C. R. Leslie, edited by P. Leslie, London, 1932.
Correspondence, edited by R. B. Beckett, Ipswich, 6 vols., 1962–68.
Discourses, edited by R. B. Beckett, Ipswich, 1970.

Further Documents and Correspondence, edited by Leslie Parris, Ian Fleming-Williams, and Conal Shields, London, 1975.

On CONSTABLE: books—

Holmes, Charles J., *Constable,* London, 1901.
Holmes, Charles J., *Constable and His Influence on Landscape Painting,* London, 1902.
Windsor, J., *Constable,* London and New York, 1903.
Holmes, Charles J., *Constable, Gainsborough, and Lucas,* London, 1921.
Clark, Kenneth, *Constable: The Hay Wain in the National Gallery,* London, 1944.
Bunt, Cyril G. E., *Constable, the Father of Modern Landscape,* Leigh-on-Sea, 1948.
Rickard, G. O., *Constable's Country: A Guide to the Vale of Dedham,* Colchester, 1948.
Shirley, Andrew, *Constable,* London, 1948.
Badt, Kurt, *Constable's Clouds,* London, 1950.
Beckett, R. B., *Constable and the Fishers,* London, 1952.
Bohler, J. G., *Constable und Rubens,* Munich, 1955.
Peacock, Carlos, *Constable: The Man and His Work,* Greenwich, Connecticut, 1956.
Reynolds, Graham, *Catalogue of the Constable Collection in the Victoria and Albert Museum,* London, 1960, 1973.
Lowing, Lawrence, *Constable,* London, 1960.
Pool, Phoebe, *Constable,* London, 1963.
Taylor, Basil, *Constable,* London, 1963.
Reynolds, Graham, *Constable, The Natural Painter,* London and New York, 1965, 1975.
Baskett, John, *Constable Oil Sketches,* London, 1966.
Parris, Leslie, and Conal Shields, *Constable,* London, 1969, 1985.
Barrell, John, *The Dark Side of the Landscape: The Rural Poor in English Painting 1730–1840,* Cambridge, 1980.
Parris, Leslie, and Conal Shields, *Constable: The Art of Nature* (cat), London, 1971.
Whittingham, S., *Constable and Turner at Salisbury,* London, 1972.
Reynolds, Graham, *Constable's Sketch-Books of 1813 and 1814,* London, 3 vols., 1973.
Taylor, Basil, *Constable: Paintings, Drawings, and Watercolours,* London, 1973.
Constable, Freda, *Constable,* Lavenham, 1975.
Day, H., *Constable Drawings,* Eastbourne, 1975.
Hawes, L., *Constable's Stonehenge,* London, 1975
Kroeber, Karl, *Romantic Landscape Vision: Constable and Wordsworth,* Madison, Wisconsin, 1975.
Brooks, C. A., and Alastair Smart, *Constable and His Country,* London, 1976.
Gadney, Reg, *Constable and His World,* London, 1976.
Fleming-Williams, Ian, *Constable: Landscape Watercolours and Drawings,* London, 1976.
Gadney, Reg, *Constable: A Catalogue of Drawings, Watercolours . . . in the Fitzwilliam Museum,* Cambridge, 1976.
Parris, Leslie, Ian Fleming-Williams, and Conal Shields, *Constable* (cat), London, 1976.
Walker, John, *Constable,* New York, 1978.
Wilton, Andrew, *Constable's English Landscape Scenery,* London, 1979.

Summer Afternoon after a Shower, 1831; mezzotint

Hoozee, Robert, *L'opera completa di Constable,* Milan, 1979.

Sunderland, John, *Constable,* London, 1980.

Reynolds, Graham, *Constable with His Friends in 1806,* Paris, 5 vols., 1981.

Parris, Leslie, *The Tate Gallery Constable Collection: A Catalogue,* London, 1981.

Kauffman, C. M., *Sketches by Constable in the Victoria and Albert Museum,* London, 1981.

Paulson, Ronald, *Literary Landscape: Turner and Constable,* New Haven, 1982.

Reynolds, Graham, *Constable's England* (cat), New York, 1983.

Rosenthal, Michael, *Constable, The Painter and His Landscape,* New Haven, 1983.

Reynolds, Graham, *The Paintings and Drawings of Constable,* New Haven, 2 vols., 1984.

Fleming-Williams, Ian, and Leslie Parris, *The Discovery of Constable,* London, 1984.

Heffernan, James A. W., *The Re-Creation of Landscape: A Study of Wordsworth, Coleridge, Constable, and Turner,* Hanover, New Hampshire, 1985.

Hill, David, *Constable's "English Landscape Scenery,"* London, 1985.

Cormack, Malcolm, *Constable,* Oxford, 1986.

Rosenthal, Michael, *Constable,* London, 1987.

"Painting is but another word for feeling. . . ."

No artist is perhaps more closely identified with the natural beauty of the English countryside than John Constable. His many paintings and sketches record his deep emotional response to those places he knew intimately. The prominence of his work in the major public collections and the frequency with which his work is reproduced has led to his reputation as Britain's "Natural Painter" par excellence, but he was not always perceived so. Unlike his great contemporary Turner, whose rise to celebrity status in the art world of London was almost meteoric, Constable struggled during his entire career to have his own interpretation of landscape accepted. His letters reflect constant anxiety about the acceptance of his work. He was aware that his view of landscape art was at odds with prevailing taste. He knew his art did not fulfill the aesthetic expectations of his many Academic peers and prospective buyers. He showed no interest in the historical landscape, the classical vision of the natural world so popular in his day, and was not enticed by the sublime or the picturesque. His one trip to the Lake and Peak Districts left him unmoved.

As his first biographer, Charles Leslie, noted, Constable was a man who best enjoyed a scene in which the presence of man could be detected; his paintings and sketches are filled with small figures going about their daily tasks—the world

portrayed by Constable is one that has been domesticated by man. His work does not show any of the tremendous changes being wrought on the countryside during his lifetime. We see neither the encroachment of London towards his home in Hampstead Heath nor the intrusion of the railway and new industries in his pictorial records of his native Suffolk. This close scrutiny of a small portion of his world makes his art unique. The only other English artist to look at his environs with the same intensity was Constable's mystic contemporary, Samuel Palmer. Though their art is very different both men were concerned with their immediate world, and yet managed to transcend the particular.

From the earliest surviving sketchbooks one can detect Constable's spiritual attachment to the *genius loci* of the Stour River Valley. Observing that "The landscape painter must walk in the fields with a humble mind," he was not eager to seek out the spectacular or theatrical. He objected to the manicured wildernesses of the parklands surrounding many English country homes, though he accepted several commissions to paint them. He said, "a gentleman's park is my aversion. It is not beauty because it is not nature."

It was in order to record on canvas and paper the visual sensations he experienced out-of-doors that Constable experimented with his brushwork and the color of his pallette. He found many of the landscapes of his day plagued by "old rancid hues". Though he deeply admired the art of the Dutch 17th-century school, especially the works of Ruisdael and Cuyp, and praised the work of Claude, he did not approve of the tendency on the part of some of his contemporaries to imitate the Old Master patina in their works. His unusual practice of laying one color aside another without blending them, in order to create the scintillating effects of the reflection of light, startled many of his contemporaries, not least Delacroix, who first saw Constable's works in Paris in 1824 and was immediately struck by their freshness and vigor.

During his life his reputation rested largely on his famous "six-footers," a term he coined to describe his large canvases of life along the River Stour and its adjacent waterways, prepared for the annual Royal Academy exhibitions. These works date from 1819 to 1828. Constable was finally voted a full member of the Royal Academy in 1829, just eight years before his death.

Constable's large "studies" for the canal pictures are perplexing. They do not really appear to be preparatory studies but, rather, alternative interpretations of the same scene. Though Constable said nothing to explain these works in his letters, it may be that they were personal impression of the landscapes and not as highly finished as those works he intended for public exhibition and possible sale. These differences are readily apparent if one compares the "study" of his best-known work, *The Haywain* (Victoria and Albert Museum, London) with the finished version in the National Gallery, London.

As Constable was completing *The Haywain* he began his extraordinary series of sky studies. Aerial effects are the key to understanding his paintings. The skies in his works play the dominant role. The artist's interest in natural history and science is evident in his letters. He read Gilbert White's *Natural History of Selborne* and John Forster's *Atmospheric Phenomena* with equal intensity. With his small oil and watercolor sketches he strove to capture the movement of air masses and the play of light in a moisture-laden atmosphere. It is these skies, which often take up over 60 percent of his paintings, that lend the versimilitude to his landscapes. Increasingly after 1828 his landscapes are less topographically accurate, but throughout his career light and atmosphere are uncanny in their believability. The artist's late work became more impassioned and expressive, perhaps in response to the death of his beloved wife, Maria.

The large number of surviving letters from the artist provide us a better glimpse into an artist's character than perhaps any other artist before 1900, with the possible exceptions of Delacroix and Van Gogh. To read Constable's letters is to appreciate a lifelong commitment to a vision of the natural world he held very dear. In his last years he ventured into a publishing effort with David Lucas, who was charged with converting some of Constable's designs into mezzotints. The resulting volume, *English Landscape Scenery,* contains a revealing comment by Constable, which seems to sum up all he hoped to achieve through his art: "to increase the interest for, and promote the study of, the Rural Scenery of England with all its endearing associations, its amenities, and even in its most simple localities; abounding as it does in grandeur, and every description of Pastoral Beauty."

—Anthony Lacy Gully

COOPER, Samuel.

Born in London, probably 1608–09?; brother of the artist Alexander Cooper. Died in London, 5 May 1672. Married Christiana (or Christina) Turner. Pupil of his uncle, the miniaturist John Hoskins, and later possibly a partner with Hoskins; lived in King Street in 1640's, and in Henrietta Street, from c. 1650; worked for Charles I's court, for the Cromwells, and for Charles II's Court, and a friend of Hobbes, Butler, Audrey, Pepys, and Evelyn; appointed King's Limner to Charles II by 1663.

Major Collection: London: Victoria and Albert; Windsor Castle.
Other Collections: Broughton; Burghley House; Cambridge; Cleveland; Florence; Goodwood; The Hague; London: Portrait Gallery, Maritime Museum; New Haven; Oxford.

Publications

On COOPER: books—

Foster, Joshua J., *Cooper and the English Miniature Painters of the XVIIth Century,* London, 2 vols., 1914–16.
Long, B. S., *British Miniaturists,* London, 1929.
Reynolds, Graham, *English Portrait Miniatures,* London, 1952.
Reynolds, Graham, *The Age of Charles II* (cat), London, 1960.
Foskett, Daphne, *British Portrait Miniature Exhibition Catalogue* (cat), Edinburgh, 1965.

Foskett, Daphne, *Cooper and His Contemporaries* (cat), London, 1974.

Foskett, Daphne, *Cooper,* London, 1974.

*

Samuel Cooper's ability as one of the greatest British miniaturists has never been disputed. Charles Beale in his diary recorded that on "Sunday May 5, 1672 Mr Samuel Cooper the most famous limner of the world for a face died." Others even termed him "the Vandyck in little." At the Cooper exhibition held at the National Portrait Gallery in 1974, one reviewer remarked, "Even if they were life sized, the portraits by Samuel Cooper could not be more engrossing. . . ." He came away "tired eyed but spiritually enriched. . . ." Due to the fact that Cooper worked in his uncle's studio, his early miniatures are difficult to attribute with certainty. He must have executed some works of his own before he left his uncle, but so far no signed and dated ones occur before 1642, when the charming miniature of Elizabeth Cecil, Countess of Devonshire was painted. It is signed and dated: "Sa Cooper / pinx A° 1642," and is at Burghley House. The composition and breadth of handling show Van Dyck's influence on a small scale, but the competent modelling of the features and the use of colours show that Cooper had mastered the art of limning at an early stage in his career. His earliest signed miniature, of c. 1635, is of Margaret Lemon, Van Dyck's mistress; it is signed in monogram "S. C." and inscribed with the sitter's name. The miniature is in the F. Lugt collection in Paris. Others have been attributed on basis of style dating from c. 1630–35, but we are not on sure ground until we come to the one dated 1642, and from then to the time of his death there is a constant stream of dated and signed works by which we can judge his competence. He was in great demand throughout his career and painted through three decades of Caroline, Cromwellian, and Restoration England. His sitters included not only great and ordinary people of Britain, but also such people as Cosimo de' Medici, whom he painted in 1669. Cosimo described him as "a tiny man, all wit and courtesy, as well housed as Lely, with his table covered with velvet."

The fact that the greater number of Cooper's miniatures still remain in private collections make the study of his work difficult; because of their value and fragility these are not often lent to exhibitions where the extremes of temperature are liable to cause damage. Those accessible to the public are at the Victoria & Albert Museum, the National Portrait Gallery, the National Maritime Museum, the Fitzwilliam Museum, Cambridge, the Ashmolean Museum, Oxford, and a number of museums abroad. Cooper's miniatures have been copied by many artists, and collectors must be aware of this when purchasing examples. His most famous portrait is the unfinished one of Oliver Cromwell in the collection of the Duke of Buccleuch; this particular one has been copied many times.

Cooper's miniatures, like those of Hilliard and Oliver, are painted on vellum laid onto card, each base being prepared first with a layer of opaque white before the portrait was commenced. In some cases these seem to have been thicker than others and formed a gesso like substance into which he sometimes incised his signature. Unlike the earlier artists who copied the school of illuminators, Cooper developed a style more like that used by oil painters and used a broader and freer

Portrait of the Artist (?), 1645; watercolor on vellum; $2\frac{7}{8} \times 2\frac{1}{4}$ in (7.3 × 5.7 cm); Royal Collection

stroke and for the flesh colours used a warm reddish brown rather than the pinkish white which was hitherto more popular and has in many cases faded. Cooper's miniatures, on the other hand, have in most cases retained their brilliance, and the blending of his colours is so harmonious that his works are endowed with a richness and perfection that single him out as one of the greatest miniaturists who ever worked in Britain. Although he is said to have painted in oil as well as watercolor, no examples of his work in this medium have so far been discovered. His signatures varied, the most usual being "S. C." or "S:C" either in separate letters or in monogram, often followed by a date either on the same line or below: S. Cooper, Sa Cooper pinxet, Samuel Cooper fecit, S: Cooper: have all been noted. The lettering is in gold, dark brown, or grey, on the background of the portrait, or in rare cases on some detail or a pillar. He also occasionally inscribed some miniatures on the reverse. Although Cooper had many followers, there is no documentary evidence that he took pupils in his studio. Susan Penelope Ross was a great admirer of his work and copied numerous of his miniatures, so may have been well known to him, and many of her works have been attributed to Cooper in error.

Cooper has been, and still is considered the greatest English-born painter of the 17th century and this irrespective of scale or medium. He had the patronage of Cromwell and his followers and when Charles II returned to the throne he immediately turned to Cooper for his portrait and he painted the King and his court throughout the rest of his life. He was so popular that it was difficult to get an appointment for a sitting. Horace Walpole summed him up when he said, "The anecdotes of his life are few; noe does it signify; his works are his history."

—Daphne Foskett

COPLEY, John Singleton.
Born in Boston, Massachusetts, 3 July 1738. Died in London,
9 September 1815. Married Susannah Clarke, 1769; two
daughters and two sons, including the Lord Chancellor Lord
Lyndhurst. Trained as a painter by his step-father Peter Pel-
ham to 1751 (when Pelham died); successful portrait painter
and miniaturist in Boston from an early age until 1774; en-
couraged by Benjamin West, he visited England and Italy,
1774–76, and settled in London: RA, 1769; successful history
painter and portraitist.

Major Collections: Boston; New York; Washington.
Other Collections: Cambridge, Massachusetts; Cleveland;
Hartford, Connecticut; London: National Gallery, Christ's
Hospital, Royal Academy, Royal Collection; New Haven; New
York: Brooklyn Museum; Philadelphia: Historical Society;
Providence; Washington: Corcoran.

Publications

By COPLEY: book—

Letters and Papers of Copley and Henry Pelham 1739–1776,
edited by Charles F. Adams, Guernsey Jones, and W. C.
Ford, Boston, 1914.

On COPLEY: books—

Amory, Martha Babcock, *The Domestic and Artistic Life of
Copley,* Boston, 1882.
Bayley, Frank W., *The Life and Works of Copley,* Boston,
1915.
Wehle, Harry B., *An Exhibition of Paintings of Copley* (cat),
New York, 1936.
Parker, Barbara N., and Anne B. Wheeler, *Copley: American
Portraits in Oil, Pastel, and Miniature,* Boston, 1938.
Morgan, John H., *Copley,* Windham, Connecticut, 1939.
Flexner, James T. Jr., *Copley,* Boston, 1948.
Prown, Jules David, *Copley* (cat), Washington, 1965.
Prown, Jules David, *Copley,* Cambridge, Massachusetts, 2
vols., 1966.
Flexner, James T., Jr., *The Double Adventure of Copley,* Bos-
ton, 1969.
Frankenstein, Alfred, *The World of Copley,* New York, 1970.
Klayman, Richard, *America Abandoned: Copley's American
Years 1738-1774,* Lanham, Maryland, 1983.

articles—

Stein, Roger B., "Copley's *Watson and the Shark* and Aesthet-
ics in the 1770's," in *Discoveries and Considerations: Es-
says . . . Presented to Harold Janta,* edited by Calvin
Israel, Albany, 1976.
Jaffe, Irma B., "Copley's *Watson and the Shark,*" in *Ameri-
can Art Journal* (New York), May 1977.
Abrams, Ann Uhry, "Politics, Prints, and Copley's *Watson
and the Shark,*" in *Art Bulletin* (New York), June 1979.

Fairbrother, Trevor J., "Copley's Use of British Mezzotints for
His American Portraits: A Reappraisal Prompted by New
Discoveries," in *Arts Magazine* (New York), March 1981.

*

Copley received his first artistic training from his step-father,
the mezzotint engraver Peter Pelham. Pelham taught Copley
the rudiments of mezzotint print-making and encouraged him
to become a painter. Copley also had access to the studio of
the skilled expatriate London painter, John Smibert, who
owned painted and printed reproductions of old masters'
works, as well as casts of antique sculpture. After completing
a number of mezzotint prints, Copley began painting portraits,
such as *The Gore Children* (c.1755; Winterthur, Delaware).
These portraits are dependent on the styles of Robert Feke and
Joseph Badger. During this early period he consistently bor-
rowed figural poses from mezzotint reproductions of early
18th-century English portraiture.

By 1755 he had been introduced to the successful portrait
painter Joseph Blackburn. For the next few years Copley emu-
lated Blackburn's rococo costume portraits. Paintings such as
Copley's *Ann Tyng* (Boston), from 1756, demonstrate how
quickly he achieved extraordinary technical facility, which
probably drove Blackburn back to England. Concurrently, he
studied anatomy, as well as such art theory as Roger de Pile's
The Art of Painting and Charles du Fresnoy's *De arte
graphica,* and even attempted history painting. Yet, in large
part because of patrons' taste, his aspirations to become a his-
tory painter were never fulfilled in the colonies.

Copley's mature colonial style begins to emerge in the late
1750's. While retaining some of the earlier rococo artifice and
elegance, works such as his *Mary and Elizabeth Royall*
(c.1758; Boston) present a new naturalness, particularly in the
poses, a greater amount of detail, and a much more convinc-
ing sense of plasticity.

His first competition piece, *Boy with a Squirrel* (Boston),
from 1765, was exhibited in London in 1766. After seeing
Copley's exhibition painting, Joshua Reynolds wrote the young
artist that although he was very impressed with his technique
he thought it had "A little hardness in the drawing, coldness in
the shades, an over-minuteness. . . ." Furthermore, Reynolds
believed that Copley's full artistic development was dependent
on his leaving the colonies, writing that ". . . with the advan-
tages of the Example and Instruction which you could have in
Europe, you would be . . . one of the first painters in the
world, provided you could receive these Aids before it was too
late in Life, and before your Manner and Taste were corrupted
or fixed by working in your little way at Boston." The prag-
matic Copley did not follow Reynold's recommendation until
nearly ten years later, largely because of his concern that he
would not be able to match his substantial Boston income.

By the 1760's Copley had evolved a style which perfectly
suited the tastes of his Boston patrons. This style is the culmi-
nation of colonial American portraiture. While retaining the
detailed empirical realism of earlier colonial artists such as
Feke, Copley's art brought a new sense of dignity to his sit-
ters, and a compelling psychological content. Portraits which
exemplify his best colonial painting include *Mrs. Thomas Boy-
lston* (1766; Cambridge, Massachusetts), *Mr. and Mrs.
Thomas Mifflin* (1773; Philadelphia, Historical Society of

Pennsylvania), and *Paul Revere* (1768-70; Boston). Typically, his *Paul Revere* is a portrait d'apparat. Copley represents the famous silversmith and revolutionary in his studio, dressed in working clothes, completing one of his teapots, and looking up as if someone had just walked into his shop. Characteristically, he frames the figure with a dark background and employs a strong chiaroscuro lighting, which both illuminates the various textures (with tremendous veracity) and creates a striking sculptural quality. The psychological character manifest in this and other Copley portraits is a measure of his genius.

In June 1774, he sailed for Europe to study the works of the old masters. After spending nearly a year in Italy, he met his family in London in 1775. Because of his father-in-law's Boston political troubles, Copley soon decided against returning to the colonies. Readily adapting to London's artistic mileau, he radically altered his portrait style to emulate the fashionable painterly and animated work of Reynolds and Lawrence, and thus abandoned the detailed materiality of his earlier art. He became a successful portraitist. Important examples include such works as *Midshipman Augustus Brine* (1782; New York, Metropolitan) and *Mrs. Seymour Fort* (c. 1778; Hartford, Connecticut). Copley also painted several ambitious group portraits, such as *The Copley Family*, from 1776–77 (Washington). The majority of his English portraits lack the piercing psychological insight of his colonial American work.

Copley's move to London also allowed him to become a serious history painter. Beginning in 1775 with an *Ascension of Christ* (Boston) he was to produce a large number of religious and historical scenes. They illustrate his ambition to compete with artists such as Benjamin West. In the mold of West's unconventional contemporary history painting, the *Death of Wolfe* (1770; Ottawa), Copley painted a series of "modern" history paintings, such as his *Watson and the Shark* (1778; Washington), *The Death of the Earl of Chatham* (1779–81; London, Tate), and *The Death of Major Pierson* (1782–84; London, Tate). Elected associate of the Royal Academy in 1776 and full academician in 1779, he became well respected for his history painting. Always interested in financial gain, Copley created controversy by showing his works privately, rather than at the Royal Academy, and then charging admission.

Although he ended his career in artistic and financial decline, he had had a remarkable artistic impact. In Boston his detailed psychological portraits enabled him to occupy the dominant place in colonial American painting, and as a major late 18th-century English history painter he looked forward to the Romanticism of the early 19th century.

—Randall C. Griffin

CORINTH, Lovis.

Born Franz Heinrich Lovis Corinth in Tapiau, East Prussia, 21 July 1858. Died in Zandvoort, Netherlands, 17 July 1925. Married Charlotte Berend, 1903; one son. Studied under Professor Günther at the Art Academy in Königsberg, 1876, under Ludwig Löfftz at the Art Academy in Munich, 1880-84, and under Bouguereau and Robert Fleury at the Académie Julian, Paris, 1884-87; exhibited in Paris, 1890; settled in Munich, 1891; opened art school in Berlin, 1901; elected Chairman, Berlin Secession, 1911; suffered stroke, 1911, but continued to paint; many prints.

Major Collection: Tapiau: Corinth Museum.
Other Collections: Basel; Berlin; Berne; Bermen; Cologne; Hamburg; Hanover; London: Tate; Mainz; Munich: Neue Pinakothek, Städtische Galerie; New York: Moma; Paris: Art Moderne; Pittsburgh; Stuttgart; Vienna; Winterthur; Wuppertal; Vienna.

Publications

By CORINTH: books—

Das Erlernen der Malerei: Ein Handbuch, Berlin, 1908.
Legenden aus dem Künstlerleben, Berlin, 1909.
Das Leben Walter Leistikows, Berlin, 1910.
Gesammelte Schriften, Berlin, 1920.
Selbstbiographie, Leipzig, 1926; as *Meine frühen Jahre*, Hamburg, 1954.

illustrator: *Das hohe Lied*, 1911; *Anna Boleyn*, by Herbert Eulenberg, 1920; *Gullivers Reise*, by Swift, 1922.

On CORINTH: books—

Klein, Rudolf, *Corinth*, Berlin, 1913.
Beirmann, George, *Corinth*, Bielefeld, 1913, 1922.
Schwarz, Karl, *Das graphisches Werk von Corinth*, Berlin, 1917, 1922.
Eulenberg, Herbert, *Corinth: Ein Maler unserer Zeit*, Munich, 1920.
Hausenstein, Wilhelm, *Von Corinth und über Corinth*, Leipzig, 1921.
Singer, Hans W., *Zeichnungen von Corinth*, Leipzig, 1921.
Biermann, George, *Der Zeichner Corinth*, Dresden, 1924.
Kuhn, Alfred, *Corinth*, Berlin, 1925.
Stuhlfauth, George, *Die religiöse Kunst im Werke Corinths*, Lahr, 1926.
Bertrand, Robert, *Corinth*, Paris, 1940.
Rohde, Alfred, *Der junge Corinth*, Berlin, 1941.
Rohde, Alfred, *Corinth*, Konigsberg, 1942.
Berend, Charlotte, *Mein Leben mit Corinth*, Hamburg, 1947.
Osten, Gert von der, *Corinth*, Munich, 1955.
Berend, Charlotte, *Lovis*, Munich, 1958.
Berend, Charlotte, *Die Gemäide von Corinth: Werkkatalog*, Munich, 1958.
Röthel, Hans K., *Corinth* (cat), Munich, 1958; London, 1959.
Corinth (cat), Berne, 1958.
Muller, Heinrich, *Die späte Graphik von Corinth*, Hamburg, 1960.
Geist, H. F., *Corinth: Handzeichnungen und Aquarelle* (cat), Lubeck, 1965.
Peters, Heinz, *Corinth*, Berlin, 1967.
Eipper, Paul, *Ateliergespräche mit Liebermann und Corinth*, Munich, 1971.
Karsch, Florian, *Corinth*, Berlin, 1972.

Self-Portrait, 1921; drawing

Röver, Anne, and Bernhard Schnackenburg, *Corinth: Hand-zeichnungen und Aquarelle* (cat), Bremen, 1975.

Zweite, Armin, editor, *Corinth* (cat), Munich, 1975.

Corinth, Thomas, editor, *Corinth: Eine Dokumentation,* Tubingen, 1979.

*

Though Lovis Corinth is widely considered to be an Impressionist, similarities between Corinth's style and French Impressionism are, for the most part, purely illusory. He is often claimed to be an Expressionist, but his "tachistic" tendency, too, is more apparent than real. His work links naturalism and Neo-Idealism while his ideas connect the nationalism of the older Romantic School with cosmopolitan modernism. He was both an artistic "liberal" and "conservative." Alternatively, these linkages are regarded as merely specious by those critics who think of him as a talented opportunist (especially before his stroke in 1911).

Corinth was an important conduit for the flow of French ideas into Germany, but he was also a dedicated champion of an independent national German school. His literary figure paintings have been and continue to be criticized for their excessive sensuality as well as for their intellectualism. He was scorned by some champions of modernism (e.g., Meier-Graefe) for adhering too closely to naturalism and late Romantic posturing. (The Nazis castigated him for his gross distortions of nature.) He was and remains a controversial artist.

Corinth's early existence in the earthy rough-and-tumble of butcher shops, tanneries, and farmsteads of his native Eastern Prussia predisposed him to view life directly and influenced his early naturalistic genre paintings of similar motifs (e.g., *In the Slaughter-House,* 1893, Stuttgart, Staatsgalerie). But even though he thought highly of such "poor peoples' artists" as Bastien-Lepage, after he settled in Munich (1880), he did not really emulate similar, socially conscious artists as, for example, Liebermann or Slevogt. Instead, he opted for further training under Löfftz, who represented an alternative tradition, Munich's sentimental popular genre. Corinth's tenebristic and Rembrandtesque *Conspiracy* (1884, private collection), a vague costume genre, epitomizes this cautious development. In subsequent studies in Belgium and France (under Bouguereau at the Académie Julian), he absorbed elements of a sophisticated salon style.

In the bargain-basement of styles that was the Munich art scene in the 1890's—Corinth tried nearly all of them—the most original was Neo-Idealism. It was based on a realist technique and intent on serving "significant themes" derived from literature, history, and poetic fantasy. It was Arnold Böcklin's specialty, and he triumphed with his poetic treatments of mythological themes. Following in Böcklin's footsteps, Corinth served up "big subjects to impress academic juries" and such compositions as would make for "good exhibition pictures" (Armin Zweite). These reasons and his abiding interest in figure painting, especially the nude, determined henceforth (c. 1890–1911) the measure of his artistic ambition and the intellectual core of his mythological and biblical subjects. With *Salome,* (1899, Leipzig, Museum der Bildendenkünste) among his most original compositions, he achieved popularity and critical acclaim as well as notoriety as the *enfant terrible*

of German art. But his real celebrity did not commence until after his move to Berlin the following year, where his meteoric advancement paralleled the rapid rise to prominence of his boon, the Secessionist Movement.

In the course of the 1890's and until 1910, his palette lightened "impressionistically." However, his so-called Impressionism deviates significantly from French practice by using lots of white (instead of juxtaposing complementaries) to achieve high-keyed chromas as well as by its directional (instead of diffused) light. Simultaneously, his brush work became increasingly more agitated, his colors more "screaming," and his perception of figure and space more prone to distortion—the much debated so-called "Expressionist effect" in Corinth. These tendencies became more exaggerated after his partially disabling stroke and become most pronounced in the 1920's in his religious paintings (e.g., *The Red Christ,* 1922, Munich, Bayerische Staatsgemäldesammlungen), portraits (e.g., *Portrait of Reichspräsident Friedrich Ebert,* 1924, Basel, Kunstmuseum), and landscapes (e.g., the celebrated *Walchensee Cycle*).

Significantly, his late gestural, distorting non-realist style is not really Expressionism based on either inner need or a belief in the philosophy of modernist abstraction. Rather, it is the result of a sophisticated studio convention, decades of technical mastery of the craft of painting, and endless practice of sketching directly with color to produce bravura painterly facture. When, in the 1920's, this style merged with his deliquescent *"Altersstil"* (style of senility; E. Rumohr), the mimicry of his style with Expressionism became complete.

Corinth spent an extraordinarily long time—over 12 years—studying and trying out all the style fashions the art world had to offer. Wavering endlessly, he eventually arrived at his successful formula of "modish actuality" (P. Hahn). He thought of art in terms of conventional picture categories—history, landscape, still life, portrait—and practiced the craft of art according to academic principles governing those different genres. His mature style achieved a compromise between naturalism, Impressionism, Symbolism, salon painting, and the classic tradition of figure painting.

Whatever its undoubted merits, his oeuvre evinces no sense of unity because it does not display a cogent sense of personal urgency commensurate with his stylistic turbulence. His transitional composite style features brilliant flashes of genius and is consistent with his larger context of German *Sonderimpressionismus* (special impressionism). But, lately, it is a symbol of the *fin-de-siècle* above whose Janus-faced irresolution he could not rise.

Corinth's place in art history hovers between historical continuity and an embryonic modernism. His oeuvre foundered between historicism, empiricism, and formalism. His overarching ambition to speak for his age with "important pictorial themes" lastly failed because the 19th century had lost a sense of "objective religious or human values" on which alone a universally persuasive art can be based (C. Schulz-Hoffmann after H. Beenken). His androgynous art is too personalist to satisfy either literary historicist or objective universal requirements. On the other hand, it does not seem to be subjective *enough* to convince as an authentic statement of an autobiographical compulsion that is in keeping with the apparent agitation of his style and technique.

—Rudolf M. Bisanz

COROT, Jean Baptiste Camille.
Born in Paris, 16 July 1796. Died in Paris, 22 February 1875. Pupil of Achille Etna Michallon and Jean Victor Bertin, from 1822; in Italy, 1825–28, encouraged by Caruelle d'Aligny, then traveled in France, 1827–34, and later; exhibited from 1827, and achieved great popularity after 1855.

Major Collection: Paris.
Other Collections: Baltimore; Boston; Chicago; Florence; Geneva; Merion, Pennsylvania; New York; Ottawa; Philadelphia; Sao Paulo; Washington: National Gallery, Phillips; Williamstown, Massachusetts.

Publications

On COROT: books—

Robaut, Alfred, and Etienne Moreau-Nelaton, *L'Oeuvre de Corot,* Paris, 4 vols., 1904–06; *Supplements,* edited by Andre Schoeller and Jean Dieterle, 1948, 2nd and 3rd supplements, 1974.
Delteil, Loys, *Le Peintre-graveur: Corot,* Paris, 1910.
Lhote, André, *Corot,* Paris, 1923.
Corot raconté par lui-même, edited by Etienne Moreau-Nélaton, Paris, 2 vols., 1924; as *Corot raconté par lui-même et par ses amis,* 1946.
Bernheim de Villers, C., *Corot peintre de figures,* Paris, 1930.
Faure, Elie, *Corot,* Paris, 1931.
Jamot, Paul, *Corot,* Paris, 1936.
Bazin, Germain, *Corot,* Paris, 1942, 3rd edition, 1973.
Serullaz, Maurice, *Corot,* Paris, 1951.
Baud-Bovy, Daniel, *Corot,* Geneva, 1957.
Fosca, François, *Corot: Sa vie et son oeuvre,* Brussels, 1958.
Coquis, Andre, *Corot et la critique contemporain,* Paris, 1959.
Faison, S. Lane, *Corot* (cat), Chicago, 1960.
Bazin, Germain, *Figures de Corot* (cat), Paris, 1962.
Mauclair, Camille, *Corot, peintre-poète de la France,* Paris, 1962.
Servot, Martine, *Dessins de Corot* (cat), Paris, 1962.
Leymarie, Jean, *Corot,* Geneva and Cleveland, 1966.
Hours, Madeleine, *Corot,* New York, 1972, concise edition, 1984.
Dieterle, P., *Corot: Catalogue raisonné,* Paris, 1974.
Saint-Michel, Léonard, *L'Univers de Corot,* Paris, 1974; as *Corot's Universe,* Woodbury, New York, 1974.
Toussaint, Hélène, Geneviève Monnier, and Martine Servot, *Hommage à Corot: Peintres et dessins des collections françaises* (cat), Paris, 1975.
Leymarie, Jean, *Corot,* Geneva and New York, 1979.
Hours, Madeleine, *Corot,* Paris, 1979.
Mason, R. M., et al., *Le Cliché-verre: Corot et la gravure diaphane* (cat), Geneva, 1982.

*

Corot's place among the great painters of the 19th century is not in any doubt, and as early as 1845 he was hailed by the poet and critic Charles Baudelaire as standing at the head of the modern French school of landscape. It is sometimes difficult, however, to view as a coherent whole his vast output of works in oil, itself confused by numerous forgeries and false attributions; and within this body of work some types of painting have historically been preferred over others.

The public face presented by Corot during his lifetime was, at least initially, that of a fairly traditional painter of historical landscapes, given a narrative interest by the inclusion of figures: his first exhibit at the Paris Salon, the Poussinesque *Bridge at Narni* of 1827 (Ottawa), falls into this category. Throughout his life he described himself in the Salon catalogues as the pupil of Jean-Victor Bertin, an orthodox Neo-Classical landscapist who had taught him in the early 1820's, and his journey to Rome in 1825 was still the customary thing for a young painter to do. But even his early Salon pictures reveal his innovative evenness of tone and lightness of palette—obtained by the admixture of white with all his pigments—as well as his broad simplification of handling. These qualities are still more marked in the many oil sketches he painted from the life in Italy up to 1828, in which masses are sharply defined with heavy strokes of the brush in a manner resembling in a higher key the paintings of Constable, some of which Corot had admired at the Salon of 1824. These early sketches have been among his most admired works in this century and were singled out as models by the Cubist André Derain. However, it is unlikely that Corot regarded them as self-sufficient works of art in quite the same way, for he was simply following the well-established practice of oil sketching pursued by artists of the past like Pierre-Henri de Valenciennes.

The clear Mediterranean colours of these early works gave way to a darker palette after Corot's return to France, where he travelled widely on painting expeditions away from Paris. By the 1850's he was painting the northern landscape in a softer and more feathery manner, silvery in tone and rather nostalgic in mood. These were the pictures that were to win him fame during his lifetime, particularly after his *Souvenir de Marcoussis* (Paris, Louvre) was bought by Napoleon III from the Salon of 1855. Such landscapes were frequently entitled *Souvenirs,* or memories, to distinguish them from life sketches, generally without figures. But throughout his life, Corot retained the working methods of his apprenticeship, making life sketches (drawings occasionally, but never watercolours) during the warmer months and using these as the basis for larger canvases produced for public exhibition during the winter inside his studio.

The great satisfaction Corot always found in his work makes it misleading to think of him as a painter whose freer and more impressionistic sketching manner represented a true artistic personality that had to be toned down for public consumption. If he had a purely private side, it found expression rather in the many studies of single figures, usually female models, which he made throughout his career: a good example is the *Woman Reading in a Landscape* of 1869 (New York, Metropolitan) which was the only such work he exhibited during his lifetime. These paintings share with the later landscapes a certain self-absorbed melancholy, accompanied by a greater psychological subtlety befitting the subject.

Corot seemed untroubled by the tensions between his innovative style and the more traditional subject matter of much of his exhibited work: it has been said that he had a great capac-

Cuincy Mill, Near Douai, 1871; lithograph

ity for ignoring things. His family background was that of a prosperous petit bourgeois, and this allowed him financial independence from an early age which combined with a frugal way of life to protect him from the demands of the market place. His benevolent simplicity of character set him apart from the political and artistic controversies that raged in France during his long life: his art is hard to classify in part because he refused to classify himself. Thus he was on good terms with Millet and other landscapists of the Barbizon school, sharing with some of them the practice of painting in the forest of Fontainebleau outside Paris, but he held aloof from Millet's realism and its radical connotations. Similarly it was entirely characteristic of him that in his later years he should have been sympathetic towards the Impressionist painters without ever going so far as to endorse them publicly. Certainly he did not share their readiness to embrace modern subjects such as Parisian street scenes and railway bridges. The Impressionists admired him nevertheless for his light, opaque tones and his dedication to sketching in oils: Monet remarked in 1897 that "we are nothing compared to him." In turn, Corot's later work shows some Impressionist influence,

as in the *Douai Belltower* of 1871 (Paris, Louvre). This work readily stands comparison with the famous view of *Chartres Cathedral* of 1830, also in the Louvre, and shows his powers undiminished and still evolving at the age of 76. If Corot did not always rise to such heights, his canvasses yet stand out in most public collections as the work of a great and highly individual master.

—Simon Bradley

CORREGGIO.
Born Antonio Allegri in Correggio, c.1489. Died in Correggio, March 1534. Married Girolama Merlini, 1519 or 1520; son, the painter Pomponio Quirino, two daughters. Possibly the pupil of Mantegna; worked mainly in Parma: first recorded as a painter, 1514, and first frescoes documented, 1520; probably visited Rome before 1520.

Major Collections: Parma: Cathedral, Museum, S. Giovanni Evangelista.
Other Collections: Berlin; Budapest; Chicago; Detroit; Dresden; Florence; Hampton Court; Leningrad: London; Madrid; Milan: Brera, Castello Sforzesco; Naples; New York; Paris; Parma: convent of S. Paolo; Philadelphia; Rome: Borghese, Doria Pamphili; Vienna; Washington.

Publications

On CORREGGIO: books—

Gronau, Georg, *Correggio: Des Meisters Gemälde,* Stuttgart, 1907; as *The Work of Correggio,* New York, 1908.

Venturi, Adolfo, *Correggio,* Rome, 1926.

Ricci, Corrado, *Correggio,* Paris and London, 1930.

De Vito Battaglia, Silvia, *Correggio: Bibliografia,* Rome, 1934.

Vernet-Ruiz, Jean, editor, *Hommage à Corrège* (cat), Paris, 1934.

Quintavalle, A. G., et al., *Correggio* (cat), Parma, 1935.

Bodmer, Heinrich, *Correggio und die Malerei der Emilia,* Vienna, 1942.

Ros-Theiler, A., *Correggio-Bildnisse,* Zurich, 1947.

Rinaldis, A. de, *La Danae del Correggio,* Milan, 1949.

Bianconi, Pietro, *Tutta la pitture del Correggio,* Milan, 1953.

Longhi, Roberto, *Correggio e la Camera di S. Paolo a Parma,* Genoa, 1956; edited by A. G. Quintavalle, Milan, 1973.

Popham, Arthur E., *Correggio's Drawings,* London, 1957.

Bottari, Stefano, *Correggio,* Milan, 1961.

Panofsky, Erwin, *The Iconography of Correggio's Camera de San Paolo,* London, 1961.

Quintavalle, A. G., *Gli affreschi del Correggio in S. Giovanni Evangelista a Parma,* Milan, 1962; as *The Frescoes in San Giovanni Evangelista in Parma,* New York, 1964.

Tassi, Roberto, *La cupola del Correggio nel Duomo di Parma,* Milan, 1963.

Quintavalle, A. G., *L'opera completa di Correggio,* Milan, 1970.

Gould, Cecil, *The School of Love and Correggio's Mythologies,* London, 1970.

Mecklenburg, Carl Gregor von, *Correggio in der deutschen Kunstanschauung in der Zeit von 1750 bis 1850,* Baden-Baden, 1970.

Toscana, Giuseppe M., *Nuovi studi sul Correggio,* Parma, 1974.

Gould, Cecil, *The Paintings of Correggio,* Ithaca and London, 1976.

Riccomini, E., et al., *Correggio: Gli affreschi nella cupola del Duomo di Parma,* Parma, 1980.

Brown, David Alan, *The Young Correggio and His Leonardesque Sources,* New York, 1981.

Ercoli, Giuliano, *Arte e fortuna del Correggio,* Modena, 1982.

Muzzi, Andrea, *Il Correggio e la congregazione cassinese,* Florence, 1982.

De Grazia, Diane, *Correggio and His Legacy: Sixteenth-Century Emilian Drawings* (cat), Washington, 1984.

*

Correggio is a cuckoo-in-the-nest of Renaissance painters for several reasons. His standing is comparable with that of Titian at Venice, of Raphael in Umbria, or of Michelangelo at Florence. But while these three can be seen as the peaks of long and eminent traditions Correggio sprang from nowhere. The town of Correggio, near Reggio-Emilia, where he was born, could boast of no great painters before him. Then again he had no "middle period." He seems to pass without warning from immaturity to maturity without a transition. Finally, his greatest works—the cupola of the cathedral at Parma, or the *Nativity* ("la Notte") at Dresden seem already completely Baroque—a style which was not generally practised for nearly a century after Correggio's death.

As was to be expected of an artist who came from so relatively obscure a part of Italy there is uncertainty concerning his early life. We do not even know for certain when he was born. Vasari, who never visited the town of Correggio and consequently was ignorant of all the painter's early work, says he was about forty when he died in 1534. If that were true he would have been born in 1494. From the 17th century onwards it was assumed that he had been apprenticed to Mantegna who was then thought to have died in 1517. When it was discovered that Mantegna really died in 1506 such an apprenticeship seemed impossible. Though the situation appeared to be reversed for the second time in the present century when it looked as though Correggio was born about 1489 some uncertainty remains. But the earliest works certainly by Correggio are chiefly influenced by Lorenzo Costa who succeeded Mantegna as court painter at Mantua in 1506. The influence of Mantegna on Correggio—chiefly as regards *trompe-l'oeil* perspectives—came later.

A final controversy surrounds Correggio's putative visit to Rome. This was discounted by Vasari on the ground that if he had been there he would have drawn the human figure more accurately than he did (or than Vasari thought that he did). It was not until the 18th century that the German painter and critic Anton Raphael Mengs declared that Correggio's mature paintings leave no doubt that he had seen the frescoes of Raphael and Michelangelo in Rome, and this view is generally held today. Correggio may have visited Rome following the election of Pope Lee X in 1513.

The only early work of Correggio which is precisely dated is the *Madonna and Child with St. Francis,* now at Dresden, which dates from 1514–15. A small group of religious pictures has been associated with it on stylistic grounds, but none of them gives the impression that one of the greatest Renaissance painters was here in the making. But around the years 1518–19 Correggio moved to Parma and there, in the convent of S. Paolo, he created his first masterpiece. This was the frescoed ceiling of a room in the abbess's private suite. Though obviously inspired by the *trompe-l'oeil* backgrounds of trellises of Mantegna the work as a whole appears strikingly original. It is wonderfully lively, exquisitely beautiful and totally of the Renaissance in spirit. It was the first of three major frescoes—the others are the cupola and other work at the monastery of S. Giovanni Evangelista and the cupola of the cathedral, both at Parma, which chart the period of a little more than a decade which Correggio spent there. These frescoes would normally only have been painted in the summer. In the winter, when it was too cold to paint in the churches, Correggio produced a series of altarpieces—the *Madonna della Sco-*

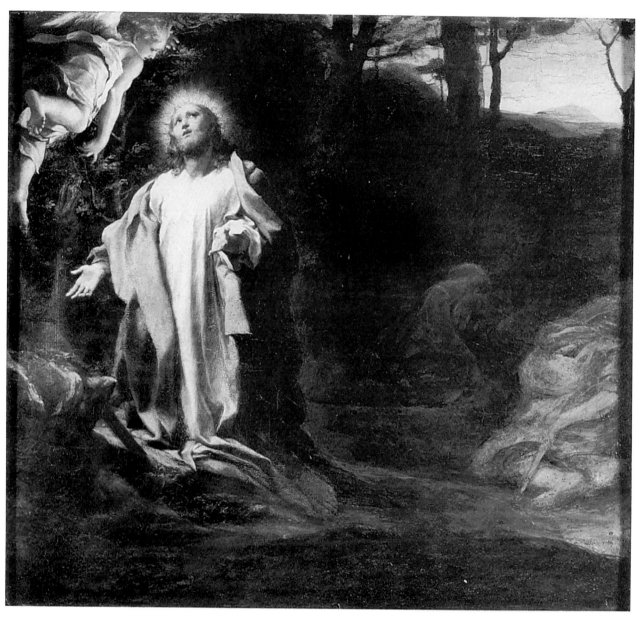

Agony in the Garden, c. 1528; 14½ × 15¾ in (37 × 40 cm); London, Wellington Museum

della and *Madonna with St Jerome* ("Il Giorno") (both at Parma), the *Nativity* ("La Notte"), the *Madonna with St Sebastian* and the *Madonna with St George* (all three at Dresden). The proto-Baroque character of these paintings, their dynamism, emotion, and the way in which the painted figures seem to acknowledge the existence of the spectator and draw him into the picture, was not entirely unique at the time. The contemporary altarpieces of Titian at Venice—the Frari *Assunta* and *Pesaro Madonna* and the *Death of Peter Martyr* (destroyed, but known from copies) show a comparable tendency in a less extreme form. The theory of "anticipation of the Baroque" is most easily explained by regarding the true Baroque, in the 17th century, as a revival—as taking up where Titian and Correggio had left off in the 1520's. But the mystery remains as to why Italian art failed to follow this example earlier and turned for a time instead in a different direction, one which, for want of a better name, is now called Mannerism.

Correggio's last works, a series of four mythological pictures painted in the early 1530's for Federigo Gonzaga of Mantua and presented by him to the Emperor Charles V, are now dispersed, the *Io* and *Ganymede* and at Vienna, the *Leda* at Berlin and the *Danäe* in Rome. These pictures seem, in their sophisticated elegance, even more of an anachronism than the proto-Baroque works of the 1520's. They seem akin to the 18th century. Once again the chief explanation lies rather in influence and revival than in prophetic vision. For two of them, the *Leda* and the *Danäe*, arrived in Paris in the early 1720's, in time to exert a crucial influence on the young Boucher and other French painters who were to set the seal on Rococo painting in France. It is not surprising that at this time Correggio was considered, with Raphael, the greatest of all painters.

—Cecil Gould

COSSA, Francesco del.
Born in Ferrara, 1435–36. Died of the plague in Bologna, probably 1477. Worked in Ferrara, 1456–1470: painted frescoes of Months in Palazzo di Schifanoia, but dissatisfaction caused him to move to Bologna, 1470.

Collections: Berlin; Bologna: S. Giovanni in Monte, Museum, S. Maria del Baraccano; Dresden; Ferrara: Museum, Palazzo Schifanoia; London; Lugano; Milan; Washington.

Publications

On COSSA: books—

Ortolani, Sergio, *Cosmè Tura, Cossa, Ercole de Roberti*, Milan, 1941.
Nicholson, Benedict, *The Painters of Ferrara . . . Cossa . . . and Others,* London, 1950.
Neppi, A., *Cossa,* Milan, 1958.
Ruhmer, Eberhard, *Cossa,* Munich, 1959.
Molajoli, Rosemarie, *L'opera complete di Cosmè Tura e i grand pittori ferraresi del suo tempo: Cossa e Ercole de' Roberti,* Milan, 1974.
Emiliani, Andrea, *Tre Artisti nella Bologna dei Bentivoglio: Cossa, Ercole Roberti, Niccolo dell'Arca* (cat), Bologna, 1985.

*

Although Cossa's documented activity begins in 1456, his surviving, datable paintings come only after 1469; it is thus difficult to reconstruct with confidence his earliest development. He was a native of Ferrara, and his style throughout his life contains in essence the Ferrarese mannerisms of the quattrocento: metallic draperies, strange landscapes, distorted anatomy, and bright, forcible coloring. Still, Cossa seems to have imbibed early the regularized and stereometric style of Piero della Francesco, who had left frescoes (now lost) in Ferrara. Cossa even seems to borrow the characteristic anatomical features of Piero. But he was hardly a follower of Piero; his art always retains a delicate and mincing quality, and his style shows the influence of miniature painting, especially in his landscapes and fluttering draperies, which recall some of the International Gothic miniaturists from Lombardy who were active in Ferrara during the time of Borso d'Este.

The largest and most famous of Cossa's surviving paintings is the east wall of the Hall of the Months in the Palazzo Schifanoia; it is his first datable work, falling to 1469. In his representations of three months of the year, Cossa painted courtly portraits, astrological figures, and triumphs of classical deities. Here the charm and sensuousness of court life in Ferrara are reflected in Cossa's gentle gardens, playful landscapes, and fanciful garments. The frescoes appear to be miniatures writ large, so again the influence of miniatures on Cossa's art is apparent. His frescoes there are a rare record of monumental, Ferrarese secular painting, nearly all of which has disappeared with the destruction over time of Este residences.

Angered at the low rate of pay that he received for the Schifanoia murals, Cossa left Ferrara in 1470 and went to Bologna. Among his first commissions there must have been his *Annunication* (Dresden, Gemäldegalerie), made for the church of the Osservanza. The aulic architecture shows an absorption of Renaissance architectural forms, which he renders as decorative and cluttered, a courtly and graceful form of Corinthian classicism. Similar in its charm and gaiety is his renovation of a trecento *Madonna and Child* in the church of the Baraccano, where Cossa added a fantasy landscape, beautiful, candlebearing angels, and striking foreshortenings in what must have appeared to contemporaries to be a radical and modern renewal of a traditional cult image.

Cossa's most important known altarpiece was his polyptych for the Griffoni Chapel in San Petronio, datable to 1473–74, made in collaboration with the young Ercole de' Roberti. Despite the old-fashioned form—a compartmentalized polyptych with some half-length figures and gold backgrounds—Cossa achieved an innovative result in his depictions of multi-colored landscapes, broken drapery folds, and a delightful artificiality of physiognomic form. Yet, the mannerisms are subservient to a powerful moral air conveyed by the three main figures, *St. Vincent Ferrara* (London, National Gallery) and *Sts. Peter and John the Baptist* (Milan, Brera). Like the *Griffoni Altarpiece,* Cossa's signed and dated *Pala dei Mercanti* (1474; Bologna, Pinacoteca) departs strongly from the gentle style of the secular frescoes in the Palazzo Schifanoia; the painting, representing the Madonna, saints, and donors, is endowed with quiet but powerful emotions, sculptural figures, and dramatic chiaroscuro. Here, as in most of his later works, Cossa's surface realism contrasts with the style of his Ferrarese predecesors, and perhaps reveals a debt to Antonello da Messina or even Netherlandish painters themselves, some of whose works were available in the Ferrara/Bologna area. Cossa's *Portrait of a Man* (Lugano, Thyssen-Bornemisza Collection) shows this minute realism and powerful modelling.

Cossa's output was varied, and included designs for stained glass (San Giovanni in Monte, Bologna), intarsia (San Petronio), and designs for sculpture (the tomb of Domenico Garganelli, now Museo Civico, Bologna). At the time of his death, Cossa was painting the Garganelli Chapel in Bologna, a project later completed by Roberti. Cossa's vault figures there, now lost but mentioned in sources, were represented in masterful foreshortening, and were apparently indebted in their skillful illusionism and overall design to dome decorations by Melozzo da Forli.

Cossa's artistic output was striking and versatile, and ranged from the charming to the dramatic. His art is always engaging, and enhanced by a gentle, courtly sensibility. His critical fortunes were adversely affected by Vasari's confusion of him with Lorenzo Costa, and his fame grew only after the rediscovery of his Schifanoia frescoes and the reconstruction of his oeuvre in the 19th century. Cossa has since rightly attained a high critical place—along with Tura and Roberti—as one of the triumvirate of Ferrarese painters of the quattrocento.

—Joseph Manca

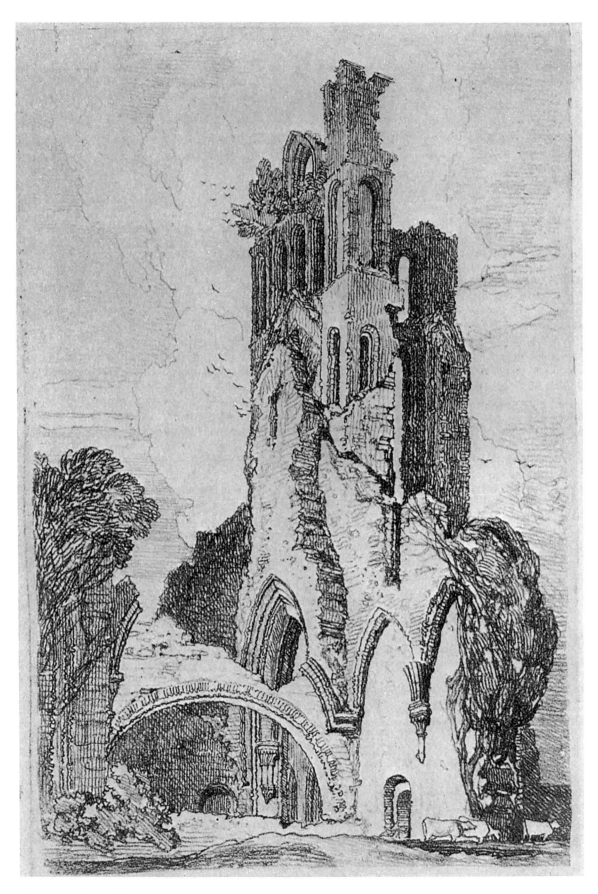

Llanthony Abbey, 1820's; etching

COTMAN, John Sell.
Born in Norwich, 16 May 1782. Died in London, 24 July 1842. Married Ann Miles, 1809; four sons, including the painters Miles Edmund Cotman and John Joseph Cotman, and one daughter. Attended local grammar school; worked in London, from 1798, partly with Dr. Munro; exhibited in London, 1800–39, and in Norwich, 1807–33; lived and worked in Norwich, 1806–12, Yarmouth, 1812–23, and Norwich, 1823–34; leading member of the Norwich Society of Artists (President, 1811, 1833); then re-settled in London, 1834: taught at King's College school, 1834–42.

Major Collections: Leeds; London: British Museum, Victoria and Albert; Norwich.
Other Collections: Birmingham; Edinburgh; London: National Gallery, Tate; Manchester; New Haven; Oxford; Pietermatirzburg; Port Sunlight; Vancouver.

Publications

By COTMAN: books—

Specimens of Norman and Gothic Architecture in the County of Norfolk, Yarmouth, 2 vols., 1816–18.
A Series of Etchings Illustrative of the Architectural Antiquities of Norfolk, London, 1818.
Antiquities of Saint Mary's Chapel at Stourbridge near Cambridge, Yarmouth, 1819.
Suffolk Brasses, London, 1819.
Engravings of the Most Remarkable of the Sepulchral Brasses in Norfolk. London, 1819.
Architectural Antiquities of Normandy, London, 2 vols., 1822.
Liber Studiorum, London, 1838.
Specimens of Architectural Remains in . . . England, London, 2 vols., 1838.
Engravings of Sepulchral Brasses in Norfolk and Suffolk, London, 2 vols., 1839.
Letters from Normandy 1817–1820, edited by H. Isherwood Kay, Oxford, 1926.

On COTMAN: books—

Binyon, Laurence, *John Crome and Cotman,* London and New York, 1897.
Dickes, W. F., *The Norwich School of Painting,* London, 1905.
Reeve, James, *Memoir of Cotman,* Norwich, 1911.
Oppe, A. P., *The Watercolour Drawings of Cotman,* London, 1923.
Kaines Smith, S. C., *Cotman,* London, 1926.
Kitson, Sydney D., *The Life of Cotman,* London, 1937.
Rienaecker, Victor, *Cotman,* Leigh-on-Sea, 1953.
Clifford, Derek, *Watercolours of the Norwich School,* London, 1965.
Mallalieu, Huon, *The Norwich School,* London and New York, 1974.
Rajnai, Miklos, and Marjorie Allthorpe-Guyton, *Cotman Drawings of Normandy in Norwich Castle Museum,* Norwich, 1975.

Holcomb, Adele M., *Cotman,* London, 1978.
Hemingway, Andrew, *The Norwich School of Painters 1803–1833,* Oxford, 1979.
Rajnai, Miklos, and Marjorie Allthorpe-Guyton, *Cotman: Early Drawings (1798–1812) in Norwich Castle Museum,* Norwich, 1979.
Holcomb, Adele M., *Cotman in the Cholmeley Archive,* Northallerton, Yorkshire, 1980.
Rajnai, Miklos, editor, *Cotman* (cat), London, 1982.
Rajnai, Miklos, editor, *Cotman,* Ithaca, New York, 1982.
Moore, Andrew W., *Cotman* (cat), Norwich, 1982.

*

Few would dispute the fact that England's most original contribution to European art was her watercolour school and that this school never produced an exponent of greater originality than John Sell Cotman. He was also an early representative of that typically 19th-century breed, the genius who was not understood, and whose longing for reputation and fame was never fulfilled this side of the grave. The outward structure of his life provides a convenient and reasonably accurate means of dividing in consecutive periods the development and changes in Cotman's art.

At his first public appearance in 1800 at the Royal Academy, after an only dimly known and probably entirely self-educating period, he is recognisable as a highly talented member of that group which successfully blends topographical interest with high emotional charge. His subjects are culled from his Welsh and later Yorkshire tours and are the ones much loved by the artists of romanticism: old buildings, especially ruined castles and churches, also humble, crumbling cottages, decayed churchyards—in one of them his own name is carved on a wooden headpiece. With his sparing use of colour, the effect is tonal, rather subdued, and tending towards the monochrome. However, one suspects that this is probably more marked now than at the time of painting, due to changes in the pigments used.

During the last of his three Yorkshire tours, Cotman spent a few rainy weeks in Rokeby Park, at Greta Bridge, in the summer of 1805. The following year, or perhaps two at most, commonly called his Greta period, saw the creation of some of the wonders of watercolour painting. The fast-flowing Greta's boulder-strewn river bed, its precipitous banks with their hanging vegetation and their diadem of trees silhouetted against the sky are—we can hardly say painted—responded to by Cotman with works of immense and strange beauty. Although he never loses his contact with three-dimensional reality, often with clear topographical connotation, he sees the scenes around him as screens on the flat surfaces of which small details coalesce into often weird patches of interlocking shapes. It is the "abstract" quality of his art which appealed to Cotman's rediscoverers whose eyes were trained on the modern movements of the late 19th and early 20th centuries.

After the bitter disappointment of being barred from membership of the newly founded Society of Painters in Water-Colours, Cotman returned to his home county and tried to make a living there. His retrenchment is not paralleled by slackening of creative energy. In fact, the following half-a-dozen years remain the peak period of his artistic career. He turns for subject matter to his immediate vicinity, the pictur-

esque corners of his native city and also to the sketches of his travels, and rethinks them in large, homogeneous forms enclosed with planes of often saturated colours in an arrangement of classical calm and simplicity. From this period date his first oil paintings, which stylistically always closely relate to his watercolours, sometimes the same composition worked out in both media with equal success.

His reluctant removal at Great Yarmouth was followed by years almost completely devoted to etchings of antiquarian interest which were published to bring him fame, and riches for his family, but did neither. What they do most successfully is to divert Cotman from the medium he is happiest with at a time when his brush can hardly touch the paper without creating yet another masterpiece of watercolour. The artistic high points of this period are the sensitive drawings done mostly for the etchings or engraved reproduction, and the monochromes developed from them. The most outstanding among the latter is his series of Normandy subjects, one of the happy results of his three Normandy tours.

By the time of his return to Norwich and to painting, life had cured Cotman of the assumption that doing things in his own way is as good a method of achieving recognition as any. Continental—mainly town—scenes, in highly pitched colours with strong contrasts, are one of the main features of the metropolitan exhibitions he visits and Cotman decides to follow suit. He does not allow himself to be *different* as he was in his Greta and first Norwich period, but strives instead to be one of the "primi inter pares." Fortunately his faultless sense of pattern and structure, which has not atrophied, often informs these trend-following works as well and lifts them clear above the mass of contemporary artistic production.

As far as stylistic traits are concerned, his second spell in Norwich and the time of his final years in London do not differ significantly. Nonetheless these last years contribute to his oeuvre two groups of work of sufficient individuality to merit particular attention. The first of these consists of mainly hilly views, probably emerging from memories of his early Welsh tours, with a colour scheme often dominated by a velvety black and painted with some body colour peculiar to Cotman. The elements of the compositions are almost interchangeable among these drawings and the mood is enticingly elegiac. The other group is the beautifully direct and movingly expressive series of black and white drawings Cotman did during his last visit to Norwich and its environment. These images of the waterlogged autumnal landscape of Norfolk were Cotman's farewell to the land of his birth.

—Miklos Rajnai

COURBET, (Jean Désiré) Gustave.

Born in Ornans, 15 June 1819. Died in La Tour-de-Peilz, Switzerland, 31 December 1877. Studied painting with Père Beau (Baud), a former pupil of Gros in Ornans; and under Charles Antoine Flajoulot at the Royal College of Besançon, 1837–39; studied law briefly in Paris, 1839; then studied in the studio of Steuben; exhibited regularly only after 1849, and also exhibited in Belgium, Netherlands, and Germany; patron-

ized by Alfred Bruyas; elected member of the Commune, 1871, and because he had proposed the destruction of the Vendôme Column, he was sentenced to pay for its restoration after the Commune ended: he therefore lived in exile after 1873 in Switzerland.

Major Collections: Besançon; Montpellier; New York; Ornans; Paris: Louvre, d'Orsay, Petit Palais; Philadelphia.
Other Collections: Alger; Basel; Berlin; Berne; Boston; Bremen; Brussels; Budapest; Chicago; Cologne; Copenhagen; Frankfurt; Glasgow; The Hague; Hamburg; Lille; London; Lons-Le-Saunier; Lyons; Marseilles; Minneapolis; Montreal; Moscow; Munich; New York: Brooklyn Museum; Northampton, Massachusetts; Ottawa; Pasadena; Saint-Gaul; San Diego; Stockholm; Tokyo; Vevey; Vienna; Warsaw; Washington: National Gallery, Phillips; Wuppertal.

Publications

By COURBET: book—

Lettres à Alfred Bruyas, edited by Pierre Borel, Geneva, 1951.

On COURBET: books—

Meier-Graefe, Julius, *Corot et Courbet,* Leipzig, 1905, 1912.
Riat, Georges, *Courbet,* peintre, Paris, 1906.
Bénédite, Léonce, *Courbet,* London, 1912, Philadelphia, 1913.
Duret, Théodore, *Courbet,* Paris, 1918.
Leger, Charles, *Courbet selon les caricatures et les images,* Paris, 1920.
Borel, Pierre, *Le Roman de Courbet,* Paris, 1922.
Chirico, Giorgio de, *Courbet,* Rome, 1925.
Fontainas, André, *Courbet,* Paris, 1927.
Leger, Charles, *Courbet,* Paris, 1929.
Courthion, Pierre, *Courbet,* Paris, 1931.
Kahn, Gustave, *Courbet,* Paris, 1931.
Boas, George, *Courbet and the Naturalistis Movement,* Baltimore, 1938.
Fosca, Francois, *Courbet,* Paris, 1940.
Huyghe, René, Germain Bazin, and Hélène Adhemar, *Courbet: L'Atelier du peintre, allégorie réelle 1855,* Tours, 1944.
Naef, Hans, *Courbet,* Berne, 1947.
Leger, Charles, *Courbet et son temps: Lettres et documents inédits,* Paris, 1948.
Courthion, Pierre, editor, *Courbet raconté par lui-même et par ses amis,* Geneva, 2 vols., 1948–50.
Zahar, Marcel, *Courbet,* Paris and New York, 1950.
Mack, Gerstle, *Courbet,* New York and London, 1951.
Mac Orlan, Pierre, *Courbet,* Paris, 1951.
Aragon, Louis, *L'Example de Courbet,* Paris, 1952.
Courbet (cat), Besançon, 1952.
Chamson, Andre, *Courbet,* Paris, 1955.
Courbet (cat), Philadelphia, 1959.
Malvano, Laura, *Courbet,* Milan, 1966.
Courbet (cat), Paris, 1966.
Boudaille, Georges, *Courbet, Painter in Protest,* Greenwich, Connecticut, 1969.
Durbé, Dario, *Courbet e il realismo francese,* Milan, 1969.

Fernier, Robert, *Courbet, peintre de l'art vivant,* Paris, 1969; as *Courbet,* New York, 1969, London, 1970.

Courbet (cat), Rome, 1969.

Fermigier, André, *Courbet,* Geneva and Cleveland, 1971.

Bowness, Alan, *Courbet's "Atelier du Peintre,"* Newcastle upon Tyne, 1972.

Clark, T. J., *Image of the People: Courbet and the Second French Republic 1848–1851,* Greenwich, Connecticut, and London, 1973.

Lindsay, Jack, *Courbet: His Life and Art,* Bath, 1973.

Nicolson, Benedict, *Courbet: The Studio of the Painter,* London, 1973.

Bonniot, Roger, *Courbet en Saintonge 1862–1863,* Paris, 1973.

Forges, M. T. de, *Autoportraits de Courbet* (cat), Paris, 1973.

Nochlin, Linda, *The Development and Style of Realism in the Work of Courbet,* New York, 1975.

Toussaint, Hélène, *Courbet* (cat), Paris 1977, London, 1978.

Hommage à Courbet (cat), Paris, 1977.

Fernier, Robert, *La Vie et l'oeuvre de Courbet: Catalogue raisonné,* Lausanne, 2 vols., 1977–78.

Chu, Petra ten-Doesschate, editor, *Courbet in Perspective,* Englewood Cliffs, New Jersey, 1977.

Foucart, Bruno, *Courbet,* Naefels and New York, 1977.

Hofmann, Werner, and Klaus Herding, *Courbet und Deutschland* (cat), Hamburg and Cologne, 1978.

Callen, Anthea, *Courbet,* London, 1980.

Ferrier, Jean-Louis, *Courbet: Un Enterrement a Ornans,* Paris, 1980.

Rubin, James Henry, *Realism and Social Vision in Courbet and Proudhon,* Princeton, 1980.

Herding, Klaus, and Katherine Schmidt, editors, *Les Voyages secrets de Monsieur Courbet* (cat), Baden-Baden, 1984.

Faunce, Sarah, and Linda Nochlin, *Courbet Reconsidered* (cat) New Haven, 1988.

*

Courbet spent his youth in the provence of the Franche-Comté, a region endowed with an abundance of rugged natural beauty. There his family figured in the socio-economic milieu of landed proprietors, and owned two large homes—one in the center of Ornans and the other in nearby Flagey. It was within this comfortable provincial context that the young Gustave first pursued the study of painting.

The Franche-Comté played a major role in forming Courbet's approach to life and art. As one of the eastern-most provinces of France, the region maintained a spirit of separateness and independence which emanated from its own long and rich history prior to formal inclusion in the French nation in 1678. Thus, Courbet's first success at the Paris Salon of 1849, *The After-Dinner at Ornans* (1848–49; Lille), presented an intimate view of life in his native region. The young artist spent little time in pursuit of traditional academic subjects and methods of his period. Instead, he brazenly preferred to render contemporary scenes from local life, recalling the ennobled tradition of 17th-century Dutch art. Early on, Courbet seemed convinced of the universality of his own experience.

The Revolution of 1848, which occurred during the first decade of Courbet's mature formation, gave impetus to his chosen role as the pictorial advocate of a new, more "demo-cratic" aesthetic in painting. *The Burial at Ornans* (1849–50; Paris, d'Orsay) was as monumental in physical scale as it was in social impact. The Parisian audience was bewildered and ultimately provoked by a scene which did not depict a known historical event nor idealize its characters.

Courbet entered the decade of the 1850's as an artist with strong political associations which were subsequently incorporated into his total philosophy. In 1851 he declared himself to be "not only a socialist, but a democrat and a Republican"; in short, he was in favor of "the whole revolution," and, above all, he was a realist. Well aware that the shocking aspects of his art could be used to further his social and artistic goals, Courbet began to interact artistically with salon criticism of his own realist aesthetic.

Following accusations that his painting glorified ugliness, Courbet responded in the Salon of 1853 by creating a picture that was more truly a mockery of the sort his critics espoused. *The Bathers* (1853; Montpellier) satirically portrays two naked corpulent women in the pool of a wooded glade. Through such depictions a new aspect of Courbet's art developed, which may be termed the "painted caricature." Courbet was thus the subject of great controversy; yet, whether in praise or in criticism, there was widespread acknowledgment of the impact of his art.

In 1855 Courbet established his own exhibition independent of the combined Salon and International Exhibition being held in Paris that year. For this occasion, he created a large canvas *The Painter's Studio: A Real Allegory of Seven Years of My Artistic Life* (1855; Paris, d'Orsay), in which he portrays himself in the act of painting. He is situated between two groups, one comprised of supportive patrons, and the other a puzzling assemblage of diverse characters and types that the artist claimed to have seen in his travels. This huge canvas has received numerous interpretations and remains problematic; yet its essential statement is clearly revealed as Courbet sees himself in the process of creating, which is quite strategically an act and role that he revolutionized.

The year 1855 also marks the innovation of a "serial approach" in Courbet's art, incorporating previous works with future projects to establish cycles of related paintings, which would compare and contrast different aspects of society. The impetus for this idea may have been drawn from Balzac's novels, and it is relevant to Courbet's oeuvre between 1855 and 1866.

A strange mixture of acclaim and adversity began to plague Courbet in 1861. It was rumored that the state would officially purchase his widely celebrated *Fighting Stags* (1860; Paris, d'Orsay) and that Courbet would be decorated with the highest honors. The talk came to nothing, and in the end he received only a second-class medal, great affront to an artist who had painted what many considered to be the best picture in the Salon. Official denial of Courbet's merit recurred in 1866, and was clearly intended to reprimand the artist's past condemnations of accepted taste.

A final reconciliation with the Salon came in 1870 when he submitted two beautiful seascapes recorded at Etretat in 1869, *The Stormy Sea* and *The Cliff at Etretat after the Storm* (both in d'Orsay). Finally, the critics were enthusiastic—Courbet had become a popular and temporarily unproblematic artist.

During the final years of the Second Empire and the Commune, Courbet's seascapes and sombre still lifes became

uniquely poetic expressions in which the sheer physicality of paint invigorates the expressive power of the work. Hence, his influence on modern art becomes clear, and is evidenced by generations of avant-garde artists who studied and even collected his works, notably Puvis de Chavannes, Matisse, and Picasso.

Throughout his life, Courbet maintained a Fourierist spirit of political optimism. And though his paintings were often deliberately conceived to inspire conflict, he nonetheless believed that through a liberated artistic manifesto man could ultimately derive a philosophy of social harmony. Courbet first tested this activist approach in his early maturity. His ideologies were subsequently strengthened in the course of relations with his greatest patron, Alfred Bruyas, and with the social philosopher Pierre-Joseph Proudhon. Their support enabled Courbet to assess his role and the nature of his art: "To know in order to be able to create, that was my idea. To be in a position to translate the customs, the ideas, the appearance of my epoch, according to my own estimation; to be not only a painter, but a man as well; in short to create living art—this is my goal."

—Claudette R. Mainzer

COUSIN, Jean [the Elder].

Born in Soucy, near Sens, c. 1490. Died in Paris, c. 1560. Son, the painter Jean Cousin the Younger. Little biographical information: spent most of his life in Sens, then worked in Paris from c. 1540, as painter, sculptor, and architectural decorator; made decorations celebrating Charles V, 1540, illustrations for a costume book, 1556, and sculpted the tomb of Admiral Chabot; most famous painting is Eva Prima Pandora.

Collections: Edinburgh; Langres: Cathedral; Montpellier; Paris: Louvre, Bibliothèque Nationale; Rennes.

Publications

By COUSIN: book—

Livre de perspective, Paris, 1560; as *Le Vraye Science de la pourtraicture descrite et demontrée,* Paris, 1671.

On COUSIN: books—

Recueil des oeuvres choisies de Cousin, edited by Ambroise Firmin-Didot, Paris, 1873.
Le Livre de fortune: Recueil de deux cents dessins inédits de Cousin, edited by Ludovic Lalanne, Paris, 1883; as *The Book of Fortune,* London, 18, 1883.
Ecole de Fontainebleau (cat), Paris, 1972.

*

Thanks to the very considerable amount of research carried out in our century, beginning with the work of Maurice Roi in

1909 and culminating in that done in preparation for the great exhibition of the Ecole de Fontainebleau held at the Grand Palais in Paris in 1972–73, we now have a better, though by no means complete, understanding of Jean Cousin than we ever had before. The image which emerges is of a very perceptive and gifted medieval craftsman-artist awakening to the new visions ushered in by the Italian Renaissance. In fact, he is one of the few French artists of his century who could be said to have a truly independent and international stature, as is attested by Vasari's adulatory remarks about him in the *Vite.*

Born around 1490 in the cathedral town of Sens southeast of Paris, Jean Cousin, in the past sometimes confused with his son Jean Cousin the Younger, began his career in his home town where he was employed as a geometrician and designer of cartoons for stained glass windows, one of which, representing St. Eutropius, is still preserved in the cathedral. He is said also to have executed an altarpiece for the Abbey of Vauluisant. In about 1540 he established himself in Paris where he continued to carry out important commissions. These included a series of eight tapestry designs on the life of St. Mammes commissioned by the Cardinal de Givry for the choir of Langres cathedral. Three of them are preserved, two at Langres and one in the Louvre. The borders of these tapestries are derived from the strapwork designs invented by Rosso Fiorentino at Fontainebleau. Cousin may also have contributed to another tapestry series on the myth of Diana commissioned in about 1549–52 by Henry II for an apartment in Diane de Poitier's Château d'Anet. Four of these can still be seen at Anet, while two are in the Metropolitan Museum in New York, and one is in the Musée Departmental des Antiquités in Rouen. In this lavish series each scene contains an inscription derived from Ovid explaining the episode represented. Cousin also collaborated with Jean Goujon and Charles Dorigny on the festival decorations for Henry II's entry into Paris in 1549. Besides these and other creative undertakings, Cousin also had a keen interest in theoretical matters. These he elaborated in his theoretical writings: the book on *Perspective,* published in 1560, for which a second volume, the *Livre de Portraiture,* was announced by the artist himself (1571?).

Only a very few of Cousin's works are preserved; and those assigned to him are mostly attributions made on the basis of style. Though some of the attributions seem quite firm, the question of authenticity must be considered tentative at best. The oeuvre includes two paintings, each in its own way a masterpiece: an *Allegory of Christian Charity* in the Musée Fabre at Montpellier, dated around 1534, and the famous *Eva Prima Pandora* in the Louvre, probably a somewhat later work. Both are painted in oil on wooden panel. The two pictures clearly show Cousin's dependence on the formal eccentricities of Rosso Fiorentino's courtly mannerism, but with an inventive originality that distinguishes Cousin's work from the more perfunctory productions of most of the French painters who followed the lead of the First School of Fontainebleu. The style of the *Allegory of Christian Charity,* in particular, can be related back to Rosso's *Moses and the Daughters of Jethro* in Florence, especially in the anatomy of the main figure and the treatment of the draperies. Yet at the same time it makes a curious paradox between the stylized refinement of mannerism and an almost primitive severity in the profile of the main figure. The blue landscape in the upper right background, with a mountain, an obelisk, an arched bridge, and other an-

cient structures, all rendered in a fanciful shorthand style, seems to parallel or perhaps even to anticipate the mannerist landscapes of Niccolò dell'Abbate and Antoine Caron. The *Eva Prima Pandora* was also influenced by Rosso Fiorentino, but there are also suggestions of Leonardo, Andrea del Sarto, and even Dürer, as well as a complicated iconographic programme.

The remainder of Cousin's preserved works, all drawings and prints, are, for the most part, equally problematic. These include an early study for a stained glass window representing Sts. Francis and Jerome (Louvre), an exquisite drawing of small children playing in the midst of ancient ruins (Louvre), and an engraved *Entombment of Christ* (Louvre). Only two of the engravings are signed: an *Annunciation* (Metropolitan Museum, New York) and an *Entombment of Christ* (Vienna, Albertina).

It is regretable that so little is preserved from Jean Cousin's hand. What we do have is indicative of a highly original and subtle artist who might be ranked with the most distinguished painters of his time, but whose full achievement must remain conjectural.

—William R. Crelly

COYSEVOX, Antoine.

Born in Lyons, 29 September 1640. Died in Paris, 10 October 1720. Married 1) Marguerite Quillerier, 1666 (died, 1667); 2) Claude Bourdy, 1679, 11 children. Trained in Paris at the Academy and under Lerambert from 1657; rapid success: became a "sculpteur du Roi," 1666; decorated the palace of Prince-Bishop of Strasbourg at Saverne, Alsace, 1667–71; much work at Versailles from 1679, both in garden statuary and inside (famous for his portrait busts); worked in Lyons, as Assistant Professor, then Professor, at the Academy, and established his own Academic School, 1676–77; settled in Paris again, 1678: taught at the Academy, had a studio at Versailles, and given an apartment in the Louvre, 1698, and pension in 1702; Director of the Academy, 1702, 1704; lived in a house near the Louvre from 1709. Pupils: the Coustous.

Major Collections: Paris: Bibliothèque Sainte-Geneviève, Louvre; Versailles: Château and gardens.
Other Collections: Aranjuez: Palace; Chantilly; Dijon; London: Wallace, Westminster Abbey; Lyons: Saint-Nizier; New York: Metropolitan, Frick; Paris: S. Eustache, Carnavalet, Invalides, S. Roch, Institut de France; Rennes; Serrant: Château.

Publications

On COYSEVOX: books—

Jouin, Henry, *Coysevox: Sa vie, son oeuvre, et ses contemporains,* Paris, 1883.
Keller-Dorian, Georges, *Coysevox: Catalogue raisoné de son oeuvre,* Paris, 2 vols., 1920.
Pocquet du Haut-Jussé, Barthélemy, *Les Aventures d'une statue: Le Louis XIV de Coysevox à Rennes,* Rennes, 1922.
Benoist, Luc, *Coysevox,* Paris, 1930.
Souchal, François, *French Sculptors of the Seventeenth and Eighteenth Centuries: The Reign of Louis XIV,* Oxford, 3 vols., 1977–78.

article—

Kuraszewski, "La Cheminée du Salon de la Guerre au Château de Versailles: Sa création et ses transformations successives," in *Bulletin de la Société d'Histoire de l'Art Français* (Paris), 1974.

*

Antoine Coysevox (he spelled his name Coyzevox) trained in Paris from 1657, notably under Lerambert, a pupil of Sarazin's who was active in the Tuileries and at Versailles and sculpted the famous Allée d'Eau child groups in bronze. Sculptor to the king in 1666, Coysevox was also employed for a time in the service of the prince-bishop of Strasbourg, though his stucco decorations for the Saverne palace have regrettably disappeared. A piece atypical of his work as a whole—a *Virgin and Child*— remains as testimony today of the artist's youthful style.

The terracotta model of this Virgin (Lyons, Musée des Hospices Civils) shows a trace of Italianism coloured by the influence of Jacques Sarazin and the Anguier. Coysevox himself does not seem to have been to Italy. The marble version (c. 1676; Lyons, Saint-Nizier) is a more stable, classical representation with marked contrapposto. Although this work shows clear traces of influence, it already contains characteristics of the artist's mature work: first and foremost, a predilection for the line (for example, *Fidelity,* on Colbert's tomb, or *Virtues,* on Mazarin's) and an attraction to a specific feminine type, both lofty and deliberately inexpressive.

In 1679, "by order of the Academy," Coysevox signed the submission piece, a marble bust of the painter Charles Le Brun (Paris, Louvre; terracotta model in the Wallace Collection in London). In the 17th century it was still customary to select a bas-relief for submission to the Academy, in the manner of Girardon, Le Hongre, and Desjardins. The later statuette by Corneille Van Cleve (*Polyphemus,* 1681) heralded the 18th-century trend in which emphasis was laid on ostentation. Creating a portrait of Charles Le Brun was no bad choice, given the painter's pre-eminence over the entire artistic world of the time. The profound influence which the painter was to exert over the sculptor dated from that time.

Coysevox swiftly established a name for himself as a portraitist with his busts of *Colbert* (1677; marble, Château de Lignières), *Michel Le Tellier* (c. 1677; marble, Paris, Bibliothèque Sainte-Geneviève), *Louis XIV* (1681; marble, Versailles), *Prince de Condé* (c. 1688; bronze, Louvre), and *Jules Hardouin-Mansart* (1698; marble, Bibliothèque Sainte-Geneviève). If *Colbert* is similar in execution to *Le Brun*— similar lack of decorative detail, similar pose, with the head turned towards the right, same fine execution in the expression of authority—the spiritual expression of *Le Tellier* heralds the psychological subtlety of the late portraits, such as *Marie Serre* (mother of the painter Rigaud; 1706; marble, Louvre)

and the architect *Robert de Cotte* (1707; marble, Bibliothèque Sainte-Geneviève). One of Coysevox's last works, the bust of *Louis XV at the Age of Nine* (1719; terracotta, Louvre; marble, Versailles) demonstrates the customary design of his busts—the whole cut off below the torso, arms cut off at the shoulders, the suggestion of some contemporary clothing which never detracts from the expression given to the face; the softness of its features betrays a mellowing of the frequently majestic Louis XIV style in anticipation of the gentler style of the Regency.

Coysevox was the great portraitist of the years 1670–1720, both more sensitive than Girardon and more prolific than Desjardins, but it should not be forgotten that he was also an important funerary sculptor. His *Tomb of the Marquis de Vaubrun and His Wife* (1677–78; marble figures, gilded lead bas-relief, Château of Serrant), in collaboration with Collignon (responsible for the large angel towering over the figures of husband and wife), was in fact conceived by Charles Le Brun. The painter's hand is readily recognized in the bas-relief representing the *Battle of Altenheim*, in which the marquis was killed, a sister work to the *Battles of Alexander*, exhibited at the Salon in 1673. The conception of the funerary monument in France in the last third of the 17th century owed much to Le Brun. It was he and Bernini who created the idea of the dramatic funerary setting, involving in particular the motif of the funerary couch. Coysevox's *Tomb of Colbert* (1685–87; marble, Paris, Saint-Eustache) was executed in collaboration with Tuby; two statues are signed by Coysevox: that of the minister himself, a traditional kneeling figure at prayer, and that of *Fidelity,* accompanied by the dog. If the image of *Colbert* has nothing innovative in its conception, the attendance of the two feminine allegories gives the composition a sense of dynamic movement worthy of the Roman Baroque.

His *Tomb of Cardinal Mazarin* (1689–93, Paris, Institut de France), based on a design by Hardouin-Mansart, has a more static quality: the cardinal (in marble) is kneeling on a sarcophagus; at his feet sit three bronze allegories (*Prudence, Peace*—attributed to Tuby—and *Fidelity),* strongly reminiscent of those of Jacques Sarazin for the monument to Henry II of Bourbon. Here Coysevox shows less innovative spirit than Girardon, whose *Tomb of Cardinal Richelieu* dates from the same time: the idea of having the cardinal lying on his bed and supported by Piety could have been inspired by Le Brun or even by Bernini.

The third sphere of Coysevox's artistic activity lay in his work on buildings and gardens to glorify Louis XIV. In the sphere of monumental and public sculpture, Coysevox executed at least two commissions to rival the work of Girardon and Desjardins. These monuments, both in bronze, are the equestrian statue constructed for the Place Royale in Rennes and a monument for the Hôtel de Ville in Paris. The equestrian statue (erected in 1726 but destroyed during the Revolution) showed the king on horseback according to the Roman prototype of Marcus Aurelius. Two bas-reliefs were saved and are in the Rennes museum. The Paris statue (Paris, Carnavalet) represents a king dressed in classical war dress and standing on a tall pedestal; the two bas-reliefs decorating the sides (also at the Musée Carnavalet) are allegories depicting the king's charity and his fight against heresy.

Apart from his large bas-relief the *Triumph of Louis XIV* in the Salon de la Guerre, it is difficult to see clearly what part

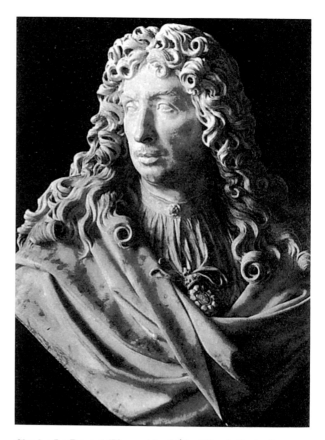

Charles Le Brun, 1679; marble; 43¼ in (65 cm); Paris, Louvre

Coysevox played in fashioning the interior decor of the Château de Versailles, especially that in the Galerie des Glaces (1679–82). His work in the gardens, on the other hand, is better known and of primary importance. He was in fact the main beneficiary of the reorganization of the gardens by Louvois, Colbert's successor, and Hardouin-Mansart. The impressive cosmogony largely sculpted from Le Brun's designs was dispersed, irrespective of subjects, and a new iconographic programme was installed in front of the now extended palace. The new preference was for serious-minded interpretations of subjects from a classical perspective (*Venus crouching, Venus with shell, Garonne, Dordogne, War Vase)* rather than complex allegories drawn from learned manuals.

At Marly, Louis XIV's pleasure residence, Coysevox designed some of his best work: four river groups (1698–1707; marble, Louvre), his Marly horses (1701–02; marble, Louvre), *Renown* and *Mercury,* and the figures of *Faun Playing a Flute, Hamadryad,* and *Flora* (1708–10; marble, Louvre). Together, these works announce a new aesthetic. Indeed, there are traces of rocaille art in these monumental figures with their sometimes precious gestures, their light, dancing poses, and their sinuous folds of clothing clinging close to the body.

The portrait of the young *Marie-Adelaide de Savoie* (1710; marble, Louvre) in the guise of Diana the huntress symbolizes the renewed vitality of the ageing sculptor: the face with its heavy, sullen features still represents a portrait, but the dynamism of the walking figure, the tunic clinging to the body, the mannered gestures of the hands caressing the dog's head and pulling at a curl of hair announce an ease free from the constraints of a programme or a restrictive drawing. Through his

nephews Nicolas and Guillaume Coustou, the heritage of Coysevox was to endure well into the 18th century and permanently enrich it.

—Guilhem Scherf

COZENS, John Robert.

Born in London, 1752; son of the artist Alexander Cozens. Died in London, 1799. Probably a pupil of his father; exhibited water colour landscapes from 1767; trips to Switzerland and Italy, 1776–79; also accompanied William Beckford to Switzerland and Italy, 1782–83; insane from 1793, and under Dr. Munro's care, where he became known to Girtin and Turner.

Collections: Aberdeen; Birmingham; Cambridge; Leeds; London: British Museum, Victoria and Albert, Tate, Soane; Manchester; New Haven; Oxford; Windsor: Castle.

Publications

On COZENS: books—

Bell, C. F., and Thomas Girtin, *The Drawings and Sketches of Cozens: A Catalogue with an Historical Introduction,* Oxford, 1935.
Oppe, A. P., *Alexander and John Robert Cozens,* London, 1952.
Hawcroft, Francis, *Watercolours of Cozens* (cat), Manchester, 1971.
Wilton, Andrew, *The Art of Alexander and John Robert Cozens* (cat), New Haven, 1980.
Sloan, Kim, *Alexander and John Robert Cozens: The Poetry of Landscape* (cat), New Haven, 1986.

*

John Robert Cozens had the advantage of being the son of the 18th century's most innovative practitioner of the medium of watercolor, Alexander Cozens. Alexander was furthermore an accomplished pedagogue, having written several works in the art of watercolor painting. John Robert first exhibited at the Society of Artists as early as 1767. An album of landscape drawings from 1768–72 (National Library of Wales, Aberystwyth) indicates a precociously gifted young man. During these formative years, John Robert made sketching tours of Derbyshire and Suffolk. In 1775 he was commissioned to do two views of Lundy Castle for Francis Grose's *Antiquities of England and Wales* (1772–87). A group of roundel drawings (private collections) of around 1776, illustrating scenes from Milton's *Paradise Lost* and Homer's *Oydssey* are the only testimony of John Robert's experimentation with the more prestigious genre of historical painting. He exhibited his only oil, *Hannibal in His March over the Alps . . .* (now lost), at the Royal Academy in 1776. His failure to sell the oil proved disheartening, and he left soon after on a three-year tour of the Continent with the gentleman scholar and landscape theorist Richard Payne Knight.

The numerous watercolors that document the journey are a contrast between the vast sublimely grand Swiss landscape and the more classically serene Italian *campagna.* John Robert returned to England in 1779, where he worked up the drawings to a more finished state for sale to several patrons, the most notable of whom was the millionaire William Beckford, author of *Vathek,* and a well-known collector. In 1782 John Robert journeyed to Italy in Beckford's entourage and sporadically remained a member of the suite until his return to England 16 months later. Shortly after, relations with Beckford were abruptly broken. Very little is known of his activities thereafter. In 1789 he published 14 soft-ground etchings of trees and auctioned 30 views of Italy and Switzerland. During these years he was most likely in the employment of Sir George Beaumont. In 1794 John Robert became mentally ill and was left in the care of Dr. Thomas Munro, who commissioned the young Thomas Girtin and J. M. W. Turner to copy from the artists' drawings that were entrusted to him. The exposure to one of the masters of the watercolor medium at a formative stage in their artistic development was to have lasting influence on both painters.

—Lynn R. Matteson

CRANACH, Lucas [the Elder].

Born in Kronach, October 1472; son of the engraver Hans Cranach. Died in Weimar, 16 October 1553. Married Barbara Brenghier, 1504 (died, 1541); sons, the painters Hans and Lucas (the Younger), and three daughters. Learned engraving in his father's shop until c. 1498; worked in Vienna, 1500 or 1503–05; in Wittenberg from 1505 as Court Painter to Electors of Saxony: met Luther in this situation, and designed propaganda woodcuts for him; had large shop, and was famous for his portraits; councillor/burgomaster many times until 1544; followed Elector John Frederick I to Augsburg, 1550, and to Weimar, 1552.

Major Collection: Dresden.
Other Collections: Berlin: Dahlem, Charlottenburg; Breslau: Bishop's Palace; Budapest; Chicago; Cleveland; Dessau; Florence; Frankfurt; Gotha: Castle Museum; Hartford, Connecticut; Indianapolis; Innsbruch: parish church; Leipzig; Leningrad; London; Munich; New Haven; New York; Nuremberg; Oslo; Prague; Vienna; Washington; Zurich.

Publications

On CRANACH: books—

Friedländer, Max J., and Jakob Rosenberg, *Die Gemälde von Cranach,* Berlin, 1932, 1979; as *The Paintings of Cranach,* New York and London, 1978.
Thöne, Friedrich, *Cranach Meisterzeichnungen,* Burg bei Magdeburg, 1939.

St. Christopher; woodcut

Lilienfein, Heinrich, *Cranach und seine Zeit*, Bielefeld, 1942.

Lüdecke, Heinz, editor, *Cranach im Spiegel seiner Zeit*, Berlin, 1953.

Thulin, Oskar, *Cranach-Altäre der Reformation*, Berlin, 1955.

Jahn, Johannes, *Cranach als Graphiker*, Leipzig, 1955.

Rosenberg, Jakob, *Die Zeichnungen Cranachs*, Berlin, 1960.

Behrend, Horst, editor, *Cranach, Maler der Reformationszeit*, Berlin, 1967.

John, Johannes, *Cranach: Das gesamte graphische Werk*, Munich, 1972.

Cranach (cat), Coburg, 1972.

Cranach und seine Werkstatt (cat), Vienna, 1972.

Hutter, Heribert, *Cranach in der Akademie der Bildenden Künste in Wien*, Vienna, 1972.

Schwarz, Herbert, *Cranach: Bibliographie*, Kronach, 1972.

Dornik-Eger, Hanna, *Die Druckgraphik Cranachs und seiner Zeit*, Vienna, 1972.

Koepplin, Dieter, *Cranachs Ehebildnis des Johannes Cupinian von 1502: Seine christlich-humanistische Bedeutung*, Basel, 1973.

Staatliche Museen Preussischer kulturbesitz: Gemäldegalerie Cranach, Berlin, 1973.

Feist, Peter, et al., editors, *Cranach: Kunstler und Gesellschaft*, Berlin, 1973.

Koepplin, Dieter, and Tilman Falk, *Cranach: Gemälde, Zeichnungen, Druckgraphik*, Stuttgart, 2 vols., 1974–76.

Schade, Werner, *Die Malerfamilie Cranach*, Dresden, 1974; as *Cranach: A Family of Master Painters*, New York, 1980.

Hintzenstern, Herbert von, *Cranach: Altarbilder aus der Reformationszeit*, Berlin, 1975, 1981.

Bax, Dirk, *Hieronymus Bosch and Cranach: Two Last Judgement Triptychs. . . .* Amsterdam and Oxford, 1983.

Ohly, Friedrich, *Gesetz und Evangelium: Zur Typologie bei Luther und Cranach: Zum Blutstrahl der Gnade in der Kunst*, Munster, 1985.

*

The humanist scholar Melancthon named Dürer, Grünewald, and Cranach as the three greatest German painters. Indeed, these three reflect the diversity of influences at work in Northern painting as the 15th century slipped into the 16th. It can be argued that Cranach was the most characteristic spokesman of his time and place, as his eclectic painting style reflects the turmoil at a time when the fundamentals of human knowledge and experience were enlarged by dramatic challenges to the accepted order of things.

Lucas Cranach the Elder was born in 1472 in Kronach, the town from which his name derives. He came from four generations of painters, and it is not surprising that his family name was originally "Maler," meaning "painter." After the usual apprenticeship, we assume in the shop of his father Hans, Lucas began his travels in 1498. Our first knowledge of him as a mature artist comes in 1500, when he was nearly 30 years old and had gone to Vienna, a renowned center of humanistic study in the 16th century. Here, Cranach produced paintings under the direct influence of the "Danube School" of artists, who utilized dramatic landscape to mirror the cosmic totality of God and Man. His *Crucifixion* (Munich) of 1503 is filled with the drama, emotion, and vibrant color that one also finds in the works of Altdorfer and Baldung Grien. Had Cranach retained his Viennese connections, he doubtless would be remembered today as a strong Danube School painter. However, the search for opportunity and economic stability occasioned by his marriage in 1504 led him toward humanist circles, and he left Vienna for the vital university town of Wittenberg.

In Wittenberg, Cranach was named Court Painter to the elector Frederick The Wise after the Venetian painter Jacopo de Barbari left the post in 1505. A tireless worker, painting was only one of Cranach's concerns. In 1524 we find him running not only a large painting studio employing sixteen assistants, but also owning a wine store, apothecary shop, bookstore, and busy printing press. With the printing shop went a paper business, which satisfied the burgeoning market for Cranach's own prints. It was in printing that Cranach developed the innovative "chiaroscuro woodcut" technique, wherein a second block is printed in color over the first impression. The result was the addition of color and tone to what had been basically a linear medium. Cranach's fame and fortune rose rapidly, and by 1528, he was the richest man in Wittenberg. In recognition for what must have been exceptional intelligence and personal popularity, Cranach was elected to a seat on the Wittenberg city council in 1519 and every year thereafter until 1544. He served a term as mayor from 1537 to 1540, all the while continuing to fill the post of painter, diplomat, and councillor to the German electors while simultaneously satisfying public demand for his paintings and prints. Lucas Cranach was also a busy family man, for his wife, Barbara, bore him two sons and three daughters before her death in 1541.

Cranach's mature painting style departs strongly from the hyper-emotional manner of his Viennese youth. The many courtly portraits and mythological scenes done for the humanist court milieu of the German electors betray a mannered sophistication characterized by rich surface pattern and titillating subject matter (see, for example, the marriage portraits of Henry the Pious and his wife Catherine, 1514, Dresden; and the *Fountain of Youth*, 1550, Berlin). Cranach replaced the depth, natural views, and drama of the Danube School with flattened silhouettes, surface decoration, and insoucient charm in his later works. Part of the reason for the change doubtless arose from the necessities of perpetuating a lucrative atelier employing several trained assistants under the directorship of Cranach's two sons Hans (who died in 1537) and Lucas the Younger. The workshop tradition accounts for some of the more formalized and repetitive features that characterize some of the later works, indicating that the shop mass-produced them to satisfy public demand. Another possible reason for Cranach's departure from the Danube School tradition was his close friendship with Martin Luther, who believed that the main function of religious art was to instruct. The simplicity and didactic force of Cranach's *Crucifixion* of 1532 (Indianapolis), and popular Lutheran propaganda prints like *Confrontation of the True and False Church* (1550) complement the Reformation move toward austerity in religious art.

In sum, it is impossible to represent the painterly output of Lucas Cranach the Elder by a single work. Style and subject matter were dependent upon the intended audience and, in Cranach's case, that audience was extremely diverse. Early in his career, while working in Vienna, he painted in the agitated, hyper-emotional style of the Danube School. Later, as Court Painter in Wittenberg, he satisfied the demands for portraits

and classical subjects indicated by the court of the German Electors. Yet a third way of painting was reserved for the followers of Martin Luther, most of whom were dubious about the place of religious art in their reform movement. Though not as enticing as one of Cranach's hedonistic mythological subjects, these works demonstrate Cranach's awareness of the religious and political intrigues of his day and identify him as a painterly spokesman for the Reformation in Germany.

Cranach's later years were marked with upheaval and dislocation. Having lived and worked for nearly half a century in Wittenberg, he was summoned by the imprisoned Elector John Frederick to Augsburg in 1550 and then to Weimar in 1552. Cranach died the following year at the age of 81. His son Hans continued the workshop, though its painterly products declined in quality after the death of Lucas the Elder. As Melancthon's tribute indicates, Lucas Cranach the Elder was recognized during his own time as a painter of great merit and exceptional industry. Active to the end and beyond, he occupies a well-deserved place among the great figures of Northern art.

—Laurinda S. Dixon

CRESPI, Giuseppe Maria. [Lo Spagnuolo.]
Born in Bologna, 16 March 1665. Died in Bologna, 16 July 1747. Taught by Canuti and Cignani, but influenced by Ludovico Carracci and Guercino; early travels to Venice, Modena, Parma, Pesaro, and Urbino; settled in Bologna by 1690, but also patronized by Prince Eugenio of Savoy and Ferdinando of Tuscany; died blind. Pupil: Pietro Longhi.

Major Collection: Dresden.
Other Collections: Bergamo: S. Paolo d'Argon; Berlin; Birmingham; Bologna: S. Alo, S. Nicola degli Albari, Palazzo Pepoli Campogrande, Museum; Boston; Brussels; Chicago, Cologne: Diocesan Museum; Edinburgh; Florence: Pitti, Uffizi; Kansas City; Leipzig; Leningrad; London: National Gallery, Courtauld; Milan; New York; Ottawa; Rome: Palazzo Venezia; Rovigo: parish church; Turin: Sabauda; Vatican; Vienna; Washington.

Publications

On CRESPI: books—

Voss, H., *Crespi,* Rome, 1921.
Arcangeli, F., Cesare Gnudi, and Roberto Longhi, *Crespi* (cat), Bologna, 1948.
Merriman, Mira Pajes, *Crespi* [in Italian and English], Milan, 1980.

article—

Volpe, C., "Antefatti bolognesi ed inizi di Crespi," in *Paragone* (Florence), 8, 1957.

Reclusive, proud, pragmatic, devout, and obstinate, the Bolognese painter G. M. Crespi, nick-named "lo Spagnoletto" from his simple student's dress, was one of the most independent and forceful personalities in Italian art during the first decades of the 18th century. Crespi was a "universal painter," who worked with ease in a wide range of subject matter—from historical to sacred and from genre paintings to portraits. Regardless of their subjects, Crespi's pictures convey, with broad effects of expression and brushwork, a highly sympathetic vision of humanity based on his close observation of daily life.

Prior to his 20th birthday, Crespi had completed a brief training with A. M. Toni, a very minor artist, and had joined the other students who went every day to S. Michele in Bosco to copy the Carracci school frescoes. His dedication attracted the attention of Domenico Maria Canuti, who took him into his studio for a year or two. Crespi later studied drawing in the academy of Carlo Cignani, the Bolognese *caposcuola,* but Canuti practiced a notably more energetic art. It was Canuti who encouraged the young Crespi in his determination to rediscover and revive the early Baroque styles of Ludovico Carracci and Il Guercino.

Crespi and Giovan Antonio Burrini, a similarly progressive painter, were sharing a studio in the later 1680's, when Crespi had the great good fortune to attract the patronage of Giovanni Ricci, a wealthy merchant. According to Giampietro Zanotti (1736), "They made an arrangement that Crespi would paint for Ricci whenever he had no other commission, and Ricci would buy the painting for a good price." Ricci's patronage included provision for studies outside Bologna; he travelled to Venice, Parma, and Urbino in order to follow in the footsteps of the Carracci, when they studied Veronese, Titian, Correggio, and Barocci. In the process, he rediscovered the Carracesque tradition of genre painting, which had more or less disappeared from the Bolognese school. Zanotti relates this development to Ricci's patronage, "lo Spagnuolo never again wanted for money, and he would make the stories and caprices that came into his imagination. Very often he painted common things, representing the lowest occupations."

Crespi had a lively sense of humor, which he frequently indulged. His two ceiling frescoes in the Palazzo Pepolo Campogrande represent Hercules and other Olympians, but with scant regard for classical decorum. It is obvious that the artist took his greatest pleasure in the ancillary figures of the Four Seasons and the Parcae who are represented in the guise of cheery peasants and nymphs.

By the turn of the century, Crespi's reputation had advanced to the point that he had as many as 30 students in his studio. Giambattista Piazzetta travelled from Venice to come under his influence. The year 1708 was a turning point in Crespi's career, when he was introduced to the patronage of the Grand Prince Ferdinand de' Medici of Florence, a great collector. In visits to Florence in 1708 and 1709, Crespi was encouraged to paint genre scenes and was shown extensive collections of paintings by the Bamboccianti and by Bernhard Keilhau. His masterpiece of this period is *The Fair at Poggio a Caiano,* 1709, in the Uffizi. The death of the Medici Grand Prince in 1713 was deeply regretted, but Crespi continued to paint a wide variety of street scenes, country fairs, laborers, and laundresses in this decade and afterwards.

About 1712, Crespi reached a new level of inventiveness in his series *The Seven Sacraments* (Dresden) painted for Cardi-

nal Ottoboni in Rome. No one before Crespi had endeavored to paint a liturgical rite as an episode of daily life that any visitor to a Catholic church or hospital would be likely to witness.

During the last decades of his career, as his sons grew up and two of them, Antonio and Luigi, became painters, Crespi was a devoted *paterfamilias*. Except to go to daily mass, he rarely went out after his wife's death in 1722. Most of Crespi's later genre pictures are pastorals. His sons often repeated his compositions and motifs, which has given rise to much confusion.

During the 1720's, Crespi became an important painter of altarpieces commissioned from churches throughout Emilian and Tuscany. Religious subjects, rendered with great emotion, increasingly occupied his mind, even for private commissions. Fittingly, however, his last masterpiece, *Saint John of Nepomuk Confessing the Queen of Bohemia,* 1743 (Turin, Galleria Sabauda) is a sacred story cast in the guise of everyday life.

—John T. Spike

CRIVELLI, Carlo.

Born in Venice, c. 1430–35; brother (?) of Vittorio Crivelli. Died in Ascoli, c. 1495. Probably trained in the Vivarini shop in Venice, but influenced also by Padua painters, especially Mantegna; imprisoned for adultery in Venice, 1457, and left the town to work on the mainland: in Zara (now Zadar), Dalmatia, 1465, in the Marches from 1468, mostly in Ascoli Piceno.

Collections: Amsterdam; Ancona; Ascoli: Cathedral; Bergamo; Berlin; Boston: Museum of Fine Art, Gardner; Brussels; Budapest; Cracow; Detroit; London; Massa Fermana: S. Silvestro; Milan; Montefiore dell'Aso: S. Lucia; New York; Paris; Philadelphia; San Diego; Tulsa; Venice; Verona: Castel Vecchio; Washington.

Publications

Rushworth, G. M'Neil, *Crivelli,* London, 1900, 1910.
Drey, Franz, *Crivelli und seine Schule,* Munich, 1927.
Davies, Martin, *Crivelli: The Annunciation,* London, 1947.
Zampetti, Pietro, *Crivelli nelle Marche,* Urbino, 1952.
Zampetti, Pietro, *Crivelli,* Milan, 1961.
Zampetti, Pietro, editor, *Crivelli e i Crivelleschi* (cat), Venice, 1961.
Bovero, Anna, *Tutta la pittura del Crivelli,* Milan, 1961; as *L'opera completa del Crivelli,* 1975.
Davies, Martin, *Crivelli,* London, 1972.

articles—

Friedmann, H., "The Symbolism of Crivelli's *Madonna and Child Enthroned with Donor* in the National Gallery," in *Gazette des Beaux-Arts* (Paris), September-October 1947.

Watkins, Jonathan, "Untricking the Eye: The Uncomfortable Legacy of Crivelli," in *Art International* (Lugano), Winter 1988.

*

Crivelli is interesting to us for the apparent expressive and decorative if not nervous intensity of his work, brought about through his training, as well as his somewhat anxiety-ridden and peripatetic life-style. His characteristic highly polished surface, evoking clearly three-dimensional effects with occasional trompe l'oeil, is achieved with an icy, linear, cross-hatched precision. As they are under the over-arching influence of Andrea Mantegna, Crivelli's works appear close to Ferrarese painting where Cosmè Tura and Francesco del Cossa produced similar but less idiosyncratic images. Crivelli's decorative look and his passion for elaborate, even exquisite detail—including swags of fruit and antique architectural ornamentation—are due to his closeness to Squarcione and Padua, and his non-fashionable interest in the archaic International Gothic. While his metallic, brittle, sculpture-like quality may be an extension of Mantegna's surface, this same sculptural quality, together with certain motifs, such as screaming angels in his Boston *Pietà,* suggests the influence of Donatello's program of interior relief sculpture in Padua.

Yet his career is often presented as a prime example of thwarted development. In 1457, for an apparent adulterous union in Venice, his birth-place, he was jailed for six months; and afterwards he left Venice never to return. His work seems produced with high skill and even enthusiasm—it has been said that his paintings always appear as if Crivelli enjoyed painting them, and he may have had the pleasure of sensing that they were appreciated. Yet they are limited in their invention through the artist's lack of contact with progressive and important art centers—in this case, Venice. His years in Dalmatia and the Marches seemingly froze his style, and in his search for confidence, his works became "virtually a caricature of Paduanism" (Levey) through a piling-up of motifs, including relief gesso surfaces and ultra-sculpturesque volumetric clarity.

As an example of this argument, the 1480's are given as Crivelli's maturity, and yet his most well-known work, *The Annunciation,* 1486 (London), was perhaps his only commission to produce a large-scale perspective stage; he was more often required to paint devotional work such as the *Pietà* or altarpieces in the old-fashioned polyptych format, with separated panels and Gothic foliate carving (e.g., the *Demidoff Altarpiece,* London). Aside from its complex architectural format, *The Annunciation* also offers a Flemish-like interior space, the room of the Virgin, which is filled with a complex still life, apparently intended as a Marian iconographic conceit. Commissioned by Ascoli Piceno, the town in which Crivelli lived, the work possibly reflects a secret visit to Venice: Antonello da Messina's *St. Sebastian* (c. 1478, London) stood in Venice and seems a likely source for the inclusion of a sacred event in the midst of mundane life; also the Flemish qualities of Antonello da Messina's art in the interior setting, with the symbolic resonance of objects, may have been decisive.

Poignantly enough, many of Crivelli's works were signed "Veneti"—that is, Venetian. It is possibly wrong to see this

only sentimentally: Crivelli may have wanted as powerful an incentive for future commissions as possible.

—Joshua Kind

CROME, John.

Born in Norwich, 22 December 1768. Died in Norwich, 14 April 1821. Married Phoebe Berney, 1792; six sons and five daughters, including the artists John Berney, William Henry, Frederick James, and Emily Crome. Apprenticed to the sign painter Francis Whisler, 1783; studied pictures in the collection of his patron Thomas Harvey, 1790's; set up as teacher in Norwich, 1790's; co-founder, Norwich Society of Artists, 1803 (President, 1808); exhibited in Norwich, 1805-21, and in London, 1806-21.

Major Collection: Norwich.
Other Collections: Edinburgh; London: National Gallery, Tate, Victoria and Albert, British Museum, Kenwood, Courtauld; New Haven; New York; Nottingham; Ottawa.

Publications

On CROME: books—

Binyon, Laurence, *Crome and John Sell Cotman,* London and New York, 1897.
Dickes, W. F., *The Norwich School of Painting,* London, 1905.
Theobald, Henry S., *Crome's Etchings,* London, 1906.
Baker, C. H. Collins, *Crome,* London, 1921.
Kaines Smith, S. C., *Crome,* London, 1923.
Mottram, R. H., *Crome of Norwich,* London, 1931.
Clifford, Derek, *Watercolours of the Norwich School,* London, 1965.
Clifford, Derek and Timothy, *Crome,* London, 1968.
Hawcroft, Francis W., *Crome* (cat), London, 1963.
Mallalieu, Huon, *The Norwich School,* London and New York, 1974.
Goldberg, Norman L., *Crome the Elder,* New York and Oxford, 2 vols., 1978.
Hemingway, Andrew, *The Norwich School of Painters 1803-1833,* Oxford, 1979.

*

John Crome is the archetypal Norwich School artist with works of a quality unmatched by the others, Cotman excepted. He was the founder of their organisation, the Norwich Society of Artists, and master of some of the major figures of the school's next generation. Considering that his was the first ever provincial art society in England and their annual exhibitions the first ever such series outside London, he must have had a more substantial personality than the jolly little fellow, half peasant, half artist, which anecdotes try to persuade us to believe. One may find mis-spellings in the very few of his

letters which have survived, but his collection and library could be easily mistaken for that of an intellectual. His easy access to the society of his social superiors suggests a more polished figure, and his rushing to Paris, to see the pictures hoarded together by Napoleon, less of an isolationist than the traditional view of him.

Crome practically never signed and dated his works, and as very few of them can be securely identified with those exhibited in his life time or traced back to early owners, his oeuvre of safely attributed pictures is distressingly small. To make dealing with him more difficult, this small oeuvre is floating—or sinking—in a quagmire of misattribution, copies and imitations far outnumbering his genuine works. However, nothing shows more clearly the power of Crome's art than that this lack of numbers and being swamped by unseemly detritus has not damaged his standing as one of the foremost landscape painters of the 19th century.

We know next to nothing about his artistic beginnings unless apprenticeship to a coachpainter is regarded as such. In spite of the fact that Norwich was almost oversupplied with teachers of art—resident as well as itinerant—in this period, his parents' purse did not hold enough to indulge in luxuries like drawing lessons for their son. He learned by studying the paintings in those private collections to which benevolent owners allowed him access and presumably in the auctions held in the city with surprising frequency. A good many works available in this way were either 17th-century Dutch or 18th-century, that is contemporary, English, and it was on them that Crome trained his eyes and developed a discerning taste in art. Tradition talks about him as a worshipper of Hobbema, which is certainly untrue and applies more to his pupil, James Stark, than to him. However, Crome was undoubtedly an admirer of the Dutch School in a broader sense, and the influence of van Goyen, Cuyp, and Ruisdael, as well as Hobbema, is clearly present in some of his pictures.

The period of his working life about which we know most is a span of 17 years, from 1805 when he started exhibiting, to 1821 when he died. The pre-1805 part of his oeuvre is a conjecture of art historians and lacks reliable evidence. His first firmly identifiable and datable work is the Norwich Museum's *Carrow Abbey,* one of his contributions to the Norwich Society's first exhibition. In spite of repeated cleaning and therefore probable loss of glazes, it is a noble work with Hubert Robert-like manipulation of proportions, a Rembrandtesque shimmer and tone, and a summary treatment, most unusual for the period. Between this painting, a mature work of an artist of 37, and his death at 53, lies an exhibited oeuvre of about 300 works, of which hardly more than a dozen can be dated on relatively firm evidence. No wonder that a Crome chronology is well nigh impossible and the bickering about his pictures' exact dates is a thankless exercise.

While it is clear to the observer that Crome's art is anchored in the 17th century painting of the Netherlands, it is equally obvious that his attitude is an affection towards this school and not a desire to imitate it. Much of the measure of similarity that exists is due to the likeness of the Dutch and Norfolk landscapes, both inland and along the sea front, and of course the similarity of the mental stance of the artist who observes it. Crome, as a rule, contemplates nature in its unspectacular forms and quiet moods. He has no interest in theatrical effects nor in awakening associations. His landscapes do not know

about thunder and lightning and they are usually devoid of landmarks and so offer delicious fodder to those who want to wrangle over the identification of the sites represented. Crome becomes one of the greatest representatives of the "paysage intime" before the term is invented. Paintings like *Norwich River: Afternoon* (private collection) and others, with their emphasis on light and atmosphere instead of subject and detail, belong to the best of their period and help us to an experience much more immediate and charged with the feeling of "here and now" than earlier artists were capable of achieving. Following the path of Crome paintings, one is advancing from the distinguished past to the glorious future of European landscape painting.

—Miklos Rajnai

CUYP, Aelbert.
Born in Dordrecht, October 1620; son of the painter Jacob Gerritsz. Cuyp. Died in Dordrecht, buried 15 November 1691. Married Cornelia Bosman, 1658. Pupil of his father; also influenced by Jan van Goyen, Salomon van Ruysdael, and Jan Both; earliest dated painting is 1639; painted little during the last 25 years of his life (magistrate, 1680–82); landscapes, portraits, poultry: collected particularly by the British in the 19th century.

Major Collections: London: Dulwich, National Gallery, Wallace.
Other Collections: Amsterdam; Antwerp; Berlin; Brussels; Budapest; Cambridge; Cardiff; Dordrecht; Edinburgh; Frankfurt; The Hague; Jerusalem: Israel Museum; Kedleston Hall; London: Kenwood; Manchester; New York: Metropolitan, Frick; Paris; Petworth House; Philadelphia; Pittsburgh; Rotterdam; Salzburg: Residenzgalerie; Toledo, Ohio; Toronto; Waddesdon Manor; Washington; Woburn Abbey.

Publications

On CUYP: books—

Reiss, Stephen, *Cuyp in British Collections* (cat), London, 1973.
Reiss, Stephen, *Cuyp*, Boston and London, 1975.
Veerman, W., J. M. de Groot, and J. G. van Gelder, *Guyp en zijn familie* (cat), Dordrecht, 1977.

*

By common consent, Cuyp is regarded as one of the greatest Dutch painters apart from the trio of Rembrandt, Hals, and Vermeer. Tantalisingly little is known about his life apart from the fact that all his long career was spent in Dordrecht. Not a single picture by Cuyp is dated, and as he worked in almost every one of the genres known in the 17th century, his art presents peculiar difficulties for the specialist, even though it

Two Cows; drawing

is primarily as a landscapist on which his fame rests.

Cuyp's landscapes have some coherent stylistic development in his early years, showing the influence of Jan van Goyen, but as soon as the artist matured there is virtually no way of working out the way in which his art developed. What is certain is that in the last two decades of his life, in the 1670's and 1680's, he painted but little, and that his most ambitious pictures were produced in the 1650's and 1660's.

In popular imagination but not in estimation, Cuyp is seen as the quintessential Dutch painter of cows. These pictures do not dominate the artist's career as much as might be supposed, even though they were among the most frequently imitated in the 18th and 19th centuries. Many of them show cows standing in water with an elegantly cloudy sky in the background. The best known of these cow pieces in *The Large Dort* in the national Gallery, London, which has stormy Italianate overtones, even though Cuyp, unlike many of his contemporaries, never went to Italy.

Many of Cuyp's best pictures fall into categories of which he

executed but few examples. Thus, *The Avenue, Meervevoort* (London, Wallace Collection) acts as a precursor to Hobbema's celebrated *Avenue at Middelharnis* (London, National Gallery).

Perhaps Cuyp's best picture is *The Dordrecht, Sunset* (Ascott, Buckinghamshire), which is one of his two topographical pictures. It shows Dordrecht with shipping, bathed in an evening light. The approach is essentially Romantic, but without the sense of anecdote which characterises so much Dutch painting of the time.

Guyp also painted a number of excellent equestrian pieces, most of whose sitters remain unidentified (examples in Birmingham, Barber Institute, and The Hague, Mauritshuis). He also produced seascapes, battle pieces, poultry pieces, and portraits. These other genres have been little-investigated aspects of his complex art. He remains one of the most versatile artists of his time who has had the misfortune to suffer categorisation as a painter of cows.

—Christopher Wright

DADDI, Bernardo.

Born c. 1290. Died in Florence in 1348. Married; three sons, including the painter Daddo di Bernardo. Pupil of Giotto in Florence, and influenced by the Lorenzetti; member of the Florence painters guild c. 1317, and mentioned in guild records until 1348; large workshop; several large-scale works survive, but also many small pieces.

Collections: Baltimore; Berlin; Boston: Museum, Gardner; Cambridge, Massachusetts; Crespina: S. Michele; Edinburgh; Florence: Uffizi, S. Croce, Orsanmichele, S. Maria del Bigallo; London: Wallace, Courtauld; Naples; New Haven; New York: Metropolitan, Historical Society; Paris; Philadelphia; Pisa; Prato; Utrecht; Washington; York.

Publications

On DADDI: books—

Vitzthum, G. Graf, *Daddi*, Leipzig, 1903.
Offner, Richard, *The Works of Daddi*, New York, 1930.
Bacci, Peleo, *Dipinti inediti e sconosciuti di Pietro Lorenzetti, Daddi, etc. in Siena e nel contado*, Siena, 1939.

*

Bernardo Daddi is—outside of Giotto—one of the most influential painters of the first half of the Trecento. In his Novella no. 136, the late 14th-century author Sacchetti ranked Bernardo with Cimabue and Stefano, yet two hundred years later Vasari had little idea of this artist's identity. It was only in the later 19th century that documentary and artistic evidence were combined to effect his complete resurrection.

According to records of the guild to which Florentine painters belonged, Daddi became a member about 1317. However, no works appear to have survived from this most youthful phase. His importance in the Florentine art world is reflected by his role as one of the first councillors for the painters Company of St. Luke in 1339. In the late summer of 1348, he died intestate, leaving behind his widow and three sons, one of whom (Daddo di Bernardo) was inscribed in the painter's guild in the early 1350's.

Due to a large and productive workshop, the pure artistic identity of Bernardo is extremely difficult to ascertain. Moreover, the preponderance of small-scale paintings in his *oeuvre*, although undeniably important for an understanding of this master, tends to obscure his lost large-scale commissions. There are no less than five predellas ascribed to his hand, one of which—*The Story of the Virgin's Girdle* at Prato—formed part of the high altarpiece for the cathedral of that city. In addition, documents from the 1330's and 1340's attest to three lost panels or altarpieces which may also have been of considerable size.

It is, however, as a painter of an exquisite miniaturist sensibility that Daddi is best remembered. Alone among his peers, he grasped the fragility of common, but precious human interaction, and succeeded in capturing these fleeting events, redolent with multiple shades of emotion, in his art. The joy of recognition that was established among his patrons is proven by the popularity of his portable triptychs and by the existence of followers who continued in his wake well into the second half of the century.

The limits of Bernardo's development can be traced in their broad outline from the rather stiff, albeit spacious, abstractions of the 1320's, dependent on such earlier artist as the St. Cecilia Master, to the volumetric and space-defining figural attempts of twenty years later. Within this span, his sensitivity to almost all major stylistic statements, Sienese as well as Florentine, remained open. Daddi's artistic progression can further be clarified by briefly isolating some works representative of his maturing outlook.

The Madonna and Child with Sts. Matthew and Nicholas of 1328 (Florence, Uffizi) sets the tone upon which Bernardo's *oeuvre* is built. One of the earliest triptychs in Florence, it shows influences from the Sienese in its three-quarter length figures and in the posture of the Child, who gently holds his mother's robe. The flesh of Daddi's figures is possessed of a softly modelled roundness, although the contours which bind them oppose this tendency in their rectilinearity. A most noteworthy aspect of this work for the future is the wordless communication among the figures, who, closely bound by glance and gesture, manifest an ambience of serene adoration against the gold-tooled surface.

Daddi's obvious talent for suggesting the intricacies of human relationships did not, however, translate well to the vigorous and larger than life arena of fresco. In the two scenes depicting events from the life of St. Stephen in the Pulci-Berardi chapel of S. Croce, Florence (c. 1325–1330), the action is weakened by forced geometric symmetries, and the extensive architectural environment, so effective in his small-scale narratives, diffuses further the stories' effect. It is perhaps not accidental that there remains no evidence of additional mural painting in his *oeuvre*.

Instead, Daddi's genius was concentrated on panel, and in

the 1330's he succeeded in imbuing his works with a magical quality that shows no trace of effort. The delicate little panel of *The Enthroned Madonna and Child with Four Saints* (Naples, Museo Nazionale), suffused with a sweet and gentle familiarity, inaugurates a series of such subjects on a small scale, the high point of which is the Bigallo triptych of 1333. Here, a spaciousness and depth only sensed in the Naples work is fully articulated in the central panel of *The Enthroned Virgin and Child*. Daddi's figures have also undergone a decisive revision: rectilinear contours have been exchanged for graceful curves, and the figures, themselves, appear more ample within the environment of the panel. In this period, too, there is a more conscious awareness of Bernardo's instinctive sense of interval and the positive value of the gold background. Witness, for example, the spiritual depth that charges the vast and silent space of *St. Dominic's Vision of Peter and Paul,* a predella scene from a lost altarpiece for S. Maria Novella, Florence (1338; New Haven, Yale).

Around 1340, a trend to the depiction of monumental form, with its space creating properties, begins to be more strongly felt. The lateral saints of the grand polyptych created for the high altar of S. Pancrazio, Florence (Florence, Uffizi), expand to fill their discrete areas, the softly folded draperies indicating a concealed volume; while the ring of angels around the central *Enthroned Madonna and Child* attempts to carve out depth by means of overlapping, solid bodies. The predella scenes also exhibit this new emphasis on mass; here the stories are more concentrated, and the figures brought closer to the observer than before. These tendencies continue to develop in the works and workshop of Daddi, revealing his continued involvement in the evolution of contemporary style as it was developed by Taddeo Gaddi, Maso di Banco, and the Sienese, especially the Lorenzetti.

Of Daddi's latest works, *The Enthroned Madonna and Child with Angels,* painted for the Company of Orsanmichele of Florence (1346–47) possesses the full volumes and massing of the S. Pancrazio altarpiece, while a predella scene depicting *The Worship at the Tomb of the Saints* (Vatican, Pinacoteca), goes farther in the direction of Lorenzettian naturalism and compositional complexity than would have been thought possible ten years before. The signed and dated Parry polyptych of 1348 (London, Courtauld Institute), containing a central *Crucifixion* flanked by four pairs of saints, shows, perhaps, the outside edge of Daddi's style of the 1340's. Squeezed into their narrow frames, the saints and the narrative scene unsuccessfully attempt the forceful presence of epic painting. Yet, this work, executed in large part by assistants, may also serve as a reminder of the Giottesque font of Daddi's continued inspiration, and which he had, countless times, successfully transformed into the more sympathetic language of his own, unique genius.

—Carol T. Peters

DAHL, Johan Christian (Clausen).

Born in Bergen, Norway, 24 February 1788. Died in Dresden, Germany, 14 October 1857. Married 1) Emilie von Block, 1820 (died, 1827), two sons; 2) Amalie von Bassewitz, 1830 (she died 11 months later); one child. Studied with J. G. Müller in Bergen, 1803–09, and with C. A. Lorentzen at the Copenhagen Academy, 1811–17; in Italy, 1820–21; settled in Dresden: Professor at the Dresden Academy, 1824–57; friend of Friedrich.

Major Collection: Oslo.
Other Collections: Bergen; Cambridge, Massachusetts; Copenhagen; Dresden; Goteborg; Hamburg; Lillehammer; Madison, Wisconsin; Schweinfurt; Stockholm; Trondheim.

Publications

On DAHL: books—

Aubert, Andreas, *Maleren Dahl: Et stykke av forrige aarhundres kunst-og kulturhistorie,* Oslo, 1920.
Langaar, Johan H., *Dahls verk,* Oslo, 1937.
Aubert, Andreas, *Die nordische Landschaftsmalerei und Dahl,* Berlin, 1947.
Østby, Leif, *Dahl: Tegninger of akvareller,* Oslo, 1957.
Venturi, Lionello, et al., *Dahl,* Oslo, 1957.
Dahl: 49 reproduksjoner (with English introduction), Oslo, 1957.
Loftus, Else, and Leif Østby, *Dahl of Danmark* (cat), Oslo, 1973.
Malmanger, Magne, editor, *Dahls Dresden: Unstillung* (cat), Oslo, 1980.
Helliesen, Sidsel, et al., *Zeichnungen der Romantik aus der Nationalgallerie Oslo: Caspar David Friedrich, Dahl, August Heinrich* (cat), Zurich, 1985.
Dahl i Italien 1820–21 (cat), Copenhagen, 1987.
Bang, Marie Lødrop, *Dahl: Life and Works,* Oslo and Oxford, 3 vols., 1988.

*

Born into a dependent and poverty-stricken land struggling to find its place in the modern community of nations, Dahl was the first of a series of Norwegians to gain recognition abroad. In his wake followed Ole Bull, Henrik Ibsen, Bjørnstjerne Bjørnson, Edvard Grieg, and Edvard Munch, all contributing significantly to making the 19th century Norway's Golden Age of creativity.

Dahl's training with J. G. Müller combined drawing and design—Müller had studied briefly at the Academy in Copenhagen—with an apprenticeship in house painting lasting for seven years. Through the efforts of a schoolmaster to whom Müller's son had shown some of Dahl's paintings the young, now full-fledged craftsman, received a stipend from the city enabling him to go to Copenhagen where he enrolled at the Academy, becoming a student of C. A. Lorentzen, an artist strongly influenced by Dutch landscape masters. Active in Copenhagen at that time, although not yet attached to the academy, was C. W. Eckersberg, a student of Jacques-Louis David and soon to become Denmark's most influential painter. Dahl's acquaintance with Eckersberg and his art with its classically oriented form softened by limpid Italianate colors was a greater source of inspiration than any academy contact, as evi-

dent in his Danish landscapes from the second decade of the century, e.g., *View over Øresund near the Lime Works* (1818) where a hazy light blue skyscape is reflected in the cerulean surface of the sea. Other works from this period include imaginary landscapes with deep, piney forests, rock formations, and wildly cascading rivers, no doubt reflecting nostalgic thoughts of the homeland yet more directly inspired by similar works by Jacob Ruisdael and even more Ruisdael's contemporary, Everdingen, who is the first artist to have painted in Norway.

In the late summer of 1818, after seven years in Copenhagen, and no return to Norway, Dahl headed for Dresden, not intending to make the splendid Baroque city his permanent place of residence but only to remain as long as inspiration and commissions prevailed: "Although in some respects this nature is pleasant, I find it nevertheless somewhat trivial," Dahl says; "also, one sees too much the traces of human hands and of art, giving it all a forced appearance." However, new friendships and support soon changed his attitude. Especially significant was his contact with Caspar David Friedrich, whose friendship and encouragement would last until Friedrich's untimely death in 1837. "He was very much of the same opinion of art as I am," Dahl confided to his diary, "namely that an art work must first of all have an effect on those devoid of connoiseurship," and this principle of immediate appeal to the viewer is characteristic of most of Dahl's works; more so, in fact, than of Friedrich's, whose moody landscapes invariably reflect the artist's striving for a combination of the real and the spiritual.

In 1820 Dahl was invited by Prince Christian Fredrik, the future King Christian VI of Denmark, to visit him at Quisisana, his palace above the Bay of Naples. From this sojourn, which was to last a year, date a number of Italian landscapes, architectural sketches, and portraits in which the treatment of light and shadow is particularly sensitive. yet even in Italy he continued to create imaginary landscapes with the generic term *Nordic* in their titles. It was only during his visit to Norway in 1826—he had been away for 15 years—that he discovered the genuine, live ruggedness of the land and succeeded in liberating a visual energy that must have been latent in him but confined by academic formalism and tradition. From that time on and steadily fortified by subsequent visits he depicted in the most faithfully realistic mode the primeval grandeur, the spatial depth, and the humble intimacy of the scenes unfolding before him and imprinting themselves on his keen visual memory as he journeyed along the coast and across the mountains. From now on it is no longer imaginary, idealized landscapes in the Dutch tradition he depicts but nature itself, truthfully and unadorned, sometimes intimately as in the weathered timbers of the *Farm at Kroken in Sogn* (1838), more often in a grand sweep of breath-taking space as in *Stalheim* (1842) and *Hjelle in Valdres* (1850), always expressing a love for the scene yet never visually or emotionally out of control. This new realism, poetic yet unsentimental, had great effect on Dahl's German students in Dresden, who in striving for a similar approach to landscape art placed themselves in opposition to an establishment still deeply steeped in a more deliberately expressive Romanticism. Even Friedrich—with whom Dahl shared a house—must have admired the sketches and canvases based on Dahl's Norway travels, for from the late 1820's the German's works become far less rhetorical and more faithful to the actual scene.

Dahl's most enduring influence was of course on his own Norwegian students and on other Scandinavians as well who set out for Dresden to enjoy the friendship and artistic guidance of their distinguished fellow northerner. Considering the absence of any conscious art in Norway prior to the Dahl era and the richness of the field by the 1850's it is understandable that in his homeland he is known as the father of Norwegian painting: "His brilliant career was the pride of his countrymen and at the same time stimulated a new interest in art." And throughout the 19th century his reputation was strictly limited to his particular contribution to the arts of Scandinavia and Germany. More recently, however, through a greatly increased accessibility of his works in a series of international exhibitions, it has been placed in a broader context and viewed as a significant aspect of the development of European landscape art.

—Reidar Dittmann

DALÍ, Salvador (Felipe Jacinto).

Born in Figueras, Gerona, 11 May 1904. Married Gala Eluard, 1934 (died, 1982). Attended Marist Friars School, Figueras, 1914–18; studied under Juan Núñez at Municipal School of Drawing, Figueras, and at the San Fernando Academy of Fine Arts, Madrid, 1922–26; independent artist in Sitges, 1925–30, Paris, 1930–40, United States (mainly in Pebble Beach, California), 1940–48, and in Port Lligat and Figueras, Spain, since 1948; made films with Luis Bunuel (*Un Chien andalou*, 1929, and *L'Age d'or*, 1930), and designed ballets (*Bacchanale*, 1939, *Labyrinth*, 1941, *Mad Tristan*, 1944, *Sentimental Colloquy*, 1944, *Cafe de Chinitas*, 1944, *Le Chevalier remaine et la dame espagnole*, 1961); associated with Surrealist group in Paris; Dali Museums established in St. Petersburg, Florida, and in Figueras. Agent: Knoedler and Co., 21 East 70th Street, New York, New York 10021, U.S.A.

Major Collections: Figueras: Dalí Museum; St. Petersburg, Florida: Dalí Museum.
Other Collections: Amsterdam: Stedelijk; Berlin: Nationalgalerie; Cleveland; London: Tate; New York: Guggenheim, Moma; Paris: Beaubourg; Rotterdam; Zurich.

Publications

By DALÍ: books—

La Femme visible, Paris, 1930.
L'Amour et la mémoire, Paris, 1931.
Babaou, Paris, 1932.
La Conquête de l'irrationel, Paris, 1935; as *The Conquest of the Irrational*, New York, 1935.
Métamorphose de Narcisse, Paris, 1937; as *The Metamorphosis of Narcissus*, New York, 1937.
Declaration of the Independence of the Imagination and the Rights of Man to His Own Madness, 1938.
Hidden Faces, New York, 1944.
The Secret Life of Dalí, London, 1948, 1961.

Fifty Secrets of Magic Craftsmanship, New York, 1948.

Manifeste mystique, Paris, 1951; as *Mystical Manifesto,* New York, 1951.

Dalí's Moustache, with Philippe Halsmann, New York, 1954.

Les Cocus du vieil art moderne, Paris, 1956; as *Dalí on Modern Art: The Cuckolds of Antiquated Modern Art,* New York, 1957.

A Dalí Journal: Impressions and Private Memoirs of Dalí, edited by A. Reynolds Morse, Cleveland, 1962.

Le Mythe tragique de l'Angelus de Millet, Paris, 1963, 1974; as *El mito tragico del "Angelus" de Millet,* edited by Oscar Tusquets, Barcelona, 1978.

Les Diners de Gala, New York, 1963.

Journal d'un génie, Paris, 1964; as *Diary of a Genius,* New York, 1964.

Entretiens avec Dalí, by Alain Bosquet, Paris, 1966; as *Conversations with Dalí,* New York, 1969.

Lettre ouverte à Dalí, Paris, 1966; as *Open Letter to Dalí,* New York, 1967.

Ma rèvolution culturelle, Paris, 1968.

Dalí de Draeger, edited by Max Gerard, Paris, 1968; as *Dalí by Draeger,* New York, 1970.

Dalí par Dalí de Draeger, Paris, 1970; as *Dalí by Dalí,* New York, 1971.

Procés en diffamation, Paris, 1971.

Oui: Méthode paranoïaque: Critique et autres textes, Paris, 1971.

Comment on devient Dalí, with André Parinaud, Paris, 1973; as *The Unspeakable Confessions of Dalí,* New York, 1976.

Dix recettes d'immortalité, Paris, 1973.

Diccionario privado, edited by Mario Merlino, Madrid, 1980.

The Passion According to Dalí, with Louis Pauwals, St. Petersburg, Florida, 1985.

On DALÍ: books—

Soby, James Thrall, *Dalí,* New York, 1946.

Morse, A. Reynolds, *Catalogue of Worlds by Dalí,* Cleveland, 1956.

Morse, A. Reynolds, *Dalí: A Study of His Life and Work,* Greenwich, Connecticut, 1958.

Livingstone, Linda, editor, *Dalí,* Greenwich, Connecticut, 1959.

Morse, A. Reynolds, *A New Introduction to Dalí,* Cleveland, 1960.

Morse, A. Reynolds, *The Dalí Museum,* Cleveland, 1962.

Walton, Paul, *Dalí, Miró,* New York, 1967.

Gerard, Max, editor, *Dalí,* New York, 1968.

Morse, A. Reynolds, *A Dalí Primer,* Cleveland, 1970.

Morse, A. Reynolds, *The Draftsmanship of Dalí,* Cleveland, 1970.

Morse, A. Reynolds, *Dalí: The Masterworks,* Cleveland, 1971.

Descharnes, Robert, *The World of Dalí,* London and New York, 1972.

Morse, A. Reynolds, *Dalí: Catalogue of a Collection: 93 Oils 1917–1970,* Cleveland, 1973.

Dopagne, Jacques, *Dalí,* Paris, 1974, New York, 1976.

Morse, A. Reynolds, *Dalí: A Guide to His Works in Public Museums,* Cleveland, 1974.

Gómez de la Serna, *Dalí,* Madrid, 1977, London, 1984.

Crevel, René, *Dalí, o el anti-oscurantismo,* Barcelona, 1978.

Passeron, René, *Dalí,* Paris, 1978.

Maddox, Conroy, *Dalí,* London and New York, 1979.

Romero, Luis, *Dalí,* Secaucus, New Jersey, 1979.

Abadie, Daniel, *Dalí: Retrospective 1920–1980* (cat), Paris, 1979.

Ades, Dawn, *Dalí,* London, 1983.

Del Arco, Manuel, *Dalí in the Nude,* St. Petersburg, Florida, 1984.

Guardiola Rovira, Ramon, *Dalí y su museo,* Figueras, 1984.

Rojas, Carlos, *El mundo mitico y magico de Dalí,* Barcelona, 1985.

Secrest, Meryle, *Dalí, The Surrealist Jester,* London, 1986.

Gómez de Liaño, Ignacio, *Dalí,* London, 1987.

*

Salvador Dalí has become known in the popular imagination as the painter of Surrealism. Likewise his paintings have become icons of the movement. Dalí's persona revealed an inborn sense of rebellion against all moral order; at the same time, he ceaselessly sought fame. His startlingly lucid images of dream have become accepted. There is more than an ironic paradox in the conflict between moral rebel and an almost slavish pursuit of the cult of one's own personality. There were many aspects of Dalí's character which are similar to those of Andy Warhol. Self-publicity as art is one, and it is ironic that Dalí outlived the younger iconoclast. Dalí's art shared Pop art's willful ambiguity. The critic Aldo Pelligrini noted of Pop art in 1966, "an ambiguous mixture of the revolutionary and the conformist," and noted that Dalí "aims fundamentally at the mystification of the spectator and his art is the art of the showman."

Crucial to Dalí's first Surrealist canvases was his idea of the "paranoiac-critical method," which he developed in 1929. The chief feature of this method of painting was the "double image" or "simulacre," by which Dalí meant an optical illusion where one image reveals another hidden within it. The first painting utilizing the device of the "double image" was entitled *The Invisible Man* (1929–33). André Breton, the leader of the Surrealist movement, enthusiastically embraced Dalí's method, which the latter proclaimed as a radical device in subverting rationality. Throughout the 1930's Dalí sought to "systematize confusion" through such optical devices, but, at the end of the decade, Breton and the Surrealists grew tired of what was increasingly appearing to be a gimmick. Not only had Dalí embraced fascism, and irreverently applied the paranoid critical method to Lenin, but this activity appeared increasingly empty and at the service of Dalí's voracious desire for self-promotion. Breton christened him "Avida Dollars" and later wrote of him, "Monotony, genuine and profound monotony had already been lying in wait for Dalí's work. By dint of always wanting to refine on his paranoiac method, Dalí so reduced the content of his painting that it now resembles a sort of *crossword puzzle.*"

At the age of 12 Dalí first began to draw. In 1922 he went to the Academy of Fine Arts, Madrid, to study painting. Even as a youth Dalí embraced the radical. His father had been an atheist and a republican; Dalí embraced anarchism. Dalí's years at the Fine Art Academy were characterized by rebellion, and it appears much of his efforts were devoted to getting

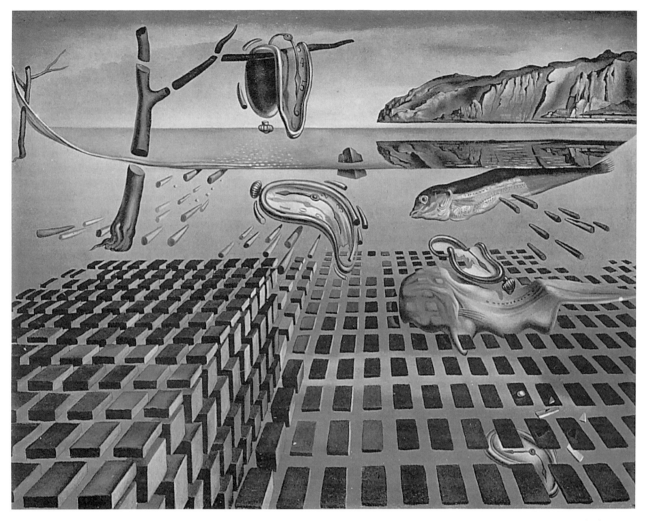

The Disintegration of the Persistence of Memory, 1952–54; 10 × 13 in (25.4 × 33 cm); St. Petersburg, Florida, Dalí Foundation

himself expelled from that institution, an event which finally occurred in 1926.

In contrast to the Academy of Fine Arts, the University Residence had a greater impact on Dalí. There he befriended Federico García Lorca and Luis Buñuel. During this period Dalí experimented with the advanced modern styles of Cubism and Purism. His works were also characterized by the influence of the Catalan Noucentisme. Dalí's *Portrait of Luis Buñuel* (1924) partakes of the realism of this tendency. Surrealism emerged at this time, and this triumvirate can be viewed as the principal artistic figures assimilating its influence in Spain, although Dalí and Buñuel would not become official adherents to the movement until 1929.

While in Madrid, Dalí had assimilated the explorations of Cubism, Surrealism, and other avant-garde movements such as Ultraism. In 1922 Breton lectured in Barcelona and in 1925 Louis Aragon lectured in Madrid at the University Residence. Buñuel had participated in Ultraism tangentially as a contributor to reviews such as *Ultra* and *Horizonte*. On returning to Catalonia in 1926, Dalí resumed such activity in the context of the review *L'Amic de les Arts,* published in Sitges, near Barcelona. Dalí joined with Sebastià Gasch and Lluís Montanyà to form the radical wing of this group. They adopted a Dada-inspired, anti-artistic stance somewhere between Ultraism and

Futurism. In 1928 Marinetti, the leader of Futurism, visited Barcelona and shortly thereafter Dalí, Gasch, and Montanyà signed the leaflet *Catalan Anti-artistic Manifesto* (known also as the *Yellow Manifesto* because of the color of the paper on which it was printed). While written in Catalan, this manifesto called for the abolition of the national dance, the Sardana, and the destruction of the historical, gothic quarter of Barcelona. By the time Dalí joined the surrealists, he was already an *enfant terrible*.

During the Spanish Civil War, Dalí embraced Catholicism and Monarchism. His later paintings reveal a mystical content as is evident in *The Madonna of Port Lligat* (1949) or in *Christ of St. John of the Cross* (1951). Dalí's turn toward a more traditional iconography paralleled a mannered attention to style. Dalí was fond of evoking the great academic masters Raphael, Velàzquez, and Vermeer. As in the case of the mature de Chirico, an interest in technique paralleled this stylistic preoccupation, but Dalí had the technical ability to achieve what eluded the Italian painter. Nevertheless, technical brilliance and stylistic bravado have proven to be both a triumph and stumbling-block, leading one to question the manifestation of any authentic content in Dalí's paintings. Paintings like *Anti-Protonic Assumption* (1956) are hard to take seriously and seem to do more to affirm the painter's virtuosity than his

sincerity. Likewise Dalí's series of society portraits reveal more of a crass commercialism, somewhere between Mannerism and kitsch.

Dalí was one of the more gifted artists of this century and his activities were not confined to the realm of painting. He was a prolific and brilliant writer of numerous books and essays. His earliest writings included insightful criticism which appeared in *L'Amic de les Arts* and in a variety of Surrealist publications in the late 1920's and 1930's. Most famous were his diary-style books, such as *The Secret Life of Salvador Dalí* and *Diary of a Genius,* where fact is embedded in the fiction of Dalí's artificially created persona.

Dalí's contribution to film is perhaps of greater import. In 1929 he collaborated with Buñuel on *Un Chien andalou,* composed of a series of dislocated images arranged in a choppy narrative sequence, which Dalí claimed was devoid of any meaning beyond "a simple recording of images." Most famous among these images are the opening close-up sequence, where a razor blade slices the eye of a woman, and the sequence where a man's efforts at approaching a woman, object of his desire, in the confined space of a room, are hindered by the burden he drags: two pianos laden with rotting donkeys. Attached to the ropes pulling the pianos are two priests, images of the moral bankruptcy Dalí ascribed to the Catholic Church. The former was a shocking assault on the numbed sensibilities of the Parisian avant-garde, proclaiming the presence of dream ("the inner eye"); the latter is one of Dalí's favorite images of "putrefaction." Dalí's second collaboration with Buñuel, *L'Age d'or,* extends the use of anti-clerical imagery and provoked violent protest when it was screened at Studio 28. The most potent of its images was that of the survivors of the orgy at the Château de Selliny based on Sade's *120 Days of Sodom.* Their leader undoubtedly resembles Jesus Christ.

Following *L'Age d'Or,* Buñuel increasingly suspected Dalí of opportunism and their friendship waned. Buñuel fondly remembered Dalí in his memoirs *My Last Breath* (1982): "Despite all the wonderful memories from our youth and the admiration I still feel for much of his work, when I think about Dalí I can't forgive him for his egomania, his obsessive exhibitionism, his cynical support of the Falange, and his frank disrespect for friendship. I remember saying a few years ago, during an interview, that I'd nonetheless like to drink a glass of champagne with him before I died, and when he read the article, he responded, 'Me too. But I don't drink anymore' ''.

—William Jeffett

DAUMIER, Honoré.
Born in Marseilles, 26 February 1808; son of a worker in glass; lived in Paris from 1816. Died in Valmondois, 11 February 1879. Married Alexandrine Dassy, 1846; one son. Messenger for a law courts bailiff, 1820–21; bookshop clerk; studied under the painter and archaeologist Alexandre Lenoir, c. 1822, studied at Académie Suisse, and apprenticed to the lithographer Beliard, late 1820's; cartoonist for *La Caricature,* 1830–35, and *Le Charivari* from 1835: produced some 4000 lithographs; imprisoned 1832–33 for caricature of King Louis Philippe; also did oils, watercolors, and sculptures; friend of

the Barbizon painters; settled in Valmondois, 1865; blind in old age, and received government pension, 1877.

Major Collections: Marseilles; Paris: d'Orsay, Bibliothèque Nationale; Washington.
Other Collections: Baltimore: Museum, Walters; Boston; Cambridge, Massachusetts; Chicago; London: National Gallery, Tate, Courtauld; Munich: Neue Pinakothek; New York: Metropolitan, Brooklyn Museum; Ottawa; Paris: Petit Palais; Pasadena; San Diego; Washington: Corcoran, Phillips.

Publications

On DAUMIER: books—

Fuchs, Eduard, *Daumier: Holzschnitte 1833–1870,* Munich, 1918.

Hausenstein, Wilhelm, *Daumier: Zeichnungen,* Munich, 1918.

Fuchs, Eduard, *Daumier: Lithographien,* Munich, 3 vols., 1920–22.

Escholier, Raymond, *Daumier, peintre et lithographe,* Paris, 1923.

Sadleir, Michael, *Daumier: The Man and the Artist,* London, 1924.

Delteil, Loys, *Le Peintre-gravure: Daumier,* Paris, 10 vols., 1925–30.

Rothe, Hans, *Daumier und der Krieg,* Leipzig, 1926; as *Daumier on War,* New York, 1977.

Fuchs, Eduard, *Der Maler Daumier,* Munich, 1927, 1930.

Bouvy, Eugène, *Daumier: L'Oeuvre gravé du maitre,* Paris, 2 vols., 1933.

Fosca, François, *Daumier,* Paris, 1933.

Roger-Marx, Claude, *Daumier* (cat), Paris, 1934.

Scheiwiller, Giovanni, *Daumier,* Milan, 1936.

Lassaigne, Jacques, *Daumier,* Paris and New York, 1938.

Roger-Marx, Claude, *Daumier,* Paris, 1938.

Courthion, Pierre, and Pierre Cailler, editors, *Daumier raconté par lui-même et par ses amis,* Geneva, 1945.

Faison, S. Lane, *Daumier's Third-Class Railway Carriage,* London, 1947.

Cassou, Jean, *Daumier,* Lausanne, 1950.

Lejeune, Robert, *Daumier,* Zurich, 1952.

Gobin, Maurice, *Daumier sculpteur, avec un catalogue raisonné et illustré de L'oeuvre sculpté,* Geneva, 1952.

Adhémar, Jean, and Claude Roger-Marx, *Daumier: Drawings and Watercolors,* Basel and New York, 1954.

Cherpin, Jean, *Daumier et le théâtre,* Paris, 1958, 1978.

Lemoisne, P. A., and Jean Laran, *Daumier: Lithographies, gravures sur bois,* Paris, 1958.

Mayor, A. Hyatt, *Callot and Daumier,* New York, 1959.

Bechstein, Hanns, *Daumier: Das Parlament der Juli-Monarchie,* Wiesbaden, 1959.

Maison, Karl E., *Daumier Drawings,* New York, 1960.

Mondor, Henri, *Les Gens de médecine dans L'oeuvre de Daumier,* Paris, 1960; as *Doctors and Medicine in the Works of Daumier,* Boston, 1960.

Bowness, Alan, and Karl E. Maison, *Daumier* (cat), London, 1961.

Toothless Laughter, c. 1832; bronze; 6¼ in (16 cm)

Durbé, Cario, *Daumier scultore* (cat), Milan, 1961.

Balzar, Wolfgang, *Der junge Daumier und seine Kampfgefähr-ten: Politisch Karikatur in Frankreich 1830 bis 1835*, Dresden, 1965.

Escholier, Raymond, *Daumier et son monde*, Nancy, 1965.

Larkin, Oliver W., *Daumier, Man of His Times*, New York, 1966, London, 1967.

Roberts-Jones, Philippe, *Daumier: Moeurs conjugales*, Paris, 1967.

Vincent, Howard P., *Daumier and His World*, Evanston, Illinois, 1968.

Adhémar, Jean, *Daumier: Les Gens d'affaires*, Paris, 1968; as *Daumier: Financial and Businessmen*, New York, 1974.

Maison, Karl E., *Daumier: Catalogue Raisonné of the Paintings, Watercolours, and Drawings*, London and Greenwich, Connecticut, 2 vols., 1968.

Wassermann, Jeanne L., *Daumier Sculpture: A Critical and Comparative Study*, New Haven, 1969.

Rossel, André, *Daumier: Oeuvres politiques et sociales*, Paris, 1971.

Cain, Julien, *Daumier: Les Gens de justice*, Paris, 1971; as *Daumier: Lawyers and Justices*, Boston, 1971.

Mandel, Gabriele, *L'opera pittorica completa di Daumier*, Milan, 1971.

Armingeat, Jacqueline, *Daumier: Moeurs politiques*, Paris, 1972.

Armingeat, Jacqueline, *Daumier: Les Gens du spectacle*, Paris, 1973.

Daumier und die ungelöten Probleme der bürgerlichen Gesellschaft (cat), Berlin, 1974.

Armingeat, Jacqueline, *Daumier: Intellectuelles (Bas Bleus) et femmes socialistes*, Paris, 1974.

Armingeat, Jacqueline, *Daumier: Le Chasse et la peche*, Paris, 1975.

Armingeat, Jacqueline, *Daumier: Les Transports en commun*, Paris, 1976.

Schrenk, Klaus, *Daumier: Das lithographische Werk*, Munich, 2 vols., 1977.

Armingeat, Jacqueline, *Daumier: Locataires et propriétaires*, Paris, 1977.

Armingeat, Jacqueline, *Daumier: Les Traces de Paris*, Paris, 1978.

Passeron, Roger, *Daumier, Témoins de son temps*, Fribourg, 1979; as *Daumier*, New York and Oxford, 1981.

Perrot, Jacqueline, *Daumier: Commerces et commerçants*, Paris, 1979.

Mongan, Elizabeth, *Daumier in Retrospect* (cat), Los Angeles, 1979.

Symmons, Sarah, *Daumier*, London, 1979.

Sagot-le Garrec, *Daumier sculpteur*, Paris, 2 vols., 1979.

Cabanne, Pierre, Michèle Gregori, and Michel Leduc, *Les Bustes des Parlementaires par Daumier*, Lausanne, 1980.

Harper, Paula Hays, *Daumier's Clowns: Les Saltimbanques et Les Parades: New Biographical and Political Functions for a Nineteenth Century Myth*, New York, 1981.

Mongan, Agnes, *Daumier: The Armand Hammer Daumier Collection* (cat), Los Angeles, 1982.

Berthold, Margot, and Thomas W. Gaehtgens, *Daumier: Caricaturana*, Paris, 1982.

Fohr, Robert, *Daumier, Georges Rouault* (cat), Rome, 1983.

*

Honoré Daumier occupies a pivotal place in the history of 19th-century art. In his role as political and social caricaturist he drew thousands of wood engravings and lithographs, most of them for two journals, *La Caricature* and *Le Charivari*, between 1830 and 1872. In addition, he made paintings, sculpture, watercolors, and drawings.

Any assessment of Daumier's work must begin with his caricatures. In them, he combined muscular and expressive draftsmanship, insight into human nature and society, and ability to conceive trenchant visual metaphors and symbols. He created comic allegorical figures that embodied an entire era of French politics and society from the beginning of the July Monarchy to the end of the Second Empire. The flourishing bourgeoisie and its self-aggrandizing ways were typified by M. Prudhomme; the greed and get-rich schemes of Louis Philippe's reign were embodied in Robert Macaire, stylish and shameless con-man; Daumier poured his hatred of Louis Napoleon's methods of manipulating the electorate into the serpentine figure of Ratapoil—a sly bully, vote buyer, and what might now be called a political "spin doctor." He was revered in his own time for these inspired inventions: Baudelaire called him a "great" caricaturist and one of the three major draftsmen of the 19th century, along with Ingres and Delacroix.

Like Delacroix, Daumier admired and copied Rubens, and in both his lithographs and paintings he continued the Baroque tradition of vigorous movement in line, dramatic contrast in tone, and active diagonals in composition. Daumier's own legacy can be seen most immediately in the work of Degas. Degas, also keenly interested in the human figure and an observer of the human comedy, collected Daumier's lithographs and studied and adapted the caricaturist's fresh viewpoints and techniques of suggesting movement.

In the 294 paintings listed in Karl Maison's catalogue raisonné and in his more than 800 watercolors and drawings, Daumier extends his mastery of expressive gesture and interaction of figures. His favored subjects—lawyers and courtroom scenes, the theatre audience and actors backstage, clowns and sideshows, Don Quixote and Sancho Panza, working mothers and children, artists in their studios, art collectors—are based on keen observation of his Parisian world. But at the same time they reveal his sympathy with the mid-century search by painters such as Millet and Courbet for new allegorical figures, extracted from contemporary actuality, to suggest new social and political realities, aspirations and issues. Daumier's urban rebel with fist raised in *The Uprising* (Washington, Phillips) is an allegorical figure in the same sense as is Millet's *Sower.* Daumier has often been called a Realist painter because he chose subjects from the urban middle and working classes, but his "realism" is deeply tinged with symbolism as well as romanticism.

Daumier set a significant precedent by overlaying the "low art" of caricature with the "high art" of painting. He carries over into his paintings the habit of a lithographer in his reliance on tone rather than color and the method of a caricaturist in his expressive distortions and his way of using a graphic image to materialize an idea. He transformed the subjects of popular, topical journalism into fine art, and stands at the beginning of a continuing tendency to blur the line—so sharply drawn in his day—between popular and high culture.

As a painter, Daumier was an innovator who wedded an intensely emotional and energetic expressionist style with a symbolic content. He expanded the possibilities for social commentary in painting and anticipated subsequent 20th-century developments in Expressionism.

—Paula Harper

DAVID, Gerard.

Born in Oudewater, near Gouda, c. 1450; son of the painter Jan David. Died in Bruges, 13 August 1523. Married the painter Cornelia Knoop, 1496. Possibly a pupil of Ouwater, or Geertgen, in Haarlem; in Bruges by 1484, when he joined the painters guild (Dean of the guild, 1501): succeeded Memling as the city's leading painter; possibly visited Italy, c. 1503-07, possibly in Antwerp, 1515-21, then back in Bruges; jailed following a dispute with a journeyman, Ambrosius Benson, 1520. Pupil: probably Adriaen Isenbrandt.

Major Collection: Bruges.
Other Collections: Amsterdam; Antwerp; Berlin; Bruges: Notre-Dame; Brussels; Chicago; Cleveland; Detroit; Escorial;

Genoa: Bianco; London; Madrid; New York: Metropolitan, Frick; Paris; Pasadena; Rouen; Washington.

Publications

On DAVID: books—

Weale, William H. J., *David, Painter and Illuminator,* London and New York, 1895.
Bodenhauser, E. F. von, *David und seine Schule,* Munich, 1905.
Friedländer, Max J., *Die altniederländische Malerei, vol. 6: Memling und David,* Berlin, 1928; as *Memling and David* (notes by Nicole Veronee-Verhaegen), New York, 2 vols., 1971.
Boon, K. G., *David,* Amsterdam, 1948.
David (cat), Brussels, 1949.

articles—

Arndt, K., "Davids *Anbetung der Könige* nach Hugovan der Goes: Ein Beitrag zur Kopienkritik," in *Münchner Jahrbuch der Bildenden Kunst,* 12, 1961.
Mundy, A. James, "David's *Rest on the Flight into Egypt*: Further Additions to Grape Symbolism," in *Simiolus* (Utrecht), 12, 1981-82.
Miegroet, Hans J. van, "New Documents Concerning David," in *Art Bulletin* (New York), March 1987.

*

The artist Gerard David was active in Bruges for most of his professional life. In 1484 he joined the Bruges painters guild, and he married the miniaturist Cornelia Knoop in 1496. He appears to have lived principally in Bruges until his death in 1523. He is recorded in Antwerp in 1515 when he joined the painters guild there, presumably to execute a particular commission.

David was born in Oudewater in Holland at some time between 1450 and 1460. It is probable that he received early training from his father, named in early documents as Jan David, a painter in Oudewater. He also is thought to have received training in Haarlem before moving to Flanders. His life and success at Bruges, which had boasted the presence of Jan van Eyck and Petrus Christus earlier in the century, corresponds in time to the commercial decline of the city in favor of Antwerp. Nonetheless, David enjoyed considerable success and contributed mightily to the emergence of 16th-century concepts of painting in Northern Europe.

David's "Dutch" style, resembling and perhaps learned from that of his near contemporary Geertgen tot Sint Jans in Haarlem, was modified in Bruges by the assimilation of Flemish traits from earlier artists of the 15th century including van Eyck and Roger van der Weyden, and from Hans Memling who was still active as the leading painter in Bruges during the first decade of David's career there. But David put his individual skills and adaptive style elements to innovative and expressive use, expounding on what he had learned. His art also shows increasing influence of Italian Renaissance style as his experience broadened.

Gerard served two elected terms on the Bruges painters guild council before 1501 when he became its Dean. In 1498 he made two paintings of the *Judgment of Cambyses* for the city council of Bruges to hang in the council room. This gruesome story of Roman justice was told by Herodotus about the crime and punishment of the unjust judge Sisamnes under the emperor Cambyses. For his acceptance of a bribe, the unfortunate judge was flayed alive. David unflinchingly made the required paintings of the seizure of the judge and the grisly enactment of the sentence. They are now in the Groenige Museum in Bruges.

Most of Gerard David's paintings are religious works of a gentler nature. His most famous is the triptych of the *Baptism of Christ* of 1502–07, also in the Groenige Museum at present. The early painting of *Christ Nailed to the Cross*, c. 1480–85, in London, still shows strong Dutch style and the influence of Dirk Bouts, another artist of Dutch origin who came to Flemish lands a generation earlier. A harsh subject, it is still suffused with characteristic Dutch stillness.

In later paintings David experimented with lowering the horizon and varying the symmetry of his compositions. He used constructed perspective and proportional distancing in the backgrounds, elements that increased the immediacy of the viewer's interaction with the painted space. The *Marriage at Cana* of c. 1503, in the Louvre, the *Mystic Marriage of St. Catherine*, c. 1505, in London, and the *Virgin and Child with Saints*, dated 1509, in Rouen, are among his best large-scale works. There are many small paintings, too. Several versions of the *Rest on the Flight into Egypt* survive, one of the best in the National Gallery in Washington.

—Charles I. Minott

DAVID, Jacques Louis.
Born in Paris, 30 August 1748. Died in Brussels, 29 December 1825. Married Charlotte Pécoul, 1782 (divorced, 1794, remarried, 1796), two sons, twin daughters. Studied under Joseph Vien from 1765; won Prix de Rome, 1774, and lived in Rome, 1775–81; member of the Academy, 1782; Deputy during the Revolution: became dictator of the arts, abolished the Academy, 1793, and helped found the Institut which replaced it; designed public festivals, monuments, etc.; imprisoned briefly; then became ardent fan of Napoleon; left France for Switzerland when Napoleon was defeated, 1814, and retired to Brussels, 1816. Pupils: Gérard, Girodet, Gros, Ingres.

Major Collection: Paris.
Other Collections: Avignon; Berlin: Charlottenburg; Brussels; Cambridge, Massachusetts; Chicago; Cleveland; Dallas; Dublin; Lille; London; Lyons; New York: Metropolitan, Rockefeller Institute for Medical Research; Northampton, Massachusetts; Paris: Musée d'Ecole des Beaux-Arts, Petit Palais; Raleigh, North Carolina; Rouen; Versailles: Museum; Warsaw; Washington.

Publications

On DAVID: books—

Villars, Miette de, *Mémoires de David*, Paris, 1850.
Delécluze, E. J., *David: Son école et son temps: Souvenirs*, Paris, 1855; edited by Jean Pierre Mouilleseaux, Paris, 1983.
David, J. L. Jules, *Le Peintre David: Souvenirs et documents*, Paris, 1880–82.
Cantinelli, Richard, *David*, Paris, 1930.
Humbert, Agnès, *David, peintre et conventionnel: Essai de critique marxiste*, Paris, 1936.
Holma, Klaus, *David: Son évolution et son style*, Paris, 1940.
Dowd, David Lloyd, *Pageant Master of the Republic: David and the French Revolution*, Lincoln, Nebraska, 1948.
Adhémar, Jean, and Jean Cassou, *David: Naissance du génie d'un peintre*, Paris, 1953.
Hautecoeur, Louis, *David*, Paris, 1954.
Lankheit, Klaus, *David: Der Tod Marats*, Stuttgart, 1962.
Gonzalez-Palacios, A., *David e la pittura napoleonica*, Milan, 1967.
Herbert, Robert L., *David, Voltaire, "Brutus," and the French Revolution*, London, 1972, New York, 1973.
Verbraeken, Rene, *David jugé par ses contemporains et la posterité*, Paris, 1973.
Wildenstein, Daniel and Guy, *Documents complémentaires au catalogue de l'oeuvre de David*, Paris, 1973.
Rosenblum, Robert, and Antoine Schnapper, *De David à Delacroix* (cat), Paris, 1974.
Howard, Seymour, *Sacrifice of the Hero: The Roman Years: A Classical Frieze by David*, Sacramento, California, 1975.
Brookner, Anita, *David*, London, 1980.
Schnapper, Antoine, *David: Témoin de son temps*, Fribourg, 1980; as *David*, New York, 1982.
David e Roma (cat), Rome, 1982.
Bordes, Philippe, *Le Serment du Jeu de Paume de David: Le Peintre, son milieu, et son temps de 1789 à 1792*, Paris, 1983.
Nanteuil, Luc de, *David*, New York, 1985.
Crow, T. E., *Painters and Public Life in Eighteenth-Century Paris*, New Haven, 1985.

*

Constrained wrath, a worried-over middle-class materialism combined with sans-souci aristocratic inspiration, and similarly ambivalent attachments to authority and benevolent affection characterized and impelled David's life and work. The fruits of temperament and biography surfaced early in his production. A duel ended the life of David's father when the boy was nine, and an apprenticeship with his generous kinsman François Boucher ended when Mme. Pompadour's protégé realized that for David the perfectionist academicism of Joseph-Marie Vien was a more compatible way, with future promise. Alternately fitful and exhaustive labors under Vien, in Paris, then in Rome, eventually resulted in David's best-known mature idiom, a militant Neoclassicism trumpeted as the first style of the Moderns.

His early history paintings and portraits, echoing Boucher and Franco-Roman artists such as J. B. H. Deshays or J. B.

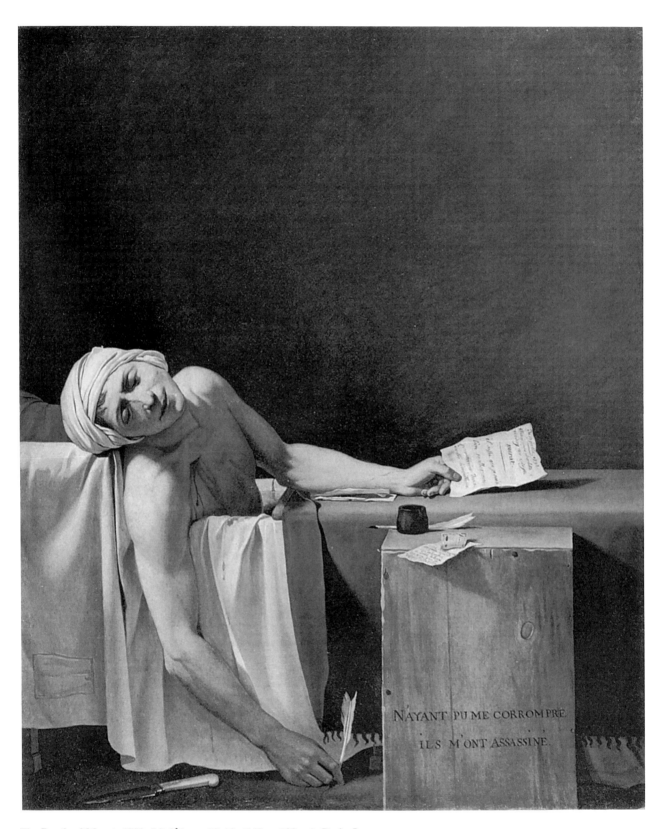

NAYANT PU ME CORROMPRE

ILS M'ONT ASSASSINÉ.

The Death of Marat, 1793; 5 ft 3¾ in × 4 ft 1 in (165 × 128 cm); Paris, Louvre

Greuze, display an accomplished Rococo bravura in line, color, mood, and execution that never wholly vanished from his method (*Seneca*, 1773, *Dr. LeRoy*, 1783, *Lavoisier*, 1788). Facility in the last, feminine style of baroque absolutism, tempered by eclectic studies of noted Italian old-master painters as well as classical sculptures, characterizes his painting in Italy (*Funeral of Patroclus*, 1778, *St. Jerome*, 1779, *St. Roch*, 1780, *Count Potocki*, 1780–81). This crucial period in his development began after he received the Prix de Rome, awarded after four mortifying rejections (*Minerva and Mars*, 1771 [first]; *Antiochus and Stratoniche*, 1774 [winner]). The authoritarian demands of Academy director Vien, "stoic and masculine" examples of Greek and Roman classicists in art, literature, and philosophy (Plato, Plutarch, Poussin, Gavin Hamilton, A. R. Mengs, J. J. Winckelmann, A. P. C. Caylus, G. E. Lessing), the interests of enlightened colleagues (J. F. P. Peyron, F. A. Vincent, J. Lamarie), and crises of affection in his personal life contributed to a radical transformation in David's vision.

Immediately after visiting Antiquity's resurrected city of the dead, Pompeii, in 1779, he adopted a hard and reductive *antico* manner, faithfully synthesizing ancient and modern norms of Classicism. His epic and archaeological subjects in that "pure and moral" New Classic style illustrated themes of virtue and vice filled with contemporary meaning as sociopolitical metaphors of momentous importance to his patrons and viewers (*Funeral Frieze of a Hero*, sketch c. 1780 [?], *Belisarius*, 1781, *Andromache and Hector* [Academy acceptance piece], 1783, *Oath of Horatii*, 1784–85, *Death of Socrates*, 1787, *Paris and Helen*, 1788, *Brutus*, 1789). Taste and talent for mime, drama, narrative exposition, and rhetorical expression; a thoroughgoing humanist and technical training; long practice, reductive genius, and controlled volatility in his work—all gave his images unrivaled power, as they reflected, prefigured, affected, and rallied the visual imagination of his time.

David returned to Paris, worked in a grand studio at the Louvre, and continued successful showings of his Salon paintings, whose importance had already been recognized by Denis Diderot. A marriage was arranged in 1782 with Marguerite Pécoul, daughter of the powerful Director of Royal Building Constructions; two years later, with the support of his father-in-law, David returned to Rome with a studio and family entourage, to paint with avowed authenticity and rigor a grand demonstration of Royalist-sponsored nationalism, reinterpreting the climactic moment implied by Corneille's epic tragedy, *Oath of the Horatii*. This colossal polarizing canvas, theatrically promoting stiff, male civic virtues and warlike, fraternal patriotism at the expense of soft and intimate distaff family ties or compromise, competed in vivid up-to-date terms with his venerable models of Franco-Italian academic Classicism, as well as with the success of works by the deceased founder-leader of Neoclassicism, Anton Raphael Mengs. Its uncompromising nature (axial symmetry, relief-like orthogonal compression, crystalline precision, disciplined ardor, an avant-garde archaeological program, severe yet masterful execution) created a sensation in Rome, where the old classicist Pompeo Batoni ceremoniously awarded David his palette, and then in Paris, where David was essentially enthroned as the principal painter of the King, and all France.

David's fortunes rose with those of the haute bourgeoise,

and his production can be viewed as mirroring its uneasy condition, obliged and archly flattering yet increasingly disaffected in its alliance with the politically disastrous policies of a weakened and dissolute monarchy. Examples of the enlightenment led by the middle class in Europe and America signalled by their successes a revolution in expectation and accomplishment, exposing the power, discontent, and ambition of its members. David avidly supported and illustrated the initial steps taken toward establishing a high-minded representative, republican French government, with its ideal populist credo of *liberté, equalité, fraternité, et patrie*. He became a zealous Jacobin and National Convention Deputy. As President of the Convention, he voted for the execution of Louis XVI; he sketched *Marie Antoinette Taken to the Guillotine* (1793). During the brooding and vengeful Terror, David, in his element, flourished as the Lebrun of his age; he served as a virtual minister-dictator of culture for the Revolutionary government, founding a new national academy, jury, and museum of the arts; he also designed a series of grand antiquarian state pageants, dramatic sets (*Triumph of the French People*, 1793), costumes, uniforms, and furniture, as well as momentous Salon paintings illustrating contemporary acts, attitudes, and events. All helped to establish the legitimizing antiquarian self-image of his new nation and its ruling citizenry.

David's revolutionary works promoted a fresh and idealized sense of history and reportage, enlisted as propaganda in the service of the Republic and to indoctrinate its masses (*Tennis Court Oath*, 1791, *St. Fargeau*, 1793, *Bara*, 1794). The *Death of Marat* (1793), his masterpiece in this idiom, is a quintessentially reduced modern icon that sanctified and white-washed his fellow politician-monster as a Classic-Messianic hero-martyr, afflicted by rashes and ostensibly sacrificed while at selfless work, in a bath of his own blood. The composition of this sublimely poignant and horrific romantic eucharist, a document commemorating the virtues of a new religion of patriotic nationalism, was itself the crystalized distillate of a long tradition of sacred and secular militant pietàs from antiquity, the Renaissance, and the painter's own work, where they had special autobiographic content.

With the fall of Robespierre, David was imprisoned and temporarily turned from "political" illustration (*Luxembourg Gardens Landscape*, 1794). Through the intervention of his estranged wife and his students, he was soon freed, and, using their younger "Hellenic" manner, he effected a rapproachment in his work between competing political and artistic factions in France, adumbrating the subsequent reigns of hypo- and hyper-Romantic Classicisms (*Sabine Women*, 1794–99, *Mme. Recamier*, 1800). Napoleon partly resurrected the dominion of David, an avid Bonapartist, making him First Painter to the Emperor. He commissioned several grand megalomaniac propaganda machines from the legendary icon-maker to celebrate his imperial achievements with unprecedented pomp and circumstance (*Napoleon Crossing the Alps*, 1800, *Napoleon's Coronation*, 1805–1807, *Distribution of Eagles*, 1810, *Leonidas*, 1814). Until Waterloo, David shared a position of authority with Pierre Prud'hon and "artistic lieutenants" from his own immense and influential international studio (F. Gérard, A. L. Girodet, A. J. Gros, J. A. D. Ingres), who expanded upon his idiom, disseminated as *the* nationalist style and lingua franca of taste throughout Europe and its colonies.

With the fall of Napoleon, David fled to Switzerland, then

Belgium. There, in exile, removed from political power and inspiration, he made vacuous antiquarian history paintings (*Cupid and Psyche*, 1817, *Mars and Venus*, 1827) and intimate portraits with an intensity and realism prefigured in earlier studies (e.g., *Pécoul*, 1784, *Sériziat*, 1795: *Mme. Tangry and Daughters*, 1818, *Wolf*, 1820). These works resemble bourgeois-Biedermeier productions made elsewhere on the continent. In absentia, David laid heavy demands for loyalty to the Neoclassic style upon former students, especially his friend, admirer, and heir as Academy director, Baron Antoine Gros. Though often characterized in monolithic terms, David's art and life were extremely complex phenomena. His own bright flame kindled many related and differing lights, against which his remained the standard as first and best, establishing for France and himself a dominion in western arts wrested from Italy and its masters.

—Seymour Howard

DAVIS, Stuart.

Born in Philadelphia, Pennsylvania, 7 December 1894. Died in New York, 24 June 1964. Married 1) Bessie Chosak, 1929 (died, 1932); 2) Roselle Springer, 1938; one son. Attended schools in New Jersey; studied at the Robert Henri School, New York, 1909–12; set up studio in New Jersey, 1912, and then in New York, 1913: exhibited in Armory Show, 1913. Contributed cartoons and drawings to Harpers Weekly and *The Masses*, 1913–16; lived in Paris, 1928–29; taught at Art Students League, New York, 1931–32; painter for Federal Art Project, New York, 1933–39; Editor, *Art Front*, New York, 1935–36; taught at New School for Social Research, New York, 1940–50, and Yale University, New Haven, 1951; Director, Artists Painting Course, 1954–64.

Collections: Bloomington: University of Indiana; Chicago; Detroit; Los Angeles; Minneapolis; New York: Metropolitan, Moma, Guggenheim; Philadelphia: Pennsylvania Academy of Fine Arts; San Francisco: Modern Art; Washington: Hirshhorn.

Publications

By DAVIS: book—

Davis (autobiography), New York, 1945.

On DAVIS: books—

Marsden Hartley and Davis (cat), Cincinnati, 1941.
Davis (cat), Washington, 1945.
Sweeney, James Johnson, *Davis*, New York, 1945.
Arnason, H. H., *Davis* (cat), Minneapolis, 1957.
Goossen, E. C., *Davis*, New York, 1959.
Blesh, Rudi, *Davis*, New York, 1960.
Davis Memorial Exhibition (cat), Washington, 1966.
Arnason, H. H., *Davis*, New York, 1966.
Kelder, Diane, *Davis*, New York, 1971.
Lane, John R., *Davis: Art and Art Theory*, New York, 1978.
Myers, Jane, editor, *Davis: Graphic Work and Related Paintings, with a Catalogue Raisonné of the Prints*, Fort Worth, 1986.
Davis: Sketchbooks (cat), New York, 1986.
Wilkin, Karen, *Davis*, New York, 1987.
Agee, William, *Davis: The Breakthrough Years* (cat), New York, 1987.

*

At 19 years old the youngest artist represented in the influential New York Armory Show of 1913, Stuart Davis fulfilled his early promise by integrating the European aesthetic of synthetic Cubism with specifically American subjects and rhythms. This stylistic development, which he referred to as Colonial Cubism, enhanced his reputation as one of the most intellectually acute and important American artists working in a modern idiom during the 1920's and 1930's. Trained as a painter of narrative urban realist scenes by Robert Henri with whom he studied at New York's Art Students League from the age of 16, Davis was inspired by French Post-Impressionism after his exposure to it at the Armory Show, and it informed his painting after 1914. In the tradition of his father, the art director for the Philadelphia *Press*, Davis worked as an illustrator for the socialist magazine *The Masses* until 1916 and later during the 1930's for the political magazine *Art Front*.

Davis turned toward Cubism during the late 1910's and had advanced a personal method of painting collage-like images of cigarette packaging by 1921. He was the first American artist to elevate the brand products of daily household use as familiar signs of contemporary American culture to the level of art, thus using them to distinquish the particularity of merchandising as an art form in America. His style became more advanced during the following year and he developed his mature personal signature style using flattened fragmented forms of brilliant colors, lettering from signs and billboards, and jazzy syncopated rhythms. These more lyrical and spatially sophisticated Cubist constructions represented subjects of New York City, still life, and the American scene that have the brilliant colors and flattened spaces of advertising posters. In these works he captured the vitality of America in jazzy active compositions that indicate the intense sensory experience of modern America. His wry sense of humor, however, led him to introduce a satirical note to the works indicating that, though American life may be exciting, it is also at base materialistic.

For the entire year of 1927 Davis worked on an experimental series of planar abstract paintings based on synthetic Cubism incorporating the disparate elements of an eggbeater, an electric fan, and a rubber glove. In this series Davis developed more complex and convoluted spaces using lines to define planes floating in space. He concentrated on form and space in the eggbeater pictures, abandoning the topical and topographical grace notes of his earlier Cubist work. Here, as always, his paintings betray their debts to familiar objects from the phenomenal world rather than appearing as images solely from the artist's imagination.

In 1928 Davis went to Paris for a year where he painted street scenes of the city in a more subdued fashion than in his American scene pictures. After his return to the United States in 1929 his style became more abstract than it had been in his

Two Figures and El, 1931; lithograph

earlier work, but he returned to the use of lettering and brilliant colors that had informed his earlier Cubist painting of the 1920's. Davis had utilized lettering in his initial Cubist compositions as the French Cubists had done to create a flattening of the picture plane. For Davis's later work, however, the letters take on graphic spatial characteristics of their own forming an integral part of the abstract design and pattern. As always in Davis's works, the lettering also contains symbolic references to the pictorial images. Influenced by the works of Leger, Davis's works of the 1930's became increasingly monumental and he was able to produce four major public murals during the decade of economic depression, an indication of his pre-eminent position as America's foremost modernist painter. The murals included *Men Without Women*, painted for Radio City, an abstraction for radio station WNYC, *Swing Landscape*, now at the University of Indiana, and the huge *History of Communication* for the 1939 New York World's Fair, which has since been destroyed.

His signature style is best represented by a series of works with ironic titles from the 1940's and 1950's defined in the painting *Colonial Cubism*, (1954; Minneapolis), a synthetic Cubist painting in flat planes of brilliant color that integrates the modern aesthetic of fragmented forms isolated in a floating space with emblems of abstracted colonial buildings and stars from the American flag. *Report from Rockport*, 1940, presents

the jazz rhythms that Davis felt were particular to America in a depiction of the summer art colony at this idyllic village on the coast of Massachusetts replete with its shop fronts and gas pumps. Among the actively dancing shapes, a banner inscribed with the word Seine proclaims the artistic lineage of the summer painters on the Left Bank of the river in Paris. Here the space is activated by vivid colors and Davis's characteristic waving ribbon shapes that direct movement across the surface of the composition.

Like many of the artists of his generation, Davis was concerned throughout his five-decade career to make contemporary American art a specifically innovative and American expression. In the characteristic nationalism of the 1920's he chose to define the native character and advanced intellectual thinking of the time fusing the style of French modernism with familiar American signs and symbols. Using elements of American merchandising such as shop signs and billboards, Davis's poster-like painting presents a humorous look at the underpinnings of American culture. Davis was the most consistently rigorous exponent of a specifically American modern aesthetic between the two World Wars, and his work serves as a bridge between the earliest modernist experiments in America to its later flourishing during the 1950's.

—Percy North

DE CHIRICO, Giorgio.

Born in Volos, Greece, to Italian parents, 10 July 1888; brother of the writer Alberto Savinio (i.e., Andrea de Chirico). Died in Rome, 20 November 1978. Married 1) Raïssa Calza, c. 1925; 2) Isabella Packswer (nom de plume: Isabella Far), 1933. Attended Volos schools; studied drawing with Mavrudis, 1897–99, and with Carlo Barbieri and Gilleron, in Athens, 1899; studied under Bolonakis and Jacobidis at the Polytechnic School, Athens, 1900–06, and at the Academy of Art, Munich, 1906–08; lived in Milan, 1908–10, Florence 1910–11, and Paris 1911–15; served as a clerk in the Italian army, 1915–18; associated with Carlo Carra with Scuola Metafisica, 1917; lived in Rome, 1919–25, and in Paris, 1925–31 (associated with Surrealists); set designer for Diaghilev ballet *Le Bal*, 1929 (later theatre works include *Bacchus et Ariane*, 1931, *I puritani*, 1933, *Protée*, 1938, *Amphion*, 1944, *Dances from Galanta*, 1945, *Don Giovanni*, 1947, *The Legend of Joseph*, 1951, *Apollon musagète*, 1956); divided his time between Paris, Italy, and the United States, then settled in Rome, 1945.

Collections: Athens; Chicago; London: Tate; New York; Philadelphia; Rome: Arte Moderna; San Francisco: Modern Art; Turin: Arte Moderna; Venice: Guggenheim; Zurich.

Publications

By DE CHIRICO: books—

Filippo de Pisis, Paris, 1926.
Piccolo trattato di tecnica pittorica, Milan, 1928.
Hebdomeros, le peintre et son génie chez l'écrivain, Paris, 1929.
1918-25: ricordi di Roma, Rome, 1945.
Une Aventure de M. Dudron, Paris, 1945.
Memoria della mia vita, Rome, 2 vols., 1945-62; as *Memoirs*, London, 1971; as *De Chirico by de Chirico*, New York, 1972.
Commedia dell'arte moderna, with Isabella Far, Rome, 1945.
Poèmes, poesie, edited by Jean Charles Vegliante, Paris, 1981.

Illustrator: *Siepe à nord-ouest* by Massimo Bontempelli, 1924; *Défense da savoir*, by Paul Eluard, 1928; *Le Mystère laïc*, by Jean Cocteau, 1928; *Auf der Galerie*, by Franz Kafka, 1969; *Iliade* by Homer, 1976.

On DE CHIRICO: books—

Vitrac, Roger, *De Chirico et son Oeuvre*, Paris, 1927.
Waldmar-George, *Chirico avec des fragments littéraires de l'artiste*, Paris, 1928.
Soby, James Thrall, *The Early Chirico*, New York, 1941, as *De Chirico*, 1955.
Carriere, Raffaele, *De Chirico*, Milan, 1942.
Lo Duca, G., *De Chirico*, Milan, 1945.
Faldi, Atalo, *Il primo de Chirico*, Venice, 1949.
Bellonzi, Fortunato, *De Chirico*, Rome, 1961.
Hedwig, Werner, *De Chirico: Periodo metafisico*, Paris, 1962.
Sistu, R., *De Chirico*, Rome, 1964.

Far, Isabella, *De Chirico*, Milan and New York, 1968.
Carluccio. Luigi, *De Chirico*, New York, 1969.
Ciranna, Alfonso, *De Chirico: Catalogo delle opere grafiche: Incisioni e litografie 1921-1969*, Milan, 1969.
Schmied, Wieland, *De Chirico* (cat), Milan, 1970.
Bruni, Claudio, *De Chirico: Catalogo generale*, Venice, 15 vols., 1971-83.
Carriere, Raffaele, and L. Cavallo, *De Chirico: L'immagine dell'infinito*, Milan, 1971.
De Chirico by De Chirico (cat), New York, 1972.
Far, Isabella, *De Chirico*, New York, 1976.
Costantini, Costanzo, *De Chirico*, Milan, 1978.
Ballis, Aristide, *De Chirico a fuoco*, Venice, 1979.
Fagiolo dell'Arco, Maurizio, et al., *De Chirico*, Milan, 1979.
Far, Isabella, and Domenico Porzio, editors, *Conoscere de Chirico*, Milan, 1979.
Ragghianti, Carlo Ludovico, *Il caso De Chirico: Saggi e studi 1934-1978*, Florence, 1979.
Ruggeri, Giorgio, *De Chirico: Pictor optimus pinxit*, Bologna, 1979.
Legrand, Gérard, *De Chirico*, Paris, 1975, New York and London, 1979.
Fagiolo dell'Arco, Maurizio, *De Chirico: Il tempo di "valori plastici"*, Rome, 1980.
De Chirico (cat), Rome, 2 vols., 1981.
Rubin, William, editor, *De Chirico* (cat), New York, 1982.
De Chirico (cat), Munich, 1982.
Lista, Giovanni, editor, *De Chirico et l'avant-garde*, Lausanne, 1983.
Martin, Rupert, editor, *Late de Chirico 1940-76* (cat), Bristol, 1985.

*

When the poet Lautréamont compared his English hero's good looks to "the fortuitous encounter on a dissecting table of a sewing machine and an umbrella" he coined for the Surrealists a wholly appropriate phrase. The painter Giorgio de Chirico, for a while another darling of the Surrealist movement, explored the artistic and intellectual possibilities of similar mismatchings in a career of mixed achievement that spanned several decades. The form and content of his paintings are derived from complex and personal sources: Greek-born, the son of a railway engineer and a dominant, sophisticated mother, de Chirico occupied himself with the study of contemporary German art and philosophy (Böcklin, Klinger, Nietzsche), classical and Renaissance painting and sculpture, and Graeco-Roman mythology. He came into his element as an artist of exceptional talent and insight in pre-war Paris, welcomed enthusiastically to the bosom of the avant-garde by the poet Apollinaire.

Paris exerted its liberating influence on de Chirico's hitherto Böcklin-inspired "classical-romantic" style: the artist set out with increasing vigour to assimilate the naive yet menacing world of Henri Rousseau's and Cubism's challenge to representation. Human figures in naturalistically rendered leafy groves were dispensed with in favour, first, of contrived, bejowled self-portraits (e.g., *What Shall I Love If Not The Enigma?*, 1911), then stark city-scapes, empty Italian squares in the dark heat of the afternoon, sparsely populated by classical or 19th-century statues and distant figures casting long

Il condottiere, 1917; drawing; Munich, Staatliche Graphische Sammlung

eerie shadows in the strange light. These and other favoured motifs recur in de Chirico's paintings of the period: facades and arcades, solidly rendered yet paradoxically two-dimensional and sham, structure the composition and collaborate with other objects to create a mistaken illusion of Albertian one-point perspective, orthogonal lines directed, however, anywhere but toward a common vanishing-point. Towers, speeding trains symbolizing departure and the artist's engineer father and the distant coast punctuate and form the horizon; displaced objects—bananas for a banquet, mysterious boxes, fragments of plaster sculptures—provide still-life interest against equally curious backdrops. Colour, predominantly sombre green, red, yellow, and black, is applied in flat, matt, unmodelled areas; the geometry of walls, facades, and squares is relieved by arches, clocks, or the billowing steam of a distant train.

The piazza compositions gradually became dominated, then superseded, by the still-life element and a greater interest in interiors, as in *Portrait of Guillaume Apollinaire,* 1914, in which a masked statue of Orpheus and a fairground target with the profile of Apollinaire dominate the composition, along with two charcoal rubbings of fish and shell moulds symbolizing the mysterious powers of Orpheus, the musical visionary.

What might loosely be termed anthropomorphic forms are explored in the paintings of 1916–17: an arrangement of mathematical instruments and wooden scaffolding is surmounted by a huge paper eye, humorously folded at one corner, in *The Jewish Angel,* 1916, a tribute to the collage works of Picasso and Braque, and a possible source of inspiration for Man Ray's *Indestructible Object,* 1923. De Chirico also adopted the form of the mannequin, anonymous, expressionless, and fettered by strings and wooden supports, alone or in pairs before blackboards scrawled with perspectival diagrams, or in the city.

In 1915 de Chirico left Paris for Florence where he signed up for military service. Later, while recovering in a military hospital, he met the erstwhile Futurist Carlo Carra; and from that time the short-lived movement Pittura Metafisica was born. De Chirico's mannequins and hermetic still lifes proved irresistible to Carra who produced a few of his own and quickly exhibited them in Italy while an irate de Chirico writhed in his hospital bed. From 1920 onwards the artist underwent a change of heart, returning to romantic, Arcadian imagery, painting baroque self-portraits and copying works of previous years. The Surrealists, who had so eagerly embraced the artist and his early work were quick to disown de Chirico in 1926. In the later years old themes were explored; but generally the paintings lacked the precision and clarity of earlier efforts. De Chirico remained interested in the play and power of contrast and incongruity: the valiant Graeco-Roman hero toils in his boat on a hotel carpet in *The Return of Ulysses,* 1968; suns melt from metaphysical interiors and jagged, "cartoon" shadows confront remorseful Orestes, a mythical castle or each other in the battle of dark against light.

—Caroline Caygill

DEGAS, Edgar.

Born Hilaire Germain Edgar de Gas in Paris, 19 July 1834. Died in Paris, 27 September 1917. Attended the Lycée Louis-Le-Grand, Paris; studied under Félix Joseph Barrias, 1853, and in studio of Louis Lamothe, 1854; studied at the Ecole des Beaux-Art, 1855; periods in Italy, 1854–59; set up his own studio, 1859; influenced by Manet from 1862, and by photography; military service, 1870–71; in Louisiana, 1872–73; exhibited in the first Impressionist show, 1874, and in most later ones; also a sculptor; almost totally blind in later years.

Major Collections: Chicago; New York; Paris: d'Orsay.
Other Collections: Berlin; Birmingham; Boston: Museum of Fine Arts, Gardner; Cambridge, Massachusetts; Cleveland; Edinburgh; Frankfurt; London: National Gallery, Tate; Lyons; Minneapolis; New Orleans; New York: Brooklyn Museum; Pau; Pasadena; St. Louis; Toronto; Washington; Williamstown, Massachusetts.

Publications

By DEGAS: books—

Lettres, edited by Marcel Guérin, Paris, 1931, 1945; as *Letters,* Oxford, 1947.
Huit sonnets, edited by J. Nepveu-Degas, Paris, 1946.

On DEGAS: books—

Lemoisne, Paul A., *Degas,* Paris, 1912.
Lafond, Paul, *Degas,* Paris, 2 vols., 1918–19.
Delteil, Loys, *Le Peintre-gravure 9: Degas,* Paris, 1919.
Grappe, Georges, *Degas,* Paris, 1920.
Meier-Graefe, Julius, *Degas,* Munich, 1920, London, 1923.
Rivière, Henri, *Les Dessins de Degas,* Paris, 2 vols., 1922–23.
Coquiot, Gustave, *Degas,* Paris, 1924.
Jamot, Paul, *Degas,* Paris, 1924.
Mason, J.B., *The Life and Work of Degas,* edited by Geoffrey Holme, London, 1927.
Vitry, Paul, *Degas, portraitiste, sculpteur* (cat), Paris, 1931.
Rivière, Henri, *Degas, bourgeois de Paris,* Paris, 1935.
Grappe, Georges, *Degas,* Paris, 1936.
Mauclair, Camille, *Degas,* Paris, 1937, New York, 1941.
Cooper, Douglas, *Pastels de Degas,* Paris, 1938; as *Pastels by Degas,* New York, 1953.
Valéry, Paul, *Degas, danse, dessin,* Paris, 1938.
Rewald, John, Degas: *Works in Sculpture: A Complete Catalogue,* New York, 1944.
Rouart, Denis, *Degas à la recherche de sa technique,* Paris, 1945; as *Degas: In Search of His Technique,* New York, 1988.
Lemoisene, Paul A., *Degas et son oeuvre,* Paris, 4 vols., 1946–49.
Rouart, Denis, *Degas: Les Monotypes,* Paris, 1948.
Borel, Pierre, *Les Sculptures meditées de Degas,* Geneva, 1949.
Browse, Lillian, *Degas Dancers,* London, 1949.
Fèvre, Jeanne, *Mon oncle Degas: Souvenirs et documents inédits,* edited by Pierre Borel, Geneva, 1949.
Rich, D. Catton, *Degas,* New York and London, 1951, concise edition, 1985.

Leaving the Bath, 1891–92; lithograph

Champigneulle, Bernard, *Degas dessins*, Paris, 1952.

Fosca, Francois, *Degas*, Geneva, 1954.

Cabanne, Pierre, *Degas*, Paris, 1957, New York, 1958.

Rewald, John, *Degas Sculpture: The Complete Works*, New York, 1957.

Boggs, Jean Sutherland, *Degas* (cat), Los Angeles, 1958.

Halevy, Daniel, *Degas parle*, Paris, 1960; as *My Friend Degas*, Middletown, Connecticut, 1964.

Boggs, Jean Sutherland, *Drawings by Degas*, New York, 1962.

Rewald, John, and Paul Moses, *Etchings by Degas* (cat), Chicago, 1964.

Kornfeld, Eberhard, *Degas: Beilage zum Verzeichnis des graphischen Werkes von Loys Delteil*, Berne, 1965.

Bouret, J., *Degas*, Paris, 1965.

Byrnes, J.B., and Jean Sutherland Boggs, *Degas: His Family and Friends in New Orleans* (cat), New Orleans, 1965.

Werner, Alfred, *Degas Pastels*, New York, 1968.

Janis, Eugenia Parry, *Degas Monotypes*, Cambridge, Massachusetts, 1968.

Adhémar, Hélène, *Degas* (cat), Paris, 1969.

Minervino, Fiorella, *L'opera completa di Degas*, Milan, 1970.

Crespelle, J.P., *Degas et son monde*, Paris, 1972.

Adhémar, Jean, and Françoise Cachin, *Degas: Gravures et monotypes*, Paris, 1973; as *Degas: The Complete Etchings, Lithographs, and Monotypes*, New York. 1974.

Millard, Charles W., *The Sculpture of Degas*, Princeton, 1976.

Reff, Theodore, *Degas: The Artist's Mind*, New York and London, 1976.

Reff, Theodore, *The Notebooks of Degas: A Catalogue of the Thirty-Eight Notebooks in the Bibliothèque Nationale and Other Collections*, Oxford, 2 vols., 1976.

Roberts, Keith, *Degas*, Oxford, 1976, 1982.

Moffett, Charles S., *Degas in the Metropolitan* (cat), New York, 1977.

Lévêque, Jean Jacques, *Degas*, Paris, 1978.

Muehlig, Linda, *Degas and the Dance* (cat), Northampton, Massachusetts, 1979.

Pickvance, Ronald, *Degas 1879* (cat), Edinburgh, 1979.

Dunlop, Ian, *Degas*, London and New York, 1979.

Keyser, Eugénie de, *Degas: Realité et métaphore*, Louvain, 1981.

Pickvance, Ronald, *Degas* (cat), London, 1983.

Terrasse, Antoine, *Degas et la photographie*, Paris, 1983.

Shackelford, George T.M., *Degas: The Dancers* (cat), Washington, 1984.

Reed, Sue Welsh, and Barbara Stern Shapiro, editors, *Degas: The Painter as Printmaker* (cat), Boston, 1984.

McMullen, Roy, *Degas: His Life, Times, and Work,* Boston and London, 1984.

Adriani, Götz, *Degas: Pastelle, Olskizzen, Zeichnungen* (cat), Cologne, 1984; as *Degas: Pastels, Oil Sketches, Drawings,* New York, 1985.

Brettell, Richard R., and Suzanne Folds McCullagh, *Degas in the Art Institute of Chicago,* New York, 1984.

Kendall, Richard, *Degas 1834-1984* (cat), Manchester, 1985.

Sutton, Denys, *Degas: Life and Work,* New York, 1986.

Lipton, Eunice, *Looking into Degas: Uneasy Images of Women and Modern Life,* Berkeley, 1986.

Pickvance, Ronald, *Degas Drawings,* London, 1987.

Kendall, Richard, editor, *Degas by Himself: Drawings, Prints, Paintings, Writings,* London, 1987, New York, 1988.

Kendall, Richard, *Degas on His Own,* London, 1987.

Thomson, Richard, *The Private Degas* (cat), London, 1987.

Boggs, Jean Sutherland, et al., *Degas* (cat), Paris and New York, 1988.

Thomson, Richard, *Degas: The Nudes,* London, 1988.

Terrasse, Antoine, *Degas,* London, 1988.

Roquebert, Anne, *Degas,* Paris, 1988.

Maheux, Anne F., *Degas Pastels,* Ottawa, 1988.

Gordon, Robert, and Andrew Forge, *Degas,* New York and London, 1988.

*

One of the founders and staunch members of the Impressionist group, Degas eschewed the *plein-air* aesthetic and remained a devoted admirer of Ingres's drawings throughout his life. Although he dabbled in socialist clubs in 1870, he adopted a conservative, anti-semitic, and militaristic nationalism by the time of the Dreyfus affair in the 1890's. Critics and historians of a conservative bent have called Degas a "reluctant modernist," someone caught between the demands of "revolutionary" formal novelty and conservative admiration for old masters and the ancients. Others taking a more leftist social perspective have pointed to the artist's seeming insecurity about technological, economic, and political changes in French society. Lipton in particular has characterized Degas and his art as having one foot in an old-fashioned, conservative world that was fast disappearing and the other in the social confusion and rapidly shifting values of modern life. Diverse assessments of Degas nevertheless seem to agree on the contradictory nature of his art, which has been interpreted from formalist, biographical, iconographic, cultural, sociopolitical, feminist, and deconstructionist points of view. These approaches can both overlap and conflict with one another. Lemoisne's catalogue of Degas's paintings, Adhémar and Cachin's catalogue of his prints, and Reff's catalogue of his notebooks provide necessary foundations for other kinds of investigations.

The formalist approach to Degas began during his own lifetime with assessments by critics who were struck by his innovative technical strategies and with statements by Degas himself, who characterized his art as an artificial construct. This construct seems simultaneously to have addressed the "objective" description of modern life and the demands of modernist picture-making. Degas's technical experimentation with *peinture à l'essence,* drawing, pastel, etching, lithography, monoprints, sculpture, and color in various media has been studied by, among others, Reff, Callen, Boggs, Dunstan, Janis, Reed and Shapiro, Rewald, Millard, and Kendall. Degas's voluminous copies after the old masters, especially in his notebooks in the Bibliothèque Nationale, Paris, have been extensively catalogued and discussed by Boggs and especially Reff. Degas's formal penchant for asymmetrical cropping, odd segmentalization, and spatial tilting and distortion has been related in various ways to Japanese prints, journalistic illustration, and photography by historians including Reff, Isaacson, Varnedoe, Janis, and McCauley. Lipton and Callen, however, have argued that Degas's spatial strategies, especially in his representations of women, should be interpreted as expressive of social meanings related to relations of power and gender—issues to which we shall return shortly.

Aside from Degas's seductive form, the myth of his troubled and cantankerous personality, punctuated by his acerbic *bon mots,* has attracted many interpreters to engage in biographical exposition. McMullen for one has explored Degas's class background, pointing out that Degas's family evidently acquired its coat of arms, not through inherited aristocracy, but rather through the "spontaneous ennoblement" that was fashionable among the *grande bourgeoisie* of the July Monarchy. This background, along with the bankruptcy and liquidation of Degas's father's bank in 1874 and related family financial problems, are seen as key biographical facts and events affecting his equivocal view of the bourgeois world. Fevre, Rewald, Boggs, Lipton, and Reff have written of the artist's relationships with friends (see his *Self-Portrait with Evariste de Valernes,* c. 1865, Musée d'Orsay, Paris) and family in France (for example, *Lorenzo Pagans and Auguste De Gas,* e. 1871–72, Musée d'Orsay, Paris), in Italy (*The Bellelli Family,* 1858–67, Musée d'Orsay, Paris), and in New Orleans (*Portraits in an Office, New Orleans,* 1873, Musée des Beaux-Arts, Pau; *Portrait of Estelle Musson,* 1872, New Orleans Museum of Art). Nicolson, Broude, McMullen, and others have explored the myth of his supposed misogyny. Koshkin-Youritzin and Thomson have focused respectively on his irony and sense of humor, while Kendall has explored the effects of his damaged eyesight. Degas's various personal traits are seen by these authors as inflecting his art in particular ways.

Iconographic studies of Degas's work include explorations by Pool, Salus, Nochlin, Loyrette, and others of his early history paintings, including *La Fille de Jephté,* c. 1859–61 (Smith College Museum, Northampton, Massachusetts), *Semiramis Founding Babylon,* c. 1860–62 (Musée d'Orsay, Paris), *Young Spartans,* c. 1860–62 (National Gallery, London), and *Scene of War in the Middle Ages,* 1865 (Musée d'Orsay, Paris). Iconographic accounts of Degas's depictions of modern life in his middle and later career inevitably overlap with cultural and social approaches.

In tracing linkages between Degas's work and the culture of his time, Broude and Vitali have pointed to the artist's connections with the Italian proto-impressionist painters known as the Macchiaioli. Reff has explored Degas's numerous friendships with contemporary writers like Duranty, Mallarmé, and Valéry and his frequent iconographic inspiration by naturalist lit-

erature including works by Zola (for example, *Interior,* 1868–69, Philadelphia Museum of Art, or the series of laundresses), the Goncourt (*Miss La La at the Cirque Fernando,* 1879, National Gallery, London, and illustrations of *The Prostitute Elisa,* 1877), Huysmans (monoprints of prostitutes), and Ludovic Halévy (illustrations of *The Cardinal Family,* 1878). Accounts by Browse, Mayne, Pickvance, Reff, Muehlig, and Shackelford document Degas's countless representations of the opera ballet (ranging from the precise modernity of *The Dance Class,* 1871, Metropolitan Museum of Art, New York to the fragmented modernism of *Dancers at the Bar,* c. 1900, Phillips Collection, Washington). Another motif of both sordid and gaudy urban entertainment frequently depicted by Degas in the 1870's—that of the café and café-concert—has been examined by, among others, Pickvance and Shapiro (for example, *L'Absinthe,* 1875–76, Musée d'Orsay, Paris, and *The Café-Concert at Les Ambassadeurs,* c. 1876, Musée des Beaux-Arts, Lyons). Sutton and others have written of Degas's favorite motif of suburban entertainment, the racetrack (ranging from *In Front of the Tribunes,* c. 1866–68, Musée d'Orsay, Paris to *Racehorses in a Landscape,* 1894, Thyssen-Bonemisza Collection, Lugano).

Dega's favored themes of *haut-bourgeois* entertainment, including the ballet and the racetrack, along with the more lower-class café-concert singers, *rats* (young dancers backstage), laundresses, milliners, prostitutes, and nude bathers of sometimes indeterminate class, have in recent years inspired interpretive approaches which are more sociopolitical, feminist, and often Marxist. Building on the work of Janis, historians including Clayson, Gronberg, Lipton, and, to a lesser degree, Thomson, have focused critical attention on Degas's representation of gender, specifically the apparently de-eroticized sexual commerce portrayed in his prostitute monoprints and in his various scenes of prostitutional *femmes de brasserie.* Lipton in particular has further explored the social groundings and ramifications of Degas's "uneasy images" of women at the racetrack, dancers, milliners, and bathers—all of which she interprets as ambiguous commentaries on the sexual availability of the subjects and the disruption of that availability. From a Marxist-feminist perspective, she debates the question of Degas's expressed social criticism—and/or lack thereof—in the face of the dominant social and sexual ideologies of his day.

The consideration of Degas's sexual ideology has led to more postmodern interpretations of his bathers and prostitutes by Bernheimer and especially Armstrong. By conflating Lacanian and deconstructionist readings, these feminist critics find in Degas's formal tensions, social conflicts, and seeming impenetrability a paradigmatic case for the expounding of their new critical methods. Armstrong, for example, discursively appreciates one of Degas's bathers (c. 1890–94, private collection) for its obstinate refusal of closure: "Thus the means of graphic and painterly definition of surface and form are disassembled, transformed into a constitutive field that will not hold together." In a similar vein, Bernheimer finds that Degas's prostitute monoprints, with their problematic construction of the gaze, oscillate inconclusively among several contradictory readings of sexual relations of power. Surely the multiplicity and open-endeness of such critical and historical interpretations of Degas attest to the complex ambiguity and richness of his art.

—M. R. Brown

de KOONING, Willem.

Born in Rotterdam, Netherlands, 24 April 1904; emigrated to the United States, 1927. Married Elaine Marie Catherine Fried, 1943; one daughter. Studied under Jongert at the Academy of Fine Arts and Techniques, Rotterdam, 1916–24, 1926–27; apprentice to commercial artists Jan and Jaap Gidding, Rotterdam, 1916; assistant to Rotterdam department store art director Bernard Romean, 1920–23; house painter, Hoboken, New Jersey, 1927; then settled in New York, 1927: commercial artist: painter for Federal Art Project, New York, 1935–39; shared studio with Arshile Gorky, 1937; taught at Black Mountain College, North Carolina, 1948, and Yale University, New Haven, 1950–51, 1959–60. Address: c/o Xavier Fourcade, 36 East 75th Street, New York, New York 10021, U.S.A.

Collections: Amsterdam; Chicago; London: Tate; Munich: Bavarian Museum; New York: Moma, Guggenheim, Whitney, Metropolitan; Paris: Beaubourg; Pittsburgh; Washington.

Publications

On de KOONING: books—

Greenberg, Clement, *de Kooning* (cat), Boston, 1953.
Hess, Thomas B., *de Kooning* (cat), New York, 1955.
Hess, Thomas B., *de Kooning,* New York, 1959.
Janis, Harriet, and Rudi Blech, *de Kooning,* New York, 1960.
Stone, Allan, *de Kooning—Newman* (cat), New York, 1962.
Goodman, Merle, *"Woman" Drawings by de Kooning* (cat), Buffalo, 1964.
Hess, Thomas B., *de Kooning: Recent Paintings* (cat), New York, 1967.
Hess, Thomas B., *de Kooning* (cat), Amsterdam, 1968.
Carandente, Giovanni, *de Kooning: Disegni* (cat), Spoleto, 1969.
Drudi, Gabriella, *de Kooning,* Milan, 1972.
Hess, Thomas B., *Drawings of de Kooning,* Greenwich, Connecticut, and London, 1972.
Garson, Inez, *de Kooning at the Hirshhorn Museum and Sculpture Garden,* Washington, 1974.
Larson, Philip, and Peter Schjedahl, *de Kooning: Drawings, Sculpture* (cat), Baltimore, 1974.
Rosenberg, Harold, *de Kooning,* New York, 1974.
de Kooning (cat), Palm Beach, Florida, 1975.
de Kooning (cat), Amsterdam, 1976.
Forge, Andrew, *The Sculpture of de Kooning, with Related Paintings, Drawings, and Lithographs* (cat), London, 1977.
Schman, Sanford, editor, *de Kooning 1969–1978* (cat), Cedar Falls, Iowa, 1978.
Waldman, Diane, *de Kooning in East Hampton* (cat), New York, 1978.
Arkus, Leon, et al., *de Kooning* (cat), Pittsburgh, 1979.
Rosenberg, Harold, *de Kooning* (cat), New York, 1979.
Wolfe, Judith, *de Kooning: Works from 1951–1981* (cat), East Hampton, New York, 1981.
Rosenblum, Robert, et al., *de Kooning* (cat), New York, 1983.
de Kooning (cat), Amsterdam, 1983.
de Kooning: Skulpturen (cat), Cologne, 1983.
Gaugh, Harry F., *de Kooning,* New York, 1983.

Untitled, 1975; 6 ft 8 in × 5 ft 10 in (203.2 × 177.8 cm); Courtesy Xavier Fourcade Inc.

Cummings, Paul, *de Kooning: Retrospektive* (cat), Munich, 1984.

Waldman, Diane, *de Kooning*, New York and London, 1988.

*

When Willem de Kooning left the Netherlands to come to New York in 1926, he brought with him a firm grounding in artistic techniques, acquired from eight years of rigorous training at the Rotterdam Academy. His skill in painting and especially drawing are evident in his early works from the 1930's, which included both figural paintings and portraits, as well as biomorphic abstractions, an interest he shared with his good friend and fellow painter Arshille Gorky. Although de Kooning was not as taken with the mythic and primitivist elements of Surrealism as his contemporaries Pollock and Rothko were, he did turn to techniques of automatism by the 1940's, when he began to synthesize Cubist fragmented forms with Surrealist ambiguity and unpremeditation.

Between 1946 and 1949, de Kooning produced a series of black and white abstract paintings whose densely packed forms and lines interlock so completely that neither black nor white can be read as figure or ground. In *Light in August* (Tehran), for example, black forms that seemingly rest on a white ground suddenly recede beneath other white areas and lines that bound and cross over them. The result is a dynamic interaction of lines and shapes that vigorously defy spatial logic. Although this ambiguity between black and white in this painting has been shown to have parallels in and perhaps derive from William Faulkner's 1932 novel, *Light in August,* most of the paintings of this period defy any direct narrative or figural associations. Unlike Pollock's classic drip canvases of the late 1940's, with skeins of paint that hover gracefully over the infinite space of the canvas, de Kooning's black and white paintings display a more muscular, vehement painterly gesture.

By 1950, de Kooning had emerged as a leader of Abstract Expressionism; his painting *Excavation* (Chicago) was chosen for exhibition at the Venice Biennale in that year, and he clearly seemed to be a major force in American abstract painting. Shortly after *Excavation* left his studio, he began work on a painting that would defy these expectations. *Woman I* (New York, Moma), completed in 1952, surprised critics, who questioned the artist's return to figural painting. The female figure, however, would remain a mainstay of the artist's artistic production. Along with de Kooning's other paintings of women, *Woman I* owes a debt to Pablo Picasso's creative distortions of the female form and to Chaim Soutine's looser, gooier surfaces. As with his earlier paintings, the artist used collage techniques and overlaid drawing to piece together a finished work. Nevertheless, it is the violent gestural paint application that gives the paintings of the *Woman* series a ferocity that borders of the demonic. With their staring eyes, enormous breasts, and toothy grins, de Kooning's women belong to a long line of representations of women as goddesses and destroyers. As the critic Sidney Geist commented in 1953, "Her image exists in the vast area between something scratched on the wall of a cave and something scratched on the wall of a urinal."

By the mid-1950's, de Kooning also turned to highly abstracted landscape subjects. As with the paintings of women, de Kooning's powerful, almost brutal brushstrokes create a physical intensity that depends more on the act of painting than

on the ostensible subject. Other works of this period move toward greater abstraction. In paintings like *Easter Monday* (1956; New York, Metropolitan) the artist used newspaper transfer imagery overlaid with bold colors and slashing brushstrokes to produce a dynamic overlapping of forms and space that, as in the earlier black and white paintings, defy spatial orientation. After moving to The Springs, near East Hampton, Long Island, in 1963, de Kooning's palette became increasingly brighter and his stroke more curvilinear. Landscapes and male and female figural subjects emerge from aggressively painted, turbulent surfaces.

In 1969 the artist began to experiment with sculpture, modelling figures in clay and then casting them in bronze or polyester resin. Together with his paintings of the 1970's and 1980's, these works signal de Kooning's continuing exploration of process and its evocative qualities.

—Kirsten H. Powell

DELACROIX, (Ferdinand Victor) Eugène.

Born in St.-Maurice-Charenton, 26 April 1798. Died in Paris, 13 August 1863. Attended Lycee Louis-le-Grand, 1806; pupil of Baron Guerin, 1815; influenced by Géricault; exhibited from 1822; visited England, 1825, and North Africa, 1832; commissions for decoration of public buildings from the mid-1830's (Rouen Town Hall, 1840, Salon d'Apollon in Louvre, 1849, S. Sulpice, 1857–60, etc.); friend of Bonington and Baudelaire.

Major Collection: Paris.
Other Collections: Baltimore: Museum of Art, Walters; Bordeaux; Boston: Museum of Fine Arts, Gardner; Chicago; Copenhagen; Florence; Hartford, Connecticut; Lille; London: National Gallery, Wallace; Lyons; Nancy; Paris: Carnavalet; Princeton, Rouen; Sao Paulo; Stockholm; Toulouse; Tours; Washington: National Gallery, Phillips, Corcoran.

Publications

By DELACROIX: books—

Oeuvres littéraires: Etudes esthetiques, Essais sur les artistes celebres, edited by Elie Faure, Paris, 2 vols., 1923.
Journal, edited by André Joubin, Paris, 3 vols., 1932; New York, 1937; selection, edited by Hubert Wellington, London, 1951, Oxford and New York, 1980.
Correspondance générale, edited by André Joubin, Paris, 5 vols., 1935–38; *Selected Letters,* edited by Jean Stewart, New York and London, 1971.
Lettres intimes, edited by Alfred Dupont, Paris, 1954.

Illustrator: *Faust,* by Goethe, 1828.

On DELACROIX: books—

Baudelaire, Charles, *L'Oeuvre et la vie de Delacroix,* Paris, 1863; as *Delacroix: His Life and Works,* New York, 1947;

Royal Tiger, 1829; lithograph

also included in *The Mirror of Art*, London, 1955, New York, 1956.

Delteil, Loys, *Le Peintre-gravure 3: Ingres et Delacroix*, Paris, 1908.

Meier-Graefe, Julius, *Delacroix: Beiträge zu einer Analyse*, Munich, 1913, 1922.

Moreau-Nélaton, Etienne, editor, *Delacroix raconté par lui-même*, Paris, 2 vols., 1916.

Signac, Paul, *De Delacroix au néo-impressionisme*, Paris, 1921.

Escholier, Raymond, *Delacroix, peintre, graveur, ecrivain*, Paris, 3 vols., 1926–29.

Courthion, Pierre, *La Vie de Delacroix*, Paris, 1927.

Planet, Louis de, *Souvenirs de travaux de peinture avec Delacroix*, edited by André Joubin, Paris, 1929.

Hourticq, L., *Delacroix*, Paris, 1930.

Joubin, André, *Voyage de Delacroix au Maroc*, Paris, 1930.

Huyghe, René, *Delacroix* (cat), Paris, 1931.

Piot, R., *Les Palettes de Delacroix*, Paris, 1931.

Escholier, Raymond, *Delacroix et sa consolatrice*, Paris, 1932.

Badt, Kurt, *Delacroix Drawings*, Oxford, 1946.

Cassou, Jean, *Delacroix*, Paris, 1947.

Florisoone, Michel, *Delacroix*, Paris, 1947.

Kehrli, J. O., *Die Lithographien zu Goethes "Faust" von Delacroix*, Berne, 1949.

Lassaigne, Jacques, *Delacroix*, New York, 1950.

Christoffel, U., *Delacroix*, Munich, 1951.

Serullaz, Maurice, *Delacroix: Aquarelles du Maroc*, Paris, 1951.

Berger, K., *Delacroix*, Vienna, 1952.

Sérullaz, Maurice, *Les Dessins de Delacroix au Musée du Louvre*, Paris, 1952.

Huyghe, René, *L'Esthetique de L'individualism à travers Delacroix et Baudelaire*, Oxford, 1955.

Horner, Lucie, *Baudelaire critique de Delacroix*, Geneva, 1956.

Bazin, Germain, *Delacroix* (cat), Venice, 1956.

Sérullaz, Maurice, *Delacroix: Album de croquis*, Paris, 2 vols., 1961.

Sérullaz, Maurice, *Les Peintures murales de Delacroix*, Paris, 1963.

Sérullaz, Maurice, *Memorial de l'exposition Delacroix*, Paris, 1963.

Baumann, Felix, and Hugo Wagner, *Delacroix* (cat), Berne, 1963.

Huyghe, René, *Delacroix*, Paris, London, and New York, 1963.

Johnson, Lee, *Delacroix*, London, 1963.

Deslandres, Y., *Delacroix: A Pictorial Biography*, London, 1963.

Huyghe, René, *Delacroix, ou le combat solitaire*, Paris, 1964.

Badt, Kurt, *Delacroix: Werke und Ideals*, Cologne, 1965.

Mras, George P., *Delacroix's Theory of Art*, Princeton, 1966.

Prideaux, Tom, *The World of Delacroix*, New York, 1966.

Bessis, Henriette, *Les Elèves de Delacroix*, Paris, 1967.

Spector, Jack J., *The Murals of Delacroix at St. Sulpice*, New York, 1967.

Trapp, Frank A., *The Attainment of Delacroix*, Baltimore, 1970.

Rossi Bortolatto, Luigina, *L'opera pittorica completa di Delacroix*, Milan, 1972.

Moss, Armand, *Baudelaire et Delacroix*, Paris, 1973.

Busch, Guenter, *Delacroix: Der Tod der Valentin*, Frankfurt, 1973.

Rosenblum, Robert, and Antoine Schnapper, *De David à Delacroix* (cat), Paris, 1974.

Spector, Jack J., *Delacroix: The Death of Sardanapalus*, London, 1974.

Lichtenstein, Sara, *Delacroix and Raphael*, New York, 1979.

Schawelka, Karl, *Delacroix: Sieben Studien zu seiner Kunsttheorie*, Mittenwald, 1979.

Johnson, Lee, *The Paintings of Delacroix: A Critical Catalogue 1816–1831*, Oxford, 4 vols., 1981–86.

Toussaint, Hélène, editor, *"La Liberté guidant le peuple" de Delacroix* (cat), Paris, 1982.

Bryson, Norman, *Tradition and Desire: From David to Delacroix*, Cambridge, 1984.

*

The 19th century saw the revolution in sensibility which divides the modern period of art from its previous history. The paintings of Delacroix belong to tradition, but at the same time play an important role in this revolution.

The scale, intellectual ambition, and sense of tragic humanity of his paintings place him alongside the old masters who celebrated the myths of western culture drawn from the Bible and classical literature. Delacroix enlarged this repertoire with the evocation of scenes from Dante, Shakespeare, and Goethe. In his Salon paintings of the 1820's and 1830's he made use of the most dynamic aspects of classical figure composition, but he added to the visual qualities of post-renaissance art the darker, visionary character of Romantic painting to create vivid and suggestive images of great distinction. His *Liberty Leading the People*, 1831, the personification of a political ideal, made such an impact on collective memory that her face has become an official symbol and now appears on every French postage stamp. Amid controversy, Delacroix exhibited at the Salon, received commissions for the decoration of churches and official buildings, became an academician, and generally fulfilled the role expected of an establishment public figure in the arts. From this point of view he was one of the last great exponents of painting in the grand manner. But he was also one of the first to be adopted as a hero of the avant garde. Cézanne painted an *Apotheosis of Delacroix*, and Baudelaire's Delacroix criticism forms a primary text for early theories of Modernism. The private, Romantic aspects of his painting with its emphasis on imagination, process, and subjectivity make Delacroix one of the great precursors of modern art.

Delacroix understood the role of color in painting in an innovatory way. The next generation saw in his painting a new kind of pictorial unity based on color rather than tone, and this new understanding provided the foundations for the development of Impressionism, an art based on nature. But the emphasis on color in its own right also led to a consideration of its expressive and musical qualities. Baudelaire had perceived these qualities in Delacroix in the 1840's and 1850's, but it was this more abstract aspect of Delacroix's use of color that begins to come into its own later in the century for Van Gogh, Matisse, and Kandinsky.

The Barque of Dante, exhibited in the Salon of 1822, began Delacroix's career as a painter of large-scale figure compositions in the grand manner, but it already indicated a direction deviating from the line of baroque painting, derived from Raphael and Poussin, which his neo-classical training in the studio of Guerin would have been preparing him to follow. Instead, Delacroix looked to Rubens whose looseness of handling and emphasis on color offered an alternative to classical compositional structure based on tonal contrast, line, and clear definitions of space and form. Rubens's unfocussed outline, his use of red for modelling shadows and the reiteration of marks and color across the picture surface indicated a kind of painting which could be held together by relationships of color rather than by relationships between composed groups of figures or depicted objects and space. It was from his studies of the nereids in Rubens's *Debarkation of Marie de Medici at Marseilles*, 1622, that Delacroix traced his starting point as a colorist. In *The Barque of Dante* he painted tiny drops of water on the foreground figures like a series of flags in red, white, and blue stripes. The idea of dividing into pure colored components an image which was conventionally handled in terms of tone or single local color was to have far-reaching implications. When Cézanne acknowledged the debt of his generation to Delacroix ("We are all in Delacroix; in his pictures everything is bound together and worked as a whole") it was a new form of pictorial unity that he was celebrating. The breaking down of an object into separate colors meant that constructing the picture could be a matter of the relationship between colors rather than depicted images. Delacroix wrote in his journal, 25 January 1837: "When we cast our eyes on the objects about us, whether in a landscape or an interior, we observe a kind of *binding-together* of the objects which meet our sight; it is produced by the atmosphere which envelopes them and by reflections of all kinds which cause each object to participate . . . in a sort of general harmony." In theory this is close to what Monet wrote on 7 October 1890: "A great deal of work is necessary . . . to succeed in rendering that which I seek: 'instantaneity' especially the 'enveloppe': the same light spreading everywhere."

In practice, however, the "binding-together" of which Delacroix spoke was slow to develop. *The Massacre at Chios*, 1824, was begun with a feeling for "that good black, that blessed dirt" that he had admired in a 17th-century Spanish portrait he had been copying believing it to be Velázquez. But having seen the two Constables in the 1824 Salon, Delacroix had been so struck by their unity of color and their surfaces scattered with flecks of paint indicating reflections of light, that he returned to rework *The Massacre*, and recalling the drops of water in the *Dante*, introduced small patches of bright color into the dark areas of the painting.

The disparity of light and dark and the tendency of large-scale, tonally constructed figure paintings to fragment were

problems to which Delacroix repeatedly returned. After 1841 he produced fewer large Salon pieces and was able to rely instead on public commissions and on the demand for easel pictures from dealers or private collectors. By 1847 he had completed an important series of official commissions: an allegorical cycle in the Library of the Chamber of Deputies in the Palais Bourbon, and the cupola and half-dome in the Library of the Chamber of Peers in the Palais du Luxembourg. One of the problems facing him was the difficulty of making the panels light enough so that they would be clearly visible. The solution led to the progressive elimination of black from his palette and the discovery of white grounds as a means of increasing the intensity and luminosity of his colors. "By using this method," he wrote, 5 October 1847, "it is even possible that the backgrounds and draperies should not blend with the treatment of the flesh . . . otherwise the disparity between them would be unendurable."

The technical innovation of painting over a white ground meant that disparity of tone could be overcome without the blending of color. The same unity was achieved in the cupola of the library in the Palais du Luxembourg by the juxtaposition of complementaries of a high pitch of intensity. The structure of the easel paintings of the late 1850's and early 1860's rely on relationships of color and color unity with an increasing independence of depicted subject matter. Baudelaire, in his review of Delacroix in the 1855 Exposition Universelle, wrote that Delacroix's color *thinks for itself,* independently of the objects which it clothes. Further, these wonderful *chords* of color often give one ideas of melody and harmony, and the impression that one takes away from his pictures is often a musical one."

—Martha Kapos

DELAUNAY, Robert (Victor Felix).

Born in Paris, 12 April 1885. Died in Montpellier, 25 October 1941. Married Sonia Terk (i.e., the painter Sonia Delaunay), 1910; one son. Studied with his uncle, Charles Damour, Paris, 1895–1900; apprentice-student of the theatre designer Ronsin, Paris, 1902; painter from 1904; military service, 1907–08; associated with the Blaue Reiter and Orphism groups; lived in Spain and Portugal, 1914–20 (set designer for Diaghilev's ballet *Cleopatra,* 1918); then lived and worked in Paris from 1920: worked on frescoes, with Fernand Léger, Pavillon de l'Ambassade de France, 1925, and sculpture hall, Tuilleries, 1938.

Collections: Berlin: Nationalgalerie; Buffalo; Chicago; Cleveland; Cologne; London: Tate; New York: Moma, Guggenheim; Paris: Beaubourg; Washington.

Publications

By DELAUNAY: books—

Du cubisme à l'art abstrait, edited by Pierre Francastel, Paris, 1957.

The Writings of Robert and Sonia Delaunay, edited by Arthur A. Cohen, New York, 1978.

On DELAUNAY: books—

Viard, Paul, *L'Ame de Delaunay,* Paris, 1945.
La Tourette, F. Gilles de, *Delaunay,* Paris, 1950.
Delaunay (cat), Paris, 1957.
Delaunay, London, 1958.
Berggruen, H., *Delaunay: Première epoque 1903–1910,* Paris, 1961.
Schmidt, Georg, *Delaunay,* Baden-Baden, 1964.
Hoog, Michel, *Robert et Sonia Delaunay,* Paris, 1967.
Vriesen, Gustav, and Max Imdahl, *Delaunay: Licht und Farbe,* Cologne, 1967; as *Delaunay: Light and Color,* New York, 1979.
Dorival, Bernard, *Delaunay et le cubisme,* Saint-Etienne, 1973.
Damase, Jacques, *Delaunay,* Paris, 1975.
Dorival, Bernard, *Delaunay: Catalogue de son oeuvre peint,* Brussels, 1975.
Hoog, Michel, *Delaunay,* Naefels and New York, 1976.
Hoog, Michel, *Delaunay* (cat), Paris, 1976.
Sonia et Robert Delaunay (cat), Paris, 1977.
Spate, Virginia, *Orphism: The Evolution of Non-Figurative Painting in Paris 1910–1914,* Oxford, 1979.
Buckberrough, Sherry A., *Delaunay: The Discovery of Simultaneity,* Ann Arbor, 1982.
Overmeyer, Gudula, *Studien zur Zeitgestalt in der Malerei des 20. Jahrhunderts: Delaunay, Paul Klee,* Hildesheim, 1982.
Duechting, Hajo, *Delaunays "Fenêtres": Peinture pure et simultane: Paradigma einer modernen Wahrnehmungsform,* Munich, 1982.
Delaunay und Deutschland (cat), Munich, 1985.
Molinari, D., *Robert et Sonia Delaunay,* Paris, 1987.

*

Robert Delaunay has generally been regarded as one of the "pioneers" of modern painting in modernist art historical and critical accounts. According to this view, his pioneering works were all painted over a period of about three years from 1910 to 1913, and his later work from between the wars is seen as of little intrinsic interest. However, it is possible to take another view: to consider Delaunay as an artist who produced different kinds of work, some of which cannot be accommodated within a strict modernist canon, and who had differing and sometimes apparently contradictory ambitions for his painting. Thus he adopted a variety of modes of working between abstraction and representation and often returned to earlier themes and styles, rather than "developing" in the "evolutionary" manner required by modernist criticism and art history.

Delaunay constructed his own individual and dynamic version of Cubism and was one of the first artists to paint purely abstract paintings (around 1913–14), while at the same time continuing to produce works which used popular and technological imagery: sport, the Eiffel Tower, the Great Wheel. His earlier work was in a late Post-Impressionist and Fauvist style. Around 1910 he began to be influenced by the work of Cézanne and the Cubist painting of Picasso and Braque. In 1909 Delaunay had met the Russian artist, Sonia Terk, who was

living and working in Paris, and they were married in 1910. Her strong sense of colour and expressionist style undoubtedly had an effect on his own work.

The use of "modern" subject matter, images of the city and in particular of the Eiffel Tower, may have been suggested by the early manifestos of the Italian Futurists which were widely circulated in Paris from 1909 onwards. Delaunay's use of such subject matter and imagery was often shared in common with poets like Apollinaire and Cendrars, to whom he and Sonia Delaunay were close at this time. Delaunay used the Tower as a symbol of "simultaneity," the multiple awareness of modern urban experience, where human beings become conscious of events taking place all over the world as a result of modern media and new technologies of communication.

Delaunay's paintings were exhibited and widely discussed in Munich and Berlin just before and just after the First World War, and they made a powerful impact on many German and central European artists. They also had an effect on German cinema—the sets of *The Cabinet of Dr. Caligari,* for example, are reminiscent of Delaunay's series of almost Expressionist paintings of the Paris church of St. Severin. His series of small paintings based on the motif of a high window overlooking the city, *Windows* (1912–14), incorporating elements from earlier series such as the Eiffel Tower and City paintings, were not exhibited in France at the time when they were painted, only in Germany where they were perceived by Klee, Kandinsky, and Marc as being close to their own work and ideas in their extreme abstraction and direct use of colour.

Shortly before starting this series, Delaunay painted a much larger work, *The City of Paris* (Musée Nationale d'Art Moderne, on loan to Musée d'Art Moderne de Ville de Paris), in a very different style, using allegorical elements like the Three Graces, combined with fragmented Eiffel Towers and views of the Seine and Paris. This was exhibited at the Salon des Indépendants in March 1912 and received a great deal of critical attention. Delaunay followed this up with *The Cardiff Team* (Musée d'Art Moderne de Ville de Paris), based on a rugby football match, exhibited at the Indépendants in 1913, and *Homage to Blériot* (Basel), a tribute to the French aviator, shown there in 1914. These more representational works were clearly aimed at the wider, Parisian audience who visited the annual art salons, while the *Windows* and the abstract paintings which Delaunay produced in 1913–14, based on disk and circle forms in bright, spectral colours, established his reputation among the international avant-garde.

Immediately after the war Delaunay painted in a number of different styles, producing relatively realisitic portraits, new Eiffel Tower paintings—no longer fractured or fragmented, but depicted as if from the air or from dramatic viewpoints below—paintings based on sports themes, like *The Runners* (1926, Charles Delaunay Collection, Paris), inspired by the 1924 Olympic Games held in Paris, and a few abstract works. He developed links with the literary avant-garde of the Dadaist and Surrealist generation of the 1920's, painting a number of portraits of writers such as Tristan Tzara and Philippe Soupault, and devoting a great deal of his time to theorizing his own earlier work in order to secure its place in modernist art histories. He also spent considerable energy promoting Sonia Delaunay's fashion and textiles designs. Models wearing her clothes or fabrics were often posed in front of his canvases. For the Ambassade de France pavilion at the 1925 Arts

Décoratifs exhibition in Paris, Delaunay painted a work which combined a single nude figure of a woman with the Eiffel Tower viewed dramatically from below. This, and an abstract painting commissioned from Léger for the same building, were removed from public view until protests in the press forced their return. In the 1920's he worked on the decor of a number of films in collaboration with Sonia Delaunay.

Around 1930 Delaunay turned increasingly once more to abstract themes, producing a new series of works based on the disk or circle, often combined to form repeated, brightly coloured images which he entitled *Rhythm Without End.* In the early 1930's he began to explore the architectural possibilities of painting, developing a technique of coloured plaster relief. With Sonia Delaunay he worked on projects for using neon light. In 1937 during the brief period of Popular Front government in France he was given the opportunity to put his ideas about public art into practice when he and Sonia Delaunay were commissioned to organise the decoration of the Railway Pavilion and the Pavilion of the Air at the 1937 Paris International Exhibition, with the assistance of 50 young artists. This was to be one of the most extensive public commissions executed between the wars.

Delaunay incorporated a synthesis of abstract elements and images of Paris from his early works in a huge monumental canvas, *Air, Fire, and Water* (Paris, Beaubourg), representing Paris and modernity, for the Railway Pavilion. He produced an equally vast but more abstract work, *Helix and Rhythm* (now lost), incorporating circle and disk forms suggesting moving propellers, for the Air Pavilion, for which he also designed a highly original abstract coloured environment to display aeroplanes and aero engines using a new thermoplastic material, rhodoid, to create looping walkways suspended dramatically in mid-air.

Until the end of his life Delaunay continued to move between representational and abstract modes of working. He painted three very large, entirely abstract works using circular motifs for the 1938 Salon des Tuileries (Musée d'Art Moderne de Ville de Paris). These were to be his last major paintings.

—Paul Overy

DELVAUX, Paul.

Born in Antheit, near Huys, Belgium, 23 September, 1897. Studied under Constant Montald, Academy of Fine Arts, Brussels, 1920–24; established studio in Brussels, 1924; stage designs for Genet's ballet *'Adame Miroir,* 1948; Professor of Painting, Ecole Nationale Sepérieure d'Art et d'Architecture, Brussels, 1950–62. Address: Fondation Paul Delvaux, 42 Kabouterweg, 8460 Saint-Idesbald, Belgium.

Major Collections: Saint-Idesbald: Fondation Paul Delvaux; Koksijde: Paul Delvaux-Museum.
Other Collections: Antwerp; Brussels; Charleroi; Chicago; The Hague: Gemeentemuseum; London: Tate; New York: Moma; Paris: Beaubourg.

Danne Lost in Thought, 1966; lithograph

Publications

By DELVAUX: book—

Sept dialogues, with Jacques Meuris, Paris, 1971.

On DELVAUX: books—

Gaffe, René, *Delvaux, ou les rêves eveillés,* Brussels, 1945.
Spaak, Claude, *Delvaux,* Antwerp, 1948.
Bock, Paul Aloise de, *Delvaux: Der Mensch, der Maler,* Hamburg, 1965.
Nadeau, Maurice, *Les Dessins de Delvaux,* Paris 1967.
Cahiers Delvaux I: Premières Lithographies, II: L'Oeuvre gravé 1966–69, Paris, 2 vols., 1969.
Terrasse, Antoine, *Delvaux: le Septième Face du dé,* Paris, 1972.
Delvaux (cat), Rotterdam, 1973.
Clair, Jean, *Delvaux: Catalogue raisonné,* Brussels, 1974.
Clair, Jean, and Suzanne Houbart-Wilkin, *Delvaux,* Brussels, 1975.
Jacob, Miro, *Delvaux: Oeuvre gravé,* Monaco, 1976.
Houbart-Wilkin, Suzanne, editor, *Hommage à Delvaux* (cat), Brussels, 1977.
Delvaux: Estampes originales (cat), Geneva, 1977.
Paquet, Marcel, *Delvaux et l'essence de la peinture,* Paris, 2 vols., 1982.
Houbart-Wilkin, Suzanne, *Delvaux: Son oeuvre aux Musées Royaux des Beaux-Arts de Belgique à Bruxelles,* Liege, 1983.
Emerson, P., *Delvaux,* Antwerp, 1985.

*

Perhaps Delvaux's principal achievement as an artist is to have adapted the conventions of pictorial representation as they have operated in Europe since the Renaissance to peculiarly modern and surrealistic effect. Taking the traditional scenarios of History and Myth—the classical architectural framework used in 16th-century painting, 17th-century tragedy, and 19th-century academic art—Delvaux converted it to a space representing the inner mind, a stage on which, as in de Chirico, unconscious fantasies and desires act out their bizarre dramas. The familiar modern elements—railways, tramlines, gaslights, rubber plants—are added to the "classical" scenario with the aim, paradoxically, of heightening the sense of dream or unreality. Delvaux also takes the nude from Renaissance or post-Renaissance painting and sculpture but juxtaposes it with modern or otherwise heterogeneous forms—tailors' dummies, skeletons, ladies in Edwardian dress, men in bowler hats. Indeed, Delvaux explores the whole range of conventional representations of the human body—whether in architecture, sculpture, or painting. The nude, male or female, thus appears in his work as statue, caryatid, bas relief, or frieze; in symbolic or allegorical forms; in classical or modern guise; stripped down to the skeleton or half swathed in garments or vegetation of various kinds. Like his Belgian contemporary (and no doubt formative influence) Magritte, Delvaux is in this way able to parody or deconstruct conventional forms of visual representation and, at the same time, to created disturbing surrealistic effects.

Delvaux's early work, viewed retrospectively, seems like a rehearsal of the themes and forms that later became his trademark: the naturalistic townscape in which railway stations appear (as in his *Vue de la gare du quartier Léopold* of 1922) or the classical scenes of the later 1920's, with their statuesque female nudes (as in *Rose et blanc,* 1929). In the early 1930's, Delvaux's work became more expressionistic and the modern and the neoclassical begin to coexist in the same pictorial context, as in *Vénus endormie* (1932), with its couples in modern dress juxtaposed with a reclining nude and a skeleton. The turning point came in the mid-1930's when Delvaux discovered or re-discovered the surrealists, especially de Chirico and Magritte. Taking from the former the hallucinatory quality of his depiction of urban space and from the latter his artful play on art's representational conventions, Delvaux went on to exploit the surrealist potential of his own favorite images (nudes, classical squares, railway stations) and in this way established himself as an important figure in the movement. The poetic quality of his work was recognized in particular by those surrealist poets most attuned to painting, André Breton and Paul Eluard.

Like that of the surrealist poets, Delvaux's aim is to explore human responses to the body—as object of art or desire—and, in particular, the huge eroticism, conscious or unconscious, invested in it. Not surprisingly, the Pygmalion theme reappears in Delvaux's painting, as it had done in 19th-century academic art. In Delvaux's *Pygmalion* (private collection, 1939), however, the roles are reversed: it is a female sculptress (the blonde nude who appears in so many of his works) who embraces the marble torso of the male (armless and legless, but otherwise intact) while a clothed man in a bowler hat seen from behind passes in a street a flower-bedecked but otherwise naked female. The preserve of fantasy within art, until the 20th century predominantly male, is thus opened to womankind whose desires are strikingly foregrounded in this work, although they are, at the same time, complemented by those of the male (it is possible to read the scene as the fantasy of the bowler-hatted male in the background). *In Praise of Melancholy* (1951) elaborates on this theme: here the marble warrior-athlete, whose eyes in 19th-century academic painting stared sightlessly out of their stone sockets, shows every sign of being aroused to life by the sight of the female nude in the foreground, whose posture is that of the odalisks who recline in so many 19th-century orientalist paintings, especially those of Ingres. Delvaux here, as elsewhere in his work, contrives to create erotic effects while maintaining the decorum of classical and neo-classical painting. The warrior-athlete's sexual desire is not registered directly in his person, but by the handle of his sword which protrudes like an erect phallus from behind his shield. The viewer's attention is drawn to it not only by the hand that grips its base but also by the gas-light which casts the sword-hilt's shadow against the pilaster decorating the niche in which the statue stands.

The eroticism of the gaze is, of course, a major preoccupation of the surrealists—whether in their painting, poetry or cinema. Indeed, the image of the eye recurs sufficiently often in their work to constitute a fetish. In Delvaux, this obsession is not only dramatised within the painting, but also explored in relation to the viewer. It is through her large and steadily staring eyes that the naked sculptress in *Pygmalion* hopes to arouse the marble torso, just as it is through his sidelong glance that the warrior in *In Praise of Melancholy* seeks a

response in the reclining nude. But the picture's observer also becomes involved in this exchange of glances, both in his or her efforts to "read" the significance of the scene but also in his or her enjoyment—prurient or uninhibited—in the desirable objects proposed to the gaze. In this way, Delvaux succeeds in implicating the viewer in the theme of voyeurism and invites him or her to confront some of the desires and taboos—conscious or unconscious—so deeply bound up in human response to the body—both in art and in life.

—David Scott

DEMUTH, Charles.

Born in Lancaster, Pennsylvania, 8 November 1883. Died in Lancaster, Pennsylvania, 23 October 1935. Studied at Franklin and Marshall College, Lancaster, 1895–98 1899–1900; Drexel Institute, Philadelphia, 1900–04; School of Industrial Design, Philadelphia, 1905; Pennsylvania Academy of Fine Art, Philadelphia, 1905–10; Académie Moderne, Paris, 1912–13; Académie Colarossi, Paris, 1913–14; Académie Julian, Paris, 1914; lived in Lancaster and New York from 1914, with later trips to Europe until 1920; illustrator, playwright, stage designer; spent summers in Provincetown, from 1915, and in Beverly, Massachusetts.

Major Collections: New York: Metropolitan, Moma, Whitney.
Other Collections: Andover, Massachusetts; Baltimore: Buffalo; Boston; Buffalo; Cambridge, Massachusetts; Chicago; Cleveland; Columbus, Ohio; Detroit; Hartford, Connecticut; Los Angeles; Merion, Pennsylvania; Philadelphia: Pennsylvania Academy, Art Museum; Providence: Rhode Island School of Design; Saint Louis; San Antonio; Utica, New York; Washington: Corcoran.

Publications

By DEMUTH: book—

The Azure Adder, New York, 1913.

On DEMUTH: books—

Gallatin, Alfred E., *Demuth,* New York, 1927.
Murrell, Williams, *Demuth* (cat), New York, 1931.
McBride, Henry, *Demuth* (cat), New York, 1937.
Ritchie, Andrew C., *Demuth* (cat), New York, 1950.
Farnham, Emily, *Demuth: Behind a Laughing Mask,* Norman, Oklahoma, 1971.
Plous, Phyllis, and David Gedhard, *Demuth: The Mechanical Encrusted on the Living* (cat), Santa Barbara, California, 1971.
Norton, Thomas E., editor, *Homage to Demuth, Still Life Painter of Lancaster,* Ephrata, Pennsylvania, 1978.
Eiseman, Alvord L., *Demuth,* New York, 1982.

Fahlman, Betsy, *Pennsylvania Modern: Demuth of Lancaster,* Philadelphia, 1983.
Haskell, Barbara, *Demuth,* New York, 1987.

articles—

Farnham, Emily, "Demuth's Bermuda Landscapes," in *Art Journal* (New York), Winter 1965.
Aiken, Edward A., "*I Saw the Figure 5 in Gold:* Demuth's Emblematic Portrait of William Carlos Williams," in *Art Journal* (New York), Fall 1987.
Weinberg, Jonathan, "Demuth and Difference," in *Art in America* (Marion, Ohio), April 1988.

*

Although he is best known for his Precisionist paintings of American industry that helped to redefine the character of American modernism during the 1920's, Charles Demuth developed a number of different modernist modes of painting in the course of his brief career. Demuth's training in Philadelphia at the Pennsylvania Academy of the Fine Arts might have inclined him toward narrative urban genre subjects which were in vogue among his contemporaries during his student years from 1905 to 1910, but he was much more inclined to the aestheticism influenced by Aubrey Beardsley and J. A. M. Whistler than to the currents of urban realism. Demuth's early student works featured the dark color and heavy brush work of the realists, but he quickly turned to watercolor illustrations of the circus, vaudeville, cafes, and of his favorite literary works. Although produced serially, the illustrations were not commissioned to accompany texts, but were conceived of as adjuncts to them by the painter.

Like most of the young American artists of his generation, Demuth looked to Paris as the mecca of the art world. When he arrived there in 1907 he quickly associated himself with a group of young progressive American painters who associated with the writer and collector Gertrude Stein. For Demuth Paris was an aesthetic springboard and he returned to the city several times to be nourished by it. When he was first in Paris Demuth was vaccilating between a career as a painter and as a writer, and like his contemporary, the peripatetic painter Marsden Hartley, Demuth continued to write throughout his life.

During the 1920's Demuth developed diabetes and his precarious health precipitated his return to his family home in Lancaster, Pennsylvania, where he was taken care of by his mother until his death in 1935. Isolated in Lancaster he painted his major series of industrial and mercantile subjects based on the buildings, grain elevators, shop fronts, smoke stacks, water tanks, and advertising signs that he found around him. His return to Lancaster not only saw a change in his subject matter, but it was attended by a change in scale and material as well. Demuth's earlier works were primarily small watercolors, but he chose a larger format, appropriate to the larger scale of the subjects, and what was considered to be a more serious medium in creating the images of his most impressive works in oil.

Inspired by futurist lines of force, which had been developed in the works of the American painters Max Weber and Joseph Stella during the 1910's under the influence of Italian Futurist painting, Demuth superimposed lines across the surfaces of

the buildings that simulate spotlights. Although he did not use lines of force as consistent directional or structural elements, he presented a prismatic vision of the modern industrial world as if it were associated with dynamic activity. Unlike the Cubists and Futurists, however, Demuth always retained the visual integrity of the architectural forms that he depicted.

Demuth utilized a precise hard-edged linear form to define the majestic and monumental structures in his major works similar to the constructive devices of his friend Charles Sheeler. Their works have been referred to as Precisionist for their precise, photographic clarity of form, smoothe paint surfaces, use of crisp outline to define form, and appropriation of subjects from American commerce and industry. The utilitarian and banal nature of their imagery defines the basic context of 20th-century American culture.

Best known of Demuth's Precisionist paintings is *My Egypt* (1927; New York, Whitney), based on a grain elevator in Lancaster. The ironic title of the painting is characteristic of Demuth's literary inclinations and his desire to define a particularly American aesthetic. Thus the grain elevator is as significant for Demuth to American culture as the pyramids were to Egyptian civilization. For Demuth industrial power represents America at its best and the grain elevator becomes an icon of American success.

While he was in Lancaster, Demuth also produced an exquisitely beautiful series of watercolors of flowers that retain the concern for aestheticism that marked his early artistic inclinations. The antithesis of the oil paintings of architectural monuments, the flowers are hauntingly lyrical and delicate, representing the most poetic of American still lifes. More ethereal than the flowers painted by his friend Georgia O'Keeffe, Demuth's botanical paintings represent his continuing love for the medium of watercolor.

In 1924 Demuth initiated a series of poster portraits of significant American artists and writers. Although there are only nine extant examples of this facet of Demuth's work, the paintings and drawings represent a significant phase of his career. He began the series with a painting for Georgia O'Keeffe, who was soon to marry Alfred Stieglitz, the photographer and gallery owner who occasionally handled Demuth's work. The so-called portraits were actually non-figurative symbolic tributes to artists and writers whom Demuth felt embodied the spirit of a specifically American artistic development. Most of the portraits were dedicated to friends such as O'Keeffe, Marsden Hartley, Eugene O'Neill, and William Carlos Williams, or associates including painters John Marin, Arthur Dove, and Charles Duncan. Demuth created the paintings as signposts or advertising posters to advertise the importance he found in these artist's works. Unfortunately Demuth's health deteriorated during the time that he was painting these poster portraits, and he only finished six of them leaving the Hartley, O'Neill, and Wallace Stevens posters in the form of preparatory sketches. The poster portraits define advertising as a major form of American art and demonstrate Demuth's desire to publicize the important artistic activities of the people who represented the apogee of American creative achievement. Thus Demuth acknowledged the role of advertising as a significant factor in American culture and incorporated it as a means to demonstrate the relation between popular culture and fine art in American life.

During the final years of his life Demuth produced an unusual series of illicit homoerotic drawings and watercolors primarily featuring sailors. In these works, Demuth revealed his continuing concern for Beardsley's decadent sexual themes and his own wickedly anti-establishment spirit. Although infrequently exhibited, Demuth's erotica illustrates the breath of his untamed creativity and a freedom of expression rare in American art.

—Percy North

DERAIN, André.

Born in Chatou, 10 June 1880. Died in Chambourcy, 8 September 1954. Married Alice, 1907; two illegitimate children. Painting lessons from 1895; studied at Académie Camillo, 1898, Académie Carrière, 1898–99, and Académie Julian, 1904, all in Paris; military service, 1901–04 and during World War I; one of the original Fauves: influenced by Vlaminck, Matisse, and Cézanne, but adopted a more traditional style after 1914; lived mainly in Chambourcy from the 1930's; book illustrator, and stage designer: *La Boutique fantasque*, 1919, *Les Soirées de Paris*, 1924, *Jack-in-the-Box*, 1926, *La Concurrence*, 1932, *Les Songes*, 1933, *Les Fastes*, 1933, *Salade*, 1935, *L'Epreuve d'amour*, 1936, *Harlequin in the Street*, 1938, *Mam'zelle Angot*, 1947, *Que le diable l'emporte*, 1948, *Les Femmes de bonne humeur*, 1949, *La Valse*, 1950, *The Abduction from the Seraglio*, 1951, *The Barber of Seville*, 1953; visited Germany with Vlaminck, 1941, and branded collaborator after the war.

Major Collection: New York: Moma.
Other Collections: Avignon; Basel; Chicago; Copenhagen: Statens Museum; Grenoble; Leningrad; Liverpool; London: Tate; Minneapolis; Moscow; Oxford; Paris: Beaubourg; Pittsburgh; St. Tropez; Washington.

Publications

By DERAIN: books—

Lettres à Vlaminck, Paris, 1955.

illustrator: *D'un lit à l'autre*, 1902, *Tout pour ca*, 1903, and *A la santé du corps*, 1919, all by Vlaminck; *L'Enchanteur pourrissant*, by Apollinaire, 1909; *Oeuvres burlesques et mystiques de frère Matorel*, by Max Jacob, 1909; *Mont-de-Piété*, by André Breton, 1916; *La Ballade du pauvre Macchabé*, by R. Dalize, 1919; *La Boutique fantasque*, 1919; *La Cassette de plomb*, 1920, and *Nez de Cléopatre*, 1922, both by G. Gabory, 1920; *La Calumet*, by André Salmon, 1920; *Etoiles peintes*, by Pierre Reverdy, 1921; *En suivant la Seine*, by G. Coquiot, 1926; *Les Travaux et les jeux*, by Vincent Muselli, 1929; *Héliogabale*, by Antonin Artaud, 1934; *Satyricon*, by Petronius, 1934; *Voyage en Grèce, été*, by R. Vilnes Vega, 1935; *Réflexions d'une innocente*, by Rosemonde Wilnes, 1935; *Paris 1937*, 1937; *Les Heroïdes*, by Ovid, 1938; *Salome*, by Oscar Wilde, 1938; *Pantagruel*, by

Bathers; etching

Rabelais, 1946; *L'Eloge des Pierreries,* by Heron de Villefosse, 1947; *Récits, Romans, Soties,* by André Gide, 1948; *Oeuvres,* by Saint Exupery, 1950; *Contes et nouvelles,* by La Fontaine, 1950; *Odes anacreontiques,* 1955; *Ami et amie,* 1957.

On DERAIN: books—

Kahnweiler, D. H., *Derain,* Leipzig, 1920.
Faure, Elie, *Derain,* Paris, 1923.
Salmon, André, *Derain.* Paris, 1923.
Carrà, Carlo, *Derain,* Rome and London, 1924.
Basler, Adolphe, *Derain,* Paris, 1931.
Vaughan, Malcolm, *Derain,* New York, 1941.
Diehl, Gaston, *Les Fauves,* Paris, 1943.
Leymarie, Jean, *Derain, ou le retour à l'ontologie,* Paris, 1948.
Duthuit, Georges, *Les Fauves,* Geneva, 1949.
Adhémar, Jean, *L'Oeuvre gravé de Derain,* Paris, 1955.
Nacenta, Raymond, and Georges Hilaire, *Derain* (cat), Paris, 1955.
Muller, J. E., *Le Fauvisme,* Paris, 1956.
Sandoz, Marc, *Eloge de Derain,* Paris, 1958.
Hilaire, Georges, *Derain,* Geneva, 1959.
Sutton, Denys, *Derain,* London, 1959.
Leymarie, Jean, *Les Fauvisme,* Geneva, 1959.
Dunoyer de Segonzac, André, *Album Derain,* Paris, 1961.
Derain, Alice, and Jacques Perrin, *Derain: Oeuvre sculpté* (cat), Paris, 1962.
Diehl, Gaston, *Derain,* Paris and New York, 1964.
Cailler, Pierre, *Catalogue raisonné de l'oeuvre sculpté de Derain,* Geneva, 1965.
Carrà, Massimo, *Derain,* Milan, 1966.
Sutton, Denys, *Derain* (cat), London, 1967.
Lévy, Denise, *Derain,* Paris, 1970.
Bertrand, Gérard, *L'Illustration de la poésie à l'epoque du cubisme 1909–1914: Derain, Dufy, Picasso,* Paris, 1971.
Derain (cat), Paris, 1976.

*

Before and just after the First World War, André Derain was considered one of the leading members of the French avant-garde. Seen as an upholder of the great national tradition of painting, he appeared to be the successor to the masters of the 19th century. Yet, by the close of his life he was largely forgotten; from a leader in innovation, he had become a painter who had ceased to experiment and had relinquished the quest for originality in favor of the pursuit of his own artistic desires.

A versatile artist, Derain worked as a painter, sculptor, potter, set and costume designer, and book illustrator over the course of his career. His affinity for the old masters led him to study and to copy at the Louvre; but a 1901 Van Gogh exhibition at the Bernheim-Jeune Gallery in Paris was the turning point in his artistic development. It prompted him to look to the artists a generation older than he for inspiration. Under the influence of Van Gogh, Gauguin, Signac, and Cézanne, he enjoyed a new freedom with color that was enhanced when he joined forces with Henri Matisse and Maurice Vlaminck to found Fauvism. The period of 1905–07, when Fauvism emerged as one of the new modern art movements, is often viewed as the high point of Derain's career and as the moment of his contribution to art history. He experimented with the optical contrasts of strong, luminous colors, treated as independent decorative elements, and showed little concern for the contours and substance of the original objects. During the Fauve period he painted many portraits, figure compositions, landscapes, and street scenes, as well as his celebrated London views.

The desire to compose in terms of form and not just color attracted him to the emerging Cubist movement. Derain never produced work that was as abstract or systematic in its investigation of form as Picasso and Braque. He subdued his color in favor of structure, concentrating on the internal architecture of his subjects, much in the manner of Cézanne. By 1910 he no longer wished to impose a style onto his painting, but rather sought to maintain a tradition that selectively cultivated the old masters. His landscapes had a new, naive quality borrowed from the artists of the early Italian Renaissance; he also produced still-lifes and in 1914 reintroduced the figure in his work. In all of these paintings, he sought to resolve a conflict between two elements that challenged him: the instinctive quality of primitivism, which renewed his sources of inspiration, and the solidity of construction gained from Cézanne, which provided a means to represent the substance of objects or nature.

A visit to Rome in 1921 reaffirmed his reliance on the past. While never a classicist, he felt sympathetic toward earlier periods and toward work that seemed to constitute a tradition of art through the ages. His painting tended to amalgamate many different styles—Florentine painting, the frescoes of Pompeii, Caravaggio's canvases, and the work of 17th-century Dutch masters. Firmly believing that no single approach to painting lasts forever, he concluded that contradictory conventions could be employed, sometimes in a single picture, and that different subjects merited treatment in distinct styles.

Late in the 1920's, he reached the peak of his reputation and prosperity, winning the Carnegie Prize in 1928 for his *Still-Life: Dead Game.* Simultaneously criticism mounted over his indifference toward any particular style and to his preoccupation with the past. For the remainder of his life, he continued his interest in landscape and still life, treating them with a lighter, more decorative touch.

Derain's sculpture resembles ancient and non-European forms rather than those of the 20th century. His first stone carvings, done in 1905, are geometrical in shape. After a lapse, he resumed sculpting in 1914–18 when he made masks from granite shells. in 1939 he returned to sculpture once again, modeling expressive heads, masks, figurines, and reliefs that were posthumously cast in bronze. Their primitive archaisms are reminiscent of Romanesque sculptures and Benin bronzes.

The sets and costumes Derain designed were a great success. His first effort, for Diaghilev's *La Boutique fantasque* of 1919, garnered much praise. The lyrical, comprehensible designs translated into painted sets retained a sketchiness that was both witty and charming. Involved with ballet designs and book illustration throughout his life, Derain demonstrated his inventiveness and artistic diversity. This very diversity, in artistic forms and styles, is largely responsible for his weaknesses as well.

—Jennifer Gibson

DESIDERIO DA SETTIGNANO.

Born in Settignano, 1428–31; son of the stone mason Barto-lommeo di Francesco; younger brother of the sculptors Francesco and Geri. Died in Florence: buried 16 January 1464. Trained in the Rossellino workshop, and influenced by Donatello; joined the Florence guild of sculptors, 1453; shared studio with his brother Geri in the 1450's; adopted the low relief (rilievi schiacciato) invented by Donatello; did delicate busts, as well as monumental tomb of Carlo Marsuppini (S. Croce), and tabernacle of the Sacrament (S. Lorenzo); influenced the work of his brother Geri, Mino da Fiesole, Benedetto da Maiano, and other sculptors.

Collections: Berlin; Florence: S. Croce, S. Lorenzo, Bargello; London: Victoria and Albert; New York: Pierpont Morgan Library; Paris: Louvre, Jacquemart André; Philadelphia; Toledo, Ohio; Turin; Vienna; Washington.

Publications

On DESIDERIO: books—

Kennedy, C., *The Tabernacle of the Sacrament by Desiderio*, Northampton, Massachusetts, 1929.
Planiscig, Leo, *Desiderio*, Vienna, 1942.
Cardellini, Ida, *Desiderio*, Milan, 1962.

articles—

Kennedy, C., "Documenti inediti su Desiderio e la sua famiglia," in *Rivista d'Arte* (Florence), 12, 1930.
Schulz, Anne Markham, "Desiderio and the Workshop of Bernardo Rossellino, in *Art Bulletin* (New York), 45, 1963.
Parronchi, A., "Sulla collacazione originaria del Tabernacolo di Desiderio," in *Cronache di Archeologia e di Storia dell'Arte* (Catania), 4, 1965.
Spenser, J. R., "Francesco Sforza and Desiderio," in *Arte Lombarda* (Milan), 13, 1968.
Avery, Charles, "The Beauregard Madonna: A Forgotten Masterpiece by Desiderio," in *Connoisseur* (New York), 1976.
Wittkower, Rudolf, "Desiderio's *St. Jerome in the Desert*," in *Idea and Image: Studies in the Italian Renaissance*, London, 1978.
Middeldorf, Ulrich, "Die zwölf Caesaren von Desiderio," in *Mitteilungen des Kunsthistorisches Instituts in Florenz*, 23, 1979.
Strom, Deborah, "Desiderio and the Madonna Relief in Quattrocento Florence," in *Pantheon* (Munich), 40, 1982.

*

Desiderio was born in Settignano, a hilltown suburb of Florence celebrated for its quarries and stoneworkers. From the same community came Bernardo and Antonio Rossellino in whose shop Desiderio must have received his training as a sculptor. While his personal style shows the effect of this influence, his approach to carving is distinguished by a unique sensitivity for the nature of the marble with which he primarily worked. It formerly was supposed that Desiderio had worked for a time under Donatello. Giorgio Vasari said that "he imitated the style of Donatello, being naturally endowed with gracefulness and lightness in the treatment of heads" and claimed for him the pedestal for Donatello's bronze David, but this is most unlikely since that sculpture dates from the 1430's. Donatello, actually, was absent from Florence in those years in which the young Desiderio would have been in training and whatever Donatellesque influences there are in his work were second-hand or acquired after Donatello's return to Florence in 1453 and after Desiderio had developed his own style.

Desiderio matriculated into the Guild of Stone and Woodworkers in 1453, but his abilities must already have been recognized, for, in the same year, he and Antonio Rossellino gave an estimate for the Cavalcanti pulpit in Santa Maria Novella. In 1456 he and Geri purchased a house together and a year later, according to their tax declarations, both sculptors were renting a shop near the Ponte Santa Trinita. In 1459, he entered a competition for sculptures for a chapel in the Orvieto Cathedral and, two years later, was paid for the designs he had submitted; nothing apparently came of this project. A small payment made to him in 1463 in connection with the Chapel of the Cardinal of Portugal in San Miniato al Monte shows his continuing association with the Rossellino workshop. The cause of his early death is unknown but he was buried in the church of San Pier Maggiore on 16 January 1464. Among his possible pupils and assistants were his elder brother Geri (really his collaborator), Benedetto da Maiano and Francesco di Simone Ferrucci, who later worked in Forli and Bologna.

Little of Desiderio's work is documented or can be dated with certainty beyond the Marsuppini Tomb and the San Lorenzo Tabernacle. Consequently, his development as an artist is difficult to reconstruct and a chronological catalogue of his work must rely on stylistic analysis and comparison. Throughout his oeuvre, one of the most notable characteristics of his technique was his unusual ability to give to his sculptures a textural sensuousness that demands touch. Of all the sculptors of the Quattrocento, Desiderio was, perhaps, the most tactile in his appeal. Scholarship has varied concerning the extent of Desiderio's autograph output; many works sometimes attributed to his hand might better be associated with followers, imitators, or his brother Geri. What remains is of great technical merit and illustrates Desiderio's sensitivity for surface nuance and his eye for decorative detail. Desiderio understood the crystalline luminosity of marble and how a gently polished and modulated surface could come almost to radiate an inner glow and how Donatello's *rilievo schiacciato* could be further refined to convey a sense of light, softly diffused by its passage through atmosphere. He worked the surface of the marble in a pictorial fashion achieving coloristic contrasts of tone and shading. At his best, Desiderio was a sculptor of soft persuasion and subtle effect.

Vasari attributes to Desiderio the tomb monument to the Beata Villana in Santa Maria Novella. That monument is the work of Bernardo Rossellino and his shop which, however, might well have included (c. 1451) the younger Desiderio. Among the first works given to Desiderio with some certainty are a number of the cherub medallions in the exterior frieze of Brunelleschi's Pazzi Chapel. In their execution can be seen the

particular talent Desiderio was to display in his later renditions of children.

One of Desiderio's most significant commissions came in 1453 when he was awarded a contract to execute a tomb monument in Santa Croce for the Florentine State Chancellor Carlo Marsuppini. It seems only appropriate that Desiderio based his work upon that which his master, Bernardo Rossellino, had executed in Santa Croce a few years earlier for Leonardo Bruni. Marsuppini had followed Bruni in office and, in fact, had composed the epitaph inscribed on Bruni's tomb. Desiderio took over the essential compositional scheme of an elevated triumphal arch containing a sarcophagus and effigy bier from the Bruni monument but transformed the sobriety of that memorial into a work of greater decorative fancy. In the Marsuppini monument, Desiderio placed standing children bearing heraldic shields on either side of the sarcophagus, draped long festoons from an ornate candelabra surmounting the lunette arch, and positioned running youths above the pilasters to help support their weight. Within the niche, he broke the paneled background into four fields, tilted Marsuppini's effigy forward to increase its visibility, and carved elaborate floral decorations on the corners of the lion-footed sarcophagus. The motifs are all classicizing in design and the effect of the whole is light, charming, even joyous, but somewhat unfocused.

Clearly the greatest influence upon Desiderio's style was that of the Rossellino brothers, but his interests reached beyond the workshop in which he had trained and first practiced to other Florentine sculptors, in particular Donatello. A comparison of Desiderio's wooden Mary Magdalene of c. 1455 in Santa Croce (said by Vasari to have been completed by Benedetto da Maiano) with Donatello's celebrated masterpiece is instructive. It shows the problems of imitation and Desiderio's emotional limitations. The fanatical beauty of Donatello's radiantly emaciated saint is better translated in Desiderio's Martelli Saint John in the Bargello Museum. Here, working in his favored marble, the gentler treatment of the young prophet is more suited to Desiderio's nature but the intensity of expression preserves the awesome spirituality of Donatello's Magdalene.

Once again, as in the Marsuppini tomb, a Rossellino prototype served as Desiderio's model when he executed, c. 1460–61, the splendid tabernacle in San Lorenzo, and, once again, his proclivity for the decorative is obvious. While he was at work on this project, Desiderio came under the immediate influence of Donatello who, newly returned to Florence, was at work designing the bronze pulpits for San Lorenzo. In contrast to the more delicate treatment of his earlier relief of the Faulc Madonna in Philadelphia, his execution of the Panciatichi (Florence, Bargello) and Dudley (London, Victoria and Albert) Madonnas and of the beautiful tondo of the youthful Christ and Saint John the Baptist has been seen as evidence of the renewed impact of Donatello's more vigorous handling of relief.

The famous relief of the Praying Saint Jerome of c. 1461–65 and now in Washington is rendered in a *schiaccato* technique rivaling that of Donatello. This pictorially presented sculpture demands considerable attention before all its delicate details (lion, lioness, cave, gesticulating onlooker, skull, second cross, etc.) reveal themselves. It must be counted among the artist's most accomplished creations. Strangely, Desiderio's authorship was not accepted in the past, with attributions varying from Benedetto da Maiano to Francesco di Giorgio to, even, Leonardo.

Vasari noted that Desiderio's "women and children possess a soft, delicate and charming manner, due as much to nature as to art." No doubt inspired by children busts of the Augustan age, Desiderio made a specialty of carving angelic, Christlike, Florentine children. These sculptures (examples in Vienna and Washington) are typified by animated and, often, open-mouthed expression which convey a sense of immediacy. Acceptance of the several female busts attributed to him has varied, but among the several possibilities, the example in the Bargello is, perhaps, the most convincing with its soft, ethereal beauty and a marble surface that glows with inner luminosity. The finesse of Desiderio's gentle touch is obvious. Curiously, but perhaps predictably, the busts given him with certainty are only of women and children, all executed with a typically gentle grace.

A magnificently carved marble, free-standing ciborium, now in Washington, may be the one described by Vasari as having been intended for the church of San Pier Maggiore. The composition of this ciborium would seem to have been derived from that in the Sienese Baptistery via that executed (c. 1462) by the Rossellino workshop for the lower church in Pienza. If so, it would have been among the last works of Desiderio, done for the church in which he soon would be interred.

—Charles R. Mack

DE STAEL, Nicolas.

Born in St. Petersburg, Russia, 5 January 1914; moved with his family to Poland, 1919, and to Brussels, 1922; naturalized French citizen, 1948. Died in Antibes, 16 March 1955. Lived with Jeannine Guillou from 1937 (died, 1946), one daughter; married François Chapouton, 1946, three sons. Attended schools in Belgium; studied at Académie St. Gilles and Royal Academy of Fine Arts, Brussels, under Professor van Haelen, 1932–34; settled in Paris, 1938: worked with Fernand Léger at Académie Libre, 1938; served in French Foreign Legion, 1940; lived in Nice, 1941–43; worked on ballet projects with René Char and Pierre Lecuire; settled in Antibes, 1954.

Collections: Antibes; Buffalo; Chicago; Cincinnati; Dijon; New York: Moma; Paris: Beaubourg; Washington: Phillips; Zurich.

Publications

By DE STAËL: books—

Lettres à Pierre Lecuire, Paris, 1966.
Lettres à Jacques Dubourg, Paris, 1981.

Illustrator: *Poèmes,* by René Char, 1952; *Ballets-minute,* by Pierre Lecuire, 1954.

On DE STAËL: books—

Duthuit, Georges, *De Staël,* Paris, 1950.

Gindertaël, Roger van, *De Staël,* Paris, 1950.

Courthion, Pierre, *De Staël,* Geneva, 1952.

Lecuire, Pierre, *Voie de Staël,* Paris, 1953.

Tudal, Antoine, *De Staël,* Paris, 1958.

Sutton, Denys, *De Staël,* Paris, 1959, New York and London, 1960.

Gindertaël, Roger van, *De Staël,* Paris, 1960.

Cooper, Douglas, *De Staël,* London and New York, 1962.

Guichard-Meili, Jean, *De Staël: Peintures,* Paris, 1966.

Sutton, Denys, *De Staël,* Milan, 1966.

Dubourg, Jacques, and Francoise de Staël, *De Staël,* Paris, 1968.

Chastel, André, *Staël: L'Artiste et l'oeuvre,* Paris, 1972.

Dumur, Guy, *Staël,* Paris, 1975, New York, 1976.

Dorival, Bernard, *De Staël,* (cat), Zurich, 1976.

Lemoine, Serge, *Staël au Musée des Beaux-Arts de Dijon,* Dijon, 1976.

De Staël (cat), Paris and London, 1981.

Jouffroy, Jean Pierre, *La Mesure de De Staël,* Neuchatel, 1981.

Sutton, Denys, and Nicolas Barker, *De Staël: Drawings and Engraved Work* (cat), London, 1981.

*

De Stael was a slow starter. Although he began attending art schools in 1932 it wasn't until nine years later that he produced any work that he felt was satisfactory enough to keep. We know what he was looking at in his student days—French modernism and 17th-century Dutch art were particular enthusiasms—but we can only speculate about what the pictures from the period looked like.

The first surviving works, melancholic portraits of his mistress Jeannine, are relatively timid essays in Post-Impressionist stylizing reminiscent of Derain, Laurencin, and many others. But in 1942 de Stael suddenly switched to a non-figurative idiom. The change occurred because de Stael had come to feel that figurative painting lacked expressive power. He saw emotional experience as immensely complex. The experience, for example, of seeing Jeannine was made up of numerous strands of feeling. This complexity, he now decided, could only be conveyed by abstract painting. Belief in the expressive power of non-figurative art had been current in European culture since the early part of the century and de Stael spent the next ten years working in an abstract style.

Because he was unable to obtain materials due to the war, de Stael's abstractions were mostly small scale, often made with charcoal and crayon on paper. Their forms tended to be clean and geometrical, usually with some sense of movement, and they were consistent with a lot of contemporary European non-figurative art, particularly the work of Gabo and Kandinsky. Around 1946, however, de Stael developed a more individual style in which diagonal slabs knifed on in thick impasto clash violently together. The period was a bad one for de Stael. Jeannine had died in that year, and the works register de Stael's suffering, obvious also in the titles he used like *The Hard Life* (Collection Galerie Louis Carré, Paris).

By 1948 de Stael had weathered the crisis and his work changed accordingly. The new pictures, many of which are called simply *Composition,* replace violence with stasis. Instead of the melee of warring strokes images are now built very simply out of a few irregularly shaped forms which interlock. There is great attention to the sensuous qualities of paint texture. Lighting also changes with the dramatic tonal contrasts of the earlier abstracts giving way to a more tranquil range of greys and earths. The final phase of de Stael's non-figurative work occurred in 1951 when he adopted a technique in which short mosaic-like strokes are laid over a flat, scarcely modulated background plane effecting the impression of glittering movement. The pictures use a brighter colour range and, as titles like *Roofs* (Collection Petere Gimpel, London) and *Fallen Leaves* (Collection Pierre Granville, London) suggest, are mainly concerned with evoking the experience of light and landscape.

De Stael's change to landscape themes in his abstraction was significant. In his earlier non-figurative paintings he had concentrated on expressing emotional states like grief and suffering. By the 1950's he had moved to expressing the feelings that something before his eyes gave him. He had drawn closer to the world of objects again. In 1952 de Stael saw a floodlit football international. Wondering how to translate this visual experience into paint he realized that it could only be achieved in a figurative image. The resulting pictures simplify the footballers drastically and maintain abstract qualities like very dense paint surfaces. But they are legible representations as well, the first in de Stael's work for ten years.

All of the rest of his painting before his suicide in 1955 was in a simplifying but representational style. The only real technical change in the last years is the switch to using much more dilute paint in 1954. De Stael's subjects were unexceptional—nudes, landscapes, and still lifes—things that gave him acute visual pleasure. His capacity to produce expressive images with the most economical means, on the other hand, was remarkable. By placement, control of paint saturation, and manipulation of tone de Stael could make the most tellingly descriptive paintings from the simplest designs. De Stael's return to figurative painting at the end of his life attracted adverse criticism at the time and he felt himself to be extremely isolated, something which may have contributed to his suicide. Whatever de Stael's reason or reasons for killing himself, his death cut short a phase of work of considerable fertility.

—Roger Mills

DIX, Otto.

Born in Untermhaus bei Gera, Thuringia, 2 December 1891. Died in Hemmenhofen, 25 July 1969. Married Martha Lindner, 1923; three children. Attended Schools in Gera; apprenticed to painter-decorator in Gera, 1905–09; studied in Kunstgewerbeschule, Dresden, 1910–14; served in German army during World War I; studied under Max Feldbauer and Otto Guszmann, Academy of Art, Dresden, 1919–22, and under Heinrich Nauen and Wilhelm Herberholt, Academy of Art, Dusseldorf, 1919–22; co-founder, Dresden Sezession group, 1919, and member, Das Junge Rheinland group, 1923; series of etchings *Der Krieg,* 1924; lived in Berlin, 1925–27;

Stormtroops Advance under Gas, from War, 1924; etching and aquatint

taught at the Academy of Art, Dresden, 1927–33; blacklisted
by the Nazis, and prohibited from exhibiting, 1933; moved to
Schloss Randegg bei Singen in 1933, and to Hemmenhofen in
1936; imprisoned, Colmar, France, 1945–46, then settled in
Hemmenhofen.

Collections: Berlin: Nationalgalerie; Bologna: Arte Moderna;
Dresden; Cologne; Dresden; Hanover; New York: Moma;
Paris: Art Moderne; Stuttgart; Wiesbaden; Zurich.

Publications

By DIX: book—

Illustrator: *Das Evangelium nach Matthäus,* 1960.

On DIX: books—

Pommeranz-Liedke, Gerhard, *Dix: Gemälde und Graphik
 1912–1957* (cat), Berlin, 1957.
Löffler, Fritz, *Dix: Leben und Werk,* Dresden, 1960, 4th ed.,
 1977; as *Dix,* London and New York, 1982.
Lüdecke, Hans, *Dix: Der Krieg,* Berlin, 1963.
Conzelmann, Otto, *Dix: Handzeichnungen,* Hanover, 1968.
Stegen, Ina, *Dix* (cat), Salzburg, 1969.
Feldbusch, Hans, and Fritz Löffler, *Dix* (cat), Aachen, 1970.

Karsch, Florian, and Hans Kinkel, *Dix: Das graphische Werk,*
 Hanover, 1970.
Dix zum 80. Geburtstag (cat), Stuttgart, 1971.
Dix (cat), Paris, 1971.
Dix (cat), St. Gall, 1972.
Dix (cat), Berlin, 1977.
Veit, Ludwig, *Dokumente zu Leben und Werk des Malers Dix,*
 Nuremberg, 1977.
Schmidt, Diether, *Dix im Selbstbildnis,* Berlin, 1978.
Jensen, Jens Christian, *Dix: Zeichnungen aus dem Nachlass
 1911–1942* (cat), Kiel, 1980.
Schubert, Dietrich, *Dix in Selbstzeugnissen und Bilddokumen-
 ten,* Reinbek, 1980.
Barton, Brigid S., *Dix und die neue Sachlichkeit 1918–1925,*
 Ann Arbor, 1981.
Fishcher, Lothar, *Dix: Ein Malerleben in Deutschland,* Berlin,
 1981.
Keuerleber, Eugen, *Dix, Menschbilder* (cat), Stuttgart, 1981.
Löffler, Fritz, *Dix: Werkverzeichnis der Gemälde,* Reckling-
 hausen, 1981.
Loers, Veit, *Dix und der Krieg: Zeichnungen und Graphik
 1913–1924* (cat), Regensburg, 1981.
McGreevy, Linda F., *The Life and Works of Dix, A German
 Critical Realist,* Ann Arbor, 1981.
Conzelmann, Otto, *Der andere Dix: Sein Bild vom Menschen
 und von Krieg,* Stuttgart, 1983.
Karcher, Eva, *Eros und Tod im Werk von Dix,* Munster, 1984.

*

Otto Dix's contributions to the development of modernism have long been acknowledged on the continent, though assessments by English-speaking writers have tended to parrot the often confusing stylistic terminology devised by the Germans. Largely for this reason, the problem of Dix's categorization remains an enigmatic one, and he has consequently fallen through art history's delimiting theoretical cracks.

But the confusion arises for good reason. Dix was an aesthetic chameleon, regularly altering his approach to suit his topical intent, stubbornly adhering to what had long seemed the outmoded, even retrogressive style of realism, and thus has consistently evaded the field's standard modernist categories. As a young artist, trained first in the applied arts tradition and then at Dresden's Academy of Fine Arts, Dix set out upon a singular path that deviated considerably from pre-war Expressionism's self-absorption, never following the structural lines set by Cubism or its more frenetic offshoot, Futurism. While Dix did adopt this fragmented mode during the war years for a series of catastrophic scenes of trench warfare, his post-war emergence, as a particularly scabrous commentator on the inflationary scene among the social activists of the *Novembergruppe,* called for a more traditional approach than that practiced by politicized German Dadaists. Even more quickly than his Berlin counterpart, George Grosz, Dix turned to a brutal realism (in both the formal and thematic senses) that functioned with clear criticality. His approach was deliberately conventional, aimed at the general viewer rather than at the cognoscenti, who were invariably horrified by his blatancy. Inspired by the folk-oriented naïveté of the side-show banner, Dix's drily brushed paintings of ubiquitous street denizens—cripples, prostitutes, and profiteers—established him as a vehement critic of social collapse. Throughout the immediate post-war years, Dix developed this definitive style, which flourished in the interstices between acceptable formal approaches and extremes of expressionistic intent. By attitude a moralist, by form a realist whose adherence to objectivity was seldom as rigid as his outrage might ordain, Dix became one of the first Critical Realists of his generation.

His *magnum opus,* comprising the fifty plates of the etching cycle *Der Krieg,* an eidetic document of his nightmarish years in the First World War's trench system, encapsulates the characteristics of this style and serves as a perfect example of his subjectively objective approach to art. This memoir, verifying unimaginable atrocities with dates and locations (as in "Seen on the Heights of Clery-sur-Somme" or "Shell Crater with Flowers: Spring 1916, Before Reims," both from the third portfolio), was produced in 1924, ten years after the war's outbreak, as part of a national leftist effort to prevent its recurrence.

Dix utilized a variety of technical approaches, from full line-etch to aquatint and soft-ground for three interrelated themes: the daily degradation of trench life (forty-two images of troglodytic dugout activities, the moon-scapes of No-Man's Land, and off-duty carousings); the grim experience of actual combat (a mere trio of plates, reflecting the infrequency of hand-to-hand contact); and the corruption and confusion of civilians trapped within—or drawn by—the conflict (five plates). Only two of these prints can be construed as allegory: the "Skull," from the fourth portfolio and the "Dead at Their Post Near Tahure," the last plate in the cycle. The worm-infested skull, while surely a realistic document, serves to position the cycle within the apocalyptic tradition implied by the title *Dance of Death, Anno 17* from the second portfolio, a hellishly illuminated nocturnal No-Man's Landscape with its corpses entangled in the barbed labyrinth.

The cycle, which was completed in six months of isolation, was ready for its sixteen-city tour on the first of August, 1924. The five portfolios of ten prints, drawn from over 600 gouaches and drawings completed in the trenches, as well as from his sergeant's pay-book, letters, and postcards sent to friends and family, recall his three-year tour of both eastern and western fronts as a machine-gunner and flight trainee. Beginning with the autumn campaign of 1915 in Champagne, and surviving the Somme battles of 1916, Dix ended the war in the relative calm of West Prussia, having suffered only one wound and surviving most of his *Kamaraden. Der Krieg* serves as their memorial.

In an expressionistic amalgam ranging from primitivist crudity to semi-abstraction, that was influenced by the historical cycles of Goya and Callot, as well as by the Renaissance master-works of Altdorfer and the Pisan Camposanto murals of Traini, Dix's chronicle of death suits its style to its subject. The drunken antics in the "Canteen at Haplincourt" are detailed in a childish line etch, which the artist also employs for the "Wounded Man Fleeing (Somme Battle, 1916)," adding the nervous, shattered line seen in "Lens Attacked by Bombs," with its precipitous angular composition. The "Ruined Trench" (portfolio I) and the "Abandoned Position Near Neuville" (portfolio II), with their soft-ground density, resemble Altdorfer's corrosive approach, while "A House Destroyed by Flying Bombs (Tournai)," spilling lacerated victims, is a literal homage to Goya's "Ravages" in the *Disasters of War.*

Dix's unflinching commitment to revelation makes *Der Krieg* an examplar of ethical print-making, a cathartic chronicle of the external and internal landscapes of the Great War. Falling midway between subjectivity and objectivity, this cycle conflates the force of both, with an intensity that inevitably abated after 1924, though the artist returned to the subject frequently over the next decade. His great triptych *Krieg,* finished in 1932 under the threats of an increasingly reactionary government, is considerably cooler in tone, old-masterish in approach, and paradoxically beautiful, exhibiting the characteristic detachment of the *Neue Sachlichkeit.* The print cycle's scarifyingly didactic immediacy by contrast, necessitated the honesty that imbues Dix's Critical Realism with its enduring ability first to shock and finally to convince.

—Linda F. McGreevy

DOBSON, William.

Born in London, baptized 4 March 1611; son of a protégé of Francis Bacon. Buried in London, 28 October 1646. Married 1) Elizabeth (died, 1634); 2) Judith Sander, 1637. Possibly studied under the painter and designer Francis Sleyn; apprenticed to in late 1620's to print-seller and picture-dealer William Peake, London; freeman of the Painter-Stainers Company; succeeded Van Dyck as court painter, and active in Oxford c. 1642–46 painting Charles I, members of his family, and serving officers.

Collections: Birmingham; Dunedin, New Zealand; Edinburgh: Portrait Gallery; Kingston upon Hull; Liverpool; London: Portrait Gallery, British Museum, Courtauld, Tate, Maritime Museum; Manchester: University; New Haven.

Publications

On DOBSON: books—

Millar, Oliver, *Dobson* (cat), London, 1951.
Vaughan, William, *Endymion Porter and Dobson,* London, 1970.
Rogers, Malcolm, *Dobson* (cat), London, 1983.

article—

Edmond, Mary, "Limners and Picturemakers," in *Publications of the Walpole Society* (London), 1980.

*

Dobson's contemporary, the antiquary John Aubrey, rightly called him "the most excellent painter that England hath yet bred," and he remained so until Hogarth (1697–1764). He was the portraitist of the defeated royalists in the English civil war, and died at the early age of thirty-five.

Before the war, Dobson lived in St. Martin's Lane in London, an area much favoured by foreign artists, and through his neighbour Abraham van der Doort, the royal Surveyor, he would have gained access to Charles I's imcomparable art collection, notably of the great Venetians, which clearly had a potent influence on the formation of his style. He is said to have received instruction for a time in the London studio of the German artist Francis Cleyn; but there is no evidence that he ever studied under Van Dyck, his predecessor as Court Painter, and their styles are quite dissimilar.

Dobson probably set up independently in the late 1630's: a self-portrait of striking virtuosity and a charming companion portrait of his first wife, Judith Sander (both private collection), are his earliest attributable works. As it is now known that the marriage took place in December 1637, the two paintings perhaps belong to around that date. The dramatic lighting of the self-portrait, and of an *Unknown man* (Methuen collection), proclaims the influence of followers of Caravaggio. It seems likely that such works, and the *Endymion Porter* (Tate), form a group painted in London, and that it was their quality which encouraged someone—perhaps Porter himself—to recommend Dobson to Charles I at the outbreak of war in August 1642 or after the removal of the Court to Oxford in October. Van Dyck had died in December 1641, and the Serjeant-Painter John de Critz two or three months later, and Dobson would have been seen as the man to fill the gap, although there is no evidence that he ever had any formal appointment.

The artist is said to have painted the King several times at Oxford, but only one dubious example is known to survive. The Prince of Wales and the King's nephew Prince Rupert were probably among the first sitters. The *Prince Rupert,* known only from an engraving by Faithorne, is lost, but *Charles II When Prince of Wales* (Edinburgh, National Portrait Gallary), and *John, 1st Baron Byron* (Manchester University,

Tabley collection), both three-quarter length, are exceptional examples of Dobson's version of the baroque style—dramatically conceived, and rendered in a range of rich Venetian reds, blues, and golds, taking their high key from the crimson royalist sashes. The legs of the young prince are cut off just below the knee, those of Byron just above, thrusting the figures forward in most un-Van Dyckian manner. The prince's helmet (held by his page) and the cuirass he wears accurately portray part of a suit now in the Armouries at the Tower of London. The *Byron* is the most ambitious and complex of Dobson's portraits of soldiers: the sitter, a cavalry commander who is accompanied by his black page and white horse, stares boldly out at the spectator, a scar on the left cheek presumably recalling a wound received in a night skirmish at Burford in January 1643.

Among the noblest portraits of the doomed royalists is a full-length (one of only two by Dobson known to survive) of *Sir William Compton,* a younger brother of the third Earl of Northampton (Marquess of Northampton). He is said to have been eighteen when the portrait was painted, which would date this work, too, to about 1643. It is on six pieces of canvas of different sizes joined together, a poignant reminder of the difficulties the artist must have faced in securing his materials in wartime Oxford. No doubt for similar reasons, and because he was so much in demand, Dobson restricted himself almost entirely to modest heads-and-shoulders in his late work, and applied the paint thinly, and in a limited colour range.

Two group portraits are of startling originality. *Prince Rupert, Colonel William Murray, and Colonel John Russell* (private collection), which perhaps shows Murray receiving his commission in the prince's regiment, conveys a feeling for historical and psychological drama without precedent among group portraits painted in England. The other, *Portrait of the Artist with ?Nicholas Lanier and Sir Charles Cotterell* (Duke of Northumberland), a precocious English conversation piece, may date to the last year of Dobson's life. If the identification of Lanier is correct, the artist is standing between one of the greatest connoisseurs of an earlier generation and the most youthful of his patrons. With the fall of Oxford to Cromwell in 1646 and the flight of the royalists, he returned to his old lodgings in St. Martin's Lane in London, where he died in poverty in October. He had had no chance to re-establish himself in the capital, and was denied elements so important for the further development of a highly gifted artist—enlightened patronage, economic security, proper working conditions, and perhaps foreign travel. He was an original, and left no school.

—Mary Edmond

DOMENICHINO.

Born Domenico Zampieri in Bologna, October 1581. Died in Naples, 6 April 1641. Married Marsibilia Barbetti, 1619; two sons and one daughter. Pupil of Calvaert, then in the Academy of the Carraccis: assistant to Ludovico in Bologna, then worked with Annibale in Rome (on Palazzo Farnese) after 1602; painted frescoes for Villa Aldobrandini in Frascati, c. 1607; other commissions in or near Rome until c. 1617; altarpiece for S. Francesco in Fano, 1618-19; in Bologna, 1619-

Study for The Last Communion of St. Jerome; drawing;
Royal Collection

21; in Rome, 1621–31: architect for Pope Gregory XV, then
decorated S. Andrea della Valle; in Naples after 1631: deco-
rated the S. Gennaro chapel in Naples Cathedral, and other
Naples churches. Pupil: Fortuna.

Major Collection: Paris.
Other Collections: Berlin; Beziers; Bologna; Cambridge;
Chantilly; Darmstadt; Fano: Cathedral; Florence; Frascati:
Villa Aldobrandini; Genoa: Rosso; Grottaferrata: S. Maria;
Hampton Court; London; Madrid: Milan; Munich; Naples:
Cathedral, Galleria Nazionale; Oxford; Rome: Borghese, Do-
ria Pamphili, Palazzo Farnese, Capitolina, S. Andrea della
Valle, S. Gregorio Magno, S. Luigi dei Francesi, S. Maria in
Trastevere; Rotterdam; York.

Publications

On DOMENICHINO: books—

Serra, Luigi, *Domenichino*, Rome, 1909.
Premoli, Orazio, *I pennachi del Domenichino in S. Carlo a'
Catinari*, Rome, 1915.
Pope-Hennessy, John, *The Drawings of Domenichino . . . at
Windsor Castle*, London, 1948.
Neppi, Alberto, *Gli affreschi del Domenichino a Roma*,
Rome, 1958.
Fagiolo dell'Arco, Maurizio, *Domenichino, ovvero classi-
cismo del primo-seicento*, Rome, 1963.
Borea, Evelina, *Domenichino*, Milan. 1965.
Asioli, Luigi, *La cattedrale basilica di Fano*, Urbania, 1975.
Spears, Richard E., *Domenichino*, New Haven, 2 vols., 1982.

articles—

Spear, Richard E., "Looking at Art: Domenichino's *Last
Communion of St. Jerome*," in *Art News* (New York), No-
vember 1983.
Cropper, E. Elizabeth, "New Documents Concerning Do-
menichino's *Last Communion of St. Jerome*," in *Burlington
Magazine* (London), March 1984.
Spear, Richard E., "Domenichino Addenda," in *Burlington
Magazine* (London), January 1989.

*

Domenichino was in many ways the perfect product of the
Carracci Academy. Serious, studious, and single-minded, he
was even more committed than his teachers to reviving the
careful preparatory techniques of the Renaissance and to a re-
turn to the classical canons of Raphael and the antique. He was
the father of 17th-century Classicism; in contrast to the easy
and sensuous grace of Guido Reni and opposed to the sweep-
ing early Baroque drama of Giovanni Lanfranco (both also
Carracci pupils), his formal directness, compositional clarity,
and balanced intellectual rigour inspired painters like Andrea
Sacchi, Nicolas Poussin, and Carlo Maratta, and became one
of the foundations of 18th-century Neoclassicism.

Domenichino lacked the technical gifts of Reni, and his
early works suffered from a clumsiness in execution, and even
in conception, which was to surface occasionally throughout
his career. This is evident in his first independent commission,
frescoes of *Scenes from the Lives of SS. Nilus and Bartholo-
mew* in the Abbey of Grottaferrata (1608–10), where the pa-
tron was Cardinal Odoardo Farnese, for whom Domenichino
had already assisted Annibale Carracci on the famous *Galleria*
in Palazzo Farnese in Rome. In Rome during the same period
(1609) he painted a fresco of the *Scourging of St. Andrew*
(Oratory of St. Andrew, S. Gregorio Magno) which reveals his
strengths as much as his weaknesses. It was commissioned by
Cardinal Scipione Borghese as a companion piece to Reni's *St.
Andrew Adoring the Cross*, and to the latter's elaborate compo-
sition, graceful figures, and decorative landscape setting it
provides a stark, sombre, and severe obverse, all elements
reduced to the essentials of the narrative; but the power of the
result is undercut by Domenichino's inelegant handling, par-
ticularly of the figures, and by his naive device of reducing the
proportionate size of the spectators to emphasize their distance
and unimportance.

During the next few years, however, he achieved a notable
maturing of his style. In 1611 he began his first major altar-
piece, the *Last Communion of St. Jerome* (dated 1614; Vati-
can). In it he presented a carefully considered critique of
Agostino Carracci's version of the subject, painted in the
1590's (Bologna). Domenichino reversed Agostino's composi-
tion and made it more static and balanced; he simplified the
grouping of his fewer figures, modelling the forms more
firmly and giving faces and gestures more measured expres-
siveness, cooled the colour range, and concentrated the light-
ing; in short, he replaced a strongly Venetian atmosphere with
Roman gravity. These tendencies are even more marked in his

fresco for the Polet chapel in S. Luigi dei Francesi, Rome, with *Scenes from the Life of St. Cecilia* (1612–15). In some ways they are his greatest achievement. He invested the scenes with a solemn grandeur that even encompasses details of humorous genre. The settings are further simplified and the protagonists increased in size; the monumentality of the figures is frequently derived from specific antique sources, but they are also carefully characterized by expressive gestures and fully realized emotional reactions, which are intensified by the clarity of their positioning. Archaeologically accurate details appropriately evoke ancient Rome, and the aura of classic harmony recalls Raphael. Some of the bulk and immediacy of Annibale Carracci is retained, but equally his warmth and vivid energy are lost.

Domenichino followed this high point of Classicism with something of a retreat. His wooden ceiling in S. Maria in Trastevere, Rome (1616–17), is more remarkable for the architectural effect of its star-shaped coffering than for the central painting of the *Assumption of the Virgin*, which reprises the *Assumption of St. Cecilia* in richer colours. The *Myths of Apollo* he frescoed in a garden pavilion of Villa Aldobrandini, Frascati (1616–18; some *in situ*, the rest in London) are suitably rustic and even quaint in tone, and have a marvellously still quality which infuses their exquisitely calm and harmonious landscapes with a timeless air; but the ineptnesses of the figure-drawing and especially of the illusionistic details cannot entirely be ascribed to the considerable intervention of assistants.

In 1618 Domenichino retreated physically from Rome, where he had not been financially successful and whence he was tempted by the lucrative offer to provide frescoes and an altarpiece for the Nolfi chapel in S. Francesco, Fano. From there he returned to Bologna, where he renewed his acquaintanceship with the early Baroque origins of his style, and whence he was summoned by the election of his compatriot Gregory XV as Pope in 1621. His altarpieces of this period show an uneasy attempt to express in his essentially static style some of the drama of Baroque movement, and also a newly abstruse erudition.

One of his first works after his return to Rome, a ceiling painting in Palazzo Costaguti of the *Chariot of Apollo* (1621–23), is still a clumsy effort to assimilate Baroque illusionism. But in his frescoes in S. Andrea della Valle (1622–27) he finally achieved an effective compromise. His pendentives of the *Four Evangelists* borrow a powerful and dynamic grace from Correggio—perhaps in response to the inspiration of the dome fresco by his arch-rival Lanfranco—and introduce some novel illusionistic tricks. His *Scenes from the Life of St. Andrew* in the choir and apse are more restrained, but still represent a return to the controlled vigour, dynamic compositions, and forceful landscape backgrounds of the Carracci. Domenichino also painted some of his finest pure landscapes at this period, infusing the classically balanced harmonies of Annibale Carracci with a new strength and monumentality.

Domenichino's later works represent a considered reaction from this second high point of his career. His pendentive frescoes in S. Carlo ai Catinari, Rome (1628–30), describe the *Cardinal Virtues* with an array of subsidiary figures which, while extending the illusionistic details of S. Andrea della Valle, reduce the force of individual effects to an undifferentiated mass. Even more confused are his designs for the Cap-

pella del Tesoro in Naples Cathedral, the decoration of which occupied the last ten years of his life (1631–41). Here the large fields of frescoed lunettes and pendentives (some damaged) depict the *Life of St. Januarius* with crowded scenes of frozen figures whose frequently beautiful poses and telling gestures are vitiated by unordered compositions and uncontrasted colours.

Domenichino's last works have rarely been admired. But the austerely original classicism he created in the first years of his maturity, 1610–15, became a canon of reference for all artists and amateurs opposed to the specious and superficial aspects of Baroque, Rococo, and Realist art until well into the 19th century.

—Nigel Gauk-Roger

DOMENICO VENEZIANO.

Born probably in Venice, 1405? Died in Florence, May 1461. Probably apprenticed to Gentile da Fabriano in Florence in 1420's; possibly in Rome, c. 1426–32, then working independently in Florence, c. 1432–37; first recorded in Perugia, 1437–38; then worked in Florence after 1439 (his assistant was Piero della Francesca); few signed works.

Collections: Berlin; Bucharest; Cambridge; Florence: Uffizi, S. Croce; London; Settignano: I Tatti; Washington.

Publications

On DOMENICO: books—

Salmi, Mario, *Pablo Uccello, Andrea del Castagno, Domenico,* Milan, 1936.
Bacci, Mina, *Domenico,* Milan, 1965.
Wohl, Helmut, *The Paintings of Domenico,* New York and Oxford, 1980.

articles—

Muraro, Michelangelo, "Domenico at S. Tarasio," in *Art Bulletin* (New York), 41, 1959.
Shell, C., "Domenico: Two Clues," in *Festschrift U. Middeldorf,* Berlin, 1968.
Welliver, W., "The Symbolic Architecture of Domenico and Piera della Francesca," in *Art Quarterly* (New York), 36, 1975.
Ames-Lewis, F., "Domenico and the Medici," in *Jahrbuch der Berliner Museen,* 21, 1979.

*

In a letter written to Piero de'Medici in 1438 from Perugia Domenico Veneziano declares that he "longs to do some famous work," and that the "marvelous things" he hopes to paint "will bring honor" to the Medici and will be fully equal to "the good masters like Filippo Lippi or Fra Angelico."

Domenico's own evaluation of his high merit is confirmed by Alamanno Rinuccini writing in 1472 who declares that Domenico Veneziano, Filippo Lippi, and Fra Angelico, while "different among themselves in their variety" are "alike in excellence and goodness," and, therefore, "can deservedly be compared with the ancients." No modern scholar would deny that Domenico was one of the major artists of the 15th century. But there are very few artists of the early Renaissance about whom so little is known and whose works have survived in such small number—an even dozen, half of which once formed a single altarpiece.

Since Vasari's life of Domenico Veneziano has been shown to be unusually unreliable (particularly his supposed rivalry with and murder of Andrea Castagno), most of what is known about the artist has been deduced from his works themselves and a scattering of documentary evidence. As his name implies Domenico was a Venetian but, it is generally agreed, trained in Florence and Rome by Gentile da Fabriano and Pisanello in a north Italian International Gothic style characterized by a high regard for naturalistic details and ornamental surface designs. Perhaps he even had a first-hand acquaintance with Netherlandish art further north and its particular sensitivity to light. Given this training he seems to have responded to the beauty of late Gothic art in Florence (e.g., Lorenzo Monaco, aspects of Fra Angelico), and especially to its high keyed and light colored palette. But as his letter to Piero de'Medici suggests he was also aware of the most avant garde developments in Florence, including the perspective illusionism and earthy naturalism of Masaccio's works, and the aesthetic energy (linear and sculptural) and ecstatic piety of Donatello's. Perhaps only an outsider could have brought together all these currents and cross-currents of artistic possibilities in Florence in the second quarter of the fifteenth century. In any case, he was certainly the first to achieve a synthesis, and one of exceptional power and beauty, in his later works of the *St. Lucy Altarpiece* (c. 1445–47) in the Uffizi and the fresco of *SS. John the Baptist and Francis* (c. 1450–53) for the Cavalcanti Chapel in S. Croce. In the *St. Lucy Altarpiece* he also gave visual form to the paradoxical implications of the *sacra conversazione* as no artist, with the possible exception of Fra Angelico, had before.

There seems to be little doubt that Domenico's works were enormously influential, but so much has been lost that it is difficult to be very precise about the degree and nature of that influence. At the least it seems safe to say that the abstract grandeur and light color harmonies of Piero della Francesca (who was an assistant for the execution of the frescoes of S. Egidio, and probably even a pupil), the anguished spirituality of Andrea del Castagno (who may have been an apprentice), and the linear dynamism of Antonio Pollaiuolo all seem to owe much to the example of the brilliant works of Domenico Veneziano.

—Loren Partridge

DONATELLO.

Born Donato di Niccolo di Betti di Bardi in Florence, 1383 or 1386. Died in Florence, 13 December 1466. Worked on Baptistery doors with Ghibert; 1403–06; then worked with Nanni di Banco on Cathedral; in partnership with Michelozzo, 1425–c.33 (developed low relief—*relievo schiacciato*); in Rome, 1431–33; made pulpit for Prato Cathedral in 1430's, and worked on S. Lorenzo, Florence (including bronze doors); in Padua, 1443–54: equestrian monument to Gattamelata; then in Florence after 1454. Pupil: Bertoldo.

Collections/Locations: Berlin; Boston; Faenza; Florence: Bargello, Orsanmichele, Duomo, Baptistery, Cathedral, S. Croce museum, Piazza della Signoria; Lille; London: Victoria and Albert; Naples: S. Angelo a Nilo; Padua: Santo, Piazza del Santo; Pisa; Rome: S. Peter's; Siena: Baptistery; Venice: S. Maria de' Frari; Washington.

Publications

On DONATELLO: books—

Kauffmann, Hans, *Donatello: Eine Einführung in sein Bilden und Denken*, Berlin, 1935.

Planiscig, Leo, *Donatello*, Vienna, 1939.

Cecchi, Emilio, *Donatello*, Rome, 1942.

Goldscheider, Ludwig, *Donatello*, London, 1944.

Janson, H.W., *The Sculpture of Donatello*, Princeton, 2 vols., 1957, 1963.

Fiocco, Giuseppe, *Donatello al Santo*, Padua, 1961.

Castelfranco, Giorgio, *Donatello*, Milan, 1963, New York and London, 1965.

Grassi, Luigi, *Tutta la scultura di Donatello*, Milan, 1963; as *All the Sculpture of Donatello*, New York, 2 vols., 1964.

Busignani, Alberto, *Donatello: L'altare del Santo*, Florence, 1965.

Paolucci, Antonio, *Donatello*, Milan, 2 vols., 1966.

Marchini, Giuseppe, *Il pulpito donatelliano del duomo di Prato*, Prato, 1966.

Carli, Enzo, *Donatello a Siena*, Rome, 1967.

Cessi, Francesco, *Donatello a Padova*, Padua, 1967.

Salmi, Mario et al., editors, *Donatello e il suo tempo* (cat), Florence, 1968.

Wundram, Manfred, *Donatello und Nanni di Banco*, Berlin, 1969.

Guerrieri, Francesco, *Donatello e Michelozzo nel Pulpito di Prato*, Florence, 1970.

Hartt, Frederick, *Donatello, Prophet of Modern Vision*, New York, 1973.

Rosenauer, Artur, *Studien zum frühen Donatello: Skulptur im projektiven Raum der Neuzeit*, Vienna, 1975.

Bertela, Gaeta, *Donatello*, Florence, 1975, London, 1978.

Becherucci, Luisa, *Donatello: I pergami di S. Lorenzo*, Florence, 1979.

Paoletti, J., *The Siena Baptistery Font*, New York, 1979.

Lightbown, R.W., *Donatello and Michelozzo: An Artistic Partnership and Its Patrons in the Early Renaissance*, London, 2 vols., 1980.

Parronchi, Alessandro, *Donatello e il potere*, Florence, 1980.

Poeschke, Joachim, *Donatello: Figur und Quadro*, Munich, 1980.

Greenhaugh, Michael, *Donatello and His Sources*, London, 1982.

Lamentation over the Dead Christ, c. 1440; bronze; 23½ in (59.7 cm)

Bennett, Bonnie A., and David G. Wilkins, *Donatello,* Oxford, 1984.

Munman, Robert, *Optical Corrections in the Sculpture of Donatello,* Philadelphia, 1985.

*

Of all 15th-century sculptors, Donatello received the most lavish praise by his contemporaries who were in awe of his genius and extraordinary versatility. Working in many centers in Italy, he was an innovator of the emerging Renaissance style, introducing new principles of representation and creating new forms of relief and figural sculpture. Fascinated by the world around him and by the inner life of his subjects, he had a capacity for boldness, drama, and pathos that had no parallel. Despite the accolades and a large number of documented works, few facts about the character and personality of this complex individual have come down to us from reputable sources.

After training in the shop of Ghiberti, with Nanni di Banco on the Porta della Mandorla of the Cathedral of Florence, and on independent commissions for buttress figures of the Cathedral, Donatello's creative genius forcibly appears in the *St. George* statue and relief for Or San Michele. The statue, set within an unusually shallow niche, projects forward into the space of the observer as a startling presence, a real, not an ideal, hero. He is ready for action, alert, confident, and very human in his psychological and postural tensions.

The most innovative element of the St. George tabernacle is the marble relief depicting the hero on his horse killing a dragon. Donatello is concerned not only with the dramatic force of the narrative, but with creating an optical illusion which enriches his real world, not by the rules of perspective which were to be examined later by Brunelleschi and Alberti, but by the use of *rilievo schiacciato* (very thin flattened relief) and a sketchy, almost pictorial, style of carving. It is these concerns with optical principles and the psychological tensions of the figure that were to form the basis of his sculpture of the 1420's and 1430's.

Foremost among these were the marble prophets, set in niches of the Campanile high above street level, especially the so-called *Zuccone* and the *Jeremiah.* Their deliberate ugliness pulses with the intensity of their divine message and the tension of their stance. The powerful loop of drapery of the *Zuccone* draws the eye to his impassioned face and bald head, and the complexity of *Jeremiah*'s folds of drapery creates a terrifying tension within his calmer pose. Behind the concept of both figures lie classical sources adapted so brilliantly by Dona-

tello, but it is the power of his imagination that transforms the prophets into examples of individualized humanity.

Donatello's versatility in the use of materials and techniques is demonstrated in a group of works in bronze executed in the 1420's and 1430's. The *St. Louis* for the Parte Guelfa niche on Or San Michele, a hollow figure enveloped in massive robes, was built of a number of bronze plates and pieces, moulded, cast, and fire-gilt separately and then assembled, an innovative method, perhaps necessitated by its unusually large size. The sculptor seems to have had more trouble with the casting of the bronze *David* in the Bargello (date uncertain) which shows several flaws and patches. However, the sensuous form, the modelling of the convexities and concavities of the nude body to reflect light in varieties of rhythm, and the unusual pose and iconography of the figure testify to the unique imagination of the master.

For nine years Donatello and Michelozzo formed a partnership to execute three large tomb projects (Coscia in the Baptistry, Brancacci in Naples, Aragazzi in Montepulciano) and other important commissions. Although it is difficult to separate their individual contributions and responsibilities for each piece of sculpture, Donatello is usually credited with the most creative or innovative parts, the bronze effigy of Coscia, for instance; Michelozzo probably designed most of the architectural frameworks and some of the figures; and various assistants of the shop executed the less important parts.

Although Michelozzo may have been the "manager" or supervisor of the shop in which the bronze casts were produced, Donatello was solely responsible for the design and concept of the revolutionary *Feast of Herod* relief (1423–37) for the Baptismal Font in Siena. This is the first relief of the Renaissance displaying the newly discovered linear perspective, the purpose of which is to enhance the action by providing "stages" against and in which the explosive force of the drama occurs. The architectural compartments receding in space are imaginary, but based on Brunelleschi's perspective system with creative adaptations by Donatello.

A major change occurred in Donatello's life when he moved to Padua in 1443; he remained there for over ten years and was influential in the development of a "Paduan" school of painting. The sculptor was probably called to the north to design and execute a colossal bronze statue of the Venetian general Gattamelata, placed on a high pedestal in front of the Church of Sant'Antonio. Although this was not the first equestrian monument since antiquity, it was the most closely related to classical examples, used by Donatello more as inspiration than as imitation. Because of its height and distance from the observer, the design emphasized bold masses and dramatic tensions; the difficulties of casting a group on such an enormous scale tested his technical abilities to the fullest.

The masterpiece of Donatello in both technique and aritstry is the sculpture for the high altar of Sant'Antonio comprising seven life size statues, four large narrative reliefs, a powerful crucifix and numerous other reliefs. The original arrangement of these pieces is unknown (the altar was dismantled in the 17th century), but perhaps are indicated by Mangegna's later *San Zeno Altarpiece*. The four reliefs depicting miraculous events of Saint Anthony build on the optical principles enunciated in the *Herod* relief for the Siena Baptistry some twenty years earlier but are more elaborate in their architectural backgrounds and present a new, explosive concept of space. In the relief called *The Miracle of the Angry Son,* for instance, over eighty figures, each dramatically displaying their individualized psychological reaction to the foreground action, are contrasted with the overpowering architectural space which hints at, but does not slavishly render, classical sources and the Albertian perspective system. The agitation of the sketchy figures and drapery increases the tension and excitement created by the disquieting perspective of the buildings, touched with flickers of gold. In contrast, the six statues of saints and the Madonna and Child are calm, dignified, and monumental, infused with the master's spiritual and humanly expressive qualities.

Returning to Florence in 1454, Donatello briefly re-established his partnership with Michelozzo, but independently created works in bronze which gloriously culminate a long career of remarkable achievements. During these last twelve years his style became even more intense, frenzied and expressive, and he continued to experiment with new techniques of bronze casting. Tight, nervous folds of drapery; expansive, sometimes contorted, gestures; agonized facial expressions of determination, remorse, or pain; a seering sense of realism that startles and occasionally offends; macabre details of blood, ugliness, and insanity; tension, anxiety, excitement, and drama: these qualities characterize the last great works of the master. His *Judith and Holofernes* provides an excellent example. Perhaps allegorical and certainly symbolic, the statue was originally located in the garden of the Medici Palace, but was later moved to the Palazzo Vecchio. Judith is determined, almost obsessed, by her bloody task, raising her sword high above her head to administer a second blow. Her voluminous drapery hangs in taut nervous lines and complex rhythms. The realism is enhanced by the head of Holofernes whose contorted body leaves indentations on the pillow below him, and by the veil of Judith which was cast by using actual lace. The expressive power and dramatic tensions of the group are undeniable and reveal the aging sculptor as even more innovative, passionate, and complex than he had been in his youth. *Judith* and the late works show that he still possessed the most profound understanding of suffering, courage, inspiration, and the human experience.

—Harriet McNeal Caplow

DORÉ, (Louis Auguste) Gustave.

Born in Strasbourg, 6 Janury 1832; moved with his family to Bourg-en-Bresse, 1841. Died in Paris, 23 January 1883. Attended school in Bourg-en-Bresse, and Mlle. Jeannot's Art Academy; drawing prodigy: first book of lithographs published at age 15; lithographer for Paris weekly *Le Journal pour Rire*, 1848–52, and studied at Lycée Charlemagne, 1848–50; then illustrator for *Le Musée, Francais-Anglais*, etc., illustrated books and albums (well-known for his illustrations of Rabelais, Balzac, Dante's Inferno, the Bible, London Life, Paradise Lost, etc.); friend of Rossini and Offenbach; visited Spain, 1855, and England, 1868–69 and often thereafter (established Doré Gallery).

Collections: Boston; Grenoble; Montpellier; Northampton,

Massachusetts; Paris: Art Moderne; Rheims; Rouen; Troyes;
Versailles; Wellesley, Massachusetts.

Publications

On DORÉ: books—

Rümann, A., *Doré: Bibliographie der Erstausgaben*, Munich,
 1921.
Leblanc, Henri, *Catalogue de l'oeuvre complet Doré*, Paris,
 1931.
Haug, Hans, *Doré*, Paris, 1933.
Lehmann-Haupt, Hellmut, *The Terrible Doré*, New York,
 1943.
Rose, Millicent, *Doré*, London, 1946.
Baudson, F., *Doré* (cat), Bourg-en-Bresse, 1963.
Farner, Konrad, *Doré, der industrialisierte Romantiker*, Dres-
 den, 2 vols., 1963, 1975.
Stevens, James, *A Doré Treasury*, New York, 1970.
Gosling, Nigel, *Doré*, Newton Abbot, 1973, New York, 1974.
Maré, Eric de, *The London Doré Saw: A Victorian Evocation*,
 London, 1973.
Rose, Millicent, *The Doré Bible Illustrations*, New York,
 1974.
Adhémar, Jean, *Doré* (cat), Paris, 1974.
Forberg, Gabriele, *Doré: Das graphische Werk*, Munich, 2
 vols., 1975.
Damase, Jacques, *Doré, peintre et sculpteur*, Paris, 1979.
Richardson, Joanna, *Doré: A Biography*, London, 1980.
Guratzsch, Herwig, and Gert Unverfehrt, editors, *Doré* (cat),
 Hanover, 1982.
Clapp, Samuel, *Doré* (cat), London, 1983.
Renonciat, Annie, *La Vie et l'oeuvre de Doré*, Paris, 1983.
Noël, Bernard, *Londres de Doré*, Paris, 1984.

article—

Woods, A., "Doré's London: Art and Evidence," in *Art His-
 tory* (Oxford), September 1978.

*

Born in Strasbourg, a city of spires, quaint gables, and totter-
ing roofs, Gustave Doré had much that was Gothic and medie-
val impressed upon his consciousness from an early age. His
home contained a spiral staircase dating from the Renaissance.
On Sundays he would accompany his father and his two broth-
ers on walking and climbing excursions in the mountains
which in his memory and perhaps even in actuality seemed to
bristle with jagged pines, tortured outcrops of rock, and the
ruins of ancient castles. Later the Swiss Alps, the Pyrenees,
the Scottish Highlands (as in his *Twilight in Scotland*, 1877),
and the steep banks of the Rhine were to be drawn into his art.
His visual memory and a corresponding fluency of draughts-
manship were evident at the age of 13 when his humorous
lithographs and satirical drawings of the citizens of Bourg-en-
Bresse where his family had moved were accepted by the edi-
tor of a comic journal. He then began work in Paris with the
Journal pour Rire. In 1848 he made his debut at the Salon
with two pen drawings, and two years later confirmed his

Acrobats; bronze; 50 in (127 cm)

range of talents by exhibiting his oil *The Wild Pines*. It is remarkable that Menzel and Doré, two of the greatest of 19th-century draughtsmen, both began their careers as lithographers and both were self-taught.

Until his early death at the age of 52, Doré turned out oils, watercolours, lithographs, etchings, and drawings at a hectic pace. His imagination was fired by literary works—Dante, Perrault, the Bible, Cervantes, Rabelais, Tennyson, Milton, Byron, and Dumas were among the subjects of his brush and pencil—and the resulting folios of woodcut illustrations were popular all over the world. Towards the end of his life he took up sculpture with considerable success, his statue of Alexandre Dumas being particularly effective: as a state monument it was erected in the place Malesherbes. An accolade to his industry and moral standing was evinced by his being received by both the English and French sovereigns in 1860 and 1864 respectively. He became an officer of the Legion of Honour in 1879. Doré never married and until her death two years before his own lived with his mother. The last word to fall from his lips was "Shakespeare"—the writer whose works he never illustrated although he actually began the preparatory work for *Macbeth*.

The precocious talent shown by Doré (he adopted the French form in preference to his real name of Dorer which sounded too Germanic) was not entirely original. He lived in an age of great illustrators: the abundance of cheap publications, whether in book or magazine form, during the 19th century saw the rise of an immense school of illustrators whose brilliance has never since been equalled: Menzel, Daumier, Gavarni, Bewick, Busch, Cruikshank, and Beardsley are among the names that first come to mind. Rodolphe Toepffer, who adorned his own stories with lively, seemingly spontaneous pen drawings, and Grandville, with his fantastic woodcut illustrations to Lafontaine's *Fables* (1838), Old Nick's *Petites misères de la vie humaine* (1843), and, even more, *Un Autre Monde* (1844), were early and persistent influences on his graphic work, the one encouraging the vivid sketchiness of his *Histoire pittoresque, dramatique, et caricaturale de la Sainte Russie* (1854) and the other inspiring the apocalyptic contrasts of light and dark, enclosure and vast, open space, dizzy heights and awful abysses, as in his Dante's *Inferno* (1861) and Milton's *Paradise Lost* (1866). Nevertheless, Doré had a creative imagination all his own: detail is subordinated to the grand effect, and foreshortening is used with panache and great skill, even if to excess on occasion. There was undoubtedly an element of the theatre and of showmanship about his illustrations, but this corresponds to an aspect of his age which manifested itself in the court of Louis Napoleon, the rhetoric of Victor Hugo, and the acting of Sarah Bernhardt—one of his admirers—but the imaginative truthfulness and sheer visual impressiveness of his work set their seal on all those who once pored over it and have influenced all subsequent illustrators. ·

The bubbling turmoil of Doré's *Contes drôlatiques* was also to be seen in his oil paintings on which he placed great store. His *Battle of the Alma* and the *Battle of Inkermann* (1855 and 1857; both exhibited at the Salon) were crowded with incident but their popularity did not rest alone on the patriotic fervour aroused by the Crimean War but on his command of the situations he depicted. He also made an appeal to the religious sensibilities of his day with his *Triumph of Christianity* (1868),

Night of the Crucifixion (1873), *Jesus Condemned* (1876), and other such works which were direct descendants from the horrendous panoramas of Martin and Danby. Engraved and sold in his gallery-shop in London, they further increased his prestige. There were pictures devoted to profane subjects and to landscape. Among the most worthy and charming (an epithet little used in connection with Doré's work) were his watercolours, particularly of landscape, such as *The Rainbow*. Unlike his wood and steel engravings which were usually farmed out to journeymen engravers, the pictures are the direct results of his own hand. This is equally true of his sepia sketches which fascinate far more than do his printed illustrations. In very recent years, in line with the current revaluation of late 19th-century art, Doré's oil paintings of beggars in Spain and the London homeless are receiving a recognition of their true quality. Despite the true and the preposterous grandeur of his woodcut illustrations, Doré was essentially a sad, childlike man; and it is when he casts aside his pretentious grandeur that we can recognise his more human and approachable voice speaking to us today.

—Alan Bird

DOSSI, Dosso.

Born Giovanni de Lutero in Ferrara, c. 1490. Died in Ferrara, 1542. Possibly trained by the painter Lorenzo Costa, in Mantua, and by Giorgione in Venice; worked in Mantua, 1512, and in Ferrara for the court of Duke Alfonso d'Este (later Duke Ercole II) from 1514: besides frescoes and paintings, did cartoons for tapestries and designs for majolica; also trips to Venice, Florence, Modena, Mantua, and Trento; younger brother, Battista Dossi, was his helper and collaborator.

Collections: Baltimore; Birmingham; Cleveland; Detroit; Dresden; Ferrara: Museum, Belvedere and Belriguardo villas; Florence; Glasgow; Hampton Court; Hartford, Connecticut; London; Malibu; Milan; Modena: Cathedral, Museum; Naples; New York; Ottawa; Oxford; Paris; Parma; Philadelphia; Rome: Borghese, Galleria Nazionale, Doria Pamphili; Trento: Castello del Buonconsiglio; Vienna; Washington; Worcester, Massachusetts.

Publications

On DOSSI: books—

Zwanziger, W. C., *Dossi*, Leipzig, 1911.
Mendelsohn, Henriette, *Das Werk der Dossi*, Munich, 1914.
Mezzetti, Amalia, *Il Dosso e Battisti Ferraresi*, Ferrara, 1965.
Puppi, L., *Dossi*, Milan, 1965.
Gibbons, Felton, *Dosso and Battista Dossi, Court Painters at Ferrara*, Princeton, 1968.

articles—

Antonelli-Trenti, Maria Grazia, "Notizie e precisazioni sul Dosso giovane," in *Arte Antica e Moderna*, 28, 1964.

Dreyer, Peter, "Die Entwicklung des Jungen Dosso: Ein Beitrag zur Chronologie der Jugendwerke des Meisters bis zum Jahre 1522," in *Pantheon* (Munich), 22–23, 1964–65.

*

Dosso Dossi, also known as Giovanni de Lutero, is an Italian painter of the school of Ferrara. He was born near Mantua c. 1479 and died in Ferrara in 1542. Originally the family came from Trent, owned land in Mantua, and lived in Ferrara under the tutelage of the Este family.

Dosso had a younger brother, Battista (d. 1548), with whom he collaborated in numerous commissions. The brothers painted palaces and churches as well as prepared cartoons for tapestries and designs for majolica, and for festival decorations for the court of Ferrara. Ariosto mentions both artists in *Orlando Furioso.*

Dosso trained under Giorgione and Raphael. From these teachers, he developed a warm and colorful palette with a strong sense of light and transparency of surfaces as well as a pastoral Venetian atmosphere in the overall composition and a love for the antique. Dosso adds to the Venetian artistic and Roman experience his own personal style, a sense of magical and literary qualities. His early decorative commissions were executed in fresco, and some were mixed with oils and tempera, for example, the decorations in the Castello in Trent and in the Villa Imperiale at Pesaro (c. 1533).

In fact, though Titian was named as Giorgione's official heir, in some ways Dossi is the more likely continuator of Giorgione's pastoralism, and even after he moved to Ferrara he maintained the courtly pastoral ideals. Later his style, however, took on characteristics of Florentine and Roman mannerism: his draughtsmanship became firmer, the figures more "aggressive," and the landscape elements pushed to the background. This work is fresh, imaginative, even eccentric. Later commentators noticed the proto-baroque elements in his later work, which was dominant in Ferrara during much of his lifetime.

—Liana Cheney

DUBUFFET, Jean.
Born in Le Havre, 31 July 1901. Died in Paris, 12 May 1985. Married 1) Paulette Pret, 1927 (divorced, 1936), one daughter; 2) Emilie Carlu, 1937. Attended school in Le Havre, and studied at Académie Julian, Paris, 1918; painter from 1918; military service, 1923–24; worked in family wine business, 1925, and managed his own wine business 1930–42, then concentrated on painting again; lived in Algeria, 1947–49, then in Paris and Vence; first experimental music works, with Asger Jorn, 1960; first architectural environments, 1967, and theatre sets, 1971.

Collections: Amsterdam: Stedelijk; Basel; Buffalo; Chicago; Dusseldorf; New York: Moma, Guggenheim; Otterlo; Paris: Beaubourg, Musée des Arts Décoratifs.

Man Eating a Small Stone, 1944; lithograph

Publications

By DUBUFFET: books—

Prospectus aux amateurs de tout genre, Paris, 1946.
Asphyxiante culture, Paris, 1968.
Edifices, Paris, 1968.
Prospectus et tous ecrits, Paris, 2 vols., 1967.
L'Homme du commun à l'ouvrage, Paris, 1973.
La Botte à nique, Paris, 1973.
Bâtons rompus, with Marcel Péju, Paris, 1986.

illustrator: *Matière et mémoire*, 1945, and *Les Murs;* 1950, both by Francis Ponge; *La Metromanie*, by Jean Paulhan, 1950; *Les Mirivis des Naturgies*, by André Martel, 1963; *Le Coeur en fête*, by Jacques Berne, 1984.

On DUBUFFET: books—

Limbour, Georges, *Tableau bon levain à vous de cuir la pate: L'Art brut de Dubuffet*, Paris, 1953.
Fitzsimmons, James, *Dubuffet: Brève introduction à son oeuvre*, Brussels, 1958.
Ragon, M., *Dubuffet*, Paris, 1958.
Volboudt, Pierre, *Les Assemblages de Dubuffet*, Paris, 1958.
Cordier, Daniel, *Les Dessins de Dubuffet*, Paris, 1960; as *The Drawings of Dubuffet*, New York, 1980.
Mathey, Francois, *Dubuffet 1942–1960* (cat), Paris, 1960.

Fabbro, B. del, *Esperienze musicali di Dubuffet*, Venice, 1962.

Barilli, Renato, *Dubuffet materiologo*, Bologna, 1962.

Selz, Peter, *The Work of Dubuffet*, New York, 1962.

Loreau, Max, *Catalogue integral des travaux de Dubuffet*, Paris and Geneva, 32 vols., 1964–82 (ongoing)

Trucchi, Lorenza, *Dubuffet*, Rome, 1965.

Loreau, Max, *Dubuffet et le voyage au centre de la perception*, Paris, 1966.

Loreau, Max, *Dubuffet: Délits, déportements, lieux de haut jeu*, Geneva, 1971.

Gagnon, Francois, *Dubuffet aux sources de la figuration humaine*, Montreal, 1972.

Picon, Gaéton, *Dubuffet* (cat), London, 1972.

Loreau, Max, *Dubuffet: Stratégies de la création*, Paris, 1973.

Picon, Gaéton, *Le Travail de Dubuffet*, Geneva, 1973.

Rowell, Margit, and Thomas M. Messer, *Dubuffet: A Retrospective* (cat), New York, 1973.

Hulten, K. G. Pontus, *Dubuffet: Passages castillans, sites tricolors* (cat), Paris, 1975.

Barilli, Renato, *Dubuffet: Oggetto e progetto: Il ciclo dell'Hourloupe*, Milan, 1976.

Gribaudo, Ezio, *Dubuffet* (cat), Turin, 1978.

Franzke, Andreas, *Dubuffet Zeichnungen*, Munich, 1980.

Merkert, Jorn, *Dubuffet Retrospektive* (cat), Berlin, 1980.

Ruhrberg, Karl, and Christoph Brockhaus, *Dubuffet* (cat), Cologne, 1980.

Schjedahl, Peter, *Brefs exercises d'école journalière* (cat), New York, 1980.

Franzke, Andreas, *Dubuffet*, Munich, 1980, New York, 1981.

Bozo, Dominique, and Daniel Abadie, *Dubuffet: Sites aux figurines et psycho-sites* (cat), Paris, 1981.

Woimant, Francoise, and Antoine Coron, *Dubuffet: Livres et estampes: Récents enrichissement*, Paris, 1982.

Zeichnungen 1942–1981 (cat), Tübingen, 1983.

Dubuffet Retrospective (cat), Saint-Paul-de-Vence, 1985.

Franzke, Andreas, *Dubuffet* (cat), Berlin, 1987.

Glimcher, Mildred, *Dubuffet: Towards an Alternative Reality*, New York, 1987.

*

Jean Dubuffet arrived in Paris from Le Havre in 1918 with the idea of becoming a painter, a desire not fully realized until 1942. Dubuffet's school friends included Armand Salacrou, Georges Limbour, and Raymond Queneau, future writers with whom he would associate after his move to Paris. Through Limbour and Queneau, Dubuffet came into contact with the artistic and literary circle known as the "rue Blomet group," which included André Masson, Joan Miró, and the writer Michel Leiris. During this period Dubuffet studied painting, first, at the Académie Julien and, second, independently in conjunction with his exploration of music and modern languages. In 1919 his circle expanded to include Suzanne Valadon, Raoul Dufy, Max Jacob, and Fernand Léger. In 1924 he gave up painting, returning the following year to his family's wine business in Le Havre, with another painting interlude in the 1930's.

Dubuffet returned to painting for good in 1942. A solo exhibition at the Galerie René Drouin in 1944 of recent works received a largely hostile reception on the part of established critics. Nevertheless, a small group of highly influential writers—Paul Eluard, Louis Parrot, Jean Paulhan, and André Frenaud—all published supportive texts. What shocked the public was the crude, child-like rendering of the figures, which were presented through the bold application of brightly coloured pigments. Dubuffet had been aware of the art of the insane and of children since the 1920's. He had read Hans Prinzhorn's *Artistry of the Mentally Ill*, published in 1922; likewise, he was aware of the fanciful paintings of Paul Klee and the pictographic language of Micró, both evocative of the marvellous world of infancy, that time before the onset of individuation so indicative of what Jacques Lacan called "the mirror stage."

From the 1920's on, Dubuffet evidenced a skepticism to all forms of intellectual formulation in ideas or in art. His aim was to speak to the man in the street in the untutored vocabulary or ordinary experience. It is not surprising that, among his first paintings, Dubuffet painted such familiar scenes as the Paris Metro (*Metro*, 1943) or a little girl skipping rope (*Ropeskipper*, 1943). In 1946 he wrote in *Prospectus aux amateurs*, "It is the man in the street that I'm after, whom I feel closest to, with whom I want to make friends and enter into confidence and connivance, and *he* is the one I want to please and enchant by means of my work."

By the end of the 1940's Dubuffet openly embraced what he called *art brut*: the art of outsiders, the mad or the naive craftsman, all autodidacts without the burden of culture. In 1953 his friend Georges Limbour published a book entitled *L'Art brut de Jean Dubuffet*. Dubuffet championed the cause of *art brut*, discovering a variety of artists, the most important of which was Gaston Chaissac. Dubuffet was instrumental in getting Chaissac's writings, *Hippobosque au bocage*, published in 1951. In 1957 Dubuffet wrote that, "my art is an attempt to bring all disparaged values into the limelight."

René Drouin gave Dubuffet his second one-man exhibition in 1946, entitled "*Mirabolus, Macadam and Cie.*" This series of paintings turned away from any traditional concern with what painting was to a meditation on *how* the raw material of painting presented itself. In this series Dubuffet initiated his use of "haute pâte," a thick impasto material consisting of such diverse materials as paint, sand, plaster, and tar. The images of these paintings are striking for their simplified linearity and their transparent corporeality. Dubuffet, in treating the figure-as-material, identifies the image with the ground, thereby erasing representational distinctions. His point of departure owes something to the more tortured figures of Miró painted in 1937–38, but Dubuffet's sensibility is altogether different. In 1945, Dubuffet, in an essay entitled "Notes pour les fins-lettrés" wrote: "Art must be born out of material. Spirituality must borrow the language of the material."

In 1949 René Drouin organized the first public exhibition of *art brut*. At that time Dubuffet met André Breton, who shared similar interests in untutored forms of expression. Dubuffet's fascination with such material and his relentless attempts to subvert so-called "objective reality" were ultimately indebted to Surrealism, but, at the same time, went beyond that movement. Dubuffet's closest friends, Queneau and Limbour, had also been deeply marked by Surrealism's unconventional attempts at prompting the marvellous realms of the imagination.

Like the Surrealists, Dubuffet was taken with the writing of Alfred Jarry, especially the burlesque and grotesque *Ubu Roi*

(1896). This had been apparent in the 1946 exhibition of the "haute pâte" paintings. In 1960 the "Collège de Pataphysique" commissioned Dubuffet to make a series of drawings to be published as a book (*Les Dessins de Jean Dubuffet*). Jarry had defined Pataphysics in his *Gestes et opinions du Docteur Faustroll, Pataphysicien* (1897–98; published in 1910): "Pataphysics is the science of imaginary solutions, which symbolically attributes to lineaments the properties of objects described by their own virtuality."

Not surprisingly, Dubuffet's new series of drawings gave rise to something called *L'Hourloupe* which would preoccupy Dubuffet for the period 1962–74. *L'Hourloupe* began as a doodle, executed first as Dubuffet talked on the telephone. Executed in coloured ball-point pens, and consisting of a red outline filled in with parallel blue lines, *L'Hourloupe* soon extended itself into painting, sculpture, architecture, and, even, theatre. Suffice it to say, for Dubuffet *L'Hourloupe* was a new cosmology. According to him, "L'Hourloupe . . . invented just for the sound of it. In French it calls to mind some object or personnage of fairy tale-like and grotesque state and at the same time also something tragically growling and menacing. Both together." Perhaps, the equivalent of *L'Hourloupe* in literature is Queneau's involvement in *OuLiPo* (1960; "l'Ouvroir de Littérature Potentielle"), both leaps of the imagination owing something to the idea of Pataphysics. Indeed, Queneau was also a member of the Collège de Pataphysique.

L'Hourloupe was a culmination and continuation of Dubuffet's creative trajectory, a trajectory he articulated in 1949: "The very *raison d'être* of art is its being a means of operation that does not follow the road of ideas." While it was the task of Dubuffet to unlearn the cultured conception of art, it was also his mission to recognize the clairvoyance of the untutored vision.

—William Jeffett

DUCCIO Di Buoninsegna.

Born in Siena, c. 1255 or c. 1260. Died in Siena, c. 1318–19. Married Domina Taviana; seven children. First recorded in Siena, 1278 and 1279; painted Madonna for S. Maria Novella, Florence, 1285, but noted as working in Siena in 1285–99, 1302, and 1308–11 (*Maestà*, or *Majesty*).

Collections: Berne; Boston; Florence; Fort Worth; London; Lugano; New York: Frick; Perugia; Siena, Museum, Cathedral Museum; Washington.

Publications

On DUCCIO: books—

Weigelt, Curt H., *Duccio*, Leipzig, 2 vols., 1911.
Brandi, Cesare, *Duccio*, Florence, 1951.
Carli, Enzo, *Duccio*, Milan, 1952.
Brandi, Cesare, *Duccio: La Maestà*, Rome, 1954.
Brandi, Cesare, *Il restauro della Maestà di Duccio*, Rome, 1959.
Carli, Enzo, *Duccio*, Milan, 1962.
Baccheschi, Edi, *L'opera completa di Duccio*, Milan, 1972.
Stubblebine, James H., *Duccio and His School*, Princeton, 2 vols., 1979.
White, John, *Duccio: Tuscan Art and the Medieval Workshop*, London, 1979.
Carli, Enzo, *La Maestà di Duccio*, Florence, 1981.
Deuchler, Florens, *Duccio*, Milan, 1984.

article—

Sullivan, Ruth Wilkins, "The Raising of Lazarus Reexamined," in *Art Bulletin* (New York), 70, 1988.

*

Duccio di Buoninsegna was the pre-eminent Sienese painter of his day. Although his fame was eclipsed for centuries, a critical reexamination of his work has recently been underway which culminated in two major monographs in 1979, followed by a spate of articles and other writings on him and his successors. Duccio's position in Sienese painting is compartable to that of his younger contemporary Giotto in Florentine painting. Both of their masterpieces, Gitto's Scrovegni Chapel in Padua and Duccio's *Maestà* (Cathedral Museum, Siena), were painted in the early years of the 14th century, a time of transition that saw the formulation of a new pictorial language focusing on a new understanding of man and his place in the natural world.

Duccio's birth and death dates are unknown; nor is anything known about his early training as an artist. His name is first mentioned in a document in the Archivio di Stato, Siena, dated November 1278, recording forty soldi to *Duccio pictori* for decorating twelve coffers in which the official documents of the Commune were to be kept. Referred to as a "painter," he must have been an independent master by that time, and probably about twenty years of age. This, together with the dates of his major commissions, has led scholars to hypothesize his date of birth around 1255. In an entry of 1318–1319, his wife Taviana is referred to as the "wife of the late Duccio." Sporadic documents spanning forty years provide tantalizing clues to the artist's life and character, that frequently raise as many questions as they answer. Depending upon the interpretation of these documents, in conjunction with the evidence of his surviving works, Duccio is alternately presented as a capable entrepreneur directing a sizable workshop, or a procrastinator, frequently fined and in debt, unable or unwilling to meet his commitments to his patrons or his community. In 1302, the same year that he received payment for his now lost *Maestà* for the Palazzo Pubblico, he also received several fines for various offenses, including three for debt, and one for avoidance of military service. Since he continued to receive official commissions during the same periods as his fines, it is evident that his offenses did not disqualify him from receiving public patronage.

A critical evaluation of Duccio as an artist is complicated by the lack of agreement on the attribution of certain early works (like the *Crevole Madonna*, Cathedral Museum, Siena), as well as differences of opinion on the chronology of others,

Raising of Lazarus, from the Maestà; tempera on panel; $17\frac{1}{8} \times 18\frac{1}{4}$ in (43.5 × 46.4 cm); Fort Worth, Kimbell

such as the *Madonna of the Franciscans* (Pinacoteca, Siena) and the Perugia *Madonna*. For these reasons, it becomes essential to turn to his only two extant paintings that are both dated and documented, the Rucellai *Madonna* (1285) and the *Maestà* for the high alter of the Cathedral of Siena, finished 9 June 1311. These two major commissions must provide the framework for assessing Duccio's career and judging him as an artist.

Duccio's earliest documented work is the panel now known as the Rucellai *Madonna* (Uffizi, Florence), so-named after the chapel in which it hung for several centuries. Its contract is dated 15 April 1285. That Duccio, a Sienese, was called to the rival city of Florence in 1285 and awarded a major commission by the *Compagnia dei Laudesi* for their chapel in the Dominican church of Santa Maria Novella, is proof of the artist's high reputation outside his native city at that time.

Duccio is sometimes described as a retardataire artist, but his Rucellai *Madonna,* with its convincing perspectival throne, its delicate color harmonies, and its sinuous, flowing Gothic line, reveals his familiarity with the most advanced art of his time. Indeed, it was probably for this very reason that the Laudesi commissioned Duccio to paint "with the most beautiful picture a certain large panel . . . in honor of the blessed and glorious Virgin Mary." By eschewing the old-fashioned gold striations used by the Byzantines to suggest drapery folds, and by robing his Virgin in an ultramarine mantle embellished only with a narrow, flowing golden border, Duccio here turns his back on Byzantine tradition in favor of the new northern Gothic style.

About twenty-five years later, Duccio painted the masterpiece of mature years, the *Maestà,* the two-sided altarpiece that has been called the richest and most beautiful panel ever

painted in Italy. Its complex iconographic program relates the story of man's salvation through the life and sacrificial death of Jesus Christ. The Enthroned Madonna on the front, graciously receiving homage from her celestial court of saints and angels, shows a Duccio still inspired by northern Gothic conceptions. Thus one might expect the artist to have given up his ties to the old-fashioned Byzantine prototypes. But such does not prove to be the case, since the small narrative scenes depicting the Life of Christ on the back of the *Maestà* for the most part continue to derive from Byzantine models. While retaining these traditional formats, however, Duccio inserted his own formal and iconographic inventions. He also drew upon his Sienese predecessors, Guido da Siena and the Saint Peter Master. Influenced by Nicola Pisano's Siena Cathedral pulpit, he found even more compelling the powerfully expressive Gothic sculptural forms of his younger friend, Giovanni Pisano, for the facade of Siena Cathedral (now in the Cathedral Museum).

As the summation of Duccio's life and career, the *Maestà* demonstrates the artist's continuing interplay between tradition and innovation. Although Duccio's painting was based on an art deeply rooted in the past, he introduced far-reaching stylistic, spatial, and iconographic innovations, sharing with Giotto, Giovanni Pisano, and others the creation of a new pictorial language that provided the basis for the new Renaissance art of the Quattrocento.

—Ruth Wilkins Sullivan

Duchamp: Self-Portrait, 1959; silkscreen

DUCHAMP, (Henri Robert) Marcel.
Born in Blainville, Normandy, 28 July 1887; brother of the artists Jacques Villon, Raymond Duchamp-Villon, and Suzanne Duchamp; naturalized United States citizen, 1955. Died in Neuilly-sur-Seine, 2 October 1968. Married 1) Lydie Sarazine-Levassor, 1927 (divorced, 1928); 2) Alexina Sattler, 1954. Attended Ecole Bossuet, Rouen, 1898–1904; studied at the Académie Julian, Paris, 1904–05; national military service, 1905–06; worked for a printer and engraver, Rouen, 1905, then cartoonist for *Le Courier Français* and *Le Rire,* Paris, 1905–10; settled in New York, 1915: librarian, French Institute, New York, 1915; founding member of Society of Independent Artists, 1916, and associated with the magazines *The Blind Man* and *Rong Wrong,* New York; associated with Surrealists, and with Société Anonyme; made film, with Man Ray, *Anaemic Cinema,* 1925; editorial adviser, *VVV* magazine, 1942, and adviser on surrealist museum exhibitions; also a chess champion.

Major Collection: Philadelphia.
Other Collections: Canberra; Chicago; New Haven; New York: Moma, Guggenheim; Ottawa; Paris: Beaubourg; Rouen; Venice: Guggenheim.

Publications

By DUCHAMP: books—

L'Opposition et les cases conjugées sont reconciliées, with V. Halberstadt, Paris, 1932.
La Mariée mise à nu par ses célibataires, même, Paris, 1934; as *The Bride Stripped Bare by Her Bachelors, Even: Towards a Typographical Rendering of the Green Box,* edited by Richard Hamilton, London, n.d.
Rrose Selavy, Paris, 1939.
Box in a Valise, New York, 1941.
Marchand de Sel, edited by Michel Sanouillet, Paris, 1958; as *Salt Seller,* edited by Elmer Peterson, New York, 1973; London, 1975.
A l'infinitif: Notes of 1912–20, New York, 1966.
Entretiens, with Pierre Cabanne, Paris, 1967; as *Dialogues,* New York, 1971.
Notes and Projects for the Large Glass, edited by Arturo Schwarz, New York, 1969.
Ingénieur du temps perdu: Entretiens, with Pierre Cabanne, Paris, 1976.
Notes, edited by Paul Matisse, Paris, 1980.

On DUCHAMP: books—

Dreier, Katherine, and Matta Echaurren, *Duchamp's Glass,* New York, 1944.
Carrouges, Michel, *Les Machines célibataires,* Paris, 1954.
Lebel, Robert, *Sur Duchamp,* Paris, 1959; as *Duchamp,* New York, 1959.
Hopps, Walter, Ulf Linde, and Arturo Schwarz, *Duchamp: Readymades, etc.,* Paris, 1964.
Tomkins, Calvin, *The Bride and the Bachelors,* New York, 1965.

Hamilton, Richard, *The Almost Complete Works of Duchamp* (cat), London, 1966.

Tomkins, Calvin, *The World of Duchamp*, New York, 1966.

Paz, Octavio, *Duchamp, o el castillo de la pureza*, Mexico City, 1968; as *Duchamp, or The Castle of Purity*, New York and London, 1970.

Schqarz, Arturo, *The Complete Works of Duchamp*, New York, 1969.

Golding, John, *Duchamp: The Bride Stripped Bare by Her Bachelors, Even*, London, 1972; New York, 1973.

d'Harnoncourt, Anne, and Kynaston McShine, editors, *Duchamp*, Greenwich, Connecticut, 1973.

Paz, Octavio, *Apariencia desnuda: La obra de Duchamp*, Mexico City, 1973; as *Duchamp: Appearance Stripped Bare*, New York, 1979.

Cabanne, Pierre, *Les 3 Duchamp*, Neuchatel, 1975; as *The Three Duchamps*, Boston, 1976.

Calvesi, Maurizio, *Duchamp invisible: La construzione del simbolo*, Rome, 1975.

Clair, Jean, *Duchamp, ou le grand fictif*, Paris, 1975.

Maschek, Joseph, editor, *Duchamp in Perspective*, Englewood Cliffs, New Jersey, 1975.

Schwarz, Arturo, *Duchamp*, New York, 1975.

Oliva, Achille Bonito, *Vita di Duchamp*, Rome, 1976.

Alexandrian, Sarane, *Duchamp*, Naefels and New York, 1977.

Clair, Jean, *Duchamp: Catalogue raisonné*, Paris, 1977.

Clair, Jean, *Duchamp et la photographie*, Paris, 1977.

Gough-Cooper, Jennifer, *Plan pour écrire une vie de Duchamp*, Paris, 1977.

Steefel, Lawrence D., *The Position of Duchamp's Glass in the Development of His Art*, New York, 1977.

Clair, Jean, editor, *Duchamp: Abécédaire: Approches critiques*, Paris, 1977.

Lyotard, Jean F., *Les Transformateurs* Duchamp, Paris, 1977.

Duchamp Readymades (cat), Vancouver, 1978.

Spate, Virginia, *Orphism: The Evolution of Non-Figurative Painting in Paris 1910–1914*, Oxford, 1979.

Marquis, Alice G., *Duchamp: Eros, c'est la vie*, Troy New York, 1981.

Zaunschirm, Thomas, *Robert Musil und Duchamp*, Klagenfurt, 1982.

Adcock, Craig E., *Duchamp's Notes from the Large Glass: An N-Dimensional Analysis*, Ann Arbor, 1983.

Molderings, Herbert, *Duchamp: Parawissenschaft, das Ephemere, und der Skeptizismus*, Frankfurt, 1983.

Bailly, Jean Christophe, *Duchamp*, Paris, 1984.

Dive, Thierrry de, *Nominalisme pictural: Duchamp: La Peinture et la modernité*, Paris, 1984.

Lebel, Robert, *Duchamp*, Paris, 1985.

Barucello, G., and H. Martin, *Why Duchamp?*, New York, 1985.

Kotte, Wouter, *Duchamp als Zeitmaschine*, Cologne, 1987.

Bonk, Ecke, *Duchamp: La Boite en valise*, London, 1988; as *Duchamp: Box in a Valise*, New York, 1989.

Moure, Gloria, *Duchamp*, New York and London, 1988.

*

Having as great an influence on modern art by his attitudes in general as by his own individual works, Marcel Duchamp was a brother of artists Jacques Villon and Raymond Duchamp-Villon. He was first a librarian in Paris then he worked as a draughtsman and illustrator for *Courrier Francais*. Between 1908 and 1910 his first experiments in painting were made deliberately in the style of the Impressionists to acquaint himself with their techniques. Then in 1910 he joined the Section d'Or Group, and the following year showed with them his notorious *Nude descending a staircase*.

Included in the historic 1913 Armory Show in New York, it aroused immediate controversy for its depiction of five human figures partially superimposed as they climbed down a spiral staircase. It was palpably linked with the breakdown of form initiated by analytical Cubism and the inspired aims of the Futurists towards a representation of time and simultaneous movement in a work of art.

In New York, giving French lessons for a livelihood, he met Picabia. He did not produce many pictures; he never did—but between 1915 and 1923 he created his major work *The Bride Stripped Bare by her Bachelors, Even*. More than nine feet high, it showed the bride connected by wires to nine uniformed swains. Constructed of cut-out metal on transparent glass the work was uniquely reflective of the decade's *zeitgeist* when Dada and Surrealism spread their propaganda from Zurich and Paris to New York, Berlin, and London. Duchamp also created scandals of deliberately multiplying effect with his exhibited ready-mades, such as a bottle dryer, a urinal and a reproduction of the Mona Lisa on which he added a moustache and the joke title L.H.O.O.Q.

Duchamp was an articulate writer and critic and by 1917 he was editing two magazines, *The Blind Man* and *Rong-Wrong*. In 1920 he was making experimental films. Deeply involved in Surrealism, he invented the ceiling of coal sacks for the 1938 International Surrealist Exhibition in Paris. He also helped organise the New York Surrealist exhibition in 1941, and its postwar equivalent in Paris in 1947.

His twenty canvases and glass panels, sold to friends during his lifetime, found their way by bequest as he wished to the Philadelphia Museum, where is concentrated the greatest collection of his works. It comprises the material evidence of a genius who, more than any other recognised the self-contained capacity of mundane objects to be exploited for publicity purposes, and for altering outworn interpretations of art in a context of changing social and philosophical standards.

New York was his chosen home for most of his life. American artists' iconoclastic feelings towards the decadent art of the European museums were attuned to his own. To those feelings, Duchamp created something revealing and lasting by his cock-snooking at tradition and at supporters of redundant conventions in pictorial ideas—especially necrophiliac official connoisseurs.

—G. S. Whittet

DUCHAMP-VILLON, Raymond.

Born Pierre Maurice Raymond Duchamp in Damville, 5 November 1876; brother of the artists Marcel Duchamp and Jacques Villon. Died in Cannes, 7 October 1918. Married, 1903. Attended Lycée Corneille, Rouen; studied medicine, University of Paris, 1894–98: while recuperating from illness,

Baudelaire, 1911;
bronze; 15¾ in (40 cm)

studied sculpture: exhibited from 1902; influenced by Rodin, then the cubists; joined army as medical under-officer, 1914, and died of typhoid fever.

Collections: Chicago; Detroit; London: Tate; New Haven; New York: Moma, Guggenheim; Paris: Art Moderne; Washington: Hirshhorn, Phillips.

Publications

On DUCHAMP-VILLON: books—

Pach, Walter, *A Sculptor's Architecture*, New York, 1913.
Pach, Walter, *Duchamp-Villon, sculpteur*, Paris, 1924.
Pach, Walter, *Duchamp-Villon* (cat), New York, 1929.
Salmon, André, *Sculpture of Duchamp-Villon* (cat), Paris, 1931.
Frigerio, Simone, *Sculptures de Duchamp-Villon* (cat), Paris, 1963.
Cassou, Jean, et al., *Duchamp-Villon* (cat), Paris, 1966.
Dorival, Bernard, *Duchamp-Villon, Duchamp,* Paris, 1967.
Agee, William C., *Duchamp-Villon,* New York, 1967.
Cassou, Jean, *Les Duchamps* (cat), Rouen, 1967.
Cabanne, Pierre, *Les 3 Duchamp,* Neuchatel, 1975; as *The Three Duchamps*, Boston, 1976.
The Brothers Duchamp, New York, 1986.

articles—

Hamilton, George Heard, "Duchamp, Duchamp-Villon, Villon," in *Bulletin of the Associates in Fine Arts at Yale University* (New Haven), March 1945.
Pradel, Marie-Noëlle, "Dessins de Duchamp-Villon," in *Revue des Arts: Musées de France* (Paris), 10, 1960.
Gindertael, R.V., "L'Oeuvre majeure de Duchamp-Villon," in *XXe Siècle* May 1964.
McMullen, Roy, "Duchamp-Villon's *Horse,*" in *Art News* (New York), September 1966.
Goldin, Amy, "Duchamp-Villon: The Cubist Core," in *Art News* (New York), September 1967.
Elsen, Albert, "The Sculpture of Duchamp-Villon," in *Artforum* (New York), October 1967.
Popovitch, Olga, "Oeuvres de Jacques Villon et de Duchamp-Villon," in *Revue du Louvre* (Paris), 1980.
Zilczer, Judith, "Duchamp-Villon, Pioneer of Modern Sculpture," in *Bulletin of the Philadelphia Museum of Art,* Fall 1980.
Zilczer, Judith, "In the Face of War: The Last Works of Duchamp-Villon," in *Art Bulletin* (New York), March 1983.
Robbins, Daniel, "The *Femme Assise* by Duchamp-Villon," in *Yale University Art Gallery Bulletin* (New Haven), Winter 1983.

*

In the words of his brother, the painter Marcel Duchamp, Raymond Duchamp-Villon was "the first exponent of Cubist sculpture." His work superseded Rodin's romantic naturalism and successfully translated theories of Cubist painting and machine imagery into modern sculpture.

One of the few self-taught artists of the first generation European vanguard, Duchamp-Villon was the second of six children in a close-knit artistically gifted family. He did not turn to sculpture until 1900, when illness forced him to abandon his medical studies at the University of Paris. His medical training, however, provided him with a sound knowledge of anatomy evident in his early modelled figures.

At first, Duchamp-Villon experimented with various styles ranging from the linearity of Art Nouveau to the expressive surface modelling of Rodinesque naturalism. Gradually, he developed a simplified, figurative style and thus joined contemporary sculptors such as Aristide Maillol and Constantin Brancusi in the trend toward greater structural order.

During the four-year period from 1910 to 1914, Duchamp-Villon developed classic simplicity into radical abstraction. Inspired by archaic Greek sculpture, his *Torso of a Young Man* (1910, plaster, Hirshhorn Museum and Sculpture Garden, Washington) distilled the human form into broadly defined planes and infused the classically stable pose of the striding youth with an energetic sense of implied movement. In the austere head of *Baudelaire* (1911, bronze, Museum of Modern Art, New York), Duchamp-Villon further subordinated surface texture to planar mass to create a symbol of intellectual power. This process of formal reduction approached mechanistic abstraction in the anonymous contours of *The Lovers* (1913, plaster, Philadelphia Museum of Art) and the *Seated Woman* (1914, bronze, Yale University Art Gallery, New Haven), which has been likened to an artist's mannequin. Duchamp-Villon's reductive abstraction culminated in *The Horse* (1914, bronze, Peggy Guggenheim Collection, Venice). He transformed the organic forms of a traditional equestrian monument into gears, pistons, and flywheels to create a symbol of horse power in the new industrial age. Never enlarged to full scale or cast in permanent material during his lifetime, *The Horse,* nevertheless, remains his most enduring achievement.

While Duchamp-Villon's fusion of machine imagery with Cubist abstraction marks his most original contribution to modern art, he also explored several other aspects of vanguard sculpture. In collaboration with André Mare, he produced abstract reliefs of animal motifs for an interior design. Their joint experiment in architectural design, the lost maquette for the *Cubist House,* represented a utopian search for a unified, modern environment. His interest in texture and color led him occasionally to apply color as in the gilded patina of the *Seated Woman* (1914, cast 1915, bronze, Museum of Art, Rhode Island School of Design) or in the painted plaster relief of *The Gallic Cock* (1916, Phillips Collection, Washington). A strain of primitivism may also be traced in his mature work. The grossly exaggerated facial features of the head of *Maggy* (1911, bronze, Solomon R. Guggenheim Museum, New York) are comparable to the distortions Henri Matisse introduced in his series of heads of *Jeannette I–V* (c. 1910–11, Museum of Modern Art, New York). Such deliberate distortions derive in part from the tribal arts of Africa. Primitive expressionism is still more apparent in Duchamp-Villon's last works—*Head* (c. 1917, bronze, private collection) and the severe *Portrait of Professor Gosset* (c. 1917–18, plaster, Philadelphia Museum of Art). In the former, Duchamp-Villon fused the image of gas mask with a tribal mask; in the latter he simplified the surgical

mask of the doctor who treated him to create an ominously austere visage. Created at the front during World War I, both works transcend Cubist formal reduction to produce disturbing images of anonymous humanity in the machine age.

The unfulfilled promise of Duchamp-Villon's career, tragically curtailed by World War I, should not overshadow his lasting contribution to modern sculpture. Less innovative technically than either Picasso or the Russian constructivists, Duchamp-Villon invested Cubist formal reduction with a fundamental classicism. This delicate balance between radical abstraction and underlying classicism endows Duchamp-Villon's work with its enduring power.

—Judith Zilczer

DUFY, Raoul.

Born in Le Havre, 3 June 1877. Died in Forcalquier, 23 March 1953. Married Emilienne Brisson, 1911. Attended school to age 14; pupil of Charles Lhullier at School of Fine Arts, Le Havre, from 1892; worked for coffee importers Luthy and Hauser, Le Havre, 1891–98; military service, 1898–99; pupil of Léon Bonnat, Ecole des Beaux-Arts, Paris, 1900–01; exhibited from 1901; influenced by the Fauves; designed textiles from 1911; stage designer for Cocteau's *Le Boeuf sur le toit*, 1920 (later stage works include *Palm Beach*, 1926, *Beach*, 1933); ceramics from 1923; mural decorations for Jardin des Plantes and Relais de Chaillot; book illustrator, designed carpets and furniture.

Major Collections: Le Havre; Nice.
Other Collections: Chicago; London: Tate, Courtauld; New York: Moma; Paris: Art Moderne; Rouen.

Publications

By DUFY: books—

Illustrator: *Le Bestiare*, by Apollinaire, 1910; *Elégies*, by Duhamel, 1920; *Les Nourritures terrestres*, by Gide, 1928; *Poésies* by Mallarmé, 1928; *Les Fiancés du Havre*, by Salacrou, 1944, *Pour un herbier*, by Colette, 1950.

On DUFY: books—

Allard, Roger, *Dufy*, Paris, 1925.
Carré, Louis, *Dessins et croquis extraits des cartons et carnets de Dufy*, Paris, 1944.
Telin, Robert, *L'Art de Dufy*, Paris, 1945.
Cassou, Jean, *Dufy, poète et artisan*, Geneva, 1946.
Cocteau, Jean, *Dufy*, Paris, 1948.
Roger-Marx, Claude, *Dufy*, Paris, 1950.
Courthion, Pierre, *Dufy*, Geneva, 1951.
Gieure, Maurice, *Dufy: Dessins*, Paris, 1952.
Cassou, Jean, et al., *Dufy* (cat), Paris, 1953.
Dorival, Bernard, "*La Belle Histoire de la fée Electricité*," by *Dufy*, Paris, 1953.

Love, c. 1910; woodcut

Werner, Alfred, *Dufy*, New York, 1953.
Lassaigne, Jacques, *Dufy*, Geneva and Cleveland, 1954.
Hunter, Sam, *Dufy*, New York, 1954.
Gauthier, Maximilien, *Dufy*, Paris, 1955.
Cogniat, Raymond, *Dufy decorateur*, Geneva, 1957.
Roger-Marx, Claude, *Dufy aux courses*, Paris, 1957.
Brion, Marcel, *Dufy: Paintings and Watercolours*, London, 1958.
Roudinesco, A., and Jean Tardieu, *Dessins de Dufy*, Lausanne, 1958.
Cogniat, Raymond, *Dufy*, Paris, 1962.
Arnould, Reynold, *Dufy* (cat), Le Havre, 1963.
Guichard-Meili, Jean, *Dufy—musique*, Paris, 1964.
Cogniat, Raymond, *Dufy*, New York, 1968.
Werner, Alfred, *Rousseau, Dufy*, New York, 1970.
Lafaille, Maurice, and Bernard Dorival, *Dufy: Catalogue raisonné de l'oeuvre peint*, Geneva, 4 vols., 1972–77; supplement by Lafaille and Fanny Guillon-Lafaille, Paris, 1985.
Lafaille, Maurice, and Fanny Guillon, *Dufy* (cat), Munich, 1973.
Hak, Andree Abdul, *Oeuvres de Dufy* (cat), Paris, 1976.
Dufy à Nice: Collection du Musée des Beaux-Arts Jules Chéret, Nice, 1977.
Guillon-Lafaille, Fanny, *Dufy, Catalogue raisonné de aquarelles, gouaches, et pastels*, Paris, 2 vols., 1981.
Robertson, Bryan, and Sarah Wilson, *Dufy* (cat), London, 1983.
Werner, Alfred, *Dufy*, New York and London, 1987.
Perez-Tibi, Dora, *Dufy*, New York, 1989.

*

Raoul Dufy was born in Le Havre in 1877. His first job was at a coffee importers overlooking the shipyards, but during the evenings he attended classes at the Ecole des Beaux-Arts. His father worked in a metal business and was a committed music enthusiast who introduced Raoul, one of nine children, to the

great composers. Young Dufy then had to do a year's military service, but was released early as a result of the enrollment of one of his brothers as a piper. Aged 23, he left Le Havre to go to Paris and study at the Ecole des Beaux-Arts there, under Léon Bonnat. Dufy did not feel inspired by its academic atmosphere and he was reputedly "terrified" by the Louvre. However, he could devote his time to painting: his early work, until 1905, is in an Impressionist manner. As his preferences led him away from the Louvre, they took him towards the avantgarde galleries of Paris where influential dealers such as Vollard and Durand-Ruel displayed not just the Impressionists but also Gauguin and Van Gogh. All other formative influences were overtaken when he saw Matisse's painting *Luxe, calme, et volupté,* which inspired him to join the Fauve movement. Fauve literally means wild beast, and the term was adopted in order to explain the extent of the artists' rejection of conventional colours.

The Fauve movement can be seen as the foundation of Dufy's ultimate importance as an artist. His Fauvist period is characterized by a rejection of traditional likeness to nature and the formation of a luminous style of pure, unmixed colours. Some of his greatest canvases emerge from this early period. However, his fame rests not only not in his fine painting but in the popularization of his innovations. He can be cited as a leading originator, not just in painting, but in most fields of the applied arts as well. He promoted his art towards a form which came to filter down to affect all levels of 20th-century visual perception from fabric design and book jackets to haute couture. His influence thus extends from a position of one of the leaders of Fauvism to the huge realm of decorative and applied arts. This popularization attracts criticism from the aesthetes, yet Dufy should be commended posthumously for adopting the best means of ensuring that the visual arts can affect all facets of vision.

Between 1922 and 1932 and then again in 1937-39, Dufy collaborated with the Catalan ceramicist J. L. Artigas: they created about 109 unique vases, and Artigas wrote, "I started up in France and worked out of doors in my very plain stoneware with Raoul Dufy, an artist who was full of life, imagination and talent. . . . Dufy really knew how to put decoration in the right place. . . ." Dufy's hand was instrumental throughout the whole process. Artigas and he would experiment with shapes together; after the first glaze and enamelling, Dufy would create an "esgrafiat" or incised pattern with a painted tool.

In 1923 he first visited England where he was immensely seduced by the ceremonies of British sporting occasions: Henley rowing regatta, Ascot horse racing, Cowes sailing, and, the most famous flat race in the world, the Derby at Epsom. Dufy celebrated the pure enjoyment of occasions like these, whose appeal transcended all classes. Thus the representations of these events, executed in such an attractive and immediate style, in turn become universally seductive.

Dufy's drawing has been described as his handwriting—the lightness of touch and fluency appear effortless; compared to his earlier French contemporaries' work, his pictures are not striving towards the creation of an atmosphere (the Impressionists) and their effect is almost totally unlaboured.

Tragically, Dufy was confined to a wheelchair by rheumatism during the last years of his life. Due to the polyarthritis that he had contracted in 1937 (aged 60), his hands were crippled, but he continued to paint and his wit did not desert him or his work. The influence of Dufy is immeasurable, and his work will always be commemorated in that of his successors who choose to use pure colour in a deceptively simple way.

—Magdalen Evans

DÜRER, Albrecht.

Born in Nuremberg, 21 May 1471. Died in Nuremberg, 6 April 1528. Married Agnes Frey, 1494. May have attended Latin school of St. Sebald; studied with his goldsmith father, then apprenticed to the painter Michael Wolgemut; traveled in Germany, Switzerland, Venice, 1494-95, and again in Venice, 1505-07 (met Giovanni Bellini); commissions for Frederick the Wise, 1496-1524, the Emperor Maximilian, 1512-20, and Charles V, 1520-28, among others; lived and traveled in the Netherlands and lower Rhine, 1520-21 (attended the coronation of Charles V in Aachen); greatest influence was through his graphic work, and publications on human proportion and the teaching of "measurement" (including perspective); series on the Apocalypse, 1494, Great Passion, 1498-1510, Life of the Virgin, 1501-11, and Little Passion, 1509-11. Pupils include Hand Baldung, Hans Süss von Kulmbach, Hans Dürer, Hans Leu, Barthel and Sebald Beham, Jörg Pencz.

Major Collections: Berlin; Dresden; Munich; Vienna: Albertina.

Other Collections: Boston: Gardner; Cologne: Darmstadt; Florence; Frankfurt; Karlsruhe; Kassel; Leipzig; Leningrad; Lisbon; Madrid; New York; Nuremberg; Ottawa; Paris; Prague; Providence, Rhode Island; Vienna; Washington; Weimar.

Publications

By DÜRER: books—

Unterweysung der Messung mit dem Zirkel vn Richtscheyt, Nuremberg, 1525.
Vier Bücher von menschlicher Proportion, Nuremberg, 1525.
Unterricht über die Befostigung der Städte, Schlösser, und Flecken, Nuremberg, 1527.
Schriftlicher Nachlass, edited by Hans Rupprich, Berlin, 3 vols., 1956-69.
Writings, edited by Alfred Werner, New York, 1958.
Schriften, Tagebücher, Briefe, edited by Max Steck, Stuttgart, 1961.
Dürer: Diary of His Journey to the Netherlands 1520-21, edited by J. A. Goriz and G. Marlier, revised by Dieter Kuhrmann, London, 1971.

On DÜRER: books—

Staigmüller, Nermann C. O., *Dürer, als Mathematiker,* Stuttgart, 1891.

Wölfflin, Heinrich, *Die Kunst Dürers,* Munich, 1905, 6th edition, 1926, edited by K. Gerstenberg, 1943; as *The Art of Dürer,* London, 1971.

Panofsky, Erwin, *Dürers Kunsttheorie,* Berlin, 1915.

Panofsky, Erwin, and Fritz Saxl, *Dürers "Melencolia I,"* Leipzig, 1923.

Flechsig, Eduard, *Dürer: Sein Leben und seine Künstlerische Entwicklung,* Berlin, 2 vols., 1928–31.

Tietze, Hans, and Erika Tietze-Conrat, *Kritisches Verzeichnis der Werke Dürers,* Augsburg, 3 vols., 1928–38.

Winkler, Friedrich, *Dürer: Des Meisters Gemälde, Kupferstiche, und Holzschnitte,* Stuttgart, 1928.

Meder, Joseph, *Dürer-Katalog: Ein Handbuch über Dürers Stiche,* Vienna, 1932; New York, 1976.

Winkler, Friedrich, *Die Zeichnungen Dürers,* Berlin, 4 vols., 1936–39.

Panofsky, Erwin, *Dürer,* Princeton, 2 vols., 1943; 4th edition, as *The Life and Art of Dürer,* 1955.

Steck, Max, *Dürers Gestaltlehre: Der Mathematik und der bildenden Künste,* Halle, 1948.

Würtenberger, Thomas, *Dürer: Kunstler, Recht, und Gerechtigkeiten,* Frankfurt, 1951.

Winkler, Friedrich, *Dürer und das Illustration zum Narrenschiff,* Berlin, 1951.

Musper, Thomas, *Dürer,* Stuttgart, 1952; New York and London, 1966.

Lüdecke, Heinz, and Susanne Heiland, editors, *Dürer und die Nachwelt: Urkunden, Briefe, Dichtungen, und wissenschaftliche Betrachtungen aus vier Jahrhunderten,* Berlin, 1955.

Grote, Ludwig, *"Hier bin ich ein Herr": Dürer in Venedig,* Munich, 1956.

Ripley, Elizabeth, *Dürer: A Biography,* New York, 1958; London, 1959.

Rupprich, Hans, *Dürers Stellung zu den agnöstischen und kunstfeindlichen Strömungen seiner Zeit,* Munich, 1959.

Hollstein, F. W. H., *German Engravings, Etchings, and Woodcuts ca. 1400–1700, 7: Albrecht and Hans Dürer,* edited by K. G. Boon and R. W. Scheller, Amsterdam, 1962.

Knappe, Karl-Adolf, *Dürer: Das graphische Werk,* Vienna, 1964; as *Dürer: The Complete Engravings, Etchings, and Dry-Points,* New York and London, 1965.

Levey, Michael, *Dürer,* London and New York, 1964.

Steck, Max, *Dürer and His World,* New York, 1964.

Gladeczek, Leonhard, *Dürer und die Illustrationen zur Schedelchronik,* Baden-Baden, 1965.

Grote, Ludwig, *Dürer,* Geneva and Cleveland, 1965.

Musper, Thomas, *Dürers Kaiserbildnisse,* Cologne, 1969.

Dornik-Eger, Hanna, *Dürer und die Graphik der Reformationzeit,* Vienna, 2 vols., 1969.

Anzelewsky, Fedja, *The Drawings and Graphic Works of Dürer,* London, 1970.

Strieder, Peter, *The Hidden Dürer,* Chicago, 1970; Oxford, 1978.

Lüdecke, Heinz, *Dürer,* Leipzig, 1970; New York, 1972.

Anzelewsky, Fedja, *Dürer: Das malerische Werk,* Berlin, 1971.

Dürer (cat), Nuremberg, 1971.

Hoetinck, Hans, *L'Univers de Dürer,* Paris, 1971; as *Dürer,* London, 1970.

Hofmann, Walter J., *Uber Dürers Farbe,* Nuremberg, 1971.

Hütt, Wolfgang, *Dürer: Das gesamte graphisches Werk,* Munich, 2 vols., 1971.

Jahn, Johannes, *Entwicklungsstufen der Dürerforschung,* Berlin, 1971.

Koschatzky, Walter, and Alice Strobl, *Die Dürer Zeichnungen der Albertina,* Salzburg, 1971; as *Dürer Drawings in the Albertina,* Greenwich, Connecticut, 1972.

Koschatzky, Walter, *Dürer: Die Landschafts-Aquarelle: Ortlichkeit, Datierung, Stilkritik,* Vienna, 1971; as *Dürer: The Landscape Water-Colours,* London, 1973.

Mende, Matthias, *Dürer-Bibliographie,* Wiesbaden, 1971.

Rowlands, John, *The Graphic Art of Dürer* (cat), London, 1971.

Schade, Herbert, editor, *Dürer: Kunst einer Zeitwende,* Regensburg, 1971.

Talbot, Charles W., editor, *Dürer in America: His Graphic Work* (cat), Washington, 1971.

Ullmann, Ernst, et al., editors, *Dürer: Kunst im Aufbruch,* Leipzig, 1971.

Winzinger, Franz, *Dürer in Selbstzeichnungen und Bilddokumenten,* Reinbek, 1971.

Dürer, Master Printmaker (cat), Boston, 1971.

White, Christopher, *Dürer: The Artist and His Drawings,* London, 1971. *Dürer* (cat), Munich, 1971.

Kauffmann, Hans, *Dürer: Die Vier Apostel,* Utrecht, 1972.

Strauss, Walter L., *Dürer: The Human Figure: The Complete "Dresden Sketchbook,"* New York, 1972.

Timken-Zinkann, R. F., *Ein Mensch namens Dürer: Des Künstlers Leben,* Ideen, Umwelt, Berlin, 1972.

Strauss, Walter L., *The Complete Engravings, Etchings, and Dry-Points of Dürer,* New York, 1972; as *The Intaglio Prints,* 1976.

Strauss, Walter L., *The Book of Hours of the Emperor Maximilian the First Decorated by Dürer . . .,* New York, 1974.

Strauss, Walter L., *The Complete Drawings of Dürer.* New York, 6 vols., 1974, supplement, 1977.

Strauss, Walter L., *Dürer: Woodcuts and Wood Blocks,* New York, 1975.

Wiederanders, Gerlinde, *Dürers theologische Anschauungen,* Berlin, 1975.

Anzelewsky, Fedja, et al., *Dürer aux Pays-Bas* (cat), Brussels, 1977.

Vorbild Dürer (cat), Munich, 1978.

Anzelewsky, Fedja, *Dürer: Werk und Wirkung,* Stuttgart, 1980; as *Dürer: His Art and Life,* New York, 1981, London, 1982.

Strieder, Peter, *Dürer,* Konigstein im Taunus, 1982; as *Dürer: Paintings, Prints, Drawings,* New York, 1982.

Koreny, Fritz, *Dürer und die Tier- und Pflanzenstudien der Renaissance* (cat), Vienna, 1985.

Bialostocki, Jan, *Dürer and His Critics,* Baden-Baden, 1986.

*

Albrecht Dürer was one of the two or three most influential artists of the western world. At the time of his death in 1528 at the age of 57, only Raphael and Michelangelo were more famous than he. Dürer was one of only two artists mentioned favorably by the Council of Trent, which cited him as a guardian of public morality for his purity of thought and for his

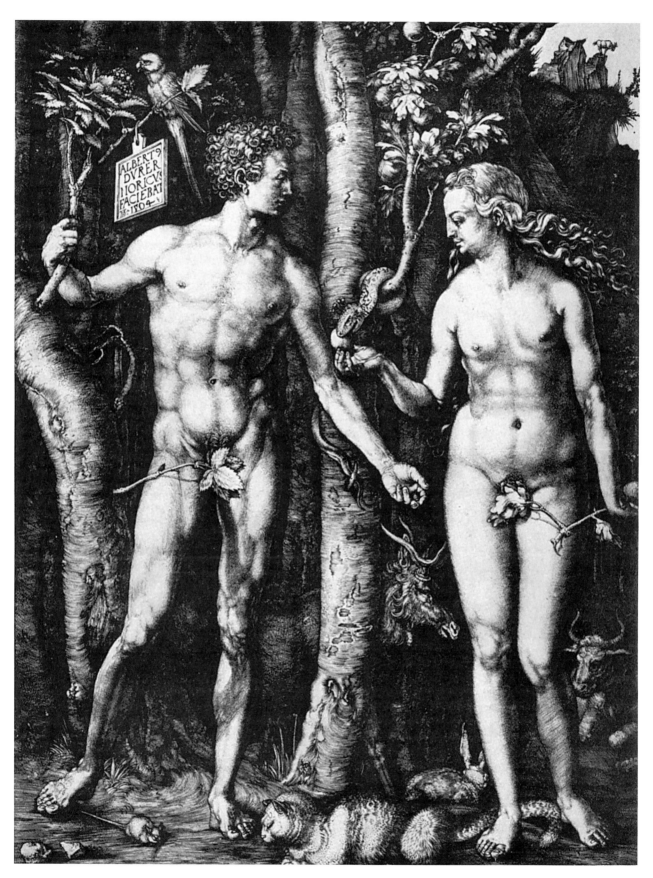

Adam and Eve, 1504; engraving

refusal to print anything obscene or sinful. On the other hand, his professed interest in the teachings of Martin Luther, his personal friendship with Luther's protector, Frederick the Wise, and his engraved portrait of the reformer Philip Melanchthon endeared him to a growing Protestant public over the years. Dürer's woodcuts and engravings were used as models for paintings, sculpture, graphics, ceramics, and goldwork by artists all over Europe, and his graphic art was imported to the New World by Spanish missionaries in the 16th and 17th centuries. He was the first German to publish on the physical sciences in the German language, and his contributions to artistic theory and to the history of mathematics, quickly translated into other European languages, were fundamental ones which held the interest of scholars during the Thirty Years' War and the Enlightenment, and his published concern for the future of German art made him the cultural idol of the Nazarene brotherhood, as well as of the age of Kaiser Wilhelm and of Adolph Hitler, who copied one of Dürer's watercolors as an art student. His book on the theory of fortifications was dutifully read by the German officer corps as late as 1917, while his depictions of the fantastic and the melancholic earned him the approbation of Victor Hugo, Delacroix, Baudelaire and Jean-Paul Sartre.

Dürer was the first artist in history to leave both a series of self-portraits and a body of autobiographical writing. He was the first artist to be honored with a public monument—the bronze statue by Christian Daniel Rauch (1828–40; Nuremberg, Albrecht-Dürer-Platz)—as well as the first whose house and tomb were restored in the name of historic preservation. An annual "Albrecht Dürer Day," like the feast day of a saint, was celebrated by German artists from 1815 until the end of the 19th century, while national and, in the anniversary years of 1928 and 1971, even international centenary festivals have been *de rigeur*. The professional literature on Dürer compiled by Matthias Mende in 1971 extends to thousands of items, and his professional reputation is the subject of one of the last books by the late Polish art historian, Jan Bialostocki.

Unlike such masters as Rembrandt and Raphael, whose reputations have undergone periods of drastic decline and dramatic recovery over the centuries, Dürer's position as an artist of enduring fame can be demonstrated in many ways, not least by the fact that prices paid for his paintings and graphic works have steadily increased since his death. His graphic works and watercolor studies were eagerly sought out by such 16th-century collectors as Erasmus of Rotterdam, Nicolas Perrenot, prime minister to Charles V, and the Emperor Rudolph II. His lasting popularity was due in part to his having revolutionized the media of engraving and woodcut, which ensured him a much wider public than would have been the case had he limited his work to commissioned paintings. He not only produced graphic art of higher quality and greater vigor than any ever seen before, but he also employed sales agents to carry his prints to Italy and elsewhere. Most importantly of all, however, he was chosen by Konrad Celtis, the "arch humanist," and by their mutual friend, the historian and translator of the classics, Willibald Pirckheimer, to spearhead the movement to "bring Apollo to Germany"—i.e., to raise the level of quality of, and interest in, the visual arts in Germany to rival that of Renaissance Italy. In this, Dürer was successful beyond his sponsors' wildest dreams.

—Jane Campbell Hutchison

EAKINS, Thomas

Born in Philadelphia, Pennsylvania, 25 July 1844. Died in Philadelphia, 25 June 1916. Married Susan H. Macdowell, 1884. Studied at Pennsylvania Academy of Fine Arts, Philadelphia, and anatomy at Jefferson Medical School, Philadelphia, 1861–66; studied under Gérôme at Ecole des Beaux-Arts, Paris, 1866–69, and briefly with Léon Bonnat, and in Spain, 1870; successful teacher and painter in Philadelphia from 1870: at Pennsylvania Academy from 1876: head of the Academy from 1879 to 1886 (resigned over his insistence on using nude models); then taught at his own school for 8 years and at Arts Students League of Philadelphia; also made photographic experiments.

Major Collection: Philadelphia

Other Collections: Andover, Massachusetts; Boston; Fort Worth; New Haven; New York: Metropolitan, Brooklyn Museum; Philadelphia: Pennsylvania Academy of Fine Arts, Jefferson Medical College; Washington: National Gallery, Corcoran, Phillips.

Publications

On EAKINS: books—

Goodrich, Lloyd, *Eakins, his Life and Work,* New York, 1933, Cambridge, Massachusetts, 2 vols., 1983.

McKinney, Roland, *Eakins,* New York, 1942.

Eakins Centennial Exhibition (cat), Pittsburgh, 1945.

McHenry, Margaret, *Eakins, Who Painted,* New York, 1946.

Porter, Fairfield, *Eakins,* New York, 1959.

The Sculpture of Eakins. Washington, 1960.

Goodrich, Lloyd, *Eakins* (cat), Washington, 1961.

Schendler, Sylvan, *Eakins,* Boston, 1967.

Domit, Moussa M., *The Sculpture of Eakins,* Washington, 1969.

Hendricks, Gordon, *Eakins: His Photographic Works* (cat), Philadelphia, 1969.

Goodrich, Lloyd, *Eakins* (cat), New York, 1970.

Hoopes, Donelson F., *Eakins Watercolors,* New York, 1971.

Hendricks, Gordon, *The Photographs of Eakins,* New York, 1972.

Hendricks, Gordon, *The Life and Works of Eakins,* New York, 1974.

Rosenzweig, Phyllis D., *The Eakins Collection of the Hirshhorn Museum and Sculpture Garden,* Washington, 1977.

Siegl, Theodor, *The Eakins Collection* [of the Philadelphia Museum of Art], Philadelphia, 1978.

Parry, Ellwood C., Jr., and Robert Stubbs, *Photographer Eakins* (cat), Philadelphia, 1981.

Sewell, Darrel, *Eakins* (cat), Philadelphia, 1982.

Johns, Elizabeth, *Eakins: The Heroism of Modern Life,* Princeton, 1983.

Lubin, David M., *Act of Portrayal: Eakins, Sargent, James,* New Haven, 1985.

Fried, Michael, *Realism, Writing, Disfiguration: On Eakins and Stephen Crane,* Chicago, 1987.

*

Thomas Eakins is America's best Academic painter. Sincere, hardworking, thick-headed, honest, vulgar, secretive, a closet homosexual, independent, uncommercial, forgotten during his lifetime, etc., his life and character have traits that make him a model "misunderstood hero." His withdrawal from the public life and the public exhibition practices of his contemporaries, his refusal to court society, his refusal to travel for most of his life outside a triangle of his home town Philadelphia, New York City, and the Jersey shore indicate a "pure American." To sustain this myth, that of Eakins as the great American hero, two generations of scholars have discounted his studies at the French Academy and ignored the similarity of his production to contemporary academic production in Europe. Habitually considered outside his tradition, he may be America's least understood major painter.

The several years he spent in Europe were probably the most important in his life: he entered the Ecole des Beaux Arts when it was undergoing one of its periodic reforms, and he enrolled with a leading professor of that reform, Gérôme, whose works he had learned to admire in America. Gérôme's importance as a reformer lay not in any innovations he made, but rather in the integrity with which he revived and taught the established, but long neglected, academic routine. He visited his classes on schedule (unusual at the Ecole), and pushed his students into related studies he thought they needed. He got Eakins to study sculpture, to take anatomy classes, attend autopsies, and to study portraiture with Léon Bonnat. But most of all he taught Eakins that painting was a serious matter: a mixture of craft and intellect. But he could not teach a rather

stiff draughtsman to draw with ease, or a clumsy painter to paint with bravura or *sprezzatura*. Nonetheless, Eakins referred to Gérôme all his life as his master, and took his great sense of responsibility to his art back to America and to the schools in which he taught, effectively installing Gérôme's reforms into the curricula of the Pennsylvania Academy of Fine Arts and of the New York Academy of Design.

A true representative of the realist generation Eakins believed that painting was a descriptive science; his art theory was even less concerned with aesthetic effects than that of his almost equally hard-headed master Gérôme. The advent of photography no more frightened him than it did Gérôme: for both it was another tool to assure accuracy in drawing.

For various reasons Eakins had more of a public life as a teacher than as a painter. His teaching career at the Pennsylvania Academy ended in just the kind of scandal that Americans admire: he took the loin cloth off a male model before a class of mixed male and female students better to explain the anatomy of the groin.

This scientific obstinacy cost him popularity and commissions. He often asked aristocratic ladies as they posed for portraits to remove their blouses, or tapped the chests—wanting to see where the bones were. They seldom returned to his studio; there are many unfinished portraits among his works. Not only that, in pushing for clarity of bone structure, he defatted the faces of young girls, making them seem older. But the results are at times among the glories of American painting as in *Miss Amelia Van Buren,* (c. 1891; Washington, Phillips); the preparatory photograph taken by Eakins show that this brooding, desiccated 40 year old was actually painted from a bright young girl under 20. Eakin's portraits were frequently rejected by the sitters, then by the juries; and soon he was working in relative obscurity, painting portraits mainly of friends who did not take the finished paintings home with them.

His isolation was his downfall as an artist; had he cavorted with high society, along with his contemporaries William Merritt Chase and John Singer Sargent, or had he "palled around" with Winslow Homer, critical and professional discussion, competition, exposure to new ideas might have kept him on his toes. He probably would never have achieved an easy brush style or a more fluid manner of composing—he was too ponderous in thought for that. But a critical atmosphere might have prevented him from leaving so many dead areas in his late works, or protected his figures from the woodenness of so many of them.

Eakins had a good eye for character and anatomy, and he was an excellent portrait painter, but his European training had instilled in him the ambition to do complicated figure compositions. He did a series of beguiling realist genre scenes, prepared with all the care of academic routine: grand machines of boxers, musicians, chess players; modest scenes of cowboys, hunters, children at play, and so forth. Nevertheless it was in combining his talent for portraiture with the standards of history painting that he produced his two masterpieces, the fascinating *Gross Clinic* (1875; Philadelphia, Jefferson Medical College) and the slicker *Agnew Clinic* (1889; Philadelphia, University of Pennsylvania), works still deep in the academic realist tradition of Europe in which he had been trained, and quite consistent, even parallel, with the work of his academic colleagues in Paris.

The Gross Clinic and *The Agnew Clinic* show the height and limits of his achievement as well as the disappointing results of his later unguided development. Dr. Gross stands over the chloroformed patient, pausing before he speaks to his attentive students in the amphitheater around him. His intelligence and control (his monumentality, his marvelous insouciance at the blood on his hands) dominate the picture and distract attention from the compositional deficiencies (such as the incomprehensible foreshortening of the patient's body, the wooden poses and clumsily painted hair of the assistants). The second clinic, painted 14 years later, is more fluid in its technique, surer in its anatomy: the head of Dr. Agnew is splendid, but spiritual insight has deferred to politeness; the energy, the conviction, the intellectual energy that transformed Dr. Gross into an image of science is gone.

—Gerald M. Ackerman

ELSHEIMER, Adam.
Baptized in Frankfurt am Main, 18 March 1578. Buried in Rome, 11 December 1610. Married Carla Antonia Stuarda, 1606, one son. Probably a student of Philipp Uffenbach; in Venice, 1598 (associated with the painter Hans Rottenhammer, a friend of Rubens), and in Rome, 1600-10; patron/pupil in Rome: Goudt.

Collections: Berlin; Braunschweig; Cambridge; Copenhagen; Dresden; Edinburgh; Frankfurt; The Hague; Kassel; Leningrad; London: National Gallery, Wellington; Munich; New Haven; Venice; Royal Collection.

Publications

On ELSHEIMER: books—

Bode, Wilhelm, *Elsheimer, der römische Maler deutscher Nation,* Munich, 1920.
Weizsäcker, Heinrich, *Die Zeichnungen Elsheimers im Skizzenbuch des Städelschen Instituts,* Frankfurt, 1923.
Drost, Willi, *Elsheimer und sein Kreis,* Potsdam, 1933.
Weizsäcker, Heinrich, *Elsheimer, der Maler von Frankfurt,* Berlin, 2 vols. (vol. 2 edited by Hans Möhle), 1936-52.
Bothe, Friedrich, *Elsheimer, der Maler von Frankfurt,* Frankfurt, 1939.
Drost, Willi, *Elsheimer als Zeichner,* Stuttgart, 1957.
Held, Jutta, *Elsheimer* (cat), Frankfurt, 1966.
Waddingham, Malcolm R., *Elsheimer,* Milan, 1966.
Möhle, Hans, *Die Zeichnungen Elsheimers,* Berlin, 1966.
Andrews, Keith, *Elsheimer: Il Contento,* Edinburgh, 1971.
Andrews, Keith, *Elsheimer: Paintings, Drawings, Prints,* Oxford and New York, 1977.
Lenz, Christian, *Elsheimer: Die Gemälde im Städel,* Frankfurt, 1977.

articles—

Waddingham, Malcolm R., and Christopher Wright, "El-

Study for Aurora; drawing; Frankfurt, Städelsches Kunstinstitut

sheimer: A Third Piece for the Frankfurt Tabernacle," in *Burlington Magazine* (London), April 1970.

Kennedy, I. G., "Elsheimer: Two Predellas from the Frankfurt Tabernacle," in *Burlington Magazine* (London), February 1971.

Andrews, Keith, "One More Elsheimer," in *Burlington Magazine* (London), March 1979.

Waddingham, Malcolm R., "Elsheimer's Frankfurt Tabernacle: Discovery of the Final Piece," in *Burlington Magazine* (London), June 1981.

Andrews, Keith, "Elsheimer's *Latona* Uncovered," in *Burlington Magazine* (London), June 1981.

Waddingham, Malcolm R., "Elsheimer Revised," in *Burlington Magazine* (London), September 1982.

*

Elsheimer's highly original, gem-like copper panels are not easily categorized. They combine fantasy and observation in a potent blend that would feed the imaginations of such dissimilar artists of the first rank as Rubens, Rembrandt, and Claude. Indeed, there were few painters of a poetic disposition in early 17th-century Italy who were not similarly affected (e.g., Fetti, Orazio Gentileschi, and Saraceni). In addition, his pictures served almost as blueprints for a host of lesser Dutch masters—from the figure painters David Teniers the Elder and Lastman (who may both have studied under Elsheimer in Rome) to landscapists such as the Pynas brothers, Poelenburgh, and Breenbergh. Elsheimer's glowing colors and sensitive realizations of the pulse of human and inanimate life strike a mysterious, quasi-mystical note, of which some have discerned an echo in the comparably spirited technique, bright tones, and unforced poses of Samuel Palmer's visionary Shoreham landscapes of the late 1820's.

All of Elsheimer's 40-odd surviving paintings bar one were done on copper with fine hairline brushes and, probably, the aid of a magnifying glass. They vary in size between the small and the very small (13 x 20 in. to 3 ½ x 3 in.—with the majority from the middle or lower end of the range). Although practised in Italy, painting on copper was a north European speciality, and Elsheimer's beautifully measured technique was rooted in his German training under Philipp Uffenbach, who was himself the pupil of a son of a pupil of Grünewald. The popularity of Elsheimer's panels with leading Italian collecters reflects not merely the power of his imagination but the appeal of well-executed copper paintings as precious objects. It is possible that a number of Elsheimer's were used for furniture decoration, such as inlaying into cabinets, as was customary, while some sets of panels, such as those for *The Finding and Exaltation of the True Cross,* c. 1603–05 (Frankfurt, seven scenes) were done for portable house-altars.

Elsheimer's achievement rests on his skill and inventiveness on three fronts—figure painting, lighting (including nocturnal lighting), and landscape. His figures stem from the meticulous yet elegant naturalism of the German Renaissance (e.g., Schongauer, Dürer, Altdorfer, and Cranach), which he imbibed from the many figure-filled altarpieces in and around Frankfurt. Some of the protagonists of his pre-Italian pictures, however, have stocky bodies and limbs and eminently natural poses, which suggest a deep absorption in drawing from life. In Venice, his preoccupation with the manifold postures into which the body naturally falls was fuelled, in such works as his *Flood* (Vienna), by contact with the multi-figure compositions of Tintoretto and his still-living German disciple Rottenhammer. Venice also further stimulated his brilliant German colorism, especially in the softening of contours and the rendering of atmosphere. He there first became fully conscious of the need to integrate a figure with its surroundings by means of light and color, and of a certain suave amplitude of the human form, which owes much to Veronese.

Elsheimer's poses and his sense of volume became even more assured in Rome, possibly partly in response to the inno-

vative, contemporary formulations of Annibale Carracci and Caravaggio. On occasions one discerns quite clearly an Annibalesque classicism of gesture and body type (e.g., in *Il Contento,* Edinburgh, c. 1607–09) or a Caravaggio-inspired piece of illusionistic bravado, as with the kneeling figure of St. Stephen, thrusting the soles of his bare feet up against the picture plane in the Frankfurt *Exaltation of the True Cross.*

For all his sensitive assimilation of ideas and techniques from other artists, however, Elsheimer's passion for observation issues in a wide range of unconventional poses and attitudes. Some of these, such as the naked woman hanging up her clothes to dry in *The Shipwreck of St. Paul on Malta* (London, c. 1603), only seem incongruous if we are guided by a narrowly academic sense of decorum. In fact, these figures' unpretentious involvement in what they are doing contributes forcefully to the sense of narrative. For Elsheimer is, in the best traditions of German art, a master storyteller, capable of bringing life and interest to a well-worn image. His three versions of *Tobias and the Angel* are conceived in terms of a solicitous young man (the angel) taking a boy (Tobias) for a walk (in one version, the marvellous Frankfurt "Small Tobias," c. 1607–08, accompanied by Tobias's amusing pet dog, who barks protectively at the strange angel). In another instance, the visit in disguise of *Jupiter and Mercury at the House of Philemon and Baucis* (Dresden, c. 1608–09) provides the opportunity not only for a masterly display of still life painting but for characterizations which are inventively in keeping with the story: the arthritic old peasants, barely able to walk, bring food and hospitality to the two god guests who, relaxing with their feet up on cushions, give all the appearance of noblemen recovering in a peasant cottage after a day's hunting. A mythological saga is recast in the class language of Elsheimer's own day.

This latter scene is lit by the light of lamps, reminding us that Elsheimer was renowned for his night pieces. They have sometimes been compared with Caravaggio's essays in *chiaroscuro,* but very few of Caravaggio's pictures are lit by internal light sources and Elsheimer's approach has its roots, rather, in the night scenes of Altdorfer in Germany and the Bassani in Venice. Some of Elsheimer's outdoor night scenes, with their illumination from fires and lightning (e.g., *The Burning of Troy,* Munich, c. 1600–01, and *St. Paul on Malta*) are decidedly in this tradition. But he also broke new ground in the rendering of vibrant highlights and reflections in nocturnal interiors, such as *Judith Slaying Holofernes* (London, Apsley House, c. 1603), and pioneered the compositional use of the silhouette in both night and day scenes (e.g., *Il Contento* and *The Stoning of St. Stephen,* c. 1607, Edinburgh). This range of effects was to prove of special interest to Honthorst and Rembrandt.

Elsheimer's rendering of light also formed his major contribution to the development of landscape painting. Although only one of his pictures, the sun-drenched *Aurora* in Brunswick (c. 1607), can rank as a fully independent landscape by virtue of the subsidiary role of the staffage, Elsheimer's unprecedented ability to depict light and atmosphere marks him as the precursor of Claude and a pioneer of modern approaches to the art. His early, more conventional landscape settings have been connected with Coninxloo and the Frankenthal School but their towering trees and luxuriating vegetation perhaps owe even more to Altdorfer. The turning point for Elsheimer occurred in Italy, as he began to see and depict light

as a unity, masking the sharpness of form and color, and sparkling over surfaces. Apart from the *Aurora,* which is damaged, his depiction of sunlight on landscape is seen at its best in the series of tiny, single-figure Saints and Old Testament figures at Petworth House, Sussex, c. 1605.

Elsheimer's influence, and his reputation as a master of light (both day and night), were greatly facilitated by the seven fine reproductive etchings made after his pictures by his friend, Hendrick Goudt.

—John Gash

ENSOR, James (Sydney).

Born in Ostende, 13 April 1860, son of a British father and Belgian mother. Died in Ostende, 19 November 1949. Studied at the Académie Royaux des Beaux-Arts, Brussels, 1877–90; then lived and worked in Ostende; exhibited with Les XX, 1884, but expelled, 1889; created Baron, 1929.

Major Collections: Antwerp; Ostende: Ensor Museum.
Other Collections: Brussels; Cologne; Detroit; London: Tate; Malibu; New York: Moma; Paris: Art Moderne.

Publications

By ENSOR: books—

Ecrits, Brussels, 1921; 5th edition, Liège, 1974.
Lettres à André de Ridder, Antwerp, 1960.
Lettres à Franz Hellens-Eugène Demolder, Liège, 1969.

On ENSOR: books—

Demolden, Eugene, *Ensor,* Brussels, 1892.
Maeterlinck, Maurice, et al., *Ensor,* Paris, 1899.
Verhaeren, Emile, *Ensor,* Brussels, 1908.
Leroy, Grégoire, *Ensor,* Brussels, 1922.
Cuypers, Firmin, *Ensor: L'Homme et l'oeuvre,* Paris, 1925.
Delteil, Loys, *Catalogue de l'oeuvre gravé d'Ensor,* Paris, 1925.
Desmuth, Paul, *Ensor,* Brussels, 1926.
Dommartin, Henry, *Les Eaux-fortes d'Ensor,* Brussels, 1930.
Ridder, André de, *Ensor,* Paris, 1930.
Colin, Paul, *Ensor,* Berlin, 1931.
Lebeer, Louis, *Ensor, aquafortiste,* Antwerp, 1942.
Fierens, Paul, *Ensor,* Paris, 1943.
Fierens, Paul, *Les Dessins d'Ensor,* Brussels, 1944.
Arnold, Sydney, *L'Ecole de peinture d'Ostende: Le Groupe d'Ensor (1925-1930),* London, 1946.
Cuypers, Firmin, *Aspects propos d'Ensor,* Bruges, 1946.
Avermaete, Roger, *Ensor,* Antwerp, 1947.
Croquez, Albert, *L'Oeuvre gravé d'Ensor,* Geneva, 1947.
Ensor, Brussels, 1950.
Ridder, André de, *Ensor herdacht,* Brussels, 1950.
Tannenbaum, Libby, *Ensor,* New York, 1951.

Bathing Cabins at Ostend, 1899; lithograph

Vanbeselaere, Walter, *Retrospective Ensor* (cat), Antwerp, 1951.

Vanbeselaere, Walter, *L'Entrée du Christ à Bruxelles*, Brussels, 1957.

Ebedau, Frank Patrick, *La Maison d'Ensor*, Brussels, 1957.

Haesaerts, Paul, *Ensor*, Brussels, 1957; London and New York, 1959.

Fels, Florent, *Ensor*, Brussels, 1958.

Ensor, Brussels, 4 vols., 1959.

France, Hubert de, *Ensor: Essai de bibliographie commentée*, Brussels, 1960.

Hammacher van den Brande, Renilde, *Ensor*, (cat), Otterlo, 1961.

Schwob, Lucien, *Ensor*, 1963.

Ensor (cat), Basel, 1963.

Damase, Jacques, *L'Oeuvre gravé d'Ensor*, Geneva, 1967.

Piron, H. T., *Ensor: Een psychoanalytische studie*, Antwerp, 1968.

Croquez, Robert, *Ensor et son temps*, Ostend, 1970.

Lebeer, Louis, *Prints of Ensor*, New York, 1971.

Legrand, Francine-Claire, *Ensor, cet inconnu*, Brussels, 1971.

Croquez, Robert, *Ensor et le Rotary*, Ostend, 1973.

Haesaerts, Paul, *Ensor*, Brussels, 1973.

Taevernier, Auguste, *Ensor: Catalogue illustré de ses gravures, leur description critique, et l'inventair/Ensor: Illustrated Catalogue of His Engravings, Their Description, and Inventory of the Plates*, Ghent, 1973.

Gindertael, Roger van, *Ensor*, Boston and London, 1975.

Farmer, David, *Ensor* (cat), New York, 1976.

Kiefer, Theodore, *Ensor*, Recklinghausen, 1976.

Ollinger-Zinque, Gisèle, *Ensor par lui-même*, Brussels, 1976; as *Ensor by Himself*, Brussels, 1977.

Taevernier, Auguste, *Le Drame ensorien: Les Auréoles du Christ, ou les sensibilités de la lumiere*, Ghent, 1976.

Janssens, Jacques, *Ensor*, Paris and New York, 1978.

Delevoy, Robert L., *Ensor* [in English], Antwerp, 1981.

Elesh, James N., *Ensor: The Complete Graphic Work*, New York, 1982.

Ensor (cat), Zurich, 1983.

Hoozee, Robert, Sabine Bown-Taevernier, and J. F. Heijbroek, *Ensor* (cat), Ghent and Amsterdam, 1987.

articles—

Maeyer, Marcel De, "Derrière le masque: L'Introduction du masque, du travesti, et du squelette comme motifs dans l'oeuvre d'Ensor," in *L'Art Belge* (Brussels), December 1965.

Kaplan, Julius, "The Religious Subjects of Ensor 1877–1900," in *Revue Belge d'Archéologie et d'Histoire de l'Art* (Brussels), 3–4, 1966.

Schiff, Gert, "Ensor the Exorcist," in *Art the Ape of Nature: Studies in Honor of H. H. Janson*, New York, 1981.

Eisenman, Stephen F., "Allegory and Anarchism in Ensor's *Apparition: Vision Preceding Futurism*," in *Record of the Art Museum* (Princeton), 46, 1987.

*

James Ensor's art spanned more than seven decades and he continued to paint until his death in 1949. His paintings, prints, and drawings—especially those produced during the 1880's and 1890's—identify him as a precursor of Expressionism through an art that is radical and hallucinatory, with solitary images of alienation and crowd scenes filled with a grotesque bourgeoisie. Yet there are other sides to his art: vividly accurate reflections of reality and poetic visions based upon delicacy and nuance.

The earliest paintings were of the sea and dunes, executed with a light touch and a general sense of grace remarkable for a young artist. A small picture of a wooden bathing cabin standing alone on the sand, painted when Ensor was 17, is revealing of his personality: the cabin, with its solitary, narrow window and its closed door, is like a shell hiding a silent inhabitant who fears to reveal its self to the dangers of the outside world.

Ensor was solitary, distrustful of outside contact, and fortified against it. A tall, thin figure dressed in black and seen walking alone on the dunes, he was characterized by the Flemish as "Pierrot la mort," an observation that was to reflect the development of the macabre in his art. Ensor and his sister, Mitche, were raised by their mother, grandmother, and aunt in the apartment above their Ostend curio shop. Their lives were regulated by the tourist season: in summer when thousands filled the beaches and the shop was busy, Ensor caricaturized the annual wave of self-indulgent strangers; during the rest of the year, when ennui filled the days and the women slept the long afternoons away, Ensor turned to his own family for artistic inspiration.

In 1877 he left Ostend to study at the Brussels Académie Royale des Beaux-Arts where he endured three years, disparaged, as he reported, as "an ignorant dreamer." Home again in Ostend, he established a studio on the top floor of his family's home and worked there until his death. He experimented with a number of styles, from the traditional Chardin-inspired painting of *The Ray* to the monumental *Woman Eating Oysters* (both in Antwerp). The latter, a bold picture celebrating mealtime and the bourgeois appetite, was rejected by the Antwerp Salon in 1882 and the avant-garde group L'Essor in 1883.

In 1883 Ensor broke new ground with *Scandalized Masks* (Brussels), a spare painting of a masked man and woman— references to Ensor's English father and Flemish grandmother—shown in an ominous encounter. With this picture masks were to become a leitmotif for much of his art. The tradition of Belgian carnivals and religious festivals and the psychological implications inherent in the use of the mask were significant for Ensor's iconography.

It has been claimed that Ensor's preoccupations with his art, his birthplace, and the sea kept him isolated from the mainstream of European society, a society he vilified and condemned in his art. Yet it can be seen that Ensor's isolation was a conscious effort to preserve the authenticity of his work and to affirm his nationalism. Ensor was an armchair traveler whose knowledge of the literary, philosophical, and political world of contemporary Europe enabled him to infuse his own art with a combination of tradition and innovation. Physically removed from the mainstream, his art nevertheless speaks pointedly and often caustically about that mainstream, so much so and with such radical innovation that a great deal of it was rejected even by his closest peers, members of Les Vingt, the avant-garde Belgian group that Ensor helped found in 1883.

In 1887 Ensor's interests in religion, history, and philosophy resulted in a picture that can be seen as the boldest painting produced by any artist in that year: the *Tribulations of Saint Anthony* (New York, Moma). The artist created a hallucinatory image with a surface thick with scumbled paint and violent color suggestive of blood and feces. The ooze and slime of matter's beginnings are suggested (theories concerning evolution and the nature of matter were topical intellectual concerns), as well as the ultimate outcome, matter's end in excrement: they can be seen through the evolutionary development of the fish who crawls out of the sea and appears on the land and through the hybrid creatures who populate the painting; through classical civilization as seen in the skeletons of colonnaded buildings and the destruction of cities in a cataclysmic fire; and through Ensor's own personal torments and pleasures which appear as autobiographical symbols near the image of the saint.

Self-portraits, a consuming interest throughout Ensor's art, were used to express self-mockery and disparagement and also to explore metaphysical concerns. In a number of prints and drawings Ensor appears skeletonized or transubstantiated, thus effecting a symbolic metamorphosis reflective of his affinity with major literary movements and a developing symbolist aesthetic.

The amazing *Skeletons Trying to Warm Themselves* (Fort Worth) of 1889 is a scene rich with references to art, literature, and religion. Here three skeletons are frighteningly alive and comically amusing: endearing while at the same time pathetic, they reveal the bare bones and bottom line of our human condition.

Ensor's conflict between self and society assumed such a critical form that his art became aggressively irrational and internalized. In a society that he believed to be in danger of total disintegration, one in which the church was a shall of its former self, Ensor would speak through an art guaranteed to shock the bourgeoisie—with caricature, with symbolic references to past history, and with increasingly vicious, coarse, and vulgar scatalogical imagery.

When Ensor's art is considered, it is the crowd scenes that first come to mind: the intricate complexity of a thousand heads in the remarkable etching *The Cathedral* (1886 and 1896) and the billboard-sized mass of teaming humanity in *The Entry of Christ into Brussels* (1888, Malibu). Yet the importance of his creative oeuvre—with its remarkable assimilation of sources, its multiplicity of themes, and its varied artistic experimentation—transcends any single image and speaks collectively for a unique vision.

—Diane Lesko

EPSTEIN, (Sir) Jacob.
Born in New York, 10 November 1880; naturalized British citizen, 1910. Died in London, 19 August 1959. Married 1) Margaret (Peggy) Dunlop, 1905 (died, 1947), three daughters, one son; 2) Kathleen Garman, 1955. Studied at the Art Students League, New York, 1894–1902; worked in bronze factory, and studied under George Gray Barnard, New York,

1902; studied under Professor Thomas at Ecole des Beaux-Arts, Paris, 1902, and under Jean Paul Laurens at the Académie Julian, Paris, 1902–04; then independent sculptor in London from 1905: several of his public sculptures caused scandals; Co-Founder of the Vortex group, 1913; served in Royal Fusiliers, 1917–18; stage designs for ballet *David,* 1936. Knighted, 1954.

Collections/Locations: Aberdeen; Bristol; Conventry: Cathedral; Edinburgh; Glasgow; Hull; Leicester; Llandaff: Cathedral; London: Tate, War Museum, Westminster Abbey, St. Paul's, Zimbabwe Embassy; New York: Moma; Oxford: Ashmolean, New College; Paris: Père Lachaise Cemetery; Washington: Hirshhorn.

Publications

By EPSTEIN: books—

The Sculptor Speaks: Conversations with Arnold Haskell, London, 1931.
Let There Be Sculpture: An Autobiography, London, 1940 revised edition as *An Autobiography,* London and New York, 1955.

Illustrator: *The Spirit of the Ghetto,* by Hutchins Hapgood, 1902; *The Book of Affinity,* by Oyved, 1933; *Flowers of Evil,* by Baudelaire, 1940.

On EPSTEIN: books—

Dieren, Bernard van, *Epstein,* London, 1920.
Wellington, Hubert, *Epstein,* London, 1925.
Powell, L. B., *Epstein,* London, 1932.
Black, Robert, *The Art of Epstein,* Cleveland, 1942.
Ireland, Geoffrey, *Epstein: A Camera Study of the Sculptor at Work,* London, 1950.
Buckle, Richard, *Epstein* (cat), Edinburgh, 1961.
Epstein, Kathleen. *Epstein: Drawings,* London, 1962.
Buckle, Richard, *Epstein,* London and Cleveland, 1963.
Schinman, Edward P. and Barbara, *Epstein: A Catalogue of the Collection of Edward P. Schinman,* Rutherford, New Jersey, 1970.
Silber, Evelyn, *Rebel Angel: Sculpture and Watercolours by Epstein* (cat), Birmingham, 1980.
Cork, Richard, *Art Beyond the Gallery in Early 20th Century England,* New Haven, 1985.
Silber, Evelyn, *The Sculpture of Epstein,* Oxford, 1986.
Pennington, Michael, *An Angel for a Martyr: Epstein's Tomb for Oscar Wilde,* Reading, 1987.
Silber, Evelyn, and Terry Friedman, *Epstein: Sculptures and Drawings* (cat), Leeds and London, 1987.

article—

Barker, Elizabeth, "New Light on Epstein's Early Career," in *Burlington Magazine* (London), December 1988.

*

Dolores, 1923; bronze; life-size

Jacob Epstein's career is one of contrasts. His carvings and public commissions were considered shockingly primitive and sexual in their time, and aroused vilification and controversy, yet he was assured a prominent and respectable position with his conventional, naturalistic portraits in bronze. He was at the vanguard of sculptors who discovered "direct carving," but the majority of his works were modelled not carved. He was one of the first modern artists to collect primitive artifacts and draw on archaic sources, yet his better-known bronzes respect the Renaissance tradition. While associated with the avant garde Vorticist group just before the Great War, he was untouched by Surrealism and abstraction, and soon came to be regarded as "old hat" by the new generation.

In his 1959 obituary of Epstein, Henry Moore paid tribute to the fact that the way was much easier for his own generation because of the older sculptor's stubborn perseverence. "He took the brickbats, he took the insults, he faced the howls of derision with which artists since Rembrandt have learned to become familiar. And as far as sculpture in this century is concerned, he took them first." The public reception of Epstein's work was the catalyst in his Jekyll and Hyde career. In his first major commission, the 18 figures on the facade of the new British Medical Association building exploring the primal themes of pregnancy, birth, reproduction, the primal forces of life, he first aroused public wrath. The nudity and frankness of these figures shook Edwardian sensibility, and became a *cause célèbre* among the intellectuals of the day. In fact, similar responses greeted most of his public commissions, such as the *Tomb of Oscar Wilde,* 1912, in Père Lachaise, where instead of providing the Grecian youth and broken column that might have been expected he carved an exotic winged angel, modelled on the Assyrian winged bull in the British Museum; or the figures of *Night* and *Day* on the London Underground Headquarters Building, 1928, uncompromisingly harsh, brutal, primitive depictions, albeit in traditional allegorical poses.

The press vilification of Epstein mixed sexual prurience, xenophobia (Epstein was an American Jew by birth), and artistic philistinism. He became the butt of caricatures and limericks, but more seriously, he was humiliatingly forced to modify works, when for instance, in 1928 he remounted the scaffold of the Underground building to shorten a male organ! Furthermore, his works were destroyed during his lifetime (the BMA figures were butchered when the building changed owners), and important carvings were actually displayed as novelties in fairground "peepshows." Ultimately he was denied public commissions; Charles Holden, an architect with whom he collaborated, was presented with an important contract actually stipulating that he should not use Epstein.

His denial of public space, coupled with a growing success as a portraitist in bronze, led to an unusual reversal in his working method: His "public" work, that for which he was popular and respected, were his busts of society figures, artists, authors, military men, the aristocracy, even though portraiture is essentially intimate, interior art, while he financed his own "private" work, carvings in stone of universal themes on a "public" scale. The fact that he turned out more portraits than carvings should not lead us to conclude that, to him, the one was more important than the other. On the contrary, his carvings, which occupied him to the end of his life, are more obsessively worked and ambitiously conceived.

Moore also paid tribute to Epstein's pioneering experimentation with "primitive" artforms, firstly archaic Egyptian and Sumerian material, and from around 1912 Negro art. Epstein formed one of the most important collections of "primitive" art in his day, and influenced Moore in the direction of non-European sources. Epstein's great carvings throughout his career have a strong, primordial, primitive feel about them, for he found in the African pieces he so admired bold and expressive gestures which corresponded with his own sculptural vision. *Genesis,* 1929, in saravezza marble, clearly echoes an African mask in the pregnant mother's concave face and rounded forehead, while the posture of *Adam,* 1938-39, a seven-foot high, three-ton alabaster carving, evokes a variety of primitive sources. Like *Ecce Homo,* 1934-35, another bold, declammatory giant of a sculpture, *Adam* shocked audiences in its defiantly anti-European, unorthodox treatment of a religious theme.

Moore perhaps unfairly insisted that Epstein "was a modeller not a carver," considering the tenacity with which he pursued his carving career, but we should not overlook the exceptionally fine quality of his work in bronze. The portraits were understandably popular, for they expressively capture the personality of their sitters, not just in the sensitively modelled facial features but in the superb quality of composure. The Baroque feel of the busts lend themselves particularly to interpretations of the great and famous, and Epstein sculpted many leading figures of the day, including Conrad, Einstein, Vaughan-Williams, Rabindranath Tagore. The technological divide between modelling and carving was perhaps finally bridged in Epstein's late public commissions, arguably among his finest works. One thinks in particular here of his ecclesiastical commissions, such as *St. Michael and the Devil,* 1958-59, on the facade of Coventry Cathedral, or *Madonna and Child,* 1950-52, on the convent of the Holy Child Jesus, London, where one feels Epstein brings together the monumentality and power he sought in carving with the tenderness and compassion he found in modelling.

—David Cohen

ERNST, Max(imilian).

Born in Brühl, Germany, 2 April 1891; naturalized United States citizen, 1948; naturalized French citizen, 1958. Died in Paris, 1 April 1976. Married 1) Luise Strauss, 1918 (divorced, 1921), one son; 2) Marie-Berthe Aurenche, 1927 (divorced, 1936); 3) the collector Peggy Guggenheim, 1941 (divorced); 4) the painter Dorothea Tanning, 1946. Attended schools in Brühl; studied art history and philosophy under Wilhelm Worringer at the University of Bonn, 1909-12; member of the Young Rhineland Circle, 1911; served as an artillery engineer in France and Poland, 1914-17; lived in Cologne, 1918-22, and Paris, 1922-38: involved with J. T. Baargeld, Hans Arp, and Tristan Tzara in Dada movement, and with Surrealists in Paris; worked on set design for *Romeo and Juliet* (ballet by Daighilev), 1926, and Jarry's *Ubu enchaîné,* 1937; also participated in films and other stage works; interned by Germans, 1939, then lived in the United States, 1941-53; returned to Paris, 1953, and settled in Huismes, near Chinon, 1955.

Collections: Amsterdam: Stedelijk; Berlin: Nationalgalerie; Brühl; Duisberg; Dusseldorf; Essen; Hartford, Connecticut; London: Tate; New York: Moma; Paris: Beaubourg; Philadelphia; Stockholm: Moderna Museet; Tel Aviv; Venice: Guggenheim; Vienna; Museum des 20. Jahrhunderts.

Publications

By ERNST: books—

Les Malheurs des immortels, with Paul Eluard, Paris, 1922; as *Misfortunes of the Immortals*, New York, 1943.
Histoire Naturelle, Paris, 1926; augmented edition, Cologne, 1964.
Le Femme 100 têtes, Paris, 1929.
Rêve d'un petite fille qui voulut entrer au Carmel, Paris, 1930.
Une Semaine de bonté, ou les sept éléments capitaux, Paris, 1934.
A l'intérieur de la vue, with Paul Eluard, Paris, 1947.
Beyond Painting and Other Writings by the Artist and His Friends, New York, 1948.
At Eye Level: Poems and Comments; Paramyths: New Poems and Collages, Beverly Hills, 1949; translated in part as *Paramythen: Gedichte und Collagen*, Cologne, 1955.
Sept microbes, vus à travers un temperament, Paris, 1953.
Das Schnabelpaar, Basel, 1953.
Maximiliana, ou l'exercise illégal de l'astronomie, Paris, 1964.
Ecritures, Paris, 1970.

Illustrator: *Dichtungen*, by J. T. Kühlemann, 1919; *Repetitions*, by Paul Eluard, 1923; *Au défaut du silence*, by Eluard, Paris, 1926; *Gedichte*, by Hans Arp, 1930; *Le Château étoilé*, by André Breton, 1936; *Le sublime*, by Benjamin Péret, 1936; *La Maison de la peur*, by Léonora Carrington, 1938; *La Dame ovale*, by Léonora Carrington, 1939; *Chanson complète*, by Paul Eluard, 1939; *La Brebis galante*, by Benjamin Péret, 1949; *La Chasse au Snark*, by Lewis Carroll, 1950; *La Loterie du jardin zoologique*, by Kurt Schwitters, 1951; *Galapagos*, by Antonin Artaud, 1955; *Poèmes*, by Hölderlin, 1961; *La Rose est nue*, by Léna Leclercq, 1961; *Les Chiens ont soif*, by Jacques Prévert, 1964; *Logique sans peine*, by Lewis Carroll, 1966; *Dent prompte*, by René Char, 1969.

On ERNST: books—

Guggenheim, Peggy, *My Life with Ernst, End of My Life with Ernst*, New York, 1946.
Bousquet, Joë, and Michel Tapié, *Ernst*, Paris, 1950.
Brauer, Josa, editor, *Ernst: Gemälde und Graphik 1920–1950* (cat), Brühl, 1951.
Trier, Eduard, *Ernst*, Cologne, 1956, Recklinghausen, 1959.
Waldberg, Patrick, *Ernst*, Paris, 1958.
Arp, Hans, et. al., *Hommage à Ernst*, Cologne, 1960.
Bataille, Georges, et al., *Ernst*, Paris, 1960.
Lieberman, William S., *Ernst* (cat), New York, 1961.
Russell, John, *Ernst: Life and Work*, New York and London, 1967.
Spies, Werner, *Ernst: Frottages*, London and New York, 1969, 1986.

The King Playing with the Queen, 1959; bronze; $37\frac{3}{4}$ in (96 cm)

Gatt, Giuseppe, *Ernst*, London and New York, 1970.
Spies, Werner, *The Return of the La Belle Jardinière: Ernst 1950-1970*, New York, 1971.
Brusberg, Dieter, *Jenseits der Malerei: Das graphische Oeuvre Ernst* (cat), Hanover, 1972.
O'Hara, J. Philip, *Ernst*, Chicago, 1972.
Penrose, Roland, *Ernst's Celebes*, Newcastle upon Tyne, 1972.
Schneede, Uwe, *The Essential Ernst*, London and New York, 1972.
Spies, Werner, *Ernst: Collagen, Inventar, und Widerspruch*, Cologne, 1974.
Rossabl, A. W., *Ernst*, New York, 1975.
Leppien, Helmut R., Werner Spies, and Sigrid and Günther Metken, *Ernst: Oeuvre Katalog*, Cologne and Houston, 4 vols., 1975–78.
Pritzker, Pamela, *Ernst*, London, 1975.
Bailly, Jean-Christophe, *Ernst: Apprentissage, énigme apologie*, Paris, 1976.
Quinn, Edward, editor, *Ernst*, London, 1977.
Spies, Werner, *Ernst: Retrospektive 1979* (cat), Munich, 1979.
Turpin, Ian, *Ernst*, Oxford, 1979.
Herzogenrath, Wulf, *Ernst in Köln: Die rheinische Kunstszene bis 1922*, Cologne, 1980.
Konnertz, Winfried, *Ernst: Zeichnungen, Aquarelle, Ubermalungen*, Cologne, 1980.

Spies, Werner, *Ernst, Loplop: Die Selbstdarstellung des Künstlers,* Munich, 1982; as *Ernst, Loplop: The Artist's Other Self,* London, 1983; as *Ernst, Loplop: The Artist in the Third Person,* New York, 1983.

Ernst (cat), Saint-Paul-de-Vence, 1983.

Gee, Malcolm, *Ernst: Pietà, or Revolution by Night,* London, 1986.

Rainwater, Robert, *Ernst: Beyond Surrealism: A Retrospective of the Artist's Books and Prints* (cat), Oxford, 1986.

*

The otherwise elusively describable works of Max Ernst could be characterized by the following passage of Nietzsche, "that if we create new names, formulate new entities and put forward new probabilities we should also, in the long run, create new 'things' ". Max Ernst is an artist who has devoted himself to the creation of new things, although, paradoxically, this creation has been motivated by a profound disgust with the destructiveness of our world, a disgust, one hastens to add, akin to Nietzsche's own disdain for European decadence. Ceaseless change, evasive of any systematic or logical classification, is one result of this disgust, and Ernst has written, "Rebellious, heterogenous, full of contradictions, it [my painting] is unacceptable to the specialists—in art, in culture, in conduct, in logic, in morality."

Indeed, Ernst studied philosophy at the University of Bonn until the First World War, where he developed his taste for reading Nietzsche. At that time he became fascinated with psychiatric writings, an interest more than apparent in paintings such as *Oedipus* (1922) and *Pietà or Revolution by Night* (1923). Geoffrey Hinton, Malcolm Gee, and Elizabeth Legge have indicated that Ernst borrowed images directly from Freud's case studies in his paintings of 1921–23. These paintings also bear a close resemblance to those of the Italian painter Giorgio de Chirico, with whose paintings Ernst became familiar through the pages of *Valori Pastici,* which he had seen in Munich in 1919. Arnold Böcklin and Casper David Friedrich were among the other artists Ernst was taken with during these years, and, while, to an extent, he partakes of the Romantic spirit, he constantly sought to go beyond the fantastic and portray what Roland Penrose has called "the necessity of the poetic spirit."

Collage was among Ernst's major contributions to the two movements of Dada and Surrealism, his work providing a vivid alternative to that of the Cubists. In 1921 Ernst exhibited his hallucinatory collages at the gallery *Au Sans pareil,* images cut and assembled from the plates of old books, consisting largely of 19th-century engravings. André Breton wrote the text for this exhibition, and the following year Ernst joined the Parisian group surrounding the review *Littérature.* In 1924 he painted *Two Children Are Threatened by a Nightingale,* the last of the collage-like and proto-surrealist paintings beginning with *The Elephant Celebes* (1921) and inspired by de Chirico. And in October 1924 the *First Manifesto of Surrealism* appeared signalling the birth of the new movement.

Ernst used collage actively to subvert what he once labelled "holy art," later describing this project as an attempt "to go beyond painting," by means of "forcing inspiration," often through surprisingly unnerving chance encounters. In 1930 he participated in the collage exhibition *La peinture au défi* (with

a preface by Louis Aragon), which included works by all the major Surrealists; the following year his collages were exhibited again at the Galerie Pierre. Collage revealed, by virtue of chance, a pre-existing reality through the surprise of disorientation, an element as shocking for the poet-painter as for the viewer. Ernst noted in 1937, in the pages of *Cahiers d'Art,* which devoted a special number to him, that his intervention was at best minimal; "collage was a process of discovery, not a means of expression." His collage novels *La Femme 100 têtes* and *Une Semaine de bonté* reveal to what extent the minor alteration of an existing image could produce a shocking experience.

Birds were a constant obsession for Max Ernst. In his *Informal Life* (1967), he recalls the childhood experience of the death of his pet cockatoo, just at the time of the birth of his sister, to whom he naturally ascribed responsibility. In 1930 Ernst remembers the visitation of an aviary vision: "I am visited almost daily by the Bird Superior, Loplop—my private phantom." Around 1930 images of this spectral bird recur as a presenter of paintings within paintings; in others he becomes the subject of the painting, in most he is an unreal presence hiding in the recesses of the image.

While dynamic and eclectic, Ernst's work tended to fall into series. In the 1920's he painted the *Hordes* and *Forest* paintings, both using *frottage* (rubbing) or *grattage* (scraping) techniques, and both frankly apocalyptic. In 1937 Ernst painted three versions of *The Angel of Hearth and Home,* in which the bird is metamorphosed into a voracious monster. Between 1936 and 1938 Ernst returned to the forest theme, in which nature takes on a devouring role of the angel of destruction. Here vegetation is presented as a kind of primeval soup in which biological gestation occurs, occasionally the heads of birds, omniscient, appearing in the forest. These paintings represent the darkness of war and the return to natural processes in the wake of destruction, a feeling even more present in the *decalcomania* (squashing wet paint onto the canvas) paintings (1940–42), in which metamorphosis is exaggerated to such an extent that foliage emerges from a kind of post-apocalyptic osmosis. The great masterpiece of this period is *Europe after the Rain* (1940–42), where the human presence remains merely corpse-like in the midst of botanical profusion.

In 1934 Max Ernst first explored the use of sculpture, when he visited the Swiss sculptor Alberto Giacometti at Maloja, although he would only return to this activity a decade later, while in New York. Ernst's first sculptures were inspired by the large granite rocks he and Giacometti found, which he then modified. The molding of found materials and objects, borrowing from the collage principle, is apparent in works like *Human Head* (1934) and *Chimeras* (1934). These experiments prompted him to make other sculptures, based on found materials, which appear to depict bird-like or extraterrestrial figures, as in *Head-Bird* (1934). With the exception of the kinetic *Mobile Object Recommended for Family Use* (1937), included in the special number of *Cahiers d'Art,* Ernst did not return to sculpture until his move to New York (1941). While in Great River, Long Island, he returned to sculpture in the exploration of lunar images in sculptures like *Moonmad* (1944). Ernst moved with his wife Dorothea Tanning to Sedona, Arizona, in 1946, where he continued working in sculpture, making concrete wall reliefs and the monumental *Capricorn.*

Ernst's period in America was of great importance to the

emerging New York School. For example, in 1942 Ernst explored the possibility of dripping paint in an haphazard manner, by punching a hole in a tin can, filling it with paint and then swinging it above a canvas. Paintings like *Young Man Inspired by the Flight of a Non-Euclidian Fly* (1942–47) and *The Bewildered Planet* (1942) would not have been lost on younger painters such as Jackson Pollock. Ernst's *Surrealism and Painting* (1942) codified this idea of random marks in an aviary "artist and model," mocking of Picasso's treatment of the same theme. Perhaps more importantly, Ernst's explorations of process as the basis of art had an impact on younger Americans. Furthermore, as a major painter within Surrealism, Ernst's activities surrounding the review *VVV* established firm links between the European and American avant-gardes.

—William Jeffett

FABRITIUS, Carel

Baptized in Middenbeemster, 27 February 1622. Died in Delft, 12 October 1654. Married 1) Aeltge van Hasselt, 1641 (died, 1643), two children; 2) Agatha van Pruyssen, 1650. Pupil of Rembrandt, 1641-43; lived in Middenbeemster and Amsterdam from 1643, and in Delft after 1650; joined Delft guild, 1652; few documented works; died in the explosion of the town arsenal.

Major Collections: Groningen; The Hague.
Other Collections: Amsterdam; London; Rotterdam; Schwerin; Warsaw.

Publications

On FABRITIUS: books—

Tietze-Conrat, Erika, *Die delfter Malerschule: Fabritius, Pieter de Hooch, Jan Vermeer,* Leipzig, 1922.
Schuurman, K. E., *Fabritius,* Amsterdam, 1947.
Brown, Christopher, *Fabritius: Complete Edition with a Catalogue Raisonné,* Oxford, 1981.

articles—

Wheelock, Arthur K., Jr., "Fabritius: Perspective and Optics in Delft," in *Nederlands Kunsthistorisch Jaarboek* (Amsterdam), 24, 1973.
Liedtke, W. A., "The View in Delft by Fabritius," in *Burlington Magazine* (London), 118, 1976.

*

Carel Fabritius is one of the enigmas of art history. He was a versatile and experimental artist, admired by contemporaries as a painter of perspectives and murals. Yet there remain only eight authenticated easel paintings by him, only two of which are perspectives or *bedriegertjes (trompe l'oeil).* All of his murals have disappeared.

His contemporary notoriety was enhanced by the drama of his tragic death. In 1654, when only 32 years old, he was killed in the explosion of the Delft powder magazine, which devastated almost a third of the city. It is thought that an appreciable number of his pictures were also destroyed in the accident.

Fabritius did not specialise in any one type of subject matter.

Thus, the eight remaining pictures reveal an original and accomplished artist. They comprise a large canvas showing *The Raising of Lazarus* (Warsaw, c.1642); four portraits, two of which are probably self-portraits; *View of Delft with an Instrument Seller* (London, 1652), which is painted in distorted perspective to accomodate a location inside a perspective box or "peep show"; *The Goldfinch* (The Hague, 1654), a tiny *trompe l'oeil* of a bird chained to its perch, and *The Sentry* (Schwerin, 1654), a mysterious picture of a seated soldier loading his rifle beside one of the gates of Delft.

Of the paintings known through descriptions and inventories there were a number of history paintings, several portraits and heads, a perspective view painted as if seen through a window, and an innovative *Family Portrait,* of which a watercolour reconstruction exists. This latter belonged to the Boymans-van Beuningen Museum in Rotterdam but was destroyed by fire in 1864. In the 17th century it was recorded in a Delft inventory bearing one of the highest known valuations for a non-aristocratic portrait in Delft.

Fabritius began his career as a carpenter or builder (*faber,* from which his name is derived) in his home town of Middenbeemster. His initial instruction probably came from his father, who was a schoolteacher and amateur artist. Carel's two younger brothers, Barendt and Johannes, also became painters, causing subsequent identification problems where inventories refer to the artist simply as "Fabritius."

The Raising of Lazarus is the only extant work from Fabritius's years in Rembrandt's studio. It shows a strong dependence on the master for dramatic gesture, pallette, and technique, and is a virtuouso compositional synthesis of a number of Rembrandt's ideas and versions of the same subject. It may have been painted specifically as a student exercise, the circumstances of any commission being quite unknown.

Unlike many of Rembrandt's pupils, Fabritius seems to have made use of his time with Rembrandt without being bound by it. His two self-portraits mark an important departure. Half-length self-portraits were, of course, a lifelong preoccupation of Rembrandt. What differentiates Fabritius's treatment is lighting. In the earlier version (The Hague, c.1648–50), he daringly places himself in full daylight and almost halfway down the canvas, set against a crumbling plaster wall. The emphasis is on naturalism and ordinariness. The effects of daylight on both animate and inanimate textures are being explored, in stark contrast to Rembrandt's charismatic use of darkness and suggestive modelling of features.

In the later self-portrait these effects are more fully realised.

It is a picture that declares Fabritius's transition to Delft, and his partaking in the involvement of contemporary Delft painters with space, light, and perspective.

Fabritius paints himself against a background of sky and clouds, necessitating a significantly lighter pallette. Flesh tones are more subtly differentiated and do not depend on strong highlighting of the forehead, and area around the eyes, as in the earlier version. Impasto technique is relinquished in favour of smoother brushstrokes. Rembrandt lingers only in the breastplate worn by the sitter.

Fabritius's *Sentry* has no precedent in 17th-century Dutch art. It is probably an image related to *acedia*, sloth: an image of vulnerability, of inattention to duty, of being caught "off-guard." (A related, but much less accomplished picture by his brother Barendt—*Soldier with a Pipe*, Rome, Galleria Nazionale dell'Arte Antica—certainly carries this meaning.) As such, it is in interesting contrast to Rembrandt's famous image of active military potential *The Nightwatch* (Amsterdam, 1642), on which he was working during Fabritius's time in his studio. *The Sentry*, painted in the last year of Fabritius's life is also an ironic precursor of his own tragic death, caught "off guard" in his studio at the mercy of a loaded weapon of far greater potency.

Fabritius's purpose in going to Delft in 1650 may have been to work with Leonart Braemer, one of a very few muralists working in northern Europe. He may also have hoped to work for the Prince of Orange, whose two new houses, Honselaersdijk and Rijswijck, were close to Delft and in need of decoration. There is no documentary evidence of his having achieved this. His widow described him as "painter in his lifetime to the Prince of Orange." This is contradicted, however, by Samuel van Hoogstraeten, who studied with Fabritius under Rembrandt (1641–43). He specifically states "it is regrettable that his work was never placed in a large royal building or church."

His fascination with perspective and optical effects would also have provided him with a reason. Not only were such artists as Hendrick van Vliet, Gerard Houckgeest, Emmanuel de Witte, and later Pieter de Hooch and Jan Vermeer working on just such problems. Delft was also the site for much of the scientific research into optics in the 17th century. It was the home of the well-known lensmaker Leeuwenhoek.

Even allowing for losses, the smallness of Fabritius's oeuvre is remarkable. He returned to Middenbeemster in 1643 after the death of his wife and two children, and though he could have maintained contact with nearby Amsterdam, it is possible that he reverted to carpentry until his removal to Delft in 1650. Indeed, the casual, workman-like clothing and setting of the earlier self-portrait may allude to this role. His skill in carpentry also explains his renowned facility with perspective boxes, sometimes built in unusual shapes, such as the housing of *View of Delft*.

Had Fabritius lived, comparisons with Rembrandt would not have been so inhibited by disparity in the size of their oeuvres. His originality, daring, and capability are not in doubt. It is not unreasonable to conjecture that the group of painters with whom he shared his interests (tentatively known as the "Delft School") may not, towards the end of the 1650's, have refragmented into other areas. Instead they might have retained a more lasting existence around the fulcrum of this talented, versatile artist.

—Lindsay Bridget Shaw

FALCONET, Etienne Maurice.

Born in Paris, 1 December 1716. Died in Paris, 24 January 1791. Married at age 23; four children. Apprentice to J. B. Lemoyne, 1734–45; member of the Academy, 1754 (Professor, 1761; appointed Rector, 1790, but declined because of ill health); patronized by Mme. de Pompadour: director of sculpture at Sèvres porcelain factory, 1757–66: created or directed the production of models, and made small marble sculptures as well as more monumental works; directored decoration of chapels for S. Roch, Paris, 1753–66; appointed by Catherine the Great to create a bronze statue to Peter the Great, 1766, and lived in St. Petersburg, 1767–78; lived in the Hague as guest of Prince Galitzine, 1778–80; then returned to Paris. Pupil: M. A. Collot.

Major Collection: Paris.
Other Collections: Angers; Lyons; Paris: S. Roch.

Publications

By FALCONET: books—

Oeuvres, Lausanne, 6 vols., 1781.
Correspondance avec Catherine II 1767–1778, edited by Louis Reau, Paris, 1921.
Diderot et Falconet: Le Pour et le contre: Correspondance. . . . edited by Yves Benot, Paris, 1958.
Diderot et Falconet: Correspondance: Les Six Premières Lettres, edited by Herbert Dieckmann and Jean Seznec, Frankfurt, 1959.

Translator: *Traduction des XXXIV, XXXV, et XXXVI livres de Pline*, 1772.

On FALCONET: books—

Pelissier, G., *Falconet: His Life and Work*, New York, 1907.
Hildebrandt, Edmund, *Leben, Werke, und Schriften des Bildhauers Falconet*, Strasbourg, 1908.
Reau, Louis, *Falconet*, Paris, 2 vols., 1922.
Vallon, Fernand, *Falconet*, Senlis, 1927.
Weinschenker, Anne Betty, *Falconet: His Writings and His Friend Diderot*, Geneva, 1966.
Levitine, George, *The Sculpture of Falconet*, Greenwich, Connecticut, 1972.

article—

Seznec, Jean, "Falconet, Voltaire, et Diderot," in *Studies on Voltaire and the Eighteenth Century*, 2, 1956.

*

Falconet's career attests on the one hand to the traditional nature of French art and culture and on the other to the growing appreciation during the latter half of the 18th century of a new spirit of naturalism and also a purer form of classicism—elements which were often in opposition to each other and far

Bathing Nymph, 1757; marble; 32¼ in (82 cm); Paris, Louvre

from easily amalgamated. Reacting against the academic aridity of sculpture under Louis XIV—and partly because the court could no longer afford extensive patronage—sculptors began working for patrons who wanted portrait busts which did not exemplify status but which actually looked like them. There was no call for massive statuary intended for parks or facades of buildings; and even before the death of Louis XIV such sculpture had begun to take on a more playful character with curves, broken lines, shell work, and rockery, known in France as *rocaille*. Towards the middle of the 18th century, however, excavations at Herculaneum and Pompeii, among other factors, reminded sculptors that ancient art had been based on observation and directed them towards a stricter, more restrained form of sculpture whether for public display or, as was becoming more frequently the case, interior decoration.

As a pupil of Lemoyne, Falconet was quickly noted for the able fluency of his work which seemed to combine the qualities of his *rocaille* predecessors with something of the new neo-classical spirit. He entered the Salon with his *Milon of Croton Devoured by a Lion,* a plaster cast, in 1745; and as his reception piece for the Academy ten years later he produced a marble of the same subject, perhaps hoping to rival the turbulent *Milon* by his hero Puget. Every door was open to him: in 1761 he became professor and in 1783 Assistant Rector at the Academy as well as being appointed director of sculpture at the Sèvres porcelain factory between 1757–66. Catherine the Great commissioned him to create a bronze statue to Peter the Great and to teach at the Imperial Academy of Arts, 1766–78; he then resided for two years at the Hague as the guest of Prince Galitzine before returning to Paris where he refused further academic offices and did little original work, contenting himself with turning out copies of his earlier work. The tide of taste had turned against him and the colder classicism of the Empire style now prevailed, in which Falconet's charm had no place.

With two notable exceptions—his equestrian monument to Peter the Great and his *Christ* for S. Roch, Paris, to a lesser degree—Falconet's work was intended for the salons, not the exhibition halls but those of private homes. Madame de Pompadour was represented as Aegle in his *Music* which with his *Menacing Cupid* display obvious signs of the *rocaille*. His *Pygmalian and Galatea, Alexander and Campaspe,* and *Sweet Melancholy* mark his adjustment to neo-classicism. Yet Falconet's *Bather* (1758, Louvre) has none of the severity of Thorwaldsen of a later generation or even of Canova: slim, elongated, and certainly not without charm, it seems more related to Parmigianino than to Giambologna and Riccio, and to Carpeaux than to Houdon. In fact, during his years at the Sèvres factory, Falconet produced some hundred figures and groups in biscuit, mostly based on his own designs apart from a known three by Boucher, which despite a certain animation are not especially distinguishable from the work of other sculptors and modellers. With the death of Madame de Pompadour in 1764 and the chronic shortage of money in France, it must have seemed to him that his career in France might well be sadly circumscribed. The invitation to Russia, despite the smallness of the fee, was especially welcome and, indeed, was to result in his masterpiece. It is surely significant, however, that he took with him his pupil M. A. Collot (later to marry his son, the painter Pierre-Etienne Falconet, a pupil of

Reynolds and a successful painter in England) whose skill in portraiture he clearly lacked.

Falconet's career falls into three sections: the early years as a sculptor and teacher, the period spent at the Sèvres factory, and the decade in Russia. In France he never received a royal commission but he was patronised by members of the wealthy middle class, notably by Lalive de Jully who together with Morduel, Curé of S. Roch in the rue Saint-Honoré, entrusted him with the decoration of the church and the construction of the tomb of Madame de Jully, now mostly destroyed. He was at home in the company of the *philosphes* and *encyclopédistes*—Voltaire, Diderot, D'Alembert, Helvetius, and Rousseau—and, in fact, it was Diderot who commended him to Catherine II. These men were aware of the spirit of neo-classicism sweeping Europe but at the same time they were aware that neo-classicism at its most potent centre—Rome, the imperial city—was dominated by Scandinavian, British, and German painters and sculptors and that there was no place for French classicism, based as it was, not on theory, but on observation, realism, tradition, and incorporating elements of the baroque and *Rocaille*. Both in his earliest years and at Sèvres he had their encouragement. Only in Russia, left to his own devices, did he contrive to fuse all these elements in his equestrian masterpiece. The protection he had received in France left him ill-prepared for the indifference shown him by the public in his latter years when, stricken by ill-health, he contented himself with over-seeing reproductions of his earlier works and publishing his own theoretical observations.

—Alan Bird

FATTORI, Giovanni.

Born in Livorno, 25 October 1825. Died in Florence, 30 August 1908. Married 2 times. Studied under Baldini in Livorno, and under Giuseppe Bezzuoli in Florence, 1847; fought in war of independence, 1848–49; then painter: member of the Macchiaioli group: anti-academic, influenced by Barbizon painters and Corot; also did etchings; taught at Florence Academy.

Collections: Florence: Pitti; Livorno; Milan: Arte Moderna; Naples; Rome: Arte Moderna.

Publications

By FATTORI: book—

Scritti autobiografici, edited by Francesca Errico, Rome, 1980.

On FATTORI: books—

Franchi, Anna, *Fattori: Studio biografico,* Florence, 1910.
Ghiglia, Oscar, *L'opera di Fattori,* Florence, 1913.
Paolieri, Ferdinando, *Fattori, il maestro toscano dei secolo XIX,* Florence, 1925.
Cecchi, Emilio, *Fattori,* Rome, 1933.

Francini Ciaranfi, Anna M., *Incisioni del Fattori,* Bergamo, 1944.
Franchi, Anna, *Fattori, Silvestro Lega, Telemaco Signorini,* Milan, 1953.
Di Micheli, Mario, *Fattori,* Busto Arsizio, 1961.
Malesci, Giovanni, *Catalogazione illustra della pittura ad olio di Fattori,* Novara, 1961.
Servolini, Luigi, *177 acqueforti di Fattori,* Milan, 1966.
Vitali, Lamberto, *Fattori* (cat), Amsterdam, 1969.
Durbè, Dario, *Disegni di Fattori del Museo Civico di Livorno* (cat), Rome, 1970.
Bianchiardi, Luciano, *L'opera completa di Fattori,* Milan, 1970.
Omaggio a Fattori, Cortina d'Ampezzo, 1972.
Bonagura, Maria Christina, editor, *L'acqueforti di Fattori della collezione Rosselli* (cat), Florence, 1976.
Durbè, Vera, editor, *Disegni inediti di Fattori* (cat), Florence, 1976.
Durbè, Vera and Dario, editors, *La giovinezza di Fattori* (cat), Rome, 1980.
Durbè, Dario, *Fattori e i suoi 20 Ricordi dal vero,* Rome, 1981.
Durbè, Dario, *Fattori e la scuola di Castigloncello,* Rome, 2 vols., 1982–83.
Bonagura, Maria Cristina, editor, *Fattori da Magenta a Montebello* (cat), Rome, 1983.
Dini, Piero, *Inediti di Fattori,* Turin, 1987.
Broude, Norma, *The Macchiaioli: Italian Painters of the Nineteenth Century,* New Haven, 1988.

*

In the complex context of Italian ottocento painting, Fattori appears as a leading figure: that of an independent who dominated the Tuscan scene for five decades. He was a determining force in the formation of the so-called macchiaiolo movement (a term coined from the Italian "macchia" meaning "spot" in reference to the ways these artists apply the paint in broad areas of colors), which in Florence was the most innovative fringe of those artists advocating a return to nature. But throughout his enormous production, Fattori vacillated between academic Romanticism (his training) and an extremely personal interpretation of Realism. Both directions inform his two main sources of inspiration, military paintings and landscapes. Portraits are rare in Fattori's oeuvre, and always intimate representations of personal friends or family members, not commissioned pieces. His production included also a great number of masterful etchings which alone would suffice to immortalize him as one of the greatest 19th-century printmakers. In the later part of his life, Fattori was able to conciliate the tradition of history painting conceived as "a reconstitution" with the innovations he had brought to the language of painting in the field of landscape. This evolution marks an interesting reversal of the path he had followed during his youth to conquer nature. His first training at the Florence Academy, under the conservative master Bezzuoli, had taught him the pre-eminence of drawing over color and of the tradition of painting over nature. Through his involvement in the First War of Independence (1848–49), in which he served as a messenger, and had to sketch military action for his superiors, he learned to annotate in a highly personal way the ever-

changing reality he was confronted with. After 1850, when, finally able to return to painting, he began to compose military canvases, the sketchbooks of drawings he had accumulated during these two years would serve as source material. The dichotomy between "recorded" reality and "directly observed" reality became very apparent to him then. His entire evolution can be viewed as a gradual coming to terms with these two entities.

The 1850's were decisive years for him: he joined the animated discussions on art, politics, and life which were being debated at the Cafe Michelangiolo by the young artists returning from the war, and he was influential in the formation of the "macchia" aesthetics. Risorgimento ideals were then viewed as parallel to a strong rebellion against the Academy, Realism as the only possible path for the artists of a "reborn nation," and the exploration of nature as having to be resolved in studies "en plein air," the light becoming the central theme in this exploration. During that decade, he studied the Florentine masters of the quattroncento, whose simplified handling of pictorial space appealed to him as a lesson in simplification of forms. This is also the time in which he became acquainted with the paintings of Corot and the realists of the French school of Barbizon which were part of the collection in the Villa Demidoff in Florence. His friendship with the highly educated painter Nino Costa, a deep connoisseur of English contemporary art and interpreter of the Pre-Raphaelite style in Italy, broadened his cultural background and confirmed him in his studies of nature and the search for a simplified language based on the exploration of the tonal possibilities of colors, sharp outlines that define the form, and a brushstroke that expands in large areas of color.

The 1860's marked the purely "macchiaiola" phase of Fattori's evolution, when his friendship with other involved macchioioli such as Telemaco Signorini and Silvestro Lega had a deep impact on his vision. Equally important was his friendship with Diego Martelli, the critic and mentor of the macchiaioli, who in his villa of Castiglioncello, on the Tuscan coast, gave to the group a point of reference to gather to paint, theorize, and study out of doors. It is through Martelli—a personal friend of Manet, and therefore among the first Italians to be aware of the Impressionist revolution in Paris—that he became personally acquainted with the Impressionist group. In 1875 when Fattori traveled to Paris on the occasion of the presentation at the Salon of his painting *I Barrocci Romani* (a small panel work executed in 1872, and today in the Palazzo Pitti in Florence), Martelli put him directly in contact with Manet whose works he admired greatly and gave him the opportunity to assimilate a decade of Impressionist works in a relatively short time. While Fattori saw in Manet's vision a great deal of similarities with his own (both define the form by dark outlines and construct their image by well-defined shapes), he rejected the fluidity of the Impressionist rendition of nature, their reduction of the perception to the shimmering effects of the light, and above all their emphasis on the immediacy of the instant to be captured on the canvas. What interested him in nature was not the fleeting perception the artist can isolate on the canvas, but rather a permanent quality which, working from memory more than immediate response, the artist should render and immortalize. This attitude, which was reflected in his own teaching at the Florence Academy until his death, was shared by most of the macchiaioli and

make them closer to Cézanne and the most intellectualized form of the reaction against Impressionism. It suffices to invalidate the term "pre-Impressionist" often used to define them.

Fattori enjoyed an enormous popularity during his lifetime. His prize-winning *Italian Encampment after the Battle of Magenta* (1862) made him famous as a painter of contemporary history whose Risorgimento subjects—many of them on a very large scale—were viewed as the symbol of the country's political unification. his contemporaries praised him more as a painter of the Risorgimento than as a landscape artist. In a 20th-century perspective, however, the critics have given more importance to his small landscape studies on wood panel such as the *Rotunda dei Palmieri* or to studies of similar format, drawn from the countryside around Livorno, herdsmen, horses, and cattle in which the observed nature, an end in itself, is rendered in a synthetic geometry. A simple nobility permeates these works. They are based on a strict observation of the chiaroscuro, and intense luministic effects are created by structuring the colors in broad zones defined by a precise contour. Even though they were painted out of doors and in one sitting, they are not a mere impression of nature but rather a summary of it, a synthetic interpretation of its essential qualities. The 1860's and first half of the 1870's correspond to the most purely macchiaiola phase of Fattori's development. These were also years of great mastery in the handling of portraiture (for instance, the portrait of his first wife, c. 1865, in the Modern Art Gallery, Rome). Relying on his deep knowledge of the sitters, close friends or family members, Fattori renders in an almost austere way their features, simplifying them in an incisive design which reveals their psychological characters in a bare setting which conveys a sense of aristocratic elegance.

In the four last decades of his life, his role as a teacher occupied him a great deal. Landscapes and portraits became less important in his oeuvre as he chose to concentrate on reconstructed fragments of life, composed in the studio from previous sketches, resulting in powerful compositions on large canvases, whose realism is achieved by a balance between certain theatrical effects and a quasi-photographical visions (see, for instance, *I Butteri*, 1893, a huge canvas of 2 x 3 meters, today in the Fattori Museum in Livorno).

—Annie-Paule Quinsac

FEININGER, Lyonel.

Born Charles Leonell Feininger in New York, 17 July 1871. Died in New York, 13 January 1956. Married 1) Clara Furst, 1901 (divorced, 1905), two daughters; 2) Julia Lilienfeld-Berg, 1906; three sons. Attended New York schools, and studied the violin with his father; studied art in Hamburg, and under Ernst Hancke and Waldemar Friedrich at the Akademi der Künste, Berlin, 1888–91, at the Studio Schlabitz, Berlin, 1891, and at the Atelier Colarossi, Paris, 1892 and 1906; settled in Berlin, 1893, and cartoonist and illustrator for *Ulk, Narrenschiff, Lustige Blätter,* 1894–1906; cartoonist in Paris for *Chicago Sunday Tribune,* 1906–07; associated with Robert Delaunay and the Orphic Cubism group, 1911, and with the

Blaue Reiter group, 1912, the November group, 1918–22, and the Bauhaus: Lecturer and form master in Weimar, Dessau, and Berlin, 1919–33; settled in New York, 1937.

Collections: Berlin: Nationalgalerie; Cambridge, Massachusetts; Cologne; Dusseldorf; Hamburg; New York: Moma, Whitney, Guggenheim; Philadelphia; Washington.

Publications

By FEININGER: books—

Feininger [letters and writings], edited by June L. Ness, New York, 1974, London, 1975.
The Kin-der-Kids, New York and London, 1980.

On FEININGER: books—

Wolfradt, Willi, *Feininger,* Leipzig, 1924.
Miller, Dorothy C., *Feininger, Marsden Hartley* (cat), New York, 1944.
Villon, Jacques, *Feininger* (cat), Boston, 1950.
Wright, Frederick S., *The Work of Feininger,* Cleveland, 1951.
Dorfles, Gillo, *Feininger,* Milan, 1958.
Feininger: Memorial Exhibition (cat), San Francisco, 1959.
Hess, Hans, *Feininger,* Cologne, 1960, New York, 1961.
Ruhmer, Eberhard, *Feininger: Zeichnungen, Aquarelle, Graphik,* Munich, 1961.
Scheyer, Ernst, *Feininger: Caricature and Fantasy,* Detroit, 1964.
Feininger, Lux, *Feininger: City on the Edge of the World,* New York, 1965.
Prasse, Leona E., *Feininger: Das graphische Werk,* Berlin, 1972; as *Feininger: A Descriptive Catalogue of His Graphic Work,* Cleveland, 1972.
Barr, Alfred H., *Feininger,* New York, 1977.
Feininger: Aquarelle, Zeichnungen, Druckgraphiken (cat), Berlin, 1978.
Feininger: Karikaturen, Comic Strips, Illustrationen 1888–1915 (cat), Hamburg, 1981.
Feininger: The Early Years 1889–1915: Watercolours and Drawings (cat), London, 1987.

articles—

"Feininger: Frühe Werke," in *Du* (Zurich), 5, 1986.
Thiel, P., "Bemerkungen zum Frühwerk Feiningers," in *Bildende Kunst* (East Berlin), 34, 1986.

*

Feininger, an American whose career developed in Germany, combined the spirit of both nations in his art. At sixteen the young American moved to Germany to further his education and stayed for 50 years. Already in 1893, he had found that, for his own personal approach, "Drawing is the soul of art." Feininger developed a career as an important cartoonist and satirist in Germany and in the U.S., especially with the comic Kin-der-Kids for the *Chicago Tribune.* Graphic energy and the humor and fantasy of his early cartoons often appear in his paintings.

Feininger's breakthrough to a career as a painter came at age 36. His mature art reflects a distinctly modernist style, where the influences of Cubism, Futurism, and Delaunay's prismatic handling of form are readily recognizable, but Feininger's approach to form, color, and light are intensely personal. His paintings are based on experiences in nature. He generally began by recording in drawing what he experienced on solitary walks or cycle rides through the countryside. Motifs which he discovered became his own as he repeatedly returned to them for new experiences of the interaction of shape, space, and tonal variations. He worked in the studio from sketches, transforming and crystalizing his images to discover a refined and elusive perception of a heightened awareness of reality.

His thematic focus included a fascination with locomotives and boats. Recalled from his youth, they had often been represented in his early caricatures. He was also particularly drawn to the landscape around Weimar in the region of Thuringia and later to Deep (Pomerania) and the Baltic Sea. Architectural themes too were favored subjects for this artist with a tendency to geometric clarity. The favorite of his own early works was a series of paintings, *Zurchow* (7 versions of a church near Halle), and the painting of the Gelmeroda church. In this latter case, a series of 13 compositions which he began in 1913, resulted in 10 paintings. *Gelmeroda XIII* was painted in the winter of 1936, shortly before the artist departed from Germany. Many of the German Expressionists and Delaunay favored the subject of Gothic architecture as a symbol of the perfect expression of an idealized spiritual age. Feininger found the churches of small German villages to be pure geometric structures, significant as form and appropriate as a spiritual expression immediately visible in reality.

Feininger was introduced by the artist Alfred Kubin to Herwalth Walden, director of Berlin's Sturm Gallery, and in 1917 a Sturm exhibit of 111 works marked the beginning of recognition for the artist as a painter. Feininger's reputation was also strengthened by his being one of the first artists to be invited by Walter Gropius to join the faculty of the Bauhaus in 1919. He was appointed Master of Form, and his example as a committed artist was deemed highly valuable. He personally did not believe art could be taught, for he believed each artist must pursue a course of development as individual as his own direction had been. One of Feininger's most well-known images is the 1919 woodcut for the Bauhaus manifesto, *Cathedral of Socialism.* Though he had just begun to work in woodcut, it is a work appropriate to his own development and a fitting Bauhaus symbol of utopian aspiration. Feininger found the involvement with the creative environment of the Bauhaus a positive one, and he was the only artist invited at the beginning to remain at the school from its inception in Weimar to its final closing in 1933.

Two interrelated yet stylistically distinct directions are found in Feininger's paintings. On the one hand, there are images of fantasy, recollections of childhood memories of the United States. These works also reveal the love he had of carving toys for his children. In wood he created miniature cities, caricatures of reality in grotesque angularity. Some of his paintings recall these exaggerated figures in their mixture of childish humor and adult irony. On the other hand, the artist also recreated reality as an idealized image. These more formal images

Villa on the Shore, 1920; woodcut

too are once removed from nature, but seen as reality penetrated beyond irregularity, expressed with a strict linearity and the clarity of interpenetrating planes.

This second approach to form was strongly influenced by Cubism. Feininger's works perhaps suffer from a superficial similarity to the many imitators of Cubism who were unable to adapt Cubist conventions with the honesty and elegance characteristic of Feininger's style. Feininger found a method in his Cubism and incorporated the use of fractured planes of space to his own graphically oriented and geometric style. An important distinction remains between his expressionism and the Cubist's cooler approach to form. As he himself wrote: "my Cubism . . . is visionary, not physical" (letter to Alfred Vance Churchill dated 13 March 1913). At their best Feininger's paintings surpass a cool analysis of form and lead the viewer to a universal, spiritual vision synthesized from nature.

Feininger's paintings are often compared with a fugue. The artist was an accomplished musician and composed fugues which were publically performed during the 1920's and praised by the composer Ernest Bloch. His paintings do seem to echo a fugal development, where themes overlap and repeat. Though associated with Kandinsky and Klee at the Bauhaus, Feininger did not theorize about the relationship between art and music, but it was for him a parallel and influ-

ential aspect of his creative personality. In retrospect certain aspects of Feininger's life may be said to have their own thematic echoes. In 1927 he had been sought out in Germany by the young professor Alfred Barr, Jr. Later he returned to the United States, and at 65 he was relatively unknown in his native country. In 1944, Barr organized an exhibit at the Museum of Modern Art. In a joint exhibit with his old acquaintance Marsden Hartley, Feininger was represented by 70 paintings. In 1984, 54 paintings, which had been stored and "inaccessible" in Germany, were legally rescued and returned to the U.S. through the efforts of Theodor Lux Feininger, Lyonel's son and also a painter.

Returning to live in the U.S. in 1937, Feininger painted only after two years. No paintings are listed in the Hess monograph for 1938 and three are listed for 1939. Only in the winter of 1940–41 did Feininger feel he had adequately made the adjustment to the spirit of his new environment to warrant a return to painting. Many of the late works are paintings of the architecture of Manhattan. Line dominates, and the oils are less powerful than the more refined watercolors. Some paintings are very rugged in character, especially those influenced by his own woodcuts; some are elegant. Each approach is a reflection of Feininger's imperturbable personality.

—Janice McCullagh

FETTI, Domenico.

Born in Rome, c. 1589; brother of the painter Lucrina Fetti (a nun). Died in Venice, April (?) 1623. Studied under Lodovoci Cigoli, in Rome; follower of Correggio in Rome; court painter for Cardinal Ferdinando Gonzago (later Duke of Mantua), in Mantua, 1613–21: some frescoes in Ducal Palace, also worked in local churches; in Venice, 1621–23.

Collections: Baltimore: Walters; Birmingham; Boston; Caen; Dresden; Dublin; Florence: Pitti, Uffizi; Frankfurt; Hampton Court; Kansas City; London: Courtauld; Manchester; Mantua: Ducal Palace, Cathedral; Munich; Naples; New York; Paris; Prague; San Diego; Venice; Vienna; Washington; York.

Publications

On FETTI: books—

An Exhibition of Paintings by Fetti and Magnasco (cat), London, 1977.
Potterton, Homan, *Venetian Seventeenth Century Painting* (cat), London, 1979.
Braham, Helen, *The Princes Gate Collection* (cat), London, 1981.
Pallucchini, Rodolfo, *La pittura veneziana del seicento* (cat), Milan, 2 vols., 1981.

articles—

Wilde, Johannes, "Zum Werke des Fetti," in *Jahrbuch des Kunsthistorischen Sammlungen in Wien,* 10, 1936.
Michelini, Paola, "Fetti a Venezia," in *Arte Veneta* (Venice), 9, 1955.
Askew, Pamela, "The Parable Paintings of Fetti," in *Art Bulletin* (New York), 1961.

*

The highly distinctive complexion of Fetti's art is in part due to the stylistic influences which he sustained in the course of a geographically unusual career-journey: from Rome through the Gonzaga court at Mantua, to Venice. Although trained in Rome under the moderately innovative Florentine reformer Cigoli, a proponent of the new naturalism, he was more responsive to the bolder experiments of Caravaggio's Venetian-oriented followers, Saraceni and Borgianni, and, especially, to the radical techniques and fertile imaginations of the two great resident northerners, Elsheimer and Rubens. His development towards an expressive Baroque style was closely intertwined with Ruben's art, for on Fetti's arrival in Mantua (where he was to pass the major part of his career) he again encountered important examples of the Antwerp master's work. Mantua, too, with its priceless art treasures and proximity to Venice, served as an antechamber for Fetti to the great art of the Venetian 16th century (especially that of Veronese, Tintoretto, and the Bassani). He found in their vivid naturalism, sparkling color, and lively brushwork a reinforcement of the lessons of Rubens and Elsheimer (themselves great devotees of Venetian art) and not a few further technical and coloristic refinements. Yet if Rubens

and the Venetians served as his main mentors, it was Elsheimer, with his loving eye for homely details and his visionary streak, who struck the most sensitive chord in Fetti, liberating something genuinely mystical in the nature of this difficult and complex man, who had been trained as a Jesuit and would eventually succumb to debauchery.

In Mantua the relative hesitancy of such early pictures as the six small half-lengths of Martyr Saints (Ducal Palace) gradually gave way to an art of the figure which is bolder in characterization, coloring, and brushwork (including a second group of larger saints, e.g., *St. Barbara,* Royal Collection, and two virtuoso renderings of ancient Roman poets in the Louvre and the National Museum, Stockholm—all from the late 1610's or early 1620's). Several of these imaginative studies (with their fluently painted draperies, alert poses, and fleeting, poetic light) seem to anticipate (and might even have influenced) Fragonard's fancy portraits of the 1770's. They are the obverse of Fetti's few but significant experiments in actual portraiture at Mantua (e.g., *The Priest Vincenzo Avogrado,* Royal Collection). The real portraits are tamer in conception but usually enlivened by some original variation of pose, gesture, or setting.

It is the combination of this acute, novelist's eye for telling detail with his expressive color and brushwork that makes for Fetti's originality. His many religious pictures are suffused with an alert sense of a firmly individualized yet spiritually transfigured reality. Humans, animals, and plants are linked in a mystical glow through the play of color and some ingenious, proto-Baroque arrangements of space. He increasingly painted subjects which required landscape settings and here he would often place the protagonists in the center foreground, with the varied forms of nature floating freely round the periphery, or radiating, as a kind of frame, from the central figures themselves.

The religious pictures (which were mainly Gonzaga commissions) included the very large lunette of *The Miracle of the Loaves and the Fishes* (Ducal Palace), but Fetti was at his best on a much more modest scale—in works which range from the Elsheimerian *Dream of Joseph* and the Tintorettesque *Flight into Egypt* (both Vienna) to the memorable series of small parable paintings on panel.

The parable pictures show Fetti at his most original. Their crisp delineation of a range of individual characters amounts to more than a gallery of types. The often contemporary costumes and some of the settings (such as street scenes) help to drive home the message, while even the landscape backgrounds are full of echoes of the Lombard and Venetian countryside, with its plains, hill-towns, and pollarded trees. Sometimes the ideas for both landscapes and figures are based closely on other artists (especially Veronese) but they are always completely reformulated in terms of Fetti's own feeling for nature and narrative. Thus in the masterly *Blind Leading the Blind* (versions in Dresden and the Barber Institute, Birmingham) the landscape derived from Veronese and the blind troop based broadly on Bruegel's famous picture are transformed through a surge of brush and imagination into something more homespun and humane—with the addition of the girl and boy and the clear implication that this particular blind foursome propelling themselves into the ditch are also drunk peasants on the way home from a fair.

If the parables mark the apogee of Fetti's achievement as a poeticizing genre painter, he was to produce one even more

purely poetic flourish in some small mythological paintings of stories from Ovid, executed either in Mantua or Venice in the last years of his life—three wooden panels, which may have been intended as furniture decorations, of *Perseus and Andromeda*, *Hero and Leander* and *The Triumph of Galatea* (all Vienna) and a copper of *Vertumnus and Pomona* (London, Courtauld). The Mantuan court had already played host to a comparable revitalization of mythology in the form of Monteverdi's music dramas and madrigals (e.g., his setting, c. 1610, of the poet Marino's *Lament of Leander*). In Fetti's pictures the revivication also acquires an almost musical dimension, with figures and forms brushed in freely and some truly striking interlacings of color—as with the azure blue, lemon yellow, and grey of the *Hero and Leander*. In the *Vertumnus and Pomona*, reminiscences of Elsheimer and Rubens come together with a rich Venetian colorism (notably in the sky) in a recapitulation of Fetti's artistic journey. From here it is but a short step to the technical and imaginative radicalism of Fetti's immediate heir in Venice, the German Johann Liss, and only a slightly bigger one to the Rococo fantasies of Watteau and Fragonard.

—John Cash

FLAXMAN, John.

Born in York, 6 July 1755; son of the cast-maker and sculptor John Flaxman, Sr. Died in London, 9 December 1826. Married Anne Denman 1782 (died, 1820). Trained in his father's shop, London, and in Royal Academy school, 1770; first exhibited, 1767; worked for Wedgwood from 1775; in Italy, 1787-94, then did mainly monumental pieces; illustrator: Homer and other works; also did silverwork and medals; member of the Royal Academy, 1800 (Professor of Sculpture, 1810); famous during his lifetime.

Collections/Locations: Bath: Abbey; Chichester: Cathedral; Copenhagen; Edinburgh: Portrait Gallery; Glasgow; Gloucester; Cathedral; London: Victoria and Albert, Portrait Gallery, Royal Academy, University College, Soane Museum, St. Mary Lewisham, Westminster Abbey, St. Paul's; Madras; Petworth House; Quebec.

Publications

By FLAXMAN: books—

A Letter to the Committee for Raising the Naval Pillar, or Monument, London, 1799.
Lectures on Sculpture, London, 1829, 1838.

On FLAXMAN: books—

Robertson, William, *Anatomical Studies of the Bones and Muscles for the Use of Artists from Drawings by Flaxman*, London, 1833.

Colvin, Sydney, *The Drawings of Flaxman in the Gallery of University College, London*, London, 1876.
Sparkes, J. C. L., *Flaxman's Classical Outlines*, London, 1879.
Beutler, Ernst, *Flaxmans Zeichnungen zu Sagen des klassischen Altertums*, Leipsiz, 1910.
Constable, William, *Flaxman*, London, 1927.
Flaxman (cat), Durham, 1958.
Bentley, G. E., Jr., *The Early Engravings of Flaxman's Classical Designs*, New York, 1964.
Whinney, Margaret, and Rupert Gunning, *The Collection of Models by Flaxman at University College London*, London, 1967.
Wark, Robert R., *Drawings by Flaxman in the Huntington Collection*, San Marino, California, 1970.
Bindman, David, et al., *Flaxman* (cat), London, 1976.
Essick, Robert N., and Jenijoy La Belle, *Flaxman's Illustrations to Homer*, New York and London, 1977.
Irwin, David G., editor, *Flaxman* (cat), London, 1979.
Irwin, David G., *Flaxman, Sculptor, Illustrator, Designer*, London and New York, 1979.
Flaxman: Mythologie und Industrie (cat), Hamburg, 1979.
Symmons, Sarah, *Flaxman and Europe: The Outline Illustrations and Their Influence*, New York, 1984.

*

John Flaxman's career passed through several distinct and quite unusual phases. He began as a prodigy of sculpture, winning awards at the Royal Academy when he was fifteen. Unfortunately, his work from this period does not survive. Then he ran afoul of Joshua Reynolds, the Academy's president, apparently over the awarding of a medal. Flaxman then worked, as his father had, for Josiah Wedgwood, providing models of classical figures to decorate Wedgwood's ornamental pottery. Subsequently, Flaxman travelled to Rome where he produced highly successful illustrations for classical literature. Finally, he returned to England to take up monumental sculpture once again.

Presumably disappointed in his early bid for stardom as a sculptor, Flaxman assisted in his father's workshop, and for years was the favored designer for Wedgwood. Flaxman provided models of compositions from Greco-Roman vases and other classical sources. These were translated into reliefs on Wedgwood's classical vases, particularly those in blue and white Jasper ware. He based his designs mainly on publications such as that of *The Antiquities of Herculaneum* and on Sir William Hamilton's collection. *The Apotheosis of Homer* (1778), from one of Hamilton's vases, shows Flaxman at his best. The relief style emphasizes clarity and elegance of line while, particularly in the central figure of the poet, maintaining an appropriate robustness and gravity. Compared to the illustration in Hamilton's book Flaxman's version has been altered in proportions and pose to emphasize flatness and linearity. This is virtually always the case in these works, and while it may be due in part to the technical demands of ceramic decoration, it may also be said that Flaxman's designs were more classical—in the 18th-century sense—than the originals. Unfortunately, few of Flaxman's wax models survive so that we have only the final product from which to make judgments. Wedgwood had no qualms about making alterations in

TO THE MEMORY OF HARRIET SUSAN, VISCOUNTESS FITZHARRIS,
OF FRANCIS BATEMAN DASHWOOD ESQ^r OF WELL VALE, IN THE COUNTY OF LINCOLN,
OF JAMES EDWARD VISCOUNT FITZHARRIS, OF HERON COURT IN THIS PARISH,

FLAXMAN,
R.A.
SCULPTOR.

Harriet Susan, Viscountess Fitzharris, c. 1815; marble; Christchurch Priory

these designs, so the many versions that survive on his pottery represent a collaboration between artist and potter, one that was fruitful for Wedgwood and pivotal for Flaxman.

The artist's long-delayed trip to Rome in 1787 was partly financed by Wedgwood, and Flaxman continued to send back new classical designs. He found, however, new English patrons in Rome for a different kind of work. For Mrs. Hare-Naylor he made illustrations of the *Iliad* and the *Odyssey* (1793) followed by a set of Aeschylus for the Dowager Countess Spencer and of Dante's *Divine Comedy* for Thomas Hope. The experience of making bas-reliefs for so many years was obviously a telling one. These illustrations are reductive in the extreme: line drawings, actually, with virtually no modelling. They are extraordinarily virtuosic in their use of line to suggest form, but despite dramatic subject matter they are quite without feeling.

Ironically, these designs made Flaxman famous but not rich. They were widely reproduced for many years, but his patrons kept the plates and copyrights. What Flaxman gained, however, was a reputation. He returned to England in 1794 to commissions for large sculptural monuments—mostly memorials such as that for *Lord Mansfield* (Westminster Abbey)—and a professorship at the Royal Academy, a full circle if there ever was one.

Flaxman was a talented artist of limited scope who managed to win the admiration of more gifted contemporaries including Canova, Goya, and Shelley.

—Frank Cossa

FLORIS, Frans

Born Frans Floris de Vriendt in Antwerp between 17 May 1519 and 1 October 1520; son of the stonemason Cornelis Floris; brother of the architect and sculptor Cornelis Floris II, the glass painter Jacob Floris, and the potter Jan Floris. Died in Antwerp, 1 October 1570. Married Clara Boudewijns, 1547; two sons, the painters Baptiste and Frans II, and one daughter. Pupil of Lambert Lombard in Liège; joined the Antwerp guild, 1540-41; in Italy, 1541-47; set up studio in Antwerp on his return from Italy: many commissions for secular and religious works, including portraits; members of his studio included Marten de Vos, Lucas de Heere, and Frans Pourbus the Elder.

Collections: Amsterdam; Antwerp; Arnstadt; Bamberg; Basel; Berlin; Boston; Braunschweig; Brussels; Caen; Cambridge; Cape Town; Cologne; Dresden; Dublin; Florence; Ghent S. Bavo; Gottingen; The Hague; Léau, Belgium: S. Leonard; Leningrad; Lier, Belgium; Liverpool; London: National Gallery, Wallace; Madrid; Munich; New Haven; New York; Ponce, Puerto Rico; Prague; Stockholm; Vienna; Wiesbaden.

Publications

On FLORIS: books—

Zuntz, Dora, *Floris*, Strasbourg, 1929.
Velde, Carl Van de, *Floris: Leven en werken*, Brussels, 2 vols., 1975.

articles—

Velde, Carl Van de, "The Labours of Hercules: A Lost Series of Paintings by Floris," in *Burlington Magazine* (London), 107, 1965.
Velde, Carl Van de, "A Roman Sketch-Book of Floris," in *Master Drawings* (New York), 2, 1969.

*

The Flemish painter and biographer of artists Carel van Mander, writing in his *Schilderboeck* of 1604, described Frans Floris de Vriendt as "the glory of painting in the Netherlands." More than a half century earlier, while Floris was yet alive, Giorgio Vasari, although never one to laud a non-Italian, had praised Floris as being, among the Flemings, "the first for painting and many copper-engravings" and as being "considered most excellent." Vasari went on to say that "no one has better expressed the emotions of grief, joy and other passions, or has displayed such original fancy, so that they call him the Flemish Raphael." According to van Mander, Floris began his artistic training as a sculptor of funeral brasses but by 1539 was in Liège studying painting as a member of the "academy" of the premier Flemish Romanist, Lambert Lombard. From that master, Floris acquired his taste for the classicizing style and themes of the Italian High Renaissance, as well as a mannerist approach to draughtsmanship. To the basic lessons of Lambert Lombard were added influences from other early Flemish and Dutch admirers of the Italian Renaissance, including Joos van Cleve, Jan van Scorel, and Pieter Cock. Lambert's tutelage of Floris was brief, and by 1540 he was back in his native Antwerp where his name was inscribed in the membership list of that city's guild of painters.

In the following year, emulating Lambert Lombard, Floris set off for Italy, where he remained for six years, visiting Rome, Mantua, Genoa, and Venice. Floris was in Rome when Michelangelo completed his *Last Judgement* fresco in the Sistine Chapel and may well have been present at its unveiling in October 1541. His sketchbook, now in Basel, reveals the extent of his careful studies as he drew from antique monuments and from the compositions of Michelangelo, Polidoro da Caravaggio, and Giulio Romano. By October 1547, Floris was back in Antwerp and in the same year he finished his first signed and dated printing, the *Mars and Venus Surprised by Vulcan*. In this work, as well as in his *Banquet of the Sea Gods* of 1550, the influence of the frescoes in the Farnesina is apparent, thus supporting Vasari's claim for Floris's Raphael-esque tendencies. Many of the similarities to the Italian master could also have been picked up from the great series of cartoons from which the Sistine Chapel tapestries were woven in Brussels; quotations from the Raphael cartoons are frequent in Floris's ouevre (e.g., the *Judgement of Solomon* in Antwerp). In addition to the noticeable impact of Michelangelo and Raphael upon his work, elements and adaptations also appear from Vasari, Salviati, Bronzino, Rosso Fiorentino, Giulio Romano, and, even, Tintoretto. In the exploding spaces of both the *Fall of the Rebel Angels* of 1554 and, especially, in the *Last*

Judgement of 1565 in which the bottom of the composition acts as an entrance into the pit of Hell, we are reminded of Giulio Romano's frescoes of the *Fall of the Giants* in the Palazzo del Te in Mantua. In fact, Floris seems to come by his Raphaelism through the mannerist intervention of Giulio. His intertwined nudes are assembled piecemeal across the surface of the canvas and, although they may echo the Italian masters of the Italian Renaissance in individual elements, compositionally they display a closer kinship to the mannered posturing of Giulio, Rosso, and Tintoretto.

Floris's repertory included religious works executed for the altars of many churches in the Low Countries (Antwerp, Delft, Brussels), mythological scenes that found favor with such princely patrons as William of Orange, the Counts Egmont and Horn, and members of the Antwerp commercial oligarchy, and a number of penetrating portraits. In contrast to his more contrived compositions devoted to mythology or to his muscular *Fall of the Rebel Angels* or *Last Judgement*, Floris could also produce works (e.g., the *Adoration of the Shepherds* in Antwerp) that are tightly focused, gentle in mood, and earthy in their warm tonalities of color. In general, Floris rejected the brilliant jewel-like colors of his Flemish predecessors in favor of more even and generalized color harmonies which, in their brownish hues, pointed towards the colors used by the Dutch masters of the next century. Although his religious and mythological paintings were painted in the style of the Italian mannerists, his portraits preserved and continued the detailed and naturistic approach of the Netherlandish school, thus setting the stage for the great portraits of Rubens, van Dyck, Hals, and Rembrandt.

By 1560 Floris was the absolute leader of the Antwerp Romanists and a painter of renown and wealth. His prominent position is attested by his selection as the artist who decorated the temporary triumphal arches erected for the entry of Emperor Charles V and his son Philip into Antwerp in 1549 and, again, for King Philip's second entrance in 1556. Floris's great mansion in Antwerp (purchased in 1563) must certainly have inspired the aspirations of Peter Paul Rubens for just such a palatial residence. Like Ruben's later house, it too featured the artist occupant's own frescoes on the exterior, including the Liberal Arts which, van Mander says, were painted "in yellow, as if made of brass" and, no doubt, recalled Floris's initial sculptural efforts.

Floris's atelier, again a prototype for Ruben's, was enormous and operated almost as an assembly line with a reputed 120 pupils and assistants passing through it during its quarter century operation. Floris is known to have been responsible for some 200 extant or otherwise recorded paintings, many of which were collaborative efforts. Van Mander has left a description of the procedure followed in the Floris workshop: "After he had sketched with chalk the subject he had in mind, Floris allowed the pupils to proceed, saying, 'Now put such and such faces in here.' He had a number of examples on panels always at hand. In this way, his pupils developed a certain bold ability, so that they could lay out large canvases themselves and could make original compositions and paint according to their inspirations." Among those taught the "Floris Method" were Martin de Vos, Pieter Aertsen, Frans Pourbus, Crispen van den Broecke, and the Francken brothers, Frans, Ambrosius, and Hieronymus. Floris's compositions were endlessly copied by his pupils and many were

turned into prints (particularly by Cornelius Cort and Hieronymus Cock), thereby aiding the spread of the Frans Floris's Italianate style.

—Charles R. Mack

FOUQUET, Jean.

Born in Tours, c. 1420. Died in Tours, c. 1477–81. Married; had children. Visited Italy: in Rome in the mid-1440's; then worked in Tours from 1448 for Charles VIII; appointed Painter to the King, 1475, and produced portraits and books of hours (one for Etienne Chevalier, 1452–60); few documented works.

Major Collections: Paris; Louvre, Bibliothèque Nationale.
Other Collections: Amsterdam; Antwerp; Berlin; Chantilly; London: British Museum; Munich: Bayerische Staatsbibliothek; Nouans: parish church; Tours; Washington.

Publications

On FOUQUET: books—

Gruyer, Francois A., *Chantilly: The Quarante Fouquet*, Paris, 1897; as *Les Quarante Fouquet à Chantilly*, 1910.
Lafenestre, Georges, *Fouquet*, Paris, 1905.
Durrieu, Paul, *Les Antiquités judaïques et le peintre Fouquet*, Paris, 1908.
Martin, H., *Les Fouquet de Chantilly*, Paris, 1920.
Durrieu, Paul, *Livre d'heures peint par Fouquet pour maitre Etienne Chevalier*, Paris, 1923.
Heywood, Florence, *The Life of Christ and His Mother According to Fouquet*, London, 1927.
Cox, Trenchard, *Fouquet, Native of Tours*, London, 1931.
Perls, Klaus G., *Fouquet*, Paris, London, and New York, 1940.
Malo, Henri, *Les Fouquet de Chantilly: Livre d'heures d'Etienne Chevalier*, Paris, 1942.
Moe, E. A. van, *Les Fouquet de la Bibliothèque Nationale*, Paris, 1943.
Wescher, Paul R., *Fouquet und seine Zeit*, Basel, 1945; as *Fouquet and His Times*, London, 1947.
Alazard, J., *Fouquet*, Milan, 1951.
Laurain, M., *Fouquet et son temps*, Paris, 1957.
Exposition de la Collection Lehman de New York (cat), Paris, 1957.
Ferrari, R. de, *Fouquet*, Milan, 1965.
Castelnuovo, E., *Fouquet*, Milan, 1966.
Bazin, Germain, *Fouquet*, Milan, 1966.
Sterling, Charles, and Claude Schaefer, *Les Heures d'Etienne Chevalier de Fouquet*, Paris, 1971; as *The Hours of Etienne Chevalier*, New York, 1971, London, 1972.
Meiss, Millard, *French Painting in the Time of Jean de Berry, the Limbourgs, and Their Contemporaries*, London, 1974.
Malet-Sanson, J., *Fouquet*, Paris and New York, 1977.
Reynaud, Nicole, *Fouquet* (cat), Paris, 1981.

Lombard, Sandro, *Fouquet,* edited by Roberto Salvini, Florence, 1983.

articles—

"Fouquet Issue" of *Revue de l'Art* (Montrouge), 67, 1985.
De Vaivre, Jean Bernard, "Miniatures inédites de Fouquet et la Pietà de Nouans," in *Bulletin Monumental* (Paris), 144, 1986.

*

At the end of the Middle Ages, by the mid-15th century when individuality and realism became objectives of the European artists, the most prominent Frenchman to emerge was Jean Fouquet. In fact, he was the very first well-known French artist.

Born in Tours c. 1420, the son of a priest and an unmarried mother, it seems he received his early artistic training in Paris. He rose to such artistic prominence while still in his 20's that he was commissioned by both the French king Charles VII and the Roman Pope Eugenius IV to paint their portraits. It was about the same time (c.1450) that he produced a miniature self-portrait in gold and enamel on copper (3″ in diameter). It has been aptly pointed out (by Janson) that this work is the "earliest clearly identified self-portrait that is a separate painting, not an incidental part of a larger work."

Returning from Rome Fouquet is believed to have painted frescoes in Notre-Dame-la-Riche in Tours (1450–60). Among the panel portraits he painted was that of Guillaume Jouvenel des Ursins (c.1455; Paris). However, the most famous and often reproduced is his portrait of Etienne Chevalier (c.1450; Berlin), Minister of Finance to the French king. This work was part of the Melun Diptych, the other panel depicting the Virgin and Child (Antwerp) in which the Virgin has an uncanny resemblance to Agnes Sorel, the king's official mistress, who died in 1450.

When his patron Charles VII died in July 1461, Fouquet was commissioned to paint a leather effigy of the king to serve in funeral ceremonies. In 1474 along with the sculptor Michel Colombe, he designed the tomb of the king and was also appointed "peintre du Roi" by Louis XI.

A remarkable panel painting by Fouquet known as the "Nouans Pieta" was only discovered in 1931. This scene of the Descent from the Cross has great power and restrained emotionalism. In fact, it has been said to be "a summation of the outstanding elements of Fouquet's art" (Cuttler).

Fouquet's extraordinary talents were also much in evidence in the realm of manuscript illumination. At Blois in 1472 he illuminated a prayer book for Marie of Cleves, widow of Charles of Orleans. He was responsible for illuminating three other prayer books in 1476–77. The most famous series of miniature paintings he created are found in the Book of Hours for Etienne Chevalier (Chantilly). In this splendid manuscript one sees remarkably realistic renderings of French buildings, including Notre Dame at Paris and the Chateau at Vincennes. In addition, his Italian experience is reflected in the setting for the Marriage of the Virgin where we see the Arch of Constantine combined with the twisted columns from Old St. Peter's. In these paintings Fra Angelico's influence can also be dis-

cerned, but certainly Flemish miniature painting formed the foundation for Fouquet's advanced approach.

Other manuscripts he illuminated include a Boccaccio's *Des Cas des Nobles Hommes et Femmes Malheureuses* (c.1458, Munich), *Grandes Chroniques de France* (c.1458, Paris), and a two-volume translation of Josephus's *Antiquités Judaïques* (1470's, Paris).

Combining as he did the monumental forms and classical motifs from Renaissance Italy with the delicate refined International Style as seen in the work of the Limbourg brothers, Fouquet had a profound influence on subsequent French artists. He died before 8 November 1481, in Tours, having left an endurable imprint on the history of European painting.

—A. Dean McKenzie

FRAGONARD, Jean Honoré.

Born in Grasse, 5 April 1732; moved to Paris with his family, 1738. Died in Paris, 22 August 1806. Married Marie Anne Gérard, 1769; son, the painter Alexandre Evariste Fragonard. Apprenticed to a notary at age 14; then pupil of Chardin briefly, 1750, and Boucher, 1750–52: Prix de Rome, 1752; worked under Carle van Loo and Bernard Lepicié at Ecole des Elèves Protégés, 1753–55; worked at the French Academy in Rome, 1755–61 under C. J. Natoire; then settled and worked in Paris from 1761: patronized by Mme. du Barry, and did not attempt an Academy career; series of illustrations for *Orlando Furioso;* visit to Italy, Austria, and Germany, 1773; rescued from poverty after the revolution by David, and given job in the museums service.

Major Collections: London: Wallace; New York: Frick; Paris.
Other Collections: Amiens; Angers; Barcelona; Besancon; Boston; Leningrad; Liverpool; London; New York; Paris: Banque de France; Pasadena; San Diego; Sao Paulo; Tucson: University of Arizona; Washington; Williamstown, Massachusetts.

Publications

On FRAGONARD: books—

Tourézy, M. A., *Bergeret et Fragonard: Journal inédit d'un voyage en Italie 1773-1774,* Paris, 1895.
Mauclair, Camille, *Fragonard,* Paris, 1904.
Kahn, Gustave, *Fragonard,* Paris, 1907.
Grappe, Georges, *Fragonard,* Paris, 2 vols., 1913.
Grappe, Georges, *Fragonard, peintre de l'amour au XVIIIe siècle,* Paris, 1921.
Feuillet, Maurice, *Les Dessins de Fragonard et Hubert Robert des Bibliothèque et Musée de Besançon,* Paris, 1926.
Grappe, Georges, *La Vie et l'oeuvre de Fragonard,* Paris, 1929, 1942.
Réau, Louis, *Fragonard,* Geneva, 1938.
Mongan, Elizabeth, Philip Hofer, and Jean Seznec, *Fragonard: Drawings for Ariosto,* New York, 1945, London, 1946.

Satyr Carrying Off a Nymph; etching

Fosca, F., *Les Dessins de Fragonard*, Lausanne, 1954.

Réau, Louis, *Fragonard: Sa vie, son oeuvre*, Brussels, 1956.

Wildenstein, Georges, *Fragonard: L'oeuvre complète*, Paris, 1960; as *The Paintings of Fragonard: Complete Edition*, London, 1960.

Wildenstein, Georges, *Fragonard, aquafortiste*, London, 1960.

Ananoff, Alexandre, *L'Oeuvre dessinée de Fragonard*, Paris, 4 vols., 1961–70.

Seligman, E. and G., *Portraits by Fragonard: Paintings and Drawings*, New York, 1961.

Thuillier, Jacques, *Fragonard*, Geneva, 1967; New York, 1987.

Daintry, Adrian, *On Fragonard's "Le Billet doux"*, London, 1969.

Mazar, Pierre, *L'Univers de Fragonard*, Paris, 1971.

Mandel, Gabriele, *L'opera completa di Fragonard*, Milan, 1972.

Wakefield, David, *Fragonard*, London, 1976.

Williams, Eunice, *Drawings by Fragonard in North American Collections*, Washington, 1978.

Lévêque, Jean Jacques, *Fragonard*, Paris, 1980.

Rosenberg, Pierre, editor, *Fragonard* (cat), Paris, 1987, New York, 1988.

Cuzin, Jean Pierre, *Fragonard: Vie et oeuvre: Catalogue complet des peintures*, Fribourg, 1987; as *Fragonard: Life and Work*, New York, 1988.

Sollers, Philippe, *Les Surprises de Fragonard*, Paris, 1987.

Ashton, Dore, *Fragonard in the Universe of Painting*, Washington, 1988.

*

When writing about the rococo in general or a particular artist of that period, one is frequently defensive. It is by no means uncommon to find the century treated, if not with contempt, then with a kind of breezy indifference. Fragonard's talent is recognized, but his seriousness is often missed. Although recent studies of the rococo and Fragonard show increasing respect, the notion persists that something frivolous was going on in the 18th century. There somehow is the suspicion that the entire rococo holds a marginal position in the history of art and that the art of love, which in fact does preoccupy many artists of the period including Fragonard, is something supplemental to the serious concerns of life. In this view, the pursuit of love and pleasure is, at its worst, dangerous and, at its best, of questionable consequence. But "le bon Frago" with his artistic dreams and wishes may be as central to the study of art history as Raphael, Bernini, and Rembrandt.

Artists and critics alike struggle with the meaning of meaning in art. Dore Ashton, in her important work on Fragonard, mentions Jean-Paul Sartre's paradoxical comment on the *Mona Lisa* that it does not mean anything but nonetheless has meaning. In other words, the *Mona Lisa*, like most portraits, contains no explicit narrative nor any conventional symbols. Even her identity is in dispute. But the manner in which she is

presented and her sensibility mean a great deal. There is something similar going on with Fragonard. For the most part, his meaning is not exclusively nor perhaps even primarily vested in the putative subject or explicit imagery of his paintings. On the other hand, we should not make a quasi-modernist judgment and say that style is all. Meaning for Fragonard lies in the tension among numerous elements: his awareness of and quotation from historical art and the tradition of love poetry; his draughtsmanlike and gestural application of paint; his employment of unusual motifs such as garden statuary to give a provocative internal gloss on the narrative; his evocation of utopian and arcadian realms; and his open, often shifting compositions.

His early academic works, those pieces done for the Rome prize (*Jerobam Sacrificing to the Idols,* 1752) and the reception piece for the Academy completed upon his return from Italy (*Coresus Sacrifices Himself to Save Callirrhoe,* 1765), are fairly conventional pieces inspired by Baroque rhetoric. The clearly delineated figures gesture broadly, express themselves with great emphasis, and dwell in magnificent settings. But as Fragonard moved away from the French Academy in the later 1760's, his style became less imitative and more expressive. His love of the romantic and pastoral poetry of Tasso and Ariosto (probably developed during his time with Boucher), his fascination with the spectacle of street life, strolling players, and marionnette shows, together with his recollections of Rome, the Roman Campagna, and the gardens of Tivoli overtook the impulses of academic training and transformed his vision.

The Goncourt Brothers and others (the Abbé de Saint-Non, in particular) commented on Fragonard's "fiery" artistic spirit. Although such variations on fire and "gem-like" flames are common in the 18th and 19th centuries, the characterization is appropriate. Fragonard is one of those artists who lets the viewer see the work of his hand, as if with each brush stroke the artist were signing himself, leaving tracks of his identity. In such a way does the artist's spirit and fire become visible.

And his range of imagery startles as well. His themes include sexuality, allegorical portraits, non-allegorical portraits, fanciful-dress portraits, theatrical portraits, domestic scenes, park scenes, landscapes, frolicking putti, allegories of the progress of love or the fountain of love, nymphs bathing, achingly beautiful children, mythologies, caperings, and . . . the list goes on. Fragonard was interested not only in all forms of experience, but in ways of mythologizing, allegorizing, and sometimes even defamiliarizing experience. His pleasances in the *Progress of Love* (New York, Frick) are part of an earthly paradise that is real only in the sense that it is exquisitely desirable. The plenitude of flowers, the riot of colors, the dream-like pursuit and conquest, the strangeness of the animated but inanimate statues, a suspicion of the mock heroic, and the breath-taking execution all combine to create a series of paintings that is beyond anything the Academy could have sanctioned or even understood. For all this strange and unique treatment of a subject, Fragonard quotes from an old literary tradition, dating at least from the time of troubador love poetry in the 12th century, and re-examines motifs of the pastoral landscape, familiar to us from Jacopo Sanazzaro, Titian, and Giorgione. In other words, he is part of well-established and privileged cultural traditions. These combinations of the con-

ventional and the new, the real and the imagined, the familiar and the exotic, the clear and the obscure, the accessible and the longed-for distinguish Fragonard's genius and establish his greatness. When he died in 1806, Fragonard may have been largely forgotten, but in his day he commanded considerable attention, and perhaps again in the historical view his significance will be appreciated.

—Vernon Hyde Minor

FRANCESCO DI GIORGIO.

Born Francesco Maurizio di Giorgio di Martini in Siena: baptized 23 September 1439. Died in or near Siena, buried 29 November 1501. Married 1) Cristofana di Niccolò di Campagnatico, 1467; 2) Agnese di Benedetto di Neroccio, 1469. Possibly a student of Vecchietta; first recorded as painter and sculptor, 1464: worked in Siena (in joint studio with Neroccio) until 1475: worked on fountains and aqueducts, 1469–73; in Urbino, 1475–85: worked on Urbino palaze for Federigo (and Guidobaldo) da Montefeltro; repatriated as Siena citizen, 1485 or 1489: appointed city engineer, consultant, possible diplomatic missions, and served on Supreme magistracy; also made trips to Lucca, Naples, Cortona, and Jesi, and adviser on Milan Cathedral.

Collections: Amiens; Cambridge, Massachusetts; Coral Gables, Florida; Florence: Uffizi, Palazzo Davanzati; London; New York; Paris; Pasadena; Perugia; Siena: S. Domenico, Museum, Archivio di Stato; Urbino: Palazzo Ducale; Washington.

Publications

By FRANCESCO: books—

La praticha di giometria, Florence, 1970.
Trattati di architettura ingegneria e arte militare, edited by Pietro C. Marani, Florence, 2 vols., 1979.

On FRANCESCO: books—

Brinton, Selwyn, *Francesco di Giorgio of Siena, Painter, Sculptor, Engineer, Civil and Military Engineer,* London, 2 vols., 1934–35.
Weller, Allen Stuart, *Francesco di Giorgio,* Chicago, 1943.
Papini, Roberto, *Francesco di Giorgio, architetto,* Florence, 3 vols., 1946.
Salmi, Mario, *Desegni di Francesco di Giorgio collezione Chigo Saracini,* Siena, 1947.
Fredericksen, Burton B., *The Cassone Paintings of Francesco di Giorgio,* Malibu, 1969.

*

Before Leonardo, there are few 15th-century artists who could be described as embodying all the ideals of the "Renaissance"

Nativity, 1475; 7 ft 10 in × 6 ft 8 in (238.8 × 203.2 cm); Siena, Pinacoteca

artist. Francesco di Giorgio comes close to this ideal: he was a painter, miniaturist, sculptor, engineer, architect and architectural theorist, and sometime diplomat. His popularity with the ruling powers of Siena, Urbino, and Naples is attested in letters and documents, and he was much respected and sought after as a fortifications architect and hydraulic engineer in a country wracked by internal strife and fluctuating political fortunes.

The span of his career from c. 1464 until his death in 1501 produced some surprising stylistic contrasts, but it seems that as an artist he was flexible and inventive. His cassone paintings and early religious paintings adhere to prevailing Sienese traditions, while his sculptures are imbued with an awareness

of classical art and anticipate developments in 16th-century sculpture.

He is first recorded as an illuminator of a figure of *Chastity* (Osservanza, *De animalibus*), and a *Nativity* decorating the N in an antiphonary at the cathedral of Chiusi, and as a cassone painter (Malibu). These delicate works follow in the refined tradition of Sienese painting, as well as reflecting the influence of Girolama da Cremona and Liberale da Verona. Yet the colourful architecture depicted on the cassone paintings also shows Francesco's knowledge of classical buildings and anticipate some of the architectural designs that appear later in his treatises and buildings. Like his teacher, Vecchietta, he was also active as a sculptor and an early documented work is the

haggard polychrome wood figure of St. John the Baptist (1464, Siena).

During the earlier part of his documented career, in partnership with Neroccio di Bartolomeo Landi (his wife's cousin), their studio produced traditional decorative Madonna and Child compositions suited to the Sienese market: in these the figures of the Virgin and angels are delicately drawn with pale straw hair, translucent skin, rosy cheeks, and pursed lips that continue in the artistic tradition of Sassetta. Not until the large *Coronation of the Virgin* painted for Monte Oliveto Maggiore in 1471 (now in Siena) do we see Francesco's personal style assert itself throughout the composition. Strongly influenced by the works of painters outside Siena, particularly Botticelli and Baldovinetti, and even looking back to the works of earlier masters like Fra Angelico and Fra Filippo Lippi, it appears to derive from a niello possibly based on a design by Pollaiuolo. Although the arrangement of saints ranged in banks below the coronation follows a conventional design (for instance, Fra Angelico's *Coronation* in the Louvre), there is a new sense of plasticity. The figures have a tangible weight, and draperies fall heavily, moulding and defining them. Cast shadows are logically placed, and within the compressed foreground planes, defined by the classically inspired architecture, the saints occupy a real space. The red cherub supporting Christ might be a painted rendition of one of Donatello's putti, a reminder of Francesco's sculptural bias. The use of brightly coloured and decorated draperies still binds the painting to the Sienese tradition.

A new departure is noted in the slightly later *Nativity* painted in 1475 for the church of Monte Oliveto at Porta Tufi (now in Siena), his only signed work. In a dawn landscape the Virgin kneels before the infant Christ watched by Joseph, angels, and Sts. Bernardino and Ambrosius. For the first time, the landscape becomes a dominant and important part of the composition, and the circular temple behind the rocky stable introduces the first example of a centralized building in Francesco's paintings. Knowledge of Baldovinetti's *Adoration* in SS. Annunziata in Florence may be noted in the setting of the scene in an expansive landscape, and the vigorous modelling of the angels suggests that Francesco had seen Verrocchio's paintings.

These monumental paintings represent the last paintings undertaken by Francesco before his move to Urbino in 1475. Concurrent with his career as a painter, he had been involved as an engineer for the Sienese authorities, constructing acqueducts and fountains; these activities are documented between 1469 and 1473. Clearly it was for these skills and as a fortifications expert that he was employed by Duke Federigo da Montefeltro and later by the Duke of Calabria. For Montefeltro he constructed a number of forts and perhaps was involved in the design of the Palazzo Ducale at Urbino. A number of outstanding sculptural works may be related to his sojourn at the Urbino court: the *Deposition* in the Carmine church in Venice, the *Flagellation* (Perugia), and the *Discord*, known in two stucco versions (London, Victoria and Albert; Chigi-Saraceni Collection). Most striking in these works is the force of movement of the figure which is quite absent in his paintings. As if rising to the challenge of the humanistic environment of Montefeltro's court, Francesco imbues these works with a greater sense of the antique, setting the action in the *Flagellation* and the *Discord* against loggias and buildings of strongly classical design. The square loggia in the *Flagellation* prompts clear comparison with Piero della Francesco's painting of the same scene (Urbino), and no doubt Francesco came into contact with the painter at the Urbino court. Although the subject of the *Discord* is obscure, the work is the most classical of this group: here he contrasts frenetic movement with statuesque calm, like bronze statuettes applied to the shallow surface of the relief. In this device he seems to have learnt from Donatello's reliefs. The elegant seated figures at the corners and foreground of both reliefs look forward to 16th-century Mannerist compositions.

Throughout the period at Urbino, Francesco continued to practice as an architect, beginning work on his influential architectural treatises, and designing in 1485 the church of S. Maria del Calcinaio in Cortona. This elegant and refined domed church is one of the landmarks in 15th-century Renaissance church planning, incorporating his theories on proportion and clarity of design. He continued to design churches, secular buildings, and fortifications in Siena, Gubbio, Jesi, and Naples during the 1480's and 1490's, after being repatriated in Siena. Documents show that the Sienese authorities were loathe to lose his services for any length of time, despite repeated attempts by the Duke of Calabria and Guidobaldo da Montefeltro to borrow him, and a trip to Milan in 1491 to advise on the tribune for the cathedral (where he certainly met Leonardo da Vinci).

He produced two bronze candle-bearing angels for the high altar of Siena Cathedral in 1489, and in 1497 was commissioned to execute two bronze standing Angels for the same altar, completed in 1499. The earlier angels are in the tradition of Verrocchio's bronzes (such as the *Putto with a Dolphin*), but the standing angels are startling in their proto-Mannerist elegance and swaying poses. Their stance and sinuous draperies relate them to Botticelli's most sophisticated figures, but a comparable highly polished finish and refinement of chasing and design are not found until the following century. These works with a late *Nativity* for San Domenico in Siena (1485–90), with its mannered and contorted shepherds, and the grisaille paintings for Sant'Agostino in Siena, make it clear that Francesco di Giorgio's art belongs as much to the 15th century as it heralds the art of the 16th century.

—Antonia Boström

FRANCKE, Master.

Born c. 1380, probably in Zutphen. Died probably in Hamburg, after 1430. Documented in Hamburg from c. 1405 to 1424, but possibly trained in a French manuscript workshop; earliest work is the St. Barbara Altar, but his major work is the St. Thomas à Becket Altar, 1424.

Collections: Hamburg; Helsinki; Leipzig.

Publications

On FRANCKE: books—

St. Thomas à Becket Altar—detail, 1424; Hamburg, Kunsthalle

Lichtwark, Alfred, *Meister Francke,* Hamburg, 1899.
Martens, Bella, *Meister Francke,* Hamburg, 2 vols., 1929.
Pylkkänen, Riitta, *Master Francke: Sancta Barbara . . . The Legend of Saint Barbara,* Helsinki, 1966.
Pee, Herbert, *Meister Francke: Der Englandfahrer-Altar,* Stuttgart, 1967.
Puttfarken, Thomas, editor, *Meister Francke und die Kunst um 1400* (cat), Hamburg, 1969.

articles—

Reincke, Heinrich, "Probleme um den 'Meister Francke,' " in *Jahrbuch der Hamburger Kunstsammlungen,* 4, 1959.
Rensing, Theodor, "Uber die Herkunft des Meister Francke," in *Wallraf-Richartz Jahrbuch* (Cologne), 29, 1967.

*

Master Francke is a Hamburg painter who seems to occupy the same position in Hamburg during the early 15th century that Master Bertram occupied in the previous generation. Though few of his works survive, they suggest his great gifts. The place and date of his birth, and details of his early life, are not known, but he is probably to be identified with the Dominican friar or monk Brother Frank of Zutphen (in Gelderland), whose mother was a native of Hameln, near Hamburg. Whatever his origins, he seems not to have been trained in a workshop like that of Master Bertram, but rather in the French school of miniature painting; the painter Konrad von Soest is also possibly an influence. In contrast to Bertram's use of pastel color schemes and stocky figures, and his lack of interest in pictorial space, Francke's art is centered on the traditional characteristics of the International style—with slender often bending figures, strong colors (usually blue and scarlet—with their symbolic values), and a strong interest in suggesting depth. His earliest extant work is the *St. Barbara Altar,* now in the Helsinki Museum, but originally in the small church in Nykyrko in southwestern Finland. How it came to be in Nykyrko is unclear—a local tradition says that it was miraculously washed ashore from the sea. The most logical explanation is that the altar was originally in the cathedral of Turku (which had a St. Barbara altar), but was removed to an out-of-the-way church during the Reformation. But Francke's masterpiece is the *St. Thomas à Becket Altar,* now in the Hamburg museum but originally made for the chapel of the English Trading Company in the Dominican church of St. John in Hamburg. Its dedication in 1424 is documented in the company records. An engraving of the altar as it appeared in the 18th century was published in 1731, but only the movable wings and fragments of the central panel survive. They consist of a *Nativity,* an *Adoration of the Magi,* and two scenes from the life of St. Thomas (one unsuccessful attempt at his murder, and the successful attempt by Henry II's assassins in Canterbury Cathedral). The scenes from Christ's infancy show the influence of the *Revelationes* of St. Bridget of Sweden (who claimed that Christ's birth was instantaneous and painless). Two half-length panels paintings of Christ as the Man of Sorrows are also attributed to Francke (they are in Leipzig and Hamburg).

FRIEDRICH, Caspar David.
Born in Greifswald, 5 September 1774. Died in Dresden, 7 May 1840. Married, 1818. Trained at the Academy of Copenhagen, 1794–98; worked in Dresden after 1798: friend of Runge, and specialized in landscapes; taught at the Dresden Academy from 1824.

Major Collections: Berlin; Dresden: Schloss Pillnitz; Hamburg.
Other Collections: Berlin: Charlottenburg; Bremen; Hanover; Leipzig; Leningrad; Potsdam; Vienna: Albertina; Weimar.

Publications

By FRIEDRICH: book—

Friedrich in Briefen und Bekenntnissen, editen by Sigrid Hinz, Munich, 1968, 1974.

On FRIEDRICH: books—

Aubert, Andreas, *Friedrich: "Gott, Freiheit, Vaterland,"* edited by G.J. Kern, Berlin, 1915.

Eberlein, Kurt Karl, *Friedrich: Bekenntnisse*, Leipzig, 1924.

Wiegand, Friedrich, *Aus dem Leben Friedrichs*, Greifswald, 1924.

Wolfradt, Willi, *Friedrich und die Landschaft der Romantik*, Berlin, 1924.

Nemitz, Fritz, *Friedrich: Die unendliche Landschaft*, Munich, 1938.

Einem, Herbert von, *Friedrich*, Berlin, 1938.

Eberlein, Kurt Karl, *Friedrich, der Landschaftsmaler*, Bielefeld, 1940.

Schmidt, Matthias, *Friedrich: His Life and Work*, New York, 1940.

Grote, Ludwig, *Friedrich: Skizzenbuch aus den Jahre 1806 und 1818*, Berlin, 1942.

Richter, Gottfried, *Friedrich: Der Maler der Erdenfrömmigkeit*, Stuttgart, 1953.

Trautscholdt, Eduard, *Friedrich: Die Landschaft mit dem Gebirgssee am Morgen*, Dusseldorf, 1957.

Bauer, Franz, *Friedrich, Ein Maler der Romanitk*, Stuttgart, 1961.

Platte, Erica, *Friedrich: Die Jahreszeiten*, Stuttgart, 1961.

Eimer, Gerhard, *Friedrich and die Gotik*, Hamburg, 1963.

Emmrich, Irma, *Friedrich*, Weimar, 1964.

Tassi, Roberto, *Friedrich*, Milan, 1966.

Sumowsky, Werner, *Friedrich-Studien*, Wiesbaden, 1970.

Vaughan, William, et al., *Friedrich: Romantic Landscape Painting in Dresden* (cat), London, 1972.

Geismeier, Willi, *Friedrich*, Vienna, 1973.

Börsch-Supan, Helmut, and Karl Wilhelm Jähnig, *Friedrich: Gemälde, Druckgraphik, und bildmässige Zeichnungen*, Munich, 1973; abbreviated version, as *Friedrich*, New York, 1974.

Bernhard, Marianne, *Friedrich: Das gesamte graphische Werk*, Munich, 1974.

Jensen, J. C., *Friedrich: Leben und Werk*, Cologne, 1974.

Schmied, Wieland, *Friedrich*, Cologne, 1975.

Eimer, Gerhard, *Friedrich: Auge und Landschaft*, Frankfurt, 1975.

Börsch-Supan, Helmut, *L'opera completa di Friedrich*, Milan 1976.

Hinz, Berthold, et al., *Bürgerliche Revolution und Romantik: Natur und Gesellschaft bei Friedrich*, Giessen, 1976.

Traeger, Jörg, editor, *Friedrich*, Munich and New York, 1976.

Fiege, Gertrud, *Friedrich in Selbstzeugnissen und Bilddokumenten*, Reinbek, 1977.

Gärtner, Hannelore, editor, *Friedrich: Leben, Werk, Diskussion*, Berlin 1977.

Schott, Alexander, *Die Friedrich-Sammlung der Greifswalder Museums: Handzeichnungen, Druckgraphiken*, Greifswald, 1977.

Winter; drawing; Hamburg, Kunsthalle

Siegel, Linda, *Friedrich and the Age of German Romanticism*, Boston, 1978.

Möbius, Friedrich, *Friedrichs Gemälde "Abtei im Eichwald"* . . ., Berlin, 1980.

Hofstätter, Hans H., *Friedrich: Das gesamte graphischen Werk*, Herrsching, 2 vols., 1982.

Eimer, Gerhart, *Zur Dialektik des Glaubens bei Friedrich*, Frankfurt, 1982.

Dobrzecki, Alina, *Die Bedeutung des Traumes für Friedrich*, Giessen, 1982.

Becker, Ingeborg Agnesia, *Friedrich: Leben und Werk*, Stuttgart, 1983.

Unverfehrt, Gerd, *Friedrich*, Munich, 1984.

articles—

Siegel, Linda, "Synaesthesia and the Paintings of Friedrich," in *Art Journal* (New York), Spring 1974.

Möseneder, Karl, "Friedrichs Kreidefelsen auf Rügen und ein barockes Emblem in der romantischen Malerei," in *Zeitschrift für Kunstgeschichte* (Munich), 46, 1983.

Ohara, Mayumi, "Über das sog. Grosse Gehege Friedrichs," in *Zeitschrift für Kunstgeschichte* (Munich), 47, 1984.

Mitchell, Thimothy F., "Friedrichs *Der Watzmann*: German Romantic Landscape Painting and Historical Geology," in *Art Bulletin* (New York), September 1984.

Boime, Albert, "Friedrich: *Monk by the Sea*," in *Arts Magazine* (New York), November 1986.

Mitchell, Timothy F., "What Mad Pride: Tradition and Innovation in the *Ramdohrstreit*," in *Art History* (Oxford), September 1987.

*

Following Friedrich's death in 1840, his close friend Carl Gustav Carus eulogized the artist as having created through "absolutely original means" a "new, brilliant direction" in the history of landscape painting. This remains an appropriate memorial, for Friedrich's importance lies in his bold inventions. His motivations and motifs reveal much about the dynamic forces which altered German art and culture at the turn of the century.

In 1798, when Friedrich arrived in Dresden from his studies in Copenhagen, landscape art was popular but considered of limited potential. This opinion was shaped by contemporary art theory in which nature occupied an ambivalent position. On the one hand, nature was honored as the storehouse of images which stimulated powerful emotions in the viewer, but at the same time nature was seen as lifeless and the emotions were considered vague and inchoate. The active agent in producing these sensations was believed to be not nature but the mind. Theory also held that art was valuable to the extent that it could convey ideas clearly. This caused problems for the landscape artist. In the words of Georg Sulzer, a leading authority on art, landscape art spoke a "mute language" and required the presence of an accompanying "text." Conse-

quently, landscape as a subject in art was considered a powerful tool only when combined with an appropriate story. The most respected landscapes of the time were those of Nicolas Poussin and Claude Lorrain where idealized settings were backdrops for great events from classical history or mythology.

Friedrich was a product of this tradition but gradually came to follow a different set of assumptions. Friedrich was deeply religious, adhering to a form of pietism. He accepted the notion that nature's value for the artist was as a source of powerful emotions, but he became convinced that nature was a living, organic whole suffused with divine will. The principal tenet of Friedrich's entire career was the belief that God was present in and experienced directly through nature. Schelling is acknowledged to be the main philosopher of the concept of man, nature, and God existing in a transcendental union. Schelling presented nature as a living body and condemned those who saw in nature "nothing more than the lifeless aggregate of an indeterminate crowd of objects" rather than recognizing "the holy, ever-creative, original energy of the World, which generates and busily evolves all things out of itself." To the German Romantics, nature was a book of God and revealed His active presence through the language of moon, clouds, trees, and mountains. Friedrich saw the world as a dynamic, living, spiritual entity linking man with God, and art was the mediator between the two.

Friedrich's radical innovations were a product of his desire to manifest in landscape art this Divine presence. But a new element was added to the aesthetic equation—historicism. In Germany during the early 19th century, landscape and climate came to be seen as decisive factors in historical process. Friedrich came not only to share this view but also to believe in a living bond between artist and the era and that, in fact, style was an organic part of that historical moment; it was fruitless to attempt the revival of pasty styles. Art was no longer understood by Friedrich as a set of conventions established to tell traditional stories, but as a device shaped by history to embody cultural moments. By deciding to achieve a new landscape form, uniquely configured for his own time, Friedrich helped forge the origins of the modern tradition.

The components of landscape art were thus reshaped by Friedrich's beliefs. He boldly expressed his goal: "The task of the artist is not the accurate representation of air, water, rocks, and trees, but his soul, his sensations should be mirrored in his artwork. The artist must recognize the spirit of nature, absorb it and feel it in his entire heart and being and then reproduce it in his work." The word *Empfindung* (sensation) appeared frequently in Friedrich's writings, but he did not mean to imply that his art would stimulate the same feelings in all spectators, but only that he desired to embody his own strong feelings in unique images. His paintings were intensely personal.

Friedrich rejected most of the traditional landscape modes and relied on his feelings as a test for the efficacy of his forms. One of his most often quoted aphorisms is "Close your bodily eye, so that you may see your picture first with the spiritual eye." The result was a new landscape form in which the emotions were quickened by the intensity of the natural effects depicted. Friedrich employed an almost hallucinatory vividness of detail in his imagery, and structured nature around new patterns. The subjectivity of his work is evidenced by the presence of the "Rückenfigur," the spectator within the painting turned inward toward the scene and away from us. *Woman in the Morning Light* (Essen) is a prime example. The woman stands in rapt wonder as if about to receive some spiritual stigmata. Her position draws the viewer into the work as a witness to this natural epiphany. The painting renders neither the simple objective facts of nature, nor a narrative, but rather depicts pure sensation. We are required to contemplate the painting with the same intensity that the woman gives to the sun.

Friedrich's popularity was great but relatively brief. He began his professional career in Dresden, then the leading center of landscape art in Germany. His first successes were small sepia landscape drawings. His fame grew as he began to invest these images with greater meaning. The devices Friedrich employed to achieve greater emotional effects were original and controversial. His first major oil painting set the tone for much of his career. *The Cross in the Mountains* (Dresden) was displayed in his studio during the Christmas holidays of 1808. The public debate over the aesthetic worth of Friedrich's painting, known now as the *Ramdohrstreit*, centered on the issue of rules in art. The heart of Ramdohr's attack was that Friedrich had ignored "the principles proved by long experience or made venerable through the example of great masters." Friedrich's friends countered and used history as their defense. They claimed that "rules" were nothing more than the description of historically conditioned patterns. It was the task of the artist to invent new devices which would express the modern age.

Friedrich continued to create the types of landscapes Ramdohr decried as mystical and dangerous. In 1810 he sent two landscapes to the art academy exhibition in Berlin. There two oil paintings, *The Monk by the Sea* and *The Abbey in the Oak Forest*, were purchased by the Prussian king Friedrich Wilhelm II. Friedrich's reputation was set and the new direction in landscape was fully evident. From this point, until his declining health prevented him from working, Friedrich produced a string of emotive landscapes. His style changed slightly but his storehouse of images remained the same. He was noted for his love of the German terrain, staying close in his images to the particular characteristics of German skies, mountains, fields, and trees. His paintings alternated between those clearly intended as symbolic and others seemingly direct and unassuming. But whether blatant or hidden, the spirit which informed all of these landscapes was the guiding passion of his life—his discovery of God in nature.

Friedrich continued to be an influence from 1810 to 1820, but with lessening impact. Carl Gustav Carus and Johann Claussen Dahl were closest to him in their art, but many others reflected his unique style in their own works. In 1814 Friedrich was being hailed as the creator of a new age in landscape, and in 1818 he was even counted among the greatest landscapists who ever lived. This was his apogee as his international fame was slowing submerged beneath the tide of changing taste which swept Germany in the 1820's. The religious intensity of his works and the symbolic reading of nature which they suggested were increasingly seen as overly emotional: "From year to year Friedrich advances further into the thick fog of mysticism," wrote one reviewer in 1820. Even more damaging was the growing complaint that his works were too artificial and unnatural. By the 1830's he was suffering not only from ill-health but also from a lost market. By his death, he was practically forgotten.

—Timothy F. Mitchell

FRITH, William Powell.

Born in Aldfield, Yorkshire, 9 January 1819: lived in Harrogate from 1826. Died in London, 2 November 1909. Married 1) Isabelle Baker, 1845 (died, 1880), twelve children; 2) Mary Alford, 1881: seven children. Attended school in Knaresborough, Yorkshire, and at St. Margaret's School, near Dover, 1833-35; studied at the art school of Henry Sass, London, 1835, and at Royal Academy Schools from 1837; first exhibited at the R. A., 1840 (last year he exhibited was 1902): many historical and literary pictures, as well as portraits; successful: the exhibition of *Ramsgate Sands*, 1854, established his reputation, and *Derby Day,* 1858, sealed it; member, R. A., 1853; patronized by the Royal Family.

Collections: Baroda, India; Egham: Royal Holloway and Bedford College; London: Portrait Gallery, Tate, Victoria and Albert, Royal Academy; Providence, Rhode Island School of Design; Royal Collection.

Publications

By FRITH; books—

My Autobiography and Reminiscences, London, 3 vols., 1887-88, New York, 2 vols., 1888; edited by Neville Wallis as *A Victorian Canvas,* London, 1957.
John Leech: His Life and Works, London, 2 vols., 1891.

articles—

"Crazes in Art: 'Pre-Raphaelitism' and 'Impressionism,' " in *Magazine of Art* (London), 1888.
"Realism Versus Sloppiness," in *Magazine of Art* (London), 1889.

On FRITH: books—

A Festival of Britain Exhibition of the Paintings of Frith (cat), Harrogate, 1951.
Maas, Jeremy, *Gambart, Prince of the Victorian Art World,* London, 1975.
Maas, Jeremy, *The Prince of Wales's Wedding (1865): The Story of a Picture,* London, 1977.
Noakes, Aubrey, *Frith, Extraordinary Victorian Painter: A Biographical and Critical Essay,* London 1978.

article—

Cowling, Mary, "The Artist as Anthropologist in Mid-Victorian England: Frith's *Derby Day,* the *Railway Station,* and the New Science of Mankind," in *Art History* (Oxford), 6, 1983.

*

Although his initial ambition was to become an auctioneer, Frith had a facility for drawing and copying from an early age. His enrollment in Sass's Academy in London at the age of 16 was intended to groom him for the more prestigious Royal Academy Schools, but Frith was quickly bored by Sass's tedious training programme, which involved making drawings of antique busts and white plaster balls. However, through these lessons he improved his ability to reproduce objects accurately and precisely, and he gained admittance to the Royal Academy Schools. His early painting consisted largely of portraits produced on commission, and in 1839 he worked as an itinerant portraitist in Lincolnshire, where he received a number of patrons but little prestige. His fascination with literature and the theatre led him to try his hand at a different kind of painting, and from 1839 he began producing scenes from Shakespeare's plays and Goldsmith's and Scott's novels.

These literary subjects were in the line of such artists as Charles Robert Leslie and Daniel Maclise, whose styles Frith admired and imitated. In early works such as *Malvolio Cross-Gartered* (exhibited RA 1840; present location unknown), Frith adopted Maclise's minute attention to detail and somewhat unnatural colour scheme, but pastiches of Maclise began to disappear as Frith became more confident. In these early subjects from literature, Frith also evinced a concern for historical exactitude and literal interpretation of text. For a painting of a scene from Scott's *Kenilworth* (exhibited RA 1841; present location unknown) Frith went to Knole House to study architectural and decorative details which he felt would be appropriate for such a subject.

The modest success Frith attained through his exhibited paintings did not satisfy him, and he felt frustrated in his attempt to invent new subjects in an age when the subject painting was so widespread. Scenes of modern life—a possible alternative for an artist facing this dilemma—repelled him at first, as he saw modern fashion to be ugly and unpicturesque. Frith compromised between the historical and modern life paintings in his scenes from Dickens's *Dolly Varden* (1842; version London, Victoria and Albert), where the charm of "laughing Dolly" compensated for the limitations of her modern dress. Frith's other early attempts at modern life subjects were tentative and unconvincing, and it was only with his painting of *Life at the Seaside (Ramsgate Sands)* (1854; Royal Collection) that he attained a satisfactory solution.

Although one critic called *Ramsgate Sands* "a tissue of vulgarity," others were delighted by its depiction of a variety of people enjoying themselves at the seaside. Frith combined a number of individual incidents to create a satisfying overall composition, and the diversity of these scenes allowed observers to enjoy a lengthy scrutiny of the painting. The formula of a multi-figured modern-life subject set in a favourite English location inspired a number of imitators in subsequent years, and the painting itself impressed Queen Victoria, who purchased the work and engraving rights for £3000.

In the following years Frith devoted his attention primarily to three major works—*Derby Day* (1858; London, Tate), the *Railway Station* (1862; Royal Holloway and Bedford College) and the *Marriage of the Prince of Wales* (1865; Liverpool, Walker). The first two continue in the manner of *Ramsgate Sands,* and through them Frith earned enthusiastic critical appraisal as well as unprecedented financial rewards. In the *Marriage of the Prince of Wales,* a royal commission, Frith turned his hand to a different type of crowd scene. Frith sketched the general composition of the wedding *in situ* and spent the next three years filling in the detail. His painstaking attention to accuracy involved him in taking portraits from each individual

in the wedding party, and using photographs when he could not arrange a sitting. However, the resulting mass of faces gives an impression of anonymity rather than individuality, and the work itself seems to have sapped a great deal of Frith's remaining creative energy.

In subsequent years, Frith continued to paint modern-life scenes, but they were often mawkish or unconvincing. Works such as *English Archers, Nineteenth Century* (1873) or *Christmas Morning: Santa Claus's Gifts* (exhibited RA 1888; present location unknown) were depictions of modern life, but were seriously limited in their scope. In an effort to give weight to his subject matter, Frith also experimented in the modern-life moral subject. His five-part series of paintings, *The Road to Ruin* (1878; Baroda) and its successor *The Race for Wealth* (1880) were in the moralizing serial tradition of Hogarth's *Rake's Progress* (c. 1733), but their melodramatic nature lacked the power of Hogarth's satire. For these works, Firth continued to exhibit an obsession with realism, and he made sketches and took photographs of the Old Bailey and Millbank prison in preparation for *The Race for Wealth*. He felt that this process allowed him to render the horrific results of fraud more convincingly. Frith also continued to paint scenes from literature and history, which were more appealing, if less original. His later paintings include episodes from *Tom Jones, Pamela,* and *The Vicar of Wakefield*, revealing his continued interest in the 18th century and in the old-fashioned costume painting.

In 1878 Frith stood for Ruskin when the famous critic was sued by Whistler for damaging remarks made about one of his paintings. Frith's testimony was less in support of Ruskin than in opposition to Whistler's seemingly subjectless paintings. Frith's defense of realism and narrative carried over into large quantity of writing he published in the late 1880's. His massive *Autobiography* was humorous, gossipy, and full of information about late 19th-century art life, but it was also a defense of his style of painting and a re-assertion of the idea that an artist should copy nature. Frith's attacks on Impressionism and Aestheticism were nevertheless abortive, as these styles had already begun to supersede his own rather blunt realism.

—Shearer West

FUSELI, Henry.

Born Johann Heinrich Füssli in Zurich, 6 February 1741; son of Johann Caspar Füssli, a painter and art critic. Died in London, 16 April 1825. Married Sophia Rawlins, 1788. Ordained a Zwinglian clergyman, 1761; studied art in Berlin, 1763, then in England as translator and in France as a tutor; studied in Rome, 1770–78, then settled in London; exhibition of *The Nightmare* brought fame, followed by important illustrations to Lavater's *Physiognomische Fragmente*, 1781–86; worked for Boydell's Shakespeare Gallery, 1789; member of the Royal Academy, 1790 (Professor of Painting, 1799, Keeper, 1804): pupils included Etty, Haydon, Leslie, Mulready, Constable, Landseer; also knew Blake and Gerard.

Collections: Auckland; Cambridge; Cardiff; Detroit; Dresden; Frankfurt: Goethemuseum; London: Tate, British Museum, Courtauld, Royal Academy; New Haven; Paris; Weimar; Zurich.

Publications

By FUSELI: books—

Lectures on Painting, London, 3 vols., 1801–30.
Briefe, edited by Walter Muschg, Basel, 1942.
Aphorismen über die Kunst, edited by Eudo C. Mason, Basel, 1944.
Unveröffentliche Gedichte, edited by Eudo C. Mason, Zurich, 1951.
The Mind of Fuseli: Selections from his writings, edited by Eudo C. Mason, London, 1951.
Remarks on the Writings and Conduct of J. J. Rousseau, edited by Eudo C. Mason, Zurich, 1962.
Collected Letters, edited by David Weinglass, New York and London, 1982.

Translator, *Reflections on the Painting and Sculpture of the Greeks,* by J. J. Winckelmann, London, 1765.
Translator, *Aphorisms on Man,* by Lavater, London, 1788.

On FUSELI: books—

Knowles, John, *The Life and Art of Fuseli,* London, 3 vols., 1831.
Federmann, Arnold, *Fuseli, Dichter und Maler,* Zurich, 1927.
Beutler, Rudolf, *Fuseli,* Halle, 1939.
Wartmann, Wilhelm, and Marcel Fischer, *Fuseli* (cat), Zurich, 1941.
Jaloux, Edmond, *Fuseli,* Geneva, 1942.
Ganz, Paul, *Die Zeichnungen Fusslis,* Berne, 1947; as *The Drawings of Fuseli,* London, 1949.
Powell, Nicholas, *The Drawings of Fuseli,* London, 1951.
Mason, E., *The Mind of Fuseli,* London, 1951.
Antal, Frederick, *Fuseli Studies,* London, 1956.
Schiff, Gert, *Zeichnungen von Fuseli,* Zurich, 1959.
Schiff, Gert, *Fuseli: Ein Sommernachstraum,* Stuttgart, 1961.
Schiff, Gert, *Fuselis Milton-Galerie,* Stuttgart, 1963.
Schiff, Gert, *Fuseli und Michelangelo,* Zurich, 1964.
Schiff, Gert, *Echtheits- und Zuschreibungsprobleme bei Fuseli,* Zurich, 1965.
Tomory, Peter, *A Collection of Drawings by Fuseli* (cat), Auckland, 1967.
Viotto, Paolo, *L' opera completa di Fuseli,* Milan, 1967.
Schiff, Gert, *Fuseli* (cat), Zurich, 1969.
Tomory, Peter, *The Life and Art of Fuseli,* New York and London, 1972.
Schiff, Gert, *Fuseli,* Zurich, 2 vols., 1973.
Powell, Nicholas, *Fuseli: The Nightmare,* London and New York, 1973.
Hofmann, Werner, editor, *Fuseli* (cat), Hamburg, 1974.
Keay, Caroline, *Fuseli,* London, 1974.
Schiff, Gert, and Werner Hoffmann, *Fuseli* (cat), London, 1975.
Pressly, Nancy L., *The Fuseli Circle in Rome: Early Romantic Art of the 1770's* (cat), New Haven, 1979.

Prometheus; drawing; Basel, Kunstmuseum

Henry Fuseli's erudite, witty, and quite wild personality infused his bizarre and imaginative paintings and drawings with energy and power. This long-lived and prolific artist is often regarded, along with his contemporary and good friend William Blake, as a forerunner of the Romantic art movement. Certainly, his themes derived from the writings of Dante, Shakespeare, Milton, and the Niebelungenlied, to name just a few of the wealth of literary sources used by Fuseli, often concentrated on moments of fantasy and horror.

Fuseli's choice of sources and themes throughout his life, was strongly influenced by his education under Professor J. J. Bodmer. Bodmer was one of the early promoters of the *Sturm und Drang* movement in Fuseli's native Switzerland. Bodmer was also extremely well read, spoke a variety of languages, and had the type of ruthless wit and fiery temperament for which Fuseli, himself, would later become renowned. Fuseli celebrated his association with Bodmer in a painting entitled *Fuseli in Conversation with Professor Bodmer* (1778, Zurich), which depicts the two men on either side of a bust of Homer. It was Bodmer's esteem for Jean Jacques Rousseau that undoubtedly led Fuseli to his own analysis of the writer's work in a pamphlet published anonymously in 1767 three years after he moved to England, as *Remarks on the Writings and Conduct of J. J. Rousseau*. This English work was produced at a time when he was very actively employed as a translator. Significant in this regard is the fact that Fuseli was the first to trans-

late the writings of the German Neo-Classical theorist Johann Wincklemann into English.

On the advice of Sir Josuah Reynolds, who encouraged Fuseli to pursue a career in art after viewing his drawings, Fuseli traveled to Italy. His stay there from 1770 to 1778 made a profound impact on him and also brought him to the attention of other foreign artists working in Rome. Among the Fuseli circle there were the Scotsmen Alexander and John Runciman, the Swedish sculptor Johan Tobias Sergel, and the English painter John Brown. In Rome, Fuseli came under the spell of antique monuments, but he was particularly inspired by Michelangelo. He did numerous studies after this Renaissance master and is said to have even effected Michelangelo's dress and manner. For the rest of his life, Fuseli would use Italian classical art as a reference source. It is typical of Fuseli that his often classically oriented theoretical writings would be in contrast to the romantic style of his works, which were dark in tone and freely expressive in execution. Fuseli was constantly contradicting himself, both in his writings and his conversation, which was dubbed "incessant" by contemporaries.

Fuseli's works often depict scenes involving dreams, demons, terror, or death. The first known painting by Fuseli was *Joseph Interpreting the Dreams of the Butler and Baker of Pharaoh* (1768; painting by Franz Hegi after Fuseli's work, 1807, Basel). This was one of many biblical themes illustrated by Fuseli, who had been ordained a Zwinglian minister in

1761. Later dream images include *The Shepherd's Dream* (1798; London, Tate) from Milton's *Paradise Lost* and *Titania's Dream* (1822, Sir Robert Witt Collection) inspired by Shakespeare.

Fuseli's style was conducive to the selection of dream images, since he used dramatic chiaroscuro lighting, an unnatural foreshortening, and undetailed, often vague settings. This stylistic approach met with much criticism concerning Fuseli's relationship to nature and deficiencies in employing color. Fuseli, himself, admitted his problems in this area, declaring that he had courted and continued to court "colour, as a lover courts a distainful mistress," and "Hang Nature, she always puts me out!"

The best known of Fuseli's dream images is certainly his infamous *Nightmare* (1781, Detroit). This work was so popular that he painted several other versions on request. It was also engraved and widely circulated, as well as satirized. This shocking and erotic work, involving a languishing female mounted by a demonic looking incubus, gained much fame for the artist after it was exhibited at the Royal Academy in 1789.

Although considered quite decadent to some critics, the *Nightmare* was mild compared to the many overtly erotic, even pornographic, drawings executed by the artist. He did a number of works showing two or three women very graphically satisfying the sexual desires of a single male. Examples of this include his *Symplegma of a Man with Two Women* (1770–78; Florence, Horne) and *Symplegma of a Man with Three Women* (1809–10; London, Victoria and Albert). In these erotic works, especially, Fuseli demonstrated his keen eye for the outrageous hairdos fashionable at the time, leading many to credit him with a hair fetish.

His treatment of women is an interesting aspect of Fuseli's *oeuvre*. The menacing and aggressive depictions of his courtesans, as well as his penchant for choosing villainous women as the central characters of his works (examples include Lucretia Borgia, Brunhilde, and Lady Macbeth as well as an array of witches), make it easy to view him as an avowed misogynist. His letters and writings support his negative view of women. During his life, however, Fuseli had many female admirers, including the early feminist writer Mary Wollstonecraft, who was eventually banned from Fuseli's house by his wife, Sophia Rawlins. Described by contemporaries as pretty but not particularly intelligent, Sophia burned many of Fuseli's erotic drawings after his death.

The two most ambitious projects of Fuseli's career were the paintings he did for Boydell's Shakespeare Gallery and for his own Milton Gallery. For Boydell he depicted eight scenes from Shakespeare, including the *Appearance of the Ghost* (1796, Zurich). The idea for the Milton Gallery was suggested by the publisher Johnson, who requested 30 scenes inspired by Milton to be included in a projected edition of the poet's work by Cowper. This project was never concluded, but Fuseli continued on his own eventually to paint 47 works based on Milton. The first 40 of these were exhibited in 1799 in a rented space formerly belonging to the Royal Academy. In these, Fuseli particularly revelled in his numerous depictions of Satan. These included the large *Satan Calling Up His Legions* (1799–80, Private Collection) and *Adam and Eve First Discovered by Satan* (1793, Hamburg). Although Sir Thomas Lawrence called the Milton Gallery the work of a genius, most critics were negative in their review and the whole project was a financial failure. Even so, many friends came to his aid and bought the paintings, including his long-time patron Thomas Coutts.

Considering the often negative criticism directed towards Fuseli, it is a testament to his talent and charm that he was not only elected as a member of the Royal Academy (1790), but also awarded the esteemed honor of being named professor of painting (1799) and Keeper of the Royal Academy (1804). As a teacher he provoked awe and respect from his students. Ironically, one of his most famous students, John Constable, was ridiculed by Fuseli. But Fuseli's life was full of ironies and contradictions. He was a classicist who painted romantically, a misogynist loved by women, a happy, successful man who had a terrible temper, and was described by many as mad. William Blake humorously summarized the character of Fuseli, in the following tribute to him:

The only man that e'er I knew
Who did not make me almost spew
Was Fuseli: he was both Turk and Jew—
And so, dear Christian friends, how do you do?

—Kathleen Russo

G

GABO, Naum.

Born Neemia Borisovich Pevsner in Briansk, Russia, 5 August 1890; brother of the sculptor Antoine Pevsner; adopted name of Gabo, 1915; naturalized United States citizen, 1952. Died in Waterbury, Connecticut, 23 August 1977. Married Miriam Israels, 1937; one daughter. Attended schools in Russia; studied medicine, University of Munich, 1910–12; spent war years in Scandinavia, and returned to Russia, 1917: collaborated on architectural monuments and public buildings in Russia and Germany, 1919–31; lived in Berlin, 1922–32; designed the Diaghilev ballet *La Chatte,* 1927; lived in Paris, 1932–35, and England, 1935–46: co-editor, Circle, 1937; lived in Connecticut from 1946: taught architecture, Harvard University, Cambridge, Massachusetts, 1953–54.

Collections: Berlin; Buffalo; Chicago; Dallas; London: Tate; New Haven; New York: Moma, Guggenheim; Paris: Beaubourg; Zurich.

Publications

By GABO: books—

Realisticheskii Manifest [Realist Manifesto], Moscow, 1920.
Of Divers Art, Princeton, 1962.

On GABO: books—

Constructivistes russes: Gabo et Pevsner: Peintures, constructions (cat), Paris, 1924.
Olson, Ruth, and Abraham Chanin, *Gabo, Antoine Pevsner,* New York, 1948.
Read, Herbert, and Leslie Martin, *Gabo,* Cambridge, Massachusetts, and London, 1957.
Pevsner, Alexei, *A Biographical Sketch of My Brothers Naum Gabo and Antoine Pevsner,* Amsterdam, 1964.
Read, Herbert, et al., *Gabo* (cat), London, 1966.
Rickey, George, *Constructivism: Origins and Evolution,* New York, 1967.
Haftmann, Werner, et al., *Gabo* (cat), Berlin, 1971.
Leymarie, Jean, et al., *Gabo* (cat), Grenoble, 1971.
Bann, Stephen, editor, *The Tradition of Constructivism,* London, 1974.

Newman, Teresa, *Gabo: The Constructive Process* (cat), London, 1976.
Lodder, Christina, *Russian Constructivism,* New Haven, 1983.
Nash, Steven A., and Jörn Merket, editors, *Gabo: Sixty Years of Constructivism* (cat), Munich and New York, 1985, London, 1987.
Bowness, Alan, *Sixty Years of Constructivism,* New York, 1987.
Williams, Graham, *Gabo: Monoprints,* Ashford, Kent, 1987.
Lodder, Christina, and Martin Hammer, *Gabo,* (cat), Oxford, 1988.

*

Gabo's work is generally associated with Constructivism. It has only recently become clear how far his version of the movement, which was to be taken up in the West, differed from that in the Soviet Union. From the beginning, Gabo had strong links with the West, doing scientific training in Munich and travelling in Italy and in France where he came into contact with Cubism before the war. Gabo's constructivist style was pioneered with the "stereometric" heads made in Scandinavia during the war, before he returned to the Soviet Union. In the *Constructed Heads* mass is suggested by space enclosed by solid planes which build up a figurative image. His first *Constructed Head* was made in 1915 from plywood, the second in iron.

When Gabo went back to the Soviet Union after the February Revolution of 1917 with his brother Antoine Pevsner, he did so with a distinctive and developed style of his own. Although both brothers worked at the Moscow State Free Art Studios, only Pevsner seems to have had an official post there.

Gabo's first non-figurative pieces were made in 1919 but they used the same method as the earlier heads. The original *Construction en creux* (now lost) used opaque planes to build up an abstract spatial form. Gabo remade the piece in 1921 using transparent celluloid, a material he first used in 1920. The use of transparent materials was a significant departure, for it involved a shift away from volume defined by space to an emphasis on the planes themselves and their interrelations, and on playing with the concept of absent and present planes. For instance, in the *Monument for an Airport* series there are spaces where we logically assume there will be planes. We are lead to read planes rather than volumes in space.

Head of a Woman, c. 1917–20; celluloid and metal; $24\frac{1}{2} \times 19\frac{1}{4}$ in (62.2 × 49 cm)

During the 1920's contacts between Soviet and Western artists were fairly limited and while some articles were written on the hard-line Constructivists who wished to eliminate art as a separate practice, the movement was usually associated with the work of Gabo. This was partly because he used the same word to describe his work and partly because of his presence in the West from 1922.

This characterization masks the considerable differences between Gabo and the Soviet constructivist movement, differences that led Gabo to publish the famous *Realist Manifesto* in 1920. While in Russia Gabo had used the term *postroenie* (built-up) to distinguish his work from that which was "constructed." The manifesto was written to coincide with the opening of a small show on Tverskoi Boulevard in Moscow and was published in the form of a broadsheet which was pasted up around the city by the students of the Free Art Studios. Considerable paper shortages caused by the civil war lead to most official information being issued in the form of broadsheets, so the manifesto was guaranteed attention. While much of it was concerned with the formal implications of the stereometric method, it also made a clear stand against the more extreme forms of constructivism that threatened to reduce art to an adjunct of utilitarian design. While Tatlin's work could be seen as research towards a use of materials and their qualities, Gabo's transparent sculptures were far more to do with the abstract exploration of spatial concepts as such. This could really only be justified in aesthetic terms and the *Manifesto* stated the value of art as an autonomous entity, as an expression of human experience. Of course, this did not exclude the possibility of work that is not purely autonomous, and certain pieces of Gabo's work made both in the Soviet Union and shortly after he left were clearly meant for some practical purpose. A drawing which forms a *Project for a Radio Station* (1919–20) and an architectural *Column* of 1923, as well as later projects for fountains and airports, show that Gabo thought his spatial researches could have practical applications.

The *Manifesto* also recommended the exploration of kinetic effects, and in 1920 Gabo made a *Kinetic Construction* which consisted of a metal rod which was made to vibrate by a motor. There was an attempt here to express the fourth dimension by making the viewer aware of time as an additional element acting on spatial dimensions. This path in Gabo's work was not really followed up: all the movements in Gabo's later sculpture are rotational and there are relatively few examples. The *Monument for the Institute of Physics and Mathematics* (1925) in glass and bronze contains rotating elements and the *Vertical Construction No. 2* (1964–65) is rotated by a motor, but otherwise motion is confined to the hanging sculptures that rotate freely. The concept of the fourth dimension as a spatial concept remained highly pertinent to the later work and was manifested in the emphasis on transparency, in the tracing and distortion of lines on three-dimensional surfaces, and in the complex shadows cast by the sculptures on walls and floors that remind us of the idea of three dimensional objects as shadows of four dimensional beings. The fourth dimension also had a role as an analogy at least, if not a real repository, of the spiritual and the anti-materialistic, as a guarantor of the value of autonomous art that Gabo had argued for in the *Manifesto* of 1920.

—Julian Stallabrass

GADDI, Agnolo.

Born in Florence before 1351; son of the painter Taddeo Gaddi; brother of the painter Giovanni Gaddi. Died in Florence: buried 16 October 1396. Married Giovanna di Landozzo Lolli; one son. Trained by his father in the Giottesque tradition; assistant to his brother Giovanni in the Vatican, 1369; in Florence by 1376, and member of the painters guild by 1381; painted several cycles in Florence (Loggia dei Lanzi, 1383–86, S. Croce, c. 1390, S. Miniato al Monte 1394–96) and Prato (Palazzo Datini, 1391, Cathedral, 1393–95); associated with Florence Cathedral from 1383; few proven works.

Collections: Berlin; Florence: S. Croce, S. Miniato al Monte, Cathedral, S. Felicità; Gottingen: University; Indianapolis; Jacksonville, Florida; London; New York ; Paris; Prato: Cathedral, Palazzo Datini; Paris; Santa Barbara; Washington.

Publications

On GADDI: books—

Salvini, Roberto, *L'arte di Gaddi,* Florence, 1936.
Cole, Bruce, *Gaddi,* Oxford and New York, 1977.

articles—

Tosi, L., "Gli affreschi della Cappella Castellani in Santa Croce," in *Bollettino d'Arte* (Rome), 9, 1929–30).
Poggi, G., "La Cappella del Sacro Cingolo nel duomo di Prato e gli affreschi di Gaddi," in *Rivista d'Arte* (Florence), 14, 1932.
Cole, Bruce, "The Interior Decoration of the Palazzo Datini in Prato," in *Mitteilungen des Kunsthistorischen Institutes in Florenz,* 13, 1967.
Boskovitz, M., "Some Early Works by Gaddi," in *Burlington Magazine* (London), 110, 1968.

*

Agnolo Gaddi is one of the most important artists of the later trecento. The son of Taddeo Gaddi, a major Florentine painter of the early fourteenth century, Agnolo was instrumental in revitalizing the great tradition which his father, a pupil of Giotto, had helped to shape.

The earliest known works by the artist can be dated to the 1380's, and show him to be an accomplished painter. Agnolo is responsible for two scenes from the life of John the Evangelist, located on the left entrance arch of the Castellani chapel in S. Croce, Florence. *The Baptism of Crato* and *The Miracle of the Sticks and Stones* reveal Agnolo's talents in combining two distinct stories in one harmonious composition. The narrative is restricted to the foreground, with the action curving around the *Baptism* (left), across to the *Miracle* (right), while background city and countryside serve as a screen to deep space. The simple rhythms of the composition are enhanced by figures wrapped in soft, full garments with curved folds that complement their movements, and by an even-tempered color harmony of rose, golden yellow, light

blue, and cream that recalls the expansive and humane tenor of the art of Agnolo's father, Taddeo.

The more recent stylistic phase of mid-century—exemplified by Orcagna and his followers—was also integral to the formation of Agnolo's style. The treatment of three-dimensional form as two-dimensional pattern, a feature of the stern, hieratic art of mid-century, is a major organizational principle in Agnolo's early panels such as *The Coronation of the Virgin* (London, National Gallery). Here, a severely symmetrical placement of the figures is combined with the flat, patterned brocades worn by Christ and Mary. The angular folds, sharply highlighted with white, also contribute to the work's psychologically removed character. Similar formal tendencies are present in *The Virgin and Child with Saints* polyptych from S. Maria degli Angeli, Florence (Berlin, Staatliches Museum), of the late 1380's. In this latter work, however, the two groups of small, musical angles at the feet of the Virgin introduce a bit of interaction with their gentle conversation. This genrelike detail betrays a more pervasive interest in human involvement and will blossom in Agnolo's subsequent work.

The central period of Agnolo's development (late 1380's, early 1390's) contains works that balance opposing stylistic principles: an increasing attention to deeper space and clarified figural volume and mass against an interest in rich surfaces and decorative detail; a tighter, more integrated composition against a passion for enlivening the picture with incidental detail. The cycle depicting *The Legend of the True Cross* in S. Croce, Florence, chronicles Agnolo's manipulation of the above stylistic features. The scene depicting *The Discovery and Testing of the True Cross* is composed with an emphasis on the foreground narrative similar to the earlier frescoes in the nearby Castellani chapel, discussed above. In the choir, however, the figures' proportions are more naturalistic, their long, elegant gestures more incisive, and their interpersonal relationships of greater complexity. They now act before a fairytale environment that extends into deepest space, and that is replete with mountains and streams, castles and monasteries, wild animals and men going about their daily chores. But although Agnolo has enriched his painted world, the wall surface also remains important to him: the varied hues of his diversified but delicate palette keep the eye moving across the surface.

Agnolo's panels of this period show a similarly complex balance. The great opulence of the brocaded and gold tooled surface of his second *Coronation* (Washington, National Gallery), in contrast to his earlier essay in London, is held in check by broad, movemented rhythms of monumental forms and the mass and volume suggested by the soft folds of the draperies. Even more than in the early Berlin polyptych (above), the figures communicate by intimately shared glances and gestures.

In the last phase of Agnolo's career (early 1390's to 1396), his narratives become more synthetic and his figures mature into a grand, measured dignity. Executed on the three walls of a chapel erected to hold the miracle-working girdle of the Virgin, the fresco cycle of *The Story of the Holy Girdle* in Prato Cathedral, occupies a central place in the understanding of this artist's late style. Less space is devoted to the extensive landscapes of *The True Cross* cycle and more to the foreground stage and figural interaction. The flow of narrative has become extremely accomplished. In *The Betrothal of the Virgin* the eye moves from a cluster of multiple points of activity exemplified by a variety of human types to the serene verticals that compose the direct participants in the betrothal. Agnolo's general composition reflects his father's *Betrothal* in the Baroncelli chapel of S. Croce, but Agnolo's figures display a more generous sense of spatial interval and a greater seriousness.

In the space of his career, Agnolo Gaddi developed a renewed emphasis on the non-hieratic, larger-than-life forms of the Giotteschi. But his taste was also more nominalist, reflecting the importance of the single individual and the details of his world in the later 14th century. Through his work, Agnolo helped to lay the foundations not only for the delicate tonalities and evocative environments of the International Style, soon to sweep Florence, but also for the monumental forms of Masaccio and his peers in the bright morning of the Renaissance.

—Carol T. Peters

GADDI, Taddeo.

Born Taddeo di Gaddo Gaddi in Florence, c. 1300; son of the mosaicist Gaddo di Zanobi. Died in Florence, 1366. Married Francesca Albizzi Ormanni; sons, the painters Agnolo and Giovanni, and Zanobi. Trained from c. 1313? in Giotto's studio, Florence, and member of the painters guild, c. 1330; worked on fresco cycle in Baroncelli Chapel in S. Croce, Florence, early 1330's; also worked in Pisa and in Pistoia (S. Giovanni Fuorcivitas, 1348–53); worked in hospital of S. Maria Nuova, Florence, 1365; relatively few proven works.

Major Collecitons: Florence: S. Croce.
Other Collections: Bagni a Ripoli: S. Giorgio a Ruballa; Berlin; Berne; Cambridge, Massachusetts; Castelfiorentino: S. Verdiana Museum; Dijon; Fiesole: Bandini; Florence: Uffizi, Accademia, S. Miniato al Monte, Bargello; Indianapolis; Munich; New York; Pistoia: S. Giovanni Fuorcivitas; San Diego.

Publications

On GADDI: books—

Wehrmann, Martin, *Gaddi, ein Florentiner Maler des Trecento,* Stettin, 1910.
Borsook, Eve, *The Mural Painters of Tuscany,* London, 1960, 1980.
Baldini, Umberto, *Giotto e giotteschi in Santa Croce,* Florence, 1966.
Donati, Pier Paolo, *Gaddi,* Florence, 1966.
Ladis, Andrew: *Gaddi: Critical Appraisal and Catalogue Raisonné,* Columbia, Missouri, 1982.

articles—

Longhi, Roberto, "Qualità e industria in Gaddi" (2 parts), in *Paragone* (Florence), 10, 1959.

Marcucci, Luisa, "Per gli 'Armari' della Sacrestia in Santa Croce," in *Mitteilungen des Kunsthistorischen Institutes in Florenz*, 9, 1959–60.

Cascalina, E., "Una tavola di Gaddi già alla SSma Annunziata di Firenze," in *Studi Storici dell Ordine del Servi di Maria*, 12, 1962.

Gardner, J., "The Decoration of the Baroncelli Chapel in Santa Croce," in *Zeitschrift für Kunstgeschite* (Munich), 34, 1971.

Cole, Bruce, "Gaddi, Giotto. and Assisi," in *Acta Historiae Artium* (Budapest), 22, 1976.

Smart, Alistair, "Gaddi, Orcagna, and the Eclipses of 1333 and 1339," in *Studies in Late Medieval and Renaissance Painting in Honor of Millard Meiss*, New York, 1977.

*

Taddeo di Gaddo Gaddi occupies a prominent place in Italian trecento painting. Although most commonly known as a pupil of Giotto, he also had family ties to the Florentine artistic community as the son of a successful mosaicist (Gaddo di Zanobi), and as father to at least two more painters, one of whom (Agnolo Gaddi) enjoyed a notable career at the end of the century. Taddeo's working life of almost half a century is studded with a number of influential commissions and civic appointments which reveal a high standing among his contemporaries. While undeniably indebted to the revolutionary visual world created by Giotto, Taddeo's own significant contributions to the development of Florentine painting should not be overlooked. Moreover, his artistic personality, emotional and vigorously experimental, was intrinsically at odds with the classical restraint espoused by his teacher.

The earliest works by Taddeo are datable to the early 1320's, and reveal a unique personality emerging from within the husk of Giotto's compositional forms and ideas. The large panel of *The Stigmatization of Saint Francis* (Cambridge, Massachusetts, Fogg Art Museum), while closely derived from Giotto's Louvre *Stigmatization*, shows an idiosyncratic body type, an interest in and feeling for space, and the evocative qualities of environment that would continue to develop in his *oeuvre*.

Taddeo's most expansive phase of the 1330's continued alongside the flowering of Florentine art and culture. The fresco cycle dedicated to the Annunciate Virgin in the Baroncelli chapel of S. Croce, Florence (c. 1328–30), celebrates the artist's youthful vigor. There is here a debt to, rather than a dependence on Giotto, and an obvious inspiration from Sienese art in terms of spatial and narrative ideas. Enlivened by a rich palette which includes orange, aqua, and reddish-purple, Taddeo's spry and extroverted personages are posed in a sometimes daring foreshortening that conceals a profile or punctures the picture plane with a bent arm. And while his spatial experiments are not always successful—at least from a Renaissance point of view—they often result in such striking scenes as *The Presentation of the Virgin in the Temple* where the architectural complex becomes an imposing protagonist in the child Mary's brave and lonely climb away from her family and up the tiers of steps to the waiting high priest. Boldness is also present in Taddeo's experiments with illusionism: in the fictive aumbries of the dado level, which hold receptacles for the Mass; and in the naturalistic use of light—especially for the *Cardinal Virtues* in the main vault which are so consistently modelled in respect to the window behind the altar that the *Prudence* appears theatrically lit from below. In tandem with this overt melding of the real and fictive worlds is the presence of the divine, golden light of Revelation, personified by an announcing angel in four of the eleven scenes.

After the Baroncelli frescoes, Taddeo pursued a more subtle and reserved quest for compositional stability and complexity. His reinterpretation of such monumental scenes as Giotto's *St. Francis and the Sultan* in one of the twenty-four quatrefoils used to decorate a sacristy cupboard in S. Croce, Florence (now Florence, Accademia; Berlin, Gemäldegalerie; and Munich, Alte Pinakothek), is testimony to his growing expertise in fashioning concentrated and effective narrative. During the later 1330's and early 1340's, a shift towards more monumental figures and more architectonic compositions (perhaps under the influence of another Giotto follower, Maso di Banco) makes itself felt. Taddeo's fragment of a frescoed *Lamentation*, formerly above the north door of the nave of S. Croce, Florence, is an example of this phase. Here the remnant of a taut compositional scaffolding is wedded to a somber restraint and gravity that depart from his youthful work.

At mid-century Taddeo is seen to participate in a general shift in art that draw away from the tenets of Giotto and his close followers. The signed dated panel of 1355, of *The Virgin and Child Enthroned* (Florence, Uffizi), is a comment on the opposing stylistic values of the old and new generations of Florentine art. Richly clad and coolly rigid within their sharply enclosed contours, the Madonna and Child partake of the iconic distance currently in fashion. Yet, Taddeo's choice of figural disposition in the kneeling and adoring angels, the slightly lateral twist he gives to the Virgin, her subtle occupation of space and her direct eye contact with the viewer still owe much to the humane idealism of Giotto's *Ognissanti Madonna*.

As in his early career, Taddeo's last years are distinguished by a prestigious commission for the Florentine Franciscans. The monumental fresco on the east wall of the former refectory of S. Croce, which depicts St. Bonaventure's *Lignum Vitae* with a *Last Supper* below and four flanking stories of saints, began a tradition of decoration for monastic refectories. The great *Tree of Life* with Christ crucified that rises up in the center forms an eloquent pattern of undulating curves. To either side, the figures in the four narrative inhabit a space that exists behind the frame, while below, the participants in the *Last Supper* are thrust in front of it and into the viewers world. The compositional tension is heightened by a spiritual ardor and abstracted monumentality of form.

Taddeo's late works, with their often despairing emotional intensity, gain power from the well of generosity and humanity that marked his more optimistic art in the early trecento. Moreover, it was Taddeo Gaddi's presence well into the seventh decade of the century that helped to secure these ideals as a living heritage for a still younger generation of Florentine artists.

—Carol T. Peters

GAINSBOROUGH, Thomas.

Born in Sudbury, Suffolk, baptized 14 May 1727. Died in London, 2 August 1788. Studied in London under Gravelot, and possibly Hayman, from 1740; influenced by Dutch landscape painters; set up as portrait painter in Sudbury, 1748, in Ipswich, 1752–59, and in Bath, 1759–74, then settled in London; exhibited in London from 1761, and original member of the Royal Academy, 1768. Pupil: Gainsborough Dupont.

Major Collection: London
Other Collections: Amherst, Massachusetts; Birmingham; Cambridge; Cambridge, Massachusetts; Cincinnati; Edinburgh; Egham: Royal Holloway College; Hartford, Connecticut; Indianapolis; London: Kenwood, Buckingham Palace, Tate, Victoria and Albert, Wallace; Malibu; New York: Frick; Philadelphia; San Marino, California; San Diego; Sarasota, Florida; Toronto; Washington.

Publications

By GAINSBOROUGH: book—

Letters, edited by Mary Woodall, London, 1961, Greenwich, Connecticut, 1963.

On GAINSBOROUGH: books—

Armstrong, Walter, *Gainsborough and His Place in English Art,* London, 1898; New York, 1906.
Whitley, William T., *Gainsborough,* London, 1915.
Dibdin, E. Rimbault, *Gainsborough,* London, 1923.
Stokes, Hugh, *Gainsborough,* London, 1925.
Woodall, Mary, *Gainsborough's Landscape Drawings,* London, 1939.
Millar, Oliver, *Gainsborough,* London, 1949.
Woodall, Mary, *Gainsborough: His Life and Work,* London, 1949.
Waterhouse, Ellis K., *Gainsborough* (cat), London, 1953.
Waterhouse, Ellis K., *Gainsborough,* London, 1958.
Hayes, John, *Gainsborough: Drawings* (cat), London, 1960.
Ripley, Elizabeth, *Gainsborough: A Biography,* London, 1964.
Leonard, Jonathan Norton, *The World of Gainsborough,* New York, 1969.
Hayes, John, *The Drawings of Gainsborough,* New Haven, 2 vols., 1970.
Hayes, John, *Gainsborough as Printmaker,* New Haven, 1971.
Williamson, Geoffrey, *The Ingenious Mr. Gainsborough,* London and New York, 1972.
Hayes, John, *Gainsborough: Paintings and Drawings,* London and New York, 1975.
Potterton, Homan, *Reynolds and Gainsborough,* London, 1976.
Einberg, Elizabeth, *Gainsborough's "Giovanna Baccelli"* (cat), London, 1976.
Worman, Isabelle, *Gainsborough: A Biography,* Levenham, Suffolk, 1976.
Stainton, Lindsay, *Gainsborough and His Musical Friends* (cat), London, 1977.

Clifford, Timothy, Antony Griffiths, and Martin Royalton-Kisch, *Gainsborough and Reynolds in the British Museum* (cat), London, 1978.
Barrell, John, *The Dark Side of the Landscape: The Rural Poor in English Paintings 1730–1840,* Cambridge, 1980.
Hayes, John, *Gainsborough* (cat), London, 1980.
Hayes, John, *Gainsborough* (cat), Paris, 1981.
Lindsay, Jack, *Gainsborough: His Life and Art,* London and New York, 1981.
Hayes, John, *The Landscape Paintings of Gainsborough: A Critical Text and Catalogue Raisonné,* Ithaca, New York, 2 vols., 1982.
Hayes, John, and Lindsay Stainton, *Gainsborough Drawings* (cat), Washington, 1983.

*

Gainsborough's first portraits were influenced by the French rococo manner of his master, François Gravelot. *Self-Portrait with His Wife, Margaret,* c. 1746–47, shows the recently married young couple in an idealized sylvan setting. The animation and play of light on the figures, and the sinuous swirls of Margaret's pink dress, are typically rococo. By contrast, Gainsborough took sober, meticulously observed 17th-century Dutch art as his model in landscape painting, as can be seen in *The Charterhouse* with its crisp shadows and ordered perspective (London, Coram Foundation). This picture was one of a group donated in 1748 by Hogarth and other artists to Coram's Foundling Hospital, an act that was a mixture of charity and self-publicity.

On returning to Sudbury in 1748 Gainsborough made his living painting portraits of the local landed gentry (such as *Mr. and Mrs. Andrews,* London, National Gallery). He also produced landscapes, the genre which he said in later years was his favourite. He continued this pattern of mixing portraiture and landscape after moving to Ipswich in 1752. His portraits, such as *William Wollaston,* c. 1758, are delightfully informal paintings of landowners at ease on their estates. Wollaston leans on a stile, his adoring dog at his feet, his house in the background; his expression is alert and sharply characterized.

During the Ipswich period Gainsborough's landscapes moved away from the realism shown in *Mr. and Mrs. Andrews* to a gently rococo, idealized view of rural life. *Woodcutter and Milkmaid,* 1755 (Duke of Bedford), has as its focus a bucolic courting couple more suited to opera than real life, though the crisply impasted paint and gnarled oak trees are still influenced by 17th-century Dutch landscapes. At the same time Gainsborough was making elaborate, imaginary landscape drawings. The pencil drawing *Wooded Landscape with Herdsman and Cow,* c. 1758–59 (private collection), is constructed from sinuous, S-curving lines that accord with Hogarth's idea of the perfect rococo "Line of Beauty."

Gainsborough's move to Bath in 1759 brought him into contact with the cream of fashionable society who went there to take the waters. His eminence grew to such an extent that he was invited to become a founder member of the Royal Academy in 1768. His painting style became looser, brilliantly conveying the textures of lace and silk (*Mary, Countess Howe,* c. 1763–64; London, Kenwood House). He could evoke both the elegance of youth and characterful old age, as in his portrait of

A Woodland Glade; etching

Mary, Duchess of Montagu (Bowhill, Duke of Buccleuch and Queensberry).

Throughout the 1770's the drama of Gainsborough's portraits increased in response to the promotion of the "Grand Style" of painting by his rival Reynolds. An element of fantasy was introduced thanks to the fashion for portraits in fancy dress. The famous "Blue Boy" *Jonathan Buttall*, 1770 (San Marino, California, Huntington), is wearing Van Dyck costume. The style of the painting emulates the aristocratic poise of Van Dyck's portrait of the youthful *Lords John and Bernard Stuart* (London, National Gallery) reflecting glory on the sitter by associating him with an older portrait tradition. *The Hon. Frances Duncombe*, c. 1778 (New York, Frick) is also in Van Dyck dress. In contrast to Gainsborough's earlier informal portraits, she is stiffly if elegantly posed, and unapproachable, a goddess-like figure in a sunset landscape. Instead of the pastel tones used in *Mary, Countess Howe*, this painting is full of strong, deep blues, gold, and russet—with a Rubensian richness and flickering touch that would have appeared at its best by candlelight.

The influence of Rubens was also seen in landscapes such as *The Watering Place*, 1777 (London, National Gallery). Gainsborough's interest in rich and theatrical lighting was also ap-

parent in his construction of a peep-show box to display glass transparencies painted by him with landscapes that could be lit from behind (London, Victoria and Albert). His obsession with the correct way to view his pictures (contemporaries remarked on his odd scratches and brush marks which fell magically into place at the right distance) led to rows in 1773 and 1784 with the Royal Academy hanging committee.

Although Reynolds was the major art theorist of his day and President of the Royal Academy, it was Gainsborough who became the favourite painter of the royal family after producing portraits of *George III* and *Queen Charlotte* in 1781. His flamboyant, glittering style perfectly suited the personality of *George, Prince of Wales (later George IV)*, 1784 (private collection). His portraits of the 1780's are notable for their ever looser paint handling and sense of movement. In *Giovanna Baccelli*, 1782 (London, Tate), the dancer sweeps up the train of her skirt in a cascade of flounces that merges into the windswept tree behind her. Gainsborough became increasingly interested in integrating his portrait figures with their landscape background. This was consummately achieved in *Mrs. Sheridan*, 1785 (Washington, National Gallery), where the figure of Richard Brinsley Sheridan's beautiful singer wife is enveloped in the lines of the sparkling, breezy landscape.

In these years Gainsborough also painted romantic figure ensembles like *The Mall*, 1783 (New York, Frick), which shows groups of fashionable figures drifting in and out of the shadows beneath tall trees. He also tried his hand at the "history subjects" promoted by Reynolds as the most prestigious type of art (*Diana and Actaeon*, c. 1784–85, Royal Collection). In *Diana* Gainsborough is less interested in painting figures than in blending them into the landscape.

Gainsborough responded to the sentimentality of the 1780's with a group of large-scale "fancy pictures" which idealize the rural poor: *The Girl with Pigs*, 1782 (Castle Howard) and *The Cottage Girl with Dog and Pitcher*, 1785 (Russborough, Sir Alfred Beit, Bt.). The beautiful barefoot children share the wistfully pensive expressions of Gainsborough's fine ladies. Gainsborough's last landscapes also stray far into the realms of the imagination. *Mountain Landscape with Peasants Crossing a Bridge*, c. 1784 (Washington, National Gallery) is fluid, with textures and forms barely differentiated—a dream-Italianate landscape enveloped in soft contours and sunset glow. It is a world away from Gainsborough's "first imitations of little Dutch Landskips" which he recalled so fondly at the end of his life.

—Susan Morris

GAUGUIN, Paul.

Born in Paris, 7 June 1848. Died in Atuana Hiva-Oa, Marquesas Islands, 8 May 1903. Married Mette Gad, 1873 (separated, 1885); five children. Spent part of his childhood in Peru; worked at sea, 1865–71, then a stockbroker, Paris, 1871–83; Sunday painter: exhibited at the Salon, 1876, and with the Impressionists from 1879; worked in Brittany, 1886–90; stayed two months with Van Gogh in Arles, 1888; lived in Tahiti and other Pacific islands, 1891–93 and after 1895.

Major Collection: Paris.
Other Collections: Basel; Boston; Buffalo; Chicago; Cleveland; Copenhagen: Carlsberg; Essen; Glasgow; Grenoble; Honolulu; Indianapolis; London: Courtauld, Tate; Moscow; New York; Rheims; Sao Paulo; Washington, DC: National Gallery, Phillips.

Publications

By GAUGUIN: books—

Noa Noa, Paris, 1901; other versions published Paris, 1924, 1954; translated as *Noa Noa*, New York, 1919, Oxford, 1961; edited by Nicholas Wadley as *Noa Noa: Gauguin's Tahiti*, Oxford, 1985.
Avant et après, Leipzig, 1918; Paris, 1923; as *The Intimate Journals of Paul Gauguin*, New York, 1921.
Lettres à Daniel de Monfried, Paris, 1919; edited by A. Joly-Segalen, Paris, 1950; as *Letters to Georges-Daniel de Monfried*, New York, 1922, London, 1923.

Lettres à André Fontainas, Paris, 1921.
Letters to Ambroise Vollard and André Fontainas, edited by John Rewald, San Francisco, 1943.
Lettres à sa femme et à ses amis, edited by Maurice Malingue, Paris, 1946, 1949; as *Letters to His Wife and Friends*, Cleveland and London, 1949.
Ancien culte Mahorie, edited by René Huyghe, Paris, 1951.
Racontars de Rapin, edited by A. Joly-Segalen, Paris, 1951.
Le Sourire (magazine), edited by L.-J. Bouge, Paris, 1952.
Les Guêpes (magazine), Paris, 1952.
Lettres à Emile Bernard, Geneva, 1954.
Notes synthétiques, edited by Raymond Cogniat and John Rewald, New York, 1962.
Cahier pour Aline, edited by Suzanne Samiron, Paris, 1963.
Oviri: Ecrits d'un sauvage, edited by Marcel Guérin, Paris, 1974; as *The Writings of a Savage*, edited by Wayne V. Andersen, New York, 1978.
45 Lettres à Vincent, Théo, et Jo van Gogh, edited by Douglas Cooper, Lausanne, 1983.
Correspondance: Documents témoignages, vol. 1 1873–88, edited by Victor Merlhes, Paris, 1984.

On GAUGUIN: books—

Rotoncamp, J. de, *Gauguin*, Weimar, 1906; Paris, 1925.
Morice, Charles, *Gauguin*, Paris, 1920.
Alexandre, Arsène, *Gauguin: Sa vie et le sens de son oeuvre*, Paris, 1920.
Rey, Robert, *Gauguin*, Paris and New York, 1924.
Guerin, Marcel, *L'Oeuvre gravé de Gauguin*, Paris, 2 vols., 1927.
Cogniat, Raymond, *Gauguin*, New York, 1936.
Burnett, Robert, *The Life of Gauguin*, London, 1936; New York, 1937.
Rewald, John, *Gauguin*, Paris, 1938; New York, 1949.
Bernard, Emile, *Souvenirs inédits sur l'artiste Gauguin*, Lorient, 1941.
Leymarie, Jean, and René Huyghe, *Gauguin* (cat), Paris, 1949.
Huyghe, René, *Le Carnet de Gauguin*, Paris, 1952.
Dorival, Bernard, *Gauguin: Carnet de Tahiti*, Paris, 1954.
Rewald, John, *Post-Impressionism: From Van Gogh to Gauguin*, New York, 1956; 3rd edition, 1978.
Goldwater, Robert, *Gauguin*, New York, 1958; concise edition, 1984.
Rewald, John, *Gauguin: Drawings*, New York, 1958.
Wildenstein, Georges, editor, *Gauguin: Sa vie, son oeuvre*, Paris, 1958.
Rookmaaker, H. R., *Synthesist Art Theories: Genesis and Nature of the Ideas of the Art of Gauguin and His Circle*, Amsterdam, 1959.
Alley, Ronald, *Gauguin*, London, 1961.
Boudaille, Georges, *Gauguin*, Paris, 1963; New York, 1964.
Gray, Christopher, *Sculpture and Ceramics of Gauguin*, Baltimore, 1963.
Wildenstein, Georges, *Gauguin: Catalogue I*, Paris, 1964.
Bodelsen, Merete, *Gauguin's Ceramics*, London, 1964.
Danielsson, Bengt, *Gauguins Söderhavsar*, Stockholm, 1964; as *Gauguin in the South Seas*, London, 1965; New York, 1966.

Nave Nave Fenua; woodcut

Sutton, Denys, and Ronald Pickvance, *Gauguin and the Pont-Aven Group* (cat), London, 1966.

Mittelstaedt, Kuno, *Gauguin: Self-Portraits,* Oxford, 1968.

Russell, John, *Gauguin,* New York, 1968.

Jaworska, Wladyslawa, *Gauguin and the Pont-Aven School,* Boston, 1972.

Andersen, Wayne V., *Gauguin's Paradise Lost,* New York, 1971.

Le Prohon, Pierre, *Gauguin,* Paris, 1975.

Field, Richard, *Gauguin: The Paintings of the First Voyage to Tahiti,* New York, 1977.

Jirat-Wasintynski, Vojtech, *Gauguin in the Context of Symbolism,* New York, 1978.

Wadley, Nicholas, *Gauguin,* Oxford, 1978.

Huyghe, René, *Gauguin Sketchbook,* New York, 1978.

Rechnitzer-Pope, Karen Kristine, *Gauguin and Martinique,* Austin, Texas, 1981.

Teilhet-Fish, Jehanne, *Paradise Reviewed: An Interpretation of Gauguin's Polynesian Symbolism,* Ann Arbor, Michigan, 1985.

Le Pichon, Yann, *Sur les traces de Gauguin,* Paris, 1986; as *Gauguin: Life, Art, Inspiration,* New York, 1987.

Boyle-Turner, Caroline, *The Prints of the Pont-Aven School: Gauguin and His Circle in Brittany,* New York, 1987.

Le Paul, Judy and Charles-Guy, *Gauguin and the Impressionists at Pont-Aven,* New York, 1987.

Hoog, Michael, *Gauguin: Life and Work,* London and New York, 1987.

Thompson, Belinda, *Gauguin,* London, 1987.

Gauguin (cat), New York, 1988.

*

Gauguin, like many innovators, had to use all his persistence and determination to maintain his artistic integrity during a life filled with incident. He was not trained as a painter, and after he married a Danish girl in 1873 (when he was 25, and working in a stockbroker's office) and had five children, it seemed he would settle down and become a Sunday painter. But his passion for painting deepened, and he came to spend all his spare time at it. He had a painting (in the Corot style) accepted in the Salon of 1876. Soon afterwards, he met Camille Pissarro, and was introduced to the group of Impressionists who had been holding their own exhibitions outside the more "established" circle of the Salon. Gauguin's tenacity and rapid artistic progress soon impressed the Impressionists, and he was accepted by and exhibited with them by 1879. By 1883, Gauguin was so immersed in his painting that he decided to give up his job and paint full-time. A period of declining resources followed, and he went to live with his wife and children in Copenhagen in 1884–85, but he finally separated from them in 1885.

By the mid-1880's, Cézanne and Degas were major influences, and the next few years were crucial for Gauguin. He spent several months in the small Brittany town of Pont-Aven in 1886, and worked on ceramics in Paris in 1886–87 (when he met Van Gogh). At this time, the first manifesto declaring the new Symbolism movement was published, and the decline of Impressionism was apparent to most theorists. In 1887, Gauguin visited Martinique, his first experience of an exotic "paradise," and the strong light and intense colors impressed him. But his second stay in Pont-Aven in 1888 was the turning point of his style. Though he had earlier become aware of Seurat's experiments with pure color (he had seen Seurat's *Sunday Afternoon on the Island of Le Grand Jatte* at the Impressionist exhibition in 1886), his own interest was in a strong line and the contrast of colors. The young Emile Bernard, only 20 years old but already involved in art theory and experimentation, was at Pont-Aven that year. Bernard had already gone through a phase of Pointillism similar to that of Seurat, but he and Gauguin painted together during the stay in Pont-Aven in a style they called "cloisonnism" and "synthetism," The main characteristics were heavy outlines, areas of strong color, flat forms, and few shadows. Bernard was later to quarrel with Gauguin because the older man had been given the credit for the new "synthetism." But Gauguin pursued his work with terrific intensity, and was also able to intellectualize his art, and probably deserved the credit.

One work by Gauguin from this period, *Still Life with Three Puppies* (1888; New York, Moma) is startling with its utter disregard for traditional composition. There is fruit in the foreground, three goblets in the middleground, and three puppies drinking from a large pot in the background—but because there is no sense of relationship between the three elements, one should call "foreground" the bottom of the canvas and "background" the top of the canvas. The colors are also un-"natural," as if a child had chosen them.

The Vision after the Sermon (Jacob Wrestling with the Angel) (1888, Edinburgh) is a major example of the new style. A group of peasant women wearing their unusual bonnets almost completely fill the foreground (some have their back to the viewer), and most are facing the smaller figures of Jacob wrestling with an Angel on a large red ground. An apple tree and a cow divide the canvas diagonally, in the manner of a Japanese print (he decorated his Pont-Aven studio with Utamaro prints), and Gauguin was well aware of the division. As he wrote to Van Gogh, "I have attained in these figures a great rustic and *superstitious* simplicity. It is all very severe. . . . To me in this painting the landscape and the struggle exist only in the imagination of these praying people, as a result of the sermon. That is why there is a contrast between these real people and the struggle in this landscape, which is not real and is out of proportion."

Gauguin's friendship with Van Gogh should not be taken to suggest that they had a similar painting style, though they were evidently sympathetic to each other and could share their ideas. However, Van Gogh liked human drama and the modeled form (as in the works of Daumier and Millet), whereas Gauguin was cool and analytical, and preferred heavy outlines, a lack of shadows, and flat planes (as in the work of Ingres and Degas). Neither painter was successful, and even Gauguin, who had come to the public's attention in the 1880's, sold few of his new works.

The story of Gauguin's trips to the Pacific islands of Tahiti and the Marquesas has become embroidered with details of poverty and romance, but artistically Gauguin's style changed very little after 1890. His interest in Egyptian sculpture, Japanese prints, the Italian primitives, and Persian miniatures had begun before he went to the Pacific, though motifs from these art styles were used effectively in his Pacific works. The monumentality and frieze-like effects are obvious results of the Egyptian influence, and the restricted range of poses suggest a

strong traditionalism. As most commentators have mentioned, his interest in the provincial customs, costumes, and religiosity of Brittany is not remote from his interest in similar elements in Tahiti, and some of his Breton women or boys can be paralleled in his Tahitan figures.

Gauguin is usually classed with Van Gogh, Cézanne, and perhaps Seurat in reacting against the Impressionists and preparing the way for "modern painting." What emerges is a style that was surprisingly consistent during its rather short period of maturity (roughly 1888 to 1903). As he himself said, "I wanted to establish the right to dare to do anything. . . . The public owes me nothing, since my pictorial oeuvre is but relatively good, but the painters who today profit from this liberty owe me something."

—George Walsh

GAULLI, Giovanni Battista. Also called Baciccio.

Born in Genoa, baptized 10 May 1639. Died in Rome, 26 March 1709. Married a woman surnamed Murani; children. Left Genoa in mid-1650's, and studied with an unidentified French painter; friend of Bernini; joined the S. Luca academy in Rome, 1662; first public commission was for a chapel in S. Rocco a Ripietta, 1660–66; then decorator and portrait painter (for 7 popes); S. Agnese pendentives, c. 1666–72; decorations for Il Gesù church, 1672–85; SS. Apostoli ceiling, 1707. Pupils/assistants: Giacomo del Po and Giovanni Odazzi.

Collections: Cleveland; Dusseldorf; Fermo: Carmine Church; Florence; Genoa: Doria; Manchester; New York; Oberlin, Ohio; Rome: Spada, Il Gesù; Sao Paulo.

Publications

On GAULLI: books—

Enggass, Robert, *The Paintings of Baciccio*, University Park, Pennsylvania, 1964; addenda in *Burlington Magazine* (London), 106, 1963.
Brugnoli, Maria Vittoria, *Il Baciccio*, Milan, 1966.
Graf, Dieter, editor, *Die Handzeichnungen von Guglielmo Cortese und Gaulli*, Dusseldorf, 2 vols., 1976.

articles—

"Paintings, Bozzetti, and Drawings Made by Baciccio" (cat), in *Allen Memorial Art Museum Bulletin* (Oberlin, Ohio), 24, 1967.
Chiovenda, B. C., "Ancora del Bernini, del Gaulli, e della Regina Cristina," in *Commentari* (Rome), 20, 1969.
Lurie, Ann T., "A Bozzetto for the Four Prophets by Gaulli," in *Bulletin of the Cleveland Museum of Art*, 58, 1971.
Macandrew, Hugh, "Baciccio's Early Drawings," and (with Dieter Graf) "Baciccio's Later Drawings," in *Master Drawings* (New York), 10, 1972.

Graf, Dieter, "Gaullis Olskizzen in Kunstmuseum Düsseldorf," in *Pantheon* (Munich), 31, 1973.
Graf, Dieter, "Gaulli: Entwürfe zur Dekoration des Vorraums der Taufkapelle von St. Peter," in *Pantheon* (Munich), 32, 1974.
Dunn, Marilyn R., "Nuns as Art Patrons: The Decoration of S. Marta al Collegio Romano," in *Art Bullentin* (New York), September 1988.

*

Giovanni Battista Gaulli, commonly called il Baciccio, although Genoese by birth, ascended to a leading position in Roman painting beginning in the 1660's. As an artist favored by Gian Lorenzo Bernini, the leading sculptor in Rome, Baciccio became the major exponent of an energetic and colorful style of painting established in sharp opposition to a more classical language championed by Carlo Maratti. Baciccio's projects included both large-scale fresco work as well as more conventional altarpiece commissions; he was also the leading portraitist in Rome in the second half of the 17th century. Although he remained active into the first decade of the 18th century, Baciccio's style underwent significant changes marked primarily by a reduction in color and a rejection of illusionary devices.

Important sources for Baciccio's life and career include biographies by Nicola Pio (1724), Leone Pascoli (1730), and Carlo Giuseppe Ratti (1769). Although there is little consensus among these authors, all date Baciccio's arrival in Rome to the later 1650's after he was orphaned in Genoa. In spite of the fact that no work is extant from Baciccio's years in Genoa, his initial style as evidenced by his earliest Roman works in drawing and painting was strongly influenced by Genoese masters, among them Valerio Castello, Giovanni Benedetto Castiglione, and the Flemish painter Anthony Van Dyck, a visitor to Genoa on two occasions in the 1620's. Baciccio may have apprenticed with artists active in Rome upon his arrival—both Gaspard Dughet and Guglielmo Cortese have been mentioned—but the early works have a freedom of handling associated with the Genoese tradition. For example, the S. Rocco altarpiece (c. 1660–66), his earliest documented work, as well as the Chigi *Pietà* (1667; Rome, Collection of the Incisa della Rocchetta) both demonstrate a taste for dark backgrounds against which lively colors applied in a painterly manner play, and while the figures are large, they are described by loose and flowing lines.

In 1666 Baciccio began his first large-scale public work, a commission awarded by the Pamphili family to fresco the pendentives of the church of S. Agnese. These were unveiled in 1672, and the period of their execution is a critical one in Baciccio's career. Ratti states that Baciccio received the commission because he had been recommended by Bernini. The statement has not been confirmed by documentary evidence; however, there is no question that it was around the time of the S. Agnese commission that Baciccio came into contact with Bernini. When Baciccio went to Parma in 1669 to study the frescoes of Correggio, he went with a letter of introduction from Bernini in hand. Moreover, it appears that Baciccio had painted Bernini's portrait as early as 1666, and some of Baciccio's drawings from the later 1660s show the influence of the famous sculptor. The S. Agnese pendentives depicting the Virtues introduce a more restrained and linear style for the de-

scription of the large, volumetric figures, but the vitality of the early works remains, now more isolated in the flowing draperies, the piling of figures and cloud masses and the gorgeous play of colors throughout the compositions. Based on the success of these, Baciccio received a commission in 1671 for ceiling decorations in the small church of S. Marta. This is Baciccio's first ceiling project in which he opts for an illusionary treatment rather than a strict *quadro riportato* or framed solution. It is also the commission that so impressed Gian Paolo Oliva, Father-General of the Society of Jesus, that he immediately added Baciccio to the list of possible candidates for the prestigious commission to decorate the interior of Il Gesù.

In receiving the Gesù commission Baciccio, who was selected over his leading rivals in Rome, Maratti, Giacinto Brandi, and Ciro Ferri, received one of the largest and richest commissions of the second half of the 17th century. He was contracted for the work beginning in 1672 and his association with various portions of the project continued until 1685. He is responsible for the frescoes of the dome and pendentives, the nave vault, the apse, and the vault of the left transept. In each case the painted solutions for these various fields are ingenious and complex, but it is the design of the nave vault (1676–79) that brought Baciccio his greatest recognition. Here, through an ambitious combination of sources, Baciccio designed a powerful image fusing the subject of the *Triumph of the Name of Jesus* with the *Fall of the Damned*. The design solution relies on both the establishment of a framed composition and the violation of that frame. The upper portions of the composition accommodate the Adoration image, while the lower zone erupts as massive figures are shown being thrown out of the painted space as if into the real space of the nave. In all, the painting represents a *summa* of illusionistic ceiling painting as it had evolved by mid-century, borrowing in form from the works of Pietro da Cortona, particularly his Barberini Ceiling, and in content from the nearly contemporary work of Brandi at S. Carlo al Corso (begun in 1674).

Another essential ingredient in the design of the nave vault is the influence of Bernini. The two artists must have been in close association by the time Baciccio began work on the nave of the Gesù. Baciccio's large altarpiece of *The Adoration of the Shepherds* for S. Maria del Carmine in Fermo (c. 1672) evidences considerable stylistic influence from Bernini. Baciccio's own interest in color and large figures is complemented by a more sculptural description of the draperies of the figures as if in imitation of Bernini's carved drapery passages, and the image is infused with a spiritual warmth provoked by the mystical light surrounding the new-born Child and the intensity of the gestures. Around 1675 Baciccio painted the altarpiece of the *Virgin and Child with St. Anne* for the Altieri Chapel (Rome, S. Francesco a Ripa) which furnishes the backdrop for Bernini's sculpture of *The Blessed Ludovica Albertoni*.

Not only is Bernini's aesthetic apparent at the Gesù in the opening of the vault to a deep illusionistic space, reminiscent of the vault design executed by Guidobaldo Abbatini for Bernini's Cornaro Chapel (1652; Rome, S. Maria della Vittoria), but the scale of the Gesù decorations, the placement of stuccoed angels by Antonio Raggi and Leonardo Retti in the vault architecture in concert with the painted figures, and the triumphant spirit of the whole all recall Bernini's notion of the *bel composto* and his own designs for the Cornaro Chapel and the Cathedra Petri (1656–66). Moreover, there is also the possibil-

ity of Bernini's actual involvement in Baciccio's designs for the Gesù. There is evidence that Bernini encouraged Oliva to select Baciccio for the commission and even guaranteed the younger artist's work. An *avviso* or news dispatch from 1675 explicitly states that Bernini designed the vault that Baciccio painted. While Bernini's biographers are mum about his involvement, the scale and invention of the Gesù decorations certainly suggest Bernini's encouragement of, if not his critical participation in, Baciccio's work. With the completion of the vault in 1679, just a year before Bernini's death, it must have appeared to the Roman audience that Baciccio's work demonstrated for the first time on this scale a painted equivalent to the grand sculptural inventions of Bernini.

Although Baciccio continued working on the Gesù decorations until 1685, the taste for his colorful and energetic painting lapsed, and his leading position was usurped by Carlo Maratti. The taste for the classical language in Roman painting in the last quarter of the 17th century coincides both with the death of Bernini and with the ultimate triumph of a critical attitude growing among connoisseurs of painting beginning with Giovanni Battista Agucchi in the early 17th century and fueled by the painting of Nicholas Poussin, Andrea Sacchi, and his student Maratti. Baciccio adapted his late style to this classical taste. His large commissions, such as the Torri altarpiece in S. Maria Maddalena (1697–98) and the Altieri altarpiece in S. Maria in Campitelli (c. 1698), have a new reserve and control. Although still colorful, the images are now pale in tonality; the figures are staid; and the compositions are more balanced and often repetitive. During this time, Baciccio seems also to have concentrated on smaller commissions. His popularity as a portraitist was maintained and there is some suggestion that he renewed his contacts with Genoese patrons furnishing smaller history paintings such as *The Continence of Scipio* (c. 1695–1700; Genoa, Palazzo Doria). Of Baciccio's official commissions in Rome from the end of his career, two are of particular note. In 1709 he painted the ceiling of SS. Apostoli, and in the same year he began final preparations for work on a mosaic composition for the vault of the Baptismal Chapel at St. Peter's. This last was a commission that Baciccio received from Clement X. Recent research suggests that Baciccio also had been awarded the commission for the altarpiece of the Baptismal Chapel; however, the altarpiece was given over to Maratti in the last years of the 17th century, and the vault commission passed to Francesco Trevisani on Baciccio's death. The SS. Apostoli ceiling fresco, representing *Christ in Glory Receiving Franciscan Saints*, is disappointing in its total lack of *bravura* and in the conservative nature of its spatial illusion. In all, Baciccio's late works document the controlling taste for classicism firmly planted in official Roman painting by the beginning of the 18th century.

—Dorothy Metzger Habel

GEERTGEN tot Sint Jans.

Born Geertgen van Haarlem in Leiden, c. 1455–65. Died in Haarlem before 1495 (age 28). Possibly a pupil of Ouwater of Haarlem; may have trained as a miniaturist; lived in monastery of the Brotherhood of St. John (whose name he took) in Haar-

lem toward the end of his life; only about 15 pictures now accepted as his.

Collections: Amsterdam; Berlin; Cleveland; Leipzig; Leningrad; London; Milan: Ambrosiana; Paris; Prague; Rotterdam; Utrecht: Archbishop's Museum; Vienna.

Publications

On GEERTGEN: books—

Balet, Leo, *Der Frühholländer Geertgen,* The Hague, 1909.

Friedländer, Max J., *Die altniederländische Malerei, vol.5: Geertgen und Hieronymus Bosch,* Berlin, 1928; as *Geertgen and Jerome Bosch,* (notes by E. Lemmens), Leiden, 1969.

Kessler, J. H. H., *Geertgen,* Urecht, 1930.

Vogelsang, W., *Geertgen,* Amsterdam, 1942.

Síp, Jaromír, *Geertgen's The Adoration of the Magi,* London, 1963.

Boon, K. G., *Geertgen,* Amsterdam, 1967.

Chatelet, Albert, *Les Primitifs hollandais,* Fribourg, 1980; as *Early Dutch Painting,* New York, 1981.

Lane, Barbara G., *The Altar and the Altarpiece: Sacramental Themes in Early Netherlandish Painting,* New York, 1984.

article—

Snyder, James, "The Early Haarlem School of Painting II: Geertgen," in *Art Bulletin* (New York), 42, 1960.

*

All the facts of the life of Geertgen tot Sint Jans (Little Gerard of St. John) come to us from the 1604 chronicle by Karel van Mander, who described the lives of many Dutch artists, including Geertgen's. Evidently, he was a student of Albert van Ouwater (today known for only a single work) in Haarlem before entering the Brotherhood of St. John as a lay member.

Mander described two works of Geertgen's in Vienna, and from these two works his style has been determined and his corpus established.

The Vienna *Lamentation* is a work of considerable sophistication in composition. The main group at the front of the picture plane consists of mourners arranged in an inverted V over the horizontal figure of the dead Christ, with vertical elements at each end of the flattened triangle. In the left middle ground a group of soldiers is dismantling the crosses. Behind them to the right is a beautiful wooded landscape receding in a picturesque manner: there is a ruin on a hillock and a town or city beyond a lake or stream; the wood is formed of a variety of trees, and other single trees provide focal points. The mourning figures in the main group are in static poses; the women, especially those seen in three-quarter or half-profile, have the egg-shaped heads characteristic of Geertgen's work. All the faces are characterized, and they are all looking in a slightly difference direction. The instruments of the passion (crown of thorns, gigantic nails) are casually placed beside the dead Christ at the bottom edge of the picture.

The other Vienna picture, which with the *Lamentation* once formed part of a large altarpiece, is the *Burning of the Bones of St. John.* This represents the rescue of the relics of St. John, no doubt commissioned by the authorities of Geertgen's own order. The painting includes a number of portraits of members of the order, and the panel constitutes, according to the Viennese art historian Riegl, the earliest group portrait produced in the Low Countries. The composition of the picture is more complicated than that of the *Lamentation,* but a triangular arrangement at the front of the picture is noticeable, and Geertgen again uses a landscape background, with water, buildings, and single trees for accents.

Holy Kinship (Amsterdam) is probably his earliest picture. It is formal and symmetrical, but it also has a charm centering on the children playing in the church (though we know the children will be martyred). This double-edged use of detail is characteristic of Geertgen—representing the commonplace full of grave, even mystic significance.

Hugo van der Goes's influence is strong, especially on Geertgen's series of *Adoration of the Magi.* There are four of them, in Winterthur, Amsterdam, Cleveland, and Prague. The Prague version, the most complex and mature, is a finely composed work. Jesus sits upright on his mother's lap accepting the kiss of the oldest Magi. The ruined shelter, also used in Hugo's version, allows the background to be opened up to reveal a village and a stone-built town beyond the village. The village includes a camel, evidently part of a Magi's entourage, and a stream which reflects several figures; some horses also water themselves in the stream. The left panel includes a male donor and St. Bavo, with a donkey and a cow in the background; the right panel includes the female donor and St. Adrian, with a peacock and a fenced pool. All three panels have possibly been cut down (the central panel would probably have originally included the figure of Joseph). But the overall sense is of a carefully organized work, with a fusion of the concrete and the poetic, the robust and the restrained. Many of the details are unexpected but thoughtful.

Another painting which suggests Geertgen's mastery of landscape is St. John the Baptist in the Wilderness (Berlin). The painting is tiny ($16\frac{1}{2} \times 11$ inches), almost a miniature, but even in such a small work, Geertgen shows a skill in showing continuous space in a receding landscape not matched by any other Netherlandish artist. The "wilderness" (really a pleasant wood, behind which can be seen a solid-looking town) consists of a great variety of trees, some single ones, small shrubs, and a few animals. St. John, in a dark robe, bare-footed, with his face resting in the palm of one hand, strikes a dismal if moving note amid such surroundings. The *Christ as the Man of Sorrows* (Utrecht), on the other hand, has no background: the figures are all pushed forward in a flattened, three-layered plane, with Christ carrying the cross in the middle, three angels behind him, and three mourners in front of him. This strongly emotional work is not completely characteristic of Geertgen's work.

A delightful work in the National Gallery in London is the *Nativity.* Again, critics have noted the influence of Hugo van der Goes's *Portinari Altarpiece:* in both pictures light seems to radiate from the small figure of Christ. But Hugo's picture is not a "night" picture, and the main lighting anomaly is that the angel immediately above the Virgin is actually lit from below. In Geertgen's picture, Christ lies in a cradle and is the sole light source for the central scene—a supernatural radiance

emanating from this miracle; even the animals who are turned toward the child and are lit by this unearthly radiance look astonished. In the background, an angel above a group of shepherds also emanates an unearthly light, outshining the shepherds' own bonfire. A more notable similarity between the two paintings is that in both works the Virgin is not touching the child. In the Hugo altarpiece, Christ lies on the bare ground, and his mother kneels above him. In Geertgen's work, the child lies in a cradle, and the Virgin Mary sits regarding him with a serious and intense look—a simple composition full of mystery. The picture has been called a fitting prefiguration of some of the more moving works of Georges de La Tour.

—George Walsh

GENTILE da Fabriano.

Born Gentile di Nicolò di Massio in Fabriano c. 1385. Died in Rome before 14 October 1427. Recorded in Venice, 1408: worked in Doge's Palace and elsewhere; in Brescia (chapel for Pandolfo Malatesta, 1414–19), and in Fabriano, 1420; worked in Florence, 1420–25: entered guild, 1422 (*Adoration of the Magi* altarpiece, 1422–23); then in Siena and Orvieto, and in Rome, 1427. Pupil/assistant: Jacopo Bellini in Florence in mid-1420's.

Collections: Berlin; Cambridge, Massachusetts; Florence; Milan: Poldi-Pezzoli, Brera; New Haven; New York: Metropolitan, Frick; Orvieto: Cathedral; Paris; Perugia; Vatican; Velletri: Cathedral; Washington; Royal Collection.

Publications

On Gentile: books—

Colasanti, Arduino, *Gentile,* Bergamo, 1909.
Malojoli, Bruno, *Gentile,* Fabriano, 1927, 1934.
Grassi, Luigi, *Tutta la pittura di Gentile,* Milan, 1953.
Bellosi, Luciano, *Gentile,* Milan, 1966.
Micheletti, Emma, *L'opera completa di Gentile,* Milan, 1976.
Christiansen, Keith, *Gentile,* Ithaca, New York, 1982.

articles—

Davidson, Bernice, "Gentile's *Madonna and Child with Saints,*" in *Art News* (New York), 68, 1969.
Davidson, Bernice, "Tradition and Innovation: Gentile and Memling," in *Apollo* (London), 93, 1971.
Auld, Sylvia, "Kuficising Inscriptions in the Work of Gentile," in *Oriental Art* (Richmond, Surrey), Autumn 1986.

*

Gentile da Fabriano's artistic reputation was established in contemporary accounts by Bartolomeo Fazio (*De viris illustribus,* 1455–56) who praised his powers of expression and the truthfulness of his portraits; Giovanni Santi (Raphael's father) put him at the head of a list of the most eminent painters of the century, and he was discussed in the company of the greatest artists of his day, Brunelleschi and Ghiberti. However, with time and the vissicitudes of taste his reputation has suffered; it has only been in recent years that his revolutionary contribution to the development of naturalism in early 15th-century painting has been fully explored. While closely identified with the International Gothic Style, Gentile's Florentine work introduced a fundamental change in the direction of painting "because it expounds a new relation between painting and experience" (Christiansen, 1982).

Gentile's early training and career are undocumented. However, the group of works associated with the period before his move to Venice (where he is recorded in 1408), which includes the *Virgin and Child with Saints and a donor* (Berlin) and the *Valle Romita* polyptych (Milan, Brera), illustrate a familiarity with Lombard painting, in particular with manuscript illuminations, as well as with 14th-century Sienese painting. These display all the characteristics of the courtly, ornate, and precious styles current in northern Italy: the tooling of the gold ground, the sinuous contours of the draperies, and the precise attention to the details of nature and musical instruments held by the angels. Probably to be dated in this period are the two *Virgin and Child with Angels* compositions (Perugia and New York) in which the Virgin is seated on a throne overgrown with box hedge and flora, combining the image of the Virgin as the Madonna of Humility and the Madonna in Majesty, reflecting Lombard iconographic traditions.

A startling and consistent attention to a single and defined light source is illustrated in the *St. Francis Receiving the Stigmata* (private collection), which probably originally decorated one side of a standard on whose reverse was the *Coronation of the Virgin*. Here the light cast from the image of Christ in an aureole of red seraphim is reflected on the crags of the mountain, blinding St. Francis's companion and illuminating the sturdy figure of the saint. Following Cennino Cennini's recommendation that gold foil is used to depict light, the painted surfaces are given a heightened brilliance by their gold base.

Gentile's fame in Venice rests principally on the destroyed frescoes he executed for the Sala del Maggior Consiglio in the Doge's Palace depicting the *Naval Battle Between Otto III and the Venetians*. The importance of this commission suggests that by this date (1409) he was held in high regard in that city. It is evident that Gentile's work left its impression on Venetian art; indeed, Jacopo Bellini followed him as a pupil to Florence.

Documents record Gentile's activity in Brescia from 1414 to 1419 working on a painted chapel in the Broletto for Pandolfo III Malatesta; again no record of its appearance remains. Before his arrival in Florence, he was itinerant, working in Rome, Fabriano and Siena although the works of this period cannot be clearly identified.

By 1422 he was in Florence where he was commissioned to paint his most sumptuous, assured, and inventive work, the *Adoration of the Magi* (Florence, Uffizi), finished for Palla Strozzi by 1423. In this work Gentile demonstrates his great powers of invention and meticulous attention to details of costume, composition, and light. Painted as a continuous narrative which appears to occupy a single landscape, the procession of the Magi and their courtly retinue winds its way

The *Quaratesi Altarpiece* (panels in London, Florence, Vatican, and Washington) shows a greater awareness of Sienese painting and was certainly influential for the development of Sassetta's style as well as for Florentine painters such as Fra Angelico. (His lost altarpiece for the Piazza del Campo in Siena must also have provided new impulse for Sienese painting.) The elegant Madonna is seated before a brocade cloth of honour, drawn around her by angels. She is flanked by four saints who appear to occupy the same continuous arched space. The colour of their robes is confined to deep maroon, brown, and red, and the embroidered scenes from the life of Christ on St. Nicholas of Bari's cope are dazzling. More innovative, however, are the predella panels illustrating scenes from the Life of St. Nicholas; these prompted particular praise from Vasari. The clarity of these scenes and the vivacity and solidity of the figures show Gentile had graduated from the overtly decorative style of his earlier works. Moreover, details such as the three boys resuscitated by St. Nicholas demonstrate his debt to Masaccio—the modelling of these figures sets them along-side the figures in Masaccio's *Baptism of the Neophytes.*

The clearly drawn and modelled figures in his Frick *Madonna and Child* pre-figure the pronounced modelling of the figures and spatial unity in Fra Angelico's compositions of some 20 years later. In this work the vivacious expression of the Child is unusual, anticipating the mischievous standing Child in Orvieto who pulls at the crooked finger of his mother's outstretched hand, balancing himself as though in danger of collapse. Such delightful and humorous details suggest a full command of painterly and imaginative capabilities.

Gentile received payment for the lost frescoes on the nave arcade for St. John Lateran in Rome between January and July of 1427. The only visual document of the frescoes is a drawing (Berlin) by an assistant in Borromini's studio made prior to their destruction to make way for the baroque redecoration of the basilica. Fazio praised Gentile for these works which were "represented in such a way as to appear not painted, but portrayed in marble: Gentile is considered to have outdone himself in this work, almost as if he foresaw his death." The series of narrative scenes were continued by Pisanello.

Though he is known today only by his panel paintings, it was nevertheless in several fresco decorations that Gentile was given the opportunity to display his compositional and inventive skills on a broader scale. The loss to our full understanding of his oeuvre, considered in his day as one of the most preeminent, is necessarily all the greater.

—Antonia Boström

Madonna and Child with Angels, 1425; panel; $55\frac{1}{2} \times 32\frac{1}{2}$ in (140.4 × 82 cm); Royal Collection

to the new-born Christ. Revolutionary for its consistent and unified light source, the work nevertheless retains the brilliance of the International Gothic style and is impressive (as would have been its intention) in its sumptuous use of gold for the applied decoration and horses' tackle, and in the rich brocades. The painting demonstrates also that Gentile was aware of current developments in the paintings of Masaccio and Masolino and in the sculpture of Donatello.

GENTILESCHI, Artemisia.
Born in Rome, 8 July 1593; daughter of the painter Orazio Gentileschi. Died in Naples, c. 1652. Married Pietro Antonio di Vicenzo Stiattesi, 1612; at least one daughter. Trained by her father; studied perspective with Agostino Tassi in Rome (he was imprisoned in 1612 for raping her); after her marriage, lived in Florence to c. 1620 and attended the Academy of Design, 1616; then, often with her father, worked in Genoa, and settled in Naples, 1630; trip to England, 1638–40, where she collaborated with her father on a series of canvases for the

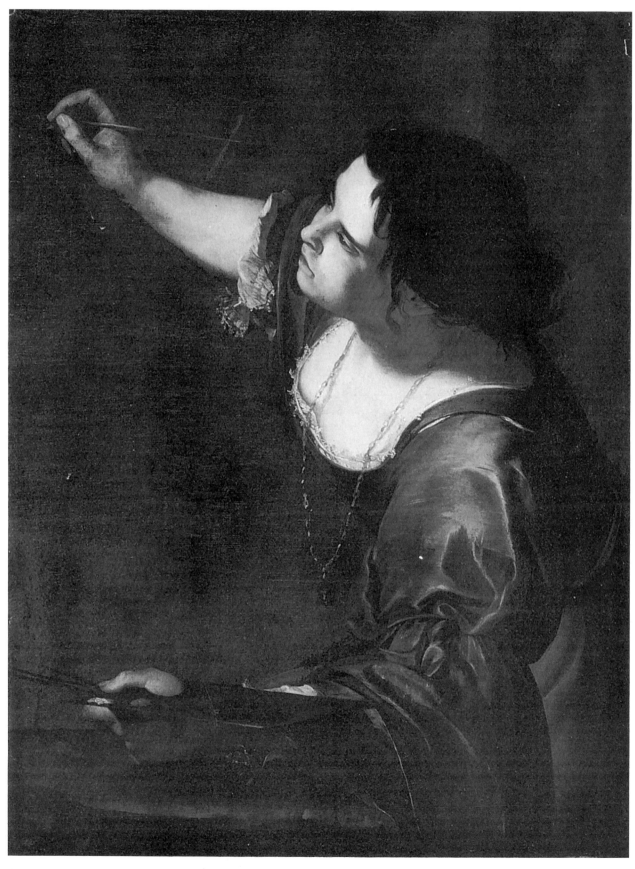

Self-Portrait; 38 × 29 in (96.5 × 73.7 cm); Royal Collection

Queen's House, Greenwich (now in Marlborough House, London).

Collections: Berlin; Bologna; Cambridge, Massachusetts; Columbus, Ohio; Detroit; El Paso, Texas; Florence: Pitti, Uffizi, Casa Buonarroti; Hampton Court; London: Marlborough House; Madrid; Naples; New York; Pozzuoli: Cathedral; Rome: Galleria Nazionale; Windsor Castle.

Publications

On GENTILESCHI: books—

Moir, Alfred, *The Italian Followers of Caravaggio*, Cambridge, Massachusetts, 2 vols., 1967.
Garrard, Mary D., *Gentileschi: The Image of the Female Hero in Italian Baroque Art*, Princeton, 1989.

articles—

Bissell, R. Ward, "Gentileschi: A New Documented Chronology," in *Art Bulletin* (New York), 1968.
Longhi, Roberti, "Gentileschi padre e figlia," in *Scritti giovanili 1912-1922*, Florence, vol. 1, 1961.

*

The 16th and 17th centuries in Italy saw the emergence of an increasing number of accomplished female artists, who were often members of artistic families—e.g., Sofonisba Anguissola, Lavinia Fontana, Giustina Fetti, and Elisabetta Sirani. The outstanding talent among them was Orazio Gentileschi's daughter, Artemisia.

Our perception of Artemisia has been colored by the legend surrounding her. Her alleged rape by her father's colleague, the "quadratura" painter Agostino Tassi, when she was 17, was the subject of a protracted legal action brought by Orazio (1611) and although she was subsequently "married off" (1612), she soon separated from her husband and led a strikingly independent life for a woman of her time—even if there is no firm evidence for the reputation she enjoyed in the 18th century as a sexual libertine. Yet is is tempting to adduce the established biographical data in partial explanation of the contexture of her art: the sympathy and vigour with which she evokes her heroines and their predicaments, and her obsession with that paradigmatic tale of female triumph, Judith and Holofernes. But such possibilities should not distract attention from the high professional standards which Artemisia brought to her art. In a letter, dated 3 July 1612, to the Grand Duchess of Tuscany, Orazio claimed that "Artemisia, having turned herself to the profession of painting, has in three years so reached the point that I can venture to say that today she has no peer." And despite the obvious exaggeration, one can agree that Artemisia's art was of a consistently high quality virtually from the beginning.

Her earliest surviving work may be a tender *Madonna and Child* of c. 1609 in the Spada Gallery, Rome. But two other pictures give a clearer idea of her consummate early style: *Judith and Her Maidservant with the Head of Holofernes* in the Pitti Palace, which could be a picture referred to in the transcript of the Tassi rape trial, and a *Susanna and the Elders* (Pommersfelden, Schloss Weissenstein) dated 1610. Both pictures owe a good deal (in their crisp compositions, attractive physiognomies, and sparkling costumes) to Orazio, who might have contributed to both their design and execution. They are also, in their focussed realism, obviously works of the Caravaggist school—especially the former, with its bold *chiaroscuro*. But they introduce us to some distinctive traits of Artemisia's own: in the *Judith* a greater freedom of brushwork than that of her father (at this stage not yet an altogether positive quality) and in both cases a certain authenticity of emotion (in the alert stare of Judith, for example; or the brilliantly evoked sense of violation conveyed by the defensive gesture and startled gaze of Susanna).

While Artemisia's style during her Florentine and Roman years (1610's and 1620's) was a development of the idiom adumbrated by her father, her own vigorous sense of drama (more akin to that of Caravaggio than Orazio) lends most of the works a distinctive, cutting edge. Her characterizations of her heroines (and nearly all of her pictures have female leads) are emotional without being sentimental. She is highly observant of both psychology and action and has a keen eye too for the natural disposition of flesh. Her sustained achievement can be seen in a series of masterpieces which includes the two versions of *Judith slaying Holofernes; The Penitent Magdalen*, Florence, Pitti Palace, c.1617–20; the powerful *Lucretia* of c. 1621 from the Palazzo Cattaneo-Adorno, Genoa; and *Judith and Her Maidservant with the head of Holofernes* (Detroit, c. 1625). These works are also distinguished by an opulent drapery style, with spirited highlights, that must have gone down well at the sartorially conscious Medicean court, where Artemisia enjoyed the high patronage of Duke Cosimo II.

The Detroit *Judith and her Maidservant*, which is a candle-lit night scene, also breaks new ground for Artemisia in its thorough exploration of the effects of light radiating from an internal source. It was probably influenced by the fashionable candle-lit scenes of Honthorst executed in Rome in the late 1610's and well-known in Florence. But her employment of the flickering illumination is, as Spear has noted, predictably bolder than Honthorst's. Indeed this picture, like another of the very few of her works which have survived from the 1620's (a second *Susanna and the Elders*, Burghley House, Northamptonshire), is redolent of the spirit of the emergent High Baroque. Painterly and sensuous handling, flow of action, theatrical deployment of light and gesture, and judicious selection of dramatic moment combine to effect a riveting illusion. In such pictures Artemisia may be said to have played her part in the formulation of the new idiom, rather than merely imitating what others had initiated. The Burghley House *Susanna*, in particular, reveals her empathetic originality, since it parallels without, in any way being dependent upon, the early style of Guercino.

If the 1620's represent the high watermark of Artemisia's achievement, her subsequent career, spent mostly in Naples, succumbed to a fragmentation of purpose. While retaining, on occasions, much of the vigour of her mature style (*Self-Portrait as the Allegory of Painting*, London, Kensington Palace), she grew increasingly attracted to the idealizations both of the Bolognese and, after her visit to England, c. 1638–40, of her father's late style. The former can be discerned in the

poses and figure types of such works as the Capodimonte *An-nunciation* of 1630; while the powerful impact of the latter is evident in the wholesale translation of the elongated, mannered figures of Orazio's Castle Howard *Finding of Moses* (c. 1633) into her own elegantly artificial *Bathsheba* (late 1640's, Potsdam, Neues Palast).

Artemisia's influence on her contemporaries is still in need of detailed assessment. But it is clear that she greatly stimulated the imagination of Guerrieri in Florence (so much so that some of their works have been confused) and of Vouet in Rome, and her contribution to the development of the Neapolitan school, particularly through her impact on Stanzione and Cavallino, was arguably profound.

—John Gash

GENTILESCHI, Orazio.

Born in Pisa, baptized as Orazio di Giovanni Battista Lomi, 9 July 1563; son of a goldsmith. Died in London, c. 1639–40. Married Prudentia Montoni; daughter, the painter Artemisia Gentileschi. In Rome by 1576 or 1578, and established there: worked in the Vatican; then worked in Genoa, 1621–24, possibly including a visit to Turin (some work for Charles Emanuel of Savoy): in Paris (worked for Marie de' Medici), c. 1624–25; court painter to Charles I in England from 1626: painted the ceiling for the Queen's House, Greenwich (now in Marlborough House, London).

Collections: Berlin; Birmingham; Detroit; Dublin; Hartford, Connecticut; London: Marlborough House; Madrid; Milan; Paris; Prague; Rome: Corsini, Spada, Casino of the Nine Muses; Turin: Museo Civico, Sabauda; Vienna; Washington.

Publications

On GENTILESCHI: books—

Rosci, Marco, *Gentileschi,* Milan, 1965.

Bissell, R. Ward, *Gentileschi and the Poetic Tradition in Caravaggesque Painting,* University Park, Pennsylvania, 1981.

Schleier, Erich, et al., *The Age of Caravaggio* (cat), New York, 1985.

articles—

Emiliani, Andrea, "Gentileschi: Nuove proposte per il viaggio marchigiano," in *Paragone* (Florence), 9, 1958.

Sterling, Charles, "Gentileschi in France," in *Burlington Magazine* (London), 100, 1958.

Schleier, Erich, "Panico, Gentileschi, and Lanfranco at San Salvatore in Farnese," in *Art Bulletin* (New York), 52, 1970.

*

Gentileschi is usually thought of as the foremost Italian fol-

lower of Caravaggio. But the critic Giulio Mancini (c. 1620) included him in his group of those artists who "have worked in their own individual and personal manners." The truth lies somewhere in between.

Gentileschi, who was older than Caravaggio, hailed from a Pisan family of goldsmiths. His paintings would always reflect the precision and grace of the metalworker's art, as well as a pronounced Tuscan elegance of design. He was well-established as a fresco painter in Rome in the 1580's and 1590's, contributing to some important fresco cycles in the Vatican (c. 1588–89), and St. John Lateran (c.1600). His emergence as an independent master is evident in the decidedly Mannerist altarpiece of *The Conversion of Saul* (c. 1596, St. Paul Outside the Walls) which, although later destroyed by fire, is known in an etching by Callot. Nevertheless, Gentileschi was already demonstrating a more naturalistic bent before he came into contact with Caravaggio's mature art, c. 1600, as is shown by a group of paintings done for the Abbey of Farfa, near Rome, c. 1598–99.

Orazio was a close friend of Caravaggio by the time of the Baglione libel trial of 1603, at which he was accused, together with Caravaggio and Onorio Longhi, of writing satirical verses against the painter Baglione. Perhaps the most telling piece of information regarding Gentileschi to emerge from the trial transcript was the news that he had lent Caravaggio a pair of wings and a Capuchin's frock to dress his models. This evidence underscores a new-found passion for studio realism, which is apparent in such very early Gentileschi paintings of the new century as the two versions of *St. Francis Supported by an Angel* (Rome, Palazzo Corsini, and Madrid, Prado). We know that Orazio employed his barber as a model on several occasions and once (in 1611) got an old man of 72 to pose, stripped to the waist, for a *St. Jerome*. Indeed, several of Gentileschi's works done in the first decade are so closely dependent on the model that the figures look stiff and posed, especially in scenes of action (*St. Michael Overcoming the Devil,* Farnese, San Salvatore, and *David Slaying Goliath,* Dublin—both c. 1605–08). This frozen quality, which was explicitly noted by critics in Caravaggio's paintings, was one of the potential pitfalls of the new studio practice of working direct from models onto the canvas.

Gentileschi established a fruitful dialogue with Caravaggio's art in other ways too. He was more attracted by the lyrical, light-colored realism of Caravaggio's earlier works (such as *The Rest on the Flight into Egypt, The Penitent Magdalen,* and *The Lute Player*) than the bold *chiaroscuro* and melodramatic poses of some of the master's mature religious pictures. And when he does use a Caravaggesque *chiaroscuro* to enhance the spirituality and drama of a scene (especially in works, c. 1610–15, such as the Hartford, Connecticut, *Judith and Her Maidservant,* the Detroit *St. Cecilia* and the Washington *Luteplayer*—the latter also distinctly Caravaggesque in its deployment of a beam of "cellar lighting") he does not let the shadows mask the rich colors. Caravaggio-inspired too was Gentileschi's bold geometry of poses and groups and, very often, his choice of subjects (e.g., *Judith and Holofernes; The Luteplayer; The Stigmatization of St. Francis; St. Jerome; David and Goliath; The Penitent Magdalen;* and *The Rest on the Flight into Egypt*).

Such enthusiasms, however, were circumscribed by factors of personality and training. Gentileschi's conception of drama

was more restrained and pensive, less violent than Caravaggio's, while his refined Tuscan sensibility made him a devotee of decorative detail—whether of costume, jewellery, or finely wrought hair. Roberto Longhi called him "the most marvellous tailor and weaver who ever worked among painters." This penchant for prettiness is equally evident in his un-Caravaggio-like fascination with female beauty.

Gentileschi also worked on commissions, in media, and in styles quite different from Caravaggio. His career as a decorative ceiling painter blossomed with the frescoed ceiling of the Casino of the Muses (Rome, Palazzo Rospigliosi-Pallavicini, 1611–12) and bore fruit with a number of commissions during the English years. He also painted on both wood and copper as well as canvas (in contrast to Caravaggio's virtually exclusive preference for the last). Some of Gentileschi's most affecting works are beautiful, small, Elsheimer-inspired, copper panels of figures in landscape (e.g., *St. Christopher,* Berlin-Dahlem).

Gentileschi's Tuscan affiliations were always a factor in the equation. In the years around 1600 his development of a more gentle, less doctrinaire realism than Caravaggio's may owe something to the recent innovations of the Florentine reformers, Cigoli and Santi di Tito, and he became increasingly aware during visits to Tuscany and the Marches during the second decade of the century of an even older Florentine tradition stretching back to Botticelli and Baldovinetti. His absorption of Quattrocento canons of color, idealization, and stylization culminates in the two versions of *The Annunciation* which he executed in Genoa, c. 1623 (Genoa, S. Siro, and Turin, Sabauda—the latter painted for the court of Savoy). Gentileschi's subsequent propulsion into a court environment (first with Marie de Medici in Paris and then Charles I in London) cemented his drift towards a style of surface polish and decorative beauty. Affected no doubt by the presence in England of van Dyck, as well as by the fashions, etiquette, masques, and poetry of the Stuart court, Gentileschi's late masterpieces, such as *The Finding of Moses* (Prado, c. 1629–30) and *Joseph and Potiphar's Wife* (Hampton Court, c. 1632), speak a more enchanted and rarefied (though still powerful) language.

Gentileschi's impact on European art was piecemeal and sporadic rather than volcanic. In Italy he played a small part in shaping the Caravaggism of Saraceni and Manfredi, while being a more fundamental guide for such second-generation Tuscan Caravaggists as Cavarozzi, Guerrieri, and Riminaldi. Abroad, some of the most original and technically accomplished artists of the age (Terbrugghen; the Le Nain brothers) responded perceptively if selectively to the beauty of his color, costumes, and landscape backgrounds.

—John Gash

GÉRICAULT, (Jean Louis André) Théodore.

Born in Rouen, 26 September 1791; grew up in Paris. Died in Paris, 26 January 1824. Attended Collège Louis-le-Grand, Paris; pupil of Carle Vernet, 1808–10, and Pierre-Narcisse Guérin (with Delacroix), from 1810; influenced by Gros; visited Italy, 1816–17, and England, 1820–22; friend of the psychologist Georget (who dealt with the insane), and painted portraits of the insane; relatively few works (often horses); also did lithographs; influential on Delacroix.

Collections: Alençon; Baltimore: Walters; Bayonne; Brussels: Modern Art Museum; Buffalo; Cambridge, Massachusetts; Chalon-sur-Saone; Chicago; Detroit; Ghent; Hartford, Connecticut; London; Lyons; Montpellier; Munich; Providence; Richmond, Virginia; Springfield, Massachusetts; Stockholm; Washington; Zurich.

Publications

On GÉRICAULT: books—

Clement, Charles, *Géricault: Etude biographe et critique, avec catalogue raisonné de l'oeuvre du maître,* Paris, 1867, 1879; catalogue edited and supplemented by Lorenz Eitner, Paris, 1973.

Rosenthal, Leon, *Géricault,* Paris, 1905.

Delteil, Loys, *Le Peintre-gravure 18: Géricault,* Paris, 1924.

Régamey, Raymond, *Géricault,* Paris, 1926.

Oprescu, Georges, *Géricault,* Paris, 1927.

Gauthier, Maximilien, *Géricault,* Paris, 1935.

Berger, Klaus, *Géricault: Drawings and Watercolors,* New York, 1946.

Courthion, Pierre, *Géricault raconté par lui-même et par ses amis,* Geneva, 1947.

Berger, Klaus, *Géricault und sein Werk,* Vienna, 1952; as *Géricault and His Work,* Lawrence, Kansas, 1955.

Aimé-Azam, Denise, *Mazeppa: Géricault et son temps,* Paris, 1956.

Géricault (cat), Winterthur, 1956.

Eitner, Lorenz, *Géricault: An Album of Drawings in the Art Institute of Chicago,* Chicago, 1960.

Guercio, Antonio del, *Géricault,* Milan, 1963.

Dubaut, Pierre, *Géricault* (cat), Paris, 1964.

Berger, Klaus, *Géricault,* Paris, 1968.

Aimé-Azam, Denise, *La Passion de Géricault,* Paris, 1970.

Eitner, Lorenz, *Géricault's Raft of the Medusa,* London, 1972.

Grunchec, Philippe, *Tour l'oeuvre peint de Géricault,* Paris, 1978.

Thuillier, Jacques, *L'opera completa di Géricault,* Milan, 1978.

Grunchec, Philippe, *Géricault* (cat), Rome, 1979.

Géricault: Tout l'oeuvre gravé et pièces en rapport (cat), Rouen, 1981.

Eitner, Lorenz, *Géricault: His Life and Work,* Ithaca, New York, and London, 1982.

Grunchec, Philippe, *Géricault: Dessins et aquarelles de chevaux,* Lausanne, 1982; as *Géricault's Horses: Drawings and Watercolours,* London, 1984.

Aimé-Azam, Denise, *Géricault: L'Enigme du peintre de la Méduse,* Paris, 1983.

Grunchec, Philippe, *Master Drawings by Géricault* (cat), Washington, 1985.

Mameluke Defending a Wounded Trumpeter, 1818; lithograph

article—

Szczepinska-Tramer, J., "Notes on Géricault's Early Chronology," in *Master Drawings* (New York), 1982.

*

Throughout his all-too-brief career as a painter—there is only a span of 12 years between the date of his first exhibited oil and his death in 1824—Géricault displayed to an extraordinary degree the ability to study and absorb the works of a broad range of past masters, transforming his lessons into intensely individual and original works of art. There is little evidence, however, that Géricault's first two teachers, Carle Vernet and Pierre-Narcisse Guérin, exerted any influence on the young artist. With the exhibition of the *Charging Chasseur* (Paris, Louvre) at the salon of 1812, it is apparent that new sources have been tapped with precocious success: the full-throated virility of the subject, the high coloration, and the active brushstrokes all indicate a study of Baroque art (Rubens especially) and Baron Gros, then at the height of his popularity. In the short years that foliow, no works live up to the promise of the *Chasseur*. A pendant, *Wounded Cuirassier* (Paris, Louvre), was exhibited at the salon of 1814, but the militaristic exuberance of the earlier picture has given way to a graceless and unresolved image. Desultory studies of military and mythological subjects—usually scenes of elemental conflict—continue for several years. In 1816, partly to break a turbulent love affair, Géricault left for Italy to study antiquities and the Italian masters. A sketchbook of the trip in the Kunsthaus, Zurich, indicates an artist full of curiosity, noting scenes of street and village life next to copies of paintings by Raphael and Baroque artists. Géricault's finest work done during the sojourn are the numerous paintings and studies of the Barberi Races which combine a classical economy of gesture and composition with the will to portray modern life.

Géricault returned to Paris in 1817 and, after a period of some lassitude, documented by that icon of the despondent romantic artist, *Portrait of a Young Man in a Studio* (1818; Paris; Louvre), he began to work on a monumental painting commemorating the scandalous shipwreck of the *Medusa* and the abandonment of its crew that had occurred off the coast of Senegal in 1816. The result of over a year of intense work, *The Raft of the Medusa* (1819; Paris, Louvre) was monumental in scale and shocking in content, and clearly meant to portray, with its echoes of past masters (Michelangelo and Rubens) and its often grisly attachment to realistic detail, a modern tragic subject cast in heroic form. Critical reaction was mixed. Disappointed with its reception, and in a turbulent frame of mind, Géricault left in 1820 for London to exhibit the painting, eventually to great success. While in England he turned to the depiction of everyday life, culminating in a suite of lithographs, *Various Subjects Drawn from Life and on Stone* (London, 1821). The English school of genre and equestrian painting greatly influenced the artist. Géricault returned to Paris in late 1822, ill and despondent, but he continued to paint "English" subjects of postilions, horse races, and genre scenes. His last major works were portraits of inmates of an insane asylum, done with both withering objectivity and compassion.

—Lynn R. Matteson

GÉRÔME, Jean Léon.

Born in Vesoul, 11 May 1824. Died in Paris, 10 January 1904. Married Marie Goupil, 1863; one son, three daughters. Attended schools in Vesoul; in Paul Delaroche's studio, Paris, 1839–44, and spent a year in Rome with Delaroche, 1844–45; studied with Charles Gleyre, 1845; exhibited in Salon, 1847: praised by Gautier: private commissions, as well as public recognition: worked on restoration of S. Martin refectory, murals for S. Jérôme chapel in S. Severin, 1852; professor at Ecole des Beaux-Arts, from 1863; also a sculptor. Pupils: Eakins, Leger.

Major Collection: Baltimore: Walters.
Other Collections: Boston; Dayton, Ohio; Lawrence, Kansas; London: Wallace; New Haven; Paris: d'Orsay; Phoenix, Arizona; Ponce, Puerto Rico; Princeton; Rochester: University; San Francisco; Sheffield; Toronto; Versailles: Chateau.

Publications

On GEROME: books—

Moreau-Vauthier, Charles, *Gérôme, peintre et sculpteur, l'homme et l'artiste,* Paris, 1906.
Isaacson, Robert, *Gérôme and His Pupils* (cat), Poughkeepsie, New York, 1967.
Ackerman, Gerald M., and Richard Ettinghausen, *Gérôme* (cat), Dayton, Ohio, 1972.
Rameau, H., *Regards sur Gérôme,* Vesoul, 1978.
Cugnier, Gilles, *Gérôme, peintre, sculpteur, et graveur* (cat), Vesoul, 1981.
Weinberg, H. Barbara, *The American Pupils of Gérôme,* Fort Worth, 1984.
Ackerman, Gerald M., *The Life and Work of Gérôme, with a Catalogue Raisonné,* London, 1986.

articles—

Boime, Albert, "Gérôme, Henri Rousseau's *Sleeping Gypsy,* and the Academic Legacy," in *Art Quarterly* (Detroit), 34, 1971.
Said, Edward, "Gérôme's Oriental Paintings and the Western Genre Tradition," in *Arts Magazine* (New York), March 1986.

*

Gérôme's career lasted too long for the good of his reputation. His greatest period as a painter, from 1850 to 1880, parallels the career of Courbet, but his old age overlaps those of Manet and the Impressionists. The objectivity, the precisely seen anatomy, technical perfection, and perfect surfaces prized in his works in the 1850's had lost their appeal by the 1880's when spontaneity, *spezzatura*, and a bold facture were in fashion.

The masterful, impersonal facture is a lifelong trait of his painting, consistent through several changes of the style. His first popular works were in the witty Néo-Grec style, a humorous neo-classicism that made fun of idealistic painting by

setting genre scenes in antiquity. He defined the style of the Salon of 1847 with his first success, *The Cock Fight* (Paris, d'Orsay), which showed a nude Greek boy and girl watching two gaming cocks flying at each other.

The exquisitely painted Néo-Grec scenes such as the *King Candaules* (1859; Ponce, Puerto Rico) were gradually replaced by more serious histories, usually placed in antiquity, that were based on realist principles: they were non-heroic and non-idealistic in their presentation of the "facts" of an ancient event. Gladiators were shown not as glamorous athletes, but as brutal and wily survivors in *Pollice Verso*, (1872; Phoenix); and the assassinated Julius Caesar is simply a corpse abandoned on the Senate floor in *The Death of Caesar*, (1868; Baltimore, Walters). Gérôme used all the techniques of the academic tradition (perspective, anatomy, expression, archeological research, chiaroscuro, and so on) to recreate convincing figures in accurate settings, "as if he had been present," producing an objective Academic realism that for a while rivaled optical realism in popularity.

Like many of his contemporaries, Gérôme was an avid traveler and hunter. In the late 1850's he spent six months in Egypt, some of the time in Cairo, some on a boat on the Nile. This was the first of many extended stays in the Near East. In 1859 he exhibited five oriental subjects based upon sketches and studies made in Egypt. Thenceforth, fully half his production was of oriental subjects. It is odd to note that none of the famous histories that define his style for the public are concerned with the Near East.

His oriental works are like exercises in precise realist observation. He prided himself on correctness of costuming and accurate depictions of ethnic types; in fact, he was called an "ethnographic painter" before the term "Orientalist" caught on.

Gérôme was not adventurous in picking subjects to paint. One can find most of his oriental subjects in Dutch 17th-century genre: street life, merchants, cafe life, dancing, singing, game playing, pipe smoking, household and garden tasks. Very few seem inspired by a revealing insights into the Near Eastern life. The main difference between his genre scenes and traditional ones was the lack of moralizing about their activities, except as a reflection on the ways of the West; for instance, an undaunted anti-cleric himself, he admired the simple, direct piety of the Muslims; he often depicted them at prayer. Nonetheless, it is now fashionable to condemn his oriental scenes as examples of western imperialism.

Gérôme's *Arabs Crossing the Desert* (1870; private collection) demonstrates his virtues and his proclivities: a strong yet delicate composer, a great draughtsman, a brilliant colorist, a master of oil techniques, and a love for the masculine atmosphere of the Islamic Near East. Despite heat, aridity, wind, sandstorms, and endless spaces, the Arabs move stalwartly—in a wondrous rhythm of limbs—across the stone-cluttered sands. On horseback or on foot they think neither of the distance they must cover nor of their goal: their steadfastness makes them symbols of their acceptance of fate, and—by contrast—of the refusal of Western man to recognize his own.

In his own time, his standards of accuracy, preparation, thought, and technical finish were so high that he gradually became isolated from both his contemporaries and artists of the past, and he, a drawing master for over 40 years, frequently attacked the newer painting that seemed to ignore the rules of drawing, particularly that of Manet and the Impressionists. He was better at publicity than at politics, for although his tirades always got into print, they had little effect on public taste or governmental policy. Nonetheless, he became a symbol of academic opposition to the avant-garde, and was described as a pompous, insincere painter. This characterization has become sacroscrant for most modern critics, but the public—fatigued by repeated scholastic attempts to define a "correct" avant garde—has come to regard his works with favor. Gérôme's reputation is in a similar position to that of Ingres's in the 1950's, when an undercurrent of popular appreciation was building up that eventually forced the critics to take him seriously. Furthermore Gérôme has become a hero and a model for many young figure painters who feel isolated because of the contemporary emphasis upon subjectivism and abstraction.

Gérôme noticed and caught the effect of light in a room, on a figure, on a fabric, in dark corners, under a chair with the affection of a Dutch master of the 17th century. His placement of figures in a scene is impeccable; alone or in groups they always command the space and atmosphere around them. His accessories, although finely detailed, always behave: they never detract from the composition. His mastery of the human figure is uncontested, but its depth is seldom appreciated. Each figure is seen as a living individual with bones, muscles, cartilage, blood, and a brain. His figures always have what artists call *snap*: a sense of organic unity that extends from the top of the head to the tips of the fingers and toes. Like certain Dutch or Italian masters he can be considered a "master of joints": his drawing of wrists and fingers, ankles and necks is formidable. And no one in the century can show the full presence of a body under a blouse or of an arm under a sleeve better than he can. And throughout his works there is an apparent love of painting: a love of oils, and a pride in his skill with them.

—Gerald M. Ackerman

GHIBERTI, Lorenzo (di Cione di Ser Buonaccorso).
Born c. 1378. Died near Florence, 1 December 1455. Married Marsilia di Bartolomeo di Luca; sons, the artists Tommaso and Vittorio. Trained in the workshop of his stepfather, Bartoluccio; worked in Florence as goldsmith and painter; won competition to make the bronze Baptistery door, 1402: the rest of his life was devoted to the doors (second commission, 1425), using a large workshop (including Donatello, Masolino, and Uccello); other works for Orsanmichele, font of Baptistery in Siena, model of Florence Cathedral dome (built by Brunelleschi), and stained-glass window designs; two trips to Rome; also worked in precious metals (no surviving works).

Collections: Florence: Baptistery, Bargello, Orsanmichele, Cathedral, S. Croce, S. Egidio, S. Maria Novella; Siena: Baptistery.

Publications

By GHIBERTI: book—

I commentari, edited by Julius von Schlosser, Berlin, 2 vols., 1912; edited by Ottavio Morisani, Naples, 1947.

On GHIBERTI: books—

Gollob, Hedwig, *Ghibertis künstlerischer Werdegang*, Strasbourg, 1929.
Planiscig, Leo, *Ghiberti*, Vienna, 1940, Florence, 1949.
Schlosser, Julius von, *Leben und Meinungen des florentinischen Bildners Ghiberti*, Basel, 1941.
Goldscheider, Ludwig, *Ghiberti*, London, 1949.
Poggi, G., *La porta del paradiso di Ghiberti*, Florence, 1949.
Krautheimer, Richard, and Trude Krautheimer-Hess, *Ghiberti*, Princeton, 1956, 1970.
Krautheimer, Richard, *Ghiberti's Bronze Door*, Princeton, 1971.
Krautheimer, Richard, et al., *Ghiberti* (cat), Florence, 1978.
Bellini, Fiora, *I disegni antichi degli Uffizi i tempi del Ghiberti* (cat), Florence, 1978.
Marchini, Giuseppe, *Ghiberti architetto*, Florence, 1978.
Rosito, Massimiliano, editor, *Ghiberti e la sua arte nella Firenze del '3-'400*, Florence, 1979.
Ghiberti nel suo tempo (colloquium), Florence, 2 vols., 1980.
Euler-Künsemüller, Sabine, *Bildgestalt und Erzählung: Zum frühen Reliefwerk Ghibertis*, Frankfurt, 1980.

*

Although neither date nor place is certain, Ghiberti was born about 1480 in or near Florence where he was raised and trained as a goldsmith by his stepfather, Bartoluccio. After a remarkably successful and productive life he retired in 1447 to his estate at San Giuliano a Settimo, leaving his son Vittorio in charge of his workshop. At San Giuliano he soon began writing his *Commentari* which was unfinished when he died in 1455. He is buried in the Florentine Church of S. Croce.

The *Commentari* is divided into three books; the first, on Greek and Roman art, sets forth antiquity as the ideal for the artist. The second, the most significant, is a history of Tuscan art from Giotto to Ghiberti himself. Rather than being anecdotal, his focus is directed towards works of art which are analyzed and appreciated for their formal and stylistic qualities; in short, it is the first history of modern art. Sienese art of the trecento, especially that of Ambrogio Lorenzetti, not only elicited great praise in his writing; it had provided a source of inspiration in his work, a source from which he had gladly drawn. His attention, however, was not centered only on Tuscany, for he expressed admiration of the Rhenish Master Gusmin whose International Gothic work he had seen in cast copies. Book III, unfinished at his death, is a curious assortment of materials on anatomy, proportion, and, significantly, optics. These are derived from medieval sources and interestingly suggest the kind of learning recommended for a sculptor by Alberti.

In his own biography, Ghiberti tells us he learned of the competition sponsored by the guild in charge of the fabric of the Florentine baptistry, the Arte di Calimala, for a new set of bronze doors when he was working as a painter at Pesaro. Returning home to enter the contest, he found himself one of

St. John the Baptist, 1414; bronze; 8 ft 4½ in (255 cm)
Florence, Orsanmichele

seven finalists, amongst whom were Jacopo della Quercia and Filippo Brunelleschi, formidable rivals for anyone, let alone an untried 20-year-old. Each contestant was to produce a bronze relief of the sacrifice of Isaac set within a quatrefoil. Brunelleschi's and Ghiberti's entries survive and it is not difficult to see why Ghiberti's carried the day. His composition, space, classical references, not to mention elegance and grace, differ markedly from Brunelleschi's abruptly divided composition, brutal energy, and blatant naturalism.

Because work on the doors lasted from 1404 to 1424 they clearly demonstrate the development of Ghiberti's style from the International Gothic of his youth to the more open composition and volumetric figures of the Renaissance. Indeed, this development is echoed in the large bronze sculptures he completed for Or San Michele while work on the doors continued. The *St. John the Baptist* (1412–15), the largest bronze cast to date in Florence, attests to both Ghiberti's skill in the foundry and his mastery of the International Gothic. The craggy face surmounting some of the most exquisite drapery ever crafted perfectly captures the expectant vitality of the desert prophet. In contrast, the St. Matthew (1419–22) is a figure of calm, monumental as it stands in classical contraposto, a finely wrought Renaissance sculpture.

Unquestionably Ghiberti's masterpiece, the Gates of Paradise was commissioned, again by the Calimala, in 1425. Most of the work was done in the 1430's but continued until the installation in 1452. Freed from the Gothic restrictions of the quatrefoils, the rectangular format allowed Ghiberti to pursue a pictorial illusionism only hinted at in his earlier work. In these ten gilded panels Ghiberti brought to perfection the compositional, spatial and figural concepts that had preoccupied him throughout his career. His handling of his medium is so secure and so subtle that marvelously natural forms can be seen to exist in solid three-dimensionality or to hover like wisps in the atmosphere. Indeed, his study of optics, nature, and antiquity—fortified by two trips to Rome—combine here with his technical mastery to create the quintessential Renaissance sculptural relief.

In addition to the doors and three bronze figures for Or San Michele, Ghiberti's other most notable works include two bronze reliefs for the baptismal font in Siena, delivered in 1427, two reliquaries, three tomb slabs, the tabernacle for Fra Angelico's *Linaiuoli Madonna*, and designs for stained glass for the Cathedral. His autobiography also tells us of papal commissions for goldsmithy, two mitres and a morse, which are regrettably no longer extant.

In many ways Ghiberti is the prototype for the humanist artist of the Renaissance. In addition to having the requisite skill in several media—trained as a goldsmith, he worked as a painter, excelled as a sculptor, and was appointed with Brunelleschi as builder of the cathedral dome—his creative genius was coupled with intellectual curiosity, while his social ability not only placated various patrons over long periods but also brought him in contact with the leading intellectual and theological minds of Florence. In fact, more than presaging an ideal, humanist artist, he was the ideal Florentine, quick witted, hard working, expert in practical matters and so adept at each he could retire to his manor to assemble and record at well-earned leisure his perceptions and ideas on the development of art.

—Olan A. Rand, Jr.

GHIRLANDAIO.

Born Domenico di Tommaso Bigordi in Florence, 1449; son of the goldsmith Tommaso Bigordi, and brother of Davide and Benedetto. Died in Florence, 11 January 1494. Son: Ridolfo. Probably studied with Alesso Baldovinetti: first works were frescoes in Church of the Ognissanti, c. 1472; then set up studio with brother Davide in Florence; worked on the Sistine Chapel in the Vatican with Botticelli, 1481–82. Apprentice: Michelangelo, 1488.

Collections: Berlin (East); Cambridge; Cambridge, Massachusetts; Cercina: S. Andrea; Detroit; Florence: Cathedral, Uffizi, Ognissanti, Ospedale degli Innocenti, Palazzo Vecchio, S. Maria Novella, S. Trinita; London; Munich; Narni; New York: Metropolitan, Morgan Library; Paris; Philadelphia; Pisa; S. Gimignano: S. Maria Assunta; Vatican; Washington.

Publications

On GHIRLANDAIO: books—

Steinmann, Ernst, *Ghirlandaio,* Bielefeld, 1897.
Davies, Gerald S., *Ghirlandaio,* London, 1908.
Hauvette, Henri, *Ghirlandaio,* Paris, 1908.
Kuppers, P. E., *Der Tafelbilder des Ghirlandaio,* Strasbourg, 1916.
Biagi, Luigi, *Ghirlandaio,* Florence, 1928.
Lauts, Jan, *Ghirlandaio,* Viennca, 1943.
Sabatini, Attilio, *Ghirlandaio,* Florence, 1944.
Bargellini, Piero, *Il Ghirlandaio del bel mondo fiorentino,* Florence, 1945.
Weiser von Inffeld, Josepha, *Das Buch um Ghirlandaio: Eine florentiner Chronik,* Zurich, 1957.
Chiarini, Marco, *Ghirlandaio,* Milan, 1966.

articles—

Rosenauer, A., "Zum Stil der frufien Werke Ghirlandaios," in *Wiener Jahrbuch fuř Kunstgeschichte,* 22, 1969.
Ames-Lewis, Francis, "Drapery Pattern-Drawings in Ghirlandaio's Workshop and Ghirlandaio's Early Apprenticeship," in *Art Bulletin* (New York), March 1981.
Cadogan, Jean K., "Observations on Ghirlandaio's Method of Composition," in *Master Drawings* (New York), Summer 1985.

*

Vasari, writing about Ghirlandaio, says that he received his earliest training from his father Tommaso, a goldsmith, and that he was later apprenticed to Alessio Baldovinetti. Other artists, however, must have influenced his works, among these Castagno, Domenico Veneziano, and Verrocchio. Ghirlandaio never reached the thoughtful intensity of Botticelli or Pollaiuolo, yet at times he paints with unsurpassed participation in the subject, with a colloquial, effective style that makes many of his compositions, to say the least, interesting and amusing if not intellectually compelling. Among the most popular artist of his day, and unable to fulfill the many commis-

Portrait of a Young Man; 15½ × 11 in (39 × 28 cm); Oxford, Ashmolean

sions he received, he had to avail himself of the help of a large and well-organized *bottega,* with the consequent result of a general lowering of the artistic level and the dry monotony that mark large part of his later compositions. Above all an excellent painter of portraits, his frescos are filled with personages faithfully but rather superficially depicted. Ghirlandaio's eye always skimmed pleasantly on the outward appearance of people, rarely trying to search for a character behind a face, content to paint in a dignified and formal manner and with charming, convincing immediacy the proud and satisfied burghers of Florence and their social world, who received Ghirlandaio's work with great satisfaction.

Among his first works, dating probably from 1472, is the *Virgin of Mercy* (Florence, Ognissanti) a fresco in which the rigorous formalism of Baldovinetti is tempered by the luminous clarity of the color, learned from Domenico Veneziano. Rather insipid is the figure of the Virgin, but already pulsating with life are the members of the Vespucci family, gathering under her mantle. A facile, graceful storyteller, Ghirlandaio reaches notes of smiling poetry in the two frescos for the chapel of Santa Fina, painted around 1475, for the Colleggiata of San Gimignano. In the *Three Miracles of the Saint* the solemnity of the scene is broken and lighted by a profusion of incidental, minor details, captured from real life, that transform the drama into a delightful, festive gathering seen against the towered profile of the city, a detail which adds credibility to the story being told. In the second related composition, the *Death of Santa Fina,* the discursive manner becomes more restrained: a sparse monastic cell with a few, humble and common objects as simply drawn as the actors of the scene. The tender body of the saint, her servants, and the miraculous apparition of St. Gregory are depicted with such sincerity and touching affection, such an emotional participation, that for once we feel that Ghirlandaio has reached the threshold of poetry.

In San Gimignano, Ghirlandaio gave the best of himself: soon after the spontaneity and balanced inspiration gave way to the trite formulas and easy virtuosity found in the *Last Supper* frescoed in 1480 for the church of Ognissanti, a mediocre work that follows the earlier composition by Andrea del Castagno; or the coeval altarpiece from San Giusto alle Mura depicting the *Virgin and Child Enthroned with Four Saints,* in which Ghirlandaio imitates the polished color and robust yet graceful figures of Verrocchio.

Called to Rome in 1481 to paint in the Sistine Chapel, certainly conscious of the high distinction bestowed on him, Ghirlandaio tries to combine, with little success, monumentality and nobility in his *Christ Calling the Saints Peter and Andrew.* Dignified and severe, although brightened by the green vivacity of the wide, open landscape, the composition is filled with portraits of members of the Florentine colony of Rome, as such, as in the later cycles in Santa Trinita or Santa Maria Novella, the religious impact, the sacred meaning of the story seem to become a mere appendage, even an excuse for the worldly display of a purely contemporary gathering.

The mature expression of his style enforms the cycle painted in 1486 for the Sassetti chapel in Santa Trinita. Although Ghirlandaio certainly provided all the cartoons, only the altarpiece, and the two portraits of the donors flanking it, represented with sober, solemn realism, are by his hand. Replete with portraits of the Medici family and their extended clan,

many scenes are set in the familiar cityscape of Florence. Indeed the episodes from the life of St. Francis seem a pretext to pay homage, with the usual charm, to the painter's hometown and its ruler. Full of joy and pageantry is the panel, dated 1485, for the altar of the Sassetti chapel: a splendid *Nativity* in which Flemish influences, already present in the earlier *St. Jerome* (1480) of Ognissanti, add a touch of meticulous precision to the graceful scene.

The last, great cycle undertaken by Ghirlandaio covers the whole choir of Santa Maria Novella. Completed in 1490, its execution was largely the work of assistants, although his supervision, as in earlier cycles, ensured the smooth, stylistic uniformity of the whole. Religious episodes, in this case scenes from the life of the Virgin Mary and the Baptist, become yet again a pretense for a massive intrusion upon the stage of the Florentine middle-class, depicted with skill and easygoing loquacity.

There is no doubt that Ghirlandaio's uncommon skill in the fresco technique, helped by a vivid imagination, often reached a high qualitative level; unfortunately the intellectual content of his compositions is, at times, superficial. Untroubled and untroubling, Ghirlandaio is the honest, competent, humble painter documenting his times for an often corrupt clientele. Through Ghirlandaio's vision we perceive that the patrician Florentine merchant class was satisfied with itself and happy to be placed next to divinity.

—Norberto Massi

GIACOMETTI, Alberto.

Born in Bogonova, near Stampa, Switzerland, 10 October 1901; son of the painter Giovanni Giacometti; brother of the designer Diego Giacometti. Died in Chur, 11 January 1966. Married Annette Arm, 1949. Studied with his father, and under David Estoppey, Ecole des Beaux-Arts, Geneva, 1919; studied sculpture under Maurice Sarkissoff, Ecole des Arts et Métiers, Geneva, 1919; studied drawing and sculpture in Bourdelle's class at the Académie de la Grande Chaumière, Paris, 1922–24; then lived and worked in Paris: shared studio with his brother Diego from 1925; associated with the Surrealists; designed furniture, etc., executed by Diego; lived in Geneva during the German occupation of Paris; stage designs for the play *Waiting for Godot,* 1953.

Major Collection: Zurich: Giacometti Foundation.
Other Collections: Detroit, London: Tate; New York: Moma; Paris: Beaubourg; Pittsburgh; Saint-Paul-de-Vence; Zurich.

Publications

On GIACOMETTI: books—

Jedlicka, Gotthard, *Giacometti als Zeichner,* Olten, 1960.
Bucarelli, Palma, *Giacometti,* Rome, 1962.
Dupin, Jacques, *Giacometti,* Paris, 1963.

Woman with Her Throat Cut, 1932; bronze; 9 in (22.8 cm)

Leymarie, Jean, *Quarantacinque disegni di Giacometti*, Turin, 1963.

Moulin, Raoul Jean, *Giacometti: Sculptures*, Paris, New York, and London, 1964.

Lord, James, *A Giacometti Portrait*, New York, 1965, London, 1981.

Selz, Peter, *Giacometti* (cat), New York, 1965.

Sylvester, David, *Giacometti*, (cat), London, 1965.

Soavi, Giorgio, *Il mio Giacometti*, Milan, 1966.

Coulonges, Henri, and Alberto Martini, *Giacometti peintures*, Paris, 1967.

Hall, Douglas, *Giacometti*, London, 1967.

Sylvester, David, *Giacometti*, London, 1967.

Martini, Alberto, *Giacometti*, Milan, 1967.

Carluccio, Luigi, *Giacometti: A Sketchbook of Interpretive Drawings*, New York, 1968.

Mayer, Franz, *Giacometti: Eine Kunst existentieller Werklichkeit*, Frauenfeld, 1968.

Giacometti (cat), Paris, 1968.

Bouchet, Andre du, *Giacometti: Dessins 1914–1965*, Paris, 1969.

Negri, Mario, and Antoine Terrasse, *Giacometti sculpture*, Paris, 1969.

Yanaihara, Isaku, *Friendship with Giacometti*, Tokyo, 1969.

Negri, Mario, *Giacometti*, Milan, 1969.

Huber, Carlo, *Giacometti*, Zurich, 1970.

Lust, Herbert C., *Giacometti: The Complete Graphics and Fifteen Drawings*, New York, 1970.

Rotzler, Willy, and Marianne Adelman, *Giacometti*, Berne, 1970.

Lord, James, *Giacometti: Drawings*, Geenwich, Connecticut, 1971.

Hohl, Reinhold, *Giacometti: Sculpture, Painting, Drawing*, Stuttgart, 1971; London and New York, 1972.

Soavi, Giorgio, *Disegni di Giacometti*, Milan, 1973.

Giacometti: A Retrospective Exhibition (cat), New York, 1974.

Bovi, Arturo, *Giacometti*, Florence, 1974.

Salzmann, Siegfried, *Giacometti: Plastiken, Gemälde, Zeichnungen*, Duisberg, 1977.

Hartmann, Hans, editor, *Giacometti: Ein Klassiker der Moderne* (cat), Chur, 1978.

Hall, Douglas, *Giacometti's Woman with Her Throat Cut 1932*, Edinburgh, 1980.

Hohl, Reinhold, and Dieter Koepplin, *Giacometti: Zeichnungen und Druckgraphik* (cat), Stuttgart, 1981.

Rotzler, Willy, *Die Geschichte der Giacometti-Stifftung: Eine Dokumentation*, Berne, 1982.

Lord, James, *Giacometti: A Biography*, New York, 1985, London, 1986.

Juliet, Charles, *Giacometti*, Paris, 1985.

Matter, Mercedes, *Giacometti*, London, 1988.

Schneider, Angela, editor, *Giacometti* (cat), Berlin, 1988.

Fletcher, Valerie J., *Giacometti*, London and Washington, 1988.

*

One does not approach a sculpture of Giacometti. . . . Approach her and everything vanishes; there remains the corrugations of the plaster. . . . He puts distance

within reach of your hand, he thrusts before you a distant woman—she remains distant, even when you touch her with your fingertips. . . . (Jean-Paul Sartre)

Primarily a sculptor of anthropomorphic forms, Giacometti's abilities also extend to painting and drawing as well as furniture and ceramic design. Drawing in particular helped to define his artistic goals: it was via this medium and two decades of sculptural experiment that he arrived, in the 1940's, at his mature style—the very familiar and idiosyncratic statues of tall, slender men and women.

Exposure in the early 1920's to ancient and primitive art as well as the paintings of Cimabue and Giotto inspired Giacometti's early work. His interest in non-western art and its European re-evaluations grew as he rejected the classical training he had received from the sculptor Bourdelle. Consequently he began to produce works from the imagination in a Cubist style influenced by African and Cycladic art and the sculpture of Lipchitz and Laurens. *Torso,* 1925, is the first of a short series of works composed of flat, reduced angular forms. The solid masses of these sculptures were gradually whittled away from within until Giacometti arrived at the cage-like structures that characterize his work of the late 1920's and early 1930's. At this time Giacometti was introduced to the Surrealists through André Masson, and found himself identifying with their interest in the effect on art of the imagination and the unconscious. The two definitive works of this period, *The Palace at 4 A.M.* (1932–33) and *Invisible Object (Hands Holding the Void)* (1934), are both explorations of space and form as well as manifestations of Giacometti's interest in Surrealism. The sculptor described the former as "a construction of a palace with a bird skeleton and a dorsal spine in a cage and a woman at the other end," and maintained that it was inspired by the memory of a past love affair. The incongruous grouping of forms in this cage within a cage lends a feeling of loneliness and isolation rather than the sense of restriction of the earlier cage constructions. *Invisible Object* appears at first to be a less disquieting image, but this belies its sinister undertones. Still composed within a cage-like frame, the tall, thin female, prototype of the later statues, cups her hands around an unseen object. With more than a passing reference to Cubism and primitive art, this form, with its smooth contours and stylized head, implies a fear of the void, a fear of woman—themes that were in keeping with Surrealist fantasy and subject matter.

Giacometti found this mode of expression ultimately unsatisfying—for while it provided him with a shorthand vocabulary of psychic expression, Giacometti felt unable satisfactorily to express his view of external reality. There followed in 1935–40 a barren period, the sculptor returning to working from the model and destroying almost everything he made. During the Nazi occupation of Paris, Giacometti resided in his native Switzerland and there began again to work from memory and imagination; but, as he explained, "wanting to create from memory what I had seen, to my terror, the sculptures became smaller and smaller . . . often so small that with one touch from my knife they disappeared into dust. . . ." According to legend, when he eventually returned to Paris his total works fitted into six matchboxes.

It was finally through painting that Giacometti discovered his "mature" style. The key to his thought and direction lay in his fascination for the work of Cézanne, who had explored in the medium of painting the eye's relationship to distance as well as the relationship of volume to space and the contour that divides them. Giacometti's quest for the means by which to explore the same problems in three dimensions led him from the cage constructions where space is form and form is space to the slender anthropomorphic forms. The paintings and drawings were seen partially as a means to this end, although they also exist as masterpieces in their own right. Form and space merge in Giacometti's drawings; space is given a certain solidity through the artist's use of "erasure" (smudging and highlighting with the use of an eraser), perspective is elongated, while near extremities are enlarged, the overall effect being like peering through the wrong end of a telescope. Such optical manipulations were transferred to sculpture: Giacometti's long, thin, immobile figures are rooted by their massive feet to solid bases which, serving as the sculptural equivalent of the picture plane, hinge together the realities of object and viewer. The sculpture "recedes" from the base as a landscape recedes in a traditional painting. Also, just as a landscape changes the further the explorer penetrates, so Giacometti's statues alter their state according to the distance from which they are viewed. Close to, the statues' rough contours flicker and blur, becoming paradoxically out of reach. However, when surveyed at a distance—ideally nine feet—the sculptures become whole, their true reality revealed.

Giacometti continued working with this format, his standing female and male figures differentiated mainly by their subtle differences in posture and their varying sizes. He also created groups of figures, e.g., *City Square,* 1948, relating each component to the whole. Giacometti's statues seem so conspicuous by their pervading sense of isolation and loneliness that the sculptor is invariably linked with postwar existentialism. However, the figures hold their own against the pressure of physical and spiritual emptiness that surrounds them; and indeed their distance, that to which Sartre refers, above, may enable them to reach the god that the rest of us are too close to, too dazzled, to see.

—Carolyn Caygill

GIAMBOLOGNA [Giovanni Bologna].

Born Jean Boulogne in Douai, 1529. Died in Florence, 13 August 1608. Trained in Flanders under Jacques Dubroeucq from age 14; in Rome c. 1550, then settled in Florence: paid salary by Francescso de' Medici by 1561: set up workshop and foundry, and small bronze models of his works were produced in large quantities: many assistants, including Pietro Francavilla, Antonio Susini, Pietro Tacca, and Adriaen de Vries; works were commissioned for Lucca Cathedral and Bologna; some preliminary models survive.

Collections/Locations: Bologna: Neptune Fountain; Brisbane; Florence: Loggia de' Lanzi, S. Marco, Piazza dell' Annunziata, Bargello; Genoa: University Chapel; Hartford, Connecticut; London: Victoria and Albert; Oxford: Christ Church; Vienna; Washington.

Flying Mercury, 1564–65; bronze; 5 ft 11 in (180 cm); Florence, Museo Nazionale

Publications

On BOLOGNA: books—

Desjardins, Abel, *La Vie et l'oeuvre de Jean Bologne,* Paris, 1883.

Patrizi, P., *Il Giambologna,* Milan, 1905.

Gramberg, W., *Bologna,* Berlin, 1936.

Pope-Hennessy, John, *Samson and a Philistine by Bologna,* London, 1954.

Dhanens, Elisabeth, *Jean Bologne, Giovanni Bologna Fiammingo,* Brussels, 1956.

Holderbaum, James, *Giambologna,* Milan, 1966.

Avery, Charles, and Anthony Radcliffe, editors, *Giambologna, Sculptor to the Medici* (cat), London, 1978.

Holderbaum, James, *The Sculptor Bologna,* New York, 1983.

Avery, Charles, *Giambologna: The Complete Sculpture,* Oxford, 1987.

*

A truly protean genius who created brilliantly in all sculptural formats of the *cinquecento,* Giambologna was undoubtedly the greatest sculptor of the century after Michelangelo, as well as the most exquisite virtuoso of the *bella maniera* style. Moreover, Giambologna was an artist whose gift and culture could combine the finest elements of both northern European and Italian taste. The ideal human figure was central in his art, as it had been for Michelangelo, his inspiration.

A fountain-competition opened Giambologna's career in Florence, that for the colossal marble *Neptune* of 1560, a contest won by Ammanati. Giambologna's rejected project secured for him the patronage of Francesco de' Medici, and culminated in the great bronze *Neptune Fountain* at Bologna, c. 1563–66 (Piazza Maggiore). The focal figure stands atop a columnar base, as in virtually all his fountains; his graceful balance predicts the famous *Flying Mercury* (Florence, Bargello).

The *Samson Slaying a Philistine,* 1561–62, marble (London, Victoria and Albert), was created for a fountain of the Casino Mediceo at Florence. This is a virtuoso design intended to proclaim his carving skill in the face of his defeat in the fountain competition. An astonishing quality of lightness marks this precisely balanced group, due to the great opened spaces surrounding the fallen figure—a *maniera* flourish that pointedly counters the "block aesthetic," the compactness of form typical of a Michelangelo carving.

Another marble, the *Venus of the Grotticella,* c. 1570 (Florence, Boboli Gardens), is, for Holderbaum, the penultimate expression of Giambologna's *maniera* concept of beautiful feminine form and movement. For him, the *Venus* embodies "an equilibrium so delicate and so complex" as "necessarily" to be "of the most fleeting transitoriness." Furthermore, her state of motion "is abstracted from" its "attendant temporal context in nature," as it would not be "in classic or baroque art," a fundamental notion for *maniera* taste. Polychromy occurs in the variegated marble of the basin for the *Venus* fountain, as it does in the central mound of igneous rock and sea shells on which she stands—choices of design emphasis and material that are a link with the great outdoor figure of the *Apennine.*

Surely the most astonishing of Giambologna's inventions is the colossal seated figure of the *Apennine,* c. 1570–83, carved in the living rock, and constructed of stone and brick, accented with lava fragments (Pratolino, Villa Demidoff). This craggy giant that struggles slowly to rise to its feet is an incredible vista for the garden of a cinquecento villa, though its pictorialism and its exaggerated textures are linked with grotto fantasies, and the reflecting pond that lies before it might recall the garden basins of the Villa d' Este.

The famous *Rape of the Sabine Woman,* marble, c. 1581–82 (Florence, Loggia dei Lanzi), is a virtuoso, three-figure composition that completes the series of giantesque sculptures for the Piazza della Signoria that were created in response to the challenge of Michelangelo's *David.* The inventive richness of *The Rape of the Sabine Woman* clearly surpasses the frontal designs of its earlier counterparts in the piazza, the *Hercules and Cacus* of Bandinelli, the *Perseus* of Cellini. Giambologna's concept began as a two-figure composition and progressed to one of three figures, quite independently of the demands of a specific ancient or literary text, for the sculpture was named only after its completion.

Hercules Slaying the Centaur, marble, 1595–1600, is also in the Loggia dei Lanzi. Unlike the forced acrobatics of the marble *Hercules and Centaur* group by Vincenzo de' Rossi, in which the hero bends both backward and sideward to strike at the *Centaur,* Giambologna's design is more simply organized as a spiral that unwinds in the vertical plane, with the agonized, inverted face of the *Centaur* at its center. Thus it is a planar, relief-like design of one major view, a classical concept with clear implications for sculpture of the early baroque.

The official portraits, whether standing figures, busts, or equestrian monuments, embody an idealized likeness redolent of the painted portraiture of Bronzino. These likenesses meld qualities of sternness—as would befit a ruler in the dawning age of absolutism—and a sort of transcendental, otherworldly gaze, reminiscent of the colossal *Head of Constantine* (Rome, Museo Captiolino), a special effect of the stylized, linear outline about the eyes, and a slight upward cast of the gaze. The stately equestrian bronzes are closely related, and derive from the Cosimo I de' Medici, c. 1587–93 (Florence, Piazza della Signoria). Giambologna's horse-type combines the tightly reined head position and the stylized treatment of mane and tail of Verrocchio's Colleoni Monument in Venice with the distinctive gait of the ancient Marcus Aurelius in Rome, in which only two legs rest solidly on the earth, while the hoof-tip of a third leg just touches the plinth for stability.

The varied relief styles of Giambologna are marked by both an assured virtuosity and artistic reminiscences. The bronze pedestal relief for the Rape of the Sabines marble group is a powerful and personal *tour de force.* Its beautiful interweaving of figures, an *intracciamento,* recalls Michelangelo's *Battle of Lapiths and Centaurs* relief (Florence, Galleria Buonarroti), and his *Battle of Cascina* cartoon. Violent action is transcribed as a system of roiling arcs. Gradual changes in relief projection are displayed, from *schiacciato* to *rilievo alto.* Both linear perspective and relief projection achieve an emphatic spatial development. A *maniera* isolation of several discrete centers of narrative emphasis is clear.

Two elegant reliefs for the Grimaldi Chapel in San Francesco di Casteletto (demolished 1815), embody quite disparate styles. The *Flagellation of Christ,* bronze, c. 1580 (Genoa,

University Chapel), has the symmetry of classicism, a relation of figures to somewhat miniaturized architecture like that of Raphael's *Tapestry Cartoons,* whereas the *Entombment of Christ,* bronze, after 1585? (Genoa), is very northern European in its pathos, its imagery of cowled women, its fluidity of long lines—a style somewhere between Rogier van der Weyden and Germain Pilon.

—Glenn F. Benge

GIORDANO, Luca.

Born in Naples, 18 October 1632; son of the painter Antonio Giordano. Died in Naples, 3 January 1705. Married Margherite d'Ardi, 1656. Possibly a pupil of Ribera in Naples, but also was in Rome (influenced by Pietro da Cortona), Florence, and Venice as a young man: member of the Naples guild from 1655: large studio, with many pupils and prolific output: several fresco cycles; worked in Florence on Palazzo Medici-Riccardi, 1682–83; court painter in Spain for Charles II, 1692–1702: painted ceilings in the Escorial, and worked in Madrid, Toledo, and Guadelupe; then returned to Naples, 1702.

Major Collections: Chicago; Cleveland; Escorial; Naples; New York; Raleigh, North Carolina; Toledo, Ohio.
Other Collections: Birmingham; Bucharest; Crispano: parish church; Florence: Medici-Riccardi, church of the Carmine; London; Madrid; Naples: S. Pietro ad Aram, S. Brigida, S. Gregorio Armeno, S. Martino, Chiesa dell'Ascensione a Chiaia, S. Agostino degli Scalzi; Oberlin, Ohio; Rome; Toledo: Cathedral; Venice: Accademia, church of the Salute; Vienna.

Publications

On GIORDANO: books—

Petraccone, Enzo, *Giordano,* Naples, 1919.
De Rinaldis, Aldo, *Giordano,* Florence, 1922.
Benesch, Otto, *Giordano,* Vienna, 1923.
Manzoni, G., *Giordano e la pittura napoletana nel 600,* Matera, 1924.
Milkovich, Michael, *Giordano in America* (cat), Memphis, Tennessee, 1964.
Ferrari, Oreste, and Guiseppe Scavizzi, *Giordano,* Naples, 3 vols., 1966.
Paintings by Giordano (cat), London, 1975.

articles—

Ferrari, Oreste, "Drawings by Luca Giordano in the British Museum," in *Burlington Magazine* (London), 108, 1966.
Ferrari, Oreste, "*The Entombment:* A Youthful Work by Luca Giordano," in *Bulletin of the Detroit Institute of Arts,* 54, 1975.

*

Triumph of Bacchus; Kedleston Hall

Luca Giordano was a Neapolitan painter whose breathless speed and virtuosity was recalled in his nickname ("Luca fa presto"—Luca, paint quickly). He was possibly a student of Ribera in Naples, but Ribera's dark style was lightened by the influence of Pietro da Cortona's grand manner and the Venetian colorists. In fact, Luca was something of the epitome of the itinerant painter, and worked throughout Italy (he did three altarpieces for the church of St. Maria della Salute in Venice before 1674—in a proto-Rococo style), and spent ten years in Spain as the court painter for Charles II (his work in the Escorial is thought to be among his best). He was well aware of all the past masters, and one can find Dürer, Lucas van Leyden, Titian, and Raphael among his influences. (But he never copied others.) He was famous for his light touch and bright colors—and liked to juxtapose white and blue, much as Tiepolo would do a half century later. In fact, his influence in Venice was very strong, but he began a decorative tradition in Naples that lasted throughout the 18th century as well, headed by Francesco Solimena.

GIORGIONE.

Born Giorgio da Castelfranco in Castelfranco, 1477 or 1478. Died of the plague in Venice, before 25 October 1510. Pupil of Giovanni Bellini in Venice; shared a studio with Catena, 1506; worked in Doge's Palace, 1506-07, and did frescoes for Fondaco dei Tedeschi, 1508; mysterious career, and few documented paintings: several pictures possibly completed by Titian or Sebastiano del Piombo.

Major Collection: Venice
Other Collections: Berlin; Braunschweig; Castelfranco: S. Liberale; Dresden; Leningrad; San Diego; Vienna; Washington.

Publications

On GIORGIONE: books—

Justi, Ludwig, *Giorgione,* Berlin, 1908, 3rd edition, 2 vols., 1936.

Venturi, Lionello, *Giorgione et il giorgionismo,* Milan, 1913.

Ferriguto, Arnaldo, *Il significato della "Tempesta,"* Padua, 1922.

Hartlaub, G.F., *Giorgiones Geheimnis,* Munich, 1925.

Conway, Martin, *Giorgione: A New Study of His Art as a Landscape Painter,* London, 1929.

Hourtique, Louis, *Le Problème de Giorgione: Sa légende, son oeuvre, ses élèves.* Paris, 1930.

Ferriguto, Arnaldo, *Attraverso i "misteri" di Giorgione,* Castelfranco, 1933.

Phillips, Duncan, *The Leadership of Giorgione,* Washington, 1937.

Richter, Goerge Martin, *Giorgione,* Chicago, 1937.

Fiocco, Giuseppe: *Giorgione*; Bergamo, 1941, 1948.

Batz, G. de, *Giorgione and His Circle,* Baltimore, 1942.

Morassi, Antonio, *Giorgione,* Milan, 1942.

Venturi, Lionello, *Giorgione,* Rome, 1954.

Pallucchini, Rodolfo, *Giorgione,* Milan, 1955.

Pergola, Paolo della, *Giorgione,* Milan, 1955.

Pignatti, Terisio, Giorgione, Milan, 1955.

Zampetti, Pietro, *Giorgione e i giorgioneschi* (cat), Venice, 1955.

Fossi, Piero, *Di Giorgione et della critica d'arte,* Florence, 1957.

Wolpi, C., *Giorgione,* Milan, 1963.

Baldass, Ludwig von, *Giorgione,* Vienna, 1964, New York, 1965.

Zampetti, Pietro, *L'opera completa di Giorgione,* Milan, 1968; as *The Complete Paintings of Giorgione,* New York, 1968, London, 1970.

Wind, Edgar, *Giorgione's "Tempestà," with Comments on Giorgione's Poetic Allegories,* Oxford, 1969.

Pignatti, Terisio, *Giorgione,* Venice, 1969, 1978; as *Giorgione: Complete Edition,* London, 1971.

Magugliani, Lodovico, *Introduzione a Giorgione el alla pittura veneziana del rinascimento,* Milan, 1970.

Waterhouse, Ellis K., *Giorgione,* Glasgow, 1974.

Tschmelitsch, Günther, *Zorzo, genannt Giorgione: Der Genius und sein Bannkreis,* Vienna, 1975.

Carpeggiana, Paolo, editor, *Giorgione* (cat), Castelfranco, 1978.

Settis, Salvatore, *La "Tempesta" interpretata: Giorgione, i committenti, il soggetto,* Turin, 1978.

Benzoni, Guido, et al., *Giorgione et el Veneto: Guida alle opere,* Venice, 1978.

Lazzarini, Lorenzo, editor, *Giorgione: La Pala di Castelfranco Veneto* (cat), Milan, 1978.

Ruggeri, Adriana Augusti, et al., *Giorgione a Venezia* (cat), Milan 1978

Pallucchini, Rodolfo, editor, *Giorgione e l'umanesimo veneziano,* Florence, 2 vols., 1981.

Conti, Angelo, *Giorgione: Studio,* Florence, 1984.

Hornig, Christian, *Giorgiones Spätwerk,* Munich, 1987.

articles—

Muraro, Michelangelo, "The Political Interpretation of Giorgione's Frescoes on the Fondaco dei Tedeschi," in *Gazette des Beaux-arts* (Paris), 76, 1975.

Kaplan, Paul H. D., "The Storm of War: The Paduan Key to Giorgione's *Tempesta*," in *Art History* (Oxford), December 1986.

*

Giorgione, or "Zorzon" in Venetian dialect, was born in Castelfranco Veneto, a tiny village in the Treviso region, in 1477 or 1478. Because the Barbarella family of Castelfranco began in the early 17th century to claim him as an ancestor, he is sometimes referred to as Giorgione Barbarelli; in fact, however, nothing is known of his parentage.

The Three Philosophers; 48¾ × 57 in (124 × 145 cm); Vienna, Kunsthistorisches Museum

He moved to Venice at an early age and according to Vasari, after a period of self-instruction joined Giovanni Bellini's workshop. Giorgione's fascination with nature and his many early paintings of Our Lady show Bellini's influence. Leonardo visited Venice in 1500–01, and his subtle modulation of color and the deep spatiality achieved through dark shadows and atmospheric haze also fascinated Giorgione. Among Venetians, Giorgione's most important older contemporary was Carpaccio, with whom Giorgione shared a new ability to achieve poetic effects through a harmony of colors. His most important younger contemporary was Titian, who abandoned Bellini's tutelage to follow Giorgione and then became his rival through his success in combining Giorgione's sensitive use of color with a monumentality that Giorgione had not yet attempted.

"Giorgione" means "Big George," and Giorgio da Castelfranco won this nickname not only for his imposing physical appearance, but also for his open-heartedness and wide intellectual interests. A lutist who enjoyed performing for friends, he moved comfortably in Venice's literary and philosophical circles. His consistent interest in scenes of Arcadian innocence is also to be found among these scholars and poets, such as Marcantonio Michiel, Pietro Contarini, and Pietro Bembo.

If the appeal of his expansive personality was immediate, that of his paintings was no less so. Their directness, achieved through his use of color, light, and atmosphere, is, however, strangely contradicted by an equally immediate sense that while each painting's theme is important, many of its referents are unfathomable. In brief, viewers find his paintings both forthright and incomprehensible. Although study of Giorgione's literary friends' work may be suggestive, it is unlikely that complete certainty about his themes will ever be achieved.

This uncertainty is complicated by two other problems: the

question of authorship (which of the paintings attributed to Giorgione are wholly by him and which were done partly or entirely by Titian or Sebastiano del Piombo) and the question of chronology (the order in which the twenty or so extant works generally attributed to Giorgione were painted).

Dealing adequately with any one of these three problems depends on solving the other two. Fortunately, there are four works whose dates and attribution are undisputed, and it is possible to group other paintings with these and on the basis of this grouping offer coherent if still tentative answers to the questions of theme and authorship. The four markers are *The Madonna and Child with Saints Liberale and Francis* of 1504, *Portrait of a Lady* (or *Laura*) of 1506, the frescoes on the exterior of the Fondaco dei Tedeschi of 1508 (now mostly destroyed), and the *Portrait of a Man* of 1510 (now in San Diego).

The extant works which precede the *Madonna and Child with Saints* include the *Madonna and Child* now in Bergamo, the *Holy Family* in Washington and a *Judith* in Leningrad. Although these are the works closest to those of the Bellini family, they also disclose a painter who, influenced by the works of Flemish artists, is seeking a new realism and a spatiality that is defined by light rather than Bellini's geometric forms and who prefers smaller dimensions and more intense colors. Giorgione's background landscape is more conspicuous than in the Bellini models, and leaves the latter's Virgilian countryside by incorporating real-world elements. Terisio Pignatti calls attention to the way Giorgione's color treatment serves as a comment on the painting's theme: the harmony of colors in an atmospheric unity "suggests the tenderness of the Holy Family" and "Judith rises like a pink and gold flame against the reassuring green of the landscape" (*Giorgione*, p. 52).

Giorgione moved conspicuously away from the stage-set approach of Bellini's compositions in his *Madonna and Child with Saints* of 1504. The landscape commands as much attention as the foreground figures. Fortunately, this duality of forms is overcome: Giorgione gives the viewer a downward perspective on the saints and most of the landscape alike, and he unifies foreground and background space by generating both of them through color. Here, and in all his subsequent paintings as well, one finds a creation of space, new to his time, in which the depth is immeasurable, but becomes more rather than less real for being vague.

Between this painting and the *Laura* of 1506 come several small landscapes with figures: *The Trial of Moses, The Judgement of Soloman,* and *The Adoration of the Shepherds.* In all of them one sees an integration of half-tones and light that Carpaccio's work also achieves. They all coordinate their theme with (if they do not subordinate it to) an Arcadian harmony of human and natural elements. In *The Adoration of the Shepherds,* for example, over half of the canvas is given to a poetically suggestive landscape which does not, in spite of its relative size, overwhelm the infant Christ, placed in front of a dark cave, or the shepherds bowing before him, for the landscape functions as a comment on the child's birth and enhances its significance.

The culmination of this series is a highly celebrated masterpiece, *The Tempest,* in which a soldier (or shepherd) and a nude gipsy suckling an infant are placed on opposite sides of a stream in front of ruins and a distant village and under a sky in whose distance a storm is gathering. Unaware of each other and of the lightning overhead, the two figures are fully human and at the same time belong as much to the magically poetic landscape as the pool, reflecting the sky, and the bridge behind them do. *The Tempest* comes from near the time of *Laura,* as do *Portrait of a Young Man* and *Madonna and Child in a Landscape.*

Although Giorgione decorated many buildings with frescoes, including his home at San Silvestro, he was indifferent to public commissions. One of the few he accepted was for frescoes on the Fondaco dei Tedeschi in 1508. With the Fondaco frescoes, Giorgione essays monumentality, and tries to join the monumental, which he saw emerging in Titan's work, with the lyrical, which he had consummately achieved in *The Tempest.* The frescoes being almost entirely obliterated by weather, one can only guess at how successfully Giorgione integrated the two elements. Paintings like the *Three Philosophers, Sunset Landscapes, Venus,* and *The Dead Christ,* which likewise manifest a concern for both monumentality and lyricism, may well come from the time of Fondaco frescoes. In the *Three Philosophers,* wise men of three different ages and cultural origins swell into a volume that is denied the figures in the earlier *Adoration of the Shepherds,* but while the landscape occupies much less of the canvas, it is no less lyrical. Similarly, the figure of Venus is much larger than the nude mother in *The Tempest,* but the harmony of the natural and the human in *Venus* is no less fully realized.

Still, Giorgione may have been ill at ease with his work in this period, and an uncertainty about his direction may have caused him to leave paintings unfinished (*Venus, Dead Christ*) or designs unexecuted (*Concert Champêtre?*). His insecurity has now become the scholar's: just where does his work end and another's (usually Titian's) begin in these paintings?

Whatever the answer to that bundle of questions, Giorgione seems to have found himself again by 1510, the year of his *Portrait of a Man* (in San Diego). Compared to his earlier portraits, this one is more psychologically insightful and its grip on the viewer stronger; its appearance of spontaneity suggests the impression made by a particular person rather than the realistic presentation of a typical person; the color combinations are unusual, and the range of colors narrower. These features also characterize other close-up portraits, which may, one suspects, likewise come from the year just before Giorgione died in the plague: *Shepherd Boy with a Flute, The Old Woman, Three Ages of Man, Portrait of a Venetian Gentleman, Self-Portrait as David* (now lost) and *Christ Carrying the Cross* (San Rocco; some scholars see the hand of Titian in this piece).

Giorgione's impact on his century was immense. His themes were popular and popularized. His work was in great demand, and called into being a new segment of the art market—the private collectors who, delighted by owning his small-scaled pieces, put his successors' work into demand. The poetry of his landscapes and the sense he conveyed that deep religious significance may be linked to great sensual pleasure gave rise to a new kind of harmony between nature and human concerns. This poetry and harmony manifested a freedom which in turn liberated his successors to become candidly innovated and to ask their art to create new kinds spaces by concentrating on atmosphere and subtle modulations of tones.

—David B. Greene

GIOTTO (di Bondone).

Born in Verpignano near Florence, 1266–67, or 1276. Married twice (second wife was Monna Ciuta); two daughters, one son. First recorded in 1301: in Florence; worked on frescoes of the Legend of St. Francis in the Upper Church at Assisi (probably in the 1300's), in the Arena Chapel in Padua (in 1300's and 1310's); possibly in Rome before 1313; frescoes in S. Croce, Florence, 1320's or 1330's; frescoes done in Naples, 1329-33, are now lost; supervisor of Florence Cathedral, 1334-37 (the Campanile is known as Giotto's Tower); also painted works on wooden panels, though many are from his studio rather than by himself. Died in Florence, 1337.

Major Collections: Assisi: Upper church of S. Francesco; Padua: Cappella degli Scroveni all'Arena.

Other Collections: Berlin; Boston: Gardner; Florence: Uffizi, Museo Horne, S. Croce, S. Giorgio alla Costa, S. Maria Novella; London; New York; Padua: Museo Civico; Paris: Jacquemart-André; Raleigh, North Carolina; Rimini: Tempio Malatestiano; San Diego; Settignano: Berenson; Strasbourg; Washington, D. C.

Publications

On GIOTTO: books—

Moschetti, A., *La Cappella degli Scrovegni*, Florence, 1904.

Rintelen, F., *Giotto und die Giotto-Apokryphen*, Munich, 1912, Basel, 1923.

Siren, Oswald, *Giotto and Some of His Followers*, Cambridge, Massachusetts, 2 vols., 1917.

van Marle, Raymond, *Recherches sur l'iconographie de Giotto et de Duccio*, Strasbourg, 1920.

Supino, Igino B., *Giotto*, Florence, 2 vols., 1920.

Hausenstein, Wilhelm, *Giotto*, Berlin, 1923.

Carra, Carlo, *Giotto*, Rome, 1924, London, 1925.

Rosenthal, E., *Giotto in der mittelalterlichen Geistsentwicklung*, Augsburg, 1924.

Wiegelt, Curt H., *Giotto: Des Meisters Gemälde,* Stuttgart, 1925.

Cecchi, Emilio, *Giotto*, Milan, 1937, 1942, New York, 1960.

Salvini, Roberto, *Giotto bibliografia*, Rome, 1938, supplemented by G. De Benedictis, Rome, 1973.

Toesca, P., *Giotto*, Turin, 1941.

Carra, Carlo, *Giotto: La Cappella degli Scrovegni*, Milan, 1945, New York, 1950.

Carra, Carlo, *Giotto*, Verona, 1951.

Carli, Enzo, *Giotto*, Milan, 1951.

Battista, Eugenio, *Giotto*, Lausanne, 1960.

Gabrielli, M., *Giotto e l'origine del realismo*, Rome, 1960, 1981.

Meiss, Millard, *Giotto and Assisi*, New York, 1960.

Tintori, Leonetto, and Millard Meiss, *The Painting of the Life of Saint Francis in Assisi, with Notes on the Arena Chapel*, New York, 1962, 1967.

Gioseffi, Decio, *Giotto architetto*, Milan, 1963.

Schrade, Hubert, *Franz von Assisi und Giotto*, Cologne, 1964.

Borsook, Eve, and Leonetto Tintori, *Giotto: The Peruzzi Chapel*, New York, 1965.

Previtali, Giovanni, *Giotto e la sua bottega*, Milan, 1967.

Bologna, Ferdinando, *Novita su Giotto*, Turin, 1969.

Stubblebine, James H., *Giotto: The Arena Chapel Frescoes*, New York, 1969.

Bacceschi, E., *L'opera completa di Giotto*, Milan, 1966; as *The Complete Paintings of Giotto*, New York, 1966, London, 1969.

Baxandall, Michael, *Giotto and the Orators*, Oxford, 1971.

Smart, Alastair, *The Assisi Problem and the Art of Giotto*, Oxford, 1971

Trachtenberg, M., *The Campanile of Florence Cathedral: Giotto's Tower*, New York, 1971.

Schneider, Laurie, editor, *Giotto in Perspective*, Englewood Cliffs, New Jersey, 1974.

Cole, Bruce, *Giotto and Florentine Painting*, New York, 1976.

Behles, Joseph, *Giottos Ognissanti-Madonna in Florenz*, Frankfurt, 1978.

Brandi, Cesare, *Giotto*, Milan, 1983.

Bonsanti, Giorgio, *Giotto*, Padua, 1985.

Pleynet, Marcelin, *Giotto*, Paris, 1985.

Bellosi, Luciano, *La pecora di Giotto*, Turin, 1985.

Stubblebine, James H., *Assisi and the Rise of Vernacular Art*, New York, 1985.

Barasch, Moshe, *Giotto and the Language of Gesture*, Cambridge, 1987.

Goffen, Rona, *Spirituality in Conflict: Saint Francis and Giotto's Bardi Chapel*, University Park, Pennsylvania, 1988.

articles—

Alpatoff, Michel, "The Parallelism of Giotto's Paduan Grescoes," and Howard M. David, "Gravity in the Paintings of Giotto," both in *Giotto in Perspective*, edited by Laurie Schneider, Englewood Cliffs, New Jersey, 1974.

*

Giotto di Bondone was born near Florence c. 1267 and died in 1337. He remained a Florentine in spirit and style even though he worked throughout Italy and possibly also in Avignon. He is widely considered to have introduced many of the innovations that would characterize the Renaissance style in 15th-century paintings, although the momentum of the new developments was interrupted by the plague of 1348.

Giotto's reputation for innovation and genius is reflected in many contemporary references. Boccaccio, for example, said that Giotto brought back to light the art of the past, which had lain buried in darkness since antiquity. Plutarch called him the Prince of the Age because of his great contribution to the revival of naturalism in painting. The tradition of Giotto's early work with Cimabue in Rome is reflected in the famous story of his youth as a shepherd. Cimabue reportedly came upon the young Giotto drawing a sheep on a rock, immediately recognized his talent, and took him into his studio. Dante, in the *Purgatorio*, asserted that while Cimabue had been the leading Italian artist, Giotto now held sway. Giotto's skill and appeal to the wise is illustrated by the famous anecdote, cited by Vasari, in the 16th century, of "Giotto's 'O.' " It was reported that the pope, searching for the best artists in Italy, sent his messengers throughout the land for samples of their work. When Giotto was approached, he drew a circle. The surprised messenger

returned to Rome with Giotto's "O," which was instantly recognized as a work of genius by the pope.

All these anecdotes underline the fact that Giotto's style marked a revolutionary departure from the medieval styles in which artists had been working for some nine centuries. For the first time since antiquity, an Italian artist began to depict three-dimensional space and organic figures modelled in terms of light and dark rather than outlined in black and occupying a flat, vertical space as in the byzantine style. Giotto's talent for representing the illusion of natural reality is expressed in another anecdote, namely that he painted so realistic a fly on the nose of one of Cimabue's figures that the older artist tried to brush it off.

Giotto's early work at Assisi in the Church of San Francesco has been the subject of considerable controversy. It is generally agreed that he painted biblical scenes in the Upper Church; but the authorship of the Saint Francis cycle is rightly disputed. His accepted work in San Francesco clearly shows the influence of Cavallini and Cimabue, the two leading Italian artists of the 13th century.

The frescoes in the Arena Chapel in Padua, which were probably done between 1304 and 1312, constitute the great masterpiece of Giotto's extant oeuvre. In these paintings we encounter all the innovations for which Giotto was known during his lifetime and up to the present day. Solid monumental figures are set in a narrow, three-dimensional space; they move and turn as in nature. They also react psychologically on a human scale, permitting the average person to identify with the drama unfolding before him. Likewise, the *Navicella*, a mosaic in Saint Peter's in Rome, which has suffered extensive damage, was known for its insightful gesture language which reveals the emotional states of the apostles as they witness the power of faith.

In c. 1311 or 1312, Giotto painted the *Ognissanti Madonna*, originally for the Ognissanti Church and now in the Uffizi in Florence. This was a monumental altarpiece and thus contains more conservative elements than do the narrative scenes in Padua. For example, the gothic pointed arches of the throne, the gold byzantine background, the slightly slanted and outlined eyes of the figures, are all remnants of medieval influence. Nevertheless, these *retardataire* elements are greatly outweighed by the innovative qualities of the new style. The space of the painting is three-dimensional, and throne and figures, convincingly supported by horizontal surfaces, obey the natural laws of gravity. Unlike Byzantine and gothic Madonnas, Giotto's wears drapery which outlines the forms of her body in terms of shading rather than line and she convincingly supports the infant Christ. He, in turn, is represented with more natural baby-like qualities, such as baby fat and a large head, than his medieval predecessors. The music-making angels on the front step of the throne form an avenue of space from observer to Madonna that creates the illusion of both the void and the solid forms as being three-dimensional.

Apart from a few panel paintings and the crucifix in Padua, Giotto's only other extant major works are the two fresco cycles in the Florentine church of Santa Croce. Probably executed some ten years or more after the Arena Chapel frescoes, these last two cycles represent scenes from the lives of Saint Francis in the Bardi Chapel and Saints John the Baptist and John the Evangelist in the Peruzzi Chapel. Unlike the Arena Chapel, which is architecturally more horizontal, the Bardi and Peruzzi frescoes consist of three large rectangular scenes, which are arranged vertically and face each other. This distinction affects the narrative flow of the scenes and their relationship to each other. At Padua, the observer follows the narrative in a left-to-right horizontal movement, while at Santa Croce the narrative moves from above to below. At the same time, however, each cycle also has significant correspondences in opposing directions so that in the Arena Chapel upper and lower scenes may be related while at Santa Croce horizontal oppositions contain symbolic meaning.

As was true of the Arena Chapel frescoes, those in Santa Croce are characteristic of Giotto in their dramatic tension, their psychological insights revealed through pose and gesture, and their formal humanistic qualities. One of the best examples of such tension in the Bardi Chapel occurs in the scene of *Saint Francis Renouncing His Wordly Goods*. The dramatic conflict which this decision created between the saint and his father is emphasized by the void between the two groups of figures and the contrast between the saint's calm gestures and his father's anger. At the same time, however, that there is mutual underlying tension between them is reflected in the two children, one on either side of the picture plane, who have to be restrained by adults; Giotto thus displaces the anger of the protagonists onto the children. Further, the permanence of the separate life choices made by father and son is emphasized by the massive architectural form filling the space between them.

Giotto's innovations had enormous influence on his immediate followers such as Taddeo Gaddi; but it was not until the beginning of the 15th century in Florence that his real impact was felt. Reaction to the Black Death of 1348 inhibited artistic progress for several decades. By 1400, the cultural revolution known as the Renaissance became a widespread phenomenon and it was then that a whole generation of artists was ready to pursue and develop Giotto's new approach to the art of painting.

—Laurie Schneider

GIOVANNI DA MILANO.

Born Giovanni di Jacopo di Guido da Caversaccio, in Caversaccio; active, c. 1346 or c. 1350 to 1369. First documented in Florence among the foreign painters, 1436; member of the painters guild, 1363; citizen (with his sons), 1366; contracted to decorate Rinuccini Chapel, S. Croce, Florence, 1365; signed and dated Accademia Pieta, 1365; worked on the decoration of two chapels in the Vatican, 1369 (work doesn't survive).

Collections: Amsterdam; Berlin; Florence: Uffizi, Accademia, S. Croce; London; Mendrisio, Switzerland: S. Maria delle Grazie; Milan; New York; Paris; Pisa; Prato; Rome; Turin: Sabauda; Williamstown, Massachusetts: Williams College.

Publications

On GIOVANNI: books—

Marabottini, Alessandro, *Giovanni,* Florence, 1950.
Castelfranchi-Vegas, Liana, *Giovanni,* Milan, 1965.
Gregori, Mina, *Giovanni alla Cappella Rinuccini,* Milan, 1965.
Boskovits, Miklos, *Giovanni,* Florence, 1966.
Cavadini, Luigi, *Giovanni,* Valmorea, 1980.

articles—

Gregori, Mina, "Giovanni: Storia di un polittico," in *Paragone* (Florence), 265, 1972.
Ladis Andrew, "A Newly Discovered Enthroned Madonna by Giovanni," in *Apollo* (London), July 1982.
Proto Pisani, Rosanna Caterina, "Un inedito di Giovanni: La Tavola di San Bartolo in Tuto," in *Bollettino d'Arte* (Rome), May-June 1983.

*

In the paintings of Giovanni da Milano sacred events are made tangible through solid figures in convincing spaces. Giovanni thus belongs to the Giottesque tradition, which he modifies by a greater attention to the material aspect of things. Descriptive details—elegant costumes and still life elements—create a worldly ambience, but the emotional reserve of the noble gives a sober tone. His art also reflects the interest in narrative particulars of his native Lombardy and the courtly world of Sienese painting. In Florence he wed these elements to scenes of solemn majesty and rich decoration, as in the work of Orcagna and his school, but stands apart from this trend through his creation of real spaces.

In his early works, made in the 1350's to the early 1360's, naturalism prevails. Figures are modeled smoothly in delicate chiaroscuro; their volume creates a sense of space, as do simple interiors and furnishings. Faces are given individual variety but show little emotion. Colors tend to be vibrant and rich, with a profusion of reds and blues. Decorative detail is kept to a minimum.

In his mature works of the mid-to late 1360's, scenes emphasize ritual monumentality, where the figures themselves have architectonic functions in elaborate spaces. Figures are more ample and are draped with more voluminous folds. Their faces tend to be reduced to a monotonous repetition of types but sometimes show more emotional expression. Colors are generally more muted, and a greater role is given to decorative trappings.

His signed altarpiece in Prato (Pinacoteca Comunale) showing saints flanking the Madonna and Child, and including a double predella with scenes from saints' lives, the Annunciation, and events from the life of Christ, illustrates his early tendencies. The subtle modeling of figures recalls the firm volumes in the *Crucifixion* fresco by Giotto followers in S. Gottardo, Milan. The attention given to St. Catherine's fashionable costume is a worldly, contemporary touch. Decorative detail, as on garment edges and on the Madonna's throne, is sparing; bright color predominates. The double predella gave Giovanni an opportunity for episodic elaboration. He drew on the Lombard love of expressive details (as seen in the frescoes in the chapel of the castle at Montiglio): e. g., the violent gestures, grimaces, and flowing blood in the scene of the flaying of St. Bartholomew. In the scenes of the Annunciation and the appearance of the Virgin to St. Bernard strongly foreshortened furniture creates a compelling sense of recession, and still life details of books on stands give a sense of reality and daily life to these sacred scenes; these elements recall Giusto dei Menabuoi's frescoes of the doctors of the church at Viboldone, near Milan.

His *Crucifixion* in Amsterdam (Rijksmuseum) is typical of his early devotional works: restrained pathos is combined with realistic details. The saints, arranged in a curved row below the cross, meditate silently. The event is made palpable through the sensitive modeling of Christ's body, the emphasis on the blood running from his wounds, the fine detailing of the wood grain of the Cross, and the individuality of facial descriptions.

Giovanni's mature period probably opened with his fragmentary altarpiece that once stood on the high altar of the Church of the Ognissanti in Florence (portions are in the Uffizi in that city and in a private collection in Venice; one panel, whose present location is unknown, was formerly in the Torcuato di Tella collection in Buenos Aries). Martyr saints in pairs flank the scene of the Incoronation of the Virgin, with the celestial choirs below; the creation cycle from Genesis is seen in little roundels in the spandrels of the panels with saints. The whole is crowned by the image of the Trinity (Throne of Grace) in the pinnacle. God the Father in the pinnacle is hieratic, as in the works of Orcagna, but the throne upon which God sits suggests volume. As also in Orcagna, a great role is given to decoration, as in the damask draperies of the Virgin and Christ and the ornate throne upon which they sit. The celestial choirs have a worldly quality with attention given to the costumes of ecclesiastics, military saints, and aristocratic female saints.

The Rinuccini Chapel frescoes (S. Croce), dated 1365, of the Lives of the Virgin and the Magdalen show Giovanni's incorporation of a worldly element into the sacred: the attention given to costumes and hairstyles in the *Expulsion of Joachim,* the homey details of ladies bustling about in the *Nativity of the Virgin,* the still life details in the *Supper in the House of the Pharisee.* But these details of real life are subsumed in solemn, ritualized scenes in which figures have grave expressions and deliberate movements. Here Giovanni shows an interest in spatial elaboration, coupled with an architectonic organization of figures. The vast space of the temple in the *Expulsion of Joachim,* with its recession in parallel layers, may be indebted to the Giottesque tradition in Assisi. The statuesque poses of the aristocratic participants, their repetitive gestures, and their alignment in receding rows make them seem part of the temple structure. Geometric decoration harmonizes with the placement of figures in the *Supper at the House of the Pharisee.* There is an increase in emotional expression in some of the scenes: the ferocious stares of Joachim and the priest in the expulsion scene, the disapproval of the onlookers in the *Raising of Lazarus.*

Emotional appeal is also a feature in the *Pietà* in the Accademia, signed and dated 1365. The overt display of emotion through the mourners' tears and grimaces is not a full expression of grief, but marks a shift from the restraint of mourners in his other devotional works.

Giovanni's legacy was his infusing sacred events with as-

pects of real life. His graceful courtly world is carried on by international Gothic painters like Masolino. His spatial experiments is continued in northern Italy by Giusto and Altichiero.

—Annette Dixon

GIOVANNI di PAOLO.

Born in Siena, c. 1395–99 Or c. 1403. Died in Siena, 1482 Trained in Siena, probably in the shop of Taddeo di Bartolo; also influenced by French Gothic art, and Gentile da Fabriano, the Lorenzetti, Duccio, Jacopo della Quercia, and others; documented works range from 1417 to c. 1475; also worked as an illuminator.

Major Collection: Siena.
Other Collections: Baltimore: Walters; Berlin; Cambridge; Castelnuovo Berardenga: Prepositura; Chicago; Cleveland; Cologne; Detroit; Florence: Uffizi, Bargello; London; New Haven; New York; Otterlo; Oxford; Pasadena; Philadelphia; Pienza; Siena: Archivio di Stato; Utrecht; Washington.

Publications

On GIOVANNI DI PAOLO: books—

Pope-Hennessy, John, *Giovanni di Paolo,* London, 1937.
Brandi, Cesare, *Giovanni di Paolo,* Florence, 1947.
Pope-Hennessy, John, *A Sienese Codex of the Divine Comedy,* London, 1947.
Christiansen, F., L. B. Kanter, and C. B. Strehlke, *Painting in Renaissance Siena 1420–1500* (cat), New York, 1988.

articles—

Baransky-Job, L., "The Problem and Meaning of Giovanni di Paolo's *Expulsion from Paradise,*" in *Marsyas,* 7, 1959.
Van Os, L., "Giovanni di Paolo's Pizzicaiuolo Altarpiece," in *Art Bulletin* (New York), 53, 1971.
Dixon, Laurinda S., "Giovanni di Paolo's Cosmology," in *Art Bulletin* (New York), December 1985.

*

The birth date of the Sienese painter Giovanni di Paolo is uncertain. Since he was paid in 1417 for work done for the convent library of San Domenico (several miniatures in a Book of Hours), it is highly unlikely that he was the same Giovanni di Paolo recorded baptized in 1403. Though it is possible that a youth of 14 could have been an accomplished illuminator, it is also true that the name "Giovanni di Paolo" was common in the 15th century, and could have belonged to many people. The painter Giovanni di Paolo probably apprenticed with Taddeo di Bartolo or Martino di Bartolomeo, from whom he learned to paint in a charming, archaistic manner indicative of the conservative artistic tradition of 15th-century Siena. Giovanni was a prolific craftsman, and works from his hand can be found in collections all over the world, though the majority exist in Sienese collections. Unlike many major Renaissance artists, enough of Giovanni's paintings are documented to form a strong body of work and suggest a chronology of stylistic development.

The general dates and patrons are known for several of Giovanni di Paolo's major projects, some of which fortunately still exist, though in fragmented form. He seems to have worked both as a panel painter and illuminator. Apart from the miniature done for the library of San Domenico in 1417, there exists an illustrated manuscript of Dante's *Divine Comedy,* painted for Alfonso V of Aragon, king of Naples from 1438 to 1444, (British Museum). Other manuscript projects included five illuminated initials in a Roman missal done for the Siena Duomo (1457–71) and several more that appear in a Sienese Antiphonary (Siena, Biblioteca Comunale). Indeed, the jewel-like, miniaturistic quality of Giovanni's painting owes much to the International Style of manuscript illumination practiced most notably by the Limbourg brothers of France.

Giovanni di Paolo painted four altarpieces for chapels in San Domenico. Notable among the works done for the Dominican milieu is an altarpiece of the life of Saint Catherine of Siena, commissioned in 1418 by Francischino Castiglione (now dispersed among public and private collections in Cleveland, New York, Detroit, and Lugano). The Pecci (c. 1426) and Guelfi (c. 1445) altarpieces were also ordered by Dominican patrons. Giovanni apparently continued service to this religious order all his life, though he did not work exclusively for them. Fragmented works illustrating the legends of Franciscan, Augustinian, Antonite, and Cistercian saints also exist. These include an elegant series of panels devoted to the life of St. John the Baptist, now dispersed in collections on both sides of the Atlantic ocean. Giovanni's late works show a decline in freshness and quality that perhaps indicates the increasing participation of shop assistants (such as the predella of the San Galgano Altarpiece, Siena, Pinacoteca). Indeed, Giovanni di Paolo lived to be a very old man. On January 29, 1482, he made a death-bed will and died sometime before March 27 of that year. He was buried in the destroyed church of Sant 'Egidio.

Stylistically, the paintings of Giovanni di Paolo and his Sienese contemporaries display none of the fascination with visual theory that characterized the "cutting edge" of Italian Renaissance painting. Instead, the decorative charm, crisp shapes and vivid color of Giovanni's paintings pay homage to the accomplishments of French manuscript illuminators and earlier Sienese masters such as Duccio, Simone Martini, and the Lorenzetti. The archaic treatment of space and geometrically layered background forms belong more to the courtly International Style of the 14th century than to mainstream 15th-century painting, which was centered in Florence. Nonetheless, the influence of artists outside Giovanni's home town, such as Jacopo della Quercia, Gentile da Fabriano, and Fra Angelico, can be seen in several of his works, though such borrowings are more compositional and iconographical than technical. In sum, Giovanni di Paolo can be said to have enriched the conservative Italo-Byzantine tradition by the addition of Gothic grace and fervor. The result of this amalgamation of influences was an art full of energy, brilliance, and charm.

—Laurinda S. Dixon

GIRARDON, François.

Born in Troyes, baptised 10 March 1628; son of metal-founder Nicolas Girardon. Died in Paris, 1 September 1715. Married the flower-painter Catherine Duchemin in 1657 (died, 1698); ten children. Precocious artist: fresco of the life of S. Jule, Troyes, age c. 15; apprenticed to the cabinet-maker and sculptor Claude Baudesson in Troyes; protégé of Chancellor Séguier: sent to Rome, 1648–50, and then in Paris after 1651: studied in studio of Anguiers and "very closely" with Le Brun; Sculpteur du Roi; accepted into the Academy, 1657 (Professor, 1659, Rector, 1674, and Chancellor, 1695); lived in the Louvre from 1667; much work at Versailles: made models for fountains, 1667, designed grouping of marble groups, from 1685, and supervised bronze casting: with Hardouin-Mansart, directed the sculptural decoration of the Dôme des Invalides; in semi-retirement from c. 1700. Made a Chevalier, 1690.

Major Collections/Locations: Paris; Troyes; Versailles: Château and Park.

Other Collections: Fontainebleau: Palace; Paris: church of the Sorbonne, S. Germain-des-Près, church of the Capuchines; S. Germain-en-Laye: Museum; Troyes: S. Rémy, Hôtel de Ville, S. Jean au Marche; Vaux-le-Vicomte: Château.

Publications

On GIRARDON: books—

Francastel, Pierre, *Girardon: Biographie et catalogue critique: L'Oeuvre complète de l'artiste,* Paris, 1928.

Mignard et Girardon (cat.), Troyes, 1965

Souchal, François, *French Sculptors of the Seventeenth and Eighteenth Centuries: The Reign of Louis XIV,* vol. 2, Oxford, 1981

articles—

Oudinot, M., "François Girardon: Son role dans les travaux de sculpture à Versailles et aux Invalides," in *Bulletin de la Société de l'Histoire de l'Art Français* (Paris), 1937

Landais, H., "Some Bronzes from the Girardon Collection," in *Connoisseur* (London), 148, 1961.

Souchal, François, "La Collection du sculpteur Girardon d'après son inventaire après décès," in *Gazette des Beaux-Arts* (Paris), 82, 1973.

Rambaud, M., "Les Dernières Années de François Girardon," in *Gazette des Beaux-Arts* (Paris), 82, 1973.

*

Girardon underwent a multi-disciplinary apprenticeship, first with a cabinet-maker, thanks to whom he was noticed by the powerful Chancellor Séguier, and later with a local sculptor. In 1648 he was sent to Rome by Séguier who had by then extended his wholehearted patronage to him. In Rome, Girardon formed a friendship with his fellow countryman Pierre Mignard. On his return to France, he ended his apprenticeship

with the Anguier, got to know Charles Le Brun, and was accepted as a member of the Academy in 1657. His submission was the *Dolorous Virgin* (bas-relied in marble; Paris, Louvre). (The use of bas-relief was customary for this type of work up until the end of the 17th century; only a few artists infringed this rule by choosing either the portrait, after the fashion of engravers—Coysevox, bust of *Le Brun,* 1679—or the statuette—Van Cleve, *Polyphemus,* 1681.) Girardon's *Virgin,* strongly influenced by Le Brun's feminine figures, offers a splendid study in drapery—later recreated for his figure of the *Princesse de Conti,* which formed part of the princess's funerary monument (1672–75; marble, New York)—and a virtuoso exercise in the possibilities of rendering volumes using relief, by playing with the effects of light and shade, density and space.

The most glorious episode in Girardon's career is inseparable from that of his friend Charles Le Brun, whose strong personality exercised a permanent influence on the sculptor. Their collaboration began in 1659 with the stucco decoration, of Fouquet's Château of Vaux-le-Vicomte. Le Brun and Girardon were involved in particular with the ceiling of the Chambre du Roi (winged female figures), the vaulted ceiling of the Cabinet du Roi (cupids and sphinx), and the 16 terminals of the oval Grand Salon—the most sumptuous room in the château, situated under the central dome—Le Brun's drawings for which are conserved in Stockholm. Drawings by Le Brun also provided the basis for various allegorical figures on the vaulted ceiling of the Galerie d'Apollon in the Louvre which Girardon executed with Regnaudin and the Marsy brothers. Of particular note are a monumental river god of classical inspiration and a pair of chained slaves reminiscent of figures by Michelangelo.

But it was above all at Versailles that Girardon gave of his best, producing his *Apollo Served by the Nymphs* (1666–75, marble) in the Grotto of Thetis, the *Fountain of the Pyramid* (1668–70; lead) at the entrance to the Allée d'Eau—the master drawing for which, executed by the Le Brun workshop, is in the Bibliothèque Nationale in Paris—and *Nymphs Bathing* (1668–70; lead). Here were three very different works. The group *Apollo Served by the Nymphs* (three of the seven figures were sculpted by Regnaudin) marks the high point of French classical sculpture with a bias towards the works of antiquity, as seen directly at Rome or interpreted from collections of engravings. The fountain is a fascinating three-dimensional transcription of Le Brun's own style, further imbued with that of Pietro da Cortona. The *Nymphs Bathing,* a long, finely sculpted bas-relief, combines characteristics from the School of Fontainebleau and Correggio in the 16th century, and Clodion (bathroom decor in the Hôtel de Besenval) in the 18th.

Following the execution of these three works, Girardon submitted to the direction of Le Brun, who held sole responsibility for orchestrating the remaining sculptural decoration of the château and gardens. In 1674, Le Brun drew up the plans for a Parterre d'Eau to be created in front of the château. His aim was to personify the elements if four colossal groups (only three were sculpted) and assemble in six quartets of statues an entire cosmogony: Elements, Parts of the World, Seasons, Hours of the Day, Temperaments of Man, and Poems. The purpose of this was to flatter the king by turning his gardens into a microcosm of the universe. Le Brun found the source material for his allegories in the descriptions given by Cesare

Rape of Proserpina, 1677–99; marble; Versailles

Ripa's *Iconologie,* whose illustrative figures possessed precisely detailed attributes. It is to Girardon—and to Desjardins, Marsy, and Le Hongre—that we owe the finest pieces: *Winter* (1675–83; marble), an impressive figure representing an old man shivering beside a fire, and especially the *Rape of Proserpine* (1677–99; marble), a monumental masterpiece, the ultimate variation on the theme of the three-person group developed by Michelangelo, Giambologna, and Bernini.

Girardon did not limit his activity to Versailles. He was one of the most important funerary sculptors of the second half of the 17th century, a rival of Coysevox. In his *Tomb of Cardinal Richelieu* (1675–94; marble; Paris, Sorbonne), the emphasis of the composition lay in the cardinal's wish to be represented "in the position of offering himself up to God": stretched out on his death bed, he gives up his soul in the arms of *Faith* while *Christian Doctrine* weeps at his feet. This dramatic setting is treated with dignity and restraint, and *Christian Doctrine* has rightly been compared with Poussin's figure of *Extreme Unction.* Among the other funerary monuments by Girardon, it is worth mentioning that of Marie de Landes, of which the marble bas-relief—representing the burial of the dead woman—is all that now remains (before 1677; Troyes). Once again Girardon shows his virtuosity in the field of the relief.

As a portraitist, Girardon was destined to take over from his rival Coysevox in glorifying the achievements of Louis XIV. For his first commission, he elected to create an equestrian monument representing the king in classical fashion, seated on a rearing horse. However, the large plaster model was accidentally burned in 1683 and the work was never resumed. Girardon's project for the Place Louis-le-Grand (now Place Vendôme), on the other hand, was completed and a great success: Louis XIV in classical dress, seated on a walking horse, following the tradition established by the classical Marcus Aurelius. It was cast in bronze in a single piece, which for the time was a remarkable technical achievement. (This exceptional casting technique was invented by the metal founder J. B. Keller in 1692.) A century later, the monument was destroyed during the Revolution.

Girardon was also responsible for sculpting part of the minister Louvois's funerary monument (1693–1702; now in Tonnerre, Chapelle de l'Hospice), which was situated in the family chapel in the Paris church of the Capucines. Girardon executed one of his final masterpieces there, his *Body of Christ Carried to the Tomb* (1693–1702; gilded bronze, now in Paris, Notre-Dame). Everything about this piece is impressive: its composition, subtly organized round the central void, its integration of figures into the landscape, the subtlety of formal links between the two principal groups, those of the Dolorous Virgin and of the dead Christ, and the incredible virtuosity of its relief technique.

This key work of French classicism was the ageing sculptor's swan song; unlike Coysevox, he was unable to adapt to the increasing fashion for lightness of style. The pleasant, pre-rocaille, "proto-Regency" style of Louis XIV's declining years was alien to Girardon. Now old and estranged from the new work sites Marly, Dôme des Invalides), he died eclipsed by the glory of his rival Coysevox, whose talented nephews Nicolas and Guillaume Coustou successfully took up where their uncle left off.

—Guilhem Scherf

GIRTIN, Thomas.

Born in London, 18 February 1775. Died in London, 9 November 1802. Married Mary Ann Borrett, 1800; one son. Apprenticed to watercolourist Edward Dayes, 1788–91, and possibly worked for the publisher James Moore, 1791; worked for Dr. Munro in London with Turner, c. 1795; exhibited from 1794; in Paris, 1801–02; member of the Royal Academy, 1802; mainly worked in watercolor.

Collections: Brighton; Bristol; Cambridge; Cardiff; Edinburgh; London: Tate, British Museum, Victoria and Albert; Guildhall, Courtauld; Manchester; New Haven; New York; Newcastle upon Tyne; Ottawa; Oxford; San Marino, California; Sheffield; Swansea.

Publications

On GIRTIN: books—

Binyon, Laurence, *Girtin: His Life and Work,* London, 1900.
Stokes, Hugh, *Girtin and Bonington,* London, 1922.
Davies, Randall, *Girtin's Watercolours,* edited by Goeffrey Holme, London, 1924.
Hardie, Martin, *A Sketch-Book of Girtin,* London, 1939.
Mayne, Jonathan, *Girtin,* Leigh-on-Sea, 1949.
Girtin, Thomas, and David Loshak, *The Art of Girtin, with a Catalogue,* London, 1954.
Hawcroft, Francis W., *Watercolours by Girtin* (cat), London, 1975.
Morris, Susan, *Girtin* (cat), New Haven, 1986.

*

Girtin's apprenticeship to Edward Dayes, while not long (1788–91), was important for the young artist's early style and choice of subject. Under Dayes's mentoring Girtin was exposed to the vital English tradition of topographical watercolor painting by one of its best practitioners. It was a tradition that Girtin would never entirely abandon, but which, together with J. M. W. Turner, he was to transform into a vehicle of intense poetical feeling.

Much of Girtin's early work retains the flavor of the traditional topographical artist: a picturesque building, usually a church or ruin, is located in a middle distance behind a dark foreground that is often occupied by a clutch of people in some innocent pastime. The forms are contained within a strong, and in the case of buildings often intricate, outline, to which are added dotted accents and washes of color, usually brown or blue-gray.

Girtin's allegiance to the conventional canon of picturesque composition was to wane with his discovery of the work of John Robert Cozens. Around 1794 both Girtin and Turner were employed by Dr. Thomas Munro to copy some watercolors by Cozens that had been entrusted to him during the artist's mental breakdown. Both artists—now called "The Munro Academy"—copied from the collection every winter until 1797, the year of Cozens's death. This intense and sustained exposure to Cozens's work, especially the sublime scale

of Cozens's alpine subjects, was to affect the young artists profoundly.

Cozens's influence is seen almost immediately in the imposing images of British monuments that were the subjects of the sketching tours that Girtin began in 1794, the most notable of which is *Lichfield Cathedral* (New Haven), exhibited at the Royal Academy that same year. Girtin continued to exhibit at the Academy in the years following. By 1799 Girtin's reputation was such that he was favorably compared to Turner in a review of the Academy exhibition. Girtin's growing intellectual and artistic stature is also seen in his membership in the Sketching Society, which was founded in 1799 "for the purpose of establishing by practice a school of Historic landscape, the subject being designs from poetick passages"; included among its members Robert Ker Porter, Louis Francia, and, later, John Sell Cotman.

With a hugely commercially successful panorama by Porter in mind, Girtin began around 1800 to work on a vast (108 x 18 feet) view of London that he called the *Eidometropolis*. The work has not survived, although it was on exhibition at the time of his death; several watercolor studies of the project are in various collections. It was about this time that he painted *The White House, Chelsea*. Indeed, with its broad expansive foreground, and a horizon punctuated by the silhouettes of buildings and trees, the work resembles several studies from the *Eidometropolis* project. But the artist has gone beyond the portrayal of a physical location. The lambent reflections of the clouds and eponymous house on the river, the infusion of the soft, radiant afterglow of a sunset, result in Girtin's most intensely felt response to a particular mood of nature. Unfortunately, Girtin, now at the acme of his artistic power, shortly became ill and died in 1802 after his return from a brief trip to Paris.

—Lynn R. Matteson

GIULIO ROMANO.

Born Giulio Pippi, in Rome, c. 1499. Died in Mantua, 1 November 1546. Chief assistant to Raphael, c. 1514–20: worked on Stanza dell'Incendio frescoes, Vatican, and on Sala di Constantino, then completed some of Raphael's unfinished works; also worked in Genoa; settled in Mantua, 1524: did frescoes in Palazzo del Te for the Gonzaga family, 1532–34.

Collections: Detroit; Dresden; Edinburgh; Florence; Genoa: S. Stefano; London; Madrid: Mantua; Casa di Giulio Romano, Palazzo Ducale, Palazzo del Te, S. Andrea; Moscow; Naples; Paris; Rome: Barberini, S. Maria dell'Anima; Stockholm; Vatican; Vienna; Washington.

Publications

On GIULIO: books—

Carpi, Piero, *Giulio ai servigi di Federico II Gonzega,* Mantua, 1920.

Berzuini, Dante, *Guida descrittiva del Palazzo del Te di Mantova,* Mantua, 1927.

Richter, I. P., editor, *La Collezione Hertz e gli affreschi di Giulio nel Palazzo Zuccari,* privately printed, 1928.

Lukomskii, G. K., *Jules Romain,* Paris, 1932.

Hartt, Frederick, *Giulio,* New Haven, 2 vols., 1958.

Tibaldi, Umberto, *Il Palazzo del Te a Mantova,* Bologna, 1967.

Carpeggiani, Paolo, et al., *Studi zu Giulio,* San Benedetto Po, 1975.

Verheyen, Egon, *The Palazzo del Te in Mantua: Images of Love and Politics,* Baltimore, 1977.

Jules Romain: L'Histoire de Scipion: Tapisseries et dessins (cat), Paris, 1978.

Dunand, Louis, and Phillipe Lemarchand, *Les Compositions de Jules Romain intitulées Les Amours des dieux* (cat), Lausanne, 1978.

Giulio Romano (cat), Mantua, 1989.

articles—

Gombrich, Ernst, "The Sala dei Venti in the Palazzo del Te," in *Journal of the Warburg and Courtauld Institutes* (London), 13, 1950.

Shearman, John, "Giulio: Tradizione, licenze, artifici," in *Bollettino del Centro Internazionale di Studi d'Architettura "A. Palladio,"* 9, 1967.

Carpeggiani, Paolo, "Giulio architetto di villa," in *Arte Lombarda* (Milan), 17, 1972.

Verheyen, Egon, "Die Malereien in der Sala di Psiche des Palazzo del Te," in *Jahrbuch der Berliner Museen,* 14, 1972.

Verheyen, Egon, "Studien zur Baugeschichte des Palazzo del Te zu Mantua," in *Mitteilungen des Kunsthistorischen Institutes in Florenz,* 16, 1972.

Bukovinska, Beket, et al., "Zeichnungen von Giulio Romano und seiner Werkstatt in einem vergessenen Sammelband in Prag," in *Jahrbuch der Kunsthistorischen Sammlungen in Wien,* 80, 1984.

*

Giulio Romano has the distinction of being the only artist mentioned by Shakespeare (*The Winter's Tale*). Born in Rome in the 1490's—the date of his birth is variously believed to be 1492 or, more probably, 1499—he was Raphael's major disciple. His artistic training and formation took place entirely in the circle of Raphael, whose workshop in Rome Giulio entered around the year 1514 and where he remained until the master's death in 1520. During this period, in which Giulio established himself as Raphael's favorite and most trusted pupil, he was schooled in fresco and panel painting, architecture, drawing, and presumably in stucco technique. His tenure in the workshop saw Giulio emerge as Raphael's "deputy"—the assistant entrusted with overseeing several of the numerous artistic commissions in which Raphael was engaged in the last years

of his life. Giulio's partner and frequent collaborator in these years was the far less talented Gianfrancesco Penni, and the two artists together inherited Raphael's workshop following his untimely and sudden death. They supervised this operation until 1524, when Giulio left Rome for Mantua to enter the service of Duke Federico Gonzaga, assuming the role of court artist that Mantegna had filled a quarter century earlier. He remained attached to the Gonzaga court for the rest of life, although, according to Vasari, Giulio had resolved to return to Rome to become architect of Saint Peter's just before his death in 1546.

Giulio's early style closely approximates the manner of Raphael. So similar, in fact, is the early style of the pupil to that of the master that scholars at one time considered many of Raphael's autograph works, and even such masterpieces as the Sistine Chapel Tapestry Cartoons (1515; Royal Collection, on permanent loan to the Victoria and Albert) and the *Transfiguration* (1519–20; Vatican), to be largely or in significant part the effort of Giulio. Current opinion favors a more restrictive view of Giulio's contribution to Raphael's late works, although there is no doubt that he had a major hand in the frescoes of the Stanza dell'Incendio (1514–17), for example, and in such panel paintings as the *Holy Family of Francis I* (1518; Paris, Louvre) and the *Christ Carrying the Cross* (1516; Madrid, Prado), among others. While Raphael furnished drawings for the decorations of the Stufetta of Cardinal Bibbiena in the Vatican (1515) and the Psyche Loggia of the Villa Farnesina (1518), the execution of the frescoes was now entirely owing to Giulio, Penni, and other members of the workshop with no involvement in this stage of the work from the master. But in both of these cycles Raphael's invention and artistic idiom are faithfully translated. Even the *Battle of Constantine* in the Sala di Costantino in the Vatican (1520–21), executed by Giulio following Raphael's death but presumably in part after the latter's designs, reflects the latest direction of the master's style, particularly in the strictly archaeologizing, *all'antica* character of the composition which derives from antique battle sacophagi.

Giulio's adherence to a Raphaelesque manner in this period is perhaps most evident in the numerous devotional images that the artist executed in Rome: the *Madonna of the Cat* (Naples, Capodimonte) *is* closely based on Raphael's *Holy Family (La Perla)* in the Prado, while the composition as well as the touching intimacy of the *Madonna and Child with Saint John* (Paris, Louvre) recall the *Madonna della Sedia* (Florence, Pitti). And the murky shadow, brilliant, radiant colors, and metallic surfaces of the *Anima Altarpiece* (1521; Rome, S. Maria dell'Anima) and the *Stoning of St. Stephen* (c. 1520; Genoa, S. Stefano) have as their point of departure Raphael's last masterpiece, the *Transfiguration*. Where Giulio's manner differs from that of Raphael is in the grotesque brutality and exaggerated drama that emerge in such works as the *Stoning of St. Stephen*—features which herald the turn his style would take in Mantua.

In Mantua, Giulio Romano became an artistic impresario of astounding versatility, active as a painter, architect, designer of tapestries, silver, and ephemeral festival decorations, and overseer of public works. The major monument of his Manutuan period is the celebrated Palazzo del Te, the leisure villa of Federico Gonzaga located on the outskirts of the city which was begun shortly after the artist's arrival in Mantua. The

architecture of the Palazzo del Te, with its raised basement, heavy rustication, broken entablatures, sagging keystones, and organic vitality, is a consummate Mannerist invention which willfully subverts High Renaissance principles of rational order, balance, and symmetry. The Palazzo del Te is not a re-evocation of the heroic grandeur of classical antiquity, but rather a conjuring of antique forms in flux and disolution. In the vast interior suite of rooms, Giulio illustrated the personal mythology of his patron and celebrated his pleasurable pursuits: the Camera delle Impress abounds in the symbolic, often cryptic emblems which the Gonzaga, in keeping with Renaissance fashion, adopted to express their particular political ambitions, social status, moral posture, and personal predilections. The Cupid and Psyche Room, in which Giulio depicted the extravagant, bacchanalian wedding celebration of the god and nymph, alludes to Federico Gonzaga's dalliances with his mistress which took place at the villa. The duke's passion for horses determined the subject of the Sala dei Cavalli, in which the Gonzaga stud are prominently depicted before open-air arcades flanked by classical deities, while the Renaissance passion for astrology informs the Room of the Zodiac. And in the famous *Fall of the Giants* artist and patron paid homage to the Gonzaga Duke's Imperial protector, the Emperor Charles V, who is metaphorically likened to Jupiter defeating the rebel giants. In the *Fall of the Giants*, all is chaos and disorder, the sense of flux and movement that characterize the palace's exterior here introduced to the interior and pushed to its extreme. Indeed, the architecture that crashes down on the heads of the brutish, grotesque, and vaguely comical giants is ironically close to that of the Palazzo del Te itself. In the *Fall of the Giants*, as in this entire artistic ensemble, Giulio's artistic fancy and imagination were given free reign and find their fullest expression.

In addition to the Palazzo del Te, Giulio also executed decorations in the Palazzo Ducale in Mantua, designed the frescoes of the apse of the Verona cathedral, painted an altarpiece representing the *Nativity* for the church of Sant'Andrea (1532–34; Paris, Louvre), and produced a number of mythological and secular scenes such as the *Allegory of Immortality* (Detroit) and the mildly erotic *Two Lovers* (Leningrad). But it was to the field of architecture that Giulio increasingly turned his energies in the later years of his life, allowing his assistants (who varied considerably in artistic ability) to execute many of his paintings after his designs. He designed his own house in Mantua (extant) and a villa for the Gonzaga at Marmirolo (destroyed), and was responsible for the interior renovation of the cathedral of the city, and of the Benedictine monastic church of S. Benedetto Po. In concentrating on architecture, Giulio came, perhaps unwittingly, to emulate Raphael, who, in the final years of his life, devoted considerable effort to the building of St. Peter's and the Villa Madama. That he wished to be seen primarily as an architect is perhaps expressed by the portrait of Giulio painted by Titian during a visit to Mantua, in which the artist holds one of his architectural designs (1536–38; private collection), and by the fact that he planned to become architect of St. Peter's at the time of his death. Giulio Romano's greatest legacy is, indeed, his architecture—the Palazzo del Te has profoundly influenced later generations of architects up to the present day—but his prodigious power of invention is manifest in his entire artistic production.

—Linda Wolk-Simon

GOLTZIUS, Hendrick

Born in Mühlbracht, 1558; son of a glass painter. Died in Haarlem, 1616 or 1617. Married at 21; stepson, the artist Jacob Matham. Studied with the Haarlem engraver Dirck Volkertsz. Coornhert in Xanten, Germany and followed Coornhert to Haarlem, 1577; worked for the Antwerp engraver Philips Galle, 1577–82, then opened his own printshop and publishing house in Haarlem, 1582; associated with Cornelis Cornelisz and Carel van Mander in invigorating Haarlem art; his work brought him fame and wealth; trip to Italy, 1590–91; also did some painting from 1600; innovative engraver: color wood-blocks for landscapes, chiaroscuro woodcuts. Pupils: his stepson Jacob Matham, Jacob de Gheyn II, Jan Saenredam.

Collections: Amsterdam; Arras; Baltimore: Walters; Basel; Haarlem; Hague; Leningrad; Paris: Philadelphia; Providence; Rotterdam; Utrecht.

Publications

On GOLTZIUS: books—

Hirschmann, Otto, *Goltzius als Maler 1600–1617*, The Hague, 1916.

Hirschmann, Otto, *Goltzius*, Leipzig, 1920.

Hirschmann, Otto, *Verzeichnis des graphischen Werks von Goltzius*, Leipzig, 1921.

Goltzius als Tekenaar (cat), Rotterdam, 1958.

Reznicek, Emil, *Die Zeichnungen von Goltzius, mit einem beschreibenden Katalog*, Utrecht, 2 vols., 1961.

Reiss, Ruth Bromberg, *Incisioni di Goltzius conservate all' Ambrosiana.* Vicenza, 1969.

Strauss, Walter L., *Goltzius: The Complete Engravings and Woodcuts*, New York, 2 vols., 1977.

Magnaguagno-Korazijia, Eva, *Goltzius: Eros und Gewalt*, Dortmund, 1983.

*

Goltzius was the most influential among Dutch artists during that transitional period when the mannerist style that prevailed during the latter 16th century gave way in favor of the naturalism that characterized Dutch art through most of the 17th century. It was through his drawings and prints that his influence spread, even far beyond the borders of the Dutch Republic. The training of young artists at this time was based to a considerable extent on prints that their teachers had them copy. Besides making prints after his own designs and providing drawings for other engravers to copy, Goltzius made reproductive prints with the utmost skill and versatility.

His exceedingly fine control of pen and burin is all the more impressive in view of the fact that Goltzius's right hand was permanently crippled by an injury in childhood. That, given this serious drawback, he would even attempt an artist's career must be attributed to his family tradition. From his great grandfather on down, the men of his family on record as professional artists; his father was a glass painter. At the age of nineteen, in 1577, Hendrik came to Haarlem to work with Dirck Volkertsz. Coornhert, a poet and philosopher, as well as

The Large Hercules; engraving

an admired printmaker. who continued to be Goltzius's mentor for some years. When he was twenty-one, Goltzius married a widow nine years his senior, the daughter of a Haarlem shipbuilder. She had an eight-year-old son, Jacob Matham, who was to become his stepfather's pupil and, later, his accomplished collaborator in printmaking. The marriage presumably brought Goltzius financial security.

Carel van Mander, who had spent the years from 1573–77 in Italy, wrote later that he had taught Goltzius "the Italian style." The fashionable style to which he introduced his young friends when he arrived in Haarlem in 1583 was the mannerist mode, in which artificiality, elegance, and eroticism were prime objectives. It seems, in fact, to have been mainly drawings by the Antwerp mannerist, Bartholomeus Spranger, that van Mander showed to Goltzius, who within two years had made engravings after Spranger and prints of his own design in similar style.

In 1582 Goltzius had established his own publishing house in Haarlem. He continued to work in an ever more extreme mannerist style. In 1585, for example, he engraved and published a dynamic, dramatic, and erotic version of *Mars and Venus Surprised by Vulcan,* based on his own drawing. In his engraving, dated 1587, after Spranger's *Marriage of Cupid and Psyche,* virtually countless elongated nudes disport in all possible—and many impossible—poses. Through the 1580's he continued to make many sensitive portrait drawings and prints, as well as narrative and allegorical subjects in these media. He was credited with remarkable skill in imitating the

styles of other artists. Carel van Mander wrote that Goltzius's *Circumcision* in the style of Durer and *The Adoration of the Magi* in the manner of Lucas van Leyden impressed connoisseurs in "Rome, Venice, Amsterdam, and elsewhere" as works by those revered masters.

It was in about 1586 that Goltzius introduced in his drawings the swelling lines and crosshatching to create darkened areas that approximate the effect of engraving, an innovation that is said to have made him famous all over Europe. In his series of engravings of *Roman Heroes* of that year, each print portrays in this powerful style a full-length, muscular, active figure in a landscape setting, with narrative scenes in small scale distributed in the distance.

In 1590 Goltzius left on a long-postponed trip to Italy. Van Mander relates that Goltzius "spat blood three years" and "decided, despite his weak condition, to undertake the trip to Italy, if not to improve his state of health, then at least to have seen its beauty and art before he died." In Italy, he made many drawings of sculpture, both ancient and Renaissance, as well as portraits, some of Italian artists. His bust-length *Portrait of Giovanni da Bologna* (Haarlem, Teyler's Museum), a bold chalk drawing, is an insightful study. He is reported to have been impressed by the works of the great Venetian Renaissance painters Titian and Veronese and by Correggio. Certainly after he returned to Haarlem late in 1591, his art was profoundly changed. He had given up mannerist extravagance in favor of the late Renaissance standards of fidelity to nature, but an improved nature.

As a portrayer of landscape, Goltzius was a pioneer. His drawings of a mountain landscape of 1595 (Dresden, Staatliche Kunstsammlungen, Graphische Sammlung) is one of the earliest panoramic landscape depictions. In this and other landscape drawings he showed a remarkable ability to create gradations of tone, indicating aerial perspective, solely through variations in the pen line. In his *Arcadian Landscape*, probably of the same year, he showed his inspired skill in a new medium, chiaroscuro woodcut. He also made close-up studies of natural forms: clumps of trees, plants, animals.

Glotzius's gift for landscape depiction contribution to the success of a new kind of project in 1598: the creation of a print to record the news and make it widely available. His drawing (Haarlem, Teyler's Museum) of a dead whale that had washed ashore in February 1598, reflects the interest in natural phenomena that was related to the scientific trends of the time. The engraving that his step-son, Jacob Matham, made after Goltzius's drawing, which carried an extensive explanatory inscription, spread the news of this dramatic event. People shown climbing on the carcass establish the scale of the huge creature. Goltzius took care to give a clear picture not only of the whale and the crowds of curious visitors, but also of the extensive coastal landscape and the sailing vessels in the sea. This is an early example of the carefully observed landscape rendition that was to become one of the glories of Dutch 17th-century art. The inscription on the engraving, which describes the whale as a "wonderwork of God," suggests that even what appear to be objective portrayals of the natural world might have been intended to foster religious meditation.

In about 1600 Goltzius began to paint and to give up printmaking. His paintings failed to reach the high level of his graphic works. He continued to make splendid drawings at least until 1615, a year or two before his death. Several of his drawings were allegorical representations of his motto "Eer Boven Golt" ("Honor above Gold"), a pun on his name. One of the most brilliant of his late works was the *Portrait of a Young Man with Skull and Tulip* (New York, Pierpont Morgan Library), a pen drawing of 1614.

—Madlyn Millner Kahr

GONZALEZ, Julio.

Born in Barcelona, 21 September 1876. Died in Arceuil, 27 March 1942. Married 1) Jeanne Berlan, 1909, one daughter, Roberta; 2) Marie Thérèse Roux, 1937. Evening classes at School of Fine Arts, Barcelona, 1892, while working in his father's metalworking shop, and making jewelry with his brother Joan; settled in Paris and began painting, 1899; lifelong friendship with Picasso; stopped painting on his brother's death, 1908, and began work as sculptor; apprentice-welder during World War I; worked with Picasso on welded iron sculptures, 1930; lived in Arceuil from 1937.

Collections: Amsterdam: Stedelijk; Berlin; Nationalgalerie; Cologne; London: Tate; New York: Moma, Guggenheim; Paris: Beaubourg; Rome: Arte Moderna; Stockholm: Moderna Museet.

Publications

On GONZALEZ: books—

Grugiere, P. G., *Gonzalez* (cat), Amsterdam, 1955.
Ritchie, Andrew, *Gonzalez* (cat), New York, 1956.
Salles, George A., *Gonzalez: Dessins et aquarelles* (cat), Paris, 1957.
Kramer, Hilton, *Gonzalez* (cat), New York, 1961.
Pradel de Grandry, Marie, *Gonzalez*, Milan, 1966.
Aguilera Cerni, Vicente, *Julio, Joan, Roberta Gonzalez: Itinerario du una dinastía*, 1970.
Descargues, Pierre, *Gonzalez*, Paris, 1971.
Gilbert, Josette, *Gonzalez: Dessins*, Paris, 9 vols., 1975.
Martinez, Carmen, *Catalogue raisonné des dessins de Gonzalez*, Paris, 1976.
Withers, Josephine, *Gonzalez: Sculpture in Iron*, New York, 1978.
Gonzales: Esculturas y dibujos (cat), Madrid, 1980.
Krauss, Rosalind, *Gonzalez: Sculpture and Drawings* (cat), New York, 1981.

*

Gonzalez's contribution to modern sculpture is considerable, although his significance has been somewhat eclipsed by the greater fame of his friend and compatriot Picasso. Trained in the applied arts, Gonzalez held painting and sculpture in higher regard; but later in life succeeded in reconciling the two very separate schools of fine art and metalcraft. Gonzalez left

Montserrat, 1937; sheet iron; 63¾ in (162 cm)

his native Barcelona for Paris, resolving to become a painter, and quickly acquainted himself with the current members of the French avant-garde—most notably Picasso, whose family he had known in Spain—and their work. In the first decade of the 20th century Gonzalez looked back to the art of the 1880's and 1890's in France, imitating in pastels the styles of Degas and Puvis de Chavannes, considered by then to be the grand old men of new painting. Puvis's compositions, pale and introspective, represented both in medium and sensibility a desirable alternative to metalwork. However, during these years of artistic experimentation it was less Gonzalez's painterly accomplishments than his skill as a draughtsman, vestige of his training as an artisan, that emerged and in turn led him back to working in metal and on to the "drawing in space," a definition he felt best fitted his mature sculptural works and ideals.

While working in a Renault factory during the war years Gonzalez learned the technique of oxyacetylene welding, a method that greatly facilitated the manipulation of metals. He began to transfer to sculpture the skills and materials employed hitherto for the applied and decorative arts. The artist's first significant works in the sculptural medium were executed between 1926 and 1930, consisting of small masks and figurines inspired by Cubist and primitive art. Exposure to Picasso and to the Catalan sculptor Gargallo, both of whom Gonzalez assisted in the 1920's, helped orientate him in the next decade. During the period of collaboration with Picasso, which resulted in the design and construction of six welded metal sculptures, Gonzalez produced independently a small number of works in 1929, sheets of metal incised and cut with a saw to create areas of light and shadow, acknowledging in part the austere, planar concerns of Cubist painting and assemblage. However, in the 1930's Gonzalez abandoned Cubist faceting, translating instead the draughtsman's line into three dimensions in an attempt to abolish the tyranny of solid masses and single viewpoints of conventional sculpture. He borrowed from Picasso a new vocabulary of forms and devices, explored and substantiated in the former's *Woman in the Garden*, 1929–30, which provided a point of reference for Gonzalez's experiments. The linear quality of his raw standing female figures is emphasized by the paring of form to a minimum with narrow iron bars and perforated open spaces. *Little Peasant Woman*, 1930–31, refers directly to Picasso's paintings and sculptures in style as well as subject matter, the head cup-shaped and open, save for abbreviated facial features.

As well as inspiration from Picasso's quarter Gonzalez felt some affinity with the Paris Surrealists. The abstract sculptures of the 1930's do indeed convey a distinct Surrealist feel, especially *Cactus-Man*, 1938–39, a grimly humorous amalgamation of animal, vegetable, and mineral forms; but toward the latter years of the decade Gonzalez gravitated away from contemporary artistic concerns in favour, generally, of something more accessible and monumental. This took the form of *Montserrat*, 1936–37, Gonzalez's contribution to the Spanish Pavilion of the World Exhibition in Paris, 1937, and an emblem of national pride at the time of the Civil War. A life-size statue of a peasant woman and her child created in sheet metal, *Montserrat* was named after the holy mountain of Catalonia and echoes the tragic theme of Picassos's *Guernica* of the same time. With Gonzalez more interested in symbolic effect than stylistic experimentation, his work loses a great deal of the idiosyncrasy and visual impact that typifies the earlier sculp-

tures. War shortages necessitating the abandonment of the metal medium, Gonzalez continued working, using plaster as a substitute and drawing and painting in watercolour. However, he died before his second version of the *Montserrat*, a kneeling, screaming woman intended as an indictment to the horror of war, could be completed.

—Caroline Caygill

GORKY, Arshile.

Born Vosdanig Manoog Adoian in Khorkom, Vari Haiyotz, Dzor, in the Armenia region of Turkey, 15 April 1904; adopted the name Arshile Gorky, 1930; naturalized United States citizen, 1939. Died (suicide) in Sherman, Connecticut, 21 July 1948. Married 1) Marny George, 1935 (divorced, 1935); 2) Agnès Magruder, 1941; two children. Attended schools in Khorkom, Van, and Yerevan, and in Providence, Rhode Island; studied at the Rhode Island School of Design, Providence, 1921–22, New School of Design, Boston, 1923–24, and Grand Central School of Art, New York, 1925; lived in New York from 1925; worked in mural division, Federal Art Project, 1935; underwent cancer operation, 1946, and serious automobile accident (painting arm paralyzed), 1948.

Collections: Canberra; Chicago; London: Tate, Munich: Stadtsche Galerie; New York: Metropolitan, Moma, Guggenheim, Whitney; San Francisco: Modern Art; Washington: National Gallery, Hirshhorn.

Publications

On GORKY: books—

Schwabacher, Ethel K., *Gorky*, New York, 1957.
Schwabacher, Ethel K., *Gorky* (cat), New York, 1961.
O'Hara, Frank, *Gorky Drawings* (cat), New York, 1962.
Rosenberg, Harold, *Gorky: The Man, The Time, The Idea*, New York, 1962.
Seitz, William C., *Gorky* (cat), New York, 1962.
Melville, Robert, and William C. Seitz, *Gorky: Paintings and Drawings* (cat), London, 1965.
Levy, Julien, *Gorky*, New York, 1966.
Joyner, Brooks, *The Drawings of Gorky* (cat), College Park, Maryland, 1969.
Gorky Drawings, New York, 1970.
Baber, Alicia, et al., *Gorky: Drawings to Paintings* (cat), Austin, 1975.
Reift, Robert Frank, *A Stylistic Analysis of Gorky's Art from 1943–1948*, New York, 1977.
Bowman, Ruth, et al., *Murals Without Walls: Gorky's Aviation Murals Rediscovered* (cat), Newark, New Jersey, 1978.
Mooradian, Karlen, *Arshile Gorky Adoian*, Chicago, 1978; as *The Many Worlds of Gorky*, Chicago, 1980.
Rosenzweig, Phyllis, *Gorky* (cat), Washington, 1979.
Rand, Harry, *Gorky: The Implication of Symbols*, Montclair, New Jersey, and London, 1981.
Waldman, Diane, *Gorky: A Retrospective* (cat), New York, 1981.
Jordan, Jim M., and Robert Goldwater, *The Paintings of Gorky: A Critical Catalogue*, New York, 1982.
Lader, Melvin P., *Gorky*, New York, 1985.
Waldman, Diane, *Gorky*, New York, 1987.

*

Out of his tenacious character, romantic personality, and background and experiences as an emigrant from Armenia to America, Arshile Gorky developed some of the most intriguing, sensuous, and accomplished paintings to appear during the 1940's from among the first generation of Abstract Expressionists. On his route toward this accomplishment, Gorky put himself through a series of self-styled "apprenticeships," studying the masters of earlier 20th-century painting including Cézanne, Picasso, Miró, and Kandinsky, each of whom helped him locate the various ingredients for his own artistic synthesis and transformation.

Independent Gorky can be seen and felt in his series title *Garden in Sochi* (1940–43), in which biomorphic shapes intermingle to take on a life of their own. In many pictures of 1943-44, Gorky's essential character becomes fully present. His use of fragmented shapes which are at once suggestive of animal/vegetable/plant/human correspondences have become more abstracted, capable of numerous associations, and the liquid painterly atmospheres in which they live show both Gorky's knowledge of and independence from previous painters and styles. In *One Year the Milkweed* (1944), Gorky allows his liquidified paint to drip down the surface freely, creating a feeling of liveliness in process and motion and stressing at the same time the materiality of paint as paint. This picture, along with others from the same year, contain all the elements of the idea underlying Abstract Expressionist painting. Working from within the most personal recesses of his psyche and combining memory and experience, Gorky was communicating universally felt states of mind in abstract painterly form.

It is a mistake to see Gorky's picture as either landscapes or particular figures, although they contain associations with both. He studied Nature "close up" in order to discover the essential qualities inherent in organic form as they differ and overlap from one species to another, and it is this inner nature, that is character quality, which he brings to vision in his works. It is also a mistake to place all emphasis either on the abstract elements of the work or on the connections with Gorky's personal experience, since it is the blending of both which determines the whole feeling and visualization in Gorky's pictures from the early 1940's to the end.

Gorky's vision of Nature led to proliferation of shapes; scrambled imagery evoking male/female, plant/human, earth/spirit, tend to pile up, overlap, intermingle, spread across the surface, slithering and swimming as if in lifelike intercourse. *The Liver Is the Cock's Comb* (1944), perhaps Gorky's greatest picture, exemplifies this tendency most admirably by its field of vibrating colors inhabited by forms part mammal, part amoeba, part cellular. *The Limit* (1947) suggests the possibility of a move away from such outward proliferation; large areas of misty painted space seem to envelop the shapes over much of the canvas's surface. Gorky was only 44 when he

Mannikin, c. 1931; lithograph

committed suicide in 1948, and we can only guess what he might have done after his magnificent early Abstract Expressionism of the 1940's.

—Barbara Cavaliere

GOSSAERT, Jan. [Mabuse.]

Born in Maubeuge, Hainault, c. 1476 or c. 1478. Died probably in Middelburg, 1532–36. In the Antwerp guild, 1503, as Jennyn van Hennegouwe [Hainault]; also used the names Jennin Gossaert and Johannes Malbodius; in the service of Philip of Burgundy, and accompanied him to Italy, 1508; introduced nudes in classical subjects to Flanders; decorated Philip's palace at Duerstede, 1517, and designed his tomb, 1524; then worked for Philip's brother Adolph in Middelburg, 1524–33.

Collections: Antwerp; Barnard Castle; Berlin; Berlin (East); Brussels; Cleveland; Hampton Court; London: National Gallery, Courtauld; Munich; Ottawa; Palermo; Paris; Prague; Toledo, Ohio; Vienna; Royal Collection.

Publications

On GOSSAERT: books—

Gossart, Maurice, *Un des peintres peu connus de l'école flamande de transition: Jean Gossart de Maubegue: Sa vie et son oeuvre*, Lille, 1902.
Weisz, Ernst, *Gossaert*, Parchim, 1913.
Ségard, Achille, *Gossaert*, Brussels, 1923.
Friedländer, Max J., *Die altniederländische Malerei, vol. 8: Gossaert und Bernart van Orley*, Berlin, 1926; as *Gossaert and van Orley* (notes by H. Pauwels and S. Herzog), Leiden, 1972.
Boëz, H., *Gossaert: Etail-it maubeugeois?*, Hautmont, 1961.
Pauwels, H., H. P. Hoetink, and S. Herzog, *Gossaert* (cat), Rotterdam, 1965.
Carpi, Fabio, *Mabuse*, Milan, 1982.

articles—

Glück, G., "Mabuse and the Development of the Flemish Renaissance," in *Art Quarterly* (New York), 8, 1945.
Folie, J., "Les Dessins de Gossaert, avec catalogue," in *Gazette des Beaux-Arts*, 1951–60 (index in December 1960 issue).
Schwarz, H., "Gossaert's Adam and Eve Drawings," in *Gazette des Beaux-Arts* (Paris), 1953.
von der Osten, G., "Studien zu Gossaert," in *Essays in Honor of Erwin Panofsky*, New York, 1961.
Gibson, Walter S., "Gossaert: The Lisbon Triptych Reconsidered," in *Simiolus* (Utrecht), 17, 1987.
Silver, Larry, "The 'Gothic' Gossaert: Native and Traditional Elements in a Mabuse Madonna," in *Pantheon* (Munich), 45, 1987.

Jan Gossaert, also known as Mabuse after his birthplace, the town of Maubeuge in Hainault, provides one of the most telling examples of the shift in Romanist interests that characterized many 16th-century Flemish artists. He was trained in the late 15th-century style, probably in Bruges, and his early work is clearly within that tradition. In 1508, however, Gossaert accompanied his patron, Philip of Burgundy, to the Vatican in order to make drawings of the Roman monuments for him. While there, Mabuse developed a passion for the antique that he carried back with him to Flanders. Gossaert began to sign his works in Latin and include Michelangelesque figures and classical architectural elements in his paintings. In doing so he became the first Romanist among the northern artists. After his return to the Netherlands in 1509, Mabuse continued to work in Mechelen, Utrecht, and Middelburg. As his work as a painter and teacher flourished, he influenced a whole generation of northern painters such as Frans Floris and Marten de Vos who changed the character of Flemish painting forever.

Mabuse's early style is evident in the *Adoration of the Magi* (1507–08, London, National Gallery). Influences of Hugo van der Goes and Gerard David are visible in the high airy building and the graceful, slender bodies. The figures are enveloped by their setting in the spirit of fifteenth-century Flemish painting, but there is already a hint of Gossaert's changing interests: the dog in the right foreground is derived from Dürer's engraving of St. Eustace. Like Dürer, Mabuse was about to turn his interests to Italy.

After his return from Italy, Mabuse divided his work between two interests. In some works, especially those that he painted for the Italian patrons that he had acquired during his southern sojourn, he worked in a style and technique based on the work of 15th-century Flemish masters. A rich oil medium, highly glazed surfaces, and detailed brushstrokes evoke the work of Van Eyck especially. In the *Malvagna Triptych* (1510–11, Palermo, Galleria Nazionale della Sicilia), a Madonna with features derived from Gerard David sits in a lacy Gothic architectural setting that recalls works by Van Eyck and Van der Weyden; only the little angels at her feet hint at Mabuse's new acquaintance with Italian figure types. Similarly, in a diptych painted for Antonio Siciliano in 1513–14 (Rome, Galleria Doria Pamphili), Mabuse copied Jan Van Eyck's *Madonna in a Church*, albeit in a somewhat heavy manner, for one panel, and in the adjoining panel placed the donor and his patron saint in a landscape that sparkles with Flemish detail. His *Deësis* from the same period (Madrid, Prado) is similarly copied after a Van Eyck composition found in the Ghent Altarpiece.

On the other hand, the *St. Luke Painting the Virgin* (c. 1515, Prague, National Gallery) shows Mabuse's self-conscious break with traditional Netherlandish art forms. Although the Madonna's face and the drapery treatment have been compared to the work of the Master of Flémalle, the tone of the picture as a whole is overwhelmingly Italianate, the Christ Child is muscular, the architecture is heavy-handedly classical in form and largely pagan in decoration, and the space is virtually a school study of the rules of one-point perspective. Yet Mabuse betrays his Netherlandish interests in the wealth of "hidden symbolism" that also appears: the statue of Hercules on the corner above the Madonna probably alludes to the power of Christ, as the owl below suggests the wisdom of Mary as a Christian Athena.

The Children of Christian II of Denmark; 13½ × 18⅛ in (34.2 × 46 cm); Royal Collection

Mabuse's Italianism was even more apparent, if less successful, in other works. The nudes in the *Neptune and Amphitrite* of 1516 (East Berlin, Staatliche Museen zu Berlin), though sometimes hailed as the first idealized classicizing nudes in Flemish painting, are muscle-bound caricatures of the Michelangelesque forms they seek to imitate.

Mabuse's conversion to Italian Renaissance forms was to prove somewhat tentative, however. In his *St. Luke Painting the Virgin* of c. 1520 (Vienna, Kunsthistorisches Museum), Mabuse retains the classicizing architecture that marked his earlier treatment of the subject and treats the figures of Christ and the angels in a similarly herculean spirit. The mood of the piece as a whole, however, is more northern. The perspective of the scene is so truncated that the foreground appears almost tilted, and the figures' draperies are agitated to reveal the emotions of the figures more than their bodies. Moreover, unlike the earlier painting, in which the Virgin and Child are seated solidly in the foreground, here they float in an aureole of luminescent clouds, casting an otherworldly light over the entire scene. Clearly spirituality has overtaken the clear rationality that characterized the earlier scene.

A similar mixture of Italian and northern interests appears in Mabuse's *Danaë* (1527, Munich, Alte Pinakothek). The subject itself is a pagan theme popular among Italian humanists, and the setting at first seems classical with its Corinthian columns. But its rounded form suggests a church apse and Danae's blue gown recalls the Virgin. Some of the buildings in the background look Gothic, suggesting that Mabuse may have been less comfortable with his adopted Italianism than one might first conclude.

In his portraits, finally, Mabuse's loyalty to his Netherlandish roots is particularly apparent. Many of his portraits show his noble partrons and their associates, but members of the wealthy mercantile class also appear in his canvases. Though their costumes are 16th-century, the sitters are presented in the tradition of 15th-century painters such as Van Eyck: set normally in a three-quarters pose against either a black background or a cluttered environment indicating the sitter's profession, it is only the new monumentality of the figures that suggests Mabuse's contact with Italy. Thus, although he achieved his most lasting fame as a Romanist, Mabuse remained a strikingly Flemish artist.

—Jane Nash Maller

GOUJON, Jean.

Born c. 1510. Died in Bologna, c. 1568–69. Influenced by the first school of Fontainebleau, and by Cellini; first recorded in Rouen at S. Maclou, 1540; worked in Paris from 1544 on the Louvre (caryatid figures, panels, courtyard facade, Fontaine des Innocents, 1547–49) and at S. Germain l'Auxerrois; became King's Architect, 1547; also contributed appendix and designs to 1547 edition of Vitruvius; designed decorations for entry of Henry II into Paris, 1549; worked at Hotel des Ligneris (nor Carnavalet Museum) and Chateau d'Ecouen; last documented in Paris, 1562; left Paris for Bologna c. 1563, because he was a Huguenot.

Major Collection: Paris.
Other Collection/Locations: Chantilly; Ecouen; Paris: Carnavalet; Rouen: Cathedral, S. Maclou.

Publications

By GOUJON: book—

Architecture, ou Art de bien bastir (appendix and designs), by Vitruvius. Paris, 1547.

On GOUJON: books—

Pottier, Andre, *Oeuvre de Goujon . . . ,* Paris, 1844.
Gailhabaud, J., *Quelques notes sur Goujon,* Paris, 1863.
Lister, Reginald, *Goujon: His Life and Work,* London, 1903.
Jouin, Henry, *Goujon,* Paris, 1906.
Vitry, Paul, *Goujon: Biographie critique,* Paris, 1908.
Du Colombier, Pierre, *Goujon,* Paris, 1949.

articles—

Miller, Naomi, "The Form and Meaning of the Fontaine des Innocents," in *Art Bulletin* (New York), 50, 1968.
Hoffman, Volker, "Le Louvre de Henri II: Un palais imperial, in *Bulletin de La Société de l'Histoire de l'Art Francais,* 1982.

*

Little is known about the life of the artist who represents the apex of Renaissance classicism in France. Goujon was born c. 1510, and hence is part of that generation who effected the artistic revolution initiated by Francis I. The Corinthian columns supporting the organ of St. Maclou in Rouen, dated 1540, is his first recorded work; they are so classical that a trip to Italy is assumed. At the same time, he probably had some role in the design of the tomb of Louis de Brèze, husband of Diane de Poitiers.

Goujon has been cited in documents as architect as well as sculptor and it is the felicitous merging of the two arts that characterizes the work executed in Paris from 1544 to the late 1550's. In the rood screen of St. Germain l'Auxerrois, he begins his collaboration with Pierre Lescot; here, the *Pietà,* a bas-relief panel in the narrative mode, is allied to the style of Cellini and the School of Fontainebleau, particularly Rosso,

Fountain of Innocents—detail, 1549; stone; Paris, Square of the Innocents

while the surrounding evangelists bear the imprint of Michelangelo's Sistine prophets. Works attributed to Goujon for the Connétable Anne de Montmorency at Ecouen (1544 to c. 1550) include the decor of the chapel (portal, sculptures of virtues above the altar, and woodwork), the figures of Fame in the triumphal arch of the western wing, and those on the northern pediment, as well as Fame brandishing a sword above the fireplace of the Salle d'Honneur.

With the accession of Henry II to the throne in 1547, Goujon's sculpture partakes in the imitation of the antique that begins to permeate the letters and arts. In the *Fountain of the Innocents,* he created a work completely in the classical spirit, one in which the contrapposto of the urn-bearing nymphs forms a harmonious part of its architectural enframement.

As "Sculptor of the King" from 1546 to 1555, Goujon worked on the bas-reliefs of the Louvre facade in the Cour Carrée, the original courtyard, where, in collaboration with Lescot, he executed a program designed specifically for the architecture, to glorify the "very Christian King." Personifications frame the oculi of the three pavilions: Mars and Minerva (War and Peace) in the central portal (with appropriate accoutrements of victories, prisoners, and crowns), while at either side are figures representing History and Victory, and Victory and Fame. Gebelin (1924) noted the parallels of this imagery to that contained in the state entry of the King into Paris in 1549, for which Goujon did much of the decor. All the ornamental motifs have been interpreted in an emblematic way, the whole bespeaking a propaganda in praise of the King's virtues and learning, and the benefits and material abundance bestowed by the monarch. In fact, the program has been judged as one worthy for an imperial palace, in accord with the reigning theology of the court. As Hoffman states, allegories representing the universal kingdom, peace, and felicity revive the iconography of imperial Rome, as befits a palace for the ruler of the Holy Roman Empire.

Within the Louvre, Goujon's caryatids for the musical Tribune are without precedent. Only the marble maidens of the Erechtheum come to mind, leading to the possibility that these figures, lacking the grace of both the antique and the nymphs on the *Fountain of the Innocents,* may have been from ancient casts (Gebelin), and as studies for Goujon's own illustrations of the pertinent Vitruvian passage. Here the architectural quality is uppermost, for the strength of the caryatids is manifest in the symmetry and the disposition of the draperies as they perform their function as columnar supports.

From 1548 to 1550, Goujon probably worked on the Hôtel des Ligneris, now the Carnavalet. Figures on the entry tympanum as well as the reliefs of the Four Seasons have been attributed to him, or to his atelier. However, that very symbol of the French Renaissance, the *Diane d'Anet,* once deemed his masterpiece, has been withdrawn from his oeuvre by most scholars.

Concurrently, Goujon supplied the decorations for the Entry of Henry II into Paris in 1549. Of greatest significance, however, is his collaboration with Jean Martin on the latter's first French translation of Vitruvius, published in 1547. In his dedication to the King, Martin states that this edition "was enriched by new figures concerning the art of masonry by meister Jean Goujon, formerly architect of Monseigneur le Connétable and now one of yours." But even more intriguing is Goujon's own appendix at the end of the book, writing as

"student of architecture" to explain his designs. He acknowledges his debt to Serlio, "whom today we have in this Kingdom of France . . . who introduced [Vitruvian] doctrines . . . ," and cites Fra Gioconda, Alberti, Budé, Philander, Raphael, Mantegna, Sangallo, Bramante, in addition to the French architects Lescot and Delorme.

Goujon's contribution to Martin's edition of Vitruvius's *De Architectura* affirms the essential role of architecture in his work, of which sculpture is an integral part. Primary to the spirit of his oeuvre is the elegant application of a classical vocabulary, more Greek than Roman, to French art at mid-century.

After 1562, Goujon's name does not appear in royal accounts. Evidence points to his presence in Bologna—an odd choice for a Protestant seeking refuge—and his death there c. 1568–69. A decade later, in 1578, Lefèvre de la Boderie in the *Galliade* praises Goujon, citing the sculpture of the Louvre and the illustrations for the Vitruvius edition.

—Naomi Miller

GOYA (y Lucientes), Francisco (José).

Born in Fuendetodos, 30 March 1746. Died in Bordeaux, 16 April 1828. Married Josefa Bayeu, 1773. Studied in Saragossa; in Madrid by 1763; in Italy, 1770–71; worked on Saragossa Cathedral, 1771; settled in Madrid, 1775: produced tapestry cartoons for royal manufactory, 1776–92; appointed Deputy Director of the Academy, 1785, Painter to the Kind, 1786, Court Painter, 1789, and First Court Painter, 1799; published Los Caprichos, series of satirical etchings, 1799; etched Los Desastres de la Guerra, inspired by Napoleonic invasion of Spain, 1808–20; moved to outskirts of Madrid, 1819; continued to work at Spanish Court until 1824; then settled into exile in Bordeaux.

Major Collections: Madrid: Prado, Royal Academy of San Fernando.
Other Collections: Agen; Amsterdam; Bayonne; Berlin; Besansçon; Budapest; Buenos Aires; Chicago; Lille; London; Madrid: Capilla de S. Antonio de la Florida; Mexico City; Minneapolis; Munich; Naples; New York: Metropolitan, Frick, Hispanic Society; Paris; San Diego; Sao Paulo; Toledo, Ohio; Washington; Williamstown, Massachusetts.

Publications

On GOYA: books—

Beruete, Aureliano, *Goya pintor de retratos,* Madrid, 3 vols., 1917–18; as *Goya as a Portrait Painter,* London, 1922.

Rich, D. Catton, and F. Schmid, *The Art of Goya,* Chicago, 1941.

Rothe, Hans, *Goya: Handzeichnungen,* Munich, 1943.

Sambricio, Valentin de, *Tapices de Goya,* Madrid, 1946.

Lafuente Ferrari, Enrique, *Goya: El dos de mayo y los fusilamientos,* Barcelona, 1946.

Lafuente Ferrari, Enrique, *Antecedentes, conididencias, e influencias del arte de Goya*, Madrid, 1947.

Malraux, André, *Dessins de Goya au Musée du Prado*, Paris, 1947.

Klingender, Francis D., *Goya in the Democratic Tradition*, London, 1948, New York, 1968.

Malraux, André, *Saturne: Essai sur Goya*, Paris, 1949; as *Saturn: An Essay on Goya*, London, 1957.

Sánchez Cantón, F. J., *Vida y obras de Goya*, Madrid, 1951; as *Life and Works of Goya*, New York, 1964.

Lafuente Ferrari, Enrique, *Los desastres de la guerra de Goya y sus dibujos preparatorios*, Barcelona, 1952.

Lopez-Rey, José, *Goya's Caprichos: Beauty, Reason, and Caricature*, Princeton, 2 vols., 1953.

Lafuente Ferrari, Enrique, *Goya: The Frescoes in San Antonio de la Florida*, Geneva and New York, 1955.

Tügel, Richard, *Goya: Der Erschiessung von der Dritte Mai, 1808*, Stuttgart, 1960.

Sambricio, Valentin de, *Goya* (cat), Madrid, 1961.

Lafuente Ferrari, Enrique, *Goya: Complete Etchings, Aquatints, and Lithographs*, London, 1962.

Nordström, Folke, *Goya, Saturn, and Melancholy: Studies in the Art of Goya*, Stockholm and New York, 1962.

Sánchez Cantón, F. J., *Goya y sus pinturas negras en la quinta del sordo*, Barcelona, 1963; as *Goya and the Black Paintings*, London, 1964.

Helman, Edith, *Transmundo de Goya*, Madrid, 1963.

Harris, Tomás, *Goya: Engravings and Lithographs*, Oxford, 2 vols., 1964.

Held, Jutta, *Farbe und Licht in Goyas Malerei*, Berlin, 1964.

Guidol, José, *Goya*, New York, 1964.

Trapier, Elisabeth du Gué, *Goya and His Sitters: A Study of His Style as a Portraitist*, New York, 1964.

Sanchez Canton, F. J., *Goya: La Quinta del Sordo*, Florence, 1965.

Harris, Enriqueta, *Goya*, London and New York, 1969.

Guidol, José, *Goya*, Madrid, 4 vols., 1970.

Gassier, Pierre, and Juliet Wilson, *Vie et oeuvre de Goya*, Fribourg, 1970; as *Goya: His Life and Work, with a Catalogue Raisonné of His Paintings, Drawings, and Engravings*, London, 1971, 1981.

Helman, Edith, *Jovellanos y Goya*, Madrid, 1970.

Held, Jutta, *Die Genrebilder der Madrider Teppichmanufaktur und die Anfänge Goyas*, Berlin, 1971.

Thomas, Hugh, *Goya: The Third of May 1808*, London, 1972.

Gassier, Pierre, *Goya: Das Skizzenbücher*, Frankfurt, 1973.

Gassier, Pierre, *Les Dessins de Goya*, Fribourg, 2 vols., 1973-75; as *The Drawings of Goya*, London and New York, 2 vols., 1973-75.

Sayre, Eleanor, *The Changing Image: Prints by Goya*, Boston, 1974.

Williams, Gwyn A., *Goya and the Impossible Revolution*, London, 1976.

Symmons, Sarah, *Goya*, London, 1977.

Glendinning, Nigel, *Goya and His Critics*, New Haven, 1977.

Young, Eric, *Goya*, London, 1978.

Licht, Fred, *Goya: The Origins of the Modern Temper in Art*, New York, 1979, London, 1980.

Salas, Xaver de, *Goya*, London, 1979.

Perez-Sánchez, Alfonso E., *Goya: Caprichos, Desastres, Tauromaquia, Disparates* (cat), Madrid, 1979.

Díaz-Plaja, Guillermo, *Goya en sus cartas y ortas escritos*, Zaragoza, 1980.

Bareau, Juliet Wilson, *Goya's Prints: The Tomás Harris Collection in the British Museum*, London, 1981.

López Vázquez, José Manuel B., *Los Caprichos de Goya y su interpretacion*, Santiago de Compostela, 1982.

Gassier, Pierre, *Goya: Témoins de son temps*, Fribourg, 1983.

Guillaud, Jacqueline and Maurice, *Goya: Les Visions magnifiques*, Paris, 1987.

Hull, Anthony, *Goya, Man among Kings*, Lanham, Maryland, 1987.

Symmons, Sarah, *Goya: In Pursuit of Patronage*. London, 1988.

Tomlinson, Janis A., *Goya: The Tapestry Cartoons and Early Career at the Court of Madrid*, Cambridge, 1989.

Perez-Sánchez, Alfonso E., et al., *Goya and the Spirit of the Enlightenment* (cat), Boston, 1989.

*

Although recent scholarship casts Francisco Goya as a revolutionary precursor and spiritual father of modern painting, the artist's earliest documented works were in fact commissioned by the Building committee of the cathedral of Saragossa, and required the artist to fresco a vault of the *coreto* or little choir: the subject given was *The Adoration of the Name of God* (1771). Rows of saints and angels—all idealized and massive figures—sit upon ranges of solidly painted clouds, as they turn to a central triangle, inscribed with the divine monogram. While the technique has been compared to that of Corrado Giaquinto, whose Roman frescoes Goya he would have seen during his largely undocumented trip to Italy (1770-71), the theme continues a long tradition of All Saints pictures, such as the *Gloria* painted by Titian for Philip II.

It was undoubtedly Goya's artistic success in his native Saragossa that led to his 1773 marriage into the Bayeu clan, three of whom—the brothers Francisco, Ramon and Manuel—were painters. Like Goya, the family was of Aragonese origin. The eldest, Francisco, was by this time a salaried painter at the court of Charles III, and probably obtained for his brother-in-law work producing tapestry cartoons for the Royal Tapestry Factory of Santa Barbara in Madrid. From 1775 to 1792, Goya would paint at least fifty-seven such designs, which depict scenes inspired by life in contemporary Madrid, by popular theatre, and by earlier genre traditions. These cartoons had to be the size of the tapestries woven after them and thus forced the artist to paint genre scenes of a scale traditionally reserved for history and religious painting. Recent scholarship suggests that in theme as well as scale, he attempted to enrich his subject matter by referring to baroque iconographic traditions. Such ulterior meaning would accord with the description Goya offered of his works up to 1800 as *historia*.

In 1780, the tapestry factory closed due to economic difficulties resulting from Spain's war with Great Britain. Following his election to the Royal Academy in May 1780, Goya returned to Saragossa to fresco a dome of the Cathedral under the supervision of Francisco Bayeu. Comparison with the vault of the *coreto*, painted almost a decade earlier, betrays the influence of lessons learned in painting the anecdotal tapestry cartoons. In *The Queen of Martyrs* (1780-81) we again find a multitude of saints in adoration: now, however, they are differ-

entiated by gesture, posture, and expression to enliven the composition that anticipates Goya's well-known fresco for the cupola of San Antonio de la Florida in Madrid, painted eighteen years later.

A similar animation characterizes Goya's next major religious commission, *Saint Bernadine of Siena Preaching Before Alfonso of Aragon.* This large painting was to adorn the royally patronized convent church of San Francisco el Grande in Madrid. It was one of seven paintings, commissioned from as many artists then active at court, and was extremely important for Goya's career, since it gave him the opportunity to paint a work in a respected genre that, unlike the tapestry cartoons, would be permanently exhibited before the public. In it, the artist conflates history painting and religious imagery by recreating the 15th-century miracle in which a star appeared above the head of Saint Bernardine as he preached before a large crowd that included the Spanish king of Naples. Although no contemporaneous criticism has survived, it would seem that the painting was a success, for after 1784, Goya began to enjoy the patronage of a diverse aristocratic clientele who commissioned works ranging from altarpieces, to portaiture, to decorative cabinet paintings.

Thus, by the mid-1780's the general features of Goya's career seem to be sketched out. From this point onward, he would work in a variety of genres far wider than that witnessed in the work of any other painter of his epoch. Yet despite apparent differences, these works are linked by Goya's acute awareness of narrative and human emotions.

No where are these interests seen more clearly than in a small uncommissioned painting (oil on copperplate), *The Madhouse at Saragossa.* From Goya's correspondence to the Vice-Protector of the Royal Academy, we know that this was the twelfth painting in a series presented to that institution, undertaken to distract the artist from the worries caused by a serious illness of 1792–93 which had left him deaf for life. Goya explains that these uncommissioned paintings enabled him to exercise freely his *capricho,* or fancy. The viewer might wonder if the madhouse is real, or merely a vehicle for Goya's exploration of human passions. Figures are isolated from any narrative context; emerging from the shadows, half-seen and loosely painted, they offer painterly metaphors for the disorientation of insanity.

As intriguing as such works might be, it is important to recognize them as only one facet of the artist's career. After his promotion to court painter in 1789, Goya was assigned a variety of tasks: he was clearly the preferred portraitist of King Charles IV and his wife, Maria Luisa, and for their coronation in 1789 painted no less than six pairs of portraits. His reputation as a portraitist grew, and by the mid-1790's he was regularly employed in this capacity by aristocrats, ministers, and ambassadors. One such work is the portrait *Ferdinand Guillemardet,* who served as French ambassador to Madrid from November 1798 to March 1800. Perhaps realizing that this work would return, with the Ambassador, to France and there represent his *oeuvre,* Goya seems to have lavished special care in his characterization and execution; his usual somber palette is enlivened by the sitter's tricolor sash and plumed hat, held in equilibrium by the golden accents on the chair, the sword, and the table cloth. Guillemardet's haughty gallantry seems a just reflection of his personality: a small-town doctor, his political success is probably more to be credited to his vote for

The Colossus; mezzotint

the death of Louis XVI than to any innate aptitude. While in Spain, he seemed to care little for affairs of state; the main concern voiced in his correspondence is for the safe arrival of the Bordeaux wine he imported.

The introduction of Guillemardet leads to another intriguing question: the impact of the French revolution in Spain, and more specifically, on Goya. To what extent was he affected or influenced by the liberal ideas that had led to the execution in 1793 of the French king—cousin to Goya's own royal patron? The most persuasive evidence for such ideological influences is Goya's first major series of etching, *Los Caprichos,* in which the artist satirizes social foibles ranging from the idleness of the nobility to popular superstition. But any supposition of liberal influence, or of an intentional and direct attack on the nobility, is difficult to reconcile with the historical fact that Goya worked in the service of the King, and that he was promoted to the position of First Court Painter in October 1799, eight months after the publication of the series.

Many interpretations have been offered for the eighty etchings of *Los Caprichos.* Goya drew inspiration from several sources, including emblemata, satirical prints, and literature. Etched from about 1796 through 1798, these works attest Goya's untiring experimentation with the etching medium. Although certain images were created predominantly by line etching, others illustrate an attempt to create a painterly figure with the use solely of aquatint. A technical study of these etchings proves Goya's fascination with the medium, which he had previously used to reproduce paintings after Velazquez

that hung in the royal collection (1777–78) and to which he would return in *Los Desastres de la Guerra* (1810–20), *La Tauromaquia* (1815–16) and *Los Disparates* (1819–24).

There is little documentation for Goya's career from 1800, when he painted *The Family of Charles IV* to 1808, when he was at work on an equestrian portrait of Spain's future king, Ferdinand VII. We know that he returned to Saragossa to document in painting the resistance of the Aragonese to the Napoleonic forces in 1808–09. It was probably upon returning to Madrid that he began work on *Los Desastres de la Guerra,* inspired by the Napoleonic war that ravaged Spain until 1813. Noteworthy is the fact that Goya decided not to publish those etchings upon the restoration of Ferdinand VII (son of Charles IV) in 1814; he instead added to them several imaginative and satirical scenes that betray the artist's disillusion with the repressive and conservative regime of the restored monarch.

On 24 February 1814 Goya addressed a memorandum to the Regency requesting permission to record the notable and heroic events of the Spanish insurrection against Napoleon; on 9 March he was granted permission, and 1500 *reales* to cover expenses. The results of his labors were the pendants for which he is universally known, *The Second of May* and *The Third of May.* Yet if Goya had intended to ingratiate himself with the returning monarch, he seems to have failed: under Ferdinand VII, he was supplanted at court by the younger painter, Vincente Lopez. Although this fact has been credited to his possible involvement with the French during the Napoleonic occupation, documents in the Palace Archive show that such was not the case. For although Goya's contemporary, Mariano Maella, suffered a decrease in salary because of his collusion, Goya was retained at the salary he had earned prior to the war, because no infidelity to the Spanish monarch could be proven.

In 1815, the artist was investigated by the Inquisition for having painted the *Naked Maja,* which during the war had been discovered in the collection of the Prince of Peace, Manuel Godoy. Although he was acquitted, his experiences probably exacerbated his disillusion with the conservative regime. His role at court continued to diminish in subsequent years, and in 1819, he moved out of the city, where he had resided since 1774, to a country house known as the Quinta del Sordo, on the opposite shore on the Manzanares River.

Here he painted, in oil directly on the plaster walls, the scenes of popular pilgrimages, witches, duels, and haunting figures that have become popularly known as the "black" paintings. The meaning of these works still eludes us. Scale as well as scenes of popular pilgrimages seem to recall Goya's earliest tapestry cartoons, while the eerie image of cannibalism, known to us as *Saturn Devouring His Son,* recalls Rubens's painting of the subject that Goya would have seen in the royal collection. In style, these paintings recall the figures of the *Madhouse of Saragossa,* whose painterly faces, distorted by exaggerated grimaces, likewise emerge from a dark netherworld. Like that earlier cabinet painting, the "black" paintings offered Goya the opportunity to explore the capricious images of human passions; but now they assume a nearly life-size scale, and, as originally placed in two large rooms of Goya's house, would confront the viewer dared to enter this private sanctum, dedicated to caprice and invention.

On 2 May 1824, Goya, still in royal employ, requested permission to go to France to take waters to relieve the pains that accompanied his advanced age. That permission would be subsequently renewed, enabling the artist to settle, after a brief visit to Paris in 1824, in Bordeaux where he lived until his death on 16 April 1828. At the age of 79, he seems still to have been eager to learn, and created a series of four bullfight scenes in lithography—a technique to which he had first been introduced in Madrid in 1819. Drawing with lithographic crayon directly upon the lithographic stone positioned, according to one account, like a canvas upon an easel, he discovered a freedom unequaled by the more laborious technique of etching. In the lithograph *Dibersion de Espana,* a quick, calligraphic style describes the boisterous energy and apparent hilarity of the commoners who have poured into the ring to test themselves against the bulls. More than a document, it is an imaginative—and not all together flattering—remembrance of the crowds' uncontrollable energy. It would seem, perhaps, that the artist laughs at them; yet the commoners get their revenge, as one participant mawkishly gestures to the signature in the lower left: Goya.

—Janis A. Tomlinson

GOYEN, Jan (Josephs) van.

Born in Leiden, 13 January 1596. Died in The Hague, 27 April 1656. Three daughters: one married the painter Jan Steen, and another married the still-life painter Jacques de Claeuw. Pupil of Isaac van Swanenburgh in Leiden, and then of Willem Gerritsz. in Hoorn; spent a year in France, 1615 or 1616, then worked under Esaias van de Velde in Haarlem from 1617–18; worked in Leiden 1618 until c. 1632, then settled in The Hague; painted landscapes from 1618 (and painted his own figures in his landscapes); many drawings, including sketchbooks, often recording his travels around Holland; dealt in real estate, tulips, often in debt. Pupil (and son-in-law): Jan Steen.

Collections: Amiens; Amsterdam; Antwerp; Berlin; Birmingham; Bordeaux; Braunschweig; Bremen; Cambridge; Carcassonne; Chicago; Cleveland; Dresden; Enschede; Frankfurt; Glasgow; Hoorn; Leipzig; Leningrad; London; Manchester; Munich; Oxford; Pasadena; Rotterdam; San Francisco; Schwerin; Sheffield; Toronto; York.

Publications

On GOYEN: books—

Beck, H. U., *Ein Skizzenbuch von Van Goyen,* The Hague, 1966.
Dobryzcka, Anna, *Van Goyen* [in French], Poznan, 1966.
Beck, H. U., *Van Goyen: Ein Oeuvreverzeichnis,* Amsterdam, 2 vols., 1972–73.
Wright, Christopher, *Van Goyen, Poet of the Dutch Landscape* (cat), London, 1977.
Van Goyen (cat), Amsterdam, 1981.

River Landscape with a Ferry; drawing

Jan van Goyen's career, unusually for a Dutch 17th-century painter, falls into a series of easily definable categories. This is because he dated almost all his paintings, thus allowing his development to be recorded with uncanny accuracy.

He began somewhat inauspiciously in Haarlem as the pupil of Esaias van de Velde, and his early works are heavily dependent on van de Velde's small-scale winter scenes. These pictures were soon abandoned, and from the late 1620's van Goyen entered his second phase, which was also short-lived. These pictures tend also to be small in scale but are dominated by greys and greens and usually depict canals and sand dunes. The likely influence here is that of Pieter de Molijn, the innovative Haarlem landscapist.

Van Goyen settled in Leiden although he travelled widely in the Dutch Republic as well as living in the nearby The Hague. Away from the Haarlem influences his art became more inventive and at the same time closer to the accurate observation of nature.

It was in the early 1630's that van Goyen developed what has been called his monochrome style. His pictures, mostly small in scale, record the greyness of the Dutch sky and the dampness of the ground. His horizons tend to be low and most of the pictures are rapidly brushed, using such a free technique that it was not to be parallelled in landscape until the 19th century. Few commissions came van Goyen's way, but the isolated examples show a dramatic change in style. At the end of his life he was commissioned by the municipal authorities of The Hague to paint a panorama of the town to be hung in the town hall (where it still remains). For such a formal commission, van Goyen utilised a much more meticulous technique even though he still emphasised the broadness of the sky. The

existence of a rather similar *View of Leiden* (private collection) would imply that van Goyen received a similar commission for that town as well.

Later in the 1630's and in the 1640's van Goyen reintroduced colour into his pictures, especially with touches of blue in the skies, and he tended to make his trees return to a greenish hue rather than the grey-browns he had preferred earlier. These mature and late pictures are compositionally inventive—he was using many different sites, especially Dordrecht, Arnhem, Rhenen, and Nijmegen. His brushwork retained its rapidity and even in his last pictures in the 1650's his work never seems to have lost its momentum. Over a thousand works by van Goyen survive, and a few are large in scale. No painter until the 19th century was able to depict the effects of grey skies and moist air with such bravura and accuracy.

—Christopher Wright

GOZZOLI, Benozzo.

Born Benozzo di Lese in Florence, 1420 or 1421. Died in Pistoia, 1497. Seven children. First documented as assistant to Ghiberti on Baptistery doors, 1444; then assistant to Fra Angelico: on the frescoes for the S. Marco convent, Florence, in the Vatican, 1446–47, and at the Chapel of San Brizio in Orvieto Cathedral (chapel was eventually completed by Signorelli); work on the Church of S. Francesco, Montefalco, 1450, was his first solo work, then worked in Viterbo (S. Rosa convent), early 1450's, the Medici Palace in Florence, 1459,

S. Agostino in San Gimignano, 1463-65, and the Campo Santo, Pisa.

Collections: Florence: Uffizi, Medici-Riccardi; London: National Gallery, British Museum; Milan; Pisa: Campo Santo; Royal Collection.

Publications

On GOZZOLI: books—

Wingenroth, Max, *Die Jugendwerke des Gozzoli,* Heidelberg, 1897.
Stokes, Hugh, *Gozzoli,* London, 1904.
Mengin, Urbain, *Gozzoli,* Paris, 1909.
Contaldi, Elena, *Gozzoli: La vita, Le opere,* Milan, 1928.
Hoogewerff, Goffredo J., *Gozzoli,* Paris 1930.
Lagaisse, Marcelle, *Gozzoli: Les Traditions trecentistes et les tendances nouvelles chez un peintre florentin du quattrocento,* Paris 1934.
Bargellini, Piero, *La fiaba pittorica de Gozzoli,* Florence, 1946.
Rowe, Robert, *Gozzoli,* London, 1956.
Boschetto, Antonio, *Gozzoli nella chiesa di San Francesco a Montefalco,* Milan, 1961.
Scarpellini, Pietro, *Gozzoli,* Milan, 1966.
Padoa, Rizzo, Anna, *Gozzoli, pittore fiorentino,* Florence, 1972.
Amaducci, Alberto, *La Cappella di Palazzo Medici,* Florence, 1977.

article—

Roberts, Ann M., "North Meets South in the Convent: The Altarpiece of Saint Catherine of Alexandria in Pisa," in *Zeitschrift für Kunstgeschichte* (Munich), 50, 1987.

*

Benozzo Gozzoli was among the most popular and prolific Florentine artists of the second half of the 15th century. Specializing in fresco painting, he decorated chapels throughout Tuscany, Umbria, and Rome, and executed numerous altarpieces. Among Benozzo's patrons were Pope Nicholas V, the Medici, and the commune of Pisa, the painting of whose Camposanto provided his livelihood for nearly 20 years. While many 20th-century critics have considered Benozzo a lesser master, his popularity—and the survival of many of his works, if in damaged condition, from a period in which so much has perished—reveal his importance to our understanding of the Renaissance.

Benozzo apprenticed with the most prominent artists of his day, the sculptor Lorenzo Ghiberti (c. 1445) and the painter Fra Angelico (c. 1438/40-50). Although efforts to identify his hand in the Gates of Paradise have not been entirely convincing, the influence of its organized if profuse narrative, detailed background, and ornate surfaces remained throughout his career. Benozzo's figure and facial types, drapery, and palette are descended from those of Angelico, with whom he worked on the cells of San Marco, Florence, the Chapel of Nicholas V, Vatican, and the Capella di San Brizio, Orvieto, in the 1440's.

Gozzoli's ability as an independent master is amply evident in the paintings he executed in Montefalco in the early 1450's. While lacking the grace and beauty of both his teachers' works, his frescoes of the life of Saint Francis in the choir of San Francesco (1452) display a sensitivity to the Franciscan hagiographic and narrative tradition that is remarkable. Through this commission as well as numerous others in this region, he became a major influence on Umbrian painting. A year after the completion of the Montefalco cycle, another Franciscan church, Santa Rosa at Viterbo, entrusted him with a now-lost cycle (1453; destroyed 1632) of their titular saint's life. This established his reputation in Lazio. He completed yet another chapel, this time of the life of Saint Anthony of Padua, for the chapel of the Albertini, a prominent Roman family, in Santa Maria in Aracoeli, Rome.

Benozzo's celebrity surely won the commission for the chapel (1459) of the recently finished Palazzo Medici in Florence. Relinquishing the interest in framed, sequential narrative that had characterized his earlier work, Benozzo simulated the appearance of tapestry in a brilliantly colored landscape panorama traversed by the magi and their entourage. The inclusion of recognizable portraits and the vast space teeming with cunning flora and fauna are major innovations. With this work, he joined the illustrious rank of artists, from Donatello and Verrocchio to Angelico, Uccello, and Botticelli patronized by the Medici. It was no doubt due to his relationship with them that he obtained the commission for the *Altarpiece of the Purification* (1461; main panel, London), for a confraternity affiliated with San Marco, itself supported by the Medici. Indeed, the contract for this work specified that the panel simulate Fra Angelico's *San Marco Altarpiece,* commissioned by Cosimo de' Medici some 20 years earlier, reiterating this association.

Between 1462 and 1465, Benozzo worked in and around San Gimignano. His painting of the choir of Sant'Agostino there represents the only Tuscan Renaissance fresco cycle of Augustine's life. The scenes are significant not only for their lucid and dramatic narrative, but for an iconography that reflects the spiritual ideals of the Augustinian reform movement. Benozzo's many frescoes, altarpieces, and tabernacles for the town and its environs suggest how very prolific was his activity.

In 1468 Benozzo obtained the most important commission of his career, one sought by Botticelli, Mantegna, and Cosimo Tura. The painting of some 25 frescoes of the Old Testament for the Camposanto of Pisa engaged his substantial energies until 1484. While the disastrous bombing of the Camposanto in World War II destroyed most of the frescoes, engravings and photographs as well as the painstakingly restored fragments suggest, if dimly, their original grandeur. The monumental horizontal field is disposed with multiple episodes of dramatic action set amidst sweeping landscapes and grandiose architecture. Only the frescoes lining the walls of the Sistine Chapel (1481-82) are of comparable scale and scope, but they pale by contrast to the Camposanto cycle. While in Pisa, Benozzo executed innumerable projects for the Cathedral, the nunnery of San Benedetto and local churches, as well as for Legoli, Volterra, and environs. Forced to leave Pisa by adverse political events, Benozzo spent his last years in Florence and Pis-

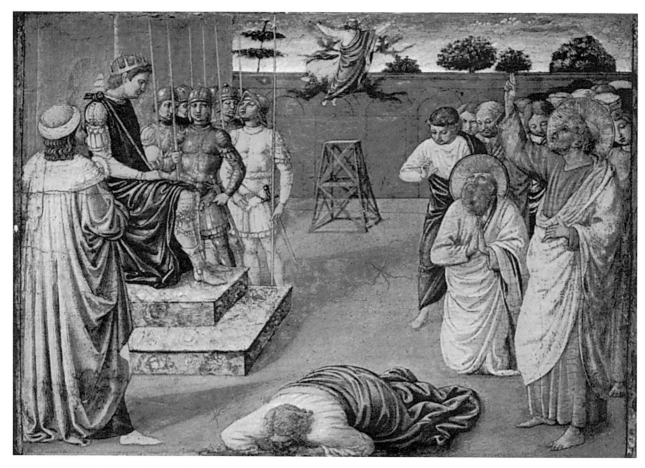

The Death of Simon Magus; 9½ × 14 in (24 × 35.4 cm); Royal Collection

toia. Painted in oil, his *Raising of Lazarus* (Washington) and *Deposition* (Florence, Museo Horne) translate the innovative perspective vistas, infinite landscapes, and eloquent figures of the Camposanto frescoes to canvas. He died in 1497 in Pistoia, where he is buried.

Benozzo was a most venerated artist in his own day. Though he painted numerous altarpieces, most were executed in a formulaic, uninspired fashion. His true metier was fresco, where the broad expanse of wall allowed him to organize the most diffuse of narratives into decorative and aesthetic coherence. He expressed the unique spirit of each commission—the austerity of the Montefalco cycle bespeaking the Franciscan ethos, the pageantry of the Palazzo Medici chapel conveying the expansive wealth of its patrons, the majesty and breadth of the Camposanto cycle translating the spirit of the Old Testament themes it chronicles. This peripatetic master brought the innovations of Florentine Renaissance art to all the places for which he painted, decisively influencing local styles. In addition, the vast quantity of his drawings and *sinopie,* as well as the abundance of documents, contracts, and letters that have survived him allow scholars to reconstruct the milieu in which he worked. For all of these reasons, Benozzo Gozzoli is pivotal to our understanding of Renaissance painting.

—Diane Cole Ahl

GRECO, EL.

Born Domenikos Theotokopoulos in Candia, Crete, 1541. Died in Toledo, 6 or 7 April 1614. One son, by Jerónima de las Cuevas, the painter Jorge Manuel. Established as a painter in Crete by 1566; possibly studied under Titian in Venice, 1568; member of the painters guild in Rome, 1572; then recorded in Toldeo from 1577 to 1614: worked in S. Domingo el Antiguo, 1577–79, Toledo Cathedral, the Seminary of the Incarnation (Madrid), 1596–99, and Hospital of St. John the Baptist Outside the Walls, Toledo, from 1608.

Major Collection: Madrid.
Other Collections: Bucharest; Chicago; Escorial; Illescas: church of the Hospital de la Caridad; Lille; London; Minneapolis; Modena; Munich; New York: Hispanic Society, Metropolitan; Parma; Toledo: Cathedral, Hospital of St. John the Baptist, Museum Parroquial de S. Vicente, S. Vicente, S. Domingo el Antiguo, S. Juan Bautista, S. Nicolas, S. Tome; Toledo, Ohio; Washington: National Gallery, Phillips; Worcester, Massachusetts.

Publications

On EL GRECO: books—

Cossío, Manuel B., *El Greco,* Madrid, 2 vols., 1908.

Trapier, Elisabeth du Gué, *El Greco,* New York, 1925.

Mayer, August L., *El Greco,* Munich, 1926.

Mayer, August L., *El Greco,* Berlin, 1931.

Goldscheider, Ludwig, *El Greco,* 1938, 3rd ed., 1954.

Gómez Moreno, Manuel, *El entierro del Conde de Orgaz: Estudio crítico,* Barcelona, 1943.

Caturla, Maria L., *La Verónica: Vida del tema y su transformación por El Greco,* Madrid, 1944.

Lozoya, Marqués de, *El San Mauricio del Greco: Estudio critico,* Barcelona, 1947.

Camón Aznar, José, *Domenico Greco,* Madrid, 2 vols., 1950, 1970.

Guinard, Paul, *El Greco,* Lausanne and New York, 1956.

Marañón, Gregorio, *El Greco y Toledo,* Madrid, 1958, 4th ed., 1963.

Trapier, Elisabeth du Gué, *El Greco: Early Years at Toledo 1576–1586,* New York, 1958.

Kehrer, Hugo, *Greco in Toledo: Höhe und Vollendung 1577–1614,* Stuttgart, 1960.

Wethey, Harold E., *El Greco and His School,* Princeton, 2 vols., 1962.

Lafuente Ferrari, Enrique, *El Greco: The Expressionism of His Final Years,* New York, 1969.

Manzini, Gianna, *L'opera completa del Greco,* Milan, 1969.

Gudiol, José, *El Greco,* Barcelona, 1971, New York, 1973.

Lassaigne, Jacques, *El Greco,* London, 1974.

Davies, David, *El Greco,* Oxford and New York, 1976.

Baccheschi, Edi, *El Greco,* Milan, 1979, as *El Greco: The Complete Paintings,* New York and London, 1979.

Marías, Fernando, and Agustín Bustamente García, *Las ideas artísticas de El Greco,* Madrid, 1981.

Brown, Jonathan, et al., *El Greco of Toledo* (cat), Boston, 1982.

Brown, Jonathan, editor, *Figures of Thought: El Greco as Interpreter of History, Tradition, and Ideas,* Washington, 1982.

Allen, George R., *El Greco: Two Studies,* Philadelphia, 1984.

El Greco: Italy and Spain (colloquium), Washington, 1984.

Mann, Richard G., *El Greco and His Patrons: Three Major Projects,* Cambridge, 1986.

*

El Greco, known today as a painter of the Spanish "Golden Age", was born in Candia, Crete, in 1541. The contents of El Greco's library at the time of his death in 1614 reveal that he was well educated, and the annotations in some of those books shed light on his inquiring and intelligent mind. Although El Greco obviously received a sound education, an early document recorded before a Cretan notary public indicates that he was from an early age "Master Domenikos Theotokopoulos, painter."

The Crete of El Greco's birth was under Venetian rule, and there was a large Greek colony in Venice. Venice was thus a logical attraction for a painter who was trained in the Byzantine icon tradition, as El Greco was, but whose earliest works, notably the *Modena Triptych* (Modena) demonstrate a will to westernize and thereby up-date his painting style. This triptych, signed "Master Domenikos," reveals an impulse on the part of its maker away from the flat gold background of the Byzantine icon toward the suggestion of real space that was the common goal of all western painters since the early Renaissance. As well, the figures are endowed with more naturalistic volume, and their poses and garments are treated in a much less stylized manner.

We do not know when El Greco first arrived in Venice, though he is first documented there on 18 August 1568. He probably spent no more than three and a half years in Venice, but in that time El Greco became a Venetian painter. Several years later her was mentioned in a letter by his friend Giulio Clovio as a "disciple of Titian," though there is no evidence that he actually worked in Titian's shop. What is clear is that El Greco avidly studied and learned from the works of Titian, Tintoretto, Veronese, Jacopo Bassano, and others who contributed to the glory of late 16th-century Venetian painting.

El Greco's *Purification of the Temple* (Washington) perfectly represents the radical transformation that his style underwent during his Venetian sojourn. As was the habit of many artists who needed a bit of help in organizing pictorial space, El Greco evidently based this painting on a composition invented by Michelangelo. If El Greco's handling of Renaissance pictorial space in this small painting is as yet imperfect, he has, in a painterly technique, infused the work successfully with rich color and animated movement, both derived from his study of the Venetian masters.

In 1570 El Greco arrived in Rome, where his artistic education benefitted from new lessons. There he met Giulio Clovio, the well-known miniatures painter, who recommended him to the household of Cardinal Alessandro Farnese. In July 1572 "el pittore greco" is recorded at work on the decoration of the Hall of Hercules in the Farnese villa at Caprarola. On 18 September 1572 he was admitted to the Rome painters Academy as a painter of miniatures. El Greco's stay in Rome is otherwise hardly documented, except by further changes in his style.

On his way to Rome, El Greco evidently stopped at Parma and was much impressed by the paintings of Correggio. In Rome itself he added to his potential repertory the High Renaissance achievements of central Italy, as exemplified in the works of Raphael and Michelangelo. The lessons learned are evident in the version of *Christ Healing the Blind* (Parma), painted sometime after El Greco arrived in Rome. The painter has not relinquished the luminous color of Venetian painting, but he is now fully capable of populating a dramatically receding architectural space with more monumental figures that demonstrate an enhanced command of the human form. A slightly later version of the same subject (New York) repeats the conjunction of Venetian and central Italian ideals and adds a new interest—the Mannerist style practised by such Roman painters as Francesco Salviati and Federico Zuccaro.

El Greco, now thoroughly grounded in all permutations of the Italian Renaissance style, arrived in Spain in 1577. That journey, which was to prove crucial to his career and to his reputation today, was undoubtedly prompted by several reasons: his inability to obtain important commissions in an arena zealously guarded by Italian painters, his friendship with several Spaniards in Rome who had important friends and relatives in Toledo, and the lure of the enormous project underway to decorate Philip II's monastery/church/palace at El Escorial.

El Greco may have first stopped in Madrid, but soon settled at Toledo. His son Jorge Manuel, who became his father's collaborator and closest follower, was born there in 1578. Already in July 1577 El Greco was at work on a commission much more important than any he had had in Italy. That was the large painting of *The Disrobing of Christ*, called *El Espolio*, which was destined for the sacristy of the Cathedral of Toledo. It is entirely probable that the commission came about through the intervention of a friend from Rome, Luis de Castilla, whose father, Diego de Castilla, was dean of the Toledan cathedral chapter.

El Espolio, created on a scale unprecedented in El Greco's earlier career, demonstrates the power and individuality of the synthesis derived from his experience. Fluid passages of brushwork and the brilliant carmine of Christ's robe recall Venice, the monumental figures symmetrically disposed recall the Roman High Renaissance, and the elongation of the figure of Christ and the crowding of the figures into a compressed space are Mannerist traits. The lack of a sense of "place" in this painting suggests El Greco's return to an aspect of Byzantine practise; from the completion of *El Espolio* to the end of his life, El Greco very rarely situated his figures within the sophisticated and elaborate architectural spaces he had created while in Italy.

From 1577 through 1579 El Greco was working on an even larger commission for the altarpieces of the church of Santo Domingo el Antiguo. The *Assumption of the Virgin* (Chicago), the center of the main altarpiece, and the *Trinity* (Madrid), placed above it, are two of the great masterpieces of El Greco's early years in Spain. Both are indebted to Italy, but are also markedly original in style.

El Greco's first attempt to attract the attention of Philip II was evidently the painting called *The Allegory of the Holy League* (Escorial), which commemorates the defeat of the Turks at the Battle of Lepanto in 1571, a defeat made possible by an alliance of Spain, Venice, and the Vatican. This strange composition, with its medieval connotations in the great maw of the Leviathan rising from the sea, may indeed have been a foot in the door for El Greco at court. In 1580 Philip granted El Greco a commission for an altarpiece at the Escorial.

The royal commission called for a depiction of *The Martyrdom of Saint Maurice and the Theban Legions* (Escorial); El Greco worked on the painting for two years, delivering it in person to the Escorial on 16 November 1582. He was paid the handsome sum of 800 ducats for his work, but Philip soon had the work replaced with a mediocre version by the Italian painter Romulo Cincinnato, dashing any hopes that El Greco might have had for future commissions from the king. El Greco had utilized a common Mannerist device, that of placing the main action (in this case, the scene of martyrdom itself) in the background. By so doing, he removed the proper subject of contemplation far from the eye of the devout viewer and thus violated the rules of Counter-Reformation art to which Philip firmly adhered.

El Greco's definitive return to Toledo was also fraught with problems, for he was involved in lengthy litigation over payment for *El Espolio* and was thus effectively cut off from future commissions from the cathedral chapter. He busily set up a workshop, however, which could contract for all phases of creating the typical Spanish *retablo*, an ensemble consisting of a gilded architectural framework, paintings, and polychromed sculpture. El Greco thus added to his repertory the work of architect and sculptor and was able independently to attract the patronage of Toledo's clergy, nobility, and intellectual aristocracy, all of whom supported his highly individual gifts (in spite of his somewhat arrogant and litigious personality) for the rest of his life.

In 1585 El Greco's workshop undertook the manufacture of the frame for *El Espolio*, for which he was paid as much as for the painting itself, and soon thereafter began work on the ephemeral decorations used for the triumphal procession celebrating the return of the relics of Saint Leocadia to the Cathedral of Toledo in 1587. El Greco received the commission for the most famous of his paintings, the *Burial of the Count of Orgaz* (Toledo, Santo Tomé) in 1586 and completed the enormous work two years later.

One of the finest examples of El Greco's skill as a portraitist is his portrayal of *Fray Hortensio Félix Paravicino*, a brilliant Trinitarian friar. The portrait, today in the Boston Museum of Fine Arts, was probably painted around 1609. El Greco pulls the seated figure illogically close to the picture plane and rejects any hint of ambiant space, yet these Mannerist devises serve to intensify the sensitive naturalism of his treatment of the sitter's face and expressive hands and to allow Paravicino's intelligent gaze to engage us.

In response to the artistic demands of the Counter-Reformation, El Greco created images of saints and apostles, *Christ Carrying the Cross,* and *Christ Crucified* in a number of variations. Many of these are among his most moving works; many are less successful productions of his workshop. Among these deeply moving devotional paints is a *Pietà* (Stavros S. Niarchos Collection) which exemplifies the way in which El Greco's style perfectly expresses the emotional content of a subject. Joseph of Arimathea aids the Virgin Mary in supporting the body of her son; they are accompanied by Mary Magdalen. The figures are arranged horizontally in a severely narrow space, as if to press the livid, elongated form of the dead Christ toward the viewer (in a manner much like that of Roger van der Weyden's *Deposition* (Madrid). Grief is expressed through a stunned and frozen silence.

From the year 1596, when El Greco signed a contract for an altarpiece for the College of Doña María de Aragón, his shop continued to attract major commissions. In 1597 and 1607 El Greco contracted for decorating private chapels, and in 1603 and 1608 he signed agreements to provide a new altarpiece for two hospitals. The painter died in 1614 in the city that had adopted him and his art.

Domenikos Theotokopoulis, as he always signed his paintings, is unique in the history of art. He is the only painter of Greek origins to have moved so fully out of the Byzantine tradition and so ably into the pictorial world of the Italian Renaissance. His extremely Mannerist style, continuously exaggerated in terms of the elongation of forms and brio of technique as he aged, attracted the patronage of the learned clerics and intellectuals of Toledo. For centuries, his work was not well known outside that city, certainly not outside Spain. At the turn of this century, El Greco's daring, highly personal style was re-evaluated in light of the equally daring break with pictorial traditions forged by such artists as Picasso. His works are today widely considered as among the masterpieces of European painting.

—Suzanne L. Stratton

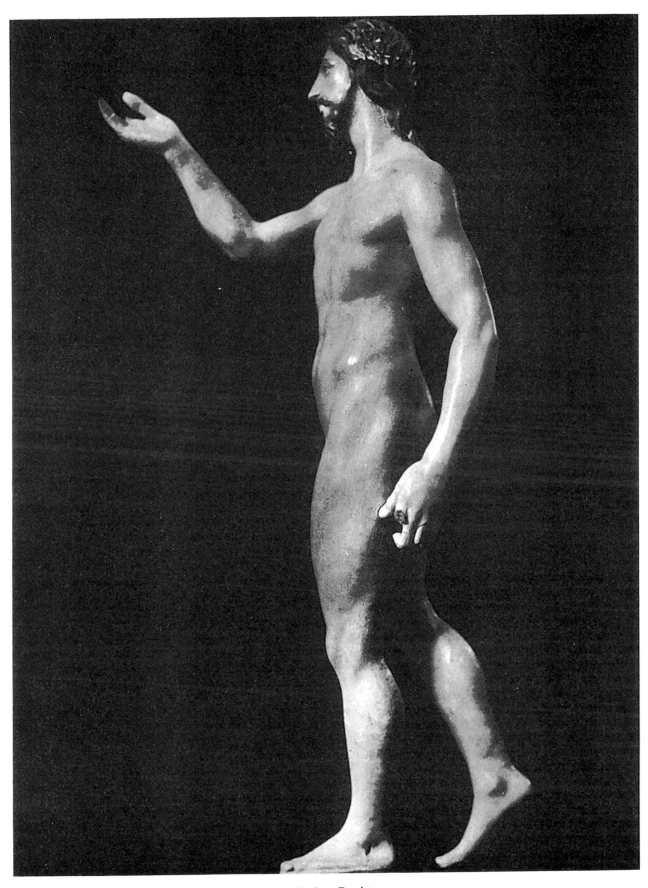

The Risen Christ; wood; 17¾ in (45 cm); Toledo, Hospital of S. Juan Bautista

GREUZE, Jean Baptiste.

Born in Tournus, 21 August 1725. Died in Paris, 21 March 1805. Married Anne Gabrielle Babuty, 1759; three daughters. Studied in the studio of Charles Grandon, Lyons, in late 1740's; studied under Natoire at the Academy in Paris by 1755; immense popularity followed his exhibition of *Grandfather Reading the Bible to His Family* at the Salon of 1755; in Italy, 1755–57; though he had a studio in the Louvre, he did not allow himself to be elected to the Academy, and refused to exhibit at the Salon from 1769 to 1800; neglected after the revolution. Pupil: Pierre-Alexandre Wille.

Major Collections: London: Wallace; Montpellier; Paris; Tournus: Musée Greuze.

Other Collections: Angers; Cherbourg; Edinburgh; Leningrad; Lyons; Metz; New York: Frick, Metropolitan; Paris: Jacquemart-Andre; Stockholm; Versailles: Museum; Washington.

Publications

On GREUZE: books—

Prost, J. C. A., *Deux oeuvres de Greuze,* Paris, 1904.

Mauclair, Camille, *Greuze: Sa vie, son oeuvre, son epoque,* Paris, 1905.

Mauclair, Camille, *Greuze . . . catalogue raisonné de l'oeuvre peint,* Paris, 1906.

Martin, Jean, *Catalogue raisonné de l'oeuvre peint et dessiné de Greuze,* Paris, 1908.

Pilon, Edmund, *Greuze, peintre de la femme et la jeune fille du XVIIIe siecle,* Paris, 1912.

Hautecoeur, Louis, *Greuze,* Paris, 1913.

Monod, F., and Louis Hautecoeur, *Les Dessins de Greuze conservés a l'Académie des Beaux-Arts de Saint-Pétersbourg,* Paris, 1922.

Waldram, Beatrice A., *Greuze,* London, 1923.

Mauclair, Camille, *Greuze et son temps,* Paris, 1926.

Brookner, Anita, *Greuze: The Rise and Fall of an Eighteenth-Century Phenomenon,* London and Greenwich, Connecticut, 1972.

Munhall, Edgar, *Greuze* (cat), Hartford, Connecticut, 1976.

Bryson, Norman, *Word and Image: French Painting of the Ancien Regime,* Cambridge, 1981.

articles—

Munhall, Edgar, "Greuze and the Protestant Spirit," in *Art Quarterly* (Detroit), Spring 1964.

Sauerländer, W., "Pathosfiguren im oeuvre des Greuze," in *Walter Friedlaender zum 90. Geburtstag,* Berlin, 1965.

Russo, Kathleen, "A Comparison of Rousseau's 'Julie' with the Heroines of Greuze and Fuseli," in *Woman's Art Journal* (Knoxville, Tennessee), Spring-Summer 1987.

*

J. B. Greuze was a late 18th-century genre painter whose works echoed in spirit and sentimentality the popular trend toward *sensibilité* seen in the literature of Rousseau, Richardson, and Diderot. He was influenced by the Dutch painters Teniers and Wouvwerman, as well as his contemporary Chardin. His *Boy with a Lesson Book* (1757; Edinburgh) particularly reflects his indebtedness to Chardin's unassuming scenes, such as *A House of Cards* (1741; Paris, Louvre).

Greuze is best known for his moralizing narratives. He was the first French painter to take a cue from William Hogarth's visual sermons. The rising middle-class morality of the French public inspired the great initial appeal of these works. His first success in this vein came with *The Bible Reading* (1753, private collection), which was purchased by La Live de Jully and exhibited in the Salon of 1755. Others soon followed. He won universal acclaim with his well-known *The Village Bride,* (1761, Louvre), in which he depicts a betrothal scene between two attractive youths and the emotional responses this event inspired in themselves and their families. This work responded to public interest in family life and the promotion of marital bliss. It was a theme carried even further in his *Well Loved Mother* (1769; Madrid, Laborde Collection), where a mother is looking almost indecently ecstatic as she is surrounded by her children and admired by her appreciative husband. The model for the central figure in both of these works was Greuze's wife, Anne Gabriele Babuty.

It is ironic that Greuze painted these scenes of domestic harmony with a focus on the likeness of his wife, since in reality his marriage was a disaster. Described as having an innocent, though sensual beauty in her youth, certainly captured in *The Village Bride* painted only two years after they married, Babuty later seduced many of his clients and pupils and caused him much embarrassment. There are hints that she was the mistress of Greuze's champion Diderot, both before and after her marriage. This involvement may have aided the eventual rift between the artist and this important critic.

The mixture of an innocent appearance mixed with sexual experience certainly held a great appeal for Greuze. He painted numerous youthful female figures that involved the theme of lost virginity. *Girl Crying over Her Dead Bird* (1765; Edinburgh) and *The Broken Pitcher* (1773, Louvre) are only two of many works he did denoting this passage from youth to womanhood. Birds out of their cages, broken pitchers, broken mirrors, and broken eggs were all well-known contemporary symbols for lost virginity used by the artist.

Although Greuze's works were widely acclaimed by the public, his incorrigible personality, vanity, and stubbornness, gained him many enemies. Even his early supporters, including the Marquis de Marigny and Diderot, later became disenchanted with him. His relationships with members of the Royal Academy were hindered because of his temperament, thus abetting his refusal for membership as a history painter. He was, instead, admitted to the Academy as a genre painter (1769), even though his *Morceau de reception* was an ambitious historical piece entitled *Septimus Severus and Caracalla* (1769, Louvre). The enmity with which this painting was received by critics, and his rejection for membership at the highest level cast him into despair. After this he avoided the official salons and showed his works elsewhere, most successfully in his Louvre studio where he was visited by many important European dignitaries. He resumed exhibiting at the Salon only in 1800.

Although he spent two years in Italy (1755–57), Greuze was

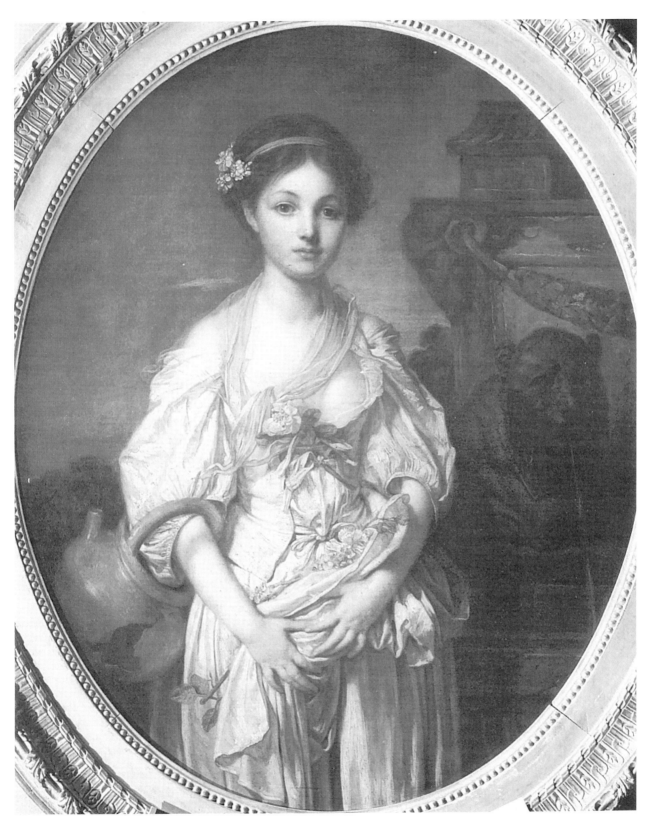

The Broken Pitcher, 1785; $43\frac{1}{4} \times 33\frac{1}{2}$ in (110×85 cm); Paris, Louvre

not greatly influenced by Italian art. He did claim admiration for Correggio and Guido Reni, and some works involve Italian themes, including *La Paresseuse Italienne* (1757, Hartford, Connecticut) and *Le Geste Nepolitain* (1757, Worcester, Massachusetts).

The painterliness of his early works, inspired by Rubens and Van Dyck, becomes dryer and darker in his later narratives. These works also show a negative, rather than positive concern with family situations. *The Father's Curse* (1777, Louvre) and *The Punished Son* (1777, Louvre) are overly theatrical and bleak depictions of domestic life.

Although known as a genre painter, some of his most admired pictures, both by contemporary and present critics, are his portraits. He depicted his father-in-law *Babuti* (1759, Paris, private collection) and his friend and collector *J. G. Wille* (1765; Paris, Jacquemart-André) in a strong, moving, and very personal way that belie his notoriety for isolation and ingratitude.

Greuze's popularity faded fast after the revolution and he has not yet received renewed appreciation, although his works are presently getting more attention along with a reconsideration of the entire period.

—Kathleen Russo

GRIS, Juan.

Born José Victoriano Carmelo Carlos González Pérez in Madrid, 23 March 1887; adopted the name Juan Gris c. 1906. Died in Boulogne-sur-Seine, 11 May 1927. Had one son by Lucie Belin, 1909; lived with Josette Herpin from 1914. Studied engineering at the School of Arts and Sciences, Madrid, 1902–04; studied painting with José Moreno Carbonero, 1904–06; illustrator for *Blanco y Negro,* 1904–06; settled in Paris, 1906; illustrator for *L'Assiette au Beurre* and *Le Cri de Paris,* 1906–12; lived in Boulogne-sur-Seine in the 1920's; stage designs for the ballet *Les Tentations de la Bergère,* 1924 (revised version, *The Gods Go A-Begging,* 1928), and for *La Colombe* and *L'Education manquée,* both 1924.

Collections: Basel; Berlin: Nationalgalerie; Berne; Buffalo; Chicago; New York Moma, Guggenheim; Otterlo; Paris: Beaubourg; Philadelphia.

Publications

By GRIS: books—

Letters 1913–1927, edited by Douglas Cooper, London, 1956.
Posibilidades de la pintura y otros escritos, Cordoba, Argentine, 1957.

Illustrator: *Alma América,* by José Santos Chocano, 1906; *Poèmes en prose,* 1915, *La Guitare endormie,* 1919, and *Au soleil du plafond,* 1956, all by Pierre Reverdy; *Horizon carré,* 1917, and *Tremblement de ciel,* n.d., both Vicente Huidobro; *Beautés de Paris 1918,* by Paul Dermée, 1919; *Ne coupez pas,* *mademoiselle,* by Max Jacob, 1921; *Le Casseur d'assiettes,* by Armand Salacrou, 1924; *Zywe Linje,* by Tadeusz Pieper, 1924; *Mouchoir de nuages,* by Tristan Tzara, 1925; *Denise,* by Raymond Radiguet, 1926; *A Book Concluding with As a Wife Has a Cow,* by Gertrude Stein, 1926.

On GRIS: books—

Raynal, Maurice, *Gris: Vingt tableaux,* Paris, 1920.
George, Waldemar, *Gris,* Paris, 1931.
Kahnweiler, D. H., *Gris: Sa vie, son oeuvre, ses écrits,* Paris, 1946; as *Gris: His Life and Work,* London and New York, 1947, 1969.
Cooper, Douglas, *Gris, ou le goût du solennel,* Paris, 1949.
Schmidt, Georg, *Gris und die Geschichte des Kubismus,* Baden-Baden, 1957.
Soby, James Thrall, *Gris* (cat), New York, 1958.
Perucho, Juan, *Gris . . . Selección de dibujos,* Barcelona, 1969.
Gris (cat), Paris, 1974.
Gaya Nuño, Juan Antonio, *Gris,* Barcelona, 1974; London and Boston, 1975.
Gris (cat), Baden-Baden, 1974.
Judkins, Winthrop, *Fluctuant Representation in Synthetic Cubism: Picasso, Braque, Gris 1910–20,* London and New York, 1976.
Cooper, Douglas, *Gris: Catalogue raisonné de l'oeuvre peint,* Paris, 2 vols., 1977.
Rosenthal, Mark, *Gris* (cat), New York, 1983.

articles—

Camfield, William, "Gris and the Golden Section," in *Art Bulletin* (New York), March 1965.
Green, Christopher, "Synthesis and the 'Synthetic Process' in the Painting of Gris 1915–19," in *Art History* (Oxford), March 1982.
Green, Christopher, "Purity, Poetry, and the Painting of Gris," in *Art History* (Oxford), June 1982.

*

Juan Gris's career was relatively short: after a period of commercial graphic work, lasting until about 1912, he became interested in the Cubist work of Picasso and Braque, and his paintings for the next 15 years constitute his enduring oeuvre. From the beginning of his painting career, his work was championed by his dealer and friend Daniel-Henry Kahnweiler.

After studying engineering in Madrid for two years—study that obviously appealed to the intellectual bent of his nature—Gris studied art with José Moreno Carbonero, and began making graphic illustrations for magazines and newspapers, first in Madrid until 1906, then in Paris until 1912. In Paris, he rented a studio adjoining that of Picasso, and became friendly with Picasso and Braque and the writer Apollinaire. But only in 1911 did he begin working in oils. His progress was rapid, and he exhibited with the Cubists in 1912. His earliest work, replacing the Art Nouveau/Jugendstil of his commercial work, reflects his interest in earlier French art as well as the Cubist work of Picasso and Braque. He revered Jean Fouquet's "stern geometry" and "abstract" color (to use Kahnweiler's terms),

as well as Ingres's strong line. (His *Portrait of Josette* in Madrid in based on Corot's *Girl with a Mandolin* in St. Louis.) Such early work as *Bottle of Wine and Water Jar* (1911; Otterlo) can be seen as the equivalent of the early Cubist painting of Picasso and Braque. The point is not that Gris was imitating the works of the older painters, but that he had to work his way through the artistic inheritance of Cubism—rapidly and thoroughly. Whereas Picasso and Braque had assimilated Cézanne and Seurat, for instance, thoroughly into their later work, Gris's paintings reflects such influences more obviously.

But his advance was rapid enough for his 1912 *Portrait of Picasso* (Chicago) to be thoroughly competent in his handling of both full-face and profile views of the head and in evoking volume generally. His use of a single light source was something not notable in Picasso's and Braque's Cubist works—and the resulting chiaroscuro is worked into the pattern of the picture.

Gris's use of color, however, is possibly his most characteristic feature. Picasso and Braque often used a monochromatic or neutral palette in their Cubist works, but Gris's color is always an important element in his paintings: it is varied, even unpredictable, evocative, idiosyncratic, and often charming, though some critics have felt it could become too artificial and merely decorative—especially in his later works.

His use of collage was also very personal. An early work using such a device is *The Washstand* (1912; private collection), which incorporates a fragment of a mirror in the place where a mirror would be expected in the actual representation. His technique was also distinctive. In *The Teacup* (1914; Dusseldorf), for instance, almost the entire surface of the canvas is covered with pasted paper arranged in a carefully planned geometrical form—with a Cubist composition drawn on top of it. He also used collage to suggest depth. In *Still Life in Front of an Open Window: Place Ravignan* (1915; Philadelphia), the collage elements of pale blue at the back represent the window and a view of the exterior, while warmer tones at the front, of the canvas suggest the transition to interior space. He also used dotting for both perspective and ornamentation.

Gris's interest in geometrical shapes is based on a serious theoretical interest: he was not an intuitive painter, and wanted to use mathematics (even compass rulings) in his efforts to solve any compositional or formal problems. (Most of his compositions after 1911 are based on either the golden section or mathematical ratios of whole numbers.) Whereas Picasso might solve formal problems dramatically, or Braque lyrically, Gris wished to solve them architectonically. He was also a confirmed talker and explainer, and was influential on such artists as Gleizes, Metzinger, and Marcoussis.

The series of paintings done from about 1915 to 1919 constitute for many critics his most important work. His theoretical interests had begun producing pictures in which no overall image is present, but only elements or aspects of parts of an image, to be assembled by the viewer's eye, to be integrated by our own expectations and sense of synthesis.

In fact, this sort of "synthetic" arrangement was the basis of what came to be called Synthetic Cubism. In personal statements as well as in a lecture delivered at the Sorbonne, Gris explained his theoretical views:

> I work with the elements of the intellect, with the imagination. I try to make concrete that which is abstract. I proceed from the general to the particular, by which I mean I start with an abstraction in order to arrive at a true fact. Mine is an art of synthesis, of deduction. . . .
>
> I consider that the architectural element in painting is mathematics, the abstract side; I want to humanize it. Cézanne turns a bottle into a cylinder, but I begin with a cylinder and create an individual of a special type: I make a bottle—a particular bottle—out of a cylinder.

This is an inside-out sort of method of painting, and it leads to discovery: he is a spectator in the making of the picture as much as the viewer is at a later stage of the painting: "Until the picture is finished, I do not know exactly which modification it is that gives the picture its character." This might sound very dry, but there is also mystery and evocative power in Gris's work, mainly the result of his brilliant range of color and his subtlety of composition.

—George Walsh

GROSZ, George.

Born Georg Ehrenfried Gross in Berlin, 26 July 1893; naturalized United States citizen, 1938. Died in Berlin, 6 July 1959. Married Eva Louise Peters, 1920; two sons. Attended schools in Berlin and Stolp; Dresden Arts Academy, 1909–11; Kunstgewerbeschule, Berlin, 1912–16; Atelier Colarossi, Paris, 1913; volunteer in army, but given a medical discharge, 1914; worked for *Die Neue Jugend,* Berlin, 1915–17; conscripted into army, but given mental discharge, 1917; illustrator and cartoonist in Berlin: indicted several times for slander and/or obscenity in the 1920's; settled in New York, 1932: taught at Art Students League, 1933–36, 1940–44, 1950–53, Columbia University, 1941–42, and Skowhegan School, Maine, 1956.

Collections: Berlin; Boston; Cambridge, Massachusetts; Chicago; Cologne; Dusseldorf; Hamburg; London: Tate; Los Angeles; New York: Moma, Whitney; Paris: Beaubourg; Stuttgart.

Publications

By GROSZ: books—

Das Gesicht der Herrschenden Klasse, Berlin, 1921; as *The Face of the Ruling Class,* London, 1984.
Ecce Homo, Berlin, 1923, New York, 1966.
Abrechnung folgt: 57 Politische Zeichnungen, Berlin, 1923; as *The Day of Reckoning,* London, 1984.
Der Speisser-Spiegel: 60 Berliner Bilder, Dresden, 1925; New York, 1966.
Die Kunst ist in Gefahr, with Wieland Herzfelde, Berlin, 1925.
Das neue Gesichte der Herrschenden Klasse, Berlin, 1930; as *The New Face of the Ruling Class,* London, 1984.

Die Gezeichneten, Berlin, 1930.
Uber alles die Liebe, Berlin, 1930; as *Love above All,* New York, 1971, London, 1985.
A Post-War Museum, London, 1931.
Interregnun, New York, 1936.
A Piece of My World in a World Without Peace, New York, 1946.
A Little Yes and a Big No: The Autobiography, New York, 1946, London, 1982.
Grosz, edited by Imre Hofbauer, London, 1948.
Ade Witboi, edited by Walther G. Oschilewski, Berlin, 1955.
Briefe 1913–1959, edited by Herbert Knust, Reinbek, 1979.
Pass auf: Hier kommt Grosz: Bilder, Rhythmen, und Gesänge 1915–1918, edited by Wieland Herzfelde and Hans Marquardt, Leipzig, 1981.

illustrator: *Tragigrotesken der Nacht: Träume,* by Wieland Herzfelde, 1920; *Die rote Woche,* 1921, and *Arbeitsfriede,* 1922, both by Franz Jung; *Sächsische Miniaturen,* 1922, and *Hedwig Courths-Mahler,* 1922, both by Hans Reimann; *Brokenbrow,* by Ernst Toller, 1926; *The Voice of the City and Other Stories,* by O. Henry, 1935; *Happy Man,* by Hermann Kesten, 1947.

On GROSZ: books—

Mynona [i.e., Salomo Friedlaender], *Grosz,* Dresden, 1922.
Bazalgette, Leon, *Grosz: L'Homme et l'oeuvre,* Paris, 1926.
Rey, Marcel, *Grosz,* Paris, 1927.
Ballo, Ferdinando, editor, *Grosz,* Milan, 1946.
Baur, John I. H., *Grosz,* New York, 1954.
Mehring, Walter, *Berlin Dada,* Zurich, 1959.
Grosz (cat), Vienna, 1965.
Bittner, Herbert, editor, *Grosz,* London, 1965.
Dückers, Alexander, *Grosz: Frühe Druckgraphik, Sammelwerke, illustrierte Bücher 1914–1923* (cat), Berlin, 1971.
Lewis, Beth Irwin, *Grosz: Art and Politics in the Weimar Republic,* Madison, Wisconsin, 1971.
Hess, Hans, *Grosz,* New York and London, 1974, 1986.
Schneede, Uwe M., *Grosz: Leben und Werk,* Stuttgart, 1975; as *Grosz: His Life and Work,* London, 1979, New York, 1980.
Fischer, Lothar, *Grosz in Selbstzeugnissen und Bilddokumenten,* Reinbek, 1976.
Dückers, Alexander, *Grosz: Das druckgraphische Werk,* Berlin, 1979.
Sabarsky, Serge, et al., *Grosz: The Berlin Years,* New York, 1980.
Flavell, M. Kay, *Grosz: A Biography,* New Haven, 1988.

*

The life and career of George Grosz offer a paradigmatic example of the fate of the oppositional artist, who thrives in a corrupt and problematic society but is unable to sustain his art in exile from it. Driven by hatred and rendered convincing by corrosive linear skills, Grosz's early mature style—a combination of international avant-garde strategies and topical realism—was forged in an atmosphere of militaristic frenzy, nascent political revolution, and spiraling social conflict aris-

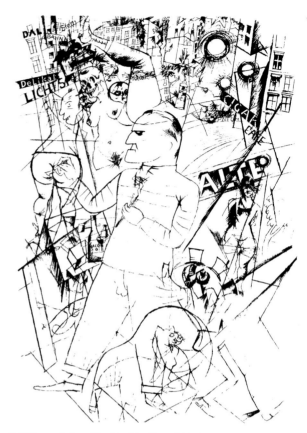

Self-Portrait for Charlie Chaplin, 1919; lithograph

ing from the last years of the First World War and the halting genesis of the Weimar Republic. It is not unorthodox to hold that Wilhelminian Germany created in Grosz one of its most acerbic Critical Realists and, despite recent revisionist attempts to prove the contrary, that American democracy destroyed him.

Grosz's *métier* was the exposé, and from 1916 onward he found his subjects on the teeming streets of Berlin, Germany's cosmopolitan capital. The philosopher Hannah Arendt has pointed out the pervasive banality of evil; in Grosz's drawings it peers from every bourgeois visage. His types, the prostitutes, profiteers, war cripples, beggars, militarists, and stolid citizens attending to business, are recognizably passive protagonists in the urban struggle for survival.

Like many of his peers, Grosz suffered the demands of military service, experiencing a cycle of breakdowns, malingering, and beatings at the hands of aggressive comrades. His lengthy recuperative periods in Berlin during wartime positioned him, perhaps uniquely, on both sides of the fence; he was privy to the chaos of the battlefield and to homefront deprivations, and became increasingly cynical toward both. His sardonic viewpoint, combining pragmatism and incipient nihilism channeled by a clarified technical skill, assured him a central position in Germany's politicized version of the Dada movement, which—in Berlin at least—remained less aestheticized in content than the style's other branches.

In his autobiography, published over 20 years later, Grosz categorized art as an "international contagious disease," and it is significant that his Dadaist works were couched in the for-

mal context of Cubo-Futurist strategies. Alternating between socially confrontational drawings, allegorical oils, and spontaneous Dada performances, Grosz participated fully in the group movement for years, the only time in his long career he would do so. As he recalled in the autobiographical *A Little Yes and a Big No,* he was known as the "Propagandada," an apt persona which reflected the didacticism of his aggressive public appearances in print under the auspices of the radical Malik-Verlag, run by his colleague Wieland Herzfelde. He carried a traditional calling card, embellished with that pseudonym sandwiched between his given names and including the seeds of his—and the society's—future vacillations in the subscript, "What will I believe tomorrow?"

If he could be vitriolic in his attacks on the military, seen in *The White General*'s cruel protagonist sweeping past his victims, monocle focussing his glimmering eye, he could be equally harsh to himself. *The Gold-Digger* (1916) features a scarred and toughened treasure hunter who strongly resembles the *Self-Portrait (for Charlie Chaplin)* of 1920. In both a gimlet-eyed fellow actively pursues his intentions (a lucrative dig or, in the latter, the simultaneous depiction of urban decadence rendered in a conflated Futurist vortex of universal greed), a stance so common in Critical Realism that it can be seen as a group cliché. Like Otto Dix, who seizes viewers with his rock-like jaw and fierce gaze in innumerable images, Grosz seemed determined to set himself up as the granite arbiter of justice.

His allegorical paintings likewise belong squarely in the Critical Realist camp, a distinct subset within German Dada which concentrated its fury (masking its creators' sense of impotence) on social corruption. Grosz eschewed the naivety of Dix's folk art-inspired approaches in the immediate postwar years, preferring to remain in the international mainstream by utilizing the Cubo-Futurist format. In his apocalyptic duo began in 1917, *Funeral Procession,* dedicated to a notorious anarchist, Oskar Panizza, and *Germany: A Winter's Tale,* Grosz subverts Cubism's formal emphasis and objectivity, stressing instead the confusion, congestion, and subjective reality of revolution and republican collusion.

His more distanced watercolors with their ubiquitous automata, featuring Dada collage and barren urban scapes reminiscent of Italy's Metaphysical School, are more intellectual meditations on dominance and acquiescence. These images, alongside his Dada appearances as a Death's Head, as Propagandada, and other deliberate public provocations, earned Grosz the attentions of the fragile new Republic's authorities. He underwent several trials for "public insults": he, Rudolf Schlichter, and Herzfelde were tried for the anti-militaristic imagery that pervaded the First Dada Fair of 1920; his portfolio of critical drawings on similar subjects, published by the Malik-Verlag, likewise netted a fine of 300 marks (an inflationary pittance); his omnibus volume *Ecce Homo* was deemed "obscene" in 1924; and drawings from the journal *Hintergrund* appeared before tribunals repeatedly for blasphemous content from 1928 until 1931.

Throughout the inflationary years, until 1924, he attacked with a stiletto every facet of German society, belaboring inequities with a ferocious tenacity. If he is never so brutal and coarse as Otto Dix in these examples of Critical Realism, nor as compassionate as Käthe Kollwitz, his representations of denizens of the joyless street (to appropriate the title of a con-

temporary film) are compellingly ordinary, and entirely recognizable.

These chilling expressions of everyday evil inevitably secured for Grosz a prime position on the Right's list of enemies and caused him to flee into exile on the eve of the Nazi's assumption of power. In New York, the United States's largest metropolis and seat of the arts, Grosz, a longtime aficionado of things American, succumbed to his desires for normality, comfort, and status. He wanted, he ruefully admitted later, "to totally assimilate; I repressed everything in me that seemed too Grosz-like . . ." and in the long, slow process—despite the publication of the premonitory cycle *Interregnum*—he lost the edge that made him Critical Realism's avatar.

—Linda McGreevy

GRÜNEWALD, Mathis.

Born Mathis Gothardt-Neithardt, perhaps in Wurzburg, c. 1445–50 or c. 1475–80. Died in Halle a.d. Saale, August 1528, or 1531–32. One adopted son. Possibly in Aschaffenburg, then first documented in Seligenstadt, 1501; court painter to Archbishop-Elector of Mainz, 1508–14, then to the Cardinal Albrecht, Elector of Mainz: painted the Isenheim altar, c. 1515; recorded in Frankfurt, 1526, and Halle, 1528.

Collections: Aschaffenburg; Basel; Colmar; Donaueschingen; Frankfurt; Freiburg; Karlsruhe; Munich; Stuppach: parish church; Washington.

Publications

On GRUNEWALD: books—

Schmid, Heinrich Alfred, *Die Gemälde und Zeichnungen von Grünewald,* Strasbourg, 2 vols., 1907–11.
Mayer, August, *Grünewald,* Munich, 1919, 1920.
Réau, Louis, *Grünewald et le retable de Colmar,* Nancy, 1920.
Beitz, Egid, *Grünewalds Isenheimer Menschenwerdungsbild und seine Quellen,* Cologne, 1924.
Feurstein, Heinrich, *Grünewald,* Bonn, 1930.
Knapp, Fritz, *Grünewald,* Bielefeld, 1935.
Fraenger, Wilhelm, *Grünewald in seinen Werken: Ein physiognomischer Versuch,* Berlin, 1936.
Burkhard, Arthur, *Grünewald: Personality and Accomplishment,* Cambridge, Massachusetts, 1936.
Zülch, Walter Karl, *Der historische Grünewald,* Munich, 1938.
Hürlimann, Martin, *Grünewald,* Zurich, 1939.
Brion, Marcel, *Grünewald,* Paris, 1939.
Schoenberger, Guido, *The Drawings of Grünewald,* New York, 1948.
Behling, Lottlisa, *Die Handzeichnungen der Grünewald,* Weimar, 1955.
Dittman, Lorenz, *Die Farbe bei Grünewald,* Munich, 1955.
Zülch, Walter Karl, *Grünewald,* Leipzig, 1956.

Meier, Michael, *Grünewald,* Zurich, 1957.

Vogt, Adolf Max, *Grünewald, Meister gegenklassischer Malerei,* Zurich, 1957.

Pevsner, Nikolaus, and Michael Meyer, *Grünewald,* New York, 1958.

Ruhmer, Eberhard, *Grünewald: Die Gemälde,* Cologne, 1959; as *Grünewald: The Paintings: Complete Edition,* New York and London, 1959.

Hoffmann, Hans, *Das Bekenntnis des Meisters Mathis: Eine Deutung der Erasmus-Mauritius-Tafel des Grünewald,* Munich, 1961.

Hotz, Walter, *Meister Mathis der Bildschnitzer: Die Plastik Grünewalds und seines Kreises,* Aschaffenburg, 1961.

Weixlgärtner, Arpad, *Grünewald,* Vienna, 1961.

Gasser, Helmi, *Das Gewand in der Formensprache Grünewalds,* Berne, 1962.

Lanckoronska, Maria, *Gothardt-Neithardt: Sinngehalt und historischer Untergrund der Gemälde,* Darmstadt, 1963.

Kehl, Anton, *"Grünewald"-Forschungen,* Neustadt a.d. Aisch, 1964.

Lanckoronska, Maria, *Neithardt Sculptor: Der Meister des Blaubeurer Altars und seine Werke,* Munich, 1965.

Lanckoronska, Maria, *Neithardt in Italien,* Munich, 1967.

Hütt, Wolfgang, *Grünewald: Leben und Werk im Spiegel der Forschung,* Leipzig, 1968.

Ruhmer, Eberhart, *Grünewald: The Drawings: Complete Edition,* London and New York, 1970.

Bianconi, Piero, *L'opera completa di Grünewald,* Milan, 1972.

Burkhard, Arthur, *Seven German Altars,* Cambridge, Massachusetts, 1972.

Saran, Bernhard, *Grünewald: Mensch und Weltbild,* Munich, 1972.

Eckert, Georg, *Der Isenheimer Altar: Seine geistigen Weuzeln und sein spirituell-künstlerische Gehalt,* Freiburg, 1973.

Grünewald et son oeuvre (colloquim), Strasbourg, 1974.

Kromer, Joachim, *Grünewald: Die Schlüssel-Kompositionen seiner Tafeln,* Badeb-Badeb, 1978.

Behling, Lottlisa, *Gothart oder Nithart,* Konigstein im Taunus, 1981.

Bonsanti, Giorgio, *Grünewald: La pittura,* Florence, 1981.

Richter, Gottfried, *Der Isenheimer Altar des Grünewald,* Stuttgart, 1981.

Fraenger, Wilhelm, *Grünewald,* Dresden, 1983.

Sarwey, Franziska, *Grünewald Studien: Zur Realsymbolik des Isenheim Altars,* Stuttgart, 1983.

Mellinkoff, Ruth, *The Devil at Isenheim: Reflections of Popular Belief in Grünewald's Altarpiece,* Berkeley, 1988.

*

In his treatise on rhetoric (1531), the Protestant Reformer Philip Melanchthon placed Grünewald second to Dürer in the ranks of German artists. The ideal, classicizing elements with which Dürer infused German late gothic style were missing from Grünewald's art, and yet Melanchthon felt its sublimity, as we do today. Unlike Dürer—a vivid personality known to us in letters and diaries—Grünewald remains a shadowy figure.

The epithet "Grünewald" ("green wood") given to Mathis Gothardt, called Nithardt, by Joachim Sandrart in his *Teutsche Akademie* (1675) was perhaps the result of a surprising confu-

Middle-Aged Woman with Clasped Hands; drawing

sion between Grünewald and Hans Baldung, a Dürer-pupil nicknamed "Grün" or "Grien." Sandrart's blurring of two such utterly different artists point to the primary problem still facing students of Grünewald: what were the influences which shaped his art, and what were his relationships with contemporary artists?

Some links between Grünewald and other artists can be traced. The *Annunciation* on Baldung's altarpiece for the Cathedral of Freiburg shows affinities with the same scene on Grünewald's contemporary masterpiece in nearby Isenheim. There are also single-sheet woodcuts by Baldung dating between 1515 and 1517 that betray a Grünewaldian expressionism. Grünewald's grisaille panels of saints in the Städelsches Kunstinstitut, Frankfurt, may have been part of the *Heller Altar,* whose destroyed central panel was completed by Dürer. Grünewald knew Dürer's woodcut and engraved *Resurrections* when he composed the same scene on the *Isenheim Altarpiece,* as he knew Martin Schongauer's *Temptation of Anthony* engraving when he conceived that Isenheim panel. Scholars have also suggested links to the Master WB and Jacopo de' Barbari. None of these, however, adds up to a definitive relationship.

In many ways, Grünewald stands alone. The thematic content of his art is limited: Christ's Passion, Mary, and the saints dominate. These are drawn together on the *Isenheim Altarpiece.* Unlike others of his generation, he showed no interest

in humanistic or mythological subjects. And the Christian content of his paintings is interpreted with an intensity that suggests his own mystical proclivities. We know he was steeped in St. Bridget's *Revelations,* published in Germany in 1502 by Dürer's godfather, Anton Koberger.

Unlike Dürer, Baldung, Lucas Cranach, or Albrecht Altdorfer, Grünewald did not make prints, despite the superb graphic sensibility displayed in his drawings. This is a remarkable choice to have made in early 16th-century Germany, where printmaking flourished. Stylistically, too, Grünewald is exceptional. His expressionistic realism and his rich, iridescent colorism only find dim echoes in other German artists of the period. Nowhere are these qualities, or the ecstatic religiosity they express, duplicated with such single-minded intensity.

Sandrart characterized Grünewald as "melancholy," but it is wrong to see him as a reclusive mystic. The scant documentary evidence points to another, more worldly personality, and it is important to note that "melancholy" was a standard attribute of artists in the 16th and 17th centuries. We know that Grünewald was a court painter, attached to two successive Archbishops of Mainz, Uriel von Gemmingen and Albrecht of Brandenburg (later a Cardinal). As a court painter and "Wasserkunstmacher" (designer and maker of fountains), Grünewald supervised building activities at the Castle of Aschaffenburg, the second city of the Archbishops after Mainz. (Perhaps in lost architectural and fountain designs, Grünewald did explore secular subject matter). Although we have no record of a marriage, we know he adopted a son. And Grünewald was certainly immersed in the religious turmoil of his time. He probably left Albrecht's service because of his involvement in the Peasant Revolt of 1525. Although pardoned, he never returned. When he left Frankfurt for Halle in 1528, the year of his death, he left behind a collection of Protestant writings, including the "Twelve Articles of the Christian Faith," the so-called "Peasant Articles." We are probably justified in concluding that Grünewald, like his almost exact contemporary Dürer, became preoccupied with the theological questions raised by Luther. Unlike Dürer, however, who moved toward an orthodox Lutheranism in his late years, Grünewald sympathized with the radical fringes of the Reformation.

It is possible to see Grünewald's involvement in the Reformation as contradicting the deeply Catholic content of his art (its veneration of Mary and the saints, and its incomparable statement of the salvific power of the body of Christ as present in the Eucharist), but this would be to misunderstand the early Reformation, when the lines between Catholic and Protestant were far from clear. Indeed, it may have been Grünewald's sincere Catholicism that initially led him to Luther, who was understood by many (Dürer included) as a man who brought truth back to the interpretation of scripture, which the Church had corrupted. Had Grünewald lived longer, we may have been able to observe the effects of Protestant thought, essentially unsympathetic to ecclesiastical art, on the most brilliant painter of altarpieces in Germany.

Although Melanchthon's judgment still seems valid today, 20th-century Expressionism has given us a firmer critical appreciation of Grünewald that only promises to grow as his life and art are better understood. There is still more to be said on the theological and psychological complexities of the *Isenheim Altarpiece,* for example. And Grünewald's stylistic evolution—

from the early *Mocking of Christ* in the Alte Pinakothek, Munich (1503), to the Isenheim panels, to the huge *Crucifixion* (ca. 1525) in the Staatliche Kunsthalle, Karlsruhe—needs further study. Finally, more stylistic comparison between Grünewald's works and those of his contemporaries should help clarify relationships between figures like Dürer and Baldung and this most Germanic of artists.

—Linda C. Hults

GUARDI, Francesco.

Born in Venice, baptized 5 October 1712; son of the painter Domenico Guardi; brother of the artists Giovanni Antonio and Nicolo Guardi; his sister married Tiepolo. Died in Venice, 1 January 1793. Married Maria Pagani, 1757 (died 1769); four children, including the painter Giacomo Guardi. Worked with his brothers; joined the painters guild of Venice, 1761; painted views of Venice, religious works, and capriccios; commemorated Pope Pius VI's visit to Venice, 1782.

Collections: Belvedere d'Aquileai: parish church; Bergamo; Berlin; Boston; Brussels; Cambridge, Massachusetts; Chicago; Cleveland; London: National Gallery, Victoria and Albert; Milan: Poldi Pezzoli; Montreal; Munich; Nantes; New York; Paris; San Diego; Sarasota, Florida; Toulouse; Venice: Correr, Rezzonico; Vigo d'Anaunia: parish church; Vienna; Waddesdon; Washington.

Publications

Damerini, Gino, *L'arte di Guardi,* Venice, 1912.
Fiocco, Giuseppe, *Guardi,* Florence, 1923.
Pallucchini, Rodolfo, *I disegni del Guardi al Museo Correr di Venezia,* Venice, 1943.
Goering, Max, *Guardi,* Vienna, 1944.
Byam Shaw, James, *The Drawings of Guardi,* London, 1951.
Moschini, Vittorio, *Guardi,* Milan, 1952.
Fiocco, Giuseppe, *Guardi: L'Angelo Rafaele,* Turin, 1958.
Parker, K. T., and James Byam Shaw, *Canaletto e Guardi,* Venice, 1962.
Problema Guardeschi, Venice, 1965.
Pallucchini, Rodolfo, *Guardi,* Milan, 1965.
Zampetti, Pietro, *Guardi* (cat), Venice, 1965.
Kultzen, Rolf, *Guardi in der Alten Pinakothek,* Munich, 1967, supplement, 1968.
Pignatti, Terisio, *Disegni di Guardi,* Florence, 1967.
Morassi, Antonio, *Guardi: Antonio e Francesco Guardi,* Venice, 2 vols., 1973.
Bortolatto, Luigina Rossi, *L'opera completa di Guardi,* Milan, 1974.
Morassi, Antonio, *Guardi: Tutti i disegni di Antonio, Francesco, e Giacomo Guardi,* Venice, 1975.
Binion, Alice, *Antonio and Francesco Guardi: Their Life and Milieu, with a Catalogue of Their Figure Drawings,* New York, 1976.

Triumphal Arch at the Water's Edge; drawing and watercolor; Leningrad, Hermitage

Pilo, Giuseppe M., *Guardi: I paliotti,* Milan, 1983.
Guardi: Metamorfosi dell'immagine (cat), Venice, 1987.

*

Francesco Guardi, the son of the painter Domenico Guardi, and the younger brother of the painter Giovanni Antonio Guardi, worked in his brother's studio during the early part of his career, probably as a figure painter. Gianantonio's work as a painter has been extensively studied only in this century, but he was obviously a competent painter who expanded the studio set up by his father. The first works by Francesco to be documented are two allegorical works, figures of *Hope* and *Faith* (Sarasota, Florida), dated 1747. Otherwise, Francesco's name is not mentioned as a painter until the death of Gianantonio in 1760. Soon afterwards he was called a notable "student" of Canaletto. Since none of these early works in the style of Canaletto are dated, it is possible that he began imitating Canaletto's early style of painting views in the 1750's. It is unlikely that he actually studied with Canaletto, but he could have known engravings or even the paintings in the collection of the British Consul Joseph Smith.

But if comparisons with Canaletto are necessary—both painted views of the same city, and their working life overlapped—many things suggest contrasting aims and styles, even among the paintings of views. As Canaletto grew older, his paintings tended to become more precise; with a technical virtuosity that is often a bit overwhelming, full of grandeur and even nobility. Guardi, however, seems to aim at the atmospheric and picturesque; there is a highly textured look to his paintings, with free and often wispy brushwork; the figures are often merely dabs of white paint, picked out as if to tack the picture together. He is a painter of movement, as if he were constantly viewing the city from a wobbling gondola, never quite at rest. In fact, the freedom of his brushwork and his evocative style were influenced as much by Alessandro Magnasco as by Canaletto.

Though it is difficult to date his pictures and thereby gain a sense of his artistic development, Guardi's later style seems to be even more free and picturesque. Even in his views, he seems less intent on giving a carefully measured perspective view. In renditions of Piazza, for instance, one range of buildings will be the same color as the other, even though one is in sunshine and the other in shadow, and the Campanile will be presented as taller and slimmer, and the Piazza itself wider, than they actually are. The result is evocative rather than photographic. Some of the religious paintings also have the same quality of extremely free brushwork and overemphatic elements, e.g., the *Tobias* series in S. Raffaele, Venice.

Late in life, he was accepted into the Venice Academy, and also given a few official commissions. He was asked to record the visit of Pope Pius VI to Venice in 1782 in a series of four paintings, and two are now in Cleveland: though they are relatively small in size, the scale of each picture is large (the figures are tiny), with an impressionist technique.

Leading directly from his picturesque and impressionist views and religious painting was his immense series of capriccios and fantasies. His evocative technique was admirably suited to ruined arches, often framing an imaginary landscape or a distant city view, or seashores with ruins. The swift broken lines, brown washes of varying intensity, and quivering lagoons give a great deal of variety to subjects that could have become repetitious. What is technically a "view" but with many of the characteristics of a "capriccio" is the *View on the Venetian Lagoon with the Tower of Malghera* (London, National Gallery). The sky in this low, wide painting occupies about two-thirds of the space, the horizon broken only by the tower on the right. There is little else in the picture except a small fishing boat on the left, its horizontal alignment balancing the vertical of the tower. But these few elements have an evocative appeal, and reminds us that Guardi was a Venetian who used his eyes carefully, seeing Venice afresh from a viewpoint few visitors would know.

—George Walsh

GUERCINO.

Born Giovanni Francesco Barbieri in Cento, baptized 8 February 1591. Died in Bologna, 22 December 1666. Trained under Benedetto Gennari the Elder; influenced by Ludovico Carracci, and worked in Bologna on frescoes for the Casa Pannini, 1615; in Rome, 1621; worked for Pope Gregory XV on the Casino Ludovisi, and for the Ludovisi family; worked in Cento 1623 to the 1640's, then worked in Bologna from c. 1644.

Collections: Birmingham; Bologna; Brussels; Cambridge; Cento; Cleveland; Florence: Uffizi, Pitti; Genoa; Leningrad; London: National Gallery, Dulwich, Royal Academy, Lancaster House, British Museum; Madrid; Milan; Minneapolis; Modena; Munich; Naples; New York; Oxford: Ashmolean, Christ Church; Paris; Parma; Sarasota, Florida; Vienna; Washington.

Publications

On GUERCINO: books—

Russell, Archibald, *Drawings by Guercino,* London, 1923.
Grimaldi, Nefta, *Il Guercino,* Bologna, 1957.
Marangoni, Matteo, *Guercino,* Milan, 1959.
Bottari, Stefano, *Guercino: Disegni,* Florence, 1966.
Mahon, Denis, *I disegni del Guercino della collezione Mahon,* Bologna, 1967.
Mahon, Denis, *Il Guercino* (cat), Bologna, 2 vols., 1968–69.
Roli, Renato, *I fregi centesi del Guercino,* Bologna, 1968.
Bagni, Prisco, *Guercino a Piacenza: Gli affreschi nella cupola della Cattedrale,* Bologna, 1983.
Bagni, Prisco, *Guercino a Cento: Le decorazioni di Casa Pannini,* Bologna, 1984.
Bagni, Prisco, *Benedetto Gennari e la bottega del Guercino,* Bologna, 1986.
Mahon, Denis, and David Ekserdjian, *Guercino Drawings: From the Collections of Denis Mahon and the Ashmolean Museum* (cat), London, 1986.

The Raising of Tabitha; drawing; Leningrad, Hermitage

Mahon, Denis, and Nicholas Turner, *The Drawings of Guercino . . . at Windsor Castle,* Cambridge, 1988.
Salerno, Luigi, *Guercino,* Rome, 1988.

*

Francesco Barbieri from Cento near Bologna was known a "il Guercino" because of his squint. His great natural facility as an artist is evident in his many surviving drawings, of which there are large numbers in the Royal Collection at Windsor Castle. He was especially adept at handling his drawing medium (chalk, oiled charcoal, pen and wash) to convey light and shade, although the often very beautiful pen and wash drawings of his maturity also display a marked, squiggly elegance of line.

Such concerns and development are mirrored in his paintings. His first manner, which many consider his best, was the product of his youth in Cento and Bologna, prior to his move to Rome in 1621. It is distinguished by naturalistic figures, fluid brushwork, and a flickering, romantic light. The paradox of Guercino's career is that, after the great popularity of this style and his brief though apparently successful sojourn-by-invitation in Rome during the pontificate of the Bolognese Pope, Gregory XV (1621–23), he should have returned to Cento and developed a much more classical style, in which *chiaroscuro,* although still important, is far less pronounced, figures become more idealized, and form and outline more defined.

Guercino's first style can lay claim to being among the earliest and most eloquent manifestations of the Baroque spirit. In his case it echoes the unique blend of unearthly lighting and unpretentious, rural naturalism associated with the nearby Ferrarese School. In the three altarpieces which he produced, c. 1613–15, for the parish church of S. Sebastiano at Renazzo di Cento, the homely yet graceful figures and imaginative, smooth weave of chromatic light are indebted to such contemporary Ferrarese masters as Scarsellino and Bonone. But it was from the individualistic head of the Bolognese School, Ludovico Carracci, that Guercino derived the means for his major breakthrough—as did, to a lesser degree, that other pioneer of the High Baroque, Lanfranco. The contrapuntal axes and form-dissolving, dappled light used to merge figures with

their surroundings in Guercino's pictures from c. 1616–20 take their cue from Ludovico's marvellously mystical *Holy Family with St. Francis* (1591)—then, as today, in Cento (now Museo Civico). In works like *The Virgin with Saints* (Brussels, 1616), *Elijah Fed by Ravens* (London, c.1619), *The Incredulity of St. Thomas* (London, c.1620), and *St. William of Aquitaine Receiving the Habit* (Bologna, 1620), Guercino established a vigorous personal idiom prompted, but not circumscribed, by Ludovico's example. The lighting and paintwork are more rhythmically allied than in Ludovico's and the transparent delicacy of the shadows is quite distinctive. In addition, Guercino seems to be consciously rivalling Caravaggio's realism and *chiaroscuro,* occasionally adapting specific poses and compositions but for the most part construing Caravaggio's equation in his own terms: the peasant types are his rather than Caravaggio's, while the central religious characters are adulterated, in keeping with his softer *chiaroscuro* and modulated grey/brown palette, punctuated with blues or reds. The large *St. William* marks the culmination of these tendencies: its sweeping diagonals, turning poses, patchy lighting, and ambiguous space strike a spiritually dynamic, Baroque note—to be elaborated, in a different mode, on the *Aurora* ceiling in Rome.

Yet it was at this very moment of illusionistic boldness that Guercino tightened his reins, as can be seen in another huge altarpiece, *The Burial and Reception into Heaven of St. Petronilla,* done for St. Peter's in 1621 (now Rome, Capitoline Gallery). For although there is a distinct Baroque breaking of barriers in this work, as the saint is seemingly lowered out of the picture space, there are also conscious revisions of the style enshrined in the *St. William:* shadow no longer completely shrouds certain passages, gestures are more restrained, and both forms and space more crisply defined. From here it is a gradual but logical progression to Guercino's indisputably classicizing, Reni-orientated works of the post-Roman years.

According to what Guercino told his biographer, Scannelli, it was his patrons themselves who precipitated the change, objecting principally to his plebeian types and to the way in which his *chiaroscuro* obscured details, causing the pictures to look unfinished. Indeed, one can understand how those re-

sponsible for artistic patronage at the highest level in the Rome of Gregory XV (the Pope's nephew, Cardinal Ludovisi, and his Secretary of State, Monsignor Agucchi, who was a close friend of Domenichino and had written an idealizing *Treatise on Painting*), disapproving of what they saw, imprecisely, as Guercino's Caravaggism, would have sought to redirect him to the lighter color-schemes and more sculpturally idealized figure canon of Bolognese classicists such as Domenichino and Reni. But whether Guercino also experienced a genuine aesthetic conversion we do not know.

Even if Guercino's partial accommodation to Reni's style in the 1620's and 1630's, and his move to Bologna on the latter's death in 1642, were spurred by expediency, he responded with originality to the prevailing orthodoxy—as he had with his brilliant fusion of the ideas of Ludovico and Caravaggio in the 1610's. He was a masterly consolidator rather than a radical innovator. It seems questionable to view Guercino's realignment, as some have done, as synonymous with both a failure of nerve and a decline in quality. For while the extensive use of studio assistants undoubtedly led to uneven results, a nucleus of impressive pictures remains. *The Virgin and Child with St. Bruno* (Bologna, 1647), for example, offers some thought-provoking comparisons with the earlier *St. William.* Its more anchored composition, idealized figures, and clearer deployment of line and *chiaroscuro* could be viewed as expressive and technical improvements. Such works chart a personal course between Reni's refinements and the more corporeal classicism of Domenichino and are only inferior to Guercino's first style from a Romantic/Expressionist perspective. Symptomatic, rather, of the long-standing appeal of this distilled Grand Manner was the popularity of another subtly orchestrated work, *The Cumaean Sibyl* (Mahon Collection, 1651)— its perceived classical grace recommending it as a model for English female portraits of the second half of the 18th century. These later Guercinos were painted with a great delicacy of touch (comparable to that of the late Murillo) and vibrant color schemes still dominated, though in a higher key, by his bold blues and reds.

—John Gash

H

HALS, Frans.

Born probably in Antwerp, c. 1580; brother of the painter Dirck Hals. Buried in Haarlem, 1 September 1666. Married 1) Annetje Harmansdr., c. 1610 (died, 1615); two children; 2) Lysbeth Reyniers, 1617; at least eight children: several of his sons were painters, including Frans the Younger, Reynier, Nicolaes, Johannes, and Harmen. Probably a pupil of Karel van Mander in Haarlem, 1600–03; entered the painters guild by 1610 (officer, 1644); portraits, and group portraits (Civic Guard groups, etc.), with a large workshop: 20 versions of some works are known; granted annuity by the municipality, 1662. Pupils: Adriaen Brouwer, Jan Molenaer, Judith Leyster, Adriaen van Ostade, Philips Wouwerman, his brother Dirck.

Major Collections: Amsterdam; Berlin; Cincinnati; Haarlem; London; Paris; Washington.
Other Collections: Amiens; Antwerp; Birmingham; Brussels; Cambridge; Chicago; Detroit; Kassel; Leningrad; London: Wallace; Los Angeles; Moscow; New Haven; Prague; St. Louis; Sarasota, Florida; Toronto.

Publications

On HALS: books—

Bode, Wilhelm von, and M. J. Binder, *Hals: Sein Leben und seine Werke,* Berlin, 2 vols., 1914; as *Hals: His Life and Work,* Berlin, 2 vols., 1914.
Valentiner, W. R., *Hals: Des Meisters Gemälde,* Stuttgart, 1921, 1923.
Dülberg, Franz, *Hals: Ein Leben und ein Werk,* Stuttgart, 1930.
Riegl, Alois, *Das holländische Gruppenporträt,* Vienna, 1931.
Valentiner, W. R., *Hals Paintings in America,* Westport, Connecticut, 1936.
Trivas, N. S., *The Paintings of Hals, Complete Edition,* London and New York, 1941, 1949.
Gratama, G. D., *Hals,* The Hague, 1943, 1946.
Slive, Seymour, *Das Festmahl der St. Georgs-Schutzengilde 1616,* Stuttgart, 1962.
Slive, Seymour, and H. P. Baard, *Hals* (cat), Haarlem, 1962.
Slive, Seymour, *Hals,* London and New York, 3 vols., 1970–74.

Grimm, Claus, *Hals: Entwicklung, Werkanalyse, Gesamtkatalog,* Berlin, 1972.
Montagni, E. C., *L'opera completa di Hals,* Milan, 1974.
Wright, Christopher, *Hals,* Oxford and New York, 1977.
Baard, H. P., *Hals,* London and New York, 1981.
Smith, David R., *Masks of Wedlock: 17th-Century Dutch Marriage Portraiture,* Ann Arbor, 1982.

articles—

Jongh, E. de, and P. J. Vinken, "Hals als voortzetter van een emblematishce traditie," in *Oud Holland* (The Hague), 76, 1961.
Imdahl, Max, "Regie und Struktur in den letzten Gruppenbildnissen von Rembrandt und Hals," in *Festschrift Max Wegner,* Münster, 1962.
Slive, Seymour, "On the Meaning of Hals' *Malle Babbe,*" in *Burlington Magazine* (London), 105, 1963.
Grimm, Claus, "Hals und seine 'Schule,'" in *Münchner Jahrbuch der Bildenden Kunst,* 22, 1971.
Jowell, Frances Suzman, "Thoré-Bürger and the Revival of Hals," in *Art Bulletin* (New York), 56, 1974.
Koslow, Susan, "Hals's Fisherboys: Exemplars of Idleness," in *Art Bulletin* (New York), 57 1975.
Storm van Leeuwen, J., "The Concept of Pictology and Its Application to Works by Hals," in *Authenticity in the Visual Arts,* Amsterdam, 1979.
Smith, David R., "Courtesy and Its Discontents: Hals's Portrait of Isaac Massa and Beatrix van der Laen," in *Oud-Holland* (The Hague), 100, 1986.
Grimm, Claus, "Le *Joueur de luth* de Hals au Louvre," in *Revue de Louvre* (Paris), 5, 1988.

*

Frans Hals is one of the founding masters of 17th-century Dutch realism and one of the greatest of baroque portrait painters. Largely because of the straightforward accessibility of his subject matter and the apparent spontaneity of his style, his works have an especially modern appeal. The people in his portraits and genre scenes are sociable, outwardly directed beings. For the most part, they look out of the picture, engaging the viewer in a dialogue of sorts. When they do not, it is almost invariably to carry on a conversation with someone else, as in his group portraits, for example. To all these social interactions, Hals brings a sure grasp of the subtlest nuances

of gesture and expression and an ability to sustain a sense of the fleeting moment. Crucial to this impression of immediacy is his virtuoso technique of loose, flickering brushwork, which has been termed "dazzling," "phenomenal," "occult." All the evidence suggests that Hals did, in fact, paint remarkably quickly. Yet for all their freedom, his brushstrokes never lack purpose or control: they model form, suggest the play of light and shadow, remind one always of the texture of paint and of the presence of the artist's hand.

Nevertheless, we now recognize that there is more to Hals than the sincere and direct recorder of appearances—the "proto-impressionist"—that earlier generations of critics and art historians took him to be. His paintings also reveal a keen and critical artistic intellect, intensely conscious of his own artfulness and concerned with important problems of meaning. In this context it is important to recognize the large role that convention plays in his art. Even a brief glance at Hals's life's work shows that the same poses and gestures reappear time and again. This is as true of the lively, informal portraits as it is of the more formal and decorous ones. While some of these portrait-types are Hals's inventions, most of them belong to what was by then an international vocabulary in the genre, which had its origins in the 16th-century court portraiture of artists such as Titian. Moreover, these conventions of manner and appearance are generally anchored in contemporary canons of etiquette and polite behavior, which were also adapted from aristocratic models. To this extent, the imagery of character in Hals's portraits exists within a framework of social norms and social ideals.

Far from hindering Hals's creativity, such established patterns of form and meaning enhanced his art. His virtuosity, for example, surely depends to a great extent on the conventionality of his vocabulary. For by relying on formulas and archetypes, he could focus his creative energies on problems of style and technique. He could never have painted so swiftly and so effortlessly had he felt called upon to reinvent the *persona* of each of his sitters. This is not to say that Hals was therefore any less concerned with depth of characterization. The norms of civility and decorum that define pose and demeanor in so many of his portraits are not just attributes of a desirable social status. As the marks of a gentleman or a lady, they also embody a moral and intellectual ideal of civilized humanity. Nor does the essentially rhetorical way in which his sitters "perform" their character and identity in a "social theatre" diminish their depth or complexity. The ethos of civility carries with it an emphasis on moderation and self-control, qualities that reflect a concern with understatement and, consequently, a sensitivity to subtle shades of thought and feeling. In most of Hals's portraits, the most telling signs of character lie in the subtlest variations from the norm: a small gesture, a slight shift in pose, a hint of movement in the eyes or the mouth. By the same token, it was the onlooker's familiarity with social norm and artistic convention that allowed him to detect these variations and, hence, to grasp the special meaning of the portrait before him.

No less conventional are the genre scenes that Hals painted frequently during the first half of his career. They are almost all half-length images of low-life subjects—tarts, rakes, drunkards, musicians, fisherfolk, unruly children, and one witch, the *Malle Babbe* in Berlin. Aside from their low social standing, all these figures share a lively disregard for decorum and

self-possession. In this they are the social and psychological antithesis of the respectable burghers and their wives in Hals's portraits. Indeed, the two groups of images seem to reflect a basic conflict that was taking shape in early modern Europe between a traditional popular culture and an increasingly refined and sophisticated high culture. Many of the artist's genre scenes are, in fact, directly associated with the riotous popular festival of carnival, notably the *Shrovetide Revellers* in New York and various characters and types drawn from the popular theatre. No doubt, Hals meant such rowdy pictures to be understood in admonitory terms by cultured patrons. Yet the moralizing is never heavy-handed, and the laughter of these figures is infectiously real. The artist also seems to have felt a certain liberation in painting such "free spirits," for his loosest, most spirited brushwork appears in his genre scenes much earlier than in his portraiture.

Wherever the balance lies between morality and celebration in Hals's low-life paintings, his social perspective often seems shifting and ambivalent, even ironic on occasion. Despite the fact that the majority of his sitters fit the norms of courtly decorum, some of them conspicuously do not. Both the *Pieter Cornelisz. van der Morsch* in Pittsburgh and the *Portrait of Verdonck* in Edinburgh adopt the imagery and some of the rough informality of Dutch popular culture. Likewise, the lively, spontaneous *Daniel van Aken Playing His Violin* in Stockholm repeats the pose and expression of a fiddling fisherman in a genre scene in Lugano. Much more provocative in its way, however, is the *Portrait of Isaac Massa and Beatrix van der Laen* in Amsterdam. Apparently painted for the couple's wedding in 1622, the picture shows them casually seated in a landscape, while behind them elegantly attired courtiers and ladies promenade in a garden of love. In their clothing, their poses, and their gestures, Massa and his wife present a contrasting image of a straightforward, unassuming burgher couple. Hidden symbols also identify them with the fidelity and fruitfulness of married love and their aristocratic counterparts with pride and lust. In other words, Massa self-consciously sets himself in opposition to the courtly values that were exerting such an influence on Dutch portraiture and Dutch sociability alike in this period. Considering how rapidly Dutch society was changing in these years of great economic growth and social mobility, it is not surprising that the basic nature of middle-class identity should come into question in this way.

In a real sense, Hals's sitters belonged to a society of "new men." Like Isaac Massa or the artist himself, they were often immigrants from the Spanish Netherlands, and many of their fortunes were newly made. It is true that the ideals of civility that underlie the dominant conventions of portraiture were moderate and flexible enough, particularly in the hands of an artist as gifted as Hals, to provide an adequate definition of character and identity for such individuals. But the lure of the aristocratic image was such that only a couple of years after painting the "iconoclastic" Massa double portrait, Hals could paint a portrait that breaks the norm in the opposite direction. This is his monumental, full-length *Portrait of Willem van Heythuyzen* in Munich, which shows him as the virtual embodiment of the courtly, van-Dyckian *persona* that the Massa portrait criticizes. No doubt, an aspiration to high social status partly accounts for this Haarlem merchant's lavish self-image. At the same time, however, he must have been drawn to aristocracy's association with cultivation, refinement, and, not

Portrait of a Man, 1630; 45¾ × 35½ in (116.1 × 90.1 cm)
Royal Collection

least, with artfulness and grace. These qualities are, in some ways, even more apparent in Hals's small-scale portrait of Heythuyzen in Brussels of about a decade later. Here the dashing pose, the jaunty attire, the spurs, and the riding crop of an elegant cavalier are combined with daring foreshortenings, subtle color, and unusually free brushwork. In other words, the portrait's stylishness belongs as much to the artist as to his patron. Indeed, this is not the only case in which Hals uses these qualities in a small format to make the picture itself an exquisite aesthetic object. And some of his most inventive portraits are closely bound up with courtly imagery. One thinks of the glove the chivalrous Michael de Wael seems about to drop in his portrait in Cincinnati or of the lover's rose Pieter Tjarck dangles in his fingers in his portrait in Los Angeles. Perhaps the best example of this mingling of social and aesthetic artifice is *The Laughing Cavalier* of 1624 in London, in which a rakish air and dazzling effects of color and tone are added to a half-length version of a pose this young man shares with the Munich Heythuyzen portrait and any number of staider, more conventional sitters in Hals's *oeuvre*.

The social implications of Hals's work are most readily apparent in his group portraits. This is especially so of the militia companies he painted between 1616 and 1639, for they show how his approach to the same problem changed and developed as his art came to maturity. It is in the earlier works, the three banquet scenes of 1616 and 1627, that a descriptive, anecdotal naturalism is the dominant note. The chief officers are not obviously seated by rank, and the compositions are built on lively, informal conversations and interchanges. Many of the individual poses, in fact, resemble those found in his

genre scenes. In the 1630's, however, Hals moved toward greater formality, both socially and aesthetically. In both *The Meagre Company* in Amsterdam and *The St. Hadrian's Company* in Haarlem, which he painted about the same time, there is a sharp distinction between officers and men. The former are formally grouped around the seated commander on the left, while the latter spread out in a looser, more centrifugal arrangement on the right. Behind these oppositions lie abstract issues of authority and the social order quite separate from the apparently spontaneous, carefree festivity of the earlier militia pieces. At the same time, however, Hals's interest in making social meanings more articulate in the later works has also led him into greater aesthetic sophistication. The standard bearer on the far left in *The Meagre Company,* for example, is one of the most elegant and most artfully rendered beings in 17th-century Dutch art.

In his old age Hals moved toward a greater directness and, to some degree, a greater intimacy. The disappearance from his work of the civic theme of the militia portrait seems to be part of this development. In effect, its place is taken by two large family portraits from the late 1640's in London and Lugano. Each is set in a landscape, and in them parents and children engage in warmly informal and spontaneous interactions. This domestic mood may explain the increasing appearance of informal poses in his single portraits, including, for the first time, those of women. Certainly, it inspired one of the last and greatest of his marriage portraits, the pendants of Stephanus Geraerdts and Isabella Coymans in Antwerp and Paris. Ignoring their audience, the two merrily and lovingly exchange a rose across the frames. Even in more traditional, formal portraits, such as the great companion pieces of the regents and regentesses of the Haarlem Old Men's Home of 1664, Hals's brushwork enlivens the image and suggests the directness and immediacy of his response. For by the end of his career, his brushstrokes become so loose and free that they almost seem to dissolve the forms. Among late styles his is one of the most magnificent and distinctive in Western art, and it grows organically out of the whole body of his work.

—David R. Smith

HEDA, William Claesz.
Born probably in Haarlem, c. 1594. Died probably in Haarlem, c. 1680. Son, the painter Gerrit Heda. Dated paintings from 1621, and documented in guild records from 1631 in Haarlem (officer of the guild, 1637, and later). Pupils: his son Gerrit, Maerten Boelema de Stomme (The Mute).

Collections: Amsterdam; Boston; Budapest; Dresden; Dublin; The Hague: Mauritshuis, Bredius; Hamburg; Karlsruhe; Madrid; Munich; Paris; Schwerin; Vaduz; Vienna; Worcester.

Publications

On HEDA: book—

Gelder, H. E. van, *Heda, A. van Beyeren, W. Kalf,* Amsterdam, 1941.

articles—

Penan, C., "Een nieuwe Heda," in *Oud-Holland* (The Hague), 69, 1954.

Rich, D. Catton, "A Masterpiece of Dutch Still-Life," in *Worcester News Bulletin and Calendar* (Worcester, Massachusetts), 25, 1959.

<p style="text-align:center">*</p>

In common with most Dutch still-life painters, remarkably little is known about the career of Willem Claesz. Heda. He spent his entire life in his native Haarlem and trained his son Gerrit Willemsz. Heda to imitate his style. This the son did so successfully that even today their work is frequently confused.

A few of Heda's pictures are dated; this provides enough evidence to show that the artist underwent very little stylistic evolution once he had matured. The refined and closed nature of his specialist art meant that he did not have the broad influence of many of his Haarlem contemporaries, especially the landscapists such as Berchem.

The almost retiring nature of Heda's art has sometimes led to his achievements being overlooked, especially as he was virtually forgotten in the 18th and 19th centuries. He was the greatest master of the *Breakfast Piece* (in Dutch *ontbijtje*). He specialized in half-eaten fruit or meat pies with broken pastry, glasses half-filled with wine, and half-peeled lemons. These pictures have a restrained colour scheme which often verges on the monochrome. The composition is always very carefully balanced in a way also found in the other great Haarlem still-life painter Pieter Claesz.

Although this has probably never been pointed out, the near-obsession with order and calm in Heda's compositions is later found in some aspects of the still-life painting of Cezanne.

—Christopher Wright

HEEM, Jan Davidsz. de
Born in Utrecht, c. 1606; son of the still-life painter David de Heem. Died in Antwerp between 14 October 1683 and 26 April 1684. Married, 1626; son, the painter Cornelis de Heem. Trained probably with his father, and possibly with Balthasar van der Ast; worked in Utrecht to 1625, in Leiden, 1625 to c. 1631; then lived and worked in Antwerp, 1636 to c. 1668, and after 1672, with a period in Utrecht again, 1669–72.

Collections: Amsterdam; Berlin (East); Birmingham: Barber; Braunschweig; Cambridge; Cheltenham; Dresden; Dublin; Edinburgh; Gotha; The Hague; Leiden; London: National Gallery, Wallace; Madrid; Munich; Oberlin, Ohio; Ottawa; Oxford; Paris; Philadelphia; Southampton; Toledo, Ohio; Vienna; Washington.

Publications

On DE HEEM: articles—

Martin, W., "Figuurstucken van de Heem," in *Oud-Holland* (The Hague), 42, 1925.

Bergström, Ingvar, "De Heem's Painting of His First Dutch Period," in *Oud-Holland* (The Hague), 71, 1956.

Mirimonde, A. P. de, "Musique et symbolisme chez Jan Davidsz. de Heem, Cornelis-Janseoon, et Jan II Janszoon de Heem," in *Jaerboek van het Koningklijk Museum voor Schone Kunsten Antwerpen,* 10, 1970.

<p style="text-align:center">*</p>

Because of his long career and inventiveness, de Heem was one of the most influential of all Dutch still-life painters. His origins were in Utrecht, where he evolved a personal and easily recognizable style. He was the virtual inventor of what can be termed the baroque still life. This type of still-life and flower piece used the standard elements familiar in the earlier works of painters such as Ambrosius Bosschaert and Balthasar van der Ast, but they were arranged in a new way.

De Heem integrated the main elements of his compositions, especially flowers, fruits, and glasses, to produce a strong sense of movement. His pictures were therefore much more decorative than contemplative. They were thus the opposite of the type of work produced in Haarlem by Pieter Claesz and William Claesz Heda.

Unusually for a Dutch painter, de Heem spent a large part of his career in Antwerp in the southern Netherlands, where he became one of the leading still-life painters. It was in Antwerp that he produced some of his most significant works, including ambitious still-life pictures containing, unusually, representations of the Host.

De Heem's influence is found in a very large number of painters, and his pivotal position in his chosen genre has tended to be overlooked owing to the fact that his seductive style has a familiar ring about it. In Utrecht his main influence was on the German-born Abraham Mignon who adopted de Heem's compositions but used a rather harder painting technique where the surface is much more restless. A very high proportion of the flower painters and some of the still-life painters from the last third of the century in Holland owe a heavy debt to de Heem. This is seen in the flower pieces of Jacob van Walscapelle, Simon Verelst, and, particularly, Rachel Ruysch.

—Christopher Wright

HEEMSKERCK, Maerten van.
Born Maerten Jacobsz. van Veen in Heemskerk, 1498. Died in Haarlem, 1 October 1574. Married 1) Marie Jacobs Coningsdochter, 1540–41 (died, 1542–43); 2) Marytgen Gerritsdochter. Studied with Cornelis Willemsz. in Haarlem, and with Jan Lucasz. in Delft; worked with Scorel in Haarlem, 1527–29; in Italy, 1532–37, then settled in Haarlem (with a period in Amsterdam, 1572–73): worked for the Oude Kerk, Amsterdam,

St. Peter's Square, and the Vatican; drawing

1538–41, Altarpiece for St. Lawrence, Alkmaar, 1538–42, and for St. Bavo, Haarlem, 1546; also designed many prints. Pupils: Jacob Rauwaert, Cornelis van Gouda, Symon Jansz. Kies.

Collections: Amsterdam; Barnard Castle; Berlin; Braunschweig; Brussels; Cambridge; Cologne; Ghent; Haarlem; Kassel; Lille; Linköping: Cathedral; New York; Potsdam: New Palace; Rotterdam; Strasbourg; Waldheim: Schloss.

Publications

On HEEMSKERCK: books—

Preibisz, Leon, *Heemskerck,* Leipzig, 1911.

Hülsen, Christian, and Hermann Egger, *Die römische Skizzenbücher von Heemskerck im Königlichen Kupferstichkabinett zu Berlin,* Berlin, 2 vols., 1913–16.

Friedländer, Max J., *Die altniederländer Malerei, vol. 13: Anthonis Mor und seine Zeitgenossen,* Leiden, 1936; as *Anthonis Mor and His Time* (notes by H. Pauwels), Leiden, 1975.

Malfatti, Cesare, *Caroli V victoriae ex multis praecipuae . . . The Chief Victories of Charles V,* Barcelona, 1962.

Garff, Jan, *Tegninger af Heemskerck* (cat), Copenhagen, 1971.

Cnattingius, B., *Heemskerck's St. Lawrence Altarpiece in Linköping Cathedral,* Stockholm, 1973.

Veldman, Ilja M., *Heemskerck and Dutch Humanism in the Sixteenth Century,* Maarssen, 1977.

Grosshans, Rainald, *Heemskerck,* Berlin, 1980.

articles—

Reznicek, E. K. J., "De reconstructie von't *Atlaer van San Lucas* van Heemskerck," in *Oud Holland* (The Hague), 120, 1955.

Cast, David, "Heemskerck's *Momus Criticizing the Works of the Gods:* A Problem in Erasmian Iconography," in *Simiolus* (Utrecht), 7, 1974.

Bangs, Jeremy D., "Heemskerck's *Bel and the Dragon* and Iconoclasm," in *Renaissance Quarterly* (New York), 30, 1977.

Saunders, Eleanor Ann, "A Commentary on Iconoclasm in Several Print Series by Heemskerck," in *Simiolus* (Utrecht), 10, 1978–79.

Silver, Larry, "Heemskerck: Die Gemälde," in *Zeitschrift für Kunstgeschichte* (Munich), 47, 1984.

Thoenes, Christof, "St. Peter als Ruine," in *Zeitschrift für Kunstgeschicte* (Munich), 49, 1986.

*

A significant influence in Maerten van Heemskerck's early career is Jan van Scorel, an adventurous, ultimately highly successful artist who spent ten years of his youth traveling throughout Central Europe, to Italy, and even took part in a pilgrimage to the Holy Land. On his return to Holland in 1524 he established a workshop in Utrecht, where he was also a member of the clergy, and later in Haarlem, where he was joined by Heemskerck, a few years his junior. It is likely that Heemskerck was Scorel's assistant rather than his student, for the younger artist, already in his late twenties, must have had his apprenticeship well behind him. The direct relationship between them must have ended with Scorel's return to Utrecht in 1529, and there are in fact indications of a subsequent rivalry.

Heemskerck's earliest known works date from 1532 by which time he was already 34 years old and must obviously have produced other works. Had he had a hand in some of Scorel's commissions, such as the *Haarlem Jerusalem Brotherhood* panel or *The Baptism of Christ,* both produced in 1528–29, the years of his association with this artist? Heemskerck's own works from 1532—there are four—show the influence of Scorel and his Italianate approach with its echoes of Raphael and Michelangelo and hints of early Mannerism. Such tendencies are shown in Heemskerck's modeling and gestures in *St. Luke Painting the Virgin,* donated to the Haarlem Guild of St. Luke immediately prior to the artist's own departure for Italy. It is a highly posed yet imaginative canvas rife with classical references, from the robust Christ child to the Winged Victory stance of the torch bearer to the artist's possible self-portrait as an Apelles supervising the creative process.

In 1532 Heemskerck left for Italy to remain for nearly four years, no doubt well prepared for his journey by his contact with Scorel. Friedländer suggests that he was not particularly excited by what he saw and experienced, which is difficult to accept considering the intensity with which he recorded his encounters. Two of his sketchbooks have survived and provide a fascinating visual journal of his reaction to the sites. Among his drawings are views of Old St. Peter's in the Vatican showing the 4th-century structure in the process of being dwarfed by its grandiose High Renaissance-Mannerist replacement.

Heemskerck returned to Haarlem in 1535 and remained there until his death in 1574. In his career he made abundant use of his Italian sketches which became a rich source of visual information not only for himself and his contemporaries but for future generations of artists as well. His own production, in Friedländer's opinion, is characterized by a pervasive quest for grandeur resulting in "noisy and blatant compositions." Between 1538 and 1542 he completed a huge altarpiece for the cathedral in Alkmaar, a triptych dedicated to St. Lawrence with a central panel depicting a violent, distorted *Crucifixion* in which the two robbers writhe in contortions reminiscent of the *Laocoön,* only more crudely grotesque.

The altarpiece, dismantled in the Dutch religious strife and purchased by a German merchant intent on selling it to the Russians, was captured by the Swedes in the Baltic Sea and has for centuries been part of the decor of Linköping Cathedral.

While much negative criticism has been directed at Heemskerck's altarpieces and his paintings of classical subjects, his portraits have earned great acclaim, with only Friedländer issuing a minority report: "His billowing contours often change direction sharply, which invests his likenesses with an effect of vigour. At first glance his abundant shapes bespeak energy, assurance, intellectual stature; but on closer scrutiny one notes that his bone structure is none too firm and

that the more delicate character traits have been sacrificed to an overall effect of pompousness."

The portraits of Pieter Bicker and wife Anna Codde, certainly intended to be viewed as a pair as indicated by the way the room behind each sitter merges into a single totality, is a masterpiece of traditional domesticity with the master of the household in firm but benevolent control and the wife by the spinning wheel the very symbol of loyalty and virtue.

His *Family Portrait* from 1540, now in Kassel—its attribution long disputed but now safely assigned to Heemskerck—is a key work in Dutch portraiture, pointing toward its ultimate achievement a century later in similar works by Rembrandt and his contemporaries. The Heemskerck canvas, a carefully composed group picture combining required formal elements with the casual and familial, attains its grandeur and dignity without in the least resorting to the deliberate pursuit of effect so bemoaned by Friedländer.

In 1553 Heemskerck painted a *Self-Portrait Before the Colosseum,* a slightly nostalgic recollection of his Roman sojourn 20 years earlier. His features, close enough to those of the Apelles figure in the *St. Luke* altarpiece of 1532 to justify that also as a self-portrait, may indicate that he had aged well. On the other hand, these lingering touches of youth may also be part of the artist's melancholy remembrance of days gone by.

Heemskerck played a very special role as a graphic artist, creating hundreds of designs for engravings that would become standard illustrative material in Dutch studios and provide significant inspiration and guidance for future artist. This and much else in his active life make him an important forerunner of 17th-century Dutch art. Even Friedländer, although with considerable reluctance, grants as much: "To his credit let it be said that he staked out the limits within which the art of the 17th century was to unfold. It took a certain recklessness, unmindful of cultural traditions, to beat the drum so loudly and reach for the highest laurels with such audacity."

—Reidar Dittmann

HEPWORTH, (Dame Jocelyn) Barbara.

Born in Wakefield, Yorkshire, 10 January 1903. Died in St. Ives, Cornwall, 20 May 1975. Married 1) the painter John Skeaping, 1925 (divorced, 1931), one son; 2) the painter Ben Nicholson, 1932 (divorced, 1951), triplets (one boy and two girls). Attended Wakefield schools; then studied at the Leeds School of Art, 1919–20, Royal College of Art, London, 1920–23, and British School, Rome, 1924–26: studied carving under Ardini; settled in London, 1926; friend of Henry Moore; member of 7 x 5 Society in 1930's; lived in St. Ives, Cornwall, from 1939; stage designs for *Electra,* 1951, and *The Midsummer Marriage,* 1955. D. B. E. (Dame Commander, Order of the British Empire), 1965.

Major Collections: St. Ives: Hepworth Museum.
Other Collections: Aberdeen; Buffalo; Leeds; London: Tate, British Council; Manchester: University; New York: Moma, United Nations; Otterlo; St. Ives: Borough Council; Wakefield.

Publications

By HEPWORTH: books—

A Pictorial Autobiography, Bath, 1970; edited by Anthony Adams, Bradford on Avon, 1978.

illustrator: *Stone and Flower: Poems 1935–43,* by Kathleen Raine, 1943; *Stones: Poems,* by Paul Merchant, 1973.

On HEPWORTH: books—

Gibson, William, *Hepworth, Sculptress,* London, 1946.
Read, Herbert, *Hepworth: Carvings and Drawings,* London, 1952.
Baxandall, David, *Hepworth: Retrospective Exhibition* (cat), London, 1954.
Hammacher, A. M., *Hepworth,* London, 1958.
Hodin, J. P., *Hepworth,* Neuchatel, London, and New York, 1961.
Robertson, Bryan, *Hepworth* (cat), London, 1962.
Reichart, Jasia, editor, *Hepworth,* London, 1963.
Bowness, Alan, *Hepworth: Drawings from a Sculptor's Landscape,* London, 1966.
Alley, Ronald, *Hepworth* (cat), London, 1968.
Hammacher, A. M. *Hepworth,* London, 1968, 1987.
Bowness, Alan, *The Sculpture of Hepworth 1960–69,* London and New York, 1971.
Bowness, Alan, *Hepworth,* London, 1971
Gardiner, Margaret, *Hepworth: A Memoir,* Edinburgh, 1982.
Hepworth Carvings (cat), London, 1982.
Jenkins, David Fraser, *Hepworth: A Guide to the Tate Gallery Collection at London and St. Ives, Cornwall,* London, 1982.
Spencer, Gillian, *Hepworth* (cat), Wakefield, 1985.

*

Barbara Hepworth, one of the most important British artists of the 20th century, and a leading figure in world sculpture, was a native of Yorkshire, like Henry Moore, her senior by a few years, and the art critic Herbert Read, the staunchest champion of both sculptors. Hepworth's and Moore's careers overlap in many instances: they studied together at the Leeds School of Art, and at the Royal College of Art; they belonged to the same avant garde groups in the 1930's; and they went on to establish international reputations in the post-war period. Hepworth has been slightly eclipsed by Moore's phenomenal stature and success, even though she anticipated him in certain key formal innovations, and certainly never aped his style. She was justly fêted in her day as a great woman achiever.

Hepworth's generation of sculptors rebelled against Victorian academic values still prevalant in the 1920's. They believed in "truth to materials," approaching the stone directly rather than copying models or slavishly following sketches. Hepworth's early torsos reveal an awareness of Maillol's simplified arcadian vision, while her animals and birds are in-

Large and Small Forms, 1945; Cornish elm; 24¾ in (62 cm); private collection

debted to Gaudier-Brzeska, a hero of the new sculptors who had been killed in the Great War. Gill and Epstein were also mentors, the influence of the latter clearly felt in Hepworth's more "primitive" looking *Figure of a Woman,* 1929–30, with its bulky limbs, clasped hands, and hair arranged in a bun.

Hepworth was an early and courageous pioneer of abstract art in Britain, a leading member of the Hampstead set, which in the 1930's was a lively alternative to Bloomsbury. She participated in various avant garde groups, for instance Unit One, which in 1934 set out to represent "the expression of a truly contemporary spirit." Her statement in their catalogue, which summed up her concept of sculpture, remained valid throughout her career:

Carving is interrelated masses conveying an emotion; a perfect relationship between the mind and the colour, light and weight which is the stone, made by the hand which feels. It must be so essentially sculpture that it can exist in no other way, something completely the right size but which has growth, something still and yet having movement, so very quiet and yet with a real vitality. A thing so sculpturally good that the smallest section radiates the intensity of the whole and the spatial displacement is as lovely as the freed and living stone shape.

". . . the spatial displacement is as lovely as the freed and living stone shape"—these words pinpoint two central aspects of Hepworth's aesthetic. Firstly, that empty space is as vital to the sculpture as the carved material itself, by which she means the "holes" pierced into, and sometimes right through, her sculptures. Her earliest such carving, *Pierced Form,* 1931, predates Moore's use of the device by some months, and yet the innovation is often attributed to him. (Hepworth was also earlier in using string in her compositions.) Secondly, she appears to believe, as Michelangelo did, in liberating the image from the block, only in her case, being an abstract artist, the "image" is something more intrinsic to the material itself. Hepworth enjoyed a sort of empathy with the grain, colour, and texture in the wood or stone she worked, allowing these subtly to suggest the shape. Adrian Stokes described her as "one of the rare living sculptors who deliberately renew stone's essential shapes," a statement surely borne out by the exquisite pebble shapes in her work, and the sensation that the holes are the result of natural erosion.

In the 1930's Hepworth was increasingly drawn towards pure abstraction. With her second husband, Ben Nicholson, she joined the international group "Abstraction-Création." Her art in this period reflects the influence of Brancusi, Mon-

drian, Miro, Arp, and Calder, all of whom became friends during her trips to Paris. In clean-cut, sparse and minimal composition she experimented with a more extreme geometrical abstraction, introducing cones and cylindrical shapes. However, the organic metaphor would return and persist in her art after she moved to St. Ives in 1939. She was deeply affected by the dramatic scenery of Cornwall, the cliffs and caves, the sounds of the sea, and the glowing light for which that part of the country is renowned. She felt the sensation of discovering in the landscape elements she had already pursued in her sculpture in London. Formal developments such as painting the scooped-out areas blue or white, and the use of string seemed to respond to nature. "The colour of the concavities plunged me into the depth of water, caves or shadows deeper than the carved concavities themselves," she wrote. "The strings were the tension I felt between myself and the sea, the wind or the hills." She made her home in St. Ives, and stayed there after her divorce from Nicholson until her death in 1975. During this period she presided over a flourishing artists' colony, for many of Britain's leading abstract artists were concentrated in this fishing village at some time or another.

As well as their affinity with nature, Hepworth's sculptures reminded sympathetic critics of prehistoric monoliths for their robust, totemic presence. As an archaeologist pointed out, neolithic art was in its time something like modernism, a reaction against the naturalism of cave painting; in other words, the megaliths, like Hepworth's carvings, were sophisticated formal reductions! Just as the monoliths must have played a crucial role in communal life, so Hepworth sought a public role for her sculpture without compromising the formal integrity of her work by reverting to figuration or iconography. (The only exception is the *Madonna and Child* she carved for her parish church in 1953 as a memorial to her son killed in the RAF.) As her reputation grew, she was able to realise the "public" side of her aspiration in architectural commissions, culminating with *Single Form*, 1963, which sits in front of the UN Secretariat Building in New York, a memorial to the first secretary general, Dag Hammarskjöld. This 21-foot-high bronze megalith adds an asymmetrical, timeless element to the rigorously angular high modernist architecture. Hepworth started using bronze, and employing assistants, with some reluctance, remaining a trenchant "direct carver" throughout her career. With bronze she explored a rich variety of patination, rough, encrusted textures for the outdoor, monumental pieces, highly polished, sometimes even coloured surfaces for more intimate works which echo the smooth, sensuous finishes of her carvings in natural materials. Whichever material she used, the size and feel always seemed, like the shapes themselves, imbued with perfect serenity and composure.

—David Cohen

HILLIARD, Nicholas.

Born in Exeter, c. 1547. Died, in London, buried 7 January 1619. Married 1) Alice Brandon, 1576, seven children, including the miniaturist Lawrence Hilliard; 2) possibly Susan Gysard. Apprenticed to the London goldsmith and jeweller Robert Brandon (future father-in-law), 1562–69; freeman of the Goldsmiths Company, 1569; first miniature of Queen Elizabeth, 1572; in France, 1576–78; designed the second Great Seal of Elizabeth, 1584–86; granted annuity, 1599, renewed by James I. Pupils: include Isaac Oliver, Rowland Lockey, and his son Lawrence.

Major Collection: London: Victoria and Albert.
Other Collections: Birmingham; Bowhill; Cambridge; Cleveland; Liverpool; London: Portrait Gallery, Maritime Museum; New Haven; New York.

Publications

By HILLIARD: book—

Treatise Concerning "The Art of Limning," edited by Philip Norman, London, 1911–12; also edited by R. K. R. Thornton and T. G. S. Cain, Manchester, 1981; and by Linda Bradley Salamon, Boston, 1983.

On HILLIARD: books—

Long, Basil S., *English Miniaturists*, London, 1929.
Winter, Carl, *Elizabethan Miniatures*, London 1943.
Reynolds, Graham, *Hilliard and Oliver* (cat), London, 1947, 1971.
Pope-Hennessy, John, *A Lecture on Hilliard*, London, 1949.
Reynolds, Graham, *English Portrait Miniatures*, London, 1952, Cambridge, 1988.
Auerbach, Erna, *Hilliard*, London, 1961.
Foskett, Daphne, *British Portrait Miniatures*, London, 1963.
Reynolds, Graham, *Hilliard and Isaac Oliver*, London, 1971.
Strong, Roy, *Hilliard*, London, 1975.
Brett, Edwina, *A Kind of Gentle Painting* (cat), Edinburgh, 1975.
Hotson, Leslie, *Shakespeare by Hilliard*, London, 1977.
Noon, Patrick J., *English Portrait Drawings and Miniatures* (cat), New Haven, 1979.
Murdoch, John, et al., *The English Miniature*, New Haven, 1981.
Edmond, Mary, *Hilliard and Oliver: The Lives and Works of Two Great Miniaturists*, London, 1983.
Strong, Roy, *The English Renaissance Miniature*, London, 1983.
Strong, Roy, and Jim Murrell, *Artists of the Tudor Court: The Portrait Miniature Re-discovered* (cat), London, 1983.

article—

Edmond, Mary, "Limners and Picturemakers," in *Publications of the Walpole Society* (London), 1980.

*

The English art of portrait-miniature, or "limning" as it was called in Elizabethan and Jacobean days, has been described as a unique contribution to the Renaissance, and Nicholas Hilliard was its first great practitioner, acquiring an international

King James I; watercolor on vellum; $1\frac{1}{2} \times 1\frac{3}{8}$ in (4 × 3.8 cm); Royal Collection

reputation in his lifetime. He was extremely versatile, excelling not only as a limner but as a goldsmith, jeweller, calligrapher, engraver and medallist. There is no conclusive evidence that he ever painted large-scale portraits, although a few continue to be attributed to him. He did, however, paint several of the larger "cabinet" miniatures commissioned by wealthy and prominent sitters from the late 1580's, notably the *George Clifford, 3rd Earl of Cumberland* (National Maritime Museum, Greenwich), which probably portrays the Earl dressed for the tournament of 1590 celebrating the anniversary of Elizabeth I's accession day.

It is not known who instructed Hilliard in the art of limning (then executed in watercolour on vellum), but his seven-year apprenticeship to a leading London jeweller and goldsmith, Robert Brandon—whose daughter Alice he married—obviously influenced his style. When he became a freeman of the Goldsmith's Company at the age of twenty-two he was already an assured artist, and soon painted his first miniature of the Queen. Limning was then regarded as the highest form of art, "for the service of noble persons very meet," as Hilliard wrote in his *Treatise Concerning the Arts of Limning,* and it was centred on the Court. He believed that the supreme function of art was "to imitate the face of mankind"; but although he revered Holbein— who had died in London some four years before his own birth— above all others, he did not follow his method of scaling down miniatures from preliminary drawings, but painted directly from life, a practice which gives compelling immediacy to his work. He was able to convey character and appearance in a limning usually not more than about two inches high, and it is largely thanks to him that we know what leading figures of Elizabethan and early Jacobean days—among them Sir Walter Ralegh, Sir Francis Drake, and Robert Dudley, Earl of Leicester—actually looked like. He strongly believed that the main ingredient of painting lay "in the truth of the line . . . without shadowing"; and he used disciplined hatching to model his sitters' features, whereas other miniaturists adopted a freer and more naturalistic treatment of the flesh.

Technically, Hilliard was remarkably innovative, inventing new methods of portraying fabrics, metals, and jewels. For example, he emphasized the starched crispness of the lace of ruffs by drawing the complicated patterns with a brush loaded with white lead, so that when dry they stood up in relief as though embossed. He used gold and silver paint with unprecedented lavishness, and, unlike earlier limners, he burnished them—using a small animal tooth—so that instead of appearing as metallic coloured pigments, they presented surfaces of gleaming metal. To represent diamonds, he drew and shaded the cut of the stone with transparent black and greys over burnished silver: the technique is so convincing that a tiny real diamond, set in one miniature of the Queen, cannot immediately be distinguished from the surrounding counterfeits. For coloured gem stones, he mixed the appropriate pigment with a little turpentine resin, then laid and modelled it over burnished silver with a heated metal point.

Hilliard was the first portrait-miniaturist to challenge the convention of the plain blue background. In the 1590's he substituted a crimson curtain, using a so-called "wet-in-wet" technique to portray the subtle transitions of light on draped satin. The first surviving example of this is in a limning in 1594 of the young *Henry Wriothesley, 3rd Earl of Southampton,* Shakespeare's Earl (Fitzwilliam Museum, Cambridge).

Hilliard's special talents equipped him ideally to portray the exuberance of contemporary fashion—and above all to promote the image of the Queen, so important to the sovereign in days long preceding the invention of photography and television. Here the limnings become increasingly formalized with the passing years, until the sitter resembles a jewelled icon, her pale face showing little sign of age. The artist was also adept at executing the miniature as a "device," often with calligraphic inscriptions and elaborate symbolism whose meaning is usually now obscure.

The artist's self-portrait (Victoria and Albert), done in 1577 at the age of thirty while he and his wife were on a two-year visit to France, shows a lively, dark-eyed, confident man. In spite of his renown he was constantly short of money, and it was not until 1599 that he received any regular payment—a royal annuity of £40, awarded soon after he had written to Sir Robert Cecil (later first Earl of Salisbury) that he was "in great extremes." He remained active almost to the end of his long life, although it is apparent that James I, who maintained the royal patronage, did not inspire him as Elizabeth had done. His work has always been highly esteemed, and a limning for which he was probably paid about £3 in 1574 realized £75,000 in 1980, an auction record for any portrait-miniature, not exceeded until 1988.

—Mary Edmond

HOBBEMA, Meindert.

Baptized Meindert Lubbertsz. In Amsterdam, 31 October 1638. Died in Amsterdam, 7 December 1709. Married, 1668 (wife died, 1704); one son and two daughters. Pupil and friend of Jacob van Ruisdael, and his early pictures are almost indistinguishable from his teacher's; earliest dated picture, 1658; after marriage, worked as Sealer of Weights and Measures in the excise department, and painted less.

Major Collections: Berlin; Brussels; London: National Gallery, Wallace; Washington.
Other Collections: Cincinnati, Copenhagen; Dresden; Dublin; Edinburgh; Frankfurt; Geneva; Grenoble; Indianapolis; Kansas City; Melbourne; New York: Frick, Metropolitan; Norwich; Oberlin, Ohio; Richmond, Virginia; Rotterdam; Vienna.

Publications

On HOBBEMA: book—

Broulhiet, Georges, *Hobbema*, Paris, 1938.

article—

Stechow, Wolfgang, "The Early Years of Hobbema," in *Art Quarterly* (New York), 22, 1959.

*

Meindert Hobbema's *The Avenue at Middelharnis* is one of the best known and best loved of all Dutch landscapes, but its creator remains obscure. In common with so many Dutch landscapists of the period, tantalisingly little is known about Hobbema's short painting career; it lasted from 1658 to 1671, even though he was not to die until 1709. A few early pictures survive from the late 1650's, and these are all rather rapidly painted, somewhat unskilled river scenes which show little talent.

About 1660 Hobbema spent at least a year in the studio of Jacob van Ruisdael, who was newly installed in Amsterdam from his native Haarlem. The transformation in Ruisdael's studio was dramatic, and Hobbema became a competent uninspired follower of Ruisdael. Most of his works from this period repeat Ruisdael's compositions with little added flair. This period lasted until c. 1663, and then for the next six or seven years Hobbema entered his productive phase. He produced a modest series of large-scale and essentially repetitive woodland scenes of few motifs. These pictures, mostly now in British or American public collections, form the most picturesque woodland scenes of the whole century. A few of them are dated, allowing some form of stylistic development to be worked out. This development took the form of an opening out of the compositions and lightening of the palette from c. 1665, and from then on there was a gradual darkening and a perceptible increase in the attention to detail. In 1668 Hobbema became a wine gauger in Amsterdam, and his last dated picture is 1671.

The one exception is *The Avenue at Middelharnis*. The present reading of the date is 1689, which is stylistically difficult to accept (1669 being preferable). This picture is unique in Dutch landscape painting in its almost classical attention to a refined sense of order. The "niggling" of which Ruskin so rightly and aptly accused Hobbema is hardly apparent; instead there is great breadth, almost a panoramic effect. It is on this one picture that Hobbema's fragile fame rests.

—Christopher Wright

HOCKNEY, David.

Born in Bradford, Yorkshire, 9 July 1937. Studied at Bradford College of Art, 1953–57, and Royal College of Art, London, 1959–62; then independent painter and photographer in London, and since 1964 in Los Angeles; taught at Maidstone College of Art, 1962, University of Iowa, Ames, 1964, University of Colorado, Boulder, 1965, and University of California, Berkeley, 1967; stage designs for *Ubu Roi*, 1966, *The Rake's Progress*, 1974, *The Magic Flute*, 1978, *Parade*, 1981, *Tristan und Isolde*, 1987, etc. Agent: Cavan Butler, 2 Heathfield Terrace, London W.4, England.

Collections: Amsterdam: Stedelijk; Bradford; Chicago; Krefeld; London: Tate, Victoria and Albert, Arts Council; Los Angeles; Melbourne; Minneapolis; New York: Moma, Metropolitan, Public Library; Paris: Beaubourg.

Publications

By HOCKNEY: books—

Hockney by Hockney, edited by Nikos Stangos, London, 1976, New York, 1977; shortened version, as *Pictures by Hockney,* 1979.
The Artist's Eye: Hockney Looking at Pictures in a Book at the National Gallery, London, 1981.
Hockney Photographs, London and New York, 1982.
China Diary, with Stephen Spender, London and New York, 1982.
On Photography (lecture), New York, 1983, Bradford, 1985.
Martha's Vineyard and Other Places: My Third Sketchbook from the Summer of 1982, London and New York, 2 vols., 1985.
Hockney on Photography: Conversations with Paul Joyce, London, 1988.

illustrator: *A Rake's Progress*, 1963; *Fourteen Poems*, by C. P. Cavafy, 1966; *Six Fairy Tales from the Brothers Grimm*, 1970; *The Blue Guitar: The Man with the Blue Guitar*, by Wallace Stevens, 1977.

On HOCKNEY: books—

Amaya, Mario, *Paintings and Prints* by Hockney (cat), Manchester, 1969.
Glazebrook, Mark, *Hockney* (cat), London, 1970.
Gercken, Günther, *Hockney* (cat), Bielefeld, 1971.
Hockney: Tableaux et Dessins/ Paintings and Drawings (cat), Paris, 1974.
Pillsbury, Edmund, *Hockney: Travels with Pen, Pencil, and Ink: Selected Prints and Drawings 1962-1977* (cat), New York and London, 1978,
Brighton, Andrew, *Hockney Prints 1954-77* (cat), London, 1979.
Stangos, Nikos, *Hockney: Paper Pools,* London and New York, 1980.
Glazebrook, Mark, *Hockney: Paintings and Drawings for "Parade,"* London, 1981.
Livingstone, Marco, *Hockney,* London, 1981, 1988.

Dancer, 1980; 48 × 36 in (121.9 × 91.4 cm); Courtesy Waddington Galleries

Sayag, Alain, *Hockney: Fotografien 1962–1982* (cat), Basel, 1983.

Kasmin's Hockneys (cat), London, 1983.

Friedman, Martin, *Hockney Paints the Stage,* London, 1981; Minneapolis and New York, 1983.

Panicelli, Ida, editor, *Hockney fotografo* (cat), Florence, 1983.

Weschler, Lawrence, *Hockney: Cameraworks,* New York and London, 1984.

Wilder, Nicholas, *Hockney: Paintings of the Early 1960's* (cat), New York, 1985.

Kitaj, R. B., et al., *Hockney: A Retrospective* (cat), Los Angeles and London, 1988.

Shanes, Eric, *Hockney: Posters,* London, 1987.

Livingstone, Marco, *Hockney: Faces,* London and New York, 1987.

Webb, Peter, *Portrait of Hockney,* London, 1988.

"Hockney Issue" of *Art and Design* (London), February 1988.

Hockney: A Retrospective (cat), Los Angeles and London, 1988.

*

David Hockney made his first mature pictures in the early 1960's when he was still a graduate student at the Royal College of Art in London. The new work was the result of two realizations, both of which were to be crucial to his later painting. Firstly, encouraged by friends at the college like R. B. Kitaj, he decided that rather than paint stock Art School subjects like nudes and still lifes he would paint about what really mattered to him. What mattered to him in the early 1960's was acknowledging his homosexuality, and in pictures like the 1961 *We Two Boys Together Clinging* (London, Arts Council) Hockney became the first artist openly to describe gay life. His subsequent subjects were never as strident, but he has never been satisfied by formal, technical interests alone in a picture, and his work is always *about* something, be it a friend's personality, some visual experience, or even intellectual questions about the nature of painting itself. He has always opposed complete abstraction, seeing it as incapable of carrying significant meanings.

Hockney's second discovery was the representational "sign." He became fascinated by the way in which non-naturalistic tokens—like the primitive figures in *We Two Boys,* for example—manage to work as expressive representations while looking nothing like the things they represent. This exciting intellectual ambiguity was first explored in Cubism, which for Hockney has always been a method rather than merely a style. He has tried out numerous different types of representational "signs," sometimes using several in one picture, and it's his fascination with this idea that makes his work seem to be so extremely varied.

There has been one period of Hockney's work in which the "sign" has been shelved. In the later 1960's he became increasingly interested in the problems of describing human personalities and in depicting the character of Los Angeles, where he had moved in 1963. The highly unnaturalistic sign was ill-suited to this, and so he shifted to more conventional representation, finding the move, a retrogresive one in the modernist book, as exciting as the discovery of an avant-garde technique.

The new style can be seen in works like the 1967 *A Bigger Splash* (London, Tate Gallery) and *Christopher Isherwood and Don Bachardy* 1968 (private collection) which, although they still use some stylizing formulae, are nevertheless poles apart from the work of the early and mid-1960's. Given that Hockney's aim is to characterize, it may seem odd that these works appear so emotionless. But for Hockney California is a land of glossy too-good-to-be-true surfaces while his abiding understanding of people is their relative isolation and separateness from one another. These paintings are about a kind of emotional blankness.

As might be expected in someone who experiments with technique so widely, Hockney tires of an idiom once he has used it thoroughly. By the mid-1970's he felt that he had taken his brand of naturalism as far as it could go, and in the wake of Picasso's death in 1972 he began to reassess the Cubist message. The non-naturalistic sign became an important element in his pictures again and in works like the 1975 *Invented Man Revealing a Still Life* (private collection) Hockney pitted his naturalistic style against a "sign" man in a witty display of the modern painter's resources and the kinds of reality they can offer.

Picasso was also the principal inspiration for the next development in Hockney's painting. Picasso and the Cubist masters had used shifting perspectives and multiple viewpoints to give a much more "conceptual" image of an object than could be had from a fixed viewpoint. Hockney found the same perspective ideas in Chinese art, and furthermore saw a link between them and the stress on the element of time in modern physics. In a series of large paintings of the early 1980's he created the pictorial equivalents of travelling through a landscape or walking through a house. The 1980 *Mulholland Drive* (Los Angeles) is a prime example. These pictures also used a new brilliance of colour and a drawing style which was often frankly derived from Picasso.

The period from the late 1970's has also been conspicuous for experiment with new media. In a series of swimming pool pictures from 1978 Hockney tried out making images with liquid colour paper pulp. The early 1980's saw the development of a photocollage technique in which numerous photos taken at different distances and viewpoints are fitted together to give a "travelling" perspective similar to that in the contemporary paintings. More recently Hockney has become interested in making art using modern colour photocopying, using it to subvert the normal processes of fine art print production.

Hockney's fascination with Cubism has also made him a highly inventive stage designer. His first theatre designs, for a performance of Alfred Jarry's *Ubu Roi* at the Royal Court Theatre, London, were produced in 1966. Since then he has excelled as a designer for opera, making brilliant sets for *The Rake's Progress* and *The Magic Flute,* both seen at Glyndebourne in the 1970's. Further designs have followed and Hockney will be in demand for stage work as long as he is interested in it.

Hockney is only in his early fifties. The first thirty years of his work have seen a breathtaking range of ideas and achievement. No post-war British painter has rivalled his variety, largely because no one has shared his interest in and understanding of Cubism. It seems certain that a wealth of painting is yet to come.

—Roger Mills

HODLER, Ferdinand.

Born in Berne, 14 March 1853. Died in Geneva, 19 May 1918. Married 1) Bertha Stucki, 1889 (divorced, 1891); 2) Bertha Jacques, 1898; also had one son by Augustine Dupin, and one daughter by Valentine Godé-Darel. Assisted his stepfather Gottlieb Schüpbach in his sign-painting business as a youth; apprenticed to the painter Ferdinand Sommer, 1868–70; pupil of Barthélemy Menn at the Ecole des Beaux-Arts, Geneva, 1872–78; visited Madrid, 1878–79; independent artist in Geneva from 1881; exhibited in Switzerland, and in Paris from 1891; concentrated on large historical/mythological works: Jena University 1907, Hanover Town Hall, 1911.

Major Collections: Berne; Geneva; Zurich.
Other Collections: Basel; Chicago; Essen; Hanover: Town Hall; Jena: University; Lucerne; Munich: Neue Pinakothek; Solothurn; Stuttgart.

Publications

By HODLER: book—

Briefwechsel, with Ulrich Diem, edited by Rudolf Hanhart, St. Gallen, 1977.

On HODLER: books—

Muhlestein, Hans, *Hodler,* Weimar, 1914.
Maeder, Alphonse, *Hodler: Eine Skizze seiner seelischen Entwicklung und Beteutung für die schweizer-nationale Kultur,* Zurich, 1916.
Loosli, Carl A., *Hodler: Mappenwerk und Textbank,* Zurich, 2 vols., 1919–21.
Loosli, Carl A., *Hodler: Leben, Werk, und Nachlass,* Berne, 4 vols., 1921–24.
Bender, Ewald, *Das Leben Hodlers,* Zurich, 1921.
Frey, Adolf, *Hodler,* Leipzig, 1922.
Bender, Ewald, and Werner K. Müller, *Die Kunst Hodlers,* Zurich, 2 vols., 1923–41.
Roffler, Thomas, *Hodler,* Frauenfeld, 1926.
Muhlestein, Hans, and Georg Schmidt, *Hodler: Sein Leben und sein Werk,* Erlenbach, 1942.
Ueberwasser, Walter, *Hodler: Kopfe und Gestalten,* Zurich, 1947.
Ankwicz-Kleehoven, Hans, Cuno Amiet, and Kolo Moser, *Hodler und Wien,* Zurich, 1950.
Hugelshofer, Walter, *Hodler,* Zurich, 1953.
Dietschi, Peter, *Der Parallelismus Hodlers,* Basel, 1957.
Guerzoni, Stephanie, *Hodler: Sa vie, son oeuvre, son enseignement, souvenirs personelles,* Geneva, 1957.
Brüschweiler, Jura, *Hodler: Dessins* (cat), Geneva, 1963.
Tavel, Hans Christoph von, *Hodler: Die Nacht,* Stuttgart, 1969.
Brüschweiler, Jura, *Hodler im Spiegel der zeitgenössischen Kritik,* Lausanne, 1970.
Selz, Peter, et al., *Hodler* (cat), Berkeley, 1972.
Brüschweiler, Jura, *Ein Maler vor Liebe und Tod: Hodler und Valentine Gode-Darel: Ein Werkzyklus 1908–1915* (cat), Zurich, 1976.

Brüschweiler, Jura, *Eine unbekannte Hodler-Sammlung aus Sarajewo,* Berne, 1978.
Brüschweiler, Jura, *Hodler: Selbstbildnisse als Selbstbiographie,* Berne, 1979.
Zelger, Franz, *Hodler* (cat), Glattburg, 1981.
Zelger, Franz, and Lukas Gloor, *Der Frühe Hodler: Das Werk 1870–1890* (cat), Berne, 1981.
Dreyer, Colette, *Hodler: Die Mission des Künstlers/La Mission de l'artiste* (cat), Berne, 1981.
Hirsh, Sharon L., *Hodler,* Munich, 1981, New York and London, 1982.
Hirsh, Sharon L., *Hodler's Symbolist Themes,* Ann Arbor, 1983.
Jossen, Susanne, editor, *Hodler und das schweizer Künstlerplakat 1890–1920* (cat), Zurich, 1983.
Brüschweiler, Jura, and Rudolf Koella, *Hodler: Zeichnungen: Vom Entwurf zum Bild* (cat), Winterthur, 1983.
Hodler (cat), Zurich, 1983.
Brüschweiler, Jura, *Hodler: Olbilder und Zeichnungen aus der Sammlung Josef Müller sowie aus Schweizer Privatbestiz,* Zurich, 1986.
Eisenman, Stephen, *Hodler Landscapes* (cat), Zurich, 1987.
Hirsh, Sharon L., *The Fine Art of the Gesture: Drawings by Hodler* (cat), Montreal, 1988.

*

A major painter of the Post-Impressionist era, Ferdinand Hodler moved to Geneva in 1872. There he worked under the Swiss "Barbizon" painter Barthélemy Menn, who led him through a rigorous curriculum that focused on the study of past masterpieces, analysis of classical literature and Renaissance theory, and the mastery of traditional technique. Menn's method was a traditional one which Hodler maintained throughout his career, developing his paintings in careful stages beginning with preliminary sketches, theoretical notations, and mock-up compositions. Only when all of these cautious steps were taken would Hodler turn to the actual canvas. Like Menn, Hodler managed to balance this rigid working method with creative spontaneity and felt free to change the painting while in progress, often denying most of the preparatory work in the process. Hodler was a dedicated student, as evidenced in his early self portrait entitled *The Student* (1874, Zurich), and he soon began to win prizes in local competitions, primarily for compositions celebrating Swiss history.

Like his contemporaries Van Gogh and Munch, Hodler in the late 1870's and early 1880's turned to the depiction of social issues, painted in a highly illusionistic style. Throughout these years, Hodler fought both poverty and critical rejection; support came from a relatively small group of young artists and writers who together established—with close ties to Paris—Geneva's Symbolist movement. Most influential for Hodler was Louis Duchosal, known by his early twenties as Switzerland's greatest Symbolist poet, and who served throughout his lifetime as Hodler's close friend and loyal critic.

Although encouraged by Duchosal's idealism, Hodler had been trained to render realistic depictions, and the expression of ideistic content was not easy; like many of his Symbolist contemporaries, he devoted years to the problem of tangibly representing the most intangible sensations and ideas. Primary

Study for View of Eternity, 1914; drawing; Basel, Kunstmuseum

among Hodler's themes was that of death. Having been orphaned at a young age, and having subsequently lost all his four brothers and one sister to tuberculosis by the late 1880's, Hodler lived in constant fear of the disease and its brutal toll. As with all the themes that obsessed him, however, the fear of death gradually acquired universal significance and evolved from the individual death depicted in his earlier paintings of the 1870's to a symbolic expression in *Night* of 1890, in which he portrays himself as a man who, surrounded by other sleeping figures in a deliberately timeless, barren world, awakens in the night to face a dark-draped phantom of death. In *Night,* it is the collective impact of abstraction and reiterative pattern that makes the emotional trauma of a very personal theme both stronger and more universal.

To achieve this impact Hodler devised the theory of Parallelism, a concept of art and a philosophy of life based on the premise that all nature and humanity are bound by some underlying order, "a world law of universal validity" which maintains, in spite of apparent external differences, an important commonality in all living things. Although these concepts of unity bear theoretical comparison to the later *de Stijl* movement, Hodler's Parallelism was distinctly humanistic in orientation. While *de Stijl's* theories found visual enunciation in codified abstract forms and formulas, Hodler's best expressions of Parallelism were those concerning deep human feelings. To express this, Hodler worked throughout his life with the human figure and images of nature, but used abstracted patterns and multiples for greater Parallelistic effect. Figures were arranged symmetrically, as repetitions of one basic image; each individual varies in detail, yet is deliberately likened to the others in overall appearance for a cumulative effect. In landscapes, views with inherently patterned or even symmetrical layouts were chosen, and their underlying order constantly emphasized by repetition of line, color, and form. Perceiving his own emotional traumas as extreme exponents of a universal

passion, he began to transform his most inner feelings into monumental and public statements.

With *Night,* Hodler not only established his first figurative Parallelistic composition, but also began an extensive series of paintings that dealt with basic questions of existence—life and death, faith and despair. This series typified the Symbolists' approach to an art of significant content. Hodler's series bears comparison to other Symbolist projects like Gauguin's *Where do we come from, who are we, where are we going?* (1898, Boston) or Munch's series the *Frieze of Life* (1892–1900). The thematic idealism of Hodler's paintings had its roots in the German Romantic movement of the early 19th century and sought to convey the essential meaning that lay behind the seemingly random occurrences of nature. Hodler's presentation of these transcending themes was never programmatically complete; although he expressed his intention to illustrate fully the symbolic times of day, certain portions like "Twilight" never emerged from their sketched beginnings. Most important, Hodler did not plan a narrative or even cyclic sequence for his series; rather, he searched for a comprehensive harmony of opposites that would symbolically balance one another. Just as the harmony of Parallelism was based on the symmetrical equation of figures and their emotions, or on natural views and their hidden order, so also are the paintings of Hodler's series necessary pendants for one another. *Night* is balanced by *Day* (1900, Berne), and the old men of *Eurythmy* (1895, Berne), elsewhere titled "Autumn" by Hodler, have their counterparts in the adolescents of *Spring* (1901, Essen). The series also included images of old age and despair in *The Disillusioned* (1892, Neue Pinakothek, Munich); this has its converse in the hope-filled, and youth-oriented *The Consecrated One* (1893–94, Berne). Finally, *Night's* emphasis on superstition and evil is banished by the light of *Truth* (1902, Zurich). Thus seen as a totality, Hodler's works of the 1890's were meant to signify the eternal harmony that underlies

seeming opposite forces of life. Unfortunately, the paintings were separately acquired for different collections and are therefore rarely seen together. But when Hodler was able to exhibit the entire series in a retrospective in 1904, the Viennese critic Franz Servaes noted that the work seemed "a living part of an organic entirety."

That the series ended with the life-affirming paintings *Day* and *Truth* reveals a new optimism in Hodler's life. With the new century came public commissions and numerous international awards, resulting in new confidence as well as a brighter palette retrospective in Vienna; his work, internationally exhibited, had a great influence on the entire generation of Expressionist artists. His paintings of the 20th century grew increasingly large and idealistic, and included several public commissioned murals on a variety of historical and nationalistic themes, including the Hall of Armour murals for the Swiss Landesmuseum in Zurich, a memorial to the *Departure of the Jena Students* commissioned in 1907 for the Friedrich Schiller University of Jena, and the *Oath of the Hanover Reformers,* commissioned in 1911 for the Hanover Town Hall. In 1910 Hodler received a commission that paid homage to his international reputation by allowing him full control of the subject and style of a mural for the newly build Zurich Kunsthaus: the result was *View into Infinity* of 1916.

In the 20th century, Hodler also painted numerous portraits in an increasingly rich and free style; as his figures became simpler and bolder, so also did his handling of color, line, and texture. Although immensely sought after as a portraitist, he undertook only those portraits of some personal interest and concentrated on a circle of close friends and collectors. In these portraits, strengths rather than weaknesses are emphasized. Unlike the contemporary portraits of Schiele or Klimt, whose sitters are subsumed by their surroundings, Hodler's sitters dominate the canvas. According to Hodler's usual method of figural painting, the length of the brush stroke varies in direct proportion to the area depicted, with broad flat planes of background space, long broad strokes delineating the figure itself, and small intricate brush work creating the individual's face. In a manner similar to that of Matisse, Hodler utilized the brush stroke as a dual indication of form; although each stroke of pigment becomes an autonomous element of the painting surface, each also echoes the underlying mass of the visage it portrays. The resulting portraits present figures who are vital, colorful, and full of interesting vagaries, but whose essential beings are totally ordered and in control of their own situation. This emphasis on order was in fact more reflective of the artist than the sitter: even in middle age, and at the height of his career, Hodler clung to his theory of Parallelism and the measured stability that it ensured.

It is for his landscapes that Hodler is most appreciated today. His approach in these works is never as a mere view, but rather as a complete artistic and philosophical statement. Like many others at the turn of the century, Hodler sought to revive the Romantic belief in the spiritual uplifting that results from a oneness with the grandeur of nature. This idea was already evident in Hodler's 19th-century landscapes by means of the inclusion of obvious symbols and figures. Beginning with the 1884 *Dialogue with Nature* (Berne), in which a nude young man communes with the verdant nature around him, Hodler expressed his belief that through nature one could achieve a vision of infinity. This same belief is expressed more simply

and forcefully in Hodler's 20th-century landscapes, which are usually without figuration, and present instead cosmic vistas of lakes, forests, or mountains. His depictions of the majestic mountains of Switzerland are most well known. Ignoring traditional landscape convention that balanced foreground, middleground, and background, Hodler allowed his mountains to tower above misting, melting, and intangible clouds, or massively to rise up as the only foreground below an endless sky. Like Cézanne, Hodler utilized deliberate distortions of pictorial perspective in order to present a view that was at once based on nature and yet eternally transformed on canvas, in brightly colored and heavily pigmented, freely painted forms.

By the 20th century, however, death had re-entered Hodler's life. In 1909 Hodler's first love, Augustine Dupin, was dying, and for several months the painter and their son, Hector, kept a vigil by her deathbed, resulting in a moving series of deathbed portraits that are Expressionist in their free and almost frenetic style as well as their revelation of the emotionally empathetic involvement on the part of the artist. Hodler's subsequent relationship with Valentine Godé-Darel ended with her untimely death in 1915; this in turn resulted in another extensive series of paintings bearing an uncanny resemblance to the earlier one of Augustine Dupin. Hodler's lifelong encounters with death, like the similar experiences of Munch and Ensor, strengthened his conviction that he had to expose through art his most personal traumas in order to express the most universal human concerns. Five years after Augustine's death, when he could already foresee the ordeal of Valentine's death before him, Hodler said, "If you accept death with all your conscience and all your will, this will give birth to great work . . . this concept orders all our existence and imprints on it an entirely different rhythm; to have an awareness of this transforms the idea of death into an enormous power." To augment his death cycles, Hodler painted what he himself termed "paysages planetaires," cosmic landscapes that increasingly reiterated the horizontality that for Hodler meant calm, peace, and death. In this last decade, Hodler himself was stricken with rheumatism, but nevertheless taught advanced drawing at the Ecole des Beaux-Arts of Geneva. Although suffering relapses of his illness, as well as lung edema in 1917, Hodler continued to paint from his sick room until his death in 1918.

—Sharon Hirsh

HOFMANN, Hans.

Born in Weissenberg, Germany, 21 March 1880; naturalized United States citizen, 1941. Died in New York, 17 February 1966. Married 1) Maria Wolfegg, 1923 (died, 1963); 2) Renate Schmidt, 1964. Studied under Willi Schwarz at Moritz Heymann's Art School, Munich, 1898; attended evening classes at the Atelier Colarossi and the Académie de la Grande Chaumière, Paris, 1904–06; friend of Robert Delaunay in Paris, and involved with Cubism in Paris, 1910–14; founder-teacher, Schule für Moderne Kunst, Munich, 1915–32; moved to New York, 1932: founded Hans Hofmann School, New York, 1933, and summer school, Provincetown, Massachusetts, 1935; closed schools, 1958, to concentrate on his own painting.

Collections: Berkeley: University; Buffalo; Chicago; Dallas; Montreal; New York: Moma, Metropolitan; Toronto.

Publications

By HOFMANN: books—

Form und Farbe in der Gestaltung, Berkeley, 1932.
Search for the Real and Other Essays, Andover, Massachusetts, 1948, 1967.

On HOFMANN: Books—

Wight, Frederick S., *Hofmann,* Berkeley, 1957.
Greenberg, Clement, *Hofmann,* Paris, 1961.
Hunter, Sam, *Hoffman,* New York, 1963.
Seitz, William C., *Hofmann* (cat), New York, 1963.
Geldzahler, Henry, *Hofmann: The Renate Series,* New York, 1972.
Bannard, Walter Darby, *Hofmann* (cat), Houston, 1976.
Goodman, Cynthia, *Hoffman,* New York, 1986.
Hofmann (cat), London, 1988.

article—

Landau, Ellen G., "Space and Pictorial Life: Hofmann's Smaragd Red and Germinating Yellow", in *Bulletin of the Cleveland Museum of Art,* September 1985.

*

Hans Hofmann provided one of the key links between European modernism and American Abstract Expressionism. In his early years, first in Paris and then in Munich, he befriended the leading Fauvist, Cubist, and Expressionist artists, including Henri Matisse, Robert Delaunay, and Wassily Kandinsky. From 1915 through 1958 Hofmann directed his famous School of Painting, in Munich and after 1932 in New York City and Provincetown, Massachusetts. In fact Hofmann did not actively paint between 1915 and 1937, and it might be argued that his influence as a teacher was even greater than that as an artist. In New York City from the early 1930's through the late 1940's, his was the only school where modern art was taught. Hofmann's friendships with the great European artists made him interesting to the younger Americans. While Lee Krasner was the only important Abstract Expressionist painter actually to study with Hofmann, she brought her husband Jackson Pollock and the most influential critic of the period, Clement Greenberg, to his lectures. Robert Motherwell, William Baziotes, and Adolph Gottlieb, among others, also heard Hofmann speak on modern art. Although Hofmann's lectures and classes were delivered in a thick German accent and consisted of an idiosyncratic mixture of continenal art theories, two contrasting points stood out. On one hand, Hofmann emphasized dynamic, two-dimensional pictorial structure, his famous theory of "push and pull." Simultaneous to this analytic view, Hofmann stressed the individuality of each of his pupils and the need for spontaneous, improvisational artistic invention, an idea he probably derived from Kandinsky. These two goals, two-dimensional structure and improvisation, were essential to

the genesis of Abstract Expressionism. The notable lacuna in Hofmanns's teaching was Surrealism, against which he claimed to have aesthetic and moral objections, but whose disturbing content profoundly influenced the Americans independently of Hofmann.

Hofmann's own paintings from 1936 through 1941 were still-lifes taken from nature. In them the flattened planes of Cubism were paired with high-keyed colors whose sources were in Fauvism. Despite their complex shapes and rich colors, which would influence his later works, these paintings were tamely bound to visual appearances. In 1942 Hofmann's paintings grew increasingly impulsive. In their organic abstract appearances and suggestions of mythic creatures, they moved closer to a direction already taken in the works of Gorky, Pollock, Motherwell, Baziotes, and Gottlieb. Although Hofmann continued to disparage Surrealism in his classes, he had clearly re-evaluated it in his art. In 1944 Hofmann carried this spontaneity to an extreme in a number of small abstractions, like *Effervescence,* consisting of splashed and dripped pigment. Their randomness was opposed to the more analytic side of Hofmann's temperament, but their freedom seemed necessary to prod him toward total abstraction. After some vigorously brushed and high-keyed paintings in the late 1940's, a grid-like structure reimposed itself upon Hofmann's paintings after 1952. In these works oblong planes of color alternate with areas of free calligraphy. Eventually these planes of color came to dominate the entire surfaces. In these paintings Hofmann's intuition and artistic enthusiasm were embodied in vivid, dissonant colors which seemed about to explode from their rectangular containers. During the 1960's Hofmann denied the usual density of his pigment and painted in thin, rectangular washes of glowing color. Hofmann paralleled the discoveries of such color-field painters as Helen Frankenthaler and Morris Louis.

The push and pull tension between colorful planes found throughout Hofmann's painting was symbolic in his eyes of the underlying force-counterforce dynamic of nature. In Hofmann's art the act of painting does yield psychological meanings; in his case the rich colors and clear structures are signs of a temperament that is at once analytical and sensual. In all, Hofmann's art is a synthesis of Fauvism, geometric abstraction, and some aspects of Abstract Expressionism. His works typically convey a joyous vision of life and are rarely given tragic overtones. It is this quality that distinguishes them from the more pessimistic pictures of the Abstract Expressionists.

—Robert Saltonstall Mattison

HOGARTH, William.

Born in London, 10 November 1697. Died in London, 25 October 1764. Married Jane Thornhill, daughter of James Thornhill, 1728. Apprenticed to the engraver Ellis Gamble, London; studied at St. Martin's Lane Academy; set up as an engraver, c. 1720, and painter, c. 1728: series of "moral" sets, such as the *Rake's Progress;* visited Paris, 1743, 1748; appointed sergeant-painter, succeeding James Thornhill, 1757, and reappointed by George III, 1760.

Idle Apprentices at Play—detail; engraving

Major Collections: London: British Museum, Tate.
Other Collections: Columbus, Ohio; Farmington, Connecticut: Lewis-Walpole Library; London: Lincoln's Inn, National Gallery, Portrait Gallery, Soane, Dulwich, St. Bartholomew's Hospital; Louisville, Kentucky; Minneapolis; Montreal, New Haven; New York: Metropolitan, Frick; Oxford: Ashmolean, Bodleian; Philadelphia; San Marino, California; Truro; Washington.

Publications

By HOGARTH: books—

The Analysis of Beauty, London, 1753; edited by Joseph Burke, Oxford, 1955.
Apology for Painters, edited by Michael Kitson, Oxford, 1968.

On HOGARTH: books—

Ireland, John, *Hogarth, Illustrated from His Own Manuscripts*, London, 3 vols., 1791; 3rd ed., 1812.
Lichtenberg, Georg C., *Ausführliche Erklärung der Hogarthischen Kupferstiche*, Gottingen, 14 vols., 1794–1833; as *The World of Hogarth: Lichtenberg's Commentaries on Hogarth's Engravings*, London, 1966.
Brown, Gerald B., *Hogarth*, New York, 1905.

Hind, Arthur M., *Hogarth: His Original Engravings and Etchings*, New York, 1912.
Klingender, Francis D., *Hogarth and the English Caricature*, London, 1944.
Ayrton, Michael, *Hogarth's Drawings*, London, 1948.
Moore, Robert E., *Hogarth's Literary Relationships*, Minneapolis, 1948.
Oppe, A. P., *The Drawings of Hogarth*, London, 1948.
Beckett, Ronald B., *Hogarth*, London, 1949.
Mitchell, Charles, editor, *Hogarth's Peregrinations*, Oxford, 1952.
Quennell, Peter, *Hogarth's Progress*, London, 1955.
Antal, Frederick, *Hogarth and His Place in European Art*, London and New York, 1962.
Berry, Erick, *The Four Londons of Hogarth*, New York, 1964.
Paulson, Ronald, *Hogarth's Graphic Works: First Complete Edition*, New Haven, 2 vols., 1965, 1970.
Mandel, Gabriela, *L'opera completa di Hogarth*, Milan, 1967.
Burke, Joseph, and Colin Caldwell, *Hogarth: The Complete Engravings*, London, 1968.
Wensinger, Arthur S., and William B. Coley, *Hogarth on High Life: The "Marriage à la Mode" Series from Lichtenberg's Commentaries*, Middletown, Connecticut, 1970.
Gowing, Lawrence, *Hogarth* (cat), London, 1971.
Paulson, Ronald, *Hogarth: His Life, Art, and Times*, New Haven, 2 vols., 1971.

Shesgreen, Sean, *Engravings by Hogarth*, New York, 1973.

Paulson, Ronald, *The Art of Hogarth*, London, 1975.

Jarrett, Derek, *The Ingenious Mr. Hogarth*, London, 1976.

Lindsay, Jack, *Hogarth: His Art and His World*, London, 1977, New York, 1979.

Gaunt, William, *The World of Hogarth*, London, 1978.

Webster, Mary, *Hogarth*, London, 1979.

de Voogd, Peter Jan, *Henry Fielding and Hogarth: The Correspondences of the Arts*, Amsterdam, 1980.

Wehrli, Rudolf, G. C. *Lichtenbergs ausführliche Erklärung der Hogarthischen Kupferstiche*, Bonn, 1980.

Bindman, David, *Hogarth*, London, 1981.

Cowley, Robert L. S., *Marriage-a-la-Mode: A Re-view of Hogarth's Narrative Art*, Manchester, 1982.

Shesgreen, Sean, *Hogarth and the Times-of-the-Day Tradition*, Ithaca, New York, 1983.

Hogarth (cat), Zurich, 1983.

Finberg, Elizabeth, *Manners and Morals: Hogarth and British Painting 1700-1760* (cat), London, 1987.

Dabydeen, David, *Hogarth's Blacks*, Manchester, 1987.

Dabydeen, David, *Hogarth, Walpole, and Commercial Britain*, London, 1987.

*

William Hogarth was one of the founders of the English school of painting and, at the same time, the originator of a counter tradition to the very school he helped establish. Born in London and trained there, first by himself and then at John Vanderbank's drawing school, he made important contributions to portraiture, landscape painting, history painting, and aesthetic theory through his *Analysis of Beauty*. A man of remarkable versatility, Hogarth made an even greater impact on popular satires and the modern moral "progress" which he invented and sold to a broad audience of English men and women who had not owned or bought art before.

At the age of 17, poverty compelled Hogarth to leave home to apprentice himself to a silver monograph engraver named Ellis Gamble who had a shop at the Golden Angel in Leicester Fields. After his father's death (1718), Hogarth abandoned this trade to become a copperplate engraver, producing shop cards, coat of arms, tickets for funerals and plays, illustrations for books (most notably Samuel Butler's *Hudibras*) and satirical engravings on topical subjects.

After eloping with Sir James Thornhill's daughter in 1728, he turned for a livelihood to painting "conversations," small group portraits showing families or friends in informal poses and settings. His success in such conversations as *A Children's Party* (1730), *The Fountaine Family* (1730-32), *The Jeffreys Family* (c. 1730), and *The Cholmondeley Family* (1732) arose from his accurate likenesses and his spirited style. It was also due to his magical treatment of children—Hogarth and his wife had no offspring of their own. These conversation pieces, executed between 1728 and 1732, propelled him to undertake more ambitious portraiture, life-size likenesses. From 1736 to 1744, Hogarth produced his greatest portraits: *Peg Woffington* (1742), *Lavinia Fenton* (1740), *Captain Coram* (1740), *Mrs. Salter* (1744), and the famous *Graham Children* (1742), celebrated for its warm color, its spontaneous arrangement of subjects, and its flesh, lively face painting. Although he executed few portraits by commission after 1744, he continued to paint

self-portraits and likenesses of people he admired or knew. *Hogarth's Servants* dates from the mid-1750's; the colorful, elegant, witty *Garrick and his Wife* was done in 1757; and *Hogarth Painting the Comic Muse* dates from around 1758.

John Constable claimed that Dutch and English artists had impoverished landscape painting until Hogarth "aroused the minds of our countrymen and directed them to nature" by his own splendid example. The "splendid example" Constable had in mind certainly included *The Four Times of the Day* (paintings c. 1736, engravings 1738), Hogarth's manifesto about the theory and practice of English art, particularly landscape art. Many 17-century landscapists had used the times-of-the-day trope to celebrate, in a repetitious way, the beauties of the countryside. By the 18th century the trope had become a cliché. So Hogarth revolutionized the theme by using it to depict city life and satirize the mores of city knaves, charlatans, and ordinary people. Showing actual London neighborhoods, recognizable times of the year, and identifiable individuals, Hogarth replaced the romantic portrayal of nature with a realistic, humorous depiction of the city. In such details as the Covent Garden setting of *Morning*, the September 3rd time of *Night*, and in the portraits of real-life rogues like Dr. Rock and Justice De Veil in the same two pictures, the artist created an urban pastoral that was English to the bone.

Competitive and deeply ambitious, Hogarth also aspired to paint in "the grand manner," the lofty style of history painting practiced by the Old Masters and advocated by the renowned continental academies of France and Italy. He believed that history painting, then dominated by foreign artists and connoisseurs, could easily be executed by English painters, including himself. To show what he could do in the sublime style, Hogarth decorated the great stairway of St. Bartholomew's Hospital with seven-foot figures at his own expense, painting two scripture stories, *The Pool of Bethesda* (1736) and *The Good Samaritan* (1737).

To his disappointment, his essays in religious history painting went unrecognized. He made several later attempts to win fame in the realm of history painting—*Moses Brought to Pharaoh's Daughter* (1746), *Paul Before Felix* (1748), and *Sigismunda* (1759)—but none of these pictures won Hogarth the prestige or wealth he craved. And the last picture brought him humiliation and defeat. Commissioned by Sir Richard Grosvenor who admired his *Lady's Last Stake* (1758-59), *Sigismunda* was done in the Bolognese manner. Grosvenor disliked the work, however, and refused to pay for it, leaving the artist angry and bitter.

In his own day and in the history of British art, Hogarth achieved lasting fame in the realm of satiric painting and engraving and in the "progress." The artist first ventured into satiric prints shortly after he set up as a copperplate engraver. Drawing on current events for his targets, he attacked crack-brain economic speculation (*An Emblematical Print on the South Sea Scheme*, 1721), the evils of state lotteries (*The Lottery*, 1721), and London theatre owners' neglect of British dramatists in favor of foreign pantomimes, farces, and circuses (*A Just View of the British Stage*, 1724). In technique, these first satires were rough and unpolished; in conception, they were bold, cudgel-like, and lacking in subtlety.

Over the course of his career of 24 years, Hogarth issued more than 25 satires in single sheets, refining his style and sophisticating his ideas and imagery. He engraved small satires

to give as receipts to people who had subscribed to his progresses. In such diminutive images as *Boys Peeping at Nature* (1731), *Characters Caricatures* (1743), *The Battle of the Pictures* (1745), and *Time Smoking a Picture* (1761), he made arguments about taste and connoisseurship or issued manifestos about his own art. He also painted, engraved, and sold large satires on a broad range of topics—from the evils of gambling to the mad pride of Grub Street poets. His attack on the French in *O the Roast Beef of Old England* (painting 1748, engraving 1749) and his burlesque of the English guards in *The March to Finchley* (painting 1746, engraving 1751) are among his wittiest, most mordant satires.

Hogarth's most distinctive contribution to British art is his progress, a tale with a moralistic twist told in two plates or more. The artist seems to have discovered the progress form by accident. One day, he painted a small picture of a harlot rising from her bed at noon in her Drury Lane apartment. Visitors to Hogarth's studio admired the design and urged him to add another picture to it to create a pair of matching images, which he did. However, his fertile imagination refused to stop at two, and he kept on working until he had painted a total of six tableaus telling the life of Moll Hackabout, from her arrival in London out of York to her death from venereal disease at the age of 23. Entitled *A Harlot's Progress*, the suite of paintings caused a sensation, captivating "the minds of most persons of all ranks and conditions from the greatest quality to the meanest," according to the art historian George Vertue. Spurred by the popularity of the oil paintings, Hogarth proposed to engrave his *Harlot* and sell it by subscription, priced at one guinea a set.

Issued in April 1732, Hogarth's engraved *Harlot* was an immediate success. Indeed the work was so popular that it was soon pirated and sold all over England; clearly the artist had discovered his metier. The harlot's story inspired Hogarth to tell in turn the tale of the rake who squanders his father's fortune and his wife's dowry. Published in 1735 as a suite of eight prints engraved from paintings (c. 1733), this companion to the *Harlot* charts the decline and fall of Tom Rakewell who whores, drinks, gambles, and ends his life in chains in Bethlehem Hospital for madmen.

Though *A Rake's Progress* is deeply moralistic, not all of Hogarth's early ensembles were didactic. *Before and After* (paintings c. 1730-31, engravings 1736) contrasts, in two plates, the shifting, opposite moods of a man and woman before sexual intercourse and after. These humorous pendants, said to have been commissioned at the particular request of a certain vicious nobleman, were executed in two different versions, one set indoors and the other in a forest glade.

Hogarth's progresses are broad in themes, and their targets are many. At one end of this spectrum stands the ambitious, complex, and sophisticated *Marriage-à-la-Mode* (paintings c. 1743, engravings 1745) with its condemnation of aristocratic decadence and bourgeois ambition. At the other end stands *The Four Stages of Cruelty* (1751), a shocking condemnation of the mistreatment of animals which leads directly to murder, according to the artist. Whether Hogarth was urging apprentices to hard work in *Industry and Idleness* (1747) or condemning politicians for corruption and venality in *The Election Entertainment* (paintings c. 1754, engravings 1755-58), he left behind a vivid, engaging account of the age of the common man and a biting picture of human foibles and vices,

from petty narcissism to homicidal mania. The energy, intellectual power, and vision of his paintings and prints are aptly summed up in Samuel Johnson's epitaph:

> The Hand of Art here torpid lies
> That traced the essential form of grace:
> Here Death has closed the curious eyes
> That saw the manners in the face.

> —Sean Shesgreen

HOLBEIN, Hans, the Younger.

Born in Augsburg, c. 1497-98; son of the painter Hans Holbein the Elder, and brother of Ambrosius Holbein; nephew of Hans Burgkmair. Died in London, apparently of the plague, between 7 October and 29 November 1543. Married Elsbeth Schmid, c. 1520; two sons and two daughters; his will provided for a mistress and two illegitimate children. Studied with his father, and probably apprenticed to Hans Herbst in Basel, 1515; worked in the house of Jacob Hertenstein, Lucerne, 1517; joined the Basel painters guild, 1519, and citizen of Basel, 1520, and worked for Eramus; did *Dance of Death* and *Old Testament* woodcut series in the 1520's; visited England, 1526-27, associated with Thomas More's circle, and settled in England, 1532; after 1537, court painter to Henry VIII.

Major Collections: Basel; Berlin; Royal Collection.
Other Collections: Boston; Gardner; Braunschweig; Darmstadt; Detroit; Dresden; Edinburgh; Florence; Frankfurt; Freiburg; The Hague; Karlsruhe; London: Portrait Gallery, National Gallery; Los Angeles; Nuremberg; New Haven; New York: Frick, Metropolitan; Paris; Rome; St. Louis; Solothurn; Toledo, Ohio; Vienna; Washington, Zurich.

Publications

On HOLBEIN: books—

Ganz, Paul, *Die Handzeichnungen Holbeins: Kritische Katalog*, Berlin, 2 vols., 1911-37.
Ganz, Paul, *Holbein: Des Meisters Gemälde*, Stuttgart, 1912.
Chamberlain, Arthur B., *Holbein*, London, 2 vols., 1913.
Manteuffel, K. Zoege von, *Holbein: Zeichner für Holzschnitt und Kunstgewerbe*, Munich, 1920.
Schilling, Edmund, *Zeichnungen der Künstlerfamilie Holbein*, Frankfurt, 1937.
Parker, Karl T., *The Drawings of Holbein . . . at Windsor Castle*, London, 1945.
Ganz, Paul, *Holbein: Die Gemälde*, Basel, 1950; as *The Paintings of Holbein*, London and New York, 1950.
Waetzoldt, Wilhelm, *Holbein*, Konigstein, 1958.
Die Malerfamilie Holbein in Basel (cat), Basel, 1960.
Strong, Roy, *Holbein and Henry VIII*, London, 1967.
Levey, Michael, *Holbein's Christina of Denmark, Duchess of Milan*, London, 1968.

Grohn, H. W., *L'opera pittorice completa di Holbein,* Milan, 1972; as *Holbein: The Complete Paintings,* London, 1980.

Langdon, Helen, *Holbein,* Oxford and New York, 1976.

Boureanu, Radu, *Holbein,* Bucharest and London, 1977.

Holbein and the Court of Henry VIII (cat), London, 1978.

Roberts, Jane, *Holbein,* London, 1979.

Klemm, Christian, *Holbein im Kunstmuseum Basel,* Basel, 1980.

Strong, Roy, *Holbein,* New York, 1980.

Rowlands, John, *Holbein: The Paintings of Holbein: Complete Edition,* Oxford, 1985.

Roberts, Jane, *Drawings by Holbein from the Court of Henry VIII* (cat), Toronto, 1988.

Holbein (cat), Basel and New York, 1988.

*

Hans Holbein the Younger, arguably the most skillful portrait artist who ever lived, was the first great German painter who could count the Renaissance as his birthright. Born in the wealthy city of Augsburg, home of the millionaire Fugger and Welser families and gateway to the old Roman road leading to Italy, Augsburg had maintained close commercial ties with the south since ancient times. Holbein's uncle by marriage, Hans Burgkmair, rivalled Albrecht Dürer in mastery of Renaissance perspective, proportion, and formal composition, and his father, Hans Holbein the Elder, left a series of sensitive silverpoint portrait drawings that reveal a full-blown interest in individuality as well as a nearly complete mastery of the art of characterization.

The younger Holbein's natural gift for drawing and for satire was recognized by Erasmus of Rotterdam while the artist was still a teen-aged journeyman in the publishing capital of Basel, and it is to the descendants of Erasmus's heir, Bonifacius Amerbach, that the Basel Museum owes much of its great collection of early Holbein paintings and drawings. The simple grandeur of the so-called *Solothurn Madonna,* which rivals Raphael in the perfection of its design, and the touching *Madonna of Burgomaster Meyer* (Darmstadt) offer a glimpse of Holbein's gifts as a painter of altarpieces—a career option cut short by the Zwinglian Reformation in Basel. His *Christ in the Tomb,* a depiction of the dead Saviour as a stiffened and sightless cadaver, so shocked Dostoevsky, who saw it during a trip to western Europe in the late 1860's, that his wife mistook his reaction for an epileptic seizure. Dostoevsky included a literary description of such a picture in *The Idiot* (1869), after which Prince Myshkin muses that, if Christ could have seen himself thus, he might not have submitted to the Crucifixion. Andre Suares (*An Italian Journey*) declared the painting evidence that Holbein must have been a convinced atheist, contrasting it to Grünewald's crucified Christ in Colmar, whose wounds, though grievous, can still be the object of the viewer's devotions. Holbein, in his view, "though more for Luther than for Rome," was ah artist of "icy denial, and not of mere doubt," and thus a total nonbeliever. In point of fact, however, Holbein's dead Christ seems to have been partially inspired by Grüenwald's, which he could have seen while visiting his father at Isenheim, and there is virtually no evidence as to what Holbein's religious views may or may not have been, beyond his refusal in 1530 to attend the new Reformed services in Basel, requesting a more satisfactory explanation of the Lord's Supper. This could be interpreted in any number of ways, but it is worth remembering that the most important of his Basel clients were Erasmus of Rotterdam and Jacob Meyer "zum Hasen," both of whom remained Catholic after the Reformation. His English host, Sir Thomas More, of course, remained Catholic as well, and was canonized after his execution by order of Henry VIII.

The mocking tone of Holbein's *Dance of Death* woodcut series, in which Death attacks a mendicant friar who tries to save his money-box, and snuffs the nun's candle as she is entertained by her clandestine lover, is often adduced as further evidence of Holbein's atheism; however, it should be noted that this famous and caustic series is the last of a long line of medieval depictions of Death as the great, unwelcome, and democratic leveler who robs every class and profession of its status symbols.

Although Holbein designed weapons, jewelry, tableware, Biblical illustrations, and mantlepieces, and painted several illusionistic murals (now lost), he is best known as a portrait artist, and in particular as court painter to Henry VIII, to whom he seems to have been recommended by Anne Boleyn and Thomas Cromwell. His painted portraits of Henry's queens, Jane Seymour and Anne of Cleves, and of the Princess Christina of Denmark to whom Henry unsuccessfully proposed, are justly famous, as are his portrait paintings, drawings, and miniatures of various members of the court, including the stunning full-length double portrait of the French ambassador and his house guest, the Bishop of Lavour (*The Ambassadors,* London, 1533) with its haunting anamorphic skull presented as a footnote to youth, intellect, and robust health. Equally impressive, however, are his portraits of Sir Thomas More (New York, Frick) and the young German merchants of the Hansa headquarters, or "Steelyard," in London, such as Georg Gisze and Derick Tybis. The basis for each portrait was a careful drawing, usually in three colors of chalk; many of these drawings, and a great number of others which were never worked up into paintings, are preserved at Windsor Castle.

Despite his enormous natural gifts, and the fact that his portrait work was cherished by its owners from the very beginning, Holbein's posthumous reputation has been limited to a certain extent by lack of exposure. Knowledge of his English portrait work, for example, was limited to a very small circle of admirers before the advent of color photography, and enthusiasm for Hobein in Germany has been somewhat tempered by the fact of his immigration, first to Switzerland and later to England. Recently, however, Holbein, his father, and his brother Ambrosius have been the subjects of two important exhibitions in Basel, the most recent of which (1988) included a generous selection of the Windsor drawings and has also been shown in New York.

—Jane Campbell Hutchison

HOMER, Winslow.

Born in Boston, Massachusetts, 24 February 1836. Died in Prout's Neck, Massachusetts, 29 September 1910. Apprenticed to the lithographer J. H. Burford, Boston, 1854–57; worked as magazine illustrator for *Harper's* and other maga-

zines in Boston, and in New York after 1859; visited France, 1866-67, and England, 1881, 1882; settled in Prout's Neck, 1883.

Major Collection: New York
Other Collections: Andover, Massachusetts; Boston; Buffalo; Chicago, Cleveland; Los Angeles; New Haven; New York: Cooper-Hewitt, Brooklyn Museum; Paris; Philadelphia: Museum of Art, Pennsylvania Academy of Fine Arts; Portland, Maine; St. Louis; Toledo, Ohio; Washington: Phillips, National Gallery; Williamstown, Massachusetts; Youngstown, Ohio.

Publications

On HOMER: books—

Downes, William Howe, *The Life and Works of Homer*, Boston, 1911.

Cox, Kenyon, *Homer*, New York, 1914.

Foster, Allen E., *A Checklist of Illustrations by Homer in Harper's Weekly and Other Periodicals*, New York, 1936.

Goodrich, Lloyd, *Homer*, New York, 1944.

Goodrich, Lloyd, *American Watercolor and Homer* (cat), Minneapolis, 1945.

Gardner, Albert Ten Eyck, *Homer* (cat), Washington, 1958.

Fosburgh, James W., *Homer in the Adirondacks*, Blue Mountain Lake, New York, 1959.

Goodrich, Lloyd, *Homer*, New York, 1959.

Gardner, Albert Ten Eyck, *Homer, American Artist: His World and His Work*, New York, 1961.

Beam, Philip C., *Homer at Prout's Neck*, Boston, 1966.

Flexner, James Thomas, *The World of Homer*, New York, 1966.

Goodrich, Lloyd, *The Graphic Art of Homer* (cat), New York, 1968.

Gelman, Barbara, *The Wood Engravings of Homer*, New York, 1969.

Goodrich, Lloyd, *Homer's America*, New York, 1969.

Hoopes, Donelson F., *Homer: Watercolors*, New York and London, 1969.

Wilmerding, John, *Homer*, New York, 1972.

Goodrich, Lloyd, *Homer* (cat), New York, 1973.

Grossman, Julian, *The Echo of a Distant Drum: Homer and the Civil War*, New York, 1974.

Davis, Melinda D., *Homer: An Annotated Bibliography of Periodical Literature*, Metuchen, New Jersey, 1975.

Beam, Philip B., *Homer's Magazine Engravings*, New York, 1979.

Hendricks, Gordon, *The Life and Works of Homer*, New York, 1979.

Tatham, David, *Homer and the New England Poets*, Worcester, Massachusetts, 1980.

Spassky, Natalie, *Homer at the Metropolitan Museum of Art*, New York, 1982.

Tatham, David, *Homer in the 1880's*, Syracuse, New York, 1983.

Curry, David Park, *Homer: The Croquet Game* (cat), New Haven, 1984.

Cooper, Helen A., *Homer: Watercolors* (cat), Washington, 1986.

Goodrich, Lloyd, *Homer in Monochrome* (cat), New York, 1986.

Murphy, Alexandra R., *Homer in the Clark Collection*, Williamstown, Massachusetts, 1986.

Simpson, Mark, *Homer and the Civil War*, San Francisco, 1988.

articles—

Cikovsky, Nicolai, Jr., "Homer's Prisoners from the Front," in *Metropolitan Museum Journal* (New York), 12, 1977.

Gerdts, William H., "Homer in Cullercoats," in *Yale University Art Gallery Bulletin* (New Haven), Spring 1977.

Quick, Michael, "Homer in Virginia," in *Los Angeles County Museum of Art Bulletin*, 24, 1978.

Adams, Henry, "Mortal Themes: Homer," in *Art in America* (Marion, Ohio), February 1983.

*

For the first 40 years of his career Winslow Homer supported himself chiefly as an illustrator. At the age of 19 his father apprenticed him to John H. Bufford, a commercial lithographer in Boston. While he hated the drudgery of the work, Homer rapidly developed considerable technical skill at producing portraits and illustrated covers for the sheet music of popular songs. After two years his contract released him, and rather than continuing with Bufford, Homer turned to supporting himself as a free-lance illustrator—producing vignettes of such subjects as crowded city streets, or football games at Harvard, for various popular magazines. From this time onward Homer always worked independently, and never accepted regular employment.

In the fall of 1859, Homer moved to New York, where most of the successful American magazines were located. There he rapidly developed a reputation as one of the finest American illustrators. Of particular significance were his Civil War drawings, many of which were reproduced in full-page and double-page spreads in *Scribner's Magazine* and *Harper's Weekly*. Most of these concentrated not on military engagements but on camp life and the efforts of the soldiers to entertain themselves between battles. One of his first oil paintings, *Prisoners from the Front* (New York), concentrated on the contrast between a cocky Union officer and three bedraggled Confederate prisoners. Its successful characterization of the figures, and its sympathetic portrayal of the vanquished, were widely admired and discussed by contemporary critics.

In the mid 1870's, at the peak of his popular acclaim, Homer virtually abandoned illustration and began to rely for his income chiefly on the sale of watercolors. He also executed a number of genre paintings in oil, many of which concentrated on the games of children, the most notable being *Snap the Whip* (Youngstown, Ohio). The careful draftsmanship and homely American subject matter of these works connect Homer with earlier American genre paintings, such as George Caleb Bingham or William Sidney Mount, but his interest in outdoor light and his bold handling of pigment reveal the influence of modern French painting, and of such progressive American figures as William Morris Hunt and John La Farge.

Critics of the 1870's admired Homer's individuality, although they sometimes disparaged a certain roughness and lack of delicacy in his work, which they felt marred both the sentiment of his paintings and their execution.

In 1880 Homer moved to the remote and picturesque village of Cullercoates, on the northeast coast of England, and spent about a year painting watercolors of the fisherfolk there. Here he first concentrated on the theme which would preoccupy him for much of the remainder of his career—the struggle between men and the sea.

A few years later Homer returned permanently to the United States. Instead of moving back to New York City, he settled at Prout's Neck, Maine, a particularly rugged and desolate stretch of rocky New England coastline. There he lived a virtual hermit's existence for the remainder of his career, concentrating on seascapes and wilderness scenes. Many of his paintings from this period focus on tragic events, such as shipwrecks or the death of wild animals and fish. While they are often cited as examples of a distinctively American realism, the bold forms and powerful brushwork of these paintings show that Homer was well aware of French artists of the period—notably of Gustave Courbet, who was much admired in Boston.

In addition to his large, carefully pondered oil paintings, which he released at the rate of only one or two a year, Homer created large numbers of watercolors, with a freshness and boldness of execution that has never been excelled. Sometimes the subjects of these watercolors parallel those of his oils, but Homer also executed delightful records of such tropical locales as Cuba and Bermuda, places which he often visited in the winter months to escape the bleakness of Prout's Neck.

—Henry Adams

HONTHORST, Gerrit van.

Born in Utrecht, 4 November 1590; son of the painter Herman Gerritsz. van Honthorst. Died in Utrecht, 27 April 1656. Married Sophia Coopmans, 1620. Trained under Abraham Bloemaert, c. 1606, then lived in Rome, 1610 (or 1612) to 1620: worked for the Marchese Giustiniani, a patron of Caravaggio, on religious works and for Cardinal Scipione Borghese; in Utrecht from 1620: entered painters guild, 1622 (dean, 1625, and later); then visited England in late 1620's, and worked for Charles I; settled in The Hague, and entered its guild, 1637, where he taught the children of the Queen of Bohemia (the sister of Charles I); ended his career in Utrecht, 1652–56. Pupil: Joachim van Sandrart.

Major Collections: Florence; Leningrad; London; Rennes; Utrecht.
Other Collections: Albano Laziale: Convento dei Cappucini; Alkmaar; Amsterdam; Berlin; Braunschweig; Cologne; Ghent: S. Bavo; Hamburg; Hampton Court; London: Portrait Gallery; Montecompatri: Convento di S. Silvestro; Munich; Ottawa; Rome: Borghese, S. Maria della Scala; Vienna.

Publications

On HONTHORST: books—

Hoogewerff, Godefritus J., *Honthorst*, The Hague, 1924.
Judson, J. Richard, *Honthorst: A Discussion of His Position in Dutch Art*, The Hague, 1956, 1959.
Blankert, Albert, and Leonard H. Slatkes, *Holländische Malerei in neuem Licht: Hendrick ter Brugghen und seine Zeitgenossen* (cat), Braunschweig, 1987.

*

Honthorst was a leading north European exponent of Caravaggism in Italy and one of its prime exporters to the Netherlands. Together with his co-citizens, Terbrugghen and Baburen, whose careers followed a similar course, he is known as one of the "Utrecht Caravaggisti." His encounter in Rome with Caravaggio's art was indeed highly significant for Honthorst, but it did not close the door on influence from other new artistic styles (e.g., that of the Carracci) or iconographical traditions (especially those of the Netherlands). On one level it could be claimed that Caravaggio's pictures, themselves partly inspired by northern precedent, precipitated in Honthorst a finer appreciation of his own Netherlandish roots.

His training under Abraham Bloemaert, a painter who straddles the gulf between Mannerism and the newly fashionable naturalism, must have predisposed him to look sympathetically at previous, early 16th-century manifestations of realism (whether in the figure-types and spatial organization of Lucas van Leyden or the nighttime light effects of Baldung and Altdorfer). He is also likely to have read the account in van Mander's *Het Schilder-Boeck* (1604) of the stir caused in Rome by Caravaggio's self-consciously iconoclastic, antiacademic stance, and it has been plausibly argued that both Honthorst and other Dutch artists may have been encouraged by this very passage to visit Italy.

Honthorst's (mainly religious) Roman paintings are often night pieces illumined by candles or torches, which earned him the nickname "Gherardo delle Notti" (Gerrit of the Nights). His taste for such lighting stems from north European tradition, augmented by his experience of the works of the Bassani and Elsheimer in Italy. Caravaggio himself rarely used light sources internal to the picture and by no means all of his "dark" scenes are even set at night. Yet the lineaments of his style were eminently susceptible to treatment in this way, and Honthorst adopted and adapted many of Caravaggio's devices—from the realistic figure-types viewed close up (often with furrowed brows), through the restricted color range to the dramatic patterning effect of the *chiaroscuro* itself. His development of a candle-, lantern-, torch-, or Christchild-lit version of Caravaggio's style can be traced, during the period c. 1616–20, from the simple, two-figure conception of *Christ and Joseph in the Carpenter's Shop* (Montecompatri, Convent of S. Silvestro) to multi-figure compositions such as *Christ Before the High Priest* (London), *The Beheading of John the Baptist* (Rome, S. Maria della Scala) and *The Nativity* (Florence). These pictures were executed, respectively, for Cardinal Scipione Borghese, the Marchese Vincenzo Giustiniani, the Order of Discalced Carmelites, and the Grand Duke of Tuscany, all of whom had been patrons of Caravaggio. It would seem,

therefore, that they regarded Honthorst as a worthy inheritor of Caravaggio's mantle. Indeed, there are instances in which Honthorst even eschews his beloved candlelight in pursuit of a direct feat of emulation. Thus, in the masterly *Liberation of St. Peter* also done for Giustiniani (Berlin, Kaiser Friedrich Museum, c. 1619), with its strong sunlight beaming into the room, the source in Caravaggio's *Calling of St. Matthew* is obvious enough. Nevertheless, at this very moment of identification we see some characteristic points of divergence: Honthorst's figures are more idealized and graceful than Caravaggio's, his colors more delicate, and the creamy, fluid texture of the paint is uniquely appealing.

He was also greatly influenced by the work of one of Caravaggio's main Italian disciples, Bartolomeo Manfredi. From Manfredi he acquired a taste for less compact compositions than those of Caravaggio and also, towards the end of his Roman sojourn, a new type of subject matter: banqueting or merry-company scenes. Honthorst modulated Manfredi's compositions to his own favoured illumination by candles, exploring especially the effect of figures silhouetted against the light.

Honthorst continued to deploy this secular iconography after his return to Utrecht (e.g., *Merry Company,* Munich, 1622) and also developed some of the types into single-figure, half-length pictures of jocund male or female musicians. The latter found a ready echo in Hals's singing musicians, while the group scenes were much imitated by Honthorst's pupils and disciples (Bijlert, Bronchorst, and Stomer). Although the mood of the participants in Honthorst's amorous assemblies varies from the intense through the melancholy to the ebullient, so many of the figures seem bursting with an uncomplicated mirth and sexuality that this remains the abiding impression—as it does of many of his mythological and historical pictures too (e.g., *The Steadfast Philosopher,* private collection, early 1620's). Honthorst was, despite his withdrawn and melancholy nature, perhaps the greatest of all painters of laughter.

The Catholic Honthorst continued to practise as a religious painter for private commissions in Utrecht, but the shift there towards a strict Calvinism meant that there were few opportunities to work for churches. He embarked instead on an active career as a painter of historical, mythological, and allegorical pictures (e.g. *The Philosopher Solon Before Croesus,* Hamburg, 1624). While continuing to paint candlelit scenes (e.g., *The Procuress,* Utrecht, 1625), Honthorst developed for his new range of subject matter (including some scenes, such as *Granida and Daifilo,* Utrecht, 1625, inspired by the recent Arcadian movement in Dutch literature) a lighter, more colorful palette and an increased idealization of face and figure. This new classicism was fuelled by the rarefied and hedonistic culture of the courts which, with his growing fame, became Honthorst's principal patrons: those of the Stadtholder, Prince Frederik Hedrik of Orange at the Hague, of Charles I of England, and of Christian IV of Denmark. Works such as the Diana pictures done for the Stadtholder's palace of Honselaarsdijk or the giant *Allegory* for Charles I (Hampton Court, 1628) have about them a van Dyckian elegance, but they also retain a good deal of Honthorst's *joie de vivre*. They are often more beautiful (in handling of paint and characterization) than conventional wisdom would allow. But it was the Caravaggesque Honthorst, with his atmospheric and dramatic lighting and

repoussoir silhouettes, who had the greatest impact on the imagination of his countrymen—not least Rembrandt.

—John Gash

HOOCH, Pieter (Hendricksz.) de

Born in Rotterdam, 20 December 1629; spelled his name de Hoogh in later life. Died in Amsterdam, buried 24 March 1684. Married Jannetge van der Burch, 1654; seven children. Pupil of Nicolaes Berhcem in Haarlem; resident of Delft by 1652; possible commercial relationship with Justus de la Grange, a linen merchant, 1653; in Delft painters guild, 1655; earliest dated work, 1658—mainly domestic interiors and courtyards; then settled in Amsterdam from c. 1660; resident in insane asylum in last years of life.

Major Collections: Amsterdam; Berlin, London; Paris; Washington.
Other Collections: Basel; Cincinnati; Cleveland; Cologne; Copenhagen; Dublin; The Hague; Leipzig; London: Wallace, Wellington; Los Angeles; Rome: Barberini, Borghese; St. Louis; Toledo, Ohio; Vienna; Waddesdon; Washington: Corcoran.

Publications

On HOOCH: books—

de Rudder, Arthur, *Hooch et son oeuvre,* Brussels, 1914.
Tietze-Conrat, E., *Der Delfter Malerschule: Carel Fabritius, Hooch, Jan Vermeer,* Leipzig, 1922.
Plasschaert, Albert, *Vermeer en Hooch,* Amsterdam, 1924.
Baker, C. H. Collins, *Hooch,* London, 1925.
Valentiner, W. R., *Hooch,* Berlin, 1929, London and New York, 1930.
Coremans, Paul B., *Van Meegeren's Faked Vermeers and De Hooghs: A Scientific Examination,* Amsterdam, 1949.
Rowe, Robert, *Hooch,* London, 1958, 1969.
Sutton, Peter C., *Hooch: Complete Edition with a Catalogue Raisonné,* New York, 1979, Oxford, 1980.

articles—

Fleischer, Roland E., "An Altered Painting by Hooch," in *Oud Holland* (The Hague), 90, 1976.
Fleischer, Roland E., "Ludolf de Jongh and the Early Work of Hooch," in *Oud Holland* (The Hague), 92, 1978.
Smith, David R., "Irony and Civility: Notes on the Convergence of Genre and Portraiture in Seventeenth-Century Dutch Painting," in *Art Bulletin* (New York), September 1987.

*

The great skill of Pieter de Hooch lay in his ability to compose

The Card-Players, 1658; 30 × 26⅛ in (76.2 × 66.4 cm); Royal Collection

peaceful images of modest domestic interiors. Many of these pictures focus on the role of woman as virtuous wife and mother. In this they reflect the popular literature of the Dutch lawyer and poet Jacob Cats. In contrast to other Dutch painters of domestic genre such as Jan Steen (also in Delft 1654–57), de Hooch subdues specific moral messages in favour of overall

mood. Narrative is never intrusive. Instead, he presents images of simple domestic comfort, revolving around ordinary tasks.

Most of de Hooch's working life was lived in Amsterdam. Yet the eight developmental years he spent in Delft (1652–60/ 1) were his most successful and innovative. His early Rotter-

dam pictures (c. 1650) are of a conventional stable or tavern type, usually involving soldiers. Dark, rural interiors are described with a restricted pallette, bright light falling only on the figures. Already there are hints of his later preoccupations: an interest in the complex geometric division of the picture plane, and occasionally a "doorkijkje" through to a room beyond. Already, too, he likes to include women and children, combining military subject matter with domestic genre in a way that was entirely apt: Dutch soldiers were billeted with families wherever they were stationed, and were notorious for their socially and financially disruptive effect on rural communities.

A Man with Dead Birds and Other Figures in a Stable is a good example of these early indicators (c. 1655–57, London). It is also an unusual picture. Recent examination has revealed overpainting. The original subject was a man dressing the leg of a wounded soldier, an unusually compassionate military subject, but one which harmonizes with the humane sentiment of de Hooch's mature work.

His Delft pictures partake of a general trend, following the signing of the Treaty of Münster in 1648, towards more quiet subject matter than the tavern, brothel, and low-life scenes of the early part of the century. Jacob Cats's *Maegdenplicht* (A Maiden's Duty, 1617) and *Houwelijck* (Marriage, 1625), as well as his (and other) emblem books, reached a peak of circulation around 1650. At 50,000 copies, Cats was the most popular author next to the Bible.

De Hooch's Delft years were also the liveliest in the city's artistic community. His interaction with such artists as Hendrick van Vliet, Gerard Houckgeest, Emmanuel de Witte, Carel Fabritius, and Jan Vermeer profited all concerned. Ranging over a wide spectrum of subject matter, these artists shared important concerns: spatial relationships and perspective *trompe l'oeil* effects and the use of optical devices the visual effects of daylight and air on spaces and surfaces, both interior and exterior. With the exception of Vermeer, most of these artists were, like de Hooch, only temporarily resident in Delft, and their community was further enriched by the briefer visits of Jan Steen and Gerard ter Borch, as well as the proximity of Nicholas Maes in Dordrecht.

This artistic environment encouraged a change in de Hooch's work. Umbrageous rural interiors metamorphosed into urban households flooded with daylight. Light is admitted through an open doorway, or filtered through glass. The resultant dialogue between exterior and interior led him to experiment with the interconnection of spaces themselves: a courtyard beyond a room; a passage leading outdoors, or indoors, or both in succession; a dwelling visible beyond a dwelling; an open door, glimpsed across the horizontal intersection of a canal, implying further passages, rooms, courtyards. Physical details articulate these structural complexes: receding floor tiles, brickwork, and masonry, which alter their pattern on the threshold of a new space.

De Hooch's development of the courtyard as a domestic setting is one of his innovations. It illustrates his special ability to organize spaces, and out of that organization to create new subject matter. This outdoor element combines with the sheer spatial complexity of his work to prevent any feeling of claustrophobia to which such muted action, such regularity might have fallen prey. That de Hooch was himself deeply affected by his environment is evident from the change in his work

after his move to Amsterdam, and by the concordance of his Delft compositions with the structure of Delft itself, uniquely organized into a regular, grid-like plan.

De Hooch's move to Amsterdam (c. 1660) was part of a drift of artists to the capital in search of greater cultural dynamism and richer patrons. He scaled up his domestic subjects to the elevated status of his new metropolitan clientele. Formal gardens replaced courtyards as an outdoor setting. Elegance and refinement were emphasized in place of the simpler, unpretentious subjects of the Delft years. Even where mother and child scenes persist, there is the presence of a servant to underline the social standing of the family.

In subject matter and technique, de Hooch responded to the influence of both Vermeer and ter Borch. Thus he treats of such themes as letters, music lessons, concerts, and exchanges with servants. While retaining much of Vermeer's compositional sympathies, he imitated ter Borch's virtuosity in the rendering of tiny variations in tone upon reflective textiles. He also adopted some specific motifs from ter Borch, such as the woman captured in lost profile (e.g., *A Party of Four Figures at a Table,* c. 1675–77, Washington, Corcoran).

Formally his work differed in being horizontal in format, and, from 1674, significantly larger. His pallette darkened and light contrasts strengthened. Again, the fashion for ter Borch's contrived mode of lighting overpowered de Hooch's interest in daylight. His Amsterdam interiors deliberately shut light out, admitting only a small invasion through a partly drawn curtain, or through a single doorway which sends a solitary shaft across one part of the floor. The combination of this deliberate darkness with the impressive scale and relative spatial simplicity of these interiors is surprisingly oppressive. The natural development of certain technical interests of de Hooch's earlier work, such as the use of silhouette and repoussoir figures, secondary reflections, and especially his preference for pure, unmixed colours articulated by daylight, is truncated by his adoption of this mode. Indeed, the whole basis of his work, with daylight as the governor of his design, with figures consciously inserted into the light, rather than light being designed around them, is laid aside. The result is somewhat forced.

Yet 45% of his oeuvre comes from the later Amsterdam period (1670–84), a prolificacy that was intended, perhaps, to meet his expenses. In contrast to the wealthy subjects he found himself painting, de Hooch was poor. In 1674 he was even disqualified from taxation. His technique, developed in the more leisurely, craft-respecting environment of Delft, probably could not cope with this greatly increased production: the quality of this later work is very uneven. Yet in spite of shortcomings he remained capable of producing some fine work, such as *The Jacott-Hoppesack Family Portrait,* (c. 1670, private collection) and *Woman and Serving Girl with a Fish* (c. 1670–74, Rotterdam). Occasionally, and perhaps with some nostalgia, he returned to the courtyard, and even stable scenes of his earlier years.

His death in a lunatic asylum has caused critics to attribute this late deterioration to mental illness. We know nothing, however, of the nature of this malady. The existence of a dated work from the year of his death (*A Sportsman and a Lady in a Landscape,* private collection) suggests that his stay in the *Dolhuys* may, after all, have been mercifully short.

—Lindsay Bridget Shaw

HOPPER, Edward.

Born in Nyack, New York, 22 July 1882. Died in New York, 15 May 1967. Married the painter Josephine Verstille Nivison, 1924. Attended schools of Nyack; studied at the Correspondence School of Illustrating; studied painting under Robert Henri, Kenneth Hayes Miller, and William Merritt Chase at the New York School of Art, 1900–06; visited Paris, 1906–07, 1909, and 1910; associated with the Ashcan group, and worked as commercial artist and illustrator, New York, until 1924; spent summers in South Truro, Massachusetts, from 1930.

Major Collection: New York: Whitney
Other Collections: Boston, Chicago; Dallas; London: British Museum, Victoria and Albert; New York: Metropolitan, Moma, Brooklyn Museum; Philadelphia; Washington: Hirshhorn.

Publications

On HOPPER: books—

DuBois, Guy P., *Hopper,* New York, 1931.
Barr, Alfred H., Jr., *Hopper: Retrospective Exhibition* (cat), New York, 1933.
Hopper, New York, 1945.
Goodrich, Lloyd, *Hopper,* New York, 1949, London, 1950.
The Complete Graphic Work of Hopper (cat), Philadelphia, 1962.
Goodrich, Lloyd, *Hopper* (cat), New York, 1964.
Goodrich, Lloyd, *Hopper: Selections from the Hopper Bequest to the Whitney Museum of American Art,* New York, 1971.
Goodrich, Lloyd, *Hopper,* New York, 1976, 1978.
Levin, Gail, *Hopper as Illustrator,* New York, 1979.
Levin, Gail, *Hopper: The Complete Prints,* New York, 1979.
Levin, Gail, *Hopper: The Art and the Artists* (cat), New York, 1980.
Levin, Gail, *Hopper,* Naefels and New York, 1984.
Levin, Gail, *Hopper's Places,* New York, 1985.
Ward, J. A., *American Silences: The Realism of James Agee, Walker Evans, and Hopper,* Baton Rouge, Louisiana, 1985.
Hobbs, Robert, *Hopper,* New York, 1987.

article—

Levin, Gail, "Hopper," in *New England Quarterly* September 1988.

*

Edward Hopper is recognized as the greatest representational painter of 20th-century America. His work is frequently celebrated for its poignant depictions of alienation and loneliness so often associated with modern life. Proponents of abstract art have also praised his work for the aesthetic qualities of his compositions, his forms, and his use of light. Although known primarily for his oils and watercolors, during his formative years Hopper was forced to support himself through work as a commercial illustrator. He received his first recognition as an artist for the etchings and drypoints that he produced during the 1910's.

Exposure to the work of the Impressionists in Paris helped Hopper drop the somber palette of the paintings he had produced in art school in New York. He began to work out-of-doors, turning to landscapes from the routine portraits and figure paintings he had produced as an art student. After his three visits to Paris, Hopper, who remained a life-long francophile, found it difficult to drop French subject matter which recurs in his etchings as late as 1923.

As nationalistic critics began to notice and praise his depictions of commonplace American scenes, Hopper began to concentrate on these slice-of-life subjects, particularly urban themes. But as he divided his time between New York City and various artist havens in rural New England, small-town vernacular American architecture and seascapes also figured in his work. Inspired by his future wife, the painter Josephine Nivison, during the summer of 1923, in Gloucester, Massachusetts, he began to work seriously in watercolor, a medium that he had previously relegated to caricatures or commercial work. It was with these Gloucester watercolors that Hopper found his first critical and financial success.

By the mid-1920's, Hopper's paintings appeared to suggest traditional American values and his straightforward realism appeared far less menacing than the European-influenced modernist styles then practiced by many American artists. Exhibitions, museum purchases, critical approbation, and awards came Hopper's way with increasing frequency. At this time, Hopper had established his mature style and the range of his subject matter. Subsequently, the formal elements of his pictorial vocabulary altered very little. From the time of his marriage in 1924, his wife became his only model and he painted figurative works more frequently, transforming Jo into an entire cast of characters.

When they are not empty, Hopper's pictures are usually populated by solitary figures or a single disenchanted couple. The settings are typically bedrooms, restaurants, theaters, offices, hotel rooms or lobbies, trains, and gas stations. Hopper's deserted scenes include urban streets just after dawn, solitary light houses, lonely country roads, and ordinary houses. These still pictures employ light as their dramatic vehicle, focusing the viewer's attention on the tedium of waiting for something to happen. But in Hopper's painting, the main activity is always cerebral—the psychological statement implied by his suggestive symbolic content.

—Gail Levin

HOPPNER, John.

Born in London, 4 April 1758. Died in London, 28 January 1810. Married a Miss Wright, 1782. Chorister in Royal Chapel, and encouraged by George III to study art: entered Royal Academy schools, 1775; exhibited from 1780, and set up as a painter: royal commissions soon followed, and he became popular as a follower of Reynolds and a rival of Lawrence: named Portrait Painter to the Prince of Wales, 1789 (Principal Painter, 1793); R. A., 1795.

Hopper: Evening Wind, 1921; etching

Major Collections: London: Tate; New York.
Other Collections: Cambridge; Cape Town; Chicago; Detroit; Dublin; Frankfurt; Glasgow; Kansas City; London: Victoria and Albert, Royal Academy, Wallace, Wellington, Portrait Gallery, Kenwood; Melbourne; New Haven; New York: Frick; Ottawa; Paris; Philadelphia; Pittsburgh; Raleigh, North Carolina; San Marino, California; Washington; Royal Collection.

Publications

By HOPPNER: books—

Oriental Tales Translated into English Verse, London, 1805.
Essays on Art, edited by F. Rutter, London, 1908.

On HOPPNER: books—

McKay, William, and William Roberts, *Hoppner,* London, 1909.

The Masterpieces of Hoppner, London, 1912.

article—

Wilson, John, "Hoppner's 'Tambourine Girl' Identified," in *Burlington Magazine* (London), October 1988.

*

Hoppner was one of the most unpredictable portraitists of his generation. Like his near-contemporary Raeburn he could be careless. Like Raeburn he could produce work of surprisingly high quality, although one hesitates to use the word "masterpiece" of any one of his paintings as one can of the occasional Raeburn. Like Raeburn, too, he had a gift for the direct, honest, and true likeness. The longer one looks at a Hoppner portrait the more convinced one is that this must be the sitter to the life.

Hoppner matured when Reynolds was dominant. As with Lawrence, the example of Reynolds was always before him.

His early work is modelled on Reynolds's. He was never, however, tempted, as was Lawrence, to essay "History Painting" in the style advocated by Reynolds in his annual discourses to the students of the Royal Academy Schools (which Hoppner must have attended) and in this his instinct was right. He broke away from portraiture only occasionally. His *Sleeping Venus and Cupid* (c. 1806, Petworth House) based fairly obviously on some such Reynolds as *Cymon and Iphigenia* (Royal Collection) is mediocre, but his seapiece *A Gale of Wind* (London; Tate) is remarkably successful in evoking storm and cold. His *Self-Portrait* (1795; London; Royal Academy of Arts) shows an intelligent, searching but moody countenance. Although at the beginning of his career he had good fortune (George III commissioned portraits of three of his daughters in 1795) he was sensitive to slights, and William Gifford, in his poem *The Maeviad*, referring to Hoppner, hinted at early professional disappointment when "Hate, ill supprest/Advantage took of thy ingenuous breast," when Lawrence, ten years his junior, overtook him. A temperamental volatility and a certain ill-health may partly account for the unequal quality of his work.

Some of Hoppner's portraits of women and many of his portraits of children have genuine charm, less sophisticated than the charm of Romney (whom he sometimes patently imitated) but tender and appealing. *The Misses Frankland* (1795, Washington) is a prime example. In his backgrounds, based largely on the landscape backgrounds of Reynolds, the touch is loose. The modelling of the heads is dogged, sometimes clumsy, but a very honest interpretation of character comes through. In this respect he was particularly successful in portraits of men. *Sir George Beaumont* (c. 1806, London) and *William Pitt* (1804, private collection) are outstanding.

A few of Hoppner's portrait groups have achieved popularity, notably that of his own children (c. 1798, Washington) and *The Sackville Children* (1797, New York). They are direct and unaffected. When he was more ambitious or tried to be academic he failed, as for instance in *Mrs. Jordan As the Comic Muse* (1786, Royal Collection). In this he was at one with most of his contemporaries.

Hoppner's reputation has never stabilized and it needs reassessing today. There has never been a comprehensive Hoppner exhibition. He was not in the same league as Reynolds, Gainsborough, Romney, or Lawrence, but his best work can take its place on the wall with theirs without apology.

—Kenneth Garlick

HOSKINS, John.

Born in London, c. 1595?. Died in London, 22 February 1665. Married Sarah; son, the miniature painter John Hoskins II. Earliest work probably dates from c. 1620–25; named limner to Charles I, 1640, and given an annuity (though it was seldom paid); influenced by Van Dyck (he copied some of Van Dyck's work in miniature); brought up and taught his nephews Alexander and Samuel Cooper.

Collections: Amsterdam; Cambridge; The Hague; Ham House; London: Victoria and Albert, Wallace; Oxford; Royal Collection.

Publications

On HOSKINS: books—

Williamson, George C., *The History of Portrait Miniatures*, London, 1904.

Bourgoing, Jean de, *English Miniatures*, edited by George C. Williamson, London, 1928.

Long, Basil S., *English Miniaturists*, London, 1929.

Winter, Carl, *English Miniatures*, London, 1943.

Reynolds, Graham, *English Portrait Miniatures*, London, 1952, Cambridge, 1988.

Foskett, Daphne, *British Portrait Miniatures*, London, 1963.

Brett, Edwina, *A Kind of Gentle Painting* (cat), Edinburgh, 1975.

Noon, Patrick J., *English Portrait Drawings and Miniatures* (cat), New Haven, 1979.

Murdoch, John, et al., *The English Miniature*, New Haven, 1981.

*

One of the few positive details noted about John Hoskins's painting comes down to us from a notable Physician, Sir Theodore Turquet de Mayerne who, when he visited Hoskins in his studio in 1634, made notes on how he used his paints. These were put into small turned ivory dishes so that they did not dry up too quickly. Hoskins used a turned ivory palette about four inches in diameter and slightly hollow in the middle. He placed his colours in small quantities one beside the other at the end of the palette and these were mixed with gum and water as required, when the artist first moistened his brush in clear water before applying the colours. He kept whites and blues in separate little ivory pots.

Hoskins followed Hilliard's tradition of painting his portraits on vellum stuck onto card and used mainly the oval upright format with the exception of his large "Cabinet miniatures" which were rectangular. His best known examples of these large miniatures include the copy of *Mercury, Venus, and Cupid* after Correggio at Burghley House, and the superb portrait of Charles I in the Beauchamp collection. This is signed and dated 1632 and thought to have been taken from life as opposed to many others which were based on paintings by Van Dyck.

Although in his early works Hoskins painted in the Hilliard-Oliver tradition, he was certainly influenced by Van Dyck and adapted his style to conform with the new ideas which sprang up. Hoskins painted the sitters' eyes in the manner of Hilliard, showing the pupils clear with light reflected in them, but tended to use more subdued colours for the costume and background. Those painted before c. 1632 were usually on a blue or brown background with the occasional introduction of a red curtain, or landscape. The whole effect of his portraits is to show his sitters in a simple though dignified manner. After he came under the influence of Van Dyck, he abandoned the use of the soft yellowish colours which merged so perfectly with the others used in his early work. From c. 1644 onwards,

Hoskins painted his miniatures with a freer and more vigorous brush stroke and introduced a *pointilliste* dotting of a greenish tint, a method which came from the Continent.

On 20 April 1640, Charles I appointed Hoskins his "limner" and granted him a life annuity of £200 "providing he work not for any other without his Majesty's license." In the event Hoskins only received one payment of £50 and twenty years later was obliged to petition for a sum of £4,150 which was in arrears. Hoskins signatures vary, his earliest ones were "1H" or "IH" in monogram, the crossbar of the H being traversed by an I. The next type is an H without a dot above the first stroke of the H, and a further method was to elongate the first stroke of the H into a J. The punctuation also varies and a semi-colon is often found after the initials. Some signatures are in gold and others in brown or red. In spite of failing health, Hoskins is thought to have been painting up to the end of his life by which time his nephew Samuel Cooper, whom he had taught, had become a serious rival. Hoskins lived through an interesting time in British history: his early career began during the reign of James I, he was well patronised by Charles I, worked undisturbed throughout the Commonwealth, and was still an important figure in the art world when Charles II was restored to the throne in 1660.

—Daphne Foskett

HOUDON, Jean Antoine.

Born in Versailles, 20 March 1741. Died in 15 July 1828. Married Marie Ange Cécile Langlois, 1786; three daughters. Studied under Michel Ange-Slodtz, Lemoyne, and Pigalle at the Ecole Royale de Sculpture, 1753–61: Prix de Rome, 1761, and worked in Rome, 1760–69; made his reputation in Rome, and consequently received commissions from leading figures of the day, including Voltaire (whom he sculpted from a death mask); member of the Academy, 1777; visited the United States, 1785, and did bust of Washington; worked during the Empire, and taught at the Ecole des Beaux-Arts until 1823 (then senile).

Collections: Angers; Boston; Cambridge; Glasgow; Gotha; Lisbon: Gulbenkian; London: Victoria and Albert, Wallace; Montpelleir; New Haven; New York; Paris: Louvre, Comédie Française; Richmond, Virginia; Rome: S. Maria degli Angeli; St. Louis.

Publications

On HOUDON: books—

Darl, Jacques, *Le Buste de la Diane de Houdon,* Paris, 1906.
Hart, Charles Henry, and Edward Biddle, *Memoirs of the Life and Works of Houdon,* Philadelphia, 1911.
Bapst, Germain, *Diane Huntress by Houdon,* Paris, 1915.
Giacometti, Georges, *Le Statuaire Houdon et son époque,* Paris, 3 vols., 1918–19.
Michel, André, *Statue de Washington de Houdon,* Paris, 1918.
Giacometti, Georges, *La Vie et l'oeuvre de Houdon,* Paris, 2 vols., 1921.
Chinard, Gilbert, *Houdon in America,* Baltimore, 1930.
Réau, Louis, *Houdon,* Paris, 1930.
Maillard, Elisa, *Houdon,* Paris, 1931.
Levron, Jacques, *Les Oeuvres de Houdon à Angers,* Paris, 1941.
Claparède, Jean, *Houdon et la Société des Beaux-Arts de Montpellier,* Paris, 1950.
Houdon (cat), Berlin, 1955.
Sauerländer, Willibald Saurel, *Houdon: Voltaire,* Stuttgart, 1963.
Arnason, H. H., *Sculpture of Houdon* (cat), Worcester, Massachusetts, 1964.
Réau, Louis, *Houdon: Sa vie et son oeuvre, suivi d'un catalogue systematique,* Paris, 2 vols., 1964.
Arnason, H. H., *The Sculpture of Houdon,* London, 1975.

*

Houdon remained a part of the French Royal Academy from his earliest years of training until his last years of teaching. Despite his adherence to the hierarchical and privileging tendencies of the academic tradition, he found his style and established his reputation in the relatively modest form of the portrait: certainly not, at least in the traditional view, one of the more esteemed genres of art. But he had a talent. His portrait busts of "Great Men" (a popular concept in the 18th century), American and French, have in a certain way become those men. How does one imagine Jefferson, Franklin, and Washington, Diderot, Rousseau, and Voltaire without Houdon's busts coming to mind? Is it that he had an uncanny knack of capturing what we think of as the essential characteristics of these men, or are his images of them so well established in our collective memory that, to a certain extent, his images have become those men? Perhaps there is truth in both points of view.

In his early training, especially at the Ecole des Elèves Protégés before going to Rome in 1764, he learned the rococo manner of his master Michel-Ange Slodtz and knew the styles of Jean-Baptiste Lemoyne and Jean-Baptiste Pigalle. At the French Academy in Rome, 1764–68, his work clearly reflects the great classical tradition of European art. One of his first known pieces, the *Vestal* (marble version, Paris) is done à la antique. Her eyes are without irises or pupils, and she is frontal and timeless. No mood passes over her face. His *Ecorché,* a famous anatomical work that has been admired and studied for its realism, also dates from these early years. However dramatic the flayed man may be, he nonetheless retains classical reserve and dignity by assuming the pose of contrapposto, with an engaged and a free leg, a loose hanging arm and a straight, reaching arm. This ability to combine the conventional, contrived, and formal with the fresh and appealing appears in many pieces throughout the rest of his life.

There are no portraits from his Roman sojourn. The first important likeness he did from life is that of Denis Diderot, exhibited at the Salon of 1771. Here he establishes those elements that characterize his well-known presentational mode. So that Diderot immediately finds himself associated with the worthies of history, Houdon quotes from Roman republican and imperial portrait busts by abbreviating the torso and by

leaving the shoulders undraped. Then Houdon transforms the antique tradition by creating a frank and vital appearance. Diderot's face shows a slight jowliness, and the marks above his eyes and on his neck just below and behind his ears are the topographical creases of real human skin. This could, in fact, look like a republican portrait derived from a death mask (and Houdon did work from death masks); but the parted lips, deeply drilled eyes, and tousled, impressionistically handled hair fix the image and its presence in a moment of time. In other words, the sculptor has found the sculptural equivalents of vivacity and alertness. Houdon appears to have removed conventions and artifice in order to present directly a particular man and his distinctive nature. But, as with Frans Hals before him, this sense of spontaneity is achieved with great artistry.

Portraiture in the Renaissance emphasized decorum, which is the dignity and appropriateness of human demeanor. In Raphael's *Castiglione,* for example, the Italian man of taste and manners presents himself to us nearly in half length, so that we can admire his clothing, bearing, and status. His individuality and identity spring from Raphael's way of showing us Castiglione's public persona. But in the 18th century, individual wit and personality came to be valued. An emphasis upon uniqueness may have been associated in the past with *superbia*—pride—but no longer. The human face bears not only likeness, but intelligence and therefore identity. The representative men and women of the 18th century wished for full experience and acute sensation. Because Houdon shows us that desire, he reveals a time in history as well as notable men and women.

—Vernon Hyde Minor

HUBER, Wolf(gang).
Born in Feldkirch in the Vorarlberg region of Austria, c. 1485. Died in Passau, 3 June 1553. Had children. Early training uncertain; first dated work is 1510 drawing of Mondsee near Salzburg; by 1515, head of a workshop in Passau: given commission for large altarpiece with wood reliefs for Feldkirch, completed 1521; official "servant" of the Bishop Administrator Ernst of Passau; court architecture to Nicholas II of Salm, Count of Neuberg am Inn, from 1529, and probably visited Vienna with Nicholas, 1530; his younger brother, Prince Bishop Wolfgang von Salm, was a patron from 1542. Pupils or artists influenced by Huber include Hans Leu the Younger, Georg Lemberger, Augustin Hirschvogel, and Hanns Lautensack.

Collections: Berlin; Bregenz; Dresden; Dublin; Erlangen: University; Feldkirch: parish church; Hamburg; Kremsmunster: Benediktinerstift; London: British Museum; Merion, Pennsylvania; Munich; Philadelphia; Rotterdam; St. Florian, Austria: Augustiner-Chorherrenstift; Strasbourg; Vienna.

Publications

On HUBER: books—

Voss, Hermann, *Altdorfer und Huber*, Leipzig, 1910.
Weinberger, Martin, *Huber*, Leipzig, 1930.
Halm, Peter, *Huber* (cat), Passau, 1953.
Heinzle, Erwin, *Huber*, Innsbruck, 1953.
Heinzle, Erwin, *Der Sankt-Annen-Altar des Huber*, Wiesbaden, 1959.
Stange, Alfred, *Malerei der Donauschule*, Munich, 1964.
Die Kunst der Donauschule (cat), Linz, 1965.
Shestack, Alan, and Charles Talbot, *The Danube School* (cat), New Haven, 1969.
Rose, Patricia, *Huber Studies: Aspects of Renaissance Thought and Practice in Danube School Painting*, New York, 1977.
Winzinger, Franz, *Huber: Das Gesamtwerk*, Munich, 2 vols., 1979.

articles—

Halm, Peter, "Die Landschaftszeichnungen des Huber," in *Münchner Jahrbuch der Bildenden Kunst*, 7, 1930.
Hugelshofer, W., "Huber als Bildnismaler," in *Pantheon* (Munich), 1939.
Oettinger, Karl, "Zu Hubers Frühzeit," in Jahrbuch der *Kunsthistorischen Sammlungen in Wien*, 53, 1957.
Künstler, Gustav, "Huber als Hofmaler des Bischofs von Passau Graf Wolfgang von Salm," in *Jahrbuch der Kunsthistorischen Sammlungen in Wien*, 58, 1962.

*

Wolf Huber had a long, productive, and distinguished career as the ecclesiastical court painter in Passau. Sadly, few of his paintings survive. Of the 30 or so extant panels, fully a third belong to the *St. Anne Altar* of 1521 (panels divided between the Dom St. Nikolaus, Feldkirch, and the Landesmuseum in Bregenz). Whether because of the vagaries of taste or the loss of so many of his panels, Huber was all but forgotten for centuries, though the 20th century has witnessed a revived interest in his work. Along with Albrecht Altdorfer, Wolf Huber was a leading figure of the so-called Danube School or Danube Style—that widely practiced, inherently German style of painting and drawing in the early 16th century in which nature in its primal state dominates over the affairs of men. Vitality and expressiveness are often conveyed in Danube Style works by means of a loose, spontaneous drawing or painting style.

Besides the paintings, there are hundreds of extant drawings and 13 woodcuts by Huber. Huber's drawings are in a variety of media and served different purposes. First and foremost, they are studies for paintings, but many are so finished and exquisite that they seem to be the end products. The fact that Huber often signed and dated his drawings and that many were copied (by Huber and others) also suggests that they were created as works unto themselves for collectors.

Huber did portrait drawings in chalk that, in their objectivity, are reminiscent of Holbein's portrait drawings, yet stylistically very different as Huber's line is quick and loose throughout. Also in chalk are the studies of heads of 1522

Landscape with a Castle and a Pollarded Willow; drawing; Oxford, Ashmolean

(most in Hamburg), character studies, no doubt from models, of ugliness and distorted facial expressions. These studies were used for a number of figures in the *Raising of the Cross* panel of c. 1525 (Vienna).

The most evocative of Huber's drawings are the numerous pen and ink landscape studies. Usually figureless, these drawings often show man's presence in nature by way of architecture or pollarded willows. Huber's line is usually pure outline. Forms are summarily yet definitively rendered in quick, powerful strokes of the pen. Often large areas of the paper are left blank, whereby negative space becomes a forceful visual entity. Huber returns again and again to characteristic compositional format: a low horizon line and an off-center, dominant vertical (usually a tree or group of trees) in the fore or middle ground that rises to, and is cut off by, the top frame.

In Huber's figural drawings the subjects are picked, so it seems, for the overall theme of figure(s) in a landscape. Sts. Christopher, Sebastian, Hubert, Jerome, or Pyramus and Thisbe, or even the Crucifixion—all bear witness to Huber's overriding interest in portraying the mysteries of the wild.

Huber's style is evident in the thirteen woodcuts he created, though these are not as successful as his drawings for the personality of his line is lost in the stiff cutting of the blocks.

Although there are some differences in Huber's drawings when they are seen sequentially (mostly in terms of what part of the deep space he emphasizes), there is a great continuity in his linear style and approch to space and subject matter throughout his long career.

Because of the fragmentary state of his painted oeuvre, a developmental scheme for Huber's painting career is dangerous to infer. Rather, some generalities about his visual interests present themselves. Huber's paint is always thin; often the underdrawing is visible and plays an important part of the visual effect. In the *Presentation in the Temple* and *Rejection of Joachim's Offering* from the wings of the *St. Anne Altar* of 1521 (Bregenz) the underdrawing of the architecture gives a startling unfinished effect. In the 1519 *Christ Taking Leave of Mary* (Vienna) the underdrawing gives bold linear accents to the paint. Huber's portraits also utilize a certain thinness to the paint and looseness to the renderings, as in the double panels of *Anton and Margarete Hundertpfund* of 1526 (Dublin and Philadelphia).

Luminosity of color is an important effect in Huber's paintings. This is most notable in the wings of the *St. Anne Altar* of 1521 (Bregenz) where the luminous yellows and greens of drapery make the figures glow. Often Huber repeats reds in a composition to give visual directives and unity. This can be seen in the 1521 *Lamenation* from the *St. Anne Altar* (Feldkirch), the 1519 *Christ Taking Leave of Mary*, and the c. 1525-30 *Flight into Egypt* (Berlin).

The 1525 *Christ Crowned with Thorns* (St. Florian) shows Huber to be a master of gesture and the powerfulness of depicting the moment before an action. Here, Christ is shown innocently speaking and gesturing upward as a figure above him with a raised wooden paddle is about to clobber him on the head. The power of the implied action makes one wince.

Huber uses foreshortening for its expressive effect in a number of works. The gruesome foreshortening of Christ's face in the c. 1525 *Raising of the Cross* increases the drama of the work. The heavily foreshortened figure of the sleeping Peter in the c. 1525 *Christ on the Mount of Olives* (Munich) is reminis-

cent of Mantegna's *Dead Christ* (Milan) and here conveys the uncomfortableness of the apostle's heavy slumber.

Though Huber was an artist well versed in perspective and aware of new humanist trends in Germany through his patrons in Passau, his art was first and foremost inspired by nature. The viewer appreciates Huber's evocative works directly for the beauty of his powerful line, the expressiveness of his forms, and the luminosity of his color.

—David Heffner

HUGUET, Jaume.

Born in Valls, 1414. Died 1492. Married Joana Baruta, 1454; possibly one son named Pere. Probably trained by his uncle Pere Huguet, in Tarragona; then probably worked in Zaragoza, and briefly in Tarragona in the mid-1440's; first mentioned in Barcelona in 1448: commissions for several works are documented by the Guild of Bridle-Makers, etc.

Major Collections: Barcelona: Museum of Catalan Art, Palau Real Major.
Other Collections: Berlin; Madrid; Paris; Terrassa: S. Maria; Tortosa: Cathedeal; Vich: Museo Episcopal.

Publications

On HUGUET: books—

Rowland, Benjamin, Jr., *Huguet: A Study of Late Gothic Painting in Catalonia,* Cambridge, Massachusetts, 1932.
Gudiol, José, and Juan Ainaud de Lasarte, *Huguet,* Barcelona, 1948.
Ainaud de Lasarte, Juan, *Huguet,* Madrid, 1955.
Alcolea i Blanch, Santiago, and José Gudiol, *Pintura gótica catalana,* Barcelona, 1987.

*

Jaume Huguet is the architype of the 15th-century Spanish municipal painter. Born in the town of Valls, near Tarragona, in 1414, he probably received his early training from his uncle, Pere Huguet in Tarragona. After a probable stay in the Aragonese capital of Zaragoza, he came back briefly to Tarragona in the mid 1440's, but finally settled in Barcelona in 1448, where he was to remain for the rest of his life.

Though he had no formal training with Bernat Martorell, the foremost Barcelona painter of the first half of the 15th century, Huguet became Martorell's successor as the most important municipal painter in the city during the second half of the century. Huguet's style too begins as a logical continuation of Martorell's manner, but tempered with other elements as well. In the beautiful center panel of the *Retable of the Virgin and*

Child from the Parish Church of Vallmoll (Barcelona, Museum of Catalan Art), the kneeling angels at the foot of the throne seen from the back with lost profiles are reminiscent of similar figures in Martorell's work, but the gothic throne, and, above all, the jewel-trimmed garment of the Virgin, show the impact of the Flemish-influenced Lluis Dalmau, whose *Virgin of the Councillors,* painted for the city of Barcelona, had only recently been completed (1445).

Even more audacious were parts of a small retable, now in the Museo Episcopal of Vich, which show the *Epiphany* and the *Crucifixion,* both set against blue sky instead of the usual gold backgrounds, with atmospheric landscapes. In the *Epiphany,* the action takes place in a foreshortened stable which, if not perfect in perspective, gives a convincing illusion of depth equal to works by Huguet's Flemish contemporaries.

Such experiments, however, were short lived. The bulk of Huguet's subsequent career was devoted to large retables, many painted for Barcelona's trade brotherhoods, in which the gold grounds of the panels, textured by the use of raised, molded gesso known as *embutido,* tended to flatten out any spatial illusion. Martorell had begun the use of *embutido* in Barcelona, but Huguet and his contemporaries were to take it further. It is used with restraint in the *Retable of Saints Abdon and Sennin* (Terrassa, Santa Maria), mainly for haloes and garment and tile borders. But in the central effigy of this retable, even though the terrace on which the two male saints stand is worked out in nominal perspective, the composition appears flattened because of the patterned gold sky behind the figures and the *embutido* accents.

Embutido is used with more exuberance in such retables as that of Saint Vincent for the church of the same name in Sarrià, the *Retable of Saint Michael* for the Retailer's Brotherhood (both now in the Museum of Catalan Art, Barcelona), and the great *Retable of Saint Anthony Abbot,* painted for the brotherhood of animal racers (destroyed, 1909). Perhaps the best example of the flattening qualities of this technique can be seen in the beautiful *Retable of the Constable,* commissioned by Pedro, Constable of Portugal (and momentary sovereign of Catalonia during the civil war against Juan II), in the Royal Chapel of Saint Agatha. The center *Epiphany* (with presumed portrait of Pedro as one of the Kings) has in its sky a foliate pattern of *embutido* leaves which, along with the copious use of gold brocades, flattens out the composition—a direct contrast to the spaciousness of the painter's earlier *Epiphany* in Vich.

All of this, however, does not cancel out the great charm and elegance of the *Retable of the Constable,* for Huguet was the master of the slender, rhythmically posed figure, of gentle emotion. These compositions take on a monumental quality where the focus is on both the emotional content of the effigy or narrative and the beautiful surface rhythms of the compositions as a whole, in which subtle tensions of three dimensionality in the figures themselves are expertly balanced with the large patterns of brocades and textured grounds. It is the perfect aesthetic compromise between two and three dimensional illusion needed to sustain the rhythm of the many large and heavily framed panels that make up the late 15th-century Catalan retable. In Huguet, such a tension and balance achieve a high artistic standard. In lesser followers and contemporaries the compositions become frozen, heavily outlined, and flat.

—Judith Berg Sobré

HUNT, William Holman.

Born in London, 2 April 1827. Died in London, 7 September 1910. Married 1) Fanny Waugh, 1865 (died, 1866); one son; 2) Marion Edith Waugh, 1875; one son and one daughter. Assistant to a surveyor-estate agent, and then to a calico printer and politician Richard Cobden; to 1843; attended the R. A. schools, 1844–46, and exhibited from 1846; co-founder, with Millais and Rossetti, the Pre-Raphaelite Brotherhood, 1848, and remained faithful to its principles; friend of Ruskin; visited near east, 1854–56, and several later trips. Pupil: Robert Brathwaite Martineau.

Collections: Birmingham; Hartford, Connecticut; Johannesburg; Liverpool; London: Guildhall, St. Paul's Cathedral, Tate; Manchester; Newcastle upon Tyne; Ottawa; Oxford: Keble College, Jesus College, Ashmolean; Port Sunlight.

Publications

By HUNT: books—

The Obligations of the Universities Towards Art, London, 1895.
Pre-Raphaelitism and the P.R.B., London, 2 vols., 1905, New York, 1914.
The Story of the Painting of the Pictures on the Walls and the Decorations on the Ceiling of the Old Debating Hall, Oxford, 1906.
A Pre-Raphaelite Friendship: The Correspondence of Hunt and John Lucas Tupper, edited by James H. Coombes et al., Ann Arbor, 1986.

On HUNT: books—

Ruskin, John, *Notes on the Pictures of Hunt,* London, 1886.
Rossetti, W. M., editor, *Pre-Raphaelite Diaries and Letters,* 1900.
Gissing, Alfred C., *Hunt,* London, 1936.
Bennett, Mary, *Hunt* (cat), Liverpool, 1969.
Hunt, Diana Holman, *My Grandfather: His Wives and Loves,* London, 1969.
Hilton, Timothy, *The Pre-Raphaelites,* London, 1970.
Fleming, Gordon H., *That Ne'er Shall Meet Again: Rossetti, Millais, Hunt,* London, 1971.
Staley, Allen, *The Pre-Raphaelite* Landscape, 1973.
Landow George P., *Hunt and Typographical Symbolism,* New Haven, 1979.
Wood, Christopher, *The Pre-Raphaelites,* New York, 1981.
Bell, Quentin, *A New and Noble School: The Pre-Raphaelites,* London, 1982.
Bell, Quentin, *The Pre-Raphaelites* (cat), London, 1984.
Maas, Jeremy, *Hunt and the Light of the World,* London, 1984.
Ladies of Shalott (cat), Providence, Rhode Island, 1985.

articles—

Roskill, Mark, "Hunt's Differing Versions of *The Light of the World,*" in *Victorian Studies* (Bloomington, Indiana), March 1963.

Landow, George P., "Hunt's *The Shadow of Death*," in *Bulletin of the John Rylands University Library of Manchester*, Autumn 1972.

Landow, George P., "Shadows Cast by the Light of the World," in *Art Bulletin* (New York), 65, 1983.

Bronkhurst, Judith, " 'An Interesting Series of Adventures to Look Back Upon': Hunt's Visit to the Dead Sea in November 1854," and Diana Holman Hunt, "The Hunt Collection: A Personal Recollection," both in *Pre-Raphaelite Papers*, edited by Leslie Parris, London, 1984.

*

Unlike his co-founders of the Pre-Raphaelite Brotherhood, D. G. Rossetti and J. E. Millais, William Holman Hunt was neither a romantic spirit nor a natural talent; rather, his strengths lay in his intensity and will. Hunt's personal tenacity helped cement the Brotherhood, at least for 5 or 6 years. His thoroughness led him to construct an artistic dogma combining exacting realism with deep religious iconography. This doctrine derived from Ruskin's *Modern Painters*, from Blake's writings, and from Hunt's experience of Netherlandish masterpieces, and the artist applied it doggedly throughout a very long working life. Hunt's adherence to the principle of even treatment of every inch of canvas was to influence a subsequent generation of minor late-Victorian artists, and can even be said to "link Hogarth to Surrealism" (Wilenski, p. 227).

Products of his obsessive personality and doctrinaire rigor, Hunt's pictures are seldom easy to like. His book and periodical illustrations are more immediately appealing, but less revealing of his characteristic intensity. Although his published illustrations are "always distinguished" (Reid, p. 47), they are few and dispersed, except for the group of seven in the Moxon Tennyson (*Poems*, 1857).

Some of Hunt's early paintings are themselves "illustrative" in that they interpret literary texts, and if these lack the moral fervor that gives Hunt's religious works their force and originality, they bear many of the hallmarks of his approach. In the bright daylight of *Rienzi* (1849, private collection), with its foreground of individually captured pebbles and gravel, we can see Hunt putting Ruskinian theory into very literal practice. In his Shakespearean pictures, *Valentine Rescuing Sylvia from Proteus* (1851, Birmingham Museum and Art Gallery), or *Claudio and Isabella* (1849, Tate Gallery, London), we can also see the moral preoccupation that would dominate all his later work.

Valentine, although an advance on the clumsiness of Hunt's earlier figure-groups, is weakened by theatricality and a curious sense of anti-climax—an air of much ado about nothing—that can also be felt in the earliest of the artist's "Christian historical" paintings, *A Converted British Family Sheltering a Christian Missionary from the Persecution of the Druids* (1849–50, Ashmolean Museum, Oxford). Increasing experience did not enable Hunt to solve the problems of stasis and contrivance in his compositions. In this regard he was perhaps hampered by his abbreviated academic background, as well as by his absorption in meaning and principle to the detriment of simple aesthetic pleasure.

Even such a picture as *The Hireling Shepherd* (1851, City of Manchester Art Galleries), regarded by some as Hunt's "finest major painting" (Hilton, p. 83), is infected by his failure to establish a relationship between its two figures. The shepherd is clearly distracted from his duties by the pretty wench, but she does not look at him, or even at the moth he holds out to her, while his gaze is directed to a point just beyond her toes. In none of Hunt's major paintings do the figures actually engage with one another: no glances are exchanged and no two people focus on the same object.

Our English Coasts (1852, Tate Gallery, London) shares with *The Hireling Shepherd* in the richness of the English landscape tradition. The light of its late afternoon setting softens Hunt's sometimes garish palette and allows this picture considerable beauty. Although it includes no human figures, its popular title, *Strayed Sheep*, suggests its firm connection to a moral theme. The loveliness of the closely observed flowers leads first to brambles and then to a cliff-edge: the leaderless sheep reflect the perils facing souls astray.

"Downfall" is also the theme of one of Hunt's best-known paintings, *The Awakening Conscience* (1853, Tate Gallery, London). Here the piling on of symbolic detail, the strident colors, and the jumble of objects in their assertive quiddity take Pre-Raphaelite tenets to a point of near self-parody. Much of this excess was intentional: a condemnation of Victorian materialism and a demonstration that Pre-Raphaelite art was not solely archaizing. By contrast, in *The Scapegoat* (1854–55, Lady Lever Art Gallery, Port Sunlight; second version 1854–55, 1858, City of Manchester Art Galleries) Hunt pares his imagery to an economical minimum and still produces a painting capable of transfixing the spectator with horror at its uncompromising dissonance. Hunt painted *The Scapegoat in situ*, at the Dead Sea, and while contemporary critics applauded the labor and dedication involved in its meticulous portrayal, we may feel that its message of suffering and desolation is too heavy to be borne even by a sacrificial animal.

Hunt's sojourns in Egypt and the Near East resulted in a number of paintings of Oriental subjects, including *The Finding of the Savior in the Temple* (1854–60, Birmingham Museum and Art Gallery), in which elaborate attention to "Hebrew" dress and setting obscures rather than expresses the symbolic significance the details possess. No exoticism complicates *The Light of the World* (Keble College, Oxford), an image that has assumed an existence of its own as a religious icon, independent of its artistic merit.

Although Wilenski condemns Hunt's "aggressive . . . failures in sensibility and taste" (p. 227) and even admits that "most of his works are failures," he also praises Hunt's imagination and influence, and the insistence on intense observation that "brought him in line with the latest developments in European painting." While Hunt's work as a whole may never find a large body of admirers, either popular or sophisticated, it remains of interest both for its allusive typology and for its meticulous attention to minute surface detail. The most *retardataire* of all the Pre-Raphaelites, Hunt's subordination of paint to "idea" paradoxically makes him the most modern as well.

—Patricia Dooley Lothrop

I

INGRES, Jean Auguste Dominique.

Born in Montaubal, 29 August 1780; son of the artist Jean Marie Joseph Ingres. Died in Paris, 14 January 1867. Married 1) Madeleine Chapelle, 1813 (died, 1849); 2) Delphine Ramel, 1851. Trained by his father; then studied with the sculptor J. P. Vigan and the painter G. J. Roques at the Academy of Toulouse, 1791-94; worked in the studio of J. Briant, and studied violin with Lejeune (played 2nd violin in the Orchestre du Capitole); in David's studio, Paris, 1797; won the Prix de Rome, 1801; worked as portraitist in Paris, 1801-06; then in Rome, 1806-20, and Florence, 1820-24; settled in Paris, 1824, as popular painter, and member of the Institute, 1825; served as Director of the French Academy in Rome, 1834-41; Senator, 1862. Pupil: Chassériau.

Major Collections: Montauban: Musée Ingres; Paris.
Other Collections: Aix-en-Provence; Antwerp; Autun: Cathedrul; Baltimore: Walters; Brussels; Cambridge, Massachusetts; Chantilly; Cincinnati; Dampierre: Chateau; Florence; London: National Gallery, Victoria and Albert; Luttich; Montauban: Cathedral, Eglise de Sapiac; Nantes; New York: Metropolitan, Frick; Paris: Carnavalet, Ecole Nationale des Beaux-Arts; Rouen; Toulouse; Washington: National Gallery, Phillips.

Publications

By INGRES: books—

Ecrits sur l'art, edited by Raymond Cogniat, Paris, 1947.
Cahiers littéraires inédits, edited by Norman Schlenoff, Paris, 1956.

On INGRES: books—

Amaury-Duval, Eugène, *L'Atelier d'Ingres*, Paris, 1878.
Lapauze, Henry, *Les Dessins d'Ingres du Musée de Montauban*, Paris, 8 vols. 1901.
Boyer d'Agen, A., *Ingres d'après une correspondance inédite*, Paris, 1909.
Lapauze, Henry, *Ingres: Sa vie et son oeuvre*, Paris, 1911.
Fröhlich-Bum, Lili, *Ingres: Sein Leben und sein Stil*, Vienna, 1924; as *Ingres: His Life and Art*, London, 1926.
Fouquet, Jacques, *La Vie d'Ingres*, Paris, 1930.

Pach, Walter, *Ingres*, New York, 1939.
Longa, R., *Ingres inconnu*, Paris, 1942.
Malingue, Maurice, *Ingres*, Monaco, 1943.
Gatti, Lelio, *L'idealistica della forma*, Milan, 1945.
Cassou, Jean, *Ingres*, Brussels, 1947.
Cassou, Jean, *Ingres; ou, Le Dessin contre la couleur*, Paris, 1949.
Courthion, Pierre, *Ingres raconté par lui-même et par ses amis*, Geneva, 2 vols., 1947-48.
Alazard, Jan Jean, *Ingres et l'ingrisme*, Paris, 1950.
Wildenstein, Georges, *Ingres: Catalogue complet des peintures*, Paris, 1954; as *The Paintings of Ingres*, London, 1954; as *Ingres*, London, 1956.
Ingres: Drawings from the Musée Ingres Montauban (cat), London, 1957.
Ternois, Daniel, *Les Dessins d'Ingres au Musée de Montauban: Les Portraits*, Paris, 1959.
Naef, Hans, *Rome vue par Ingres*, Lausanne, 1960.
Lbreot, J., *Le Martyre de Saint Symphorien*, Dijon, 1960.
Ingres: Zeichnungen aus dem Ingres-Museum in Montauban (cat), Hamburg, 1961.
Naef, Hans, *Schweizer Künstler in Bildnissen von Ingres*, Zurich, 1963.
Durbe, Dario, *Ingres*, Milan, 1965.
Ternois, Daniel, *Montauban—Musée Ingres I: Peintres: Ingres et son Temps*, Paris, 1965.
Ternois, Daniel, and Hans Naef, *Ingres* (cat), Paris, 1967.
Rosenblum, Robert, *Ingres*, New York, 1967.
Picon, Gaëton, Ingres, *Geneva*, 1967.
George, Waldeman, *Dessins d'Ingres*, Paris, 1967.
Mongan, Agnes, and Hans Naef, *Ingres Centennial Exhibition* (cat), Cambridge, Massachusetts, 1967.
Ingres et son temps (cat), Montauban, 1967.
Ingres et Firenze (cat), Florence, 1968.
Angrand, Pierre, *Ingres et son époque*, Paris, 1968.
Camesasca, Ettore, *L'opera completa d'Ingres*, Milan, 1968.
Naef, Hans, *Ingres in Rome* (cat), Washington, 1971.
Ingres et le néo-classicisme (colloquium), Montauban, 1975.
Hattis, Philip, *Ingres's Sculptural Style: A Group of Unknown Drawings* (cat), Cambridge, Massachusetts, 1977.
Naef, Hans, *Die Bildnisszeichnungen von Ingres*, Berne, 5 vols., 1977-80.
Pansu, Evelyne, *Ingres: Dessins*, Paris, 1977.
Whiteley, John, *Ingres*, London, 1977.
Noël-Burton, V., editor, *Ingres et son influence*, Montauban, 1980.

Odalisque, 1825; lithograph

Picon, Gaëton, *Ingres,* Geneva and New York, 1980.

Cohn M. B., and S. C. Siegfried, *Works by Ingres in the Collection of the Fogg Art Museum,* Cambridge, Massachusetts, 1980.

Ternois, Daniel, *Ingres,* Paris, 1980.

Edelstein, Debra, editor, *Ingres in Pursuit of Perfection* (cat), Louisville, 1983.

Weber, Wilhelm and Norbert Suhr, editors, *Ingres: Handzeichnungen* (cat), Mainz, 1983.

Mraz, Bohumir, *Ingres: Dessins,* Paris, 1984.

Toussaint, Helene, *Les Portraits d'Ingres: Peintures des musées nationaux,* Paris, 1985.

Ingres et Rome (colloquium), Montauban, 1986.

*

Born in 1780, and reaching nearly 90 before he died, Ingres witnessed the successive revolutions in 19th-century painting: Romanticism and Realism. To the idea gaining currency through Baudelaire, Courbet, and Manet of the importance of modern life ás subject matter for art ("il faut être de son temps") Ingres was temperamentally and as a matter of principle opposed. A large part of his life was spent at the French Academy in Rome in exile from contemporary French taste and thought, an environment more sympathetic to the "grandeur, purity and the ideal" of Raphael and the antique. To the colorism, looseness of technique, intimacy, and subjectivity of Romanticism, Ingres was equally opposed, He and Delacroix became the great 19th-century adversarial figureheads respectively defending the traditions of classical line versus color. In contrast to Delacroix, Ingres's insistence on sharp visual focus, and surfaces as smooth and glassy as a lens, may constitute one of the least approachable aspects of his work. "The touch," he wrote, "however able, should never be apparent—otherwise it prevents the illusion and makes everything motionless." Ingres was dogmatic on the importance of illusion. To disguise the stuff paintings were made of was something of a model of achievement in itself. In this respect Ingres was a very traditional painter: art should be concealed with art. These positions, technically and ideologically opposed to contemporary movements in art, made Ingres appear very much an establishment figure. This was a role to which his natural paranoia, inflexibility, and reactionary politics suited him and which he played to the hilt. He took up a position on the extreme right wing of the Academy and "Ingrisme" came to stand for some of the most academic and backward-looking aspects of 19th-century painting.

In spite of this reputation, however, the interest in Ingres—by the generation of artists after his death, Degas, Gauguin, Seurat, and, later, Picasso and Gorky—and after a crises within Impressionism led to the acknowledgement of a tension between the illusion of reality and the forming of painting, indicates the extraordinary modernism of his attitude to painting. Ingres's reputation had been based on the success of a number of major history paintings, notably *Archilles and Agamemnon's Envoys,* which in 1801 won him the Prix de Rome,

The Vow of Louis Xlll, 1820, following the exhibition of which at the Salon of 1824 he was awarded the Legion of Honour and elected a member of the Academy, and the controversial *Martyrdom of St. Symphorian,* 1834. But it is primarily his portraits and his "display nudes," odalisques and bathers (a genre of which he was virtually the inventor), rather than his history paintings, that interest artists of the modern period.

Ingres seems to have become aware, soon after his arrival in David's studio as his pupil in 1797, of a conflict between David's definition of classicism and the qualities of line currently being rediscovered in classical art. Roman wall paintings at Herculaneum and Pompeii had been brought to light relatively recently. Engravings from Greek vases were in wide circulation. David's *Oath of the Horatii,* 1784, had revived the classical point of view in painting, but his interest in the emblematic meaning of actual classical imagery confined the formal aspects of painting, particularly line, to the naturalistic reconstruction (in almost archeological detail) of helmets, weapons, furniture, gestures of the body, etc. There was an increasing literalness in the way that David insisted on line as representing a world of fact, separable, touchable, solid objects, and this left its mark on all later academic painting. Line was identified with making objects and figures real. "Painters have made the principal quality of a painting consist of detaching objects; this attitude is still held by many who experience the greatest satisfaction when they see a painted figure around which it seems, so they say, they may walk. I do not care a fig for that!"

Compared with the stagey and sophisticated illusionism of David, Ingres's early classical paintings, *Jupiter and Thetis,* 1811, for example, have the edginess, shape, and flatness of Herculaneum and Pompeii: and abstracted arabesque quality of line that is much less insistent on being real. The format of the painting and the placing of images, one full face, the other in profile, are deliberately primitivising. These ideas were particularly unconventional when applied to portraiture where baroque formulas for grandeur and nobility were entrenched practice. Ingres's *Portrait of Napoleon Bonaparte on the Imperial Throne,* 1806, dispenses with baroque swank (tumbling light and tumbling drapery) and has Bonaparte under an edgy glaring light posed frontally as a hieratic cult image.

But while it is constant in its emphasis on edges and line, Ingres's painting reflects a world of obsessive detail. He is relentless in his pursuit of the light falling on each individual tassel, the tiny reflections of windows in spheres of marble. The sharp focus and articulation of details seduce the viewer into a suspension of disbelief. In effect, the high degree of illusionism acts as a disguise for the extraordinary liberties which Ingres in fact takes with the illusion of realty. It is as if all of the rigid structures, the perspectival construction of space, the continuation of an arm under a piece of drapery, have been put to one side, and instead we find, as in the *Valpinçon Bather,* 1808, images made-to-order in an ideal relation to the space created by the frame. Her right leg is strangely grafted onto a piece of drapery, while the darkened right edge of her figure makes a perfect half-oval. Relationships of interval and shape are paramount. It is particularly with respect to images of women, *The Grande Odalisque,* 1814, *The Turkish Bath,* 1863, and his female portraits, *Mme. de Sennones,* 1816, *Mme. de Haussonville,* 1845, and *Mme. Moitessier,* 1856, that a sensuous abundance of shapes and a malleability of materials produce an extraordinarily modern inventiveness and imaginative freedom.

—Martha Kapos

J

JOHN, Augustus (Edwin).

Born in Tenby, 4 January 1878. Died in Fordingbridge, 31 October 1961. Married Ida Nettleship, 1901 (died, 1907), five sons; also had three sons and one daughter by Dorelia Mac-Neill. Attended Slade School of Art, London, 1894–98; taught at University College, Liverpool, 1901–02; then settled in London: painted portraits, large decorative schemes; official artist to the Canada Corps, World War I; also made etchings; R. A., 1928 (resigned, 1938, re-elected, 1940).

Collections: Aberdeen; Birmingham; Buffalo; Cambridge; Cardiff; Detroit; Dublin; Leeds; Liverpool: Walker, University Club; London: Tate; Manchester; Melbourne; New Haven; Ottawa; Oxford; Rochdale, Lancashire; Sheffield; Stockholm; Swansea; Toronto; Washington.

Publications

By JOHN: books—

Autobiography, edited by Michael Holroyd, London, 1975 (comprising two volumes, *Chiaroscuro*, London, 1952, and *Finishing Touches*, edited by Daniel George, London, 1964).

On JOHN: books—

Dodgson, Campbell, *A Catalogue of Etchings by John 1901–1914*, London, 1920.
Browse, Lillian, *John: Drawings*, London, 1941.
Rothenstein, John, *John*, London, 1944, 1945.
Kelly, G., *Works of John* (cat), London, 1954.
Cecil, David, *John: Fifty-Two Drawings*, London, 1957.
Rothenstein, John, *John*, London, 1967.
Easton, Malcolm, *John: Portraits of the Artist's Family* (cat), Hull, 1970.
Easton, Malcolm, and Michael Holroyd, *The Art of John*, London, 1974.
Holroyd, Michael, *John: A Biography*, London, 2 vols., 1974, 1976, New York, 1975.
Easton, Malcolm, and Romilly John, *John* (cat), London, 1975.
John (cat), Cambridge, 1978.
Jenkins, A. D. Fraser, *John: Studies for Compositions* (cat), Cardiff, 1978.

Shone, Richard, *John*, Oxford and New York, 1979.
John: The Marchesa Casati, Toronto, 1987.

*

There are few British artists whose pictures have been so continuously reappraised as Augustus John's, and whose personality has attracted such attention as almost to eclipse the significance of his work. When John first arrived at the Slade in 1894, he drew cautiously and as a character was barely noticed: the group of women there, later to include his elder sister Gwen, had a much higher profile. It is said that his whole personality changed in 1897 after he had hit his head on submerged rocks while bathing off the Welsh coast. There was no doubt that he returned to the Slade less shy, both in his manner and in his approach to art. From using an old-fashioned life-drawing method known as "stumping," which was a smudge and stipple technique that he had learnt at Tenby School of Art, he adopted short cross-hatched pencil strokes that generated a far more strikingly original style. John won a scholarship in 1896 from the Slade, and his first major oil painting, *Moses and the Brazen Serpent*, won the summer composition prize there in 1898.

When John left the Slade in 1898, main-stream English art was undergoing a gradual change: from the High Victorian to the beginnings of the modernist period. The artists of both epochs are characterized by a great consciousness of their European contemporaries, and John's visits to Paris, in particular, were to formulate much of the direction of his early career. The two periods of his subsequent life provide interesting contrasts: his livelihood was ensured by his commissions to paint many of his distinguished contemporaries (including W. B. Yeats, T. E. Lawrence, Dylan Thomas, Lady Ottoline Morrell, Madame Suggia, George Bernard Shaw, Thomas Hardy, Lloyd George, Viscount d'Abernon, Wyndham Lewis, Dr. Kuno Meyer, James Joyce, etc., though not all those mentioned were formal commissions); whereas his bohemian life-style with his extensive family could not have been further removed from London society portrait painting.

About 1908 John painted what was considered to be the first oil painting to "make his name": *The Smiling Woman*, a portrait of Dorelia, his second wife, in a russet dress with a dark green headdress, exhibited at the New Gallery in 1909. "Here at last," wrote Roger Fry, "Mr. John has 'arrived' in painting as definitely as he has long ago done in drawings." This admiration for John's drawing ability is echoed by the words of his American contemporary J. S. Sargent, who admiringly praised

Standing Figure of a Woman; drawing

him as the "greatest draughtsman since the Renaissance." Although John was noted for his portraits in oil above all, he was also a prolific landscape painter, and his talents, for example, as an etcher, have often been overlooked. Drawing did remain one of the most important facets of his artistic career, and even his preparatory sketches provide some of the finest examples of English drawing of this century.

While at Liverpool, John made friends with the University librarian there, John Sampson, who was a leading scholar of gypsy lore and language. It was his influence that first moved John away from the conventional. He encouraged John to learn Romani, and on their travels together, they discovered the last survivors to speak it in its ancient Welsh version. John mastered the language fluently and even learnt the authentic Welsh inflection. Through his ability to communicate with a hitherto incomprehensible source of rural knowledge, he was able to become familiar with north Wales: in between sketching he wrote learned articles and translations for the Gypsy Lore Society. It was in Wales that he consolidated his admiration for the "travelling people," and he was subsequently accepted by gypsies wherever he went in Europe.

John went travelling before the outbreak of the war: to Provence and Italy; to Dorset and to Ireland with his family; and constantly between 1911 and 1914 with James Dickson Innes and Derwent Lees in north Wales. His trip to France and Italy in 1910, financed by his American patron John Quinn, proved a definitive time in his career: the brilliant Mediterranean light encouraged him to abandon the tight and symbolic figure groups in favour of small landscapes on panel, rapidly sketched in, using high-keyed colours and loose brushwork. In Wales, John and the two younger artists camped with gypsies and lived in a succession of remote cottages, though John did keep in touch with occurrences in London, such as the Post-Impressionist exhibitions organized by Roger Fry: these new influences, combined with the significant amount of time spent with J. D. Innes contributed to the "liberation" of his colours: they became clearer and brighter while his handling of paint became broader. This intense working period has been cited as one of the most important in the development of modernism in British painting: its historical importance began with Quinn's insistence that all three were well-represented at the highly significant Armory Show in New York in 1913.

The period in Wales, probably John's most individual, was followed by a reversion back to the more conventional, to pictures painted for a specific market. In August 1913 he went to Paris again and his meetings with Modigliani and Epstein heralded the advent of a more international style. One of the major influences of his earlier visits, Puvis de Chavannes, was also still in force. The cottages in Wales were given up early in 1914, and his country visits became tamer: he went to Lamorna Cove in Cornwall with the Knights and Alfred Munnings, for example. However, unwittingly and with great bouts of loneliness, John increasingly became a member of the establishment. In 1914 he was elected President of the National Portrait Society, and the necessity for him to make a living steered him towards more and more portrait commissions, some of which he had ample autonomy over—for example his portrait of Madame Suggia—but the majority of which were fairly conservative.

Due to a knee injury John was not able to join the army, but in 1917 he did go to Aubigny in France as a Major with the Canadian Corps. In 1919 he was Official War Artist at the Paris Peace Conferences. He and Dorelia moved from Alderney Manor in Dorset to Fryern Court in Hampshire in 1927. His subject matter was increasingly taken up with respectable portraiture and pretty flower painting. John continued to travel considerably: in 1937 he went to Jamaica for four months: Michael Holroyd states that "without doubt, portraits of coloured models constitute John's most successful *genre* during his later years." John continued to visit France, and before the outbreak of World War II hired a house in St. Remy, from which he visited Matthew Smith in Aix-en-Provence. The Johns had to leave hurriedly in 1939, but were back again in 1946. The house was finally relinquished in 1950. They did find a house in his birthplace, Pembrokeshire, but could not live there as it did not suit Dorelia. In 1955 Augustus made his last visit to Wales. He worked on right until his death; his last painting, which took him several years to complete, is a tribute to St. Mary of the Carmargue, the patron saint of gypsies.

The paradox of John's life and work was reinforced during most periods of his working life: for instance, he had run an art school in Chelsea between 1903 and 1907 with William Orpen and was probably the best-known young man in the London art world, yet he had been branded as one of its enemies. Although they found him fascinating and his work appealing, the public did not respond well to his strange mixture of tempestuous bohemianism and undependable respectability. Sir John Rothenstein, Director of the Tate Gallery from 1938 until 1964, wrote in his important first volume of "*Modern English Painters*" (published in 1952) that John was "on the way to becoming the 'forgotten man' of English painting," yet in Volume II (published in 1956) explains how he emerged from the shadows to become the somewhat undependable "grand old man." This illustrates how well Augustus John, as a character, sustains the vagaries of contemporary criticism, and the extent to which his work, despite the fact that that of his sister Gwen's has quite rightly equalled if not surpassed his own in recent critical acclaim, survives to be constantly re-examined and re-evaluated.

—Magdalen Evans

JOHNS, Jasper.

Born in Augusta, Georgia, 15 May 1930. Attended schools in South Carolina, and the University of South Carolina, Columbia, 1948–49; commercial art school, New York, 1949; served in the United States Army in Japan, 1949; bookstore salesman and window display artist, New York, 1952–59; designed ballets for Merce Cunningham Dance Company: *Walkabout Time*, 1968, *Second Hand*, 1970, *Landrover*, 1970, *TV Re-Run*, 1970, *Borst Park*, 1972, *Un Jour ou deux*, 1973. Address: c/o Leo Castelli Gallery, 420 West Broadway, New York, New York 10012, U.S.A.

Collections: Amsterdam: Stedelijk; Basel; Buffalo; London: Tate; New York: Moma, Whitney, Guggenheim; San Francisco: Modern Art; Stockholm: Moderna Museet; Tokyo: Seibu.

Light Bulb, 1976; lithograph

Publications

On JOHNS: books—

Ellin, Everett, *Johns* (cat), Los Angeles, 1962.
Steinberg, Leo, *Johns,* New York, 1963.
Solomon, Alan, et al., *Johns* (cat), New York, 1964.
Tono, Yoshiaki, *Johns* (cat), Tokyo, 1965.
Munsing, Stefan, *The Drawings of Johns* (cat), Washington, 1966.
Kozloff, Max, *Johns,* New York, 1967.
Castleman, Riva, *Johns: Lithographs* (cat), New York, 1970.
Field, Richard S., *Johns: Prints 1960–1970* (cat), New York, 1970.
Huber, Carlo, *Johns: Die Graphik,* Berne, 1970.
Bernstein, Roberta, and Robert Lottman, *Johns' Decoy: The Print and the Painting* (cat), Hempstead, New York, 1972.
Crichton, Michael, *Johns,* New York and London, 1977.
Goldman, Judith, *Foriades/Fizzles* (cat), New York, 1977.
Field, Richard S., *Johns: Prints 1970–77* (cat), Middletown, Connecticut, and London, 1978.
Robertson, Bryan, *Johns* (cat), London, 1978.
Geelhaar, Christian, *Johns: Working Proofs,* Basel, 1979, London, 1980.
Francis, Richard, *Johns,* New York, 1984.
Shapiro, David, *Johns Drawings 1954–84,* New York, 1984.
Bernstein, Roberta, *Johns' Painting and Sculptures 1954–1974,* Ann Arbor, 1985.

Castleman, Riva, *Johns: A Print Retrospective* (cat), New York, 1986.
Goldman, Judith, *Johns: L'Oeuvre graphique de 1960 à 1984* (cat), Saint-Paul-de-Vence, 1986.
Cuno, James, editor, *Foriades/Fizzles: Echo and Allusion in the Art of Johns,* with Samuel Beckett, Chicago, 1988.
Rosenthal, Mark, *Johns: Work since 1974,* London, 1988.
Boudaille, Georges, *Johns,* New York, 1989.

articles—

Hughes, Robert, "Johns' Elusive Bulls-Eye," in *Horizon* (New York), Summer 1972.
Debs, Barbara Knowles, "On the Permanence of Change: Johns at the Modern," in *Print Collector's Newsletter* (New York), September-October 1986.
Johnston, Jill, "Tracking the Shadow: John's Increasingly Autobiographical Work," in *Art in America* (Marion, Ohio), October 1987.

*

Jasper Johns is with Robert Rauschenberg the most influential of the American artists who followed Abstract Expressionism and reacted against it, raising some fundamental questions about art in the process. But in contrast to Rauschenberg's great variety, Johns has confined himself to much simpler means and a very small range of subjects. And unlike Raus-

chenberg he does not "act in the gap between art and life" or relate to life in any way, but instead his formal enigmas constantly question the nature of art. His images are not merely simple and banal, but very, very cool, and often ironic as well, so they weren't so easily dismissed as mere neo-Dada, as Rauschenberg's could be.

The era of Pop art is usually dated from Johns's first one-man show early in 1958, which included paintings of flags, of targets, of numerals and letters of the alphabet, all chosen as familiar images from everyday life, which are not only simple but also essentially two-dimensional. Numbers and letters by their very nature have no depth, and the flags are painted flatly on the surface, covering the whole canvas, or set off against a simple border. But the encaustic (wax-based) paint is richly and vibrantly handled, focusing attention on the act of painting and bringing out the profound ambiguity between image and object, and the constant interplay between painted illusion and real object. These ordinary, banal images thus become thought-provoking, and since such formal problems of pictorial reality as flatness and the two-dimensional nature of paintings were the sort of intellectual problem American critics of the 1950's and 1960's loved to discuss, "Johns provided everything the New York critical intelligence requires to requite its own narcissism," as Brian O'Doherty aptly observed. These were in fact seminal influences, though ambiguous ones which could lead to such different lines of development as Pop and Minimalism, and which prompted one of the great critical axioms of the period, Leo Steinberg's dictum that "Whatever else it may be, all great art is about art."

Johns focuses attention on the painting as an object, a thing in its own right, rather than as representation. And this is made even clearer in those paintings which incorporate such things as rulers, brooms and spoons. Thus his target with four boxes over it, each containing a plaster model of a face cut off below the eyes, creates a powerful interplay of thwarted alternatives, making the human association and the formal geometry equally impersonal, and contradicting the flatness of the target with the spatial levels of the boxes. He breaks down and isolates the elements of painting itself and the ideas of illusion and literal fact in such paintings as *False Start* (1959), a series of visual puns in which patches of bright red, blue, orange, or yellow are falsely identified by stencilling the names of other colours over them. Later paintings in which the public motifs such as flags and maps are replaced by more homely and domestic images such as coathangers and coffee cups are similarly relentless explorations of different ways of seeing.

The theme of illusion versus reality and the constant questioning of reality and identity is also basic to his sculptures. His bronze reproductions of beer cans, flashlights, or cans with paint brushes in them are so carefully sculptured and painted that it is sometimes difficult to tell them from the originals, though they provide a highly ambiguous substitute. His irony directed towards art is seen in *The Critic Smiles*, a toothbrush cast in sculptmetal, and *The Critic Sees*, a pair of spectacles in the same material, with glass lenses reflecting opaquely back at the viewer.

Johns has regularly been compared with Duchamp. and certainly has the same sort of cool intelligence which has led him to challenge some cherished preconceptions about aesthetics and perception. But the limitations of an art so severely about art are seen all too clearly when carried to absurdity in the

extreme reductivism of some of John's followers such as Frank Stella. Sir Karl Popper has mocked the reductive aridity of modern linguistic philosophy by comparing it to constantly polishing a pair of spectacles instead of ever looking through them at the world. Something similar might be said about the reductive path of much contemporary American art, and there may be greater irony in *The Critics Sees* than Johns himself ever intended.

—Konstantin Bazarov

JONGKIND, Johan Barthold.

Born in Lattrop, 3 June 1819. Died in La Côte-Saint André, 9 February 1891. In the studio of Steffens in the Hague, and studied under Andreas Schelfhout at the Drawing Academy; moved to Paris in 1846, and entered the studio of the marine painter Eugène Isabey, and studied the figure under F. R. Picot; exhibited at the Salon from 1848, and did much work in Le Havre; worked in Holland, 1855-60, then in Paris again from 1860, and in Côte-Saint André from 1878; first album of etchings, 1862; increasingly alcoholic.

Collections: Aix-les-Bains; Amsterdam; Stedelijk, Rijksmuseum; Angers; Bagnères-de-Bigorres; Birmingham; Douai; Glasgow; Grenoble; Ghent; The Hague: Gemeentemuseum; London; Ottawa; Paris; Rheims; Rotterdam; San Francisco; Toledo, Ohio.

Publications

On JONGKIND: books—

Delteil, Loys, *Le Peinteur-graveur, vol. 1: Jongkind*, Paris, 1906.

Moreau-Nelaton, Etienne, *Jongkind racconté par lui-même*, Paris, 1918.

Signac, Paul, *Jongkind*, Paris, 1927.

Colin, Paul, *Jongkind*, Paris, 1930.

Roger-Marx, Claude, *Jongkind*, Paris, 1932.

Hennus, M. F., *Jongkind*, Amsterdam, 1945.

Roger-Marx, Claude, *Jongkind* (cat), Amsterdam, 1948.

Madero, Anita Fesser de, *Jongkind*, Buenos Aires, 1948.

Jongkind en Dauphiné (cat), Grenoble, 1955.

Jongkind (cat), Amsterdam, 1960.

Hommage à Jongkind (cat), Honfleur, 1963.

Bakker-Hefting, Victorine, *Jongkind*, Amsterdam, 1963.

Bakker-Hefting, Victorine, *Jongkind d'après sa correspondance*, Utrecht, 1969.

Jongkind (cat), Enschede, 1971.

Aquarelles de Kongkind (cat), Paris, 1971.

Hefting, Victorine, editor, *Jongkind: Sa vie, son oeuvre, son époque*, Paris, 1975.

Hefting, Victorine, *L'Univers de Jongkind*, Paris, 1976.

Cunningham, Charles C., Susan D. Peters, and Kathleen Zimmerer, *Jongkind and the Pre-Impressionists: Painters of the Ecole Saint-Simon* (cat), Williamstown, Massachusetts, 1977.

Imagine, on a page, a profusion of shapeless spots of color, set down haphazardly it seems by a careless brush, with slashes, dribbles, and childish blots covering the imprecise outlines of a quick sketch . . . imagine all the crudeness, all the approximations, all the abbreviations of a spirit furiously rushing to seize the image glimpsed, the spectacle soon to vanish. And what you are inclined to consider a drunken outburst is simply the inspiration of genius, and the motley aspect of these mad strokes of pencil and brush nothing but the bursting proof of an impeccable skill! (Roger-Marx)

While never considered to be an especially prominent figure among the Impressionist circle, Jongkind, together with Boudin and a few adherents, is nevertheless an important precursor of the movement, inspiring Monet to paint out of doors and anticipating Pissarro with his depictions of Paris street life. Never at his best in the medium of oil—these paintings reflect but do not better the works of the great Dutch landscapists Ruisdael and Van Goyen—Jongkind's true ability lay with watercolours and drawings, rendered swiftly and dextrously "en plein air."

Raised in Holland with its seafaring tradition and consequent influx of exotic and oriental art, Jongkind, like Van Gogh, was inspired by the style and character of Japanese prints and kakemonos. The emphasis of the flat, two-dimensional surface and the limitless possibilities suggested by a few cursory brushstrokes proved appealing to an entire generation of artists who were tired of the academicism rife in the orthodox art schools. Holland's indigenous art lay in the best tradition of sea- and city-scapes; this, combined with the social realism practiced by the influential Courbet and Manet in France, summarizes the style and subject matter of Jongkind, a Dutchman in Paris.

Jongkind arrived on the artistic scene in the 1850's, his work at this time reflecting a great interest in landscape—mainly mills and rivers—and the inspiration of his Dutch predecessors. However, it was during the 1860's, with the encouragement of his partner Joséphine Fesser-Borrhée, that Jongkind came to the fore. Basing himself in Paris, with regular trips to the Channel coast, working outdoors, often with Boudin, creating spontaneous watercolours and drawings that reflected his excellent draftsmanship and keen eye for detail. Jongkind rarely, if ever, worked in oils outside, differing radically in this respect from Boudin. He would "finish" his paintings in the studio, in the traditional manner, but relying on his sketches and recollections of time and atmosphere of the given location. However, many of the oil compositions, particularly of the early period, consist of composite elements gleaned from various sources; but, testament to Jongkind's skills, these nevertheless convey a sense of co-ordination and vividness. The freedom with which the artist executed his paintings encouraged the young Impressionists to re-evaluate the accepted approach to art.

Courbet's friend Castagnany said of Jongkind: "With him everything lies in the impression." The artist was not concerned with what he knew of any given subject, but rather how it seemed under varying atmospheric conditions.

To this end, he was one of the first artists to discover the versatility of white tones in painting, thereby capturing on canvas the effect of all-important light on a subject. In 1863-64

Jongkind painted two views of the same apse of Notre Dame Cathedral in Paris, noting how the "local color"—first the white light of a winter's morning, then the blaze of a summer sunset—changed the entire surface appearance and texture of the building. Monet later attempted the same experiment under the guidance of his mentor and also marvelled at the dramatic changes apparent in his two paintings of a Normandy road.

—Carolyn Caygill

JOOS VAN GHENT, [Justus van Ghent].

Born c. 1430; also called Joos van Wassenhove; Jodocus or Justus van Ghent. Died in Urbino (?) c. 1480. Painter probably to be identified with the Flemish painter known as Joos van Wassenhove who later worked in Italy; joined the painters guild in Antwerp, 1460, and the painters guild in Ghent, 1464: he sponsored Hugo van der Goes's admission into the Ghent guild, 1468; possibly in Italy as early as 1468; in Urbino, 1471-80: worked for Duke Federigo da Montefeltro, 1473-75 (did a series of 28 paintings of famous men); also did *Institution of the Eucharist or Communion of the Apostles* (his only documented work) for a religious fraternity.

Major Collection: Urbino.
Other Collections: Ghent: Cathedral; London; Milan; New York; Paris; Urbino: Palazzo Ducale; Royal Collection.

Publications

On JOOS: books—

Ceuleneer, A. de, *Juste de Gand*, Brussels, 1911.
Schmarzow, August, *Joos van Gent und Melozzo da Forli in Rom und Urbino*, Leipzig, 1912.
Friedländer, Max J., *Die Altneiderländische Malerei 3: Dieric Bóuts und Joos van Gent*, Berlin, 1925; as *Dieric Bouts and Joos van Ghent* (notes by Nicole Veronee-Verhaegen), Leiden, 1967.
Lavalleye, Jacques, *Juste de Gand, peintre de Frédéric de Montefeltre*, Brussels, 1936.
Juste de Gand, Berruguete, et la cour d'Urbino (cat), Brussels, 1957.
Joos van Ghent (cat), Ghent, 1957.

articles—

Roques, M., "Les Peintres du studio du Duc d'Urbin," in *L'Information de l'Histoire de l'Art*, 3, 1958.
Sulzberger, S., "Juste de Gand et l'école de Harlem," in *Revue Belge d'Archéologie et d'Histoire de l'Art* (Brussels), 29, 1960.
Lavalleye, Jacques, "Le Palais Ducal d'Urbin," in *Les Primitifs Flamands*, vol. 1, Brussels, 1964.
Lavin, Marilyn Aronberg, "The Altar of Corpus Christi in Urbino: Paolo Uccello, Joos van Ghent, Piero della Francesca," in *Art Bulletin* (New York), 49, 1967.

Federigo di Montefeltro and his Son Guidobaldo Listening to a Discourse; panel; 4 ft 3½ in × 7 ft 4¾ in (130 × 224.5 cm); Royal Collection

Despite a dearth of records, certain reasonable assumptions and educated conjectures may be made regarding the artist's activities and his place in the evolvement of late 15th-century painting. Joos van Wassenhove, i.e., Joos van Ghent, entered the Antwerp painters guild in 1460. Four years later he is referred to in Ghent as a master painter there and in 1465 is recorded as sponsor of Hugo van der Goes's entry into the Ghent painters guild, suggesting that he was Hugo's senior, hence born before 1440.

In Ghent, where in the early part of the century the van Eycks had dominated the arts and left their noble legacy in St. Bavon's *Mystic Lamb* altarpiece, no immediate heir had appeared after Jan van Eyck's death in 1440. With Rogier van der Weyden active in Brussels, Petrus Christus in Bruges, and Dirk Bouts in Haarlem—then the seat of Ghent's exiled royal patron Jacoba of Bavaria—Ghent was quickly placed in the shadow by these newer art centers. However, the entry of Hugo van der Goes into the painters guild of Ghent in 1465 suggests that a new blossoming must have been in progress, very likely brought about by the presence of Hugo's sponsor, Joos van Ghent, who by that time may have completed the *Adoration of the Magi*, considered the earliest of his extant works, and begun the *Crucifixion* triptych for the chapel of St. Lawrence in St. Bavon's cathedral.

Historical circumstance and each artist's pictorial approach tend to support the claim that Joos and Hugo both had learned from Dirk Bouts in Haarlem. In the case of Joos, compositional details such as his tendency to create elongated figures tend to bear this out. The *Adoration of the Magi* owes aspects of its structure to the *Adoration* panel in Dirk Bouts's *Infancy* altarpiece, although Joos presents a more open, freer, less

symmetrically rigid composition. In the more elaborate *Crucifixion* triptych the most striking feature is the artist's remarkable landscape treatment, close and confined in the wings, infinitely deep, cosmic, in the central panel with the crucified Christ in soaring heights projected against a distant, turbulent sky.

Joos may have migrated to Italy by 1468 and spent several years in Rome where painters were much in demand. There he must have come to the attention of Duke Federigo da Montefeltro who in 1473 summoned him to his court in Urbino to complete an altarpiece for the confraternity of *Corpus Domini*, begun a decade earlier by Paolo Ucello, above whose predella Joos painted *The Institution of the Eucharist*, his only documented work.

His stay in Urbino coincided with that of Piero della Francesca whose *Madonna with Child and Saints* was painted there between 1472 and 1474. Also in Urbino at the time was Melozzo da Forli, soon to proceed to Rome, where his vibrant colors and realistic figure composition in the surving Vatican Library fresco may owe something to Joos.

While Joos and Piere della Francesca must have been in close communication in the intimate society of Urbino there is little in their works to suggest mutual influence, although both portrayed the Duke and his recently departed wife, Battiste Sforza, Piero in two small portraits in profile, Joos by placing the Duke, in the same unmistakable profile, to the viewer's right of the communion table in *The Institution of the Eucharist* and the Duchess, holding the child whose birth took her life, shrouded by shadows in a background niche.

In Frederigo's *studiolo* in the palace were once a series of half-length portraits of *Illustrious Men*, now generally attrib-

uted to Joos, although more likely painted by members of his workshop under his direct supervision. According to Friedländer, these portraits have "been ignored to a disgraceful degree." With their unique blend of the Netherlandish and the Italian, he claims, they are of landmark importance as a likely product of a collaborative effort of Joos and an Italian artist, perhaps Melozzo da Forli.

There are neither records nor works of Joos van Ghent postdating his presence in Urbino. However, the quality of his works there make him a worthy pioneer for other artists of the Netherlands intent on making Italy their adopted land.

—Reidar Dittmann

JORDAENS, Jacob.

Born in Antwerp, 19 May 1593. Died in Antwerp, 18 October 1678. Married Catharina van Noort, 1616, three children. Studied with Adam van Noort, and then assistant to Rubens; member of the Antwerp guild as a watercolorist, 1614; then set up as a painter, and established a large studio: commissions from both Protestant and Catholic patrons; decorated with Huis ten Bosch in The Hague, 1652; also made tapestry designs.

Collections: Antwerp: Museum, Augustinerkirche, S. Jacob, S. Paulus; Belfast; Boston; Braunschweig; Brussels; Cologne; Copenhagen; Grenoble; The Hague: Mauritshuis, Huis ten Bosch; Karlsruhe; Kassel; Leningrad; London: National Gallery, Wallace; Madrid; Mainz; Munich; New York; Paris; Stockholm; Tournus.

Publications

On JORDAENS: books—

Buschmann, Paul, *Jordaens et son oeuvre* (cat), Brussels, 1905.
Fierens-Gevaert, Hippolyte, *Jordaens*, Paris, 1905.
Rooses, Max, *Jordaens leven en werken*, Antwerp, 1906; as *Jordaens: His Life and Work*, London and New York, 1908.
Drost, Willi, *Motivübernahme bei Jordaens und Adriaen Brouwer*, Konigsberg, 1928.
Delen, A. J. J., *Jordaens*, Antwerp, 1943.
Stubbe, A., *Jordaens en de Barok*, Antwerp, 1948.
Puyvelde, Leo van, *Jordaens*, Brussels and New York, 1953.
d'Hulst, R. A., *De tekeningen van Jordaens* (cat), Brussels, 1956.
Jaffé, Michael, *Jordaens* (cat), Ottawa, 1968.
d'Hulst, R. A., *Jordaens Drawings*, Brussels, London, and New York, 4 vols., 1974.
Rubens und Jordaens: Handzeichnungen aus öffentlichen belgischen Sammlungen (cat), Dusseldorf, 1979.
d'Hulst, R. A., *Jordaens*, Ithaca, New York, and London, 1982.
Tijs, Rutger, J., *Ruben en Jordaens: Barok in eigen huis*, Antwerp, 1984.

articles—

Held, Julius S., "Notes on Jordaens, " in *Oud-Holland* (The Hague), 80, 1965.
Nelson, Kristi, "Jordaens' Drawings for Tapestry," in *Master Drawings* (New York), Summer 1985–86.

*

Jordaens's life is the archetype of the Flemish bourgeoisie during the 17th century. An agreeable man who made a good living as an artist, he spent nearly all of his 85 years in Antwerp, traveling only to Brussels and the northern provinces on specific occasions. In 1616 he married Catharina van Noort, the daughter of his teacher Adam van Noort, an event probably commemorated in the family portrait in Kassel. They had three children: Elizabeth, Jacob, Jr., and Anna Catharina. A steady flow of commissions, real estate holdings, and inheritances allowed Jordaens to live comfortably in a fashionable house on the Hoogstraat in the neighborhood in which he had been raised. The vitality with which he painted numerous allegories of fertility reflect his cheerful and exuberant approach to art and his life-affirming temperament.

Throughout his life he remained closely tied to his northern heritage, painting what he saw in the world around him with honesty, directness, and good humor. Although he never visited Italy, his art reflects knowledge of the work of Titian, Veronese, Bassano, Caravaggio, and Elsheimer. The earliest portraits, mythologies, and religious works exhibit strong ties with Flemish mannerist traditions and a palette characterized by pink, blue, yellow, and violet tones applied in a loose and spotty manner. Pictures illustrating the fable of the satyr and peasant demonstrate his strong debt to Caravaggism in their rich, earthy tones, chiaroscuro effects, and the reflected glow of artificial light.

Rubens exerted a strong influence on Jordaens's style and subject matter, especially in the adaptation of compositional ideas, poses of figures, and quality of execution. He remained, however, independent in the use of light, bold color, an undulating rhythm of line, and love of grandiose effects. He was more crudely provincial than Rubens in his celebration of the Flemish taste for good cheer. He assisted Rubens in the preparation of the decorations for the triumphal entry of the Archduke Ferdinand into Antwerp in 1635 and for the many paintings sent to Philip IV in Spain during the 1630's.

By the late 1620's Jordaens had developed a fully Baroque style where various groups of figures are well integrated in an intelligible space, frequently defined by monumental architecture. Glances and gestures of participants are well-studied and placed so as to lead the viewer's eyes to the key moment, building to a well-held tension. In the large religious and mythological paintings, he preferred to mass figures together to achieve a balance among design, richness, and expression. Saturated colors are applied with a variety of brush strokes. His work in the 1640's becomes more classical; and a noticeable decline in quality is evident in much of his production in the 1660's.

Jordaens is best remembered as the painter of Flemish celebrations and customs, especially for his numerous depictions of *The King Drinks* and *As the Old Sing, So Pipe the Young*. His fondness for filling pictures with healthy, robust figures is

Birds of a Feather Flock Together; drawing; Copenhagen, Statens Museum for Kunst

evident in the crowds of market folk aboard the Antwerp ferry or in a rollicking Twelfth Night feast. These paintings are for the most part evocations of peasant and middle-class life, executed with balanced measures of sympathy and spirited energy. His penchant for illustrating Flemish proverbs reveals a literary and didactic inclination in his work.

Jordaens received numerous commissions to decorate palaces and churches from Flanders, England, Spain, Sweden, and the northern provinces. Already in the 1620's he had several pupils. By the 1630's the studio was fully established and had assumed a significant role in the completion of his many and varied projects.

Religious paintings occupy a significant position in his *oeuvre*. Although born of Catholic parents, Jordaens's wife's family was Protestant, and from about 1650 he belonged to the Reformed Church. Many of paintings at this time focus on parables, moralizing, and preaching, although he still continued to paint for Catholic patrons. When he died in Antwerp on 18 October 1678, with his daughter Elizabeth, of the "Antwerp plague," he was buried in the Protestant cemetery at Putte which today overlaps the Belgian-Dutch border.

In addition to his tremendous output as a painter and draftsman, he created numerous designs for tapestry c. 1630–70. At least seven cycles have been traced, and his work in this area may have been even more extensive due to the existence of cartoons for untraced pieces in his estate when he died. What is even more remarkable is that the quality remained high throughout these years, with the exception of some of the very late designs. His work for the tapestry industry includes some of his most sophisticated and innovative inventions in any medium.

High in his lifetime, Jordaens's reputation throughout history vacillated. He is often overshadowed by the two other great Flemish painters of the 17th century, Rubens and Van Dyck, as he could never compete with the former's bravura technique and intellectual acumen nor the latter's artistic elegance. It should be noted, however, that following the death of Rubens in 1640 and Van Dyck in 1641, Sir Balthasar Gerbier, an English agent residing in Brussels, considered Jordaens to be the major painter in Antwerp. Sandrart, who was personally acquainted with Jordaens, wrote that in his 78th year (1671) the artist was hale, well-to-do, and held in high esteem. A few years earlier, in 1665, the Guild of St. Luke presented him with a chased silver ewer in appreciation for three paintings he had donated to the Schilderskamer of the Antwerp Academy in the Exchange Building. The gift was accompanied with verses that show the respect he commanded in his native city and in the eyes of fellow painters.

—Kristi Nelson

JORN, Asger.
Born Asger Oluf Jørgensen in Vejrum, Denmark, 3 March 1914; used name Jorn from 1945. Died in Aarhus, 1 May 1973. Married 1) Kirsten Lyngborg, 1939; 2) Matie van Domselaer, 1951; 3) Nanna Enzenberger, 1973. Studied with Martin Kaaland-Jørgensen, 1930, at Silkeborg Teachers Training College, 1930–35, under the painter Fernand Léger, Paris, 1936–37, and at Art Academy, Copenhagen, 1938–40; co-

founder, *Helhesten* magazine, Copenhagen, 1941–44; worked on tapestries with Pierre Vermaere, 1947; co-founder, with Karel Appel and others, Cobra group, 1948–51; lived in Albissola, Italy, working on large-scale ceramics, 1954–55; then lived in Paris, 1955–72.

Major Collection: Silkeborg.
Other Collections: Aarhus; Amsterdam: Stedelijk; Boston; Brussels; Buffalo; Cincinnati; Copenhagen; Goteborg; The Hague; Humlebaek, Denmark; Munich; New York: Moma; Oslo; Pittsburgh; Stockholm: Moderna Museet.

Publications

By JORN: books—

Jadefløjten: Nogle kinesiske digte [The Jade Flute: Some Chinese Poems], Copenhagen, 1943.
Held og Hasard: Dolk og guitar [Fortune and Chance: Dagger and Guitar], Silkeborg, 1952, Copenhagen, 1963.
Fin de Copenhague, Copenhagen, 1957.
Guldhorn og Lykkehjul/Les Cornes d'or et la rue de la fortune, Copenhagen, 1957.
Pour la forme, Paris, 1958.
Mémoires, with Guy Ernest Debord, Copenhagen, 1959.
Critique de la politique économique, Paris, 1960.
Le Chevelure de choses, with Christian Dotremont, Paris, 1961.
Naturens orden [The Order of Nature], Aarhus, 1962.
Vaerdi og økonomi [Value and Economy], Copenhagen, 1962.
Signes gravés sur les églises de l'Eure et du Calvados, Copenhagen, 1964.
Ting og polis, Copenhagen, 1964
Arsberetning fra instituttet for sammenlignende vandalisme [Annual Report of the Institute for Comparative Vandalism], Silkeborg, 1965.
Gedanken eines Künstlers, Munich, 1966.
Une Fille dans le feu, with Guenia Richez, Paris, 1966.
La Langue verte et la cuite, with Noël Arnaud, Paris, 1968.
Tegn og underlige gjerninger [Signs and Wonders], Copenhagen, 1970.
Magi og skønne kunstler [Magis and the Fine Arts], Copenhagen, 1971.
Indfall of udfall [Cut and Thrust], Copenhagen, 1972.

Editor, *Nordens teoretiske aestetik fra Julius Lange til Yrvjö Hirn* [Scandinavian Theories of Aesthetics from Lange to Hirn], Copenhagen, 1967.

illustrator: *Pigen i Ilden*, by Genia Katz Rajchmann, 1938; *Salvi Dylvo*, 1945, *Leve Livet*, 1948, and *Stavrim, Sonetter*, 1960, all by Jørgen Nash; *Friedhof der Maulwürfe*, by C. Caspari, 1959; *Skanes stenskulptur*, by Erik Cinthio, 1965.

On JORN: books—

Atkins, Guy, *Jorn's Aarhus Mural*, Westerham, Kent, 1964.
Atkins, Guy, *Jorn*, London, 1964.

Atkins, Guy, and Virtus Schade, *A Bibliography of Jorn's Writings to 1963*, Copenhagen, 1964.
Atkins, Guy, and Hans Kjaerholm, *Jorn: Malerier/Paintings* (cat), Silkeborg, 1964.
Schade, Virtus, *Jorn* [in English], Copenhagen, 1965.
Atkins, Guy, *Jorn in Scandinavia 1930–1953 [The Crucial Years 1954–1964; The Final Years 1954–1964]: A Study of Jorn's Artistic Development . . . and a Catalogue of His Oil Paintings*, London, 3 vols., 1968–80.
Gribaudo, Ezio, *Jorn: Cuba*, Turin, 1970.
Lambert, Jean Clarence, *Jorn: Calui Qui*, Paris, 1972.
Schmied, Wieland, *Jorn* (cat), St. Gallen, 1973.
De Michele, Mario, *Jorn scultore*, Milan, 1973.
Jorn: A Catalogue of Works in the Silkeborg Kunstmuseum, Silkeborg, 1974.
Gribaudo, Ezio, *Le Jardin d'Albisola*, Turin, 1974.
Weihrauch, Jürgen, editor, *Jorn: Werkverzeichnis Druckgrafik*, Munich, 1976.
Andersen, Troels, *Jorn* (cat), New York, 1982.
Andersen, Troels, *Jorn's samlinger* (cat), Silkeborg, 1982.
Lambert, Jean-Clarence, *Cobra*, Paris, London, and Totowa, New Jersey, 1983.

*

Characteristic of the best in Scandinavian creativity is its persistent tendency to depict a deep brooding rooted in an awareness of the negative forces at work within and without. Expressed already in the Viking Age in torturously twisting reptilian forms it is present also in the Christian Middle Ages in agonized human gestures carved and painted in religious imagery. In more recent times this spirit contribute to the glacial chill emanating from Ibsen's plays; it is the essence of the all-consuming angst crying out from Munch's fin-de-siècle paintings and is part of the plaintive undercurrent sometimes throbbing to the surface in Sibelius's tone poems. In this uninterrupted sequence of creative pessimism the principal 20th-century exponent is Asger Jorn.

Born to schoolmaster parents in the village of Vejrum, north central Jutland, in 1914, Asger Oluf Jørgensen moved with his widowed mother and brothers and sisters to nearby Silkeborg in 1929, remaining there until 1936, taking painting lessons from a local artist, Martin Kaaland-Jørgensen, and finishing his teacher training.

In 1936, seeking a creative atmosphere unhampered by the oppressive parochialism of his local environment, he went to Paris and became a student of Fernand Léger, who paved his way into the avant-garde world of the French capital, allowing him to assist with large-scale decorations for the 1937 World's Fair and introducing him to Le Corbusier, whose Functionalist architecture did not appeal to the much more emotionally oriented Dane.

He returned to Denmark in time for an international exhibit in Copenhagen in 1937 entitled *Linien* (The Line), which juxtaposed works by Kandinsky, Mondrian, Klee, Arp, and others with a selection of works by leading Danish progressives: Richard Mortensen, Ejler Bille, Carl-Henning Pedersen, Egill Jacobsen, and, as a newcomer, Asger Oluf Jørgensen. Already the following year, while a student at Copenhagen Art Academy, he presented a one-man show with prints and paintings reflecting influences from Kandinsky, Léger, and Arp.

War and occupation followed, and in those years, 1940–45, he remained in Denmark, painting and writing. From this period dates *Helhesten* (The Hell Horse, a Norse mythological concept), a cultural magazine of which he was the co-founder and where his essays and other literary efforts were first published. In the same years, while engaged in painting and psychological experiments related to imagery, he also produced a series of etchings, later published under the title *Occupations: 1939–1945*.

In 1945, perhaps to emphasize his international rather than local aspirations, he denationalized his name by contracting it into the more generic Jorn. Then, after years of minimal contact with the greater art world he began to travel, first to Swedish Lappland to experience and depict the primal quality of its landscape and culture, then to Tunisia for an extended stay, on to Normandy, and to Paris, where he exhibited for the first time in 1948. In the same year, with the poet Christian Dotremont and fellow artists, among them Appel, Constant, and Corneille, he founded COBRA—an acronym for Copenhagen, Brussels, Amsterdam—a select group deriving from, yet in opposition to, the Surrealists whose doctrinaire adherents they found too calculating, too structured, not sufficiently devoted to the joy of the act of painting. "The principal error in the aesthetic program of Surrealism is that it is too literary," Jorn wrote. "Painters have experimented with visions, images, dreams, but not with painting, not with colour."

The group's aim, to restore spontaneity to the arts and to stress the primacy of expressive freedom, was spelled out in a series of articles in *Petit Cobra*, a publication edited by Jorn whose pivotal role is everywhere evident, in the polemics, in their bold exhibits, in the vitality of his own works, and ultimately in the group's sudden demise when Jorn, seriously ill with tuberculosis, returned to Denmark.

Following an initially uncertain then painfully slow recovery, during which he had been able to complete his first important book, *Held og Hasard: Dolk og guitar*, he plunged into the most intense creativity, working simultaneously at painting, engraving, and ceramics. His major accomplishment was a decorative scheme for Silkeborg Public Library (1951–52) consisting of panels and supporting sketches, its centerpiece entitled *On the Silent Myth*. Here symbolic and mythical elements blend together in a free flow of colour and form with abstraction yielding to vaguely identifiable figural elements. In its cyclical form the work owes something to Munch's *Frieze of Life*, which Jorn had seen in a Copenhagen exhibit in 1945. Also, his broad, sweeping curvilinear brush strokes seem munchian, reminiscent of the Norwegian's Oslo Fjord landscapes with their softly undulant shorelines and ponderous trees. Figures and facial features, on the other hand, while

vaguely recalling Munch, are of a much more violent nature, reflecting not only a subjective inner agony but alluding to a potential external chaos.

In 1953, determined to play an active role on the international art scene, Jorn left Denmark, settling first in Switzerland, then in Albissola on the Ligurian Riviera, a ceramics center, and finally, in 1956, establishing himself in Paris where, with paintings such as *Letter to My Son* (1956–57) and *Stalingrad* (1956–59), he won recognition as a leading artist of the day and had his works shown in major galleries and museums throughout Europe and ultimately also in the United States. While cultivating art as an instinctive process whose finished product seems to evolve from random lines and blotches, his instincts are rooted in an innate sense of pictorial order resulting in images which, in spite of their floating uncertainties, appear tightly, deliberately controlled.

A unique achievement from the late 1950's is Jorn's colossal ceramic wall created for the secondary school in Aarhus, the capital city of Jutland. Produced at the Mazzotti factory in Albissola and shipped piecemeal to Denmark, it is an eighty-foot-long gleaming revelation in brilliantly luminous colours conjured forth by one man's creative ingenuity and nature's capricious ways: the artist planning, shaping, colouring, and the hot kiln adding its share by altering, blending, and bonding. Viewed in its northern latitude this extravaganza appears exuberantly exotic. "If Jorn was once a Nordic artist, " Guy Atkins observes, "he has meanwhile taken a swim in the Ligurian Sea." And yet his inherent creative pessimism is still there, only camouflaged by the very richness of the display: a man and a woman, scarred members of suffering humanity, gaze at the surging multitude of creatures inhabiting the primal sea. These panels, in a deliberate departure from earlier abstract and semi-abstract works, present uncompromisingly figural images. Yet they are so richly varied and skillfully interwoven that they do not impose their individuality on the overall decorative pattern of the fabric.

In subsequent works such ambivalences continue: the figural emerging from the apparently arbitrary and abstract. Gradually, however, his pictorial emphasis becomes more oriented toward color and undulant lines as in *The Living Souls* (1963), *The Wind Bears Us Away* (1970), and *Written in Sand: Alpona* (1971), mystic titles inviting the viewer into the artist's private world of pain and pleasure.

In his last years he worked in sculpture as well, carving marble in Carrara and creating bronze figures in his Paris studio. In 1973, terminally ill with cancer, he returned to Denmark and died in Aarhus on May 1 that year.

—Reidar Dittmann

K

KALF, Willem.

Born in Rotterdam, baptized 3 November 1619. Died in Amsterdam, 31 July 1693. Married Cornelia Pluvier, 1651. Probably a student of Francois Rijckhals in Middleburg; in Paris, 1642–46; settled in Amsterdam, 1651: specialized in ornate still lifes; stopped painting c. 1680, but remained active as art dealer.

Major Collections: Berlin; Le Mans.
Other Collections: Amsterdam; Chicago; Cincinnati, Cologne; Copenhagen; Detroit; Glasgow; The Hague; Heino: Het Nijenhuis; Indianapolis; Karlsruhe; Leningrad; Malibu; Melbourne; New York; Paris; St. Louis; Schwerin; Vienna; Washington.

Publications

On KALF: books—

Gelder, H. F. van, *W. C. Heda, A. van Beyeren, Kalf*, Amsterdam, 1941.
Grisebach, Lucius, *Kalf*, Berlin, 1974.

*

Willem Kalf was the most respected still-life painter of his generation. His distilled images, with their fine control of composition, brushwork, light, and colour, commanded such a following that his commercial success almost belied the low esteem in which still life, as a subject, was held among Dutch critics and connoisseurs.

Kalf's work achieves a formidable technical combination of high finish leavened by an occasional broad touch. His compositions combine elements of the banquet still life, which revolved around fruit, and the *pronk*, which centered on precious objects such as wrought silver and gold, Venetian-style glass and Chinese porcelain. Yet Kalf understates rather than elaborates, thereby imbuing his compositions with a sense of mystery. While never descending to the explicitly didactic, there is an unmistakable aura of *vanitas* about his work.

Kalf painted some early genre pictures, probably during his time in Paris. These are peasant kitchens, store interiors, and outdoor scenes which display a fresh, spontaneous technique. The paint is thin, and the sketchy brushwork allows Kalf to

concentrate his attention on the interplay of light and shade, in which he became so expert in his mature work.

His Paris years are more clearly represented by large, elaborate, *pronk* still lifes in which the focus is on a profusion of objects. There is no food in these compositions. They are derived from the distinctive oeuvre of his probably teacher, Francois Rijckhals whose work emphasized precious metals. In considering Kalf's attraction to such subjects, one should note that, as the son of a wealthy cloth merchant who wielded some municipal power in Rotterdam, he probably grew up among precious metals and decorative art objects.

In Paris, Kalf lived in St. Germain des Prés, the quarter preferred by Flemish artists. The large, elaborte compositions he made there generated some following in France, but not in the Netherlands. Kalf's repertory of objects was actually quite small, and there is considerable repetition from painting to painting. Occasionally he painted objects from sketchbooks, as did flower painters. His technique was precocious. Among disrupted, overturned golden and silver vessels, highly chased and decorated, he liked to include antique objects for the further opportunity they afforded him to render intricate surfaces complicated by wear and cracks. These richly varied surfaces were contrasted with the smooth, bright white of a rumpled napkin, as in the painting of 1643 in Cologne. Kalf also experimented with devices for emphasizing depth, such as the inclusion of a foreground area, which also permitted greater variety in the heights of objects.

Between Kalf's return to the Netherlands in 1646 and his marriage in 1651, there is no documentary trace of him and no dated paintings. Following his subsequent removal to Amsterdam, however, came his most productive and innovative decade. Amsterdam was not a centre of still life before 1650, that role being filled by Haarlem and Leiden. It became, however, a centre of *pronk* still life—an appropriate role for the richest city in Europe and the biggest money market in the world. Kalf's wife, Cornelia Pluvier, was herself a craftswoman—a calligrapher and diamond engraver—and a poet. The couple embarked on an illustrious phase in Amsterdam, and were separately honoured in poems by Contantijn Huyghens and Jan Vos.

The high point in Kalf's career was the period 1658–63, distinguished by its refinement of composition and technique. Objects are fewer, their disposition more tranquil. Nothing is overturned or billowing. Only the tilt of a china bowl hints at disruption, and even that is rather a device for displaying the contents. Objects emerge from a dark background in a manner reminiscent of Rembrandt. Like Rembrandt, and some of the

Still Life, 1663; 23¾ × 19¾ in (60.4 × 50.2 cm); Cleveland, Museum of Art, Leonard C. Hanna, Jr. Fund

genre painters working for the Amsterdam market, Kalf was responding to a mid-century counter-baroque tendency: a desire for more peaceful, classical subject matter.

Again, he limited himself to a few, oft-repeated objects disposed in a general formula, their stillness relieved by a rumpled table cover—the only disruptive note. A mingling of glass, precious metal, and china is punctuated by fruit, with rug, pocket watch, and fruit knife as garnishes for the more central objects. Kalf continued to choose objects for their surface potential, preferring the curved, ambiguous silver designs of the Vianen brothers or Jan Lutma. Similarly he painted lemons not whole, but with a spiral of peel curling down, contrasting the porous outer skin with the white pith and translucent flesh. Later he took this further, placing the lemon inside a glass of wine—translucence within translucence within translucence—the peel suspended over the edge. This virtuoso performance became, above all, the hallmark of his technique.

That technique was indeed remarkable. The captivating mystique of Kalf's pictures is achieved through absolute control of light and colour. In addition he uses a careful compositional formula, whereby unstressed diagonals render depth, stabilized by verticals such as a tall flute glass. Kalf's colour system revolves around juxtapositions of warm tones with cool contrasts. Both are enhanced by the dark, neutral background which allows the warm tones to dominate, the cool to illumine. The objects themselves, particularly metal, glass, liquid, and fruit flesh, emit light in subtly different ways, emphasized by the textured foil of a carpet or velvet covering.

The difference between many of Kalf's paintings resides only in small details of content and arrangement. This limited range served to increase both his technical command and the demand for his work. His signatory style evolved in response to a market whose demands he knew well through his dealing activities. This style, in turn, evolved its own market: not for still life as such, but for "a Kalf."

Finally, Kalf knew when to stop. He painted nothing after 1680, though continuing to deal in engravings and *objets d'art*. His work influenced a number of other still-life painters, notably Juriaen van Streek, Willem van Aelst, Barendt van der Meer, and Pieter van Roestraeten. His virtuosity and his ability to concentrate expression into a modest, unpretentious composition, allowed his reputation to endure. Gerard de Lairesse, writing in 1707, could not bring himself to acknowledge the artistic value of still life. But neither could he refrain from mentioning "the celebrated *Kalf*, who has left many, splendid and excellent examples of this, excelled herein, and deserves the highest praise above all others."

—Lindsey Bridget Shaw

KANDINSKY, Wassily.

Born in Moscow, 4 December 1866; naturalized German citizen, 1928; naturalized French citizen, 1939. Died in Neuilly-sur-Seine, 13 December 1944. Married Anja Chimiakin, 1892 (divorced, 1933); lived with his student Gabriele Münter, 1902-13; married 2) Nina Andreevskaya, 1917. Attended schools in Odessa; studied law and economics, Moscow University, 1886-92; studied painting at Anton Azbe's School of Art, Moscow, 1897-99, with Paul Klee, under Franz Stück at the Kunstakademie, Munich, 1900; involved in several art groups in Germany, including Phalanx group, Munich, 1902-04, Neue Kunstler Vereinigung, Munich, 1909, and, with Marc and Macke, Der Blaue Reiter group, Munich, 1911; lived in Russia again, 1914-20: Professor, Free State Art Studios, Moscow, 1918, and created Russian Academy of Artistic Sciences, 1921; settled in Berlin, 1921, then Deputy Director and Professor, Bauhaus, Weimar and Dessau, 1922-33; when the Nazies closed the Bauhaus, 1933, settled in Neuilly-sur-Seine, and died there.

Major Collections: Neuilly-sur-Seine: Kandinsky Collection; Munich: Städtische Galerie; New York: Guggenheim.
Other Collections: Chicago; Leningrad: Russian Museum; Moscow: Modern Western Art, Tretkykov; Rotterdam.

Publications

By KANDINSKY: books—

Stikhi bez slov, Moscow, 1904.
Xylographies, Paris, 1909.
Buhnenkomposition 3 (Schwarz und Weiss), Munich, 1911.
Uber der Geistige in der Kunst, Munich, 1912; as *The Art of Spiritual Harmony*, London, 1914; as *Concerning the Spiritual in Art*, edited by Michael Sadler, New York, 1972.
Der Blaue Reiter, with Franz Marc, Munich, 1912; edited by Klaus Lankheit, Munich, 1965; as *The Blaue Reiter Almanac*, New York and London, 1974.
Rückblicke, Berlin, 1913.
Klänge, Munich, 1913; as *Sounds*, edited by Elizabeth R. Napier, New Haven, 1981.
Tekst Khudozhnika, Moscow, 1918.
Institut khudozhestvennoi kultury v Moskve, Moscow, 1920.
Punkt und Linie zur Flache: Beitrag zur Analyse der Malerischen Elemente, Munich, 1926; as *Point and Line to Plane*, New York, 1947.
Essays über Kunst und Künstler, edited by Max Bill, Stuttgart, 1955.
Ecrits complets, Paris, 2 vols., 1970-75.
Complete Writings on Art, edited by Kenneth C. Lindsay and Peter Vergo, London, 2 vols., 1972; Boston, 2 vols., 1982.
Regards sur le passé et autres textes 1912-1922, edited by Jean Paul Bouillon, Paris, 1974.
Briefe, Bilder, und Dokumente einer aussergewöhnlichen Begegnung, with Arnold Schönberg, edited by Jelena Hahl-Koch, Salzburg, 1980; as *Letters, Pictures, and Documents*, London, 1984.
Die gesammelten Schriften, edited by Hans K. Roethel and Jelena Hahl-Koch, Berne, 1980—
Kandinsky, Franz Marc: Briefwechsel, edited by Klaus Lankheit, Munich, 1983.

On KANDINSKY: books—

Zehder, Hugo, *Kandinsky*, Dresden, 1920.
Grohmann, Will, *Kandinsky*, Leipzig, 1924.
Bill, Max, et al., *Kandinsky*, Paris and Boston, 1951.

Birds, 1907; woodcut

Lindsay, Kenneth C., *An Examination of the Fundamental Theories of Kandinsky,* Madison, Wisconsin, 1951.

Eichner, Johannes, *Kandinsky und Gabriele Münter: Von den Ursprüngen moderner Kunst,* Munich, 1957.

Grohmann, Will, *Kandinsky: Leben und Werk,* Cologne, 1958; as *Kandinsky: Life and Work,* New York, 1958.

Read, Herbert, *Kandinsky,* London, 1959.

Korn, Rudolf, *Kandinsky und die Theorie der abstrakten Malerei,* Berlin, 1960.

Geddo, Angelo, *Commento a Kandinsky,* Bergamo, 1960.

Brion, Marcel, *Kandinsky,* Paris, 1961.

Kandinsky: A Retrospective Exhibition (cat), New York, 1962.

Lassaigne, Jacques, *Kandinsky,* Geneva and Cleveland, 1964.

Haftmann, Werner, *Kandinsky,* Paris, 1965.

Overy, Paul, *Kandinsky: The Language of the Eye,* London and New York, 1969.

Cassou, Jean, *Kandinsky,* Cologne, 1970.

Ringbom, Sixten, *The Sounding Cosmos: A Study in the Spiritualism of Kandinsky and the Genesis of Abstract Painting,* Abo, 1970.

Roethel, Hans K., *Kandinsky: Das graphische Werk,* Cologne, 1970.

Bovi, Arturo, *Kandinsky,* London, 1971.

Hansfstaegnl, Erika, *Kandinsky: Zeichnungen und Aquarelle* (cat), Munich, 1974.

Roethel, Hans K., *The Graphic Work of Kandinsky* (cat), New York, 1974.

San Lorence, G. di, editor, *Hommage à Kandinsky,* Paris,

1974; as *Homage to Kandinsky,* New York, 1975.

Kandinsky, Nina, *Kandinsky und ich,* Munich, 1976.

Messer, Thomas M., et al., *Kandinsky* (cat), Munich, 1976.

Roethel, Hans K., and Jean K. Benjamin, *Kandinsky,* Paris, 1977, Oxford, 1979.

Derouet, Christian, et al., *Kandinsky: Trente peintures des musées sovietiques* (cat), Paris, 1979.

Hulten, Pontus, *Kandinsky* (cat), Paris, 1979.

Weiss, Peg, *Kandinsky in Munich: The Formative Jugendstil Years,* Princeton, 1979.

Lacoste, Michel Conil, *Kandinsky,* Naefels and New York, 1979.

Bowlt, John E., and Rose-Carol Washton Long, *The Life of Kandinsky in Russian Art: A Study of "On the Spiritual Life,"* Newtonville, Massachusetts, 1980.

Long, Rose-Carol Washton, *Kandinsky: The Development of an Abstract Style,* Oxford, 1980.

Tower, Beeke Sell, *Klee and Kandinsky in Munich and at the Bauhaus,* Ann Arbor, 1981.

Zweite, Armin, editor, *Kandinsky und München: Begegnung und Wandlungen 1896–1914* (cat), Munich, 1982.

Poling, Clark V., *Kandinsky-Unterricht am Bauhaus,* Weingarten, 1982; as *Kandinsky's Teaching to the Bauhaus: Color Theory and Analytical Drawing,* New York, 1987.

Roethel, Hans K., and Jean K. Benjamin, *Kandinsky: Werkverzeichnis der Olgemälde,* Munich, 2 vols., 1982–84; as *Kandinsky: Catalogue Raisonné of the Oil-Paintings,* London, 2 vols., 1982–84.

Riedl, Peter Anseln, *Kandinsky in Selbstzugnissen und Bilddokumenten,* Reinbek, 1983.

Kandinsky: Russian and Bauhaus Years 1915–1933 (cat), New York, 1983.

Barnett, Vivian E., *Kandinsky at the Guggenheim,* New York, 1983.

Derouet, Christian, and Jacqueline Chevalier, *Kandinsky* (cat), Paris, 1984.

Bozo, Dominique, *Kandinsky* (cat), Paris, 1984.

Fineberg, Jonathan David, *Kandinsky in Paris 1906–1907,* New York, 1984.

Naylor, Gillian, *The Bauhaus Reassessed: Sources and Design Theory,* London, 1985.

Vergo, Peter, *Kandinsky: Cossacks,* London, 1986.

Targat, Francois le, *Kandinsky,* New York, 1987.

Thürlemann, Felix, *Kandinsky: über Kandinsky: Der Künstler als Interpret eigener Werke,* Berne, 1986.

<div align="center">*</div>

The "discovery" of non-representational art was Kandinsky's greatest achievement and contribution to the development of modern art. He recognized, as did other artists of his time, that art had reached a crossroads in the first decade of the century, Kandinsky's genius was equal to the challenge, not only as a painter, but as a theoretician and a leader. His integrity and the strength of his personality never failed profoundly to influence the many artists who met him.

Before arriving in Munich, where he pursued his early career as an artist, Kandinsky's first 30 years were filled with the impressions of a youth in Moscow and a university education in law and political economics. Early paintings reveal the influence of his Russian heritage in their representation of fairy-tale images. Dream-like patterns on dark backgrounds recall the tradition of Byzantine art. While living and working with Gabriele Münter, also a painter, in the Bavarian Alps in Murnau, near Munich, he painted rich landscapes in deeply saturated colors. At this time, dark outlines began to define the forms and color becomes an agent of independent power. Kandinsky also worked in the folk art technique of *Hinterglasmalerei,* painting behind glass, adopting the tradition of flat, brilliant colors and a simple style for religious images.

In 1911 Kandinsky, with Franz Marc, organized an exhibit creating a loose association of modern artists that was to be one of the most fertile grounds for artistic interaction in the century. Calling the group the *Blaue Reiter,* they were international in character and broad based in spirit, yet it focused a moment when many artists needed a forum for their creative growth. Publication of the *Blaue Reiter Almanac* in 1912, with Kandinsky and Marc as editors, was the more permanent presentation of the artistic faith they felt in the mysterious living power of good art to speak with a voice that transcends the limits of time and space.

In *Concerning the Spiritual in Art,* published in 1912, Kandinsky declared his theoretical stance in which he placed the primary emphasis of art on content. Content was primarily feeling, and feeling from a spiritual source. His conception of creativity was based on the principle of "internal necessity" where "form is the external expression of inner meaning."

It was Kandinsky's strong sensitivity to the synaesthetic reverberations of color and sound which ultimately led him to non-representational painting. He believed art, through the orchestration of color and form, had a power comparable to that of music. He believed art could lead to a mystical and religious culmination. Ultimately he saw all the arts as resulting in an experience of a great haronious whole. The *Yellow Sound,* though never performed during Kandinsky's lifetime, combined a revolutionary stage composition, art, dance, music, abstract color and sound. It was based on Kandinsky's conviction that modern art should move toward a grand synthesis, an all-encompassing, new *Gesamtkunstwerk.*

The influence of Theosophy was crucial for Kandinsky, especially as espoused by Rudolf Steiner, whose anthroposophical lectures were an influential component of the intellectual life of Munich. Kandinsky also found verification for his commitment to expressing a realm beyond the visible and material in modern scientific thinking.

Realism was for Kandinsky an art of the past. The new art would allow the viewer a more profound experience. It would lead the viewer to experience the "inner sound" of an object. In, for example, many of the paintings titled *Improvisation* and *Composition,* especially after 1910, veiled images gradually reveal hidden imagery. Only on close examination are abstracted forms identified as objects. First seen as combinations of color and shape, the forms instigate inner vibrations. By developing a new conception of space Kandinsky hoped his paintings would recreate a feeling of cosmic space. Color, form, and internal harmony would work on the viewer physically and psychologically, and ultimately speak more directly to the soul. Kandinsky was searching for a revelation reflective of an ideal world.

"Painting is like a thundering collision of different worlds, that are destined in and through conflict to create that new world called the work. Technically every work of art comes

into being in the same way as the cosmos—by means of catastrophes, which ultimately create out of the cacophony of the various instruments, that symphony we call the music of the spheres. The creation of the work of art is the creation of the world" (*Reminiscences*).

After the First World War Kandinsky was again a prominent participant in another group which advanced the notion of the positive power of art to transform society. The Bauhaus continued the spirit of cultural renewal. Walter Gropius formed an educational environment dedicated to cultivate a new student, trained in the ideas and ideals which would lead to more integrated needs of a technological society. Kandinsky was called upon as *Formmeister* for the painting class (1922–33). In *Point and Line to Plane*, (1926) the basic elements of design, Kandinsky's artistic principles of composition, were analysed and clarified.

During the Bauhaus years, Kandinsky's style grew more geometric, cooler, and yet never lost touch with the deeply spiritual sources which were present in the earlier abstract work. At this time he used the term "concrete art," preferring it to the word *abstract*. In his print series *Small Worlds (Kleine Welten)*, one can best see his micro-macrocosmic visions that lift the viewer beyond time and space. At the Bauhaus Kandinsky's friendship with Paul Klee developed into what must be counted as one of the great cooperative relationships in modern art. Two great minds, however different, worked parallel and their interaction contributed to a period of great creative growth for each.

In Paris (1933–44) Kandinsky developed a style which emphasized biomorphic forms. Works of this period are often compared with those of Juan Miro or Jean Arp. Though there are many fine works, one senses overall a waning of the vitality of Kandinsky's early development, though his belief in the messianic power of art never wavered. He continued to have faith in the artist's power to equal the immense task of elevating the world to the realm of the divine. In the midst of economic and political turmoil, he saw himself as the leader of a spiritual revolution.

—Janice McCullagh

KAUFFMANN, (Maria Anna) Angelica.

Born in Chur, 30 October 1741; daughter of the painer Johann Josef Kauffmann. Died in Rome, 5 November 1807. Married 1) Count de Horn, 1767 (died); 2) the painter Antonio Zucchi, 1781 (died, 1795). Child prodigy as both musician and painter: famous at age 11, and "toured" by her father throughout Europe; in Milan, 1754; lived in London from 1766: friend of Reynolds, and patronized by the Royal Family; founder-member of the Royal Academy, 1768, and exhibited regularly to 1782; decorated the Council Room ceiling of Royal Academy, Somerset House, and worked with the Adam brothers on decorative schemes; settled in Rome, 1782, and became center of a famous circle.

Collections: Aschaffenburg; Attingham; Berlin; Bregenz; Budapest, Dresden; Edinburgh; Florence; Innsbruck; Leningrad; London: Royal Academy, Courtauld, Kenwood, Portrait Gallery; Manchester: University; Munich: Neue Pinakothek; New Haven; New York; Providence, Rhode Island School of Design; Richmond, Virginia; Rome; Saltram; Stourhead; Stuttgart; Vienna; Weimar; Zurich.

Publications

On KAUFFMAN: books—

Gerard, Frances, *Kauffmann*, London, 1892.

Manners, Victoria, and George C. Williamson, *Kauffmann*, London, 1924.

Hartcup, Adeline, *Kauffmann*, London, 1954.

Kauffmann (cat), London, 1955.

Thurnher, Eugen, *Kauffmann und die deutschen Dichtung*, Bregenz, 1966.

Sandner, Oscar, *Kauffmann und ihre Zeitgenossen* (cat), Bregenz, 1968.

Helbok, Claudia, *Miss Angel: Kauffmann: Eine Biographie*, Vienna, 1968.

Schmidt; Dörrenberg, Irmgard, *Kauffmann, Goethes Freudin in Rom*, Vienna, 1968.

Mayer, Dorothy Moulton, *Kauffmann*, Gerrards Cross, 1972.

Kauffmann und ihre Zeit: Graphik und Zeichnungen von 1760–1810 (cat), Dusseldorf, 1979.

*

Angelica Kauffmann was one of the most successful women artists, both critically and financially, in the history of art. Her paintings of mythology and ancient history exemplify Neoclassicism in subject as well as style, and she was eagerly sought as a portraitist by clients all over Europe.

Her father, who provided her earliest training, took Kauffmann to Italy at an early age to study from the works of the great masters. In Milan, Florence, Rome, and Naples, she copied old masters, painted portraits, and soon established her reputation as a talented painter and musician as well as an intelligent, charming young woman. She made friends easily among the aristocracy, her fellow artists, and the literati, among whom were Johann Winckelmann, Benjamin West, and Nathaniel Dance. In 1766 she traveled to England where she met Joshua Reynolds who became a close friend and strong supporter of her talents. He helped to launch her career through introductions to potential patrons. She became a founding member of the Royal Academy in 1768 as one of only two women artists (the other was Mary Moser), and she continued to show her work regularly at the annual exhibitions. Some of her well-known subjects of this period were *Cleopatra Adorning the Tomb of Marc Antony* (1770), *Andromache and Hecuba Weeping over the Ashes of Hector* (1772), *Telemachus at the Court of Sparta* (1773), *Sappho* (1775), *Lady Elizabeth Grey* (1776), and *Leonardo da Vinci Expiring in the Arms of Francis I* (1778). Her works received some criticism for lack of strength, especially the portrayal of male figures—a particular difficulty for a woman artist unable to study from nude male models—but on the whole she was greatly admired and had numerous patrons.

Kauffmann participated with Reynolds, Benjamin West,

James Barry, and Nathaniel Dance in the aborted plan to paint the interior of the dome of St. Paul's Cathedral in London in 1775. In 1779 she received the important commission to paint allegorical images of *Design, Color, Invention,* and *Composition* for the ceiling of the Council Chamber of the Royal Academy of Art at Old Somerset House.

Kauffmann is most important for bringing grand-style history painting into England at a time when paintings of history, religion, allegory, or myth were unappreciated by the royal family, aristocratic patrons, and the wider public. Reynolds recognized that Kauffmann with her Continental training and experience might help to create a taste for history-painting in Britain. She and Benjamin West exhibited the first classical subjects at the Royal Academy in 1769 (*Penelope with the Bow of Ulysses, Hector Taking Leave of Andromache, Aeneas Meeting Venus, Achilles Discovered by Ulysses,* all at Saltram), and Kauffmann was the first to show subjects from British medieval history at the Royal Academy in 1770 (*Vortigern, King of the Britons, Enamoured with Rowena,* Saltram) and 1771 (*Interview of King Edgar with Elfrida,* Saltram). During her stay in England she continued to produce portraits, and she collaborated with Robert Adam on several decorative plans. Many of her works became widely popular through engravings, and she also made original engravings of her own composition.

In 1781 Kauffmann's father, who had been her protector and advisor, was nearing death, so he arranged for her to marry Antonio Zucchi, an Italian painter. The couple returned to Italy, where Zucchi assisted with Kauffmann's flourishing career and kept a memorandum of her paintings until his own death in 1795. Kauffmann was then at the height of her reputation, and became the center of the lively international art community which continued to thrive in Rome despite the political and social upheavals throughout Europe. She made several trips to Naples where she was a favorite of King Ferdinand IV's family, whose portrait she painted in 1784 (Vaduz). Queen Maria Carolina asked her to become court painter, a position Kauffmann refused, although she did tutor the princesses in drawing. She was also privileged to be one of the few artists allowed to view the excavations at Herculaneum and Pompeii. The influence of Roman frescoes and reliefs can be seen in her figure paintings of the 1780's (for example, *Cornelia, Mother of the Gracchi,* Richmond, Virginia; *Pliny the Younger at the Eruption of Vesuvius,* Princeton) which are the most severely classical of her works. Her later paintings of the 1790's appear somewhat softer, more romantic, and delicately colored (*Praxiteles and Phryne,* 1794, Providence, Rhode Island).

Other important patrons were Count Poniatowski of Poland, Catherine of Russia, Prince Youssoupoff, Emperor Franz Joseph, and several in England, especially George Bowles, who acquired over 50 paintings. Kauffmann is also well-known as a friend and correspondent of the German poets Goethe, Herder, and Klopstock.

Kauffmann's earliest biographer, her friend Giovanni Gherardo De Rossi, characterized her as both learned and inspired. According to his view, Kauffmann along with her contemporary Pompeo Batoni, deserved credit for helping to bring the "declining" art of painting back to its former glory, and he praised her work for its elegance, fluidity, and intelligence. Many later critics, while appreciative of Kauffmann's "prettified" or "feminine" style, tended to justify her fame and success by the fact that she was an attractive female. More recent studies, including several from feminist perspectives, have broadened our understanding by examining Kauffmann and her work within the larger framework of late 18th-century history, art theory, and the development of Neoclassicism.

—Wendy Wassyng Roworth

KIENHOLZ, Edward.

Born in Fairfield, Washington, 1927. Married Nancy Reddin (second wife); three children. Attended Washington State College, Pullman, Eastern Washington College of Education, Cheney, and Whitworth College, Spokane, 1945–52; independent artist in Los Angeles, 1956–73 (associated with Now Gallery and Ferus Gallery), Berlin, 1973–77, and since 1977 in Berlin and Hope, Idaho. Address: Hope Gallery, Hope, Idaho 83836, U.S.A.

Collections: Amsterdam: Stedelijk; Berlin; Humlebaek, Denmark; Los Angeles; New York: Whitney; Paris: Beaubourg; Stockholm: Moderna Museet; Stuttgart; Tokyo: Modern Art.

Publications

By KIENHOLZ: books—

Kienholz, with K.G.P. Hultén, New York, 1975.
The Art Show 1963-1977, Berlin, 1977.

On KIENHOLZ: books—

Tuchman, M., *Kienholz* (cat), Los Angeles, 1966.
Hopps, W., *Kienholz: Work from the 1960's* (cat), Washington, 1968.
Hultén, K.G.P., *Kienholz: 11 + 11 Tableaux* (cat), Stockholm, 1970.
Faye, Jean Pierre, *Kienholz Volksempfängers, Kienholz émetteur,* Paris, 1979.
Scott, David, *Kienholz: Tableaux 1961-1979* (cat), Dublin, 1981.
Weschler, Lawrence, et al., *Edward and Nancy Reddin Kienholz: Human Scale* (cat), San Franciso, 1984.

articles—

Weschler, Laurence, "The Subversive Art of Kienholz," in *Art News* (New York), September 1984.
Silberman, Robert, "Imitation of Life," in *Art in America* (Marion, Ohio), March 1986.

*

Kienholz's art constitutes not only an original synthesis of heterogeneous objects but also of techniques or lessons learned from some of the major movements in 20th-century art (Dadaism, Surrealism, Pop and Conceptual Art). For Kienholz,

every object, however trashy or banal, tells a story, and never more effectively than when juxtaposed with some other seemingly unconnected phenomenon. Sometimes his works, like those of Marcel Duchamp in the second and third decades of this century, consist of an economical confrontation of a couple of *objets trouvés*—as in *The End of the Bucket of Tar . . .* (1974; Collection J. Ehrnrood) based on an old metal bath discovered in a Cologne scrapyard. But in his best-known and most characteristic creations, objects proliferate and arrange themselves into whole scenes, interiors or shrines in which plaster casts of human bodies (whole or in parts), bits of car, animal, or furniture, achieve a state of eerie coexistence. A good example of the latter is *The Middle Islands* (1972; Louisiana Museum, Humlebaek, Denmark) an installation in which, between a series of blank "frames" formed by chromium-plated roof-racks screwed to walls and floor, a couple of half-human, half-animal forms lie on beds among various more or less threatening objects.

The roots of Kienholz's technique in Dada and Surrealism are plainly visible, but not unproblematic. Although his cult of the found object and the apparently anti-art stance of much of his work clearly relate to the Dadaists of the 1920's, Kienholz's constant concern with *meaning*—historical, sociological, sexual—distinguishes his works from the nonchalantly baffling constructs that were the speciality of Duchamp and his immediate followers. Kienholz's debts to Surrealism have been deeper and longer lasting. Of course, the art of the *trouvaille*, the juxtaposition of images and objects not normally associated, the mixing of media and genre, the techniques of *collage*, so much associated with Surrealism, have all long been absorbed into the common stock of Western artistic tradition and have been widely drawn on by many artists. What makes Kienholz's work *surrealist*, then, is its ability to *mobilize* images and objects. Like Salvador Dali, Kienholz is able to make hallucination emerge from a perfectly true-to-life decor, and in a tableau such as *The Middle Islands*, the growth of those monstrous heads from what appear to be human torsos is managed with the kind of controlled horror that was the speciality of Dali (in his early period) or the surrealist films of Buñuel.

Kienholz's relationship with the Pop Art of the 1960's is also worth exploring briefly. Although many of the tableaux of this period suggest the alienation of the consumer in a capitalist world (and these same works revel in the vulgarity of recent or contemporary cultural phenomena), Kienholz's creations, unlike those of Lichtenstein, Warhol, or Jasper Johns, consistently propose a *depth* of significance that it is part of the elegance and wit of the Warhols and Lichtensteins to withhold. Whereas, then, Warhol, in presenting his boxes of *Brillo* pads or tins of Campbell's soups will take care to preserve the maximum of their bland, supermarket triviality, Kienholz will take his objects—even those with commercial brand names—much more seriously. The beer bottles that litter the scene in *Back Seat Dodge '38* (1966; Institute of Contemporary Art, Washington), for example, have the brand name *Olympia* (the plain in the Peloponnese where the Olympic Games took place and where the statue of Hermes by Praxiteles was found) and thus, in an obscure way, invite comparison between the athletic prowess of the chicken-wire Hermes portrayed in the tableau and his classical antecedents of ancient Greece. Whereas, therefore, Pop artists, like their Dada forbears, are more interested in objects purely as objects, Kienholz is much more interested in them for the *stories* they can tell.

This interest in stories or concepts behind objects has remained a central feature of Kienholz's work. His most famous creations of the 1960's—the *Concept Tableaux* (including *The Back Seat Dodge '38*, just mentioned, and *The State Hospital*, 1966; Moderna Museet, Stockholm) were conceived and sold as *ideas* before being realized as art objects, and in the 1970's and 1980's his works, though still based on found objects and an experimental juxtaposition of all sorts of heterogeneous material, continue to propose a message. In the American works of the later 1960's, a recurrent theme was the Vietnam War. In the German works of the later 1970's (the artist and his wife and collaborator, Nancy Reddin Kienholz, have from 1973 divided their time between Berlin and Hope, Idaho), the themes of political propoganda and media distortion were brilliantly investigated in the *Volksempfängers* series (1977). The exploitation of woman is another subject to which Kienholz has frequently returned, from the early 1960's (as in *The Birthday*, 1964; Los Angeles County Museum of Art) through the 1970's (*The Queen of the Maybe Day Parade*, 1978; Louisiana Museum, Humlebaek, Denmark) to the 1980's (*The Rhinestone Beaver Peep Show*, 1980; Collection of the Artist). More recently, the theme of misinformation has reappeared, as in *In Memory of Birds* (exhibited in the L.A. Louver Gallery, Los Angeles, in 1986), which is an elegy to the birds which died in the radiation that followed the Chernobyl disaster.

It is perhaps this curiously persistent confrontation in the same work of a desire to communicate a specific message—of general historical, political, or sociological import—and a wish at the same time to provoke independent reverie—erotic or otherwise—which is the central problem posed by Kienholz's work and which separates it from the artistic movements with which it might otherwise find itself aligned. At its most successful (as in *The Middle Islands* or *The End of the Bucket of Tar*), these tensions disappear as the overpowering suggestiveness of the works takes over. At other times, the Kienholzian recipe can tend towards pastiche of itself. But viewed as a whole, Kienholz's work constitutes a remarkable synthesis of some important tendencies and developments in later 20th-century Western art and culture.

—David Scott

KIRCHNER, Ernst Ludwig.

Born in Aschaffenburg, 6 May 1880. Died in Davos, 15 June 1938. Lived with Erna Schilling from 1912. Attended schools in Chemnitz; studied at the School of Art, Munich, 1903–04, and architecture at the Technical High School, Dresden, 1904–05; then lived in Dresden: co-founder Die Brucke group, 1905–13, and worked on first lithographs, 1907, later developed his own printing techniques; lived in Berlin, 1911–15; nervous breakdown during military service, 1915, and recuperated in Switzerland; settled in Davos, 1918: co-founder, Red Blue Group, 1925–26; worked on mural for Folkwang Museum, Essen, 1934, but project cancelled by the Nazis.

Collections: Belfast; Bradford; Brussels; Canberra; Edin-

burgh; Essen; Hamburg; Lisbon: Gulbenkian; London: Tate; Melbourne; Otterlo; Purchase, New York: University; Rotterdam; Turin: Arte Moderna.

Publications

By KIRCHNER: books—

Briefe an Nele und Henry van de Velde, Munich, 1961.
Davoser Tagebuch, edited by Lothar Grisebach, Cologne, 1968.
Postkarten und Briefe an Erich Heckel in Altonaer Museum in Hamburg, Cologne, 1984.

Illustrator—*Das Stiftsfräulein und der Tod,* by Alfred Döblin, 1913; *Neben der Heerstrasse: Erzälungen,* by Jakob Bosshart, 1923; *Umbra vitae: Nachgelassene Gedichte,* by Georg Heym, 1924.

On KIRCHNER: books—

Schiefler, Gustav, *Die Graphik Kirchners,* Berlin, 2 vols., 1924–31.
Grohmann, Will, *Zeichnungen von Kirchner,* Dresden, 1925.
Grohmann, Will, *Das Werk Kirchners,* Munich, 1926.
Grohmann, Will, *Kirchner,* Stuttgart, 1958, New York, 1960.
Dube-Heynig, Anne Marie, *Kirchner: Das graphische Werk,* Munich, 1961, revised ed., 2 vols., 1980; as *Kirchner: His Graphic Art,* Greenwich, Connecticut, 1961.
Crispolti, Enrico, *Kirchner,* Milan, 1966.
Gordon, Donald E., *Kirchner,* Cambridge, Massachusetts, 1968.
Gordon, Donald E., *Kirchner* (cat), Boston, 1969.
Lenz, Christian, *Kirchner: Aquarelle, Zeichnungen, und ausgewählte Druckgraphik aus eigenem Besitz* (cat), Frankfurt, 1974.
Reidemeister, Leopold, editor, *Künstlergruppe Brücke: Fragment eines Stammbuches,* Berlin, 1975.
Kirchner: Die Handzeichnungen, Aquarelle, und Pastelle in Eigenem Besitz (cat), Berlin, 1978.
Gercken, Günther, and Uwe M. Schneede, *Kirchner: Zeichnungen und Druckgraphik 1905–1936* (cat), Hamburg, 1978.
Lenz, Christian, *Kirchner: Das Leben,* Berne, 1978.
Kirchner (cat), Basel, 1979.
Ketterer, Roman Norbert, and Wolfgang Henze, *Kirchner: Zeichnungen und Pastelle,* Stuttgart, 1979; as *Kirchner: Drawings and Pastels,* New York, 1982.
Kornfield, Eberhard W., *Kirchner: Nachzeichnung seines Lebens* (cat), Berne, 1979.
Grisebach, Lucius, and Annette Meyer zu Eissen, *Kirchner* (cat), Berlin, 1979.
Gercken, Günther, *Kirchner: Holzschnittzyklen: Peter Schlemihl: Triumph der Liebe, Absalom,* Stuttgart, 1980.
Hartmann, Hans, *Kirchner und seine Schüler* (cat), Chur, 1980.
Henze, Anton, *Kirchner: Leben und Werke,* Stuttgart, 1980.
Luckhardt, Ulrich, *Kirchner* (cat), Berlin, 1980.
Gabler, Karlheinz, *Kirchner: Zeichnungen, Pastelle, Aquarelle* (cat), Aschaffenburg, 1980.
Vogt, Paul, *Kirchner: Skizzenbuch aus der Graphische Sammlung des Museum Folkwang,* Freren, 1983.

*

Kirchner was the most brilliant artist of *Die Brücke,* a group of artists formed in 1905 in Dresden. His personal intensity and Bohemian character have helped to shape the meaning of the word Expressionism. His genius reflected his era most intently in the energy of his pre-war Berlin paintings. His versatility as an artist included paintings, drawings, prints, especially woodcuts, sculpture, including carved furniture, tapestry designs, and also writing. In each medium, he reflected his own deep and often turbulent emotional state and the precariousness of existence. Early in his career Kirchner declared his goal was to capture life and to create a picture out of the chaos of the age. He never turned to abstraction, but painted from his surroundings. He set out to be a master of a modern renewal of the greatness of German art.

The early paintings are flooded with bright colors influenced by Van Gogh and the Fauves, but Kirchner's style quickly evolved to a personal interpretation. Early paintings, such as *Recumbant Blue Nude with Straw Hat* (1908–09, Offenburg, F. Burda Collection), are raw and concentrated images. In this painting the subject of a contemporary relaxing nude strikes a dissonant chord with the aggressive brushwork and the brash color contrasts. Kirchner created disarming images with sensuous color and painterly surfaces.

At this time he developed a personal approach which in 1920 he termed "hieroglyphic." "Hieroglyphic," he wrote, "in the sense that it reduced the forms of nature to simple, surface forms to suggest their significance to the spectator. Emotion creates even more hieroglyphics which become separated from the mass of lines that seemed so random initially and become almost geometric characters." Images scratched in ink or crayon look deceptively simple and flat. In spite of their sparseness, they achieve powerful expressiveness.

In many of these works his subject was the bather. In the summers of 1909–11, Kirchner worked with others of the *Brücke* group in the area of the Moritzburg Lakes and later (1912–14) he worked in the summers on the Baltic island of Fehmarn. In these settings his drawings and paintings are calm and capture the ideal unity of man or woman in nature. Yet often an underlying awkwardness places them as modern nudes, slightly over-anxious, interlopers in the vibrant harmony of nature.

In Berlin, Kirchner's style reflected the frenzied environment. In the intensified atmosphere of the city, men and women were portrayed as physically constricted and psychologically isolated, caught up in the artificial intensity of the metropolis. Some of the finest works of his career were painted in Berlin, where the environment matched Kirchner's own introverted and agitated personality.

In 1915, Kirchner suffered a severe mental and physical breakdown in response to the tensions of the war. From this period of deep psychological despair came the wrenching self-portraits, *The Drinker* (1915, German National Museum, Nürnberg), and *Self-Portrait as a Soldier,* (1915, Allen Memorial Art Museum, Oberlin College, Ohio). Both reveal a man on the edge of mental instability. Three series of woodcuts, *Peter Schlemihl* (1915–16), *Absalom* (1918), and *The*

Karl Sternheim, 1916; engraving

Triumph of Love (1918), are inevitably seen as echoes of Kirchner's own inner conflict. *Schlemihl* is loosely based on Adalbert von Chamisso's story of the inner conflict of a man who sold his shadow to the devil. According to Kirchner, Schlemihl is "the life story of a paranoid." In these woodcuts, virtuoso performances in the medium, the harsh cuts and the color-shapes suggest the character of the subject's shattered life. Also from this period are a series of portraits of intense psychological depth, including his own *Self-Portrait with Dancing Death* (1918, Museum Folkwang, Essen). Kirchner wrote: "My work comes from the longing of solitude. I was always alone, the more I was with people, the more I felt my solitude. . . . That created a deep sadness and it was only resolved through the work" (from an exhibition catalogue, 1919, Galerie Ludwig Schames, Frankfurt).

In 1917, Kirchner was brought to Davos, Switzerland, to recover. His recuperation is gradually revealed in paintings of the vast Alpine landscapes. The space and lifestyles of the Alps obviously moved and calmed the artist. He portrayed peasants at work. Splintered forms gave way to a more geometric style. Kirchner continued to use strident colors, but now for a calmer effect. Intense pinks and violet appear sonorous among cool blues in paintings such as that of a mountain near Davos, *Die Amselfluh* (1923, Kunstmuseum Basel). Landscapes emphasize the expansive mountain spaces, often with an underlying rhythmic energy which combines a subtle restlessness with monumentality. Works of the 1920's have been referred to as in the "tapestry style" due to the building of surface in planes of interlocking color. Some compositions were designs for tapestries.

The late "abstract" style dates from 1930–33. In this period occasional paintings were worked totally from the imagination. These works often are weak, derivative, "picassoesque." Throughout his career Kirchner had been overly concerned about his reputation as an artist. He often antedated paintings to make it appear that his style had matured earlier. He denied influences and he published articles on his work under the pseudonym Louis de Marsale. In 1937 Kirchner's works were declared decadent and included in Hitler's *Entartete Kunst* exhibition. Some of his last paintings returned to the power of his work of the 1920's, but ultimately Kirchner was overcome with loneliness, isolation, and defeat. In 1938 he committed suicide.

Kirchner's work represents the contradictions of an artist who sought to express his love of humanity through work which clearly reflects an age of tumult and alienation. The intensity of the artist is translated into the work and the strength of its emotive power. For Kirchner reality was the source of the experiences of the dream and the nightmare of the existence of a passionate artist in the modern world.

—Janice McCullagh

KLEE, Paul.

Born in Münchenbuchsee, near Berne, 18 December 1879. Died in Muralto-Locarno, 29 June 1940. Married the pianist Lily Stumpf, 1906; one son. Attended Berne schools; studied at Heinrich Knirr's School of Art, Munich, 1898–1900, and, with Wassily Kandinsky, under Franz Stück at the Kunstakademie, Munich, 1900–01; professional violinist with the Berne Municipal Orchestra, 1903–05; then full-time artist, in Munich from 1906; taught evening classes, Debschitz School, 1908, and associated with the Sema Group, 1911, Der Blaue Reiter, 1912, and Der Neue München Sezession, 1914; served in the German army, 1916–18; taught at the Bauhaus, in Weimar and Dessau, 1921–31; co-founder, Der Blaue Vier, 1924; Professor, Kunstakademie, Dusseldorf, 1931; returned to Switzerland, 1933, and illness caused him to spend time in sanatoria.

Major Collection: Berne: Klee-Stiftung.
Other Collections: Amsterdam: Stedelijk; Basel; London: Tate; New York: Moma, Guggenheim; Paris: Art Moderne; Rome: Arte Moderna; Stuttgart; Zurich.

Publications

By KLEE: books—

Paedagogische Skizzenbuch, Dessau, 1925; as *Pedagogical Sketchbook,* New York, 1944.
On Modern Art, London, 1937; original version as *Uber die moderne Kunst* (lecture), Berne, 1945.
Klee Speaks in the Bauhaus 1919–1928, New York, 1938.
Das Bilderische Denken, edited by Jürg Spiller, Basel, 1956; as *The Thinking Eye: The Notebooks,* London and New York, 1961.
Tagebücher 1898–1918, edited by Felix Klee, Cologne, 1957; as *The Diaries,* Berkeley and London, 1964.
Gedichte, edited by Felix Klee, Zurich, 1960, 1980; translated in part as *Some Poems,* Lowestoft, Suffolk, 1962.
Unendliche Naturgeschichte, edited by Jürg Spiller, Basel, 1970; as *The Nature of Nature: The Notebooks,* vol. 2, London and New York, 1973.
Three Painter Poets: Arp Schwitters, Klee, edited by Harriet Watts, London, 1974.
Die Ordung der Dinge: Bilder und Zitate, edited by Tilman Osterwold, Stuttgart, 1975.
Schriften: Rezensionen und Aufsätze, edited by Christian Geelhaar, Cologne, 1976.
Beitrage zur bildnerischen Formlehre, edited by Jürgen Glaesemer, Basel, 1979.
Briefe an die Familie 1893–1940, edited by Felix Klee, Cologne, 2 vols., 1979.
Die Zwitschermaschine und andere Grotesken, edited by Lothar Lang, Berlin, 1981.

Illustrator—*Potsdamer Platz,* by Curt Corinth, 1919; *Kandide,* by Voltaire, 1920.

On KLEE: books—

Hausenstein, Wilhelm, *Kairuan, oder eine Geschichte vom Maler Klee und von der Kunst dieses Zeitalters,* Munich, 1921.
Grohmann, Will, *Klee,* Paris, 1929; London and New York, 1954.

The Witch with the Comb, 1922; lithograph

Barr, Alfred H., *Klee,* New York, 1930.

Grohmann, Will, *Klee: Handzeichnungen,* Potsdam, 1934, Wiesbaden, 1951; as *The Drawings of Klee,* New York, 1944.

Nierendorf, Karl, *Klee: Paintings, Watercolors 1913 to 1939,* New York, 1941.

Miller, Margaret, *Klee,* New York, 1945.

Soby, James Thrall, *The Prints of Klee,* New York, 1945.

Geist, H. F., *Klee,* Hamburg, 1948.

Read, Herbert, *Klee,* London, 1948.

Cooper, Douglas, *Klee,* London, 1949.

Haftmann, Werner, *Klee,* Munich, 1950, London and New York, 1954.

Kahnweiler, D. H., *Klee,* Paris and New York, 1950.

Giedion-Welcker, Carola, *Klee,* New York, 1952.

Grohmann, Will, *Klee: Aquarelles et dessins,* Paris, 1953.

Courthion, Pierre, *Klee,* Paris, 1953.

Forge, Andrew, *Klee,* London, 1954.

Grohmann, Will, *Klee,* Stuttgart, 1954, London and New York, 1955.

San Lazzaro, Gualtieri di, *Klee: La Vie et l'ouevre,* Paris, 1957; as *Klee: His Life and Work,* London and New York, 1959.

Grote, Ludwig, editor, *Erinnerungen an Klee,* Munich, 1959.

Klee, Felix, *Klee: Leben und Werk in Dokumenten,* Zurich, 169 1960 as *Klee: His Life and Works in Documents,* New York, 1962.

Giedion-Welcker, Carola, *Klee in Selbstzeugnissen und Bilddokumenten,* Reinbek, 1961.

Besset, M., editor, *Klee par lui-même et pas son fils Felix Klee,* Paris, 1963.

Roy, Claude, *Klee: Aux sources de la peinture,* Paris, 1963.

Kornfeld, E. W., *Verzeichnis des graphischen Werkes von Klee,* Berne, 1963.

Pfeiffer-Belli, Erich, *Klee: Eine Bildbiographie,* Munich, 1964.

Ueberwasser, Walter, *Klee: The Later Work* (cat), Basel, 1965.

Grohmann, Will, *Klee,* London and New York, 1967, concise edition, 1987.

Huggler, Max, *Klee: Die Malerei als Blick in den Kosmos,* Frauenfeld, 1969.

Jaffé, Hans L., *Klee,* London, 1972.

Geelhaar, Christian, *Klee und das Bauhaus,* Cologne, 1972; as *Klee and the Bauhaus,* Greenwich, Connecticut, 1973.

Glaesemer, Jürgen, *Klee: Handzeichnungen,* Berne, 3 vols., 1973-79.

Geelhaar, Christian, *Klee: Der Vorgeschichte der Tunisreise,* Zurich, 1974.

Marnat, Marcel, *Klee,* Paris and New York, 1974.

Glaesemer, Jürgen, Klee, Berne, 1976.

Pierce, J. S., *Klee and Primitive Art,* New York and London, 1976.

Schlumpf, Hans-Ulrich, *Das Gestrin über der Stadt: Ein Motiv im Werk von Klee,* Zurich, 1976.

Hall, Douglas, *Klee,* Oxford and New York, 1977.

Baumgartner, Marcel, *Klee und die Photographie,* Berne, 1978.

Naubert-Riser, Constance, *La Création chez Klee: Etude de la relation théorie-praxis de 1900 à 1924,* Ottawa, 1978.

Plant, Margaret, *Klee: Figure and Faces,* London, 1978.

Franz, E., *Klee: Späte Arbeiten 1934-1940* (cat), Bielefeld, 1978.

Short, Robert, *Klee,* London, 1979.

Osterwold, Tilman, *Klee: Ein Kind träumt sich,* Stuttgart, 1979.

Duvingnaud, Jean, *Klee en Tunisie,* Paris, 1980.

Haxthausen, Charles Werner, *Klee: The Formative Years,* New York, 1981.

Tower, Beeke Sell, *Klee and Kandinsky in Munich and at the Bauhaus,* Ann Arbor, 1981.

Werckmeister, Otto K., *Versuche über Klee,* Frankfurt, 1981.

Rosenthal, Mark, *Klee,* Washington, 1981.

Thürlemann, Félix, *Klee: Analyse sémiotique de trois peintures,* Lausanne, 1982.

Overmeyer, Gudula, *Studien zur Zeitgestalt in der Malerei des 20. Junderts: Robert Delaunay, Klee,* Hildescheim, 1982.

Kagan, Andrew A., *Klee: Art and Music,* Ithaca, New York, 1983.

Verdi, Richard, *Klee and Nature,* London, 1984.

Klee (cat), Dresden, 1984.

Jordan, Jim M., *Klee and Cubism,* Princeton, 1984.

Naylor, Gillian, *The Bauhaus Reassessed: Sources and Design Theory,* London, 1985.

Lauchner, Carolyn, *Klee* (cat), New York and London, 1987.

Rewald, Sabine, *Klee: Ninety Works from the Heinz Berggruen Collection,* New York, 1988.

*

Paul Klee's creative spirit expressed itself in music, poetry, and the visual arts. As well as being a virtuoso violinist, his writings include his diary (1898-1918), letters, notebooks (*The Thinking Eye*), many essays, (*Creative Credo,* 1920) and lectures (*Pedagogical Sketchbooks,* 1925). His approach to art was a broad and encompassing one which attempted to penetrate the secret underlying rhythms of the creative forces of the universe. Klee's career exhibits a direct and deliberate development. His always personal approach remained consistent with his careful nature and reserved personality.

In his early career a series of etchings show the results of intense observation that seeks to expose what lies beyond surface appearances through a meticulous and grotesque style. (*Hero with One Wing,* 1905, Art Institute of Chicago). A series of drawings for Voltaire's *Candide* (1911-12, published 1920) reveal his early approach was essentially that of a draughtsman. In these drawings the artist expressed a mocking humor with exaggeratedly nervous lines and spidery, elongated figures.

Between 1909 and 1914 numerous influences encouraged the development of Klee the painter. In 1909 exposure to the work of Paul Cézanne opened to Klee the world of compositional construction through plane and color. This direction was further encouraged by the inspiration of Delaunay and Cubism. The famous 1914 trip to Tunesia with fellow-artists August Macke and Louis Moilliet perfectly combined the moment of the artist's internal readiness with the exotic and colorful external stimulus, and Klee emerged as a mature artist. He was no longer limited by his proclivity to draughtmanship. His diary entry of 16 April 1914 reads: "Color has claimed me. I need no longer run after it. It has claimed me once and for all, that I know. This is the meaning of the happiest hour: I and color are one. I am a painter."

As a teacher at the Bauhaus, Klee was in the position where he was required to consolidate and verbalize his thinking. *Ped-*

agogical Sketchbook expresses his method. He emphasized process over product with the idea that art must evolve. Imitating the process of natural growth, artworks must tap into the rhythms of nature. "Follow the ways of natural creation, the becoming, the functioning of forms. That is the best school. Then, perhaps, starting from nature you will achieve formations of your own, and one day you may even become like nature yourself and start creating." Art was for him a mirror of Creation.

Klee's approach was always grounded in nature, though never naturalistic. Stylistically his images often appear deceptively simple, yet that which corresponds with the seen is honest and frequently profound. In his search for a direct passage between deep feeling and artistic expression, Klee found children's art as a continued source of inspiration. He preferred to work in small scale, so intimacy often joined a lyrical and whimsical mood in his work. Even his most abstract works, such as *Fire in the Evening* (1929, Museum of Modern Art, New York) and other paintings composed primarily of horizontal color bands or stata, time and evolution are suggested. One is not surprised to learn that they were inspired by a trip to Egypt in the winter of 1928–29, where Klee was greatly impressed by the deep sense of archeological history that he felt in the mysterious, ancient environment. Klee's artistic intent was to reach beyond the seen and make a mystical connection with the unseen. His quest was to tap an underlying geometry, to touch the ultimate mystery uniting organic and cosmic process.

In his search for a direct visual language, Klee often used ideographs or symbols. Letters, arrows, musical notations, or crescent moons and stars take on deep significance. Settings, such as a garden, a mountain, or a puppet-stage, can range in content from the most lyrical to the most somber. Music and drama were often transformed into visual expression. Klee spoke of "polyphonic painting" where time becomes a spatial element represented by transparent color planes. Frequent representations of masks and clowns give the human element in his work a feeling of distance, comic or tragic, yet the sentiment evoked is no less real. These were the characters that helped him find a new balance between outer and inner reality. Klee sought a universal language which would speak to all times and peoples. Especially in 1939–40, with the knowledge of impending death, angels join the stage as frequent characters. Titles of his paintings were often a poetic amplification of the image. The back of one painting reads: "One of these days I shall lie in nothingness/Beside an angel of some kind."

Klee was an artist of profound integrity. Strong associations in his life were critical, from his early involvement with the artists of the *Blaue Reiter* in Munich to his Bauhaus years and deep friendship with Wassily Kandinsky. In the 1920's his approach was even associated with that of the Surrealists in his insistence on the primacy of intuition over reason. "In the highest order mystery intervenes. Intuition is not to be supplanted" (*Pedigogical Sketchbook*). He could never be too closely aligned with a group nor could his style be described by any *ism*. In spite of his prolific artistic production and his writings, something about this artist remains forever remote. For Klee the artistic journey was focused on nature and nature's ways, but like a monk's, his was essentially an inward examination.

—Janice McCullagh

KLIMT, Gustav.

Born in Baumgarten, near Vienna, 14 July 1862. Died in Vienna, 6 February 1918. Attended the Austrian Museum of Art and Industry School of Arts and Crafts from 1874; worked as decorator: set up studio with his brother in Vienna, 1883–92: commissions for work in the Kunsthistorische Museum, 1891; then established as a painter; co-founder Vienna Sezession, 1898 (resigned, 1903): decorated the ceilings of Vienna University, 1900–03.

Major Collection: Vienna: Osterreichische Galerie.
Other Collections: Cambridge, Massachusetts; Dresden; London; Munich; New York: Moma; Ottawa; Prague; Rome: Arte Moderna; Strasbourg; Turin: Galatea; Venice: Arte Moderna; Vienna.

Publications

On KLIMT: books—

Salten, Felix, *Klimt: Gelegentliche Anmerkungen,* Vienna, 1903.

Eisler, Max, editor, *Klimt: Eine Nachlese,* Vienna, 1920; as *Klimt: An Aftermath,* Vienna, 1931.

Glück, Gustav, *Klimt,* Vienna, 1921.

Schmalenbach, F., *Jugendstil,* Wurzburg, 1935.

Pircham, Emil, *Klimt: Ein Kunstler aus Wien,* Vienna, 1942.

Fleischmann, B., *Klimt: Eine Nachlese,* Vienna, 1956.

Novotny, Fritz, *Klimt* (cat), Vienna, 1962.

Strobl, Alice, *Klimt: Zeichnungen und Gemälde,* Salzburg, 1962; as *Klimt,* New York, 1976.

Secession (cat), Munich, 1964.

Comini, Alessandra, and J. T. Demetrion, *Klimt and Schiele* (cat), New York, 1965.

Novotny, Fritz, *Klimt,* edited by Friedrich Welz, Salzburg, 1967; as *Klimt, with a Catalogue Raisonné of His Paintings,* New York, 1968.

Nebehay, Christian M., editor, *Klimt: Dokumentation,* Vienna, 1969.

Hofmann, Werner, *Klimt,* Salzburg and Boston, 1971, London, 1972.

Werner, Alfred, *Klimt: One Hundred Drawings,* New York, 1972.

Comini, Alessandra, *Klimt,* New York and London, 1975.

Bisanz-Prakken, Marian, *Klimt: Der Beethovenfries* (cat), Vienna, 1977.

Dobai, Johannes, *L'opera completa di Klimt,* Milan, 1978.

Breicha, Otto, editor, *Klimt: Die goldene Pforte: Werk, Wesen, Wirkung,* Salzburg, 1978.

Hofstätter, Hans H., *Klimt: Erotische Zeichnungen,* edited by Louisa Seilern, Cologne, 1979; as *Klimt: Erotic Drawings,* New York, 1979.

Kallir, Jane, *Klimt, Schiele* (cat), 1980.

Strobl, Alice, *Klimt: Die Zeichnungen,* Salzburg, 3 vols., 1980–83.

Nebehay, Christian, *Klimt, Schiele, Kokoschka: Werke auf Papier* (cat), Salzburg, 1981; as *Drawings and Watercolours,* London, 1981.

Dobai, Johannes, *Klimt: Die Landschaften Salzburg,* 1981; as *Klimt: Landscapes,* London, 1988.

Baumer, Angelica, *Klimt: Women,* London, 1986, New York, 1987.

Bouillon, Jean Paul, *Klimt: Beethoven: The Frieze for the Ninth Symphony,* New York, 1987.

Klimt (cat), Brussels, 1987.

*

Gustav Klimt started his career as an artist under the influence of Hans Makart whose decorative historical paintings set the trend for the decorative art which was so in demand with the fashion-conscious Viennese elite. Klimt, while being influenced by Makart's grandiose visions, nevertheless allowed his art to move in new directions. His own decorative paintings, influenced as they were by the mysterious tonalities of the symbolist Fernand Knopff, didn't always receive public or critical acclaim, and though Klimt received the highest honors and several public commissions, his reputation later floundered due to public opinion and differences in taste. Perhaps his origins as a decorator led Klimt to continue his artistic career within a decorative framework, deriving inspiration from sources as remote as ancient Greek and Assyrian art, the Byzantine friezes of Italy, and the flowing style of Art Nouveau.

Art Nouveau was a largely decorative style of painting which attempted to synthesize natural forms into a new order of expansive pictorial design. The movement was typified by the search for the hidden processes in nature which are manifest in the sinuous and flowing lines and biomorphic forms which suggest the organic processes of growth, expansion, and creation. The historical themes of the 19th century were abandoned, and artists struggled towards the creation of a new harmony based on the rhythmic, flowing lines of nature excused from the gravitational pull of pure naturalism. Furthermore, these free-flowing lines were suggestive of femininity, and many of the works made under this heading used women as the central motif, thus enhancing these qualities of grace and elegance.

Further influencing Klimt was the art of the Symbolist movement. Especially apparent is the influence of Jan Toorop, an artist of East African origin, whose exoticism combined with the sinuous Art Nouveau style produced works of a mysterious but decorative nature. If we compared Toorop's *The Three Brides* (1893, Otterlo) with Klimt's *Goldfish* (1901–02, Solothurn) and *Water-Snakes 1* (1904–07, Vienna), we can see clearly the connection between the two, most markedly in the stylistic use of the women's hair and their exaggeratedly narrow limbs.

The trend in Symbolism was towards a more esoteric view in art, the function of an image to remain merely documentary falling by the wayside, leaving no room for the mundane world or the commonplace. This turnabout became in Klimt a concern with both the exotic and with the life-cycle itself, and through the combined influences of Symbolist suggestion and oriental art came Klimt's erotic paintings. Perhaps Klimt's preoccupation with the erotic has been overemphasized, for many of his works are imbued with a certain tenderness of feeling. One of the many motifs Klimt used was that of union. At times this becomes a mystical union with the deep, as in

Water-Snakes, and at others the union of man and woman and the culmination of harmony. In *Fulfillment* (1905–09, Strasbourg), the figures of a man and woman embrace, their forms merging into the ornamented design of the man's cloak which, bedecked and studded with gold ovals and mosaic patterns, adds to the innate sense of harmony. Behind the couple spiralling plant tendrils are used both to decorate and to suggest the harmonious forces of nature and natural love. We can also see this recurrent theme in *The Kiss* (1907–08, Vienna). The reverse of this harmony can be seen in the painting of *Judith II (Salome)* (1909, Venice), where we sense, through Klimt's use of pallid skin tones and the angularity of Salome's pose, a convulsion against harmony, which is further emphasized by the claw-like grip of the hands. This image embodies the destructive forces of the femme fatale, a favourite Symbolist subject.

Klimt's static, symbolic images with their use of gold painted areas and mosaic-like pattern recall the art of the Byzantine era, and the obsessive flattening out of the image reinforces the spiritual or transcendental qualities of the paintings. His many portraits of a purely decorative kind, usually these of women, are studded with mosaic-like forms, purely decorative in their use of pattern juxtaposed against flat areas of paint. One recalls Whistler in the subtle, whispering tonalities of the portrait of *Margaret Stonborough-Wittgenstein* (1905, Munich, Neue Pinakothek), and in the overt Japaneism of a later date.

Throughout his life, and parallel to his other works, Klimt continued to paint landscapes. These landscapes, influenced as they were by Impressionist technique and Art Nouveau form, are dreamily poetic in nature, and in the tortuous branches of *Avenue in the Park of Kammer Castle* (1912, Vienna) one finds a certain kinship with Van Gogh, though Klimt's gentle, decorative manner is far from Van Gogh's vigorous, expressive bent. Klimt has given these landscapes a near abstract quality in their flatness and in the near uniformity of surface pattern. In these paintings Klimt foreshadows abstract expressionism, and one can almost sense in these the tenderness of a Mark Rothko, or the vibrant facades of a Hans Hofmann.

—L. A. Landers

KLINE, Franz (Josef).

Born in Wilkes-Barre, Pennsylvania, 23 May 1910. Died in New York, 13 May 1962. Married Elizabeth Vincent Parson, 1938. Attended schools in Pennsylvania; Boston Art Students League; studied under Frank Durkee, John Grosman, and Henry Hensche, Boston University, 1931–32, and under Bernard Adams, Steven Spruner, and Frederick Whiting, Heatherley's School of Fine Art, London, 1936–38; window display artist, Arnold Constable department store, Buffalo, and painted night club murals until 1942, then full-time painter; taught at Black Mountain College, North Carolina, 1952, Pratt Institute, New York, 1953–54, and Philadelphia Museum School of Art, 1954.

Collections: Basel; Dusseldorf; Houston; London: Tate; New

York: Moma, Whitney, Guggenheim, Metropolitan; Philadelphia; Toronto.

Publications

On KLINE: books—

Breeskin, A. D. *Kline* (cat), Washington, 1962.
O'Hara, Frank, *Kline* (cat), London, 1964.
Dawson, Fielding, *An Emotional Memoir of Kline,* New York, 1967.
Gordon, John, *Kline* (cat), New York, 1968.
Boime, Albert, and Fred Mitchell, *Kline: The Early Works as Signals* (cat), Binghamton, New York, 1977.
Gaugh, Harry F., *Kline: The Color Abstractions,* Washington, 1979.
Gaugh, Harry F., *Kline: The Vital Gesture* (cat), Cincinnati and New York, 1985.

articles—

Gaugh, Harry F., "Kline's Romantic Abstraction," in *Artforum* (New York), Summer 1975.
Gaugh, Harry F., "Kline: The Man and the Myth," in *Art News* (New York), December 1985.

*

Franz Kline's black and white paintings are so strongly etched upon the sensibility of the modern age that it is difficult to look at any black and white pictures and not think of Kline. Trained in an illustrative mode, Kline painted in an accomplished, though retardataire, figurative style until the mid 1940's. At that time through contact with the Abstract Expressionist gesture painters, particularly his close friend Willem de Kooning, who was then painting black and white abstractions, Kline began to broaden his drawing technique and to use fewer anecdotal details.

During the later 1940's Kline's paintings increased in scale and were executed in the energetic calligraphic abstraction which was the hallmark of works by de Kooning and Bradley Walker Tomlin. While Kline drew upon the dynamic energy of contemporary urban life symbolized in their canvases, his compositions were simpler and clearer, conveying a confident bravura. The often retold account of Kline's instant conversion to abstraction after seeing his drawings enlarged in a Bell-Opticon projector can not be true. At most this experience confirmed a direction in which the artist was already headed.

Beginning in 1950, Kline's black and white gesture paintings consist of broad swaths of paint which cut across the canvas surface and hurtle towards each other at varying velocities. The openness of the composition, the angular intersection of these painterly forces, and the definitive contrast of black and white communicate energy and absolute confidence. Yet despite the seemingly improvisational character of these works, they are actually based upon small compositional studies executed on telephone book pages, which provided source ideas for the final paintings. Also Kline's paintings, which appear to be the result of single dynamic gestures, often contain several layers of overpainting as the artist balanced the

White Forms, 1955; 6 ft 2⅜ in × 4 ft 2¼ in (188.9 × 127.6 cm)

visual forces in the works. Further, Kline labored over such refinements as the contrast of matt and gloss surfaces, and the jagged character of his paint edges.

In terms of content, Kline's early black and white abstractions provoke thoughts about the human condition as a dramatic conflict between opposing forces that is resolved in a precarious equilibrium. Although Kline was quick to note that, in his words, he was "painting experiences" and not objects, his works do call forth references. These painterly allusions mostly fall into two categories, the figure and architecture within a landscape. Many of Kline's vertical compositions contain centralized presences, and are occasionally entitled "Figure." These presences are at once powerful and somewhat comic, their battered strength paired off against awkward proportions. The frequent use of diagonal strokes in conjunction with these figures also suggests their pulling back from a hostile world and an implicit psychological restlessness. From the reports of friends, all of these characteristics were parts of Kline's complex personality.

Kline's horizontal, architectonic, and landscape compositions are reminiscent of coal country in eastern Pennsylvania, where Kline grew up, and which was a favorite representational theme in his earliest paintings. In his abstract evocations, Kline captured the sense of past romantic adventure and present decay of that region. Paintings suggest the craggy, strip-mined landscape, partly demolished factories, trestles,

and great trains (after which some like *Chief* are named). In them monumental and forceful gestures are thrust into a barren space.

In 1958 Kline began to use half-tones increasingly in his art. His angular scaffold became increasingly shrouded in a dark atmosphere. In the best of these paintings, like *Siegfried* (1958), raw power is replaced by an unsettling and evocative mystery. Shortly thereafter, Kline introduced color into the compositions. Kline's late colored paintings, which he pursued until his untimely death in 1962, were rarely as successful as the black and white compositions. His addition of color resulted from a commendable desire to expand his expressive means. But in those works color acts as an adjunct to the abstract structure rather than being a full participant. In essence Franz Kline was never a colorist; rather he was a great draftsman with the brush in the tradition of Goya, Daumier, and Picasso.

—Robert Saltonstall Mattison

KLINGER, Max.

Born in Leipzig, 18 February 1857. Died in Grossjena bei Naumburg, 5 July 1920. Married Gertrud Bock, 1919; one daughter by Elsa Asenijeff. Studied under Karl von Gussow, Karlsruhe, 1874, and followed Gussow to the Berlin Academy, 1875; lived in Paris, 1883–86, Berlin, 1886–88, and Rome, 1888–93, then settled in Leipzig, 1893; painter and sculptor, but best-known for his prints: 14 major print cycles, comprising some 265 plates.

Major Collection: Leipzig.
Other Collections: Berlin; Bremen; Dresden; Hamburg; Hanover; Melbourne; Oldenburg; Vienna: Kunsthistorisches Museum, Albertina.

Publications

By KLINGER: books—

Malerei und Zeichnung, Leipzig, 1885, 1895.
Briefe aus den Jahren 1874 bis 1919, edited by Hans W. Singer, Leipzig, 1924.

Illustrator—*Armor und Psyche,* by Apuleius, 1881.

On KLINGER: books—

Schmid, Max, *Klinger,* Bielefeld, 1906.
Kühn, Paul, *Klinger,* Leipzig, 1907.
Singer, Hans W., *Klingers Radierungen, Stiche, und Steindrücke,* Berlin, 1909.
Singer, Hans W., *Zeichnungen von Klinger,* Leipzig, 1912.
Meissner, F. H., *Klinger: Radierungen, Zeichnungen, Bilder, Skulpturen,* Munich, 1914.
Avenarius, Ferdinand, *Klinger als Poet,* Munich, 1919.
Vogel, Julius, *Klinger und seine Vaterstade Leipzig,* Leipzig, 1923.

Beyer, Carl, *Klingers graphisches Werk von 1909 bis 1919,* Leipzig, 1930.
Klinger (cat), Leipzig, 1970.
Klinger: A Glove and Other Images of Reverie and Apprehension (cat), Wichita, Kansas, 1971.
Klinger: Original-Druckgraphik (cat), Oldenburg, 1975.
Klinger (cat), Bielefeld, 1976.
Dückers, Alexander, *Klinger,* Berlin, 1976.
Mathieu, Stella W., editor, *Klinger: Leben und Werk in Daten und Bildern,* Frankfurt, 1976.
Varnedoe, J. Kirk T., *Graphic Works of Klinger,* New York, 1977.
Klinger (cat), Rotterdam, 1978.
Klinger: Love, Death, and Beyond (cat), Melbourne, 1981.
Schütz, Karl, editor, *Klinger: Malerei—Graphik—Plastik* (cat), Vienna, 1981.
Winkler, Gerhard, *Klinger,* Leipzig, 1984.

*

While acknowledged as a virtuoso print-maker, Max Klinger is still not widely appreciated as a sculptor, a painter (with a genius for large-scale decorative schemes), and a writer. Multiplicity of means, however, was central to Klinger's overall purpose, just as the combination of several techniques or media and the frequent allusion to non-visual art forms played a key role in individual works. Although one may point to the dominance of one activity rather than another throughout certain periods—print-making in the 1880's, sculpture after 1900—familiarity with the full range of Klinger's output tends to encourage awareness of an essential continuity of statement enduring through a variety of eloquent reformulations.

The coherence of Klinger's oeuvre is most easily perceived in the consequent, if unpredictable, unfolding of technical and stylistic possibilities. A pen and wash drawing from Klinger's student years at the Berlin Academy of Fine Art, *Klinger and Krogh Attempting to Kill Time* (1876; Dresden), anticipates the combination of vigorous etched line and broad areas of aquatint in Klinger's first prints, the *Radierte Skizzen* (Etched Drawings) (1879), while its amusingly literal interpretation of a figure of speech signals the continuing importance of the intellectual content of Klinger's images. The use of decorative borders to incorporate narrative details in the print cycle *The Salvation of Ovid's Victims* (1879) recurs in Klinger's design for an elaborate wood and plaster frame for his monumental painting *The Judgement of Paris* (1885–97; Vienna). The attempt to offer an alternative, symbolic perspective on realistically presented episodes in prints from the cycle *Of Death, Part I* (1889) suggests the urge to occupy several "dimensions" that prompted both Klinger's preoccupation with polychromatic stone sculpture (*The New Salome,* 1893; Leipzig) and his commitment to the Wagnerian ideal of the Gesamtkunstwerk (total work of art).

Klinger's range of subject matter was also wide; and here again it appears that the originality of his approach owed much to a judicious combination of elements from separate spheres. The free play of fantasy that devised the monstrous shellfish of the *Radierte Skizzen* or the enigmatic nudes of the painting *Die Blaue Stunde* (1890; Leipzig) also enriched the novel interpretation of mythological subjects (the print cycle *Cupid and Psyche,* 1880, or the sculpted figure of *Cassandra,* 1895;

A Glove, 1881; engraving

Leipzig), and encouraged the unorthodox treatment of biblical themes (the print cycle *Eve and the Future,* 1880 and the painting *The Crucifixion,* 1891; Leipzig). Similarly, Klinger's strong sense of the realms of passion and terror lurking just below the surface of "reality" as conventionally perceived allowed even the most banal of episodes to issue in the unexpected: the print cycle *A Glove* (1881), Klinger's best-known work, opens with two scenes at a Berlin roller-skating rink and ends in nightmare, reverie, and a lingering sense of mystery.

In his long essay *Malerei und Zeichnung* (1891) Klinger distinguished between the "dark side" of life, including the world of dreams and anxieties, that he saw as the proper concern of the draughtsman and print-maker working in black and white, and the realm of idealized visible forms that he felt to be the province of the painter (or indeed sculptor) working in colour. From this point on, however, in his own work in all media, Klinger largely dealt in complex symbolic images as far removed from the arbitrary logic of dreams as from the aesthetic perfection of a consciously idealized reality. In Klinger's most technically accomplished print cycle, *The Brahms Fantasy* (1894) and in the ambitious polychromatic *Beethoven* movement (1902; Leipzig), the heroic artist is seen as an instance of combined energy and inspiration, successfully harnessing the powers inherent in the "dark side" of life to ends both noble in themselves and, in turn, inspiring to others.

Relative wealth and security fostered Klinger's artistic independence, allowing extensive periods of residence and travel abroad and removing the need to depend on public approval for a living. Though gratified at the success of his prints, he was disappointed at the rejection in Germany of works such as *Die Blaue Stunde* or *The Crucifixion* (the first was found too "modern," the second denounced as scandalous); but he felt no need to adapt his aims accordingly. His defiance was arguably justified by the extent of his influence on other artists, both during his lifetime and afterwards: Edvard Munch learnt much in the 1890's from Klinger's powerfully expressionist form of Symbolism, and several decades later artists such as Giorgio De Chirico and Max Ernst were drawn to the proto-Surrealist aspects of Klinger's oeuvre.

The works Klinger himself most admired—and he had a marked capacity for fruitful hero-worship—included the prints of Goya and Menzel, the paintings of Böcklin, and the sculpture of Rodin. These, however, seem to account for less fundamental aspects of Klinger's achievement than does his early encounter with the bewildering world of Japanese prints with their foreshortened perspective and suggestive unworked areas. Here Klinger found crucial encouragement towards the development of his singular talent for unruffled delineation of the incongruous and the indeterminate.

—Elizabeth Clegg

KNELLER, (Sir) Godfrey.

Born Gottfried Kniller, probably in Lubeck, 8 August 1646, brother of the painter John Zachary Kniller; naturalized British citizen, 1683. Died in London, 26 October 1723. Married Susanna Grave, 1704; had one daughter by Mrs. Voss. Attended Leiden University, then studied painting under Ferdi-

nand Bol and possibly Rembrandt, Amsterdam; visited Italy, 1672–75 (possibly earlier in 1663), and worked under Carlo Maratta; in Lubeck and Hamburg, 1675–76, then settled in London, 1676: established himself quickly, and with death of Lely in 1680, became the King's favorite painter: named Principal Painter by William and Mary, 1688, and did many royal portraits: painted foreign rulers for William III, and series of Beauties, Kit Kat club, and Admirals; visited France to paint Louis XIV for Charles II, 1684–85; first Governor of the first London Academy of Painting, 1711. Knighted, 1692, and given baronetcy, 1715.

Major Collections: London: Portrait Gallery; Royal Collection.

Other Collections: Blenheim; Edinburgh; Leningrad; London: Tate, National Gallery, Maritime Museum; Lubeck; New Haven; Oxford: Christ Church; Bodleian.

Publications

On KNELLER: books—

Baker, C. H. Collins, *Lely and Kneller,* London, 1922.
Killanin, Lord, *Kneller and His Times,* London, 1948.
Waterhouse, Ellis, *Painting in Britain 1530 to 1790,* London, 1953, 4th ed., 1978.
Stewart, J. Douglas, *Kneller* (cat), London, 1971.
Stewart, J. Douglas, *Kneller and the English Baroque Portrait,* Oxford, 1983.

*

Godfrey Kneller, a German, spent his entire career painting fashionable portraits for society and the court from the reign of Charles II to that of George I. After his arrival in England (1676), he modeled his style after the hugely successful court painter Peter Lely (1618–80), and this insured his own succession as the dominant portraitist of his age. Kneller also adopted Lely's practice of running a portrait factory staffed by many assistants. While this system enabled him to turn out a great volume of paintings, much of the work is shoddy. He did, however, produce some top quality works which are the basis of his reputation.

His early style is marked by the influence of Ferdinand Bol, whose portraits show little characterization and exhibit an interest mainly in surface qualities without solid drawing—an easy model to imitate. When Kneller began to take on Lely's style, he made a similar error of adopting technique without using it as an interpretive tool. Few examples of his early style exist. The canvases are impersonal and thinly painted without Lely's rich texture and flamboyance. The palette tends toward the monochromatic and the compositions are simple.

His mature style, from c. 1685, adapted Lely's fashionable style of the mid-1660's. Kneller made use of the fluent, nervous drawing manifested in Lely's restless hands and painterly brushwork. The thin textures, restricted cool palette, simplified handling, and stock set of poses derive from Lely as well. As in most of Lely's fashionable portraits, Kneller attempted only occasional probing of character. Beyond technique, Knel-

Jean Baptiste Monneyer; drawing

ler's aim was to rival Lely's two famous series of paintings, Windsor Beauties (1660–68) and Admirals (1666–67), by producing his own series, Hampton Court Beauties (1690–91) and Admirals (1700–10).

A comparison, though, of their respective portraits of the Duchess of Portsmouth, Lely's dating from c. 1670 and two by Kneller dating from 1684 and c. 1688, reveals their differing approaches. Kneller's treatment lacks the strong languouous voluptuousness so central to Lely's work. Kneller's duchess, in contrast, is able to stand under her own power and is not barebreasted. In the earlier work, Kneller had painted her standing, retaining the disheveled gown that Lely had popularized in the Windsor Beauties series. In the later painting, close to the time of the Hampton Court Beauties series and probably intended as one of them, the suggestive dress disappears. The attitudes of William and Mary's court now prevail in the paintings which no longer exhibit the open sexual laxity of Charles II's time.

The best of Kneller's work after 1700 is for the most part among the 42 portraits of the Kit Kat Club series (1702–17), a Whig Party social group. All are half-length single portraits showing the head and one hand in relaxed poses. All degrees of painting quality are represented. While many are stereotyped and repeat the same empty gestures and poses, others create a sense of the exploration of personality. In the better productions, Kneller took more care with drapery and hands. His brushwork has become even more fluid with broken strokes. He displays a more subtle color sense. Flesh tones are of silver and pink; silver-grays and gray-greens create highlights and shadow.

Kneller's mature period coincides with a low point in British art. The lack of care he took with much of his work is considered to be an expression of a cynical age. It is to Kneller's great credit that he was also the means of raising Britain's art from this trough. As the founding head of the first Academy of Painting in London, Kneller laid the foundations of good studio practice in the instruction of the next generation of British painters and thereby ensured the continuation of portrait types standardized by Lely. It is Kneller's efforts that caused the most meaningful aspects of this tradition to be transmitted to painters such as Joshua Reynolds and Thomas Gainsborough.

—Ann Stewart Balakier

KOKOSCHKA, Oskar.

Born in Pöchlarn, Austria, 1 March 1886; naturalized United Kingdom citizen, 1947. Died in Villeneuve, Switzerland, 22 February 1980. Married Olda Pavlovska, 1941. Attended Vienna schools; studied under Gustav Klimt at the Kunstgewerbeschule, Vienna, 1905–09; lived in Switzerland, 1909–10, and Berlin, 1910–14: contributor to *Der Sturm*, 1910; served in the Austrian army, 1914–18: wounded in 1915, and made official war artist, 1915–16, Isonzo; lived in Dresden, 1917–24, and lectured at the Dresden Art Academy, 1919–24; traveled extensively in Europe, then lived in Vienna, 1930–34, Prague, 1934–38, and London, 1938–53; lived in Villeneuve, Switzerland, from 1953; Founder, School for Seeing, Salz-

burg, 1953 (and taught there, 1953–63); stage designs for *Die Zauberflöte*, 1955, and for productions in Vienna, 1960–61.

Collections: Amsterdam: Stedelijk; Berlin: Nationalgalerie; Brussels; Edinburgh; London: Tate; New York: Moma; Pittsburgh; Rotterdam; Stuttgart; Vienna: Albertina.

Publications

By KOKOSCHKA: books—

Der träumende Knaben, Vienna, 1908.
Dramen und Bilder, Leipzig, 1913.
Der brennende Dornbusch, 1917.
Hiob: Ein Drama, Berlin, 1917.
Vier Dramen, Berlin, 1919.
Der gefesselte Columbus, Berlin, 1921.
Ann Eliza Reed: Erzählung, Hamburg, 1952.
Der Expressionismus Edvard Munch, Vienna, 1953.
Thermopylae: Ein Triptychon, Winterthur, 1955.
Schriften 1907–1955, edited by Hans Maria Wingler, Munich, 1956.
Spur im Treibsand, Zurich, 1956.
Die träumende Knaben und andere Dichtungen, Salzburg, 1956.
A Sea Ringed with Visions, London, 1962.
A Colloquy Between Kokoschka and Ludwig Goldscheider, London, 1963.
Word and Vision, London, 1967.
Mein Leben, Munich, 1971; as *My Life*, London and New York, 1974.
London Views, British Landscapes, London, 1972.
Saul and David, London, 1973.
Das schriftliche Werke, edited by Heinz Spielmann, Hamburg, 4 vols., 1973–76.
Briefe, edited by Olda Kokoschka and Heinz Spielmann, Dusseldorf, 3 vols., 1984–87.

illustrator: *Die chinesische Mauer*, by Karl Krauss, 1914; *Lob des hohen Verstandes*, by Victor Dirsztay, 1917; *Tubutsch*, 1919, and *Mein Lied 1900–1931*, 1931, both by Albert Ehrenstein; *Irische Legende*, by Werner Egk, 1955; *Odyssee* by Homer, 1969; *Saul und David* by Martin Buber, 1970; *König Lear*, by Shakespeare, 1971.

On KOKOSCHKA: books—

Westheim, Paul, *Kokoschka*, Potsdam, 1918, 1925.
Rathenau, Ernst, *Kokoschka: Handzeichnungen*, Berlin and New York, 5 vols., 1936–77.
Hoffmann, Edith, *Kokoschka: His Life and Work*, London, 1947.
Plaut, James S., *Kokoschka: A Retrospective Exhibition* (cat), Boston, 1948.
Netzer, R., *Kokoschka: Lithographien*, Munich, 1956.
Wingler, Hans Maria, *Kokoschka: Das Werk des Malers*, Salzburg, 1956; as *Kokoschka: The Work of the Painter*, London, 1958.

DIE TRÄUMENDEN KNABEN.

The Dreaming Boys, 1908; lithograph

Wingler, Hans Maria, *Kokoschka: Ein Lebensbild in zeitgenössischen Dokumenten,* Munich, 1956.

Masciotta, Michelangelo, and Jacopo Recupero, *Kokoschka* (cat), Rome, 1959.

Bultmann, Bernhard, *Kokoschka,* Salzburg, 1959: London, 1961.

Gombrich, E. H., Fritz Novotny, and Hans Mavis Wingler, *Kokoschka* (cat), London, 1962.

Hodin, J. P., editor, *Bekenntnis zu Kokoschka: Erinnerungen und Deutungen,* Berlin, 1963.

Goldscheider, Ludwig, *Kokoschka,* London, 1963, Greenwich, Connecticut, 1966.

Fischer, Wolfgang, *Homage to Kokoschka* (cat), London, 1966.

Hodin, J. P., *Kokoschka: The Artist and His Time,* London and Greenwich, Connecticut, 1966.

Rathenau, Ernest, editor, *Kokoschka: Drawings 1906–1965,* Coral Cables, Florida, 1966.

Schmalenbach, Fritz, *Kokoschka,* Konigstein and London, 1968.

Bosman, A., *Kokoschka,* London, 1969.

Gatt, Giuseppe, *Kokoschka,* Florence, 1970, London and New York, 1971.

Hodin, J. P., *Kokoschka: Eine Psychographie,* Vienna, 1971.

Wingler, Hans Maria, and Friedrich Welz, *Kokoschka: Das druckgraphische Werk,* Salzburg, 2 vols., 1975–81.

Breicha, Otto, editor, *Kokoschka: Von Erlebnis im Leben: Schriften und Bilder,* Salzburg, 1976.

Reisinger, Alfred, *Kokoschkas Dichtungen nach dem Expressionismus,* Vienna, 1978.

Hagenlocher, Alfred, *Kokoschka: Themen 1906–1976* (cat), Munich, 1979.

Lang, Lothar, *Kokoschka: Buchillustrationen, 1908–1970* (cat), Burgk, 1981.

Bisanz, Hans, *Kokoschka: Die frühen Jahre: Zeichnungen und Aquarelle ausgewählt von Serge Sabarsky,* Vienna, 1982.

Schvey, Henry I., *Kokoschka: The Painter as Playwright*, Detroit, 1982.

Kokoschka (cat), Bordeaux, 1983.

Schweiger, Werner J., *Der junge Kokoschka: Leben und Werk 1904-1914*. Vienna, 1983.

Calvocoressi, Richard, editor, *Kokoschka* (cat), London, 1986.

Whitford, Frank, *Kokoschka: A Life*, London, 1986.

Carlson, Victor, *A Kokoschka Centenary: His Early Graphics* (cat), Los Angeles, 1986.

Gombrich, E. H., *Kokoschka in His Time* (lecture), London, 1986.

Kokoschka: Welt-Theater, Buhnenbilder, und Illustrationen 1907-1975 (cat), Hamburg, 1986.

Haftmann, Werner, *Kokoschka: Zeichnungen zur Antike* (cat), Munich, 1987.

*

Oskar Kokoschka is probably best known for the portraits that he made before the First World War that have often been seen as Freudian readings of the subject's personalities or expressions of the pre-war decadence of Viennese bourgeois society. More recently his later work made in exile has been favourably reassessed.

Kokoschka's early works were made under the influence of Klimt, and were angular and awkward in attitude. They were a reaction against Art Nouveau that stressed rupture and sharp edges rather than flowing natural forms. This style was evident in the picture book Kokoschka published in 1908, *Der träumende Knaben (The Dreaming Youths)*, with its swiftly drawn representation of mal-nourished children. His mentors in Vienna at this time were not only the architect Adolf Loos, his main patron, but also the writer Karl Krauss. Loos was important for his ideas of the deraciné culture of the city dweller, Krauss for his celebration of the life of the popular language of everyday life as opposed to the pomposities of academic writing or the clichés of journalism. Also important for his development was the importance attached to children's art under Karl Strasser and Franz Cizek in Vienna from 1903. Cizek ran a course for children at the *Kunstgewerbeschule* where Kokoschka studied, which stressed creativity and free expression. In general there was a trend towards nonconformism in Vienna from the turn of the century: Krauss described society as a prison. His attacks on sexual hypocrisy and his recommendation of sexual perversity as a kind of health found their expression in Kokoschka's play *Murder Hope of Women* which was performed in Vienna in 1909. Drawings for the play (published in *Der Sturm* in 1910) reveal an early interest in anatomy: nerves were traced on the outside of the form fitting costumes that the actors wore.

Kokoschka's portraits can also be seen in the light of Krauss's theories recommending the aestheticization of ugliness and on how good taste becomes an instrument of social conformism. These portraits up to around 1911 are not expressionist. They emphasize the physiognomies of the sitters, especially their hands. Their colours evoke a meat-like presence sometimes suggestive of putrefaction—especially the pictures he made of consumptives in Switzerland in 1910. Their facial features are outlined in red suggesting the presence of blood vessels. In general the sitters are inert and the pictures spatially flat.

There is almost certainly no Fruedian influence in his early portraiture despite many later interpretations. Kokoschka rather thought that he was endowed with visionary gifts that allowed him to see and paint people's essences. However, there are some similarities between the Nietzschean concept that this idea comes out of and Freudian ideas: particularly that the reason has no right to censor the outpourings of the soul of the genius and that this outpouring might take place automatically. Critics thought that Kokoschka painted with a scalpel: a comment that applied not only to the flayed aspect of some of his sitters but to the stripping away of surface features to reveal deeper essences.

The change that took place in Kokoschka's painting in 1911 was due largely to his contact with *Der Sturm*. The pictures became more modelled and structured and the artist took on more ambitious subjects such as Biblical scenes in which the figures and the background were integrated with consistent faceting. Kokoschka's mistrust of rationality was increased by the events of the First World War where the effects of a technological reason carried to a conclusion were felt. In the manifesto "On the Awareness of Visions" he attacked purposive thought and contrasted it with the true spiritual meaning that comes out of the exercise of the imagination.

After the war the art dealer Paul Cassirer financed Kokoschka's extensive travels in exchange for the fine landscapes and cityscapes that the artist regularly painted. For these more commercial works Kokoschka used thinner paint, a more linear style, and deep perspective.

Kokoschka was one of the artists named "degenerate" by the Nazis, who confiscated large amounts of his work. In 1937 he painted a self portrait which he called *Portrait of a "Degenerate Artist"* (private collection). Shallow depths are created by flicked strokes of paint over a dark ground.

During the Second World War Kokoschka painted a series of pieces attacking the policy of the Allies. The spirit of Krauss's attacks on humanity as a whole reappear in some of these works. They were informed by the English tradition of political caricature. *Marianne-Maquis* of 1942 (private collection) criticized the reluctance of the Allies to open a second front: the picture includes caricatures of Churchill and Montgomery in a cafe, accompanied by Marianne as a whore.

Kokoschka's painting was always highly individual, even during the period when he came under the influence of *Der Sturm* and appeared as a member of the avant garde. He was not an artist to follow the new trends in art after 1918 but to some extent he pursued his own course of formal experimentation particularly regarding the paint surface and the depth it implies.

—Julian Stallabrass

KOLLWITZ, Käthe (née Schmidt).

Born in Konigsberg, East Prussia, 8 July 1867. Died in Moritzburg, 22 April 1945. Married Karl Kollwitz, 1891 (died, 1940); two sons. Studied art with Rudolf Mauer and Emil Neide, and with Karl Stauffer-Bern at the School for Women Artists, Berlin, 1885-86; also studied with Ludwig

65/80

Self-Portrait, 1934; lithograph

Hertenich, Munich, 1888–89, and sculpture at the Académie Julian, Paris, 1904; lived and worked in Berlin; contributed drawings to *Simplicissimus*, 1908–11; Professor, Prussian Academy of Arts, Berlin, 1919–33; lived in Nordhausen, 1943–44, and in Moritzburg, 1944–45.

Collections: Berlin: Staatliche Museum; Cambridge, Massachusetts; Diksmuide, Belgium, Dresden; London: British Museum; Los Angeles; San Francisco; Santa Barbara, California; Storrs: University of Connecticut; Washington.

Publications

By KOLLWITZ: books—

Tagebuchblätter und Briefe, edited by Hans Kollwitz, Berlin, 1948; as *Diaries and Letters*, Chicago, 1955.
"Ich will werken in dieser Zeit": Auswahl aus den Tagebüchern und Briefen, aus Graphik, Zeichnungen, und Plastik, edited by Hans Kollwitz, Berlin, 1952.
Aus meinem Leben, edited by Hans Kollwitz, Munich, 1957.
Aus Tagebüchern und Briefen, edited by Horst Wandrey, Berlin, 1964.
Briefe der Freundschaft und Begegnungen, Munich, 1966.
Ich sah die Welt mit liebvollen Blicken: Ein Leben in Selbstzeugnissen, edited by Hans Kollwitz, Hanover, 1968.

Illustrator—*Abscheid und Tod*, by Gerhart Hauptmann, 1924.

On KOLLWITZ: books—

Lehrs, Max, *Kollwitz*, Vienna, 1903.
Sievers, Johannes, *Die Radierungen und Steindrücke von Kollwitz innerhald der Jahre 1890 bis 1912*, Dresden, 1913.
Kaemmerer, Ludwig, *Kollwitz: Griffelkunst und Weltanschauung*, Dresden, 1923.
Heilborn, Adolf, *Kollwitz und Heinrich Zille*, Berlin, 1924; Kollwitz section published in 4th edition, as *Kollwitz*, Berlin, 1949.
Diel, Louise, *Kollwitz: Ein Ruf ertönt*, Berlin, 1927.
Wagner, A., *Die Radierungen, Holzschnitte, und Lithographien von Kollwitz: Eine Zusammenstellung der seit 1912 entstandenen graphischen Arbeiten in chronologischer Folge*, Dresden, 1927.
Diel, Louise, *Kollwitz, Mutter und Kind: Gestalten und Gesichte der Künstlerin*, Berlin, 1928.
Zigrosser, Carl, *Kollwitz*, New York, 1946.
Fechter, Paul, *Kollwitz: Plastiken*, Berlin, 1947.
Bonus-Jeep, Beate, *Sechzig Jahre Freundschaft mit Kollwitz*, Boppard, 1948.
Zigrosser, Carl, *Prints and Drawings of Kollwitz*, New York, 1951.
Schumann, Werner, *Ein Herz schlägt für die Mütter: 100 Handzeichnungen von Kollwitz*, Hanover, 1953.
Klipstein, August, *Kollwitz: Verzeichnis der graphischen Werkes für die Jahre 1890–1912 unter Verwendung des 1913 erschienenen Oeuvrekataloges von Johannes Sievers*, Berne, 1955; as *The Graphic Work of Kollwitz: Complete Illustrated Catalogue*, New York, 1955.

Koerber, Lenka von, *Erlebtes mit Kollwitz*, Berlin, 1957, Darmstade, 1961.
Mansfield, Heinz, *Kollwitz: Bauernkrieg*, Dresden, 1958.
Bittner, Herbert, *Kollwitz: Drawings*, New York, 1959.
Ahlers-Hestermann, Friedrich, *Kollwitz: Der Weberaufstand*, Stuttgart, 1960.
Nagel, Otto, *Die Selbstbildnisse der Kollwitz*, Berlin, 1965.
Schmalenbach, Fritz, *Kollwitz*, Konigstein, 1965.
Meckel, Christoph, Ulrich Weisner, and Hans Kollwitz, *Kollwitz*, Bad Godesburg, 1967.
Killy, Herta Elisabeth, Peter Hahlbrock, and Walter Huder, editors, *Kollwitz* (cat), Berlin, 1967.
Bauer, Arnold, *Kollwitz*, Berlin, 1967.
Kollwitz, Hans, *Kollwitz: Das graphische Werk*, Hamburg, 1967.
Nagel, Otto, et al., *Kollwitz: Die Handzeichnungen*, Berlin, 1972, Stuttgart, 1980; as *The Drawings of Kollwitz*, New York, 1972.
Klein, Arthur and Mina C., *Kollwitz: Life in Art*, New York, 1972, 1975.
Timm, Werner, *Kollwitz*, Berlin, 1974.
Kearns, Martha, *Kollwitz, Woman and Artist*, Old Westbury, New York, 1976.
Forster-Hahn, Francoise, and Kirk deGooyer, *Kollwitz: Prints, Drawings, Sculpture* (cat), Riverside, California, 1978.
Hinz, Renate, editor, *Kollwitz: Druckgraphik, Plakate, Zeichnungen*, Berlin, 1979, 1980; as *Kollwitz: Graphics, Posters, Drawings*, London, 1981.
Kleberger, Isle, *"Eine Gabe ist eine Aufgabe": Kollwitz*, Berlin, 1980.
Kollwitz: The Graphic Works (cat), Cambridge, 1981.
Krahmer, Catherine, *Kollwitz in Selbstzeugnissen und Bilddockumenten*, Reinbek, 1981.
Schneede, Uwe M., *Kollwitz: Das zeichnerische Werk*, Munich, 1981.

*

The graphic artist Käthe Kollwitz was first of all a deeply, even tragically empathetic human being, a sensual and cerebral woman whose social advocacy, inculcated by her progressive Socialist-Christian upbringing, was expressed through interwoven themes of nurture and protection, adversity and victimization, and, ultimately, dignity before the inevitable force of death. In her private works, as in her public support for causes ranging from leftist legislation for individual rights to international famine relief campaigns and the pursuit of elusive peace, Kollwitz revealed herself as a truly political artist, actively engaged in the convulsive history of our era.

While her style, critical realism, was fueled by the emotional charge common to Expressionism, her formal choices were generally made on levels which failed to concern her contemporaries in such movements as *Die Brücke*. The context of her works was essentially extroverted, socially oriented, and initially historicist or literary. Thus, she found few colleagues until the 1920's, long after her career and renown were established. A perpetual worrier subject to long depressions, Kollwitz in her diary reveals a defensive response to the prevalence of disengaged art. In 1916 she called "pure studio art . . . unfruitful and frail," wondering why it should exist at all without "living roots." But, by 1922, her resolve was strength-

ened: "I know . . . that I do not achieve pure art in the sense of Schmidt-Rottluff [a *Brücke* leader] . . . but still it *is* art. Everyone works the way he can. I am content that my art should have purposes outside itself . . . my course is clear and unequivocal."

Likewise unequivocal, her developing style kept pace with the clarification of her vision. From the first narrative print cycles, *The Weavers' Rebellion* (1893–98), loosely based on Gerhart Hauptmann's play, and *The Peasants' War* (1903–08), partially inspired by a history of the abortive 16th-century revolution, and recurrent personal images of encounters with death, to the pre-war series entitled *Pictures of Misery* for the satirical journal *Simplicissimus,* her female protagonists are inexorably reduced to a massive simplicity, half granite self-portraits, half primal victims.

Initially influenced by literary naturalism and Max Klinger's realist-tinged symbolism (and encouraged in her choice of graphic media by his 1891 *Painting and Drawing,* which promoted the graphic arts for projection of a "critical view of reality"), Kollwitz slowly abandoned her illustrational direction, approaching modernist reductivity by elimination. The theatricalized staging disappeared, leaving enlarged figures isolated on the white ground of her prints, and the early prescriptive directorial illusion altered in favor of non-narrative allusion.

But the First World War was the linchpin, stripping Kollwitz of her emotional sanctuary, her literary—and literal—reserve. In late September 1914, the artist wrote fearfully, "All is leveled by death; down with all the youth!" Not a month later, her younger son, Peter, just 18, was killed on the Belgian front. From that moment, Kollwitz internalized the pain she had formerly experienced only empathetically—through daily contact with the distressed workers' families treated in her husband's socialist health-insurance practice.

While Kollwitz had intermittently pursued sculptural projects alongside technical experiments in printmaking, after her son's death she concentrated on plans for a memorial to the fallen, which remained in various stages of completion until 1932, when the two parents bowed by grief were installed in Roggevelde's cemetery. This deeply personal image recurred in her "home-front" contributions to the anti-war movement, a cycle of eight woodcuts comprising *War* (published in 1923), anticipating Otto Dix's own front-line memories, the fifty etchings of *The War,* by almost a year. *Parents* unites the figures of Mother and Father in a pyramid of sorrow, a composi-

tional solution that improves on the isolation of the sculptured pair, making their stricken unity a tower of strength, an intimation of the bond between the couple and a truly pivotal image for Kollwitz.

The woodcut medium, perfected by her close friend, the sculptor Ernest Barlach, but new to Kollwitz, was an obvious choice for this cycle, as it was for the iconic image memorializing the assassinated Socialist leader Karl Liebknecht, which had been prepared first as a lithograph in 1919, and then completed as her first exercise in the technique in 1920. The medium's characteristically hard edged form is more appropriate for the content of firm resolve manifested in this widely distributed print.

War, planned for an equally substantial edition and typically carved from smooth pear-wood, is similar in form, with heavily inked broad massing of alternating silhouettes, black on white, white on black, a sturdy, direct approach common to her sculpture. The theme of the hapless victim imbued with deep emotionalism echoes the more specific scenario of *The Peasants' War.* In fact, *The Volunteers,* youthful enthusiasts led to oblivion by a deadly drummer, follows the same turgid path to the left as did the peasants in *Outbreak* twenty years earlier, while a pair of *Widows* recapitulates the tragic tone of *Raped* and *After the Battle.*

Completing few self-motivated projects during the 1920's, Kollwitz focussed instead on a series of posters for leftist international relief organizations, considerably simplifying her formal repertory. It was only after the Nazi rise that she returned, with powerful understatements honed by that work, to her prints. With hundreds of others she endured the label "degenerate," banned from exhibiting and public contact. The first years of interdiction, 1934–35, saw her cycle *Death,* culminating in her own self-portrait welcoming the specter, apt metaphors for a country newly engaged in the dance of death.

In these last hard years, Kollwitz balanced her life-long preoccupation with death with reaffirmative images of maternal protection, as in her last print, the 1942 lithograph *Seed Corn Must Not Be Ground,* a final Mother of Mercy whose arms form a canopy over the children, a shield for the future. Once before, in 1918, she had used Goethe's maxim in a passionate letter publicly protesting the unending war. Her final effort visualizes the phrase and proves that Käthe Kollwitz could, as she had hoped, create "a woman watching who feels everything." She was that woman.

—Linda F. McGreevy

L

LANFRANCO, Giovanni.

Born near Parma, 26 January 1582. Died in Rome, 30 November 1647. Studied under Agostino Carracci in Parma, to 1597, and in 1600-02; Duke of Parma sent Lanfranco to Annibale Carracci's studio in Rome, 1602; worked in Palazzina Farnese, worked for Marchese Cardinale Sannesi, then for Cardinal Montalto, Cardinal Borghese (S. Gregorio, S. Sebastiano), and for Pope Paul V; worked in Piacenza, c. 1609-11; then back in Rome, and worked on Sala Regia in Quirinal Palace, and then the Casino Borghese, 1616; worked in Naples, 1634-46 (S. Gennaro chapel in the Cathedral, 1641-43); then worked on S. Carlo ai Catinari in Rome, 1646-47.

Collections: Braunschweig; Fermo: S. Filippo; Florence: Pitti; London; Marseilles; Naples: Galleria Nazionale, Certosa di S. Martino, church of the Gesu Nuovo, Cathedral, SS. Apostoli; Oxford; Paris; Parma; Rome: S. Andrea della Valle, S. Carlo ai Catinari, S. Agostino, S. Giovanni dei Fiorentini, St. Peter's, Casino Borghese; Vienna.

Publications

On LANFRANCO: books—

Causa, R., and G. Mosca, *Disegni di Lanfranco per la Chiesa dei Santi Apostoli nel Museo di Capodimonte* (cat), Naples, 1964.
Novelli, M., *Lanfranco,* Milan, 1966.
Paintings from the Blessed Sacrament Chapel of St. Paul's-Without-the-Walls, Rome by Lanfranco (cat), Dublin, 1968.
Bernini, G. P., *Lanfranco,* Parma, 1982.
Schleier, Erich, *Disegni di Lanfranco* (cat), Florence, 1983.

articles—

Salerno, Luigi, "The Early Works of Lanfranco," in *Burlington Magazine* (London), 94, 1952.
Posner, Donald, "Domenichino, and Lanfranco: The Early Development of Baroque Painting in Rome," in *Essays in Honor of Walter Friedlaender,* New York, 1965.
Schleier, Erich, "Les Projets de Lanfranc pour le décor de la Sala Regia au Quirinal et pour la Loge des Bénédictions à Saint-Pierre," in *Revue de l'Art* (Paris), 7, 1970.
Bösel, R., "Lanfranco e la Compagnia di Gesù," in *Paragone* (Florence), 28, 1977.
Mellini, G. L., "Momenti del Barocco: Lanfranco e Caravaggio," in *Comunità,* 177, 1977.
Schleier, Erich, "Two Lanfranco Paintings from the Farnese Collections," in *Speed Art Museum Bulletin* (Atlanta), 32, 1979.
Morel, Philippe, "Morfologia delle cupole dipinte da Correggio e Lanfranco," in *Bollettino d'Arte* (Rome), January-February, 1984.
Winner, Matthias, "Bernini the Sculptor and the Classical Heritage in His Early Years: Praxiteles', Bernini's, and Lanfranco's *Pluto and Proserpina,*" in *Römisches Jahrbuch für Kunstgeschichte,* 22, 1985.

*

Lanfranco's boast that "the air painted for him" is as apt a metaphor as any for his atmospheric, at times ethereal, art. It brings to mind Constable's famous characterization of Turner's pictures as "tinted steam" and draws attention to some striking similarities between Baroque and Romantic art. Such parallels revolve round a fascination with flux. The impulse was directed to perhaps only superficially different ends: in the case of the Baroque, the glorification of God through an exploration of the shifting realities of religious ecstasy and bodily Assumption; in that of Romanticism a concern with the interaction of the finite and the infinite in nature. Neither was each movement without its opponents, who tend, in both cases, to be termed "classicists." Despite some apparently genuine theoretical differences between these opposing camps of Baroque/Romantic and Classical, however (on, for example, the relative importance of coloring or drawing), the visual divergence may have temperamental roots.

Lanfranco was, according to his early biographer, Passeri, extrovert and pleasure loving (as was the high priest of the Baroque, Bernini). When the young Lanfranco was working as a page-boy in Parma, he was reluctant to pursue his study of grammar and amused himself instead by drawing incessantly "both with pen on paper and with charcoal on walls." Lanfranco's many surviving drawings (of which there are large holdings in the Uffizi and at Dusseldorf) show him to have been a rapid and intuitive draughtsman, more concerned with capturing poses and lighting than with precision of contour or detail. His drawings, whether in pen or his favorite, chalk, are remarkably evanescent, often barely rescuing form from its first principles in light and shade.

Lanfranco's painting is similarly elusive, both in composition and lighting. Despite his training in Parma under the clas-

sicizing Agostino Carracci and his subsequent activity in Rome as an assistant to Annibale Carracci, Lanfranco's Parmese background and strong artistic individualism ensured that he was never a slave to Bolognese precedent. Perhaps the prime influence on him was Correggio, the great Parmese painter of the High Renaissance, whose masterly light effects (including his much-vaunted, edge-softening *sfumato,* as well as one memorable night-piece, *La Notte,* now in Dresden), bold foreshortening of figures (especially on the dome of Parma cathedral, 1526–30), and gently sensual mysticism were never far from Lanfranco's mind. One can discern all of these qualities coalescing in one of Lanfranco's earliest masterpieces, *The Ecstasy of the Magdalen,* c. 1605, (Naples, Capodimonte), while his great dome decoration of *The Assumption of the Virgin* in the Roman church of Sant'Andrea della Valle, 1625–27, is a High Baroque elaboration of the Parma cathedral fresco. To Correggio's influence must be added an apprenticeship under Guido Reni (in the pioneeringly Baroque Quirinal Chapel, 1609–10) in the potential of mystically illusionistic church decoration; a taste, possibly encouraged by Reni, for the most poetic of the Carracci, Ludovico; and a strong affinity for the dashing brushwork and loosely structured composition of the Caravaggist Orazio Borgianni. Caravaggio's example too (as well as that of Schedoni) was instrumental in guiding him towards a monumental style of bold figurative accents.

Lanfranco's skilful assimilation of such multiple suggestions into a wholly original mature art is indicative of his rapid and transforming imagination. His criticism of his main rival, Domenichino, for plagiarism (from Agostino Carracci's *Last Communion of St. Jerome*) implies that he viewed Domenichino's more narrowly focussed allegiance to a select tradition of classic models as a failure of invention rather than an aesthetic choice. Lanfranco's own style was, by contrast, synonymous for him with innovation—a perception seemingly reinforced by the support he received from those avant-garde patrons the Sacchetti brothers.

Among the hallmarks of Lanfranco's albeit varied style are a versatile and poetic exploration of the possibilities of tenebrist lighting (ranging from spectral moonlight to a distinctive deep golden-orange "divine" light), an opening up and spreading out of his compositions through the extensive use of diagonal axes and the gravitation of figures towards the edges, his broad, square, generalized drapery folds, and, in the increasing number of ceiling frescoes with which he enlivened the domes of churches, an experimental fusion of his coloristic and spatial concerns to create vivid glimpses of immortality.

Lanfranco's newfound vision crystallizes round a sequence of oil paintings, executed in the late 1610's and early 1620's, which includes *The Virgin with St. Anthony Abbot and St. Philip* (Vienna), and *The Ecstasy of St. Margaret of Cortona* (Florence, Pitti). In these same years we find him, in the domes of the Buongiovanni chapel in Sant'Agostino and the Sacchetti chapel in San Giovanni dei Fiorentine, concocting the surging, illusionistic formula which he would soon translate onto a vast scale in S. Andrea della Valle and then adapt in his many Neapolitan dome frescoes (such as that of the Cappella del Tesoro in Naples Cathedral). These floating visions served as a blueprint for Baroque ceiling decorations for the rest of the century—for Cortona and Gaulli in Rome, Preti and Giordano in Naples. Furthermore, his major secular ceiling decoration, the *Olympus* of 1624–25 in the Villa Borghese, with its illusionistic architecture open to the sky, combined with Guercino's smaller *Aurora* (Rome, Casino Ludovisi) to stimulate a new taste.

If there is scope for debate over whether Guercino or Lanfranco was the first consistently High Baroque painter, there can be little doubt about who was the more influential. Guercino's early departure from Rome in 1623 and his drift into a classicizing vein left Lanfranco the undisputed leader of the innovative tendency. Nor should one ignore the peculiar subtlety of Lanfranco's contribution. His soft, ballooning figures, tinted with the most delicate colors, can sometimes, as on the ceiling of the Cappella della Pietà (1630) in St. Peter's, conjure up an effect almost of stained glass and of what Archbishop Laud, in a different context, called "the beauty of holiness." In other cases, such as *The Finding of Moses* in Braunschweig, from the late 1630's, his "facile and excellent brush," as his biographer Bellori called it, could skilfully blend bold decorative color, flickering light, and fluent form. In such works Lanfranco reveals himself too as a charming and original storyteller.

—John Gash

LA TOUR, Georges (Dumesnil) de.

Born in Vic-sur-Seille, 1593. Died in Lunéville, 30 January 1652. Married Diane Le Nerf, 1617; son, the painter Etienne de La Tour. Recorded as painter in Vic-sur-Seille, 1617; moved to Lunéville, 1620; small number of paintings, two bought by the Duke of Lorraine, others commissioned by the Lunéville authorities for gifts.

Collections: Berlin; Cleveland; Detroit; Epinal; Grenoble; Hartford, Connecticut; Kansas City; Le Mans; Malibu; Nancy; Nantes; New York: Metropolitan, Frick; Paris; Rennes; Rouen; San Francisco; Stockholm; Washington.

Publications

On LA TOUR: books—

Pariset, François Georges, *La Tour,* Paris, 1948.
Furness, S. M. M., *La Tour,* London, 1949.
Thuillier, Jacques, and Pierre Rosenberg, *La Tour* (cat), Paris, 1972.
Rosenberg, Pierre, and François Mace de l'Epinay, *La Tour: Vie et oeuvre,* Fribourg, 1973.
Solesmes, François, *La Tour,* Lausanne, 1973.
Thuillier, Jacques, *L'opera completa di La Tour,* Milan, 1973.
Nicolson, Benedict, and Christopher Wright, *La Tour,* London, 1974.
Wright, Christopher, *La Tour,* Oxford, 1977.
Wright, Christopher, *The Art of the Forger,* London, 1984.
Bajou, Thierry, *La Tour,* Paris, 1985.

*

St. Jerome; 24⅜ × 18½ in (62.2 × 47.1 cm); **Royal Collection**

Georges de la Tour's paintings are among the most famous in the world, though his reputation is only recent. He is one of the few painters to have been rediscovered in the last 100 years, and the story of his reputation is a lively (and controversial) one. The basic dates which focus on his current status are those of a German magazine article in 1915, an exhibit in 1934 (nine paintings were exhibited), a book by François Pariset in 1948, establishing many of the basic facts of his life and works, and a much larger exhibition in Paris in 1972.

There are documents in his birthplace as well as in his adopted town of Lunéville from 1620, but little that indicates his education as painter or definite influences on his work. Though the Duke of Lorraine bought two paintings early in La Tour's career, the town council of Lunéville itself was his most dependable patron. The most obvious influence on his work is that of Caravaggio, either through La Tour's knowledge of some of his paintings or through the intermediary of the work of Jacques Bellange.

His reputation early in this century was as a painter of candle-lit scenes, and though there have been efforts to expand the corpus of his works, these candle-lit works still rest at the base of his oeuvre. A series of early pictures (mostly dated to the 1620's) have been put forward as by La Tour, but there is the possibility that another painter altogether created this group of works: vegetable eaters, brawling beggars, hurdy-gurdy players, etc. Another small group of paintings of demi-mondaine figures (*The Cheat, The Fortune Teller*—actually a group in a brothel) have a more controversial history. A beau-

tifully painted pair, *Peasant* and *Peasant's Wife* (both in San Francisco) are more universally attributed to La Tour.

His most famous group, and the paintings least dubiously attributed to him, are the candle-lit scenes, though a few copies or forgeries have crept into lists of genuine works. Even in his works from the 1620's, interesting lighting effects are notable. In the *St. Jerome Reading* (Hampton Court) a strong light source over the saint's shoulder actually shines through the paper he is reading. Dating this work, and others, is troublesome because of the fact that more than one version exists of many of the paintings.

A group of penitent Magdalenes (one in the Louvre, one in Washington) are startling in the use of the limited light source (a candle), a mirror, and a skull which the Magdalene contemplates. Another candle-lit picture with a religious theme is *St. Joseph in the Carpenter's Shop* (Louvre): the young Jesus holds the candle and shields it with his left hand, and the light actually shines through his hand. *The Choirboy* (Leicester) also contains a half-hidden light source; as in his other late "night" pictures, the lighted areas are densely painted and the darker areas are usually simple planes. There are also several versions of *St. Sebastian* (lying horizontally, though not yet dead), and more than one dice-playing picture, each with religious implications. Even *The Flea Catcher* (Nancy) has been given a religious interpretation.

The Newborn Child (Rennes) is possibly his masterpiece, though it was attributed to the Le Nain brothers until 1915. Like many of his other paintings, there are no explicit religious details, but the implication is that the painting depicts the Virgin and Child with St. Anne, though it could equally be a mother and child, with grandmother. Its technical mastery is both simple and mysterious.

Other than the technical mastery evident in the dimly lit pictures, La Tour's ability to produce a sense of uneasy calm and mystery is notable. The fact that his works were scattered in provincial museums and not judged as the corpus of a single painter caused his work to be ignored for centuries, but he is now one of France's most famous painters.

—George Walsh

LAWRENCE, (Sir) Thomas.
Born in Bristol, 13 April 1769. Died in London, 7 January 1830. Child prodigy: exhibited as a child drawer, and worked in Bath from 1780; in London from 1787, as student at the Royal Academy schools, and exhibiter from 1787; began painting in oils; Painter-in-Ordinary to the King when Reynolds died, 1792; R.A., 1794, and served as President of the R.A., 1820-30, succeeding Benjamin West; patronized by the Prince of Wales from 1814. Knighted, 1815.

Major Collection: Windsor Castle.
Other Collections: Bristol; Cambridge, Massachusetts; Chicago; Cincinnati; Coventry: St. Mary's Hall; London: Dulwich, Soane, National Gallery, Portrait Gallery, Tate, Wallace; Montreal; New Haven; New York: Metropolitan, Frick;

Arthur, Duke of Wellington, c. 1814; $35\frac{7}{8} \times 28$ in (91 × 71 cm) London, Wellington Museum

Paris; Raleigh, North Carolina; San Marino, California; Toledo, Ohio; Washington.

Publications

By LAWRENCE: book—

Letter-Bag, edited by George Somes Layard, London, 1906.

On LAWRENCE: books—

Gower, Ronald Sutherland, *Lawrence,* London, 1900.
Clouston, R. S., *Lawrence,* London, 1907.
Armstrong, Walter, *Lawrence,* London and New York, 1913.
Goldring, Douglas, *Regency Portrait Painter: The Life of Lawrence.* London, 1951.
Garlick, Kenneth, *Lawrence,* London, 1954.
Garlick, Kenneth, editor, *Lawrence* (cat), Worcester, Massachusetts, 1960.
Lawrence (cat), London, 1961.
Garlick, Kenneth, *A Catalogue of the Paintings, Drawings, and Pastels of Lawrence,* London, 1964.
Levey, Michael, *Lawrence* (cat), London, 1979.

*

Thomas Lawrence, who by 1820 was generally acknowledged as the foremost portrait painter of Europe, began his career as a child prodigy. He progressed from profile portraits in pencil to portraits in pastel, and from pastel to oils. In 1789 at the age of twenty he was summoned to Windsor Castle to paint Queen Charlotte. This portrait (1790, London), an unprecedented commission for one so young, showed a verve in the use of oil-paint and a confidence in execution which put him at the head of the field in the race for success among his generation. Gainsborough had died in 1788, Reynolds died in 1792, and Romney was in a state of physical decline. Lawrence supplied a need and was overwhelmed with commissions. Among his most notable full-lengths of the 1790's are *Elizabeth Farren* (1790, New York) and *"Pinkie"* (1795, San Marino, California). At this stage he was not without critics. He was accused of flashiness resulting from an over-application of highlights on the face and figure, and it is true that the effect of many of his early portraits is theatrical. (He was a devotee of the theatre and a gifted amateur actor.) This tendency was perhaps exaggerated by his ambition to achieve a history picture in the Italian grand manner which Reynolds had taught should be the aim of the young painter. His essay in this manner, *Satan Summoning His Legions* (1797, London, Royal Academy of Arts) was not a success, and he turned to large-scale representations of J. P. Kemble the actor in his most celebrated roles.

Lawrence was by nature studious and hard-working. He was early acquainted with private collections of engraving and Old Master paintings in Bath and London. He was also an inspired collector of Old Master drawings. He took criticism seriously, and from about 1800 began to paint with a richer and more fluent medium, eliminating the false glitter of his early work and broadening his style from the study of Rubens and Van Dyck. When Hoppner died in 1810 he had no rival.

Lawrence was given an unrivalled opportunity when in 1815 the Prince Regent commissioned him to go to Europe and paint the allied Heads of State and military leaders who had defeated Napoleon, and for this purpose knighted him. Napoleon's escape from Elba halted the scheme but in late 1818 he set out for Aix-la-Chapelle, Vienna, and Rome, returning to England in January 1820, when he succeeded West as President of the Royal Academy. The portraits of Pope Pius VII and Cardinal Consalvi (1819, Windsor Castle), painted in Rome, are his masterpieces. His command of a loaded brush and of compositions dominated by rich areas of red or black was absolute, and this is evident in the work of the ten years following his return, when he was at the command of Society. There had always been a tendency to sentimentality in his portraits of women and children. This remained with him, and two of his most popular works exemplify it, *Master Lambton* (1824, private collection, England) and *The Calmady Children* (1825, New York). They are saved by the brilliance of his handling of the medium.

Lawrence had not the refinement of Gainsborough or the intellectual weight of Reynolds but in technical mastery he can hold his own in the European succession from Titian to his own day and beyond.

—Kenneth Garlick

LE BRUN, Charles.

Born in Paris, 24 February 1619; son of the sculptor Nicolas Le Brun; brother of painter/engraver Nicolas and Gabriel Le Brun. Studied under François Perrier; in Simon Vouet's studio from age 11, and commission from Cardinal Richelieu at age 15; in Rome, 1642–46, and associated with Poussin and Pietro da Cortona; co-founder of the French Academy, 1648 (and served as Rector, Chancellor, and Director); in charge of the Gobelins school for tapestries and furniture, 1662, and co-founder of the Academy of France in Rome, 1666; with Colbert's protection and sponsorship, the most influential artist in France, and worked at Versailles, Vaux-le-Vicomte, and Fontainebleau; Knighted, 1662, and created First Painter to the King (Louis XIV); member (and director) of Rome's painters guild, 1675; death of Colbert in 1683 restricted his influence.

Major Collections: Paris; Versailles: Chateau.
Other Collections: Arras; Bristol; Cambridge; Chateau-Gontier; Detroit; London: Dulwich, Victoria and Albert; Montreal; Nottingham; Oxford; Paris: Notre-Dame, S. Nicolas-du-Chardonnet, Carnavalet, Ecole des Beaux-Arts; Troyes; Venice.

Publications

By LE BRUN: books—

Conference . . . sur l'expansion l'expression générale et particulière, Paris, 1698; as *Conference,* London, 1701.
Méthode pour apprendre à dessiner les passions, Paris, 1698; as *A Method to Learn to Design the Passions,* London, 1734; edited by Alan T. McKenzie, Los Angeles, 1980.

Ceiling of the Salon de la Guerre; Versailles

Dissertation sur un traité . . . concernant le rapport de la physionomie humaine avec celle des animaux, Paris, 1806; as *A Series of Lithographic Drawings Illustrative of the Relation Between the Human Physiognomy and That of the Brute Creation,* London, 1827.

L'Inventaire Le Brun de 1683: La Collection des tableaux de Louis XIV, edited by Arnauld Brejon de Lavergnée, Paris, 1987.

On LE BRUN: books—

Jouin, Henry A., *Le Brun et les arts sous Louis XIV,* Paris, 1889.

Marcel, Pierre, *Le Brun,* Paris, 1909.

Thuillier, Jacques, and Jennifer Montagu, *Le Brun, peintre et dessinateur* (cat), Versailles), 1963.

Bryson, Norman, *Word and Image: French Painting of the Ancien Régime,* Cambridge, 1981.

articles—

Posner, Donald, "Le Brun's *Triumphs of Alexander,*" in *Art Bulletin* (New York), 41, 1959.

Damiron, S., "Les Dessins originaux de groupes d'un tableau de Le Brun: *Le Roi governe par lui-même* de la galerie de Versailles," in *Nouvelles Archives de l'Art Français,* 22, 1959.

Montgolfier, B. de, "Le Brun et les confréries parisiennes: Une Oeuvre méconnue de la jeunesse du maître: *St.-Jean l'Evangeliste à la porte Latine,*" in *Gazette des Beaux-Arts* (Paris), 55–56, 1960.

Knab, E., "Uber Bernini, Poussin, und Le Brun," in *Albertina Studien* (Vienna), 5–6, 1967–68.

Hedin, Thomas F., "The Parterre d'Eau at Versailles: An Eighteenth-Century Recollection," in *Minneapolis Institute of Arts Journal,* 65, 1981–82.

Larsson, Andreas, "Lebruns *L'Histoire d'Alexandre* och Skoklosters Alexandersvit," in *Konsthisforisk Tidskrift* (Stockholm), 56, 1987.

*

Charles Le Brun, the son of a sculptor, was studying with François Perrier when he attracted the attention of the Chancellor of France, Pierre Séguier (Le Brun's father was working on Séguier's house), who sent him to Vouet's studio. Le Brun later pursued his studies at Fontainebleau, and his early works show the influence of both Pierrer and Vouet, a Mannerist, as well as, possibly, that of Philippe de Champaigne. Early vigor is seen in such works as *Hercules and the Horses of Diomedes* (Nottingham).

This early exuberance was soon lost, however, because Séguier sent him to Rome in 1642, and there Le Brun came under the influence of Poussin's clear, orderly, formal style. (There might also be detected the influence, either direct or indirect, of Caravaggio.) He was also encouraged to copy antique statues and modern frescoes, useful in helping him to organize complicated groupings of figures.

Once he returned to France, his high-level contacts ensured that he was given numerous commissions for religious and mythological works, and they display a bewildering number of influences. He was very highly thought of, and helped with the founding of the Royal Academy of Painting and Sculpture in 1648.

Besides his paintings, he did tapesty designs as well as mural decoration. His first mural work may have been in the Hotel Lambert, which involved a ceiling decoration as well as imitation tapestries on the walls, using a program based on the myth of Hercules. At Vaux-le-Vicomte, he expanded his decorative endeavors, and achieved a classic harmony, by avoiding steep foreshortening and using the limits of the wall surfaces. The painted work was also combined with supporting figures in stucco.

At Louis XIV's order, Le Brun was summoned to Versailles to paint the famous *Family of Darius Before Alexander.* The large painting uses a frieze-like arrangement of classic simplicity, the shallow stage allowing little depth of action (only one glimpse into the distance) but with a rich variety of specific elements. Several other paintings centering on the life of Alexander followed, due to the success of the first, including a set of four enormous *Victories of Alexander.* These show him the master of the large-scale painting: some are 40 feet long, and Le Brun considered them his greatest achievement, though modern viewers find them a bit overblown and ineffective. The obvious models for the paintings are works by Giulio Romano and Pietro da Cortona. On a different scale is the 1661 *Portrait of Chancellor Sjeguier,* his long-time patron, painted seated on horseback with attendants holding two parasols over his head. The picture is carefully composed, with a glowing variety of gold and russet colors, with blue tints for emphasis. Almost as if it were a reply to the exuberant Baroque fancies of Rubens, the painting has a simple dignity, with an alignment based on the series of faces of the Chancellor and four of his attendants, a fusion of the naturalistic and the formalized.

In 1661 Fouquet fell from royal favor, and under Colbert, Le Brun's career blossomed. He was put in charge of the Gobelins manufactory in 1662. This workshop provided the production of all furnishings of the royal palaces, ensuring a uniformity of style. Tapestries, and engravings based on them, represented a major feature of Le Brun's work for the Gobelins factory, all intended to glorify the king.

Le Brun also worked at the Louvre for the king, and decorated the Galarie d'Apollon in 1663 with painted figure compositions surrounded by white and gilded stucco. Versailles, however, was the royal palace which saw the major work of Le Brun: he decorated the Grands Appartements in 1671–81, the Galerie des Glaces in 1679–84, and the Salon de la Paix and the Salon de la Guerre, completed in 1684. This includes an amazing range of work in his ceiling paintings, each scene set in an architectural surround, adorned with painted and relief work. Much of this work used an iconography based on Apollo or the Sun God. Work in the Grands Appartements includes some illusionist panels where groups of spectators look down into the room, a Baroque device going back to the work of Veronese in the Villa Masur. (Much of the splendor of these rooms was short-lived, since the marble floors were taken up and the silver furniture was melted down during the crisis in 1689.) He also worked at Saint-Germain-en-Laye and Marly-le-Roi, and on Colbert's own villa at Sceaux. All this work was accomplished using a large corps of helpers, specialists in each aspect of the arts.

His royal patronage and encouragement by Colbert had

made him the most influential artist in France, and he was also made Chancellor of the Academy in 1668. For the next 15 years he controlled Academy policy generally, and its pedagogical program specifically. Later commentators have noted that, just as the king could say, "L'etat, c'est moi," so Le Brun could have said, "L'art, c'est moi." His commentaries were simple, ingenious, and plausible, and he embraced easily understood aims: unity of action, the predominance of outline over color, a hierarchy of genres. His doctrine of the passions was influential (even on such a painter as Hogarth), based on conventionalizing emotions using standards set by Aristotle (and Aquinas). (The famous printed version of his *Method to Learn to Design the Passions* includes some drawings taken from his own work, e.g., *Fright* is from *The Battle of Arbellen*.)

Colbert's death in 1683 changed Le Brun's fortunes. Colbert's successor, Louvois, favored Le Brun's rival Mignard, and Le Brun's pride was injured by the eventual loss of large-scale commissions, exacerbated by the king's financial difficulties. He reverted to painting rather dull religious pictures. But the Academy he helped found and whose course he set out-lived him, and became his monument, for good or bad.

—George Walsh

LÉGER, Fernand.

Born in Argentan, 4 February 1881. Died in Gif-sur-Yvett, 17 August 1955. Married 1) Jeanne Lohy, 1919 (died, 1950); 2) Nadine Khodossevitch, 1952. Attended schools in Argentan and Tinchebray, 1890–97; apprenticed to an architect, Caen, 1897–99; studied under Léon Gérôme and Gabriel Ferrier at the Ecole des Arts Decoratifs, Paris, and at the Académie Julian, Paris, 1903–04; draftsman and photographic retoucher in architect's office, Paris, 1900–04, and set up studio in Paris as painter and designer; served in French engineers corps, 1914–17; gassed and discharged, 1917; first stage designs for ballet *Skating Rink*, 1921 (later stage works include *La Création du monde*, 1923, *Le Ballet mechanique*, 1924, *David triomphant*, 1937, *Leonard da Vinci*, 1952); taught at the Académie Moderne, 1924–31; lived in the United States, 1940–45; first church commissions, 1946, and ceramics, 1952; settled in Gif-sur-Yvett, 1952.

Major Collection: Biot: Léger Museum.
Other Collections: Amsterdam: Stedelijk; Basel; Jerusalem; London: Tate; New York: Moma, Guggenheim; Ottawa; Otterlo; Paris: Beaubourg.

Publications

By LÉGER: books—

Le Cirque, Paris, 1949.
Entretiens avec Blaise Cendrars et Louis Carré, Paris, 1956.
La Ville, Paris, 1959.
Léger, Paris, 1959.

Fonctions de la peinture, Paris, 1965; as *The Functions of Painting*, edited by Edward Fry, New York and London, 1973.
Lettres à Simone, edited by Christian Derouet, Paris, 1987.

illustrator: *La Fin du monde filmé par l'ange Notre Dame*, by Blaise Cendrars, 1919; *Lunes en papier*, by André Malraux, 1921; *Liberté*, by Paul Eluard, 1953.

On LÉGER: books—

Raynal, Maurice, *Léger: Vingt tableaux*, Paris, 1920.
Tériade, E., *Léger*, Paris, 1928.
George, Waldemar, *Léger*, Paris, 1929.
Couturie, Marie A., et al., *Léger: La Forme humaine dans l'espace*, Montreal, 1945.
Elgar, Franck, *Léger: Peintures 1911–1948*, Paris, 1948.
Cooper, Douglas, *Léger et le nouvel espace*, Geneva and London, 1949.
Roy, Claude, *Léger: Les Constructeurs*, Paris, 1951.
Zervos, Christian, *Léger: Oeuvres de 1905 à 1952*, Paris, 1952.
Maurois, André, *Mon ami Léger*, Paris, 1952.
Jardot, Maurice, *Léger: Dessins*, Paris, 1953.
Kuh, Katherine, *Léger*, Urbana, Illinois, 1953.
Elgar, Franck, *Picasso et Léger*, Paris, 1954.
Descargues, Pierre, *Léger*, Geneva, 1955.
Verdet, André, *Léger: Le Dynamisme pictural*, Geneva, 1955.
Léger (cat), Paris, 1956.
Jardot, Maurice, *Léger*, Paris, 1956.
Cooper, Douglas, *Léger: Dessins de guerre*, Paris, 1956.
Aragon, Louis, *Léger: Contrastes*, Paris, 1959.
Cooper, Douglas, *Léger: Contrastes de formes 1912–1915* (cat), Paris, 1962.
Delevoy, Robert, *Léger*, Geneva and Cleveland, 1962.
Tadini, Emilio, *Léger*, Milan, 1964.
Deroudille, Rene, *Léger*, Paris, 1968.
Garaudy, Roger, *Pour un réalisme du XXe siècle: Dialogue posthume avec Léger*, Paris, 1968.
Verdet, André, *Léger*, Florence, 1969, London, 1970.
Dane, Marie Claude, *Léger*, Paris, 1969.
Francia, Peter de, *Léger's "The Great Parade,"* London, 1969.
Golding, John, and Christopher Green, *Léger and the Purist Paris* (cat), London, 1970.
Fueglister, Robert, *Léger: Mensch, Maschine, Malerei*, Berne, 1971.
Le Noci, Guido, *Léger*, Milan, 1971.
Cassou, Jean, and Jean Leymarie, *Léger: Dessins et gouaches*, Paris, 1972; as *Léger: Drawings and Gouaches*, London, 1973.
Leymarie, Jean, *Léger* (cat), Paris, 1972.
Green, Christopher, *Léger and the Avant Garde*, New Haven, 1976.
Schmalenbach, Werner, *Léger*, New York, 1976.
Léger (cat), New York, 1976.
Léger: Das figürliche Werke (cat), Cologne, 1978.
Saphire, Lawrence, *Léger: The Complete Graphic Work*, New York, 1978.
Spate, Virginia, *Orphism: The Evolution of Non-Figurative Painting in Paris 1910–1914*, Oxford, 1979.

Black Profile, 1928; $46\frac{1}{2} \times 34\frac{3}{4}$ in (118.1 \times 88.2 cm); Bior, Léger Museum

Ruckhaberie, Dieter, et al., *Léger* (cat), Berlin, 1980.

Laugier, Claud, and Michèle Richet, *Oeuvres de Léger,* Paris, 1981.

Léger: La Poésie de l'objet 1928-34 (cat), Paris, 1981.

Léger: Gouaches et dessins 1911-1955, Paris, 1981.

Hommage à Leger (cat), Biot, 1981.

Léger et l'esprit moderne (cat), Paris, 1982.

Léger (cat), Salzburg, 1982.

Buck, Robert T., et al., *Léger* (cat), New York, 1982.

Francia, Peter de, *Léger,* New Haven, 1983.

Diehl, Gaston, *Léger,* Naefels and New York, 1985.

Schmalenbach, Werner, *Léger,* New York, 1987.

Freeman, Judi, Sara Wilson, and Simon Willmoth, *Léger: The Later Years* (cat), London, 1987; New York, 1988.

Flam, Jack, *Léger* (cat), New York, 1987.

Bauquier, Georges, *Léger: Vivre dans le vrai,* Paris, 1987.

*

Fernand Léger is rightly ranked with Picasso and Braque among the major Cubists. Considered as such by his contemporaries, Léger, nonetheless, always remained somewhat on the perimeters of the movement. Unlike the Cubists, he did not extensively analyze the object-space relationship; instead his images resulted from the superimposition of angles onto the objects.

The son of a Norman cattleman, Léger had moved to Paris in 1900 to work as an architectural draftsman, but an interest in painting led him to study art. The influence of the 1907 Salon d'Automne Cézanne retrospective is apparent in his paintings of 1908-10 with their block-like volumes set in a conventionally illusionistic space. In close contact with Cubist circles—he met Picasso, Braque, and Delaunay during that time—he became a member of the Section d'Or group and exhibited in their 1912 show. His paintings of 1909-13 are among the most abstract of his career. Reducing his palette to the tans, greens, and silvery grays of Analytic Cubism, he imposed geometrical volumes onto the natural forms of his subjects.

Contrast of Forms, 1913, typifies his work of 1912-14. Initially nonrepresentational, but spatially illusionistic, the paintings from this period consist of cylindrical and cubic volumes rendered with a restricted vocabulary of straight and curved lines. The forms are banded with primary colors, imparting a dynamic tension to the compositions that is restrained by the counterbalancing forces of the forms. Gradually he fused these motifs with recognizable subjects such as houses among trees, still lifes, and figures.

More than any other Cubist artist, Léger wanted to go beyond the manipulation of forms for purely artistic purposes to create an art accessible to all classes in modern society. His experiences in the First World War clarified this for him when he exchanged the isolation of the studio for the camaraderie of the trenches. Both the men and machinery of the battlefield transformed his notion of the artist from a maker of abstract forms to a painter of "everyday poetic images." Initially he applied his pre-war cylindrical style to the war and machine pictures. Subsequently he combined his new subject matter with the formal elements of Synthetic Cubism, enlivened by a simultaneity gained from Delaunay. Preoccupied with objects, particularly with those that were precise, clear, and definite—characteristics he attributed to machine forms and mass-produced items—Léger presented images that had an intrinsic beauty, which possessed neither sentimental nor descriptive values. He even borrowed the principle of interchangeable parts from the mechanical world; his completed compositions are often comprised of elements occurring in other works combined in new and different ways. Léger became the painter of modern life as seen rather than felt, capturing the beauty in the unpicturesque aspects of the urban landscape. *The City*, 1919, summarizes his concerns in the post-war period. With its bright colors, colliding planes, and fragmentary city views, the painting records the movement of a spectator through the streets as he catches fragmentary glimpses of the passing array of images.

During the 1920's, Léger was a leading spokesman of the machine aesthetic and a participant in the Purist movement, founded by Amédée Ozenfant and Charles-Edouard Jeanneret (better known as Le Corbusier). In his effort to purge his compositions of all but pure elements, his work, which was intended to enhance the new architectural spaces designed by Le Corbusier, appears almost nonrepresentational. Even his handling of the human figure, posed in broad frontal view or side profile, recalls the regularity of machine forms. Its presence in his paintings declared his solidarity with the working class while satisfying his formal and stylistic impulses. In 1924 he made one of his best-known films, *Ballet mécanique*, a movie without scenario, consisting of the interation of rythmic images.

The principal achievements of Léger's later life are the large paintings of popular, often proletarian subjects, such as *Cyclists*, 1948–49, *Constructors*, 1950, and *The Great Parade*, 1954. The last painting summarizes his aesthetic and social concerns. The painting is populated with human figures and circus characters presented in simple outline and modelled like his earlier machine forms. They are part of the grand design; their monochromatic bodies, forming a pattern of lines across the canvas, are free of sentimental or anecdotal details. Broad bands and circles of bright color, independent of line, animate the picture, and give a sense of the figures being set in motion.

Throughout his life, Léger wrote, spoke, and incorporated in his art the ideas that were important to him. The social context of art, the socio-economic realities of the world in which he worked, and the creation of an art for the common man were his constant themes. Despite his determination and persistence, there is little evidence that his audience included the workers who served as his subjects.

—Jennifer Gibson

LEIBL, Wilhelm (Maria Hubertus).

Born in Cologne, 23 October 1844. Died in Wurzburg, 4 December 1900. Attended Munich Academy, studying mainly under von Ramberg; first exhibited, 1869; worked in Paris, 1870, and Munich, 1870–83; after 1873, lived in various Bavarian towns, finally settling in Aibling.

Major Collections: Berlin; Cologne; Munich: Neue Pinakothek.

Other Collections: Dresden: Schloss Pillnitz; Frankfurt; Karlsruhe; Hamburg; Karlsurhe; Leipzig; Stuttgart; Vienna.

Publications

On LEIBL: books—

Gronau, Georg, *Leibl*, Bielefeld, 1901.

Mayr, Julius, *Leibl: Sein Leben und Schaffen*, Berlin, 1907, 4th ed., 1935.

Gebhardt, Otto, *Leibl, aus seinem Lebenswerk*, Mainz, 1909.

Wolf, Georg Jacob, *Leibl und sein Kreis*, Hanover, 1924.

Waldmann, Emil, *Leibl: Eine Dartstellung seiner Kunst: Gesamt verzeichnis seiner Gemälde*, Berlin, 1930.

Hanfstaengl, Eberhard, *Leibl: Das bauerliche Antlitz*, Burg bei Magdeburg, 1938.

Förster, Otto H., *Leibl in Wallraf-Richartz-Museum Köln*, Munich, 1940.

Waldmann, Emil, *Leibl als Zeichner*, Munich, 1943.

Kubsch, Hugo, *Leibl*, Murnau, 1950.

Römpler, Karl, *Leibl*, Dresden, 1955.

Hanfstaengl, Eberhard, *Leibl: Die Dorfpolitiker*, Stuttgart, 1958.

Sailer, Anton, *Leibl: Ein Maler—und Jägerleben*, Bonn, 1959.

Langer, Alfred, *Leibl*, Leipzig, 1961, 1977.

Petzet, Michael, *Leibl und sein Kreis* (cat), Munich, 1974.

Ruhmer, Eberhard, *Munich and American Realism in the 19th Century* (cat), Sacramento, California, 1978.

Jüngling, Armin, *Leibl: Bilderreise durch ein Leben*, Munich, 1984.

*

Wilhelm Leibl, a member of the Munich School, specialized in naturalistic portraiture and peasant genre with passive figures. Most German critics contemporary with him dismissed his mature "peasant style" as vulgar or ridiculed his cumbersome enameling technique. By contrast, ever since his earliest success with his *Portrait of Frau Gedon* (1868–69, Munich) segments of the Parisian art world celebrated him as "the new Holbein" and an artistic equal of his fellow realist and friend Courbet.

Leibl wanted to differentiate himself from the two dominant strains of Munich art, history painting and anecdotal genre, by opting for an objective realist approach. To find sources, he leapfrogged the dramatic, history set art of his teacher K. V. Piloty to study "origins": Rubens, Van Dyck, Velazquez, Hals. He opposed the dominant trends of the Munich School, Böcklin's Neo-romantic *Ideenmalerei* (idea painting), and

Lenbach's psychologically heightened portraiture. He loathed the former's literary themes and the latter's spurious technical bravura.

Leibl developed a form of "early German Impressionism" which differs from its French counterpart (where light effects dominate) by equating optical considerations with a "graduated color scale" and "the human figure and its volumes" (S. Wichmann). Simultaneously, he wanted to disengage himself from other German Impressionists who juxtaposed complimentaries, used optical mixture of colors, and infused white into the palette. These features resulted in the dissolution of pictorial form. But by stressing "local color and plasticity" as well as directional light, Leibl strengthened pictorial form (C. Schuch).

Courbet encouraged him to pursue his chosen direction. It is not known whether or not Leibl also met some of the future Impressionists during his stay in Paris. It would appear, however, that, on the basis of stylistic analysis, Manet influenced him more than Courbet. *The Cocotte's* (1870 Cologne) debonair pose and svelte demeanor echo the prostitute types done by Manet (e.g., *Olympia*, 1865). *Tischgesellschaft* (Company at Table; 1972–73, Cologne) was influenced by Hals. But its planar construction of form with color is demonstratively Manet-like. Overall, Leibl's paintings repeat the Frenchman's sober objectivity, psychological indifference to his objects, emotional unrelatedness of his figures, negation of spirituality, and lack of a "social agenda." All this indicates a complete break not only with the Romantic tradition but also with Courbet's politically charged doctrinaire realism. "Art must start from the beginning and from nothing" (Leibl).

By 1870 Leibl had disassociated himself from virtually all stylistic directions in Munich, steering an independent course. His great technical facility, which ranged from his arduous *alla prima*, wet-in-wet enamels all the way to a dynamic Impressionism, added to the growing demand for his portraits. Munich feted him as the "King of Painters" (Diem). His pragmatic approach to perception and creativity—"the true is the beautiful" (Leibl)—kept at bay those who scoffed at his portrayal of an unvarnished reality. The group of younger artists who formed the Leibl Circle—Theodor Alt, Louis Eysen, Victor Müllen, Fritz Schider, Carl Schuch, Otto Scholderer, Hans Thoma, Wilhelm Trübner—represented the "Bavarian echelon" of German realism, naturalism and Impressionism.

From 1873 onward, Leibl lived a solitary life in the countryside. Peasant genre, usually with one or two figures, occupied a central position in his work. *Dorfpolitiker* (Village Politicians, 1876/77, Winterthur, Stiftung Oskar Reinhart) is a rare exception of a multi-figural grouping. With *Three Women in Church* (1882, Hamburg, Kunsthalle) he celebrated his last and greatest triumph. Because of problems with foreshortening and perspective he segmented his two most ambitious paintings, *The Poachers* (1882–86, Berlin, Nationalgalerie) and *Girl with Carnation* (1880's, Cologne). To avoid the recurrence of such tragic mishaps, "he acquired a large photographic camera" as a compositional aid (Karl Leibl).

In the 1880's the bright chromas of Holbein dominated Leibl's palette. The late 1890's displayed a mysterious chiaroscuro, brought on by his discovery of Rembrandt as a stylistic ideal (e.g., *Girl at Window*, 1899, Cologne). His figure paintings, and alternatively, portraits, where passive personages mark a suspended time, lack a compelling psychological interest or obvious "Innerlichkeit" (inwardness or subjectivity; R. Zeitler). Having effectively transformed "subjective" reality into "objective fact," Leibl suspended their existence in a disengaged sphere.

Leibl, who socialized with the bourgeoisie (Diem) and aristocrats, was separated from his subject matter, the peasants, by differences in education, cultural background, geographic region, and dialect. He really only knew peasants as models, i.e., as repositories of visual data. By contrast, Courbet's intuitive familiarity with country folk and his "social program" for art endowed his figures with authentic social roles. Leibl's villagers, on the other hand, lack a similar, class-conscious contextual integration. Nor are they symbolically intensified or part of a narrative. Thus, they stand in no apparent causative relationship to each other, to their environment, *or* to the viewer.

Leibl "did not enrich the poetic and ideative ground" of German art (E. Hanfstaengl). Instead, he shared a common German penchant for an "art for technique's sake." His paintings "live as beautiful works of craft" (E. Diem). Objective peasant genre, his confessed artistic mission, seems to be all surface materiality without ideative depth. In the process, people have become still-lifes (E. Ruhmer), dissociated and devoid of narrative or symbolical identification as social "types" or "cultural castes," though endowed with myriad specific characterizations. And yet, remarkably, Leibl's figures manage to emerge from his unrelenting positivist treatment with their own pure dignity as individuals intact. As his style exhausts itself in an empirical process of defining the minutiae of color, light, space, and form, his figures literally "become art." His compulsive creative psychology calls for painting as an end in itself. In turn, by mercilessly revealing unvarnished existence, his "scientific" style lays bare essential humanity. Both his psychology and style manifest the same impulse to primal experience and existential irreducibles.

—Rudolf M. Bisanz

LEIGHTON, Frederic [Lord Leighton of Stretton].

Born in Scarborough, 31 December 1830. Died in London, 25 January 1896. Began studies at an early age on the continent with his traveling family: in Berlin, Florence, and especially in Frankfurt (Städelsches Kunstinstitut); influenced by the Nazarenes; settled in Rome, 1852 (friend of Nino Costa); painted the large Cimabue's Madonna Borne in Procession, which was exhibited in London, 1855, and bought by the queen; he settled in London, 1860; also a book illustrator, sculptor; member, R.A., 1868 (and President, 1878); only British artist to be ennobled.

Collections: Boston; Fort Worth; Frankfurt; Leicester; London: Portrait Gallery, Tate, Victoria and Albert, Leighton House; Manchester; Minneapolis; New Haven; New York; Ottawa; Oxford; Philadelphia; Ponce, Puerto Rico; Port Sunlight; Sydney; Royal Collection.

Cimabue's Celebrated Madonna ..., 1853; 7ft 3½ in × 17ft 1 in (221 × 519 cm); Royal Collection

Publications

By LEIGHTON: book—

Illustrator: *Romola* by George Eliot, 1880.

On LEIGHTON: books—

Rhys, Ernest, *Leighton: An Illustrated Record of His Life and Work,* London, 1900.

Barrington, Mrs. Russell, *The Life, Letters, and Work of Leighton,* New York, 2 vols., 1906.

Staley, Edgcumbe, *Lord Leighton of Stretton,* London and New York, 1906.

Baldry, A. Lys, *Leighton,* London and New York, 1908.

Gaunt, William, *Victorian Olympus,* London, 1952, 1975.

Ormond, Leonée and Richard, *Lord Leighton,* New Haven, 1975.

Ormond, Richard, *Leighton's Frescoes in the [Victoria and Albert] Museum,* London, 1975.

Ormond, Leonée and Richard, et al., *Victorian High Renaissance: Watts, Leighton, Moore, Gilbert* (cat), Manchester and Minneapolis, 1978.

*

Just before his death Leighton was elevated to the peerage. This honor showed the high esteem that painters in general had achieved by the end of the 19th century. At the same time Lenbach lived like a lord himself in a palace in Munich, and Meissonnier entertained like royalty in his large Parisian hotel. It was a sign that the struggle started in the Renaissance to raise the social reputation of the artist had been won.

Leighton had made the Royal Academy respectable by several qualities: his cosmopolitanism—he had spent most of his youth abroad, and had studied in German, Italian, and French institutions and spoke the appropriate languages fluently; his very fine administration of the institution over 20 years; the general attractiveness of his character which made him a good liaison between the artists of the organization and the aristocratic patronage upon which they depended; his general intelligence which made him a friend of intellectuals and writers as well as artists of all countries; and the good taste and elevated thought evident in his paintings, a compromise made between Victorianism and classicism without heroics or fatigue.

His earliest training had been in Frankfurt where he learned the German love of detailed and accurate historical scenes, and his earliest works are richly detailed narratives (for example, *The Death of Brunelleschi,* 1852, London, Leighton House). These are splendid achievements technically, but not so impressive as his later works wherein his forms have simplified with a resulting clarity of composition which he learned through further studies in Paris and Rome.

He broke the established format and set up his own style in *Cimabue's Celebrated Madonna Is Carried in Procession Through the Streets of Florence* (1853, Royal Collection). It is a wide composition, measuring 87.5 x 203 cm. Many costumed figures march through Siena carrying the *Maestà,* which is seen only in foreshortening. Despite the respect for Gothic art shown in the choice of subject, the figures are all shown in vigorous academic correctness.

The wide format became gradually his own, although in later procession scenes the figures are larger, the rhythms more decorative, and the subjects usually classical: *The Syracuse Bride* (1865; private collection), the subject taken, as is often the case in late 19th-century classicism, from a very obscure text, the proportions even wider, with the figures in almost frieze like proportions; *Hercules Wrestling with Death for the Body of Achilles,* (1869; Toronto, Tanenbaum Collection); *The Daphnephoria,* (1876; Port Sunlight), again over 2 meters long; *Captive Andromache* (1889; Manchester) with lush colors that dance as much as his figures. These wide, frieze-like works are the pinnacle of English classicism; museum pieces all, they show a control of form and color of the most exalted degree. In them, Leighton has gotten—as if through Sophocles—to the highest emotion of classicism and

combined it with the richness of Hellenistic and Renaissance forms. The stuffiness in them must be accepted as we accept the stuffiness in favorite Victorian novels.

Smaller genre pieces, often classical, and portraits counterpointed his output of large histories, but the end of his life was glorified by a series of single classical female figures often in the high and narrow format favored by many of his contemporaries. *The Bath of Psyche* (c. 1890; Leighton House) measures 74.5 x 24.5 centimeters. In the composition Leighton balances the interest between the solidity of the body and the counterpoint of the figure's contours against fragments of architecture to either side: staid but sensual, animated yet balanced.

Despite technical competence and fine imagination, Leighton's work is uneven; mediocrity of conception and execution lame many of his works; his anatomy is often superficial, and his skin surfaces often overworked. But his profound concern with the balance of aesthetic and sensual forms, and his rich Venetian color, raised a whole string of his works to the highest level.

These traits are distilled to the highest level in *Flaming June* (c. 1895; Ponce, Puerto Rico) where the rhythms of the arrangement (solid limbs surrounded by fragile drapery) are brought to overripe sensuality through the strident intensity of the colors. The legend of the sexual coldness of the Victorians is given the lie.

—Gerald M. Ackerman

Unidentified Lady; drawing; Royal Collection

LELY, (Sir) Peter.

Born Pieter van der Faes in Soest, Westphalis, to Dutch parents, 14 September 1618. Died in London, 30 November 1680. Married Ursula (died, 1674); one daughter, two sons. Pupil of Frans Pieter de Grebber by 1637, and member of Haarlem guild by 1637; in England in early 1640's: patronized by aristocrats who remained in London during the Civil War, and most popular portrait painter by 1660; named Principal Painter by Charles II, 1661, succeeding Van Dyke; popular prints made from his portraits, which included a series of Windsor Beauties and of Admirals. Pupils/assistants: Robert Hooker, John Greenhill; P. H. Lankrink, Joseph Buckshorn. Knighted, 1680.

Collections: Ham House; Hampton court; Leicester; London: Courtauld, Dulwich, Guildhall, National Gallery, Tate, Greenwich, Syon House; Manchester; New Haven; New York; Ottawa; York; Royal Collection.

Publications

Baker, C. H. Collins, *Lely and the Stuart Portrait Painters,* London, 2 vols., 1912.
Baker, C. H. Collins, *Lely and Kneller,* London, 1922.
Beckett, R. B., *Lely,* London, 1951.
Waterhouse, Ellis, *Painting in Britain 1530 to 1790,* London, 1953, 4th ed., 1978.
Millar, Oliver, *Lely* (cat), London, 1978.

articles—

Talley, M. Kirby, Jr., "Extracts from the Executors Account-Book of Lely, 1679-1691: An Account of the Contacts of Sir Peter's Studio," in *Burlington Magazine* (London), November 1978.
Rogers, Malcolm, "Some Beauties of Lely," in *Connoisseur* (London), February 1979.

*

Peter Lely, a Dutch artist, is a typical example of the many foreign artists who came to work at the English court from the late 16th into the 18th centuries, in many cases such as Lely's for their entire careers. Lely is best known as the major portraitist of the English Restoration; but already by 1660 he had popularized portrait types which prevailed up to the Romantic period of the 19th century. His phenomenal output, made possible by his adoption of the continental practise of building a "portrait factory," insured that huge numbers of his paintings would survive. Ellis Waterhouse calculated that 400-500 paintings could be catalogued that are "more or less" from Lely's own hand.

Lely's initial training in Haarlem with Pieter de Grebber coincided with the career of Frans Hals; but he displays no influences from Hals or from his own master. Lely's arrival in England coincided with the death in 1642 of the Flemish

painter Anthony Van Dyck, Principal Painter to Charles I and the most influential painter living in England. Lely at first concentrated on landscapes and history paintings, but later turned to painting portraits which show a deliberate Van Dyck influence. Gradually Lely filled the vacuum left by the great Flemish painter. His early portrait style was fully developed by 1647 when he painted Charles I and the Duke of York (1647) and the three younger children of the King (1646–47). Such portraits as these popularized the use of drapery and columns for backdrops and incorporated wooded landscape settings. Lely did not pioneer these features but in using them in highly visible and hugely numerous works, he set a lasting type. The paintings of this early period, 1641–50, are characterized by a uniform all-over thin enameled surface and flesh smoothly and evenly painted with subtle tones. Rich highlights have been created by an application of thicker paint; warm shadows have been produced by the addition of a layer of gray over a purple-gray ground. By 1650, Lely had formed ideas he had mined from Van Dyck into his own idiom. His figures, in contrast to Van Dyck's more static ones, exhibit movement, either of the entire body or of only the hands. The gracious ease of his previous work became accentuated; a generalized voluptuousness entered; coloration became softer.

During the Commonwealth period, 1650–60, Lely changed his style to suit the political scene. His portraits become somewhat austere, the "correct" demeanor of the sitter being emphasized. Painterly effects are played down. More importantly, he made a more serious effort to give some insight into the character of his sitter. His group portraits of this period, in which the figures are dispersed across the picture plane with an assured balance and relate to one another as well as to the viewer, also set a lasting type like his earlier single-subject portraits. As the Commonwealth wore on, Lely moderated this severe approach, even beginning to paint his female sitters in an un-Puritan like flattering fashion.

At the beginning of the Restoration (1660), Lely again adjusted his style to suit the times. The two famous series for which he is best remembered were painted during this period. The Windsor Beauties (by 1668), a group of portraits of the most beautiful women at court, were painted at the request of the Duchess of York. For the Beauties, Lely augmented his established set of poses with a return to a voluptuousness type. The sitters often display half-closed eyes and a suggestive dishevelment. This group is regarded as less accomplished work. For the Duke of York he painted the Admirals series (1666–67). The subjects are the flag officers at the Battle of Lowestoft. For the male portraits, he retained the more austere treatment of the Commonwealth period, supporting the seriousness of their role. His technique remained much the same as during Commonwealth period.

Lely's late style remained much the same with some advances. He made a conscious effort, for example, to increase the subtlety of his brushwork using loose, separate strokes. He also shifted to somewhat thinner surfaces which have a dryer, rougher appearance created by allowing underpaint to show through. Standardization of palette was augmented by an emphasis on cool blue-gray and red-brown. It is surprising that despite the huge volume of work turned out by his factory-studio, his standards remained as high as they did. Lely's technical innovations and his popularization of portrait types, all in all, provided a long lasting model for future painters; his

achievement, however, was ultimately undermined by his inability or lack of desire to allow them to convey any great insight.

—Ann Stewart Balakier

LE NAIN, Louis.

Born in Laon, c. 1600–10. Died in Paris, 23 May 1648. Closely linked with his two brothers, Antoine (born c. 1600–10) and Mathieu (born c. 1607), but few details of their lives: Antoine is recorded in Saint-Germain-des-Près, 1629, and Mathieu is noted as a master painter of Paris, 1633; all three were original member of the French Academy, 1648, but both Louis and Antoine died that year; Mathieu went on to become a "peintre du Roi" before dying in 1677.

Major Collection: Paris
Other Collections: Aix-en-Provence; Birmingham; Boston; Bristol; Brussels; Cardiff; Detroit; Glasgow; Hartford, Connecticut; Leningrad; London: National Gallery, Victoria and Albert; Minneapolis; Nevers: S. Pierre; Orleans; Philadelphia; Puy; Rheims; San Francisco.

Publications

On LE NAIN: books—

Valabregue, Antony, *Les Frères Le Nain*, Paris, 1904.
Jamot, Paul, *Les Le Nain*, Paris, 1929.
Fierens, Paul, *Les Le Nain*, Paris, 1933.
Jamot, Paul, *Georges de La Tour, The Brothers Le Nain* (cat), New York, 1936.
Leymarie, Jean, *Le Nain*, Paris, 1956.
Bloch, Vitale, *Le Nain*, Milan, 1968.
Thuillier, Jacques, *Les Frères Le Nain* (cat), Paris, 1978.

article—

Thuillier, Jacques, "Documents pour servir à l'etude des frères Le Nain," in *Bulletin de la Société de l'Histoire de l'Art Français* (Paris), 1963.

*

Since the discovery of the brothers Le Nain by the 19th-century novelist and critic Jules Champfleury (*Les Peintres de la réalité sous Louis XIII*, 1862), much has been written about them, and they have been studied in many important exhibitions, most especially the exhibition organized at the Grand Palais by Jacques Thuillier in 1978–79. Despite these scholarly attempts to elucidate the three brothers, we still have only the vaguest notion of their personalities, and many problems still attach to their works as well.

The factual information we do have is quickly summarized. The brothers, Antoine, Louis, and Mathieu, were natives of the old cathedral town of Laon in the north of France. An-

toine, who was certainly the oldest, and Louis were between 1600 and 1610 (not in the last decades of the sixteenth century as formerly assumed), and Mathieu in about 1607. In 1629 Antoine's request to become a master in the guild of Painters of St. Germain-des- Près was granted, and he moved to Paris to be followed in the same year by his two brothers with whom he shared his shop thereafter. In 1632 Antoine signed a contract with the magistrates to paint a group portrait of the municipal officials of Paris. All three brothers participated in the founding of the Royal Academy, in 1648, long before the Academy developed the rigidly classicistic outlook that characterized its later years. In May 1648 both Antoine and Louis died but Mathieu continued to prosper up to the time of his death in 1677. In 1633 he was named Peintre Ordinaire de la Ville de Paris and in the same year became an officer in the civic militia. In 1649 he presented a portrait of Cardinal Mazarin (lost) to the Royal Academy. Mathieu seems to have acquired a considerable amount of property during his later years, and in 1658 he assumed the title Sieur de la Jumelle which was the name of his farm near Laon. This might be taken to suggest that the family connections with Laon had been maintained after the brothers were settled in Paris.

These sparse bits of information afford only very superficial glimpses of the Le Nain, and we are hardly on firmer ground with regard to the paintings attributed to them. There are only about 15 paintings in all, and though many of them are signed Le Nain, no initials are given to distinguish the work of one brother from another. It is possible also that some of the paintings were collaborative efforts. Nor are we able to discern different stylistic phases in the works since those that are dated all bear dates in the 1640's. Thus the attribution of pictures to the three artists is based largely on style and conception: and the confusion is especially great between Antoine and Louis. In spite of the problems of documentation and attribution, there now seems to be a general agreement about most of the pictures; and three more or less homogeneous groups of paintings have come to be associated with the three brothers. Accordingly Antoine's style would be exemplified by a group of small pictures, mostly on copper, and representing genre-like group portraits executed with a distinctive stiffness and awkwardness that are almost primitive. In contrast to these primitive little artistic curiosities attributed to Antoine Le Nain, those given to Mathieu show far more skill and technical sophistication. Though most of his work seems quite routine, a few are of exceptional quality. An example of this is Mathieu's most famous work, the so-called *Corps de Garde* (Louvre) which again combines genre with groups portraiture. The picture has always been associated with the artist's activities in the Paris militia. Here in the intimate space of what is probably a guard room the members of the militia company are shown enjoying their pipes and flasks of wine attended by a black servant, while on the left one member, overcome by the wine, has fallen asleep on the table. The composition is made all the more vivid by the sharp contrasts of light and shadow caused by the candle in the candlestick in the middle of the table—a subtle use of chiaroscuro that recalls the light effects of Caravaggio and his followers.

Most extraordinary and artistically significant is the group of paintings attributed to Louis Le Nain. These works surpass anything done by the other two Le Nain brothers and, if the attributions are correct, reveal him to have been one of the most sensitive and inventive painters of his age. Indeed, the Le Nain brothers would have attracted scant interest were it not for the special qualities of Louis's pictures. These are painted in a larger format than the paintings of Antoine and Mathieu; and they are executed characteristically in cool greyish brown, green, and blue with sudden passages of bright crimson to counter the propensity to monochrome. It has been remarked that Louis Le Nain's color is as impoverished as the personages who appear in his paintings. Likewise the compositions tend to be contrived and arbitrary, or even a bit primitive; but in Louis's pictures the result is rather a virtue than a detriment. His works are entirely lacking in the refined embellishment and artifice seen in paintings by the more fashionable artists of his day; yet he seems the more profound because of his very simplicity.

Perhaps the most intriguing aspect of Louis Le Nain's paintings is in the rustic iconography which he invented. His pictures are mostly genre scenes (a few religious subjects are also given to him) showing humble country folk in their cramped and smoky hovels or against the background of fields and farmyards, sometimes with a ramshackle farm building or a country church in the distance. The figures range in age from childhood to old age, and they are shown isolated singly or in small groups usually with omnipresent domestic animals such as dogs, cats, pigs, and chickens. The figures are motionless and self-absorbed; but occasionally one will look out of the picture as though the person has noticed the spectator, reciprocally as the spectator looks into the painted scene, thereby blurring the separation between the reality of the picture and that of the spectator. And sometimes these rustic scenes seem to be almost sacramental in their meaning, as when in the Louvre *Peasants at Supper* an old woman solemnly holds up a glass of wine as though she were presenting an element of the Eucharist; or in the *Hay Wain,* also in Louvre, where a peasant woman sits upon the ground holding an infant, like a rustic Madonna of Humility. While Louis's paintings tend to remain enigmatic, it seems clear that his aim was not merely to describe country scenes but to create poetic evocations of rural places and rural people. We know nothing of the patronage of the Le Nain brothers, but one might guess that Louis's haunting scenes of country life would have had a strong appeal to people with rural origins who were thronging into the newly bourgeoning city of Paris in the time of Henry IV and Louis XIII. In any case, his art is quite different from the spiritualized realism of Caravaggio (whose work he would have known if it is true that he visited Italy) or from the visual documentation of 17th-century Flemish and Dutch realists.

—William R. Crelly

LEONARDO da Vinci.

Born Leonardo di Ser Piero da Vinci, in Vinci, 15 April 1452. Died in Amboise, France, 2 May 1519. Probably studied with Verrocchio in Florence, c. 1470–77: member of the Florence guild, 1472, and living in Verrocchio's house in 1476, but set up his own studio in late 1470's; then worked for Lodovico Sforza in Milan from c. 1482–99 on both artistic and scientific projects (including a bronze horseman, not completed): Last

War Machines; drawing; Florence, Uffizi

Supper in S. Maria delle Grazie; worked in Florence, 1500–06: Mona Lisa is from this period; worked for Louis XII of France, 1507–19, as painter and engineer: lived in Amboise, (but was in Rome, 1513–16); about a dozen paintings survive, with many notebooks and other writings.

Major Collection: Paris; Royal Collection.
Other Collections: Cracow; Florence; Leningrad; London; Milan: Abrosiana, S. Maria della Grazie; Munich; Vatican; Washington.

Publications

By LEONARDO: books—

I manoscritti e i disegni di Leonardo, edited by Adolfo Venturi, Rome, 7 vols., 1928–52.
Literary Works, edited by J. P. Richter, New York, 2 vols., 1939; commentary by Carlo Pedretti, Berkeley, 2 vols., 1977.
Notebooks, edited by Edward MacCurdy, London, 2 vols., 1938, New York, 2 vols., 1941–42, 1955, London, 1956; edited by J. P. Richter, New York, 2 vols., 1970; edited by Pamela Taylor, New York, 1960.
Paragone: A Comparison of the Arts, edited by Irma A. Richter, New York, 1949.

Scritti scelti, edited by Anna Maria Brizio, Turin, 1952, 1966.
Treatise on Painting, edited by L. H. Heydenreich and A. Philip McMahon, Princeton, 2 vols., 1956.
Fragments at Windsor Castle from the Codex Atlanticus, edited by Carlo Pedretti, London, 1957.
The Manuscripts of Leonardo . . . at the Biblioteca Nacional of Madrid, edited by Ladislao Reti, New York, 5 vols., 1974.
Il Codice Atlantico della Biblioteca Ambrosiana di Milan, edited by Augusto Marinoni, Florence, 12 vols., 1975–80.
I pensieri, edited by Bruno Mardini, Florence, 1977.

On LEONARDO: books—

Vasari, Giorgio, *The Life of Leonardo* (tr. by Herbert Horne), London, 1903.
Freud, Sigmund, *Eine Kindheitserinnerung des Leonardo,* Vienna, 1910; as *Leonardo: A Psychsexual Study of Infantile Reminiscence,* New York, 1916, London, 1922.
Bode, Wilhelm von, *Studien über Leonardo,* Berlin, 1921.
MacCurdy, Edward, *The Mind of Leonardo,* London, 1928, New York, 1940.
Verga, Ettore, *Bibliografia Vinciana 1493-1930,* Bologna, 2 vols., 1931; continued in *Raccolta Vinciana,* and in *Bibliografia Vinciana 1964-1979* by Alberto Lorenzi and Pietro Marani, Florence, 1982.
Clark, Kenneth, *A Catalogue of the Drawings of Leonardo . . . at Windsor Castle,* Cambridge, 2 vols.,

1935; revised ed., with Carlo Pedretti, London, 3 vols., 1968.

Clark, Kenneth, *Leonardo*, Cambridge, 1939, 5th ed., edited by Martin Kemp, New York and London, 1988.

Panofsky, Erwin, *The Codex Huygens and Leonardo's Art Theory*, London, 1940.

Douglas, Robert Langton, *Leonardo: His Life and His Pictures*, Chicago, 1944.

Goldscheider, Ludwig, *Leonardo: Paintings and Drawings*, New York, 1944.

Popham, Arthur E., *The Drawings of Leonardo*, New York, 1945, London, 1946, 1964.

Chastel, Andre, *Leonardo par lui-même*, Paris, 1952; as *The Genius of Leonardo*, New York, 1961.

O'Malley, Charles D., and J. B. de C. M. Saunders, *Leonardo on the Human Body*, New York, 1952.

Bazardi, Alessandro, *La botanica nel pensiero de Leonardo*, Milan, 1953.

Heydenreich, Ludwig H., *Leonardo*, Basel, New York, and London, 2 vols., 1954.

Pedretti, Carlo, *Studi Vinciana*, Geneva, 1957.

Goldscheider, Ludwig, *Leonardo*, Cologne and London, 1960.

Eissler, Kurt, *Leonardo: Psychoanalytic Notes on the Enigma*, New York, 1961, London, 1962.

Hart, Ivor B., *The World of Leonardo, Man of Science, Engineer, and Dreamer of Flight*, New York, 1961.

Einem, Herbert von, *Das Abendmahl des Leonardo*, Cologne, 1961.

Heydenreich, Ludwig H., *Leonardo architetto*, Florence, 1963.

Cooper, Margaret, *The Inventions of Leonardo*, New York, 1965.

McLanathan, Richard B. K., *Images of the Universe: Leonardo: The Artist as Scientist*, New York, 1966.

Wallace, Robert, *The World of Leonardo*, New York, 1966.

Avane, Luisa Cogliati, *I disegni di Leonardo e delle sua scola a Venezia*, Venice, 1966.

O'Malley, Charles D., editor, *Leonardo's Legacy*, Berkeley, 1969.

Calder, Ritchie, *Leonardo and the Age of the Eye*, New York, 1970.

Pedretti, Carlo, *Leonardo: A Study in Chronology and Style*, Berkeley, 1973.

Heydenreich, Ludwig H., *Leonardo: The Last Supper*, New York, 1974.

Gould, Cecil, *Leonardo: The Artist and the Non-Artist*, Boston and London, 1975.

Wasserman, Jack, *Leonardo*, New York, 1975.

Argan, Giulio C., et al., *Leonardo: La pittura*, Florence, 1977.

Pedretti, Carlo, *Leonardo architetto*, Milan, 1978; as *Leonardo, Architect*, London, 1986.

Mona Lisa im 20. Jahrhundert (cat), Duisberg, 1978.

Beck, James, *Leonardo's Rules of Painting*, New York, 1979.

Pedretti, Carlo, and Kenneth Keele, *Leonardo: Corpus of Anatomical Drawings in the Collection of Her Majesty the Queen*, New York, 3 vols., 1979–80.

Kemp, Martin, *Leonardo: The Marvelous Works of Nature and Man*, Cambridge, Massachusetts, 1981.

Snow-Smith, Joanne, *The Salvator Mundi of Leonardo*, Seat-tle, 1982.

Brown, David Alan, *Leonardo's Last Supper: The Restoration*, Washington, 1983.

Keele, Kenneth, *Leonardo's Elements of the Science of Man*, London and New York, 1983.

Heydenreich, Ludwig H., *Leonardo Studies*, New York, 1987.

*

Born on 15 April 1452 in Vinci, a small village near Florence, Leonardo died on 2 May 1519 at Cloux, near Amboise in France. He, more than any other, embodies the idea of the "Renaissance Man," a person versed in many different fields of knowledge and endeavor. Leonardo was not only a genius in painting; he left thousands of pages of drawings, which reveal his advanced knowledge of the sciences as well as the arts. Although he did surprisingly few paintings and did not finish all of them, his nineteen extant notebooks contain drawings and writings on architecture, botany, physics, engineering, cartography, different facial types, draperies, and some of the greatest anatomical studies ever made. He wrote a treatise on painting, discussed emblems, collected jokes, drew portraits, studies for uncompleted sculptural projects, buildings, and paintings.

Leonardo's long career was filled with variety and contradictions. He studied painting in Verrocchio's studio where his first known work is the angel in the older artist's *Baptism*. Even in that early figure, one can discern qualities such as soft yellow light in the angel's hair and the gradual shading softening the facial features that would become hallmarks of Leonardo's style. An early complete painting executed by Leonardo is the Uffizi *Annunciation*, in which the *sfumato* background of the harbor announces his characteristic use of bluish misty light in distant horizons. Leonardo recommended the blue horizon in his treatise on painting on the grounds that in reality horizons are blue. Also present in the early *Annunciation* is Leonardo's genius for transitional metaphorical forms, in this case the sarcophagus supporting Mary's lectern. One side of the sarcophagus has lion's feet turned outward, repeating the position of Mary's legs and feet; this formal repetition of the Virgin echoes the iconographic relation of Mary to Christ's tomb, for she was called the "womb" and "tomb" of Christ. Similar transitional forms occur in Leonardo's drawings—for example, playing and fighting horses which resemble rats and, as noted by the artist himself, the water flowing around a pole which resembles the movement of a woman's long hair.

Though Leonardo's paintings include traditional Christian themes as well as portraits, several of them are iconographically quite unusual. A curious problem in Leonardo's oeuvre is the two versions of the *Virgin on the Rocks*, one in the Louvre and the other in the National Gallery in London. There has been much scholarly debate over these pictures, mainly revolving around questions of authenticity and the degree of Leonardo's contribution to each. A painting of this title was commissioned for the Confraternity of the Immaculate Conception; but it is not known why two works of this unprecedented subject exist. In both pictures, a triangular organization of Mary, Christ, John the Baptist, and an angel is constructed; in both the rocky background relates to the architectural enclosure of the chapel intended to house the picture. The misty blue *sfumato* recurs in the distance.

The Virgin and Child with Saint Anne in the Louvre is a traditional scene, although Leonardo has introduced some unprecedented elements. The most often discussed feature of this painting is the youth of St. Anne, Mary's mother, who in reality would have been an old woman. Rather than representing St. Anne in a way that accents the differences between the three generations represented, as previous artists had done, Leonardo makes mother and grandmother seem to be the same age. One explanation for this, originally proposed by Freud and later accepted by Kenneth Clark, is the fact of Leonardo's having had two young mothers himself. He was illegitimate at birth and remained with his natural mother until his father married another young woman and brought Leonardo to live with him. It is likely that the memory of these two women, and their youth, explains the absence of a generation gap between Mary and St. Anne.

The blue misty background of this picture, as well as the formal parallels between the heads of the two women and the landscape rocks, is found in several of Leonardo's other works, especially the portraits. In the *Ginevra dei Benci* in the National Gallery in Washington, the woman seems to emerge from the landscape as if she were one with it. The yellow light around the edges of her hair echoes the outlines of the trees and the patterns of dark lacing against her white skin repeats the dark tree forms against the lighter sky. The best-known example of this parallelism between woman and landscape can be seen in the *Mona Lisa,* Leonardo's most famous picture, now in the Louvre. The *Mona Lisa* is also the work that has evoked the most discussion of, and controversy about, Leonardo's entire oeuvre. Sometimes called *La Gioconda,* the woman in the painting has eluded identification for centuries. She sits on a balcony in the three-quarter view that became typical of 16th-century portraits and her gaze seems to follow us wherever we go. Her landscape background is as mysterious as she is; it cannot be identified as a specific locale and contains a dream-like quality as elusive as the woman herself.

Another puzzling aspect of Leonardo's artistic career concerns the *Last Supper,* a fresco dating from the 1490's on the refectory wall of Santa Maria della Grazia in Milan. Universally acknowledged as one of the great masterpieces of High Renaissance art, the poor technical execution of this painting combined with the humidity in the building has resulted in its virtual extinction. Leonardo was such a meticulous worker that he attempted to slow down the drying process of fresco by mixing oil and other substances insoluble in water; this prevented the absorption of the paint into the wall that is necessary to preserve fresco. Restorers have done extensive work on the picture in an attempt to save it, but little of the original effect remains.

Despite these problems, the image itself is nearly as well known as the *Mona Lisa.* Set in a mathematically composed symmetrical space, the scene of Christ's last meal is enacted in a new way. For the first time among the monumental examples of this event in 15th-century Italy, Judas sits on the same side of the table as Christ and the other apostles. As each apostle reacts dramatically to Christ's announcement that one of them will betray Him, Judas is identified as separate by the sudden thrust of his diagonal plane away from Christ. Thus, geometry and formal arrangement echo the psychology of the scene. Along the side walls, the four rectangular tapestries echo the fourfold division of apostles into groups of three as they dis-

cuss Christ's statement. Christ Himself, with His outstretched arms, forms a triangle, at once echoing the grouping of apostles into three and the three windows on the back wall, and referring symbolically forward in time to the Trinity as a central precept of the church. The round arch above the central rear window forms a symbolic halo over Christ's head, a geometric reference to His divinity. Also focusing attention on Christ, and emphasizing His ecclesiastical centrality, is the perspective construction of the painting so that Christ is at the mathematical center of the composition. It is at Christ that all the orthogonal lines, lines perpendicular to the picture plane, would meet if extended. By this arrangement, Leonardo controls the observer's vision and directs it toward the figure of Christ. He, in turn, stretches His arms and hands forward so that, just as He receives the observer through the mathematical construction of the picture, He also reaches out to him.

In addition to Leonardo's curious technical experiments on the *Last Supper,* it is surprising that he left a number of works unfinished. These include the *Adoration of the Magi* in the Uffizi, the *Saint Jerome* in the Vatican, and the *Saint John the Baptist* in the Louvre. Of these, the latter is the most puzzling. The effeminate character of Saint John does not seem to have a precedent either in the literary or the pictorial tradition. Nor is the meaning of his gesture, pointing upwards, clear. Saint John has been depicted through a subtle play of golden light which softens the texture of his skin and barely distinguishes his form from the murky background.

Not only was Leonardo puzzling as an artist, he was also contradictory in regard to his patrons. He worked as an engineer for two of the most anti-Florentine tyrants in Italy, Lodovico Sforza and Cesare Borgia. Leonardo's designs of military machines for the enemies of Florence, which are recorded in drawings among his notebooks, are among the most sadistic known.

Leonardo ended his long career at the French court of Francis I and died in France. On his death bed, he is reported to have said that he regretted having neglected his real genius, which was as a painter, and having spent so much of his life in the pursuit of science.

—Laurie Schneider

LICHTENSTEIN, Roy.

Born in New York City, 27 October 1923. Studied under Reginald Marsh at the Art Students League, New York; Ohio State University, Columbus, 1940–42, 1946–49, M.F.A. 1949; served in the army, 1943–46; taught at Ohio State University, 1946–51, State University of New York, Oswego, 1957–60, and Douglass College, Rutgers University, New Brunswick, New Jersey, 1960–63. Address: c/o Leo Castelli Gallery, 420 West Broadway, New York, New York, 10012, U.S.A.

Collections: Aachen; Amsterdam; Stedelijk; Chicago; Cologne; Detroit; London: Tate; New York: Metropolitan, Moma, Whitney, Guggenheim; Stockholm: Moderna Museet.

Publications

On LICHTENSTEIN: books—

Boatto, Alberto, and Giordano Falzoni, editors, *Lichtenstein,* Rome, 1966.

Coplans, John, *Lichtenstein* (cat), Pasadena, 1967.

Morphet, Richard, *Lichtenstein* (cat), London, 1968.

Waldman, Diane, *Lichtenstein* (cat), New York, 1969.

Kerber, Bernhard, editor, *Lichtenstein: Ertrinkendes Mädchen,* Stuttgart, 1970.

Waldman, Diane, *Lichtenstein: Drawings and Prints,* New York and London, 1971.

Waldman, Diane, *Lichtenstein* Milan, 1971, New York, 1972.

Alloway, Lawrence, *Lichtenstein* (cat), Houston, 1972.

Coplans, John, editor, *Lichtenstein,* New York, 1972, London, 1973.

Abadie, Daniel, *Lichtenstein: Dessins sans bande* (cat), Paris, 1975.

Dieterich, Barbara, et al., *Lichtenstein: Zeichnungen,* Berlin, 1975.

Zerner, Henri, *The Graphic Art of Lichtenstein* (cat), Cambridge, Massachusetts, 1975.

Glenn, Constance W., *Lichtenstein: Ceramic Sculpture* (cat), Long Beach, 1977.

Sussman, Elisabeth, *Lichtenstein: The Modern Work 1965–1970* (cat), Boston, 1978.

Kuspit, Donald B., *Lichtenstein: Recent Work* (cat), Coral Gables, 1979.

Cowart, Jack, *Lichtenstein 1970–1980* (cat), New York and London, 1981.

Alloway, Lawrence, *Lichtenstein,* New York, 1983.

Glenn, Constance W., and Jack Glenn, *Lichtenstein: Landscape Sketches 1984–1985,* New York, 1986.

Rose, Bernice, *The Drawings of Lichtenstein* (cat), New York, 1987.

Tomkins, Calvin, and Bob Adelman, *Lichtenstein: Mural with Blue Brushstroke,* New York, 1988.

*

Roy Lichtenstein was a seasoned artist, approaching 40, when he created the first of his apparently "dumb," radically new paintings that stunned a broad spectrum of both the art audience and the general public. Ending an era when an increasingly wide variety of realist subject matter was creeping back into art, clothed in expressionist rendering, he abruptly presented low-art themes completely shorn of painterly gestures. His early 1950's adaptations of well-known Americana (e.g., Emanuel Leutze's *Washington Crossing the Delaware)* rendered in a whimsical Klee-like manner; the intrusive titles he began to letter on the surface of Cubist-style works such as *The Explorer,* c. 1952, taken from a 1949 *Life* advertisement and prominently featuring the message touting the benefits of eating corned beef; text book engineering drawings represented as precisionist paintings, c. 1954; a ten-dollar bill lithograph of 1956; and the expressionist drawings of Donald Duck, Mickey Mouse, and Bugs Bunny, c. 1958, might have blunted the shock if Lichtenstein's always orderly development had been observed. Instead, in 1961, his dead-pan reiteration of mass communication images—a carefully wound electric

cord, an electric cooker, a step-on trash can, and, most notably, the first of his single-frame cartoon paintings taken seemingly unaltered from pulp comics—angered even sophisticated critics.

Many of the brutally spare objects he first drew in pencil and then outlined in black on white canvas (until 1963) were punctuated with his ubiquitous Benday dots, recalling an elephantine half-tone screen. It was this commercial art idiom, when combined with his similarly enlarged, arbitrarily colored cartoon images, that brought Lichtenstein fame and notariety as a founder of American Pop Art.

As he continued to appropriate the conventions of the reproduction process, and to mine the cartoon imagery that appeared to represent the ultimate vulgarization of "real" art, he also began to develop bodies of work that, though often overlapping, have been divided into distinct categories. The frontal, single-image, centrally organized compositions of 1961-64 have been referred to as "advertising imagery" (*Roto Broil* and *Black Flowers,* 1961) and "common objects" (*Golf Ball* and *Tire,* 1962). Related subjects included what John Coplans called "foodstuffs" (*Cup of Coffee,* 1962). Coplans went on to divide the comic-strip paintings (1961–66) into "war and violence," "science fiction," and "love and romance" categories, and, by the mid-1960's, works from this series, such as *Drowning Girl,* 1963, *Hopeless,* 1963, and *As I Opened Fire,* 1964, had become synonymous with classic Pop Art.

In 1963 preparatory drawing began to play a vital role in the realization of the large-scale paintings when Lichtenstein formed the habit of making small, colored-pencil studies designed to be used in an opaque projector. The process, which he continues to use today, initially had the advantage of allowing him further to distance the final work from the original source, as he projected the drawings and then drew on canvas from his own increasingly free studies. In the transposition from drawing to painting, compositions were modified, refined, and compacted; elements were either eliminated or emphasized with a fluid, almost Art Nouveau-like line. Color was applied stereotypically: yellow for hair or the flash of an explosion; blue for sky, for eyes, for shadow; Benday red for skintone, solid red for fire. Even the text balloons were subject to generalization, simplification, or the complete invention of humorous personal commentary (i.e., references to the dealers Ivan Karp and Richard Bellamy).

In selecting his subject matter—beyond the cartoon images—Lichtenstein chose, as always, art itself (e.g., *Femme au Chapeau,* 1962, after Picasso), plus the traditional subjects of art—landscape, and still life. At the same time, he used his system of pencil-study/projection to modify images of his own conception in a variety of series that included "Landscapes" (1964-65), "Brushstrokes" (1965–66), and "Mirrors" (1970-72).

It is, perhaps, too convenient to categorize and enumerate Lichtenstein's vast array of subjects. He has quoted from both the content and style of artists as diverse as Mondrian and Matisse. He has quoted style itself, from Art Deco to German Expressionism. And often he pictorially reassembles or quotes from his own work of earlier years. Thus, in cataloguing his sources—a veritable textbook of modernism—it is possible to overlook the fact that achieving visual synthesis is Lichtenstein's life-long subject. From the beginning, he has used pro-

Forms in Space (American Flag), 1985; screenprint

vocative, sometimes wickedly referential images (as in the case of giant cartoon brushstrokes that parody the mystique of gestural abstraction) as containers for formalist exploration. In order technically to facilitate his search for consonance, since the mid-1950's he has used a variety of rotating easels (of his own design), which can be positioned at any angle, allowing him to pursue pictorial unification from the widest variety of viewpoints. This procedure is but one of many that offers evidence of his chief concern: the irrefutable balance of all of the elements of the composition.

If Lichtenstein's selection of themes is historicist, so is his ongoing interest in style, as apart from subject matter. Cubism, Surrealism, the flat-patterning of the School of Paris, Expressionism, and even Primitivism have been both the subjects of the work and provided methodologies for his invention. In recent years, it has been the context of a particular historic style or theme that has afforded his orderly definition and confinement of each emerging series, whether painting or sculpture.

Since the mid-1970's, the Benday dot pattern, which is irrevocably his, has been used less frequently as a compositional device, while linear patterns (diagonal parallel lines) and a broader pallette have taken precedence as the energizing forces. Simultaneously, the work has veered from the reductive codification of the "Mirrors" to the dense abstract complexity of the 1980's expressionist "Brushstroke Cycle," which includes references to Van Gogh and Max Beckmann.

Quotation that was once blatant has become increasingly difficult to "read," especially in these expressionist works that place emphasis on the bravura of the brushstroke rather than on the thing depicted.

In 1986 Lichtenstein once again unexpectedly shifted gears with the "Perfect and Imperfect" series, reuniting the Benday system with an angular structure and an implied simplicity that deceptively evoked works of the 1960's, but, in reality, commented on early 20th-century abstraction as seen from the post-modern vantage point. Today, he is in the process of creating works that derive their figurative elements from a broad spectrum of his own past work. Early Pop images will be "matted and framed" (frames have long been a subject), and visually interrupted by references to reflection—a phenomenon first explored in the early 1970's in his "Mirrors." Just as it seems possible to predict the path of Roy Lichtenstein's personal, archaeological journey, he finds yet another subject, another style, to reinvent, to hold before the mirror of an art form he has, ironically, made inimitable.

—Constance W. Glenn

LIMBOURG BROTHERS.
Paul (Pol), Hermann, and Johan (Jean, Janneken, Henneken) de Limbourg, were born in Nimwegen after 1385; sons of the

sculptor Arnold van Limburg, and nephews of the painter Jean Malouel. Died before February 1416. Hermann and Jean were apprenticed to a Paris goldsmith; in 1402 Paul and Jean were contracted to illuminate a Bible for the Duke of Burgundy; then all three worked for the Duke's brother, the Duke of Berry, 1411: Très Riches Heures.

Collections: Chantilly; New York; Paris: Bibliothèque Nationale.

Publications

On THE LIMBOURGS: books—

Durrieu, P., *Les Très Riches Heures de Jean de France, Duc de Berry,* Paris, 1904.

Malo, H., *Très Riches Heures,* Paris, 1945.

Porcher, J., *Très Riches Heures,* Paris, 1950.

Panofsky, Erwin, *Early Netherlandish Painting: Its Origins and Character,* Cambridge, Massachusetts, 2 vols., 1953.

Porcher, J., *Les Belles Heures de Jean de France, Duc de Berry,* Paris, 1953.

Rorimer, J. J., and M. B. Freeman, *The Belles Heures of Jean, Duke of Berry,* New York, 1958.

Cuttler, C. D., *Northern Painting from Pucelle to Bruegel, 14th, 15th, and 16th Centuries,* New York, 1968.

J. Longnon, Raymond Cazelles, and Millard Meiss, *The "Très Riches Heures" of Jean, Duke of Berry,* New York, 1969.

Meiss, Millard, *The Master of the Breviary of Jean Sans Peur and the Limbourgs,* London, 1971.

Meiss, Millard, *The Limbourgs and Their Contemporaries,* New York, 1974; as *French Painting in the Time of Jean de Berry: The Limbourg Brothers and Their Contemporaries,* London, 1974.

articles—

Hulin de Loo, G., "Les Très Riches Heures de Jean de France, duc de Berry, par Pol de Limbourc et ses frères," in *Bulletin du Gand,* 11, 1903.

Winkler, F., "Paul de Limbourg in Florence," in *Burlington Magazine* (London), 56, 1930.

Bober, H., "The Zodiacal Miniature of the *Très Riches Heures* of the Duke of Berry: Its Sources and Meaning," in *Warburg Journal* (London), 11, 1948.

Freeman, M. B., "A Book of Hours Made for the Duke of Berry," in *Bulletin of the Metropolitan Museum of Art* (New York), 15, 1956.

Alexander, J. J. G., "The Limbourg Brothers and Italian Art: A New Source," in *Zeitschrift für Kunstgeschichte* (Munich), 46, 1983.

Cazelles, Raymond, "Les Très Riches Heures," in *Du* (Zurich), 4, 1984.

Byrne, Donal, "Manuscript Ruling and Pictorial Design in the Work of the Limbourgs, the Bedford Master, and the Boucicaut Master," in *Art Bulletin* (New York), March 1984.

McKenzie, A. Dean, "French Medieval Castles in Gothic Manuscript Painting," in *The Medieval Castle: Romance and Reality,* Minneapolis, 1984.

Bath, Michael, "Imperial Renovatio Symbolism in the *Très Riches Heures,*" in *Simiolus* (Utrecht), 1987.

*

In the late 14th century Arnold de Limbourg, a wood sculptor living in the Flemish town of Nimwegen, married Mechteld, the sister of the painter Jean Malouel, *valet de chambre* of Philippe le Hardi, Duke of Burgundy. They had six known children. Among them the most famous was Paul followed by Herman and Jean (or Jannequin). These three were to become some of the most renowned northern painters of the time. Hubert and Jean began as apprentices with a Parisian goldsmith but were sent home because of the threat of the plague in 1399. In 1402 Jean and Paul were hired by Philippe le Hardi for four years to illustrate a Bible. By 1408 Paul was in the service of Jean, Duc de Berry to decorate his Chateau de Bicetre. By 1410 all three brothers were in the employ of Jean de Berry. The Duke's inventories and accounts often mention the three brothers and the gifts he gave them and vice versa. Eventually they were honored with the title of *valet de chambre.* The references seem to indicate that Paul was the head of the fraternal workshop. When the Duc de Berry's principal artist, Jacquemart de Hesdin, died c. 1409, the three Limbourg brothers seem to have taken his place. All three apparently died, possibly from an epidemic, during the year 1416. The eldest (Paul) was possibly about 30 years old at the time.

Among the illuminated manuscripts that these gifted artists produced, the two most important extant are the *Belles Heures* (The Cloisters, New York) and the *Très Riches Heures* (Chantilly). The inventories mention a "très belle et très notable Bible" illuminated by Paul and Jean (c. 1402-03) for the Duc de Bourgogne. This is believed to be the *Bible moralisée* dated 1401 and preserved in Paris (Bibliothèque Nationale). Paul or Jean de Limbourg it seems painted 384 small miniatures of the 5,000 in this manuscript. Also, the Limbourg brothers have been credited with individual pages in several other manuscripts of the period.

A particularly handsome illuminated manuscript by the Limbourg brothers is the *Belles Heures* (1405-06—1408-09). Among the 158 miniatures in this manuscript are seven novel cycles which include scenes from the life of St. Catherine, the Great Litany, Diocres and Bruno, St. Jerome, SS. Paul and Anthony, the Emperor Heraclius and the Cross, and the Hours of the Passion. Four lines of text appear below most of the large illustrations which are surrounded by a delicate gold frame and a rinceau of ivy vines that fill in the blank part of each page. Representative of the International Style which characterizes the Limbourg brothers' style are the rich colors, sophisticated postures and gestures, and lavish use of gold.

The most important work produced by these brothers is the justly famous masterpiece, the *Très Riches Heures* which contains 63 large and 66 small miniatures. Begun in 1412, the manuscript was left unfinished in 1416, the year that all three artists apparently died, along with their major patron, Jean de Berry. The calendar pictures at the beginning of the manuscript have been called by Meiss "the greatest pictorial accomplishment of the early 15th century." Each illustration is on the verso side facing the text listing the saints to be venerated for that month. Although previously illustrated calendar cycles were used in Books of Hours, none had emphasized so much

the patron and his properties. Some of the Duke's castles appear in the calendar pages, and even a life-like portrait of the Duke appears in the feasting scene of the *January* page where he is seen surrounded by his courtiers before a large fireplace. Hanging on the wall behind him is seen a richly decorated tapestry illustrating the battle of Troy.

The *February* scene, undoubtedly by Paul, is a winter scene. Although there were several earlier manuscripts that showed snow scenes, this is the first realistic example of such a snow landscape. Emphasis is placed on convincing depth and an accumulation of genre details indicating a remarkably observant eye. The first post-antique use of consistent shadows appears in the *March* and *October* pages. These progressive elements add to the increasing realism that is especially seen in the work of Paul. In the *April* page elegant courtiers are shown, and it is plausible that this scene depicts the betrothal of Charles d'Orléans and Bonne d'Armagnac.

The eight meticulously rendered contemporary castles that appear in the *Très Riches Heures* are amazingly exact for this early date. They constitute a remarkable series of architectural "portraits." Three of these castles are royal (the Louvre, Palais de la Cité, and Vincennes), and four were owned by the Duc de Berry.

The Limbourg brothers' paintings reflect mainly the art of Burgundian panel painter Jean de Beaumetz and the early work of Jean Malouel. However, Italian influence is clearly seen as well, not only in individual figures but in some cases in entire compositions. The *Purification* miniature in the *Très Riches Heures,* for example, copies a fresco by Taddeo Gaddi in S. Croce, Florence. Other illuminations reflect the influence of the Lorenzetti, Giotto, Altichiero, and Lorenzo Ghiberti, leading to the conclusion that the Limbourg brothers had journeyed to Tuscany.

The influence of the Limbourg brothers was profound, and the *Très Riches Heures*'s calendar pages, among others, were copied or adapted by several subsequent artists. But in the 15th century panel painting gradually replaced manuscript illumination as the major realm of painting. What the Limbourg brothers had accomplished was carried further by the great Flemish panel painters Robert Campin and Jan van Eyck.

—A. Dean McKenzie

LIPCHITZ, Jacques.

Born Chaim Jacob Lipchitz in Druskieniki, Lithuania, 22 August 1891; naturalized French citizen, 1924. Died in Capri, 27 May 1973. Married 1) Berthe Kitrosser, 1924 (divorced, 1946); 2) Yulla Halberstadt, 1948, one daughter. Studied under Jean Antonine Injalbert at the Ecole des Beaux-Arts, and under Raoul Verlet at the Académie Julian, Paris, 1909–11; associated with the cubist painters, Paris, and produced the first cubist sculptures, 1913; lived in New York, 1941–47, in Hastings on Hudson, New York, 1947–63, and in Pieve di Camaiore, Italy, 1963–73.

Collections: Amsterdam: Stedelijk; Jerusalem: Israel Museum; London: Tate; New York: Moma, Guggenheim, Metropolitan; Otterlo; Paris: Beaubourg; Rome: Arte Moderna.

Publications

By LIPCHITZ: books—

Symposium on "Guernica," New York, 1947.
Amadeo Modigliani, New York, 1952; London, 1968.
My Life in Sculpture, with H. H. Arnason, New York and London, 1972.

On LIPCHITZ: books—

Raynal, Maurice, *Lipchitz,* Paris, 1920.
George, Waldemar, *Lipchitz,* (in Yiddish), Paris, 1928.
Vitrac, Roger, *Lipchitz,* Paris, 1929.
Raynal, Maurice, *Lipchitz,* Paris, 1947.
Goldwater, Robert, *Lipchitz,* Amsterdam, 1954; London, 1958; New York, 1959.
Hope, Henry R., *The Sculpture of Lipchitz* (cat), New York, 1954.
Hammacher, A. M., *Lipchitz: His Sculpture,* New York, 1960, 1975.
Patai, Irene, *Encounters: The Life of Lipchitz,* New York, 1961.
Bork, Bert van, *Lipchitz: The Artist at Work,* New York, 1966.
Arnason, H. H., *Lipchitz: Sketches in Bronze,* New York, 1969.
Weyl, Mostin, et al., *Lipchitz: Bronce Sketches* (cat), Jerusalem, 1971.
Wadley, Nicholas, *Lipchitz* (cat), London, 1973.
Stott, Deborah A., *Lipchitz and Cubism,* New York and London, 1978.
Barbier, Nicole, *Oeuvres de Lipchitz,* Paris, 1978.
Jenkins, David Fraser, and Derek Pullen, *The Lipchitz Gifts: Models for Sculptures,* London, 1986.
Wilkinson, Alan G., *Lipchitz: A Retrospective* (cat), Toronto, 1989.

*

The work of Jacques Lipchitz is marked by a number of radical shifts of style. In some of these he can be seen to be following the general course of artistic fashion in Paris, from analytic to a more synthetic and hermetic Cubism, and then to a more fluid and biomorphic style which was related to Surrealism. Even his conventional portrait busts of 1920 (of Gertrude Stein, Cocteau, and Radiguet), while related to his financial difficulties during this period, can be seen as analogous to the parallel styles practiced by Picasso who at this time was making both Cubist and neo-classical works.

In looking at Lipchitz's work of 1914 we see pieces such as *Jeune fille à la tresse* in which there is some Cubist dislocation but of a rather limited scope, allied fashionably with a conventional representation of the primitive, manifested by the "Egyptian" eye. The alliance between the two was far from arbitrary, however: the eye that looks straight forwards out of a head seen in profile is only the most celebrated example of the practice of multiple viewpoints in "primitive" works of art

Pierrot Escaping, 1927; iron; 19¼ in (49 cm)

which was very widespread, as Boas was to point out in 1921. The angular surfaces of this work are juxtaposed with certain features that are very distinctly defined, such as the eyes, ears, and fingers. These are rendered in such a formulaic way as to be signs rather than representations of the objects concerned. This is, of course, a standard device of Cubist painting.

The shift in the work of Lipchitz in 1915 is a very radical one. The highly abstract nature of works such as *Figure assise* (1915) and *Personnage debout* (1916) makes of the body a kind of vertical and angular architecture. This change can be seen as part of the classicizing movement in French art of the post-war years in a reaction to what were perceived by some to be the excesses of the past. However, the work of Lipchitz is distinguished in this respect not only by its emergence in the middle of the war, but by its abstract nature, for the trend was towards greater legibility, even in synthetic Cubism that was supposed to be derived from abstract forms.

One of the champions of the new ordered Cubism, Léonce Rosenberg, was attracted to the hermetic style of these sculptures and gave Lipchitz his first one-man show at the Galerie de l'Effort Moderne in 1920. The wooden figures of 1916 such as the oak *Figure* could be disassembled. The idea of sculpture made up of parts, a sculpture that was constructed rather than carved or modelled, was particularly suited to machinist aesthetic supported by the gallery. Lipchitz, however, did not stick with this style and the association with Rosenberg was not a long one. Indeed, features such as the sculptor's interest in the painting of the 18th century (in Watteau, particularly) manifested in pieces like *Harlequin with Accordion* in which such details of Commedia dell' Arte costumes as ruffs and buttons are included did not fit in well with the sober aesthetic of the Rosenberg gallery.

From 1925 the Cubist idiom of Lipchitz's work began to break up and the material was more fluidly handled in a way which permitted the inclusion of space into the heart of the sculpture. *Seated Man* (1925) represented the breakthrough with its curvilinear forms and the void at its centre. There were, of course, precedents for this use of space in sculpture in the pre-war work of both Archipenko and Picasso, but these developments had not been systematically explored. Part of the impetus may have come from Constructivist ideas that were receiving some attention in Paris following Naum Gabo and Antoine Pevsner's show at the Galerie Percier in 1924. While the sculpture of Gabo and Pevsner is not formally close to the work of Lipchitz at this time, the idea of "stereometric" form (where volume is defined by space) is precisely what Lipchitz took up.

The first piece in which the centre of the sculpture is completely hollowed out is the little bronze *Pierrot* of 1925. It can be argued that there is more than just a formal innovation here. In France at this time, the idea of the unconscious was receiving much attention because of the translation into French of works by Freud and the controversy that these theories aroused. A widely used literary device employed the metaphor of darkness or the void to describe the unconscious, famously in the case of Apollinaire who in *Le Poète assassiné* (1916) wrote of a monument built to the dead poet by digging a hole in the ground in his shape. The shape in the centre of the *Pierrot* may then be read as a psychological one.

This interpretation is further supported by the development of the style. The figure is generally literally split into two pieces joined tenuously by arms, or hinged at some point. This is an obvious enough metaphor for the division of the mind. In *Harlequin with Banjo* (1926) two slightly bent planes are connected by arms: each section contains both the silhouette of half of the figure and a cut-out of the other half filled with criss-crosses representing the diamond shapes of the harlequin's costume. The figure can only be seen as a whole when these halves are combined as they are when the piece is viewed from the front. The volume of the body is then of course represented by the space between the two planes. That the unity of the mind, the creation of consciousness should only be apparent from one point of view is a sophisticated comment on the idea of the consciousness as epiphenomena, or of its status as one aspect of the mind, something that might appear differently when looked at in different ways.

Lipchitz's later work went on to explore organic forms and sexual themes that were close to the concerns of the Surrealists. His work during and after the First World War was not only formally innovative but was very much tied to the Parisian intellectual milieu and as such it was able to convey complex meanings of a non-formal kind.

—Julian Stallabrass

LIPPI, Filippino.

Born in Prato 1457–58; son of the painter Filippo Lippi. Died in Florence, 18 April 1504. Student of Botticelli in Florence from early 1470's; completed fresco cycle begun by Masaccio in the Brancacci Chapel in the Carmine church, Florence, mid-1480's; worked on the Caraffa Chapel, S. Maria sopra Minerva, Rome, 1488–93, and on the Strozzi Chapel, S. Maria Novella, Florence, completed 1502.

Major Collection: Florence.
Other Collections: Berlin; Bologna: S. Domenico; Chantilly; Cleveland; Copenhagen; Edinburgh; Florence: Badia, S. Maria Novella, Pitti, Accademia, S. Spirito; Genoa; London; New York; Ottawa; Oxford: Christ Church; Paris; Rome: S. Maria dopra Minver Minerva, Pallavicini-Rospigliosi; San Gimignano; Toledo, Ohio; Utrecht; Vaduz; Washington.

Publications

On LIPPI: books—

Supino, Igino B., *Les Deux Lippi,* Florence, 1904.
Konody, George, *Lippi,* London, 1905.
Sacher, Helen, *Die Ausdruckskraft der Farbe bei Lippi,* Strasbourg, 1929.
Mengin, Urbain, *Les Deux Lippi,* Paris, 1929.
Scharf, Alfred, *Lippi,* Vienna, 1935.
Neilson, Katharine B., *Lippi: A Critical Study,* Cambridge, Massachusetts, 1938.
Salmi, Mario, *Masaccio, Masolino, Lippi: La Cappella Brancacci a Firenze,* Milan, 2 vols., 1948.
Fossi, M., *Disegni di Lippi e Piero di Cosimo* (cat), Florence, 1951.

Berti, Lucaino, and Umberto Baldini, *Lippi*, Florence, 1957.

Brandi, Cesare, et al., *Saggi zu Lippi*, Florence, 1957.

Gamba, Fiammetta, *Lippi nella storia della critica*, Florence, 1958.

Sale, J. Russell, *Lippi's Strozzi Chapel in Santa Maria Novella*, New York, 1979.

Geiger, Gail L., *Lippi's Caraffa Chapel: Renaissance Art in Rome*, Kirksville, Missouri, 1986.

articles—

Borsook, Eve, "Documenti relativi alle cappella di Lecceto e delle Selve di Filippo Strozzi," in *Antichità Viva* (Florence), 9, 1970.

Borsook, Eve, "Documents for Filippo Strozzi's Chapel in Santa Maria Novella and Other Related Papers: I and II: The Documents," in *Burlington Magazine* (London), 112, 1970.

Freidman, David, "The Burial Chapel of Filippo Strozzi in Santa Maria Novella in Florence," in *L'Arte* (Milan), 9, 1970.

Geiger, Gail L., "Lippis Wunder des heiligen Thomas von Aquin im Rom des späten Quattrocento," in *Zeitschrift für Kunstgeschichte* (Munich), 47, 1984.

*

The son of Fra Filippo Lippi, whose famous elopement with the nun Lucrezia Buti took place in 1456, Filippino Lippi is believed to have received his earliest artistic training from his father, and, after Fra Filippo's death in 1469, from his assistant Fra Diamante. By 1472 he was in the workshop of Botticelli, who exerted a profound influence on him. This is especially manifest in his early works, such as the *Tobias and the Angel* (Washington), and still evident in those of his first maturity, such as the *Vision of St. Bernard* (Florence, Badia) and the *Annunciation* (San Gimignano), in which the figures follow a Botticellesque canon of wistful beauty.

By the mid-1480's, having received important commissions for provincial centres in Tuscany, Filippino had established his reputation in Florence. He completed Masaccio's and Masolino's unfinished frescoes in the Brancacci Chapel, S. Maria del Carmine, so successfully imitating Masaccio's style that the division of hands in the *Raising of the Son of Theophilus and St. Peter Enthroned* is debated. He painted a large altarpiece of the *Virgin and Child with Sts. John the Baptist, Victor, Bernard, and Zenobius* (Florence, Uffizi) for the Palazzo della Signoria and produced other works for distinguished private patrons. Most notable among these was Lorenzo de' Medici, for whom he painted frescoes in the villas of Poggio a Caiano and Spedaletto, the latter (since destroyed) in tandem with Botticelli, Ghirlandaio, and Perugino. On Lorenzo's recommendation he was invited by Cardinal Oliviero Carafa to decorate his chapel in S. Maria sopra Minerva, Rome, with frescoes of the *Assumption of the Virgin* and the *Triumph of St. Thomas Aquinas*. The large scale of the frescoes, painted between 1488 and 1493, prompted developments in Filippino's orchestration of space, more ambitious than hitherto, and in his use of movement to articulate emotion, while the impact of antique models seen in Rome generated a copious vocabulary of classical motifs.

During the 1480's the "sweet" style of Filippino's early work was increasingly modified by new qualities, gaining in vigor and characterisation, with a degree of asceticism overlaying its earlier sensuality. Ideals of conventional beauty came to be less important than emotional effect, to which end forms grew more agitated and were often subtly distorted, with an air of intense melancholy, even peturbation. These trends are already manifest in the slightly mannered poses and psychological tension of the *Vision of St. Bernard*, datable to the mid-1490's, and intensify in the works of the following decade.

Returning from Rome in 1493 Filippino resumed his Florentine career, continuing to produce frescoes and altarpieces for prominent individuals and religious foundations. In 1496 he painted a large *Adoration of the Magi* (Florence, Uffizi) for the convent of S. Donato a Scopeto, commissioned in place of the altarpiece ordered some 15 years earlier from Leonardo da Vinci and never completed. A major undertaking during these years was the fresco cycle in the Strozzi chapel, S. Maria Novella, depicting scenes from the lives of Sts. Philip and John the Evangelist. Commissioned in 1487, it had been interrupted by Filippino's departure for Rome and was not completed until 1502, after the death of the chapel's patron Filippo Strozzi. Typical of his late work, the *Adoration* and the Strozzi frescoes are characterised by heightened emotional content and considerable surface activity. Other prestigious commissions at the end of Filippino's career included high altarpieces for the Certosa of Pavia and SS. Annunziata, Florence, both unfinished when Filippino died prematurely in 1504.

Filippino was among the most imaginative and individual painters of his generation. He was much in demand, doubtless partly because, as Vasari notes, he was both diligent and amiable; he left a large following in provincial Tuscany, having worked in several of its towns. He was a sensitive colourist, and his use of the oil medium then gaining currency in Italy shows him to have been an innovative technician; his drawings are executed with remarkable spontaneity and freedom of handling. Filippino's style marries typically late-quattrocento ideals of beauty with an unusual degree of nervous energy, expressive power and a sense of the bizarre that has been seen as proto-mannerist and was influential for painters of the next generation.

—Paula Nuttall

LIPPI, Fra Filippo.

Born in Florence, c. 1406. Died in Spoleto, 10 October 1469. One son, the painter Filippino, and a daughter by the ex-nun Lucrezia Buti. Registered in the Carmelite friary of S. Maria del Carmine, Florence, 1421–31; sub-prior of the Carmelites of Siena for one year from November 1428; formal training unknown: recorded in Padua as a painter in 1434; patronized by the Medici family in Florence; worked on murals in S. Stefano, Prato, 1452–65, and in Spoleto Cathedral, 1466–69. Pupil: probably Botticelli.

Major Collection: Florence.

Other Collections: Baltimore: Walters; Berlin; Cambridge; Cleveland; Florence: Pitti, Palazzo Medici, S. Lorenzo; Lon-

don; Milan; Castello Sforzesco, Poldi Pezzoli; New York: Metropolitan, Frick; Oxford; Paris; Prato; Rome: Doria Pamphili; Spoleto: Cathedral; Vatican; Washington.

Publications

On LIPPI: books—

Mendelsohn, Henriette, *Lippi,* Berlin, 1909.
Oertel, Robert, *Lippi,* Vienna, 1942.
Pittaluga, Mary, *Lippi,* Florence, 1949.
Baldini, Umberto, *Lippi,* Milan, 1964.
Neumayer, Alfred, *Lippi: Anbetung des Kindes,* Stuttgart, 1964.
Marchini, Giuseppe, *Lippi,* Milan, 1975.
Ruda, Jeffrey, *Lippi Studies: Naturalism, Style, and Iconography in Early Renaissance Art,* New York, 1982.

articles—

Fausti, Luigi, "Le pitture di Lippi nel Duomo di Spoleto," in *Archivio per la Storia Ecclesiastica dell'Umbria,* 2, 1915.
Berenson, Bernard, "Fra Angelico, Fra Filippo e la cronologia," in *Bollettino d'Arte* (Rome), 26, 1932.
Pudelko, Georg, "Per la datazione delle opere di Lippi," in *Rivista d'Arte* (Florence), 18, 1936.
Pudelko, Georg, "The Early Work of Lippi," in *Art Bulletin* (New York), 18, 1936.
Borsook, Eve, "Lippi and the Murals for Prato Cathedral," in *Mitteilungen des Kunsthistorisches Institutes in Florenz,* 19, 1975.
Ames-Lewis, Francis, "Lippi and Flanders," in *Zeitschrift für Kunstgeschichte* (Munich), 42, 1979.
Lavin, Marilyn Aronberg, "The Joy of the Bridegroom's Friend; Smiling Faces in Lippi, Raphael, and Leonardo," in *Art the Ape of Nature: Studies in Honor of H. W. Janson,* New York, 1981.
Ruda, Jeffrey, "Flemish Painting and the Early Renaissance in Florence: Questions of Influence," in *Zeitschrift für Kunstgeschichte* (Munich), 47, 1984.
Ruda, Jeffrey, "Style and Patronage in the 1440s: Two Altarpieces of the Coronation of the Virgin by Lippi," in *Mitteilungen des Kunsthistorischen Institutes in Florenz,* 28, 1984.
Christiansen, Keith, "New Light on the Early Work of Lippi," in *Apollo* (London), 122, 1985.

*

Fra Filippo Lippi made two distinctive contributions to the burgeoning naturalism of early Renaissance art. He brought sacred figures closer to ordinary human appearance than any Italian artist had done, and he developed a coloring system that subdued the ornamental beauty of pure hues to a new standard of optical truth. His figures were animated and psychologically varied as well as individualized in looks, dignified as often as charming, and they were widely imitated during the later 15th century. Though his coloring was rejected by other artists in favor of a different style and technique based on Flemish painting, his daring and subtle effects were the first painted equivalent of Donatello's revolutionary low-relief sculpture. They made atmospheric naturalism a central issue in Florentine painting when his contemporaries were more narrowly interested in spatial structure and figure design.

As a friar at Santa Maria del Carmine in Florence, Fra Filippo began his career literally in the shadow of Masaccio's Brancacci chapel frescoes. Yet none of his possible early works simply imitates Masaccio. Rather, they suggest that he grafted the very diverse naturalisms of Donatello and other sculptors, and of Gentile da Fabriano as well as Masaccio, onto ideals of grace due to a conventional late-Gothic training.

His major works fall into three groups: a cluster of altarpieces completed during the late 1430's; a *Coronation of the Virgin* for the high altar of Sant' Ambrogio, Florence, delivered in 1447; and a mural cycle for Santo Stefano, Prato, carried out sporadically from 1453 to 1466, with some intervening panel commissions.

The first group is dominated by three of his best-known pieces, the *Barbadori Madonna in Majesty with Angels and Saints,* documented in progress in March 1437 (Paris; Florence); the *Tarquinia Madonna and Child Enthroned,* dated to 1437 (Rome, Palazzo Barberini); and an *Annunciation* of about 1439–40 (Florence, San Lorenzo). All three show dynamic and complicated actions unprecedented in their subjects. The figures are largely based on sculpture by Donatello, Luca della Robbia, and Ghiberti, but go farther as studies of human appearance. The pictorial spaces are very complicated, worked up less through linear perspective (implicit in their design) than through gradations of color tone and value; through figure actions; and through a chiaroscuro with remarkably dark shading. As the paintings have come down to us, these elements sometimes pull apart, disrupting the illusionism but showing a much greater concern with problems of optics than any contemporary Italian paintings.

All three illustrate complex programs. The Barbadori commission was for a sacristy funerary chapel (a Florentine tradition) in Santo Spirito, church of the Augustinian friars. It combines personal themes of death and resurrection with elements of Augustinian teaching. The *Tarquinia Madonna* probably depends on Psalm 17:6, as adapted in St. Ambrose's Nativity hymn and the liturgy of Matins, to identify Christ with the sun, rising like a gigantic bridegroom from his divine wedding with the Church. The San Lorenzo *Annunciation* gathers many Christological and Marian emblems with the rare extra angels from patristic writings about the Incarnation of Christ. These commissions suggest that Fra Filippo was sought out for an ability to give vibrant life to elaborate doctrines; and that he himself was a more intellectual painter, and that thematic concerns were more central to early Florentine naturalism than have often been supposed.

These qualities recur in his later work. Filippo developed a new subject, the Adoration of the Christ Child in the Wilderness, which combines penitential imagery with atmospheric forest settings (best seen in the original altarpiece of the Medici Palace chapel, c. 1459, now in Berlin, Prussian State Museums). The *Madonna and Child with Two Angels* painted in the 1460's (Florence), restates the theme of Mary and Christ as divine Bride and Groom, in terms of radically humanized figures and radically naturalistic, non-decorative coloring.

The Sant' Ambrogio *Coronation of the Virgin,* now in the Uffizi, has its own doctrinal richness, but was most admired

for refined naturalism. The many figures are highly individualized in looks and expressions. The psychological nuances are legible, rather than lost in the crowd, thanks to gentle spatial groupings reinforced by color gradations, from vivid chiaroscuro and pure hues at the center to delicate blended tones at the edges.

The *Stories of St. John the Baptist and St. Stephen* at Prato were worked up in gold, ultramarine, and other "dry" pigments over true fresco to be the costliest Tuscan mural program of the century. While the coloristic effects are badly diminished, Fra Filippo's most enduring legacy is the richness and subtlety of human character in these stories, combining grandeur of scale with intimacy of feeling, unequaled in their time and esteemed by generations of painters.

In the most important 15th-century Florentine evaluation of artists, Cristoforo Landino distinguished Fra Filippo above all others for his inventiveness and imagination, and for the elegance and coloring of his work (1480). Later, Vasari testified to Michelangelo's praise and imitation of Fra Filippo, stressing both his grandeur and the depiction of feelings "difficult to imagine let alone to express," and "impossible to look at without being moved." Especially the dramatic content of Florentine art of the 1470's and 1480's (Botticelli's early work, Verrocchio, and the Pollaiuolos), depends on this achievement.

—Jeffrey Ruda

LOCHNER, Stefan.

Born probably in Meersburg am Bodensee, c. 1400–10. Died in Cologne between 22 September 1451 and 7 January 1452. Married Lisbeth. Completed his training in the workshop of Robert Campin; in Cologne from c. 1430: member of the guild (and a councillor in 1447 and 1450); painted a famous altarpiece for the Town Hall in 1440's (now in the cathedral); documented from 1442 to 1451.

Collections: Cologne: Cathedral, Museum; Darmstadt; Frankfurt; Lisbon: Gulbenkian; London; Munich; Nuremberg; Raleigh, North Carolina.

Publications

On LOCHNER: books—

Schrade, Hubert, *Lochner*, Munich, 1923.
Bombe, W., *Lochner*, Berlin, 1937.
Brand, Lotte, *Lochners Hochaltar von St. Katharinen zu Köln*, Hamburg, 1938.
Förster, Otto H., *Lochner: Ein Maler zu Köln*, Frankfurt, 1938, 3rd ed., 1952.
Kauffmann, H., *Lochner*, Bonn, 1952.
May, Helmut, *Lochner und sein Jahrhundert*, Cologne, 1955.
Lobeck, H., *Lochner*, Stuttgart, 1960.
Kerber, Bernhard, *Lochner*, Milan, 1965.

Paatz, Walter, *Verflechtungen in der Kunst der Spätgotik zwischen 1360 und 1530*, Heidelberg, 1967.
Landolf, Hanspeter, *German Painting: The Late Middle Ages (1350–1500)*, Geneva, 1968.

articles—

Baldass, Ludwig, "Zur künstlerischern Entwicklung Lochners," in *Wallraf-Richartz-Jahrbuch* (Cologne), 2–3, 1933–34.
Schmidt, J. Heinrich, "Zu Lochners farbige Gestaltung," in *Wallraf-Richartz-Jahrbuch* (Cologne), 10, 1938.
Wallrath, R., "Lochners Darstellung Christi im Tempel," in *Die Sammlungen des Baron von Hupsch* (cat), Cologne, 1964.
Wallrath, R., "Lochners Rosenhagmadonna: Mitte eines Triptychones?," in *Bulletin der Museen in Köln*, 5, 1966.
Wolfson, Michael, "Hat Dürer das Dombild gesehen? Ein Beitrag zur Lochner-Forschung," in *Zeitschrift für Kunstgeschichte* (Munich), 49, 1986.

*

The Swabia into which Stefan Lochner was born, long dormant in German cultural affairs, had experienced a sudden upswing early in the 15th century, principally through the extended deliberation of the Councils of Constance and nearby Basel with their impressive assemblies of ecclesiastical and secular dignitaries whose presence placed the region in the focal point of European activities. The careers of three artists coincide with these events, Lucas Moser, Hans Multscher, and in particular Konrad Witz. Characteristic of Swabian painting as seen in the works of these pioneers is a certain stolid severity in figure composition combined with an obvious desire to create images emphatically realistic. The result is a ritual solemnity of considerable impact with the added quality of clearly identifiable settings, such as in Konrad Witz's *Geneva Altarpiece* with its rigidly majestic Christ projected against an unmistakable Alpine landscape.

Although Stefan Lochner may have received his initial training in Swabia, his works clearly show that his main impetus came from Flemish art and that he may have served his apprenticeship in the workshop of Robert Campin. In the mid-1430's, with Jan van Eyck's brilliantly conceived and masterfully executed works fresh in mind, he must have arrived in Cologne, where another influence took root: the mystic poetry of the works of his Rhenish predecessors seen in the *St. Veronica* panel and in paintings by followers of the St. Veronica Master. It was through his blend of Flemish clarity and Rhenish lyricism that Lochner came to make his contribution to the northern Renaissance.

His first major commission may have been the triptych now housed in the cathedral, whose central panel is an *Adoration of the Magi* with the patron saints Ursula and Gerion and attendants on the wings. A gilded background highlighted by Gothic tracery runs the full length of the three panels; poses, expressions, and the elaborately colored textiles of the attire of the groups surging toward the enthroned Madonna show the artist's familiarity with the works of the Limbourg Brothers, while the gently tilted head and melancholy expression of the Madonna closely resemble the St. Veronica.

The Last Judgment in its portrayal of the damned shows a kinship with Konrad Witz; so also do the many gruesome details depicted inside the wings. However, such harshness is partly offset by the radiant triumph of the central image in regal red, blue, and green on a gold background where Christ, judge and redeemer, reaches out toward Mary and John the Baptist.

One of his dated works, commissioned in 1447 by the Knights of the Teutonic Order for their church of St. Cetherine in Cologne, has as its central panel a *Presentation in the Temple* showing, under a gilded canopy of God's radiance, a kneeling Mary presenting the infant Christ to Simeon, the priest who had received the promise that he would not die before he had seen the Anointed One. These principal participants in the ritual and their attendants flank a splendid altar depicting Moses with the Tablets of the Law and, below, the Sacrifice of Isaac, each a foreshadowing of Christ's fulfillment of the Covenant. In the lower foreground a miniature procession of choir boys moves toward the center, their burning candles mere spots in the overwhelming brightness of this festival of divine light.

Among Lochner's smaller pictures are two Marian images, one a *Madonna with the Violet,* where the Virgin, standing, magnificently robed in red and holding the Christ child, is watched over by God and the Holy Spirit, while a donor kneels at her feet, the other his ultimate masterpiece, *Madonna in the Rose Bower,* a hushed, contemplative poem in color and light through which the Cologne Style with its mystic lyricism reaches its pinnacle of achievement.

—Reidar Dittmann

LONGHI, Pietro.

Born Pietro Falca in Venice, 1702. Died in Venice, 8 May 1785. Married Catarine Maria Rizzi, 1732; son, the painter Alessandro Longhi. Pupil of Antonio Balestra and G. M. Crespi at Bologna; then worked in Venice: in the register of Venetian painters from 1737 to 1773; though he did some frescoes in the grand style, his specialty was depicting contemporary life; one of the first members of the Academy, 1756 (and taught alternate years until 1780); also director of an academy of drawing and printmaking, 1763–65.

Major Collections: Venice: Ca' Rezzonico, Accademia, Querini-Stampalia.
Other Collections: Bassano; London; Milan; New York; Oxford; Padua; Paris; Rovigo; Washington; Royal Collection.

Publications

On LONGHI: books—

Rava, Aldo, *Longhi,* Florence, 1923.
Moschini, Vittorio, *Longhi,* Florence, 1956.
Valcanover, Francesco, *Longhi,* Milan, 1964.
Pignatti, Terisio, *Longhi,* Venice, 1968; as *Longhi: Paintings and Drawings: Complete Edition,* London, 1969.
Mucchi, Ludovico, *Alla ricerca di Longhi,* Milan, 1970.
Pignatti, Terisio, *L'opera completa di Longhi,* Milan, 1974.
Pignatti, Terisio, *Longhi: Dal disegno alla pittura* (cat), Venice, 1975.
Sgarbi, Vittorio, *Longhi: I dipinti di Palazzo Leoni Montanari* (cat), Milan, 1982.
Longhi: The Paintings in the Palazzo Leoni Montanari in Vicenza (cat), Edinburgh, 1988.

*

Pietro Longhi was easily the dominant figure in Venetian genre painting in the 18th century. He has been compared to Jane Austen for his detailed chronicling of the banalities of daily life. Trained by Balestra to paint in the grand manner, he soon proved unequal to the task. He had the good fortune to work for a time with Giuseppe Maria Crespi in Bologna. Crespi, and his more illustrious pupil Piazzetta, painted dark, emphatic images of Italian peasantry. Longhi occasionally followed suit but this was not to be his *métier.*

Longhi is remembered—and was highly praised in his day— for his numerous small canvasses showing patrician or middle-class Venetians beguiling the time with simple pleasures: visiting, card playing, sipping coffee, sewing, and, occasionally, a langorous attempt at reading a book or studying a map. Sometimes Longhi's idle Venetians venture forth, often masked, to attend some carnival event and mix with the low life. *The Rhinoceros* (London) shows such a group—some masked, others not—viewing a forlorn and hornless rhino who actually appeared in Venice in 1751. Its horn, a sexual symbol, is wielded by a huckster trying to excite the group of jaded onlookers, already bored with this emasculated creature from exotic Africa reduced to a mild curiosity.

A large room in the Ca' Rezzonico has its walls virtually covered with Longhi's small scenes of Venetian interiors of the sort where his pictures must originally have hung. Non-event follows non-event, enlivened only by the odd frisking dog or domestic *contretemps.* Nor are these characters particularly memorable as they sit or stand stiffly, preoccupied or staring blankly out as if waiting for *us* to do something. Sometimes the *dramatis personae* is interesting if only for being so arbitrary. In *A Concert* (Venice, Accademia) a monk plays cards with another cleric while three musicians play to an audience consisting of a dog—a subject one would expect from Picasso rather than an 18th-century genre painter. In *The Masked Visit* (Ca' Rezzonico) a servant brings a coffee tray to a woman who stops her needlework to gaze out at us. An ordinary looking man stands near her while a figure in a dark cloak, tricorn hat, and carnival mask sits menacingly in the shadows.

The appearance of carnival costume may seem reminiscent of Watteau's use of theatrical types, but whereas Watteau's *fete galante* pictures take place in a poetic never-never land it is the very realism of Longhi's settings that makes these masked visitors so disquieting, rather like the spectres in *Don Giovanni* or *The Phantom of the Opera.*

Longhi was compared to Watteau by no less a connoisseur than Pierre-Jean Mariette, who ought to have known better. While a connection between Venice and the circle of Watteau was established by Rosalba Carriera, there is nothing of Wat-

Blind Man's Buff, 1740's; 19 × 23 in (48.3 × 58.4 cm); Royal Collection

teau's wistful elegance in Longhi. The dramatist Goldoni praised him for his truthfulness to life, and it was for this that his works fetched "grossi prezzi." Also compared to Hogarth and Goya, Longhi lacked the wit of one, the savagery of the other, and the ability of both. His compositions are casual and his figures awkward. These qualities have sometimes been seen as a deliberate and charming naiveté, but this is doubtful.

A large recently catalogued collection of drawings, mostly of individual figures, in the Biblioteca Correr, Venice, tells a somewhat different story. They show abilities as observer and draughtsman one would not suspect from looking at the paintings only, and suggest that the comparisons with his greater contemporaries, Watteau and Goya, were not entirely inapt after all.

Longhi was an artist without great intellect or technique but with sufficient flashes of color, satire, and mystery to keep our attention for as long as there is interest in 18th-century Venice. His realism, unlike that of mid-century French painting, had nothing to do with the assertion of moral values nor was it the harbinger of revolution. Like the *ancien régime,* the Venetian Republic was in decline; Longhi was there to record its sillier moments.

—Frank Cossa

LORENZETTI, Ambrogio.
Born in c. 1290's; brother of the painter Pietro Lorenzetti. Died of the plague, 1348. Active in Siena between 1319 and 1347; but also worked in Florence, where he had matriculated in the painters guild by 1327; his few documented works include frescoes in S. Agostino, Siena, 1333–35 and in the Town Hall, Siena, 1337–39, and the Maestà in the Municipio of Massa Marittima, 1335–37.

Major Collection: Siena.
Other Collections: Asciano Senese; Florence: Uffizi, Museo Diocesano; Massa Marittima: Municipio; Milan; New Haven; Roccalbegna: SS. Pietro e Paolo; Siena: S. Agostino, Town Hall.

Publications

On LORENZETTI: books—

Sinibaldi, Giulia, *I Lorenzetti,* Siena, 1933.
Carli, Enzo, *Lorenzetti,* Ivrea, 1954.

Carli, Enzo, *La pittura senese del Trecento,* Milan, 1955, 1981.

Rowley, George, *Lorenzetti,* Princeton, 2 vols., 1958.

Borsook, Eve, *The Mural Painters of Tuscany,* London, 1960, Oxford, 1980.

Borsook, Eve, *Lorenzetti,* Florence, 1966.

Carli, Enzo, *Pietro e Ambrogio Lorenzetti,* Milan, 1971.

article—

Skaug, Erling, "Notes on the Chronology of Lorenzetti," in *Mitteilungen des Kunsthistorisches Institutes in Florenz,* 20, 1976.

*

Ambrogio Lorenzetti of Siena was one of the boldest innovators of the already experimental generation of artists active in the first half of the trecento. His *oeuvre* is consistently distinguished by a mind impatient with received formulae. All is rethought and then revised anew in every work, be it the relationship between Virgin and Child to which he gave a psychological depth and new naturalistic form impressive both in breadth and nuance; or the use of line, which he envisioned as a carrier not only of decorative or emotional power, but as an indicator of three-dimensional volume and depth. Like other Sienese artists of the time, Ambrogio was well-received in Florence. He entered into the Florentine guild of painters in the 1320's, and his style is reflected there in the art of Bernardo Daddi and those influenced by him, including Andrea di Cione (Orcagna). Ambrogio's stature in his native city during his later life is testified to by the extant as well as the lost, but otherwise documented, works executed for the seat of government, the Palazzo Pubblico.

One of Ambrogio's earliest known works is the panel of a *Madonna and Child* from Vico L'Abate, south of Florence, and inscribed 1319 (Florence, Uffizi), in which the old-fashioned shape of the frame and unyielding frontality of the Virgin harken back to hieratic dugento taste. Most certainly modelled on an older image, Ambrogio's version has, nonetheless, been brought up-to-date in the suggestion of Giottesque volume and weight (displayed through the contours, rather than the modelling) of his two figures, and in the naturalistic manner in which the Virgin holds her muscular child. In this relationship of serene maternal verticality versus dynamic, youthful diagonality Ambrogio reveals a genius for the subtleties of mother-child interaction never equalled by either his contemporaries or followers.

The Vico L'Abate painting is also an early example of this master's interest in the balance of pattern and space. The throne, inset with decorative and wooden bands, repeats the flat shape of the panel's angular gable while also revealing depth through its arms and generous seat—at once affirming and denying the reality of the surface that the gable encloses.

Further spatial mastery, and an influx of influence from Simone Martini, according to some scholars, distinguishes Ambrogio's *oeuvre* of the early 1330's, when evidence suggests he was once more in Florence. The four small panels depicting stories from the life of St. Nicholas (Florence, Uffizi) may have shown a debt to Simone's altarpiece of *The Blessed Agostino* of c. 1328, if the proposed original arrangement of two scenes arranged vertically to either side of a full-length St. Nicholas is correct. However, Ambrogio's talents here surpass those shown by Simone in terms of naturalism and narrative synthesis.

Inspired by, but more convincing than, the architectural environment that houses *The Denial of Peter* and *Christ Before Annas* in Duccio's *Maestà,* Ambrogio's panel of *St. Nicholas Reviving a Dead Child* combines five episodes in the orbit of one rich red and green town house. There are intimations in these stories, too, of works yet to come. The vast expanse of sea, filled with billowing sails in *The Famine at Myrna* evokes, in essence, a feeling for panorama seen in the Sienese *contado* of *The Effects of Good Government,* frescoed some six years later; and the interior of the small church, with its columns and tiled floor that draw the viewer into the measured perspective of *The Consecration of St. Nicholas,* reappears again, more grandly, in *The Presentation* of 1342.

The mastery and economy of means asserted in the compositions of the *St. Nicholas* narratives accompany an increased intensity of emotion, which begins to simmer in the middle 1330's. Ambrogio's *Maestà* in the town hall of Massa Marittima, southwest of Siena, exposes a concentrated fervor rivaling that of the sculptor Giovanni Pisano, whose work Ambrogio certainly knew. Here, a limited spatial illusion and two-dimensional design conspire to construct the vast body of adoring saints and angels that flanks and encloses the Virgin and Child—the axis of an imposing compositional triangle. In this pair, thrust cheek to cheek within the protective wings of kneeling angels, Ambrogio has realized an almost physical fusion of mother and son that contracts from the sublimated violence of attending angels who pelt roses and lilies and the unswerving eyes of the ever-watchful crowd. Below these two, on three oval steps, a wraithlike red Charity and her two sister virtues, Faith and Hope, check the observer's access as they form a minor, internal triangle in line with the principle one dominated by the holy couple.

Ambrogio's famous *Madonna del Latte* (Siena, Palazzo Arcivescovile), probably of the later 1330's, shows a much gentler aspect of the Virgin and Child relationship. Mary, holding her heavy, active child, leans slightly to the right, as if to steady herself against the very inner frame that encloses her. The pair's position, nearer to the observer than might be expected, is enhanced by haloes that also overlap the inner painted frame, and by the Child's big right toe, which appears boldly to impinge on the outer, gilded frame.

Toward 1340, Ambrogio's figures take on a formal simplicity and a slow, measured rhythm that render them self-contained and monumental. This phase, already sensed in the allegorical figures in the Sala dei Nove of Siena's town hall, documented to 1338–39, is fully manifested in *The Presentation in the Temple* (Florence, Uffizi), the central panel of an altarpiece for Siena Cathedral. As the prophetess Anna pronounces Christ, the Deliverer, to the hushed participants, the Infant, tightly bound, his finger in his mouth, paradoxically reveals the innocence and frailty of his human nature. The scene takes place in an elaborately conceived edifice where perspectival space, diminishing to a central axis, draws the viewer into the central area between Simeon and the Child, and the waiting Virgin.

Ambrogio's final dated work, *The Annunciation* of 1344 (Siena, Pinacoteca), takes the relationship between the viewer

and the painted world to its furthest extreme. Here, in a measured, deep and empty space, the massive forms of the Virgin and the kneeling Gabriel face one another. The angel's words issue from his mouth, across the tip of the palm he holds in his left hand and behind the colonette (etched, like the inscription, from the gold background) toward the Virgin. Never had the ambiguities of implied depth versus surface, of passing time versus the eternal present, been so evocatively displayed. As in his earliest work, Ambrogio shows himself a painter of intellect and ingenuity, always searching for more profound visual solutions that also embody the questioning spirit of his age.

—Carol T. Peters

LORENZETTI, Pietro.

Active in Siena between 1306 and 1348; brother of the painter Ambrogio Lorenzetti. First documented, 1306, then worked in Cortona, 1315, Arezzo, 1320, Assisi, and Siena, 1330's, sometimes in collaboration with Ambrogio.

Collections: Arezzo: S. Maria; Assisi: S. Francesco; Berne; Cambridge, Massachusetts; Cortona: Cathedral Museum; Florence; London; New Haven; Pasadena; Philadelphia; Siena: Museum, Cathedral Museum; Vatican; Washington; Zurich: Abegg.

Publications

On LORENZETTI: books—

Cecchi, Emilio, *Lorenzetti*, Milan, 1930.
DeWald, Ernest T., *Lorenzetti*, Cambridge, Massachusetts, 1930.
Sinibaldi, Giulia, *I Lorenzetti*, Siena, 1933.
Brandi, Cesare, *Lorenzetti: Affreschi nella Basilica di Assisi*, Rome, 1958.

articles—

Seidel, M., "Das Frühwerk von Lorenzetti," in *Städel Jahrbuch* (Frankfurt) 8, 1981.
Maginnis, Hayden B. J., "Lorenzetti: A Chronology," in *Art Bulletin* (New York), June 1984.

*

. . . in the course of his life, he was employed and loved by all Tuscany. . . . he imitated so successfully the style of Giotto, which had become known throughout Tuscany, that men thought that he would become a better master than Cimabue, Giotto and the others, as he actually did.

Although Giorgio Vasari wrote these laudatory words about Pietro Lorenzetti, he had only a limited knowledge of the artist or the extent of his work. First, Vasari misinterpreted his signature on a panel of the *Madonna*, now in the Uffizi, to read

PETRUS LAURATI DE SENIS. Unaware of the artist's true name, Vasari was thus unable to make the connection between Pietro and his brother, Ambrogio Lorenzetti, whose name and fame were well known to Vasari, having earlier been recorded by Ghiberti. The error of Pietro's surname was perpetuated for centuries, thus obscuring his close collaboration with Ambrogio, and their mutual influence upon each other, a relationship now believed to have been even closer than surviving documents might suggest. In fact, the now-lost frescoes in the Sienese Hospital of Santa Maria della Scala, cited by Vasari as Pietro's earliest success, were actually the work of *both* brothers, a fact attested by their inscription, which Vasari had overlooked. Because Pietro is named first in this inscription, and Ambrogio is described as "his brother," Pietro is regarded to have been the older of the two.

Pietro's birth and death dates remain unknown, although he is generally believed to have been born around 1280, and to have died around 1348, a victim of the Black Death. Despite Vasari's explicit claim that Pietro was a pupil of Giotto, he probably received his early training in the workshop of Duccio, or certainly within Duccio's inner circle. James Stubblebine, the American scholar, has proposed that Pietro was among the hands (along with Ambrogio, Simone Martini, and others) who worked on Duccio's 1311 Siena Cathedral *Maestà*. And, indeed, Pietro's earliest Madonnas have a refinement and delicacy reminiscent of Duccio, while demonstrating Pietro's own unique color harmonies.

Because so little is documented concerning Pietro's life, the answers must come from his extant works. His earliest signed altarpiece is the polyptych commissioned 17 April 1320, by the Bishop of Arezzo, Guido Tarlati, for the high altar of the Pieve di Santa Maria in Arezzo. Since this was a major commission, Pietro must have been well established by this time. A landmark in the development of Sienese altarpieces, the Arezzo polyptych offers daring new iconographic and formal solutions. Deriving its general format from Duccio's Polyptych No. 47 (Siena), Pietro breaks with tradition by incorporating two narrative subjects on the central axis, the *Annunciation*, crowned by the *Assumption of the Virgin*. He thus uses the central axis to make a strong theological statement glorifying Mary, as would be appropriate for a church dedicated to the Virgin. In the double-arcaded interior view of the *Annunciation*, Pietro's lifelong preoccupation with illusionistic effects is demonstrated by his inventive treatment of pictorial space. Here he blurs the demarcation between the real arches of the frame and the painted architectural setting of the sacred narrative. Pietro's three-quarter length figures, with their twisting postures, often awkward gestures, and piercing glances convey a spiritual intensity that derives from Giovanni Pisano's sculpted figures from the facade of Siena Cathedral. Thus, in this earliest signed work, many of the artist's lifelong traits are already well established and demonstrated.

Pietro's next signed and dated work, the Carmelite Altarpiece of 1329, was a Sienese commission of major significance, costing the considerable sum of 150 gold florins. This suggests that Pietro, in 1329, was one of the leading artists of Siena. Commissioned for propagandistic purposes, the altarpiece was intended to support the Carmelite Order's claim of descent from the Prophets Elijah and Elisha. This would give their Order priority over the Dominicans and Franciscans. Using a complex iconographic program, Pietro supported their

claim visually, while further demonstrating divine recognition of the Carmelite Order. Dismantled and dispersed, most of the principal elements of the altarpiece have been preserved and are now reassembled in the Siena Pinacoteca. Pietro's innovation here is the introduction of full-length figures flanking a central Madonna. This work shows a new sense of scale and monumentality: a more painterly, less linear approach. The figures are more volumetric and more skillfully foreshortened in space. Using less active poses and less agitated glances, Pietro nonetheless retains his special quality of spiritual intensity. The small narrative scenes of the predella are remarkably inventive in their depiction of figures within complex architectural settings, using such elements as arched doorways, space-creating tiled floors, and vaulted ceilings.

Pietro's *Birth of the Virgin* (Cathedral Museum, Siena), signed and dated 1342, was originally the central panel of the Saint Savino altarpiece in the Duomo, Siena. A late work, it shows a continuation of all the artistic concerns set forth in the Carmelite Altarpiece, particularly the artist's involvement with illusionistic devices. Pietro again uses the tipped-up, space-creating tile floors and the complex configurations of rib-vaulted ceilings, previously depicted in the Carmelite predella. He also elaborates upon the spatial devices of the Arezzo *Annunciation,* with its view into a double-arched interior. He constructs his painted architectural setting in such a way that it incorporates the four wooden uprights of the frame, once again blurring the boundary between elements of the real and fictive worlds. The figures retain the amplitude and calm, full drapery that reflect the influence of Giotto. Only the halos signal that this everyday bourgeois scene actually depicts a sacred event. But the real subject here is Pietro's manipulation of space, his use of shifting viewpoints to achieve this end, and his obvious delight in every minute element that contributes to this effect.

A more monumental aspect of Pietro's work is to be found in his fresco cycle of the Passion, in the left transept of the Lower Church of San Francesco in Assisi. Because Vasari's misattribution of this cycle to other hands went unchallenged for centuries, it has not been until modern times that Pietro's full achievement as an artist could be appreciated. Pietro's authorship of the Passion cycle was first recognized in 1864 by G. B. Cavalcaselle, who dated the frescoes around 1320. Alternate dates, ranging from 1315 to the 1330's, have since been proposed by other critics, who raised questions concerning the degree of workshop involvement. Based on a 1973 examination of the intonaco conducted by Leonetto Tintori and Hayden B. J. Maginnis, the latter confirmed the participation of a comparatively large workshop, and concluded that the cycle was produced in a single continuous work campaign. Maginnis further proposed a date prior to September 1319, before the Ghibelline uprising in Assisi, the theft of the papal treasure from San Francesco, and the series of political upheavals that followed. Nonetheless, both the date of the cycle and the extent of Pietro's participation remain open questions. But considering the heroic quality and intensely focused power of expression of Pietro's *Deposition* and *Entombment,* it seems difficult to consider the Passion cycle as anything other than a mature work of the artist.

Pietro's most extraordinary invention at Assisi is his *trompe l'oeil* fur-covered bench, painted on the end wall of the left transept, beneath his *Deposition.* Its illusionism is signifi-cantly enhanced by its cast shadow, which is appropriately angled in relation to the natural light source. On the immediately adjacent abutting wall, on the left, is Pietro's fictive altarpiece of the Madonna and Child flanked by Saints Francis and John the Evangelist. With their ethereal, blond beauty, these figures reflect the powerful influence of Simone Martini. To the lower right of this altarpiece is a further unexpected piece of illusionism, a fictive niche containing liturgical vessels and a book, placed immediately above a real cupboard that presumably held their actual counterparts. In combining this *trompe l'oeil* bench, altarpiece, and niche, Pietro was in effect creating a fictive chapel. Pietro was not the first to experiment with illusionistic effects; they appeared earlier in Assisi and elsewhere. But Pietro seems to have taken special delight in such fool-the-eye creations.

Although the full facts of Pietro's life will never be known, he is generally regarded today (along with Giotto and Simone Martini) as one of the leading Italian painters of the second decade of the 14th century. While his art probably had its origins in Duccio's studio, he borrowed from Giovanni Pisano, Giotto, Simone, and others. Influences also flowed back and forth between him and his brother Ambrogio. But whatever his debt to others, Pietro remained true to his own particular vision and pictorial idiom. While retaining the overall refinement and grace of his native Sienese style, Pietro integrated into his art the solidity and gravity of Giotto, matching that artist's observation of, and truth to, the natural world. In comparison with Simone's courtly, ethereal imagery, Pietro's art might sometimes appear inelegant or earthbound. But it was his extraordinary observation of the everyday, material world that made possible his virtuoso illusionism.

—Ruth Wilkins Sullivan

LORENZO MONACO [Lorenzo the Monk].
Born Piero di Giovanni, probably in Siena, c. 1370–71. Died in Florence, c. 1423–25. Became Camaldolite monk, 1391: deacon, Convento degl Angeli, Florence, 1396; earliest documented work is an altarpiece for the Ardinghuli Chapel in the Carmine, Florence, 1399; member of the Florence painters guild, 1402; also did frescoes in the Cappella Bartolini, S. Trinità, Florence, 1420's.

Major Collection: Florence: Accademia.
Other Collections: Altenburg; Amsterdam; Baltimore: Walters; Berlin; Bologna; Braunschweig; Cambridge; Edinburgh; Empoli; Florence: Uffizi, Bargello, Museo di S. Marco, S. Trinità, Biblioteca Laurenziana; London: National Gallery, Courtauld; New Haven; New York; Pasadena; Philadelphia; Posnan; Siena; Toledo, Ohio; Vatican; Washington; Worcester, Massachusetts.

Publications

On LORENZO: books—

Siren, Osvald, *Lorenzo Monaco,* Strasbourg, 1905.

Golzio, Vincenzo, *Lorenzo Monaco,* Rome, 1931.

Bellosi, Luciano, *Lorenzo Monaco,* Milan, 1965.

Fremantle, Richard, *Florentine Gothic Painters,* London, 1975.

Cole, Bruce, *Masaccio and the Art of Early Renaissance Florence,* Bloomington, Indiana, 1980.

Eisenberg, Marvin, *Lorenzo Monaco,* Princeton, 1989.

articles—

Gronau, H., "The Earliest Works of Lorenzo Monaco," in *Burlington Magazine* (London), 82, 1950.

Zeri, F., "Investigations into the Early Period of Lorenzo Monaco," in *Burlington Magazine* (London), 106, 1964, 107, 1965.

Gonzalez-Palacios, A., "Indagini zu Lorenzo Monaco," in *Paragone* (Florence), 21, 1970.

*

The ethereal world created by the painter and miniaturist Don Lorenzo Monaco reflects one facet of the complex artistic milieu of Florence in the first decades of the quattrocento. Born in Siena as Piero di Giovanni, Lorenzo took his vows and new name with the Florentine Camaldolites of S. Maria degli Angeli in 1391, probably at the age of twenty-one. Although his exact relationship with the monastery is difficult to ascertain (he appears to have lived outside the cloister from at least 1406), his debt to the artistic traditions of Florence is not. From his many attributed works it is apparent that he enjoyed a large shop in that city, and his influence on its artists, especially those of his own generation in the first two decades of the new century, is striking.

The character of Lorenzo's youthful phase, which would reveal his formative relationship to one or more masters, is extremely problematic. His earliest dated pieces—attributed miniatures in two Antiphonaries dated 1394 and 1395 (Florence, Laurentian Library, Corale 5 and Corale 8)—suggest the ample figural proportions and fluid draperies of the later paintings of Lorenzo's older contemporary Spinello Aretino, and the swarthy complexions of the Cionesque style that was carried on from the middle of the century. These tendencies are confirmed in *The Agony in the Garden,* a large panel datable to the later 1390's (Florence, Accademia). Here, rather ample and self-enclosed figures are set within the rocky landscape of the Mount of Olives where a lion (symbol of Christ, or of the spiritual wilderness in which he is placed) emerges to the right, and a small donor kneels on the lower left. The bold contrasts in modelling, the soft, ductile cascades of Christ's garments, and the curving contours of the sleeping apostles are wholly in the spirit of late trecento style. The graceful linearism of the angel, who holds the gold chalice of Christ's commitment, and the delicate color chords of coral, lavender, saffron, and apple green (perhaps transformed from the variegated combinations of Agnolo Gaddi or the delicate arrangements of Nardo di Cione at mid-century) are, however, beacons of what is to come.

Of the two dated works of 1404 that mark a change in Lorenzo's development toward the more calligraphic exercises of his mature phase, the triptych depicting *The Madonna of Humility with Four Saints* in Empoli (Museo della Collegiata) shows this shift most explicitly. In the central panel, the torso of the slender Virgin and her child are united, not only by the pure plane geometry of the curve that circles from the Child's right foot, around his mother's shoulders and down through her right hand, but also by linear arabesques that begin to play diagonally across the interior of the forms. Further refinements and syntheses of these tendencies quickly develop. A second *Agony in the Garden* of 1408 (the left wing of a small, dismembered triptych, now united with the opposite wing showing *The Three Maries at the Tomb;* Paris, Louvre), reveals how far Lorenzo has come since his version of this subject of about ten years earlier. Now, the emotional qualities of Christ's anguish are stressed by enclosing the arc of his raised arms, clad in bright crimson, within the hard, labyrinthine contours of the dark and rocky landscape.

The fullness of Lorenzo's evolution in this phase—seen in his only signed and documented work, *The Coronation of the Virgin,* for the high altar of S. Maria degli Angeli, Florence (1414; Florence, Uffizi)—is paralleled closely in the contemporary works of the sculptor Lorenzo Ghiberti: for example, the *St. John the Baptist* for Or San Michele of 1412-16. In both the painting and the sculpture the calligraphy of the garments' folds—the main vehicles of movement and psychological intent—have taken on a plasticity paradoxical to their decorative nature: a nascent tension of surface versus weight and mass that will find a fuller evolution in the 1420's. The substantiality and earthly tempo of Lorenzo's trecento compositional precedents have here been subsumed in the atmosphere of a soaring, high-keyed palette of golden yellow, coral, green, and rich blue clarified by the white Camaldolite habits and the Virgin's white mantle. In the main panel, the heavenly entourage floats upon gradated blue, heavenly spheres; in the predella below, small white-robed figures of monks and nuns glisten against their coral or mossy green-tinged settings.

Beyond *The Coronation,* a pattern of extremities, emotional and figural, take hold of Lorenzo, and he remains under its sway until the late style of the 1420's. The depths of passion which fused a deeply felt religious devotion to a pure and scintillating style is still the motivation behind the clarion simplicity of *The Adoration of the Magi,* probably completed for S. Egidio, the hospital church of S. Maria Nuova, Florence, in 1422 (Florence, Uffizi). Yet, even in this wilderness, cleansed of all externals, a greater heaviness is perceived in the movements of the figures; and in the construction of buildings, fantastic hats, and the smooth globes of some skulls, a tangible interest in solid geometry presents itself.

Lorenzo's *Annunciation* altarpiece (c. 1423-24), set amid his frescoes of *The Life of the Virgin* in the Florentine church of S. Trinità, furthers the attempted break from his mature style. The palette of the main panel, with a dominant vermillion, is more somber than anything done since the early years of the century; and like Ghiberti at this time, Lorenzo expresses an urgency to manifest the space and gravity of the actual world. In this, perhaps his final, work, there are strong indications of a more secular spirit—not only gleaned from the work of Gentile da Fabriano, a visitor to Florence in these years, but from inner changes in Florentine art itself. For Lorenzo, a more intensive encounter with the new artistic vistas glimpsed in *The Annunciation* remained unresolved. Yet his heritage in the quite different world then forming was assured

survival. Seeds of his visions live on in Fra Angelico, Filippo Lippi, and Botticelli, marking the vitality of a spiritual current that continued to enrich the substance of Florentine quattrocento painting.

—Carol T. Peters

LOTTO, Lorenzo.

Born in Venice, c. 1480. Died in Loreto, after 1 September 1556. Earliest documented works are in Treviso from c. 1503–06, then worked in Recanati, 1508, Rome, 1508–12 (worked in the Vatican with Raphael, though this work is lost), Bergamo, 1513–20's, Venice, 1526 or 1527–40, Treviso, 1542–45, Venice, 1546–49, Ancona, 1550; entered the monastery of Santa Casa at Loreto, 1552, and became a lay brother, 1554, and died there; his account-book survives.

Collections: Allentown, Pennsylvania; Ancona; Asolo: Cathedral; Bergamo: Museum, S. Bartolomeo, S. Bernardino, S. Spirito, S. Maria Maggiore; Berlin; Brescia; Budapest; Cambridge, Massachusetts; Celana: parish church; Cingoli: S. Domenico; Dresden; Florence; Hampton Court; Jesi; Leningrad; London: National Gallery, Courtauld; Loreto: Palazzo Apostilico; Madrid; Milan: Brera, Poldi Pezzoli; Monte S. Giusto: S. Maria in Telusiano; Munich; Naples; Paris; Philadelphia; Recanati; Rome: Borghese, Doria Pamphili, Capitoline, Barberini, Castel Sant-Angelo; S. Cristina Altiverone: parish church; Sarasota, Florida; Siena; Trescore: Oratorio Suardi; Treviso, Venice: Correr, Accademia, SS. Giovanni e Paolo; Vienna; Washington; Royal Collection.

Publications

By LOTTO: books—

Il libro di spese diverse (1538–1556) [diary-account book], edited by Pietro Zambetti, Venice, 1969.
Lettere inediti, edited by Luigi Chiodi, Bergamo, 1962; revised ed. in *Bergomun*, June 1968.

On LOTTO: books—

Berenson, Bernard, *Lotto*, London, 1895, Milan, 1955; as *Lotto: Complete Edition*, New York and London, 1956.
Biagi, Luigi, *Lotto*, Rome, 1942.
Angelini, Luigi, *Gli affreschi di Lotto in Bergamo*, Bergamo, 1953.
Coletti, Luigi, *Lotto*, Venice, 1953.
Pignatti, Terisio, *Lotto*, Milan, 1953.
Zampetti, Pietro, *Lotto* (cat), Venice, 1953.
Zampetti, Pietro, *Lotto nelle Marche*, Urbino, 1953.
Banti, Anna, and Antonio Boschetto, *Lotto*, Florence, 1953; as *Rivelazione di Lotto*, Florence, 1981.
Liberali, Giuseppe, *Lotto, Pordenone, et Tiziano a Treviso*, Venice, 1963.
Siedenberg, Margot, *Die Bildnisse des Lotto*, Lörrach, 1964.

Zampetti, Pietro, *Lotto*, Milan, 1965.
Pouncy, P., *Lotto disegnatore*, Vicenza, 1965.
Mascherpa, Giorgio, *Lotto a Bergamo*, Milan, 1971.
Caroli, Flavio, *Lotto*, Florence, 1975.
Mariani-Canova, Giordana, *L'opera completa di Lotto*, Milan, 1975.
Caroli, Flavio, *Lotto e la nascita della psicologia moderna*, Milan, 1980.
Cortese Bosco, Francesca, *Gli affreschi dell'Oratorio Suardi: Lotto nella crisi della riforma*, Bergamo, 1980.
Mascherpa, Giorgio, *Invito a Lotto*, Milan, 1980.
Bergamo per Lotto (cat), Bergamo, 1980.
Zampetti, Pietro, *Lotto*, Bologna, 1980.
Dillon, Gianvittorio, editor, *Lotto a Treviso: Ricerche e restauri*, Treviso, 1980.
Zampetti, Pietro, editor, *Lotto nel suo e nel nostro tempo*, Urbino, 1980.
Grimaldi F., editor, *Lotto a Loreto e Recanati* (cat), Loreto, 1980.
Atti del convegno . . . Lotto, Asolo, 1980.
Dal Poggetto, Paolo, and Pietro Zampetti, *Lotto nelle Marche* (cat), Ancona, 1981.
Zampetti, Pietro, and V. Sgarbi, editors, *Lotto* (colloquium), Treviso, 1981.
Gentili, Augusto, *I giardini di contemplazione: Lotto*, Rome, 1985.

articles—

Galis, Diana, "Concealed Wisdom: Renaissance Hieroglyphic and Lotto's Bergamo Intarsie," in *Art Bulletin* (New York), September 1980.
Christiansen, Keith, "Lotto and the Tradition of Epithalmic Paintings," in *Apollo* (London), September 1986.

*

"O Lotto, as good as goodness and as virtuous as virtue, no one approaches you, no one is your equal in religious duty." So Pietro Aretino saluted the elderly painter in a letter written in 1548. Twenty years later, Vasari too mentioned the artist's piety, although he did not routinely do so in his biographies of artists, noting that Lotto died as he had lived, a devout Christian. These contemporary or near contemporary observations on Lotto's character are significant, because they confirm the impression left by a survey of his surviving work and the documents on works since destroyed or of unknown whereabouts, namely, that interests and attitudes that are popularly considered medieval persisted in and governed this artist of the Renaissance. Patronage mainly by the more conservative elements of Italian society—religious orders, the minor nobility, and bourgeoisie—while no doubt a factor, only partly explains this phenomenon. Like does, after all, seek like.

Overwhelmingly Lorenzo Lotto painted religious subjects and portraits, and even the portraits are sometimes moralizing or have religious overtones. Outstanding in this class is the early *Portrait of Bernardo de' Rossi*, or, more precisely, its allegorical cover (1505, Washington, National Gallery of Art). Whatever the cover's specifics of meaning—an often discussed topic over the years—clearly the general subject is the choice between virtue and vice, the rewards of the former and the

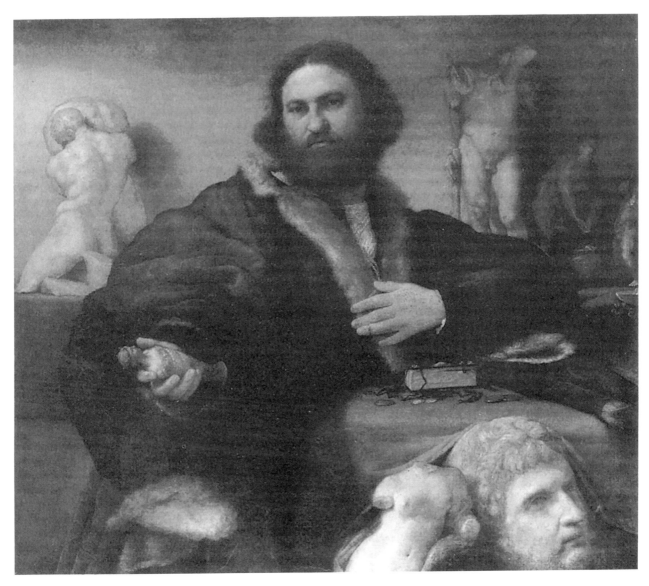

Andrea Odoni, 1527; 41 × 45⅞ in (104.1 × 116.6 cm); Royal Collection

punishment of the latter. Another noteworthy portrait is the *Man in Black* (c. 1529) today in the Borghese Gallery in Rome. The plucked blossoms and charm-like skull under the gentleman's right hand leave no doubt that this is a *memento mori* as well as a likeness. These morality lessons masquerading as portraits, not, incidentally, isolated examples from Lotto's corpus, are strikingly different from the proud visages that, say, Titian has left to us from the same period.

The works from Lotto's hand that are not either portraits, including didactic portraits such as those mentioned above, or overtly religious in content are few in number, allegorical in character, and moralizing in intent. Probably the best example of this small class is the allegory usually and appropriately titled the *Triumph of Chastity* (Rome, Pallavicini Collection, c. 1530). In this work the nude Venus, one of Lotto's rare nudes, and her son, the personifications of sensual pleasure, cower and flee before the wrath of an amply draped Chastity. The figure of Venus, which may have its source in a nereid sarcophagus, is as cold as the stone of the antique source. Super-

ficially influenced by the antique, Lotto has created a traditional Christian psychomachia.

The emotional pitch of Lotto's religious paintings is typically fairly high, perhaps further testimony to the fervor of the man himself. This animated effect is the result of the palette Lotto chooses, his disposition of figures in pictorial space, and sometimes his handling of light and shade, as well as the more obvious means of pose, gesture, and facial expression. (To some extent, this effect is also apparent in some of Lotto's portraiture. But given the constraints upon artistic expression inherent in the genre, portraiture does not provide the most telling examples.)

Lotto's palette, which includes vivid yellows in addition to rich blues and greens, and gives preference to scarlet over more sedate crimson, appeared harsh to the Venetian critic Lodovico Dolce in 1557, whose standard no doubt was the rich yet relatively subdued palette of Titian and his ilk. The merits of Dolce's criticism, which was directed toward Lotto's *St. Nicholas of Bari in Glory* of 1529 (Venice, Church of the

Carmine), are irrelevant. His observation is significant because it is evidence of an "alien" character in Lotto's colorism. Modern observers have from time to time suggested a northern European influence on Lotto's palette, and, indeed, in this respect Lotto's paintings often seem more akin to Durer's than to Titian's.

Since the purest and most intense color is carried by the drapery on figures, Lotto's general tendency to hold his figures to the foreground of pictorial space, which itself is typically relatively shallow, or, if deep, is not inhabited and continuous from foreground to background, heightens the excitement. The exceptions to this general tendency in figure placement are few but significant because they may reveal trans-Alpine influence on another aspect of Lotto's art. The exceptional works are narratives that include two or more episodes in a single frame; they include the biblical histories that Lotto designed for the intarsia choir stalls of Santa Maria Maggiore in Bergamo (1523–30) and the panoramic *Life of St. Barbara* (1524) in the frescoed Suardi Oratory near the same city. In the design of landscape and disposition of small figures throughout pictorial space, these works recall those of Hans Memling and Lucas van Leyden more than any Italian precedent.

Lotto's painted world is seldom illuminated by the bright, even, descriptive light of midday. Contrasts between light and shade may be only slightly greater than in nature or extreme, but in either case contribute to the surface animation of the artist's works and their emotional tone. Figural pose and often facial expression provide the final enlivening touches. Indeed, occasionally the latter borders on the ecstatic, as if Lotto anticipated the sensibility of the Baroque (for example, in his *Madonna and Child with Saints Roch and Sebasian* of 1522 formerly in the Contini-Bonacossi Collection). Lotto's figures are seldom static but instead lean into and out of space, tilting and swaying this way and that, if only slightly. The effect is of a myriad of short diagonals criss-crossing the surface of his works.

The characteristics outlined here are found to a greater or lesser extent throughout the entire corpus of Lorenzo Lotto—in general, greater in the mature works, lesser in the youthful works, and greater in the numerous religious paintings than in the portraits. The final effect is that Lotto's works have direct appeal and are relatively easy to comprehend, notwithstanding the occasional symbol that is unintelligible to the 20th-century observer. His works reflect the simple Christian piety and morality of their creator, and they speak to those qualities in observers.

—Diana Galis

LOUIS, Morris.

Born Morris Louis Berstein in Baltimore, Maryland, 28 November 1912. Died in Washington, D.C., 7 September 1962. Married Marcella Brenner 1947. Attended Baltimore schools; Maryland Institute of Fine and Applied Arts, Baltimore, 1928–33; worked for both mural and easel divisions of federal art projects in mid-1930's; lived in New York, 1936–40, Baltimore, 1940–47, and Silver Spring and Washington, D.C., from 1947; lectured at Washington Center for the Arts, 1952–56, and Howard University, 1953.

Collections: Belfast; Boston; Buffalo; Jerusalem; New York: Metropolitan, Moma, Guggenheim; Waltham, Massachusetts: Brandeis University.

Publications

On LOUIS: books—

Alloway, Lawrence, *Louis* (cat), New York, 1963.
Rosenblum, Robert, *Louis* (cat), Amsterdam, 1965.
Solomon, Alan, *Louis* (cat), London, 1965.
Louis: Veils and Unfurleds (cat), Seattle, 1967.
Fried, Michael, *Louis* (cat), Los Angeles, 1967.
Fried, Michael, *Louis* (cat), New York, 1970.
Krauss, Rosalind E., *Louis*, Auckland, New Zealand, 1971.
Louis (cat), London, 1974.
Carmean, E. C., Jr., *Louis: Major Themes and Variations* (cat), Washington, 1976.
Swanson, Dean, and Diane Upright Headley, *Louis: The Veil Cycle* (cat), Minneapolis, 1977.
Moffett, Kenworth, *Louis in the Museum of Fine Arts, Boston*, Boston, 1979.
Headley, Diane Upright, *The Drawings of Louis* (cat), Washington, 1979.
Upright, Diane. *Louis: The Complete Paintings: A Catalogue Raisonné*, New York, 1985.

*

Morris Louis's works can be seen as a bridge between the Abstract Expressionists of the 1940's and early 1950's and the Op art of the early 1960's. Chronologically and stylistically located between the two, his work vacillates between the unique and the derivative.

None of Louis's student or early works are extant. In the 1930's he was employed by the Works Project Administration, a federal body, and at one point was part of the Mexican muralist Siqueiros's workshop in New York at the same time as Jackson Pollock. This workshop experimented with new materials and new techniques, which Siqueiros heralded as the appropriate means to make truly modern art. Whatever Louis may have learned there did not immediately reveal itself in his own work. His style in the 1940's is largely derivative, showing the influence of diverse members of the New York School, such as Motherwell and Pollock, through whom he explored collage and automatism; later, in the early 1950's, he came under the influence of the gestural painting of de Kooning and Kline. Although he was not at this point an innovator, he had an established reputation in his home town of Washington, D.C., as artist and private teacher.

In 1954 Louis made his first departures in painting, in his *Veil* series. Experimenting with his friend Kenneth Noland with the-staining technique they had seen in the studio of Helen Frankenthaler in 1953, Louis began to concentrate on color at the expense of the sculptural, which was in part obliterated by the union of the painted surface with the canvas.

Grotto, 1958; 7 ft 9¼ in × 11 ft 11½ in (237 × 364 cm); Courtesy Waddington Galleries

Although clearly readable lines, which we see in Frankenthaler's work of this period, are absent in Louis's painting, forms are distinguishable. For example, in *Untitled A* (1954) gestural spreadings of paint emanating from a dark center give the work a sense of depth in contrast to its stained surface. In his more successful works in this series, those that were chosen by Greenberg to be shown in New York that year, Louis suppressed the element of depth. Although he still layered his colors, by juxtaposing contrasting colors and bringing the composition to the edges of the picture space, Louis emphasized its flatness. This flatness is retained throughout the rest of his extant work.

Louis has left little in explanation of his work and the intentions underlying it, yet it is clear that, having concluded the *Veil* series of 1954, he had reached another turning point in his career. According to Greenberg, Louis's work from 1955, which drifted back toward painterly Abstract Expressionism, was considered by both of them to be retrogressive. Louis destroyed all of them. This suggests that he was consciously striving toward a completely new style.

The next major body of works was the second *Veil* series, which Louis started in 1956. Monumental in scale, and hung so that the poured paint reaches vertically up the canvas in great fan shapes, this series is arguably Louis's most memorable. Described by some critics as transcendent in their sweeping motion and lack of referential imagery, they certainly are the closest to the color-field paintings of Newman and particularly Rothko in surface and palette. Although Rothko heavily painted his surfaces with many layers of different shades of color to achieve luminosity, the thinness of Louis's paint allows the canvas to illuminate the surface. Like that of Rothko, his predominant use of browns, greens, and ochres also lends many of the works in this series a sobriety which is lacking from the more decorative works such as *Blue Veil* (1958–59).

The remaining three years of Louis's career were spent developing a more reductive type of abstraction. The *Where* series of 1959–60 marks a new interest in pure color: unlayered bands of it are juxtaposed. This use of void space occupied Louis for the rest of his career. In the *Unfurleds* and the *Stripe* paintings the void is used as a space in which to hang colorforms. Although the diagonal orientation of the color streaks in the *Unfurleds* do suggest movement, and in the *Stripes* there is occasional evidence of the painting process, causing the colors to appear as streaks, both these sets of works lack the dynamism of Louis's earlier series.

—Nancy Jachec

LUCA DELLA ROBBIA.

Born Luca di Simone di Marco in Florence, 1399 or 1400. Died in Florence, 20 February 1482. Trained as a goldsmith; possibly trained as a sculptor by Nanni di Banco; in the wool guild, Florence, 1427, and in sculptors guild, 1432; first documented work is the singing gallery (Cantoria) in Florence cathedral; sculptor in bronze and marble, and most famous for

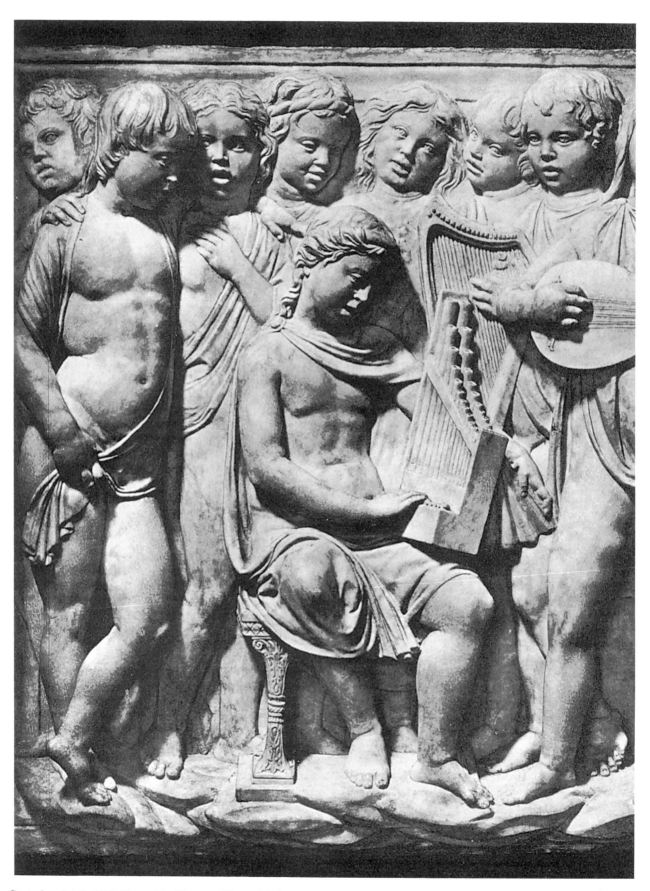

Cantoria—detail, 1432–37; marble; Florence, Museo dell'Opera del Duomo

enamelled terracotta sculptures from the early 1440's; his large workshop was continued by his nephew Andrea and great-nephew Giovanni, and four other great-nephews.

Collections: Berlin; Buffalo; Florence: Cathedral Museum, Bargello, S. Miniato al Monte, Campanile, S. Trainità, Orsanmichele; Impruneta: Collegiata; London: Victoria and Albert; New York; Paris: Louvre, Cluny, Jacquemart-André; Peretola: S. Maria; Pescia; Pistoai: S. Giovanni Fuorcivitas; Toledo, Ohio; Urbino: S. Domenico; Vienna; Washington.

Publications

On LUCA: books—

Cruttwell, Maud, *Luca and Andrea della Robbia and Their Successors,* London and New York, 1902.

Schubring, Paul, *Luca della Robbia und Seine Familie,* Bielefeld, 1905.

Marquand, Allan, *Della Robbias in America,* Princeton, 1912.

Marquand, Allan, *Luca della Robbia,* Princeton, 1914.

Bode Wilhelm, *Die Werke der Familie della Robbia,* Berlin, 1914.

Marquand, Allan, *Andrea della Robbia and His Atelier,* Princeton, 2 vols., 1922.

Planiscig, Leo, *Luca della Robbia,* Vienna, 1940, Florence, 1948.

Salvini, Roberto, *Luca della Robbia,* Novara, 1942.

Brunetti, Giulia, *Luca della Robbia,* Paris, 1954.

Lisner, Margrit, *Luca della Robbia: Die Sängerkanzel,* Stuttgart, 1960.

Baldini, Umberto, *La bottega dei della Robbia,* Florence, 1965.

Bargellini, Piero, *I della Robbia,* Milan, 1965.

Petrioli, A. M., *Luca Della Robbia,* Milan, 1966.

Bertela, Giovanna Gaeta, *Luca, Andrea, Giovanni della Robbia,* Florence, 1977, London, 1979.

Pope-Hennessy, John, *Luca della Robbia,* Oxford, 1980.

*

To posterity, the name Luca della Robbia has been associated with charming works in glazed terracotta, usually with pure white figures against a blue background, or sometimes with polychrome decorations of leaves and fruit. But his first documented commission was for the marble *Cantoria* in the Duomo, and in the 1440's he was working in bronze. Thus, Luca was a master of many mediums, and the inventor and developer of a new technique.

Absolutely nothing is known about Luca's early training and career before 1431, but perhaps he was employed in the shop of Nanni di Banco working on the Porta della Mandorla of the Cathedral. The *Cantoria,* a marble gallery intended to hold an organ or small choir, was placed high above the North Sacristy of the Cathedral, but has now been removed to the Museum of the Opera del Duomo. Each of its eight marble panels, arranged in two rows, interprets a phrase of Psalm 150 inscribed in classical letters directly above it; for instance, "Praise Him with tambourines" depicts young children playing the appropriate musical instruments. On other panels, they dance, sing, and play instruments in a wonderful variety of poses and gestures, the compositions related and paired. The style is based on Roman sarcophagi and other antique sources, but the naturalistic, charming, very human children and adolescents seem to record the actual world Luca saw. Their calm demeanor and controlled movements contrast with the frenzied action on Donatello's *Cantoria* set above the opposing sacristy door, but both sculptors faced the problem of impaired visibility of reliefs with relatively small figures located high above eye level.

The problem of seeing marble sculpture in an elevated architectural framework may have been part of the reason Luca began experimenting with glazed terracotta late in the 1430's, not because it was less expensive or because the glaze acted as a preservative as was stated by Vasari. The milky white glazed figures against a dark blue background, as seen on the large *Resurrection* and *Ascension* lunette reliefs for the Duomo, would illuminate and add color to a shadowed interior, reflecting light from their shiny surfaces. Having perfected the technique, Luca received many commissions for roundels and ceiling decorations in chapels and churches in Florence. The influence of Nanni di Banco and Ghiberti, evidenced in his early marble works, began to diminish in favor of a personal style based somewhat on classical sources, but more on his observation of human nature. It is interesting to note that many of his terracotta projects in the 1430's and 1440's were associated with the two prominent architects of the period: Brunelleschi and Michelozzo (roundels in the Pazzi Chapel, San Miniato tabernacle, etc.).

For the palace of an important private patron, Piero de' Medici, Luca executed twelve roundels, depicting the Labors of the Months, in a new technique. Instead of molding the figures in clay, he drew them in white against a blue terracotta ground, creating an image more pictorial than sculptural and unique among his works.

The growing popularity of his glazed terracotta brought commissions from guilds and families for *stemme* (coats of arms) on palaces and public buildings. Among the most beautiful of these is the *stemma* for the Guild of Doctors and Apothecaries whose device was the Madonna and Child. It is located in a roundel on Or San Michele, and is an example of Luca's use of many vivid colors instead of his more common blue and white reliefs. This full-length Madonna dressed in multi-colored robes is seated under a white arch supported by columns and affectionately holds a standing nude child.

During his long career, Luca created a large number of Madonna and Child reliefs intended for private worship; most of them are in glazed terracotta. They reflect the responses of an artist to the repeated challenge of a single theme, and show that his inventiveness is rooted in his observations of everyday life. Although there is great variety in pose and composition, the Madonnas are always young, graceful, and loving toward the Child who looks and acts like a real baby. Luca's emphasis on the human qualities of the relationship may be reflected in the later paintings of Raphael. Some of the reliefs were produced as single, unique pieces, but the greater number were designed for reproduction in terracotta, stucco, and other materials to satisfy an ever-increasing market. These copies were

produced in the shop which Luca shared with his nephew Andrea but most were designed by the master.

Although he may have executed reliefs and small works in bronze, the only documented large commission was for the bronze doors of the north sacristy of the Cathedral, undertaken with two partners, Michelozzo and Maso di Bartolommeo, in 1445 but not completed until the 1460's. The ten panels with seated figures flanked by angels and the frames with projecting heads may have been at least partially designed by Luca, but were cast and polished by others. Without any sense of spatial complexity, the reliefs are traditional and somewhat unimaginative in their repetitive themes.

At his death in 1482, Luca was the last survivor of the heroic generation of early Renaissance sculptors. An instinctive classicist, his art grew from the ordinary world around him; an innovator of a new medium, he explored its communicative possibilities in a manner that was direct and easy to understand. Although lacking the expressive genius of his contemporaries, his colorful, tender, charming images of compassionate humanity have universal appeal.

—Harriet McNeal Caplow

LUCAS van Leyden.

Born Lucas Heyghensz. in Leiden, 1489 or 1494; son of the painter Hughe Jacobsz. Died in Leiden, between the end of May and 5 August 1533. Married Lysbeth van Boschuysen, c. 1526; one illegitimate daughter. Youthful prodigy; probably trained by his father and by the painter Cornelis Engelbrechtsz.; worked in Leiden, but made two trips to Antwerp, in 1521, and at age 33; also produced prints.

Collections: Amsterdam; Berlin; Boston; Braunschweig; Brussels; Cambridge, Massachusetts; Haarlem: Episcopal Museum; The Hague: Royal Library; Leiden; Leningrad; Lille; London: British Museum, National Gallery, Courtauld; Munich; Nuremberg; Philadelphia: Rotterdam; Strasbourg; Washington.

Publications

On LUCAS: books—

Dülberg, Franz, *Lucas,* Haarlem, 1912.
Beets, Nicolaas, *Lucas,* Brussels, 1913.
Kahn, Rosy, *Die frühen Stiche des Lucas,* Strasbourg, 1917.
Kahn, Rosy, *Die Graphik des Lucas,* Strasbourg, 1918.
Baldass, Ludwig von, *Die Gemälde des Lucas,* Vienna, 1923.
Friedländer, Max J., *Lucas,* Leipzig, 1924.
Friedländer, Max J., *Die altniederländische Malerei, vol. 10: Lucas und andere hollandische Meister seiner Zeit,* Berlin, 1926; as *Lucas and Other Dutch Masters of His Time* (notes by G. Lemmens), Leiden, 1973.
Beets, Nicolaas, *Lucas,* Amsterdam, 1940.
Wubbern, J. C. Ebbinge, *Lucas en tijdgenoten* (cat), Amsterdam, 1952.

Wachtmann, H. G., *Die Bildform in des frühen Graphik des Lucas,* Munster, 1960.
Friedländer, Max J., *Lucas,* edited by Friedrich Winkler, Berlin, 1963.
Levalleye, Jacques, *Lucas, Peter Bruegel l'Ancien: Gravures,* Paris, 1966; as *Peter Bruegel the Elder and Lucas: The Complete Engravings, Etchings, and Woodcuts,* New York, 1967.
Petrioli, Annamaria, *Luca,* Florence, 1966.
Hollstein, F. W., *The Graphic Art of Lucas,* Amsterdam, 1968.
Vos, Rik, *Lucas,* Maarssen, 1978.
Kok, Jan Piet Filedt, *Lucas: Graphiek* (cat), Amsterdam, 1978.
Jacobowitz, Ellen S., and Stephanie Loeb Stepanek, *The Prints of Lucas and His Contemporaries* (cat), Washington, 1983.

articles—

Gibson, Walter S., "Lucas and His Two Teachers," in *Simiolus* (Utrecht), 4, 1970–71.
Silver, Lawrence A., "The *Sin of Moses:* Comments on the Early Reformation in a Late Painting by Lucas," in *Art Bulletin* (New York), 55, 1973.
"Lucas Issue" of *Nederlands Kunsthistorisch Jaarboek* (Amsterdam), 29, 1978 (includes "Underdrawings and Other Technical Aspects of the Paintings of Lucas" by Jan Piet Filedt Kok, "The Drawings of Lucas" by Wouter Kloek, "The Life of Lucas" by Karel van Mander, edited by Rik Vos, and "Carnal Knowledge: The Last Engravings of Lucas" by Lawrence A. Silver and Susan Smith).
Harbison, Craig, "Lucas, the Magdalen, and the Problem of Secularization in Early Sixteenth Century Northern Art," in *Oud Holland* (The Hague), 98, 1984.

*

For some time both collectors and scholars alike tended to think of Lucas van Leyden as a gifted but rather callow country cousin to the great genius of his age, Albrecht Dürer. In recent years critical opinion on this matter has changed. Lucas's congenial wit, his curiosity for the day to day, and his clever narrative strategies have claimed a distinctive place for his paintings and prints in the rich tradition of northern Netherlandish art.

Lucas's active career probably began around 1505, and legend has it that he was barely in his middle teens by the time his earliest surviving prints were issued. So reports Carel van Mander in his biography of Lucas written in 1604, almost a century after the beginnings of Lucas's recorded activity. There has been much debate about Lucas's birth date, but this is less important than the early work itself which evidences a draftsman of talent still groping to master basic problems of perspective and proportion. His reputation as a child prodigy in van Mander's time may just as well have been based upon the exploratory and frequently inept character of these initial graphic experiments as on any real knowledge of an actual birth date. However uncertain his draftsmanship, in his very first steps Lucas created certain of his most innovative and engaging images. For example, there are engravings unprece-

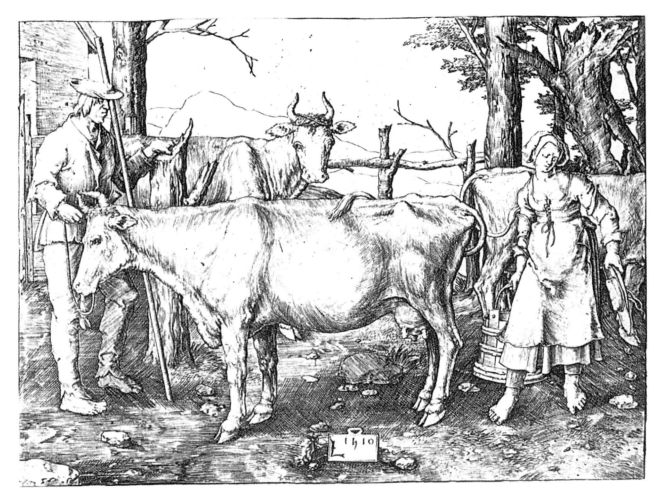

The Milkmaid; engraving

dented as independent subjects (from *Mandeville's Travels* the *Mohammed and the Monk Sergius* of 1508), or unprecedented moments chosen from more familiar stories (*St. Christopher* being hailed from across the river by the Christ Child, c. 1506).

Though adept and widely recognized as a painter, Lucas was at heart a printmaker. The decision was perspicacious for the time. Lucas was trained in the artistically vigorous town of Leiden which had a number of painters probably with substantial workshops. Given his imaginative gifts, the realm of printmaking offered Lucas a degree of freedom of invention that could only be constrained by taking up the more tradition-bound medium of religious painter. As an engraver, woodcut designer, and occasional etcher, Lucas gained an international public already within the first decade of his activity. We find his prints being copied in Italy almost immediately. And a well-known report from the Frankfurt Fair of 1520 remarks on the fact that Lucas's engravings were everywhere to be found, and Albrecht Dürer's by contrast little in evidence.

Lucas's greatest contribution to northern art, and most particularly to the art of his own region, rests on his investigation of the possibilities for generating pictorial narratives. Here his work is distinctive not only for its unusual choice of subjects, but also for its handling of time and space in the pictorial field, for its means of engaging the attention and participation of the viewer, and oftentimes for incisive touches of irony. For example, it was typical of him to suppress the conventional moment within a common subject, thereby compelling the viewer to supply it for himself and so fill out the tale. In cases like the *Conversion of St. Paul* (1509), Lucas relegates the dramatic moment of Saul being struck from his horse to the distant background, and centers our attention on the pathetic figure of a fallen hero being led away blind by his attendants. In his engraving of *David Before Saul* (1508) Lucas describes the agitation, indeed dementia, of the old king torn by envy in the presence of his servant and predestined successor. This print was singled out by van Mander who praised its psychological acumen. One could cite many examples of this type. It is precisely in Lucas's love of telling stories, especially in his exploration of human motive and of moral dilemma, that we recognize him to be a major forerunner of Rembrandt's art.

It has often been said that in contrast to the stark, graphic brilliance of Dürer, Lucas's prints have a painterly and delicately atmospheric quality to them. Thus, it is fair to say that his time spent with palette and colors had a salutary effect on his style of engraving. Predictably, the relationship was reciprocal. The flurry of creative energy that animates Lucas's print production is also evident in his painting. There too he carried on his explorations of narrative style and of new subject matter. For example, the earliest group of paintings representing

secular genre themes in western art emerged from Lucas's workshop beginning in the first decade of his activity. A series of scenes depicting chess and cardplayers shown in half-length (Berlin; Wilton House) portrays a common social occasion which Lucas then laces with suggestions of intrigue and love play. These panels are the genesis of the genre painting which became a mainstay of Dutch art a century later. His paintings of religious subjects are likewise often startling. For example, the little triptych portraying the Old Testament story of the *Dance Around the Golden Calf* (Amsterdam) serves him as an opportunity to display a degree of bacchic indulgence worthy of Mantegna. Recently cleaned, this panel painting shows Lucas's lush and often lurid color at its best. It surely did not escape Lucas's ironic temperament that here he made his patron a seductive painting about the biblical commandment against images, a sort of moral contradiction.

It would seem that Lucas's love of a good story has always been recognized, but somehow the clever literalness of his narratives did not stand up in critics' minds to the more erudite inventions of certain of his Renaissance contemporaries. Un-like Dürer, Lucas had no humanist aspirations, little interest in classical or allegorical themes, and apparently never made a trip to Italy. Only in his last years can we see evidence that Lucas recognized a Renaissance underway across the Alps. During the late 1520's he made a series of engravings that reflect an enthusiastic interest in contemporary Italian style (for example, his cycles of the *Fall of Man* from 1529 and the *Seven Virtues* of 1530, or the masterful *Mars and Venus* also of 1530). But this discovery at the end of his life has also been held against him, for it is often said that Lucas came slavishly under the sway of Marcantonio Raimondi's engravings, and that he relinquished the parochial charm which had always been his true merit. One might recast this unduly patronizing judgment to point out that in the full maturity of a highly successful career Lucas could open his mind to a radically new style and technique, to take command of it, and set off in a new direction. Such a view simply reaffirms a continuing sense of curiosity and love of invention that we recognize in the artist's first steps.

—Peter W. Parshall

M

MACKE, August.

Born in Meschede, Germany, 3 January 1887. Died in Perthes, 26 September 1914. Married Elisabeth Gerhardt, 1909. Attended the Dusseldorf Academy of Art, and the School of Arts and Crafts, 1904–06; studied with Lovis Corinth in Berlin, 1907–08; member with Kandinsky, Marc, and Jawlensky, of Der Blaue Reiter group; settled in Switzerland, 1913; visited Tunis with Klee, 1914; died during World War II.

Major Collections: Munich: Stadtisches Galerie; Munster.
Other Collections: Aachen; Berlin: Nationalgalerie; Bonn; Bremen; Cologne; Dortmund; Duisberg; Dusseldorf: Jägerhof; Essen; Karlsruhe; Mannheim; Munich: Neue Pinakothek; New York: Moma; Paris: Art Moderne; Saarbrücken; Stuttgart.

Publications

By MACKE: books—

Briefwechsel, with Franz Marc, edited by Wolfgang Macke, Cologne, 1964.
Briefe an Elizabeth and die Freunde, edited by Werner Frese and Ernst-Gerhard Güse, Munich, 1987.

On MACKE: books—

Cohn, Walter, *Macke,* Leipzig, 1922.
Vriesen, Gustav, *Macke: Katalog der Werke,* Stuttgart, 1953, 1957.
Macke (cat), Westfalen, 1957.
Holzhausen, Walter, *Macke,* Munich, 1958.
Macke, Wolfgang, *Macke: 44 Aquarelle,* Munich, 1958.
Bänfer, Carl, *Macke: 44 Zeichnungen aus den Skizzenbuch,* Munich, 1959.
Erdmann-Macke, Elisabeth, *Erinnerung an Macke,* Stuttgart, 1962.
Busch, Günter, *Macke: Handzeichnungen,* Mainz, 1966.
Bussmann, Klaus, and Brigitte Kühn, *Macke: Aquarelle und Zeichnungen* (cat), Munster, 1976.
Macke und die Rheinischen Expressionisten: Aus dem Stadtischen Kunstmuseum Bonn, Hanover, 1978.
Bartmann, Domenik, *Macke: Kunsthandwerk: Glasbilder,* Stickerien, Keramiken, Holzarbeiten, und Entwürfe, Berlin, 1979.
Bongers, Aurel, Joachim Heusinger von Waldegg, and Dierk Stemmper, *Die rheinischen Expressionisten: Macke und seine Malerfreunde* (cat), Recklinghausen, 1979.
Güse, Ernst-Gerhard, *Macke und die Tradition: Zeichnungen aus den Skizzenbüchern von 1904 bis 1914,* Munster, 1979.
Güse, Ernst-Gerhard, *Die Tunisreise: Klee, Macke, Moillet* (cat), Munster, 1982.
Güse, Ernst-Gerhard, *Macke: Gemälde, Aquarelle, Zeichnungen,* Munich, 1986.

*

August Macke's career was in many ways filled with good fortune, and his personality was one of humor, optimism, and free-spirited enthusiasm for life. His career was stabilized by the early and close emotional support he found with his wife and by the financial assistance and artistic encouragement he found in a close relationship with her uncle, the Berlin manufacturer and art collector, Bernhard Koehler. When he was killed at age 27 in World War I, Macke had already produced more than 550 oil paintings, as many watercolors, and countless drawings and sketches. Even in his short life, he had reached maturity as an artist and showed promise for the greatness achieved by his fellow-artists, such as Kandinsky and Klee, whose careers were not so abruptly ended. Macke's paintings show a fresh brilliance of color and clarity of conception that is immediate. For this reason his depth and intellectual strength as an artist have been overlooked.

Macke had expressed very early in his career his desire to paint a "Bridge of Life" or a "Lost Paradise." Early in his development at the Düsseldorf theater (1906), he became involved with artists dedicated to the visual enactment of the dramatic patterns of life. Designing stage sets, he was able to express and develop in an atmosphere of free creativity, where the focus was the human condition through the dramas of Shakespeare, Büchner, and even *Little Red Riding Hood.* He later found a deep affinity for this dramatic aspect of art in the works of Edvard Munch, though Macke's art was devoid of the Norwegian artist's psychological anguish, which was foreign to Macke's character.

Early letters reveal an intellectual basis which united Macke naturally with other artists of the Expressionist generation. Schopenhauer and Nietzsche form the theoretical foundation of his artistic approach. When Macke met Franz Marc and

Greeting, 1912; lino-cut

developed his association with the *Blaue Reiter,* it was fortuitous to discover an artist whose thinking ran so closely parallel to his own. Though Macke and Marc were radically different in personality, they became close friends and were artistically compatible.

Macke's essay "Masks" was a significant contribution to the *Blaue Reiter Almanac.* Macke found in reality evidence of what he called the "holy riddle," and he lifted what he saw out of the present day into the realm of the mythic. Macke's paintings never lose touch with their time. He always had his sketchbooks at hand. Drawings, sketches, and caricature must be considered a crucial part of his creative *oeuvre,* but in painting he sought to reach through the visible world to an ultimate and spiritual vision.

Macke's career has often been perceived as having focused primarily on his association with the artists of the *Blaue Reiter* in Munich (1910-11). This was a pivotal period for his evolution as an artist, as it was for most of those involved, but Macke's career developed outside the activities of the Munich art scene. At least as important for Macke's development was his association with the other artists of the Rhineland and his close involvement with French artist Robert Delaunay.

Much of the power of Macke's paintings lies in his genius as a colorist. He studied color theories, but it was in his natural ability to weave brilliant surfaces of bright colors that his truly unique talent is revealed. Through the influence of Impressionism and Delaunay, Macke quickly recognized and put into practice the depth-creating energies of color. A painting such as *Girls under Trees* (1914, Bavarian State Coll., Neue Pinakothek, Munich) declares his debt to Impressionism, as well as his departure from its momentary effects. Forms seem to glow under the dappling light of the trees, yet the result is a sense of permanence that reaches beyond the representation of the incidental, to a timeless view of the beauty of innocent young girls immersed in a shimmering mosaic of green trees and blue sky. Color and structure are balanced on the surface to create an image of complete harmony.

A two week trip to Tunisia in 1914 resulted in 37 watercolors which are some of the finest works in that medium in the modern tradition. They express, with a seemingly effortless simplicity, the strength of Macke's mature talent and make his death just 5 months later all the more poignant. Traveling together, Macke, Paul Klee, and the Swiss artist Louis Moillet, followed the tradition of modern artists to seek inspiration in the sun and exoticism of a non-Western culture. In North Africa Macke found new forms for his favorite motifs of landscape, architecture, and the people in the streets. In *Kairouan III* (Westfälisches Landesmuseum für Kunst und Kulturgeschichte, Münster) transparent planes of pigment alternate with more intense color to create a planarly structured world of bright luminosity and classical order.

Macke's paintings reveal an idealized world. His vision was one of a crystalized utopia, where the conflicts of the sexes, the generations, social class or of humanity and the environment seem to have resolved into a perfect balance. Sadly, his short life stands as cruel evidence that his dream was not applicable to a problematic and complex world on a political scale, and his luminous paradise was real only in the glowing moments of his personal drama. His works must be seen in the tradition of Matisse, where rich color and reality blend in the search for serenity through art.

—Janice McCullagh

MAGNASCO, Alessandro [Il Lissandrino].

Born in Genoa, 1667; son of the painter Stefano Magnasco. Died in Genoa, 12 March 1749. One daughter. Studied with his father until his death in 1677, then a student of Filippo Abbiati in Milan; worked mainly as a portraitist until c. 1690, then began painting landscapes with small staffage figures, which made him famous; lived in Milan until 1735, except for trips to Genoa and an extended stay in Florence as guest of the Grand Duke Gian Gastone de' Medici, 1703-11; after 1735 lived in Genoa.

Collections: Bassano; Berlin; Chicago; Cleveland; Detroit; Florence; Genoa: Bianco, S. Francesco in Albaro; London; Milan: Poldi-Pezzoli; Naples: Capodimonte; New York; Oberlin, Ohio; Paris; Raleigh, North Carolina; St. Louis; Seitenstetten: Abbey; Venice: Brass; Washington.

Publications

On MAGNASCO: books—

Geiger, Benno, *Magnasco,* Vienna, 1923.
Pospisil, Maria, *Magnasco,* Florence, 1944.

Geiger, Benno, *I disegni del Magnasco*, Padau, 1945.
Bonzi, Mario, *Saggi sul Magnasco*, Geneva, 1947; 3rd edition, 1971.
Geiger, Benno, *Magnasco*, Bergamo, 1949.
Roli, R., *Magnasco*, Milan, 1965.
Dürst, Hans, *Magnasco,* Teufen, 1966.
Franchini Guelfi, Fausta, *Magnasco*, Genoa, 1977.

*

Alessandro Magnasco is famous for his sketchy compositions, his free and rapid brush-strokes, his flashy luminosity, and his morbid imagination. Where all this came from is difficult to determine: he studied first with his father, the painter Stefano Magnasco, and then with Filippo Abbiati in Milan. Other influences seem to be Morazzone's early Baroque mysticism, Callot's etchings, Castiglione, and the romantic Salvator Rosa; he was a friend of Sebastiano Ricci. He is most famous for his phantasmagoras, often with storm-tossed seas or trees, frantic monks, cruel martyrdoms—and the people are often defined by only a splash of white. A work like *The Synagogue* (c. 1725-23; Cleveland) represents a magnificent temple filled with wraiths, while *Bay with Shipwreck* (after 1735; Raleigh, North Carolina) is dominated by a turbulent sky and lashing sea, with workers almost completely freed from their bodily form. In *St. Anthony Preaching to the Fishes,* the wind-lashed sea is curiously similar to the rugged mountains in the background. Besides the strictly visual grotesquerie, Magnasco manages to invert traditional iconography (in *Triumph of Bacchus,* Bacchus rides a leopard and Venus's chariot is drawn by a blind-folded cupid). After about 1735 he painted mainly seascapes. Though his personal idiom was too idiosyncratic to be transmittable, his style was invigorating on several Venetian painters of the 18th century.

MAGRITTE, René (François Ghislain).

Born in Lessines, Hainault, 21 November 1898. Died in Brussels, 15 August 1967. Married Georgette-Marie-Florence Berger, 1922. Attended schools in Châtelet and Charleroi; studied under Victor Servranckx, Académie des Beaux-Arts, Brussels, 1916-18; designer and graphic artist, Peters Lacroix Company, Haren, 1919-21; military service, 1921-22; designer, Norine and Paul Gustave Van Hecke fashions and for Samuel Furs, and other companies, Brussels, 1923-27; associated with the Surrealists from early 1920's; lived in Brussels, except for period of 1927-30 when he lived near Paris; active as photographer after 1956.

Collections: Antwerp; Brussels; Charleroi; Chicago; Edinbrugh; Knokke-le-Zoute; Los Angeles; Melbourne; New York: Moma; Toronto; Zurich.

Publications

By MAGRITTE: books—

La Destination: Lettres à Marcel Marien, Brussels, 1971.
Manifestes et autres écrits, Brussels, 1972.
Le Fait accompli, Brussels, 1973.
Lettres à Paul Nougé, Brussels, 1974.
Deux entretiens, with Jean Neyens, Brussels, 1974.
Le Surréalisme en plein soleil, with Jacques Wergifosse, Brussels, 1974.
82 Lettres à Mirabelle Dors et Maurice Rapin, Paris, 1976.
Les Couleurs de la nuit, Brussels, 1978.
Croquer les idées, Brussels, 1978.
Ecrits complets, edited by André Blavier, Paris, 1979.

On MAGRITTE: books—

Marien, Marcel, *Magritte*, Brussels, 1943.
Nougé, Paul, *Magritte, ou les images défendues*, Brussels, 1943.
Scutenaire, Louis, *Magritte*, Brussels, 1948.
Soby, James Thrall, *Magritte* (cat), New York, 1965.
Waldberg, Patrick, *Magritte*, Brussels, 1965.
Sylvester, David, *Magritte* (cat), London and New York, 1969.
Lebel, Robert, *Magritte: Peintures*, Paris, 1969.
Gablik, Suzi, *Magritte*, London and Greenwich, Connecticut, 1970.
Passeron, René, *Magritte*, Paris, 1970, Chicago, 1972, London, 1980.
Robert-Jones, Philippe, *Magritte: Pòete visible*, Brussels, 1972.
Blavier, André, *Ceci n'est pas une pipe*, Brussels, 1973.
Foucault, Michel, *Ceci n'est pas une pipe*, Montpellier, 1973; as *This Is Not a Pipe*, edited by James Harkness, Berkeley, 1983.
Schneede, Uwe M., *Magritte: Leven und Werk*, Cologne, 1973; as *Magritte: Life and Work*, Woodbury, New York, 1982.
Hammacher, A. M., *Magritte*, New York, 1973, London, 1974, concise edition, 1986.
Larkin, David, *Magritte*, Paris, 1975.
Scutenaire, Louis, *La Fidelité des images: Magritte, le cinématographe et la photographie*, Brussels, 1976.
Noël, Bernard, *Magritte*, Paris, 1976.
Dopagne, Jacques, *Magritte*, Paris, 1977, London and New York, 1979.
Scutenaire, Louis, *Avec Magritte*, Brussels, 1977.
Torczyner, Harry, *Magritte: Signes et images*, Paris, 1977; as *Magritte: Ideas and Images*, New York, 1977.
Clair, Jean, et al., *Retrospective Magritte* (cat), Brussels and Paris, 1978.
Gablik, Suzi, *Magritte*, Brussels, 1978.
Calvocoressi, Richard, *Magritte*, Oxford and New York, 1979, 1984.
Torczyner, Harry, *Magritte*, Paris, 1979; as *Magritte: The True Art of Painting*, London, 1979.
Passeron, René, *Magritte*, New York, 1980.
Schiebler, Rolf, *Die Kunsttheorie Magrittes*, Munich, 1981.
Magritte und der Surrealismus in Belgien (cat), Berlin, 1982.
Paquet, Marcel, *Magritte, ou l'éclipse de l'être*, Paris, 1982.
Paquet, Marcel, *Photographies de Magritte*, Brussels, 1982.
Roque, Georges, *Ceci n'est pas un Magritte: Essai sur Magritte et la publicité*, Paris, 1983.

The Master of Pleasure, 1928; 25$\frac{1}{2}$ × 31$\frac{1}{2}$ in (65 × 80 cm); Courtesy Marlborough Fine Art (London)

Pierre, José, *Magritte*, Paris, 1984.

Schreier, Christoph, *Magritte: Sprachbilder 1927–1930*, Hildescheim, 1985.

Gimferrer, Pere, *Magritte*, New York, 1987.

Daulte, Francois, et al., *Magritte* (cat), Lausanne, 1987.

<p style="text-align:center">*</p>

If asked to cite a painter whose works best summed up the aims and achievements of Surrealism, the answer would surely be Magritte. For his work constitutes not only an original and suggestive creative effort in its own right, but also an encyclopaedia of Surrealist images—and strategies in relation to the image, an illustrated theory of Surrealist aesthetics, and a comprehensive demonstration of the Surrealist deconstruction of the conventions of pictorial—and also linguistic—representation. Although the creative period of Magritte's life as an artist spans half a century (the 1920's to the 1960's), the works he produced in this time are remarkable both in the consistency of their style (few artists' works are more immediately recognizable) and in their steadfast confrontation of fundamental aesthetic issues. Technically unremarkable (Magritte

painted most of his works in a meticulously "realist" style in oils on canvas, though there are some surrealist "objects" and small-scale sculpture), his pictures continue to provoke and to mystify, to provide the authentic Surrealist "frisson" and yet, at the same time, to remind us that we are looking at "art" and thus to introduce a certain critical distance in our response.

In the first place, Magritte's paintings provide a perfect introduction to Surrealist cosmology, a view of the universe that is relativist and anti-positivist, one which privileges subjective perception over the hegemony of received opinion. Thus the law of gravity is pictorially refuted in Magritte's painting *The Great War* (1964; Galerie A. Ioatas, Paris) in which Newton's apple does not fall to the ground but remains suspended in front of the face of the bowler-hatted rationalist. In another version of this picture, *The Son of Man*, also 1964 (Collection Harry Torczyner, New York), the bowler-hatted rationalist's left eye peeps round the side of the apple. In *Presence of Mind* (1960; Collection Rudolf Zwirner, Cologne), the conventional hierarchy of intelligence the natural sciences normally impose on sentient life on earth is radically modified as bird, fish, and man are presented pictorially in such a way as to suggest equality of mental powers (they are the same size and their

heads are on the same level). Meanwhile, in *Time Transfixed* (1938; Tate Gallery), the locomotive that steams out of the drawing-room fireplace reminds the viewer that the convulsive surrealist image can indeed make time stand still.

The relativisation of the phenomena of the natural world has obvious implications for the latter's representation in pictorial terms. The human body, then, will not necessarily appear as conventionally represented in European painting but as imagined by the desiring or perceiving consciousness. In *The Acrobat's Ideas* (1928; Collection M. & Mme. J. B. Urvater, Rhode-Saint-Genèse), the female body or bodies take on the fluid and acrobatic forms desired by the eroticized glance, Magritte's almost exclusive use of monochrome in this picture emphasizing its dream-like nature. In *Loving Perspective* (1935; Collection Robert Giron, Brussels), the desiring gaze has already smashed through the barrier of the closed door and is focussing on the membrane-like tree that softly touches the mauve-coloured house to the right of the picture, with a pale blue sea beyond. Magritte's ability to *surrealize* even a fairly conventional piece of land-or townscape is shown in *The Empire of Light* (1950; Museum of Modern Art, New York), which contrives, while apparently conforming to the rules of realist pictorial representation, to create a mysteriously hallucinatory effect.

In the work just mentioned, the apparent disparity between title and work (*The Empire of Light* designating a dusky scene) may be sufficient to explain the hallucinatory effect this picture produces. In the same way, it may be said more generally that as soon as the conventions of pictorial or linguistic representation are subverted, even in a subtle or minor way, the viewer/reader is plunged into a *surrealist* world. Certainly there is plenty of evidence of this in Magritte's work. Sometimes, admittedly, Magritte's demonstration of the arbitrariness of conventions becomes, itself, academic—as in the many variations on the theme *Ceci n'est pas une pipe* (*La Trahison des Images*, 1928- 29; Collection William N. Copley, New York; *L'Air et la chanson*, 1964; private collection; *Les Deux Mystères*, 1966; private collection; etc). But at other times they take on surrealist potential, as in *La Clef des songes* (1930; Collection Claude Hersaint, Paris) in which six pictorial images are (mis-)identified by words designating six quite unrelated objects or concepts. If the mind cannot respond to the image or the object according to conventional logic, Magritte seems to be suggesting, then let it turn to that most surrealist of all faculties, the imagination.

Magritte's works tend to fall, then, into two distinct but related categories. First, those that indicate the arbitrariness or emptiness of linguistic or pictorial conventions of representation—as in *The Human Condition* (1934; Collection Claude Spaak, Paris), in which a landscape painting on an easel merges into the landscape seen through the window behind it and thus, implicitly, poses the question: What is the point of attempting to reproduce in art what we are in any case conditioned to see in reality? The second category of Magritte's works (mostly the best) not only make this point but go on to suggest other, and sometimes unfathomable, patterns of meaning—as in the aptly titled *On the Threshhold of Liberty* (1929; Collection M. & Mme. J. B. Urvater, Rhode-Saint-Genèse) which, while presenting a series of panels of conventional pictorial decor (trees, wood, sky, windows, naked flesh) dynamizes these clichés by juxtaposing them with a cannon

(seemingly aimed at the fragment of nude). In this way, Magritte contrives to offer both a critique of Western habits in painting and a demonstration of their continuing vitality and suggestive power.

—David Scott

MAILLOL, Aristide.

Born in Banyuls-sur-Mer, 8 December 1861. Died in Banyuls-sur-Mer, 27 September 1944. Married Clotilde Marcisse, 1893; one son. Attended schools in Banyuls and Perpignan; studied painting under Gérôme at Ecole des Beaux-Arts, Paris, then at the School of Decorative Arts, Paris, then returned to the Beaux-Arts to study under Cabanel, 1882–89; worked as tapestry maker in Banyuls, 1892–94; moved to Paris in 1894, and worked as sculptor from 1895; also worked on majolica; lived in Villeneuve-Saint-Georges, 1899–1903, and from 1903 lived in Marly-le-Roy in summer and Banyuls in winter; many commissions for war memorials (e.g., Céret, 1922, Port-Vendres, 1923, and Banyuls, 1933), female nudes, etc; Cézanne monument commissioned by Aix-en-Provence, but rejected in 1925, and placed in Tuileries, Paris; also did monuments for Debussy, in Saint-Germain-en-Laye, 1933, Hoffman, in Basel cemetery, 1934, and Toulouse, 1938.

Collections: Baltimore; Buffalo; London: Tate; New York: Moma, Metropolitan; Paris: Art Moderne; Richmond, Virginia; Utica, New York; Washington.

Publications

By MAILLOL: books—

Conversations de Maillol, edited by Henri Frère, Geneva, 1956.

illustrator: *Eclogues*, 1925, and *Georgics*, 1950, both by Virgil; *Belle Chair*, by Emile Verhaeren, 1931; *Art of Love*, by Ovid, 1935; *Daphnis et Chloé*, by Longus, 1937; *Chansons pour elle*, by Villon, 1939; *Livre des Folastries*, by Ronsard, 1940; *Le Concert d'été*, by J. S. Pons, 1946; *Dialogue des courtisanes*, by Lucian, 1948.

On MAILLOL: books—

Denis, Maurice, *Maillol*, Paris, 1925.
Kuhn, Alfred, *Maillol: Landschaft, Werke, Gespräche*, Leipzig, 1925.
Lafargue, Marc, *Maillol: Sculpteur et lithographe*, Paris, 1925.
Zervos, Christian, *Maillol*, Paris, 1925.
Camo, Pierre, *Maillol*, Paris, 1926.
George, Waldemar, *Le Miracle de Maillol*, Paris, 1927.
Abbot, Jere, *Lehmbruck and Maillol*, New York, 1930.
René-Jean, *Maillol*, Paris, 1934.

Lithograph for Ovid's Ars Amatoria, 1935

Cladel, Judith, *Maillol: Sa vie, son oeuvre, ses idées*, Paris, 1937.

Rewald, John, *Les Ateliers de Maillol*, Colmar, 1938.

Rewald, John, *Maillol*, Paris, London, and New York, 1939.

Denis, Maurice, and Pierre du Colombier, *Maillol: Dessins et pastels*, Paris, 1942.

Rewald, John, *The Woodcuts of Maillol*, New York, 1943, 1951.

Lafargue, Marc, et al., *Aspects de Maillol*, Albi, 1945.

Ritchie, Andrew C., *Maillol, with an Introduction and Survey of the Artist's Work in American Collections*, Buffalo, 1945.

Roy, Claude, *Maillol vivant*, Geneva, 1947.

Camo, Pierre, *Maillol, mon ami*, Lausanne, 1950.

Rewald, John, *Maillol*, New York, 1950.

Remszhardt, G., *Maillol: Gefühle der Liebe*, Feldafing, 1954.

Linnekamp, Rolf, *Maillol und der goldene schnitt der Fläche*, Hamburg, 1957.

Uhde-Bernays, Hermann, *Maillol*, Dresden, 1957.

Hackelsberger, Berthold, *Maillol: La Méditerranée*, Stuttgart, 1960.

Linnekamp, Rolf, *Maillol: Die grossen Plastiken*, Munich, 1960

Hoetink, H. R., *Maillol: La Méditerranée*, Rotterdam, 1963.

George, Waldemar, *Maillol*, Neuchâtel, 1964, Greenwich, Connecticut, 1965.

Guérin, Marcel, *Catalogue raisonné de l'oeuvre gravé et lithografié*, Geneva, 2 vols., 1965–67.

Grand-Chastel, P. M., and Henri Coulonges, *Maillol*, Paris, 1969.

Busch, Günter, *Maillol als Illustrator*, Neu-Isenburg, 1970.

Chevalier, Denys, *Maillol*, Lugano and New York, 1970.

George, Waldemar, *Maillol*, Paris, 1971.

Rewald, John, *Maillol* (cat), New York, 1975.

Peters, Hans Albert, *Maillol* (cat), Baden-Baden, 1978.

Maillol: Bronzeskulpturen (cat), Stuttgart, 1980.

Slatkin, Wendy, *Maillol in the 1890s*, Ann Arbor, 1982.

*

Rodin was an early admirer of Maillol, and is recorded as having said, "Maillol is a genius, and one would have to be either a fool or a charlatan not to recognise it." This praise is all the more generous when one considers that, far from aping the great master, Maillol's art consciously breaks away from the achievements of Rodin; his sculpture eschews the latter's expressionistic surface drama in favour of an arcadian simplicity and a harmony of masses. It is for this reason that some critics view Maillol as a key figure in the emergence of Modernism in sculpture, his classical nudes formally anticipating abstract developments.

Although it was his chief métier, Maillol took up sculpture fairly late in his career, starting off as a painter, ceramicist, and weaver. He was associated with the Nabis group, and was heavily influenced by Gauguin, who called him a "spirit of gold," and opened his eyes to primitivism. While African carving impressed Maillol, he was drawn more towards Buddhist art, in which he discerned "the stamp of a magnified and inspired Hellenism." Gauguin's simplified style and naive pastoral subjects influenced Maillol from his earliest wood carving, *La Source*, 1896, right up to his last paintings of the 1940's.

In the 1890's he established a reputation for his tapestries, but had to change direction due to deteriorating eyesight. There is something symbolic, perhaps, in his turn from weaving, an activity to do with detail and surface, to sculpture, an art of form and mass. He was associated with the cult of "direct carving," and although he also cast in bronze, the character of his sculpture tends towards the carved, putting mass before surface. Maillol's statement, "I always start from a simple geometric figure, a square, a lozenge, or a triangle, because these are the figures that stand up best in space," obviously recalls Cézanne's famous words, "treat nature by the cylinder, the sphere, the cone."

Maillol's years of poverty and obscurity came to a close with the success of *La Méditerranée* at the Salon d'Autonme, 1905. It was bought by Count Harry Kessler, his greatest patron and admirer. Kessler, who owned the influential Cranach Presse in Weimar, was responsible for Maillol's important woodcuts, commissioned for fine limited editions of Virgil's *Eclogues* and *Georgics*, Longus's *Daphne and Chlöe*, and Ovid's *Art of Love*. Maillol was also a prolific lithographer.

With Kessler and the Austrian poet von Hoffmannsthal, Maillol visited Greece, where he was struck by the parity of the landscape and ambiance with his own native Banyuls, a fishing village in the French part of Catalonia. Maillol's sculptural subject is the classical nude, rooted very much in a pastoral tradition. Octave Mirbeau said that "Maillol's woman is chaste, ardent and dignified." Apart from one or two male nudes, and his few portraits (of Renoir, for instance; Renoir was inspired to take up sculpture after sitting for Maillol), all

Maillol's figures are of beautiful young women, nude or draped, in groups or solitary, even armless and headless, such as *Torso of the Ile de France*, 1921. Here he is not concerned, however, in fragmentation for its own sake, in simulating archaeological finds or creating some sort of surreal effect, but rather in emphasising the central qualities in his art; composure, the relation of masses, stasis. By removing distracting features and de-individualising the figures, attention is focused on these formal elements.

Maillol's women tend to be stocky, well-built, sometimes muscular, a fact of which the Italian poet D'Annunzio complained, prompting Maillol to exclaim that he did not understand his art, which was not about creating pretty and superficially appealing figures, but about exploring relationships of form. Nonetheless, Maillol's popularity between the wars had a lot to do with his vision of health, vigour, natural balance and calm assurance at a time when classical order in art was welcome. A whole school of classical sculptors emerged, although Maillol is the only name to have survived. Maillol's oeuvre remained aloof from turbulent decades of Modernist experimentation.

The artist's relationship with his model is an important factor in Maillol's career, in a way that links him with an older generation. His wife Clotilde sat for *La Nuit* 1902, *La Méditerrannée* 1905, *L'Action Enchaînée* 1905, and also the immense number of life drawings which continued to furnish ideas for the rest of his career. However, as his marriage tired he took a younger model, Dinah Vierny, who also became his muse. She was the model for his last masterpiece, *L'Harmonie*, 1940.

Like many great sculptors, it was Maillol's professed ambition to produce public sculpture for a worthy architecture, but apart from his Banyuls War Memorial, 1930, he had little opportunity to make monumental pieces. Thanks to the timeless advocacy of Dina Vierny, however, a Maillol Museum was established, in 1963, in the gardens of the Louvre.

—David Cohen

MAINO [MAYNO], Juan Bautista.

Born in Pastrana, 1578. Died in 1649. Traveled to northern Italy in 1590's; in Rome, c. 1600–10, where he was influenced by Caravaggio and his followers; in Toledo by 1611: became Dominican friar, 1613; moved to Madrid before 1620; drawing master to the future king Philip IV; helped decorate the Buen Retiro palace, Madrid.

Collections: Barcelona; Basel; Leningrad; Madrid; Oxford; Toledo: San Pedro Martir, Museo de Santa Cruz.

Publications

On MAINO: articles—

Harris, Enriquetta, "Aportaciones para el estudio de Maino," in *Revista Española de Arte* (Madrid), 1935.

García Figar, Fray Antonio, "Maino, pintor español," in *Goya* (Madrid), 1958.
Angulo, Diego, and Alfonso Pérez Sánchez, "Maino," in *Pintura Madrilena, primer tercio del signo XVII*, Madrid, 1969.

*

Juan Bautista Maino (or Mayno, as he sometimes wrote it) is an artist who, in actuality, painted very little. Nonetheless, the small number of surviving works by his hand are among the most beautiful and interesting produced in early 17th-century Spain, and, significantly, provide the clearest link between the revolutionary artistic developments inspired at the dawn of the new century by Caravaggio and his followers in Italy and the developing baroque style of the Iberian peninsula. While Maino's religious proclivities and court duties ultimately kept him from often taking up his brushes, his obvious knowledge of and sympathy for the progressive art currents of his day led him to play an important role in early 17th-century Spain as an arbiter of artistic taste.

The dualistic nature of Maino's art and ideas may perhaps be related to the circumstances of his birth, upbringing, and training. The son of a hispanic noblewoman and a well-to-do Milanese nobleman posted to the small court of the princess of Eboli at Pastrana, Maino was born there in 1578. Sometime near the end of the century he was sent to Italy to receive his artistic training. While his whereabouts cannot be clearly pinpointed, it is likely that he worked for some time in Milan, a city where the Maino family held property (interestingly, some have speculated that the painter may have been related to a family of sculptors with the same surname who practiced their art in Milan). While no paintings from this time have been identified, Maino's surviving works—all of which postdate his return to Spain around 1610 or 1611—suggest that the young artist studied late 16th-century north Italian painting, particularly the works of Giovanni Girolamo Savoldo. Paintings by Savoldo and others were available for study in Milan, and indeed, in the decade previous to Maino's arrival in northern Italy, had helped stimulate the art of Caravaggio, whose naturalistic style would shortly provide a decisive model for Maino.

Contemporary sources relate that Maino spent time in Rome during the first decade of the new century. Although a source notes that Maino was a disciple of the Bolognese master Annibale Carracci and a friend of Guido Reni and while their influence is notable in the works later produced by Maino in Spain, it was, above all, the Caravaggesque manner that most affected the young painter and from which he molded the essential ingredients of his own individual style.

By 1611 Maino had returned to Spain and was working as a painter for the Cathedral of Toledo. In 1612 the artist contracted with San Pedro Martir, Toledo's Dominican establishment, to paint canvases for the high altar of the monastery church. Before completing the ensemble, Maino professed as a Dominican monk at San Pedro and beneficently reduced the cost of his paintings for the monastery. With his priestly responsibilities (to which would shortly be added courtly duties), Maino would hereafter devote himself to painting only occasionally, and thus the Dominican retable commission remains his most extensive project.

The four primary images of the altar include the *Adoration of the Shepherds* and the *Adoration of the Magi*, the *Pentecost* and the *Resurrection of Christ* (all are now in the Prado Museum, Madrid). The chiaroscuro lighting, the forceful concretization of accessory details, and the naturalistic figures, conceived with bold three-dimensionality (often elaborately foreshortened and sometimes used as foreground *repoussoir* elements with feet projecting outward), clearly denote the impact of Caravaggio. Notwithstanding, Maino's compositions are generally more elaborate, his light effects more subdued and intimate, his palette both richer and more subtle, and his interest in rendering the appearance of textural materials more encompassing. Some of Maino's individual stylistic features bear a relationship to northern Italian examples, particularly the works of Savoldo, in addition to suggesting that Maino had a clear affinity for works by Caravaggio's immediate successor like Orazio Gentileschi, Carlo Saraceni, and the enigmatic Cecco da Caravaggio (to whose works Maino's have their closest relation). What is clear is that Maino's sense of verisimilitude possesses a lyric streak and a gentler, more refined accent than the directness of Caravaggio's example.

The tempering of the most agressive qualities of Caravaggism in Maino's art may also be due to his experience with the idealized Bolognese manner of the early baroque period. It is of note that the two predella panels of the San Pedro altar (*Saint John the Baptist* and *St. John the Evangelist*) recall in their landscape backgrounds the serene, classicized settings utilized in the works of Annibale Carracci, Domenichino, and Albani. Similarly, several figures from a group of fresco paintings by Maino in San Pedro Mártir point to the influence of Bolognese painter Guido Reni. The fresco technique—in which these images of Old Testament patriarchs, allegorical personifications, and a glory of angels are painted—was surely learned in Italy, and Maino remains among a handful of Spanish painters able to work in this medium.

Because of the altar's documented nature and the fully mature style of its works, these paintings serve as the touchstone upon which the attributions of the few additional works ascribed to Maino are based. They include canvases which are variations on the San Pedro altar themes (*Adoration of the Shepherds*, Leningrad; *Pentecost*, Madrid), various images of saints (including a striking painting, long mistaken as a Caravaggio, of *St. John the Baptist*, Basel), and a signed portrait of an unidentified, aristocratic gentleman, which provides some evidence to uphold the contemporary claim that Maino was a sought-after portraitist.

Around the third decade of the century, Maino was called into service at the court of Philip III in Madrid where, according to tradition, he served as the drawing master to the prince, the future Philip IV. Maino remained at court after Philip's ascension in 1621 serving as both courtier and artistic advisor to the new king in addition to fulfilling his duties as a Dominican priest. Again, sources indicate that Maino's artistic opinions regarding both contemporary Italian and Spanish paintings were influential; one account, for instance, gives Maino credit for stimulating the king's visit to see Alonso Cano's innovative canvas the *Miracle of the Well*, and his perceptive recognition of Velázquez's superior talent helped advance the young Sevillian painter's career and standing at court.

In the early 1630's Maino worked with Velázquez to help select painters and themes for the decoration of Philip's newly constructed palace in Madrid, the Buen Retiro. While Maino himself contributed only a single painting to the palace's Hall of Realms, his depiction of the 1625 *Recapture of Bahia* (painted 1634–35), in which combined Spanish and Portuguese forces captured the Brazilian port back from the Dutch, is clearly one of the most interesting and original paintings of the entire ensemble. Together with Velázquez's *Surrender of Breda* for the same series, Maino's painting redefines the traditional battle painting in which vanguished generals usually supplicate themselves before horse-born victors. In the foreground of Maino's monumental painting, women, providing aid and comfort to Spanish and Portuguese soldiers fallen in battle, emblematically refer to the Christian virtue of charity. At the right, the Spanish commander stands before kneeling Dutch troops calling their attention (and ours) to a tapestry in which Spain's chief minister Olivares, accompanied by a classical Victory, crowns the head of Philip IV with a laurel wreath. Underfoot the king treads upon personified representations of Heresy, Wrath, and War. The painting, inspired in its telling by a play by Lope de Vega (*El Brasil restituido*), magnificently salutes the monarch's victory, his care for his subjects, and his clemency for the vanguished. Stylistically, the work relies upon an elaborate, carefully wrought composition of boldly generalized forms. The figures are more clearly hispanic in their guise, the palette is relatively pallid in comparison to earlier works, and the whole illuminated with the bright light of a tropical setting.

While the number of works from Maino's hand are few and, not surprisingly, his artistic evolution difficult to trace and define, his paintings no doubt had an impact upon the continuing development toward naturalism in early 17th-century Spain and did provide the latest example of the Italian Caravaggesque style. Perhaps even more influential than his paintings, however, were Maino's artistic opinions, based as they were upon first-hand knowledge and sympathy for the most progressive currents of European art of his day, and given credence by both the prestige of his habit and his access to the court under the protection of an artistically astute monarch.

—David Martin Kowal

MAITANI, Lorenzo.

Born in Siena, c. 1270. Died before 10 July 1330. Married Nicol Niccola, 1302; two sons, the architects and sculptors Nicola and Vitale. Sculptor and architect: first mentioned in 1290 in Siena; worked on Siena Cathedral, 1300–08; designed and began Orvieto Cathedral 1308–30, with a few diversions (aqueducts in Perugia, 1317, 1319–21, Siena, 1322; etc.); termed "universalis caput magister," 1310: his main monument is the Orvieto Cathedral facade: succeeded at this work by his two sons.

Locations: Orvieto: Cathedral; Siena: Cathedral.

Publications

On MAITANI: books—

Carli, Enzo, *Le sculture del Duomo di Orvieto,* Bergamo, 1947.
Carli, Enzo, *Il Duomo di Orvieto,* Rome, 1965.
Bonelli, R. *Il duomo di Orvieto e l'architettura ilaliana del duecento e trecento,* Rome, 1972.

articles—

White, John, "The Reliefs on the Facade of the Duomo at Orvieto," in *Journal of the Warburg and Courtauld Institutes* (London), 22, 1959.
Brandi, Cesare, "Duomo di Siena e Duomo di Orvieto," in *Palladio* (Rome), 28, 1979.
Previtali, G., "Due lezioni sulla scultura umbra del trecento," in *Prospettiva* (Florence), 31, 1982, and 33, 1983.
Gaborit-Chopin, Danielle, "Un Christ en bronze doré du trecento au Musée du Louvre," in *Revue de l'Art* (Paris), 64, 1984.

*

Only the most minimal records exist regarding Maitani's biography—a tax return from 1290, by which his birth some twenty years earlier is presumed, and a notation of his marriage in 1302, both documents in Siena; then, in 1310 and in great detail, his contract appointing him supervisor and master of the construction and decoration of the cathedral in Orvieto; in 1317 and again 1319 passing references to his participation in the erection of a fountain and the shoring up of aqueducts in Perugia; and finally in 1322 his role as a member of a commission appointed to examine the structural soundness of the cathedral of Siena.

From the elaborate and flattering introduction to his Orvieto contract may be inferred that he was by that time an acknowledged master in his field, actively involved in the erection of the Siena cathedral, where specifics of his contribution remain conjectural. However, considering that the principal builder, Giovanni Pisano, had abandoned the project at the end of the 1290's it may be assumed that Maitani's participation was of major importance and that his own departure from the project must in part have been motivated by misgivings about its viability. This assumption is borne out by his later service as a consultant to the Sienese when he recommended that further work on the cathedral be abandoned in favor of a new beginning. His advice was not followed.

In Orvieto's Cathedral Museum are two drawings suggesting solutions to the erection of the facade. The first, perhaps not by Maitani, showing a steeply gabled soaring central mass inspired by French Gothicism, already contains elements included in the second drawing, now safely attributed to Maitani. While the first features extremely narrow flanking structures crowned with pure Gothic pinnacles, the second adds breadth to allow more generous space for sculptured decor. The finished facade, the most exquisite example of Italian Romanesque-Gothic architecture, is a synthesis of the two drawings, adjusted and refined in keeping with structural requirements.

While the total impression of the cathedral facade with its honey-coloured marble, wide pilasters below slender spires, and dazzling mosaics—most of these of much later date than its origin—is one of breath-taking beauty, the principal achievement of its master are the four sculptured surfaces flanking the three portals. Scholars tend to agree that these, as well as significant other sculptural elements, are by Maitani, although the sheer quantity of the work must have commanded the activities of a well-manned workshop. The reliefs, each c. 30 feet high and 12 feet wide, represent (a) Genesis Scenes from the Creation to the descendant of Cain, (b) the Life of Christ, (c) the Tree of Jesse, and (d) the Last Judgment, all composed in detailed scenes presented in continuous narrative strips moving from the base to the top, no doubt inspired by the Roman approach shown in Trajan's Column. Framings are created by winding trunks of vines rising perpendicularly in the center of each pilaster and by their foliate, horizontal branches that simultaneously separate and link the scenes, thereby contributing to their continuity.

The artist's familiarity with Nicola and Giovanni Pisano's reliefs in Siena Cathedral is in evidence; however, in the creation of the illusion of space and movement, and in the carving of airily flowing, diaphanous draperies Maitani surpasses his predecessors. His Orvieto panels may therefore be viewed as a link between late Gothic and early Renaissance sculpture, pointing toward the reliefs of Andrea Pisano and Lorenzo Ghiberti in their Bronze Doors of the Baptistery in Florence.

—Reidar Dittmann

MALEVICH, Kasimir (Severinovich).

Born in Kiev, 26 February 1878. Died in Leningrad, 15 May 1935. Married first, 1901 (divorced); 2) Sofia Rafalovich, 1915, one daughter. Studied at the Kiev School of Fine Arts, 1895–1901, and Moscow School of Fine Arts, 1903; attended life-drawing classes, Stroganov School, Moscow; associated with Futurist group, 1913, and founder of the Suprematist group, 1913; stage designs for opera *Victory over the Sun,* 1913 (also designs for Mayakovsky's *Mystery-Bouffe,* 1918); supporter of the revolution, and taught at the Vitebsk Art Institute, 1919–22 (replaced Chagall as director of the Institute); co-founder, with El Lissetzky and others, Unovis group, 1920; continued to teach and work in Petrograd and Leningrad; visited Warsaw and Berlin, 1927.

Collections: Amsterdam: Stedelijk; Basel; Copenhagen: Carlsberg; Leningrad: Russian Museum, Theatrical Museum; Lodz; London: Tate; Moscow; New Haven; New York: Moma.

Publications

By MALEVICH: books—

From Cubism and Futurism to Suprematism [in Russian], Moscow, 1914; as *Du Cézanne à Suprématisme,* edited by Jean Claude Marcadé, Lausanne, 1974.

Essays on Art, edited by Troels Anderson, Copenhagen, 4 vols., 1968–78.

Ecrits, edited by Andrei B. Nakov, Paris, 1975.

On MALEVICH: books—

Gray, Camilla, *The Great Experiment: Russian Art 1863–1922*, London, 1962.

Hauftmann, Werner, *Malevich*, Cologne, 1962.

Andersen, Troels, *Malevich: Catalogue Raisonné of the Berlin Exhibition, 1927, Including the Collection of the Stedelijk Museum, Amsterdam*, Amsterdam, 1970.

Karshan, Donald H., *Malevich: The Graphic Work 1913–1930: A Print Catalogue Raisonné*, Jerusalem, 1973.

Malevich: Dessins (cat), Brussels, 1975.

Martineau, Emmanuel, *Malevich et le philosophie: La Question de la peinture abstraite*, Lausanne, 1976.

Malewitsch—Mondrian und ihre Kreise (cat), Cologne, 1976.

Nakov, Andrei B., *Malevich* (cat), London, 1976.

Bojko, Szymon, et al., *Malevich zum 100. Geburtstag* (cat), Cologne, 1978.

Zhadova, Larissa A., *Suche und Experiment: Russische und sowjetische Kunst 1910 bis 1930*, Dresden, 1978; as *Malevich: Suprematism and Revolution in Russian Art 1910–1930*, London and New York, 1982.

Marcadé, Jean Claude, editor, *Malevich* (colloquium), Lausanne, 1979.

Bowlt, John E., *Journey into Non-Objectivity* (cat), Dallas, 1980.

Douglas, Charlotte, *Swans of Other Worlds: Malevich and the Origins of Abstraction in Russia*, Ann Arbor, 1980.

Martin, Jean Hubert, *Malevich: Oeuvres*, Paris, 1980.

Harten, J., and K. Schrenk, editors, *Malevich: Werke aus sowjetischen Sammlungen* (cat), Dusseldorf, 1980.

Simmons, W. Sherwin, *Malevich's Black Square and the Genesis of Suprematism 1907–1915*, New York, 1981.

Cardoza y Aragon, Luis, *Malevich: Apuntes sobre su aventura icárica*, Mexico City, 1983.

*

Kasimir Malevich was not Russian in origin (his father was Polish) and, unlike the majority of his fellow-artists, he was a Roman Catholic—neither Poles nor Roman Catholics were highly thought of in the Russia of his youth. In addition—and, perhaps, to some extent because of these isolating factors—he was a man of strong convictions, fervent belief in his own artistic evolution, demonic single-minded energy, and very little charity for others. From 1910, in the space of little more than ten years he created a new artistic language which was to have immensely important repercussions on painting, printing, architecture, and the applied decorative arts. Within a further ten years he had returned to a form of recognisably figurative painting, but whether frustration, a new line of development, an attempt to placate ideological authorities, or a sense of the new spirit of the 1930's was the cause has never been nor can be fathomed, for Malevich was untypically silent on this different style. Within these two decades he had passed from a modified impressionism through primitivism to suprematism which he had single-handed devised to a style of monumental figurative portraiture which owed much to Italian art of the

Dinamonaturschik, 1911; lithograph

early Renaissance. In 1930 he was to paint *The Flower Girl* (Leningrad, Private Collection), a version of a picture he had originally created in 1904. Such is the complexity of Malevich's development and his career seen in its totality.

In addition to painting, Malevich created lithographs, stage designs, and decorations for revolutionary festivals (in co-operation with his students), illustrated and designed booklets of verse by his cubo-futurist friends, and wrote provocative and controversial pamphlets, manifestos, and articles which are by no means easy to comprehend. He taught, and at Vitebsk named his teaching aims and results UNOVIS (Affirmation of New Art). He first belonged to the Jack of Diamonds group (the Cézannists), which he left, together with Larionov and Goncharova, exhibiting with them in the more nationalistic Donkey's Tail and The Target (1913), sharing to a degree in their primitivist and rayonnist tendencies; but from 1910 impressed as were his contemporaries by French cubism and Italian futurism (especially its literary manifestations), he, too, became part of the Russian cubo-futurist movement. His paint-

ings, such as *Peasant Fetching Water* (1911; New York, Moma), present a strange dichotomy: the human figures are interpreted in terms of cones and cylinders in which sense they may be said to be a corollary of the surrounding landscape (in a sense, there is an indebtedness to Cézanne here), but they are painted as metallic, non-human objects, robot-like, thus introducing undertones of industrial, urban life.

Never a man to be left out of any progressive movement, Malevich next affiliated himself with the Union of Youth, an avant-garde grouping of artists, musicians, and poets in St. Petersburg. In 1913 they presented *Victory over the Sun*, a cubo-futurist opera with music by Matyushin and costumes and settings by Malevich, among them a back cloth with a painted black square—in effect the spectator was being presented with the possibility of projecting his own reactions and sensations onto the setting, rather than the customary form of the setting dictating the mood of the spectator. At the same time Malevich was experimenting with his a-logical paintings in which there are elements derived from synthetic cubism such as letters, words, numbers yoked with apparently heterogeneous objects which have to be "read" to yield the full meaning of the pictures, as in *1914—Soldier of the First Division* (1914; New York, Moma). But Malevich's spirit was ruthlessly logical, and putting aside a-logism with its quasi-literary connotations, he pushed ahead with the creation of new pictorial language he called Suprematism, emphasising the supremacy of sensation over logic and literatism in their creation and appreciation. The use of squares in black or white represented the most extreme and austere form of Suprematism, the great majority of the paintings showing a white background on which float brightly coloured geometric shapes. Suprematism provided a new artistic language which his many followers, especially those in UNOVIS, were able to employ in decorations for mass demonstrations, for china and books as well as in painting. In fact, Suprematism was the major style of revolutionary Russia.

In the early 1920's Malevich began to concern himself with the overall shape of future housing, particularly with habitations in space, basing them of Suprematist forms and, indeed, distinguishing the different units by the use of colours associated with the language he had evolved. These units he called Architectons or Planits. Finally, towards the beginning of the 1930's, he began what he called "symbolic" pictures, presenting isolated human figures, sometimes with heads bereft of features, which seem to exist in a void between his early primitivist works, the floating elements of Suprematism and the early Renaissance. Malevich's death in 1935 put an end to further experimentation but his Suprematism remains a potent force in Soviet artistic creation.

—Alan Bird

MANET, Edouard.
Born in Paris, 23 January 1832. Died in Paris, 30 April 1883. Attended the Collège Rollin, Paris, 1844–48; cadet on the *Guadeloupe* to Rio de Janeiro, 1848–49; then in studio of the academic painter Thomas Couture, 1850–57 intermittently, but reacted against history painting; in group centered on the Salon des Refusés in early 1860's; visited Spain, 1865; did not exhibit with the Impressionists, though friendly with several of them; book illustrator.

Major Collections: New York; Paris: d'Orsay.
Other Collections: Berlin; Boston; Cambridge, Massachusetts; Cardiff; Chicago; Copenhagen; Essen; Frankfurt; Hamburg; London: National Gallery, Courtauld; Lyons; Mannheim; Merion, Pennsylvania; Munich: Neue Pinakothek; Philadelphia; Providence, Rhode Island; Tournai; Washington: National Gallery, Phillips.

Publications

By MANET: books—

Lettres de jeunesse, Paris, 1929.
Lettres illustrées, edited by Jean Guiffrey, Paris, 1929.
Une Correspondance inédite: Lettres du siège de Paris, edited by Adolphe Tabarant, Paris, 1935.

On MANET: books—

Zola, Emile, *Manet*, Paris, 1867.
Duret, Théodore, *Histoire de Manet et de son oeuvre*, Paris, 1902, 1926; as Manet, New York, 1927.
Moreau-Nélaton, Etienne, *Manet graveur et lithographe*, Paris, 1906.
Duret, Théodore, *Manet and the French Impressionists*, London and Philadelphia, 1910.
Horticq, Louis, *Manet*, Paris and London, 1912.
Meier-Graefe, Julius, *Manet*, Munich, 1912.
Proust, Antonin, *Manet: Souvenirs*, Paris, 1913.
Blanche, Jacques-Emile, *Manet*, Paris, 1924, New York, 1925.
Rosenthal, Léon, *Manet aquafortiste et lithographie*, Paris, 1925.
Moreau-Nelaton, Etienne, *Manet raconté par lui-même*, Paris, 2 vols., 1926.
Flamant, Albert, *La Vie de Manet*, Paris, 1928.
Tabarant, Adolphe, *Manet: Histoire catalographique*, Paris, 1931.
Jamot, Paul, Georges Wildenstein, and M. L. Bataille, *Manet*, Paris, 2 vols., 1932.
Jedlicka, Gotthard, *Manet*, Zurich, 1941.
Mortimer, Raymond, *Manet: Un Bar aux Folies-Bergère*, London, 1944.
Guérin, Marcel, *L'Oeuvre gravé de Manet*, Paris, 1944.
Courthion, Pierre, and Pierre Cailler, editors, *Manet raconté par lui-même et par ses amis*, Geneva, 1945; as *Portrait of Manet by Himself and His Contemporaries*, London and New York, 1960.
Florisoone, Michel, *Manet*, Monaco, 1947.
Tabarant, Adolphe, *Manet et ses oeuvres*, Paris, 1947.
Rewald, John, *Manet: Pastels*, Oxford, 1947.
Leymarie, Jean, *Manet*, Paris, 1951.
Mathey, Francois, *Olympia*, Paris, 1948.
Sandblad, N. G., *Manet: Three Studies in Artistic Conception*, Lund, 1954.

Cats, c. 1869; etching

Hamilton, George H., *Manet and His Critics*, New Haven, 1954, 3rd ed., 1986.

Faison, Lane, *Manet*, New York, 1954.

Vandoyer, J. L., *Manet*, Paris, 1955.

Batille, Georges, *Manet*, Geneva and New York, 1955.

Busch, Günther, *Manet: Un Bar aux Folies-Bergère*, Stuttgart, 1956.

Martin, Kurt, *Manet: Aquarelle, Pastelle*, Stuttgart, 1958; as *Manet: Watercolors and Pastels*, New York, 1959.

Richardson, John, *Manet: Paintings and Drawings*, London, 1958; 4th ed., Oxford, 1982.

Perruchot, Henri, *La Vie de Manet*, Paris, 1959; as *Manet*, London, 1962.

Courthion, Pierre, *Manet*, London, 1959, New York, 1961.

Mathey, Jacques, *Graphisme de Manet*, Paris, 3 vols., 1961–66.

Charansonney, Roger, *Manet*, Paris, 1964.

Hanson, Anne C., *Manet* (cat), Philadelphia, 1966.

Orienti, Sandra, *L'opera pittorica di Manet*, Milan, 1967; as *The Complete Paintings of Manet*, New York, 1967, London, 1970, 1985.

Niess, Robert J., *Cézanne and Manet*, Ann Arbor, 1968.

Hopp, Gisela, *Manet: Farbe und Bildgestait*, Berlin, 1968.

Leiris, Alain de, *The Drawings of Manet*, Berkeley, 1969.

Harris, Jean C., *Manet: Graphic Works: A Definitive Catalogue Raisonné*, New York, 1970.

Isaacson, Joel, *Manet: Le Déjeuner sur l'herbe*, New York, 1972.

Bazin, Germain, *Manet*, Antwerp, 1974.

Rouart, Denis, and Daniel Wildenstein, *Manet: Catalogue raisonné*, Paris, 2 vols., 1975.

Maurer, George, *Manet, peintre-philosophe: A Study of the Painter's Themes*, University Park, Pennsylvania, 1975.

Reff, Theodore, *Manet: Olympia*, New York and London, 1976.

Gay, Peter, *Art and Act: On Causes in History: Manet, Gropius, Mondrian*, New York, 1976.

Hanson, Anne C., *Manet and the Modern Tradition*, New Haven, 1977.

Farwell, Beatrice, *Manet and the Nude*, New York, 1981.

Reff, Theodore, *Manet and Modern Paris* (cat), Washington, 1982.

Ross, Novelene, *Manet's "Bar at the Folies-Bergère" and the Myths of Popular Illustration*, Ann Arbor, 1982.

Bareau, Juliet, *Manet*, Paris and New York, 1983.

Cachin, Francoise, and Charles S. Moffett, *Manet* (cat), Paris and New York, 1983.

Wilson, Michael, *Manet at Work* (cat), London, 1983.

Clark, T. J., *The Painting of Modern Life: Paris in the Art of Manet and His Followers*, New York, 1984, London, 1985.

Adler, Kathleen, *Manet*, Oxford, 1986.

Florence, Penny, *Mallarmé, Manet, and Redon*, Cambridge, 1986.

Garden, Robert, and Andrew Forge, *The Last Flowers of Manet*, New York, 1986.

Rand, Harry, *Manet's Contemplation at the Gare Saint-Lazare*, Berkeley, 1987.

Bazin, Germain, *Manet*, London, 1988.

*

Edouard Manet has been seen as the first modernist and/or the last "old master" and has been considered in many respects the founder of Impressionism, even though he never formally exhibited with the Impressionist group or completely adopted the *plein-air* aesthetic. Various interpretations of Manet have attested to his so-called "duality of temperament." As a member of the *haute-bourgeoisie*, Manet apparently combined inner rebellion with outward social conformity. His self-critical art may well have provided him with what Schapiro has described as a "field of freedom for an enlightened bourgeois detached from the official beliefs of his class." Critics and historians ranging from modernism to post-modernism have offered predictably contradictory readings of his work according to formalist, iconographic, cultural, and sociopolitical points of view. Catalogues of Manet's prints, drawings, and paintings by Guérin, Harris, De Leiris, and Wildenstein have provided foundations for other kinds of investigations.

Formalist interpretations of Manet, ranging from Zola to Greenberg, have subordinated the significance of his chosen subject matter to what is seen as the superior importance of his painterly picture surface, which is read as a flat harbinger of modernist "abstraction." The roots of Manet's modernism are found by Hanson and Boime, for example, in his technique, a personal adaptation (and alteration) of that of his teacher Thomas Couture, who himself challenged academic standards of finish. By privileging at the executive stage the sketchiness that had traditionally been relegated to the generative phase of painting, Manet, like the Impressionists who followed his example, thus proclaimed the modernist pictorial values of tonal abruptness, gestural spontaneity, and original innovation. What some critics, including Bowness and Howard, would read as "compositional difficulties" or "artful errors" in Manet's paintings like *The Old Musician*, 1862 (National Gallery, Washington) or *Le Déjeuner sur l'herbe*, 1863 (Musée d'Orsay, Paris) others would interpret as a conscious effort to eschew traditional unity for the sake of modernist form. Some, including, most notably, Fried, Reff, Farwell, and Hanson, have enumerated Manet's extensive formal borrowings from the old masters and popular journalistic imagery so as to interpret his modernist "art about art" as being both grounded in tradition and responsive to modernity.

Faced with formalist interpretations, and given the distinctive way in which Manet seemingly emptied out traditional narrative content from his works, the task of interpreting his iconography can be perplexing. But with a critical shift from abstract to more representational concerns in the last twenty years, more effort has been devoted to deciphering Manet's "hidden meanings." Reff in particular has sought both biographical and literary meanings in, for example, Manet's *Olympia*, 1863 (Musée d'Orsay, Paris), his *Portrait of Zola*, 1868 (Musée d'Orsay, Paris), and his frontispiece etching of Polichinelle published by Cadart in 1862. De Leiris, Maurer, Brown, and others have discussed personal, philosophical, cultural, and historical meanings of *The Old Musician* as a bohemian manifesto and "naturalist allegory." One of the more sustained iconographic debates has centered on *Le Déjeuner sur l'herbe*, that *succès de scandale* of the Salon des refusés of 1863. Historians including Anderson, Maurer, Wechsler, and Wilson have interpreted the painting variously: as a restatement of Raphael's *Judgment of Paris* with the City of Paris (Manet's public) as judge and with Venus as a prostitute; as an exposition of philosophical duality implying a theme of choice, as a *tableau vivant* based on the teachings of Lecoq de Boisbaudran; and as an allegory of sacred and profane love. Despite the diversity of such interpretations, they argue collectively against a purely formalist reading.

Increasingly, historians have attempted to situate Manet's works in a historical, cultural context in which modernism of form is seen as directly expressive of the modernity of subject. Cultural studies by Reff, Collins, Bowness, Harris, Roos, Flescher, and others have emphasized connections between Manet's subjects and the modern literature of his day, most especially the works of Baudelaire, Zola, Renan, and Mallarmé. Reff in particular has connected the Baudelairian aspects of Manet's works with the street and boulevard culture of the *flâneur* and the *demi-monde*, that is, with the transformed urban setting of the Paris of Baron Haussmann.

The more sociopolitical aspects of that world of spectacle, leisure, and conspicuous consumption—aspects discussed brilliantly by the critic Walter Benjamin—have inspired an increasing number of historians to discuss Manet's works from political, feminist, and Marxist perspectives. Manet's success—or lack thereof—in communicating an oppositional political message in his several works depicting the execution of Maximilian (1867) and scenes related to the Paris Commune (1871) has been debated from a variety of points of view by, among others, Sloan, Sandblad, Mainardi, Collins, Ruggiero, Brown, and Darragon. Lipton, Gronberg, and Nochlin have given feminist readings to Manet's "radicalized female imagery," including *Olympia*, 1863 (Musée d'Orsay, Paris), *Gare Saint Lazare*, 1873 (National Gallery, Washington), *Ball at the Opera*, 1873–74 (National Gallery, Washington), *In the Conservatory*, 1879 (Nationalgalerie, Berlin), and several café scenes of the 1870's, including *The Plum*, 1878 (National Gallery, Washington). According to these interpretations, Manet's seemingly casual formal strategies speak of the erotic commerce and changing roles of women in late 19th-century society. The question of whether Manet's seemingly provocative sociopolitical stance was critical of, or in complicity with, the dominant social order of his time is debated.

Clark in particular has investigated what he sees as the abstract social relations out of which Manet's distinctively modernist formal ideology was produced. In his controversial

Marxist account, Clark connects the pictorial displacement with the specific social process, begun in Haussmann's Paris, in which capitalism would eventually turn all modern life into spectacle. Thus he interprets *Olympia* as a representation of the equivocal truth of Haussmann's Paris: a prostitute with mutable class readings. He reads the petty bourgeois characters in *Argenteuil, les canotiers*, 1874 (Musée des Beaux-Arts, Tournai) as awkwardly tucking their class indeterminacy behind deadpan facades as flat as the picture surface. Drawing upon the sociology of Simmel and the psychology of Lacan, he interprets the ambiguity of the personal and social relationships depicted in *A Bar at the Folies-Bergère*, 1882 (Courtauld Institute, London) as an intentional expression of a particularly modern vertigo in which human values have become replaced by monetary ones. He regards the painting's lack of depth and emphasis of surface as appropriate to the equivocal, conflicted social forms Manet chose to depict.

Yet Clark's discursive reiteration of the unresolvable tensions and elusive meanings of Manet's modernist art seems to suggest a more postmodern interpretation—one in which Manet's very resistance to interpretation, reinforced by his unbridled image-appropriation, can be read as constructing freely floating signs, signifiers, and simulations of meaning. As Carrier has put it: "Whether or not that makes [Manet] a postmodernist, it does demonstrate why today his art is relevant."

—M. R. Brown

Hind, Arthur M., *Mantegna and the Italian Pre-Raphaelite Engravers*, New York, 1911.

Bell, Mrs. Arthur, *Mantegna*, London and New York, 1911.

Blum, Andre, *Mantegna*, Paris, 1912.

Law, E., *Mantegna's Triumph of Julius Caesar*, London, 1921.

Blum, Ilse, *Mantegna und die Antike*, Strasbourg, 1936.

Fiocco, Giuseppe, *Mantegna*, Milan, 1937.

Fiocco, Giuseppe, *La Cappella Ovetari nella chiesa degli Eremitani*, Milan, 1947, 1978; as *The Frescoes of Mantegna in the Eremitani Church*, Padua, Oxford, 1978.

Tietze-Conrat, Erica, *Mantegna: Paintings, Drawings, Engravings*, London and New York, 1955.

Meiss, Millard, *Mantegna as Illuminator*, New York, 1957.

Fiocco, Giuseppe, *Le pitture del Mantegna*, Milan, 1959.

Fiocco, Giuseppe, *L'arte di Mantegna*, Venice, 1959.

Paccagnini, Giovanni, *Mantegna* (cat), Venice, 1961.

Camasasca, Ettore, *Mantegna*, Milan, 1964.

Garavaglia, Nina, *L'opera completa del Mantegna*, Milan, 1967.

Puppi, Lionello, *Il trittico di Mantegna per la basilica de S. Zeno Maggiore in Verona*, Verona, 1972.

Milesi, R., *Mantegna und die Reliefs der Brauttruhen Paolo Gonzagas*, Klagenfurt, 1975

Martindale, Andrew, *The Triumph of Caesar by Mantegna . . . at Hampton Court*, London, 1979.

Camasasca, Ettorie, *Mantegna*, Florence, 1981.

Mistani, Wando, *Mantegna e le sue opere*, Suzzara, 1981.

Lightbown, Ronald, *Mantegna, with a Complete Catalogue of Paintings, Drawings, and Prints*, Berkeley, 1986.

*

MANTEGNA, Andrea.

Born in Isola di Cartura, 1430 or 1431. Died in Mantua, 13 September 1506. Married Nicolasia Bellini (sister of Giovanni and Gentile). Pupil and adopted son of Squarcione, 1442–48; and in Padua guild at early age; decorated the Ovetari Chapel, Eremitani church, Padua, completed 1459; painted an early "sacred conversation"-type picture for S. Zeno, Verona, c. 1457–59; court painter for the Gonzaga family in Manuta, 1460–1506: completed decorations for Camera degli Sposi, 1474; spent 1488–90 in the Vatican; also an engraver.

Collections: Bergamo; Berlin; Cincinnati; Cleveland; Dresden; Florence; Hampton Court; London; Madrid; Mantua: Palazzo Ducale; Milan: Brera Poldi-Pezzoli; Naples; New York; Paris; Tours; Venice: Ca d'Oro; Verona: S. Zeno; Vienna; Worcester, Massachusetts.

Publications

Thode, Henry, *Mantegna*, Bielefeld, 1897.

Cruttwell, Maud, *Mantegna*, London, 1901.

Kirsteller, Paul, *Mantegna*, London and New York, 1901.

Yriarte, Charles, *Mantegna*, Paris, 1901.

Knapp, Fritz, *Mantegna: Des Meisters Gemälde und Kupferstiche*, Leipzig, 1910.

Andrea Mantegna, who was born c. 1431 near Padua and died in 1506, was the most important northern Italian painter of his generation. In the humanist tradition of Giotto, Masaccio, and Castagno, Mantegna's intense interest in the revival of classical antiquity is evident in virtually all of his work. His figures are organic, they turn freely in three-dimensional space, and more than any artist before him, Mantegna created radical foreshortening which monumentalized the impact of his images. That he was an avid engraver as well as a painter can be seen in the crisp linear quality of his figures, particularly the draperies which recall Roman sculpture.

Mantegna's earliest work is unknown. He was adopted by an unusual painter, Francesco Squarcione, and he left his studio in 1440 after winning a lawsuit against him. There is no extant work by Mantegna from Squarcione's studio. Between 1441 and 1445 he joined the painter's guild in Padua and some time later was commissioned to paint frescoes illustrating the lives of Saints James and Christopher in the Ovetari Chapel of the Eremitani Church.

Despite extensive damage from Allied bombs in World War II, these early frescoes reflect the main characteristics of Mantegna's known style. What does remain is the *Assumption,* and the *Martyrdoms of Saints James and Christopher.* The receding perspective lines on the floors reveal a familiarity with Albertian principles of spatial construction. The artist's intense interest in archeology is evident in his painted architecture, such as the Roman triumphal arch, which is replete with details imitating classical relief sculpture. The draperies too

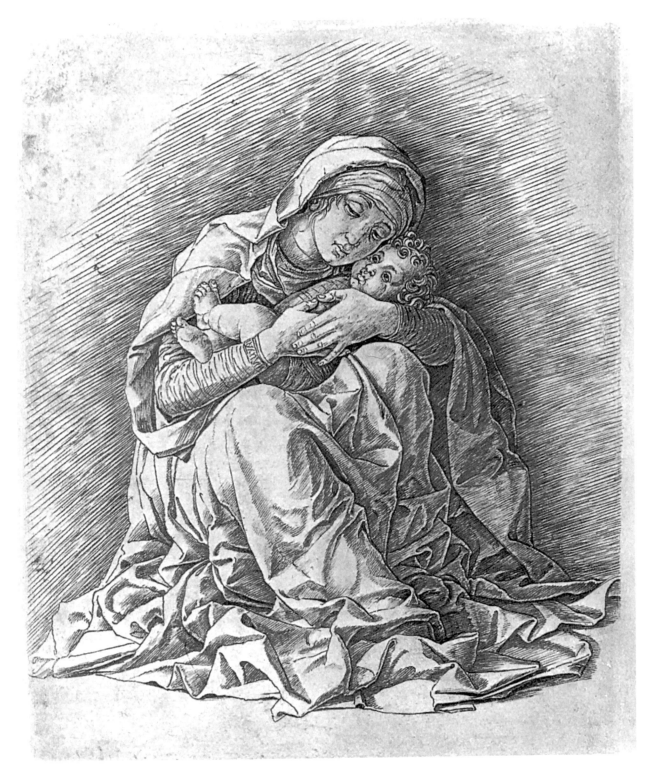

Virgin and Child, 1480's; engraving

are reminiscent of ancient sculpture. Here, as elsewhere in his oeuvre, we encounter Mantegna's taste for clear crisp edges, precise details of landscape which diminish in size to create the illusion of great distance but which do not diminish in clarity. Mantegna's radical foreshortening, one of the hallmarks of his style, is already present in these frescoes.

Mantegna's last documented work in Padua is the *San Zeno Altarpiece*, dating from 1457 to 1459, in which the main panel and three predellas are united by a classical architectural frame. In the course of his career, Mantegna painted many altarpieces including the *Madonna of Victory*, now in the Louvre. In addition to the emphasis on classical architecture and imitations of antique sculpture, these works are characterized by their bright colors and complex iconographic details such as the coral over the Virgin in the *Madonna of Victory*, which refers to rebirth and also functioned as an apotropaic device to guard against the evil eye. Other details of iconography, for example the small scene depicting the *Fall of Man* beneath the Virgin's throne, remind the observer of Mary's role as the new Eve and Christ as the new Adam. In this way, Mantegna unites history by the Christian typological system in which events and personages of the Old Testament prefigured the New as well as by reviving the structures and details of the classical era.

From the late 1450's Mantegna worked for the Gonzaga family in Mantua. He most famous commission for them was the Camera degli Sposi, or bedroom, in the Ducal Palace at Mantua, which he finished in 1474. In this series of frescoes covering the walls and part of the ceiling of the ducal bedroom, Mantegna painted members of the Gonzaga family as if they were sitting on a balcony extending beyond the wall. Scenes include distant landscapes, pages with horses and dogs, putti, fruit swags, as well as family and visitors. The linear quality of some of the portraits suggests the influence of Flemish painters with whom Mantegna probably had some contact.

The illusionism that began with Giotto in the early 14th century became steadily more sophisticated throughout the Renaissance. Mantegna's entire set of Mantuan frescoes is illusionistic, in particular the ceiling tondo, a painted occulus through which the sky is visible. Figures, including putti, peer at the couple through the opening in the roof.

Mantegna's most striking use of foreshortening occurs in the *Dead Christ*, a tempera painting on canvas in the Brera Museum in Milan. Although there is radical foreshortening elsewhere in his oeuvre, in this picture Mantegna foreshortens the main figure of Christ, thereby condensing and monumentalizing the entire space. Other figures, such as the infant Christ in the *Adoration of the Shepherds* in the Metropolitan Museum in New York, the horse on the right of the Louvre *Crucifixion* and the Mantua putti, as well as details of figures in most of his work, are also foreshortened; but none has the impact of the Brera painting.

Also on canvas is Mantegna's series of the *Triumph of Caesar*, now at Hampton Court, in which a Roman procession is seen from below as if through architectural piers unifying the composition. The non-Christian iconography of this work illustrates Mantegna's ease with antique subject matter as well as portraiture, landscape, and history. Mantegna's interest in Greek and Roman mythology, as well as in the formal qualities and architectural structures of antiquity, resulted in commissions such as Isabella d'Este's for the so-called *Parnassus*.

This painting, now in the Louvre, was one of two works by Mantegna intended for Isabella's personal "Grotta," or cave, where she housed her collection of minor arts, among them antique gems and coins. The *Parnassus* actually represents a version of the mythological romance between Mars and Venus. The two gods embrace in the upper center of the picture while Vulcan, the blacksmith god and cuckolded husband of Venus, protests from his cavernous forge at the left. Other mythological figures populate the picture space—Mercury and Pegasus on the right, Cupid at the feet of Mars, and Orpheus playing his lyre as nine nymphs dance to his tunes. Like the *Triumph of Caesar*, the *Parnassus* offers an example of non-Christian subject matter and its frankly erotic subject matter was permissible among Renaissance humanists.

This variety of subject matter in the oeuvre of a single artist is one of the distinguishing qualities of the Renaissance in contrast to the preceding periods of Christian art. Mantegna expressed the Renaissance spirit not only in the formal characteristics of his style but also in his search for historical and mythological background, notably the revival of all aspects of classical antiquity.

—Laurie Schneider

MARC, Franz (Moriz Wilhelm).

Born in Munich, 8 February 1880; son of the painter Wilhelm Marc. Died in Verdun, 4 March 1916. Married 1) Marie Schnür, 1907 (divorced, 1908); 2) Maria Franck, 1911. Attended schools in Munich; studied art with his father; studied philosophy, University of Munich, 1899; military service, 1899–1900; studied drawing under Gabriel Hackl and painting under Wilhelm von Diez at the Academy of Fine Arts, Munich, 1900–02; painter in Munich: associated with the Scholle group, 1905; close friendship with the animal painter Jean Bloe Niestle from 1905, and taught animal anatomy in his studio, 1907–10; co-founder, with Macke and Kandinsky, Der Blaue Reiter group, 1911; lived in Ried-bei-Benediktbeuern, 1911–14; served in the German army from 1914, and died in battle.

Major Collection: Munich: Städtisches Galerie.
Other Collections: Basel; Berlin: Nationalgalerie; Essen; London: British Museum; Munich: Bavarian Museum; New York: Guggenheim.

Publications

By MARC: books—

Der Blaue Reiter, with Wassily Kandinsky, Munich, 1912; edited by Klaus Lankheit, Munich, 1965; as *The Blaue Reiter Almanac,* New York, 1974.
Briefe, Aufzeichnungen, Aphorismen, Berlin, 2 vols., 1920; edited by Günther Meissner, Leipzig, 1980.
Briefe aus dem Felde 1914–1916, Berlin, 1959; edited by Klaus Lankheit and Uwe Steffen, Munich, 1982.

Tiger, 1912; woodcut

Briefwechsel, with August Macke, edited by Wolfgang Macke, Cologne, 1964.

Botschaften an den Prinzen Jussuff, edited by Georg Schmidt, Munich, 1974; as *Postcards to Prince Jussuff,* New York, 1988.

Schriften, edited by Klaus Lankheit, Cologne, 1978.

Briefwechsel, with Wassily Kandinsky, edited by Klaus Lankheit, Munich, 1983.

On MARC: books—

Schardt, Alois J., *Marc,* Berlin, 1936.

Bünemann, Hermann, *Marc: Zeichnungen, Aquarelle,* Munich, 1948.

Erhart, Georg, *Marc,* Stuttgart, 1949.

Lankheit, Klaus, *Marc,* Berlin, 1950.

Lanhkeit, Klaus, *Marc: Tierstudien,* Wiesbaden, 1953.

Lankheit, Klaus, *Marc: Skizzenbuch aus dem Feld,* Berlin, 1956.

Seiler, Harald, *Marc,* Munich, 1956.

Schmidt, Georg, *Marc,* Berlin, 1957.

Lankheit, Klaus, *Marc: Watercolors, Drawings, Writings,* New York, 1959.

Lankheit, Klaus, editor, *Marc im Urteil seiner Zeit: Einführung und Erlauternde,* Cologne, 1960.

Lankheit, Klaus, *Marc: Der Turm der blauen Pferde,* Stuttgart, 1961.

Schinagl, Helmut, *Der blaue Kristall: Des Lebensroman des Malers Marc,* Cologne, 1966.

Tavel, H. C. von, *Marc: Das graphische Werk* (cat), Berne, 1967.

Lankheit, Klaus, *Marc: Katalog der Werke,* Cologne, 1970.

Lankheit, Klaus, *Marc: Sein Leben und seine Kunst,* Cologne, 1976.

Rosenthal, Mark, et al., *Marc: Pioneer of Spiritual Abstraction* (cat), Berkeley, 1979.

Levine, Frederick, S., *The Apocalyptic Vision: The Art of Marc as German Expressionism,* New York, 1979.

Golek, Rosel, et al., *Marc* (cat), Munich, 1980.
Marc/Lasker-Schüler (cat), Munich, 1987.
Rosenthal, Mark, *Marc,* New York, 1989.

*

Many of the themes of the work of Franz Marc and their mode of expression can be related to his early interest in German romanticism and his study of theology and philosophy, particularly Nietzsche. The tone of his work can be related to the back-to-nature movement prevalent in Germany which looked to the primitive and the animal as exemplifying an authenticity lacking in modern urban society. These concerns were married to a modernist idiom that owed much to French painting. On his visit to Paris in 1907, Marc was especially impressed by the work of Van Gogh, Cézanne, and Gauguin. His contact with Auguste Macke from 1910 was important in encouraging him to come to terms with the legacy of French painting, and he was further helped in this by the exhibitions of Matisse and Gauguin in Munich. In 1912 Marc went back to Paris, this time with Macke, where they meet Robert Delaunay, who had a great influence on Marc's work. He certainly knew of the work of the Italian Futurists and even defended it in an article in *Der Sturm.* The modernist idiom which Delaunay used to glorify contemporary life was employed by Marc to represent the power of the primitive and the spiritual.

Marc is best known as a painter of animals, especially horses. The *Large Lenggries Horse Painting I* (1908) is the first time that Marc uses the image of the horse as a poetic symbol for natural forces. He had painted horses before but these had been naturalistic depictions of domesticated animals. The different gestures that the horses make in this piece all have discreet symbolic meanings. The iconography of the horse as a symbol of the untamed power of nature is familiar from Géricault, and it was a theme that had been picked up by German painters such as Adolf Schreyer. Marc's piece is already striking for its use of shallow space and its unnatural colors—orange, yellow, and pink.

Marc's contact with Kandinsky from 1911 was very important for both artists, involving a lifelong exchange of ideas. The two formed the Blaue Reiter in 1911. It was a loose alliance of artists which included Klee, Macke, and David and Vladimir Burliuk, and which also published a journal. The artists were agreed that a new epoch was dawning that would replace the materialism of the modern world with a more spiritual order. an artistic style was needed to express this new attitude, and the clues to the shape of this were found largely in Worringer's book *Abstraction and Empathy* (1908), which argued that primitive societies expressed their unease and awe at nature in the use of highly abstracted natural forms: it was only in comfortable and materialistic societies that you found realist art. These ideas were expressed in Marc's work by pieces like *The Red Horses* (1911) where there is a new intensity of color shown in the red of the horses, the blue rocks, and the yellow ground. There is a shift away from naturalism in such works towards a more abstract play of color oppositions which were supposed to have symbolic significance.

Color symbolism was a matter of common ground between Kandinsky and Marc. Blue was generally seen as a color of spiritually and maleness, yellow of sensuality and the feminine, red of a terrestrial materiality. There is a programmatic application of these symbolic colors in many of Marc's works. So the color of *The Yellow Cow* of 1911 is no accident. Shapes as well as colors had their symbolic associations for the artists of the Blaue Reiter: the triangle, for instance, so evident in Marc's work, is a symbol of the soul striving for divinity, as explained in Kandinsky's celebrated book, *Concerning the Spiritual in Art.* These symbols were not conventional or private in operation. For Marc they fixed on something permanent in human nature and communicated directly with the spirit.

From 1913 particularly his work began to show the strong influence of Futurism, at least as mediated by Delaunay. Force lines appear in *Seated Mythical Animal* (1913), and in *Deer in the Forest* transparent planes unify animal and landscape. Later in the year a quite abstract style emerged, again under the influence of Delaunay. The *Stables* is his last major work to deal with the theme of the horse: the subject here is nearly lost in the dominant structure of the picture. The horses are really only recognizable in the curved lines that are played off against the diagonal lines of force.

There is a gloomy and foreboding feel to many of Marc's later works and some critics have related this to premonitions of war. *The Unfortunate Land of Tyrol* (1913) seems to be a clear comment on the consequences of war with its cemetery, its dark bird and sad landscape: the title is a direct reference to the Balkan war and the supposed danger to the Tyrol. Other works like *Fate of the Animals* were to express a more generalized apocalyptic vision. In his celebration of the natural Marc had never turned his back on modern means of expression. It was a relatively simple matter for him during the war that finally killed him to turn the Futurist element of his style from a celebration of natural conflict and rebirth to a condemnation of mechanical warfare.

—Julian Stallabrass

MARÉES, (Johann) Hans (Reinhard) von.

Born in Elberfeld, 24 December 1837. Died in Rome, 5 June 1887. Attended the Berlin Academy, 1853, and the Atelier Steffecks, 1854–55; military service, 1855–56; patronized by Count Adolf Friedrich von Schack in 1860's; to Spain, France, and Holland, 1869; served in the Franco-Prussian War, 1870–71; settled in Italy, 1873; did frescoes for the Naples Zoological Station, with Adolf von Hildebrand, 1873, his most famous work; relatively small oeuvre.

Major Collection: Munich: Neue Pinakothek.
Other Collections: Berlin: Nationalgalerie; Berlin (East); Bremen; Cologne; Dresden: Staatliche Kunstsammlungen; Hamburg; Hanover; Karlsruhe; Mannheim; Munich: Schack; Nuremberg; Winterthur; Wuppertal; Zurich.

Publications

By MAREES: books—

Briefe, Munich, 1920; edited by Anne S. Domm, 1987.

On MAREES: books—

Fiedler, Conrad, *Bilder und Zeichnungen von Marées, Seinem Andenken gewidmet*, Munich, 1899.

Hartwig, Paul, *Marées: Fresken in Neapel*, Berlin, 1909.

Meier-Graefe, Julius, *Marées: Sein Leben und Sein Werk*, Munich, 3 vols., 1910.

Baum, Julius, *Ein unbekanntes Skizzenbuch von Marées*, Munich, 1921.

Justi, Ludwig, *Marées*, Berlin, 1921

Pfister, Kurt, *Marées: Der deutsche Maler in Rom*, Munich, 1921.

Meier-Graefe, Julius, *Der Zeichner Marées*, Munich, 1925.

Kutter, Erich, *Marées: Die Tragödie des deutschen Idealismus*, Zurich, 1937, Dresden, 1958.

Grote, Ludwig, *Marées: Die Neapler Fresken*, Berlin, 1947.

Lankheit, Klaus, *Marées*, Wuppertal, 1952.

Degenhart, Bernhard, *Marées Zeichnungen*, Berlin, 1953, 1963.

Degenhart, Bernhard, *Marées: Die Fresken in Neapel*, Munich, 1958.

Geller, Hans, *Deutsche Künstler in Rom von Mengs bis Marées*, Rome, 1961.

Liebmann, Kurt, *Marées*, Dresden, 1971.

Gerlach-Laxner, Uta, *Marées: Katalog seiner Gemälde*, Munich, 1980.

Lenz, Christian, editor, *Marées* (cat), Munich, 1987.

*

The word "tragic" occurs frequently in writings about Marées. His bad health, early death, heroic struggle in behalf of his ellusive artistic goals, ill-starred friendship with the pre-Modernist sculptor Adolf von Hildebrand, his tortured relationships with his patrons—Count Schack and the art theorist K. Fiedler—his quixotic aim of establishing a "German School" of monumental art, his obsessive yearning to create utopian *Gesamtkunstwerke* (works of total art)—these somber traits define Marées's biography. He has been hailed as the "only artist deservant of the term" in the 19th Century (by J. Meier-Graefe), as a "pure formalist" (by K. Fiedler), an exemplar of an anti-social "l'art pour l'art" (by L. Justi) and a "mystic of classicism" (by K. Scheffler). Recently, he has been "re-classified" as a "social realist" (! . . . by K. Liebmann). What are some of the "facts" about Marées?

Rest at the Forests's Edge (1863, present location unknown), his first acclaimed work, features a contemporary group of "picnickers" and an equestrian motif. It was influenced by his teacher K. Steffek and resembles Delacroix's *Halt of the Greek Cavaliers* (1859, Cleveland, Museum of Art). His suave handling of the landscape had been fostered by A. Lier, another of his teachers, who mediated Barbizon tonal painting for him as well as Corot's realist management of modish yet timelessly classic staffage. Beyond that, the painting conforms to up-to-date Parisian aesthetics—e.g., Courbet's satiated facture, Manet's cool naturalism.

Bath of Diana (1863, Munich, Neue Pinakothek), an ensemble consisting of a female nude and semi-nudes, horse, and whippets in a wooded setting, was a repeat *success d'estime* for him. The "generic classical motif," without a specific literary meaning, echoes Corot and directly parallels Puvis de Chavannes, an artist with whom Marées bears close comparison. Stylistically, *Diana* is identical to *Rest* (in the decisive tonal landscape), except for its extraordinary coloristic brilliance in selected areas. The glowing flesh tones and effulgent red and blue drapery betray the influence of Delacroix. His admiration for Delacroix resurfaces with his equestrian *Philip and the Ethiopian Eunuch* (1869-70, Berlin, Nationalgalerie), done during or after his Paris trip, and is confirmed, albeit cautiously, in his late triptychs.

The climax of Marées creative activity in 1873 was occasioned by the only commission for frescoes he ever obtained, the joint project with Hildebrand (who did the sculptures) for the German Zoological Station in Naples (1873). The subjects of the wall paintings in the common room of the institution—*Departure of the Fishermen, Rowers, Orange Pickers, Two Women in the Park, Friends Drinking Wine*—are generic commonplaces endemic to the region. The style here is surprisingly fresh, spontaneous, high keyed, light-filled, realistic, and proto-Impressionistic. *Two Women* and (similarly) *Friends* resemble *Family Reunion* (1867) by F. Bazille and *Music in the Tuileries Gardens* (1860) by Manet. Marées wavered here between a classical concept—the nude figures—and a mostly modernist perception of art—art as chronicle of modern life in the Zolaesque sense.

In his subsequent works he tilted toward classical motifs done in a style that occupies a middle position between Mantegna, Poussin, Corot, and Puvis de Chavannnes. His contents focus on a "general classic condition" and are expressed by such formal means as balance, equipoise, and a harmonious resolution of tensions. His themes totter on the edge between an enigmatic humanism and a diffuse spirituality, on the one hand, and blandness and ennui on the other. *Praise of Modesty* (1879– 85) and the two versions of *The Golden Age* (1879-85, all in Munich, Neue Pinakethek) exemplify this uncertain trend. Overall, in the 1870's, his style shifted from a kind of improvisational naturalism and his quasi-Impressionistic so-called *Fleckentechnik* (spotting technique with color; J. Meier-Graefe) to a conditional form of classic monumentalism and accentuation of planar effects. To compensate for his want of fresco commissions, he turned to the triptych format as a suitable "wall-like" substitute with which to accommodate his solemn designs. A kind of generic "Neorenaissance" styling, warm tonalities, languorous moods, and dreamy multi-figural stagings circumscribe his four triptychs (1880-87): *Judgment of Paris* (Berlin, Nationalgalerie), *The Hesperides* (Munich, Neue Pinakethek), *The Three Riders* (idem), and *The Courtship* (idem).

Marées's oeuvre attests to thematic irresolution and stylistic inconsistencies. His vaunted reach for a grand synthesis between history and the present by means of intellectual "Idea-Painting" seems to have eluded him. Lastly, it *must* have escaped him because he revelled in the cult of individualism and genius that defined 19th-century creative psychology. This overweening personalism had made "objectivity" in the "absence of a superimposed community" of shared religious or cultural ideas (H. Beenken) impossible to attain. And it was especially "impossible" for Marées because he eschewed literature, the one remaining cultural "unifier." Reversing course after the Neapolitan frescoes, he decided on a fateful return to a conditional academicism that links up with the program of the Nazarenes and, especially, Peter von Cornelius. In so do-

ing, he soon foundered on the shoals of vagueness, the "mystical and unclear," and "got stuck in questionable artistic intentions (R. Hamann). Infuriated by the "stupid dilettantism, rotten taste and nonsense of [bourgeois] art" (Marées), he made an ominous choice of artistic "weapons" with which to combat those trends.

Marées chose humanism, historicism, and classicism as means of expression. But his forms inched their way toward a kind of reductionism and self-referentiality that is akin to modern abstraction—Cézane, Gauguin. He and they believed that the artist must "construct" nature anew from formal elements like an architect structures a building. But while art may originate in nature, creative construction can only grow from within the artist. To be right, the construction must obey its own indelible rules—follow its "own inner law" (K. Fiedler)—and scale the lofty spheres of an unvarnished ideality. Thus all art is personal expression reaching for universal validation. The Expressionists Nolde, Heckel, Mueller, and Beckmann were among those of a younger generation of artists who emerged from the long puzzling shadow of the "tragic master" of German art to vindicate the "significant form" which was a salient part of his artistic patrimony.

—Rudolf M. Bisanz

MARINI, Marino

Born in Pistoia, 27 February 1901. Died in Viareggio, 6 August 1980. Married Mercedes Pedrazzini, 1938. Studied painting under Galileo Chini and sculpture under Domenico Trentacosta at the Academy of Fine Arts, Florence, 1919-26; taught at Villa Reale art school in Monza, 1929-40, and at the Brera Academy of Fine Arts, Milan, 1940-70; lived in Tenero, Switzerland, 1941-46, and then in Milan, 1946-53, and in Forte dei Marmi after 1953.

Major Collection: Milan: Marini Museum.
Other Collections: Antwerp; Basel; Berlin: Nationalgalerie; Brussels; Detroit; Dusseldorf; Florence: Arte Moderna; Hamburg; Hartford, Connecticut; London: Tate; Milan: Arte Moderna; New York: Moma; Otterlo; Paris: d'Orsay; Portland, Oregon; Rotterdam; San Francisco; Toronto; Trieste: Arte Moderna; Vienna: Albertina; Zurich.

Publications

By MARINI book—

Design e forme nuove nell'arredamento italiano [in Italian and English], with Paolo Portoghesi, Rome, 1978.

On MARINI: books—

Fierens, Paul, *Marini*, Paris, 1936.
Pisis, Filippo, *Marini*, Milan, 1941.
Carriere, Raffaele, *Marini*, Milan, 1948.

Ramons, Mario, *Marini*, Bologna, 1951.
Apollonio, U., *Marini, scultore*, Milan, 1953.
Cooper, Douglas, *Marini, Sculptor*, Milan, 1959.
Trier, Eduard, *Marini*, Stuttgart and New York, 1961; as *The Sculpture of Marini*, London, 1961.
Biermann, Hartmut, *Marini*, Berlin, 1963.
Russoli, Franco, *Marini*, London, 1965.
Busignani, Alberto, *Marini*, Florence, 1968, London, 1971.
Carandente, Giovanni, *Marini: Lithographs 1942-1965*, New York, 1968.
Haftmann, Werner, *Marini: A Suite of 63 Recreations of Drawings and Sketches*, New York, 1969.
Waldberg, Patrick, et al., editors, *The Complete Works of Marini*, New York, 1970.
Hammacher, A. M., *Marini: Sculpture, Painting, Drawings*, New York and London, 1971.
Garberi, Mercedes Percenutti, *Marini* (cat), Milan, 1973.
San Lazzaro, G. di, *Omaggio a Marini* (cat), Milan, 1974.
Pirovani, Carlo, *Marini, scultore*, Milan, 1975.
Marini: Acquaforti e litografie 1914-1975 (cat), Turin, 1976.
Schulz-Hoffmann, Carla, editor, *Marini Druckgraphik* (cat), Munich, 1976.
Guastalle, Giorgio and Guido, *Marini: Dipinti inediti 1950-1965*, Livorno, 1979.
Caballo, Ernesto, et al., *Marini*, Milan and London, 1980.
Klepac, Lou, editor, *Marini: Etchings and Lithographs* (cat), Perth, Western Australia, 1980.
Marini: Gli anni nel Ticino (cat), Lugano, 1981.
Marini: Sculture, pitture, disegni dal 1914 al 1977 (cat), Venice, 1983.
Fath, Manfred, *Marini* (cat), Mannheim, 1984.
Steingräber, Erich, *Marini: Zeichnungen aus dem Nachlass* (cat), Milan, 1987.

*

When Marino Marini died at his home in Viareggio in 1980, he had long been regarded as one of Italy's leading artists. His *Horse and Rider* and *Pomona* series are among the most instantly recognizable and strongly emotive sculptures created this century, and there are examples of his work in most major European and American museums. Although best-known as a sculptor, Marini trained as a painter in Florence and Paris and continued to produce paintings and graphic work throughout his career; these were often reinterpreted in three-dimensional form.

The simple and timeless nobility of the common human condition is central to Marini's artistic world—a world peopled by a cast of horses and warriors, acrobats and jugglers, and anonymous, silent personifications of female beauty. Seldom has an artist been able to concentration on such a restricted range of subjects without becoming repetitive, even monotonous. Marini's gift is to create variations of these themes that constitute a continuous process of development of the original. As he said himself: "It is like playing cards—the cards are always the same, but the games are different."

Also central to Marini's work is his love of archaic Greek art and, in particular, Etruscan sculpture. At the time he completed his first sculpture, *Popolo*, in 1929, excavations were underway at the Etruscan tombs of Volterra and Chiusi that were to add to the world's still flimsy knowledge of this sim-

Acrobat on Horseback, 1944; drawing

ple, civilized, and peace-loving race of the 8th to 4th century BC. Just a glance at this rough-textured double portrait bust in terracotta suggests how strongly Marini was fired by the Etruscans and their art; a closer look reveals the roots of much of what was to come in his later sculpture. Stylistically, the unclassical proportions, the solid, sturdy lines of shoulders and arms, and the rough, expanded chests look forward to the *Pomona* of 1941. More importantly, perhaps, Marini is declaring in this solemn, moving portrait of two unremarkable people his commitment to exploring the common human condition, regardless of race or time—what he liked to call "the silent history of the people." It is this ready identification with the common lot and refusal to put himself, as an artist, above the rest of humanity that makes Marini's work so accessible; it could also perhaps help to explain what has often been construed as his "flirtation" with the Fascist establishment in the 1930's.

By the mid-1930's Marini had completed his first works in the *Horse and Rider* series. *The Rider* (1936), *Gentleman on Horseback* (1937), and *Pilgrim* (1939) are in the classical mode, almost direct descendants of the Marcus Aurelius equestrian portrait on the Capitoline Hill in Rome—simple, very strongly figurative works, where both horse and rider are upright, poised, and active. But the Second World War had a profound effect on Marini and a resonating one on the serenity and classical structure of his earlier work. The *Horse and Rider* series becomes, from this point, the theme through which Marini expresses his growing sense of the tragedy of 20th-century man, in control of his destiny, yet holding the seeds of his own destruction within his own breast. The *Riders* of the 1940's, head held back and legs hanging limp and impotent as in the *Rider* of 1947, of arms outstretched, crucifix-like, a resigned sitting target, as in *The Town's Guardian Angel* of 1949, are expressive of the wars going on inside man, while the memories of the wars going on outside are still fresh and poignant.

By the 1950's the balance between resignation and resistance in these figures is at crisis point. Some of the huge bronze *Miracle* series show the horse straining, phallus-like, towards the sky, while the rider, thrown on his back, seems to be slipping down to despair and oblivion. Others, such as the painted wood *Miracles* of 1954, show the horse broken and collapsed, resigned to defeat, with its head stretched out along the floor, while the rider struggles to throw off his weakness and resist. Nowhere is the balance more precarious and perfect than in a bronze study of 1957–58, where figuration is pared down to a complete minimum, and the rider, recognizable as such through association with the rest of the series, is present as a cylindrical projection at almost 90 degrees from the back of the rearing animal.

This move towards abstraction grows more marked in the final works in the series—the anguished *Warriors* and *Cries* of the late 1950's and 1960's. The former sense of balance disappears, and both horse and rider lie crumpled and broken, their bodies reduced to a conglomeration of harsh, geometric shapes. Echoes of the carnage and ruin of countless battlefields—this is Marini at the height of his powers, pouring his all into these despairing expressions of mankind's apparently incurable propensity for self-injury and possibly self-eclipse. On the base of one of the *Warrior* series the artist inscribed: "Such a disturbing and tragic dirge must never

again be heard in this world." 30 years on, they have lost none of their relevance.

Marini's range of portrait sculptures demonstrates the more positive side of the artist's fascination with the fate of humanity. He has a gift of identifying the innate and distinctive characteristics of a face, making these busts and heads more than superficial likenesses and transforming them into an exploration of the intimate mental world of the sitter. In his studies of artists such as *Carlo Carrà, Igor Stravinsky, Henry Miller, Henry Moore, Kokoschka,* and *Chagall,* we are transported back to the spirit of his earliest works and the solemn, unpompous beauty of Etruscan sculpture.

It is perhaps fitting to end with the other great series of Marini's career: the *Pomonas,* which develop from early terracotta nudes and small seated figures to the solid strength and timeless power of the 1941 bronze *Pomona* that was installed in the Uffizi Galleries in 1974—"the first time a modern work of art has penetrated this sanctuary." The unidealised proportions, bellies ripe like fruit, and legs that might well have known work in the fields make them less like classical Venus figures and more akin to timeless fertility symbols. They also show Marini's infinite skill in dealing with the surface of bronze, here polished and carved with an etching tool and often coloured.

Marini's own description of the *Pomonas* can be used to sum up our response to the rest of his work: "Anonymous, as befits the foster-mothers of history, they are like statues in a cemetery of people you don't know, but who move you even after 2000 years with their essential humanity, free of subjective overtones."

—Elspeth Thompson

MARTINI, Simone.

Born Simone di Martino in Siena, c. 1284. Died in Avignon, July 1344. Married Giovanna, daughter of Memmo di Filipuccio, and sister of the painter Lippo Memmi, 1324. Possibly a student of Duccio; painted *Maestà (Majesty)* in Siena Town Hall, 1315; in Naples: worked for King Robert and knighted 1317; worked in S. Caterina, Pisa, 1320; then worked in Siena again from 1321; lived in Avignon from 1340: friend of Petrarch.

Collections: Altomonte: S. Maria della Consolazione; Antwerp; Assisi: S. Francesco; Avignon: Palais des Papes; Berlin; Boston: Gardner; Cambridge; Cambridge, Massachusetts; Florence; Leningrad; Liverpool; London: Courtauld; Milan: Ambrosiana; Naples; New Haven; Orvieto: Cathedral; Ottawa; Paris; Pisa; Siena: Palazzo Pubblico, S. Agostino; Vatican.

Publications

On MARTINI: books—

Marle, Raimond van, *Simone Martini et les peintres de son école,* Strasbourg, 1920.

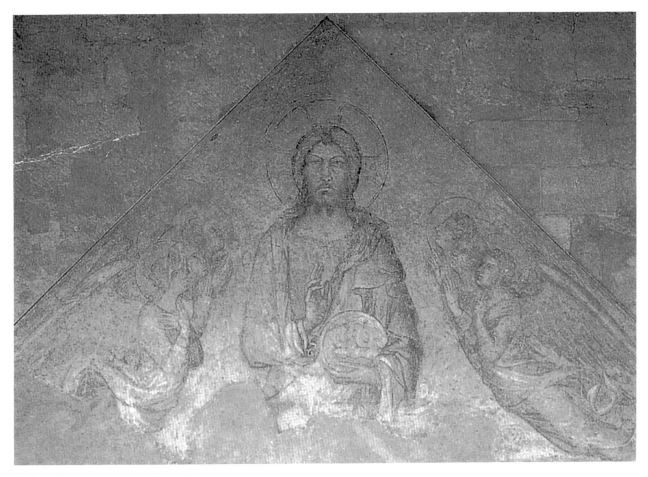

Christ—Sinopia; Avignon, Palace of the Popes

Micheli, M., *Simone Martini*, Turin, 1931.

Rinaldis, Aldo de, *Simone Martini*, Rome, 1936.

Sandberg-Vavala, E., *Simone Martini*, Florence, 1952.

Paccagnini, Giovanni, *Simone Martini*, Milan, 1955; London, 1957.

Carli, Enzo, *Simone Martini*, Milan, 1959.

Borsook, Eve, *The Mural Painters of Tuscany*, London, 1960, 1980.

Volpe, Carlo, *Simone Martini e la pittura senese*, Milan, 1965.

Volpe, Ferdinando, *Simone Martini*, Milan, 1966.

Bologna, Ferdinando, *Gli affreschi di Simone Martini a Assisi*, Milan, 1966.

Mariani, Valerio, *Simone Martini e il suo tempo*, Naples, 1968.

Contini, Gianfranco, and Maria C. Gozzoli, *L'opera completa di Simone Martini*, Milan, 1970.

Grob, Walter, *Simone Martini Verkündigung*, Zurich, 1970.

Os, Henk van, *Sienese Altarpieces 1215–1460*, Groningen, vol. 1, 1984.

Bagnoli, A., and L. Bellosi Luciano Bellosi, editors, *Simone e "chompagni"* (cat), Florence, 1985.

Martindale, Andrew, *Simone Martini: Complete Edition*, Oxford, 1988.

Bellosi, Luciano, editor, *Simone Martini* (colloquium), Florence, 1988.

articles—

Enaud, François, "Les Fresques de Simone Martini à Avignon," in *Les Monuments Historiques de la France* (Paris), 9, 1963.

Denny, Don, "Simone Martini's *The Holy Family*," in *Journal of the Warburg and Courtauld Institutes* (London), 30, 1967.

Hueck, Irene, "Frühe Arbeiten des Simone Martini," in *Münchner Jahrbuch der Bildenden Kunst*, 19, 1968.

Boskovitz, Miklos, "A Dismembered Polytych: Lippo Vanni and Simone Martini," in *Burlington Magazine* (London), 116, 1974.

Degenhart, Bernhard, "Das Marienwunder von Avignon: Simone Martinis Miniaturen für Kardinal Stefaneschi und Petrarca," in *Pantheon* (Munich), 33, 1975.

Brink, Joel, "Simone Martini's Orsini Polyptych," in *Jaarboek van het Koninklijk Museum voor Schone Kunsten Antwerpen*, 1976.

Gardner, Julian, "Saint Louis of Toulouse, Robert of Anjou, and Simone Martini," in *Zeitschrift für Kunstgeschichte* (Munich), 39, 1976.

Brink, Joel, "Simone Martini, Francesco Petrarca, and the Humanistic Program of the *Virgil Frontispiece*," in *Mediaevalia*, (Binghamton, New York), 3, 1977.

Brink, Joel, "Simone Martini's *St. Catherine of Alexandria:*

An Orvietan Altarpiece and the Mystical Theology of St. Bonaventure," in *National Gallery of Canada Bulletin* (Ottawa), 3, 1979–80.

Eisenberg, Marvin, "The First Altar-piece for the 'Cappella de'Signori' of the Palazzo Pubblico in Siena: '. . . tales figure sunt adeo pulcre . . .,' " in *Burlington Magazine* (London), 123, 1981.

Cannon, Joanna, "Simone Martini, the Domenicans, and the early Sienese Polyptych," in *Journal of the Warburg and Courtauld Institutes* (London), 45, 1982.

Loujon, Marianne, "Quatre médaillons de Simone Martini: La Reconstitution du retable de l'église San Francesco à Orvieto," in *Revue du Louvre* (Paris), 33, 1983.

Frinta, Mojmir, "Unsettling Evidence in Some Panel Paintings of Simone Martini," in *La pittura nel XIV e XV secolo: Il contributo dell'analisi tecnica alla storia dell'arte,* Bologna, vol. 3, 1983.

Brink, Joel, "Sts. Martin and Francis: Sources and Meaning in Simone Martini's Montefiore Chapel," in *Renaissance Studies in Honor of Craig Hugh Smyth,* Florence, 1985.

Polzer, Joseph, "Simone Martini's *Guidoriccio* Fresco: The Polemic Concerning Its Origin Reviewed, and the Fresco Considered as Serving the Military Triumph of a Tuscan Commune," in *Revue d'Art Canadienne* (Montreal), 14, 1987.

*

One of the foremost painters of the Sienese Trecento, Simone Martini is noted for his elegant, courtly style. Little is known of the first 30 years of his life, and there are numerous problems in establishing the chronology of his works. Simone's earliest known work, the signed and dated (1315) fresco of the *Maestà* dominates the end wall of the Council Chamber, the Sala del Mappamondo, of the Palazzo Pubblico in Siena. The composition of a central, enthroned Virgin surrounded by angels and saints is derived from Duccio's great high altarpiece for the Sienese Cathedral finished in 1311, but also displays Giottesque influences in its centralized perspective, and the integrated, coherent and spacious arrangement of the 30 saints and angels around the Virgin. The city of Siena was dedicated to the Virgin, and she appears in the fresco in her dual role as Queen of Heaven and terrestrial Governor of the city. Inscriptions admonish the rulers to govern with wisdom and justice. Although the fresco is presently in poor condition, the surface was originally very rich: Simone's *a secco* technique allowed for elaborate decorative details and a liberal application of gold.

Shortly after finishing the *Maestà*, Simone entered the service of Robert of Anjou, the French ruler of Naples. This was the first of many tasks he undertook outside of Siena. For Robert, he created the altarpiece of *St. Louis of Toulouse Crowning Robert of Anjou, King of Naples* in 1317. A remarkable piece of dynastic iconography, the painting was intended to legitimize Robert's succession to the throne and to solemnize his older brother St. Louis of Toulouse's canonization. In the large gabled panel, angels crown Louis, who had abdicated his throne in 1296 to become a Franciscan and was canonized in 1317, while Robert kneels before him to receive his earthly crown. The surface has suffered with time, but the altarpiece once displayed a sumptuous surface with much goldsmith work, jewel-studded clothes, and rich colors typical of Simone's refined, courtly style. An innovative concern with pictorial and spatial unity is evident in the predella scenes of the Life of St. Louis where, for the first time, the orthogonals of all five scenes recede towards a clearly defined vanishing axis in the central scene.

From Naples, Simone moved to Pisa where he painted a large polyptych for the Dominican convent of S. Caterina in 1319. The format of the *S. Caterina Polyptych* of saints surrounding a central image of the Virgin and Child was derived from a type previously developed by Duccio and his workshop, but here made more complex with an elaborate frame with numerous pinnacles and pilasters resembling a gothic church facade. The integrated design of many half-length figures was enlivened by the once rich colors. From Pisa, Simone went on to Orvieto to paint another polyptych, again for the Dominicans, signed and dated 1320 (five remaining panels in Museo dell'Opera del Duomo, Orvieto). A number of other panels from polyptychs, now dismembered and scattered, have been associated with the Orvieto period.

In the 1320's Simone was again in Siena where he repainted several faces of the Palazzo Pubblico *Maestà* and executed a number of other works for the town hall, now lost but documented between 1321 and 1329. Surely the most controversial topic in Simone studies at present is his supposed second fresco in the Sala del Mappamondo, the *Guidoriccio da Fogliano,* painted on the opposite wall from the *Maestà*. The imposing *condottiere* rides across a desolate, panoramic landscape, a remarkable symbol of military power. An inscribed date of 1328 below the rider probably refers to the Sienese defeat of Montemassi in that year. Long accepted as a work of Simone Martini, opinion is now divided as to whether Simone painted the *Guidoriccio* and whether it was even executed in the 14th century. The discussion, still unresolved, focusses on technical, stylistic, and iconographic issues. If the *Guidoriccio* is by Simone, the work is a major example of purely secular iconography, and a unique example of an equestrian portrait in 14th-century painting.

Simone also created official works for the cathedral in Siena. His most important panel painting was the *Annunciation* created for one of the subsidiary altars in 1333 as part of a deliberate program for the Sienese cathedral in honor of the Virgin. The first example of the *Annunciation* as the main subject of an altarpiece, the work is notable for its combination of dramatic intensity and decorative elegance.

There are a number of problems with the chronology of Simone's *oeuvre* due to works that cannot be dated by inscriptions or documents, such as the altarpiece of the Blessed Agostino Novello (variously dated to the 1320's or 1330's). One of the most controversial problems is the date of the Montefiore Chapel in the lower church of S. Francesco in Assisi, which has been variously dated from 1317 to 1339. The chapel is extraordinary for its decorative richness and unity: in addition to the frescoes, Simone designed the brilliantly colored stained glass windows and the coral and white marble inlays on the lower walls and pavement. The paintings includes eight full-length saints on the underside of the entrance arch, a dedicatory image of St. Martin receiving the patron, Cardinal Gentile da Montefiore on the inner wall, and 18 busts of saints in the window embrasures. The narrative, comprising ten episodes from the life of St. Martin, unfolds on the side walls and

vault, moving upwards through worldly events to the 4th-century bishop saint's death and funeral. Brilliant narrative skills and a courtly, elegant style are equally present in the scenes. Probably from the same period are the frescoed busts of Sts. Francis, Louis of Toulouse, Elizabeth of Hungary, Clare and Louis of France, in the right transept of the lower church of S. Francesco. Apparently earlier is the fresco of the *Madonna and Child with Two Crowned Saints* in the same transept.

Simone's last years were spent in Avignon, where he resided at the papal court from about 1340 until his death in 1344. There are few extant works from his Avignon years, among them sinopie and fragments of frescoes from Notre Dame-des-Doms, which offer a rare glimpse into the creative process of a 14th-century artist. Simone met and worked for Petrarch in Avignon, illustrating the frontispiece of the great Italian poet's copy of Servius's *Commentary on Virgil,* and drawing or painting a lost portrait of Laura. A number of panel paintings can be associated with the artist's last years in Avignon, including the scattered parts of the Antwerp *Passion Polyptych* and the dated (1342) Liverpool *Holy Family.*

Noted for his dramatic presentation of narrative, elegant, graceful figures, and brilliant decorative effects of saturated color and sumptuous gold tooling, Simone Martini exerted extraordinary influence on subsequent generations of Sienese painters and on northern exponents of the International Gothic Style such as the Limbourg brothers.

—Barbara Dodge

MASACCIO.

Born Tommaso di Giovanni di Simone Guidi [Masaccio = Big Tom] in Castel San Giovanni di Val d'Arno, 21 December 1401. Died in Rome, 1428. Possibly pupil of Masolino, and a member of the guild in 1422 (Speziali) and 1424 (St. Luke); worked in Rome in c. 1423, and 1427–28 (S. Clemente); in Florence he worked on the Brancacci Chapel of the church of the Carmine, and in S. Maria Novella; in Pisa, in S. Maria del Carmine; left Florence for Rome, 1428, and died shortly thereafter.

Collections: Berlin; Boston: Gardner; Florence: Uffizi, S. Maria del Carmine, S. Maria Novella; London; Naples; Pisa; Vienna; Washington.

Publications

On MASACCIO: books—

Wood-Brown, J., *The Dominican Church of Santa Maria Novella*, Edinburgh, 1902.
Gigiolo, O. H., *Masaccio*, Florence, 1921.
Somare, Enrico, *Masaccio*, Milan, 1924.
Mesnil, Jacques, *Masaccio et les débuts de la renaissance*, The Hague, 1927.
Salmi, Mario, *Masaccio*, Rome, 1932
Pittaluga, Mary, *Masaccio*, Florence, 1935.
Salmi, Mario, *Masaccio, Masolino, Filippino Lippi: La Cappella Bransacci a Firenze*, Milan, 2 vols., 1948.
Steinbart, Kurt, *Masaccio*, Vienna, 1948.
Hendy, Philip, *Masaccio: Frescoes in Florence*, Greenwich, Connecticut, 1956.
Berti, Luciano, *Masacci*, Florence, 1964, University Park, Pennsylvania, 1967.
Einem, Herbert von, *Masaccios "Zinsgroschen,"* Cologne, 1967.
Volponi, Paolo, and Luciano Berti, *L'opera complete di Masaccio*, Milan. 1968.
Bologna, F., *Masaccio: La Cappella Brancacci*, Milan, 1969.
Fremantle, Richard, *Masaccio e l'Angelico: Estratto da "Antichita viva,"* Florence, 1970.
Fremantle, Richard, *Florentine Gothic Painters from Giotto to Masaccio*, London, 1975.
Longhi, Rodolfo, *Fatti di Masolino e di Masaccio e altri studi sul quattrocento*, Florence, 1975.
Beck, James, *Masaccio: The Documents*, Locust Valley, New York, 1978.
Hertlein, Edgar, *Masaccios Trinität: Kunst, Geschichte, und Politik der Frührenaissance in Florenz*, Florence, 1979.
Cole, Bruce, *Masaccio and the Art of Early Renaissance Florence*, Bloomington, Indiana, 1980.

*

Born Tommaso di Giovanni on 21 December 1401, in the small town of San Giovanni Valdarno near Florence, Masaccio died in 1428 at the age of twenty-seven. Despite his short life, Masaccio became the leading painter of his generation. Taking up the innovations introduced by Giotto a century before, Masaccio established the principles of the Renaissance style in painting in the same manner as two of his contemporaries, Donatello for sculpture and Brunelleschi for architecture.

There is disagreement among scholars about Masaccio's early training; but is is clear that he was strongly influenced by both Donatello and Brunelleschi, particularly in regard to the use of perspective. Some of his earliest work was done in collaboration with Masolino although there has been some controversy over each man's contribution to their joint efforts. In the Uffizi panel representing *Mary and Christ on the Knees of Saint Anne*, it seems clear that Masolino was responsible for the Saint Anne and the angels and Masaccio for Mary and Christ. The latter are more massive, their draperies bulkier, and their faces have the slightly puffy texture that characterizes Masaccio's mature style.

In 1961 Berti attributed the triptych from the church of San Giovannale at Cascia di Regello to Masaccio and this has been generally accepted as the artist's work. It appears to be a forerunner of Masaccio's later central panel of the *Pisa Altarpiece*. The Cascia Christ holds grapes in his left hand which signify the Eucharist and the two fingers held in his mouth express the oral character of infancy. Likewise, the Pisa Christ eats grapes, also referring to the Eucharist and to the oral reality of childhood. Masaccio has thus followed Giotto in combining the symbolic Christian iconography of his scenes with his observations of psychological truth.

Both panels also contain a box-like three-dimensional space planned according to the laws of one-point perspective, figures

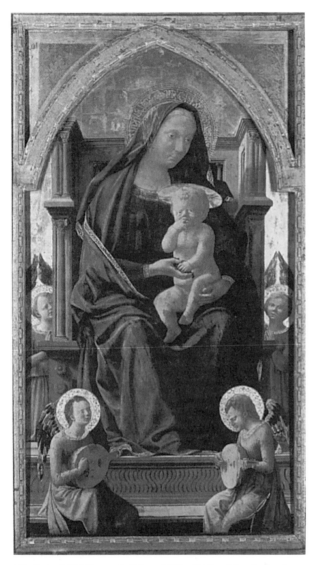

Virgin and Child; panel; $53\frac{1}{2} \times 28\frac{3}{4}$ in (136×73 cm); London, National Gallery

heads of the two figures nailing Saint Peter's hands to the cross are foreshortened, their poses, like the back view of John the Baptist's headsman, obscure their faces. This elimination of the faces deprives them of an identity, which was typical of the anonymous character of executioners in western Europe. In *The Crucifixion*, on the other hand, Mary Magdalen is seen from the back, faceless, and radically foreshortened. Nevertheless, we recognize her by her traditional attribute in Christian art of long hair so that she retains her identity.

Masaccio's only major fresco cycle is in the Brancacci Chapel in the Church of Santa Maria del Carmine in Florence; it illustrates scenes from the life of Saint Peter. Masaccio began working in 1425 or 1426, having taken over from Masolino who had left Florence for a commission in Hungary. There is dispute among scholars over each artist's contribution to the Brancacci Chapel, which was completed after Masaccio's death by a third artist, Filippino Lippi. But it is generally agreed that Masaccio did the *Expulsion* on the entrance wall, the *Tribute Money, Saint Peter Baptizing, Saint Peter Curing by the Fall of His Shadow, Saint Peter Distributing Alms*, and possibly parts of the other scenes.

The powerful monumentality of these scenes inspired Michelangelo, who made drawing studies of them when he was in Florence. The figures stand in a mathematically perspectival space constructed according to the new system established by Brunelleschi. Masaccio's figures wear simple, heavy draperies, which, like the figures themselves, are modelled in terms of *chiaroscure*, or light and dark. Nothing extraneous detracts from the tension and drama that Masaccio conveys in these scenes and the backgrounds, whether landscape or architecture, reinforce the power of the figures by accenting their grandeur.

Masaccio's other important late work is the *Trinity*, a fresco on the left wall of the church of Santa Maria Novella in Florence. Commissioned by Don Lorenzo Cardoni, the fresco appears to occupy a barrel-vaulted chapel flanked by Corinthian pilasters and set into the side aisle wall. The success of this illusion is largely the result of the precise mathematical perspective which Masaccio used in constructing the painted space. Inside the space, we see a round arch supported by Ionic columns with an abacus over the volute. Mary stands to the right of the Crucifixion and John the Apostle to the left. On a ledge behind the cross are God the Father and the Holy Ghost and at the base of the cross, which is also the vanishing point of the painting and eye level of the average observer, is the skull of Adam. On the outer step are two members of the donor's family whose inclusion at Christian events became a characteristic of Renaissance art.

The geometric organization of this painting reveals Masaccio's integration of abstraction with figuration, of narration with symbolism. Viewed as a flat surface, the figures form a triangle whose top angle is at God's head and whose sides continue down through Mary and John to the two donors. Viewed as a three-dimensional form, the same area creates a pyramid, a solid geometric shape, thereby combining solid with plane geometry and also referring the abstract form of the triangle to the Christian symbolism of the Trinity. As in Masaccio's earlier works, this one is characterized by the monumentality of its figures and their quiet, intense power which draws the observer into the dramatic event before him.

—Laurie Schneider

of angels that turn freely and create an avenue of space from observer to Mary and Christ. The *Pisa Altarpiece* is now separated and in various collections throughout Europe. The predella panels, illustrating the *Beheading of John the Baptist*, the *Crucifixion of Saint Peter*, and the *Adoration of the Magi*, together with the upper panel of the *Crucifixion*, reveal Masaccio's taste for compact, radically foreshortened figures which make him one of the most powerfully monumental artists of the Italian Renaissance.

In the *Beheading*, Masaccio depicts the executioner from the rear and emphasizes the force with which he swings his sword by the spatial compression of the shoulders and the movement of his short tunic skirt. Saint Peter's Crucifixion contains one of the most convincing renditions of the pull of gravity, as the martyr's whole body weighs on his head. By turning the picture upside down and noting that Saint Peter seems to shoot up against a ceiling, we realize how carefully Masaccio has studied nature and conveyed its illusion to us. The torsos and

MASO DI BANCO.

Active in the second quarter of the 14th century; possibly died of the plague, 1348; certainly dead before 1357. Pupil of Giotto; in Florence painters guild, probably before 1328; most famous work is painted St. Sylvester cycle in Bardi Chapel of S. Croce, Florence, c. 1336–41; Ghiberti also called him a sculptor.

Collections/Locations: Berlin; Florence: S. Croce, Uffizi; New York.

Publications

On MASO: book—

Wilkins, David G., *Maso di Banco: A Florentine Artist of the Early Trecento*, New York, 1985.

*

Maso was a pupil of Giotto: few things by him are not perfect. He brought a greater unity of narrative into painting. . . . In the Minorite Church [Santa Croce] he painted a chapel with the stories of Saint Sylvester and the Emperor Constantine. He was a very noble spirit and deeply learned in both arts: he was a marvelous marble carver . . . and a man of the greatest talents.

Lorenzo Ghiberti

Although modern scholarship recognizes Maso di Banco as Giotto's most brilliant pupil, little documentation of either his life or his art has survived. From his own period, his name appears four times in the records of the Arte dei Medici e Speziali, the guild to which painters belonged. The earliest mention refers to him as "Maso di Bancho, dipintore." He probably matriculated into that guild before 1328, and is mentioned in their records of 1346. Documents from 1341, concerning legal difficulties between Maso and his Bardi patrons, record the confiscation of two panels of an altarpiece, its predella, a painted cassone, as well as various household goods and artist's materials. The circumstances surrounding this action are not known. Maso's name is entered in the membership list of the Guild of Saint Luke, followed by the numerals MCCCL (1350), which is not taken as his death date since the same numerals appear after fifty-five other names on the list. Maso is believed, however, to have died in the Black Death of 1348, and certainly prior to 1356, when a list of the "best masters of painting in Florence" from that year does not include his name. Nor does his name appear in the 1358 membership roster of the Saint Luke Guild.

Maso was recognized in his lifetime as a great master, and his reputation survived his death. A brief notice, in 1392, refers to him as "Maso dipintore, grande maestro." Among the early literary sources, Filippo Villani, Lorenzo Ghiberti, and Cristoforo Landino mention Maso as a pupil of Giotto. Villani, writing around 1400, states that Maso painted "most delicately of all, with marvelous loveliness." Ghiberti, who asserts in his *Commentarii* (about 1447) that Maso was also a sculptor, names his Florentine paintings: a Santo Spirito *Pente-*

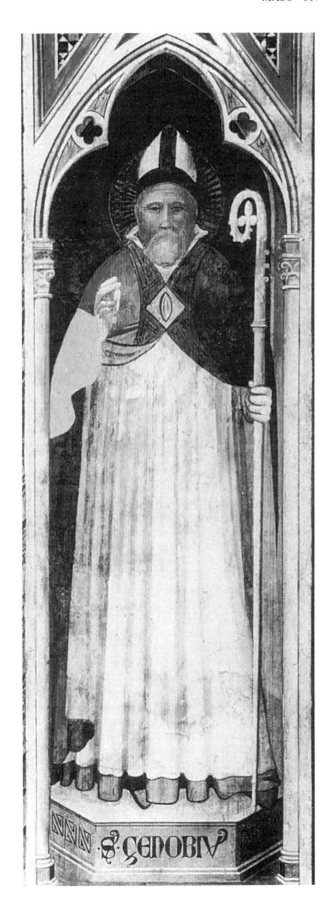

St. Zenobia; Florence, S. Croce

cost, a *Madonna Tabernacle*, and the Saint Sylvester frescoes of the Bardi di Vernio Chapel at Santa Croce. Of these three, only the Santa Croce frescoes survive. In his 1510 *Memoriale*, Francesco Albertini precipitated a long-standing confusion by attributing to a certain "Giottino" the *Tabernacle* that Ghiberti had previously given to Maso. The "Libro di Antonio Billi," written about 1516–1530, repeated this attribution to Giottino. The problem was further compounded in an anonymous work written between 1537 and 1542, where this same *Tabernacle* was attributed to *both* Maso and Giottino. In 1550 Vasari attempted to reconcile these inconsistencies by creating a "Tommaso di Stefano, detto Giottino," apparently on the assumption that "Maso" and "Giottino" were two nicknames for the same person. As usual, Vasari triumphed and his Giottino, rather than Ghiberti's Maso, went down in history as the author of the Saint Sylvester frescoes at Santa Croce. It was not until Richard Offner's 1929 article defining Maso's style that the pendulum swung back, and Ghiberti's original attribution of this major fresco cycle to Maso was reinstated.

Since none of Maso's extant works are signed, dated, or documented, a study of his *oeuvre* must start with his acknowledged masterpiece, his frescoes in the Saint Sylvester Chapel at Santa Croce. The patronage of this chapel was revealed by the presence of Bardi and Bardi di Vernio arms in the chapel's decoration. The frescoes were probably painted between 1336 and 1341, when the Bardi took legal action against Maso. In any event, they represent the mature work of the artist. They include the *Legend of Saint Sylvester* as well as the *Resurrection and Judgment of a Member of the Bardi di Vernio Family*.

In the cycle's most remarkable scene, *Saint Sylvester Raising Two Magicians in the Forum*, Sylvester is shown wearing his papal tiara, reviving the two victims of a deadly dragon. In a dramatically lit architectural setting, Rome is represented as a pagan city, which has fallen into ruins. The scene is divided by a single classical column, which serves to separate the two episodes of the narration. To the left, Sylvester stands in a trench binding the jaws of the dragon; to the right he raises the two magicians. Maso's use of pure, non-realistic color is original, and highly evocative. His crimson, plum, mauve, and yellow combinations are heightened by the contrast of bright whites. This more resonant palette goes far beyond Giotto's placid, pastel color harmonies.

Maso's other masterpiece in the Sylvester Chapel is his *Resurrection and Judgement of a Member of the Bardi di Vernio Family*. This fresco, set above a Bardi family tomb, shows Maso's complete understanding of Giotto's humanistic values. A stern, frontal Christ in a mandorla hovers overhead, surrounded by angels blowing trumpets and bearing instruments of the Passion. Below, in a desolate landscape, the Bardi donor is shown as if arising from his tomb. This figure conveys the sense of a unique personality, as he gazes up at his Judge and Redeemer with the assurance and self-confidence of a righteous man. This appears to be a distinct portrait of a particular individual.

Additional works by Maso have been identified by their stylistic relationship to the Saint Sylvester Chapel frescoes in Santa Croce. These include the *Coronation of the Virgin Lunette*, now in the Museum of Santa Croce, Florence; the Santo Spirito Polyptych (Florence); and the Solly Polyptych (Berlin and New York). Other paintings have been attributed to Maso, but many are still disputed. Maso's recognized works are of such consistently superb quality that they live up to Ghiberti's high praise.

The monumentality of Maso di Banco's Santa Croce frescoes, with their solemn, heroic figures set in unusual architectural and landscape settings, confirms that Maso not only understood, but advanced his master's naturalistic style. However, Maso's own achievements were not advanced by the following generation of Florentine painters. Maso had no real successor in Florentine art until Masaccio, whose *Tribute Money* (Brancacci Chapel, Florence) and *Trinity* (Santa Maria Novella, Florence) signaled the start of the new Italian Renaissance style.

—Ruth Wilkins Sullivan

MASOLINO da Panicale.

Born Tommaso di Cristofano Fini, in Panicale di Valdarno, c. 1383–84. Died c. 1440 or c. 1447. In Florence painters guild, 1423; worked in Empoli, 1424, and in Florence, 1425 (on the Brancacci Chapel, in S. Maria del Carmine); worked for Cardinal Branda in Castiglione Olona in the 1420's and 1430's; also recorded in Hungary, 1425–27.

Collections: Breman; Castiglione Olona: Baptistery; Detroit; Empoli; Florence: Uffizi, S. Maria del Carmine; London; Munich; Naples; New York; Philadelphia; Rome: S. Clemente; Todi: S. Fortunato; Vatican; Washington.

Publications

On MASOLINO: books—

Toesca, Pietro, *Masolino,* Bergamo, 1908.
Wassermann, Gertrud, *Masaccio und Masolino: Probleme einer Zeitenwende und ihre Schöpferische Gestaltung,* Strasbourg, 1935.
Barili, Antonio, *Castiglione Olona e Masolino,* Milan, 1938.
Toesca, Pietro, *Masolino a Castiglione Olona,* Milan, 1946.
Salmi, Mario, *Masaccio, Masolino, Filippino Lippi: La Cappella Brancacci a Firenze,* Milan, 2 vols., 1948.
Micheletti, Emma, *Masolino,* Milan, 1959.
Bianchini, M. A., *Masolino,* Milan, 1965.
Berti, Luciano, *Masaccio,* University Park, Pennsylvania, 1967.
Argenti, M., *Masolino: Il battistero di Castiglione Olona,* Bergamo, 1975.
Longhi, Rodolfo, *Fatti di Masolino e di Masaccio e altri studi sul quattrocento,* Florence, 1975.
Cole, Bruce, *Masaccio and the Art of Early Renaissance Florence,* Bloomington, Indiana, 1980.

articles—

Procacci, Ugo, "Sulla cronologia delle opere di Masaccio e di Masolino tra il 1425 e il 1428," in *Rivista d'Arte* (Florence), 28, 1953.

Berti, Luciano, "Macaccio 1422," in *Commentari* (Rome), 12, 1961.

Vayer, L., "Analecta incongraphica Masoliniana," in *Acta Historiae Artium*, 2, 1965.

Wakayama, Eiko Maria Lucia, "Novita di Masolino a Castiglione Olona," in *Arte Lombarda* (Milan), 16, 1971.

Mode, Robert L., "Masolino, Uccello, and the Orsini 'Uomini Famosi,'" in *Burlington Magazine* (London), 114, 1972.

Wakayama, Eiko Maria Lucia, "Il programma iconografico degli affreschi di Masolino a Castiglione Olona," in *Arte Lombarda* (Milan), 50, 1978.

Arasse, Daniel, "Espace pictural et image religieuse: Le Point de vue de Masolino sur la perspective," and "La prospettiva come strumento di visualizzazione dell' 'istoria': Il caso di Masolino," by Eiko Maria Lucia Wakayama, both in *Prospettiva rinascimentale: Codificazioni e trasgressioni*, Florence, 1980.

*

Masolino da Panicale is perhaps most famous as Masaccio's collaborator on a number of works executed in the 1420's. His earliest years remain unclear. Born near Florence in Panicale, he was a pupil of the elusive painter Gherardo Starnina, according to Vasari, and an assistant of Ghiberti's on the North Doors of the Baptistery. While this remains unproven, it may account for his relatively late enrollment in the painters guild of Florence, in 1423. In the same year, he painted his first dated work, a small *Madonna and Child* in Bremen. The delicate, sweet faces and curvilinear folds of drapery of this early Madonna demonstrate Masolino's debt to the elegant, courtly style of Lorenzo Monaco and Ghiberti.

Of his early fresco cycle of the *Story of the True Cross* in S. Stefano in Empoli from 1424, only the sinopie and a few areas of fresco survive. While it is still imbued with a refined gothic style, a number of scholars have also seen reflections of Masaccio's style in the Empoli works.

After Empoli, Masolino worked in the Brancacci Chapel in S. Maria del Carmine, Florence, where he collaborated with Masaccio on the fresco cycle of the *Life of St. Peter*. The lack of documentary information for the chapel has made dating, attribution and identification of the patron problematic. The nature of the bond between Masaccio and Masolino is also rather mysterious. Their association may have stemmed from the fact that both were from the Valdarno outside Florence. Masaccio was 17 years younger than Masolino, and the most innovative painter in Italy in the early 15th century. While the two painters worked together a number of times in the 1420's, present opinion no longer seeks Masaccio's artistic origins, exemplified by the rough naturalism of his early (1422) S. Giovenale *Madonna and Child with Saints*, in Masolino's more refined style.

In the Brancacci Chapel, it now seems clear after much debate, that Masolino began the Brancacci Chapel frescoes around 1424 or 1425. His first works, all lost after a fire in 1771 in the church, were the *Four Evangelists* in the vault, and scenes from the life of St. Peter in the three lunettes, most probably the *Calling of St. Peter and St. Andrew, Peter Walking on the Water,* and *Peter's Denial and Remorse.* Sometime in 1425, Masaccio joined Masolino in painting the first tier of frescoes on the chapel walls. During Masolino's absence in Hungary (September 1425 to July 1427), Masaccio worked alone in the chapel and seemingly took over the dominant role. There is general consensus that Masolino painted the *Healing of the Cripple and the Raising of Tabitha* on the right wall of the upper tier, and the *Temptation of Adam and Eve* on the right entrance pier; many scholars also give him the *Peter Preaching* to the left of the window on the end wall. The other scenes in the upper tier, including the famous *Tribute Money*, are all by Masaccio. The lowest tier was begun by Masaccio and finished by Filippino Lippi in the 1480's. Masolino's more conservative style is clearly evident in the *Temptation* where Adam and Eve lack the sense of drama and volume of the opposite figures of the *Expulsion* by Masaccio.

Technical evidence presented by Watkins indicates that Masaccio and Masolino may have painted side by side on the same scaffolding. They may also have painted together in the same scene; Longhi suggested that Masolino painted Christ's face in Masaccio's fresco of the *Tribute Money* on the first tier of the left wall, and that Masaccio painted the background architecture in Masolino's *Raising of Tabitha*. The recent cleaning of the Brancacci Chapel frescoes has revealed the once brilliant colors of the frescoes, darkened by smoke in 1771, and contributed new technical evidence that is not yet fully analyzed. Two new sinopie from the window wall have been discovered, variously attributed to Masolino and Masaccio.

The collaboration between Masolino and Masaccio extended to panel paintings as well. Probably in the mid-1420's the two executed the *Madonna and Child with St. Anne* for the church of Sant'Ambrogio in Florence. Masaccio took the larger share in the *St. Anne* panel, painting the figures of the Virgin and Christ child, which display his characteristic advanced *chiaroscuro* and spatial recession. The sweeter, more doll-like faces, slender bodies, and pastel coloring of the angels indicate Masolino's hand; he may also have painted the St. Anne. The clear disparity in styles evident in the *St. Anne* panel is unusual and may indicate that Masaccio began the painting and Masolino finished it when the younger artist stopped working for unknown reasons.

The collaboration between Masolino and Masaccio continued in Rome, where, probably in the later 1420's, Pope Martin V Colonna commissioned a large, double-sided altarpiece for his family chapel in the church of S. Maria Maggiore in Rome. Now dismembered and dispersed, the triptych originally contained full-length saints flanking central images of the *Founding of S. Maria Maggiore* on the front and the *Assumption of the Virgin* on the back. Again, a lack of stylistic uniformity among the panels distinguishes the two artists' contributions to the altarpiece. In this case, Masolino took the larger share, and Masaccio's contribution is limited to the *St. John the Baptist and St. Jerome* (London) and perhaps to the early stages of *St. Liberius and St. Matthias* (London).

Masolino and Masaccio's collaboration ended in 1428, with Masaccio's death in Rome. Masolino's later work is characterized by a return to a more conservative, gothic style. He was patronized particularly by Cardinal Branda Castiglione who commissioned several fresco cycles from him. Branda, titular cardinal of S. Clemente in Rome between 1411 and 1431, first commissioned Masolino to paint a fresco cycle of the lives of St. Ambrose and St. Catherine of Alexandria for a chapel in S. Clemente, probably sometime between 1427 and 1431. The

question of a possible participation by Masaccio in this cycle has been suggested but never conclusively demonstrated.

Some time after, Masolino worked for Cardinal Branda again, in the cardinal's native village of Castiglione Olona, in Lombardy. Masolino painted two fresco cycles in this small hill town. The first, dated as early as the mid-1420's by some critics but more probably painted in the early 1430's, comprises scenes of the *Annunciation*, the *Marriage of the Virgin*, the *Nativity*, the *Adoration of the Magi*, and the *Coronation of the Virgin* in the vault of the Collegiata's choir. The entire interior of the Baptistery was painted with the *Annunciation*, the *Evangelists*, the *Doctors of the Church*, *God the Father with Angels*, and scenes from the Life of St. John the Baptist. A *terminus ante quem* is provided by the date 1435 inscribed on the chancel arch of the Baptistery.

While Masolino's style lies principally in the elegant International Gothic mode, these later works demonstrate his command of the new principles of pictorial composition outlined by Leon Battista Alberti in his *De Pictura* fo 1435. Eiko Wakayama has argued that both the number of figures in the scenes and the perspective rendering are among the earliest examples of Alberti's influence on Italian painters.

A number of panel paintings can be assigned to Masolino's later years, including two paintings of the *Annunciation* in the National Gallery of Art, Washington, D.C., as well as a dated fresco (1432) of the *Madonna with Angels* in S. Fortunato at Todi. The Todi fresco still contains reminiscences of Masaccio's style in the perspective of the throne; the panels again demonstrate Masolino's strong reversion to more conservative, gothic formulas in the works executed after his collaboration with Masaccio ended.

—Barbara Dodge

MASSON, André (Aimé René).

Born in Balagny, Oise, 4 January 1896; moved with family to Brussels, 1904. Died in Paris, 28 October 1987. Married 1) Odette Cabale, 1920, one daughter; also second marriage. Studied at the Academy of Fine Arts, Brussels; under Paul Baudouin at the Ecole Nationale Supérieure des Beaux-Arts, Paris, 1912; served in the army, 1915-19; worked as ceramic decorator, deliveryman, proof reader, etc., in Paris in the 1920's; associated with the Surrealists in the 1920's; cofounder, *Minotaure*, 1930; ballet and theatre designs from 1933 (*Les Présages*, 1933, *Hamlet*, 1946, *Wozzeck*, 1946); lived in Spain, 1934-37; lived in Connecticut, 1941-45, but returned to France after the war; Lyell Lecturer, Oxford, 1972-73.

Collections: Berlin; Nationalgalerie; Cologne; Essen; London: Tate; Melbourne; New York: Moma; Paris: Art Moderne; Washington: Hirshhorn.

Publications

By MASSON: books—

Mythology of Being, New York, 1942.
Anatomy of My Universe, New York, 1943.
Nocturnal Notebook, New York, 1944.
Bestiare, New York, 1946.
Mythologies, Paris, 1946.
Carnet de croquis, Paris, 1950.
Le Plaisir de peindre, Nice, 1950.
Voyage à Venise, Paris, 1952.
Metamorphose de l'artiste, Geneva, 1956.
Le Mémoire du monde, Geneva, 1974.
L'Allegorie, Paris, 1974.
Vagabond du surréalisme, Paris, 1975.
Le Rebelle du surréalisme: Ecrits, edited by Francoise Will-Levaillant, Paris, 1976.
The Pictorial Catalogue: Mural Decoration in Libraries, Oxford, 1981.

illustrator: *Soleils bas*, by Georges Limbour, 1924; *Simulacre*, 1925, *Glossaire, j'y serre mes gloses*, 1939, and *Toro*, 1951, all by Michel Leiris; *C'est les bottes . . .*, by Robert Desnos, 1926; *Ximenes Malinjoude*, by Marcel Jouhandeau, 1927; *Le Con d'Irène*, by Louis Aragon, 1928; *Histoire de l'oeil*, 1928, *L'Anus solaire*, 1931, and *Sacrifices*, 1936, all by Georges Bataille; *Le Serpent dans la galere*, by Georges Duthuit, 1945; *Poèmes*, by Jean Wahl, 1945; *Terre sur terre*, by Tristan Tzara, 1946; *Les Conquérants*, by André Malraux, 1949; *Un Saison en enfer*, by Rimbaud, 1960; *L'Idiot*, by Dostoevsky, 1966; *Aurélia*, by Gérard de Nerval, 1970; *Martinique, charmeuse de serpents*, by André Breton, 1972.

On MASSON: books—

Pia, Pascal, *Masson*, Paris, 1930.
Barrault, Jean-Louis, et al., *Masson*, Rouen, 1940.
Leiris, Michel, and Georges Limbour, *Masson et son univers/ Masson and His Universe*, Geneva, 1947.
Limbour, Georges, *Masson: Dessins*, Paris, 1951.
Juin, Hubert, *Masson*, Paris, 1963.
Hahn, Otto, *Masson*, Paris and New York, 1965, London, 1966.
Clébert, Jean-Paul, *Mythologie d'André Masson*, Geneva, 1971.
Leiris, Michel, *Masson: Massacres et autres dessins*, Paris, 1971; as *Masson: Drawings*, London, 1972.
Passeron, Roger, *Masson: Gravures 1924-1972*, Fribourg, 1973.
Sapphire, L. M., *Masson*, New York, 1973.
Leiris, Michel, et al., *Masson: Opere 1925-1973* (cat), Rome, 1974.
Passeron, Rene, *Masson et les puissances du signs* (cat), Paris, 1975.
Rubin, William, and Caroline Lauchner, *Masson* (cat), New York, 1976.
Masson, Paris, 1979.
Schultze, Jürgen, et al., *Masson und die Metamorphose: Blätter und Bilder 1923 bis 1945* (cat), Hanover, 1985.
Masson: 90 oeuvres sur papier (cat), Paris, 1986.
Sylvester, David, Dawn Ades, and Michel Leiris, *Masson: Line Unleashed: A Retrospective Exhibition of Drawings* (cat), London, 1987.

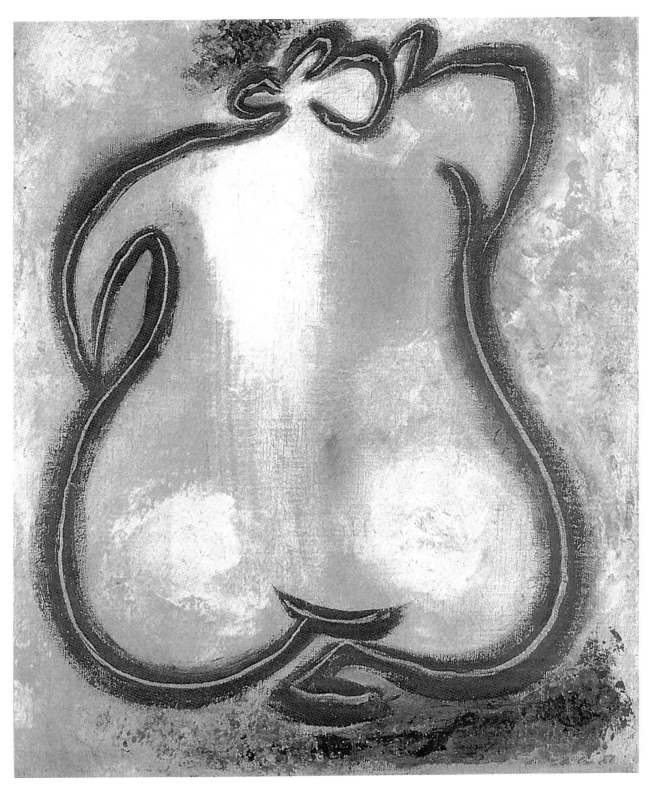

Blue Nude, 1946–47; 18⅞ × 14⅛ in (48 × 36 cm)

article—

Birmingham, Doris A., "Masson's *Pasiphaë*: Eros and the Unity of the Cosmos," in *Art Bulletin* (New York), June 1987.

*

At an early age André Masson revealed an intense interest in art. Wanting to be a fresco painter, he attended the Royal Academy of Fine Arts and the School of Decorative Arts, Brussels at the age of 11. In 1912 he became aware of Cubism through the review *Je sais tout*, and in 1914 he received a grant from the School of Fine Arts to travel in Italy for the purpose of studying monumental painting. The coming of the war in 1914 interrupted his work, and in January 1915 he enlisted as an infantry soldier. The following year he participated in the battle of the Somme, the majority of his company being killed, and in 1917 he was seriously wounded, which resulted in almost a year of convalescence before his discharge on the eve of the Armistice.

Masson returned to Paris in 1921 where he met Max Jacob, Roland Tual, and Georges Limbour. Perhaps that same year, he met, at the Café Savoyard, through Jacob, the painter Joan Miró; both painters had recently taken up studios at 45 rue Blomet, although the exact date of this meeting is uncertain. Together Masson and Miró formed the nucleus of the rue Blomet group, which included Georges Limbour, Roland Tual, and Michel Leiris. Masson's earliest paintings of these years are portraits of these friends who formed an intimate circle devoted to literature, most notably writers such as Jarry, Dostoevsky, Sade, and Nietzsche, not to mention the Symbolist writers Rimbaud and Mallarmé. In 1923 Masson turned to Cubism in a belligerent manner with an eye toward "seizing the knife immobilized on the Cubist table." These paintings incorporated images antithetical to Cubism: bird's wings, knives, dice, cards, flickering candles, and suggestively severed pomegranates all alluded to a violent motion. In 1922 Kahnweiler, the legendary representative of Picasso, offered Masson a contract, which he accepted; he remained associated with Kahnweiler's Galerie Simon, later known as Galerie Louise Leiris, throughout his life. In 1924 André Breton, the leader of the Surrealist movement, visited Masson, at 45 rue Blomet, and purchased the painting *The Four Elements*. At this time Masson became an adherent to the Surrealist movement, producing numerous "automatic" drawings, in which his hand was supposedly allowed to move randomly and unprovoked across the surface of a piece of paper. The resulting drawings, revealing relative degrees of success, some retaining a kind of Cubist armature, were published in the pages of the new review *La Révolution surréaliste*. Masson was a prolific and insightful writer, his first writings appearing in the pages of this review. There he wrote in the autumn of 1925, in uncompromising language reminiscent of Nietzsche: "We are several men who proclaim that life such as western civilization knows it, no longer has any reason to exist, that it is time to plunge into the interior night in order to find a new and profound reason for being." Written only months after the appearance of the *First Manifesto of Surrealism* this letter, addressed to André Breton, bears an appropriately militant tone in accordance with Surrealism's rejection of established values.

Masson and Breton were to remain in contact throughout the 1920's but toward the end of the decade Masson, together with Desnos, Leiris, and Miró became increasing frustrated with what they viewed as Breton's dogmatism. In 1926–27 Masson extended his automatic drawing technique into painting in a dramatic series of highly fluid sand paintings such as *The Battle of the Fishes* (1926), now in the Museum of Modern Art, New York. These canvases parallel the prodigious "dream paintings" of Miró. Growing "dissidence" within Surrealism accompanied the emergence of an alternative faction led by Georges Bataille who successfully attracted Masson and his circle toward the new review *Documents*, first published in 1929. Surrealism itself underwent dramatic transformations in 1929; a schism occurred, excommunications followed, and the *Second Manifesto of Surrealism* banished several former adherents.

Masson's work of the 1930's reveals a new direction preoccupied with violence and myth. Most important are his series of *Massacres* (1933) and the *Terres érotiques* (1939) which equate sexuality with the violence of war. In 1934 he designed the cover of Bataille's review *Acéphale*, an image depicting a decapitated man carrying his own head, and contributed to the review *Minotaure*, published by Tériade and sympathetic to Surrealism. Throughout the 1930's Masson was preoccupied with the legend of the Minotaure, emblem of unleashed irrationality, and in 1939 he painted that subject in the canvases *The Labyrinth* and *Birth of the Minotaur*. Such mythic subjects reflected Masson's response to the Civil War in Spain, where Masson resided between 1934 and 1937, as well as an ominous premonition of the forthcoming events in the Second European War.

Due to the German invasion and occupation of Paris, in 1940 Masson fled to Marseilles, where he found himself in temporary exile with Breton and the other Surrealists. Receiving refuge from Varian Fry, and the American Committee of Aid to European Intellectuals, at the Chateau Bel Air, Masson awaited a ship which would take him to New York by way of Martinique. As a result of their experience in Martinique, Masson and Breton collaborated in the making of the book *Martinique, Charmeuse des serpents*. While in New York, Masson was reconciled with Breton and participated in a variety of Surrealist activities and publications such as the review *View*. Masson had an undoubted impact on the younger generation of American artists. His major canvas *Pasiphaë* bears some relationship to the canvas of the same title by Jackson Pollock, as does his etching *Rape*, made at S.W. Hayter's Atelier 17, to the development of what has been called the "all over style."

After the war Masson returned to France where he concluded his exploration of mythic concerns in paintings like *Niobé*, an *hommage* to the suffering of women and children during the Second World War. During the course of the 1940's and 1950's Masson developed an increasingly calligraphic style, rooted in primary mark making, and returning to his first "automatic" drawings. Masson's later canvases reveal his strength as a draughtsman, a characteristic which always underpinned his work in painting. These works often reveal a fascination with primitive themes, as is apparent in *Genesis I* (1958), or a kind of oriental or Buddhist-inspired writing as in *Semailles* (1955).

Masson's activity was not limited to painting and drawing.

His exploration of print making was prodigious. Often he worked in collaboration with writers such as Desnos, Limbour, Bataille, and Leiris in the making of artist's books. Masson's first work in lithography served as the basis for the volume of poetry by Leiris entitled *Simulacre* which was written in Masson's studio.

Masson's first attempt at sculpture began with *Metamorphoisis* (1927). Executed with the technical assistance of Alberto Giacometti, it revealed a tactile expression of his preoccupation with transformation in which a bizarre figure appears to eat itself. In 1938 Masson contributed a mannequin to the International Exhibition of Surrealism (Paris), and in 1942 he turned to bronze in the lattice-work *Mantes accouplées* (executed in New York and not without importance to the work of David Smith). Nevertheless, there was no consistency in Masson's sculptural preoccupations. Unlike the example of Aimé Maeght, who represented Giacometti and Miró, and encouraged their work in sculpture, Masson's representative, Kahnweiler, seems to have had little interest in sculpture. Sculptural themes appeared sporadically in Masson's drawings, and shortly before his death a series of bronze casts based on this documentary evidence was undertaken with the blessing of the artist, perhaps illuminating a long-neglected aspect of his work?

—William Jeffett

MASSYS, Quentin [Quinten Matsys].

Born in Louvain between 10 September 1465 and 10 September 1466. Died in Antwerp between 13 July and 16 September 1530. Married twice; two sons, the painters Jan and Cornelis. Trained as a blacksmith, and worked in Louvain; admitted to the Antwerp guild, 1491, and practiced painting there: painted the Pieta in the Cathedral, 1511; may have visited Italy, c. 1514–19 (or earlier); the painter Patinir may have painted the landscapes in some of his works; also did portraits.

Major Collection: Antwerp.
Other Collections: Berlin; Brussels; Chicago; Detroit; Edinburgh; Frankfurt; Lisbon; London: National Gallery, Courtaul; Lyons; Madrid; Munich; New Haven; New York; Ottawa; Paris: Louvre, Jacquemart-André; Philadelphia, Posnan; Rome; Vaduz; Venice: Doge's Palace; Worcester, Massachusetts.

Publications

On MASSYS: books—

Cohen, Walter, *Studien zu Massys,* Munich, 1904.
Bosschère, Jean De, *Massys,* Brussels, 1907.
Brising, Hra Harald, *Massys und der Ursprung des Italianismus in der Kunst in Niederlände,* Leipzig, 2 vols., 1908.
Delen, A. J. J., *Massys,* Brussels, 1926.
Friedländer, Max J., *Die altniederländische Malerei, vol. 7:*
Massys, Berlin, 1926; as *Massys* (notes by H. Pauwels), Leiden, 1971.
Dos Santos, Reynaldo, *O poliptico da Madre de Deus de Massys,* Lisbon, 1940.
Roosen-Runge, Heinz, *Die Gestaltung der Farbe bei Massys,* Munich, 1940.
Boon, K. G. *Massys,* Amsterdam, 1942.
Reis-Santos, L., *Le Portrait de Saint Bernardin de Sienne par Massys,* Lisbon, 1949.
Bosque, Andrée de, *Massys,* Brussels, 1975.
Silver, Larry, *The Paintings of Massys with Catalogue Raisonné,* Montclair, New Jersey, 1984.

articles—

Campbell, Lorne, et al., "Massys, Erasmus, Pieter Gillis, and Thomas More," in *Burlington Magazine* (London), November 1978.
Dunbar, B. L. "The Question of Cornelis Massys' Landscape Collaboration with Quinten and Jan Massys," in *Jaarboek van het Koninklijk Museum Antwerpen,* 1979.

*

Quentin Massys, the leading painter of Antwerp in the first three decades of the 16th century, was a virtual folk hero for that dynamic mercantile city. Born in Louvain, he began life as a blacksmith's assistant. His early artistic training is unknown. The 16th-century biographer Carel van Mander asserts that Massys was self-trained, though it is more likely that he studied in the leading workshop in Louvain run by Dirk Bouts. If so, it is curious that Massys, who was an eclectic artist who borrowed widely from all sorts of artists, shows relatively little evidence of Bouts's influence. In any case, he was working independently when he joined the Guild of St. Luke in Antwerp in 1491. By 1510 he was Antwerp's leading painter and would remain so until his death in 1530. In the process, he helped lead Antwerp from its 15th-century position as an artistic backwater to its 16th-century status as a leading cultural center.

Massys's interests were apparently quite broad. He was acquainted with the humanists Erasmus and Pieter Gilles. He also was apparently quite an enthusiastic art collector; during his visit to Antwerp, Dürer visited Massys's house which was known as a showplace for Netherlandish art. Massys drew his style not only from the major 15th-century Netherlandish artists he collected, but also from such foreign contemporaries as Dürer and Leonardo da Vinci.

Massys's early work is problematical. There are no known signed or documented works by him from before 1507. Those that have been attributed to him are marked by eclectic borrowings from Campin, Van Eyck, Van der Goes, Van der Weyden, and Memling. Experiments with a Leonardesque *sfumato* technique and chiaroscuro have led some scholars to postulate a trip to northern Italy some time around 1500, but this again is undocumented.

All of these influences are apparent in Massys's first fully accepted major work, the *St. Anne Altarpiece* (1507–09, Brussels, Musées Royaux des Beaux-Arts), which he painted for the Brotherhood of St. Anne in Louvain. The triptych originally had an Italianate frame which would have helped accen-

Caricature drawing; Chatsworth House

tuate the classical tone of the altarpiece as a whole. The central panel is strictly symmetrical in its division into three groups of figures, each of which is organized around the inverted triangles formed by their heads. The central group of the Virgin, Child, and St. Anne is framed by a domed structure derived from Renaissance examples from northern Italy. The hazy mountains in the background recall some of Leonardo's landscapes. The carefully handled perspective reveals Massys's knowledge of Italian theory, while the use of a new palette of pastels and their treatment as broken and changing colors reflects his interest in contemporary Venetian painting. The painting and the figures within it have a monumentality new in Netherlandish painting. Yet despite these Italian elements, the work is unmistakably northern: not only are the costumes, facial types, and landscape details derived from Flemish prototypes, but so too is the tight, crisp painthandling.

Massys's next major commission, the *Deposition Altarpiece* (1508–11, Antwerp, Musée Royal des Beaux-Arts), painted for the Chapel of the Carpenters Guild in Antwerp Cathedral, shows a similar interest in earlier artists' work. The stiff, angular figure of the dead Christ comes from Petrus Christus, whereas the flattened and self-contained grouping of the figures calls to mind Roger van der Weyden's famous *Deposition* in Madrid. Massys has not simply copied his predecessors, however, but has incorporated features of their work into a piece which is fully contemporary in its Mannerist taste for distorted space and lush costumes. The unidealizing distortions that go beyond an interest in naturalism are similarly mannerist: already noted in the Christ figure, this ugliness is carried further in the right wing, in which the executioners surrounding John the Evangelist's cauldron are marked by hideously distorted faces which suggest a growing interest in Leonardo da Vinci's caricatures. They certainly herald a change in Massys's style as he began to leave behind the soft monumentality of his religious triptychs to develop a new interest in genre subjects.

This new development could take one of two forms in Massys's oeuvre. His interest in caricature can be seen in works like the *Ugly Duchess* (1513, London, National Gallery), which was apparently based on a drawing by Leonardo. The man in Massys's *Unequal Pair* (c. 1515–20, Washington, National Gallery of Art) is similarly ugly; facial features, in fact, serve as a visual metaphor for his lechery and stupidity as we watch him being robbed by the prostitute he is fondling.

A similar moral interest marks some of Massys's genre paintings that he began to paint at this time. These are reminiscent of 15th-century scenes by masters such as Van Eyck, Petrus Christus, and Van der Weyden. The most famous is the *Banker and His Wife* (1514, Paris. Louvre), in which Massys uses what at first appears to be a vignette from everyday life to present a discussion of the opposing powers of material wealth and spiritual devotion. Elements of both caricature and genre make their way into some of his religious paintings, most notably the *Ecce Homo* (c. 1520, Madrid, Prado), in which the grotesque faces surrounding Christ indicate the evil of his tormenters in a spirit worthy of Bosch, an artist to whom Massys has sometimes been compared.

With all the comparisons to other artists, it might seem easy to dismiss Massys as merely an eclectic artist. He was not. Rather, he was a synthesizer and an important link between artists of different places and periods. He introduced earlier Netherlandish art to the new and bustling city of Antwerp, and thereby gave his successors a clear sense of their heritage. In turning to Italian sources, he showed how one could at the same time be open to Mediterranean influences yet still remain a distinctly northern painter. In so doing, he helped formulate the aesthetics that would mark Netherlandish painting throughout the following two hundred years.

—Jane Nash Maller

MASTER OF THE HOUSEBOOK [Master of the Amsterdam Cabinet].

Born c. 1445. Died c. 1505. Active in the Rhine valley between Mainz and the Palatine court at Heidelberg in the period 1470–95; inventor of the drypoint engraving technique.

Collections: Amsterdam; Basel; Berlin; Berlin (East); Boston; Coburg; Dresden; Frankfurt; Freiburg; Gotha; Hamburg; Leipzig; Munich; New York; Paris: Bibliothèque Nationale; Washington.

Publications

On the MASTER OF THE HOUSEBOOK: books—

Waldburg-Wolfegg, Johannes, Graf, *Das mittelalterliche Hausbuch,* Munich, 1957.
Stange, Alfred, *Der Hausbuchmeister,* Baden-Baden, 1958.
Hutchison, Jane Campbell, *The Master of the Housebook,* New York, 1972.
Lanckoronska, Maria, *Das mittelalterliche Hausbuch des fürstlich Waldburgschen Sammlung: Auftraggeber, Entstehungsgrund, und Zeichen,* Darmstadt, 1975.
Kok, J. P. Filedt, *The Master of the Amsterdam Cabinet; or, The Housebook Master* (cat), Amsterdam and Princeton, 1985.

articles—

Hutchison, Jane Campbell, "The Housebook Master and the Folly of the Wise Man," in *Art Bulletin* (New York), 48, 1966.
Becksmann, Rudiger, "Das 'Hausbuchmeisterproblem' in der mittelrheinischen Glasmalerei," in *Pantheon* (Munich), 11, 1968.
Hutchison, Jane Campbell, "The Housebook Master and the Mainz Marienleben," in *Print Review,* 5, 1976.
Kok, J. P. Filedt, "Uber den Meister des Amsterdamer Kabinetts oder den Hausbuchmeister: Forschungsergebnisse des Ausstellungen in Amsterdam und Frankfurt," in *Städel-Jahrbuch* (Frankfurt), 2, 1987.

*

The Three Living and the Three Dead, c. 1490; drypoint

The Master of the Housebook is so called in reference to the Wolfegg "Housebook" (privately owned), a munitions officer's album containing a few drawings of the Children of the Planets by his hand, among drawings of tournaments, and of courtly life and military tactics and armaments by other artists. He is also known as the Master of the Amsterdam Cabinet because the Rijksprentenkabinet in Amsterdam owns 80 of his 91 known drypoint engravings, most in unique impressions. Research with infrared reflectography has authenticated a number of paintings previously attributed to the same artist, including six panels from a dismantled altarpiece said to have been made for a church in Speyer (Freiburg, Frankfurt, East and West Berlin); and a Life of Mary series by the master and assistants (Mainz). A large half-length *Pair of Lovers* (Gotha) is by the same artist, as are several drawings in silverpoint and in pen and ink (Berlin, Leipzig, and elsewhere). The Master's surviving prints were taken from plates made of a metal softer than copper—perhaps pewter—incised, not with an engraver's burin, but with a tool more like a modern etching needle. The artist could not have been a printmaker by profession, for the drypoint process is not commercially feasible, yielding only half a dozen impressions of good quality from each plate. Part of its effect is due to ink trapped in the burr of waste metal thrown up on both sides of each incised line, which prints as a soft, velvety shadow, but which breaks down rapidly under the pressure of the printing press. Some of the Master's prints are quite small, and may have been intended to serve as models for book illustration, either for illuminated manuscripts or for books printed from movable type. Others, like the *Aristotle and Phyllis,* are larger and more highly finished, and would have been suitable for sale to a small number of clients. The Amsterdam collection has the character of an artist's file, with some impressions pricked for transfer, while others show flecks of color or grey washes applied with a brush. The drawings from the series of seven Planetenkinder (Children of the Planets) in the Housebook manuscript, and the miniatures of the Four Evangelists from a Gospel book (Cleveland) support the conclusion that the artist was originally trained as a miniaturist. More than a dozen attempts have been made in the past by scholars to discover the identity of the artist, whose work has at various times been attributed to such historical figures as the youthful Grunewald, the Elder Holbein, and Erhard Reuwich of Utrecht and Mainz, who illustrated and published the *Peregrinationes in terram sanctam* (Mainz, February 1486), the travel memoir of Canon Bernhard von Breydenbach of the Mainz Cathedral. Reuwich himself made the journey to Palestine at the expense of Breydenbach's patron, the young Count Johann zu Solms-Lich.

—Jane Campbell Hutchison

MATISSE, Henri (Emile Benoit)

Born in Le Cateau-Cambrésis, 31 December 1869. Died in Nice, 3 November 1954. Married Amélie Noémie Alexandrine Parayre, 1898; one daughter, two sons. Attended schools

in St. Quentin; studied Law at the Sorbonne, Paris, 1887–88, and worked as a lawyer's clerk in St. Quentin, 1889–91; studied drawing at the Ecole Quentin de la Tour, 1890; studied under Bouguereau at the Académie Julian, Paris, 1892–93, and with Gustave Moreau from 1893–97, first unofficially, then, after 1895, as a student of the Ecole des Beaux-Arts; studied sculpture with Bourdelle, 1900–03; associated at the Salon d'Autumn of 1905 with group known thereafter as Fauves; ran an art school, Paris, 1908–11; settled in Nice, 1917, and lived in Nice and Paris from 1922; stage and costume designs for Diaghilev ballet *Le Chant du Rossignol,* 1920, and for *Rouge et Noir,* also known as *L'Etrange Farandole,* 1939; trip around the world, 1930; painted mural for the Barnes Foundation, Merion, Pennsylvania, 1931–33; first "cutouts," 1938; designed and illustrated books, including Mallarmé's *Poésies,* Joyce's *Ulysses, Florilège des Amours de Ronsard,* and *Jazz,* 1930's–1940's; lived in Vence, 1943–48, and decorated Dominican Chapel there, 1948–51; worked in Nice on large decorative commissions based on paper cutouts until his death.

Major Collections: Baltimore; Le Cateau-Cambrésis: Matisse Museum; Copenhagen; Grenoble; Leningrad; Moscow; New York: Moma; Nice: Matisse Museum; Paris: Beaubourg; Philadelphia.

Publications

By MATISSE: books—

Portraits, Monte Carlo, 1954.
Ecrits et propos sur l'art, edited by Dominique Fourcade, Paris, 1972, 1978.
Matisse on Art, edited by Jack D. Flam, New York and London, 1973.

On MATISSE: books—

Sembat, Marcel, *Matisse,* Paris, 1920.
Faure, Eli, et al., *Matisse,* Paris, 1920, 1923.
Basler, Adolphe, *Matisse,* Leipzig, 1924.
Fels, Florent, *Matisse,* Paris, 1929.
Fry, Roger, *Matisse,* Paris and New York, 1930.
Jedlicka, Gotthard, *Matisse,* Paris, 1930.
McBride, Henry, *Matisse,* New York, 1930.
Zervos, Christian, *Matisse,* Paris, 1931, New York, 1931.
Barnes, Albert C., and Violette de Mazia, *The Art of Matisse,* New York, 1933.
Courthion, Pierre, *Matisse,* Paris, 1934.
Escholier, Raymond, *Matisse,* Paris, 1937.
Romm, Alexander, *Matisse,* Moscow, 1937, as *Matisse: A Social Critique,* New York, 1947.
Courthion, Pierre, *Le Visage de Matisse,* Lausanne, 1942.
Swane, Leo, *Matisse,* Stockholm, 1944, Copenhagen, 1945.
Matisse (cat), Philadelphia, 1948.
Duthuit, Georges, *Les Fauves,* Geneva, 1949; as *The Fauvist Painters,* New York, 1950.
Barr, Alfred H., Jr., *Matisse: His Art and His Public,* New York, 1951, 1975.

Verdet, André, *Prestiges de Matisse,* Paris, 1952.
Greenberg, Clement, *Matisse,* New York, 1953.
Diehl, Gaston, *Matisse,* Paris, 1954.
Lieberman, William S., *Matisse: 50 Years of his Graphic Art,* New York, 1956, London, 1957.
Escholier, Raymond, *Matisse, ce vivant,* Paris, 1956; as *Matisse from the Life,* London, 1960; as *Matisse: A Portrait of the Artist and the Man,* New York, 1960.
Lassaigne, Jacques, *Matisse,* Geneva, 1959.
Wheeler, Monroe, *The Last Works of Matisse: Large Cut Gouaches* (cat), New York, 1961.
Selz, Jean, *Matisse,* Paris and New York, 1964.
Leymarie, Jean, Herbert Read, and William S. Lieberman, *Matisse: Retrospective* (cat), Los Angeles, 1966.
Guichard-Meili, Jean, *Matisse: Son ouevre, son univers,* Paris, 1967; as *Matisse,* New York, 1967.
Gowing, Lawrence, *Matisse: 64 Paintings* (cat), London and New York, 1968.
Bowness, Alan, *Matisse et le nu,* Paris, 1968.
Russell, John, *The World of Matisse 1969–1954,* New York and London 1969.
Schneider, Pierre, *Matisse: Exposition du centénaire* (cat), Paris, 1970.
Carlson, Victor I., *Matisse as a Draughtman* (cat), Baltimore, 1971.
Luzi, Mario, and Massimo Carra, *L'opera di Matisse dalla rivolta "fauve" all'intimismo 1904–1928,* Milan, 1971.
Elsen, Albert, *The Sculpture of Matisse,* New York, 1972.
Jacobus, John, *Matisse,* New York, 1972.
Matisse: Dessins et sculpture (cat), Paris, 1975.
Elderfield, John, *"The Wild Beasts:" Fauvism and Its Affinities* (cat), New York, 1976.
Cowart, Jack, et al., *Matisse: Paper Cut-outs* (cat), St. Louis, 1977.
Izerghina, A., *Matisse: Paintings and Sculptures in Soviet Museums,* Leningrad, 1978.
Elderfield, John, *Matisse in the Museum of Modern Art,* New York, 1978.
Gowing, Lawrence, *Matisse,* London and New York, 1979.
Monod-Fontaine, Isabelle, *Oeuvres de Matisse* [in the Musée National d'Art Moderne], Paris, 1979.
Bock, Catherine C., *Matisse and Neo-Impressionism 1898–1908,* Ann Arbor, 1981.
Duthuit-Matisse, Marguerite, and Claude Duthuit, *Matisse: Catalogue raisonné de l'oeuvre gravé,* 2 vols., Paris, 1983.
Monod-Fontaine, Isabelle, *The Sculpture of Matisse,* London, 1984.
Elderfield, John, *The Drawings of Matisse,* New York and London, 1984.
Pierre Schneider, *Matisse,* Paris, 1984, New York, 1984.
Mazzatesta, Michael, *Matisse: Sculptor/Painter: A Formal Analysis of Selected Works* (cat), Fort Worth, 1984.
Flam, Jack D., *Matisse: The Man and His Art,* Ithaca and London, 1986.
Cowart, Jack, and Dominique Fourcade, *Matisse: The Early Years in Nice 1916–1930* (cat), Washington 1986.
Cahiers Henri Matisse: Matisse et Tahiti, Matisse photographies, Matisse L'Art du livre, Matisse Ajaccio—Toulouse, Nice, 4 vols., 1986.
Delectorskaya, Lydia, *Matisse . . . l'apparente facilité: Peintres 1935–39,* Paris, 1986.

Odalisque in Dancing Girl's Trousers, 1925; lithograph

Benjamin, Roger, *Matisse's "Notes of a Painter"*: *Criticism, Theory and Context 1891-1908*, Ann Arbor, 1987.

Hahnloser, Margrit, *Matisse, Meister der Graphik*, Zurich, 1987; as *Matisse: The Graphic Work*, New York, 1988.

Flam, Jack D., *Matisse: A Retrospective*, New York, 1988.

Klein, John, *Matisse: Autoportraits* (cat), Le Cateau-Cambrésis, 1988.

*

Henri Matisee, toward the end of his life, acknowledged that the artistic problems he had addressed in his youth were those that the era had presented to him, not ones that he had chosen on his own. "Given our epoch and what was behind us, we did what we were obliged to do" (Duthuit, 1949). What had preceded Matisse, when he came to Paris to study art in 1892, was Impressionism and its scientific offspring, Neo-Impressionism (or Divisionism). The Impressionists had used color to achieve, in pigments, an equivalent of light reflections and refractions on objects under particular atmospheric conditions. The Neo-Impressionists, utilizing physics and color psychology, had rendered impressionist color more predictable and less naturalistic by employing exact color relationships in exact amounts. Matisse inherited this abstract color usage and combined it with two new innovations. First, in his Fauve works of 1905-07, he released color from a narrow interpretation of the theories of color harmony and simultaneous contrasts of oppositional hues; he manipulated these harmonies and contrasts according to feeling, rather than rules. Successful color harmonies corresponded to the artist's sensation, his emotional reaction to nature, not to local color or to color "laws." Color became the painter's chief element: it controlled the composition, suggested space, generated light, and conveyed emotional tone. Secondly, Matisse integrated his use of pure expressive color into an ideal of decorative art. From 1908 through 1918, he created works which had the intensity of easel paintings and the flattened, all-over rhythm proper to murals. Often, the decorative panel played its expressive color against an active pattern, harmonizing both into a calm environmental ensemble.

Matisse's innovations in the first two decades of the 20th century involved expressive color and decorative pattern. But he did not neglect the other preoccupation of his era, that which was the driving force of Cubism and Futurism: the expression of the relativity of space. "The sensation of depth without recourse to traditional perspective," Matisse acknowledged, "that was the contribution of my generation" (Courthion, 1942). Around 1911, Matisse set himself to explore the new spatial construction of pictorial space that Picasso and Braque had pioneered. While he never adopted the prismatic break-up of forms of early Cubism, nor the flat, overlapping planes of later Cubism, his investigation of his colleagues' work, especially that of Picasso and Juan Gris, resulted in monumental paintings of simplified, tectonic spatial allusions, for example, in *Notre Dame* (1914), *Goldfish* (1915), and *Bathers by the River* (1916).

After World War I, Matisse spent the better part of the year in Nice, a move which corresponded with a decade-long change of style. From 1916, Matisse began to concentrate on smaller easel paintings, in a more realistic, relaxed style that seemed like a reversion to Impressionism. The artist himself said he was seeking a new synthesis, a union of the innovations in color and space developed in the previous dozen years, with the elements that had been abandoned in that experimental process. The latter elements he named as chiaroscuro, the illusion of deep space, modeling with reflected light, and a certain human quality of sentiment and intimacy. The canvases of the Nice period, which were highly popular in the 1920's, seemed to convey the post-war desire for the private over the public, the modest over the ambitious, the concrete over the abstract, the individual over the universal. They are a celebration of phenomena that are fleeting, sensual, and immediate. Toward the end of the decade, the artist concentrated on drawing, sculpture, and printmaking; restless, he made a trip around the world spending six months in Tahiti and visiting the United States.

The decade of the 1930's was eventful for the artist, then in his sixties. He recommended a more abstract style, occasioned by several important decorative commissions. The first of these was a mural for the Barnes Foundation in Merion, Pennsylvania, on which he worked for three years. He also did a large triptych on the theme of Leda and the Swan, and decorated an overmantel area in a music room for Nelson Rockefeller. A major area of decorative work during this decade was the books that Matisse designed and/or illustrated, the first being the *Poésies* of Mallarmé. Here again the artist delighted in creating the entire decorative ensemble, from cover to cover, from choice of typeface to the design of the endpieces. Matisse often chose classical themes to illustrate (including the non-contemporary sections of Joyce's *Ulysses*), and he was challenged by the more complex poses and compositions that these illustrations entailed. The habitually discreet and sexually sublimating artist also allowed himself greater freedom and sensuality in handling erotic themes in these works, as the texts themselves demanded it. This sensuality can also be found in the otherwise highly abstracted and decorative canvases of the 1930's, including such works as the *Pink Nude, La Rêve*, and *Nymph and Faun*. These, and other works of the 1930's such as *Music*, the artist characterized as a return to Fauvism, with pure, bright, unmodulated colors in large, flat areas.

The trauma of World War II coincided with an operation that nearly proved fatal to the artist at the beginning of the 1940's. While convalescent, Matisse began to work in colored paper, cutting out simple silhouettes and placing them on colored grounds. This new technique, which the artist hailed as a synthesis of drawing, painting, and sculpting, i.e., carving contours out of pure color, culminated in one of the artist's finest books, *Jazz*, published in 1947. The artist's absorption in this new process did not prevent him from painting some of his most beautiful oils, such as *The Large Red Studio* of 1948, or from continuing to produce drawings and lithographs.

Although the artist was required to spend the major part of his day in bed, he regarded his escape from death a license to great freedom, simplicity, and joy; the almost childlike technique of the cut-outs was a creative play he allowed himself in his mature years. As a culminating master-work of his old age, Matisse had the opportunity to design a *Gesamtkunstwerk* into which he poured all of his genius and experience with decoration, line, and color. This was the Dominican chapel, Our Lady of the Rosary, at Vence, for which Matisse designed the windows, interior decor, devotional images, vestments, liturgi-

cal objects, and steeple. It was dedicated in 1951, three years before his death. After this exhaustive effort, he worked on other major commissions up to his death, including stained glass window, tiled wall decorations, and carpets designs.

If Matisse was an innovator in technical and formal matters, he was a traditionalist in his subject matter. He never departed from the established genres: still life, landscape, portrait, life studies from the model, and classical subjects. He delighted in taking a theme, pose, or motif that was utterly conventional or banal and giving it new vitality and depth through the force of his emotional sincerity and originality of approach. By far the most frequent subject of the artist was the female face and form. Often, in his monumental panels, the female is generalized as a life-force or "natural" being, portrayed dancing, bathing, dreaming, or relaxing in outdoor settings. When using the costumed model, say, an Odalisque or harem woman, Matisse generalizes a type from 19th-century practice: the fantasy of an exotic, sensual female who is wholly available to the masculine viewer. In these works, the artist least transcends the limitations of his genre. In dealing with a particular model, however, either in a portrait or figure-study, Matisse attempts to capture an essential quality of her character or personality, that is, to portray, as his friend Gertrude Stein would say, her "bottom nature." In any case, the artist demanded subject matter that was always inherently graceful, serene, pleasurable; he consciously eschewed the painful, depressing, or troubling.

Impressionism and Divisionism had grounded Matisse's aesthetic in a search for equivalents of light, harmony, and emotional peace. Matisse pursued these goals in every media he used, as well as in his subjects. When painting, he attempted to arrange and quantify color so that it generated radiant light and an atmosphere of resolved excitement. Space was also treated as a light-saturated ambiance that spread across the picture-plane, suggesting atmosphere that stretched from behind the viewer to the farthest point of the horizon. In his black-and-white media, namely drawing and printmaking, he used his black marks to render the white of the paper luminous, a source of light and air. In sculpture, which he pursued all his life, forms were organized, even distorted when necessary, to achieve a harmonious balance of parts to the whole, in spite of the expressively worked surfaces that caught and modulated light. Since qualities of order, balance, and sensual delight were of utmost importance to Matisse, he had no difficulty bending his efforts to decorative commissions. Indeed, besides being a child of Impressionism, he was also heir to the decorative *fin-de-siècle,* with its interest in applying a history-free modern style to all aspects of applied art and decor. If the paper cut-outs of the last period were able to synthesize Matisse's painting, drawing, and sculpture, they also gave him a medium for expanding his decorative interests. The late, large mural projects, including the Chapel at Vence, allowed Matisse to combine all the elements of his art into an ensembles that surrounded the viewer with a man-made, sensual environment of serenity and joy. Here, nature and art, unity and variety, tension and release are brought into a "purity, balance, and harmony." This is what Matisse had named as his goal for his art as early as 1908. His extraordinary, self-renewing, 60-year career testifies to its continuing validity as a generative goal, and his *oeuvre* witnesses his success in achieving it.

—Catherine C. Bock

MAZZONI, Guido.

Born in Modena, c. 1450, Died in Modena, 12 September 1518. Active from 1473: first recorded as supervising a pantomime in celebration of Eleanora of Aragon, wife of Ercole I of Este; worked on a terracotta entombment of S. Francesco, Bussetto, worked in Modena, 1477–80, Crema, 1485, Venice, 1489; in Naples from 1489, where he worked for Alphonso Duke of Calabria; accompanied Charles VIII to France, 1495, and executed his tomb for S. Denis (destroyed); also worked for Louis XII at Blois; returned to Modena after Louis's death in 1515.

Collections: Modena: Museum, Cathedral, S. Giovanni Battista; Naples: S. Anna dei Lombardi; Padua.

Publications

On MAZZONI: books—

Pettorelli, A., *Mazzoni da Modena,* Turin, 1925.
Riccomini, E., *Mazzoni,* Milan, 1966.
Hersey, George Leonard, *Alfonso II and the Artistic Renewal of Naples 1485–1495,* New Haven, 1969.
Verdon, Timothy, *The Art of Mazzoni,* New York, 1978.

articles—

Pane, R., "Mazzoni e la Pieta di Monteoliveto," in *Napoli Nobilissima,* 11, 1972.
Mingardi, C., "Problemi mazzoniani," in *Contributi dell'Istituto di Storia dell'Arte Medioevale e Moderna,* 2, 1972.

*

Because he was raised by an uncle with close ties to the Este Dukes of Ferrara, Guido Mazzoni's early training was probably related to the principal artistic project of the ducal court in the 1460's and early 1470's, the decoration of Palazzo Schiffanoia. Indeed, Mazzoni's first terracotta works strongly echo the style of the master-in-charge at Schiffanoia, Francesco del Cossa, and it is likely he worked under Cossa's guidance on the mixed-media fresco and stucco program; early documents (1472, 1485, 1488) in fact refer to him as a painter. He is also mentioned in these years as involved with theater: in 1472 Guido produced a festival in Modena to honor Ercole I d'Este and his bride, Eleonora d'Aragona, probably designing the major props as well as directing the spectacle. This connection with theater is perhaps the most characteristic feature of these years; an early 16th-century chronicler says that Guido's sculptural career began in fact with the fabrication of realistic festival masks.

The works for which Mazzoni became famous combine these several talents. In his own day, as in ours, Guido was known above all for his tableaux of lifesize, naturalistically pigmented terracotta figures that with unmatched realism involve the beholder in an intense emotional experience. He specialized in *Lamentation* groups showing seven mourners around the corpse of Christ: Mary, Christ's mother; Mary of Magdala; Mary Cleofa; Mary Salome; John the Beloved Dis-

Lamentation, c. 1476–77; terracotta; Modena, S. Giovanni della Buona Morte

ciple; Joseph of Arimathea; and Nicodemus. Normally one or more of these figures are portrait likenesses of the donors of the ensemble, which thus functioned as an *ex voto*, dramatically recording individual piety.

Mazzoni was appreciated by his contemporaries especially as a religious portraitist. By the 1480's, the generic naturalism and broad handling of form typical of early works like the *Lamentation* group in Busseto (S. Maria degli Angeli), had given way to a microscopic realism of detail—based on the use of life casts of faces and hands—that inserted the donor in the most literal fashion into the emotional fabric of the scene. Every scar and wrinkle are faithfully reproduced in works like the *Lamentation* in Modena (S. Giovanni Battista), but mimesis is subordinated to religious feeling as Guido reformulates the details or furnished by the cast into facial expressions eloquent of grief. Fragments of a *Lamentation* made in the late 1480's for a church in Venice, which are now in Padua, suggest moreover that Guido was aware of Venetian painting: strident characterization gives way to an inwardness of mood reminiscent of Giovanni Bellini's art in the same years. Finally, in the last of his works in Italy, the *Lamentation* group modelled in Naples in 1492 for the Duke of Calabria, later Alfonso II (Naples, S. Anna dei Lombardi), Mazzoni imbued his virtually Flemish realism with a formal monumentality and rhetorical grandeur that reflect the humanist interests of his patron and perhaps Guido's own newfound interest in classical art.

When Naples fell to Charles VIII in 1495, Mazzoni entered the service of the conqueror at a high salary and returned with him to France, where he was honored with knighthood. From 1496 to 1515, Guido functioned as director of an international atelier based in Paris, probably availing himself of the assistance of French and Flemish as well as Italian collaborators to execute his designs. His main works in France were the tomb of Charles VIII in St.-Denis, destroyed in 1793 but known

from old delineations; the tomb of Charles's chronicler, Philippe de Commines (Louvre); a *Dormition of the Virgin* in Fécamp (Abbaye de la Trinité), Of these only the royal funerary monument is documented, but all embody elements of the drama and realism for which Guido had distinguished himself in Italy; the surviving monuments, in stone rather than terracotta and uneven in quality, are clearly the work of several hands and suggest that Guido's role in this period was restricted to providing models. Mazzoni is also recorded as "supplying" carved marble medallions for the decoration of Cardinal Georges d'Amboise's Château at Gaillon; here, too, though, he may have served more as entrepreneur than as artist, importing ready-made decorative components from Milan for the Cardinal, who was also Louis XII's Viceroy in that subject city. In much the same capacity, he provided a detailed design for a tomb for Henry VII of England, amply documented, which was rejected in favor of the monument by Pietro Torrigiani. On the death of Louis XII in 1515, perhaps sensing his inability to satisfy the cultural demands of Francois I, Guido left France for his native Modena, where he died in 1518.

—Timothy Verdon

MELÉNDEZ, Luis (Egidio).

Born in Naples, 1716; descendant of a long line of Spanish painters; son of Francisco Meléndez; brother of the painter José Agustín Meléndez; sometimes used the spelling Menendez; taken to Madrid with his family, 1717. Died in Madrid, 11 July 1780. Married Maria Redondo. Studied in his father's workshop; then worked in Louis-Michel van Loo's studio at

Self-Portrait, 1746; 38½ × 31¾ in (98 × 81 cm); Paris, Louvre

court, 1737–43; entered Fine Art Academy co-founded by his father, 1745, in Madrid; expelled in 1748 (due to his father's anger about a lost commission); visited Italy: Rome, then several years in Naples, to 1753; returned to Madrid, 1753, and worked for his father in Madrid painting full-page miniatures for choir books; also did a series of 45 still lifes for Palace of Aranjuez, 1760–73; specialized in "bodegones," pictures featuring food or kitchenware.

Major Collection: Madrid.
Other Collections: Antwerp; Barcelona: Catalan Art; Bielefeld; Bilbao; Bonn; Boston; Cleveland; Escorial; Fort Worth; Hartford, Connecticut; Madrid: Royal Palace; Munich; New York; Paris; Raleigh, North Carolina; Vallodolid; York.

Publications

On MELENDEZ: books—

Rocamora, Manuel, *Breves datos biograficos del pintor Meléndez,* Barcelona, 1972.
Luna, Juan J., *Meléndez: Bodegonista español del siglo XVIII,* Madrid, 1982.
Tufts, Eleanor, *Meléndez, Eighteenth-Century Master of the Spanish Still Life, with a Catalogue Raisonné,* Columbia, Missouri, 1985.

*

The culmination of still-life painting in the 17th and 18th century was realized in the works of Luis Meléndez. After a rich beginning in this subject matter occurred early in the 17th century in Italy and Spain, many Dutch and Flemish painters took up the new genre, becoming specialists in breakfast pieces, flowers, and *Vanitas.* The works of these early practitioners were known to Meléndez through two specific channels: (1) during the Baroque period, when the Low Countries belonged to Spain, the paintings of Dutch and Flemish still-life painters entered Spanish collections in abundant numbers, and (2) Meléndez had first-hand experience with Italian painting when he visited Italy in 1748 and took up residence in Naples, then under Spanish dominion, married there, and remained until 1753.

Meléndez found his true metier in the 1760's and 1770's, and his work from these two decades won him the distinction of being Spain's greatest still-life painter of the 18th century. Choosing simple objects, such as food and kitchen containers, he crated masterpieces through his clear depiction of texture, his ability to convey three-dimensional forms, and his clever structuring of a variety of geometric shapes.

In his youth he had become a portrait miniaturist as a result of initial study with his father, Francisco Meléndez, painter of miniatures in the Spanish court. Miniature portraits were placed at the center of a necklace or inserted in bracelets and used by the king as gifts for envoys and ambassadors. In order to learn oil painting Luis worked as an assistant to Louis Michel van Loo, a French artist who had been invited by Philip V to Madrid as a court painter in 1737. Luis Meléndez's best-known painting of this period is his self-portrait (Paris, Lou-

vre) in which the artist represents himself very objectively with bushy black eyebrows and a little dark stubble above his mouth. He proudly holds up for the viewer to admire an academic drawing of a muscular nude model as evidence of his draftmanship. A youthful indulgence can be seen in his debonair attire: he is garbed in a black velvet jacket and a white linen shirt with ruffled cuffs. A jabot enhances the sartorial splendor of his white vest, while a blue mantle swirls loosely around his back and is caught by two tapering fingers of the artist's porte-crayon-holding hand. This self-portrait, signed and dated 1746, was painted while he was a student at a provisional Academy of Fine Arts, established largely through the efforts of his father, who had lived in Italy and seen the leading academies of art in Italian cities. Luis's uncle, Miguel Jacinto Meléndez, had been a court painter to King Philip V of Spain, and quite possibly his experience as a portraitist set an example for the nephew. Francisco Meléndez took umbrage with the Academy's decision to give a commission to a rival painter, and he issued a public denunciation of the institution, whereupon the Academy expelled Luis. This peremptory dismissal caused Luis to rethink his plans, and he decided to follow an earlier path taken by his father and travel to Italy.

The Italian odyssey ended in 1753 when Luis's talents were requested back in Madrid by his father who had been given a large commission to replace the illuminated choir books destroyed in the Alcázar fire with enough books for the opening of the new royal chapel then nearing completion. Because of the immensity of the task, Francisco needed help and formed a workshop that included his two sons, Luis and José Agustín.

The miniatures, measuring $25^1/_2$" x $16^1/_2$," are painted in brilliant colors. Among these figural compositions by Luis are *The Surrender of Seville to St. Ferdinand* (Madrid, Royal Palace), signed and dated 1757, and *Adoration of the Magi* (Madrid, Royal Palace) in which his precise, volumetric style may be contrasted with his father's looser, more porous depiction. It is in the capital letters and in the borders of the large miniatures with their profusion of grapes and leaves that the future still-life painter is adumbrated.

In 1760, a year after the completion of this commission, Luis Meléndez petitioned Charles III for a position as court painter, reminding the king that, when they were both in Naples, he had given his Majesty three paintings. No court appointment was forthcoming, and Meléndez at this point turned away from figure paintings and began to devote himself entirely to still-life painting. In 1772 he submitted a second petition to the king, describing his current work as follows: "all the species of comestibles that the Spanish climate produces in the four seasons," adding that he had been able to finish only "those pertaining to the fruits of the earth, not having the means to continue nor even the requisites to feed" himself. This request for an appointment was declined because there were already "twelve court painters with large salaries." Although not officially placed on the court payroll, Meléndez does appear to have been encouraged to paint still lifes to decorate the dining room at the king's summer palace in Aranjuez. The thirty-nine still lifes by Meléndez now in the Prado Museum were described in the inventory conducted at this palace in 1800.

Meléndez still lifes are generally composed of food and utensils on a bare wooden kitchen table. Exceptions are scenes of foods displayed in a landscape setting. The paintings are

usually of three sizes: ca. 19$^{1}/_{4}$" x 13$^{3}/_{4}$", 16$^{1}/_{8}$" x 24$^{1}/_{2}$", and 24$^{3}/_{4}$" x 33".

Meléndez painted one more self-portrait (Madrid, private collection) which offers a telling contrast to his earlier buoyant depiction. A mature Meléndez gazes out at the viewer now: a painter of realities who delineates himself with the same somber treatment he has given his still lifes—an uncompromising yet exquisitely sensitive affirmation of the object as he sees it. His shirt is open at the neck, his head is bound in a plain white working turban, and he is no longer accompanied by any tools of his trade or evidence of his handiwork. His left arm crosses his waist in a quiet, protective motion, and his nearly frontal pose is self-contained. Earlier his stance was open and his gestures elegant and assured. Now the contemplative expression speaks of a familiarity with the humble course of daily life, and we see a weary man confronting reality.

Indeed, the reality was that sickness confined him to bed in his Madrid home on Calle de Reloj, and he wrote a declaration of poverty in June 1780, naming his wife as his only heir. On July 11 he died, according to the death certificate in the archive of his parish church, San Martín.

The earliest impact of Meléndez's still lifes can be seen in the paintings of Francisco Goya who undoubtedly saw Meléndez's paintings of food at the palace in Aranjuez and who late in life undertook the painting of still life; Goya's *Salmon* (Winterthur, Oskar Reinhart Collection) may well have been inspired by his memory of Meléndez's painting of this subject. Edouard Manet visited an exhibition of Spanish painting in Paris and in order to see more Spanish works traveled to Spain in 1865. Among Manet's works upon return to Paris were two paintings of salmon placed on a simple table parallel to the picture plane. In the 19th century Meléndez's thirty-nine still lifes were hung in one room in the Prado where copyists studied the master's technique. Meléndez's predilection for the close scrutiny of objects has continued to fascinate artists in the 20th century, for example, Salvador Dalí and the Columbian painter Fernando Botero. Among contemporary artists Janet Fish, Audrey Flack, and Nicholas Orsini have expressed their admiration for such Spanish still-life painters as Meléndez; the Spanish painter Maria Pilar Blanco is frankest in expressing her stylistic descent from the 18th-century master.

—Eleanor Tufts

MELOZZO DA FORLI.

Born Michelozzi degli Ambrogi, in Forli, 1438. Died in Forli, 8 November 1494. Possibly studied under Piero della Francesco in Borgo San Sepolcro; then possibly worked under Ansinuo of Forli; then worked in Rome and the Vatican during the 1470's: Apostoli church, 1472, and frescoes in the Vatican, 1475–80; oné of the original members of the painting guild in Rome; and was famous for his extreme foreshortening ("sotto in su"); then lived and worked in Forli, 1480–94. Pupil: Marco Palmezzano.

Collections: Florence; Forli: S. Biagio, Museum; Loreto: Treasury chapel; Paris; Rome: S. Marco, Galleria Colonna, SS. Apostoli; Urbino: Palazzo Ducale, Museum; Vatican.

Publications

On MELOZZO: books—

Okkonen, Onni, *Melozzo und seine Schule,* Helsinki, 1910.
Ricci, Corrado, *Melozzo,* Rome, 1911.
Schmarsow, August H., *Joos van Gent und Melozzo in Rom und Urbino,* Leipzig, 1912.
Melozzo, Forli, 1937.
Gnudi, Cesare, and L. Bacherucci, *Melozzo* (cat), Forli, 1938.
Buscaroli, Rezio, *Melozzo,* Rome, 1938.
Buscaroli, Rezio, *Melozzo e il Melozzismo,* Bologna, 1955.

article—

Paolo, Roberto di, "L'oratorio di San Sebastiano in Forli e Pace di Maso, architetto della Brigada di Melozzo: Appunti sull'architettura della fine del '400 in Romagna," in *Bollettino d'Arte* (Rome), July-September 1982.

*

Little is known of Melozzo da Forli's early training or style. He was born in Forli, in the Romagna region of Italy, in 1438 and died in 1494. The influence of Piero della Francesca on his style is evident, and possibly he spent time at the court of Urbino when the Flemish painter, Justus von Ghent, was also working there. Like both Piero and Justus, Melozzo worked in the tradition of Renaissance humanism, and his style reflects contact with the monumental painters of 15th-century Italy and Flanders. His first documented painting, the *Portrait of Sixtus IV and his Nephews,* shows the influence of Piero in its attention to perspective. Also suggesting Piero's influence is the pervasive white light and the crisp edges of the figures, who wear massive draperies and whose poses are deceptively rigid. Alberti's influence is evident in the strict architectural symmetry defining the picture space and the presence of architectural features, such as the Corinthian column and the decorative elements in gold, which are Roman. Flemish influence appears in the lined faces of the two central figures as well as the glass windows in the back-ground; Melozzo might have known these motifs through contacts with Justus von Ghent at Urbino.

Melozzo's other known works are fragmentary. For example, an *Ascension,* completed by 1480 for the apse of Rome's SS. Apostoli and now in the Quirinal Palace, originally occupied a greater space and is thought to have been the first monumental ceiling fresco intended to create the illusion of the sky itself. The necessary foreshortening of such an image indicates that Melozzo was influenced by such innovative Florentine painters as Uccello, Castagno, and Mantegna. Certainly the folds of Christ's outer white drapery are strongly reminiscent of Mantegna, while Christ's facial details again recall Justus von Ghent. His later work, either done with assistants or in fragmentary condition, includes the Loreto vault frescoes of prophets and angels and Saints John the Baptist and Benedetto in the Uffizi.

—Laurie Schneider

MEMLING [Memlinc], Hans.
Born in Seligenstadt-am-Main, near Frankfurt, c. 1440. Died in Bruges, 11 August 1494. Married Anne de Valkenaere (died, 1487), three sons. Probably a pupil of Roger van der Weyden; citizen of Bruges, 1465, and member of the painters guild; Bruges's leading painter.

Major Collection: Bruges: Museum of St. John Hospital.
Other Collections: Antwerp; Berlin; Bruges; Brussels; Cincinnati; Danzig; Florence; Frankfurt; Glasgow; Granada; The Hague; London; Lubeck: St.-Annen-Museum; Madrid; Munich; New York: Morgan Library, Metropolitan; Ottawa; Paris: Louvre, Jacquemart-Andre; Stuttgart; Turin: Sabauda; Venice; Vienna; Washington.

Publications

On MEMLING: books—

Bock, Franz, *Memling-Studien,* Dusseldorf, 1900.

Huisman, Georges, *Memling,* Paris, 1923.

Marlier, Georges, *Memling,* Brussels, 1934.

Bazin, Germain, *Memling,* Paris, 1939.

Guillaume-Linephty, Maur, *Memling in the Hospital of St. John at Bruges,* Paris, 1939.

Guillaume-Linephty, Maur, *The Shrine of St. Ursula,* Paris, 1939.

Lambotte, Paul, *Memling: Der Meister des Schreins der heiligen Ursula,* Vienna, 1939.

Drost, Willi, *Das jüngste Gericht des Memling in der Marienkirche zu Danzig,* Vienna, 1941.

Baldass, Ludwig von, *Memling,* Vienna, 1942.

Dumont, G. H., *Memlinc, ou la fin du monde,* Paris, 1947.

Heise, Carl Georg, *Der Lübecker Passionsaltar von Memling,* Hamburg, 1950.

Lavalleye, Jacques, *Memling à l'Hôspital Saint-Jean* (Bruges), Brussels, 1953.

Johnson, Charles, *Memling,* London, 1955.

Molle, Frans van, *Identification d'un portrait de Gilles Joye attribué à Memlinc,* Brussels, 1960.

Hasse, Max, *Memlings Altarschrein,* Lübeck, 1967.

Faggin, Giorgio T., *L'opera complete di Memling,* Milan, 1969.

Eemans, Marc, *Memling,* Brussels, 1970.

McFarlane, K. B., *Memling,* edited by Edgar Wind, Oxford, 1971.

Lane, Barbara G., *Memling,* Frankfurt, 1980.

Hull, Vida Joyce, *Memlinc's Paintings for the Hospital of St. John in Bruges,* New York, 1981.

Lobelle-Caluwe, H., *Memlingmuseum Bruges: Saint John's Hospital,* Bruges, 1985.

article—

McNamee, M. B., "The Good Friday Liturgy and Memling's Antwerp Triptych," in *Journal of the Warburg and Courtauld Institutes* (London), 37, 1974.

*

In 1494, Rombout de Doppere, a notary in service to the Church of St. Donation in Bruges, noted in his diary that the painter Hans Memling, " . . . the most accomplished and excellent painter in the entire Christian World," had died. Since that time, Memling's reputation has risen and fallen in response to the fickle preferences of art lovers, and is now, at the end of the 20th century, finally being re-evaluated in the context of the painter's own cultural context. The exalted station held by Memling at his death in 1494 was revived in the 19th century, when his work was rediscovered and labeled the very summit of medieval art. Perhaps to the everlasting detriment of his reputation, Queen Victoria proclaimed Memling her favorite painter, a distinction she also bestowed on the composer Felix Mendelssohn in the realm of music. This dubious distinction was doubtless on Erwin Panofsky's mind when, in the next century, he compared Memling to Mendelssohn as one who "occasionally enchants, never offends and never overwhelms," an artist who, in distinctly Gilbert-and-Sullivanesque terms, was the very model of a "major minor master." Recently, James Snyder has described Memling properly as the "last glimpse and vision of an ideal Christian world, a Late Gothic dream." Memling's quiet, sweet, idyllic paintings reflect the last glimmer of the Golden Age of Burgundy—a way of life based upon pious medieval virtues and courtly chivalry.

The first mention of Hans Memling comes from the city of Bruges and is dated 30 January 1465. On this date, Memling applied for citizenship in order to establish a painter's workshop. According to civic law, he would have had to be at least 25 years old and have lived in Bruges less than a year and one day. After that time, citizenship would have automatically been bestowed. The documents describe Memling as German by birth, coming from the city of Seligenstadt, and some art historians have consequently suggested that the "cupie-doll" sweetness of the Cologne school of painting (epitomized by such works as Stephen Lochner's *Madonna in the Rose Garden,* c. 1440, Cologne) was an early influence that may have affected Memling's mature style. Numerous documents after 1465 attest to Memling's status within the community of Bruges painters. We know, for example, that he was one of the city's wealthiest citizens, owning three houses in the best section of town. In 1480 Memling was listed as one of 247 citizens who lent money to the city to help finance the Emperor Maximilian's war with France. Though his name appears several times in the records of the painter's guild of St. Luke, his own admission as a master is not recorded and he never seems to have held a guild office. Some have suggested that this omission points to a court appointment in the service of Duke Charles the Bold. However, the absence of any documented commissions from the Burgundian court tends to rule out this possibility. Though Memling's own record of admission is lost, he did register several apprentices with the guild, and he was listed on the guild's obituary records when he died a wealthy man in 1494. His many commissions included works done for the prosperous merchants and government officials of Bruges as well as Italian bankers (the Portinari family), English diplomats (Sir John Donne of Kidwelly) and the wealthy Hospital of St. John. Many of these paintings can still be seen in Bruges, where they have been brought together in the museum of the Hospital of St. John.

Memling's style draws heavily upon the inheritance of the founders of the Netherlandish tradition, namely Jan van Eyck

and Rogier van der Weyden. The debt to Rogier is especially strong, as evidenced most strikingly in the similarities between Memling's *Danzig Last Judgment* (Marienkirche, Danzig) and Rogier's *Beaune Last Judgment* (Musée de l'Hôtel Dieu, Beaune) and Memling's borrowing of Rogier's diptych portrait format (see Memling's *Nieuwenhove Diptych*, St. John's Hospital, Bruges), among others. This undisguised debt to the earlier master has caused many scholars to place Memling in the Brussels workshop of Rogier van der Weyden in the early 1460's. Some also see the hand of Memling in some of the late works of Rogier's shop (for example, the donor portrait in the *Columba Altarpiece*, Alte Pinakothek, Munich). Indeed, Memling's bid for Bruges citizenship occurred only six months after the death of Rogier van der Weyden, and could have marked a break from the Brussels workshop necessitated by the death of the master. Art historians have also noticed that Memling drew upon many of Rogier's compositions which were widely dispersed throughout Northern Europe and not easily available for study—some were even in private collections. It is therefore logical to suggest that the young Memling saw these models in a workshop setting before striking out on his own as an independent master. Since we have no record of Memling's whereabouts before 30 January 1465, the question of his early training and influences will always be a matter of debate; however, evidence strongly suggests that Memling was, as Vasari claims, Rogier's "disciple."

In sum, Memling's works should be appreciated as the summation of 15th-century Netherlandish currents in art. His paintings represent a harmonious melding of Eyckian motifs and Rogierian compositions enlivened by a sense of explicit narrative that would form part of the later Dutch artistic tradition (see, for example, the concise pictorial rendering of the events of the Apocalypse in the *Altarpiece of the Two St. Johns,* Hospital of St. John, Bruges). Memling's paintings display none of the *sturm und drang* preferred by 20th-century lovers of the *avant garde.* Instead, they document the wistful end of a lost age of courtly elegance and aristocratic wealth. Memling stands not at the beginning of a new tradition, but at the end of an old one, using the inherited artistic wealth of a century in the creation of highly finished, original works of art.

—Laurinda S. Dixon

MENGS, Anton Raphael.

Born in Aussig, Bohemia, 22 March 1728; son of the Danish painter Ismael Mengs. Died in Rome, 29 June 1779. Grew up in Dresden where his father was court painter; studied in Rome from 1741; he himself became court painter in Dresden for the Elector of Saxony, 1745; spent much time in Rome (in 1754 became director of the Vatican school of painting), and in Spain (worked for Charles III as court painter, and decorated royal palaces, 1761–71, 1773–77); worked in the Vatican, 1772–73; studied excavations at Herculaneum, and an early neo-classicist; also did portraits.

Collections: Amsterdam; Aranjuez: Royal Palace; Bassano;

Berlin; Bologna; Chicago; Cologne; Copenhagen; Dresden: Museum, Hofkirche; Hamburg; Karlsruhe; Leningrad; London: Victoria and Albert, Portrait Gallery, Wellington; Madrid: Prado, Royal Palace; Milan; Munich: Bavarian Museum; New York; Oxford: All Souls, Ashmolean; Paris; Rome: Arte Antica, S. Eusebio, Villa Albani; Vatican; Vienna; Washington: Corcoran.

Publications

By MENGS: books—

Gedanken über die Schönheit und den Geschmak in der Malerey, Zurich, 1762.
Hinterlassene Werke, edited by Christian F. Prange, Halle, 3 vols., 1786.
Opere, edited by Giuseppe Niccola d'Azara, Rome, 1787.
The Works, London, 2 vols., 1796.
Sämmtliche hinterlassene Schriften, edited by G. Schilling, Bonn, 2 vols., 1843–44.
Der schriftliche Nachlass, edited by U. Christoffel, Basel, 1918.
Briefe an Raimondo Ghelli und Anton Maron, edited by Herbert von Einem, Gottingen, 1973.

On MENGS: books—

Woermann, C., *Ismael und Anton Raphael Mengs,* Leipzig, 1893.
Sánchez Cantón, Francisco, *Mengs en Espana,* Madrid, 1927.
Gerstenberg, K., *Winckelmann und Mengs,* Halle, 1929.
Sánchez Cantón, Francisco, *Mengs* (cat), Madrid, 1929.
Geller, Hans, *Deutsche Künstler in Rom von Mengs bis Hans von Marées,* Rome, 1961.
Hanisch, Dieter, *Mengs und die Bildform des Frühklassizismus,* Recklinghausen, 1965.
Menegassi, Luigi, *Mengs,* Milan, 1966.
Pelzel, Thomas, *Mengs and Neoclassicism,* New York, 1979.
Mengs (cat), Madrid, 1980.
Martinelli, Rossa C., *La ragione dell'arte: Teoria e critica in Mengs e Winckelmann,* Naples, 1981.

articles—

Röttgen, Steffi, "Two Portraits by Mengs in the Art Institute of Chicago, in *Art Institute of Chicago Museum Studies,* 5, 1970.
Röttgen, Steffi, "Storia di un falso: *Il Ganimede* di Mengs," in *Arte Illustrata* (Turin), August 1973.
Pelzel, Thomas, "Mengs and His British Critics," in *Studies in Romanticism* (Boston), 15, 1976.
Agueda, Mercedes, "Precisiones sobre los dibujos de Mengs en la Biblioteca Nacional," in *Archivo Espanol de Arte* (Madrid), July-September 1986.

*

In most recent histories of art Anton Raphael Mengs has been assigned a rather ambivalent role. On the one hand, he is recognized as having achieved in his *Parnassus* ceiling in the

Memling: Drawing; London, British Museum

Villa Albani in Rome the first significant pictorial statement of the neo-classical movement, thus opening a path that would lead to Jacques-Louis David and the threshold of modern painting. On the other hand, due largely to the brittle academicism of that same painting, he has been denigrated as a painter of severely limited talents and eclectic taste.

Mengs's penchant for eclecticism is in part explained by his very name. He was born in 1728, the son of a portrait painter of minor distinction attached to the Dresden court. By his own account Mengs was christened Anton Raphael by his ambitious father as a public declaration that he was destined one day to rival both Antonio da Correggio and Raphael of Urbino. In order to fulfill this prophecy, young Mengs was trained to make endless free-hand copies after engravings of the old masters, particularly Raphael, thereby developing an exceptionally perceptive eye for the style of earlier artists and a rarely facile hand as a draftsman.

Mengs emerged to local prominence as a child prodigy, producing in the 1740's a series of fresh and charming pastel bust

portraits of various members of the Dresden court. Remarkable in their technical skill and grasp of the sitters' personalities, these portraits are too frequently ignored in favor of his later neo-classicizing works; they deserve a place along with those of Rosalba Carriera and Quentin de La Tour as fine examples of Rococo portraiture.

Mengs settled in Rome in 1752, where his style underwent a profound change under the stimulus of Raphael and classical antiquity and through his close friendship with the primary oracle of neo-classicism, Johann Joachim Winckelmann. With the completion of his *Parnassus* ceiling in 1761, Mengs's reputation as the foremost classicizing painter in Rome was firmly established. In the same year Mengs accepted an invitation to Madrid as court painter to Carlos III with perhaps the highest salary of any painter of his time: 7,000 Roman scudi plus house, coach, and stable. The fact that in Madrid Mengs did not further pursue the neo-classical style introduced in the *Parnassus* fresco was no doubt due to the dictates of a conservative court rather than to his own inclinations. (Mengs

never fully adapted to the cultural climate of Spain, which he declared to be hostile to the cultivation of good taste.) He was chiefly occupied with two large ceiling frescoes for the royal palace, an *Apotheosis of Hercules* (1762–70) and an *Apotheosis of Trajan* (1775–76). Probably in competition with Giambattista Tiepolo, who was then employed with other ceiling paintings in the same palace, Mengs reverted to the opulent color and illusionistic devices of the Baroque tradition. Once removed from Rome, it would seem that the influence of Correggio, the other painter after whom Mengs had been named, had supplanted that of Raphael. In Madrid Mengs had ample opportunity to develop his native talents as a portraitist in a series of imposing oil canvases of members of the royal family. The Prado canvases of Carlos III and Maria Luisa of Parma, in their opalescent color and scintillating brushwork, for example, invite a reappraisal of Mengs's reputation as a cold and unpainterly master. In the history of Spanish painting they served to perpetuate the tradition of Velázquez into the age of Goya.

Pleading ill health, Mengs returned to Rome in 1777, where he lived in a palatial house, dispensing drawing lessons and critical evaluations to an international roster of young painters eager to emulate his success. Following his death in 1779 he was granted funeral solemnities worthy of a pope and assigned a cenotaph in the Pantheon (since removed) close to the tomb of Raphael himself.

Mengs was even more celebrated among *cognoscenti* of the late 18th century as an aesthetician and historian of art than as a painter. Relatively few had seen his paintings, while his collected writings on art, published in Italian in 1780, and soon thereafter in various editions in Spanish, French, German, and English, were known throughout Europe. His concepts of connoisseurship and the history of art were heavily influenced by his association with Winckelmann. The influence was in fact reciprocal, with Mengs's knowledge of the creative process of the artist complementing the literary and historical erudition of Winckelmann.

His treatises are a curious mixture of derivative art theory leavened with occasional flashes or originality. He was the first to have advanced the opinion that many of the most admired antique statues (such as the various Niobid groups), then thought to be Greek originals, were in fact later Roman copies. His formal analysis of shapes and rhythms in a painting, independent of the subject matter they depict, curiously foreshadows the advent of modern abstract art, though Mengs would no doubt have been horrified at the idea.

For the most art, however, his theory was conventional and retardataire. His most important treatise, *Thoughts on Beauty and Taste in Painting*, was first published in German in 1762, and thereafter included in all editions of his collected works. Mengs here reiterates a basic precept of traditional Italian theory, arguing that the greatest artists have never been content with a slavish imitation of nature, but rather have attempted the creation of a more perfect world conceived in the imagination. Mengs suggests that the best route to the development of proper taste is through the emulation of earlier masters in whose work the difficult distillation of the ideal from the natural has been demonstrated.

While agreeing with Winckelmann that the foremost examples of the triumph of art over nature are embodied in Greek art, Mengs is rather more catholic in his own standards, admitting to almost equal honor a few masters from modern times, especially Raphael and Correggio. Mengs's eclectic bent is expressed in one of the most familiar passages in his *Thoughts on Beauty* in which he compares the painter to the honey-bee, which produces the sweetest honey by visiting a variety of flowers.

In another treatise on the practical instruction of young painters, Mengs proposes a discipline similar to his own as a youth. The hand of the fledgling artist would first be trained through copying engravings after the best masters. He may then progress to originals or casts of classical statues and only then, his taste firmly formed, should he be allowed to draw directly from nature. The end result of such training should be a style of universal purity, purged of any distinctive personal expression.

Despite his fame as a painter and a teacher, Mengs left no direct followers of significance, yet he exerted a profound influence upon the following generation. This was especially so in the Germanic north, where he was honored as the first German painter since Dürer to attain international recognition. In many of the northern academies founded in the late 18th century, the precepts of Mengs provided the basic curriculum. His influence was ultimately more negative than positive, however; the young artists of the *Sturm und Drang*, intent upon expressing their artistic individuality, soon bolted at Mengs's advocacy of an impersonal, universal style. This generation found their golden *Zeitalter* in the Middle Ages rather than in ancient Greece or Renaissance Rome. The prevailing attitude by the dawning 19th century was that Mengs, along with Winckelmann, had done more to inhibit than to encourage a creative evolution of art.

A similar attitude still dominates most modern criticism of Mengs. This is largely due to the almost exclusive stress upon the *Parnassus* ceiling which, for all its historical importance in the development of 18th-century neo-classicism, has tended to reduce Mengs to a stereotype. As his late works in Madrid prove, Mengs was in fact an artist of considerable dimension and facility, able as a painter to transcend those limitations as a theorist which have so beclouded his reputation.

—Thomas Pelzel

MENZEL, Adolph (Friedrich Erdmann) von.

Born in Breslau, 8 December 1815. Died in Berlin, 9 February 1905. Apprenticed in his father's lithographic business in Berlin, 1830–32, and support of the family after death of father, 1832; studied briefly at Berlin Academy, 1833, book illustrator from 1833, and painter from 1836; member of the Academy of Arts, 1853, and Royal Prussian Professorship from 1856. Order of the Black Eagle (i.e., ennobled), 1898.

Major Collections: Berlin; Hamburg.
Other Collections: Berlin (East); Cologne; Dusseldorf; Hanover; London; Mannheim London: Tate, Mannheim; Munich: Neue Pinakothek; Vienna: Neue Galerie.

Room with a Balcony, 1845; 22$\frac{3}{4}$ × 18$\frac{1}{2}$ in (58 × 47 cm) Berlin-Dahlem, Staatliche Museen

Publications

By MENZEL: book—

Briefe, edited by Hans Wolff, Berlin, 1914.

On MENZEL: books—

Biberfeld, Arthur, *Menzel: Architekturen,* Berlin, 4 vols., 1906.
Knackfuss, Hermann, *Menzel,* Bielefeld, 1906.

Meier-Graefe, Julius, *Der junge Menzel*, Leipzig, 1906, 1914.

Scheffler, Karl, *Menzel: Der Mensch, das Werk*, Berlin, 1915, edited by Carl Georg Heise, Munich, 1955.

Wolff, Hans, *Zeichnungen von Menzel*, Dresden, 1920.

Kurth, Willy, *Menzels graphische Kunst*, Dresden, 1920.

Liebermann, M., *Menzel: 50 Zeichnungen, Pastelle, und Aquarelle aus dem Besitz der Nationalgalerie*, Berlin, 1921.

Becker, Robert, *Menzel und seine schlesische Verwandtschaft*, Strasbourg, 1922.

Bock, Elfried, *Menzel: Verzeichnis seines graphischen Werkes*, Berlin, 1923.

Waldmann, Emil, *Der Maler Menzel*, Vienna, 1941.

Tanner, Friedrich, *Menzel und der Harz*, Braunschweig, 1949.

Kaiser, Konrad, *Menzels Eisenwalzwerk*, Berlin, 1953.

Schmidt, Werner, *Menzel* (cat), Berlin, 1955.

Kaiser, Konrad, *Menzel*, Berlin, 1956.

Weinhold, Renate, *Menzel-Bibliographie*, Leipzig, 1959.

Menzel: Handzeichnungen (cat), Bremen, 1963.

Longstreet, Stephen, *The Drawings of Menzel*, Los Angeles, 1964.

Vossberg, Herbert, *Kirchliche Motive bei Menzel*, Berlin, 1964.

Hütt, Wolfgang, *Menzel*, Vienna, 1965.

Wirth, Irmgard, *Mit Menzel in Berlin*, Munich, 1965.

Kaiser, Konrad, *Menzel der Maler*, Stuttgart, 1965.

Wirth, Irmgard, *Mit Menzel in Bayern und Osterreich*, Munich, 1974.

Kaiser, Konrad, *Menzel*, Munich and New York, 1975.

With, Christopher Becker, *Menzel: A Study in the Relationship Between Art and Politics in Nineteenth Century Germany*, Los Angeles, 1975.

Ebertshäuser, Heidi, *Menzel: Die graphische Werk*, Munich, 2 vols., 1976.

Trost, Edith, *Menzel*, Berlin, 1980.

Feist, Peter H., et al., *Menzel* (cat), Berlin, 1980.

Hütt, Wolfgang, *Menzel*, Leipzig, 1981.

Jensen, Jens Christian, *Menzel* (cat), Kiel, 1981.

Hofmann, Werner, *Menzel, der Beobachter* (cat), Munich, 1982.

Jensen, Jens Christian, *Menzel*, Cologne, 1982.

Grisebach, Lucius, *Menzel* (cat), Berlin, 1982; as *Prints and Drawings by Menzel*, Cambridge, 1984.

Prints and Drawings by Menzel: A Selection from the Collections of the Museums of West Berlin, Berlin, 1984.

articles—

Forster-Hahn, Françoise, "Menzel's 'Daguerreotypical' Image of Frederick the Great: A Liberal Bourgeois Interpretation of German History," in *Art Bulletin* (New York), 59, 1977.

Forster-Hahn, Françoise, "Authenticity into Ambivalence: The Evolution of Menzel's Drawings," in *Master Drawings* (New York), 16, 1978.

*

Apart from a brief period at the Berlin Academy in 1833, Menzel was self-taught. He had acquired technical expertise in lithography, then a comparatively new technique, in his father's printing business; and he was well aware of the potential effectiveness of pen-and-ink drawing in reproduction, yet another novel technique. This interest in new media remained with him all his life. His first works were a series of pen-and-ink sketches called *The Pilgrimage of an Artist* which he followed by lithographed scenes from the history of Brandenburg. He was next called upon to illustrate Kugler's *History of Frederick the Great* and a deluxe edition of that monarch's works. He had now found what seemed to be his ideal subject matter, much to the taste of the German public already in the throes of nationalism which was to lead to the country's unification under Bismarck and the domination of Prussia in 1870. In 1836 his *Chess-Players* showed he had gained a command of oil-paint; and from his brush there came a series of pictures depicting episodes from the life of Frederick the Great.

In this quest of historicism Menzel was by no means alone, since all over Europe there reigned the cult of the historical picture-it was not history painting as the 18th century had conceived it but the depiction of genre scenes with the characters in fancy dress, vaguely appropriate to the period but adapted to mid-19th-century taste. Menzel saw Sans-Souci as a pleasure drome of concerts, balls and elegant suppers—a happier, more humane rival of Versailles. As late as 1878 he still painting his hero in *Frederick the Great at the Coffin of the Great Elector*. But if Frederick's character fascinated him, corresponding, perhaps, to some emotional need of his own, it did not necessarily draw forth the highest element of his talent—too often the compositions are overfull, the drawing is restless, and the painting itself fussy. But single-handed Menzel had taken German art away from the cold religiosity of the Nazarenes and from the neo-classicism which had hitherto prevailed.

Throughout his life Menzel claimed that the highest form of art was that of history painting; and most of his professional life was dedicated to a glorification of the Prussian monarchy past and present. But this is not the whole story. He began his career with illustrations to a poem by Goethe and historical sketches of Frederick the Great by Kugler, an obvious dichotomy of interests. However, his own incredible draughtsmanship and the ingenuity of his wood-engravers combined to create a kind of illustration which was unique in that it more nearly approached painting—history painting, in fact—than anything produced before him. At the same time, he was investigating a painterly naturalism that might superficially be taken to be photographic in its random selection of viewpoint and which was decidedly far from grandiose or historical in its choice of subject matter. A work such as *The Artist's Sister with Candle* (1847; Munich, Bavarian State Collection) is miles apart from his *Coronation of King William at Königsberg* not only in theme but also in technique. The quiet intimacy of the former surely represents an absolute rejection of the neo-classical, pretentiously elevated, or romantic (as typified by Géricault, Delacroix, or Turner). In *Room with a Balcony* (1845; Berlin) carried out with fluent brushstrokes, the breeze blowing through an open window disturbs the light curtains of a bedroom—there is nothing more. But who before him had so successfully captured the spirit of place, the emptiness, the strangeness of the room devoid of human presence? *The Artist's Sister with Candle*, also painted in broad strokes, shows his mastery of artificial light: ostensibly a tranquil, lamplit domestic interior it hints, as does *Room with a Balcony*, at an emotion once experienced and which haunts us still

but to which we cannot put a name. The inconsequential, the fleeting, and the insignificant are recorded as never before. *Memories of the Théâtre Gymnase* (1856; Berlin) further displays his mastery of artificial light and captures the essence of the theatrical moment as his admirer Degas was to do some 16 years later in *Ballet from "Robert le Diable."* An extra dimension in Menzel's art is revealed by his *Garden of Prince Albrecht's Palace in Berlin* (1846; East Berlin) in which his study of diverse styles of landscape painting ranging from Poussin to Karl Blechen, J. C. Clausen Dahl, and even Constable are blended together to produce an impression of carefree spontaneity. The unpretentiousness as well as the directness of these paintings surprises us no less than they did Menzel's contemporaries when they were first shown late in his career, by which time he had moved on to more public commentary and a style which occasionally lapsed into meretriciousness despite the commanding vigour of the composition and the exactitude of the preliminary studies.

Menzel's *Coronation of King William at Königsberg* (1861–65; Berlin) marked his move into observation of the contemporary world—his fine *Cortege of the Victims of the March Revolution* (1848; Hamburg) remained unfinished. A visit to Paris brought him face to face with the colourful realism of French art and, in particular, with the growth of open-air painting. *Sunday in the Tuileries Garden* (1867), *Street Scene in Paris* and *Old Elephant in the Jardin des Plantes* (both 1869) reveal his fascination with the gaiety and elegance of life in the French capital and a newly acquired skill in using large groups of people and perspectives. Menzel heightened his palette and adopted a brisker, less finished manner which anticipated the impressionism of the next decade. It is also true that his work was appreciated in Paris: in particular, Degas had a life-long admiration of his draughtsmanship. In mid-life Menzel radically changed his style, bringing colour and freshness to German painting. He began to work in water colour and gouache with the mastery to which his admirers had become accustomed, while his draughtsmanship showed a direct forcefulness that made most other artists of the day look merely inept. Equally important, Menzel had begun to paint the world around him in Berlin—not that of a latter-day Sans-Souci but a powerful, ruthless modern state in which, for instance, *Supper at a Ball* (1878) represents the frivolous frontage for a heartless industrial social structure.

Despite his tremendous reputation and wide-spread influence and his sending works to exhibitions as far afield as the Chicago Great Exhibition, Menzel remains comparatively unknown outside continental Europe. A man of substantial culture—he adored the rococo and baroque towns of Germany and went regularly to Wagner performances at Bayreuth—he moved increasingly into the contemporary world, a hectic world that was different from but similar to that of the French Impressionists but observed with greater depth of understanding.

—Alan Bird

METSU, Gabriel.

Born in Leiden, January 1629; son of the painter Jacob Metsu. Buried in Amsterdam, 24 October 1667. Married Isabella de Wolff, 1658. Mentioned as a pupil of Gerard Dou, but also influenced by Jan Steen; among the first members of the Leiden painters guild, 1648, and active in Leiden until 1657; settled in Amsterdam, 1657: painted both historical/allegorical and domestic pictures.

Major Collections: Amsterdam; Leningrad; London.
Other Collections: Aix en Provence; Berlin; The Hague; Karlsruhe; Kassel; Leiden; London: Wallace; Madrid; Montpellier; New York; Paris; Rome; Rotterd Rome: Capitolina; Rotterdam; Stockholm; Venice; Vienna; Waddesdon; Washington; Royal Collection.

Publications

On METSU: books—

The Masterpieces of Metsu, London, 1912.
Wessem, J. N. van, and Lucia Thyssen, *Metsu* (cat), Leiden, 1966.
Robinson, Franklin, W., *Metsu: A Study of His Place in Dutch Genre Painting of the Golden Age,* New York, 1974.

articles—

Regteren Altena, J. Q. van, "Metsu as a Draughtsman," in *Master Drawings* (New York), 1, 1963.
Schneede, Uwe M., "Metsu und der holländische Realismus," in *Oud Holland* (The Hague), 83, 1966.
Smith, David R., "Irony and Civility: Notes on the Convergence of Genre and Portraiture in Seventeenth-Century Dutch Painting," in *Art Bulletin* (New York), September 1987.

*

Gabriel Metsu was one of the liveliest Dutch genre painters working in the second half of the 17th century. He was an eclectic artist. His special contribution lay in synthesising the ideas and methods of others, and combining that synthesis with a gifted technique and a serious interest in compositional problems. His ability to animate quite mainstream subject matter gives his work a characteristic vitality that elevates his eclecticism above that of a merely derivative artist.

Metsu's main themes were established early. During his Leiden years, tavern and brothel scenes, blacksmiths' shops, and domestic scenes focussing on women predominate, the latter often emphasizing a contrast between youth and age. In the late 1650's these themes metamorphosed with changing fashion. Taverns, brothels, and humble homes are displaced by wealthy, bourgeois interiors, their inhabitants engaged in the epistolary activities, musical gatherings, and amorous encounters made popular by Gerard ter Borch.

Metsu also painted about a dozen religious scenes, spread throughout his career. The finest is a *Crucifixion* from the 1660's (Rome, Museo di Roma). The attitude to women that informs his genre scenes also pervades these religious subjects: that of the suffering, virtuous woman, assaulted—even punished—by men. Thus, he chooses subjects such as *Christ*

Music Company; 23 × 17⅜ in (58.5 × 44 cm); The Hague, Mauritshuis

and the Adulterous Woman (1653, Paris) or *Hagar Dismissed by the Angel* (formerly art market, London). These pieces show strong dependence on Rembrandt—as do some of Metsu's female facial types—who was also a native of Leiden.

Metsu's Leiden training and background predisposed him to enduring influence from his probable teacher, Gerrit Dou. He was particularly affected by Dou's approach to structure and his emphasis on technique. Dou's tiny scale and tight control are loosened by Metsu, however. Indeed, his work achieves a vigor and breadth that bears witness to early contact with Jan Steen, who entered the Leiden guild with Metsu in 1648, and whose vivacious prolificacy left few genre painters unaware and unmoved. In his work of the 1650's, too, Metsu responds as much to the influence of Dou's gifted pupil Frans van Mieris as to Dou himself.

For a painter working in Metsu's area of subject matter, the influence of ter Borch was irresistible. Indeed, Metsu's whole development occurs out of the effort to synthesize these two coexisting strands of art: the Leiden school and the fashionable Amsterdam painters. To some extent his career represents a common struggle among painters trained in the provinces, to reconcile their ability and training with the demands of the Amsterdam market. Metsu was arguably more successful in this than, say, Pieter de Hooch. Yet it was through the work of de Hooch, who moved to Amsterdam in 1658 from Delft, that Metsu resolved his own fine sense of spatial clarity. Metsu's struggle was not simply that of a provincial background wrestling with metropolitan demands. It was the struggle of an eclectic to reconcile *all* desirable influences into a mode that was itself distinctive. In this he was successful, whereas Pieter de Hooch's already distinctive manner became abraded after his move to the capital.

For anecdote and composition, the work of ter Borch and of Nicholas Maes was of paramount importance to Metsu. Maes's time in Rembrandt's studio left his pallette more sombre, his use of highlights more robust that the Leiden artists to whose subject matter his relates. Metsu's paintings of fish-sellers, milk-sellers, and old women show a clear relationship to the ideas of Maes, as does his use of thick, bright whites as a descriptive contrast to browns and reds. Similarly, ter Borch's handling of textiles is technically sympathetic to the Leiden *fijnschilders*, but his subject matter has an ambiguity and breadth that transcends their domesticity.

It is in technique that Metsu's originality lies. He solves problems through execution rather than conception. He could boast an enviable command of contrast within a picture. He would employ a meticulous brushstroke for still-life details, such as the gleaming pail. In *Vegetable Market at Amsterdam* (Paris) the vegetables in *The Fish Seller* (London, Wallace), or the silver writing set and ceiling lamp in *A Musical Company* (c. 1666, The Hague). Yet he could change with ease to a lively, enervating brushstroke for figures and textiles. He became adept at juxtaposing unlike textures, as in *Oyster Eaters* (1650's, Leningrad), where satin is surrounded by the density of velvet and fur, the opaque skin of a hand with the slippery surface of oysters.

His use of colour became highly accomplished. Like de Hooch and ter Borch he would juxtapose pure, unmixed hues. These he countered with a background of soft neutrals, highlighted with strong, thick whites which he sometimes modelled with the butt of the brush.

He particularly favoured a juxtaposition of light, clear green with red. He could load his brush with colour, and still succeed in suggesting lightness, as in his rendering of women's clothing. This hallmark of his remarkable technique depended on the use of daylight for its success, however, Later attempts to defer to the artificial lighting that ter Borch manipulated so well disabled Metsu's compositions. The two pendants in the Beit Collection from the 1660's, of a man writing and a woman reading a letter, signal his wise return to the daylit mode he knew best.

Metsu was also an excellent draughtsman. His compositions emphasize the figures, and for each he made careful, finished studies. Even Metsu's early work displays this emphasis, with areas such as knees and stomach carefully observed. In this he differs from ter Borch and de Hooch, for whom context and spatial organisation respectively were more important.

Yet Metsu, too, needs structure. What contains and animates his figures, endowing them with character and conviction, is not the rigid, external, architectural devices of Dou, but the structure of anecdote itself. Metsu's shrewd awareness of his limitations saved him from ever attempting to do without it.

Like Pieter de Hooch, Metsu's late work declined in quality, succombing to a certain stiffness and a marked loss of technique. This was possibly a result of illness, as it is more or less confined to the last year of his life.

His great contribution lay in his ability to manipulate trends in both narrative and technique. Through slow and careful application to synthetic problems, he achieved the animation and vigour that resulted from an open-minded eclecticism that strove continually to be creative.

—Lindsay Bridget Shaw

MICHELANGELO.

Born Michelangelo Buonarroti in Caprese, 6 March 1475. Died in Rome, 18 February 1564. Apprenticed to Ghirlandaio in Florence at age 13, and familiar with the Medici garden sculpture; also studied anatomy; patronized in Florence by the Medici (worked briefly in Bologna, c. 1495); in Rome, 1496–1501: patronized by Jacopo Galli and Cardinal Jean de Villiers de la Grolaie; then in Florence: completed his David, 1504; again in Rome, 1505: worked for Pope Julius II in the Sistine Chapel and on his tomb; in Florence, 1522–34: worked on Medici monuments and library; then in Rome from 1534: worked for Leo X, Clement VII, and Paul III; also architect, writer of verse. Pupils: Sebastiano del Piombo, Ascanio Condivi.

Collections: Bologna: S. Domenico; Bruges: Notre Dame; Florence: Casa Buonarroti, Uffizi, Bargello, Accademia, S. Lorenzo, Cathedral Museum; London: National Gallery, Royal Academy; British Museum; Milan: Castello; New York; Oxford; Paris; Rome: S. Pietro in Vincoli; Vatican; Royal Collection.

Publications

By MICHELANGELO: books—

Rime, edited by E. N. Girardi, Bari, 1960.

Sonnets, translated by Elizabeth Jennings, London, 1961.

Complete Poems and Selected Letters, edited by Creighton Gilbert and R. N. Linscott, New York, 1963.

Letters, edited by E. H. Ramsden, Stanford, California, and London, 2 vols., 1963.

Il carteggio di Michelangelo, edited by Giovanni Poggi, then revised by Paolo Barocchi and Renzo Ristori, Florence, 4 vols., 1965–69.

On MICHELANGELO: books—

Steinmann, Ernst, *Die Sixtinische Kapelle,* Munich, 3 vols., 1901–06.

Frey, Carl, *Michelangelos Jugendjahre,* Berlin, 1907.

Frey, Carl, *Die Handzeichnungen Michelangelos,* edited by Fritz Knapp, Berlin, 3 vols., 1909–11.

Brockhaus, Heinrich, *Michelangelo und die Medici-Kapelle,* Leipzig, 1911.

Frey, Dagobert, *Michelangelo-Studien,* Vienna, 1920.

Panofsky, Erwin, *Die Sixtinische Decke,* Leipzig, 1921.

Steinmann, Ernst, and Rudolf Wittkower, *Michelangelo Bibliographie 1510–1926,* Leipzig, 1927; supplement by Luitpold Dussler, Wiesbaden, 1974.

Delacre, Maurice, *Le Dessin de Michel-Ange,* Brussels, 1938.

Delogu, Giuseppe, *Michelangelo: Plastik, Gemälde, und Handzeichnungen,* Zurich, 1939.

Goldscheider, Ludwig, *The Sculptures of Michelangelo,* London, 1940.

Tolnay, Charles De, *Michelangelo,* Princeton, 5 vols., 1943–60; 1-vol. edition, 1975.

Tolnay, Charles de, *The Sistine Chapel,* Princeton, 1945.

Schiavo, Armando, *Michelangelo architetto,* Rome, 1949; as *La vita e le opera architettoniche,* Rome, 1953.

Goldscheider, Ludwig, *The Drawings of Michelangelo,* New York and London, 1951, 1966.

Goldscheider, Ludwig, *Michelangelo: Paintings, Sculpture, Architecture,* London and New York, 1953.

Russoli, F., *Tutta la scultura di Michelangelo,* Milan, 1953, 1962.

Wilde, Johannes, *Michelangelo's "Victory,"* London, 1954.

Goldscheider, Ludwig, *Michelangelo's Bozzetti,* London, 1957.

Dussler, Luitpold, *Die Zeichnungen des Michelangelo: Kritischer Katalog,* Berlin, 1959.

Einem, Herbert von, *Michelangelo,* Stuttgart, 1959, London, 1973.

John, R., *Dante und Michelangelo: Das Paradiso terrestre und die Sixtinische Decke,* Krefeld, 1959.

Clements, Robert John, *Michelangelo's Theory of Art,* New York, 1961.

Ackerman, James S., *The Architecture of Michelangelo,* New York, 2 vols., 1961, 1966.

Goldscheider, Ludwig, *A Survey of Michelangelo's Models in Wax and Clay,* London, 1962.

Barocchi, Paolo, *Michelangelo e la sua scuola,* Florence, 2 vols., 1962.

Vasari, Giorgio, *La vita di Michelangelo nelle redazioni del 1550 e del 1568,* edited by Paola Barocchi, Milan, 5 vols., 1962.

Clements, Robert John, editor, *Michelangelo: A Self-Portrait,* Englewood Cliffs, New Jersey, 1963.

Mariano, Valerio, *Michelangelo,* Milan, 1964.

Tolnay, Charles de, *The Art and Thought of Michelangelo,* New York, 1964.

Zevi, Bruno, *Michelangelo architetto,* Turin, 1964.

Ettlinger, L. D., *The Sistine Chapel Before Michelangelo,* Oxford, 1965.

Hartt, Frederick, *Michelangelo: Paintings,* New York, 1965.

Salmi, Mario, editor, *Michelangelo: Artista, pensatore, scrittore,* Novara, 1965.

Salmi, Mario, et al., *The Complete Works of Michelangelo,* New York, 1965.

Salvini, Roberto, *La Capella Sistina in Vaticano,* Rome, 1965; as *The Sistine Ceiling,* New York, 1971.

Berti, L., *Michelangelo: Le tombi Medici,* Florence, 1966.

Camesasca, Ettore, *L'opera completa di Michelangelo,* Milan, 1966; as *The Complete Paintings of Michelangelo,* New York and London, 1969.

Gould, Cecil, *Michelangelo: Battle of Cascina,* Newcastle upon Tyne, 1966.

Keller, H., *Michelangelo,* Konigstein, 2 vols., 1966.

Procacci. U., *La Casa Buonarroti a Firenze,* Milan, 1967.

Seymour, Charles, Jr., *Michelangelo's David: A Search for Identity,* Pittsburgh, 1967.

Weinberger, Martin, *Michelangelo the Sculptor,* New York and London, 2 vols., 1967.

Alker, Hermann R., *Michelangelo und seine Kuppel von St. Peter in Rom,* Karlsruhe, 1968.

Parronchi, Alessandro, *Opere giovanili di Michelangelo,* Florence 3 vols., 1968–81.

Hartt, Frederick, *The Complete Sculpture of Michelangelo,* New York, 1969.

Parronchi, Alessandro, *Michelangelo scultore,* Florence, 1969.

Bardeschi Ciulich, Lucilla, and Paolo Barocchi, editors, *I ricordi di Michelangelo,* Florence, 1970.

Gould, Cecil, and Michael Levey, *Michelangelo's "Entombment of Christ": Some New Hypotheses and Some New Facts,* London, 1970.

Hartt, Frederick, *The Drawings of Michelangelo,* New York, 1971.

Mancusi-Ungaro, H. R., Jr., *Michelangelo: The Bruges Madonna and the Piccolomini Altar,* New Haven, 1972.

Seymour, Charles, Jr., *Michelangelo: The Sistine Chapel Ceiling,* New York, 1972.

Hibbard, Howard, *Michelangelo,* New York, 1974, London, 1979.

Beck, James, *Michelangelo: A Lesson in Anatomy,* New York, 1975.

Condivi, Ascanio, *Vita di Michelangelo,* translated as *The Life of Michelangelo,* edited by Hellmut Wohl, Baton Rouge, Louisiana, and Oxford, 1975.

Gere, J. A., *Drawings by Michelangelo* (cat), London, 1975.

Steinberg, Leo, *Michelangelo's Last Paintings,* New York and London, 1975.

Tolnay, Charles de, *Corpus dei disegni di Michelangelo,* edited by Mario Salmi, Novara, 4 vols., 1975–80.

Hupka, P., *Michelangelo: Pieta*, New York, 1975.

Hartt, Frederick, *Michelangelo's Three Pietas*, New York and London, 1976.

Perrig, Alexander, *Michelangelo Studien*, Frankfurt, 4 vols., 1976–77.

Dal Poggetto, Paolo, *I disegni murali di Michelangelo e della sua scuola nella Sagrestia Nuova di San Lorenzo*, Florence, 1978.

Heusinger, Lutz, *Michelangelo: Life and Works in Chronological Order*, London, 1978.

Maio, Romeo de, *Michelangelo e la controriforma*, Rome, 1978.

Salvini, Roberto, *The Hidden Michelangelo*, Oxford, 1978.

Wilde, Johannes, *Michelangelo: Six Lectures*, Oxford, 1978.

Murray, Linda, *Michelangelo*, New York and London, 1980.

Baldini, Umerto, *Michelangelo scultore*, Florence, 1981; as *The Complete Sculpture of Michelangelo*, London, 1982.

Summers, David, *Michelangelo and the Language of Art*, Princeton, 1981.

Guidoni, Enrico, *Il Mosè de Michelangelo*, Rome, 1982.

Liebert, Robert S., *Michelangelo: A Psychoanalytic Study of His Life and Images*, New Haven, 1983.

Giacometti, Massimo, editor, *The Sistine Chapel: Michelangelo Rediscovered*, London, 1986.

Hartt, Frederick, *David—by the Hand of Michelangelo: The Original Model Discovered?*, London, 1987.

Burban, Michael, *Lessons from Michelangelo*, New York, 1987.

Hirst, Michael, *Michelangelo and His Drawings*, New Haven, 1988.

*

Michelangelo is the greatest sculptor and the greatest draughtsman in history. He is also pre-eminent as a painter and architect. His views on the history of painting and sculpture are extant in the form of an answer to a questionnaire sent out by the humanist Benedetto Varchi, in which Michelangelo said that in his view painting was good to the extent that it resembled relief (that is, sculpture) and sculpture bad to the extent that it resembled painting. He always referred to himself simply as sculptor, and in later life minimized his training as painter, though we know that as a boy of 13 he was apprenticed for a time to the painter Domenico Ghirlandaio in Florence. Later he studied sculpture under the guidance of Bertoldo who had been a pupil of Donatello. His work as a practical architect was a relatively late development, but he had already shown a preference for architectural backgrounds of his own devising to show off his figures, whether in sculpture (the tomb of Pope Julius) or painting (the Sistine ceiling).

In sculpture and painting alike Michelangelo's favorite subject was the male nude. His females are unfeminine. His painting was almost exclusively in fresco: only one surviving portable picture is documented (the *Holy Family* in the Uffizi, Florence), and despite its brilliance of draughtsmanship and invention its technique is traditional. But his method of carving was revolutionary. He said in one of his sonnets that is was possible to imagine any figure in any pose as already existing in any block of marble. The sculptor merely had to release it. Thus, instead of blocking out the marble all round and then gradually getting down to the final surface—as most marble

and stone sculptors have always done—he started by chipping away a small area down to almost the final surface. His method is best understood by imagining a statue lying in a box filled with water. As the water is drained away from the base the most elevated portions of the statue will emerge above the horizontal surface of the water like mountains from the sea. Sculptures which Michelangelo left unfinished, such as the St. Matthew and four Slaves (all in the Accademia, Florence) illustrate this method and his theory of releasing the figures from the block.

In architecture also Michelangelo's approach was revolutionary. He took the view that Renaissance architects were following the precepts of the Roman writer, Vitruvius, too slavishly. His own architecture consciously breaks Vitruvius's rules, whether by using a colossal order of pillars to span several superimposed rows of windows, or by letting the pediments of the windows invade the capital zone, or by altering the proportions.

Most of Michelangelo's career can be seen as a form of bondage to the changing whims of successive Popes. His early sculptures of Bacchus (Florence, Bargello) or the *Pietà* (St. Peter's, Rome) had already earned him a certain reputation. But it was the unveiling of the colossal marble David in Florence in 1504 which made him the most famous artist in Italy at the age of 29, and thus to his services being monopolised by the Pope of the day. The David was was primarily a technical triumph. No other sculptor had dared to tackle the huge, abandoned block of marble without adding pieces to it. With his ideas on releasing a figure already hypothetically imprisoned in the block Michelangelo said he could do it without adding—and did. The fame of the David led to his being commissioned to paint a huge battle piece for the great hall of the Palazzo Vecchio as pendant to Leonardo's *Battle of Anghiari*, and also to carve twelve apostles for the cathedral. But he was able to complete only the preliminary cartoon for the *Battle of Cascina* (now destroyed) and half of one apostle (St. Matthew, Florence, Accademia) when he was summoned to Rome by Pope Julius II in 1505. Julius was planning a gigantic tomb for himself and proposing to rebuild St. Peter's in order to set it off. But soon after Michelangelo started work the Pope changed his mind. Michelangelo thereupon rushed back to Florence and sent defiant messages to Julius. After a reconciliation Julius set him to work to model a gigantic statue of the Pope himself, to be cast in bronze and set up a Bologna which he had recently conquered at the head of the papal army. Soon after it was installed the Bolognese rulers returned and threw down Michelangelo's statue for political reasons. Then, back in Rome, instead of continuing with Julius's tomb, he was diverted in 1508 to painting the ceiling of the Sistine chapel. The charge which he made later in life that this was a plot of Bramante's in the hope that he, Michelangelo, would be unequal to the task was an example of the persecution complex which Michelangelo suffered by that time. In reality Bramante had tried to prevent the commission on the ground that Michelangelo was primarily a sculptor. Though he did experience difficulty of a practical kind in the early stages of the undertaking, he soon overcame it and in the event produced what was probably his greatest triumph. In its combination of figures and painted architecture the ceiling can be seen as an adaptation of his project for the tomb of Julius. The sensational cleaning of the frescoes in the 1980's has been a revela-

Ideal Head; drawing

tion. It is clear that in the later stages Michelangelo worked directly on the plaster without the use of cartoons and that he evolved a new technique, a kind of short-hand designed to allow for the paintings to be seen from a distance. With characteristic impatience Julius had insisted on a public showing of the work in 1511 when it was only partly finished. It was finally finished at the end of October 1512.

After the death of Pope Julius in 1513 his successor, the Medici Pope, Leo X, preferred Raphael to Michelangelo as the chief papal artist. This enabled Michelangelo to continue work on Julius's tomb. The Moses, which is actually on the much reduced tomb in S. Pietro in Vinculis in Rome, and two of the Slaves intended for the tomb but now in the Louvre, probably date from this time. During these years Michelangelo was also coaching the young venetian painter Sabastiano del Piombo as rival to Raphael. He gave Sebastiano drawings for some of the figures in three of his paintings, the *Pietà* (Viterbe), the *Flagellation* (Rome, S. Pietro in Montorio) and *Raising of Lazarus* (London). The last was executed in direct rivalry with Raphael, whose contribution, the *Transfiguration,* was still not quite finished at the time of his death in 1520.

Probably in 1515 Pope Leo commissioned Michelangelo, as a result of a competition, to design a facade for the Medici church at Florence, S. Lorenzo. Michelangelo's plans were never executed (S. Lorenzo still lacks a facade to this day) but as with the tomb of Pope Julius and the Sistine ceiling Michelangelo seems to have adapted something of his plan to the next undertaking, namely a mausoleum for the Medici family, to be built at the same church of S. Lorenzo. The general lines of the interior were intended to match those of Brunelleschi's sacristy on the other side of the church. But inside the main structural arches Michelangelo constructed sham architecture, intended, as in his plan for the facade, to show off his sculptures to the best advantage.

Though the result is his greatest composite work in sculpture it remains unfinished. Michelangelo's activity in fortifying the city of Florence against the Medici in 1527 had not unnaturally aroused their hostility on their return. And though he was officially pardoned he fretted under the rule of the young Alessandro de'Medici, who was little short of a homicidal maniac, and in 1534 he left Florence and never returned. The present appearance of the Medici chapel is therefore how it happened to look at the time of his departure, lacking the river gods at the base of the tombs of Lorenzo and Giuliano and lacking the principal tomb (of the Magnifico and his brother) altogether.

At this period Michelangelo executed a series of presentation drawings of classical subjects (most of them new at Windsor) for a young friend, Tommase de'Cavalieri. The extremely high finish of these led scholars at the beginning of the present century to regard them as copies. More recently they have been recognised not only as the originals but as marking a high water mark in the art of the draughtsman.

On arrival in Rome Michelangelo was commissioned by the Farnese Pope, Paul III, to paint the *Last Judgement* on the altar wall of the Sistine chapel. The gigantic fresco which resulted threw his ceiling out of scale by as much as the ceiling had thrown the 15th-century decoration out of scale. It signals the beginning of a new and disquieting phase in Michelangelo's art. Whereas the elegance of the nudes on the ceiling had led to widespread imitation and exaggeration by Michelangelo's followers, and had constituted one of the main sources of

the so-called Mannerist style, the late style, starting with the *Last Judgement,* deliberately avoided concessions to beauty and elegance. This phase of his art may be called expressionist. The mood is one of terror and bitterness. Michelangelo himself tended to play down his next and final frescoes, in the Pauline chapel of the Vatican *Conversion of Saul* and *Crucifixion of Peter)* saying he was too old to paint such large-scale work. These frescoes were disregarded for centuries but have been much admired in recent years.

From 1547 to the end of his life Michelangelo was in charge of the rebuilding of St. Peter's. Little practical work had been done on it since Bramante's death, more than thirty years previously. Michelangelo simplified Bramante's plan. He built three of the four arms of the crossing, and the cupola up as far as the top of the drum. The dome itself was executed after his death, but more or less according to his design, by Giacomo della Porta. A nave was added by Maderna in the early 17th century-a step which was in line with the current ideas on the liturgy but which went against Michelangelo's wishes.

Other building work executed according to Michelangelo's plans included the transformation of the Capitol and the adaptation of the Baths of Diocletian into the church of S. Maria degli Angeli. The latter, and the new eastern gate of Rome, the Porta Pia, were designed by Michelangelo in his eighties. In all eases the design is strikingly original and revolutionary.

In his extreme old age, and apparently for his own satisfaction (he was becoming increasingly religious), Michelangelo carved at least two marble groups of the *Pietà* (a third, the so-called *Palestrina Pietà,* in the Accademia at Florence, is of doubtful authenticity). In these sculptures (at Florence and Milan) the infirmities of old age, which are evident, do nothing to impair the effect of the work of art and perhaps even augment its pathos. The Florence group includes a self-portrait of Michelangelo in the role of St. Joseph of Arimathea.

Michelangelo died in Rome in 1564. His body was brought back to Florence and buried in S. Croce. A biography published in 1552 by his pupil, Ascanio Condivi, was based on information which Michelangelo himself supplied but which reflects his prejudices. It was used by Vasari in his second edition (1568). Vasari had planned his great history of Italian artists on a pyramidal plan, leading up to Michelangelo as its apex, as being supreme in all three of the visual arts and as the only artist in modern times who was considered to have surpassed classical Antiquity. During the next two centuries the reputation of Raphael, who was then regarded as the purer heir of antiquity, tended to exceed that of Michelangelo. In modern times the pendulum has swung back again in his direction.

—Cecil Gould

MICHELOZZO.

Born Michelozzo di Bartolommeo in Florence, 1396. Died in Florence: buried 7 October 1472. Trained as a goldsmith; bronze caster in the Florence mint, 1410; worked with Ghiberti on bronze doors for Florence Baptistery, c. 1417–24 (worked with Ghiberti in 1437–42 also); in partnership with Donatello, 1425-c. 38 (tombs and exterior pulpit, Prato Cathe-

dral); sculptural masterpiece is the Aragazzi Tomb in Montepulciano, 1427–38; also an architect: patronized by Cosimo de' Medici: Palazzo Medici-Riccardi, 1444; also worked on the San Marco Library, convent, and cloister, Florence, 1437–52, remodelled the interior of the Palazzo Vecchio, and succeeded Brunelleschi as architect of Florence Cathedral, 1446; also planned fortifications in Ragusa in Dalmatia and on Chios Island.

Collections: Florence: Baptistery, Cathedral Museum; London: Victoria and Albert; Montepulciano: Cathedral; Naples: S. Angelo a Nilo.

Publications

On MICHELOZZO: books—

Morisani, Ottavio, *Michelozzo architetto*, Turin, 1951.

Gori-Montanelli, L., *Brunelleschi e Michelozzo*, Florence, 1957.

Casalini, Eugenio, *Il Chiostro grande della SS. Annunziata di Firenze nel ridacimento michelozziano e nella transformazione del sec. XVI*, Florence, 1967.

Gurrieri, Francesco, *Donatello e Michelozzo nel pulpito di Prato*, Florence, 1970.

Caplow, Harriet McNeal, *Michelozzo*, New York, 2 vols., 1977.

Lightbown, R. W., *Donatello and Michelozzo: An Artistic Partnership and Its Patrons in the Early Renaissance*, London, 2 vols., 1980.

*

Michelozzo di Bartolomeo was one of the most prolific sculptors and architects of the 15th century and is connected with many of the major monuments in Florence.

Always under the shadow of more famous men, his artistic quality is not imaginative and profound like that of Donatello, not dominated by the intelligent control and rationality of Brunelleschi, nor infused with the lyrical grace and perfection of Ghiberti. But his ability to assimilate their language and technique, his organizational powers, and his easily appreciated and understood vocabulary of sculptural and architectural forms, enabled Michelozzo to undertake an enormous quantity of work in sculpture and architecture which appealed to both patron and public.

In his early partnership with Ghiberti, the youthful Michelozzo was under the control of the master and little of his personal style is evident in their three projects: the North Doors of the Baptistry, the *St. Matthew* statue on Or San Michele, and the Sacristy of Santa Trinità. The younger man's expertise in bronze casting and chasing, acquired at the Florentine mint, seems to have been his major contribution to the collaboration.

During the nine-year partnership with Donatello, Michelozzo's sculptural style clearly emerges in the three large tomb projects begun by 1427. Although it is difficult to determine precisely the role played by each sculptor and their assistants in the concept and execution of the various parts of the tombs,

certain figures are generally ascribed to Michelozzo. The three *Virtues* on the Coscia tomb in the Baptistry of Florence exhibit qualities that were to become the basis of his mature sculptural style: classical heads, large fold drapery, pedantic gestures, polished surfaces, squat proportions, and awkward passages. More expressive and bold are the caryatids supporting the tomb of Cardinal Brancacci in Naples, especially the right figure whose powerful stance and tragic austerity of expression tend to mask the classical sources.

The tomb of the humanist, poet, and papal secretary Bartolomeo Aragazzi in Montepulciano is generally acclaimed as the greatest work of Michelozzo, with little, if any, of Donatello's participation. In the nine surviving marble pieces of the dismantled tomb, his mature style of the 1430's is clearly apparent. The two reliefs depict Aragazzi in the presence of the Madonna and Child and his family. The figures are unified by gesture and glance, are set in shallow space, and are dependent on classical Roman sources like the Ara Pacis and on the influence of medieval sculptors (Nicola Pisano and Tino da Camaino). A powerful life-size figure, clothed in female garments, has been called "the first free-standing statue of the Renaissance." The pronounced contrapposto stance, classical drapery and face, and vigorous turn of the head of the statue prefigures Michelangelo's *David* and *Moses* in its intensity, and represents Michelozzo's highest achievement.

The strongly classical flavor of his early and middle career turns to a Gothic elongation in the 1452 statuette of *St. John the Baptist*, the centerpiece of the silver altar for the Baptistry. A greater emphasis on anatomical and drapery details, replacing the previous soft folds and abstracted planes, may be due to the use of different materials and techniques: carved marble vs. cast silver. It may also reflect his renewed association with Ghiberti working on the *Gates of Paradise* for the Baptistry.

Throughout his life Michelozzo and his shop were engaged in the production of a large number of Madonna and Child reliefs. Whether documented or attributed, they exhibit similar characteristics of style: the iconography is affectionate and human, not formal; the Madonna has a long, classic face with a melancholy expression; her wavy hair is parted in the middle and is partially covered by a veil; a heavy mantel encloses the Child within her silhouette; he is usually playful and well proportioned; the modelling of both figures is clearly delineated but classically restrained. The beauty, elegance, humanity, and careful workmanship belie the 19th-century unfounded critical judgment that "if it's good, it's by Donatello; if bad, by Michelozzo."

The sources of Michelozzo's sculptural style lie principally in late classical Roman art which he approached directly and literally, and in the heritage of trecento masters. His sculpture is always clearly articulated, highly polished, and concerned with the unclouded representation of simple forms, reflecting a lyrical gracefulness derived from Ghiberti and an integral solidity acquired from Donatello, without, however, absorbing their more revolutionary techniques. Sometimes coldly classical in his early works and spiritually fervid in his maturity, Michelozzo's sculptural vocabulary is always clear and direct, emphasizing the integrity of the individual figure. Without ever making a radical break with the past, Michelozzo creates a bridge between the medieval world of tradition and the emerging triumphs of the Renaissance.

—Harriet McNeal Caplow

MILLAIS, (Sir) John Everett.

Born in Southampton, 8 June 1829; lived with his family in Jersey, 1829–35, and Dinan, France, from 1835. Died in London, 13 August 1896. Married Mrs. Effie Ruskin (previously married to John Ruskin), 1855; four sons and four daughters. Attended Sass's School, and the Royal Academy Schools, London, from 1840; co-founder of the Pre-Raphaelite Brotherhood, with Hunt and Rossetti, 1848, but abandoned the group's principles by the 1860's; illustrator of novels by Trollope in the 1860's, and other books and periodicals; member of the Royal Academy, 1863 (President, 1896, succeeding Lord Leighton). Knighted, 1885.

Major Collection: London: Tate.
Other Collections: Birmingham; Cambridge; Egham: Royal Holloway College; Liverpool; London: Victoria and Albert, Portrait Gallery, Guildhall; Manchester; Melbourne; Minneapolis; New Haven; New York; Oxford; Paris; Port Sunlight.

Publications

By MILLAIS: books—

Illustrator: *Poems* by Tennyson, 1857; *Framley Parsonage*, 1861, all by Trollope; *Parables of Our Lord*, 1864; *Egmont*, by Goethe, 1868; *Barry Lyndon*, by Thackeray, 1879; *The Hampdens*, by Harriet Martineau, 1880.

On MILLAIS: books—

Ruskin, John, *Notes on Some of the Principal Pictures of Millais*, London, 1886.
Spielmann, Marion, *Millais and His Works*, Edinburgh, 1898.
Baldry, Alfred L., *Millais: His Art and Influence*, London, 1899.
Millais, John Guille, *The Life and Letters of Millais*, London, 2 vols., 1899.
Rossetti, W. M., editor, *Pre-Raphaelite Diaries and Letters*, 1900.
Pythian, John E., *Millais*, London, 1911.
Fish, Arthur, *Millais*, London, 1923.
Bennett, Mary, *Millais* (cat), Liverpool, 1967.
Luytens, Mary, *Millais and the Ruskins*, London, 1967.
Hilton, Timothy, *The Pre-Raphaelites*, London, 1970.
Fleming, Gordon, H., *That Ne'er Shall Meet Again: Rossetti, Millais, Hunt*, London, 1971.
Staley, Allen, *The Pre-Raphaelite Landscape*, 1973.
Millais, Geoffrey, *Millais*, London, 1979.
Wood, Christopher, *The Pre-Raphaelites*, New York, 1981.
Bell, Quentin, *A New and Noble School: The Pre-Raphaelites*, London, 1982.
Luytens, Mary, and Malcolm Warner, editors, *Rainy Days at Brig O'Turk: The Highland Sketchbooks of Millais*, Westerham, 1983.

articles—

Reid, Forrest, "The Pre-Raphaelite Group," in *Illustrators of the Sixties*, London, 1928.

Warner, Malcolm, "Millais's *Autumn Leaves:* 'A Picture Full of Beauty and Without Subject,' " in *Pre-Raphaelite Papers*, edited by Leslie Parris, London, 1984.
Cooper, Robyn, "Millais's *The Rescue:* A Painting of a 'Dreadful Interruption of Domestic Peace,' " in *Art History* (Oxford), December 1986.

*

Millais's renown today rests mainly on the paintings he did while involved with the Pre-Raphaelite movement. In the light of his very long career, however, the painter's 10-year association with the Pre-Raphaelites looks like an erratic detour in an otherwise straightforward progression from child prodigy to President of the Royal Academy. The founding members of the Pre-Raphaelite Brotherhood (Millais, Dante Gabriel Rossetti, and William Holman Hunt) were influenced by the writer and art critic John Ruskin. After the scandalous annulment of Ruskin's marriage, Millais married the former Effie Ruskin, became a Royal Academician and a wealthy portraitist, and was awarded a baronetcy. The brief episodes of artistic and romantic non-conformity were only temporary deviations, for Millais's natural artistic facility and his conventional, unintellectual temperament did not suit him for the role of rebel.

From childhood Millais demonstrated his gifts as a draftsman with a "lynx eye" (Wilenski, p. 227). Acute observation and accurate delineation were well within his grasp, and they became the central tenets of Pre-Raphaelitism. His natural abilities won Millais a place in the Royal Academy Schools at the age of 11, the youngest student then on record, as well as the silver medal for drawing three years later. In the book illustrations Millais produced during the 1850's and 1860's his superb technique and clear line contrast sharply with the softness of the Etty-dominated Academy style. For the famous Moxon Tennyson (*Poems*, 1857) Millais contributed 18 strongly linear and highly contrasted drawings, notably "St. Agnes' Eve" and "The Death of the Old Year." In these designs for wood engraving a quality of intensely poetic feeling suffuses the dramatic play of black and white. Trollope praised the 87 drawings Millais did for his novels; their confident composition and fidelity to the text assure their success as illustrations, and augur the artist's eventual acclaim as a society painter. The drawings for *Parables of Our Lord* (1864, but issued 1863 according to Forrest Reid) are generally regarded as Millais's masterpieces of illustration. "The Lost Piece of Silver" and "The Sower" are especially powerful, and their essential simplicity of design still appeals to the modern eye.

In striking contrast to the dramatically effective composition of these drawings is the deliberate awkwardness and unstable space in Millais's early Pre-Raphaelite paintings. *Isabella* (1848–49, Liverpool), the first revolves around a blank patch of tablecloth, angling a crowded line of profiled heads towards an ambiguous background plane, and balancing a violent foreground horizontal with an isolated vertical figure on the far right. The extreme particularity of detail, the naturalism of the faces and stiff poses, and the bright, clear palette, are all typical of Pre-Raphaelite practice. These elements appear again in *Christ in the House of His Parents*, also known as *The Carpenter's Shop*, and in his other early masterpiece, *Ophelia* (1851–52, London, Tate).

Ophelia is one of many Pre-Raphaelite pictures interpreting a literary subject. Characteristically, the figure is not dignified by a conventionally sanctioned pose or composition, the colors are glowing, and the flowers and foliage are as dense and minutely depicted as in a millefleurs tapestry, and given the same evenness of surface treatment. About this time, Millais began to reveal a susceptibility to pathos; he chose subjects neither heroic nor tragic, but rather melancholic. Numerous paintings in the middle of his period focus on the wistful (or Pre-Raphaelite even stricken) faces of youthful females. In some of this group a narrative is suppressed and the emotion alone appears to comprise the subject. Among the most notable of these pictures are *Mariana* (1850–51, Makins Collection), *The Bridesmaid* (1851, Cambridge), *Waiting* (1854, Birmingham Museum and Art Gallery), *Sir Isumbras at the Ford* (1857, Port Sunlight), and *The Vale of Rest* (1858, Tate). At their apex is *Autumn Leaves* (1855–56, Manchester), considered by some to be Millais's finest painting. The broadness of the theme, coupled with the specificity of detail in these pictures, keeps their melancholy from shading over into sentimentality.

Love and death, the themes of *Ophelia*, resurface in another group of paintings from this period, including *A Huguenot* (1851–52, Makins Collection), *The Order of Release, 1746* (1852–53, Tate), *The Proscribed Royalist,1651* (1852–53, private collection), *The Rescue* (1855, National Gallery of Victoria, Melbourne), and *The Black Brunswicker* (1859–60, Port Sunlight). If these pictures, even in their virtuousity, predict Millais's decline into the "commonplace, conceited, and sentimental" (Wilenski, p. 227)—at its most notorious in a picture such as *Bubbles* (1886, A & F Pears, Ltd.)—the full-length portrait of John Ruskin at Glenfilas (1853–54, private collection) heralds Millais's later achievement in portraiture. Such works as the splendid *Mrs. Bischoffsheim* (1873, Tate), or the discerning *Gladstone* (1879, National Portrait Gallery, London) and *Tennyson* (1881, Port Sunlight) remind us that Millais's successful career honored his natural talent and brilliant technique. Millais painted more than 400 pictures, and made countless drawings and sketches: his industry, no less than his later sentimentality, mark him as Victorian. The study of his work reveals a genius which, if it did not surpass his age, yet perfectly expressed it.

—Patricia Dooley Lothrop

MILLET, Jean-François.
Born in Gruchy, 4 October 1814. Died in Barbizon, 17 January 1875. Married 1) Pauline Virginie Ono, 1841 (died, 1844); 2) Catherine Lemaire, 1853; nine children. Worked on the family farm, 1835–37; then in Paris: in the studio of Paul Delaroche at the Ecole des Beaux-Arts, 1837–39; lived in Cherbourg, 1844–45, Le Havre, 1845, and Paris, 1845–49; then settled in Barbizon, 1849, and eventually was center of a group of painters.

Major Collections: Boston; Paris.
Other Collections: Algiers; Birmingham; Cardiff; Cherbourg; Edinburgh; Frankfurt; London: National Gallery, Vic-

toria and Albert; Lyons; Montpellier; Ottawa; Pittsburgh; Rheims; Rouen; Vienna.

Publications

On MILLET: books—

Bénédite, Leonce, *The Drawings of Millet,* London and Philadelphia, 1906.
Deiteil, Loys, *Le Peintre-gravure, vol. 1: Millet et Théodore Rousseau,* Paris, 1906.
Cain, Julien, *Millet,* Paris, 1913.
Hoeber, Arthur, *The Barbizon Painters,* New York, 1915.
Moreau-Nélaton, Etienne, *Millet raconté par lui-même,* Paris, 3 vols., 1921.
Latourette, Louis, *Millet à Barbizon,* Barbizon, 1927.
Huyghe, René, *Millet et Théodore Rousseau,* Geneva, 1942.
Gay, P., *Millet,* Paris, 1951.
Gurney, John, *Millet,* London, 1954.
Bouchot, J., *Dessins of Millet,* Paris, 1960.
Herbert, Robert L., *Barbizon Revisited* (cat), Boston, 1962.
Forges, Marie-Thérèse, *Barbizon,* Paris, 1962, 1971.
Dali, Salvador, *Le Mythe tragique de L'Angélus de Millet,* Paris, 1963, 1978.
Durbè, Dario, and Anna Maria Damigella, *La scuola di Barbizon,* Milan, 1969.
Lepoittevin, Lucien, *Millet: Sa vie, son oeuvre, ses écrits,* Paris, 4 vols., 1971–73.
Bouret, Jean, *L'Ecole de Barbizon,* Neuchatel, 1972; as *The School of Barbizon,* London, 1972.
Bacou, Roseline, *Millet dessins,* Paris, 1975; as *Millet: One Hundred Drawings,* New York and London, 1975.
Herbert, Robert L., *Millet* (cat), Paris, 1975, London, 1976.
Leveque, Jean-Jacques, *L'Univers de Millet,* Paris, 1975.
Fermigier, André, *Millet,* Geneva and New York, 1977.
Pollock, Griselda, *Millet,* London, 1977.
Lepoittevin, Lucien, *Millet: Bibliographie générale,* Cherbourg, 1980.
Murphy, Alexandra R., *Millet* (cat), Boston, 1984.

*

As a leader of the Barbizon School of mid-19th-century French artists, Millet is best known for his views of rural life. Even when they perform acts of back-breaking labor, Millet's peasants, shepherds and shepherdesses, domestic laborers, and families are depicted in moments of quiet dignity. Two of the artist's best-known works, *The Sower,* (1850; Boston) and *The Angelus* (1857–59; Louvre), exemplify Millet's desire to record a rapidly vanishing pre-industrial way of life in ways that may now appear over-sentimentalized, but which at the time struck the art establishment as subversive statements.

Born in 1814 in the hamlet of Gruchy, Millet was the son of prosperous and well-respected peasants. From the village priests he received a broad education that included mastery of Latin and the works of ancient and modern authors. His command of the classics would both directly and indirectly inform his representations of French rural life. As a student of Paul Delaroche at the Ecole des Beaux-Arts, he aspired to success as an Academic painter. However, after his works were repeat-

Peasant Carting Manure, 1855; etching

edly rejected from the Salon, he began to associate with other artists working outside Academic circles, including Constant Troyon, Narcisse Diaz, Charles Jacque, Honoré Daumier, and Theodore Rousseau. Although in 1847 his painting *Oedipus Taken Down from the Tree* (1847; Ottawa) was received successfully at the Salon, a new direction would be announced in the following year, when the new government formed after the Revolution of 1848 acquired Millet's *Winnower* (1848; London).

Although Millet's paintings conformed to growing interest in depicting realistic, contemporary subject matter, they also have roots in traditional themes and motifs. In *The Sower,* the artist's first major statement of his desire to monumentalize the labors of the French peasant, Millet placed a figure familiar from medieval representations of the labors of the months in a contemporary setting. The figure's twisting torso and barely controlled energy reflect sources in Renaissance and ancient Greek sculpture, yet the subject struck many critics as violently "savage." Other subjects from the laboring classes continued to provoke hostile reactions from conservative critics; when *The Gleaners* (Louvre) appeared in the Salon of 1857, reviewers scorned Millet's choice of subject and his references to earlier art.

Millet's paintings drew attention to rural workers in ways that contradicted accepted representations of labor. Unlike many popular painters of the peasantry, Millet presents labor as a private act rather than a communal celebration; his workers are usually anonymous, representing a faceless caste whose power could erupt from beneath an undefinable, impersonal surface. While the artist's purpose was to link the present with the past, to show relationships between the lot of the peasant in contemporary times with the position of the man of the land in the Bible and in the literature of antiquity, his intentions were often misinterpreted by a public becoming increasingly fearful of the power of the proletariat. Increasingly Millet's paintings were described as socialist manifestos, despite the artist's protestations to the contrary. Nevertheless, in many of his paintings, he provoked such reactions by choosing subjects that reflected social issues with which elite audiences were uncomfortable. *Death and the Woodcutter,* based on a fable by the 17th-century poet Jean de La Fontaine, was rejected from the Salon of 1859 because Millet's treatment of the subject emphasized the dejection and fatalism of the contemporary peasant, rather than the wit and cunning suggested in the fable.

Despite such setbacks, by the 1860's Millet was recognized as a leader of the Barbizon artists. Patronage and commissions increased and in 1864 Millet received a first-class medal when he exhibited the Shepherdess (1864;Louvre) at the Salon. Toward the end of the decade, he began to turn to landscape rather than figural works. He also began concentrating on drawings and pastels that, with their evocative subjects and filmy surfaces, presage developments in drawing during the Symbolist period. By 1872 Millet's paintings were exhibited regularly by Durand-Ruel, and his works fetched considerably high prices at auction sales. In 1874 Millet received an important commission to paint scenes from the life of St. Geneviève for the Pantheon, indicating official recognition of his position as an artist. Work on this project had only reached the stage of preliminary drawings when the artist died in 1875.

—Kirsten H. Powell

MIRÓ, Joan.

Born in Barcelona, 20 April 1893. Died in Palma de Majorca, 25 December 1983. Married Pilar Junicosa, 1929; one daughter. Attended school in Barcelona; studied under Modesto Urgell and José Pasco at the Escuela Oficial de Bellas Artes de la Lonja, Barcelona, 1907, and at Francesco Gali's Escuela d'Arte, Barcelona, 1912–15; painter in Barcelona, then settled in Paris, 1920, and associated with the Surrealists; stage designs for Diaghilev's ballet *Romeo and Juliet,* 1926 (also designs for *Jeux d'enfants,* 1932); lived in Barcelona and Paris, 1936–56, and in Barcelona and Majorca from 1956.

Major Collection: Barcelona: Miró Foundation.
Other Collections: Amsterdam: Stedelijk; Berlin: Nationalgalerie; London: Tate; Los Angeles; New York: Moma, Guggenheim; Paris: Beaubourg; Philadelphia; Zurich.

Publications

By MIRÓ: books—

Gesammelte Schriften, edited by E. Scheidegger, Zurich, 1957.
Ceci est la couleur de mes rêves: Entretiens, with Georges Raillard, Paris, 1977.
Selected Writings and Interviews, edited by Margit Rowell, Boston, 1986, London, 1987.

illustrator: *Il étail une petit pie,* by Lise Hertz, 1928; *Enfrances,* by Georges Hugnet, 1933; *L'Antitête,* by Tristan Tzara, 1947.

On MIRÓ: books—

Sweeney, James Johnson, *Miró,* New York, 1941.
Greenberg, Clement, *Miró,* New York, 1948.
Cirici, Alejandro, *Miró y la imaginación,* Barcelona, 1949.
Cirlot, Juan E., *Miró,* Barcelona, 1949.
Hunter, Sam, *Miró: His Graphic Work,* New York, 1958.
Erben, Walter, *Miró,* Munich and London, 1959.
Soby, James Thrall, *Miró,* New York, 1959.
Dupin, Jacques, *Miró: Life and Work,* New York, 1960.
Lassaigne, Jacques, *Miró,* Paris, 1963.
Bonnefoy, Yves, *Miró,* Paris, 1964, New York, 1967.
Perucho, Juan, *Miró y Cataluña* (in Spanish and English), Barcelona, 1968.
Penrose, Roland, *Miró,* New York, 1969.
Gomis, Joaquim, and Joan Prats, *The Miró Atmosphere,* New York, 1969.
Apollonio, Umbro, *Miró,* London, 1969.
Bucci, Mario, *Miró,* London, 1970.
Rowell, Margit, *Miró,* New York, 1970.
Chilo, Michel, *Miró: L'Artiste et l'oeuvre,* Paris, 1971.
Taillandier, Ivon, *Mirógráfias,* Barcelona, 1972.
Krauss, Rosalind, and Margit Rowell, *Miró: Magnetic Fields,* New York, 1972.
Leiris, Michel, *Miró, Lithographe,* Paris, 4 vols., 1972–81; as *Miró: Lithographs,* New York, 4 vols., 1972–81.
Dopagne, Jacques, *Miró,* Paris and London, 1974.

Parler Seul, 1948–50; lithograph

Miró (cat), Paris, 1974.

Melis, Josep, *Miró: Vida y testimonio,* Barcelona, 1975.

Picon, Gaëtan, *Miró: Carnets Catalans,* Geneva, 2 vols., 1976; as *Catalan Notebooks,* London, 1977.

Cirici, Alejandro, *Miró mirall,* Barcelona, 1977.

Gimferrer, Pere, *Miró y su mundo,* Barcelona, 1978.

Gállego, Julián, *Miró, pintura* (cat), Barcelona, 1978.

Teixidor, Joan, *Miró: Obra gráfica* (cat), Barcelona, 1978.

Drawings by Miró (cat), London, 1979.

Miró (cat), Saint-Paul-de-Vence, 1979.

Millard, Charles W., *Miró: Selected Paintings* (cat), Washington, 1980.

Corredor-Matheos, Jose, *Los carteles de Miró,* Barcelona, 1980.

Miró Milano (cat), Milan, 1981.

Miró's People (cat), Edinburgh, 1982.

Rose, Barbara, et al., *Miró in America* (cat), Houston, 1982.

Català-Roca, Francesc, *Miró: Ninety Years,* London, 1986.

Rowell, Margit, *The Captured Imagination: Drawings by Miró from the Fundacio Miró,* Philadelphia, 1987.

Miró (cat), New Haven, 1987.

Moure, Gloria, *Miró der Bildhauer* (cat), Cologne, 1987.

Malet, Rosa Maria, and William Jeffett, *Miró: Paintings and Drawings 1929–41* (cat), London, 1989.

article—

Rowell, Margit, "Miro at the Museum: Works in the Philadelphia Museum of Art," in *Bulletin of the Philadelphia Museum of Art,* Fall 1987.

*

In 1913, at age 20, Miró rented his first studio in his native city of Barcelona. He painted in a Fauve and Cubist manner, and read advanced poets such as Apollinaire. Before this, the intense and inward Miró had spent time at a commercial college and in business, but a serious bout of typhoid fever had been followed by profound depression. He recovered at the family's country house at Montroig, where he would often return throughout his life for the renewal and solitude that his intensely retiring nature craved. By the time of his first one-man exhibition in 1918, he had become influenced by a Vollard exhibition sent to Barcelona including Cézanne, Monet, and Matisse, more than by Picabia, who at the time published his periodical *391* in Barcelona. Miró's show was a total failure, and he retreated again to Montroig and began to work in a micro-focused, quasi-primitive manner perhaps inspired by traditional Catalan art. In *The Farm* (Hemingway Collection), a view of the Montroig property which Miró kept all his life, there appears a kind of inventory of motifs he would return to constantly, for instance, the ladder with a bird on it. From 1920, Miró lived most of each year in Paris, spending the summer in Montroig.

Miró was able in about 1923 to assume his mature idiom when he synthesized the French Romantic tradition found in his favorite Surrealist poets with the guileless, child-art inspired work of the Swiss Paul Klee. Other influences include both Tanguy's protoplasmatic forms and primordial dreamscapes, and Arp's pulsating and organic (though somehow aloof) shapes. With his Surrealist friends urging the use of chance and dream in art, Miró was able to hold consciousness at bay in the hypnotic freedom of the witty and brittle fragments of *Catalan Landscape* (*The Hunter*) (1923–24, New York, Moma). His works of this period, with their hermetic yet accessible figuration, fearlessly present an open field against which all floats. The well-known "picture-poems" of the mid-1920's project the sounds of dream via Cubist collage onto loosely brushed color fields (*Le Corps de ma brune,* 1925, Hermanos Collection). Symbolist that he is, Miró was able with complete confidence to condense his imagery to a few words with a simple shape or two, as in *Person Throwing a Stone at a Bird* (1926, Moma). If little appreciated by the larger art world at the time, Miró was deeply admired by the Surrealist circle. He brought older traditions of fantasy into the world of 20th-century modernity, and at about this time Breton made the famous remark: "He may be considered the most surrealist among us." The introverted Miró, however, never participated in any of the public manifestations of the Surrealists.

In the 1930's Miró began introducing collage elements into his works (e.g., *Painting,* 1930, DeMenil Collection), perhaps in an effort to reaffirm the tangibility of images which were otherwise drifting too far towards non-representation, but he soon returned to revery for inspiration. The so-called "savage paintings" of the 1930's are often images in which frenzy, dislocation, and disgust with the human condition appear (*Man and Woman in front of a Pile of Excrement,* 1935, Miró Collection). In 1938 he began a series of portraits which culminated in at least one work marking his despair (and on a minute scale), *Head of a Woman* (1938, Winston Collection). Here a new 1930's motif, the feral-beaked woman, is added to the repertory; such primordial horror is also present in the large *Seated Woman I* (1938, Venice, Guggenheim). But due to

Miró's personal penchant for revery, he is able to produce work which turns from the onrush of daily life to the lyrical. On his return to Spain in 1940, uncertain of his future there because of his opposition to the Franco regime, he took the beginning of the *Constellation* series, poetical works free of foreboding.

He also found new energy in turning to new media. In 1944 the 50 lithographs of the *Barcelona Suite,* in their dark spontaneity, allowed him to express the mood of the time. In the same year, he began experiments in ceramics with his friend Artigas. These were to bloom into large-scale sculpture and mural projects for both the United States and Europe (*Wall of the Sun* and *Wall of the Moon,* 1957, Paris, Unesco Building). With such projects, and his small-scale paintings, Miró attempted with good cheer and frequent success to keep alive the radical idiom of his early maturity.

—Joshua Kind

MODERSOHN-BECKER, Paula.

Born Paula Becker in Dresden, 8 February 1876. Died in Worpswede, 21 November 1907. Married Otto Modersohn, 1901; one daughter. Attended a London art school, 1892; Teachers Training College, Bremen, 1893–95; studied with the painter Bernard Wiegandt, then with Jeanna Bauck and Ernst Freidrich Hausmann at Drawing and Painting School of Association of Women Artists, Berlin, 1896–98; settled in the artists colony Worpswede, near Bremen, c. 1900; attended the Académie Colarossi, Paris, 1900, 1903, and Académie Julian, Paris, 1905, 1906–07; friend of the poet Rilke.

Major Collections: Bremen: Kunsthalle, Modersohn-Becker Museum (planned).
Other Collections: Berlin: Nationalgalerie; Cologne; Detroit; Dortmund; Essen; Frankfurt; The Hague; Hamburg; Hanover; Kiel; Munich; Munster; Oldenburg; Stuttgart; Worpswede: Haus im Schluh; Wuppertal.

Publications

By MODERSON-BECKER: books—

Briefe und Tagebuchblätter, edited by S. D. Gallwitz, Hanover, 1917; 3rd edition, Munich, 1920; as *Letters and Journals,* edited by J. Diane Radycki, Metuchen, New Jersey, 1980.
Modersohn-Becker in Briefen und Tagebüchern, edited by Günter Busch and Liselotte von Reinken, Frankfurt, 1979; as *Letters and Journals,* edited by Arthur S. Wensinger and Carole Clew Hoey, New York, 1983.
Briefe und Aufzeichnungen, edited by Beata Jahn, Leipzig, 1982.

On MODERSOHN-BECKER: books—

Pauli, Gustav, *Modersohn-Becker,* Munich, 1919; 3rd edition, Berlin, 1934.

Hetsch, Rolf, editor, *Modersohn-Becker: Ein Buch der Freundschaft,* Berlin, 1932.
Busch, Günter, *Modersohn-Becker: Handzeichnungen,* Bremen, 1949.
Stelzer, Otto, *Modersohn-Becker,* Berlin, 1958.
Busch, Günter, *Modersohn-Becker: Aus dem Skizzenbuch,* Munich, 1960.
Werner, Wolfgang, *Modersohn-Becker: Oeuvreverzeichnis der Graphik,* Bremen, 1972.
Busch, Günter, et al., *Modersohn-Becker* (cat), Bremen, 1976.
Schneede, Uwe M., editor, *Modersohn-Becker: Zeichnungen, Pastelle, Bildenwürfe* (cat), Hamburg, 1976.
Perry, Gillian, *Modersohn-Becker: Her Life and Work,* New York and London, 1979.
Murken-Altrogge, Christa, *Modersohn-Becker: Leben und Werke,* Cologne, 1980.
Busch, Günter, *Modersohn-Becker, Malerin, Zeichnerin,* Frankfurt, 1981.
Reinken, Liselotte von, *Modersohn-Becker,* Reinbek, 1983.
Busch, Günter, et al., *Modersohn-Becker Stiftung: Die Landschafter,* Bremen, 1982, 1985.
Rover, Anne, *Modersohn-Becker Stiftung: Das Frühwerk,* Bremen, 1985.
Harke, Peter J., *Stilleben von Modersohn-Becker,* Worpswede, 1985.
Kirsch, Hans-Christian, *Worpswede: Die Geschichte einer deutschen Kunstlerkolonie,* Munich, 1988.

article—

Oppler, Ellen C., review of recent literature, in *Art Bulletin* (New York), December 1988.

*

A pioneer of early 20th-century modernism, Modersohn-Becker forged her own style while assimilating the Post-Impressionism of Cézanne, Van Gogh, and Gauguin. Within the decade of her untimely death in 1907, she created well over 700 paintings and some 1,700 drawings. Her letters and journals are essential texts that illuminate this innovative artist, her milieu, and times.

These achievements are especially remarkable considering her provincial associations. Born in 1876 in Dresden into a large and cultured family that moved to Bremen in 1888, Paula Becker had to complete the more useful teachers training program before being allowed to study art. After two years at the school run by the Berlin Association of Women Artists—the prestigious Prussian Academy was closed to women—she settled in Worpswede, the artists colony near Bremen. The "Old Worpsweders" were considered the vanguard of the 1890's, though they rejected modern city life and painted idealized peasant themes and atmospheric landscapes—a German equivalent of the much earlier Barbizon School.

Paula Becker worked with the celebrated figure painter Fritz Mackensen, and in May 1901 she married the landscapist Otto Modersohn. Having already recognized their limitations, she traveled alone to Paris—an audacious move in 1900 for the 24-year-old daughter of proper bourgeois parents—to discover modern art for herself at the Exposition Universelle, in muse-

ums and commercial art galleries. During this sojourn of almost six months, she also attended the Académie Colarossi where she returned, even after her marriage, in spring 1903; in spring 1905, she worked at the Académie Julian, the other private school open to foreigners and women. In February 1906, she left her husband, intending to devote herself totally to art. He followed her to Paris in October, and finally persuaded her to return in 1907 to married life in Worpswede. She gave birth to her only child, her daughter Tille, in early November, and a fortnight later, suffered an embolism and fatal heart attack; she was 31 years old.

Modersohn-Becker's artistic goals emerge early, in broadly simplified landscapes and peasant portraits, and in her journal entries criticizing the Worpswede style as too conventional, too genre-like. She would "achieve grandeur through simplicity" (April 1903). Since she rarely signed and dated her work, written texts help to clarify her stylistic development, whose later chronology continues to be debated. In a November 1905 letter, for instance, she writes about painting her friend Clara Rilke-Westhoff, a sculptor who studied with Rodin in 1900; the sociologist Werner Sombart is discussed in January 1906 (the portraits are in Hamburg and Bremen). Her most famous portrait is the small, mask-like image of Rainer Maria Rilke (May 1906; private collection). Having first ignored her work, the poet visited her Worpswede studio at Christmas 1905 and then wrote about her remarkable achievement, paintings that are typical of Worpswede yet resemble Van Gogh.

This productive summer of 1905 followed her Parisian visit that took her to the vast Van Gogh retrospective at the Indépendants, and also aroused her interest in Gauguin. The paintings that Rilke admired surely included her portraits of the weary, fatalistic villagers who posed for her, such as the *Old Peasant Woman Praying* (in Detroit, the only major work in an American museum), and the mysterious *Poorhouse Woman in the Garden* (Bremen, Modersohn-Becker), although some German scholars favor the late date of 1907 for these masterpieces. The artist now depicted this favorite model as an elemental primeval creature with an ominous crystal ball and looming foxglove and poppies, flowers of magical potency.

Modersohn-Becker had discovered Cézanne by 1900, and his influence may be detected in her earliest landscapes. (She painted landscapes very rarely after 1902; an exception is a beautifully abstracted snowscape from winter 1905–06.) Her debt to the French master, however, is obvious in her still lifes, especially in 1905, when she accomplished some splendid paintings, rich in tonality and construction (examples in Bremen and Cologne).

The year 1906 became her *annus mirabilis* in Paris. After unexpected, much-needed encouragement from Bernhard Hoetger, a German sculptor working in Paris, she experienced a burst of creativity: "the most intense, happiest period of [her] life." She documented her personal and artistic growth with some extraordinary self-portraits: *On Her Fifth Wedding Anniversary* (1906; Bremen, Modersohn-Becker, half-nude, her pregnant appearance symbolizes artistic creativity, not the conventional family life from which she had just fled); an astonishing full-length nude (private collection); two versions of half-nude self-portraits that again combine healthy sexuality with the implication of spiritual energy (Bremen and Basel). In mid-1906 she also painted smaller canvases of her face, stylistically so advanced that one thinks of Picasso's "primitiv-

ism" and proto-Cubism, the *Portrait of Gertrude Stein,* completed later in 1906. Her very last self-portraits, probably of early 1907, are modern equivalents of the Coptic funerary icons she admired, *Self-Portrait with Camellia Branch* (Essen; similar examples in private collections), suggesting the transitoriness of nature yet eternal renewal of life.

Other outstanding paintings of 1906 return to the mother-and-child theme first sketched in 1898. Her maternities of an Italian model, posed naked, range from the naturalistic *Reclining Mother and Child* (Bremen, Modersohn-Becker), curled protectively around her infant on the ground, to starkly iconic images, the most famous being the *Kneeling Mother, Nursing* (Berlin, Nationalgalerie), a primordial fertility goddess evoking modern "primitivism" from Gauguin to Picasso.

After Modersohn-Becker returned to Worpswede in March 1907, a difficulty pregnancy and renewed domestic responsibilities sapped her creative energies; she painted comparatively little (despite the tendency to assign her best work to that last year). Some of the brilliantly colored small still lifes, however, and the *Young Nude with Goldfish Bowl* (Munich), with sonorous tones like Gauguin's tropical paradise, prove that she had attained her artistic goals. She had achieved "grandeur through simplicity" and had "assimilated, digested Impressionism," had created "exciting, intoxicating fullness of color" (letter to Hoetger, summer 1907). Working independently, unaware of the *Brücke* and *Blaue Reiter* artists with whom she is often discussed in art surveys and exhibition catalogues, she avoided the subjective, sometimes blatant expressionism of her German compatriots. Like the French Fauves, Matisse and his friends, she sought simplification and the most direct expression of artistic means, of color, line, and form. In the transformation of late 19th-century styles to the art of our century, her position is secure.

—Ellen C. Oppler

MODIGLIANI, Amedeo.

Born in Livorno, Italy, 12 July 1884. Died in Paris, 25 January 1920. Had one daughter by Jeanne Hébuterne. Studied under Guglielmo Micheli in Livorno, and under Giovanni Fattori in Florence; also studied in Venice until 1903; settled in Paris, 1906; also a sculptor after 1909, under Brancusi's influence.

Collections: Buffalo; Chicago; Cincinnati; Dusseldorf; London: Tate, Courtauld, Victoria and Albert; Milan: Arte Moderna; New York: Moma, Guggenheim; Norwich: University of East Anglia; Paris: Art Moderne; Philadelphia; Washington: National Gallery, Phillips; Zurich.

Publications

On MODIGLIANI: books—

Salmon, Andre, *Modigliani: Sa vie, son oeuvre,* Paris, 1926.
Vitali, Lamberto, *Disegni di Modigliani,* Milan, 1929, 1936.

Head, 1910–13; stone; 24⅜ in (62 cm); London, Tate

Pfannstiel, Arthur, *Modigliani,* Paris, 1929.

Scheiwiller, Giovanni, editor, *Omaggio a Modigliani,* Milan, 1930.

Basler, Adolphe, *Modigliani,* Paris, 1931.

Scheiwiller, Giovanni, *Modigliani,* Paris, 1937.

San Lazzaro, Giovanni di, *Modigliani: Peintures,* Paris, 1947, 1953.

Nicolson, Benedict, *Modigliani: Paintings,* London, 1948.

Marchiori, Giuseppe, *Modigliani,* Milan, 1949.

Raynal, Maurice, *Modigliani,* Geneva, 1951.

Descargues, Jacques, *Modigliani,* Paris, 1951.

Soby, James Thrall, *Modigliani* (cat), New York, 1951, 3rd edition, 1963.

Carli, Enzo, *Modigliani,* Rome, 1952.

Lipchitz, Jacques, *Modigliani,* New York, 1952, London, 1968.

Jedlicka, Gotthard, *Modigliani,* Erlenbach, 1953.

Pfannstiel, Arthur, *Modigliani et son oeuvre: Etude critique et catalogue raisonné,* Paris, 1956.

Salmon, André, *La Vie passionnée de Modigliani,* Paris, 1957; as *Modigliani: A Memoir,* New York, 1961.

Pfannstiel, Arthur, *Dessins de Modigliani,* Lausanne, 1958.

Ceroni, Ambrogio,*Modigliani, peintre* (in French and English), Milan, 1958.

Modigliani, Jeanne, *Modigliani senza Leggenda,* Florence, 1958; as *Modigliani: Man and Myth,* New York, 1958, London, 1959.

Roy, Claude, *Modigliani,* Geneva and New York, 1958, concise edition, 1985.

Scheiwiller, Giovanni, *Modigliani,* Zurich, 1958.

Russoli, Franco, *Modigliani,* Milan and New York, 1958, London, 1959.

Werner, Alfred, *Modigliani le sculpteur,* Geneva, 1962; as *Modigliani the Sculptor,* New York, 1962, London, 1965.

Russell, John, *Modigliani* (cat), London, 1963.

Ceroni, Ambrogio, *Modigliani: Dessins et sculptures,* Milan, 1965.

Pavolini, Corrado, *Modigliani,* Milan, 1966.

Werner, Alfred, *Modigliani,* New York, 1967.

Diehl, Gaston, *Modigliani,* Lugano, 1969, 1977, New York, 1969.

Gindertael, Roger V., *Modigliani e Montparnasse,* Milan, 1969.

Ponente, Nello, *Modigliani,* Florence and London, 1969.

Russoli, Franco, *Modigliani: Zeichnungen und Aquarelle,* Stuttgart, 1969; as *Modigliani: Drawings and Sketches,* New York and London, 1969.

Piccioni, Leone, and Ambrogio Ceroni, *I dipinti di Modigliani,* Milan, 1970.

Hubbard, H. I., *Modigliani and the Painters of Montparnasse,* Milan and New York, 1970.

Lenthemann, Joseph, *Modigliani: Catalogue raisonné, so vie, son oeuvre complet, son art,* Barcelona, 1970.

Daleveze, Jean, *Modigliani,* Lausanne, 1971.

Werner, Alfred, *Modigliani* (cat), New York, 1971.

Patani, Osvaldo, *Modigliani: Disegni,* Milan, 1972, 1976.

Fifield, William, *Modigliani: The Biography,* New York, 1976, London, 1978.

Lanthemann, Joseph, and Christian Paristo, *Modigliani inconnu, suivi de Modigliani: Analyse structurale de la plastique,* Turin, 1978.

Hall, Douglas, *Modigliani,* Oxford, 1979, 1984.

Mann, Carol, *Modigliani,* London and New York, 1980.

Zurcher, Bernard, *Modigliani,* Paris, 1980, London, 1981.

Marchesseau, Daniel, *Modigliani* (cat), Paris, 1981.

Parisot, Christian, *Modigliani: Disegni* (cat), Naples, 1984.

Modigliani: Gli anni della scultura (cat), Milan, 1984.

Modigliani, Jeanne, *Jeanne Modigliani racconta Modigliani,*
Livorno, 1984.

Castieu-Barrielle, T., *La Vie et l'oeuvre de Modigliani,* Paris,
1987.

*

Modigliani exists in a class of his own as a "modern" artist and painter of nudes, defying as he does certain conventions of nude painting as well as the Cubist and Futurist obsession with the disintegration of form. Modigliani was taught the skills of painting by a local Livorno painter, Micheli; in his late teens he saw much of southern Italy, Rome, and Venice and became enthralled by Renaissance and Mannerist art. Further inspiration came from Paris, from 1906 onwards with exposure to the avant-garde and its interest in primitive and naive art. Of especial significance to Modigliani's development were Cézanne for his rich colour and solid form and Picasso for the sinuous line and flat colour areas of his blue period. However, Modigliani's links with the past were stronger than peer pressure, for he refused to sign the Futurist manifesto when asked by his friend Severini, on the grounds that he disapproved of their condemnation of old art.

In 1909, after some experimenting with nude drawing, sexually explicit and comparable in this regard with the great nudes of 1916–17, Modigliani turned to sculpture. He felt that his drawings had become disjointed, and needed to resolve the problems of form by working in three dimensions. Modigliani worked exclusively in stone, usually limestone quarried nocturnally from building sites in Montmartre, and scorned plaster and clay as mud, thus adhering to the tradition of much-admired negro and Khmer sculpture which also rejected all other media. The works are severe representations of human heads with no plinth or frivolous decoration, almost architectural in their lack of rear carving. The theme of architecture is continued in Modigliani's sketches of the sculptures: the works are represented from the front, the top of the head often transformed into a Doric capital crowned with an abacus. The necks of the heads become pedestals, heralding Modigliani's interest in long, slim "mannequin" necks as both aesthetic objects and mediators between the physical and the cerebral. Modigliani drew sculptural inspiration from the work of his contemporary Brancusi and from the monumental heads of Easter Island. He was also intrigued by the caryatid form, drawing for himself many of these "columns of love," as part of a plan for a temple of beauty that never materialized. On a trip to Italy in 1912 the artist visited Michelangelo's quarries in Carrara and was probably impressed by the former's *Dying Slaves,* crude and half-embedded as they seemed in the rock. However, Modigliani was compelled to cease sculpting at the outbreak of war, mainly due to the scarcity of materials.

With the death of his sculpture, so painting was reborn: Modigliani's compositions testify to a strong sculptural heritage, being solid, largely unmodelled, and unreliant on props or background. He found the human form infinitely fascinat-

ing, and devoted himself almost exclusively to portraits and nudes after a few unsuccessful attempts at landscape painting. Sitters for the portraits were invariably friends: the Polish poet Leopold Zborowski, and Haviland and Rivera, painted soon after Modigliani's conversion to painting and rendered in a semi-Divisionist technique which is less a tribute to Seurat than a simple joy at rediscovering colour. Last but not least, Modigliani painted his various girlfriends, though rarely as nude compositions, capturing Beatrice Hastings and Jeanne Hébuterne in dignified poses.

Angular, Cubist-inspired compositions gave way in 1915 to a more individual perception. Modigliani apparently turned to nude painting in 1916 after a premonition of his death: he had always lived in a decidedly decadent manner, modelling himself on his hero, fellow debauchee Lautréamont, whose poetry Modigliani read aloud in graveyards. The nudes are considered the best of the artist's oeuvre: female, raw, carnal, and, above all, indifferent. Unlike the cultivated, self-conscious nudes of Titian or Manet, they sprawl like lionesses across the canvas, often positioned parallel to the picture plane and executed in rust-coloured impasto that is almost sculptural. Their bodies consist of oval and round forms, long necks, and blank yet staring eyes. Modigliani's nudes are said to correspond to two distinct types upon which the Italian art of the Renaissance was based: earth Venus, dark, full-breasted, and Mediterranean, and celestial Venus, child-like and fair. The nudes caused a riot when exhibited in 1917 at Berthe Weill's gallery, mainly because of their defiant postures and pubic hair. However, nudity took a less controversial form in a series of penitents and crucifixions featuring naked and praying men and women, a religious reaction to the cruelties and inspired by the artist's recently converted friend Max Jacob. Other late works include pictures of buoyant young men, peasants, and a few post-war landscapes from the south of France where Modigliani, sick, was convalescing. His last paintings, e.g., *Paulette Jourdain,* 1919, have lost their individuality and become almost iconic, luminous and self-sufficient.

—Caroline Caygill

MONDRIAN, Piet.

Born Pieter Cornelis Mondriaan in Maersfoort, Netherlands, 7 March 1872; son of the painter Pieter Cornelis Mondriaan. Died in New York, 1 February 1944. Attended Winterswijk schools; studied drawing with his father, and painting with his uncle, Frits Mondriaan; teachers training in drawing; studied with Joh-Braedr van Uberfeldt at the Rijksakademie, Amsterdam, 1892–94, and attended evening drawing classes, 1894–97; independent painter of portraits, draughtsman, and designer; in Paris, 1912–14; friend of the painter Jan Toorop, in Amsterdam; co-founder, with Theo van Doesburg, De Stijl, 1917; lived in Paris, 1919–38, London, 1938–40, and in New York from 1940.

Collections: Amsterdam: Stedelijk; Eindhoven; The Hague: Gemeentemuseum; London: Tate; New York: Moma, Guggenheim; Ottawa; Pittsburgh; Stockholm: Moderna Museet; Zurich.

Tree, c. 1909–10; drawing

Publications

By MONDRIAN: books—

Neo-Plasticism: The General Principle of Plastic Equivalence, Paris, 1920.
The New Art, The New Life: The Collected Writings, edited by Harry Holzmann, New York, 1972; revised edition, edited by Holzmann and Martin S. James, Boston, 1986; London, 1987.

On MONDRIAN: books—

Jaffe, H. C. L., *De Stijl 1917–1931: Dutch Contributions to Modern Art,* London, 1956.
Seuphor, Michel, *Mondrian: Sa vie, son oeuvre,* Paris, 1956; as *Mondrian: Life and Work,* London and New York, 1956.
Morisani, Ottavio, *L'astrattismo di Mondrian,* Venice, 1956.
Lewis, David, *Mondrian,* New York, 1957.
Hunter, Sam, *Mondrian,* New York, 1958.
Wijsenbeck, L. J. F., *Mondrian,* Zeist, 1962; New York, 1968; London, 1969.
Menna, Filiberto, *Mondrian: Cultura e poesia,* Rome, 1962.
Ragghianti, Carlo, *Mondrian e l'arte del XX secolo,* Milan, 1962.
Blok, Cor, *Mondrian in de collectie van het Haags Gemeentemuseum catalogus,* The Hague, 1964.
Welsh, Robert P., *Mondrian* (cat), Toronto, 1966.
Jaffe, H. C. L., *Mondrian und De Stijl,* Cologne, 1967; as *Mondrian and De Stijl,* London, 1970.
Elgar, Frank, *Mondrian,* Paris and London, 1968.

Busignani, Alberto, *Mondrian,* Florence, London, and New York, 1968.
Tomassoni, Italo, *Mondrian,* London, 1970.
Holzman, Harry, *Mondrian: The Process Works,* Los Angeles, and New York, 1970.
Jaffe, H. C. L., *Mondrian,* New York and London, 1970.
Apollonio, Umbro, *Mondrian e l'astrattismo,* Milan, 1970.
Joosten, Joop, and Welsh, Robert P., *Mondrian Centennial Exhibition* (cat), New York, 1971.
Blok, Cor, *Mondrian: Een catalogus van zijn werk in Nederlands openbaarbesit,* Amsterdam, 1974.
Ottolenghi, Maria Grazia, *L'opera completa di Mondrian,* Milan, 1974.
Seuphor, Michel, *Les Sources littéraires chez Arp et Mondrian,* Geneva, 1974.
Gay, Peter, *Art and Act: On Causes in History: Manet, Gropius, Mondrian,* New York, 1976.
Malewitsch—Mondrian und ihre Kreise (cat), Cologne, 1976.
Rembert, Virginia Pitts, *Mondrian, America, and Abstract Painting,* Ann Arbor, 1977.
Welsh, Robert P., *Mondrian's Early Career: The "Naturalistic" Period,* New York, 1977.
Carmean, E. A., *Mondrian: The Diamond Compositions* (cat), Washington, 1979.
Weyergraf, Clara, *Mondrian und Theo van Doesburg: Deutung von Werk und Theorie,* Munich, 1979.
Henkels, Herbert, *Mondrian in Winterswijk,* The Hague, 1979.
Troy, Nancy, *Mondrian and Neo-Plasticism in America* (cat), New Haven, 1979.
Henkels, Herbert, et al., *Mondrian* (cat), Stuttgart, 1980.

Sillevis, John, and Herbert Henkels, *Mondrian and the Hague School* (cat), Manchester, 1980.

Verso l'astrattismo: Mondrian e la scuola dell'Aia (cat), Florence, 1981.

Champa, Kermit Swiler, *Mondrian Studies*, Chicago, 1985.

Mondrian: De la figuration a l'abstraction (cat), Saint-Paul-de-Vence, 1985.

Blotkamp, Carel, et al., *De Stijl: The Formative Years 1917–22*, Cambridge, Massachusetts, 1986.

Henkels, Herbert, *Mondrian: From Figuration to Abstraction*, London, 1988.

*

Mondrian's best-known work was made in association with the group De Stijl. In many ways, though, he was an exceptional member of this collective movement. He came into contact with the other artists in the movement comparatively late, meeting Oud and Vantongerloo, for instance, only in 1920. His relations with Theo van Doesburg, the other major artist and theoretician of De Stijl, were rather cool. This coolness was caused by disputes and uncertainties about the direction of the movement, particularly about the role architecture had to play in the evolution of the new style. Furthermore, Mondrian's position in the group was unique in that he was very much the senior member in terms of both age and reputation.

By 1920 he already had extensive international contacts so his work and writing carried considerable authority within the group. As early as 1900, he had gained some reputation as a landscape painter in the style of the Hague School and since then had come to terms with and reworked the major styles of the epoch. From 1907, in works such as *Windmill in Sunlight* (1908), he was influenced by the Fauves; in 1911 he had travelled to Paris and made contact with Cubism from which he developed his own style. Pieces such as *Still Life with Gingerpot II* (1911) show a Cubist analysis of forms in space that is based almost entirely on fragmentary lines, rather than on the use of facetting or surface variation. Retrospectively it is easy to identify the formal direction of the development of Mondrian's work: the gradual simplification of the subject, the increasing domination of straight lines, and the elimination of diagonals in favor of a structure based on right angles. Mondrian himself saw the development of his style as a progression towards a pre-ordained goal. In his Cubist work of 1914 it becomes increasingly difficult to recognise the roots these works have in still life as the pattern of lines and areas of color become more and more important in their own right. However, it is only with the pier and ocean pictures of 1915–17 (which were made back in Holland) that the decisive move in the transition to abstraction was made. By the time Mondrian made contact with De Stijl he saw himself as having made a long evolution towards an abstract style that the younger members of the group arrived at or adopted in a much briefer time.

De Stijl was a collective movement which stressed depersonalisation, exactness, and a formulaic adherence to a technique based on a precise theory. Mondrian's definitive abstract style, which had emerged by 1921, was one of the purest manifestations of the idealist theory of the movement. His lack of involvement with the broader issues of architecture and design, however, marked him off from the other members of the group. The works of the Dutch philosopher Schoenmaekers, particularly *The New Image of the World* (1915) and *The Principles of Plastic Mathematics* (1916), had enormous influence on the De Stijl movement as a whole. In the earlier work the philosopher argued that the orthogonal opposition of horizontal and vertical was of cosmic significance, as were the contrasts between the primary colors. Yellow stood for the movement of the sun's rays, blue for horizontality and the sky, and red for the product of their mixture. Yellow radiates in space, blue recedes, and red floats. These neo-Hegelian theories about the mathematical structure of the universe, of its inherent but spiritual rationality, were important because they made concrete suggestions about the expression of the spirit in visual terms. Mondrian was in contact with Schoenmaekers in 1917–18, and his major theoretical statement came out of this encounter. *Neo-Plasticism* was published in the first 12 numbers of *De Stijl,* the journal of the movement. Mondrian's paintings of 1921 onwards follow Schoenmaeker's recommendations quite precisely. The vision of the entire De Stijl movement was resolutely utopian: it visualized the possibility of an end to painting and all art in a state where life itself would become aestheticised, bearing the artistic qualities of harmony and order. Art was currently the refuge of these qualities only because they were lacking in life: the role of pictures was to be signs or exemplars of the coming utopia.

It is only within this context that sense can be made of Mondrian's break with the De Stijl movement in 1925 over the apparently trivial issue of whether diagonals should be permitted in painting. Van Doesburg's use of the diagonal broke from the orthogonal structure ordained by Schoenmaekers. It was because of the symbolic and spiritual associations that the forms and colors took on that this argument could have such significance.

In Mondrian's later years the stricter aspects of his abstract style began to break up. In his last works this was to lead to paintings which obviously used aspects of the environment, and even of popular culture, in the creation of their forms. Most famously, *Broadway Boogie-Woogie* (1942–43), with its little bright squares of color laid out in a grid pattern that suggests a street plan, evokes illuminated buildings, traffic lights, and jazz.

—Julian Stallabrass

MONET, Claude.

Born in Paris, 14 November 1840; grew up in Le Havre. Died in Giverny, 5 December 1926. Married 1) Camille Doncieux, 1870 (died, 1879), two sons; 2) Alice Raingo Hoschedé, 1892 (died, 1911). Attended the Académie Suisse, Paris (student with Pissarro), 1859–60; Gleyre Academy, Paris (student with Renoir and Bazille) 1862; military service, 1860–61; exhibited first picture in the Salon, 1865; in England, 1870, and in the Netherlands, 1871–72; lived in Argenteuil, 1872–78, Vétheuil, 1878–83, and in Giverny, 1883–1926; exhibited at the first Impressionist Exhibition (in fact, the name is derived from his painting *Impression: Sunrise*); several famous series of paintings, including Rouen Cathedral, Water-Lilies, etc.

Major Collections: Boston; Chicago; New York: Paris: d'Orsay, Marmottan.

Other Collections: Berlin; Bremen; Buffalo; Cambridge, Massachusetts; Dallas; Frankfurt; Lisbon: Gulbenkian; Moscow; Munich: Neue Pinakothek Pittsburgh; Rouen; Stockholm; Vienna; Washington.

Publications

On MONET: books—

Alexandre, Arsène, *Monet*, Paris, 1921.

Geffroy, Gustave, *Monet: Sa vie, son temps, son oeuvre*, Paris, 1922, 2 vols., 1924.

Elder, Marc, *Chez Monet à Giverny*, Paris, 1924.

Mauclair, Camille, *Monet*, Paris and New York, 1924.

Fels, Florent, *Monet*, Paris, 1925.

Gillet, Louis, *Trois variations sur Monet*, Paris, 1927.

Fosca, François, *Monet*, Paris, 1927.

Clemenceau, Georges, *Monet: les Nymphéas*, Paris, 1928; as *Monet: The Waterlilies*, New York, 1930; as *Monet: Cinquante ans d'amitié*, Paris, 1965.

Fels, Marthe de, *La Vie de Monet*, Paris, 1929.

Léger, Charles, *Monet*, Paris, 1930.

Werth, Léon, *Monet*, Paris, 1930.

Gwynn, Stephen L., *Monet and His Garden: The Story of an Artist's Paradise*, London, 1934.

Grappe, George, *Monet*, Paris, 1941.

Cetto, A. M., *Monet*, Basel, 1943.

Malingue, Maurice, *Monet*, Monaco, 1943.

Roger-Marx, Claude, *Monet*, Lausanne, 1949.

Besson, George, *Monet*, Paris, 1951.

Westheim, P., *Monet*, Zurich, 1953.

Rouart, Denis, *Monet*, Geneva, 1958.

Stokes, Adrian, *Monet*, London, 1958.

Seitz, William Chapin, *Monet*, New York and London, 1960, concise edition, 1984.

Seitz, William Chapin, *Monet: Seasons and Moments* (cat), New York, 1960.

Hamilton, George H., *Monet's Paintings of Rouen Cathedral*, London, 1960.

Hoschedé, Jean Pierre, *Monet ce mal connu*, Geneva, 2 vols., 1960.

Mount, Charles Merrill, *Monet: A Biography*, New York, 1967.

Wildenstein, Daniel, *Monet: Impressions*, Lausanne and New York, 1967.

House, John, *Aspects of the Work of Monet*, London, 1969.

Daulte, F., and C. Richebé, *Monet et ses amis* (cat), Paris, 1971.

Rouart, Denis, and Jean Dominique Rey, *Monet: Nymphéas, ou les miroirs du temps*, Paris, 1972.

Isaacson, Joel, *Monet: Le Déjeuner sur l'herbe*, London and New York, 1972.

Bartolatto, Luigina Rossi, *L'opera completa di Monet*, Milan, 1972; as *L'Oeuvre complet de Monet*, Paris, 1981.

Wildenstein, Daniel, *Monet: Biographie et catalogue raisonné*, Lausanne, 3 vols., 1974–79.

Joyes, Claire, *Monet at Giverny*, London, 1975, New York, 1976.

Levine, Steven Z., *Monet and His Critics*, New York, 1976.

House, John, *Monet*, New York and Oxford, 1977, 1981.

Murphy, Alexandra, and Lucretia H. Giese, *Monet Unveiled*, Boston, 1977; as *Monet in the Museum of Fine Arts*, Boston, 1985.

Isaacson, Joel, *Monet: Observation and Reflection*, Neuchâtel, New York, and London, 1978.

Hoog, Michel, *Monet*, Paris and London, 1978.

Wildenstein, Georges et al., *Monet's Years at Giverny: Beyond Impressionism*, New York, 1978.

Petrie, Brian, *Monet, The First of the Impressionists*, Oxford, 1979.

Hommage à Monet (cat), Paris, 1980.

Leveque, Jean Jacques, *Monet*, Paris, 1980.

Seiberling, Grace, *Monet's Series*, New York, 1981.

Tucker, Paul Hayes, *Monet at Argenteuil*, New Haven, 1982.

Taillandier, Yvon, *Monet*, Naefels and New York, 1982.

Shore, Stephen, *The Gardens at Giverny: A View of Monet's World*, Millerton, New York, 1983.

Aitken, Geneviève, and Marianne Delafond, *La Collection d'estampes japonasies de Monet à Giverny*, Paris, 1983.

Gordon, Robert, and Andrew Forge, *Monet*, New York, 1983.

Guillaud, Jacqueline and Maurice, *Monet au temps de Giverny* (cat), Paris, 1983.

Rewald, John, and Frances Weitzenhoffer, editors, *Aspects of Monet*, New York, 1984.

Hoog, Michel, *Les Nymphéas de Monet au Musée de l'Orangerie*, Paris, 1984.

Sagner-Düchting, Karin, *Monet: Nymphéas: Eine Annäherung*, Hildesheim, 1985.

Joyes, Claire, *Monet: Life at Giverny*, London, 1985; as *Monet: The Gardens at Giverny*, New York, 1985.

Stuckey, Charles F., editor, *Monet: A Retrospective*, New York, 1985.

House, John, *Monet: Nature into Art*, New Haven, 1986.

Monet: Nymphéas (cat), Basel, 1986.

Skeggs, Douglas, *River of Light: Monet's Impressions of the Seine*, London, 1987.

Wildenstein, Daniel, *Monet*, London, 1988.

*

A founding member of Impressionism who exhibited in five of the eight group shows, Monet was the kind of artist Degas described rather disdainfully as making "paintings by which you can tell the time of day as by a sundial." According to Cézanne's famous epithet, Monet was "nothing but an eye, but what an eye." This sort of purely empiricist assessment of Monet led to the construction of a myth of an artist reponding instantaneously to *plein-air* motifs, painting spontaneously and even hastily on successive canvases around the clock, despite inclement weather and with no regard for either traditional pictorial structure based on chiaroscuro or the significance of subject matter. Paradoxically, Monet the empiricist soon became, from the hindsight of 20th-century modernism, Monet the abstractionist, valued for his pure chroma, painterly "formlessness," and apparently improvisational surfaces. But as critical perspectives have shifted in recent years from abstraction back to representation, and as historical methods have shifted from formalism towards more contextual concerns, so the interpretation of Monet has changed. Along with

Haystacks; drawing

lingering formal and empirical issues, there has emerged, on the one hand, a concern for social iconography in an historical context and, on the other hand, a psychoanalytical approach to Monet's biography and the meanings of his art.

Levine's study of critical responses to Monet during his own lifetime traces a trajectory from naturalist praise of the works of his early and middle career (1860's–1870's) by, for example, Castagnary and Zola, along with negative formalist assessments by the like of journalists Leroy and Wolff, to both symbolist and formalist appreciations of the late series paintings. Perhaps the strongest reiteration of the empiricist interpretation in the early 20th-century came from the American Impressionist painter Lilla Cabot Perry, who proclaimed the primacy of Monet's vision over all else and asserted that subject matter was a mere pretext. The latter issue was underscored and shifted into a more abstract mode by the Expressionist painter Kandinsky, who claimed not to have recognized the subject matter of one of Monet's *Haystacks*—something he saw as indicative of Monet's "pure painting." Similarly, the Abstract Expressionist generation in post-war America came especially to admire late Monet, whose mural scale and swirling surfaces it read as a precedent for and vindication of its own notions of painting as the expression of inner emotion. This kind of "abstract" reading was articulated most clearly in the 1950's by the critics Seitz and Greenberg, who emphasized above all Monet's "rhythmic brushstrokes and coloristic pulsation."

Subsequent historical studies of Monet, most notably the catalogue raisonné by Wildenstein and a monograph by Isaac-son, have documented his chronological and stylistic development (including the influence of artists like Boudin, Courbet, and Jongkind and of photography and Japanese prints) and favored motifs. These include: early caricatures of local personalities in Le Havre, where the artist grew up in the 1850's; rural landscapes painted in the mode of the Barbizon school in the early 1860's in Fontainebleau forest, for example, *Le Pavé de Chailly,* c. 1865 (Musée d'Orsay, Paris); large-format depictions of the effects of colored light on fashionable city people in the country and in gardens—most notably *Le Déjeuner sur l'herbe,* 1865–66 (known now only in fragments and sketch form) and *Women in the Garden,* 1866 (Musée d'Orsay, Paris); scenes of the harbors, beaches, and new resorts on the Normandy coast, for example, *Terrace at Saint-Addresse,* 1866 (Metropolitan Museum of Art, New York); flickering cityscapes of bustling modern life in Paris, for example, *The Quai du Louvre,* 1867 (Gemeentemuseum, The Hague); the incipient Impressionism of scenes of bourgeois leisure painted in the company of Renoir at suburban bathing and boating establishments along the Seine, for example the several views of La Grenouillère, 1869; the paradigmatic Impressionist depictions of similar sites at Argenteuil and the more rural Vétheuil in the mid-to-late 1870's; the series of representations of the Boulevard des Capucines, the Gare Saint-Lazare, and the Parc Monceau in Paris, likewise in the mid-to-late 1870's; the shift to more solitary, apparently isolated natural sites in the 1880's, including Etretat, Pourville, Varengeville, Belle-Ile, and La Creuse; the development of the series paintings in and around Giverny in the 1890's, including the haystacks and

poplars (1891) and Rouen Cathedral (1894); subsequent scenes of the Thames, Venice, and Norway; culminating with the water lilies painted in various campaigns until the artist's death.

Individual works and motifs in Monet's early and middle career have been singled out for formal analysis and iconographical identification, including: Isaacson's studies of the *Déjeuner sur l'herbe* and the cityscapes painted from the Louvre balcony in 1867; Pickvance's exploration of the renditions of La Grenouillère; House's documentation of sites painted in London during the Franco-Prussian War and the Commune (1870-71); and Levine's account of the window motif. More attention has been given to the formal and technical development of the later series paintings, including Hamilton's published lecture on the cathedrals, Seiberling's dissertation on the series as a whole, and two exhibitions on the paintings in and around Giverny, at the Metropolitan Museum of Art, New York (1987) and at the Centre Culturel du Marais, Paris (1983). Stuckey and Gordon have further explored the chronological development of the idea of the *Nymphéas* mural rooms (eventually installed in the Orangerie, Paris, after Monet's death) and the complicated and conflicted relationship between the artist and the French state during the long process of securing and completing the commission (1897-1927).

Interest in Monet the empiricist has meanwhile continued in both art historical and medical studies of his eyesight—especially the cataracts he developed during late life and for which he wore special glasses and was operated upon in 1923. Such studies include those by Stuckey, Moreau, and Ravin. Continuing formalist interest in Monet's techniques, including canvas, priming, pigments, and brushwork, has resulted in extensive critical description by Forge and Gordon and exacting historical analysis by House.

The issue of Monet's method has led Herbert in particular to a complete reassessment of the artist's meanings in relation to social iconography. Arguing from a close scrutiny of Monet's complex layering of brushstrokes, including, among others, "corrugations," "texture strokes," and "surface colors," Herbert rejects the myth of Monet's mindless spontaneity and suggests that throughout his career the artist was as painstakingly concerned about the careful and calculated structuring of compositions as Cézanne. This technical revision of Monet leads Herbert to a new reading of subject matter in light of social history, ranging from the commerce and leisure of early suburban idylls to the "sublime" neo-Romanticism of the solitary later landscapes and the "psychological structure" of the series paintings. In related studies Herbert has opened up an assessment of Monet's changing attitudes to the enchroachment of the Industrial Revolution upon the landscape—from the seemingly peaceful coexistence of nature and industry in the depictions of the leisure industry at Argenteuil, to the intense concentration on "progressive" technology at the Gare Saint-Lazare, to the eventual retreat from the industrial world into the carefully cleansed nature found in parks, gardens, and seacoasts from which tourism has been expunged.

This particular kind of social approach to Monet's industrial and suburban scenes has been further elaborated by Tucker in studies of Monet at Argenteuil and of the painting *Impression, Sunrise,* 1872 (formerly Musée Marmottan, Paris)—the latter being interpreted in light of contemporary politics as well. Clark has examined the same material at Argenteuil from a Marxist perspective and concluded that Monet and others were acting out a specifically petty-bourgeois construction of suburban leisure in which industry was masked and bourgeois class identity confirmed. Further studies by Herbert suggest that the Rouen Cathedral series responded to Ruskinian notions of the decorative and the natural so as to oppose the mechanical and the industrial, but that Monet's later creation of his own elaborate water gardens commemorated "a bourgeois version of an aristocratic estate" and that the paintings depicting the gardens symbolized "industrial man's mastery over nature," that is, an "artifically incubated nature."

There has been less historical assessment of Monet's art from a cultural point of view than from a social one, but occasional studies do appear. Bondeville, for example, has examined analogies between the art of Monet and the music of Debussy. In a study of the *Nymphéas,* Sagner-Düchting has likewise traced the analogy to music, as well as to late 19th-century literature, including works of Mallarmé and Proust. This kind of study would seem to merit further exploration.

The major counterpoint to the social-historical approach is, however, provided by the psychoanalytical one. Although Rewald laid the basis for later biographical studies of Monet, the psychoanalytical exploration of possible relationships between his states of personality and visual products is a recent development. Monet's own letters, especially in the 1890's, speak moodily of frustration in attempting to render, not what he sees, but what he feels (*ce que j'éprouve*). Citing the symbolist poet and critic Jules Laforgue, who described the "flashes of identity between subject and object" in Impressionism, the art historian Shiff has suggested that the artistic goal of Impressionism as a whole, that is, the unification of objective and subjective "truth" to nature, was codified at exactly the time when psychology was being born as a science in the work of Emile Littré and others. The more specifically psychoanalytical approach to Monet by Levine takes a pronouncedly Freudian slant, yet seeks documentation for this interpretation not only in Monet's biography and works (most notably the repeated motif of water reflections), but also in his verbal statements and those of his friends and contemporary critics. Levine connects Monet's works with the Narcissus complex and with obsessive, even morbid, melancholy. The fact that Mary Gedo, evidently working from the same material in a forthcoming study, reaches the opposite conclusion that the artist had a basically healthy temperament, indicates the contradictions, and perhaps shortcomings, of the psychoanalytical approach to Monet. In some ways, this approach seems to reinvent Monet's biography without Rewald's reassuring set of certainties. In any event, historians and critics who take social and especially feminist points of view often see this kind of Freudian interpretation as reinforcing and retrenching myths of the hero-artist.

Alternative approaches to Monet not yet explored (albeit hinted at by Herbert and others) include feminist readings of the artist's problematic relationship with women and with nature mythified as feminine passivity, and more economic explorations of his aggressive pursuit of, and accomodations to, dealers and the art market. (What effect, for example, did the shift from group to one-man shows have on the development of the series?) Whether deconstructionist, Lacanian, or other approaches to Monet might prove fruitful remains to be seen.

—M. R. Brown

MOORE, Henry (Spencer).

Born in Castleford, Yorkshire, 30 July 1898. Died in Much Hadham, Hertfordshire, 31 August 1986. Married Irina Radetzky, 1929; one daughter. Attended schools in Castleford; served in the British army, 1916-19; attended Leeds College of Art, 1919-21, and Royal College of Art, London, 1921-24; sculptor in London; Lecturer in sculpture, Royal College of Art, 1924-32; founded the department of sculpture, and Lecturer, Chelsea School of Art, London, 1932-39; settled in Much Hadham, Hertfordshire, 1940, and also worked in Forte dei Marmi, Italy, after 1977; official war artist during World War II; large workshop with many assistants; many commissions for open-air works.

Major Collections: London: Tate; Much Hadham: Moore Foundation; Toronto.
Other Collections: Amsterdam: Stedelijk; Buffalo, Jerusalem: Israel Museum; Leeds: Moore Centre, City Art Galleries; London: British Museum, Victoria and Albert, St. Paul's; Melbourne; Mexico City: Experimental Museum; New York: Moma; Washington: Hirshhorn.

Publications

By MOORE: books—

Heads, Figures, and Ideas, London, 1958.
Moore on Sculpture, edited by Philip James, London, 1966; New York, 1971.
Moore Sculpture, with Comments by the Artist, edited by David Mitchinson, London and New York, 1981.
Moore Wood Sculpture, Commentary by Moore, London, 1983.

On MOORE: books—

Read, Herbert, *Moore, Sculptor,* London, 1934.
Grigson, Geoffrey, *Moore,* London, 1943.
Read, Herbert, and Alan Bowness, *Moore, Sculpture and Drawings,* later vols. called *Complete Sculpture,* London, 6 vols., 1944-87.
Sweeney, James Johnson, *Moore,* New York, 1946.
Wingfield-Digby, George, *Meaning and Symbolism in Three Modern Artists: Edvard Munch, Moore, Paul Nash,* London, 1955.
Neuman, Eric, *The Archetypal World of Moore,* New York, 1959.
Grohmann, Will, *The Art of Moore,* London, 1960; as *Moore,* New York, 1960.
Read, Herbert, *Moore: A Study of His Life and Work,* London, 1965.
Melville, Robert, *Moore: Carvings 1923-1966,* London, 1967.
Hedgecoe, John, *Moore,* New York, 1968.
Jianou, Ionel, *Moore,* Paris, 1968.
Sylvester, David, *Moore* (cat), London, 1968.
Russell, John, *Moore,* London, 1968, Baltimore, 1973.
Melville, Robert, *Moore: Sculpture and Drawings 1921-1969,* London and New York, 1970.

Carandente, Giovanni, *Moore* (cat), Florence, 1972.
Mitchinson, David, *Moore: Unpublished Drawings,* New York, 1972.
Argan, Giulio C., *Moore,* New York, 1973.
Cramer, Gerald and Patrick, et al., *Moore: Catalogue of Graphic Works,* Geneva, 4 vols., 1973-87.
Seldis, Henry J., *Moore in America,* London and New York, 1973.
Clark, Kenneth, *Moore: Drawings,* London and New York, 1974.
Gilmour, Pat, *Moore: Graphics in the Making,* London, 1975.
Finn, David, *A Moore Odyssey,* New York, 1976; as *Moore,* London, 1977.
Sanesi, Roberto, *Sul linguaggio organico di Moore,* Pollenza-Macerata, 1977.
Wilkinson, Alan G., *The Drawings of Moore* (cat), London, 1977.
Lveine, Gemma, *With Moore: The Artist at Work,* London and New York, 1978.
Shakerley, Goeffrey, and Stephen Spender, *Moore: Sculptures in Landscape,* London and New York, 1978.
Carandente, Giovanni, *Moore e Firenze* (cat), Florence, 1979.
Read, John, *Moore: Portrait of an Artist,* London, 1979.
Wilkinson, Alan G., *The Moore Collection in the Art Gallery of Ontario,* Toronto, 1979.
Finn, David, *Moore at the British Museum,* London, 1981.
Teague, Edward H., *Moore: Bibliography and Reproduction Index,* Jefferson, North Carolina, 1981.
Liebermann, William B., *Moore: 60 Years of His Art,* London, 1983.
Strachan, W. J., *Moore: Animals,* London, 1983.
Hansen, Jorn Otto, editor, *Moore* (cat), Herning, 1984.
Wilkinson, Alan G., *The Drawings of Moore,* New York, 1984.
Berthoud, Roger, *The Life of Moore,* London, 1987.
Spender, Stephen, *In Irina's Garden with Moore's Sculpture,* London, 1987.
Carey, Frances, *Moore: A Shelter Sketch Book,* London and New York, 1988.
Garrould, Ann, *Moore: Drawings,* London and New York, 1988.
Compton, Susan, *Moore* (cat), London, 1988.

*

Nearing the end of a career covering some 70 years, Henry Moore summed up his overriding concerns as a sculptor thus: "The whole of my development as a sculptor is an attempt to understand and realize more completely what form and shape are about, and to react to form in life, in the human figure, and in past sculpture. This is something that can't be learnt in a day, for sculpture is a never-ending discovery." Together with his adherence to a number of themes that recur throughout his career, namely those of the reclining figure, the mother and child and the internal and external form, Moore engaged in a continual pursuit of learning, discovery, and experimentation which compelled him to work in a wide range of styles and media. In each of his chosen motifs, it is possible to trace their organic roots, and, as stated by Peter Fuller, "Moore's work seemed inspired, at least in part, by a yearning for harmonious

Reclining Mother and Child I Profile, 1979; etching and drypoint

fusion between image and matter, infant and mother, figure and ground, subject and object."

Despite sharp criticism in his later career for "tastefulness and attachment to the past," it is the very constancy with which Moore pursued his need to "observe, to understand, to experience the vast variety of space, shape and form in the world" that earned him his wide following and an international reputation as the most important British sculptor of the 20th century, and as a sculptor whose works have a universal and enduring power.

Of his first carving, the *Roll of Honour*, Moore recalled "the pleasure I felt when I first used a hammer and chisel," and his preference for carving over modelling is witnessed by his earliest works produced at the Royal College of Art in London. Although his tutors insisted on the supremacy of classical sculpture and the need for modelling in plaster and clay, Moore was drawn to examples of pre-Classical, pre-Columbian, and African art exhibited in the British Museum. Besides Etruscan reclining funerary figures, Mayan sculpture, such as the reclining figure of *Chacmool* which he had seen in a German art book, reminded him of 11th century Yorkshire church carvings. In these sculptures Moore was drawn to the concept of direct carving, and, like his contemporaries Brancusi and Epstein, he experienced an "almost fanatical belief in making the sculpture by direct carving." His virtuoso copy of Domenico Rosselli's *Madonna* in the Victoria and Albert Museum was carved direct, rather than by the pointing method, though to mislead his tutors Moore added shallow pit marks which would have been left by the pointing machine.

The profound impression of non-European art, fostered also by Roger Fry's essay on Negro sculpture in *Vision and Design*

(1920), is evident in works of this decade, such as the monumental *Reclining Figure* (Leeds, 1929) and the *Masks* (Leeds, 1929 and private collections). They also illustrate his use of a wide variety of English stones "because I thought that, being English, I should understand our stones." Study of the Italian "giants" Giotto, Masaccio, and Michelangelo, during a first visit to Italy in 1925, had an important effect and he later described Italy as "my artistic home." The sentimental bond was confirmed later in his life when, in the 1950's, he established a summer home at Querceta, enabling him to choose and carve marble fresh from the Henraux quarry.

A first opportunity to carve direct into stone, the commission for the *West Wind* (1928) for the London Underground Railways in Westminster, revealed to Moore his antipathy to working on this scale and in an architectural context. For him it symbolised "the humiliating subservience of the sculptor to the architect," and he was rarely to repeat the experience, the notable exception being the carved relief screen for Time-Life Building in London (1952). However, here, to his dissatisfaction, instead of the pivoted reliefs set into a pierced screen intended by Moore, for reasons of security and insupportable weight the work had to be set into the already constructed wall, and so high and obscured from view that few passers-by are aware even now of its existence.

His involvement with the Surrealist movement during the 1930's never caused Moore to abandon his fundamental adherence to organic forms, and he reiterated his allegiance to human features in sculpture in his contribution to the collection of essays, *Unit One*, edited by Herbert Read (1934): "Abstract qualities of design are essential to the value of a work, but to me of equal importance is the psychological, human element.

If both abstract and human elements are welded together in a work, it must have a fuller, deeper meaning."

In the 1930's he began to experiment with stringed sculpture, inspired by mathematical models in the Science Museum in London, and in bio-morphic sculpture, many of which show clearly the influence of Barbara Hepworth's works. His first explorations of the hole motif occur also at this date, seen in the voids gouged out of the mass of the *Reclining Figure* (1935) in Buffalo. In the reclining figure for the terrace of Serge Chermayeff's house in Bentley Wood, Moore for the first time had the opportunity to set his sculpture against the landscape and the sky, which he considered "the perfect background for sculpture." Later in his career the setting of sculptures in the landscape played an intrinsic part in their aesthetic and symbolic appeal. The first of his internal/external works, such as the lead *The Helmet* (1939-40) prefigures the more aggressive helmets of the immediate post-war period, and reflects the unsettled, threatening atmosphere during which it was created. Nevertheless, the seeds are planted here of the powerful image of *Nuclear Energy* (University of Chicago, 1964-5), and Moore demonstrates his ability to disconcert and harrass the spectator with these ominous images.

With the outbreak of war, Moore was unable to continue working on large-scale sculptural works, and relied increasingly on drawing, a medium he had explored from an early age, and had always used as a preparatory stage of the sculptural process. Nevertheless, he was aware of the danger of a drawing becoming a substitute for the sculpture. However, after an unexpected journey on the London Underground, he became fascinated by the sight of sleeping figures who found refuge in the disused tunnels during the Blitz. These drawings, later worked up from memory into two shelter sketchbooks, and the sketches of the miners from the Wheldale Colliery in Castleford (1942) led to an increasingly sympathetic reception from a public hitherto cautious of his abstract work. Confirming this was the important commission in 1942 for the *Madonna and Child* (St. Matthew's Church, Northampton), which takes its place in the history of art as an archetypal sculptural image of the Mother and Child.

With the birth of his only daughter in 1946, Moore further developed the family group, this time to include the father, illustrated in his family groups of the years 1948-49. His rocking chair groups of 1950, with their allusions to prehistoric Egyptian fertility godesses, testify to the joy experienced by Moore in the relationship between mother and child. During these years, however, despite a renewed confidence in post-war Britain, Moore's work increasingly assumed a more uneasy tenor. Figures such as the *Reclining Figure* in plaster (Tate Gallery, 1951) executed for the Festival of Britain, numerous skeletal bronzes and the openwork heads of 1950 are more jagged—lacking the monumentality and humanity of his pre-war works. Yet these years are also significant for his development of the large draped bronze seated women of the later 1950's, whose crumpled folds of cloth (modelled on real cloth at the plaster stage) are drawn taut across their torsos. In his *Warrior with the Shield* (1953-54) and the *Fallen Warrior* (1956-57) he openly acknowledges his debt to classical Greek sculpture studied in Greece and in the British Museum. The return to carved sculpture, occasioned by the commission in 1956 for the *Reclining Figure* for the UNESCO headquarters, inspired what has been described as "perhaps the most imper-

turbable of Moore's works." Reflecting the curves of the Apuan mountains (it is carved from Travertine marble), it accords closely with Moore's thesis that the most moving sculpture is one "giving out something of the energy and power of great mountains."

The importance of this theme is dominant in his work of the 1960's. Nurtured and promoted by the British Council and the Arts Council since his success at the 1948 Venice Biennale, Moore was compelled to produce, in ever greater scale, the massive interlocking figures for public buildings and squares around the world. In order to meet the inceased demand, he abandoned his former use of plaster models enlarged from maquettes, for polystyrene—a light-weight, easily carved material. This allowed Moore to concentrate his attentions on the small maquettes, leaving the running and production of the large-scale commissions to a workshop of skilled assistants. His revival of a form of Renaissance studio practice was in part through practical necessity but also reflected his reverence for such traditions.

Throughout his career the use of *objets-trouvés* such as shells, bones, and pebbles provided him with constant formal inspiration: for his bio-morphic works in the 1930's; for the development of organic forms such as the *Nuclear Energy,* linked with his etching of an elephant's skull; and for the knife-edge theme directly based on the form of a jagged bone. The vast 2-3 piece interlocking figures of the 1960's and 1970's, typified by his Lincoln Center fountain *Reclining Figure,* are significant for the move to massive rock-like forms inspired by childhood memories of the Adel Rock near Leeds in Yorkshire. In late works the affinity with the landscape and nature of his home at Much Hadham is illustrated by the tender drawings of sheep (1972) and the *Sheep Piece* (1972) placed in his sheeps' grazing ground.

Despite accusations about his alignment with the establishment and criticisms levelled at his later works whose "inflation of scale produce grandiose, rhetorical statements," his integrity as a sculptor was undisputed even at the end. The establishment of the Henry Moore Foundation is the concrete testament of his generosity and humanity, best described in his own words: "The great (the continual) everlasting problem (for me) is to combine sculptural form (POWER) with human sensitivity and meaning, i.e., to try to keep primitive power with humanist content."

—Antonia Boström

MOR, Anthonis [Antonio Moro]

Born Anthonis Philipsz. van Dashorst in Utrecht, c. 1520. Died in Antwerp, 4 November 1576. Pupil of Jan van Scorel in Utrecht; then practiced as a portraitist; visited Rome, c. 1550; painted Queen Mary Tudor (presumably in London), 1554; court painter to Philip II of Spain, 1559, and also worked for Duke of Alva, in Brussels. Pupil: Sanchez Coello.

Major Collection: Madrid.
Other Collections: Amsterdam; Barnard Castle; Berlin; Brussels; Cambridge; Dresden; Florence; Glasgow: University;

The Hague; Kassel; London: National Gallery, Portrait Gallery; Munich; New York: Hispanic Society; Ottawa; Paris; Parma; Petworth; Vaduz; Vienna; Washington.

Publications

On MOR: books—

Hymans, Henri, *Moro: Son oeuvre et son temps,* Brussels, 1910.
Mor in the Collection of the Hispanic Society of America, New York, 1927.
Marlier, Georges, *Mor,* Brussels, 1934.
Friedländer, Max J., *Die Altniederländische Malerei, vol. 13: Mor und seine Zeitgenossen,* Leiden, 1936; as *Mor and His Contemporaries* (notes by H. Pauwels), Leiden, 1975.
Frerichs, L. J. C., *Moro,* Amsterdam, 1947.
Moffitt, John F., *Spanish Painting,* London, 1973.
Jenkins, M., *Il ritratto di stato,* Rome, 1977.

*

Mor, although himself a stiff and rather unappealing artist, is of the greatest art historical importance, since he had set into place an international Mannerist style of court-portraiture in Spain. Establishing an official iconography for the representation of the Imperial Hapsburgs, showing them as physically and spiritually remote and superior beings, Mor's mode was to become canonical in Spanish painting for nearly 200 years. Nevertheless, Mor did not really "invent" this style of portraiture; on the contrary, he only took certain pre-existent ideas and gave them a specifically painterly expression. The look and the meaning of these monumentally scaled royal images is literally icon-like. As befits any representation of the king's divine simulacrum, an imposed canon of form rigidly follows sacralized function. In strictly visual terms, generations of post-Mor Spanish court-portraitists were to treat all but the faces of their aristocratic subjects in a decorative and planarized manner, placing their somberly dressed (usually in black) regal subjects into ritualized and hieratic postures set against plain backgrounds.

The underlying motivations for all this formularized iconography—the black vestments, the sitters' emotionless visages, and their stiff, upright, quasi-saintly poses expressing the ideology of all subsequent Spanish royal portraiture—are best understood by reference to Baltasar Castiglione's *Il cortegiano (Book of the Courtier)* (1516). This book is a storehouse of humanist conventional wisdom in the Mannerist period. As it turned out, *Il cortegiano* was to become THE canonic book of aristocratic etiquette of its time and place, particularly once this manual had been translated into Spanish by Juan Boscán (*El cortesano*) in 1534, and it was so commissioned by the Emperor Charles V. According to Castiglione, the visual sign of the consummate courtier, which is to say his artfully concocted self-image, was unaffected *sprezzatura,* or, "nonchalance, being the real source from which grace springs." "A quiet manner," states Castiglione, is an enviable mark of the grave and dignified man, "ruled by reason rather than by appetite." In the larger sense, and quite according to then-reigning neo-platonic principles, semi-divine, "outward

beauty is a true sign of inner goodness," being "an index of the soul, by which it is outwardly known." As was understood by Castiglione's many readers, works of art, especially portraits, confer immortality; they "are made as memorials," performing a signal "service to memory."

Such memorializing art is above all else a royal enterprise: "Emperors adorned their triumphs with paintings, dedicated them in public places, bought them as cherished objects." Art is itself a visual code, being the direct reflection of certain rigidly observed, didacticizing social strictures. The painter recording the undying and largely symbolic image of the perfect *cortesano* must employ, states Castiglione, "a single brushstroke, made with ease, so that the hand seems of itself to complete the line desired by the painter, without being directed by care or skill of any kind." Castiglione was additionally a precocious advocate of what would later be called "tenebrism" in painting: "Good painters, by their use of shadow, manage to throw the light of objects into relief, and, likewise, by their use of light, deepen the shadows of planes and bring different colors together so that all are made more apparent through the contrast of one with another." Besides tenebrismo and *sprezzatura* in handling, both being techniques of form and content directly aligned to the calculated effects of nonchalance in the ambitious sitter's public persona, one also recognizes how "a man's attire is no slight index of the wearer's fancy." In this matter, as Castiglione authoritatively concluded, "black is more pleasing in clothing than any other color; and if not black, then at least some color on the dark side." (Boscán: " . . . y ya que no sea negro, sea a lo menos oscuro"). Moreover, this is the color most specifically suitable to the offical look of the Hapsburg courts in Iberia: "I would have our Courtier's dress show that sobriety which the Spanish nation so much observes, since external things often bear witness to inner things."

In the light of these statements, arising from the imperial commission for the translation of a prestigious ethical manual, we may best regard that frigid court-portraiture mainly institutionalized in Spain by Mor as a social document—and not, in the modern sense, as an "aesthetic statement." Mor the portraitist was, above all else, the conscientious illustrator of the visible lineaments of a certain kind of exemplary (and obligatory) courtly deportment, such as this had been specifically defined by Castiglione in a manual which was to become required reading for generations of Princes, their servile Courtiers, and, of course, the obedient painters who were commissioned to make those undying memorials of their masters' transient corporeal appearances—those outer marks of their emblematically "undying" spiritual presences.

—John F. Moffitt

MORANDI, Giorgio.

Born in Bologna, 20 July 1890. Died in Grizzana, 18 June 1964. Worked in the import-export business, 1906–07; then studied at the Academy of Fine Arts, Bologna, 1907–13, and set up as a painter in Bologna; associated with de Chirico, Carrà, and the Scuola Metafisica, 1916–18; spent summers in Grizzana, and settled there in 1938; taught drawing in elemen-

tary school, Bologna, 1914–30, and director of elementary schools for Reggio Emilia and Modena provinces, 1926–27; Professor of Engraving, Academy of Fine Arts, Bologna, 1930–56; etcher as well as painter.

Collections: Amsterdam: Stedelijk; Birmingham; Edinburgh; The Hague: Gemeentemuseum; Hamburg; Jerusalem: Israel Museum; Leningrad; London: Tate; New York: Moma; Paris: Beaubourg; Rome: Arte Moderna; Toledo, Ohio; Turin: Arte Moderna.

Publications

On MORANDI: books—

Beccaria, Arnaldo, *Morandi,* Milan, 1939.

Brandi, Cesare, *Morandi,* Florence, 1952.

Bloch, Vitale, and Lamberto Vitali, *Morandi* (cat), London, 1954.

Brandi, Cesare, *Ritratto di Morandi,* Milan, 1960.

Arcangeli, Francesco, *Morandi,* Milan, 1964.

Valsecchi, Marco, *Morandi,* Milan, 1964.

Vitali, Lamberto, *L'opera grafica di Morandi,* Turin, 2 vols., 1964–68.

Vitali, Lamberto, *Morandi: Pittore,* Milan, 1964.

Forge, Andrew, *Morandi* (cat), London, 1970.

Guiffre, Guido, *Morandi,* Florence and London, 1970.

Vitali, Lamberto, *Morandi* (cat), Bologna, 1975.

Zurlini, Valerio, *Il tempo di Morandi,* Reggio Emilia, 1975.

Pozza, Neri, *Morandi: I disegni,* Rome, 1976; as *Morandi: Dessins/Drawings* (in French and English), Paris, 1976.

Vitali, Lamberto, *Morandi: Catalogo generale,* Milan, 2 vols., 1977.

Solmi, Franco, *Morandi* (cat), Ferrara, 1978.

Petrioli Tofani, Anna Maria, *Morandi: Acqueforti* (cat), Florence, 1978.

Massari, Stefania, editor, *80 acqueforti di Morandi* (cat), Rome, 1980.

Armin, Franz, et al., *Morandi* (cat), Munich, 1981.

Magnani, Luigi, et al., *Morandi* (cat), New York, 1981.

Tavoni, Efrem, editor, *Morandi: Disengi,* Sasso Marconi, 1981—*Morandi* (cat), San Francisco, 1981.

Burger, Angelika, *Die Stilleben des Morandi: Eine koloritgeschichtliche Untersuchung,* Hildesheim, 1984.

Solmi, Franco, editor, *Morandi in Galleria* (cat), Bologna, 1985.

Tardito, Rosalba, Franco Solmi, and Marilena Pasquali, *Morandi: 100 opere su carta,* Milan, 1986.

Solmi, Franco, Jean Clair, and Lamberto Vitali, *Morandi,* New York, 1988.

article—

Fagiolo Dell'Arco, Maurizio, "The World in a Bottle: Morandi's Variations," in *Artforum* (New York), December 1987.

*

Some years ago I asked one of the directors of New York's Museum of Modern Art why they didn't mount a Morandi retrospective. He replied that the subject had been brought up a number of times at meetings, but the idea had always been rejected—"too many bottles" was the consensus. This nearly incredible over-simplification from an institution responsible for more than one display of repetitious work on one note, gives some idea of the peculiar prejudices that can crop up at any one time in the art establishment. Could one have submitted at the same time "too many squares" (Albers)? or "too many fuzzy rectangles" (Rothko)? Surely the point was being begged: it is the *painting* that makes Morandi's pictures of value, not their subject matter. Having evidently to paint *something,* Morandi found bottles more malleable than people. And, if one is to make an effort at accuracy, he was a superb and subtle landscape painter as well.

The Chardin of our epoch, or perhaps, closer (he included no people), the Zurbarán (of the still lifes), Morandi shares with these masters that captivity of pearly still-ness that encloses their works. Close tonalities, even light, the treatment of shadow as substance, complex suggestions of metaphysical dramas—all serve to enlarge the "narrowness" of what we are shown. On the surface, some boxes, bottles, containers a slab of wall, pale trees; suggestively, a walled town, a holy compound, a sacred grove.

As a painter in love with the art of painting, in search of a subject neither "abstract" or "real," Morandi found the cubes and volumes of his beloved Cézanne in everyday tea tins, vases, bottles. These he transformed through the application of paint, the accumulation of dust, and the actions of time, into symbols of themselves so that they could be painted "impersonally" as it were. And the lessons these still lifes taught him he applied to his landscapes of sun-patinaed houses and silvery olive farms. In the end his simplifications led to a way of seeing as limited and as large as that of Mondrian.

—Ralph Pomeroy

MOREAU, Gustave

Born in Paris, 6 April 1826. Died in Paris, 18 April 1889. Attended Collège Rollin, Paris, 1835–39; studied under François Picot at the Ecole des Beaux-Arts, Paris, 1846–49, and influenced by Chasseriau; first exhibited at the Salon, 1852; traveled in Italy, 1857–59; last appearance in Salon, 1880; elected Officier of the Legion of Honor, 1883; elected to the Académie des Beaux Arts, 1888; taught at the Ecole des Beaux-Arts from 1892; students include Rouault (the first curator of the Gustave Moreau Museum), Matisse, Marquet; his home transformed into a museum, 1895–96.

Major Collection: Paris: Gustave Moreau Museum
Other Collections: Bourg-en-Bresse; Bristol; Cambridge, Massachusetts; Chicago; Dijon; Frankfurt; Hartford, Connecticut; London: National Gallery, Victoria and Albert; Los Angeles; Malibu; Neuss; New York; Ottawa; Paris: Louvre, Petit-Palais; Rouen; St. Louis: Washington University.

St. George and the Dragon; 55$\frac{1}{2}$ × 38 in (141 × 96.5 cm); London, National Gallery

Publications

By MOREAU: books—

Moreau et Eugène Fromentin (correspondence), edited by Barbara Wright and Pierre Moisy, La Rochelle, 1972.
L'Assembleur de rêves: Ecrits complets, edited by Pierre-Louis Mathieu, Fontfoide, 1984.

On MOREAU: books—

Thévenin, Léon, *L'Esthétique de Moreau,* Paris, 1897.
Flat, Paul, *Le Musée Gustave Moreau,* Paris, 1899.
Renan, Ary, *Moreau,* Paris, 1900.
Desvallières, Georges, *L'Oeuvre de Moreau,* Paris, 1913.
Laran, Jean, and Léon Deshairs, Moreau, Paris, 1913.
Moreau, Paris, 1914.
Holten, Ragnar von, *L'Art fantastique de Moreau,* Paris, 1960.
Holten, Ragnar von, *Moreau* (cat), Paris, 1961.
Bou, Gilbert, *Moreau à Decazeville,* Rodez, 1964.
Mahlow, Dietrich, et al., *Moreau* (cat.) Baden-Baden, 1964.
Moreau (cat.) Neuss, 1964.
Moreau (cat.) Tokyo, 1964.
Cadars, Pierre, *Les Débuts de Moreau 1848-1864,* Toulouse, 1965.
Holten, Ragnar von, *Moreau, Symbolist,* Stockholm, 1965.
Paladilhe, Jean and José Pierre, *Moreau,* Paris, 1971, New York, 1972.
Catalogue des peintures, dessins, cartons, aquarelles exposées dans les galeries du Musée Gustave Moreau, Paris, 1974.
Kaplan, Julius D., *Moreau* (cat.), Los Angeles, 1974.
Hahlbrock, Peter, *Moreau, oder das Unbehagen in der Natur,* Berlin, 1976.
Mathieu, Pierre-Louis, *Moreau: Sa vie, son oeuvre, catalogue raisonné de l'oeuvre achevé,* Paris, 1976; as *Moreau, with a Catalogue of the Finished Paintings, Watercolors, and Drawings,* Boston, 1976, Oxford, 1977.
Selz, Jean, *Moreau,* Naefels and New York, 1979.
Kaplan, Julius D., *The Art of Moreau: Theory, Style, and Content,* Ann Arbor, 1982.
Mathieu, Pierre-Louis, *Catalogue des dessins de Moreau,* Paris, 1983.
Segalin, Victor, *Moreau, maître imagier de l'orphisme,* Fontfroide, 1984.
Mathieu, Pierre-Louis, *Moreau: Aquarelles,* Fribourg, 1984; as *Moreau, The Watercolors,* New York, 1985.
Stoss, Toni, *Moreau Symboliste* (cat.) Zurich, 1986.
Lacambre, Genevieve, *Maison d'artiste maison-musée: L'Exemple de Moreau,* Paris, 1987.

articles—

Leprieur, Paul "Moreau et Son Oeuvre," in *L'Artiste* (Paris), 59, 1889.
Schiff, Gert, "Die seltsame Welt des Malers: Gustave Moreau," in *Du* (Zurich), May 1965.

*

While Moreau partook of many of the stylistic and philosophical issues of 19th-century art, he always synthesized them in an original way, seeming unique to his contemporaries as he still does today. He served as a professor at the Ecole des Beaux Arts, bastion of tradition, while teaching and encouraging artists like Matisse and Rouault, who would soon become infamous as the *fauves,* among the earliest initiators of 20th-century abstract art.

All aspects of his work can be examined in the Moreau Museum in Paris. There one sees his studies after the Old Masters, the extensively developed draftsmanship of his student work, more copies of earlier art made during his two year stay in Italy in the late 1850's. His earliest experiments with full scale ambitious oil paintings occured between 1851 and 1853 in the form of government commissions, in the painterly, expressive, and literary tradition of the Romantics, especially Chasseriau (*Song of Songs*; 1863, Dijon). Traces of this youthful fascination with exotic, literary, and sexual themes and a painterly style always appear in his later work.

Moreau developed his first original style in the early 1860's. At this time he attracted attention as a painter of startling, large-scale interpretations of mythology, legend, and history, often with sexual overtones. The first was *Oedipus and the Sphinx,* 1864 (New York), which referred to the famous Ingres painting of the same theme in the static confrontation between feminine monster and idealized young male. Similar dichotomies between male and female, good and evil, the sensual versus the ideal—all based on an essentially Neo-Platonic philosophy—were pursued throughout his career and fascinated an establishment audience. Moreau continued for the next few years to paint similar full-size figural compositions that were usually static, enigmatic, full of stylistic references of Renaissance art (precise contours, cross-hatched modeling, traditional symbolism), as well as serious and sometimes cynical comments on heroism, romance, creativity, and human achievement (*Jason and Medea,* 1865, Cambridge, Massachusetts; *Orpheus,* 1866, d'Orsay; *Prometheus,* 1869, Moreau Museum). His interpretations were partly biographical, but all were directly related to contemporary literary concerns as well: *Jason and Medea* was probably prompted by a play by Ernest Legouve, *Prometheus* by a poem by Louis Menard.

In the late 1860's when critical enthusiasm waned, he stopped exhibiting and returned to his earlier painterly style. He restudied baroque art, experimented with sculptural models for his paintings, and introduced a new technique in *Salome Dancing Before Herod,* 1876 (Los Angeles). Following early Rembrandt, Moreau placed small figures in an elaborate architectural setting; Salome, who floats before an idol-like Herod, is surrounded by symbols that underlie her sexual and destructive powers (e.g., Diana of Ephesus, the goddess of fertility; a panther, who was believed to tempt its victims by the sweetness of its breath). The endless fascination of this painting results from Moreau's eclectic mix of innumerable decorative details from all the world's cultures creating the most sumptuous, imaginative, and mysterious setting possible, comparable to the mood of contemporary Parnassian poetry by Theodore de Banville and Leconte de Lisle, as well as the more original and ultimately more influential Baudelaire and Mallarmé. His nearly obsessive interest in Salome and other femme fatales is part of a cultural hallmark of mid to late 19th-century European culture. Moreau repeated this subject in *Apparition,* 1876 (Louvre), a watercolor made famous by

its heated description in J.-K. Huysmans's novel *A rebours* (1884), and reinterpreted the theme of good and evil in *Hercules and the Hydra of Lerna*, 1876 (Chicago), possibly referring to the recent hostilities of the Franco-Prussian war.

Despite the sensation he created, Moreau shied away from regular exhibitions of major paintings after 1880, perhaps feeling out of step both with the hardened academic tradition and with the now triumphant realism of Manet and the Impressionists. While constantly reworking but never finishing hundreds of huge canvases that filled his studio, he turned to smaller-scale works of one or two figures for which there was strong commercial demand. A major commission from the Marseilles collector Anthony Roux for the *Fables of La Fontaine* (private collection) occupied Moreau until 1886. In these works, in the many others of similar size and medium and in small oils in the Moreau Museum, he satisfied his aesthetic curiosity and his imagination. The paintings run the gamut of stylistic experimentation. Some were so freely sketched they seem non-objective; however, they were always preparatory studies and were never intended as independent works of art.

His appointment as professor at the Ecole des Beaux-Arts in 1892 was the appropriate cap for a lengthy and still active career. He began a complicated synthetic, multi-panel work (*The Age of Humanity,* 1886) and completed his last major painting, *Jupiter and Semele,* 1889–95, both Moreau Museum. Unlike earlier work, where each painting had essentially one symbolic meaning, *Jupiter and Semele* is filled with both traditional and personal symbols. Any one of these symbols would have been the subject of a painting in the 1860's or 1870's, but now each contributes to a more complex meaning. Moreau also utilized a style begun in 1880 in which thick protrusions of paint look like jewels encrusted on the canvas. Like Munch and Gauguin at about the same time, Moreau attempted to sum up the meaning of life in the large metaphorical *Jupiter and Semele.* His two written statements explain that it is about the human desire to move from the material world to the spiritual realm, which he expressed in terms of darkness and light. If this did not place Moreau squarely in the Symbolist movement of the Time, then his directive to viewers to "dream" in front of the painting to understand it would. Yet Moreau never considered himself part of this movement. Rather he saw himself as unique, with a lifetime of study and experience from which others could learn.

—Julius D. Kaplan

MORISOT, Berthe.

Born in Bourges, 15 January 1841. Died in Paris, 2 March 1895. Married Eugène Manet (the brother of the painter Edouard Manet), 1874; one daughter. Studied painting with Geoffrey-Alphonse Chocarne and Joseph Guichard, and with Camille Corot, 1860–63, and with Achille Oudinot, 1863; first exhibited in the Salon, 1864; also exhibited in all but one of the Impressionist exhibitions.

Major Collection: Paris: d'Orsay.
Other Collections: Boston; Brussels: Ixelles; Chicago; Cleve-

land; Edinburgh; London: Tate, Courtauld; Montpellier; New York; Oxford; Paris: Bibliotheque Nationale, Marmottan, Petit-Palais; Pasadena; Stockholm; Toledo, Ohio.

Publications

By MORISOT: book—

Correspondance avec sa famille et ses amis, edited by Denis Rouart, Paris, 1950; as *The Correspondence with Her Family and Friends,* London and New York, 1957; edited by Kathleen Adler and Tamar Garb, London, 1986.

On MORISOT: books—

Fourreau, Armand, *Morisot,* Paris and New York, 1925.
Angoulvent, Monique, *Morisot,* Paris, 1933.
Rouart, Louis, *Morisot,* Paris, 1941.
Rouart, Denis, *Morisot,* Paris, 1949.
Rouart, Denis, *Renoir et Morisot* (cat), Paris, 1952.
Mongan, Elizabeth, *Morisot: Drawings, Pastels, Watercolors, Paintings* (cat), New York, 1960, London, 1961.
Morisot (cat), Paris, 1961.
Bataille, Marie Louise, and Georges Wildenstein, *Morisot: Catalogue des peintures, pastels, et aquarelles,* Paris, 1961.
Huisman, Philippe, *Morisot,* Lausanne, 1962.
Huisman, Philippe, *Morisot: Charmes,* Lausanne, 1962; as *Morisot: Enchantment,* New York, 1963.
Rey, Jean-Dominique, *Morisot,* Naefels and New York, 1982.
Adler, Kathleen, and Tamar Garb, *Morisot,* Ithaca, New York, and Oxford, 1987.
Stuckey, Charles F., William P. Scott, and Suzanne G. Lindsay, *Morisot, Impressionist* (cat), New York and London, 1987.

articles—

Bailly-Herzberg, Janine, "Les Estampes de Morisot," in *Gazette des Beaux-Arts* (Paris), 93, 1979.
Scott, William P., "Morisot's Experimental Techniques and Impressionist Style," in *American Artist* (New York), December 1987.

*

Morisot's art education started in 1857 with Geoffrey-Alphonse Chocarne, a disciple of Ingres, whose teaching was so mechanical that she and her sister Edma turned to Joseph Guichard who encouraged their copying Old Masters at the Louvre in 1858. By 1860 the Morisot sisters wanted to draw directly from nature and studied with Achille Oudinot and Jean-Baptiste Camille Corot, who became a family friend. They met Charles Daubigny in 1863 when they worked at Le Chou on the Oise River where they were introduced not only to painting out of doors but also to river landscapes done from a boat. By 1864 both sisters were ready to submit works to the Paris Salon where Berthe exhibited annually between 1864 and 1873.

Another important influence for Morisot was her friendship with Edouard Manet to whom she was introduced at the Lou-

In the Boat (Summer's Day); 18 × 29⅞ in (45.7 × 75.2 cm); London, National Gallery

vre in 1868 by Henri Fantin-Latour. Morisot was never a pupil of Manet but there was reciprocal influence between them, her technique becoming less conventional and he becoming more appreciative of the tenets of Impressionism which he incorporated in a number of his works, though he refused to exhibit with the group, valuing Salon recognition more highly. Berthe married Manet's younger brother Eugène, also a painter, in 1874.

Morisot's art is most identified with the Impressionist movement. She was one of the founding members, helped organize several of the exhibitions and showed her work in all but one of the eight exhibitions, missing the fourth exhibition of 1879 as she was recovering from the birth of her daughter, Julie, on 14 November 1878. In the first exhibition of the group in 1874 she exhibited such important paintings as *The Cradle* (Musée d'Orsay, Paris), *The Harbor at Cherbourg* (Mr. and Mrs. Paul Mellon, Upperville, Virginia), *Hide and Seek* (Mrs. John Hay Whitney) and *Reading* (Cleveland Museum of Art). The seascape and two landscapes still show some allegiance to the palette and compositional methods of Corot, but *The Cradle* is totally original in its meditative and unsentimental view of motherhood and its interlocking composition of the vaporous veil of the cradle echoed in the background curtains. Here Morisot demonstrates the unparallel delicacy of the whites of her palette, modulated from transparent film to bluish areas of shadow.

The critic Gustave Geffroy declared, "No one represents Impressionism with more refined talent or with more authority than Morisot." Although her early style continued the tonalities of Corot, by 1879 she composed directly from nature, her canvas animated by a variety of painterly brushstrokes that recorded her visual sensations, often dominated by white tonalities. Working with unblended colors on a pale ground she preserved the spontaneity and freedom discovered from her watercolor technique in her oil paintings. Like her artistic colleagues Renoir, Degas, Monet, and Cassatt, Morisot created her own distinctive style within a modern, contemporary idiom and approach which discarded history painting, mythology, and sentimental narrative for a closer approximation of the reality of perceptions and the concerns of everyday life.

Morisot's range of subject matter was broader than has usually been perceived. She painted landscapes, domestic interiors, portraits, still lifes, and works showing female occupations. An exceptional work in this category, *Woman at Her Toilette* of c. 1879 in the Art Institute of Chicago, a symphony in white, was in the fifth Impressionist exhibition of 1880.

In general critics have concentrated on labeling Morisot's style as "feminine," "charming," and "delicate" without scrutinizing the range and unusual aspects of her painting. It has not been recognized that almost a fifth of her catalogued subjects are marine paintings, either seascapes, harbor scenes, or river and lake views. This proportion is particularly significant as Morisot could only paint seascapes when she was on vacation. As Charles Stuckey pointed out in the catalogue of Morisot's 1987 exhibition at the National Gallery of Art, Washington, Morisot's seascapes of 1875 from the Isle of Wight were variations on single motif, anticipating Monet's railroad stations, haystacks, and later series, and exhibited at the second Impressionist exhibition a year before Degas showed his dancer series in the next group exhibition. Degas's *Jockeys Before the Start* of c. 1879 (Birmingham, Barber Insti-

tute) with a vertical pole dividing the painting in the right foreground may have been inspired by Morisot's *Harbor Scene, Isle of Wight* of (1875 private collection) where a strong vertical mast in the foreground bisects the composition. Morisot also evolved the theme of the garden in her art, in all the media in which she worked: oils, watercolors, pastels, and drawings. In these she seems to depict a modern lost Eden where people and nature interact harmoniously.

Around 1888 Morisot developed a new style, a change similar to the ones her colleagues Renoir and Pissarro were experiencing. This included making preparatory drawings for works rather than composing spontaneously before a motif as she had done earlier, as in her sanguine studies for several versions of *The Cherry Tree* 1891–92 (private collection), a project that may have inspired Mary Cassatt's women picking fruit in a mural commissioned for the Women's Building of the 1894 World's Columbian Exhibition in Chicago, and Maurice Denis's *Women on a Ladder in the Leaves* (1892, Saint-Germain-en-Laye). Another aspect of Morisot's late style was her exploration of a new subject, female nude studies, as in *Young Woman Drying Herself* (Galerie Hopkins and Thomas, Paris) or the pencil drawing, *The Cheval Glass* of 1890 (Paris, Louvre). This subject also appears in the drypoints, a new technique she worked on in 1889–90. There was also a change in her painting style as she began to use long, form-defining brushstrokes and deeper color harmonies. This development is best exemplified in *Girl with a Greyhound* (Julie Manet and Laertes) of 1893, an oil in the Musée Marmottan, Paris, with graceful, rhythmic arabesques of design, and orange-beige and deep blue color contrasts.

Professional recognition came to Morisot in her first solo exhibition of 1892 at the Boussod and Valadon gallery where a number of works were sold, and with the French government's purchase in 1894 of her oil painting *Young Woman in a Ball Gown* (Paris, d'Orsay). Morisot died at age 54 in 1895 of pulmonary congestion following influenza caught while nursing her daughter. A year after her death a memorial exhibition of her work at the Durand-Ruel gallery had as its installation committee Edgar Degas, Claude Monet, and Pierre-Auguste Renoir, her artistic colleagues, friends, and admirers. The preface to the catalogue was written by the poet Stéphane Mallarmé, another devoted friend. Morisot was acknowledged as a leader of the Impressionist movement. She explored unusual subjects such as the seascape and the nude which were seldom essayed by women, and she brought to all the media she worked in the distinction of a personal vision and style.

—Alicia Craig Faxon

On MOSER: books—

Waldburg-Wolfegg, Johannes, Graf von, *Moser*, Berlin, 1939.
Bauch, Kurt, *Der Tiefenbronner Altar des Moser*, Bremen, 1940.
Boeck, Wilhelm, *Der Tiefenbronner Altar von Moser*, Munich, 1951.
May, Helmut, *Moser*, Stuttgart, 1961.
Piccard, Hernard, *Der Magdalenenaltar des Moser in Tiefenbronn*, Wiesbaden, 1968.

articles—

Gamer, Jörg, "Zur Rekonstruktion des Magdalenenaltars von Moser in Tiefenbronn," in *Freiburger Diözesan-Archiv*, 74, 1954.
Straub, Rolf E., "Einige technologische Untersuchungen am Tiefenbronner Magdalenenaltar des Moser," in *Jahrbuch der Staatlichen Kunstsammlungen in Baden-Wurttemberg*, 7, 1970.

*

Lukas Moser in perhaps identical with the glass painter known as "Master Lukas" recorded as working in the Ulm Minster in 1420, 1424, and 1434. Further references to "Master Lukas" can be found in Ulm archives dating from 1409 to 1449. Surviving original glass in the Besserer Chapel of the Minster, completed in 1434, has stylistic similarities to Moser's only documented painting, the Mary Magdalene Altarpiece at Tiefenbronn, dated 1431. The name of the painter appears on this work as "Lukas Moser, maler von wil, meister des werx. bit got vir in." (Lukas Moser, painter from Weil, master of this work, pray God for him.") "Wil" is almost certainly to be identified as the Swabian town of Weil der Stadt; however, since no documents relating to Moser or to his workshop have been found there, "Wil" must have been his ancestral home. If he was active as early as 1409, and had been trained primarily in stained glass, this would explain the antiquated technique of the Tiefenbronn altar, which is painted on vellum-covered panels in a mixture of oil colors and metallic foil. The highly original seascape depicted on the altarpiece has been explained both as due to the artist's possible presence at the Council of Constance (1414–18), and alternatively as the result of the influence of Robert Campin. Recent scientific examination of the altarpiece proves conclusively, however, that Moser was the contemporary, rather than the student, of Campin.

—Jane Campbell Hutchison

MOSER, Lukas.
Place and date of birth and of death unknown, but active in southern Germany in first half of the 15th century. His masterpiece is Tiefenbronner Altar, in the Tiefenbronn parish church, 1431.

Publications

MOTHERWELL, Robert.
Born in Aberdeen, Washington, 24 January 1915. Married 1) Maria Emilia Ferreira y Moyers, 1941; two daughters; 2) Betty Sittle, 1950; 3) Helen Frankenthaler, 1958; 4) Renate Ponsold, 1972. Attended California School of Fine Arts, San Francisco, 1932; Stanford University, California, 1932–37, B. A. 1937; Harvard University, Cambridge, Massachusetts, 1937–38; Columbia University, New York, 1940; also studied

Gauloises, 1967; aquatint

under Kurt Seligman, 1941, and Stanley William Hayter, 1945; taught at the University of Oregon, Eugene, 1939, Black Mountain College, North Carolina, 1945, 1951, Hunter College, New York, 1951-58; Education Adviser, Guggenheim Foundation, 1968-73; Editor, Documents of Modern Art series, 1944-55, and Documents of 20th Century Art, 1968-80. Address: c/o Knoedler Gallery, 19 East 70th Street, New York, New York 10021, U. S. A.

Collections: Amsterdam: Stedelijk; Buffalo; Chicago; Cleveland; New York: Moma, Metropolitan, Whitney; San Francisco: Modern Art; Washington.

Publications

By MOTHERWELL: books—

Editor, *Plastic Art and Pure Plastic Art,* by Piet Mondrian, New York, 1945.
Editor, *Beyond Painting,* by Max Ernst, New York, 1948.
Editor, *On My Way: Poetry and Essays 1912-1947,* by Hans Arp, New York, 1948.
Editor, *The Dada Painters and Poets: An Anthology,* New York, 1951.
Editor, with Ad Reinhardt, *Modern Artists in America,* New York, 1951.

On MOTHERWELL: books—

Sweeney, James Johnson, *Motherwell* (cat), New York, 1944.
Motherwell: Collages 1943-1949 (cat) , New York, 1949.
Goosen, Eugene C., *Motherwell: First Retrospective Exhibition* (cat), Bennington, Vermont, 1959.
Hunter, Sam, *Motherwell Collages 1958-60* (cat), Paris, 1961.
Leavitt, T. W., et al., *Motherwell: A Retrospective Exhibition* (cat), Pasadena, 1962.
Hunter, Sam, *Collages by Motherwell* (cat), Washington, 1965.
O'Hara, Frank, *Motherwell* (cat), New York, 1965.
McKendry, John, and Diane Kelder, *Motherwell's "A la pintura": The Genesis of a Book* (cat), New York, 1971.
Carmean, E. A., Jr., *The Collages of Motherwell* (cat), Houston, 1972.
Hunter, Sam, *Motherwell: Recent Works* (cat), Princeton, 1973.
Cohen, Arthur A., *Motherwell: Selected Prints 1961-74* (cat), New York, 1974.
Woelffler, Emerson, et al., *Motherwell in California Collections* (cat), Los Angeles, 1974.
Ashton, Dore, *Motherwell* (cat), Mexico City, 1975.
Hobbs, Robert C., et al., *Motherwell* (cat), Dusseldorf, 1976.
Arnason, H. H., *Motherwell,* New York, 1977, 1982.
Carmean, E. A., Jr., *Motherwell: Reconciliation Elegy,* Geneva and New York, 1980.
Terenzio, Stephanie, *Motherwell and Black* (cat), Storrs, Connecticut, 1980, London, 1982.
Terenzio, Stephanie, and Dorothy C. Belknap, *The Painter and the Printer: Motherwell's Graphics 1943-1980* (cat), New York, 1980; as *The Prints of Motherwell,* 1984.
Ashton, Dore, and Jack Flam, *Motherwell,* New York, 1983.
Mattison, Robert Saltonstall, *Motherwell: The Formative Years,* Ann Arbor, 1987.
Glenn, Constance, *Motherwell: The Daedalus Sketchbooks,* New York, 1988.

*

Robert Motherwell was a founding member of American Abstract Expressionism during the 1940's and 1950's. Today he is considered, along with Willem de Kooning, one of the greatest living American artists. In addition to his creations in painting, collage, drawing, and printmaking, Motherwell has been a major teacher, lecturer, writer, and editor on the history of modern art.

The most salient condition of Motherwell's childhood was life-threatening asthma. He believes that his close encounters with death as a result of that illness have influenced his concern with life and death metaphors in his art. Motherwell came to painting from an intellectual and university background rather than through studio experience. While an undergraduate at Stanford University, Motherwell studied Freudian psychology and literature, particularly that of the French Symbolists. As a graduate student in philosophy at Harvard University, he was drawn to the empiricism of John Dewey and the symbolic logic of Alfred North Whitehead. At Columbia University in 1940, he attended art history classes with Meyer Schapiro. Motherwell still reads at least one book per day, and

paints at night when totally undisturbed. Motherwell credits this intellectual background with fostering his early ability to think abstractly in the visual arts. This background has also led to a continuing dialogue between immediate, sensual motivations and more rationalized approaches to his art.

Motherwell turned to painting after contact with the European emigré artists, particularly the Surrealists, in New York in 1940. Because of his knowledge of European culture and his ability to speak French, he was one of the Americans closest to that group. From the Surrealists, Motherwell adopted the idea of "automatism," which principle he discussed in 1941 with the painters William Baziotes, Lee Krasner, and Jackson Pollock, who would also become known as Abstract Expressionists. Automatism has remained a generative force in Motherwell's art to this day. At the same time that Motherwell was associating with the Surrealists, he studied the more carefully constructed modern paintings of Piet Mondrian, Pablo Picasso and Henri Matisse.

Artistic automatism, like free association in psychoanalysis, entails beginning the creative process spontaneously with no preconceived ideas. Motherwell believes that these spontaneous marks made on the canvas contain clues to deeply held and individual beliefs. In a second stage of the painting process, Motherwell then will consciously elaborate his first painting gestures to make their expression more coherent and consistent with the principles of modern art.

This creative dialectic informed Motherwell's early works during the 1940's and still does today. His early paintings were often begun with splashed pigment or random brush drawing; then a geometric structure was conceived over these areas. Yet the underlying automatism influenced the overpainted structure, and the results were a kind of emotive geometry meant to symbolize interactions between freedom and control, chaos and order, emotion and intellect. The best of these works, like many modern experiences, are tenuous, anxious, and unresolved.

In 1949 Motherwell accidently rediscovered a small drawing he had made a year before to accompany a poem by the critic Harold Rosenberg, which was to be published in *Possibilities,* a magazine they jointly edited. The drawing so struck Motherwell that he created a large varient which even more charged his imagination. The image became the first in a series that has become the leitmotif of his career, the *Elegies to the Spanish Republic.* The *Elegies* now number over 150 paintings and span 40 years. The group of paintings are generally large-scale and linked by the common motif of black organic ovals squeezed by stiff vertical bars, on a white ground. In these signs, the artist recognizes basic elements of his personality, forcefulness and vulnerability, or even the life and death impulses. The dialectic between emotion and structure in his earlier works had been transformed into grand and tragic statements.

Motherwell discovered the *Elegies* at roughly the same time that the other Abstract Expressionist painters arrived at their mature styles. Jackson Pollock, for instance, developed his large-scale drip paintings between 1947 and 1949, and Mark Rothko painted his first color-field canvases during the same period. These common discoveries are linked to the particular history of the epoch. For a brief time immediately after World War II, it seemed to many that America spoke for the world, and yet there was a somber realization of the tragedies of the war and an apocalyptic fear of the nuclear age. Motherwell meant to suggest in the *Elegies to the Spanish Republic* not merely the tragedy of Republican Spain, but his fear for humanity.

By the mid-1950's Motherwell had unconsciously developed several modes of expression in his art. The *Elegies* remained vehicles for his most profound expressions. More intimate feelings, both joyful and anguished, were expressed in smaller oil paintings like the *Je t'aime* series. During the 1950's Motherwell increased his interest in collage, a medium he had begun to explore in 1943 and one in which he has remained a pre-eminent American artist. In his collages, he began to incorporate materials from his daily studio life, labels from artists' supplies, cigarette logos, and package wrappings. The collages became abstract records of daily experiences, and, as such, modern successors to the traditional studio still-life.

In 1968 Motherwell began his series of *Open* paintings which were the focus of his art until 1972. These paintings mark an important shift in emphasis in his work. Most consist of a single field of color filling the entire canvas and accented only by three black lines forming a partial rectangle. Before the *Opens,* the majority of Motherwell's work had been based upon an aggressive investigation of painterly signs reworked through a series of overpaintings. Rather than embodying such conflicts, the *Opens* contain unified areas of color which create feelings of harmony for the artist. On that surface, Motherwell made instantaneous, but minimal, marks which are in complete accord with the rectangular shape of the canvas and yet refuse to create a figure/ground relationship or even to enclose a particular segment of the composition.

Motherwell's *Opens* are partly related to the more fluid color-field paintings then being created by such artists as Morris Louis and Motherwell's wife Helen Frankenthaler. Yet, in a larger context, the paintings demonstrate an interest in reflective Eastern philosophies, like Zen, in which he was then involved, as opposed to his earlier interest in Western philosophy and psychology dominated by the struggling individual ego. The *Opens* are also abstract equivalents to representative works showing views through open windows, symbols of the interior and exterior worlds, as particularly found in European paintings of the Romantic school and the art of Henri Matisse.

Since the *Opens,* Motherwell has not engaged in such a prolonged series of paintings upon a single theme, nor are his various media as distinct as they were during the 1950's and 1960's. He has gathered different modes into imagery that is both new and familiar. While some critics find his style eclectic, Motherwell's synthesis of gestural painting, collage, and color-field modes has enabled him to evoke a wide range of emotions using abstract forms throughout his long career.

—Robert Saltonstall Mattison

MULTSCHER, Hans

Born c. 1400 in Reichenhofen bei Leutkirch im Allgäu. Died before 1467 in Ulm. Possibly traveled in his youth to Burgundy, and influenced by Van Eyck and Robert Campin; then

active in Ulm from 1427: originator of monumental realism in Swabia; also worked in Innsbruck and Sterzing (1458–59).

Collections/Locations: Berlin; Frankfurt: Liebighaus; Innsbruck; Landsberg: S. Maria Himmelfahrt; Munich: Bavarian Museum; New York: Frick; Rottweil: Kunstsammlung Lorenzkapelle; Tübingen: Stiftskirche; Ulm: Cathedral, Rathaus; Ummendorf: parish church; Vipiteno: parish church, Multscher Museum.

Publications

On MULTSCHER: books—

Stadler, Frans J., *Multscher und seine Werkblatt: Ihre Stellung in der Geschichte der schwäbischer Kunst,* Strasbourg, 1907.

Gerstenberg, Kurt, *Multscher,* Leipzig, 1928.

Paatz, Walter, *Süddeutsche Schnitzaltäre der Spätgotik,* Heidelberg, 1963.

Rasmo, Nicolo, *L'altare di Multscher a Vipiteno,* Bolzano, 1963.

Tripps, Manfred, *Multscher: Seine Ulmer Schaffenzeit 1427–1467,* Weissenhorn, 1969.

Baxandall, Michael, *The Limewood Sculptors of Renaissance Germany,* New Haven, 1980.

articles—

Schädler, A., "Die Frühwerk Multschers," in *Zeitschrift für Württembergische Landesgeschichte,* 14, 1955.

Schädler, A., "Beiträge zum Werk Multschers," in *Anzeiger des Germanischen Nationalmuseums,* 1969.

*

Though his three most important large commissions exist today in fragmentary and dispersed forms, Hans Multscher is considered a central figure in the development of 15th-century German sculpture. Combining the visual traditions of his native Swabia with the vivid new style flourishing in the Netherlands and Burgundy since around 1400, his large Ulm workshop produced a series of altarpieces and smaller objects that established not only solid, compelling figural types, but also effective compositional solutions that were quickly taken up by contemporaries and followers.

Much of what was to distinguish the later work of Multscher and his circle was certainly apparent in one of his early monuments, the altarpiece he produced in 1433 for Konrad von Karg in Ulm Cathedral. The work fell victim to the iconoclasm of 1531 and exists now as a depopulated "stage" recessed in the wall of the church, with angels supporting a backcloth that had offered a dramatic setting for the now absent trio of stone figures, a Virgin and Child flanked by two saints. Also remaining in the niche are two carved windows originally occupied by figures observing the holy group at center. Hinged, painted panels were affixed to the sides of the monument, permitting the covering of the carved center until its ceremonial opening on designated days of the church calen-

St. Florian, 1456–58; wood; Vipiteno, Civic Museum

dar. These elements, including the formal dialogue between painted wings and a deep, sculptural center, all point strongly to Multscher's absorption of the forms recently evolved in the art of the Netherlands and northern France. It has long been assumed that Multscher travelled and perhaps trained in these areas early in his career, judging not only from the arrangement of his Karg and later altarpieces, but also from the full, vital forms of his figures.

The chronology of Multscher's early work remains uncertain, but several stone figures still *in situ* in Ulm are dated close to 1430, providing a fair reflection of his style soon after his presumed contact with the products and craftsmen of the progressive western shops. A group of five figures on the ceremonial east windows of the Rathaus represent Charlemagne with two squires and two kings. While their bold, rather smooth surfaces may recall the eastern sculptural legacy of the Prague-based Parler workshop, which still echoed in much German production of the early 15th-century, Multscher's Rathaus figures have also begun to breathe the animating air of the great Burgundian idiom crystallized in Claus Sluter's work at Dijon from the 1390's. Though writers sometimes describe German sculpture of this period as a sort of dialectical exchange between the Parler and Sluter traditions, the individual creative powers of an artist like Multscher must always be kept in mind. Perhaps the clearest remnant expression of his early genius appears in the figure of Christ as *Man of Sorrows* on the west portal of the Ulm Cathedral, also dated around 1430. Here the autonomous, rounded forms of Burgundy enhance the figure's dynamic, even confrontational immediacy. Placed within a narrow gothic aedicula, he leans to his side, defying the central axis of his setting and seemingly prepared to step forward from it. The figure's unsettled stance, outward gestures, and concentrated gaze acknowledge the presence of viewers and strive to approach them both physically and psychologically.

This rethinking of the traditionally declared boundaries between the object and its environment characterizes a number of Multscher's works, including the Karg altar, where the unusual combination of the "opened wall," backing drapery, and window-figures reveals keen attention to the possibilities of presentation. Another variation on the theme appears in a model Multscher created for a grave monument ordered by Herzog Ludwig den Gebarteten von Ingolstadt in 1435 (Munich, Bavarian Museum). In a complex image of the patron kneeling before a vision of the Holy Trinity, several elements from within the scene boldly exceed the edges of the rectangular frame, suggesting a heightened, nearly aggressive level of reality for the objects and figures depicted. This original, deftly realized relief bespeaks Multscher's skill not only as a carver in the round, but also as a pictorial designer.

In fact, Multscher may have been a painter as well as a sculptor. His name appears in an inscription on a set of eight painted panels comprising the wings of the Wurzacher altarpiece, painted in 1437 (Berlin). While some have cited this to prove Multscher's activity as a painter, others have noted that it may simply name him as the head of the workshop of specialized craftsmen that produced the entire altarpiece, which originally included a sculptural center. Whether or not Multscher actually executed the panels produced in his shop, which show four scenes from the life of Mary and four from the passion of Christ, they represent a striking episode in the de-velopment of late gothic painting in Germany. The figures share a bulky, humble presence that slips at times from rustic coarseness toward simple ugliness, even in the members of the Holy Family. This is a far cry from the graceful characterizations typical of most German painting from the beginning of the 15th century. In various compositional elements and in the handling of draperies, the paintings presuppose an awareness of the powerful Netherlandish styles developed by contemporary painters like Jan Van Eyck, Robert Campin, and Rogier Van der Weyden, styles which proved nearly irresistable to painters, sculptors, and printmakers in much of northern Europe through the remainder of the century. In addition to their squat stature and rough faces, the Wurzacher figures are memorable for their broad range of dramatic expressions and the emphatic, almost exaggerated tenor of their gestures.

Multscher's surviving work after the Wurzacher altarpiece includes a series of single figures, most carved in wood, and a group of scattered components of the dismantled Sterzing altarpiece of 1456–59. Most of the figures attributed to him in this period, like the remarkable *Virgin and Child* now in Landsberg (S. Maria Himmelfahrt), maintain and refine the weighty, forceful style apparent in the earlier works. Here, as in all of Multscher's figures, there is an energetic surface inevitably attuned to the subtle movements of the body, though drapery and limbs are never allowed to swing substantially or illogically beyond a strongly defined central core. Their faces project a contemplative, often melancholy character that never lapses into the formulaic prettiness familiar from much gothic statuary of the late 14th century. They are thoughtful heads on imposing bodies, and contributed much to the rich shapes taken by south German sculpture in the fertile decades to follow.

—Alfred J. Acres

MUNCH, Edvard.

Born in Löten, 12 December 1863. Died in Oslo, 23 January 1944. Pupil of Christian Krohg, and at the Royal School of Drawing, Oslo, 1881; studied under Léon Bonnat in Paris, 1889–96; exhibited from 1883, including one scandalous exhibition in Berlin, 1892; many graphic works; lived in Berlin and Paris until nervous breakdown brought him back to Norway, 1909; frescoes for Oslo University Festival Hall completed 1913; lived in Ekely, near Oslo, from 1916.

Major Collections: Bergen: Rasmus Meyers Samlinger, Bergen Bildegalleri; Oslo, Munch Museum, National Gallery.
Other Collections: Basel; Berlin; Boston; Cologne; Copenhagen; Hamburg; Helsinko; London: Tate; Moscow; Minneapolis; Moscow; Oslo: Rathaus, University; Paris: d'Orsay; Prague; Stockholm; Washington; Zurich.

Publications

By MUNCH: books—

Brev. Familien, edited by Inger Munch, Oslo, 1949.

Self-Portrait with Skeleton Arm, 1895; lithograph

Briefwechsel 1902–1928, with Max Linde, edited by Gustav Liedtke, Lubeck, 1974.

On MUNCH: books—

Schiefler, Gustav, *Verzeichnis des graphischen Werks Munchs,* Berlin, 2 vols., 1907–28.

Stenersen, Rolf, *Munch: Naarbild ar ett geni,* Stockholm, 1944; as *Munch: Close-Up of a Genius,* Oslo, 1969.

Willoch, Sigurd, *Munch Etchings,* Oslo, 1950.

Deknatel, Frederick B., *Munch,* (cat), Boston, 1950.

Kokoschka, Oskar, *Der Expressionismus Munchs,* Vienna, 1953.

Madsen, Stephan, *An Introduction to Munch's Wall Paintings in the Oslo University Aula,* Oslo, 1959.

Langaard, Johan H., and Reidar Revold, *Munch: The University Murals, Graphic Art, and Paintings,* Oslo, 1960.

Langaard, Johan H., and Reidar Revold, *Munch fra ar kil ar / A Year by Year Record of the Artist's Life,* Oslo, 1961.

Smith, John Boulton, *Munch,* Berlin, 1962, Oxford, 1977.

Langaard, Johan H., and Reidar Revold, *Munch: Mesterverker i Munch-Museet,* Oslo, 1963; as *Munch: Masterpieces from the Artist's Collection in the Munch Museum in Oslo,* New York, 1964.

Timm, Werner, *Munch: Graphik,* Braunschweig, 1969; as *The Graphic Art of Munch,* Greenwich, Connecticut, 1969.

Hodin, Josef Paul, *Munch,* New York and London 1972.

Bock, Henning, and Günter Busch, editors, *Munch: Probleme, Forschungen, Thesen,* Munich, 1973.

Heller, Reinhold, *Munch: The Scream,* New York, 1973.

Selz, Jean, *Munch,* Naefels and New York, 1974.

Munch (cat), Paris and London, 1974.

Stang, Ragna, *Munch: Mennesket og kunstneren,* Oslo, 1977; as *Munch: The Man and His Art,* New York, 1979.

Eggum, Arne, *The Masterworks of Munch* (cat), New York, 1979.

Werner, Alfred, *Graphic Works of Munch,* New York, 1979.

Weisner, Ulrich, *Munch: Liebe, Angst, Tod: Themen und Variationen: Zeichnungen und Graphiken aus dem Munch-Museum, Oslo* (cat), Bielefeld, 1980.

Dittmann, Reidar, *Eros and Psyche: Strindberg and Munch in the 1890s,* Ann Arbor, 1982.

Eggum, Arne, *Munch: Malerier, Skisser, og studier,* Oslo, 1983; as *Munch: Paintings, Sketches, and Studies,* New York, 1984.

Prelinger, Elizabeth, *Munch, Master Printmaker,* New York, 1983.

Heller, Reinhold, *Munch: His Life and Work,* London, 1984.

Smith, John Boulton, *Frederick Delius and Munch: The Friednship and Correspondence,* Rickmansworth, 1985.

Lippincott, Louise, *Munch: Starry Night,* Santa Monica, 1988.

*

Although born in central Norway far from the sea and growing up in the heart of Oslo—then called Kristiania—Edvard Munch was soon drawn to the shores of the fjord that gradually opens up to the world beyond. In childhood summers and in adult years he spent holidays in villages along these shores whose soft contours and lingering twilight nights are featured in so many of his paintings. Somehow, this modest, subdued landscape, so radically different from the drama of the west coast, became a recuperative haven for this artist whose principal contribution to modern painting is his bold depiction of the emotional agony inherent in the human condition.

Trained in the period of Naturalism—briefly under the guidance of his countryman Christian Krohg—and maturing through his exposure to Manet and the French Impressionists, Munch in turn broke with both movements and developed an art of his own devoted to the uncompromising unveiling of the psychological forces that determine our course from the prenatal stages through death.

His contact with Krohg in the studio and even more so in the *avant-garde* circle known as the Bohèmes tended to free him from the restraint of a family tradition steeped in its consciousness of generations of socio-cultural leadership, while his encounter with the French freed him from the strictures of a traditional approach to the arts. Most decisive for his development, however, was his relentlessly bleak childhood and youth filled with anxiety, sickness, and death, and most of his early, pioneering works, such as *Sick Girl, The Scream, Death in the Sickroom,* are the result of deliberate efforts at coming to terms with these experiences and thereby ensure his own emotional survival.

From his debut in 1883 until his first exile in 1892 Munch participated in the annual Norwegian autumn *salon,* and twice, 1889 and 1892, he mounted his own one-man shows. With some rare exceptions critics viewed his efforts with blatant scorn, one calling them " 'art-of-the-future' absurdities," then noting that some—referring to certain other artists—actually found these absurdities to make sense: "Of course! For there is no earthly beauty or truth that cannot be twisted into its own caricature, and there is no madness or inanity in this world that some fool or other won't eagerly admire."

Among these fools was a Norwegian artist residing in Berlin, Adelsteen Normann, who arranged for a Munch exhibit in the Prussian capital; and in the autumn of 1892 Munch set out for Berlin, certain to find a more sophisticated and receptive art public. In that respect Berlin did not live up to his expectations, for no sooner had the exhibit opened than it was closed by city authorities "in the name of decency and proper art." Yet the ensuing controversy, *der Fall Munch* as it was called in the German press, focused attention on the young artists and paved the way for new opportunities. It is therefore entirely appropriate to consider this particular event Edvard Munch's artistic breakthrough.

Of the many whose company inspired him in his two years in Berlin the most important were August Strindberg, the Swedish dramatist whose extreme misogynist views are clearly discernible in several canvases, most notably *Self-Portrait under a Female Mask* and *Self-Portrait in Hell;* Stanislaw Przybyszewski, the Polish writer and critic who produced the first book-length study on Munch; and Dagny Juell, the Norwegian cultural activist whose sensitive features can be seen in *Madonna, The Hands,* and other works, and who remained the single most influential woman in Munch's life.

Many of his most crucial paintings, although often developed from much earlier sketches, were brought to completion in Berlin, among them *Puberty, The Day Thereafter, The Scream, Ashes, Woman in Three Stages;* and traces of the Berlin experience linger in many subsequent works. While pro-

foundly original there is much in these efforts reminiscent of other artists. Their often grotesque distortions may recall works by Bosch, and therein lies perhaps the critic's reference to absurdities and madness. The anguish that seems to burst out of all control may derive from Goya. Much more apparent, however, than such possible influences from artists of a more remote paste is the obvious indebtedness to Gauguin and Van Gogh. The synthesized, stylized figure composition and radical juxtaposition of pure colours through which Gauguin zooms in on the elemental, primeval emotional quality of his subject, and the twisting and twirling curvilinear sweeps that charge Van Gogh's final canvases with an almost unbearable dynamic tension are also part of Munch's approach to painting. However, his agonized statements extend beyond the deeply personal, subjective expressions of his remote and immediate predecessors and take on the character of passionate interpretations of universal human suffering.

The brooding spirit that permeates his creativity in the 1890's, although never entirely absent, gradually yields to a more positive point of view. In the first decade of the new century he turns to the landscape in its shifting seasons, producing boldly conceived, exuberantly coloured canvases depicting the seething, regenerative energy inherent in planting, growth, and harvest. This creative outpouring reaches its monumental climax is his Oslo University decorations where *Mother Earth* nurses her young, *History* links the past and the present, and *The Rising Sun* floods the Festival Hall with the life-giving primeval light of the Day of Creation.

—Reidar Dittmann

Self-Portrait; 48½ × 42 in (122 × 107 cm); Royal Collection

MURILLO, Bartolomé Esteban (Pérez).

Born in Seville, 1617, baptized, 1 January 1618. Died in Seville, 3 April 1682. Married Beatriz Cabrera, 1645 (died, 1663); nine children. Trained with the painter Juan del Castille from c. age 15 in Seville; given major commissions in his 20's, and encouraged by Velazquez in Madrid in the early 1640's; frescoes for the convent of San Francisco, 1640's, S. Maria la Blanca, 1665, Convent de las Capuchinos, Augustinian Convent, etc.; co-founder of the Academy of Seville, 1660, and its first president; prolific. Pupils: Pedro Núñez de Villavicencio, Sebastián Gómez el Mulato.

Major Collections: Madrid; Seville.
Other Collections: Budapest; Cambridge, Massachusetts; Chicago; Cologne; Dresden; Dublin Florence: Pitt; Genoa: Bianco; Houston; Leningrad; Liverpool; London: National Gallery, Wallace, Dulwich, Wellington; Madrid: Academia de Bellas Artes; Munich; New York; Ottawa; Paris; Pasadena; Raleigh, North Carolina; Seville: Cathedral, Hospital de la Caridad; Toulouse; Washington.

Publications

On MURILLO: books—

Calvert, Albert F., *Murillo: A Biography and Appreciation,* London and New York, 1907.

Valencina, Fr. A., *Murillo y los Capuchinos,* Seville, 1908.

Mayer, August L., *Murillo,* Stuttgart, 1913, 1923.

Vega, J. de la, *Murillo,* Seville, 1921.

Mayer, August, *The Work of Murillo,* New York, 1921.

Mayer, August L., *Murillo, der Maler der Bettlejungen und Madonnen,* Munich, 1921.

Montoto, Santiago, *Murillo,* Seville, 1923.

Dominguez, Luis Leon, *La Caridad de Sevilla: Manara, Murillo, y Valdes Leal,* Madrid, 1930.

Pantorba, B., *Murillo,* Madrid, 1947.

Abbad Rios, F., *Las Immaculadas de Murillo,* Barcelona, 1948.

Elizalde, Ignacio, *En torno a las Immaculadas de Murillo,* Madrid, 1955.

Lopez Alonso, A., *Murillo en el museo del Prado,* Madrid, 1958.

Causa, Raffaelo, *Murillo,* Milan, 1964.

Sánchez de Palacios, Mariano, *Murillo,* Madrid, 1965.

Costa, J., *Murillo,* Barcelona, 1972.

Angulo Iniguez, Diego, *Murillo y su escuela en colecciones particulares,* Seville, 1975.

Brown, Jonathan, *Murillo and His Drawings* (cat), Princeton, 1976.

Gaya Nuno, J. A., *L'opera completa di Murillo,* Milan, 1978.

Angulo Iñiguez, Diego, *Murillo: Su vida, su arte, su obra,* Madrid, 3 vols., 1981.

Angulo Iñiguez, Diego, *Murillo* (cat), London, 1982.

Valdivieso, E., and J. M. Serrera, *La época de Murillo* (cat), Seville, 1982.

Murillo y su tiempo, Seville, 1982.

Ressort, Claude, *Murillo dans les musées francais* (cat), Paris, 1983.

Ayala Mallory, N., *Murillo,* Madrid, 1983.

*

About Murillo very little is actually known, an anomaly given his once-great international fame. His first (only known) painting master was Juan del Castillo, with whom he stayed until 1638. Castillo, now otherwise largely forgotten, was one of the few local painters heading a workshop at that time, and another notable student of his was Alonso Cano. The city's other great artists—Pacheco, Velázquez, and Zurbarán—were either busy elsewhere or not admitting students (Seville at this time was in economic decline). Murillo's first identifiable paintings date from 1639–40, but these show little of the verve characterizing dated works produced half a decade later. Murillo apparently passed his entire career in his native city, with the exception of two documented visits to the Spanish Court in Madrid, around 1642/43 and once again in 1658. To the first sojourn in the capital (of uncertain duration) are credited the great advances in Murillo's style, immediately perceptible in his first major commission, the thirteen paintings for the Claustro Chico in the Seville church of San Francisco (c. 1645–7). In this case, the seemingly miraculous transformation of Murillo's technique and expressive means is surely due to his intense scrutiny of the great masters on view in the Spanish Royal Collection (and now forming the backbone of the Prado's holdings); as reported by Antonio Palomino in 1724, Murillo industriously copied many works by Titian, Rubens, and Van Dyck in Madrid. From this crucial moment on, and practically singlehandedly, Murillo set in place the new style defining (and eventually dominating) mainstream Spanish painting for another hundred years. Richly colored and forcefully modelled, the visionary *estilo vaporoso* represents Murillo's suave baroque synthesis of succulent Venetian color and solid Flemish modelling. In this case, however, the assimilation of borrowed foreign forms was to be decisively re-shaped by pre-existent Spanish content: the estatic didacticism of Counter-Reformation orthodoxy. In Seville, Murillo formed a busy and efficient workshop. Besides producing several notable pictorial cycles for local religious foundations, the locally popular painter also executed portraits and various genre-paintings, most of which are today assumed to have been commissioned by members of a large community of Flemish businessmen resident in Seville.

Murillo is a truly great artist whose marvellous paintings (best studied in the well-lighted Provincial Museum of Art in Seville) have currently fallen—quite unjustifiably—into critical disgrace. This homebound Sevillian painter was once ranked with the likes of Titian, Raphael, and Van Dyck, and justifiably so, since he consciously took these foreign masters as models for his spontaneous renovation of *Siglo de Oro* painting. For example, Roger de Piles (*Cours de peinture par principes avec une balance des peintres,* 1708) awarded Murillo fifteen points for "color" as opposed to eighteen for Titian, twelve for Raphael, and seventeen for Van Dyck. How do we account for his subsequent fall from critical grace? Murillo seems the hapless victim of anachronizing modern taste, hav-ing little to do with strictly aesthetic issues, prejudicial (if not outright hostile) in regards to certain categories of subject matter, and, worse, signally ignorant of the cultural necessities of Murillo's essentially didactic religious art. In short, Murillo's dulcet and estatic imagery—Catholic art par excellence—cannot be rightly appreciated except in its own, art historically specific, context.

Murillo's unabashedly orthodox, completely self-explanatory, and immediately ingratiating paintings represent the epitome of fundamental ideals impelling baroque art, and the governing aesthetic dictum of that age was "delectare, docere, et permovere"; thus art was enjoined "to delight, to instruct, and so to move the soul of the beholder." In fine, this now severely underrated painter was, and still is, one of the most gifted and spontaneously accomplished technicians belonging to an age in which spectacular competence was a given, a *sine qua non.* For this very reason—sublime virtuosity—Murillo's art was to gain its most enduring fame in Georgian and Victorian England, paradoxically a Protestant country, but one still held very much in the thrall (since 1630) of Van Dyck's elegant painterly rhetoric. Nevertheless, in his own country Murillo was somewhat less well received, largely (as one may believe) because he had never chosen to attach himself to the court in Madrid where, doubtlessly, he would have at least rivalled the professional accomplishments (and worldly success) of Diego Velázquez. A somewhat hostile contemporary appraisal of Murillo's fame is provided by a Spanish painter of markedly middling talents, Antonio Palomino de Castro y Velasco, also the partisan champion of Velázquez's courtly art. As he observed in his *Parnaso español pintoresco laureado* (1724), "outside of Spain, today one canvas by Murillo is valued more than one by Titian or Van Dyck. This just shows what the delights of color can do to win popular favor! In truth, those men who have achieved the greatest vulgar approval have not necessarily been the greatest of draftsmen." Typical of the tastes of all his contemporaries attached to the Spanish Court, the colorless and non-populist Palomino's biases are all too evident; he was himself a bad colorist—and a mediocre draftsman to boot. Instead, this dry academician and art theoretist favored "Michelangelo, Raphael, Annibale and the rest of the Carracci School," because, as he erroneously believed, "they all drew better than did Titian, Rubens, Van Dyck, Correggio and our Murillo, who, in spite of this lack, are the artists who have won the greatest popular praise." Palomino's biases explain Murillo's present critical malaise; as he put it, the likes of a Murillo are devoid of high-minded rigor, an elitist trait represented by Palomino's own dry linearisms. Murillo, undeniably a seductive colorist and exemplar of baroque painterliness (additionally, to our eyes, an absolutely superb draftsman), only succeeded, states Palomino, in "eliciting the vulgar applause of the multitude." As one concludes, such are the nearly inevitable critical misfortunes of any great artist who provides sheer pictorial delights and, worse, who prefers the retiring isolation of the provinces in place of the lucrative competitiveness of the world's cramped capitals.

—John F. Moffitt

N

NANNI di Banco.

Born in Florence in the mid-1370's; son of the stonemason Antonio di Banco. Died in Florence, December 1421. Joined stonemasons guild, 1406; worked at Florence Cathedral with his father, 1406–07; major works include a statue of Isaiah for the Cathedral, 1408, a statue of St. Luke for the Cathedral, 1413, St. Philip for Orsanmichele, c. 1410–12, *Four Saints* (Quattro Santi Coronati) for Orsanmichele, c. 1415, St. Eligius for Orsanmichele, c. 1417–21, and *Assumption of the Virgin* for the Cathedral, 1414–21.

Collections: Florence: Cathedral, Cathedral Museum, Orsanmichele.

Publications

On NANNI: books—

Planiscig, Leo, *Nanni di Banco,* Florence, 1946.
Vaccarino, Paolo, *Nanni,* Florence, 1950.
Bellosi, Luciano, *Nanni de Banco,* Milan, 1966.
Wundram, Manfred, *Donatello und Nanni di Banco,* Berlin, 1969.

articles—

Lanyi, J., "Il profeta Isaia di Nanni di Banco," in *Rivista d'Arte* (Florence), 18, 1936.
Seymour, Charles, "The Younger Masters of the First Campaign of the Porta della Mandorla 1391–1397," in *Art Bulletin* (New York), 41, 1959.
von Einem, H., "Bemerkungen zür Bildhauer-darstellung des Nanni di Banco," in *Festschrift für Hans Sedlmayr,* Munich, 1962.
Janson, H. W., "Nanni di Banco's Assumption of the Virgin on the Porta della Mandorla," in *Studies in Western Art* (colloquium), Princeton, 2 vols., 1963.
Brunetti, G., "I profeti sulla porta del campanile di Santa Maria del Fiore," in *Festschrift U. Middelford,* Berlin, 1968.
Herzner, V., "Donatello und Nanni di Banco: Die Prophetenfiguren für die Strebefeiler der Florentiner Domes," in *Mitteilungen des Kunsthistorischen Institutes in Florenz,* 17, 1973.
Herzner, V., "Bemerkungen zu Nanni di Banco und Donatello," in *Wiener Jahrbuch für Kunstgeschichte,* 26, 1973.

Lisner, M., "Josua und David: Nannis und Donatellos Statuen für den Tribuna Zyklus des Florentiner Doms," in *Pantheon* (Munich), 32, 1974.
Bergstein, Mary, "La vita civica di Nanni di Banco," in *Rivista d'Arte* (Florence), 3, 1987.
Horster, Marita, "Nanni di Banco: Quattro santi coronati," in *Mitteilungen des Kunsthistorischen Institutes in Florenz,* 31, 1987.
Bergstein, Mary, "The Date of Nanni di Banco's *Quattro santi coronati,*" in *Burlington Magazine* (London), December 1988.

*

The Florentine Nanni di Banco was a powerful designer of monumental figure sculpture and one of the first empirical realists of the Italian Renaissance. A contemporary of the architect Filippo Brunelleschi, Nanni was at the summit of his productivity when he died prematurely in 1421. His relatively brief career was filled with some of the most prestigious sculptural projects in Florence, including ensembles for three of the outdoor tabernacles at Orsanmichele and the imposing *Assumption of the Virgin,* which has since given the name "Porta della Mandorla" to the northeast door of the cathedral. Descended from generations of stonemasons and carvers, Nanni rose to an eminent social status in the Florentine republic: he served repeatedly as a consul of the stonemasons guild, and held public office frequently. Nanni's earliest critical fortunes tended to characterize him as a clumsy follower of Donatello, or as a rather prosaic copier of Roman stones, albeit the first Florentine artist to demonstrate a concrete interest in classical antiquity. More recent scholarship has recognized Nanni as a pioneering artist, who had a considerable impact upon the development of Donatello, Masaccio, and others; Nanni's great contribution to the Renaissance revival of antiquity is found precisely in his interpretive re-invention of classical forms.

The *Isaiah* (originally intended to stand atop a buttress of the cathedral tribunes) served as the official prototype for Donatello's marble *David* (Bargello). As the first free-standing statue to have been completed by Nanni or Donatello, it set a precedent for the monumental figure sculpture to follow, culminating a century later in Michelangelo's *David* (itself originally conceived as a buttress statue.) A simultaneous presence of International Gothic and classicizing features in the *Isaiah* has defined the critics' response to the work. Indeed, Nanni di Banco's statue monumentalizes in scale a figure and drapery style that is best known in the bronze panels of Lorenzo Ghi-

Porta della Mandorla; Florence, Cathedral

berti's first set of Baptistry doors, which themselves may contain reflections of northern Gothic goldsmiths' work. But beneath the swirling, arabesquing draperies and in spite of the tentative, swaying quasi-*contrapposto* stance, the *Isaiah* is a beardless, muscular young hero in the classical mode, reminiscent of Nicola Pisano's nude Daniel at the Pisan Baptistry, to name one local "proto-Renaissance" example.

By the second decade of the Quattrocento Nanni di Banco's work can be described as fully classical. During this phase, Nanni was primarily inspired by the art of antiquity and his own firsthand observation of life. In the *St. Luke* (made for the cathedral facade) hardly a trace of the Internatinal Gothic flavor remains; here the closely observed pose of the head and face completes the organically normative equipoise of the seated figure. The upward tilt of the face and lowered eyelids counterbalance one another as realistically as if the spine, head, and eyelids were all caught in a fleeting natural movement. Although the head of the *St. Luke* recollects the sensuous, momentary charm of the portraiture of the Traiano-Hadrianic age, it ought to be emphasized that for Nanni di Banco the study of classical portraits was not an end in itself, but rather a means, together with the keen observation of living men, toward phenomenal and psychological realism. Similarly, in his *Quattro Santi Coronati* at Orsanmichele, where four figures unified in the semicircle of a single niche interact in grave but harmonious conversation, Nanni seems to have consulted Roman portraits from the Republican and Imperial periods to create four distinctly individual—even idiosyncratic—characters. Just as an anatomically correct stance has now replaced the conventionalized sway of Trecento figures, the heads of the statues no longer adhere to the medieval formula of stylized inscrutability. The *St. Luke* and *Quattro Coronati* mark a new direction in art away from the symbolical realm of divine figures toward a world of human emotions and human values, toward an expression of the actual conditions of life, including physical and mental fatigue, and the passage of time through human aging. Ultimately, the heads of Nanni di Banco's saints communicate a warmer, more empathic, rendition of personality than had ever been evinced in the portraits of rulers or ancestors produced in ancient Rome.

Almost all critics recognize a departure from Nanni's earlier style in the great *Assumption of the Virgin* in the gable above the Porta della Mandorla. One feels for the first time in this relief a softness and curvilinearity that has often been characterized as a nostalgic return to the Gothic aesthetic—in effect a turning away from classical models and the new realism. Although certain figures and forms in the *Assumption* deliberately refer to types originating in 14th-century sculpture—most particularly the *Assumption* relief on Orcagna's tabernacle at Orsanmichele—Nanni's relief is progressive in terms of pictorial design. He infused the essentially symmetrical composition, which had to be compressed in a steep triangular space, with unprecedented representational variety and psychological animation: Nanni achieved the richness of movement and refinement of compositional structure that Alberti would advocate in his manifesto *De pictura* of 15 years later. The youthful *personae* of the *Assumption* hardly invite the artist to describe the surface of the faces with the plain, hard realism he had in his earlier statues: nevertheless a variety of textue and atmospheric color is brought forth in the crackling oak bark, the alternately flame and rope-like strands that make up the hair of

the lower left angel, the highly suggestive confection of hair and amaranth leaves crowning the semi-nude oboist above, and the puffy softness of the cheeks of the right-hand oboe player. Critics who described Nanni's *Assumption* as Baroque may have intended to disparage the insistently curvilinear rhythms of the draperies, the dynamic propulsion of the angels, and the exquisite ascendant torsion of the Virgin Mary. But a comparison with 17th-century sculpture may not be irrelevant to Nanni's *Assumption,* where he has anticipated the texture and animation that we discover some two hundred years later in a work of sculpture such as Bernini's *Apollo and Daphne.*

—Mary Bergstein

NEWMAN, Barnett.

Born in Manhattan, New York, 29 January 1905. Died in New York, 4 July 1970. Married Annalee Greenhouse, 1936. Attended National Hebrew School, and DeWitt Clinton High School, New York; studied under Duncan Smith, John Sloan, and William von Schlegell at the Art Students League, New York, 1922, 1929; City College of New York, 1923–27, B.A. 1927; later studied botany and ornithology, 1939–41; worked in his father's clothing manufacturing business, New York, 1927–29, then painter and teacher: taught at the University of Saskatchewan, Saskatoon, 1959, University of Pennsylvania, Philadelphia, 1962–63, and University of Bridgeport, Connecticut, 1968.

Collections: Basel; Essen; London: Tate; Minneapolis; New York: Moma, Longview Foundation; Paris: Beaubourg; Stockholm: Moderna Museet.

Publications

By NEWMAN: book—

Can We Draw (cat), New York, 1938.
American Modern Artists (cat), New York, 1943.
Adolph Gottlieb (cat), New York, 1944.
Pre-Columbian Stone Sculpture (cat), New York, 1944.
Northwest Coast Indian Painting (cat), New York, 1946.
The Ideographic Picture (cat), New York, 1947.
Stamos (cat), New York, 1947.
Herbert Ferber (cat), New York, 1947.
Amlash Sculpture from Iran (cat), New York, 1963.
18 Cantos 1963–64, West Islip, New York, 1964.

On NEWMAN: books—

Stone, Allan, *Newman and Willem de Kooning* (cat), New York, 1962.
Alloway, Lawrence, *Newman: The Stations of the Cross* (cat), New York, 1966.
Hess, Thomas B., *Newman,* New York, 1969.
Huber, Carlo, *Newman: 22 Lithographien* (cat), Basel, 1969.
Newman (cat), Pasadena, 1970.

Newman: Das graphische Werk (cat), Berne, 1970.

Hess, Thomas B., *Newman* (cat), New York, 1971.

Imdahl, Max, *Who's Afraid of Red, Yellow, and Blue III*, Stuttgart, 1971.

Rosenberg, Harold, *Broken Obelisk and Other Sculptures*, Seattle and London, 1971.

Hess, Thomas B., *Newman* (cat), London, 1972.

Rosenberg, Harold, *Newman*, New York, 1978.

Heynen, Julian, *Newmans Texte zur Kunst*, Hildesheim, 1979.

Richardson, Brenda, *Newman: The Complete Drawings* (cat), Baltimore, 1979.

Brockhaus, Christoph, *Newman: Das zeichnerische Werk* (cat), Cologne, 1981.

Hepp, Nicolas, *Das nicht-rationale Werk: Jackson Pollock, Newman*, Mulheim, 1982.

articles—

Zakian, Michael, "Newman and the Sublime" and "Newman: Painting and a Sense of Place," both in *Arts Magazine* (New York), February and March 1988.

*

Barnett Newman, a leading figure of Abstract Expressionism, arrived at his mature style in 1948 after a long period of meditation and abstention from painting between about 1939 and 1944. After this period of intense intellectual debate Newman again started to work with a series of biomorphic drawings, applying the technique of automatism. In these drawings, influenced by Surrealism and his involvement with the natural sciences, he investigated aspects of floral and animal life such as growth, decay, and rebirth.

Between 1945 and 1947 Newman explored for the first time, in works such as *The Command* and *The Moment* (both 1946) the formal possibilities of the straight vertical line ("zip") which became the most characteristic element of his art. *Onement I* (January 1948) is, by Newman's own reckoning, his breakthrough and hitherto most radical statement, providing the starting point for most of his later work. He achieved this position through a long examination of and confrontation with European art, and especially the geometric abstraction of Mondrian. Newman repudiated Mondrian's compositions for still adhering to the structure of the Renaissance picture, creating only "an empty world of geometric formalisms—a *pure* rhetoric of abstract mathematical relationships." To Newman European art failed because it clung to the ideal of beauty and the reality of sensations, instead of "creating a new sublime image." Newman substituted the notion of beauty for that of the sublime, making possible the experience of "absolute emotions." The American artist, "free from the weight of European culture," is concerned "with the reality of transcendental experience," while the European with his refined sensibility is still preoccupied with the transcendence of objects. Newman's rejection of European culture was also closely related to his interest in primitive art and "the essence of myth," which he shared with his friends Mark Rothko and Adolph Gottlieb. They saw the similarities of primitive and modern society: both lived in times of great "terror." The intuitive primitive artist was able to combine form and content in his abstract works, directly expressing a transcendental and metaphysical

Untitled, 1961; lithograph

vision without the illusion and realism inherent in Surrealist art.

Barnett Newman's style reached full maturity with *Vir Heroicus Sublimis* (1950–51) his first painting on a large scale and with a long rectangular format. Throughout his career, with only a few exceptions, Newman maintained this format and the basic composition of straight vertical lines or parallel fields of colour. In spite of the minimum of means he employed, he was able to achieve the maximum effect. The treatment of the surface and the detailing of the so-called "zips" revealed the significance of the act of painting. Though usually seen as bearing an affinity with the work of the colour-field painters Mark Rothko and Clyfford Still, his "zips" could equally be seen as having the sensual and emotional appeal of the gestural modes of Jackson Pollock.

In reaction to the scale of *Vir Heroicus Sublimis* Newman executed a series of extremely narrow paintings (*The Wild*, 1950, $95^3/_4$ x $1^5/_8$ inches), which have been called the first "shaped canvases." In the same year he also created his first sculpture, *Here I*, in whch he gave three-dimensional expression to two narrow "zips" of contrasting tactile qualities set up on a flat base. His most important sculpture is *Broken Obelisk* (1963–67) combining the forms of a pyramid and an inverted obelisk.

Though Newman only received wide recognition in the late 1950's and 1960's, he had a great impact on younger painters such as Morris Louis and Kenneth Noland, as well as on the

Minimal art of Donald Judd. Newman himself developed the possibilities of the "shaped canvas" in two triangular shaped works, *Chartres* and *Jericho* (both 1969), in which he attempted to deny and "transform the shape[s] into a new kind of totality" through their internal composition. In 1963 and 1964 he investigated the relationship of image and format in a series of lithographs, *18 Cantos*.

Between 1958 and 1966 Newman executed a series of 14 paintings he titled *The Stations of the Cross*. It was not Newman's intention to illustrate a traditional iconographical theme through a series of anecdotes, but to express through the unity of 14 related parts the experience of the Passion as one event.

The central issue of Newman's painting was always content, rejecting formalist interpretations purely concerned with form, color, and spatial arrangement. This is indicated by the titles of works which refer to the Old Testament, the Talmud, or Jewish mysticism. It was Newman's aim to provide each viewer with an emotional and transcendental experience of his own being. "I became involved with the idea of making the viewer present: the idea that 'Man Is Present.' " Through the sublime Newman is able directly to represent ideas and "absolute emotions" without the use of analogies. His paintings are "visual configurations, displays of colour and form, that become iconographic through internal development and repetition" (Lawrence Alloway). Through his painting and writings Newman was able to make art and life inseparable. For his supreme intention always was "the defence of human dignity."

—Christoph Grunenberg

NICCOLÒ Dell'Arca

Born c 1435–40. Died in Bologna, 2 March 1494. First documented in Bologna, 1462: Lamentation group for S. Maria della Vita, c. 1463; also worked on the Arca of S. Domenico Maggiore, 1460's to 1470's: very elaborate group, worked on later by other artists.

Collections/Locations: Bologna: S. Maria della Vita, S. Domenico Maggiore, S. Giovanni in Monte; Escorial.

Publications

On NICCOLO: books—

Gnudi, C., *Niccolò dell'Arca,* Turin, 1942.
Bottari, S., *L'arca di S. Domenico in Bologna,* Bologna, 1964.
Novelli, M., *Niccolò dell'Arca,* Milan, 1966.
Gnudi, C., *Nuove recerche su Niccolò dell'Arca,* Rome, 1972.
Emiliani, Andrea, editor, *Tre artisti nella Bologna dei Bentivoglio: Cossa, Roberti, Niccolò dell'Arca* (cat), Bologna, 1985.

articles—

Beck, James H., "Niccolò dell'Arca: A Re-examination" in *Art Bulletin* (New York), 47, 1965.

Del Bravo, C., "Niccolò Dell'Arca," in *Paragone* (Florence), 25, 1974.
Gramaccini, N., "La Déploration de Niccolò Dell'Arca: Religion et politique aux temps de Giovanni II Bentivoglio," in *Revue de l'Art* (Paris), 1983.
Grandi, R., "Sculture del secondo Quattrocento," in *La Basilica di San Petronio,* Bologna, 1984.

*

Nothing certain is known of the origins or training of Niccolò dell'Arca, who is first mentioned in a Bolognese document of 1462 as "Niccolò di Puglia"; the document in question is a rental contract for a shop belonging to the Fabbriceria, or "Works," of S. Petronio, the church of the city's principal patron saint. It seems likely, therefore, that Niccolò was an itinerant sculptor either born or trained in southern Italy and attracted to Bologna by the prospect of work on the vast, as yet unfinished shrine. It may be possible to recognize his hand in certain terracotta decorations around the windows on the eastern flank of the church.

The rent for this workshop was paid on Niccolò's behalf by the Hospital of S. Maria della Vita, which was run by a pious confraternity known as the Compagnia dei Battuti. The *Ospedale* continued to pay for Niccolò's working premises through 1463 and, on April 8 of that year, the Confraternity Rector, Antonio Zanolino, paid Niccolò for consignment of a "sepulcher" for the Hospital church. A Bull of Indulgence of 1464 then recommended this sculptural group to the piety of the faithful, and thus seems to establish a firm range of dates for the creation of one of Niccolò's most impressive works, the *Lamentation on the Dead Christ* still conserved in S. Maria della Vita, signed "Opus Nicolai de Apulia." This tableau of seven lifesize terracotta figures, some with clear traces of their original polychromy, evinces such powerfully expressionistic qualities in its articulation of frenzied grief that some scholars have concluded it must depend stylistically from expressive innovations in Ferrarese painting in the 1470's, however, and from Guido Mazzoni's first groups. According to this theory, the documents cited above refer to a first group of figures, replaced by Niccolò himself with the present ones in the mid-1480's. Recent cleaning of the figures, and a reassessment of the archival evidence, tends to support the earlier dating.

Part of the problem arises from the mystery of Niccolò's beginnings, which makes it difficult to reconstruct a trajectory of artistic development. Early documents that speak of him as "Apulian" or "from Bari" and "from Ragusa" conflict with other sources that identify him as Dalmatian, and have given rise to the notions that he was Yugoslav by birth but trained in Naples, or, alternatively, a southern Italian who had emigrated to Dalmatia before coming to Bologna. In addition, some indirect Burgundian influence, perhaps through exposure to the sculpture of the Catalan Sagrera in Naples, is generally accepted as a component of Niccolò's style, and there is a growing willingness to see Tuscan elements, perhaps derived from Desiderio da Settignano and Verrocchio, in certain of his works. What no one can plausibly explain is the order in which these several stylistic currents were absorbed.

Niccolò's principal work, the *fastigium* or "crown" of the tomb of St. Dominic (Bologna, S. Domenico), incorporates all these features. This elaborate cover for the 13th-century *arca*

St. John the Evangelist, 1469–73; marble; 23⅝ in (60 cm);
Bologna, S. Domenico

carved by Nicola Pisano and assistants was commissioned in 1469, and was to consist of 21 small statues in addition to architectural elements. The lid, with 16 of the statues, was assembled in 1473. In their poetry of characterization, heavy draperies, and general exoticism of costume, the statues fuse Italian with Franco-Flemish late gothic features, distantly echoing Claus Sluter. In the elegant fish-scaled shingling of the lid, though, and in the scrolled volutes of the pinnacle and rich garlands supported by *putti*, this work calls to mind Desiderio's Marsuppini tomb in Florence (S. Croce). The lyric fantasy of these figures, and exquisite marble cutting in both the statues and decorative elements of the *arca*, would influence the 19-year-old Michelangelo Buonarroti, who made three of the missing statues following Niccolò's death in 1494. Niccolò himself was so proud of this work that from the time of its assembly he styled himself "Niccolò *dell'Arca*".

Later works by Niccolò include a marble *St. John the Baptist,* undated but close to the style of the *Arca* figures (Escorial); a highly realistic half-figure in polychrome terracotta of St. Dominic (1474, S. Domenico, Bologna); a monumental terracotta relief of the *Madonna and Child* for the facade of the Palazzo Comunale (Bologna), called the "Madonna di Piazza" and signed and dated 1478, and a brilliant, veristic *Eagle of St. John* in terracotta, for S. Giovanni in Monte (Bologna). It is tempting to read the preponderance of terracotta work in the 1470's and 1480's as proof that Niccolò came to that medium late, after marble carving—and thus that he modelled the S. Maria della Vita *Lamentation* figures in the 1480's rather than in the 1460's. But such a seemingly logical scheme simply may not apply to this individualistic master whom contemporary sources described as "*phantasticus et barbarus*," "*agrestis*," and stubborn ("*caput durum habens*").

—Timothy Verdon

NICHOLSON, Ben

Born in Denham, Buckinghamshire, 10 April 1894; son of the artist Sir William Nicholson. Died in London, 6 February 1982. Married 1) the painter Winifred Dacre, 1920; two sons and one daughter; 2) the sculptress Barbara Hepworth, 1932 (divorced, 1951), triplets; 3) the journalist-photographer Felicitas Vogler, 1957. Attended schools in London; studied at the Slade School of Fine Art, London, 1910–11, and studied French in Tours, 1911–12, and Italian in Milan, 1912–13; set up as painter in London, with periods in Cumbria until 1931; friend of Henry Moore and Naum Gabo; lived in Carbis Bay, Cornwall, 1939–43, St. Ives, 1943–58, near Ascona, Switzerland, 1958–72, Cambridge, 1972–75, and London from 1975.

Collections: Berlin: Nationalgalerie; Edinburgh; Eindhoven; London: Tate; Los Angeles; New York: Moma, Guggenheim; Toronto; Zurich.

Publications

By NICHOLSON: book—

Editor, with Naum Gabo and J. L. Martin, *Circle: International Survey of Constructivist Art,* London, 1937.

On NICHOLSON: books—

Summerson, John, *Nicholson,* London, 1948.
Read, Herbert, *Nicholson: Paintings, Reliefs, Drawings,* London, 1948.
Soby, James Thrall, *Nicholson,* New York, 1949.
Read, Herbert, *Nicholson: Works since 1947,* London, 1956.
Hodin, J. P., *Nicholson: The Meaning of His Art,* London, 1957.
Alley, Ronald, *Nicholson,* London, 1962.
Baxandall, David K., *Nicholson: Art in Progress,* London, 1962.
Read, Herbert, *Nicholson, Paintings,* London, 1962.
Read, Herbert, *Nicholson: Architectural Suite,* London, 1966.
Reid, Norman, and Charles Harrison, *Nicholson* (cat), London, 1969.
Russell, John, *Nicholson: Drawings, Paintings, and Reliefs 1911–1968,* London, 1969.
Nash, Steven A., *Nicholson: 50 Years of His Art* (cat), Buffalo, 1978.
Lewison, Jeremy, *Nicholson: The Years of Experiment 1919–1939* (cat), Cambridge, 1983.

*

Abstraction has played a vital role throughout Ben Nicholson's career; in the 1920's he was as alive to Cubism as any other British artist, and in the 1930's he was at the forefront of the Constructivist movement both in England and internationally. Yet, throughout his career he produced "figurative" art, that is to say still-lifes and landscapes, even alongside his most uncompromisingly "non-objective" or abstract pieces. The unifying principle throughout his work is his protean pursuit of the art object "as a real thing," his enthralment with all aspects of art which emphasise its physical, tactile qualities. This involved him in experiments and creative acts dedicated to the breakdown of the picture as an illusion, a Modernist concern which cuts across the abstraction-figuration divide.

Born into a leading family of academic Victorian artists, "with a silver spoon in his mouth," as Herbert Read put it, Nicholson sharply rejected the teaching offered at the Slade, where contemporaries included Nash, Roberts, Bomberg and Spencer. He actually spent most of his time playing billiards in a nearby hotel! The emphasis in the drawing classes of Henry Tonks was on shading and building up masses, but Nicholson's earliest painting, *Striped Jug,* 1911, can be noted for its elimination of chiarascuro, its isolation of the object, its almost Byzantine flatness.

In the 1920's, together with Christopher Wood, he experimented with landscape painting in a way described by one critic as "sophisticated primitive." The influence of Cézanne and Gauguin is less striking than the impact of the naive painter Alfred Wallis, a retired Cornish fisherman they "discovered" in 1928. What excited Nicholson about Wallis was his innate understanding of the materials he used, his integration of the support, and his instinctive homing-in on essential

elements in a scene he depicted. All these elements can be seen in Nicholson's *Holmhead, Cumberland,* 1929, where he flattens-out into a decorative design, bringing in the whiteness of the canvas as part of the composition. The scratchy, reluctant brushstrokes seem intentionally to reveal the mechanics of the painting.

When Nicholson first saw one of Picasso's Cubist still-lifes in 1921 he recalled being most struck by the "absolutely miraculous green" at the centre which was "very deep, very potent and absolutely real." It is revealing that at this early stage it should be the reality of the painting that struck him first, not the academic or esoteric nature of the abstraction. In one of his best Cubist-inspired paintings, *Au Chatte Botté,* 1932, Nicholson was absorbed by the different planes that confronted him in a Dieppe shop window, the glass with the lettering on it, the objects displayed, the reflection of the street within the glass. This concern with real and ambiguous space, and with the interaction of planes, would occupy him in many later works, both landscape drawings and abstract relief carvings.

In the 1930's Nicholson took a leading role in the British avant garde, and became increasingly committed to "pure abstraction," or Constructivism. During constant trips to France he befriended, and was influenced by, Brancusi, Miró, Arp, Calder, and above all Mondrian. In 1933 Nicholson joined Abstraction-Création, the international organisation of Constructivists, and from then on took a belligerent role in the conflicts which divided abstract artists, Surrealists, and realists. He forced the exhibiting group to which he belonged, the Seven and Five, to adopt an "abstract artists only" policy, and contributed to the early break-up of Unit One, the avant garde group that included Nash, Moore, Hepworth, and other artists increasingly divided between abstraction and Surrealism. He also co-edited with Naum Gabo and the architect J. L. Martin an important anthology on abstract art, *Circle,* and contributed to the magazine *Axis.* In 1939, he, his wife Barbara Hepworth, and Gabo moved to St. Ives which after the war flowered into Britain's liveliest art colony.

In his work in the 1930's Nicholson continued to experiment with the physical texture of the art object. He took old still-lifes he had done and rubbed away at their surface with a razor until only a ghost of the original remained, and then began painting anew. Alternatively, he coated his canvas with heavy grounds—gesso, plaster—and then actually engraved lines into the surface, a technique which naturally lead him on to relief carving. In his famous *White Reliefs,* his most original contribution to Constructivist art, he worked in "pure" geometric shapes, producing austere compositions around the simple interaction of squares and circles. However, even in these sparse works there is a delight in the physicality of the object. He found that by varying the roughness or smoothness of the surfaces he could differentiate individual planes. Later, Nicholson perfected a variety of burnishing and scrumbling effects, and played around with shapes and sizes and different materials.

There is certainly a contrast between Nicholson's clean, unequivocal geometric abstractions, using rulers and compasses, and the more robust, spontaneous line of which he was capable in his thick pencil drawings of nudes, churches, or Cornish landscape. Herbert Read's admonition is surely right, however, that "it is not possible to accept certain still life compositions of Ben Nicholson's and at the same time reject his severe

Jan 1956 (Zennor Head), 1956; $20\frac{5}{8} \times 44\frac{7}{8}$ in (52.4 \times 114 cm); Courtesy Waddington Galleries

abstractions without confessing to a prejudice which has nothing to do with the essential qualities of art."

In the mature period of Nicholson's output, from the time he went to St. Ives, there is a constant interaction between his geometric abstractions and his figurative still-lifes and landscapes. In his views of abandoned Cornish tin mines or of the clustered houses around St. Ives harbour, for instance, he geometricises the relationships between planes, basic shapes, perspectives; or, alternatively, the elements of landscape feed and inform his treatment of surfaces in the abstract relief, for instance the whitewashed walls of seaside cottages. Certain very minimal architectural sketches, for instance *Urbino 2,* 1965, a study of an isolated crossing in a renaissance cloister, bridge the gap between his two activities, as do his almost "synthetic cubist" still-lifes, where overlapping grid marks, selectively coloured in, denote the objects set against treated segments. Generally, the figurative works were done *au plein air,* and are fast, reactive, and often witty; the more finished abstractions, while they of course utilize elements of chance, play, and physical responses to material, were worked out carefully and meditatively in the studio. In the best of them we can detect the qualities that already excited Adrian Stokes in the 1930's: "the slow elucidation and isolation of factors that are constant in all that is pleasurable in the process of visual perception."

—David Cohen

NOLDE, Emil.

Born Emil Hansen in Nolde, 7 August 1867; adopted name Nolde in 1902. Died in Seebüll, 13 April 1956. Married 1) Ada Vilstrup, 1902 (died, 1946); 2) Jolanthe Erdmann, 1948. Studied at the Kunstgewerbeschule, Karlsruhe, 1884-88; Sauermann School of Carving, Flensburg; studied privately with Friedrich Fehr and Adolf Holzell, Munich, 1898, and at the Académie Julian, Paris, 1899; worked as carver, designer, and cabinet maker while studying; taught at the Museum for Industrial Arts, St. Gallen, Switzerland, 1892-98; lived in Copenhagen, 1900-02, then lived in Berlin, with trip to Sicily, 1903-05; member, with Kirchner and Heckel, Die Brucke group, 1906-08, and co-founder, with Max Pechstein, Neue Sezession, Berlin, 1910; associated with Der Blaue Reiter group, 1912; trip to Russia, Japan, and New Guinea, 1913-14; lived in Utenwarf, 1916-27, and in Seebüll from 1927; joined the Nazi party, 1933 or 1934, but declared degenerate, his work confiscated by the Nazis, 1937, and forbidden to paint and to exhibit, 1941; made Professor of Art by government of Schleswig-Holstein, 1946.

Major Collection: Seebüll: Nolde Foundation.
Other Collections: Cologne; Copenhagen; Essen; Hamburg; Hanover; Kiel; London: Tate; Los Angeles; Munich; New York: Moma; Solingen-Oligs; Zurich.

Publications

By NOLDE: books—

Briefe aus den Jahren 1894-1926, edited by Max Sauerlandt, Berlin, 1927, Hamburg, 1967.
Dan eigene Leben: Die Zeit der Jugend 1867-1902, Berlin, 1931; Flensburg, 1949.
Jahre der Kämpfe 1902-1914, Berlin, 1934; Flensburg, 1958.
Welt und Heimat: Die Sudseereise 1913-1918, Cologne, 1965.
Reisen—Achtung—Befreiung 1919-1946, Cologne, 1967.
Mein Leben (abridged version of preceding four books), Cologne, 1976.

On NOLDE: books—

Schieffler, Gustav, *Nolde: Das graphische Werk.* Berlin, 2

vols., 1911–27; edited by Christel Mosel, Cologne, 2 vols., 1966–67.

Sauerlandt, Max, *Nolde*, Munich, 1921.

Schmidt, Paul F., *Nolde*, Leipzig, 1929.

Haftmann, Werner, *Nolzschnitte* [and *Radierungen*] von Nolde, edited by Rudolf Hoffmann, Bremen, 2 vols., 1947–48.

Busch, Günter, *Nolde: Aquarelle*, Munich, 1957, 1973.

Gosebruch, Martin, *Nolde: Aquarelle und Zeichnungen*, Munich, 1957; as *Nolde: Watercolours and Drawings*, London, 1972; New York, 1973.

Klein, Käthe, editor, *Bilder von Nolde in Essen*, Essen, 1957.

Bayl, Friedrich, *Nolde: Holzschnitte*, Feldafing, 1957.

Haftmann, Werner, *Nolde*, Cologne, 1958; London and New York, 1959.

Urban, Martin, *Nolde: Sudsee-Skizzen*, Munich, 1961, 1980.

Haftmann, Werner, *Nolde: Ungemalte Bilder: Aquarelle und Worte am Rande*, Cologne, 1963, 1971; as *The Forbidden Pictures*, London and New York, 1965, 1971.

Selz, Peter, *Nolde* (cat), New York, 1963.

Hentzen, Alfred, *Nolde: Das Abendmahl*, Stuttgart, 1964.

Urban, Martin, *Nolde: Blumen und Tiere: Aquarelle und Zeichnungen*, Cologne, 1965, 1972; as *Nolde: Flowers and Animals*, New York and London, 1966.

Hall, Douglas, *Nolde: Watercolours from the Nolde Foundation, Seebüll*, London, 1968.

Urban, Martin, *Nolde: Landschaften: Aquarelle und Zeichnungen*, Cologne, 1969; as *Nolde: Landscapes: Watercolours and Drawings*, London and New York, 1970.

Urban, Martin, et al., *Nolde: Aquarelle und Handzeichnungen aus dem Besitz der Stifftung Seebüll Ada und Emil Nolde* (cat), Bremen, 1971.

Urban, Martin, and Klaus Hoffmann, *Nolde* (cat), Bielefeld, 1971.

Nolde (cat), Cologne, 1973.

Carpi, Pinin, *Nolde: La collana di pietre blu*, Milan, 1978.

Pois, Robert, *Nolde*, Washington, 1982.

Reuter, Helmut, *Betrachtungen zur Sozialpsychologie der bildenden Kunst—dargestellt am Beispiel Noldes und seiner Kunst*, Munich, 1984.

Urban, Martin, *Nolde: Catalogue Raisonné of the Oil Paintings*, vol. 1, 1895–1914, London and New York, 1987.

*

Nolde's life was one full of contradictions—a Nazi whose attempt to create a true northern European art was proscribed by his party and exhibited as degenerate; a religious painter whose works were never commissioned by or permanently installed in a church and whose depictions of Christ and the disciples as too obviously Jewish brought criticism from the Protestant church; a German nationalist and racist who objected to the destruction of other societies by the German empire and the display of their art works as mere ethnologoical exhibits: these criticisms sometimes formed subjects for his painting as in *The Missionary* (1912, Solingen-Oligs) where a hideous masked prelate is trying to convert a native woman at his feet. These paradoxical aspects of his work can be summed up by the way that his series of paintings *The Life of Christ* was rejected by the Brussels International Exhibition of Modern Religious Art to which Nolde had submitted them but were

Gloomy Man's Head, 1907; lithograph

displayed by the Nazis in 1937 in the notorious Degenerate Art Exhibition. It seems as though Nolde was a revolutionary in spite of his best efforts.

Some of these contradictions can be quickly resolved. Nolde's interest in the work of "primitives" is a result of his adherence to blood-and-soil ideology. Indeed much of his artistic output can be said to be an attempt to try to create a kind of German primtivism that would put art back in touch with the eternal and natural elements that Nolde thought was at its base. The idea that even in civilised societies these factors were still latent were linked to Jung's ideas of racial memory.

We can examine three paintings of dance by Nolde, a subject in which he had a long interest, in which he tries to fulfil this project in different ways. In *Wildly Dancing Children* (1909, Kiel) he combines fauve colour and a sense of movement that is almost futurist in its interpenetration of forms rendered by small agitated brush strokes. This results in a merging of the children with the background. The painting shows the signs of very quick execution and illustrates Nolde's idea that "labour is the death of painting." Primitive ecstasy and loss of control are rendered by the speed of both the dancer's movements and of the artist's marks. In *Dance Around the Golden Calf* (Staatsgalerie Moderner Kunst, Munich), painted the next year, the brush stroke is far more controlled. To some extent this is due to the need to provide at least some narrative content in order to illustrate the Biblical iconography of the piece: we can distinguish a background in this painting and in it lies the golden calf of the title. Movement is expressed in the frantic movements of the dancers' limbs rather than in the brush-

strokes themselves. It is emphasized by the strong push-pull effect in space of the very warm and cold colors that are juxtaposed. The purpose of the painting is broadly similar to that of the earlier piece, but the means used to achieve it are less literal. *Candle Dancers* of 1912 (Seebüll) is another representation of wild dancers, and like *Dance Around the Golden Calf* it is a dance associated with ritual. However, here there is no representational background as such, merely a ground of red. The hot overall tonality of the work is a sign of the sensuality expressed in the dance while the emphasis on the breasts and lips of the dancers also signals these dancers as sexual objects. Nolde had a great interest in dance. He was fascinated by Lo!!ie Fuller and was a friend of Mary Wigman, an exponent of modern dance. His frequent return to this subject in painting was due to the idea of dance as a repository of authentic primitive culture, as a release of the primitive forces inherent in the body. A painting manner that was wild enough could also be seen as such a release.

Apart from his painting Nolde also produced many very accomplished prints. From 1911 his main interest was lithography, and he constantly experimented with different states and variations. His coloured lithographs were technically very complex and used up to five different stones.

In the years after the First World War, Nolde attempted to express many of the same ideas about an authentic racially based culture in a quieter and more deliberate fashion through the painting of landscapes and seascapes. While many of Nolde's works are extraordinary in formal terms, especially in their color harmonies, it is difficult to escape from the racist basis of his work that determined not only its iconography but ironically the interest in primitive or elementary forms of expression that the Nazis found so unpalatable.

—Julian Stallagrass

Sir Thomas and Lady Salusbury, 1777; marble; Offley, St. Mary Magdalen

NOLLEKENS, Joseph.

Born in London, 11 August 1737; son of the Flemish painter Joseph Franciscus Nollekens. Died in London, 23 April 1823. Married Mary Welch, 1772 (died 1817). Entered the studio of the sculptor Peter Scheemakers, 1750; lived and worked in Rome, 1762–70; settled in London, and member of the Royal Academy, 1772: exhibited regularly until 1816; his bust of George III, 1773, brought him great attention, and he became the most fashionable portrait sculptor of his time: 70 replicas of his bust of Pitt were produced; also did groups, allegorical works, and church monuments. Pupils: John Thomas Smith, Alexander Goblet.

Collections/Locations: Cambridge; Edinburgh; London: Westminster Abbey, British Museum, Victoria and Albert, Wellington, Kenwood, Royal Society; Oxford; Royal Collection.

Publications

On NOLLEKENS: books—

Smith, John Thomas, *Nollekens and His Times,* London, 2 vols., 1828.
Cunningham, Allan, *The Lives of British Sculptors,* London, 1840.

articles—

Esdaile, Katharine A., "A Group of Terracotta Models by Nollekens," in *Burlington Magazine* (London), 85, 1944.
Howard, Seymour, "Boy on a Dolphin: Nollekens and Cavaceppi," in *Art Bulletin* (New York), 46, 1964.
Kenworthy-Browne, John, "A Monument to Three Captains," in *Country Life* (London), 161, 1977.
Penny, N. B., "Nolleken's Statue (of Pitt) in the Cambridge Senate House," in *Country Life* (London), 1977.
Kenworthy-Browne, John, "Nollekens: The Years in Rome," in *Country Life* (London), 1979.
Lord, John, "Nollekens and Lord Yarborough," in *Burlington Magazine* (London), 1988.

*

As a youth, Nollekens was civil and inoffensive but not clever. His ability in modelling astonished the Society of Arts. With his prize money he went to Rome where he worked in the studio of Cavaceppi, restoring antique sculpture. After a few years he seems to have set up independently in this trade which was not only lucrative but gave him first-hand knowledge of the antique. His first portrait bust, of David Garrick (1764; Althorp, Northamptonshire), is a remarkable performance, simple, graceful, and lively. Another, of Lawrence Sterne (1766, London, National Portrait Gallery), was sent to London for exhibition, and on his return to London Nollekens was already well known. In 1770 the demand for portrait busts in England was rather low, but by his abilities Nollekens revived the fashion. During a working life of some 65 years, Nollekens made some 200 busts, besides a few portrait statues, about a hundred funeral monuments, and a number of mythological statues.

Generally speaking, his style is classical (or neo-classical), because that was increasingly demanded; but he admired Roubiliac and might have done better in a baroque climate. His portrait style did not develop much. A few busts were in contemporary dress with tie-wig or periwig and thus have something of a baroque air. The last of these was of Dr. Burney (1802, London, British Museum). However, by 1771 he had adopted his pseudo-antique format, which was easier to execute: close-cropped hair, shoulders hidden by a cloak in folds. His busiest years were the last, from 1800 to 1816, and in his later works one can detect simpler contours, less detailed modelling, less intensity in expression. The difference, however, is a subtle one, and perhaps is easier to observe in the female busts.

Because his training had been essentially academic, Nollekens felt his fame would endure in the "historical" style. There was no great demand in England for mythological works before 1814, but he sold four marble goddesses to Lord Rockingham (1773–78; three now at the Getty Museum, Malibu, one at the Victoria and Albert, London), and two to Lord Yarborough (Lincoln, Usher Art Gallery). Though decorated and well studied in the different views, these figures do not have the poetical qualities that were sought at the time. Definitely more pleasing are the small terracotta models, of which dozens appeared at the studio sale in January 1823, and were called "pensiere." Sixteen of them are now known, including a notable group at the Victoria and Albert. Some are working models related to monumental figures, while others, as J. T. Smith recalled, were made merely for the pleasure of sketching figures in clay and were neither for sale nor realisation in marble.

Of the funeral monuments, most are either simple tablets or include sentimental putti or mourners in relief. Such works were merely commercial, some being repeated several times. His range of allegory was limited and simplified, but remained correct and academic. Of the larger monuments we can distinguish half a dozen with full-size statues. The best perhaps are the statue of *Hope* for Lady Henrietta Williams-Wynn (1773, Ruabon, Denbighshire); of Sir Thomas Salusbury pledging his love to his wife under an oak tree (1777, Great Offley, Hertfordshire); and of Mrs. Howard and her infant, dying, comforted by Religion (1800, Wetheral, Cumbria). The last was highly praised, and considered by Fuseli to be superior to anything by Canova. Curiously, Nollekens was not much in demand for this kind of work. The only official commission was the monument to *Three Captains* (1788, London, Westminster Abbey), reduced by the committee to a somewhat lifeless allegory. Nollekens was given no more public monuments, though he competed for one or two.

He made a grotesque figure, with his low stature, long body, and large head; he was homely and simple in speech, uneducated, mean, and miserly. Nonetheless, he was good-humoured and by no means the figure of fun depicted by J. T. Smith. He was a respected member of the Royal Academy and his opinions on antique sculpture were sought and quoted by connoisseurs. However, he had little judgment to offer on the Elgin marbles; and, as he knew, Flaxman reckoned him low because of his lack of intellect. "Nollekens, in all things else a boor, had the rare merit of rivalling higher and more accomplished minds in his art" (Cunningham). Nobody else could equal the quality or quantity of his portrait busts, though the next generation considered them rather commonplace. From his youth he was an early riser and hard worker. His studio in Mortimer Street, London, was efficient, his assistants were well paid, and his customers never complained. On his death he left a fortune of £200,000. His former pupil, and disappointed legatee, J. T. Smith, at once set about writing a mischievous biography. A few years later Allan Cunningham wrote a more charitable account.

—John Kenworthy-Browne

O'KEEFFE, Georgia.

Born in Sun Prairie, Wisconsin, 15 November 1887. Died March 1986. Married the photographer Alfred Stieglitz, 1924 (died, 1946). Studied under John Vanderpoel, Art Institute, Chicago, 1905-06; under William Merritt Chase, F. Luis Mora, and Kenyon Cox, Art Students League, New York, 1907-08; under Alan Bement, University of Virginia, Charlottesville, 1912; under Arthur Dow and Bement, Columbia University, New York, 1914-16; commercial artist, Chicago, 1908-10; teacher in Amarillo, Texas, public schools, University of Virginia, summers, 1913-16; Columbia College, South Carolina, 1915, and West Texas State Normal School, Canyon, 1916-18; after meeting Stieglitz, moved to New York to concentrate on her painting, 1918-29; settled in Taos, New Mexico, 1929.

Collections: Buffalo; Chicago; Dallas; London: Tate; New York: Metropolitan, Moma, Brooklyn Museum; Nashville: Fisk University; Washington: National Gallery, Phillips.

Publications

By O'KEEFFE: books—

Some Memories of Drawings, New York, 1974; edited by Doris Bry, Albuquerque, 1988.
Georgia O'Keeffe, New York, 1976.

On O'KEEFFE: books—

Alfred Stieglitz Presents 100 Pictures . . . by O'Keeffe (cat), New York, 1923.
Alfred Stieglitz Presents 51 Recent Pictures . . . by O'Keeffe, New York, 1924.
Hartley, Marsden, *O'Keeffe* (cat), New York, 1936.
Lane, James, and Leo Katz, *The Work of O'Keeffe: A Portfolio of 12 Paintings,* New York, 1937.
Rich, Daniel Catton, *O'Keeffe* (cat), Chicago, 1943.
Rich, Daniel Catton, *O'Keeffe: 40 Years of Her Art* (cat), Worcester, Massachusetts, 1960.
Wilder, Mitchell, editor, *O'Keeffe . . . from 1915 to 1966* (cat), Fort Worth, 1966.
O'Keeffe: Drawings, New York, 1968.
Goodrich, Lloyd, and Doris Bry, *O'Keeffe* (cat), New York, 1970.

Young, Mahonri Sharp, *Early American Moderns: Painters of the Stieglitz Group,* New York, 1974.
Homer, William Innes, *Alfred Stieglitz and the American Avant-Garde,* Boston, 1977.
Naef, Weston J., *The Collection of Alfred Stieglitz,* New York, 1978.
Lisle, Laurie, *Portrait of an Artist: A Biography of O'Keeffe,* New York, 1980, Albuquerque, 1986, London, 1987.
Hoffman, Katherine, *An Enduring Spirit: The Art of O'Keeffe,* Metuchen, New Jersey, 1984.
Woody, Jack, *O'Keeffe: The Artist's Landscape,* Pasadena, 1984.
Castro, Jan Gordon, *The Art and Life of O'Keeffe,* New York, 1985.
Haskell, Barbara, *O'Keeffe: Works on Paper,* Santa Fe, 1985.
Morris, Margaret, *O'Keeffe: Selected Paintings and Works on Paper,* Santa Fe, 1986.
Callaway, Nicholas, *O'Keeffe: One Hundred Flowers,* New York and Oxford, 1987.
Cowart, Jack, Sarah Greenough, and Juan Hamilton, *O'Keeffe: Art and Letters,* Boston, 1987.
Messinger, Lisa Mintz, *O'Keeffe,* London, 1988.

*

Georgia O'Keeffe's archetypal American character, a blend of independence, clear-sightedness, and the stubborn streak characterized as "cussedness," has always fascinated a public more eager for personal revelation than for artistic analysis. Her resistance to the superficial interest readily afforded her by the press had the adverse effect of making her a rigid codifier of her intentions. It is necessary to avoid O'Keeffe's protective prescriptiveness and read between her well-laid, oft repeated party-lines to find the essence of her undoubted appeal.

O'Keeffe was an instinctual modernist, beginning with recognizable subject matter—flowers, shells, bones, western expanses of mesa and sky—and transforming it into elemental symbols of nature's generative power. She sought the universal in the specific, a quest that places her squarely in the reductive modernist mainstream. Unlike the more cerebral Mondrian, whose Platonically theoretical explanations of the harmony he perceived in nature are not readily apparent in his geometric compositions, O'Keeffe devised abstractions, maintaining clear links to extrinsic natural forms.

Her work, by necessity created within—and to some extent, against—the male-dominated context of the art world, has suffered from that milieu's overly sentimentalized preconceptions

of the character of "women's work." More than once O'Keeffe's response was covertly acerbic; her most famous subversive canvas and also her "Great American Painting," the *Cow's Skull: Red, White, and Blue* of 1931, served as a rejoinder to her colleagues' creative ambitions, often expressed in conversations tinged with braggadocio. A more subtle responsive irony pervades the series of urban architecture which includes *The Shelton with Sunspots, Street—New York, No. 1, The Radiator Building—Night, New York,* and *City Night,* created during her years in residence in New York, which many art historians find uncharacteristic of her work. These, however, reflect not only her physical environment but her psychic one as well; for O'Keeffe, these hard-edge skyscrapers thrusting their bulk heavenward function as alter egos, rampant icons of male dominance rendered in "male style" by a woman. Like Charles Sheeler's Depression-era paeans to resurgent industrial sites, they are geometric emblems of mechanistic power, a detached, intellectual force alien to O'Keeffe's nature-oriented inclinations. Further, these tumescent images are entirely consistent within her *oeuvre,* for embedded in her art is the central concept of sexuality—nature's dualistic generative drive.

Torn between the social constraints ordained for her sex and the liberated choices allowed artistic individuals, O'Keeffe mirrors her era. Her work, at once supremely sensual and drily controlled, echoes her life, with its oppositions of freedom and discipline, experienced against urban enclosure or the vast expanses of the west. Her work's ultimate direction demanded isolation and transcendence of personal desire, an immersion in untrammeled nature that led her finally to reject the city for a hermetic existence in New Mexico.

For an American woman artist, her life was exceptionally privileged. She was catapulted from self-imposed isolation into the midst of the only avant-garde circle in the Untied States, the painters and photographers—like Arthur Dove, John Marin, Marsden Hartley, Paul Strand, and Edward Steichen—surrounding Alfred Stieglitz, who maintained a series of ill-funded but influential galleries in New York from 1905 to 1946, where he mounted the earliest exhibitions of African sculpture, children's art, and such European innovators as Matisse, Rodin, Cézanne, and Picasso. O'Keeffe's first solo exhibition took place at Stieglitz's 291 Gallery in 1917, which led to their affair and cohabitation, surprising perhaps for a well-bred midwestern woman, but indicative of her independent convictions and of her responsive passion for the man who had already begun the acclaimed series of erotically obsessive photographs of her. O'Keeffe's free choice was compromised by her decision to marry Stieglitz in 1924, a union that would become the source of recurrent tension in her life for over two decades. The artist's life with the gregarious, extroverted Stieglitz and his ever-present entourage seemingly left little time for introspection, but despite the demands made upon O'Keeffe she benefitted from the contacts Stieglitz's circle offered, though she often scorned their intellectual pretensions.

In this group she was stylistically closest to Arthur Dove, joining him in the experimental pursuit of quintessential abstraction from natural forms. Perhaps following Gauguin's dictum to "dream before nature" (and similarly to Kandinsky and Franz Marc in his last pre-war canvases), both produced rhythmic, subtle compositions whose descriptive intentions are subsumed by expressive ones. As early as 1918, O'Keeffe became clearly non-objective, creating two allusive series of oils, one entitled *Special* and the other merely numbered. Implying the formative flux of natural energy through surging intertwined forms rendered in a luminous Rococo palette of bright pinks, reds, and blues, O'Keeffe extended her range to infinity.

But she failed to remain there, withdrawing to a more descriptive realism with her conservative—and most beloved—canvases of flowers. It was with these that her troubles with popular interpretation began, for the blooms' overtly sexual connotations—be they "female" irises with deep, secret centers or "male" Jack-in-the-Pulpits springing rigidly to attention—elicited superficial and potentially scandalous commentary that plagued her throughout her career. The limitations of both popular and feminist critical approaches are readily apparent, for each, whether sentimentally or ideologically, subverts O'Keeffe's importance to the history of style. For Georgia O'Keeffe, nature's mystery could be penetrated only by instinct and translated into art only by disciplined imagination. Her seminal contribution to visionary abstraction, long overlooked by critics and historians, attests to the power of her vision.

—Linda F. McGreevy

OLDENBURG, Claes (Thure).

Born in Stockholm, Sweden, 28 January 1929; naturalized United States citizen, 1953. Married 1) Pat Muschinski, 1960; 2) Coosje van Bruggen. Attended Latin School for Boys, Boston; Yale University, New Haven, 1946–50, B.A. 1950; studied under Paul Weighardt, Art Institute, Chicago, 1952–54; apprentice reporter, City News Bureau, Chicago, 1952–54; illustrator, *Chicago Magazine,* 1955–56; settled in New York, 1956: involved in performance art. Address: c/o Leo Castelli Gallery, 420 West Broadway, New York, New York 10012, U.S.A.

Collections: Amsterdam: Stedelijk; Basel; Chicago; Los Angeles; London: Tate, Victoria and Albert; Los Angeles; New York: Moma, Whitney; Ottawa; Stockholm: Moderna Museet.

Publications

By OLDENBURG: books—

Store Days, Documents from The Store (1961), and Ray Gun Theatre (1962), with Emmett Williams, New York, 1967.
Injun and Other Stories (1960), New York, 1966.
Some Program Notes about Monuments, Mainly, New York, 1967.

Proposals for Monuments and Buildings 1965–1969, Chicago, 1969.

Notes in Hand: Miniatures of My Notebook Pages, New York, 1971.

Raw Notes . . . , edited by Kasper Koenig, Halifax, Nova Scotia, 1973.

More Ray Gun Poems (1960), Philadelphia, 1973.

Photo Log, Stuttgart, 1976.

Press Log, Stuttgart, 1976.

Large-Scale Projects 1977–1980: A Chronicle, with Coosje van Bruggen, New York, 1980.

Cross Section of a Toothbrush with Paste in a Cup on a Sink, with Gerhard Storck, Krefeld, 1985.

The Course of the Knife/Il corso del coltello, with others, Milan, 1986.

On OLDENBURG: books—

Johnson, Ellen, *Dine, Oldenburg, Segal: Painting, Sculpture* (cat), Toronto and Buffalo, 1967.

Oldenburg: Notes (cat), Los Angeles, 1968.

Baro, Gene, *Oldenburg: Drawings and Prints* (cat), New York and London, 1969.

Rose, Barbara, *Oldenburg* (cat), New York, 1969.

Haskell, Barbara, *Oldenburg: Object into Monument* (cat), Pasadena, 1971.

Johnson, Ellen, *Oldenburg,* Baltimore and London, 1971.

Shestack, Alan, and Susan B. Casteras, *The Lipstick Comes Back* (cat), New Haven, 1974.

Friedman, Martin, *Oldenburg: Six Themes* (cat), Minneapolis, 1975.

Doty, Robert, *Oldenburg: The Inverted Q* (cat), Akron, Ohio, 1977.

Monuments and Monoliths: A Metamorphosis (cat), Roslyn, New York, 1978.

van Bruggen, Coosje, *Oldenburg: Mouse Museum—Ray Gun Wing,* Cologne, 1979.

Blok, Cor, *Oldenburg: Het Schroefbook-projekt,* Rotterdam, 1983.

Storck, Gerhard, and Coosje van Bruggen, *The Haunted House,* Krefeld, 1987.

*

Claes Oldenburg is regarded as one of the initiators of the American Pop art movement. A sculptor and environmentalist, his work differs from that of Andy Warhol and Roy Lichtenstein because of his intimate approach and his links with the earlier movements of Dada and Surrealism, a position he shares with Jim Dine and Jasper Johns.

His childhood was marked by a constant shift between Sweden, Norway, and America, making Oldenburg somewhat introverted but with a large imagination, living for much of the time in his fantasy world of "Neubern."

His artistic life began when he moved from Chicago, where he had worked as a reporter, to New York joining Jim Dine, Jasper Johns, and other artists involved in the theatrical "happenings." Precursors of the 1970's "Performances" and inspired by Dada stage work, happenings were improvised, unadvertised events involving diverse objects and satirising the banality of New York life. Oldenburg also began making relief work and sculpture from junk material, which he incorporated in an early exhibition, *The Store,* where works for sale questioned the line between art and commodity. At this time Oldenburg was also interested in the "numerous identities he could impose upon himself," which led to the creation of his alter ego "Ray Gun" who was "only alive when he was constantly arranging to upset his existence." In a sense Ray Gun continued the pessimistic disposition while Oldenburg began to see beauty within the urban situation. This transition can be seen in his drawings of street grafitti which "celebrate irrationality, discontention, violence and stunted expression—the damaged life forces of the city and street."

Oldenburg's mature work began with a move to a large studio in which he could realize less throwaway sculpture. The influences of Abstract Expressionism made him consider tactile qualities, questioning the meanings of soft and hard. Partly inspired by *Gulliver's Travels,* he made his first soft sculptures of everyday objects including toilets, ladders, and plugs on a large scale, from canvas stuffed with kapok. A chance by-product of these works was the influence of gravity, making the finished objects sag. The softness also gave them a "sensual pleasure rather than hardcore social comment," and shows an interest in sexual metaphor shared by the Surrealists, especially Salvador Dali.

Of great importance to Oldenburg at this time was his love of drawing. He sketched wherever he went, working many ideas into print and watercolour. Among the sketches are drawings superimposed on advertisements from magazines, causing a metamorphosis of the original photograph. Inspired perhaps by the childhood memory of his Swedish aunt sending advertisements which he pasted in a scrapbook, Oldenburg says he collects "the most obvious or appealing examples of object-pornography." An example is a pair of women's gusseted pants which become the facade of the stock exchange. "The walls should be soft—people could lean into them at lunch-time."

From these works on paper arose the first concepts of huge-scale sculptures for specific environments. Some of the more humorous and whimsical of these have been realized, including a giant spoon bridge, counter-balanced by a cherry, and a screw in the shape of an arch. Although sometimes brash and bright, these sculptures seem to be the perfect size, fitting harmoniously in the chosen environment, and earned Oldenburg the American Institute of Architects Award in 1977.

Many concepts, however, lie dormant in sketch-books, either awaiting financial backing for their construction, or rejected by planning officials because of their overt political, social, historical, or sexual implications. These include a replacement of the Statue of Liberty by a giant electric fan to blow away rather then beckon potential immigrants, and a massive car wing-mirror placed next to Nelson's Column in London, implying the city's keeness on looking back at history for guidance. But perhaps it is Oldenburg himself who is holding back their construction, waiting for "their poetic merger, metamorphosis, and relationship through association. The poetic symbol." A three-way plug may be converted into Donald Duck, a cannon, or a windmill, but it may also contain a more important meaning, an epiphany, as Joyce calls it, waiting to be unleashed.

—Justin Piperger

OLIVER, Isaac.

Born in Rouen, c. 1560–65; son of the goldsmith Pierre Oliver. Buried in London, 2 October 1617. Married 1) Elizabeth (died, 1599), son, the miniaturist Peter Oliver; 2) Sara Gheeraerts, 1602 (died, 1605); 3) Elizabeth Harden (Harding), 1606, six children. Taught the techniques of limning by Nicholas Hilliard, and possibly trained in other forms of art on the continent; first dated miniature, 1587; visited Italy, 1596; was patronized by the Earl of Essex in the 1590's; appointed limner to Queen Anne, 1605, and patronized by Prince Henry by 1609 and by Prince Charles after Henry's death in 1612.

Major Collections: London: Victoria and Albert; Royal Collection.
Other Collections: Amsterdam: Koninklijk Paleis; Bowhill; Knowsley House; London: British Museum, Portrait Gallery.

Publications:

On OLIVER: books—

Long, Basil S., *English Miniaturists,* London, 1929.
Winter, Carl, *Elizabethan Miniatures,* London, 1943.
Reynolds, Graham, *Hilliard and Oliver* (cat), London, 1947, 1971.
Reynolds, Graham, *English Portrait Miniatures,* London, 1952, Cambridge, 1988.
Foskett, Daphne, *British Portrait Miniatures,* London, 1963.
Strong, Roy, *The English Icon: Elizabethan and Jacobean Portraiture,* London, 1969.
Brett, E. A., *A Kind of Gentle Painting: . . . Hilliard and Oliver* (cat), Edinburgh, 1975.
Noon, Patrick J., *English Portrait Drawings and Miniatures* (cat), New Haven, 1979.
Murdoch, John, et al., *The English Miniature,* New Haven, 1981.
Finsten, Jill, *Oliver: Art at the Court of Elizabeth I and James I,* New York, 1981.
Strong, Roy, *The English Renaissance Miniature,* London, 1983.
Edmond, Mary, *Hilliard and Oliver: The Lives and Works of Two Great Miniaturists,* London, 1983.
Strong, Roy, and Jim Murrell, *Artists of the Tudor Court: The Portrait Miniature Re-discovered* (cat), London, 1983.

article—

Edmond, Mary, "Limners and Picturemakers," in *Publications of the Walpole Society* (London), 1980.

*

Isaac Oliver was a child when in 1568 he was taken to London by his parents, protestant refugees from Rouen: his year of birth is not known, but his first dated miniatures belong to the late 1580's, from which it can be deduced that he had then recently completed his tuition under the renowned English practitioner Nicholas Hilliard. It has recently been argued that he went to the older man as "master to master," a fully-trained

Henry, Prince of Wales, c. 1612; watercolor on vellum; $5\frac{1}{8} \times 4$ in (13 × 10.2 cm); Royal Collection

artist who simply wished to learn the techniques of limning: however that may be, a contemporary reference describes him as Hilliard's "well profiting scholar," and he became a formidable rival at Court and in high society. He usually portrays his sitters in a style of sober three-dimensional realism, employing dramatic *chiaroscuro* and a generally sombre palette range, in complete contrast to Hilliard's clear unshadowed style and bright colours; he also rapidly abandoned the decorative use of dated inscriptions (which often makes even approximate dating of individual works extremely difficult); in any case, unlike Hilliard he was not highly skilled in calligraphy. Nor did he follow his own father in pursuing the craft of goldsmithery as Hilliard had done.

Oliver's early miniatures include two of girls aged four and five (Victoria and Albert), both dated 1590, which have always been among his most popular works. Portraits of children in his day, apart from royal ones, are extremely rare; and Oliver's girls really look like children rather than scaled-down adults. The artist's *self-portrait* (National Portrait Gallery), which can profitably be compared with Hilliard's done at the age of thirty (Victoria and Albert), was probably painted a little later.

The circumstances of Oliver's life remain largely obscure, but his work must be seen in an international context: like Holbein and unlike Hilliard, he approached limning from a tradition of large-scale portraiture stemming from such artists as Antonio Moro. He remained firmly within the immigrant community in London, allowing his name to be anglicized from Olivier to Oliver but always describing himself as French. It has often been stated that he was in the Low Coun-

tries in the 1580's, but there is no conclusive evidence for this, and he could have acquired training as an artist, and knowledge of artistic developments on the continent, from immigrant colleagues in London. By his second marriage, in 1602, he became a brother-in-law of the fashionable portrait painter Marcus Gheeraerts the Younger, and also acquired family connexions with the future Serjeant-Painter at the Jacobean Court, John de Critz; while by his third, in 1606, he allied himself with an immigrant family of French musicians also employed at Court. Elizabeth I's favourite, Robert Devereux, Earl of Essex, was an early patron, and there is such a close facial resemblance in Gheeraerts's famous full-length of him at Woburn Abbey and a miniature by Oliver (Portrait Gallery), both dated c. 1596, that they may have been companion pieces. Also dated to the 1590's is a striking miniature of the Queen (Victoria and Albert), painted with no attempt to conceal her advancing age. The costume is unfinished, and the straight edges of the playing-card mount at top and bottom, which have not been trimmed to fit an oval frame, suggest that the artist retained the work in his studio as a face-pattern for reference.

Oliver visited Italy at least once, as an inscription on the back of a miniature in the Victoria and Albert is dated Venice May 1596. Italy had a considerable influence on him, and he was encouraged to take up the limning of "histories"; he also did drawings, of which a considerable number survive. They often depict religious subjects, and mostly derive from mannerist artists such as Parmigianino. Oliver seems to have been the first man working in England to conceive of drawings as works of art in their own right.

Works by Oliver show striking variations in style, presumably reflecting the varying requirements of his clients. For example, among the larger "cabinet" miniatures which he did from time to time, a rectangular full-length of *Richard Sackville, 3rd Earl of Dorset* (Victoria and Albert) painted in 1616, the last year of the artist's life—conservative, formalized, and brightly coloured—is totally unlike two sophisticated undated round head-and-shoulder portraits, both five inches in diameter, of great ladies, done in the italianate mannerist style. Each sitter is enveloped in billowing gauze veils and each has hand on breast. One (Victoria and Albert), formerly called *Frances Howard,* Countess of Essex and later Somerset, is a *chiaroscuro* essay in grey to grey-black, with touches of white and tiny highlights of silver and gold, and may reflect the artist's response to an Italian tradition stemming from Leonardo da Vinci; the other (Fitzwilliam Museum, Cambridge) has been plausibly identified as *Lucy Harington,* Countess of Bedford, patron of poets and men of letters.

—Mary Edmond

ORCAGNA.

Born Andrea di Cione in Florence, c. 1308 or c. 1320; brother of Nardo, Jacopo, and Matteo de Cione; sons of a Florentine goldsmith. Died in Florence after 25 August 1368. Painter, sculptor, and architect: in the Florence painters guild, 1343–44, and in stonemasons guild, 1352; only documented painting is the altarpiece in Strozzi Chapel, S. Maria Novella,

Florence, 1354–57; tabernacle for Orsanmichele, Florence, 1352–60; headmaster of Orvieto Cathedral, 1358–c.64: supervised mosaic decoration of facade, 1359–60, with his brother Matteo, worked in Florence Cathedral, 1364–66.

Collections: Berlin; Budapest; Florence: Uffizi, S. Maria Novella, S. Croce, Orsanmichele, Accademia; Liverpool; London: National Gallery, Victoria and Albert, Courtauld; New Haven; New York: Metropolitan, Historical Society; Oxford; Philadelphia; St. Louis; Utrecht; Vatican; Washington; Royal Collection.

Publications

On ORCAGNA: books—

Gronau, Hans-Dietrich, *Orcagna und Nardo di Cione,* Berlin, 1937.
Meiss, Millard, *Painting in Florence and Siena after the Black Death,* Princeton, 1951.
Offner, Richard, *Andrea di Cione: Corpus of Florentine Painting,* New York, 1962.
Giles, Kathleen, *The Strozzi Chapel in Santa Maria Novella: Florentine Painting and Patronage 1340–1355,* Ann Arbor, 1978.

articles—

Steinweg, Klara, "Rekonstruktion einer orcagnesken Marienkronung," in *Mitteilungen des Kunsthistorischen Institutes in Florenz,* 10, 1961.
Smart, Alistair, "Taddeo Gaddi, Orcagna, and the Eclipses of 1333 and 1339," in *Studies . . . in Honor of Millard Meiss,* New York, 1977.
Fabbri, Nancy Rash, and Nina Rutenberg, "The Tabernacle of Orsanmichele in Context," in *Art Bulletin* (New York), September 1981.

*

The few remaining works of Andrea di Cione (called Orcagna) have become synonymous with mid-14th-century art in Florence. Highly regarded in his own day, Andrea filled prestigious commissions not only as a painter, but also as a sculptor, and, to an extent, an architect. His influence on painting in the last half of the 1300's was notable, and traces of his style lingered on in more conservative artists well into the 15th century. Yet, the paucity of the signed, documented, or securely attributed works that remain from this artist's *oeuvre* has proved a continuing frustration for scholars who must reconcile meager data with Andrea's historical position as a major source of change in Florentine trecento painting.

Most of what is understood of Andrea di Cione is centered on the decade of the 1350's, although it is certain that he was active from c. 1343, as his membership in the painter's guild and as his name on a document relating to S. Maria Novella, Florence, indicate. At his death, probably in 1368, his commission for a panel of St. Matthew was finished by a younger brother, Jacopo, with results that leave the extent of Andrea's

Crucifixion with Virgin and Child and St. John; London, Courtauld (Seilern Collection)

contribution debatable. In the present context, what appears most important for a fundamental understanding of this artist is the establishment of his stylistic boundaries through those works that are most firmly positioned in his *oeuvre*.

The best known of these is without doubt the polyptych commissioned from Andrea by Tommaso di Rossello Strozzi for the family chapel in the Dominican church of S. Maria Novella, Florence (1354–57). The style of this altarpiece has been interpreted as the result of the debilitating influences on society caused by the Black Death of 1348 and the mid-century economic disasters which preceeded it. Recently the painting has been viewed in a more contextual light—as the result of a specific funerary commission for which it fulfilled a didactic and symbolic role in the greater, frescoed environment of the chapel. Whether or not Andrea adapted his style to the exigencies of the commission, his "inner direction"—the basic building blocks of his artistic identity—was weighted to-

ward an expression of power, energy, and mass, a legacy from Giotto and, more importantly, Maso di Banco (active 1330's–1340's).

From Maso, too, Andrea learned to create compositions composed of perfect geometric intervals, and expressed in the Strozzi altarpiece in both two and three dimensions. Beginning at each end of the main panel, compositional diagonals rise to the climactic vision of the central Christ, the axis of a great, equilateral triangle. That the figure on this line of equilibrium is, however, manifested in visionary form is one of the para-doxical elements that separate Andrea from his predecessors. In the Stozzi work we see Andrea bringing together and crys-talizing many of the trends of the earlier trecento, and in so doing, creating a new idiom. Certainly, the ornate tapestries on floor and garments, the elaborate tooling and punching of the gilded ground, had already been established as stylish in the preceding decades; yet these space-flattening devices are

combined with an untamed palette and contrast with the massive personages whose volumes can only jut forth with striking immediacy. Only the predella follows, more purely, earlier developments. In the human element injected into the narratives, as well as in the physical features of certain of his figures, there is a reminiscence of the innocence and humanity of another predecessor, Bernardo Daddi (active 1317-1348).

Andrea's massive tabernacle, half sculpture, half architectural invention, dominates the oratory and former grain market of Or San Michele, Florence, and further confirms the complex messages of the Strozzi alterpiece. The domed structure, with scenes from the life of the Virgin, virtues, saints, prophets, and angels, occupied him from about 1352 until 1360. In form it has rightly been said to resemble a small church, with references to the Florentine Duomo, as well as to the earlier marble pulpits of the Pisani in its architectural details and its inlaid marble decorations. Like the Strozzi alterpiece, the tabernacle also satisfied the extravagant tastes of mid-century, its opulence a monument to the staggering funds garnered in the wake of the Black Death by the miracle-working image of the Virgin and Child it was constructed to house. The single figures and the reliefs that punctuate the balustrade of this imposing structure correspond, in many ways, to the figures and narratives of Andrea's paintings—for example, in the proportions and the tight, sharp folds that pull across the bodies and emphasize their sculptural plasticity. Human emotions of affection, wonder, and grief are also found in these small dramas; and some of the settings, such as that of *The Birth of the Virgin,* are well outfitted, detailed interiors enclosed in a developed, proscenium-like stage similar to those of Pietro Lorenzetti.

Andrea's dramatic range, his ability to command figures in action, is nowhere better glimpsed than in the fragments of his monumental *Last Judgment* cycle, formerly on the right nave wall of S. Croce, Florence (now in the S. Croce Museum). Although undated, the attribution to him has always been uncontested. Here, three scenes (the so-called *Triumph of Death,* left; *The Last Judgment,* center; and *The Inferno,* right) were conceived as a giant triptych lying behind an illusionistically projected cornice and divided by massive, twisted, inlaid columns. The sheer audacity of this fictive, architectural conceit has roots in the earlier schemes of Taddeo Gaddi's Baroncelli chapel, also in S. Croce, and is seen in Andrea's own spatial illusions wrought by the tooled columns of his Strozzi altarpiece. The vigorous, loose technique of fresco, much different than this artist's exacting panel style, has led some students to place the cycle before 1350, and closer to the sweeping, monumental conceptions of Maso di Banco. Some broadly painted fragments of heads in the choir of S. Maria Novella, which Andrea has been credited with painting around 1350, would seem to confirm this trend, as would the overt dependence on Maso's compositions for a pair of altarpieces attributed to this period (a triptych in Utrecht, Archbishop's Museum, of 1350; a polyptych: Florence, Accademia, of about 1353). A hardening of Andrea's subtle stylistic balance—visible in close followers such as the Pentecost Master—and the endless simplifications of his ideas throughout the remaining trecento pay homage to, while they further obscure the identity of this intriguing and most talented master.

—Carol T. Peters

OROZCO, José Clemente.

Born in Ciudad Guzman, Jalisco, 23 November 1883. Died in Mexico City, 7 September 1949. Married Margarita Valladares, 1923; three children. Attended Agricultural College of San Jacinto and National University, Mexico City; studied architectural drawing, Academy of San Carlos, Mexico City, 1900-04, and National Academy of Fine Arts, Mexico City 1908-14; architectural draughtsman, with Carlos Herrera, 1904-09; cartoonist for *El Imparcial* and *El Hijo del Ahuizote* newspapers, Mexico City, from 1911; lived in the United States, 1917-20, 1927-34; continued to work as cartoonist, and, with Diego Rivera and David Alfaro Siqueiros, as mural painter; settled in Guadalajara, 1936.

Major Collection: Guadalajara: Museo Orozco.
Other Collections: Havana; Mexico City: Museo Carrillo Gil, Museo de Art Moderno; New York: Moma.

Publications

By OROZCO: books—

Textos, edited by Justino Fernández, Mexico City, 1955, 1983.
Autobiografía, Mexico City, 1945; as *An Autobiography,* Austin, 1962.
The Artist in New York: Letters to Jean Charlot and Unpublished Writings 1925-29, Austin, 1974.

On OROZCO: books—

Reed, Alma, *Orozco,* New York, 1932.
Merida, Carlos, *Orozco's Frescoes in Guadalajara,* edited by Frances Toor, Mexico City, 1940.
Helm, MacKinley, *Man of Fire: Orozco: An Interpretive Memoir,* New York, 1953.
Zuno, José G., *Orozco y la ironía plástica,* Mexico City, 1953.
Fernández, Justino, *Orozco: Forma e idea,* Mexico City, 1956, 1975.
Myers, Bernard S., *Mexican Painting in Our Time,* New York, 1956.
Reed, Alma, *Orozco,* New York, 1956.
Cardoza y Aragon, Luis, *Orozco,* Mexico City, 1959, 1974.
Guerico, Antonio del, *Orozco,* Milan, 1966.
Hopkins, John H., *Orozco: A Catalogue of His Graphic Work,* Flagstaff, Arizona, 1967.
Cardoza y Aragon, Luis, *Orozco* (cat), Paris, 1979.
Cardoza y Aragon, Luis et al., *Orozco: Malerei und Graphik* (cat), Vienna, 1980.
Baqué, Egbert, and Hans Spreitz, editors, *Orozco* (cat), Berlin, 1981.
Elliot, David, *Orozco* (cat), Oxford, 1981.
Goldman, Shifra M., *Contemporary Mexican Painting in a Time of Change,* Austin, 1981.
Orozco: Antología crítica, Mexico City, 1982.
Orozco: Una reelectura, Mexico City, 1983.

*

Rearguard, 1929; lithograph

At the San Carlos Academy in Mexico City, José Clemente Orozco received a solid artistic training. His first works show the academy's influence and at various moments throughout his career, he returned to formal themes and elements echoing his early artistic studies.

From 1911 to 1924 he worked on several newspapers and he first became known as an illustrator. This field of work gave him great liberty of expression. The world of the theatre and cabaret and the city's nightlife fascinated this caustic critic of social reality. His caricatures conveyed the atmosphere and portrayed the characters of the underworld and employed satire to reveal injustice and corruption. Orozco drew with charcoal, tempera, and pencil. His handling of chiaroscuro was masterly, his drawing simple and economical. His capacity for synthesis was marked even at this early stage of his career. In 1916, he began to use the absurd in his iconography with the series *Las colegialas,* corrupt and prostituted schoolgirls. He was to use it as a means of emphasizing the content of his work. The main influences on Orozco during this period were those of the Symbolist painter Julio Ruelas and the popular illustrator José Guadalupe Posada.

In his first murals at the National Preparatory School in Mexico City (1923–24) he returned to classicism. At an iconographic level, this was to serve as a way of dealing with the civic concerns of the themes of the murals. Such is the case of

La trinchera or *La huelga.* In formal terms, classicism is seen in the monumental and serene figures, composed with the use of the golden mean. He also used caricature to denounce and satirize the corrupt priests and politicians and the sanctimonious and hypocritical high society.

In 1932, he began a new phase in his artistic career with the Dartmouth College murals. He replaced the monumental and silent figures of anonymous revolutionaries with gods and heroes with pathetic and passionate expressions. The people, dignified and serene, gave way to anonymous, agitated masses. His new work was invaded by an apocalyptic feeling accompanied by a new formal language. From the use of serene and sacerdotal forms, he passed on to that of nervous lines and brushstrokes. He used the immediacy of the front view to provoke the spectator's emotions. He employed dissonant colours. Grey is the colour of impotence and defeat; in the upper part of the wall it becomes reddish, symbolizing fire and hope.

Orozco used form and colour in order to express emotions and, to the same end, he distorted his figures. These features of his work indicate his contact with German Expressionsism. One very important influence at this time was that of El Greco's later works, such as *El séptimo sello* and *Laocoonte.* From these paintings Orozco takes his extended and pathetic figures and his liking for artificial light.

During the same period, he began to use some iconographic

elements from futurism, like the machine and the bayonet. He also used simultaneity, very much in Boccioni's fashion. Unlike the futurists, however, Orozco saw the machine as a symbol of the destructive nature of modern man.

The following important stylistic development in Orozco's work did not occur until 1940. His six mobile panels, *Dive bomber* and *Tank,* painted for the Museum of Modern Art in New York, were a prelude to this change. They were the first of a series of poetic abstractions from reality. Orozco felt that the moment had come to leave realistic forms that conveyed discursive messages because they had exhausted their powers of expression. He declared, "Painting is poetry and nothing else." From that time onwards, the formal languages and iconography he had used up until then began to be abandoned.

Throughout this evolution he painted a series of works that represent the period of transition. Among them the series *Los teules*—the white gods (1947, pyroxylene on mazonite, Hospicio Cabañas, Guadalajara)—stands out. These murals clearly show the artist's capacity for synthesis that, even within realism and without discursive props, he transmits the horror of the destruction that can be caused by mankind.

The following murals in this evolution towards the abstract are constituted by the series *Alegoría de la nación* at the National School for Teachers in Mexico City. This was the first outdoor mural Orozco painted in Mexico. In it, he introduced important innovations in form and material. He painted it with athyel silicate on a parabolic concrete wall, six stories high. This is an immense geometrical composition, that appears to be made of stone, with a metallic structure. In his picture *Paisaje metafísico,* Orozco's evolution reaches its logical conclusion in one of his most beautiful compositions. This is an abstract painting, full of poetic feeling and which could well be included among the best examples of Abstract Expressionism. In it we see only a grey sky, in the center of which a black rectangle is suspended from on high.

—Alicia Azuela

OVERBECK, (Johann) Friedrich.

Born in Lubeck, 3 July 1789. Died in Rome, 12 November 1869. Married Anna (Nina) Hartl, 1818; one son. Attended the Lubeck Gymnasium; studied under Füger at The Vienna Academy, 1806–10; co-founder, with Franz Pforr, of the Lukasbrüderschaft (Nazarenes), in Vienna, 1809; lived in Rome from 1810: with his friends Pforr, Josef Wintergerst, et al., he formed a little commune in old monastery of San Isidro; later joined by Cornelius Veit and Wilhelm Schadow: decorated the villas of Prussian Consul Bartholdi and of Prince Massimo; influenced the Pre-Raphaelite Brotherhood.

Collections: Assisi: S. Meria degli Angeli; Basel; Berlin; Berlin (East); Cologne: Cathedral; Frankfurt; Karlsruhe; Lubeck: Behnhaus; Munich: Neue Pinakothek; Posnan; Rome: Casino Massimo.

Publications

By OVERBECK: books—

Briefe und schriftlicher Nachlass, edited by Margaret Howitt, Freiburg, 2 vols., 1886.

On OVERBECK: books—

Atkinson, J. Beavington, *Overbeck,* New York and London, 1882.
Howitt, Margaret, *Overbeck: Sein Leben und Schaffen,* Freiburg, 2 vols., 1886.
Lütgendorff, W. L. von, *Das Overbeck-Zimmer im Museum am Dom zu Lübeck,* Lübeck, 1915.
Heise, C. G., *Overbeck und sein Kreis,* Munich, 1928.
Jensen, Jens Christian, *Overbeck: Die Werke im Behnhaus,* Lübeck, 1963.
Andrews, Keith, *The Nazarenes,* Oxford, 1964.
Jensen, Jens Christian, *Die Zeichnungen Overbecks in der Lübecker Graphiksammlung,* Lübeck, 1969.

article—

Seeliger, S., "Overbecks 7 Sakramente, in *Jahrbuch der Berliner Museen,* 6, 1964.

*

Despite its successes, Overbeck's Nazarenes, the academic break-off movement of "German-Romans" based on Catholicism, early Italian renaissance and German late medieval art, as well as nature studies, had many critics. As its spiritual leader, he was the perennial scapegoat for the perceived sins of the neophyte group as a whole, e.g., its collective "hypocrisy and return to old Germanism . . . [and its] patriotic and nationalist form" (J. H. Meyer, J. W. Goethe). Alternatively, supporters praised him for his "rich fantasy, lovely grace and sincere feeling for beauty . . . [and] expression" (F. Schlegel).

Raising of Lazarus (1808, Lübeck, Museum der Hansestadt), an accomplished student work of his, reveals the influence of his classicist teacher, H. Füger, but also an integrity of feeling and a spirituality that suggest Romantic influences— Ph. O. Runge, E. Wächter, G. Schick, A. Carstens—as well as new historical models, e.g., Dürer, Perugino, the young Raphael. *The Entry into Jerusalem* (begun in Vienna in 1810, finished in Rome in 1824 destroyed in 1942), his most brilliant *succès d'estime,* embodies the larger changes implicit in his mature style. It is typified by influences of the conservative quattrocento tradition, especially of the Lombardian and Umbrian schools, simple lines, clear contours, flat planar shapes, intensive local colors, balance, simplicity and two-dimensional clarity. He also echoes poetic sentiments about the spirit of the Middle Ages, when "art and life were one" (F. Schlegel) and about the medieval craftsman-artist who "was honest, guileless, thoughtful and also chaste and a little awkward" (W. H. Wackenroder).

Joseph Being Sold by His Brothers, Berlin, Nationalgalerie (1816–17) is one of two paintings he completed for a seminal joint Nazarene project, the decoration of the Palazzo Zuccari

(Bartholdi) in Rome with subjects from *Genesis*. It was influenced by Raphael and Pinturicchio and done in *buon fresco*, a technique the Nazarene had rescued from oblivion on the basis of historical studies and field research. He skilfully interwove several distinct chronological phases of the story and balanced them with the requirements of a harmonious formal array. Its lyricism, linear rhythm, and fine harmonies, to the contrary, also betray a serious flaw of his artistic goal to combine "monumentality" of overall effect with "intimacy" in detail and with narrative description in large-scale decorations, a problem that may be "impossible to solve" (R. Zeitler). By contrast, his *Seven Lean Years* (1816, Berlin, Nationalgalerie), the companion to *Joseph* in one of the lunettes, is redolent with an "intensity of expression . . . unique in such sharpness in [his] oeuvre" (K. Andrews). Unfortunately, it thus also contributes its share to the stylistic disunity of the group effort as a whole. Interestingly, with his second endeavor at frescoing—themes from *Jerusaleme Liberata* for the Tasso Room in the Villa Massimo in Rome (1818–25)—he solved most of those problems in favor of intimacy, narration, and uniformity in his control of fine detail. Especially in *Preparation for the Siege of Jerusalem* (idem) he achieved a credible balance between the naturalism of select parts with an ideal overall conception and a fine coloristic integration.

His "private" works express personal sentiments, friendship and the joys of family life—e.g., *Italia and Germania* (begun 1811, finished 1828, Munich, Neue Pinakothek), *Portrait of Franz Pforr*, (1810, Berlin, Nationalgalerie), *The Artist with his Wife and Son* (begun 1820–22; 1830). Unencumbered by programmatic or didactic doctrines, works such as these have been widely hailed by 20th-century critics as Overbeck's most successful efforts because they clearly express his heartfelt sentiments and sincere feelings. Conversely, the same critical priorities—priorities based on the need for originality and personalism as well as unity between form, subject, and content in art—have reduced his *opus magnum, The Triumph of the Arts in Religion* (1833–40, Frankfurt, Städelsches Kunstinstitut), to a state of abject failure. A colossal "discourse of ideas on art" aiming at "unashamed and undiguised dogmatic propaganda" (K. Andrews), the painting is often cited as the litmus for the historical failure of Nazarenism. Because the Nazarenes had "confused feelings with religiosity," their "vi-tal sense of form soon froze into a lifeless schema" (H. Lussow).

As early as the 1840's and against the background of the enormous success and influence of the Nazarenes at the academies, it was fashionable to argue that Overbeck had stumbled egregiously. His "errors," as manifest in *Triumph* as well as in his larger oeuvre, are proven by an "art which has made itself the subject" of its own endeavors and projects a mere "*Afterbild* [anal image] of beauty." Meandering hopelessly "between philosophy and art," Overbeck had reduced art to an allegorical "ghost of itself." His art recalls "almanachs and fashion journals," amounting to little more than "love's labors lost to convince us with dogma to go back to ancient times in, of all times, the days of the steam engine . . . tailcoats and neckties" (F. T. Vischer). Similarly uncharitable views concerning his "blandness, plainness and uniformity" have permeated criticism ever since. Yet, despite their partial truth they miss the point of Overbeck's contribution to modern art history. The eclecticism, iconographic complexity, and formulaic nature of large portions of his uneven and problematical oeuvre are real but may also be regarded as merely "empirical impediments to his revolutionary new aesthetic principles.

It is necessary to distinguish between *what* Overbeck expressed and what is often orthodox from the *how*, the fundamental causes that prompted his actions. As to the latter, he revolutionized the creative process with psychological urgency and personalist *Weltanschauung*. The autobiographical cogency of his subject matter and the inner necessity of his iconography flow from the same source, the view that art and life are one. In due course, this "shifted the essence of his art from the creative to the confessional" (J. C. Jensen). The same position engendered a social awkwardness and aesthetic self-consciousness as well as a need to reinvent art daily from scratch while persistently reaffirming its ideological bases. Lastly, these are the semiotics of Expressionism. To "pray with paintings" (Overbeck) was for him an existentialist cry for self-affirmation through art, as well as an emotive act of both self-revelation and survival as a human being. With his new Romantic psychology of creation through self-validation he helped implant the seed of modernism.

—Rudolf M. Bisanz

P

PACHER, Michael.

Born in Neustift, near Brixen (Bressanone), c. 1430–35. Died in Salzburg, 1498. Married Ottilia; son, the painter Hans Pacher; one daughter. Influenced by Mantegna; burgher and painter in Bruneck (Brunico), 1467–96: his masterpiece is the altarpiece in St. Wolfgang am Abersee parish church in upper Austria: wood carving with paintings; other altars in the Tyrol district at Bozen, Sankt Lorenzen, Salzburg, though many of his works have been destroyed. Assistant: Friedrich Pacher.

Collections/Locations: Basel; Brixen: Cathedral; Graz; Gries: parish church; London; Munich: Bavarian Museum, Alte Pinakothek; St. Wolfgang: parish church; Salzburg: St. Francis; Vienna: Belvedere, Kunsthistorische Museum.

Publications

On PACHER: books—

Mannowsky, Walter *Die Gemälde des Pacher,* Munich, 1910.

Semper, Hans, *Michael und Friedrich Pacher: Ihr Kreis und ihre Nachfolger,* Esslingen, 1911.

Doering, Oscar, *Pacher und die Seinen: Eine Tiroler Künstlergruppe am Ende des Mittelalters,* Munchen Gladbach, 1913.

Stiassny, Robert, *Pachers St. Wolfganger Altar,* Vienna, 1919.

Allesch, Gustav J. von, *Pacher,* Leipzig, 1931.

Hempel, Eberhard, *Pacher,* Vienna, 1931.

Schwabik, Aurel, *Pachers Grieser Altar,* Munich, 1933.

Hempel, Eberhard, *Das Werk Pachers,* Vienna, 1937, 6th ed., 1952.

Schürer, Oskar, *Pacher,* Bielefeld, 1940.

Strohmer, E., *Der Pacher-Altar in St. Wolfgang,* Vienna, 1940.

Theil-Salmoiraghi, E. D., *Pacher in Neustift,* Milan, 1946.

Scheffler, Karl, *Pachers Altar von St. Wolfgang,* Konigstein, n.d.

Halm, P., *Pacher: Der Kirchväter-Altar,* Stuttgart, 1957.

Schwabik, Aurel, *Pacher,* Milan, 1966.

Fuhrmann, Franz, *Der St.-Wolfram-Altar,* Stuttgart, 1967.

Rasmo, Nicolo, *Pacher,* Milan, 1969, London, 1971.

Burkhard, Arthur, *Seven German Altars,* Cambridge, Massachusetts, 1972.

Baxandall, Michael, *The Limewood Sculptors of Renaissance Germany,* London, 1980.

Michael Pacher was a sculptor and painter who lived in the South Tyrol on the border between Austria and Italy. His workshop produced large altarpieces in the Tyrol, Germany, and Austria, combining great skills in sculpture and painting. Pacher's most famous work is the *St. Wolfgang Altarpiece,* made for the parish church of Sankt Wolfgang on the Abersee in Austria.

Pacher was born in Neustift near Brixen (Bressanone) which lies on the southern slopes of the Alps along the route leading north to the Brenner Pass. For much of his life he was a citizen of Bruneck (Brunico) in the Pusterthal some forty kilometers east of Brixen. It was in the workshop at Bruneck that most of Pacher's commissions were executed. Contracts for his altarpieces specified that he would act as the designer of the works. Friedrich Pacher, who is considered by some scholars to be Michael's brother, and who was also a painter, worked in the shop as did Michael's son, Hans, after 1480.

The style of the sculpture in Michael Pacher's works is predominantly German and late Gothic. It relates to the work of Hans Multscher of Ulm, who is known to have worked in the Tyrol, and to Niclaus Gerhaert, who worked in the Upper Rhine area. There is not complete consistency of sculptural style, suggesting that Pacher freely used members of his shop to execute his works while he retained overall command of the design.

Pacher's painting style is also varied, combining Northern influences from German and Flemish art with elements of Italian Renaissance art. Pacher's paintings incorporate Late Gothic realism with constructed perspective that emphasizes foreshortening of figures and structures. He uses a low horizon producing an upward view of figures and structures. The works of Andrea Mantegna provide the closest parallel with this aspect of Pacher's art. The problems of attribution are complex, awaiting careful analysis.

A sculpture of the Virgin and Child from a destroyed altarpiece of 1462–63, preserved in the parish church of S. Lorenzo in Pusteria, seems to be the artist's earliest surviving work. The next works, both documented to 1471, are the high altarpiece for the church at Gries, near Bolzano, and the St. Wolfgang altarpiece. The contract for each of these altarpieces is preserved. The altarpiece at Gries is only partially preserved because of alterations when it was moved in the 18th century. The *St. Wolfgang Altarpiece* has survived in good condition.

From 1481 to 1484, Pacher worked on an altarpiece for the parish church at Bolzano, dedicated to St. Michael. It does not survive. A 17th-century description notes that it had shutters,

and that carved and gilt figures of the Virgin, flanked by Sts. Michael and Martin, were in the center.

The *Altarpiece of the Church Fathers* in the Alte Pinakothek in Munich dates from 1483–84. It was made for the Collegiate Church of Neustift in the Alto Adige region of the Tyrol. It consists only of paintings though some sculptures must have graced the frame of the altarpiece, now lost. Open, this altarpiece showed the four Church fathers, Jerome, Augustine, Gregory, and Ambrose, seated at desks or lecterns, writing or gesturing and accompanied by small figures as symbols or attributes of their lives. The wings, with Sts. Jerome and Ambrose, closed over the others to reveal paintings of the life of St. Wolfgang on their outer faces. These narrative scenes typically combine the elements of Northern Renaissance painting with Italian Renaissance perspective. The composition is often innovative and energetic.

From 1484 to 1498, Pacher's shop was at work on an immense high altar for the city parish church of Salzburg. The altarpiece is lost except for the central figures of the Virgin and Child. Even these are in poor condition having suffered in a clumsy restoration attempt. Pacher died in Salzburg in 1498.

—Charles I. Minott

PALMA VECCHIO.

Born Jacopo Negretti in Serina, 1480; uncle of Jacopo Palma il Giovane. Died in Venice, 30 July 1528. Possibly a pupil of Andrea Previtali and of Giovanni Bellini in Venice; influenced by Titian; famous for his beautiful blondes (e.g., S. Barbara in S. Maria Formosa, c. 1510); also made a specialty of Sacra Conversaziones; member of the Scuola di S. Marco, 1513; commissions in the Veneto as well as in Venice; many works completed by his pupils.

Collections: Berlin; Braunschweig; Cambridge; Dresden; Florence; Frankfurt; Leningrad; London: National Gallery, Courtauld, Royal Academy; Lugano; Milan: Brera, Poldi Pezzoli; Paris; Philadelphia; Prague; Rome: Borghese, Palazzo Venezia, Capitoline, Galleria Nazionale; Venice: S. Maria Formosa, Querini-Stampalia, Scuola di S. Marco; Vicenza: S. Stefano; Vienna; Zerman: S. Elena.

Publications

On PALMA VECCHIO: books—

Boehn, Max von, *Giorgione und Palma Vecchio,* Bielefeld, 1908.
Spahn, Annemarie, *Palma Vecchio,* Leipzig, 1932.
Gombosi, György, *Palma Vecchio,* Stuttgart, 1937.
Ballarin, A., *Palma il Vecchio,* Milan, 1965.
Mariacher, Giovanni, *Palma il Vecchio,* Milan, 1968.
Serina a Palma il Vecchio, Bergamo, 1981.

Pacher: St. Michael Slaying the Dragon, 1471–75; wood; Bolzano-Gries, Parish Church

articles—

Ballarin, A., "Tre disegni: Palma il Vecchio, Lotto, Romanino, e alcune osservazioni sul ruolo del Romanino al Buonconsiglio," in *Arte Veneta*, 24, 1970.

Sohm, Philip L., "Palma Vecchio's *Sea Storm:* A Political Allegory," in *Revue d'Art Canadienne*, 6, 1979-80.

*

Palma's life and career are only sketchily documented. But, largely through traditional attributions of a number of works of notable quality and consistent style, a distinctive artistic personality has been identified for him. His paintings are chiefly of four types: altarpieces, *sacre conversazioni,* portraits, and idealised depictions of beautiful women.

His altarpieces are comparatively few, but important both as examples of the gradual development in Venetian art from the intellectually illusionistic images of Giovanni Bellini to the more directly beguiling sensuousness of Giorgione and Titian, and as markers charting Palma's own artistic progress. An early example is the *Assumption of the Virgin* (1513; Venice, Accademia) which, with its clear, strong colours, elegantly elongated figures, static composition and contemplative mood, is clearly a product of a sensibility still rooted in the late Quattrocento. A considerable advance is evident in the polyptych of the *Presentation of the Virgin with Saints* (c. 1514; Serina, SS. Annunziata). In the figures here Palma has abandoned the angular canon of his putative teacher, Andrea Previtali, in favour of the broad, sculptural solidity of Bellini; the brilliant colours and the unified background of sky in the subsidiary panels also indicate his desire to present an effect of greater immediacy. A similar, though sadly damaged, polyptych—roughly contemporaneous and also painted for a church in Palma's native province—is the *St. James Altarpiece* (c. 1514-15; Peghera, S. Giacomo Maggiore): which achieves both a more consistent directness and a greater variety in the figures, with the central St. James, derived from a much-copied *Redeemer* (Dresden) by Cima da Conegliano, flanked by a St. Sebastian based on a classicising print by Marcantonio Raimondi and a freely moving St. Roch. Another altarpiece for a provincial centre was the *Virgin and Child with Saints* (1518-19; Zerman, S. Elena), in which the disposition of the components is entirely traditional, based on Bellini and Carpaccio, but which also contains elements, such as the subtle lighting and the directly engaging glances of the Virgin and St. Helen, indicating a new attitude. This is more fully expressed in the *St. Peter Enthroned with Saints* (c. 1521-22; Venice), a superficially similar composition, and with some identical details; here the landscape background is virtually suppressed, allowing no distraction from the large figures crowding towards the picture plane, surrounding a St. Peter whose bulky drapery and naturalistic gesture make him a convincing presence.

The *St. Peter* was a prelude to Palma's finest example, the *St. Barbara Altarpiece* (c. 1522-3; Venice, S. Maria Formosa), a polyptych commissioned by the Scuola dei Bombardieri (artillerymen) whose patron St. Barbara was. Her central figure, filling a panel enlarged to a much greater size than the subsidiary ones—a novel departure—is at once easy and Classically poised, physically insistent yet gracefully idealised, compositionally dominant in her ample folds but related harmoniously to the surrounding figures through pose, colour, and a unified effect of light. The influence of Titian's *Assumption of the Virgin* (1518; Venice, Frari) is evident in the volumetric bulk and naturalistic surface of all the figures. A more ambitious attempt at compositional unity is embodied in the huge canvas of the *Adoration of the Magi with St. Helen* (1525; Milan) painted for the high altar of S. Elena, Isola. The result suffers from the oppressive effect of the ruined architecture and fantastic landscape filling the upper part; but the vigorously moving group of the Magi (perhaps indicating some knowledge of Pordenone), and the vibrantly shot colours of the protagonists' robes, indicate that Palma had begun to define a more progressive role in Venetian developments.

The artistic progress of Palma's *sacre conversazioni* was less exaggerated and more consistent. The informality, immediacy and lack of convention inherent in the mode encouraged originality and licence, and in fact Palma developed a new style within it. Its origins lay probably in Bellini's devotional Madonnas, which are sometimes flanked by adoring saints. These were usually half- or three-quarter-length figures, and Palma sometimes used this format, as in the *Virgin and Child with SS. John the Baptist and Mary Magdalene* (c. 1513; Bergamo), his consistency in this field is shown by the later, very similar version of the same subject (c. 1520; Genoa, Bianco), where, however, the bulk, movement, and colour of the figures have been toned down to create a softer, more contemplative and melancholy mood. It was probably Titian (although also following the lead of Bellini) who originated the type that Palma more typically employed, with the Virgin full-length, seated in a clam landscape, surrounded by sitting or kneeling saints. Sometimes the theme is elaborated from a more formal subject such as the *Rest on the Flight into Egypt* (c. 1514; Florence) or the *Adoration of the Shepherds* (c. 1525; Paris); occasionally a patron's portrait is included, as in the superbly composed *Virgin and Child with SS. Mary Magdalene, John the Baptist, and Catherine of Alexandria and a Donor* (c. 1519; Lugano). But mostly Palma presents a generalised, gently beautiful image for private contemplation. The atmosphere gradually becomes less bucolic and more sophisticated, culminating in perhaps the finest example, the *Virgin and Child with SS. Celestine, Catherine of Alexandria, Barbara, and John the Baptist* (c. 1521; Vienna). Here St. Catherine, disposed with a Mannerist contorted grace, gazes outwards with a secular frankness, while St. Barbara contemplates more modestly St. John leaning forward to look at the Child with a touching tenderness; the colours are brilliantly variegated, and Palma shows an unwanted sensitivity to surface texture. He repeated the pose of St. John in one of his last works, the *Virgin and Child with SS. Catherine and John* (c. 1527; Hampton Court), which, with its concerted interchange of melancholy glances, is one of his most poignantly moving evocations of feeling.

Psychological insight was not normally one of Palma's strengths, and his portraits are not distinctive. The most interesting are the vigorous *Man in Fur Cloak* (Munich), thought by some to be Palma's self-portrait, but by others still attributed to Giorgione, and the famous and beautiful *Portrait of a Poet* (London), frequently identified as Ariosto, an image of masterly composition and tender grace. More characteristic were Palma's pictures, evidently not true portraits, of idealised blonde women. They conform to the type of beauty then most

admired in Venice, and were probably based on popular courtesans. The earliest examples, from 1512–14, are comparatively respectable, like the *Woman in Green* and *Woman in Blue* (both Vienna). Gradually their clothes become more sumptuous, their decolletages more pointed, and their glances more challenging, as in the *Violante*, also in Vienna (c. 1517), and the magnificent *Bella* (c. 1519; Lugano). Some have spurious attributes, such as *Lute-Player* (Alnwick) and the *Three Sisters* (Dresden)—three all-too-contemporary Graces—both of 1518–20. Subsequently, under the influence of Titian's overtly erotic *Flora* (c. 1520; Florence), they dress only in their linen shifts, and loosely at that: the *Sibyl* (Hamptom Court), the *Courtesan* (Milan, Poldi-Pezzoli), and the *Woman with Bared Breast* (Berlin), all from the first half of the 1520's. Full nakedness appears in mythological guise, and with borrowings from the elegant early Mannerism of Rosso Fiorentino and Parmigianino, in more elaborate and distanced compositions of the mid-1520's, the enigmatically graceful *Venus and Cupid* (Cambridge) and the complex *Bathing Nymphs* (Vienna). These works show Palma, just before his death, addressing and assimilating the latest developments in Italian art, and giving them his personal stamp of warm beauty.

—Nigel Gauk-Roger

PALMER, Samuel.

Born in London, 27 January 1805. Died in Redhill, Surrey, 24 May 1881. Married Hannah Linnell, 1837; two sons and one daughter. Attended Merchant Taylors School, London, 1817; studied with William Wate; met William Blake, 1824, and became member of the Ancients group, with Calvert and George Richmond, etc.; lived in Shoreham, Kent, 1826 to mid-1830's, in London until 1861, and Redhill, Surrey from 1861; visited Italy, 1837–39.

Major Collection: London: Tate.
Other Collections: Cambridge; Carlisle; Edinburgh; London: Victoria and Albert, Courtauld, British Museum; Manchester; Melbourne; New Haven; Ottawa; Oxford; Philadelphia; Princeton.

Publications

By PALMER: books—

An English Version of the Eclogues of Virgil, London, 1883.
Letters, edited by Raymond Lister, Oxford, 2 vols., 1974.
The Parting Light: Selected Writings, edited by Mark Abley, Manchester, 1985.

On PALMER: books—

Palmer, A. H., *The Life and Letters of Palmer*, London, 1892.
Binyon, Laurence, *The Followers of William Blake: Edward Calvert, Palmer, George Richmond, and Their Circle*, London, 1925.

Hardie, Martin, *Palmer*, London, 1928.
Alexander, R. G., *A Catalogue of the Etchings of Palmer*, London, 1937.
Grigson, Geoffrey, *Palmer: The Visionary Years*, London, 1947.
Palmer and His Circle: The Shoreham Period, (cat), London, 1956.
Grigson, Geoffrey, *Palmer's Valley of Vision*, London, 1960.
Butlin, Martin, editor, *Palmer: Sketch-Book 1824*, Paris, 2 vols., 1962.
Malins, Edward, *Palmer's Italian Honeymoon*, London, 1968.
Cecil, David, *Visionary and Dreamer: Two Poetic Painters: Palmer and Edward Burne-Jones*, Princeton, 1969.
Lister, Raymond, *Palmer and His Etchings*, London, 1969.
Lister, Raymond, *Palmer: A Biography*, London, 1974.
Gleeson, Larry, *Followers of Blake*, Santa Barbara, 1976.
Fawcus, Arnold, et al., *Palmer: A Vision Recaptured: The Complete Etchings and the Paintings for Milton and Virgil*, London, 1978.
Lister, Raymond, *Palmer in Palmer Country*, London, 1980.
Brown, David Blayney, *Palmer* (cat), London, 1982; Oxford, 1983.
Bentley, G. E., Jr., et. al., *Essays on the Blake Followers*, San Marino, California, 1983.
Viscomi, Joseph, *Prints by William Blake and His Followers*, Ithaca, New York, 1983.
Lister, Raymond, *Palmer and "the Ancients"* (cat), Cambridge, 1984.
Lister, Raymond, *The Paintings of Palmer*, Cambridge, 1985.
Strudwick, R. F., *A Catalogue of Palmer's Etchings*, London, 1985.
Lister, Raymond, *Palmer: His Life and Art*, Cambridge, 1987.
Lister, Raymond, *Catalogue Raisonné of the Works of Palmer*, Cambridge, 1988.

*

Samuel Palmer, the son of an eccentric London bookseller of gentle background, received little formal education apart from a short period at the Merchant Taylors School, from which, as he was so unhappy, his parents withdrew him. As a boy he read widely from his father's stock, and became especially fond of poetry, particularly the works of Spenser and Milton.

He learned watercolour from an obscure painter, William Wate, and for a period made studies in the manner of David Cox; Wate probably used Cox's *Treatise on Landscape Painting and Effect in Water Colours* (1813) as a textbook.

In 1822 Palmer met John Linnell, a dynamic painter of landscapes and portraits, who took him under his wing, conducting him around exhibitions, especially the Dulwich Gallery, and pointing out which works he ought to be studying, including those of Claude Lorrain, Aelbert Cuyp, Albrecht Dürer, Meindert Hobbema, and others. Linnell's influence helped to transform Palmer's art, and this became apparent in a sketchbook begun in 1824 (British Museum). Here he introduced a visionary dimension to his portrayals of English landscape, depicting the countryside as a paradisal land flowing with milk and honey. In this he was confirmed by the vision of his friend William Blake, who had written of building Jerusalem "in England's green and pleasant land." Linnell introduced him to Blake in 1824, and he was immediately stimulated by the old

poet-painter. He showed Blake, "with fearfulness," some of his work, "and the sweet encouragement he gave me (for Christ blessed little children) did not tend basely to presumption and idleness, but made one work harder and better that afternoon and night." Palmer's exaltation was further reinforced when he saw Blake's wood-engravings for Thornton's *Pastorals of Virgil* (1821), echoes from which are to be found in many of his designs.

At about this time, Palmer also met several other like-minded young artists: Edward Calvert, George Richmond, Francis Oliver Finch, Welby Sherman, Henry Walter, Frederick Tatham and his brother Arthur, a clergyman, and Palmer's cousin John Giles, a stockbroker. With "poetry and sentiment" as their watchwords, they called themselves "The Ancients." Palmer, who had a small independence, moved to Shoreham in Kent during the mid-1820's, and the surrounding area became his "Valley of Vision," and Shoreham itself the rural headquarters of the Ancients. Here Palmer was inspired to create some of his most brilliant works, including *The Magic Apple Tree* (1830; Cambridge), *Coming from Evening Church* (1830; London, Tate), and many more.

Palmer fell in love with Linnell's eldest daughter, Hannah, and, with the responsibilities of married life looming before him, moved back to London to teach painting. In 1835 and 1836 he visited north Wales, where he made some impressive studies in the picturesque style, particularly of waterfalls, such as *Pistyll Mawddach* (Tate). His work begun to lose its visionary quality, a tendency that accelerated when, after marrying Hannah in 1837, the young couple visited Italy on an extended honeymoon, in the company of Mr. and Mrs. George Richmond and their young son. The visit, which lasted until 1839, saw a deterioration in Palmer's relationship with his father-in-law, who wrote long, often scolding letters, subjecting him and his wife, and their every activity, to close and censorious scrutiny. This, to which Palmer reacted weakly, marked the onset of deep lifelong unhappiness.

Palmer's Italian watercolours are mostly conventional topographical studies, though there are some exceptions which show a flash of his old vision; such is *Civitella, near Subiaco* (Manchester, Whitworth).

Back in England, Palmer continued to paint conventional watercolours (and a few oil paintings), some including a narrative element in the contemporary fashion. Again there were exceptions, such as the Claude-like *Evening in Italy* (1845; private collection, England). Few of these sold and he supplemented his meagre income by teaching.

His relationship with Hannah deteriorated, and what was worse, first his daughter and then his elder son died. His misfortunes did not affect the quality of his technique which never fell below his self-imposed high standard.

In 1850 he turned to etching, his first plate being a simple composition *The Willow*. Afterwards he completed thirteen plates. Four more were completed posthumously by his surviving son, Alfred Herbert. In some of these he recaptures much of his early intensity; such are *The Sleeping Shepherd* (1857), *The Bellman*, and *The Lonely Tower* (both 1879), and *Opening the Fold* (1880). The closely worked texture of Palmer's etchings, painstakingly achieved, explains why he made so few; the time he expended in realizing and ripening them was prodigious.

In 1865 he began work on a commission from John Ruskin's solicitor, Leonard Row Valpy, to paint eight large watercolours: illustrating passages from Milton's "L'Allegro" and "Il Penseroso," including *A Towered City* (1868?, Amsterdam) and *Morning, or The Dripping Eaves* (1869?, Chatsworth). They are conceived in textures as deep and closely worked as oil painting; every resource of watercolour and body colour is fully exploited. Moreover, they are deeply poetic, and, with Palmer's etchings, represent the sum of a lifetime of experience, not only in the handling of technique, but in visual and visionary perception; they vindicate the years of more conventional painting which underpin them.

Simultaneously with the Milton watercolours, Palmer worked on a series of illustrations for his own translation of Virgil's *Eclogues*. They are nearly all in monochrome wash over pencil or pen and ink, and were intended to be worked into etchings; in the event only one, *Early Morning*, reached the etched stage; four others were completed by his son. Designs, etchings, and translation were published posthumously in 1883. Examples of the designs are in the British Museum, the Victoria and Albert Museum, the National Gallery of Scotland, Edinburgh, Carlisle Museum and Art Gallery, the Art Museum, Princeton University, New Jersey; and there are several in private collections.

—Raymond Lister

PANNINI, Gian Paolo [Giovanni Paolo Panini].

Born in Piacenza, c. 1692. Died in Rome, 21 October 1765. Married. Studied architecture in Lucca; recorded in Rome c. 1717: earliest dated picture, 1727; made decorations for the Fete given by the Cardinal de Polignac for the Dauphin, 1729: began long connection with the French and the French Academy in Rome; specialized in Roman ruins, as well as modern city views; influenced Piranesi and Canaletto.

Collections: Berlin; Boston; Budapest; Dublin; Hanover; Hartford, Connecticut; London: Victoria and Albert, Wellington; Madrid; Naples; New York; Paris; Potsdam: San Souci; Rome: Quirinale.

Publications

On PANINI: books—

Ozzola, Leandro, *Panini*, Turin, 1921.
Arisi, Ferdinando, *Panini*, Piacenza, 1961.

*

Gian Paolo Pannini (or Giovanni Paolo Panini) occupies a niche in the history of Roman 18th-century art as a *veduta* (or view) painter analagous to that of Batoni as a portraitist. Both fall within the category of "Grand Tour painters" in that their production catered primarily to the taste of foreign visitors eager to purchase works of art as mementos of their Roman sojourn.

Flaying of Marsyas; drawing

As a young man Pannini studied architecture in his native Lucca, where he absorbed the influence of the Bibiena, a dynasty of *quadratura* painters specializing in illusionistic sets for the stage or for the elaborate public festivals so popular in 18th-century Italy. Upon settling in Rome c. 1717, he soon established close connections with the local French colony (his wife was French) which led to important commissions in which he was able to combine his talents as both theater designer and view painter. In 1729 he designed the sets for the various stages of the celebration honouring the birth of the French Dauphin and again in 1745 commemorating the Dauphin's marriage; he also painted the *vedute* recording these events. Other examples of Pannini's status as the foremost Roman painter of official pomp and ceremony are the canvases commissioned by the Bourbon King of Naples, Carlos III, to document his state visit to Rome in 1745.

The eye of the trained architect is evident in Pannini's splendid "portraits" of important monuments of ancient and contemporary Rome, such as the interiors of the Pantheon and the Basilica of St. Peter. While conceived essentially for the taste of the Grand Tour visitor to Rome, their appeal is by no means dated. No other painter has surpassed Pannini in his ability to manipulate scale and perspective so as to achieve in a two-dimensional medium a sense of the actual experience of the spatial grandeur of these interiors. By animating his settings with throngs of human figures, Pannini not only articulates the sense of scale, but by investing these figures with a variety of groupings, attitudes and costumes reflecting all ranks and stations, he has recorded lively portraits of the daily social intercourse of 18th-century Rome.

In his landscapes, Pannini was influenced by Benedetto Luti (with whom he briefly worked), Andrea Locatelli, and especially Salvator Rosa. He ultimately developed his own distinctive style, featuring imaginary groupings of ancient ruins evocative of Rome's ancient grandeur. In these ruin-landscapes, the most familiar and numerous of his various types of *vedute,* he typically juxtaposes within a single vista several familiar monuments, such as the Colosseum, the Column of Trajan, the Basilica of Constantine, and the Pyramid of Cestius, which are in topographical fact scattered all over Rome and could not possibly be viewed from a single vantage point. At times, he even "imports" Roman monuments from abroad, such as the Maison Carrée at Nimes. The foreground is usually enlivened by antique statues, such as the Hercules Farnese or the Dying Gaul, "borrowed" from Roman museums. Possibly in deference to the hierarchical dignity of subject matter in painting as established in French academic theory (Pannini himself held a teaching post with the French Academy at Rome), he frequently included in the foreground some sort of narratival action, such as Alexander visit-

ing the Tomb of Achilles or a Christian apostle preaching amidst the ruins, in order to elevate his *vedute* from simple landscape to the more dignified level of "history painting."

While he did not invent the ruin-landscape, Pannini occupies a central position in a tradition stretching back to Claude Lorraine and anticipating, through his student and collaborator Hubert Robert, an important school of French ruin-painters of the late 18th century.

—Thomas Pelzel

PARMIGIANINO.

Born Girolamo Francesco Maria Mazzola in Parma, 11 January 1503; son of the painter Filippo Mazzola, and nephew of the painters Pier Ilario and Michele Mazzola. Died in Casalmaggiore, 28 August 1540. Brought up by his uncles Michele and Pier-Ilario, and influenced by Correggio; prodigy: did frescoes in Parma Cathedral, 1522, and S. Giovanni Evangelista, 1522–23; then worked in Rome on the Sala de-'Pontifici, Vatican, 1523–27; captured in the sack of Rome by Charles V, 1527, but escaped, and was in Bologna, 1527–31, Verona, and Venice for three years; in Parma again, 1530–40: frescoes for S. Maria della Steccata; imprisoned for defaulting on a contract, but escaped to Casalmaggiore; also etchings, one of the first Italians to practice the art.

Collections: Bardi: S. Maria; Bologna: S. Petronio, Museum; Copenhagen; Detroit; Dresden; Florence: Uffizi, Pitti; Frankfurt; Glasgow; London: National Gallery, Courtauld; Madrid; Milan: Ambrosiana; Naples; Parma: S. Giovanni Evangelista, S. Maria della Steccata, Canonica di Bardi, Museum; Rome: Doria Pamphili, Borghese; Vienna; York.

Publications

On PARMIGIANINO: books—

Fröhlich-Bum, Lili, *Parmigianino und der Manierismus*, Vienna, 1921.

Copertini, Giovanni, *Il Parmigianino*, Parma, 2 vols., 1932.

Quintavalle, Armando O., *Il Parmigianino*, Milan, 1948.

Copertini, Giovanni, *Nuovo contributo di studi e ricerchi Sul Parmigianino*, Parma, 1949.

Freedberg, Sydney J., *Parmigianino: His Works in Painting*, Cambridge, Massachusetts, 1950.

Popham, A. E., *The Drawings of Parmigianino*, London and New York, 1953.

Oberhuber, Konrad, *Parmigianino und sein Kreis* (cat), Vienna, 1963.

Quintavalle, Augusta Ghidiglia, *Gli affreschi giovanili del Parmigianino*, Milan 1968.

Fagiolo dell'Arco, Maurizio, *Il Parmigianino*, Rome, 1970.

Quintavalle, Augusta Ghidiglia, *Gli ultimi affreschi del Parmigianino*, Milan, 1971.

Quintavalle, Augusta Ghidiglia, *Parmigianino: Disegni*, Florence, 1971.

Popham, A. E., *Catalogue of the Drawings of Parmigianino*, New Haven, 3 vols., 1971.

Godi, Giovanni, *Nicolò dell'Abate e la presunta attività del Parmigianino a Soragna*, Parma, 1976.

Rossi, Paola, *L'opera completa del Parmigianino*, Milan, 1980.

articles—

Davitt-Asmus, U., "Zur Deutung von Parmigianinos *Madonna dal collo lungo*," in *Zeitschrift für Kunstgeschichte* (Munich), 4, 1968.

Cropper, Elizabeth, "On Beautiful Women, Parmigianino, Petrarchismo, and the Vernacular Style," in *Art Bulletin* (New York), September 1976.

Asmus, Ute Davitt, "Fontanellato II: La trasformazione dell'amante nell'amato, Parmigianinos Fresken in der Rocca Sanvitale," in *Mitteilungen des Kunsthistorische Institutes in Florenz*, 31, 1987.

*

Parmigianino is the most obviously "mannerist," the most influential, and the most famous of the painters of his generation. Though the works of his early years are complex and show multiple influences (Correggio, Michelangelo, Raphael, Pordenone), they also reveal those characteristics that have come to be called mannerist, and look forward to the works of his impressive maturity, including his most famous work, the *Madonna of the Long Neck* (Uffizi).

Parmigianino was brought up in Parma. Correggio was working in Parma during Parmigianino's early life, and by the time the young painter was commissioned to work on frescoes for the south transept of the cathedral, which contained frescoes by Correggio, he had absorbed Correggio's influence to a strong degree. Correggio's soft, painterly style, combined with Raphael's idealized and assured work and Michelangelo's large scale, was soon modified into something distinctive. Vasari's use of the word "maniera" to define a work based on intellectual rather than on visual conceptions can perhaps be regarded as helpful in considering Parmigianino's work. When we consider that the word "imparmiginare" has come to mean to submerge the subject in elegance and delicacy, we can perhaps see how his contemporaries saw his work.

An early *Self-Portrait in a Convex Mirror* (1524; Vienna) is suggestive of Parmigianino's cast of mind. The mirror had been discussed by Leonardo as an illustration of the "perfect painter," but Leonardo was also aware that a curved mirror would not reflect truthfully but distort. Parmigianino's self-portrait thus combines the true likeness of his face in the convex center of the painting, as well as the distortions of his hand and arm at the bottom and the window at the top. Though earlier painters had used curved mirrors as details in larger works (e.g., Van Eyck's *Arnolfini Wedding Group*), in Parmigianino's work the distortion is the basis for the entire picture.

The 1527 *Vision of St. Jerome* (London) was painted for the Bufalini Chapel in the church of S. Salvatore in Lauro in Rome. Here especially is seen the influence of both Michelangelo in the scale of the work and Raphael in the elegant content and form. The figures in the painting are exquisitely distorted, with St. John the Baptist in an almost impossible

Four Female Profiles; drawing

the work is a very personal expression of Parmigianino's sensibility.

A painting roughly contemporary with the *Madonna of the Long Neck* is *Cupid Carving His Bow* (1535; Vienna). The epicene youth, pushed forward to the front of the picture area, is naked and with his back to us: as he carves his bow, he looks back over his shoulder at the viewer, in a slightly tantalizing way. Between his legs are two small putti, one evidently trying to force the other to touch cupid's leg. Rubens made a copy of this work.

In his later life, Parmigianino became austerely religious (and also interested in alchemy, according to Vasari). But his inventive facility continued unabated, and his vault decorations for S. Maria della Steccata are typical of his late work as well as such works as *Madonna and Child with St. Stephen, John the Baptist, and a Donor* (1538–40; Dresden). Parmigianino was also an etcher, and the reproduction of his compositions in engraved form helps to account for his influence.

—George Walsh

pose, kneeling on his right knee, but with his right arm pointing over his left shoulder to the Virgin and the young Christ directly over him. Behind and to one side of this vivid image is a smaller representation of the sleeping St. Jerome (who is dreaming the scene). There is a strong vertical axis, with glassy surfaces and extreme clarity (as in a dream?). The Virgin and Child seem related to the Bruges Madonna (1503–04) of Michelangelo, both works focusing on a modest (though highly charged) Madonna and a forward-stepping Jesus. The distortion of the figures and the fact that no one is looking at each other or at the viewer give a slightly uneasy feel to the work.

Other early works establish his interest in the unstable, the perilous, even the lack of equilibrium in his compositions. *St. Roch and a Donor* (1527; Bologna, St. Petronio) exaggerates the dangerous balance and asymmetry of the *Vision of St. Jerome*. A slightly later *Madonna of the Rose* (1528–30; Dresden) is more painterly but equally astonishing in its underlying assumptions about both subject matter and composition: the Christ Child holds a rose toward his extremely long-fingered mother, but the draperies and textures seem self-contained, as if they themselves were the subject of the painting.

His most famous work, the *Madonna of the Long Neck* (1534–40), was originally commissioned for the Church of the Servi in Bologna in 1534, but never completed. The Virgin shares characteristics with the Virgin in the *Vision of St. Jerome*—elongated figure, sloping shoulders, refined facial expression, even a chill eroticism—but all these features are exaggerated to a startling extent, making it an unforgettable work. The child (very large) lies back on his mother's lap almost as if he were dead, and there is a reflection of Michelangelo's St. Peter's *Pietà*, especially in the way the left arm hangs limply. To the left is a crowded group of five sexually ambiguous figures, while behind is one highly finished column (without a capital), meant to be part of a portico. At the base of the column is a figure unrolling or reading from an enormous scroll. (Preparatory drawings reveal that this is St. Jerome.) The somewhat mystifying nature of the painting, as well as the unexpected elegance of the Virgin, makes one feel

PASMORE, Victor.
Born in Chelsham, Surrey, 3 December 1908. Married the painter Wendy Lloyd Blood, 1940; one son and one daughter. Attended London schools; evening classes at the Central School of Arts and Crafts, London, 1927–30; worked in local government service, 1927–37; co-founder, with Claude Rogers and William Coldstream, Euston Road School, London, 1937–40; taught at Camberwell School of Art, London, 1945–49, and Central School of Arts and Crafts, 1949–54; director of painting, University of Durham at Newcastle upon Tyne, 1954–61; consultant for urban design, Peterlee New Town, County Durham, 1954–77; now lives in Malta. Address: c/o Marlborough Fine Art, 6 Albemarle Street, London W1X 3HF, England.

Collections: Buffalo; Edinburgh; London: Tate; Melbourne; New York: Moma; Ottawa; Rome: Arte Moderna; Rotterdam; Sydney.

Publications

By PASMORE: books—

A Developing Process in Art Teaching, Newcastle upon Tyne, 1959.
Colour as a Function of Multi-Dimensional Space, London, 1976.

On PASMORE: books—

Bell, Clive, *Pasmore,* London, 1945.
Schmalenbach, Werner, *Pasmore* (cat), Hanover, 1962.
Reichardt, Jasia, *Pasmore,* London, 1963.
Read, Herbert, *Pasmore,* Paris, 1964.
Alley, Ronald, *Pasmore* (cat), London, 1965.

Black Symphony—The Pistol Shot, 1977; 3 ft × 6 ft (91 × 183 cm); private collection

Bowness, Alan, and Luigi Lamert Lambertini, *Pasmore, with a Catalogue Raisonné of the Paintings, Constructions, and Graphics 1926–1979,* London and New York, 1980.
Pasmore (cat), London, 1980.
Laughton, Bruce, *The Euston Road School,* London, 1986.
Pasmore (cat), New Haven, 1988.

*

The art of Victor Pasmore can be seen as a continual state of progression. Certain characteristics underlie it, primarily a commitment to nature and an exploration of the definition of the "modern" painting. Although his earliest works were in the Impressionist manner, he was soon to become interested in abstract art, stemming from contact with French painting, including the work of Gauguin, Van Gogh, Rousseau, and Picasso. In response he produced five wholly abstract pictures (now destroyed) in the years 1932 and 1933, yet his inability to part from the visual model led him to return to representational painting. His work remained representational until around 1948, although during this period he mingles his approach with various abstract concepts. For example, the beach scene *The Evening Star* (1945–47), with its uneasy mix of abstract and natural elements, illustrates this: the signs along the pier, as well as the pier itself are flat, geometric, and monochrome, contradicting the naturalistic figures, the depth implied by the horizon line and the aerial perspective. In 1948 Pasmore begins to resolve this tension between abstraction and naturalistic representation by developing a loose system of symbols into which natual elements are translated. The spiral motifs characteristic of several of his 1949–50 works functions as a metaphor for many elements in nature, such as wind, water and swirling snow. Accompanying this break with representation came an intensification of color: *Spiral Development in Green, Violet, Blue, and Gold: The Coast of the Inland Sea*

(1950) is composed of brilliantly colored spirals, blue and white clouds, and deep green and red spirals of earth. This work is also something of a watershed since, although still readable as a landscape, Pasmore himself noted that it was not from nature, but from within himself. Art, in Pasmore's mind, was beginning to separate itself from visual reality.

Pasmore is best known for his "relief paintings," which he developed throughout the 1950's and into the early 1960's, and which are a theoretical development of particular ideas about abstract art, primarily that an art object should be seen as a thing in its own right. This objectification of the art work encouraged him to part from the flat surface of the picture plane. The work of Charles Biederman, an American artist of Pasmore's generation, was influential in that it pointed the way to the three-dimensional surface in painting, and reinforced the primary importance of structure in art. This concept is based on the premise that structure is the parallel element between man and nature. Painting should be an independent manifestation of this relationship, the product of a subjective creative process. Creative activity characterizes both nature and the artistic ouput of man. A change, therefore, from visual abstraction to organic construction, to use Pasmore's words, is necessary. The planes projecting from the picture surface complete the piece's identity as an independent object through its three-dimensional occupation of space, like any other non-art object.

In the 1960's Pasmore began to feel that he had exhausted the possibilities of relief constructions. He was already gradually returning to the two-dimensional painted surface since 1960, executing both reliefs and paintings in tandem. Feeling that all art forms are ultimately constricting, painting and relief by their surfaces, and sculpture and architecture by their volume, he decided to look for a way to expand their subjective identities. His subsequent work is characterized by the use of different tools to apply paint to the picture surface, thereby

capturing the essence of both the medium and its method of application. This, in theory, allows the surface to attain an identity of its own, freed from the constriction of volume. *Green and Indigo* (1965), a relief painting, shows how Pasmore has synthesized what he learned from the relief constructions with his new ideas about the identity of the painting. The indigo, being a wash, shows the painted surface for what it is, the wood grain emphasized by the color. Yet the green, by nature a thicker pigment, successfully masks the texture of the wood, asserting its own identity as pure color. Paintings like this still have an identity as an independent object, but whereas with the constructions this was defined by the object's existence in space, the paintings are identified sheerly through their medium. Since the paint only represents itself, it can have no other identity. In this respect they are perhaps too reticent, having no explicit or implied meanings or associations beyond their own surfaces.

—Nancy C. Jachec

PATINIR, Joachim.

Born in Dinant or Bouvignes, c. 1475–85; name also spelled Patinier and Patenier. Died in Antwerp before 5 October 1524. Married twice (Dürer attended his 2nd wedding, 1521); had children (Massys was their guardian). Member of the Antwerp guild, 1515; among the first Netherlands landscape painters: painted landscapes for paintings by Massys; few documented works.

Major Collections: Antwerp; Karlsruhe; Vienna.
Other Collections: Basel; Berlin; Birmingham; Brussels; Cambridge; London; Madrid; Minneapolis; New York; Oxford; Paris; Philadelphia; Rome: Borghese; Rotterdam; York; Zurich.

Publications

On PATINIR: books—

Friedländer, Max J., *Die altniederländische Malerei, vol. 9: Joos van Cleve, Jan Prevost, Patinir*, Berlin, 1931; as *Joos van Cleve, Jan Prevost, Patinir* (notes by Henri Pauwels), Leiden, 2 vols., 1972.
Gerard, E., *Dinant et la Meuse dans l'histore du paysage*, Lammersdorf, 1960.
Koch, R. A., *Patinir*, Princeton, 1968.
Piron, André, *Patinir, Henri Blès: Leurs vrais visages* Gembloux, 1971.
Zinke, Detlef, *Patinirs "Weltlandschaft,"* Frankfurt, 1977.
Barret, André, *Patinir; ou, L'Harmonie du monde*, Paris, 1980.
Falkenburg, Reindert L., *Patinir: Landscape as an Image of the Pilgrimage of Life*, Amsterdam and Philadelphia, 1988.

articles—

Gerard, Ed., "Les Paysagists Patenier et Henri de Bouvigne," in *Communications du XXXVIIe Congrès de la Fédération Archéologique et Historique de Belgique*, Brussels, 1958.
Bengtsson, A., "A Painting by Patinir," in *Idea and Form*, 1, 1959.
Kunel, M., "Patenier au Musée du Prado," in *Cahiers des Arts* (Paris), 7, 1964.
Dupont, A., "Une Vue de Namur dans un paysage de Patenier au Musée du Prado," in *Namurcum* (Namur), 37, 1965.
Barret, A., "Patinir: Au crepuscule du moyen age un élève de Jérôme Bosch invente fantastiques panoramas," in *Connaissance des Arts* (Paris), December 1967.

*

On his travels in the Netherlands in 1550–21, Dürer met with Patinir in Antwerp and called him "the good landscape painter," possibly coining a new designation for an artist. Others, both in Italy and the North, had preceded Patinir in depicting the landscape—from Masaccio to Bosch—but in Patinir's works the landscape advanced from its customary backdrop position to a dramatic dominance of the entire stage.

While the countryside around Dinant, Patinir's homeland, is characterised by jagged cliffs and deep valleys whose broken contours must have lingered in the artist's memory, it is neither as ruggedly awesome, nor spatially deep, nor structurally organised as in the artist's vast yet meticulously detailed views.

His registry as a master in the Antwerp guild in 1515 suggests that his age at that time must have been somewhere in the mid-twenties to early thirties—Friedlander claims thirty-five—hence placing him in mid-career. Even so none of his extant works can be dated prior to his nine-year stay in Antwerp, ending with his death in 1524, and whatever his activities before that time they cannot compare with those carried out in the creatively and commercially thriving atmosphere of the grand Flemish seaport where Joos van Cleve, Quentin Metsys, and no doubt many other artists maintained flourishing workshops.

A tiny *Flight into Egypt*, still in Antwerp, is considered one of his earlier works and contains in miniature many of the elements characteristic of his major panels: the floating depth of the landscape with its high horizon line, a distant, winding body of water, foreground rocks, like colossal tilting towers, and within this cosmic expanse small, crisply painted farms worked by miniscule people. In a large Prado panel, *Rest on the Flight to Egypt*, the same landscape elements are featured, except that the jagged frontal rocks have been replaced by tall trees. Farm workers are still tiny commentaries on the everyday, while the Holy Virgin is prominently placed in the foreground, possibly painted into Patinir's landscape by Joos van Cleve.

The Vienna *Baptism of Christ*, signed by the artist, shows great balance between figures and landscape: in the center in a shaft of light Christ as the incarnation of the Holy Trinity—as in Gerard David's triptych on the same subject in Bruges—to his right John, fresh from his wilderness preaching masses as shown in the left middle ground, performing his prophetic rite, and at the foot of a massive rock the open tomb.

While Vienna possesses the greatest number of Patinir's works, he is nowhere more impressively present than in the Prado where five of his masterpieces are displayed; in addition to *Rest on the Flight to Egypt*, the Madrid museum has a *St. Jerome*, a *St. Christopher*, and *Charon Crossing the Styx*, all with the title figures superimposed on vast landscape expansions, as well as the *Temptation of St. Anthony* referred to in the Spanish inventory of 1574 as a joint effort with Quentin Metsys.

—Reidar Dittmann

PEALE, Charles Willson.

Born in Queen Anne's County, Maryland, 15 April 1741; brother of the painter James Peale. Died in Philadelphia, 22 February 1827. Married three times; 17 children, including the painters Raphaelle, Rembrandt, Rubens, and Titian Peale. Self-taught in painting, 1761–66, with single lessons from John Hesselius and Copley; then studied in London under Benjamin West, 1767–69; painted George Washington, 1772 (and later), and other famous men; served as militia captain in War of Independence, and member of Pennsylvania Assembly, 1779–80; established Peale's Museum in Philadelphia, 1791; led expedition to excavate mastodon, New York, 1801; co-founder, Pennsylvania Academy of Fine Arts, Philadelphia, 1805.

Major Collection: Philadelphia: Independence National Historical Park Collection.
Other Collections: Annapolis: Maryland State House, Hammond-Harwood House; Baltimore: Peale Museum, Museum, Maryland Historical Society, Mount Clare Museum; New York: Historical Society, Metropolitan; Philadelphia: Museum, Historical Society, American Philosophical Society, Pennsylvania Academy of the Fine Arts; Washington: National Gallery, Portrait Gallery, American Art; Williamsburg, Virginia: Colonial Williamsburg Foundation; Winterthur, Delaware.

Publications

By PEALE: books—

An Epistle to a Friend, on the Means of Preserving Health . . . , Philadelphia, 1803.
Guide to the Philadelphia Museum, Philadelphia, 1805.
An Essay to Promote Domestic Happiness, Philadelphia, 1812.
Historical Catalogue of the Paintings in the Philadelphia Museum . . . , Philadelphia, 1813.
The Collected Papers of Peale and His Family: A Guide and Index to the Microfiche Edition, edited by Lillian M. Miller, Millwood, New York, 1980.
The Selected Papers of Peale and His Family, edited by Lillian B. Miller, New Haven, 7 vols., 1983–

On PEALE: books—

Sellers, Charles C., *Peale*, Philadelphia, 2 vols., 1947, New York, 1969.
Briggs, Berta N., *Peale, Artist and Patriot*, New York, 1952.
Sellers, Charles C., *Portraits and Miniatures by Peale*, Philadelphia, 1952; supplement, 1969.
Dwight, E. H., *Paintings by the Peale Family* (cat), Cincinnati, 1954.
The Fabulous Peale Family (cat), New York, 1960.
Hunter, Wilbur Harvey, *The Peale Family and Peale's Baltimore Museum*, Baltimore, 1965.
Elam, Charles H., editor, *The Peale Family* (cat), Detroit, 1967.
Four Generations of Commissions: The Peale Collection of the Maryland Historical Society (cat), Baltimore, 1975.
Sellers, Charles C., *Mr. Peale's Museum*, New York, 1980.
Richardson, Edgar P., Brooke Hindle, and Lillian B. Miller, *Peale and His World* (cat), New York, 1983.

articles—

Miller, Lillian B., "Peale as History Painter: *The Exhumation of the Mastodon*," in *American Art Journal* (New York), 3, 1981.
Stein, Roger, "Peale's Expressive Design: *The Artist in His Museum*," in *Prospects*, 6, 1981.
Hart, Sidney, " 'To Increase the Comforts of Life': Peale and the Mechanical Arts," in *Pennsylvania Magazine of History and Biography*, 110, 1986.

*

Three important factors in the life of Charles Willson Peale, one of America's most important colonial painters, explain the emphases in his art: his artisan training, which stressed empiricism and observation; his studies in 18th-century London at the height of the development of the British portrait tradition by such eminent British artists as Benjamin West, Joshua Reynolds, Francis Cotes, and Allen Ramsay; and his later commitment to a museum of natural history, work for which provided him with a philosophy of art and nature that influenced the course of his later artistic development.

Such a portrait as *Mrs. Thomas Harwood* (c. 1771; New York) in composition, treatment of materials, and delicate coloring reveal Peale's mastery of the subtleties of the British portrait tradition. Mrs. Harwood is placed close to the picture plane, her arm resting easily on a table parallel to the frame. In her precisely drawn yellow gown she appears as a woman of means and dignity and also of feminine grace. Similarly, the careful rendering of materials, furniture, and other details in *The Edward Lloyd Family* (1771; Winterthur, Delaware) reveals Peale's keen observation of detail; and in his solution to the compositional problem of placing a tall husband in loving relation to a small wife and even smaller child, the artist demonstrates his capacity to master the complexities of the British conversation piece. Such a concern with fact marks Peale's mourning picture *Rachel Weeping* (1772, 1776; Philadelphia Museum of Art) in which Peale paints with the clarity of still-life Rachel's tears and translucent medicine bottles, along with pillow creases, pleated gown, and binding ribbon. Illusionistic detail characterizes Peale's most successful early works—*The*

George Washington, 1780; mezzotint

Peale Family (c. 1770–73 and 1808; New York Historical Society), with its still-life of fruit, knife, and orange peel signature; *The Stewart Children* (1770–75; Lugano), an outdoor conversation piece marked by a rich rendering of fruit; *Mary Sterett Gittings* (1788; Baltimore), in which one of Peale's stuffed birds from his museum plays a thematic part; and *The Staircase Group* (1795; Philadelphia Museum of Art), with its life-sized figures, illusionistic steps, and interesting perspective.

In his gallery portraits, Peale's art assumes an almost photographic quality—a crisp, austere image that renders them more representative of general qualities that Peale believed were fundamental to republican government. The vigorously painted *Thomas Jefferson* (1791; Philadelphia, Independence National Historical Park Collection) is particularly noteworthy in this respect.

Peale's later portraits reflect a maturing of the artist's painterly talents as well as insight into character. The portrait of his third wife, *Hannah Moore Peale* (1816; Boston), for example, is most Rembrandtesque in its effective lighting, deep shadows, and beautiful expression; and his monumental self-portrait, *The Artist in His Museum* (1822; Philadelphia, Pennsylvania Academy of the Fine Arts), is not only replete with symbols of his life and dual interests of art and natural history but also reflects his continuing interest in effective lighting and perspective.

Along with their emphasis on fact, Peale's portraits tend to idealize their subjects in accordance with the artist's belief that it was his obligation to present sitters in their most attractive aspects. His 1795 portrait of *George Washington* (New York Historical Society), painted in severe black and white, portrays the first president as the ideal civic leader, the embodiment of republicanism. Earlier in his career, during the political turbulence preceding the War for American Independence, Peale tended to use the portrait as a vehicle for political allegory, as in *John Beale Bordley* (1770; The Barra Foundation, Inc.), *Washington at the Battle of Princeton* (1779; Pennsylvania Academy of the Fine Arts), and *Conrad-Alexandre Gerard* (1779; Philadelphia, Independence National Historical Park Collection). Later, in *The Exhumation of the Mastodon* (1806–08: Baltimore, Peale Museum), he tried his hand at history painting, dramatizing through narrative the significance of his archaeological discovery for understanding the world's origins and development.

Peale regarded art as a didactic force. The message he hoped to convey through his art included the themes of domestic harmony, as in *Mr. and Mrs. James Gittings and Granddaughter* (1791; Baltimore, Peale Museum), responsibility of parents for posterity, as in *Thomas McKean and His Son, Thomas Jr.* (1787; Philadelphia Museum of Art); and the necessity for mankind to live peacefully in accordance with nature, as in his various landscapes of his farm at Belfield (private collection), his copy of Catton's *Noah's Ark* (1819; Pennsylvania Academy of the Fine Arts), and the numerous symbols of nature included in his portraits. These themes reflected Peale's education in enlightenment philosophy—in the 18th-century belief that the processes of nature constituted moral principles which provided a standard of personal behavior necessary for a moral society, and that man learned from nature how to live in harmony with his fellow man.

—Lillian B. Miller

PERINO DEL VAGA

Born Pietro Buonaccorsi, 1501. Died in Rome, 19 October 1547. Married Caterina Penni, c. 1524; one daughter. Member of Raphael's workshop (with Giulio Romano, Giovanni da Udine, and Polidoro), in Rome, 1516–20: decorated the Sala dei Pontefici in the Vatican, and many chapels in Rome; worked in Rome, 1520–27: designed series of *Loves of the Gods;* worked in Genoa and Pisa, c. 1527 or 1528 to c. 1537 or 1538; back in Rome in the late 1530's: worked for Angelo Massimi (Massimi Chapel in S. Trinità dei Monte— destroyed—and Palazzo Massimo); completed work in S. Marcello al Corso; also decorated the Sala Regia in the Vatican and the Sala Paolina in Castle Sant'Angelo, Rome.

Collections/Locations: Genoa: Palazzo Doria, Accademia Ligustica; Hampton Court; Rome: S. Marcello al Corso, SS. Trinità dei Monti, St. Stefano del Cacco, Palazzo Baldassini; Vaduz; Vatican; Vienna: Albertina; Washington.

Publications

On PERINO DEL VAGA: books—

Vasari, Giorgia, *Vita di Perino del Vaga,* edited by Mario Labò, Rome, 1912.
Davidson, Bernice, *Perino del Vaga e la sua cerchia* (cat), Florence, 1966.
Bruno, Raffaele, *Perin del Vaga e la sua cerchia a Castel Sant'Angelo,* Rome, 1970.
Harprath, Richard, *Papst Paul III als Alexander der Grosse: Das Freskenprogramm der Sala Paolina in der Engelsburg,* Berlin and New York, 1978.
Gli affreschi di Paolo III nel Castel Sant'Angelo, Rome, 2 vols., 1981.
Parma Armani, Elena, *Perin del Vaga: L'anello mancante: Studi sul manierismo,* Genoa, 1986.

articles—

Popham, A. E., "On Some Works by Perino del Vaga" and "Sogliani and Perino del Vaga at Pisa," both in *Burlington Magazine* (London), 86, 1945.
Askew, Pamela, "Perino del Vaga's Decorations for the Palazzo Doria, Genoa," in *Burlington Magazine* (London), 98, 1956.
Frabetti, G., "Sulle tracce di Perin del Vaga," in *Emporium* (Bergamo), 127, 1958.
Davidson, Bernice, "Drawings by Perino del Vaga for the Palazzo Doria, Genoa," in *Art Bulletin* (New York), 41, 1959.
Torriti, Pietro, "Dipinti inediti o poco conosciuti di Perino del Vaga a Genova," in *Studies . . . Dedicated to William E. Suida,* 1959.
Gere, J. A., "Two Late Fresco Cycles by Perino del Vaga: The Massimi Chapel and the Sala Paolina," in *Burlington Magazine* (London), January 1960.
Brugnoli, Maria Vittoria, "Gli affreschi di Perin del Vaga nella Cappella Pucci," in *Bollettino d'Arte* (Rome), 47, 1962.

Architectural Decoration; drawing

Davidson, Bernice, "Early Drawings by Perino" (two parts), in *Master Drawings* (New York), 1, 1963.

Hirst, Michael, "Perino and His Circle," in *Burlington Magazine* (London), August 1966.

Oberhuber, Konrad, "Observations on Perino del Vaga as a Draughtsman," in *Master Drawings* (New York), 4, 1966.

Davidson, Bernice, "Perino del Vaga e la sua cerchia: Addenda and Corrigenda," in *Master Drawings* (New York), 7, 1969.

Wolk, Linda, "The *Pala Baciadonne* by Perino del Vaga," in *Studies in the History of Art* (Hanover, New Hampshire), 18, 1985.

Davidson, Bernice, "The *Furti di Giove* Tapestries Designed by Perino del Vaga for Andrea Doria," in *Art Bulletin* (New York), September 1988.

Wolk-Simon, Linda, review of *Perin del Vaga* by Elena Parma Armani, in *Art Bulletin* (New York), September 1989.

*

Perino del Vaga was born in Florence but spent his artistic career in Rome and Genoa. Celebrated in his youth as a consummate draftsman, the artist first earned a reputation through his copies after Michelangelo's famous *Battle at Cascina* cartoon, "the school of the world," according to Vasari, which served as an example for an entire generation of Florentine painters. He is regarded as a key protagonist of the late Renaissance style known as Mannerism, of which the first fullblown statement was Perino's cartoon, executed for the church of S. Salvatore di Camaldoli in Florence, for an unrealized fresco representing the *Martyrdom of the Ten Thousand* (1522, lost; modello preserved in the Albertina, Vienna). Despite its overtly dramatic, even brutal subject matter, a compelling sense of drama is entirely absent, and the composition is fundamentally a stylized, graceful ballet, the figures posturing elegantly in rhythmic patterns across the surface. Artifice replaces the heroic drama of Raphael, and Perino in this work signaled the direction in which both Florentine and Roman art would evolve over the next half century.

Perino received his earliest training in fresco and panel painting in the workshop of Ridolfo Ghirlandaio, and then went on to join Raphael's atelier in Rome. According to Vasari, he travelled in the company of an enigmatic, journeyman-artist known as "il Vaga," from whom Perino took his name. In Raphael's workshop, where Perino was active from 1516 until the master's death in 1520, he was assigned to the tutelage of Giovanni da Udine, the greatest stuccoist of the Renaissance and the leading innovator of the Renaissance *all'antica* style. In this period, Perino collaborated with Giovanni and other members of Raphael's circle on the decorations of the Loggetta of Cardinal Bibbiena (Vatican, 1516) and the Vatican Logge (1517–19). The culminating effort of the partnership of Perino del Vaga and Giovanni da Udine is the astrological vault of the Sala dei Pontefici in the Vatican (c. 1520), which represents the horoscope of Pope Leo X. In this work, which is closely based on surviving examples of ancient Roman wall painting known in the 16th century, the archaeologizing and antiquarian artistic culture of Medicean Rome finds rich pictorial expression. The mixture of fresco decoration and stucco reliefs, and the sheer visual wealth and opulence of the decoration, anticipate such later works by Perino as the Loggia degli

Eroi of the Palazzo Doria in Genoa (c. 1530–31) and the Sala Paolina in Castel Sant' Angelo in Rome (1545–47). The artist's four diaphanous, winged victories in the central oculus of the vault, who appear to descend from the celestial Empyrean into the space of the room, are a brilliant illusionistic experiment, Perino in this work responding to Raphael's invention in the dome of the Chigi Chapel in S. Maria del Popolo.

In the years between Raphael's death and the sack of Rome in 1527, Perino del Vaga became the pre-eminent mural painter in the city, receiving almost every major fresco commission initiated in this period. The now ruined fresco cycle in the Palazzo Baldassini (1520–22), and the frescoed vaults of the Pucci Chapel in SS. Trinità dei Monti (1521–22) and the Cappella del Crocifisso in S. Marcello al Corso (1525–27), reveal the artist mediating between the examples of Raphael and Michelangelo: the Pucci Chapel *Visitation* descends from Raphael's frescoes in the Vatican Stanze, while the *Creation of Eve* in S. Marcello is the most Michelangelesque invention of Roman art of the 1520's. In the prophets in the entrance arch of the Pucci Chapel (c. 1525), Perino synthesizes references to Raphael's sibyls in the Chigi Chapel in S. Maria della Pace and Michelangelo's ancestors in the Sistine Chapel lunettes.

The sack of Rome by Imperial troops in 1527 brought artistic life to an abrupt demise. Most artists left the city and sought employment in other centers. Through this exodus and relocation, the Mannerist style that had developed in Rome in the 1520's at the hands of Perino, Parmigianino, Polidoro da Caravaggio, and Rosso Fiorentino—a style characterized by extreme artifice, grace, and precious refinement, and exquisite emotional intensity—was disseminated throughout Italy. Perino del Vaga transmitted this style to Genoa, where he entered the service of the newly proclaimed prince and celebrated admiral Andrea Doria. The major effort of his Genoese period was the interior embellishment of the Palazzo Doria (1529–34), with its large suite of public rooms and private apartments. The *Fall of the Giants* in the west salone is one of the artist's masterpieces and a paradigmatic statement of the stylistic tenents of Mannerism in its artifice, stylized grace, and lack of dramatic energy. A rich compendium of fresco and stucco decoration, the Palazzo Doria, for which Perino also designed tapestries, historiated exterior facades (never executed), and entrance portals, comprises one of the greatest decorative ensembles of the Renaissance.

Perino returned to Rome in late 1537 or 1538 and soon entered the service of the Farnese Pope, Paul III, reprising the role of court artist he had assumed in Genoa. In addition to designs for costumes, table service, and theatrical sets, he was also entrusted with two major pictorial campaigns: the Sala Regia in the Vatican (1542–c.1545) and the papal apartments in Castel Sant'Angelo. The stucco vault and overdoor figures of the Sala Regia amply reveal Perino's prodigious skill in this medium, although his abilities as a history painter in this period remained untested, for he never executed the projected wall frescoes. Instead, his energies in the last two years of his life were devoted to the Castel Sant'Angelo campaign. Although they depict narrative subjects, the monumental, gold monochrome frescoes in the Sala Paolina representing scenes from the life of Alexander the Great (an allusion to the baptismal of the Pope) are utterly drained of all dramatic or emotional content: in this work, narrative has become pure formal decoration.

Perino's religious compositions, most of which were executed during his Genoese period, represent a strikingly different sensibility. His altarpieces such as the *Nativity with Saints* (the *Pala Baciadonne;* 1534; Washington), the *Madonna and Child Enthroned with St. Francis* (c.1535; Genoa, S. Giorgio), and the *St. Erasmus Polyptych* (c.1536; Genoa, Accademia Ligustica) are characterized by a pervasive conservatism, straightforward content, and retrospective aspect. The style of these altarpieces recalls Fra Bartolommeo and Perugino rather than Raphael or Michelangelo, the artist adjusting his formal vocabulary to accommodate the devotional function of these works and the provincial tastes of his private patrons in Genoa.

Perino del Vaga is perhaps most acclaimed as a draftsman, and it is in the artist's numerous pen and ink sketches—rapid but extraordinarily deft scribbles embellishing every inch of the surface—that his artistic genius and power of invention are most fully revealed. For Perino, it was the stage of invention rather than execution that captivated his imagination, and the artist's interest seems to have flagged when it came time to translate his ideas into paint. Thus Perino, like Raphael before him, although for rather different reasons, relied on a large corps of assistants to help him carry out his numerous commissions. By the time of such late works as the Sala Paolina, he did little of the execution himself.

A link between Raphael, Michelangelo, and the golden age of Renaissance Rome under Julius II and Leo X, and the renewed artistic culture of mid-century cultivated by his patron, Paul III, following the devastation of the sack and the Lutheran revolt, Perino del Vaga was a seminal figure in the development of Mannerism—an early innovator of the style and a fundamental source of inspiration for later generations of 16th-century painters, for whom his grace and precious refinement provided a point of departure for their own explorations of an ever-more mannered and artificial style.

—Linda Wolk-Simon

PERRÉAL, Jean [Jean de Paris].

Born c. 1455. Died in 1530. Married; two daughters and two sons. Member of the Lyons guild from its beginnings in 1484: head of a large workshop as painter, architecture, sculpture designs, and other crafts, including pageants for entry of royalty; court painter to Charles VIII of France, and his successors Louis XII and François I; in Italy, 1509 and 1515, and in London, 1514.

Collections: Autun; Boston; Brussels; Chantilly; Chicago; Glasgow; London: National Gallery, Portrait Gallery, Victoria and Albert, British Library; Lyons: Cathedral; Moulins: Cathedral, Museum; Munich; Nantes: Cathedral; New York; Paris: Louvre, Cluny, Bibliothèque Nationale, Marmottan; Washington: Corcoran; Royal Collection.

Publications

On PERRÉAL: books—

Penicaud, A., *Notice sur Perréal*, Lyons, 1858.

Renouvier, J., *Jehan de Paris*, Paris, 1861.

Bancel, E. M., *Jean Perréal, dit de Paris*, Paris, 1885.

Maulde la Claviere, R. de, *Jean Perréal, dit Jean de Paris*, Paris, 1896.

Dupieux, P., *Les Maîtres de Moulins*, Moulins, 1946.

Pradel, P., *Michel Colombe*, Paris, 1953.

Huillet d'Istria, Madeleine, *Maître de Moulins*, Paris, 1961.

articles—

Feydy, J., "Le Maître de Moulins et la Vierge de Bourbon," in *Amour de l'Art* (Paris), 1938.

Châtelet, Albert, "A Plea for the Master of Moulins," in *Burlington Magazine* (London), December 1962.

Hours, Madeleine, "Le Maître de Moulins: Etude radiographique," in *Art de France* (Paris) 3, 1963.

Dupont, Jean, "Jean Prévost, peintre de la cour de Moulins," in *Art de France* (Paris), 3, 1963.

Sterling, Charles, "Une Peinture certaine de Perréal enfin retrouvée," in *Oeil* (Paris), July-August 1963.

Sterling, Charles, "Du nouveau sur Maître de Moulins," in *Oeil* (Paris), November 1963.

Sterling, Charles, "Jean Hey, dit le Maître de Moulins," in *Revue de l' Art* (Paris), May 1968.

Reynaud, N., "Jean Hey, peintre de Moulins, et son client Jean Cueillette," in *Revue de l'Art* (Paris), May, 1968.

Souchal, Geneviève, "Un Grand Peintre français de la fin du XVe siècle: Le Maître de la Chasse à la Licorne," in *Revue de l'Art* (Paris), 22, 1973.

Wells, William, "Four Loire Valley Tapestries in the Clark Collection," in *Catalogue of . . . the Clark Collection at the Corcoran Gallery of Art*, Washington, 1978.

Wells, William, "Abbot Nicaise Delorme and Jean Perréal: Glasgow's Master of Moulins Reconsidered," in *Apollo* (London), September 1981.

Backhouse, Janet, "Pierre Sala, Emblesmes at devises d'amour," in *Renaissance Painting in Manuscripts from the British Library*, London, 1983.

Wells, William, "The Winged Stags Tapestry at Rouen," in *Apollo* (London), June 1984.

Wells, William, "French Fifteenth Century Miniature Painting: A New Hypothesis: Jean Perréal—from the René to the Bourbon Master," in *Apollo* (London), July 1986.

*

In spite of the large number of contemporary documents relating to this French court painter of the late 15th and early 16th centuries recorded by Audin and Vial in their dictionary (1919) of artists working in Lyons and its region (far exceeding in number those relating to any other French artist of the period), what he actually produced in the way of art to justify the very high esteem in which he was held remains a matter of controversy. The hypothesis first advanced in the 1890's that he was the painter known to art historians as the Moulins (or Bourbon) Master from the famous triptych in Moulins Cathedral in which Pierre II, duc de Bourbon, his wife Anne de France, and their daughter Suzanne appear as donors, is by no means unanimously accepted today, more especially not in France. In fact, the sumptuously illustrated *Larousse Dictio-*

Frontispiece to Complainte de Nature; 7⅛ × 5¼ in (18.1 × 13.4 cm); Paris, Musée Marmottan

nary of Painters favours Jean Hey, an artist of Netherlandish birth, also famous in his day but now known from only one oil painting, an *Ecce Homo* in the museum of ancient art in Brussels, which it is claimed shows similarities of modelling with that of the master.

Prior to the rediscovery in 1963 of the only work which was undoubtedly both conceived and executed by Perréal—the frontispiece miniature missing from his poem, *Nature's Complaint to the erring Alchemist*, itself only rediscovered about 20 years previously—the evidence in favour of Perréal being the Master of Moulins was deduced from a work of sculpture which is known from his own testimony to have been designed by him but not executed. This was the tomb of the Duke and Duchess of Brittany now in the cathedral at Nantes. It was sculpted by Michel Colombe, the foremost French sculptor of the time, from Perréal's designs and under his supervision, between 1502 and 1506, at a date therefore when almost all of the 15 or so works ascribed to the Moulins Master had been completed and the ageing Colombe was nearing the end of his career. The tomb is then the joint product of the two mature artists both pre-eminent in their own fields of painting and sculpture who had been working in mutual harmony for many years. A number of art historians at the beginning of this century became convinced that the artist who designed the tomb must also have been the master who painted the pictures, so close were the affinities between them.

A striking example, first observed by Paul Vitry in a review of an exhibition of French Primitives in 1904, is the resemblance between the sculpted figure of Temperance, one of the four Cardinal Virtues guarding the Nantes tomb, and the figure of St. Mary Magdalene in the panel painting in the Louvre attributed to the Moulins Master representing an elderly donor (identified as Madeleine de Bourgogne, Dame de Laage, a natural daughter of Charles the Bold of Burgunday) whose homely appearance enhances the youthful elegance of her patron saint, just as the solemn proximity of the tomb does that of Temperance whose posture as she holds her attribute of a clock in her left hand echoes that of the Magdalene holding her ointment jar in the painting.

Paul Vitry, the author of a book on Colombe, was inclined to minimise Perréal's role as a designer, presuming that he merely indicated the general shape and lay-out of the monument. The implication was that the very special appeal of the four Virtues, so much admired by Stendhal when he wrote of "the naive grace and touching simplicity of these charming statues," each one an individual rather than the copy of a cold ideal of beauty, derived solely from the sculptor, whereas this charm is already apparent in the oil painting ascribed to the Master painted probably at least ten years before Colombe sculpted the tomb. Moreover, Colombe's reported statement that Perréal was in all his best works and the warmth with which he spoke of him in his letter of 3 December 1511 when both were employed by Margaret of Austria on the tomb of her late husband at Brou, the model for which he writes he made "selon le pourtrait et tres belle ordonnance faite de la main de maitre Jehan Perreal de Paris" leaves no doubt of his indebtedness. Unfortunately, Colombe died the following year and the tombs of Brou were completed by a Flemish sculptor not of Perréal's choosing who failed to transmit the unique flavour of the Nantes sculptures.

This quintessentially French flavour combined with a ravishing sense of colour also seen in the paintings is nowhere more apparent than in some of the so-called Loire valley tapestries of the late 15th and early 16th centuries, and perhaps most of all in the set of *mille fleurs* tapestries in the Cluny Museum, Paris. In this last, the elegant lady representing Touch who stands holding a banner bearing the arms of the Le Viste family, with the hand of her left arm lightly touching the horn of the unicorn beside her, foreshadows the pose of the warrior saint in the panel painting, probably once part of a diptych, attributed to the Moulins Master in the Glasgow Art Gallery called *St. Victor and Donor* probably painted in 1505 when the donor, now identified as Nicaise Delorme, 33rd abbot of St. Victor in Paris, celebrated the jubilee of his religious life.

That Perréal produced designs for tapestry weavers may be deduced from the copious documents in the municipal archives in Lyons relating to the pageants which he devised for the receptions made to honour royal and other important visitors to the city between 1485 and 1518, for some of which Perréal's own detailed expense accounts have been preserved. In the account, for example, submitted for payment after the entry of king Charles VIII and Anne of Brittany on 15 March 1494, numerous items occur relating to molds for casting three naked ladies, a swan, and a dolphin which at once evokes a mental picture of the supremely beautiful tapestry bearing the Guillard arms with Perseus riding Pegasus and Cupid shooting arrows towards three naked nymphs, two of whom ride a swan and a dolphin.

Another hitherto neglected source which illumines Perréal's probable involvement in the designing of tapestries is a volume of pen and wash drawings in the Bibliothèque Nationale which almost certainly belonged to the Bourbon dukes at Moulins. Most of these drawings are not above average workshop quality, but some 30 at the end of the volume have been recognised as being by the hand of the master. They include a set of 12 representing the sibyls, and, as these are accompanied by the verses on the sibyls composed by the poet Jean Robertet, who from 1461 served successive dukes of Bourbon as councillor and secretary, it is reasonable to suppose them to be studies for the lost set of sibyl tapestries recorded in the inventory of the contents of the Robertet's residence at Bury. With their slender elegance and refinement these sibyls are the natural sisters of the Cluny Senses and the Nantes tomb Virtues, and indeed the Moulins Master's Saints. Moreover, some of these drawings are so close in pose and details of costume to the woodcuts of the sibyls in the *Encomium trium Mariarum* reproduced by Emile Mâle in the relevant volume of his famous book on Christian iconography as to render it certain that Perréal was also supplying the Parisian printing trade with designs.

The rediscovery in 1963 of Perréal's miniature from the manuscript of his poem on a discussion between Nature and an alchemist (written and illustrated in 1516 while convalescing in Lyons on his return from Italy after the battle of Marignan as a gift for king Francis I) should have been marked by a major advance in the reconstruction of his artistic output, but its immediate effect was the revival of an earlier belief that he was primarily a portraitist and that the old hypothesis identifying his as the Moulins Master was no longer tenable. It is, of course, difficult to establish links between a secular miniature and the central panel of a large altarpiece like the Moulins triptych, but it could be said that they are linked by an underlying similarity of theme, the immaculacy of the Madonna in

the triptych and the threatened immaculacy of the nature of the miniature. It also escaped notice that the newly discovered miniature offers a solution to another long-standing problem which has bedevilled the history of French art at least as long as the problem of the Moulins Master, namely the identity of the René Master, sometimes known as the Coeur Master from the sixteen miniatures in the manuscript called the *Livre du Cuer d'amour epris* (Book of the Heart Stricken by Love). According to this theory, Perréal was employed as writer and artist at the court of King René of Anjou until the king's death in 1481, and a comparison between the new miniature and the miniature which acts as a frontispiece in the manuscript of the *Livre du Cuer* in the National Library of Vienna reveals a stylistic kinship which cannot be disregarded lightly.

—William Wells

PERUGINO.

Born Pietro di Cristoforo di Vannucci in Citta della Pieve, c. 1450. Died in Fontignano, February or March 1524. Married Chiara Fancelli, 1493. Articled to a painter in Perugia at age 9; possibly a pupil of Piero della Francesco in late 1460's; then probably in Verrocchio's shop in Florence in early 1470's (co-pupil with Michelangelo); worked in Perugia, 1475, and in nearby Castel Cerqueto, 1478; in Rome c. 1480: worked on frescoes in Sistine Chapel, early 1480's; then worked on the Villa Albani in Florence, 1486–99; also worked on an altarpiece for S. Pietro in Perugia, 1496–98, and decorated the Bankers guildhall in Perugia, 1500; worked at the Certosa of Pavia, c. 1500; also did frescoes for S. Maggiore at Spello, S. Maria della Lagrime at Trevi, S. Agnese at Perugia, and the church at Castello di Fontignano, 1523; also painted portraits; many assistants; completed his ex-assistant Raphael's frescoes in S. Severo, Perugia. Other pupils: Giovanni lo Spagno, Mannia.

Collections: Altenburg; Baltimore; Brussels; Cambridge; Cerqueto; Chicago; Citta della Pieve: S. Maria dei Bianchi; Cremona: S. Agostino; Edinburgh; Fano: S. Maria Nùova; Florence: Uffizi, Accademia, Pitti, SS. Annunziata, S. Maria Maddalena de' Pazzi; Frankfurt; Liverpool; London; Lyons; Munich; Nancy; Nantes; New York; Paris: Louvre, Jacquemart-Andre; Perugia: Sala del Cambio, S. Severo, Museum; Philadelphia; Rouen; Vatican; Vienna.

Publications

Broussole, Abbe, *La Jeunesse de Pérugin et les origins d'école ombrienne,* Paris, 1901.

Williamson, George C., *Perugino,* London, 1903.

Knapp, Fritz, *Perugino,* Bielefeld, 1907, 1926.

Hutton, Edward, *Perugino,* London and New York, 1907.

Bombe, Walter, *Perugino: Des Meisters Gemälde,* Stuttgart, 1914.

Gnoli, Umberto, *Perugino,* Spoleto, 1923.

Alazard, Jean, *Pérugin,* Paris, 1927.

Canuti, Fiorenzo, *Il Perugino,* Siena, 2 vols., 1931.

Venturi, Lionello, and Giovanni, Carandente, *Il Perugino: Gli affreschi del Collegio del Cambio,* Turin, 1955.

Camesasca, Ettore, *Tutta la pitture del Perugino,* Milan, 1959; as *L'opera complete di Perugino,* 1969.

Negri Arnoldi, Francesco, *Perugino,* Milan, 1965.

Scarpellini, Pietro, *Perugino,* Milan, 1984.

Le Pérugin: Exercises sur l'espace (cat), Caen, 1984.

article—

Russell, Francis, "Perugino and the Early Experience of Raphael," in *Studies in the History of Art* (Hanover, New Hampshire), 17, 1985.

*

Perugino developed a style in the last quarter of the 15th century that anticipated the style of the High Renaissance during the first two decades of the 16th century. Although Perugino lived until 1523 and was active up until the end, his own work could never be described as High Renaissance. Perugino, in short, summed up and brought to a close the traditions of the early Renaissance, was influential in initiating the High Renaissance, but was unable to follow the lead of the three great new innovators at the turn of the century—Leonardo da Vinci, Michelangelo, and his own pupil, Raphael.

As his name implies, Perugino was born near Perugia in Umbria where he was heir to the tradition of Piero della Francesca. From Piero's work he seems to have learned how to create large pictorial spaces defined by vast architectural constructions rigorous in their application of a mathematically proportioned and geometrically precise one-point perspective. It was probably also in Umbria that he first developed his keen sensitivity to broad misty landscapes punctuated by feathery trees. According to Vasari, Perugino studied with Verrocchio in Florence, where in 1472 he was enrolled as a "master" in the Florentine painters' confraternity of St. Luke. The realistic and vital anatomies, and the dynamic and graceful contrappostos of his figures, as well as the highly detailed, almost jewel-like rendering of the flora and fauna of nature, in fact, do seem close to the work of Verrocchio, although the influence of Netherlandish art could have played a role. The subtle, portrait-like features that his figures sometimes exhibit may also have been learned from Verrocchio and northern art.

All these elements were brought together in his first great masterpiece, *Christ Consigning the Keys to St. Peter* (1481–82), which was part of a larger fresco cycle on the walls of the Sistine Chapel illustrating in sixteen scenes the typologically parallel lives of Moses and Christ. In this work there was an unprecedented breath of perspective space, depth of landscape, grandeur of architectural backdrop, gracefulness of figures, and harmony of color. But there was also a tendency, which would become more evident in his later work, to conceive of color, figures, space, architecture, and landscape as separate elements and to repeat with only slight variations postures, drapery patterns, gestures, and facial types. And it was precisely this lack of integration of elements, and this use of stock motifs, which characterized all of Perugino's produc-

tion, that prevented him from ever developing a High Renaissance style.

If Vasari is to be believed, Perugino had a morbid fear of poverty, having been born poor. For this reason he resorted to painting by formula in order to boost his income by painting as much and as fast as possible. This is perhaps born out by the large number of extant or lost works (close to two hundred) and his seeming willingness to travel anywhere for a commission (he is documented in Città della Pieve, Perugia, Florence, Rome, Siena, Pisa, Orvieto, Cremona, Pavia, and Venice). Vasari also claimed that Perugino was a confirmed atheist, which may help account not only for the extremely limited range of emotional response of his figures, but also the conventional, and, to most modern eyes, saccharine piety of their expressions—usually either head lowered with eyes looking inward and reflecting, or head raised with eyes rolled heavenward and imploring. The lack of almost any emotional conflict in his figures was further reinforced by the repeated use of a stock facial type—oval head, bow-shaped lips, straight nose, almond eyes, and arched eyebrows.

But in spite of the limitations of Perugino's art he was extremely popular, and his piety and sentimentality, whether cynical or not, clearly appealed to many. He was also one of the greatest portraitists of the 15th century, and had a feel for the openness, atmosphere, light, color, and detail of nature matched by almost none of his contemporaries. Furthermore, at his best—for example, the *Vision of St. Bernard* in Munich (1490's)—his deep colors, relaxed figures, grand architectural settings, and delicate landscapes evoked an exceptionally poignant blend of poetic calm, lyrical gracefulness, intellectual clarity, and spiritual mystery.

—Loren Partridge

PEVSNER, Antoine.

Born in Orel, Russia, 18 January, 1886; brother of Naum Gabo; naturalized French citizen, 1930. Died in Paris, 12 April 1962. Married Virginia (Pevsner), 1917. Attended the School of Fine Arts, Kiev, 1902-1909, and the Academy of Fine Arts, St. Petersburg, 1910; then painter and sculptor in Moscow; lived in Paris, 1912-14, and Oslo, 1915-16; supported the revolution, and named Professor of the Academy of Fine Arts, Moscow, 1917; co-signer, with Gabo, Realist Manifesto, Moscow, 1920; settled in Paris, 1923; stage designs, with Gabo, for Diaghilev's ballet *La Chatte*, 1927; associated with other non-figurative artist groups.

Collections: Amsterdam: Stedelijk; Baltimore; Basel; Chicago; Jerusalem: Israel Museum; London: Tate; Moscow; New Haven; New York: Moma, Guggenheim; Paris: Beaubourg; St. Louis: Washington University; Venice; Washington; Zurich.

Publications

On PEVSNER: books—

Duchamp, Marcel, et al., *Pevsner*, Paris, 1947.

Olson, Ruth, and Abraham Chanine, *Gabo, Pevsner* (cat), New York, 1948.

Massat, Rene, *Pevsner*, Paris, 1956.

Peissi, Pierre, *Pevsner*, Neuchatel, 1961.

Pevsner, Alexei, *A Biographical Sketch of My Brothers Naum Gabo and Pevsner*, Amsterdam, 1964.

Pevsner au Musée National d'Art Moderne, Paris, 1964.

Dorival, Bernard, *Les Dessins dans l'oeuvre de Pevsner*, Paris, 1965.

Dorival, Bernard, *Pevsner*, Milan, 1966.

*

While often seen in the shadow of his more famous brother, the sculptor Naum Gabo, Pevsner evolved his own personal style from the constructivist concerns that they both shared.

The early encaustic paintings such as *Formes abstraites* of 1923 (private collection) prefigure the sculptures in their geometry and in the translucency of the wax paint which has a similar quality to the plastic he was to use later. The texturing and the facture of these works relate to constructivism in their stress on the quality of material in the work of art. The traditional medium signals these paintings as art works rather than design experiments for industry. We would expect this from the co-signator with Gabo of the celebrated *The Realist Manifesto* of 1920, a document that criticised the anti-aesthetic stance of the constructivists. The idea that the encaustics are related to Pevsner's later sculpture is reinforced by a bas-relief of 1923 where plastic elements protrude from the paint surface. The piece seems to be a half way house between painting and sculpture.

Much of Pevsner's early sculpture was made in a style influenced by Gabo who probably stimulated his brother's interest in the medium when they lived together in Norway during the First World War. His *Tête de femme* (1924, private collection) is a good illustration of this with its use of planes to define spaces that stand for the volumes of the head. However, he adds to this style an interest in West African sculpture which was very current in Paris at the time. A tension is set up in pieces such as *Torse* (1924, New York, MOMA) between the high tech plastic and the primitivist subject matter.

In 1924 we can also see the beginnings of Pevsner's development towards abstraction. This is at first still influenced by Gabo and has an architectural air. The title of *Construction en rond* of 1925 (private collection) suggests that it is an abstract piece, but it has very much the feel of a cubist head with the hole standing for the eye. The interpretation is reinforced by finding similar elements in his *Portrait de Marcel Duchamp* created a year later.

Pevsner returns to encaustic to develop his new style. *Naissance de l'univers* (1933) is a cosmological fantasy in which radiating lines intersect on a dark ground. These lines are to appear in sculpture and their use here in a piece in which their associations are made clear by the title allow us to relate them to ideas of the fourth dimension. Pieces such as *Projection dans l'espace* (1938, private collection) bear some relationship to the projections of four dimensional shapes that Jouffret published in his *Traité élémentaire de géometrie à quatre dimensions* in 1903: both show spaces partially enclosed by forms meeting at sharp points, although Jouffret's projections were

World Construction, 1947; brass and iron; 29½ in (75 cm)

of regular geometric forms, Pevsner's curvilinear. The deformation of two dimensional lines on a three dimensional plane is a well-known way of illustrating the concept of the fourth dimension, and this is precisely what we now see in Pevsner's sculpture. The separation of these lines from their planes so that they float in space, as in *Construction pour un aéroport* (1934–35; Amsterdam, Stedelijk), is a better example still. In later pieces the lines are engraved so close together as to negate the distinction between them and the ground. The title *Construction spatiale aux troisième et quatrième dimensions* (1961) directly expresses his concerns.

However, the scientific and mathematical are only part of Pevsner's concerns. There is a possible sexual reading to be made of pieces like *Construction dans l'oeuf* (1948, private collection) which is gestured at in the reproductive nature of the title. Pieces like *Germe* of 1949 also refer to a general organic metaphor—an interest in the natural that is related to his earlier interest in the primitive. Because of the early connection with constructivism and because of the close formal similarities of much of his work with Gabo's, Pevsner's work has tended to be seen as largely unrelated to the intellectual life of Paris where most of it was produced. A reassessment of Pevsner's art in these terms might reveal it to be more complex than was previously thought.

—Julian Stallabrass

PIAZZETTA, Giovanni Battista (Valentino).

Born in Venice, 13 February 1683; son of the sculptor Giacomo Piazzetta. Died in Venice, 29 April 1754. Married Rosa Muzioli, 1724; seven children. Left the school of Antonio Molinari at age 20 and was associated with G. M. Crespi in Bologna, 1703; set up a school in Venice; in the Venice guild, 1711; decorated the ceiling of SS. Giovanni e Paolo, Venice, before 1727; director of the Venice Academy, 1750; illustrated Tasso's *Le Gerusalemme Liberata*, 1745, and made drawings for the book *Studi di pittura*, 1760, but relatively few of his drawings survive (especially compared to, say, Tiepolo's). Students: Giuseppe Angeli, Domenico Fedeli called Maggiotto, Francesco Daggiù called Capella, Antonio Marinetti called Chiozzotto.

Collections: Boston; Cambridge; Chicago; Cleveland; Cologne; Detroit; Dresden; Dublin; Florence; London; Milan; Padua: S. Antonio; Paris; Philadelphia; Rome: Academy of S. Luca; Venice: SS. Giovanni e Paolo, S. Stae, S. Maria della Fava, Gesuati, Accademia, Ca Rezzonico, Palazzo Barbaro, S. Maria del Carmine, S. Vitale; Vicenza; Washington; Worcester, Massachusetts; Royal Collection.

Publications

On PIAZZETTA: books—

Rava, Aldo, *Piazzetta*, Florence, 1921.

Pallucchini, Rodolfo, *L'arte de Piazzetta*, Bologna, 1934, Rome, 1942.

Three Baroque Masters: Strozzi, Crespi, Piazzetta (cat), Baltimore, 1944.

Nicodemi, G., *Ventisette disegni del Piazzetta nella Collezione Trivulzio*, Milan, 1944.

Pallucchini, Rodolfo, *Piazzetta*, Milan, 1956.

Ruggeri, Ugo, *Disegni piazzetteschi: Disegni inediti di raccolte bergamasche*, Bergamo, 1967.

White, D. Maxwell, and A. C. Sewter, *I disegni di Piazzetta nella Biblioteca Reale di Torino*, Rome, 1969.

Garberi, Mercedes, *Piazzetta e l'Accademia* (cat), Milan, 1971.

Jones, Leslie, *The Paintings of Piazzetta*, Ann Arbor, 1981.

Mariuz, Adriano, *L'opera completa del Piazzetta*, Milan, 1982.

Knox, George, *Piazzetta* (cat), Washington and Cambridge, 1983.

Piazzetta: Il suo tempo e sua scuola (cat), Venice, 1983.

Piazzetta: Disegni, incisioni, libri, manoscritti (cat), Vicenza, 1983.

*

Of the important Venetian painters of the 18th century, Piazzetta is probably the most enigmatic, for his approach to painting does not follow the expected norm of development. The difficulty in tracing his career centers on Piazzetta's indecision over whether to adopt a painting style which imitated the immediately preceding generation of painters, who favored a dark and somber palette, or a newer style, favored by his contemporaries who used a brighter palette and light-filled canvas.

After a seven-year apprenticeship in Venice with Antonio Molinari, Piazzetta was a fully trained painter. Instead of setting up shop in Venice, however, he chose to travel to Bologna where he was introduced to the painting style of Carracci and Guercino and where he participated in Crespi's workshop. He was almost 30 years old when he returned to Venice in 1711 and was just beginning his career. Although few of his works have survived from this early period, he probably specialized in easel paintings.

His first commission of the 1720's was a large altarpiece entitled *St. James Major Led to Execution* and painted for S. Stae. In it, large, weighty figures fill the canvas and his darkened palette reveals the influence of the 17th-century artists. However, the spiritual theme of the composition allowed him to express his understanding of drama and movement in a large canvas.

In the next ten years, from 1725 to 1735, he changed his approach to painting, and like his contemporaries, began to open up the pictorial space and include more light in the canvas. The completion of the *Apotheosis of Saint Dominic* ceiling for SS. Giovanni e Paolo marked his understanding of a stylistic change to a truly settecento style. As his first and only ceiling decoration, *Saint Dominic* depicts powerful illusionism and penetrating light that characterized the Venetian rococo. Color is somewhat restrained, but it is lighter and brighter than before.

During the same period, further development of Piazzetta's settecento style is evidenced by three major altarpieces, the *Virgin and Child Appearing to S. Filippo Neri* for S. Maria

Head of a Young Man Wearing a Hat; drawing; Vienna, Albertina

della Fava, the *Guardian Angel with Saints Anthony of Padua and Luigi Gonzaga* for the parish church of S. Vitale, and *Saint Francis in Ecstasy* for the Vicentine Church of the Aracoeli. In these altarpieces, Piazzetta kept the background tones of his canvas dark and lighted the foreground. He added pastel hues to his palette and introduced a rapidly moving zig zag composition.

His first international commission came in the mid-1730's with the completion of the *Assumption of the Virgin*, painted for the Church of the Teutonic Order in Frankfurt, but today displayed in the Louvre. He filled the canvas with luminous sunlight.

The decade of 1735 to 1747 was Piazzetta's most active as he gained his greatest reputation and success. In addition to painting, Piazzetta was successful in a variety of other activities. He authenticated pictures, gave estimates, and worked as a restorer. He was employed as a book illustrator, and produced illustrations for the *Oeuvres* of Bossuet and Tasso's *Gerusalemme Liberata* published by Albrizza in 1745. He also sold large chalk genre drawings to European collectors.

Later in the decade of 1735 to 1745 Piazzetta continued to explore the ideas of light and color in his paintings, but, as his contemporaries pursued these ideas, Piazzetta began to return to the familiar, earlier, dark palette and within a few years abandoned his experiments with rococo luminism.

Three paintings of the 1740's, *The Fortune Teller*, today in the Accademia Gallery, *The Pastoral Scene* (Chicago), and the *Idyll on the Shore* or *Parasol* (Cologne), show the transition from the luminous style of his middle period to the darker palette, cool light, and generalized forms of his late style. All of these paintings contain individual elements that combined finally about 1743-44 to form his late style. It is an approach to painting totally at odds with the work of his contemporaries, but reflect for him personally an evolutionary result rather than a retardataire one. His late pictures, the *Virgin and Child*

Appearing to Saint Joseph, Saint John the Baptist, and Saint Andrew the Apostle, for the Church of S. Filippo in Cortona, and the *Beheading of St. John* for the Basilica del Santo in Padua, are dark with restrained color.

In his last years, Piazzetta's fortune declined as he obtained fewer commissions from foreign courts and Venetian churches. Piazzetta's difficult manner and reputation as a slow painter may have contributed to his decline. He apparently died in poverty and left his family to petition the Doge for a stipend to ward off poverty. The altarpiece for the Pietà for S. Maria della Visitazione was his last work.

—Susan Harrison Kaufman

PICABIA, Francis (Marie).

Born in Paris, 22 January 1879. Died in Paris, 30 November 1953. Married 1) the musician Gabrielle Buffet, 1909 (divorced, 1931), four children; 2) Olga Mohler, 1940; also had one child by Germaine Everling. Attended the Lycée Monge and Collège Stanislas, Paris; studied at the Ecole des Arts Décoratifs, Paris, 1895-97; also studied with Ferdinand Humber, Albert Georges Wallet, and Fernand Cormon, 1899; painter in Paris; associated with several art groups, and ran his own gallery (Galerie L'Ourse) for a year; attended the Armory Show in New York, 1913; edited the magazine *391*, 1917-24, and associated with the Dadaists in Zurich and the Surrealists in Paris; stage designs for the ballet *Relâche*, 1924; lived in Château de Mai, Mougins, 1925-33, and Yacht, 1933-45.

Collections: Basel; Chicago; Geneva: Petit-Palais; Leeds; London: Tate; New Haven; New York: Moma; Paris: Art Moderne, Beaubourg; Pittsburgh; Stockholm: Moderna Museet; Turin: Arte Moderna.

Publications

By PICABIA: books—

Cinquante deux miroirs 1914-1917, Barcelona, 1917.
Poèmes et dessins de la fille née sans mère, Lausanne, 1918.
Rateliers platoniques, Lausanne, 1918.
Pensées sans langage, Paris, 1919.
Jesus Christ Rastaquouere, Paris, 1920.
Explorations, Paris, 1947.
Choix de poèmes, Paris, 1947.
Caravansérail 1924, edited by Luc-Henri Mercié, Paris, 1974.
Ecrits, edited by Oliver Revault d'Allonnes, Paris, 2 vols., 1975-78.

Illustrator: *Les Champs magnétiques*, by André Breton and Phillippe Soupault; *Kodak*, by Blaise Cendrars, 1924; *Deuil pour deuil*, by Robert Desnos, 1924; *Immortelle maladie*, by Benjamin Péret, 1924; *Le Peseur d'âmes*, by André Maurois, 1931; *5 poèmes*, by Pierre de Massot, 1946; *Janela do Coas*, by Murilo Mendès, 1949; *3 mots chantés 99 fois*, 1950, and *Ma solitude*, 1952, both by Pierre André Benoit.

On PICABIA: books—

Andre, Edouard, *Picabia, le peintre et l'aqua-fortiste,* Paris, 1908.

La Hire, Marie de, *Picabia,* Paris, 1920.

Isarlov, George, *Picabia peintre,* Paris, 1929.

Arp, Jean, et al., *Picabia,,* Paris, 1955.

Arnaud, Noël, *La Religion et la morale de Picabia,* Verviers, 1958.

Sanouillet, Michel, *Picabia,* Paris, 1964.

Massot, Pierre de, *Picabia,* Paris, 1966.

Sanouillet, Michel, *Picabia et 391,* Paris, 1966.

LeBot, Marc, *Picabia et la crise des valeurs figuratives 1900–1925,* Paris, 1968.

Camfield, William A., *Picabia* (cat), New York, 1970.

Picabia: La Peinture animée, Brussels, 1973.

Mohler-Picabia, Olga, *Picabia,* Turin, 1975.

Bois, Yves Alain, *Picabia,* Paris, 1975.

Hulten, Pontus, et al., *Picabia* (cat), Paris, 1976.

Fagiolo dell'Arco, Maurizio, *Picabia,* Milan, 1976.

Camfield, William A., *Picabia: His Art, Life, and Times,* Princeton, 1979.

Spate, Virginia, *Orphism: The Evolution of Non-Figurative Painting in Paris 1910–1914,* Oxford, 1979.

Mohler-Picabia, Olga, *Für Picabia,* Berlin, 1981.

Picabia (cat), Cologne, 1983.

Picabia (cat), Stockholm, 1984.

Borràs, Maria Lluïsa, *Picabia,* Barcelona and London, 1985.

Picabia (cat), Edinburgh, 1988.

*

Picabia was a painter whose daring was particularly well suited to the fervid atmosphere of Parisian modernism before the First World War. He was able to produce realist works of considerable delicacy, but through much of his career he turned away from this manual facility towards art that was combative and challenging. He became notorious for witty and anti-artistic pieces (which combined words and images) produced during his association with Dada. This has been regarded as his natural ambiance, but he subsequently undertook more orthodox easel painting which presented different challenges. This approach has lent his career a perplexing diversity, which is united conceptually by an underlying exploration of different states of experience, particularly sexuality. His affairs were numerous, but his paintings reveal a melancholic realization of the ephemeral nature of these desires, and serve as incisive comments on the parallels and paradoxes of procreation and artistic production.

After an academic training, Picabia came to prominence painting in an Impressionist style influenced by Pissarro, whose sons he knew. However, in 1908 he became dissatisfied with naturalism and turned away from his growing reputation in order to explore Synthetist theories. These replaced painting from the motif with painting from memory, a process which shed inessential forms but retained the emotion of the original experience. He combined these ideas, which would remain important to him, with the Symbolist notion of "correspondences," which proposed parallels between painting and the purity of music.

These theories were probably introduced to him by the mu-

Here, This is Stieglitz, 1915; drawing; New York, Guggenheim Museum

sician Gabrielle Buffet, whom he married in 1909. She also had contacts with the avant garde, and by 1911 Picabia was friendly with the painter Marcel Duchamp and the poet and critic Guillaume Apollinaire. Through Duchamp's brothers the two painters were already familiar with Cubism, but their combination of its techniques with the emotional content of Synthetist theory was unorthodox. Together with the experiments of Kupka, Delaunay, and Léger, they moved towards abstraction by developing pictorial structures that were increasingly autonomous. In the autumn of 1913, Apollinaire stressed the musical analogy by applying to their work the mystical title Orphism; and during 1913–14 Picabia's series of huge non-representational works experimented with conveying mood solely through form and colour.

These experiments were interrupted by the war, which Picabia spent in both official and unofficial travel. Although Duchamp had abandoned oil painting in 1913, he continued as an important influence, and together they produced an art of intellect and wit, rather than mere visual delight. Picabia's abstractions gave way to a quite different approach, in which a detached diagrammatic style was used in small drawings showing restructured machines. By cropping and adding words these took on unexpected sexual meanings, derived from Picabia's concept of the machine as man's "daughter born without a mother," as well as from Duchamp's contemporary projects.

These mechanomorphic works were begun in 1915 in New York, where Picabia's abstractions and presence at the 1913 Armory show had established a reputation for controversy. Together with Duchamp and those associated with Steiglitz's periodical *291*, he continued to undermine established values through exhibitions, publication and provocations. During a brief stay in Barcelona in 1917, he extended this approach in his own periodical *391*, before moving to Switzerland. There he met the Zurich Dada group (headed by Tristan Tzara), whose reaction against bourgeois society and whose disgust with the blood-bath of the war manifested itself in terms similar to those of the New York group. Admiring their chance compositions and sound poems, he immediately contributed drawings and poetry to the Dada periodicals.

With peace, Picabia and Tzara joined forces with a number of young poets in Paris for a rich period of performances and manifestations. By revealing the hypocricies of the establishment, they sought to confound those who were attempting to re-instate the pre-war political and artistic status quo. In this Picabia excelled: in 1921 he exhibited a canvas signed by 50 friends (*Cacodylic Eye*), and in 1922 he produced two equally minimal works predictably rejected by the "jury-less" Salon des Indépendants (1922). He followed these provocations with caustic attacks in *391*. However, an aversion to establishments meant the inevitable disintegration of the group and, although the Surrealists, who emerged from Parisian Dada, saw him as an important influence, Picabia found their approach too serious and theoretical.

Severing these links, Picabia developed the mechanomorphic style towards an exploration of the parallels between sexual powers and the deceptive effects of geometric patterns. These esoteric pursuits culminated in his 1924 designs for the ballet *Relâche*, and for René Clair's associated film *Entr'acte*. The years of independence coincided with a move to the south of France and the artist's unexpected return to more orthodox figurative styles associated with his hedonistic existance. The so-called *Monster* paintings saw a return of a painterly technique, which evolved into the layered figures of the *Transparencies;* during the 1940's a lurid heightened realism was developed for the depiction of nudes. At the end of the war, these were abandoned, and Picabia embarked on a richly textured abstraction which brought him to the attention of the avant garde group, Réalités Nouvelles, with whom he exhibited. Even though they show the artist's continuing investigation of sexuality, the works of the middle years have appeared to many critics as a creative trough between Dada and the late abstractions. Picabia had little patience with classifications and his defence may be summed up in his aphorism: "There is only one way to save your life: sacrifice your reputation."

—Matthew Gale

PICASSO, Pablo (Ruiz).

Born in Málaga, 25 October 1881; son of the painter José Ruiz Blasco. Died in Mougins, France, 8 April 1973. Lived with Fernande Olivier, 1905–11; lived with Eva Gouel, 1911–15; married Olga Koklova, 1918 (died, 1955), one son; lived with Marie Thérèse Walter, one daughter; lived with Dora Maar, 1936–46; lived with Françoise Gilot, 1946–53, two children; married Jacqueline Roque, 1961. Attended School of Fine Arts, La Coruña, 1892–95; School of Fine Arts, Barcelona, 1895–97; Royal Academy of San Fernando, Madrid, 1897–98; prodigy: exhibited in Barcelona from 1896, and set up studio in Barcelona, 1898; visited Paris, 1900, and in subsequent years, and settled in Paris, 1904 (exhibited in Paris from 1901); involved in almost every possible artistic activity of his time: revolutionary painting and sculptures, ceramics, stage design, book illustration, etc.; associated with Braque in the beginnings of cubism, and with Diaghilev for stage designs (e.g., *Parade*, 1917, *The Three-Cornered Hat*, 1919, *Pulchinella*, 1920, *Cuadro Flamenco*, 1921, *Le Train bleu*, 1924, *Mercure*, 1927; other stage designs include *Antigone*, 1922, *Le 14 juillet*, 1936, *Les Rendez-vous*, 1945, *Oedipe Roi*, 1947, *Chant funèbre*, 1954, *Icare*, 1962, *L'Après-midi d'un faune*, 1965); lived mainly in his country houses La Californie, near Antibes, 1955–58, Vauvenargues, near Aix-en-Provence, 1958–61, and Notre-Dame-de-Vie, near Mougins, 1961–73.

Major Collections: Antibes: Musée Picasso; Barcelona: Museo Picasso; Paris: Musée Picasso.
Other Collections: Chicago; Leningrad; London: Tate; New York: Moma; Paris: Beaubourg; Philadelphia.

Publications

By PICASSO: books—

Le Désir attrapé par la queue, Paris, 1945; as *Desire Caught by the Tail*, London, 1970.
Poemas y declaraciones, Mexico City, 1944.
Hunk of Skin, San Francisco, 1968.
The Four Little Girls, London, 1970.
On Art, edited by Dore Ashton, New York, 1972.
Collected Writings, edited by Michel Leiris, New York, 1989.

Illustrator: *Metamorphoses*, by Ovid, 1931; *Le Chant des morts*, by Pierre Reverdy, 1948; *Carmen*, by Prosper Merimée, 1949; *La tauromaquia*, by José Delgado, 1959.

On PICASSO: books—

Zervos, Christian, *Catalogue de l'oeuvre de Picasso*, Paris, 33 vols., 1932–78.
Geiser, Bernhard, *Picasso, peintre-graveur: Catalogue illustré de l'oeuvre gravé et lithographié 1899–1931*, Berne, 2 vols., 1933–68.
Barr, Alfred H., *Picasso: Forty Years of His Art* (cat), New York, 1939; as *Picasso: Fifty Years of His Art*, 1946.
Larrea, Juan, *Picasso: Guernica*, edited by Walter Pach, New York, 1947.
Kahnweiler, Daniel-Henry, *Les Sculptures de Picasso*, Paris, 1948; as *The Sculptures of Picasso*, London, 1949.
Mourlot, Fernand, *Picasso lithographe 1919–1963*, Monte Carlo, 4 vols., 1939–64.
Geiser, Bernhard, *Picasso: 55 Years of His Graphic Work*, London, and New York, 1955.
Camon Aznar, Jose, *Picasso y el cubismo*, Madrid, 1956.

Study of Profiles, 1948; lithograph

Kahnweiler, Daniel-Henry, *Picasso: Keramik, Ceramic, Ceramique,* Hanover, 1957.

Cooper, Douglas, *Picasso: Carnet Catalan,* Paris, 1958.

Penrose, Roland, *Picasso: His Life and Work,* London, 1958, 3rd ed., Berkeley, 1981.

Arnheim, Rudolf, *Picasso's Guernica: The Genesis of a Painting,* Berkeley, 1962.

Blunt, Anthony, and Phoebe Pool, *Picasso: The Formative Years: A Study of His Sources,* London and Greenwich, Connecticut, 1962.

Jaffe, Hans L. C., *Picasso,* New York and London, 1964, 1980.

Daix, Pierre, Georges Boudaille, and Joan Rosselet, *Picasso 1900-1906: Catalogue raisonné de l'oeuvre peint,* Neucha-tel, 1966; as *Picasso: The Blue and Rose Periods: A Cata-logue Raisonné of the Paintings,* Greenwich, Connecticut, and London, 1966.

Penrose, Roland, and Alicia Legg, *The Sculpture of Picasso,* New York, 1967.

Lecaldano, Paolo, *L'opera completa di Picasso: Blu e rosa,* Milan, 1968.

Bloch, Georges, *Picasso: Catalogue de l'oeuvre gravé et li-thographié 1904-1969,* Berne, 4 vols, 1968-79.

Dufour, Pierre, *Picasso 1930-1968,* Geneva and Cleveland, 1969.

Lasarte, Juan Ainaud de, *Carnet Picasso: La Coruna 1894-1895,* Barcelona, 2 vols., 1971.

Lasarte, Juan Ainaud de, *Carnet Picasso: Paris 1900,* Barce-lona, 2 vols, 1972.

Minervino, Fiorella, *L'opera completa di Picasso, cubista,* Milan, 1972.

Hilton, Timothy, *Picasso,* London, 1975.

Lipton, Eunice, *Picasso Criticism 1901-1939: The Making of an Artist-Hero,* New York, 1976.

Schiff, Gert, editor, *Picasso in Perspective,* Englewood Cliffs, New Jersey, 1976.

O'Brien, Patrick, *Picasso: A Biography,* London, 1976.

Ferrier, Jean Louis, *Picasso: Guernica,* Paris, 1977.

Kibbey, Ray Anne, *Picasso: A Comprehensive Bibliography,* New York, 1977.

Larrea, Juan, *Picasso: Guernica,* Madrid, 1977.

Oriol Anguera, A., *Guernica al desnudo,* Barcelona, 1979.

Palau i Fabre, Josep, *El "Gernika" de Picasso,* Barcelona, 1979.

Daix, Pierre, and Joan Rosselet, *Le Cubisme de Picasso: Cat-alogue Raisonné de l'oeuvre peint 1907-1916,* Neuchatel, 1979; as *Picasso: The Cubist Years,* Boston and London, 1979.

Palau i Fabre, Joseph, *Picasso vivo 1881-1907,* Barcelona, 1980; as *Picasso: Life and Work of the Early Years,* Oxford and New York, 1981.

Russell, Frank D., *Picasso's Guernica: The Labyrinth of Nar-rative and Vision,* London, 1980.

Rubin, William, editor, *Picasso: A Retrospective* (cat), New York, 1980.

Raeburn, Michael, editor, *Picasso's Picassos* (cat), Paris and London, 1981.

McCully, Marilyn editor, *A Picasso Anthology: Documents, Criticism, Reminiscences,* London, 1981, Princeton, 1982.

Fernandez-Quintanilla, Rafael, *La odisea del Guernica,* Bar-celona, 1981.

Geelhaar, Christian, et al, *Picasso: Das Spätwerk: Themen 1964-1972* (cat), Basel, 1981.

Picasso: Obra grafica original 1904-1971 (cat), Madrid, 2 vols., 1981.

Giraudy, Daniele, *L'Oeuvre de Picasso à Antibes* (cat), An-tibes, 1981.

Daix, Pierre, *Picasso,* Paris, 1982.

Spies, Werner, *Picasso: Das plastische Werk,* Stuttgart, 1983.

Passeron, Roger, *Picasso,* Paris, 1984.

Lieberman, William S., *Picasso: Linoleum Cuts,* New York, 1985.

Besnard-Bernadoc, Marie-Laure, and Michele Richet, *The Musée Picasso: Catalogue of the Collection,* New York and London, 2 vols., 1986-88.

Glimcher, Arnold and Marc, editors, *Je suis le cahier: The Sketchbooks of Picasso,* New York, 1986.

Fairweather, Sally H., *Picasso's Concrete Sculpture,* London, 1987.

Cooper, Douglas, *Picasso théâtre,* Paris and New York, 1987.

Oppler, Ellen C. editor, *Picasso's Guernica,* New York and London, 1988.

Le Dernier Picasso 1953-1973 (cat), Paris, 1988; as *The Late Picasso,* London, 1988.

Leal, Brigitte, *Picasso: The Demoiselles d'Avignon: A Sketch-book,* London, 1988.

Les Demoiselles d'Avignon (cat), Paris, 1988.

Hoffeld, Jeffrey, *Picasso: The Late Drawings,* New York, 1988.

Picasso: Linoleum Cuts: Bacchanals, Women, Bulls, and Bull-fighters, New York, 1988.

Chipp, Herschel, *Picasso's Guernica: History, Transforma-tions, Meanings,* Berkeley, 1988.

Rubin, William, *Picasso and Braque: Pioneering Cubism* (cat), New York, 1989.

*

In March 1913, the poet Guillaume Apollinaire captured the prodigious power of Picasso's work when he wrote: "He is a newborn child who orders the universe for his personal use." Picasso had already achieved an unmatched position through his development of Cubism in partnership with Georges Braque, which had produced a fundamental shift in modes of representation. For many years after he would epitomise the spirit of modern art: forceful and sensual, iconoclastic and eclectic.

The continuous outpouring of works in different media and in unforeseen styles was Picasso's point of contact with the outside world. His dealer, Daniel-Henry Kahnweiler, charac-terized the concentration of his work as "fanatically autobio-graphical"; on a personal level, its intensity is clear from the subjugation of his wives and mistresses. At the same time, the works became the mirror of the age, reflecting universal expe-riences of the fundamentals of life: love and conflict, revela-tion and alienation, faith and death. They oscillated between the expression of these emotions and the investigation of pictorial form, coalescing these concerns with remarkable frequency.

Part of Picasso's unique position in 20th-century art stemmed from his self-imposed exile in Paris. There, between 1900 and 1914 he became familiar with contemporary devel-opments and became friends with some of the major artists of his generation: Matisse, Derain, Braque, Gris. The experi-

ments of this revolutionary period, driven by the exchange and rivalry between them, saw Picasso's progression from academic through emotive realism, to a conceptual restructuring of representation.

He had been a child prodigy, trained at the academies in La Coruña and Barcelona, where his father taught. In 1898 he had abandoned the Royal Academy in Madrid to return to the progressive atmosphere of Barcelona, where he discovered the graphic style of Toulouse-Lautrec. He saw Impressionist paintings during his first trip to Paris in 1900, and his dance-hall and street scenes under their influence secured exhibitions which laid the foundations of his reputation.

His first personal style, the Blue period, concentrated on melancholic images of deprivation. This was partly instigated by the suicide of his friend Casagemas, which he commemorated in *Evocation (Burial of Casagemas)* (1901; Musée d'Art Moderne de la Ville de Paris), and which confronted Picasso with the polarity of love and death. He made explicit the inclusion of the artist among those marginalized by society in another work featuring Casagemas, and painted at the height of the Blue period: *La Vie* (1903; Cleveland). However, his definitive move to Paris in 1904 helped to lift this atmosphere, and his depiction of travelling circus artists in *The Family of the Saltimbanques* (1905; Washington), used the optimistic hues of the Rose period.

In Paris, Picasso met the poets Max Jacob, Guillaume Apollinaire, and André Salmon, and was introduced to Matisse and Derain, whose violent brushwork and colour had caused controversy at the 1905 Salon d'Automne. In them Picasso found his most challenging contemporaries against whose work he measured his own. In this new atmosphere the emotion of his previous works was abandoned in favour of a re-consideration of the structure and proportions of the figure. While he considered the properties of ancient Iberian sculpture, Matisse and Derain had been experimenting with forms derived from African sculptures. When Picasso also became aware of the African pieces, he grasped that they offered a more radical alternative to European figurative conventions. In the revolutionary *Les Demoiselles d'Avignon* (1907; New York, Moma) he adopted harsh colouring and striations to mark the planes of the faces, and pushed the distortions of the body to new extremes.

This startling work was followed by other figure paintings in which the relief-like depth moved towards an integration of the subject and ground in a unified pictorial whole. However, in this he was anticipated by Braque, who under the influence of Cézanne had developed an overall structure from a layering of planes. It was his paintings, rejected by the 1908 Salon d'Automne but exhibited by Kahnweiler, which provoked the term Cubism. In 1909 Picasso undertook his own investigation at Horta in Spain. From his study of Cézanne he learned that the integrity of the surface could be maintained by bleeding from one plane into the next (known as "passage"), and that the whole could be held together by modifying the shading of planes.

The resulting paintings were Picasso's first Cubist works, dissecting the object into constituent facets. In the initial Analytical phase, the picture surface appeared fragmented, and its depth reduced to a minimum. In 1910, the images virtually lost touch with the subject, presenting the observer with an unrecognisable web. At this most radical stage, when their collaboration was most intense, Picasso and Braque took the audacious step of painting a series of portraits whose disintegration remarkably retained the appearance of the sitter.

By 1911, when Analytical Cubism was at its height, their experiments had spawned a following among Parisian artists—Metzinger, Gleizes, Léger, Delaunay, and others—who constituted the Cubist movement. Within two years Cubism would have an international impact, influencing avant garde painters and sculptors in Italy, Germany, Russia, and elsewhere.

Among Picasso and Braque's most important developments was the invention of collage; achieving flat areas of colour with non-painterly materials—newspaper and wallpaper. Associated with this Picasso also made constructions from strips of card or metal, which allowed drawing in one plane (with the edge) and the creation of form in another (with its depth). These new approaches liberated painting and sculpture formally and materially, and opened the way for the differing experiments of Dada and of Constructivism.

The Synthetic Cubist phase, in which the object was re-invented on the canvas, grew out of these developments. Flat planes and exuberant colour began to feature in Picasso's work and that of Juan Gris, but this experimental period was cut short by the outbreak of war in 1914. As a Spaniard, Picasso remained neutral, but he was affected by the events of the war: both Braque and Apollinaire were wounded in the head and, in the winter of 1915, his mistress, Eva Gouel, died of tuberculosis. As a means of escape, he agreed to Jean Cocteau's request that he make designs for *Parade* for Diaghilev's Ballets Russes. In Rome for the project, he met the ballerina Olga Koklova, whom he married in 1918.

The inter-war period marked the height of Picasso's influence on contemporary art, as he was acclaimed from all sides. Cubism survived, although the close collaboration with Braque was not resumed, but he also undertook explorations of different styles and media, many associated with Surrealism. However his imagery, reflecting the dominance of his personal life, became increasingly redolent with anxiety.

During the war, Picasso began the practice of depicting the same subject in his Synthetic and in a realistic style. This surprising parallelism reached a peak around 1921–23 when he produced monumental figures recalling classical sculpture, such as *Three Women at the Spring* (1921; New York, Moma). This coincided with a widespread reassessment of realism throughout Europe associated with the need for post-war reconstruction as well as a reaction against the avant garde. However, through his parallelism Picasso indicated the possibility of a unity across styles in the place of this opposition. His stage designs encouraged the return of theatrical subjects which emerged in the two versions of the *Three Musicians* (1921; Philadelphia and New York, Moma), and in *The Dance* (1925; London, Tate). Although their size matched the realistic works, all three were Synthetic Cubist in style. The dark restraint of the musicians gave way to a frenzy in the later work, which mourned the death of his friend Ramon Pichot, but also hinted at the slow disintegration of his marriage.

This venting of frustrations was encouraged by the influence of the Surrealists. Using Freud's theories, they sought to unleash the creative powers of unconscious and suppressed desires. Their leader, André Breton, tried to persuade Picasso to join them, but he preferred to remain independent, adapting their techniques for his own purposes. However, he was represented in the first Surrealist exhibition (1925). Responding to

this contact, Picasso made a series of cloth and string constructions aggressively pierced by nails, while the women in his works took on nighmarish and predatory distortions, reaching their apogee in the murderous *Woman with Stiletto* (1931; Paris, Musée Picasso).

From 1928, Picasso made a number of fine welded wire sculptures with Julio Gonzales, which adapted the linear style of contemporary paintings to three dimensions. These constructions, and ones transforming found objects, rekindled his interest in sculpture and from 1932, he made large scale plaster heads.

In 1936, civil war broke out in Spain; in acknowledgement of his solidarity, the republican government made Picasso nominal director of the Prado and commissioned him to paint a mural for their pavilion at the 1937 Paris International Exposition. The theme was furnished by the bombing of a Basque town in April; he completed *Guernica* (1937; Madrid, Prado) in six weeks. As a summation of the destruction of innocents, its fame was immediate as it travelled to England and the USA. Its echoes continued in the anguish of subsequent double profile portraits of Dora Maar, which captured the threatening atmosphere in which Europe was becoming engulfed.

Picasso's production in the period between the Second World War and his death was marked by independence. In his diverse pursuits, he moved away from the contemporary avant garde and, particularly in later years as his contemporaries passed away, his work became autonomous, self-generating and self-fulfilling, showing the sustained power of his creativity.

He supported the left when it mobilized against Fascism in the late 1930's and defiantly remained in Paris throughout the German occupation, protected by neutral citizenship and fame. The wartime works showed both the continual presence of death and the resilience bred by oppression, and they were triumphantly exhibited in the Salon de la Libération in 1944. At the same moment he joined the Communist party and for a number of years campaigned for the maintenance of peace, recording the atrocities of war in works such as *The Charnel House* (1945; New York, Moma).

During the 1950's, like Matisse and Bonnard before him, Picasso gradually withdrew to the south of France. However, this removal did not signal a slowing of productivity or innovation. In his painting he was inspired to a lyrical treatment of the figure by Françoise Gilot and, after 1955, by Jacqueline Roque (whom he married in 1961). He explored new media in series of lithographs and linocuts, as well as large public works, notably the *Chapel of Peace* at Vallauris and the *Fall of Icarus* mural for the UNESCO building in Paris. He also experimented with painted ceramics at Vallauris (from 1947), and with folded sheet metal sculptures such as *Woman with Outstretched Arms* (1961; Paris, Musée Picasso). This appetite for new media was born of a feeling of urgency as he began the struggle with the prospect of his own death. Distortions were turned against the inadequacies of the male as his failing sexual powers were confronted in the final years. These works, though subject to some critical indifference, show an intensification and distillation of Picasso's whole personal investigation; they are the essence of a relentless confrontation with mortality. The inevitability of defeat nevertheless bred an unparalleled scale and diversity of work, whose formal mastery had already ensured a revolution in pictorial conventions.

—Matthew Gale

PIERO DELLA FRANCESCA.

Born in Borgo San Sepolcro (now Sansepolcro), c. 1410–20. Died in Borgo San Sepolcro, 12 October 1492. First recorded in Florence: frescoes in S. Egidio (done with Domenico Veneziano), 1439; town councillor in Borgo, 1442; polyptych for Compagnia della Misericordia, Borgo, 1445 (paid in 1462); worked on frescoes in S. Francesco, Arezzo, 1452–66; recorded in Rome, 1459; altarpiece in Borgo, 1454–69; probably stopped painting in the 1470's.

Collections: Arezzo: S. Francesco, Cathedral; Berlin; Boston: Gardner; Florence; Lisbon; London; Milan: Brera, Poldi Pezzoli; New York: Metropolitan, Frick; Oxford: Christ Church; Perugia; Rimini: S. Francesco, Tempio Malatestiano; Rome: S. Maria Maggiore; Sansepolcro; Urbino: Palazzo Ducale; Vaduz; Venice; Washington; Williamstown, Massachusetts.

Publications

By PIERO: books—

Mathematical Treatises: The Trattato d'abaco and Libellus de quinque corporibus regularibus, edited by Margaret D. Davis, Ravenna, 1977.

On PIERO: books—

Venturi, Adolfo, *Piero,* Florence, 1922.

Graber, Hans, *Piero,* Basel, 1922.

Longhi, Roberto, *Piero,* Rome, 1927, 4th ed., 1975, London, 1930.

Salmi, Mario, editor, *Piero: Gli affreschi di San Francesco in Arezzo,* Bergamo, 1944.

Salmi, Mario, *Piero e il Palazzo Ducale di Urbino,* Florence, 1945.

Alazard, Jean, *Piero,* Paris, 1948.

Stokes, Adrian, *Art and Science: A Study of Alberti, Piero, and Giorgione,* London, 1949.

Chiasserini, Vera, *La pittura a Sansepolcro e nell'alta valle Tiberina, primo di Piero,* Florence, 1951.

Clark, Kenneth, *Piero,* London, 1951, 1969.

Focillon, Henri, *Piero,* Paris, 1952.

Wittgens, F., *La pala urbinate di Piero,* Milan, 1952.

Berenson, Bernard, *Piero, or The Ineloquent in Art,* London and New York, 1954.

Venturi, Lionello, *Piero,* Geneva, 1954.

Longhi, Roberto, *Piero: La leggenda della croce,* Milan, 1955.

Bianconi, Piero, *Piero,* Milan, 1957, New York, 1962.

Previtali, Giovanni, *Piero,* Milan, 1965.

Tolnay, Charles de, *Religious Conceptions in the Painting of Piero,* New York, 1966.

Vecchi, Pierluigi de, *L'opera completa di Piero,* Milan, 1967; as *The Complete Paintings of Piero,* New York, 1967, London, 1970, 1985.

Hendy, Philip, *Piero and the Early Renaissance,* New York, 1968.

Gilbert, Creighton, *Change in Piero,* Locust Valley, New York, 1968.

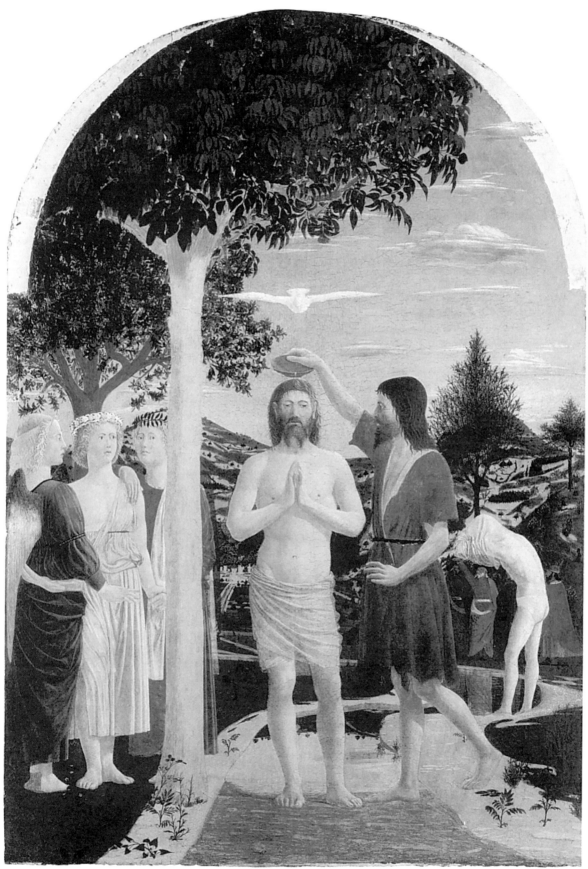

Baptism; 66⅛ × 45⅝ in (168 × 116 cm); London, National Gallery

Gore, Frederick, *Piero's The Baptism,* London, 1969.

Battista, Eugenio, *Piero,* Milan, 2 vols., 1971.

Lavin, Marilyn Aronberg, *Piero: The Flagellation,* New York, 1972.

Agnoletti, E., *La Madonna della Misericordia e il Battesimo di Cristo di Piero,* Sansepolcro, 1977.

Salmi, Mario, *La pittura de Piero,* Novara, 1979.

D'Ancona, Paolo, *Piero: Il ciclo affrescato della Santa Croce nella chiesa di S. Francesco in Arezzo,* Milan, 1980.

Convegno internazionale sulla Madonna del parto di Piero (1980), Monterchi, 1980.

Ginsburg, Carlo, *Indagini su Piero,* Turin, 1981; as *The Enigma of Piero,* London, 1985.

Lavin, Marilyn Aronberg, *Piero's Baptism of Christ,* New Haven, 1981.

*

Piero was born in the small village of Borgo San Sepolcro c. 1420 and died on October 12, 1492. Little is known of his early training or life; he apparently worked with Domenico Veneziano, whose influence is evident in Piero's consistent use of white light and clear, crisp edges. Piero was an extremely complex artist, both iconographically and technically. His works contain many levels of meaning and his conviction that geometry is an essential and integrated quality of painting is evident from his two treatises, written in Latin, on perspective, drawing, and color: *De prospectiva pingendi* and *Libellus de quinque corporibus regularibus.*

Although a relatively small number of works by Piero are extant, they nevertheless reveal a range of subject matter, technical skill and complexity of thought equalled by few western artists. His portraits include the Duke and Duchess of Urbino, Federigo da Montefeltro and Battista Sforza, rulers of the advanced and enlightened humanist court in that city. This pair of pictures, dated 1465 and now in the Uffizi in Florence, depicts each figure in profile, overlooking a landscape very much like the one the Duke and Duchess ruled in central Italy. In each case, the relationship between the figure and the landscape is underscored by formal parallels. For example, the pearl necklace of the Duchess echoes the white light falling on the fortified town walls in the distance. The triangular shapes of the necklace, accented with a red edge, repeat the landscape hills. In the Duke's portrait, too, details of physiognomy echo aspects of the landscape. For example, the dark patterns formed against his light skin by his facial moles and the curls of hair around his ear repeat the dark patterns of the trees against the lighter hills. Likewise, the triangular shape under the Duke's chin echoes the triangular hills, as does his wife's necklace. The reverse of the portraits depicts the triumph of each figure.

Federigo's portrait is included in another important painting by Piero, the altarpiece of 1472, now in the Brera in Milan. Here, the Duke kneels before an imposing Madonna supporting a sleeping Christ on her lap. She is surrounded by saints and angels in a symmetrical architectual space, which is pervaded by a white light. One of the unique iconographic elements of this painting is the egg suspended from the apse which has been extensively discussed by scholars. Millard Meiss has demonstrated that the egg is, in fact, an ostrich egg, symbolic of the immaculate conception as the ostrich was popularly believed to be fertilized by the wind. Also symbolic is the sleeping figure of Christ with a coral necklace, referring to death and resurrection. These references contained a personal significance for the Duke of Urbino, whose first son, his sixth child and heir, Guidobaldo, had just been born. His wife Battista is absent from the painting because she died in childbirth. The large size of Mary herself is a standard symbol of her role as the Church and "House of God," which is reinforced in this painting by the arched position of her hands over Christ. The church building itself is referred to in the apse, which Mary seems to fill with an aloof, imposing majesty.

These qualities of Mary recur in the heroic women represented by Piero throughout his oeuvre. The *Madonna del Parto,* for example, a fresco in a small funerary chapel in Monterchi, depicts the unusual subject of the pregnant Virgin. She is flanked by angels, mirror images of each other, who open the flaps of the tent in which Mary stands, and she, in turn, indicates her pregnancy through a slit in her dress. In this work, as in the Brera picture, Mary and the building—whether tent or apse—are symbolically one. Her regality in the Monterchi fresco is inherent not only in her imposing, monumental form and pose, but also in the act and gesture of revealing her pregnancy to the world just as an earthly queen does in order to confirm the impending arrival of an heir to her subjects.

Other heroic women, who share the quality of a self-consciously geometric oval head and an architectural presence, include the Mary Magdalene in the duomo of Arezzo and the Madonna, Queen of Sheba, and St. Helena in the True Cross cycle in the Church of San Francesco, also in Arezzo. The columnar character of Mary in the San Francesco *Annunciation,* for example, expresses Piero's associations between figure and architecture, figure and geometry. Mary had even been called a column in the medieval literature and the fact that Piero's column is not Doric, but nevertheless bulges outward, as only Doric columns did, confirms the relation between the pregnant Virgin and the column. These associations are partly the result of Renaissance humanism, particularly that of Alberti, which derive from classical antiquity and which relate human form and proportion to architectural ideals.

Equally architectural in their form and pose are Piero's figures of Christ and angels in the *Baptism* in the National Gallery in London, the resurrected Christ in the Borgo San Sepolcro *Resurrection,* and the flagellated Christ in the Urbino *Flagellation.* In the *Baptism,* Christ's statuesque pose and the white light on his body echo the vertical of the white tree as do the angels standing on the left. In the *Flagellation,* architecture and geometry have been extensively analyzed by Wittkower, and both are intimately related to the figures and to the many layers of meaning in this complex scene. A most puzzling aspect of the *Flagellation,* which has been discussed by many scholars, is the juxtaposition of contemporary, probably portrait, figures and 15th-century street architecture in the foreground with the biblical event and classical architecture in the background.

Piero's geometry, as seen in the *Flagellation,* is not limited to the two-dimensional picture plane. Rather, it informs the entire spatial organization of the painting. In particular, Piero shows a preference for the circular or semi-circular arrangement of figures around a central figure. This configuration,

which first appears in the work of Giotto and is continued by Masaccio, has been shown by Meiss to symbolize the concept of Christ as the center of the church, the latter being implied by the circle. In the *Flagellation,* Christ and the column stand in the center of a literal, black circle on the floor of the building. In other works, such as the *Death of Adam* in the True Cross cycle at Arezzo, the central figure, in this case Adam, may be symbolic of Christ, who was called the "New Adam."

The frescoes at Arezzo are the best extant example of Piero's complex and mature iconographic thinking on a grand narrative scale. They are his only preserved cycle of paintings in which narrative is combined with geometry, architecture, symbol, and liturgy. The subject of the True Cross legend had been depicted before, but never so elaborately. Earlier True Cross cycles were straightforward narratives, whereas Piero's relates figures and events through their underlying liturgical, symbolic, historical, or typological meaning, thereby enriching the events of the legend.

—Laurie Schneider

PIERO DI COSIMO.

Born Piero di Lorenzo in Florence, 1461 or 1462; son of the goldsmith Lorenzo di Piero d'Antonio. Died in Florence, 1521? Pupil of Cosimo Roselli, and took his name; assisted Rosselli on frescoes in Sistine Chapel, c. 1481–82; interested in mythology; designer of *trionfi* processions (notable Triumph of Death, 1506 or 1507). Pupils: Andrea del Sarto, Jacopo Pontromo.

Collections: Amsterdam; Berlin; Borgo San Lorenzo: SS. Crocifisso dei Miracolo; Cambridge, Massachusetts; Chantilly; Dresden; Edinburgh; Fiesole: S. Francesco; Florence: Uffizi, Galleria dello Spedale degli Innocenti; The Hague; Hartford, Connecticut; London: National Gallery, Wallace, Dulwich; Munich; Montevettolini: S. Michele; New Haven; New York; Ottawa; Oxford; Paris; Philadelphia; Prague; Rome: Borghese, Galleria Nazionale; St. Louis; San Diego; Stockholm; Strasbourg; Toledo, Ohio; Vaduz; Washington.

Publications

On PIERO: books—

Knapp, Fritz, *Piero,* Halle, 1899.
Haberfeld, H., *Piero,* Breslau, 1902.
Douglas, R. Langton, *Piero,* Chicago, 1946.
Fossi, M., *Desegni di Filippino Lippi e Piero* (cat), Florence, 1955.
Bacci, Mina, *Piero,* Milan, 1966.
Bacci, Mina, *L'opera completa di Piero,* Milan, 1976.
Jouffroy, Alain, *Piero, ou La Forêt sacrilege,* Paris, 1982.
Piero's The Forest Fire, Oxford, 1984.

articles—

Panofsky, Erwin, "The Discovery of Honey by Piero," in *Worcester Art Museum Journal* (Massachusetts), 1936–37.
Panofsky, Erwin, "The Early History of Man in a Cycle of Painting by Piero, in *Studies in Iconology,* New York, 1939.
Lavin, Irwin, "Cephalus and Procris: Transformation of an Ovidian Myth," in *Journal of the Warbug and Courtauld Institutes* (London), 1954.
Zeri, Federico, "Rivedendo Piero," in *Paragone* (Florence), July 1959.
Matthews, T. F., "Piero's Discovery of Honey," in *Art Bulletin* (New York), 1963.
Fahy, Everett, "Some Later Works of Piero," in *Gazette des Beaux-Arts* (Paris), 1965.
Craven, Stephanie J., "Three Dates for Piero," in *Burlington Magazine* (London), 1975.
Callman, Ellen, "Apollonio di Giovanni and Painting in the Early Renaissance Room," in *Antichità Viva* (Florence), 1989.

*

Piero di Cosimo is certainly one of the most colorful and imaginative painters of the Italian Renaissance. He reflects the century's interest in naturalism to an extreme and he is also the first truly bohemian artist. Since there are few documents concerning Piero, much information about him derives from Vasari's amusing anecdotal account of this rugged individualist.

A Forest Fire; panel; 28 × 76⅛ in (71 × 196 cm); Oxford, Ashmolean

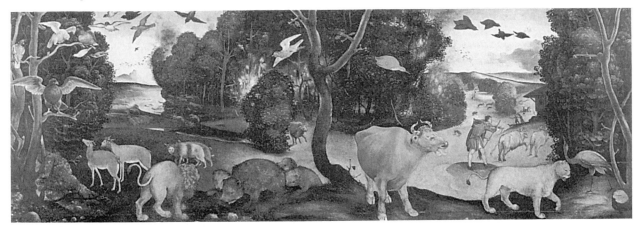

His birth date, approximately 1462, is derived from his father's (Lorenzo, a goldsmith) tax report, which in 1480 lists Piero as 18 years of age and in the *bottega* of Cosimo Rosselli (from whom Piero took his name). In 1481–82, Piero accompanied his master to Rome to assist in painting the prestigious commission on the walls of the Sistine Chapel for Pope Sixtus IV. Vasari relates that he painted the landscape in the *Preaching of Christ*, revealing early his penchant for nature.

Piero, who was very influenced by Flemish painting, was no doubt attracted to the *Portinari Altarpiece* of Hugo van der Goes when it arrived in Florence and was exhibited in the church of Sant' Egidio in 1483. Piero was attracted to its hyper-realism, rich oil color, complex symbolism, and bizarre elements, and he strove to capture the same vivid naturalism. He was successful to such an extent that Vasari reports that he "counterfeited" the book and balls of St. Nicholas in his *Visitation* (Washington); the painting was completed in 1490 for the Capponi Chapel in Santo Spirito. Despite Piero's study and admiration of Flemish painting and its techniques, his work always retains the generalizing tendencies of the Italian school, although he somewhat escapes its strong idealism with his more plebeian types.

When Piero's father died in 1490, "Piero di Lorenzo dipintore" was listed as the head of the family. Nevertheless, Piero seems to have remained dependent on his artistic mentor, remaining in Cosimo Rosselli's shop longer than was usually the custom. He was only inscribed in the Campagnia di San Luca, the Florentine confraternity of artists, in 1503 or 1505, and matriculated rather tardily in the painters' and druggists' guild, the Arte dei Medici e Speziali, on May 8, 1504. Rosselli was probably an anchor for Piero, because Vasari relates that after his death in 1507, Piero began to show his strangeness even more, locking himself up in an unkempt house and refusing to prune his trees because it pleased him that everything should look wild like his own nature.

The 16th-century historian paints a portrait of Piero as the solitary misanthrope, hallucinating on spittle on walls and infatuated with castles in the air as well as with the bizarre mistakes and caprices of nature (no doubt due to firsthand knowledge of the composite animals Piero painted in such works as *The Forest Fire* (Oxford) and *The Lapiths and the Centaurs* (London). Vasari, who owned Piero's *Mars and Venus* (Berlin, Staatliche Museum), describes two series of paintings that Piero created for the houses of Giovanni Vespucci in the Via dei Servi and Francesco del Pugliese in the Via de' Serragli. The exact reconstruction of these series is still debated, although scholars have accepted that the humorous *Discovery of Honey* (Worcester, Massachusetts) and its pendant (Cambridge, Massachusetts) belonged to the bacchanalian scenes with Silenus, satyrs, and fauns painted for the Vespucci house. The identification of the Pugliese panels, however, remains disputed. Candidates include a number of panels that seem to illustrate earlier times in human history when composite creatures existed. These creatures encompass not only of the more mythologically established hybrid, such as satyrs and centaurs, but also ones that seem to illustrate primitive times for evolutionary humanity. For example, *The Forest Fire* contains two animals with human faces. At first these "missing links" appear to have more in common with the evolutionary theories of Charles Darwin than with the Italian Renaissance. But they and other details in Piero's paintings

make sense because the Florentine humanists had discovered the evolutionary theories of the ancients in Lucretius's *De Rerum Natura* and Pliny's *Historia Naturalis*. Most likely Piero's antipathy toward civilized life, together with his keen imagination, enabled him to depict primitive life so vividly and poetically.

Toward the end of the first decade of the new century, Piero's painting commissions dwindled, although he gained notoriety for inventing triumphal floats or cars for festivals. Vasari praises his ingenious, macabre "Car of Death" for Carnival in 1507. It was drawn by black buffaloes, painted with white skeletons, and contained coffins from which the dead would issue forth. The figure of Death holding a scythe crowned the horrible car, which no doubt led to the legend that Piero was fascinated by death. Further demonstrating his Florentine training in design, Piero is also documented as working on other multi-media events—a *mummeria* paid for by Filippo Strozzi in 1506, the festival of San Giovanni in 1514, and the triumphal entry of Leo X into Florence in 1515.

During the first decade of the 16th century, Piero remained an esteemed individual. On 24 January 1504, he, along with 28 artists and artisans (including Leonardo, Botticelli, Filippino Lippi, and Cosimo Rosselli), participated in a meeting to discuss the permanent location of Michelangelo's *David*. Piero's first reply, perhaps motivated by diplomacy toward his friend, was that he agreed with Giuliano da Sangallo (Piero's portraits of Giuliano and his father are in Amsterdam). However, Piero demonstrates his good sense by adding that the place should agree with the creator of the statue (Michelangelo). By 1504 Raphael, who was in Florence, Fra Bartolomeo, and the peripatetic Leonardo, who returned to his native city, were painting in a simpler more monumental style, often referred to as the Florentine High Renaissance. Their impact on Piero's art appears most tangibly in his *Incarnation* for the Tedaldi Chapel in the Servite Church (new in the Uffizi) dated stylistically between 1504 and 1506. In the main panel and its predella, one can also see the application of Leonardesque *sfumato*.

In the later years, Piero's paintings seem to attempt with increasing frustration to respond to this new style, also practiced by his pupil Andrea del Sarto. He continues, however, to include his hallmark quirky landscapes, influenced by the Flemish school, and genre details. Vasari, always concentrating on the sensational and exotic, tells that Piero painted a marine monster for Giuliano de' Medici (Duke of Nemours) during this period. Piero is also documented in 1510 as working for Filippo Strozzi in his own rooms in the family palace, perhaps on the problematic *Perseus Liberating Andromeda* (Uffizi) which Vasari states he painted for Strozzi.

Outmoded, unable to escape his quattrocento roots, Piero lived out his last years as a crotchety eccentric. According to Vasari, he had a number of phobias, of lightning and fire (no doubt the reports were fed by the content of some of his paintings). Similarly, Vasari relates that he subsisted on a diet of boiled eggs, which he prepared 50 at a time while boiling his glue (the story may owe its origins to Piero's purchase of eggs for tempra painting). Vasari places Piero's death in 1521, at about 80 years of age, when, in fact, he was closer to 60. He was buried in the church of S. Pier Maggiore.

Piero di Cosimo remains a painter of great originality, whose very uniqueness testifies to the breadth of the Italian

Renaissance. It is easy to see why he became a hero for André Breton and the Surrealists. Vasari admitted that he was considered a madman, who by his uncouth ways did not achieve the promise of his intellect. Piero bequeathed a certain propensity for the bizarre to both of his prominent pupils: Andrea del Sarto and Jacopo Pontormo, although it was Pontormo who followed his master's footsteps toward the extreme.

—Roberta J. M. Olson

PIETRO da Cortona.

Born Pietro Berrettini in Cortona, 1 November 1596; son of the stonemason Giovanni di Luca Berrettini. Died in Rome, 16 May 1669. Trained in the studio of the Florentine painter Andrea Commodi in Cortona, 1609–11, and in Rome, 1612–13; and also in the workshop of Baccio Carpi, from 1614; settled and worked in Rome: worked for the Sacchetti family, 1623, and the Barberini family: S. Bibiana, 1624–26, and ceiling in the Barberini Palace—now the Galleria Nazionale—1633–39; "principe" of the Rome guild, 1634–38; completed work on the Chiesa Nuova, 1665; also did frescoes for the Pitti Palace in Florence, 1637, 1641–47; also an architect from c. 1625, and designed tombs and monumental sculpture; wrote a treatise on painting, 1652, and did anatomical studies. Pupils: Ciro Ferri, G. F. Romanelli.

Collections: Berlin; Bristol; Casaletto del Pigneto: Villa Sacchetti; Castelfusano: Villa Sacchetti; Cortona: S. Francesco, S. Agostino; Florence: Pitti; Hartford, Connecticut; Leningrad; London: Dulwich; Madrid; Munich; New York; Paris; Rome: Doria Pamphili, Galleria Nazionale, Palazza Quirinale, Capitolina, S. Bibiana, S. Salvatore in Lauro, Palazzo Mattei di Giove, Chiesa Nuova; Sarasota, Florida; Toledo, Ohio; Vatican; Vienna; Royal Collection.

Publications

By PIETRO da Cortona: book—

Tabulae anatomicae, edited by Gaetano Petrioli, Rome, 1741; as *The Anatomical Plates of Pietro da Cortona: 27 Baroque Masterpieces*, edited by Jeremy M. Norman, New York and London, 1986.

On PIETRO da Cortona: books—

Munoz, A., *Pietro da Cortona*, Rome, 1921.
Marabottini, A., and L. Bianchi, *Pietro da Cortona* (cat), Cortona, 1956.
Briganti, Giuliano, *Pietro da Cortona o della pittura Barocca*, Florence, 1962, 1982.
DuBon, David, *Tapestries from the Samuel H. Kress Collection at the Philadelphia Museum of Art: The History of Constantine the Great, Designed by Peter Paul Rubens and Pietro da Cortona*, Philadelphia, 1964.

Campbell, Malcolm, *Disegni di Pietro da Cortona per Palazzo Pitti* (cat), Florence, 1965.
Noehles, Karl, *La chiesa dei SS. Luca e Martina nell opera di Pietro da Cortona*, Rome, 1970.
Campbell, Malcolm, *Pietro da Cortona at the Pitti Palace*, Princeton, 1977.
Giannatiempo, Maria, *Disegni di Pietro da Cortona e Ciro Ferri* (cat), Rome, 1977.
Pietro da Cortona: Architetto (colloquium), Cortona, 1978.
Duhme, Lüdike, *Die Tabulae anatomicae des Pietro da Cortona*, Cologne, 1980.
Il voltone di Pietro da Cortona in Palazzo Barberini, Rome, 1983.
Merz, J. M., *Pietro da Cortonas Entwicklung zum Maler des römischen Hochbarock*, Göttingen, 1988.

articles—

Blunt, Anthony, "The Palazzo Barberini: The Contributions of Maderno, Bernini, and Pietro da Cortona," in *Journal of the Warburg and Courtauld Institutes* (London), 29, 1958.
Briganti, Giuliano, "L'altare di Sant Erasmo, Poussin e il Cortona," in *Paragone* (Florence), 11, 1960.
Wirbal, N., "Contributi alle ricerche sul Cortonismo in Roma, i pittori della corte di Alessandro VII nel Palazzo Quierinale," in *Bollettino d'Arte* (Rome), 45, 1960.
Ost, H., "Studien zur Pietro da Cortonas Umbau von S. Maria della Pace," in *Römisches Jahrbuch für Kunstgeschichte*, 13, 1971.
Preimersberger, R., "Zu Pietro da Cortonas Galleria Pamphili . . . ," in *Sitzungsberichte Kunstgeschichtliche Gesellschaft zu Berlin*, 21, 1972–73.
Kemp, M., "Dr. William Hunter on . . . His Volume of Drawing Attributed to Pietro da Cortona," in *Burlington Magazine* (London), 118, 1976.
Coffey, C., "Pietro da Cortona's Project for the Church of San Firenze in Florence," in *Mitteilungen des Kunsthistorischen Institutes in Florenz*, 22, 1978.
Kenworthy-Browne, John, "Rysbrack, Hercules, and Pietro da Cortona," in *Burlington Magazine* (London), April 1983.

*

Pietro da Cortona was almost an exact contemporary of Gian Lorenzo Bernini and Francesco Borromini. He is rightfully identified as the third member of this trio of artists who shaped the style we have come to identify as the Roman High Baroque. Like Bernini and Borromini, Cortona was an architect, but, unlike either of them he was primarily a painter. Overshadowed by his two contemporaries in the literature of art, his full contribution remains to be essayed. Whereas Bernini and Borromini enjoyed relatively swift recognition once they had received individual commissions, Cortona's emergence was gradual. In fact, his earliest work reveals little of the hot breath of genius. The Florentine artists from whom he received his first training can have offered him little more than technical instruction, but they did have connections with Tuscan prelates, especially the Sacchetti family, and, even more significantly, with the artists, advisors, antiquarians, and connoisseurs in the circle of Pope Urban VIII Barberini. Through these connections Cortona was able to study the paintings of

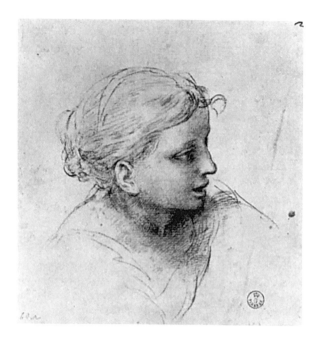

Head of a Young Woman; drawing; Florence, Uffizi

Raphael, Michelangelo, Veronese, and Titian, to draw from the antique, and to work in association with Domenichino, the most distinguished painter in Rome in the early 1620's, and with the younger, talented Nicholas Poussin.

In his frescoes on the nave walls of S. Bibiana, 1624–26, he created a series of intensely dramatic scenes from the life of the saint in which large-scale figures interact along strongly stated diagonal lines of movement, and an illusionistic architecture frames the scenes and presents life-like figures of the saint's family posed in niches. The richness of effect suggests the study of Venetian painting, especially that of Veronese, and also points to Cortona's absorption of the colorism of Peter Paul Rubens, whose work the younger artist would have known at S. Maria in Vallicella. In contrast to the freize-like compositions preferred by Domenichino and generally adopted by Poussin, Cortona seems to have returned to the work of Annibale Carracci and to have imbued the figures of that master's Farnese Gallery with the movemented forms of the contemporary sculpture of Bernini. This stylistic development reaches splendid fruition on Cortona's *Rape of the Sabines* painted c. 1629, when he was in his early thirties and on the eve of his first monumental commission, the ceiling of the great Salone of the Barberini Palace in which he worked 1633–39. This ceiling, the masterpiece of his early maturity, established him as the leading Roman painter of monumental decorative programs. In 1637, while the Salone decorations were underway, Cortona journeyed to Venice, stopping in Florence, where he started a cycle of frescoes depicting the *Four Ages of Man* in a small room in the Pitti Palace, then the residence of the grand ducal Medici. The *Ages* opened the way to an extensive commission to decorate the ceilings of five large rooms comprising the grand ducal formal presentation rooms. These ceilings, each dedicated to a planetary diety, were decorated over nearly a quarter century and completed by Cortona's pupil, Ciro Ferri. As an ensemble they demonstrate the extraordinary variety of Cortona's compositional style,

ranging from the Venus Room, where the ceiling painting is treated almost as if it were a framed wall painting, to the Mars Room where the structure of the room appears to stop at the cornice and the vault is illusionistically painted to suggest the figural action takes place in completely open space. In each room the ceiling frescoes are set in a rich panoply of highly ornamented and richly figural surrounds of white and gilded stucco. In richness and grandeur the effect was unprecedented and profoundly influenced future development of the secular decorated ceiling. At Versailles Charles Lebrun and his *équipe* of artists adopted Cortona's system at the Pitti Palace in both form and content. It is now generally acknowledged that the "Style Louis XIV" owes more to the decorations of Cortona at the Pitti Palace than to any other single source. The free dispersal of figures and rich colourism of the Mars Room was to be a fundamental influence on Luca Giordano and Gianbattista Tiepolo.

Returning to Rome in 1647, Cortona undertook two major fresco commissions in addition to many paintings. At S. Maria in Vallicella he frescoed the dome and its pendentives (1647–51) and then later (1655–60) he extended the theme of the dome—*The Trinity to Glory*—to the apse, where he frescoed the *Assumption of the Virgin* and also produced a separate fresco of a *Miracle of S. Charles Borromeo* in the nave vault. While at work at S. Maria in Vallicella, Cortona painted for Pope Innocent X the ceiling of the long gallery in the Pamphili Palace (1651–54).

Of the Bernini, Borromini, and Cortona triumvirate, only Cortona was a major practioner of painting as well as architecture. Like his two rival architects, Cortona trained in the studio of Carlo Maderno and he worked on the Barberini Palace (c. 1628–33). During the same years he designed the Villa del Pigneto and a villa at Castelfusano for the Sacchetti. He emerged as a major figure in the field of architecture in the design of the church of SS. Martina e Luca (1635–64). A greek-cross-plan church whose highly innovative, richly columned interior wall articulation and convexly curved facade point to inspiration from Michelangelo and Palladio. Cortona's other principal completed commissions were modifications of existing churches. At S. Maria della Pace (1656–57) he added a frontispiece that greatly expanded the facade of the church and redesigned the space in front of it where three narrow streets converged into a seemingly spacious piazza. At S. Maria in Via Lata (1658–62) he added a portico to an existing church, creating an elegant two-storied porch. An amalgam of his two earlier church facades, this design is also a critique of the more ostentatious facade Borromini had designed for S. Carlo alle Quattro Fontane. Other important projects include a reconstruction of the Roman temple sanctuary at Praeneste (now Palestrina) and a series of proposals that came to naught: the transformation of the facade and gardens of the Pitti Palace (c. 1640), designs for the Florentine church of S. Firenze (1645–64), which brilliantly revised Vignola's scheme for the Gesù, a fountain and palace facade project for the Chigi Palace in Piazza Colonna (1658), and an entry in the 1664 design competition for the east facade of the Louvre. Cortona's designs, both those executed and projected, influenced his contemporaries, including Bernini, and also the architects of the late Baroque, especially Nicola Salvi's design for the Trevi Fountain.

—Malcolm Campbell

PIGALLE, Jean-Baptiste.

Born in Paris, 26 January 1714. Died in Paris, 21 August 1785. Trained with the sculptor Robert Le Lorrain from the age of eight; then studied with Jean Baptiste Lemoyne, Paris, c. 1734, and also at the Royal Academy; attended the French Academy in Rome, 1736–39; lived in Lyons 1739–41; then settled in Paris: commissions for churches, and also patronized by Mme. de Pompadour and the king; member of the Academy 1744 (Professor, 1752, and Chancellor, 1785); works include Tombe of Maréchal de Saxe, S. Thomas, Strasbourg, 1735–36, and the nude Voltaire, 1776.

Major Collection: Paris.
Other Collections: Abbeville; Baltimore; Bayonne; Berlin; Cambridge; Lyons: Eglise de la Chartreuse; New York; Orleans; Paris: S. Sulpice, S. Eustache, Jacquemart-André; Strasbourg; Versailles.

Publications

On PIGALLE: books—

Rocheblave, Samuel, *Le Mausolée du Maréchal de Saxe par Pigalle*, Paris, 1901.
Pélissier, Georges, *Pigalle: His Life and Work*, New York, 1907.
Pélissier, Georges, *The Mercury and the Venus aux Colombes*, New York, 1908.
Rocheblave, Samuel, *Pigalle*, Paris, 1919.
Réau, Louis, *Pigalle*, Paris, 1950.
Gaborit, Jean Rene, *Pigalle: Sculptures due Musée du Louvre* (cat), Paris, 1985.

article—

Gordon, Katherine K., "Madame de Pompadour, Pigalle, and the Iconography of Friendship," in *Art Bulletin* (New York), September 1968.

*

Jean-Baptiste Pigalle was without doubt, with Edme Bouchardon, Guillaume Coustou, and Jean-Antoine Houdon, one of the most famous artists of the 18th century, and the most renowned in his lifetime. At the end of his career he even became chancellor of the Royal Academy of Painting and Sculpture (1785), a supreme honour never received before him by a sculptor.

He was descended from a dynasty of woodcarvers which for three generations had lived in the old Parisian quarter of the Faubourg Saint-Martin. Pigalle's father intended him to become a stone carver, and he entered first the studio of Robert Le Lorrain, a sculptor attached to the Rohan family, then that of Jean-Baptiste Lemoyne II, whose influence is felt in the first known work by the artist, a *Head of a Triton* (1735, terracotta, Berlin), particularly in the vivacity of the pose and expression and the broad treatment of the hair.

Having failed at the sculpture competition (the "prix de Rome"), he made the Italian journey at his own expense and stayed three years in Rome. He must have copied from the antique, but we know that he was impressed by the Italian Baroque. On his return to Paris in 1741 via Lyons, where the four *Evangelists* in the pendentives of the church of the Chartreux are attributed to him, Pigalle was accepted into the Academy with a figure of *Mercury Attaching His Winged Sandals* (1744, Louvre) which he produced in marble as an acceptance piece. A terracotta at the Metropolitan Museum, New York, is thought to relate to the acceptance piece. The work had a lively reception. Together with a statue of Venus ordering him to transport a message, the *Mercury* was produced by Pigalle on a monumental scale by royal command in 1742. The two statues were sent as diplomatic gifts to Frederick II, King of Prussia (formerly in the park of the palace of Sans-Souci at Potsdam; now Bode Museum, East Berlin). With the perfect balance between the idealization of the faces, the rendition of anatomy after a living model, the subtle composition, and the turning of each pendant figure, the success of the sculptures was also sanctioned by the interest shown in the artist by the Madame de Pompadour. He executed the bust of Louis XV's favourite (New York) from a block of marble excavated from a French quarry which had just been discovered in the French Pyrenees. The quarry proved definitively unsuitable for statuary, and the monopoly of the Italian quarries such as Carrara were not threatened!

It was for Madame de Pompadour that Pigalle produced one of his masterpieces, *Friendship* (1753, marble, Louvre), whose face depicts the Marquise's features; simply dressed in white dress, she presents her heart in a grand gesture of welcome towards the statue of the king that was its pendant in a grove in the park of her castle at Bellevue. The sheaf of flowers of all seasons spread out at her feet signifies that in contrast to the ephemeral Love, Friendship is durable and flowers in all the seasons of life. Favoured by Mme. de Pompadour, this iconography is found in another work by Pigalle intended for the gardens of Bellvue, the *Love Embracing Friendship*.

The activity of the sculptor in the service of Mme. de Pompadour did not distract him from two important jobs of an eminently political character. The first was a royal commission in 1753 for the marble *Tomb of the Maréchal de Saxe* which was to be installed in 1776 in the temple of St. Thomas in Strasbourg. The iconography is ambitious: the standing marshal descends towards the tomb; to his right are frightened animals, symbols of the conquered nations. France in mourning attempts to restrain him and to distance Death, a skeleton dressed in a large veil. The work is lyrical, influenced by Baroque scenography (particularly Bernini), and in spirit is close to compositions by Roubiliac. The genius of Pigalle can be recognized in a sober treatment of the figures, without idealization or gesticulation.

The second monumental commission is linked to a programme of urban renovation for the town of Rheims, which decided to erect in the center of town a new royal square a monument in bronze representing Louis XV (1755). The monument created by Pigalle can be considered the beacon of the century of the Enlightenment, conceived in close collaboration with Diderot (and the advice of Voltaire). The king, in classical dress, dominates the two allegorical figures in the *Gentleness of Royal Government* and the *Happy Citizen* (an overwhelming self-portrait of the artist). The sovereign is not

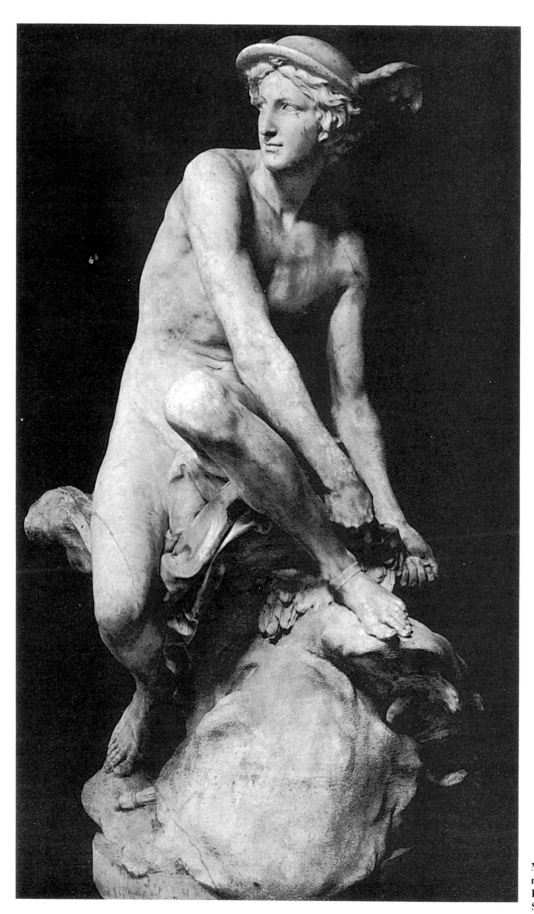

Mercury, 1746–48;
marble; 6 ft 1 in (185 cm);
East Berlin,
Staatliche Museen

the warlike conquerer of slaves or commander of soldiers, according to the usual theme of Desjardins and Lemoyne, but an enlightened despot, bringing abundance and happiness to his people.

Pigalle's capacity to take on large projects brought him important commissions such as the tomb of the comte d'Harcourt (1770, marble, Paris, Notre-Dame), the completion of the bronze equestrian monument of Louis XV (1763–72; destroyed during the Revolution) conceived by Bouchardon for the present Place de la Concorde, and what can be considered his masterpiece, the *Nude Voltaire*. Alongside this was the production of religious sculptures of beautiful quality and, above all, portraits of intimates in which the expressiveness, the reality, and the concern for psychological characterization revealed to them make the sculptor one the the great portraitists of the century.

—Guilhem Scherf

PILON, Germain.

Born c. 1528; son of the sculptor André Pilon. Died 3 February 1590. Married 1) Marguerite Alain, one son and two daughters; 2) Madeline Beaudoux, 1559, two daughters; 3) Germaine Durand, 1567, nine children. Influenced by Primaticcio's mannerist plaster decorations at Fontainebleau; worked in marble, bronze and plaster: commissions from the goldsmiths group from 1555; made sculptures for the tomb of Francis I, 1560–63; devised elaborate decorations (architecture, sculpture, and painting) for the Entry of Charles IX and Elisabeth of Austria into Paris, 1570; named Contrôleur Général des Monnaies, 1572; took on other courtly tasks such as busts, statues, and medals.

Major Collection: Paris.
Other Collections: Ecouen; Le Mans: Notre Dame de la Couture; London: Wallace; Orleans; Paris: St.-Paul-St.-Louis, St.-Jean-St. François; St. Denis: Basilica.

Publications

On PILON: books—

Babelon, Jean, *Pilon: Biographie et catalogues critiques: L'Oeuvre complète de l'artiste*, Paris, 1927.
Terrasse, Charles, *Pilon*, Paris, 1930.

article—

Grodecki, Catherine, "Les Marchés de Pilon pour la chapelle funéraire et las tombeaux des Birague en l'église Sainte-Catherine du Val des Ecoliers," in *Revue de l'Art* (Paris), 1981.

*

Germain Pilon's working years span the most troubled of the 16th century, a time of great strife for France, torn apart by the Wars of Religion. Perhaps one of the most characteristic of Pilon's traits was his ability to proceed along the path of his career and to rise steadily in his social, financial, and professional life, the contentions and difficulties of the time apparently not affecting him. However, his work, though free from exaggerated signs of tension, and full of grace and precision, often does not hide the quality of restlessness typical of the period.

We know little about the first years of Pilon's artistic life, but his early training must have been in his father's workshop. Ultramontane influences were assimilated into his art, but no documentary evidence supports a trip to Italy. We know from his tall female figures, with their elongated hands and feet, how much he was attracted to the models of the first school of Fontainebleau. In 1558 he worked under Primaticcio, executing figures for the tomb of Francis I. They were never put in place but one remains, now in Ecouen, a torch-bearing putto, which is already a mature work. Pilon stamped it with several traits he was going to use during his whole career: the gently spiralling pose, the weight of the body borne on one leg, both aspects of mannerism, the closely rolled curls framing the face, and the sympathetic treatment of the child, added to the naturalistic attention he gave to the round and health body.

The most important work of the first part of his career is the *Monument for the Heart of Henry II*, now in the Louvre, which was commissioned in 1560. Though the work was carried out by several artists Pilon received the lion's share, and from that time broke ahead of the group of sculptors working on royal projects. During the rest of his life he was never without a royal commission. The lack of serious competition, and the fact that his talent suited the wishes of Marie of Medicis and Primaticcio, gave Pilon supremacy.

In this monument, three Graces, back to back on an ornamental pedestal by Dominique Florentin, balance the urn on their heads. Never before had so pagan a monument been conceived for the heart of a king. Pilon idealized the long figures, played with their attitudes, dress, and hair, and coaxed the surface of the marble to a full softness. Their bodies give in to an almost unconscious transition of pose, which has been likened to a dance. The fine, crumpled drapery which covers them often breaks the very linear style of Fontainebleau with a fluid billowing, resulting in a fullness around the waist and hips. This type of drapery is often to be found in Pilon's art, but in more formal works it takes on a weight and geometry all its own, as in the heavy coat of the kneeling Cardinal de Birague.

Beginning in 1563 Pilon was engaged in work for the funerary chapel of the Valois in St. Denis, where the *Tomb of Catherine of Medicis and Henry II*, a *Resurrection Group*, and the statue of a *Deploring Virgin*, now both in the Louvre, were to be placed.

For the tomb, whose design was not Pilon's responsibility, he sculpted the effigies of the rulers, using bronze for the kneeling statues and marble for the image of their "gisants," or cadavers. Both representations of Henry II are striking in their veracity (though there is no trace of the wound which was fatal to the king), and are reminiscent of contemporary portrait drawing, the kneeling statue reflecting intense life. Those of Catherine of Medicis are idealized, the praying figure a little conventional, the "gisant" a sinuous, spiralling feminine body

Christ Risen, c. 1572; marble; life-size; Paris, Louvre

untouched by age, holding a highly unlikely pose, which contrasts with the rigidity of her husband. The head is not thrown back, but only resting on the pillow supporting her, the youthful face at rest.

The religious statues for the Valois chapel, executed in the 1580's, and other religious commissions, illustrate different tendencies in Pilon's art. In the risen *Christ* there remains the Renaissance hankering after formal beauty, the manneristic elegance of hands and feet, the sinuosity of the forward move-

ment found in previous years. The intense religiosity emanating from the pyramidal figure of the *Deploring Virgin* is unusual in the sculptor's oeuvre, as is the fervor expressed in the statue of *Staint Francis* in the church of St. Jean-St. François. The first is more enclosed in grief than the medieval deplorations she calls to mind, for she does not hold the body of Christ; the second, because of the saint's outbursting ardor, one is tempted to dub a precursor of the baroque though it recapitulates Pilon's artistic manner. In other religious works, such as the *Virgin* of the church of La Couture in Le Mans, Pilon bypassed deep spirituality and gave the statue something more like the thoughtfulness of his allegorical figures.

In 1572 Pilon was named Contrôleur Général des Monnaies, and in this capacity he provided drawings and wax models for the moneymakers. From the 1570's are dated a series of royal busts (for example *Charles IX* is the Wallace Collection) and medals most often attributed to Pilon on purely stylistic grounds. We know from the medal of *René de Birague* that Pilon's talent in that area was unusual, the engraving being particularly fine, his precision of detail and psychological acumen admirable.

Pilon, not an entirely original talent, nevertheless developed his own particular style, a blend of the "maniera" and naturalistic details. He reached a high level of technical ability and psychological finesse, fitting tools for his personal interpretation of others' ideas, and for his true and sensitive portraits which certainly left their mark on 17th-century sculpture (though Pilon had no close followers).

—Deborah Palmer

PINTORICCHIO. [Pinturicchio.]

Born Bernardino di Betto di Biagio, in Perugia, c. 1454. Died in Siena, 11 December 1513. Probably a pupil of Fiorenzo di Lorenzo, and worked with him on *Adoration of the Magi*, S. Maria Novella, Florence; assisted Perugino on frescoes in Sistine Chapel, early 1480's: also worked on Ara Coeli, c. 1484, and S. Maria del Popolo, c. 1500, both in Rome; worked on Orvieto Cathedral, 1492, 1496, Borgia Apartments in the Vatican, 1493, S. Maria de' Fossi, Perugia, 1496–98, San Severino Cathedral, c. 1498, S. Maria Maggiore, Spello, 1501, and Siena Cathedral, Piccolomini Library, 1502–07.

Collections: Baltimore: Walters; Berlin; Boston: Gardner, Museum of Art; Budapest; Cambridge; Cleveland; Dresden; London; Milan; Naples; New York; Oxford; Paris; Perugia; Philadelphia; San Gimignano; San Marino, California; Siena: Cathedral, Museum; Spello; Spoleto: Cathedral; Vatican; Washington.

Publications

On PINTORICCHIO: books—

Schmarsow, August, *Raphael und Pintoricchio in Siena*, Stuttgart, 1880.

Schmarsow, August, *Pintoricchio in Rom*, Stuttgart, 1882.

Ehrle, Francesco, and Enrico Stevenson, *Gli affreschi del Pintoricchio nell'appartamento Borgia del Palazzo Apostolica Vaticano*, Rome, 1897.

Phillipps, Evelyn March, *Pintoricchio*, London, 1901.

Ricci, Corrado, *Pintoricchio*, London and Philadelphia, 1902.

Goffin, Arnold, *Pintoricchio*, Paris, 1908.

Carli, Enzo, *Pintoricchio*, Geneva, 1953.

Carli, Enzo, *Il Pintoricchio*, Milan, 1960.

article—

Oberhuber, Konrad, "Raphael and Pintoricchio," in *Studies in the History of Art* (Hanover, New Hampshire), 17, 1985.

*

In any discussion of painters of the High Renaissance, Pintoricchio, if mentioned at all, is invariably placed in the second rank, far below Perugino, Signorelli, and of course Raphael, his considerably younger contemporary. Primary blame for such facile dismissal of an artist who in his day enjoyed considerable standing in a highly competitive creative community must be placed on Vasari who in his *Lives* introduces the Umbrian as one of "fortune's favorite children . . . who depend on her only, unaided by ability of any kind." And he goes on to say that Pintoricchio, "although he performed many labours and received aid from many persons, had nevertheless a much greater name than was merited by his works." Vasari then proceeds to describe the artist's frescoes in Siena's Piccolomini Library, boldly prefacing his remarks by claiming that "the sketches and cartoons for all the stories which he executed in that place were by the hand of Raphael of Urbino, then a youth," and on that basis, we must assume, feels free to view this remarkable work in a rather favorable light: "The pictures are all painted with the finest and most animated colours; they are besides decorated with ornaments in gold, and the ceiling is divided very well into designed compartments."

The Perugia into which Pintoricchio was born was a flourishing commercial and artistic center. The splendid Palazzo Communale, whose somber Romanesque-Gothic bulk is superbly graced by medieval Italy's most beautiful exterior staircase, features frescoes by Benedetto Buonfigli and Fiorenzo di Lorenzo. The most important artist of that time, however was Perugino, and while Pintoricchio in his early days, as claimed by Ricci, may have worked with Fiorenzo di Lorenzo, who "has in embryo those tints of mother-of-pearl, which in the hands of the younger [Pintoricchio] developed into the richer radiance of the opal," and whose motives, groups, and figures seem to recur in Pintoricchio's later works, a much stronger influence was that of Perugino, who, despite Vasari's disparaging observation, must have found in Pintoricchio both ability and merit. Had this not been the case he would certainly not have invited him to assist with the completion of the frescoes in the Sistine Chapel. The contract for these frescoes—now often totally ignored by the throngs of visitors whose eyes immediately turn upward to Michelangelo's ceiling—was signed by the four principal artists, Rosselli, Botticelli, Ghirlandaio, and Perugino in 1481, Pintoricchio's 27th year. Attributed to

him are key sections of Perugino's *The Journey of Moses* and *The Baptism of Christ*, where figures, gestures, and other details relate closely to drawings in *The Venice Sketch Book*, now generally accepted to be from the artist's hand. Comparison between these two works and subsequent Pintoricchio frescoes in the Bufalini Chapel and the Piccolomini Library also suggests his considerable participation in the landscape features so prominent in Perugino's Sistine Chapel frescoes.

That his contribution to these works must have met with complete approval is borne out by his subsequent commissions, first the S. Bernardino sequence in the Bufalini Chapel of Santa Maria in Aracoeli, a sensitively conceived and skillfully executed series of narratives of the Umbrian saint for whom he was named. Much of the purely decorative work—painted pilasters, gilded vaultings, ribbons of framing—areas in which even Vasari acknowledges Pintoricchio's mastery, has not survived well. Yet even in their ruinous state they reveal an inventive and subtly elegant approach in decorative design, and, in keeping with the sober subject at hand, muted rather than flamboyant. His recent encounter with his seniors in the Sistine Chapel are in evidence: the landscape in *S. Bernardino in the Desert* relates to Perugino's *The Journey of Moses* as well as Signorelli's *The Last Days of Moses*, and *The Funeral of S. Bernardino* owes its compositional scheme and architectural details to Perugino's *Christ Handing the Keys to St. Peter*. However, the representations of the saint and the surrounding figures are painted with passionate devotion to the subject, and in the central fresco, *Glorification of S. Bernardino*, the decorative and spiritual merge into an image of moving humility and solemn grandeur.

In the early 1490's Pope Alexander IV, the notorious Rodrigo Borgia, commissioned Pintoricchio to decorate the family's apartments in the Vatican. In five consecutive rooms the artist and his assistants painted lunettes and vaultings with subjects from the Classical and the Christian world, the sheer bulk of the work threatening its content and continuity and tending to reduce the viewer's impression to a repetitious display of decorative skill. Yet within this multiplicity of images are some of considerable charm, such as the Della Robia-like music-making angels in *The Assumption of the Virgin*, calm spirituality, as in *The Annunciation*, and great vitality as in *The Dispute of St. Catherine of Alexandria*, "protectress of those who bear the name Alexander and of bastards," so that the pope "had good reason to commend his sons to her."

The Borgia frescoes were neither appreciated nor cared for by subsequent popes and therefore went into rapid decay, reaching their nadir in the 17th and 18th centuries when the rooms were divided into small cells intended to accommodate cardinals during the conclaves. It was only in 1891 that the rooms were restored, although with much of their former glory only faintly visible. Very recently the Borgia Rooms serve as the setting for the papal collection of modern art, through which Pintoricchio's frescoes have become available to the public. Yet the majority of visitors to the rooms, having chosen a detour on the way to the Sistine Chapel, merely stroll through, viewing the new display on the walls and ignoring the richly painted pilasters, lunettes, and vaultings.

Following a hectic life in Rome, where several churches and palaces feature frescoes attributed to him, Pintoricchio left the papal city in the mid-1490's, returning to his Umbrian home base. During the last years of the century he produced frescoes

AENEAS SILVIVS PICOLOMINEVS NATVS EST PATRE SILVIO MATRE VI
CTORIA XVIII · OCTOB · ANN · MCCCC · V · CORSIANI INFVNDIS
GENTILITIIS BASILEAM AD CONCILIVM CONTENDENS VI TEMPESTA
TIS IN LYBIAM PROPELLITVR·

Life of Enio Silvio—detail, 1505–07; Siena, Piccolomini Library

in the apse of the Orvieto cathedral—now only faintly visible—in the Eroli Chapel of Spoleto cathedral, in Pilazzo Communale in Assisi, and, in the early 1500's, in Santa Maria Maggiore in Spello. To this period belong also his best-known panel paintings, most of them now in various European and American collections, although perhaps the finest, an altarpiece in Santa Maria dei Fossi, is a key work in Perugia's National Gallery of Umbria. Painted within architectural spaces separated by pilasters and pediments, very similar to Renaissance church facades such as that of Alberti's enhancement of Santa Maria Novella in Florence, the polyptych has as its center an enthroned Madonna clearly derived from the same figure in the Borgia *Annunciation*—facial features, pose, and attire are nearly identical—only with an expression more youthfully mellow. Two works from the same period, each a Madonna and Child, one in the Fitzwilliam Museum in Cambridge, the other in the National Gallery, London, show the same relationship to the Borgia *Annunciation*, hence also the Madonna in the Santa Maria dei Fossi altarpiece.

In 1502 Pintoricchio settled in Siena to begin working on the decoration of the Piccolomini Library, a structure extending from the left side aisle of the cathedral and built to accommodate the impressive book collection accumulated by Enea Silvio Piccolomini, a poet and scholar who became Pope Pius II. Cardinal Francesco Piccolomini, Enea Silvio's nephew, who, as Pius III would occupy the papal throne for two months in 1503, had begun the library construction in 1492. Finely crafted shelves and bronze gratings and a magnificently carved marble entrances were already in place when Pintoricchio reached an agreement with the cardinal in 1502. Among other details the agreement stated that while engaged in this work the artist would accept no other commission, that he would paint all figures *al fresco* and thereafter finish them off *a secco* using only good quality colors. After many delays and considerable preparatory work Pintoricchio began working on the frescoes in 1505 to finish them in two years. He depicts ten crucial episodes in the life of Enea Silvio, beginning with his journey to the Council in Basel and ending with the heroic stage in his papacy when, mortally ill, he awaits the Venetian fleet in Ancona to bless its crusading efforts.

Vasari claims that the preparatory cartoons for the frescoes were largely the work of Raphael, but newer investigations tend to discount that possibility. While Pintoricchio must have had many able assistants working with him in the library—the fresco technique required many hands—the exuberantly brilliant appearance of the room must be considered the artist's crowning achievement. Says Ricci: "If we contemplate the whole from the end of the room, under the windows, so that we are not dazzled by the direct light, everything we see . . . melts into a music which, if not invariably harmonious, is jubilant with vibrating high-toned voices; we are in a garden, which, if not sweet with dreamy poetry, is full of brilliant flowers, of vivid spring sunshine, of twittering birds."

Several fresco commissions followed, in Siena, Spello, and Rome, and there are panel paintings as well from these last years of the artist's life, among them an impressive *Assumption of the Virgin with Saints Gregory and Bernardo* painted for the Abbey of Monteoliveto Maggiore and now in the Civic Museum of San Gimignano, characterised by clarity of design and lofty dignity.

—Reidar Dittmann

PIRANESI, Giovanni Battista.

Born in Moiano di Mestre, 4 October 1720. Died in Rome, 9 November 1778. Married Angela Pasquini, 1752; daughter, Laura, and son, Francesco, both his collaborators, and three other children. Studied architecture with his uncle Matteo Lucchesi and with Giovanni Antonio Scalfarotto in Venice, and etching with Carlo Zucchi in Venice; in Rome, 1740: studied perspective and stage design with Domenico and Giuseppe Valeriani, and etching with Giuseppe Vasi; first published book of etchings, 1743 (*Prima parte di architetture e prospettive*), followed by trips to Venice; settled in Rome, c. 1745: series of antique Roman views, imaginary prisons, etc. also an architect: rebuilt S. Maria del Priorato, Rome, 1764–65; other books of adornment and decoration.

Collections: Berlin; Copenhagen; Florence; Hamburg; London: British Museum; Madrid: Biblioteca Nacional; New York: Columbia University, Morgan Library.

Publications

By PIRANESI: books—

The Polemical Works (includes *Lettere di giustificazione, Della magnificenza, Parere, Diverse maniere*), edited by John Wilton-Ely, Farnborough, 1972.

On PIRANESI: books—

Hermanin, Federico, *Piranesi, architetto ed incisiore,* Turin, 1915, Rome, 1922.

Focillon, Henri, *Piranesi: Essai de catalogue raisonné de son oeuvre,* Paris, 2 vols., 1918; edited by Maurizio Calvesi and Augusta Monferini, Bologna, 1967.

Focillon, Henri, *Piranesi,* Pairs, 1918, 1963.

Munoz, A., *Piranesi con prospetto bibliografico e un indice di tutti le opere incise,* Rome, 1920.

Morazzoni, Giuseppe, *Piranesi, architetto ed incisore,* Rome, 1921.

Hind, Arthur, M., *Piranesi: A Critical Study with a List of His Published Works and Detailed Catalogues of the Prisons and the View of Rome,* London, 1922.

Ferrari, E. L., *Piranesi en la Biblioteca Nacional: Estudio preliminar y catalogo,* Madrid, 1936.

Mariani, V., *Studiando Piranesi,* Rome, 1938.

Pane, Roberto, *L' acquaforti di Piranesi,* Naplies, 1938.

Huxley, Aldous, and Jean Adhémar, *Prisons,* London, 1949.

Stampfle, Felice, *Piranesi* (cat), New York, 1949.

Corfiato, Hector O., *Piranesi Compositions,* London, 1951.

Mayor, A., Hyatt, *Piranesi,* New York, 1952.

Thomas, Hylton, *The Drawings of Piranesi,* London and New York, 1954.

Vogt-Göknil, U., *Piranesi: Carceri,* Zurich, 1958.

Parks, R. 0., editor, *Piranesi* (cat), Northampton, Massachusetts, 1961.

Praz, Mario, and L. Jannattoni, *Piranesi: Magnificenza di Roma,* Milan, 1961.

Adhémar, Jean, and Mme. Bonefant, editors, *Piranèse* (cat), Paris, 1962.

The Arch of Constantine, 1748; etching

Isola, Maria Catelli, et al., editors, *Incisioni di Piranesi* (cat), Bologna, 1963.

Volkmann, Hana, *Piranesi: Architekt und Graphiker,* Berlin, 1965.

Hermanin, Federico, L. Volpicelli, and C. A. Perucci, *Piranesi: Carceri d'invenzione,* Rome, 1966.

Keller, Luzius, *Piranèse et les romantiques français: Le Mythe des escaliers en spirale,* Paris, 1966.

Calvesi, M., editor, *Giambattista Piranesi e Francesco Piranesi* (cat), Rome, 1967.

Croft-Murray, E., editor, *Piranesi: His Predecessors and His Heritage* (cat), London, 1968.

Rossier, E., *Piranesi* (cat), Geneva, 1969.

Ebert, H., and R. Kroll, *Rom in Ansichten von Piranesi* (cat), Berlin, 1970.

Fouchet, M. P., *Piranesi: Les Prisons imaginaires,* Paris, 1970.

Murray, Peter, *Piranesi and the Grandeur of Rome,* London, 1971.

Hofer, Philip, *The Prisons (Le carceri) by Piranesi,* New York, 1973.

Bacou, Roseline, *Piranèse: Gravure et dessins,* Paris, 1974; as *Piranesi: Etchings and Drawings,* Boston and London, 1975.

Cressedi, G., *Un manoscritto derivato dalle Antichita del Piranesi,* Rome, 1975.

Nyberg, D., and H. Mitchell, *Piranesi Drawings and Etchings at the Avery Architectural Library, Columbia University, New York: The Arthur M. Sackler Collection,* New York, 1975.

Praz, Mario, *Piranesi: Le carceri,* Milan, 1975.

Scott, Jonathan, *Piranesi,* London and New York, 1975.

Levit, Herschel, *Piranesi: Views of Rome, Then and Now,* New York and London, 1976.

Piranèse et les français 1740–1780 (cat), Rome, 1976.

Wilton-Ely, John, *The Mind and Art of Piranesi,* London, 1978.

Stampfle, Felice, *Piranesi: Drawings in the Pierpont Morgan Library,* New York, 1978.

Miller, Norbert, *Archäologie des Traums: Versuch über Piranesi,* Munich, 1978.

Piranèse et les français (colloquium), Rome, 1978.

Bettagno, Alessandro, *Disegni di Piranesi* (cat), Venice, 1978.

Penny, Nicholas, *Piranesi,* London, 1978.

Lecaldano, Paolo, *Piranesi nel suo tempo* (cat), Milan, 1978.

Wilton-Ely, John, *Piranesi* (cat), London, 1978.

Harvey, Miranda, *Piranesi: The Imaginary Views,* London and New York, 1979.

Piranesi nei luoghi di Piranesi (cat), Rome, 1979.

Reudenbach, Bruno, *Piranesi: Architektur als Bild,* Munich, 1979.

Pane, Roberto, *Paestum nelle acqueforti di Piranesi,* Milan, 1980.

Robinson, Andrew, *Piranesi: Early Architectural Fantasies: A Catalogue Raisonnè of the Etchings,* Chicago, 1986.

*

Piranesi was an artist, architect, archeologist, and author, who is best known for his dramatic and imaginative engravings detailing the architecture of Rome and its vicinity.

Although he will forever be linked by his work to the City of Rome, Piranesi was a Venetian. He studied architecture in Venice, first with his uncle, Matteo Lucchesi, and later with Giovanni Antonio Scalfarotto, whose imaginative and eclective works were more in keeping with Piranesi's temperament than his uncle's more practical Neo-Palladianism. He also studied etching in Venice under Carlo Zucchi, but would receive further training in Rome with Guiseppe Vasi.

Piranesi first went to Rome when he was 20 years old as part of the Venetian ambassador's entourage. He was immediately overwhelmed by the beauty of a city he already knew well historically, thanks to the instruction of his older brother, a Carthusian monk. He traveled throughout the city and its environs making drawings of ancient and modern monuments. The result of this initial impact of the city was the publication of *Prima Parte di Architetture e Prospettive* in 1743. This work included 12 etchings of imaginary ruins, palaces, temples, and one prison scene. *The Ancient Temple of Vesta* is typical of these scenes. It includes a temple, based on the Pantheon, with coffered ceiling and oculus. The worm's-eye view and dwarfed figures monumentalize the architecture in a manner that became the hallmark of Pirenesi's style.

The artist returned to Venice, after a trip to Naples (1743), due to financial considerations. Although he remained only a year, it was a crucial period spent in the studio of Giambattista Tiepolo. Tiepolo's influence on Piranesi can be seen particularly in the many drawings done by the artist. Piranesi's *Group of Masqueraders* (Hamburg) is very similar, both stylistically and thematically, to Tiepolo's drawings. He was also influenced at this time by the *Capricci* of Canaletto and the stage designs of the Bibiena family.

Piranesi returned to Rome, following his year's stay in Venice (1744), never to leave again. He concentrated on making a living through his engravings, which he perfected in style and technique. This can certainly be seen in what is now one of his most celebrated works, the *Carceri*. The one prison scene included in the *Prima Parte* led to an extensive exploration of this theme. He designed 14 etchings for the *Carceri*, published in 1750 by Bouchard. This series was not very popular with the tourists that usually patronized Piranesi's works. He reworked them later, making them more darkly romantic and mysterious. This new set included two additional plates, as well as the torture devices and other dramatic aspects he introduced into the existing plates. Even with these changes, the *Carceri* did not really receive attention until later, when romantics appreciated the awe and horror they inspired in the viewer.

Piranesi is best known for his many ancient and modern views of Rome detailed in a variety of publications. His earliest views of Rome consisted of 48 small ($4^{1}/_{2}$″ x 7″) plates included in *Varie Vedute de Roma Antica e Maderna* (1745) which also contained works by the artists Anesi, Duflos, LeGeay and Bellicord. His best-known views of Rome, however, are those included in his four-volume *Antichità Romane* (1756) and the 133 plates of *Vedute di Roma* (1748–78). The second and third volumes of the *Antichità Romane* are dedicated to detailing the magnificent mausoleums built by the Romans, many of which lined the Appian Way. A fanciful array of these mausoleums fills the dedicatory plate of volume 2. This work was originally dedicated to Lord Charlemont, but due to controversy over his support, Piranesi later deleted the dedication.

His magnificent *Vedute di Roma* depicted the most popular tourist attractions in Rome, including the Colosseum, Pantheon, St. Peter's, and the Baths of Caracalla. These views were often sold separately to tourists, who could piece together their own souvenir of the city. Stylistically the works progress from a rather dry, detailed rendering of the monuments to powerful, monumentalized views highlighted with dramatic chiaroscuro. Some of the best-executed works in this series depict Hadrian's villa, which Piranesi took part in excavating.

Piranesi's passonate personality and loyalty to his Italian culture rendered him perfect champion for the superiority of Roman antiquities over those of the Greeks. His argument for this cause was promoted in a work entitled *Della Magnificenza ed Architettura de'Romani* (1761).

Mid-18th-century Rome attracted artists from all over Europe, many of whom became friends with Piranesi. He was especially close to the artists studying at the French Academy in Rome, including the painters Vien and Robert.

The studio of Piranesi was maintained by his sons after his death, continuing the strong influence that Piranesi's powerful, theatrical, and creative depictions of Rome had on his contemporaries. Original etchings by Piranesi are included in a variety of collections, most notably the Ashmolean Museum, Oxford, and the Cabinet des Estampes of the Bibliothèque Nationale, Paris.

—Kathleen Russo

PISANELLO, Antonio.

Born Antonia Pisano, probably in Pisa, in or shortly before 1395, of a Pisan father and a Veronese mother, who moved her family back to Verona in Antonio's early childhood. Died, perhaps in Rome, 1455. Primarily a painter: his earliest certain work that survives, the S. Fermo *Annunciation* of c. 1426, shows the formative influences of Gentile da Fabriano and Stefano da Verona (Stefano da Zevio), although he was not a pupil of either artist; his experience, starting in 1438–39, of low relief sculpture in 22 medal designs influenced his painting and drawing style; some 400 drawings attributed to Pisanello and his followers also survive, for the most part in the Louvre.

Collections: Bergamo; Florence: Bargello; London: National Gallery, Victoria and Albert; Mantua: Ducal Palace; Paris; Verona: S. Anastasia, S. Fermo; Washington; medals and drawings in many other locations.

Publications

On PISANELLO: books—

Hill, George F., *Pisanello*, London and New York, 1905.
Guiffrey, Jean, *Les Dessins de Pisanello et de son école conservés au Musée du Louvre*, Paris, 4 vols., 1911–20.
Hill, George F., *Dessins de Pisanello*, Paris, 1929.
Degenhart, Bernhard, *Pisanello*, Vienna, 1940; Turin, 1945.
Brenzoni, Raffaello, *Pisanello*, Florence, 1952.
Sindona, Enio, *Pisanello*, Milan, 1961; New York, 1963.
Fossi Todorow, Maria, *I disegni del Pisanello e della sua cerchia*, Florence, 1966.
Schmitt, Annegrit, *Disegni del Pisanello e di maestri del suo tempo* (cat), Venice, 1966.

Weiss, Roberto, *Pisanello's Medallion of the Emperor VIII Paleologus*, London, 1966.

Baxandall, Michael, *Giotto and the Orators: Humanist Observers of Painting in Italy and the Discovery of Pictorial Composition 1350–1450*, Oxford, 1971.

Chiarelli, Renzo, *L'opera completa di Pisanello*, Milan, 1972.

Paccagnini, Giovanni, *Pisanello e il ciclo cavalleresco di Mantova*, Milan, 1972, as *Pisanello*, London, 1973.

Paccagnini, Giovanni, and Maria Figlioli, *Pisanello alla corte dei Gonzaga* (cat), Milan, 1972.

Da Pisanello alla nascita dei Musei Capitolini: L'antico a Roma alla viglia del Rinascimento (cat), Rome, 1988.

Woods-Marsden, Joanna, *The Gonzaga of Mantua and Pisanello's Authurian Frescoes*, Princeton, 1988.

articles—

Hill, George F., "On Some Dates in the Career of Pisanello," in *Numismatic Chronicle* (London), 11, 1931.

Baxandall, Michael, "Guarino, Pisanello, and Manuel Chrysoloras," in *Journal of the Warburg and Courtauld Institutes* (London), 28, 1965.

Degenhart, Bernhard, "Pisanello in Mantua," in *Pantheon* (Munich), 31, 1973.

Toesca, Ilaria, "A Frieze by Pisanello," in *Burlington Magazine* (London), 116, 1974.

Toesca, Ilaria, "More about the Pisanello Murals at Mantua," in *Burlington Magazine* (London), 118, 1976.

*

Study drawing; Rotterdam, Boymans-van Beuningen Museum

The painter and low relief sculptor Pisanello was the quintessential court artist of the early Italian Renaissance. He is notable for his role as the virtual reinventor of the art form of the medal, for the large number and quality of his surviving drawings, for the political eminence of his patrons, and for the praise which their court humanists lavished on his work.

A strong case can be made that Pisanello's patronage had a bearing on the formation and development of his artistic style and interests. Establishing his residence in 1422 in Mantua on the payroll of the 13-year-old Lodovico Gonzaga, Antonio settled early into his lifelong pattern of moving along various North Italian courts, especially Ferrara and Mantua. By the beginning of the next decade he had created work for the Duke of Milan and Pope Eugenius IV, and begun his long association with Leonello d'Este of Ferrara, at whose court he resided periodically during the 1430's and 1440's. In the 1440's he also worked for the Malatesta of Rimini and, again, the Gonzaga of Mantua before moving in 1448 to the Neapolitan court of King Alfonso V of Aragon.

The Este attracted a number of well-known humanists to Ferrara, including Pisanello's compatriot Guarino da Verona. It became fashionable among them to write poems and rhetorical eulogies in praise of Antonio's artistic skill. Since it was the job of the court humanist to articulate his prince's aspirations and values, these efforts indicate that Pisanello's work corresponded to an ideal in 15th-century court circles. The humanists focused on the convention of naturalism as the outstanding characteristic of Pisanello's work, and the artist's skill in giving eternal life to princes became the central theme of their literary exercises. Pisanello's contemporary fame thus rested primarily on his portraits and what was perceived, or at least vaunted, as their verisimilitude.

Little art is left to show for Pisanello's high-powered patronage and the humanists' unstinting praise. The two fresco cycles on which he succeeded Gentile de Fabriano, working in the Ducal Palace in Venice probably in the late teens and in St. John Lateran in Rome in 1431, are both lost. Until recently only frescoes in poor condition survived in two Veronese churches, S. Fermo (c. 1426) and S. Anastasia (probably mid or late 1430's). The only remaining panels that, although undocumented, are universally accepted as his are portraits in Bergamo and Paris and two private devotional panels in London. Although Pisanello always signed his medals OPVS PISANI PICTORIS, "the work of Pisano the Painter," his modern reputation was thus inevitably based on his medals and drawings until the discovery, in the mid-1960's, of the unfinished Authurian frescoes in Mantua (probably c. 1447–48). As his only known large-scale cycle on a secular narrative theme, it makes a significant addition to his meager corpus of surviving paintings.

While working at the Este court, Pisanello virtually reinvented the antique art form of the bronze medallion in 1438–39 with a medal of the Emperor of Constantinople. He was no doubt stimulated by Leonello d'Este's collection of Roman coins, his own drawings of Roman monuments, and his contact with the humanists Guarino da Verona and Leon Battista Alberti. Becoming enthusiastic over the possibilities of this new art form, Leonello ordered as many as nine medals of himself from Pisanello alone, and other rulers followed suit, so that

during the 1440's Pisanello created medals for many of the dominant personalities in contemporary Italian politics.

Pisanello's graphic work forms one of the largest and most important bodies of drawings to survive prior to that of Leonardo da Vinci, although only approximately 25 per cent of the extant folios can be attributed to the master himself. Since they illustrate the consuming interests of his patrons, however, the copies made by Pisanello's *bottega* and followers give an excellent idea of the range of tasks faced by a court artist. Some sheets show the appurtenances of war that was one of the chief preoccupations of these rulers, others the precious objects, textiles, and costumes that they loved. Pisanello also recorded their features and drew the delights of nature for them: flowers, birds, and animals. Many of these studies appear to have been drawn directly from life rather than based on formulas, the method followed by most contemporary artists. While many of the sheets undoubtedly represent a stockpiling of useful motifs in the manner of medieval modelbooks, they nonetheless also reveal much about early Renaissance workshop practice.

The salient characteristics of Pisanello's painting style were his extensive use of glittering gilded relief, his love of decorative patterning created by the juxtaposition of many motifs, and the rhythmic contours and sophisticated elegance of his figures. The gift for direct observation of nature that is evident in Pisanello's drawings was, however, in his paintings usually confined to the marginal areas of the content, such as horses, beasts, costumes, and background details. It was his acuity of observation of such details of nature which perhaps gave reality, and hence credibility, to his narrative and his idealized protagonists in the eyes of his first viewers. Pisanello rarely used any version of linear perspective construction although a drawing of a vaulted hall in perspective proves that he was conversant with the Albertian convention.

Pisanello is sometimes classified in surveys of the history of art as a late-medieval artist, but it is only by hindsight that the label "international Gothic" is attached to his work and that his style is assessed as less "humanist" than that of his successor as court painter in Mantua, Mantegna. For his patrons in the 1440's, Pisanello was *the* "humanist artist." The virtual reinventor of the ancient medal, he was also one of the first artists to study and collect classical art. The only 15th-century artist to be the focus of much humanist rhetoric, he also had the honor, unprecedented for an artist, of having two bronze medals dedicated to him during his lifetime.

—Joanna Woods-Marsden

PISANO, Andrea.

Born in Pontedera, c. 1290-95. Probably dead by October 1349. Sons: the sculptors Nino and Tommaso Pisano. Probably trained as a goldsmith; first mentioned in 1330 as working on bronze Baptistery doors, Florence, completed 1336; designed hexagonal reliefs for cathedral Campanile, 1334–c. 43; succeeded Giotto as capomaestro of Campanile, 1337–c. 43; operated a workshop in Pisa, c. 1343-47: Madonna and Child, Sts. Peter and Paul, S. Maria della Spina, Pisa,

Saltarelli Monument, S. Caterina Pisa; head of Orvieto Cathedral, 1347-49: succeeded by his son Nino.

Collections/Locations: Florence: Baptistery, Campanile; Pisa: S. Caterina; Orvieto: Museo dell'Opera del Duomo.

Publications

On PISANO: books—

Falk, Isle, *Studien zu Pisano,* Hamburg, 1940.
Toesca, Ilaria, *Andrea e Nino Pisano,* Florence, 1950.
Becherucci, Luisa, *Pisano nel Campanile di Giotti,* Florence, 1965.
Castlenuovo, Enrico, *Pisano,* Milan, 1966.
Burresi, Mariagiulia, and A. Caleca, *Andrea, Nino, e Tommaso, scultori pisani* (cat), Milan, 1983.
Kreytenberg, G., *Pisano und die toskanische Skulpture des 14. Jahrhunderts,* Munich, 1984.
Moskowitz, Anita F., *The Sculpture of Andrea and Nino Pisano,* New York and Cambridge, 1986.

article—

Becherucci, Luisa, "La bottega pisana di Andrea da Pontedera," in *Mitteilungen des Kunsthistorischen Institutes in Florenz,* 9, 1965.

*

Andrea Pisano is universally acknowledged as the most important Italian sculptor of the 14th century. He was trained as a goldsmith, presumably in Pisa, home of the founding fathers of Renaissance sculpture, Nicola and his son Giovanni Pisano—no relation to Andrea. Indeed, the artistic clarity of design and technical perfection gained in his early training remain evident throughout his career. Rather than aligning himself with the followers of Giovanni Pisano, whose intensely emotional style with its hyperenergetic forms continued to dominate Tuscan art, Andrea adhered more closely to a counter current represented by such Sienese artists as Tino di Camaino and Lorenzo Maitani. The painting of Giotto was also of fundamental importance to his style, as was French gothic art, examples of which he most likely knew by means of small imported objects of goldsmithwork rather than through direct acquaintance of French monumental art.

Andrea arrived in Florence c. 1329 when he was commissioned to design a set of bronze doors, signed and dated 1330, for the Baptistry of Florence. The doors, cast by means of the ancient lost wax method, illustrate 20 scenes from the life of John the Baptist and, on the two lowest rows, personifications of Virtues—all enclosed within decorative quatrefoil frames and rectangular moldings that contribute to the unity of the design as a whole. The narratives are based upon episodes both in the Gospel of St. Luke and in apocryphal writings popular in the 14th century. The doors reveal a remarkable stylistic and technical development from the earliest narratives on the left valve, which reveal some archaisms and a linear and decorative mode of design, to the later narratives on the

The Disciples Visiting St. John the Baptist in Prison—detail; bronze; Florence, Baptistery

right valve, which tend toward a more plastic and monumental relief conception.

The latter tendency continues in Andrea's next commission, a series of marble reliefs enframed in hexagons for the Campanile (bell-tower) of Florence Cathedral. The Campanile was designed by Giotto in 1334. Upon the his death in 1337, when only the lowest zone of the tower was complete, Andrea became Capomaestro (master architect) of the Campanile. He altered Giotto's design in favor of a solution that more intimately integrates Gothic and classicizing features. At the same time he continued work on the hexagonal reliefs. The Campanile hexagons divide into three stylistic groups. The earliest are conceptually and stylistically closest to the Baptistry reliefs, and these may be dated c. 1334–37. A second group, executed between 1337 and 1343, is markedly more monumental than the preceding reliefs and, moreover, are conceived *all'antica*. The earlier concern with three-dimensional space and lyrical forms is abandoned in favor of simple, monumental compositions in which the figures are placed against a flat, textured, but neutral background. Iconography, figure style, and relief mode are clearly based on antique models. A third series of hexagons betrays a retreat from the protohumanistic ideals of the preceding group and anticipates the style that has been associated in Tuscan painting with the years following the Black Death of 1348; these were created by a new workshop called in after Andrea's departure for Pisa c. 1343. In addition to the hexagons, Andrea executed the *Madonna and Child* in the lunette of the upper portal on the north side of the Campanile and several of the Sibyls and Prophets that embellish the niche zone. His Campanile statues, however, despite their warm humanity, show that the conflict between the figure conceived in three dimensions and the surface qualities of relief design has not been completely resolved.

Documents together with several sculptures that can be connected with them indicate that after leaving Florence Andrea returned to Pisa where he directed a workshop from c. 1343–47 and employed, among others, his son Nino. The Saltarelli monument in Sta. Caterina, Pisa, appears to be a product of this period. The master himself executed the *Madonna and Child* and closely supervised the design and execution of the angels on the upper and lower levels; Nino and other assistants were responsible for the rest of the statues and reliefs. Although the tomb was moved and reassembled several times and some minor elements are lacking, the extant parts combine into a masterpiece of integration and harmony. The eschatological components are not simply juxtaposed but are organized to introduce the element of *time* in the journey to salvation—that is, from life (the lowest zone with reliefs concerning the life of Archbishop Saltarelli) to death (the effigy on its bier) to the ascent of the soul (represented in the middle zone), and finally to heaven (the Virgin and Child at the pinnacle of the composition).

Also executed in Pisa are the *Madonna del Latte* and the *Madonna and Child,* both Sta. Maria della Spina. While retaining much of the lyrical quality of his Florentine statues, these sculptures demonstrate a more sophisticated handling of the relationship between body and drapery, a stronger distinction between the skeletal structure of the head and its fleshy covering, and a more harmonious balance between structural and decorative requisites. A *Maesta* group (Museo dell'Opera del Duomo, Orvieto), begun in Pisa and shipped to Orvieto for completion, includes the most classicizing of his Madonna and Child groups. Small in scale but monumental in conception, the Orvieto *Madonna* exhibits an articulate contrapposto stance and a naturalistic relationship of drapery to body in both front and back views. The *Madonna*'s warm serenity is the same, however, as seen in the Campanile sibyls, the *Madonna* in Sta. Maria della Spina, and the *Madonna del Latte.* The Orvieto *Madonna* and an accompanying angel (a second angel is the work of Nino) are Andrea's last known sculptures. He became Capomaestro of Orvieto cathedral sometime before May 1347 and may have contributed some architectural elements to the almost completed building.

Andrea Pisano was a creatively eclectic artist. In addition to Sienese sculpture, and northern Gothic art, he was profoundly influenced by the painting of Giotto. As a younger contemporary, he became the great painter's truest disciple and was the only 14th-century master capable of translating Giotto's narrative power into the language of sculpture. Finally, his strong response to classical sculpture heralded, and even inspired, some of the artistic achievements of early Renaissance sculptors in Italy.

—Antia F. Moskowitz

PISANO, Giovanni.

Born in Pisa, c. 1248; son of the sculptor Nicola Pisano. Died after 1314. Collaborated with his father on the great piazza, Perugia, 1274–78; cloister of the Campo Santo, Pisa, 1278–83; then worked on Siena Cathedral from 1285: began the facade, and was the master of the Cathedral, 1290–96; pulpits for S. Andrea, Pisoia, 1297–1301, and for Pisa Cathedral, 1302–10 (now reconstructed); monument to Margaret of Luxembourg in S. Francesco di Castelletto (fragments in Palazzo Bianco), 1312–13; several versions of the Madonna and Child are attributed to him; also worked in ivory and wood; many pupils.

Collections/Locations: Genoa: Bianco; London: Victoria and Albert; Padua: Arena Chapel; Perugia: Piazza; Pisa: Cathedral; Pistoia: S. Andrea; Prato: Cathedral; Siena: Cathedral.

Publications

On PISANO: books—

Brach, Albert, *Nicola und Giovanni Pisano und die Plastik des XIII Jahrhunderts in Siena,* Strasbourg, 1904.
Venturi, Adolfo, *Pisano,* Bologna and New York, 1928.
Keller, Harald, *Pisano,* Vienna, 1942.
Marangoni, M., *Omaggio a Pisano,* Urbino, 1943.
Wallace, R. Dan, *L'Influence de la France gothique sur deux des precurseurs de la renaissance italienne: Nicola et Giovanni Pisano,* Geneva, 1953.
Einem, Herbert von, *Das Stutzengeschloss der Pisaner Domkanzel: Gedanken zum Altarswerk des Pisano,* Cologne, 1962.

Adam (pulpit detail); marble; Pistoia, S. Andrea

Sauerlandt, Max, *Uber die Bildwerke des Pisano,* Dusseldorf, 1964.

Seidel, Max, *Pisano: Il pulpito di Pistoia,* Florence, 1965.

Ayrton, Michael, *Pisano, Sculptor,* London and New York, 1969.

Mellini, Gian Lorenzo, *Il pulpito di Pisano a Pistoia,* Milan, 1969.

Mellini, Gian Lorenzo, *Pisano,* Milan, 1970.

Seidel, Max, *La scultura lignea di Pisano,* Florence, 1971.

Carli, Enzo, *Pisano,* Pisa, 1977.

Middeldorf-Kosegarten, Antje, *Sienesische Bildhauer am Duomo Vecchio: Studien zur Skulptur in Siena 1250–1350,* Munich, 1984.

articles—

Seidel, Max, "Die Elfenbein-Madonna im Domschatz zu Pisa . . ." in *Mitteilungen des Kunsthistorischen Institutes in Florenz,* 16, 1972.

Ferber, Stanley H., "Jean Pucelle and Pisano" in *Art Bulletin* (New York), March 1984.

Seidel, Max, "Opus heburneum: Eine Entdeckung einer Elfenbeinskulptur von Pisano" in *Pantheon* (Munich), July–September 1984.

*

Giovanni Pisano is first documented in 1265 when he was working as one of the assistants to his father Nicola on the Siena Duomo pulpit. The influence of Nicola's classical style, which was inspired by surviving ancient sculpture in Pisa, underlies Giovanni's own work. However, it was for his personal stylistic development of Gothic handling, realism, and expression, clearly dependent upon knowledge of northern Gothic sculpture, that Giovanni was most renowned and influential.

The Gothic elements discernible in the Siena pulpit have often been attributed to Giovanni, but due to his youth at the time, it is more likely that these aspects fired his imagination, and were further established in his work on the *Fontana Maggiore* at Perugia, dated 1278 (again under Nicola's supervision). The hiatuses in Giovanni's documented history around this time (1268–77 and 1278–84) have led to the contention that he visited France; this has been used to explain parallels between his work and French monumental sculpture. However, despite direct comparisons (such as the Deacon on the Pistoia pulpit and an angel with a chalice at Reims cathedral), his insight into French practice could have been gained from ivories and other small-scale works which were available in Tuscany, together with drawings/sketchbooks of artists who did make the journey north. Giovanni himself worked in ivory, exemplified by the Madonna and Child (c.1299) in the Duomo Treasury at Pisa (which has been associated with a documented tabernacle), but his major achievements lie in his monumental sculpture.

His change to Sienese citizenship and exemption from taxation in 1285 demonstrates the rising status of the artist and heralds what is held to be Giovanni's own revolutionary design for the Siena facade. Sculpture dominates the upper storey; his prophets and sibyls appear to lean out of their niches, crying their prophecies to the passers-by, no longer subordinate to the architecture. A striking example is the figure of Miriam,

where the artist also retains the classicism in the body, clearly delineated beneath the drapery. The exaggerated poses and distortions were deliberately made to compensate for the high viewpoint, and Giovanni's distinctive use of technique to enhance the visibility and dramatic effect can be seen in the use of the drill to create an expressive *chiaroscuro* (see, for example, the Isaiah).

This technical ability in both surface treatment and three-dimensionality is pursued in his next major project, the pulpit for S. Andrea, Pistoia, completed in 1301. It is in the development of narrative and emotional expression, however, that Giovanni's work was most influential, crossing artistic boundaries. Inspiration from his pulpits (Pistoia and Pisa Duomo) can be seen in the work of Giotto and Duccio, although how this has occurred is not always clear. One telling comparison can be made between the Massacre of the Innocents at Pistoia and Giotto's Lamentation fresco in the Arena (Scrovegni) Chapel at Padua (1304–13), for which Giovanni carved an outstanding Virgin and Child (c.1305). Giotto must have known the sculptor's dramatic use of physiognomy and gesture in the portrayal for human emotions.

The last, and by far the largest, of the Pisani pulpits, for the Duomo at Pisa (1302–10), was much more of a workshop production (as were the Siena facade figures). The requirements of the patron and the proximity of Nicola's Baptistery pulpit and the classical sculpture no doubt influenced Giovanni's approach. The supporting figure of Hercules is an excellent example of the sculptor's ability to produce a wiry, Gothic figure with an inherent classicism. He also retained his individual Gothicism in the relief panels with the use of exaggerated poses and sensitive inter-relationships.

Giovanni's skill at portraying these inter-relationships is paramount in his *Madonna and Child* groups. The stylistic influences from French Gothic are clear, but Giovanni develops an intimacy between mother and child even in the early group in the Camposanto in Pisa (c.1280). The image prompts human understanding of the relationship which can also be found in trecento painting, particularly in the works of Pietro and Ambrogio Lorenzetti. This tenderness, together with the solidity of the forms found also in the work of Giotto, suggests a direct influence from Giovanni as well as from sculpture generally.

The last documented commissions Giovanni received were from Emperor Henry VII who was resident in Pisa briefly in 1312 and 1313. In addition to statuary for the Porta di S. Ranieri of Pisa Cathedral, he commissioned a tomb for his Queen, Margaret of Luxembourg, in S. Francesco di Castelletto at Genoa (possibly completed by August 1313). The church was demolished in 1798–1807 and the tomb dismantled with only scant evidence surviving of its original form and setting. This sad loss prevents adequate assessment of the influence of Arnolfo di Cambio's tomb sculpture on Giovanni's only documented funerary monument. The remants of a scene depicting the *Resurrection of the Empress* appear to be based on the *Awakening of the Virgin* at Senlis. This particular influence of large-scale French sculpture may be explained by the presence of French members of Henry's court.

The last documentary evidence of Giovanni Pisano places him in Siena in 1314 and in 1319 his immunity from taxation was scratched from the record. His influence on Italian Gothic art was immediate, both on trecento painting and on other sculptors, such as Lorenzo Maitani and Tino da Camaino. The

power of his work has been recognised by modern masters, including Henry Moore, who praised his "tremendous dramatic force."

—Peta Evelyn

PISANO, Nicola.
Born probably in Apulia, southern Italy; active 1258–78. Son, the sculptor Giovanni Pisano. First documented work is the pulpit in the Pisa Baptistery, 1259; also executed two reliefs on Lucca Cathedral, the Arca di San Domenico in San Domenico, Bologna, 1264–67, the Altar of St. James in Pistoia Cathedral, 1278 (dismantled in the 18th century), the pulpit in Siena Cathedral, 1265–68, the Fontana Maggiore (great fountain) in Perugia, with Giovanni, 1278. Pupils: Giovanni Pisano, Arnolfo di Cambio, Lapo, Fra Guglielmo.

Collections/Locations: Bologna: S. Domenico Maggiore; Perugia: Piazza; Pisa: Baptistery; Siena: Cathedral.

Publications

On PISANO: books—

Brach, Albert, *Nicola und Giovanni Pisano und die Plastik des XIII Jahrhunderts in Siena*, Strasbourg, 1904.
Swarzenski, Georg, *Pisano*, Frankfurt, 1926.
Crichton, E. R., *Pisano and the Revival of Sculpture in Italy*, Cambridge, 1938.
Nicco-Fasola, Giustiana, *Pisano: Orientamenti sulle formazione del gusto italiano*, Rome, 1941.
Carli, Enzo, *Il pulpito di Siena*, Bergamo, 1943.
Gnudi, C., *Nicola, Arnolfo, Lapo*, Florence, 1949.
Nicco-Fasloa, Giustiana, *La fontana di Perugia*, Rome, 1951.
Bottari, Stefano, *Saggi su Pisano*, Bologna, 1969.
Poeschke, J., *Die Sieneser Domkanzel des Pisano*, Berlin, 1973.
Middeldorf-Kosegarten, Antje, *Sienesische Bildhauer am Duomo Vecchio: Studien zur Skulptur in Siena 1250–1350*, Munich, 1984.
Testi Cristiani, Maria Laura, *Pisano, architetto scultore*, Pisa, 1987.

articles—

Seymour, Charles, "Invention and Revival in Pisano's Heroic Style," in *Studies in Western Art*, Princeton, 1963.
White, John, "The Reconstruction of Pisano's Perugia Fountain," in *Journal of the Warburg and Courtauld Institutes* (London), 33, 1970.
Seidel, Max, "Studien zur Antikenrezeption Pisanos," in *Mitteilungen des Kunsthistorischen Institutes in Florenz*, 19, 1975.
Angiola, E, "Pisano, Federigo Visconti, and the Classical Style in Pisa," in *Art Bulletin* (New York), 59, 1977.

The revival of an art approaching the standards and ideals of classical antiquity was initiated in Pisa with the arrival of Nicola Pisano from southern Italy. Abandoning what must have appeared to be the static formulas of Italian Romanesque sculpture, with its puppet-like figures, stylized drapery patterns, and stilted movements, Nicola revitalized sculpture, in part by combining monumental forms and compositions derived from Roman antiquity with the expression of human emotions that were first adequately conveyed in northern Gothic art. Vasari, writing his *Lives of the Most Eminent Painters, Sculptors, and Architects* in the 16th century, warmly appreciated Nicola's achievements and considered him the master who "liberated" sculpture from the "crude" art of the past.

Nicola's originality is first seen in the Pisa Baptistry pulpit, completed in 1260. He rejected the traditional Tuscan rectangular format in favor of a polygonal structure, a shape happily suited to the centralized plan of the Baptistry. Unlike most earlier pulpits, his is free-standing, with reliefs illustrating the life of Christ on five of the six sides (the sixth is the opening to the entrance platform). The colorful effect of the red, green and white marbles from which the pulpit is composed was even stronger originally: although some areas retain the colored glaze tesserae that filled the background of each relief, the rich polychromy of the figures themselves is now all but lost. But it is the narrative reliefs that are the most revolutionary aspect of the pulpit. Lacking a tradition of realism in his immediate past, Nicola found in antique sculpture representations of physical forms that closely reflected the experience of nature. Indeed, several figures of the pulpit are direct quotations of Roman sculptures extant in Pisa in the 13th century. Basing both his style and technique (particularly the use of the drill) on Roman sarcophagi, Nicola carved large, full-bodied figures with ample draperies and naturalistic body movements. The figures act out their roles with majestic dignity, while also conveying a sense of the drama of human interaction.

In 1264 Nicola was commissioned to design a tomb for St. Dominic, the founder of the Dominican Order, in the church of San Domenico, Bologna. The form and structure of the Arca di San Domenico was no less original than the design of the pulpit, and it became the prototype for an entire class of tombs through the 15th century. The Arca consisted of a sarcophagus, embellished with densely carved narrative reliefs illustrating scenes from the life of the saint, supported by eight caryatids representing Virtues and Dominican friars. (The tomb has been moved and extensively altered several times; only five of the caryatids are extant, in the Boston Museum of Fine Arts, the Louvre, and the Bargello.) The execution of the tomb was largely left to assistants, including Arnolfo di Cambio, for in 1265 Nicola was called to Siena to sign a contract for another pulpit, larger and more complex than the first, for the cathedral of Siena.

There are significant differences between the Pisa Baptistry pulpit and the one in Siena cathedral. The latter is octagonal in shape, allowing for the inclusion of the emotional wrenching *Massacre of the Innocents,* and a *Last Judgement* that now spreads over two fields, with Christ the Judge a full-length figure between the reliefs. Indeed, instead of the column clusters that frame the narratives of the Pisa pulpit, here corner figures assume that role. As a result, the viewer's eye is led in a continuous movement from relief to corner figure to relief,

Adoration of the Magi (pulpit detail); marble; Siena, Cathedral

and so on. The heavier, more classicizing forms of the earlier pulpit are replaced by more elegantly proportioned figures with softer draperies and more refined features—a figural ideal greatly influenced by French Gothic art. In the narratives the figures are smaller in relation to the relief field, more densely packed, and for the first time there is a limited suggestion of movement into depth. Space, to be sure, inclines upwards but nevertheless offers scope for an increase in narrative realism.

With respect to the Tuscan tradition, Nicola's pulpits show an expansion of iconographic content. Biblical history is augmented by representations of Virtues and Vices, Liberal Arts and pagan prophetesses. Here is revealed the same impulse that informs the encyclopedic content of French Gothic cathedral decoration, "the visible counterpart" of the "intellectual edifice" developed by the Scholastic theologians (Male, *The Gothic Image*, 1958). In sculpture and stained glass, 13th-century cathedrals attempted to encompass the sum total of human knowledge, moral ideals, and God's cosmic plan for the universe.

The encyclopedic urge expresses itself even more fully on one of the most remarkable secular and civic monuments of the Italians Gothic age: the Fontana Maggiore in Perugia, completed in 1278, with sculptures by Nicola and contributions by his son Giovanni. Included are scenes from Genesis, an array of prophets and saints, the Labors of the Months, the Liberal Arts, various fables and allegorical figures, and even contemporary civic personalities. The reliefs are characterized by relatively simple configurations and an even freer handling of figures than on the pulpits. Like the pulpits, however, the fountain is polygonal in shape. A ring of steps serves as a base from which rises a 25-sided basin embellished by low reliefs and articulated by colonettes. Above this rises a second basin of 12 sides with figures at the angles and the center of each face. From here a column emerges supporting a small bronze basin that in turn contains three graceful female caryatids; these may originally have supported a smaller basin, now lost. The columns and figures that articulate the lower basins do not line up, resulting in a subtly syncopated rhythm that encourages movement about the structure. Simultaneously, the vertical elements, together with the diminishing sizes of the basins,

draw the eye upward. The effect, ultimately, is of a spiral movement that culminates in and is resolved by the caryatid group.

Aside from the much damaged *Deposition* on the tympanum and the *Annunciation, Nativity,* and *Adoration of the Magi* on the architrave of Lucca Cathedral, whose dating and attribution are problematic, there remains to be noted the group of monumental heads, busts, and full figures that Nicola, and at some point Giovanni too, carved for the exterior of the Pisa Baptistry, for the most part between 1269 and 1279. (Many are still *in situ* but several are in the Museo dell'Opera del Duomo and the Museo Nazionale.) Despite the extreme weathering of these sculpturally powerful forms—conceived to be viewed from a great distance—the expressive content is still evident. Here collaboration between father and son, and the increasingly expressive quality of Nicola's work, make the problem of attribution difficult.

Nicola's style evolved from the monumental, if stark, grandeur of his early Pisan reliefs to the rich pictorial images at Siena; it mellowed finally into a more fluid, accessible mode on the Fontana Maggiore in Perugia. Nicola's sculpture provided the source and impetus for the development of his two major assistants: his son, Giovanni, was to develop the emotional current of Nicola's style, in part by transforming the decorative vocabulary of northern art into a very personal and highly charged idiom; Arnolfo di Cambio's temperament led him in the opposite direction, toward a starkly monumental and classicizing mode. Nicola Pisano's art profoundly influenced not only his immediate successors but also the painting of Giotto and, indeed, the entire naturalistic and classicizing tradition of Renaissance art.

—Anita F. Moskowitz

PISSARRO, Camille (Jacob).

Born in St. Thomas, Danish West Indies, 10 July 1830, to French and Creole parents. Died in Paris, 13 November 1903. Married Julie Vellay, 1871; son, the painter Lucien Pissarro, four other sons, and two daughters. Attended school in Paris, 1841–47; then worked in his father's store in St. Thomas; ran away to Venezuela, and arrived in Paris, 1855: friend of Corot, then of Courbet, Manet, and Monet; worked in the open air, though unsuccessfully at first, often in Pontoise; worked in Brittany and London, 1870–71; worked with Cézanne in Pontoise, 1872, and with Gauguin, 1879–81; exhibited in all eight of the Impressionist Exhibitions; eye-trouble intermittently from 1895.

Major Collections: Paris: d'Orsay.
Other Collections: Chicago; Douai; Florence: Arte Moderna; Goteborg; London: Tate; Mannheim; New York; Oxford; Philadelphia; Prague; Rheims; Stockholm; Williamstown, Massachusetts.

Publications

By PISSARRO: books—

Lettres à son fils Lucien, edited by John Rewald, Paris, 1950; as *Letters to His Son Lucien,* 4th ed., New York and London, 1980.
Correspondance 1865–1885, edited by Janine Bailly-Herzberg, Paris, 1980.
Quatorze letters, Pontoise, 1984.

On PISSARRO: books—

Holl, J. C., *Pissarro et son oeuvre,* Paris, 1904.
Lecomte, Georges, *Pissarro,* 1922 Paris, 1922.
Delteil, Loys, *Le Peintre-graveur, vol. 17: Pissarro, Sisley, Renoir,* Paris, 1923.
Tabarant, Adolphe, *Pissarro,* Paris, 1924, New York, 1925.
Tabarant, Adolphe, and Robert Rey, *Pissarro* (cat), Paris, 1930.
Francastel, Pierre, *Monet, Sisley, Pissarro,* Paris, 1939.
Pissarro, Ludovico-Rodo, and Lionello Venturi, *Pissarro: Son art et son oeuvre,* Paris, 2 vols., 1939.
Rewald, John, *Pissarro au Musèe du Louvre,* Paris, 1939.
Jedlicka, Gotthard, *Pissarro,* Berne, 1950.
Daulte, F., *Pissarro* (cat), Berne, 1957.
Rewald, John, *Pissarro,* New York and London, 1963.
Rewald, John, *Pissarro in Venezuela,* New York, 1964.
Reward, John, *Pissarro* (cat), New York, 1965.
Malvano, Laura, *Pissarro,* Milan, 1965.
Boulton, Alfredo, *Pissarro en Venezuela* (in Spanish and English), Caracas, 1966.
Russell, John, *Pissarro in England* (cat), London, 1968.
Shapiro, Barbara S., *Pissarro, the Impressionist Printmaker* (cat), Boston, 1973.
Cogniat, Raymond, *Pissarro,* Paris and New York, 1974.
Adler, Kathleen, *Pissarro: A Biography,* London and New York, 1978.
Lloyd, Christopher, *Pissarro,* Oxford and New York, 1979.
Brettell, Richard and Christopher Lloyd, *A Catalogue of the Drawings by Pissarro in the Ashmolean Museum Oxford,* Oxford, 1980.
Shikes, Ralph E., and Paula Harper, *Pissarro: His Life and Work,* New York and London, 1980.
Lloyd, Christopher, *Pissarro* (cat), Paris, London, and Boston, 1981.
Recchilongo, Benito, *Pissarro: Grafica anarchia,* Rome, 1981.
Lloyd, Christopher, editor, *Studies on Pissarro,* London, 1986.
Reed, Nicholas, *Pissarro at the Crystal Palace,* London, 1987.
Kunstler, Charles, *Pissarro,* London, 1988.

*

Camille Pissarro has often been called "The Father of Impressionism." The homage is appropriate, not only because he was bearded and patriarchal, a supportive teacher and dependable counselor, but because of his place—often overlooked—as a pioneer in the Impressionist movement, contributing to the formation of its style, practices, and exhibition polices.

Pissarro's early, pre-Impressionist, landscapes of the 1860's are indebted to Courbet in their firm structure and to Corot in their sensitive attention to what the older painter called the

Paul Cézanne, 1875; etching

When he returned to a more spontaneous expression of his sensations of nature, his work shows an integration of the pointillist experience in his increased mastery of color and structure. He painted rapid *plein-air* landscapes from the late 1880's, but during the early 1890's he also worked on monumental, static groupings of laboring peasants, based on drawings, finished in the studio over many months. In his late landscapes, cityscapes, and market scenes, up to his death in 1903, the emphasis is again on direct observation of nature, often in series of the same motif under differing conditions. Pissarro never fully resolved the conflict between his need for a rational pictorial structure and his wish to record this immediate sensations of nature. He alternated between the two poles rather than finding a personal synthesis, as did Cézanne.

In his approximately one hundred etchings and lithographs, Pissarro employed experimental and unorthodox techniques, particularly in the etchings he made about 1880 while working with Degas and Mary Cassatt. Combining lessons from the inventive Degas and from Japanese printmakers and his own mastery of tone in painting, Pissarro arrived at unique painterly effects in his prints.

Throughout his life, Pissarro was immersed in the fundamental concerns of Impressionism: the experience of color, light, atmosphere, movement, and especially time. Some of his earliest drawings in Venezuela are of a subject he often took up—people passing each other on the road—the coincidental contact of ordinary humans in the kind of fleeting event which is unique and yet often repeated. In his paintings of carriages and people passing each other at twilight on a rainy road in Louveciennes he evokes the puzzling melancholy of the recognition of a distinct moment of time. That moment shimmers for an instant and is gone each time we look at the painting, which paradoxically continues to exist. In his Paris cityscapes and busy Le Havre seascapes, time is rushing by with a sense of urban and industrial urgency. In many of his paintings of peasants working in the fields around Eragny, he suggests the cyclical nature of the seasons and their labor: time revolves in the great circles of the agricultural calendars so beloved by the French Gothic illustrators and by Bruegel.

In the fictional, composite Impressionism of historical imagination, objects dissolve in the luminous flux of their constantly changing appearance. But Pissarro's firmly structured perspectives are a statement of permanence. If the world of appearances changes, the implied viewer is stable. Monet, in many of his last paintings of his water garden, eliminates not only the figure, but any reference to space on a human scale of gravity as a human experience—he dissolves the viewer into the scene. Pissarro, in contrast, remains as always a humanist. He constantly reasserts the fact of human interaction with the natural world both in his subjects and in his insistence on a logically constructed space seen from a still point.

—Paula Harper

"envelope" of light. Because almost all of Pissarro's paintings from 1868 and 1869 were destroyed when his house in Louveciennes was occupied by Prussian troops in 1870 and 1871, it has been difficult to establish an exact chronology of his development at this crucial time in the history of Impressionism. But it is certain that he worked closely with Monet in the 1860's and experimented with *plein-air* landscape painting along the Seine at Marly, Bougival, and LaGrenouillère with both Renoir and Monet during 1869, the year in which the style rather suddenly took on its characteristic broken brushstrokes, divided color and "all-over" surface texture. In Pissarro's securely dated paintings of the early 1870's, he uses these techniques, although favoring more muted colors and closer tonalities than his colleagues.

Pissarro, with Monet, initiated the first Impressionist exhibition in April 1874, recruiting artists for the cooperative society and furnishing the model for its charter, that of the baker's union of Pontoise. Since his support of an alternative exhibition system was based on principled opposition to the official government Salon, which tended to impose conventional, "bourgeois" standards of taste, he was unusually loyal to the concept and was the only member of the group to show in all eight Impressionist exhibitions between 1874 and 1886.

Impressionism has sometimes been described as a simple naturalism, but Pissarro's work, experimental, varied, and complex, shows the inadequacy of this description. He was the only member of the Impressionist group to experiment, between 1883 and 1887, with Neo-Impressionist techniques, which he thought of as "scientific" and therefore linked to progress. He abandoned the "dot" only when the laboriousness of the technique cut down his production too severely.

POLLAIUOLO, Antonio.

Born Antonio di Jacopo Benci in Florence, c. 1430; his father was a poulterer, hence his nickname Pollaiuolo; brother of the painter Piero Pollaiuolo. Died in Rome, 4 February 1498.

Battle of the Nude Gods; engraving

Married Marietta, two daughters. Apprenticed as to the gold-smith Bartoluccio Ghiberti (step-father of Lorenzo), and possibly worked with Ghiberti; continued to work as a goldsmith, and belonged to a guild that included goldsmiths; made reliquary crosses, candelabra, etc.; also designed embroideries; set up shop with his brother Piero, and distinguishing between their work is difficult; one engraving (Battle of the Ten Nudes) is known; also made large bronze tomb for Pope Sixtus IV, Vatican, 1484–92, and monument for Innocent VIII, St. Peter's, 1490's; also an architect.

Collections: Berlin; Berlin (East): Bode; Florence: S. Miniato al Monte, Uffizi, Bargello, Museo del Duomo; London; New Haven; San Gimignano: Collegiata; Staggia: Pieve di S. Maria; Turin: Sabauda; Vatican: St. Peter's.

Publications

On POLLAIUOLO: books—

Cruttwell, Maud, *Pollaiuolo*, London, 1906.

Schwabacher, Sascha, *Die Stickerein nach Entwürfen des Pollaiuolo in der Opera di S. Maria del Fiore zu Florenz*, Strasbourg, 1911.

Lopez-Rey, J., *Pollaiuolo y el fin del quattrocento*, Madrid, 1935.

Colacicchi, Giovanni, *Pollaiuolo*, Florence, 1943.

Sabatini, Attilio, *Antonio e Piero del Pollaiuolo*, Florence, 1944.

Ortolani, Sergio, *Il Pollaiuolo*, Milan, 1948.

Bovi, Arturo, *Pollaiuolo*, Milan, 1965.

Chiarini, M., *Il Pollaiuolo*, Milan, 1966.

Busignani, Alberto, *Pollaiuolo*, Florence, 1970.

Ettlinger, Leopold D., *Antonio and Piero Pollaiuolo: Complete Edition with a Critical Catalogue*, Oxford, 1978.

articles—

Ettlinger, Leopold D., "Pollaiuolo's Tomb of Pope Sixtus IV," in *Journal of the Warburg and Courtauld Institutes* (London), 1, 1953.

Bertelà, G. G., et al., "Firenze, Museo del Bargello: Il restauro della croce del Pollaiuolo e di Tre Paci," in *Bollettino d'Arte* (Rome), January-February 1984.

*

Antonio Pollaiuolo—goldsmith, sculptor, painter, draftsman, engraver, embroidery designer—worked with his brother Piero who seems to have been primarily a painter. It has proved impossible to separate the hands of the two artists with any degree of confidence, but it is generally agreed that Antonio was the real genius and provided most of the designs for the workshop productions in all media. In any case, there is no question that the art from the workshop of the Pollaiuolo

brothers is some of the most significant of the 15th century. Its importance lies in the introduction of a more accurate description of human anatomy, a new intensity of anatomical movement, and a new breath and naturalism in the rendition of landscape.

Recent studies have cast doubt on Vasari's assertion that Antonio learned anatomy by dissection, because the muscles of his figures. especially in the famous signed engraving of the *Battle of Ten Nudes,* show too many inaccuracies. Yet the figures of Pollaiuolo are the first in the history of art since antiquity to look as if they might have been based on a solid knowledge of anatomy, and were surely important stimulants for further anatomical exploration and study by artists like Michelangelo and Leonardo, who certainly did do dissections only slightly later. Furthermore, Pollaiuolo had a brilliant gift for defining his figures by gesture, posture, and the use of a taut, wiry, incisive contour line in order to create a silhouette of highly charged, almost electric energy and movement. In painting, such as in the frieze of dancers in the Villa Gallina or the *Battle of the Ten Nudes,* these figures are related to each other to form rhythmical patterns of the utmost sophistication and elegance with the intervals between forms being almost as interesting as the relationships between the forms themselves. In sculpture, such as the bronze statuette in the Uffizi of *Hercules and Antaeus,* Pollaiuolo's flair for figural composition led to works, among the first in the Renaissance, that read brilliantly from almost any point of view.

The landscapes in many of Pollaiuolo's paintings—the *Hercules and the Hydra* in the Uffizi, *Apollo and Daphne* in London, or the *Hercules, Nessus, and Deianeira* at Yale—are exceptional for their detailed accuracy in representing the Arno valley around Florence and for their very high viewpoint which give them almost a cosmic scale. Equally exceptional is the integration of the landscapes with the narrative. In the paintings cited above the flow of the river reinforces the course of the narrative and unifies the action; the breadth and depth of the terrain monumentalize the actors and add a deep and poetic resonance to the drama.

As a story teller, in fact, whether the medium was painting, relief sculpture, or embroidery, Pollaiuolo had few rivals. His ability to unify perspective space, architectural or landscape backgrounds, gesture, expression, and figural movement into a clear, direct, and forceful narrative was very influential. But his impact was even greater on the development of tomb design and drawing techniques. With the bronze tombs for Sixtus IV and Innocent VIII in the Vatican he developed forms that gave such vivid expression to papal claims of regal status and temporal and spiritual supremacy that no less an artist than Michelangelo, to mention only one of many, paid homage to them. The technique of drawing with ink on paper had just been introduced on a large scale in Pollaiuolo's lifetime, and he developed such a vigorous, probing, varied, and rhythmical line that he pushed the medium at its inception almost to the maximum of its potential. Only Leonardo could equal the spontaneity, precision, and vitality of Pollaiuolo's draftsmanship.

Pollaiuolo, in sum, introduced to Italian Renaissance art a race of human beings that were passionate and dynamic in the extreme, often even violent and brutal, acting within a natural world that was both familiar and grand.

—Loren Partridge

POLLOCK, (Paul) Jackson.

Born in Cody, Wyoming, 28 January 1912; moved with his family to San Diego, California, 1912, to Phoenix, Arizona, 1913, and to Chico, California, 1914. Died (in automobile accident) in Easthampton, 11 August 1956. Attended California schools; studied under Frederick John de St. Vrain Schwankovsky at the Manual Arts High School, Los Angeles, 1928; studied painting under Thomas Hart Benton and sculpture under Robert Laurens, Art Students League, New York, 1930–33. Married 1) Elizabeth England, 1931; 2) the painter Lee Krasner, 1945. Painter: lived and worked in New York from 1930; worked for the Works Progress Administration Federal Arts Project, 1935–42; hospitalized for alcoholism 1938; worked in Stanley William Hayter's engraving studio, 1944–45; lived in Easthampton, Long Island, from 1946; produced first sculpture in Lawrence Larkin's studio, 1949.

Collections: Amsterdam; Stedelijk; London: Tate; New York: Whitney, Moma, Guggenheim; Pittsburgh; Rio de Janeiro; Rome: Arte Moderna; Stuttgart; Zurich.

Publications

On POLLOCK: books—

O'Hara, Frank, *Pollock,* New York, 1959.
Robertson, Bryan, *Pollock,* New York and London, 1960.
Hunter, Sam, *Pollock* (cat), New York, 1964.
O'Conner, Francis V., *Pollock* (cat), New York, 1967.
Tomassoni, I., *Pollock,* London, 1968.
Lieberman. W. S., and B. H. Friedman, *Pollock: Black and White* (cat), New York, 1969.
Rose, Bernice, *Pollock: Works on Paper,* New York, 1969.
Busignani, Alberto, *Pollock,* Florence, 1970; London, 1971.
Wysuph, C. L., *Pollock: Psychoanalytic Drawings,* New York, 1970.
Friedman, B. H., *Pollock: Energy Made Visible,* New York, 1972; London, 1973.
Putz, Ekkehard, *Pollock: Theorie und Bild,* Hildesheim, 1975.
O'Connor, Francis V., *Pollock: A Catalogue Raisonné of Paintings, Drawings, and Other Works,* New Haven, 4 vols., 1978.
McFee, Graham, *Much of Pollock is Vivid Wallpaper: An Essay in the Epistemology of Aesthetic Judgments,* Washington, 1978.
Namuth, Hans, *L'Atelier of Pollock,* Paris, 1978.
Namuth, Hans, *Pollock Painting,* New York, 1980.
Rose, Bernice, *Pollock: Drawing into Painting,* New York, 1980.
O'Connor, Francis V., *Pollock: The Black Pourings 1951–1953,* Boston, 1980.
Hepp, Nicolas, *Das nicht-rationale Werk: Pollock, Barnett Newman,* Mulheim, 1982.
Rubin, William, et al., *Pollock* (cat), Paris, 1982.
Frank, Elizabeth, *Pollock,* New York, 1983.
Frascina, Francis, *Pollock and After: The Critical Debate,* New York, 1985.
Potter, Jeffrey, *To a Violent Grave: An Oral Biography of Pollock,* New York, 1986.

Untitled, 1951; screenprint

Rohn, Matthew L., *Visual Dynamics in Pollock's Abstractions*, Ann Arbor, 1987.
Solomon, Deborah, *Pollock: A Biography*, New York, 1987.

*

In a radio interview in 1950, the Abstract Expressionist painter Jackson Pollock observed, "It seems to me that the modern painter cannot express this age, the airplane, the atom bomb, the radio, in the old forms of the Renaissance or of any other past culture. Each age finds its own technique." Pollock's search for a technique that would express his age led him to create a visual language unlike that of any of his predecessors. With their skeins of flung, spotted, and dribbled pigments, his mature drip paintings like *Autumn Rhythm* (New York, Moma) both shocked and stimulated the art world when they were first shown at the Betty Parsons Gallery in 1948. The new all-over style, in which traditional object-ground relationships were abandoned for a new non-space of floating, intertwined lines and shapes, allowed the artist to depart from conventional subject matter in order to explore the expressive potential of the process of painting.

Born in Cody, Wyoming, Pollock first studied painting between 1930 and 1932 at the Art Students League in New York with the American Regionalist painter Thomas Hart Benton. Although he would later describe Benton's primary role as someone against whom he could later react, Benton introduced him to Renaissance and Baroque masters while still offering the example of a staunchly independent, decidedly American artistic voice. After working on the WPA Artists Project in 1935, Pollock encountered the work of the Mexican muralists Clement Orozco, Diego Rivera, and David Siqueiros, whose activities in New York introduced him to large-scale, epic works with totemic and mythic subjects. By the early 1940's, he was included in the circle of European Surrealists centered around Peggy Guggenheim's Art of This Century Gallery, where his work was shown. Like the Surrealists, he was interested in the role of the unconscious in the creative process, although he was drawn to Jungian rather than Freudian psychological theories. Exposure to works in New York museums by Picasso, Kandinsky, Miró, and Masson also had a strong impact of Pollock.

In 1942 Pollock exhibited his paintings in his first New York group show at the McMillen Gallery. Included was the canvas *Pasiphae* (originally titled *Moby Dick*), which signalled the artist's interest in mythic and sublime imagery, expressed with an increasingly loose and dynamic brushstroke. While works such a *Male and Female* owe a debt to Picasso's multiple viewpoints and introduction of numbers and letters into the fictive space of the painting, the charged, unrestrained paint application has roots in Surrealist techniques of automatism. Despite these sources, however, the works Pollock produced and exhibited in the early 1940's went beyond those of his predecessors in their reliance on the act of painting as a carrier of meaning. As Pollock would later put it, "Technique is just a means of arriving at a statement."

In 1947 Pollock began to eliminate all recognizable imagery from his paintings, in order to focus on the painting gesture and the emotional content it could convey. Freed from conventional subjects, the artist produced his greatest works, huge all-over paintings comprised of interwoven, fluid lines that hover over the flat picture plane. With *Number I* (1948) Pollock abandoned the dense, muscular surfaces of such transitional works as *Gothic* in favor of lyrical, quivering linear webs that seem to extend beyond the confines of the picture plane into infinity. While increasing the size of his canvases, Pollock retained the idea of the unified painting field, in which no one element takes precedence. the lines and shapes that dance across the surface are records of the trajectory and speed of the paint as applied to the canvas; the artist insistently denied that they resulted from accident or chance. Nevertheless, in his classic drip paintings he remained receptive to the creative possibilities inherent in the surprises resulting from the spontaneous action.

After 1950 Pollock moved away from the style that had earned him the nickname "Jack the Dripper," and returned to the human figure as subject. Although his later works incorporate some of the techniques used in the drip paintings, they are generally far less successful. By 1953 Pollock's art and life were in a state of decline, as the artist succumbed to the alcoholism that he had battled throughout his adult life. He was killed in an automobile accident in 1956.

—Kirsten H. Powell

PONTORMO, Jacopo.

Born Jacopo Carucci in Pontormo, 24 May 1494; son of the painter Bartolommeo Carucci. Died in Florence, buried 2 January 1557. Apprenticed to or influenced by Leonardo, Albertinelli, and Piero di Cosimo in Florence; entered the workshop of Andrea del Sarto at age 18 (co-pupil of Rosso); did fresco for SS. Annunziata and altarpiece for S. Michele Visdomini; decorated the Medici villa at Poggio a Caiano, 1521, the Certosa di Val d'Erna, 1522, and S. Felicità, c. 1525–28; frescoes at S. Lorenzo, 1546–56 (destroyed); kept a diary, 1554–56. Pupil (and adopted son): Agnolo Brozino.

Collections: Amsterdam; Baltimore; Cambridge, Massachusetts; Carmignano: parish church; Chicago; Dijon; Dublin; Florence: Uffizi, Pitti, Accademia, S. Felicità, S. Michele Visdomini, SS. Annunziata; Frankfurt; Hanover; Leningrad; London; Lucca; Milan: Castello; Munich; Naples; New Havne; Oxford: Christ Church; Paris: Louvre, Jacquemart-André; Poggio a Caiano: Medici Villa; Pontormo: S. Michele; Rome: Borghese, Palazzo Quirinale, Galleria Nazionale; San Francisco; Vienna; Washington.

Publications

By PONTORMO: book—

Diario fatto nel tempo che dipingeva il coro di San Lorenze 1554–1556, edited by Emilio Cecchi, Florence, 1956.

On PONTORMO: books—

Goldschmidt, F., *Pontormo, Rosso, und Bronzino,* Leipzig, 1911.
Clapp, Frederick M., *Les Dessins de Pontormo: Catalogue Raisonné,* Paris, 1914.
Clapp, Frederick M., *Pontormo: His Life and Work,* New Haven, 1916.
Becherucci, Luisa, *Disegni del Pontormo,* Bergamo, 1943.
Toesca, Elena, *Il Pontormo,* Rome, 1943.
Nicco-Fasola, G., *Pontormo, o del cinquecento,* Florence, 1947.
Gamba, C., *Contributo alla conoscenza del Pontormo,* Florence, 1956.
Baldini, Ugo, et al., *Pontormo e il primo manierismo fiorentino* (cat), Florence, 1956.
Cox-Rearick, Janet, *The Drawings of Pontormo,* Cambridge, Massachusetts, 2 vols., 1964, 1981.
Berti, Luciano, *Pontormo,* Florence, 1964.
Berti, Luciano, *Pontormo: Disegni,* Florence, 1965.
Foster, Kurt, *Pontormo: Monographie mit kritischem Katalog,* Munich, 1966.
Tempesti, A. Forlani, *Disegni del Pontormo del Gabinetto di Disegni e Stampe degli Uffizi,* Milan, 1970.
Shearman, John, *Pontormo's Altarpiece in S. Felicità,* Newcastle-upon-Tyne, 1971.
Berti, Luciano, *L'opera completa di Pontormo,* Milan, 1973.
Cox-Rearick, Janet, *Dynasty and Destiny in Medici Art: Pontormo, Leo X, and the Two Cosimos,* Princeton, 1984.

Lebensztejn, Jean Claude, and Alessandro Parronchi, *Dossier Pontormo,* Paris, 1984.
Beckers, Petra, *Die Passionsfresken Pontormos für die Certosa del Galluzzo,* Salzburg, 2 vols., 1985.

articles—

Tolnay, Charles de, "Les Fresques de Pontormo dan le choeur de S. Lorenco," in *La Critica d'Arte* (Modena), 9, 1950.
Winner, M., "Pontormos Fresko in Poggio a Caiano: Hinweise zu seiner Deutung," in *Zeitschrift für Kunstgeschichte* (Munich), 35, 1972.
Steinberg, Leo, "Pontormo's Capponi Chapel," in *Art Bulletin* (New York), 56, 1974.
Strehlke, Carl Brandon, "Pontormo, Alessandro de' Medici, and the Palazzo Pazzi," in *Bulletin of the Philadelphia Museum of Art,* Fall, 1985.

*

A native of the village of Pontormo near Empoli in Tuscany, Jacopo Pontormo spent his entire artistic career in Florence where he became one of the leading innovators of Florentine Mannerism. According to Vasari, he studied briefly in the workshops of several leading painters in Florence, among them Leonardo da Vinci and Piero di Cosimo, at the end of the first decade of the 16th century before entering the *bottega* of Andrea del Sarto in 1512. His status in this workshop was at once pupil and journeyman-artist: Pontormo had, by this date, already been schooled in the mechanics and principles of painting, but his own artistic style was not yet fully formed, and he was keenly responsive to the manner of Andrea del Sarto, in whose orbit he worked for almost a decade. Around the year 1512, while a member of Sarto's workshop, Pontormo and his contemporary Rosso Fiorentino executed the now-lost predella for the master's San Gallo *Annunciation* (Pitti). Pontormo's first secure independent work is the now ruined fresco representing *Faith and Charity Flanking the Arms of Pope Leo X,* executed in 1513–14 to commemorate the elevation to the papacy in 1513 of the Florentine Leo X (Giovanni de' Medici, son of Lorenzo the Magnificent). This fresco, which is indebted to Michelangelo's Ancestor Lunettes in the Sistine Chapel, embellished the entrance lunette of SS. Annunziata (recently removed to prevent further deterioration and now on deposit in Florence)—the church with which Andrea del Sarto was associated for much of his career and where Pontormo was to execute a fresco of the *Visitation,* a commission he probably received in part through the offices of Sarto, in 1514–16. In this work, the fluid posturings of the figures and Pontormo's warm, glowing colors reveal his debt to the older master. On the occasion of Pope Leo X's triumphal entry into Florence in November 1515, Pontormo was commissioned to decorate the Cappella del Papa in the papal apartments in S. Maria Novella. The *all'antica* vault, divided into geometric compartments ornamented with *grotteschi* and the heraldic devices of the pope, recalls the Cappella dei Priori in the Palazzo Vecchio, executed in 1514 by Ridolfo Ghirlandaio to whom the Cappella del Papa campaign was first awarded. In the serpentine torsion of Saint Veronica in one of the lunettes, and the Archangel Michael of 1518–19 (Pontormo, S. Michele) an incipient Mannerism that Pontormo would later elaborate is al-

Boy; drawing; London, Courtauld (Seilern Collection)

ready evident. One of the two panels comprising Pontormo's contribution to the Joseph cycle commissioned in 1515 by Pierfrancesco Borgherini, the *Joseph in Egypt* (London, 1518), with its disjunctive space and graceful, twisting figures, reveals a similar sensibility. A reprieve in the artist's evolution of an increasingly artificial, personal, and spiritual style is evident in the engaging naturalism and rustic spirit of the celebrated *Vertumnus and Pomona* lunette at the Medici Villa of Poggio a Caiano, executed around 1520. The apparent casualness and informality of the composition are belied by Pontormo's drawings, which reveal the painstaking effort that the artist lavished on this invention.

In 1523 Florence was stricken by the plague and Pontormo sought refuge at the Certosa of Galluzzo just outside the city. In this monastic milieu, removed from the cosmopolitan, urban culture of Florence and inspired by the prints of the German master Dürer which he presumably had in his possession, Pontormo created some of the most moving and haunting images in the history of western art: five frescoes illustrating the Passion of Christ (Galluzzo [Florence], Museum). The pastel palette, elongated, weightless figures, and shallow, congested pictorial space of the ruinous but expressive Certosa frescoes are characteristic of the artist's mature style and of Florentine Mannerism.

These stylistic tenets characterize the artist's masterpiece, the *Deposition* in the Capponi Chapel in S. Felicità in Florence (in situ), executed between 1525–26 and 1528 (S.V.). The *Deposition* altarpiece is the major pictorial component of a cycle that originally included a frescoed dome representing God the Father and Old Testament Patriarchs (destroyed upon the construction of the Uffizi corridor in the second half of the 16th century), a fresco of the *Annunciation* on the right wall of the chapel, and four tondi in the spandrels depicting the Evangelists. Of the latter, Saints Luke and Mark are probably the work of Pontormo's pupil and adopted son, Bronzino. The inflated, weightless, and balletic figures in the *Annunciation* and the *Deposition* enact a poignant and timeless drama in shallow, congested spaces vitually devoid of temporal references. The effortless, graceful torsion of Pontormo's figures, and the hot, pastel palette favored by the artist, render these works paradigmatic Mannerist inventions. Pontormo's next major work, the *Visitation* in the parish church of Carmignano (in situ) executed in 1528–29, represents an elaboration of ethereal, dematerialized style of the Capponi Chapel: the four enormous, inflated figures float weightlessly in a surreal space, the religious drama now assuming the aspect of an apparition.

Major works from Pontormo's later years—the frescoes from the Medici Villas at Careggi (1535–36) and Castello (1538–43), and the choir of S. Lorenzo in Florence (1546–57)—are lost, but preparatory drawings by the artist reflect his continuing move away from the tenets of High Renaissance classicism and elaboration of a personal and subjective style based on the art of Michelangelo. This style reveals itself particularly in the artist's grotesquely elongated figures with tiny heads who float weightlessly in irrational spaces. The biographer Vasari reports that Pontormo developed an increasingly reclusive and suspicious nature in his later years. His artistic style of the last period of his life, particularly the San Lorenzo frescoes which, according to Vasari, were lacking in "any order, proportion, and perspective," seems to reflect something of the artist's growing isolation and social estrangement,

which is documented in the meticulous diary that Pontormo kept during the last two years of his life.

To the spiritual drama, emotional intensity, and increasingly personal style of Pontormo's religious compositions is contrasted the suavity and elegance of the artist's portraits. In works like the *Portrait of a Young Man* of 1515–26 (Lucca), the *Halberdier* of c. 1530 (Malibu), and the *Niccolò Ardinghelli* (Washington), Pontormo captures the sober and restrained aesthetic and comportment of the Florentine aristocracy of his day. His example was paramount for Bronzino, who would become the preeminent portraitist of ducal, Medicean Florence in the second half of the 16th century. In the hands of the courtly and urbane Bronzino, the portrait style formulated by Pontormo is elevated to a new height of preciousness, refinement, formality, and extreme stylization that signals the shift to the late *maniera*.

—Linda Wolk-Simon

PORDENONE.

Born Giovanni Antonio de' Sacchis in Corticelli, near Pordenone, 1483 or 1484. Died in Ferrara, 13 or 14 January 1539. Married 1) Anastasia, 1504; 2) Elisabetta de' Quagliati, 1513; 3) Elisabetta Frescolino, 1533. Pupil of Pellegrino da S. Daniele in Udine; influenced by Mantegna, and then by Giorgione and the young Titian; perhaps in Rome, c. 1515–16; then worked in Treviso, 1519–20, Mantua, Genoa, Cremona (in the Cathedral), Piacenza, 1529–30, before settling in Venice. Knighted by King John of Hungary, 1535.

Collections/Locations: Bergamo; Borgo Torre di Pordenone: parish church; Budapest; Conegliano; Corbolone; Cortemaggiore: church of the Francescani; Cremona: Cathedral; London; Milan; Murano: S. Maria degli Angeli; Naples; Philadelphia; Piacenza: Madonna di Campagna; Pordenone: Cathedral; Prague; Sarasota, Florida; Susegano: S. Maria Elisabetta; Treviso: Cathedral; Udine; Vacile: S. Lorenzo; Valeriano: parish church; Venice: Accademia, S. Rosso, S. Stefano, S. Maria dell'Orto, S. Giovanni Elemosinario; Vienna; Royal Collection.

Publications

On PORDENONE: books—

Fiocco, Giuseppe, *Pordenone*, Udine, 1939, 3rd ed., Pordenone, 3 vols., 1969.

Molajoli, B., *Pordenone e la pittura friulana del rinascimento* (cat), Udine, 1939.

Liberali, Giuseppe, *Lotto, Pordenone, e Tiziano a Treviso*, Venice, 1963.

Furlan, I., *Pordenone*, Bergamo, 1966.

Cavalcaselle, G. B., *La pittura friulana del rinascimento*, Vicenza, 1973.

Rizzi, Alberto, *Interventi sugli affreschi friulani dopo il terrimoto*, Venice, 1977.

Study drawing

Pantaleoni, G., *Affreschi e dipinti del Pordenone a Piacenza e a Cortemaggiore,* Piacenza, 1978.

Ceccato, P., *Tavola del Pordenone: Moriago della Battaglia,* Vittorio Veneto, 1980.

Cohen, Charles E., *The Drawings of Pordenone,* Florence, 1980.

Lavagetto, P. Ceschi, editor, *Giornata di studio per il Pordenone,* Piacenza, 1981.

Furlan, Caterina, and M. Bonelli, *Il Pordenone a Vacile,* Udine, 1982.

Furlan, Caterina, and M. Bonelli, *Il Pordenone a Traversio,* Udine, 1984.

Furlan, Caterina, editor, *Il Pordenone* (cat), Milan, 1984.

articles—

Rizzi, Alberto, "Novità su alcuni dipinti specie murali in Friuli," in *Antichità Viva* (Florence), July-August 1980.

Cohen, Charles, "Pordenone, not Giorgione," in *Burlington Magazine* (London), September 1980.

Douglas-Scott, Michael, "Pordenone's Altar-piece of the Beato Lorenzo Giustiniano for the Madonna dell'Orto," in *Burlington Magazine* (London), September 1988.

*

Friuli, the Venetian land between the Julian Alps and the sea, although rich in local art tradition, has, according to Bernard Berenson, produced only "one painter of remarkable talents and great force, Giovanni Antonio Pordenone." Berenson then modifies this positive assessment by adding that "neither talents nor force, nor even later study in Venice, could erase from his works that stamp of provincialism which he inherited from his first provincial master."

Pellegrino da S. Daniele from Udine, an artist specializing in stage designs, is thought to have been that first teacher. This may in fact explain the persistent theatrical quality in Pordenone's works. From Udine he must have proceeded to Venice before 1510 and come into contact with Giorgione, whose closest associate was Titian.

Pordenone's talent, no doubt apparent at an early state, earned him a number of regional commissions already before his mid-twenties, long before his first assignment at a more distant site, the fresco of 1515 in Alviano near Orvieto. Considering Orvieto's important place within the Roman sphere of interest, it stands to reason that Pordenone must have spent some time in the Papal city, gaining experience and stature, for on his return to the north he quickly attained a position of lofty distinction among artists and patrons, not only in the northern provinces but also in Venice proper. Thus when Titian in 1516 completed his magnificent and epoch-making *Assuption of the Holy Virgin* for the Church of the Friars, it may have been Pordenone, fresh back from Rome, who inspired the astonishingly dramatic treatment of the subject, an approach that

seemed suddenly to have severed Titian's link with the demure spirituality and bucolic calm of his Bellini-Giorgione past and projected him directly into an age still only in its formative phase, the Baroque.

It was Pordenone's Roman encounter with Raphael and Michelangelo, coupled with his own innate sense of the theatrical, that made him such a popular artist in early 16th-century Venice, where so far only a brighter colour scheme had intruded on the static three-dimensionality of the High Renaissance. To this Pordenone added new vitality by bringing into play the dynamic elements of time and motion. The resulting excitement among secular and ecclesiastical patrons brought him numerous distinguished commissions not only in the province but within the city itself, among these several exterior palace and cloister decorations, none—as with Giorgione's at Fondaco dei Tedeschi—having resisted the ravages by later copyists. His major triumph in Venice, however, was a series of frescoes in the Doges Palace, these also lost, destroyed by the fires of 1574 and 1577. Consequently, it is nearly impossible to assess the extent of the influence such works, at the time so conspicuously part of the Venetian cultural scene, may have had on Titian, Tintoretto, and other Pordenone contemporaries. There can be little doubt, however, that Tintoretto's openly dramatic treatment of biblical subjects had its roots in Pordenone, and literary as well as visual evidence exists to support the claim that for a limited time Pordenone's star threatened to eclipse that of Titian.

Because of the unfortunate destiny of his major works in Venice, his accomplishments can be judged primarily on the basis of his surviving fresco cycles, and a limited number of panels in the surrounding territories, all dating from the 1520's and 1530's, among them some highly commendable efforts. None the less, for the most part they fail to measure up to the masterful contributions of Titian and Tintoretto, to whose works Pordenone's are inevitably compared.

His many decorative projects for the city of Pordenone began in 1516 with a commission for an altarpiece for the cathedral and continued with frescoes and panel paintings for ecclesiastical and civic authorities for the next 20 years. Meanwhile his skill was in demand elsewhere as well. In 1519 he signed a contract for the decoration of the dome of the Malchiostro Chapel of the cathedral of Treviso, his most ambitious undertaking and one that pitted him directly against Titian, whose *Annunciation* for the same chapel may have been painted only two years earlier. Pordenone's frescoes portray *Augustus and the Sybil, God the Father and the Angels,* and *The Adoration of the Magi,* all designed with deliberate flamboyance. Titian's, on the other hand, although only two or three years removed from his elaborate Friars' *Assumption,* is tranquil and contemplative, and, compared to Pordenone's lavish wedges, quietly balanced and convincingly original. Even so, Pordenone's Treviso work was impressive enough to earn him his next important commission, a four-part fresco of *The Passion* in the cathedral of Cremona, the contract dated 1520. The centerpiece is a voluptuous rendition of the agony of Christ as witnessed by the masses in a profuse display of emotions ranging from mockery to profound compassion. Although decidedly rhetorical with its boldly foreshortened figures and restlessly pulsating action spilling out onto arches and pediments, the depiction nevertheless leaves an impression of shudder, awe, and admiration. And the placing of this ex-

travagantly decorative quartet of works within the somber stoniness of the ancient Romanesque sanctuary makes the virtuoso display even more effective. Here, as in other Pordenone works, the influence of Michelangelo is strongly, at times crudely, in evidence.

In the subsequent decades a number of well-paid commissions came his way, sometimes several in the course of a single year, such intense activity no doubt affecting the quality of his works. An agreement for the decoration of the choir of San Rocco in Venice was signed in 1527 and was followed by additional commissions in the city, among them a series of cloister frescoes for San Stefano, and for the church of the Madonna dell'Orto an altarpiece, now in the Accademia. This particular panel, portraying the Blessed Lorenzo Giustiani with Sts. John the Baptist, Louis of Toulouse, Bernardino of Siena, and Francis, was for centuries considered the single most important feature of the church and was included in several written accounts of treasured Venetian sights. In 1797 the church was looted and the panel removed to Paris. Since its return to Venice in 1815 it has remained in the Accademia.

The ceiling frescoes in Camera dello Scrutinio and Camera del Maggior Consiglio of the Doges Palace, both now destroyed, were completed in 1538, immediately before Pordenone's acceptance of an invitation from Duke Tebaldi of Ferrara, resulting in his departure for that city where, on January 12 or 13, 1539, he died under mysterious circumstances, Vasari claiming that he was poisoned.

While Pordenone's works indisputably contain coarse elements of the violent and the grotesque, often to the detriment of the spiritual message that ought to be their primary emphasis, they also reveal talent, skill, a vivid artistic personality, and rich creative experience, positive aspects quite sufficient to justify a careful re-examining of his contribution.

—Reidar Dittmann

POUSSIN, Nicolas.

Born in Les Andelys, June 1594. Died in Rome, 19 November 1665. Married Anne Marie Dughet, 1630 (died, 1664). Studied with the local Normandy painter Quentin Varin; then in the studio of Ferdinand Elle from 1612, and in studio of L'Allemand (from Lorrain); worked for Philippe de Champaigne on decorations in the Luxembourg Palace; a period of wandering in France; settled in Rome, 1624: attended the academy of Domenichino, and patronized by cardinals Barberini, Omodei, and de Richelieu, and by Vicenzo Giustiniani, Cassiano dal Pozzo, and Ftéari de Chantelou; returned to France, 1640-42, where he was named first painter in ordinary by Louis XIII; returned to Rome, and worked for Scarron and for the Duke of Crequi. Pupil: Gaspard Dughet, his brother-in-law who took Poussin's name.

Major Collections: Paris.
Other Collections: Baltimore; Berlin; Birmingham; Boston; Cambridge, Massachusetts; Chantilly; Chicago; Cleveland; Detroit; Dresden; Edinburgh; Hartford, Connecticut; Kansas City; Leningrad; London: National Gallery, Dulwich, Wal-

lace; Madrid; Minneapolis; Montreal; Moscow; Munich; New York; Ottawa; Philadelphia; Providence, Rhode Island; Rouen; Sarasota, Florida; Stockholm; Toronto; Vaduz; Vatican; Vienna; Washington.

Publications

By POUSSIN: books—

Oeuvres complètes, Paris, 2 vols., 1845.
Correspondance, edited by Charles Jouanny, Paris, 1911; selection, as *Lettres et propos sur l'art,* edited by Anthony Blunt, Paris, 1964.

On POUSSIN: books—

Félibien, Ardre, *Entretiens sur la vie et les ouvrages de Poussin,* Paris, 1666–68; as *Félibien's Life of Poussin,* edited by Claire Pace, London, 1981.
Freidlaender, Walter, *Poussin: Die Entwicklung seiner Kunst,* Munich, 1914.
Grautoff, Otto, *Poussin: Sein Werk und sein Leben,* Munich, 2 vols., 1914.
Magne, Emile, *Poussin,* Brussels, 1914.
Marotte, Léon, and Charles Martine, *Dessins de maîtres francaises I: Poussin,* Paris, 1921.
Courthion, Pierre, *Poussin,* Paris, 1929.
Malo, H., *Cent-deux dessins de Poussin,* Paris, 1933.
Wengström, G., and R. Hoppe, *Poussin,* Malmo, 1935.
Hourticq, Louis, *La Jeunesse de Poussin,* Paris, 1937.
Friedlaender, Walter, and Anthony Blunt, *The Drawings of Poussin,* London, 5 vols., 1939–74.
Christoffel, Ulrich, *Poussin und Claude Lorrain,* Munich, 1942.
Jamot, Paul, *Connaissance de Poussin,* Paris, 1948.
Licht, Fred S., *Die Entwicklung der Landschaft in den Werken von Poussin,* Basel, 1954.
Wildenstein, Georges, *Poussin et les graveurs au XVIIe siècle,* Paris, 1957.
Chastel, André, editor, *Poussin,* Paris, 2 vols., 1960.
Kauffmann, Georg, *Poussin-Studien,* Berlin, 1960.
Blunt, Anthony, and Charles Sterling, *Poussin* (cat), Paris, 1960.
Thuillier, Jacques, *Poussin et ses premiers compagnons français à Rome,* Paris, 1960.
Delacroix, Eugène, *Essai sur Poussin,* edited by Pierre Jaquillard, Geneva, 1965.
Friedlaender, Walter, *Poussin: A New Approach,* New York, 1965.
Blunt, Anthony, *The Paintings of Poussin: A Critical catalogue,* London, 1966.
Blunt, Anthony, *Poussin,* Princeton, 2 vols., 1967.
Badt, Kurt, *Die Kunst des Poussin,* Cologne, 2 vols., 1969.
Hibbard, Howard, *Poussin: The Holy Family on the Steps,* New York and London, 1974.
Thuillier, Jacques, *L'opera completa di Poussin,* Milan, 1974.
Rosenberg, Pierre, *Poussin* (cat), Rome, 1977.
Blunt, Anthony, *The Drawings of Poussin,* New Haven, 1979.
Grillo, Francesco, *Tommaso Campanella nell'arte de Andrea Sacchi e Poussin,* Cosenza, 1979.
Wild, Doris, *Poussin,* Zurich, 2 vols., 1980.
Thompson, Colin, *Poussin's Seven Sacraments in Edinburgh,* Glasgow, 1980.
Poussin: Sacraments and Bacchanals (cat), Edinburgh, 1981.
Mildner-Flesch, Ursula, *Das Decorum: Herkunft, Wesen, und Wirkung des Sujetstils am Beispiel Poussins,* Sankt Augustin, 1983.
Santucci, Paolo, *Poussin: Tradizione ermetica e classicismo gesuita,* Salerno, 1985.
Wright, Christopher, *Poussin Paintings: A Catalogue Raisonné,* London, 1985.
Thuillier, Jacques, *Poussin,* Paris, 1988.
Oberhuber, Konrad, *Poussin: The Early Years: The Origins of French Classicism,* Oxford and New York, 1988.

*

Nicolas Poussin is deemed the greatest French painter of the 17th century, although he spent practically his entire active career in Rome, and is venerated as one of the outstanding and most influential artists of European art. He remains, however, somewhat of an enigmatic figure. In the intellectual sphere, hardly a month goes by without new interpretations of his works being published, and controversy persists over attribution and chronology. A neo-Stoic, he created some of the most profound and arresting images of the New Testament, enriched by his interest and research into the early church. An Individual of great erudition and a theorist whose observations on painting and whose discussion of "modes" in his famous letter to his Paris patron Paul Fréart de Chantelou profoundly impacted the training structure and visual criteria of the Académie Royale, this cool and intellectual painter could create paintings of sensuous colorism and powerful, vivid eroticism—even humor. Because of his great subtlety, his works, studied "by those who know how to read them," as he wrote to his colleague and patron Jacques Stella, reveal many layers of meaning and intellectual and psychological response to his subject matter. He also could create among the boldest, most direct and haunting images of human terror and grief in the history of Western painting. He was a daunting figure in the artistic realms of Rome and Paris, and his works were sought by the most discriminating and influential collectors of his day, including Richelieu and Louis XIII (whose famous aphorism, "Voilà Vouet bien attrapé!" when Poussin was introduced to the monarch in France was later recounted by the artist himself). Yet he never succeeded in gaining the commissions for battle paintings and major decorative cycles in Rome for which he aspired.

An artist whose company was sought by some of the greatest minds and most powerful political figures of his time, Poussin lived a life of remarkable simplicity, married to the woman who nursed him to health in 1630, the sister of Gaspard Dughet, and seeking the companionship of fellow artists and members of the bourgeoisie who shared his intellectual interests. Poussin is also an artist virtually buried beneath the interpretations and inferences of admirers. The image of the artist as the great standard-bearer of classicism and stoic virtue seems embraced by the artist himself in that iconic and celebrated, if austere, *Self-Portrait* of 1650 at the Louvre, painted for his friend and patron Paul Fréart de Chantelou.

Despite the recent researches of Walter Freidlaender, An-

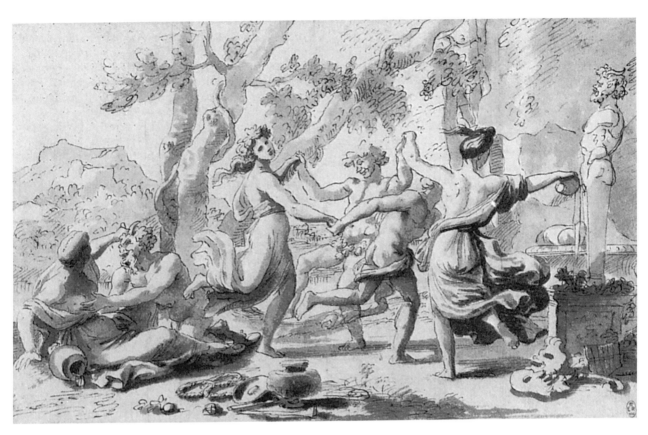

Dance in Honor of Pan; drawing; Royal Collection

thony Blunt, Denis Mahon, Pierre Rosenberg, Jacques Thuillier, and Konrad Oberhuber, among others, the outlines of Poussin's early years in France remain obscure. Thuillier's recent monograph (1988) on the artist has attempted to construct a plausible, if conjectural, early training and study consistent with the scant information provided from earliest sources. Clearly the artist did not speak much about his youth. He was attracted to painting by the indifferent artist Quentin Varin, who worked in a style informed by the Second School of Fontainebleau as well as by Flemish and Italian Late Mannerist painting. Poussin apparently received initial training from Noël Jouvenet in Rouen before traveling to Paris about 1616. These Paris years, between 1616 and 1624, remain a troubling mystery. The dominating artistic currents were Flemish and the late Second School of Fontainebleau, as embodied in Rubens and Georges Lallemant. In Paris, through a courtier to the Queen Mother, he had exposure to the Royal collections and prints after Raphael and Giulio Romano. He also worked together with the Flemish-trained artist Philippe de Champaigne on the decoration of the Luxembourg Palace. The evidence of one important commission, a painting of *The Death of the Virgin* for Notre-Dame in Paris, survives in a watercolor in a private British collection, evidencing the influence of Rubens and Franck as well as Lallemant and Dubreuil on the young artist. Several of Poussin's earliest surviving drawings and a series of classical and mythological drawings after Ovid that the artist prepared for his early admirer, the visiting Italian poet Marino, known through a set of copies (as Oberhuber has recently convincingly re-attributed them from the artist himself), confirm strong Flemish and especially Late

Fontainebleau influence on the artist's earliest graphic style.

In 1624, with the encouragement of Marino, Poussin reached Rome. Poussin's earliest years in Rome have been profoundly re-examined by Konrad Oberhuber (1988), and despite certain controversy over specific datings and attributions, his study has led to a critical re-appreciation of the breadth of styles, prodigious quantity, and brilliance of the artist's work during his first six years in Rome. The artist passed through Venice in 1624, and also studied the works of Titian in Rome, together with his friend the Flemish sculptor Francois Duquesnoy. In Rome, Poussin attended the studio of Domenichino and studied to advantage a broad range of other artistic styles including those of Raphael, Pietro da Cortona, Andrea Sacchi, Guido Reni, and, of course, the art of Roman antiquity. Arguably the pre-eminent masterpiece of this period is *The Death of Germanicus* (Minneapolis) of 1628, an important commission for Cardinal Francesco Barberini in which the sober, tragic subject matter, anticipating Poussin's mature style, is composed in the complementary spirit of monumental sculptural relief, looking back to the Meleager sarcophagus. The classically inspired figures are painted in deep but brilliant colors as they express with noble decorum the range of personal responses of grief and relationship to the deceased hero. Yet the artist was equally capable at the same time of painting works of the erotic intensity of the *Venus and Adonis* (Fort Worth) and *Mars and Venus* (Boston) and such lyrical tenderness as the Chatsworth *Arcadian Shepherds,* Louvre *Inspiration of the Epic Poet,* and slightly later Detroit *Diana and Endymion,* where Venetian colorism, the study of Pietro da Cortona, and an extraordinary sensitivity to the nuances of

gesture and expression are expressed in a new, monumental, classical balance between evocative sensuous tactility and nobility of form reminiscent of Classical Greek art.

The period of the 1630's was essentially one of stylistic consolidation for the artist. The *Parnassus* at the Prado (which we concur with Oberhuber in dating to about 1631) is as much a critique on Raphael's work as a paean to it, presenting the subject with even greater balance and symmetry than the original fresco. The Chantilly *Massacre of the Innocents* of about the same date, with reductive eloquence simplifies Marcantonio's composition after Raphael and Guido Reni's 1611 painting of the subject into one of the most singularly intense and horrific images of human tragedy in Baroque art. The narrative is expressed by a minimal number of characters on a proscenium of Classical architecture pressed to the picture plane, their diversity of responses and emotional states to a focal, brutal act thereby concentrated, the action itself frozen in time and eternalized as in a classical Greek relief. *The Kingdom of Flora* (Dresden) of 1631, transforms the garden of Flora into the mythologically personified characters described by Ovid, yet maintains a balance between the anecdotal vignettes that populate the composition and an overall compositional symmetry and unity. The blond tonality of the work is derived from Sacchi, the figures based on careful study of classical sources.

By 1633, in the Dresden *Adoration of the Kings,* Poussin had defined his aesthetic and intellectual concerns, specifically, increased attention to historical accuracy of setting and, equally importantly, the creation of carefully structured compositional scheme in which the viewer is directed by pose and gesture in the reading of both intellectual and psychological meaning. By the time Poussin executed the 1635-36 *Rape of the Sabine Women* (Metropolitan), he could synthesize the emotional intensity of the earlier *Massacre of the Innocents* with a new-found severity of compositional structure, embracing a large cast of characters with the intensity of a battle scene. From 1634 to 1637 the artist executed a series of four Bacchanals with triumphant processions for Richelieu. These works conjoin the study of Raphael (as in the *Triumph of Neptune and Amphitrite* in Philadelphia) with a re-examination of northern Italian elegiacal painting, as in *The Triumph of Pan* (London). At the same time he executed the *Pan and Syrinx* (Dresden) for his friend Jacques Stella. This potent image of tragic lust is set in a magnificent landscape, reflecting the artist's earlier study in the Campagna with northern landscape painters. Towards 1640, just before his commanded trip to Paris (1640-42) which resulted in new intellectual friendships among French neo-Stoics and the personal friendship with such patrons as Chantelou, Pointel, and Cerisier, he must have painted the most celebrated elegiacal *memento mori* in art, the *Et in Arcadia Ego* (Louvre), as well as the conceptually related *Dance to the Music of Time* in the Wallace Collection.

Between about 1635 and 1642, Poussin painted for Cassiano dal Pozzo the first of his two great series of *Seven Sacraments* (the six surviving works at Belvoir Castle and the National Gallery of Art, Washington), embodying in a novel concept of separate paintings in sequence for each of the Church's sacraments the artist's mature artistic and intellectual concerns. The images are set with as great precision as contemporary scholarship permitted in the historical setting of the ancient world. the sacred acts are enacted with serene simplicity in settings and compositions of austere yet monumental sobriety, according to the descriptions of the New Testament or the rites of the primitive Church. The tonalities and colorism appropriately reflect subjects ranging from *Marriage* to *Extreme Unction*. It was at this time that the artist must have begun consciously theorizing his famous if somewhat vague theory of modes, set forth in a letter to Paul Fréart de Chantelou in 1647—in response to a complaint by Chantelou over the tonality of *Ordination* from the second, even more severe and profound series of *Seven Sacraments* (1644-48), arguably Poussin's greatest masterpieces (Duke of Sutherland Collection, on loan to the National Gallery of Scotland). The theory essentially states that the compositional conception, the figure types and gestures and the pictorial colorism and overall tonality should complement the subject matter, and this correspondence is called the "mode" of the painting. The idea of appropriating the modes that the ancient Greeks applied to their music (incorporating, more specifically, the musical theories of Gioseffe Zarlino's *Instituzioni Harmoniche* of 1553) for the visual arts was Poussin's invention. Color, light, and design should function as harmonies to satisfy the mind and spirit.

In the mid and later 1640's, in such works as the *Madonna of the Steps* (Cleveland) and *Judgment of Solomon* (Louvre) the artist's compositions become increasingly severe and symmetrical. In the latter the intellectual sobriety and compositional severity almost overwhelm the emotional communication of content. The starkness of such paintings as the tragic *Testament of Eudamidas* (Copenhagen) and *Crucifixion* (Hartford), and the contemplative *Phocian* landscapes and *Landscape with St. John on Patmos* (Chicago) are eloquently served by this restraint. In *The Infant Bacchus Entrusted to the Nymphs* (Fogg Art Museum, Cambridge, Massachusetts) of 1657, a narrative derived from Ovid and Philostratus, a sophisticated program contrasting life with death and nurturing and fertile love with barren and self-obsessed love serves to synthesize classical myth with Christian allegory. During his final years, while continuing in such searing images as *Lamentation over the Dead Christ* (Dublin) and the Munich *Annunciation* to create utterly simple compositions of profound spirituality and mystery, he explored in a series of landscapes, culminating in the four *Seasons* (Louvre). In these introspective paintings the elemental powers of nature, seen through his stoic philosophical disposition, are painted with a new and ethereal delicacy of touch and gentle, yet deeply stirring love for the Campagna. Poussin always sought the synthesis of mind and emotion through the spiritually enhancing pleasure in the beauty of art, for as he observed of his own efforts, "sa fin est la Delectation."

—Hilliard T. Goldfarb

POZZO, Andrea.

Born in Trento, 30 November 1642. Died in Vienna, 31 August 1709. Trained in north Italy; novice in order of Discalced Carmelites at Convento delle Laste, near Trento, 1661-62; became a Jesuit lay brother, 1665, but encouraged to continue painting by his superiors; worked in Rome, 1681-1702: masterpiece of illusionism (and *sotto in su*) is the ceiling of S.

Ignazio, 1691–94 (he also wrote a pamphlet about it); also worked on Casa Professa of the Jesuits, altars in the Gesù church, and festive and devotional decorations; he also worked in Vienna from 1703, and died there.

Collections/Locations: Arezzo; Badia; Florence; Frascati: Jesuit church; Genoa: SS. Ambrogio e Andrea; Modena: S. Bartolomeo; Mondovi: S. Francesco Saverio; Montepulciano: Palazzo Contucci; Novi Ligure: S. Maria Maggiore; Rome: Il Gesù, S. Ignazio; San Remo: S. Stefano; Trento: Museum; Vienna: Liechtenstein Palace.

Publications

By POZZO: books—

Tractatus perspectivae pictorum et architectorum, Rome, 1693–1700; as *Rules and Examples of Perspective Proper for Painters and Architects, in English and Latin*, London, 1707.
Significati delle pitture fatte nella volta della chiesa di S. Ignazio, Rome, 1828.

On POZZO: books—

Chandlery, Peter John, *Le camere di Sant Ignazio di Loyola nel Gesù di Roma*, Rome, 1899.
Tacchi-Venturi, Pietro, *La casa di S. Ignazio di Loiola in Roma*, Rome, 1929; as *La prima di S. Ignazio Loyola in Roma o le sue cappelletta al Gesù*, Rome, 1951.
Fabrini, Natale, *La chiesa di S. Ignazio in Roma*, Rome, 1952.
Marini, Remigio, *Pozzo, pittore*, Trento, 1959.
Carboneri, Nino, *Pozzo, architetto*, Trento, 1961.
Calvo, Francesco, *Kirche des hl. Ignatius in Rom*, Bologna, 1968; originally published as "Sant'Ignazio, Roma," in *Tesori d'Arte Cristiana* (Bologna), 5, 1967.
Kerber, Bernhard, *Pozzo*, Berlin, 1971.
De Feo, Vittorio, *Pozzo: Architettura e illusione*, Rome, 1988.

article—

Lavagnino, Emilio, "Il restauro della cupola di S. Ignazio," in *Studi Romani*, 10, 1962.

*

Andrea Pozzo, the most famous of the Jesuit artists active in Europe in the 17th century, is a curious individual. Facile in both painting and architecture, Pozzo is famous for his perspectival frescoes. Although his major works were carried out in Rome during the last quarter of the century, they depend primarily on northern Italian traditions. In fact, Pozzo remained aloof from developments in Roman painting at the end of the 17th century, but his work, unlike that of his Roman colleagues, contributes substantially to later developments in European painting, and especially to the evolution of rococo ceiling painting in Austria and Germany.

Pozzo's career can be divided into three periods of activity.

His pre-Roman work, dating from about 1670, involved the production of both altarpiece images as well as perspectival painting. Almost without exception Pozzo worked for the Society of Jesus, the order which he joined as a lay brother in Milan in 1665. While most of the early works pale in comparison with his later achievements, they were sufficiently recognized to prompt Gian Paolo Oliva, Father-General of the Society of Jesus, to invite Pozzo to Rome. The invitation, supported by Carlo Maratti, one of Rome's leading painters at the time, was issued in 1681, and although Oliva died in that year, Pozzo was welcomed to Rome by his successor. Here, he was assigned a number of decorative tasks ranging from altarpiece painting to altar design, and decorative festival design to large-scale architectural painting. His name appears with regularity in the accounts of the Society.

Of Pozzo's Roman works the most important campaign was for the decorations of the interior of the church of S. Ignazio, the church attached to the Jesuit educational institution of the Collegio Romano. Known as the "second" Jesuit church in Rome—second to the Mother Church of Il Gesù—S. Ignazio was begun in 1626, but the building history of the church was a long one and by 1680 the accounts had run dry. Pozzo was asked in 1685 to propose a scheme for the completion of the dome of the church. The solution—only partly architectural—was ingenious: Pozzo directed the design and painting of a view into a dome on a large circular canvas which was then attached to the surface over the crossing of the church. Carried out within only four months time, the solution was heralded as remarkable, although its limitations were also acknowledged. Not only did the canvas darken to become almost indistinguishable within a short period of time, but also as a fictive presentation of architecture, the effect of the illusion demanded a single vantage point, marked on the floor immediately before the crossing with a yellow marble disk. Nevertheless, the Jesuits were relieved of the expense of the dome construction and delighted with the deftness of the illusion.

Pozzo was also awarded the commission to decorate the pendentives, the apse and, in 1691, the enormous nave vault fresco. For the nave he designed an elaborate solution based on the construction of a painted stage of architecture that appears as an extension of real architecture of the nave space. This type of illusionary architecture, called *quadratura* or painted architecture, although it restricts the viewer's mobility (the illusion only "works" from one isolated vantage point), affords the presentation of a grand architectural realm beyond the real space of the church. Here Pozzo stages the complex imagery of the Allegory of the Jesuit missions through the agency of St. Ignatius. Ignatius is shown floating in heaven where he receives from the Trinity above a great beam of divine light that he, in turn, deflects to the corners of the earth represented by allegorical figures of the four continents. In all, the image is a celebration of the missionary activities of the society initiated by its founder Ignatius of Loyola. The creation of an entirely illusionary space, defined by a grander and more muscular architecture than is the church of S. Ignazio itself, implies an infinite depth that is then filled with a cast of characters. At the center of the ceiling is the relative calm saint who becomes merely the agent of the flurry of activity that surrounds him in the space projected toward the viewer. Unlike the solution of Giovanni Battista Gaulli, called il Baciccio,

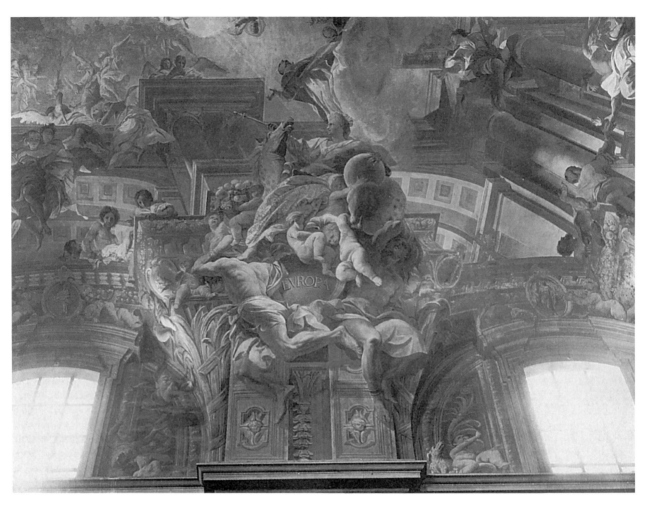

Ceiling—detail; Rome, S. Ignazio

for the decoration of the vault of Il Gesù (1676–79) where the painting seems to impinge on the zone of the viewer, Pozzo's image recedes from the viewer. The created space of the painting extends the real space of the church, but the viewer is left quite apart. This is the realm of infinite space and of all time.

In addition to his commissioned work Pozzo began in the 1690's to write about his painting and architecture. He wrote and illustrated a treatise on perspectival inventions in painting and architecture entitled *Tractus perspectivae pictorum et architectorum*. The first volume of this work appeared in Rome in 1693; the second appeared in 1700. In 1702 Pozzo travelled to Vienna where he worked for the Prince of Liechtenstein with whom he had contact as early as 1694 when he wrote to the Prince explaining the iconography of his nave vault fresco for S. Ignazio. Although Pozzo continued to work for the Jesuits in Vienna and elsewhere in northern Europe, his most remarkable achievement from this last period of activity is the frescoed vault of the reception hall of the Liechtenstein Palace, also a *quadratura* construct representing the Labors of Hercules. This ceiling painting is consistent with the work of S. Ignazio in the type of architecture that is painted and in the power of the architectural illusion, but there are important changes in the relationship of the figural composition to the architectural one. In this case the figures are smaller in scale, they are more loosely arranged and they appear to float in the

space framed by the painted architecture. The effect is of two independent compositions: The architecture looms overhead, while the figures appear distant and ethereal. Moreover, these changes in Pozzo's work mirror developments in the change from the heavier and more didactic ceiling programs of the baroque to the lighter and more purely decorative character of the rococo.

Pozzo's position relative to developments in both Italian and European painting in the 17th and 18th centuries is intriguing. On the one hand, he remained outside the mainstream of painting as it had evolved in Rome by the 1680's. There is no evidence of his response to the growing taste for a more classical and reserved image championed by painters such as Maratti. Rather, Pozzo seems to have specialized in his perspectival inventions, and given his personal ties to the Jesuits, he never seems to have to compete for commissions. Equally foreign to Roman tastes is the dependency of his painted constructs on the traditions of large-scale painting as it evolved in northern Italy. The interest in painted architecture as a substitute for real built architecture may have been fueled by his knowledge of Donato Bramante's work in the late 15th century on the apse of S. Maria presso S. Satiro in Milan, where Pozzo lived from about 1662 until his transfer to Rome in 1680. His fascination with the establishment of elaborate architectural constructs as the stage for painted figure composi-

tions has been related to the grand paintings of the Venetian painter Paolo Veronese.

If the sources for Pozzo's work are removed from Rome, so too is his influence. Although admired by Roman audiences, his paintings there provoked almost no reaction among other artists. Rather his work appealed to northern Italian painters and especially to Giovanni Battista Tiepolo, whose ceiling paintings in the church of the Gesuati and the Palazzo Rezzonico, both in Venice, and in the Residenz in Würsburg demonstrate his clear knowledge of Pozzo's work. The dissemination of his work was insured with the publication of his treatise of the 1690's. Translated into various languages (even Chinese), the *Tractus perspectivae pictorum et architectorum* promoted Pozzo's reputation with both artists and patrons across Europe, and while Pozzo's works for the Jesuits were primarily propagandistic in nature and so tied to the traditions of the baroque, his writings and his late work usher in the 18th-century concern with formal invention and decoration.

—Dorothy Metzger Habel

PRENDERGAST, Maurice (Brazil).

Born in St. John's Newfoundland, 1858; grew up in Boston from age two; brother of the painter Charles Prendergast. Died in New York, 1 February 1924. Studied at the Académie Colarossi and the Académie Julian, Paris, 1890-95; influenced by Whistler and the Nabis; settled in Boston, but made later trips to Europe, 1898-99, etc.; exhibited with the Eight, 1908, and moved to New York, 1914; also did monotypes.

Collections: Boston; Cleveland; Detroit; Merion, Pennsylvania; Washington: Phillips.

Publications

By PRENDERGAST: books—

Illustrator: *The Shadow of a Crime,* by Hall Caine, 1895; *My Lady Nicotine,* by James Barrie, 1895.

On PRENDERGAST: books—

Breuning, Margaret, *Prendergast,* New York, 1931.
Rhys, Hedley Howell, *Prendergast* (cat), Boston, 1960.
Wick, Peter A., *Prendergast: Water-Color Sketchbook 1899,* Boston, 1960.
Green, Eleanor, et al., *Prendergast: Art of Impulse and Color* (cat), College Park, Maryland, 1976.
Owens, Gwendolyn, *Watercolors by Prendergast from New England Collections* (cat), Williamstown, Massachusetts, 1978.
Prendergast (cat), New York, 1979.
Langdale, Cecily, *Monotypes of Prendergast in the Terra Museum of American Art,* Chicago, 1984.

Prendergast: The Large Boston Public Garden Sketchbook, New York, 1987.
The Remembered Image: Prendergast Watercolors 1896-1906 (cat), New York, 1987.
Clark, N., Nancy Mowll Mathews, and G. Owens, *Maurice and Charles Prendergast: Catalogue Raisonné,* New York, 1989.

articles—

Wattenmaker, R. J., "Prendergast," in *Allen Memorial Art Gallery Bulletin* (Oberlin, Ohio), 40, 1982.
Langdale, Cecily, "The Late Watercolor-Pastels of Prendergast," in *Antiques* (Craven Arms, Shropshire), November 1987.

*

While he showed his work with that of "The Eight," Maurice Prendergast was a different sort of rebel than the other members of the group—not a social realist, concerned with the urban scene, but an adventurous manipulator of color and form. Alone of American painters of his time, Prendergast was aware of modernist developments in France, and of the work both of the Nabis and of Cézanne. In fact Prendergast was the only American artist to produce modern-looking paintings prior to the Armory Show of 1913—the event which finally shocked the American art world into an awareness of European developments.

Born in Newfoundland in 1859, Prendergast moved to Boston at an early age. After leaving school in the eighth grade, he worked as a clerk in a drygoods store, and his exposure at that time to printed fabrics gave him a life-long appreciation of brilliant color and decorative design. Thanks to the financial help of his brother Charles, a successful framemaker, at the age of 30 Prendergast was able to leave his clerkship and study art in Paris. He enrolled both at Colarossi's and the Académie Julian, but showed no interest in copying plaster casts or in developing an academic technique. Instead, he worked from life, sketching in the morning from the model in the studio, and spending his afternoons in the cafes, sketching the people on the parks and boulevards.

A close friend at this time was the Canadian artist Charles Wilson Morrice, who belonged to a group that gathered at the cafe Chat Blanc in Montparnasse. Most members of this circle were British, including the painters Charles Condor, Walter Sickert, and Aubrey Beardsley and the writers Arnold Bennett and Somerset Maugham. Morrice had also known Gaugin and had very open-minded tastes. His rooms in the Quai des Grand Augustins were eventually decorated with a Condor fan, a Picasso sketch, and a Modigliani drawing, as well as several watercolors by Prendergast. Morrice's own work was influenced by the flat color patterns of Bonnard and Vuillard, and his works showing this influence served as a model for those of Prendergast. In some cases the two artists even sketched the same site in Paris from the same vantage point.

In 1895 Prendergast returned to Boston, his home base until 1914, from which he made occasional trips to Europe. He continued to rely on the support of his brother Charles, with whom he always remained very close. One notable visit to Venice, in 1898-99, resulted in a group of splendid water-

Orange Market, 1900; monotype

colors. Like the masters of the so-called "Boston school," such as Frank Benson, Joseph De Camp, Demund Tarbell, and William Paxton, Prendergast concentrated on the genteel aspects of life, specifically on well-dressed women, whom he treated as decorative compositional accessories without interest in personality or psychology. Prendergast's formal interests, however, set him apart from the other Boston painters, who were stylistically *retarditaire* and worked in either a tightly realistic mode or an academic-impressionist manner. Only the gifted but uneven Charles Hopkinson, with whom Prendergast exhibited in 1905, ever shared any similar interest in stylistic experiment.

Prendergast won the favor of relatively conservative Bostonians, who had little interest in modernist tendencies but enjoyed the cheerfulness of his work. His most enthusiastic patronage, however, came from collectors like Duncan Phillips and Albert Barnes whose primary interest was modernist European art.

After 1900 Prendergast exhibited frequently in New York, where he could reach a larger audience. In 1908 he joined the controversial exhibition staged by the Eight at the Macbeth Gallery. At that time his "explosion in a color factor" was singled out for attack: one critic termed his paintings "artistic tommy-rot" and "unadulterated slop," and declared that "the show would be better if it were that of the Seven rather than the Eight." In 1913 Prendergast showed seven works in the Armory Show.

Despite the important role of women in his work, Prendergast never married. His later years were increasingly

marred by debilitating deafness. In 1914 he and his brother Charles finally moved to New York and took a studio above that of William Glackens at 50 South Washington Square. Prendergast worked there until his death.

—Henry Adams

PRETI, Mattia. [Il Cavaliere Calabrese.]

Born in Taverna, near Catanzaro, 24 February 1613; brother of the painter Gregorio Preti. Died in Valletta, Malta, 3 January 1699. Presumably trained in Rome; Knight of Malta (in Rome), 1641; traveled in the 1640's: visited Venice and Emilia; then worked in Rome: S. Andrea della Valle, S. Carlo ai Catinari, 1650–51; worked in Modena, c. 1652, and in Naples, 1653–60: frescoes on the seven city gates, S. Pietro a Maiella; Palazzo Pamphili at Valmontone, 1660; then settled in Malta, 1661: many works, including the vault and apse of St. John Co-Cathedral, Valletta.

Major Collection: Naples.
Other Collections: Birmingham; Brussels; Chantilly; Genoa: Rosso; Grenoble; Houston; Leningrad; Madrid; Modena: S. Biagio; Naples: Palazzo Reale, S. Lorenzo Maggiore, S. Pietro a Maiella; New York; Oxford; Rome: S. Carlo ai Catinari, Doria Pamphili, S. Andrea della Valle; Sambughe (Treviso): parish church; San Francisco; Toledo, Ohio; Toronto; Tours; Valletta: Museum, St. John's Co-Cathedral, S. Catherine of Italy.

Publications

On PRETI: books—

Pujia, Carmello, *Preti nel terzo suo centenario,* Naples, 1913.
Chimirri, Bruno, and Alfonso Frangipane, *Preti,* Milan, 1914.
Sergi, Antonio, *Preti: La vita, l'opera, catalogo delle opere,* Acireale, 1927.
Mariani, Valerio, *Preti a Malta,* Rome, 1929.
Frangipane, Alfonso, *Preti,* Milan, 1929.
Frangipane, Alfonso, *La pittura e il dramma di Preti,* Naples, 1931.
Refice, Claudia, *Preti: Contributo alla conoscenza del cavaliere calabrese,* Brindisi, 1959, Naples, 1970.
Carandente, G., *Preti a Taverna,* Rome, 1966.
Causa, Raffaello, et al., *The Order of St. John in Malta, with an Exhibition of Paintings by Preti, Painter and Knight* (cat), Valletta, 1970.
Pelaggi, Antonio, *Preti e il seicento italiano, col catalogo delle opere,* Catanzaro, 1972.

articles—

Spike, John T., "Preti's Passage to Malta," in *Burlington Magazine* (London), 120, 1978.
De Conciliis, D., and R. Lattuada, "Unpublished Documents for Preti's Paintings in S. Pietro a Majella in Naples," in *Burlington Magazine* (London), 121, 1979.

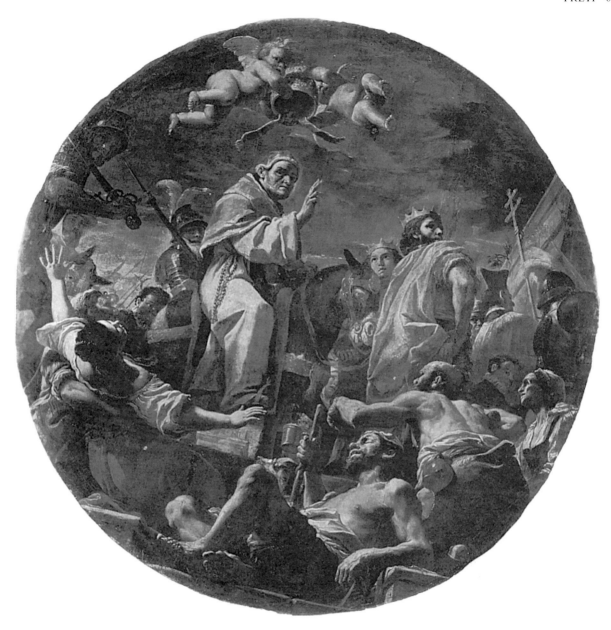

The Entrance of St. Peter Celestine into Aquila; Naples, S. Pietro a Maiella

Abbate, Vincenzo, "Appunta per la committenza di Preti," in *Bollettino d'Arte* (Rome), January-March 1980.

Clifton, J., and John T. Spike, "Preti's Passage to Naples," in *Storia dell'Arte*, 1989.

*

Although Preti is chiefly associated with Neapolitan baroque painting, which he decisively influenced, he was trained and won his first honors in Rome. The young Calabrese painter seems to have arrived in Rome at the beginning of the 1630's. He is documented as sharing an apartment in Rome in 1636 with his elder brother, Gregorio, who was a painter of much less attainment. Preti's early biographers, Lione Pascoli (1730) and Bernardo De Dominici (1741–44), and other sources knew but little regarding Preti's Roman formation and could only hazard contradictory guesses as to whether he had been the pupil of Lanfranco of Guercino. It seems most likely, in fact, that he learnt the rudiments of painting from Gregorio Preti and then educated himself an eclectic study of other masters' paintings.

Roberto Longhi's reconstruction of Preti as the last important follower of Caravaggio, notwithstanding the silence of his biographers on this question, was doubtless on the mark. Preti's Roman works cannot be dated precisely, but the general outline of Preti's development seems as follows. The artist's juvenilia of the 1630's, e.g., *The Draughtsplayers* (Oxford), pertain to the brand of Caravaggism that Sandrart termed the *methodus Manfrediana* in respect of the influential Bartolomeo Manfredi. Before the end of the decade, however, the young artist had broadened this somewhat out-of-fashion grounding in Caravaggism with an heroic figure style adapted from Lan-

franco and Guercino and with brighter, neo-Venetian tonalities and freer brushwork inspired by Nicolas Poussin and, to some extent, Andrea Sacchi.

Undocumented journeys north of Rome during the mid-1640's were described by Bernardo De Dominici. A study voyage to Venice seems proved by the depth of the artist's attraction to Venetian Renaissance prototypes, Paolo Veronese in particular. The *Return of the Prodigal Son* (Le Mans) is representative of Preti's early maturity. Wittkower (1958) described Preti as "Grave, problematical, dramatic, a moralist, and throughout his life a *Caravaggista*. . . ." It is true that Preti's gifts for forceful and persuasive expression made it possible for him to forge a definitive style out of the seemingly conflicting qualities of Caravaggesque naturalism and Veronesian theatricality.

Details on Preti's Roman patrons are unfortunately scarce. It appears that his paintings entered nearly every important collection of the time, without bringing him the special protection of any single family. In 1641, Preti was elevated by Pope Urban VIII Barberini to a Knighthood of Obedience in the Order of St. John of Jerusalem (the Knights of Malta), an honor he received, according to De Dominici, through the intervention of Donna Olimpia Aldobrandini, Princess of Rossano. Thereafter Preti was commonly known to contemporaries by the sobriquet, "Il Cavalier Calabrese."

By mid-century, Preti's place in the first rank among Roman painters was demonstrated by the prestigious commission to paint three huge frescoes of the *Martyrdom of St. Andrew* in the apse of S. Andrea della Valle (1650-51). Preti's St. Andrew frescoes were compared unfavorably, however, to Domenichino's frescoes on the vault of the same church; it appears that this discouragement caused Preti to lose his appetite for Rome. During the period of 1651-52 he made at least one visit to Modena to paint frescoes in the Duomo and in S. Biagio. By January of 1653 he had abandoned Rome altogether and transferred to Naples.

A legend promulgated by the Neapolitan biographer, Bernardo De Dominici, held that Preti had entered Naples during the plague of 1656. Recently, Clifton and Spike (1989) have published the records of Preti's bank accounts and other documents which establish that Preti was resident in Naples from January 1653 until December 1660. In recent years Preti's critical activity in Naples has been greatly illuminated by archival researches—mostly to De Dominici's discredit.

Soon after his arrival in Naples, Preti had gained the approval of Gaspar Roomer and other collectors; he then began to garner the lion's share of major public commissions. Neapolitan painting at mid-century was dominated by the bland and repetitious products of Massimo Stanzione and his innumerable followers. Preti's ex-voto frescoes over the seven gates of the city and his cycle of 12 canvases for the ceiling of S. Pietro a Maiella were revelations to local artists, especially Luca Giordano, the local prodigy. Nikolaus Pevsner (1932) astutely observed that Preti's paintings from his Neapolitan years pioneered the evolution of Late Baroque style, of which Luca Giordano eventually emerged as the exponent *non pareil.*

While in Naples, Preti attracted a commission from the Grand Master of the Knights of Malta. After a short visit to Malta in 1659, Preti took an active interest in pursuing the career and patronage possibilities that the Knights could offer him. At the end of 1660 he left Naples for Rome, where,

besides politicking, he painted an ebullient replacement to Pierfrancesco Mola's *Allegory of Air* in the Palazzo Pamphili, Valmontone (1661). With the requisite dispensation of Pope Alexander VII in hand, Preti's rank was raised to Knight of Grace in Malta in September of 1661.

His immediate task in Malta proved to be his masterpiece. Between 1661 and 1666, Preti painted on the vault and apse of the conventual church of St. John, Valletta, a vast cycle of scenes from the life of John the Baptist with portraits of the heroes and saints of the Knights of Malta. For the remainder of his long life Preti lived on Malta, placing altarpieces in each of the myriad churches on the three Maltese islands and dispatching as many canvases to patrons abroad, to Naples especially.

Generations of Neapolitan painters continued to fall under the spell of Preti's revolutionary style. The most notable of his adherents was Francesco Solimena, who was *caposcuola* in Naples throughout the first half of the 18th century. According to De Dominici, Solimena praised particularly Preti's remarkable skill at drawing.

—John T. Spike

PRIMATICCIO, Francesco.

Born in Bologna, 30 April 1505. Died in Paris between 15 May and 14 September 1570. Pupil of Giulio Romana from 1525 or 1526 to 1532 in Mantua; from 1532, worked at Fontainebleau for Francis I (with Rosso): painting and high relief stucco decoration and sculpture; in Rome 1540-42 buying art works for Francis; then again worked at Fontainebleau with Abbate: particularly on the Galerie d'Ulysse; after the death of Francis, responsible for Gallery of Henry II.

Major Collection: Fontainebleau: Château
Other Collections: Barnard Castle; Bologna; Chantilly; Florence; Glasgow; Leningrad; Montpellier; Naples; Paris: Louvre, Cluny; Pittsburgh; Providence, Rhode Island; Stockholm; Toledo, Ohio; Vienna.

Publications

On PRIMATICCIO: books—

Dimier, Louis, *Le Primatice, peintre, sculpteur, et architecte des rois de France,* Paris, 1900, 1928.
Beguin, Sylvie, *Rosso e Primaticcio al castello di Fontainebleau,* Milan, 1966.

articles—

Briganti, G., "Contributi a Ercole de' Roberti, Parmigianino, Primaticcio," in *Emporium* (Bergamo), 53, 1947.
Barocchi, P., "Precisazione sul Primaticcio," in *Commentari* (Rome), 2, 1951.
Bertini, A., "Un misconosciuto ciclo di affreschi del Primaticcio," in *Emporium* (Bergamo), 58, 1952.

Escalier du Roi—detail, 1541–45; Fontainebleau Palace

Francesco Primaticcio was an assistant to Giulio Romano in Mantua from the mid-1520's until 1532, and helped him especially at the Palazzo del Te. His only known work to survive from the Palazzo del Te is the Triumph of Sigismund, a stucco frieze. This is appropriate, since one of the characteristics of his most famous work, that for the French Chateau of Fontainebleau, was its use of stucco.

In 1532 Primaticcio was called to Fontainebleau on the recommendation of Giulio Romano, and at first worked under the overall supervision of Rosso Fiorentino. Rosso had worked at Florence, then at Rome for some years up to the sack of Rome in 1527. After some wandering, he had come to Fontainebleau to decorate the greatly expanded chateau Francis I was building. With Pontormo, Rosso is credited with being one of the founders of the new Mannerism—and its use at Fontainebleau

is seen as its first passage into the international artistic language.

Fontainebleau's major galleries were long, narrow, and low, unlike the large rooms of the Palazzo del Te, and worked as a challenge to the decorator. From his earliest years at Fontainebleau, Primaticcio used high stucco ornamentation to "frame" his painted works, but because of the loss of much of the early artistic work done at Fontainebleau, it is difficult to say whether Rosso or Primaticcio was the first responsible for the decorative manner evolved here. Over the centuries, critics tended to emphasize the differences between the two men, and made unwarranted attributions in order to support their views that Rosso was the noble heir of Raphael, and that Primaticcio was the debased heir of Michelangelo. The answer lies somewhere between—and Rosso seems now to be regarded as the

originator of the stucco style, and Primaticcio the originator of the manner of figure drawing used in the chateau.

In Primaticcio's figure drawing style there is also apparent a Michelangelesque element (probably through Rosso), with strongly developed torsos of men, strong thighs of women, and in general a physical glorification of humankind. The influence of Parmigianino is also apparent—whether from personal knowledge of his work (on his trips back to Italy in 1540 and later), or from the possible appearance in Fontainebleau of Parmigianino's assistant Antonio da Trento (possibly the same as Antonio Fantuzzo who assisted Primaticcio at Fontainebleau): here the characteristics are strong hips, small fine faces, and long necks for his portraits of women. There is also a decided classical influence on Primaticcio's work. He was sent back to Rome by Francis I to buy antiquities in 1540–42.

Some of his early work—e.g., that for the Cabinet du Roi, 1541–45—is still in the style of Giulio Romano. But all the influences mentioned above are apparent in the major work at the chateau, the Chamber of the Duchess d'Etampes, c. 1541–45. The major decorative program in this room is the story of Campaspe and Alexander the Great, with allusions to the relationship between the Duchess and Francis I. The decorations are completely original, attributed by Anthony Blunt to the combination of ancient Roman sculpture (especially late Hellenistic work) and the Mannerist influence from Parmigianino: the caryatids in the Duchess's chamber have the long tapering limbs, thin necks, and small heads with exaggeratedly classical profiles of Parmigianino. His work in the Galerie Henri II (Salle de Bal) also survives, much restored. More impressive is the elaborate neo-classical ceiling of the Galerie d'Ulysse (known only from engravings), combining classical forms with motifs from Perino del Vaga: the great variety of forms includes figures combining with grotesques in complicated panels. Some later work involving bold illusionism and steep perspective systems is possibly influenced by his later assistant Niccolò del'Abate, first documented at Fontainebleau in 1552. Perino del Vaga's influence is again possible.

Primaticcio's mature style was very influential, not only in France until the end of the century, but also among Flemish, Prague, and German artists.

—George Walsh

PRUD'HON, Pierre Paul.
Born in Cluny, 4 April 1758. Died in Paris, 16 February 1823. Married unhappily; lived with his pupil Constance Mayer from 1803 (died, 1821). Educated at the abbey of Cluny, then studied under François Devosge at Dijon art school, from 1774; worked with the engraver Ville in Paris, 1778–81: Prix de Rome; lived in Rome, 1781–87: friend of Canova, and influenced by Correggio; settled in Paris, 1787: book illustrator for editions of Firmin Didot; decorated Hôtel de Landry (now Rothschild), Versailles; patronized by both of Napoleon's empresses: drawing lessons, duties as court painter, designed furniture.

Major Collection: Paris.

Other Collections: Amsterdam; Chantilly, Chateauroux; Dijon; Lille; London: Wallace; Minneapolis; New York: Metropolitan, Historical Society; Paris: Carnavalet, Jacquemart-André; St. Louis; Versailles.

Publications

By PRUD'HON: book—

Du principe de l'art et de sa destination sociale, Paris, 1865.

On PRUD'HON: books—

Clément, Charles, *Prud'hon: Sa vie, son oeuvre, sa correspondance*, Paris, 1872.
Goncourt, Edmond de, *Catalogue raisonné de l'oeuvre peint, dessiné, et gravé de Prud'hon*, Paris, 1876.
Bricon, Etienne, *Prud'hon*, Paris, 1907.
Forest, Alfred, *Prud'hon, peintre français*, Paris, 1913.
Guiffrey, Jean, *L'Oeuvre de Prud'hon*, Paris, 1924.
Régamey, Raymond, *Prud'hon*, Paris, 1928.
Grappe, Georges, *Prud'hon*, Paris, 1958.
Prud'hon (cat) Paris, 1958.

articles—

Delacroix, Eugène, "Prud'hon," in *Revue des Deux Mondes* (Paris), November 1846.
Seznec, Jean, "Racine et Prud'hon," in *Gazette des Beaux-Arts* (Paris), July–December 1944.
Brookner, Anita, "Prud'hon Retrospective at the *Musée Jacquemart-André*," in *Burlington Magazine* (London), January 1959.
Brookner, Anita, "Prud'hon, Master Decorator of the Empire," in *Apollo* (London), September 1964.
Weston, Helen, "Prud'hon: Justice and Vengeance," in *Burlington Magazine* (London), June 1975.
Weston, Helen, "Prud'hon in Rome: Pages from an Unpublished Sketchbook," in *Burlington Magazine* (London), January 1984.
Kanter, Laurence B., "*Andromache and Astyanax* by Prud'hon and Charles Boulanger de Boisfremont," in *Metropolitan Museum Journal* (New York), 19-20, 1984-85.

*

It was Prud'hon's misfortune to arrive at his artistic maturity during an era dominated and frequently controlled by an even more remarkable talent, Jacques-Louis David, Prud'hon's senior by ten years (David died in 1825). Despite the ubiquitous presence of David's more rigorous and archaeologic style of neoclassicism, and the enmity of Giordet, Gros, and others influenced by David, Prud'hon developed his own distinctive style that was acclaimed by Géricault and Delacroix (both of whom copied paintings by Prud'hon).

The three years Prud'hon spent in Rome, 1785–88, having won the Academy of Dijon's Prix de Rome, were crucial to the formation of his style. He studied many of the same antique sculptures that informed the work of Flaxman, David, and later, Ingres; he responded instinctively to the work of Leo-

Reading, 1822; lithograph

nardo and Correggio, although he saw few of their paintings; he formed a friendship with Canova whose elegantly mannered figures recall those by Prud'hon.

Increasing recognition came to Prud'hon in 1799 with the Salon success of *Wisdom and Truth Descend to Earth* (Paris), and in the Salon of 1801 with the drawing *The Triumph of Bonaparte* (Chantilly). The latter, in the drawing medium he usually preferred, black and white chalk on gray paper, was commissioned by the Danish naturalist, T.-C. Brun-Neergaard, to serve as the frontispiece for a study of French art under the Directory. The subject assigned by Brun-Neergaard for the drawing was the glorification of Napoleon, who had triumphantly returned from his Italian campaign, as well as an allegory of Peace.

The composition is a *trionfo* in strict formation, recalling that of the *Triumphal Procession* from the Arch of Titus in Rome. Napoleon, flanked by the allegorical figures of Victory and Peace, stands in a chariot which is drawn by four horses. Three Muses walk beside the chariot, followed by classically idealized females representing Painting, Architecture, Sculpture, and the Sciences. Putti and youths, Pleasures and Rites, bearing the olive branch, lead the procession. What is most distinctive in this brilliant drawing is Prud'hon's use of chiaroscuro to heighten the illusionism present in the Roman relief rather than reduce the images to the pure linear style of the engravings after Greek vases that appealed to David's followers, Les Primitifs, and to Flaxman and Ingres.

The great success of two paintings of extraordinarily different subjects at the Salon of 1808, *Justice and Vengeance* and *The Abduction of Psyche* (both in the Louvre), marked the

beginning of a brief period of scarcely seven years during which Prud'hon created some of his most famous work: *Venus and Adonis* (London, Wallace Collection), *The Young Zephyr* (Louvre), and *Venus at Bath* (Louvre). With the exception of *Justice and Vengeance,* a political allegory, the vaguely mythological and erotic subjects which he frequently chose reflect the continuing popularity of 18th-century themes associated with Boucher and Greuze. Prud'hon, however, invests the scenes with an ambiguous ambiance of reverie, of languid and delicately poised figures enveloped by sfumato. The atmospheric chairoscuro that distinguishes virtually all of his mature work recalled, for his admirers, that of Correggio.

Prud'hon was fascinated with the graceful pose of a seated figure. It occurs in numerous examples of his subjects from mythology and sentimental genre, as well as in portraits such as that of *Empress Josephine* (Louvre), painted in 1805. Preliminary studies for the painting indicate that as the final composition developed he increasingly extended the elongated forms of Jospehine's body to a degree that was extreme, even for Prud'hon. Correspondingly, the shawl, which is loosely stretched across her legs and draped over the rock against which she leans, appears self-consciously extended (Delacroix, generally an admirer of Prud'hon's work, was critical of this element).

Prud'hon was fully aware of Girodet's earlier exploitation of the poetic effects of moonlight in the latter's 1792 Salon painting, *The Sleep of Endymion,* but it was Prud'hon who seized this romantically charged element to evoke the mystery and wistfulness that prefigure later romantic painting in France, notable that of Delacroix.

Prud'hon's last project was *The Crucifixion* (Louvre), commissioned for the cathedral at Metz in 1822 and exhibited in its unfinished state at the Salon of 1824, the year following his death. From the initial conception through the succeeding stages in the evolution of the work, it is clear that Prud'hon turned toward a baroque rather than classical composition for this final project (the low eye-level and oblique composition, the pathetic figure of the kneeling Magdalen thrust into the right foreground). The exaggerated chiaroscuro of Christ's body and the sense of immediacy and mystery that pervade the agonized scene suggest the degree to which Prud'hon had absorbed emerging romantic tendencies.

In order to achieve the nacreous surface which he, as well as other neoclassicists, sought in their paintings Prud'hon applied coat after coat of unstable pigments that eventually cracked and darkened. As a result, the finished paintings rarely achieved the level of brilliant visual expression present in many preliminary studies in chalk on paper.

—James H. Slayman

PUGET, Pierre.

Born in Marseilles, baptized 16 October 1620; son of the master mason Simon Puget, and brother of the decorator Gaspard Puget. Died in Marseilles, 2 December 1694. Married 1) Paule Boulet, 1647; son, the painter François Puget; 2) Madeleine de Tamborin, 1691. Apprenticed to the master carpenter and decorator Jean Roman, c. 1634, in Marseilles; visited It-

Louis XIV as Alexander, 1685–88; marble; 43¼ in (110 cm); Paris, Louvre

aly, 1638: worked as painter and decorator in wood and stucco in the studio of Pietro da Cortona, Rome, 1640–43, and in Florence, 1643; entered the studio of Nicolas Levray, Toulon, c. 1644, and designed and supervised the decoration of the ship *Le Magnifique,* c. 1645 (renamed *La Reine,* 1646); Worked on decoration of Toulon fountains (Porte S. Lazare), 1649; painter from 1651 in Toulon and Marseilles: paintings for Church of La Valette, 1654, and Hotel de Ville, Toulon, 1655; worked for the Duke of Mantua in Genoa, 1663–67; then mainly worked in Toulon on arsenal design, ship design, and decoration; also designed houses; several visits to Paris.

Major Collections: Marseilles; Paris.
Other Collections: Aix en Provence; Amiens; Cleveland; Genoa: S. Maria Assunta in Carignano, S. Siro; New York; Puy-Ste.-Reparade: Fonscolombe castle; Quebec: Laval University; Toulon: Museum, Naval Museum; Versailles.

Publications

On PUGET: books—

Auquier, Philippe, *Puget, decorateur naval et mariniste,* Paris, 1903.

Auquier, Philippe, *Puget: Son oeuvre à Marseille* (cat), Marseilles, 1908.

Brion, Marcel, *Puget,* Paris, 1930.

Alibert, François P., *Puget,* Paris, 1930.

Baumann, Emile, *Puget, sculpteur,* Paris, 1949.

Vitzthum, Walter, *Puget,* Milan, 1966.

Herding, Klaus, *Puget: Das bildnerische Werk,* Berlin, 1970.

Bonifay, Charles, et al., *Puget* (cat), Marseilles, 1971.

Puget et son temps (colloquium), Aix-en-Provence, 1972.

Souchal, François, *French Sculptors of the Seventeenth and Eighteenth Centuries: The Reign of Louis XIV,* Oxford, 3 vols., 1977–78.

Gloton, Marie-Christine, *Pierre et François Puget, peintres baroques,* Aix-en-Provence, 1985.

article—

Walton, Guy E., "The Abduction of Helen of Troy: A 17th-Century French Bronze," in *Detroit Institute of Arts Bulletin,* Summer 1983.

*

The first half of Pierre Puget's career belongs to the history of Mediterranean art; it was only from around 1685 that the artist integrated himself with French sculptural trends.

Born in Marseilles in 1620, he did his apprenticeship in the workshop of a sculptor specializing in the decoration of war ships. Between 1638 and 1643 he stayed in Rome and Florence where he worked under the direction of Pietro da Cortona. His influence should not be neglected: Puget certainly owed to the baroque master his taste for vigorously modelled, powerful forms in action, always taking account of the impact of the play of light and shadow. On his return to Provence he resumed his work in the naval dock-yards. His first important commission was for the decoration of the portal of the town hall of Toulon (the present-day naval museum), 1656–57. The conception of the ensemble is Italian, and shows Puget's debt to Pietro da Cortona. The massive atalantes in Toulon are inspired by those painted in trompe-l'oeil in the Palazzo Barberini in Rome. Anthony Blunt rightly points out that the principal characteristic of the atalantes is the feeling of anguish, unknown in Bernini's work, but present in Michelangelo's *Slaves,* which may have been Puget's true source. In 1659 the artist was called to Paris in order to execute two statues for Claude, Marquis de Girardin, collaborator of the superintendent Fouquet; the works were destined for the Château de Vaudreuil in Normandy. The *Ceres and Juno* has disappeared, but the *Hercules and the Hydra of Lerna* (stone, Rouen), although well weathered, is a dynamic composition, its expression and gesture exaggerated, and recalling Florentine Mannerism.

This commission attracted the attention of Fouquet who asked Puget to create a *Hercules at Rest* (also called *Hercules of Gaul*) for Vaux-le-Vicomte (marble, 1663–68; Louvre). The *Hercules* holds the golden apples from the garden of the Hesperides (one of the contests forming part of his twelve labours); the laurel branch and the oak leaves are symbols of glory and strength, the last being underlined by the club enveloped in the skin of the Nemean lion. The work is a synthesis of a traditional antique image of Hercules at rest (the face is a Roman portrait, thought to be Nero's) and its rediscovery by a celebrated senior of Puget, Michel Anguier (the *Hercules* on the Montmorency tomb in the chapel at Moulins). But the style, in which the ruggedness of the marble contrasts with the inner force of the figure, is Puget's alone.

Puget had gone to Carrara to choose the marble, and he settled in Genoa to execute the statue. The fall of the ambitious Fouquet in 1661 occurred before the completion of the work. Puget decided to stay in Genoa (1663–67), probably feeling that he was too closely linked with Fouquet and his followers. The sculptor's Genoese career, which was both productive and of a high quality, begins with two statues commissioned by the Sauli family for the decoration of niches on the transept piers in the church of S. Maria Carignano. The *Blessed Alessandrao Sauli* (marble, 1664–68, terracotta in Aix-en-Provence) and *Saint Sebastian* (terracotta in Philadelphia) are works which come close to the Roman baroque, and Puget may have made a second trip to Rome around 1661–62. The *Immaculate Conception* in the Oratory of S. Filippo Neri (marble, 1669–70) may be compared with the famous *St. Agnes* by Ercole Ferrata, one of Bernini's most gifted pupils. The *Assumption of the Virgin* for the chapel of the Ducal Palace in Mantua (marble, 1664–1665, Berlin) is a large adorned low-relief, in the style of the numerous marble reliefs which decorate Roman churches of the second half of the 17th century, but less imposing in size than the *Alexander and Diogenes* that Puget was to execute later in France.

Nevertheless, Puget returned to Toulon; he had always made intermittent visits there. At the same time as his work for the arsenals of Toulon and Marseille, the artist entreated with Colbert in order to participate on the great artistic project of the reign of Louis XIV at Versailles. In 1670 Puget asked permission to sculpt three blocks of marble, left unused in Toulon. In 1671 he sent Colbert the drawings for two of his projects, *Milo of Crotone* and *Meeting of Alexander and Diogenes.* Colbert authorised him to install himself in a special studio to sculpt at

leisure; he worked on the three blocks simultaneously. In 1674 the *Milo* was well advanced, although the two other blocks were only roughed-out. The *Milo* (now in the Louvre) was installed at Versailles in the summer of 1683, but its conception, known to us through a superb wash drawing (Rennes), dates from 1671. The immense low-relief of *Alexander and Diogenes* (Louvre), of which two-thirds was finished by 1683, was damaged in 1685 and finally completed only in 1689. Intended to decorate the vestibule of the chapel at Versailles, it never reached Versailles. Puget may have sought inspiration in antique low-reliefs (for instance, the *Triumph of Marcus Aurelius*, Rome, Palazzo dei Conservatori) or in Roman portraits. However, the memory of large Roman baroque low-reliefs, such as Algardi's *Meeting of Pope Leo I and Attila* in St Peter's, is even stronger. Here, the dialogue between Louis XIV, the new Alexander, and Diogenes, spokesmen for intelligence and for poverty, can be understood as a Christian message at the doors of the chapel of Versailles.

The third work by Puget intended for Versailles, *Perseus and Andromeda* (Louvre), completed in 1684, is a compromise between high and low relief and was conceived to be seen against a background of green parkland. The group was placed in 1685 at the entrance to the Allée Royale (the Tapis Vert) as a pendant to the *Milo*.

Louvois, Colbert's successor, had suggested to Puget in 1683 the idea of a fourth group for Versailles, the *Paris Abducting Helen* (now in Genoa). Puget made the model in 1683. The marble was partly executed by his pupil Veyrier. Several reductions in bronze are known, some of which show some variations, such as the one in the Metropolitan Museum, without doubt cast during Puget's lifetime. The artist enjoyed working on the three-figure group theme, a celebrated virtuoso subject in the history of sculpture since Michelangelo's first attempts. Puget's regard for 16th-century Florentine art may have led him to conceive two projects for equestrian statues glorifying Louis XIV on a rearing horse. Leonardo da Vinci's famous idea had never been repeated, with the exception of Tacca's modest attempt (Madrid). Unfortunately, the two projects for Aix-en-Provence and Marseilles failed, probably because of the high cost of producing them.

The last works by the sculptor, among others the *S. Carlo Borrommeo Praying for an End to the Plague in Milan* (low-relief, 1688–94, Marseilles) and the *Faune Playing the Flute* (marble, 1692–93, Marseilles), are characterized by a rough style, close to a *non finito* style in the relief, and, in the case of the incomplete *Faune,* by a renewed regard for Michelangelo. The artist was disorganized, even misunderstood, with overambitious projects for art that was too powerful. Of a ferocious personality, Puget is one of the great "artistic figures" of western art.

—Guilhem Scherf

PUVIS DE CHAVANNES, Pierre (Cécile).
Born in Lyons, 14 December 1824. Died in Paris, 24 October 1898. Married Princess Cantacuzène, 1897. Attended Lyons Collège and Lycée Henri IV in Paris; then studied painting under Henry Scheffer and three months with Thomas Couture;

first exhibited at the Salon, 1850 (refused 1851–58); set up studio, 1852, and specialized in large canvases giving the appearance of frescoes; decorated many public buildings, including the Musée de Picardie, Amiens, 1861–65, Marseilles Museum, 1867–69, Pantheon, Paris, 1874–78, Hôtel de Ville, Paris, 1890–93, Rouen Museum, 1890, and Boston Public Library, 1893–96.

Collections: Amiens; Baltimore; Bayonne; Birmingham; Boston: Public Library; Chicago; Lyons; Marseilles; New York; Paris: Hôtel de Ville, Sorbonne, Petit-Palais, Pantheon, Louvre; Rouen; Zurich.

Publications

On PUVIS DE CHAVANNES: books—

Aynard, Edouard, *Les Peintres decoratives de Puvis de Chavannes au Palais des Arts de Lyon,* Lyons, 1884.
Vachon, Marius, *Puvis de Chavannes,* Paris, 1895.
Vachon, Marius, *Puvis de Chavannes: Un Maître de ce temps,* Paris, 1900.
Alexandre, Arsène, *Puvis de Chavannes,* London, 1905.
Adam, Marcelle, *Les Caricatures de Puvis de Chavannes,* Paris, 1906.
Scheid, Gustave, *L'Oeuvre de Puvis de Chavannes à Amiens,* Paris, 1907.
Michel, André, *Puvis de Chavannes,* Paris, 1911; Philadelphia and London, 1912.
Werth, Léon, *Puvis de Chavannes,* Paris, 1926.
Mauclair, Camille, *Puvis de Chavannes,* Paris, 1928.
Lagaisse, M., and J. Vergnet-Ruiz, *Puvis de Chavannes et la peinture lyonnaise de XIXe siècle* (cat), Lyons, 1937.
Wattenmaker, Richard J., *Puvis de Chavannes and the Modern Tradition* (cat), Toronto, 1975, 1976.
Argencourt, Louise d', et al., *Puvis de Chavannes* (cat), Paris and Ottawa, 1976.
Foucart-Borville, Jacques, *La Genèse des peintures murales de Puvis au Musée de Picardie,* Amiens, 1976.
Catalogue des dessins et peintures de Puvis de Chavannes, Musée de Petit-Palais, Paris, 1979.

articles—

Brown, Aimée Price, "Two Portraits of Vincent van Gogh and Two Portraits by Puvis de Chavannes," in *Burlington Magazine* (London), November 1975.
Mitchell, Claudine, "Time and the Idea of Patriarchy in the Pastorals of Puvis de Chavannes," in *Art History* (Oxford), June 1987.

*

Puvis de Chavannes studied under Henri Scheffer and Thomas Couture, the history and portrait painter whose best-known work is *Romans of the Decadence,* with its famous "soft" colors. But Puvis always claimed that his primary influences were those of Chassériau and Delacroix, whose large decorative schemes include the *Justice of Trajan* for Rouen Town

Sacred Grove; Paris, Sorbonne

Hall, and other town hall, library, and museum commissions—work that is not among his most highly regarded today.

Puvis exhibited at the Salon from 1850, and did his first mural decoration in 1861, for Amiens Museum. He deliberately set out to recreate something of the monumental Italian fresco style: though done in oil, the works were painted in such a way as to suggest fresco (they were almost always painted on canvas, then transferred to the walls). Works for other museums and public buildings followed, and he became the single artist most responsible for the revival of mural decoration in France.

Puvis's highly individual style is distinctive, and it was always appreciated by traditionalists as well as by progressives. His subject matter was not particularly original—his works have titles like *Hope, War, Peace, Happy Land, Sacred Grove, Summer, Winter.* His originality lies in his particularly flat, only slightly modeled figures, use of simple contours, pale, chalky color range, and ample uncluttered spaces. The decorative flatness is that found in Italian primitive wall paintings; he raises the ground plane very steeply so that all the figures are given their own space, with little overlapping of figures. In other words, there is little perspective recession, and the various sections of the paintings function almost separately, with little attempt at narrative movement.

One of his first notable works was *Massilia, Greek Colony* (1869; Marseilles): though some critics were hostile, deriding

his interest in "the anachronistic, the monochromatic, the planiform," this very style was also deemed appropriate to the pre-Christian subject, and suggested a visual nostalgia for a long-lost Arcadia, a world before industry, poverty, and constant change. The reminder of a past which offered solace to a stultified modern public was not lost on such later artists as Seurat, Gauguin, and Munch in specific works, and on a wider range of other artists in terms of overall understanding. In fact, Strindberg in 1885 noted that of all the artists of the time, only Puvis de Chavannes was admired by all, a sentiment echoed by other critics and artists.

There is nothing of Moreau—the epitome of the symbolist painter—in Puvis's works. Rather than complicating his paintings with a symbolic program, Puvis tended to simplify, not only his lines and colors, but also his ideas. He used tranquil gestures, large rhythms, subdued colors which suggest serenity, and simplified drawing going back to the basic essentials. He was able to attain a limpid simplicity because he accepted the fact that the walls on which his paintings are placed are, after all, walls, both limited and two-dimensional—the result is a frieze-like technique rather than deep-perspective effects. His admirers appreciated his attempt to go beyond Impressionism without becoming academic, and even those who did not like his style admired his attempt to stand back from too much realism, too much color, too much verity.

—George Walsh

QUERCIA, Jacopo della.

Born probably in Siena, c. 1374; son of the goldsmith and woodcarver Piero di Angelo. Died in Siena, 20 October 1438. Earliest surviving work is relief in Lucca Cathedral, 1392; possibly worked in Bologna before 1400; entered competition for Baptistery Doors in Florence, 1401–03; worked on the Silvestri Altar, Ferrara, completed 1406; then in Siena: at work on Fonte Gaia until 1419; member of the City Council, 1418, 1435, overseer of the Cathedral, and knighthood of the city; also worked on a chapel in S. Frediano, Lucca, and the facade of S. Petronio, Bologna, 1425–38.

Collections Locations: Bologna: S. Petronio, S. Giacomo; Ferrara: Cathedral; Lucca: Cathedral; New York; San Gimignano; Siena: Palazzo Pubblico, Baptistery; Washington.

Publications

On QUERCIA: books—

Supino, Igino, *Le sculture delle porte di S. Petronio in Bologna,* Florence, 1914.
Supino, Igino, *Quercia,* Bologna, 1926.
Bacci, Peleo, *Quercia: Nuovi documenti e commenti,* Siena, 1929.
Gielly, Louis J., *Quercia,* Paris, 1930.
Nicco, Giusta, *Quercia,* Florence, 1934.
Biagi, Luigi, *Quercia,* Florence, 1946.
Carli, Enzo, *Quercia,* Florence, 1949.
Morisani, Ottavio, *Tutta la scultura di Quercia,* Milan, 1962.
Bertini, A., *L'opera di Quercia,* Turin, 1965.
Hanson, Anne C., *Quercia's Fonte Gaia,* Oxford, 1965.
Beck, James H., *Quercia e il portale di San Petronio a Bologna,* Bologna, 1970.
Seymour, Charles, Jr., *Quercia, Sculptor,* New Haven, 1973.
Quercia nell'arte del suo tempo, Siena, 1975.
Chelazzi Dini, Giulietta, editor *Quercia fra gotico e rinascimento* (colloquium), Florence, 1977.
Emiliani, A., editor, *Quercia e la facciata di San Petronio a Bologna,* Bologna, 1982.

articles—

Bellosi, L., "La 'porte magna' di Quercia," in *La Basilica di San Petronio in Bologna,* Bologna, 2 vols., 1983.

List-Freytag, Claudia, "Beobachtungen zum Bildprogramm der Fonte Gaia Quercias," in *Münchner Jahrbuch der Bildenden Kunst,* 36, 1985.

*

Jacopo della Quercia is considered the greatest Sienese sculptor. It is possible that he was trained in Bologna or in Florence, but there are no documents to prove it. Most of his work was done in marble or other stone, though he did compete in the famous competition for the Florence Baptistery bronze doors in 1401–03. He did not win the competition and his submission has been lost.

His first authenticated work, a Madonna at Ferrara, dated 1406 (commissioned 1403), shows the influence of Nanni di Banco. Another early work, the tomb of Ilaria del Carretto, in Lucca Cathedral, dates from 1406–08. Since it was first made, it has been dismantled and reassembled at least once, and the exact relationship of the sections is not clear. It combines classical motifs (the putti decorating the side of the Roman-style sarcophagus is possibly the first re-creation of a classical Roman motif) with gothic, possibly even transalpine, ones. The relief of the lady atop the sarcophagus shows her with arms crossed at the waist, her head resting on two pillows, her feet resting on a dog (fidelity). It is unique to Tuscany.

His next major commission was the Fonte Gaia in Siena (the extant parts are now in the Palazzo Pubblico). It was commissioned in 1409, begun in 1414, and completed in 1419. This outdoor fountain occupies the same place in the town as the Fontana Maggiore by the Pisanos did in Perugia over a century before. Again there is combination of classical and northern sources. The figure of Acca Larentia (the foster-mother of Romulus and Remus) is based on the antique, but the central relief of the Virgin and Child does not show the classical model clearly, and the handling is very personal. There is a dramatic use of shadow, and the entire arrangement of figures, seat, and the curtain behind them is a rhythmic whole. Some commentators have seen a link between this fountain and that by Claus Sluter at Champmol (based on the similar relationship between figures and ground), though there is no evidence that the two knew each other's work. The reliefs include the *Creation of Adam, Wisdom, Hope, Fortitude, Prudence, Virgin and Child, Justice, Charity, Temperance, Faith,* and the *Expulsion from Paradise.*

A more obvious use of figure and ground is seen in the Trenta Altar (1416–22; Lucca, S. Frediano). It consists of five figures in niches with rich canopies, with a *Virgin and Child*

in the center surrounded by SS. Ursula, Lawrence, Jerome, and Richard. There is profuse drapery, especially on the Virgin, which billows out seemingly unrelated to the body underneath it. The figures are in deep relief and not actually statues, and the shapes are static and elongated. The predella shows scenes related to the reliefs above: the *Massacre of the Virgins,* the *Martyrdom of St. Lawrence, Christ in the Tomb, St. Jerome and the Lion,* and a *Miracle of St. Richard.* The commissioner, Lorenzo Trenta, was a merchant with extensive northern ties.

Ghiberti, who had won the Florence Baptistery competition in 1401–03, collaborated with Quercia in 1417–31 on reliefs for the font in Siena Cathedral. Ghiberti did two reliefs, and though Quercia was originally commissioned to do two also, he delayed doing the work, and one of his two subjects was reassigned to Donatello. Quercia's single relief in gilt bronze is based on the story of Zacharias in the Temple. For the superstructure over the font basin, Quercia made marble figures of five Prophets in niches and a statuette of St. John the Baptist, in a seemingly Burgundian style.

Quercia's last work, and his masterpiece, is the monumental doorway of St. Petronio in Bologna. It was commissioned in 1425 and incomplete when he died in 1438. In consists of a *Virgin and Child* plus two saints in the lunette above the doorway, ten Old Testament relief panels in two vertical series of five on each side of the door, a further five New Testament reliefs above the door and some 18 Prophets surrounding the door. The exact nature of the subject of the reliefs probably reflect a tradition in current use in Emilia, since a few of the subjects (obviously set by the church officials) are slightly different from comparable reliefs in other areas. The Old Testament subjects are the *Creation of Adam,* the *Creation of Eve,* the *Fall,* the *Expulsion from Paradise,* the *Labors of Adam and Eve,* the *Sacrifices of Cain and Abel,* the *Murder of Abel,* the *Release from the Ark,* the *Drunkenness of Noah,* and the *Sacrifice of Isaac.* The New Testament subjects are the *Nativity,* the *Adoration of the Magi,* the *Presentation in the Temple,* the *Massacre of the Innocents,* and the *Flight into Egypt.* Though the reliefs are relatively small, Quercia is able to suggest a large scale and the results are what can only be called monumental figures, which made a strong impression on Michelangelo when he saw them in 1494.

The overall development in Quercia's work is difficult to evaluate since he seems to have been an artist who was eager to introduce northern elements into his work. Though some art historians have suggested direct contact with such sculptors as Sluter, current feeling is that any contact with the north was indirect and through the medium of French illuminations.

—George Walsh

R

RAEBURN, (Sir) Henry.
Born in Stockbridge, near Edinburgh, 4 March 1756. Died in Stockbridge, 8 July 1823. Married Anne Leslie: two sons. Attended Heriot's Hospital, Edinburgh; apprenticed to the goldsmith James Gilliland, Edinburgh, age 15; also helped by David Martin; visited London and Italy, c. 1784–87; then practiced as painter in Edinburgh: influenced by Reynolds: many portraits of leading Scots, and became leading Edinburgh portrait painter; visits to London; member of the R.A., 1815, and appointed King's Limner for Scotland, 1822, and Knighted, 1822. Assistants: John Watson Gordon, John Syme.

Major Collections: Edinburgh: National Gallery, Portrait Gallery; Fyvie Castle; Glasgow.
Other Collections: Aberdeen; Baltimore; Boston; Budapest; Cardiff; Chicago; Cincinnati; Cleveland; Detroit; Dunfermline: Town Hall; Edinburgh: Portrait Gallery, University; Kansas City; London: Portrait Gallery, Royal Academy, Courtauld, Kenwood, National Gallery; Los Angeles; Melbourne; Montreal; New Haven; New York: Metropolitan, Frick, Brooklyn Museum; Ottawa; Paris; Raleigh, North Carolina; San Marino, California; Washington: National Gallery, Corcoran.

Publications

On RAEBURN: books—

Andrew, William Raeburn, *Life of Raeburn,* London, 1894.
Armstrong, Walter, *Raeburn,* London and New York, 1901.
Pinnington, Edward, *Raeburn,* London, 1904.
Clouston, R. S., *Raeburn,* London, 1907.
Greig, James, *Raeburn: His Life and Works,* London, 1911.
Dibdin, Edward R., *Raeburn,* London, 1925.
Baxendall, David, *Raeburn* (cat), Edinburgh, 1956.
Macmillan, Duncan, *Painting in Scotland: The Golden Age* (cat), Oxford, 1986.

*

Henry Raeburn was born in 1756, the younger of two sons of a textile manufacturer in Stockbridge, then a village separate from Edinburgh. He was orphaned at an early age, and his brother, who was some years his senior, took over the family business while the young Henry went to be educated at Heriot's Hospital in Edinburgh. This school had close links with the trade of silversmithing and like many distinguished artists before him, Raeburn received his artistic training as a metalworker in the workshop of James Gilliland, an Edinburgh silversmith. His early biographers tell us that during this time he began producing miniatures and that he abandoned his apprenticeship to become an artist. He was essentially self taught, and the degree of involvement in his training of David Martin, formerly Allan Ramsay's assistant, is unclear, but both this artist and a seal engraver called David Deuchar are said to have helped the young painter. It is unknown at what date he married the wealthy Anne Leslie, née Edgar, but they produced the first of two sons in May 1781. The artist's wife already had children by her first marriage to a minor landowner in Stockbridge. Raeburn and his family were later to build one of Edinburgh's most beautiful suburban streets on this property calling it Ann Street after his wife. Now close to the centre of Edinburgh the planning of the street is novel in having gardens in front of the houses, resulting in them being placed well back from the road. That this arrangement is now the norm makes it difficult to see how imaginative the scheme was for its time.

Vitually nothing is known about Raeburn's early work, and although it would be foolhardy to dogmatise, the *George Chalmers of Pittencrieff* at Dunfermline, which is generally believed to be one of his first oil portraits and normally dated to 1776, seems to be very insecurely placed at this point in his career (see Duncan Macmillan, 1986). The portrait of *James Hutton,* the geologist, in the Scottish National Portrait Gallery is another work given a date prior to the trip to Rome in c. 1784 but only on the basis of the sitter's apparent age. Miniatures and early works in oil are noticeable by their absence, and it seems likely that Raeburn's career does not begin in earnest until the late 1780's, after the trip to Rome. From then until his death in 1823, having been knighted and made King's Limner for Scotland in 1822, he was one of the most outstanding portrait painters anywhere in Europe. He produced only portraits and did not use preparatory drawings. At first he shows the influence of Reynolds, but essentially we are dealing with the perplexing situation of an outstanding artist appearing almost overnight in a country which at the time was producing figures of European standing in all fields of the arts and sciences.

Most students of Raeburn are beguiled by the seeming naturalism of his portraits, describing his work as direct records of visual fact. Raeburn's ability to create a lively likeness of a sitter which to this day remains a convincing record of a real

person does make it tempting to look at Raeburn in this manner, but it is at best an incomplete view. If instead the composition is examined in terms of an abstract pattern, very different conclusion will be drawn. Raeburn composed his portraits very carefully, constantly re-using the same compositional structure, and it is onto these geometrical frameworks that a sense of naturalism is draped. Such portraits as the *Neil Gow* in the Scottish National Portrait Gallery have repeatedly been viewed as naturalistic records, leading to statements that Gow is shown performing specific bowing techniques as he plays his fiddle. Such an analysis becomes suspect when the underlying compositional structure is isolated. In the case of the *Neil Gow* this is a pyramid created by Gow's arms, fiddle, and bow. Gow's instrument and his limbs do not find themselves in this configuration by chance but because Raeburn pressed them into this pattern. Such uncomplicated geometric structures underlie these very natural-looking portraits. It is the view of the present writer that Raeburn's portraits should be viewed as carefully constructed images in which the artist's concern with compositional arrangement is at least as great as his interest in truth to natural apearances. It is a measure of the artist's quality that these compositional elements hardly obtrude on the sense of realism he creates. Such features have been overlooked in the limited study of this artist.

Raeburn made only a couple of visits to London but did exhibit at the Royal Academy, resulting in his election to that body in 1815. He was extremely prolific but the use of studio hands seems to be limited at most. From about 1800 the colour range in Raeburn's portraits becomes autumnal and deep in tone, the mood is less lively, the whimsical sense of humour encountered in paintings of the 1790's is no longer found, and the sense of social interchange we find in the early portraits also departs. He also abandons the unusual brushwork described as his "square touch," not in itself a feature of the *Rev. Walker* but all too often termed the artist's hallmark when it was present for only a brief time. For the last dozen or so years of his career Raeburn's portraits became increasingly detached from the real world. They lack a sense of individuality and a poetic, ageless idealisation of the features is the norm. The sitters are aristocratic, regardless of social station, withdrawn from the considerations of everyday life. The artist's aim was now the representation of heightened emotional states, as in the *Mrs. Scott Moncrieff* in the National Gallery of Scotland, rather than the frank depiction of character that we encounter in his earlier works. In this, Raeburn was making his own responses to contemporary changes in European painting.

—David Mackie

RAMSAY, Allan.

Born in Edinburgh, 13 October 1713; son of the poet Allan Ramsay. Died in Dover, 10 August 1784. Married 1) Anne Bayne, 1739; 2) Margaret Lindsay, 1752. Possibly a pupil of James Norrie in Edinburgh, then a pupil of Hans Hysing in London, and possibly a student at the St. Martin's Lane Academy, 1734; worked in the studio of Imperiali (Ferdinandi), and at the French Academy under Vleugels in Rome, 1736–38

(and a brief period under Solimena in Naples); also influenced by Benedetto Luti; then set up in London: did successful "grand manner" portraits before Reynolds did; later trips to Italy in 1754, 1775, and 1782; appointed principal painter to the King, 1767 (succeeded Shackleton); career was ended by an arm injury. Assistants: David Martin, Philip Reinagle, Alexander Naysmyth.

Major Collections: Edinburgh: National Gallery, Portrait Gallery.
Other Collections: Birmingham; Glasgow; Liverpool; London: Portrait Gallery, Tate, Courtauld, Victoria and Albert; New Haven; Newcastle; Ottawa; Richmond, Virginia; Warwick; Royal Collection.

Publications

On RAMSAY: books—

Smart, Alastair, *The Life and Art of Ramsay,* London, 1952.
Smart, Alastair, *Paintings and Drawings by Ramsay* (cat), London, 1958.
Hutchison, Robin, and Colin Thompson, *Ramsay: His Masters and Rivals* (cat), Edinburgh, 1963.
Browne, Iain G., *Ramsay's Rise and Reputation,* London, 1984.
Browne, Iain G., *Poet and Painter: Allan Ramsay, Father and Son 1684-1984,* Edinburgh, 1984.
Macmillan, Duncan, *Painting in Scotland: The Golden Age* (cat), Oxford, 1986.

articles—

Smart, Alastair, "An Unknown Portrait of James Adam," in *Burlington Magazine* (London), April 1954.
Holloway, James, "Two Projects to Illustrate Ramsay's Treatise on Horace's Sabine Villa," in *Master Drawings* (New York), Autumn 1976.

*

To describe Allan Ramsay simply as a painter is to do him a great disservice, as the range of his talents and cultural achievements was unusually wide. He was born in Edinburgh in 1713, to a father who was a wig maker by trade, but he was a poet by inclination and at some point around 1721 Ramsay senior abandoned his profession to devote his life entirely to letters. No other 18th-century artist could boast the education that Ramsay received. The future painter had an extensive knowledge of the classics and was familiar with three modern European languages, he was also to count as friends some of the greatest thinkers of the age, such as David Hume, Adam Smith, and Samuel Johnson. This upbringing, and the company he kept, goes some way towards explaining his life-long desire to achieve the reputation of a man of letters. But in 1729 we find the young Ramsay's signature on the list of artist members of the Academy of St. Luke, newly formed in Edinburgh, indicating his choice of career. He continued his studies in painting in London with Hans Hysing possibly having studied

George III; 8 ft 2 in × 5 ft 4 in (249 × 162.6 cm); Royal Collection

with James Norrie in Edinburgh beforehand. In 1736 he proceeded to Rome where he worked under Imperiale and at the French Academy in Rome under Vleugels. He also visited Naples, then a major artistic centre in Europe, to study with Solimena. On his return to London his technique of underpainting the face in deep red was derived from the practice of Benedetto Luti.

On his return to London in 1738 Ramsay brought with him artistic qualities which could only have been acquired abroad and a talent for knowing the right people. Portraiture in Britain had until this time been dominated by formulae introduced decades previously by foreign artists whose legacy was a stock of conventions decrepit with over use, now in the hands of painters of limited ability who were for the most part incapable of producing recognisable likenesses. Ramsay brought home a style of painting which to modern eyes may seem stultified and grandiloquent, the last stages of Italian Baroque, but in the London of 1738 was vigorous and new.

One example of his early style is the *Sir John Hinde Cotton, 4th Bt.*, signed and dated 1740. In such works as this the emphasis is on creating a heroic and noble depiction of the sitter. The gestures of the sitters are lively and elegant, with the hands in most of these cases drawn from life by the artist and later painted by him. Except for the face and hands, much of the painting was done by assistants, working from composi-

tional drawings supplied by Ramsay. Many of the drawings used in the production of these portraits survive and they show the high calibre of Ramsay's draughtmanship which was not equalled by any of his British contemporaries. One disadvantage of this fragmentary approach to producing a portrait is the inevitable disparity between the different elements of the design.

Ramsay's style is tough and forceful in these early works. But in spite of the conventional poses, he succeeds in persuading us that we are looking at a real person engaged in conversation and not simply posing for his portrait in an inert and vacuous way. Of great significance is Ramsay's unpoetic frankness in depicting the sitter's face, giving us in his portraits individualised facial features and not simply emblematic representations, masquarading as people. These portraits were popular and Ramsay, who was an astute businessman, made a fortune from his practice.

A number of factors led Ramsay back to Italy in 1754 with his second wife, and during this time his mature style developed. By the late summer of 1757 Ramsay was back in Britain, and became the favoured painter at court, his command of German endearing him to the Royal household. Although he did not become Court Painter until the death of Shackleton in 1767 Ramsay did produce all the Royal portraits from shortly after his return and greatly reduced the number of private sitters. Ramsay had many assistants who did much of the repetitive work in his Royal portraits, and they included David Martin, Philip Reinagle, and Alexander Nasmyth. However, the drugery of the work with which Ramsay was involved seems to have destroyed his talent, and his creative capacity as an artist departed even before a debilitating injury occurred to his arm in the 1770's. One unusual feature of Ramsay's career is his contentment with portraiture as his means of expression. At a time when face painting was ranked very low in the hierarchy of artistic pursuits, only two figures in British painting adopted portraiture for their careers, finding in it total satisfaction, and both of them were Scotsmen, Allan Ramsay and, later, Henry Raeburn. Ramsay's interest in literary matters increased in middle age and by the time of his death in 1784 he was remembered as a political commentator and man of letters, his activities as one of the foremost painters of his generation having faded from the public memory.

Ramsay's achievement as a painter is still not fully recognised, and when at last this omission is corrected the histories of Reynolds and Gainsborough, his great contemporaries, will have to be reviewed.

—David Mackie

RAPHAEL.

Born Raffaello Santi (or Sanzio), in Urbino, 6 April 1483; son of the painter Giovanni Santi. Died in Rome, 6 April 1520. Commuted between Perugia and Citta di Castello, probably as junior partner to Perugino, 1500–04; based at Florence by 1504, then settled in Rome, 1508; did frescoes for the Vatican Stanza della Segnatura for Julius II, 1509–11, and did other rooms, helped by assistants; after the accession of Leo X (1513), was artistic supremo in Rome; did frescoes for the Farnesina, Rome; succeeded Bramante as architect for the new

St. Peter's, 1514; also made tapestry designs for the Sistine Chapel, 1515-16. Pupils/assistants: Giulio Romano, Giovanni da Udine, Perino del Vaga, Penni, Polidoro da Caravaggio.

Major Collections: Florence: Pitti; Paris; Vatican.
Other Collections: Baltimore; Bergamo; Berlin; Bologna; Boston: Gardner; Brescia; Budapest; Chantilly; Citta di Castello; Edinburgh; Florence; Cracow; Leningrad; Lisbon; London: National Gallery, Dulwich; Madrid; Milan; Munich; Naples; New York; Pasadena; Perugia: S. Severo; Raleigh, North Carolina; Rome: Borghese, Doria Pamphili, S. Maria del Popolo, S. Maria della Pace; Urbino: Palazzo Ducale; Vienna; Washington.

Publications

By RAPHAEL: book—

Il pianto di Roma: Lettera a Leone X, Turin, 1984.

On RAPHAEL: books—

Fischel, Oskar, *Raphaels Zeichnungen,* Berlin, 8 vols., 1913–41, vol. 9 edited by Konrad Oberhuber, 1972.
McCurdy, Edward, *Raphael,* London and New York, 1917.
Holmes, Charles J., *Raphael and the Modern Use of the Classical Tradition,* London and New York, 1933.
Golzio, Vincenzo, *Raffaello nei documenti, nelle testimonianze dei contemporanei, e nella letterature del suo secolo,* Vatican, 1936.
Middeldorf, Ulrich A., *Raphael's Drawings,* New York, 1945.
Hetzer, Th., *Die Sixtinische Madonna,* Frankfort, 1947.
Venturi, Adolfo and Lionello, *Raphael,* Milan, 1952.
Putscher, Marielene, *Raphaels sixtinische Madonna: Das Werk und seine Wirkung,* Tubingen, 1955.
Stokes, Adrian, *Raphael,* London, 1956.
Biermann, H., *Die Stanzen Raffaels,* Munich, 1957.
Pouncey, John, and J. A. Gere, *Italian Drawings in the Department of Prints and Drawings in the British Museum: Raphael and His Circle,* London, 1962.
Redig de Campos, Deoclecio, *Raphael nelle stanze,* Milan, 1965.
Dussler, Luitpold, *Raphael: Kritisches Verzeichnis des Gemälde, Wandbilder, und Bildteppiche,* Munich, 1966; as *Raphael: A Critical Catalogue of His Pictures, Wall-Paintings, and Tapestries,* London and New York, 1971.
Ponente, Nello, *Who Was Raphael?,* Geneva and Cleveland, 1967.
Pope-Hennessy, John, *The Complete Paintings of Raphael,* Cleveland, 1967.
Becherucci, Luisa, et al., *Raffaello: L'opera, le fonti, la fortuna,* Novara, 2 vols., 1968.
Salmi, Mario, et al., *The Complete Works of Raphael,* New York, 1969.
Wagner, Hugo, *Raffael im Bildnis,* Berne, 1969.
Shearman, John, *Raphael's Cartoons in the Collection of . . . the Queen and the Tapestries for the Sistine Chapel,* London and New York, 1972.

The Phrygian Sybil; drawing; Oxford, Ashmolean

Ray, Stefano, *Raffaello architetto,* Rome, 1974.
Beck, James H., *Raphael,* New York, 1976.
Dacos, Nicole, *Le logge di Raffaello: Maestro e bottega di fronte all'antico,* Rome, 1977.
Mussini, Massimo, *La Bibbia de Raffaello,* Brescia, 1979.
Pope-Hennessy, John, *Raphael* (lectures), New York, 1979.
Partridge, Loren, and Randolph Starn, *A Renaissance Likeness: Art and Culture in Raphael's "Julius II,"* Berkeley, 1980.
Vecchi, Pier Luigi de, *Raphael: La pittura,* Florence, 1981.
Oberhuber, Konrad, *Raphael,* Milan, 1982.
Pedretti, Carlo, *Raphael,* Bologna, 1982.
Oberhuber, Konrad, *Raphaels "Transfiguration": Stil und Bedeutung,* Stuttgart, 1982.
Knab, Eckhart, Erwin Mitsch, and Konrad Oberhuber, *Raphael: Die Zeichnungen,* Stuttgart, 1983.
Mulazzani, Germano, *Raffaello,* Milan, 1983.

Cuzin, Jean Pierre, *Raphaël: Vie et oeuvre,* Fribourg, 1983.

Raphael in der Albertina, Vienna, 1983.

Brown, David Alan, *Raphael and America* (cat), Washington, 1983.

Gere, J. A., and Nicholas Turner, *Drawings by Raphael: From the Royal Library, the Ashmolean, the British Museum, Chatsworth, and Other English Collections* (cat), London, 1983.

Joannides, Paul, *The Drawings of Raphael, with a Complete Catalogue,* Berkeley and Oxford, 1983.

Jones, Roger, and Nicholas Penny, *Raphael,* New Haven, 1983.

Raphaël dans les collections françaises (cat), Paris, 1983.

Béguin, Sylvie, *Les Peintures de Raphaël au Louvre,* Paris, 1984.

Frommel, C. L., et al., *Raffaello architetto,* Milan, 1984.

Fichtner, Richard, *Die verborgene Geometrie in Raphels "Schule von Athen,"* Munich, 1984.

Raffaello in Vaticano (cat), Milan, 1984.

Raffaello a Firenze (cat), Florence, 1984.

Davidson, Bernice F., *Raphael's Bible: A Study of the Vatican Logge,* University Park, Pennsylvania, 1985.

Ames-Lewis, Francis, *The Draftsman Raphael,* New Haven, 1986.

Ettlinger, Leopold and Helen, *Raphael,* Oxford, 1987.

Jacoby, Joachim W., *Den Papsten zu Diensten: Raffaels Herrscherzyklus in der Stanza dell'Incendio im vatikanischen Palast,* Hildesheim, 1987.

*

His name was Raffaello Santi or Sanzio. The anglicised form, Raphael, has been current in English-speaking countries since at least the 17th century. Throughout the 17th and 18th centuries, and during much of the 19th, when the art of classical antiquity was regarded as the fountain-head of excellence in sculpture and painting, Raphael was considered the greatest of all painters. This was chiefly because his art was thought to have approached the spirit of antiquity more closely than that of any other painter. Since then, when the Romantic revival elevated the primitives, the art of Greece and Rome has been less deified; and in our own day admiration of the painterly qualities exemplified by Titian and the Venetians has had the effect of making many of Raphael's paintings appear dry. Finally, the excessive prominence given by the Victorians to engravings and photographs of the more sentimental Raphael Madonnas has led to a further reaction. For all of these reasons his reputation has suffered, though he is still recognised as one of the key masters of the High Renaissance style.

Raphael's farther, Giovanni Santi, worked as painter for the ruling family of Urbino, the Montefeltro but he died when the boy was only eleven. From the time of Vasari in the mid-16th century it has been assumed that the young Raphael was then apprenticed to Perugine, who was then active both in Perguia and Florence. But documents indicate that Raphael remained in Urbino until his seventeenth birthday in 1500, by which time he was officially no one's apprentice but a master painter. For the next four years he *was* in association with Perguino at Perugia but in the capacity of junior partner, not of pupil. It follows that Vasari's misleading deduction of an apprenticeship to Perugine is likely to have arisen from the fact, which he

himself noted, that the pictures which Raphael painted between the years 1500 and 1504 are almost indistinguishable from those of Perugino. They consist primarily of three altarpieces—the Crucifixion (London, National Gallery), the Coronation of the Virgin (Vatican) and the Marriage of the Virgin (Milan, Brera). There are also fragments (at Naples, Bergamo, and in the Louvre) of the earliest of all Raphael's altarpieces, representing St. Nicholas of Tolentino.

Between 1504 and 1508 Raphael based himself at Florence as a free lance, but spent much time away from it, in Urbino, Perugia, and elsewhere. He may have paid a short visit to Rome at this time. During this time the influence of Leonardo da Vinci, who was living in Florence in the years from 1500 to 1506, prevails over that of Perguino. The most notable paintings were small Madonnas, such as the Madonna del Granduca (Florence, Pitti), or "La Belle Jardinière" (Louvre) and some portraits, such as those of Angelo and Maddalena Doni (Florence). His chief patrons at this time were Florentine merchants.

At the end of 1508 Raphael settled in Rome where he was to die, twelve years later. His first work there, the so-called Stanza della Segnatura in the Vatican, was the first of a series of such rooms which he covered with frescoes at the direction of successive Popes, Julius II and Leo X. The decoration of the Stanza della Segnatura seems to have been finished around the end of 1511. It includes the *School of Athens,* one of the most highly esteemed and most famous of all his works. The frescoes in this room represent a great advance on Raphael's earlier work. The main influence is still that of Leonardo, but at this time Michelangelo was painting the Sistine ceiling in an entirely new and highly dynamic manner. There was a public showing of the first half of the ceiling in August 1511, but Raphael had apparently contrived to have a look at it before that, and the sight of it had some effect on his latest work in the Stanza della Segnatura, introducing a kind of grandeur that had not been there before.

In the years 1510–11 Pope Julius was away from Rome on a campaign in north Italy, and during this time the enormously rich banker from Siena, Agostino Chigi, started to employ Raphael both as painter and architect. This patronage continued, sandwiched between work for the papacy, until Chigi died, within a week of Raphael, in 1520. This work consisted, apart from panel pictures of the fresco of Galatea in Chigi's villa, now called the Farnesina, and later, the Loggia of Psyche in the same villa, some frescoes of prophets and sibyls in the church of S. Maria della Pace, the design and decoration of Chigi's chapel at S. Maria del Popolo, and the design of his stables (now almost totally destroyed) at his villa. Two of Raphael's most famous altarpieces, the Madonna of Foligno (Vatican) and the Sistine Madonna (Dresden), date, in all probability, from the years 1511–13, as does the Madonna of the Chair (Pitti) and several famous portraits, including that of Pope Julius (London).

During Raphael's early years in Rome he was involved in an important development. A draughtsman from Bologna, Marcantonio Raimondi, had been imitating, and, in effect, forging the prints of Dürer which had been having a very large circulation in Italy at this time. Now Marcantonio settled in Rome and established a partnership with Raphael, making engravings not from his paintings but from his drawings, and thereby spreading his reputation.

At the time of Pope Juliu's death in February 1513, the second of the Vatican apartments, the stanza d'Eliodoro, was about three quarters finished. It is totally different from the Stanza della Segnatura in that the frescoes are dynamic, dramatic, and asymmetrical in their composition, revealing the strong influence of Michelangelo, and, in their technique, surprising indications of Venetian influence in the form of a broader and more painterly handling of paint.

The death of a Pope automatically brought with it the cessation of work commissioned by him. In this case the Pope Leo X, allowed Raphael to finish the Stanza d'Eliodoro and to continue the series with the Stanza dell'Incendie. But in August 1514 he appointed him architect to St. Peter's in succession to his kinsman, Bramante, who had started the rebuilding of the Basilica but had completed very little. This appointment marked the turning point in Raphael's life. From now on he completed relatively few paintings unaided. Most of his time was given to architectural work at St. Peter's (none of it visible today) and elsewhere, and to supervising the execution of his designs for frescoes, altarpieces, tapestry and decorative arts by a team of assistants whom he trained. Examples of this are the tapestry cartoons (London, Victoria and Albert Museum, on loan from the Queen), the Stanza dell'Incendio, already mentioned, the Vatican Loggia, and the start of work on the Sala di Costantino.

These works saw the birth of the so-called Grand Manner, which had been adumbrated by Leonardo da Vinci in his *Last Supper*. This was based on the art of antiquity and aimed to eliminate incidental details generalising the features and the costumes, and raising the effect to a superhuman level of nobility. Naturally this involved a certain sacrifice of realism, and the somewhat stereotyped style which resulted was suited to, and partly a result of, the delegation of the execution to assistants. Between the years 1514 and 1519 the only paintings which issued from Raphael's studio with a high proportion of his own paintings were a few portraits, notably the Baldassare Castiglione (Louvre) and Leo X and Cardinals (Uffizi).

At last according to Vasari, Raphael himself felt that he had carried delegation too far. Around the year 1516 the Pope's cousin, Cardinal Guilio de'Medici, later Pope Clement VII, had commissioned altarpieces from Raphael and Sebastiano del Piombo to send to the cathedral of Narbonne, in France, of which he was bishop but which he never visited. Sebastiano's picture (*The Raising of Lazarus,* now in London) was in fact sent to Narbonne, but Raphael's contribution, *The Transfiguration,* remained in Rome (now Vatican). It was probably not started until 1519 and as though conscious that it was to be his last work he set out to execute it all himself. Opinions differ as to what extent he had finished it at the time of his death. But it was immediately regarded as the testament of the demigod, and for centuries was regarded as the greatest picture in the world. Raphael, who had amassed a considerable fortune, was buried in the Pantheon.

—Cecil Gould

RAUSCHENBERG, Robert.

Born Milton Rauschenberg in Port Arthur, Texas, 22 October 1925. Married Susan Weil, 1950 (divorced, 1952); one son. Studied at the Kansas City Art Institute and School of Design, 1946–47, Académie Julian, Paris, 1947, and under Josef Albers at Black Mountain College, North Carolina, 1948–50; artist and teacher in New York since 1950: taught at Black Mountain College, 1952 (participated in first "happening," with John Cage and others); also associated with Merce Cunningham Dance Company as stage and costume designer (*Three Epitaphs,* 1956, *The Tower,* 1957, *Images and Reflections,* 1958, *Antic Meet,* 1958, *Summerspace,* 1958, *Tracer,* 1962, *Field Dances,* 1963, *Winterbranch,* 1964, etc.). Address: c/o Knoedler Gallery, 19 East 70th Street, New York, New York 10021, U.S.A.

Collections: Aachen; Amsterdam: Stedelijk; Cologne; Krefeld; Los Angeles; New York: Moma, Guggenheim, Whitney; Ottawa; Stockholm: Moderna Museet; Toronto.

Publications

By RAUSCHENBERG: book—

Illustrations for Dante's Inferno, New York, 1964.

ON RAUSCHENBERG: books—

Dorfles, Gillo, *Rauschenberg* (cat), Milan, 1961.
Alloway, Lawrence, et al., *Rauschenberg* (cat), Paris, 1963.
Solomon, Alan R., *Rauschenberg* (cat) New York, 1963.
Geldzahler, Henry, *Rauschenberg: Paintings, Drawings, and Combines 1949–1964* (cat), London, 1964.
Swanson, Dean, *Rauschenberg: Paintings 1953–1964* (cat), Minneapolis, 1965.
Forge, Andrew, *Rauschenberg* (cat), Amsterdam, 1968.
Forge, Andrew, *Rauschenberg* (cat), New York, 1969.
Wissman, Jürgen, *Rauschenberg: Black Market,* Stuttgart, 1970.
McCracken, William, and Donald Saff, *Rauschenberg at Graphic Studio* (cat), Tampa, Florida, 1974.
Young, Joseph E., *Rauschenberg's Pages and Fuses* (cat), Los Angeles, 1974.
Perocco, Guido, et al., *Rauschenberg* (cat), Venice, 1975.
Rauschenberg (cat), Washington, 1976.
Zanetti, Paola Serra, et al., *Rauschenberg* (cat), Ferrara, 1976.
Adriani, Götz, *Rauschenberg: Zeichnungen, Gouachen, Collagen 1949 bis 1979* (cat), Munich, 1979.
Tomkins, Calvin, *Off the Wall: Rauschenberg and the Art World of Our Time,* New York, 1980.
Rauschenberg: Werke 1950–1980 (cat), Berlin, 1980.
Rauschenberg: Peintures récentes (cat), Saint-Paul-de-Vence, 1984.

article—

Feinstein, Roni, "The Early Work of Rauschenberg: The White Paintings, the Black Paintings, and the Elemental Sculptures," in *Arts Magazine* (New York), September 1986.

Gold Strike Glut, 1987; painted metal; 49½ in (125.7 cm); Courtesy Waddington Galleries

As one of the most resourceful innovators in postwar American art, Robert Rauschenberg changed the look of painting, blurred the boundaries between the visual and the performing arts, and engaged in ambitious if sometimes problematic sculptural and theatrical collaborations with engineers. His controversial "combine" paintings of the 1950's—works that offer three-dimensional objects as well as flat images—significantly expanded the range of available art materials by offering such unconventional ingredients as stuffed birds, ladders, electric fans, clocks, and radios. Perceived in the late 1950's as a wayward, neo-Dadaist prankster in the second-generation school of Abstract expressionism, he was viewed in the early 1960's as a prophet of Pop art. Being a maverick and a one-man school of his own, suspicious of all formalist utopias, Rauschenberg found himself at odds both with the Abstract Expressionists, who were too insular and introverted for his taste, and the Pop artists, who impressed him as too imitative and blatantly obvious.

Stylistically, Rauschenberg's art has touched many bases, from proto-Minimalist all-white and all-black abstractions made in the early 1950's to silkscreened paintings and electronic sculptures that invite spectator "participation" in the 1960's to freewheeling assemblages of highway and street signs in the 1980's.

In addition to his combine paintings and junk sculptures, Rauschenberg developed an original form of draftmanship, deriving "found" images from newspapers and magazines and transferring them to drawing paper through an unorthodox technique: he moistened the printed illustrations with a solvent (turpentine or cigarette-lighter fluid), placed the damp side against his drawing paper, then rubbed a pencil or empty ball-point pen on the reverse of the image, thereby transferring it to the paper in the form of hatched pencil strokes. The technique enabled him to "collage" heterogeneous images from various sources and yield a unified, homogeneous surface. His most important "transfer drawings" are a sequence of 34 illustrations, to which he added passages of spontaneous drawing in pencil and wash, for Dante's *Inferno* (1959–60).

Almost from the beginning, Rauschenberg demonstrated a compositional preference for unrelated and scattered ready-made images, deployed in ways that provoke viewers into pondering their juxtapositions. In 1962 he began silkscreening photographic images onto his canvases; like the earlier transfer drawings, the silkscreen technique facilitated his use of ready-

made images, which he now combined with luscious, hand-painted passages of amorphous abstraction. This series included many spectacular paintings, such as the 32-foot-wide *Barge* (1963) with its arresting kaleidoscope of photographic images reflecting the American scene.

Rauschenberg prefers collaborative ventures to solitary work in the studio, which helps account for his prolific output as a printmaker. His collaborative printmaking projects have taken him to Ambert, France, where he produced a series of molded-paper works, to Ahmedabad, India, where he made sculptural as well as two-dimensional works, and to Jing Xian in the People's Republic of China, where he turned out exquisite paperworks incorporating cutouts from posters and embroidered silk. Many of his prints are notable for their ambitious large scale: *Currents* (1970) is 54 feet long.

In the mid-1960's, Rauschenberg collaborated with engineer Billy Klüver to devise *Oracle* (1965), a quintet of wheeled junk sculptures equipped with radios that produces a "collage of sound." With Klüver, he also founded Experiments in Art and Technology, Inc. (E.A.T.), an organization intended to foster collaborations between artists and scientists. Since the mid-1980's, Rauschenberg has concentrated much of his energy on the Rauschenberg Overseas Culture Interchange (R.O.C.I.), a privately funded program to promote world peace by touring a traveling show of his work to more than 20 nations and making collaborative artworks with regional artists and artisans in many of those countries.

—David Bourdon

RAY, Man.

Born Emmanuel Rudnitzky in Philadelphia, Pennsylvania, 27 August 1890. Died in Paris, 18 November 1976. Married 1) Adon Lacroix, 1914 (divorced, 1918); lived with Alice Prin, 1924–30; married 2) Juliet Browner, 1946. Studied art at evening classes, including the National Academy of Design, New York, 1908–12; life-drawing at the Francisco Ferrer Social Center, New York, 1912–13; self-taught in photography, from 1915; painter and sculptor in New York, from 1911; designer in advertising agency, 1913–19; free-lance painter and photographer in Paris, associating with the Surrealists, 1921–40; filmmaker (films include *The Return to Reason*, 1923, and *L'Etoile de Mer*, 1928) worked in Hollywood, 1940–50, and taught photography, Art Center School, Los Angeles, 1942–50; worked in Paris and Cadaques, Spain, from 1951.

Collections: Albuquerque: University of New Mexico; Chicago; Lawrence: University of Kansas; New Haven; New Orleans; New York: Moma; Oakland, California; Paris: Art Moderna; Rochester: Eastman House.

Publications

By RAY: books—

Revolving Doors 1916–17, Paris, 1926.

Kiki Souvenirs, Paris, 1929.
Facile, with Paul Eluard, Paris, 1935.
Les Mains libres, with Paul Eluard, 1937.
La Photographie n'est pas l'art, Paris, 1937.
Alphabet for Adults, Los Angeles, 1948.
To Be Continued Unnoticed, Los Angeles, 1948.
Self-Portrait, Boston and London, 1963.
Tous les films que j'ai realisé, Paris, 1965.
Les Mannequins, Paris, 1966.
Les Invendables, Vence, 1969.
Mr. and Mrs. Woodman, Amsterdam, 1970.
Bonsoir, Man Ray (interview), with Pierre Bourgade, Paris, 1972.
Les Voies lactées, New York, 1974.
Femmes 1930–35, Milan, 1981.

On RAY: books—

Tzara, Tristan, *Les Champs delicieux: Album de photographies* [by Man Ray], Paris, 1922.
Ribemont-Dessaignes, Georges, *Man Ray*, Paris, 1924.
Bost, Pierre, *Man Ray: Electricité*, Paris, 1931.
Breton, André, et al., *Man Ray: Photographies 1920-1934*, Paris, Paris, 1934; as *Man Ray: Photographs 1920-1934*, New York, 1934.
Adhémar, Jean, er al., *Man Ray: L'Oeuvre photographique* (cat), Paris, 1962.
Gruber, L. Fritz, *Man Ray: Portraits*, Paris, 1963.
Langsner, Jules, *Man Ray*, Los Angeles, 1966.
Argan, C. G., *Oggetti d'affezione: Rayographs*, Turin, 1970.
Aragon, Louis, et at., *Man Ray*, Milan, 1971.
Man Ray (cat), Rotterdam, 1971.
Janus, *Man Ray*, Milan, 1973.
Alexandrian, Sarane, *Man Ray*, Paris, 1973.
Man Ray: Opera grafica, Turin, 1973.
Man Ray (cat), Turin, 1974.
Penrose, Roland, *Man Ray*, London, 1975.
Man Ray: L'occhio e il suo doppio (cat), Rome, 1975.
Schwarz, Arturo, *Man Ray: The Rigour of the Imagination*, Milan, New York, and London, 1977.
Bussmann G., et al., *Man Ray: Inventionen und Interpretationen* (cat), Frankfort, 1979.
Perl, Jed, *Man Ray*, Millertown, New York, 1979.
Bramly, Serge, *Man Ray*, Paris, 1980.
Martin, Jean-Hubert, *Man Ray photographe* (cat), Paris, 1981, 1982; as *Man Ray: Photographs*, London and New York, 1982.
Sayag, Alain, *Atelier Man Ray 1920-1935* (cat), Paris, 1982.
Objets de mon affection (catalogue raisonné . . . des objets . . . fabriqués par Man Ray), Paris, 1983.
Janus, *Man Ray*, London, 1984.
Kuenzli, Rudolf E., *Dada and Surrealist Film*, New York, 1987.
Esten, John, and Willis Hartshorn, *Man Ray: Bazaar Years*, New York, 1988.
Baldwin, Neil, *Man Ray, American Artist*, New York, 1988.
The Perpetual Motif: The Art of Man Ray, New York, 1988.

*

Man Ray defies definition, both in terms of national identity

and artistic medium, alternating between America and France and donning the different mantles of painting, sculpture, photography, and film throughout his career. Man Ray always insisted that painting was his greatest love, though he made his name and money in the medium of photography, with innovating and interesting results. Refusing at the outset a scholarship for architectural studies and working instead in lettering and layout in New York, Man Ray initiated himself into the world of art by attending life classes with the primary aim of becoming acquainted with the female form. He also fraternized with fellow members of Alfred Stieglitz's avant-garde group 291, and benefitted from exhibitions of modern European art, photography, and primitive sculpture held at the Fifth Avenue gallery. The artist's first work of note, *Tapestry*, 1911, was stimulated by his exposure to new Cubist painting, though somewhat surprisingly constructed from tailor's cloth samples into an abstract patchwork of muted colours. While untrue to the Cubists' media, the composition reflects a Dada predisposition towards the unexpected. Man Ray's exposure to the crucial and controversial Armory Show of 1913 and his friendship with Marcel Duchamp strengthened his artistic resolve. Cubist-oriented drawings and paintings culminated in 1916 with *The Rope Dancer Accompanies Herself with Her Shadows,* the epic and descriptive title owing much to Duchamp, the subject matter inspired by an act in a vaudeville show. While blocking in forms with cut-out paper Man Ray noted by chance the rejected pieces lying beneath the easel-like shadows. Pleased, he then incorporated this effect into the painting, the brightly coloured panels complementing the star-like dancer.

Between *The Rope Dancer* and Man Ray's departure for Paris, the artist was busily engaged in creating works that reflected the spirit of New York Dada. Naturally, Duchamp provided the greatest inspiration for the movement, and under his influence Man Ray began constructing incongruous Dada sculptures and collages. The irreverance and dispensability of the "ready-made assisted " had tremendous appeal: thus when Man Ray's cardboard spiral lampshade was accidentally destroyed and his *Object of Destruction,* 1923, a metronome with a photographed female eye affixed, was smashed by reactionary art students, he happily remade both objects, wittily renaming the latter *Indestructible Object.* Man Ray also invented the *Aerograph* at this time, creating with an airbrush ethereal images, almost photographic in quality and texture, with the added bonus of being untouched by the artist. He was already using the camera, encouraged by Stieglitz, but as yet only to photograph his own work. However, in 1920 Man Ray set up his equipment in Duchamp's dim studio and took an hour long exposure of the *Large Glass* covered with six months of dust: *Evelage de poussière* (Dust Farm) looked for all the world like an aerial photograph and pleased Duchamp so much that he varnished and thus retained a dusty corner of the *Large Glass.*

Man Ray finally reached Paris in 1921 and found a ready-made circle of friends in the form of the Dadaists and future Surrealists. He soon realised that he could not earn a living from painting alone, and took to supplementing his income with society and fashion photography, earning himself a strong reputation with *Vogue, Harper's Bazaar,* and the Parisian elite. However, he continued to work on his own projects: from the early years in France date *Gift,* the famous tribute to the avant-garde composer Erik Satie, and the *Rayograph,* invented accidentally when Man Ray placed some objects on light-sensitive paper. Tzara called the discovery pure Dada. Experimental photography was indeed welcome ammunition for the Dada and Surrealist arsenals: photography was the perfect vehicle for experimenting with space and time, as well as surprising or shocking a complacent public. The solarization technique (or "Sabattier effect") was discovered accidentally by Lee Miller and Man Ray when they exposed a negative to premature light and found the image had undergone a reversal of tones. The consequent solarized portraits and compositions, e. g., *Lee Miller,* 1930, took on a luminous, surreal effect with precise black contour lines that were the envy of draughtsmen. Several solarizations and "straight" photographs were published in an album entitled *The Age of Light* in 1934, though this publication did not reveal the darker side of Surrealist fantasy, which took a pornographic form.

Although photography in its various guises occupied much of Man Ray's time and energy during his nineteen-year sojourn in Paris, he nevertheless continued to paint. *The Lovers, or Observatory Time,* 1932, one of the artist's most famous canvases, explores the world of the surreal and the unconscious with the erotic image of a pair of lips, originally belonging to Lee Miller, suspended over a barren landscape, the painting itself hung over Man Ray's bed and chess set. His paintings and drawings of the late 1930's contain a strong mix of Surrealism and classicism very much in the manner of late de Chirico: in *Le Beau Temps,* 1939, the bright mannequin figures express through gesture and symbolism a sinister sense of foreboding, of war. Forced to leave Paris in 1940 because of the German occupation Man Ray retreated to California where he spent eleven years before returning to France, maintaining a low profile and devoting himself to his painting. A new series of works entitled *Shakespearian Equations* appeared in the late 1940's based on mathematical objects and deriving their individual titles from Shakespeare's plays, a gesture calculated to offend the purists of abstract art. Photography no longer featured in the old man's oeuvre; instead, previous collages and assemblages were remade and reassessed and the painting continued.

—Caroline Caygill

REDON, Odilon.

Born Bertrand-Jean Redon in Bordeaux, 22 April 1840; grew up in Peyrelebade. Died in Paris, 6 July 1916. Married Camille Falte, 1880; two sons. Attended school in Bordeaux from 1851; drawing lessons with Stanislas Gorin from 1855; briefly a pupil of Jean-Léon Gérôme, 1864; taught printmaking by Rodolphe Bresdin; exhibited from 1860 in Bordeaux, from 1867 in Paris, and from 1886 in Brussels; became known in Paris in late 1870's; friend of the poet Mallarmé; many albums of lithographs, from 1879.

Major Collections: Otterlo; Paris.
Other Collections: Basel; Bordeaux; Bristol; Cleveland; De-

troit; London: National Gallery, Victoria and Albert; New York: Moma, Metropolitan; Paris: Petit Palais; Pittsburgh.

Publications

By REDON: books—

A soi-même: Journal (1867–1915), edited by Jacques Morland, Paris, 1922, 1961; as *To Myself: Notes on Life, Art, and Artists*, New York, 1986.
Lettres 1878–1916, Paris, 1923.

On REDON: books—

Mellerio, André, *L'Oeuvre graphique complet de Redon*, Paris, 1913, as the *The Graphic Works of Redon*, New York, 1969.
Mellerio, André, *Redon: Peintre, dessinateur, et graveur*, Paris, 1923.
Fegdal, Charles, *Redon*, Paris, 1929.
Leblond, M. A., *Les Fusains de Redon*, Paris, 1941.
Seznec, Jean, *Nouvelles études sur "La Tentation de Saint Antoine,"* London, 1949.
Roger-Marx, Claude, *Redon: Fusains*, Paris, 1950.
Sandström, Sven, *Le Monde imaginaire de Redon: Etude iconographique*, Lund and New York, 1955.
Bacou, Roseline, *Redon*, Geneva, 2 vols., 1956.
Bacou, Roseline, *Redon* (cat), Paris, 1956.
Redon, Moreau, Bresdin (cat), New York, 1961.
Berger, Klaus, *Redon: Phantasie und Farbe*, Cologne, 1964; as *Redon: Fantasy and Color*, New York, 1965.
Svendsen, Louis A., *Rousseau, Redon, and Fantasy* (cat), New York, 1968.
Bacou, Roseline, and Claude Roger-Marx, *Redon à l'Abbaye de Fontfroide*, Paris, 1970.
Selz, Jean, *Redon*, New York and Paris, 1971.
Binney, Edwin, 3rd., *One Man's Vision: The Graphic Works of Redon* (cat), Washington, 1973.
Hobbs, Richard, *Redon*, Boston and London, 1977.
Wilson, Michael, *Nature and Imagination: The Work of Redon*, Oxford and New York, 1978.
Eggeldinger, Marc, *Suite pour Redon*, Neuchatel, 1983.
Koella, Rudolf, *Redon* (cat), Winterthur, 1983.
Le Donation Arï et Suzanne Redon, Paris, 1984.
Redon (cat), Bordeaux, 1985.
Redon (cat), Enschede, 1985.
Florence, Penny, *Mallarmé, Manet, and Redon: Visual and Aural Signs and the Generation of Meaning*, Cambridge, 1986.
Harrison, Sharon, R. P., *The Etchings of Redon: A Catalogue Raisonné*, New York, 1986.
Bacou, Roseline, *Redon: Pastels*, New York and London, 1987.

*

It is important not to set Redon apart as idiosyncratic for a full understanding of both his work and of the development of 19th-century French painting. At first sight, his work undoubtedly appears strange: several albums of complex black and

Day, 1891; lithograph

white lithographs, all in series and with captions bearing a more or less oblique relation to the images; and beautiful pastels whose sensuous colour seems far from the lithographs, which he called "mes noirs." In addition, he painted a few oils and, in later life especially, did some finely observed drawings. While it would be misleading to ignore the manifest division in his major output between the albums and the pastels, it would equally be false to separate them out. Descriptions of the lithographs as horrific or designed to shock are symptomatic of this divided approach. While their effect may be disruptive, their aim is serious and far from sensational. The emotive quality of the pastels, together with Redon's excellent writings, is a sure guide.

Think of a rock. See it. Now find one. Look at it. From a distance and in minute detail. Consider the nature of the rock and of your activity in looking. Repeat with a leaf. How is your sense of the rock modified? How has the process of looking changed as it moves you towards insight? An inquiry of this kind into the interrelations between seeing and understanding, between the mind and the natural world, is never far from any work of Redon's

Redon's only formal studies of painting, under Gérôme, were brief and not particularly productive. Bresdin, master printmaker, was his mentor, and a vital branch of Redon's roots is to be found here and in illustrators such as Grandville.

But Redon is not an "illustrator" as such, even though much of his work was inspired by literature, especially Flaubert, Poe, Baudelaire, and Mallarmé. This connexion is quite explicit in the case of his albums of lithographs, although his

practice in relation to literature is variable; sometimes the verbal component is taken directly from the writer, as with Flaubert, Bulwer-Lytton, and Baudelaire, sometimes not, as with Poe. In the case of his friend Mallarmé, there are fascinating structural parallels to be drawn which facilitate understanding both of verbal and visual language. Redon's images are never simply juxtaposed with words or literary references as "illustration," a word which Redon rejected: "C'est un mot à trouver: je ne vois que ceux de transmission, d'interprétation." The lithographic albums are visionary journeys undertaken through a combination of words and images which extends the meanings of language and of the image towards the limits of what we are accustomed to see as sense or as rational. This is where the feelings which have often been misnamed as terror and madness arise. In Western patriarchal culture we are not accustomed to combine words and images into a complex sign where meaning is released at a level outside the immediate verbal or visual frame. We find it hard to respond to words and images in the same way, which means having to open language on a level which equalises factors such as sound-shape with syntax and to images which both internally and in sequence construct a visual syntax.

A contemporary of the painters who began to revolutionise Western art, Redon also explored the nature of painting and of visual perception/meaning in complementary ways to them. This is easier to see now that the old way of classifying painters into movements is being fundamentally rethought. Our understanding of his work suffered from being seen as a "Symbolist." To understand Redon we need to look not only at Moreau and Bresdin, but also at Manet, Gauguin, Monet, and Courbet. To understand the art of a century of rapid social and political change, we need to see its breadth, and if it appears to defy description within our present framework, then the framework is inadequate.

—Penny Florence

REMBRANDT.

Born Rembrandt Harmensz. van Rijn in Leiden, 15 July 1606. Died in Amsterdam, 4 October 1669. Married Saskia van Uylenburgh, 1634 (died, 1642), son, Titus; lived with Hendrickje Stoffels from the 1640's (died, 1663), daughter, Cornelia. Attended the Latin School in Leiden, and Leiden University briefly; apprenticed to the painter Jacob van Swanenburgh, Leiden, 1621–24; worked in the studio of the history painter Pieter Lastman, Amsterdam, 1624–25; set up as painter in Leiden, 1625–31, associated with Jan Lievens; settled in Amsterdam, 1631: soon established his reputation with Anatomy Lesson of Dr. Tulp; also etchings, portraits, historical paintings, and group portraits; well-known in his own day. Pupils: almost an academy of students rather than the "apprenticeship" method: Gerard Dou, Ferdinand Bol, Govaert Flinck, Gerbrand van den Eeckhout, Philips Koninck, Aert de Gelder, Carel Fabritius, Samuel van Hoogstraeten, Nicolaes Maes.

Major Collections: Amsterdam; Berlin; Leningrad; London; New York.

Other Collections: Amsterdam: Six; Braunschweig; Boston; Braunschweig; Cambridge, Massachusetts; Chicago; Detroit; Frankfurt; The Hague; Kassel; Lisbon; London: Wallace, Kenwood; Los Angeles; Moscow; Munich; New York: Frick, Historical Society; Nuremberg; Paris; Pasadena; Philadelphia; Rotterdam; Stockholm; Stuttgart; Vienna; Washington.

Publications

By REMBRANDT: book—

Seven Letters, edited by Horst Gerson, The Hague, 1961.

On REMBRANDT: books—

Dvorak, M., *Die Nachtwacht*, Vienna, 1921.

Hind, Arthur M., *A Catalogue of Rembrandt's Etchings*, London, 2 vols., 1923; New York, 1967.

Hind, Arthur M., *Rembrandt*, Cambridge, Massachusetts, 1932.

Bredius, Abraham, *Rembrandt: Gemälde*, Vienna, 1935; revised by Horst Gerson as *The Complete Edition of the Paintings*, London, and New York, 1969.

Borenius, Tancred, *Rembrandt: Selected Paintings*, London, 1942.

Visser 't Hooft, W. A., *Rembrandt et la Bible*, Neuchatel, 1947; as *Rembrandt and the Gospel*, New York, 1960.

Rosenberg, Jakob, *Rembrandt*, Cambridge, Massachusetts, 2 vols., 1948; as *Rembrandt: Life and Work*, New York and London, 1964.

Münz, Ludwig, *A Critical Catalogue of Rembrandt's Etchings*, London and Philadelphia, 2 vols., 1952.

Slive, Seymour, *Rembrandt and His Critics 1630–1730*, The Hague, 1953.

Benesch, Otto, *The Drawings of Rembrandt: Complete Edition*, London, 6 vols., 1954–57, Oxford, 6 vols., 1973.

Bauch, Kurt, *Rembrandt: Die Nachtwache*, Stuttgart, 1957.

Heckscher, W. S., *Rembrandt's Anatomy of Dr. Nicholas Tulp: An Iconographical Study*, New York, 1958.

Heiland, Susanne, and Heinz Lüdecke, *Rembrandt und die Nachtwache*, Leipzig, 1960.

Bauch, Kurt, *Der frühe Rembrandt und seine Zeit*, Berlin, 1960.

Benesch, Otto, *Rembrandt as a Draughtsman*, London, 1960.

Focillon, Henri, and Ludwig Goldscheider, *Rembrandt: Paintings, Drawings, and Etchings*, London and New York, 1960.

White, Christopher, *The Drawings of Rembrandt*, London, 1962.

White, Christopher, *Rembrandt and His World*, London and New York, 1964.

Scheidig, Walter, *Rembrandt's Drawings*, London, 1965.

Slive, Seymour, *Drawings of Rembrandt*, New York, 2 vols., 1965.

Bauch, Kurt, *Rembrandt Gemälde*, Berlin, 1966.

Clark, Kenneth, *Rembrandt and the Italian Renaissance*, London, 1966, New York, 1968.

Fuchs, R. H., *Rembrandt en Amsterdam*, Rotterdam, 1968; as *Rembrandt in Amsterdam*, New York, 1969.

Gerson, Horst, *Rembrandt Paintings*, New York, 1968

Haak, Bob, *Rembrandt: Zijn Leven, zijn werk, zijn tijd*, The Hague, 1968; as *Rembrandt: His Life, His Work, His Time*, London, 1968, New York, 1969.

Gerson, Horst, *Rembrandt*, Paris, 1969.

Held, Julius S., *Rembrandt's "Aristotle" and Other Rembrandt Studies*, Princeton, 1969.

Kitson, Michael, *Rembrandt*, London, 1969, 3rd edition, Oxford, 1982.

Kok, T., *Rembrandt's Night Watch: A Fascinating Story*, Amsterdam, 1969.

Rotermund, H. M., *Rembrandt's Drawings and Etchings for the Bible*, Philadelphia, 1969.

White, Christopher, *Rembrandt as an Etcher*, London, 2 vols., 1969.

White, Christopher, and KG. Boon, *Rembrandt's Etchings: An Illustrated Critical Catalogue*, Amsterdam, 2 vols., 1969; as *Rembrandt: All the Etchings Reproduced in True Size*, London, 1977.

Rembrandt after Three Hundred Years (cat), Chicago, 1969.

Rembrandt: Experimental Etcher (cat), Boston, 1969.

Benesch, Otto, *Rembrandt*, edited by Eva Benesch, London, 1970.

Loewinson-Kessing, V., *Rembrandt: Paintings from Soviet Museums*, Leningrad, 1971.

Kok, J. P. Filedt de, *Rembrandt Etchings and Drawings in the Rembrandt House*, Maarsen, 1972.

Gerson, Horst, *Rembrandt: La Ronde de nuit*, Fribourg, 1973.

Haak, Bob, *Rembrandt: Zeichnungen*, Cologne, 1974; as *Rembrandt Drawings*, Woodstock, New York, and London, 1976.

Waal, Henri van de, *Steps Towards Rembrandt*, Amsterdam and London, 1974.

Wright, Christopher, *Rembrandt and His Art*, London, 1975.

Sciolla, Gianni Carlo, *Rembrandt: Disegni*, Florence, 1976.

Bernhard, Marianne, *Rembrandt: Druckgraphik, Handzeichnungen*, Munich, 2 vols., 1976.

Bolton, Jaap, and H. Bolten-Rempt, *The Hidden Rembrandt*, Chicago, 1977; Oxford, 1978.

Tümpel, Christian, *Rembrandt in Selbstzeugnissen und Bilddokumenten*, Reinbek, 1977.

Clark, Kenneth, *An Introduction to Rembrandt*, London, 1978.

Hijmans, Willem, et al., *Rembrandt's Nightwatch: The History of a Painting*, Alphen aan den Rijn, 1978.

Vries, Ary B de, et al., *Rembrandt in the Mauritshuis*, Alphen aan de Rijn, 1978.

Strauss, W. J., and Marjon van der Meulen, *The Rembrandt Documents*, New York, 1979.

Vogel-Köhn, Doris, *Rembrandts Kinderzeichnungen*, Cologne, 1981.

Halewood, William, *Six Subjects of Reformation Art: A Preface to Rembrandt*, Toronto, 1982.

Schupbach, W., *The Paradox of Rembrandt's Anatomy of Dr. Tulp*, London, 1982.

Wright, Christopher, *Rembrandt: Self-Portraits*, New York and London, 1982.

Bruyn, Joshua, et al., *A Corpus of Rembrandt Paintings, vol. I, 1625-1631*, The Hague, 1982; *vol.II, 1631-1634*, Dordrecht, Boston, and Lancaster, 1986.

Haverkamp-Begemann, E., *Rembrandt's "The Nightwatch,"* Princeton, 1982.

White, Christopher, *Rembrandt*, London, 1984.

Schwartz, Gary, *Rembrandt: His Life, His Paintings*, New York and London, 1985.

Alpers, Svetlana, *Rembrandt's Enterprise: The Studio and the Market*, London, 1988.

Bomford, David, Christopher Brown, and Ashok Roy, *Rembrandt: Art in the Making*, London, 1988.

*

It is impossible to give an exact count of the drawings, prints, and paintings produced by Rembrandt, as experts continue to disagree about numerous attributions. But all would agree that his output was peerless in both quality and quantity. Even during his early years as an independent master in Leiden, from 1625 to 1631, he was so confidently skilled in his craft that he could use his brush—or pen, or chalk, or etcher's needle—freely for expressive purposes. And he was already capable of manipulating light and shadow sensitively for emotional effect, a capacity that enriched his work throughout his career.

Rembrandt's small painting of *The Flight into Egypt* of 1627 (Tours, Musée des Beaux-Arts) is an early example of his mastery of the expressive use of illumination, showing the Holy Family plodding on in isolation in the dark of night, aided by seemingly miraculous radiance. It also foreshadows his lifelong bent for interpreting stories from Scripture as human experiences. Rembrandt was only twenty-one when he painted this original and profoundly moving interpretation of a traditional subject. The young artist's paintings were lavishly praised, and his reputation spread beyond his native city. By 1631 he was receiving commissions to paint portraits of prosperous residents of Amsterdam—the most lucrative possibility for a Dutch painter at this time.

Living in Amsterdam by the middle of 1632, Rembrandt painted in that year a large group portrait to be hung in the meeting rooms of the Surgeons' Guild, *The Anatomy Lesson of Dr. Tulp* (The Hague, Mauritshuis), in which he demonstrated his remarkable ability to characterize each individual, while subordinating them all to a comprehensive design. With this important commission, he managed to outdistance the Amsterdam painters of group portraits who had led the field until his arrival there.

On 22 June 1634, Rembrandt was married to Saskia van Uylenburgh, a young woman from Leeuwarden, whose family surpassed his in wealth and social position, and she appears often in his drawings and paintings until her death on 14 June 1642. *Saskia as Flora* (Leningrad, Hermitage) was painted in the year of their marriage. The goddess Flora is associated with love, and this affectionate allegorical portrait gave Rembrandt the opportunity to revel in the visual riches of damask and embroidery and colorful flowers, as well as a glowing youthful face. At this period he depicted details of costume and accessories with evident delight.

Five scenes of the Passion of Christ, all now in Munich, commissioned by the Stadholder, Frederick Hendrick, were the subject of seven letters, the only letters in Rembrandt's hand that are known today. They were addressed to Constantijn Huygens, who arranged for the commission and to whom Rembrandt as "a token of appreciation" offered to send "a piece ten feet long and eight feet high which will be worthy of my lord's house." It is instructive to note that in a later letter,

The Three Cottages; etching

dated January 27, 1639, the artist added in a postscript: "My lord hang this in a strong light so that one can stand at a distance from it; then it will sparkle at its best." The gift to Huygens is assumed to have been *The Blinding of Samson* (Frankfurt, Städelsches Kunstinstitut), which is inscribed with the date 1636, a dramatic scene of raw horror in the fashionable baroque style in which he worked in the 1630's. *Danaë* (Leningrad, Hermitage), another large painting dated 1636, shows evidence of later revisions in his broader style of the 1640's or early 1650's.

In 1639, the year in which Rembrandt delivered the final two paintings in the Passion series, he had reached a high point in his career. He moved into a large house on St. Anthonie-Breestraat, the cost of which plunged him into the financial difficulties that plagued him for the rest of his life. He identified himself with elegant and accomplished men in his etched *Self-Portrait Leaning on a Stone Sill* of that year, and in the painted version of the following year (London, National Gallery), for both of which he borrowed from portraits by Raphael and Titian. Such adaptations belie the old legend that Rembrandt disdained Italian art and theory. It is true,

however, that he never visited Italy, as many of his compatriots did.

While he lived on the St. Anthonie-Breestraat, where he was to remain for two decades, Rembrandt began to spend more time in the nearby countryside, observing landscapes, which he drew and etched profusely. He also occasionally painted a landscape. There is no solid evidence that he, or any Dutch artist in the 17th century, painted landscapes anywhere but in the studio, though there are paintings that show artists *drawing* landscapes in the open. Rembrandt's *Winter Landscape* of 1646 (Kassel, Gemäldegalerie), a very small panel painted wet-in-wet, so convincingly evokes a specific time, place, and condition of weather, however, that it is tempting to suppose that this unique sketchlike painting was made on the scene, from life.

The Militia Company of Captain Frans Banning Cocq ("The Night Watch", Amsterdam, Rijksmuseum) was a major commission in 1639. There is no basis for the myth that this painting was a failure and led to Rembrandt's financial ruin. It is true, however, that in the early 1640's there began to be a preference in Amsterdam for more polished and status-

enhancing portraiture, and Rembrandt received fewer commissions for portraits from that time on. But even into the 1660's he had some portrait commissions, and his drawings and prints, as well as paintings of other subjects, continued to sell, and fees from students added to his income. His undoubted financial difficulties were presumably exacerbated by expensive purchases for his collection of art, antiquities, and curiosities of all kinds, some of which embellish his paintings and prints.

The personal problems that afflicted him in the 1640's, above all the death of Saskia in 1642, may have contributed to the more somber and introspective quality that increasingly characterized his work. The ministry of Christ often occupied him during this period, as is exemplified by the famous etching (combined with drypoint and burin work, as was often the case with his etchings) *Christ Healing the Sick*, more often called *The Hundred Guilder Print*. This composition, based on verses from the Gospel According to St. Matthew, Chapter 19, may have been conceived early in the 1640's and completed toward the end of the decade. The symbolic significance of light and darkness is at the heart of this strongly composed and technically superlative proof of Rembrandt's unparalled mastery as a print maker.

The *Self-Portrait Drawing at a Window* of 1648 is Rembrandt's first etched portrayal of himself after the *Self-Portrait Leaning on a Stone Sill*. It chronicles the changes in his self-perception and his style brought about in the intervening nine years. No longer does he pose as a dandy, nor does he refer to the great painters of the Italian Renaissance. Instead of the baroque emphasis on spatial depth through the body's position perpendicular to the picture plane, with his head turned to look over his shoulder, in the 1648 composition he is seen frontally, with a brimmed hat squarely on his head replacing the dashing sweep of the beret in the earlier etching. The window, with its emphatic verticals, is the visible source of the light that defines the forms; it is sharply contrasted with the black shadows. Dressed in the simplest of clothing, his hair cut short, his elegant beard shaved off, now he is simply an artist at work, at the age of forty-two.

In the great period of the 1650's, Rembrandt produced paintings, drawings, and etchings prolifically, with unsurpassed powers of invention and technical mastery. The 1653 painting, *Aristotle with the Bust of Homer* (New York, Metropolitan Museum), displays his affinity for the contemplative moment. The Sicilian nobleman who commissioned it was so pleased with it that he later ordered two more paintings by Rembrandt, and, still later, shortly before Rembrandt died in 1669, he bought one hundred eighty-nine of his etchings. Modern connoisseurs have been no less moved by the emotional power of Rembrandt's *Aristotle* and impressed by the free touch, rich paint surface, and poetic distribution of light and darkness that characterize the paintings of Rembrandt's maturity. Scholars continue to propound different interpretations of this masterpiece.

In 1655 Rembrandt painted *Titus as his Desk* (Rotterdam, Boymans-van Beuningen Museum). His only surviving child, the pensive fourteen-year-old boy is placed in space between the firmly constructed desk and the recessive darkness of the background. Only his head and hands are visible, along with the papers on which he is thinking of writing. This picture conveys most intensely the beauty of paint itself. Similarly

broad and painterly in style is *Hendrickje at an Open Door* (Berlin-Dahlem, Staatliche Museen), a portrait of the woman who became Rembrandt's steadfast helpmate from about the late 1640's until her death in July 1663, though they were never married. In 1654 Hendrickje became the mother of his daughter, Cornelia, who was to be his only survivor. In these portraits of his nearest and dearest, clearly the artist enjoyed both his emotional involvement and his freedom from the constraints imposed in any commissioned portrait. His *Self-Portrait at the Age of Fifty-Two* (New York, Frick Collection), dated 1658, is similarly balanced and contained in composition and rich in color and paint application.

After Rembrandt moved, with Titus and Hendrickje, to a smaller house, on 15 December 1660, he continued to have pupils and to paint, but he made few drawings and even fewer etchings. The large painting of *The Apostle Peter Denying Christ* (Amsterdam, Rijksmuseum) of that year is evidence of his unflagging creativity. A burning candle, the source of light within the picture, seems to draw the forms out of the darkness, exposing the Apostle at the moment of his faithlessness.

Rembrandt's painting *The Oath of the Batavians* (surviving fragment now in Stockholm, National Museum), a night scene with dramatic lighting, is on record as having been in the place for which it was painted in the new Town Hall of Amsterdam in 1662. This historical subject, based on the text of Tacitus, was originally sixteen feet square. Exactly why or when it was removed is not known, but it was apparently returned to Rembrandt and cut down and reworked by him. A pen-and-wash drawing gives us an idea of the composition as the artist planned it (Munich, Staatliche Graphische Sammlung).

That Rembrandt continued to be appreciated by at least some prominent members of Amsterdam society is proved by the fact that he was chosen to paint *The Sampling Officials of the Cloth-Makers' Guild* (Amsterdam, Rijksmuseum), a group portrait designed for public display, which he signed in 1662. He succeeded in endowing each of the six men pictured with vibrant individuality. Commissions for single portraits and pairs of portraits also came his way during his last decade.

The Downfall of Haman (Leningrad, Hermitage), painted in about 1665, demonstrates the aging artist's unique ability to communicate emotions through facial expressions and postures. As with a number of his late works, his interpretation of this Old Testament theme shows his increasing detachment from the drama of events and his concern with situations of inner crisis in which each individual is solitary. He deploys his paint—thick and thin, light and dark, in bold juxtaposition—to create not just forms, but feelings.

Rembrandt's remarkable visual autobiography also went on into the very last year of his life. Two splendid *Self-Portraits* (London, National Gallery, and The Hague, Mauritshuis), each inscribed with the date 1669, show him as clear and candid in gaze, strong and free in command of brush and paints.

—Madlyn Millner Kahr

RENI, Guido.
Born in Bologna, 4 November 1575. Died in Bologna, 18 August 1642. Apprenticed to the painter Denis Calvaert in Bologna, from the mid-1580's, but joined the Carracci's studio in the mid-1590's: several church and palace commissions while with the Carracci; in Rome by 1601: patronized by Cardinal Sfondrato, and by the Borghese family, 1607–12; worked in Naples, 1612, and in Ravenna, c. 1614–15, then worked mainly in Bologna again. Pupil: G. G. Sementi.

Collections: Bologna; Cambridge; Florence: Longhi; Genoa: S. Ambrogio; London: National Gallery, Dulwich; Manchester; Milan; Munich; Naples; Paris: Louvre, Notre Dame; Rome: Capitoline, S. Gregorio al Celio, Casino Rospigliosi, Borghese, S. Gregorio Magno; Sarasota, Florida; Siena: S. Martino; Vatican; Vienna.

Publications

On RENI: books—

Boehn, Max von, *Reni,* Bielefeld, 1910, 1925.
Premoli, O., *Reni e i Barnabiti,* Rome, 1914.
Costantini, V., *Reni,* Milan, 1928.
Valeri, Francesco Malaguzzi, *Reni,* Florence, 1928.
Benini, A., *Reni et le pitture della Cappella del Sacramento in Duomo,* Ravenna, 1930.
Marchi, G. M., *Le vicende di un Reni del Gesù di Roma,* Rome, 1935.
Bellori, G. B., *Le vite inediti (Reni, Sacchi, Maratta),* edited by M. Piacentini, Rome, 1942.
Cavalli, Gian Carlo, and Cesare Gnudi, *Reni* (cat), Bologna, 1954.
Cavalli, Gian Carlo, and Cesare Gnudi, *Reni,* Florence, 1955.
Emiliani, Andrea, *Reni,* Milan, 1964.
Baccheschi, Edi, *L'opera completa di Reni,* Milan, 1971.
Malvasia, Carlo Cesare, *Le "vite" di Reni e di Simone Cantarini,* Bologna, 1980; translated in part as *The Life of Reni,* edited by Catherine and Robert Enggass, University Park, Pennsylvania, 1980.
Birke, Veronika, *Reni: Zeichnungen* (cat), Vienna, 1981.
Pepper, D. Stephen, *Reni: A Complete Catalogue of His Works,* Oxford, 1984.
Emiliani, Andrea, et al., *Reni* (cat), Bologna and Los Angeles, 1988.

articles—

Schlegel, Ursula, "Bernini und Reni," in *Jahrbuch der Berliner Museen,* 27, 1985.
Gash, John, "Reni: The Ideal of Painting: Pietro Testa's Dusseldorf Notebook," in *Art History* (Oxford), December 1986.
Spear, Richard D., "Re-viewing the 'Divine' Guido," in *Burlington Magazine* (London), May 1989.

*

Reni is best known by his *Aurora,* 1614 (Casino Rospigliosi,

Cleopatra with the Asp; $44\frac{3}{4} \times 37\frac{3}{8}$ in (113.7 × 95 cm); Royal Collection

Rome) and thus identified with an overtly serene classical idiom, securely tied with the influence of Raphael in both idealized figure style and harmonious compositional mode. His creativity, however, is attractive in our time for its greater depth which came about only through Reni's apparent career-long rethinking of the significance of style in its application to a specific commission. For instance, in worldly pictures, with their corporeal necessity and forceful expressivity, he turned to influences that flowed from his contact with his second teacher in his native Bologna, the Carracci in their Academy where life drawing as well as the sensual poetry of the Venetian school and Correggio were surrounded by study of the High Renaissance. For ethereal, heavenly images, Reni always retained a feeling for the teaching of his first mentor, Denys Calvaert, a late Mannerist who felt that art must have elegance and elaboration. Rare enough in the mythic annals of visual artists' lives, young Guido was urged to take up a creative profession by his father, a well-known musician who wished him to follow in his career. Only if he agreed to a 10-year-long apprenticeship with Calvaert—which Guido did—would the elder Reni permit him to become a painter. Perhaps as a result of this overly long subservience, Reni appears throughout his career to have been highly sensitive to any claims upon his independence, even to the risk of great damage to that career. With firm success and high-placed patronage, Reni was about to blossom in Rome with the triumphal completion of the authoritative *Aurora* in 1614 in a garden casino of the grand Cardinal Schipione Borghese. But he painted only under the threat of

arrest, since he had a year before left Rome intending to re-
main in Bologna, so oppressed was he by the Roman patrons'
treatment of art and artists. For the remainder of his life, be-
coming the chief master in Bologna with a revered status dur-
ing his last decade, Reni only rarely returned to Rome.

Reni first came to Rome in 1600, and after some modest and
small early works there, it may be that his emotional and intel-
lectual curiosity as well as northern Italian naturalism, led him
to Caravaggio. In such well-known work as *The Crucifixion of
St Peter* (1604-05, The Vatican) and the only recently uncov-
ered *David Slaying Goliath* (1606-07; formerly Lodi Collec-
tion) one can note the characteristic marks of that idiom, so far
removed from Reni's idealizing training: the raking light, with
its concommitant close-up view revealing the literality of tex-
ture and person, a careful physiognomic study—all interpreted
by Reni's essential search for graceful form. He can quickly
move from this psychological and dense material to more ab-
stracted Academic rendering in such work as the radiant fres-
coes in the Quirinale Palace (Rome) *Scenes from the Life of the
Virgin*, 1610, and the *Aurora*, but easily return to that strain of
appreciation for immediacy even in work overtly classicizing
such as the famous *Massacre of the Innocents*, 1611 (Bolo-
gna).

A fascinating insight into the meaning of style for Reni may
be his 1635 completion—marked so by a final payment of the
three recorded, the others in 1601 and 1622—of the *St. Job
Receiving the Gifts of the People* (Notre Dame, Paris), com-
missioned originally in 1601 by the silk Guild of Bologna. A
generous and appealing work, symphonic in its idealized
bodily features and types, nonetheless it still preserves a rich
corporeality perhaps initially with a stronger Caravagesque
cast still preserved in the essentially Carracci-like bodily
forms. A group of images with nudes in the early robust Bolo-
gnese period also evinces, although within the parameters of
the classical, a vivid and sensual elegance.

It was not for paintings such as the *Samson*, 1618-19 (Bolo-
gna), or the *Atalanta and Hippomenes*, 1618-19 (Madrid),
with their lithe figures before darkened sweeping landscape,
that Reni was to be honored as one of the great masters of the
beautiful. By the mid-1620's, his ardor perhaps lessened, such
work as the *Cleopatra*, 1626 (private collection), presents the
increasingly austere and restrained aura which permeates his
work beyond religious images. Although the work by his stu-
dio, in countless Magdalenes, Ecce Homo, Saints heads, and
other bland and characterless devotional pictures diffused Re-
ni's celebriity into the following century, Reni himself pro-
duced one more personal adaptation of the Italian tradition of
the ideal. For apparent want of a better term by which to ap-
praise it, there arises in the mid-1630's his "unfinished" man-
ner. In paintings such as the *Salome with the Head of John the
Baptist*, 1639-40 (Chicago), or the *Moses with Pharoah's
Crown*, 1640-42 (Edinburgh), Reni seems to have understood
the late manner of Titian, its concision and confidence, its
emotional symbolism. But Reni's interpretation, often baffling
to his contemporaries, was rendered in terms of an obverse, a-
coloristic, and fleshlessly exquisite language. In their calculat-
edly lightly brushed and pastel surfaces often approaching a
monochromatic delicacy, these works are an expected close to
a career well able to present harmonious and normative mas-
terworks, but always self-conscious about other possibilities.

—Joshua Kind

RENOIR, (Jean) Pierre Auguste.

Born in Limoges, 25 February 1841. Died in Cagnes, 3 De-
cember 1919. Married Aline Charigot, 1890; three sons, in-
cluding the film director Jean Renoir. Apprenticed to a
porcelain manufacturer, and became a china painter; then en-
tered Gleyre's studio, 1861-64; influenced by Courbet until c.
1868, then painted outdoors with Monet, and became an en-
thusiastic Impressionist: exhibited at the first three and the
seventh Impressionist exhibitions; visited North Africa, 1879,
Guernsey, 1880, Italy, 1881-82, and much later travel; settled
in Cagnes, 1906: arthritic in later life; very prolific.

Major Collection: Paris.
Other Collections: Boston; Budapest; Cambridge, Massachu-
setts; Cardiff; Chicago; Cologne; Frankfurt; London: Na-
tional Gallery, Courtauld, Tate; Merion, Pennsylvania;
Moscow; Munich: Neue Pinakothek; New York: Moma, Met-
ropolitan; Ottawa; Philadelphia; Toronto; Washington: Phil-
lips, National Gallery; Williamstown, Massachusetts.

Publications

On RENOIR: books—

Vollard, Ambroise, *Tableaux, pastels, et dessins de Renoir*,
Paris, 2 vols., 1918.
Vollard, Ambroise, *Le Vie et l'oeuvre de Renoir*, Paris, 1919;
as *Renoir: An Intimate Portrait*, New York, 1925.
André, Albert, *Renoir*, Paris, 1919.
Rivière, Georges, *Renoir et ses amis*, Paris, 1921.
Delteil, Loys, *Le Peintre-graveur, vol. 17: Pissarro, Sisley,
Renoir*, Paris, 1923.
Fosca, François, *Renoir*, Paris, 1923, New York, 1924.
Duret, Théodore, *Renoir*, Paris, 1924, New York, 1927.
Geffroy, Gustave, *Renoir: Sa vie, son oeuvre*, Paris, 2 vols.,
1924.
Coquiot, Gustave, *Renoir*, Paris, 1925.
Besson, Georges, *Renoir*, Paris, 1929.
André, Albert, and Mark Elder, *L'Atelier de Renoir*, Paris, 2
vols., 1931.
Barnes, Albert C., and Violette de Mazia, *The Art of Renoir*,
New York, 1935.
Roger-Marx, Claude, *Renoir*, Paris, 1937.
Bazin, Germain, *Renoir*, Paris, 1939.
Graber, Hans, *Renoir nach eigenen und fremden Zeugnissen*,
Basel, 1943.
Drucker, Michel, *Renoir*, Paris, 1944.
Rewald, John, *Renoir: Drawings*, New York, 1946.
Lhote, André, *Renoir: Peintures*, Paris, 1947.
Haesaerts, Paul, *Renoir sculpture*, Brussels, 1947; as *Renoir,
Sculptor*, New York, 1947.
Renoir, Jean, *Renoir: Souvenirs de mon père*, Paris, 1948; as
Renoir, My Father, New York, 1958.
Baudot, Jeanne, *Renoir: Ses amis, ses modèles*, Paris, 1949.
Raynal, M., *Renoir*, Geneva, 1949; New York, 1950.
Pach, Walter, *Renoir*, New York, 1950; London, 1951.
Roger-Marx, Claude, *Les Lithographies de Renoir*, Monte
Carlo, 1951.

Gaunt, William, *Renoir*, London, 1952; revised with Kathleen Adler, Oxford, 1982.

Rouart, Denis, *Renoir*, Geneva, 1954.

McCann, G. L. et al., *Renoir* (cat), Los Angeles, 1955.

Daulte, François, *Renoir: Aquarelles, pastels, et dessins en couleur*, Basel, 1958; as *Renoir: Watercolors, Pastels, and Drawings in Color*, New York and London, 1959.

Bünemann, Hermann, *Renoir*, Ettal, 1959.

Perruchot, Henri, *La Vie de Renoir*, Paris, 1959.

Fosca, François, *Renoir: L'Homme et son oeuvre*, Paris, 1961.

Pach, Walter, *Renoir*, London, 1964; concise edition, 1984.

Hanson, Lawrence, *Renoir: The Man, the Painter, and His World*, New York, 1968.

Daulte, François, *Renoir: Catalogue raisonné de l'oeuvre peint [Figures, 1860-1890]*, Lausanne, vol. 1 only, 1971.

Fezzi, Elda, *L'opera completa di Renoir nel periodo impressionnista 1869-1883*, Milan 1972.

Daulte, François, *Renoir*, London, 1973.

Fouchet, Max-Pol, *Les Nus de Renoir*, Lausanne, 1974.

Stella, Joseph G., *The Graphic Work of Renoir: Catalogue Raisonné*, London, 1975.

Wheldon, Keith, *Renoir and His Art*, London, 1975.

Martini, Alberto, *Renoir*, Milan and New York, 1978.

Callen, Anthea, *Renoir*, London, 1978.

Leymarie, Jean, *Renoir*, Paris, 1978.

White, Barbara Ehrlich, *Renoir: His Life, Art, and Letters*, New York, 1984.

House, John, Anne Distell, and Lawrence Gowing, *Renoir* (cat), London and Boston, 1985, 1986.

*

Unlike the impressionist painters Renoir was trained in the trade of porcelain painting and this left him with a respect for artisan methods which affected his technique until the end of his career. In the 1880's when he became dissatisfied with the outcome of the Impressionist style he partly resolved these problems by a re-examination of his painting technique in the light of the practice of the old masters. His love of French 18th-century painting, in particular the art of Fragonard, Watteau, and Boucher, may also have been due to its affinity with porcelain painting. Certainly the work to be found in the Louvre was a constant source of inspiration.

Renoir differed from the other Impressionist painters by allowing the Salon, the officially sanctioned exhibition held regularly in Paris which tended to promote the work of conservative artists, to shape and define his art practice. The only other independent artist in the 1860's and 1870's who upheld the Salon as a standard against which to measure his achievement was Manet. Indeed, Renoir had several early successes at the Salon, although he destroyed *La Esmaralda*, after its exhibition in 1864. His 1867 submission *Diana* (Washington) was refused by the jury, perhaps because of what was judged to be an inappropriate reworking of a traditional theme. Renoir devoted a large canvas to his treatment of the nude goddess of hunting who holds a bow and had a fallen deer at her feet. However, like Manet in *Déjeuner sur l'Herbe* and *Olympia* he treated a favourite old master theme in a frankly contemporary way by including a nude who owed nothing to allegorical figures but was robustly modern. The jury must also have discerned much of Courbet's handling in the figure

Dance in the Country, c. 1890; etching

and surrounding background. The work is broadly painted with thick impasto, and its dark tones and its height of almost two meters demonstrates that it was painted in the studio.

In the summer of 1869 Renoir and Monet worked together out of doors at La Grenouillère on the Seine and produced a series of canvases which are generally regarded as marking the inception of the mature Impressionist style. In these works dealing with the theme of leisure in an urban environment, both painters began to analyse colour much more closely, observing that the local colour of an object was affected by the light in which it is observed and by reflections from surrounding objects. They began to introduce colours into their shadows and a much looser style in which the brushstrokes were much more clearly visible.

Renoir has been credited with the adoption of the so-called rainbow palette which used only pure tones at their maximum saturation and totally eliminates black. However, as can be seen in a work of 1874, exhibited at the first Impressionist exhibition that same year, *The Theatre Box (La Loge)*, Renoir was aware of the expressive quality in rich velvety blacks. In this work black is used to maximum effect in the evening clothes of the two figures.

During the 1870's Renoir produced some of his most memo-

rable canvases, creating scenes of leisure in which the figures are set within a sun-dappled environment—*the Swing* (1876; d'Orsay), *Ball at the Moulin de la Galette* (1876; d'Orsay) and *Luncheon of the Boating Party* (1880–81; Washington, Phillips). These works seem to be a deliberate hommage to the 18th-century *fêtes gallantes* in which the courting figures are set within a timeless and idealized landscape.

Renoir exhibited with the Impressionists in 1874, 1876, and 1877, and thereafter sent his work to the Salon rather than to the independent exhibition. The *Portrait of Madame Charpentier and Her Children* was well-received at the 1878 Salon. His work was included in the penultimate Impressionist show in 1882, but that was because of the insistence of the group's dealer, Durand-Ruel, who was concerned to present a united group to potential buyers. Increasingly Renoir became dissatisfied not only with the institutional framework of the group shows but much more fundamentally with the aims and methods of the Impressionist style. He embarked on a series of trips to North Africa and Italy, and in a number of canvases he appears to be wrestling with technical problems. *The Umbrellas* (London), begun c. 1881 but not finished until the mid-1880's, demonstrates quite clearly the tightening in style which resulted from his placing much more emphasis on drawing after studying the old masters in Italy. The right-hand side of the canvas is executed in the soft, feathery style characteristic of the earlier period, while the left-hand side is much more clearly defined. Although the work dealt with the subject of the fashionably dressed figures which had preoccupied Renoir in the 1870's, there was now no attempt to suggest that these people had been painted out of doors. He has synthesised the lessons of Impressionism with conventional studio practice. This period of exploration culminated in *the Bathers* (1887; Philadelphia). In 1890 Renoir exhibited at the Salon for the last time and effectively withdrew from Paris to the south of France as he achieved financial independence. He turned increasingly to the traditional subject of the female nude, and his handling became much more sensuous and painterly, in marked contrast to the "dry period" of the 1880's. His debt to the 18th century becomes evident in the monumental and timeless works such as *The Judgment of Paris* (c. 1913–14; Hiroshima). The late work has opened Renoir to the charge of insularity because he failed to deal with contemporary events. The desire to be placed alongside the old masters, however, had long been evident in his works, and in this sense he realized his ambition.

—Lesley Stevenson

REPIN, Ilya (Efimovich).

Born in Chuguiev, 5 August 1844. Died in Kuokkala, Finland, 29 September 1930. Pupil of Bunakov, and painted religious murals for three years; studied at Academy of Fine Arts, St. Petersburg, 1863–69; then settled in St. Petersburg and worked mainly in the nationalistic mode: subjects were peasants, historical themes, portraits; visited western Europe, 1871, studied in Paris, 1873–76, and visited Paris again in 1883; Professor of Painting, St. Petersburg Academy from 1894; lived in Finland after 1917.

Major Collection: Moscow: Tretyakov.
Other Collections: Helsinki; Leningrad: Russian Museum; New York.

Publications

By REPIN: books—

Dalekoe blizkoe, edited by Kornei I. Chukovsky, Moscow, 1944.
Izbrannie pisma 1867–1930, edited by I. A. Brodsky, Moscow, 2 vols., 1969.

On REPIN: books (selection)—

Grabar, I. E., *Repin* (in Russian), Moscow, 2 vols., 1937.
Grabar, I. E., and I. S. Zilbershtein, editors, *Repin: Khudozhestvennoe masledstvo*, Moscow, 2 vols., 1948.
Stephanowitz, Traugott, *Repin: Eine Einführung sein Leben und Werk*, Dresden, 1955.
Sternia, G., *Repin* (in Russian and English), Leningrad, 1974.
Parker, Fan and Stephen Jan, *Russia on Canvas: Repin*, University Park, Pennsylvania, 1980.
Lyaskovskaya, O., *Repin: His Life and Work* (in Russian, with English summary), Moscow, 1982.

*

Ilya Efimovich Repin was and is Russia's foremost national artist. In both pre-revolutionary and Soviet Russia he has enjoyed the highest esteem, alongside Dostoevsky and Tolstoy, Mussorgsky and Rimsky-Korsakov, as an artist who best reflected the spirit of his people, their thoughts and aspirations, in forms understandable to the people.

His entry into the Academy of Art in 1864 corresponded with the birth of a new critical-realist movement in Russian painting. Repin, as it were, received two educations. He excelled in the traditional classical curriculum of the Academy, winning the Small Gold Medal (1869) for *Job and His Friends* and the Grand Gold Metal (1871) for *The Resurrection of Jairus's Daughter*, the latter providing six years of subsidized study, half of them abroad in Paris. At the same time, by his own preference and consonant with the new realism in Russian painting fostered by the Society of Wandering Artists, he executed one of the notable paintings in Russian history, *Volga Boatmen* (1871–73). As noted, "no one before [had] dared to undertake such a theme." Selecting Russian outcasts and vagabonds as his subjects, Repin clearly demonstrated his exceptional promise as a realist and portraitist.

Repin flirted briefly with the new impressionist movement (*Little Vera à la Manet*, 1874; *On the Grassy Bank*, 1876), but then turned decisively to realism: "The face, the soul of man, the drama of life, nature, its life and meaning, the spirit of history—these, it seems to me, are our themes. Paint is our tool to express our thought, express not graceful spots, but the whole mood of the painting, its soul, winning the viewer's favor and totally capturing him like a chord in music." Between the late 1870's and the early 1890's he completed his finest works, addressing both historical and contemporary Russian subjects: *The Ruler Tsarevna Sophia Alexseevna*

(1879), *Ivan the Terrible and His Son Ivan* (1885), *Zaporozhie Cossacks Writings a Reply to the Turkish Sultan* (1891), among the former, and *Under Military Conveyance* (1877), *Religious Procession in the Province of Kursk* (1883), *The Unexpected* (1884), *Refusal from Confession Before Execution* (1885), *Arrest of the Propagandist* (1892), among the latter. Because of his modest background and his personal experience with poverty and deprivation, Repin committed his art to themes which bespoke Russia's injustices, past and present: the madness of past rulers, the dissolute life of the clergy, the unjust imprisonment of the innocent, the resistant qualities of the common people.

Repin, moreover, stood as the recording center of Russian cultural life from the mid-1870's into the early 20th century. His voluminous correspondence with the intellectuals of his time complemented his creation of an extraordinary portrait gallery of the most notable cultural figures of his age: the artists Kuindzhi, Shishkin, Polenov, Chistyakov, Ge. Kramskoy, Bogolyubov, Myasoedov, Surikov, Antokolsky, Serov; the musicians and composers Mussorgsky, Rubinstein, Glazunov, Borodin, Cui, Rimsky-Korsakov; the writers Turgenev, Aksakov, Pisemsky, Fet, Garshin, Tolstoy, Gorky, Andreev, Korolenko. Working in many genres, he also illustrated the works of most of his literary contemporaries with more than 150 drawings.

Repin's acknowledged greatest strength was as a portraitist. Going beneath the pictorial surface, he had the singular ability to capture the psychological substance of his subjects. One need only observe the face of the dying, half-mad Mussorgsky, the Christlike countenance of Garshin, the moral strength and pseudo-peasant posing of Tolstoy to recognize the work of a brilliant master painter. His career as a portraitist was capped with a commission to render a group portrait of the members of the State Council. In his monumental *The State Council in Session* (1901–03) Repin presents all 70 members at work in the Council Chambers, with most of the figures presented in full or partial face as individual and recognizable subjects. It is a prodigious accomplishment which displays in abundance his mastery as a portraitist.

—Stephen Jan Parker

REYNOLDS, (Sir) Joshua.

Born in Plympton, 16 July 1723. Died in London, 23 February 1792. Apprenticed to the portrait painter Thomas Hudson, London, 1740–43; then worked in Devon and London, from 1743; in Rome, 1749–52; adopted the grand style for his portraits; leading portraitist in London by late 1750's, and noted success in intellectual society; first president of the Royal Academy, 1768–92, and gave important discourses; visited Flanders and Holland, 1781; appointed Painter to the King, 1784; his sight failed after 1789. Knighted, 1769.

Major Collections: London: Tate, Portrait Gallery, Wallace; San Marino, California.

Other Collections: Cambridge, Massachusetts; Chicago; London: National Gallery, Maritime Museum, Royal Academy, Kenwood; New Haven; New York; Port Sunlight; Washington.

Publications

By REYNOLDS: books—

Discourses on Art, London, 1778; edited by Robert R. Wark, San Marino, California, 1959, New Haven, 1975.
Works, edited by Edmond Malone, London, 2 vols., 1797, 3 vols. 1798.
Notes and Observations on Pictures . . . , edited by W. Cotton, London, 1859.
Letters, edited by Frederick Whiley Hilles, Cambridge, 1929.
Portraits: Character Sketches of Oliver Goldsmith, Samuel Johnson, and David Garrick . . . , edited by Frederick Whiley Hilles, London, 1952.

On REYNOLDS: books—

Northcote, J., *The Life of Reynolds,* London, 2 vols., 1818.
Leslie, Charles Robert, and Tom Taylor, *The Life and Times of Reynolds,* London, 2 vols., 1865.
Cronin, William V., and Algernon Graves, *A History of the Works of Reynolds,* London 4 vols., 1899–1901.
Armstrong, Walter, *Reynolds,* London, 1900.
Hilles, Frederick Whiley, *The Literary Career of Reynolds,* Cambridge, 1936.
Waterhouse, Ellis, *Reynolds,* London, 1941.
Hudson, Derek, *Reynolds,* London, 1958.
Wark, Robert R., *Reynolds' Portrait of Mrs. Siddons as the Tragic Muse,* San Marino, California, 1965.
Waterhouse, Ellis, *Reynolds,* London and New York, 1973.
Potterton, Homan, *Reynolds and Gainsborough,* London, 1976.
Clifford, Timothy, Antony Griffiths, and Martin Royalton-Kirsch, *Gainsborough and Reynolds in the British Museum* (cat), London, 1978.
Reynolds (cat) Paris, 1985; edited by Nicholas Penny, London, 1986.
Wind, Edgar, *Hume and the Heroic Portrait,* Oxford, 1986.

articles—

Moore, R. E., "Reynolds and the Art of Characterization," in *Studies in Criticism and Aesthetics 1660–1880,* Minneapolis, 1967.
Cormack, M., "The Ledgers of Reynolds," in *Walpole Society,* 42, 1968–70.
Mannings, D., "The Sources and Development of Reynolds's Pre-Italian Style," in *Burlington Magazine* (London), April 1975.
Weinsheimer, J., "Mrs. Siddons, the Tragic Muse, and the Problem of Art," in *Journal of Aesthetics and Art Criticism* (Philadelphia), Spring 1978.
Busch, Werner, "Hogarths und Reynolds' Porträts des Schauspieler Garrick," in *Zeitschrift für Kunstgeschichte* (Munich), 47, 1984.

Miss Frances Kemble, 1784; mezzotint

Musser, J. F., "Reynolds's Mrs. Abington as 'Miss Prue,' " in *South Atlantic Quarterly* (Durham, North Carolina), Spring 1984.

Barrell, John, "Reynolds and the Political Theory of Painting," in *Oxford Art Journal*, 9, 1986.

Buckley, Barbara A., "Reynolds, the Ladies Amabel and Mary Jemima Yorke," in *Bulletin of the Cleveland Museum of Art*, November 1986.

Postle, Martin, "Patriarchs, Prophets, and Paviours: Reynolds's Images of Old Age," in *Burlington Magazine* (London), October 1988.

*

Sir Joshua Reynolds was the leading portrait painter and the single most influential artist in Britain in the period 1755–1790. He maintained his position of pre-eminence despite considerable technical fallibility, which led to widespread criticism of his abilities, and despite being challenged by a series of rivals: Cotes and Dance in the 1760's, Gainsborough, Romney, Copley, and Hoppner in his later years. Much of his prestige was sustained by the fact that he was the first President of the Royal Academy, a position which he occupied from 1768 until his death.

Reynolds's fundamental ambition was to elevate portraiture, Britain's most widely practised and fully developed form of painting, from a peripheral to a central position in the canons of High Art. His efforts to do this took two closely related but violently antithetical paths. First of all, he instinctively ad-

hered to a belief that portraiture did not, as traditional Academic-based aesthetics stated, occupy a lowly rank in the hierarchies of art, but in its own way provided an equally stern test of the artist's intellectual and imaginative faculties as did, say, history and religious painting. In this belief he may have been partly confirmed by the writings of Jonathan Richardson (and also by the example of some of Allan Ramsay's best portraits); but it remains worth stressing what a difficult and unusual position this is not simply in 18th-century England but in the whole history of western art. For Reynolds the problems raised by attempting to distil the essence of another human being in paint on a flat rectangle of canvas were actually more profoundly satisfying than other forms of painting and to the solution of these problems he remained centrally committed all his life. One only has to look at his excursions into history and fancy painting in his later years for this to be self-evident. In seeking to prove that portraiture was "other" and more valuable than was generally perceived by his contemporaries, Reynolds educated his audience to regard "Meer Face Painting" as nevertheless partaking of the same aesthetics and the same pictorial language as history and religious painting. Primed by a three-year trip to Italy, 1749–52, where he studied voraciously the entire range of Italian figural art, and in any case less original than eclectic by temperament, Reynolds developed an immense repertoire of poses borrowed or adapted from earlier art (especially, although not exclusively, Italian) as the basis of his formal portraiture. Side by side with this, he brought to sitters' features, dress, and accessories a generalised, classicising style, and made frequent use of elevated references and intellectual allusions. It was a language calculated to appeal resonantly to a new generation of collectors and connoisseurs, while still serving, at the deepest level, the concerns of portraiture.

The difficulties inherent in this position, which coloured Reynolds's entire career, were exacerbated by three further factors. Firstly, such a highly elevated and idealistic view of portraiture was under constant threat from sheerly practical constraints; many Reynolds portraits were doomed to be simple routine assignments if sitters could not spare the time to sit, or made their own demands, or if the artist found it difficult to relate to their personalities. The reduction in Reynolds's output after the high-water mark of the late 1750's, when he was at the height of fashion, his deliberate pricing himself above his rivals, and his use of studio assistants, all reflect his awareness of the dangers which success posed for his ideals and the complexity of his response which success posed for his ideals and the complexity of his response to it.

Secondly, Reynolds's painting was compromised by his technical limitations. Most notable, he never fully mastered the art of figure drawing, and complex problems of scale, foreshortening, or multiple-figure composition often defeated him. It can be argued against him that his whole approach to portraiture, his generalisation of the sitter towards a physical ideal and a moral type, and his avoidance of the particular and the specific, is grounded in an awareness of this liability. Temperamentally Reynolds veered, in his admiration of the great masters, towards colourists—Titian and Rubens above all—rather than draughtsmen; and his thinking about art was dominated by this typology. His own limitations as a draughtsman were offset by ambitions as a colourist which led him to indulge in complex multi-layering of colours and glazes and to experi-

ment with pigments and vehicles, sometimes fugitive or unsound, which contributed to the early deterioration of many of his paintings.

Thirdly, Reynolds's difficulties were increased by his Presidency of the Royal Academy. Whiggish and empirical by temperament, he was in some ways quite unsuited to preside over the kind of body which was, in principle, an ornament of royal prerogative and an "official" arbiter of public taste in art. Throughout his career, Reynolds was privately associated with political factions opposed to King and Court, just those to whom such an institution would seem ideologically most suspect. Though the most obvious candidate for President, Reynolds was uncongenial to the King and failed to maximise the opportunities presented to British art by the foundation of the Academy. Nevertheless, he was shrewd enough to recognize that the Presidency conferred historical stature upon him and was sufficiently committed to the institution to allow its orthodox expectations to colour both his practice and his theories of art. The strain of this can be traced at times in his later paintings and is the key to the intellectual tension and sophisticated empiricism of his famous *Discourses,* which were influential on generations of future English artists.

Reynolds's success depended, upon two factors. He became identified with a style of portraiture which, though it depended upon no grand originality of vision but instead upon an intellectual and urbane response to precedents, became a staple of English painting for decades. His reputation benefited enormously, too, from the dissensions within the Royal Academy in the 20 years after his death—dissensions which his own policies had helped in large measure to sow. In combination, these factors caused posterity to establish him as a father-figure of the national school of painting. In his own day, before the operation of these cultural forces, Reynolds would have seemed a much more ambiguous figure: an idealist whose career was rooted in compromise, an artist embodying an unfamiliar and lonely cause, ambitious for fame but plagued by self-doubt, cynical and self-aware. His portraits ask us to witness the efforts of such a complex person to relate to his contemporaries.

—Alex Kidson

RIBALTA, Francisco.
Born in Solsona, 1565. Died in Valencia, 13 January 1628. Married Inés Pelayo; son, the painter Juan Ribalta, two daughters. In Madrid in 1582, and associated with El Escorial; settled in Valencia, c. 1599: patronized by the Archbishop-Patriarch Juan de Ribera; large shop, including his son Juan, Vicente Castello, and Gregorio Bausa.

Collections:Bilbao; Leningrad; London; Madrid: Valencia: Museum, church of the Colegio de Corpus Christi, church of Algemesí.

Publications

On RIBALTA: books—

Huguet Segarra, Ramon, *Los cuadros del pintor Ribalta existentes en Castellón*, Castellón, 1913.
Darby, Delphine Fitz, *Ribalta and His School*, Cambridge, Massachusetts, 1938.
Espresati, C. G., *Ribalta*, Barcelona, 1948.
Los Ribalta y la escuela valenciana (cat), Granada, 1956.
Camón Aznar, José, *Los Ribaltas: Estudio y catalogo*, Madrid, 1958.
Kowal, David M., *Ribalta y los Ribaltescos*, Valencia, 1985.
Kowal, David M., *Ribalta and His Followers: A Catalogue Raisonné*, New York, 1985.
Benito Domenech, F., *Los Ribaltas y la pintura valenciana de su tiempo* (cat), Valencia, 1987.

articles—

Ainaud de Lasarte, J., "Ribalta: Notas y comentarios," in *Goya* (Madrid), 1958.
Kowal, David M., "Unpublished Drawings and a Probable Source for Ribalta's *Vision of St. Francis*," in *Burlington Magazine* (London), 1984.

The art of Francisco Ribalta occupies an important place in the development of baroque realism in Spain. Unlike most of his Spanish contemporaries, Ribalta successfully made the transition from the eclectic, late 16th-century mannerist idiom in which he was trained to a highly naturalistic, 17th-century early baroque style consonant in its spirit with the spiritual objectives of the Catholic Counter-Reformation. Ribalta's work, spanning the opening of a new era with a new outlook, points both backward to the forces which shaped the 17th century and forward toward much of what was still to come in Spain's Golden Age.

The first evidence of Ribalta's artistic activity comes in 1582, when shortly after moving to Madrid from his native Catalonia, he signed and dated the *Preparations for the Crucifixion* (Leningrad). Ribalta's presence in Castile was surely motivated by a desire to continue his training and by the hope of acquiring commissions in Spain's most active artistic center, El Escorial, where a host of Spanish and Italian painters were then employed in the decoration of Phillip II's monastery-palace. While no documentation specifically links Ribalta to the Escorial, the style and expression of his first-known canvas makes his schooling in this eclectic ambiance evident. An elaborate composition populated by figures in foreshortened poses finds its model in the works of Italian mannerist practitioners at the Escorial. The incipient realism of particulars and Ribalta's utilization of a luminous, crepuscular lighting is dependent upon his study of 16th-century Venetian examples in which the royal collections abounded. The closest parallel can be drawn with the works of Juan Fernandez Navarette, a Spanish student of Titian's who, from 1568 to his premature death in 1579, produced for El Escorial paintings of marked realism and Counter-Reformation spirit. Ribalta's immature canvas displays a similar vein of naturalism and Tridentine piety, ingredients which eventually develop into the substance of his mature images.

By 1599 Ribalta had moved to Valencia, having undoubtedly come to the attention of that city's doctrinaire archbishop, Juan de Ribera. Ribera was then engaged in the decoration of the Colegio de Corpus Christi, a seminary dedicated to the promotion of Counter-Reformation religious reform. Ribalta's early Valencian years were occupied with the production of works for Ribera's Colegio and the parish churches and conventual establishments of the area in the "reformed mannerist" vocabulary he had acquired in Castile. His first important commission (1603–10)—paintings for the large, multipaneled high altar of the parish church at Algemesí—is based on an eclectic assortment of sources known from the Escorial; the panels abound in specific compositional, figural, and stylistic references to works by Navarette and Titian, the Italian "reformed mannerists" at the Escorial in the 1590's (including Frederico Zuccaro, Pellegrino Tibaldi, and Luca Cambiaso) and Albrecht Dürer. While the style of the altarpiece is uneven and retardataire in its mannerist leanings, from a thematic standpoint it is a clear statement of Tridentine religious orthodoxy. Its primary panels, episodes referring to Santiago's divine guidance of the Spanish "reconquista" over the Moors, accent the purity of Christian faith that motivated this past victory. These paintings are a clear allusion to a contemporary situation in which the archbishop Ribera and others, having despaired of converting Valencia's sizeable population of *moriscos* to the faith, were advocating their final expulsion.

Other works of the first decade of the 17th century begin to show movement toward a less mannered and a more convincingly naturalistic presentation. *Christ Appearing to St. Vincent Ferrer* (1604–05) for the Colegio de Corpus Christi seeks to capture a sense of the intimate and indivisible bond between man and God; the prayers of a pious St. Vincent, who is depicted with natural features and emotions, are rewarded by a concrete manifestation of God before him. The *Last Supper* (1605) for the Colegio's high altar is no less dramatic in its fusion of the everyday and the supernatural; naturalistically featured apostles ecstatically focus their attention upon an ennobled Christ who silently institutes the sacrament of the eucharist (a Tridentine concept strongly endorsed by Ribera). The liturgical iconography follows a precedent set in the 16th century by the Valencian artist Juan de Juanes (whose works Ribalta sometimes copied), although Ribalta changes Juanes's horizontal format to a more heavenly aspiring vertical and eliminates mannerist embellishments in favor of simplicity and poignancy of statement.

By the second decade of the century, Ribalta's work approached the threshold of an early baroque style. The artist's deepest religious emotions seem to have been sparked by a commission of 1612 for a panel celebrating a Valencian priest, Father Francisco Jeronimo Simon, who had recently died after experiencing several visions of Christ (Ribalta also produced drawings of Simon's life used as models for an engraving by Michael Lasne). Ribalta's painting (London) depicts a remarkably individualized Simon communing directly with Christ who has materialized on his way to Calvary in the very streets of Valencia. The composition of the painting, its large figures and dramatic lighting are based upon models by the 16th-century Italian painter Sebastiano del Piombo, whose works Ribalta knew at the Escorial (and which he copied on other occasions). Ribalta's renewed experience with Piombo's art—itself a harmonious mixture of Venetian and central Italian

learning, the two currents which Ribalta had previously struggled to assimilate—led the Spaniard to his own successful combination.

Most forcefully in the paintings of the 1620's—by which time the multitudinous influences on Ribalta's art were fully assimilated—works tend toward simple, geometrically immutable compositions in which strongly modeled, realistically conceived figures occupy the immediate foreground in close proximity to the spectator. The paintings are lit with a dramatic spotlighting that accentuates the concreteness of the event at the same time that it contributes an otherworldly air. Ribalta's light—both physical and spiritual in its effect—is often viewed as a result of direct contact with the art of Caravaggio; in fact, it is an outgrowth of the Spaniard's Venetian precedents and his study of Piombo. If Ribalta did make a much debated trip to Italy—which could only have taken place in 1618–19—his already developed sense of spiritual realism would only have been reinforced, not engendered, by Caravaggio's example.

Among the best works of the 1620's are the canvases executed for the strict Capuchin order of Valencia. *St. Francis's Vision of the Musical Angel* (Prado) depicts the infirm saint—an unassuming, ascetic man of the people—responding to the divine messenger with cathartic rapture. In *St. Francis Embracing the Crucified Christ*, the humble saint from Assisi, whose life was devoted to imitating Christ's, is crowned by the crucified Lord into whose wound St. Francis thrusts his face, thus achieving mystical union of his body and soul with God. These works, as well as Ribalta's last paintings for the Carthusian monastery of Porta Coeli near Valencia, convert subjective, visionary imagery into concrete and convincing material form, irresistibly drawing in the worshipper, who is able to discern and comprehend both its tangible reality and spiritual meaning clearly.

From the high altar of Porta Coeli, the image of *St. Luke Painting the Virgin* is the self-portrait of an artist devoted to painting sacred themes in a manner which enhances their piety by accentuating their physical realism. Akin to the mystical writers of his day, Ribalta was able spiritually to elevate the everyday and humanly to realize the otherworldly, effectively fusing the two and thus translating the religious dictates of the Catholic Counter-Reformation into visible form.

—David Martin Kowal

RIBERA, Jusepe [José] de [also called "Lo Spagnoletto"]. Born in Jativa, Spain, 12 January 1591. Died in Margellina, near Naples, 3 September 1652. Married Caterina Azzolino y India, 1616; six children. Possibly apprenticed to the painter Francisco Ribalta in Valencia, 1601–07; in Naples, 1607–12(?), Lombardy and Parma, c. 1610–12, Rome, 1615 (member of the Rome painters guild, 1616), then settled permanently in Spanish-controlled Naples; influenced by Caravaggio and the Bolognese school of the Carracci and Reni; commissions for Spanish as well as Naples churches and aristocracy; also an etcher. Pupils: Juan Do, Passante, Francesco Francanzano.

Major Collection: Madrid.
Other Collections: Aachen; Amiens; Baltimore; Barcelona; Berlin; Bilbao; Budapest; Cambridge, Massachusetts; Dresden; Glasgow; Hartford, Connecticut; Helsinki; Leningrad; Lisbon; Los Angeles; Madrid: Real Academia; Milan: Poldi Pezzoli; Montreal; Munich; Naples: Galleria Nazionale, Museo di S. Martino; New York: Metropolitan, Hispanic Society; Pasadena; Philadelphia; Rome: Borghese, Doria Pamphili; St. Louis; Stockholm; Worcester, Massachusetts.

Publications

On RIBERA: books—

Mayer, August L., *Ribera*, Leipzig, 1908, 1923.
Lafond, Paul, *Ribera et Zurburán*, Paris,1909.
Tormo y Monzó, Elías, *Ribera en el Museo del Prado*, Barcelona, 1912.
Tormo y Monzó, Elías, *Ribera*, Barcelona, 1922.
Conte, Edouard, *Ribera*, Paris, 1924.
Pillement, Georges, *Ribera*, Paris, 1929.
Morassi, Antonio, *Ribera*,Milan, 1936.
Borzelli, A., *Ribera*, Naples, 1942.
Pantorba, Bernardino de, *Ribera*, Barcelona, 1946.
Sarthou Carreres, Carlos, *Ribera y su arte: El Españoleto y su patria*, Madrid, 1947.
Trapier, Elizabeth du Gué, *Ribera*, New York, 1952.
Cuoco, Alina, and C. Alegret, *Ribera*, Paris, 1968.
Brown, Jonathan, *Ribera: Prints and Drawings* (cat), Princeton, 1973.
Camasasca, Ettore, *Ribera*, Barcelona, 1973.
Pérez Sánchez, Alfonso E., *Los Ribera de Osuna*, Seville, 1978.
Spinosa, Nicola, *L'opera completa del Ribera*, Milan, 1978.
Felton, Craig, and William B. Jordan, *Ribera* (cat), Fort Worth, 1982.

*

The art of 17th-century painter Jusepe Ribera usually conjures up an image of a rustic saint undergoing excruciating martyrdom or self-inflicted penitential torture. Yet this popular outlook, originally fostered in the writings of the 19th-century Romantics responsible for reviving interest in Ribera's art, is only a partial characterization. More properly, Ribera's reputation should be founded on the breadth and originality of his subject matter and the stylistic variation with which he treated these themes, the moving depth of meaning—often spiritual and moral—which permeates his pictures, and the textural virtuosity with which he handled his painterly materials. Viewed from this more encompassing perspective, Ribera stands out as one of the 17th century's finest and most innovative artists, albeit one whose life and art have sometimes been problematical to decipher.

The facts known of Ribera's life, particularly the formative years, are meagre. While his birth in 1591 in Jativa, Spain (near Valencia), is now clear, with whom he studied in his youth (traditionally said to be Francisco Ribalta, although this is most doubtful), why and when he left Spain to take up permanent residence in Italy (presumed to be around 1607), where in Italy he went (17th-century sources place him in Lombardy and Parma) and what he saw before his firmly documented presence in Rome in 1615, remain essentially hypothetical. Late in 1616 Ribera moved to Naples and, except for brief trips to northern Italy and Rome, thereafter remained in the Spanish-controlled city whose pre-eminent painter he became. Ribera was patronized by, among others, the Spanish Viceroys of Naples and the Carthusian monastery of San Martino, as well as by aristocratic and ecclesiastical clients in his native Spain, where many of his canvases were sent and still remain.

In contrast to the paucity of the knowledge about Ribera's life is the vast quantity of paintings traditionally associated with his name. While Ribera himself was a prolific artist, he often utilized the help of assistants. Moreover, the popularity of his art was such that his style and often his very canvases were imitated or copied. Only recently has a more definitive corpus of authentic works emerged. A correspondingly clearer assessment of Ribera's own style has enhanced a debate over whether the artist is essentially a Spanish or an Italian painter. Surely the naturalism and spiritual intensity of his works, the predilection for painting saints in ecstacy and penitance, and an obvious fascination with the grotesque are, in great part, due to his Spanish heritage. Yet, it is equally apparent that Ribera's art was highly influenced by his interest in the traditions of the classical antique and, most especially, by his first-hand acquaintance with and acceptance of baroque artistic innovations of contemporary Italy.

Ribera's earliest known work (produced in Rome around 1615-16) consists of a series of canvases (some lost) depicting the five senses. Quite unlike contemporary renditions in which the theme is rendered in sophisticated allegorical terms, Ribera's works display crudely realistic figures—all firmly modeled with thick, gestural strokes of paint—engaged in mundane activities. The bold, large-scale forms, raked by an intense spotlighting from beyond the canvas, relate Ribera's earliest known style to that of Caravaggio and his followers. Nonetheless, Ribera's emphatically physical interpretation and aggressive brushwork already establish his individuality.

Seemingly in contradiction to his Caravaggesque tendencies, Ribera was also drawn at an early stage to both the classical tradition and the gentler, more idealized style of painting exemplified by the contemporary Bolognese school. Ribera's naturalistic Spanish heritage and his acquired Italianate erudition interestingly meet in a key work of the artist's first period, the *Drunken Silenus* (signed and dated in 1626; Naples, Capodimonte). For all its realism of style, the composition of the work is based upon a classical prototype, likely a Hellenistic relief. In addition, Ribera has included symbolic trappings which indicate that the world of classical myth cannot be separated from real life and imply that the painting should be viewed as a commentary on the human condition. Ribera would frequently return to classical themes, and his compositions and figures often are inspired by ancient sources, sometimes very directly, as in the case of the now dismembered canvas of the *Triumph of Bacchus* (1634-36).

Likewise, the young painter drew upon the example of contemporary Bolognese art; in his early *Martyrdom of St. Sebastian* (1616-18; Osuna)—a theme much repeated by Ribera—the ecstatic pose of the saint is inspired by the example of Guido Reni (who, incidently, was also drawn early in

Duns Scotus; 5 ft 6½ in × 5 ft 4½ in (168.2 × 163.1 cm); Royal Collection

his career to the art of Caravaggio) and results in a more rhetorical application of Caravaggesque realism.

Beginning at this early stage and continuing throughout his career, Ribera produced many paintings (and between 1616–23, prints) of Christian saints—penitent, contemplative, or in the throes of martyrdom. While the Romantics of the 19th century considered Ribera the quintessential painter of saints and emphatically prized the gruesome aspects of much of his work, in greater part these paintings serve as uplifting statements, stressing the deeply felt religious convictions of their protagonists whatever the tortures they may be subjected to; Ribera's heroes ultimately experience spiritual ecstacy and achieve triumph over the pains of penance, physical persecu-

tion or death. In the *Martyrdom of St. Philip* (or Bartholomew as he is usually called; 1639?; Madrid, Prado), the plebeian saint, cruelly tortured, nonetheless gazes longingly toward heaven, oblivious of mortal death and secure in his everlasting heavenly rewards.

Still, Ribera's interest in Christian themes did not preclude attention to the classical world. His Christian martyrs have their parallel in images depicting the tortures of Sisyphus, Tantalus, and other Olympian "giants," while the artist's many half, three-quarter, and full-length saints (some are parts of "Apostolados") have their counterparts in imaginary portraits of ancient philosophers like Diogenes, Heraclitus, and Democritus.

Around 1630 the temper and tonality of some of Ribera's works begin to lighten, in part due to the influence of Velázquez whom Ribera met when he visited Naples. Over subsequent years, Ribera's works increasingly denote the influence of the developing, ecstatic baroque style as well as an acquaintance with the neo-Venetian art of Anthony van Dyck. Between approximately 1634 and 1640—Ribera's most dynamic phase—his paintings are often characterized by complex, activated compositions, a thinner and more fluid brushwork, heightened color, and more luminous light effects. While some of these paintings continue the themes of the previous period, Ribera produces new imagery, the most imposing of which is his monumental *Immaculate Conception* (1635) painted for the Convent Church of the Descalzed Augustinians of Salamanca. Also from this moment are several works of classical subject matter, including various renditions of *Venus Discovering the Dead Body of Adonis* and *Apollo Flaying Marysas*. Undoubtedly based upon the artist's reading of the moralized Ovid, the paintings establish a neo-platonic allegorical and moralistic link between the profane world of classical antiquity and the sacred realm of Christian ethics.

In Ribera's final phase (from around 1640 to his death in 1652), the artist continued to expand and explore a wide range of subject matter, sometimes employing a strictly naturalistic style, at other times a more refined style. His best works, however, are those where he seeks to harmonize the two tendencies and in which he acutely examines the psychological nature of his subjects. In his late masterpiece, the *Mystical Marriage of St. Catherine* (1648; New York), Ribera has carefully constructed the composition so as to focus attention upon the sublime religious revelry of the central figures—Christ, the Madonna and St. Catherine. Softly modeled and colored, the liquid quality of paint with which the forms are defined reiterates their quiet manner and serves to contrast them with the rugged depiction of Sts. Ann and Joseph, who, on the periphery, serve as naturalistic foils. A similar counterpoint of technique is utilized in the *Communion of the Apostles* for the Certosa di San Martino, Naples, which is designed like a classical frieze with a richly painted curtain added above and seemingly pulled back to reveal the event.

Perhaps the finest example of Ribera's poignant emotional insight (a feature of his art amply displayed in earlier works, particularly the portrait of the bearded *Magdelena Ventura and Her Family*, Toledo, 1631) is his portrait-like canvas of the *Club Footed Boy* (1642; Paris). The work depicts a crippled street urchin, a crutch over his shoulder, an alms bag in one hand, and a note requesting donations in the other, looking out at the spectator with an engaging, toothless grin. Placed before a low horizon over which he monumentally towers, the decrepit boy stands like a soldier and becomes a Christian symbol of both knighthood and charity.

While Ribera could be the painter of refined as well as humble images, his style nonetheless remains based upon the concrete facts of visual reality. Employing brushwork that could range from corrugated, impasto surfaces to thinly washed, fluid applications of pigment, his paintings engender an immediate and engaging tactile response from the viewer. Yet, while the visible world is emphasized in his painterly technique, Ribera takes pains to impregnate what he sees with deeper meaning—often exploring the innermost human and spiritual qualities of mankind. Ultimately, for all their reality, his works

rise in spirit far above the level of the mundane. Ribera's ability to transcend the concrete facts of the observable world while still relying upon them as the basis of his art clearly justifies his reputation as one of the 17th century's most innovative artists.

—David Martin Kowal

RICCI, Sebastiano.

Baptized in Belluno, 1 August 1659. Died in Venice, 15 May 1734. Married Maddalena van der Meer, 1682, one daughter; and possibly one illegitimate daughter. Became a pupil of the painter Federico Cervelli in Venice, 1671, and of Sebastiano Mazzoni; in his youth was imprisoned briefly for attempted poisoning of his future wife; then a wandering career: lived in Bologna, 1680, Rome, 1685, Parma, 1686–90, Rome, 1691–1700 (decorated the Farnese Palace, and worked in the Lateran Palace for Pope Innocent XII, and also for the Colonna family), Padua, 1700, Venice, 1700, Vienna, 1702 (worked on Schönbrunn Palace), Belluno, 1703–04 (Palazzo Fulcis-Bertoldi), Venice, 1707–12, London, 1712–16 (Chelsea Hospital Chapel, Burlington House—completed by Kent), then Venice again after 1717. Assistant and collaborator: his nephew Marco Ricci.

Major Collection: Royal Collection.
Other Collections: Bergamo; Berlin; Bologna; Boston; Cleveland; Florence: Uffizi, Pitti; London: Chelsea Hospital, Chiswick House, Dulwich, National Gallery, Royal Academy; Memphis; Munich; Padua: S. Giustina; Paris; Parma; Piacenza; Prague; Raleigh, North Carolina; Rome: Colonna, Palazzo Taverna, Quirinale; Toledo, Ohio; Turin: Sabauda; Venice: Accademia, S. Marziale, S. Rocco, S. Stae, Doge's Palace; Vienna; Schönbrunn, Kunsthistorisches Museum; Washington.

Publications

On RICCI: books—

Derschau, Joachim von, *Ricci,* edited by Georg Gronau, Heidelburg, 1922.
Milkovich, Michael, *Sebastiano and Marco Ricci in America* (cat), Memphis, 1965.
Rizzi, Aldo, *Ricci disegnatore* (cat), Milan, 1975.
Daniels, Jeffrey, *L'opera completa di Ricci,* Milan, 1976.
Daniels, Jeffrey, *Ricci,* Hove, 1976.
Pilo, Giuseppe M., *Ricci e la pittura veneziana del settecento,* Pordenone, 1976.
Rizzi, Aldo, *Ricci* (cat), Milan, 1989.

article—

Knox, George, "Ricci at Burlington House: A Venetian Decoration alla Romana," in *Burlington Magazine* (London), September 1985.

Sebastiano Ricci's training was with Federico Cervelli. Cervelli's style was similar to that of Luca Giordano, whose altarpieces in S. Maria della Salute in Venice no doubt influenced the young Ricci. He also studied with Sebastiano Mazzoni, whose style derived from Strozzi and focused on the bizarre and eccentric, and lived and worked while young in Bologna, Parma, and Rome. Thus by the age of 30 he had at his command the entire range of late Baroque possibilities (including stage design—he worked with Ferdinando Bibiena in Parma and Rome in the 1690's). In Rome he worked for both Pope Innocent XII (in the Lateran Palace) and the Colonna family (a ceiling fresco of *The Allegory of the Battle of Lepanto,* derived from Annibale Carracci's Palazzo Farnese *Galleria*). After years of travel, he returned to Venice, in 1700, and some of his Venetian works are among his best. The decorative ceiling in S. Marziale, for instance, is difficult to date, but its splendor was evidently astonishing at the time it was displayed, and after a recent cleaning is still exciting: the gaily colored figures, hovering above the viewer (especially in *The Miraculous Arrival of the Virgin's Statue*), have something of the softness of pastel or fresco, though they are painted on canvas. With the roughly contemporary frescoes for the Palazzo Marucelli in Florence (an extrovert *Hercules and the Centaur*), the luminous virtuosity of the Venetian 18th century is released.

Commentators always mention the influence of Veronese on Ricci that began about the turn of the 18th century, and a rather "grand" manner entered his work, though always coupled with the nervous brush-strokes. An early work (probably about 1695) that suggests the characteristics that made his work admired (and later criticized) is *The Continence of Scipio* (Royal Collection). Without being completely faithful to history (in terms of dress, after-battle atmosphere, etc.) it does manage to suggest a highly charged emotion with a neo-classic atmosphere, though this work, and much of Ricci's subsequent work, was eventually to be faulted for its lack of seriousness.

RIEMANSCHNEIDER, Tilman.

Born in Osterode, near Hildesheim, Saxony, c. 1460. Died in Wurzburg, 1531. Married four times; several children. Entered the guild of Wurzburg, 1483, and became a citizen, 1485 (councilman, 1504, other offices, and served as burgomaster, 1520–21): had a large shop which turned out scores of wood carvings, as well as stone sculptures; earliest documented work is a wooden altarpiece for S. Mary Magdalene, Münnerstadt parish church, 1490–92; other works for Wurzburg and towns nearby (including Frankfurt); took part in the peasants' revolt, and tortured in 1525 for taking the part of the peasants.

Collections/Locations: Bamberg: Cathedral; Berlin; Biebelried: parish church; Boston; Cleveland; Creglingen: Herrgottskirche; Dettwang: parish church; Heidelberg; Kirchberg bei Volkach: pilgrimage church; London: Victoria and Albert; Maidbronn: parish church; Munich: Bavarian Museum; New York: Cloisters; Providence, Rhode Island: School of Design; Rothenburg: S. Jakobskirche; Steinach an der Saale, parish church; Vienna; Wurzburg: Mainfränkisches Museum, Cathedral, Marienkapelle.

Publications

On RIEMANSCHNEIDER: books—

Bier, Justus, *Riemanschneider: 1. Die Frühen Werke,* Wurzburg, 1925; *2. Die reifen Werke,* Augsburg, 1930; *3. Die späten Werke in Stein,* Vienna, 1973; *4. Die späten werke in Holz,* Vienna, 1978.

Schrade, Hubert, *Riemanschneider,* Heidelberg, 2 vols., 1927.

Knapp, Fritz, *Riemanschneider,* Bielefeld, 1935.

Demmler, Theodor, *Die Meisterwerke Riemanschneiders,* Berlin, 1936.

Bier, Justus, *Riemanschneider: Ein Gedenkbuch,* Vienna, 1936.

Stein, Karl, *Riemanschneider im deutschen Bauernkrieg,* Vienna, 1937.

Bachmann, L. G., *Meister, Bürger, und Rebell: Das Lebensbild Riemanschneiders,* Paderborn, 1937.

Gerstenberger, Kurt, *Riemanschneider,* Vienna, 1941, 5th ed., 1962.

Freeden, Max L. von, *Riemanschneider,* Leipzig, 1954, 3rd ed., Munich, 1965.

Poensgen, Georg, *Die Windsheimer Zwölfbotenaltar von Riemanschneider im Kurpfälzischen Museum zu Heidelberg,* Munich, 1955.

Flesche, Herman, *Riemanschneider,* Hanau, 1957, 3rd ed., Dresden, 1967.

Schaeff, G. H., *Erlebnis und Deutung: 4 Altäre des Riemanschneiders,* Rothenburg, 1959.

Scheffler, Karl, *Der Creglinger Altar des Riemanschneider,* Konigstein, n.d.

Strache, Wolf, *Riemanschneider-Gestalten,* Stuttgart, 1966.

Freeden, Max H. von, *Riemanschneider,* Hamburg, 1976.

Hotz, Joachim, *Riemanschneider,* Munich, 1977.

Bloch, Peter, *Riemanschneiders vier Evangelisten vom Münnerstädter Altar,* Berlin, 1978.

Muth, Hanswernfried, *Riemanschneider und seine Werke,* Wurzburg, 1978, 1980.

Scheele, Paul Werner, and Toni Schneiders, *Riemanschneider: Zeuge der Seligkeiten,* Wurzburg, 1980.

Buczynski, Bodo, et al., *Riemanschneider: Frühe Werke* (cat), Regensburg, 1981.

Kirsch, Jans Christian, *Riemanschneider: Ein deutsches Schicksal,* Berlin, 1982.

Seelkopf, Martin, *Riemanschneider im Spiegel der Literatur* (cat), Wurzburg, 1981.

Zum Frühwerk Riemanschneiders: Eine Dokumentation, Berlin, 1982.

Bier, Justus, *Riemanschneider: His Life and Work,* Lexington, Kentucky, 1982.

Streit, Karl, *Riemanschneider: Leben und Kunstwerk des fränkischen Bildschnitzlers,* Berlin, 1988.

*

In a Würzburg chronicle written in the early 1700's Riemenschneider is referred to as a master known far and wide, famous for two princely tombs and for a number of other works in sanctuaries throughout Franconia and even beyond. Yet, although his works are found outside the Franco-

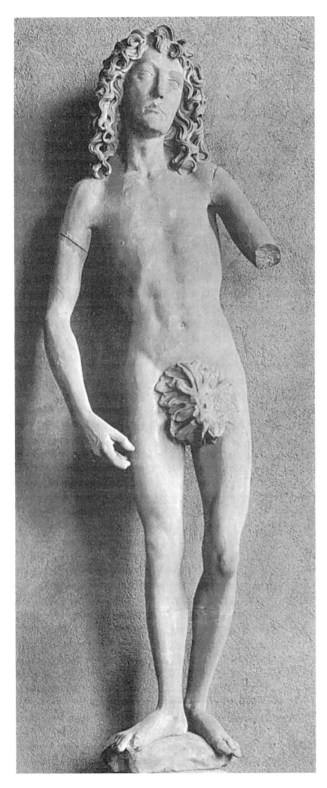 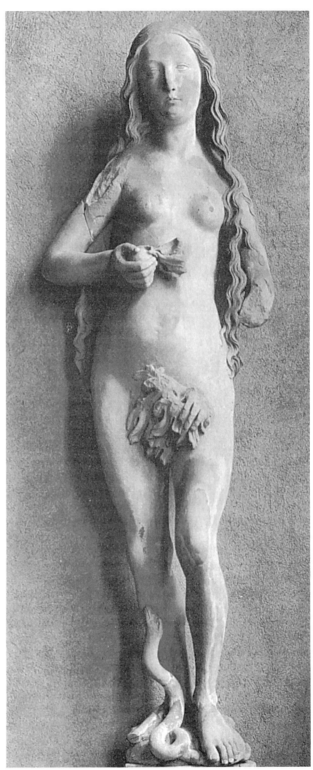

Adam and Eve, 1491–93; sandstone; life-size; Würzburg, Mainfränkisches Museum

nian boundaries in nearby Thuringia and Swabia, the "far and wide" was no doubt intended as a regional reference.

From the first direct documentation of his activities, his journeyman's oath in Würzburg, 1483, at which time he would be in his early twenties, an approximate birth date of 1460 has been established. There are records of a Riemenschneider family in Heiligenstadt and Osterode, both near Hildesheim in Lower Saxony, one referring to a Tile Riemenschneider, the artist's father, who with his wife Margaretha was once excommunicated. Another family member, however, the uncle, Nikolaus, attained distinction as a cleric and public official, ending his career as chief financial officer of the diocese of Würzburg, and it is likely that he was of considerable assistance to his nephew during the latter's years of apprenticeship.

True to tradition among artisans and artists Riemenschneider must have traveled in the years prior to his arrival in Würzburg, and an analysis of his works by media, manner, and content suggests that he may have been in Strasbourg where he would have seen sculpture in the Netherlandish style of Nikolaus von Leyden and also become acquainted with Schöngauer's altar paintings in nearby Colmar. Later he would look to Schöngauer's engravings for guidance and inspiration in his carvings. He may have spent an extended period of time in Ulm, where the sculptor Michel Erhart maintained a shop producing works in stone and wood. Justus Bier considers it more than likely that Riemenschneider worked and trained with Erhart, basing this on a comparison between details in Riemenschneider's earliest known works and those by Erhart. He may also have spent some time in Erfurt working in alabaster.

When well established in Würzburg, Riemenschneider married a widow with three young sons and a good house. She died ten years later and had in the meantime brought him a daughter. In a second marriage he had a daughter and three sons, all becoming artists. Although there are records of two additional marriages there apparently were no more children.

In Würzburg Riemenschneider must have been well connected, primarily through associates of his late uncle, for he received distinguished and lucrative commissions such as the marble and sandstone tomb monuments in the cathedrals of Würzburg and Bamberg, works begun in 1496 and 1499 respectively. Prior to that, however, he had completed an altarpiece in lindenwood dedicated to Mary Magdalene for the parish church at Münnerstadt, the contract signed in 1490, making this the artist's first documented work. The altar was dismantled in the 19th-century, its principal pieces placed in museums in Berlin and Munich. In a radical departure from tradition Riemenschneider left the pale lindenwood in the Münnerstadt altar and subsequent works in its natural state, preferring the expressive quality of the interplay of light and shadow to the polychrome effect favored by medieval carvers. However, such subtlety was not appreciated by his clients who later had the colors added.

A number of separate works, most of them from detached altarpieces, are now in museums throughout the world, testifying to Riemenschneider's skill and expressive range. The vivid representations of *Virgin and Child* in lindenwood in Berlin and Kansas, showing a young, mournful Mary, her Germanic features highlighted by her beautifully cascading hair, holding an energetically vivacious child appear derived from Schön-

gauer's engraved Madonnas, although with a deeper sense of melancholy. A *Pieta* in Providence, Rhode Island, has been accepted as entirely by the artist's own hand rather than a product of his workshop and is by Justus Bier considered "a precious document of the master's most personal style." The most complete and convincing evidence of Riemenschneider's artistry, however, is found in the surviving works still in their original sites in towns and villages whose importance has been greatly enhanced by their presence: *Altarpiece of the Holy Blood* in St. James Church, Rothenburg ob der Tauber (1501–04), *Altarpiece of the Assumption of the Virgin* in Herrgottskirche, Creglingen (1505–10), and the *Alterpiece of the Crucifixion* in Dettwang (1512–13).

In the years that elapsed between his involvement in the Peasant War and his death in 1531 Riemenschneider and his workshop appear to have been idle, no doubt as a result of his loss of patronage in high places. And in subsequent times he was all but forgotten, until the Romantics in the 19th century with their passion for the medieval towns and villages along the *Romantische Strasse,* the road from Würzburg to Augsburg and into the Bavarian Alps, rediscovered his works and placed him in rank with other great artists of late Gothic-early Renaissance Germany, Schöngauer, Dürer, Grünewald, and the Cranachs.

—Reidar Dittmann

RIVERA, Diego.

Born José Diego Maria Rivera in Guanajuato, 13 December 1886. Died in Mexico City, 24 November 1957. Married 1) Angelina Beloff, 1914, one son; 2) Guadalupe Marin, 1932, two daughters; 3) the painter Frida Kahlo, 1929 (divorced, 1939; remarried, 1940); 4) Emma Hurtado, 1955; also had a daughter by Marevna Vorobev-Stebelska. Attended schools in Mexico City; San Carlos National Academy of Fine Arts, Mexico City, 1898–1905; also studied in Spain, 1907–08; lived in Paris, 1911–21; Director, Academy of San Carlos, 1929–30; painter and muralist in Mexico and the United States.

Collections/Locations: Berkeley: University of California; Cambridge; Chapel Hill, North Carolina; Cuernavaca; Detroit; Guadalajara; Guanajuato; Honolulu; Leeds; London; Mexico City: Academy of San Carlos, National Museum of Art, Museum of Modern Art, Palace of Fine Arts, Carrillo Gil Museum, Rivera Studio Museum, Frida Kahlo Museum, National Preparatory School, Ministry of Education, University of Chapingo, National Palace, Ministry of Health, Reforma Hotel, National Institute of Cardiology, Hotel del Prado, Hospital de la Raza, Lerma Waterworks, Insurgentes Theatre; Monterret; New York: Moma, Brooklyn Museum; Philadelphia; San Francisco: Fine Arts Museum, Museum of Modern Art, Pacific Stock Exchange, Art Institute College of San Francisco; Veracruz.

Publications

By RIVERA: books—

La acción de los ricos yanquis y la servidumbre del obrero mexicano, Mexico City, 1923.
Abraham Angel, Mexico City, 1924.
Genius of America, New York, 1931.
Portrait of America, with Bertram D. Wolfe, New York, 1934.
Portrait of Mexico, with Bertram D. Wolfe, New York, 1938.
My Art, My Life, with Gladys March, New York, 1960.
Confesiones, edited by Luis Suarez, Mexico City, 1962

On RIVERA: books—

Acevedo, Jesus T., *Los pintores Gonzalo Arquelles Bringas y Rivera*, Mexico City, 1920.

Maceo y Arbeu, Eduardo, *Rivera y el pristinismo*, Mexico City, 1921.

Guzman, Martin Luis, *Rivera y la filosofia del cubismo*, Mexico City, 1921.

Evans, Ernestine, *The Frescoes of Rivera*, New York, 1929.

Weissing, H. L. P., *Rivera*, Amsterdam, 1929.

Edwards, Emily, *The Frescoes of Rivera in Cuernavaca*, Mexico City, 1932.

Abbott, Jere, *The Frescoes of Rivera*, New York, 1933.

Merida, Carlos, *Frescoes in Chapingo by Rivera*, Mexico City, 1937.

Wolfe, Bertram D., *Rivera: His Life and Times*, New York and London, 1939.

Puccinelli, Dorothy, *Rivera: The Story of His Mural at the 1940 Golden Gate Exposition*, San Francisco, 1940.

Guido, Angel, *Rivera: Los dos Diegos*, Rosario, Argentina, 1941

Chavez, Ignacio, *Rivera: Sus frescoes en el Instituto Nacional de Cardiologia* [in Spanish and English], Mexico City, 1946.

Oleacha, Elena A., *Rivera*, Mexico City, 1946.

Wolfe, Bertram D., *Rivera*, Washington, 1947.

Rodriguez, Antonia, *Rivera*, Mexico City, 1948.

Gual, Enrique F., *Fifty Years of the Work of Rivera: Oils and Watercolors 1900-1950*, Mexico City, 1950.

O'Gorman, Juan, *La tecnica de Rivera en la pintura mural*, Mexico City, 1954.

Spilimbergo, Jorge Enea, *Rivera y el arte en la revolución mejicana*, Buenos Aires, 1954.

Secker, Hans, *Rivera*, Dresden, 1957.

Díaz del Castillo, Bernal, *Rivera: Sus frescos en el Palacio Nacional de Mexico*, Mexico City, 1958.

Ramos, Samuel, *Rivera*, Mexico City, 1958.

Torriente, Lolo de la, *Memoria y razón de Rivera*, Mexico City, 2 vols., 1959.

Henestrosa, Andres, et al., *Testimonios sobre Rivera*, Mexico City, 1960.

Crespo de la Serná, Jorge Juan, *Rivera: Pintura mural*, Mexico City, 1962.

Silva, R. S., *Mexican History: Rivera's Frescoes in the National Palace and Elsewhere in Mexico City*, Mexico City, 1963.

Wolfe, Bertram D., *The Fabulous Life of Rivera*, New York, 1963.

Mitler, Max, editor, *Rivera: Wort und Bekenntnis*, Zurich, 1965.

Arquin, Florence, *Rivera: The Shaping of an Artist 1889-1921*, Norman Oklahoma, 1974.

Micheli, Mario de, *Rivera*, Mexico City, 1973.

Thiele, Eva-Maria, *Rivera*, Dresden, 1976.

Downs, Linda, and Mary Jane Jacob, *The Rogue: The Image of Industry in the Art of Charles Sheeler and Rivera* (cat), Detroit, 1978.

Debroise, Oliver, *Diego de Montparnasse*, Mexico City, 1979.

Cardoza y Aragón, Luís, *Rivera: Los frescos en la Secretaria de Educación Pública*, Mexico City, 1980.

Taracena, Berta, *Rivera: su obra mural en la Ciudad de Mexico*, Mexico City, 1981.

Reyero, Manuel, editor, *Rivera*, Mexico City, 1983.

Favela, Ramon, *Rivera: The Cubist Years* (cat), Phoenix, 1984.

Rodriguez, Antonio, *Guia de los murales de Rivera en la Secretaria de Educación Pública*, Mexico City, 1984.

McMeekin, Dorothy, *Rivera: Science and Creativity in the Detroit Murals*, East Lansing, Michigan, 1986.

Downs, Linda, and Ellen Sharp, editors, *Rivera: A Retrospective* (cat), New York and London, 1987.

Rochfort, Desmond, *The Murals of Rivera*, London, 1987.

*

Diego Rivera was one of the leaders of the Mexican mural renaissance of the 1920's and 1930's. In his life and work he celebrated indigenous Mexican culture and promoted social change through revolution. He has not received continuous critical acclaim in the United States and Europe because of his Communist political activism. However, he has had an enormous popular following on an international scale from the 1930's to the present. His work is officially designated a national treasure of Mexico.

Until he developed a distinctive mural style in 1923, Rivera's work reflected both the European academic tradition and the concerns of the avant-garde. The Academy of San Carlos in Mexico City, where Rivera received his early training, relied on a regimen that was heavily influenced by 19th-century French academic practice. The academy emphasized the development of technical expertise as well as study from nature and scientific investigations of such things as proportion and perspective. During his ten-year sojourn in Spain and Paris, Rivera experimented with historical styles from El Greco to Cézanne, and became part of the Cubist circle (1913-18).

One of the finest paintings of this period, inspired by the events of the Mexican Revolution, is the *Zapatista Landscape—The Guerrilla*, 1915 (Mexico City), in which a Cubist iconic image of revolutionary leader Emiliano Zapata floats on the picture plane in front of a realistic landscape depicting the Valley of Mexico. This first evidence of political content in Rivera's work reflects his concern for events in Mexico and his emerging interest in the relationship between art and revolution.

It was while he was in Paris that Rivera began to develop his extraordinary persona by mythologizing every aspect of his life—artistic accomplishments, political dedication, sexual prowess. Rivera's need for recognition and acceptance became a double-edged sword which ignited controversies that often hindered his career. In 1917 he was ostracized from the Cubist circle after engaging in a fist fight with the critic Pierre Re-

verdy. Only in 1984 with the exhibition *Diego Rivera: The Cubist Years* was his extraordinary body of Cubist work brought to light and critically acknowledged.

Rivera's first mural commission after his return to Mexico in 1921 (the Anfiteatro Bolívar of the Escuela Nacional Preparatoria) in Mexico City was neither a critical nor an artistic success. His study of Italian Byzantine mosaics and Renaissance frescoes is clearly evident in visual quotations that are held together by a curvilinear Art Nouveau style. At this point, Rivera still maintained a predominantly European perspective. Through travel (particularly to the Tehuantepec area) and through study, Rivera gradually began to understand the indigenous beauty and rich cultural heritage of his native land and to begin to incorporate it into his work.

Rivera first used indigenous Mexican subjects in the Ministry of Education, Mexico City. While he continued to rely upon the compositions of Italian Renaissance murals, he abandoned allegorical figures, the use of gold leaf, and western European themes. In the Ministry of Education murals he devised an integrated program of images related to the festivals and the occupations typical of the various regions of Mexico. He viewed his use of the medium of true fresco as another link to Mexico's pre-Columbian past. His political activism also emerges in his murals in the form of overt Communist themes and symbols. Rivera's figural style owes much to the 14th-century Italian artist Giotto. The simplified forms of Mexican peasants in traditional clothing enacting events from their own history and culture became the focus of his murals. The universal didactic themes interpreted through idealist revolutionary eyes became the hallmark of Rivera's murals.

The Ministry of Education mural was the most ambitious mural commission of his entire career. But the apogee of his early mural work is the chapel at the Universidad Autónoma de Chapingo, 25 miles northeast of Mexico City. Here Rivera created a spiritual realm through the depiction of secular themes—natural evolution and social revolution. This masterpiece is both a catechism of the ideal of social change through revolution and control of nature by the resulting new society of Mexicans. As with the Ministry of Education murals, there are explicit Communist themes and symbols which do not detract from the aesthetically pleasing conception and form.

Rivera painted over 17 major mural commissions in Mexico. The finest work of his mature style, however, is not in Mexico but in the United States. From 1930 through 1934 Rivera painted six murals in San Francisco, Detroit, and New York. (The New York mural in Rockefeller Center no longer exists. Rivera insisted on including in it a portrait of Lenin and a controversy erupted which led to the work's destruction.)

Rivera's murals in the United States show his fascination with industrial and architectural technology. Like his Mexican works, they are didactic, but the subject is no longer social change through revolution but rather through the use of technology to benefit the working class. Only one mural sequence (New Workers School, New York) was overtly Communist in subject matter, and it was painted in the heat of the controversy over the Rockefeller commission. Rivera's most accomplished mural in the United States is at the Detroit Institute of Arts (completed in 1933) and depicts the industrial environment of Detroit and Michigan, primarily by focusing on activities at the Ford Motor Company's Rouge Plant. In 27 panels in the central court of the museum Rivera painted a mural cycle that represents the evolution of technology and alludes to the universal forces that created the raw materials used in industry and to the four races that transform the raw materials and benefit from that transformation. The murals present a microcosm of the industrial age, and they both celebrate the productive uses of technology and condemn its destructive effects.

After the Rockefeller controversy in 1934, Rivera returned to Mexico. He continued to paint major mural commissions there as well as one last mural in the United States. Two of the most successful of this group of murals are the reproduction of the Rockefeller mural, *Man, Controller of the Universe*, 1934 (Mexico City), and the *Dream of a Sunday Afternoon in the Alameda*, 1947–48 (Pinacoteca, Mexico City).

After his Cubist period Rivera's easel paintings follow no continuous development, except that he reserved his "muralist" style for traditional Mexican subjects. Some of the most fascinating easel paintings of the late 1930's and early 1940's show his interest in Mexico's *arte fantástico* and its counterpart—European surrealism inspired by Mexican folk art and the surrealist writer André Breton, who lived with the Riveras during his visit to Mexico.

Rivera's life was filled with contradictions: a pioneer of Cubism who promoted art for art's sake, he became one of the leaders of the Mexican Mural Renaissance; a Marxist Communist, he received mural commissions from the United States corporate establishment; a champion of the worker, he had a deep fascination with the form and function of machines; a greater revolutionary artist, he also painted society portraits. In reality Rivera's philosophy corresponded to no specific dogma. He had an extraordinarily well-developed intuitive sense that shaped his understanding of the world and his humanistic understanding of the role of the artist and the role of art in society. His ability to represent universal images and ideas in his art continues to captivate the viewer today.

—Linda Downs

RIVERS, Larry.

Born Yitzroch Loiza Grossberg in the Bronx, New York, 17 August 1923. Married 1) Augusta Burger, 1945, one son; 2) Clarice Price, 1960, two children. Studied music at Juilliard School, New York, 1944–45; painting at Hans Hofmann's School, New York, 1947–48; New York University, 1948–51, B.A. 1951; first one-man show, 1949; lived with his mother-in-law, Berdie Burger, his favorite model, 1953–57; designer, *Oedipus Rex*, New York, 1966; has taught at Slade School, London, 1964, University of California, Santa Barbara, 1972, and in Russia, 1976. Address: c/o Marlborough Gallery, 40 West 57th Street, New York, New York 10019, U.S.A.

Collections: Chicago; London: Tate; New York: Metropolitan, Moma, Whitney; Provincetown, Massachusetts; Waltham, Massachusetts: Brandeis University; Washington: Corcoran, Hirshhorn, National Gallery.

Publications

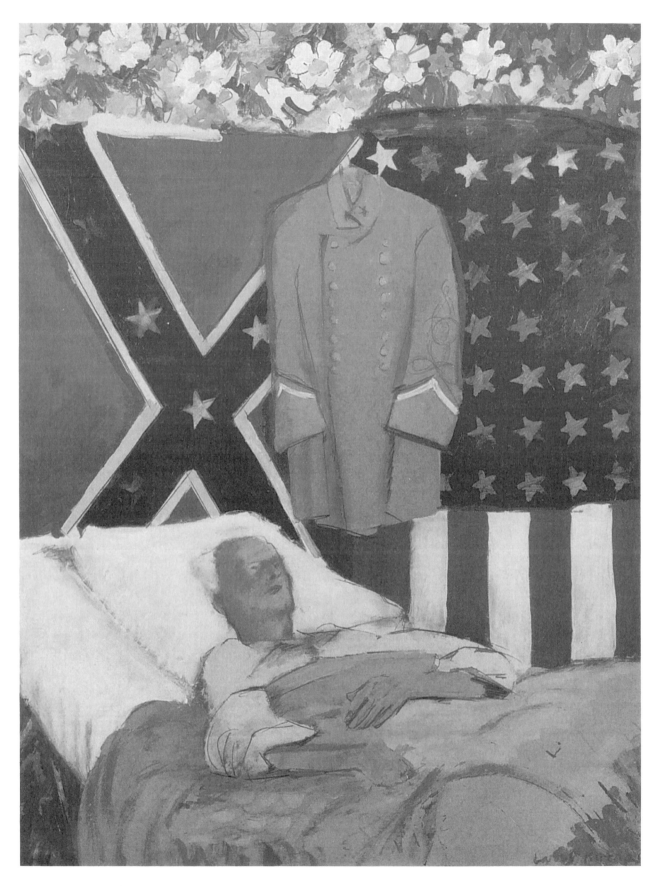

The Last Civil War Veteran, 1962; 30 × 22½ in (76.2 × 57.4 cm); Courtesy Waddington Galleries

By RIVERS: books—

illustrator: *Coloring Book of Japan,* 1973; *The Donkey and the Darling,* by Terry Southern, 1977; *Drawings and Digressions,* with Carol Brightman, 1979.

On RIVERS: books—

Ashbery, John, and Thomas B. Hess, *Rivers* (cat), 1962.
Hunter, Sam, *Rivers* (cat), Waltham, Massachusetts, 1965.
Hunter, Sam, *Rivers,* New York, 1969.
Selle, Carol O., *Rivers: Drawings 1949–1969* (cat), Chicago, 1970.
Rivers (cat), New York, 1970.
Rivers 1970–1973 (cat), New York, 1973.
Rivers: From the Coloring Book of Japan (cat), New York, 1974.
Rivers: Works of the 50's and 60's (cat), London, 1976.
Rivers: Recent Works, Golden Oldies (cat), New York, 1979.
Shapiro, David, *Rivers* (cat), Caracas, 1980.
Haenlein, Carl, editor, *Rivers Retrospektive: Bilder und Skulpturen, Zeichnungen* (cat), Hanover, 2 vols., 1980.
Rosenzweig, Phyllis, *Rivers: The Hirshhorn Museum and Sculpture Garden Collection,* Washington, 1981.
Harrison, Helen A., *Rivers,* New York, 1984.
Rivers: Relief Paintings (cat), New York, 1986.
Hunter, Sam, *Rivers,* New York, 1989.

*

For many years Larry Rivers was more famous for his flamboyant, Hollywood-style personality than for his original and thought-provoking paintings. After being discharged from the army in 1943, aged 20, he earned his living as a jazz musician playing the saxaphone. It was a chance encounter that brought him to painting. He was introduced to Jane Feilicher, the artist wife of a fellow musician who encouraged him to take up painting. Rivers was soon hooked and began painting by day and playing the saxaphone at night.

Rivers's first One-Person show was held at the Jane Street Co-operative Gallery in 1949. It attracted the attention of the right people. The art critic Clement Greenberg called Rivers an "amazing beginner." On the strength of this, Rivers was selected by Greenberg and Schapiro for the Kootz Gallery's New Talent '50 Exhibition the following year. All this before the young saxaphonist, born in the Bronx, had even graduated in Fine Art. It was a promising beginning.

The Burial, 1951 (Fort Wayne Museum of Art, Indiana), was Rivers's first ambitious large composition. In it Rivers combines art historical imagery, technical experimentation, and personal experience. In composition and inspiration *The Burial* is ostensibly historical, deriving from Courbet's *A Burial at Ornans.* The style, however, is not primarily retrospective, and Rivers has not chosen a somber colour scheme. The influence of de Kooning's swift brushstrokes and colour rhythms is clearly visible. *The Burial* is also personal, inspired, Rivers tells us, by the memory of his grandmother's funeral. This synthesis between nostalgia and tradition creates an aesthetic and ideological tension in Rivers's work which gives his painting their unique quality.

Throughout the early 50's Rivers produced a series of studies of his mother-in-law, Berdie Burger. These drawings and studies developed Rivers's artistic style. His palette lightened and he began to apply thin, transparent washes of paint. Rivers established his own painterly technique through drawing: "Drawing is the ability to use a line or mark to produce air, space, distinctions, peculiarities, endings, beginnings. It is like the back-field in a football games, it is the star."

Rivers went on to produce a series of "academies" of his friends and family. Rivers painted them, nude, with startling frankness and exceptional candour. The stiff figures and bizarre heroic poses recall the conventions of 19th-century Salon paintings. Rivers explores an art form that is both unfashionable and very difficult to classify or interpret. His work shocked the traditional and the unconventional alike. In the immediate context of the pro-abstraction art establishment and the emerging strands of Pop, this is perhaps not surprising.

In *The Studio,* 1956 (Minneapolis) Rivers took the conventions of art historical portraiture even further. Based on Courbet's *The Painter's Studio,* Rivers painted a frieze-like sequence of people—including his sons and mother-in-law—each in their own space. Rivers mistrusted the principle of pure invention and used art history to expand and forward his ideas. In spite of this, Rivers approached the emergence of Pop art in America with some cynicism, although he did experiment with explicitly Pop themes in the early 1960's.

Rivers effectively side-stepped Pop art in favour of a more exploratory use of mass media imagery. He was also a great technical experimenter. *The History of the Russian Revolution: From Marx to Mayakovsky,* 1965, was a giant multimedia construction, 32 feet long, 14 feet tall. It combined freehand painting, photographs, stencils, contructions, and found objects. Despite the serious intent of the artist, the work was rejected by the art world as a "caprice," a mere act of showmanship. It was some time before Rivers could shake off his reputation as a frivolous bon viveur.

In the early 1970's, Rivers's interest in modern media led him into experimenting with video. The videos were essentially dialogues between the artist and a chosen subject. These included marchers of gay rights, transsexuals, and members of his family. Rivers uses video to explore people and ideas in a frank and immediate way. In *Tits* Rivers takes a sharp look at the American fascination with breasts. *Shirley* is an intensely personal work about the artist's mother which—as with many of his video pieces—is as much about Rivers himself as his subject.

The *Golden Oldies* series, more than any other work, begins to unravel the conceptual principle at the core of Rivers's art. In 1977 Rivers began a reinvestigation of his entire oeuvre, a process which he has described as "editing." In *Golden Oldies* Larry Rivers writes his own visual history by collaging and superimposing imagery. John Ashbery has written of the series that it "seem[s] to have been assembled to prove the truth of Kierkegaard's statement that 'repetition is reality, and it is the seriousness of life.' "

Golden Oldies is the culmination of nearly three decades of artistic investigation and revision. A vivid and poignant representation of the principle—in sympathy with recent post-modernist theories—that the 20th-century quest for "originality" is better understood as the perpetual redefinition of history.

—Lauretta Reynolds

ROBERTI, Ercole (d'Antonio) de'.
Born in Ferrara, c. 1451–56. Died in Ferrara, 1496. Married Lucia de Fanti. Possibly a pupil of Cossa, and worked with Cossa in Bologna; also influenced by Tura and Giovanni Bellini; active in Ferrara from 1479 to 1481, and succeeded Tura as court painter to the Este family in 1486; some confusion because of another Ercole: Ercole di Giulio Cesare de'Grandi.

Collections: Berlin; Bologna; Chicago; Dresden; Ferrara; Fort Worth; Liverpool; London; Milan; Paris; Philadelphia; Rotterdam; Vatican; Washington.

Publications

On ROBERTI: books—

Filippini, Francesco, *Ercole da Ferrara*, Florence, 1922.
Ortolani, Sergio, *Cosmè Tura, Francesca del Cossa, Roberti*, Milan, 1941.
Nicholson, Benedict, *The Painters of Ferrara: Tura, Cossa, Roberti and Others*, London, 1950.
Puppi, L., *Roberti*, Milan, 1966.
Molajoli, Rosemarie, *L'opera complleta di Cosmè Tura e i grand pittori ferraresi del suo tempo: Cossa e Roberti*, Milan, 1974.

articles—

Manca, Joseph, "An Altar-Piece by Roberti Reconstructed," in *Burlington Magazine* (London), August 1985.
Manca, Joseph, "Roberti's Garganelli Chapel Frescoes: A Reconstruction and Analysis," in *Zeitschrift für Kunstgeschichte* (Munich), 49, 1986.

*

Born a generation after Cosmè Tura and Francesco del Cossa, Ercole de' Roberti was the youngest of the triad of painters who dominated the field of painting in Ferrara in the 15th century. The stylistic evidence and the tradition as related by Giorgio Vasari indicate that Roberti was trained by Cossa. The master brought young Roberti to Bologna, where Ercole spent the first years of his career (ca. 1473–78). Roberti's earliest works—including his striking predella for the Griffoni Altarpiece (now Vatican, Pinacoteca), the Bentivoglio portraits in the National Gallery of Art in Washington, and the *St. Jerome* in the Barlow Collection (Wendover)—are close in style to Cossa's works, characterized by bright, enamel coloring, brittle textures, mannered, curvilinear draperies, elegantly artificial anatomy, and fanciful, rocky landscapes. Roberti's *San Lazzaro Altarpiece* of the later 1470's (destroyed in Berlin in 1945) was a busy and delightfully bizarre example of the mannered Ferrarese style that had developed after the mid-15th century.

After Cossa's death, Roberti was in Ferrara, where beginning in early 1479 he kept a workshop for one year. Roberti's only documented, surviving painting is his *Pala portuense*, made in 1480–81 for Santa Maria in Porto, outside of Ravenna (now Milan, Brera). The altarpiece reflects the vertical, airy

sacre conversazioni recently introduced in Venice. Along with other works from the same period, including the Vendeghini *Madonna* (Ferrara, Pinacoteca Nazionale), the *Pala portuense* shows that Roberti was aware of the unifying light, broad figures, and softer draperies of Giovanni Bellini. From this point on, Roberti tempered some of the more bizarre mannerisms characteristic of the Ferrarese school with moderating stylistic features borrowed from Venice. Still, his art never completely lost the stylistic artificialities characteristic of Ferrarese painting of the quattrocento; a streak of artful stylism pervades all of his works.

By 1481, Roberti was back in Bologna, in order to paint frescoes of the *Crucifixion* and the *Dormition of the Virgin* for the Garganelli Chapel in San Pietro. The murals—now lost save for one fragment, but known in large part through copies—received a lengthy description in Vasari's biography of Ercole, and they established the artist's high reputation for centuries to come. During the early or middle 1480's, Roberti also painted a three-part predella of the Passion of Christ, originally for San Giovanni in Monte in Bologna (now divided between the Gemäldegalerie in Berlin and the Walker Art Gallery in Liverpool). Both the Garganelli Chapel frescoes and the Passion predella revived the expressionistic and copious Passion iconography that had prevailed in Italy in the trecento and that still dominated religious imagery in northern Europe in the late 15th century. Roberti combined the inventiveness and variety of the Ferrarese tradition with the dramatic tradition of late-medieval Passion imagery. He represented Christ's suffering with the brutality and vernacular directness of contemporary religious drama. Roberti's paintings made in Bologna in the 1480s are his most powerful and moving works.

Roberti returned to Ferrara after 1486 to work as official court painter for the Este rulers, a position he held until his death in 1496. In this last period, some mannerisms returned in his art. His panels of famous women—including the *Wife of Hasdrubal* in Washington (National Gallery) and the *Brutus and Portia* (Fort Worth, Kimbell Art Museum)—are brightly colored, and tell their violent stories with a restraint and gentility that would have gratified the courtly recipients. His *Saint John the Baptist* (Berlin, Gemäldegalerie) includes the distorted anatomy characteristic of the Ferrarese tradition, although here it is used for expressive purposes, not for mere variety or decoration. In addition to his paintings, Roberti was busy in his last years (1494–96) designing sculpture and architecture, including a large equestrian monument for Duke Ercole I d'Este and the church of Santa Maria in Vado, both created *all'antica*, in the aulic, classicizing style that the Duke wanted for his urban renewal and expansion of Ferrara.

The Italian connoisseur Roberto Longhi judged Roberti to be the leading artist in Italy toward the end of the 15th century, equalled perhaps only by Leonardo. Yet, Roberti has fared less well in Anglo-American criticism, which has had something of a bias against the artificiality and decorativeness of Ferrarese painting of the quattrocento. Roberti's contribution to Italian art was to fuse the mannered style of Ferrara with other sources of inspiration, including contemporary painting in Venice, German engravings, manuscript illuminations, and classical sculpture and architecture. His surviving oeuvre is rich and varied, and marked by a high level of technical competence.

—Joseph Manca

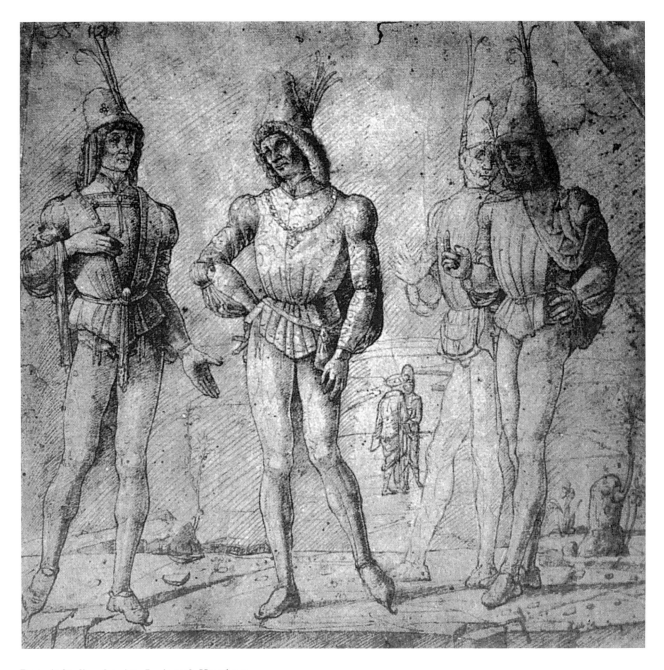

Portrait Studies; drawing; Leningrad, Hermitage

RODIN, (François) Auguste (René).
Born in Paris, 12 November 1840. Died in Meudon, 17 No-
vember 1917. Married Rose Beuret, 1917; one son. Worked
as a mason; attended school of Decorative Arts and the Mu-
seum of Natural History; then entered the studio of Carrier-
Belleuse, 1864–70: accompanied Carrier-Belleuse to Brussels,
1871; worked with Van Rasbourg on the Brussels bourse,
1871–77; then achieved fame with *Bronze Age* (some 150 rep-
licas were eventually made); exhibited in the New Salon,
1892; several later commissions were controversial, and *Gates
of Hell*, commissioned in 1880, was not completed by his
death; also did etchings.

Major Collections: Cleveland; London: Tate; Meudon: Rodin
Museum; Paris: Rodin Museum; Philadelphia; San Francisco.
Other Collections: Copenhagen; New York: Moma, Cantor
Sculpture Center; Stanford, California; Washington

Publications

By RODIN: books—

Art, Boston, 1912; as *On Art and Artists*, London, 1958; as
 Art: Conversations with Paul Gsell, Berkeley, 1984.

Les Cathédrales de France, Paris, 1914; as *Cathedrals of France,* Boston, 1965.

Dialogues with Rodin, by Helene von Nostitz, New York, 1931.

Correspondence, edited by Alain Beaurire and Helen Pinet, Paris, 1985—

On RODIN: books—

Rilke, Rainer Maria, *Rodin,* Leipzig, 1913, New York, 1919.

Coquiot, Gustave, *Rodin à Hotel Brion et à Meudon,* Paris, 1917.

Bourdelle, Antoine, *L'Art de Rodin,* Geneva, 1919.

Bénédite, Léonce, *Rodin,* Paris, 2 vols., 1924–26.

Grappe, Georges, *Catalogue du Musée Rodin,* Paris, 1927, 1944.

Grappe, Georges, *Le Musée Rodin,* Paris, 1934.

Cladel, Judith, *Rodin: Sa vie glorieuse, sa vie inconnue,* Paris, 1936, 1950; as *Rodin,* New York and London, 1938.

Bourdelle, Antoine, *La Sculpture et Rodin,* Paris, 1937.

Charbonneaux, Jean, *Les Sculptures de Rodin,* Paris, 1951.

Story, Sommerville, *Rodin,* New York, 1951, 3rd edition, 1964.

Gantner, Josef, *Rodin und Michelangelo,* Vienna, 1953.

Elsen, Albert E., *Rodin's Gates of Hell,* Minneapolis, 1960.

Goldscheider, Cécile, *Rodin: Sa vie, son oeuvre, son heritage,* Paris, 1962.

Geissbuhler, Elisabeth Chase, *Rodin's Late Drawings,* Boston, 1963; London, 1964.

Sutton, Denys, *Triumphant Satyr: The World of Rodin,* London, 1963; New York, 1966.

Elsen, Albert E., *Rodin,* New York, 1963.

Goldscheider, Ludwig, *Rodin: Sculptures,* London and New York, 1964.

Elsen, Albert E., editor, *Rodin: Readings on His Life and Work,* Englewood Cliffs, New Jersey, 1965.

Descharnes, Robert, and Jean-François Chabrun, *Rodin,* New York, 1967.

Taillandier, Yvon, *Rodin,* Naefels and New York, 1967.

Champigneulle, Bernard, *Rodin,* Paris, London, and New York, 1967.

Cassou, Jean, *Rodin, sculptures,* Paris, 1970.

Elsen, Albert E., and J. Kirk T. Varnedoe, *The Drawings of Rodin,* New York, 1971.

Elsen, Albert E., Stephen McGough, and Steven Wander, *Rodin and Balzac,* New York, 1973.

Thorson, Victoria, *Rodin's Graphics: A Catalogue Raisonné of Drypoints and Book Illustrations* (cat), San Francisco, 1975.

Tancock, John, *The Sculpture of Rodin: The Collection of the Rodin Museum in Philadelphia,* Philadelphia, 1976.

Rodin et les ecrivains de son temps: Sculpture, dessins, lettres, et livres de fonds Rodin (cat), Paris, 1976.

Elsen, Albert E., and Mary Jo McNamara, *Rodin's Burghers of Calais,* New York, 1977.

Caso, Jacques de, and Patricia Sanders, *Rodin's Sculpture: A Critical Study of the Spreckels Collection, California Palace of the Legion of Honor,* San Francisco, 1977.

Laurent, Monique, Claude Joudrin, and Dominique Viéville, *Rodin: Les Monuments des Bourgeois de Calais (1884–*

1895) dans les collections du Musée Rodin et du Musée des Beaux-Arts, Paris, 1978.

Laurent, Monique, and Claude Joudrin, *Rodin et l'extrême-orient,* Paris, 1979.

Butler, Ruth, editor, *Rodin in Perspective,* Englewood Cliffs, New Jersey, 1980.

Elsen, Albert E., *In Rodin's Studio: A Photographic Record of Sculpture in the Making,* Oxford and Ithaca, New York, 1980.

Elsen, Albert E., editor, *Rodin Rediscovered* (cat), Washington, 1982.

Joudrin, Claude, *Rodin: Dessins et aquarelles,* Paris, 1982; as *Rodin: Drawings and Watercolors,* New York and London, 1983.

Schmoll, Josef Adolf, *Rodin-Studien: Persönlichkeit, Werke, Wirkung, Bibliographie,* Munich, 1983.

Gassier, Pierre, *Rodin* (cat), Martigny, 1984.

Elsen, Albert E., *The Gates of Hell by Rodin,* Stanford, California, 1985.

Elsen, Albert E., *Rodin's Thinker and the Dilemmas of Modern Public Sculpture,* New Haven, 1985.

Güse, Ernst Gerhard, *Rodin: Drawings and Watercolors,* New York, 1985.

Lampert, Catherine, *Rodin: Sculpture and Drawings,* New Haven, 1986, London, 1987.

Grunfeld, Frederic V., *Rodin: A Biography,* London, 1987.

Fonsmark, Anne-Birgitte, *Rodin: La Collection du Brasseur Carl Jacobsen à la Glyptothèque et oeuvres apparentées,* Copenhagen, 1988.

*

Auguste Rodin was turned down three times for entrance to the Ecole des Beaux-Arts. Certainly, his approach to sculpture was antithetical to that of his academic contemporaries. As he told Paul Gsell in 1910, "I see all the truth, and not only that of the outside. I accentuate the lines which best express the spiritual state that I interpret." Rodin's expressive naturalism, his belief in the power of the human form to communicate spiritual truths, was often considered offensive by his contemporaries.

Born the son of a minor Parisian police official, Rodin was largely self-educated. He did poorly in school, possibly because of myopia, and remained shy, uncertain, and mistrustful of words throughout his life. At the age of 14, Rodin entered the Petit Ecole, where he learned to draw from memory and copied French 18th-century artists. Unable to receive any official recognition, Rodin began his career as a commercial sculptor, eventually working as an assistant in the studio of Albert Carrier-Belleuse. Most of Rodin's early work consists of pretty busts of women, such as the *Young Woman with Flowered Hat* (c. 1864), in the Fashionable Second Empire manner of Carpeaux and Carrier-Belleuse. Though Rodin did not really produce any fully independent works until the 1870's, his *Man with the Broken Nose* (1863–64) stands out as an original conception and foreshadows many aspects of his later work; as Rodin told one interviewer, "That mask determined all my future work." The choice of models was always an important part of his coulptural process. In this case, Rodin selected Bibi, a local odd-jobs man, as his sitter. Working directly from the model, Rodin created a tragic portrait in the spirit of the

Victor Hugo in Three-Quarter Profile, 1884; drypoint

Greeks. The mask itself is a fragment, the clay having frozen in the studio and broken. The work was rejected in the Salon of 1864 for the very reasons which became the hallmark of Rodin's mature style: its lack of idealization, its unfinished quality, and the mobility of its surfaces.

The outbreak of the Franco-Prussian War made public commissions scarce, so Rodin went to Brussels for several years. There he received his first public recognition with his life-size nude, *The Age of Bronze* (1875–76). During the winter of 1875, Rodin had visited Italy, where he sketched the works of both Donatello and Michelangelo. The influence of Renaissance sculpture is evident in Rodin's choice of pose. The work raises two issues about Rodin's sculpture: his ambivalence about titles and his relationship to realism. The sculpture was exhibited in Brussels in 1877 under the title *The Conquered Man,* perhaps a reference to the French defeat in 1871; originally the figure held a spear in his left hand, but Rodin had removed this attribute. When exhibited later that year in the Paris Salon under the new title, *The Age of Bronze* caused a critical controversy which launched Rodin into the public eye. First, some detractors charged that the work had been cast from life; Rodin fought them in the press with testimonials from his model, a Belgian soldier named Auguste Neyt, and artist-friends. Rodin had worked directly from nature, as he would throughout his life. Secondly, the subject matter was so unclear that one critic asked, "Can this be the statue of a sleep-walker?" Rodin's removal of the spear precluded any reference to literary or historical context; the human body had to communicate anguish without the help of narrative. In this way, Rodin furthered his break with the academic tradition, even while attempting to produce an acceptable Salon nude.

His next Salon figure, *St. John the Baptist Preaching* (1878), was slightly larger than life-size in order to avoid criticism. As he had in his *Man with the Broken Nose* and *Age of Bronze,* Rodin used an untrained model, an Italian peasant named Pignatelli. The pose, a powerful walking movement, was one chosen by the model, and not imposed by the sculptor from an academic repertory. The notoriety and eventual success of both of his standing nudes made Rodin's reputation and brought him to the attention of the state, which was then in search of an artist to sculpt the bronze doors for the new Museum of Decorative Arts.

In 1880 Rodin began work on the Gates of Hell. He selected the subject from Dante's *Inferno.* Probably his most well-known work, the *Gates* remained unfinished at the sculptor's death; the state had abandoned the plan for a new museum by 1904, and the *Gates* had become Rodin's own personal monument to the torment of modern man. The first sketches of 1880 show that his conception was based on Ghiberti's doors for the Florence Baptistry, with narrative scenes arranged in panels. But by the end of that year, Rodin's figures were already beginning to spill over their architectural framework. It was during this project that Rodin devised his working method of experimenting with partial or whole figures in various configurations, thereby creating different meanings with each new configuration. Due to the impressive size of the *Gates,* Rodin had to execute each figural group separately. Many of his sculptures from the 1880's and 1890's, the period of his most intensive work on this commission, were conceived in conjunction with the Gates: *The Kiss, The Helmet Maker's Beautiful Wife,* and *The Thinker.* The Gates are unprecedented in their composition: figures writhe in and out of a primordial mud, some etched in very low relief, some nearly free-standing. The only two subjects which derive specifically from Dante are *Ugolino Devouring His Sons* and *Paolo and Francesco.* The rest are anonymous human beings, tortured by the limitations and failures of the flesh. In many ways, the figures in the *Gates* can be seen as the summary of Rodin's sympathetic view of humanity: like his stormy love affair with his student Camille Claudel, which ended in 1898, these people would remain trapped by the boundaries of their own skin, forever acting out their doomed passions.

During the 1880's and 1890's, Rodin was besieged with work. He had several studios at this time, each busy with different projects, including *The Burghers of Calais* (1884) for the city of Calais, the *Monument to Claude Lorrain* (1889) for the city of Nancy, and the *Monument to Victor Hugo* (1889) for the Panthéon. Rodin approached each of these public monuments in a highly original way, and assured each of his commissioners repeatedly that theirs was the most important work at hand. Even *The Burghers of Calais,* considered his most successful monument, was not erected until 11 years after its initial conception—and then the site and pedestal were contrary to the sculptor's wishes. Rodin's conception of the suffering *Burghers* was influenced by his contemporaneous work on the *Gates.* Both the unusual composition, with six figures sharing the same ground line, and the theme of martyrdom may have been derived from medieval sculpture, long a passion of Rodin's.

The 1880's was a period of public recognition of the merits of Rodin's work. He received a number of portrait commissions, including the popular bust of Mme. Vicuna, wife of the Chilean ambassador to France. Rodin created some 250 marbles. He would model the clay original and add only finishing touches to the marble; professional workmen were actually responsible for executing the work in marble. Marble fulfilled the 19th-century ideal for sculpture, and Rodin's marbles were much in demand during his lifetime. The *Mme. Vicuna,* with its rough unfinished base, is reminiscent of Michelangelo's treatment of his marble blocks. Essentially a modeller, Rodin once stated, "When God created the world, it is of modeling He must have thought first of all." Rodin's bronze bust of his friend and fellow-sculptor, Jules Dalou (1883), captures the republican's spirit with a vitality of surface as eloquently as his marble of Mme. Vicuna insinuates her sensuousness. His marbles tend to look more finished than his bronzes, and their themes are often more sentimental. The strength of his genius is apparent in the fact that his clay originals could retain their power when translated into different materials. Frequently the same work would be rendered in both bronze and marble, suggesting that dedication to experimenting with the sculptural process which is characteristic of his entire career.

The decade ended with the enormously successful Monet/Rodin exhibition at the Galerie Georges Petit in 1889. There, Rodin showed 36 works, among them the plaster of the *Burghers,* seen for the first time as a whole. Soon after, the Société des Gens de Lettres was seeking a sculptor to produce a monument to Balzac. Henri Chapu, who had originally been awarded the commission, died in 1891, having completed only a rough maquette showing the author seated between two allegorical figures. Rodin was granted the project in 1891, and, as he had done with the *Burghers,* he used local models, this

time from Touraine, the region of Balzac's birth. His working method was also like that of the earlier project, beginning with nude studies, and only later clothing the figure in a dressing gown. The exhibition of the final plaster in the Salon of 1898 caused such a scandal that the artist removed it from the exhibition. One critic referred to it as, "nothing but a big side of beef," and another imagined that, "it's Balzac being woken up by a creditor." The figure, in its expressive distortions, offended the public's image of Balzac. But Rodin's is a portrait of artistic genius, a very 19th-century romantic belief; his conception, though, was so personal that it could no longer address its public. In defending his work, Rodin told a newspaper reporter, "the artist does not always realize his dream; but I believe in the truth of my principle, and Balzac, rejected or not, is nevertheless in the line of demarcation between commercial sculpture and the art of sculpture as we no longer have it in Europe." The Société rejected Rodin's monument, and like the *Gates,* this figure was cast only posthumously.

Following the debacle of the *Balzac,* Rodin was in critical disfavor in the 1890's. He completed his several public commissions, and in 1900 he exhibited over 150 sculptures, including a plaster of the *Gates of Hell,* in a pavilion adjacent to the grounds of the Paris Exposition Universelle. This retrospective was a financial success and secured Rodin's international fame. In 1901 Camille Mauclair, a contemporary biographer, wrote, "Basically, the only source of adoration for Rodin—and it is also the source of his genius—is the life of permanent forms." Rodin's sculpture belies this summary, his passion for the essence of humanity, for the changing aspects of Nature is almost religious in its intensity. His late drawings and watercolors, mostly of female nudes and many of which are quite erotic, bespeak the sculptor's desire to bear witness to life.

—Caroline V. Green

ROMNEY, George.

Born George Rumney near Dalton-in-Furness, Lancashire, 15 December 1734; adopted spelling Romney in 1764. Died in Kendal, Westmorland, 15 November 1802. Married Mary Abbot, 1756; one son and one daughter. Worked at home for his carpenter-cabinet maker father, 1744-45 to 1755; apprenticed to the painter Christopher Steele, Kendal, 1755-57; set up as a painter in Kendal, 1757-61, and in London from 1762; visited Paris, 1764, and Rome, 1773-75; involved in Boydell's Shakespeare Gallery; director, Society of Artists, 1772; retired to Ulverston, 1799 (senile). Pupils: his brother Peter Romney, Thomas Barrow, Thomas Robinson, Thomas Sanderson.

Major Collections: Cambridge; San Marino, California.
Other Collections: Cardiff; Kendal; London: Tate, Portrait Gallery, Wallace, Dulwich, Kenwood; Melbourne; New Haven; New York: Metropolitan, Frick; Port Sunlight.

Publications

Lady, 1790; mezzotint

On ROMNEY: books—

Hayley, William, *The Life of Romney,* Chichester, 1809.

Romney, John, *Memoirs of the Life and Works of Romney,* London, 1830.

Ward, Humphrey, and William Roberts: *Romney: A Biographical and Critical Essay with a Catalogue Raisonné of His Works,* London and New York, 2 vols., 1904.

Chamberlain, Arthur B., *Romney,* London, 1910.

Conran, G. L., et al., *Romney* (cat), London, 1961.

Wark, Robert R., *The Drawings of Romney,* Alhambra, California, 1970.

Jaffe, Patricia, *Lady Hamilton in Relation to the Art of Her Time* (cat), London, 1972.

Rump, Gerhard C., *Romney: Zur Bildform der bürgerlichen Mitte in der englischen Neoklassik,* Hildesheim, 2 vols., 1974.

Jaffe, Patricia, *Drawings by Romney* (cat), Cambridge, 1977.

Watson, Jennifer C., *Romney in Canada* (cat), Waterloo, Ontario, 1985.

articles—

Crookshank, Anne, "The Drawings of Romney," in *Burlington Magazine* (London), 1957.

Burke, Joseph, "Romney's Leigh Family: A Link Between the Conversation Piece and the Neo-Classical Portrait Group," in *Bulletin of the National Gallery of Victoria* (Melbourne), 1960.

Grandal, Hortensia, "Romney: El clasicismo en la escuela inglesa," in *Goya* (Madrid), July–December 1986.

*

George Romney emerged as one of Britain's leading portraitists in the second half of the 1770's. Over the next 20 years he developed an easy, fluid, informal manner characterised by elegant draughtmanship and high-keyed colour which may be seen as forming a natural bridge between the styles of the mature Reynolds and the early Lawrence. However, Romney was less committed to portraiture than these rivals and seems to have regarded himself as a history painter manqué forced into painting portraits to make a living. Romney's many drawings and cartoons often inspired by literary and mythological subjects reveal him to be a key figure both of later British Neo-Classicism and also infant Romanticism. If he lacked the time or the energy to convert these preliminary designs into paintings except in a very few instances, it is nevertheless this aspect of Romney's art, rather than his contribution to portraiture, which is generally viewed today as the more significant.

As a portraitist, Romney is usually judged in the light of Sir Joshua Reynolds. Conventionally, Romney is regarded as the fresher, more spontaneous painter and generally superior as a draughtsman, but intellectually derivative of Reynolds, taking on board the latter's devices in a half-baked way. The relationship between the two, however, is more complex than this. Romney's developing maturity as an artist at the end of the 1760's (witnessed most notably in the *Leigh Family* group of 1768) appears to have induced Reynolds himself to close the gap between them, and thereafter awareness of each other's work seems highly developed in both. It is often stated (by partisans of Romney) that Reynolds's jealousy led to Romney's exclusion from the Royal Academy, though there is little concrete evidence for this and there are circumstantial grounds for supposing Romney himself found the idea of membership uncongenial.

Romney's attitude to his sources was different form Reynolds's. It centered on a passionate admiration for classical statuary, the aesthetic qualities of which he attempted to recreate in his best portraits. To judge from these, it was above all the element of heavy and sensuous physicality in classical figure sculpture which appealed to him, and in more than a cerebral way. There is an emotive and repressed strain in his love of classical antiquity and it is the expression of this (above all in his full-length female portraiture), which singles Romney out as an unusual and proto-Romantic artist.

Partly owing to the nature of later writing about him, it is difficult to judge the impact which Romney had upon the artistic life of his time. His supposed rivalry with Reynolds and exclusion from the academic milieu create an image of isolation, and this idea receives a certain indirect confirmation from what we know of his huge output of portraits, which suggests an enslavement to the studio; of his personal life, which was such as to discourage his acceptance in the highest social strata; and of his political sympathies, which brought him into the orbit of leading radical circles. Furthermore, his most imaginative works, his drawings and cartoons, were of a private nature. On closer inspection, however, Romney appears to have been deeply involved in many of the more progressive movements of his day: he was part of the influential circle of artists who went to Rome in the mid-1770's—among them Fuseli and Flaxman, who guided the British contribution to European neo-classicism of the 1790's and 1800's; he was, for example, highly active in Boydell's Shakespeare Gallery project; and as with Reynolds he moved into leading literary and theatrical circles. Many such aspects of his life and his practice are still in need of extended enquiry.

—Alex Kidson

ROSA, Salvator.

Born in Arenella, near Naples, 20 June or 21 July 1615. Died in Rome, 15 March 1673. Married Lucrezia Paolina, 1673. Studied with his uncle Domenico Antonio Greco, his brother-in-law Francesco Francanzano, and possibly Jusepe Ribera; also had some instruction from Aniello Falcone; worked in Rome, 1635–37, Naples, 1637–38, Rome again, 1639–40, Florence, 1640–49, then settled in Rome, 1649: painted religious pictures, mythological allegories, battle-scenes, landscapes, often with a wild "romantic" quality; also etchings; poet.

Collections: Althorp, Northamptonshire; Berlin; Cambridge; Chantilly; Chicago; Copenhagen; Detroit; Florence: Pitti; Fort Worth; Glasgow; Hartford, Connecticut; Leningrad; Liverpool; London: National Gallery, Wallace, Dulwich; Malibu; Melbourne; Modena; New Haven; New York; Oxford: Ashmolean, Christ Church; Paris; Richmond, Virginia; Rome; Sarasota, Florida; Viterbo.

Publications

By ROSA: books—

Poesie e lettere, edited by G. A. Cesareo, Naples, 2 vols., 1892.
Lettere inedite a G. B. Ricciardi, edited by Aldo de Rinaldis, Rome, 1939.
Poesie el lettere inedite, edited by Uberto Limentani, Florence, 1950.

On ROSA: books—

Ozzola, Leandro, *Vite e opere di Rosa, pittore, poeta, incisore,* Strasbourg, 1908.
Pettorelli, A., *Rosa, pittore, incisore, musicista, poeta,* Turin, 1924.
Manwaring, Elizabeth Wheeler, *Italian Landscape in Eighteenth Century England: A Study Strictly in the Influence of Claud Lorrain and Rosa 1700–1800,* New York, 1925.
Cattaneo, Irene, *Rosa,* Milan, 1929.
Lopriore, G. I. *Le "Satire" di Rosa,* Florence, 1950.
Limentani, Uberto, *Bibliografia della vita e delle opere di Rosa,* Florence, 1955; supplement in *Forum Italicum* (Buffalo), 7, 1973.
Salerno, Luigi, *Rosa,* Florence, 1963.

Frontispiece to Varia et Concinna Delineamenta; engraving

Tomory, Peter, *Rosa: His Etchings and Engravings after His Works* (cat), Sarasota, Florida, 1971.

Kitson, Michael, et al., *Rosa* (cat), London, 1973.

Bozzolato, Giampiero, *Le incisioni di Rosa*, Padua, 1973.

Rotili, Mario, *Rosa incisore*, Naples, 1974.

Salerno, Luigi, *L'opera completa di Rosa*, Milan, 1975.

Maffeo, Pasquale, *Rosa*, Naples, 1975.

Mahoney, Michael, *The Drawings of Rosa*, New York, 2 vols., 1977.

Roworth, Wendy Wassyng, *"Pictor Succensor": A Study of Rosa as Satirist, Cynic, and Painter*, New York, 1978.

Wallace, Richard W., *The Etchings of Rosa*, Princeton, 1979.

*

Salvator Rosa is best known as the creator of wild, picturesque landscapes of jagged rocks, shaggy trees with broken branches, and small picturesque figures. His darkly evocative, romantic landscapes were collected avidly and copied through the 18th and 19th centuries, especially in England where his works were seen as the savage counterpart of Claude Lorrain's sunny, idealized scenes. Rosa's own ambition, however, was to be known as a painter of religious, mythological, and historical subjects; he despised landscapes which he considered beneath his talents. He believed along with his contemporaries in

Italy, that the highest form of painting was history painting, for it required knowledge of literature and philosophy. In fact, much of Rosa's artistic production was in the form of large-scale figure paintings which he sold to an appreciative, well-educated clientele in Florence and Rome.

As a young man Rosa went to Rome, which was then the center of artistic patronage as well as theoretical debates on painting in the Academy of St. Luke. Many of Rosa's early paintings of small figures in landscapes have been associated with the Bamboccianti, the painters of low-life genre scenes who were active in Rome during the 1630's. His religious paintings show the influence of his Neapolitan background, especially the work of Jusepe Ribera, with whom he may have had contact. As he matured his works became lighter in tonality, more classical in composition and themes, and they show the influence of Florentine and Roman painting. Rosa was a prolific and fluent draughtsman throughout his career and his numerous surviving drawings cover the full range of subjects that appear in his paintings. Rosa also wrote lyric poems and is the author of seven long verse satires. These bitter, stinging satires castigated the state of the arts of music, poetry, and painting, and the corruption of society in general. They were never published in Italy during his lifetime, but were widely known through manuscripts and readings. In *Pittura* (1650), the satire on painting, he caricatured low-life artists and hypocritical patrons as a way of distancing himself from his own early works as well as criticizing those who did not appreciate his current efforts. The satire *Invidia* (1653) was a personal defense against the envious attacks of those who claimed Rosa was not really the author of the *Satires*. Contrary to popular legend he was not a musician or composer himself, although several of his verses were set to music by others.

By his second trip to Rome Rosa had established a reputation as a painter of startling and dramatic subjects and a lively, outspoken wit. He was soon invited to Florence to work for the Medici where he settled for nearly ten years painting a variety of subjects for a large, appreciative clientele. He made several life-long friends, most notable the poet Giovanni Battista Ricciardi with whom he later had an extensive correspondence. Rosa took up writing and founded the Accademia dei Percossi, a group of learned gentlemen who met periodically for dinners and literary entertainments. Some of Rosa's important paintings made in Florence are the *Self-Portrait* (?) (London), *Battles Scene* (Uffizi), *Alexander and Diogenes* and *Cincinnatus Called from the Plow* (Althorp), and *The Philosophers Grove* (Pitti).

In Rome during the 1650's and 1660's he continued to work on major history paintings as well as landscapes. His compositions became increasingly monumental, his figures larger in scale and more expressive. When the general market for paintings declined due to economic conditions he produced original etchings to sell and to advertise his talents. These include the *Genius of Rosa, Alexander in the Studio of Apelles,* and the series of small, individual figures known as the *Figurine*. More than any other artist Rosa made use of the annual public art exhibitions in Rome held on religious feast days at some of the major churches. Among the works of this period are the pair of philosophical subjects, *Democritus in Meditation* (1651) and *Diogenes Throwing Away His Bowl* (1652, Copenhagen), *Attilius Regulus* (1652, Richmond, Virginia), *Self-Portrait with a Skull* (1656, New York), *Humana Fragilitas*

(1657, Cambridge), *Apollo and the Cumean Sibyl* (c.1660, London, Wallace), *Saul and the Witch of Endor* (1668, Louvre), and *Allegory of Fortune* (1659, Malibu), a pictorial satire on unenlightened Papal patronage that almost caused Rosa's excommunication before the Pope Alexander VII's brother came to his defense on the grounds of artistic license.

Rosa helped to create his own reputation for being an abrasive cynic who rejected the Church and society in order to maintain his independence as an artist. He admired the Cynic Diogenes, professed to be a Stoic, and self-consciously adopted the stance of a moralizing critic. He turned down invitations to work at the French Court and for Queen Christina of Sweden on the grounds that he wished to maintain his freedom. His contemporary biographers and Rosa's own numerous letters are filled with other anecdotes and comments that have fostered the characterization of Rosa's independent personality. While there is some truth to this exaggerated image of the melancholic misanthrope, Rosa's real desire was to gain public recognition and acceptance. His later biographers, especially Lady Sidney Morgan in her biography-cum-novel *The Life and Times of Salvator Rosa* (1824), perpetuated the myth of the artist at odds with society who lived among bandits in the wild landscapes he painted. Much of Rosa's historic importance lies in his role as part of the developing idea of "artistic temperament"; nevertheless, his paintings and prints did have a direct influence in terms of style and subjects on many 18th- and 19th-century painters, including Allesandro Magnasco, Domenico Tiepolo, Joseph Wright of Derby, and J. M. W. Turner. Rosa's striking imagery and distinctive style in both landscapes and complex allegories made his paintings a prime example of what Joshua Reynolds (1772) called the "Original of Characteristical Style." While Rosa may not have achieved the career success he wanted, his independent stance as cynic, satirist, and painter has ensured his popularity to later generations to whom the image of the artist was perhaps even more important than his art.

—Wendy Wassyng Roworth

ROSSELLINO, Antonio.

Born in Florence, 1427; brother of the sculptor Bernardo Rossellino (other brothers include Giovanni, Domenico, and Tommaso). Died 1479. Probably trained under his brother Bernardo in Florence; carved capitals for S. Lorenzo, 1449; first dated work is bust of Giovanni Chellini, 1456; most famous work is the monument for Cardinal of Portugal in S. Miniato al Monte, Florence, 1461–66; also did S. Sebastian altar in the Collegiata, Empoli; completed some of Bernardo's commissions after his death in 1464; bust of Matteo Palmieri, 1468; worked on the Baptistery, Florence, 1471; and pieces for Prato Cathedral, S. Giorgio, Ferrara, and S. Anna dei Lombardi, Naples; works often confused with those of Desiderio da Settignano.

Collections/Locations: Berlin; Ferrara: S. Giorgio; Florence: S. Spirito, S. Miniato al Monte, S. Croce; London: Victoria and Albert; Naples; S. Anna dei Lombardi; New York; Prato: Cathedral.

Publications

On ROSSELLINO: books—

Gottschalk, Heinz, *Rossellino*, Leigmitz, 1930.
Planiscig, Leo, *Bernardo und Antonio Rossellino*, Vienna, 1942.
Hartt, Frederick, G. Corti, and C. Kennedy, *The Chapel of the Cardinal of Portugal 1434–1459 at San Miniato al Monte in Florence*, Philadelphia,1964.
Schulz, A. Markham, *The Sculpture of Bernardo Rossellino and His Workshop*, Princeton, 1977.

*

One of the most gifted sculptors of the third quarter of the 15th century was Antonio Rossellino by whose nickname ("little red head") his whole family of sculptors became known; Antonio was the youngest of five brothers. The technical mastery and diversity of his works are extraordinary: pulpits, tombs, altarpieces, portrait busts, and Madonna and Child reliefs were produced in great number by him and his shop. Vasari praises Antonio's "sweet, delicate, refined, finished" style, the depth and roundness of the figures, his clever compositions and his facile handling of marble; most critics through the centuries have agreed. Antonio's career, spanning three decades, falls into three periods: early (1450's), mature (1460's) and late (1470's); it is characterized by a progression from surface effects and shallow relief to livelier forms and denser masses.

The key example of the early period is the bust of the humanist physician Giovanni Chellini, dated 1456 by inscription. In spite of the rigid requirements of this type of sculpture, Rossellino shows extraordinary sensitivity in the modelling of wrinkled skin and the underlying bony structure of the face. In fact, the head is modelled so closely after nature that a life mask made when the subject was 84 is presumed to have served as the basis for the carving. Chellini wears contemporary clothing, not the antique attire more common in portrait busts, and he communicates the characteristics of an old gentleman who is learned, shrewd, and kindly. The smoothly polished surface, reflecting gradations of light, departs from the linearity of Mino da Fiesole and shows the influence of Desiderio da Settignano and Antonio's brother, Bernardo Rossellino, with whom he worked on several projects in the 1450's.

Another portrait bust, that of Matteo Palmieri, executed during Antonio's mature period (1468), exhibits a greater liveliness, physical vigor, and harmony of form but the same technical mastery. Despite the damage to which the surface has been subjected (it was placed outside above the portal of Palmieri's Palace in Florence), it is one of the most striking examples of the artistic type which became popular in Florence in the mid and late Quattrocento. Palmieri, a distinguished Latinist, statesman and poet, radiates intelligence and good will, his course features and tousselled hair indicating a remarkable sense of realism and plasticity.

The masterpiece of Antonio Rossellino is the tomb of the Cardinal of Portugal at San Miniato in Florence, executed between 1461 and 1466. It is the most brilliant element in a chapel which is an extraordinary interdisciplinary enterprise, including architecture, sculpture, and painting. Although uti-

Tomb of Francesco Nori; marble; Florence, S. Croce

lizing elements from two previous monuments in Florence—the tomb of John XXIII by Donatello and Michelozzo and that of Carlo Marsuppini by Desiderio da Settignano—Antonio's concept is both innovative and integrated. Set into a deeply shadowed niche instead of projecting from the wall, the tomb is spatially complex, and the figures are more active and vibrant than their staid predecessors. The concept of the tomb as a *tableau vivant* was completely new. Classical models and references, forms handled with plastic freedom, and a robust yet refined figural style indicate that Rossellino has reached the height of his mature development. Although such a large and complex project which was completed in just over four years would have required the use of shop assistants and the documented participation of his brother Bernardo, Antonio clearly maintained control of the sculptural style and the unified design. Its influence can be seen not only in the direct copy by Antonio for the tomb of Maria of Aragon in Naples but also in the tomb designs of other sculptors, particularly Benedetto da Maiano, his pupil.

During his late career (1470's) Antonio Rossellino undertook a diversity of projects in which his style seems to become more profound and expressive. He expanded the Madonna and Child relief in size and scope, engaged in formal and iconographic innovations, and developed complex forms of male anatomy. The climax of this late period is the magnificent life-size figure of Saint Sebastian in the Collegiata in Empoli. Totally nude except for the tightly wound loincloth, the figure is modelled with freedom, confidence, and a mastery of the organic harmony of inner structure and surface flesh. The whole body, in a straining contrapposto stance, seems to twist upward to the rapturous upturned face with its expression of gravity and transfixed majesty. Here the full force of Rossellino's dramatic power is clearly evident, enhanced by the expressive qualities and the subtly modulated surfaces. St. Sebastian has been termed "the finest expression of the nude in the figure sculpture of this phase of Florentine art."

The refinement, dexterity, and sensitivity of Rossellino's sculptural style were admired by his contemporaries—both patrons and colleagues—and were transmitted to the next generation by his students and followers (most notably Benedetto da Maiano and Matteo Civitale) and by his influence in artistic centers outside Florence. At the end of the century even Michelangelo was deeply impressed by Antonio's mastery of realistic forms and by the intense, mournful sweetness of his work.

—Harriet McNeal Caplow

ROSSELLINO, Bernardo.

Born in Settignano, 1409; brother of the sculptors Antonio, Giovanni, and Domenico. Died in Florence, 23 September 1464. Married Mattea, 1438. Assumed responsibility for the facade of the Misericordia at Arezzo, 1433; earliest surviving work is a relief of the Madonna, 1434–36; did tabernacles for the Badia di SS. Fiora e Lucilla, Arezzo, and the Badia, Florence, 1435–36; worked on Florence Cathedral, 1441–44; important work was the monument to Leonardi Bruni, S. Croce, Florence, c. 1446–48; also designed buildings, doorways, cul-

minating in the "new city" of Pienza where Pope Pius II employed him to design the cathedral and palaces, 1459–64; chief of Florence Cathedral, 1461–64. Pupils/assistants: his brother Antonio, Desiderio da Settignano, Matteo Civitale, Buggiano, Mino da Fiesole.

Collections: Arezzo: Palazzo della Fraternita dei Laici; Empoli: Museo della Collegiata; Florence: Badia, S. Croce, S. Maria Novella, S. Egidio, S. Spirito, SS. Annunziata, Palazzo Spinelli, Palazzo Rucellai; Pienza: Cathedral and palaces; S. Miniato al Tedesco: S. Domenico; Siena: Palazzo Pubblico.

Publications

On ROSSELLINO: books—

Tyskiewicz, Maryla, *Rossellino*, Florence, 1929.
Planiscig, Leo, *Bernardo und Antonio Rossellino*, Vienna, 1942.
Schulz, Anne Markham, *The Sculpture of Rossellino and His Workshop*, Princeton, 1976.
Finelli, Luciana, *L'umanismo giovane: Rossellino a Roma e a Pienza*, Rome, 1985.
Mack, Charles R., *Pienza: The Creation of a Renaissance City*, Ithaca, New York, 1987.

articles—

Sanpaolesi, Paolo, "Construzioni del primo Quattrocento nella Badia Fiorentina," in *Rivista d'Arte* (Florence), 24, 1942.
Saalmann, Howard, "Tommaso Spinelli, Michelozzo, Manetti, and Rossellino," in *Journal of the Society of Architectural Historians*, 25, 1966.
Mack, Charles R., "The Rucellai Palace: Some New Proposals," in *Art Bulletin* (New York), 56, 1974.
Salmi, Mario, "Rossellino ad Arezzo," in *Scritti di storia dell'arte in onore di Ugo Procacci*, Milan, 1977.
Mack, Charles R., "Rossellino, L. B. Alberti, and the Rome of Pope Nicholas V," in *Southeastern College Art Conference Review*, 10, 1982.
Mack, Charles R., "Building a Florentine Palace: The Palazzo Spinelli," in *Mitteilungen des Kunsthistorischen Institutes in Florenz*, 27, 1983.
Mack, Charles R., "Nicholas the Fifth and the Rebuilding of Rome: Reality and Legacy," in *Light on the Eternal City*, University Park, Pennsylvania, 1987.

*

Born into a family of farmers and quarry owners, Bernardo Rossellino probably received his initial training as a stonemason from his father, Matteo di Domenico di Luca Gamberelli, or from his uncle, Jacopo. Shortly before 1420, he was in Florence and probably apprenticed to one of the better-known masters. A stylistic connection with Nanni di Bartolo, called il Rosso, might be argued and might explain the nickname of Rossellino, later given to Bernardo and his brothers. In 1433 Bernardo and three companions from Settignano were

commissioned to complete the facade of the chapterhouse of the Fraternità di Santa Maria della Misericordia in Arezzo, the lower story of which had been executed in the Gothic manner over a half century earlier. The project, which Bernardo directed, involved both sculptural and architectural elements. The completed facade is dominated by the relief of the Madonna of Mercy spreading her protective mantle over the citizenry of Arezzo and is flanked by the kneeling figures of Saints Laurentius and Persentinus. These figures, set within a mixed-element frame, were executed between June 1434 and February 1435. In June of 1435, Bernardo received his final payment for two freestanding figures of Saints Gregory and Donatus which occupy pilaster-framed aediculae on either side of the relief. Now sadly damaged and worn, these figures and the other sculptural and architectural elements of the palace facade clearly demonstrate Bernardo's familiarity with the achievements of his contemporaries in the first generation of the Florentine Renaissance as well as his own peculiar genius for rapid assimilation and facile adaptation. Throughout his career an unwavering commitment to *il modo antico* would place Bernardo in the forefront of the humanist movement in sculpture and architecture in step with Michelozzo and only a few paces behind Brunelleschi, Donatello, and Alberti.

Between 1436 and 1438 Bernardo was at work at two Benedictine cloisters in Florence. At the Cloister of the Oranges of the Badia Fiorentina, he served as an assistant to the actual builder, Antonio di Domenico, supplying architectural materials and elements including an elegant and progressively designed doorframe and a *bifora*-cross window. He also furnished (1436) the Badia Fiorentina with a stone tabernacle of which only part of a garland swagged entablature and a console in the form of an eagle survive. This tabernacle may have been similar to one he had executed a year earlier for the Abbey of Saints Flora and Lucilla in Arezzo (lost). At the Campora Monastery, he designed what is probably the earliest cloister in the Renaissance style. In 1444 he received a commission to sculpt two altar figures for the oratory of the Annunciation Company in the church of St. Stephen in Empoli. In these two figures of the Virgin Annunciate and the Archangel Gabriel, we find a further development of the artist's decoratively graceful and classical style and a reflection of the manner of Donatello, Ghiberti, and Michelozzo.

Bernardo Rossellino's devotion to the "new wave" classicism in Renaissance art is apparent in his two great pieces of architectural sculpture of the late 1440's, the portal of the Sala del Concistoro in the Palazzo Pubblico of Siena (doc. 1446) and the funeral monument to Leonardo Bruni (c. 1446–48) in Santa Croce in Florence. By any estimation, these two works stand out as highpoints in the development of the Renaissance style. Even before his trip to Rome in the 1450's and his contact with Alberti, Bernardo was able to demonstrate a thorough appreciation for the nature of the antique revival. This is apparent not only in the sculptural accomplishments of the Siena doorframe and the Bruni Tomb, but also in the finest architectural achievement of Bernardo's early years—the Spinelli Cloister at Santa Croce in Florence (1448–51). The rhythmic beauty of that cloister, perhaps the loveliest of the early Renaissance, is due to a carefully formulated series of mathematical ratios and proportions worthy of Brunelleschi. The finely executed architectural sculptures of the Spinelli Cloister (doorframes, capitals and corbels, entrance portal,

the latter distinctly reminiscent of that done for the Sala del Concistoro in Siena) are stylistic indicators of what might be termed the "Rossellino Manner." Other examples of this style may be found in Rossellino's Santa Maria Nuova Tabernacle of 1449-50 (now in San Egidio, Florence) and in the courtyard and entry passage to the Ruccelli Palace of 1448-55. In 1451 he received an important sculptural commission for the Tomb of the Beata Villana in Santa Maria Novella, Florence, largely executed by his brother Antonio and members of the workshop (including Desiderio da Settignano) and now dismembered.

It was his sojourn in Rome (1451-55) as a member of Pope Nicholas V's architectural staff, however, that set Bernardo Rossellino firmly apart from the other stonemasons of Florence. Despite the fact that his actual contribution to the papal projects was greatly exaggerated by Vasari and limited to little more than renovations in San Stefano Rotondo, Rossellino's approach to design was altered emphatically. He already had demonstrated a commitment to the classical manner but he now was brought into an extended contact with the great monuments of imperial Rome and into an intimate and working association with another member of the papal team, the humanist scholar and architectural theoretician Leone Battista Alberti.

Upon his return to Florence, his workshop, which had operated during his absence under the direction of his brother Antonio, continued its sculptural output but Bernardo increasingly turned his attention to matters architectural. He may have participated in designing tomb monuments for the Beato Lorenzo da Ripafratta in San Domenico, Pistoia, and Beato Marcolino in San Giacomo, Forli, Neri Capponi in Santo Spirito, Florence, Gemignano Inghirami in San Francesco, Prato, Giovanni Chellini in San Domenico, San Miniato al Tedesco, and Filippo Lazzari in San Domenico, Pistoia, as well as the funerary chapel and monument for Cardinal James of Portugal in San Miniato ai Monte, Florence but their execution and real direction was in the hands of his shop and his brothers Antonio, Giovanni, and Domenico. His involvement with the Tomb of Orlando de'Medici in SS. Annunciata, Florence was more personal and it is interesting to note that its conception is architectural rather than sculptural. Among the Florentine projects of his last years were the Spinelli Palace and the design and/or execution of the celebrated facade of the Rucellai Palace. Bernardo Rossellino's artistic prominence was recognized in his appointment as *capomaestro* of the Florence Cathedral in 1461.

Bernardo Rossellino's career culminated in his stunning achievements at Pienza which he rebuilt for Pope Pius II Piccolomini between 1459 and 1464. There, at the Piccolomini Palace he followed the antique example of the Colosseum or the Villa of Le Mura and used three tiers of pilasters to articulate the exterior of the building block and opened up the garden facade into three tiers of loggias from which to view a splendid panorama. At the Cathedral, he achieved an easy answer to the problem of the church facade which had perplexed and confounded even such notable masters as Alberti and Brunelleschi. The Cathedral of Pienza contains good sculptural examples of the Rossellino workshop style in the elegant Altar of St. Andrew and in the ornate baptismal font of the lower church. Bernardo Rossellino's greatest triumph at Pienza was in his conception of the town as a totality, symbolized by the cincture of buildings about the central square and

spreading out through the community along a "curial row" of residences and other remodelled dwellings. The result was one of the most pleasing and harmonious cityscapes in the history of urban design. Final projects included designs for the Piccolomini-Todeschini Palace in Siena and for a bell tower for the church of San Pietro in Perugia (based on that of Pienza's new cathedral).

—Charles R. Mack

ROSSETTI, Dante Gabriel.

Born in London, 12 May 1828; sister of the poet Christina Rossetti. Died in Birchington on Sea, Kent, 9 April 1882. Married the model Elizabeth Siddal, 1860 (died, 1862). Studied drawing under Cotman, and briefly studied painting under Ford Madox Brown; then studied with Hunt, 1848, and with him became leading member of the Pre-Raphaelite group from 1849; with Burne-Jones and William Morris, decorated the Oxford Union Debating Society Library, 1857; used studio assistants; also illustrated literary works in watercolor; also a well-known poet and translator (especially from early Italian writers); after the death of his wife, became reclusive, and eventually a drug addict.

Major Collection: London: Tate.
Other Collections: Birmingham; Cambridge; Cambridge, Massachusetts; Dublin; Kelmscott Manor; Lawrence: University of Kansas; Liverpool; London: National Gallery, Portrait Gallery, Guildhall, Victoria and Albert; New Haven; Ottawa; Oxford; Port Sunlight; Wilmington, Delaware.

Publications

By ROSSETTI: books (selection)—

The Early Italian Poets, London, 1861; as *Dante and His Circle*, 1874.
Poems, London, 1869, 1881.
Ballads and Sonnets, London, 1881.
Collected Works, edited by W. M. Rossetti, London, 2 vols., 1886-87.
Poems, edited by W. M. Rossetti, London, 2 vols., 1904.
Works, edited by W. M. Rossetti, London, 1911.
The House of Life, edited by P. F. Baum, Cambridge, Massachusetts, 1928.
The Blessed Damozel, edited by P. F. Baum, Chapel Hill, North Carolina, 1937.
Letters, edited by Oswald Doughty and J. R. Wahl, Cambridge, Massachusetts, and Oxford, 4 vols., 1965-67.
The P.R.B. Journal: Rossetti's Diary of the Pre-Raphaelite Brotherhood 1849-1853 . . . , edited by William R. Fredeman, Oxford, 1975.

On ROSSETTI: books—

Rossetti, W. M., *Rossetti as Designer and Writer*, London, 1889.

Rossetti, W. M., *Ruskin, Rossetti, Pre-Raphaelitism: Papers 1854–62*, London, 1899.

Cary, Elisabeth, *The Rossettis: Dante Gabriel and Christina*, New York, 1900.

Rossetti, W. M., editor, *Pre-Raphaelite Diaries and Letters*, London, 1900.

Hueffer, Ford Madox, *Rossetti: A Critical Essay on His Art*, London, 1902.

Rossetti, W. M., editor, *Rossetti Papers 1854 to 1862*, London, 1903.

Beerbohm, Max, *Rossetti and His Circle*, London, 1922; edited by N.John Hall, New Haven, 1987.

Caine, T. Hall, *Recollections of Rossetti*, London, 1928.

Waugh, Evelyn, *Rossetti: His Life and Works*, London, 1928.

Gray, Nicolette M., *Rosetti, Dante, and Ourselves*, London, 1947.

Angeli, Helen Rossetti, *Rossetti: His Friends and Enemies*, London,1949.

Doughty, Oswald, *A Victorian Romantic, Rossetti*, London, 1949, 1960.

Fleming, Thomas, *Die stilistische Entwicklung der Malerei von Rossetti*, Berlin, 1964.

Grylls, Mary R. G., *Portrait of Rossetti*, London, 1964.

Pedrick, Gale, *Life with Rossetti*, London, 1964.

Fleming, Gordon H., *Rossetti and the Pre-Raphaelite Brotherhood*, London, 1967.

Johnson, Robert D., *Rossetti*, New York, 1969.

Hilton, Timothy, *The Pre-Raphaelites*, London,1970.

Cooper, Robert M., *Lost on Both Sides: Rossetti, Critic and Poet*, Athens, Ohio, 1970.

Surtees, Virginia, *The Paintings and Drawings of Rossetti: A Catalogue Raisonné*, Oxford, 2 vols., 1971.

Fleming, Gordon H., *That Ne'er Shall Meet Again: Rossetti, Millais, Hunt*, London, 1971.

Howard, Ronnalie R., *The Dark Glass: Vision and Technique in the Poetry of Rossetti*, Athens, Ohio, 1972.

Staley, Allen, *The Pre-Raphaelite Landscape*, Oxford 1973.

Grieve, Alastair, *The Art of Rossetti*, Hingham, Norfolk, 3 vols., 1973–78.

Henderson, Marina, *Rossetti*, London and New York, 1973.

Nicoll, John, *Rossetti*, London, 1975.

Stein, Richard Lewis, *The Ritual of Interpretation: The Fine Arts as Literature in Ruskin, Rossetti, and Pater*, Cambridge, Massachusetts, 1975.

Ainsworth, M. R., *Rossetti and the Double Work of Art*, New Haven, 1976.

Boos, Florence S., *The Poetry of Rossetti*, The Hague, 1976.

Dobbs, Brian and Judy, *Rossetti, An Alien Victorian*, London, 1977.

Weintraub, Stanley, *The Four Rossettis*, New York, 1977, London, 1978.

Rees, Joan, *The Poetry of Rossetti: Modes of Self Expression*, Cambridge, 1981.

Wood, Christopher, *The Pre-Raphaelites*, New York and London, 1981.

Bell, Quentin, *A New and Noble School: The Pre-Raphaelites*, London,1982.

Benedetti, Maria Teresa, *Rossetti: Disegni*, Florence, 1982.

Riede, David G., *Rossetti and the Limits of Victorian Vision*, Ithaca, New York, 1983.

Gizzi, Corrado, editor, *Rossetti* (cat), Milan, 1984.

Dunn, H. T., *Recollections of Rossetti and His Circle, or Cheyne Walk Life*, edited by Rosalie Mander, Westerham, Kent, 1984.

Langlade, Jacques de, *Rossetti*, Paris, 1985.

articles—

Meisel, Martin, " 'Half Sick of Shadows': The Aesthetic Dialogue in Pre-Raphaelite Painting," in *Nature and the Victorian Imagination*, edited by U. C. Knoepflmacher and G. B. Tennyson, Berkeley, 1977.

Mander, Rosalie, "Rossetti and the Oxford Murals, 1957," in *Pre-Raphaelite Papers*, edited by Leslie Parris, London, 1984.

Shefer, Elaine, "A Rossetti Portrait: Variations on a Theme," in *Arts in Virginia* (Richmond), 27, 1987.

*

Dante Gabriel Rossetti was best known in his own time, and is best remembered now, as one of the founders of the Pre-Raphaelite Brotherhood, a small group of upstart students who challenged the artistic establishment of the mid-Victorian age. But Rossetti's role in the PRB represents only a small part of the achievement that made him one of the most admired and influential artists of his time. A poet as well as a painter, Rossetti epitomized the Victorian ideal of a painter whose works are to be "read" as inspired poems, but as his career progressed his art increasingly moved away from the representation of literary themes on canvas and toward a more pure painterly ideal.

Rossetti's career as a painter falls neatly into three distinct phases. From about 1847 to 1853, he experimented in a variety of media, and with a variety of styles and subjects; he had little patience with learning his craft, and in fact never became a very good draughtsman, and never even learned the basic rules of perspective. He instead devoted himself to finding ways to instill poetry into painting, to provide literary significance for his drawings and paintings by introducing "readable" symbolism. By far his most successful early works were his so-called "Art-Catholic" paintings, *The Girlhood of Mary Virgin* and *Ecce Ancilla Domini!* in which he loaded the canvas with typological symbolism and, insisting on the literary quality of the work, he even appended explanatory sonnets to the frames, one of which began, staightforwardly enough, "These are the symbols." But at the same time that Rossetti was seeking to fill his paintings with a rather quaint symbolism, he was helping to form the Pre-Raphaelite Brotherhood, a group much influenced by John Ruskin's admonition in *Modern Painters* to copy nature with absolute fidelity and in minute detail. Rossetti simply did not have the skills to paint from nature with the mimetic accuracy of his Pre-Raphaelite Brethren Holman Hunt and John Everett Millais, but he did his best in the Art-Catholic paintings to paint the human figures from nature—and produced moving portraits of his mother as St. Anne and his sister as the Virgin. Archaic symbolism, affecting portraiture, and even perhaps the stylistic incompetence that led to certain oddities in perspective and design, all contributed to strikingly original and oddly impressive paintings.

Rossetti's lack of technical expertise also paradoxically contributed to the successes of the next phase of his career, which

lasted from about 1853 to 1859. Never having mastered oils, Rossetti began to work primarily in water-colors, and never having mastered the elements of accurate drawing, he became less and less concerned with the Pre-Raphaelite imperative of accurate representation of nature. He also, apparently, became less concerned that his paintings be translatable into words, perhaps because he had no clear message to communicate anyway. An agnostic, he had never really believed in his Catholic symbolism, and he had nothing to substitute for it except a vague love of the romance of the middle ages. Though he continued to fill his pictures with objects that seemed somehow symbolic, the symbols no longer had any very precisely definable referents. Such paintings as *Arthur's Tomb, The Blue Closet, The Tune of the Seven Towers, The Wedding of St. George and the Princess Sabra, A Chistmas Carol, Chapel before the Lists,* and *Before the Battle* are all characterized by a vaguely "poetic" sentiment, but all depend for their effect on purely non-literary characteristics—extraordinarily vivid colors that suggest both medieval manuscript illuminations and stained glass, and compositions that are designed to emphasize formal elements in the painting rather than to tell a story or capture a moment of narrative time. Even the objects that cram the picture space are less effective as poetic symbols than as additions to the elaborate patterns that approach abstract design. The vague symbolism, claustrophobic crowding, distortions of the figures to fit into the surface pattern, the luminous coloring all contribute to a fascinating effect of dream or reverie.

The final and longest phase of Rossetti's career began in 1859 with a return to oils, an ambition to paint on a larger scale than the relatively small water-colors of the 1850's, and a change in subject matter from the chivalric scenes of Arthurian legend to robustly sensual women. In the 1850's his favorite model had been his wife, Elizabeth Siddal, but with the painting of his mistress, Fanny Cornforth, in 1859 as *Bocca Baciata,* he went abruptly from representations of demure maidens with downcast eyes to portraits of staring, full-lipped, and full-bodied temptresses. The major exception during this period, a portrait of Elizabeth Siddal (completed after her death) as *Beata Beatrix,* is filled with Dantean symbolism and represents the figure in, apparently, a trance of prayer. But the titles of some of the works from this period reflect the more usual subject matter: *Aspecta Medusa, Helen of Troy, Pandora, Venus Verticordia, Proserpine, Lady Lilith, Astarte Syriaca.* With the change in medium and subject matter came a major change in style. In his earlier work, even in oils, Rosetti had spread his paint extremely thinly, creating an extraordinary luminousness approaching the translucency of stained glass. But in the paintings of temptresses and love goddesses, Rossetti continued to draw rich coloring from a palate heavy with gold, purple, and deep green, but now laid the paint on thickly and lavishly, with a formal sensuality to match the subject matter. These paintings, usually three-quarter length portraits, are consistent with Rossetti's earlier work in presenting an abundance of apparent symbols, often musical instruments or, as William Rossetti put it, "floral adjuncts," and they are also consistent in sustaining the literary ideal of painting—their titles are taken from literature and they are often accompanied by poems. But even more than the paintings of the 1850's, the late paintings in fact owe very little to literary associations. Their impact results directly from their

richness of coloring, from the elaborate patterns created by swirling clothing and "floral adjuncts," and from the uncompromising immediacy of the massive portraits. Rossetti's ideal of beauty, expressed in the late portraits of women, so dominated the age that Oscar Wilde credited him with inventing a whole new type of female beauty.

—David G. Riede

ROSSO, Medardo.

Born in Turin, 21 June 1858. Died in Milan, 31 March 1928. Married Giuditta Pozzi, 1885; one son. Military service, 1879; trained as a painter briefly, then as a sculptor, Brera Academy, Milan; influenced by the Scapigliati; first stay in Paris, 1885–86, then settled in Paris, 1889–1902; than led an itinerant life until his death; favorite medium was wax; influential on Futurist and other avant garde groups in the early 20th century.

Major Collections: Barzio: Rosso Museum; Rome: Arte Moderna.
Other Collections: Cardiff; Cologne; Edinburgh; Florence; Pitti; Milan: Arte Moderna; New York: Moma; Paris: Rodin Museum, Petit Palais; Turin: Arte Moderna; Venice: Arte Moderna; Vienna: Moderner Kunst.

Publications

On ROSSO: books—

Soffici, Ardengo, *Il caso Rosso,* 1909.
Pierard, Louis, *Un Sculpteur impressioniste, Rosso,* Paris, 1909.
Soffici, Ardengo, *Rosso,* Florence, 1929.
Cozzani, Ettore, *Rosso,* Milan, 1931.
Papini, Giovanni, *Rosso,* Milan, 1945.
Borghi, Mino, *Rosso,* Milan, 1950.
Barbantini, Nino, *Rosso,* Venice, 1950.
Barr, Margaret Scolari, *Rosso,* New York, 1963.
Caramel, Luciano, and Paola Mola, *Rosso* (cat), Milan, 1979.
Weiermair, Peter, editor, *Rosso* (cat), Frankfurt, 1984.

articles—

De Sanna, Jole, "Rosso," in *Artforum* (New York), September 1986.

*

Medardo Rosso occupies a unique place in the history of sculpture. The body of his work—limited in scale and in volume—reveals a vision that challenges most of the principles of sculpture as tradition has transmitted them to us since the Renaissance. It is the essence of sculpture that Rosso revolutionizes, taking to Paris the plasticity of three-dimensional language whose limitations he wants to overcome: matter will no

Sick Boy, 1893; bronze; 9½ in (24 cm)

longer have to be the only element of his investigation, but also the transient effects of light upon matter, suggesting an endless field of metamorphosis. As he wrote in an article ("Impressionism in Sculpture," in *Nouvelle Revue*, 1901), "What counts for me is to make one forget matter."

The encounter with the French Impressionist painters was of some importance to him; however, his personal development is deeply rooted in the Lombard school of the Scapigliatura (dishevelment), at its peak during Rosso's years in Milan. Painters such as Daniele Ranzoni and Tranquillo Cremona, whose loose brushwork was able to capture any changing moment of the light, prepared him to understand the lesson of Impressionism. The sketchy brushwork translates the immediacy of the vision.

Rosso, however, because he deliberately chose a medium by definition alien to this kind of reduction—plasticity—goes much further than the Impressionists did: his is a revolution which is an end in itself. Except for Boccioni and the first generation of Futurists who, unsuccessfully, tried to create a sculpture able to suggest the modification of the environment, a sculpture meant to transcend motion, and therefore resolutely anti-plastic, Rosso remained without spiritual heirs. Like the Futurists, Rosso suggests a reality which is an "anti-reality" in the sense that its perception depends upon the light it is displayed in—and it is fundamental to realize that each of Rosso's pieces is accompanied by a lengthy description of how it should be lit.

For that reason, Rosso chose material suggestive of matter in fusion, endlessly changing—plaster, bronze—but using a very broad technique of lost wax. Wax over plaster became, after 1889, his favorite medium because it presents a natural opalescence which he felt evoked the transparency of the ephemeral world he wanted to capture.

His work never became popular because it was too alien from what his contemporaries expected from sculpture. Recognition was for him a difficult battle, and financial survival a hardship until 1910. Exiled in Paris by his own will, he lived in semi-solitude there, rejected by the official art milieu as much as by the avant garde, snubbed by the critics who, except in relation to lively polemics upon his relationship with Rodin, ignored his work. Success came late and indirectly, after Etha Fles, a Dutch woman influential on the European art world (and who became his lover), began promoting his work, in Holland, in Germany with the help of the critic Julius Meier-Graefe, and finally in London and Vienna. In his native country, the first retrospective took place in 1914, when 20 of his works were presented at the Biennale of Venice, but if was not until 1979 that the definitive exhibition was presented in Milan by a team of scholars who illustrated powerfully the importance of Rosso in 20th-century sculpture, though an earlier retrospective was help in New York (Moma) in 1963.

The traditional notion that Rosso met Rodin while working as an apprentice in Dalou's atelier in 1884 is erroneous. His first stay in Paris lasted a few months between the winter of 1885 and the spring of 1886. Three years later, moved by a desire for more political freedom—he was a socialist with anarchist tendencies, and his Milan milieu was too conservative for his taste—and a search for a deeper truth in art, he decided to settle in Paris. His training has been as much in painting as in sculpture, and he was producing small bronzes of striking realism, such as *El Locch*, in which a social statement is made by the choice of the protagonist, a lower-class figure of Milan's under-privileged class. For Rosso, the subject matter was always of fundamental importance; its rendition became the object of research—towards an almost total dematerialization. Rosso's relationship with Rodin was misunderstood by his contemporaries. Rodin thought so highly of Rosso's work that he resigned from the Salon committee in 1898 when Rosso's bronzes were rejected by the jury. Their friendship dated from Rosso's first stay in Paris: he gave to Rodin his bronze *La Rieuse*, and Rodin reciprocated with his *Torso*. Contrary to what has often been written, it is Rodin who was influenced by the revolutionary vision of Rosso, and not the other way round. The final version of Rodin's *Balzac* took into account Rosso's *L'Homme qui lit* and *Bootmaker*. Nevertheless, Rodin's towering sense of mass and need for a visceral presence of matter is the antithesis of Rosso's approach. It is fascinating that the sculptor who was the most remote from Rosso was among the first to understand him.

—Annie-Paule Quinsac

ROSSO Fiorentino.

Born Giovanni Battista di Jacopo di Guasparre, in Florence, 8 March 1494. Died in Paris, 14 November 1540. In Andrea del Sarto's workshop (with Pontormo), Florence, c. 1512; worked in Florence, 1513–23; then in Rome, 1523 until the sack of Rome, 1527, then wandered until he turned up in Venice, 1530; then employed by Francis I at Fontainebleau (with Primaticcio), 1531, and court painter from 1532.

Group of Naked Figures; drawing; Florence, Uffizi

Collections: Arezzo; Berlin; Boston; Citta di Castello: Cathedral; Florence: Uffizi, Pitti, S. Lorenzo, SS. Annunziata; Fontainebleau: Chateau; Frankfurt; Leningrad; Liverpool; London: Royal Academy, National Gallery; Los Angeles; Naples; Paris; Pisa; Rome: Borghese, S. Maria della Pace; Sansepolcro: S. Lorenzo; Siena; Villamagna: parish church; Volterra; Washington.

Publications

On ROSSO: books—

Goldschmidt, Fritz, *Pontormo, Rosso, und Bronzino*, Leipzig, 1911.

Kusenberg, Kurt, *Le Rosso*, Paris, 1931.

Barocchi, Paolo, *Il Rosso*, Parma, 1950.

Lovgren, S., *Il Rosso a Fontainebleau*, Stockholm, 1951.

Bologna, F., et al., *Fontainebleau e la maniera italiana* (cat), Florence, 1952.

Borea, Evelina, *Rosso*, Milan, 1965.

Carroll, Eugene A., *The Drawings of Rosso*, New York, 2 vols., 1976.

Carroll, Eugene A., *Rosso* (cat), Washington, 1987.

articles—

Berti, Luciano, "Per gli inizi del Rosso," in *Bollettino d'Arte* (Rome), March–April 1983.

Franklin, David, "Rosso, Leonardo Buonafé, and the Francesca de Ripoi Altar-Piece," in *Burlington Magazine* (London), October 1987.

*

Rosso's Italian career may be understood as a series of erratic and often brilliant moves but seemingly always under continual suppression of opportunity to manifest his talent fully. And then comes the complete reversal of both fortune and career when he goes to France in 1530, to become at Fontainebleau painter to Francis I and the creator of a French national style. Of the delicious irony, surely the arrogant and intelligent personality he appears to be was aware in his ultimate triumph over his enemies and creative loss in his native land.

During those Italian years, his influence was widespread, not through his painted art, but rather through his drawings, translated by craftsmen into engravings and etchings, both in Rome and later in France. The artist seems to have aroused enmity continually—both in his native Florence and later in Rome—the reasons not clearly recorded, and large-scale commissions occurred but rarely. It appears that this is why *The Deposition of Christ*, 1521 (Volterra)—ironically the work by which he is today best known and in fact represents, through its use in various art history text books, *the* Mannerist mode—was painted for a small provincial church where it was lost to history for centuries; Rosso was unable to find work in Florence. The compositional and psychological violence, its reigning ambivalence, are seemingly dependent on Michelangelo in the Sistine Chapel and the Julius tomb figures, both the *Moses* and the *Dying Slave*. Whatever exasperation with the Classical mode Rosso held, which also led to the spectacular *Moses and the Daughters of Jethro*, 1524 (Florence), his last Florentine work, he was able to hold in check when he produced the slightly earlier *Marriage of the Virgin*, 1523 (Florence, S. Lorenzo), clearly quieter and less drained of an affective psychology.

But standing behind all these works, as demonstration of Rosso's skill and deep torment if not rage, is the great bizarre Italian work of this time, *Allegory of Death and Fame*, 1517. This drawing (Florence, Uffizi) was used to Agostino Veneziano in Rome to produce a large engraving showing the two principles debating over a skeleton and surrounded by chorus-like array of ghastly figures. Rosso himself is not recorded in Rome until 1524, and his contact with the printmaking industry there is continued in various series of engravings, *The Labors and Adventures of Hercules* and *The Gods in Niches*, for which a few supporting drawings are still extant. Rosso seems to have painted little; *The Dead Christ Supported by Angels*, c. 1525–26 (Boston) survives to serve as insight into Rosso's fascination with the grace of Raphael and his sense of Michelangelo—together, it appears that Rosso responded with his most erotic work, through the fleshly translation of the omnispresence of scupture and Raphael's elegance. It is also felt that such a work, since it was made for higher clergy, may well reflect the prevailing cynicism in the Vatican at that moment. After the sack of Rome, during which Rosso suffered greatly, he went north and left a dark *Pietà*, 1527–28, in Borgo S. Sepolcro, once again reminscent of the disorder and ambivalence of *The Deposition*, and perhaps demonstrating the sources of that mode within Rosso's personal psychology. Here the sculptural force of Rome survives in the fantastic carapace-like torso of Christ, mixed together with his fascination with Raphaelesque decor; but here the seeming disappearance of Christ's head from its torso attachment—through shadow and tilt—the press of the hysterical crowd with its insectile finger play, and the extraordinary leering head at the back, with clenched tongue, all reflect Rosso's sense that art must be personal expression, as idiosyncratic as possible within the commission in order to convey the moment as covert message.

One quite hypnotic drawing, and an engraving after it, survives from this transitional moment in Rosso's career. The *Mars and Venus*, 1530 (Paris), clearly points to Rosso's stay in Venice with Pietro Aretino—a brief view of Rosso's library survives to give a feeling of his intellectual intentions—where he went to receive the call to France at the request of King Francis I. This work, with its long-bodied and small-headed attendants to Venus, all with their mask-derived features, looks forward to the aloof and erotic Fontainebleau style.

As principal artist to the King, Rosso had tasks other than the designs for which he is best known, *The Gallery of Francis I* in the newly built palace. And some of these other commissions, for instance, church sculpture and costumes for masques, convey him at his best. They are recorded in engravings—most of his drawings are lost—the St. Paul and St. Peter, with the head of Paul recalling the Joseph of Arimathea in *The Deposition;* and the enthralling *Three Fates*. As earlier in his career, these engravings carried the force of his inventions far abroad: that of *The Nymph of Fontainebleau*, a part of the decorative scheme of the Gallery, became in effect the emblem of the court and the most well-known work made in 16th-century France. Rosso's command of a mode of darker violence served him well in what must have been exquistie and

moving draftsmanship in the many drawings produced for the iconographic scheme of the Gallery—primarily complex mythologies revolving around the King, and the origins and power of the Monarchy.

—Joshua Kind

ROTHKO, Mark.

Born Marcus Rothkovich in Dvinsk, Russia, 25 September 1903; emigrated with his family to the United States; naturalized citizen, 1938. Died (suicide) in New York, 25 February 1970. Married 1) Edith Sacher, 1932 (divorced, 1945); 2) Mary Alice Beistle, 1945; two children. Attended schools in Portland, Oregon; Yale University, New Haven, 1921–23; studied under George Bridgemen and Max Weber, Art Students League, New York, 1924–26; worked in easel division, Federal Art Project, 1936–37; taught at California School of Fine Art, San Francisco, 1947, 1949, Brooklyn College, 1951–54, University of Colorado, Boulder, 1955, Tulane University, New Orleans, 1956, and University of Californa, Berkeley, 1967.

Collections: Amsterdam: Stedelijk; Berlin: Nationalgalerie; Chicago; Houston: Rothko Chapel; London: Tate; New York: Moma, Whitney; Paris: Beaubourg; Rio de Janeiro: Arte Moderna; Rotterdam; Zurich.

Publications

By ROTHKO: books—

Clyfford Still, New York, 1946.
Milton Avery, with Adelyn D. Breeskin, New York, 1969.

On ROTHKO: books—

Robertson, Bryan, *Rothko* (cat), London, 1961.
Selz, Peter, *Rothko* (cat), New York, 1961.
Baumann, Felix Andreas, editor, *Rothko* (cat), Rotterdam, 1971.
Waldman, Diane, *Rothko: A Retrospective* (cat), New York and London, 1978.
Seldes, Lee, *The Legacy of Rothko,* New York and London, 1978.
Nodelman, Sheldon, *Marden, Novros, Rothko: Painting in the Age of Actuality,* Seattle, 1979.
Towards a New Strategy for Development: A Rothko Chapel Colloquium, New York, 1979.
Ashton, Dore, *About Rothko,* New York, 1983.
Sandler, Irving, *Rothko: Paintings 1948–1969.* New York, 1983.
Clearwater, Bonnie, *Rothko: Works on Paper,* New York, 1984.
Rothko (cat), London, 1987.
Chave, Anna C., *Rothko: Subjects in Abstraction,* New Haven, 1989.

articles—

Harris, Jonathan, "Rothko and the Development of American Modernism 1938–1948," in *Oxford Art Journal,* 11, 1988.
Rivera, Javier Hernández, "Expresionismo cromatico en España: La lección de Rothko," in *Goya* (Madrid), January-February 1985.

*

Mark Rothko, a major exponent of Abstract Expressionism, is best known for his paintings of atmospheric colour fields on a large scale. He is usually seen, with Barnett Newman and Clyfford Still, in opposition to the linear gesturalism of Jackson Pollock. At the beginning of his career in the 1920's Rothko worked in the then dominant realistic style influenced by his teacher Max Weber. In the late 1920's his style changed to a more expressionistic mode, influenced by Milton Avery as well as Matisse. In the 1930's isolated distorted figures painted in sombre colours appear in New York cityscapes (*Street Scene,* before 1936) and in interior spaces (*Interior,* 1932, and *Subway Scene,* 1938). An exploration of the relation of the human figure to pictorial and architectural space is of central interest to Rothko, recurring in his mature work.

Under the influence of Surrealism and Friedrich Nietzsche's *Birth of Tragedy,* Rothko started to explore the theme of Greco-Roman myths in 1938, not, as he put it, "the particular anecdote but rather the spirit of myth." Most of these mythological paintings, dating from the late 1930's and early 1940's show a stratified composition similar to Roman sarcophagae, with rows of heads, limbs, or ornaments (*The Omen of the Eagle,* 1942). As with other Abstract Expressionists, primitivism was of central importance to Rothko's development. He was particularly influenced by James Frazer's *The Golden Bough* and the psychoanalytic theories of Jung. Rothko believed in the fundamental affinity of primitive and modern emotions and the timeless universality of archaic art which represented for him "eternal symbols upon which we must fall back to express basic psychological ideas."

In the early and mid-1940's diffused biomorphic figures or groups painted in a loosely calligraphic style, influenced by the automatism of the Surrealists and Rothko's study of natural sciences, dominate his works (*Slow Swirl at the Edge of the Sea,* 1944). The stratified structure of his background, reminiscent of geological strata or submarine worlds, have been associated with layers of subconsciousness.

In 1946 to 1947 the forms in his painting become increasingly simplified and abstract and loose their figurative associations. The softer and more colourful shapes merge with the background and build a diffuse pattern of irregular abstract shapes. In the development of Rothko's non-objective style Clyfford Still had a great influence; both felt symbols and references to the visible world limiting to the communication of the "tragic and timeless" content. Around 1948 the shapes again become roughly parallel to the rectangular structure of the frame (*Number 18,* 1948–49).

In 1949 Rothko achieved his mature style, which he maintained, with only a few exceptions, until the end of his life: large standing rectangular canvases filled almost to the edges with parallel rectangles of colour. The spatial ambiguity of the figure-ground relationship was achieved through the feathery

edges of the rectangles and the translucent surfaces of airy colours. Rothko applied subtle nuances of colour change, often complementary, with a visible and expressive brushstroke, resulting in atmospheric textures (*Light, Earth and Blue*, 1954). In the course of the 1950's Rothko was refining his basic composition, reducing the rectangles to merely two or three in order to achieve greater clarity, to move towards "the elimination of all obstacles between the painter and the ideas, and between the idea and the observer."

As with all Abstract Expressionists, Rothko was not interested in formal relationships but in subject matter—in the communication of a "religious experience." Like Barnett Newman, Rothko preferred his paintings to be viewed from a close distance. The visual field, dominated by large areas of colour together with the blurred image of peripheral vision, creates the possibility for a regression of the mind into a more elemental state opening the way to an "adventure into an unknown world."

Rothko's interest in the communication of an experience through his pictures within an environment led to the creation of a series of related works for specific architectual settings. The murals Rothko painted for the restaurant of the *Seagram Building* in New York were determined in their format and internal organization by the architecture (1958–60, now mostly in the Tate Gallery, London). He changed the standard orientation of his paintings to a horizontal format and abandoned layered rectangles in favor of a central "window- and door-like" theme. His ultimate refusal to deliver the paintings showed Rothko's "deep sense of responsibility for the life of . . . [his] pictures." He thought them suitable for a space that would be a "quiet place for reflection" but not a restaurant. Rothko's formal language developed in these works and those of the 1960's from a painterly style with feathery edges to a more hard-edged style, the colours from bright red and orange to dark maroon and black hues. This is especially true for the 14 panels he painted for the chapel of the Institute of Religion (known today as the Rothko Chapel) in Houston, Texas, the last of Rothko's environmental commissions.

Rothko's last major statements were his *Black on Grey* paintings on paper from 1968 and 1969. The dense fields of colour painted in rough brushstrokes, with a grey field at the bottom (avoiding conventional associations of landscape), are surrounded by thin, carefully proportioned white margins, which indicate Rothko's continuing concern with the emotional impact of his works on the spectator. Rothko's supreme interest was always to communicate, through his art, "basic human emotions—tragedy, ecstacy, doom."

—Christoph Grunenberg

ROUAULT, Georges.

Born in Paris, 27 May 1871. Died in Paris, 13 February 1958. Married Martha Le Sidaner, 1908; three daughters and one son. Studied painting with his grandfather Alexandre Champdavoine, 1881; evening classes at the Ecole des Arts Décoratifs, Paris, 1885; apprenticed to the stained-glass makers Tamani, and later Hirsch, 1885–90; studied under Elie De-launay at the Ecole des Beaux-Arts, Paris, 1891–92, and under Gustave Moreau, 1892–95; curator, Gustave Moreau Museum, Paris, 1898; lived in Versailles, 1911–16, and did engraving experiments, 1914; settled in Paris, 1917; Ambroise Vollard purchased all his artwork, and became his agent (leading to lawsuit after Vollard's death in 1939); stage designs for Diaghilev's ballet *The Prodigal Son*, 1929; tapestry cartoons for Madame Cuttoli, 1932.

Collections: Amsterdam: Stedelijk; Basel; London: Tate, Victoria and Albert; New York: Moma; Paris: Art Moderne, Bibliothèque Nationale; Pittsburgh; Zurich.

Publications

By ROUAULT: books—

Souvenirs intimes, Paris, 1926.
Paysages legendaires, Paris, 1929.
Petite banlieue, Paris, 1929.
Le Cirque de l'étoile filantes, Paris, 1938.
Divertissement, Paris, 1943.
Soliloques, Neuchatel, 1944.
Stella Vespertina, Paris, 1947.
Miserere, Paris, 1948.
Correspondance, with André Suarès, Paris, 1960; as *Correspondence 1911–1939*, edited by Alice B. Low-Beer, Ilfracombe, 1983.
Sur l'art et sur la vie, Paris, 1971.

Illustrator: *Les Fleurs de mal*, by Baudelaire, 1926; *Les Carnets de Gilbert*, by Marcel Arland, 1931; *Réincarnations du Père Ubu*, by Ambroise Vollard, 1932; *Passion*, by André Saurès, 1939.

On ROUAULT: books—

Charensol, Georges, *Rouault: L'Homme et l'oeuvre*, Paris, 1926.
Venturi, Lionello, *Rouault*, New York, 1940, Paris, 1948.
Soby, James Thrall, *Rouault: Paintings and Prints* (cat), New York, 1945, 3rd ed., 1947.
Jewell, Edward Alden, *Rouault*, New York, 1945.
Brion, Marcel, *Rouault*, Paris, 1950.
Lassaigne, Jacques, *Rouault*, Geneva and New York, 1951.
Rouault: Retrospective Exhibition (cat), New York, 1953.
Dorival, Bernard, *Cinq études sur Rouault*, Paris, 1957.
Venturi, Lionello, *Rouault*, Lausanne and Cleveland, 1959.
Roulet, Claude, *Rouault: Souvenirs*, Neuchatel, 1961.
Courthion, Pierre, *Rouault*, Paris, 1961, New York, 1962.
Dorival, Barnard, *Rouault*, Paris, 1963.
Dorival, Bernard, *Rouault: Oeuvres inachevées données à l'Etat* (cat), Paris, 1964.
Getlein, Frank and Dorothy, *Rouault's Miserere*, Milwaukee, 1964.
Marchiori, Giuesppe, *Rouault*, Milan, 1965.
Kind, Joshua B., *Rouault*, New York, 1969.
Dyrness, William A., *Rouault: A Vision of Suffering and Salvation*, Grand Rapids, Michigan, 1971.

the Sphinx, 1864 (New York, Metropolitan), it was not this side of his mentor that obsessed the young disciple. Deeply moved by music all his life, Moreau developed an "unfinished" and abstracted manner in both watercolors and oils. Most survive in Moreau Museum (Paris) and in these truly Symbolist works—suggestive and allusive, e.g., *Temptation of St. Anthony*, c. 1890—lay the poetic idiom that Rouault would develop, most often with high poignance, as the "last" Catholic artist. But such affinities in Rouault's art would be felt only later, about the time of World War I. In the first decade of the century, the social commitment of his Catholicism operated in that urban arena which included the clown, the cabaret, and the prostitute, the vaudeville show, the law court, and characteristic human types and professions. And these are all, no matter how absolutely linked to and forged in the dark volatility of Rouault's temperament, obviously related to his French predecessors similarly portraying their social world—from Daumier through Degas and Toulouse-Lautrec, and even the popular illustrators such as Steinlein. With his use of Christian subjects, Rouault separates himself from both Fauves and realists alike, but his frequent use of a transparent watercolor medium, with a network of nervous linearity, as in *Dancing the Chahut*, 1905 (Paris, Art Moderne) or the famous *Head of Christ*, 1905 (Chrysler Collection), show his admiration for Moreau. But this feeling appears overlaid by the artist's absorption in a *Human Comedy*-like parade of character types, seen usually in either profile or three-quarter view, and with an almost caricatural, even loathing, intensity (*The Academician*, 1913–15, Chicago).

About the time of World War I, Rouault met the art dealer and publisher Vollard, through whose urgings he began his extended involvement with graphic art, most especially intaglio, which would ultimately result in the 50 plates of the *Miserere*. Perhaps it was Rouault's work with these monochromatic drawings, or perhaps his need to assert more forceful boundaries for the color areas of his paintings, which moved him to begin edging his contours with strong black bars (e.g., *Three Clowns*, c. 1917, Pulitzer Collection). One of his most well-known works, *The Old King*, 1937 (Pittsburgh), is in this mode, though it is also an example of the bust-length, profile character type of two decades before; since Rouault often kept his works for many years in an unfinished state, *The Old King* was probably begun much earlier. (In late 1948 Rouault burned 315 of his "unfinished" paintings returned to him by court order from the estate of the deceased Vollard.) The clown type is the only earlier emblem to occur with any frequency in the last three decades of his life; "Biblical" landscapes and other Christ images recurred often.

The main irony of Rouault's career is that his late manner, usually cited as affirming an Expressionist modernism, is in reality a triumph of piety and Romanticism.

—Joshua Kind

Self-Portrait, 1925; lithograph

George, Waldemar, and Geneviève Nouaille-Rouault, *Rouault: Aquarelles*, Paris, 1971.

George, Waldemar, *L'Univers de Rouault*, Paris, 1971; as *Rouault*, London, 1971.

Bellini, Paolo, *Rouault, uomo e artista*, Milan, 1972.

Fortunescu, Irina, *Rouault*, Bucharest, 1974, London, 1975.

Wofsy, Alan, *Rouault: The Graphic Work*, London and San Francisco, 1976.

Courthion, Pierre, *Rouault*, Paris, 1977; London, 1978.

Chapon, Francois, and Isabelle Rouault, *Rouault: Oeuvre gravé*, Monaco, 2 vols., 1978.

Rouault (cat), Cologne, 1983.

*

Oft cited as seminal in Rouault's development were his apprenticeship years, from about age 14, and subsequent restoration work with stained-glass artisans. The humble handicraft experience and understanding of intense areas of unmodulated color edged by a firm contour were heightened by his friendship with the modernist Fauve circle in the years 1903–12. But is was probably the extraordinary circumstance of Rouault's curatorship of his former teacher Gustave Moreau's studio and museum that formed the pervasive continuity of his art. Rouault had met Moreau at the Ecole des Beaux-Arts where traditional figuration was taught, with traditional literary narrative as the goal. Although Moreau is still known for his meticulously painted Romantic fantasies such as *Oedipus and*

ROUBILIAC, Louis François.
Born in Lyons, 31 August 1702. Died 11 January 1762. Married 1) Catherine Helot, 1735; 2) Catherine Smart, 1741, two daughters; 3) Elizabeth Crosby, 1752. Possible a pupil of Bal-

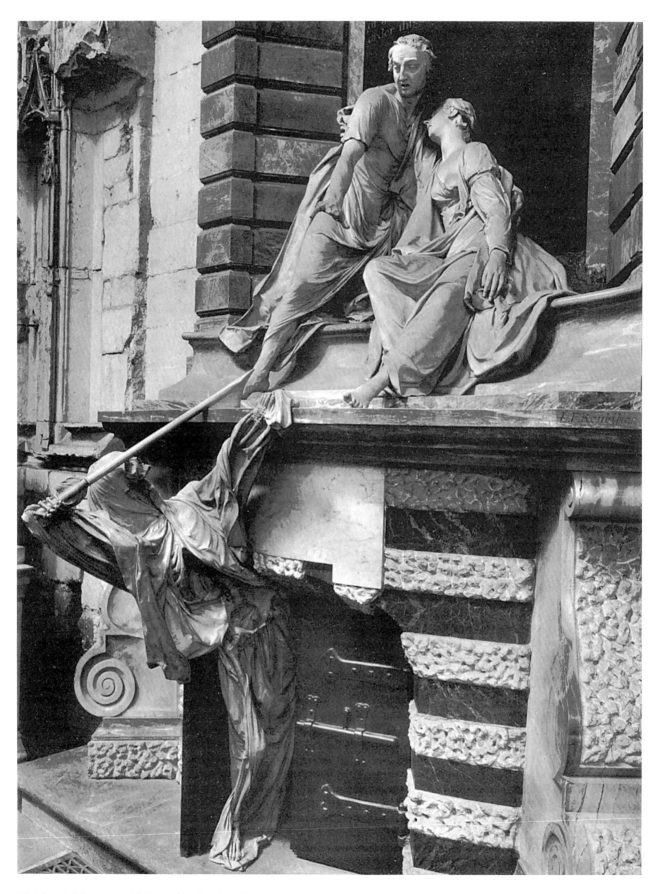

Nightingale Monument, 1761; marble; London, Westminster Abbey

thasar Permoser in Dresden, and of Nicholas Coustou in Paris; in England from c. 1730: patronized by Edward Walpole: his statue of Handel was used in the decoration of the new Vauxhall gardens, 1738, and he became very popular; taught at St. Martin's Lane Academy from 1745; visited Italy, 1752; seven Westminster Abbey tombs (including General Hargrave, Duke of Argyll and Greenwich, and Lady Elizabeth Nightingale), and a series of busts for Trinity College, Cambridge.

Major Collections: Cambridge: Trinity College; London: Westminster Abbey.
Other Collections: Birmingham; Cambridge; Leeds; London: Victoria and Albert, St. Mary's Battersea, Portrait Gallery, Royal Academy, Maritime Museum; New Haven; Wilton; Worcester: Cathedral; Royal Collection.

Publications

On ROUBILIAC: books—

LeRoy de Sainte-Croix, F. N., *Vie et ouvrage de Roubiliac, sculpteur lyonnais*, Paris, 1882.
Esdaile, Katharine A., *Roubiliac's Work at Trinity College Cambridge*, Cambridge, 1924.
Esdaile, Katharine A., *The Life and Works of Roubiliac*, London, 1928.

articles—

Hodgkinson, T. W. I., "Handel at Vauxhall," in *Victoria and Albert Museum Bulletin* (London), 1, 1965.
Kerslake, J "Roubiliac's Handel: A Terracotta Restored," in *Burlington Magazine* (London), 108, 1966.
Bindman, David, "Roubiliac in Westminster Abbey," in *Oxford Art Journal*, 6, 1981.
Murdoch, Tessa, "Roubiliac as an Architect? The Bill for the Warkton Muniment," in *Burlington Magazine* (London), 122, 1980.
Baker, Malcolm, "Roubiliac and His European Background," in *Apollo* (London), August 1984.
Murdoch, Tessa, "Roubiliac's Monuments to Bishop Hough and the Second Duke and Duchess of Montagu," in *Church Monuments*, 1, 1985.
Baker, Malcolm, "Roubiliac's Models and Eighteenth-Century English Sculptors' Working Practices," in *Entwurf und Ausführung in der europäischen Barockplastik*, edited by P. Volk, Munich, 1986.
Bindman, David, "Roubiliac: Some Problems," in *The Rococo in England*, edited by C. Hind, London, 1986.

*

Roubiliac was baptized at the Catholic church of St. Niziers, in Lyons, but his early training as a sculptor is uncertain. He is said to have been apprenticed to Balthasar Permoser in Dresden. He is recorded in Paris in August 1730, when, as a pupil of the Royal Academy, he won second prize. Roubiliac is said to have worked in the Paris studio of the lyonnais Nicholas Coustou, but in 1730 his name is included in the list of mem-

bers of the White Bear Masonic Lodge, in King Street, Golden Square, London.

Roubiliac may have left Paris because of his conversion to Protestantism (Hugenots were still persecuted and precluded from office), and it is likely that he came to London in search of work. He is said to have worked for Thomas Carter and for Henry Cheere before setting up on his own. In 1735 he married Catherine Helot, a Huguenot, at St. Martin's in the Fields.

Roubiliac "met with small encouragement at first," but obtained from Jonathan Tyers, the new proprietor of Vauxhall Gardens, a commission for a marble statue of the composer *George Frederick Handel* (London, Victoria and Albert) which was set up in April 1738. The statue attracted considerable publicity in both English and French newspapers and established Roubiliac's reputation.

By 1740 Roubiliac's studio was in St. Peter's Court, off St. Martin's Lane. In 1741, George Vertue noted Roubiliac's "models in Clay . . . from the Life several Busts or portraits extreamly like . . . Mr. Pope . . . more like than any other Sculptor . . . Mr. Hogarth very like." Roubiliac evolved a new pattern for each bust. *Alexander Pope* is portrayed in loose classical drapery with closely cropped hair, *William Hogarth* (London, Portrait Gallery) is shown "en negligé," in the French tradition for busts of artists and writers. Through his friendship with Hogarth, from 1745 Roubiliac taught sculpture at the St. Martin's Lane Academy.

Roubiliac married Catherine Smart of Lambeth in Dorking in 1741, and two daughters by this marriage were baptized at St. Martin's in the Fields in 1743 and at the Huguenot chapel at Spring Gardens in 1744. Nicholas Sprimont, a goldsmith from Liège, who later became manager of the Chelsea Porcelain Manufactory, stood godfather to the latter.

Roubiliac's two earliest surviving large-scale monuments which date from the later 1740's are to *Dr. John Hough, Bishop of Worcester* in Worcester Cathedral (1744–47) and to *John Campbell, 2nd Duke of Argyll and Greenwich* (1745–49) in Westminster Abbey.

In 1749, Roubiliac obtained through Martin Folkes the commission for a monument to *John, 2nd Duke of Montagu* in Warkton Church, Northamptonshire. This was extended in 1751 to include another monument to the *2nd Duchess of Montagu* and is arguably the most important commission of Roubiliac's career. Although work was interrupted by a brief visit to Rome in the company of Thomas Hudson, Arthur Pond, and Francis Hayman in autumn 1752, the design for the monument to the Duchess was inspired by contemporary English funeral cards. It incorporates the three Fates, spinning, weaving, and cutting the thread of life. The bill shows that Roubiliac was responsible for refurbishing the chancel to house the monuments which took 17 weeks to install in the summer and autumn of 1754. The commission was said to have cost about £3000.

The 1750's were an extraordinarily productive decade for Roubiliac, and his commissions included six further monuments in Westminster Abbey, a series of portrait busts for the library at Trinity College, Cambridge (1751–57), and marble statues of *Sir Thomas Molyneux* (1752; Armagh Cathedral), *Lord President Forbes* (1748–52; Parliament House, Edinburgh), *Sir Isaac Newton* (1754–55; Trinity College, Cambridge), *William Shakespeare* (1757–58; London, British Museum), and *Religion* (c.1761, Leicester). In 1751 Roubiliac

produced a lead figure of *Sir John Cass* which was set up in a niche on the facade of the Charity School in Aldgate.

The Monument to Joseph and Lady Elizabeth Nightingale (1758–61) in Westminster Abbey was commissioned by their only surviving daughter. Lady Elizabeth had died in childbirth in 1731, and the monument is a dramatic recreation of that tragedy. Joseph Nightingale holds his stricken wife while trying to fend off the dart aimed at her by death in the form of a skeleton emerging from a vault beneath. The Nightingale monument has a pathos which is characteristic of his later works.

Roubiliac continued to sculpt portrait busts in a variety of idioms during his last decade. The classical yet dignified *Philip Stanhope, 4th Earl of Chesterfield* (1755; London, Portrait Gallery) contrasts with the distinguished *Field Marshal Ligonier* in contemporary dress which was produced as pair to that of *George II* (Windsor Castle).

The increased volume of work undertaken by Roubiliac during the 1750's required the support of a workshop of assistants and apprentices. His first recorded apprentice, Edward Keyt, was taken on in 1747, and was joined by Nicholas Read in 1750 and Nathaniel Smith in 1755. His assistants included Mr. Siste ("an ingenious man draws very well & modells in good manner and Taste"—Vertue). Roubiliac's workshop appears to have been reorganized on his marriage to Elizabeth Crosby, a Deptford heiress with ten thousand pounds in January 1752. In that year the sculptor opened an account with Drummond's Bank and his ledgers record regular payments to his assistants, including the additional names John Atkins and John Lambert. After Roubiliac's death, Nicholas Read took over the sculptor's studio, and John Atkins and Nathaniel Smith joined Joseph Wilton's workshop.

"Roubiliac only was a statuary, the rest stone-cutters," Philip Stanhope, 4th Earl of Chesterfield remarked. Roubiliac's contemporary and posthumous reputation was nurtured by his compatriot Dr. Mattew Maty who praised the statue of Handel in the *Mercure de France* in 1744, and acquired 17 plaster casts and terracotta busts at the sale of the sculptor's effects, which, as under-Librarian, he presented to the British Museum. In 1771 John Wesley considered that, of the tombs in Westminster Abbey, "the two with which I still think none of the others to be compared are that of Mrs. Nightingale, and that of the Admiral [General Hargrave] rising out of his tomb at the resurrection." In 1985 Roubiliac's marble of *Philip Stanhope, 4th Earl of Chesterfield* (London, Portrait Gallery) achieved the auction record for an English portrait bust.

—Tessa Murdoch

ROUSSEAU, HENRI (Julien Félix).

Born in Laval, 21 May 1844. Died in Paris, 2 September 1910. Married 1) Clémence Boitard, 1869 (died, 1886), seven children; 2) Joséphine Noury, 1899 (died, 1903). Worked in attorney's office (served short prison sentence for theft, 1863); in army, 1864–68; lived in Paris from 1869, and worked in the Paris Customs service (hence his nickname "Douanier"), 1871–93; exhibited with the Independents, 1886, and kept a school; suspended prison sentence for financial fraud, 1907.

Collections: Basel; Buffalo; Chicago; Cleveland; Frankfurt; Hamburg; Leningrad; London: National Gallery, Tate, Courtauld; Merion, Pennsylvania; Moscow; New York: Metropolitan, Moma, Guggenheim; Northampton, Massachusetts; Paris: Louvre, d'Orsay; Philadelphia; Pittsburgh; Prague; Washington: National Gallery, Phillips; Winterthur; Zurich.

Publications

By ROUSSEAU: books—

La Vengeance d'une orpheline russe (play), Geneva, 1947.
Une Visite à l'Exposition de 1889: Vaudeville, Geneva, 1947.
Dichtung und Zeugnis, edited by Peter Schifferli, Zurich, 1958.

On ROUSSEAU: books—

Basler, Adolphe, *Rousseau*, Paris, 1927.
Salmon, André, *Rousseau*, Paris, 1927.
Soupault, Philippe, *Rousseau*, Paris, 1927.
Zervos, Christian, *Rousseau*, Paris, 1927.
Rich, Daniel Catton, *Rousseau* (cat), New York, 1942, 1946.
Uhde, Wilhelm, *Rousseau*, Lausanne, 1948.
Gauthier, Maximilien, *Rousseau*, Paris, 1949.
Soupault, Philippe, *Rousseau*, Paris, 1949.
Cooper, Douglas, *Rousseau*, Paris, 1951.
Garçon, Maurice, *Rousseau, accusé naïf*, Paris, 1953.
Wilenski, R. H., *Rousseau*, Paris, 1953.
Courthion, Pierre, *Rousseau*, Paris, 1956.
Gauthier, Maximilian, *Rousseau*, Paris, 1956.
Werner, Alfred, *Rousseau*, Amsterdam, 1956.
Perruchot, Henri, *Rousseau*, Paris, 1957.
Bouret, Jean, *Rousseau*, Neuchatel and Greenwich, Connecticut, 1961.
Certigny, Henry, *La Verité sur Rousseau*, Paris, 1961, supplements, Paris, 1966, Lausanne, 1971.
Salmon, André, *Rousseau*, Paris, 1962.
Leonard, Sandra E., *Rousseau and Max Weber*, London, 1970.
Raboff, Ernest, *Rousseau: L'Art pour les enfants*, Geneva, 1971.
Bihalji-Merin, Lise and Oto, *Rousseau*, Dresden, 1971.
Descargues, Pierre, *Rousseau*, Geneva, 1972.
Larkin, David, *Rousseau*, Parish, 1975.
Keay, Carolyn, *Rousseau*, London and New York, 1976.
Alley, Ronald, *Portrait of a Primitive: The Art of Rousseau*, Oxford and New York, 1978.
Vallier, Dora, *Rousseau*, Naefels and New York, 1979.
Margonari, Renzo, *Rousseau: The Paintings*, Woodbury, New York, 1979.
Elgar, Frank, *Rousseau*, Paris, 1980, London, 1981.
Le Pichon, Yann, *Le Monde de Rousseau*, Paris, 1981; as *The World of Rousseau*, New York, 1982.
Shattuck, Roger, et al., *Rousseau* (cat), Paris, 1984, New York, 1985.
Hugonot, M. C., *Rousseau*, Paris, 1984.

*

"Le Douanier," as Rousseau was known to his friends, was

employed as a Paris toll collector until he gave up his job in the late 1870's to become an artist. Rousseau had no formal training in the art of painting, although he was advised by the celebrated painter Gérôme, and mixed with the avant-garde in Paris. An entire mythology has been constructed around his life and works, the embers of half-truths fanned principally by the poet Guillame Apollinaire who took especial delight in Rousseau's "primitive" style and simple character. His work appealed to those radical artists interested in naive art and the deconstruction of the representational image, though the paradox of Rousseau's work is the innocent but futile striving toward his ideal of academic realism which he felt, if attained, would enable him to exhibit in the official Salon exhibitions.

Rousseau's art resists chronological evolution; his style was already established as early as 1886 with *Carnival Night*, a composition that contains elements characteristic of the artist's entire oeuvre. A sense of mystery, even foreboding, pervades the works, enhanced by queer light and incongruous subject matter as well as certain technical idiosyncrasies. Rousseau's light has no particular source; it emanates from every corner of the canvas and casts no shadows, findings its natural equivalent in the hard light of high noon, or cool, milky moonlight. Occasionally, as evident in certain of the jungle paintings, the effect is akin to that of stage lighting, encroaching forms illuminated from behind. The intense sensation of apprehension and drama created by these tricks of light was later exploited by Giorgio de Chirico and the Surrealists for their own pictorial nightmares. Rousseau's light penetrates squat, solid forms sitting parallel to the picture plane. Depth is implied only in terms of thinly applied rich, pure colour, for Rousseau never mastered the tricks of perspective. The result, therefore, is a surface or mosaic effect, to which Rousseau's forms further contribute. Painstakingly executed foliage and well-defined beasts seem to strain against the cage of the picture plane creating even more profound a sense of claustrophobic tension.

Consistency of style is balanced by variety of subject matter. Rousseau produced a number of striking portraits and self-portraits, particularly at the start of his artistic career (e.g., *Monsieur and Madame Stevene*, 1884). In these and the later "portrait-landscapes" Rousseau applied his own personal vocabulary of forms, measuring first each of his sitters' features and transferring them proportionally correctly to canvas, but then sacrificing the formers' physiognomical quirks for a ubiquitous straight mouth, defined round eyes, and continuous line forming nose and brow. Indeed, it would seem that the owner of the prototype face was none other than Rousseau himself! The notion of a portrait in a landscape developed out of a self-portrait (*Myself: Portrait-Landscape*,1890) defies the norms of traditional portraiture in which all emphasis is placed, naturally enough, on the face. Rousseau's landscapes complement his figures: the artist hovers in his world of artist's tools, flags, and Paris sights and suburbs; Apollinaire and Marie Laurencin and the artist's wife, too, are transported to exotic leafy bowers. From 1893 onwards Rousseau produced several paintings of children in simplified landscapes that echo their ostensibly childlike minds. However, these children have defiant, ugly features and resemble old men rather than babes. This series perhaps expresses most sharply the childish but knowing aspect of Rousseau's sensibility.

Rousseau produced a vast quantity of landscapes and still lifes, consisting of views of rural Paris suburbs and well-lit vases of bright flowers on plain ground. His landscapes generally contain a human element: small Rousseau lookalikes wander in parks inhabited by vast trees in a style akin to fellow "naive" painter Grandma Moses, and bucolic havens feature church steeples or the occasional incongruous street lamp. However, most significant of Rousseau's oeuvre are the jungle paintings, produced late in his career and in greater quantities, mainly because they sold best of all. Jungle subjects are always frozen at a tense moment of time: a rather woolly beast prepares to attack its prey in *Sleeping Gypsy*,1897, and a pipe-player attempts to subdue nature in *The Snake Charmer*,1907. Popular mythology stated that Rousseau had spent time in Mexico with the French troops supporting Maximilian and that his paintings indicate first-hand experience of South American flora and fauna. However, Rousseau's army records reveal that he had never left France; moreover it was far likelier that the sources of jungle iconography consisted of photographs and paintings of exotic climes (Gérôme, Delacroix), as well as African and Asian art, particularly Japanese prints. Moreover, long days in the zoological garden and the careful study of stuffed animals and toys aside, it was Rousseau's own fertile imagination which, despite attempts to paint objectively, always got the better of him. Apollinaire remarked that while at work Rousseau would throw open his windows when the intensity of his fantasies grew too great.

In 1908 Picasso organised a banquet at his studio in the "bateau lavoir" in celebration of Rousseau's splendid achievements. This was the greatest in a long line of gatherings of which Picasso, Rousseau, and others had all been hosts. A cruel joke at the expense of the ingenuous painter or a genuine homage to the man and his art, the "banquet Rousseau" was nevertheless a tremendous success, although Rousseau, drunk and seated in the throne of honour, uncomplainingly endured being dripped on by candle wax for the entire evening.

—Caroline Caygill

ROUSSEAU, (Pierre Etienne) Théodore.
Born in Paris, 15 April 1812. Died in Barbizon, 22 December 1867. Lived with Elisa Gros from c. 1848. Studied under Charles Rémond from age 14, and under Guillon Lethière; exhibited from 1831, but mainly refused by the Salon from 1836 to 1848 (termed "le grand refusé"); settled in Barbizon, 1847, and became the center of a group of sympathetic painters; friend of Millet, who lived in Barbizon from 1849.

Major Collection: Paris.
Other Collections: Baltimore: Walters; Boston; Boulogne; Brussels; Cincinnati; Copenhagen; Glasgow; The Hague; London: National Gallery, Wallace, Victoria and Albert; Lyons; New York: Frick; Ottawa; Rotterdam; Toledo, Ohio; Valenciennes.

Publications

On ROUSSEAU: books—

Delteil, Loys, *Le Peintre-gravure, vol. 1: Millet et Rousseau,*
Paris, 1906.

Dorbec, Prosper, *Rousseau,* Paris, 1910.

Hoeber, Arthur, *The Barbizon Painters,* New York, 1915.

Huyghe, René, *Millet et Rousseau,* Geneva, 1942.

Rousseau (cat), London, 1961.

Herbert, Robert L., *Barbizon Revisited* (cat), Boston, 1962.

Forges, Marie-Thérèse, *Barbizon,* Paris, 1962, 1971.

Forges, Marie-Thérèse, and H. Toussaint, *Rousseau* (cat),
Paris, 1967.

Durbè, Dario, and Anna Maria Damigella, *La scuola di Bar-
bizon,* Milan, 1969.

Bouret, Jean, *L'Ecole de Barbizon,* Neuchatel, 1972; as *The
School of Barbizon,* London, 1972.

Terrasse, Antoine, *L'Univers de Rousseau,* Paris, 1976; as
Rousseau's Universe, Woodbury, New York, 1983.

*

Théodore Rousseau studied with his cousin Alexandre Pau de
Saint-Martin from an early age, and by 14 was studying with
the painter Charles Rémond, as well as copying Claude Lor-
rain and the Dutch painters. He also studied briefly with Guil-
lon Lethière.

He exhibited at the Salon from 1831 to 1836, and his early
success at the Salon of 1833 with *View Taken along the Nor-
man Coast at Granville* (now in the Hermitage) made him
well-known. In fact, because of his precocious success, he
dominated French landscape painting in the early 1830's.
Early critics noted the influence of Ruisdael and Hobbema on
his work, and another obvious influence was that of Con-
stable, whose *Haywain* had been exhibited in Paris in 1824:
in fact, the *View Taken along the Norman Coast at Granville*
uses several motifs from the Constable work—pond and horse-
drawn wagon in foreground, houses partly hidden by trees in
the middle ground, then a rocky outcrop and a thin line of
the sea.

He travelled greatly during his early years, painting in the
Auvergne, Landes, and Berry. And some of the early land-
scapes, especially those done in the Auvergne, are rather ro-
mantic in their wild, unruly elements. These early works also
tend to have a relatively light palette. Over the years, his work
gradually became darker in tone, possibly due to a combina-
tion of factors—his personal nature, domestic misfortunes,
continued dejection at being rejected by the Salon from 1836
to 1849 (he was known as "le grand refusé," in fact). From
1837 he worked regularly in the forest of Fontainebleau, and
settled in the village of Barbizon in 1847. Over the next 30
years, the village became the center of what is known as the
Barbizon "school" because of the presence of so many land-
scape painters who lived or worked there, most notably Millet.

The Barbizon painters are a link between the earlier painters
of the finished studio picture and the artists who preferred to
sketch from life *en plein air*. Studies *were* displayed at the
Salon, but only as studies. The "noble landscape," as per-
fected in the 17th century by Poussin and Claude, was the
basis of the completed studio composition. The underlying im-
plication behind much of the interest in landscape painting was
that nature in itself was impermanent and uninteresting unless
it could be idealized, formalized, embellished (often with hu-
man figures or allusions to narrative), or made to carry a
moral overtone (as in *Vanitas* or moralized genre scenes).
Rousseau was among the first of the *plein air* painters to make
the assumption that nature should be recorded as it is. He was
serious about painting in the open air and had special easels
and lean-tos constructed.

Much of the interest in the Barbizon school has been that it
seemed to lead to or even influence the slightly later Impres-
sionists, who also painted *en plein air* and made an attempt to
capture or record the "present moment." But to some extent
Impressionism is an "urban" view of nature—and the beach,
the village, or the harbor is often the setting of the painting.
Rousseau paints things like ordinary rocks, rough bark, dense
undergrowth. There is nothing beautiful or enjoyable about his
nature. His interest seems scientific rather than artful: he is
interested in the geology or the botany of it rather than the
charming, limpid, poignant, or tranquil elements that might be
associated with it or drawn from it. There *is* often a timeless
quality about Rousseau's work, suggesting a simpler world
that has existed a long time, and that can exist without man-
kind, but without the melodramatic poignancy of a Claude or
a Poussin, and without the plangency or charm of the later
Impressionists.

Rousseau's clotted brushwork seems appropriate to the
messy clumps of undergrowth or dense patches of weeds he
often paints. There is almost always a great variety of texture
in his landscapes, and his quasi-scientific interest can often be
a bit disconcerting: the *Marais en Vendée* (Cincinnati) is with-
out charm, the *Plain of Chailly* (private collection) is diluted
and washed-out. Different regions of the country elicit slightly
different styles. The flat Berry and Landes districts call forth a
central copse or line of trees parallel to the picture plane to
emphasize distance (*Village in Berry,* Cincinnati); another pic-
ture of this region, *Under the Birches* (also called *The Curé,*
Toledo, Ohio), features a range of birches in a line across the
center of the work, but each birch is different from the other,
and the sunken lane with the curé on horseback in the middle
is almost lost from view: nothing is regular. Another work,
Marshy Landscape (private collection), has an even more
striking arrangement, with a series of horizontals (bands of
vegetation, the horizon, then a waving line of cloud), with
short spiky vegetable verticals, almost as if to show how it is
possible to use only light and space without any recourse to
figures or narrative content to give interest.

Rousseau's early fame dwindled after the Revolution of
1848, when Millet and Courbet brought social awareness to
their landscapes in a way that obviously didn't interest Rous-
seau. He *had* given up prettified or historical subjects, but it
was left to Millet, with *The Winnower* of 1848, to paint a
genuine "peasant-subject," and above all to Courbet, with
such works as *After Dinner at Ornans* and *The Stone-
Breakers,* to make a radical breakthrough. Rousseau continued
with his own method of painting, and the later influence of
Japanese prints in the 1860's was in some ways a reinforce-
ment of certain motifs of flattened composition seen in his
earlier work.

—George Walsh

ROWLANDSON, Thomas.

Born in London, 14 July 1756. Died in London, 22 April 1827. Married a Miss Stuart, 1800. Attended Dr. Barrow's School, London, and the Royal Academy schools, 1772–74; trip to Paris, 1775 (first of many continental trips); exhibited at the Royal Academy from 1775, and set up as portrait painter in London, 1777; humorous and satirical tastes predominated, and his graphic works for the publsher Ackermann from the mid-1790's brought fame: several *Dr. Syntax* volumes, *Microcosm of London*, 1808, and other volumes illustrated by him.

Collections: Boston: Public Library; London: Courtauld, British Museum, London Museum, Victoria and Albert, University College; New Haven; New York; Oxford; San Marino, California; Royal Collection.

Publications

On ROWLANDSON: books—

Grego, Joseph, *Rowlandson the Caricaturist*, London, 2 vols., 1880.

Gibbs, Arthur Hamilton, *Rowlandson's Oxford*, London, 1911.

Oppe, A. P., *Rowlandson: His Drawings and Watercolours*, edited by Geoffrey Holme, London, 1923.

Image, Selwyn, *Some Reflections on the Art of Rowlandson and George Morland*, London, 1929.

Sitwell, Osbert, *Rowlandson*, London, 1929.

Young, Art, *Rowlandson*, New York, 1938.

Summerson, John, *The Microcosm of London by Rowlandson and A. C. Pugin*, London, 1943, 1947, New York, 1947.

Hintzelman, Arthur W., *The Watercolor Drawings of Rowlandson from the Albert H. Wiggin Collection in the Boston Public Library*, New York, 1947.

Wolf, Edward C., *Rowlandson and His Illustrations of 18th Century English Life*, Copenhagen, 1945.

Roe, Frederic Gordon, *Rowlandson: The Life and Art of a British Genius*, Leigh on Sea and New York, 1947.

Falk, Bernard, *Rowlandson: His Life and Art*, London, 1949.

Bury, Adrian, *Rowlandson Drawings*, London, 1949.

Hayes, John, *A Catalogue of the Watercolour Drawings by Rowlandson in the London Museum*, London, 1960.

Wark, Robert R., *Rowlandson's Drawings for "A Tour in a Post Chaise,"* San Marino, California, 1963.

Wark, Robert R., *Rowlandson's Drawings for "The English Dance of Death,"* San Marino, California, 1966.

Schiff, Gert, *The Amorous Illustrations of Rowlandson*, New York, 1969.

Meier, Kurt von, *The Forbidden Erotica of Rowlandson*, Los Angeles, 1970.

Hayes, John, *Rowlandson: Watercolours and Drawings*, London and New York, 1972.

Paulson, Ronald, *Rowlandson: A New Interpretation*, New York and London, 1972.

Wark, Robert R., *Drawings by Rowlandson in the Huntington Collection*, San Marino, California, 1975.

Baskett, John, and Dudley Snelgrove, *The Drawings of Rowlandson in the Paul Mellon Collection*, London, 1977.

Riely, John, *Rowlandson Drawings from the Paul Mellon Collection* (cat), New Haven and London, 1977.

*

If one idly picks up a social history of Regency England the chances are very good that one or more works by Thomas Rowlandson will be used to illustrate the quality of life in late 18th and early 19th century Britain. Perhaps no other artist better captured the vagaries and tastes of British society than Rowlandson. He possessed an omnivorous appetite for subject matter. Aside from Gillray he was the only popular caricaturist of his day to receive formal training at the Royal Academy. His drawings have a grace and assurance not to be seen in the work of other contemporary comic artists. Parallels are often drawn between his skillful delineations of female beauty and fashion and those of the French school. It is known he spent some time in Paris; he returned to England with a delicacy of line and color only matched by late rococo masters such as Boucher and Fragonard. The artist's best works are reed pen drawings, using a sepia ink with delicate, often pastel, watercolor washes. If Rowlandson could be charming, he could also be crude and even pornographic. Rowlandson's comic art was much appreciated by his contemporaries. He could count among his clients the Prince Regent himself. His watercolors of the fashionable enjoying themselves at the racecourses, gaming tables, pleasure gardens, and hunting parties in the countryside, and his comic views of rustics and low life were popular, especially in the 1790's.

Though almost nothing is really known about Rowlandson's life, it has been suggested by all his biographers that he lived life to the fullest—that he enjoyed drinking, gambling, and the company of pretty women—that he was a spendthrift and a poor manager. Certainly, soon after 1800 a crises does apear to occur. Rowlandson found it to his advantage to produce working drawings for graphic prints or actual engravings for the highly successful publishers in London, especially the gifted entrepreneur Rudolf Ackermann. It was in Ackermann's periodical *The Poetical Magazine* that Rowlandson's comic creation Dr. Syntax made his first appearance in monthly installments. The light-hearted design drawn and etched by Rowlandson caught the public fancy. The prints were hand-colored by Ackermann's assistants and the story was so popular that the comic tale of the misadventures of the pedantic, picturesque sketching Syntax was bound into boards in 1812, and two subsequent adventures were illustrated by Rowlandson, as well as several imitations by other artists. Dr. Syntax is the earliest and most extended instance of illustrations preceding the text. Rowlandson's experience as a caricaturist of the foibles and faults of his contemporaries served him well for this venture. In addition to Dr. Syntax, Rowlandson illustrated most of the important English novelists of the 18th century and a good deal of popular literature of his day.

Perhaps most remarkable are his illustrations of the novels of Fielding, Smollett, and Sterne. Clearly the artist had read and appreciated the texts and used his art to amplify the comic character of the novels. If Rowlandson's early work is marked by a thin, elegant line, and a deep regard for female beauty and a picturesque sensibility towards the landscape (he created many pure landscapes and illustrated several books on the rendering of the picturesque), his late work is often coarse both in

A Print Sale, 1788; etching

terms of subject matter and style. His "potboilers," as he called them, were hastily executed broadsides for dealers wishing to cash in on the most recent scandal or social sensation. In desperate need of funds, Rowlandson worked very quickly. The resulting prints are often made even less appealing by the intervention of another hand doing the engraving.

Like so many of his contemporaries Rowlandson was intrigued with the sexual byplay in society. The erotic is an essential part of his art. It was handled with a good deal of lighthearted humor and delicacy in his early work, but many of his late productions are intentionally crude and shocking.

Rowlandson's comic art offers much more than the other comic artists of his time. He did not limit his art to the political arena as James Gillray tended to do or focus on the middle and lower classes like Isaac Cruikshank. He is never condescending or censorious as George Cruikshank often is. The appeal of Rowlandson is the ebullient line and warm fellow-feeling his art emits. He took people as he found them. Unlike Hogarth, whose work deeply influenced him, he was not interested in using his art to reform society. He clearly saw his role as that of an entertainer.

—Anthony Lacy Gully

RUBENS, (Sir) Peter Paul.

Born in Siegen, Westphalia, to Flemish parents, 28 June 1577. Died in Antwerp, 30 May 1640. Married 1) Isabella Brant, 1609 (died 1626), one daughter and two sons; 2) Helena Fourment, 1630, three daughters and two sons. Lived in Cologne as a child, 1578–87; returned to Antwerp with mother following father's death in 1587; attended Verdonck's school; served as page to the Countess de Ligne Arenberg, 1590–91; pupil in Tobias Verhaecht's studio, c. 1591–92; apprentice to Adam van Noort, 1592–96; in studio of Otto van Veen, 1596–98; became master in the Antwerp guild, 1598, but probably remained in Van Veen's studio until departure for Italy in 1600. Court painter to Vincenzo Gonzaga, Duke of Mantua, for whom he made diplomatic trip to Spain in 1603; also received important commissions in Genoa and Rome, 1605–08; returned to Antwerp at end of 1608 and in 1609 was appointed court painter to the regents, Archdukes Albert and Isabella; set up studio in Antwerp to undertake commissions from the archdukes, the church, civic groups, local and foreign patrons; frequent collaborators (mostly for animals/landscapes) included Jan Brueghel, Frans Snyders, Jan Wildens, Lucas van Uden, and Paul de Vos; with help of assistant Anthony van Dyck, executed 39 ceiling paintings for Antwerp's Jesuit church, 1620–21, for which he painted altarpieces and de-

signed sculpture; in 1620's he painted allegorical cycle for the queen mother of France, Maria de' Medici, and undertook diplomatic assignments for Archduchess Isabella, culminating in missions to Madrid (1628) and London (1629–30) to negotiate peace between England and Spain (for which he was knighted by Charles I in 1630 and by Philip IV in 1631); following remarriage and retirement from diplomacy in 1630's, purchased country residence Het Steen in 1635, which inspired magnificent landscapes; designed triumphal decorations for arrival of new governor, Cardinal-Infante Ferdinand, in 1635, and a vast series of mythologies for Philip IV in 1636; continued extraordinary output of paintings until his death. Most famous assistant/pupil: Van Dyck.

Major Collections: Antwerp (including churches); London; Madrid; Munich; Paris; Vaduz; Vienna.

Other Collections: Bayonne; Berlin; Boston; Brussels; Florence; Leningrad; London: Courtauld, Dulwich, Whitehall, Wallace; New York; Rotterdam; Stockholm; Washington.

Publications

On RUBENS: books—

Correspondance et documents epistolaires concernant sa vie et ses oeuvres, edited by Charles Ruelens and Max Rooses, Antwerp, 6 vols., 1887–1909; *Letters*, edited by Ruth Sanders Magurn, Cambridge, Massachusetts, 1955, 1971.

Burckhardt, Jacob C., *Erinnerungen aus Rubens*, Basel, 1898; as *Recollections of Rubens*, New York, 1950.

Evers, Hans G., *Rubens, und sein Werk: Neue Forschungen*, Brussels,1943.

Held, Julius S., *Rubens: Selected Drawings*, London, 2 vols., 1959, Oxford, 1 vol., 1986.

Burchard, Ludwig, and R. A. D'Hulst, *Rubens Drawings*, Brussels, 2 vols., 1963.

Wedgwood, C. V., *The World of Rubens*, New York, 1967.

Stechow, Wolfgang, *Rubens and the Classical Tradition*, Cambridge, Massachusetts, 1968.

Martin, John Rupert, *The Ceiling Paintings for the Jesuit Church in Antwerp*, Brussels, London, and New York,1968. (vol. 1 of 26-volume Corpus Rubenianum Ludwig Burchard).

Martin, John Rupert, editor, *Rubens: The Antwerp Altarpieces*, New York, 1969.

Baudouin, Frans, *Rubens* (French and English versions), Antwerp, 1977.

Downes, Kerry, *Rubens*, London, 1980.

Held, Julius S., *The Oil Sketches of Rubens: A Critical Catalogue*, Princeton,2 vols., 1980.

Held, Julius S., *Rubens and His Circle: Studies*, Princeton, 1982.

Vergara, Lisa, *Rubens and the Poetics of Landscape*, New Haven, 1982.

Scribner, Charles, III, *The Triumph of the Eucharist: Tapestries Designed by Rubens*, Ann Arbor, 1982.

White, Christopher, *Rubens, Man and Artist*, New Haven,1987.

Scribner, Charles, III, *Rubens*, New York, 1989.

Peter Paul Rubens is an artist's artist. His influence over the centuries is legendary: Van Dyck, Jordaens, Watteau, Boucher, Fragonard, Reynolds, Gainsborough, Delacroix, Renoir—all owed an essential debt to the Flemish master and paid him homage with their brushes. Even such unlikely heirs as Cézanne and Matisse studied Rubens and painted copies of his masterpieces. Yet the painter's Rubens represents but one side of this multifaceted genius. His contemporary and friend General Ambrogio Spinola said of him: "Of all his talents, painting is the least." Rubens was equally renowned throughout Europe as a diplomat. He was also a dedicated scholar and Christian humanist, a learned classicist and antiquarian, a prodigious correspondent (in several languages), an amateur architect—in short, a true Renaissance man. His nephew Philip described his life as "but one long course of study." The court chaplain in Brussels eulogized him as "the most learned painter in the world"—a ranking that still applies three centuries later.

Rubens was a shrewd businessman, an organizational genius who assembled and presided over the most famous painter's studio in Europe, where scores of pupils, assistants, and collaborators, many of them accomplished artists, assisted the master in translating his conceptions onto canvas or into sculpture, tapestries, and engravings. Rubens was an impresario of vast decorative programs and multimedia productions without peer in northern Europe; for his equivalent one must look south, a generation later, to Gian Lorenzo Bernini. Rubens was a devout Catholic, a loyal subject of the Spanish Hapsburgs, a devoted husband, the father of eight children, a prosperous, energetic, life-loving, thoroughly balanced man who lived in harmony with his society and, we may assume, with himself. No one could be further from the modern conception of the struggling artist who pays dearly—economically, spiritually, and socially—for exerting his genius. Like Shakespeare, Rubens drew deeply from a once-common wellspring of imagery and allusions—biblical, theological, and mythological. To experience the essential Rubens, to appreciate the profound interpretative powers underlying his shimmering surfaces requires a familiarity with his symbolic vocabulary of images. He was as much a great narrative and allegorical artist as he was a master of color and form. The 18th-century archaeologist Johann Winckelmann compared him to Homer in his "great fertility of imagination."

Born on 28 June 1577, in the German town of Siegen, to Flemish parents living in exile, Rubens began his formal artistic training in Antwerp in 1591 with his apprenticeship to Tobias Verhaecht, a landscape painter of modest talent. A year later he moved on to the studio of Adam van Noort, also the teacher and later the father-in-law of Jacob Jordaens. There he remained for approximately four years before being apprenticed to Antwerp's leading master of the day, Otto van Veen, who combined a sober and refined (if uninspiring) style influenced by Barrocci, Michelangelo, and Raphael with a strict adherence to the principles of Renaissance humanism. The author of several books on emblems, Van Veen imbued the young Rubens with a lively sense of painting as a lofty, humanistic endeavor.

In 1600 Rubens headed south to Italy. In Venice he absorbed the luminosity and dramatic expressiveness of Titian, Tintoretto, and Veronese. Rubens proceeded to Mantua, where his chief duties were to make copies of Renaissance paintings,

**Study for The Garden of Love; drawing; Frankfurt,
Städelsches Kunstinstitut**

especially portraits of court beauties for Duke Vincenzo I
Gonzaga. There were compensations: a gallery of master-
pieces by Titian, Mantegna, Correggio, Raphael, and his lead-
ing pupil Giulio Romano. By the end of his first year with the
duke, Rubens had traveled throughout Italy, sketchbook in
hand.

Rubens's arrival in Rome in 1601 coincided with the dawn
of the baroque style heralded by Caravaggio and the Carracci.
Their fusion of a new naturalism or verisimilitude in painting
with a classical revival of the heroic, High Renaissance con-
tours of Michelangelo and Raphael was quickly assimilated by
Rubens. A year before, the Carracci's monumental frescoed
ceiling in the Palazzo Farnese had been unveiled. Its combina-

tion of sensuality and erudition anticipates Rubens's distinctive
approach to classical mythology, as well as his impassioned—
often ecstatic—illusion of reality that characterizes the baroque
style. His studies of ancient sculpture appear as though
sketched from life, not marble. Like the mythical sculptor
Pygmalion, Rubens infused the statues with sensual immedi-
acy; he drew them from unusual vantage points, charging the
familiar images with dramatic intensity. In his posthumously
published treatise *De imitatione statuarum* (On the Imitation of
[Ancient] Statues), Rubens wrote that one must "above all
else, avoid the effect of stone." Throughout his myriad trans-
formations of antiquity—in drawings, paintings, and designs
for title pages—Rubens exemplified this underlying credo, his
belief in artistic metamorphosis.

In 1606 Rubens wrote that he had received "the finest and
most splendid opportunity in all Rome," the high altar of the
Chiesa Nuova, Sta. Maria in Vallicella. He was granted a six-
month extension in Rome to complete his monumental *sacra
conversazione*—a classically Roman vision for a triumphantly
Roman Church. In Genoa, where he painted portraits of the
ruling families, he established a new canon for aristocratic
portraiture that was to be followed by Van Dyck and his En-
glish successors Reynolds and Gainsborough. He avidly stud-
ied the city's architecture, which he eventually published as a
book of engravings entitled *Palazzi di Genova* (Antwerp,
1622).

Ruben's arrival back in Antwerp in the autumn of 1608
could not have been more timely. Negotiations for a Twelve-
Years' Truce were being concluded between the United Prov-
inces (the Dutch separatists) and Spain, which raised the
prospects of lasting peace and economic recovery for war-torn
Flanders. Rubens was commissioned to paint for the town
hall, where the truce was to be signed, a celebratory *Adoration
of the Magi* (Prado, Madrid), which quickly established his
reputation at home. Yet Rubens still yearned for Italy: To their
everlasting credit, the regents, Albert and Isabella, made Ru-
bens an offer he could not refuse. As their new court painter,
Rubens was exempted from all taxes, guild restrictions, and
court duties in Brussels. He could remain in Antwerp and
organize his own studio. On 3 October 1609, two weeks after
the appointment, Rubens married the nineteen-year-old Isa-
bella Brant, and celebrated their happy union in his famous
double portrait under a honeysuckle bower.

The Twelve-Years' Truce prompted a full-scale refurbishing
of Antwerp, especially her many churches, and major com-
missions immediately fell to Rubens. He transformed his
Netherlandish heritage in the first of his great Antwerp trip-
tychs, the *Raising of the Cross* (Cathedral, Antwerp), commis-
sioned in 1610. Reflections of Tintoretto and Caravaggio were
combined with Flemish realism—the faithful representation of
the natural world—in that dramatic affirmation of redemptive
suffering. Rubens was no less proficient on a small scale. He
designed book illustrations and title pages for Antwerp's
Plantin-Moretus Press—a series of magnificent emblematic,
miniature architectural and sculptural constructions that he de-
veloped over the next three decades.

The decade from 1610 to 1620 witnessed an enormous pro-
duction of altarpieces: Assumptions, Adorations of Shepherds
and Magi, Lives of the Saints, Nativities, Crucifixions, Last
Judgments. Rubens had already become the chief artistic ad-
vocate of Counter-Reformation spirituality in the north. Yet his

output of secular pieces—mythologies, hunting scenes, portraits, history, and allegory—remained undiminished thanks to his studio of assistants, students, collaborators, and highly skilled engravers. Their prints guaranteed the wide dissemination of Rubens's compositions throughout Europe. Among his assistants was the young Anthony van Dyck. Twenty-two years younger than Rubens, Van Dyck was still an apprentice when he arrived at his studio, probably around 1616. He stayed until 1620, by which time he had assisted Rubens on his two most ambitious projects to date, his first tapestry cycle (Decius Mus) and a series of ceiling paintings for the Antwerp Jesuit Church.

The 17th-century Italian biographer Filippo Baldinucci credited Bernini as being "the first to unite painting, sculpture, and architecture in such a way that together they form a pleasing whole." The same claim might be made for Rubens in view of his multiple contributions—in all three media—to the new Jesuit Church in Antwerp. Rubens participated in every important aspect of its design and adornment, including a series of thirty-nine ceiling paintings—the first northern revival of the Venetian ceilings of Titian, Tintoretto, and Veronese. The final canvases perished by fire in the 18th century. But fortunately most of Rubens's autograph *modelli* (oil sketches) are preserved. They offer revealing glimpses into his creative genius and extraordinary verve—what Bellori called "la gran prontezza e la furia del pennello," or the great speed and frenzy of his brush. From 1615 to 1620 there was a gradual but noticeable shift in Rubens's style—from the early sculptural, polished forms toward a broader, more painterly expression already discernible in the *Rape of the Daughters of Leucippus*. In this dynamic revolution of flesh and drapery, the inherent tension of a composition about to burst its geometric construction is heightened by animated brushwork and vibrant colors.

In 1621 King Philip III of Spain died and was succeeded by his son, Philip IV. That same year, the Twelve-Years' Truce expired. The Archdukes Albert and Isabella had sought—in vain—to negotiate an extension. Around this time, Rubens was engaged by the Infanta Isabella as her confidential agent in the clandestine and thoroughly Byzantine diplomatic maneuvers in search of peace between the two (Dutch and Spanish) Netherlands. His widespread fame as "the painter of princes and prince of painters" permitted Rubens to travel freely among royal courts while minimizing speculation as to ulterior motives for his meetings with sovereigns and their ministers, who were included among his most avid patrons and who frequently discussed matters of state while sitting for portraits.

In 1622 Rubens was called to Paris by the queen mother of France, Maria de' Medici, to draw up plans for the decoration of the two main galleries in her new Luxembourg Palace. (Her son, Louis XIII, purchased Rubens's next tapestry cycle, *The Life of Constantine*.) As a large narrative cycle of twenty-four paintings devoted to a historical ruler—in this case, a living though eclipsed heroine—Rubens's *Medici Cycle* required an unprecedented dose of poetic license and allegory, a display of Rubens's fertile powers of invention. Having completed the commission in 1625, he undertook for the Infanta a tapestry cycle known as the *Triumph of the Eucharist* (1626–27)—his most elaborate and complex program of liturgical art, a thoroughly Baroque expression of his Catholic faith.

Summoned to Madrid in 1628 in preparation for a diplo-

matic mission to England, Rubens took full advantage of the royal gallery of paintings, especially the extensive collection of Titian's paintings. He proceeded to paint copies after Titian, to whose style he was by now completely attuned. The great Venetian's brushwork and luminous modeling were to serve as the fount of inspiration throughout Rubens's last decade. Philip IV gave Rubens the title Secretary of the King's Privy Council of the Netherlands, in order to elevate the standing of his painter-envoy at the English court of Charles I: in the eyes of his Spanish masters, Rubens was never to eradicate the stigma attached to one who "lived by the work of his hands." Despite Madrid's endemic procrastination, Rubens succeeded in negotiating an exchange of ambassadors as the prelude to peace between England and Spain. In London, he also secured the commission for the ceiling of the Banqueting House in Whitehall, nine glorious canvases of royal propaganda. On the eve of departure, in 1630, King Charles I knighted him—*Sir Peter Paul Rubens*.

Back in Antwerp, Rubens devoted himself to his "beloved profession" On 9 December 1630, he married Helena Fourment, the youngest daughter of the silk and tapestry merchant Daniel Fourment. Rubens was by then a widower of fifty-three; Helena, a girl of sixteen—she was to inspire some of the most personal and poignant portraits of his career. This twilight decade also witnessed some of the most exuberant works of the rejuvenated master. Soon after his marriage, Rubens designed his fourth and final tapestry cycle, the *Life of Achilles*, for his new father-in-law, Daniel Fourment. In this Homeric cycle Rubens distilled his extensive experience in tapestry design and epic narrative.

In 1631 Philip IV knighted Rubens—the only painter so honored by kings of both England and Spain. As a young man Rubens had witnessed (and perhaps participated in) the triumphal entry of the Archdukes Albert and Isabella in 1599. Now, thirty-five years later, he was given the commission by the city of Antwerp to design a series of (temporary) triumphal arches and stages to greet the new governor of the Spanish Netherlands, the Cardinal-Infante Ferdinand. Rubens's most monumental—if ephemeral—undertaking was preserved in print, through the magnificent etchings by Theodoor van Thulden. Ruben's surviving oil sketches offer colorful reflections of these Baroque *Gesamtkunstwerke*, total-artworks of painting, sculpture, and architecture.

At his country estate, Het Steen in Elewijt, he painted the most expansive and glowing landscapes of his career, poetic odes in oil to the natural order of creation, an Arcadian vision of man living in harmony with nature. These canvases alone would ensure his fame as a landscapist, if no other works survived. For Philip IV's new hunting lodge, the Torre de la Parada outside Madrid, Rubens was commissioned in 1636 to paint a vast series of mythologies. It was an enormous undertaking—wall-to-wall Rubens—requiring the employment of virtually every able painter in Antwerp. Rubens painted some sixty-odd oil sketches inspired by Ovid's *Metamorphoses*. They rank among his liveliest and most spontaneous, charged as they are with all the powers of his literary imagination and fecundity of invention. At the same time, Rubens painted, either for his own pleasure or for private patrons, glowing mythologies such as the *Judgment of Paris* (National Gallery, London), landscapes, and portraits. In his late *Self-Portrait* (Kunsthistorisches Museum, Vienna) Rubens pre-

sented himself not as an artist but as a knight, wearing the jeweled sword that Charles I had presented to him, the self-confident and proud—if now aging and visibly weary—*uomo universale*.

Following a severe attack of gout, Rubens died on 30 May 1640. He was buried in the parish church of St. James in Antwerp. His eventual successor as Antwerp's premier painter was Jacob Jordaens (Van Dyck died the year after his former master, in 1641). Rubens's immediate artistic legacy extended far beyond the Netherlands. In Italy his influence was decisive among such high and late baroque masters as Pietro da Cortona, Luca Giordano, and Giovanni Battista Gaulli ("Il Bacciccio"); it may even be detected in the most painterly of sculptors, Gian Lorenzo Bernini. In Spain, Rubens's early impression on the young Velázquez, more personal than stylistic, was superseded by his impact on the art of Murillo. In France, the champions of color over line, the baroque over the classical, found in Rubens their model. The leader of the *Rubénistes* at the Academy, Roger de Piles, ranked Rubens first (in a tie with Raphael) in the entire history of painting. The advent of the rococo at the beginning of the 18th century signaled the triumph of the *Rubénistes:* his French heirs included Watteau, Boucher, and Fragonard. In the 19th century, the great Romantic colorist Eugène Delacroix noted in his diary that Rubens was quite simply a "magician." Rubens's recurrent impact on artists and his enduring reputation among critics and connoisseurs ultimately transcended all temporal bounds; his art has proved as universal as the man himself. Painter, diplomat, impresario, scholar, antiquarian, architect, humanist—Peter Paul Rubens embodied the baroque fulfillment of the Renaissance man.

—Charles Scribner III

RUBLEV, Andrei.
Born near Moscow, 1360 or 1370. Died in Moscow, c. 1430. Probably taught by Prokhor of Gorodets; monk in Trinity-St. Sergius Monastery near Moscow; earliest surviving works are pillar frescoes in Cathedral of the Dormition, Zvenigorod, c. 1400; worked with Prokhor and Theophanes the Greek in Cathedral of the Annunciation, Moscow; worked with Daniel Chorny in Cathedral of the Dormition, Vladimir, 1408; and in his own monastery: created famous icon of the Trinity (in honor of St. Sergius); later lived in the Andronikov Monastery in Moscow (now houses the Rublev Museum).

Collections: Leningrad: Russian Museum; Moscow: Tretyakov, Annunciation Cathedral; Vladimir: Museum; Zagorsk: Trinity-Sergius Monastery.

Publications

On RUBLEV: books (selection)—

Alpatov, M., *Rublev*, Moscow, 1959.

Lebedewa, Julia A., *Rublev und seine Zeitgenossen*, Dresden, 1962.
Lazarev, Victor N., *Rublev i ego shkola*, Moscow, 1966.
Lazarev, Victor N., *Old Russian Murals and Mosaics*, London, 1966.
Lazarev, Victor N., *Moscow School of Icon Painting*, Moscow, 1971.
Plugin, V. A., *Mirovozzrenie Rubleva*, Moscow, 1974.

*

Andrei Rublev is unquestionably the most famous Russian painter and is generally considered the founder of the Moscow School of painting. Despite the fact that he was a devout, Orthodox Christian monk who painted exclusively religious subjects, the atheistic Soviet government celebrated the 600th anniversary of his birth in 1960. In addition, a lengthy film on the life of Rublev was made in the 1960's by Andrei Tarkovsky. This film became a classic, even though its accuracy leaves much to be desired.

A master of both panel and mural painting, Rublev apparently received his early artistic training from Prokhor of Gorodets in the Trinity-Sergius Monastery. Rublev's earliest frescoes (c.1400) are to be found on the altar pillars in the Dormition Cathedral at Zvenigorod. Already one can see in the faces of the holy figures the serenity and contemplativeness that characterizes Rublev's later saints. In 1405 he worked alongside the older master Theophanes the Greek, along with Prokhor of Gorodets painting the icons of the iconostasis and the frescoes of the Annunciation Cathedral in the Moscow Kremlin. The themes from the Festival row of icons attributed by Lazarev to Rublev include the *Annunciation, Nativity, Baptism of Christ, Transfiguration of Christ, Resurrection of Lazarus, Christ's Entry into Jerusalem*, and the *Presentation of the Christ Child in the Temple*. Since the Annunciation Cathedral was reconstructed 1484–89, the original frescoes have not survived.

About five years after painting for the Annunciation Cathedral Rublev was back in Zvenigorod, this time in the Savvina-Storozhevskii Monastery. He was commissioned to paint the major icons for the iconostasis of the Cathedral of the Nativity. Three of these large icons (*Christ Pantocrator, St. Paul*, and the *Archangel Michael*) have survived. Especially impressive and characteristic is the image of Christ. Even in its damaged state Rublev's poetic spirituality is clearly visible. With his intense soul-searching glance, Christ does not look out at us as a stern judge typical of earlier images of Christ from Moscow (e.g., *Christ of the Angry Eye*, c.1300), but rather as a kind and compassionate Savior. Yet the godliness and majesty of the Son of God are also remarkably captured. The influence of Theophanes the Greek and Byzantine Paleologan art in general is especially evident in the way Rublev rendered the drapery of the figures.

In 1408 Rublev and Daniel Chorni were commissioned to paint frescoes and icons for the venerated Dormition Cathedral in Vladimir. Most of Rublev's frescoes of the *Last Judgment* have survived. These frescoes have a certain lyrical quality that is distinctly Rublev's. Among the icons that have survived, those attributed to Rublev by Lazarev are *Christ in Glory, St. John the Baptist*, and the *Ascension of Christ*.

Rublev's most significant surviving icon and the best known

of all Russian icons is one that was commissioned c. 1411 by Abbot Nikon of the Trinity-Sergius Monastery. This icon of three angels known as the *Old Testament Trinity* was painted in honor of the founder of the monastery, St. Sergius who had died in 1392. This extraordinary masterpiece is now in the Tretyakov Gallery in Moscow. Rublev also painted a number of the major icons for the iconostasis of the Trinity Cathedral in the Trinity-Sergius Monastery. This, his last major work (1425–27), was assisted once again by Daniel Chorni. The surviving icons that are attributed to the master himself by Lazarev are *St. Paul* and *Archangel Gabriel* from the Deesis row and the *Baptism of Christ* from the Festival row. These remain in situ on the iconostasis in the Trinity Cathedral.

Two other, earlier icons by Rublev worth noting are the relatively small *Christ in Majesty* (c.1411, now in the Tretyakov Gallery, Moscow) and the *Vladimir Mother of God* (c.1409, Vladimir Museum). The former is a beautiful rendering of the golden-robed Christ seated on a transparent throne and surrounded by cherubim and the four Evangelistic symbols. Reds, blues, and golds are combined in a lyrical and harmonious fashion. Disputed icons and icons from Rublev's workshop are too numerous to be discussed here.

Rublev's last years were spent at the Andronikov Monastery on the outskirts of Moscow. He and Daniel Chorni were responsible for painting the frescoes on the interior of the Church of the Savior in this monastery. Unfortunately, only small fragments of the frescoes have come down to us. Both Andrei and Daniel were buried in this church. Today the Andronikov Monastery is the Rublev Museum, and it contains an important icon collection and research center.

Rublev's lyrical, linear style and his subtle variations of the traditional compositions had considerable influence on later icon painters, but none could capture the elusive spiritual depth, the purity and harmony that characterize his work. The fact that Archbishop Macarius at the Stroglav (Church) Council of 1554 declared that icon painters should use Rublev as a prime example when painting icon themes, particularly the *Old Testament Trinity*, clearly shows that Rublev's abilities were well recognized a century after his death. His importance in the history of religious painting in Russia cannot be overemphasized. He alone in all of Russia was unexcelled as a master who could capture the spiritual essence of the holy themes in icon painting.

—A. Dean McKenzie

RUISDAEL, Jacob (Isaacsz.) van.

Born in Haarlem, 1628 or 1629; son of the painter Izaack van Ruisdael; nephew of the painter Salomon van Ruysdael; cousin of Jacob Salomonsz. Ruysdael. Died probably in Amsterdam, buried 14 March 1682. Probably the pupil of his father or uncle, or possibly of Albert van Everdingen; documented first in 1648 as member of Haarlem guild; settled in Amsterdam, c. 1656: citizen of Amsterdam, 1659, and lived there until his death; possibly visited western Germany in early 1650's, perhaps with Claes Berchem, who sometimes painted the figures in Ruisdael's landscapes; influenced by Rembrandt on his distant city views. Pupil: Hobbema.

Major Collections: Amsterdam; Berlin; Detroit; Dresden; London.

Other Collections: Boston; Chantilly; Chicago; Cleveland; Dublin; Frankfurt; Fort Worth; Frankfurt; The Hague; Hartford, Connecticut; Indianapolis; Leningrad; Munich; New York; Philadelphia: Pennsylvania Academy; Rotterdam; Vienna; Zurich.

Publications

On RUISDAEL: books—

Michel, Emile, *Ruisdael et les paysagistes de l'école de Haarlem,* Paris, 1890.
Riat, Georges, *Ruisdael,* Paris, 1905.
Rosenberg, Jakob, *Ruisdael,* Berlin, 1928.
Simon, K. E., *Ruisdael,* Berlin, 1930.
Levey, Michael, *Ruisdael: Jacob van Ruisdael and Other Painters of His Family,* London, 1977.
Slive, Seymour, and H. R. Hoetink, *Ruisdael* (cat), Amsterdam and New York, 1981.
Schmidt, Winfried, *Studien zur Landschaftskunst Ruisdaels: Frühwerke und Wanderjahre,* Hildesheim, 1981.

articles—

Kusnetzov, Juri, "Sur le symbolisme dans les paysages de Ruisdael," in *Bulletin du Musée National de Varsovie,* 14, 1973.
Burke, James D., "Ruisdael and His Haarlempjes," in *M: Quarterly Review of the Montreal Museum,* Summer 1974.
Stone-Ferrier, Linda, "Views of Haarlem: A Reconsideration of Ruisdael and Rembrandt," in *Art Bulletin* (New York), September 1985.

*

Ruisdael's earliest dated works, in 1646, were done when he was 17 or 18, and he was permitted to join the quite strict Haarlem artists guild in 1648. For some unknown reason, the orderly and patient Ruisdael regularly dated only his works from 1646 until 1653; afterwards, only a few appear. Consequently an art historical overview of style and subject has been difficult among the more than 700 surviving paintings. Ruisdael was fortunate in that from birth he was surrounded by an intense world of art. His father was an art dealer and sometime artist, and his uncle Salomon was a leading "tonal" landscapist, along with Jan van Goyen. Although he favored earth tones, Salomon's many sensitive river views and seascapes were gentle—rustic ferry boats were among his specialities— and attentive to light effects and the immediate vibrancy of nature. Other Haarlem painters who influenced and inspired Ruisdael are Cornelis Vroom, Pieter de Molijn, and Allart van Everdingen. So as a child prodigy, Ruisdael absorbed and transmitted with more than mere technical confidence such Dutch landscape types as dune views, rural farm scenes, oak groves, at times with one overwhelming tree, river scenes, townscapes with sea views, and panoramic views. All these works, large and small, are suffused with an intense poetic urgency; beyond this, there is a growing power of synthesis

Fishing Scene with a Windmill; drawing

and structure which asserted the onset of Dutch Baroque landscape art. While others worked in but one or two of these pictorial types, Ruisdael would go on to explore the whole range of landscape possibility; some, the forest, and the windmill, were mysteriously enough, left almost untouched, to him alone. Only one category of landscape art, the Italianate landscape, made popular by, among others, his old friend Claes Berchem, was apparently of no intrest to him, its idyllic pastoral too far removed from both Holland and his own, Sibelius-like search for a peculiarly northern European, uneasy grandeur.

Either as an aspect of youthful wanderlust, or search for new motifs, Ruisdael went to Westphalia in 1650 with Berchem. Although just launched in his personal career, Ruisdael was already acquainted with the nature of Dutch art traditions; and so the flowing rivers and their mills, the hills, the castles, and even vernacular building types which he found on the German border, were to offset the limitations in the typical Dutch reportory of the earlier generations: tonal colorations, lowland scenes, anecdotal and picturesque views. These newer motifs were combined with ideas from the more literal Scandanavian images brought back and painted in Haarlem from about 1645 by Allart van Everdingen. Given their large number, these "waterfalls" with raging water, boulders, and crags with sky-piercing firs, and often seen from a very low viewpoint so that castles and houses appear at the distant tips of hills, must have been very successful in the years after his move to Amsterdam. Admired for their dark exotic force at the

time, and explicitly for their depiction of the transparency of water against the solidity of rock, such works' further meaning has recently been suggested. A 17th century emblem—in a larger moralizing text where visual signs are presented together with epigrams explaining the meaning of the signs—has been found which presents the waterfall as symbol of earthly clamour, a "valley of noise,"—in Dutch *Ruis-dal*—seen in contrast to the silence of God. The artist, a convert to the Reformed Church in 1657, may have taken some pleasure in the playfulness of this dignified moralism.

Like Everdingen, Ruisdael was influenced by Roelandt Savery in his search for a new and Baroque drama. The symphonies of the oak forest, a life-long motif, are complex, even rhetorical, yet always plausibly realist in the context of the older artist's Mannerist artificiality. Later, in the 1660's, Ruisdael's groves are calmer and move more slowly into the rearground. Another debt to the Mannerist generation might have been to the even earlier Gillis van Coninxloo where delicate light effects upon water are seen in the forest depths. And in such works as *The Three Great Trees in a Mountainous Landscape with a River* (c. late 1660's, Pasadena), there is often an archaistic reference—in this work, a sweeping "cosmic panoramic view"—to Patenir and Bruegel.

At the end of the 1660's, Ruisdael painted what has become, along with Rembrandt's *The Nightwatch* (1642, Amsterdam), *the* representative Dutch painting, *The Mill at Wijk* (c. 1670, Amsterdam). Parallel to his enhanced treatment of the woods motif, he here monumentalized a theme earlier familiar to

him. Only recently dated to this time is the almost equally well-known *The Jewish Cemetery,* c. 1670, (Detroit), where Ruisdael offered a rich catalog of his familiar motifs—florishing and dead trees, running water, a racing and foreboding cloudscape, together with ruins—and also included tombs and a rainbow, both rare for him. The insistence and passion of this grouping, by its apparent clear allegorical intent, led this work to be held as unique within the entire corpus of Ruisdael's art; its interpretations ran from an image of the unsettled state of the Jews, even in death, as a storm sweeps by the burial ground, to a more general *vanitas* work, which might then become Christian-tempered were the rainbow held as a Resurrection emblem. Only recently, and under the impress of the wide-spread semiotic theory now current, the Detroit painting has lost such unique status as the whole body of Dutch landscape have undergone scrutiny to ascertain the possible moral and religious symbolic reference in their iconography. For instance, as a grain mill, *The Mill at Wijk,* from older tradition, would function as a symbol of the Eucharist and Redemption, and its blades could form the Cross; the worn millstones in the foreground might function as a *vanitas* element, as might the sunbeams playing upon the tower be evidence of man's dependence on Providence. The rebuttal to this exegetical turn is that it was common Dutch practice at this time to present moralization of the world's events and objects, but that this outlook was held secondary to the overt meaning of these situations.

At this high point of invention at the end of the 1660's, Ruisdael turned toward subject matter with which he had produced his earliest body of pictures in the later 1640's—traditional panoramic views. In this category, Ruisdael, who like all of the masters of Dutch landscape could work easily in any scale, always preferred a very small image. Since none of such small paintings ever appear duplicated by larger images, they were not "sketches" but intended as fully formed ideas. Among the panoramic views, a large group of views of Haarlem came to be so well known at the time that they were recognized by a "brand-name," *Haarlempje.* These works are often vertical, with the exultant cloudscape nonetheless carefully treated to reflect the patterns of light and object on the earth below.

Such structural manipulation for the purpose of compositional order is a Dutch variant of the reigning European mid-century classicism. This abstraction may be the ultimate attraction of Ruisdael. As Sutton has said, "He sought heroic effects without sacrificing the individuality of each oak . . . and clod of earth." In the Haarlem and Amsterdam townscapes, the overall lineaments are accurately portrayed, though recent research has shown that the viewing spot for these panoramic scenes was rarely an exact place and the total view is never exactly represented. Similarly the press of the market may have caused Ruisdael to use artist collaborators to add *staffage,* that is, people, animals, and other accessories, to the landscape foregrounds. Those pictures in which he himself painted *staffage* are done without strain, and it has been observed that Ruisdael's people are rarely occupied—mostly, they observe and meditate as if projections of the artist himself. Unmarried throughout his life and his own physiognomy apparently vanished forever, this solitary evanescence is mocked by the fierce love of place celebrated in his works.

—Joshua Kind

RUNGE, Philipp Otto.

Born in Wolgast, 23 July 1777; Died in Hamburg, 2 December 1810. Married Pauline Bassenge, 1802; four children. Apprenticed to a shipping company in Hamburg, 1795, and took private art lessons; then studied in Copenhagen under Jens Juel and others, 1799–1801; settled in Dresden, 1801, and befriended by the painter Anton Graff; also a friend of Goethe and Tieck.

Major Collection: Hamburg.
Other Collections: Berlin; Berlin (East); Vienna; Weimar.

Publications

By RUNGE: books—

Farbenkugel, Hamburg, 1810.
Hinterlassene Schriften, edited by Daniel Runge, Hamburg, 2 vols., 1840–41.
Briefwechsel mit Goethe, edited by Hellmuth von Maltzahn, Weimar, 1940.
Briefwechsel, with Clemens Brentano, edited by Konrad Feilchenfeldt, Frankfurt, 1974.
Scherenschnitte, edited by Werner Hofmann, Frankfurt, 1977.
Briefe und Schriften, edited by Peter Betthausen, Berlin, 1981.
Die Begier nach der Möglichkeit neuer Bilder: Briefwechsel und Schriften zur bildenden Kunst, edited by Hannelore Gärtner, Leipzig, 1982.

On RUNGE: books—

Aubert, Andreas, *Runge und die Romantik,* Berlin, 1909.
Roch, Wolfgang, *Runges Kunstanschauung und ihr Verhältnis zur Frühromantik,* Strasbourg, 1909.
Schmidt, Paul Ferdinand, *Runge: Sein Leben und sein Werk,* Leipzig, 1923.
Grundy, J. B. C., *Tieck and Runge,* Heidelberg, 1930.
Böttcher, Otto, *Runge: Sein Leben, Wirken, und Schaffen,* Hamburg, 1937.
Bohner, Theodor P., *Runge: Ein Malerleben der Romantik,* Berlin, 1937.
Isermeyer, Ch. A., *Runge,* Berlin, 1940.
Einem, Herbert von, *Runge: Das Bildniss der Eltern,* Berlin, 1948.
Berefelt, Gunnar, *Runge: Zwischen Aufbruch und Opposition 1777–1802,* Uppsala, 1961.
Langner, Johannes, *Runge in der Hamburger Kunsthalle,* Hamburg, 1963.
Grützmacher, Curt, *Novalis und Runge,* Munich, 1964.
Bisanz, Rudolf M., *German Romanticism and Runge: A Study in Nineteenth Century Art Theory and Iconography,* DeKalb, Illinois, 1970.
Matile, Heinz, *Die Farbenlehre Runges,* Berne, 1973, 1979.
Franchke, Christa, *Runge und die Kunstansichten Wackenroders und Tiecks,* Marburg, 1974.
Traeger, Jörg, *Runge und sein Werk: Monographie und kritischer Katalog,* Munich, 1975.
Hofmann, Werner, et al., *Runge in seiner Zeit* (cat), Munich, 1977.

Jensen, Jens Christian, *Runge: Leben und Werk*, Cologne, 1977.

Mathier, Stella Wega, editor, *Runge: Leben und Werk in Daten und Bildern*, Frankfurt, 1977.

Traeger, Jörg, *Runge, oder die Geburt einer neuen Kunst*, Munich, 1977.

Krüger, Renate, *Aus Morgen und Abend der Tag: Runge*, Berlin, 1977.

Batthausen, Peter, *Runge*, Leipzig, 1980.

Möseneder, Karl, *Runge und Jakob Böhme*, Marburg, 1981.

Richter, Cornelia, editor, *Runge: "Ich weiss eine schöne Blume": Werkzeichnis der Scherenschnitte*, Munich, 1981.

*

Runge counts alongside C. D. Friedrich as the most important German Romantic painter. His oeuvre consists of a truncated body of paintings and drawings, a color theory (*Farbenkugel*, 1810) and a fragmentary theory of art (*Hinterlassene Schriften*, 1840). Yet, his diversity and originality "have not been surpassed in the 19th century" (S. Waetzold) and the sum of his endeavors represents a "plan for a theory of life" (J. Traeger). Runge criticism revolves around the apparent gap between the "potential art" inferred by his theories and his actual painted oeuvre. His paintings are naive, charming, even provident and unique. However, a sober examination of his oeuvre cannot but arrive at the conclusion that his comprehensive theories, though they are unsystematic and in many respects provisional, are more far-reaching. They imply an artistic revolution for the 19th century and prophesy modernism.

Runge avoided studying art in Italy because he sensed that the experience would rob him of his "native expression" and heartfelt vision for a reformed art. J. Juel's instruction at the Copenhagen Academy taught him *one* alternative, realistic *native* landscape painting. Runge's Weltanschauung was shaped by his Protestant faith, readings in the Bible and theosophy (e.g., Jakob Böhme) as well as Romantic literature (e.g., Tieck, Novalis, and Schlegel). He based his ideas for the overthrow of classicism on polarities and the victory of north over south, Germanic over Mediterranean, mystical over rational, naturalistic over idealistic, and romantic over classic.

He believed that the artist must first "view the present moment in his life with all its pains and pleasures." Accordingly, his plan called for an art that must grow out of an artist's immediate condition of life, i.e., his personal "inner necessity." Alternatively, he believed that "the elements of art can only be found in the elements as such," i.e., the artist needs science as a tool. But because "the elements are also all within us," he admonished artists that philosophy and psychology must become part of their approach to an art that is a "heightened product of nature." He presaged Gestaltism by perceiving reality in organically integrated patterns. Collectively, his insights foretokened fundamental consequences for modern art and its creative psychology including mandates for scientism, subjectivisim, psychological authenticity, originality, and structuralism.

With his color theory he explored the science of reproducing nature's palette on the canvas. This resulted in more intense colors for him as well as, in anticipation of Gauguin's notion that "colors have moods," the possibility of "psychological

color." This symbolist insight and his firm belief that "the world of the Titans exists . . . in the relationships of angles and signs" without recourse to conventional imagery, augured radical abstraction, including abstract expressionism (e.g., he influenced Hölzel, Klee, Itten, Marc, Kandinsky, Schlemmer, Ernst). Runge's small, tentative, and experimental artistic oeuvre is divided into several categories: portraits, religious and mythological subjects, allegorical landscapes, and "hieroglyphic" fantasies. Landscape plays a major role in *The Hülsenbeck Children* (1803 Hamburg, Kursthalle), *We Three* (1805) and similarly *The Portrait of His Parents with Two Grandchildren* (1806). The powerful scaling, extravagant naturalism, impressive formal massiveness, vivid coloristic presence, light filled space and atmosphere and impressionistic landscapes of these paintings, originate a new style, "monumental realism." These paintings, with their emphasis on middle-class existence, close description of a homely milieux, the dignity of its subjects, and affective compositionl balances, anticipate Biedermeier effects by some twenty years and realism by some fifty years.

Runge's *Farbenkugel* called for a proto-Impressionist or luminist palette, highly graduated color schemes, and the need for representing the diffusion, reflection, and absorption of light in nature. Simultaneously, his combined metaphysical and gestaltist theories called for a new-nature art that will replace the classic anthropomorphic landscape tradition with a new Romantic pantheistic approach. His allegorical landscapes reflect these sentiments: *The Nightingale's Lesson*, second version, (1805), *The Mother at the Source* (1805) *Rest on the Flight* (1806), and *Peter Walking on the Sea* (1806-07). These paintings fuse naturalistic landscapes with fantasy settings and allegorical passages to weave compelling dreams of religious contemplation. But even more unusual in their fusion of reality and mystical vision are Runge's late hieroglyphic landscapes.

"I want to depict my life in a series of works of art," he said. The resulting *Cycle of the Times of Day* (1803-09), his *opus magnum*, consists of numerous drawings and cartoons as well as two paintings, *Morning*, small version (1808) and *Morning*, large version (1809, unfinished, reconstructed from nine fragments). With these works he wanted to encompass the properties of a fugue, of architecture, painting, and poetry in a holistic *Gesamtkunstwerk* (a work of total art; anticipating Richard Wagner). Here, his deeply mystical propensities fulfill religious fervor in a naturalist epiphany: facticity reflects mystery, Christian revelation flares as nature's afterglow. Runge's ingeneous "free" iconography is based on his personal flower and figure symbols, theosophic speculation, and psychologically weighted, translucent colors. A palpable feeling of transcendence of the real to the super-real or spiritual reaches in *Morning* for an organismic concept of the universe. In combining sharp perceptual realism with meandering notions of a magically exalted universe, his visionary hieroglyphic landscapes—even though they merely hint at the possibilities implied by his theories—have no equal in art history.

Runge's oeuvre was curtailed by his untimely death from tuberculosis at 33. It is imperfect and, in Runge's view, tentative, experimental, and incomplete. But it does give us an inspiring glimpse of a liberating future for art. Runge engendered no school or immediate cult following. But in the early

20th century modernism vindicated him by evolving along lines that parallel the essentials of his bold Romantic precepts.

—Rudolf M. Bisanz

influence of Jan van Huysum, who set the tone for the whole of the 18th century.

—Christopher Wright

RUYSCH, Rachel.

Born in Amsterdam, 1664. Died in Amsterdam, 12 August 1750. Married the portrait painter Juriaen Pool, 1693 (died, 1745), two children. Pupil of Willem van Aelst from age 15; member of The Hague guild, 1701; court painter of the Elector Palatine, 1708–16; then settled in Amsterdam, 1716; almost all her works were of flowers and other still-life subjects.

Major Collection: Cambridge
Other Collections: Amsterdam; Braunschweig; Brussels; Cheltenham; Dresden; Florence: Uffizi, Pitti; Ghent; Glasgow; The Hague; Hanover; Karlsruhe; Leipzig; London: National Gallery, Victoria and Albert; Melbourne; Munich: Bavarian Museum; New York; Oxford; Preston; Toledo, Ohio; Vienna; Washington: National Museum of Women's Art.

Publications

On RUYSCH: book—

Grant, M H., *Ruysch,* Leigh-on-Sea, 1956.

article—

Sip, J., "Notities bij het stilleven van Ruysch," in *Nederlands Kunsthistorisch Jaarboek* (Amsterdam), 19, 1968.

*

Even though the career of Rachel Ruysch was uneventful, she achieved a great fame with her contemporaries and was rightly considered to be one of the greatest masters of flower painting of her time. She was the pupil of Willem van Aelst, but soon evolved her own type of late baroque composition which was derived in principle from the work of Jan Davidsz. de Heem. Many of her paintings are signed and a few bear dates. This provides enough evidence for the fact that in her incredibly long career which spanned nearly 70 years her style changed but little and her skill did not decline.

Each flower in her compositions was delineated with that curious clarity which characterises much late 17th-century Dutch painting in all the genres. Ruysch was then able to integrate each one of these potentially disparate elements into a harmonious whole by using a dark background and subtle shading round the edges of each flower.

Almost all of Ruysch's pictures are so obsessive about clarity and detail that were it not for her unerring sense of harmony of tone and colour they would appear almost naive in their approach. She was not imitated in the later part of her career, as the newer style of flower painting was under the

RYDER, Albert Pinkham.

Born in New Bedford, Massachusetts, 19 March 1847. Died in Elmhurst, New York, 28 March 1917. Pupil of William E. Marshall; also attended the National Academy of Design, 1870–74; visited London, 1877, and made later European trips; painted mainly seascapes, but also pictures based on Literature, the Bible, and Wagner; reclusive in later life.

Major Collection: Washington: American Art.
Other Collections: Andover, Massachusetts; Boston; Buffalo; Chicago; Cleveland; Detroit, New York; Northhampton, Massachusetts: Smith College; Princeton; Washington: National Gallery, Corcoran, Phillips; Worcester, Massachusetts.

Publications

On RYDER: books—

Price, Frederic N., *Ryder*, New York, 1920.
Sherman, Frederic Fairchild, *Ryder*, New York, 1920.
Price, Frederic N., *Ryder*, New York, 1932.
Goodrich, Lloyd, *Ryder* (cat), New York, 1947.
Goodrich, Lloyd, *Ryder*, New York, 1959.
Trump, Richard S., *A Selection of Paintings by Ryder and Albert Bierstadt*, New Bedford, Massachusetts, 1960.
Goodrich, Lloyd, *Ryder* (cat), Washington, 1961.

articles—

Mather, Frank Jewett, Jr., "Ryder's Beginnings," in *Art in America* (Marion, Ohio), April 1921.
Robinson, John, "Personal Reminiscences of Ryder," in *Art in America* (Marion, Ohio), June 1925.
Taylor, Kendall, "Ryder Remembered," in *Archives of American Art Journal* (Washington), 24, 1984.
Evans, Dorinda, "Ryder's Use of Visual Sources," In *Winterthur Folio* (Chicago), Spring 1986.
Studing, Richard, "Two American Shakespeareans in Art: Ryder and Edwin Austin Abbey," in *Gazette des Beaux-Arts* (Paris), September 1987.

*

Albert Pinkham Ryder was one of America's 19th-century visionary painters (some would say he is pre-eminent among them), a group distinguished not so much by style or subject as by attitude. Like the contemporary Symbolists in Europe, they produced an art of suggestion, one based more on fantasy than on palpable reality.

Ryder's early work of the 1870's, done probably shortly after he settled in New York from his native New Bedford, A

sea coast city in southeastern Massachusetts, is his most "normal" appearing. This consists mostly of farm scenes, showing flocks of sheep on meadows, grazing cows or horses, horses drawing wagons or standing in stables. But even in these there is sometimes the sense of the untoward, as in a picture of a white horse standing in a stable (Princeton University), where through the closeness of the animal to the frontal plane and the look in its eye a strange empathetic bond is struck with the viewer.

Recurrent in the 1880's are the marine works in which a lone small boat is adrift in a vast sea beneath a great expanse of sky. Nature is seen as a relentless force, an attitude that may derive from earlier Romanticism and surely in large part from Ryder's early memories of the sea when New Bedford was one of the world's great whaling centers. The paint is now built up in a fairly heavy impasto. These marines can often be appreciated as well as taut abstract designs, with objects standing as powerfully simplified shapes.

From the 1880's Ryder's scenes became more imaginative and inward, more divorced in appearance from the recognizable world. Many of his subjects he drew from literature, from the writings of Byron, Poe, Chaucer, Shakespeare, the Bible, and Wagner. In these the human figures are dwarfed by an activated nature which might mirror or set the key for human emotions. An all-enveloping mood is captured, sometimes turbulent, sometimes peaceful, which transcends the details of the story.

From the Book of Jonah, Ryder showed the disobedient prophet, below the boat which cast him out, flailing about in the sea, a maelstrom of dark heaving forms (reminiscent of the handling in some Abstract Expressionist canvases) going nearly to the top of the painting, above which is seen the bearded face and upper torso of God, who holds a glove in his right hand (National Museum of American Art). From the operatic writings of Richard Wagner he painted *The Flying Dutchman* (National Museum of American Art), in which above a boat sailing the seas he showed the sky, materializing out of the mists, the lineaments of a shrouded figure, presumably a personification of the fate besetting the hero who was condemned to sail the seas until he could find a woman's true love. The painter seems only once to have drawn from a contemporary event, when a waiter whom he befriended committed suicide upon losing his savings through betting at horse racing. To commemorate this tragedy Ryder showed the mounted figure of death circling a race track set in the deserted country-side, observed only by a long snake (which perhaps symbolizes the idea of temptation) (Cleveland).

In the last 25 or so years of his life Ryder became much of a recluse. At the end of his life he became a legendary figure to the painter Marsden Hartley, the poet Kahlil Gibran, and others. In part because of his weak eyes he went out mainly at night, sometimes walking to the Palisades of New Jersey and returning quite late, as he enjoyed the moonlights. He never cleaned his room and never threw out anything, until he became surrounded by great piles of discards, with paths left only to the toilet and stove. He was innocent of the ways of the world, and was extremely kind, taking great care not to hurt anyone through word or deed.

Because Ryder worked very slowly, sometimes laying a painting aside for years to take it up again, he produced only some 165 works. He could not bear to let his paintings go,

even if this meant losing or postponing the money promised by a patron. He built up his surfaces with layer upon layer of glazes and pigments, often changing forms and details as he went along. Because of the unsteady rates of work and unsound methods (he sometimes used candlegrease for a medium), both resulting in uneven drying, most of the paintings are in a poor state, with the canvas crackled like a crocodile's skin and much detail lost. Next to Ralph Albert Blakelock, Ryder may be the most forged artist in the history of American Art, with the marines a particularly frequent target. X-rays have been used to advantage to separate the forgeries from the genuine paintings.

—Abraham A. Davidson

RYSBRACK, (John) Michael.

Born in Antwerp, 24 June 1694; son of the landscape painter Peter Rysbrack, and brother of the painter Peter Rysbrack the Younger. Died in London, 8 January 1770. Apprenticed to the sculptor Michel Van der Voort (or Vervoort), 1706–12; member of the Antwerp guild by 1714; settled in London, 1720; collaborated with the architect James Gibbs in his early works (e.g., the Matthew Prior monument): almost immediate recognition, and became the leading English sculptor; later collaborated with William Kent on the Isaac Newton monument, 1731; many other monuments, busts; bronze equestrian statue of William III in Bristol, 1735; founder-member of the Royal Academy, 1769; retired, 1764.

Major Collection: Stourhead.
Other Collections: Badminton: St. Michael's; Blenheim; Bradford on Avon: Holy Trinity; Bristol: Queen Square, Lord Mayor's Chapel, All Saints, Redland Chapel, Museum; Great Witley, Worcestershire: St. Michael's; Hagley Hall; Harefield, Middlesex: St. Mary's; Lisbon: Gulbenkian; London: Westminster Abbey, Victoria and Albert, Portrait Gallery, St. Martin in the Fields, Wallace, British Museum; New Haven; Plymouth; Salisbury: Cathedral.

Publications

On RYSBRACK: books—

Esdaile, Katharine A., *The Art of Rysbrack in Terracotta* (cat), London, 1932.
Webb, Margaret I., *Rysbrack, Sculptor*, London, 1954.
Eustace, Katharine, *Rysbrack, Sculptor* (cat), Bristol, 1982.

articles—

Green, David, "Rysbrack at Blenheim," in *Country Life* (London), 149, 1971.
Wilson, A., "Rysbrack in Bristol," in *Apollo* (London), 103, 1976.

collaboration, which began with the monument in Westminster Abbey to the poet Matthew Prior, designed by Gibbs. For this, Rysbrack made the standing figures of the Muses Clio and Euterpe in 1721. This was followed by a number of other monuments to Gibbs's designs in Westminster Abbey and one to Edward Colston in Bristol All Saints.

Rysbrack established his reputation in the 1720's as the foremost sculptor working in England. At this time he was working on Lord Burlington's Palladian Villa at Chiswick, and for William Kent at Kensington Palace. His antique-inspired marble reliefs, such as the overdoors and chimney piece in Kent's Stone Hall at Houghton (1726–30), are one of the innovative features of the English Palladianism. In the 1730's he continued to work for the leading architects of the day, including Giacomo Leoni at Clandon Park.

At Blenheim Palace he executed the monument to John Churchill, 1st Duke of Marlborough (1733), the most flamboyant example of High Baroque in English Sculpture, while the monuments to Sir Isaac Newton (1731) and James, 1st Earl of Stanhope (1733) in the nave of Westminster Abbey are strictly classical and mark a dramatic stylistic change from the Colston monument of the previous decade. His outstanding public monument, the superbly classical, technically masterful bronze equestrian statue of William III in Queen Square, was commissioned by subscription among the Merchants of Bristol, and completed in 1736.

In mid-career Rysbrack appears to have suffered something of a decline in popularity, following his failure to obtain the commission for the monument to John Campbell, 2nd Duke of Argyll, for Westminster Abbey, in 1745. His output, however, did not decline either in quantity or quality, as is evidenced by the virtuoso handling of the marble busts of Rubens and Van Dyck in 1747 (Hagley Hall). In 1748 he carried out the full-length marble standing figure of Dr. Radcliffe, for the Trustees of the Radcliffe Library, Oxford. One of the Trustees, Charles Noel, 4th Duke of Beaufort, subsequently commissioned a monument to the 2nd and 3rd Dukes of Beaufort at Badminton, in 1754.

Of Rysbrack's later statuary for gardens, Horace Walpole considered his Hercules of 1756 "the principal ornament of the noble temple at Stourhead, that beautiful assemblage of art, taste and landscapes." It is a very free interpretation of the classical theme, whereas the Stourhead Flora, executed for Henry Hoare in 1759, is strictly, according to the contract, "from the antique."

Robert Adam recommended the employment of Rysbrack to carve a chimneypiece for the Red Drawing Room at Hopetoun House in 1754, and collaborated with Rysbrack on the monuments to Admiral Boscawen at St. Michael Penkevil, Cornwall (1763), and Sir Nathaniel Curzon at Kedleston (1764). He suffered extreme ill-health from a dropsical disorder in the last ten years of his life, and retired from practice in 1764.

—Katharine Eustace

Inigo Jones, c. 1725–30; marble; 18½ in (47 cm); Chatsworth House

Steward, J. Douglas, "New Light on Rysbrack, Augustan England's 'Classical Baroque' Sculptor," in *Burlington Magazine* (London), 120, 1978.

Kenworthy-Browne, John, "Portrait Busts of Rysbrack," in *National Trust Studies* (London), 1980.

Kenworthy-Browne, John, "Rysbrack, Hercules, and Pietro da Cortona," in *Burlington Magazine* (London), April 1983.

Kenworthy-Browne, John, "Rysbrack's Saxon Deities," in *Apollo* (London), September 1985.

*

The sculptor Rysbrack is thought to have trained under Michael Van der Vort between 1706 and 1712. In 1714–15 he was among the Masters of St. Luke's Guild of Antwerp, though no work from this period has yet been identified. In 1720 he came to London, where his first recommendation was to the architect James Gibbs. This became a long a fruitful

S

SACCHI, Andrea.

Born probably in Rome or Fermo, shortly before 30 November 1599; son of the painter Benedetto Sacchi. Died in Rome, 21 June 1661. Pupil of his father, and of Albani; influence by the the Carracci school in Bologna; taken into the household of Cardinal del Monte, and gained recognition by a painting for the Vatican, 1616; did Casino for the Cardinal, 1626; patronized by Cardinal Antonio Barberini from the early 1630's, rivaling Pietro da Cortona; flourishing shop or school. Pupils: Maratta, Poussin.

Collections: Berlin; Cardiff; Fabriano: S. Niccolo; Fonte: S. Giovanni; Leningrad; Madrid; Minneapolis; Ottawa; Rome: S. Isidore, Galleria Nazionale, S. Carlo ai Cartinari, S. Giuseppe, Borghese, Villa Chigi; Vatican; Vienna.

Publications

On SACCHI: books—

Posse, Hans, *Der römische Maler Sacchi,* Leipzig, 1925.
Bellori, G. P., *Le vite inedite (Reni, Sacchi, Carlo Maratta),* edited by M. Piacentini, Rome, 1942.
Harris, Ann Sutherland, and Eckhardt Schaar, *Die Handzeichnungen von Sacchi and Carlo Maratta,* Dusseldorf, 1967.
Harris, Ann Sutherland, *Sacchi: Complete Edition of the Paintings with a Critical Catalogue,* Oxford, 1977; New York, 1978.
Grillo, Francesco, *Tommaso Campanella nell'arte di Sacchi e Nicola Poussin,* Cosenza, 1979.
D'Avossa, Antonio, *Sacchi,* Rome, 1985.

articles—

Refice, Claudia, "Sacchi, disegnatore," in *Commentari* (Rome), 1, 1950.
Lechner, George, "Tommaso Campanella and Sacchi's Fresco of *Divina Sapienza* in the Palazzo Barberini," in *Art Bulletin* (New York), March 1976 (see reply by Ann Sutherland Harris, 1977).

*

It has become customary to regard Sacchi as one of the prime exponents of what Rudolph Wittkower termed "High Baroque Classicism"—as distinct from the unqualified "High Baroque" of Cortona and Bernini. This claim derives in part from the nature of Sacchi's painting style, which is more restrained than that of Lanfranco or Cortona, but more specifically from the assertion of Melchior Missirini, the early 19th-century historian of the Academy of St. Luke (the Roman academy of painters), that, between 1634 and 1636, Sacchi and Cortona were embroiled in fierce debates in the Academy about artistic ends and means.

Unfortunately, Missirini's account, which seems to derive from now lost documentary sources, is disappointingly brief. What does emerge is that Sacchi disapproved of what he saw as Cortona's overcrowded compositions, since they distracted attention from the painter's central purpose—the clear expression of meaning and emotion. And we find this objection usefully elaborated upon in Sacchi's studio talk recorded by his pupil Francesco Lauri, who stresses Sacchi's belief in a decorous use of natural movement and facial expression, and distaste for excesses of ornamentation and rhetorical gesture. Such a position is classical by virtue of its reaffirmation of the classic formulations of expression and decorum found in Alberti's *Treatise on Painting* (1430's), rather than in the sense of a revival of canons of antique beauty (to which Sacchi was not strongly committed). On the other hand, his training under the Mannerist (but idealizing) Cavaliere d'Arpino and, more especially, under Annibale Carracci's pupil Francesco Albani, left an indelible stamp—not least in the Albanesque delicacy of expression and refinement of color which permeate Sacchi's mature art. It must have been from Albani, too, that he first imbibed the theory and syntax of an Albertian classicism.

Sacchi's translation of this background into what is called a High Baroque mode of Classicism does not imply that he sacrificed his classical priorities, but rather that he utilized some of the new Baroque ideas and techniques to further his own ends. Indeed, there are some grounds for arguing that he helped to give them shape, encouraged perhaps by the love of novelty of his first patron, Cardinal del Monte. Thus we find him, at the beginning of his fame, in *St. Gregory and the Miracle of the Corporal* (Rome, Chapter House of St. Peter's, 1625–26), if not actually creating, then clarifying a new formula for religious art: a climactic moment of drama evoked with the aid of dynamic diagonal axes and a rich fabric of light and color. Together they establish a compelling illusion of the intervention of the supernatural in human affairs, and this preoccupation with illusionism was taken further by Sacchi in his

ceiling of *Divine Wisdom* in the Palazzo Barberini.

Nevertheless, Sacchi does not attempt to shatter the integrity of the picture plane with figures foreshortened into the space of the viewer or distract attention, through formal or coloristic embellishment, from the subject matter. On the contrary, refined colors and restrained gestures focus attention on the concentrated groupings of figures, with their even more concentrated facial expressions. Sacchi's absorbed yet self-aware heads are hardly ever drawn in a formulaic or bravura fashion but seem, rather, to convey a palpable aura of introspection and of almost ritualistic consciousness of the import of their actions. In his pursuit of such clarity of exposition he was guided less by classical sculpture (although the philosophical gravity of his heads may owe something to Roman portrait busts) than by qualities of naturalism and psychology in the art of the Bolognese (Annibale, Albani, Reni, and Reni's pupil Filippo Birizio). It is, however, evident that he eschewed the more artificial Bolgnese tendencies towards stylized gesture and hyper-idealized figures. He even succumbed, on occasion, to the spell of Caravaggio's naturalism—in, for example, the spiritually emotive use of *chiaroscuro* in *St. Anthony Abbot and St. Francis* (London, 1623–24). Sacchi's direct and sensitive response to nature is crystallized in his few but masterly portraits (e.g., *A Cardinal,* Ottawa, c.1630), which subtly circumvent convention in capturing the variously cultivated humanity of his sitters.

Sacchi's distilled eloquence, though perhaps rather hesitant in terms of design, draws attention to the inner life and thoughts of his protagonists. And, as in the near-contemporary French classical drama of Corneille and Racine, uncontrolled extremes of emotion or violent action are either avoided or channeled through the filter of reported speech. Thus one finds him, in *Daedalus and Icarus* (Genoa, Palazzo Rosso), done, like many of his works, for the Barberini family, selecting an unusual, psychologically charged, yet physically quiescent episode from the famous story: not the popular fall of Icarus from the skies, but the moment of his dawning formulation, as his father straps on the wings, of his scheme to fly too high—brilliantly conveyed by Sacchi through a finely thought out counterpoint of glance and gesture. While in Sacchi's most celebrated easel painting, *The Vision of St. Romuald* (Vatican Gallery, 1631), we are shown the Saint recounting his vision of a stairway to Heaven to a group of monks who look more like philosophers. One might suspect, in his avoidance of the chance of depicting the saint actually experiencing the vision, a pointedly polemical decision to challenge the dawning ascendancy of Cortona's Baroque aesthetic. The ordered simplicity of the composition and the internalization of the drama form the basis of a new iconic and philosophical concentration—seen subsequently at its most pared down in the great series of scenes from the life of the Baptist done for the Baptistery of St. John Lateran in the 1640's (now Lateran Palace). They show Sacchi at his intuitive best as he treads a tightrope between the differing demands (and opportunities) of nature, ritual, and beauty.

In pursuit of such serious and conciliatory goals Sacchi was the spiritual mentor both of his friend Poussin and of his own brilliant and prolific pupil Carlo Maratta, whose dignified yet decorative classicism dominated the Roman scene in the later 17th and early 18th centuries.

—John Gash

SAENREDAM, Pieter (Jansz.).

Born in Assendelft, 9 June 1597; son of the engraver Jan Pietersz. Saenredam. Buried in Haarlem, 31 May 1665. Married Aefjen Gerrits, 1638 (died by 1651). Pupil of his father (until his death in 1607); in the workshop of Frans de Grebber, 1612; joined painters guild, 1623 (Steward, 1640, Dean, 1642): may have worked as an architectural draughtsman, as well as making drawings for independent prints and for plates in Samuel Ampzing's *Description and Praise of the City of Haarlem,* 1628; first known painting is dated 1628; active mainly in Haarlem, but did work in Utrecht, 1636–41, Amsterdam, 1641, and Rhenen, 1644.

Major Collections: Amsterdam; Rotterdam.
Other Collections: Haarlem: Gemeentearchief; The Hague: Mauritshuis, Koninklijke Bibliotheek; London: National Gallery, British Museum; Malibu; Paris: Institut Neerlandais; Utrecht: Centraal Museum, Gemeentearchief; Washington.

Publications

On SAENREDAM: books—

Macandrew, Hugh, et al., *Dutch Church Painters: Saenredam's ''Great Church at Haarlem'' in Context,* Edinburgh, 1984.
Ruurs, Rob, *Saenredam: The Art of Perspective,* Amsterdam, 1987.

articles—

Schwartz, Gary, "Saenredam, Huygens, and the Utrecht Bull," in *Simiolus* (Utrecht), 1, 1966–67.
Carter, Sam, "The Use of Perspective in Saenredam," in *Burlington Magazine* (London), 1967.
Liedtke, Walter, "Saenredam's Space," in *Oud Holland* (The Hague), 86, 1971.
Liedtke, Walter, "The New Church in Haarlem Series: Saenredam's Sketching Style in Relation to Perspective," in *Simiolus* (Utrecht), 8, 1975–76.
Kemp, Martin, "Simon Stevin and Saenredam: A Study in Mathematics and Vision in Dutch Science and Art," in *Burlington Magazine* (London), 1986.

*

Pieter Saenredam was the first painter in the Netherlands to make portraits of actual Dutch churches the main concern of his career. Earlier artists, such as Hendrick van Steenwyck the Elder, had painted identifiable buildings as well as imaginary architectural views. For Saenredam, however, fidelity to the site was an essential concern in all his architectural drawings, and the topographical interest of his paintings was probably more important to his patrons than the artist's often striking compositional ideas.

Saenredam's early drawings of the 1620's include small portraits, plant studies, maps, and landscapes with ruined castles in the area of Haarlem. This work is consistent with the subsequent drawings of architectural views in their close recording

Tower of the Cunera Church and the Castle in Rhenen; watercolor; Amsterdam, Rijksprentenkabinett

of appearances, an approach that aligns Saenredam with the founders of other genres and realistic styles in Haarlem, such as Esaias van de Velde, Jan van Goyen, Pieter Claesz, and Hendrick Vroom.

Most of Saenredam's subjects would have been immediately recognizable to contemporary viewers, although his paintings of the Pantheon, the Colosseum, and Santa Maria della Febbre in Rome, which were based on drawings by Maerten van Heemskerck, and some of Saenredam's motifs, such as tomb monuments, were of more specialized archaeological and topographical interest. Another example of the latter is the series of drawings and paintings of the Mariakerk in Utrecht, a Romanesque church of interest to the stadholder's secretary and artistic advisor, Constantijn Huygens, whom Saenredam knew through either of the Haarlem architects Jacob van Campen or Salomon de Bray. However, the views of St. Bavo's in Haarlem, of other churches, and of the town halls in Haarlem and in Amsterdam, were familiar and meaningful monuments, rich in their evocation of civic pride, religious commitment, and other convictions. Occasionally, Saenredam's subjects were topical, as in the 1636 painting of St. Bavo's (Amsterdam) that reflects Huygens's argument on the proper use of organ music in church; and the stylized view of the Brewers' Chapel in St. Bavo's (Copenhagen), also dated 1636, in which the setting is modified to resemble Roman architecture, and the figures represent Christ driving merchants from the temple.

Saenredam was an exceedingly methodical man, to judge from the way in which he would select various views in a church, record the subject, plan a painting, date and even cross-reference his preparatory material. For example, an on-site sketch of St. Odulphus' Church in Assendelft (Fodor Collection, Amsterdam) is dated 31 July 1634. The corresponding construction-drawing (Rijksdienst, The Hague), made in preparation for a painting, is inscribed in Saenredam's hand with two sentences describing the exact subject, and the date, "9th day December in the year 1643." Later, in different ink, the artist added, "This was painted on the same scale as this drawing, on a panel of one piece, and the painting was finished on the 2nd day of the month October in the year 1649, by me Pieter Saenredam." The panel (Amsterdam, Rijksmuseum), finally, is inscribed, "this is the church at Assendelft, a village in Holland by Pieter Saenredam, this painted in the year 1649, the 2nd October."

Saenredam's construction-drawings do not merely transfer the sketched views into precisely drawn perspective cartoons, but embody numerous design decisions that determine the composition of a painting, and also its format, since the original view is often cropped. The construction-drawings were blackened on the verso and traced onto smooth wood panels, which were then painted with great sensitivity to values of colour and light. Saenredam's restricted and usually light tonalities strike one now as elegant and subtle, ideally complementary to his spare and exquisite sense of design. Contemporary viewers, however, would have seen these qualities essentially in terms of simplicity and sobriety, Calvinist virtues, which in the churches themselves were expressed by whitewashed walls and the removal of "Popish" appointments.

During the first eight years of his activity as an architectural painter Saenredam concentrated on the subject of St. Bavo's (the Great Church) in Haarlem. Three paintings depict exten-

sive views of the church, to the east, to the west, and along the entire length of the transept; other panels represent the Brewers' Chapel, the southern aisle, the southern ambulatory, and five very various views across the choir. The series exhibits a characteristic attempt to record each interesting view in the church, without repetition, and at the same time to explore different compositional schemes, such as long recessions along elevations, views through elevation with framing motifs in the foreground, and other views that were never tried in the genre before, and that deal with the difficult problem of representing monumental architectural at close range.

The same approach is found in the Utrecht sketches made between June and October 1636. Saenredam devoted the first months to interior and exterior views of the Romanesque Church of St. Mary's (the Mariakerk, now lost), and then turned to the Buurkerk and the Jacobskerk, the Janskerk, the Cathedral, and finally the Catharinakerk, in that order, and in each case proceeding from principal to subordinate views.

Saenredam is considered a major Dutch artist because he was the pioneer, if not inventor, of a genre, and because of the sheer quality of his work. But there is more: in his meticulous attention to visual experience, and his constant regard for aesthetic effect, Saenredam combines the two qualities in a manner that may be considered the essential achievement of Dutch art in the 17th century, and its legacy to later periods.

—Walter Liedtke

SALVIATI, Francesco.

Born Francesco de' Rossi in Florence, c. 1510. Died in Rome, 11 November 1563. Pupil of Andrea del Sarto in Florence, 1529-31; in Rome from 1531: worked on decorative projects at the Palazzo Farnese, S. Giovanni Decollato, S. Marcello, and Palazzo Sacchetti; also worked in Venice and on the Palazzo Vecchio in Florence; in France, 1554; close friend of the painter and writer Vasari.

Collections/Locations: Bologna: S. Cristina; Dublin; Florence: Uffizi, Pitti; London; New York; Parma; Paris; Rome: Palazzo Sacchetti, S. Giovanni Decollato, S. Francesco a Ripa; Springfield, Massachusetts; Turin; Vienna; Washington; Worcester, Massachusetts.

Publications

On SALVIATI: book—

Dumont, Catherine, *Salviati au Palais Sacchetti du Rome et la decoration murale italienne (1520-1560)*, Rome, 1973.

articles—

Bucarelli, P., "Tesori d'arte nei palazzi romani: Gli affreschi di Salviati nel Palazzo Sacchetti," in *Capitolium* (Rome), 9, 1933.
Hirst, Michael, "Three Ceiling Decorations by Salviati," in *Zeitschrift für Kunstgeschichte* (Munich), 26, 1963.

Cheney, I. H., "Salviati's North Italian Journey," in *Art Bulletin* (New York), December 1963.

Carrolli, E. A., "Some Drawings by Salviati Formerly Attributed to Rosso Fiorentino," in *Master Drawings* (New York), May 1971.

Freedberg, S. J., "The Formation of Salviati: An Early Caritas," in *Burlington Magazine* (London), November 1985.

*

Salviati was the most talented of the second generation of Florentine Mannerist painters whose activities in central and northern Italy created the influential mode of extreme decorative High Mannerism in the 1530's, 1540's, and 1550's. His training with various masters in Florence had little lasting effect on his style, although the influence of one, Bandinelli, can be seen in his early drawings, while that of another, Andrea del Sarto, dominates Salviati's earliest attributed work, a *Virgin and Child* (Hampton Court). By 1531, however, he was in Rome, and it was his studies there—particularly of the products of Raphael's pupils such as Giulio Romano and Perino del Vaga—which shaped his personal manner.

He went to Rome under the protection of Cardinal Salviati, of the noble Florentine family, who gave him lodgings and wages, and after whom he came to be called. His precocious technical and creative gifts also attracted the attention of other Florentines in Rome, such as Filippo Sergardi and Bindo Altoviti; he decorated the facade of the latter's palazzo, but this, together with his other frescoes of the period (such as those in the chapel of Palazzo Salviati), is lost. His earliest surviving Roman work is the altarpiece of the *Annunciation* in S. Francesco a Ripa (c. 1533), which reflects the elegant classicism of Perino.

Salviati's acceptance into the artistic milieu of Rome was signalled by his participation in the decorative schemes celebrating the entries of the Emperor Charles V into Rome (1535) and of Pope Paul III's son Pier Luigi Farnese into his newly created Dukedom of Castro (1537). Salviati's position was consolidated by the success of his most important early work, the *Visitation* (1538; Rome, Oratory of S. Giovanni Decollato). This was his first contribution to the fresco cycle, begun two years earlier by his compatriot Jacopino del Conte, in the chapel of a pious confraternity of Florentine residents. Salviati's work, while evidently immature, containing direct references to Andrea del Sarto and to Raphael, and composed on lines borrowed from Perino and Peruzzi, nevertheless reveals his controlling hand, translating formal and narrative values into decorative elaboration through the consistent application of ornamental linear effects.

Perhaps news of this success was sent to Florence, where Cardinal Salviati's nephew, Cosimo I de' Medici, had just seized power. Certainly Salviati himself followed, soon enough to contribute to the decorations for Cosimo's marriage in 1539. However, perhaps because of the dominant presence of Bronzino at the Florentine court, Salviati quickly left to join his friend Giorgio Vasari in Bologna; but there too he failed to find immediate patronage. He moved on to Venice (possibly stopping at Parma on the way), where he was welcomed by the Partiarch Grimani. In Palazzo Grimani he executed two ceiling paintings, in elaborate stucco frames by Giovanni da Udine, of antique scenes: these indicate a knowledge of Parmigianino's

works (whether in Bologna or Parma), which gives new fluency to Salviati's line, imparting elegant grace to his powerful complexity. They were much admired in Venice, not least by Pietro Aretino, but seem to have had little influence. His other surviving works from this period, such as the altarpiece of the *Virgin and Child with Saints* painted for the Camaldolese nunnery of S. Cristina, Bologna (1540; *in situ*), show him somewhat uneasily trying to combine the effect of Parmigianino on his own *disegno* with an appreciation of Venetian colourism.

During 1540–41 Salviati left Venice and, after a short stay in Mantua—where he was again unsuccessful at securing commissions, but was able to study the superb decorations of the reigning court painter, Giulio Romano—returned to Rome. It was at this time that, inspired equally, perhaps, by Bronzino, Parmigianino, and the Venetians, Salviati first turned consistently to portraiture. He depicted various notable Tuscans, including Annibale Caro and Aretino, with adequate dignity and specific likeness; later he gradually dispensed with details and distractions in order to provide his sitters—mostly male and usually young—with a direct and comprehensive image of subtly artless artificiality. In the same years in Rome, 1541–43, Salviati also produced designs, both religious and mythological, which were published by a variety of engravers. Finally he was recalled to Florence through the offices of Cardinal Salviati's brother Alamanno, and introduced into the service of Cosimo I de' Medici.

Salviati's major work in Florence is the superb decoration of the Sala dell'Udienza in the Palazzo Vecchio (1543–45), with a series of *Scenes from the life of Furius Camillus* and various interpolated *Allegories*. The ensemble represents the highest point of Salviati's distilled transformation of apparently realistic figures and scenes into insistently artificial ornamentation. Forms crowd towards the picture plane, and settings are reduced to theatrical backdrops, while archaeologically and naturalistically accurate details proliferate; all are described with superbly decorative draughtsmanship, indiscriminately realising battle scenes and triumphal processions as equally ornamental effects, expressed in gracefully posed figures and brilliant but cold colours. The result translates two-dimensional decoration into almost sculptural or lapidary solidity.

This brilliant display of Salviati's talent, though never completely finished, did not fail to impress his patrons. His other works in Palazzo Vecchio include the decoration of the ceiling of the writing-room of Cosimo I's wife, Eleanora de Toledo, with antique grotesques, and an elaborate design for the *Dream of Pharaoh*, the last of a series of tapestries illustrating the *Story of Jospeh* (the others by Pontormo and Bronzino) which hang in the Sala dei Dugento. During the next few years Salviati produced other designs for Cosimo I's newly established *Arazzeria*, including an *Ecce Homo*, *Deposition*, and *Resurrection* (all in the Uffizi). He also painted the portraits of some of Cosimo's family, including his son Garzia (Florence, Pitti); and perhaps for the same patron a superb *Charity* (c. 1545; Uffizi) which, while clearly dependent on Michelangelo's Doni *tondo* (Uffizi), achieves both a naturalistic sensuality and an artificial polish greater than in Salviati's Palazzo Vecchio *Allegories*, probably in response to Bronzino's contemporaneous *Allegory with Venus, Cupid, Folly, and Time* (London).

Salviati's most important easel-picture of the period was his

altarpiece for the chapel of the Dini family in S. Croce, Florence, the *Deposition* (c. 1547; Florence, Museo di S. Croce). This monumental religious work presents a deliberate contrast to the Palazzo Vecchio decorations, more naturalistic and static as well as appropriately serious and sombre. But the dominant effect is still of the beauty of graceful lines and of the ornamental patterns of light and colour, even though here they describe passages of inventively expressive emotion and classically dignified pathos.

In 1548 Salviati, disappointed by his treatment in Florence (he felt he had not sufficiently dominated the scene), returned to Rome, where Annibale Caro had secured for him the commission from Cardinal Alessandro Farnese to decorate the Cappella del Pallio in the Cancelleria. Salviati's frescoes, embedded in an astonishingly elaborate scheme of decorative architecture, grotesque panels, and garlands, represent a retreat from the High Mannerism of Florence towards the normative Classicism of Rome; their small scenes, graceful and light, are arranged with exemplary clarity, and full of references to Michelangelo and Raphael, and also to Salviati's own work. Still more conservative was his second contribution to the Oratory of S. Giovanni Decollato, the *Birth of the Baptist* of 1551: the reflections of earlier examples of this type of scene, perennially popular in Florence, and even those of his own inventions, appear without liveliness or indeed his customary grace. He attempted more with the adjacent figures of *St. Andrew* and *St. Bartholomew*, but their combination of the power of Michelangelesque breadth with the elegance of Mannerist contortion is slightly absurd. Salviati regained his form in some minor but highly decorative frescoes in S. Marcello al Corso, Rome, which combine Venetian, Roman, and Emilian elements in compositions of delightful fantasy. Fantasy was also the keynote of Salviati's supurb decorations in the Palazzo Sacchetti (c. 1553). Here he used for the first time specific illusionistic effects, but with consummate ease. Languid nudes recline on draperies above real doorways; feigned architecture surrounds scenes of violent movement; painted frames encompass bloody battles. Also for the first time Salviati contrasted his vividly sculptural figures with dizzyingly vast landscape vistas. This rich decorative complexity, encompassing several layers of apparent reality, illustrated the *Story of David*. Equally complex, and even denser with ornamental forms, was Salviati's decoration of the Sala dei Fasti Farnesi in Palazzo Farnese (begun 1549), in which he invested the different levels of illusion and simulation with distinct dimensions of meaning, combining scenes of historical events wtih mythological allegories, purely decorative figures with allegorical portraits of actual members of the Farnese family. The spectacular and grandiose result far outclassed in inventive subtlety and vigour Vasari's scheme in the Sala dei Cento Giorni of the Cancelleria (1546), just as both developed in sophisticated elaboration their Roman models, Giulia Roman's Sala di Costantino in the Vatican and Perino del Vaga's Sala del Consiglio in Castel Sant'Angelo.

In 1554, while still at work in Palazzo Farnese, Salviati suddenly left Rome for France, perhaps as a result of some slight imagined by his impatient and quarrelsome nature. Probaby for much the same reason he returned to Italy equally abruptly after little more than a year, during which he had executed decorations for the Cardinal of Lorraine in the Chateau de Dampierre (destroyed), but had received few other commissions. Travelling via Milan and Florence he arrived back in Rome in 1556, and resumed his Palazzo Farnese frescoes (finished after his death by Taddeo Zuccaro). He also completed the decoration of the Chigi chapel in S. Maria del Popolo, begun by Raphael. After the accession of Pius IV in 1559 Salviati finally achieved a commission he had long coveted, for half the decoration of the Sala Regia in the Vatican. However, his difficult behaviour again intervened, and he retired to Florence. By 1562 he was back in the Vatican, working on a fresco of *Alexander III and Frederick Barbarossa*; but he died before it was more than half-finished (it was completed by his pupil Giusseppe Porta). It still bears eloquent testimony that Salviati was the most accomplished High Mannerist painter in Rome.

—Nigel Gauk-Roger

SÁNCHEZ-COTÁN, Juan.

Born in Orgaz, 1561. Died in 1627. In Toledo from early in his career; became an Carthusian monk in Granada, 1603, but continued painting: one of the first painters of *bodegones* to be influenced by Caravaggio, and also did a few religious works; austere style preceded that of Zurbarán's by a generation.

Major Collection: Granada.
Other Collections: Chicago; Granada: Monasterio de la Cartuja; Madrid; San Diego; Seville: Cathedral.

Publications

On SÁNCHEZ-COTÁN: books—

Orozco Díaz, Emilio, *Las Vírgenes de Sánchez Cotán*, Granada, 1954.
Angulo-Iñiquez, D., and A. E. Perez-Sánchez, *Pintura toledana primera mitad del siglo XVII: Sánchez-Cotán, Tristan, Orrente*, Madrid, 1972.

articles—

Orozco Díaz, Emilio, "El pintor certujo Sánchez-Cotán y el realismo español," in *Clavileno*, 3, 1952.
Orozco Díaz, Emilio, "On Sánchez-Cotán," in *Zurbarán*, by M. L. Caturla, Madrid, 1953.
Orozco Díaz, Emilio, "Realismo y religiosidad en la pintura de Sánchez-Cotán," in *Goya* (Madrid), 1954.

*

The enigma of Sánchez-Cotán's known works is the style distinction between his relatively bland and idealized figural work, both religious and secular, and the vivid naturalism of his renowned still lifes. This has led to the frequent linkage between him and Caravaggio. In fact, some commentators have suggested an "experimental" status for his small number of still lifes (about six) in order to account for this discrepancy

and to place it somehow within Sánchez Cotán's personality, apparently withdrawn and mystically inclined.

His clear rendering of foodstuff must have been influenced by mid-16th-century Netherlandish art such as the powerful and self-confident work by Aertsen and Beuckelaer; their paintings were well known in Italy, where they were imitated by, for instance, the Cremona painter Vincenzo Campi. In 1585 Antonio Campi, his brother, wrote that many such paintings (*bodegones de Italia* in Spanish) and been sent to Spain. The delicate flower paintings of Jan Bruegel were also known in Spain before the turn of the century, and his work may be related to the Sánchez Cotán *Still Life with Roses, Lillies, and Iris* (present location unknown), which presents an array of flowers in his familiar window setting.

Our understanding of the early life of Sánchez Cotán derives from the *Arte de la pintura* by Francesco Pacheco, also a painter and teacher of Velazquez. The book, completed in 1638, deals with a wide spectrum of the art world. Sánchez Cotán's master is given as Blas de Prado, the earliest documented still-life painter in Spain. Prado and Sánchez Cotán are the only two still-life artists mentioned by name in the book. Although examples of Prado's still lifes have only recently been tentatively identified, his portrait and figural paintings show Italian sources, and his fruit and flower images also are comparable to contemporary Lombard paintings by Galizia and Procaccini. Recent studies of collectors' inventories in Toledo and Madrid show the widespread popularity of still life at the time.

In 1603 Sánchez Cotán decided to leave secular life and live as a lay brother in the monastic community of the Carthusian Order at the Charterhouse of Granada. The testament and inventory of his belonging, signed 10 August 1603, show that his patrons included members of the highest ranks of the priestly and secular nobility, as well as pointing to the existence of some 12 still-life paintings. It is known that Sánchez Cotán owned a book of Archimedes's geometry, as well as Vignola's book on perspective and a book on music. Some of the hyperbolas in Archimedes's *Opera non nulla* have been suggested as the source of the arrangement of the foodstuff in the *Quince, Cabbage, Melon, and Cucumber* (San Diego).

—Joshua Kind

SANSOVINO, Andrea.

Born Andrea Contucci in Florence, c. 1467. Died in Monte San Savino, between 30 March and 11 April 1529. Married, 1504. Studied or worked with Pollaiuolo, Bertoldo di Giovanni, and Giuliano da Sangallo; Vasari says he spent nine years in Portugal, but this claim is undocumented; entered the Florence guild, 1491; worked on the *Baptism of Christ* for the Florence Baptistery, 1502–05 (incomplete); in Rome, 1505: did wall tombs for S. Maria del Popolo and works for S. Maria dell'Anima and S. Agostino; director of building and decoration of the Holy House at Loreto, 1513: many sculptors involved (later demoted to directing sculpture only); worked in Monte San Savino, 1523–24, and after 1527. Pupil: Jacopo Sansovino.

Collections/Locations: Florence: Baptistery; Genoa: Cathedral; Loreto: Basilica of the Holy House; Rome: S. Maria del Popolo, S. Agostino.

Publications

On SANSOVINO: books—

Schönfeld, Paul, *Sansovino and seine Schule*, Stuttgart, 1881.
Batelli, Guido, *Il Sansovino in Portogallo*, Coimbra, 1929.
Huntley, George H., *Sansovino, Sculptor and Architect of the Italian Renaissance*, Cambridge, Massachusetts, 1935.
Weil-Garris, K., *The Santa Casa di Loreto: Problems in Italian Sixteenth Century Sculpture*, New York, 1977.

articles—

Bonito, Virginia Anne, "The Saint Anne Altar in Sant' Agostino: A New Discovery," December 1980, and "The Saint Anne Altar in Sant'Agostino: Restoration and Interpretation," May 1982, both in *Burlington Magazine* (London).
Lisner, Margrit, "Sansovino und die Sakramentskapelle der Corbinelli mit Notizen zum alten Chor von Santo Spirito in Florenz," in *Zeitschrift für Kunstgeschichte* (Munich), 50, 1987.

*

Andrea Contucci, known as Andrea Sansovino after his birthplace, Monte San Savino in southern Tuscany, was one of the most gifted young marble sculptors working in Florence at the end of the 15th century and was subsequently a leading exponent of the High Renaissance style in Rome. According to Vasari, Sansovino trained with Antonio Pollaiuolo; this is borne out by the dynamic qualities of Andrea's figure-style and the energy of his modelling. It is, nevertheless, likely that he also spent time in the workshop of a marble sculptor, possibly Benedetto da Maiano. Certain of his early commissions additionally brought him into contact with Giuliano da Sangallo and the Della Robbia workshop.

Sansovino's first major work is the Corbinelli altar in Florence (S. Spirito) of c.1485–91. It is an intricate and ambitious complex of reliefs and statues set within a typically late quattrocento triumphal arch framework, in which the influence of Antonio Rosellino and Benedetto da Maiano is modified by the nascent classicism of Sansovino's mature style.

During the 1490's Andrea was sent by Lorenzo de' Medici on an artistic mission to Portugal, but the evidence for his activity there is inconclusive. On his return to Florence he began the large-scale group of the *Baptism* for the exterior of the Baptistry, which was abandoned when he went to Rome in 1505 and completed 50 years later by Vincenzo Danti. While it is uncertain to what extent the latter was responsible for the appearance of the finished work, its suave forms and graceful proportions bear the hallmarks of Sansovino's invention. Also from this period are his two statues of the Virgin and Child and St John the Baptist in Genoa cathedral which, with the *Baptism*, epitomise the High Renaissance style in sculpture.

Sansovino was summoned to Rome by Pope Julius II, where he executed the tombs of Cardinals Ascanio Sforza and Basso

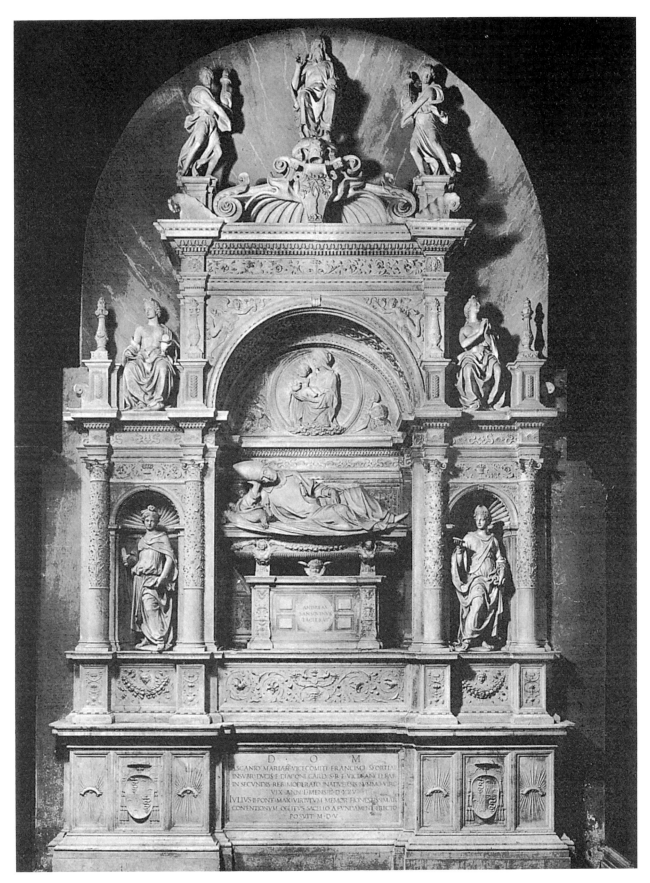

Tomb of Ascanio Sforza; marble; Rome, S. Maria del Popolo

della Rovere in S. Maria del Popolo (1505–09) as part of the remodelling of the choir of that church then being undertaken by Bramante. The two wall-tombs are based, like the Corbinelli altar, on the triumphal arch motif, but are more purely classical in their approach to architectural forms and figure style. This is attributable to the impact on Andrea not only of the antique, but also of the work of his great contemporaries Bramante and Raphael.

It is a measure of Sansovino's artistic standing in Rome during the High Renaissance that his masterpiece, the *Virgin and Child with St Anne* of 1512 (S. Agostino) was commissioned as the sculptural pendant to Raphael's fresco of the prophet Isaiah. The elegant *contrapposto* of Andrea's figures, and the contrast between the idealised classicism of the Virgin's features and the strong characterisation of St Anne's, caused Vasari to praise this sculpture as "the best in modern times." There is further testimony to Sansovino's reputation at this date in the allocation to him in 1512 of two of the statues of Apostles for Florence cathedral.

Sansovino's later career was almost entirely dominated by his duties as superintendent of the construction and decoration of the Holy House in the Basilica of Loreto, to which he was appointed by Pope Leo X in 1513. His responsibilities were largely administrative, and of the numerous sculptures with which the Holy House is clad, only two large reliefs, the *Annunciation* and the *Adoration of the Shepherds,* were executed by him. The *Annunciation,* with its dramatic movement and spatial illusionism, was commended by Vasari as a model for artists on account of the virtuosity of its carving and perspectival construction. Sansovino also played an important role as leader of the team of younger sculptors, among them Tribolo and Baccio Bandinelli, who were engaged on this vast project, which was not completed until after his death.

—Paula Nuttall

SANSOVINO, Jacopo.

Born Jacopo Tatti in Florence, 2 July 1486. Died in Venice, 27 November 1570. Son, the writer Francesco Sansovino. Pupil of Andrea Sansovino from 1502 in Florence, and took his name; then worked in Florence as sculptor and architect; followed Andrea to Rome, 1505 or 1506, and worked there until 1511; then returned to Florence, 1511–18 (shared studio with Andrea del Sarto for a period); worked in Rome again, 1518–27: worked in S. Agostino, S. Marcello, etc.; then settled in Venice, 1527: became city architect: designed the Library of St. Mark, and other buildings; made statues of Mars and Neptune for the Doge's Palace, and designed the Loggetta and did some figures for it. Pupils: Alessandro Vittoria; Danese Cattaneo.

Collections: Florence: Cathedral; Lugano; Rome: S. Agostino; Venice: Doge's Palace, Loggetta.

Publications

On SANSOVINO: books—

Pittoni, Laura, *Sansovino scultore*, Venice, 1909.
Lorenzetti, Giulia, *Sansovino*, Venice, 1910.
Vasari, Giorgio, *Vita di Sansovino*, edited by Giulia Lorenzetti, Florence, 1913.
Sapori, Francesco, *Sansovino*, Rome, 1928.
Lorenzetti, Giulia, *Itinerario Sansoviniano a Venezia*, Venice, 1929.
Wiehrauch, Hans R., *Studien zum bildnerischen Werke des Sansovino*, Strasbourg, 1935.
Mariacher, Giovanni, *Il Sansovino*, Milan, 1962.
Paolucci, A., *Sansovino*, Milan, 1966.
Tafuri, Manfredo, *Sansovino e l'architettura del '500 a Venezia*, Padua, 1969, 1972.
Howard, Deborah, *Sansovino: Architecture and Patronage in Renaissance Venice*, New Haven, 1975.

articles—

Lotz, W., "The Roman Legacy in Sansovino's Venetian Buildings," in *Journal of the Society of Architectural Historians* (Louisville, Kentucky), 22, 1963.
Boucher, Bruce, "Sansovino and the Choir of St. Mark's," in *Burlington Magazine* (London), 118, 1976, and 121, 1979.
Stott, D., "Fatte a Sembianza di Pittura: Sansovino's Bronze Reliefs in S. Marco," in *Art Bulletin* (New York), 64, 1982.
Lewis, D., "Sansovino, Sculptor of Venice," in *Titian: His World and His Legacy*, New York, 1982.
Hirthe, Thomas, "Die Libreria des Sansovino," in *Münchner Jahrbuch der Bildenden Kunst*, 37, 1986.

*

"You are the man who knows how to be Vitruvius." Thus in 1545 did the writer and poet Pietro Aretino, then a permanent resident of Venice, express the essential historical importance of his fellow Florentine Jacopo Sansovino. When Sansovino fled to Venice in 1527 at age 41 to escape the sack of Rome, he brought with him a thorough and mature understanding of classical architecture. In the course of the rest of his long forty-three-year career in Venice he almost single handedly changed the architectural style of the city from Gothic and proto-Renaissance to classicizing High Renaissance, but with a distinctly Venetian flavor. He also introduced a new style of classicizing sculpture which fundamentally altered the course of Venetian sculpture, and he trained the two most important sculptors of the next generation, Danese Cattaneo and Alessandro Vittoria.

Jacopo Tatti was initially trained in Florence at the beginning of the century as a sculptor by Andrea Sansovino whose name he took. But he also spent two long period in Rome (1505 or 1506–11 and 1518–27) where he became intimately familiar with classical sculpture by restoring and coping it, including a copy of the famous Laocoon discovered in 1506. He was attracted by the architecture of ancient Rome as well and by Bramante's original use of classical vocabulary and forms. By the end of his second Roman sojourn he was competent enough as an architect to win a competition (unexecuted) for S. Giovanni dei Firentini over Raphael, Peruzzi, and Antonio da Sangallo the Younger.

In both Florence and Rome he was closely associated with painters including Raphael, Raphael's teacher Perugino, for whom he provided a sculptural model for an altarpiece, and Andrea del Sarto, with whom he shared a workshop in Florence and for whom he also provided models for paintings. By the time Sansovino was reaching artistic maturity the authority of Michelangelo's genius was becoming so overwhelming that no artist could ignore it. In an effort to come to terms with Michelangelo's essentially inimitable style and still maintain his own personality he turned to High Renaissance painters like Raphael. His *Bacchus* (1512) in the Bargello of Florence and the *Madonna del Parto* (1518-19) in S. Agostino in Rome are highly successful Raphaelesque critiques of Michelangelo's *Bacchus* and *Moses*.

In Venice he continued to associate with painters and was a friend of Titian, Lotto, and Tintoretto. And the strikingly beautiful and original bronze reliefs which he cast in Venice were particularly painterly in character. For example, in the reliefs in St. Mark's on the singing tribunes or *cantorie* (south, 1537; north, 1541-44) and on the door to the sacristy (designed 1545-46, installed 1569) Titian's impact was evident in the use of grand rhetorical gestures and *dal sotto in su* illusionism. Sansovino relied even more heavily on Raphael, especially on the Sistine Chapel tapestries for the structure, meaning, drama, and motifs of the tribune reliefs, and on the Borghese *Entombment* for the sacristy door reliefs.

In his free-standing sculpture in bronze and marble (*Minerva, Apollo, Mercury, Peace*, Loggetta, 1540-45; *Mars and Neptune*, Scala dei Giganti, commissioned 1554, installed 1567; *Faith and Charity*, Venier Tomb, 1556-61) he continued to confront the work of Michelangelo, but in terms of a much stricter imitation of classical models. In certain works, such as the sacristy door, or the Frari *St. John the Baptist* (1554-56), he even reached back over Michelangelo to draw inspiration from Ghiberti and Donatello. As an architect Sansovino also showed unusual sensitivity to integrating his sculpture with its architectural setting.

Although one of the greatest sculptors of the 16th century, Sansovino was, in fact, far more important to the history of Venetian art as an architect. He arrived in Venice when the combined commercial and military pressures from the Turks in the east and from a variety of Italian and European states to the west and north had begun to produce a slow but inevitable decline of the city's power. In response to this decline, and encourage by the increasing impact of central Italian humanist culture on the intellectuals of Venice, the Venetians proclaimed themselves ever more loudly to be a New Rome. Although a consistent theme of state ideology since the 13th century, it was particularly dear to the vigorous doge who was in office when Sansovino arrived in Venice, Andrea Gritti (1523-38). With his enlightened patronage Sansovino showed the Venetians for the first time how to give convincing architectural expression to that ideology.

In the city center Sansovino removed a series of stalls to open up the view from the Piazzetta to the water, enlarged and regularized the Piazza San Marco to make the church of St. Mark's more prominent, isolated the campanile to integrate more successfully the Piazza and the Piazzetta, designed classicizing porticos to unify the new construction, and build a loggia against one flank of the campanile to unite the campanile to the rest of the new construction. In other words, using

to the extent possible the classical design principles of axiality, symmetry, hierarchy, and unity, Sansovino created a Venetian forum worthy of the New Rome. The buildings which he built on this forum (Shops, 1531; Library, 1537-91; Mint, 1536-47—third story, 1558-66, probably not by Sansovino; Loggetta, 1537-45), as well as the palaces and religious and commercial structures he built elsewhere in the city (Palazzo Dolfin-Marin, 1538-50's; Palazzo Corner, c. 1545-80's; S. Francesco della Vigna, c. 1534 onward; Fabbriche Nuove, 1554-58), introduced to Venice the High Renaissance style he had begun to develop already in Rome. This style was both strict in its application of classical vocabulary and structural principals while at the same time highly varied, brilliantly inventive, and richly sculptural. Yet Sansovino was also able to accommodate his buildings to the unique social, political, economic, and cultural circumstances of Venice as well as to its aesthetic preference for festive and lavishly elaborated facades. That the Library provided so well for so many functions (library, academy, sculpture museum, shops, covered portico) and harmonized so well with the Gothic Doge's Palace opposite provides vivid testimony to Sansovino's superb ability to innovate while working within Venetian traditions. Palladio justly called the Library, Sansovino's undisputed masterpiece, "the richest and most ornate building since antiquity."

—Loren Partridge

SARGENT, John Singer.

Born in Florence, 12 January 1856, to United States parents; grew up in Nice, Rome, Dresden, and Florence. Died in London, 15 April 1925. Drawing lessons as a child; entered studio of Carolus-Duran, Paris, 1874; exhibited at Salon, 1878: many commissions, and became famous by the mid-1880's; settled in London, 1884 (lived in Tite Street from 1885): R.A., 1897; did few portraits after 1910; series of mural decorations: Boston Public Library, 1890-1916, Boston Museum of Fine Arts, 1916-25, and Harvard University chapel.

Major Collection: Boston.
Other Collections: Boston: Public Library, Gardner; London: Tate, Portrait Gallery; Minneapolis; New York: Brooklyn Museum, Metropolitan; Paris: Art Moderne; Washington: Corcoran, National Gallery; Williamstown, Massachusetts.

Publications

On SARGENT: books—

Fenollosa, Ernest F., *Mural Painting in the Boston Public Library,* Boston, 1896.
Meynell, Alice, *The Work of Sargent,* London and New York, 3 vols., 1903.
Pousette-Dart, Nathaniel, *Sargent,* New York, 1924.
Decoration of the Main Stairway and Library: Sargent, Boston, 1925.

Downes, William Howe, *Sargent: His Life and Work,* Boston, 1925.

Sargent Memorial Exhibition (cat), Boston, 1925, London, 1926.

Charteris, Evan, *Sargent,* New York and London, 1927.

Flint, Ralph, and Walter C. Clark, *Drawings by Sargent* (cat), New York, 1928.

Hardie, Martin, *Sargent,* London and New York, 1930.

Birnbaum, Martin, *Sargent: A Conversation Piece,* New York, 1947.

Sweet, Frederick A., *Sargent, Whistler, Cassatt* (cat), Chicago, 1954

Mount, Charles Merrill, *Sargent: A Biography,* New York, 1955.

McKibben, David, *Sargent's Boston* (cat), Boston, 1956.

Sargent and Boldini (cat), San Francisco, 1959.

Hoopes, Donelson F., *The Private World of Sargent* (cat), Washington, 1964.

Gross, Ellen, and James Harithas, *Drawings by Sargent in the Corcoran Gallery of Art,* Alhambra, California, 1967.

Hoopes, Donelson F., *Sargent Watercolors,* New York, 1970.

Ormond, Richard, *Sargent: Paintings, Drawings, Watercolors,* New York, 1970.

Lomax, James, and Richard Ormond, *Sargent and the Edwardian Age* (cat), Leeds, 1979.

Adelson, Warren, *Sargent: His Own Work* (cat), New York, 1980.

Ratcliffe, Carter, *Sargent,* New York, 1982, Oxford, 1983.

Nygren, Edward J., *Sargent: Drawings from the Corcoran Gallery of Art* (cat), Washington, 1983.

Lubin, David M., *Act of Portrayal: Eakins, Sargent, James,* New Haven, 1985.

Getscher, Robert H., *James McNeil Whistler and Sargent: Two Annotated Bibliographies,* New York, 1986.

Hills, Patricia, *Sargent* (cat), New York, 1986.

Olsen, Stanley, *Sargent: His Portrait,* London and New York, 1986.

Olsen, Stanley, Warren Adelson, and Richard Ormond, *Sargent at Broadway: The Impressionist Years* (cat), London and New York, 1986.

*

John Singer Sargent is best known as a portrait painter, although he also painted well-received landscapes and murals. Despite straddling two major stylistic movements— impressionism and modernism—he had allegiance to neither, although he was in Paris during impressionism's prime years, studied its painters, and became a close friend of Monet. In fact Sargent lived in Paris for about 10 years, as a student and while first building his reputation. He left in 1884 primarily because of the scandal caused when he exhibited *Madame X* at that year's Salon. Apparently Virginie Aregno Gautreau's strange lavender skin tone and generous décolletage were too much for Parisian sensibilities. Sargent moved permanently to England, a country where he proved himself, first with the pastoral, impressionist-influenced *Carnation, Lily, Lily, Rose* (1887), at last with *Lady Agnew* (1893), which clinched his reputation as a portraitist. (Curiously, although he never lived in the United States for other than prolonged visits, Sargent considered himself American—to the point of refusing an En-

Henry James, 1912; drawing

glish knighthood because it would mean losing his American citizenship.)

Sargent's portraits are traditional in presentation, with emphasis on fashion and social standing. He painted mostly the middle and upper classes, and the poor only in a glamorous, stylized manner. This was inevitable since most of his portraits were commissioned by the well-off. But Sargent was comfortable with this system of patronage; he was apolitical, never choosing subjects that were controversial or provocative. He didn't make statements with his work, except perhaps visually, and even then it was mostly surface bravura.

Sargent's style emphasizes light and dark, and colour. His work is most frequently described as luminous, with bright, deep swathes of colour applied in broad, bold strokes. He used light to create a shadowy backdrop against which the faces— usually full frontal with a direct gaze—are highlighted. There is no attempt to delve beneath the surface; light and how it falls temporarily on the subject is all. Sargent developed this style during his studies at the Paris studio of Carolus-Duran, who demanded that his students paint *au premier coup* (at first glance): with no preliminary sketches allowed, they sketched briefly, directly onto the canvas, and then applied the main planes of the composition in broad strokes. There was no layering of tones to indicate internal structure; nor were they blended. As Carter Ratcliffe describes, in using this technique one "sacrificed solid architecture to the momentary effects of light on form."

The paintings are not *completely* surface, however; if they were they would leave no lasting impression. Although they

rarely challenge precepts, they do capture, often in the people, sometimes in the landscapes, a sense of movement under the pretty surfaces, of thoughts being thought, of growth. They have a certain psychological resonance—sadly not pushed far enough, perhaps, but something that keeps traces of the paintings in the mind's eye for a long while.

—Tracy Chevalier

SASSETTA.

Born Stefano di Giovanni, in Siena or Cortona, c. 1392. Died in Siena, 1450. Worked in Siena: first documented work is the chapel for Arte della Lana in Siena, 1423–26 (now dispersed); works for Siena Cathedral; also worked for S. Francesco, in Borgo Sansepolcro, 1437–44 (dispersed).

Collections: Barnard Castle; Berlin; Boston; Budapest; Chantilly; Cleveland; Cortona: S. Domenico; Detroit; Florence; Frosseto; London; Melbourne; Montpellier; New York: Metropolitan, Frick; Paris; Siena; Vatican; Washington.

Publications

On SASSETTA: books—

Berenson, Bernard, *A Sienese Painter of the Franciscan Legend,* London, 1909; as *Sassetta,* Florence, 1947.
Pope-Hennessy, John, *Sassetta,* London, 1939.
Brandi, Cesare, *Quattrocentisti senesi,* Milan, 1949.
Carli, Enzo, *Sassetta e il Maestro dell' Osservanza,* Milan, 1957.
Bellosi, Luciano, and Alessandro Angelini, editors, *Sassetta e i pittori toscani tra XIII e XV secolo,* Florence, 1986.

articles—

Seymour, Charles, Jr., "The Jarves 'Sassettas' and the St. Anthony Altarpiece," in *Journal of the Walters Art Gallery* (Baltimore), 15–16, 1952–53.
Wyle, Martin, and Joyce Plesters, "Some Panels from Sassetta's Sansepolcro Altarpiece," in *National Gallery Technical Bulletin* (London), 1, 1977.
Braham, Allan, "Reconstructing Sassetta's Sansepolcro Altarpiece," in *Burlington Magazine* (London), June 1978.

*

Despite his status as the most important Sienese painter of the 15th century, little is known about the life of Stefano di Giovanni, commonly called Sassetta. His father was from Cortona, but he may have been born in Siena. Although nothing is known of his early training, his artistic origins are Sienese. He signed his works Stefano di Giovanni, and the name Sassetta seems to have originated in the 18th century for unknown reasons, although not in connection with the town of that name in the Maremma, southwest of Siena. Sassetta's *oeuvre* is rela-

tively small, and a number of his major works have been dismembered and scattered. His works are notable for their integration of Sienese gothic traditions of lyrical and elegant line and rich colors, with coherent spatial recession and a command of *chiaroscuro* learned from early 15th-century Florentine masters.

In scholarly literature, understanding of Sassetta has been hampered by a relative paucity of research on the Sienese Quattrocento. The studies of John Pope-Hennessy and Enzo Carli in particular have made significant progress towards defining Sassetta as a clear artistic personality, distinct from the closely related Master of the Osservanza, so-called because of the triptych of an *Enthroned Madonna and Sts. Jerome and Ambrose* painted for the Church of the Osservanza outside Siena and dated 1436. Taken from Sassetta's *oeuvre* and generally given now to the Master of the Osservanza are the Osservanza altarpiece, the *Birth of the Virgin* panel in the Museum of Asciano, and the eight panels of the Life of St. Anthony Abbot, now in a number of European and American collections, that once formed an altarpiece. Brandi has proposed that the Osservanza Master may be the youthful Sano di Pietro, but further study is necessary on this question.

Sassetta's activity is closely associated with Siena; even his most complex work, the double-sided altarpiece commissioned for the church of S. Francesco in Sansepolcro, was painted in Siena and then delivered and set up in the southern Tuscan town. While primarily a panel painter, he also received numerous other commissions, particularly for the Sienese cathedral, including a design for a historiated scene for the mosaic pavement (1420's), and for a stained glass window for the facade in 1440 (never executed), and a scale design of the baptismal font. At the time of his death in 1450, he was working on the fresco decoration for the Porta Romana in Siena.

Sassetta's earliest known altarpiece was painted for the chapel of the Sienese wool guild, the Arte della Lana, between 1423 and 1426. The altarpiece was removed from the chapel and sawn apart by the early 19th century. Many elements have been lost, and the predella panels, the only remaining parts, are now mostly in the Siena Pinacoteca. Originally, the altarpiece displayed an image of the *Exaltation of the Host* (Corpus Domini) in its center, surrounded by four panels of saints. Above was a *Coronation of the Virgin,* flanked by the Archangel Gabriel and the Annunciate Virgin. Below was a predella with scenes of the lives of St. Thomas Aquinas and St. Anthony, and images of miracles of the sacrament, on either side of a *Last Supper.*

Following the Arte della Lana altarpiece, Sassetta's next major work is the *Madonna della Neve* (*Madonna of the Snow*), painted between 1430 and 1432 for the Sienese Cathedral (now in Contini Bonacossi Collection, Florence). In the main panel, the enthroned Madonna and Child are flanked by angels and Sts. John the Baptist, Peter, Francis, and Paul. The predella presents the legend of the miraculous snowfall of August 352 that outlined the ground plan of the Roman basilica of S. Maria Maggiore. The Cathedral was the site of works by Siena's most famous artists, the 14th-century masters Duccio, Simone Martini, and the Lorenzetti brothers, and, consequently, the commission to Sassetta was prestigious. Despite its present poor condition, the surface of the altarpiece was originally refined and elegant, exhibiting brilliant colors, including large amounts of gold and ultramarine blue, and ele-

gant patterning in the brocades of the large Madonna. The coherent spatial relationship of the figures to each other marks a new understanding of spatial effects in Sienese 15th-century art. That same sense of space is evident in the predella panels where the events take place amidst spacious and unified landscape and architectural settings.

Sassetta's most complex and impressive work is the high altarpiece painted for S. Francesco in Sansepolcro between 1437 and 1444. Now dispersed among collections in Paris, Florence, London, and Chantilly, the work originally displayed the *Virgin and Child with Angels* in its central front panel, flanked by four full-length saints. A *St. Francis in Ecstasy* formed the central back image and was surrounded by eight scenes from the Life of St. Francis arranged on two levels to either side. In this mature work, Sassetta again displays his sophisticated integration of Sienese lyricism and Florentine naturalism. Typically Sienese are his slender and graceful figures, his poetic and enchanted narratives, and his emphasis on elegant line and color. Incorporated into that tradition is his awareness of the achievements of Masolino and Gentile da Fabriano, as evidenced in his sweeping landscape backgrounds and subtly modelled forms.

Sassetta's extant *oeuvre* remains small. Other panel paintings given to him include fragments of a crucifix of 1433 for the church of S. Martino (Chigi-Saracini Collection, Siena); and a polyptych with a Madonna and Child flanked by four saints for the church of S. Francesco at Cortona from 1433–37 (Museo Diocesano, Cortona).

—Barbara Dodge

SCHIELE, Egon.

Born in Tullin, 12 June 1890. Died in Vienna, 31 October 1918. Married Edith Harms, 1915. Attended schools in Krems and Klosterneuberg; Academy of Fine Arts, Vienna, 1906–09; influenced by Klimt and Hodler, and by Freudian psychology; began exhibiting early, and did portraits, erotic drawings (jailed briefly for erotic work in Neulengbach, 1912); served in the Austrian Army, 1915–18, and died in the influenza epidemic.

Major Collection: Vienna: Osterreichische Galerie.
Other Collections: Darmstadt; Geneva: Waechter; The Hague; Linz; Minneapolis; Munich: Neue Pinakothek; Prague; Stuttgart.

Publications

By SCHIELE: books—

Briefe und Prose, edited by Arthur Roessler, Vienna, 1921.
Briefe, Gedichte, edited by Christian Michael Nebehat, Vienna, 1979.

On SCHIELE: books—

Karpfen, F., *Das Schiele-Buch*, Vienna, 1921.

Roessler, Arthur, *In Memorian Schiele*, Vienna, 1921.
Roessler, Arthur, *Erinnerungen an Schiele*, Vienna, 1922, 1948.
Nirenstein, Otto, *Schiele: Persönlichkeit und Werk*, Vienna, 1930.
Künstler, Gustav, *Schiele als Graphiker*, Vienna, 1946.
Benesch, Otto, *Schiele as a Draughtsman*, Vienna, 1951.
Mitsch, Erwin, *Schiele: Ziechnungen und Aquarelle*, Salzburg, 1961, 3rd ed., 1969.
Fischer, W., *Schiele* (cat), London, 1964.
Comini, Alessandra, and J. T. Demetrion, *Klimt and Schiele* (cat), New York, 1965.
Benesch, Heinrich, *Mein Weg mit Schiele*, edited by Eva Benesch, New York, 1965.
Kallir, Otto, *Oeuvre Katalog der Gemälde/Oeuvre Catalogue of the Paintings*, Vienna and New York, 1966.
Kallir, Otto, *A Sketchbook by Schiele*, New York, 2 vols., 1967.
Hofmann, Werner, *Schiele: Die Familie: Einführung*, Stuttgart, 1968.
Koschatzky, Walter, *Klimt, Schiele* (cat), Vienna, 1968.
Fischer, W., and Hans Rose, *Schiele: Drawings and Watercolours*, London, 1969.
Kallir, Otto, *Schiele: Das druckgraphische Werk / The Graphic Work*, Vienna and New York, 1970.
Leopold, Rudolf, *Schiele: Gemälde, Aquarelle, Zeichnungen*, Salzburg, 1972; as *Schiele: Paintings, Watercolors, Drawings*, New York, and London, 1973.
Comini, Alessandra, *Schiele in Prison*, Greenwich, Connecticut. 1973.
Comini, Alessandra, *Schiele's Portraits*, Berkeley, 1974.
Mitsch, Erwin, *Schiele*, Salzburg, 1974; as *The Art of Schiele*, London and New York, 1975.
Comini, Alessandra, *Schiele*, New York, 1976.
Wilson, Simon, *Schiele*, Ithaca, New York, and Oxford, 1980.
Sabarsky, Serge, *Schiele: Zeichnungen und Aquarelle* (cat), Vienna, 1981; as *Schiele: Watercolors and Drawings*, New York, 1983.
Sabarsky, Serge, *Schiele: Disegni erotici*, Milan, 1981.
Nebehay, Christian, *Klimt, Schiele, Kokoschka: Werke auf Papier* (cat), Salzburg, 1981: as *Drawings and Watercolours*, London, 1981.
Whitford, Frank, *Schiele*, New York and London, 1981.
Kuchling, Heino, *Schiele und sein Kreis*, Ramerding, 1982.
Sabarsky, Serge, *Schiele vom Schüler zum Meister* (cat), Milan, 1984; as *Schiele*, New York, 1985.
Schiele (cat), Charleroi, 1987.

*

The painter Gustav Klimt, in his efforts to create a new surface beauty and elegance, became the symbol for the bourgeois longing for pagentry and facade, and though he certainly had broken with tradition, in retrospect his new art had acquired a certain superficial function. It was obvious that Klimt's ability to articulate human experience was limited, and thus it was left to a younger artist to find new and radical ways of expression that would lead the way further into the future.

This artist was Egon Schiele. Here was a youth who had not grown up in the contentment of a happy family life; his father's gradual paralysis and death from syphilis, and his mother's

Male Nude, 1912; lithograph

and turns of nature into angular, structural forces. Areas of contrast are played against each other, creating an abstract quality. By using the negative spaces around the object to carry as much meaning as the positive shapes, thus taking the flattening-out process one step further, Schiele creates new spatial tensions across the surface of the canvas. In these arrangements, positive formal elements are pushed, as it were, to the edges, increasing the sense of bleakness. We can also see this tendency in *Self-Portrait with Outspread Fingers* (1909, private collection), which seems to foreshadow minimalism in its apparent emptiness. Though the influence of Klimt remains in this painting, his glorious ornamentation has become a single strip of muted color against a sombre green background.

Schiele also produced allegories using a certain amount of religious imagery to convey intense personal feeling. In these paintings, such as *Madonna* (1911, Vienna, Sammlung Hans Dichand) and *Agony* (1912, Munich, Neue Pinakothek), Schiele's painterly technique seems to be one of a gradual building outwards from a hidden centre. The process reminds one of the organic formation of natural substances, but as one elemental form gels quietly with another, one becomes aware that these are not images of growth but the morbid encounter with death. Perhaps in memory of his mother's sad fate, Schiele painted *Pregnant Woman and Death* (1911, Prague). His mother's first three children had been still-born, and another died at the age of ten. But this image of death is not only significant in light of her experiences but also strangely prophetic, as Schiele's own wife was to die while still carrying his unborn child.

One aspect of Schiele's oeuvre which remains bright in the memory is that of landscape. The facets of buildings are flattened out to some degree, giving way to the stacking process which was later to influence the painter Friedensreich Hundertwasser. These colored formations, conveying more of the artist's personality than that of place, loom out of the darkness, and seem to convey Schiele's desire to hold on to the precious and meaningful things in life which remain trapped in the mind like so many bright spots against a dark and oppresive background.

—L. A. Landers

wasting away due to the disease, must have weighed heavily on the child Schiele's mind. Such an oppressive background must have been doubly burdensome to an over-sensitive boy whose artistic talents showed at an early age. Yet by questioning himself and the roles of both life and death, Schiele became the supreme painter of empathy, and of human experience as understood by the individual in the throes of an existential malaise. Parallel to the psychoanalytical thought of the time, his work focuses on the self, on being as origin of desire, receptical of neurosis, as the entity which feels pain, remorse, fear. These qualities of the human psyche are embodied in his many self-portraits and paintings of the nude. Nothing, it seems, was omitted from view or elevated beyond or above normal recognition; by plundering the depths of the human psyche turned inside out, Schiele achieves an art that is close to the bone. With a terse line and pungent color Schiele reveals the human figure in various contortions, posed crouching or sprawling, nude or semi-nude. At times the orange or red of a piece of drapery signals youthful passions and embraces the image in a glow of color or sings out from it. Movement is suggested, a piece of colored drapery or clothing indicating models in the process of getting dressed or undressed, animating the figures and moving them away from the frozen poses of the academy. In the self-portraits Schiele used gestural or directional attitudes of the hands to indicate human fragility and pathos. Schiele positions his figures at oblique angles or at extreme points on the paper or canvas, giving these works a quality of urgency and crisis.

In *Autumn Tree* (1909, Darmstadt) we can see how Schiele has rid Art Nouveau of its sinuosity and converted the twists

SCHLEMMER, Oskar.

Born in Stuttgart, 4 September 1888. Died in Baden-Baden, 13 April 1943. Married Helena Tutein, 1920; three children. Attended schools in Goppingen; apprenticed to an inlay-carpenter, Stuttgart, 1903–05; attended Kunstgewerbeschule, Stuttgart, 1905; studied under Potzelsberger, von Keller, Landenberger, and Adolf Koelzel at the Academy of Fine Arts, Stuttgart, 1906–09, 1912; friendship with Willi Baumeister from 1908; first dance projects, 1912; designed murals, 1914; served in the German Army, 1914–18 (wounded in action); founder, with other students of Hoelzel, Uecht group, 1919; stage designs for Kokoschka's *Murderer* (later designs for *Das Nusch-Nuschi*, 1921, *Triadic Ballet*, 1922, and many other dances); lecturer at the Bauhaus, Weimar and Dessau, 1921–29; murals for Essen Folkwang Museum, 1928–33; taught at

Group of 14 Figures, 1930; 36¼ × 47⅝ in (92 × 121 cm); Cologne, Wallraf-Richartz-Museum

Breslau Art Academy, 1929–32, and School of Fine Arts, Berlin, 1932–33, but dismissed by the Nazis; lived in Eichberg-bei-Dettig and Sehringen-bei-Badenweiler, then in Stuttgart as house painter, 1938–40, and in Wuppertal as consultant to paint manufacturer.

Collections: Basel; Breslau; Cambridge, Massachusetts; Cologne; Dessau; Duisberg; Essen; Frankfurt; Hanover; Hartford, Connecticut; Munich: Neue Pinakothek; New York; Saarbrucken; Stuttgart.

Publications

By SCHLEMMER: books—

Die Bühne im Bauhaus, with Laszlo Moholy-Nagy and Farkas Molnar, Munich, 1925; as *The Theatre of the Bauhaus,* edited by Walter Gropius, Middletown, Connecticut, 1961; London, 1979.
Otto Meyer-Amden: Aus Leben, Werk, und Briefen, Zurich, 1934.

Briefe und Tagebücher, edited by Tut Schlemmer, Munich, 1958, 1977; as *Letters and Diaries,* Middletown, Connecticut, 1972.
Der Mensch: Unterricht am Bauhaus, edited by Heimo Kuchling, Mainz, 1969; as *Man: Teaching Notes from the Bauhaus,* Cambridge, Massachusetts, and London, 1971.

On SCHLEMMER: books—

Hildebrandt, Hans, editor, *Schlemmer,* Munich, 1952.
Borries, J. E. von, *Schlemmer: Die Wandbilder für den Brunnenraum im Museum Folkwang Essen,* Stuttgart, 1960.
Aust, G., *Schlemmer: Das Spätwerk 1935–1942* (cat), Wuppertal, 1963.
Schmidt, G., *Das Gesamtwerk von Schlemmer* (cat), Berlin, 1963.
Grohmann, Will, *Schlemmer: Zeichnungen und Graphik,* Stuttgart, 1965.
Maur, Karin von, *Schlemmer* (cat), New York, 1968.
Goldberg, Roselee, *Some Aspects of Schlemmer 1915–1925,* London, 1970.
Maur, Karin von, *Schlemmer,* London, 1972.
Herzogenrath, Wulf, *Schlemmer: Die Wandgestaltung der*

neuen Architektur, mit einem Katalog seiner Wandestaltungen, Munich, 1973.

Maur, Karin von, *Schlemmer und die Stuttgarter Avantgarde 1919,* Stuttgart, 1975.

Maur, Karin von, *Schlemmer* (cat), Stuttgart, 1977.

Schlemmer: Aquarelle und Handzeichnungen 1919–1936 (cat), Krefeld, 1978.

Maur, Karin von, *Schlemmer,* Munich, 2 vols., 1979; supplement, 1982.

Naylor, Gillian, *The Bauhaus Reassessed: Sources and Design Theory,* London, 1985.

Schlemmer: Man and Abstraction in the Twenties and Thirties (cat), Amsterdam, 1987.

article—

Kirstein, Lincoln, "Triadic Ballet," in *Movement and Metaphor,* New York, 1970.

*

Oskar Schlemmer, a member of the extraordinary German art school known as the Bauhaus, added his "solution" to the problem of dealing with the figure in painting in this century to the long list of innovators which includes Duchamp and Picasso and Bacon. Where they broke-up or re-shuffled or twisted the human form in an attempt to re-see it, Schlemmer left such things as eyes and legs in their accustomed places while simplifying forms into doll-like shapes which gave different non-realistic value to various parts of the body: for example, wide hips narrowing to tiny feet echoed by exaggerated shoulders. In Schlemmer's paintings these figures have wooden-clothespin-like heads and suggest puppets or robots of some sort.

Because of the way they *look,* these figures dictate the way we imagine them to move. And Schlemmer's choice of setting assists our participation. Although static and stopped in time, the fact that figures are seen, say, on a stairway, tells us that they are going up or down. Their often strange, top-like quality also suggests that they might suddenly begin to spin as well. Thus are two major subjects of modern art—space and time—dealt with by one painter.

And a painter who was notable also for his stage work. Dance after all is about duration of movement within a specific space, and Schlemmer was a great innovator in transforming dancer's bodies through costumes and masks so that their proportions were altered and their features displaced or erased. And because of what they were wearing they changed the way they moved. Picasso had achieved much the same thing with his revolutionary cubist costumes for the ballet *Parade* in which our idea of how humans look was totally sabotaged.

If this de-humanization ends up with mechanical, toy-like human figures, it at least forces us to rethink our own existence, how we look, how we move, where we are.

—Ralph Pomeroy

SCHONGAUER, Martin.

Born in Colmar, Alsace, c. 1440–45; son of Caspar Schongauer, goldsmith; brother of three goldsmiths and one painter. Died in Breisach 2 February 1491. Matriculated at the University of Leipzig 1465 but did not remain there; returned to Colmar and may have studied with the painter Caspar Isenmann, whose works reveal the influence of Rogier van der Weyden; worked mainly in Colmar, primarily as a printmaker, and established a school of engraving; of many paintings attributed to him the most likely authentic is the *Madonna of the Rosehedge* in his own church, St. Martin in Colmar; painted the *Last Judgment* fresco in St. Stephen Breisach, on the opposite side of the Rhine, 1488–91.

Collections/Locations: Basel; Berlin; Boston: Gardner; Breisach: St. Stephan; Colmar: St. Martin, Museum; Frankfurt; London: National Gallery, British Museum; Munich; Vienna.

Publications

On SCHONGAUER: books—

Wendland, Hans, *Schongauer als Kupferstecher,* Berlin, 1907.

Girodie, Andre, *Schongauer et l'art du Haut-Rhin au XV siècle,* Paris, 1911.

Rosenberg, Jakob, *Schongauer: Handzeichnungen,* Munich, 1923.

Champion, Claude, *Schongauer* Paris, 1925.

Lehrs, M., *Katalog der Kupferstiche Schongauers,* Vienna, 1925.

Büchner, Ernst, *Schongauer als Maler,* Berlin, 1941.

Baum, Iulius, *Schongauer,* Vienna, 1948.

Flechsig, Eduard, *Schongauer,* Strasbourg, 1951.

Winzinger, Franz, *Die Ziechnungen Schongauers,* Berlin, 1962.

Shestack, Alan, *The Complete Engravings of Schongauer,* New York, 1969.

Minott, Charles Ilseley, editor, *Schongauer,* New York, 1971.

Baumgart, Fritz, *Schongauer: Incisioni,* Florence, 1978.

Schnack, Jutta, *Der Passionszyklus in der Graphik Israhel van Meckenems und Schongauers,* Münster, 1979.

Kromer, Joachin, *Die Entwicklung der Schlusselkompositionen in der spätmittelalterischen Kunst um 1500: Meister ES, Schongauer, Grünewald,* Baden-Baden, 1979.

Bernhard, Marianne, *Schongauer und sein Kreis: Druckgraphik, Handzeichnungen* Munich, 1980.

article—

Winzinger, Franz, "Eine frühes Christusbild Schongauers," in *Pantheon* (Munich), November 1972.

*

Admired during his lifetime and in his own surroundings as an important painter, Schongauer today is given primary consideration as a pioneering printmaker, a contribution certainly also recognized by his contemporaries, for his prints became widely known and imitated throughout Europe, and Vasari reports that one of them, *The Tribulations of St. Anthony,* so

The Madonna with an Apple, c.1475–80; engraving

art, in particular that of Rogier van der Weyden and Hugo van der Goes, so prominent in Schongauer's drawings and engravings and also in panel paintings attributed to him. At the completion of his apprenticeship he must have undertaken the traditional journeyman's travels and visited German art centers as well as such centers in the Netherland and Burgundy. Among his drawings is a copy of the Christ in Rogier van der Weyden's *Last Judgment* altarpiece in Hotel-Dieu in Beaune, dated 1469, suggesting the young artist's presence there at that time.

The most important of the paintings attributed to him is the *Madonna of the Rosehedge*, dated 1473, and painted for his own church, St. Martin's in Colmar, where it can still be seen.

In 1489, having the previous year made a substantial parting donation to St. Martin's, Schongauer moved a few miles eastward, out of Alsace, to Breisach, a river town on the opposite shore of the Rhine, where he had been commissioned to paint frescoes in the minster of St. Stephen. The project, a major work in three parts, has as its centerpiece a *Last Judgment* in the manner of Rogier van der Weyden's in Beaune from which Schonegauer earlier had made a drawing of the Christ figure. The fescoes, in later time irreverently whitewashed, were rediscovered in a severly reduced state in 1931. They are presumed to be incomplete, for the artist died in Breisach in 1491, at the height of his creative power.

While Schongauer's engravings, pictorially inventive and technically perfect, are the products of an artist of consummate skill and vivid imagination, his few surving paintings at first glance appear less original, compositon and imagery derived from careful observation of works by his Flemish and German predecessors. Yet on closer scrutiny they reveal a structural deliberation combined with a reduction and simplification of the subject in a striving for greater clarity, which brings the traditional a step forward, away from the purely decorative toward a more dignified, expressive totality.

—Reidar Dittmann

impressed Michelangelo that he was inspired to paint a copy of it. And Albrecht Dürer, the foremost printmaker of the Renaissance, having seen Schongauer's engravings in Nuremberg, set out for Colmar to meet the artist, only to find that he had died shortly before his arrival. One specific reason for his greater reputation as a printmaker rather than a painter is that all of his 116 engravings have survived, whereas extremely few of his paintings have been located and safely attributed to him.

Born into an Augsburg family having migrated to Colmar in the 1440's he is first recorded in the entry books of the University of Leipzig in 1465. Considering that the average age at matriculation was twenty years it may be assumed that he was born around 1445. A portrait of Schongauer attributed to Thoman Burgkmair and clearly dated 1483—with certain biographical data of the sitter attached to the back of the panel—shows a man quite likely in his thirties, giving validity to the presumed birth year.

In the Colmar street where the Schongauers resided lived also the city's leading artist at that time, Caspar Isenmann, whose apprentice the young Martin may have been. At the same time he was no doubt apprenticed to his goldsmith father and learned to master the art of engraving. Pictorially, however, his early inspiration must have come exclusively from Isenmann, whose works show the strong influence of Flemish

SCHWITTERS, Kurt (Hermann Edward Karl Julius).
Born in Hanover, 20 June 1887; naturalized British citizen, 1948. Died in Kendal, Westmorland, 8 January 1948. Married Helma Fischer, 1915 (died, 1945); one son. Attended schools in Hanover; studied at the Kunstgewerbeschule, Hanover, 1908, Art Academy, Dresden, 1909–14, and Art Academy, Berlin, 1914; lived and worked in Hanover from 1914; served in the German army as a draftsman, 1917–18; first Merz experiments, 1918, and first Merzbau begun, 1920; associated with the early Dada group; editor, *Merz* magazine, 1923–32; labeled degenerate by the Nazis, and settled in Oslo, 1937: began second Merzbau; escaped to Britain before the Nazi invasion of Norway, 1940, and interned in Edinburgh, then the Isle of Man, 1940–41; lived in London, 1941–45, and Ambleside, from 1945: began third Merzbau, 1947.

Collections: Amsterdam: Stedelijk; Berlin: Nationalgalerie; Berne; Chicago; Hamburg; London: Tate; Los Angeles; New York: Guggenheim, Moma; Stockholm: Moderna Museet.

Publications

By SCHWITTERS: books—

Anna Blume: Dichtungen, Hanover,1919.
Sturm-Bilderbucher, Hanover, 1922.
Auguste Bolte, Berlin, 1923, edited by Ernst Schwitters, Zurich, 1966.
Die Scheuche, with Kate Steinitz and Theo van Doesburg, Hanover, 1925.
Pin, with Raoul Hausmann, London,1962.
Anna Blume und Ich, edited by Ernst Schwitters, Zurcih, 1965.
Literarische Werk, edited by Friedhelm Lach, Cologne, 5 vols., 1973–81.
Merzhefte (facsimile reprints), edited by Friedhelm Lach, Berne, 1975.
Wir spielen, bis uns der Tod abholt: Briefe aus funf Jahrzehnten, edited by Ernst Nündel, Frankfurt, 1975.

On SCHWITTERS: books—

Themerson, Stefan, *Schwitters in England*, London, 1958.
Steinitz, Käte Trauman, *Schwitters: Erinnerungen aus den Jahren 1918-30*, Zurich, 1963; as *Schwitters: A Portrait from Life*, Berkeley, 1968.
Schwitters Retrospective (cat), New York,1965.
Schmalenbach, Werner, *Schwitters: Leben und Werk*, Cologne, 1967, Munich, 1984; as *Schwitters*, London and New York, 1970.
Lach, Friedhelm, *Der Merz Künstler, Schwitters*, Cologne, 1971.
Wright, Philip, *Schwitters* (cat), Edinburgh), 1976.
Rubinger, Krystyna, *Schwitters* (cat) (in English and German), Cologne, 1978.
Scheffer, Bernd, *Anfänge experimenteller Literatur: Das literarische Werk von Schwitters*, Bonn, 1978.
Berkett, M. E., *Schwitters, Creator of Merz*, Kendal, 1979.
Nündel, Ernst, *Schwitters ins Selbstzeugnissen und Bilddokumenten*, Reinbek, 1981.
Schwitters in Exile: The Late Work 1937-1948 (cat), London, 1981.
Elger, Dietmar, *Schwitters: Der Merzbau*, Cologne,1984.
Gohr, Siegfried, *Schwitters: Die späten Werke* (cat), Cologne, 1985.
Elderfield, John, *Schwitters*, London, 1985.
Elderfield, John, *Schwitters* (cat), London, 1986.

*

"Merz," Schwitters's highly idiosyncratic contribution to 20th-century art, should be seen both in terms of its place in post-war German culture and with regard to the personality—cautious, parsimonious, ironic—of its creator. Schwitters's attitude corresponded to the ambivalent spirit of the 1920's and 1930's, concerned on the one hand with an optimistic "Call to Order," yet on the other with the sardonic aggression reflected in Dada and Neue Sachlichkeit (New Objectivity). A mechanical draughtsman in a Hanover ironworks during wartime, Schwitters came into his own in 1918-19. His academic realist compositions, which were to resurface sporadically throughout his career, gave way at this time to Expressionist and Futurist influences, resulting in a short series of angular, derivative landscapes and abstract drawings. However, with exposure to Cubist collage, and the birth of Dada, Schwitters's style changed radically. While never fully accepted into the Dada clique because, according to Hans Richter, Huelsenbeck took an instant dislike to his "bourgeois face," Schwitters nevertheless developed and maintained single-handedly Hanover Dada, making his home town one of the most artistically fashionable cities in Germany.

The work of and around the 1920's constitutes the best of Schwitters's oeuvre: from his suburban home the artist began producing collages and assemblages, supplemented with poetry and noise-recitals, all of which he gave the name "Merz." Fond as he was of word-games, Schwitters had borrowed "Merz" from "Kommerz und Privatbank" (Commerce and Private Bank), simultaneously applauding its ambiguous relationship to other words such as "Schmerz" (pain), "ausmerzen" (to reject), or the French "merde" (shit). "Merz" and Schwitters were indebted in concept and medium to Synthetic Cubism, for its recognition of collage and assemblage as radical means of artistic expression. Invaluable inspiration came as well from Russian Constructivism and Dutch de Stijl, Schwitters celebrating with these artists their bold typography and geometric forms. True to the spirit of Dada, Schwitters began collecting rubbish—sweet wrappers, tram tickets—that he found on his many walks around Hanover, which he then pasted, layer by layer, onto compact canvases. Ostensibly chaotic in appearance, the collages are in fact skilfully composed and tightly organised: the assorted papers interact like the elements of a conventional landscape painting to shape Schwitters's view of the world as conveyed by its rubbish. The assemblages, or "Merzbilder" (Merz-pictures), reminiscent of Picabia's machinist creations of the recent past, are larger and appear more pointedly aggressive than the collages: in *Construction for Noble Women*,1919, the composition is dominated by a contrived mechanical arrangement, loaded with promised energy yet ultimately obsolete and futile. Unlike the collages, whose components are presented with planar equality, the assemblages protrude from the canvas into our own reality, challenging the passivity of the two-dimensional image and the complacency of the viewer.

Schwitters's greatest ambition was to create a "Gesamtkunstwerk" or total work of art that would span every artistic medium. He found its expression in the form of "Merzbau" (Merz Construction) which he began in 1923 and worked on for several years. Intended as a private monument to art and to the 20th century as well as a home for Schwitters's guinea-pigs, the "Merzbau" consisted of several columns and compartments bearing various bizarre objects. The grottoes were dedicated to friends and filled with souvenirs pertaining to those individuals: Schwitters stole toenails, urine, and other personal effects from unsuspecting donors and inserted them into the appropriate chambers. Other sections of the "Merzbau," such as the "Merz Columns" or the "Gold Grotto," displayed or contained mementos of the artist's past and present, signifiers of a bourgeois, post-war obsession with acquisition and preservation. The "Merzbau" assumed an organic character, increasing so rapidly in size that Schwitters was obliged to expand onto the upper floor of his house. As it developed so it documented the changes in Schwitters's

style, from Constructivist geometry to curvilinearity. Existing grottoes were sealed by the new growth, and new ones created.

Regrettably the Hanover "Merzbau" was destroyed by Allied bombing in 1943. Schwitters fled Nazi Germany three years earlier for Lysaker in Norway, a previous holiday haunt, where he began a second "Merzbau." However, the Nazi invasion of Norway required him once again to leave, this time for England, where he finally settled in the Lake District. Despite ill health and poverty Schwitters continued to work on his "Merz" collages, supplementing these works and his income with the unremarkable figurative art he had never quite abandoned. The rural life was reflected in collage, assemblage, and the third "Merzbau," the artist exploiting fragments of the natural environment—stones, feathers—in the place of previous urban motifs.

—Caroline Caygill

SEBASTIANO del Piombo.

Born Sebastiano Luciani in Venice (?), c. 1485. Died in Rome, 21 June 1547. Two illegitimate sons. Worked as a lute player; then probably a pupil of Giorgione, and perhaps finished some of Giorgione's incomplete works; in Rome by 1511: worked at the Villa Farnesina with painters of the Raphael circle, but soon influenced by Michelangelo, and several of his works are in the Michelangelo style; received a Papal sinecure ("il piombo"—sealer of briefs), 1531; renowned for his portraits; a couple of his paintings are on slate. Pupil: Tommaso Laureti.

Collections: Arezzo: Palazzo Pubblico; Basel; Berlin; Cambridge; Dublin; Florence: Uffizi, Pitti; Houston; Leningrad; London; Lugano; Madrid; Naples; Paris; Parma; Philadelphia; Rome: Farnesina, Doria Pamphili, S. Maria del Popolo, S. Pietro in Montorio; Sarasota, Florida; Venice: Accademia, S. Giovanni Crisostomo, S. Bartolomeo a Rialto; Vienna; Viterbo; Washington.

Publications

On SEBASTIANO: books—

Milanesi, G., *Les Correspondents de Michel-Ange: Sebastiano,* Paris, 1890.
Benkard, E. A., *Die venezianische Frühzeit des Sebastiano,* Frankfurt, 1907.
Bernardini, Giorgio, *Sebastiano,* Bergamo, 1908.
d'Archiardi, Pietro, *Sebastiano,* Rome, 1908.
Dussler, Luitpold, *Sebastiano,* Basel, 1942.
Pallucchini, Rodolfo, *Sebastiano,* Milan, 1944.
Lucco, Mauro, *L'opera completa di Sebastiano,* Milan, 1980.
Hirst, Michael, *Sebastiano,* Oxford, 1981.

articles—

Brandi, Cesare, "The Restoration of the Pieta of Sebastiano" in *Museum* (Paris), 3, 1950.

Fenyö, I., "Der Kreuztragende Christus Sebastianos," in *Acta Historiae Artium* (Budapest), 1, 1953.
Garas, K., "Zu einigen Malerbildnissen der Renaissance, I: Sebastiano," in *Acta Historiae Artium* (Budapest), 16, 1970.

*

Sebastiano's earliest works are embedded in the minefield of art-historical attributions, the circle of Giorgione, in which a variety of paintings, more or less beautiful and accomplished, uneven and clumsy, unfinished or of dual authorship, have been regularly transferred between Giorgione himself, Titian, and Sebastiano, and even such lesser figures as Cariani, Campagnola, and Licinio. Such confusion, while constituting an effective indictment of art-historical methodology, has a venerable precedent: Vasari, in the first (1550) edition of his *Vite,* ascribed Sebastiano's first major altarpiece, for the high altar of S. Giovanni Crisostomo, Venice, to Giorgione. This mistake (rectified in the 1568 edition) was perhaps understandable in a devotee of Florentine *disegno* as opposed to Venetian *colore;* and indeed the echoes of Giorgione in the altarpiece (datable 1510–11, just after Giorgione's death) are clear, as are those of Sebastiano's other chief Venetian influence, Giovanni Bellini. Bellini's lucid illusionism and Giorgione's sensuous warmth are already, however, overlaid with some of Sebastiano's own powerful weightiness. This element of his style, detectable too in the Giorgione picture Sebastiano almost certainly completed, the *Three Philosophers* (c.1506–10; Vienna), made him particularly susceptible to the lure of Rome where antique monumentality was currently being equalled and surpassed by Raphael and, above all, by Michelangelo.

The effect of Michelangelo's genius on the development of 16th-century Italian art can hardly be overemphasised. The manner of his arch-rival Raphael underwent an immediate change, as Pope Julius II remarked to Sebastiano in 1512, as soon as Raphael saw Michelangelo's works (or at least the Sistine Chapel frescoes). Their effect on Sebastiano was immediate, and far more dominant and lasting. Sebastiano had been invited to Rome by the Papal banker Agostino Chigi, to join Raphael and Peruzzi on the decoration of Chigi's villa, now known as the Farnesina. Sebastiano's contributions to the Sala di Galatea, the lunettes depicting the creatures of the upper air and a vigorous wall-fresco of *Polyphemus* (1511–12), show him investing his stately sensuousness with a more articulately sculptural sense of anatomical action. His most important and characteristic work of this period was the *Death of Adonis* (c.1512–13; Florence) in which the broad and solid forms embody the new naturalistic artifice of Michelangelo, while the insistent shadows recall Leonardo. The background view of Venice, the leafy chestnuts, and the warm tonality introduced Venetian sensuous realism to Rome; the classical dignity of the figures reflects Sebastiano's own response not only to the Roman achievements of Raphael and Michelangelo but also to direct experience of the antique.

Soon Sebastiano's artistic relationship with Michelangelo became more specific. The latter's rivalry with Raphael, fanned by both followers and patrons, threatened to become one-sided as a new pope, Leo X, put Raphael in charge of the decoration of the Vatican and the construction of St Peter's, while Michelangelo wanted solely to concentrate on sculpture. He therefore elected Sebastiano to be his pictorial deputy, partly, presumably, because Sebastiano's Venetian training

Cardinal Carondelet Dictating to His Secretary; panel; 44⅛ × 34¼ in (112 × 87 cm); Lugano, Thyssen-Bornemisza Collection

made him Raphael's superior as a pure, painterly colourist. The relationship was different from Michelangelo's with his studio helpers, who gave him only technical assistance, or indeed from Raphael's with his circle of brilliantly talented pupils, who more or less faithfully executed his ideas. its exact nature is disputed; but it is clear that Michelangelo suggested compositions and provided preparatory drawings, and that Sebastiano translated these thoughts and designs into carefully considered personal interpretations.

The earliest and most evident of their collaborations was a *Pietà* (1515; Viterbo) in which the simplicity and power of the concept, grandiosely sculptural (and specifically Michelangelesque in proportion and detail), is transmuted by dramatic lighting, strong yet restricted colour, and an emotionally evocative landscape setting into an image of brooding intensity and atmospheric tragedy. The combination, however, is not entirely successful, and in the next example, the *Raising of Lazarus* (1517-19; London), Michelangelo's contribution was probably restricted to the invention of particular figures and groups. The composition, in fact, shows the obvious influence of Raphael's most recent work in its powerful diagonal thrusts and development in depth. This was hardly surprising, since the work was commissioned by Cardinal Giulio de'Medici (later Pope Clement VII) in direct competition with Raphael; and it was the latter's *Transfiguration* which the pope insisted on keeping in Rome, while the Sebastiano was shipped off to the cardinal's diocese of Narbonne. Nevertheless, the *Raising of Lazarus* is a work of great emotional strength and dramatic beauty, richly developed, enhanced by a distant landscape of classically harmonious power and by an almost abstract disposition of luminous colour.

An area in which Sebastiano successfully challenged and indeed influenced Raphael was that of portraiture. He introduced into Rome not only the boldly direct and opulently coloured manner of Venice, but also the specific iconographical type of the group portrait, as in his sumptuous *Cardinal Bandinello Sauli and suite* (1516; Washington) and the more original *Cardinal Ferry Carondelet and Secretary* (Lugano), in which the predominantly pale colours and the classical background architecture act as effective foils to the cardinal's eagerly intelligent and handsome physiognomy. Sebastiano's effective depiction of masculine beauty is epitomised by his *Clement VII* (1526; Naples), in which the sensitive delineation of the withdrawn and duskily arresting face is contrasted with the grandly abstracted forms of the papal robes.

This formal abstraction was characteristic of Sebastiano's later work, as he tried to reconcile the artificial canons of Mannerism with his own religious conversion after the Sack of Rome (1527). The *Christ in Limbo* (c.1532; Madrid) is typical: an image of bold simplicity, reminiscent of the *Flagellation* designs Michelangelo had provided for him in the 1520's, but elaborated with a rhythmic grace and surface elegance which recall not only contemporary works of Michelangelo but even the precious and etiolated world of Parmigianino. Subsequently the religious content dominated, as in the late *Pietà* (1537-39; Seville, Casa di Pilatos), based on a Michelangelo drawing, which, though not eschewing pictorial abstraction and formal artifice, creates a movingly simple and poignantly hieratic icon. After this he virtually ceased to paint.

—Nigel Gauk-Roger

SEGANTINI, Giovanni

Born in Arco di Trento, 15 January 1858. Died in Maloja, 28 September 1899. Lived with Bice Bugatti from 1880; three sons and one daughter. Studied at the Brera museum, Milan, 1874-77; settled in Brianza, near Como, 1880-86, and then lived in Switzerland from 1886; painted mainly Alpine scenery and symbolic works.

Major Collection: St. Moritz: Segantini Museum.
Other Collections: Adelaide; Basel; Berlin; Budapest; The Hague; Hamburg; Leipzig; Liverpool; Milan: Brera, Arte Moderna; Munich: Neue Pinakothek; Rome: Arte Moderna; San Francisco; Vienna: Neue Galerie; Zurich.

Publications

By SEGANTINI: books—

Scritti e lettere, edited by Bianca Segantini, Turin, 1910.
Trent' anni di vita artistica europea nei carteggi inediti, edited by Annie Paule Quinsac, Oggiono, 1985.

On SEGANTINI: books—

Villari, Luigi, *Segantini: The Story of His Life*, London, 1901.
Servaes, Franz, *Segantini: Sein Leben und sein Werk*, Vienna, 1902.
Montendon, Marcel, *Segantini*, Bielefeld, 1904.
Segantini, Gottardo, *Segantini: Sein Leben und sein Werke*, Munich, 1918.
Calzini, R., *Segantini*, Geneva, 1947.
Segantini, Gottardo, *Segantini*, Zurich, 1949.
Zbinden, Hans, *Segantini: Leben und Werk*, Berne, 1951.
Segantini, Gottardo, *Segantini pittore*, Trento, 1955.
Barbantini, Nino, *Segantini*, Venice, 1955.
Nicodemi, Giorgio, *Segantini*, Milan, 1956.
Zieger, A., *La giovenezza di Segantini*, Trento, 1958.
Carli, Giulio de, *Segantini* (cat), Trento, 1958.
Budigna, Luciano, *Segantini*, Milan, 1962, 1964.
Quinsac, Annie Paule, *La Peinture divisionniste italienne: Origines et premiers developments*, Paris, 1972.
Arcangeli, F., and M. C. Gozzoli, *L'opera completa di Segantini*, Milan, 1973.
Kelly, C. J., *Segantini, Previati, and the Early Futurist Painters*, London, 1973.
Bosshard, Emil, et al., *Die Welt des Segantini* (cat), Zurich, 1977.
Noseda, Irma, *Segantini: Ein verlorenes Pardies? / Un paradiso perduto?*, Zurich, 1977.
Quinsac, Annie Paule, *Segantini: Zeichnungen* (cat), Zurich, 1978.
Roedel, Reto, *Segantini*, Rome, 1978.
Lüthy, Hans A., and Corrado Maltese, *Segantini*, Zurich, 1981.
Quinsac, Annie Paule, *Segantini: Catalogo generale*, Milan, 2 vols., 1982.
Lardelli, Dora, et al., *75 Jahre Museum Segantini St. Moritz 1908-1983* (cat), St. Moritz, 1983.

Farm Scene with Sheep; $31\frac{1}{4} \times 52\frac{3}{8}$ in (79.5 cm \times 133 cm); private collection

Belli, J., and Annie Paule Quinsac, *Segantini* (cat), Trento, 1987.

article—

Sackerlotzky, Rotraud, "Segantini: Stone Pine and Alpine Roses," in *Bulletin of the Cleveland Museum of Art*, January 1986.

<center>*</center>

Italian by birth and culture, Austrian by political destiny, and Swiss by the landscapes he chose to paint and live in, Segantini has been claimed by all three countries. This complexity has contributed to the limbo to which history has relegated him. Outside Italy, Switzerland, and Japan (where he is particularly well-known and loved), his name is no longer part of the compendium of artists dealt with in art surveys. It is difficult today from an Anglo-Saxon public to realize that when he died in 1899 he was among the most famous artists of his day.

Born to Italian parents in a small village still under Austrian rule, his iconography and vision are linked with an almost primal need to express the beauty of the mountains of his early childhood. His years of maturity are divided into three periods of production, corresponding to a search for a specific milieu to portray in his paintings.

From 1880 to 1886 Segantini spent most of his time in Brianza, where the gentle scenery of lakes and hills is often veiled by fog. This mellow landscape dominates his first period. The green and gray tones are muted, with bitumen often used as a primer to give more depth to the darker hues. Values are more important than colors; his compositions are based on a strict observance of chiaroscuro. The subject matter is often peasant life, in which J. F. Millet's lesson is often reflected (e.g., *The Last Fatigue of the Day*), though a melancholy streak often generates genre scenes of sentimentality (*Father Is Dead, The Dead Hero, The Two Mothers*). His international fame began during this period with the Amsterdam International Exhibition gold medal in 182 for *Ave Maria a Trasbordo*. The period ended with a synthesis of his previous attempts to depict the life of the lower Alps, the masterpiece *At the Tether* (Rome, Modern Art Gallery). It is a huge canvas, centering on the watering of a flock of cows just before sunset against a panoramic view of the plains, hills, and Alps. He painted from paid models, planting the canvas on the ground every day for a month. Bitumen was not used in this work, and the palette was considerably lightened. The composition of parallel horizontals is the result of a conscious manipulation of the observed fragments of a magic moment in which every element is part of a perfect order. Since the vastness of the landscape could not be seen at a glance, the artist added elements that could be perceived in sequence, thus suggesting an endless panorama.

After *At the Tether*, Segantini's need to be confronted by a more majestic type of mountain impelled him to emigrate to Switzerland. He lived in Savognin from 1886 to 1894, a period marked by a drastic change in his vision and technique, and associated with his powerful form of Divisionism. Segantini developed a paradoxical way to relate to the world. The myth of the superman who realizes Ibsen's and Michelet's dream of a loner courageous enough to abandon the perverse life of the dehumanizing cities to live the pure, vivifying existence only found in the awesome mountains became Segan-

tini's image. The myth contributed to his popularity, and eventually to its downfall when, after World War II, all those exaggerations of certain existential attitudes were viewed as complacencies of a decadent era to be discarded like other obsolete fashions.

Though his international reputation continued to grow, his personal isolation became stronger. Short trips to Milan provided occasional contacts with an artistic milieu. But his communions with the landscape surrounding Savognin became an almost obsessive force—and he elaborated a new pictorial language to express in quasi-pantheistic terms his objectification of a scenery he had literally appropriated. In order to render the crystaline light of the rarefied atmosphere of the Alps, the transparency of the rocks, or the density grass, he devised ways of expressing light through color intensities, and no longer through a value system. Chiaroscuro was still impotant but no longer crucial.

In Italy color theories were particularly debated in the 1880's and 1890's, and a rich Divisionist movement (similar to the Neo-Impressionism or Pointillism in France) flourished. From his Swiss exile, Segantini first experimented with divisionist technique when he repainted his 1882 *Ave Maria a Trasbordo* in 1886 (chronologically parallel to Seurat's first masterpieces), and became the symbol of Italian Divisionism. But theory gave way to instinct, and in his years at Savognin he perfected a highly personal technique in which an embroidery-like brushwork defines the forms; texture and chromatism are used to capture the light, its static quality and the magic reality of the Grisons landscape. There is no sentimentalism now: the life of the peasants is related to nature and the landscape, and from this point onwards Segantini used very few models. The pantheism of his last years is clearly apparent in such works as *The Melting of the Snow* (St. Gall, Fischbacher Foundation).

His final five years, spent in the Engadine in the village of Maloja, mark the culmination of his symbolism. In full possession of his technical means, and confronted with a more austere and awesome nature, Segantini began to move toward an even more decorative language in which the arabesque and a graphically defined bruskwork express a visionary interpretation of nature including the anxiety-ridden themes of the time. Death is the protagonist of his most ambitious works: (*The Return to the Native Land, Love Confronted by Faith*), but it is not just the serene resolution of human fate but the unfathomable union with nature.

In Segantini realism and symbolism are not two contradictory moments of an evolution. They partake of each other to the point that his most allegorized realisations (e.g., *The Evil Mothers*) are rooted in an intensely naturalist vision, a sort of hyper-reality which conveys tangibility to the dream. Because each of his great symbolist works is the restitution of a landscape which has become for him a mental and emotional place, a privileged territory upon which to project his inner emotions and conflicts, Segantini's place in European symbolism is a unique one. The ambivalence of fin de siècle's image-makers toward women is powerfully reflected in his series dedicated to motherhood (*The Tree of Life, The Evil Mothers* cycle, *Vanità*), but in the all-encompassing pantheism of these work the same ambivalence is attributed to nature. In that sense, Segantini expresses the most existential preoccupation of his time.

—Annie-Paule Quinsac

SEGHERS, Hercules (Pietersz.).

Born probably in Haarlem, 1589 or 1590; used spelling Segers from 1621. Died in The Hague, 1638 or earlier. Married 1) Anneken van der Brugghen, 1614; 2) Cornelia de Witte (called his "widow"); one illegitimate child. Pupil of Gillis van Coninxloo in Amsterdam to 1606; entered the Haarlem guild, 1612; established in Amsterdam, 1619, and moved to Utrecht, 1631,and The Hague, 1632; virtuoso etcher (about 50), with unprecedented methods; fantastic landscapes influenced by Elsheimer, and influence on Rembrandt; paintings are rare.

Major Collections: Berlin; Rotterdam.
Other Collections: Amsterdam; Detroit; Florence; Paris: Bibliothèque Nationale; Philadelphia.

Publications

On SEGHERS: books—

Springer, Jaro, *Die Radierungen des Seghers*, Berlin, 3 vols., 1910–12.
Pfister, Kurt, *Seghers*, Munich, 1921.
Fraenger, Wilhelm, *Die Radierungen des Seghers: Ein physiognomischer Versuch*, Erlenback, 1922.
Collins, Leo C., *Seghers*, Chicago, 1953.
Haverkamp-Begemann, E., *Seghers* (cat), Rotterdam, 1954.
Leusden, Willem dan, *The Etchings of Seghers and the Problem of His Graphic Technique*, Utrecht, 1961.
Boon, K. G., *Seghers* (cat) (in Dutch and English), Amsterdam, 1967.
Haverkamp-Begemann, E., *Seghers* (in English), Amsterdam, 1968.
Haverkamp-Begemann, E., *The Complete Etchings of Seghers*, Amsterdam, 2 vols., 1973.
Rowlands, John, *Seghers*, New York and London, 1979.

*

Two documents witness Hercules Pietersz. Seghers's apprenticeship to Gillis van Coninxloo, a Mannerist landscape artist in Amsterdam. One records Pieter Seghers's debt to Coninxloo's estate for his son's apprenticeship, and another records the sale of a painting of a rocky landscape, as well as prints and drawings, from this estate to Hercules Pietersz. Coninxloo was a Flemish religious refugee like Seghers's father, and one of the artists who carried the imaginary landscape heritage of Joachim Patinir and Pieter Bruegel the Elder—with its Alpine vistas, jewel-like colors, stratified space, and overt recomposing of nature—into an early 17th-century Dutch context. This context is best known for its generation of a naturalistic approach to indigenous scenery, taken early by Esaias van de Velde, Willem Buytewech, and Hendrik Goltzius of Haarlem, where Seghers entered the painters guild in 1612. But there was also a strong tradition of fantastic landscape, and some of the artists who made strides in the new naturalism also followed this path. The imaginary Dutch landscape tradition culminated in the brooding mountain scenes of Seghers and Rembrandt.

The Moss-Clad Larch; etching

Seghers didn't stay long in Haarlem. By December 1614, he was in Amsterdam, engaged to a Flemish woman (he already had an illegitimate daughter by another woman). His wife may have bought his expensive home. According to Samuel van Hoogstraeten, Rembrandt's pupil and author of *Introduction to the High School of Painting* (1678), debt followed Seghers doggedly, as it did Rembrandt. Van Hoogstraeten entitled the chapter dealing with Seghers's life, "How the artist should behave in the face of adverse fortune." He stressed Seghers's difficulty in selling his prints, his poverty (Seghers reputedly resorted to using his wife's linen for prints and paintings), and his falling down stairs while intoxicated. Van Hoogstraeten's romantic biography is colored by the standard personality-profile of the melancholic artist—the genius whose brilliance was coupled by mental instability and lucklessness.

Van Hoogstraeten's biography is based on his knowledge of Seghers's prints, whose scarcity and oddness insured their small audience. His paintings were more successful. In 1640, an Amsterdam dealer is reported to have possessed twenty-one paintings by Seghers and twelve "rolled-pieces" (unmounted canvasses or etchings?). Only about a dozen paintings by Seghers have come down to us. Except for *The Skull* in a private collection in New England, all are landscapes. *The Skull*—itself a kind of craggy "landscape" of the human cranium—probably reflects Seghers's larger painting used by the Amsterdam Surgeons Guild as a teaching tool. Seghers also painted a lost *Virgin and Child*, but certainly landscape was his abiding interest. He conceived it primarily in terms of a flat Dutch panorama, like the topographical *View of Rhenen* (Staatliche Museen, Berlin-Dahlem), or as a desolate valley flanked on one or both sides by forbidding cliffs, as in *The River Valley* in Amsterdam and the Uffizi *Mountain Land-scape*. This latter work was evidently owned and altered by Rembrandt. Moreover, *View of Rhenen* and other Seghers paintings were altered by the addition of sky-panels, so that his long, low proportions became more squarish.

Seghers's vision of nature is related to that of Roelandt Savery, Joos de Momper, Hendrik Goltzius, and Jakob Pynas—a follower of Adam Elsheimer, whom Seghers may have met on a conjectural trip to Italy. But Seghers's style is essentially idiosyncratic, and perhaps best seen in his etchings. With few exceptions, Seghers's prints are landscapes of valleys, mountain gorges, trees or forests (like Coninxloo's late works), and buildings overgrown with foliage. We know little about the audience for these odd prints, generally pulled in few impressions. Most of the Rijksmuseum's holdings belonged to the Amsterdam lawyer Michiel Hinloopen (1619–1708).

Egbert Haverkamp-Begemann has only recently untangled Seghers's convoluted printmaking procedures. He used differently colored inks, retouched impressions, cut up his plates for re-use, printed on colored papers and different cloths, and employed counterproofing, by which an impression is taken not from an inked plate but from another impression. The *Mossy Tree*, in which a Danube-School-style pine is isolated against a sky changing from pink to blue, is known only in one impression in Amsterdam. It may be the first example of the lift-ground technique in the history of etching. Seghers thought of his etchings almost as printed paintings and emphasized the uniqueness of each impression.

Seghers's understanding of etching as a process admitting considerable change between states is the main legacy he left to Rembrandt as a printmaker. We know that the younger artist owned Seghers's plate for *Tobias and the Angel* after Elsheimer and Hendrik Goudt. Rembrandt vigorously scraped and burnished it, reworking it into a *Flight into Egypt*.

Rembrandt's 1656 inventory also listed eight paintings by Seghers, including *The Mountain Landscape* in the Uffizi, which he repainted. Along with Philips de Koninck, known for his panoramic landscapes, Frans de Momper, and the printmaker Johannes Ruischer, Rembrandt was one of the few artists influenced by Seghers. Why this is so remains an open question, like the pinpointing of the exact influences contributing to Seghers's style, and the basic chronology of his works. Seghers's vision of nature serves as a reminder of the variety possible within the basically naturalistic tradition of Dutch baroque landscape.

—Linda C. Hults

SEURAT, Georges (Pierre).
Born in Paris, 2 December 1859. Died in Paris, 29 March 1891. One son by Madeleine Knoblock. Pupil of Henry Lehmann at the Ecole des Beaux-Arts, Paris; specially interested in theory of color; military service in Brest; exhibited *La Baignade* at Salon, 1884, and *La Grande Jatte* at the Impressionist exhibition, 1886; met Signac, working on same lines: pointillism.

Major Collection: Paris.
Other Collections: Baltimore; Boston; Brussels; Cambridge, Massachusetts; Chicago; Edinburgh; Glasgow; Indianapolis; Kansas City; London: National Gallery, Courtauld, Tate; Merion, Pennsylvania; Minneapolis; Munich; New York; Metropolitan, Moma; Northampton, Massachusetts; Otterlo; Prague; St. Louis; Tournai; Washington.

Publications

On SEURAT: books—

Consturier, Lucie, *Seurat*, Paris, 1921, 1926.

Lhote, André, *Seurat*, Rome, 1922.

Coquiot, Gustave, *Seurat*, Paris, 1924.

Kahn, Gustave, *Les Dessins de Seurat*, Paris, 2 vols., 1928.

Roger-Marx, Claude, *Seurat*, Paris, 1931.

Rich, Daniel Catton, *Seurat and the Evolution of "La Grande Jatte,"* Chicago, 1935.

Rewald, John, *Seurat*, New York, 1943, 1946.

Cooper, Douglas, *Seurat: Une Baignade, Asnières*, London, 1946.

Seligman, Germain, *The Drawings of Seurat*, New York, 1947.

Lhote, André, *Seurat*, Paris, 1948.

Laprade, Jacques de, *Seurat*, Paris, 1951.

Rich, Daniel Catton, and Robert L. Herbert, *Seurat: Paintings and Drawings* (cat), Chicago, 1958.

Dorra, Henri, and John Rewald, *Seurat: L'Oeuvre peint: Biographie et catalogue critique*, Paris, 1959.

Hauke, César Meyer de, *Seurat et son oeuvre*, Paris, 2 vols., 1961.

Herbert, Robert L., *Seurat's Drawings*, New York, 1962, London, 1965.

Homer, William Innes, *Seurat and the Science of Painting*, Cambridge, Massachusetts, 1964.

Blunt, Anthony, and Roger Fry, *Seurat*, London and Greenwich, Connecticut, 1965.

Russell, John, *Seurat*, London and New York, 1965.

Perruchot, Henri, *La Vie de Seurat*, Paris, 1966.

Courthion, Pierre, *Seurat*, New York, 1968, London, 1969.

Minervino, Fiorella, *L'opera completa di Seurat*, Milan, 1971.

Hautecoeur, Louis, *Seurat*, Milan, 1972.

Muller, Joseph Emile, *Seurat: Dessins*, Paris, 1975.

Gould, Cecil, *Seurat's "Bathers, Asnières," and the Crisis of Impressionism*, London, 1976.

Terrasse, Antoine, *L'Univers de Seurat*, Paris, 1977.

Broude, Norma, editor, *Seurat in Perspective*, Englewood Cliffs, New Jersey, 1978.

Morris, Johnny, *Seurat: A Sunday Afternoon on the Island of La Grande Jatte*, London, 1979.

Franz, Erich, and Bernd Growe, *Seurat: Zeichnungen* (cat), Munich, 1984; as *Seurat: Drawings*, Boston, 1984.

Thomson, Richard, *Seurat*, Oxford, 1985.

article—

Lee, Alan, "Seurat and Science," in *Art History* (Oxford), June 1987.

*

Georges Seurat is primarily remembered as the inventor of Divisionism (also known as Pointillism) and also for his two most famous paintings, *Bathers at Asnières* and *Sunday on the Island of La Grande Jatte*. However, he must also be recognised as a pivotal figure in the development of modern art. It was Seurat's vision of a modern aesthetic, coupled with an extraordinary desire to educate himself in the science of visual depiction, that makes him a necessary subject for even the most casual student of 19th- and 20th-century art.

Seurat was educated at the Ecole des Beaux-Arts in the heyday of Impressionism. However, he was too inquisitive and expectant an individual to be satisfied with the aging theories of Impressionism. Mere imitation of nature did not satisfy his desire to create a formal vocabulary of expression that would reflect his interest in the breakdown of colours to basic form and his faith in an academic approach to design.

Close examination of the artist's work shows a man determined to come to terms with the disciplines of painting. In an uncharacteristic moment of self-justification, he is reported to have told Félix Fénéon, the art critic, that he was preoccupied with the problem of what a painting ought to be from as early as 1880. As far as can be construed (the artist died a year before the proposed publication of a synopsis of his work), Seurat was looking for objectivity where the Impressionists sought a subjective vision. He was looking for method and reason where Monet and Degas valued freedom and improvisation.

Seurat's career can be divided into three main periods. The first, evolutionary, stage that involved the reading of a great number of books on the science of optics, including Ogden Rood's work on modern chromatics, the colour theories of Eugene Chevreul, and the work of Charles Blanc. Work produced in these early years included hundreds of black and white crayon drawings. This work shows the influence of Millet and even Courbet on the choice of subject matter. Simple rustic scenes of peasants and stonebreakers are portrayed, often in heavy chiaroscuro, heavy cross-hatching used to describe a form or a shadow. This period also illustrates the artist's apparent abandonment of natural perspective.

The second most celebrated period involved the completion of *Bathers at Asnières* and *La Grande Jatte*. The first painting completed in 1884 was shown at an exhibition organised by the Salon des Indépendants, having been refused by the Salon, while *La Grande Jatte* was shown at the Salon thanks to the efforts of Pissarro.

The last five years of the artist's short life were sent developing his theories of Divisionism in paintings such as *Les Poseurs* of 1887, *Le Parade* of the same year, a series of paintings of the harbour at Honfleur, *Le Chalut*, and the unfin-

Study for La Grande Jatte; drawing

copyists whom he felt were using the motif of the dot as a fashionable alternative rather than as a logical vehicle of expression. His later work is less colourful, more sombre in outlook. *Le Parade* is a dark and gloomy picture, while *Le Cirque* can only be described as an unfinished academic exercise. Nonetheless, Seurat had created a logical and new answer to the problem of what sort of style should be adopted, so that the artist might feel that he or she were making an important and valid statement. We may not be able to recognise this today, but it is important to realise that this is how Seurat was seen in his day. He was idolised because he had recognised a need for change and had been able to create a new style that could be used to instrument a change.

And there is beauty in the work of Seurat. One only needs to look at the work of followers such as Henry Van de Velde or Luce to relise that Seurat was the finest exponent of Divisionism. His early drawings show an enormous sensibility, perhaps at its height in the drawing of Edmond Aman-Jean, Seurat's first acceptance into the Salon in 1883. Seurat had the capability to produce work that stands the test of time. As Felix Fénéon so eloquently and pertinently pointed out, in his "The Impressionists in 1886," "If Monsieur X were to study treatises on optics for all eternity he could never paint *La Grande Jatte.*"

—Rupert Walder

ished *Le Cirque.* There was also an extraordinary, perhaps symbolic, picture of the unfinished Eiffel Tower painted in 1889.

Yet a formal description of the artist's oeuvre does not explain why Seurat was considered such a radical, and why he acquired such a fanatical following. Signac, Pissarro, and even Gauguin were among those artists who saw that Seurat had a valuable contribution to make in his quest to create an aesthetic based on learning and the formalisation of every component.

The values of painting that Seurat stressed in his work were necessarily antagonistic. To imply that it was possible to learn a method of depiction and use it to create an objective vision that could be read by all men was to imply that any other form of depiction was elitist and undemocratic. Seurat was reticent about his own political persuasion, but his friends included such vocal reformers as Paul Signac and Maximilien Luce. Whatever his own conviction may have been, he was certainly seen as a critic of contemporary society by those who saw his work in the 1880's and 1890's. Paintings such as *La Grande Jatte, Le Parade,* and even *Le Cirque* were read as lampooning contemporary social behaviour, this interpretation much accelerated by the formal style of depiction used to depict an apparently motionless, stylised, and ultimately soulless society. Perhaps Seurat's vision of art did not allow for the fact that the viewer enjoys involvement beyond the formal values of colour design and composition.

Seurat was notoriously secretive about his technique. It seems that he felt that any complete explanation of his work would devalue its impact. He was also unimpressed by his

SEVERINI, Gino.

Born in Cortona, 7 April 1883. Died in Paris, 26 February 1966. Married Jeanne Fort, 1913; one daughter. Attended schools in Cortona and Rome; studied painting with Giacomo Balla, Rome, 1902; lived in Paris from 1906, and co-signed futurist manifestoes with Balla and Boccioni; returned to Italy, and painted murals, panels, etc., in a neo-classical style; stage designs for the ballet *Pulchinella,* 1940 (later designs for *La Casa Nova, Scarlattiana, Flamino,* 1940–42).

Collections: Amsterdam: Stedelijk; Cortona; London: Tate; New York: Guggenheim; Ottawa; Paris: Beaubourg; Rome: Arte Moderna.

Publications

By SEVERINI: books—

Du cubisme au classicisme, Paris, 1921.
Ragionamenti sulle arte figurative, Milan, 1936.
Arte indipendente, arte borghese, arte sociale, Rome, 1944.
Tutta la vita di un pittore, Milan, 1946; as *La vita di un pittore,* 1965.
The Artist and Society, London, 1947.
Mosaique et art mural dans les temps modernes, Paris, 1952.
Témoignages: 50 ans de réflexion, Paris, 1963.
Dal cubismo al classicismo e altri saggi sulla divina proporzione e sul numero d'oro, edited by Piero Pacini, Florence, 1972.

Spanish Dance, 1960–61; lithograph

Illustrator: *L'Amour enfant*, 1930, *Le Cimetière marin*, 1930, *Fleurs et masques*, 1930, all by Paul Fort

On SEVERINI: books—

Cassou, Jean, *Severini*, Paris, 1931.

Lassaigne, Jacques, *Dessins de Severini*, Paris, 1947.

Gambillo, Maria Drudi, and Teresa Fior, *Archivi del futurismo*, Rome, 2 vols., 1958-62.

Falqui, Enrico, *Bibliografia e iconografia del futurismo*, Florence, 1959.

Taylor, Joshua C. *Futurism*, New York, 1961.

Carrieri, Raffaele, *Futurismo*, Milan, 1961; as *Futurism*, Milan, 1963.

Venturi, Lionello, *Severini*, Rome, 1961.

Pacini, Piero, *Bibliografia di Severini*, Cortona, 1967.

Martin, Marianne W., *Futurist Art and Theory 1909-1915*, Oxford, 1968.

Apollonio, Umbro, editor, *Futurismo*, Milan, 1970; as *Futurist Manifestos*, London and New York, 1973.

Quinti, Aldo and Jolanda, *Severini e Cortona*, Rome, 1976.

Pacini, Piero, *Severini: Disegni e incisioni*, Florence, 1977.

Fagiolo dell'Arco, Maurizio, *Severini*, Rome, 1977.

Fagiolo dell'Arco, Maurizio, *Severini*, Bologna, 1981.

Ruggeri, Giorgio, *Il tempo di Severini*, Bologna, 1981.

Hanson, Anne Coffin, *The Futurist Imagination* (cat), New Haven, 1983.

Severini (cat), Milan, 1987.

Of the original Italian Futurist artists, Gino Severini was always the most closely connected to the French avant-garde. Brought into the movement in 1910 through his friendship with Umberto Boccioni, Severini would act as an important link between artists in France and Italy during the vital years of Futurism.

Severini first met Boccioni in 1901 as a student in Rome, and, through Boccioni, Giacomo Balla who later, like Boccioni, would become his ally in Futurism. From Balla both young painters learned the rudiments of Italian Divisionism and developed an interest in subject matter drawn from modern life. Predisposed by his early experience with Divisionism to its French variant Neo-Impressionism and to the carefully ordered art of Seurat, Severini left Italy for Paris in 1906. Within a few years he had comfortably settled on the fringes of the Parisian avant-garde enjoying friendships with Braque, Picasso, Dufy, Léger, Metzinger, Gleizes, the Duchamp brothers, and Gris, as well as the literary figures Jules Romains, Max Jacob, Apollinaire, and Paul Fort, whose daughter he married in 1913.

Given his Parisian vantage point, Severini was first among the Futurists to realize the potential of the new vocabulary of Cubism for the visualization of the Futurist goal of depicting the simultaneity of vision of objects in motion as a paradigm of modern life. One of his first Futurist paintings was *The Boulevard* (1910; London, Estorick Collection), where he moved his Neo-Impressionist investigation of color into a new, Futurist-inspired analysis of movement, creating a patchwork of colored angular shapes, to synthesize the "human figure . . . [to] the whole of its surrounding atmosphere," as

the *Technical Manifesto of Futurist Painting* demanded. Severini handles his theme, the movements of a crowd in modern Paris, with what will become the hallmark of his style—a lightness and grace, far removed from the more emotionally charged art of his fellow Futurist Boccioni.

As early as 1910, the thoroughly Parisian subjects of the dancer and the cabaret had already become a central preoccupation for Severini, and during the critical years of his stylistic evolution, 1912-14, the dancer became probably his most important vehicle. In *White Dancer* and *Blue Dancer,* both of 1912 (Milan, Jucker Collection; Milan, Mattioli Collection), Severini convincingly evokes the continuous movement of the dance, adapting Cubist facets to fragment the body's various shifting positions, and to render the "dynamic sensation" eternal, in the rhetoric of the movement. In the large and ambitious *Dynamic Hieroglyphic of the Bal Tabarin* (1912; New York, Moma), Severini expands the dancer's environment to include the nightclub setting adding sequins and words to draw the viewer into the painting on both visual and auditory levels. In all three paintings, Severini provides recognizable clues—a high heel, a ruffle, a ring of curls—to create the sensation of rapid glimpses of the constantly evolving dance.

By late 1913 a gradually increasing degree of abstraction is evident in a series of paintings that follow Severini's theory of the "plastic analogy of dynamism"—the idea of a dynamic relationship between complementary images—which he developed in a contemporary manifesto. For example, the painting *Sea-Dancer* (1913-14; New York Winston Malbin Collection) was inspired by such a linking of related images from visual experience and memory: "The sea," explained Severini, "with its dance on the spot, its zig-zag movements and scintillating contrasts of silver and emerald, in my plastic sensibility evokes the far off vision of a dancer covered with sparkling sequins in her surroundings of light, noises and sounds."

In paintings that immediately followed, entitled *The Spherical Expansion of Light* (1914; Milan, Jucker Collection; New York, Private Collection), all that remains of the dancers is a sequence of expansive rhythms rendered as abstract movements of singing color and glowing light. Interestingly enough, Severini returns at this point to his Divisionist-Neo-Impressionist roots for both the emphatic mosaic-like brushstrokes and the breakdown of light into its component colors. *The Spherical Expansion of Light* represents an equivalent or—in Severini's words—a plastic analogy for the Futurist concept of universal dynamism; he has enclosed "the universe in the work of art. Objects no longer exist." Like his fellow Futurist Balla, although independently of him, Severini moves Futurism into abstraction, joining the first generation of nonobjective artists.

However, Severini did not stay with this direction for long. With the Italian entry into the war in 1915, the Futurist painters, who from the very beginning of the movement had verbally embraced the glories of war following Filippo Tommaso Marinetti's lead in his initial *Manifesto of Futurism* of 1909, turned to war-related subject matter as part of their involvement with all aspects of contemporary life. The gentle Severini produced a series of war paintings, *guerrapittura*, introducing imagery of modern machinery which had been largely absent from his previous work, as in *The Armored Train* (1915; New York, Zeisler Collection) and *Red Cross Train Passing a Village* (1915; New York, Guggenheim). In the latter the artist

aimed for a synthesis of visual impressions, memories, and symbols of war through a melange of stylized planes evoking rapid movement through a landscape.

By 1916 the Futurist movement had largely dissolved, and although a second phase led by Balla and Marinetti would emerge in Rome after the war, Severini was to play no part in it. Instead, he moved through a period of exploration of Synthetic Cubism, influenced in part by his close friendship with Gris, and then, in the 1920's, to figurative subjects and to more classical systems of construction in line with the widespread post-war return to order. Severini's association with the Parisian avant-garde and with the challenges of Futurism in the opening decades of the 20th century resulted in his strongest and most personal work, but throughout his life his art as a whole revealed a sure sense of compositional elegance which was uniquely his own.

—Susan Barnes Robinson

SHAHN, Ben.

Born in Kovno, Lithuania, 12 September 1898; naturalized United States citizen. Died in New York City, 14 March 1969. Married 1) Tilly Goldstein, 1922; one daughter and one son; 2) Bernarda Bryson, 1935; two daughters and one son. Apprenticed to the lithographer Heisenberg, New York, while completing high school, 1913–17; studied at Art Students League, New York, 1916 (and 1940 under Jean Charlot), New York University, 1919; studied painting, National Academy of Design, New York, 1917–22; studied biology, City College of New York, 1919–22, and Marine Biological Laboratory, Woods Hole, Massachusetts, 1920–22; studied painting at the Académie de La Grande Chaumière, Paris, 1925; painter and photographer in New York, 1926–39, and in Roosevelt, New Jersey, from 1939; shared studio with Walker Evans, 1928; assisted Diego Rivera on Rockefeller Center mural, 1933; photographer and designer, Farm Security Administration, 1935–38; worked for Graphic Arts Section, War Information Office, 1942–44; taught at Boston Museum of Fine Arts summer school, Pittsfield, 1947 (later taught at University of Colorado, Boulder, 1950, Brooklyn Museum Art School, 1951, Black Mountain College, North Carolina, 1951; also Charles Eliot Norton Professor of Poetry, Harvard University, Cambridge, Massachusetts, 1956); designed sets for the ballet *New York Export—Opus Jazz*, 1958 (later stage designs for the play *Him* by E.E. Cummings, 1960, and the ballet *Events*, 1960).

Collections: Chicago; London: Tate; New York: Moma, Metropolitan, Brooklyn Museum; St. Louis; Syracuse, New York: University; Waltham, Massachusetts: Brandeis University.

Publications

By SHAHN: books—

Partridge in a Pear Tree, New York, 1947.
Paragraphs on Art, New York, 1952.

The Alphabet of Creation, New York, 1954.
The Autobiography of a Painting, Cambridge, Massachusetts, 1956.
The Shape of Content, Cambridge, Massachusetts, 1957.
Love and Joy about Letters, New York, 1963.
The Cherry Tree Legend, New York, 1967.
Shahn (selection), edited by John D. Morse, New York, 1972.

Illustrator: *The Sorrows of Priapus*, 1957; *Ounce Dice Trice*, 1958; *Love Sonnets*, 1963; *Ecclesiastes, or The Preacher*, 1964; *Kuboyama and the Saga of the Lucky Dragon*, by Richard Hudson, 1965; *Notebooks of Malte Laurids Brigge*, by Rainer Maria Rilke, 1968.

On SHAHN: books—

Soby, James Thrall, *Shahn*, New York and London, 1947.
Rodman, Selden, *Portrait of the Artist as an American: Shahn: A Biography with Pictures*, New York, 1951.
Soby, James Thrall, *Shahn: His Graphic Art*, New York, 1957.
Soby, James Thrall, *Shahn: Paintings*, New York, 1963.
Bentivoglio, Mirella, *Shahn*, Rome, 1963.
Bush, Martin, *Shahn: The Passion of Sacco-Vanzetti*, Syracuse, New York, 1968.
Weiss, Margaret R., editor, *Shahn, Photographer: An Album from the Thirties*, New York, 1970.
Shahn, Bernarda Bryson, *Shahn*, New York, 1972.
Prescott, Kenneth W., *The Complete Graphic Works of Shahn*, New York, 1973.
Pratt, Davis, editor, *The Photographic Eye of Shahn*, Cambridge, Massachusetts, 1975.
Prescott, Kenneth W., *Shahn* (cat), New York, 1976.
Takach, Mary, *The Mural Art of Shahn* (cat), Syracuse, New York, 1977.
King, A.S., *Shahn* (cat), Santa Fe, 1981.
Prescott, Kenneth W., *Prints and Posters of Shahn*, New York and London, 1982.

article—

Amishai-Maisels, Ziva, "Shahn and the Problem of Jewish Identity," in *Jewish Art*, 12–13, 1986–87.

*

One of the best-known American protest painters of the 1930's, Ben Shahn appropriated a political stance for his painting after his return to the United States from Paris in 1929 as a revolt against the art for art's sake formalism of Parisian painting. He initiated his social activism with a series of paintings commemorating the recently publicized trial and execution of the Italian anarchists Nicola Sacco and Bartolomeo Vanzetti in Massachusetts. Utilizing newspaper clippings of press photographs of the principals in the trial, Shahn detailed the activities of what he perceived to be the inherent injustices in the American political system, which he titled *The Passion of the Sacco and Vanzetti*.

The trial was a *cause célèbre* for Americans with liberal political leanings at a time of great conservatism in the country. The liberals felt that Sacco and Vanzetti had been framed and sentenced to death on the basis of public sentiment against

Supermarket, 1957; screenprint

their being politically unattractive aliens. Although Shahn's stylized paintings of the events of the trial, about 20 of which were exhibited in 1932, are compelling documents dramatizing the inequity of the American judicial system, recent historical evidence has suggested that Sacco and Vanzetti were guilty of the actions for which they were convicted. Within the series, Shahn built up a case as if he were a lawyer for the defense, presenting a cumulative historical documentation of events. The finale of the series, an amalgam of disparate newspaper photographs, presents the lawyers and judge, holding lilies, at the open caskets of the executed immigrants against the backdrop of a stylized pattern of the court house. The stark pattern and calculated expressions leave no doubt as to the quilt of the establishment figures and the serene innocence of the deceased Italians. The Sacco and Vanzetti series was followed by similar treatment of the imprisonment of the labor leader Tom Mooney.

In *The Passion of Sacco and Vanzetti*, as in the majority of his mature works from the 1930's and 1940's, Shahn worked in gouache or tempera, a dryer and flatter medium than oil. He reduced his figures to simplified silhouettes and utilized abbreviations and distortions of figures in a consciously primitive caricatured style to affect emotive responses to the general social messages in his works. His stylized drawings and flat paint application lends the quality of a poster to his major works, and many of them, such as *The Passion of Sacco and Vanzetti*, actually appear to be a form of political proselytizing. The title of the series even lends a religious charge to the message of the works.

Shahn's social realist style was characteristic of much of the political fervor among urban American artists during the

1930's as a response to the complacent xenophobic values of the American regionalist artists of the period, who captured greater public attention during the decade. Having worked as a mural assistant with the well-known Mexican muralist Diego Rivera on the RCA building at Rockefeller Center and the New Workers School, Shahn became one of the most active American painters in the production of publicly sponsored murals during the economically troubled decade of the 1930's. His murals include compositions for the Bronx Central Annex Post Office, the community center, school building, and administrative building for a housing project in Roosevelt, New Jersey, and the Social Security building in Washington. The narrative mural compositions adhere to the same political and stylistic considerations of Shahn's easel pictures, which were particularly well suited to public murals in their dramatic simplified design and didactic content.

From 1935 to 1938 Shahn worked as a photographer for the Farm Securities Administration, like the Precisionist painter Charles Sheeler. His depression-era photographs depicted the plight of workers in rural areas and they supplied him with many subjects for his painting. The photographs, however, present a stronger message of the horrors of American life during the depression than the paintings, since they are actual documents of degradation rather than interpretations of it.

Not surprisingly Shahn was politically active for leftist causes. A member of the American Artists Congress, he joined the editorial staff of the periodical *Art Front* in 1934. Always a crusader against injustice, Shahn managed to temper the anger in his works with irony so that they carry a particularly biting edge. Utilizing art as a means of communicating a social message, Shahn depicted miners, steel workers, bridge

builders, children in isolated urban settings, and the desolation of America during the 1930's.

After the Second World War his paintings became more lyrical and colorful, but they never lost their crusading message. In his late works Shahn abandoned the biting edge of satire for a more personal and private expression in images of loneliness. Although still dry and linear, the late paintings present a meditative, poetic brooding in subjects of children at play, lovers in a park, and the old and homeless on park benches. Shahn also became more interested in decorative linear pattern and produced lyrical posters and book illustrations that extend the range of his artistic consciousness.

—Percy North

SICKERT, Walter (Richard).

Born in Munich, 31 May 1860; son of the painter Oswald Adalbert Sickert; grew up in London from 1868. Died in Bathampton, Somerset, 22 January 1942. Married 1) Ellen Cobden, 1885 (divorced, 1899); 2) Christine Drummond, 1911 (died, 1920); 3) the painter Thérèse Lessore, 1926. Attended King's College, London, 1875-77; brief stint as an actor; studied under Alphonse Legros, Slade School, London, 1881; then studied under Whistler in London; influenced by Degas, whom he met in 1883; lived in France, 1900-05; taught at Westminster Technical Institute, 1908-10, and later ran the private school Rowlandson House, 1910, and other schools; co-founder, Camden Town Group, 1911, and later belonged to the London Group; lived in Dieppe, 1920-22, and later in London, Broadstairs, Kent, and Bath; member, R.A., 1934 (resigned, 1935); also etching.

Major Collections: Liverpool; London: Tate.
Other Collections: Aberdeen; Bradford; Cambridge; Cambridge, Massachusetts Dieppe; Fredericton, New Brunswick; London: Courtauld, British Council, Islington Public Library, Museum of London; Manchester; Melbourne; New Haven; New York: Moma; Nottinghm; Ottawa; Sydney; Toledo, Ohio.

Publications

By SICKERT: books—

A Free House, or The Artist as Craftsman, edited by Osbert Sitwell, London, 1947.
Advice to Young Artists, Norwich, 1986.

On SICKERT: books—

Woolf, Virginia, *Sickert: A Conversation,* London, 1934.
Emmons, Robert V.B., *The Life and Opinions of Sickert,* London, 1941.
Bertram, A., *Sickert,* London, 1955.
Browse, Lilian, *Sickert,* London, 1960.
Sickert (cat), London, 1960.
Rothenstein, John, *Sickert,* London, 1961.

Lilly, Marjorie, *Sickert: The Painter and His Circle,* London, 1971.
Baron, Wendy, *Sickert,* London, 1973.
Sickert in Dieppe (cat), Eastbourne, 1974.
Sutton, Denys, *Sickert: A Biography,* London, 1976.
Troyen, Aimee, *Sickert as Printmaker* (cat), New Haven, 1979.
Hollis, Marianne, *Late Sickert: Paintings 1927 to 1942* (cat), London, 1981.
Sickert and Jacques-Emile Blanch, and Friends in Dieppe (cat), London, 1982.
The Sickerts in Islington, London, 1987.
Shone, Richard, *Sickert,* Oxford, 1988.
Sickert (cat), Liverpool, 1989.

*

A figurative painter trained by Whistler and influenced by Degas, Sickert is a dominant figure in 20th-century British art. Originally at the forefront of the British avant-garde, he was an acknowledged leader to British painters, sheltered from the French avant-garde. His reputation was made in the 1880's and his subject matter and technique were widely imitated into the inter-war years, but his influence became stultifying as it continued to dominate British art school teaching well into the 1950's. In 1981 an exhibition of his late work again established his reputation as a controversial artist.

He is known as an "English" artist, for low-key interiors and lower class nudes, painted in tones of sepia and tea in the subtle drab light of overcast weather, but these cover only about a decade of his 60-year output, and many were made in Venice or Dieppe.

The early paintings with which Sickert first attracted attention on his own account (his first exhibited works were signed "pupil of Whistler") are scenes of the cockney music hall, sketched since c. 1884, and first painted in 1887. The theme, not previously treated in English art, had obvious attractions: complex spatial relationships especially in the tier and balcony arrangements of the hall, extreme contrasts of dark and light and an excessively decorated architectural background. In studies like *The P.S. Wings in an O.P. Mirror* (1889-90; Rouen) and *Little Dot Heatherington* (1888-89; private collection) mirror reflections redouble these effects and allow an emotionally and visually oblique view. The evident difficulty of the subject and Sickert's own inventiveness won him critical recognition.

Sickert showed as a "London Impressionist" in the late 1880's but he cannot helpfully be considered an Impressionist: he had parted company with Whistler largely over his "Impressionist" practices, especially his risky "alla prima" technique which made him a victim of chance and in Sickert's view an eternal sketcher. Sickert himself came to follow Degas's method of constructing paintings from preliminary drawings or photographs and successive over-painting; he therefore had no interest in capturing translent effects of light and weather, and indeed the very darkness of his palette may have been a perverse reaction to the influence of Impressionism. He did lighten his palette in 1907-10, under the influence of Spencer Frederick Gore and Lucien Pissarro, but his painting technique continued to evolve over decades, as he balanced his need to build up a picture in layers and his fastidious dislike of

Ennui, c. 1913; 59⅞ × 43¾ in (152 × 111 cm); Royal Collection

thick and dirty impasto (he loathed van Gogh's bumpy surfaces). Eventually he settled on a very thin, rubbed-in undercoat with thin successive layers of undiluted paint that kept clear colour and smooth surface.

After 1890 Sickert dropped the music hall and worked as a portrait painter; he was commissioned by magazines, and did some society portraits, but his best portraits are those of people in the art world he knew well. His portraits of George Moore (1890–91) and Aubrey Beardsley (1894) are not psychological characterisations but subtle and acute caricatures. The ethereal Beardsley is barely earthbound in Sickert's version, propped on legs of a single flimsy layer of dry chalk coloured paint.

Moving to Dieppe in 1898, Sickert turned to "picturesque" work, streets and buildings in Dieppe and Venice, concentrating on painting technique and hoping that landscapes would sell. It was on one of the Venice trips that the intimate figure subjects started, apparently as a result of bad weather that kept him inside. Often compared with the *intimiste* scenes of Bonnard and Vuillard, the familiarity in Sickert's nudes is actually medical and dispassionate. They are usually neither domestic nor warm, but consist of prostitute models in hired rooms. The boarding room stuck thereafter as a setting. Sickert hired a variety of cheap rooms as studies but his taste for them may well derive from Balzac, whose prostitute (in *Gobseck*) nicknamed *la belle Hollandaise* probably provided the title for one of the first such nudes, *La Hollandaise* (1905–6; London, Tate). The obliteration of facial detail, low tonal range, cold light, and Sickert's apparent lack of sexual interest in the

models establish the mood which continued to pervade the *Camden Town* paintings in the teens.

The arrangement of these nudes in interiors differs, despite the occasional washstand prop, from Degas's "keyhole" vantage point. The figures are not active and the viewpoint is clear of intervening furniture. In Sickert, the presence of a male cause for nakedness is implicit, and soon explicit, giving rise to the notorious anecdotal titles that provide explanations for the scenes. *Jack Ashore* is the title given to the same nude subject as *La Hollandaise* with an additional clothed male figure sitting on the bed's edge. The two-figure theme was further explored on his return to London and was developed before and after the formation of the *Camden Town* group as an exhibiting society in 1911.

It is frequently noted that Sickert gave different, apparently incompatible, titles to the same picture, most famously with the *Camden Town Murder* series, where the same painting goes under the titles *What Shall We Do for the Rent? The Camden Town Murder* and *Summer Afternoon*. His use of anecdotal titles has caused some critical confusion in that it appears to align him with 19th-century narrative painting, but it is consistent with both his disdain for Whistler's aestheticism and his admiration for Balzac's *Comédie humaine*, where bedsit and boarding house inhabitants are impassive witnesses to the banal and the bizarre.

After several decades of continuous refinement of technique, a high degree of public acceptance, and excellent sales, in the late 1920's Sickert lightened his palette drastically, abandoned both preliminary drawing and etching, and painted from photographs and Victorian engravings. The change was contemporary with his last marriage in 1926 to Thérèse Lessore. She probably influenced the change and certainly assisted him with the late work, which was not critically accepted, and quickly lost favour. The portraits especially are schematic and detached to the point of irony. Clive Bell's suggestion that he took his painting "not entire seriously" in the last years, is partially correct.

Sickert's career was as complex as it was long. His work is demonstrably the product of intelligence and acquired craft skills; he is a consummate practitioner of the anti-Romantic approach to art.

—Abigail Croydon

SIGNORELLI, Luca.

Born Luca d'Egidio di Ventura in Cortona, c. 1441–50. Died in Cortona, 16 October 1523. Probably apprenticed to Piero della Francesca (Perugino was a fellow pupil), in Arezzo; in the ten years from 1474 to c. 1484, he worked in Arezzo, Citta di Castello, Florence, Cortona, Loretto, Vatican (Sistine Chapel frescoes), Gubbio, and Perugia; then settled in Cortona (with some later work in Monteoliveto and Siena: S. Agostino, 1498); a member of the Magistracy of Cortona, 1488, and worked on the Cathedral, 1502; his masterpiece is the series of frescoes for Orvieto Cathedral, 1499; later work was often done by assistants.

Collections: Amsterdam; Arezzo: S. Francesco; Baltimore: Museum, Walters; Berlin; Birmingham; Boston; Città di Castello; Cortona; Detroit; Florence; Liverpool; London; Milan: Brera, Poldi Pezzoli; Monteoliveto Maggiore; Munich; New Haven; New York; Orvieto: Cathedral; Paris: Louvre, Jacquemart-Andre; Perugia; Philadelphia; Toledo, Ohio; Urbino: Palazzo Ducale; Venice: Ca d'Oro; Volterra; Washington.

Publications

On SIGNORELLI: books—

Gianuizzi, P., *Le pitture di Signorelli in Loreto,* Cortona, 1903.

Scarpellini, Pietro, *Signorelli,* Florence, 1922.

Venturi, Adolfo, *Signorelli,* Florence, 1922.

Dussler, Luitpold, *Signorelli: Des meisters Gemälde,* Stuttgart, 1927.

Carli, Enzo, *Signorelli: Gli affreschi nel Duomo di Orvieto,* Bergamo, 1946.

Moriondo, Margherita, editor, *Signorelli* (cat), Florence, 1953.

Salmi, Mario, *Signorelli,* Novara, 1953.

Signorelli: The Martyrdom of St. Catherine and the Bichi Altar, Williamstown, Massachusetts, 1961.

Scarpellini, Pietro, *Signorelli,* Milan, 1964.

Carra, Massimo, *Gli affreschi del Signorelli ad Orvieto,* Milan, 1965.

Baldini, Umberto, *Signorelli,* Milan, 1966.

Coste-Messeliere, M. G. de la, *Signorelli,* Paris, 1975.

Kury, Gloria, *The Early Work of Signorelli, 1465–1490,* New York, 1978.

Carli, Enzo, *Le storie di San Benedetto a Monteoliveto Maggiore,* Cinisello Balsamo, 1980.

Meltzoff, Stanley, *Botticelli, Signorelli, and Savonarola: "Theologia Poetica" and Painting from Boccaccio to Poliziano,* Florence, 1987.

articles—

Martindale, Andrew, "Luca Signorelli and the Drawings Associated with the Orvieto Frescoes," in *Burlington Magazine* (London), 103, 1961.

Seidel, Max, "Signorelli um 1490," in *Jahrbuch der Berliner Museen,* 26, 1984.

Gilbert, Creighton, "Signorelli and Young Raphael," in *Studies in the History of Art* (Hanover, New Hampshire), 17, 1985.

*

Luca Signorelli's most famous work—the *Last Judgment* frescoes in the Chapel of St. Brizio in Orvieto Cathedral—has always been famous. Luca was extolled as a master of a "difficult" work, involving as it did elaborate foreshortening, seemingly deep relief, and forceful movement, as well as a complicated theoretical program. He was, for centuries, and especially in the 19th century, acclaimed as a strong influence on Michelangelo, because of the similarity of the subject of the *Last Judgment* as well as the muscularity of the figures. Luca,

Old Man; drawing; Berlin–Dahlem, Staatliche Museen

however, did other work; in fact, he worked in most of the central Italian cities, usually with Cortona as a base (he was born and died there).

Luca was trained in Piero della Francesco's shop in Arezzo, and there is a strong Florentine influence also from the Pollaiuolo brothers, Leonardo, and Botticelli. One of the first documented works of Luca is the Sistine Chapel frescoes in the Vatican, 1481–83, where he was one of a group including Perugino (a fellow pupil in Piero's shop), Rosselli, Ghirlandaio, and Botticelli. He is associated with two panels titled *Testament of Moses* and *St. Michael Defends the Body of Moses,* involving a complicated iconographical program. Luca probably worked with Perugino on the *Testament* section, but it is difficult to "locate" Luca in these frescoes.

A work that is more useful in discovering Luca's style is the Sacristy of St. John in S. Maria di Loreto. This is a small octagonal room, not large enough for the program to get too complicated, but interesting enough for cartoons and assistants to be used. Three stages in the work can be determined: original design, execution in broad terms, and finishing details. Both the walls and the vault are covered, and Luca used a similar iconographic arrangement as in the later Orvieto frescoes: the vault is used for the "traditional" set of characters (e.g., Sibyls, Doctors, Prophets, etc.), while Doubting Thomas and the conversion of St. Paul occupy the walls. The style, and even some details, are based on previous Florentine

examples of this type of chapel. Other early works include such panel paintings as *The Flagellation* (Milan) and the *Vagnucci Altarpiece* (Perugia), both examples of his "difficult" style involving complex subjects and bizarre inventions. *The School of Pan* (destroyed) had strong homoerotic content, and foreshadowed the Orvieto frescoes in the virile beauty of the nudes.

Another large series of frescoes precede the Orvieto works, that for the cloister of the Abbey of Monteoliveto Maggiore, near Siena. This consists of ten scenes from the life of St. Bernard (1497-98), though there is some unevenness of quality, attributed by most critics to Luca's use of assistants. Another fresco series, from S. Agostino in Siena, has been broken up.

The frescoes for the vaults of the Chapel of St. Brizio in Orvieto Cathedral, and then later for the walls as well, were begun by Fra Angelico and Benozzo Gozzoli in 1447. Luca was given the commission to complete them in 1499, and they were probably completed by 1502.

The walls include the figures of the *Antichrist* and the *Last Judgment*, the *Resurrection of the Body*, the *Damned*, the *Blessed*, and *Arrival in Paradise and Hell,* along with figures of famous men, pagan, classical, and Christian, and illustrations from the *Divine Comedy* at the base. The iconography is complicated, and the *Last Judgment* evidently contains amplifications of traditional iconography based on a program established by the theologians of the Cathedral (based on the *Apocalypse* and the gospels of Mark and Matthew). The appearance of the *Antichrist* is rare in Italian art, and some critics have suggested that it can be explained as a specific reference to Savonarola. Other sources are traditional including the *Golden Legend,* German engravings, Perugino's architectural imagery, and motifs and decorations from Pintoricchio.

Luca used assistants in the Orvieto frescoes, and some critics have claimed to find other hands in various elements of the works, though the names of the artists who helped Luca are known (and include his nephew Francesco Signorelli).

A number of nude drawings relating to the Orvieto frescoes survive. The frescoes were the first use of varied nude figures on such a large scale, and they were immediately recognized as something new. Overall, the frescoes have a splendid unity, suggesting a moving and vigorous profundity and intensity.

—George Walsh

SIQUEIROS, David Alfaro.

Born in Chihuahua, 29 December 1896. Died in Mexico City, 7 January 1974. Attended the Academy of San Carlo, Mexico City, 1911; Mexican Academy, Mexico City, 1913-14; served on the general staff of the Mexican Army during the revolution in Mexico, 1914-22: at Mexican Embassy, Madrid, 1919; worked as painter and muralist in Mexico City: worked with Diego Rivera on mural projects; worked with workers unions, Guadalajara, 1925-30; imprisoned for political activities, 1930; organized mural teams in the United States and South America, 1932-34, and lived in New York, 1936-37; fought in Spain with the International Brigade, 1937-39; returned to

Mexico City, 1939; Executive Secretary of the Mexican Communist Party from 1959; jailed, 1962-64.

Collections: Mexico City: Arte Moderno; New York: Moma

Publications

By SIQUEIROS: books—

L'Art et la revolution, Paris, 1973; as *Art and Revolution,* London, 1975.
Como se pinta un mural, Mexico City, 1951, Cuernavaca, 1977; as *How to Paint a Mural,* London, 1987.
Siqueiros, edited by Rafael Carrillo Azpeitia, Mexico City, 1974.
Textos, edited by Raquel Tibol, Mexico City, 1974.
Me llamaban el Coronelazo: Memorias, Mexico City, 1977.

On SIQUEIROS: books—

Tibol, Raquel, *Siqueiros; Introductor de realidados,* Mexico City, 1961; as *Siqueiros,* New York, 1969.
Micheli, Mario de, *Siqueiros,* 1968.
Rodriquez, Antonio, *Siqueiros,* Mexico City, 1974.
Solis, Rith, editor, *Vida y obra de Siqueiros: Juicios críticos,* Mexico City, 1975.
Siqueiros e il muralismo messicano (cat), Florence, 1976.
Goldman, Shifra M., *Contemporary Mexican Painting in a Time of Change,* Austin, 1981.
Folgarit, Leonard, *So Far from Heaven: Siqueiros' "The March of Humanity" and Mexican Revolutionary Politics,* Cambridge, 1987.

*

The Mexican painter David Alfaro Siqueiros was an essentially innovative artist for whom experimentation with modern techniques, instruments, and expressive idioms was symbolic of revolutionary change in art and in history. His own stylistic development is linked with the many innovations he produced throughout his life in different aspects of artistic creation. One of his early concerns was the incorporation of the Mexican artistic tradition, especially the prehispanic tradition, into modern art. To this end, he sought to integrate into his own work the essential elements of the artistic values of the Mexican tradition so as to create modern work which was not anachronistic or folkloric.

His time in Europe from 1919 to 1922 was vital to his artistic development. He was strongly influenced by Michelangelo's grandiose manner of conveying the power and the movement of his figures. He was impressed by the audacious use of perspective found in Baroque art. The use of exaggerated plastic images, of dynamic and foreshortened masses, were both elements that Siqueiros was permanently to incorporate into his own work. His passion for modernity, nourished in Mexico by the modernist and positivist spirit that still formed part of the cultural climate while he was a student, took a new direction when he met the futurist Boccioni. It was then that his love of machinery and speed was born, as well as

Portrait of the Bourgeoisie—detail, 1939–40; Mexico City, National Electricity Workers Union

his fascination with science and technology. He introduced the futurist manner of simulating movement into his own artistic language. However, his use of this and other elements was always with the aim of putting them at the service of an art that was for the people and concerned with social issues.

In 1923, when Siqueiros painted his first murals at the National Preparatory School in Mexico City, he still employed the traditional techniques of fresco painting and encaustic, and also a realistic idiom that continued to be within the academic canons, despite the prehispanic influence in the massivity of some of the figures. There are, however, elements that point to his recent time in Europe. These would become permanent in his work, and their appearance in these early murals presages the features and the themes that would later define his work. We see his tendency to use complex and moving structures to avoid the static effect of the front view, the latter a consequence of his baroque treatment of perspective. In his murals *Los elementos,* the monumental figures point to Michelangelo's transitory influence.

The following stage in his artistic career is strongly marked by his stay in the United States from 1932 to 1938. His innovative powers were stimulated by the contact with industrial, scientific, and technological progress and led him entirely to change the techniques, materials, and forms of representation that he had employed up until that moment. He substituted the use of new chemical materials like the acrylics, resins, and asbestos for the fresco techniques, and carried out important research on the use of pyroxylene. The change in materials was accompanied by the use of the air brush that he employed to apply paint.

Materic painting and the controlled accident are two of the possibilities derived from these new techniques, in which the material itself becomes an important means of expression. Siqueiros tried using all sorts of apparatus that might prove useful in the creative process: as well as the air brush, he employed the projector and the camera. He researched the relationship between painting and photography and began to use the latter as a means of directly apprehending reality and thus, as a basis for the definition of the image, anticipating what would later be hyper-realism. The Experimental Workshop served to develop and divulge his experiments. He spent 1936 working with this group of artists, including Jackson Pollock, who later was to develop many of these ideas into Abstract Expressionism.

His return to Mexico in 1939 marked the end of his experimental period, which was then to bear fruit. The murals in the Hospital de la Raza stand out among the numerous works Siqueiros subsequently painted, *La tecnología que destruye convertida por el trabajador en instrumento de paz, libertad, y bienestar.* He brought together all the techniques, tools, and materials that he had experimented with and created what he called "the active surface," a dynamic, polyangular surface which the spectator animates with his own movement, revealing the meaning of the work. It is in these murals that the interplay of all these elements is most fully realized. In 1952 Siqueiros painted the outdoor mural *El pueblo a la universidad y la universidad al pueblo* at the National University in Mexico City. Here, he creates an urban mural to be viewed from a distance and in movement. The enormous voluminous figures, that have a poster-like simplicity, are a prelude to his interest in "pinto-escultura," which attempts to fuse the values

of painting and sculpture with those of architecture.

In 1965 Siqueiros carried out his *La marcha de la humanidad en America Latina,* and example of his "pinto-escultura" in the Hall of Conventions of the Hotel de Mexico. Here he achieves the integration of all three forms of art.

The artistic career of Siqueiros can be summarized as the constant struggle to make revolutionary change a part of his political praxis and of his artistic activity, a struggle which produced a fruitful artistic career, full of innovation and challenge.

—Alicia Azuela

SISLEY, Alfred.

Born in Paris of English parents, 30 October 1839. Died in Moret-sur-Loing, 29 January 1899. Married Marie Lescouezec, 1866; one son and one daughter. Sent to England to prepare for a commercial career, but preferred art and studied under Gleyre at the Ecole des Beaux-Arts, Paris, 1862–63; exhibited at several of the Impressionist shows; made several visits to England and Wales; lived in Marly-le-Roi, 1874–77, Sèvres, 1877–80, Veneux-Nadon, 1880–89, and Moret-sur-Loing from 1889.

Collections: Aberdeen; Boston; Bristol; Buffalo; Cambridge, Massachusetts; Cologne; Copenhagen; Detroit; Le Havre; London: Courtauld, Tate; Melbourne; New York; Ottawa; Paris: Petit Palais, d'Orsay; Rotterdam; Rouen; Southampton; Washington: National Gallery, Phillips; Zurich.

Publications

On SISLEY: books—

Delteil, Loys, *Le Peintre-graveur, vol. 17: Pissarro, Sisley, Renoir,* Paris, 1923.
Geffroy, Gustave, *Sisley,* Paris, 1923.
Besson, G., *Sisley,* Paris, 1947.
Colombier, Pierre du, *Sisley au Musée du Louvre,* Paris, 1947; as *Sisley aux Musées du Louvre et du Jeu de Paume,* 1965.
Francastel, P., *Monet, Sisley, Pissarro,* Geneva, 1947.
Jedlicka, Gotthard, *Sisley,* Berne, 1949.
Daulte, François, *Sisley,* Berne, 1958.
Daulte, François, *Sisley: Catalogue raisonné de l'oeuvre peint,* Lausanne, 1959.
Daulte, François, *Les Paysages de Sisley,* Paris, 1961; as *Sisley Landscapes,* New York, 1962.
Schard, Aaron, *Sisley,* London, 1966.
Sisley (cat), New York, 1966.
Sisley: Landscapes (cat), Nottingham, 1971.
Daulte, François, *Sisley,* Milan, 1972.
Cogniat, Raymond, *Sisley,* Naefels and New York, 1978.
Shone, Richard, *Sisley,* Oxford and New York, 1979.
Nathanson, R., *Sisley* (cat), London, 1981.

Lassaigne, Jacques, and Sylvie Gache-Patin, *Sisley,* Paris, 1983.

Lloyd, Christopher, and Nobuyuki Sensoku, *Retrospective Sisley* (cat) (in Japanese and English), Fukuoka, 1985.

Daulte, François, *Sisley,* London, 1988.

*

Of the artists who exhibited at the first Impressionist exhibition in 1874 it was Alfred Sisley who was the purest landscape painter. In an oeuvre of almost 900 oil paintings he produced less than a dozen still lifes and only one or two genre scenes. All of his remaining works are landscapes, and throughout his career he favoured the same kind of environment whether in the forest of Fontainebleau, in Louveciennes, London, Moret, or Wales. His works tend to be calm with little attention paid to cityscapes or recent industrialization. They are often devoid of people, any figures or staffage in them being used as compositional devices or perhaps narrative elements rather than as a means of representing a humanized landscape.

Although born in France, Sisley was the son of English parents, and he died without becoming a naturalized Frenchman. On his first trip to London (1857–61) he discovered the work of the English landscape painters Turner, Constable, and Bonnington, and the influence of England and English art was to remain firm throughout his career. In this Sisley was not unusual—other members of the Impressionist group such as Monet, Pissarro, and Renoir were looking to recent precedents in their desire for an art which reflected landscape in as naturalistic a way as possible. They deliberately flouted the strict academic precepts of the Ecole des Beaux-Arts, with its emphasis on the historical landscape which derived ultimately from Claude and Poussin, and turned instead to the Barbizon painters. Sisley's landscape at the Salon of 1868, *Avenue of Chestnut Trees near La Celle Saint-Cloud* (Southampton), demonstrates an acquaintance with the soft tonality of Corot and the dramatic massing of Courbet, both of whom were to remain influential.

At the first Impressionist exhibition, Sisley exhibited six landscapes (only five appeared in the catalogue) with little critical or financial success. His *Autumn: Banks of the Seine near Bougival* (1873; Montreal) was criticized for being sketch-like and apparently unfinished, a common complaint levelled against other Impressionist painters who adopted an uncomprising stance to painting out of doors with a much freer execution than found in the work of older artists. In this work Sisley's mature characteristics are evident: an emphasis on the sky to light the picture and create atmosphere and give an indication of time and weather conditions (with which Constable had been concerned). This was emphasized with a clear tonality coupled with judicious use of colour—the autumnal oranges are offset against the blue sky. The seemingly informal composition of the work is constructed with great feeling for space.

After the exhibition Sisley returned to England, this time under the patronage of the French baritone Jean-Baptiste Faure, from July to October 1874. In London he painted a series of canvases at Hampton Court which are remarkably fresh and spontaneous. *Molesey Weir, Hampton Court* (1874; Edinburgh) is compositionally daring with the posts of the weir creating a system of rigid verticals which holds the pic-

ture together and leads the viewer's eye into the picture space in no less a contrived way than Poussin might have done. Yet it appears relaxed and informal with thick white impasto, and the figures of the naked bathers are executed with great economy of means.

Sisley exhibited at the second and third Impressionists exhibitions but met with little critical acclaim until he received a mention in Georges Rivière's *L'Impressioniste,* which was sympathetic to the Impressionist cause. He wrote of Sisley's charming talent, his taste, subtlety, and tranquillity. It is in these terms that present-day reviewers regard Sisley. Unlike Monet or Renoir he did not confront urban life in his landscapes, and his view of nature was not shaped by anarchist politics like Pissarro's. Instead he painted a timeless yet unsentimentalized view of nature in which man, although present, is never the controlling force.

—Lesley Stevenson

SLOAN, John.

Born in Lock Haven, Pennsylvania, 2 August 1871. Died in Hanover, New Hampshire, 7 September 1951. Married 1) Anna M. Wall, 1901 (died, 1943); 2) Helen Farr, 1944. Co-student with William Glackens and Albert C. Barnes at Central High School, Philadelphia; worked for a book and print dealer in Philadelphia, from 1887: taught himself to etch; illustrator for the *Philadelphia Inquirer,* 1892–95; studied with Anschutz at the Pennsylvania Academy of Fine Arts, 1892; friend of Robert Henri; worked for *Philadelphia Press,* 1895–1904; began to paint, 1897, and exhibited from 1900; first major etching work was 53 plates for collected novels of Charles Paul de Kock, 1902 (later etched plates for *Of Human Bondage* by Maugham, 1938); moved to New York, 1904, and worked for *Collier's, The Century,* and *Harper's Magazine;* joined the Ash Can group (with Henri, Glackens, and others), and member of The Eight (Ash Can members plus Prendergast and Arthur B. Davies): helped organize the Armory Show, 1913; art editor, *Masses,* 1912–14; taught at the Art Students League, New York, 1914–38 (President, 1931–32), and briefly at other schools; annual visits to Santa Fe from 1920.

Major Collection: Wilmington, Delaware: John Sloane Trust.
Other Collections: Andover, Massachusetts; Boston; Cleveland; Colorado Springs; Detroit; Hartford, Connecticut; Madison: University of Wisconsin; Minneapolis; New York: Whitney, Metropolitan, Brooklyn Museum; Philadelphia; Syracuse, New York; Washington: National Gallery, Phillips, Corcoran; Wichita, Kansas.

Publications

By SLOAN: books—

Introduction to American Indian Art, with Oliver La Farge, New York, 1931.

Nude Reading, 1928; etching

The Gist of Art: Principles and Practise Expounded in the Classroom and Studio, New York, 1939, 1944; London, 1977.

Sloan's New York Scene: From the Diaries, Notes, and Correspondence 1906–1913, edited by Bruce St. John, New York, 1965.

On SLOAN: books—

Gallatin, A. E., *Sloan,* New York, 1925.

Pene du Bois, Guy, *Sloan,* New York, 1931.

Mather, Frank Jewett, *Sloan,* New York, 1936.

Sloan (cat), New York, 1951.

Goodrich, Lloyd, *Sloan,* New York, 1952.

Brooks, Van Wyck, *Sloan: A Painter's Life,* New York, 1955.

Glackens, Ira, *William Glackens and the Ashcan Group,* New York, 1957.

Sloan, Helen Farr, *The Life and Times of Sloan,* Wilmington, Delaware, 1961.

The Art of Sloan (cat), Brunswick, Maine, 1962.

Perlman, Bernard E., *The Immortal Eight: American Painting from Eakins to the Armory Show,* New York, 1962.

Bussabarger, Robert F., and Frank Stack, *Selection of Etchings by Sloan,* Columbia, Missouri, 1967.

Homer, William Inness, *Robert Henri and His Circle,* Ithaca, New York, 1969.

Morse, Peter, *Sloan's Prints: A Catalogue Raisonné of the Etchings, Lithographs, and Posters,* New Haven, 1969.

St. John, Bruce, *Sloan,* New York, 1971.

Scott, David W., and E. John Bullard, *Sloan* (cat), Washington, 1971.

Scott, David W., *Sloan,* New York, 1975.

Sloan, Helen Farr, *Sloan: New York Etchings (1905–1949),* New York and London, 1978.

Gordon, Robert, *John Butler Yeats and Sloan: The Records of a Friendship,* Dublin, 1978.

McGrath, Robert L., *Sloan: Paintings, Prints, Drawings,* Hanover, New Hampshire, 1981.

Sloan: A Representative Show of Prints (cat), Nottingham, 1983.

Elzea, Rowland, and Elizabeth Hawkes, *Sloan, Spectator of Life* (cat), Wilmington, Delaware, 1988.

article—

Hopper, Edward, "Sloan and the Philadelphians," in *Arts* (New York), April 1927.

*

John Sloan attained notoriety as a leading member of "The Eight," a group of dissident artists, most of them social-

realists, who gathered together under the leadership of Robert Henri. In 1908, after being excluded from the shows of the National Academy of Design, the Eight staged their own exhibition at the Macbeth Gallery in New York. This was greeted with a storm of controversy and won them the sobriquet "The Ash Can School." With the exception of Maurice Prendergast, whose work stood apart from the rest, Sloan is now generally regarded as the strongest painter in the band, and his work epitomizes the gritty urban realism for which the Eight is known.

Born in 1877, in Lock Haven, Pennsylvania, Sloan received his only formal education at Central High School in Philadelphia, where his classmates included William Glackens, who later also became a member of the Eight, and the noted collector of modern art Albert Barnes. After graduation, while working in a bookstore, Sloan taught himself to draw through such exercises as copying all the illustrations in the dictionary. By 1890 he had begun a career in art, designing calendars and greeting cards, and in 1892 he found employment as a newspaper illustrator. In the next decade he worked for several Philadelphia newspapers, including the *Philadelphia Press* (whose art editor was Edward Davis, the father of the painter Stuart Davis). Three of the other member of the Eight, William Glackens, George Luks, and Everett Shinn, worked alongside Sloan at this time as illustrators for Philadelphia newspapers.

Two aspects of Sloan experience during this early period proved of fundamental significance to his mature work: his training as an artist-reporter and his association with the charismatic painter Robert Henri. While photographs were published in *Harper's* as early as 1889, the camera was still too bulky, fragile, unreliable, and slow in recording movement to be useful for journalistic purposes. Consequently, for another decade illustrator-reporters were sent off to make on-the-spot drawings of such happenings as fires, runaway horses, criminal trials, and streetcar accidents. This work trained artists to observe quickly and accurately and make brief notations that they could elaborate on later back at the office. A rapid sketch of a fire, for example, might contain a drawing of a typical window, notes about how many stories high the building stood, and marks and crosses to indicate where the fire-fighting apparatus was placed.

Sloan himself always preferred to make drawings in the newspaper office rather than on the site of disasters, but he was deeply affected by the immediate contact with real life provided by newspaper work. From the relentless pressure of producing drawings in time for a deadline he learned to take in a scene in a few seconds, to work from memory, and to compose with bold, simple shapes which would retain a strong impact even when poorly reproduced. Edward Hopper later commented on the significance of this early commercial practice to Sloan's development, noting that "this hard early training has given to Sloan a facility and a power of invention that the pure painter seldom achieves."

Sloan's technical gifts, however, might have been squandered had he not befriended Robert Henri, of whom Sloan later remarked: "I don't think I would have been a painter if I hadn't come under his direction." Though only six years older than Sloan, Henri was considerably more cosmopolitan and assured, having grown up in Nebraska and New York and studied art in Philadelphia and Paris. To Sloan he became like a surrogate father, introducing him to new movements in literature and art, commenting on his technique, and encouraging, indeed exhorting him, to grapple with the largest issues of life. In 1893 Sloan began to attend Tuesday evening gatherings at Henri's studio on Walnut street in Philadelphia, which became the setting for artistic discussion, as well as the local for parties and skits, including a humorous parody of George Du Maurier's novel *Trilby,* in which Sloan performed the role of "Twillbe" in drag.

Sloan's emergence into artistic maturity was sparked by a specific event: the loss of his full-time position at the *Philadelphia Press* and his consequent move to New York late in 1904, where he settled on the outskirts of the seething "Tenderloin" district, a center of prostitution. "I emerged into real interest in the life around me, with paint in my hand, *after* I came to New York," he later recalled. An outsider to New York, overwhelmed by the scale and bustle of the city, Sloan painted the scenes that he witnessed in the streets or that he viewed from the window of his lofty studio. With his tiny and energetic wife Dolly, an ardent politico, he often visited Madison Square, the site of *The Coffee Line,* to pass out copies of the socialist paper, *The Appeal to Reason.*

During a period of about eight years, from 1905 to 1913, Sloan produced a series of memorable images of city life. This group of paintings seems to have been one of the principal influences on the career of Edward Hopper, who often specifically echoed the compositions and subject matter of Sloan. After the Armory Show, however, which introduced Americans to modernist European art, Sloan's sense of artistic direction grew confused, and the quality of his painting rapidly declined. Only seldom after 1913 did he produce work whose quality is comparable to that of his best period.

—Henry Adams

SLUTER, Claus.

Born probably in Haarlem, c. 1340. Died between 24 September 1405 and 31 January 1406. Early life is not well documented: probably in Brussels, c. 1379-80, then in Dijon from 1385: worked mainly at the Dijon court for Philip the Bold, Duke of Burgundy: assistant to the Duke's sculptor Jean de Marville, 1385-89, then court sculptor: worked on the sculptural decoration of the Chartreuse de Champmol, 1391-96/97, and on The Well of Moses (or Calvary), 1395-1403; also worked on Philip's tomb.

Collections/Locations: Champmol: Chartreuse; Dijon: Archaeological Museum; Cleveland.

Publications

On SLUTER: books—

Kleinzlausz., Arthur J., *Sluter et la sculpture bourguignonne au XV siècle,* Paris, 1905.
Troescher, Georg, *Sluter und die burgundische Plastik um die Wende des XIV. Jahrhunderts,* Freiburg, 1932.

St. John the Baptist and Philip the Bold, c. 1391; stone; Champmol, Charterhouse

Liebreich, Aenne, *Sluter*, Brussels, 1936.
Roggen, Domien, *Les Pleurants de Sluter à Dijon*, Antwerp, 1936.
David, Henri, *Sluter*, Paris, 1951.
Sulzberger, S., *La Formation de Sluter*, Brussels, 1952.
Arnoldi, Francesco N., *Sluter e la scultura borgognona*, Milan, 1966.

*

Claus Sluter was a sculptor, probably of Dutch origin, who is best known for the work he did for Philip the Bold, duke of Burgundy. Working between 1385 and his death in 1405–06 at the Chartreuse de Champmol, Philip's foundation near Dijon, Sluter became the most renowned and most advanced among the many artists in the duke's employ. Little is known of Sluter's work prior to his arrival in the duke's service. His style has been recognized in some sculptures in the city halls of both Brussels and Bruges and scholars feel he may have been employed in these cities from about 1380 to 1385. Essentially, however, his training and early practice remain uncharted.

At the court of Philip the Bold, Sluter was assistant to Jean de Marville, the chief sculptor for the duke. He succeeded to the post at Marville's death in 1389. After 1396 Sluter was assisted by his nephew, Claus de Werve. The sculptural projects with which he is associated include Philip's tomb, the portal figures for his mortuary chapel at the Chartreuse de Champmol, and the so-called *Well of Moses,* a monumental sculptural complex mounted at a well-head in the cloisters of the monastery.

Philip the Bold's tomb was begun by Jean de Marville around 1381. It was taken over by Sluter in 1389 and he has been given the primary credit for its form though it was finally completed by Claus de Werve in 1411 after the death of both Sluter and the duke. A life-sized effigy of the duke lies atop the large, black marble lid of his sarcophagus. The walls of the tomb are of alabaster atop a large, black marble base. On the alabaster sides is a continuous architectural frieze sheltering in its bays a procession of forty "pleurants," figures of mourning Carthusian monks. These small figures, each just over 15 inches tall, expressing grief and sorrow, are the most effective and successful element of the tomb.

Sluter also did most of the work on the portal sculptures for the chapel at the Chartreuse, finished by 1397. These are vital and vigorous figures, mantled in heavy drapery with numerous swirling folds. The Virgin on the trumeau is depicted as a mature, unidealized human, looking quizzically at the infant in her arms. On the portal jambs at the left are Duke Philip the Bold backed by a huge figure of John the Baptist. On the right is Margaret of Flanders in company with St. Catherine. Philip and Margaret kneel in adoration of the Madonna and Child. Sluter portrayed them as true portraits, distinctly and unflatteringly lifelike. The scale and gestures of the figures successfully unite the entire portal complex into a single composition.

Sluter's *Well of Moses* was originally part of a large Crucifixion group mounted on a pedestal in the midst of a pool in the great cloister of the monastery. Little of the Calvary group the once topped it still survives, none of it in place. Moses is the most imposing of a group of six life-sized sculptures of prophets who still appear on the pedestal. Each has a scroll with a prophecy related to the Crucifixion.

The works of Claus Sluter, along with others of the duke's artists, particularly Jacques de Baerze and Melchior Broederlam, help to define the northern phase of the International Gothic Style, a vigorous late Gothic movement on the eve of the Birth of the Renaissance.

—Charles I. Minott

SMIBERT, John.

Born in Edinburgh, 1688. Died in Boston, Massachusetts, 2 April 1751. Married Mary Williams, 1730; nine children. Apprenticed to a house painter in Edinburgh; then went to London, worked as a coach painter, and a copyist for London dealers; worked in Italy, 1719–22, and set up in London as a portrait painter, 1722; in 1728, went with the philosopher George Berkeley to the Americas to found a "Universal College" in the Bermudas, but when the money did not materialize and Berkeley returned to England, Smibert settled in Boston, 1729: successful career as portrait painter and art dealer; organized the first art exhibition in the colonies.

Collections: Boston; Brunswick, Maine: Bowdoin College; Edinburgh: Portrait Gallery; London: Portrait Gallery; New Haven; New York.

Publications

By SMIBERT: book—

Notebook, edited by David Evans, Boston, 1969.

On SMIBERT: book—

Foote, Henry Wilder, *Smibert, Painter, with a Descriptive Catalogue of Portraits*, Cambridge, Massachusetts, 1950.

articles—

Burroughs, Alan, "The Development of Smibert," in *Art in America*, April 1942.
Mooz, R. Peter, "Smibert's *Bermuda Group*—A Reevaluation," in *Art Quarterly* (Detroit), Summer 1970.
Jaffe, Irma B., "Found: Smibert's *Portrait of Cardinal Guido Bentivoglio*," in *Art Journal* (New York), Spring 1976.
Chappell, Miles, "A Note on Smibert's Italian Sojourn," in *Art Bulletin (New York)*, March 1982.
Dietz, Paula, "The First American Landscape," in *Connoisseur (New York)*, December 1982.
Miles, Ellen G., "Portraits of the Heroes of Louisbourg," in *American Art Journal*, Winter 1983.
Saunders, Richard H., "Smibert's Italian Sojourn—Once Again," in *Art Bulletin (New York)*, June 1984.

*

Through a career shaped by training in England and in Italy, Smibert was the most influential artist in the development of painting in Boston in the 18th century. What in New England were limners of different styles became with Smibert a school characterized by a combination of the latest London manner with an indigenous love of visual truth, a style exemplified in works by younger contemporaries such as Robert Feke and John Singleton Copley. The extent of Smibert's production is documented by his notebook, and his reputation as an accomplished artist who emigrated to the Colonies is recorded by the early biographers George Vertue, F. M. N. Gabburri, Horace Walpole (*Anecdotes of Painting in England*, 1762–67), and

William Dunlap (*A History of the Rise and Progress of the Arts of Design in the United States*, 1834), and Foote (1950).

Smibert's career was motivated by desires to paint and to instruct. His portraits done in 1722–28 in London show that he was greatly influenced by the example of late Kneller, especially in the Kit Kat Club format, and that he was an able competitor of Dahl, Richardson, and Highmore.

Portraiture gave way to pedagogy in 1728 through Smibert's friendship with the philosopher George Berkeley. The two met in Florence in 1720 and again in London, and Smibert joined Berkeley in 1728 in the plan to create an ideal school in the colonies, an endeavor commemorated in *The Bermuda Group*. Discussing such a university and teaching the fine arts may have inspired Smibert's activities in Italy as a copiest and as a collector of casts, prints, and drawings.

Smibert enjoyed great success in America with his prosperous patrons, and he had an important role in creating what Craven (1986) termed the Colonial mercantile portrait style. Although well documented, Smibert's activities in Boston pose questions yet to be answered. His success there is known from the notebook that for the years 1729–46 lists some 240 portraits (many still are lost or unidentified). He also did history paintings and landscapes that are documented but now lost, with some possible exceptions such as *The View of Boston* (Dietz, 1982). While often seen as one of the pioneers of the American tradition of realism in art, Smibert was clearly an accomplished painter working in the English technique and style as shown by his compositional schemes and his combination of likeness with interpretation evocation of tastes of the 1720's. He was one of the earliest of the English painters to take up the conversation piece and then to introduce this new type of portrait almost immediately in his painting done in Boston. Although Smibert had important commissions to the end, it is generally held that his career and style declined in the 1740's due to failing eyesight (Burroughs, 1942). His son Nathaniel is his one known pupil, but numerous younger artists in Boston, such as Robert Feke, John Greenwood, Joseph Badger, and John Singleton Copley, took inspiration from his works.

Smibert supplemented his living by selling colors and supplies, prints and imported artworks and by displaying his collection in his studio, which remained intact until the early 19th century and which contributed greatly to the development of art in Boston. His studio was a virtual museum where younger artists could see good and, for the distance, precious reflections of ancient art in his plaster casts and of the Old Masters in painted copies after artists such as Titian and Poussin. The significance of his copy after Van Dyck's *Cardinal Bentivoglio* for Copley, John Trumbull and Washington Allston is well know (Saunders, 1987). Smibert's collection of some 140 drawings are believed to have been among those acquired by James Bowdoin III and bequeathed in 1811 to the college he founded. Smibert's significance was summed up by Allston (quoted in Dunlap): "I had a higher master in the head of Cardinal Bentivoglio, from Vandyke. . . . This copy was made by Smybert . . . I thought it was perfection, but when I saw the original some years afterward, I found I had to alter my notions of perfection. However, I am grateful to Smybert for the instruction he gave me—his work rather."

—Miles L. Chappell

SMITH, David (Roland).

Born in Decatur, Indiana, 9 March 1906. Died in Bennington, Vermont, 23 May 1965. Married 1)Dorothy Dehner, 1927 (divorced, 1952); 2) Jean Freas, 1953 (divorced, 1961); two daughters. Attended schools in Paulding, Ohio; studied drawing, Cleveland Art School correspondence course, 1923; woodcutting, Ohio University, Athens 1924–25; Notre Dame University, Indiana, 1925; studied under Richard Lahey, John Sloan, Jan Matulka, and Kimon Nicolaides at the Art Students League, New York, 1927–32; worked for the Fine Arts Section, Treasury Relief Project, 1934, and for the Federal Art Project, 1937; taught at Sarah Lawrence College, Bronxville, New York, 1948–50, University of Arkansas, Fayetteville, 1953, University of Indiana, Bloomington, 1954, and University of Mississippi, Oxford, 1955.

Collections: Chicago; Duisberg; London: Tate; Los Angeles; New York: Moma, Guggenheim; Washington: Hirshhorn.

Publications

By SMITH: books—

Smith by Smith, edited by Cleve Gray, London, 1968; New York, 1969.
Smith, edited by Garnett McCoy, New York, 1973.

On SMITH: books—

Kramer, Hilton, *Smith* (cat), Los Angeles, 1965.
Cone, Jane Harrison, *Smith* (cat), Cambridge, Massachusetts, 1966.
Smith (cat), New York and London, 1966.
Fry, Edward E., *Smith* (cat), New York, 1969.
Krauss, Rosalind, *Terminal Iron Works: The Sculpture of Smith,* Cambridge, Massachusetts, 1971.
Krauss, Rosalind, *The Sculpture of Smith: A Catalogue Raisonné,* New York, 1977.
McClintic, Miranda, *Smith* (cat), Washington, 1979.
Cummings, Paul, *Smith: The Drawings* (cat), New York, 1979.
Carmean, E. A., Jr., *Smith* (cat), Washington, 1982.
Fry, Edward, and Miranda McClintic, *Smith: Painter, Sculptor, Draughtsman* (cat), New York, 1982.
Marcus, Stanley E., *Smith: The Sculptor and His Work,* Ithaca, New York, 1983.
Rikhoff, Jean, *Smith: I Remember,* Glen Falls, New York, 1984.
Wilkin, Karen, *Smith,* New York, 1984.
Merkert, Jörn, Editor, *Smith: Sculpture and Drawings* (cat), Munich, 1986.

*

The aesthetic excellence and expressive power of his art, his innovations and his influence, make David Smith America's most important sculptor. Over the course of a 34-year career Smith produced a prodigious number of sculptures and in doing so redefined the history and changed the direction of sculp-

Untitled (Voltri), 1962; steel; 20½ in (52 cm); Courtesy Waddington Galleries

ture in America. His development was not linear: different themes, styles, techniques, and materials occupied him concurrently.

Smith began his career as a painter in the late 1920's but in the early 1930's became aware of the possibilities of sculpture. Within a few years he would concentrate on sculpture, yet throughout his career he continued to explore options traditionally associated with painting, including planar composition, color and surface facture, as well as to draw and to paint.

His initial move from painting into sculpture came about through the process of collage. Smith began attaching found materials to the painting's surface, and as he described it, gradually the canvas became the base and the painting the sculpture. Impressed by reproductions he saw of Picasso's Cubist sculpture and Julio Gonzalez's welded iron pieces, and drawing on his own background as a riveter in a Studebaker plant in Indiana, Smith began to weld his sculptures. A series of heads formed his first group of welded steel sculptures (for example, *Agricola Head,* 1933, Candida and Rebecca Smith Collection; *Head with Cogs for Eyes,* 1933, New York, Fisher Collection). By incorporating discarded machine parts and

scraps into these works, he extended the language of Cubist collage to include industrial materials. However, unlike Picasso, Smith did not retain the identities of his found objects; instead, at a very early point, he succeeded in transforming the found object into a new kind of non-literal structure, so that its former existence is no longer obvious.

Surrealist figurative influence was particularly evident in Smith's work from the late 1930's to the mid-1940's when he developed a symbolic and expressive style based in part on the lessons he had learned from European modernism. For example, in *Home of the Welder* (1945; Candida and Rebecca Smith Collection), Smith sets up an autobiographical drama full of visual free associations and secret references to explore the tensions of his relationships to his wife/woman, to his work, and to his own male identity, within a house-tableau in the manner of Giacometti. Themes of memory, sexuality, aggression, violence, and death are central to Smith's sculpture, and the symbol-laden works he generated to express this content earned him his reputation as a serious artist. Smith always retained his interest in subject matter, although in later years he would come to visualize it in increasingly abstract terms.

In the 1940's, Smith used a variety of processes and metals, working with solid cast forms as well as introduction the essentially pictorial device of the open space frame. First seen in *Head as a Still Life* (1940; Candida and Rebecca Smith Collection) and *Widow's Lament* (1942–43; private collection), the space frame was to provide him with a format for a large part of his work in the 1940's and early 1950's, and would reappear in the monumental gates of the late Cubi series. Such seminal pieces as *Blackburn Song of an Irish Blacksmith* (1949–50; Duisberg) and *Hudson River Landscape* (1951; New York, Whitney), characterized by open construction, interaction among multiple images, and, in the latter, a strong horizontal thrust, affirm Smith's interest in moving away from the traditions of monolithic sculpture.

Gradually, Smith also turned away from the recondite symbolism of the 1940's, vested in sculptures of rather intimate dimensions, to a more public scale and concomitantly, to a new vocabulary of forms that could function independently of private meanings. This transformation was made explicit in the Tanktotems, one of Smith's first consciously developed series consisting of ten works spanning the years 1952–60, where he combined found forms—steel boiler tank ends—into sculptures that successfully synthesized his growing abstract and long-standing figurative concerns. Now committed almost exclusively to welded steel and iron, Smith expanded his range of industrial materials to include sliced I-beams which he first composed into large scale anthropomorphic forms in the Sentinel series, and would continue to use as late as 1964.

At the end of the 1950's, Smith once again expanded the range and character of his work through a series of personal innovations, among which the most important were his discovery of the potential of stainless steel for monumental sculpture, and the reintroduction of color, culminating in two series, the Zigs, and his last works, the twenty-eight Cubis, still in process at the time of the accident that claimed his life.

Smith's work was an original fusion of Cubist-constructivist techniques with surrealist and expressionist overtones. He pioneered the use of industrial materials and invented a new vocabulary of structure and form that is still influential today; by realizing the potential of welding as a means of working metal directly into sculptural form, he made possible sculptures of large scale but limited cost.

Smith resisted critical distinctions within his *oeuvre*. "The works you see," he wrote, "are segments of my work life. If you prefer one work over another, it is your privilege, but it does not interest me. The work is a statement of identity, it comes from a stream, it is related to my past works, the three or four works in process and the work yet to come."

—Susan Barnes Robinson

SNYDERS, Frans.

Baptized in Antwerp, 11 November 1579. Died in Antwerp, 19 August 1657. Married Margaretha de Vos, sister of the painters Cornelis and Paul de Vos, 1613. Pupil of Pieter Bruegel the Younger, and of Hendrick van Balen; visited Italy, 1608–09; then settled in Antwerp as painter of still-lifes, animal and hunting pictures: often painted in details of animals and other still-life elements in the paintings of Jordaens and Rubens; principal painter to Archduke Albert, Governor of the Low Countries, and also had commissions from Philip III.

Major Collections: Madrid.
Other Collections: Amsterdam; Antwerp; Berlin; Boston; Braunschweig; Brussels; Cape Town; Detroit; Dresden; Edinburgh; Ghent; The Hague; Kassel; Leningrad; London: National Gallery, Kenwood; Milan; Munich; Ottawa; Paris; Toronto.

Publications

On SNYDERS: books—

Gregor, Carl, Herzog zu Mecklenburg, *Flämische Jagdstilleben van Snyders und Jan Fyt,* Hamburg, 1970.
Greindl, Edith, *Les Peintres flamands de nature morte au XVIIe siecle,* Brussels, 1956.

articles—

Ninane, L., "Rubens et Snyders," in *Miscellanea Leo von Puyvelde,* Brussels, 1939.
Funk, H., "Snyders oder Paul de Vos?," in *Festschrift für Edwin Redslob,* Berlin, 1955.
Robels, Hella, "Snyders Entwicklung als Stillebenmaler," in *Wallraf-Richartz-Jahrbuch* (Cologne), 31, 1969.
Jaffe, Michael, "Rubens and Snyders: A Fruitful Partnership," in *Apollo* (london), March 1971.
Sullivan, Scott A., "Snyders: Still Life with Fruit, Vegetables, and Dead Games," in *Detroit Institute Bulletin,* 59, 1981.

*

Beginning with Snyder's earliest works, two distinct types of still life can be found within his oeuvre. One is a grandiose kitchen or market picture in which figures are combined with

a still-life display set in a pantry or market interior. These works were influenced by the 16th-century paintings of Pieter Aertsen and Joachim Beuckelaer. They also reflect the influence of Peter Paul Rubens's 1610 oil sketch *The Recognition of Philipoemen* in the Louvre, Paris.

The second type of painting by Snyders was an independent still life of a smaller and more intimate scale. Here, an arrangement of fruit and game was most often seen. The objects would be placed on a table set and against a monochromatic background. The genre figures in these works were eliminated and the still life was brought closer to the viewer. This type of composition was paralleled in the fruit and breakfast pieces of other early 17th-century Flemish artists such as Ambrosius Bosschaert the Elder and Osias Beert. Compositions of this type by Snyders were carefully composed using a series of diagonals to unify the diverse elements of the display and suggest a recession into space. A strong even light acted to intensify the master's rich and high-keyed palette. Throughout his career, Snyders employed a combination of red and its complement green to enliven the arrangement. Most typically, he used a red tablecloth as a foil to the green fruit and foliage. In larger compositions, the artist would add a gathered white cloth on top of the red drapery to act as a focal point. A similar effect was also achieved when a large white swan or goose with one or both wings outstretched was introduced into the arrangement.

The swan motif originated with Rubens in his Louvre sketch and was often found in Snyder's large pantry still lifes. Snyders also frequently employed Rubens's compositional device wherein pyramidal arrangements of game were united by long sweeping diagonals. In general, Snyders's pantry scenes evolved from tightly composed geometric arrangements to lighter and more casual displays. The sharpness of his light in early pictures is gradually softened as his palette grows warmer and deeper. Half-length figures persist in his pantry scenes as a device to increase the sense of animation and drama. To the same end, Snyders is fond of including parrots, squirrels, and occasionally monkeys.

In the accessories chosen by Snyders for his still lifes, the mundane vegetables and earthen or copper vessels seen in the works of his 16th-century predecessors are eliminated. Rather, he introduces more ornate objects such as Chinese porcelains, gilted fruit compotes, and fine Venetian crystal. Magnificent game animals, costly lobsters, and other gastronomic delicacies create the impression that the table is laid for aristocratic tastes.

Towards the 1630's Snyders's still lifes became more simplified as the number of accessories was reduced and an increased spatial freedom developed. As a result of greater collaboration with Rubens, Snyders's brushwork also became more fluid. As for the smaller still lifes, their production tended to increase in the artist's later years. These works were usually executed on panel and illustrate a concern for the meticulous depiction of costly and ornate objects. There was not a great deal of change in the design of these compositions. Typically, a small cluster of game would be displayed on one side of a table with a still life of fruit on the other. As in the artist's larger works, colors grew warmer and the brushwork more open.

Frans Snyders exerted a great deal of influence upon the subsequent development of Flemish still-life painting. He had only three pupils, none of whom was particularly successful. Yet almost every important still-life painter in Flanders was affected by his work. Snyders's large dynamic compositions epitomized the Flemish baroque in their highly movemented, strongly colored, and superabundant displays of the good things in life. Every Flemish painter who came after him seemed to find something appealing in his works.

—Scott A. Sullivan

SODOMA.

Born Giovanni Antonio Bazzi in Vercelli, 1477. Died in Siena, 14 or 15 February 1549. Married Beatrice di Galli, 1510; one son and one daughter. Apprenticed to Martino Spanzotti in Vercelli, 1490, for seven years (Spanzotti moved to Casale, 1496, and Sodoma possibly accompanied him); possibly in the circle of Leonardo in Milan in later 1490's; then settled in Siena, 1501; did work in the refectory of S. Anna in Camprena, near Pienza, 1503–04, and a large series of frescoes for the monastery of Monteoliveto Maggiore, 1505–08; also worked in the Vatican and the Villa Farnesina in Rome, 1508.

Collections: Florence: Pitti; Hanover; London; Monteoliveto Maggiore; New York; Paris; Pisa: Museum, Cathedral; Rome: Farnesina; Sienna: S. Agostino, S. Bernardino, S. Domenico, Palazzo Pubblico, Museo Civico, Pinacoteca, S. Spirito, Museo del Opera del Duomo; Vatican.

Publications

On SODOMA: books—

Priuli-Bon, Lilian, *Sodoma*, London, 1900.

Faccio, Cesare, *Sodoma*, Cercelli, 1902.

Cust, Robert Hobart, *Sodoma, The Man and the Painter*, New York, 1906.

Kupfler, E. von, *Der Maler des Schoenheit, Il Sodoma*, Leipzig, 1908.

Segard, Achille, *Sodome et la fin de l'école de Sienne aux xvi siècle*, Paris, 1910.

Jacobsen, Emil, *Sodoma und das Cinquecento in Siena*, Strasbourg, 1910.

Gielly, Louis, *Sodoma*, Paris, 1911.

Hauvette, Henri, *Le Sodoma*, Paris, 1911.

Vasari, Giorgio, *Vita di Sodoma*, edited by Francesco Sapori, Florence, 1914.

Terrasse, Charles, *Sodoma*, Paris, 1925.

Carli, Enzo, *Opere di Sodoma* (cat), Siena, 1950.

Marciano-Agostinelli Tozzi, M. T., *Il Sodoma*, Messina, 1951.

Carli, Enzo, *Il Sodoma a Sant'Anna in Camprena*, Florence, 1974.

Hayum, Andrée, *Il Sodoma*, New York, 1976.

Carli, Enzo, *Le storie di San Benedetto a Monteoliveto Maggiore*, Cinisello Balsamo, 1980.

article—

Wolk, Linda, "Sodoma's Holy Family with Saint John," in *Bulletin of Detroit Institute of Arts*, 61, 1984.

*

Giovanni Antonio Bazzi, called Il Sodoma, was associated for most of his long career with the city of Siena, where he and Beccafumi were the most prominent artists in the 16th century. Born in Vercelli, Sodoma received his artistic training in the north of Italy, where he was schooled in the Lombard manner shaped by the example of Leonardo. The strong, if superficial, resemblance that his early works bear to Leonardo's style led scholars at one time to view Sodoma as an actual pupil of the older artist, although this theory is now generally discounted. Nonetheless, the formative influence of Leonardo left an enduring imprint on Sodoma's artistic style, as witnessed by the decidedly Leonardesque character of such works as the *Sant' Ansano* fresco in the Palazzo Pubblico, Siena. The artist was also responsive to the art of Signorelli, Fra Bartolommeo, and Raphael.

In addition to Siena, Sodoma was active in Rome, where he travelled at least twice, and he worked as well in Pisa, Florence, Piombino, Volterra, and S. Gimignano. Sodoma was skilled both as a fresco and a panel painter, but he earned a reputation in his own day on account of his flamboyant behavior as much as for his artistic abilities: Vasari reports that the artist had a menagerie of exotic animals, kept a racehorse, and was typically at the center of a captive group of young admirers who urged him on in his antics. His social pretentions and ambitions were rewarded when the artist was made a *cavaliere* in 1518 by Pope Leo X—a tribute to the acumen that underlay his social posturings.

The scenes from the life of Saint Benedict at the monastery of Monte Olivetto Maggiore (1505–08), which complete a cycle begun by Luca Signorelli, are Sodoma's earliest major frescoes. These were followed by frescoes in the Stanza della Segnatura in the Vatican palace (1508), of which only the *trompe l'oeil* oculus with putti in the center of the ceiling remains, the artist's other contributions soon destroyed when Pope Julius II commissioned Raphael to re-embellish this room. The artist's other major Roman mural decoration, the frescoes depicting scenes from the life of Alexander the Great in the Villa Farnesina, executed in 1517, had a happier fate. Commissioned by the powerful and extravagent Sienese banker Agostino Chigi, the cycle is a delightful evocation of the classical world. This is particularly the case with the *Marriage of Alexander and Roxanne,* one of the artist's most important works, which, in its wealth of narrative detail, closely conforms to the ancient literary source which relates this episode. The subject also alludes to Sodoma's patron, who married his mistress at the time the fresco was executed.

Sodoma's other major mural commissions, all in Siena, include the frescoes in the Oratory of San Bernardino in Siena, where the artist executed four scenes from the life of the Virgin (begun 1518; his contemporaries Beccafumi and Girolamo della Pacchia were responsible for the remaining narratives), and three standing Franciscan saints; the celebrated Chapel of St. Catherine of Siena in S. Domenico (1526); and the Cappella degli Spagnoli in S. Spirito in Siena (c. 1531), which

depicts *Saint James Vanquishing the Moors* and two standing saints. His flair for dramatic narrative and lively story telling is particularly evident in the St. Catherine cycle, the first monumental treatment of the life of this favorite Sienese subject in art. From the communal government of Siena, Sodoma received two important fresco commissions: the decoration of the Cappella della Piazza on the exterior of the Palazzo Pubblico overlooking the Campo, executed in 1537 (ruined; fragments in Museo Civico, Siena), and three standing saints in the Sala del Mapomondo in the Palazzo Pubblico (*Sant' Ansano* and *San Vittorio,* 1529, and *Beato Bernardo Tolomei,* 1533). *Sant'Ansano* and *San Vittorio,* two of Siena's patron saints, confront the enthroned Virgin Mary in Simone Martini's *Maestà* on the opposite wall of the vast chamber. Like the Virgin, they are the divine protectors of Siena and guardians of her civic liberty. These figures were, in fact, commissioned in the wake of an important Sienese military victory over the hated Florentines, and, like Simone Martini's earlier work, are pregnant with civic and communal connotations. That this commission was awarded to Sodoma attests to the prestige he enjoyed in Siena during his lifetime.

Sodoma also executed a number of altarpieces. The *Deposition* from the church of S. Francesco in Siena (1509–10; Siena, Pinacoteca) and the *Adoration of the Magi* in Sant'Agostino in Siena (c. 1528–32) rank among his most important works in this category of production. The artist's predilection for tightly knit figural groups compressed against the foreground plane is evident in the *Adoration,* as well as in the *Coronation of the Virgin* fresco in the Oratory of S. Bernardino and the *Death of Niccolo Tuldo* in the Chapel of St. Catherine of Siena. The *Deposition,* a relatively early work by the artist, reflects the influence of Filippino Lippi's altarpiece of the same subject (Florence; completed by Perugino) and shows Sodoma attuned to the latest currents of Florentine painting. In the luminous, airy landscape setting of the *Deposition,* the artist's mastery of this genre is evident; his ongoing interest in landscape painting is revealed in such contemporary works as the *Holy Family* tondo (1510; Vercelli) and the later *Saint Sebastian* (1525; Florence, Pitti), the *Resurrection* (1535; Siena, Palazzo Pubblico), and the *Madonna and Child with St. Leonard* altarpiece (c. 1536; Siena, Palazzo Pubblico). The latter work, like the artist's other representations of the Madonna and Child with Saints (Sacra Conversazione), displays a strict symmetry and balance derived from Florentine art, particularly Fra Bartolommeo.

Representatives of a lighter and more fanciful, intimate vein are the artist's small-scale paintings depicting subjects from classical antiquity such as the *Lucretia* (c. 1510; Hanover, Kestner Museum), and the so-called *Love and Chastity* (c. 1511; Paris).

A leading artist of his day, Sodoma was responsible for introducing a High Renaissance style to the somewhat provincial city of Siena in the early 16th century. While he was keenly responsive to the most progressive currents in Florentine art represented by Leonardo and Fra Bartolommeo, and later to the grand, heroic manner of Raphael in Rome, Sodoma was less an innovator than a synthesizer, studying the works of his contemporaries and absorbing their stylistic advances into his own artistic idiom. His monumental, dramatic narratives, balanced and harmonious *sacra conversazione* altarpieces, his interest in landscape and the heroic nude form, and his

responsiveness to the art and culture of classical antiquity render Sodoma an archetypal, if less than avant-garde, Renaissance painter.

—Linda Wolk-Simon

SOLIMENA, Francesco.

Born in Nocera or in Canale di Serino, 4 October 1657; son of the painter Angelo Solimena. Died in Barra di Napoli, 3 April 1747. Trained in his father's provincial workshop; in Naples, 1674: influenced by Lanfranco and Preti; he and Giordano were rivals for top honors in 1680's and 1690's: international reputation by 1700, and became rich and famous. Pupils: Conca, Allan Ramsay, Francesco de Mura.

Collections: Budapest; Cleveland; Cornigliano: Villa Bombrini; Dresden; Escorial; The Hague; Le Havre; Leningrad; Liverpool; London; Madrid; Milan; New York; Naples: Galleria Nazionale, Chiesa dei Gerolomini, S. Paolo Maggiore, Gesù Nuovo, S. Domenico Maggiore, S. Maria Donnaregina, S. Nicola alla Carità, S. Anna dei Lombardi, S. Maria Donnalbina; Oxford; Paris; Rome: Spada, Galleria Nazionale; Salerno: S. Giorgio; Toulouse; Venice; Vienna.

Publications

On SOLIMENA: books—

Bologna, Ferdinando, *Solimena,* Naples, 1958.
Sica, Manfredi, *Inediti di Solimena,* Naples, 1974.

*

In his long and extraordinarily productive career, Francesco Solimena preserved and even added new dimensions to the international prestige of Neapolitan painting. When the peripatetic Luca Giordano died in 1705, Solimena was poised to assume the leadership of the Neapolitan school. For the last three decades of his life, at least, Solimena was the most famous painter in Europe. Bernardo De Dominici's landmark *Vite de'pittori . . . napoletani* (1745) culminates with his life: "Most of the perfections described in the other biographies of famous painters can be said to be united in the admirable paintings by Signor Cavalier Francesco Solimena."

Around 1680, the young Solimena first made a name for himself with frescoes in San Giorgio, Salerno, and an altarpiece in San Nicola alla Carità, Naples (1681). Although clearly sensitive to Giordano's late Baroque vitality and splendid colorism, Solimena was in fact the pupil of his father, Angelo Solimena, a competent artist with ties to Francesco Guarino and Massimo Stanzione. Solimena was formed, therefore, with a predisposition to draftsmanship that would eventually lead him to reject Giordano's frankly decorative approach.

Dido and Aeneas; 6 ft 9½ in × 10 ft 2 in (207.2 × 310.2 cm); London, National Gallery

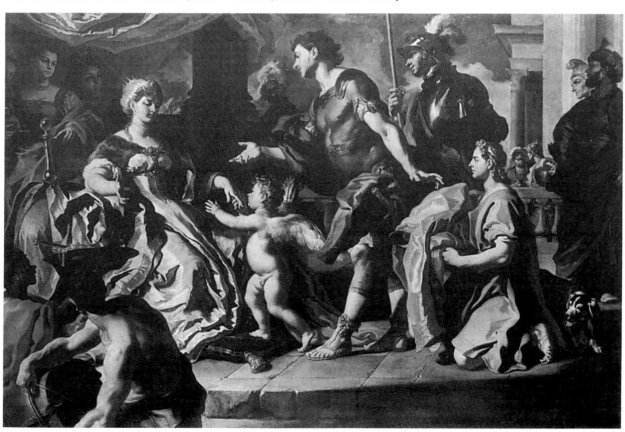

During the 1680's, Solimena made his closest approach to Giordano's style, imitating his brilliant colors and similarly taking inspiration from the animated compositions of Pietro da Cortona in Rome and Florence (which he knew from prints). But, at decade's end, Solimena's frescoes in the sacristy of San Paolo Maggiore abruptly announced his independence from Giordano's decorativeness. His new mode of composition was lucid, serious, and deliberated. His undisguised influence in this crucial development were the dramatic and expertly composed paintings of Mattia Preti, Giordano's old rival, who had departed Naples years before in 1660. According to De Dominici, Solimena was proud in later years to consider himself Preti's pupil.

The end of the 17th century brought another turning point in Solimena's development. In 1700 or shortly afterwards Solimena made his only recorded trip to Rome, where he immediately attracted influential patronage. For Cardinal Fabrizio Spada Veralli he painted *The Abduction of Orithyia* (Rome, Galleria Spada), in which he make a determined effort to evoke the dignity of classical statuary and stoic philosophy. Into a framework of late Seicento Roman classicism, as practiced by Carlo Maratti, Solimena inserted figures that represent his homage to the expressionistic style of Preti.

During the first decade of the new century Solimena operated at the height of his creative powers and organized a studio that trained the next several generations of Neapolitan painters. In 1709 he painted his most fully realized work in fresco, the *Triumph of the Dominican Order* on the vault of the sacristy of San Domenico Maggiore. In the second and third decades of the century, Solimena frequently accepted the challenge of composing paintings on a gigantic scale, e.g., three immense canvases commissioned in 1715 by the Republic of Genoa (destroyed by fire in 1777). In 1725, Solimena self-consciously set out to create a masterpiece in his fresco of *The Expulsion of Heliodorus from the Temple* in the Gesù Nuovo, a work that is ultimately disappointing for being excessively premeditated.

The late style of Solimena is traditionally associated with the Bourbons, who ruled Naples as an independent kingdom after ousting the Austrians in 1734. Even in his extreme old age, Solimena was constantly employed by Carlo di Borbone, the new king. In his last decade, this master colorist unexpectedly adopted a neo-Pretian sobriety: the atmosphere is brooding and nocturnal, yet the forms remain substantial and vigorous.

—John T. Spike

SOUTINE, Chaim.

Born in Smilovich, near Minsk, Lithuania, 1893. Died in Paris, 9 August 1943. Lived with Deborah Melnik (possibly married her), one daughter; lived with Gerda Groth in late 1930's, and with Marie-Berthe Aurench (ex-wife of Max Ernst), in early 1940's. Studied under Krueger in Minsk, 1907–10; attended School of Fine Arts, Vilna, 1910–13; studied under Cormon, Ecole des Beaux-Arts, Paris, 1913–15;

settled in Paris, and served briefly in French army during World War I; friend of Modigliani; lived in Ceret, Cagnes and Paris, Chartres, and Civry-sur-Serein, often in great poverty.

Collections: Amsterdam: Stedelijk; Berne; Chicago; Jerusalem: Israel Museum; London: Tate; New York: Moma, Guggenheim, Metropolitan; Paris: Beaubourg; Washington.

Publications

On SOUTINE: books—

George, Waldemar, *Soutine*, Paris, 1928.
Faure, Elie, *Soutine*, Paris, 1929
Cogniat, Raymond, *Soutine*, Paris, 1945.
Wheeler, Monroe, *Soutine* (cat), New York, 1950.
Cogniat, Raymond, *Soutine*, Geneva, 1952.
Szittya, Emil, *Soutine et son temps*, Paris, 1955.
George, Waldemar, *Soutine*, Paris, 1959.
Serouya, H., *Soutine*, Paris, 1961.
Castaing, Marcellin, and Jean Leymarie, *Soutine*, Paris, 1963, New York, 1964, London, 1965.
Sylvester, David, *Soutine*, London, 1963.
Forge, Andrew, *Soutine*, London, 1965.
Courthion, Pierre, *Soutine, peintre du déchirant*, Lausanne, 1972.
Soutine (cat), New York, 1973.
Groth, Gerda, *Mes années avec Soutine*, Paris, 1973.
Leymarie, Jean, *Soutine* (cat), Paris, 1973.
Werner, Alfred, *Soutine*, New York, 1977, London, 1978.
Cognait, Raymond, *Soutine*, Naefels and New York, 1979.
Güse, Ernst Gerhard, *Soutine* (cat), Stuttgart, 1981; edited by Michael Raeborn, London, 1982.

*

Unlike other Jewish artists of early modernism who came to Paris and were overwhelmed by French tradition, Soutine always remained an Expressionist, with an essentially subjective and irrational idiom. Despite his traditional subject matter—landscape, figures, and still life—his technique and attitude bring him close to a central European modernist style, as well as harboring the spell of Van Gogh.

Soutine gallicized his family (Sutin) but retained his Hebrew first name (Life). But this was not through fondness for his ghetto upbringing: he never referred directly to that life in any of his c. 600 paintings. (A possible exception might be a series of praying men, not clearly ethnic, painted in 1920–21.) If his art was a triumph over unending psychic turmoil, ironically his finest work appears as if it were achieved in a state of Chassidic rapture.

By 1918, in *Still Life with Fish* (New York), there already appears the frantic churning of his well-known 1920's works, best seen as a projection of personal unhappiness during five impoverished years in Paris; the most obvious visual reference for such formal treatment would seem to lie in the distortions of Van Gogh and the German Expressionists. Still life was a central motif for Soutine during the mid-1920's: there are a few floral works before 1920, but none later; his subject in the

following years would always be basic foodstuffs—fish, fowl, beef, an occasional rabbit.

Critics have suggested that the fish and fowl images are expressions of repressed and emblematic ethnic content. The herring is the poorest man's meal. The birds, as in *Hanging Turkey* (1926, Ziesler Collection), are painted mostly suspended and often appear to whirl. Thus such pictures might recall a once-yearly ceremony in the Jewish ghetto where a bird was turned round over the head of the penitent and made into a scapegoat for his ills. Similarly, the four paintings of a carcass of an ox possibly recall boyhood memories of anguish at a slaughtering. These works (e.g., *Carcass of Beef*, c. 1925, Buffalo) have become part of the Soutine mythology, and offer an insight into his creative methods. Although these paintings (all quite large for Soutine) were inspired by the Rembrandt painting *Beef Carcass* in the Louvre, they were produced in front of an actual side of beef which Soutine bought and had installed in his studio. (Anecdotal lore supplies a police visit when neighbors were appalled by the stench.)

His other major subject, aside from a small group of portraits, is figural studies. Even here, in his unvarying choice of certain social type, Soutine seems in the grip of unrecognizable necessity, a search for motifs to ease his insecurity. In the 1920's he painted a relatively large group of "servants," such as the *Little Pastry Cook* (c. 1922, Portland, Oregon) and the *Valet* (1928, Washington). Especially noteworthy is the extension of the "servant" type to the *Choirboy* (1930, Poses Collection).

With landscape, free as it was from the redolence of memory, Soutine was able to produce uninhibitedly his most unified and powerful images. Led by his friend Modigliani, the artist went to the Pyrenees hill town of Céret in 1919, and completed at least 200 landscapes there by 1922. The often exhilarating sense of invention (perhaps discovery is a more apt word) in the abstracted forms and textural flow at times moves to a startling degree of form disappearance (e.g., *Hill at Céret*, c. 1921, Perls Galleries, New York). In these upward-looking views, with sky almost eliminated and space flattened, the emphasis upon process and compositionless centrality influenced the Abstract Expressionists in post-World War II New York. In this body of work from Céret, Soutine achieved his signature look—the surface as an overlay of loaded brush marks. He must have continually painted wet-on-wet, since most of his works were completed at one session. An anecdote which reports his line-up of 40 brushes, each loaded with a distinct hue, would seem to have the ring of truth; it also reveals a level of creative self-awareness not usually associated with the image of the unselfconscious and maniacal Soutine.

If Bonnard was an influence on Soutine's sense of pigment and its intertwining, Cézanne may have been intuitively understood by the artist in his search for underlying structure. The introduction of house forms into the tumble of foliage (*View of Céret*, 1922, Baltimore) slowed down the organic impulse, and offered a prelude to the landscapes done at Cagnes in 1922-25 (*Landscape at Cagnes*, c. 1923, Stone Collection).

Although some critics have thought that Soutine maintained an undiminished creativity in the 1930's, the smaller number of works from that decade, and their often troubled, cloudy quality show that the vigor and invention of the 1920's was not sustained.

—Joshua Kind

SPENCER, (Sir) Stanley.

Born in Cookham-on-Thames, Berkshire, 30 June 1891. Died in Cliveden, 14 December 1959. Married 1) Hilda Carline, 1925 (divorced, 1937); two children; 2) Patricia Preece, 1937. Attended schools in Cookham, and studied painting with Dorothy Bailey, 1906; Maidenhead Technical Institute, 1907-09; studied under Henry Tonks, Slade School, London, 1908-12; served in the army medical corps, 1915-18, and official war artist, London, 1918; painter in Cookham, 1919-22, and London, 1922-39: taught at Ruskin School of Art, Oxford, 1927; worked on paintings for the Burghclere Chapel, 1927-31; worked on shipyard paintings commissioned by War Advisory Committee, 1940-46; lived in Cookham after 1942, Knighted, 1959.

Collections: Adelaide, South Australia; Amsterdam: Stedelijk; Cambridge; Fredericton, New Brunswick; London: Tate, War Museum; New Haven; New York; Moma; Perth, Western Australia; Wellington, New Zealand.

Publications

By SPENCER: books—

Diary, edited by Carolyn Leder, London, 1976.
Correspondence and Reminiscences, edited by John Rothenstein, London, 1979.

On SPENCER: books—

Wilenski, R. H., *Spencer*, London, 1924.
Rothenstein, Elizabeth, *Spencer*, London and New York, 1945.
Newton, Eric, *Spencer*, London, 1947.
Wilenski, R. H., *Spencer: Resurrection Pictures*, London, 1951.
Spencer, Gilbert, *Spencer*, London, 1961.
Collis, Maurice, *Spencer: A Biography*, London, 1962.
Behrend, George, *Spencer at Burghclere*, London, 1965.
Collis, Louise, *A Private View of Spencer*, London, 1972.
Leder, Carolyn, *Spencer: The Astor Collection*, London, 1976.
Carline, Richard, *Spencer*, London, 1977.
Carline, Richard, *Spencer at War*, London, 1978.
Stanley and Hilda Spencer (cat), London, 1978.
Robinson, Duncan, *Spencer: Visions from a Berkshire Village*, Oxford, 1979.
Bell, Keith, et al., *Spencer* (cat), London, 1980.
Bond, Anthony, *Spencer: Christ in the Wilderness*, Perth, Western Australia, 1983.

*

Spencer's triumph—still life recognized outside England—was his use of his personal life history to construct a mythological realm in his paintings; and in his use of a quasi-naive yet monumental stylistic idiom, these narrative images, in all their resplendent particularity, driving ambition, and sincerity, still manage to appear quizzical and good natured. He was brought

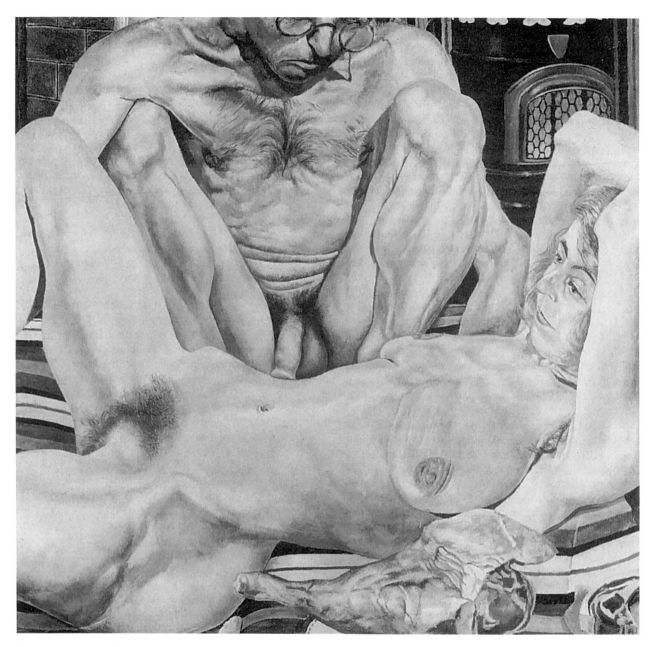

The Leg of Mutton Nude (Double Nude Portrait), 1936; 33 × 36 in (83.8 × 93.7 cm); London, Tate

up as a fragile child of a loving household in Cookham-on-Thames, where his organist and music-teacher father continually read the Gospels aloud to the children. Spencer's memory was apparently photographic, and it became tied to the town as an intense living present in which any events of human time might be placed, including of course all of the Christian panorama.

Such confidence in his imagery also allowed him to produce, well beyond the time of its actual occurrence, a body of compelling works based upon his life during World War I. As a sheltered boy, he had only been away from home to attend school at the Slade; and when he was assigned to duty in Macedonia, it was to open him forever to a complex world where he then made human love the prime goal of his paintings. The musing quietude of his pre-war Biblical images and

drawing were an essential part of Spencer's vision of life (*Zacharias and Elizabeth,* 1914, private collection). All this can be felt in a work made in 1919 after Spencer had left Greece to return home suffering from Maleria, *Travoys with Wounded Soldiers Arriving at a Dressing Station at Smol, Macedonia.* Made on commission as a war artist, the work demonstrates Spencer's grasp of imagery: all of his drawings made at the front were left there and never found, and so this scene was recreated from memory in drawings. As in every work of Spencer's—especially in his favorite subject, *The Resurrection*—where there might be violence, all is translated into a choreographic-like and profound stillness, with an equally intense patterning. This work also begins the series of extraordinary large-scale works. Spencer had received commissions for very large public works in the early 1920's; none of them

transpired, but they allowed him to think in terms which culminated in *The Resurrection: Cookham,* 1924–26 (London, Tate); its completion would make him famous. Here, his acquaintance with Renaissance frescoes, the works of Pieter Bruegel the Elder, as well a mundane mysticism derivable from Pre-Raphaelite tradition, produced a *Raising of the Dead* in the familiar churchyard of his beloved Cookham. For Spencer this was a world of leisurely quiet where the bad were only mildly censured and would rise with the good; a world of love, with black Africans emerging from baked clay, the Blessing of the Children by Christ, under the porch with God the Father behind him, through to Spencer's own nude depiction just to the right. The Resurrection for him was neither of Christ nor a Judgement, but rather a "Last Day" where no judgement was implied.

His best known work may be the *Resurrection of the Soldiers,* 1928–29, where the wonderous array of white crosses is handed to Christ by the soldiers. The work is on the east altar wall of a chapel built and dedicated in 1927 at Burghclere as a war memorial commission. Spencer who thought of the Arena Chapel of Giotto as a model, at first wanted to paint in fresco, but found it impractical. With his usual hypnotic clarity and solemn joyousness, the horror of the war is modified by a ritualistic faith in the essential goodness of mankind; Spencer also recalls his own means of confronting the unreality of that time in his images of mundane tasks, in pictures such as *Kit Inspection, Convoy of Wounded Men Filling Water Bottles at a Stream, Washing Lockers.* These paintings are filled with Spencer's precise, seemingly skeletonless bodies which bend and twist to produce the artist's characteristic, almost caricatural, figural and facial types; here at Burghclere, as Spencer worked on into the 1930's, the figures became somewhat fuller and more abstracted. This type was continued in the equally complex and similarly forceful mural-like works which Spencer produced during and after World War II through his activities as an official war artist in the ship-building area of Port Glasgow. During the war, while resident there, he came to know the people and atmosphere of the place intimately and produced the *Shipbuilding on the Clyde* series, where several 20-feet-long images, together with smaller pictures intended as one ensemble and now in the Imperial War Museum in London, display the activities of the boat yards. As this project was coming to a close, Spencer imagined a *Resurrection* for Port Glasgow which would celebrate his powerful joy—akin to that in the Cookham picture—in the community. From the mid-1940's to 1950, in *The Resurrection, Port Glasgow* (Tate), Spencer constructed his vision of unmitigatable human duration in time, always acknowledged and yet held innocently static. The complex figure groupings are shown with increasing bodily simplification and even unnatural contortion, yet with an increasing pulse in clothing patterns. As before there is the mural-sized image, with attendant smaller pictures, some of which are triptychs, such as *The Resurrection with the Raising of Jairus's Daughter,* 1947 (Southampton). There is much more detailed depiction here, as compared to 1924, as can be felt from the titles of separate images—*Waking Up, Tidying, Rejoicing, Reunion of Families.*

Trained academician that he was, within his modernist creativity he could manifest another manner; although it might be broadly brushed, it was unflinching as reportage. While Spencer used it often in portraits and rhapsodic landscapes, he used

this graphic realism in the later 1930's for the several highly fleshly pictures of himself with his second wife, Patricia Preece, such as *The Leg of Mutton Nude,* 1937 (Tate). Equally intense in this period of sexual imagery, was the series of *The Beatitudes of Love,* with their Surreal and dream-like distortions.

Earlier in his life, Spencer had apparently been deeply moved by non-Christian literature and religion. After his experiences in World War I, he came to believe in a concept of universal human love. The extraordinary picture that resulted, with the prelude in the sun-baked section of the Cookham Resurrection, as early as 1924, was *The Love among the Nations,* 1935 (Cambridge), which presents love and sexual play as breaking down national barriers, and as well conveying the central significance of sexuality in Spencer's concept of his own spiritual life. Here, as no doubt in every quasi-mythic work of Spencer, through his sophisticated narrative skills and his wonderfully controlled naivety, his essentially visionary impulse leaves the viewer quizzical and admiring.

—Joshua Kind

STEEN, Jan (Havicksz.).

Born in Leiden, 1626. Died in Leiden, buried 3 February 1679. Married 1) Margaretha, daughter of the painter Jan van Goyen, 1649 (died, 1669), four children, including two artists; 2) Marie van Egmont, 1673; one son. Possibly a pupil of Nicolas Knupfer in Utrecht, Jan van Goyen in The Hague, and Isaac Ostade in Haarlem; also attended the University of Leiden, 1646; co-founder, Leiden Guild of St. Luke, 1648 (Dean, 1674); worked in The Hague, 1649–54, in Delft (as a brewer), 1654–56, Warwond (near Leiden), 1656–60, in Haarlem, 1661–69, and settled in Leiden, 1669 or 1670: permission to open a tavern, 1672.

Major collections: Amsterdam; The Hague; Leningrad; London: National Gallery, Wallace, Wellington.
Other Collections: Basel; Berlin; Birmingham; Braunschweig; Brussels; Cologne; Copenhagen; Frankfurt; Kassel; Montpellier; Munich; Philadelphia; Prague; Rotterdam; Sarasota, Florida; Vienna.

Publications

On STEEN: books—

Rosenberg, Adolf, *Terborch und Steen,* Bielefeld, 1897.
Martin, Willem, *Steen,* Leiden, 1926.
Bredius, Abraham, *Steen,* Amsterdam, 1927.
Schmidt Degener, Frederik, *Veertig Meesterwerken van Steen,* Amsterdam, 1927; as *Steen,* London, 1927.
Jonge, C. H. de, *Steen,* Amsterdam, 1939.
Gudlaugsson, S. J., *De komedianten bij Steen en zijn Tijdgenoten,* The Hague, 1945; as *The Comedians in the Work of Steen and His Contemporaries,* Soest, 1970, Utrecht, 1974.
Groot, C. W. de, *Steen: Beeld en woord,* Utrecht, 1952.

Martin, Willem, *Steen,* Amsterdam, 1954.

Domela, P. N. H., *Steen* (cat), The Hague, 1958.

Criegern, A. von, *Ikonsgrafische Studien zu den fröhlichen Gesellschaft Steens,* Tubingen, 1971.

Vries, Lyckle de, *Steen: de schilderende Uilenspiegel,* Amsterdam, 1976.

Kirschenbaum, Baruch D., *The Religious and Historical Paintings of Steen,* New York and Oxford, 1977.

Vries, Lyckle de, *Steen "de Kluchtschilder,"* Groningen, 1977.

articles—

Salinger, M. M., "Steen's Merry Company," in *Bulletin of the Metropolitan Museum of Art* (New York), 17, 1958–59.

Tzeutschler-Lurie, A., "Steen, Esther, Ahasverus, and Haman," in *Bulletin of the Cleveland Museum of Art,* 52, 1965.

Stechow, Wolfgang, "Steen's Representations of the Marriage in Cana," in *Nederlands Kunsthistorisch Jaarboek* (Amsterdam), 23, 1972.

Sutton, Peter C., and Marigene H. Butler, "Steen: Comedy and Admonition," in *Philadelphia Museum Bulletin,* Winter-Spring, 1982–83.

*

Jan Steen's training has been related to Nicolas Knupfer in Utrech, Jan van Goyen in the Hague, and Isaac Ostade in Haarlem, and he worked in several cities in the northern part of Holland, centering on Leiden. In fact, it is hard to work out a chronology of his works, even though he left some 7–800 paintings. Only about 50 are dated or datable, and except for a pattern that seems apparent in his religious works (from simple to more complicated, even ostentatious, works), his genre paintings don't seem to have "developed." One can detect both the robust Haarlem style and the "fine painting" (*fijnschilderij*) associated with Leiden in his works, and there is no obvious relationship of style to subject.

Though his works are now popular, and he is highly regarded as a storyteller, full of a cheerful good humor, and a master colorist, it was not always so: an earlier reputation as a libertine started up in the 18th century and has only in the last century been shown to be erroneous. Yet the "dissolute" nature of some of his works is apparent (though never so vulgar or ugly as in some of the works by Brouwer or Ostade), and evidently a "Jan Steen" household is still a byword for a dissolute, helter-skelter sort of establishment. For a long time, however, the dissolute and libertine image was so strong that any moral implications were often ignored.

In his series of "Dissolute Household" paintings, for instance, there is always a moral, often as obvious as a printed motto or a phrase from a book. In the painting called *The World Upside Down (The Crazy Company)* (1663; Vienna), the room teems with details of disorder and intemperance. Although Bosch or Pieter Bruegel had used the theme earlier, ofen with a strong religious or humanistic angle, Steen tends to take a less priggish view, suggesting the liveliness and the playfulness of the scene as much as the denunciatory. The central figures of young man and girl are drinking (and the girl's smile can be interpreted as either a "so-what" or a glazed drunken look), an older couple is arguing about a

book, three children are getting into mischief, a monkey is mishandling a clock, and even a pig has decided it's safe to come in. The version in the Wellington Museum in London has several similar details, with the added touch of playing cards and oyster shells on the floor to suggest gambling and lust. (The young man with his leg thrown over the girl drinking wine and smoking a long pipe is actually a self-portrait.) A related work is a painting called *The Effects of Intemperance* (c. 1663–65; London, National Gallery). While mother sleeps and father dallies in the arbor (seen in the background), the children are up to no good, picking mother's pocket, giving wine to the parrot, letting the cat eat the pie. *The Way You Hear It Is the Way You Sing It* (The Hague) shows a prosperous groups of singers and a bagpiper around a table, while a young boy is given a puff on a long clay pipe. The title suggests the bad example the adults are setting for the children.

Another series of paintings uses characters from popular theatre to make a point, usually centering on the distinctive dress of a quack doctor or music teacher. Some of these can be baffling to experts, but the series called *The Love-Sick Woman, The Physician's Visit,* and *The Lovesick Maiden* all focus on a young matron being visited by a doctor in the presence of her maid: the quack takes her pulse delicately, and either he or the maid gives a very knowing look; often a picture of *Venus and Adonis* or a centaur abducting a woman on the wall gives away the love-sick theme. In *The Lovesick Maiden* (The Hague), two dogs sniff each other and the chamber pot is prominently displayed, but Steen is not usually so coarse. *The Music Lesson* (London, Wallace) is simpler in composition, but the *Venus and Amor* in the background, the prominent key hanging on the wall, and the elaborate costume of the music teacher emphasize the erotic theme.

Simple portraits of women sometimes suggest moral themes. *The Morning Toilet* (Royal Collection) is probably meant to portray a prostitute: she is framed by a doorway, with vanitas symbols of candle and open jewel box suggesting the saying "Neither does one buy pearls in the dark, nor does one look for love at night." She is also putting on a stocking ("kous"—a slang word for vagina). *A Girl Salting Oysters* (The Hague) is a beautiful painting, elegant and polished. The girls looks directly at us, suggesting she is preparing the aphrodisiac oyster for us.

His religious paintings, interestingly enough, seem to have genre implications as often as not. Humorous details often undercut the religious implications, so that in *Samson Mocked by the Philistines* (Cologne), a child teases Samson, almost in parody of the Bible story. Several versions of *Bathsheba Receiving David's Letter* exist, but all of them can be read as if they were genre pictures with a title like *The Love Letter.* In fact, Reynolds, who praised Steen as a genre painter, attacked him for his historical works, and there is a hint that Steen could rarely look beyond his homey, comfortable life in Holland.

Other paintings seem to have a simpler moral context. The *Tavern Garden* (Berlin) also contains a possible self-portrait in the character of the young good-natured husband sitting with his wife and child at a table under an arbor; he is eating a fish while his wife (starchily dressed) is giving her son a drink; a dog looks attentively at the husband. Few moral implications seem obvious in this, nor in such a work as *Skittle Players Outside an Inn* (1660–62; London, National Gallery), in

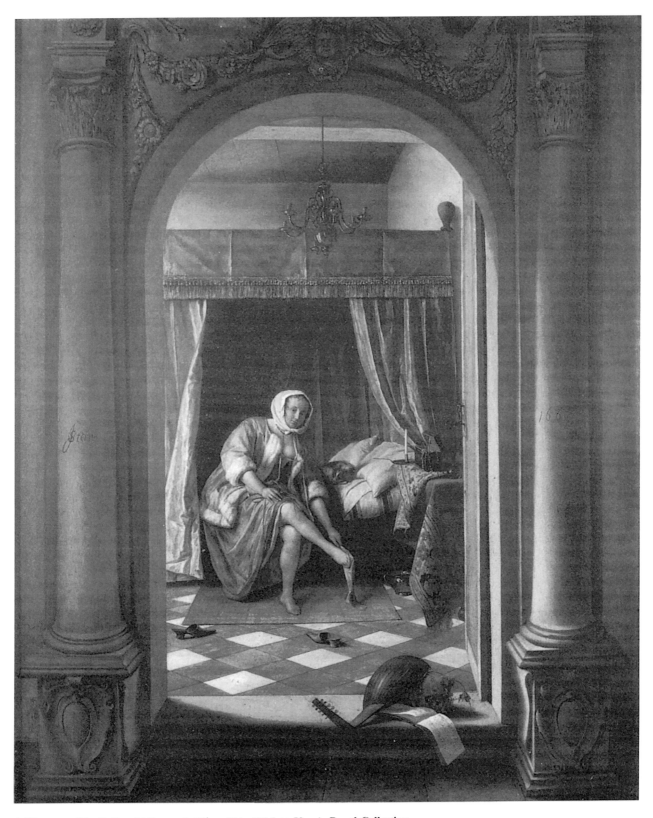

A Woman at Her Toilet, 1663; panel; 25½ × 20 in (64.7 × 53 cm); Royal Collection

which a large mass of trees dominate the scene, a gentle evocation of ordinary life.

—George Walsh

STEER, (Philip) Wilson.

Born in Birkenhead, Cheshire, 29 December 1860, son of the painter Philip Steer. Died in London, 21 March 1942. Attended Hereford Cathedral School, 1875–77; studied under John Kemp, Gloucester School of Art, c. 1878–81; under Bouguereau at the Académie Julian, Paris, and under Cabanel at the Ecole des Beaux-Arts, Paris, 1882–84: influenced by Degas and Monet; settled in London, 1884, with painting excursions into the countryside with his friend Sickert; watercolours became an important part of his output; taught at the Slade School, London, from c. 1895 to 1930.

Major Collection: London: Tate.
Other Collections: Aberdeen; Bradford; Cambridge; Cardiff; Edinburgh; Gloucester: College of Art; Leeds; Liverpool; London: Victoria and Albert, Courtauld, British Museum, War Museum; Manchester; Ottawa; Oxford; Southampton.

Publications

On STEER: books—

Ironside, Robin, *Steer,* London, 1943.
MacColl, D. S., *Life, Work, and Setting of Steer,* London, 1945.
Forge, Andrew, *Steer* (cat), London, 1960.
Laughton, Bruce, *Steer,* Oxford, 1971.

article—

Laughton, Bruce, "Unpublished Paintings by Steer," in *Apollo* (London), June 1985.

*

Although unmotivated and feckless, Steer is nevertheless acknowledged for his contribution to English art in a career that spanned sixty years but whose output was uneven in quality. He is applauded for his land- and sea-scapes, executed under the aegis of Turner, Gainsborough, and Constable, themselves masters of English painting. Aside from a brief period in his youth, during the 1880's, when Steer looked to French art for inspiration, his was quite unequivocally an English vision, academic and romantic. Hardly cosmopolitan by nature Steer nevertheless spent a period of time painting in Paris, but ignored much of the frenzied artistic activity of the French painters, preferring to mingle with fellow expatriates. A compulsory language test imposed by the bureaucrats at the Ecole des Beaux-Arts sent Steer scuttling back to England, unconfident of his linguistic abilities.

Responsible in part for the founding of the New English Art Club in 1886 along with other such notables as Walter Sickert and Fred Brown, Steer's work naturally began to reflect the aims of the group. Anxious to promote avant-gardism in English painting the NEAC looked to Impressionism and very contemporary post-Impressionism for guidance. As the effects of the latter movement were not to be felt in England until after 1900, Steer's vision therefore proved relatively radical. His first work of note, a painting of children in a French garden entitled *Chatterboxes,* now lost, was exhibited at the NEAC in 1887 and was reputed to have exploited the bright colour, broken brushstrokes, and genteel subject matter of Monet and Renoir. However, the most obvious inheritor of new French art was the series of seaside paintings executed between 1886 and 1890, in which Steer specifically referred to Impressionist and Divisionist technique and content. Important, too, at this time, to the progress of English art was Whistler, who combined English and French sensibilities to unique effect. Steer reflects the impact of this artist with his misty, atmospheric paintings of figures on the beach and slim pubescent girls. *Knucklebones,* 1888–89, typical of this period, also echoes some of the qualities of *Beach Scene,* c.1880, by Degas. Subject matter is comparable, as are the flatness and high viewpoint of both compositions. The treatment of the pebbles in *Knucklebones*—each individual stone formed by a bright dab of colour—suggests that Steer was already familiar with neo-Impressionist technique, probably introduced to the new movement in painting by the critic George Moore who kept abreast of English and French developments. It is perhaps the nature of Steer's subject matter that attracted him to Divisionism: glittering seas and rough pebbles positively invite a neo-Impressionist interpretation of paint application. Consequently, one reason for the artist's abandonment of the style was that he changed his subject matter to landscapes and interiors.

Steer's greatest problem was reconciling the modern sensibility with the irresistible pull of the old English masters, a difficulty he never managed to resolve, veering instead from one to the other. Despite his success, in the 1880's, at conveying the unique light and atmosphere of the English coastline, any indigenous qualities his art might have had were outweighed by his debt to the French. After 1894 the Divisionist method was abandoned as Steer retreated into his English shell and began imitating Romney, Turner, and Constable. *The Pillow Fight,* 1896, is an early example of the artist's new direction, an affected and tedious study of two insipid children engaged in half-hearted combat. Flat, Whistlerian areas of colour are generally superseded by surface rhythms as Steer concentrated on his draughtsmanship; subject matter changes from the depiction of open spaces to dark woodlands and gloomy interiors. However, following a decade of wholly unremarkable work, Steer emerged in the early 1900's with moody, epic landscapes in the style of Turner, e.g., *Chepstow Castle,* 1905.

The best of the late works are executed in watercolour, a medium that Steer warmed to gradually. Oil was abandoned as the artist's sight began to deteriorate, and he stopped working outdoors. At first, watercolours were used at the sketch stage and the final work completed in oil in the studio; but by the 1920's Steer had entirely converted to the new medium. A series of landscapes reveals Steer the watercolourist at his best: *Shoreham,* 1926–27, exploits to the full the limpid possi-

bilities of the medium and show the artist fully at home with his subject matter. Steer's portraits and subject paintings never achieved the quality of selected watercolours; however, in an unexpected surge of artistic creativity he produced in 1922 a portrait of his elderly housekeeper, *Mrs. Raynes,* which successfully conveyed the character and intensity of the sitter.

—Caroline Caygill

STELLA, Joseph.

Born Giuseppe Stella in Muro Lucano, near Naples, 13 June 1877; naturalized United States citizen, 1923. Died in New York, 5 November 1946. Married Mary French, 1902 (died, 1939). Studied medicine and pharmacology, New York, 1896; studied at the Art Students League, New York, 1879–98, and under William Merritt Chase, New York School of Art, 1898; also attended Shinnecock Summer School, 1901–02; settled in New York as painter; lived in Europe, 1910-13; exhibited at Armory Show, 1913; taught at Baptist Seminary, Brooklyn, 1916; lived in Europe, 1926–34; then settled in the Bronx, 1935.

Collections: Chicago; Minneapolis; New Haven; New York: Whitney, Moma, Brooklyn Museum; Newark, New Jersey; Paris; San Francisco: Modern Art; Washington: Hirshhorn, American Art.

Publications

By STELLA: articles—

"The New Art," in *Trend* (New York), June 1913.
"On Painting," in *Broom* (Paris), December 1921.
"The Brooklyn Bridge (A Page of My Life)," in *Transition* (Paris), June 1929.
"Discovery of America: Autobiographical Notes [1946]," in *Art News* (New York), November 1960.

On STELLA: books—

Dreier, Katherine, *Stella* (cat), New York, 1943.
Gerdts, William, *Drawings of Stella from the Collection of Rabin and Krueger,* Newark, New Jersey, 1962.
Baur, John I. H., *Stella,* New York, 1963.
Baur, John I. H., *Stella* (cat), Baltimore, 1968.
Jaffe, Irma B., *Stella,* Cambridge, Massachusetts, 1970, New York, 1988.
Zilczer, Judith, *Stella: The Hirshhorn Museum and Sculpture Garden Collection,* Washington, 1983.
Saunders, Robert, and Ernest Goldstein, *Stella: The Brooklyn Bridge,* New York, 1984.

articles—

Cooper, Helen, "Stella's *Miners,*" in *Yale University Art Gallery Bulletin* (New Haven), Fall 1975.

Corn, Wanda, "In Detail: Stella and *New York Interpreted,*" in *Portfolio,* January-February 1982.
Bohan, Ruth L., "Stella's *Man in Elevated (Train),*" in *Dada/ Dimensions,* edited by Stephen C. Foster, Ann Arbor, 1985.

*

Often identified as the premier American Futurist, the Italian-born painter Joseph Stella explored and developed many of the aesthetic and cultural trends that transformed American art during the early 20th century. His work encompasses a broad thematic and stylistic range from realism to Futurist abstraction and personal symbolism. The variety and scope of Stella's work offer insight into the origins of American modernism.

Stella's early career provides few clues to his embrace of avant-garde aesthetics. After a relatively brief period of formal training, he began to record the life of New York Lower East Side immigrants in graphically rendered drawings. A commission from the journal *The Survey* resulted in a major series of illustrations devoted to Pittsburgh steel workers. While Stella's focus on humble subject matter is akin to the urban genre scenes of the New York realists of the so-called Ashcan School, his exquisite draughtsmanship differs from the reportial, sketch-like style of the urban realists.

Stella's meticulous realism also reflected his innate command of the academic tradition of western painting. Around 1909 he even adopted a glazing technique for dark, tonal landscapes of his native Italian countryside. His reverence for the Renaissance artistic heritage persisted for the remainder of his long career.

Stella's reputation derives principally from the group of Cubo-Futurist paintings completed between 1913 and 1922. Exposure to the European avant-garde on a trip to Paris in 1911-12 prompted Stella's conversion to modernism. Returning to the United States, Stella applied the lessons of Italian Futurism to distinctly American subjects. He captured the brilliant spectacle of the Brooklyn amusement park, Luna Park, in a mural-scale canvas, *Battle of Lights, Coney Island, Mardi Gras,* 1913–14 (Yale University Art Gallery) and in a series of related pointillist and abstract color studies of Coney Island. Through an all-over pattern of fragmented color planes, Stella created a sense of kaleidoscopic movement worthy of the Italian Futurists.

In later paintings of the urban environment, Stella tempered Futurist exuberance within architecturally structured Cubist compositions. Most notable among these Cubo-Futurist works were *Brooklyn Bridge* (1918–20, Yale University Art Gallery) and *New York Interpreted* (1920–22, Newark Museum), in which Stella celebrated the bridge and the skyscraper as icons of modern technology. His interest in the industrial environment also resulted in a series of drawings of factories which are thematically and stylistically related to the industrial imagery of the Precisionists.

Stella's concentrated period of abstraction in the 1910's was followed by a return to more representational imagery in the 1920's. Delicate botanical studies and silver point portraits of vanguard friends complemented more ambitious symbolic paintings. *Tree of My Life* (Ebsworth Collection, St. Louis) typifies Stella's blending of private symbols with religious icons. Critical opinion about these intricately baroque compositions is divided. Stella did not entirely resolve the tension

between tradition and modernism that animated his later production.

Stella's exploration of a wide range of media—from silver point to painting on glass—matched his remarkable stylistic diversity. The most significant of his technical experiments were the abstract collages produced after 1920. Composed of refuse, newspapers, and other unlikely materials, the collages build upon the Dada tradition of the found object, while their texture and informal design anticipated the Abstract Expressionist collage.

When Stella's enchantment with the past and with exotic locales replaced the originality of his modernist vision, his romanticism and artistic independence began to border on the eccentric. His early success was followed by increasing isolation, and his reputation declined during the last two decades of his life. Although his mature works were uneven in quality, few of his American contemporaries equaled his range of ambition or experimental invention. Joseph Stella's refusal to adhere to a single style or theory typified the non-doctrinaire, intuitive modernism of the American avant-garde.

—Judith Zilczer

STOSS, Viet.

Born probably in Horb, Swabia, c. 1440–50. Died in Nuremberg, 1533. Son, the sculptor Willibald Stoss, and at least three other sons and one daughter. Influenced by the sculptor Nicolaus Gerhaert van Leiden; worked in Nuremberg, then in Cracow; created the 43-foot-high Altarpiece for the Church of St. Mary, 1477–89; also made the Stanislaus Altar in the cathedral, and the tomb of Casimir IV, 1492; returned to Nuremberg, 1496, and did important works for the Frauenkircke and Lorenzkirche; branded for forgery, 1503, and lived in Münnerstadt, 1503–05, when the Emperor repealed the sentence; also worked in stone, and made engravings

Collections/Locations: Bamberg: Cathedral; Cracow: St. Mary, Museum, Cathedral; Florence: SS. Annunziata; Nuremberg: Museum, Lorenzkirche, Frauenkirche.

Publications

On STOSS: books—

Daun, Berthold, *Stoss und seine Schule in Deutschland, Polen, und Ungarn*, Leipzig, 1903, 1916.

Daun, Berthold, *Stoss*, Bielefeld, 1906.

Lossnitzer, Max, *Stoss: Die Herkunft seiner Kunst, seine Werke, und sein Leben*, Leipzig, 1912.

Baumeister, Engelbert, *Stoss: Nachbildungen seiner Kupferstiche*, Berlin, 1913.

Lutze, Eberhard, *Stoss* (cat), Nuremberg, 1933.

Schaffer, Reinhold, *Stoss: Ein Lebensbild*, Nuremberg, 1933.

Lutze, Eberhard, *Stoss*, Berlin, 1938.

Barthel, Gustav, *Die Ausstrahlungen der Kunst des Stoss im Osten*, Munich, 1944.

Dutkiewicz, Jozef Edward, et al., *Oltarz Krakowski* [The Cracow Altar], Warsaw, 1951.

Jaeger, Adolf, *Stoss und seine Geschlecht*, Neustadt, 1958.

Keller, Harald, *Der Bamberger Marien-Altar*, Stuttgart, 1959.

Dettloff, Szczesny, *Stoss*, Breslau, 2 vols., 1961.

Dobrowolski, Tadeusz, and Jozef Edward Dutkiewicz, *Wit Stwosz: The Cracow Altar*, Warsaw, 1966.

Kepinski, Zdzislaw, *Wit Stwosz w starciu ideologii religijnych Odrodzenia: Oltars Salwatora* [Stoss and Religious Ideology of the Renaissance: The St. Salvador Altar], Warsaw, 1969.

Burkhard, Arthur, *Seven German Altars*, Cambridge, Massachusetts, 1972.

Baxandall, Michael, *The Limewood Sculptors of Renaissance Germany*, London, 1980.

Kepinski, Zdzislaw, *Stoss*, Dresden, 1981.

Kahsnitz, Rainer, *Stoss in Nürnberg: Werke des Meisters und seiner Schule in Nürnberg and Imgebung* (cat), Munich, 1983.

Stoss: Die Vorträge der Nürnberger Symposions, Nuremberg, 1985.

Gothic and Renaissance Art in Nuremberg 1300–1550 (cat), New York, 1986.

*

The German Late-Gothic sculptor Veit Stoss is first recorded in 1477 when he gave up citizenship of Nuremberg to move to Cracow in Poland. A later record, of 1502, lists him as "Vittus de Horb," a reference to his birthplace, probably the village of Horb on the Neckar River in Swabia. This accords with the influence seen in his early work of the art of Nikolaus Gerhaert van Leyden, a sculptor who worked in the neighboring Upper Rhine region in the 1460's. Otherwise there is no record of Stoss's origins, early training or developing career. He is thought to have been born around 1450.

Stoss moved to Cracow to create a huge altarpiece for the church of S. Mary. The *St. Mary Altarpiece* was a commission of the German mercantile community in Cracow. It is the sculptor's most famous work. He labored on it from 1477 to 1489. Restored and still in remarkably good condition, the altarpiece remains in the church of St. Mary to the present day.

Stoss continued to live in Cracow after completing the altarpiece. In 1492 he executed the tomb of the Jaegellonian king, Casimir IV, in Wawel Cathedral. The tomb is in red and white mottled marble. The assistants he trained and employed for these projects continued the style and influence of their master in Poland long after Veit Stoss himself returned to Nuremberg in 1496. Four of his sons, a painter, a goldsmith and two sculptors, remained in the region of Cracow, continuing their own careers there.

Upon returning to Nuremberg, Veit Stoss who had been wealthy and successful in Cracow, had to struggle for new commissions with a generation of younger artists working in a newer style. Albrecht Dürer and the sculptors Adam Kraft and Peter Vischer were working in Nuremberg and had attained established places in the community. Worse, in 1503, while attempting to re-establish himself, Stoss was convicted of a charge of forgery. The result of unfortunate financial speculation, this caused Stoss to be confined and branded on both cheeks. He regained his reputation only slowly.

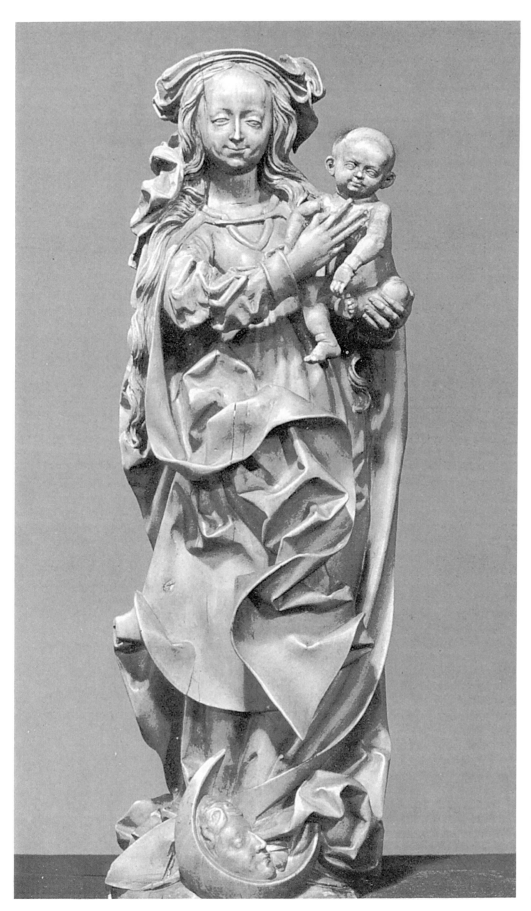

**Virgin and Child,
c. 1515–20; wood**

Stoss did find work during these difficult years. In 1499 he carved a monument in Nuremberg's St. Sebald, endowed by Paul Volckamer, a Nuremberg city treasurer. It consisted of two oak statues, of Christ and the Virgin, flanking a window in the church. A row of sandstone relief sculptures is beneath these figures, showing three scenes of Christ's Passion, the *Last Supper, Agony in the Garden* and *Capture of Christ*. He also made a High Altarpiece for the parish church of Schwaz in the Tirol in 1500–03. It is now lost.

After 1507, when Viet Stoss received Imperial recognition for his work, he was finally re-established though he retained a caustic and litigious personality, he received many commissions and his work took on its mature stature. Among the best-known works is the huge, hanging *Annunciation of the Rosary* in the Lorenzkirche in Nuremberg. There the figures of Gabriel and the Annunciate Mary are over two meters high, within a great wreathlike rosary with medallions of the joys of Mary.

In Bamberg Cathedral is a very beautiful unfinished altarpiece showing the *Adoration of the Shepherds* in relief sculpture as the central corpus and two wings with other infancy scenes from Christ's life. This work was contracted to Stoss in 1520 by his own son, Dr. Andreas Stoss, then prior of the Carmelite house in Nuremberg. Prior Stoss was forced to leave Nuremberg in the Reformation unrest of 1525 in Nuremberg. The contract was invalidated and the work was never completed. In its present state it bears the date, 1523. In 1543, the heirs of Veit and Andreas Stoss moved the altarpiece to Bamberg Cathedral where the latter had served until his death in 1540. It is Veit Stoss's last recorded work.

Many individual figures by Veit Stoss still survive in various collections, including a famed and characteristic sculpture of St. Roche in the church of the Santissima Annunziata in Florence. This latter was seen there and praised by Giorgio Vasari in 1523. Though he misattributed it, Vasari admired, as we all must, the skill of the artist in representing form and texture with great realism and the extraordinary ability of sculpture to convey these while maintaining the characteristic grain and color of natural wood.

Veit Stoss also made engravings. There are ten of these with his monogram and in the expressive style of his sculpture. In that realm they show no evidence of Dürer's influence though they are now believed to have been made after Stoss's return to Nuremberg and to date from around 1500.

There are no works recorded by Veit Stoss in the last decade of his life. Another son, Willibald, became a sculptor in Nuremberg. His only known work is a carved chandelier in the form of a dragon, made from a design by Albrecht Dürer. Stoss himself never turned to Renaissance ideas or motifs. His sculpture has a vigorous, gothic energy about it, a style sometimes termed "Late Gothic Baroque."

—Charles I. Minott

STROZZI, Bernardo [Il Cappuccino, Il Prete Genovese].
Born in Genoa, 1581. Died in Venice, 2 August 1644. Studied with Pietro Sorri in Genoa, 1595–97, then entered order of Capuchins in a monastery at Santa Barbara, 1598–1607 (or 1610): left monastery as lay brother in order to support his mother; influenced by Rubens; settled in Campi near Corrigliano in 1610's; when his mother died in 1630, he went to Venice, and was influenced by Nicolas Regnier; made a Monsignor, 1635.

Collections: Baltimore: Walters; Berlin; Chalon-sur-Saone; Cincinnati; Cleveland; Dayton, Ohio; Dresden; Florence; Genoa: S. Lorenzo, Bianco, Rosso, S. Siro, S. Annunziata del Vastato, S. Ambrogio, S. Domenico, Palazzo Spinola; Grenoble; Hampton Court; Hartford, Connecticut; Leningrad; London; Mantua: Ducal Palace; Milan; Moscow; Munich; New York; Rotterdam; St. Louis; San Francisco; Sarasota, Florida; Seattle; Toulouse; Turin: Sabauda; Venice: Accademia, S. Benedetto, S. Niccolo dei Tolentini, Palazzo Barbaro, Correr; Vienna; Washington.

Publications

On STROZZI: books—

Fiocco, Giuseppe, *Strozzi*, Rome, 1921.
Otone, T. da, *Strozzi*, Geneva, 1940.
Three Baroque Masters: Strozzi, Crespi, Piazzetta (cat), Baltimore, 1944.
Mortari, Luisa, *Strozzi*, Rome, 1966.
Matteucci, Anna M., *Strozzi*, Milan, 1966.
Milkovich, Michael, *Strozzi* (cat), Binghamton, New York, 1967.
Pesenti, Franco Renzo, editor, *Galleria Nazionale di Palazzo Spinola: L'Officina di Strozzi* (cat), Genoa, 1981.

articles—

Rosand, David and Ellen, "Barbara di Santa Sofia and Il Prete Genovese: On the Identity of a Portrait by Strozzi," in *Art Bulletin* (New York), June 1981.
Manning, Bertina Suida, "Strozzi as Painter of Still Life," in *Apollo* (London), April 1985.

*

Strozzi's artistic milieu in Genoa at the beginning of the 17th century was complex. Tuscan mannerists and Roman Baroque painters were known to him, as were the painters of the northern Renaissance. Van Dyck and Rubens both visited Genoa, and a work like *The Kitchenmaid* (Genoa, Palazzo Rosso) is a large-scale *bodegon* of a maid plucking a duck, comparable to works by Pieter Aertsen and Joachim Bueckelaer: the firelight under the large cauldron, gleaming silver, and game show his virtuosity. He also used game-bird motifs in religious works (*The Adoration of the Shepherds*, Baltimore, Walters). Other early religious works include *St. Augustine Washing Christ's Feet* (c. 1620–25, Genoa, Ligustica), which also includes polished metal still-life elements, and *The Calling of St. Matthew* (c. 1625–30; Worcester, Massachusetts). Once he settled in Venice, in 1630, he became a portraitist and well-known painter of altarpieces, and with Feti, the dominant painter in

A Concert; 40 × 48⅞ in (101 × 123 cm); Royal Collection

Venice. His work is very individual, often down-to-earth (the two figures in his *Allegory of Summer and Autumn* in Dublin are vaguely "peasant"-like, though wonderfully delicate), and touched with fantasy.

STUART, Gilbert.

Born in North Kingston, Rhode Island, 3 December 1755. Died in Boston, 9 July 1828. Married Charlotte Coates, 1786; 12 children. Studied with Cosmo Alexander, and accompanied him to Scotland, 1771–72; lived in London from 1775: then pupil of Benjamin West, 1777–82: practiced in London, 1782–87, and Dublin, 1787–92; returned to the United States, and worked in New York, Philadelphia, and Washington, D.C., painting George Washington (3 types: many versions), and other leading Americans; settled in Boston, 1805.

Major Collections: New York; Washington.

Other Collections: Boston; Cleveland; Cooperstown, New York: Historical Association; London: Portrait Gallery, Tate, Maritime Museum; Newport; Rhode Island: Redwood Library; Northampton, Massachusetts: Smith College; Williamsburg, Virginia: Capitol; Worcester, Massachusetts.

Publications

On STUART: books—

Park, Lawrence et al., *Stuart: An Illustrated Descriptive List of His Works,* New York, 4 vols., 1926.
Fielding, M., *The Life Portraits of George Washington and Their Replicas,* Philadelphia, 1931.
Fielding, M., *Stuart,* Cambridge, Massachusetts, 1932.
Whitley, William Thomas, *Stuart,* Cambridge, Massachusetts, 1932.
Morgan, John Hill, *Stuart and His Pupils,* New York, 1939.
Flexner, James Thomas, *Stuart,* New York, 1955.
Portraits by Stuart (cat), Philadelphia, 1963.

Mount, Charles Merrill, *Stuart: A Biography,* New York, 1964.

Richardson, Edgar P., *Stuart: Portraitist of the Young Republic* (cat), Providence, 1967.

McLanathan, Richard, *Stuart: The Father of American Portraiture,* New York, 1986.

articles—

DeLorme, Eleanor Pearson, "Stuart: Portrait of an Artist," in *Winterthur Portfolio,* 14, 1979.

Pressly, William L., "Stuart's The Skater: An Essay in Romantic Melancholy," in *American Art Journal* (New York), 18, 1986.

*

In 18th-century American and England, patronage favored portraiture rather than history painting, and throughout his career Gilbert Stuart was content to pursue face painting, which, if not as prestigious as historical subjects, was more reliable as a source of income. A native of Rhode Island, the son of a millwright who had immigrated from Scotland, Stuart left Newport in 1770 on a trip through the southern colonies and then on to Scotland in the company of his teacher Cosmo Alexander, a painter from Edinburgh. He was left stranded when Alexander died in the summer of 1772 and had to work his way back home as a sailor. In 1775 he departed again, this time for London, where two years later he entered the studio of his fellow American Benjamin West.

In cosmopolitan London, Stuart arrived at his mature style, his earlier naive pictures, executed with the linear precision of a provincial artist, giving way to works of remarkable sophistication. The elegance and feathery lightness of Gainsborough's brushwork, the simplicity of Romney, and the grandeur of Reynolds proved more influential than the example of West. In 1782, Stuart achieved his first major success when he exhibited a full-length portrait, now known as *The Skater,* at the Royal Academy. As the artist himself later remarked, he was "suddenly lifted into fame by the exhibition of a single picture." He had achieved a distinctive personal style of fluent virtuosity in his use of bold and decisive brushstrokes and his use of glazes of transparent luminosity. William Dunlap reported in 1834 that when the artist had been asked why he did not sign or initial his pictures, he had replied, "I mark them all over."

In England, Stuart also cultivated the manners of a gentleman. He was known for his extravagant hospitality, his love of good food and conversation, his careless indifference to financial matters, dilatory working habits, and touchiness to criticism. In addition, he seems to have identified with Van Dyck's regal image of Charles I as a melancholy intellectual of refined sensibilities, even to the point that he employed Charles as a middle name (Stuart, of course, having been the king's surname). Such a life-style soon presented difficulties. Having married in 1786, he left London for Dublin with his English wife in the following year in order to escape his creditors. In Dublin the pattern was repeated: although a social and artistic success, the artist soon found himself heavily in debt. This time America beckoned, and he sailed for New York in 1793 in hopes of prospering by capturing the portraits of such famous citizens of the new republic as George Washington.

Stuart soon moved on to Philadelphia, the nation's cultural and political capital. During the years 1795–96, Washington sat to him three times, and the results, the "Vaughan" portrait, the "Athenaeum," and the "Lansdowne," are timeless images of austere, heroic virtue that have proven to be the most influential in establishing Washington's persona for posterity. The "Lansdowne" Washington is a full-length, the most momentous Stuart had undertaken since *The Skater* in 1782. This picture, the first state portrait created in America, depicts Washington in his role as president addressing Congress. Whereas *The Skater* is a figure in motion, the brushwork itself suggesting a fluid ease, the "Lansdowne" Washington resonates with a heavy monumentality based on Roman imperial imagery and the majesty of French Baroque painting, thereby conjuring up an ancient pedigree for this leader of a new world.

From Philadelphia Stuart moved in 1803 to Washington, the new capital, and soon thereafter to Boston, where he died in 1828. Despite the fact that the quality of his work was uneven, he was the undisputed master of American portrait painting during these years. Even though increasingly afflicted with a tremor in his hand, he continued to work rapidly and with a bold, sure touch. While his style changed little from his London sojourn, he moved toward a greater simplicity in his imagery. One of his legacies was the emphasis on the sculptural bust portrait, the sitter stript of distracting details of gesture and background. In contrast to the spirited, ornamental settings of his earlier work, Stuart focused intently on the individual, creating images of stark simplicity particularly befitting the male citizenry of a democratic America.

—William L. Pressly

STUBBS, George.

Born in Liverpool, 25 August 1724. Died in London, 10 July 1806. Son, the engraver George Towneley Stubbs, by his common-law wife Mary Spencer. Studied briefly under Hamlet Winstanley, 1739, but largely self-taught; worked as a leather tanner as a boy, then painter while studying anatomy with Charles Atkinson in York; to illustrate a textbook on midwifery, he learned etching; lived and worked in Hull, then visited Italy, 1754; on his return, set up as portrait and animal painter in London, 1756; spent some time in Lincolnshire dissecting horses for his book *The Anatomy of the Horse* (he also did the engravings); book was successful, and he painted horses (and portraits) for Lord Grosvenor, the Duke of Richmond, etc.; Associate of the R.A., 1780, but refused to submit a diploma work (at his relatively late age) to become a full member; experimented with painting on enamel, and worked with Wedgwood plaques; series of horses for the *Turf Review* was suspended because of the war with France, 1790.

Major Collection: Royal Collection.
Other Collections: Baltimore; Bath: Holburne; Cambridge; Dublin; Glasgow; Leeds; Liverpool; London: National Gallery, Victoria and Albert, Portrait Gallery, Royal Academy,

Prince of Wales's Phaeton—detail, 1793; Royal Collection

Tate; Manchester; Melbourne; New Haven; Philadelphia; Port Sunlight; Washington; Worcester, Massachusetts: Public Library.

Publications

By STUBBS: book—

The Anatomy of the Horse, London, 1766, 1853.

On STUBBS: books—

Gilbey, Walter, *Life of Stubbs,* London, 1898.

Sparrow, Walter Shaw, *Stubbs and Ben Marshall,* London and New York, 1929.

Stubbs: Rediscovered Anatomical Drawings from the Free Public Library, Worcester, Massachusetts, London, 1958.

Parker, Constance-Anne, *Mr. Stubbs, the Horse Painter,* London, 1971.

Taylor, Basil, *Stubbs,* London and New York, 1971, 1975.

Doherty, Terence, *The Anatomical Works of Stubbs,* Boston and London, 1974.

Tattersall, Bruce, *Stubbs and Wedgwood: Unique Alliance Between Artist and Potter* (cat), London, 1974.

Egerton, Judy, *Stubbs: Anatomist and Animal Painter* (cat), London, 1976.

Gaunt, William, *Stubbs,* Oxford and New York, 1977.

Rump, Gerhard Charles, *Pferde- und Jagdbilder in der englishen Kunst: Studien zu Stubbs und dem Genre der "Sporting Art" von 1650–1830,* Hildesheim, 1983.

Egerton, Judy, *Stubbs: Portraits in Detail,* London, 1984.

Egerton, Judy, *Stubbs* (cat), London, 1984, 1985.

Parker, Constance-Anne, *Stubbs: Art, Animals, and Anatomy,* London, 1984.

Vincent-Kemp, Ruth, *Stubbs and the Wedgwood Connection,* Endon, 1986.

Milner, Frank, *Stubbs: Paintings, Ceramics, Prints, and Documents in Merseyside Collections,* Liverpool, 1987.

*

Stubbs succeeded in raising the lowly genre of sporting art, one of the strongest sub-strands of British domestic art, to classical heights. His life spanned the foundation of the Jockey Club, the setting up of the classic English steeplechases, the growth of interest in bloodstock and breeding, and an increased scientific precision in the taxonomy of animals.

His earliest oils from the 1740's and 1750's, when he was working in the north of England, have largely disappeared; they were competent provincial portraits of which the best is that of *James Stanley* (1755 Walker Art Gallery, Liverpool). His parallel anatomical studies of the period which led to the rather crudely engraved plates for Dr. Burton's York treatise on midwifery (1751) found full expression in the large plates for his own *Anatomy of the Horse,* prepared in the late 1750's but not published until 1766. This volume gained Stubbs a European reputation as an equine anatomist with images that were viewed by his contemporaries independent of their utility as the most beautifully observed academic figure studies of the horse yet produced.

During the decade 1760–70 after his move to London, with aristocratic Whig patronage and the support of the comparative anatomists Joseph Banks and the Hunter brothers, Stubbs developed the principal categories of his painting to include hunt pictures, single horse portraits, depictions of exotic and foreign animals, and the magnificent Mare and Foal series, in which, to this novel genre, he brought an almost neo-classical severity in the frieze-like organization of groups of horses. The linearity that he had evolved in the 1750's to describe in engraved outline the varied musculature of the horse's carcass translated into oils to give a relief bite to his animal portraits and a far greater fidelity than any of his contemporaries were able to achieve. However, his practice of painting in the foreground horse and then filling in the background, while aiding precision, can, at times, give to these works a sense of airlessness and lack of overall integration. His single horse portraits, for example *Lustre, Held by a Groom* (Paul Mellon Collection, Upperville, Virginia), also have to modern eyes a diagrammatic quality that is the result of their being not so much a transcription from nature as an exaggerated amalgam of the animal's distinctive blood points.

During the 1770's, Stubbs broadened his range, developing the Lion and Horse series, a proto-Romantic, more poetic, and savage theme that was his most serious attempt to break out of the stereotypical mould of horse and animal portraiture. Experiments with enamel color on copper plates led later in the decade to friendship with the potter Josiah Wedgwood and the use of large clay Wedgwood tablets as a base for painting. A prettier, more delicate rococo coloring and fanciful pastoral subject matter was tried for this financially unsuccessful venture. Stubbs's link with Wedgwood led to his only 2 essays in sculpture. His modelled Wedgwood jasper-ware plaques (examples at the Wedgwood Museum, Barlaston, England) have a forceful energy that conflicts with the stasis and severity of the majority of Wedgwood's ware and which probably explains better than their high retail price why they were never a popular seller in Wedgwood's range.

A further experimental sideline of the 1780's was the production of a series of small prints. Although reproductions of previously painted whole compositions or details, these exquisitely subtle images using the full range of etching, engraving, and mezzotint have earned Stubbs a place among the foremost British artist-printmakers.

Despite royal patronage in the 1790's, and a steady trickle of commissions, the last years of Stubb's life were less successful. His paint handling became variable in quality and compositional formula did not develop after about 1770, although in 1799, working on a larger scale he painted *Hambletonian Being Rubbed Down by a Stable Lad* (Mount Stewart, Northern Ireland). Never before had the exhaustion almost beyond endurance and the anguished obedience of the racehorse near collapse after a race been depicted with such sympathy and detachment.

Unlike Reynolds, Stubbs produced no grand theory, nor did he, like Wilson, attempt to teach students classical compositional values. Success brought typecasting and he was unable to break out of the role of "Mr. Stubbs, the horse painter." Relations with the Royal Academy were never easy. He was not invited to be a founder member in 1769. He became an Associate seven years later but after his invitation to be a full academician, there was friction over his refusal to deposit a

diploma picture and sensitivity, perhaps over-sensitivity, about the hanging of his work, that led to his temporarily withdrawing from exhibiting there after 1782. Although his reputation remained high after his death, the genre, albeit popular, to which he belonged remained low. Only since the Second World War has the celebration of his idiosyncratic classical genius advanced so that he now ranks along with Hogarth, Reynolds, Gainsborough, and Wilson as one of the greatest of the 18th-century British Artists.

—Frank Milner

SUTHERLAND, Graham (Vivian).

Born in London, 24 August 1903. Died in London, 17 February 1980. Married Kathleen Frances Barry, 1927. Attended schools in Sutton, Epsom College, and Battersea Polytechnic, London; apprenticed to Midland Railway Engineering Works, Derby, 1919-20; studied engraving under Stanley Anderson and Malcolm Osborne, Goldsmiths College of Art, London, 1921-26; painter and designer in London from 1924, then lived in Farningham and Eynsford, Kent, Sutton-at-Hone, Trottiscliffe, Tetbury, and in Menton, France, from 1955; taught engraving, 1928-32, and composition and book illustration, 1932-39, Chelsea School of Art, and painting, Goldsmiths College of Art, 1946-47; stage designs for the ballet *The Wanderer*, 1941; tapestry designs for Christ in Glory for Coventry Cathedral, 1954-57 (completed 1962); royal commissions for portraits, 1950's and later; established Sutherland museum, Picton Castle, Pembrokeshire, 1976.

Major Collection: Picton Castle: Sutherland Gallery.
Other Collections: Basel; Chichester: Cathedral; Coventry: Cathedral; London: Tate, War Museum, Arts Council, British Museum, Victoria and Albert; Melbourne; New York: Moma; Northampton: St. Matthew; Paris: Beaubourg; Toronto; Vienna: Albertina.

Publications

By SUTHERLAND: books—

Parafrasi della natura e altre corrispondenze, edited by Roberto Tassi, Parma, 1979.

Illustrator: *Henry VI, Part 1,* by Shakespeare, 1939; *Poems 1937-42,* by David Gascoyne, London, 1943; *Le Bestiaire,* by Apollinaire, 1979.

On SUTHERLAND: books—

Sackville-West, Edward, *Sutherland,* London, 1943, 1955.
Melville, Robert, *The Imagery of Sutherland,* London, 1950.
Paintings and Drawings by Sutherland (cat), London, 1953.
Cooper, Douglas, *The Work of Sutherland,* London, 1961.
Révai, Andrew, *Sutherland: Christ in Glory in the Tetramorph,* London, 1964.

Cooper, Douglas, F. Russoli, and V. Viale, *Sutherland,* Turin, 1965.
Révai, Andrew, *Sutherland,* London, 1966.
Cooper, Douglas, *Sutherland* (cat), Munich, 1967.
Coulonges, Henri, and Andrew Révai, *Sutherland,* Paris, 1968.
Soavi, Giorgio, *Storia con Sutherland,* Milan, 1968.
Man, Felix H., *Sutherland: Das graphische Werk 1922-1970,* Munich, 1970.
Carrieri, R., and Giorgio Soavi, *Sutherland: Dodici aquarelli,* Ivrea, 1971.
Arcangeli, Francesco, *Sutherland,* Milan, 1973, New York, 1975.
Janus, *Sutherland,* Turin, 1973.
Soavi, Giorgio, and Janus, *I luoghi di Sutherland,* Turin, 1973; as *The World of Sutherland,* London, 1973.
Sutherland: Sketchbook, London, 1974.
Sutherland in Wales: A Catalogue of the Collection at the Sutherland Gallery, Picton Castle, Haverfordwest, Dyfed, London, 1976.
Hayes, John, *Portraits by Sutherland* (cat), London, 1977.
Tassi, Roberto, *Sutherland: Complete Graphic Work,* London, 1978.
Sanesi, Roberto, *Sutherland,* Milan, 1979.
Tassi, Roberto, *Sutherland: Desegni di guerra,* Milan, 1979; as *Sutherland: The Wartime Drawings,* edited by Julian Andrews, London, 1980.
Bestiary (cat), London, 1979.
Quinn, Edward, *Sutherland: Complete Graphic Work,* London, 1979.
Hayes, John, *The Art of Sutherland,* Oxford, 1980.
Alley, Ronald, *Sutherland* (cat), London, 1982.
Berthoud, Roger, *Sutherland: A Biography,* London, 1982.
Thuillier, Rosalin, *Sutherland: Inspiration,* Guildford, 1982.

*

Although Graham Sutherland was fêted during his lifetime as one of Britain's greatest modern artists, his reputation dwindled towards the end of his career. He is now more readily associated with Neo-Romanticism, a trend in British art which draws from insular traditions. Sutherland's fascination with natural forms, and his tendency towards a spiritual, sometimes apocalyptic vision, makes him an exemplary member of this school, which also included Paul Nash, John Piper, and younger artists such as Michael Ayrton, Cecil Collins, Lucian Freud, and Keith Vaughan.

Sutherland began his career as an engraver, forming an auspicious attachment to the great Romantic visionary, Samuel Palmer. His etchings in the 1920's pursue a pastoral idiom in which churchyards and thatched cottages abound, although technically they were advanced in the way the plate is overbitten. The Wall Street crash of 1929 ended the print boom, forcing Sutherland to change direction.

He turned to oils and watercolours, but it needed the shock of nature to launch his painting career in earnest. In 1934 he visited Pembrokeshire in Wales: his experience of the landscape was revelatory, almost Wordsworthian. "It was in this country that I began to learn painting," he wrote, but significantly, he chose to live elsewhere, in Kent, where the equally dramatic landscape of the surrounding north downs never re-

Insect, 1963; lithograph

ally entered his painting. He needed his inspiration to be in some remote place, or to be surprised by chance encounters. He would wander in the countryside, with no specific destination, noting features which grabbed his attention. Later he would incorporate geographically disparate elements in single pictures, which confirms that he was a painter of nature rather than landscape, that his vision was universal rather than regional.

Eager to bridge the gap between Romanticism and more vital, avant garde art, Sutherland briefly associated with the English Surrealists, exhibiting in their international exhibition in 1936. (His boldly imaginative commercial posters of this period are surely Surrealist fantasies.) He was particularly excited by the idea of the "objet trouvé," a commonplace object rendered mysteriously exotic and marvellous by its chance discovery. Like Nash and Moore, and unlike most Surrealists, his inspiration lay in natural rather than man-made objects. His vision of nature was neither benign nor lyrical, and he always sought exotic and disturbing phenomena. What excited him were hybrids, anthropomorphic character in stones and plants, threatening conglomerations of tree roots, upturned trunks and unruly vegetal growths, such as the ambiguous form in *Gorse on Sea Wall*, 1939, rendered in organic, earthy hues, which exemplifies his fascination with metamorphosis.

Like other art of the 1930's, Sutherland's brooding, apoca-

lyptic canvases reflected the inevitable slide into conflict. He was among the first to be enlisted by Kenneth Clark as an official war artist, and the war fired his imagination with new urgency. He recorded bomb damage in Wales, and sketched among the ruins of blitzed London. The startling results continue his earlier fascination with change and growth: now twisted girders and shattered walls assume the mysterious life hitherto detected in plants and rocks.

Towards the end of the War, Sutherland undertook his first religious commission, a *Crucifixion* for St. Matthew's Parish Church, Northampton, where the enlightened vicar already had Henry Moore's *Madonna and Child*. This presented a challenge, as Sutherland had never attempted such a large work, nor a depiction of the human body, but his poignant interpretation of the theme, which combines the influence of Grünewald with photographs of concentration camp victims, marked a major new departure in his career. For most of the 1950's he was engaged in designing the tapestry *Christ in Glory in the Tetramorph*, which was unveiled in 1962 in the rebuilt Coventry Cathedral. A convert to Catholicism, Sutherland's religious painting breaks with the sentimentality which has marred modern church art, and is deeply rooted in his personal artistic preoccupations. Around the time of the Northampton commission he began a series exploring thorns both on the level of Christian metaphor and his personal obsessions with organic growth.

His visit to the Picasso Museum in Antibes in 1947 encouraged the introduction of totemic figures. These are also indebted to Moore and Bacon, but above all they derive from his own practice. It is as if the upturned trees and bombed houses, inbued with a life of their own, had now given birth to autonomous organisms, wierd figures with ambiguous animal, humanoid and vegetal references. His enormous mural for the Festival of Britain, *The Origins of the Land*, 1951, populated by such threatening beings, and his series of standing forms in gardens, dates from the same period of British culture as the Quatermas films, and John Wyndham's *Day of the Triffids*. His fascination with animals, meanwhile, reached a climax with the superb portfolio of lithographs, *A Bestiary and Some Correspondences*, 1968.

In 1949 Somerset Maugham invited him to paint his portrait, and after that many celebrities sat for him, including Kenneth Clark, Konrad Adenauer, Helena Rubinstein, and Winston Churchill, whose portrait was a gift from the British Parliament. Churchill made no bones about the fact that he hated the end result, which like all Sutherland's best portraits focuses on the psychological strain in the faces of distinguished, usually older people. Some critics have argued that the portraits, painted within a conventional, naturalistic mode, detract from Sutherland's reputation as an original, inquisitive artist. Others attribute his "falling off" to his move to the south of France, where he attempted to assimilate the mediterranean countryside and flora, but was cut off from the life-line of English countryside. In 1967 he renewed his contact with Pembrokeshire when he returned to make a documentary film, and in the last decades of his life drew inspiration from Wales, France, and Venice.

—David Cohen

T

TAMAYO, Rufino.

Born in Oaxaca, 1899. Married Olga Flores Rivas, 1934.
Studied at the San Carlos Academy of Fine Arts, Mexico City,
1917–20; worked in Mexico City and New York, 1920–34,
then in New York, 1936–54, Paris, 1954–64, and Mexico City
since 1964; designed the ballet *Antigone*, 1959; donated his
Pre-Columbian works as a museum in Oaxaca, 1974; the Mu-
seo Rufino Tamayo Arte Contemporaneo Internacional was
opened in Mexico City, 1981. Address: c/o Marlborough Gal-
lery, 40 West 57th Street, New York, New York 10019,
U.S.A.

Major Collection: Mexico City: Museo Rufino Tamayo.
Other Collections: Brussels; Buffalo; Chicago; Mexico City:
Arte Moderno; New York: Moma, Guggenheim; Oslo; Paris:
Beaubourg; Rome; Arte Moderna; Tokyo: Modern Art.

Publications

By TAMAYO: book—

Textos, edited by Raquel Ribol, Mexico City, 1988.

On TAMAYO: books—

Goldwater, Robert, *Tamayo,* Mexico City and New York,
 1947.
Gual, Enrique, *Tamayo,* Mexico City, 1947.
Cogniat, Raymond, *Tamayo,* Paris, 1951.
Villaurrutia, X., *Tamayo,* Buenos Aires, 1951.
Alba, Victor, *Coloquios de Coyoacan con Tamayo,* Mexico
 City, 1956.
Westheim, Paul, *Tamayo: Una investigación estetica,* Mexico
 City, 1957.
Paz, Octavio, editor, *Tamayo en la pintura mexicana,* Mexico
 City, 1959.
Paz, Octavio, *Tamayo,* Mexico City, 1967.
Ponce, Juan Garcia, *Tamayo,* Mexico City, 1967.
Genauer, Emily, *Tamayo,* New York, 1974.
Tamayo (cat), Florence, 1975.
Paz, Octavio, *Tamayo: Myth and Magic,* New York, 1979.
Lynch, James G., Jr., *Tamayo: 50 Years of His Painting* (cat),
 Washington, 1981.
Lassaigne, Jacques, *Tamayo,* New York, 1982.

Tamayo: Arte y proceso de la mixografia, Mexico City, 1983.
Corredor-Maltheos, José, *Tamayo,* New York, 1987.
Tibol, Raquel, et al., *Tamayo: 70 Años de creación* (cat),
 Mexico City, 1988.
Tamayo: Antología crítica, Mexico City, 1988.

*

Rufino Tamayo first became interested in painting when he
arrived in Mexico City in 1910. He did not begin his studies at
the San Carlos Academy until 1917. After 3 years he left,
dissatisfied with the conventional methods of teaching which
he felt had exhausted their possibilities.

During his last year at San Carlos he found greater freedom
of expression at the open-air schools that were reinstated at the
time. He painted out of doors and became familiar with the
secrets of Impressionism, a movement he felt was very impor-
tant despite having become unfashionable. Impressionism
awakened in Tamayo an interest in light and color which was to
accompany him throughout his life. His first works oscillated
between Impressionism and the naive style typical of the stu-
dents of the open-air schools.

In 1921 the Minister of Education, José Vasconcelos, made
Tamayo Head of the Department of Ethnographic Drawing at
the National Anthropology Museum. This experience was de-
cisive for the artist. Both types of art opened up the possibility
of experimentation in new directions, within an unconven-
tional plastic idiom. Around the same time, Tamayo became
interested in European art, especially the painting of Paul Cé-
zanne and Georges Braque. Between 1926 and 1928, when he
lived in New York, Tamayo saw the work of these artists in the
museums and galleries and also that of many other European
painters of the vanguard such as the Fauves, which influenced
his own work.

He painted a considerable number of still-life pictures,
markedly influenced by Cézanne and Picasso. He added his
own personal touch to their characteristic treatment of space,
wrapping his pictures in a dream-like atmosphere where
snails, pineapples, and mangoes replace the world of personal
objects represented by the Parisian Cubists in their work. Dur-
ing these years, he also painted portraits and female nudes of
great sensuality.

In 1936 he returned to New York and lived there for the next
fifteen years. Up until 1940, as well as pictures of still life, his
work was full of scenes of daily life, with allusions to the rural
life of the indians and mestizos of Mexico. Popular art is

strongly present in these works in the use of a primitivist style where proportions are altered and contrasting colours are used. He also drew on prehispanic art, using the sacerdotal character of the figures, an economy of means in constructing them, and precolombian masks.

His concern for the solid construction of his figures was a dominating concern in his compositions, that he defined with a minimum of very simple lines. His firmly outlined masses stand out clearly from the background which, although it is painted in various tones, underlines the solidity of the different objects of contrasting colours. Among the most important of Tamayo's works in this period are *Niña bonita* (1937; Mexico City, private collection) and *Mujeres en Tehuantepec* (1939, Buffalo).

Tamayo encountered Picasso's work again in 1939, the year of the great retrospective at the Museum of Art in New York. Through the different stages of his work, Tamayo discovered new pictures and different approximations to familiar plastic idioms. The first impact of this encounter can be seen in the series of animals that Tamayo painted between 1940 and 1942. These are closely related to the horse in *Guernica* that represents the population in anguish. Tamayo took this as a starting point for portraying states of mind. He used the array of beasts found in the prehispanic art of the west coast of Mexico. His deep knowledge of these cultures is seen both in the formal treatment of the figures and in the ambiguous and apparently contradictory portrayal of the emotional state of his characters. Drama and humor are mixed together. Among the most notable examples is *El perro aullando a la luna* (1943; New York, private collection).

In 1943 he painted his outdoor mural *La naturaleza y el artista* and *La obra de arte y el expectador* at Smith College in Northampton, Massachusetts. This work brings together the formal characteristics that distinguish his work during this period and carries them to their highest point. From 1946 onwards, Tamayo began to incorporate movement into his work. Previously he had used this element sparingly. He also abandoned the use of raw, brilliant colors. The handling of color becomes restrained and sometimes the different shades are almost painted out. While he continued to use some color, he played with an immense range of shades so that each small area of the canvas is a blend of colors applied in stages and of transparent tints.

He replaced two-dimensional compositions with a type of multi-dimensional space that allowed the artist to give a cosmic meaning to his work. From this time onwards, he introduced the presence of stars, pursued or contemplated by sculptural beings with two bodies. Once again we can see the presence of Picasso in works like *Las tres bailarinas* (1945) who, in an open composition, run along the ground near the sea.

In 1950 Tamayo began to use an expansive three-dimensional space that he achieved not with the Renaissance system of perspective, but with a handling of color that, with infinitesimal gradations, creates infinite environments populated by solitary beings. He introduced a new form of movement with the use of violent foreshortening and the futurist lines of force to insinuate it. With these lines he also includes time and space as elements of structure and composition. He then added the use of geometric drawing, substituting the moving line and imposing a monumental character on his compositions. He also worked with a minimum of means and of colours. Typical of this period are the oils *Animal imaginario* (1955; Los Angeles, Link collection) and *Telefonitis* (1957; Oslo).

During the 1960's there was a brief period in which his work became increasingly abstract, although he never totally abandoned the figure. He introduced landscape into his compositions for the first time. At the end of the 1960's, he returned to figurative painting. His handling of the figure became freer and more ambiguous, and he continued to use a rich range of colors, sometimes restrained and at others exuberant. From this time onwards, Tamayo's style has not varied in any fundamental way. He handles the elements that have characterized his work freely and continues his struggle to make painting a poetic language that speaks for itself.

—Alicia Azuela

TANGUY, Yves.

Born in Paris, 5 January 1900; naturalized United States citizen, 1948. Died in Woodbury, Connecticut, 15 January 1955. Married 1) Jeannette Ducrocq, 1927 (divorced, 1940); 2) the artist Kay Sage, 1940. Attended schools in Paris, but self-educated in art; in merchant marines, 1918–19, and served in French army, 1920–22; painter from 1923 in Paris: associated with the Surrealists, 1925; first graphics, 1932, and worked in S. M. Hayter's workshop in Paris and New York, 1934–53 (after 1939 in the United States); settled in Woodbury, Connecticut, 1942.

Collections: Basel; Buffalo; Chicago; Hartford, Connecticut; London: Tate; New York: Moma, Whitney, Metropolitan; Paris: Beaubourg; Philadelphia; San Francisco: Modern Art.

Publications

By TANGUY: books—

Illustrator: *La Vue immediate,* 1932, and *Solidarité,* 1938, both by Paul Eluard; *Primele poème,* 1934, and *L'Antité: Minuits pour géants,* 1949, both by Tristan Tzara; *A même la terre,* by Alice Paalen, 1936; *Lille d'un jour,* by Marcelle Ferry, 1938; *Ma tête à couper,* by Jehan Mayoux, 1939; *Le Mythe de la roche percée,* by Ivan Goll, 1947; *Feu central,* by Benjamin Peret, 1947; *Sept microbes, vus à travers un temperament,* by Max Ernst, 1953; *La Grande Passage,* by Jean Laude, 1954.

On TANGUY: books—

Breton, André, *Tanguy,* New York, 1946.
Soby, James Thrall, *Tanguy* (cat), New York, 1955.

Composition, 1947; gouache and watercolor; 14 × 11 in (35.5 × 28 cm); Courtesy Waddington Galleries

Eluard, Paul, et al., *Tanguy: A Summary of His Works,* New York, 1963.

Soby, James Thrall, *Tanguy,* New York, 1972.

Marchesseau, Daniel, *Tanguy,* Paris, 1973.

Tanguy: Das druckgraphische Werk (cat), Dusseldorf, 1976.

Waldberg, Patrick, *Tanguy,* Brussels, 1977.

Lebel, Robert, et al., *Tanguy: Retrospective 1925–1955* (cat), Paris, 1982.

article—

Nessen, Susan, "Yanguy's Otherworld: Reflections on a Celtic Past and a Surrealist Sensibility," in *Arts Magazine* (New York), January 1988.

*

By chance in 1923 Yves Tanguy (1900–1955) happened upon the paintings of Giorgio de Chirico, on display in the window of the Paris dealer Paul Guillaume. This experience struck him so strongly he decided to become a painter. As if by ironic chance, Tanguy later discovered that André Breton had discovered de Chirico in exactly the same manner. The painter de Chirico, like the poet Apollinaire, was to haunt the nascent Surrealist group with whom Tanguy was to associate himself in 1925.

At the beginning of 1924 Tanguy lived with Jacques Prévert and Marcel Duhamel at 54 rue du Château. Tanguy had met Prévert in 1920, during his military service. Again they had met in Paris in 1922. Together Tanguy, Prévert, and Duhamel formed the core of the rue du Château group. In 1925 they met André Breton and a strong friendship ensued. The following year, 1926, Tanguy's *Ring of Invisibility* was published in the movement's review, *La Révolution surréaliste* (No. 7). In 1925 Tanguy's circle purportedly invented the Surrealist-inspired game of *cadavre exquis:* "Game of folded paper which consists in having several people compose a phrase or a drawing collectively, none of the participants having any idea of the nature of the preceding contribution or contributions." *Cadavre exquis* embodied Surrealism's aspirations towards an anonymous and collective art. When drawn the result of this play was often a human-like figure consisting of head, trunk, and feet. Early canvases such as *Rêveuse* (1926, also known as *Dormeuse*) suggest an indebtedness to this game. Indeed it is plausible that Tanguy's frequent manipulations of the horizon line originated in the game playing of *cadavre exquis.*

Tanguy's canvases of the 1920's reveal his indebtedness to de Chirico, especially in their use of perspective put to irrational ends. There is a hazy, unreal painterliness in these early works which suggests the landscape of the dream world. De Chirico had achieved a similar disorientation through his use of urban images. In paintings like *He did what he wanted* (1927, Richard Zeisler Collection, New York) Tanguy presents the real characters who wander in misty landscapes. Tanguy has carefully placed in the foreground an upturned, seven-sided cone on which are disported disembodied letters of the alphabet. The former is reminiscent of de Chirico's use of geometry towards metaphysical ends, and the latter is suggestive of Rimbaud's poem "Vowels."

In the review *La Révolution surréaliste* Breton had called for an "integral primitivism," and Tanguy, along with the Catalan Joan Miró, best embodied this idea. not only were Tanguy's paintings characterized by a seemingly endless projection of space, but they were highly evocative of childhood memories in which even the most mundane landscape takes on magical connotations. Indeed Tanguy grew up in Lacronan, Brittany, and was exposed to prehistoric dolmans and menhirs. His paintings increasingly became suggestive of what might be called a geological archaeology evoking the very birth of life itself. More than merely personal memory, paintings such as *Genesis* (1926, Claude Hersent Collection, Meudon) evoke a recollection of the slow evolution of natural forces.

Most importantly Tanguy eschewed all external imagery. Drawing only on inner images, Tanguy sought a measure of purity perhaps unrivalled in this century. Occasionally, a chance occurrence or a haphazard mark became the starting point of the image. In his own words, "I found that if I planned a picture beforehand, it never surprised me, and surprises are my pleasure in painting." For the most part Tanguy drew on his imagination for the source of images. Perhaps this explains his consistency and the single-minded pursuit of a single image.

Tanguy's paintings are suffused with an ethereal light. While in some paintings the use of light aids legibility, in others such clarity is lacking. Even in the most legible of Tanguy's canvases the sharp Chiricoesque shadows are belied by the dark twilight landscape. Breton had written, "The powerful subjective light that floods Tanguy's canvases makes us feel less alone and surrounds us with seething life." While little but the rock and pebble configurations inhabit this landscape, far from being empty, Tanguy's paintings are full of the light of being.

In 1930 Surrealism entered a moment of crisis. With the publication of the *Second Manifesto of Surrealism* (1930) many of the best poets and painters defected from the movement. Tanguy was among the few original members to remain in contact with Breton. Along with the brilliant young Salvador Dalí, Tanguy became, for Breton, the exemplar of a new pictorial direction. The vast expanses of Tanguy's paintings ideally suited the new psychoanalytically oriented direction of Surrealism. And throughout the 1930's Tanguy participated in the variety of Surrealist exhibitions then occurring.

After his move to America in 1939, Tanguy worked in relative isolation. After 1941 he lived in rural Woodbury, Connecticut, with his wife Kay Sage. From this point on Tanguy achieved a more rarefied version of his earlier direction, always pursuing the same path. Perhaps the most significant aspect of this work is its heightened sense of precision which was developed to the point of obsessiveness. What had been metaphorical in the early canvases now achieved a tangible realism.

Tanguy's greatest masterpiece of his later years is *Multiplication of the Arcs* (1954, Museum of Modern Art, New York) in which the previously sparse rock formations have procreated to cover the entire ground of the landscape. Limited only by the boundary of the horizon line, Tanguy insists on rendering the particularity of each stony outgrowth, which then engenders other such outgrowths. The rock formations now supplant the previous emptiness of space. As in the earlier paintings, the profusion of pebbly encrustations is bathed in the crystalline illumination of plentitude.

—William Jeffett

TATLIN, Vladimir (Evgrafovich).

Born in Moscow, 1885. Died in 1953. Attended schools of Kharkov, Ukraine and at Moscow College of Painting, 1902–04; sailor, 1902 (and intermittently for next ten years); Penza School of Art, 1904–1910, under Afahasiev; Moscow College again under Korovin and Serov, 1910; then free-lance painter; associated with Larionov and Gonacharova from c. 1907: influenced by early Russian icons, and also did stage designs (stage works include Khlebnikov's *Zan-Gesi*, 1923, and Ostrovsky's *Comedy of the 17th Century*, 1933); also friendly rival of Malevich; visited Berlin and Paris, 1913; began making "painting reliefs" in 1913, then counter-reliefs, then full-blown sculpture, architectural models, and designs for gliders (Letatlin); taught in the Moscow Free Art Studio from 1917, and also at schools in Petrograd, 1919–21, and Kiev, 1925–27.

Collections: Berlin: Nationalgalerie; Leningrad: Russian Museum; Moscow: Tretyakov; New York: Moma.

Publications

By TATLIN: books—

illustrator: *Mir s kontsa* [The World Backwards], by Velimir Khlebnikov and A. Kruchenykh, 1912; *Trebnik troikh* [The Missal of the Three], by Khlebnikov, Vladimir Mayakovsky, and Kruchenykh, 1913.

On TATLIN: books—

Punin, Nikolai, *Protiv kubisma: Tatlin* [Against Cubism: Tatlin], Petrograd, 1921.
Andersen, Troels, *Tatlin* (cat), Stockholm.
Nakov, A., *Tatlin's Dream: Russian Suprematist and Constructivist Art* (cat), London, 1973.
Milner, John, *Tatlin and the Russian Avant-Garde*, New Haven, 1983.
Zhadava, Larissa Alekseevna, editor, *Tatlin*, London and New York, 1988.

article—

Harrison, Roman G., "Tatlin and Zangezi,'" in *Russian History*, 8, 1981.

*

Tatlin's approach to art was not unlike that of an explorer or scientist. For him art was a subject to be examined and redefined, investigated materially in minute detail. The result of this philosophy is a lifetime's involvement with a whole spectrum of media including painting, sculpture, reliefs, and architectural projects as well as designs for stage, films, books, clothing, and household goods.

Tatlin began his artistic life as a painter, and his subjects were often drawn from his experiences as a young sailor. Stylistically and theoretically he was caught between the new artistic principles that were emerging in Western Europe and the more traditional characteristics of native Russian arts. The first two decades of the 20th century presented most Russian artists with this dilemma, caught between a desire to evolve a indigenous art movement and the pull of an urban and cultivated movement abroad. Tatlin's early development as an artist was against the background of an attempt by Russian artists to inject the rich expressiveness and vigour of Russian art into the received artistic wisdoms of Western Europe.

A visit to Picasso's studio before the war inspired Tatlin to move away from figurative painting towards the use of cubist constructions in various media. He began to explore the possibilities of sculpture in favour of painting but made no clear distinction between the two—in fact Tatlin produced few free-standing three-dimensional works. Most of the work from this period has been lost or destroyed, including a number of relief constructions and mixed media works. Tatlin treated his work as a study of material, independent of personal taste or self-expression. Tatlin saw the artist as the "constructor" with an impersonal, objective role. Tatlin interpreted the principle of the artist as "constructor" as a guiding and unifying theory which could be applied to a whole range of "creative" practices, equally applicable to architecture, the theatre, and film as well as the so-called "applied" arts.

Tatlin's attitude towards artistic practices was in sympathy with that which developed from within Inkhuk, the Institute of Artistic Culture. In 1920 the First Workers Group of Constructivists was established, giving the movement its name. By 1921 there were "constructivist" exhibitions and a catalogue was produced. Constructivism continually discovered new areas to investigate and explore. Part of this exploration involved a redefinition of the social role of the artist, and the constructivists united in their abandonment of the primacy of individual expression in art.

In 1923–1924 Tatlin exhibited prototypes for clothing and for a cheap, efficient stove. Necessarily these had no distinctive style but were studies of material qualities—the coat, for example, had several detachable linings. Tatlin was intimately involved in the construction of utilitarian objects which would be useful to the new society. By taking a material approach to creativity Tatlin could function in more or less any field, with any media. In some ways Tatlin's approach to the design of these objects was that of a re-inventor, redefining practical and utilitarian objects for a new society. By definition the production of utilitarian objects demanded abandoning self-expression and a willingness to work collaboratively. This was carried through into an exhibition of Paintings by Petrograd Artists of All Tendencies in which Tatlin's works were stamped "Tatlin's Studio" and the group's motto was "Towards the new object through the discovery of material."

Perhaps Tatlin's most extraordinary project was his designs for the construction of an "air bicycle." Letatlin, as the glider came to be known, derives from the combination of the word, letat, the Russian word meaning to fly, and the artist's own name. Following in the experimental footsteps of Leonardo da Vinci's flying machines, Tatlin declared, "I want to give back to man the feeling of flight. We have been robbed of this by the mechanical flight of the aeroplane. We cannot feel the movement of our bodies in the air." Letatlin was to be a flying machine without modern engines; "My flying machine is built on the principle of life, of organic forms. Through the observation of these forms I concluded that the most aesthetic forms are the most economical. Creative work is giving form to ma-

terial." In fact Tatlin incorporates the human figure as part of the material structure of Letatlin. When three models of Letatlin were exhibited at the Museum of Decorative Arts, the Pushkin Museum, in Moscow, they aroused much interest and excitement. 1932 as a whole was a year which celebrated Tatlin and his version of constructivism. However, after 1932 Tatlin concentrated on theatre design and later took up easel painting, even venturing into representational art once again.

Tatlin was friendly with the poet Khlebnikov and he illustrated his book of poetry, *The World Backwards*, in 1912. Four years later Khlebnikov wrote a poem about his friend which with hindsight provides a perfect epitaph for the artist. Khlebnikov seems almost to have anticipated the course of Tatlin's artistic career, and particularly his affinity with constructivism:

<div align="center">Tatlin</div>

Tatlin, initiate of whirling blades
And austere singer of the screw-propeller,
One of the order of sun-catchers,
With a mighty hand has bent
The iron horse-shoe
To knot the spidery veil of rigging.
Dumb and blind, the pincers
Look into the heart of secrets
Which he has demonstrated.
Just as unsung and possessed of deep knowledge
Are the tin objects which which he has worked with a brush.

<div align="right">—Lauretta Reynolds</div>

TENIERS, David (the Younger).
Baptized in Antwerp, 15 December 1610; son of the painter David Teniers the Elder. Died in Brussels, 25 April 1690. Married 1) Anne Bruegel (daughter of the painter Jan Bruegel), 1637 (died, 1656), 7 children, including the painter David Teniers III; 2) Isabelle de Fren, 1656 (died in 1680's), 4 children. A pupil of his father; member of the Antwerp painters guild, 1632 (Dean of the guild, 1645–46); courtier and business agent for Archduke Leopold Wilhelm by 1647; moved to Brussels, 1651; overlooked Leopold Wilhelm's picture collection; also favored by Leopold Wilhelm's successor, Don Juan; helped found the Brussels Academy, 1663.

Major Collections: London: Wallace; Vienna
Other Collections: Amsterdam; Antwerp; Berlin; Brussels; Dresden; Edinburgh; Frankfurt; Gladgow; The Hague; Hamburg; Kassel; Leningrad; London: National Gallery, Dulwich, Kenwood, Courtauld, Wellington; Madrid; Munich: Bavarian Museum, Alte Pinakothek; New York; Paris; Vaduz; Washington; Royal Collection.

Publications

On TENIERS: books—

Rosenberg, Adolf, *Teniers*, Bielefeld, 1895, 1898.
Davidson, Jane P., *Teniers*, Boulder, Colorado, 1979, London, 1980.
Larson, Erik, *Seventeenth Century Flemish Painting*, 1985.

article—

Dreher, Faith P., "The Artist as Seigneur: Chateaux and Their Proprietors in the Work of Teniers," in *Art Bulletin* (New York), December 1978.

<div align="center">*</div>

David Teniers the Younger was born in December 1610, the son of the Antwerp mannerist David Teniers the Elder and Digna de Wilde. Teniers the Younger studied painting with his father, who was his sole teacher. In 1632 he was registered as the son of a master, a "Wynmeester," in the *Liggeren* of the Antwerp Guild of St. Luke. He married the 17-year-old daughter of Jan Bruegel the Elder, Anna Bruegel, on 22 July 1637. Anna bore him seven children, the eldest of whom was David Teniers III (born 1638), a rather minor baroque figure painter. Teniers was engaged quite early in his career as an art dealer, exporter of art, and painter. Some of the earliest records of him have to do with his travels abroad in his dealership business. He produced somewhere in excess of 2,000 paintings. Most were landscapes or peasant genre scenes, although he also executed portraits, religious subjects, paintings of witches and alchemists, and an occasional still life. Teniers was Dean of the Antwerp Guild of St. Luke for the years 1645–1646. During this period he was also active in the Guild's chamber of rhetoric which was known as "Het Violerien."

In December 1647, Teniers was recorded as having been in the service of the Archduke Leopold Wilhelm, ruler of the Southern or Spanish Netherlands. His duties expanded in 1650, when he became Court Painter. It was at this point that Teniers began executing the series of depictions of Leopold Wilhelm's *Painting Gallery*. By 1658 he had been further honored with the title of *ayuda de camera*, or Gentleman of the Bedchamber for his work in producing the engraved catalog of the Archduke's collection, the *Theatrum Pictorum*. Late in his life, the Spanish Crown awarded him a patent of nobility for his services. The exact date at which this patent was granted is still in dispute.

After Anna Bruegel and an infant daughter died in May, 1656, he remarried in October of that year, taking as his second wife Isabelle de Fren. Isabelle would bear him an additional four children before her death late in the 1680's. Teniers continued to divide his time between Antwerp and Brussels although it is clear that he lived in Brussels during this period. In 1663 he helped found the Antwerp Academy of Art. During the 1650's and the 1660's he had additional royal clients, including Queen Christina of Sweden, Charles II, and the Prince de Condé. His role at the Brussels Court ended with the departure of Don Juan of Austria, who had succeeded Leopold Wilhelm in 1656. Teniers's last years were spent in relative quiet, although he continued to work actively as an artist, and possibly still as a dealer. Teniers died on 25 April 1690, at the age of 79. He is supposed to have been buried in St. Jacques dur Coudenberg in Brussels, although all records of his burial,

Study; drawing

and the actual site of his grave are now lost. This circumstance is due to the fact that the original church and all its records burnt and the bodies of the dead interred there were removed to the city cathedral of St. Gudule. That church has no record of Teniers.

The Guild records show only three rather obscure students of Teniers, but he had a considerable impact on his father, his brothers, Theodore, Julian and Abraham, and some impact on his son, David III. Despite this lack of formal students, a large number of 17th and 18th-century artists imitated Teniers and even forged his works. The best known of his imitators are probably David Ryckaert III and William van Herp.

—Jane P. Davidson

TER BORCH, Gerard.
Born in Zwolle, December 1617; son of the painter Gerard ter Borch the Elder. Died in Deventer, 8 December 1681. Married, 1654. Studied under Pieter Molyn in Haarlem, 1633–35, and entered the Haarlem guild, 1635: worked mainly in Haarlem for the next 20 years, but widely traveled: in London, Rome, Amsterdam (1640–45), Munster (1646–48: painted members of the peace Conference), Spain (1648–50: knighted by Philip IV); settled in Deventer, 1654 (member of the town council). Pupils: Caspar Netscher, Pieter van Anraedt.

Major Collections: Amsterdam; Berlin; London; Munich.
Other Collections: Boston; Cologne; Copenhagen; Deventer, Dresden; The Hague; Hamburg; Leningrad; London: Wallace, Victoria and Albert; Los Angeles; Munster; New York: Metropolitan, Frick, Historical Society; Paris; Philadelphia; Rotterdam; Rouen; San Francisco; Toledo, Ohio; Vaduz; Vienna; Washington.

Publications

On TER BORCH: books—

Michel, Emile, *Terburg et sa famille,* Paris, 1887.
Rosenberg, Adolf, *Terborch und Jan Steen,* Bielefeld, 1897.
Hellens, Franz, *Terborch,* Brussels, 1911.
Plietzsch, Eduard, *Ter Borch,* Vienna, 1944.
Gudlaugsson, Sturla J., *Ter Borch,* The Hague, 2 vols., 1960.
Ter Borch (cat), The Hague, 1974.

article—

Smith, David R., "Irony and Civility: Notes on the Convergence of Genre and Portraiture in Seventeenth-Century Dutch Painting," in *Art Bulletin* (New York), September 1987.

*

Gerard ter Borch was an outstanding painter of elegant Dutch interiors. In both iconography and style, his work reflects the changing mood in the United Provinces following the Ratification of the Treaty of Münster in 1648. (Ter Borch himself was present at its signing, and recorded the event in the painting now in the National Gallery in London.) With the security of the Treaty, and a higher standard of living, so diligently striven

A Woman Writing a Letter; $15\frac{3}{8} \times 11\frac{3}{4}$ **in (39 × 30 cm); The Hague, Mauritshuis**

for, largely achieved, there was some moral and material relaxation in the United Provinces. People wanted to enjoy their spoils, and to see them celebrated in images. Unlike the low-life, tavern, and brothel scenes of the early part of the century, which worked to deter by example, these images were required to retain a moral message but keep it smouldering below a surface of irresistible aesthetic appeal. Thus, ter Borch's pictures discarded the urgency of dogma, deferring to a more classical, interrogative, discursive mode.

He was particularly admired by contemporaries for his accomplished technique, especially in the handling of silks and satins. Highly finished work was not, of course, a novelty in mid-century Dutch art: Gerrit Dou had established a respected manner of fine painting in Leiden, based on just this kind of technical excellence. It was the sophistication of ter Borch's work that set it apart from his contemporaries. Unlike Willem Duyster, for example, the only earlier Dutch artist to rival ter Borch's facility with reflective textiles, ter Borch's compositions contain few figures. His focus is frequently on women: tall, slender, richly dressed women, often captured in a moment of stillness or contemplation, even in the midst of activity.

Ter Borch began, in the 1630's, painting quite ordinary narrative scenes of horses and riders. From 1640, however, he began to experiment, though still within conventional bounds of tavern and gambling scenes. Soldiers became increasingly important as an ingredient in his compositions, and so they remained in his mature paintings of the 1650's and 1660's, often in the role of correspondents. By then his subject matter had become truly innovative.

His ease and self-assurance with high-life subjects probably stemmed from his cosmopolitan lifestyle. His father was an artist who had lived in Italy as a young man, and ter Borch's early training probably came from him. Ter Borch also travelled more widely than many Dutch artists, and spent some time working for a Spanish noble household. Yet he did not, ultimately, settle in the capital, where his market was. Instead he withdrew to the provincial town of Deventer in Overijsel.

It is in the 1650's that ter Borch's pictures assume the form with which we are most familiar: a vertical format focussing on a few, well-lit figures, the light source itself remaining invisible. It is partly this manipulation of light that allows ter Borch's control of reflective textiles to be so absolute. In addition, he surrounds these surfaces with juxtapositions of strong colour and soft neutrals as foils to their luminescent pallour. Thus, while light acts as a unifier, it does so unobtrusively, never detracting from the psychological moment that controls the composition. It is that moment which gives ter Borch's scenes their impact: the moment when a soldier receives the call to arms, summoning him from the arms of his lover; the moment in which a letter is received; the moment of introduction; the time of dressing, when a woman's reflection causes her momentarily to reflect on vanity itself and its implications; a moment of choice, between virtue and vice.

Many of ter Borch's pictures revolve around the writing, receiving, and reading of letters. This idea was immediately taken up by artists such as Jan Vermeer (on whom ter Borch was, arguably, the biggest single influence), Gabriel Metsu, and Pieter de Hooch. The cleansing action of a woman washing her hands, with its implications of purity or absolution, was another of ter Borch's narrative inventions, also taken up

by Metsu, and by a late-century painter of elegant interiors, Eglon van der Neer. On a more mundane level, the motif of a woman searching her child's hair for lice, imitated by Pieter de Hooch in Delft and Quirijn van Brekelenkam in Leiden, became the archetypal Dutch image of maternal duty. Lesser details of stance and setting were also seminal, such as that familiar fulcrum of ter Borch's interior designs, the classical marble fireplace, or the device of depicting a woman in lost profile, her features left as an enigma.

As his motifs became part of the genre vocabulary, ter Borch could yet find original variants. He paints a woman *sealing* her letter, at the moment of holding the bar of wax in the flame; he transfers the maternal role to a boy examining his dog for parasites, and, again, Pieter de Hooch inserts this mimesis into one of his *moedertaak* paintings: *A Woman Nursing a Child and a Child Feeding a Dog* (c. 1658–60, New York, Kress Collection).

Where narrative is not explicit (and sometimes where it is), there is an ambiguity in ter Borch's work that remains potentially unresolved, locked within particular minds and situations. Yet his characters are not closed. Even in a single figure, he can convey intense pleasure and animation, such as *Woman Reading a Letter* (c. 1662, London, Wallace). We are reminded by this subject, so rapt with delight by what she reads, of the moralizing literary sources of such subjects. Otto van Veen's *Amorum Emblemata* (Antwerp, 1608)—one of the popular emblem books circulating in the 17th-century Netherlands—tells us: "Just as, for lovers, pictures even of absent loved ones are delightful. . . . How much more delightful are letters which convey the true imprints and marks of a lover."

Portraiture was another constant strand in ter Borch's career. Again, he contrived to be both fashionable and original. Like Rembrandt, he conformed to the taste for oval portrait heads in the 1640's. His innovation, however, lay in the full length, and it is an innovation in scale. In stark contrast to the spontaneity he could achieve in his genre pictures, his full-length portraits are arrestingly small, neat, and controlled. He cultivated a distinctly mannered—even dandyish—air. This smallness and formality, so unusual in mid-century Dutch portraiture, relate them most closely to the English miniature tradition.

Ter Borch's work replaces the morally didactic with a moral and material dilemma. Without it, that of artists such as Gabriel Metsu, Frans van Mieris, Jan Vermeer, Pieter de Hooch, Eglon van der Neer, and Jan Verkolje, as well as ter Borch's own pupil, Caspar Netscher, would have been greatly inhibited. The elegance of his interiors and their occupants matches the subtlety of their psychology and interchange. Ter Borch's work is itself a psychological pause in Dutch art; a moment captured before fashion overpowered innovation, and the influence of French academicism was invited to take its disorientating course through the last quarter of the century.

—Lindsay Bridget Shaw

TERBRUGGHEN, Hendrick (Jansz.)

Born near Deventer, 1588; grew up in Utrecht. Died in Utrecht, buried 9 November 1629. Married Jacoba Verbeck, 1616; eight children. Studied with Bloemaert in Utrecht, then

lived in Rome, c. 1604–14; settled in Utrecht, and entered the guild, 1615; strong Italian influence on his work.

Major Collections: Amsterdam; Kassel; Le Havre; New York; Oberlin, Ohio.
Other Collections: Augsburg; Basel; Berlin; Bordeaux; Cambridge, Massachusetts; Copenhagen; Deventer; Edinburgh; Gothemburg; London; Malibu; Northampton, Massachusetts; Oxford; Paris; Rome; Stockholm; Utrecht; Vienna.

Publications

On TERBRUGGHEN: books—

Nicolson, Benedict, *Terbrugghen,* London, 1958.
Stechow, Wolfgang, and Leonard J. Slatkes, *Terbrugghen In America* (cat), Dayton, Ohio, 1965.
Jong, E. de, *De Slapende Mars van ter Brugghen* (cat), Utrecht, 1980.
Die Utrechter Malerschule: Caravaggisti des Nordens (cat), Cologne, 1984.
Blankert, Albert, and Leonard J. Slatkes, *Höllandische Malerei in neuem Licht: ter Brugghen und seine Zeitgenossen* (cat), Braunschweig, 1987.

articles—

Stechow, Wolfgang, "Terbrugghen's *St. Sebastian,*" in *Burlington Magazine* (London), 96, 1954.
Virch, Claus, "The Crucifixion by Terbrugghen," in *Metropolitan Museum of Art Bulletin* (New York), 16, 1958.
Nicolson, Benedict, "Second Thoughts about Terbrugghen," in *Burlington Magazine* (London), 102, 1960.
Nicolson, Benedict, "Terbrugghen since 1960," in *Album Amicorum J.G. van Gelder,* The Hague, 1973.
Gerson, H. W., "An Unknown Evangelist Series by Terbrugghen," in *Burlington Magazine* (London), 120, 1978.
Lurie, A. T., "The *Weeping Heraclitus* by Terbrugghen in the Cleveland Museum of Art," in *Burlington Magazine* (London), 121, 1979.

*

The Utrecht painter Terbrugghen was one of the most original of those who succumbed to Caravaggio's influence and arguably one of the greatest 17th-century Dutch masters. His works are full of signs that he was well acquainted with Caravaggio's Roman works, but he never allowed himself to become a slave to the master's formulations. If he follows a Caravaggio subject and design fairly closely (as in his *Doubting Thomas,* c1622, Amsterdam) he is careful to assert his independence by discernible variations to the composition, by his own very different, northern, facial and figure types, and by his creative colorism.

Terbrugghen's finely nuanced and textured color combinations, which point the way to Vermeer, are quite unlike Caravaggio's more puritanical palette. His lifelong fascination with the interplay of colors, like that of his Utrecht colleague Honthorst, stems from his training in the late Mannerist con-

ventions of Abraham Bloemaert's studio. Yet it is intriguing to observe him adjusting the priorities of a decorative colorism when confronted with the example of Caravaggio's tenebrism, and modulating (rather than abandoning) tints to the exigencies of tone. His colors are beautifully handled in terms of their patterning, and modification through light and shade, but they are also remarkably subtle and attractive hues in themselves—ranging from refined cherry and flowerpot reds through rich lead-tin yellows and deep blue-greys to distinctive pastel shades of powder blue and apple green.

Terbrugghen's early biographers all state that he was in Italy for ten years and we also know that he travelled back to Utrecht via Milan in the summer of 1614. Yet no surviving paintings can be ascribed with conviction to the Italian period. Terbrugghen's "Caravaggism" as we know it is the product of Caravaggio remembered from afar, and this may account, in part, for Terbrugghen's highly selective response to the master's work. Several of the pictures which were done between the mid-1610's and the early 1620's are Caravaggesque in subject matter and motif though barely so in lighting: e.g., in addition to the *Doubting Thomas,* the recently discovered *Supper at Emmaus* (Toledo, Ohio), which could be Terbrugghen's earliest surviving work (c. 1616), and the two *Calling of St. Matthew* canvases (Le Havre and Utrecht). He is as much indebted in these and other superficially Caravaggesque works, however, to 16th-century north European art—to, for example, Massys, van Rymerswaele, Dürer, Grünewald, and Lucas van Leyden.

The large and accomplished *Crowning with Thorns* in Copenhagen (1620) epitomizes the crosscurrents of Terbrugghen's style. Several of the formulae adopted (e.g., the preponderance of profiles, lost profiles, and three-quarter views, and the deployment of clusters of magnificently clothed oriental figures conversing in the background) hark back to the prints and paintings of Lucas and Dürer—as does the crowded, mutedly colorful composition. Yet against such decorative tendencies can be set the monumental, Italianate forms of the foreground figures, with their marked Caravaggesque affinities. For not only are some of the motifs derived from specific paintings by Caravaggio (his *Crowning with Thorns* and *Madonna of the Rosary,* both Vienna), but the bold, architectural format of this group and the way it is sculpted out of the gloom by the strong light are unthinkable without Caravaggio's example. Even so, Terbrugghen can be seen modifying Caravaggio's prescriptions at every turn—whether for aesthetic or expressive reasons. The characteristic warm pink hue, for instance, which he gives to the light on the white draperies is not to be found in Caravaggio, and Terbrugghen is more obsessive than Caravaggio in his passion for realistic detail. The truculent tormenters give him the chance of depicting the inside of an open mouth, as well as the tattered clothing and "limbs disfigured by disease" which the arch-classicist Bellori viewed as two of the distinguishing lapses of the Caravaggist style.

Terbrugghen's attachment to detail, however, extended beyond a northern Caravaggist's delight in bodily blemishes (warts, pimples, and loosened fingernails) to include a range of more pleasurable visual sensations. He was especially good at grasping the structure and texture of forms (hair, metal, glass, cloth) and at integrating a detail (such as a prunt on the base of a glass) with just sufficient emphasis into the skein of paint.

Terbrugghen's art during the 1620's developed on a variety of influential fronts. The dry and wrinkled skins of his Deventer *Evangelists* (1621) were to appeal to Georges de La Tour, while his two Kassel *Fluteplayers* (also 1621) introduced to the Netherlands (to Baburen and Hals) the Giorgione/Caravaggio motif of the half-length musician. Most striking of all is Terbrugghen's ingenious and unexpected exploration (in works like the Thyssen *Jacob and Esau,* the Toronto *Melancholy,* and the London *Concert,* 1626) of the nightpiece—possibly in competition with those of the recently returned Honthorst.

Some have argued that the increased monumentality and *chiaroscuro* of Terbrugghen's works in the 1620's (seen also in naturally lit, outdoor scenes such as *St. Sebastian* (Oberlin, Ohio, Oberlin College) and the Metropolitan Museum's *Crucifixion* in New York, c.1627) imply a renewed contact with Caravaggio's art on a second visit to Italy, maybe c. 1619-20. Yet such a trip would hardly have been necessary even if it had been possible for a busy artist: all of the developments in Terbrugghen's work are essentially clarifications of his earlier ideas, galvanized, it would seem, by the presence of the returned Caravaggists Honthorst and Baburen and the actual and talismanic proximity of one of Caravaggio's greatest masterpieces, *The Madonna of the Rosary* (Vienna)—which had probably passed through Amsterdam prior to its installation in Antwerp in 1619.

Terbrugghen's is an art of great emotional depth. His figures reveal their passions and their spirituality in totally unrhetorical, un-Italian ways. Even in Caravaggio there are few precedents for this language of understatement, unless it be in some of the late paintings (such as the Brera *Supper at Emmaus*). But Terbrugghen relies even more than in such works on a communion of gazes and glances rather than gestures. His awkward, often ugly figures, quintessentially Dutch, convey through their intense eye-contact with each other what their half-formed, fumbling hand movements scarcely begin to articulate: a rough-hewn, homespun nobility which must surely have inspired Rembrandt.

—John Gash

THORNHILL, (Sir) James.
Born probably in Woolland, Dorset, 25 July 1675 or 1676. Died in Thornhill Park, Dorset, 4 May 1734. Married Judith; one daughter, Jane (she married William Hogarth); illegitimate son, the painter John Thornhill. Apprentice to the painter Thomas Highmore, London, 1689-96; decorator and designer: stage designs from 1705 (*Arsinoe, Queen of Cyprus*): worked at Chatsworth, 1706, then did the Painted Hall, Greenwich, 1708-27: did other work while this project was underway, at Hampton Court, Oxford Colleges, Blenheim, the cupola of St. Paul's, London (1714-21), Moor Park (including paintings and plasterwork, as well as the design of the house), 1720-28; also made trips to the low countries, 1711, and France, 1716-17; associated with Kneller's Academy from 1711 (governor, 1716), and founded his own school in the 1720's; made History Painter in Ordinary to the King, 1718, and Sergeant Painter, 1720; member of parliament for Melcombe Regis, 1722-34. Assistant: Bently French. Knighted, 1720.

Collections/Locations: Blenheim Palace; Cambridge: Trinity College; Chatsworth; Hampton Court; London: St. Paul's, Greenwich Hospital, Portrait Gallery, Victoria and Albert, British Museum, Guildhall, Tate; New Haven; Oxford: All Souls.

Publications

On THORNHILL: books—

Waterhouse, Ellis, *Painting in Britain 1530 to 1790,* London, 1952, 4th ed., 1978.
Howgego, J. L., *Thornhill* (cat), London, 1958.
Croft-Murray, Edward, *Decorative Painting in England 1537–1837,* London, 1962.
Mayhew, Edgar de N., *Sketches by Thornhill in the Victoria and Albert Museum,* London, 1967.
Fremantle, Katharine, editor, *Thornhill's Sketch-Book Travel Journal of 1711: A Visit to East Anglia and the Low Countries,* Utrecht, 2 vols., 1975.
Brocklebank, Joan, *Thornhill of Dorset* (cat), Dorchester, 1975.

articles—

Allen, Brian, "Thornhill at Wimpole," in *Apollo* (London), September 1985.
Garas, Klara, "Two Unknown Works by Thornhill," in *Burlington Magazine* (London), November 1987.

*

James Thornhill worked almost exclusively as a decorative painter throughout his career, painting ceilings, walls, and staircases in great houses and public buildings. Though he also found employment as a portraitist, a scenery painter, and an architect, it is as a decorative painter—or, in contemporary terms, "history" painter—of the Baroque illusionistic tradition that he made his reputation. His work, which is characterized by the skillful combination of figures within innovative illusionistically conceived architectural settings, brings the illusionistic (scenes which appear to be beyond the actual surface on which they are painted) tradition of painting in England to its culmination.

Thornhill built his career at a time when decorative painters from the continent trained in the Baroque technique of ceiling and wall painting flooded England. They imitated the work of artists like Charles Lebrun, who had set the great example for decorative opulence at Louis XIV's Versailles; Pietro da Cortona, the Roman decorative artist most esteemed in England; and Peter Paul Rubens, whose masterly paintings, including the Whitehall Banqueting House ceiling in London (completed 1634), were admired throughout Europe.

The little that is known of Thornhill's early career following his apprenticeship is derived from his sketchbooks and the diary accounts of contemporaries like George Vertue. Edward Croft-Murray believes that the sketchbooks, which exhibit a close study of the work of Antonio Verrio, suggest the possibility that Thornhill worked with Verrio at Hampton Court Palace (1702-04) and Chatsworth (1706-07). Louis Laguerre,

who also painted at Chatsworth (1689–94), was another notable influence on the young Thornhill. From Verrio came the ease with which Thornhill achieved strong compositional massing; from Laguerre, a softness of modeling and palette in pleasing contrast to Verrio's garishness. Thornhill seems to have learned from both Verrio and Laguerre the art of scenographic architecture.

Thornhill's early style (1703–07) is characterized by narratives in the Baroque illusionistic tradition. At Stoke Edith, Herefordshire, he painted mythological scenes, framed by painted architectural elements, on the hall ceiling and walls and staircase (destroyed 1927). His innovations include a painted colonnade which appears to curve behind a fireplace chimney covered by a painted niche and statue, an elliptical arch that frames a staircase landing, and a figure seemingly falling out over the painted architecture that runs along the wall of the stair, as if shot with arrows by other ceiling figures. The subject, the *Slaughter of Niobe's Family,* is executed by Thornhill with a clarity and unity of design not heretofore found in native English ceiling painting.

Chatsworth's Sabine Room is the most accomplished example of Thornhill's early style that still remains. Its four walls are painted scenographically to represent a continuous pavilion opened to the out-of-doors, and a curved colonnade and niche appearing on the fireplace wall, as at Stoke Edith. The figure work is weak, a recurrent problem for Thornhill. Given that he used figures extensively in all of his painting, it becomes clear that action and setting are Thornhill's forte, for the figures here as elsewhere are flat and boneless.

Thornhill's most famous paintings are located in two of Christopher Wren's best-known architectural works, the Painted Hall at Greenwich Naval Hospital and the dome interior at St. Paul's Cathedral. These two commissions represent his mature period and illustrate the breadth of his artistry. Thornhill worked in two main styles which display the oppositions of the Baroque temperament: the dynamic more ornate and colorful Italianate Baroque style, and the monochromatic static Classical Baroque style. At Greenwich he employed the Italianate Baroque manner, learned probably from Verrio and Laguerre. It is characterized by a great feeling of movement, rich colors, strong *chiaroscuro,* and grandoise ornate effects. Thornhill's use of *sotto in sù* (foreshortened figures painted as if seen from below), produces the striking illusion that objects are in movement receding into space, thereby strengthening the sense of the scene's immediacy.

Thornhill's work in the Painted Hall consists of three parts, all much restored: the anteroom, the large Lower Hall, and the much smaller Upper Hall. The ceiling of the Lower Hall is the major focus of any discussion of the Painted Hall, for it was his most ambitious and successful undertaking. The entire ceiling is covered by a single painting that features scenographic architecture illusionistically opening to the sky where King William and Queen Mary hold court among a group of allegorical and mythological figures, including the astronomers Copernicus, Tycho Brahe, John Flamsteed, and possibly Galileo. This magnificently conceived, dynamically executed painting, which celebrates the reign of the royal couple and their promotion of the science of navigation, so essential to the functioning of the Royal Navy, is considered the high point of Baroque ceiling painting in England.

Thornhill's narrative in eight panels at St. Paul's Cathedral

of the life of St. Paul is a leading example of his Classical Baroque manner. The scenes are painted in *grisaille,* a technique in which shades of gray are used to imitate bas-relief stone carving. Though the *grisaille* treatment was chosen to satisfy a requirement of the Commissioners of St. Paul's, it is not the only instance of Thornhill's extensive use of monochrome (other examples include Easton Neston, Northamptonshire 1702?–13; Wimpole Hall Chapel, Cambridgeshire 1721–24). The compositions are comparatively static, spatially confined and compositionally limited. Croft-Murray argues that the selection of a monochromatic palette here was a mistake because "a splash of color" is needed in the dome to provide dramatic relief. The architectural divisions of the dome, which emphasize the static nature of the design, were also, in his view, counterproductive.

Thornhill's preparatory drawings and sketches provide a strong comparison with his finished work. Their quality of freshness was seldom translated into the finished product. When it was not, the result was somewhat dull, hence the criticism of St. Paul's dome.

—Ann Stewart Balakier

THORVALDSEN, (Albert) Bertel.

Born in Copenhagen, 19 November 1768. Died in Copenhagen, 24 March 1844. Attended Copenhagen school of art, from 1781: protégé of the painter Nicolai Abraham Abildgaard: Rome Prize, 1796: in Rome, 1797–1838: soon influenced by Asmus Jakob Carstens; successful as sculptor after creating the marble Jason, 1802; installed Christ and Apostles in the Copenhagen Fruenkirche on trip there, 1819–20; Tomb of Pius VII, St. Peter's; large studio with many assistants; appointed Professor of the Copenhagen Royal Society, 1805.

Major Collection: Copenhagen: Thorvaldsen Museum.
Other Collections: Cambridge: Trinity College; Liverpool; Minneapolis; Naples; Rome: St. Peter's; Stoke Poges: Golf Club.

Publications

On THORVALDSEN: books—

Rosenberg, Adolf, *Thorvaldsen,* Bielefeld, 1896.
Munoz, Antonio, *Thorvaldsen, danese, scultore romano,* Rome, 1944.
Rave, Paul O., *Thorvaldsen,* Berlin, 1947.
Sass, Else Kai, *Thorvaldsens portraetbuster* (in Danish and English), Copenhagen, 3 vols., 1963–65.
Hartmann, Jørgen Birkedal, *Thorvaldsen, scultore danese, romano d'adozione,* Rome, 1971.
Thorvaldsens Museum: Katalog, Copenhagen, 1975.
Wittstock, Jürgen, *Geschichte der deutschen und skandinavischen Thorvaldsen-Rezeption bis zur Jahresmitte 1819,* Hamburg, 1975.

Annunciation, 1842; plaster; $26\frac{3}{8} \times 49\frac{1}{4}$ in (67 × 125 cm); Copenhagen, Thorvaldsen Museum

Bott, Gerhard, et al., *Thorvaldsen: Untersuchungen zu seinem Werk und zur Kunst seiner Zeit,* Cologne, 1977.

Thorvaldsen (cat), Cologne, 1977.

Hartmann, Jørgen Birkedal, *Antike motive bei Thorvaldsen: Studien zur Antikenrezeption des Klassizismus,* edited by Klaus Parlasca, Tubingen, 1979.

Hemmeter, Karlheinz, *Studien zu Reliefs von Thorvaldsen,* Munich, 1984.

Jørnaes, Bjarne, and Anne Sophie Urne, editors, *The Thorvaldsen Museum,* Copenhagen, 1985.

*

Thorvaldsen regarded his date of birth as 19 November 1770 but he may well have been born on 13 November 1768. His christian name was Bertel (the Danish form of Bartholomew), but in Italy he used the name Alberto and marked his works AT. His private life was irregular despite the gravity of his public demeanour. His father was an untalented woodcarver, his home poor and, apparently, squalid yet before his death in his native Denmark the idea of a museum of his works was being transformed into a reality before his death in 1844. Throughout his youth he augmented the family income by carving ships figure-heads and mirror frames and by modelling portrait busts as well as actually drawing portraits. His mature work was monumentally classical yet the sketches in which he first set down his ideas were fiery, impressionistic, and romantic. An independent man of a generous nature, he had doors opened to him by influential patrons. As a child he wondered that grown-ups could laugh. Behind Thorvaldsen's imposing facade there were strange dichotomies, both in life and in art.

It might have been expected—as was the case—that the modelling and sculpture of his professional years would represent an utter rejection of the rococo elements associated with his poverty-stricken boyhood. Although the influence of the painter N. A. Abildgaard, whom he assisted with the decoration of the Amalienborg Palaces, working on reliefs in the late 18th-century rococo style showing early neo-classical tendencies, has been much stressed, a deeper and more enduring impact was doubtless made by the prevailing ethos of the Danish Academy of Fine Arts whose Director was the French classicist J. F.-J. Saly and whose head of sculpture was Johannes Wiedewelt. Wiedewelt had studied in Paris with Guillaume Coustou the Younger and had visited the excavations at Herculaneum in company with his friend Winckelmann. In 1762 he published his *Thoughts Concerning Taste in the Arts* in which he advocated the imitation of antiquity as the true way to "pure taste." When Thorvaldsen arrived in Rome on 8 March 1797 he declared that the snow had thawed from his eyes, but the grounds for this enlightenment had already been well tilled in his native Copenhagen. Georg Zöega, Danish representative at the Vatican, guided his appreciation of classical sculpture. The neo-classical Canova was accepted as the foremost sculptor of the day and everywhere in the Imperial city excavations were bringing to light the greatness of the classical past both in terms of architecture and sculpture—this was the actuality but the spirit of neo-classicism had already been firmly implanted.

Technically Thorvaldsen was ill-prepared for the international rivalry presented in Rome. His major work in Copenhagen had been the modelled bust of his patron the statesman P. A. Bernstoff (1795; Thorvaldsen Museum); and his first important Roman works, *Achilles and Penthesilea* (1801; Thorvaldsen Museum) and *Jason and the Golden Fleece* (1801-03; Thorvaldsen Museum) were also modelled. He had to learn the skills of carving in marble and of casting. When Thomas Hope commissioned a marble version of *Jason* and so enabled him to remain in Rome, Thorvaldsen readily agreed, but found the task so distasteful that it was not finished until 25 years later. Even at the height of his fame he employed a host

of men carving and copying for him in the large workshop he so efficiently controlled: the blandness of the carving—one of the attractive features of his work—is anonymous.

Statues, monuments, and portrait busts formed the bulk of his numerous commissions in which through the years there is little outward change in style. He did, however, tackle a wider range of work, notably a series of grand reliefs, the most popular being *Alexander the Great's entry into Babylon,* commissioned for the Quirinal Palace in 1812 when a visit from Napoleon was expected. Sensing, perhaps, the interest in Christian art which was to be a major preoccupation of Victorian aesthetes and art critics, from 1820 he worked on groups of figures for the Church of Our Lady, Copenhagen, endeavouring to replace the traditional expressiveness of Christian art by the serenity of classical sculpture. Four years later he came into direct contact with Greek sculpture when he restored architectural groups removed from the Temple of Aphaia on Aegina (Munich, Glyptothek) without any noticeable effect on his art.

Despite the harmony of Thorwaldsen's sculptures, the purity of their outlines, and the translucent modelling of the marble, there is often more than a hint of the incidental. His *Venus* (1813-16; Thorwaldsen Museum) holds the apple awarded by Paris, his *Ganymede* (1804; Thorwaldsen Museum) has a pitcher and a wine bowl, and his own self-portrait (1839; Thorwaldsen Museum) shows him with his statue of *Hope.* The art historian Julius Lange remarked that behind Thorwaldsen's figures there seemed to be an invisible landscape in which the lighting seemed to correspond to their mood. It is possible to suggest that Thorwaldsen was deeply interested in the problems not only of objects in space but the relationships of objects to each other and certainly to the central figure. The apparent blandness of Thorwaldsen's work and his own sober, jealousy preserved dignity may have blinded us to the hesitantly experimental and spatially adventurous nature of his major sculptural works.

—Alan Bird

TIEPOLO, Giovanni Battista.

Born in Venice, 5 March 1696. Died in Madrid, 23 March 1770. Married the sister of Francesco Guardi, 1719; sons, the painters Giandomenico and Lorenzo. Probably a pupil of Gregorio Lazzarini, and influenced by Piazzetta, Sebastiano Ricci, and Veronese; member of the Venice guild, 1717; after the success of his decoration of the Archbishop's Palace in Udine, 1725-28, had many commissions for similar work in north Italy; perspective work in Udine palace was done by Mengozzi-Colonna, who did this for subsequent work of Tiepolo; completed the Palazzo Labia in Venice, 1750; decorated the Wurzburg Residenz for Prince-Bishop Karl Phillip von Grieffenklau, 1750-53; First President of the Venice Academy, 1755; decorated the Royal Palace in Madrid for Charles III, 1762-66; large workshop with many assistants; also did etchings.

Major Collection: New York.

Other Collections: Amsterdam; Bergamo; Berlin; Boston: Museum, Gardner; Burano: S. Martino; Cambridge, Massachusetts; Chicago; Dresden; Edinburgh; Frankfurt; Hamburg; Hartford, Connecticut; London: National Gallery, Courtauld, Dulwich; Madrid: Royal Palace; Milan: Brera, Poldi-Pezzoli; Montreal; Munich; New Haven; New York: Frick; Ottawa; Paris; Philadelphia; St. Louis; Stockholm; Stra: Villa Pisani; Udine: Archbishop's Palace; Venice: Chiesa dell'Ospedaletto, Palazzo Labia, S. Aloise, SS. Apostili, Gesuati, Doge's Palace, Academia, S. Alvise, S. Maria della Fava, Scuola Grande dei Carmini; Verona; Vicenza: Villa Al Valmarana; Vienna; Washington; Wurzburg: Residenz.

Publications

On TIEPOLO: books—

Hadeln, Detlev von, *Handzeichnungen von Tiepolo,* Munich, 1927; as *The Drawings of Tiepolo,* Paris, 2 vols., 1928.

Hegemann, Hans W., *Tiepolo,* Berlin, 1940.

Vigni, Giorgio, *Disegni del Tiepolo,* Padua, 1942, Trieste, 1972.

Hetzer, Theodor, *Die Fresken Tiepolos in der Wurzburger Residenz,* Frankfurt, 1943.

Moraddi, Antonio, *Tiepolo,* Bergamo, 1943, 1950.

Morassi, Antonio, *Tiepolo: La Villa Valmarana,* Milan, 1945.

Pallucchini, Rodolfo, *Gli affreschi di Giambattista e Domenico Tiepolo alla Villa Valmarana,* Bergamo, 1945.

Lorenzetti, Guilio, *Il quaderno dei Tiepolo al Museo Correr di Venezia,* Venice, 1946.

Vigni, Giorgio, *Tiepolo,* Florence, 1951.

Pignatti, Terisio, *Tiepolo,* Milan, 1951.

Mazzariol, Giuseppe, and Terisio Pignatti, *Itinerario tiepolesco,* Venice, 1951.

Morassi, Antonio, *Tiepolo: His Life and Work,* London and New York, 1955.

Freeden, M. H. von, and Carl Lamb, *Das Meisterwerk des Tiepolo: Die Fresken der Wurzburger Residenz,* Munich, 1956.

Krasnick, Lucia, *Tiepolo in Milan: The Palazzo Clerici Frescoes,* Milan, 1956.

Millier, A., *The Drawings of Tiepolo,* Los Angeles, 1956.

Guglielmi Feldi, C., *Tiepolo alla Scuola dei Carmini a Venezia,* Venice, 1960.

Knox, George, *Catalogue of the Tiepolo Drawings in the Victoria and Albert Museum,* London, 1960, 1975.

Reynolds, Graham, *Tiepolo Drawings* (cat), Washington, 1961.

Crivellato, Valentino, *Tiepolo,* New York, 1962.

Morassi, Antonio, *A Complete Catalogue of the Paintings of Tiepolo,* London, 1962.

Bott, Gerhard, *Das Fresko im Treppenhaus der Wurzburger Residenz,* Stuttgart, 1963.

Levey, Michael, *Tiepolo: Banquet of Cleopatra,* Newcastle upon Tyne, 1965.

Pignatti, Terisio, *Le acqueforti dei Tiepolo,* Florence, 1965.

Rizzi, Aldo, *Disegni del Tiepolo* (cat), Udine, 1965.

Pallucchini, Anna, *L'opera completa di Tiepolo,* Milan, 1968.

Knox, George, *Tiepolo* (cat), Cambridge, Massachusetts, 1970.

Capriccio Series—detail; etching

Garberi, Mercedes, *Tiepolo: Gli affreschi,* Turin, 1970.

Rizzi, Aldo, *Le acqueforti dei Tiepolo* (cat), Milan, 1970.

Rizzi, Aldo, *Tiepolo a Udine,* Udine, 1971.

Rizzi, Aldo, *The Etchings of the Tiepolos,* London, 1971.

Knox, George, and Christel Thiem, *Tiepolo: Drawings by Giambattista, Domenico, and Lorenzo Tiepolo* (cat), Stuttgart, 1971.

Pallucchini, Anna, *Tiepolo,* Milan, 1971.

Russell, H. Diane, *Rare Etchings by Giovanni Battista and Giovanni Domenico Tiepolo,* Washington, 1972.

Porcella, Antonio, *La giovinezza di Tiepolo,* Rome, 1973.

Pignatti, Terisio, *Tiepolo: Disegni,* Florence, 1974.

Knox, George, *Un quaderno di vedute di Giambattista e Domenico Tiepolo,* Milan, 1974.

Knox, George, *Etchings by the Tiepolos in the Cooper-Hewitt Museum of Design* (cat), Ottawa, 1976.

Ewald, Gerhard, *Das Jahrhundert Tiepolos,* Stuttgart, 1977.

Tiepolo: Tecnica e immaginazione (cat), Venice, 1979.

Knox, George, *Giambattista und Domenico Tiepolo: A Study and Catalogue Raisonné of the Chalk Drawings,* Oxford, 2 vols., 1980.

Büttner, Frank, *Tiepolo: Die Fresken in der Residenz zu Würzburg,* Wurzburg, 1980.

Succi, Dario, et al., *Giambattista Tiepolo* (cat), Castello di Gorizia, 1985.

Gealt, Adelheid M., *Tiepolo: The Punchinello Drawings,* London, 1986.

Levey, Michael, *Tiepolo: His Life and Art,* New Haven, 1986.

*

It is difficult to imagine a more Venetian artist than Giambattista Tiepolo. He was born in the city to an aristocratic family and was heir to a great artistic tradition. One can hardly enter a Venetian church, palazzo, or gallery without encountering Tiepolo's work, on ceiling, wall, or altar. He was, quite simply, the last great decorative painter of the Grand Manner. For this reason he was sought by princes and kings, and spent extended periods abroad, but never for a moment considered any place but Venice as his home. Like most of his great Venetian predecessors, Tiepolo believed in hard work, and family; he did not trouble himself much with theories of art or lofty ambitions for the artist in society. Even in advanced age he worked incessantly, accepting commissions which took him, reluctantly, far from home.

Born into a family with no particular artistic leaning or connections Tiepolo seems to have entered the studio of Gregorio Lazzarini around 1710, although there are no records to substantiate this. Lazzarini, whose studio was in Castello, the district where Tiepolo lived, enjoyed a good reputation although he carried on somewhat dully in the tradition of Veronese. The training Tiepolo received from him would have been sound if uninspired.

The painting tradition handed down in Venice since the Renaissance emphasized richness of color, virtuosity in the handling of paint, and a certain extravagance of invention. These qualities Tiepolo was to develop to an astonishing degree. Ironically, his first love was something not so strongly associated with Venetian art—drawing. Tiepolo was an instinctive draughtsman and seems to have learned from the etchings of Salvator Rosa, Rembrandt, and Callot, all available to the young artist in Venice. One sees in his limpid pen and wash drawings all the brilliance and inventiveness he was to bring to his paintings with, quite naturally, greater spontaneity.

Knowing what Tiepolo was to become we might expect the strongest early influences on him to be the decorative painters Sebastiano Ricci and Gian Antonio Pellegrini who enjoyed international reputations as leaders of a resurgeance of Venetian painting. The early work of Tiepolo, however, shows that he was looking elsewhere. In 1722 Tiepolo was the youngest of a group of 12 artists chosen to execute paintings of the 12 Apostles for the church of San Stae. Among the artists were Tiepolo's master Lazzarini, and the more eminent Ricci and Pellegrini. Tiepolo's contribution, *The Martyrdom of St. Bartholomew,* still in San Stae, looks nothing like the work of these artists but is clearly a response to another painting in this series—the dark, violent, almost Caravaggesque *St. James Led to Martyrdom* by the greatest of his Venetian contemporaries, Piazzetta. While they were artists of entirely different temperaments Tiepolo would return repeatedly, throughout his long career, to the example of Piazzetta's tough-minded realism.

It is ironic that the great fame of Tiepolo, from his day to our own, is based primarily on fresco painting. Venice with its damp, salty air would seem hardly the place for fresco painting to flourish. Traditionally, Venetian ceilings, particularly in palazzi, were decorated with canvases inset within an elaborate gilded-wood framework. Earlier Venetians had painted in fresco but nearly always outside the city—Veronese's work in the mainland Villa Barbaro is a notable example. In the 18th century Ricci and Pellegrini painted frescoes but, again, not in Venice. How exactly Tiepolo came to learn the fresco technique is unclear; that he took to it early and easily is certain. Venetian taste, as that of all Europe in the 18th century, was turning to a lighter style in ceiling decoration. Apart from a lesser contemporary named Crosato there was no one else in Venice with the quickness of hand—and mind—for such work.

Literary accounts refer to early frescoes by Tiepolo which do not survive. The earliest known work by his hand is a ceiling at the Palazzo Sandi in Venice, completed around 1726, although Tiepolo made a modello for it as early as 1722 (Courtauld Institute, London). This painting has remained relatively obscure among Tiepolo's large output. Its subject is something of a rarity: an *Allegory of Eloquence,* featuring the deeds of such persuasive heroes as Orpheus, Bellerophon, Hercules, and Amphion. The artist made significant changes during the years between the modello and the completion of the fresco; then part of the fresco was re-painted, suggesting that it was damaged. At any rate Tiepolo appears, in this early essay, already a master of his medium. The theatrical gestures of the figures grouped along the periphery of the rectangular space, the wide expanses of silvery blue sky, the limpid, water-color tonalities, which would always characterize his work, were all in place at this time. Given Tiepolo's predilection for the realism of Piazzetta it is extraordinary that he was so utterly comfortable with the high flown rhetoric of this kind of allegory. We never really see formative stages in Tiepolo; as draughtsman, as realist, as decorator, he bursts on the scene full grown.

Two major works in the church of the Gesuati (Venice) show his range at a mature stage of his career. In 1737 he was commissioned to execute frescoes on the ceiling of this new church, in spaces which the architect Massari probably in-

tended for this purpose. In the main section, dominating the nave, Tiepolo painted *St. Dominic Distributing the Rosary.* Here he paid homage to his great predecessor Veronese by the use of a grand staircase leading the eye up into the illusionistic space of the painting. It is a device he was to use often—at Wurzburg, for instance—but never as dramatically as in the Gesuati. Here the viewer looks straight up at the saint, perched at the top of the stairs, at a dizzyingly steep angle. The foreshortening of the feigned architecture, and of the figures—some of whom seem to overlap the *real* architecture as they topple into the viewer's space, is nothing less than spectacular. While the colors are deep and resonant in the lower part of the fresco Tiepolo resorts, as was his wont, to the most limpid pastels in rendering angels fluttering in the sky; the Madonna and child, enthroned on a cloud, seem utterly translucent. This was an important commission in his beloved city, and a chance to interact with modern architecture; Tiepolo obviously pulled out all the stops.

As he was finishing the frescoes for the Gesuati (c. 1739) Tiepolo began work on an altarpiece for the same church; the contrast is a telling one. Once again his work was placed in opposition—two altars away—to that of his much respected rival Piazzetta. Tiepolo's narrow, arched canvas of *St. Catherine of Siena, St. Rose of Lima, and St. Agnes of Montepulciano* is similar in shape and subject to Piazzetta's *Saints Vincent Ferrer, Hyacinth and Luis Beltran.* Typically, Piazzetta uses his familiar zig-zag composition in a work that is dynamic and passionate. Tiepolos' composition is more earthbound in an architectural framework that includes a fragment of an arcade painted within the real arch of the canvas. While the Madonna in the upper portion is tonally infelicitous and compositionally arbitrary, the three saints are painted in black and buff tones in response to Piazzetta. While Piazzetta's male saints are emaciated and other-worldly, Tiepolo's females are almost disturbingly ripe. They are, however, nonetheless transported. Perhaps Tiepolo understood, as had Bernini before him, that mysticism could be expressed through sensuality as well as austerity.

Demand for Tiepolo's services drew him away from Venice for increasingly long periods of time. In 1750 he set out for what was to be a several-year sojourn in Wurzburg where he executed perhaps his most celebrated frescoes in the Residenz for the new Prince Bishop. Once again the setting was dictated by a dynamic architect, Balthasar Neumann, and, again, Tiepolo responded with a resplendent work.

Working with his sons, particularly the gifted Giandomenico, as assistants, Tiepolo found few major commissions in Venice in his latter years. He was obliged to work in a number of northern Italian cities and villas. Finally he was called to Madrid in an exerted effort by King Charles III himself. Tiepolo undertook the trip reluctantly but hopefully. He arrived in Madrid, modello in hand, in 1762 and began a fresco in the throne room of the Royal Palace. *The Triumph of Spain,* not seen to best advantage under present conditions, owes much to the Wurzburg frescoes while it recognizes in its grandeur the more global rule of the Spanish monarchy. Although he may have been uncomfortable with Spanish protocol Tiepolo seems to have enjoyed working for a real monarch and remained in Madrid until his death.

For all his fame and undeniable genius Tiepolo was seen even in his own time as something of an anachronism. He was never invited to join the *Academie* in Paris, nor did Rome have any use for him. Even the conservative Venetians turned increasingly to the new realism of Longhi and others. Such grand schemes as Tiepolo excelled at were sought in places with imperial pretensions, German principalities, Milan under the Austrians, Stockholm, and Madrid. In a few decades after his death Europe would be in upheaval and the Serene Republic of Venice would cease to exist. Tiepolo's work would be dismissed as mere *souvenirs* of the old order.

Ironically Tiepolo speaks to us today with surprising freshness and audacity. With his dazzling technique and deft characterizations, worthy of a Shakespeare or a Molière, he continues to astonish.

—Frank Cossa

TINTORETTO.

Born Jacopo Robusti in Venice, September or October 1518; son of a dyer (tintor, hence his nickname). Died in Venice, 31 May 1594. Married Faustina Episcopi, 1550; three sons, the painters Giovanni Battista, Domenico, and Marco, one daughter, the painter Marietta, and four other daughters. Probably studied with Titian briefly; referred to as "master," 1539;worked for Scuola di S. Rocco (member 1565): decorated the entire building, 1576–88; by the time of the fires in the Doge's Palace, 1574 and 1577, he and Veronese were the leading artists commissioned to redecorate the interior: painted an enormous *Paradise*; large shop with many assistants; man of phenomenal energy ("il furioso"). Pupils: his children, Martin de Vos.

Major Collections: Venice: Scuola di S. Rocco, Madonna dell'Orto.
Other Collections: Bologna; Dresden; Dublin; Fort Worth; Hampton Court; Hartford, Connecticut; Lubeck; Madrid; Milan: Brera, Cathedral Museum; Munich; New York: Metropolitan, Frick, Morgan Library; Oxford: Christ Church; Paris; Rome: Corsini; Venice: Accademia, Doge's Palace, S. Giorgio Maggiore, S. Lazzaro dei Mendicanti, S. Marcuola, S. Maria Mater Domini, S. Rocco; Vienna; Washington.

Publications

On TINTORETTO: books—

Ridolfi, Carlo, *Vita di Tintoretto,* Venice, 1642; as *The Life of Tintoretto,* University Park, Pennsylvania, 1984.
Thode, Henry, *Tintoretto,* Bielefeld, 1901.
Holborn, John B., *Tintoretto,* London, 1903.
Phillips, Evelyn M., *Tintoretto,* London, 1911.
Osmaston, P. B., *The Art and Genius of Tintoret,* London, 2 vols., 1915.
Waldmann, Emil, *Tintoretto,* Berlin, 1921.
Hadeln, Detlev von, *Handzeichnungen des Tintoretto,* Berlin, 1922.
Bercken, Erich von der, and A. L. Meyer, *Tintoretto,* Munich, 2 vols., 1923, 1942.

Pittaluga, Mary, *Il Tintoretto*, Bologna, 1925.

Fosca, François, *Tintoret*, Paris, 1929.

Barbantini, Nino, *Tintoretto* (cat), Venice, 1937.

Branca, Vittore, and Mario Brunetti, *Tintoretto a San Rocco*, Venice, 1937.

Coletti, Luigi, *Il Tintoretto*, Bergamo, 1940, 3rd ed., 1951.

Bercken, Erich von der, *Die Gemälde des Tintoretto*, Munich, 1942.

Tietze, Hans, *Tintoretto: The Paintings and Drawings*, London, 1948.

Pallucchini, Rodolfo, *La giovinezza del Tintoretto*, Milan, 1950.

Newton, Eric, *Tintoretto*, London and New York, 1952.

Delogu, Giuseppe, *Tintoretto*, Milan, 1953.

Forlani, A., editor, *Disegni di Tintoretto e della suo scuola* (cat), Florence, 1956.

Hüttinger, E., *Die Bilderzyklen Tintorettos in der Scuola di S. Rocco zu Venedig*, Zurich, 1962.

Valsecchi, Marco, *Scuola di San Rocco: Tintoretto*, Novara, 1964.

Bianchini, M. A., *Tintoretto*, Milan, 1964.

Chiarelli, R., *Tintoretto: La Scuola di San Rocco*, Florence, 1965.

Delogu, Giuseppe, *Drawings by Tintoretto*, New York, 1969.

Vecchi, Pierluigi de, *L'opera completa del Tintoretto*, Milan, 1970.

Pallucchini, Rodolfo, and Paola Rossi, *Tintoretto: Le opera completa*, Milan, 3 vols., 1974–82.

Rossi, Paola, *Tintoretto: I ritratti*, Venice, 1974.

Rossi, Paola, *I disegni di Tintoretto*, Florence, 1975.

Kleinschmidt, Irene, *Gruppenvotivbilder venezianischer Beamter (1550–1630): Tintoretto und die Entwicklung einer Aufgabe*, Venice, 1977.

Mocanu, Virgil, *Tintoretto*, Bucharest and London, 1977.

Munari, Carlo, *Tintoretto: La pittura*, Florence, 1981.

Immagini del Tintoretto (cat), Rome, 1982.

Rosand, David, *Painting in Cinquecento Venice: Titian, Veronese, Tintoretto*, New Haven, 1982.

Swoboda, Karl M., *Tintoretto: Ikonofraphische und stilistische Untersuchungen*, Vienna, 1982.

Lepschy, Anna Laura, *Tintoretto Observed: A Documentary Survey of Critical Reactions from the 16th to the 20th Century*, Ravenna, 1983.

Valcanover, Francesco, *Tintoretto e la Scuola Grande di San Rocco*, Venice, 1983.

Valcanover, Francesco, and Terisio Pignatti, *Tintoretto*, New York, 1985.

Willems, Ulrich, *Studien zur Scuola di San Rocco in Venedig*, Munich, 1985.

*

Tintoretto's surname was Robusti, and he took the name Tintoretto from his father's profession of dyer (tintore). Writing within Tintoretto's lifetime Vasari describes Tintoretto's art as extravagant, capricious, hasty, and headstrong and says he was the most aggressive personality in the history of painting. He adds that Tintoretto sold as finished pictures what were really only sketches, showing every mark of haste in exposed brushwork and lack of draughtsmanship and of judgement. This severe verdict was partly a reflection of the difference in the mid-16th century between the Roman ideal, which was professed by Vasari and which was based on antique art and on meticulous draughtsmanship, and that of Venice which depended more directly on nature and on developing the technique of painting in oils. But Vasari's words may also indicate that he considered Tintoretto's training faulty, and to that extent there may be some truth in what he said. Tintoretto's first biographer, Ridolfi, writing in the mid-17th century, claimed that he only had ten days' apprenticeship with Titian who then turned him out from jealousy. Any suggestion that Titian was envious of the young Tintoretto's talent can be easily countered by comparing his somewhat uncouth early work with the superb accomplishment of what Titian was doing at the time (in the 1530's). The truth of the matter is probably that Titian found the pushing temperament, chronic impatience, and general brashness of the young Tintoretto intolerable and expelled him for that reason. But in any case the result was the same, namely a marked lack of technical *finesse* which supports Ridolfi's implication that Tintoretto was partly self-taught. Ridolfi adds that Tintoretto aimed to combine the painterly technique of Titian with the draughtsmanship of Michelangelo. Judged singly he fell far short of both. His true genius lay rather in the dynamism of his invention, and here Vasari was right in suggesting that Tintoretto was possessed by a kind of demon which drove him to ceaseless activity, often against time, and to a need to secure all the most important jobs, even at financial loss. He withdrew for a time the picture which first brought him notoriety—the *Miracle of St. Mark* (Venice, Accademia)—in the face of criticism (it represents St. Mark flying down to rescue a slave from torture, and is painted in a violently brutal style). His aggressive manner made him so unpopular that when the officials of the Scuola di S. Rocco were putting the decoration of their headquarters out to tender one of them would only subscribe on condition that the job should *not* go to Tintoretto. In the event he obtained it by a trick. Whereas competitors were instructed to submit a small model design for the central compartment of the ceiling of the Sala dell'Albergo in the confraternity's building, Tintoretto, with extraordinary industry, contrived to execute the full-size painting in the limited time allowed for the models, and then to get it secretly installed in position. He then offered to present it to the confraternity free of charge. Despite some understandable protests at this highly unethical behaviour the confraternity were unable to resist the obvious advantage and Tintoretto was given the contract for what was to prove his greatest work and one of the most extensive schemes of decoration ever executed by a single painter. On another occasion, at the church of S. Maria dei Crociferi, on hearing that Paolo Veronese had been commissioned to paint an altarpiece of the Assumption of the Virgin Tintoretto succeeded in transferring the commission to himself by undertaking to paint it in Veronese's style (picture now in the Gesuiti, Venice).

Nearly all of Tintoretto's huge output remains in Venice, where he was born and where he died. In addition to painting all the wall and ceiling paintings in both of the upstairs rooms at the Scuola di S. Rocco and the wall paintings in the hall on the ground floor—an undertaking which took even him more than twenty years—he painted three further large pictures of the miracles of St. Mark for the Scuola of that name (now divided between the Accademia, Venice, and the Brera, Milan) and even larger pictures for the church of the Madonna

Drawing for the Resurrection; London, Courtauld

walls, or ceiling being visible and consequently no indication whether we are looking at the action from a point above it or below or on a level. In these large compositions the human element is minimized. Tintoretto is always reluctant to reveal the features of any face fully. They are usually glimpsed from the back or side or are in shadow. When he does consent to reveal a face in the foreground it is usually devoid of expression. The emotions of an individual character are expressed in his gestures, not in his face. An example is the extraordinarily moving *Visitation* (Venice, Scuola di S. Rocco). The faces of both of the principal figures, who look as though they were on top of a mountain, are almost concealed, but the exhaustion of the Virgin Mary and the sympathy of St. Elizabeth are vividly conveyed by their bodies. Tintoretto is also the master of weird lighting effects, seen at its most astounding in two of the last canvases at the Scuola di S. Rocco—*St. Mary Magdalene* and *St. Mary of Egypt* seen against landscapes which look as though they were lit by glow-worms. It was these, as well as the broad manner of painting, which influenced the young El Greco, who was in Venice in the 1560's. For all of these reasons Tintoretto's approach is essentially romantic and unmonumental. But when faced with the absolute need for a monumental composition—above all, in the huge *Crucifixion* at the Scuola di S. Rocco—he is able to achieve it in his own way.

During most of his career Tintoretto seems to have operated with the minimum of assistants. At the end of his life his son, Domenico, worked with him. Another son, Marco, and a daughter, Marietta, were also painters.

—Cecil Gould

dell'Orto. Towards the end of his life he executed some of the most conspicuous paintings for the Collegio, Senate, and Sala del Maggior Consiglio of the Doge's Palace, following fires in 1574 and 1577. His picture of *Paradise* for the latter is one of the largest paintings in existence, if not actually the largest. In addition to all this Tintoretto executed very many portraits and some mythological subjects.

Tintoretto introduced a new element into Venetian painting. The art of Giovanni Bellini had been essentially placid, and though Titian, in the years prior to about 1530, had introduced the element of drama into his altarpieces and bacchanals, the degree of movement portrayed had been moderate and an essential decorum had exercised a certain restraining influence. But with Tintoretto this does not exist. The asymmetry of his compositions, lacking a pictorial centre, enabled him to treat his figures, usually small in comparison with the size of the painting, like leaves caught up in a whirlpool. His variety of viewpoints increases this effect. The figures in his larger canvases are hardly ever seen from the level. He looks down on them or up at them. They are glimpsed from one or other side (his *Crucifixion* at S. Cassiano was one of the first to be depicted from the side) and the table in his pictures of the Last Supper is always set violently asymmetrically, seen from above and extending backwards in space at an extreme angle. Sometimes, as in the *Martyrdom of St. Catherine* (Venice, Accademia) the scene might be set in outer space, no floor,

TITIAN.
Born Tiziano Vecelli in Pieve di Cadore, c. 1480's (estimates range widely). Died in Venice, 27 August 1576. Married Cecilia, 1525; son, the painter Orazio, and other children. Probably a pupil of Gentile, then of Giovanni, Bellini, but influenced by Giorgione (and completed some of his works); in Padua, 1511; he succeeded Giovanni Bellini as Painter to the Republic of Venice, 1516: his subsequent work in the Frari church, 1516-18, led to his fame; met Emperor Charles V at Bologna, 1532: was made Court Painter, 1533, and knighted 1533; visited Rome, 1545-46, the imperial court at Augsburg, 1548-49 and 1550-51 (met Cranach); continued to work for Charles V's successor, Philip II of Spain, after 1555; had a large shop.

Major Collections: Florence: Uffizi, Pitti; London; Madrid; Vienna.
Other Collections: Berlin; Besançon; Boston: Gardner; Brescia: SS. Nazaro e Celso; Cambridge; Detroit; Dresden; Dublin; Edinburgh; Escorial; Indianapolis; Kansas City; Kassel; Leningrad; London: Wallace; Malibu; New York: Metropolitan, Frick; Paris; Rome: Borghese, Doria Pamphili; Sao Paulo; Venice: Chiesa dei Gesuiti, Accademia, Doge's Palace, S. Maria dei Frari; Verona: Cathedral; Washington.

Publications

By TITIAN: book—

Le Lettere, edited by Giuseppe Vecellio, Cadore, 1977.

On TITIAN: books—

Fischel, Oskar, *Tizian: Des Meisters Gemälde,* Stuttgart, 1904, 5th ed., 1924.

Hadeln, Detlev von, *Zeichnungen des Tizian,* Berlin, 1924; as *Titian's Drawings,* London, 1927.

Suida, Wilhelm, *Tizian,* Zurich, 1933.

Barbantini, Nino, *Tiziano* (cat), Venice, 1935.

Foscari, Lodovico, *Iconografia di Tiziano,* Venice, 1935.

Hetzer, Theodor, *Tizian: Geschichte seiner Farbe,* Frankfurt, 1935, 1943.

Tietze, Hans, *Tizian: Leben und Werke,* Vienna, 2 vols., 1936; as *Titian: Paintings and Drawings,* London, 2 vols., 1937, 1950.

Mauroner, Fabio, *Le incisioni de Tiziano,* Venice, 1941.

Preston, Stuart, *Titian's "Europa,"* London, 1944.

Riggs, Arthur Stanley, *Titian the Magnificent and the Venice of His Day,* Indianapolis, 1946.

Beroqui, Pedro, *Tiziano en el Museo del Prado,* Madrid, 1946.

Argan, Giulio Carlo, *L'amor sacra e l'amor profano di Tiziano,* Milan, 1950.

Pallucchini, Rodolfo, *Tiziano,* Bologna, 2 vols., 1953–54.

Morassi, Antonio, *Tiziano: Gli affreschi della Scuola del Santo a Padova,* Milan, 1956.

Walker, John, *Bellini and Titian at Ferrara,* London, 1956.

Pope, Arthur, *Titian's Rape of Europa,* Cambridge, Massachusetts, 1960.

Valcanover, Francesco, *Tutta la pittura di Tiziano,* Milan, 1960; as *All, the Paintings of Titian,* New York, 4 vols., 1964.

Neumann, Jaromir, *Titian: The Flaying of Marsyas,* London, 1962.

Sutton, Denys, *Titian,* New York, 1963.

Kennedy, Ruth Wedgwood, *Novelty and Tradition in Titian's Art,* Northampton, Massachusetts, 1963.

Liberali, Giuseppe, *Lotto, Pordenone, e Tiziano a Treviso,* Venice, 1963.

Morassi, Antonio, *Tiziano,* Milan, 1964; Greenwich, Connecticut, 1965.

Skårsgård, Lars, *Research and Reasoning: A Case Study on a Historical Inquiry: Titian's Diana and Actaeon: A Study in Artistic Innovation,* Göteborg, 1968.

Williams, Jay, *The World of Titian,* New York, 1968.

Gould, Cecil, *The Studio of Alfonso d'Este and Titian's Bacchus and Ariadne,* London, 1969.

Pallucchini, Rodolfo, *Tiziano,* Florence, 2 vols., 1969.

Panofsky, Erwin, *Problems in Titian, Mostly Iconographic,* New York, 1969.

Valcanover, Francesco, and Corrado Cagli, *L'opera completa di Tiziano,* Milan, 1969.

Pilla, Eugenio, *Tiziano: Il pittore dell'Assunta,* Naples, 1969.

Wethey, Harold E., *The Paintings of Titian: Complete Edition,* London, 3 vols., 1969–75.

Mezieres, Philippe de, *Figurative Representation of the Pre-sentation of the Virgin in the Temple,* Lincoln, Nebraska, 1971.

Tiziano e la corte di Spagna nei documenti dell'Archivio Generale di Simancas, Madrid, 1975.

Oberhuber, Konrad, editor, *Disegni di Tiziano e della sua cerchia* (cat), Venice, 1976.

Rearick, W. R., *Tiziano e il disegno veneziano del suo tempo* (cat), Florence, 1976.

Rigon, F., *Tiziano: Iconografia Tizianesca al Museo di Bassano,* Bassano, 1976.

Gould, Cecil, *Titian as Portraitist,* London, 1976.

Pozza, Neri, *Tiziano,* Milan, 1976.

Muraro, Michelangelo, and David Rosand, *Tiziano e la silografia veneziana del cinquecento* (cat), Venice, 1976; as *Titian and the Venetian Woodcut,* Washington, 1976.

Fisher, M. Roy, *Titian's Assistants During the Later Years,* New York, 1977.

Garberi, Mercedes, et al., editors, *Omaggio a Tiziano: La cultura milanese nell'eta di Carlo V,* Milan, 1977.

Walther, Angelo, *Tizian,* Leipzig, 1978.

Gregori, M., editor, *Tiziano nelle gallerie fiorentine* (cat), Florence, 1978.

Pallucchini, Rodolfo, editor, *Tiziano e il manierismo europea,* Florence, 1978.

Rosand, David, *Titian,* New York, 1978.

Pignatti, Terisio, *Tiziano: Disegni,* Florence, 1979.

Gentili, Augusto, *De Tiziano a Tiziano: Mito e allegoria nella cultura veneziana del cinquecento,* Milan, 1980.

Tiziano e Venezia (colloquium), Vincenza, 1980.

Fasolo, Ugo, *Tiziano,* Florence, 1980.

Hope, Charles, *Titian,* London and New York, 1980.

Pignatti, Terisio, *Titian: The Complete Paintings,* New York and London, 1981.

Rosand, David, editor, *Titian: His World and His Legacy,* New York, 1982.

Rosand, David, *Painting in Cinquecento Venice: Titian, Veronese, Tintoretto,* New Haven, 1982.

Nash, Jane C., *Veiled Images: Titian's Mythological Paintings for Philip II,* Philadelphia, 1985.

Goffen, Rona, *Piety and Patronage in Renaissance Venice: Bellini, Titian, and the Franciscans,* New Haven, 1986.

*

The most prominent artist of the Venetian Renaissance, Titian had one of the longest and richest careers in the history of art, spanning about seventy years. Though a major artist of the Italian Renaissance, he was also very much a *Venetian* painter; in fact, along with his teacher Giovanni Bellini and his colleague Giorgione, Titian defined and perfected the major elements of Venetian painting: the interest in light, color, and a free and sensual brushwork which was unique in Italy. These he combined with the grandeur and humanism that marked the works of his colleagues elsewhere in Italy so that he developed a truly Venetian Renaissance style in his portraits, religious works, historical subjects, and mythological paintings. While raising Venetian painting to new heights, he also worked to raise the social status of artists in the 16th century: he connected himself to royal patrons such as Charles V and Philip II, and took pains that he received special honors as well as payment for his work. There is even an anecdote recounting

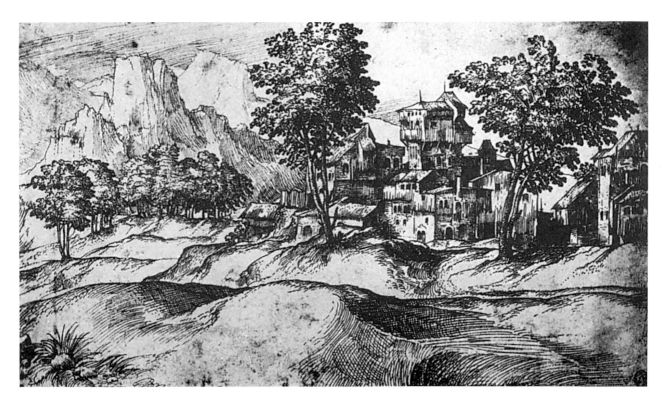

Dolomite Landscape; drawing

how Charles V stooped to pick up a paintbrush that the artist dropped in his studio, a tale which, true or not, suggests the esteem in which Titian was held by his contemporaries.

The richness and variety of Titian's talent can be already seen in two works which he painted while probably still in his twenties, the *Portrait of a Bearded Man* (c. 1511–15, London, National Gallery) and the *Assumption of the Virgin* (1516–18) which is still in its original location over the high altar of Sta. Maria Gloriosa dei Frari in Venice. The bearded man, who has been identified as the poet Ariosto by some and as a possible self-portrait by others, is above all a portrayal of the sort of aristocratic self-satisfaction enjoyed by many Venetians of the period. With no background to distract from the sitter, we focus on the lush fabric that forms the man's sumptuous sleeve but which in no way overpowers the somewhat arrogant face which looks out at us with an air of dominating composure.

In the *Assumption of the Virgin,* Mary is given as sensual a painterly treatment as she has ever received. Bathed in a golden light cast by a ring of putti, she floats upward to God who waits to receive her in heaven. The red of her garment helps create a sense of passion in the scene and at the same time leads the viewer's eye to the cloak of God above and to similar spots of red below in the group of apostles who watch her ascension in amazement. For the first time in Renaissance art, a composition is unified primarily through light and color; Titian has responded to the linear emphasis of Florentine-Roman style by asserting the superiority of his own interest in color.

As Frederick Hartt has remarked (*History of Italian Renaissance Art*, New York, 1987, p. 594) the face of the ascending Virgin "does not differ essentially from the face of Titian's nude goddesses or allegorical figures." Unlike most Christian

artists before him, he did not see spirituality and sensuality as mutually exclusive. Consequently, he would not have seen any contradiction in his use of the same model who posed for the *Assumption* in his first major pagan allegory, the *Sacred and Profane Love,* where she appears both nude and clothed in an elegant white gown. The precise meaning of this complex allegory is disputed, but it is significant that it is the nude who dominates the scene, moves to attract the attention of her companion, and may even have the loftier allegorical significance of the two figures.

The interest in painterly sensuality, whether in color, light, brushstroke, or the human nude, dominated Titian's allegorical and mythological paintings throughout the rest of his career. In the painting which he produced for Alfonso d'Este of Ferrara, the *Festival of Venus* (1518–19, Madrid, Prado), the *Bachanal of the Andrians* (c. 1522–23, Madrid, Prado), and *Bacchus and Ariadne* (1522–23, London, National Gallery), the nude female form is treated lavishly, set off against luxurious rose-colored satins, lush landscape, and the brilliantly painted ultramarine skies. The recumbent female nude, which dominated the foreground of the *Bacchanal of the Andrians* in that series, reappears as the central subject of the *Venus of Urbino,* one of the sexiest images in the history of art and the first in a long series of reclining "Venuses" that would spill from Titian's brush. Are these figures Venuses at all? There is no question that what first distinguishes Titian's "Venus" of Urbino from the nudes of his predecessors such as Botticelli or even Giorgione is his figure's move from pure nudity to nakedness. While Botticelli's Venus is marble or porcelain, Titian's is clearly flesh, and while Giorgione's is innocently asleep, Titian's is awake and coyly flirting with the viewer, challenging him not only with the pleasure of her body, but

also with the new touchable succulence that Titian has achieved with his brush.

Titian achieved this painterly sensuality with a new technique which he had begun developing virtually at the beginning of his career. He applied his paint in large, loose brushstrokes which weave a mesh of harmonizing colors through his forms. A close look at the flesh of the *Danaë* (Madrid, Prado) painted by Titian for Philip II in 1554, for instance, reveals touches of gold, rose, and mauve in dozens of variations. In addition, Titian fully explored the texture of his paint, molding his forms with contrasts of heavy impasto and thin veils of color; at times he even abandoned his brushes altogether and applied his pigments with his fingers. And over all of this he applied thin glazes, as many as thirty or forty he is said to have claimed, so that light would shimmer through the surface of his canvases to bring the image below to life. (Unfortunately the effect of his glazing has generally been lost through subsequent darkening and restoration attempts).

Titian used these techniques to increase the sensuality of his pagan subjects. He also adapted them to create dramatic and spiritual effects in his religious paintings. The use of glazes helps create the shimmering light that plays upon the forms in the *Pesaro Madonna* (1519-26, Venice, Sta. Maria Gloriosa dei Frari), and thereby aids in creating the illusion that we are looking through the wall of the church aisle to watch the miracle of the Virgin's reception of the Pesaro Family in actual daylight. The impact of this effect is heightened by the drama of the composition: anticipating the baroque painters of the following century, Titian abandons the centralized triangular composition preferred by High Renaissance artists in favor of a bold diagonal which overlays a series of interrelated triangular forms.

Even the boldness of a work such as the *Pesaro Madonna*, however, can hardly prepare us for the haunting religious images that Titian created in the last years of his life. In the *Crowning with Thorns* of c. 1570 (Munich, Alte Pinakothek) Titian returned to a subject which he had painted in the 1540's and gave it a new treatment, dissolving the muscular forms which had marked his earlier painting into a golden flickering light which suggests rather than defines the loosely painted forms. The Crowning of Thorns become less an actual event than a vision called forth by the penitent believer.

The visionary experience is sensed even more strongly in Titian's last painting, the *Pieta* (c. 1576, Venice, Accademia), which he intended to have placed over his own tomb in Sta. Maria Gloriosa dei Frari, but which remained unfinished when he died of the plague in 1576. The aged man's brush seems to search for the phantomlike figures rather than actually forming them. The light, coming from no clear source and obeying no natural laws, glows in the figure of Christ, highlights the face of Mary Magdalene, and shines off the mosaic of the self-sacrificing pelican feeding her young in the half-dome above. The mood of the painting is unmistakably spiritual and intensely personal. Titian has included his own portrait in the form of St. Jerome, who gazes at Christ's face, but even if unaware of this identification, one still senses the artist's intense search for salvation in the somber tones of the canvas.

Though rightfully renowned for his religious and mythological paintings, Titian was equally admired for his portraiture. Indeed, this "painter to princes" captured the features of many of the most notable figures of his time. He departed from the style of most of his colleagues, however, in going beyond that to explore the character of his sitters as well. Who can forget the romantic melancholy of the *Man with the Glove* (c. 1527, Paris, Louvre) who, surrounded by darkness, looks dreamily into the distance? One senses the unctuous character of Titian's unsavory friend Aretino (c. 1538, New York, Frick Collection), who puffs out his colossal frame in an attire of rich satin, fur, and an enormous gold chain. The *Portrait of Pope Paul III with his Grandsons Cardinal Alessandro and Ottavio Farnese* (1545-46, Naples, Museo di Capodimonte) captures not only the sharp features of the wily old Pope, but also the intrigues of papal politics in the obsequious genuflection of his nephew. His female portraits, whether the *Venus of Urbino,* which, besides being a possible mythological painting is also certainly a portrait, or other portrayals of the same model in such diverse paintings as the elegant *La Bella* (1536, Florence, Palazzo Pitti) or the intimate *Girl in Fur* (c. 1535-37, Vienna, Kunsthistorisches Museum), present a new portrayal of women as sensual and seductive as well as beautiful. In each of these genres Titian stands out as a leading master. What is perhaps most remarkable about him, however, is the diversity of his talents. This famous colorist created some of his most famous works with virtually monochromatic palettes. He could be as sensual in his mythological paintings as he was spiritual in his religious subjects. He, more than any other artist of his era, knew not only how to use the oil medium, but also how to exploit it and manipulate it to its full potential. It may seem contradictory, almost impossible, that a singular painter could have been a major influence on the two of the most different painters of the 17th century, Rubens and Rembrandt, but it is a sign of Titian's universality that he was.

—Jane Nash Maller

TOBEY, Mark.

Born in Centerville, Wisconsin, 11 December 1890. Died in Basel, 24 April 1976. Married briefly in the early 1920's. Attended schools in Wisconsin and Indiana; studied under Frank Zimmerman and Professor Reynolds, Art Institute, Chicago, 1906-08; worked as illustrator in a fashion studio, Chicago, 1909-10, and as interior designer, New York, 1918-22; studied calligraphy and composition under Teng Kwei, University of Washington, Seattle, 1922-25; taught at the Cornish School, Seattle, 1922-31, and at Dartington Hall, Devon, 1930-38; visited Japan and China, and renewed his contact with Teng Kwei in Shanghai, 1934-35; easel painter, Federal Art Project, 1938; settled in Basel, 1960.

Collections: Basel; Bremen; Buffalo; Krefeld; London: Tate; Milwaukee, New York: Moma, Metropolitan, Whitney; Portland, Oregon; St. Louis; San Francisco; Seattle, Stuttgart, Utica, New York.

Publications

Interspersed, 1970; gouache; 38¾ × 27¼ in (98.3 × 69.2 cm); Courtesy Willard Gallery

By TOBEY: book—

The World of a Market, Seattle, 1964

On TOBEY: books—

Roberts, Colette, *Tobey*, Paris and New York, 1959.
Thomas, Edward B., *Tobey* (cat), Seattle, 1959.
Alvard, Julien, *Retrospective Tobey* (cat), Paris, 1961.
Choay, Françoise, *Tobey*, Paris, 1961.
Seitz, William C., *Tobey* (cat), New York, 1962.
Schmied, Wieland, *Tobey*, Stuttgart and London, 1966.
Bowen, B., *Tobey's 80: A Retrospective* (cat), Seattle, 1970.
Russell, John, *Tobey*, New York, 1971.
Schmied, Wieland, *Tobey*, New York, 1972.
Taylor, Joshua C., *Tribute to Tobey* (cat), Washington, 1974.
Heidenheim, Hanns H., *Tobey: Das graphische Werk*, Dusseldorf, 1975.
Wember, Paul, *Tobey: Rückblick auf harmonische Weltbilder* (cat), Krefeld, 1975
Yao, Min-chih, *The Influence of Chinese and Japanese Calligraphy on Tobey*, San Francisco, 1983.
Dahl, Arthur L., et al., *Tobey: Art and Belief*, Oxford and St. Louis, 1984.
Rathbone, Eliza, *Tobey: City Paintings* (cat), Washington, 1984.
Ott, Gunter, *Tobey: Graphische Arbeiten* (cat), Cologne, 1987.

articles—

Giese, Lucretia H., "Tobey's 1939 Murals for the John A. Baillargeons: A Transition," in *Archives of American Art Journal* (Washington), 23, 1983.
Rathbone, Eliza, "The Role of Music in the Development of Tobey's Abstract Style," in *Arts Magazine* (New York), December 1983.

*

The calligraphic "white writing" of Mark Tobey stands as his major contribution to modernism. Secondarily, his formulation of a spatially ambiguous, overall composition of repetitious and undifferentiated line heralds the "drip" paintings of Pollock. Yet his breakthrough developed not from the secular *angst* of the American Abstract Expressionists and the School of Paris painters (to whom Tobey was regarded as the foremost American painter of those post-war years). Tobey's development of an abstract mode derived from his intense beliefs in the Bahai'i faith. In that regard, he belongs to a fellowship of stylistic pioneers in modern art (Kandinsky, Malevich, Mondrian) whose adoption of pure abstraction was spiritually or metaphysically motivated.

The Bahai'i tenets of unity, humanity, and "progressive revelation" are first seen in Tobey's use of its cosmological symbolism, lending to his early work a stilted romanticism and profundity. Tobey manifested his fascination with Oriental religion, art, and philosophy after visiting Asia in 1934, to study calligraphy and meditate at a Zen monastary. He abandoned a pseudo-Cubistic modeling of form for a linear description applied to representational elements in concert with purely abstract and spatial motifs. The small abstract tempera painting *Broadway Norm* (1935) announced this change with its matrix of coiling white line. The encroachment of Eastern pictorial modes propelled Tobey's art into its most genuinely individualistic and diverse phase—an inner expression of spiritual man and the city manifested as light, noise and energy.

Returning to Seattle at the eve of World War II, Tobey further developed his "white writing," which took the form of angular and curvilinear networks of line over a tonally dark and modulated ground. Figurative elements and intimations of architectural form (Gothic vaults and spires, city lights, vertically thrusting skyscrapers) were compressed and distributed across the picture plane. This formula eventually transfigured into non-hierarchial, non-objective abstract compositions: dense patterns of line expanding out to the picture edge, seeming to palpitate with a shifting focus and depth. Tobey's modified late style stemmed from experiments with *sumi* painting in the late 1950's. A broader stroke and more dabbled gesture took its place alongside his *repertoire* of anastomotic inscriptions; the "white writing" gave way to polychrome and black. Surface pattering became more chromatic and decorative, even serene. Controlled gestural surfaces superseded the spontaneous and energized calligraphy.

Tobey accepted the organic and dynamic Romantic conception of artistic creation as the proper analogue to a universal and religious interpretation of Creation. His deeply felt faith leads to the regard of his diverse art as emotionally and spiritually authentic despite stylistic and thematic fluctuations and inconsistencies. "The dimension that counts for the creative person is the Space he creates within himself," Tobey once wrote. "This inner space is closer to the infinite. . . ." What William Seitz has called his "world view" is Tobey's dynamic and dualistic encompassing of the inner and outer self, of internal and external space, and the synthesis of Eastern and Western thought. "At a time when experimentation expresses itself in all forms of life, search becomes the only valid expression of the spirit. . . ."

—Ron Glowen

TOULOUSE-LAUTREC, Henri (Marie Raymond de).

Born in Albi, 24 November 1864. Died in Chateau de Malrome, 9 September 1901. Broken legs in childhood stunted his growth; attended Lycée Fountaines (now Lycée Condorcet), Paris, 1872-74, then with tutors; studied painting under René Princeteau in Paris, 1882; set up in his own studio in Paris from 1885: illustrator for magazines, posters, color prints; visited Brussels, 1894, and London, 1895 and later; treated for alcoholism, 1899.

Major Collections: Albi: Musée Toulouse-Lautrec; Paris.
Other Collections: Amsterdam: Stedelijk; Boston; Bremen; Chicago; Cleveland; Copenhagen; Hamburg; Hartford, Connecticut; London: Tate, Courtauld; Munich: Neue Pinakothek; New York: Whitney; Paris: Petit Palais; Prague; Sao Paulo; Washington; Zurich.

Publications

By TOULOUSE-LAUTREC: books—

Unpublished Correspondence, edited by Lucien Goldschmidt and Herbert Schimmel, London, 1969.
Lettres 1871–1901, edited by Lucien Goldschmidt and Herbert Schimmel, Paris, 1972.
The Lautrec-W. H. B. Sands Correspondence, edited by Herbert Schimmel and Phillip D. Cate, New York, 1983.

On TOULOUSE-LAUTREC: books—

Coquiot, Gustave, *Toulouse-Lautrec*, Paris, 1913, 1920.
Delteil, Loys, *Le Peintre-graveur, vols, 19–20: Toulouse-Lautrec*, Paris, 1920.
Jedlicka, Gotthard, *Toulouse-Lautrec*, Berlin, 1929, Zurich, 1943.
Mac-Orlan, Pierre, *Toulouse-Lautrec, peintre de la lumière froide*, Paris, 1934.
Guérin, Marcel, *Lithographies de Toulouse-Lautrec*, Paris, 1948.
Delaroche-Vernet-Henraux, Marie, *Toulouse-Lautrec dessinateur*, Paris, 1949.
Dortu, M. G., *Toulouse-Lautrec*, Paris, 1950.
Julien, Edouard, *Les Affiches de Toulouse-Lautrec*, Monte Carlo, 1950, 1967; as *The Posters of Toulouse-Lautrec*, Monte Carlo, 1951.
Roger-Marx, Claude, *Yvette Guilbert vue par Toulouse-Lautrec*, Paris, 1950.
Julien, Edouard, *Dessins de Toulouse-Lautrec*, Paris, 1951.
Bellet, L. Charles, *Le Musée d'Albi*, Albi, 1951.
Jourdain, Francis, and Jean Adhémar, *Toulouse-Lautrec*, Paris, 1952.
Dortu, M. G., Madeleine Grillaert, and Jean Adhémar, *Toulouse-Lautrec en Belgique*, Paris, 1953.
Lassaigne, Jacques, *Toulouse-Lautrec*, Geneva, 1953.
Heintzelman, A. W., and M. R. O. Heintzelman, *110 Unpublished Drawings of Toulouse-Lautrec*, Boston, 1955.
Cooper, Douglas, *Toulouse-Lautrec*, Paris, 1955, New York 1956.
Roger-Marx, Claude, *Toulouse-Lautrec*, Paris, 1957.
Focillon, Henri, and Edouard Julien, *Dessins de Toulouse-Lautrec*, Albi, 1959.
Sutton, Denys, *Lautrec*, London, 1962.
Bouret, Jean, *Toulouse-Lautrec*, Paris, 1963; as *The Life and Work of Toulouse-Lautrec*, New York, 1966.
Huisman, Philippe, and M. G. Dortu editors, *Lautrec par Lautrec* Lausanne, 1964; as *Lautrec by Lautrec*, New York, 1968.
Adhémar, Jean, *Toulouse-Lautrec: Lithographies, pointes sèches, Paris, 1965; as Toulouse-Lautrec: His Complete Lithographs and Drypoints*, New York, 1965.
Fermigier, Andre, *Toulouse-Lautrec*, Paris and New York, 1969.
Sugana, Gabriele, *L'opera completa di Toulouse-Lautrec*, Milan, 1969; as *The Complete Paintings of Toulouse-Lautrec*, New York, 1969; London, 1973, 1987.
Paret, P., *Lautrec: Femmes*, Paris, 1969.
Dortu, M. G. *Toulouse-Lautrec et son oeuvre*, New York, 6 vols., 1971.

Musée Toulouse-Lautrec: Catalogue, Albi, 1973.
Desvoisins, Louis, *Le Carton à dessin de Toulouse-Lautrec du Musée d'Albi*, Toulouse, 1974.
Adriani, Götz, *Toulouse-Lautrec: Das gesamte graphische Werk* (cat), Cologne, 1976; as *The Complete Graphic Works*, London, 1988.
Polášek, Jan, *Toulouse-Lautrec: Drawings*, New York, 1976; Minneapolis, 1985.
Shone, Richard, *Toulouse-Lautrec*, London, 1977.
Thomson, Richard, *Toulouse-Lautrec*, London, 1977.
Lucie-Smith, Edward, *Toulouse-Lautrec*, Oxford, 1977, 1983.
Adriani, Götz, *Toulouse-Lautrec und das Paris um 1900*, Cologne, 1978.
Stuckey, Charles F., *Toulouse-Lautrec: Paintings* (cat), Chicago, 1979.
Wittrock, Wolfgang, *Toulouse-Lautrec: Catalogue complet des estampes*, Paris, 2 vols., 1985; as *The Complete Prints*, London, 2 vols., 1985.
Castleman, Riva, and Wolfgang Wittrock, *Toulouse-Lautrec: Images of the 1890's* (cat), New York, 1985.
Feinblatt, Ebria, *Toulouse-Lautrec and His Contemporaries: Posters of the Belle Epoque* (cat), Los Angeles, 1985.
Cate, Phillip D., *The Circle of Toulouse-Lautrec* (cat), New Brunswick, New Jersey, 1986.
Adriani, Götz, *Toulouse-Lautrec* London, 1987.

*

Like his fellow Post-Impressionists van Gogh and Seurat, Toulouse-Lautrec accomplished the invention of a visual idiom and the creation of a personal world through its use, all within a single decade of creativity. Like them, he felt the need for a form more decisive than the suggestive poetry of Impressionism in which to place his sense of person and place. For him, it was Degas and Japanese prints which moved him to modernity, and gave him access to a creativity of observation and recording—much of his art is really elegant reportage—in the Parisian night world of his acquaintances and friends.

He was brought to this world by accident: his already fragile body would not allow two leg bones broken in his teens to resume their normal growth, and so his mature torso rested upon stunted supports. Toulouse-Lautrec said that were it not for his handicap, he would most likely have become a sporting artist, recording the country activities of his aristocratic relatives and friends. Having already gone to school in Paris as a child, after some years of convalescence at home, he returned to live and attend academic art classes in Paris in 1882. Toulouse-Lautrec probably met Degas in 1885 when chance brought them to the same studio building. He already knew Degas's work, and with other influences—van Gogh and other young progressive artists in that unsettled moment—he recast with his own loving, melancholy, and sarcastic temperament the world of contemporary subject matter: cafe and music hall, the private life of women, the racecourse, the theatre, dancers, portraits (always carefully chosen, since he had no need to make money by his work)—and the brothel, no doubt inspired by the tiny but complex monotype prints that Degas might have shown him.

After working in an Impressionist manner close to Pissarro through its tightness in late 1880's, Toulouse-Lautrec gained a feeling for linear effects with emphatic shaped areas, and the

The Jockey, 1899; lithograph

more brilliant, matte paint surfaces became more assured. From then on his mature style was formed; henceforward, important changes in his work were mainly restricted to new subject matter as circles of friends altered and new personalities entered his life. This sometimes led to groups of work centered about a certain theme. For instance, through his close friend and cousin, Dr. Gabriel Tapié de Celeyran, a medical student, Toulouse-Lautrec came to be obsessed with a surgeon, Dr. Péan, and made more than 30 drawings and several paintings of the hospital world. Again, once Toulouse-Lautrec and his circle began frequenting the new "in" night spot, the Moulin Rouge, his work records its habitués and entertainers. One of his largest paintings, which he kept all his life, was *At the Moulin Rouge* (1895; Chicago, Art Institute). The work is marked by a compositional extravagance absorbed from Degas, seen in the raking angle of the floor, adjacent views of figures close-up and distant, and figures cut off by the frame. Moreover, he achieved a synthesis of flat patterning, with vivid content and shape against the rendition of space. Every figure in the work can be identified as a relative, friend, or acquaintance.

The aesthetic of *At the Moulin Rouge* is closely associated with Toulouse-Lautrec's long involvement with lithography, since its thinned paint and freely drawn quality tend to mimic the lithographic process. His famous six-foot-high Moulin Rouge poster of 1891 announced a new era for the Parisian color poster; Toulouse-Lautrec altered the pleasantly decorative effects of the successful Cheret style with his full flood of witty caricature and linear and colorist play reflecting Japonisme and the emerging art nouveau. These essential graphic qualities were to influence his painted work for the next seven years, until, deeper into illness and despair, Toulouse-Lautrec began his final manner, the more painterly mode seen in *The Modiste* (1900, Albi). In the great French tradition of rational yet incisive compassion, Toulouse-Lautrec revived the *Human Comedy* of Balzac in his own survey of human possibility.

—Joshua Kind

TRAINI, Francesco.

Active in Pisa, c. 1321–63. Associated with the circle of Simone Martini and Lippo Memmi in Pisa; principal documented work is the St. Dominic altarpiece, S. Caterina, Pisa; few other established works; associated with the *Triumph of Death* in the Camposanto, Pisa.

Collections: Nancy; Pisa: Camposanto, Museum, S. Caterina; Princeton: University.

Publications

On TRAINI: books—

Oertel, Robert, *Traini: Der Triumph des Todes im Camposanto zu Pisa*, Berlin, 1948.

Sanpaolesi, P., Mario Bucci, and Licia Bertolini, *Camposanto monumentale di Pisa: Affreschi e sinopie*, Pisa, 1960.
Procacci, U., *Sinopie e affreschi*, Florence, 1960.
Meiss, Millard, *Traini*, edited by Hayden B. J. Maginnis, Washington, 1983.

articles—

Meiss, Millard, "The Problem of Traini," in *Art Bulletin* (New York), 15, 1933.
Paccagnini, G., "Il problema documentario di Traini," in *Critica d'Arte* (Modena), 8, 1949.
Bucci, Mario, "Un 'San Michele Arcangelo' di Traini nel Museo Nazionale di Pisa," in *Paragone* (Florence), 13, 1962.
Longhi, Roberto, "Qualche altro appunto sul Traini e suo seguito," in *Paragone* (Florence), 13, 1962.
Laclotte, M., "Une 'Madonne' de Traini au Prado," in *Paragone* (Florence), 15, 1964.

*

Francesco Traini was a Pisan artist, who is known through documents to have been active about 1321–63. His artistic reputation over the centuries has depended largely upon the very brief biographical notes on him written by Giorgio Vasari in his second edition of *The Lives*. Similarly, the attendant scholarly debates and misunderstandings surrounding Traini's oeuvre also derived from this same source. In fact, Vasari's notice on Traini appears not as a separate entry, but rather as an addendum to the full-scale biography of the Florentine artist Orcagna (Andrea di Cione), whom Vasari erroneously believed to be Traini's teacher. Thus, Vasari's opening words of praise mask the first of a series of errors when he declares, "But of all Orcagna's pupils none excelled Francesco Traini. . . ." Vasari had typically scrambled the chronology, unaware that Orcagna (active about 1343–68) came after Traini, rather than the other way around.

Vasari attributed two altarpieces to Traini, both painted for the Church of Santa Caterina in Pisa. The first is the triptych of *Saint Dominic*, which includes a large central cult image of the saint flanked by eight lively narrative scenes from the saint's life, framed in quatrefoils, and surmounted by triangular prophet pinnacles. The central pinnacle shows *Christ Blessing*. Now in the National Museum of San Matteo, Pisa, this panel is signed FRANCISCUS TRAINI PIN[XIT] and datable by documents to 1344–45.

The second altarpiece that Vasari attributed to Traini is the *Glorification of Saint Thomas Aquinas*, still in the Church of Santa Caterina for which it was originally painted. Concerning this second panel, which Vasari preferred, the biographer commented, "On the completion of this work Francesco Traini acquired great name and fame, for he had far surpassed his master Andrea [Orcagna] in coloring, harmony and invention." Subsequent generations followed Vasari's lead in ranking the *Glorification of Saint Thomas* over the *Saint Dominic* altarpiece. Indeed, Vasari's writings carried such weight over the centuries that it was only in the 1930's that Traini's authorship of the *Glorification* was challenged, and its relationship to the Sienese school recognized. This panel is now widely at-

tributed to Lippo Memmi, the brother-in-law and collaborator of Simone Martini.

But it has only been since the 1930's, with the removal of the *Glorification* from Traini's oeuvre and the certain identification of the *Saint Dominic* triptych as an autograph work, that critics have been able to form a consistent notion of Traini's style. This, in turn, has allowed the reconstruction of the artist's oeuvre around the single autograph panel. This nucleus includes such works as *Saint Anne with the Virgin and Child* in the Princeton University Art Museum and the *Madonna and Child* in the National Museum of San Matteo in Pisa. While Traini's large cult images tend to be monumental and static, his narrative style is active and fluid, peopled with organic, vigorous figures set in spatially complex settings. In contrast to the Sienese school, Traini willingly sacrificed physical beauty in favor of greater emotional intensity. In this, his style goes back to Giovanni Pisano, his great Pisan predecessor.

Although critics remain divided on the issue of Traini's authorship of the vast *Triumph of Death* and related frescoes in the Camposanto, Pisa, a convincing case can be made for the artist on stylistic grounds. Indeed, in depicting the themes of Death and Judgment, Traini's fluid narrative style and forceful expression of a wide range of emotional states provide him with the means to depict the brutality, violence, and horror inherent in the subject. Despite the stylistic affinities between Traini's *Saint Dominic* panel and certain of the Camposanto frescoes, however, many Italian scholars favor a tradition handed down by Ghiberti, which ascribes the Pisan frescoes to a Florentine master, Buonamico di Cristofano, called Buffalmacco.

—Ruth Wilkins Sullivan

TRUMBULL, John.

Born in Lebanon, Connecticut, 6 June 1756; son of the Governor of Connecticut. Died in New York, 10 November 1843. Attended Harvard University, Cambridge, Massachusetts, graduated 1773; served in the war of independence: sketched plans of British works in Boston, aide-de-campe to Washington, and deputy adjutant to Gates: resigned, 1777; then studied under Benjamin West in London, 1780 (imprisoned for 7 months on charges of spying); visited Paris, 1785; then set up as painter of portraits (including Washington) and historical pictures; annuity from Yale University, 1831, in exchange for a collection of his works.

Major Collection: New Haven.
Other Collections: Boston; Hartford, Connecticut; Wadsworth Atheneum, Connecticut Historical Society; New Haven; New York: Metropolitan, City Hall.

Publications

By TRUMBULL: books—

Address Before the Directors of the American Academy of Fine Arts, New York, 1833.

Autobiography, Reminiscences, and Letters, New York, 1841; edited by Theodore Sizer, New Haven, 1953.

On TRUMBULL: books—

Weir, J. F., *Trumbull: A Brief Sketch of His Life to Which Is Added a Catalogue of His Works,* New York, 1901.
Morgan, John H., *Paintings by Trumbull at Yale University,* New Haven, 1926.
Sizer, Theodore, *The Works of Trumbull, Artists of the American Revolution,* New Haven, 1950, 1967.
Jaffe, Irma B., *Trumbull, Patriot-Artist of the American Revolution,* Boston, 1975.
Jaffe, Irma B., *Trumbull: The Declaration of Independence,* New York, 1976.
Cooper, Helen A., *Trumbull: The Hand and Spirit of a Painter* (cat), New Haven, 1982.

*

Soldier, diplomat, writer, polemicist, arts administrator, architectural designer, leading portraitist and history painter, and even sometime landscapist, John Trumbull lived an active and colorful life for eighty-seven years. Born to the illustrious Connecticut family of Jonathan Trumbull (the first Governor of the state), Trumbull was made to attend Harvard College instead of pursuing the artistic studies he would have preferred. Once in the Boston area, he read all that the college library offered on art instruction, studied the art collection (which included prints and some portraits by Copley and others), and even consulted Copley in person.

An ardent patriot, Trumbull served in the Revolutionary War, at one point as Washington's aide-de-camp. After his military service, he took up painting seriously: an early self-portrait (1777, Boston, Museum of Fine Arts) shows an eager young man with palette and Hogarth's *Analysis of Beauty* prominently displayed. The sober coloring, dramatic dark/light contrast, and placement of the figure are reminiscent of Copley's portrait style before his recent departure from the colonies.

Trumbull did not receive formal training in the arts until he was twenty-four, when, with the war still in progress, he left for England to further his artistic career. He affiliated himself with his successful fellow-American Benjamin West (1738–1820), but once again politics interfered when he was jailed on charges of espionage. (Recent research suggests that his actions may not have been entirely innocent.) Released and sent home, he doggedly strove to return, and did in 1784. Public recognition came later that year, when his portrait of *Sir John Temple, 8th Baronet* (1784, Canajoharie, N.Y., Canajoharie Library and Art Gallery) and a classical subject (unlocated) gained prominent places at the annual exhibition of the Royal Academy. *Sir John Temple* was an accomplished portrait in the English manner, the face and drapery fluidly modeled. In 1786, he showed *Priam Returning to His Family, with the Dead Body of Hector* (1785, Richmond, Virginia Museum of Fine Arts) at the Royal Academy, the earliest of his English historical compositions to survive. Classical in organization, Rubensian in figure style and color, *Priam* marks a new maturity in Trumbull's work. Travels to France and Germany at this time, in addition to introducing him to important per-

sonages such as Jacques-Louis David, opened his eyes to the wonders of baroque art, which became an important influence in his work.

Although Trumbull made his living primarily by painting portraits, Henry Tuckerman argued in 1867 that "the dominant idea of Trumbull, in his artistic labors, was to celebrate great events." The American Revolution was the great event which provided lofty subject matter, noble deeds, and sublime emotion to inspire some of Trumbull's best work: several excellent portraits of Washington (especially the 1792 version at Yale) and eight small history paintings (New Haven, Yale University Art Gallery). In 1817, the U.S. Congress requested him to paint four panels for the Capitol rotunda in Washington, D.C. This coveted commission, which took seven years to complete, netted him $32,000, making him one of the best compensated artists of the young republic. The large-scale paintings, unfortunately, lack the vitality of the smaller, earlier series at Yale.

During a final sojourn in England (1808–15), Trumbull completed a number of large compositions on religious and literary themes. *Lamderg and Gelchossa* (1808, New Haven, Yale University Art Gallery), a highly romantic subject based on Ossian's (that is, James MacPherson's) "Fingal," was exhibited at the British Institution in 1810. A scriptural narrative, *Our Saviour and Little Children* (1812, New Haven, Yale University Art Gallery), which appeared at the Royal Academy in 1812, was among the most West-like of all Trumbull's works, seeking to capitalize on the success of West's *Christ Healing the Sick* in 1811.

Two years after returning to the United States in 1815, Trumbull assumed the presidency of the American Academy of the Fine Arts, a position he retained until 1836. During the early 1820's, he reigned as autocrat and major tastemaker in New York City, seeking to educate a reluctant public to the virtues of history painting in the Grand Manner. After the installation of the Capitol panels in 1824, his career declined. He spent a lengthy and vigorous old age completing scriptural narratives begun in his youth, copying Old Masters, and writing his autobiography.

Although often uneven technically, Trumbull's work represents a valiant attempt by a "provincial" to master the subjects and style of the great artists of the past. The best of his portraits, besides being excellent likenesses, are painterly expressions of personality. His finest history paintings display vigorous draftsmanship, dynamic composition, and brilliant color. His political, literary, and artistic friendships placed him at the forefront of cultural life on two continents.

—Patricia M. Burnham

TURA, Cosmè

Born in Ferrara, c. 1430. Died in Ferrara, April 1495. Influenced by Mantegna; court painter of the Ferrara court for the Este family from 1452, though much of his output is lost (e.g., decorations for the library of Pico of Mirandola from the 1460's); succeeded as court painter by Ercole de' Roberti.

Collections: Ajaccio; Bergamo; Berlin; Boston: Gardner; Caen; Cambridge, Massachusetts; Ferrara: Museum, Museo del Duomo; Florence; London; Milan; Modena; Nantes; New York; Paris; Philadelphia; Rome: Colonna; Rotterdam; San Diego; Venice: Accademia, Correr; Washington.

Publications

On TURA: books—

Cittadella, Luigi N., *Ricordi e documenti intorno alla vita di Tura*, Ferrara, 1866.
Ortolani, S., *Tura, Francesco del Cossa, Ercole Roberti*, Milan, 1941.
Nicolson, Benedict, *The Painters of Ferrara . . .* , London, 1950.
Neppi, Alberto, *Tura*, Milan, 1952.
Salmi, Mario, *Tura*, Milan, 1957.
Ruhmer, Eberhard, *Tura: Paintings and Drawings: Complete Edition*, London, 1958.
Bianconi, P., *Tutta la pittura di Tura*, Milan, 1963.
Riccomini, E., *Tura*, Milan, 1965.
Molajoli, Rosemarie, *L'opera completa di Tura e i grand pittori ferraresi del suo tempo: Francesco Cossa e Ercole de Roberti*, Milan, 1974.

*

Cosmè Tura was among the most spirited and original artists of the Italian Renaissance. His bizarre and artificial paintings are easily recognizable, with their bent, metallic draperies, bright, phosphorescent colors, playfully distorted anatomies, quick-stepped figures, and barren landscapes with leafless trees and rocky, spiralling mountains; his textures appear brittle, and seem to be made of some fine, hard substance, such as porcelain, glass, or marble. Tura was enormously influential in Ferrara, and his style affected the works of panel painters, miniaturists, and even sculptors.

There are no documented, surviving works from Tura's early years, and it is hardly surprising that the origins of so independent a genius should remain obscure. Tura's works have some affinity with the works of Marco Zoppo and Giorgio Schiavone, and it is plausible that, like many other north Italian artists, Tura had imbibed the mannered, decorative style of Squarcione and his Paduan "academy." Tura's physiognomic types and angularity have some affinity with mid-quattrocento Venetian artists, such as Bartolomeo Vivarini, and is perhaps significant that in his will of 1471 Tura left money to the poor people of Venice, suggesting that he had spent time there before his almost continuous employment with the Este in Ferrara after the mid-1450's. It is also possible that Tura's early development was influenced by Michele Pannonio, the previous court painter in Ferrara, whose style—to judge from his fantastic, strange *Thalia* in Budapest—could have served as a model for Cosmè.

Tura's datable works fall to 1469 and after; paintings made before then must be dated hypothetically. His *Madonna and Saints* now in the Musée Fesch (Ajaccio), is among the earlier

works that can safely be attributed to him, made perhaps about 1460. The work has the primitive energy and bold coloring that would be Tura's hallmark. Tura's first datable work is one of his greatest: his organ doors for the Cathedral in Ferrara, including an *Annunciation* and a *St. George and the Dragon* (1469). The stylized linearity in the *St. George* is of an artificiality unsurpassed in Tura's oeuvre; the neighing horse and the fluttering, broken drapery of the running Princess raise a high emotional pitch. The finest surviving example of Tura's art is his *Roverella Altarpiece* of 1474, made with bold coloring and anatomical peculiarities. By this time Tura's style was fully formed; his works were perfectly suited to the prevalent courtly tastes in Ferrara, where patrons, both Este and non-Este, favored variety, witty stylization, and decorativeness in all of the arts. Some critics impute Tura's strange manner to the demonic proclivities of his patrons or to the artist's religious fury, but it is most likely that his artful and fantastic style was a response to the Ferrarese penchant for wit and inventiveness.

A salient aspect of Tura's style was his opposition to the delicate and refined International Gothic. Tura was versatile, and some of his smaller works, such as the *Madonna and Child in a Garden* (Washington, National Gallery of Art) are serene and gentle. Still, Tura's usual style, as is especially obvious in his larger public works, was brittle and biting, and would have struck Ferrarese contemporaries as revolutionary, in contradiction to the pleasant and florid Gothic style that had prevailed in north Italian courts in the previous generation. Tura pushed his opposition to sweetened Gothicism furthest in his latest works; his *St. Anthony of Padua* (Modena, Galleria Estense), datable to 1484, is an invaluable tool in judging his last style, with its grossly exaggerated anatomy, willful distortions of perspective, and caricatured emotions. It elevates to an extreme Tura's principles of willful artfulness and originality.

Tura's style was indebted to the kind of work that his position of court painter entailed. His documented output included the production of ephemera and decoration: the gilding of furniture, the painting of banners and coats-of-arms, and the design of tapestries and plate-ware. Such work as decorator must have affected his painting style, which achieves such direct and instant appeal. Our view of Tura's life and art would be very different if more of his secular work had survived, for it is there—to judge from his *Venus* in London (National Gallery)—that he applied his most capricious ideas. Of one category of secular art, portraiture, we have no secure works left, for the *Este Prince* in the Metropolitan Museum is perhaps a fragment from a larger work, and the *Portrait of a Man* in Washington is a doubtful attribution.

Tura must have been ill for the last decade of his life, for his activity peters out after the mid-1480's; he gave up his post as court painter by 1486, and he died in 1495. His style did not long survive his active years, for an artistic wave of detente and quiet piety swept Italy at the end of the quattrocento. For all of his independence, Tura had essentially remained characteristic of his generation, working in what Vasari called the "hard and stony manner" of the 15th century. Tura's style, which for all of its peculiarities and exaggerations somehow never seems excessive, is remarkable for its sophistication and vitality. Today, Tura maintains a high critical standing, and is ranked as the leading genius of 15th-century Ferrarese art.

—Joseph Manca

TURNER, J(oseph) M(allord) W(illiam).
Born in London, 23 April 1775. Died in London, 19 December 1851. Entered the Royal Academy Schools, 1789; exhibited watercolors from 1790, and oils from 1796; elected member of the Royal Academy, 1802: Professor of Perspective, 1807–37, and Deputy President, 1845–46; first visit to Italy, 1819; left his paintings to the nation.

Major Collections: London: Tate, National Gallery, Courtauld, British Museum, Victoria and Albert; New Haven.
Other Collections: Cambridge; Cambridge, Massachusetts; Cardiff; Chicago; Cincinnati; Cleveland; Dublin; Edinburgh; Indianapolis; Lisbon: Gulbenkian; Liverpool; Manchester: City Art Gallery, Whitworth; Melbourne; New York: Metropolitan, Frick; Ottawa; Washington.

Publications

By TURNER: books—

The Sunset Ship (poems), edited by Jack Lindsay, London, 1966.
Collected Correspondence, edited by John Gage, Oxford, 1980.

On TURNER: books—

Thornbury, Walter, *The Life of Turner,* London, 1862, 1877.
Rawlinson, William G., *The Engraved Work of Turner,* London, 2 vols., 1908–13.
Finberg, A. J., *A Complete Inventory of the Drawings of the Turner Bequest,* London, 2 vols., 1909.
Finberg, A. J., *Turner's Sketches and Drawings,* London, 1910, New York, 1968.
Finberg, A. J., *The History of Turner's Liber Studiorum,* London, 1924.
Finberg, A. J., *In Venice with Turner,* London, 1930.
Finberg, A. J., *The Life of Turner,* revised by H. F. Finberg, Oxford, 1939, 1961.
Butlin, Martin, *Turner: Watercolours,* London, 1962.
Kitson, Michael, *Turner,* London, 1964.
Gowing, Lawrence, *Turner: Imagination and Reality,* New York, 1966.
Lindsay, Jack, *Turner: A Critical Biography,* London and Greenwich, Connecticut, 1966.
Butlin, Martin, *Watercolours from the Turner Bequest 1819–1845,* London, 1968.
Herrmann, Luke, *Ruskin and Turner,* London, 1968.
Gage, John, *Colour in Turner: Poetry and Truth,* London, 1969.
Gage, John, *Turner: Rain, Steam, and Speed,* London and New York, 1972.
Wilkinson, Gerald, *Turner's Early Sketchbooks: Drawings in England, Wales, and Scotland from 1789 to 1802,* London, 1972.
Bacharach, A. G. H., *Turner and Rotterdam 1817, 1825, 1841,* London, 1974.
Butlin, Martin, Andrew Wilton, and John Gage, *Turner* (cat), London, 1974.

Wilkinson, Gerald, *The Sketches of Turner, 1802–20, Genius of the Romantic,* London, 1974.

Wilkinson, Gerald, *Turner's Colour Sketches 1820–1834,* London, 1975.

Herrmann, Luke, *Turner: Paintings, Watercolours, Prints, and Drawings,* London and Boston, 1975, 1986.

Turner: Works on Paper from American Collections (cat), Berkeley, 1975.

Wilton, Andrew, *Turner in the British Museum: Drawings and Watercolours,* London, 1975.

Wilton, Andrew, *Turner in Switzerland,* Zurich, 1976.

Butlin, Martin, and Evelyn Joll, *The Paintings of Turner,* New Haven, 2 vols., 1977, 1984.

Shanes, Eric, *Turner's Picturesque Views in England and Wales 1825–1838,* London, 1979.

Wilton, Andrew, *The Life and Work of Turner,* London, 1979; as *Turner: His Life and Art,* New York, 1979.

Wilton, Andrew, *Turner and the Sublime* (cat), Toronto and London, 1980.

Finley, Gerald, *Landscapes of Memory: Turner as Illustrator to Scott,* London, 1980.

Finley, Gerald, *Turner and George IV in Edinburgh* (cat), London, 1981.

Shanes, Eric, *Turner's Rivers, Harbours, and Coasts,* London, 1981.

Turner en France (cat), Paris, 1981.

Paulson, Ronald, *Literary Landscape: Turner and Constable,* New Haven, 1982.

Wilkinson, Gerald, *Turner on Landscape: The Liber Studiorum,* London, 1982.

Wilton, Andrew, *Turner Abroad: France, Italy, Germany, Switzerland,* London, 1982.

Gage, John, et al., *Turner* (cat), Paris, 1983.

Hill, David, *In Turner's Footsteps: Through the Hills and Dales of Northern England,* London, 1984.

Hartley, Craig, *Turner Watercolors in the Whitworth Art Gallery* (cat), Manchester, 1984.

Heffernan, James A. W., *The Re-Creation of Landscape: A Story of Wordsworth, Coleridge, Constable, and Turner,* Hanover, New Hampshire, 1985.

Stainton, Lindsay, *Turner's Venice,* London, 1985.

Powell, Cecilia, *Turner in the South: Rome, Naples, Florence,* New Haven, 1987.

Gage, John, *Turner: "A Wonderful Range of Mind,"* New Haven, 1987.

Wilton, Andrew, *Turner in His Time,* London, 1987.

*

J. M. W. Turner is nowadays generally acclaimed as the most outstanding painter Great Britain has yet produced. His talent manifested itself early (he had his first work accepted for exhibition at the Royal Academy shortly before his fifteenth birthday); by the time he died, aged seventy-six, he had not only a prodigious number of works to his credit (some 540 oil paintings, over 1,500 watercolors, and around 19,000 sketches and drawings), he had also displayed a technical virtuosity and a variety of achievement that are unrivalled in British art.

Nearly all of Turner's works may be classified as "landscapes," but this term must be amplified by reference to his own categorization. In his *Liber Studiorum,* a series of mezzo-

tints of his own work begun in 1807, Turner divided his landscape subjects into six groups: Architectural, Historical, Marine, Mountainous, Pastoral, and Elevated Pastoral. Turner achieved greatness in all these types of subject (sometimes, indeed, he would brilliantly combine two or even three of these modes in one and the same painting) and he did so partly through the study of those Old Masters who had excelled in the same areas (e.g., Piranesi, Nicolas Poussin, Van de Velde the younger, and Claude Lorraine), partly through intensive and prolonged study of the natural and man-made world in all its guises, and partly through that inquisitiveness and receptivity to new interests and ideas that made Constable comment on his "wonderful range of mind" after he had sat next to him at a Royal Academy dinner in 1813.

Turner came from a very humble background, his father being a barber in Covent Garden, and he was largely self-educated. When he first began to study at the Royal Academy Schools in 1789, that institution itself was a mere 30 years old and was still under the direction of its first President, Sir Joshua Reynolds. Turner was determined to succeed and he made it his life's preoccupation to raise the status of landscape, then regarded as one of the lowest genres of painting, just as Reynolds had raised that of portraiture. Although Turner's landscapes spring from the topographical tradition, in that they depict well-known and clearly recognizable places and are nearly always based on his own close study of particular stretches of countryside or coast, towns or rivers, he invariably raises his subjects above the level of mundane reality and invests them with an eternal grandeur by virtue of the lessons he had learnt from the "ideal" landscape tradition practised by Claude Lorraine in the 17th century and by Claude's first British disciple, Richard Wilson, in the 18th.

Within a very few years of Turner's earliest recorded works, he was extremely proficient in both oils and watercolor and he continued to work simultaneously in both media throughout his life, his practice in one often influencing that in the other. It was largely through Turner's adventurous experiments in watercolor technique that the status of watercolor as an art form was dramatically elevated in the early 19th century. From being a tame and descriptive art, of little use except to antiquarians and architects, watercolor developed into an art that could embrace as wide a range of expression as oil painting and could exert an equally powerful effect on the viewer. J. R. Cozens, whose work Turner studied very closely in the 1790's, had already discovered the elegiac potential of the landscape watercolour in the 1770's and 1780's, but Turner soon extended the range of watercolor even further. He used it to treat every type of subject-matter and to embody every human emotion. Over the years he developed a technique of unsurpassable complexity and coloristic brilliance which can be seen at its most breathtaking in his series of Swiss watercolors painted in the 1840's.

The most notable feature of Turner's art to strike the spectator is his lifelong fascination with light and his outstanding ability to depict it in all its variations: sunlight and moonlight, firelight and lamplight, dawn and dusk, light reflected on both calm and rough water, light streaming undisturbed through windows into interiors, bouncing radiantly back from the white or golden facades of Italian buildings or struggling for mastery against mist, rain, or snow. It was Turner's skill in handling the complex relationships between light and the ob-

The Battle of Trafalgar; 8 ft 7 in × 12 ft 1 in (260.5 × 366.8 cm); Royal Collection

jects on which it falls, be they the lakes and mountains of Switzerland or the buildings of Venice, that led to his popularity in his own time, and 20th-century viewers continue to find Turner's effects of light and atmosphere equally irresistible.

Turner's concern with chiaroscuro cannot be divorced from the fact that much of his work—indeed, around 700 of his 1,500 recorded watercolors—was executed simply in order to be engraved upon copper or steel and reproduced in monochrome in a constant stream of publications which grew increasingly sophisticated in both form and content from the 1790's onwards. Through this means Turner's art reached a far wider public than it would have done had he merely displayed his paintings in exhibitions; his engraved work brought him in a regular and sizeable income; and he could afford both to disregard the critics who scorned his work and to turn away unwelcome visitors or would-be purchasers.

One of the paradoxes of Turner's art is that he was rarely innovative in his choice of subject-matter (for example, although he had first visited Venice in 1819, he did not depict it in an oil painting until 1833, following the success of the Venetian scenes painted by Clarkson Stanfield and R. P. Bonington), while at the same time he was extremely innovatory both in his approaches to established subject-matter and in his handling of oil paint. Unlike many of his contemporaries, he could produce work that was sublime without being theatrical or melodramatic, lyrical without being sentimental, and profoundly true to nature rather than merely naturalistic at a superficial level. Turner was far more interested in the con-

cept of color, in scientific theories concerning color, and in the dynamic potential of individual colors than he was in the local colors of the world around him. This led not only to brilliant experiments in his sketches but also to paintings that shocked and disturbed his contemporaries. In his later years Turner was accused of abandoning nature altogether and indulging in arbitrary colors and slapdash handling. The most famous of all these attacks was published in *Blackwood's Magazine* in the autumn of 1836, provoking the 17-year-old Ruskin to draft a reply in Turner's defence. Although this reply remained unpublished, at Turner's own request, Ruskin nevertheless continued to revere, study, and defend Turner's art for the rest of his life, publishing numerous books and articles about it, most notably the five volumes of *Modern Painters* (1843–60).

Turner led an uneventful life, his time being almost exclusively devoted to his profession. Until he was well into his sixties, his summers were nearly always spent in long, strenuous, and usually solitary tours which eventually took him all over England, Wales, and Scotland and to most of Western Europe except for Spain and Portugal. During these tours he drew incessantly, cramming his 300 or so extant sketchbooks with an extraordinary diversity of data including tiny pencil sketches of the countryside and buildings, notes on works of art and local customs, poetical reflections on history, and colored sketches of the sea, dawns, and sunsets. His winters were always spent in London where he distilled his studies from nature into works created entirely in the studio: paintings for exhibition at the Royal Academy or in the gallery he himself

had constructed in his house in Queen Anne Street; or water-colors ordered by patrons or commissioned by publishers for engraving in books of topographical views or as illustrations to literature. Turner's social life was also uneventful, being largely centered on the Royal Academy, with its committees, dinners, and other gatherings. His few intimate friends were Academy colleagues such as Francis Chantrey and George Jones. He never married, but was looked after by his father (until his death in 1829) and by housekeepers, one of whom bore him two illegitimate daughters. With two of his patrons, however, Watler Fawkes and the 3rd Earl of Egremont, he established very close ties and he sometimes spent long periods at their country houses, Farnley Hall in Yorkshire and Petworth House in Sussex, where he could enjoy country sports and a relaxed family atmosphere.

Turner's career was marked by both notable successes and failures. Although he was elected a Royal Academician at an exceptionally early age and was ceaselessly diligent in supporting its benevolent and educational activities, he never became its President. Unlike many of his colleagues, he never received royal approval or a knighthood. On the other hand, his art made him extremely wealthy. Sometimes he bought back paintings he had previously sold, while other paintings he persistently refused to part with, and, in a complex succession of will and codicils he bequeathed his work to the British nation to be housed in a "Turner Gallery." Legal wrangling and official procrastination defeated Turner's intentions for over a century and a quarter, but in 1987 his wishes were at last honoured: the Clore Gallery for the Turner Collection, attached to the Tate Gallery in London, now houses both the oil paintings and the works on paper that constitute the Turner Bequest.

It is now possible not only to appreciate the full genius of Turner's art but also to reach a more realistic understanding of his character. Turner's reputation in his own time as a churlish and tight-fisted recluse, engrossed in his own art and living in squalid surroundings, can be seen with hindsight to have been the inevitable outcome of his humble background, his ambitious nature both for himself and for British painting, and his charitable intentions towards posterity.

—Cecilia Powell

UCCELLO, Paolo.

Born Paolo di Dono in Pratovecchio, c. 1397. Died in Florence, 10 December 1475. Married. Apprenticed to Ghiberti, age 10, and entered the Florence painters guild, 1415; in Venice: mosaic for St. Mark's, 1425–30; fresco of Sir John Hawkwood for Florence Cathedral, 1436 (also Four Prophets and stained glass for the cathedral, 1443–45); work for the Case Vitaliani in Padua, 1445, is lost; painted the *Flood* for S. Maria Novella, Florence, and the Urbino Confraternity of the Holy Sacrament, 1465–69.

Collections: Chambery; Dublin; Florence: Cathedral, S. Maria del Fiore, S. Martino alla Scala, Uffizi, S. Maria Novella; Karlsruhe; London; Oxford; Paris: Louvre, Jacquemart-André; Urbino; Washington.

Publications

On UCCELLO: books—

Soupault, Philippe, *Uccello*, Paris, 1929.
Salmi, Mario, *Uccello, Andrea del Castagno, Domenico Veneziano*, Milan, 1936.
Boeck, Wilhelm, *Uccello*, Berlin, 1939.
Pope-Hennessy, John, *Uccello: The Rout of San Romano*, London, 1944.
Pittaluga, Mary, *Uccello*, Rome, 1946.
Popo-Hennessy, John, *The Complete Works of Uccello*, London and New York, 1950; as *Uccello: Complete Edition*, 1969.
Sindona, E., *Uccello*, Milan, 1957.
d'Ancona, Paolo, *Uccello*, New York, 1961.
Carli, Enzo, *Tutta la pittura di Uccello*, Milan, 1961; as *All the Paintings of Uccello*, New York, 1963.
Tongiorni Tomasi, Lucia, *L'opera completa di Uccello*, Milan, 1971.
Parronchi, Alessandro, *Uccello*, Bologna, 1974.
Schefer, Jean L., *La Déluge, la peste: Uccello*, Paris, 1976.
Uccello's Hunt in the Forest, Oxford, 1981.

articles—

Lavin, Marilyn Aronberg, "The Altar of Corpus Domini in Urbino: Uccello, Joos van Ghent, Piero della Francesca," in *Art Bulletin* (New York), 49, 1967.
Béguin, Sylvie, "Le Cloitre vert d'Uccello," in *Connaissance des Arts* (Paris), July–August 1984.
Starn, Randolph, and Loren Partridge, "Representing War in the Renaissance: The Shield of Uccello," in *Representations*, 5, 1984.
O'Grady, John N., "An Uccello Enigma," in *Gazette des Beaux-Arts* (Paris), March 1985.

*

"Paolo used to stay up all night in his study, trying to work out the vanishing points of his perspective, and when his wife called him to come to bed he would say: 'Oh, what a lovely thing this perspective is!' " Uccello's obsession with perspective, illustrated by this well-known anecdote with which Vasari ends his life of Uccello, has become a cliché of Renaissance studies. Like most clichés it contains an essential truth. A glance at the drawing of a chalice in the Uffizi, if the traditional attribution of Uccello is correct, demonstrates that Uccello was indeed a great master of perspective. Uccello's major activity falls in the second quarter of the 15th century, after the codification of the rules of perspective by Alberti in his treatise *On Painting* of 1435. Therefore, along with a small group of other pioneers building on the work of Masaccio, Uccello was able to exploit the possibilities of Alberti's method of constructing space in order to develop a distinctive early Renaissance style that gradually broke decisively with the International Gothic. Uccello's earliest works are still in the International Gothic style of Ghiberti, with whom he seems to have trained, but there is a fairly consistent development in the sophistication with which he uses one point perspective throughout his career: i.e., from the *Creation of Animals* (early 1430's), to the *Battle of San Romano* (c. 1435), to the *Hawkwood* (1436), to the clock face (1443), and finally to the *Flood* (1450's), although the dates of these works are much debated. Since Vasari considered Uccello to be a kind of obsessive and eccentric nut of childlike simplicity, the extraordinary intelligence and sensitivity that underlie this development has often been overlooked.

By the use of a perspective grid and geometrical forms in the *Battle of San Romano*, for example, Uccello attempted for the first time in a long and well-developed tradition of battle representation to impose a sense of order and rational control on war, which by definition was chaos and flux. The artist created in the *Hawkwood*, when seen from the proper oblique viewing position in its original position high on the left aisle wall of the Florentine cathedral, the first convincing illusion in

paint of a life-sized equestrian monument seemingly of bronze on a marble base. It is documented that Uccello had to repaint the *Hawkwood* shortly after it was unveiled. Uccello's demonstration was probably so rigorous and radical that he may have been required to eliminate a "tilt" of the horse and rider and to create the present flat decorative silhouette free of perspective distortion. In any case, since careful advanced planning was required to create this kind of illusion, it is not surprising that the silverpoint drawing by Uccello for this project is the first squared *modello* known in the history of art.

By the time Uccello designed the *Flood* he was able to use perspective not only to create an effective illusion, but also to add a dramatic impact to narrative action unmatched by any of his contemporaries. On the left side of the composition the perspective rush to the background, created by the extremely long orthogonals defining the side of Noah's huge ark, focuses attention on the raging storm with lightning flashes in the central background. It also acts as a dramatic counter thrust to the debris-laden wind whistling toward the foreground, itself filled with the chaos of people fighting and trying to save themselves from the rising waters. On the right side of the composition the shorter orthogonals of the end of the ark help to create visually a mood of calm as Noah leans from the window to witness a returning dove marking the end of the deluge. Furthermore, since the lines of Uccello's ark can be projected well beyond the limits of the lunette to create both an end and side view following the Biblical dimensions of 50 by 300 cubits, it is clear that Uccello has here created the first dramatic close-up in the history of art, as if viewed through a zoom lens.

There is also another side to Uccello's art, especially his later work. In the *Hunt,* for example, probably a furniture panel, perspective is used less to order and organize the composition than to create a kind of mystical force that seems to activate and attract the brightly colored men and animals like iron to a magnet. The private, introspective, dreamlike quality of this painting is heightened by being represented at night within a vast dark forest. The profound inwardness and haunting poetry of this and other late works has much in common with the late introspective and deeply imaginative works of Donatello.

Whether for his poetry, narrative drama, or perspective illusionism, in sum, Uccello was one of the most innovative and intelligent artists of the early Florentine Renaissance.

—Loren Partridge

VALDÉS LEAL, Juan de.

Born in Seville, baptized 4 May 1622; spent his youth in Córdoba. Died 14 October 1691. Married Isabel Martínez de Morales, 1647; daughter, the painter Luisa, son, the painter Lucas, and at least one other daughter. Probably a pupil of Antonio del Castillo, in Córdoba; first dated picture in 1648; then had many commissions; worked for the Convent of Sta. Clara, Carmona, 1653; settled in Seville, 1656: co-founder, with Murillo, of the Seville Academy, 1660; served as Alcalde, 1660, major-domo, 1663, and President, 1664, of the guild, then resigned; decorated the Hospital of la Caridad, Seville; dramatic, even morbid style; huge reputation in his lifetime. Pupils: Matías de Artega y Alfaro, his son Lucas (who continued his father's studio).

Collections: Barnard Castle; Cordoba: Carmen Calzado; Dresden; Dublin; Grenoble; Hartford, Connecticut; Kansas City; London; Madrid; New Haven; New York: Hispanic Society; Paris; Seville: Museum, Hospital de la Caridad; Washington.

Publications

On VALDÉS LEAL: books—

Lopez y Martinez, Celestina, *Valdés Leal y sus discipulos*, Seville, 1907.

Beruete y Moret, Aureliano de, *Valdés Leal: Estudio critico*, Madrid, 1911.

Lafond, Paul, *Valdés Leal: Essai sur sa vie et son oeuvre*, Paris, 1914.

Gestoso y Pérez, José, *Biographía del pintor sevillano Valdés Leal*, Seville, 1916.

Valdés Leal (cat), Seville, 1922.

Trapier, Elisabeth du Gué, *Valdés Leal, Spanish Baroque Painter*, New York, 1960.

Kinkead, D. T., *Valdés Leal: His Life and Work*, New York, 1978.

*

Juan de Valdés Leal was baptized in Seville in May 1622 and appears to have shared his early years between Seville and Córdoba (where he had moved by 1647). There is an unfortu-

nate lack of information concerning this formative period and it is not clear who was responsible for his early training. Palomino (the influential biographer and artist) met Valdés Leal in 1672 and said that he was taught by the Sevillian cleric Juan de Roelas. Other sources suggest that the Córdoban Antonio del Castillo was responsible for his formation.

Valdés Leal's early style shows an inevitable debt to the work of Sevillian artists such as Francisco Herrera the Elder and Francisco Zurbarán. For instance, the over life-sized St. Andrew signed and dated c. 1647 for the Church of St. Francis in Córdoba seems to draw heavily on Herrera the Elder's drawing of the same subject (now in the Biblioteca Nacional, Madrid) showing the saint with the same monumentality and positioning. Valdés Leal was also commissioned to paint cycles for similar patrons to Zurbarán, which may have encouraged him to use the latter as a source of compositional ideas. The important series for the Hieronymite monastery of S. Jeronimo de Buenavente, Seville, in 1656 for instance, shows the influence of Zurbarán's commission for the Hieronymite monastery of Guadalupe in 1638–39, particularly in the Temptation and Flagellation of St. Jerome and the 12 single figures of Hieronymite saints.

Valdés Leal may have used some of Zurbarán's compositional ideas, but his style was very different from the latter's static, sculptural, highly finished technique. In contrast his brushwork was sketchy and fluid which helped create the remarkable drama and movement of his best work, and was responsible for the inconsistency and poor anatomical observation of his worst. His striving for fluid, graceful motion with the use of impressionistic strokes made for a painterly canvas with occasional areas barely sketched in. Palomino, who saw him paint several times, described how he "liked to back away from time to time and return quickly to make some strokes and back away again" which was "his customary way of painting, with that restlessness and vivacity of his natural spirit." In addition, Valdés Leal's palette was distinctive for his use of autumnal colours such as rose reds, faded yellows, and greens.

Valdés Leal's dramatic style is demonstrated in his many commissions for religious cycles. In particular, the *Assault of the Saracens on the Convent of San Damiano*, which was part of the series for the Convent Church of Santa Clara of Carmona of c. 1651–53, shows the chaotic movement involved in the rout of the infidel troops. It is handled with broad brushstrokes, strong light-dark contrasts, and a vibrant palette of reds, yellows, and greens, and painted with a relish which suggests an enjoyment of a somewhat unusual theme. Valdés

Leal's masterpiece, however, is the retable of the high altar of the Church of Nuestra Senora de las Carmelitas Calzados, Córdoba, in 1655–58. He provides a striking diversity of subjects, varying from the decapitated heads of St. John the Baptist and St. Paul to the poised pairs of saints St. Mary Magdalene of Pazzi and St. Agnes and St. Apollonia and a Carmelite nun (thought to be Santa Juana of Tolosa). The fluid grace of the saints contrasts with the vigorous activity of the central panel representing Elijah's ascent in his fiery chariot, his hair streaming out as if set alight and red-orange flames springing from his chariot spokes. This commission shows a development in graudeur, spaciousness, and breadth of handling and an increased interest in landscape, light, and atmosphere. In addition, Valdés Leal made use of different lighting techniques to achieve dramatic effects. For instance, the *Crucifixion* painted in 1659 for the Church of San Benito de Calatrava, Seville (now in the Church of la Magdalena) makes use of a tenebrist light which points to Caravaggesque influence in Spain. Valdés Leal also makes use of standard devices throughout his career, such as the use of repoussoir figures as in the *Dream of St. Ferdinand Before Seville* (now in the Banco Exterior, Seville). At his best, therefore, Valdés Leal could achieve a vibrant, balanced composition of great emotional appeal, such as the *St. Martha, Mary Magdalene, and Lazarus* for Seville Cathedral in 1657.

Unfortunately, however, Valdés Leal's oeuvre is inconsistent, with cramped compositions and poor anatomical observation, for instance, the *Marriage of the Virgin* painted for the Chapel of San Jose in Seville Cathedral, 1667. The poor condition of many surviving canvasses such as the Jesuit series of the Life of Loyola, c. 1675, cannot hide the weakness of such scenes as *St. Ignatius's Illness* at Pamplona or *St. Ignatius Kneeling Before the Virgin* at Montserrat. The final years, in particular, produced canvasses of very mixed quality, for instance, the *Exaltation of the Cross* for the Brotherhood of Charity, c. 1685, which probably suffered from Valdés Leal's degenerative illness and the collaboration of his son, Lucas. The problems experienced by Valdés Leal may partly account for the success of his rival, Murillo, who by 1655 was the most popular painter in Seville, and whom Valdés Leal served as deputy in the newly founded Academy in 1660. The impact of Murillo influenced Valdés Leal in canvasses such as the *Celestial Vision of St. Clare at Death,* part of the Carmona series, c. 1653. The techniques of the two artists, however, remained very different.

Ironically, Valdés Leal perhaps became better known for his unusual vanitas paintings than the religious commissions which provided the bulk of his work. The two vanitas paintings of c. 1660 occupy a distinctive place in Valdés Leal's oeuvre—the *Allegory of the Crown of Life* (believed to represent the conversion of the founder of the Brotherhood of Charity, Miguel Manara) in York, and the *Allegory of Vanity* in Hartford. More sinister in tone, however, are the 1672 commissions by the Brotherhood of Charity for the Church of San Jorge—the *In Ictu Oculis* and the *Finis Gloriae Mundi* in which earthly vanities are satirised with insects running across the decaying flesh of a people. Valdés Leal, therefore, showed imagination and ability in handling a variety of subjects. Although influenced by popular local artists his style and handling remained very free and personal.

—Susan Jenkins

VAN DE VELDE, Willem (the Younger).

Born in Leiden, 1633; son of the painter Willem van de Velde the Elder; brother of the painter Adriaen van de Velde; grew up in Amsterdam from 1636. Married 1) Patronella le Maire, 1652; 2) Magdalena Walraven, 1656; children included four painters, Willem III, Cornelis, Pieter, and Sara. Probably studied with the marine painter Simon de Vlieger, in Weesp; worked with his father, who was primarily a draughtsman; he and his father emigrated to England together in 1672, and both were official marine artists to the King and sailed with the fleet.

Major Collections: Amsterdam; Ham House; London: National Gallery, Wallace; Maritime Museum.
Other Collections: Chantilly; The Hague; Kassel; London: Dulwich, Kenwood; Rotterdam; Royal Collection.

Publications

On VAN DE VELDE: books—

Manteuffel, H. Zoege von, *Die Künstler Familie van de Velde*, Bielefeld, 1927.
Baard, Henricus P., *Willem van de Velde de oude, Willem van de Velde de jonge*, Amsterdam, 1942.
Robinson, Michael S., *Van de Velde Drawings: A Catalogue of Drawings in the National Maritime Museum Made by the Elder and the Younger Willem van de Velde*, Cambridge, 2 vols., 1958–74.
Cordingly, David, *Marine Painting in England 1700–1900*, London, 1974.
Robinson, Michael S., *The William van de Velde Drawings in the Boymans-van Beuningen Museum, Rotterdam*, Rotterdam, 3 vols., 1979.
Kaufmann, Gerhard, *Marine-Zeichnungen und -Gemälde von Willem van de Velde dem Alteren und dem Jüngeren* (cat), Herford, 1981.
The Art of the Van de Veldes (cat), London, 1982.

articles—

Fraser, Peter D., "Charles Gore and the Willem van de Veldes," in *Master Drawings* (New York), Winter 1977.
Weber, R. E. J., "The Artistic Relationship Between the Ship Draughtsman Willem van de Velde the Elder and His Son the Marine Painter in the Year 1664," in *Master Drawings* (New York), 17, 1979.

*

Willem van de Velde the Younger is the best known of all marine painters, though modern taste might prefer works by Simon de Vlieger, Jan van Cappelle, or Hendrick Vroom. He studied with Vlieger, but his father was both his teacher and later his collaborator.

The elder van de Velde was a draughtsman, usually in pen and ink on vellum or in grisaille. He was the son of a sea captain, and after he began his artistic career was often at sea himself making sketches of ships, as well as recording sea

Warships in Quiet Waters; drawing; Munich, Staatliche Graphische Sammlung

works are his masterpieces. A work such as *The Cannon Shot* (Amsterdam) combines the calm sea and clouds with the cloud of smoke from the shot itself—a technical problem set and solved. His soft coloring and poetic atmosphere are seen in such works as *Ships in a Calm* and *Boats at Low Water* (both in the Wallace Collection, London), while his more brilliant style is shown in *Dutch Vessels Close Inshore at Low Tide, with Men Bathing* (London, National Gallery) and *The Gust of Wind* (Amsterdam). Some of his paintings can be matched up to preparatory studies still extant, for instance, *Beach with a Weyschuit Pulled Up on Shore* (painting in Carter Collection; sketch in the Maritime Museum, London). His concern with his art is obvious from a comment on one of his drawings now in the British Museum: "There is much to observe in beginning a painting; whether you will make it mostly brown or mostly light; you must attend to the subject, as the air and the nature of its color, the directions of the sun and wind, whether the latter be strong or moderate, are to be chosen as may seem best. The sketching of the ordnance or ships under sail. . . ."

Because van de Velde lived and worked in England for 35 years, his influence was strong among English artists, though many 18th-century works under his influence are merely copies of a style. His interest in atmospheric effects, however, explains the strength of the interest shown in him by painters such as Samuel Scott and Edward Duncan, as well as Turner and Constable.

—George Walsh

battles. He was present at the battle of Scheveningen in 1653, and described himself in a report of the action of the battle as "draughtsman to the fleet." After he and his son emigrated to England, he continued to travel with the English fleet, and later his son continued the practice: an order from 1694 states that "William Vande Velde is appointed . . . to goe aboard their . . . fleet this Summer in ordr. to make from time to time Draughts & Figures or Imitations of what shall pass & happen at Sea by Battle or fight of the Fleet. . . ."

The younger van de Velde's series of naval encounters early in his career is based on his father's sketches or drawings, though his father had used mainly black and white and the younger van de Velde used color; in fact, their contract with Charles II of England in 1674 specified that the elder make "Draughts of Seafights" and the younger put "said Draughts into Colours." The son also put his father's works into "composed" paintings, often basing one finished picture on many sketches (as many as 51 large drawings made in the fall of 1664 were used in a single work). He also made offsets or tracings of his father's drawings, and inherited a useful model of the masts and tackle of a ship from his father. Eventually he was able to sketch in the hulls of ships freehand while at sea. Back in the studio he could complete the composition. Van de Velde also sold "finished" drawings.

Beside his "documentary" works of battles, launchings, etc., as well as "portraits" or "commemorative" paintings of individual ships, identified by such items as flags and pennants, he was also expert in natural details, especially the sky and the sea. He was a specialist in the creation of a bright, sunny atmosphere based on calm weather, with sails catching the light, often against a coastal landscape. Though storm and gale scenes and battle actions figure in his corpus, his "calm"

VAN DER GOES, Hugo.

Born in Ghent or Antwerp, c. 1440. Died at the Monastery of the Roode Klooster, near Brussels, 1482. First recorded in painters guild in Ghent, 1467 (dean of the guild, 1474); his Portinari Altarpiece, 1475, was taken to Florence; entered the Monastery of the Roode Klooster as a lay brother, 1475, but continued to paint and to travel: on a journey to Cologne, seized by melancholy, and died insane.

Collections: Baltimore: Walters; Berlin; Bruges: Cathedral Museum, Museum, S. Sauveur; Brussels; Edinburgh; Florence; Frankfurt; Kassel; Leningrad; New York; Philadelphia; Vienna.

Publications

On GOES: books—

Destrée, Joseph, *Van der Goes,* Brussels, 1914.
Pfister, Kurt, *Van der Goes,* Basel, 1923.
Friedländer, Max J., *Die altniederländische Malerei, vol. 4: Van der Goes,* Berlin, 1926; as *Van der Goes* (notes by Nicole Veronee-Verhaegen), Leiden, 1969.
Denis, Valentin, *Van der Goes,* Brussels, 1956.
Winkler, Friedrich, *Das Werk des Van der Goes,* Berlin, 1964.
Thompson, Colin, and Lorne Campbell, *Van der Goes and the Trinity Panels in Edinburgh,* Edinburgh, 1974.

articles—

Walker, Robert M., "The Demon of the Portinari Altarpiece," in *Art Bulletin* (New York), 42, 1960.

McNamee, M. B., "Further Symbolism in the Portinari Altarpiece," in *Art Bulletin* (New York), 45, 1963.

Koch, Robert A., "Flower Symbolism in the Portinari Altar," in *Art Bulletin* (New York), 46, 1964.

Koch, Robert A., "The Salamander in Van der Goes' Garden of Eden," in *Journal of the Warburg and Courtauld Institutes* (London), 28, 1965.

Kessler, Herbert L., "The Solitary Bird in Van der Goes' Garden of Eden," in *Journal of the Warburg and Courtauld Institutes* (London), 28, 1965.

Hatfield, Strens, Bianca, "L'arrivo del trittico Portinari a Firenze," in *Commentari* (Rome), 19, 1968.

Lane, Barbara G., "'Ecce Panis Angelorum': The Manger as Altar in Hugo's Berlin Nativity," in *Art Bulletin* (New York), 1975.

Koslow, Susan, "The Impact of van der Goes's Mental Illness and Late Medieval Attitudes on the *Death of the Virgin*," in *Healing and History: Essays for George Rosen*, New York, 1979.

Denny, Don, "A Symbol in van der Goes' *Lamentation*," in *Gazette des Beaux-Arts* (Paris), 95, 1980.

*

Hugo van der Goes was a painter of the first rank and the dominant figure in Flemish painting of the late 15th century. His birth date is unknown, but he was probably born in Ghent, where he entered the painters guild in 1467. His genius attracted the attention of the wealthy Burgundian court, and documents record that Hugo provided decorations for major civic events in both Ghent and Bruges, including the funeral of Duke Philip the Good in 1467 and the wedding of Duke Charles the Bold to Margaret of York in 1468. Hugo rose rapidly to fame in Ghent, and was elected dean of the painters guild in 1474. He left the courtly whirly of civic responsibility in 1478, entering the monastery of the Red Cloister (Roode Klooster) near Brussels. There, he led a privileged life as a lay brother, continuing to paint, receive visitors, and consult with important clients, including the future emperor Maximilian of Austria. Upon his return from a trip to Cologne in 1481, Hugo suffered an attack of madness during which he was crippled by depression and self-doubt. His mental state continued to alternate between periods of activity and insanity until his death in 1482.

Much has been made of Hugo's "insanity," especially by 19th and early 20th-century art historians to whom the concept of the "mad genius" held a curious fascination paralleled by the invention and implementation of the science of psychology. Nonetheless, Hugo remains one of the more enigmatic and charismatic figures in Northern Renaissance art. His mental illness was noted during his life by a German traveler, Hieronymus Munzer who, writing about Jan Van Eyck's famous *Ghent Altarpiece* in 1495, claimed that "Another painter came to this work, wanted to imitate it and became melancholy and foolish." Another account of the painter's sufferings was written by Gaspar Ofhuys, a fellow brother at the Red Cloister. This description is a detailed analysis of Hugo's condition

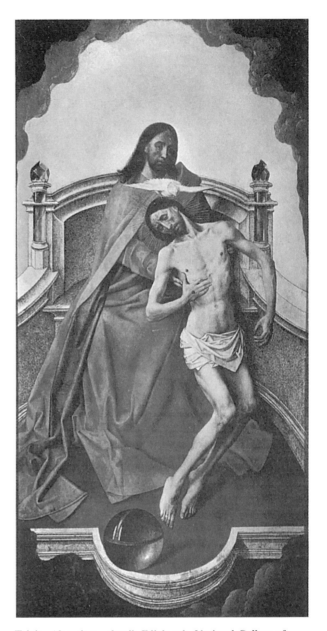

Trinity Altarpiece—detail; Edinburgh, National Gallery of Scotland

and provides a fascinating glimpse of the painter's last days, though it must be interpreted in the context of late medieval devotion and medicine. Ofhuys followed standard diagnostic procedure, for example, in attributing Hugo's "melancholia" to "passions of the soul . . . anxiety, sadness, overwork, and fear," in possible combination with "corrupt humours." The symptoms of melancholia—depression alternating with periods of productivity—were thought to be endemic to men of genius and were believed to be aggravated by an excess of black bile—or melancholy humour—in the body. Such a bodily imbalance could also be instigated by "passions" of the soul such as those Ofhuys described. Drinking wine was also implicated, though, in Hugo's case, Ofhuys suggested that " . . . this was undoubtedly done for the sake of his guests." The account record the brothers' attempts to cure Hugo's condition by play-

ing stringed instruments in his presence, " . . . remembering that Saul was relieved when David played the harp." As was usual, however, in cases that did not respond to the primitive physic of the time, Ofhuys presents an alternative cause for Hugo's madness—that it was " . . . sent by Divine Providence." Indeed, the painter " . . . was highly praised in our order because of his special artistic achievements—in fact, he thus became more famous than he would have been outside our walls." Hence, " . . . the various honors, visits, and accolades that came to him made him feel very important." It was therefore quite logical to the medieval mind that "God . . . in His compassion sent him this humiliating disease which indeed made him very contrite." It is more likely, however, that Hugo's state of mind was instigated by " . . . the thought of how he could ever finish the works of art he wanted to paint." This suggestion, Ofhuys's own personal observation, is the cause accepted by most modern historians.

Like many of the other great figures of northern Renaissance art, Hugo van der Goes neither signed nor dated his paintings. The *Portinari Altarpiece* is the only authenticated work of his that exists, and it serves as a pivot around which art historians argue the attribution of paintings to Hugo and the hypothetical evolution of his style. The altarpiece, commissioned by the Italian banker Tomasso Portinari in the mid-to-late-1470's, is generally accepted as Hugo's masterpiece and is considered typical of his well-developed, mature style. It respectfully incorporates the innovations of Jan van Eyck, while also displaying a new fervor and individuality that is a hallmark of Hugo's style. Using the *Portinari Altarpiece* as a standard, approximately 15 works are attributed to Hugo's hand, though scholars are far from unanimous regarding their chronology. In general, Hugo's insanity is considered justification for dating late in his career those paintings that display agitated forms, abrupt inconsistencies of scale, off-centered compositions, and dramatic emotion (notably the *Adoration of the Shepherds,* Berlin, and the *Death of the Virgin,* Bruges). Paintings such as the *Fall of Man* and *Lamentation* diptych (Vienna) and *Monforte Altarpiece* (Berlin) are usually dated earlier on the basis of their relatively conservative compositions, traditional iconography, and strong dependence upon the models of Jan van Eyck and Rogier van der Weyden. These assumptions, however, are still a matter of debate, and the problem of dating and attributing Hugo's works continues to inspire scholarly controversy. We may never know to what extent, or if at all, Hugo's style was influenced by his state of mind. What is certain is that, during his lifetime and long afterward, Hugo van der Goes was considered, in Ofhuys's words, an artist with "no peer this side of the Alps." Indeed, the unparalleled drama and individuality of his style strongly influenced later generations of painters in both northern Europe and Italy.

—Laurinda S. Dixon

VAN DER WEYDEN, Rogier. [Rogier de la Pasture.]
Born in Tournai, 1399 or 1400. Died in Brussels, 18 June 1464. Married 1436. Probably a student (with Jacquellotte Daret) of Robert Campin, 1427–32, in Tournai; member of the Tournai guild, 1432; the official painter of Brussels, 1435, and its leading painter: no court position, but commissions from members of the court (e.g., Chancellor Rollin); visited Italy, 1450; some difficulty with attributions, since he neither signed nor dated his works.

Collections: Antwerp; Beaune; Berlin; Boston; Brussels; Caen; Chicago; Florence; Frankfurt; Granada: Royal Chapel; Houston; Leipzig; London; Madrid; Malibu; Munich; New York; Paris; Philadelphia; San Marino, California; Vienna; Washington.

Publications

On VAN DER WEYDEN: books—

Lafond, Paul, *Van der Weyden,* Brussels, 1912.

Winkler, Friedrich, *Der Meister von Flémalle und Van der Weyden,* Strasbourg, 1913.

Friedländer, Max J., *Die altniederländische Malerei,* vol. 2: *Van der Weyden und der Meister von Flemalle,* Berlin, 1924; as *Van der Weyden and the Master of Flemalle* (notes by Nichole Veronee-Verhaegen), Leiden, 1967.

Destrée, Jules, *Van der Weyden,* Paris, 2 vols., 1930.

Renders, Emile, *La Solution du Problème Van der Weyden, Flémalle, Campin,* Bruges, 2 vols., 1931.

Beenken, Hermann T., *Van der Weyden,* Munich, 1951.

Blum, Shirley, *Early Netherlandish Triptychs,* Berkeley, 1969.

Sonkes, Micheline, *Dessins du XVe siècle: Groupe Van der Weyden: Essai de catalogue originaux du maître, des copies, et des dessins anonymes inspirés par son style,* Brussels, 1969.

Davies, Martin, *Van der Weyden: An Essay, with a Critical Catalogue of Paintings Assigned to Him and to Robert Campin,* London, 1972.

Van der Weyden en zijn tijd/Van der Weyden et son epoque (colloquim), Brussels, 1974.

Van der Weyden (cat), Brussels, 1979.

Campbell, Lorne, *Van der Weyden,* London and New York, 1980.

Schoute, Roger van, and Dominique Hollanders-Favart, editors, *Le Dessin sous-jacent dans la peinture: Le Problème de l'auteur de l'oeuvre de peinture* (colloquium), Louvain, 1981.

Lane, Barbara G., *The Altar and the Altarpiece: Sacramental Themes in Early Netherlandish Painting,* New York, 1984.

articles—

Maquet-Tombu, Jeanne, "Van der Weyden, pélerin de l'année sainte 1450," in *Arts Plastiques,* 1951.

Simson, Otto G. von, " 'Compassio' and 'Co-Redemptio' in Van der Weyden's *Descent from the Cross,*" in *Art Bulletin* (New York), 35, 1953.

Birkmeyer, Karl M., "The Arch Motif in Netherlandish Painting of the Fifteenth Century," in *Art Bulletin* (New York), 43, 1961.

Feder, Theodore H., "A Reexamination Through Documents of the First Fifty Years of Van der Weyden's Life," in *Art Bulletin* (New York), 48, 1966.

Schulz, Anne Markham, "The Columba Altarpiece and Van der Weyden's Stylistic Development," in *Münchner Jahrbuch der Bildenden Kunst,* 22, 1971.

McNamee, M. B., "An Additional Eucharistic Allusion in Van der Weyden's 'Columba Triptych,' " in *Studies in Iconography,* 2, 1976.

Blum, Shirley Neilsen, "Symbolic Invention in the Art of Van der Weyden," in *Konsthistorisk Tidschrift* (Stockholm), 46, 1977.

Lane, Barbara, "Early Italian Sources for the Braque Triptych," in *Art Bulletin* (New York), 62, 1980.

Grosshans, Rainald, "Van der Weyden: Der Marienaltar aus der Kartause Miraflores," in *Jahrbuch der Berliner Museen,* 23, 1981.

Dixon, Laurinda S., "Portraits and Politics in Two Triptychs by Van der Weyden," in *Gazette des Beaux-Arts* (Paris), June 1987.

*

Little is known about the life of Rogier van der Weyden, who, along with Jan van Eyck, is considered one of the founders of the Early Netherlandish school of painting. Added to the lacunae surrounding the actual events of Rogier's life is the troublesome fact that he neither signed nor dated his works. Furthermore, most of Rogier's major paintings had been destroyed by the year 1700, and his once-famous name was all but forgotten until the 19th century, when the so-called "Flemish Primitive" school of painting enjoyed a revival in France and England. The reconstruction of the actual events of Rogier van der Weyden's life and the dating and attribution of his paintings still engender controversy among scholars. A few sparse biographical facts have come to light from the study of documents, which also provide information concerning the patronage of certain works. In addition, art historians rely upon visual analysis in their efforts to attribute works and chart the development of Rogier's style. Recently, scientific investigation has allowed a glimpse beneath the painted surface, providing dramatic revelations about works traditionally attributed to Rogier. As more documents come to light and the discoveries of the laboratory are interpreted, new facts emerge and old assumptions are overturned. Our knowledge of Rogier van der Weyden is certain to change as these developments proceed.

Scholars continually debate the events of Rogier's life, and have proposed conflicting theories about his early background, training, and nationality. Indeed, early sources are far from unanimous with regard to these facts. Bartolommeo Facio's *De viris illustribus* (1456), for example, called Rogier a student of Van Eyck, while Vasari (1550) and Van Mander (1604) split Rogier's identity between a Rogier of Brussels and a Rogier of Bruges. It is now generally acknowledged that Rogier van der Weyden was born in Tournai and apprenticed with the painter Robert Campin before entering the Tournai Guild of St. Luke in 1432. This theory is strengthened by the fact that Rogier's wife, whom he married in 1436, had the same family name as the wife of Campin. Furthermore, Rogier continued to be involved in Tournai financial dealings even after he moved away, and, at his death, masses were said for him there. Facio's claim that Rogier was a "student" of Van Eyck was undoubtedly meant in the broadest sense, for it is obvious that Rogier admired and studied the innovations of the earlier master and

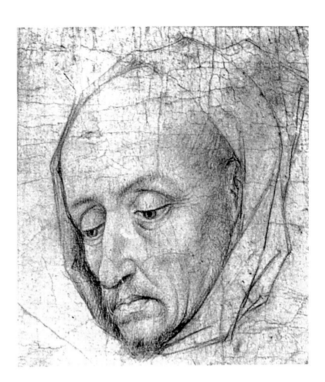

Head of an Old Man; silverpoint

absorbed them into his own distinctive painterly style (see the early *Virgin and Child in a Niche,* c. 1432–33, Vienna).

Though he began in Tournai, Rogier's fame and fortune were made in Brussels, the civic hub around which the brilliant court of Duke Philip the Good revolved. He became "painter to the city" in 1436, and established a large workshop for the purpose of satisfying the artistic demands of the Duke and his wealthy courtiers. It was at this time that Rogier's name was translated from the French "de la Pasture" to the Flemish "van der Weyden." No evidence has come to light indicating that Rogier enjoyed anything other than a prosperous, uneventful life in Brussels. He visited Italy at least once in 1450, though the effect of this journey upon his own highly personal style was mainly relegated to motifs and compositions borrowed from Italian masters. The *Entombment* (Florence) and the so-called *Medici Madonna* (Frankfurt) are both compositionally related to works he might have seen on his journey, and were probably painted for Italian patrons. Rogier van der Weyden remained a quitessential "Northern" painter, his style gradually evolving from the sturdy, bourgeois influence of his teacher Robert Campin to an elegance and urbanity reflective of the aristocratic Burgundian court.

Rogier's existing works consist of portraits and religious scenes, though he is known also to have indulged in secular subjects, such as the lost painting, described in an Italian document of 1456, of two boys peering at a bathing woman through a hole in a wall. Only a few extant works are documented in 16th and 17th-century sources as directly related to the hand of Rogier van der Weyden. These consist of a free tapestry copy of four destroyed panels depicting *The Justice of Trajan* and *The Justice of Herkinbald* done for the Town Hall of Brussels; the Prado *Descent from the Cross,* believed to be the center panel of a larger altarpiece painted before 1443; and

a *Crucifixion* (Escorial) probably given by Rogier to the Charterhouse of Scheut near Brussels between 1454 and 1460. By studying these few works and comparing them to others, Rogier's painterly style and artistic development can be charted, though scholars will forever argue the fine points of dating and attribution.

Aside from his large-scale religious paintings, Rogier was a successful and fashionable portrait painter. His single portraits of members of the Burgundian Court, composed in half-length, three-quarter facial views, display an exciting interplay of line and mass combined with a sensitive rendering of the distinctive physiognomy and personality of each sitter (see, for example, the *Portrait of a Lady,* c. 1455, Washington, and the *Portrait of Philippe de Croy,* Antwerp). Rogier's expertise in portraiture extended also to his large-scale sacred paintings, which often include the recognizable faces of people famous in his day (the *Last Judgment Altarpiece,* c. 1444–48, Beaune, and the *St. Columba Altarpiece,* c. 1460, Munich).

In sum, Rogier van der Weyden brought strength and drama to the painterly vocabulary of Northern art. He emphasized emotion by eliminating the clutter of symbolic objects that sometimes overruns the paintings of his lesser contemporaries and by arranging forms in rhythmic counterpoint at the front of the picture plane. Neither perspective depth nor background detail interferes with the expressive strength that distinguishes Rogier's highly individualistic works. His original and dramatic innovations were recognized during his life, and influenced all subsequent developments in Netherlandish painting.

—Laurinda S. Dixon

VAN DYCK, (Sir) Anthony.

Born in Antwerp, 22 March 1599. Died in London, 9 December 1641. Married Mary Ruthven, 1639; one daughter; also one illegitimate daughter. Apprenticed to the painter Hendrick van Balen (also Snyders's master), 1609; set up as independent painter by 1615, and was chief assistant to Rubens while still in his teens; member of the Antwerp guild, 1618; short visit to England, 1620, and long visit to Italy, 1621–25 (especially successful in Genoa and Rome); returned to Antwerp, and worked for the House of Orange; settled in England, 1632; patronized by the court, and very successful (knighted, 1632).

Major Collections: Antwerp; London; Munich; Royal Collection.
Other Collections: Antwerp: Augustinerkirche, S. Paul; Baltimore; Boston: Museum, Gardner; Braunschweig; Brussels; Detroit; Florence: Pitti; Ghent: S. Michael; The Hague; Hartford, Connecticut; Kassel; Leningrad; Lille; London: Dulwich, Courtauld, Wallace; Madrid; New Haven; New York: Metropolitan, Frick; Oxford: Christ Church; Palermo: Oratorio del Rosario di S. Domenico; Paris: Louvre, Ecole des Beaux-Arts; St. Louis; Saventhem: S. Martin; Toronto; Turin: Sabauda; Vaduz; Vicenza; Vienna; Washington: National Gallery, Corcoran.

Publications

On VAN DYCK: books—

Knackfuss, Hermann, *Van Dyck,* Bielefeld, 1896, New York, 1899.

Cust, Lionel H., *Van Dyck: An Historical Study of His Life and Works,* London, 1900.

Schaeffer, Emil, *Van Dyck: Des Meisters Gemälde,* Stuttgart, 1909; revised edition by Gustav Glück, 1931.

Mayer, A. L., *Van Dyck,* Munich, 1923.

Glück, Gustav, *Rubens, Van Dyck, und ihr Kreis,* Vienna, 1933.

Delacre, Maurice, *Le Dessin dans l'oeuvre de Van Dyck,* Brussels, 1934.

Adriani, Gert, *Van Dyck: Italienisches Skizzenbuch,* Vienna, 1940, 1965.

Mauquoy-Hendricks, M., *L'Iconographie de Van Dyck: Catalogue Raisonné,* Brussels, 2 vols., 1956.

Vey, Horst, *Van Dyck-Studien,* Cologne, 1958.

Puyvelde, Leo van, *Van Dyck,* Brussels, 1959.

Vey, Horst, and R. A. d'Hulst, *Van Dyck: Tekeningen en Olieverfshetsen,* Rotterdam, 1960.

Vey, Horst, *Die Zeichnungen Van Dycks,* Brussels, 2 vols., 1962.

Jaffé, Michael, *Van Dyck's Antwerp Sketchbook,* London, 2 vols., 1966.

Didière, Pierre, *Van Dyck,* Brussels, 1969.

Strong, Roy, *Van Dyck: Charles I on Horseback,* London, 1973.

Martin, John Rupert, *Van Dyck as a Religious Artist* (cat), Princeton, 1971.

Larsen, Erik, *L'opera completa di Van Dyck,* Milan, 2 vols., 1980.

McNairn, Alan, *The Young Van Dyck* (cat), Ottawa, 1980.

Brown, Christopher, *Van Dyck,* Oxford, 1982.

Millar, Oliver, *Van Dyck in England* (cat), London, 1982.

Art and Autoradiography: Insights into the Genesis of Paintings by Rembrandt, Van Dyck, and Vermeer, New York, 1982.

articles—

Stechow, Wolfgang, "Van Dyck's Betrayal of Christ," in *Minneapolis Institute of Arts Bulletin,* 49, 1960.

Roland, Margaret, "Van Dyck's Early Workshop, the Apostle Series, and the Drunken Silenus," in *Art Bulletin* (New York), June 1984.

Liedtke, Walter A., "Van Dyck," in *Metropolitan Museum of Art Bulletin* (New York), Winter 1984–85.

Spicer, Joaneath, "Unrecognized Studies for Van Dyck's Iconography in the Hermitage," in *Master Drawings* (New York), Winter 1985–86.

*

Van Dyck's career is overshadowed by that of his great rival in Antwerp, Peter Paul Rubens, from whom he learned so much (although not as a pupil) and for whom he worked a while as his chief assistant. The contrast between the two personalities, one twenty-two years older, could not have been more marked.

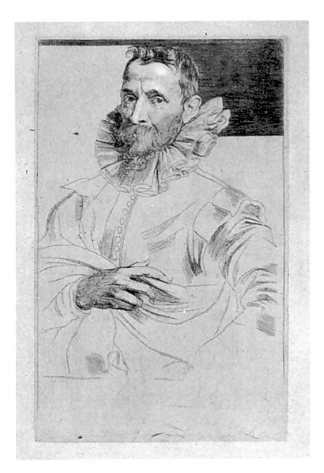

Jan Bruegel; etching

Van Dyck was ambitious, like his mentor, but also sensitive, perhaps even a bit neurotic (and today one can only guess at the personality of this retiring artist). Additionally, he seems always to have lacked Rubens's boundless energy and carefree assurance, nor was he ever able to command a similar power of endless inventiveness and the seemingly effortless command of form as that practiced by the great artist whom he was only to outlive by a year and a half. Obviously an assured administrator, Rubens ran his workshop like a factory; Van Dyck, to the contrary, seems much the solitary individual, perhaps one possessed by that ineffable air of chivalric melancholy that so commonly infects his portraits. Van Dyck appears, however, to have always enjoyed a cordial relationship with his vigorous senior and employer and, perhaps to his eventual detriment, he quickly acquired facility in imitating the older master's highly marketable style. In retrospect, Van Dyck's generally successful career seems almost like a protracted struggle to "find himself," perhaps accounting in large part for his expatriation from his native Antwerp, although this kind of purely artistic quandary seems too modern in concept, and thus unlikely. In the end, one prefers instead an economic explanation: Van Dyck simply found less competition abroad (either in Italy or in England) where his recognized strong point was a new kind of portraiture, characterized by psychic intensity realized through muted but decorative colors, artful and emblematic ambience, veiled physiognomy, and an excessive corporeal elongation, to which traits the younger Fleming added a hand-

some measure of formularized idealization wholly in conformance with the neoplatonizing artistic theories and aristocratic social ideals of his time.

When we think of Van Dyck today it is of course nearly inevitably as a portraitist, particularly as the suave memorialist of the notable personages attached to the court of King Charles I of Great Britain. This ruler was an active patron of literature, particularly that highly artificial kind, rare and exquisite, leaning heavily towards metaphor, allegory, and the metaphysical conceit, traits best exemplified by the emblematic court masques. Of Charles himself we have today an ambiguous recollection, one largely gained through the medium of Van Dyck's highly accomplished portraiture. As immortalized by the Fleming, the slight English king is viewed as a tragic figure in the light of his execution in 1649, occurring, however, eight years after the decease of the artist whose vision defines for us today the elegant and somewhat melancholy physiognomy of the "Cavalier" personality. Portraiture was, of course, the primary professional obligation of all courtpainters during the baroque period, and Van Dyck generally hewed to the strictest boundaries of the genre—even though he certainly brought the very look of it to unprecedented heights of pose and grace. Seen from a strictly historical perspective, the conventional aspect of Van Dyck's portraiture largely derives from Italian art theory, which the artist came to know well during his lengthy sojourn in Italy. In this regard, Van Dyck's evocative portraiture represents a consummate pictorialization of once-familiar (and now largely forgotten) humanistic rhetoric.

As long ago as 1435, in his widely read *Della Pittura* Leon Battista Alberti spoke of the painter's subtle manner of idealizing nature, seen by him as an adjusted mirror-image: "things taken from nature are corrected with a mirror." More importantly, he explained portraiture as a memorial, keeping alive the visages of the revered dead: "Painting contains a divine force which not only makes absent men present, as friendship is said to do, but, moreover, it makes the dead seem almost alive [conferring to them] a long life through painting." These ideas were expanded by later theoretists, such as G. P. Lomazzo (*Trattato dell'Art,* 1590), who tells us that the portraitist works from "mind and intellect," making quasi-religious icons from the likenesses of illustrious figures: "portraits of great men are like earthen idols." Since the very beginnings of artmaking, "only Princes used this art of portraiture." Thus, as Van Dyck knew best, portraiture is above all a royal art, "*per la memoria dei Rè*." Artifice and elegance are the hallmarks of this royal art. As Lomazzo affirmed, "most of the best [paintings] are the intellectual portraits," characterizing the given royal sitter; thus the painter, working from his *cosa mentale,* "will have in his intellect exactly the same idea and design for that King." Therefore, concludes Lomazzo, "it behooves the painter always to accentuate grandeur and majesty in the facial features and to correct Nature's defects." In depicting his inherently noble subjects, the painter portrays, "not the deed which perchance they actually did, but rather those actions which he *should* have done in accordance with the majesty and the decorum of his station in life."

Such were the professional strictures ordering the artificial, metaphorical, and emblematic, resonances of a typical courtportrait by Van Dyck, including his magnificent *Charles I on Horseback* (London). Nevertheless, for all of his admitted suc-

cess as a court-portraitist, Van Dyck, a devout Catholic, probably would have preferred—like his rival Rubens—to have been known as a painter of "histories," interpreting, besides mythology and classical poetry, subjects drawn from the Bible and the lives of the Saints. Sir Joshua Reynolds also intuited Van Dyck's real aspirations and vocation; speaking of his altar-piece in Mechlin, the *Crucifixion with the Two Thieves,* the English academician observed how "it may be considered as one of the first pictures in the world, and it gives the highest idea of Vandyck's powers." The sad conclusion was that, in sum, "it shews that he had truly a genius for history-painting—if it had not been taken off by portraits." To eulogize the death of the painter in 1641, his friend Abham Cowley lamented in verse how: "Vandike is Dead; but what Bold Muse shall dare / (Though Poets in that world with Painters share) / T'express her sadness?" The answer is that the late artist of the metaphorical portraits was himself a Cavalier poet, whose loss now makes all the arts mourn: "Poesie must become / An Art, like Painting here, an Art that's dumb. . . ."

—John F. Moffitt

VAN EYCK, Jan.

Born in Maaseyck, near Maastricht, c. 1390–1400; brother of the painter Hubert van Eyck. Buried in Bruges, 9 July 1441. Married; two children. Little is known of his brother Hubert (older than Jan) or of Jan's early life; was working for Count John of Holland in The Hague, 1422–24; then court painter to Philip the Good, Duke of Burgundey, and lived in Lille, 1425–29: made secret trips on the Duke's business, e.g., to Portugal, 1428–29; worked in Bruges from 1430; perfected the oil medium for painting.

Major Collection: London.
Other Collections: Antwerp; Berlin; Bruges; Detroit; Dresden; Frankfurt; Ghent: S. Bavo; Melbourne; New York: Metropolitan, Frick; Paris; Philadelphia; Turin; Vienna; Washington.

Publications

On VAN EYCK: books—

Brockwell, Maurice, and W. H. James Weale, *The Van Eycks and Their Art,* London, 1912.

Friedländer, Max J., *Die altniederländische Malerei, vol. 1: Die Van Eyck, Petrus Christus,* Berlin, 1924; as *The Van Eycks, Petrus Christus* (notes by Nicole Veronee-Verhaegen), Leiden, 1967.

Fierens, Paul, *Van Eyck,* Paris, 1931.

Renders, Emile, *Van Eyck: Son oeuvre, son style, son évolution, et la legende d'un frère peintre,* Bruges, 1935.

Tolnay, Charles de, *Le Maître de Flémalle et les frères van Eyck,* Brussels, 1939.

Beenken, Hermann T., *Hubert und Jan van Eyck,* Munich, 1941, 1943.

Puyvelde, Leo Van, *Van Eyck: The Holy Lamb,* Paris, 1947.

Coremans, Paul N., and A. J. de Bisthoven, *Van Eyck: The Adoration of the Mystic Lamb,* Antwerp, 1948.

Musper, H. T., *Untersuchungen zu Roger van der Weyden und Van Eyck,* Stuttgart, 1948.

Baldass, Ludwig, and Erwin Panofsky, *Van Eyck,* London and New York, 1952.

Panofsky, Erwin, *Early Netherlandish Painting,* Cambridge, Massachusetts, 2 vols., 1953, 1966.

Coremans, Paul N., *L'Agneau Mystique au laboratoire: Examen et traitement,* Antwerp, 1953.

Lejeune, Jean, *Les van Eyck, peintres de Liège et de sa cathédrale,* Liege, 1956.

Philippe, Joseph, *Van Eyck et la genèse mosane de la peinture des anciens pays-bas,* Liege, 1960.

Denis, Valentin, *All the Paintings of Van Eyck,* London, 1961.

Denis, Valentin, *Van Eyck: The Adoration of the Mystic Lamb,* Milan, 1964.

Thelheimer, Siegfried, *Der Genter Altar,* Munich, 1967.

Faggin, Giorgio T., *L'opera completa dei Van Eyck,* Milan, 1968; as *The Complete Paintings of the Van Eycks,* New York, 1970.

Philip, Lotte Brand, *The Ghent Altarpiece and the Art of Jan Van Eyck,* Princeton, 1971.

Dhanens, Elisabeth, *Van Eyck: The Ghent Altarpiece,* New York, 1973.

Chatelet, Albert, *Van Eyck,* Woodbury, New York, 1980.

Dhanens, Elisabeth, *Hubert and Jan Van Eyck,* New York, 1980.

Purtle, Carol J., *The Marian Paintings of Van Eyck,* Princeton, 1982.

Dhanens, Elisabeth, *De iconografie der van Eycks,* Bruges, 1982.

Denis, Valentin, *Van Eyck,* Paris, 1982.

Lane, Barbara G., *The Altar and the Altarpiece: Sacramental Themes in Early Netherlandish Painting,* New York, 1984.

Eichberger, Dagmar, *Bildkonzeption und Weltdeutung im New Yorker Diptychon des van Eyck,* Wiesbaden, 1987.

articles—

Panofsky, Erwin, "Van Eyck's Arnolfini Portrait," in *Burlington Magazine* (London), 1934.

Meiss, Millard, "Light as Form and Symbol in Some Fifteenth-Century Paintings," in *Art Bulletin* (New York), 27, 1945.

Bergstrom, Ingvar, "Medicina, Fons et Scrinium: A Study in Van Eyckian Symbolism and Its Influence in Italian Art," in *Konsthistorisk Tidskrift* (Stockholm), 25, 1957.

Chatelet, Albert, "Les Enluminures eyckiennes des manuscrits de Turin et de Milan-Turin," in *Revue des Arts,* 7, 1957.

Hall, Edwin C., "More about the Detroit van Eyck: The Astrolabe, The Congress of Arras, and Cardinal Albergati," in *Art Quarterly* (Detroit), Summer 1971.

Schabacker, Peter H., "De Matrimonio ad Morganaticam Contracto: Van Eyck's 'Arnolfini' Portrait Reconsidered," in *Art Quarterly* (Detroit), Winter 1972.

Snyder, James, "The Chronology of van Eyck's Paintings," in

Album Amicorum J. G. van Gelder, The Hague, 1973.
Ward, John L., "Hidden Symbolism in van Eyck's Annunciations," in *Art Bulletin* (New York), 57, 1975.
Sterling, Charles, "Jan van Eyck avant 1432," in *Revue de l'Art* (Paris), 3, 1977.

*

It is impossible to under-estimate the importance of Jan van Eyck to the history of art. The Italian humanist Bartolommeo Fazio (*De viris illustribus*, 1456) called him "the foremost painter of our age," and his name is acknowledged today as one of the greatest in the history of northern European art. With his contemporary Robert Campin (The Master of Flémalle) and his disciple Rogier van der Weyden, van Eyck created a new naturalistic, illusionistic style of painting which, in the words of Giovanni Sanzio, father of the painter Raphael, "challenged nature herself." Van Eyck's technical innovations in the oil medium, combined with his scientist's sense of color and light, jeweler's eye for precision, meticulous observation of minute detail, and ability to cloak common objects with erudite symbolism, produced an art that set the standard for an age and which has never been surpassed.

A hundred years after Fazio's glowing assessment, *Vasari* credited van Eyck with rediscovering the ancient art of oil painting practiced by Apelles, court artist of Alexander the Great, to whom Jan was frequently compared. Though mixing pigments in an oil base was not new to the 15th century, van Eyck was the first consistently to use thin pigmented oil glazes and varnishes concocted, said Vasari, "by means of alchemy," the scientific ancestor of modern chemistry. No matter what the means, the final result was a translucent, enamel-like surface achieved by the laborious application of layer-upon-layer of thin oil glaze. Brush strokes are imperceptible in van Eyck's paintings, and colors are so luminous and clear that the passage of five hundred years has not dimmed them.

We know little about Jan van Eyck's life, though, in fact, more is known about him than about any other 15th-century painter. He was probably born in Maastricht, a city in the southern Netherlands, and his two brothers Hubert and Lambert were also painters. The first artistic mention of Jan occurs in the famous inscription on the frame of the *Ghent Altarpiece* (St. Bavo, Ghent) dated 6 May 1432, which claims that Jan van Eyck finished the work begun by his brother Hubert. On the basis of this evidence, scholars usually assume that Jan was a full-fledged master when he took on the important task, and that he was therefore probably born around 1390. There are, however, at least two historical claims that Jan van Eyck was a young man at his death in 1441, and no works by his hand can be dated with certainty before the *Ghent Altarpiece*. A birth date closer to 1400 would make his marriage to Margaretha van Eyck, who was born in 1406, more reasonable in terms of the respective ages of husband and wife, and would also explain the young ages of his children at the time of their father's death. This argument, put forth by Lotte Brand Philip, would make Jan van Eyck aged about 20 at the time of his apprenticeship—precocious to be sure—but not beyond reason.

Jan's first position was at The Hague in the employ of John of Bavaria, unconsecrated Bishop of Liege, who hired van Eyck to help decorate his castle in 1422. Upon the death of his

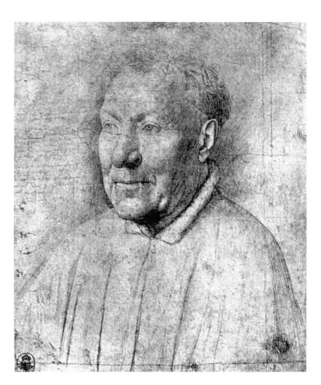

Cardinal Niccolò Albergati; silverpoint; Dresden, Staatliche Kunstsammlungen

patron in 1425, Jan began a 16-year career as *valet de chambre* to the fabulously rich and powerful Duke Philip the Good of Burgundy, and by 1430 had established an important workshop in Bruges. Thanks to the meticulous documentation of ducal chroniclers, much is known about Jan's position and responsibilities within the court milieu. Records exist of personal visits by the Duke to van Eyck's workshop, as well as extra payments, gifts and privileges that attest to the high esteem in which Philip held his court painter. The fact that Philip the Good stood as godfather (by proxy) to Jan's daughter at her baptism in 1435 suggests that the painter was both friend and servant to the Duke. It also appears that Van Eyck was appreciated for his powers of intellect and diplomacy at court as well as for his artistic brilliance. He made several "secret voyages" abroad in the company of Burgundian embassies, including two trips to the Iberian peninsula for the purpose of negotiating a ducal marriage. Duke Philip's generosity did not end with the painter's death in 1441. Both widow and daughter continued to receive support and consideration after that year. Perhaps the grateful Duke recognized that his place in history was already assured, thanks in large part to the immortal genius of his court painter.

Fazio described Jan van Eyck as a man of literary culture. The paintings themselves confirm this judgment, revealing more than a layman's knowledge of the great scholarly disciplines of the day, among them geometry, astronomy, music, theology, paleography, medicine, cartography, and ancient history. Nearly every endeavor of the human mind is reflected in the details of van Eyck's encyclopedic works. Even after half a millennium, art historians are still deciphering Jan's multifarious imagery, and each new interpretive theory is greeted, more often than not, with far-ranging scholarly controversy.

Whether the problem concerns the reconstruction of the vast iconographic program of the *Ghent Altarpiece*, or the Biblical-botanical significance of the single fruit that Eve holds to her lips in one of the panels, no avenue of investigation is too broad or too specific to be ignored, for every painted detail is significant. As the meanings inherent in Van Eyck's paintings are revealed and explained, more light is shed on the cultural and intellectual ambiance of one of the great eras in history—designated by Huizinga as the "golden age of Burgundy."

Van Eyck's paintings not only reveal impressive erudition, but also display astounding visual beauty and painterly virtuosity. With the notable exception of the *Ghent Altarpiece*, Jan's works are small in scale, yet unrivaled in the exacting depiction of every detail of the physical world. Neither microscope nor telescope—both inventions of a later age—can match the precision with which van Eyck captured the individual hairs of a fur collar, the threads comprising the warp and weft of an Oriental carpet or the minute reflection on the polished surface of a single pearl (see, for example, the rich attention to details in the *Madonna with Canon George van der Paolo*, Bruges). At the same time, Jan gloried in the depiction of things seen at great distances. The faraway cityscapes and country vistas glimpsed through the windows and archways of van Eyck's richly appointed interiors are, upon close inspection, actually comprised of a multitude of individual elements—each paving stone, flower, and tree is painted with as much scrupulous care as if it were meant to be placed in the foreground before our very eyes (such as the background vista of the *Madonna with Chancellor Nicolas Rolin*, Paris). Van Eyck also focused his fastidious eye upon human subjects. His painted portraits combine astute physiognomic verisimilitude with what eventually became the accepted formula for Netherlandish portraits. Each sitter appears in three-quarter facial view against a blank background, eyes gazing outward and directly engaging those of the viewer (see, for example, the *Man in a Red Turban*, London). The result is the disquieting sense that the face in the portrait is communicating wordlessly and telepathically with the living viewer.

In addition to investigating the technical brilliance and complex iconography of van Eyck's paintings, art historians continually debate the evolution of his style. They are aided by the fact that van Eyck actually signed many of his works with his own personal motto, "Als ich chan." In so doing, he adopted a chivalric custom practiced by the fashionable Burgundian courtiers with whom he worked. At the same time that it proclaims the painter's social and intellectual status, however, Jan's motto is also a model of self-abasement. Derived from the ancient classical proverb "ut potui, non sicut volui" (as I can, but not as I would), the words "als ich chan" ("This is the best I can do") form a perfect paragon of apologetic humility.

Excluding the controversial *Ghent Altarpiece*, there are ten paintings signed by Jan van Eyck and inscribed with dates ranging from 1433 to 1441. They include the *St. Barbara* of 1437 (Antwerp—a problematic drawing on wood panel), four devotional paintings of the Virgin Mary (the *Ince Hall Madonna*, 1433, Melbourne, not unanimously accepted as authentic; the *Madonna with Canon George van der Paolo*, 1436, Bruges; the *Madonna and Child with Saints Michael and Catherine*, 1437, Dresden; and the *Madonna by the Fountain*, 1439, Antwerp) and five portraits (the *Leal Souvenir*,

sometimes called a portrait of Gilles Binchois, 1432, London; the *Man in a Red Turban*, considered by some to be a self-portrait of the artist, 1433, London; the *Arnolfini Marriage Portrait*, signed "Johannes de eyck fuit hic," 1434, London; the *Portrait of Cardinal Albergati*, Vienna; and the *Portrait of Margaretha van Eyck*, 1439, Bruges). All these works were completed in the years following the first dated mention of Jan's artistic existence in 1432. Hence, scholars have been concerned with identifying paintings dating from before the *Ghent Altarpiece* in order to document the origins of Jan's extraordinary style. Technical laboratory examination of the paintings, however, has provided information that complicates the picture considerably. Traditionally, it has always been assumed that Jan's smallest, most miniaturistic works evolved directly from the late Gothic tradition of International Style manuscript illumination, and therefore pre-date the more austere, broadly painted *Ghent Altarpiece* of 1432. However, the recent discovery of a date of 1439 on the *Madonna of the Fountain*, the smallest, most miniaturistic (7^1/2 x 4^3/4 inches) of all the documented works, proves that it is not an early painting after all, but a late one. This discovery therefore refutes the traditional assumptions about van Eyck's "youthful" style, indicating that many factors were instrumental in determining the size and character of van Eyck's paintings. Scholars continue to re-evaluate the evidence, combining scientific documentation with investigations of patronage and iconography for clues to the origin and evolution of Jan's style.

Apart from those paintings signed and dated by the master himself, there exist several works generally accepted on the basis of historical circumstance and provenance to be by van Eyck (the *Madonna with Chancellor Nicolas Rolin*, Paris; the *Madonna in a Church*, Berlin—Dahlem; the *Lucca Madonna*, Frankfurt; the *Portrait of Baudouin de Lannoy*, Berlin—Dahlem; and the *Portrait of Cardinal Nicolas Albergati*, Vienna). In addition, other controversial paintings exist that display the unmistakable influence of Jan van Eyck, but that cannot be proven as such on any basis other than style. Scholars will always debate, for example, the attribution of the magnificent "Hand G" miniatures in the Turin-Milan Hours (*Très Belles Heures de Notre Dame*, Turin), a book owned by John of Bavaria during the time that the youthful Jan van Eyck worked at the Hague. Likewise, the brilliant *Madonna in a Church* (Washington) not only displays Jan's precision of detail and symbolic treatment of light, but also contains an entire religious-astrological sermon in its meticulously painted floor tiles. The tiny *St. Francis Receiving the Stigmata* (Philadelphia) rivals the *Madonna at the Fountain* in its miniaturistic vision of nature, and the controversial *St. Jerome in His Study* (Detroit) contains a wealth of erudite symbolism, though it bears a date of 1442. Perhaps this painting, like the *Madonna and Child with Saints and a Carthusian Monk* (New York, Frick), was finished posthumously by Jan's workshop. On the other hand, it is altogether possible that these unsigned works were painted by talented imitators of Jan's style whose names have been lost in the shuffle of history.

Ironically, no trace remains today of the specific works that Fazio praised most highly in his glowing account of Jan van Eyck. He described a beautiful *Face of Christ* and a *Map of the World* that achieved the cartographic miracle of locating recognizable cities and monuments at measurable distances from each other. History also laments the loss of a *Woman's*

Bath which reportedly showed a mirror reflecting the back of the bather, a sweating attendant and a little dog lapping up spilled water. Clearly, the portraits and religious scenes by van Eyck that remain today do not accurately reflect his entire oeuvre. They are, however, the consummate expression of the "northern Renaissance" or Netherlandish" school of painting in their unity of secular realism with pious sentiment and their seamless blending of transcendent painterly technique with iconographic content. The experience of looking at a painting by Jan van Eyck is not just an appreciative recognition of the sum of its excellent parts—it is also a spiritual encounter and a joyful celebration of material beauty.

—Laurinda S. Dixon

VAN GOGH, Vincent (Willem).

Born in Zundert, near Breda, 30 March 1853. Died (suicide) in Auvers-sur-Oise, France, 29 July 1890. Attended schools in Zundert, Zevenbergen, and Tilburg, to age 15; works as apprentice in the Goupil Gallery picture dealers, in The Hague, 1869–74, London, 1874–75, and Paris, 1875–76; taught in English schools in Ramsgate and Isleworth, 1876; worked in a bookshop, Dordrecht, 1877; prepared for theology study, then took an evangelist course in Brussels, and worked as a missionary in the coal-mining Borinage district of Belgium, 1879; focused attention on his drawing from 1880, living with his family off and on, and in other Dutch towns until 1886 (attended Antwerp Academy briefly, 1885–86); then lived in Paris, 1886–88, Arles (joined by Gauguin), 1888; then institutionalized as epileptic in Arles, 1889, Saint-Remy, 1889–90, and Auvers-sur-Oise, 1890.

Major Collections: Amsterdam: Rijksmuseum Vincent Van Gogh; Otterlo.
Other Collections: Amsterdam; Baltimore; Basel; Berlin; Boston; Bremen; Cambridge, Massachusetts; Chicago; Cleveland; Cologne; Copenhagen; Edinburgh; Essen; Glasgow; Indianapolis; Leningrad; London: Tate, National Gallery, Courtauld; Mannheim; Minneapolis; Moscow; Munich: Neue Pinakothek; New Haven; New York: Metropolitan, Moma, Brooklyn Museum; Oslo; Paris: d'Orsay, Rodin; Pittsburgh; Rotterdam; St. Louis, San Francisco; Sao Paulo; Vienna; Washington: National Gallery, Phillips.

Publications

By VAN GOGH: books—

Verzamelde Brieven, edited by J. van Gogh-Bonger, 4 vols., 1952–54; 2 vols., 1955; as *Complete Letters,* Greenwich, Connecticut, 3 vols., 1958.
Correspondance complète, enrichie de tous les dessins originaux, edited by Georges Charensol, Paris, 3 vols., 1960.
Van Gogh: A Self-Portrait, edited by W. H. Auden, Greenwich, Connecticut, 1961.
Letters, edited by Mark Roskill, London, 1963, New York, 1967.
Dagboek, edited by Jan Hulsker, Amsterdam, 1970; as *Diary,* New York, 1971.

On VAN GOGH: books—

La Faille, J. B. de, *L'Oeuvre de Van Gogh: Catalogue raisonné,* Brussels, 4 vols., 1928; supplemented by *Les Faux Van Gogh,* Brussels, 1930; revised edition, as *The Works of Van Gogh, His Paintings and Drawings,* Amsterdam, 1970.
Shapiro, Mayer, *Van Gogh,* New York, 1950, 1968, concise edition, 1985.
Leymarie, Jean, *Van Gogh,* Paris and New York, 1951.
Cooper, Douglas, *Drawings and Watercolors by Van Gogh,* Basel and New York, 1955.
Rewald, John, *Post-Impressionism: From Van Gogh to Gauguin,* New York, 1956, 3rd edition, 1978.
Elgar, Frank, *Van Gogh,* Paris, 1958; as *Van Gogh: A Study of His Life and Work,* New York, 1958.
Chetham, Charles, *The Role of Van Gogh's Copies in the Development of His Art,* New York, 1960, 1976.
Badt, Kurt, *Die Farbenlehre Van Goghs,* Cologne, 1961.
Hammacher, A. M., *Catalogue of 272 Works by Van Gogh,* Otterlo, 1963.
Graetz, Heinz, *The Symbolic Language of Van Gogh,* London, 1963.
Nagera, Humberto, *Van Gogh: A Psychological Study,* New York, 1967.
Leymarie, Jean, *Qui était Van Gogh?,* Geneva, 1968.
Szymanska, Anna, *Unbekannte Jugendzeichnungen Van Goghs,* Berlin, 1968.
Hammacher, A. M., *Genius and Disaster: The Ten Creative Years of Van Gogh,* New York, 1968, 1985.
Tralbaut, Mark Edo, *Van Gogh le mal aimé,* Lausanne, 1969; as *Van Gogh,* New York, 1969.
Roskill, Mark, *Van Gogh, Gauguin, and the Impressionist Circle,* Greenwich, Connecticut, and London, 1970.
Lecaldano, Paolo, *L'opera pittorica completa di Van Gogh e i suoi nessi grafici,* Milan, 2 vols., 1971.
Leprohon, Pierre, *Van Gogh,* Cannes, 1972.
Pickvance, Ronald, *English Influences on Van Gogh,* Nottingham, 1974.
Welsh-Ovcharov, Bogomila, editor, *Van Gogh in Perspective,* Englewood Cliffs, New Jersey, 1974.
Welsh-Ovcharov, Bogomila, *Van Gogh: His Paris Period 1886–1888,* Utrecht, 1976.
Mauron, Charles, *Etudes psychocritiques,* Paris, 1976.
Secrétan-Rollier, Pierre, *Van Gogh chez les gueules noires,* Lausanne, 1977.
Hulsker, Jan, *Van Gogh en zijn weg,* Amsterdam, 1977; as *The Complete Van Gogh: Paintings, Drawings, Sketches,* New York and Oxford, 1980, 1985.
Uitert, Evert van, *Van Gogh Drawings,* Woodstock, New York, 1978.
Zemel, Carol M., *The Formation of a Legend: Van Gogh Criticism 1890–1920,* Ann Arbor 1980.
Welsh-Ovcharov, Bogomila, *Van Gogh and the Birth of Cloisonism,* Toronto, 1981.

Peasant Woman Returning Home; drawing

Clebert, Jean-Paul, and Pierre Richard, *La Provence de Van Gogh,* Aix-en-Provence, 1981.

278 Works in the Collection of the Kröller-Müller Museum, Otterlo, 1983.

Uitert, Evert van, *Van Gogh in Creative Competition: Four Essays from Simiolus,* Zutphen, 1983.

Pickvance, Ronald, *Van Gogh in Arles* (cat), New York, 1984.

Bernard, Bruce, editor, *Vincent by Himself: A Selection of Van Gogh's Paintings and Drawings,* Boston and London, 1985.

Hulsker, Jan, *Lotgenoten: Het leven van Vincent en Theo Van Gogh,* Weesp, 1985.

Pickvance, Ronald, *Van Gogh in Saint-Rémy and Auvers* (cat), New York, 1986.

Bridgewater, Patrick, *The Expressionist Generation and Van Gogh,* Hull, 1987.

Uitert, Evert van, editor, *The Rijksmuseum Vincent Van Gogh,* Amsterdam, 1987.

Mothe, Alain, *Van Gogh à Auvers-sur-Oise,* Paris, 1987.

Stein, Susan Alyson, editor, *Van Gogh: A Retrospective,* New York and London, 1987.

Wolk, Johannes van der, *The Seven Sketchbooks of Van Gogh: A Facsimile Edition,* New York and London, 1987.

Welsh-Ovcharov, Bogomila, *Van Gogh à Paris* (cat), Paris, 1988.

Vincent Van Gogh is best known for the legacy he left to the world: more than 1000 drawings and some 800 paintings, and since in the last few years some of these pictures have been sold for sensational prices, his fame as a painter has received a new stimulus. Yet, when he started his career as an artist, he was already 27 and had an eventful life behind him, which in itself could easily have been the object of books and feature films. As a matter of fact, a sort of biography about that part of his life does already exist, for in the first 140 of his 650 letters to his brother Theo—together more than 200 printed pages—Vincent Van Gogh himself has faithfully described in eloquent and often moving words the occurrences of those years which gradually had so completely changed his ideas and his outlook on life. Here it can only be summarized in a few sentences.

Vincent Willem van Gogh was born on 30 March 1853 in Zundert, a village in the south of the Netherlands. his father was the protestant minister of the place, but three of his father's brothers were art dealers, and so it is only natural that Vincent, who had left school at fifteen and had to earn a living, became an apprentice at the shop of his uncle Vincent van Gogh in The Hague. His uncle had become a partner in the firm of Goupil & Cie, and after having worked in The Hague for four years Vincent was sent to other branches of the Goupil firm, first in London, then in Paris. A few years later, however, in April 1876, he was dismissed, probably because it had become clear that his ambitions were no longer with the world of the art business. During the years in London and Paris, Vincent had developed an intense, even fanatical love for the Church and a desire to follow in the footsteps of his father. In England he found a job as a schoolmaster, first in Ramsgate, a little later in Isleworth near London. His employer in Isleworth was a clergyman, who let Van Gogh teach Sunday school and sometimes had him give a sermon in one of the local churches, but even that could not satisfy Vincent's religious aspirations. Back in Holland, where for a few months he had found a job as a bookkeeper in a bookshop in Dordrecht, he finally succeeded in getting permission from his father and his influential uncles to start the long study to become a clergyman. From 1877 to 1878, he stayed in the house of his uncle Jan, a high-ranking naval officer in Amsterdam, taking lessons in Latin and Greek and mathematics in order to prepare himself for the entrance examination of the University, but that kind of study soon became too much for him; he wanted to bring his religious ideas into practice as soon as possible, and finally, with the reluctant help of his father, he found a job as an evangelist in a poor mining district in Belgium, the Borinage. Here, he could live up to his ideals, and his first letters from the Borinage show that he liked his work. He gave Bible classes, taught the children of the miners, and did his utmost to help the poor, the sick, and the wounded. He gave away his best clothes and for some time lived in a miserable hut. His fanaticism was probably the cause that after six months the Evangelisation Committee did not renew his appointment. For some time he tried to go on with his social work, living on the little money his father sent him, but at the same time his interest had shifted to art again and he became more preoccupied with his drawing than with the Church. In April 1881, after a year of struggling with himself in poverty and isolation, he returned to the home of his parents, who had by now settled in Etten, another village in the province of

Brabant, and it was here that his career as a professional artist really begun.

Although for more than a year Van Gogh had been making drawings of miners and other sketches (of which only very few have been preserved) and had practiced drawing by making large copies of works by Millet and by repeatedly copying the *Exercises au Fusain* by Charles Bargue, a drawing manual published by Goupil, he was almost a complete beginner when he started work in Etten. His first drawings from Etten are still very clumsy, but in a few months a great improvement is noticeable, and the progress becomes amazing as soon as he had settled in The Hague (after a row with his father about his refusal to go to church at Christmas). Here he had some help from a very good painter, called Anton Mauve, who also gave him some painting lessons. In the two years that Van Gogh spent in The Hague (1882–83), he produced some two hundred drawings, most of which are very characteristic figure studies, either after the woman who shared his life in The Hague, Sien Hoornik, or after men and women from an old people's home, but there are also excellent landscapes, such as the views of the gardens and meadows behind his house. One of the most famous of his figure studies is the seated nude, titled *Sorrow,* for which Sien had sat as a model. This portrait, of which he also made a lithograph, is typical for what his ideal in drawing was; he wanted to achieve more than mere technical perfection: his real aim was *expression.* He wanted to express the misery of the poor people with whom he was surrounded, and also their dignity. He admired the wood engravings of *The Graphic,* buying and collecting as many as he could, especially its "Heads of the People," though not its "Types of Beauty."

As life had become unbearable with her, he left Sien and her two children behind in September 1883, to find some rest and new inspiration in Drenthe, one of the northern provinces of the Netherlands. It was cold and lonely in Drenthe, and what he could achieve there were only a few dark and sombre landscape paintings and a small number of drawings, although he found an outlet in writing many long letters to his brother, who had gone on supporting him financially in spite of his disapproval of his relationship with Sien. Two happier and more productive years followed as Van Gogh was allowed to stay and work in the house of his parents again, who had moved to Neunen in the meantime, a town near Eindhoven (1884–85). Here he developed into a really great painter, while the numerous monumental drawings he made of farmers and peasant women working in the fields are not inferior to those of his reverend master Millet. Again, to be expressive was his main concern even if it was at the cost of correctness. Sending some of the drawings to Theo, he asked him to show them to a French painter, adding, "Tell him that my great longing is to learn to make those very incorrectnesses, those deviations, remodellings, changes in reality, so that they may become, yes, lies if you like—but truer than the literal truth." It was with this same concern for reality in a reinforced form that he painted what is often considered to be his masterpiece of the Nuenen-period: *The Potato-Eaters,* a group of peasant people gathered round their common meal, a picture which suggested, as he said, "that those people, eating their potatoes in the lamplight, have dug the earth with those very hands they put in the dish." At the end of 1885, shortly after his father had died, Van Gogh left Holland, never to return, and an im-

portant painting that can be seen as a symbolic farewell to that country and to his so-called "dark period" is the still-life with an open bible—representing the world of his father—in front of which is placed a French novel with yellow cover, Zola's *La Joie de vivre*—representing his own world and the world of color, light and freedom towards which he was now turning.

After a short stay in Antwerp—three months spent in poor health and misery, including a few weeks drawing after plaster casts at the Academy—he joined his brother in Paris, starting a whole new phase in his work as a painter. Under the influence of the Impressionist movement in France, his palette became much brighter and more colorful, and soon he even left Impressionist painting behind as he started experimenting with the newest tendencies in art, represented by painters like Seurat and Signac. A number of pictures in a pointillist manner were the result, but at the same time Van Gogh's painting style was strongly influenced by Japanese woodcuts with their clear outlines and flat colors which he had become to admire so much. The collection which he had assembled is still on show in the van Gogh museum in Amsterdam. For some months in the beginning of his stay in Paris, Van Gogh had worked at the studio of the French painter Fernand Cormon, drawing and painting after plaster casts and live models, and this must have contributed to his growing preference for figure painting. Some extremely beautiful portraits, done in a style all his own, date from this period: those of *La Segatori,* of *The Italian Woman,* and the two of the paint-dealer Tanguy, to name only a few. But the greatest achievement of the Paris period is perhaps his series of some 25 painted self-portraits. In the meantime he had made the acquaintance of many of the most progressive painters in Paris, some of whom, like Signac, Bernard, and Gauguin, were to remain friends in the following years; Toulouse-Lautrec made a marvelous portrait in pastel of him, John Russell one in oils, and Vincent strongly encouraged his brother Theo to go on helping the Impressionist painters by buying works from them for Goupil and by exhibiting them in his gallery. Paris has indeed played a key role in Van Gogh's development as an artist.

In February 1888, Van Gogh left Paris for Arles in the South of France, and during the year he stayed there his art reached its greatest heights. Many of the sun-drenched landscapes he painted here, like *The Drawbridge, The Harvest,* and *The Sower*—to name just a few—became known all over the world by color reproductions, and the same goes for his flowerpieces (*The Sunflowers*) and his figure paintings, such as *The Postman Roulin* and *The Berceuse, Madame Roulin.* For a few months at the end of the year, Paul Gauguin lived together with him in the little house that Van Gogh had rented, but their collaboration ended in a quarrel and in Van Gogh's insane act of cutting off part of his ear—a first sign of the mental disturbances that were to trouble him intermittently until his death.

At his own request, Van Gogh was admitted to an asylum at Saint-Rémy, not far from Arles, where he hoped to be able to work more peacefully than in Arles. Except for a few long periods of illness, he could, and the result was an astoundingly copious production of important drawings and paintings, including such famous masterpieces as *The Irises,* the expressionistic *Starry Night,* and the *Self-Portrait on a Light Background.* The last two and a half months of his life he spent at Auvers-sur-Oise, north of Paris, where we see the last outburst of his creativity with some 60 paintings, among them

such famous pictures as the one of the village church against a deep blue sky, the two portraits of Doctor Gachet, and the highly dramatic and symbolic *Wheatfield with Crows*. He was 37 when he shot himself on July 27, and died on July 29, 1890.

Van Gogh's paintings are scattered all over the world, but the two largest collections of his works are still in his native Holland, one in the Vincent van Gogh Museum in Amsterdam, and the other in the Kröller-Müller Museum in Otterlo near Arnhem. Theo, who had supported Vincent morally and financially during his whole life as an artist, became insane shortly after his brother's death, and died a few months later, himself only 33 years old. Their graves are side by side near the old church at Auvers-sur-Oise.

—Jan Hulsker

VASARELY, Victor.

Born in Pecs, Hungary, 9 April 1908; naturalized French citizen, 1959. Married Claire Spinner, 1930; two sons. Attended school in Budapest, until 1925; studied at the Academy of Painting, Budapest, 1925–27, and Bauhaus School, Budapest, 1929–30; graphic artist, Agence Havas and Editions Draeger Freres, Paris, 1930–39; also independent graphic artist from 1930, and painter from 1944; first architectural integrations, 1954, and kinetic films and writings from 1955. Address: 83 rue aux Reliques, Annet-sur-Marne, France.

Collections: Amsterdam: Stedeljik; Berlin: Nationalgalerie; Brussels; Chicago; Jerusalem: Israel Museum; London: Tate; Montreal: Art Contemporain; New York: Moma; Paris: Beaubourg; Sydney.

Publications

By VASARELY: books—

La Forme-Couleur integrée dans la cité par la technique des révêtements muraux, Paris, 1959.
Notes, réflexions, Paris, 1964; as *Notebook,* Oxford, 1964.
Entretiens, with Jean-Louis Ferrier, Paris, 1969.
Discours de la méthode de Descartes accompagné du Discours de la méthode de Vasarely, Paris, 1969.
Plasti-cité, edited by Michel Ragon, Paris, 1970.
Notes-brutes, Venice, 1970.
Folklore planetaire—Farbwelt, Munich, 1973.
Reponses à Vasarely, Paris, 1974.
Vasarely inconnu, Neuchâtel, 1977.

On VASARELY: books—

Dewasne, *Vasarely,* Paris, 1952.
Belloli, Carlo, *Vasarely* (cat), Milan, 1961.
Rene, Denise, and Jean Cassou, *Kassak-Vasarely,* Paris, 1961.
Schmied, Wieland, *Vasarely* (cat), Hanover, 1963.
Vasarely, Neuchâtel, 3 vols., 1965–74.

Pan, Imre, *Vasarely: Morphèmes,* Paris, 1966.
Rosta, M. E., *Vasarely* (cat), Budapest, 1969.
Spies, Werner, *Vasarely,* Stuttgart, 1969.
Bruck, Axel, *Vasarely Analysen,* Hamburg, 1970.
Leppien, Helmut R., *Vasarely* (cat), Cologne, 1971.
Spies, Werner, *Vasarely,* Paris and New York, 1971.
Fath, Manfred, *Vasarely* (cat), Ludwigshafen, 1972.
Hallain, Marc, *Ateliers aujourd'hui: Vasarely,* Paris, 1973.
Joray, Marcel, *Vasarely,* Neuchâtel, 1976.
Gomringer, Eugen, *Vasarely Farbstadt/City Polychrome,* Munich, 1977.
Hahn, Otto, *Le Musée imaginaire de Vasarely,* Paris, 1978.
Dahhan, Bernard, *Vasarely, ou la connaissance d'un art moléculaire,* Paris, 1979.
Desmond, William, *Vasarely plasticien,* Paris, 1979.
Gea, *Vasarely,* Paris, 1982.

article—

Joray, Marcel, "Art et industrie: Créations et recherches de Vasarely," in *Oeil,* October 1983.

*

Vasarely trained and originally practised as a graphic artist; over a number of decades he developed an abstract illusionistic idiom based on geometrical structures and achieving its impact through the exploitation of optical phenomena, especially reversible perspective and optical dazzle. His work in this field predates Op art, a movement that owed much to his research. By standardising the ingredients of his optical works, he hoped to make the system open to all, replacing reliance on the chance inspiration of an artistic elite with a system, a grammar of "plastic units," manipulable by any skilled operative, and applicable in industry, architecture, and the applied arts.

Vasarely's first skill was in conventional draughtsmanship; he had acquired a facility for exact representation before entering the Budapest "Bauhaus," a school of graphic arts which followed the functional and constructivist tendencies of the Weimar Bauhaus. Vasarely worked there on disciplined studies of the qualities of materials and on colour theory (probably preparing colour scales), and left well grounded in the theory and technique of contemporary abstract art.

On moving to Paris in 1930, Vasarely worked as a graphic artist. His posters from this time show a firm interest in optical illusion: in his *Mitin* poster (advertising a textile treatment) the presence of a schematic figure in relief is indicated only by the distortion in the pattern of the tartan ground. In tandem with commercial work, he produced experimental sketches exploring the illusionist potential of simple graphics, apparently with the idea of setting up a school. His lesson-drawings alert the viewer to the optical absurdities involved in endowing a flat surface with depth and relating a series of marks to a spectrum of experienced phenomena. Some are Renaissance-style exercises in foreshortening (*Study of Perspective,* 1935); others are more playful in the mode of the *Mitin* poster, like the shifting stripes that outline the intertwined heads and necks of two Zebras. Gradually his interest turned to these phenomena for their own sake, especially as he discovered that his experiments coincided with those of Surrealism. The transition can be seen in a *Study of Wood,* 1939. Wooden objects in

Aguia, 1957; screenprint

contrasting grains and textures (a curled plane shaving, a spoon, part of a log) are drawn with the meticulousness of *trompe l'oeil,* and from above as if in a study of perspective. The subject might be taken in the spirit of the perspective studies, were its seriousness as an exercise not undermined by the ambivalence of the artist's mannequin, who wields a giant pencil like a pole. If this gouache suggests de Chirico, an oil in the same style, actually entitled *Trompe l'Oeil,* studies the fall of shadow from a figure holding a plumbline, with suggestions of mystery in banal circumstances typical of Magritte. A third work from the 1930's (*Study MC,* 1936) openly employs Dali's "paranoiac-critical" method, animating a soft glove and juxtaposing incongruous items in disproportionate scale, although less with Dali's purpose of disorienting the rational mind than with Vasarely's consistent desire to disturb the habituated eye.

Vasarely also looked at the frottages of Max Ernst, reproducing in freehand paint the textures that Ernst obtained by rubbing. It was these which focussed his attention on minute patterns traceable in surface texture. The crazed tiles of a local station provided the basis for a series of abstract paintings (subsequently named the Denfert period), which are the first he omits in his biographical account from the category "false routes," a classification given to his gestural paintings and figurative Surrealist period. Like Ernst, Vasarely did see "bizarre towns and fantoms" in the hairline cracks, but he made the further observation that the cracking was due to "rupture at the level of the molecular structure" and that there was a genuine correspondence, on this cosmic level, between the cracks and the landscapes they evoked. The geometrised abstracts in three or four strong deep blocks of colour that resulted owe something to Purism in the interlocking planes of even flat colour. The standardisation of given units advocated in Purism certainly entered into Vasarely's thinking in the late 1940's and early 1950's: with the same micro/macro-cosmic analogy made in the Denfert series, he turned to the pebbles of the island of Belle Isle. Early examples use sandy colours and explore the representation of texture and three dimensionality: cut-out rounded shapes in sandpaper and card are superposed in measured layout, each representing a layer in the dimensions of the pebble. Later the pebble shapes become standard organic units as Vasarely stripped the source of its referential elements to use it as a molecular unit.

A third location, in the hill town of Gordes, resurrected the Gestalt theory in his mind, and he continued to explore spatial relationships and their perception in more complex and spatially ambiguous versions of the Denfert paintings. Forceful Provençal sunlight played on the complex planes of architecture, creating an optical dazzle. Pockets of vision would become slippery, with forms shifting in perception from concave to convex, near to far. The clearest description of the phenomenon dates from 1946 (*Voids and Hollows*) and shows semi-abstracted walls and tunnels in infinitely reversible perspective. The Gordes versions are wholly abstracted and geometrised in large monotone planes which relate to each other like perpetually folding screens, tonally simplified to the extremes of light and shade.

Impatient that, however remotely, his work was still limited by its relationship to pre-existing visual phenomena, Vasarely returned to serialisation, using smaller and stricter geometrical units: the technique of the *Mitin* poster and the Zebra stripes, stripped of figurative allusion to purify and intensify the optical effects. Having reached this conclusion, he was able to concentrate on retinal "irritation": the partial disturbance of serialisation against the expectations of the eye, chromatic vibration, all visual phenomena that disrupted the complacency reading an image. These grid and network paintings, plotted on graph paper frequently pulsatingly coloured, were elaborated in increasing tonal and spacial complexity during the 1960's and early 1970's and have become part of the imagery of that era.

Reducing the elements to a manipulable system, he worked for its adoption as a universal language in three-dimensional form, in architecture textiles and printed form, for the improvement of the human environment.

—Abigail Croydon

VASARI, Giorgio.
Born in Arezzo, 30 July 1511; son of a potter, grandson of the painter Lazzaro Vasari. Died in Florence, 27 June 1574. Married Niccolosa Bacci, 1550. Educated in Arezzo by Il Pollastra and in Florence at the Medici court by Pierio Valeriano; artistic training in Arezzo by Guglielmo da Marcilla (William of Marseilles); frequented the studios of Andrea del Sarto and Baccio Bandelli in Florence 1524–27; then traveled and worked in Pisa, Bologna, Modena, and Rome, patronized by Cardinal Ippolito de' Medici, 1529–31; worked under the pa-

tronage of Duke Alessandro and Ottaviano de' Medici in Florence, 1531–37; traveled extensively during the next dozen years patronized by Bindo Altoviti in Florence, Giovanni Corner in Venice, Cardinal Alessandro Farnese in Rome; then worked in Rome for Pope Julius III, 1550–55 (and a later stint under Pope Gregory XIII, 1573); worked mainly in Florence from 1555: superintendent of the restoration of the Palazzo Vecchio, and designed the Uffizi (offices); instrumental in founding the Accademia del Sidegno, 1563; his *Lives* of the artists, 1550 (revised and expanded edition, 1568), is his most famous legacy.

Major Collection/Location: Arezzo: Casa Vasari.
Other Collections/Locations: Arezzo: Badia; Camaldoli: Archienobio; Cortona: Compagnia del Gesù; Florence: Uffizi, Palazzo Vecchio, S. Maria Novella, SS. Apostoli, S. Croce; Naples: Capidomonte; Rome: Cancelleria, S. Pietro in Montorio, Vatican; Venice: Palazzo Corner Spinelli.

Publications

By VASARI: books—

Le vite di' piu eccellenti architetti, pittori, et scultori italiani . . ., Florence, 2 vols., 1550, 3 vols., 1568; edited by Gaetano Milanese, Florence, 1878–85; edited by Rosanna Bettarini and Paola Barocchi, Florence, 1966–87.
Der Literarische Nachlass, edited by Karl Frey (vols. 1–2), and Hermann Walther Frey (vol. 3), Monaco, 2 vols., 1923–30, and Burg, 1 vol., 1945.
Lo Zibaldone, edited by Alessandro del Vita, Arezzo, 1938.

On VASARI: books—

Kallab, W., *Vasaristudien*, edited by J. von Schlosser, Vienna, 1908.
Rud, Einar, *Vasari, Renaissancens Kunsthistoriker*, Copenhagen, 1961; as *Vasari's Life and Lives: The First Art Historian*, Princeton, 1963, London, 1964.
Barocchi, Paola, *Vasari pittore*, Milan, 1964.
Capriglione, Anna A., *Vasari pittore e sua influenza sulla pittura napoletana*, Naples, 1970.
Ragghianti Collobi, Licia, *Il libro de disegni del Vasari*, Florence, 2 vols., 1974.
Il Vasari storiografo e artista (colloquium), Arezzo, 1974.
Boase, Thomas S. R., *Vasari: The Man and the Book*, Princeton, 1979.
Ricco, Laura, *Vasare scrittore*, Rome, 1979.
Hall, Marcia B., *Renovation and Counter-Reformation: Vasari and Duke Cosimo in Santa Maria Novella and Santa Croce 1567–1577*, Oxford, 1979.
Corti, Laura, et al., editors, *Principi, Letterati, e artisti nelle carte di Vasari*, Florence, 1981.
Garfagnini, Gian Carlo, editor, *Vasari tra decorazione ambientale e storiografia artistica*, Florence, 1985.
Cheney, Liana de Girolami, *The Paintings in the Casa Vasari, Arezzo*, New York and London, 1986.

articles—

Jacobs, Fredrika H., "Vasari's Vision of the History of Painting: Frescoes in the Casa Vasari, Florence," in *Art Bulletin* (New York), September 1984.
Wohl, Helmut, "The Eye of Vasari," in *Mitteilungen des Kunsthistorischen Institutes in Florenz,* 30, 1986.
Herz, Alexandra, "Vasari's Massacre Series in the Sala Regio—the Political, Juristic, and Religious Background," in *Zeitschrift für Kunstgeschichte* (Munich), 48, 1986.

*

Vasari has been rightly called "the father of art history" (Boase) and aptly described as "mannerism's most eloquent exponent" (Shearman). Such labels are more of a reflection of his literary skill than a celebration of his artistic abilities. Indeed, more than his formal artistic training with Guglielmo da Marcilla in his native Arezzo, Vasari's humanistic education—first under the tuteledge of the Aretine Il Pollastra and then at the Medici court with Pierio Valeriano—is responsible for his contribution to the history of art. In 1550 the first edition of *Le vite de'più eccellenti pittori scultori ed architettori* was published. Composed of three essays concerning the materials and methods of the sister arts and four *proemii* that, in effect, provided the historical context for the lives of 142 artists, Vasari's book set forth an enduring concept of the history of Italian Renaissance art. A revised and significantly expanded second edition (the number of lives was increased to more than 160) appeared in 1568, that is, seven years after the founding of the first art academy, the Accademia del Disegno, Florence. Given the instrumental role Vasari had in establishing the Accademia, it is not surprising that he used the second edition to promulgate the aesthetic of academicism: *la bella maniera.* While it is true that Vasari's bias for Florentine *disegno* and prejudice against Venetian *colorito* unjustly slighted such masters as Giorgione and Titian, he nonetheless was and has remained the principal spokesman for the mannerist style that prevailed in Italy during the second half of the 16th century.

It is no accident that Vasari, an outspoken proponent of mannerism, practiced with the brush what he praised with the pen. Vasari's earliest works exhibit the stylization and eclectism that were to characterize his paintings throughout his career, as is evident in his study for a Deposition for San Domenico (now SS. Annunziata), Arezzo, 1536–37 (Hartford, Connecticut). Like Rosso Fiorentino's *Volterra Deposition,* 1521, which it reflects, Vasari's composition is pushed to the foreground affording little to no view into the distance. Similarly, it lacks a strong central focus, instead weaving a complexity of rigidly defined forms across the surface that engage the frame on all sides. Despite his later and lavish praise of Michelenagelo's monumentality and Raphael's ease and grace, here the debt is to Rosso's attenuated and weightless figures and oblique emotional content. When, two years later, Vasari returned to this theme in the altarpiece painted for the Camaldoli, Archicenobio, Rosso's influence had diminished significantly. Figures have acquired plastic clarity, albeit a frozen fineness, within the composition rather than on the picture plane. The intensity of feeling that had distinguished some of the figures in the Hartford study has been replaced with a stylization of Raphael's *grazia* into artificial sentiment. The artificiality that marks this image, no less than the convoluted

verbal constructs that it visualizes, was to become the hall-mark of Vasari's subsequent paintings.

The *Immaculate Conception,* painted for the Altoviti Chapel, SS. Apostoli, Florence, 1540–41, is characteristic of both the style and the artistic spirit of the second phase of mannerism. Maintaining but further clarifying the central axis, Vasari has enhanced the complexity of the composition by intertwining forms and countering each twist of a figure with a counter-curve of another form. Although Vasari based his figures on the Michelangelesque heroic type, they lack the spirit of the master, and thus appear as practised postures, devoid of originality, and abstracted from the normative representation of reality. Although these deficiencies were noted in the 17th century by theorists like Malvasia, Sanmacchini, Procaccini, and Bellori, Vasari's contemporaries recognized the ideals of their age in his style. Bindo Altoviti's pleasure with the *Immaculate Conception* opened important doors for the artist in Rome. In 1546 Altoviti, who resided in Rome, and the noted humanist Paolo Giovio, once advisor to Ippolito de'Medici, and a friend to the painter since 1532, introduced Vasari to Cardinal Alessandro Farnese, the nephew of the reigning pontiff, Paul III. Following instructions devised by Giovio, Vasari frescoed the Sala dei Cento Giorni (so-called because the project was to be completed within one hundred days) in the Palazzo della Cancelleria, Rome. Assisted by a large contingent of assistants, Vasari completed the four large histories and plethora of decorative detail on schedule. Unfortunately, Michelangelo's response to Vasari's pride of having met the deadline, "*Si vede bene* [So one sees]," is accurate. Figures appear cumbersome, their poses stilted, their gestures pedantic. Although Vasari later lamented his over-reliance on assistants, the increasing demand for his services by popes and princes made the continuation of this practice mandatory.

Between 1550 and 1553 Vasari collaborated with Bartolomeo Ammanati on the tomb for Cardinal Antonio del Monte in San Pietro in Montorio and decorated the Loggia della Vigna in Villa Giulia for Pope Julius III. In the final days of 1554 he returned to Florence. The following year Duke Cosimo I appointed him superintendent of the restoration of the Palazzo Vecchio. On December 15 he began decoration on the Sala di Elementi. In collaboration with humanists Vincenzo Borghini, Cosimo Bartoli, and Giovambattista Adriani, Vasari with the assistance of numerous artists that included Jacopo Zucchi, Francesco Poppi, Battista Naldini, Santi di Tito, and his long-time friend Franceso Salviati, spent the next decade transforming the walls of the Palazzo Vecchio into a gallery of images glorifying Medicean achievements. In conjunction with the cycle, Vasari wrote the *Ragionamenti,* an indispensable, if not always comprehensible, guide to the elaborate decorative scheme.

While engaged on the Palazzo Vecchio project, Vasari received another commission from the Duke. In 1560 Cosimo charged him with designing a building to house the governmental offices and records of the Duchy of Florence. The resultant four-story structure, the Uffizi (completed in 1580 by Vasari's pupils Bernardo Buontalenti and Alfonso Parigi), lines a narrow piazza on three sides. As is the case with his paintings, Vasari's architecture is eclectic and restrained by a rigid, formal order. Tuscan columns articulate the loggia of the ground level and upper storey. Between are a severe row of a triplet of mezzanine windows punctuated by Michelangelesque consoles, and above another triad of windows, two with gabled

pediments flanking one with an arched opening. Only the short end of the structure that fronts the Arno, a central arch with a Palladian motif, provides relief from the repetitive uniformity of the two long facades.

Vasari's last project in the Palazzo Vecchio, the decoration of the Studiolo of Francesco I de'Medici, 1570–72, is a summation of the mannerist aesthetic. No less than eight sculptors and twenty-four painters were engaged to ornament the small, windowless, and intimate room with eight bronzes and roughly thirty small, ellitically shaped canvases depicting mythological or historical events, or illustrations from practical life. Here, the small scale of the images is matched in all cases by a delicacy of color and a slenderness of figure proportions. Vasari's contribution, *Perseus and Andromeda,* exhibits the cool refinement and abundance of ornamental detail—pearls, coral, and sea grasses—wholly consonant with the lavish and jewel-like Studiolo itself. The careless grace of Andromeda, which is mirrored by Vincenzo Danti's bronze *Venus,* is both elegant and sensuous, while her frozen form and expressionless countenance captures the erect posture and crystalline gaze of Bronzino's portrait of Eleonora di Toledo that crowns the richly encrusted opposite wall.

Concurrent with his final work in the Palazzo Vecchio, Vasari painted the *salotto* (Sala delle Arti) of his home in Florence. As is true of all of his large decorative schemes, the program is a complex myriad of allusions and rich ornamentation. Here, content more than style is the more notable aspect, for it is a visualization of Vasari's concept of the history of art as put forth in *Le vite.* Based on the *Natural History* of Pliny, three *istorie* illustrate the origin of painting and scenes from the life of the most famed classical painter, Apelles. Personifications of *architettura, pittura, musica, scultura,* and *poesia* punctuate the ends of each wall. Above are 14 medallions bearing portraits of Renaissance artists that mirror the woodblock portraits introducing an artist's life in the *Vite.* Together, these images are a celebration of the history of art, an illustration of the present's debt to the achievements of the past. As such, the Sala delle Arti is a rare visualization of an artist's view of the history of art, expressing with images ideas otherwise restricted to the printed page.

—Fredrika H. Jacobs

VELÁZQUEZ, Diego (Rodríguez de Silva y).

Born in Seville, baptized 6 June 1599. Died in Madrid, 6 August 1660. Married Juana de Miranda (daughter of Francisco Pacheco), 1618; two daughters (one daughter married the painter Juan Bautista del Mazo). Entered Pacheco's Academy in Seville, 1613; independent painter in Seville by 1617; visited Madrid, 1622, and returned to Madrid to become Court Painter to Philip IV: many court portraits; visited Italy, 1629–31, and 1648–51 (to buy pictures for the royal collection); befriended Murillo; knighted by Philip, 1658. Pupils: his son-in-law Mazo, his slave Pareja.

Major Collections: Escorial; Madrid.
Other Collections: Barcelona; Berlin; Boston: Museum,

Gardner; Budapest; Chicago; Cincinnati; Cleveland; Detroit; Dresden; Edinburgh; Kansas City; Leningrad; London: National Gallery, Wellington, Wallace; Madrid: Royal Palace; Modena; Montreal; Munich; New York: Metropolitan, Hispanic Society, Frick; Rome: Doria Pamphili; Rouen; San Diego; Seville: Archepiscopal Palace; Vienna; Washington.

Publications

On VELÁZQUEZ: books—

Mayer, August L., *Velázquez*, Berlin, 1924.

Mayer August L., *Velázquez: A Catalogue Raisonné of the Pictures and Drawings*, London, 1936.

Lafuente Ferrari, Enrique, *Velázquez: Complete Edition*, London and New York, 1943.

MacLaren, Neil, *Velázquez: The Rokeby Venus*, London, 1943.

Sánchez Cantón, Francisco, J., *Las Meninas y sus personajes*, Barcelona, 1943.

Angulo Iñiguez, Diego, *Velázquez, cómo compuso sus cuadros principales*, Seville, 1947.

Ortega y Gasset, José, *Introducción a Velázquez*, San Sebastian, 1947; as *Velázquez*, New York, 1953.

Trapier, Elizabeth du Gué, *Velázquez*, New York, 1948.

Encina, Juan de la, *Sombra y enigma de Velázquez*, Buenos Aires, 1952.

Salinger, Margaretta, *Velázquez*, New York, 1954.

Pantorba, Bernardino de, *La vida y la obra de Velázquez*, Madrid, 1955.

Gerstenberg, Kurt, *Velázquez*, Munich, 1957.

Velazquez y lo velazqueño (cat), Madrid, 1960.

Varia Velazqueño, Madrid, 2 vols., 1960.

Velázquez: Homenaje . . . , Madrid, 1960.

Lafuente Ferrari, Enrique, *Velázquez*, Lausanne and Cleveland, 1960.

Maravall, José A., *Velázquez y el espiritu de la modernidad*, Madrid, 1960.

Pompey, Francisco, *Velázquez*, Madrid, 1961.

Saint-Paulien, J., *Velázquez et son temps*, Paris, 1961.

Sánchez Cantón, Francisco J., *Velázquez e "lo clásico,"* Madrid, 1961.

Salas, Xavier de, *Velázquez*, London, 1962.

López-Rey, José, *Velázquez: A Catalogue Raisonné of His Oeuvre*, London, 1963.

Velázquez: Son temps, son influence (colloquium), Paris, 1963.

Gaya Nuño, Juan Antonio, *Bibliografía crítica y antológica de Velázquez*, Madrid, 1963.

Camon Aznar, José, *Velázquez*, Madrid, 2 vols., 1964.

Troutman, Philip, *Velázquez*, London, 1965.

Orozco Diaz, Emilio, *El barroquismo de Velázquez*, Madrid, 1965.

Kehrer, Hugo, *Die Meninas des Velázquez*, Munich, 1966.

López-Rey, José, *Velázquez' Work and World*, London, 1968.

Brown, Dale, *The World of Velázquez*, New York, 1969.

Bardi, P. M., *L'opera completa di Velázquez*, Milan, 1969.

Gaya Nuño, Juan Antonio, *Velázquez: Biografía ilustrada*, Barcelona, 1970.

Braham, Allan, *Velázquez*, London, 1972.

Lassaigne, Jacques, *Les Menines,* Fribourg, 1973.

Muller, Joseph-Emile, *Velázquez,* Paris, 1974, London, 1976.

Gállego, Julián, *Velázquez en Sevilla,* Seville, 1974.

Gudiol, José, *Velázquez,* London and New York, 1974.

Braham, Allan, *Velázquez: The Rokeby Venus,* London, 1976.

Kahr, Madlyn Millner, *Velázquez: The Art of Painting,* New York, 1976.

Kemenov, Vladimir, *Velázquez in Soviet Museums,* Leningrad, 1977.

Brown, Jonathan, *Images and Ideas in Seventeenth-Century Spanish Painting,* Princeton, 1978.

López-Rey, José, *Velázquez,* Verona, 1978, London, 1980.

Campo y Francés, Angel del, *La magia de Las Meninas: Una iconología velazqueña,* Madrid, 1978.

Diez del Corral, Luis, *Velázquez, la monarquía, e italia,* Madrid, 1979.

López-Rey, José, *Velázquez: The Artist as a Maker, with Catalogue Raisonné of His Extant Works,* Lausanne, 1979.

Pérez Sánchez, Alfonso E., *Velázquez,* Bologna, 1980.

Spinosa, Nicola, *Velázquez: The Complete Paintings,* London, 1980.

Brown, Jonathan, and J. H. Elliott, *A Place for a King: The Buen Retiro and the Court of Philip IV,* New Haven, 1980.

Sérullaz, Maurice, *Velázquez,* New York, 1981, 1987.

Harris, Enriqueta, *Velázquez,* Ithaca, New York, and Oxford, 1982.

Gudiol, José, *The Complete Paintings of Velázquez,* New York, 1983.

Gállego, Julián, *Velázquez,* Barcelona, 1983.

Brown, Jonathan, *Velázquez, Painter and Courtier,* New Haven, 1986.

Wind, Barry, *Velázquez's "Bodegones": A Study in 17th-Century Spanish Genre Painting,* Lanham, Maryland, 1987.

McKim-Smith, Gridley, Greta Andersen-Bergdoll, and Richard Newman, *Examining Velázquez,* New Haven, 1988.

*

Though Diego Velázquez died more than three hundred years ago, his paintings are today as vital as ever. Besides providing delight and inspiration to art lovers over the centuries, they have proved to be an unending source of artistic stimulus to later painters. Writers too have found in Velázquez's paintings incitement to self-expression from many points of view. The abundance of pictures and words which his paintings have fostered is all the more impressive in view of the limited number of existing works that can be firmly attributed to him: not much more than one hundred paintings, almost two thirds of which are portraits, and perhaps a drawing or two.

At the customary age of about twelve, Velázquez was apprenticed to the leading teacher of painting in his home town, Seville, Francisco Pacheco, who, though now viewed as a mediocre painter, played a central role not only in artistic but also in intellectual, literary, and religious circles, and thus introduced his gifted pupil to the broader interests that were to enrich his art. Velázquez married Pacheco's daughter in 1618, the year after he qualified as an independent master. In his book, *Arte de la Pintura*, Pacheco wrote that during his apprenticeship Velázquez made many drawings from life. Presumably he made use of such drawings in composing his paintings.

Portrait of a Bearded Man, 1638–40; $29\frac{7}{8} \times 25\frac{3}{8}$ in (76 × 64.5 cm); London, Wellington Museum

Most of his early works on canvas were *bodegones;* meaning literally *taverns,* this term was extended to apply to images of ordinary people in everyday activities, usually involving food and drink, and even to compositions of the type that we now call still life. In style, as well as in subject matter, these paintings were identified with the modern trend in art that had been introduced in Italy at the turn of the 17th century by Caravaggio. How Velázquez became acquainted with Caravaggist art remains uncertain, but there can be no doubt that he moved boldly away from the prevailing style of his teacher and other prominent painters in Seville.

Velázquez's earliest dated painting known to us, *The Old Woman Frying Eggs* (Edinburgh, National Gallery of Scotland), inscribed with the date 1618, displays the strongly modeled forms, based on intense contrasts between the illuminated and the shadowed areas, painted in warm earth tones, that were typical of the Caravaggist style. The famous *Water Seller of Seville* (London, Apsley House, Wellington Museum) was probably painted in the same year; at the left in both of these paintings, the same young boy appears in the same pose, presumably based on a single drawing from life.

The individuals in his few religious paintings of this period represented physical types much like those in the *bodegones,* painted in the same emphatic style as the *genre* scenes and with as much attention to the still-life elements as to the human figures, which were distinctively characterized, whether the persons depicted were humble or revered. *The Adoration of the Magi* (Madrid, Prado), painted in 1619, was his largest and most complex composition of this period.

On visiting Madrid in 1622 and returning there to settle as Court Painter to King Philip IV in 1623, Velázquez had the opportunity to study the great royal collections of both Italian and northern paintings that had been acquired by the Emperor Charles V and King Philip II. His own art work was limited almost exclusively to portraiture. One major exception, which may be associated with the Venetian delight in such subjects, particularly the Bacchic scenes of Titian, who was well represented in the royal art collections, is known as *Los Borrachos,* or *Homage to Bacchus* (Madrid, Prado), painted in late 1628 or early 1629, which shows countryfolk paying tribute to the god of wine in gratitude for the vintage, a theme that was popular in both Netherlandish and Italian painting of this period. Velázquez's brushstroke had by this time become more fluid, his colors more varied and vivid, and the interpretation of the subject was his own.

In the summer of 1628, the great Flemish painter Peter Paul Rubens arrived in Madrid on a diplomatic mission. He and Velázquez became friends, and together they visited the enormous palace of El Escorial, some thirty miles northwest of Madrid, and admired the art housed there. It seems likely that Rubens, who himself had spent eight years in Italy, advised Velázquez to see the treasures of art there. On 10 August 1629, Velázquez set sail from Barcelona for Genoa, and from there he made his leisurely way to Rome, with stops en route at many cities whose art attracted him. In Venice he is said to have copied paintings by Tintoretto. In Rome, where he remained for about a year, he made drawings after Michelangelo's *Last Judgment* and the paintings of Raphael in the Vatican, according to Pacheco.

Stimulated by the art he saw in Italy, Velázquez painted in Rome two unprecedented multi-figure compositions in interior settings, one an Old Testament subject, *Joseph's Bloody Coat Shown to Jacob* (El Escorial), the second a mythological scene based on Ovid's text, *Apollo at the Forge of Vulcan* (Madrid, Prado), each depicting a moment of intense emotion. Large-scale, semi-nude male figures in dramatic action poses doubtless reflect Velázquez's study of antique reliefs as well as Italian Renaissance paintings. One of the new problems that he set himself was the depiction of sources of light within the picture space in Vulcan's forge.

It is reasonable to suppose that it was also during this first visit to Italy, when he is known to have stayed for two months, beginning in May 1630, at the Villa Medici, that he painted the two small, sketch-like landscapes of *The Gardens of the Villa Medici* (both now in the Prado), which so strikingly anticipate the *plein-air* paintings of the late 19th century.

Back at the Court in Madrid in January 1631, Velázquez resumed his career as portraitist, now with new painterly freedom and brilliance reflecting his experience of art in Italy. For the Great Hall of the new Buen Retiro Palace, where its presence was recorded on 28 April 1635, he painted *The Surrender of Breda* (Prado), in which life-size, full-length portraits were incorporated in an extensive landscape, reconstructing the scene of an event that had taken place some ten years earlier, on 5 June 1625, a moment of triumph of the Spanish in their war against the rebellious Dutch. The central figures, though striking in their individuality and immediacy, could not have been painted from life.

Along with his duties in the service of the King, through the 1630's and 1640's Velázquez found time to paint vivid portraits of members of the royal family, dwarfs and jesters of the Court, and some unidentified men and women whose images are no less impressive. Only rarely did he deal with other kinds of subject matter, but each one of his encounters with a novel artistic problem brought about a new achievement. *The Coronation of the Virgin* (Prado), painted before 1644 for the Oratory of Queen Isabel de Borbón, the first wife of Philip IV, displays the fluidity of his style of this period and a uniquely rich color scheme in its heart-shaped figural group wreathed in radiance.

Probably painted in the late 1640's is a subject of a very different sort, *Venus at her Mirror,* known as *The Rokeby Venus* (London, National Gallery), the only female nude by Velázquez that still exists. This sensuous painting calls to mind the Venetian tradition of reclining female nudes, particularly those of Titian. Venus turns her back to us, but we get a glimpse of her face—and thus confirmation of her three-dimensionality!—in the mirror held by her son, Cupid, who is equally nude. In the repressive, Inquisition-dominated Spain of the 17th century, to paint a nude was extraordinary. But then, a goddess from antiquity was not a mere naked woman, and the great royal collection of paintings provided entrancing prototypes, especially by Titian.

The brilliance of Velázquez's technique in the late 1640's is displayed as well in portraits, outstanding among which is the portrait of Philip IV in salmon pink and silver, known as *The Fraga Philip* (New York, Frick Collection). This well-documented work was painted in 1644, when Velazquez accompanied the King on a visit to the Spanish army fighting to regain Lérida from the French. On the way, the royal party stopped at Fraga, where, in an improvised studio, Velázquez portrayed Philip. The head and hands, painted in only three

sittings, are relatively flat. The costume, on the other hand, which the artist was able to study at leisure, is dazzling. The superb integration of figure with environment and the sparkling shorthand indications of embroidery, sword hilt, silver sleeves, white collar, and pink plume are a revelation of the potentialities of paint.

Early in 1649 Velázquez sailed from Málaga for Genoa, ordered by the King to buy paintings and sculptures in Italy and to arrange to have Italian fresco painters come to Madrid to decorate the rooms recently remodelled, under Velázquez's supervision, in the royal residence, the Old Alcázar. In Rome, in preparation for painting a portrait of the Pope, Velázquez painted from life his remarkable portrait of *Juan de Pareja* (New York, Metropolitan Museum). His portrait of *Pope Innocent X* (Rome, Galleria Doria-Pamphili) was acclaimed by public and painters in Rome for its life-like quality, and it has been the focus of admiration ever since, not only for its incisive characterization, but also for the audacity of its color scheme and its animated brushwork. In composition, Velázquez's *Innocent X* reflects the great portrait of *Cardinal Fernando Niño de Guevara* (New York, Metropolitan Museum) that El Greco had painted in about 1600. While in Rome, Velázquez also painted portraits of members of the Pope's household. He continued to travel through Italy to carry out his tasks as ordered by the King.

After he returned to the Cou in Madrid in June 1651, Velázquez was appointed Chief Chamberlain of the Palace, which imposed on him added responsibilities. Painting portraits of the royal family also demanded his attention. During his absence, Philip IV had been married to Mariana of Austria, and the Chief Court Painter was soon busy adding her to the gallery of the royal family. The image of thirteen-year-old Infanta Maria Teresa was needed for circulation to potential consorts. Portraits of Mariana and Maria Teresa, soon to be joined by portraits of Infanta Margarita, who was born on 12 July 1651, set the pattern for the rich and artificial attire of the female members of this extravagant and rigid court. Elaborately decorated wigs, unnatural makeup, figure-distorting dresses, with tight bodices and exaggerated farthingales—this is the mode that many associate with the name of Velázquez. Likewise to be permanently identified with the artist is the image of Philip IV, now visibly aging as we know him from his portraits.

The busy portraitist and Court functionary managed to continue his explorations in new directions. One of these is the large painting of *Saint Anthony Abbot and Saint Paul the Hermit* (Prado), whose color and brushwork suggest a late date in Velázquez's career, probably after 1655, when he had fulfilled his most pressing portrait obligations. here for the first time, in an extensive landscape setting, Velázquez adopted the medieval practice of depicting simultaneously a series of events in a story. His mature style, with its range of thin, fluid patches of paint and boldly stated areas of light, brought optical unity to this old-fashioned narrative composition.

Most strikingly original of his mature works is the interior scene with figures known as *Las Meninas* (Prado). Among this unique composition's many claims to interest is the fact that it includes the only known self-portrait by Velázquez, who displays himself as both painter and officer of the Court.

1565, the year in which he painted *Las Meninas,* also found Velázquez occupied with time-consuming tasks connected with the decoration of the royal residences. In 1657 he painted four mythological subjects for the *Salon de los Espejos* (Hall of Mirrors) of the Alcázar. It was probably after 1657 that he went to work on the large composition known as *Las Hilanderas (The Spinners)* (Prado). Like his other works, this painting was long admired as a realistic depiction of an actual moment. In this case it was identified as a view of workers at the royal tapestry factory with, in the background, aristocratic ladies admiring tapestries that hung on the walls. Some scholars have identified the subject as *The Fable of Arachne.* Numerous other interpretations have been proposed, among them *The Virtuous Lucretia,* a story from ancient Roman history handed down by Livy and Ovid. What *Las Hilanderas* clearly communicates is the message that art exists to remind us that there is something beyond our earth-bound daily labors, that art heightens sensibility, expands consciousness.

It is one of the intriguing ironies of the history of art that until his death in 1660, and long thereafter, the most extravagant praise of Velázquez's paintings was based on the impression that they were convincing imitations of real life, thus undervaluing the imaginative power, the creative skill in composition, the sprightly variety of his command over brush and pigments, and his uniquely expressive intimations about light—in short the resources that together enabled Velázquez to invent a self-sustaining world of art.

—Madlyn Millner Kahr

VERMEER, Jan [Johannes].

Born in Delft, baptized 30 October 1632; son of an art dealer. Buried in Delft, 15 December 1675. Married Catharina Bolnes, 1653; at least 11 children, including the painter Jan Vermeer II. Possibly pupil of Carel Fabritius or Leonard Bramer; in the Delft guild, 1653 (governor of the guild, 1662, 1670, 1671); also an art dealer; almost forgotten for two centuries, leading to many problems of attribution; only three of his pictures are dated.

Major Collections: Amsterdam; Berlin; Dresden; The Hague; New York: Metropolitan, Frick; Vienna.
Other Collections: Boston: Gardner; Brauschweig; Edinburgh; Frankfurt; London: National Gallery, Kenwood; Paris; Washington; Royal Collection.

Publications

Plietzsch, Eduard, *Vermeer van Delft,* Leipzig, 1911, Munich, 1939.

Hale, Philip L., *Vermeer,* Boston, 1913; revised by Frederick W. Coburn and Ralph T. Hale, 1937.

Bodkin, Thomas, *The Paintings of Vermeer,* New York, 1940.

Nicolson, Beendict, *Vermeer: Lady at the Virginals,* London, 1944.

Blum, André, *Vermeer et Thoré-Bürger,* Geneva, 1945.

Vries, A. B. de, *Vermeer de Delft,* Paris, 1948; as *Vermeer,* London, 1948.

Coremans, P. N., *Van Meegeren's Faked Vermeers and De Hooghs,* London, 1949.

Swillens, P. T. A., *Vermeer, Painter of Delft,* Utrecht and New York, 1950.

Malraux, André, *Tout Vermeer de Delft,* Paris, 1952.

Gowing, Lawrence, *Vermeer,* London, 1951, 1971, New York, 1971.

Bloch, Vitale, *Tutta la pittura di Vermeer di Delft,* Milan, 1954; as *All the Paintings of Vermeer,* London, 1963.

Goldscheider, Ludwig, *Vermeer: The Paintings: Complete Edition,* London, 1957, 1967.

Gelder, J. G. van, *De schilderkunst van Vermeer,* Utrecht, 1958.

Badt, Kurt, *Modell und Maler von Vermeer,* Cologne, 1961.

Brion, Marcel, *Vermeer,* Paris and New York, 1963.

Martini, Alberto, *Vermeer,* Milan, 1965.

Descargues, Pierre, *Vermeer,* Geneva, 1966.

Jacobs, John, *The Complete Paintings of Vermeer,* New York, 1967.

Konigsberger, Hans, *The World of Vermeer,* New York, 1967.

Vries, A. B. de, *Vermeer,* New York, 1967.

Bianconi, Piero, *L'opera completa di Vermeer,* Milan, 1967.

Bertram, Anthony, *Vermeer of Delft,* London, 1968.

Mistler, Jean, *Vermeer,* Paris, 1973.

Grimme, Ernst G., *Vermeer van Delft,* Cologne, 1974.

Blankert, Albert, *Vermeer van Delft,* Utrecht, 1975, 1977; as *Vermeer of Delft: Complete Edition of the Paintings,* New York and Oxford, 1978.

Wright, Christopher, *Vermeer,* London, 1976.

Menzel, Gerhard W., *Vermeer,* Leipzig, 1977.

Wheelock, Arthur, Jr., *Vermeer,* New York and London, 1981, 1988.

Slatkes, Leonard J., *Vermeer and His Contemporaries,* New York, 1981.

Montias, J. M., *Artists and Artisans in Delft,* Princeton, 1982.

Pops, Martin, editor, *Vermeer: Consciousness and the Chamber of Being,* Ann Arbor, 1984.

Aillaud, Gilles, *Vermeer,* Paris, 1986.

Aillaud, Gilles, Albert Blankert, and J. M. Montias, *Vermeer,* New York, 1988.

articles—

Kühn, Herman, "A Study of the Pigments and the Grounds Used by Vermeer," in *Reports and Studies in the History of Art,* 1968.

Berger, Harry, Jr., "Conspicuous Exclusion in Vermeer: An Essay in Renaissance Pastoral," in *Yale French Studies* (New Haven), 47, 1973.

Kahr, Madlyn Millner, "Vermeer's Girl Asleep: A Moral Emblem," in *Metropolitan Museum Journal* (New York), 11, 1972.

Welu, J. A., "Vermeer: His Cartographic Sources," in *Art Bulletin* (New York), 57, 1975.

Montias, J. M., "New Documents on Vermeer and His Family," in *Oud Holland* (The Hague), 91, 1977.

*

The rousing esteem in which they have been held in the late 20th century makes it hard to believe that the paintings of Johannes (sometimes referred to as Jan) Vermeer of Delft re-

ceived little notice in his lifetime, and his name was virtually lost from sight from the end of the 17th century to 1858, when the French critic Theophile Thoré, who signed his writings "W. Bürger," mentioned three of Vermeer's paintings in his book on Dutch museums. In 1866 Thoré-Bürger's expanded comments on Vermeer were published as three articles in the *Gazette des Beaux-Arts* and in the same year in book form. At that time Vermeer did not set the art world on fire. Perhaps it is because they lend themselves so readily to analysis—and to enjoyment—in terms of abstraction that Vermeer's paintings have found their greatest appreciation in the 20th century. Only about thirty-five paintings are accepted by most experts as autograph works by Vermeer; not a single drawing or print by him is known to exist.

Nothing is known about Vermeer's training. His paintings suggest that he was influenced by the strikingly idiosyncratic paintings of Carel Fabritius, who worked in Delft during the last four years of his life (1650-54). Four paintings, varied in subject matter and style, are generally considered to be Vermeer's early works: (1) a mythological subject, probably painted in about 1653, the year when, at the age of twenty-one, Vermeer became a member of the painters guild, *Diana and Her Companions* (The Hague, Mauritshuis), which portrays a group of female figures in a landscape setting; (2) a New Testament subject, *Christ in the House of Martha and Mary* (Edinburgh, National Gallery of Scotland), showing the three figures in a shadowy interior setting, with carefully studied still-life details; (3) *The Procuress* (Dresden, Gemäldegalerie Alte Meister), signed and dated 1656, the earliest of his three paintings that bear inscribed dates, which in subject matter and style has much in common with works by the Caravaggist painters of Utrecht; and (4) *A Girl Asleep* (New York, Metropolitan Museum of Art), a single female figure in a room setting, with emblematic allusions, in which the young painter approached the characteristic interests of his maturity.

The *Girl Asleep* is the first example of his small-format paintings of one or two figures seen against Vermeer's famous light-flooded wall in a domestic interior. As is characteristic of Vermeer's compositions, objects—in this case a chair and a rug-covered table—appear to be very close to the observer, setting up an effect of dramatic recession in space. This device removes us effectively from any sense of close contact with the individual pictured, who appears far from the foreground plane. A framed picture hanging on the wall that gives a clue to the moral implications of the content is another feature of the *Girl Asleep* that was to become typical of Vermeer's approach to his art. Such moralizing would have been widely understood and appreciated among the Dutch of his time.

In the *Officer and Laughing Girl* (New York, Frick Collection), it is the officer himself and the chair he occupies that serve the *repoussoir* function, hugely enlarged in comparison with the young woman who sits at the table with the officer in this corner of a room with its window at the left and its brilliantly illuminated rear wall viewed straight on and decorated with a map, which is also meaningful in the context of the picture. This is the setting with which Vermeer felt most comfortable.

The *Maidservant Pouring Milk* (Amsterdam, Rijksmuseum) stands in such a corner, separated from us by a table laden with foods, as well as by her preoccupation with the task at hand. That this is one of the earlier paintings from Vermeer's

A Lady with a Gentleman at the Virginals, c. 1665; $28\frac{7}{8} \times 25\frac{3}{8}$ in (73.3 \times 64.5 cm); Royal Collection

great period of mature mastery is suggested by the intense and sharply contrasted colors, the substantiality of the woman as compared with the slender, delicate type usual in this later works, the careful delineation of many small details, and the globular highlights, or *pointillé,* scattered even on very unlikely surfaces. The *Woman Reading a Letter at an Open Window* (Dresden, Gemäldegalerie Alte Meister) has a similar grainy surface, with *pointillé,* and warm flesh tones. It shows, however, Vermeer's increasing propensity for more limited and subtle color schemes and for the distancing of the figural subject. The elegant standing woman, seen in profile, is hemmed in by a drawn-back curtain that seems to be allowing us a stolen look at her, a table holding a heaped-up Turkish rug and a bowl of fruit, and the window that she faces.

It may be that the globules of highlight, which appear unnatural in these interior scenes, were derived from Vermeer's experience in painting his two town views. For the *Little Street in Delft* (Amsterdam, Rijksmuseum) he seems merely to have looked out of the window of his studio and rendered a picture of what he saw across the street. The textures of the old brickwork and the cobblestones make a varied, lively surface, sparkling with highlights. It is interesting to note that the two children, very small in scale, who are shown playing on their hands and knees in front of the house, are the only images of children in the known works by Vermeer, though he had eleven children and was survived by eight who were still minors when their father died in 1675. In the second of his town views, the magnificent *View of Delft* (The Hague, Mauritshuis), Vermeer's *pointillé* works to better effect than in any of his other paintings.

The reading or writing of letters plays a major part in several of Vermeer's paintings, usually with references to erotic arrangements provided by pictures within the picture or other clues. *The Love Letter* (Amsterdam, Rijksmuseum) is a small painting that is unique in compositional format. We seem to be eavesdropping as we steal a glance through a doorway and see a seated woman, apparently interrupted at her lute-playing by the maid who stands behind her, who presumably has handed her the letter that is central in the composition. The relationship of music to love was well understood by Vermeer's contemporaries and added zest to a number of his paintings.

Indeed, the association of Vermeer with romantic love has gone so far in the late 20th century that the *Head of a Girl* (The Hague, Mauritshuis) has aroused affectionate written responses. Along with the other so-called "pearl paintings" he painted during this period in his career, she represents an alluring feminine presence. The tiny, signed painting *The Lacemaker* (Paris, Louvre), a gleaming gem featuring Vermeer's favored yellow and blue hues, shows a woman absorbed in her work. Unlike most of his female figures, she is engaged in a respected womanly task. And the light that is cast on her comes not from the left, as is usual with him, but from the right. The intensely concentrating young woman and the equipment and materials of her work, seen against the light wall, are all there is, and it is enough to make a masterpiece.

A complex allegorical statement is made in *The Art of Painting* (Vienna, Kunsthistorisches Museum). Similarly overt in its symbolism is the *Allegory of the Faith* (New York, Metropolitan Museum), which is less harmonious than Vermeer's best and most characteristic works, perhaps because he was, in this case, not working from life.

In two compositions, Vermeer shows a man alone in an interior, in both cases a scholar, working in his study. Each of these paintings bears a date in Roman numerals. *The Astronomer* (Paris, Louvre) is dated 1668, *The Geographer* (Frankfurt, Stadelsches Kunstinstitut), 1669. They are probably related to the real scientific interests of the period. Compositional devices similar to those used by Vermeer in other paintings prevent each of these contemplative figures from communicating directly with us. The artist makes it clear that their concerns are not those of ordinary humanity.

On the contrary, both *A Lady Standing at the Virginals* (London, National Gallery) and *A Lady Seated at the Virginals* (London, National Gallery), meet our gaze directly, though their hands are on the keyboards. On the wall behind each of the two ladies who play at music while they smile in our direction is a painting that lets us know what kind of interruption each awaits. The upright lady's head overlaps a picture of a standing Cupid holding his bow in his right hand and with his left displaying a card. The same picture appears in *A Girl Interrupted at Music* (New York, Frick Collection). It is based on the illustration of an emblem that makes the point that a person should have but one love. Above the head of the *Lady Seated at the Virginals* is a picture with quite a different message: *The Procuress* by Dirck van Baburen (Boston, Museum of Fine Arts), painted in 1622. The seated young woman is perhaps less demure than she appears; the prominent viola da gamba in the immediate foreground, beside her virginals, implies her readiness for a duet, in the erotic sense. In both of these paintings, Vermeer's exquisite balance and suavity in themselves provide sensuous delights.

The Music Lesson (London, Buckingham Palace) sums up in many ways Vermeer's propelling interests and his distinctive ways of dealing with them. The woman and the man stand here together, but they do not appear to communicate. The woman has her back to us, but we see her face reflected in the mirror that hangs on the wall beyond her, and in this "reflection" Vermeer has generalized her features well beyond his usual simplified treatment of facial planes. As usual, he has faced the rear wall straight on, so that we see ceiling beams and floor line that constitute parts of the box that enclose the actors in the scene. The rectangles of mirror frame and virginals, of table, chair, and picture frame (which encloses a part of a *Roman Charity* scene) add to the stability of the design. As usual, the windows are on the left, and they, along with the squares of the floor, indicate a marked perspective recession. The apparent depth in space is emphasized by the enlarged pattern of the rug, shown so close to the foreground, and the large viola da gamba that lies on the floor, further isolating the couple from us. On the open lid of the virginals is the inscription, "Musica Letitae Comes Medicina Doloris" ("Music the companion of pleasure, the cure for sorrow"), an explicit statement of Vermeer's preoccupation with the joys and sorrows of love.

In this composition we see confirmed Vermeer's need for a controlled, reliable, structured universe, for the eternity of geometry, outside of space and time, for certainties that art, not life, could provide. As we learn to know him through his works, we see that he tended to keep his distance from human beings and to put his trust in color, texture, and the marvelous power of light.

—Madlyn Millner Kahr

VERONESE, Paolo.

Born Paolo Spezapreda in Verona, 1528; son of a stone-carver; brother of the painter Benedetto Caliari; changed his name to Caliari, 1555. Died in Venice, 19 April 1588. Sons, the painters Gabriele and Carlo. Studied with his father, and his painter uncle, Antonio Badile, and possibly with Giovanni Caroto; settled in Venice by 1555: worked on Doge's Palace; possibly did work in Rome, c. 1560, and also worked at the Villa Maser, near Treviso; many works in Venice; after the fires in the Doge's Palace in 1574 and 1577, he and Tintoretto were in charge of redecorating the interior; has a large shop, with many assistants, including his sons, his brother Benedetto, and his nephew Alvise Benfatto.

Major Collections: London; Venice.
Other Collections: Amsterdam; Baltimore; Berlin; Boston: Museum, Gardner; Caen; Cambridge, Massachusetts; Chicago; Cleveland; Detroit; Dresden; Escorial; Florence: Uffizi, Pitti; London: Courtauld, Dulwich, Westminster Hospital; Los Angeles; Madrid; Malibu; Melbourne; Milan; Modena; New York: Metropolitan, Frick; Oxford; Paris; Rome: Borghese, Capitoline; San Francisco; Sarasota, Florida; Treviso: Villa Maser; Turin: Sabauda; Venice: S. Sebastiano, S. Francesco della Vigna, S. Pantalon; Verona; Vicenza: Santuario di Monte Berico, S. Corona; Vienna; Washington.

Publications

On VERONESE: books—

Osmond, Percy H., *Veronese: His Career and Work,* London, 1927.
Fiocco, Giuseppe, *Veronese,* Bologna, 1928.
Lukomskii, Georgii K., *Les Fresques de Veronese et de ses disciples,* Paris, 1928.
Venturi, Adolfo, *Veronese,* Milan, 1928.
Orliac, Antoine, *Veronese,* Paris, 1939, New York, 1940.
Pallucchini, Rodolfo, *Veronese* (cat), Venice, 1939.
Pallucchini, Rodolfo, *Veronese,* Bergamo, 1940, 3rd ed., 1953.
Trecca, G., *Veronese a Verona,* Verona, 1940.
Harcourt-Smith, Simon, *Veronese: The Family of Darius Before Alexander,* London, 1945.
Vertova, L., *Veronese,* Milan, 1952.
Ojetti, Paolo, *Palladio, Veronese, e Vittoria a Maser,* Venice, 1960.
Pignatti, Terisio, *Veronese: Le pitture de Veronese nella Chiesa di S. Sebastiano a Venezia,* Venice, 1966.
Marini, Remigio, *Veronese: L'opera completa del Veronese,* Milan, 1968.
Delogu, Giuseppe, *Veronese: La cena in casa di Levi,* Milan, n.d.
Pignatti, Terisio, *Veronese: L'opera completa,* Venice, 2 vols., 1976.
Veronese e i suoi incisioni (cat), Venice, 1977.
Immagini dal Veronese (cat), Rome, 1978.
Hadeln, Detlev von, *Veronese,* edited by G. Schweikhart, Florence, 1978.

Gould, Cecil, *The Family of Darius Before Alexander by Veronese,* London, 1978.
Cocke, Richard, *Veronese,* London, 1980.
Badt, Kurt, *Veronese,* Cologne, 1981.
Rosand, David, *Painting in Cinquecento Venice: Titian, Veronese, Tintoretto,* New Haven, 1982.
Cocke, Richard, *Veronese's Drawings: A Catalogue Raisonné,* London, 1984.
Bettagno, Alessandro, editor, *Veronese: Disegni i dipinti* (cat), Venice and Washington, 1988.

articles—

Kahr, Madlyn Millner, "The Meaning of Veronese's Paintings in the Church of San Sebastiano in Venice," in *Journal of the Warburg and Courtauld Institutes* (London), 33, 1970.
Fehl, Phillip P., "Veronese's Decorum: Notes on the Marriage at Cana," in *Art the Ape of Nature: Studies in Honor of H. W. Janson,* New York, 1981.
Reist, Inge Jackson, "Divine Love and Veronese's Frescoes at the Villa Barbaro," in *Art Bulletin* (New York), December 1985.

*

Veronese has always been regarded as one of the greatest painters of the Venetian school, but it is relevant that he was not a native of Venice itself. As his name implies he was from Verona, which at the time of his birth was under Venetian control. This geographical factor influenced his early development. Though the native painters of Verona before the time of Veronese had not been among the most distinguished, the city was within reach of Mantua and Brescia. The first contained the greatest works of Mantegna and Giulio Romano. The second was the home of the brilliant trio, Savoldo, Romanino, and Moretto, all of whom were at their peak during Veronese's youth. There were also works by all of them in churches in Verona itself, as well as a superb early Mantegna, the S. Zeno altarpiece (still there) and a famous late Raphael, *La Perla* (Prado). Veronese is known to have painted a copy of this last picture. At Brescia there was a major Titian (the *Resurrection* polyptych, still there) in addition to numerous altarpieces by the trio already mentioned. Finally, the etchings of Parmigianino, who died at Casalmaggiore, near Mantua, in 1540, would have been circulating in Verona.

The diversity of these early influences, and the eccentricity of the art of both Giulio Romano and Parmigianino, should be borne in mind when considering the traditional image of Veronese as the classical and conservative answer to the excesses of Tintoretto. Yet there is some truth in that, too. The fact that Veronese won the competition for the decoration of Sansovino's library at Venice in 1556, that Tintoretto was not considered, and that the judges were Titian, an avowed opponent of Tintoretto, and Sansovino himself, a friend of Titian's, suggests that Veronese's presence in Venice was welcomed as a calming alternative to the almost irresistible tornado that was Tintoretto. In general Veronese and Tintoretto seem like the obverse and reverse of the same image. Almost every feature in the art of the one is the opposite of the same feature in the other. Veronese prefers a symmetrical composition, Tintoretto an asymmetrical one. Veronese favours a low eye level, Tin-

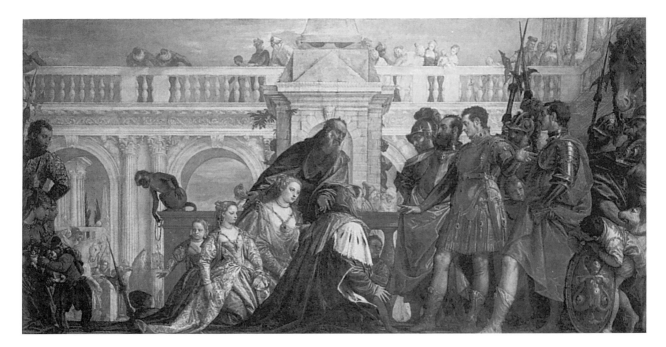

The Family of Darius Before Alexander, c. 1565; 7 ft 8⅛ in × 15 ft 5¼ in (234 × 473 cm); London, National Gallery

toretto a high one. Veronese's colours are light, Tintoretto's, dark. Veronese normally shows even lighting; Tintoretto's is dark, lurid, and dramatic. Veronese's technique is deliberate, Tintoretto's bold to the point of slapdash. Technically, Veronese was indeed one of the very greatest practitioners of oil paint. His results were obtained by straightforward methods, as distinct from the complex glazes and scumbles of Titian. For this reason Veronese's work has lasted better than Titian's.

Veronese's early work in his native city is not well defined, and we are not even certain of the date when he moved to Venice. He was working in the Veneto (at Castelfranco) by 1551, at Mantua in 1553 and in Venice itself, at the Doge's palace, by 1555 and perhaps earlier. From the end of 1555 he was working at the church of S. Sebastiano in Venice on a complicated programme including work in fresco as well as in oils. This occupied him on and off for the next fifteen years. The sharp foreshortening of the ceiling paintings (of the story of Esther) seem like an anticipation of the baroque, and show knowledge of what Correggio had done, thirty-odd years previously, in his two cupolas at Parma.

Throughout the Renaissance fresco painting had been thought unsuitable to the salt air of Venice. Titian and Tintoretto had only practiced it on rare occasions. But Veronese executed at least four major works in this medium. Of these, only fragments survive from the Câ Soranzo at Castelfranco; and those at S. Sebastino at Venice and Palazzo Trevisan at Murano are damaged. But the superlative frescoes in the Villa Barbaro at Maser (Treviso) are very well preserved and are one of his major works. In these the colours of the draperies are set off by the dazzling white painted architecture of the backgrounds, some of which incorporate *trompe-l'oeil* effects of people coming through doorways.

Probably in 1560 Veronese paid a visit to Rome. By this time his art was completely formed and the experience did not throw him off balance. The chronology of his work, however, is badly documented, particularly in his middle years. Out-

standing works which are datable somewhere in this period are the altarpiece of the Martyrdom of St. George (S. Giorgio in Braida, Verona) the series of four large paintings for the Cuccina family (Dresden) and the Family of Darius (London). There are also some superlative paintings of mythological subject (for instance, the Venus and Mars at New York and the Venus and Adonis of the Prado) and some portraits.

Nevertheless, the most famous of his pictures have always been the vast canvases of biblical feasts. One of these is at Turin (from Verona), another in the Louvre (from S. Giorgio Maggiore, Venice) another at Versailles (from the church of the Servites), a fourth in the Brera (from S. Sebastiano), a fifth at Vicenza, and the largest of all in the Accademia at Venice (from S. Giovanni e Paolo). This last work was responsible for Veronese's being arraigned before the Inquisition.

In the 1570's Veronese executed two further cycles of paintings for the Doge's palace, following the fires of 1574 and 1577. The first of these, the Sala del Collegio, is one of the most unified of his decorative schemes, since he was responsible for all the panels of the ceiling (in a variety of different shapes, some of them very awkward) as well as the most conspicuous of the wall paintings—a huge allegory of the battle of Lepanto on the end wall. In the Sala del Maggior Consiglio his oval ceiling painting of the *Triumph of Venice* extended the baroque system he had adumbrated in the Esther series at S. Sebastiano. It was adjudged the finest of the ceiling panels, a series to which Tintoretto and Palma Giovane had also contributed.

At the end of his life Veronese's colours darken and the general effect is more sombre (for example, the *S. Pantalone Healing a Child,* of 1587, the year before Veronese's death). Unlike Titian and Tintoretto, Veronese ran a very large studio, and to judge by the unified effect of paintings in which he himself can have had no more than a limited participation he was extremely skillful at delegating and controlling it. His brother, Benedetto Caliari, and his sons, Carlo and Gabriele,

carried on the studio after his death, signing the pictures as by the "heirs of Palo Veronese." During the 17th century the Paduan painter Alessandro Varotari, known as "Il Padovanino," imitated him, perhaps with fraudulent interest. Later, the brothers Sebastiano and Marco Ricci and Giambattista Tiepolo based their art on his, Tiepolo, in particular, extending Veronese's sumptuous decorative effects in a highly sophisticated fresco technique.

—Cecil Gould

VERROCCHIO, Andrea del.

Born Andrea de' Cioni in Florence, 1435. Died in Venice, 7 October 1488. Apprenticed to the goldsmith Giuliano Verrocchi (and took his name), in Florence; perhaps a pupil of Donatello; his workshop included both Leonardo and Lorenzo di Credi; few documented paintings; ranked as leading Florentine sculptor after death of Donatello, and did many works for the Medici: tomb of Giovanni and Piero de' Medici, in S. Lorenzo, 1472; statue of David, 1476; monument to Cardinal Forteguerri in Pistoia Cathedral, 1474; his last work, the equestrian statue of Colleoni in Venice, was completed by Alessandro Leopardi. Pupils: Francesco di Simone, Agnolo di Polo (or Paolo).

Collections/Locations: Edinburgh; Florence: Bargello, Cathedral Museum, S. Lorenzo, Orsanmichele, Palazzo della Signoria, Uffizi; London: National Gallery, Victoria and Albert; New York; Paris; Pistoia: Cathedral; Toledo, Ohio; Venice: Colleoni Monument; Washington.

Publications

On VERROCCHIO: books—

Mackowsky, Hans, *Verrocchio,* Bielefeld, 1901.
Cruttwell, Maud, *Verrocchio,* London and New York, 1904.
Reymond, Marcel, *Verrocchio,* Paris, 1906.
Wilder, Elizabeth, *The Unfinished Monument by Verrocchio to the Cardinal Niccolo Forteguerri at Pistoia,* Northampton, Massachusetts, 1932.
Planiscig, Leo, *Verrocchio,* Vienna, 1941.
Richardson, Edgar Preston, *The Adoration with Two Angels by Verrocchio and Leonardo da Vinci,* Detroit, 1957.
Passavant, Günter, *Verrocchio als Maler,* Dusseldorf, 1959.
Busignani, Alberto, *Verrocchio,* Florence, 1966.
Passavant, Günter, *Verrocchio: Sculpture, Paintings, Drawings: Complete Edition,* London and New York, 1969.
Seymour, Charles, *The Sculpture of Verrocchio,* Greenwich, Connecticut, 1971.

articles—

Boni, B., "La palla di rame di S. Maria del Fiore," in *Notiziario Vinciano,* 1978.
Passavant, Günter, "Boebachtungen am Lavabo von San Lorenzo in Florenz," in *Pantheon* (Munich), 39, 1981.
Covi, D., "Verrocchio and the 'Palla' of the Duomo," in *Art the Ape of Nature: Studies in Honor of H. W. Janson,* New York, 1981.
Clearfield, J., "The Tomb of Cosimo de' Medici in San Lorenzo," in *Rutgers Art Review* (New Brunswick), 2, 1981.
Herzner, Volker, "David Florentinus, iv: Der Bronze-David von Verrocchio im Bargello," in *Jahrbuch der Berliner Museen,* 24, 1982.
Covi, D., "Verrocchio and Venice," in *Art Bulletin* (New York), 65, 1983.
Cadogan, Jean K., "Linen Drapery Studies by Verrocchio, Leonardo, and Ghirlandaio" and "Verrocchio's Drawings Reconsidered," both in *Zeitschrift für Kunstgeschichte* (Munich), 46, 1983.

*

"Andrea del Verrocchio of Florence was at once a goldsmith, a master of perspective, a sculptor, a woodcarver, a painter, and a musician." This opening sentence of Vasari's life of Verrocchio captures one of the most remarkable aspects of this great artist—his versatility, both in technique and style. It is a testament to his wide-ranging interests and originality that the most inquiring and universal artist of the century, Leonardo da Vinci, was trained in his workshop, and that Verrocchio had a significant influence on artists like Rustici, Lorenzo di Credi, Domenico Ghirlandaio, Francesco Botticini, and Cosimo Rosselli.

Verrocchio inherited a tradition of 15th-century Florentine art characterized by its ever increasing naturalism as exemplified by the works of Masaccio, Donatello, Filippo Lippi, and many others. But he vastly extended the range and developed the possibilities of this tradition by his vast technical expertise, by combining his experience of one medium with another, and by stylistic innovation. In the tomb for Giovanni and Piero de'Medici, for example, he combined his skill at bronze casting (and after Donatello he was the greatest bronze caster of the century) with his initial training as a goldsmith to create a monument which had the ornamental elaboration and variety of precious materials characteristic of goldmsmith's work, yet the large scale and bold clarity of monumental sculpture. In a terracotta relief in the Bargello he projected the Virgin and Child through a window-like frame in order to establish the spatial continuity and physical relatedness between the viewer and the sacred figures offered by a perspectival construction, even though he reversed the role of the traditional perspective window in painting where figures seemed to recede behind the opening. With the bronze group on Orsanmichele of *Christ and the Doubting St. Thomas* Verrocchio created an intense psychological drama that had been attempted only in paint before, and even there never rendered with such rhetorical power or such subtle complexities of movement, gesture, and expression. And in the *Baptism of Christ* now in the Uffizi Verrocchio brought a new degree of a sculptural immediacy and anatomical truth to painting.

But however much his sculpture was enriched by his experience as a goldsmith or painter, or his painting by his experience as a sculptor, it was as a pure sculptor that Verrocchio made his greatest contributions. In Verrocchio's hands the freestanding figure, like the bronze *David* now in the Bargello, achieved a higher degree of anatomical liveliness than ever

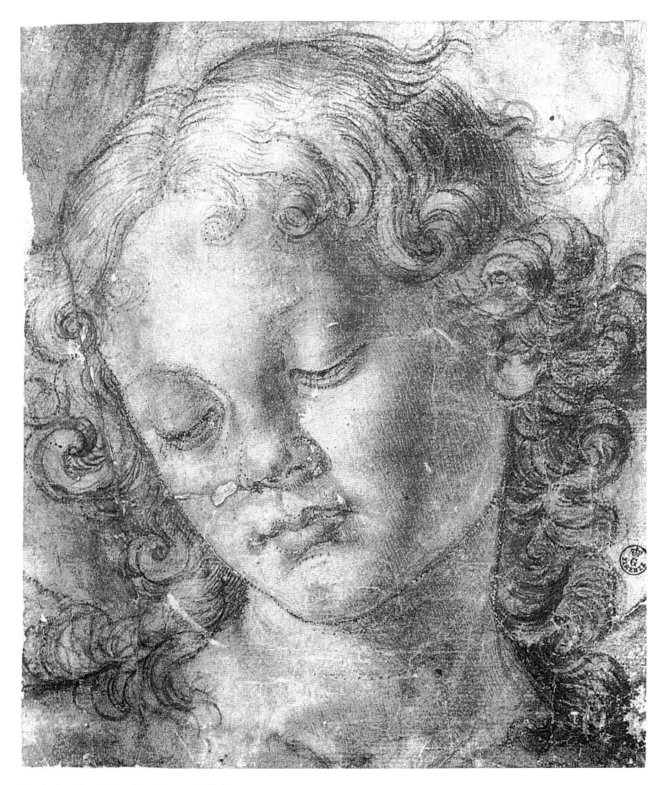

Head of an Angel; drawing; Florence, Uffizi

before. To this was added in the bronze *Putto with a Dolphin* in the Palazzo Vecchio a degree of fluid movement through a multiplicity of viewpoints that was not surpassed until the 16th century with the work of Giambologna. His terracotta *Bust of Giuliano de'Medici* in Washington raised the level of physiognomic honesty and psychological vividness to new heights. And in his equestrian monument of Bartolomeo Colleoni in Venice Verrocchio projected an expression of surging irresistible force, volcanic emotional energy, and explosive physical strength that has perhaps never been surpassed. It is no accident that nearly all the great sculptural innovations of Verrocchio were made in bronze or terracotta because only these two media had the necessary flexibility, malleability, and subtlety (at least until Michelangelo showed artists how to extend the expressive range of marble).

Since nearly all of his major commission were from either Piero or Lorenzo de'Medici, Verrocchio is also important historically as the first artist so clearly to anticipate the court artists of the 16th century under Cosimo I de'Medici, such as Giorgio Vasari or Baccio Bandinelli. This explains something of Verrocchio's preference for expensive techniques and precious materials such as bronze casting and multicolored marbles, and for refined and elaborate surfaces. But only his own industry, ingenuity, and intelligence can account for the developments in narrative drama, anatomical movement, and emotional expression which set Verrocchio apart from the great artistic tradition to which he was heir.

—Loren Partridge

VIGÉE-LE BRUN, Elisabeth (Louise).

Born in Paris, 16 April 1755; daughter of the painter Louis Vigée. Died in Paris, 30 March 1842. Married the painter and art dealer Jean Baptiste Pierre Le Brun (divorced 1793); one daughter. Studied with her father (he died 1767), and influenced by Greuze; painter by 1770, and member of the painters guild, 1774; royal commissions by 1776, and in 1779 began a series of portraits of Marie Antoinette; member of the Royal Academy, 1783; and a social as well as artistic success; exiled herself from France in 1789, to Italy, 1789–92, Vienna, 1792–95, Russia, 1795–1801; in Paris again from 1801, with stints in England (1803–04: painted Byron and the Prince of Wales) and Switzerland; also kept a country house in Louveciennes from 1809.

Major Collection: Paris.
Other Collections: Boston; Columbus, Ohio; Darmstadt: Schloss; London: National Gallery, Wallace; New York; Raleigh, North Carolina; St. Louis; Toledo, Ohio; Versailles: Museum; Waddesdon Manor; Washington.

Publications

By VIGÉE-LE BRUN: book—

Souvenirs, Paris, 3 vols., 1835–37; edited by Claudine Her-

mann, Paris, 2 vols., 1984; as *Memoirs*, London and New York, 1904.

On VIGÉE-LE BRUN: books—

Pillet, Charles, *Madame Vigée-Le Brun*, Paris, 1890.
Nolhac, Pierre de, *Vigée-Le Brun, peintre de la reine Marie Antoinette*, Paris, 1908.
Helm, William H., *Vigée-Le Brun: Her Life, Works, and Friendships, with a Catalogue Raisonné of the Artist's Pictures*, Boston and London, 1915.
Hautecoeur, Louis, *Vigée-Le Brun*, Paris, 1917.
Blum, André, *Vigée-Le Brun, peintre des grandes dames du XVIIIe siècle*, Paris, 1919.
Baillio, Joseph, *Vigée-Le Brun* (cat), Fort Worth, 1982.
Douwes Dekker, H. T., *Vigée-Le Brun: Portraits 'a l'huile: Essai d'un catalogue*, The Hague, 1984.

articles—

Nikolenko, Lada, "The Russian Portraits of Vigée-Le Brun," in *Gazette des Beaux-Arts* (Paris), July–August, 1967.
Ryszkiewicz, Andrzej, "Les Portraits polonais de Vigée-Le Brun,: in *Bulletin du Musée National de Varsovie*, 20, 1979.
Baillio, Joseph, "Identification de quelques portraits d'anonymes de Vigée-Le Brun aux Etats-Unis," In *Gazette des Beaux-Arts* (Paris), November 1980.
Baillio, Joseph, "Le Dossier d'une oeuvre d'actualité politique: Marie-Antoinette et ses enfants par Vigée-Le Brun," in *L'Oeil*(Lausanne), March and May 1981.
Baillio, Joseph, "Quelques peintures réattribuées a Vigée-Le Brun," in *Gazette des Beaux-Arts* (Paris), January 1982.

*

Vigée-Lebrun's considerable talent as a painter of elegant, and idealized portraits was well-acknowledged by her contemporaries. Many proclaimed her the greatest portrait painter of the day, and aristocratic patrons from all over Europe paid large sums of money to have her render their likeness. This popularity, made possible by hard work and dedication to her career, enabled the artist to live in comfort and style during her long life.

The artist's best known patron was the French Queen Marie-Antoinette. Vigée-Lebrun was summoned to Versailles in 1778 to paint her first official portrait of the Queen. From this time, until she fled France in 1789 on the night the king and queen were arrested, she was viewed as the official painter to Marie-Antoinette. The first portrait, called *Marie-Antoinette en Robe a Panier* (1778, Kunsthistorisches Museum, Vienna), is a stiff, overly contrived painting showing the queen in a high, feathered hair-do and elaborate, hooped-skirted dress. Subsequent portraits were much more relaxed and facile in their stylistic execution, but still formal in their pose and dress. One of the most successful renderings of the queen, called *Marie-Antoinette en gualle* (1783, Grand Ducal Gallery, Darmstadt), portrays her in the type of soft-flowing dress and straw hat popularized by the artist. The most politically important commission she received from the queen was *Marie-Antoinette and Her Children* (1787, Musée National du Château de Versailles). In this work she sought to portray the Queen more in

keeping with the rising middle-class sentiments regarding the importance of motherhood and family relationships. This Austrian Princess was hated by the French, who felt her not only vain and insipid, but a dangerous spy. Vigée-Lebrun, who praised the kindness and generosity of Marie-Antoinette, attempts to capture this aspect of the Queen's personality by showing her with her daughter and two sons. This work, however, is a far cry from J. B. Greuze's *Well-Loved Mother* (1769, Laborde Collection, Madrid) even though Greuze had a major influence on Vigée-Lebrun. The Queen's regal bearing and formal attire make her appear indifferent to the charms of her children.

Vigée-Lebrun was more successful at relaying this new philosophy of child-rearing when depicting herself with her only daughter, Julie. Julie, who may have been named after the Jean Jacques Rousseau heroine admired by Vigée-Lebrun, sweetly embraces her mother in *Portrait of the Artist With her Daughter* (1789, Louvre). This work, along with another of the same title also in the Louvre (1786), emphasizes the affection and devotion that Vigée-Lebrun lavished on her daughter. Stylistically, these portraits show a change from the subdued Rococo style of her earlier paintings to the emerging Neoclassical approach.

Although she is best known for her numerous portraits of women, one of her most admired works depicts her fellow painter and good friend *Hubert Robert* (1788, Louvre). In this work, Robert looks dramatically off to the side, while his large physique casts a strong and imposing presence. One of the major criticisms of Vigée-Lebrun's portraits is that she was not able to capture individual personalities. In the Hubert Robert portrait, however, one senses the vivacity and wit for which Robert was known even in old age.

Hubert Robert spent much time in Italy, where he painted many views of romanticized ruins. Vigée-Lebrun, herself, was to later spend four years in Italy, before traveling on to Austria, Germany and Russia. During these years in exile, she showed a romantic interest in the picturesqueness and sublimity of nature. Although totally against the politics of Rousseau, she admired his promotion of the natural nobility of man, and even visited a former residence of his while in Switzerland years later (1808). Her descriptions of the Swiss landscape, detailed in the *Souveniers* she authored, relate the powerful effect that the landscape had on her, even though it is given only minor attention in her paintings, if at all. An example of the dramatic treatment of landscape in her work can be seen in her portrait of *Francesco di Borbone* (1790, Capodimonte Museum, Naples). Here, Mt. Vesuvius is shown spewing smoke in the background, while the seventeen year old Prince of Naples appears unfazed.

Wherever she traveled, Vigée-Lebrun was deluged with requests for portraits. The richly colored *Countess Golovin* (1797–1800, Barber Institute of fine Arts, University of Birmingham, England), one of numerous works done in Russia during her six year stay there, echoes the romantic orientation seen in her writings.

Vigée-Lebrun's career spans a time of political chaos and stylistic exploration that is reflected in her work. She was trained in the Rococo manner, but absorbed well many tenets of neo-Classism and Romanticism. (Lord Byron sat for a portrait in London in 1803). During her forty years after returning to Paris, she continued to attract powerful patrons, had

many visitors to her commodious residences in Paris and Louveciennes and remained a loyal royalist until her death in 1842.

—Kathleen Russo

VITTORIA, Alessandro.

Born in Trento, 1525. Died in Venice, 27 May 1608. Probably a pupil of the sculptors Vincenzo and Gian Girolamo Grandi (from Padua), in Trento; in Venice, 1543, and entered the studio of Jacopo Sansovino; worked in Vicenza, 1551–53, then returned to Venice; after the death of Sansovino (1570) and Titian (1576), was leading artist in Venice as both sculptor and decorator: large workshop, and also practiced as an architect; decorated the Scala d'Oro in Doge's Palace and the Marcian Library, and altars in S. Francisco della Vigna, S. Maria Gloriosa dei Frari, S. Giuliano, and S. Salvatore; series of bronzes.

Collections: Berlin; Chicago; London: National Gallery, Victoria and Albert; New York; Padua; Rome: Palazzo Venezia; Rotterdam; Venice: Ca d'Oro, SS. Giovanni e Paolo, S. Zaccaria, Ateneo Veneto; Vienna; Washington.

Publications

By VITTORIA:

"Le carte e le memorie di Vittoria," edited by R. Predelli, in *Studi Trentini*, 1908.

On VITTORIA: books—

Serra, L., *Vittoria*, Milan, 1921.
Ojetti, Paola, *Palladio, Veronese, e Vittoria a Maser*, Milan, 1960.
Cessi, Francesco, *Vittoria, bronzista [scultore, 2 vols., medaglista, architetto e stuccatore]*, Trento, 5 vols., 1960–61.

*

Central in the art of Alessandro Vittoria is a dynamic interplay of naturalism and the *maniera,* the former a style altogether surprising in the oeuvre of a mid-16th century Venetian sculptor steeped in the Florentine mannerism of Jacopo Sansovino (his partner from c. 1534 in Venice), and in that of Bartolommeo Ammanati (whose tomb of Marco Mantova Benavides he had seen in nearby Padua by 1546), as well as that of the inescapable Michelangelo. Naturalism, nonetheless, was a tendency of style native to Vittoria, one well demonstrated in his life-long commitment to the art of portraiture. In view of the excellence of his art and the richness of the extant documentation, Vittoria has not received the scholarly attention he merits.

A crisp verism completely at odds with the norms of *maniera* artifice and idealizing formulae marks such portrait busts as *Doge Niccolo da Ponte* and *Pietro Zen*, terracotta

(both in Venice, Seminario Patriarcale), and *Ottavio Grimani* (Berlin). The busts are free of the exaggeratedly linear, incised eyes, and of the mechanically rigid, shelf-like beards of his more mannered portrayals, such as *Giovanni Contarini* (Berlin), *Marcantonio Grimani* (Venice, San Sebastiano), and the physician *Appollonio Massa*, 1560's (Venice, Seminario Patriarcale). A lyrical, reflective mood suffuses the cleric *Paolo Constabili* (Florence, Museo Nazionale) and the *Alvise Tiepolo* (Venice, Sant' Antonio). A Leonardesque, leonine metaphor occurs in the stylized mane of beard and full eyebrows of *Sebastiano Venier* (Venice, Seminario Patriarcale), a motif nicely echoed in the feline mask on his breastplate. A penetrating gaze is notable on one of Vittoria's finest busts, the powerfully characterized *Venetian Procurator* (Venice, Ca d'Oro), as on the *Tommaso Rangone*, c. 1571 (Venice, Ateneo Veneto), and the *Sebastiano Venier* (Venice, Palazzo Ducale).

The development of style in Vittoria's monumental human figures departs from the naturalism of his great portrait busts in several distinct tendencies: an elegant and fragile style reminiscent of the Fontainebleau School; various emulations of Michelangelo; the complete muscular tension seen in certain works by Bandinelli and Sansovino; a classical sense of unity within vigorous action, inspired by Myron; and a baroque unity of naturalism, psychological characterization and spatial continuity not unlike that of Veronese's late heroic canvas, the *Triumph of Venice* (Palazzo Ducale).

Vittoria's *St. John the Baptist*, a marble statuette of c. 1550 (Venice, San Zaccaria), is a slowly spiralling figure, both romantically dreamy in mood, and novel in its accents of layered rectilinear drapery, and the baptismal bowl held close beside the hip. Two *Caryatids* he created about 1553–55 for a portal of the Libreria di San Marco, are extremely tall female figures uncomfortably restricted within the limits of their columnar space. Their proportions and linear drapery evoke the style of Fontainebleau, as do their abstract, mask-like faces. Vittoria's three *Slave-Atalantids* at the left of the Contarini Tomb, 1555–58 (Padua, Il Santo) have proportions roughly classical rather than mannerist; they bear no weight whatsoever, belying their columnar function. Instead they sway in eurhythmical unison, their poses exaggerated. Yet naturalism marks the portrait-like face of the bald-headed nude, as it does his sleek but still plausible musculature. Medallion portraits in perfect profile format Vittoria invented c. 1555–57 include *Pietro Aretino*, a robust, naturalistic profile, its vigor and intensity redolent of the paintings of Titian, *Caterina Sandella*, the mistress of Aretino, and *Maddalena Liomparda*.

Vittoria's four separate signatures affirm his pride in the three figures of his plague-saint altar for San Francesco della Vigna, 1561–63, his first major work in Venice. *St. Anthony Abbot* is flanked by smaller figures, *St. Rocco* (left) and *St. Sebastian* (right). The *St. Anthony* has a doleful, downcast gaze, and a flattened, linear sort of layered drapery that recall Donatello's work in Florence and Padua. The captive *St. Sebastian* recalls Michelangelo's *Dying Slave*, but a sweet sadness tinged with pain replaces the ecstasy of its prototype; and the slenderer physique and grace of spiraling motion signal

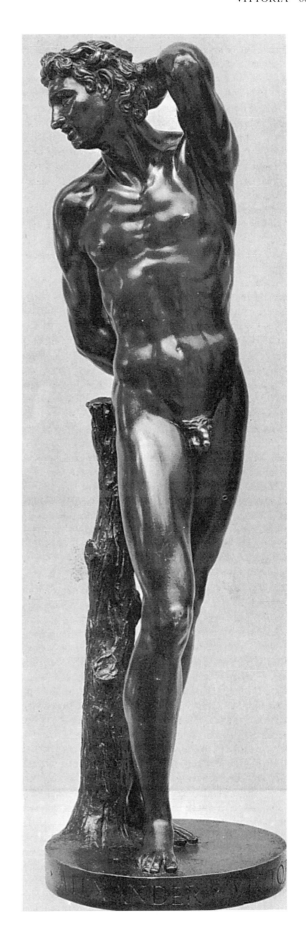

St. Sebastian, 1566; bronze; 21¼ in (54 cm)

Vittoria's taste. The slow, deliberate movement of the *St. Rocco,* clad in bulky, overlapping plates of opened drapery, recalls instead certain figures painted by Giorgione.

The standing *St. Jerome,* marble, ca. 1567 (Venice, Church of the Frari), displays a decoratively exaggerated musculature, the entire body tensed in an unreal way, reminiscent of Michelangelo's mannered nudes of the Last Judgment fresco and Bandinelli's *Hercules and Cacus.* Paraphrases of Michelangelo occur in other late works. Two marble *Atalantids* (Venice, Palazzo Rezzonico) are spiraling figures with very wide, Herculean torsos, like that of Michelangelo's *Christ the Judge* in his Last Judgment fresco. Two recumbent female personification figures frame an enthroned *Venice* (Palazzo Ducale), like the *Times of Day* that frame the Medici Princes (Florence, San Lorenzo).

St. Anthony Abbot (Venice, San Sebastiano), a tall, willowy figure, seems almost Gothic in proportion, with his tiny head and enormous robe, and is so compressed into a shallow niche as to comprise a high relief rather than a figure in the round.

An elaborate frame for the *Commemorative Tablet of Henry III,* c. 1575 (Palazzo Ducale), is flanked by two mannered *Caryatids,* the whole a nice example of the tendency in Mannerist design where many separate elements are isolated and rhythmically emphasized so as to compete for attention. The faces, arms, legs, and drapery of the *Caryatids* seem to pinwheel apart into space, rather than to cohere in a classically contained, cameo-like entity.

Vittoria created *Four Evangelists,* c. 1575, for niches on the interior of the facade of the Church of San Giorgio Maggiore (Venice). The mannered *St. Mark* gazes downward, past his Gospel Book and the lion beside him, his tall body wrapped in a barrel-like spiral of fiercely swirling drapery.

A fragment of a striding *Christ of the Resurrection,* marble, ca. 1576–77 (from the damaged Tomb of Bishop Domenico Bollani, Duomo, Brescia; now Brescia, Museo Civico), is dramatically anti-Mannerist in its deeply moving, tearful face and its naturalistic yet crisply contoured musculature.

A marble statuette, *San Zaccaria,* c. 1579, for the font of that church (Venice), has a nearly Baroque abundance of drapery gathered before the abdomen and held in the saint's right hand.

An *Annunciation* relief in gilt bronze, made for Hans Fugger, c. 1581–83 (Schloss Kirchheim) is based upon Titian's canvas in San Salvatore, Venice, according to Adolfo Venturi. Across the background plane flow the expansive arcs of the Virgin's billowing veil, the Archangel's great wing, and the cloverleaf strata of clouds surrounding the attendant cherubic angels. Nearly parallel S-curves echo closely in both Virgin and Archangel, as do the tightly repetitive lines of the tiny angels—the whole a reiterative system of parallel lines.

St. Daniel and *St. Catherine,* marble figures, c. 1583–84, frame an altar for the Scuola dei Merciai (now in Venice, San Giuliano). These mature works attain a grandeur of movement and long line, a painterly nuance of colorism and surface accent, a lyrical persuasiveness of psychological state. No longer forced or disjunctive, as were the *Caryatids* of the *Tablet of Henry III,* these saints already herald the Baroque. As Adolfo Venturi points out, however, their companion relief, *Birth of the Virgin,* eschews such unifying painterly and psychological values for a harshly emphatic cutting that isolates and emphasizes each separate figure, as it does the three nar-rative moments, clearly a survival of the "subdividing" mannerist taste.

A bronze *St. John the Baptist* (Venice, San Francesco della Vigna) moves with the grace and vigor of Myron's *Discus Thrower.* This is a paraphrase of that ancient archetype of classical unity, conceived in reaction against the divisive, isolating, and exaggeratedly emphatic tendencies of the *maniera.* Similarly well-unified in the classical sense is the kneeling *St. Jerome,* marble, 1583–84 (Venice, SS. Giovanni e Paolo), whose salient features are the mood of sadness and ecstatic transport legible in the saint's face and the passages of great anatomical accuracy in the saint's torso, hands, and feet. Vittoria's awareness of the art of Andrea del Castagno (*Vision of St. Jerome,* c. 1455, SS. Annunziata), and Leonardo da Vinci (*St. Jerome in the Desert,* 1483, Vatican), is very clear.

A late *St. Sebastian,* marble, c. 1590 (Venice, San Salvatore), embodies notable changes from the earlier figure in San Francesco della Vigna. No longer a *figura serpentinata,* this late version is virtually frontal in pose and is far heavier, less ethereal, less balletic. The saint's gaze, as he suffers under the arrows, is turned ecstatically heavenward rather than sideward in the perfect profile seen earlier, thus creating a psychologically persuasive and unified whole.

Several statuettes in bronze and terracotta appear to be autograph works by Vittoria, and share the stamp of his style with related monumental designs, in the view of Hans Vollmer. Among them are the *Winter,* bronze (Vienna), the *Standing Zeus* and *Neptune* (London, Victoria and Albert), the tiny *Four Evangelists,* only 9 centimeters high (Berlin), and an *Athena,* bronze (Este Collection).

Vittoria's architectural activity remains undocumented. Attributed to him are the Palazzo Balbi (Canal Grande), c. 1582–90, today the Foundation Peggy Guggenheim, the Cappella del Rosario in SS. Giovanni e Paolo, destroyed by fire, and the Ateneo Veneto, earlier the Scuola di San Girolamo.

—Glenn F. Benge

VLAMINCK, Maurice de.

Born in Paris, 4 April 1876. Died in La Tourillière, 11 October 1958. Married Berthe Combe; had three children by a previous wife. Professional bicycle rider, 1893–96; also billiard player and oarsman; violinist, and music teacher, 1898–1900; began painting, 1899; friendship with André Derain and Matisse; exhibited with the Fauves, 1905; lived and worked near Paris; visited Germany with Derain, 1941, and subsequently accused of collaboration.

Collections: Berlin: Nationalgalerie; Hamburg; London: Tate; New York: Moma; Paris: Beaubourg, d'Orsay.

Publications

By VLAMINCK: books—

D'un lit dans l'autre (novel), Paris, 1902.
Communications, poèmes, et bois gravès, Paris, 1921.
Histoires et poèmes de mon epoque, Paris, 1927.
Tournant dangereux: Souvenirs de ma vie, Paris, 1929; as *Dangerous Corner*, London, 1961.
Portraits avant décès, Paris, 1943.
Paysages et personnages, Paris, 1953.

illustrator: *La Chanson de Kou-Singa*, by Jean Marville, 1919; *Voyages*, 1920, and *Poèmes 1899-1950,*, 1950, both by Vanderpyl; *Trois journées de la Bribu*, by Georges Duhamel, 1921; *Mont-Cinère*, by Julien Green, 1926; *Le Diable au corps*, by Raymond Radiguet, 1936.

On VLAMINCK: books—

Carco, Francis, *Vlaminck*, Paris, 1920.
Kahnweiler, Daniel Henry, *Vlaminck*, Leipzig, 1920.
Werth, Léon, *Vlaminck*, Paris, 1925.
Fels, Florent, *Vlaminck*, Paris, 1928.
Montaigne, André, *Vlaminck*, Paris, 1929.
Perls, Klaus G., *Vlaminck*, New York, 1941.
Genevoix, Maurice, *Vlaminck*, Paris, 1954.
Sauvage, Marcel, *Vlaminck: Sa vie et son message*, Geneva, 1956.
Mac Orlan, Pierre, *Vlaminck*, Paris and New York, 1958.
Crespelle, Jean-Paul, *Vlaminck, fauve de la peinture*, Paris, 1958.
Selz, Jean, *Vlaminck*, Paris, 1962.
Walterskirchen, Katalin von, *Vlaminck: Vezeichnis des graphischen Werkes*, Berne, 1974.
Werner, Alfred, *Vlaminck*, New York, 1975.
Vallès-Bled, Mathé, and Marie-Lucie Omhoff, *Vlaminck: Le Peintre et la critique* (cat), Chartres, 1987.

*

In the summer of 1900 Maurice de Vlaminck was travelling on a suburban train from Chatou, where he lived, to Paris when he met a neighbour from his home town, with whom he struck up conversation for the first time. The neighbour's name was André Derain and their association was to form a hugely influential part of one of the seminal movements in French painting at the beginning of this century. That movement is Fauvism, a term coined from the French word "fauve" which means "wild beast": though initially considered a perjorative term, it served to emphasize the unorthodox stature of the artists who adopted it wholeheartedly for a brief but intense period in the first decade of the 20th century.

Vlaminck had lived in Chatou all his life: he had been earning his living as a racing cyclist and violinist, before he took up painting as a full-time pursuit. He very rarely dated his paintings and thus it is impossible to make a strict chronology of the works, but they do fall into distinct periods: the first lasted from 1900 for about three years, and was characterized by hesitancy as he taught himself to paint and cast around for a suitable style.

The second is that for which he is most famous—the fauve period. After striking up a lasting friendship, he and Derain had converted a disused tenement into a communal studio.

Vlaminck, as a self-taught painter, is sometimes cited as the most radical of the fauves. He himself considered his work to be a revolt against the academic schools, but there was one artist whom he did allow himself to be influenced by to a considerable degree. In the spring of 1901 Derain and Vlaminck went together to visit the Van Gogh exhibition at the Galérie Bernheim-Jeune and it was there that Vlaminck met Henri Matisse for the first time. These two events are crucial in the history of Vlaminck's painting: his admiration for Van Gogh (who had died in 1890) was unbounded, and he shared similar enthusiasms with Matisse.

The work of the fauves is characterized by the use of bright, pure, and unadulterated gradations of colour, in total contrast to the subtle tones of the Impressionists—its arresting and uncompromising directness earning it the term fauvist. The term was created in 1905, the year when Matisse, Derain, Vlaminck, Manguin, Freisz, Puy, and Valtat all exhibited at the Salon d'Automne. They had all turned their backs upon traditional likeness to nature and their experiments were concerned with the pure subordination of all ingredients of painting to the potency of colour.

An important component of the modernity of the fauves was their examination of alternative and hitherto neglected visual images: even as early as 1904 Valminck claims to have discovered two negro statuettes among the bottles in a bar and brought them home under his arm, and certainly by 1905-06 both Vlaminck and Derain had bought African masks. This was to be another decisive influence and debatably may have preceeded Picasso's fascination for tribal and primitive representations.

The third period is sometimes called that of "Cézanne": around 1907 there was a revival of interest in his work, and Vlaminck particularly admired its structural elements, while the influence of Van Gogh and Gauguin waned. Although Vlaminck had had little time for the intellectual pursuits around him, particularly the advent of Cubism, which he considered sterile, he moved on from the simplicity of pure colour. 1908 can be cited as the year in which most of the fauves abandoned it, leaving Matisse alone to continue the application of classical fauvism. Vlaminck moved from the use of unnaturally bright and arbitrary colour to a more formal approach. He investigated dark shadows and strong light which have an Expressionist feeling, reminiscent of the Der Brucke artists. Many of his landscapes from around this date record the effect of stormy weather on land. From about 1907 to 1910 the influence of Cézanne was at its strongest. Though he adhered to the aesthetics of fauvism, he reacted to the breadth of Cézanne's susceptibility to the simplicity of compositions, and to the perception of the potential to organize forms and space into graded flat tints.

In 1911 Vlaminck's individuality was confirmed and by the late 1920's he was free of all the major influences: his paintings became romantic, even traditional. The contradiction emerged that, while being a devoted member of a group, he was also obsessed by a fierce need for independence. He continued to associate closely with artists—in 1913 he and Derain went to Martigues together, for example—but he strove towards a more consciously isolated inspiration. The range and originality of Vlaminck's work leaves no doubt about his contribution to the course of modern painting in France.

—Magdalen Evans

VOUET, Simon.

Born in Paris, baptized 9 January 1590; son of the painter Laurent Vouet, and brother of the painter Aubin Vouet. Died in Paris, 20 June 1649. Married 1) Virginia da Vezzo (or Vezzi), 1626 (died, 1638), five children; 2) Rodegonde Breanger, 1640, three children. Accompanied the French Ambassador to Constantinople, 1611–12; in Venice, 1612, and in Rome, 1613–27 (with a stint in Genoa in 1621 for the Doria family): worked on S. Lorenzo in Lucina and in St. Peter's (work now lost), and "Principe" of the Rome guild, 1624–27; settled in Paris, 1627: became First Painter to the King, but rivaled by Poussin after 1640; associated with the new Royal Academy, 1648; most of his works were engraved by his sons-in-law.

Collections: Amiens; Arles; Besançon; Bourges; Braunschweig; Brussels; Cambridge; Dijon; Dresden; Florence; Genoa: S. Ambrogio; Kassel; Lyons; Madrid; Munich; Naples: S. Martino, S. Angelo a Segno; Nantes; Ottawa; Oxford; Paris: Louvre, S. Nicolas des Champs, S. Eustache, S. Merry; Rome: Corsini, Capitoline, S. Lorenzo in Lucina, S. Francesco a Ripa; Rouen; Sarasota, Florida; Strasbourg; Vienna; Royal Collection.

Publications

On VOUET: books—

Picart, Yves, *La Vie et l'oeuvre de Vouet*, Paris, 2 vols., 1958.
Crelly, William R., *The Painting of Vouet*, New Haven, 1962.

articles—

Thuillier, Jacques, "Vouet," in *Oeil* (Lausanne), 29, 1957.
Dargent, Georgette, and Jacques Thuillier, "Vouet en Italie," in *Saggi e Memorie di Storia dell'Arte*, 4, 1965.

*

Despite the growing interest in Vouet by modern scholars and collectors, he has yet to receive the recognition he deserves. Unlike his most notable contemporaries—La Tour, Poussin, and Claude, for example—Vouet has never had the distinction of a comprehensive exhibition; and many of his best works, especially those of his post-Italian years, are hardly known to the public at all. In his own lifetime the situation was quite different. Then he enjoyed an international reputation, and works from his hand were sought avidly throughout Europe. During his long Italian sojourn he had the patronage of the highest nobility, not only in Rome, his adoptive city in Italy, but also in other centers such as Genoa and Milan. In Rome he was elected Principe of the art academy, the Academia di San Luca, serving in that office for a number of years. He also received commissions for paintings in several Roman churches, including a monumental wall fresco representing the *Adoration of the Holy Cross* in the chapel of the Canons at St. Peter's (destroyed in the 18th century, but known from a copy and fragments of a modello).

Although he had been trained first in Paris, by his father,

Laurent Vouet, it was in Italy that Vouet drank in the artistic inspiration that would set the direction of his career. His first passion (as with so many other foreign artists in Rome) was for the new expressive realism of Caravaggio and his followers. The Caravaggesque influence is evident in most of Vouet's early pictures, as, for example, in the *Fortune Teller* in Ottawa, or more impressively in the two lateral scenes from the life of St. Francis of Assisi in the Alaleoni Chapel at San Lorenzo in Lucina in Rome. As his art matured the Caravaggesque shadows began gradually to diminish, and, under the influence of artists like Reni, Guercino, and Lanfranco, Vouet developed a robust and animated early baroque style of his own. This phase of his development is exemplified by such works as the intensely dramatic *Sophonisba Receiving the Poisoned Cup* in Kassel, or the splendid *Time Vanquished by Love, Hope, and Beauty* in the Prado in Madrid. It was this lively early baroque style that Vouet took back to France when he returned at the end of 1627. There it is exemplified by paintings such as the *Assumption of the Virgin* executed in two superimposed sections for the high altar of the Parisian church of St. Nicolas-des-Champs, or the well-known *Allegory of Wealth* in the Louvre. A most spectacular ensemble in this style (to judge from the engraved reproductions and written descriptions) were the decorations Vouet created for the ceiling of the gallery at the Chateau de Chilly, the country estate of Louis XIII's Minister of Finance, the Marquis d'Effiat. The principal compositions in this ceiling emulated the famous vault frescoes by Reni and Guercino in Rome: the *Chariot of Apollo* in the Casino of Palazzo Rospigliosi-Pallavicino and the *Aurora* ceiling at Villa Ludovisi. Also important for Vouet's formation were the traditions of Venice where he spent a considerable amount of time during his Italian years. The central composition in the ceiling decorations for the chapel of the Hotel Sequier in Paris are directly dependent on Veronese, for example.

Back in France Vouet's success was assured. During his stay in Italy he had been subsidized by the French Crown. Now he was named First Painter to the King and given a lodging in the Louvre. There he set up his studio which became a training ground for the most distinguished artists of the younger generation: among them Le Sueur, Le Brun, Mignard, and even Le Notre, the garden designer of Versailles. At the same time Vouet's Italian wife Virginia offered drawing lessons to young ladies of good family. Not only did Vouet have a brilliant career behind him in Italy, but he possessed the fullest and most sophisticated knowledge of Italian art of any French artist of the time. This alone would have been sufficient to qualify him as a teacher; and he seems to have been greatly appreciated by his pupils even after Poussin's arrival in Paris in 1640 (though many years later some appear to have disparaged what they had learned from their old master). While devoting much of his energy to providing decorations for the royal residences (especially at the Louvre and St. Germain-en-Laye) Vouet also worked for the most important art patrons of the day. These included Cardinal Richelieu, of course, along with other luminaries such as the Chancellor Pierre Séguier and, later, the Queen Mother Anne of Austria. Unfortunately, none of the decorative cycles for which Vouet was so famous has been preserved. They must therefore be studied from chance fragments, from engravings, and from the numerous tapestry series which he designed. His religious paintings have fared

better. Many of them can be seen in museums and private collections; and a small number are still to be found in the churches for which they were executed, the *Adoration of the Holy Name with St. Peter and St. Merry* at the church of St. Merry, for example, or the *Martyrdom of St. Eustache and his Family* in the church of St. Eustache (upper section in the Museum of Nantes).

In the last years of his life, after about 1640, Vouet's style underwent further changes. The corporeality and dramatic chiaroscuro of the Italian and early post-Italian works disappear completely. The forms become delicate and fragile and the color tones cool and clear. Examples of this late stylistic phase are pictures such as the *Death of Dido* in Dole, *The Assumption of the Virgin* in Reims, the *Allegory of Prudence* in Montpellier, and *The Presentation of Jesus in the Temple* at the Louvre. Most probably it was paintings of this sort that A. J. Dézallier d'Argenville had in mind when, in his *Abrégé*, he says that Vouet "went gray," ". . . ce que les peintres modernes apellent tomber dans la farine." In some ways the style might be seen as a reversion to the graceful, linear stylization of the 16th-century Fontainebleau tradition. i.e., to the super-refined and courtly mannerism of Primaticcio and Nicolò dell'Abbate. Indeed, the chapel decorated by these two painters at the Hôtel de Guise was the main inspiration for Vouet's ceiling decoration in the chapel of the Hotel Sequier mentioned above in connection with Veronese. In any event, Vouet's late style has more in common with Fontainebleau mannerism than it has with Poussin's new classicism.

From a certain point of view, Vouet may be said to have lived beyond his time. In the 1640's his star pupils, Le Brun and Le Sueur began to come under the influence of Poussin's clear and orderly style, the style that would become the sanctioned style of the Royal Academy after its reorganization by Le Brun in 1663. Vouet's early baroque inclinations, restrained as they were, belonged to the age of Louis XIII, not to the new heroic age of Louis XIV. It is significant that Vouet, at a venerable age, was excluded from the founding of the Academy in 1648. In fact Vouet and his friends tried to launch a counter-academy, the Académie de St. Luc, in competition with the Royal Academy. But this project came to nothing, and Vouet himself died the following year. Louis XIII's famous remark on the occasion of Poussin's arrival in France, "Violà Vouet bien attrapé," was not only malicious but prophetic too.

—William R. Crelly

VRIES, Adriaen de.

Born in The Hague, 1545. Buried in Prague, 15 December 1626. Trained in Italy as bronzeworker under the sculptor Giambologna; then worked mainly in Prague, especially for the Emperor Rudolf II from 1593: designed two fountains in Augsburg (*Mercury*, 1599, and *Hercules*, 1602), and also works for Bückeburg, Stadthagen, and Fredriksborg Castle, Denmark.

Collections/Locations: Augsburg; London: Victoria and Albert, National Gallery; Paris; Prague; Stockholm; Vienna.

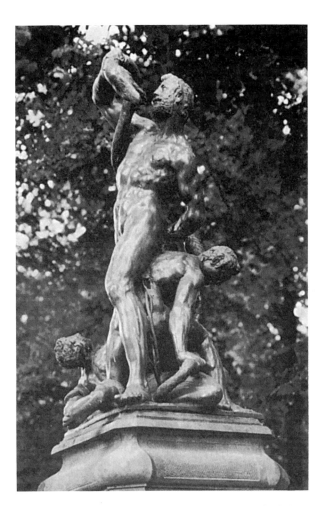

Laocoön and His Sons, 1623; bronze; life-size; Drottningholm, Palace Gardens

Publications

On VRIES: books—

Buchwald, Conrad, *Vries*, Leipzig, 1899.
Cahn, Erich B., *Vries und seine kirchlichen Bronzekunstwerke in Schaumberg*, Rinteln, 1966.
Larsson, Lars Olof, *Vries: Adrianus Fries Hagiensis Batavvs*, Vienna, 1967.
Prag um 1600: Kunst und Kultur am Hofe Rudolfs II (cat), Essen, 1988.

articles—

Strohmer, Erich von, "Bemerkungen zu den Werken des Vries," in *Nationalmusei Arsbok 1947–1948*, Stockholm, 1950.
Kaufmann, Thomas DaCosta, "Empire Triumphant: Notes on an Imperial Allegory by Vries," in *Studies in the History of Art 8*, Washington, 1979.

*

Adriaen de Vries's first dateable work is the bronze sculpture

of *Mercury and Psyche* (2.5 meters high, Paris, Louvre), which was completed in 1593. Both on account of its size and its complicated static construction, the work is a *tour de force*: Mercury is represented flying with Psyche in his arms and the weight of the entire group appears to rest only on the tip of Mercury's toe. In the work a falling drapery constitutes the most important support, but even so the composition is remarkably bold. An artist who is capable of executing such a work must have considerable experience behind him. The question is where Adriaen de Vries acquired this. Very little is known about his activity before 1593.

The *Mercury and Psyche* group was an artistic declaration of a programme aimed at making an impression upon the Emperor Rudolph II, the patron of the work, who was very critical and an expert in questions of art. In this work de Vries has combined ideas and motifs from two of the most renowned contemporary sculptures: Giambologna's *Flying Mercury* and his *Rape of the Sabines*. Through his bold static solution de Vries succeeded in surpassing these models.

Of the artist's activity before 1593 we know only that for a number of years he worked as an assistant to Giambologna in Florence, and that for a short while he was a court sculptor in Turin. No works can be securely dated to that period. However, what is certain is that the years spent with Giambologna must have been of decisive significance for his artistic development. Among Giambologna's pupils, de Vries is the one who most independently developed his ideas.

After 1593 de Vries's activities are very well documented. He established himself as one of central Europe's leading bronze sculptors. Between 1595 and 1602 he worked in Augsburg, where he executed two large fountains with bronze sculpture. After this we discover him in Prague, where he was employed as court sculptor to Emperor Rudolph II. Rudolph had gathered a large crowd of artists at his court. Among them may be noted the painters Bartholomeus Spranger and Hans von Aachen, with whom de Vries was in close contact. Curiously, the emperor appears to have allowed de Vries to work principally for the treasury. He did not allow him to produce garden sculpture or public fountains and monuments. Undoubtedly his most important work for the emperor was the large half-length bust of 1603. It portrays Rudolph in a cuirass in a majestic pose. The portrait was made as a pendant to Leone Leoni's *Bust of Charles V* which Rudolph had inherited a few years earlier. Charles V was one of Rudolph's most important models and there can be little doubt that the resemblance between the portraits was intended to express Rudolph's innate similarity to his great predecessor. The foot of the bust is formed by an eagle, Jupiter, Mercury and a ram (Capricorn). These figures function similarly to those on the obverse of a medal, i.e., to symbolize the emperor's qualities. The eagle and Jupiter can be seen as common imperial attributes; Mercury here symbolizes the emperor's wisdom, and the ram is an allusion to Emperor Augustus, who had Capricorn as his astrological sign. This symbolic content is very typical for Rudolphine court art. The glorification of the emperor also occasioned two bronze reliefs, which were kept in the treasury. One shows an *Allegory of the War of the Turks in Hungary* (c. 1603, Vienna) and pays homage to Rudolph as protector of christendom and as victorious general; the other shows an allegory of *Rudolph II as Protector of the Arts* (1609, Windsor).

After Rudolph II's death, de Vries remained in Prague, although the court moved to Vienna, because he did not want to leave his well-established foundry. His most prominent patrons after Rudolph II's death were Count Ernst von Schaumburg-Lippe, King Christian IV of Denmark, and the imperial general Albrecht von Waldstein. For Christian IV's castle of Fredriksborg he executed a *Fountain with Bronze Sculptures* (1615–18) of a similar type as the *Hercules Fountain* in Augsburg. This fountain, which is decorated with no less than 16 sculptures, of which several are life-size, was one of the most magnificent works of its type in Europe; unfortunately, in 1659 Swedish troops removed the sculptures to Stockholm. These are now in the gardens of Drottningholm Castle and in the Nationalmuseum in Stockholm. For Ernst von Schaumburg-Lippe, de Vries made a large tomb monument (1618–20) in the design of a Resurrection of Christ. The monument stands in the centre of a specially built mausoleum (designed by G. M. Nosseni) in the extension of the choir of the Church of St. Martin in Stadthagen. It consists of a sarcophagus on a high base. On the sarcophagus stands the risen Christ; around sit the tomb guards.

Adriaen de Vries's last commission was from Albrecht von Waldstein. For the garden of the palace Waldstein had built in Prague, he executed a fountain with bronze sculptures (1622–27) and a number of free-standing sculpture groups. The fountain, which met the same fate as the Fredriksborg fountain by being taken away by Swedish soldiers during the plunder of Prague in 1648, was a simplified version of earlier ones. The most interesting of the Waldstein bronzes is the *Laocöon Group* (1623). It is a bold paraphrase of the famous antique sculpture. De Vries has redesigned the model into a conical composition. The movements of the figures and the large snake with which Laocöon struggles form a spiral which leads the observer's gaze around the group without a break. De Vries's Laocöon group is one of the most convincing examples in European sculpture of a work to be viewed from every side.

—Lars Olof Larsson

VUILLARD, Edouard.

Born in Cuiseaux, 11 November 1868. Died in La Baule, 21 June 1940. Attended the Marist fathers school, Ecole Rocroy, and Lycée Condorcet, all in Paris, from 1878; studied (with Ker-Xavier Roussel) under painter Maillart, 1887, and at the Ecole des Beaux-Arts and the Académie Julian, 1888; member of the Nabis group: shared studio with Bonnard, Maurice Denis, the theatre director Lugné-Poë from 1890; exhibited from 1891 (one-man show); designed and painted decorative panels for houses, as well as for the Théâtre de la Comédie des Champs-Elysées (with Roussel), 1913, Palace of the League of Nations (also with Roussel), Geneva, 1936, and the Palais de Chaillot, 1937; also designed sets and posters for Lugné-Poë's theatre from 1893; taught at the Académie Ranson, 1906; war artist during World War I; taught at the Ecole des Beaux-Arts, 1934; also worked in mixed media, and lithography.

Breakfast, 1912; pastel; 23½ × 29½ in (59.7 × 74.9 cm); Courtesy Waddington Galleries

Collections: Basel; Birmingham; Boston; Bristol; Brussels; Cambridge, Massachusetts; Cleveland; Geneva: League of Nations; Glasgow; Hamburg; Houston; Liverpool; London: National Gallery, Tate, Courtauld; Manchester; New York: Moma; Northampton, Massachusetts; Paris: Petit Palais, Palais de Chaillot, Art Moderne, Comédie des Champs-Elysées; Pittsburgh; Toronto; Washington: Phillips; Zurich.

Publications

On VUILLARD: books—

Marguéry, Henri, *Les Lithographes de Vuillard,* Paris, 1935.
Roger-Marx, Claude, *Vuillard et son temps,* Paris, 1945; as *Vuillard: His Life and Work,* New York and London, 1946.
Salomon, Jacques, *Vuillard, témoignage,* Paris, 1945.
Chastel, André, *Vuillard: Peintures 1890–1930,* Paris, 1948.
Roger-Marx, Claude, *L'Ouevre gravé de Vuillard,* Monte Carlo, 1948.
Schweicher, Curt, *Die Bildraumgestaltung, das Dekorative, und das Ornamentale im Werke von Vuillard,* Trier, 1949.
Salomon, Jacques, *Vuillard: Cahier de dessins,* Paris, 1950.
Salomon, Jacques, *Auprès de Vuillard,* Paris, 1953.
Ritchie, Andrew C., *Vuillard* (cat), New York, 1954.
Schweicher, Curt, *Vuillard,* Berne, 1955.
Salomon, Jacques, *Vuillard admiré,* Paris, 1961.
Vuillard (cat), Hamburg, 1964.
Dugdale, James, *Vuillard,* London, 1967.
Georgel, Pierre, *Vuillard, Roussel* (cat), Munich and Paris, 1968.
Roger-Marx, Claude, *Vuillard: Intérieurs,* Paris, 1968.
Russell, John, *Vuillard* (cat), Toronto, 1971.
Perucchi-Petri, Ursula, *Bonnard und Vuillard im Kunsthaus Zurich,* Zurich, 1972.
Preston, Stuart, *Vuillard,* New York and London, 1972, concise edition, 1985.
Perucchi-Petri, Ursula, *Die Nabis und Japan: Das Frühwerk von Bonnard, Vuillard, und Denis,* Munich, 1976.
Vuillard (cat), London, 1985.
Thompson, Belinda, *Vuillard,* Oxford and New York, 1988.

*

Despite oft-cited links with Bonnard or the Nabis, Edouard Vuillard remains a painter with individual temperament and insight, and should be recognized for his contribution to both post-Impressionism and Art Nouveau. Vuillard was the master

of the cameo: with the exception of theatre designs and panel commissions for friends and associates, he painted almost exclusively on tiny boards the scenes of domestic life he knew so well. As a young man he had been exposed to his widowed mother's chaotic world of dressmaking and, devoted to her until her death in 1928, chose to paint her in her home and in her element. The character of the sober, conscientious young painter was reflected in his affectionate treatment of subject matter, attention to detail, and also in his technique of distemper, personal and painstaking, in which glue rather than oil was used to bind pigments. The resulting finish was fresh and matt, contributing to the overall effect of Vuillard's paintings.

His methodical approach to art and life aside, the youthful Vuillard was nevertheless a great adventurer. Dissatisfied with the academic realism rife in the Paris Ecole des Beaux-Arts, Vuillard and his painter friend Roussel joined the rebellious ranks at the Académie Julian, forming with a select few the Nabi (Prophet) group, dedicated to mysticism, symbolism, and Gauguin's Synthetism. In an atmosphere of intense artistic activity Vuillard naturally began exploring the possibilities of Synthetist colour theory, producing canvases daubed with large, flat patches of pure colour. Two *Self-Portraits*, 1892, reveal the results of the artist's experimentation: the compositions are dramatic, skilful, and almost Fauvist in style, but negate his true artistic sensibilities. Disdainful of the religious and boculic overtones of Nabi painting, and equally suspicious of his colleagues' secret rituals and strange costumes, Vuillard broadened his horizons with poetry, particularly Mallarmé, and took an interest in contemporary Impressionism, Divisionism, and Japanese art, all of which played a part in defining his oeuvre. The art critic Edouard Durant, in his essay entitled "La Nouvelle Peinture" of 1876, advised his readers to cultivate an interest in everyday life and to remain rigidly faithful to location and atmosphere, recommendations that Vuillard took to heart and strove to reproduce in the works, rich and decorative, that typify his style.

Although Vuillard evidently preferred to work in miniature he was compelled to adapt himself for the flurry of commissions that came his way after 1893. Apart from designing theatre programmes for his friend Lugné-Poë and drawing for the *Revue Blanche*, Vuillard's commissions included stage designs for a production of Ibsen's *Rosmersholm* and, in 1913, decorating the foyer, with appropriate theatrical subject matter, of the newly built Comédie des Champs-Elysées. He also undertook to decorate the homes of his acquaintances: in 1894 Alexandre Natanson, editor of the *Revue Blanche*, commissioned a series of nine large panels that were collectively known as *The Public Garden*. The resulting paintings conveyed something of Vuillard's characteristic intimacy, even though they depicted outdoor scenes, but owed a great deal in terms of composition and subject matter to sources as diverse as Puvis de Chavannes, Botticelli, and Monet.

Having enjoyed fame and fortune in the 1890's Vuillard began to decline, drifting into virtual obscurity by 1914. The careful, observant depictions of private family life gave way to indifferent portraits and unknown drawing-rooms as the artist was swept into the Parisian society clique. Certain paintings redeem "late" Vuillard: when painting his artist friends at home, e.g., *Study for the Portrait of Maurice Denis*, 1925, or at work, e.g., *Dr. Gosset Operating*, 1912, he loses the self-conscious, compromising air that dogs his 20th-century work.

—Caroline Caygill

WALDMÜLLER, Ferdinand Georg.

Born in Vienna, 15 January 1793. Died in Helmstretimühle near Mödling in der Hinterbrühl, 23 August 1865. Trained at the Vienna Academy 1807–13; set up in Vienna, and became leading Austrian painter; professor at the Vienna Academy from 1829, though disputatious about his teaching methods; visited Italy, 1829 and later, Paris, 1830, and London, 1856 (successful at Court).

Major Collections: Vaduz; Vienna: Oesterreichische Galerie, Historisches Museum der Stadt Wien.

Other Collections: Berlin: Nationalgalerie Bremen; Budapest; Dresden; Graz; Hamburg; Leningrad; Munich: Neue Pinakothek; Nuremburg; Paris; Vienna: Albertina; Winterthur; Wuppertal.

Publications

By WALDMÜLLER: books—

Das Bedürfnis eines zweckmässigen Unterrichts in der Malerei und plastischen Kunst, Vienna, 1846.
Vorschläge zur Reform der österreichisch-kaiserlichen Akademie der bildenden Kunst, Vienna, 1849.
Imitation, Reminiszenz, Plagiat: Bemerkungen über krankhafte Zustände der bildenden Kunst, Vienna, 1857.
Andeutungen zur Belebung der vaterländischen bildenden Kunst, Vienna, 1857.

On WALDMÜLLER: books—

Roessler, Arthur, *Waldmüller,* Vienna, 1912.
Kosch, W., *Waldmüller,* Leipzig, 1912.
Roessler, Arthur, and Gustav Pisko, *Waldmüller: Sein Leben, sein Werk, und seine Schriften,* Vienna, 2 vols., 1907.
Wolf, Georg J., *Waldmüller: Bilder und Eriebnisse,* Munich, 1916.
Eberlein, Kurt K., *Waldmüller: Das Werk des Malers,* Berlin, 1938.
Grimschitz, Bruno, *Waldmüller,* Salzburg, 1957.
Buchsbaum, Maria, *Waldmüller,* Salzburg, 1976
Schandendorf, Wulf, *Waldmüller: Gemälde aus der Sammlung Georg Schäfer, Schweinfurt* (cat), Schweinfurt, 1978.
Bisanz, Rudolf, *The René von Schleinitz Collection of the Milwaukee Art Museum: Major Schools of German 19th Century Popular Painting* (catalogue raisonné), Madison, Wisconsin, 1980.

articles—

Novotny, Fritz, "Erinnerung an den Todestag Waldmüllers am 23. August 1866," in *Mitteilungen der Osterreichischen Galerie* (Vienna), 10, 1966.
Werner, Alfred, "Waldmüller: An Austrian Artist Re-Evaluated," in *Art Journal* (New York), 39, 1971.

*

Waldmüller specialized in realistic portraits, landscapes, peasant genre, and still lifes. His art and combative manifestos advocate (inconsonantly) naturalism as well as idealism, academic reform, and even the closure of all academies. After sporadic training at the Vienna Academy (1807–13), self-study and uncertain beginnings as a peripatetic decorator, portrait miniaturist, and stage designer, he returned to painting studies at age 24. By 1827 he registered early successes, including court commissions. He drew on a pastiche of influences: the Old Masters, Dutch realists, 18th-century English portraitists, and Neoclassical conventions. The frequent comparisons between him and the respective specializations of Ingres, Corot, and Courbet are useful but not without problems. His position with the academy ended in his forced retirement in 1857, due to irreconcilable differences between him and the Viennese art establishment. Frequent travel, especially to Italy, punctuated his increasingly isolated and poverty-stricken later years.

Waldmüller helped develop bourgeois citizen's portraiture, nicely balancing the elegant costuming, measured social posturing, and frank personal demeanor of his sitters. His two portraits of the *Von Lerchenau Ladies* (both 1837, both at Munich, Neue Pinakothek), for example, attain his new spirit of Biedermeier serenity, a seemly combination of wealth, wit, temperance, courtesy, and aplomb. He promoted *Heimatlandschaft* (native landscape) in contrast to the classical or ideal landscape tradition, but consistent with Romanticism. *Das Höllengebirge bei Ischl* (1834, Vienna, Österreichische Galerie des 19. Jahrhunderts), which exemplifies this trend, features a craggy, forested Alpine motif from his preferred hangout, the near Salzkammergut. In peasant genre, he pioneered the *Sittenbild,* i.e., the imaging of significant aspects of rural morals and manners and, in particular, the social and interpersonal behavior of peasants.

From about 1840, Waldmüller's major attention shifted to

the *Sittenbild,* featuring multi-figural groupings of peasants acting out small but humanly arresting dramas. Increasingly in his later years, he staged these sentimentally intensified "scenic theater" pieces (Maria Buchsbaum) in the brilliantly lighted out-of-doors and structured his light-dark effects with piercing incisiveness. This created the sparkling color and light effects of immediacy, spontaneity, and a kind of "modern" naturalistic matter-of-factness in seeming anticipation of the Macchiaioli and early Impressionists, illustrated in *Peasant Lovers* (1863, Frankfurt), for example. The painting is histrionic and sentimental, yet staged with trenchant classical directness *and* natural optical force.

Discussions of Waldmüller must take into account three critical issues: the forthright nature of his progressive (even revolutionary) Realism, his paradigmatic Biedermeier stance, and his elective affinity for the conservative values of Viennese bourgeois society of the Metternich era, despite his vehement attacks on one of their most treasured institutions, the academy. Resulting from these intellectual schisms, his relationship to some of the central themes of progressive mid-19th-century European art—positivism, empiricism, naturalism, liberal political dialectics—is paradoxical and, at once, supportive *and* ambiguous *and* antagonistic.

The consensus among Waldmüller's critics is that meaning in his paintings arises from his late Romanticism which projects ideality on reality. His peasant genre and portraits alike delineate a fictional world of comity, normalcy, order, and tranquility. Actuality was seldom that idyllic, perfect, or simple. His art "obeys the content and not the direct language of reality." However, both his content *and* his selective images of nature are derived from his ideality; in short, they form the "framework of fanciful Biedermeier" (R. Feuchtmüller). Critics who seriously suggest that he also practiced a "form of behaviorism," especially with his portraits, by projecting "an obviously unvarnished picture" of society (R. Zeitler), are clearly in the minority.

Perhaps the most perplexing problem of Waldmüller's style lies in his naturalist technique of painting in relation to his intended contents—"the conflict between theory and practice" (Maria Buchsbaum). Nowhere does the "uncompromising nature and polemical acrimony" of his theoretical stance—"the study of nature is the one and only aim of painting"—conflict more with the true nature of his actual compositions (F. Novotny). With his painterly rich and light-filled canvases of genre in out-door settings, paralleling the School of Barbizon, Waldmüller "invented in his own right the method of painting *en plein-air*" (E. Waldmann). Still, his larger vision of reality, despite his professed anti-historicism, is engulfed by regressive compositional conventions and contextual metaphysics.

By nature he was a contentious man who battled the powers-in-being, the Vienna Academy, and the profoundly conservative bourgeoisie, including his fellow professors who supported it, causing for himself endless personal and professional grief throughout his life. By contrast, his paintings never even hint at these biographical travails. The reason for this remarkable existentialist disharmony might well be his Romantic bi-polar understanding of truth. As he saw it, truth is a function of nature—hence his need for "unconditional naturalness" in the realm of "visible manifestations." But it is also a function "of the idea"—hence the true birthplace of art is "the spirit" and its true mission the "ennoblement of feel-

ings" through the "promotion of the good." This theoretical variance gives rise to "the typical Biedermeier contradiction of idealism and realism" of which Waldmüller is a parade example (H. Kretschmer).

The authenticity of Waldmüller's complaisant Realism in its formal, psychological and social effects is at issue. Still, there is a simpler yet more fugitive critical milieu for testing Austria's foremost Realist, the irrational cultural matrix. Waldmüller was the most Austrian of artists, whose "commoner's art with a classical bent" represents "not only Austria but the entire German speaking world." He "immortalized the condition of civil life from 1830 to 1860 in its spiritual and material sweep" and did so "comprehensively, absolutely and perfectly" (Bruno Grimschitz). He felt a "strong kinship with the people and he understood what delighted, grieved and comforted the common folk" (Arthur Roessler and Gustav Pisko). That his break with analytical consistency did nothing to weaken his grasp on popular imagination may show that he was in touch with a deeper reality than reflective aesthetic reason. It may show that he discerned sentimental ethical truths in ambiguity, compromise, amalgamation, and *double entendre*. Perhaps this enabled his art to penetrate beyond appearance to the underlying psychic facts of Austro-German ethnic culture.

—Rudolf M. Bisanz

WARHOL, Andy.

Born Andrew Warhola in McKeesport, Pennsylvania, 6 August 1928. Died in New York, 22 February 1987. Studied at Carnegie Institute of Technology, Pittsburgh, 1945–49, B.F.A. 1949; illustrator, *Glamour Magazine*, New York, 1949–50, and commercial artist, New York, 1950–57; then independent artist; first silk-screen paintings, 1962; made films from 1963, often with Paul Morrissey.

Collections: London: Tate; Los Angeles; Minneapolis; New York: Moma, Whitney; Pasadena; Stockholm: Moderna Museet; Toronto; Washington: Corcoran.

Publications

By WARHOL: books—

Index Book, New York, 1967.
A: A Novel, New York, 1968.
Blue Movie (script), New York, 1970.
A to B and Back Again, New York, 1975; as *The Philosophy of Warhol,* London, 1975.
Ladies and Gentlemen, Milan, 1975.
Warhol's Exposures: Photographs, with Bob Colacello, New York, 1979.
Photographs, New York, 1980.
Popism: The Warhol '60s, with Pat Hackett, New York, 1980, London, 1981.

Andy Warhol and Mao Tse-tung

25 Cats Named Sam and One Blue Pussy; Holy Cats, London,
2 vols., 1988.

films (selection)—

Haircut, 1963; *Blow Job,* 1963; *Harlot,* 1964; *My Hustler,*
1966; *Chelsea Girls,* 1966; *I, a Man,* 1967; *Bike Boy,* 1967;
Lonesome Cowboys, 1968; *Blue Movie,* 1968; *Flesh,* 1968;
Trash, 1970; *Women in Revolt,* 1972; *Heat,* 1972; *Andy
Warhol's Frankenstein,* 1974; *Andy Warhol's Dracula,* 1974;
Andy Warhol's Bad, 1977.

On WARHOL: books—

Green, S. A., *Warhol* (cat), Philadelphia, 1965.
Crone, Rainer, *Warhol,* New York and London, 1970, 1987.
Coplans, John, *Warhol* (cat), Pasadena, 1970.
Coke, Van Deren, *Photo/Graphics* (cat), Rochester, 1971.
Gidal, Peter, *Warhol: Films and Paintings,* New York, 1971.
Koch, Stephen, *Stargazer: Warhol and His Films,* New York,
1973, 1985, London, 1985.
Warhol: Das zeichnerische Werk 1942-1975 (cat), Stuttgart,
1976.
Warhol (cat), Zurich, 1978.
Barozzi, Paolo, *Voglio essere una macchina: La fotografia in
Warhol,* Milan, 1979.
Gibson, Ralph, *SX-70 Art* (cat), New York, 1979.
Warhol: Portraits of the '70's (cat), New York, 1979.
Wünsche, Hermann, *Warhol: Das graphische Werk 1962–
1980,* Cologne, 1980.
Warhol: Bilder 1961 bis 1981 (cat), Hanover, 1981.
Ratcliff, Carter, *Warhol,* New York, 1983.
Feldman, Frayda, and Jorg Schellmann, *Warhol Prints,* New
York, 1985.
Smith, Patrick S., *Warhol's Art and Films,* Ann Arbor, 1986.
Warhol (cat), Hamburg, 1987.
The Warhol Collection (auction catalogues), New York, 6
vols., 1988.

*

Andy Warhol embodied the cool, object-oriented sensibility of
the 1960's. As a founder of American Pop art, Warhol's sub-
ject matter and techniques were borrowed from commercial
art, comic strips, television programs, movies, and advertis-
ing. As a whole, Pop art reacted against the tortured individu-
alism of Abstract Expressionism. The Pop art movement
would have been unthinkable during the Depression of the
1930's or wartime 1940's, when consumer goods were not as
readily available and low culture was considered the enemy of
high culture. This attitude changed in the 1950's, a transfor-
mation brought about by the economic boom and unprece-
dented growth of mass media, with its emphasis on advertising
consumer goods. Only when it appeared that our way of seeing
the world had been irrevocably altered could a style emerge
that dealt with that phenomenon, both in its positive and nega-
tive aspects.

Warhol was a successful commercial artist until 1960. At
that time, he began to paint comic strips and the labels of cans
in an Abstract Expressionist manner. By 1962 he suppressed

painterly handling, and continued to execute advertising im-
ages by hand in the manner of mass production. Shortly there-
after Warhol turned to silkscreening photographs, a technique
of mechanical image transfer which made his work seem even
more impersonal.

Despite the lack of mythic subject matter and personalized
touch which had characterized Abstract Expressionism, the
best of Warhol's silkscreen paintings make a haunting impres-
sion. Warhol accomplished this through choosing imagery that
is common, yet striking when removed from its original con-
text. Warhol's use of color and of "accidental" effects during
the silkscreen process also contribute to the emotional reso-
nance of some early works. In Warhol's painting *Electric
Chair* (1963), the stark newspaper image of the New York
State execution room, reproduced four times on the canvas and
ironically colored in soft pastels, drives home the horror of
that place in a manner that even the contemporary state-wide
debate over capital punishment could not equal. In *Marilyn*
(1962), the colors of the famous actress's pink flesh and
bleached yellow hair are deliberately garish and mis-registered
so that line and color areas do not match. The painting is not
easy to dismiss, because it explores the difficult realm between
beauty and vulgarity. The lonely sex goddess seems to be de-
caying in front of our eyes.

Warhol not only fashioned art but personalities. His studio,
the famous silver-foil-lined Factory in New York City, was
populated by both celebrities and unknowns that Warhol arbi-
trarily designed "stars." Warhol, like his subjects, became a
celebrity whose every activity was followed by the popular
press. Warhol's desire to live his life as an art work links him
to Marcel Duchamp before and Joseph Beuys afterwards. Like
them, the man behind the events remained an enigma.

Warhol's use of repeated images in his paintings, resembling
a film strip, led him in 1963 to begin to produce movies. Such
early films as his six hour *Sleep,* depicting a person sleeping,
exhibited a complete rejection of the action-filled story lines
and cinematic drama of traditional films.

When Warhol barely survived a sensational attempt on his
life in 1968, his art and life-style changed. Fame and money,
which had been previously treated in an ironic spirit in his art,
became the goals of his life. He recognized that through the
right combination of counter-culture and commercialism, he
could cash in on the youth market. His early and controversial
paintings were followed by slick, commissioned society por-
traits of such figures as Elizabeth Taylor. His films became
more commercially acceptable and he launched such projects
as the jet-set gossip magazine *Interview.*

There are two schools of critical thought about Warhol's art.
One argues that he is simply the product of his consumer-
oriented times, and reflects the unquestioned acceptance of
mass culture. The other contends that his work is an ironic
commentary on his age, and that it provides a lens through
which we can better see some assumptions formed in the
1960's. This author believes that the latter description best
suits Warhol before 1968, and the former one fits his art after
that date. Warhol himself would never enlighten us upon this
issue, to do so would have compromised his prized ambiguity
and mystery. Perhaps he realized that the longevity of his art
depended upon its providing a screen on which the viewer
could project his own image of the age.

—Robert Saltonstall Mattison

WATTEAU, (Jean) Antoine.

Born in Valenciennes, 10 October 1684. Died in Nogent-sur-Marne, 18 July 1721. Apprenticed to Gérin in Valenciennes, at age 14–18; in Paris, c. 1702: joined the scene-painter Metayer, then in wholesale painting factory; assistant to Gillot, a scene-painter, c. 1704–08; then, with his pupil Lancret, with Claude Audran, keeper of the Luxembourg collection; patronized by Sirois, and lived with him after a visit to Valenciennes; member of the Academy, 1717; lived with the collector Crozat, the dealer Gersaint, and le Fèvre in Nogent, 1721; his pictures were the first to be given the designation "fêtes galantes"; many drawings, few portraits.

Major Collections: Paris; London: Wallace.

Other Collections: Berlin: Dahlem, Charlottenburg; Birmingham; Boston; Chicago; Cleveland; Dresden; Edinburgh; Glasgow; Hartford, Connecticut; Indianapolis; Leningrad; London: Dulwich, National Gallery, Soane; Madrid; Muncie, Indiana; New York; Pasadena; San Francisco; Stockholm; Troyes; Valenciennes; Washington.

Publications

On WATTEAU: books—

Goncourt, Edmond de, *Catalogue raisonné de l'oeuvre peint, dessiné, gravé de Watteau*, Paris, 1875.

Rosenberg, Adolf, *Watteau*, Bielefeld, 1896.

Pilon, Edmond, *Watteau et son école*, Brussels, 1912, 1924.

Champion, Pierre, *Notes critiques sur les vie anciennes de Watteau*, Paris, 1921.

Dacier, Emile, and Albert Vauflart, *Jean de Julienne et les gravures de Watteau au XVIIIe siècle*, Paris, 4 vols., 1921–29.

Hildebrandt, Edmund, *Watteau*, Berlin, 1922.

Sitwell, Sacheverell, *Watteau*, London, 1925.

Réau, Louis, *Watteau*, Paris, 1928.

Kunstler, Charles, *Watteau l'enchanteur*, Paris, 1936.

Barker, Gilbert W., *Watteau*, London, 1939.

Brinckmann, Albert E., *Watteau*, Vienna, 1943.

Gillet, Louis, *Watteau, un grand maître du XVIIIe siècle*, Paris, 1943.

Adhémar, Hélène, *Watteau: Sa vie, son oeuvre*, Paris, 1950.

Parker, Karl T., and Jacques Mathey, *Watteau: Catalogue complet de son oeuvre dessinné*, Paris, 2 vols., 1957–58.

Mathey, Jacques, *Watteau: Peintures réapparues, inconnues, vu négligées par les historiens*, Paris, 1959.

Gauthier, M., *Watteau*, New York, 1960.

Parker, Karl T., *The Drawings of Watteau*, London, 1961.

Nemilova, I. S., *Watteau i ego proizvedenila v Ermitage* [Watteau and His Works in the Hermitage] (in Russian with French summary), Leningrad, 1963.

Schneider, Pierre, *The World of Watteau*, New York, 1967.

Camasasca, Ettore, *L'opera completa di Watteau*, Milan, 1968; as *All the Paintings of Watteau*, New York, 1971.

Huyghe, René, *L'Univers de Watteau*, Paris, 1968; as *Watteau*, New York, 1970.

Ferré, Jean, editor, *Watteau: Critiques*, Madrid, 4 vols., 1970.

Posner, Donald, *Watteau: A Lady at Her Toilet*, London and New York, 1973.

Boerlin-Brodbeck, Yvonne, *Watteau und das Theater*, Basel, 1973.

Eidelberg, Martin P., *Watteau's Drawings: Their Use and Significance*, New York, 1977.

Pelerinage à Watteau (cat), Paris, 4 vols., 1977.

Banks, Oliver T., *Watteau and the North: Studies in the Dutch and Flemish Baroque Influences on French Rococo Painting*, New York, 1977.

Guermain, Mikhail, *Watteau*, New York, 1980.

Hulton, Paul, *Watteau Drawings in the British Museum*, London, 1980.

Tomlinson, Robert, *La Fête galante: Watteau et Marivaux*, Geneva, 1981.

Bryson, Norman, *Word and Image: French Painting of the Ancien Régime*, Cambridge, 1981.

Stuffmann, M., et al., *Watteau: Finschiffung nach Cythera/L'Ile de Cythère* (cat), Frankfurt, 1982.

Börsch-Supan, H., *Watteaus Embarguement in Schloss Charlottenburg*, Berlin, 1983.

Grasselli, Margaret Morgan, and Pierre Rosenberg, *Watteau* (cat), Washington, 1984.

Jones, Louisa B., *Pierrot—Watteau: A Nineteenth-Century Myth*, Tubingen, 1984.

Michel, Marianne Roland, *Watteau: Un Artiste au XVIIIe siècle*, Paris, 1984; as *Watteau: An Artist of the Eighteenth Century*, London, 1984.

Posner, Donald, *Watteau*, London, 1984.

Held, Jutta, *Watteau: Einschiffung nach Kythera: Versohnung von Leidenschaft und Vernunft*, Frankfurt, 1985.

Moureau, François, and Margaret Morgan Grasselli, *Watteau: La Peintre, son temps, et sa légende*, Paris, 1987.

*

It may well be said that Antoine Watteau had the first truly modern career as an artist. He arrived in Paris from Valenciennes without money, connections, or conspicuously high-level training. His great celebrity was achieved in a stunningly short time without patronage in the conventional sense. For the most part he painted what he wished, and then sold or bartered the work among a group of friends and supporters. Everything about his life and art seems paradoxical. He courted fame but avoided attention; he painted sophisticated society while seeing himself as a bumpkin and an outsider; described by all his biographers as "difficult," this misanthropic loner seems never to have been alone, shuttling constantly between the homes of his friends. More has been written about him than any other French artist, yet he remains, more than any other, a mystery.

His dealings with the Royal Academy are typical. He applied for a *prix de Rome* and was awarded the much greater honor of membership. He was even granted the rare privilege of choosing the subject of his *morceau de reception* himself. Still he made the Academy wait five years—minutes of its meetings chronicle the delays, postponements, extensions, and calls to order. It was worth the wait. The picture was the *Island of Cythera* (Louvre), the most elaborate of the artist's *fetes galantes*. As the Academy had no category for this, a subject of Watteau's invention, he became the sole occupant of his own category. Which must have pleased him.

Standing Pierrot; drawing; Haarlem, Teylers Stiftung

While the *fête galante* paintings remain among the most beguiling works of western art the artist's intentions remain obscure. Are they simply a form of upper-class genre with elegant people strolling, lounging, chatting, flirting in a sylvan setting? What of the recognizable portraits of Watteau's friends, and of the artist himself? What of the sudden, unexplained appearances of figures in theatrical costume? Is this a play with a painted backdrop, or is all the world a stage? Clearly the theme of the *fête galante* is love, love at its most rarefied, a love made of glances and gestures, caught forever at the first moment of breathless recognition. The only suggestion of playful eroticism in these pictures comes from the statues and fountains—Watteau's own wry commentary on the proceedings. This humor coexists with a wistful melancholy which pervades these scenes, creating a tension peculiar to these works and contributing to their enduring appeal.

Literally and figuratively the ultimate *fête galante* is the *Shopsign of Gersaint* (Berlin, once owned by Frederick the Great) painted in 1720–21 after an ill-conceived visit to England for his health. With such health as remained to him failing Watteau offered to paint, in return for lodgings, an outdoor piece for his friend's shop on the Pont Notre Dame. Gersaint dealt in paintings and prints but never such ones, mostly of erotic subjects, as appear in this fantasy of an art dealer's shop. The interior is peopled by the elegant, insouciant types from the outdoor *fêtes galantes* but there is perhaps

sharper characterization. The "connoisseurs" pay close attention to a painting of fat nudes while ignoring the beautiful women in the room. Others admire themselves in a mirror held by a shopgirl in front of a painting of the *Adoration of the Christ Child*. A man extends his hand to help a woman up a step in front of paintings and seductions. The levels of meaning, erotic sublimations, and interplays of religion, aesthetics, and narcissism are many and complex. What is clear is that, at the end of his life, Watteau appeared ready to take the *fête galante* into another dimension.

According to Gersaint the *Shopsign* was painted in eight days when Watteau's health would only permit him to work for a few hours in the morning. It is rare among his work in that it still glistens with pearly pinks and silvery blues. Many of his paintings have deteriorated badly due to his own slapdash technique, as well as poor restoration.

It is the drawings of Watteau that maintain a startling freshness and vivacity. Executed *au trois crayons* (red, white, and black chalks) they consist mostly of single figures, sometimes captured from numerous angles as they posed in the studio. Watteau then used these figures to compose his pictures directly on to the canvas, as did the Venetians in the 16th century. The same figures, *Two Studies of a Young Girl* (Pierpont Morgan Library), for instance, appear in numerous paintings, like actors in a theatrical repertory company. At the great bicentennial exhibition of his work in 1984 the general consensus was that the drawings won the day, and on their own would rank Watteau among the greatest of European masters.

Bouchner, Fragonard, Hogarth, Longhi, and many others seized upon particular aspects of Watteau's art ot create their own visions but only the work of Watteau is greater than the sum of its parts; the more we study and describe it the more it slips through our fingers. It seems only right that an artist who tried so hard to obscure everything about himself in his lifetime should continue to elude us two hundred years later.

—Frank Cossa

WEENIX, Jan.

Born in Amsterdam, 1642; son of the painter Jan Baptist Weenix. Buried in Amsterdam, 19 September 1719. Studied under his father, then worked mainly in Amsterdam, with some time in Utrecht, and also at Bensberg Castle and in Dusseldorf for the Elector Palatine, 1702–14; took over both styles of his father—Italianate and still-life—but specialized in still-lifes of dead game and flowers, often in outdoor or architectural arrangements; huge number of works. Pupil: Dirk Valkenburg.

Major Collection: London: Wallace.
Other Collections: Aachen; Amiens; Amsterdam; Augsburg; Cambridge; Cologne; Detroit; Dublin; The Hague; Hamburg; Karlsruhe; Leipzig; Munich; New York; Philadelphia; Schleissheim.

Publications

On WEENIX: book—

Sullivan, Scott A., *The Dutch Gamepiece,* Montclair, New Jersey, and Woodbridge, Suffolk, 1984.

articles—

Stechow, Woldgang, "A Wall Paneling by Weenix," in *Allen Memorial Art Museum Bulletin* (Oberlin, Ohio), 27, 1969.
Eikemeier, Peter, "Der Jagdzyklus des Weenix aus Schloss Bensberg," in *Weltkunst,* 48, 1978.
Schloss, Christine Skeeles, "Early Italianate Genre Paintings by Weenix," in *Oud Holland* (The Hague), 97, 1983.

*

Jan Weenix painted genre scenes, a few flower pieces and portraits, pictures of live birds, and some decorative wall paintings. His reputation, though, rests on the gamepiece, or still lifes of dead game and hunting accessories. These late baroque compositions are characterized by a lively decorative style of rich colors, deftly recreated textures, and dramatic lighting. Over 130 such pictures are attributed to Jan Weenix with approximately half of them being signed and dated. Dated works fall between 1664 and 1718.

The Dutch gamepiece was a relatively late branch of still life. It did not begin to flourish until the middle of the 17th century. By and large this was a result of contemporary hunting practices and changing social values in the Netherlands. Hunting was restricted by law to the Dutch nobility who constituted a very small percentage of the population. The rapid increase in the number of game still lifes and other paintings of the hunt after 1650 was prompted by the desire of the middle class to own such works as a mark of their newly acquired wealth and heightened social consciousness. Regardless of their ability to partake in the sport, the prosperous Dutch sought gamepieces as a method of imitating the habits and tastes of the aristocracy.

Jan Weenix worked during the late style of the gamepiece, circa 1680–1720. Here, hunting still lifes became more spacious and decorative. No longer was the game depicted on a table or in a niche, but the booty was set in a lush landscape with a dramatic view into the distance. The open wing of a swan or extended leg of a hare often created elegant curves and rhythms in the composition. With the game can often be seen antique urns and statues or the facade of a classical building. An ornate park was likely to be depicted in the background where elegantly dressed couples strolled in carefully manicured gardens complete with reflecting pools and classical statuary. The intent of course was to suggest the grounds of a fine chateau and thereby associate the picture with the nobility. In this way, the gamepiece could again lend to its owner a mark of social prestige.

Weenix's basic stylistic approach to the gamepiece was formulated in the 1680's. Typically, a dead hare or other game specimen was displayed together with smaller game birds and hunting gear in a pyramidal fashion along one side of the picture. Set at an oblique angle, the arrangement led the observer's eye into the distance. Here the landscape was often bathed in the warm, rosy light of the late afternoon. In the foreground, light was more intense as the still life would be modeled in a dramatic chiaroscuro. Earthen colors dominated Weenix's palette as he carefully reproduced the textures of the game. Variations of color were added by the plumage of finches and other birds or an elaborate hunting satchel. The total impression is one of quiet, understated richness.

Weenix's style underwent few changes in the course of his career. Antique and pseudo-antique accessories appeared regularly, often with distant views into formal gardens with reflecting pools and aristocratic chateaux. Such classical motifs were largely a result of the influence of the French court style and can be seen in other types of late 17th-century Dutch painting. Increasingly, Weenix would include barking dogs, excited monkeys, or flying birds in his works to lend greater animation. Colors also became brighter and more diverse. The artist's brushwork was precise in its description of forms yet never tight or overtly meticulous in execution.

Some of Jan Weenix's greatest pictures were commissioned by Johann Wilhelm von der Pfalz, Elector of the Palinate, for his hunting castle in Bensberg, Germany. Working there between 1710 and 1714, the artist created a series of twelve huge canvases conceived as illusionistic wall paintings. Scenes of huntsmen, dogs, and game are set against panoramic landscape views. Typically, the still life is arranged on a parapet in the foreground. The horizon line of the landscape behind is kept low so that in the paintings' original positions it would have coincided with the viewer's eye level. This would create the impression of looking out over an opening in the wall into the distant landscape. The Bensberg canvases are a moving baroque climax in Weenix's art. Leaping stags, snarling boars, barking dogs, and excited hunters create a great exuberance. Magnificent displays of booty, including mighty stags and graceful swans, are rendered with vivid realism. The entire series of paintings was praised by the great German poet Goethe when he saw them *in situ* in 1774. For Goethe, Weenix surpassed nature in his ability to render these great creatures with such fidelity.

Jan Weenix had only one known pupil, Dirk Valkenburg. Valkenburg imitated his master quite closely, but his brushwork is less subtle and his pictures are often rather awkwardly composed.

—Scott A. Sullivan

WEST, Benjamin.

Born in Springfield Township, Pennsylvania, 10 October 1738. Died in London, 11 March 1820. Son: Raphael Lamar West. Set up as a portrait-painter in Philadelphia at age 18, then briefly in New York; in Italy, 1760–63, then settled in London: patronized by George III: appointed history painter to the King, 1772; helpful in founding Royal Academy, 1768: succeeded Reynolds as President, 1792; refused a knighthood; helpful to United States painters: Stuart, Copley, Allston, Peales, Trumbull.

Collections: Boston; Cambridge; Cincinnati; Detroit; Glasgow; Greenville, South Carolina; Hartford, Connecticut; Indianapolis; Leeds; Liverpool; London: Tate, Victoria and Albert,

He is not here : for he is risen . &c.

The Angel of the Resurrection, 1801; lithograph

Maritime Museum, Coram Foundation; New Haven; New York; Ottawa; Philadelphia: Historical Society, Academy of Fine Arts; Washington; Winterthur, Delaware; Royal Collection.

Publications

On WEST: books—

Galt, John, *The Life, Studies, and Works of West*, London, 2 vols., 1816–20.

Carey, W., *Critical Description and Analytic Review of Death upon the Pale Horse . . .*, London, 1817, Philadelphia, 1836.

Smart, C., *West's Gallery*, Londo, 1822.

Jackson, Henry E., *West: His Life and Work*, Philadelphia, 1900.

Evans, Grose, *West and the Taste of His Times*, Carbondale, Illinois, 1959.

Hirsch, Richard, *The World of West* (cat), Allentown, Pennsylvania, 1962.

Dillenberger, John, *West: The Context of His Life's Work with Particular Attention to Paintings with Religious Subject Matter*, San Antonio, 1977.

Alberts, Robert C., *West: A Biography*, Boston, 1978.

Evans, Dorinda, *West and His American Students* (cat), Washington, 1980.

Kramer, Ruth, *Drawings by West and His Son Raphael Lamar West*, New York, 1983.

Pressly, Nancy L., *Revealed Religion: West's Commissions for Windsor Castle and Fonthill Abbey*, San Antonio, 1983.

Abrams, Ann Uhry, *The Valiant Hero: West and Grand-Style Historical Painting*, Washington, 1985.

Erffa, Helmut von, and Allen Staley, *The Paintings of West*, New Haven, 1986.

Staley, Allen, *Benjamin West, American Painter at the English Court* (cat), Baltimore, 1989.

*

The career of Benjamin West presents a success story worthy of the "rags to riches" novels of Horatio Alger. Born of modest Quaker parents in America, on the edge of the frontier settlements, he ended his career as President of the Royal Academy and personal friend of King George the Third.

West himself was well aware of the drama of his emergence from modest beginnings, and assured his credulous biographer, John Galt, that he received his first art lessons from the Indians, who taught him the principles of the prismatic colors. In actual fact, West modeled his youthful efforts on European prints and obtained training from the itinerant English artist William Williams, who was active in Philadelphia.

But he did not remain long in the colonies. Sponsored by a group of wealthy patrons, West left for Europe in 1760 to pursue his artistic education, and never again returned to America. For three years he lived in Rome and studied the Old Masters and ancient statuary. At this time he devised from these sources a solemn, statuesque, neoclassical mode of history painting that reflected the revival of antiquity being urged in the writings of Johann Winckelmann.

West arrived in London in 1763 and achieved immediate recognition. He soon formed a lasting friendship with King George III despite his sympathy for the rebellious American colonies. In his famous *The Death of Wolfe* (1770; Ottawa), West established a new direction for history painting by showing heroic events enacted in contemporary costume instead of in classical guise.

In 1772 West was appointed historical painter to the king, and in 1792 he succeeded Sir Joshua Reynolds as President of the Royal Academy, a position he held with only one brief interruption until his death in 1820. West's egotism sometimes caused offense (he casually alluded to one of his paintings as "a little burst of genius"), but he won over the majority of his critics with his even temper and remarkable generosity. For some 30 years West's studio was a haven and training ground for American artists, including John Singleton Copley, Mather Brown, Ralph Earl, Charles Willson Peale, John Trumbull, Gilbert Stuart, Thomas Sully and Washington Allston.

Much of West's success was due to the manner in which he adjusted his style to suit the evolving demands of contemporary art theory. In his first period, in such paintings as *Agrippina Landing at Brundisium with the Ashes of Germanicus* (1776; New Haven), he developed a "stately manner" which reflected the influence of his Roman sojourn and of the "sedate grandure" which Winckelmann had extolled in ancient sculpture. In his middle period, in such paintings as *Death on a Pale Horse* (first version, 1783, Philadelphia Museum of Art; final version 1817, Philadelphia, Pennsylvania Academy of the Fine Arts), he developed a "Dread Manner" which obeyed the dictates of the "terrible sublime," an aesthetic concept recently set forth in the writings of Edmund Burke. In his final phase, in such paintings as *Christ Healing the Sick* (1811; Pennsylvania Academy of the Fine Arts), he favored a "Pathetic Style," in which the figures overtly displayed a great range of emotional states.

West's contemporaries often compared his works with those of Raphael and Titian. Twentieth-century critics have just as often castigated them as dull and ponderous—concurring with Lord Byron, who referred in "The Curse of Minerva" (1811) to the "palsied hand" of "the flattering feeble dottard, West/ Europe's worst dauber and poor Britain's best." Today, West's inflated reputation in his lifetime is difficult to understand, but a few of his history paintings of contemporary subjects, such as *The Death of Wolfe* (Ottawa), *Colonel Guy Johnson* (Washington), and *William Penn's Treaty with the Indians* (Pennsylvania Academy of the Fine Arts) have successfully defied changing standards of taste, and remain popular favorites.

—Henry Adams

WHISTLER, James (Abbott) McNeill.

Born James Abbott Whistler in Lowell, Massachusetts, 10 July 1834; added McNeill, his mother's maiden name. Died in London, 17 July 1903. Had one son by Louise Fanny Hanson; one daughter by Maud Franklin; married Beatrix Godwin, 1888 (died, 1896). Studied under Karl Briullov, St. Petersburg, 1845–48; attended United States Military Academy, West Point, New York (studied drawing under Robert Weir), 1851–54; worked for United States Coast Survey, 1854–55;

Black Lion Wharf; etching

lived in Paris, 1855–59: studied at the Imperial and Special School of Drawing, and at Gleyre's studio; first set of etchings, 1858; exhibited in Paris, 1859; settled in London, 1859: exhibited at the Royal Academy, 1860; promoted Japanese porcelain and prints, 1860's; decorated the "Peacock Room" of Frederick Leyland, London, 1876–77; sued the art critic John Ruskin for libel, 1877, and won the case; bankrupt, 1879, and lived in Italy, 1879–80; then lived in London, with intervals in Paris.

Major Collections: Glasgow: Glasgow University; Washington: Freer.
Other Collections: Amsterdam; Cambridge, Massachusetts; Cardiff; Chicago; Cincinnati; Detroit; Glasgow; Hartford, Connecticut; London: National Gallery, Tate; New York: Metropolitan, Frick; Paris; Philadelphia; Pittsburg; Toledo, Ohio; Washington: National Gallery, Corcoran.

Publications

By WHISTLER: books—

The Gentle Art of Making Enemies, London, 1890, 1892
Correspondance Mallarmé-Whistler, edited by Carl P. Barbier, Paris, 1964.

pamphlets (all published London): *Harmony in Blue and Gold: The Peacock Room,* 1877; *Whistler v. Ruskin: Art and Art Critics,* 1878; *The Piker Papers,* 1881; *Correspondence,* 1882; *L'Envoie in Notes—Harmonies—Nocturnes,* 1884; *Propositions,* 1886; *Mr. Whistler's Ten O'Clock,* 1885; *Eden Versus Whistler,* 1899; *Wilde v. Whistler,* 1906.

On WHISTLER: books—

Pennell, Elizabeth R., and Joseph Pennell, *The Life of Whistler,* London and Philadelphia, 2 vols., 1908, 6th edition, 1920.
Mansfield, Howard, *A Descriptive Catalogue of the Etchings and Drypoints of Whistler,* Chicago, 1909.
Kennedy, Edward G., *The Etched Work of Whistler,* New York, 4 vols., 1910.
Kennedy, Edward G., *The Lithographs of Whistler,* New York, 1914.
Pennell, Elizabeth R., *The Whistler Journal,* Philadelphia, 1921.
Salaman, Malcolm, *Whistler,* London, 2 vols., 1927–32.
Laver, James, *Whistler,* London, 1930, 1951.
Pennell, Elizabeth R., *Whistler the Friend,* Philadelphia, 1930.
Lane, J. W., *Whistler,* New York, 1942.
Stubbs, Burns A., *Whistler,* Washington, 1950.
Pearson, Hesketh, *The Man Whistler,* London, 1952.

Gregory, Horace, *The World of Whistler,* New York, 1959; London, 1961.

Young, Andrew McLaren, *Whistler* (cat), London, 1960.

Sutton, Denys, *Nocturne: The Art of Whistler,* London and New York, 1963.

Sutton, Denys, *Whistler: Paintings, Etchings, Pastels, and Watercolours,* London, 1966.

Young, Andrew McLaren, *Whistler,* London, 1967.

Sweet, Frederick A., *Whistler* (cat), Chicago, 1968.

Holden, Donald, *Whistler Landscapes and Seascapes,* New York, 1969; London, 1976.

Pocock, Tom, *Chelsea Reach: The Brutal Friendship of Whistler and Walter Greaves,* London, 1970.

Prideaux, Tom, *The World of Whistler,* New York, 1970.

Stanley, Allen, *From Realism to Symbolism: Whistler and His World* (cat), New York, 1971.

McMullen, Roy, *Victorian Outsider: A Biography of Whistler,* New York, 1973.

Weintraub, Stanley, *Whistler: A Biography,* New York, 1974.

Levy, Mervyn, *Whistler Lithographs: An Illustrated Catalogue Raisonné,* London, 1975.

Naylor, Maria, *Selected Etchings of Whistler,* New York and London, 1975.

MacDonald, Margaret, *Whistler: The Graphic Work* (cat), Liverpool, 1976.

Getschler, R. H., *The Stamp of Whistler* (cat), Oberlin, Ohio, 1977.

Fleming, Gordon H., *The Young Whistler,* London, 1978.

Taylor, Hilary, *Whistler,* London and New York, 1978.

Spalding, Francis, *Whistler,* London and New York, 1979.

Hobbs, Susan, *The Whistler Peacock Room,* Washington, 1980.

Young, Andrew McLaren, Margaret MacDonald, and Robin Spencer, *The Paintings of Whistler,* New Haven, 2 vols., 1986.

Hobbs, Susan, *Lithographs of Whistler* (cat), Washington, 1982.

Curry, David Park, *Whistler at the Freer Gallery of Art* (cat), Washington, 1984.

Curry, David Park, *Whistler,* New York, 1984.

Fine, Ruth E., *Drawing Near: Whistler Etchings from the Zelman Collection,* Los Angeles, 1984.

Lochman, Katherine A., *The Etchings of Whistler,* New Haven, 1984.

MacDonald, Margaret, *Whistler Pastels,* Glasgow, 1984.

Hopkinson, Martin, *Whistler Inheritance,* Glasgow, 1985.

Walker, John, *Whistler,* New York, 1987.

Fine, Ruth E., editor, *Whistler: A Reexamination,* Washington, 1988.

*

James McNeill Whistler is known for his colorful character as much as for his artistic contributions, especially the famous portrait of his mother, *Arrangement in Grey and Black No. 1: The Artist's Mother,* 1871 (Paris, Louvre). The ultimate 19th-century dandy, Whistler was actually born, much to his dismay, in a banal New England mill town. The family's relocation to Russia, where James studied arts and literature, allowed him to taste the role of the expatriate which would become his way of life. Back in the United States at West Point Military Acadamy (where he acquired a collection of poor grades, except in art), Whistler was already an entertainer and wit, singling himself out by his quick tongue and extraordinary demeanor. Although he was expelled from the Acadamy, his excellent art reputation landed him a position as cartographer with the nearby Coastal Survey, an important factor in his later exploration of the etching medium. He soon tired of the position and in 1855, Whistler left for Paris, never to return to his native soil again.

Fluent in French and quite knowledgeable of the culture, Whistler was well prepared for the fast dramatic life of the artist in Paris. (He was not a bohemian scrambling for an existence but rather a rich young American eager to play a long waited-for and well-crafted role.) He soon entered the studio of Charles Gleyre, a non-traditional artist famous for encouraging *en-plein-air* studies and for having nurtured many of the impressionists. The influence of Gleyre on Whistler cannot be overstated. Although his students often employed a wide palette, Gleyre restricted his own palette to shades of grey and black in imitation of the subtle oriental landscapes he greatly admired. Gleyre advocated painting from memory, emphasizing the importance of distilling a landscape scene into the elements necessary to recreate the initial visual experience. Hence it was not an encylopedic eye-to-hand recording which was valued in this exercise but rather a cerebral eastern aesthetic of capturing the essence. Gleyre's influence is seen above all in Whistler's landscape paintings, especially his famous *Falling Rocket,* 1875, which inspired John Ruskin to accuse Whistler of "flinging a pot of paint in the public's eye." Whistler's later account of the trial, *The Gentle Art of Making Enemies* (1911), reads as a witty art manifesto in the form of a dialogue, rather like Oscar Wilde's.

Although Whistler's paintings can be read in the traditional sense of correlating the objects depicted with those in life as experienced, this does not do justice to the atmosphere which envelops the paintings and removes them from the viewer. This created and controlled distance attracts as much as it repels. Whistler's trademark—if one must be chosen—is indeed one of manipulated distance. A key tactic in developing and maintaining this distance is the use of suggestive picture titles. Many of the titles are musical in nature, from the looser "arrangements" to the more formal "symphonies." These titles can be explained convincingly by Whistler's assertion that painting need not be anecdotal or didactic but can merely exist in its own right as does music. Just as Baudelaire saw nature as a verbal dictionary, Whistler saw it as a painterly one. Whistler was closely aligned with the symbolist poets who believed in the evocative and suggestive qualities of music, and Mallarmé, symbolist poet par excellence, was a great devotee. The two established a close friendship and both were at the forefront of the artistic and literary trends and movements in Paris and London. Detesting art critics, Whistler wrote his own art theory which in its enlightening and progressive qualities balances the vitrolic nature of his attack on Ruskin.

When not in the studio or salon, Whistler was in the museum admiring several different masters. The influences stemming from the admiration can be broken down into a few simple categories. From Velázquez, Whistler strengthened his usage of a dark palette and copied the master's vertical, full-length portraiture. Whistler executed many portraits during his career, most of which utilize the Velázquez format. *Gold and*

Brown: Self-Portrait, 1898, is quite similar to the 1630 Veláz-quez *Pablo di Valladolid*, which Whistler had seen at the Uf-fizzi. In 1865, Whistler met Albert Moore whose mixture of classical-draped figures with Japanese motifs was echoed im-mediately in Whistler's *The Artist in His Studio*, 1867–68. Moore also inspired Whistler to investigate pastels; the few published nude figures of Whistler are awkward statue-like figures who strike contrapposto while shedding kimonos. Whistler introduced Moore to Japanese prints, from which he acquired the technique of signing his painting with a stamp. All his paintings are embellished with the Whistlerian "Butter-fly," a shape which varies from a stick-like form to a thumb-print. Both artists undertook large design commissions, decorating rooms, even entire houses. In 1877 Whistler com-pleted the famous "Peacock Room" for F. R. Leyland; this ornate gold-gilded project is now in the Freer Gallery in Wash-ington, D.C. Whistler appointed himself interior designer, even at the great expense of his patrons' original wishes. Fre-quently, after he had sold a painting, he would insist upon designing the installation, even if it involved removing pre-existing art and painting walls. This habit of artistic purism—along with his acerbic wit and flamboyant manner—made Whistler an unpopular figure in Europe, especially in London and Paris where he resided.

Whistler was a passionate admirer of Rembrandt. The influ-ence of Rembrandt on Whistler can best be seen in the latter's etchings. Whistler's interest and skill in etching developed as a young cartographer in Annapolis. No sooner had Whistler ar-rived in Paris than he bought himself a small copper plate which was toted everywhere, even to parties. Whistler's early etchings are spontaneous and playful, those of a young artist on the loose. As etching is a reproductive medium, it tends to be more physical and casual than a painting. The artist can create a slight alteration by merely adding or covering a scratch. The draughtsmanship echoes writing more than paint-ing; the mechanics and the concomitant opportunities pre-sented obviously appealed to Whistler, the artist and the writer. Many of his etchings contain visual and verbal puns, which play on the art as they reveal the bilingual wit at work. In the 1858 "French Set" etchings, Whistler altered a few letters, changing the title from "Doux Eaux fortes d'Apres Nature" (twelve etchings taken from nature) to "Faux Tortes" (mistakes). In this set, Whistler appears in his etchings, sur-rounded by a crowd of admirers. Here we see the classic aes-thete at work, spectator and participant in his own performance. The self/group portrait technique can be traced to Rembrandt's family etchings where the master is both fam-ily man and artist on the outside. Early in their respective careers, both artists etched many self-portraits, head pieces, which examine the youthful facial features as they explore the parameters of the medium.

The influence of Rembrandt was as strong in the end of Whistler's career as it was in the beginning. Whistler's 1890 self-portraits recall Rembrandt's in their poignant depiction of an artist at the end of his career. Both artists employ a mixture of brown and gold hues, providing a contrast of aging, wrin-kled skin with shimmering costume. And in both, the applica-tion of paint is more corporeal than the bodies depicted, as if to say the artist is evaporating into his creation and although the person is mortal, the painting is eternal. This encapsulates Whistler's own stance on art, for as he claimed in his famous *Ten O'Clock Lectures* (1885): ". . . peoples may be wiped out from the face of the earth but Art *is*."

—Sarah E. Bremser

WILKIE, (Sir) David.

Born in Cults, Fife, 1785. Died at sea, 1841. Studied under the history painter John Graham at the Trustees' Academy, Edinburgh, from 1799, and at the R. A. Schools, London, from 1805; first important work painted at age 19; his painting *Village Politicians*, exhibited in 1806 at the R. A., made his reputation and he continued in the "Dutch" genre style for years; worked in London, though visited Edinburgh several times; first commissions from the Prince Regent, 1810; mem-ber, R. A., 1811; visited Paris, 1814; spent the years 1825–28 on the continent for his health, and was influenced by Spanish painters; succeeded Lawrence as Painter to the King, 1830; died at sea while returning from the Near East (Turner painted a picture about it). Knighted, 1836.

Collections: Aberdeen; Edinburgh: National Gallery, Portrait Gallery, United Services Museum; Fife: Town Hall; London: Tate, Wallace, Wellington; Minneapolis; Munich; New Haven; New York; Ottawa; Oxford; Toledo, Ohio.

Publications

On WILKIE: books—

Cunningham, Allan, *Life of Wilkie*, London, 3 vols., 1843.
Gower, R. C. S., *Wilkie*, London, 1902, 1908.
Bayne, William, *Wilkie*, London and New York, 1903.
Dodgson, Campbell, *The Etchings of Wilke and Andrew Ged-des: A Catalogue*, London, 1936.
Woodward, John, *Paintings and Drawings by Wilkie* (cat), Ed-inburgh, 1958.
Errington, Lindsay, *Work in Progress: Wilkie: Drawings into Paintings* (cat), Edinburgh, 1975.
Miles, Hamish, *Fourteen Small Paintings by Wilkie* (cat), Lon-don, 1981.
Brown, David Blayney, *Wilkie: Drawings and Sketches in the Ashmolean Museum* (cat), Oxford, 1985.
Errington, Lindsay, *Tribute to Wilkie* (cat), Edinburgh, 1985.
Miles, H. A. D., and David Blayney Brown, *Wilkie of Scot-land* (cat), Raleigh, North Carolina, 1987.

articles—

Miles, Hamish, "Wilkie's Columbus," and Campbell, Patri-cia, "Drawings Related to Wilkie's Painting of Columbus at the Convent of La Rabida," both in *North Carolina Museum of Art Bulletin* (Raleigh), 8, Spring 1969.
Marks, Arthur S., "Rivalry at the Royal Academy: Wilkie, Turner and Bird," in *Studies in Romanticism* (Boston), 20, 1981.

The Defense of Saragossa; 37 × 55½ in (94 × 141 cm); Royal Collection

Elliott, Bridget J., "The Scottish Reformation and English Reform: Wilkie's Preaching of Knox at the Royal Academy Exhibition of 1822," in *Art History* (Oxford), 7, 1984.

*

From inauspicious beginnings in the Scottish Highlands, Wilkie became an extraordinarily popular painter, admired by public, artistic peers, and royalty, culminating in his knighthood in 1833. His genre painting of rural Scottish life, with its moral clarity and precision of narrative, continued the vital tradition of Hogarthian didactic painting and in turn served as a model for the Pre-Raphaelites and later Victorian painting.

Wilkie's first major painting, *Pitlessie Fair* (1804; Edinburgh) already presents the essentials of his early style: a panorama of scottish village life is rendered in a style that suggests the influence of 17th-century Dutch genre painting, notably Ostade and Teniers. Wilkie moved to London in 1805 to continue his studies at the Royal Academy; his manners and wit soon brought him into London's most prominent artistic circles. Sir George Beaumont, patron of Constable and Wordsworth and a renowned collector, commissioned *The Blind Fiddler* (1806; London, Tate), giving him a Teniers from his own collection to serve as a model. This simple, affecting work was soon followed by others in a similar vein, and their enormous success propelled Wilkie's career to further heights: he was made a member of the Royal Academy in 1811 and the following year the Prince Regent commissioned *Blind Man's Bluff* for the magnanimous sum of 500 guineas.

After the defeat of the French, Wilkie visited the Continent several times to study the Old Masters. He was especially drawn to the Rubens works that he saw both at the Louvre and Antwerp. Not surprisingly, his paintings begin to exhibit more varied colors and broader brushstrokes. In 1816 Wilkie was commissioned by the Duke of Wellington to paint a scene of soldiers at a pub. This eventually evolved into *Chelsea Pensioners Reading the Waterloo Despatch* (London, Wellington) which was rapturously received when exhibited in 1822.

Always of a sickly constitution, Wilkie took a three-year sojourn in 1825 to Spain and Italy to recuperate. The work done on the trip—usually of Italian peasants or Spanish guerrillas—is characterized by an increased painterliness, higher coloration and deep tonal lighting, clearly the result of Wilkie's study of the Spanish school. This new style was coolly received by his friends at the Academy exhibition of 1829, although the King bought several works and, in the following year, named the artist Painter in Ordinary to the King. Perhaps because of his new responsibilities and status, Wilkie grew increasingly dissatisfied with the limitations of genre painting. Throughout the 1830's, Wilkie turned his attention to painting historical subjects, not all of which are successful (*The Preaching of Knox; The Entrance of George IV at Holyrood House*). His portraits, however, are in the best British tradition, recalling Van Dyck and Lawrence in their buttery surfaces and vivid colors (*William IV; Augustus, Duke of Sussex*). It is probable that Wilkie had planned a group of Biblical paintings as his next project, for he embarked on a journey to the Holy Land in 1840. On 1 June 1841, while on his return

voyage, Wilkie died at sea. He was buried off Gilbralter, a fact that is immortalized by Turner's moving painting, *Peace—The Burial at Sea of Sir David Wilkie* (1842; Tate).

—Lynn R. Matteson

WILSON, Richard

Born in Penegoes, Montgomeryshire, 1 August 1714. Died in Llanberis, Denbighshire, 15 May 1782. Studied under Thomas Wright in London, 1729–35, then set up on his own in London as portrait and landscape painter, 1735; in Italy, 1749–55 (Venice, Rome and the Campagna); then mainly a landscape painter (often several versions of the same picture); founder-member, Royal Academy, 1768 (Librarian, 1776). Pupils: Joseph Harrington, William Hodges.

Major Collection: Cardiff.
Other Collections: Adelaide; Auckland; Baltimore; Berlin; Birmingham; Edinburgh; Glasgow; Hanover; Liverpool; London: National Gallery, Tate, Portrait Gallery, Victoria and Albert, Royal Academy, Maritime Museum, Dulwich; Melbourne; Minneapolis; New Haven; New York; Philadelphia; San Marino, California; Stockholm; Washington.

Publications

On WILSON: books—

Hastings, Thomas, *Etchings from the Work of Wilson, with Some Memoirs of His Life*, London, 1825.
Fletcher, Beaumont, *Wilson*, London, 1908.
Bury, Adrian, *Wilson*, Leigh-on-Sea, 1947.
Woodall, Mary, *Wilson and His Circle* (cat), Birmingham, 1948.
Ford, Brinsley, *The Drawings of Wilson*, London, 1951.
Constable, William G., *Wilson*, London and Cambridge, Massachusetts, 1953.
Sutton, Denys, editor, *An Italian Sketchbook by Wilson*, London, 2 vols., 1968.
Jones, Elis Gwyn, *Wilson*, Caerdydd, 1973.
Solkin, David H., *Wilson: The Landscape of Reaction* (cat), London, 1982.

articles—

Ford, Brinsley, "Wilson in Rome, I: The Wicklow Wilsons," in *Burlington Magazine* (London), May 1951.
Ford, Brinsley, "Wilson, II: The Claudean Landscapes," in *Burlington Magazine* (London), November 1952.
Constable, William G., "Wilson: Some Pentimenti," in *Burlington Magazine* (London), May 1954.
Constable, William G., "Wilson: A Second Addendum," in *Burlington Magazine* (London), April 1962.

Wilson made his name as a portraitist with direct, crisply impasted works like *Flora Macdonald* (Edinburgh, Portrait Gallery). He was a member of the St. Martin's Lane Academy and his landscapes of the 1740's, such as *Extensive Landscape with Lake* (Executors of Capt. R. S. de Quincey) are in the rococo style encouraged by that institution: light, bright colors, a playful delicacy in the handling of paint, and graceful, leisured figures. Wilson was in Venice in 1750–51 and in Rome in 1751–52. *River and Farmhouse* (1751; London, Victoria and Albert), with its happy peasants and intricate foliage, shows the influence of Venetian rococo landscapes by Zuccarelli. In Rome Wilson took Claude-Joseph Vernet's advice to concentrate on landscape painting full time. His works became more sober, emulating the serenity and atmospheric distances of Claude (*Rome from the Villa Madama*; 1753–54; New Haven) and the carefully structured, classical compositions of Gaspard Dughet. A series of detailed black chalk drawings made for the 2nd Earl of Dartmouth show Wilson exploring effects of light and atmosphere on the ruins and monuments of Rome. He used these drawings made in front of the motif as a basis for paintings throughout the rest of his career.

In 1760, a year after he became a founder member of the Society of Artists, Wilson painted *The Destruction of Niobe's Children* (New Haven). The subject—a mortal punished by the gods for her effrontery—was a fitting one for a painter deeply grounded in classical literature and seeking to introduce moral themes into modern British landscape painting, in the manner of his 17th-century predecessors Claude and Gaspard. The dramatic effects in *Niobe*—lightning and craggy landscape— owe much to Salvator Rosa, whom Wilson had studied in Italy. The picture gained wide popularity as an engraving.

Wilson also imbued with classical spirit his "portraits" of English country houses, such as the five views of Wilton painted c. 1758–60 for the 10th Earl of Pembroke. In *Wilton House from the South East* (Earl of Pembroke) he emphasized the classical nature of its 17th-century architecture, setting it in a serene sunset parkland complete with lounging peasants— suggesting that 18th-century Wilton was really a timeless Arcadia where all was peace and harmony.

In a more light-hearted classic spirit, Wilson painted *The Ruined Arch at Kew Gardens* c. 1761–62 (Brinsley Ford Collection). The clear light and cypress trees tricked subsequent generations into believing that the scene was in Rome until the correct location was discovered in 1949. Wilson also produced more naturalistic landscapes like *View on Hounslow Heath*, c. 1765 (London, Tate), inspired by Dutch 17th-century art. In contrast with his Italianate views, the countryside is flat, there is no dramatic focus, and the interest of the picture lies in the subtlety of the cloudscape above the low horizon.

Wilson is at his most original in *Cader Idris, Llyn-y-Cau* c. 1765–7 (London, Tate), a bare view of the top of a Welsh mountain which is proto-Romantic in its unadorned depiction of wild countryside. A taste for the wilder parts of Britain and Europe was only just developing, and Wilson was probably the first artist to paint this scene. There was, however, a strong interest in Welsh landscape from the Welsh landed gentry who formed the bulk of Wilson's patrons, and he painted several versions of the view.

—Susan Morris

*

WITTE, Emanuel de.

Born in Alkmaar, c. 1617. Died (suicide) in Amsterdam, winter 1691-92. Married second wife in Amsterdam, two daughters. Entered the Alkmaar guild, 1636; then in Rotterdam briefly, and in Delft, c. 1640-50: joined the Delft guild, 1642; moved to Amsterdam, c. 1651: painted many churches, imaginary interiors, portrait groups, market scenes; later in life, his second wife and her daughter were convicted of theft. Pupil: Hendrick van Streeck.

Major Collections: Amsterdam; Hamburg; Rotterdam.
Other Collections: Amsterdam: Historisch Museum, Oude Kerk; Berlin; Boston; Brussels; Delft: Prinsenhof; Detroit; Dusseldorf; The Hague; Leipzig; Leningrad; Lille; London: National Gallery, Wallace.

Publications

On WITTE: books—

Jantzen, Hans, *Das niederländische Architekturbild*, Leipzig, 1910.
Manke, Ilse, *Witte*, Amsterdam, 1963.
Leidtke, Walter A., *Architectural Painting in Delft: Gerard Houckgeest, Hendrick van Vliet, Witte*, Doornspijk, 1982.

articles—

Richardson, E. P., "Witte and the Imaginative Nature of Dutch Art," in *Art Quarterly* (Detroit), 1, 1938.
Wheelock, Arthur K., Jr., "Gerard Houckgeest and Witte: Architectural Painting in Delft Around 1650," in *Simiolus* (Utrecht), 8, 1975-76.

*

De Witte and Pieter Saenredam were the most accomplished architectural painters of the Netherlands, although De Witte's work was less consistent than Saenredam's in quality, and less representative in style of the genre as a whole. The same manner, with it soft contours and emphasis upon patterns of light and shade, was employed by De Witte in a number of market scenes, a harbor view (Amsterdam) and a few other subjects, such as the memorable *Domestic Interior* that was inspired by Pieter de Hooch (Rotterdam; an autograph version in Montreal).

De Witte's work up to 1650 consists of mostly unimpressive figure paintings and portraits, such as the *Jupiter and Mercury in the Hut of Philemon and Baucis* of 1647, and *The Holy Family* of 1650, both in Delft. These interior views are arranged largely in terms of light and shade, and resemble De Witte's earliest portraits of churches (for example, the unsigned *New Church in Delft with the Tomb of William the Silent,* of about 1651, now in Winterthur, Stiftung Jacob Briner) in their casual drawing, comparatively broad brushwork, and somewhat uncertain description of space. At the same time, however, De Witte's first experiments in the new genre, painted in 1650 and 1651, are based directly on the original inventions made in the same years by Gerard Houck-

geest, who had been an architectural painter in the manner of Bartholomeus van Bassen for at least 15 years. De Witte's *New Church in Delft* in Hamburg, for example, presents a close view of the choir from the rear, in a "two-point" perspective projection, and with a fidelity to the site as it appears (or rather, as it may be transcribed from one point in the ambulatory) that are entirely characteristic of Houckgeest's contemporary portraits of the two principal churches in Delft.

Thus De Witte, like Hendrick van Vliet around the same time, turned from portraits and historical subjects to a genre that had always been a perspectivist's specialty. The sudden shift to views of national monuments—the tomb of William the Silent, the tomb of Admiral Piet Hein—and the churches that enshrine them probably responded to a mostly local demand in traditionally loyalist Delft. In Amsterdam, too, it was often a monument, rather than the specific church, that was the pretext for a picture, while in other paintings a sermon, a vanitas motif, or other moralizing subject, made a religious statement in one of the few ways open to the painters who worked in this officially Calvinist society.

De Witte shared these concerns with other artists. What sets him apart from van Vliet and especially from Houckgeest is his independence from faithful description of the actual sites. De Witte's imagination seems to have been inspired more by the great spaces, shadows, and planes of sunlight in Dutch Gothic churches than by their architectural forms. His figures, too, are more than expected details; they witness the evocative illumination, its descent into pervasive shade, which suggests some communication between the heavens and the still stone structures that embody the faith of man.

De Witte was a willful and short-term student of Houckgeest. He borrowed the older artist's perspective schemes and compositional ideas, such as the placement of columns in the immediate foreground, but sought different artistic effects. Archways and windows, even areas of sunlight, become shapes in a pictorial pattern that concedes no greater substance to a column or piece of church furniture. By around 1653 De Witte played down the diagonal recessions that are typical of architectural painting in Delft, an the older convention of direct recession into depth, in favor of forms that are arranged rhythmically from side to side. One can speak of zones of space aligned parallel to the picture plane, and interrelated by the continuous interplay of solid and void, light and shadow. In a close view the resulting effect of an "optical field" is more painterly and less illusionistic than Houckgeest's or van Vliet's style, but at a normal viewing distance De Witte's paintings can be remarkably convincing as evocations of visual experience. This is one of the seemingly modern aspects of De Witte's work that reminds one of Vermeer.

A number of De Witte's paintings dating from the mid-1650's to the late 1660's appear to adopt designs from Pieter Saenredam (for example, the *Janskerk in Utrecht,* dated 1654, in the Institut Néerlandais, Paris). Not only compositional schemes, but the use of wide-angle distortions, or fanning effects, in vaults and capitals, and the conflation of near and far forms found in areas laterally removed from the vanishing point, are among the few characteristics that De Witte and the Haarlem master share. A more revealing comparison for De Witte's work as a whole may be made with Saenredam's drawings, which, unlike his panels, explore as much as they define interior space.

De Witte's intuitive grasp of the subject allowed him to pass without hesitation from portraits of actual churches to imaginary buildings which incorporate elements of the main churches in Amsterdam. Similarly, other subjects, such as the fish-market paintings in Hartford, Leipzig, and Rotterdam reveal the same technique as the architectural pictures. It was all the same to De Witte, in a sense: it was light. But 17th-century realism is always more than what may be seen. De Witte's subjects were individually significant, his themes familiar, though his views of churches impress one as personal memories rather than as topographical reports.

—Walter Leidtke

WITZ, Konrad.

Born c. 1400-10 in Rottweil, Württemberg. Died, probably in Geneva, 1445-46. Married Ursula von Wangen, 1435; five children. Member of the Basel guild, 1434, and worked in Basel; his masterpiece is the Altar of St. Peter for the Geneva cathedral, which includes the panel *The Miraculous Draft of Fishes*.

Collections: Basel: Offentliche Kunstsammlung, Church of St. Leonhard; Berlin; Dijon; Geneva.

Publications

On WITZ: books—

Überwasser, Walter, *Witz,* Basel, 1938.
Aulmann, Hans, *Gemäldeuntersuchungen mit Röntgen-, Ultraviolett-, und Infrarotstrahlen zum Werk des Witz,* Basel, 1958.
Barrucand, Marianne, *Le Retable du Miroir du Salut dans l'oeuvre de Witz,* Geneva, 1972.
Schmidt, Georg, *Witz,* Konigstein im Taunus, 1983.

articles—

Überwasser, Walter, "Witz und sein Majesta-Altar," in *Kunstchronik,* 13, 1960.
Teasdale-Smith, M., "Witz's *Miraculous Draft of Fishes* and the Council of Basel," in *Art Bulletin* (New York), 52, 1970.

*

Konrad Witz is famous for one work, *The Miraculous Draft of Fishes,* a panel from the Geneva cathedral Altar of St. Peter painted for Cardinal de Mies in 1544. It is the first northern European panel painting representing an identifiable landscape. Its study by the Basel museum curator Daniel Burckhardt in the late 1890's lead him to realize that a number of other panels might be by the same hand, based on the characteristics of the landscape panel, including the extant remains of the Heilspiegel Altar in Basel. Witz is thought to have come to Basel at the time of the opening of the Church Council in 1431, where he might have met his future patron, Cardinal de Mies. He was a member of the Basel painters guild in 1434, and is thought to have painted the Heilspiegel Altar in the mid-1430's for the Augustinian church of St. Leonhard (the last church in which the Catholic Mass was celebrated in Basel during the Reformation). He was made a citizen of Basel in 1435, married a niece of the Dean of the guild, and was given municipal commissions; he bought a house in 1443, but died young in the mid-1440's. *The Miraculous Draft of Fishes* is one of several panels surviving from the Geneva triptych, though the center has been lost; each of the surviving panels is about five feet wide, so the entire triptych would have been placed over a large altar. The other panels that have survived illustrate the *Liberation of St. Peter from Prison,* the *Adoration of the Magi,* and *Cardinal de Mies Presented to the Virgin.*

WOLGEMUT, Michael.

Born in Nuremberg, 1434; son of the artist Valentin Wolgemut. Died in Nuremberg, 30 November 1519. Married 1) Barbara Pleydenwurff, widow of the painter Hans Pleydenwurff, 1472 (died, 1500), three step-sons, including the painter Wilhelm Pleydenwurff; 2) Christina. Studied with his father, and in Munich with Gabriel Mälesskircher, 1470-71; returned to Nuremberg, and took over the workshop of Hans Pleydenwurff when he married his widow; his step-son Wilhelm was active in his shop; worked on the altar for the Church of Our Lady in Zwickau, 1476-79, and later altars; designed woodcut illustrations for *Der Schatzbehalter* by Stephan Fridolin, 1491, and the *Weltchronik (The Nuremberg Chronicle)* by Hartmann Schedel, 1493. Pupil: Dürer.

Collections: Andechs; Kassel; Lugano; Nuremberg.

Publications

On WOLGEMUT: books—

Stadler, Fr. J., *Wolgemut und der Nürnberger Holzschnitt,* Strasbourg, 1913.
Bellm, Richard, *Wolgemuts Skizzenbuch im Berliner Kupferstichkabinett,* Baden-Baden, 1959.
Bellm, Richard, editor, *Der Schatzbehalter,* by Stephan Fridolin, Wiesbaden, 2 vols., 1962.
Wilson, Adrian, *The Making of the Nuremberg Chronicle,* Amsterdam, 1976.

articles—

Buchner, E., "Wolgemut in Andechs," in *Die Weltkunst,* 21, 1957.
Ortmayer, Robert, "Woodcuts of the Nuremberg Chronicle," in *Journal of the Perkins School of Theology,* 16, (Dallas), 1963.

*

In November 1486, against his own better judgment, Albrecht Dürer the Elder granted his fifteen-year-old son's wish to abandon the goldsmith's craft for the study of painting, and apprenticed the boy to Michael Wolgemut, his neighbor in the Nuremberg street called Unter der Vesten ("Below the Castle," today Burgstrasse No. 16).

Wolgemut, son of a minor Nuremberg painter, was both artist and entrepreneur. Trained in the Munich workshop of Gabriel Mäleskircher, and failing in his attempt to wed Mäleskircher's daughter, he had ungallantly sued that lady for breach of promise, returning to Nuremberg in 1472 to console himself by marrying the freshly widowed Barbara Pleydenwurff, whose late husband Hans had been Nuremberg's most able painter. He thus fell heir to her late husband's possessions, and gained a young stepson, Wilhelm, who in time became his collaborator, to the eternal confusion of art history. Wolgemut's style is not easily distinguished from that of the elder Pleydenwurff, whose drawings he had inherited, nor from that of Wilhelm, whose training he directed.

On the whole, Wolgemut was less remarkable as a painter than as an organizational genius, accepting commissions for sculpture, stained glass, and woodcut illustration as well as for paintings, and making liberal and judicious use of subcontractors to orchestrate his more ambitious projects. These included the large transforming altar for the church of St. Mary in Zwickau (1479) which, with its painted wings and sculptured shrine (attributed by some to the youthful Veit Stoss), cost the astronomical sum of 1400 gulden, including the shipping and installation charges—a figure several times larger than any earned later by Dürer. Wolgemut, who died only nine years before Dürer, continued to operate Nuremberg's largest workshop even during Dürer's most active years, and it was he whom Dürer asked to give temporary employment to his teenaged brother, Hans, during Dürer's protracted absence in Italy in 1506. Dürer painted the old man's portrait in 1516 (Nuremberg, Germanisches Nationalmuseum) keeping one copy of it for his own collection, and later carefully recorded on it the date of Wolgemut's death, as he had done with the charcoal drawing of his own mother a few years earlier.

Wolgemut was the first major German painter to contract directly with a publisher, and to employ his own block cutters to execute his own and his draftsmen's designs for book illustrations. The woodcuts which his workshop produced for printed books were technically among the best to be had in Europe during the 1480's and early 1490's, achieving unprecedented effects of modeling and landscape detail. Two of the best-known books illustrated in the Wolgemut shop were published by Dürer's godfather, Anton Koberger—Stephen Fridolin's *Schatzbehalter* (Treasure Chest; 1491) and Hartmann Schedel's *Weltchronik* (World Chronicle, better known as "The Nuremberg Chronicle"; 1493).

—Jane Campbell Hutchison

WRIGHT, Joseph (of Derby).

Born in Derby, 3 September 1734. Died in Derby, 29 August 1797. Pupil of Thomas Hudson, from 1751, then set up in Derby; visited Italy, 1773–75; specialized in lighting effects; patronized by Wedgwood and Arkwright; worked in Bath, 1775–77, then resettled in Derby; declined membership in the Royal Academy, 1774.

Collections: Birmingham; Derby; Hartford, Connecticut; Ipswich: Christchurch Mansion; Leningrad; Liverpool; London: Tate; New Haven; St. Louis.

Publications

On WRIGHT: books—

Smith, S. C. Kaines, and H. Cheney Bemrose, *Wright of Derby*, London, 1922.
Wright of Derby (cat), Derby, 1934.
Nicolson, Benedict, *Wright of Derby* (cat), London, 1958.
Hope, Alison, *Wright of Derby: A Bibliography*, Derby, 1967.
Nicolson, Benedict, *Wright of Derby, Painter of Light*, London, 2 vols., 1968.
Watson, Ross, *Wright of Derby: A Selection of Paintings from the Collection of Mr. And Mrs. Paul Mellon* (cat), Washington, 1969.
Busch, Werner, *Wright of Derby: Das Experiment mit der Luftpumpe: Eine heilige Allianz zwischen Wissenschaft und Religion*, Frankfurt, 1986.

articles—

Paulson, Ronald, "Wright of Derby: Nature Demythologized," in *Emblem and Expression*, New York, 1975.
Nicolson, Benedict, "Wright of Derby: Addenda and Corrigenda," in *Burlington Magazine* (London), October 1988.

*

Although Wright is primarily known for his dramatic candlelight paintings, the majority of his work consists of portraits and landscapes. Many of the portraits are stylistically indebted to his mentor, Thomas Hudson, to whom Wright was apprenticed in 1751. By 1760 Wright had embarked on a career of an itinerant portraitist, travelling extensively throughout the Midlands from his native Derbyshire. His first exhibition was the annual show in London at the Society of Artists in 1765, which included one of his earliest candlelight pictures, *The Gladiator* (private collection). The dramatically lit painting proved popular and soon thereafter he showed others in a similar style, among which is *Experiment with an Air Pump* (1766; London, Tate). From 1768 to 1771 Wright lived in Liverpool where he painted the local notables and became part of an active circle of intellectuals.

Wright was eventually to count among his friends Josiah Wedgewood, Richard Awkwright, and Erasmus Darwin. Indeed, many of the subjects of his paintings, such as *Philosopher Giving a Lecture on the Orrey* (1766; Derby) and *Iron Forge* (1773; Leningrad) reflect the scientific and industrial discoveries that were then being made in the English Midlands. Equally unconventional are the subjects of his history paintings, many of which, such as *The Old Man and Death*

(1773; Hartford, Connecticut) and *The Alchemist in Search of the Philosopher's Stone Discovers Phosphorous* (1795; Derby) are unique to Wright.

Despite his growing London reputation among peers and connoisseurs, Wright preferred to remain in the Midlands, although he continued to exhibit in the capital throughout his life. In 1773 he travelled to Italy where he studied the requisite antiquities and Old Masters, and witnessed, as is evidenced by several paintings and sketches, an eruption of Vesuvius. He returned to England in 1775 and failed in establishing himself as a fashionable portraitist in the resort city of Bath. In 1777 he permanently returned to Derby, where he remained until his death in 1797.

—Lynn R. Matteson

Z

ZADKINE, Ossip.

Born in Smolensk, 14 July 1890; naturalized French citizen. Died in Paris, 25 November 1967. Married the painter Valentine Prax, 1920. Studied at Sunderland Art School, County Durham, 1905–06; Regent School Polytechnic and Central School of Arts and Crafts, both in London, 1908; studied under Jean Antoine Injalbert at the Ecole des Beaux-Arts, Paris, 1909; served in the French Army during World War I: after being injured, served as Russian interpreter, 1915–18; lived in the United States, 1940–45: taught at the Art Students League, New York, 1941; returned to France after the war, and taught at the Académie de la Grande Chaumière, Paris, 1946–53, and at the Ecole des Beaux-Arts, Paris, 1962.

Major Collection: Paris: Zadkine Museum.
Other Collections: Amsterdam: Stedelijk; Antwerp; Brussels; London: Tate; Paris: Beaubourg, Art Moderne; Philadelphia; Rotterdam; Zurich.

Publications

By ZADKINE: books—

Comment je suis devenu sculpteur, Brussels, 1951.
Voyage en Grece: Trois Lumières, Amsterdam, 1955.
My Sculpture, Rome, 1963.
Lettres à André de Ridder, Antwerp, 1963.
Poèmes, London, 1964.
Le Monde secret de Zadkine vu par Donald Buchanan (in French and English), Paris, 1966.
Le Maillet et le oiseau: Souvenirs de ma vie, Paris, 1968.

illustrator: *Les Travaux d'Hercule*, 1960; *Portrait de l'oiseau qui n'existe pas*, by Claude Aveline, 1964; *Les Fugues*, by Robert Ganzo, 1966. *Calligrammes*, by Guillaume Apollinaire, 1967.

On ZADKINE: books—

Raynal, Maurice, *Zadkine*, Rome, 1921.
Ridder, André de, *Zadkine*, Paris, 1929.
Haesarts, Paul, *Zadkine: La Sculpture ailée*, Amsterdam, 1939.
Chevalier, Denys, *Zadkine*, Paris, 1949.
Hammacher, A. M., *Zadkine*, Amsterdam, 1954.

Marchal, G. L., *Avec Zadkine*, Paris, 1956.
Cogniat, Raymond, *Zadkine*, Paris, 1958.
Hammacher, A. M., *Zadkine*, London, 1958.
Gerz, Ulrich, *Zadkine*, Duisburg, 1963.
Jianou, Ionel, *Zadkine*, Paris, 1964, 1979.
Czwiklitzer, Christophe, *Zadkine: Le Sculpteur-Graveur de 1919 à 1967*, Paris, 1967.
Prax, Valentine, *Avec Zadkine: Souvenirs de notre vie*, Lausanne, 1973.
Cassou, Jean, *Zadkine: Vingt eaux-fortes de la guerre de 1914–1918*, St. Gallen, 1978.
Lichtenstern, Christa, *Zadkine: Der Bildhauer und seine Ikonographie*, Berlin, 1980.

article—

Bickelmann-Aldinger, Ursula, "Zadkines Dessins de guerre und das Motiv des Leidens in seinem Frühwerk," in *Pantheon* (Munich), October-December 1983.

*

Zadkine is the most stylistically catholic sculptor of the School of Paris, a formal pioneer who worked on traditional subjects in a range of traditional and ethnic materials, regarding himself as an artisan and a "peasant and romantic." He alternated his approach to humanistic themes from the primitive and archaic to the expressionist and baroque.

Zadkine became part of the immigrant art community of the School of Paris on moving into the cheap and bohemian La Rouche studio complex, where he worked alongside a cross section of the Parisian avant-garde. By the year he moved in (1910), he was already a fluent craftsman with experience as a professional ornamental wood carver. He had brushed with the British avant-garde in London, touring the non-western sculpture sections of the British Museum with David Bomberg and befriending Henri Gaudier-Brzezka. He had also exhibited with the Russian avant-garde organisation *Soyuz Molodozhi*.

His early works follow this experience closely: some in a Social Realist style, influenced by Rodin, some in imitation of Brancusi. But the strongest influences were "primitive," in particular Easter island and Chinese carving (seen in the British Museum) and Romanesque statuary discovered after his arrival in Paris. Consequently he practiced rough direct carving and a simple frontality of view, often with "primitive" awkwardnesses like the turned-in feet and dislocated head of *Demeter* (1918?, Eindhoven). The best of this work, like the

African-influenced *Tete aux yeux de Plomb* (1918, stone, Paris, Zadkine Museum) have a purity and a formal integrity apparently preserved from the natural form, texture, and grain of the material. While similar formal resources were shared by other members of the avant-garde, Zadkine was also temperamentally and philosophically attuned to peasant and primitive art forms; he had absorbed the nostalgic values of the 19th-century Russian *narodnik* movement and the notion of a "return to the soil" for moral and spiritual regeneration was inbred. From similar sources came a mystical attitude towards the forest, which emerged both in his extraordinarily respectful carving technique and as the theme of many late works.

The First World War (in the course of which he was twice gassed) temporarily fragmented Zadkine's commitment to a reassuring archaism, giving him a temporary affinity with Cubism. His etching series *Vingt Eaux Fortes de la Guerre* (1919) uses a sharp cubistic line, uprooting perspective to induce the dislocation and alienation of his subject. Post-war dissatisfaction moved him into the Cubist sculptural "research" of Henri Laurens and Jacques Lipchitz. The *Femme à l'eventail* series of 1922 (produced nearly a decade later than the earliest sculptural cubism) developed his most "dissociated" (abstracted) figures, which are nevertheless shallowly carved in solid shapes as before. The angularised limbs are folded into a pyramidal block, using hollower and lighter forms towards the top so that light would cascade down, as in a waterfall. The cubist period was relatively brief (c. 1922–26) and its products faintly scholarly, but Zadkine's formal vocabulary was greatly extended. He began to transpose positive and negative volumes, substituting convex curves for concave and to experiment with the dual perspective profile, a visual pun derived from Picasso. These formal themes appear first in *La Femme à l'eventail* (Pouillenay stone original, cast in bronze, St. Etienne) and are developed in *La Belle Servante* (1926, Zadkine Museum): fingers are picked out as negative corrugations in the block of the hand, a breast is cut like a pool in the chest, and nose and mouth appear half frontally, half in profile in a typically cubist *double entendre*.

In the same period, Zadkine refined his simple standing figures, eliminating the more flagrant primitivisms of earlier versions. His carving technique now seems merely to peel the original material, uncovering a figure with minimal violation of his material. This technical fluency produced such sensual and meticulously controlled figures as the Acacia wood *Torse d'ephebe* (1922), which merges the curve of the torso and the line of the branch from which it is formed. This theme is constantly reworked by Zadkine in woods, in marble, alabaster, and stone; the formal reductivism is controlled by the surface texture; rhythmic tool marks, an erotic high-gloss lacquered finish, polished lowlights. Gradually, the shallow carving of limbs locked to the body suggested the idea of surface drawing, a technique that could introduce activities of the limbs without violating the simplicity of form. A series of slender torsos, insinuated into trunk-like shapes, with delicately etched arm and hand laid across the body, appeared from the late 1930's to the end of Zadkine's career. The combination of the self-enclosed mass, with secret tattoo-like activities of the limbs, had tremendous lyrical and erotic potential exploited in the *Pomonas* of the 1940's and ultimately in the complex *Torse au violoncelle* where etched fingers ambivalently touch the strings of the tattooed cello and the body on which it is drawn.

In the late 1930's, in the approach of the Second World War, a separate category of baroque compositions emerged, using the distressed qualities of rough plaster to expressionist ends. The themes treated in this way provide a kind of evangelism for Zadkine's humanist philosophy: there is a series of "protest" works on the theme of war which culminates in the monumental memorial to the bombed city of Rotterdam, *La Ville détruite*; a series of tributes to creativity including monuments to the "martyrs of modernism" Lautréamont, Rimbaud, Jarry, and Apollinaire (a friend) and allegorical works dealing with isolation (the *Harlequin hurlant*), with the occupation (the *Prisonniere* series) and with post-war reconstruction (*Phénix*). Many of these are openly, even simplistically, emotive, and their accessibility and topicality gained Zadkine many admirers. In exile in New York he taught and lectured, continuing on his return to France, at La Grande Chaumière. His published writings, both poetry and prose (he had first written for the proto-Dada journal *Sic*) increased and there is no doubt that his picturesque articulacy contributed to his acceptance. In 1950 he won the Grand Prix de Sculpture at the Venice Biennale, followed by the Légion d'Honneur and other honours.

In the last two decades Zadkine worked prolifically in the full range of his styles; he continued to return to earlier themes (the eight *Orphées* span 30 years) and his treatment of merging human and vegetal forms becomes an explicit analogy in the series *La Forêt humaine*. Here the subtle merging of material and artefact found in the standing figures is replaced by a sculptural representation of limb-like primaeval growth. The baroque work (often supposed to have resulted from mounting pre-war turmoil) provided a voice for Zadkine's emotions and for the realisation of certain social messages, but its "eloquence" is finally less resonant than the enigma of the carvings.

—Abigail Croydon

ZOFFANY, Johann.

Born Johann Joseph Zauffaly near Frankfurt, 13 March 1733; son of the architect to the Prince of Thurn and Taxis. Died in Strand-on-the-Green, Middlesex, 11 November 1810. Married 1) Antonie Theopista Juliane Eiselein, late 1750's; 2) Mary Thomas, 1772 (perhaps irregular), one son, four daughters. Studied in Italy under Agostino Masucci and Mengs, 1750–57; in service of the Elector of Trier, 1757–60, in Coblenz and Trier; in England, 1760–72: worked as drapery painter for Benjamin Wilson, then set up as painter, and patronized by Garrick, and later by Queen Charlotte; in Italy again, 1772–79, mainly in Florence and Parma, then a trip to Vienna (made a Baron of the Holy Roman Empire); back in England, 1779–83, then in India, 1783–89: painted native princes and English in Calcutta and Lucknow; returned to England, 1789, and stopped painting, c. 1800.

Major Collection: Windsor: Castle.
Other Collections: Aberdeen; Birmingham; Bordeaux;

Burnley; Calcutta; Castle Howard; Edinburgh; Glasgow; Koblenz; Liverpool; London: National Gallery, Maritime Museum, Portrait Gallery, Tate, Commonwealth Relations Office; Manchester; New Haven; Newcastle; Ottawa; Oxford; Parma; Springfield, Massachusetts; Trier; Vienna; Wolverhampton.

Publications

Manners, Victoria, and George C. Williamson, *Zoffany,* London, 1920.
Zoffany (cat), London, 1960.
Webster, Mary, *Zoffany,* Milan, 1966.
Millar, Oliver, *Zoffany and His Tribuna,* London, 1967.
Webster, Mary, *Zoffany* (cat), London, 1976.

articles—

Pressly, William L., "Genius Unveiled: The Self-Portraits of Zoffany," in *Art Bulletin* (New York), March 1987.
Jackson-Stops, Gervase, "Zoffany and the Eighteenth-Century Interior," in *Antiques,* June 1987.

*

Zoffany's early training under Martin Speer in Regensberg made him aware of the diversity of contemporary styles practiced in Germany. His contact with Masucci and Mengs in Rome further exposed him to a range of styles and helped him consolidate his technical ability. From c. 1750 Zoffany painted primarily portraits and mythological and religious subjects. Although few works from this early period survive, those remaining show his experimentation with different modes of representation. His scrutiny of Italian art is evident in the choice of composition and subject, but most early works are distinguished by a sugary rococo treatment and often ponderous allegorical themes. Zoffany's skill was most apparent in portraiture, and he showed an early facility in capturing the essence of character within the constraints of the rococo style.

When Zoffany first came to England in c. 1760, his modest success in the courts of Germany did not provide him with immediate patronage. His initial employment consisted of painting clock faces and acting as a drapery painter to the portraitist Benjamin Wilson. One of Wilson's patrons, the actor David Garrick, recognized his talent and commissioned several conversation pieces from him, provoking Wilson's jealousy and animosity. The various scenes Zoffany painted of Garrick and his friends in and around his estate at Hampton were less successful than his more unusual representations of Garrick in theatrical character. The first of these, *David Garrick in "The Farmer's Return"* (1762; private collection), depicts a scene from a famous afterpiece of the time, and stands as one of the earliest examples of the genre of theatrical conversation piece in England. The work was shown at the popular Society of Artists exhibition, and the fame of David Garrick combined with the technical facility apparent in the painting to assure success. Zoffany received commissions for other theatrical conversation pieces over the next few years, but more importantly, he gained the attention of noble families and painted various small-scale portraits and conversation

John Cuff and His Assistant, 1772; $35\frac{1}{4} \times 27\frac{1}{4}$ in (89.5 × 69.2 cm); Royal Collection

pieces. These works show his versatility: they range from elaborate portraits in masquerade dress to charming and informal groups of children in outdoor settings. Some portraits, such as that of the Atholl family (1765–7; private collection), show his skill in manipulating a large number of figures. Zoffany's interior settings reveal a virtuosity in the handling of materials, pictures, and decorations, and he also painted genre scenes which allowed detailed depictions of character and costume. His concentration on detail and skill in capturing a likeness were prevalent aspects of his style throughout his career, even after Joshua Reynolds popularized a more idealized form of portraiture in the 1770's and 1780's.

Inevitably, royal attention was directed to Zoffany, and his portraits of Queen Charlotte and the royal children within various rooms in Buckingham House show an intimacy not normally associated with royal portraits. The favour of the King gained him election to the new Royal Academy, and Queen Charlotte commissioned him to paint the *Tribuna of the Uffizi* (1772–77; Royal Collection) in 1772. His fame and success while in Italy painting the *Tribuna* led to further commissions from both the British colony in Florence and the Grand-Ducal court. His portraits of the family of Pietro Leopoldo reveal Zoffany capable of a stronger sense of formality and conventionality than is present in most of his English portraits. While abroad, Zoffany visited Vienna, where he accepted the patronage of Prince Leopoldo's mother, Maria Theresa, and he also went to Parma to study the work of Correggio.

Zoffany's overwhelming popularity on the Continent did not follow him back to England, and his style of portrait painting had already gone out of fashion by the time he returned. His

conversation piece of the *Sharp Family* (1779–81; private collection) shows how he continued to excell in multi-figured compositions, just as his painting of the famous *Towneley Library* (1781–83; Burnley Borough Council) continued in the tradition of representing works of art begun in his *Tribuna*. Zoffany's trip to India took him away from the intense competition within the Royal Academy, and there he answered a need for good portrait painters in the British colony. His paintings in India reflect the tense duality between the English life-style of his subjects and the exotic settings in which they lived. Zoffany's skill in painting informal group portraits and depicting materials and furnishings provided a particularly appropriate accompaniment for such an unusual location. While in India, Zoffany also indulged in painting and drawing local scenes, which reflect his continued personal interest in genre.

After returning to England for the last time, Zoffany painted very little. He received occasional commissions for portraits and even altarpieces, and he surprisingly reverted to theatrical portraits and theatrical conversation pieces—the latter a genre which had long been out of fashion. Zoffany's most startling painting of these years is his depiction of the sacking of the Tuileries, *Plundering the King's Cellar at Paris* (1795; private collection), in which he employed his skill in painting a large number of figures to reflect the senseless violence of the French Revolution. Zoffany's diversity, technical ability, and international reputation made him one of the most unusual painters working in Britain in the second half of the 18th century.

—Shearer West

ZUCCARO, Taddeo.

Born in S. Angelo in Vado, near Urbino, 1 September 1529; older brother of the painter Frederico Zuccaro. Died in Rome, 2 September 1566. First work in Rome was facade of the Palazzo Mattei at age 18, but much of his work is lost, and mistaken for the work of his brother; some work for churches (decorations for Urbino Cathedral, 1552–53, Chapel in S. Maria della Consolazione, 1553-56, and Frangipani Chapel in S. Marcello al Corso, 1558-or 1559-66), but his most famous work is for Palazzo Farnese, Rome (completing work begun by Salviati), Villa Giulia, Rome, 1553–55, and the Villa Farnese in Caprarola, near Viterbo; much of this later work was completed by Frederico; large workshop; few oils or drawings survive.

Collections/Locations: Cambridge; Caprarola: Villa Farnese; Rome: Borghese, Doria Pamphili, S. Maria dell'Orto; Vatican.

Publications

On ZUCCARO: books—

Gere, J. A., *Disegni degli Zuccari* (cat), Florence, 1966.
Gere, J. A., *Dessins de Taddeo et Frederico Zuccaro* (cat), Paris, 1969.
Gere, J. A., *Zuccaro: His Development Studied in His Drawings,* London, 1969.

articles—

Gere, J. A., "Zuccaro as a Designer for Maiolica," in *Burlington Magazine* (London), July 1963.
Gere, J. A., "Two Panel-Pictures by Zuccaro and Some Related Compositions," in *Burlington Magazine* (London), August 1963.
Gere, J. A., "Decoration of the Villa Giulia," in *Burlington Magazine* (London), April 1965.
Frantz, M. A. G., "Zuccaro as a Precursor of Annibale Carracci," in *Essays in Honor of Walter Friedlander,* New York, 1965.
Judson, Jay R., "Van Veen, Michelangelo, and Zuccari," in *Essays in Honor of Walter Friedlander,* New York, 1965.
Berendsen, O., "Zuccaro's Paintings for Charles V's Obsequies in Rome," in *Burlington Magazine* (London), 112, 1970.
Partridge, Loren W., "Divinity and Dynasty at Caprorola: Perfect History in the Room of Farnese Deeds," in *Art Bulletin* (New York), September 1978.

*

Taddeo Zuccaro, one of the major painters of mid-16th-century Rome, died just two years before the publication of the 1568 edition of Vasari's *Lives.* Since he knew Taddeo personally, Vasari's biography of Taddeo is complete, detailed, and reliable. Although much of his work has been lost, it is clear from Vasari's account that Taddeo was primarily a decorator who worked for the Roman nobility and specialized in large-scale fresco projects of secular subject matter, mostly palace facades, loggias, and rooms. Ten rooms at the Villa Farnese at Caprarola and two scenes in the Sala Regia in the Vatican are the most important and characteristic examples of this type of work. Conversely, Taddeo did very few easel paintings (Vasari mentions about eight and only a handful survive), and very little work of religious subject matter in churches (only two chapels—the Mattei Chapel in S. Maria della Consolazione and the Frangipani Chapel in S. Marcello—could be considered important).

A large part of Taddeo's success as a decorator was a result of his ability to manage a large workshop. According to Vasari, Taddeo used many young assistants whom he shaped to his will in order to work with great speed and to produce painting that looked as if it were from a single hand. What Vasari does not say, but which has become clear since John Gere's 1969 book on the drawings of Taddeo, is that the speed and uniformity of his workshop production was primarily a result of Taddeo's almost absolute control of the design process ranging from rapid sketches to finished *modelli.* Furthermore, from the more than two hundred autograph drawings now known it is also clear that Taddeo was one of the truly brilliant draftsmen of the Renaissance.

The epitaph on his tomb in the Pantheon in Rome suggests that Taddeo was a second Raphael, noting also the coincidence that both came from the region of Urbino and died at age 37. Taddeo, who seems to have been essentially an autodidact, in fact, learned his early style primarily from the works of Poli-

Decorative Panel with an Escutcheon; drawing; Oxford, Ashmolean

doro da Caravaggio and Perino del Vaga, both of whom had trained in Raphael's workshop. This style, generally called mannerism, was characterized by a sophisticated surface patterning, curvilinear gracefulness, and artificial rhythmicality which, while growing out of Raphael's High Renaissance style, lacked its spatiality and naturalism. But in the late 1550's—especially in the Mattei and Frangipani Chapels—Taddeo began to pay greater attention to the work of Raphael and the late Michelangelo and developed a style that, while keeping some mannerist rhythmic surface patterning, combined it with a Raphaelesque realism, clarity, and spaciousness, as well as at times with a dense Michelangelesque canon of form. This synthesis of the three major stylistic possibilities at mid-century is Taddeo's principal contribution to the history of art. The restrained, sober, almost iconic style, often referred to as a classicizing mannerism or a counter-mannerism, was a highly successful and popular response to the increasingly conservative, restrictive, and austere temper of the Counter Reformation. The prolific and widely travelled Federico Zuccaro continued this counter mannerist style to the end of the century and diffused it widely outside Rome and even Italy.

—Loren Partridge

ZURBARÁN, Francisco de.

Born in Fuentes de Cantos, baptized 7 November 1598. Died in Madrid, 27 August 1664. Married in 1617; three children; married again, 1625. Studied under Pedro Díaz de Villanueva, 1614–17; altarpiece for Seville Cathedral, 1625, established his reputation; visited Madrid, 1634–35; worked for monasteries and churches in southwest Spain (some works exported to the New World), including Guadalupe Monastery, 1639; named Painter to the King (on Velázquez's recommendation), 1638, but stayed in Seville until 1650: then worked in Madrid on the Buen Retiro Palace; large workshop.

Major Collections: Bishop Auckland, Co. Durham: Bishop's Palace; Guadalupe: Monastery.
Other Collections: Berlin; Boston: Museum, Gardner; Budapest; Cadiz; Chartres; Chicago; Cincinnati; Dresden; Dublin; Dusseldorf; Edinburgh; Genoa: Bianco; Grenoble; Hartford, Connecticut; Kansas City; Leningrad; Lisbon; London; Madrid; Prado, Royal Academy; Montpellier; Munich; New York: Metropolitan, Hispanis Society; Orleans: Cathedral; Paris; Pasadena; Philadelphia; Posnan; St. Louis; San Diego; Santa Barbara; Sao Paulo; Seville; Strasbourg; Washington.

Publications

On ZURBARÁN: books—

Tormo, Elías, *El monasterio de Guadalupe y los cuadros de Zurbarán*, Madrid, 1905.
Lafond, Paul, *Ribera et Zurbarán*, Paris, 1909.

Cascales y Mūnoz, Jose, *Zurbarán: Su época, su vida, y sus obras*, Madrid, 1911, 1931; as *Zurbarán: His Epoch, His Life and His Works*, New York, 1918.
Kehrer, Hugh, *Zurbarán*, Munich, 1918.
Calzada, Andrés M., *Estampes de Zurbarán*, Barcelona, 1929.
Sánchez Cantón, F. J., *La sensibilidad de Zurbarán*, Granada, 1944.
Dos Santos, R., *Zurbarán em Portugal*, Lisbon, 1945.
Garias, Manzano, *Aportaciones a la biografia de Zurbarán*, Badajoz, 1947.
Pompey, Francisco, *Zurbarán*, Madrid, 1947.
Gaya Nuño, Juan A., *Zurbarán*, Barcelona, 1948.
Gaya Nuño, Juan A., *Zurbarán en Guadalupe*, 1951.
Caturla, M. Luisa, *Zurbarán* (cat), Granada, 1953.
Pantorba, Bernardino, *Zurbarán*, Barcelona, 1953.
Soria, Martin S., *The Paintings of Zurbarán: Complete Edition*, London, 1953, 1955; as *Zurbarán*, New York, 1953.
Guinard, Paul, *Zurbarán et les peintres espagnols de la vie monastique*, Paris, 1960.
Pemán, César, *Zurbarán en la hora actual*, Badajoz, 1961.
Torres Martín, Ramón, *Zurbarán: El pintor gótico del siglo XVII*, Seville, 1963.
Caturla, M. Luisa, *Zurbarán* (cat), Madrid, 1964.
Sanchez de Palacios, Mariano, *Zurbarán*, Madrid, 1964.
Carrascal, José M., *Zurbarán*, Madrid, 1973.
Frati, Tiziana, *L'opera completa di Zurbarán*, Milan, 1973.
Brown, Jonathan, *Zurbarán*, New York, 1974.
Gállego, Julián, and José Gudiol, *Zurbarán*, Barcelona, 1976; New York and London, 1977.
Brown, Jonathan, *Images and Ideas in Seventeenth-Century Spanish Painting*, Princeton, 1978.
Baticle, Jeannine, editor, *Zurbarán* (cat), New York, 1987.

articles—

Véliz, Zahira, "Painter's Technique: Zurbarán's *The Holy House of Nazareth*," in *Cleveland Museum Bulletin*, October 1981.
Liedtke, Walter, "Zurbarán's Jerez Altarpiece Reconstructed," in *Apollo* (London), March 1988.

*

Zurbarán was apprenticed in Seville to Pedro Díaz de Villanueva, a mediocre craftsman-painter of simple devotional images, of whose work we today know nothing. Following this inauspicious formation, in 1617 Zurbarán established himself in the provincial town of Llerena, but once again established himself in Seville in 1626 in order to execute twenty-one canvases of saints for the convent of San Pablo, his first major commission. He moved to Seville permanently in 1629, following a prestigious personal invitation from the City Council. As might be expected, his work thereafter acquired much more sophistication due to his proximity to the advanced art to be seen in the capital of Andalucia (Pacheco, Herrera, Roelas, Velázquez, Cano, Murillo, etc.). At royal invitation (probably at the bequest of Velázquez, a fellow sevillian), in 1634 he went to Madrid to paint a *Siege of Cádiz* and a cycle of *Ten Labors of Hercules* which were to be hung with several other signs of Spanish military and dynastic prowess in the Hall of

Realms of the Buen Retiro Palace. These works were evidently not well received since he was back in Seville by 1635; he soon entered, however, into his most productive and successful decade, during which time he worked for monasteries and churches all over the center and southwest of Spain. At this time he found his well-known *métier*—as a painter of large devotional pictures mostly associated with the monastic life. Records have also turned up to document a large volume of religious pictures, evidently shop-work for the most part, sent across the Atlantic to Spanish America (and about which we still know very little, except for the artist's repeated pleas for payment). In 1658 he returned to Madrid searching for new business, a largely unsuccessful enterprise given that by then his style seemed only a rustic anachronism in the capital, then very much in the thrall of the *estilo vaporoso* so intimately associated with the later career of Murillo. As a result of what may be called a mundane response to the conditions of the art market, the painter's last works are more sentimental in their devotion, while their technique becomes concommitantly more fused and smoother in surface textures.

Zurbarán represents the epitome of a strong "quietistic" (*quietismo*) undercurrent in Spanish Baroque art. His paintings are often rightly described as "monastic," serving as living documentary memorials to the solitude and inwardly directed spiritual passions of the fervent habitants of secluded monasteries. As cultural artifacts, they parallel in spirit that mood which Miguel de Molinos was to describe in words in his *Guía Espiritual* (1675), that is, the life of "the soul [which] gains more in prayer, in complete withdrawal of the senses, and in mental power." To this *vita contemplativa* Molinos compared a more active life of penitential disciplines, but the latter "punishes only the body, but by withdrawal the soul is purified." Zurbarán is another Spanish artist whose work had suffered from critical malaise until very recent times. By a paradox of taste, Zurbarán has become increasingly comprehensible to moderns as post-cubist art became increasingly abstract. Particularly because of lingering Surrealist tastes this artist is now praised for his extreme, even obsessional, concentration upon tangible form, to the degree that it almost verges upon the "*sur-réelle.*" What we have in this case is a largely *formal* reappreciation; as is the case today with all Spanish baroque painters, there is still little appreciation (and much less understanding) of the passionately didactizing symbolic meaning of their underlying, pious and meditative, Catholic imagery.

Such retrospective viewpoints aside, it was the bleak, austere piety of Zurbarán's early pictures—commissioned by the bleakest and most austere of the many religious orders flourishing in 17th-century Spain—that made him the ideal concretizer of multi-partite images of doctrinal orthodoxy. His simple and easily legible compositions are generally realized in crisply clear, sometimes bright but usually sober, colors starkly contrasted against a neutral field. Saintly heroic figures of massive solidity and inpenetrable solemnity are rigidly centered against the barest of backgrounds, usually of stygian tenebrist darkness, but also occasionally luridly lit with the otherworldly light of a fugitive but refulgent celestial vision. Rather than pointing to any foreign artistic influences (Caravaggio, etc.), the sources of Zurbarán's provincial and uniquely visionary painting are better sought in native pietism, the kind best documented in the circumstantially detailed writings of contemporary mystics, of the likes of St. John of the Cross and Sta. Teresa of Avila or, especially, in the *Spiritual Exercises* of St. Ignatius of Loyola. In such meditative texts, repeatedly the devout Catholic reader was called upon in his imagination to intensely perceive, and then to envision vividly—"see," "taste," "smell," "hear," "touch"—the tortures of hell and the pleasures of heaven. Like Zurbarán, these mystics employed a large measure of realistic minutiae to re-create the sheer tangibility of their other-worldly perceptions. Similarly, in all of these writers (and in their later followers, like Molinos) there was a consistent "tenebrist" attitude, which is to say that a striking metaphorical contrast was commonly drawn between the "darkness" of spiritual ignorance and the bright, often highly colored, light accompanying "enlightened" religious perception.

—John F. Moffitt

NOTES ON CONTRIBUTORS

ACKERMAN, Gerald M. Professor of Art, Pomona College, Claremont, California. Author of *The Life and Works of Jean-Léon Gérôme*, 1986. **Essays**: Canova (and *Pauline Borghese as Venus*), Eakins (and *The Gross Clinic*), Gérôme (and *Arabs Crossing the Desert*), and Leighton (and *Flaming June*).

ACRES, Alfred J. Ph.D. candidate, University of Pennsylvania, Philadelphia. **Essays**: Multscher (and *Virgin and Child*).

ADAMS, Henry. Samuel Sosland Curator of American Art, Nelson-Atkins Museum of Art, Kansas City, Missouri. Author of *Thomas Hart Benton: An American Original*, 1989, and articles on Homer, Bingham, and La Farge; co-author of *John La Farge* and of *American Drawings and Watercolors in the Museum of Art, Carnegie Institute*. **Essays**: Benton (and *Persephone*), Bingham (and *Fur Traders Descending the Missouri*), Homer (and *The Gulf Stream*), Prendergast (and *On the Beach No. 3*), Sloan (and *The Coffee Line*), and West.

AHL, Diane Cole. Associate Professor of Art, Lafayette College, Easton, Pennsylvania. Author of the articles on Fra Angelico and Benozzo Gozzoli, and a forthcoming book on Gozzoli. **Essays**: Fra Angelico (and *Annunciation*), and Gozzoli (and *Adoration of the Magi*).

AZUELA, Alicia. Staff member of the Instituto de Investigaciones Estéticas, Mexico City. Author of *Diego Rivera en Detroit*, 1985, and articles on Rivera and Orozco, and on Mexican art. **Essays**: Orozco (and *Hospicio Cabañas Murals*), Siqueiros (and *Portrait of the Bourgeoisie*), and Tamayo (and *The Singer*).

BALAKIER, Ann Stewart. Member of the Department of Art History, University of South Dakota, Vermillion. Author of articles on Thornhill and the poet James Thomson. **Essays**: Amigoni (and *Story of Jupiter and Io*), Kneller (and *William Congreve*), Lely (and *Two Ladies of the Lake Family*), and Thornhill (and *Painted Hall, Greenwich*).

BARRETT, Elizabeth. Freelance writer. **Essay**: Solimena's *Venus at the Forge of Vulcan*.

BAZAROV, Konstantin. Freelance writer and researcher. Author of *Landscape Painting*, 1981. **Essay**: Johns.

BENGE, Glenn F. Professor of Art History, Tyler School of Art, Temple University, Philadelphia. **Essays**: Barye (and *Tiger Devouring a Gavial Crocodile*), Giambologna (and *Rape of the Sabine Women*), and Vittoria (and *St. Jerome*).

BERGSTEIN, Mary. Lecturer in Art History, Princeton University, New Jersey. Author of articles on Titian and Nanni di Banco. **Essays**: Nanni di Banco (and *Four Saints*).

BIRD, Alan. Lecturer for the Open University. Author of *Russian Art*, 1987. **Essays**: Doré (and *Newgate–Exercise Yard*), Falconet (and *Peter the Great*), Malevich (and *White Square on White*), Menzel (and *The Iron Rolling Mill*), and Thorvaldsen (and *Cupid and the Graces*).

BISANZ, Rudolf M. Professor of Art History, Northern Illinois University, DeKalb. Author of *The Art Theory of Philipp Otto Runge*, 1968, *German Romanticism and Philipp Otto Runge*, 1970, and *The René von Schleinitz Collection of the Milwaukee Art Center: Major Schools of German Nineteenth Century Popular Art*, 1980, and of articles on Goethe, Oehme, Grützner, and others. **Essays**: Corinth (and *The Three Graces*), Leibl (and *Three Women in Church*), Marées (and *The Hesperides*), Overbeck (and *Italia and Germania*), Runge (and *Rest on the Flight*), and Waldmuller (and *Christmas Morning*).

BOCK, Catherine C. Member of the Department of Art History, School of the Art Institute of Chicago. **Essays**: Matisse (and *Harmony in Red, The Green Stripe*, and *Backs*).

BOSTRÖM, Antonia. Freelance art historian and writer, London. Contributor of the *Macmillan Dictionary of Art* and the *Guinness Encyclopedia*. **Essays**: Francesco di Giorgio (and *The Deposition*), Gentile da Fabriano (and *Adoration of the Magi*), and Moore (and *Madonna and Child* and *Reclining Figure*).

BOURDON, David. Freelance writer and art critic. Author of *Christo*, 1972, *Calder: Mobilist, Ringmaster, Innovator*, 1980, and *Warhol*, 1989. **Essays**: Calder (and *Lobster Trap and Fish Tail*), and Rauschenberg (and *Bed*).

BRADLEY, Simon. Student at the Courtauld Institute of Art, London. **Essays**: Corot (and *Chartres Cathedral*).

BREMSER, Sarah H. Assistant Curator, La Jolla Museum of Contemporary Art, California. **Essays**: Whistler (and *Arrangement in Grey and Black No. 1: The Artist's Mother*).

BROWN, M.R. Associate Professor of Art History, Newcomb, Tulane University, New Orleans. Author of *Gypsies and Other Bohemians: The Myth of the Artist in Nineteeth-Century France*, 1985, and of articles on Manet, Ingres, and Degas. **Essays**: Cézanne, Degas, Manet, and Monet.

BURNHAM, Patricia M. Lecturer at the University of Texas, Austin. Author of articles on Trumbull and Theresa Bernstein. **Essays**: Trumbull (and *The Death of General Warren at the Battle of Bunker's Hill*).

CAMPBELL, Malcolm. Professor of Art History, University of Pennsylvania. Author of *Mostra di disegni di Pietro Berrettini da Cortona per gli affreschi di Palazzo Pitti*, 1965, *Pietro da Cortona at the Pitti Palace*, 1977, *Piranesi: The Dark Prisons* (cat), 1988, and *Piranesi: Rome Recorded* (cat), 1989. **Essays**: Pietro da Cortona (and *Salone of the Barberini Palace*).

CAPLOW, Harriet McNeal. Professor of Art History, Indiana State University, Terre Haute. Author of *Michelozzo*, 2 vols., 1977, and the articles "Michelozzo at Ragusa" and "Sculptors' Partnerships in Michelozzi's Florence,". **Essays**: Donatello (and *David* and *St. George*), Luca della Robbia (and *Madonna and Child*), Michelozzo (and *Aragazzi Monument*), and Antonio Rossellino (and *Cardinal of Portugal Tomb*).

CAVALIERE, Barbara. Contributing Editor, *Arts Magazine*, New York. Author of *William Baziotes*, 1978. **Essays**: Gorky.

917

CAYGILL, Caroline. Freelance writer and research assistant. **Essays:** Boudin (and *On the Beach at Deauville*), Brancusi (and *Bird in Space*), Cassatt (and *The Bath*), de Chirico (and *Mystery and Melancholy of a Street*), Giacometti (and *Man Pointing*), Gonzalez (and *Women Combing Her Hair*), Jongking (and *River with Mill and Sailing Ships*), Modigliani (and *Italian Women*), Ray (and *The Gift*), Rodin's *Balzac*, Henri Rousseau (and *Sleeping Gypsy*), Schwitters (and *Merz 19*), Steer (and *Girls Running, Walberswick Pier*), and Vuillard (and *Woman Sweeping*).

CHAPPELL, Miles L. Chancellor Professor of Art History, College of William and Mary, Williamsburg, Virginia. Author of *Cristofano Allori (1577–1621)*, 1984, and of articles of Allori, Smibert, and Fuseli. **Essays:** Smibert (and *The Bermuda Group*).

CHENEY, Liana. Member of the Art Department, University of Lowell, Massachusetts. **Essays:** Bronzino (and *Venus, Cupid, Folly and Time*), Cellini (and *Perseus with the Head of Medusa*), and Dossi (and *Circe*).

CHEVALIER, Tracy. Publisher's Editor and freelance writer. **Essays:** Sargent (and *The Daughters of Edward D. Boit*).

CLEGG, Elizabeth. Freelance writer. Author of articles on Menzel and Malczewski. **Essays:** Klinger (and *Attunement*).

COHEN, David. Freelance art critic. Author of articles on S.W. Hayter, Thérèse Oulton, R.B. Kitaj, and others. **Essays:** Bacon (and *Three Studies for a Crucifixion*), Epstein (and *Rock Drill*), Hepworth (and *Forms in Echelon*), Maillol (and *La Méditerranée*), Nicholson (and *White Relief*), and Sutherland (and *Crucifixion*).

COLLINS, Howard. Professor of Art History, University of Nebraska, Lincoln. Author of articles on Gentile and Jacopo Bellini, Donatello, and on Chinese bronzes. **Essays:** Jacopo Bellini (and *The Procession to Calvary*).

COSSA, Frank. Assistant Professor of Fine Arts, College of Charleston, South Carolina. Author or co-author of articles on Masaccio, Josiah Wedgwood, and the "Flower Portrait" of Shakespeare. **Essays:** Chardin (and *Grace* and *The Attributes of the Arts*), Flaxman (and the *Agnes Cromwell Monument*), Longhi (and *The Geography Lesson*), Tiepolo (and *Banquet of Cleopatra* and the *Wurzburg Residenz Ceiling*), and Watteau (and *Island of Cytherea*).

CRELLIN, David. Freelance writer, London. **Essays:** Claude Lorrain (and *Marriage of Isaac and Rebekah*).

CRELLY, William R. Professor of Art History, Emory University, Atlanta. **Essays:** Cousin (and *Eva Prima Pandora*), Le Nain (and *The Forge*), and Vouet (and *The Presentation of Jesus in the Temple*).

CROYDON, Abigail. Freelance writer, London. **Essays:** Sickert (and *The Gallery of the Old Bedford*), Vasarely (and *Orion MC*), and Zadkine (and *Destroyed City*).

DAVIDSON, Abraham A. Member of the Art History depart-

ment, Tyler School of Art, Temple University, Philadelphia. **Essays:** Ryder (and *The Dead Bird*).

DAVIDSON, Jane P. Professor of Art History, University of Nevada, Reno. Author of *David Teniers the Younger*, 1979, and *The Witch in Northern European Art 1470–1750*, 1987, and an article on the alchemical paintings of Teniers. **Essays:** Brouwer (and *Peasants Quarreling over Cards*), and Teniers (and *Picture Gallery of the Archduke Leopold Wilhelm in Brussels*).

DITTMANN, Reidar. Professor of Art History, St. Olaf College, Northfield, Minnesota. Author of *Henrik Ibsen and Edvard Munch*, 1978, and *Eros and Psyche: Strindberg and Munch in the 1890s*, 1982; editor and translator of *Edvard Munch: Close-Up of a Genius* by Rolf Stenersen, 1969. **Essays:** Dahl (and *Hjelle in Valdres*), Heemskerck (and *Family Portrait*), Joos van Ghent (and *Institution of the Eucharist*), Jorn (and *In the Beginning Was the Image*), Lochner (and *Madonna in the Rose Bower*), Maitani (and *Creation of Adam and Eve*), Munch (and *The Scream*), Patinir (and *Charon Crossing the Styx*), Pintoricchio (and *Enea Silvio's Mission to King James of Scotland*), Pordenone (and *Treviso Dome Frescoes*), Riemanschneider (and *Jakobskirche Altarpiece*), and Schongauer (and *Madonna of the Rosehedge*).

DIXON, Annette. Visiting Professor, Union College, Schenectady New York. Author of catalogue entries in *Medieval and Renaissance Stained Glass from New England Collections*, 1978. **Essays:** Giovanni da Milano (and *Pietà*).

DIXON, Laurinda S. Associate Professor of Fine Arts, Syracuse University, New York. Author of *Alchemical Imagery in Bosch's "Garden of Delights,"* 1981, and *Skating in the Arts of 17th-Century Holland*, 1987, and of articles on Bosch, Cranach, Giovanni di Paolo, and Rogier van der Weyden. Co-Editor of *The Documented Image: Vision in Art History*, 1985. **Essays:** Bosch (and *Garden of Earthly Delights* and *Ship of Fools*), Petrus Christus (and *Portrait of a Carthusian*), Cranach (and *Crucifixion*), Giovanni di Paolo (and *Expulsion from Paradise*), Memling (and *Altarpiece of the Two St. Johns*), van der Goes (and *Portinari Altarpiece*), van der Weyden (and *Descent from the Cross*), and van Eyck (and *Ghent Altarpiece* and *Madonna with Chancellor Nicolas Rolin*).

DODGE, Barbara. Associate Professor of Fine Arts, York University, Toronto. Author of an article on the sinopie in the Traini cycle in the Camposanto, 1983, and other reviews and lectures. **Essays:** Martini (and *Annunciation*), Masolino (and *S. Maria Maggiore Altarpiece*), and Sassetta (and *St. Francis Altarpiece*).

DOWNS, Linda. Curator of Education, Detroit Institute of Arts. Author (with Mary Jane Jacob) of *The Image of Industry in the Art of Charles Sheeler and Diego Rivera*, 1978. Co-Editor of *Diego Rivera: A Retrospective*, 1986. **Essays:** Rivera (and *Detroit Industry*).

EDMOND, Mary. Freelance writer and researcher. Author of *Hilliard and Oliver*, 1983, and *Rare Sir William Davenant*, 1987, and of articles on Pembroke's Men, John Webster, and Jacobean painters. **Essays:** Dobson (and *Endymion Porter*),

Hilliard (and *Young Man among Roses*), and Oliver (and *Unknown Melancholy Man*).

EUSTACE, Katharine. Curator, Mead Gallery, University of Warwick. Author of exhibition catalogues *Michael Rysbrack, Sculptor*, 1982, *Thomas Howard, Earl of Arundel*, 1985, *Artists of Promise and Renown: The Rugby Collection*, 1986, and *To Build a Cathedral: Coventry Cathedral*, 1987. **Essays:** Rysbrack (and *Isaac Newton*).

EVANS, Magdalen. Researcher at Thomas Agnew & Sons, London. Author of catalogues for Agnew & Sons, and an article on Marianne Stokes. **Essays:** Appel (and *Questioning Children*), Dufy (and *The Paddock at Deauville*), John (and *Madame Suggia*), and Vlaminck (and *Le Restaurant de la Machine à Bougival*).

EVELYN, Peta. Curator in the Sculpture Department, Victoria and Albert Museum, London. Assistant author of *Northern Gothic Sculpture 1200–1450*, 1988. **Essays:** Giovanni Pisano (and *S. Andrea Pistoia Pulpit*).

FAXON, Alicia. Associate Professor of Art, Simmons College, Boston. Author of *A Catalogue Raisonné of the Prints of Jean-Louis Forain*, 1982, and *Jean-Louis Forain: Artist, Humanist, Realist*, 1982. Editor of *Pilgrims and Pioneers: New England Women in the Arts*, 1987. Author of articles on Degas, Rodin, and Cézanne. **Essays:** Cézanne's *The Card Players* and *Mont Sainte-Victoire Seen from Les Lauves*, Degas's *The Absinthe Glass* and *The Rehearsal*, and Morisot (and *In the Dining Room*).

FLORENCE, Penny. Writer and filmmaker. Author of *Mallarmé, Manet, and Redon: Visual and Aural Signs and the Generation of Meaning*, 1986. **Essays:** Manet's *A Bar at the Folies-Bergère*, and Redon (and *Il y eût peut-être une vision première essayée dans la fleur*).

FOSKETT, Daphne. Freelance writer. Author of several books, including *British Portrait Miniatures*, 1963, 1968, *Dictionary of British Miniature Painters*, 2 vols., 1972, *Samuel Cooper*, 1974, *Samuel Cooper and His Contemporaries*, 1974, and *Collecting Miniatures*, 1979. **Essays:** Cooper (and *Elizabeth Cecil, Countess of Devonshire*), and Hoskins (and *Charles I*).

GALE, Matthew. Freelance art historian. Author of "The Uncertainty of the Painter" in *Burlington Magazine*, 1988. **Essays:** Carrà, Picabia (and *I See Again in Memory My Dear Udine*), and Picasso.

GALIS, Diana. Trust Officer, Provident National Bank, Philadelphia Author of "Concealed Wisdom: Renaissance Hieroglyphic and Lorenzo Lotto's Bergamo *Intarsie*," in *Art Bulletin*, 1980. **Essays:** Lotto (and *Sacra Conversazione*).

GARLICK, Kenneth. Freelance writer. Author of several books, including *A Catalogue of the Paintings, Drawings, and Pastels of Sir Thomas Lawrence*, 1964. **Essays:** Hoppner (and *The Sackville Children*), and Lawrence (and *Pope Pius VII*).

GASH, John. Lecturer in the History of Art, University of

Aberdeen. Author of *Caravaggio*, 1980, and articles on Algardi, American baroque, and classicism. **Essays:** Algardi (and *Bust of Cardinal Laudivio Zacchia*), Caravaggio (and *Bacchus* and *Calling of St. Matthew*), Elsheimer (and *Flight into Egypt*), Fetti (and *Parable of the Wheat and the Tares*), Artemisia Gentileschi (and *Judith Slaying Holofernes*), Orazio Gentileschi (and *Allegory of Peace and the Arts*), Guercino (and *Aurora*), Honthorst (and *The Supper Party*), Lanfranco (and *Ecstasy of St. Margaret of Cortona*), Sacchi (and *Allegory of Divine Wisdom*), and Terbrugghen (and *St. Sebastian Tended by St. Irene*).

GAUK-ROGER, Nigel. Freelance writer. Author of articles on Chinoiserie, Georgian portrait sculpture, and Victorian painted furniture, and on other subjects. **Essays:** Abbate (and *Landscape with the Death of Eurydice*), Ammanati (and *Fountain of Neptune*), Carracci (and *Farnese Gallery*), Domenichino (and *Last Communion of St. Jerome*), Palma Vecchio (and *St. Barbara Altarpiece*), Salviati (and *The Deposition*), and Sebastiano del Piombo (and *The Raising of Lazarus*).

GIBSON, Jennifer. Member of the Arts Division, Maryland-National Capital Park and Planning Commission. Author of *Alice Lees* (cat), 1988, and an article on Surrealism. **Essays:** Derain (and *The Pool of London*), and Léger (and *The City*).

GLENN, Constance W. Member of the Staff, University Art Museum, California State University, Long Beach. **Essays:** Lichtenstein (and *Whaaam!*).

GLOWEN, Ron. Contributing Editor, *Artweek*, Oakland. **Essay:** Tobey.

GOLDFARB, Hilliard T. Curator for European Art, Hood Museum of Art, Dartmouth College, Hanover, New Hampshire. Author of *A Humanist Vision: The Adolph Weil Collection of Rembrandt Prints* (cat), 1988, and *From Fontainebleau to the Louvre: French Drawings from the Seventeenth Century*, 1989, and of articles on Poussin, Titian, Boucher, and Andreani. **Essays:** Poussin (and *Et in Arcadia Ego* and *Self-Portrait*).

GOULD, Cecil. Keeper and Deputy Director of the National Gallery, London, 1973–78. Author of books and catalogues on such artists as Leonardo, Michelangelo, Raphael, and Bernini. **Essays:** Correggio (and the *Assunta Cupola*), Leonardo's *Virgin of the Rocks, Last Supper*, and *Virgin and Child with St. Anne*), Michelangelo (and *Pietà, David, Sistine Chapel Ceiling, Moses*, and *Medici Chapel*), Raphael (and *School of Athens*), Tintoretto (and *St. Mark Freeing a Slave, Crucifixion*, and *Susanna*), and Veronese (and *Mars and Venus* and *Feast in the House of Levi*).

GREEN, Caroline V. Member of the Art Department, Boston University. **Essays:** Rodin (and *The Burghers of Calais*).

GREENE, David B. Director of Arts Studies, North Carolina State University, Raleigh. Author of *Temporal Processes in Beethoven's Music*, 1982, *Mahler, Consciousness, and Temporality*, 1984, and *Nativity Art and the Incarnation*, 1986, and articles on "The Artist as Philosopher" and pictorial space. **Essays:** Caravaggio's *Conversion of St. Paul*, and Giorgione (and *Tempestà*).

GRIFFIN, Randall C. Luce Fellow, University of Delaware Art History Department. **Essays:** Copley (and *Watson and the Shark*).

GRUNENBERG, Christoph. Freelance writer. **Essays:** Newman (and *Vir Heroicus Sublimis*) and Rothko (and *Green and Maroon*).

GULLY, Anthony Lacy. Associate Professor of Art History, Arizona State University, Tempe. Author of an article on Blake. **Essays:** Bonington (and *La Siesta*), Constable (and *The Haywain* and *The Leaping Horse*), and Rowlandson (and *A Statuary Yard*).

HABEL, Dorothy Metzner. Associate Professor of Art, University of Tennessee, Knoxville. Author of *European and American Drawings: Selections from the Collection of the Joslyn Art Museum* (cat), Omaha, 1978, and of articles on Raguzzini and Rainaldi, and on architecture generally. **Essays:** Gaulli (and the Gesù vault frescoes) and Pozzo (and the St. Ignazio vault decoration).

HANCOCK, Simon. Freelance writer, London. **Essays:** Hockney's *A Bigger Splash*, Seurat's *Sunday Afternoon on the Island of La Grande Jatte*, and West's *The Death of General Wolfe*.

HARPER, Paula. Associate Professor of Art History, University of Miami. Author of *Pissarro: His Life and Work* (with Ralph E. Shikes), 1980, and *Daumier's Clowns*, 1981. **Essays:** Essays: Daumier and Pissarro.

HEATH, Samuel K. Staff Member, World Monuments Fund, New York. **Essays:** Alonso Berruguete (and the *Transfiguration*).

HEFFNER, David. Ph.D. Candidate, University of Pennsylvania, Philadelphia. Author of an article on Dürer's *The Virgin and the Dragonfly*. **Essays:** Burgkmair (and *St. John Altar*) and Huber (and *Lamentation*).

HIRSH, Sharon. Professor of Art History, Dickinson College, Carlisle, Pennsylvania. Author of *Ferdinand Hodler*, 1982, *Hodler's Symbolist Themes*, 1983, and *The Fine Art of the Gesture: Drawings by Ferdinand Hodler* (cat), 1987, and articles on Hodler, Böcklin, and Carrà. **Essays:** Böcklin (and *Island of the Dead*) and Hodler (and *Night*).

HOLLOWAY, John H. Senior Lecturer in Chemistry, University of Leicester. **Essays:** Albers (with John A. Weil).

HOWARD, Seymour. Professor of Art History, University of California, Davis. Author of several books, including *Classical Narratives in Master Drawings*, 1972, *A Classical Frieze by Jacques Louis David*, 1975, *New Testament Narratives in Master Drawings*, 1976, and *Saints and Sinners in Master Drawings*, 1983. **Essays:** Jacques-Louis David (and *Oath of the Horatii*).

HULSKER, Jan. Director-General of Cultural Affairs, Ministry of Culture, The Netherlands (now retired). Author of several books on Van Gogh, including (in English) *Van Gogh's Diary*, 1971, and *The Complete Van Gogh: Paintings, Drawings, Sketches*, 1980. **Essays:** Van Gogh (and *The Potato-Eaters, The Night Cafe,* and *The Starry Night*).

HULTS, Linda C. Assistant Professor of Art History, College of Wooster, Ohio. Editor of *The Prints of Thomas Moran in the Thomas Gilcrease Institute of American History and Art*, 1987, and author of articles on Dürer, Moran, and Baldung. **Essays:** Balding (and *Eve, The Serpent, and Death*), Callot (and *Miseries and Misfortunes of War*), Dürer's *Knight, Death, and the Devil*, Goya's *Disasters of War*, Grunewald (and *Isenheim Altarpiece*), and Seghers (and *Mountain Landscape*).

HUTCHISON, Jane Campbell. Professor of Art History, University of Wisconsin, Madison. Author of *The Master of the Housebook*, 1972, *Graphic Art in the Age of Martin Luther* (cat), 1983, and forthcoming biography of Albrecht Dürer, and of articles on the Housebook Master and Dürer. Editor (or co-editor) of *Early German Artists* (the Illustrated Bartsch, vols. 8 and 9), 1980–81. **Essays:** Bertram of Minden's *Grabow Altar*, Dürer (and *Self-Portrait*), Master Francke's (*St. Thomas à Becket Altar*), Holbein (and *George Gisze* and *The Ambassadors*), Master of the Housebook (and *Aristotle and Phyllis*), Moser (and *Tiefenbronner Altar*), Witz's *The Miraculous Draft of Fishes*, and Wolgemut (and *God in Majesty*).

JACHEC, Nancy. Ph.D. Student, University College, London. **Essays:** Archipenko (and *Walking Woman*), Barlach (and *The Ascetic*), Louis (and *Theta 1960*), and Pasmore (and *Abstract in White, Black and Crimson*).

JACOBS, Fredrika H. Assistant Professor of Art History, Virginia Commonwealth University, Richmond. Author of articles on Carpaccio, Vasari, and Cellini. **Essays:** Carpaccio (and *St. Ursula Cycle*) and Vasari (and *Allegory of the Immaculate Conception*).

JEFFETT, William. Freelance writer, London. **Essays:** Dali (and *The Persistence of Memory*), Dubuffet (and *Archetypes*), Ernst (and *The Elephant Celebes*), Masson (and *Niobé*), and Tanguy (and *Indefinite Indivisibility*).

JENKINS, Susan. Staff member, Witt Library, Courtauld Institute, London. **Essays:** Coello (and *Charles II Adoring the Blessed Sacrament*) and Valdés Leal (and *Immaculate Conception*).

KAHR, Madlyn Millner. Professor Emeritus of Art History and Criticism, University of California, San Diego. Author of *Velázquez: The Art of Painting*, 1976, and *Dutch Painting in the Seventeenth Century*, 1978, and of articles on Velázquez, Veronese, Titian, and Rembrandt. Co-translator of *Principles of Psychoanalysis*, by Herman Neuberg, 1955. **Essays:** Goltzius (and *Portrait of a Young Man*), Rembrandt (and *Danaë, Night Watch, Christ at Emmaus,* and *Self-Portrait at 52*), Velázquez (and *Waterseller of Seville, Las Meninas,* and *Juan de Pareja*), and Vermeer (and *View of Delft* and *The Art of Painting*).

KAPLAN, Julius D. Professor of Art, California State University, San Bernardino. Author of *Gustave Moreau* (cat), 1974, and

Gustave Moreau, 1982, and of an article on Moreau's *Jupiter and Semele*, 1970. **Essays:** Moreau (and *Jupiter and Semele*).

KAPOS, Martha. Freelance writer and lecturer. Author of articles on Ken Kiff, Chagall, and other art subjects. **Essays:** Changall, Delacroix (and *Liberty Guiding the People*), and Picasso's *Demoiselles d'Avignon*.

KAUFMAN, Susan Harrison. Assistant Professor of Art, Fordham University, New York. Author of an article on Crosato, 1983. **Essays:** Piazetta (and *The Parasol*).

KENWORTHY-BROWNE, John. Freelance writer and art historian. Author of an article on Matthew Brettingham, 1983. **Essays:** Nollekens (and *Sir George Savile, Bart.*).

KIDSON, Alex. Assistant Keeper of British Art, Walker Art Gallery, Liverpool. **Essays:** Reynolds (and *Elizabeth Gunning, Duchess of Hamilton and Argyll*) and Romney (and *Lady Hamilton*).

KIND, Joshua. Faculty Member of the School of Art, Northern Illinois University, DeKalb. **Essays:** Aertsen (and *Christ in the House of Martha and Mary*), Andrea del Castagno (and *Last Supper*), Antonella da Messina (and *St. Jerome in His Study*), Bonnard's *Dining Room in the Country*, Boucher (and *The Rising of the Sun*), Clodion (and *Nymph and Satyr*), Crivelli (and *Annunciation*), Miro (and *Head of a Woman*), Monet's *Gare St. Lazare*, Reni (and *Aurora*), Rosso Fiorentino (and *Deposition of Christ*), Rouault (and *The Old King*), Ruisdael (and *Jewish Cemetery*), Sanchez-Cotan (and *Quince, Cabbage, Melon, and Cucumber*), Soutine (and *Carcass of Beef*), Spencer (and *The Resurrection: Cookham*), and Toulouse-Lautrec (and *At the Moulin Rouge*).

KOWAL, David Martin. Associate Professor of Fine Arts, College of Charleston, South Carolina. Author of *Ribalta y los ribaltescos*, 1985, and *Francesco Ribalta and His Followers: A Catalogue Raisonné*, 1985, and of articles on Ribera and Ribalta. **Essays:** Cano (and *S. Diego de Alcalá*), Maino (and *Adoration of the Magi*), Ribalta (and *St. Francis Embracing the Crucified Christ*), and Ribera (and *Martyrdom of St. Philip*).

LAGO, Mary. Professor of English, University of Missouri, Columbia. Editor of several books, including *Imperfect Encounter: Letters of William Rothenstein and Rabindranath Tagore*, 1972, *Max and Will: Max Beerbohm and William Rothenstein*, 1975, *Men and Memories: Recollections of William Rothenstein*, 1978, and *Burne-Jones Talking: His Conversations Recorded by His Assistant Thomas Rooke*, 1982. **Essays:** Burne-Jones (and *King Cophetua and the Beggar Maid*).

LANDERS, L.A. Freelance writer. **Essays:** Klimt (and *The Kiss*) and Schiele (and *The Family*).

LARSSON, Lars Olof. Author of *Adriaen de Vries*, 1967. **Essays:** Vries (and *Hercules Fountain*).

LAWRENCE, Cynthia. Associate Professor of Art History, Tyler School of Art, Temple University, Philadelphia. Author

of *Flemish Baroque Commemorative Monuments 1566–1725*, 1981, and *Gerrit Adriaensz. Berckheyde: Haarlem Cityscape Painter*, 1988, and of articles on Berckheyde, Rembrandt, Rubens, and others. **Essays:** Berckheyde (and *View of the Grote Markt, Haarlem*).

LESKO, Diane. Curator of Collections, Museum of Fine Art, St. Petersburg, Florida. **Essays:** Ensór (and *Entry of Christ into Brussels*).

LEVIN, Gail. Associate Professor, Baruch College, City University of New York. Author of several books on Edward Hopper, and *Synchromism and American Color Abstraction 1918–1925*, and *Twentieth Century American Painting: The Thyssen-Bornemisza Collection*, 1987. **Essays:** Hopper (and *Nighthawks*).

LEVY, Mark. Member of the Art Department, California State University, Hayward. **Essays:** Arp.

LIEDTKE, Walter A. Curator of European Paintings, Metropolitan Museum of Art, New York. Author of several books on Dutch painters and painting. **Essays:** Saenredam (and *Interior of the Grote Kerk at Haarlem*) and Witte (and *A Protestant Gothic Church*).

LISTER, Raymond. Emeritus Fellow of Wolfson College, Cambridge. Author of several books, including *Edward Calvert*, 1962, *British Romantic Art*, 1973, *George Richmond*, 1981; *Samuel Palmer: His Life and Art*, 1987, and *Catalogue Raisonné of the Works of Samuel Palmer*, 1988. **Essays:** Blake (and *Satan Arousing the Rebel Angels*) and Palmer (and *A Hilly Scene*).

LOTHROP, Patricia Dooley. Extension Lecturer, University of Washington, Seattle. **Essays:** Hunt (and *The Light of the World*) and Millais (and *Christ in the House of His Parents*).

MACK, Charles R. Professor of Art History, University of South Carolina, Columbia. Author of *Classical Art from Carolina Collections*, 1974, and *Pienza: The Creation of a Renaissance City*, 1987, and of articles on art and architecture. **Essays:** Desiderio da Settignano (and the *Tabernacle of the Sacrament*), Floris (and *Fall of the Rebel Angels*), and Bernardo Rossellino (and the *Bruni Monument*).

MACKIE, David. Mellon Fellow, Yale University, New Haven, Connecticut. **Essays:** Bassano (and *Rest on the Flight into Egypt*), Raeburn (and *Rev. Robert Walker Skating*), and Ramsay (and *Margaret Lindsay*).

MAINZER, Claudette R. Member of the Department of Fine Art, University of Toronto. Author of several articles on Courbet. **Essays:** Courbet (and *The Burial at Ornans*).

MALLER, Jane Nash. Associate Professor of Art, San Francisco State University. Author of *Veiled Images*, 1985, and an article on Titian. **Essays:** Pieter Bruegel (and *Hunters in the Snow* and *Peasant Wedding*), Gossaert (and *Danaë*), Massys (and *The Money Changer and His Wife*), and Titian (and *Sacred and Profane Love*, *Pesaro Madonna*, and *Venus of Urbino*).

MANCA, Joseph. Member of the Art and Art History Department, Rice University, Houston. Author of articles on Masolino and Roberti. **Essays:** Cossa (and *Hall of the Months*), Roberti (and *Pala Portuense*), and Tura (and *Roverella Altarpiece*).

MASSI, Norberto. Freelance writer. **Essays:** Gentile Bellini (and *Procession of the Cross in St. Mark's Square*), Giovanni Bellini (and *S. Giobbe Altarpiece* and *Doge Leonardo Loredan*), Cavallini (and *Last Judgment*), and Ghirlandaio (and *Birth of the Virgin*).

MATTESON, Lynn R. Dean of the School of Fine Arts, University of Southern California, Los Angeles. **Essays:** Cozens (and *Valley with Winding Stream*), Géricault (and *The Raft of the Medusa*), Girtin, Wilkie (and *The Blind Fiddler*), and Wright (and *An Experiment with an Air Pump*).

MATTISON, Robert Saltonstall. Member of the Department of Art, Lafayette College, Easton, Pennsylvania. **Essays:** Hofmann (and *Effervescence*), Kline (and *Chief*), Motherwell (and *Elegy to the Spanish Republic*), and Warhol (and *Gold Marilyn Monroe*).

McCULLAGH, Janice. Freelance writer. **Essays:** Feininger (and *Bird Cloud*), Kandinsky (and *Improvisation 30*), Kirchner (and *The Street*), Klee (and *Death and Fire*), and Macke (and *Zoological Garden I*).

McGREEVY, Linda F. Associate Professor of Art History and Criticism, Old Dominion University, Norfolk, Virginia. Author of *The Life and Works of Otto Dix: German Critical Realist*, 1981, and of articles on Sue Coe and Newton and Helen Mayer Harrison. **Essays:** Beckmann (and *The Night*), Dix (and *Sylvia von Harden*), Grosz (and *The End*), Kollwitz (and *Outbreak*), and O'Keeffe (and *Music: Pink and Blue II*).

McKENZIE, A. Dean. Professor of Medieval Art History, University of Oregon, Eugene. Author of several books and catalogues, including *Greek and Russian Icons*, 1965, *Russian Art, Old and New*, 1968, *Windows to Heaven: The Icons of Russia*, 1982, and *Sacred Images and the Millennium: Christianity and Russia*, 1988, and of articles on Moldavian fresco painting, Byzantine painting in Attica, and French castles in Gothic manuscript painting. **Essays:** Broederlam (and *Champmol Altarpiece*), Fouquet (and *St. Stephen and Etienne Chevalier*), Limbourg Brothers (and *October*), and Rublev (and *Old Testament Trinity*).

MILKOVICH, Michael. Director, Museum of Fine Arts, St. Petersburg, Florida. Author of catalogues on Luca Giordano, 1964, Sebastiano and Marco Ricci, 1966, Bernardo Strozzi, 1967, the age of Vasari, 1970, Impressionists in 1877, 1977, Degas, 1986, and French marine paintings, 1987. **Essays:** Giordano's *Triumph of Judith*, Magnasco's *Bay with Shipwreck*, Ricci's *Adoration of the Magi*, and Strozzi's *The Calling of St. Matthew*.

MILLER, Lillian B. Historian of American Culture, and Editor of the Peale Family Papers, National Portrait Gallery, Washington. Co-author of *Charles Willson Peale and His World*,

1982, and editor of *The Selected Papers of Charles Willson Peale and His Family*, 7 vols, from 1983. **Essays:** Peale (and *The Artist in His Museum*).

MILLER, Naomi. Professor of Art History, Boston University. Author of *French Renaissance Fountains*, 1977, *Heavenly Caves: Reflections on the Garden Grotto*, 1982, and *Renaissance Bologna: A Study in Architectural Form and Content*, 1989, and of articles on French and Italian Renaissance architecture. **Essays:** Goujon (and *Fountain of Innocents*).

MILLS, Roger. Freelance writer. **Essays:** de Stael and Hockney.

MILNER, Frank. Member of the staff, Walker Art Gallery, Liverpool. **Essays:** Stubbs (and *Horse Frightened by a Lion*).

MINOR, Vernon Hyde. Associate Professor of Art History and Humanities, University of Colorado, Boulder. Author of articles on Chracas's *Diario Ordinario*, Filippo della Valle, and Tommaso Righi. **Essays:** Fragonard (and *The Swing*) and Houdon (and *Seated Voltaire*).

MINOTT, Charles I. Associate Professor of the History of Art, University of Pennsylvania, Philadelphia. **Essays:** Altdorfer (and *The Battle of Alexander*), Campin (and *Mérode Triptych*), Gerard David (and *Baptism of Christ Altarpiece*), Pacher (and *St. Wolfgang Altarpiece*), Sluter (and *Well of Moses*), and Stoss (and *St. Mary Altarpiece*).

MITCHELL, Timothy F. Associate Professor of Art History, University of Kansas, Lawrence. Author of several articles on Friedrich and on modernism. **Essays:** Friedrich (and *Monk by the Sea*).

MOFFITT, John F. Professor of History of Art, New Mexico State University, Las Cruces. Author of *Spanish Painting*, 1973, and *Occultism in Avant-Garde Art*, 1988, and of articles on Velazquez, van der Goes, El Greco, Rembrandt, Van Dyck, Tischbein, and Ribera. **Essays:** El Greco's *View of Toledo*, Goya's *Third of May, 1808*, Mor (and *Mary Tudor*), Murillo (and *The Holy Family with a Bird*), Van Dyck (and *Charles I on Horseback*), and Zurbarán (and *St. Francis in His Tomb*).

MORRIS, Susan. Writer for *The Antique Collector*, London. Author of *Thomas Girtin*, 1986. **Essays:** Gainsborough (and *Cornard Wood* and *Mr. and Mrs. Andrews*), Girtin's *The White House at Chelsea*, and Wilson's *Snowdon from Llyn Nantlle*.

MOSKOWITZ, Anita F. Associate Professor of Art, State University of New York, Stony Brook. Author of *The Sculpture of Andrea and Nino Pisano*, 1986, and of articles on Andrea Pisano, Donatello, and Titian. **Essays:** Andrea Pisano (and *Florence Baptistery Doors*) and Nicola Pisano (and *Pisa Baptistery Pulpit*).

MURDOCH, Tessa. Senior Assistant Keeper, Museum of London. **Essays:** Roubiliac (and *George Frederick Handel*).

NELSON, Kristi. Associate Dean for Academic Affairs, College of Design, Architecture, Art, and Planning, University of Cincinnati. **Essays:** Jordaens (and *The King Drinks*).

NORTH, Percy. Visiting Assistant Professor of Fine Arts, Vanderbilt University, Nashville. **Essays:** Davis (and *Lucky Strike*), Demuth (and *I Saw the Figure 5 in Gold*), and Shahn (and *The Red Stairway*).

NUTTALL, Paula. Freelance writer. Author of articles on Cosimo Rosselli and Giuliano da Maiano, 1985. **Essays:** Filippino Lippi (and *Vision of St. Bernard*) and Andrea Sansovino (and *The Virgin and Child with St. Anne*).

OLSON, Roberta J.M. Professor of Art History, Wheaton College, Norton, Massachusetts. Author of *Italian Drawings 1780–1890*, 1980 and *Fire and Ice: A History of Comets in Art*, 1985, and of articles on Botticelli, Bartolini, Brunelleschi, Rossi, Giotto, and Palladio. **Essays:** Botticelli (and *Mystical Nativity* and *Primavera*) and Piero di Cosimo (and *The Death of Procris*).

OPPLER, Ellen C. Professor of Fine Arts, Syracuse University, New York. Author of *Fauvism Reexamined* and several articles on Modersohn-Becker, and editor of *Picasso's Guernica*, 1988. **Essays:** Modersohn-Becker (and *Self-Portrait*) and Picasso's *Guernica*.

OVERY, Paul. Free-lance critic and lecturer. Author of *Edouard Manet*, 1967, *De Stijl*, 1969, and *Kandinsky: The Language of the Eye*, 1969, and of articles on Vorticism and "the new art history". **Essays:** Delaunay (and *Windows Open Simultaneously*).

PALMER, Deborah. Freelance writer, Paris. **Essays:** Pilon (and *Tomb of Valentine Balbiani*).

PARKER, Stephen Jan. Professor of Slavic Languages and Literatures, University of Kansas, Lawrence. Co-author of *Russia on Canvas: Ilya Repin*, 1981, and author of *Understanding Vladimir Nabokov*, 1987: co-editor of *The Achievements of Vladimir Nabokov*, 1984. **Essays:** Repin (and *The Cossacks*).

PARRY, Ellwood C. III. Professor of Art History, University of Arizona, Tucson. Author of *The Image of the Indian and the Black Man in American Art 1590–1900*, 1974, and *The Art of Thomas Cole: Ambition and Imagination*, 1988, and of articles on Eakins. **Essays:** Bierstadt (and *The Rocky Mountains, Lander's Peak*) and Cole (and *Scene from "The Last of the Mohicans"*).

PARSHALL, Peter W. Professor of Art History, Reed College, Portland, Oregon. **Essays:** Lucas van Leyden (and *Last Judgment*).

PARTRIDGE, Loren. Professor of History of Art, University of California, Berkeley. Author of *John Galen Howard and the Berkeley Campus*, 1978, and (with Randolph Starn) *A Renaissance Likeness: Art and Culture in Raphael's "Julius II,"* 1980, and of articles on the Villa Farnese at Caprarola and Ucello. **Essays:** Cima da Conegliano (and *Virgin and Child*), Domenico Veneziano (and *Virgin and Child*), Perugino (and *Christ Consigning the Keys to St. Peter*), Pollaiuolo (and *Martyrdom of St. Sebastian*), Raphael's *Triumph of Galatea* and *Pope Leo X*, Jacopo Sansovino (and the *Loggetta*), Uccello (and *Battle of San Romano*), Verrocchio (and *Colleoni Monument*), and Zuccaro (and *Cardinal Farnese Entering Paris*).

PELZEL, Thomas. Associate Professor of Art History, University of California, Riverside. Author of *Anton Raphael Mengs and Neoclassicism*, 1979, of articles on Mengs, and the catalogue *The Arts and Crafts Movement in America*, 1972. **Essays:** Batoni (and *Thomas Dundas*), Mengs (and *Parnassus*), and Pannini (and *Visit of Caros III to the Basilica of St. Peter*).

PETERS, Carol T. Freelance writer. **Essays:** Daddi (and *Bigallo Triptych*), Agnolo Gaddi (and *Legend of the True Cross*), Taddeo Gaddi (and *Baroncelli Chapel*), Giotto's *Ognissanti Madonna*, Ambrogio Lorenzetti (and *Good and Bad Government*), Lorenzo Monaco (and *Adoration of the Magi*), and Orcagna (and *Strozzi Altarpiece*).

PIPERGER, Justin. Freelance writer. **Essays:** Braque and Oldenburg.

POMEROY, Ralph. Contributing Editor, Arts Magazine, New York. Author of several books, the most recent being *Stamos*, 1974, *The Ice Cream Connection*, 1975, and *First Things First*, 1977. **Essays:** Morandi and Schlemmer.

POWELL, Cecilia. Turner Scholar, Tate Gallery, London. Author of *Turner in the South: Rome, Naples, Florence*, 1987, and articles on Turner. **Essays:** Turner (and *The White Library, Petworth* and *Snow Storm – Steam-Boat Off a Harbor's Mouth*).

POWELL, Kirsten H. Member of the Art Department, Middlebury College, Vermont. **Essays:** de Kooning (and *Woman I*), Millet (and *The Gleaners*), and Pollock (and *Autumn Rhythm*).

PRESSLY, William L. Associate Professor of Art, University of Maryland, College Park. Author of *The Life and Art of James Barry*, 1981, and the catalogue *James Barry: The Artist as Hero*, 1983, and of articles on Surrealism and Zoffany. **Essays:** Barry (and *The Birth of Pandora*) and Stuart (and *The Skater*).

QUINSAC, Annie-Paule. Member of the Art Department, University of South Carolina, Columbia. **Essays:** Bonheur (and *The Horse Fair*), Fattori (and *The Palmieri Rotunda*), Rosso (and *The Conversation in the Garden*), and Segantini (and *The Evil Mothers*).

RADKE, Gary M. Associate Professor of Fine Arts, Syracuse University, New York. **Essays:** Benedetto da Maiano (and *S. Croce Pulpit*).

RAJNAI, Miklos. Freelance consultant and writer. Author of several books and catalogues on Cotman. **Essays:** Cotman (and *Greta Bridge*) and Crome (and *Poringland Oak*).

RAND, Olan A., Jr. Member of the Department of Art History, Northwestern University, Evanston, Illinois. **Essays:** Champaigne (and *The Ex-Voto of 1662*) and Ghiberti (and *The Gates of Paradise*).

REYNOLDS, Lauretta. Freelance writer. **Essays:** Arp's *Femme Amphore*, Johns's *Three Flags*, Rivers (and *Washington Crossing the Delaware*), and Tatlin (and *Monument to the Third International*).

RIEDE, David G. Professor of English, Ohio State University, Columbus. Author of *Swinburne: A Study of Romantic Mythmaking*, 1978, *Dante Gabriel Rossetti and the Limits of Victorian Vision*, 1983, and *Matthew Arnold and the Betrayal of Language*, 1988. **Essays:** Rossetti (and *The Wedding of St. George and the Princess Sabra*).

ROBINSON, Susan Barnes. Professor of Art History, Loyola Marymount University, Los Angeles. Author of *Françoise Gilot: A Retrospective* (cat), 1978, *Giacomo Balla: Divisionism and Futurism*, 1981, *The French Impressionists in Southern California*, 1984, and *The Spirit of the City* (cat), 1986. **Essays:** Balla (and *Dynamism of a Dog on a Leash*), Bellows (and *Stag at Sharkey's*), Boccioni (and *Unique Forms of Continuity in Space*), Severini (and *Dynamic Hieroglyphic of the Bal Tabarin*), and Smith (and *Cubi XIX*).

ROWORTH, Wendy Wassyng. Professor of Art History, University of Rhode Island, Kingston. Author of articles on Rosa and Kauffmann. **Essays:** Kauffmann (and *Painting, Design, Genius, and Composition*) and Rosa (and *Democritus in Meditation*).

RUDA, Jeffrey. Associate Professor of Art History, University of California, Davis. Author of *Lippi Studies*, 1982, and of articles on Lippi. **Essays:** Filippo Lippi (and *San Lorenzo Annunciation*).

RUSSO, Kathleen. Associate Professor of Art History, Florida Atlantic University, Boca Raton. Author of articles on Greuze and Fuseli. **Essays:** Carriera (and *Louis XV as a Boy*), Fuseli (and *The Nightmare*), Greuze (and *Young Girl Crying over Her Dead Bird*), Piranesi (and *The Patheon*), and Vigée-Lebrun (and *Self-Portrait with Cerise Ribbon*).

SCHERF, Guilhem. Curator in the Sculpture department, Louvre Museum, Paris. **Essays:** Bouchardon (and *Four Seasons Fountain*), Coysevox (and *Triumph of Louis XIV*), Girardon (and *Apollo Served by the Nymphs*), Pigalle (and *The Nude Voltaire*), and Puget (and *Milo of Crotone*).

SCHNEIDER, Laurie. Professor of Art History, John Jay College, City University of New York. Author of articles on Piero della Francesco, Donatello, Leonardo, and Raphael, and editor of *Giotto in Perspective*, 1974. **Essays:** Giotto (and *Arena Chapel Frescoes*), Leonardo (and *Mona Lisa*), Mantegna (and *Camera degli Sposi* and *Dead Christ*), Masaccio (and *Tribute Money* and *Trinity*), Melozzo da Forli (and *Sixtus IV and His Nephews*), and Piero della Francesca (and *Arezzo Frescoes* and *Resurrection*).

SCOTT, David. Lecturer in French, Trinity College, Dublin. Author of *Edward Kienholz: Tableaux 1961–1979*, 1981, *Pictorialist Poetics*, 1988, and the forthcoming *Paul Delvaux*. **Essays:** Delvaux (and *Sleeping Venus*), Kienholz (and *The State Hospital*), and Magritte (and *Time Transfixed*).

SCRIBNER, Charles III. Vice-President, Macmillan Publishing Company, New York. Author of *The Triumph of the Eucharist: Tapestries Designed by Rubens*, 1982, and *P.P.*

Rubens, 1989. **Essays:** Rubens (and *Rubens and His Wife Isabella Brant* and *The Rape of the Daughters of Leucippus*).

SHAW, Lindsey Bridget. Freelance writer. **Essays:** Fabritius (and *Goldfinch*), Hooch (and *A Women Lacing Her Bodice Beside a Cradle*), Kalf (and *Still Life with Chinese Bowl*), Metsu (and *The Huntsman's Present*), and ter Borch (and *A Woman at Her Toilet*).

SHESGREEN, Sean. Professor of English, Northern Illinois University, DeKalb. Author of *Engravings by Hogarth*, 1973, *Hogarth and the Times-of-the-Day Tradition*, 1983, and *The Criers, Hucksters, and Peddlers of London*, 1988. **Essays:** Hogarth (and *Hogarth's Servants*).

SHIKES, Ralph E. Freelance writer. **Essay:** Pissarro's *Boulevard des Italiens, Morning, Sunlight*.

SLAYMAN, James H. Associate Professor of Art History, Tyler School of Art, Temple University, Philadelphia. **Essays:** Prud'hon (and *Justice and Vengeance*).

SMITH, David R. Associate Professor of Art History, University of New Hampshire, Durham. Author of *Masks of Wedlock: 17th-Century Dutch Marriage Portraiture*, 1982, and articles on Hals, Rembrandt, and Raphael. **Essays:** Hals (and *The Laughing Cavalier* and *The Regents of the Old Men's House*).

SOBRÉ, Judith Berg. Associate Professor of Art History, University of Texas, San Antonio. Author of *Behind the Altar Table: The Spanish Painted Retable 1350–1500*, 1989, and articles on Spanish art and artists. **Essays:** Bermejo (and *The Pietà of Canon Lluis Desplà*, Pedro Berruguete (and *Auto da Fé*), and Huguet (and *Consecration of St. Augustine*).

SPIKE, John T. Critic and writer. **Essays:** Baschenis (and *Still Life with Musical Instruments and a Statuette*), Bernini (and *Apollo and Daphne, Ecstasy of St. Teresa,* and *Fountain of the Four Rivers*), Ceruti (and *A Group of Beggars*), Crespi (and *Confirmation*), Preti (and *St. John the Baptist Preaching*), and Solimena.

STALLABRASS, Julian. Ph.D. student, Courtauld Institute of Art. **Essays:** Gabo (and *Linear Construction: Variation*), Kokoschka (and *The Tempest*), Lipchitz (and *Figure*), Marc (and *Fighting Forms*), Mondrian (and *Composition with Red, Yellow, and Blue*), Nolde (and *Doubting Thomas*), and Pevsner (and *Portrait of Marcel Duchamp*).

STANDRING, Timothy J. Member of the Art Department, Pomona College, Claremont, California. **Essays:** Castiglione (and *Allegory of Vanity*).

STEVENSON, Lesley. Freelance writer. **Essays:** Gauguin's *Day of the God*, Manet's *Déjeuner sur l'herbe* and *Olympia*, Renoir (and *Monet Painting in His Garden* and *Bathers*), and Sisley (and *Snow at Louveciennes*).

STRATTON, Suzanne L. Curator of Exhibitions, Spanish Institute, New York. Author of *La inmaculada en el arte espanol,*

1988, and of articles of García Lorca, Goya, and Rembrandt. **Essays:** El Greco (and *Burial of the Count of Orgaz*).

SULLIVAN, Ruth Wilkins. Research Curator, Kimbell Art Museum, Fort Worth, Texas. Author of several articles on Duccio. **Essays:** Cimabue (and *S. Trinità Madonna*), Duccio (and *Maestà*), Pietro Lorenzetti (and *Birth of the Virgin*), Maso di Banco (and *St. Sylvester Cycle*), and Traini (and *Triumph of Death*).

SULLIVAN, Scott A. Professor of Art History, University of North Texas, Denton. Author of *The Dutch Gamepiece*, 1984, and of articles on van Beyeren, Snyders, Rembrandt, and Weenix. **Essays:** Snyders (and *Pantry Scene with a Serving Figure*) and Weenix (and *Still Life with a Dead Hare*).

SURTEES, Virginia. Freelance writer. Editor of Ford Madox Brown's *Diary*, 1981. **Essay:** Brown's *The Last of England*.

TEVIOTDALE, E.C. Kress Fellow, Warburg Institute London. Author of articles on manuscript music illustrations and on Monet. **Essays:** Monet's *Le Portail et la Tour d'Albane* and *Le Bassin aux nymphéas*.

THOMPSON, Elspeth. Freelance writer. **Essays:** Marini (and *Pomona*).

TOMLINSON, Janis A. Assistant Professor of Art History, Columbia University, New York. Author of *Francisco Goya: The Tapestry Cartoons and Early Career at the Court of Madrid*, 1989, and *Graphic Evolutions: On the Print Series of Francisco Goya*, 1989, and of articles on Goya. **Essays:** Goya (and *Family of Charles IV*).

TUFTS, Eleanor. Professor of Art History, Southern Methodist University, Dallas. Author of *Our Hidden Heritage: Five Centuries of Women Artists*, 1974, *American Women Artists: A Selected Bibliographic Guide*, 1984, *Luis Meléndez, Eighteenth-Century Master of the Spanish Still Life, with a Catalogue Raisonne*, 1985, and *American Women Artists 1830–1930*, 1987, and of articles on Albertinelli and Goya and Bellows. **Essays:** Meléndez (and *Still Life with Small Green Pears, Bread, Amphora, Flask, and Bowl*).

VERDON, Timothy. Professor of Art History, Florida State Study Center, Florence, Italy. Author of *The Art of Guido Mazzoni*, 1978, and of articles on Donatello and other subjects. Editor of *Monasticism and the Arts*, 1984, and *Christianity and the Renaissance*, 1989. **Essays:** Mazzoni (and *Lamentation*) and Niccolò dell'Arca (and *Lamentation*).

WALDER, Rupert. Freelance writer. **Essays:** Bonnard, Braque's *Le Portugais*, Duchamp's *The Bride Stripped Bare by Her Bachelors Even*, and Seurat.

WALSH, George. Publisher and freelance writer, Chicago. **Essays:** Bouts (and *Last Supper*), Brown, Jan Bruegel (and *Hearing*), Canaletto (and *The Stonemason's Yard*), Gauguin, Geertgen, Gris, Guardi (and *S. Maria della Salute*), La Tour (and *The Newborn Child*), Le Brun, Parmigianino (and *Madonna of the Long Neck*), Primaticcio, Puvis de Chavannes,

Quercia (and *St. Petronio Doorway*), Theodore Rousseau, Signorelli, Steen (and *The Dissolute Household*), and ven de Velde (and *The Çannon Shot*).

WANKLYN, George A. Lecturer in Art History, American University of Paris. Author of articles on Delaune and Jean Cousin. **Essays:** François Clouet (and *Pierre Quthe*), and Jean Clouet (and *Marie d'Assigny, Madame de Canaples*).

WECHSLER, Judith. Professor of the History of Art, Rhode Island School of Design, Providence. Author of *The Interpretation of Cézanne*, 1981, and *A Human Comedy: Physiognomy and Caricature in Nineteenth Century Paris*, 1982, and editor of *Cézanne in Perspective*, 1975, and *On Aesthetics in Science*, 1978. **Essays:** Cézanne's *Madame Cézanne in a Red Armchair* and Daumier's *A Third Class Carriage*.

WEIL, John A. Professor of Chemistry, University of Saskatchewan, Saskatoon. **Essays:** Albers (with John H. Holloway).

WEILAND, Jeanne E. Instructor in English, Northern Illinois University, DeKalb. **Essay:** Hogarth's *Marriage-à-la-Mode*.

WELLS, William. Member of the staff of the Burrell Collection, Glasgow (now retired). Author of articles on early Renaissance art. **Essays:** Perréal (and the *Moulins Triptych*).

WEST, Shearer. Lecturer in the History of Art, Leicester University. **Essays:** Frith (and *Derby Day*) and Zoffany (and *The Tribuna of the Uffizi*).

WHITTET, G.S. Freelance writer and consultant, London. Author of several books, including *Lovers in Art*, 1972. **Essay:** Duchamp.

WOLK-SIMON, Linda. Member of the Public Programs office, Metropolitan Museum of Art, New York. **Essays:** Andrea del Sarto (and *Madonna of the Harpies*), Fra Bartolommeo (and *Mystical Marriage of St. Catherine of Siena*), Beccafumi (and *Birth of the Virgin*), Giulio Romano (and *Fall of the Giants*), Perino del Vaga (and *Fall of the Giants*), Pontormo (and *Deposition*), and Sodoma (and *St. Sebastian*).

WOODS-MARSDEN, Joanna. Assistant Professor of Art History, University of California, Los Angeles. Author of *The Gonzaga of Mantua and Pisanello's Arthurian Frescoes*, 1988, and of articles on Pisanello and other subjects. **Essays:** Pisanello (and *Triumphator et Pacificus*).

WRIGHT, Christopher. Freelance writer and consultant. Author of many books, including *The Duch Painters*, 1978, *French Painting*, 1979, *Painting in Dutch Museums*, 1980, *Italian, French, and Spanish Paintings of the 17th Century*, 1981, *The Art of the Forger*, 1984, and *The French Painters of the Seventeenth Century*, 1985, and books on La Tour, Rembrandt, Vermeer, and Hals. **Essays:** Berchem (and *Landscape with a Man and a Youth Plowing*), Bosschaert (and *Vase of Flowers*), Cuyp (and *View of Dordrecht*), Goyen (and *Landscape with Two Oaks*), Heda (and *Still Life: The Dessert*), Heem (and *Still Life*), Hob-

bema (and *The Avenue at Middelharnis*), and Ruysch (and *Still Life of Flowers*).

ZILCZER, Judith. Associate Curator of Painting, Hirshhorn Museum and Sculpture Garden, Washington. Author of *"The Noble Buyer": John Quinn, Patron of the Avant-Garde*, 1978, and *Joseph Stella: The Hirshhorn Museum and Sculpture Garden Collection*, 1983, and of articles on synaesthesia, Quinn, and Duchamp-Villon. **Essays:** Duchamp-Villon (and *The Horse*) and Stella (and *Brooklyn Bridge*).